VICTORIAN PAINTERS

1. THE TEXT

Dictionary of British Art Volume IV

VICTORIAN PAINTERS

1. THE TEXT

Christopher Wood

*Research by Christopher Newall
and Margaret Richardson*

Antique Collectors' Club

First published 1995
© Christopher Wood 1995
World copyright reserved

ISBN 1 85149 171 6

The Dictionary of Victorian Painters by Christopher Wood, published in one volume by the Antique Collectors' Club Ltd., first appeared in 1971, reprinted 1971, 1972, 1974, 1976. A second enlarged and revised edition appeared in 1978, reprinted 1985, 1987, 1989, 1991.

This two-volume third edition comprises revised and updated text in this volume, while a companion volume comprises a much enlarged collection of plates and an illustrated survey of Victorian painting.

British Library Cataloguing-in-Publication Data
A Catalogue record for this book is available from the British Library

Printed in England by the Antique Collectors' Club Ltd., 5 Church Street, Woodbridge, Suffolk IP12 1DS

The Antique Collectors' Club

The Antique Collectors' Club was formed in 1966 and quickly grew to a five figure membership spread throughout the world. It publishes the only independently run monthly antiques magazine, *Antique Collecting*, which caters for those collectors who are interested in widening their knowledge of antiques, both by greater awareness of quality and by discussion of the factors which influence the price that is likely to be asked. The Antique Collectors' Club pioneered the provision of information on prices for collectors and the magazine still leads in the provision of detailed articles on a variety of subjects.

It was in response to the enormous demand for information on 'what to pay' that the price guide series was introduced in 1968 with the first edition of *The Price Guide to Antique Furniture* (completely revised 1978 and 1989), a book which broke new ground by illustrating the more common types of antique furniture, the sort that collectors could buy in shops and at auctions rather than the rare museum pieces which had previously been used (and still to a large extent are used) to make up the limited amount of illustrations in books published by commercial publishers. Many other price guides have followed, all copiously illustrated, and greatly appreciated by collectors for the valuable information they contain, quite apart from prices. The Price Guide Series heralded the publication of many standard works of reference on art and antiques. *The Dictionary of British Art* (now in six volumes), *The Pictorial Dictionary of British 19th Century Furniture Design, Oak Furniture* and *Early English Clocks* were followed by many deeply researched reference works, such as *The Directory of Gold and Silversmiths,* providing new information. Many of these books are now accepted as the standard work of reference on their subject.

The Antique Collectors' Club has widened its list to include books on gardens and architecture. All the Club's publications are available through bookshops world wide and a full catalogue of all these titles is available free of charge from the addresses below.

Club membership, open to all collectors, costs little. Members receive free of charge *Antique Collecting*, the Club's magazine (published ten times a year), which contains well-illustrated articles dealing with the practical aspects of collecting not normally dealt with by magazines. Prices, features of value, investment potential, fakes and forgeries are all given prominence in the magazine.

Among other facilities available to members are private buying and selling facilities, the longest list of 'For Sales' of any antiques magazine, an annual ceramics conference and the opportunity to meet other collectors at their local antique collectors' clubs. There are over eighty in Britain and more than a dozen overseas. Members may also buy the Club's publications at special pre-publication prices.

As its motto implies, the Club is an organisation designed to help collectors get the most out of their hobby: it is informal and friendly and gives enormous enjoyment to all concerned.

For Collectors — By Collectors — About Collecting

ANTIQUE COLLECTORS' CLUB
5 Church Street, Woodbridge Suffolk IP12 1DS, UK
Tel: 01394 385501 Fax: 01394 384434
——— or ———
Market Street Industrial Park, Wappingers' Falls, NY 12590, USA
Tel: 914 297 0003 Fax: 914 297 0068

Contents

Acknowledgements

Collecting and collating information for a dictionary is something of a group effort, and numerous people have helped me over particular things, namely Chris Beetles, Rodney Engen, Peyton Skipwith, Maas *père et fils,* Richard Ormond and Andrew Wilton. Simon Taylor of Sotheby's has helped to unravel such knotty tangles as the Breanksi family; Christopher Newall, my research assistant on the second edition, has kindly given me his own list of corrections and annotations. I hope that together we have managed to correct some of those persistent and recurring errors which have passed from book to book and catalogue to catalogue, for about the last hundred years.

The illustrations in the companion volume are all reproduced by kind permission of their owners or, in the case of museums, by permission of the Trustees and Curators concerned. I hope that they are all acknowledged correctly. Many of the photographs were generously given by dealers and auctioneers, and I am deeply grateful for their generosity. Art books can now hardly be produced without that kind of support.

Lastly, I must thank Diana Steel and Cherry Lewis of the Antique Collectors' Club for their determination and efficiency in bringing this very considerable project to completion. Once again, let us hope that the result is a real contribution to English art history.

Christopher Wood, 1995

Introduction

The first edition of my *Dictionary of Victorian Painters* came out in 1971, nearly a quarter of a century ago. The second, much enlarged and revised edition came out in 1978. Since then, it has been continuously in print, and I am therefore delighted to be producing a new, revised and improved third edition, this time in two volumes. This first volume contains the text, the second the illustrations, prefaced by a comprehensive survey of Victorian painting and including over forty colour plates. It is hoped that this will make both volumes equally indispensable.

Since the edition of 1978 our knowledge of Victorian painting has increased dramatically. There has been a flood of books, articles, exhibitions and catalogues. Artists have emerged from obscurity; long-lost pictures have come to light; artists' descendants have come forward with vital information. I have done my utmost to leave no stone unturned in the search for any new information, especially dates of birth and death. Absolutely every fact, every reference, every scrap of information has been included, in order to make this third edition as comprehensive as possible, while the black and white illustrations have been increased to some 750, making a greater visual record of this important period than has probably ever appeared before.

Great effort has been made, once again, to up-date the bibliographical entries as much as possible, including all new books, articles and exhibition catalogues since 1978. Important new books have been listed in the bibliographical reference section at the front of this volume, as well as a list of other useful books and catalogues published since 1973. I think I can safely say that no other dictionary has such comprehensive bibliographies of Victorian artists.

Initials after Artist's Names

A	Associate
ARA	Associate of the Royal Academy
ARCA	Associate of the Royal Cambrian Academy
ARHA	Associate of the Royal Hibernian Academy
ARPE	Associate of the Royal Society of Painters and Etchers
ARSA	Associate of the Royal Scottish Academy
ARSW	Associate of the Royal Scottish Watercolour Society
ARWS	Associate of the Royal Watercolour Society
Bt	Baronet
BWS	British Watercolour Society
FRS	Fellow of the Royal Society
FSA	Fellow of the Society of Antiquaries
H	Honorary
LG	London Group
NA	National Academy of Design (New York)
NSA	New Society of Artists
NWS	New Watercolour Society (See RI)
OM	Order of Merit
OWS	Old Watercolour Society (See RWS)
P	President
PS	Pastel Society
RA	Royal Academician
RBA	Member of the Royal Society of British Artists, Suffolk Street (SS)
RBC	Royal British Colonial Society of Artists
RBSA	Member of the Royal Birmingham Society of Artists
RCA	Member of the Royal Cambrian Academy, Manchester (if an artistt *studied* at the RCA, this refers to the Royal College of Art, London)
RE	See RPE
RHA	Member of the Royal Hibernian Academy, Dublin
RI	Member of the Royal Institute of Painters in Watercolours (formerly NWS)
RIBA	Member of the Royal Institute of British Architects
RMS	Royal Society of Miniature Painters
ROI	Member of the Royal Institute of Painters in Oil-Colours
RP	Royal Society of Portrait Painters
RPE	Member of the Royal Society of Painters and Etchers (later RE)
RSA	Member of the Royal Scottish Academy
RSW	Member of the Royal Scottish Watercolour Society
RWA	Royal West of England Academy
RWS	Member of the Royal Watercolour Society (formerly OWS)
SS	See RBA
SWA	Society of Women Artists
VP	Vice President
WIAC	Women's International Art Club

Exhibition and Gallery References

and abbreviations used in entries

AG Art Gallery

BI British Institution 1806-67. Established as a rival to the RA at Boydell's Shakespeare Gallery in Pall Mall. Aimed "to encourage and reward the talents of the artists of the United Kingdom". Organised loan exhibitions of old masters for students to copy.

BM British Museum

FAS Fine Art Society, Bond Street. Held many important one-man shows in the 1880s and 1890s.

GG Grosvenor Gallery 1877-90. Founded in Bond Street by Sir Coutts and Lady Lindsay, both amateur artists. Focus of the Aesthetic Movement of the 1880s, caricatured by Du Maurier, Gilbert and Sullivan — "greenery-yallery Grosvenor Gallery", &c. Closed soon after the opening of the rival New Gallery in 1888. Favourite of Burne-Jones and his Pre-Raphaelite followers.

Nat. Gall. National Gallery, London.

NEAC New English Art Club. Founded 1886 by a group of young artists as a kind of Salon des Refusés on the French pattern. The pictures were selected by the artists themselves, not by a committee. Among its members were W.J. Laidlay, T.B. Kennington, H.H. La Thangue, George Clausen, Whistler and Wilson Steer. Centre for French influence and Impressionism.

NG New Gallery. Founded in 1888 by C.E. Hallé and J. Comyns Carr in Regent Street as a breakaway from the Grosvenor Gallery. After the closing of the GG in 1890, most of its artists transferred to the NG. Also held big winter loan exhibitions, and the exhibitions of the International Society of Painters, Sculptors and Gravers.

NPG National Portrait Gallery, London.

NWS (RI) New Watercolour Society. Founded in 1832 to rival the monopoly of the more prestigious Old Watercolour Society. Changed name to the Institute of Painters in Watercolours in 1863, and later became Royal. Members style themselves RI. Still holds annual exhibitions at the Mall Galleries, London.

OWS Old Watercolour Society. Founded 1804 at 5a Pall Mall East by Dr. Monro and a group of watercolourists who felt that their work was not properly shown at the RA. Became Royal 1881. Members styled RWS. Now at Bankside Galleries, London SE1.

RA Royal Academy. Founded 1768. Members first have to become Associate (ARA) then full members (RA). In spite of its many rivals, the RA was during the Victorian period at the zenith of its power and prestige, and its exhibitions were the high point of the artistic season.

RSA Royal Scottish Academy. Founded 1826; modelled closely on the RA. Not until the 1850s, under the Presidency of Sir William Allan, did it achieve anything like the power and prestige of its London counterpart. It remained somewhat provincial, and most good Scottish artists exhibited mainly in London. Moved in 1855, and again in 1911 to its present location on Princes Street, Edinburgh.

SNG Scottish National Galleries, Edinburgh.

SNPG Scottish National Portrait Gallery, Edinburgh.

SS (SBA) Society of British Artists, Suffolk Street. Founded in 1824 by a rebel group of artists including B.R. Haydon, John Martin, John Glover and Thomas Heaphy (first President). Became Royal in 1887 while under the Presidency of Whistler. Members styled RBA.

VAM Victoria and Albert Museum, London.

Other Victorian Galleries, not included in this list, which held less important exhibitions, were the Portland (1848-61), the Dudley (1865-82), the Institute of Oil Painters (founded 1883), the Society of Portrait Painters (founded 1891), the Pastel Society and the Society of Lady Artists. Many provincial towns had their own art academies holding regular exhibitions, e.g. Glasgow, Manchester, Liverpool, Newcastle, Carlisle, Birmingham and Bristol.

Bibliographical References

and abbreviations used in entries

The following essential reference books have been consulted in nearly every case, and are not therefore quoted in the bibliographies:

Benezit,	*The Royal Society of British Artists 1824-1893,* 2 vols., Antique Collectors' Club, 1975
	Dictionnaire des Paintres, Sculpteurs, etc., 8 vols., 1976
Graves, Algernon	*A Dictionary of Artists 1760-1893*, first publ. 1884, repr. 1895, enlarged 1901, repr. Kingsmead Reprints, 1969
Graves, Algernon	*A Century of Loan Exhibitions 1813-1912*, 5 vols., 1913-15, repr. 1971
Graves, Algernon	*The British Institution 1806-1867,* 1908, repr. 1969
Graves, Algernon	*Royal Academy Exhibitors 1769-1904*, 8 vols., 1905-6, repr. 1970
Houfe, Simon	*Dictionary of British Book Illustrators and Caricaturists 1800-1914*, Antique Collectors' Club, 1978
Mallalieu, Huon	*Dictionary of British Watercolour Artists up to 1920*, 2 vols., Antique Collectors' Club, 1976, 1986
Thieme-Becker (TB)	*Algemeines Lexicon der Bildenden Kunstler,* 37 vols., Leipzig, 1927

The following reference periodicals and books are abbreviated as follows in the bibliographies:

Periodicals

Academy Notes:	1876-1906, ed. Henry Blackburn
Apollo:	*Apollo Magazine,* 1925-
AJ:	*Art Journal,* 1849-1912
AU:	*Art Union,* 1839-48
Athenaeum:	*Athenaeum,* 1828-1912
Burlington Mag:	*Burlington Magazine,* 1925-
Connoisseur:	*Connoisseur Magazine,* 1901-92
Country Life:	*Country Life Magazine,* 1897-
Frazers Mag:	*Frazers Magazine for Town and Country,* 1830-69
L'Art	*L'Art,* 1877-1900
Mag. of Art:	*Magazine of Art,* 1878-1904
OWS Journal:	*Journal of the Old Watercolour Society,* 1923-39
Portfolio:	*Portfolio,* 1870-93
RA Pictures:	*Royal Academy Pictures 1888-1915*, an illustrated supplement to the Magazine of Art
Studio:	*The Studio,* 1893-
Walker's Quart:	*Walker's Quarterly Magazine,* 1920-32

Books

The list of books is given here in alphabetical order, but in the text they are, where possible, listed in chronological order, starting with the earliest references, working up to the most recent:

Bate:	Percy H. Bate, *The English Pre-Raphaelite Painters,* 1899
Binyon:	L. Binyon, *Catalogue of Drawings by British Artists in the British Museum,* 1898-1907
Birmingham Cat:	City of Birmingham Art Gallery, *Catalogue of the Permanent Collection of Paintings &c.,* 1960

BM:	British Museum
Boase:	T.S.R. Boase, *English Art 1800-1870,* 1959
Brook-Hart:	D. Brook-Hart, *British 19th Century Marine Painting,* 1974
Bryan:	M. Bryan, *Dictionary of Painters and Engravers,* 1903
Caw:	Sir J.L. Caw, *Scottish Painting 1620-1908,* 1908
Clayton:	E.C. Clayton, *English Female Artists,* 1876
Clement & Hutton:	Clement & Hutton, *Artists of the 19th Century,* 1879
Clifford:	D. Clifford, *Watercolours of the Norwich School,* 1965
Cundall:	H.M. Cundall, *History of British Watercolour Painting,* 1908, 1929
DNB:	*Dictionary of National Biography*
Fredeman:	William Fredeman, *Pre-Raphaelitism, A Bibliocritical Study,* 1965
Gleeson White:	Gleeson White, *English Illustration, The Sixties,* 1908, repr. 1970
Hall:	Marshall Hall, *The Artists of Northumbria,* 1973, enlarged edition 1982
Hardie:	M. Hardie, *Watercolour Painting in Britain,* 3 vols., 1967-9
Hughes:	C.E. Hughes, *Early English Watercolours,* 1913, 1950
Hutchison:	S. Hutchison, *History of the Royal Academy 1768-1968,* 1968
Ironside & Gere:	R. Ironside and J.A. Gere, *Pre-Raphaelite Painters,* 1948
Irwin:	D. and F. Irwin, *Scottish Painters,* 1975
Maas:	J. Maas, *Victorian Painters,* 1969
Marillier:	H.C. Marillier, *The Liverpool School of Painters,* 1904
Nat. Gall:	National Gallery, London
Newall:	Christopher Newall, *Victorian Watercolours,* 1987
NPG:	National Portrait Gallery, London
Ormond:	R. Ormond, *Early Victorian Portraits,* HMSO, 2 vols., 1973
Ottley:	H. Ottley, *A Biographical and Critical Dictionary,* 1866
Pavière, Landscape:	S.H. Pavière, *A Dictionary of Victorian Landscape Painters,* 1968
Pavière, Sporting Painters:	S.H. Pavière, *Dictionary of British Sporting Painters,* 1965
Poole:	R.L. Poole, *Cat. of Oxford Portraits etc.,* 1912-15
Redgrave, Cent.:	S. and R. Redgrave, *A Century of British Painters,* 1866
Redgrave, Dict.:	S. Redgrave, *A Dictionary of Artists of the English School,* 1878
Reynolds, VP:	G. Reynolds, *Victorian Painting,* 1966
Reynolds, VS:	G. Reynolds, *Painters of the Victorian Scene,* 1953
Roget:	J.L. Roget, *History of the Old Watercolour Society,* 1891
Ruskin, Academy Notes:	J. Ruskin, *Academy Notes 1855-59,* 1875
Sparrow:	W.S. Sparrow, *British Sporting Artists,* 1922, repr. 1965
Staley:	A. Staley, *The Pre-Raphaelite Landscape,* 1973
Strickland:	W.G. Strickland, *A Dictionary of Irish Artists,* 1913, repr. 1971
Strong:	Sir Roy Strong, *And When Did You Last see Your Father?,* 1978
Tate Cat.:	Tate Gallery, London, *The Modern British Paintings, Drawings and Sculpture,* 2 vols., by Mary Chamot, Dennis Farr and Martin Butlin, 1964
VAM:	Victoria and Albert Museum, *Catalogue of Watercolour Paintings,* 1980
	Victoria and Albert Museum, *Catalogue of British Paintings 1820-1860* by R. Parkinson, 1990
Williams:	I.O. Williams, *Early English Watercolours,* 1952, repr. 1971
Wilson:	A. Wilson, *Dictionary of British Marine Painters,* 1967
Wood, Panorama:	Christopher Wood, *Victorian Panorama — Paintings of Victorian Life,* 1976, repr. in paperback 1990
Wood, Pre-Raphaelites:	Christopher Wood, *The Pre-Raphaelites,* 1981, repr. in paperback

Wood, Olympian Dreamers:	Christopher Wood, *Olympian Dreamers — Victorian Classical Painters 1860-1914*, 1983
Wood, Paradise Lost:	Christopher Wood, *Paradise Lost — Paintings of English Country Life and Landscape 1850-1914*, 1988
Wood, Painted Gardens:	Christopher Wood and Penelope Hobhouse, *Painted Gardens — English Watercolours 1850-1914*, 1988, repr. in paperback 1991

The list of useful books and exhibition catalogues published since 1973 is now becoming very considerable. Where possible, every effort has been made to include them in the individual bibliographies. I have tried to make this list as complete as possible but it is by no means exhaustive, and new publications are appearing constantly.

Peter Conrad	*A Victorian Treasure-House*, 1973
S. and K. Morris	*A Catalogue of Birmingham and West Midlands Painters of the 19th century*, 1974
Harry Turnbull	*Artists of Yorkshire — A Short Dictionary*, 1976
Peter Nahum	*Monograms of Victorian and Edwardian Artists*, 1976
William Hardie	*Scottish Painting*, 1976, repr. 1990
Jeremy Maas	*Gambart, Prince of the Victorian Art World*, 1976
Rosemary Treble	*Great Victorian Pictures*, Catalogue of Arts Council Exhibition, 1978
Beatrice Phillpotts	*Fairy Painting*, 1978
Richard Jenkins	*The Victorians and Ancient Greece*, 1980
J. Chapel	*Victorian Taste — Catalogue of Paintings at Royal Holloway College*, 1982
Jeremy Maas	*The Victorian Art World*, 1984
Delia Millar	*Queen Victoria's Life in the Highlands*, 1985
Susan Casteras	*Images of Victorian Womanhood in English Art*, 1987 (USA)
Jan Marsh	*Pre-Raphaelite Women*, 1987
Kenneth McConkey	*British Impressionism*, 1989
Christopher Newall	*The Etruscans, Painters of the Italian Landscape 1850-1900*, Cat. of exhib., Stoke-on-Trent Art Gallery, 1989
J.G. Christian	*The Last Romantics*, Cat. of exhib., Barbican Art Gallery, London 1989
Joseph Kestener	*Mythology and Misogyny*, 1989 (USA)
Maureen Beasley	*Five Centuries of Artists in Sutton*, Sutton Libraries and Art Services, 1989
Paula Gillett	*The Victorian Painter's World*, 1990 (USA)
Prof. G. Ackermann	*Les Orientalistes de l'Ecole Britannique*, 1991 (France)
Richard Jenkins	*Dignity and Decadence*, 1991
Sir Oliver Millar	*The Victorian Pictures in the Collection of Her Majesty the Queen*, 2 vols., Cambridge 1992
Deborah Cherry	*Painting Women*, 1993
Peter Phillips	*The Staithes Group*, Cat. of touring exhib., 1993
Julian Treuherz	*Victorian Painting*, 1993
Caroline Fox	*Stanhope Forbes and the Newlyn School*, 1993
Christiana Payne	*Toil and Plenty — Images of the Agricultural Landscape in England 1780-1890*, Yale University Press, 1993
John Gere	*Pre-Raphaelite Drawings in the British Museum*, 1994
G.N. Anderson and J. Wright	*Heaven on Earth — The Religion of Beauty in Late Victorian Art*, Cat. of exhib., Nottingham University Art Gallery, 1994
J. Wood	*Hidden Talents — A Dictionary of Neglected Artists Working 1880-1950*, 1994

Abbreviations in Text

AG	Art Gallery
b.	born
Bibl.	Bibliography
c.	*circa* — around
Cat.	catalogue
d.	died
Exhib.	Exhibit/exhibited/exhibiting/exhibition
fl.	*floruit* — dates that an artist was working
Illus.	Illustrated/illustration(s)
mono.	monograph
obit.	obituary
passim	here and there throughout
pl(s).	plate(s)
q.v. (qq.v.)	*quod videt* — as listed elsewhere
repr.	reprint/reprinted/reproduced
*	An asterisk by an artist's name denotes an illustration in the second volume of this Dictionary (Historical Survey and Plates), either in the survey of Victorian Painting, or in the section of black and white plates, and in some cases in both

ABBAYNE, C. fl.1857-1858
London painter. Exhib. one picture, 'The Two Windmills', at RA in 1857, and one at SS in 1858.

***ABBEY, Edwin Austin RA 1852-1911**
Painter and illustrator of historical subjects, usually medieval or Shakespearian. Born in Philadelphia, USA. Studied at Pennsylvania Academy 1869-71; employed by Harper Brothers 1871-91, and sent by them to England in 1878, where in 1880 he settled permanently. Visited Holland 1885, the first of several Continental tours. First exhib. at the RA 1885. Painted a series of large decorative panels for the Boston Library, USA, 1890-1901; reredos for the American Church in Paris 1904; the official picture of the Coronation of Edward VII 1903-4; a mural for the Royal Exchange 1904; and a series of murals for the Pennsylvania State Capitol, completed in 1910. His illustrations to Herrick's poems, Goldsmith and Shakespeare won him a great reputation. ARA 1894, RA 1898. A memorial exhib. was held at the RA in 1912.
Bibl: Studio Winter Number 1900-1; XXXI p.151; E.V. Lucas, *E.A.A. Royal Academician, The Record of his Life and Work*, 2 vols. 1921; Tate Cat.; Maas pp.231-2; E. Morris, *E.A.A. and his American Circle in England*, Apollo September 1976; Wood, Olympian Dreamers.

ABBOTT, Edwin fl.1886
Bradford portrait painter. Exhib. one portrait at RA in 1886.

ABBOTT, Richmond fl.1861-1866
Liverpool painter of animal subjects. Exhib.three pictures at BI and four at SS.

ABERCROMBY, John B. fl.1873-1896
Edinburgh painter of domestic and figure subjects. Exhib. four pictures at RA between 1873 and 1896. Titles include 'O ye needna be a-courting me', 'Threescore years and ten', etc.

ABLETT, Thomas Robert fl.1880-1932 d.1945
Yorkshire landscape painter; lived in Bradford and London. Exhib. at RA 1882-9 (5), NWS (3) and GG (1). Titles at the RA 'On the Wharfe in Autumn', 'Solitude'. 'Walberswick, from the Marsh', etc. Founded the Royal Drawing Society in 1888.

ABORN, John fl.1885-1922
Landscape painter; lived in Dolwyddelan, North Wales and Milford, Surrey. Exhib. at RA 1885-99 and SS. Subjects mainly winter landscapes, often in Wales.

ABRAHAM, Miss Lilian fl.1880-1886
London painter and watercolourist of flowers and still-life. Exhib. at SS and NWS.

ABRAHAM, R.F. fl.1846-1853
London painter of religious, historical and others subjects. Exhib. at RA 1846-51 (11) and BI (6). Titles at the RA 'From the Lay of the Last Minstrel', 'Moments of Adversity' and some religious subjects.

ABRAHAM, Robert J. fl.1877-1909
Landscape painter; lived in London and Stoke-on-Trent. Exhib. at RA (10), NWS (4) and NG (1). Titles 'A Stream in Burgundy', 'Hay Time', 'Fisher Child by the Zuyder Zee'.

ABSOLON, Hugh Wolfgang fl.1855
London painter. Exhib. one picture, 'A Study', at RA in 1855.

***ABSOLON, John 1815-1895**
Painter of landscape, seascape and genre in both oil and watercolour, and book illustrator. Began career as painter of theatrical scenery at Covent Garden. First exhib. at SS in 1832 at age of 17. Went to Paris 1835, and on his return in 1838 became a member of the NWS, of which he later became Treasurer. In 1850 he helped T. Grieve and W. Telbin (qq.v.) to produce the first diorama, 'The Route of the Overland Mail to India'. He exhib. mainly at the NWS (660 works), also at RA, BI and SS. Hardie praised his watercolours for their "fresh and breezy manner".
Bibl: Clement & Hutton; VAM; Cundall; Hardie III pp.79-80 (pl.101).

ABSOLON, John de Mansfield fl.1862-1864
London watercolourist of still-life and figure subjects. Exhib. at SS only.

ABSOLON, Louis fl.1872-1889
London painter and watercolourist. Exhib. mainly at SS (mostly watercolours), also NWS and elsewhere.

ACLAND, Miss A. fl.1875
London painter. Exhib. one picture, 'The Intruder', at the RA in 1875.

ACOCK, W.W. fl.1870-1871
Croydon watercolourist. Exhib. two watercolours of fruit at SS 1870-1.

ACRAMAN, Miss Edith fl.1847-1852
London painter of landscape, still-life and other subjects. Exhib. five pictures at RA 1847-52; titles 'The Echo of the Waves', 'A Vase of Flowers', 'The Purley Beeches', etc.

ACRAMAN, William Henry fl.1856-1868
Hastings landscape painter. Exhib. one picture at RA in 1856 — 'Brede Place, Hastings' — five at the SS (all watercolours) and elsewhere. He was also a professor and seller of music.

ACRET, John F. fl.1884-1902
London painter of portraits and figure subjects; lived in Hampstead. Exhib. at RA 1884-1902 (9) and at SS (2). Titles at RA mostly portraits, e.g. 'Lisette', 'Mary', etc.

ADAM, Joseph fl.1858-1880
London landscape painter; father of Joseph Denovan Adam (q.v.). Exhib. at RA 1858-80, BI and SS. Subjects mainly Scottish or north of England. A landscape by him is in the Guildhall AG, London.
Bibl: Corporation of London 1910 Cat. no. 264.

***ADAM, Joseph Denovan RSA RSW 1842-1896**
Glasgow landscape and animal painter Studied under his father, Joseph Adam (q.v.) and at South Kensington Schools. In the 1870s he went to live in the Crieff district, and in 1887 he settled near Stirling, founding a school of animal painting at Craigmill. Specialised in painting highland cattle. Exhib. at the RA 1860-92, BI, SS and also in Paris and Munich, where he won a gold medal. Adam's pictures have been prevented from achieving popularity because of their often bleak and wintry subjects.
Bibl: Caw pp.206, 338-9, 480.

***ADAM, Patrick William RSA 1854-1929**
Edinburgh painter of landscape and genre. Exhib. at RSA and RA 1878-1929. Titles 'The Dawn of Love', 'La Jeunesse'. 'The Edge of the Forest, Winter', etc. Also visited Italy and painted some Italian subjects of Venice and Florence. Exhib. RA in 1890. Later he lived in North Berwick, where he died in 1929. A picture of Venice by him is in Aberdeen AG.

ADAMS, Albert George fl.1854-1887
London landscape painter. Exhib. mainly at SS; also at BI and RA 1854-87. Subjects mainly views of Devon and the southern coast, and occasional genre scenes — e.g. 'A Mendicant Friar'.
Bibl: Brook-Hart.

ADAMS, Charles James 1859-1931
London landscape painter; also lived in Leicester, Horsham and Midhurst. Exhib. at RA from 1882, SS and NWS. Also painted animals, genre and historical subjects.

ADAMS, Miss Charlotte fl.1829-1843
London landscape painter. An honorary exhibitor at the RA 1829-43 (10); also exhib. at SS (8). Titles at RA 'Cottage on the Thames', 'Ickenham, Middlesex', 'Uxbridge Meadows', etc. Her sisters Caroline and Lucy were also amateur artists.

ADAMS, Douglas fl.1880-1904
London landscape painter. Exhib. at RA 1880-1904, SS, GG and NG. Subjects mostly Scottish, including loch and coastal views.

ADAMS, Eliott Ashfield fl.1870
Liverpool landscape painter. Recorded by Graves as having exhib. only one picture.

ADAMS, Harry William RBA 1868-1947
Worcester landscape painter. Exhib. at RA 1896-1927. Titles 'December's Royal Robe', 'Mountain Majesty', 'August Heat', etc. 'Winter's Sleep' (RA 1900) was purchased by the Chantrey Bequest. A landscape by him is in the Grundy Gallery, Blackpool AG.

ADAMS, James L. fl.1877-1880
Leeds painter. Exhib. one picture 'Deserted' at RA in 1880.

ADAMS, Miss Jane fl.1821-1851
London painter of domestic, genre, figures and other subjects. Exhib. at RA 1822-31 (5), BI (7), SS (4) and elsewhere. Titles at RA 'The Market Woman', 'Cottage near Billericay', etc.

ADAMS, Miss Joan fl.1890-1893
Guildford painter. Exhib. one picture 'The Labourer's Larder' at RA in 1893, and elsewhere.

***ADAMS, John Clayton 1840-1906**
Surrey landscape painter; lived in Edmonton and Guildford. Exhib. at RA 1863-93, SS, NWS, GG and NG. Subjects mainly views in Surrey and the southern counties. His landscapes, painted in a rich broad technique, are natural and realistic, and full of feeling for light and colour. Adams is one of the most individual and least recognised of the late Victorian landscape painters.

ADAMS, John Talbot fl.1861-1905
London landscape and rustic genre painter; later moved to Sutton, Surrey. Exhib. one picture at RA in 1862, and two in 1900; also at BI (7) and SS (10). Titles at RA 'The Gardener's Daughter', 'Single Anemones' and 'On the Thames'.

ADAMS, J. Seymour fl.1884-1885
London landscape painter. Exhib. one picture at RA in 1885 'A Quiet Nook', and two at SS.

ADAMS, L.B. fl.1828-1844
London painter of domestic and rural subjects. Exhib. at RA 1828-44 (5), BI (6) and SS (23). Subjects at RA 'Fisherman Mending his Nets', 'The Cottage Fireside', 'Indian Corn Baker, Venezuela', etc.

ADAMS, Miss Lucy fl.1815-1843
Billericay painter of portraits and domestic subjects. An honorary exhibitor at the RA 1819-43; also at SS (39), NWS (1) and elsewhere. Titles at RA 'The Old Cottager', 'Oliver Twist', 'The Comparison', etc., and some portraits. A portrait of Frances Trollope, copied from the NPG portrait by Auguste Hervieu, is in the BM.
Bibl: Ormond I p.468.

ADAMS, Sidney Herbert see SIDNEY, Herbert

ADAMS, Thomas fl.1865-1879
London painter and watercolourist. Exhib. still-life and figure subjects at BI, SS and elsewhere.

ADAMS, William Dacres 1864-1951
Painter and watercolourist. Studied under Herkomer (q.v.) at Bushey and in Munich. Exhib. portraits, figure subjects, landscapes and views of buildings at RA, ROI and FAS. Lived in London and later at Lewes.

ADAMSON, Miss fl.1845-1869
London painter of still-life. Exhib. at RA 1845-58 (7), and at SS (19). Titles all fruit and flowers, 'Summer Fruit', etc.

ADAMSON, David Comba fl.1887-1893
Glasgow painter. Exhib. two pictures at RA and elsewhere. Also lived in Paris.

ADAMSON, John 1865-1918
London painter of portraits and figure subjects. Studied at RA schools. Exhib. at RA, SS and elsewhere.

ADDENBROOKE, Miss Rosa fl.1891-1892
Salisbury painter of fish and flowers. Exhib. one picture at RA in 1891 and one at SS in 1892

ADDERLEY, Miss fl.1842
Painter; exhib. one picture at BI in 1842 — 'Remains of the Old Lighthouse at Cromer'.

ADDERTON, C.W. fl.1890-1892
Derby landscape painter. Exhib. at SS and NWS; mainly views in Yorkshire.

ADDISON, Mrs. fl.1831-1843
Ickenham landscape painter. Exhib. at RA 1837-43 (3) and at SS (4). Titles at RA 'Village of Ruislip', 'Dulverton, Somersetshire', etc.

ADDISON, William Grylls fl.1875-1893 d.1904
London landscape painter and watercolourist. Exhib. at RA 1876-95, SS, NWS and GG. Titles at RA 'Calm Decay', 'Waste Lands', 'A Sunny Border'.

ADERS, Mrs. C. fl.1839
London painter. Exhib. two pictures at RA in 1839, both figure subjects. Daughter of John Raphael Smith. Her copies after the old

masters were much admired, and her original work was praised by Blake.

Bibl: Clayton I pp.408-9.

ADEY, Virginia fl.1879-1881
Painter of figure subjects; lived at Lyndhurst, Hampshire. Exhib. at SS and elsewhere.

ADIE, Miss Edith Helena fl.1892-1930
London painter of buildings and gardens. Studied at South Kensington and the Slade. Exhib. at RA 1893-1912 (4), SS, NWS and elsewhere. Later lived in Sevenoaks, Kent, and also taught art in Italy.

Bibl: Wood, Painted Gardens.

ADLINGTON, Miss E.C. fl.1893
London painter. Exhib. one still-life at RA in 1893.

ADSHEAD, Joseph fl.1863-1877
Manchester landscape painter. Exhib. at RA 1864-77 (3), SS (2) and elsewhere. Titles at RA 'A Garden in Autumn', 'Early Spring', and 'By the Sand Hills — Lancashire Coast'.

AFFLECK, William b.1869 fl.1890-1915
London painter of landscapes and rustic scenes, especially old cottages. Born at Rochdale, Lancashire; studied at Heatherley's and the Lambeth School of Art. Exhib. at RA 1891-1915, also at SS, NWS and elsewhere. Member of the London Sketch Club.

AGLIO, Agostino 1777-1857
Landscape painter; born in Cremona, Italy. Came to England with William Wilkins, RA, in 1803. A versatile artist; produced theatrical scenery, church decoration and prints. Exhib. at RA 1807-46, BI and SS. His son Augustine also a landscape painter (q.v.). Neither of their works are often seen, possibly because many of Agostino's pictures were for large-scale decoration.

Bibl: Redgrave, Dict.; DNB; VAM; Hardie III p.291.

AGLIO, Augustine fl.1836-1875
London painter of landscape and portraits; son of Agostino Aglio (q.v.). Exhib. mainly at SS, also RA, BI and elsewhere. Also exhib. a few watercolours and sculptures.

AGLIO, Miss Mary Elizabeth fl.1851
London painter of religious and historical subjects. Exhib. one picture at RA and one at SS in 1851.

AGNENI, Eugenio 1832-1888
Italian painter of historical subjects. Exhib. at RA 1859-62 (5). Titles 'Deathbed of Lorenzo de Medici', 'Pope Leo X Examines Portrait of Luther', etc. Worked mainly in Italy, but while in London he worked on decorations at Covent Garden Theatre, and also painted a large picture of Queen Victoria and her family dressed for a masked ball.

AGNEW, Miss Caroline M. fl.1874-1875
Manchester landscape painter. Exhib. only two pics. at RA in 1874 'Early Morning' and 'Light', and one picture elsewhere in 1875.

AGUJARI, G. fl.1869-1877
Painter and watercolourist; exhib. Venetian scenes at SS and elsewhere.

AIDE, Charles Hamilton 1826-1906
London landscape painter. Exhib. three pictures at GG 1880-1. A close friend of Lord Leighton (see R. and L. Ormond, *Lord Leighton, passim*).

AIKEN, Walter Chetwood 1866-1899
One picture of 'A French Village' by him is in Bristol AG (Cat. p.7).

AIKMAN, George ARSA 1830-1905
Edinburgh landscape painter. Exhib. at RSA 1850-1905, RA, SS and elsewhere. Titles at RA 'Scotch Firs', 'Summer Sunset', 'Across the Moor', etc. Elected ARSA 1879. Was also an engraver, and worked on illustrations for *Encyclopaedia Britannica*.

AINSLEY, J. fl.1840
Painter; lived at Mansfield. Exhib. one picture at RA in 1840 — 'Itinerant Piper of Italy'.

AINSLEY, P. fl.1868-1871
London watercolourist. Exhib. three watercolours of old buildings at SS 1868-71.

AINSLEY, Samuel James 1806-1874
Landscape and figure painter; lived at Leyton. Exhib. at RA in 1836 and 1844; also at BI and SS. Titles at RA 'The Return from the Chase', and 'Cicero at his Villa'. Worked in Italy with C. Dennis on 'Cities and Cemeteries of Etruria'.

AITCHERSON, Miss S. fl.1839
Painter; lived at Strood, Kent. Exhib. one picture of flowers at SS in 1839.

AITKEN, James fl.1880-1935
Painter of landscapes and river scenes. Born at Newburgh, Fifeshire. Exhib. at RA, RSA, RI and elsewhere. Member of the Liverpool Academy of Arts. Lived on the Isle of Man, but also painted in France, Italy and Switzerland.

AITKEN, James Alfred ARHA RSW 1846-1897
Glasgow landscape and figure painter. Exhib. at RA, RSA, GG and elsewhere. Lived at Port St. Mary on the Isle of Man; also painted in France, Italy and Switzerland. Influenced by Horatio McCulloch (q.v.). Towards the end of his life he painted almost entirely in watercolour. A watercolour by him is in Glasgow AG.

Bibl: Glasgow AG 1908 Cat. p.3 no. 15.

AITKIN, E.V. fl.1886
London painter. Exhib. one watercolour at SS in 1886.

AKERS, John fl.1826-1844
Oxford landscape painter. Exhib. two pictures at RA in 1832 and 1844; also at BI and SS. Titles at RA 'The Lucea Baths' and 'Landscape'.

ALABASTER, H. fl.1871-1874
London painter of figure subjects. Exhib. four pictures at SS.

ALABASTER, Mrs. Henry fl.1864-1888
(Miss Palacia Emma Fahey)
Painter and watercolourist. Exhib. views of Siam at NWS; also at SS and elsewhere.

ALABASTER, Miss Mary Ann see CRIDDLE, Mrs. Harry

ALBERT, Miss B. fl.1874
London painter. Exhib. one watercolour of a coastal scene at SS in 1874.

ALBERT, Ernest fl.1891
London painter. Exhib. one picture, 'On the Tagus' at RA in 1891.

ALCOBIER, H.D. fl.1845
London painter. Exhib. one picture, 'A Study', at RA in 1845.

ALCOTT, Mary fl.1877
London painter, recorded by Graves as exhibiting one picture in 1877.

ALDHAM, Miss Harriet Kate fl.1867-1876
London painter of figure subjects. Exhib. at RA 1867-77 (5), SS (2) and elsewhere. Titles at RA 'Waiting at the Confessional', 'A Murcian Lady' and 'The Fete Day, Brittany'.

ALDIN, Alfred fl.1862-1870
London landscape and still-life painter. Exhib. one picture of fruit at RA in 1868; also at SS (10), landscapes and still-life, some in watercolours.

ALDIS, C.M. fl.1835-1842
London landscape and portrait painter. Exhib. at RA 1837-41(9), BI (4) and SS (8). Titles at RA 'On the Road to Wyresdale', 'Pastoral Landscape on the Brock', etc., and portraits.

ALDRIDGE, Miss Emily see CRAWFORD, Mrs.

ALDRIDGE, Frederick James 1850-1933
Landscape and seascape painter; worked in Worthing, Sussex. Exhib. at RA 1896-1901 and SS.
Bibl: Brook-Hart pp.82-4 (pl.154).

ALEXANDER, Miss fl.1861
London landscape painter. Exhib. one watercolour at SS in 1861.

ALEXANDER, C. fl.1874
London landscape painter, recorded by Graves as exhibiting one picture in 1874.

ALEXANDER, Charles fl.1893-1894
Portrait and landscape painter; lived at Wotton-under-Edge. Exhib. two portraits and an Italian view at RA 1893-4. A portrait by him of the Indian administrator B.H. Houghton is in the Indian Institute, Oxford.
Bibl: Ormond I p.227.

***ALEXANDER, Edwin RSA 1870-1926**
Scottish painter and watercolourist of flowers, birds, animals and Arabian subjects. Son of Robert Alexander RSA. At the age of 17 he visited Tangier with his father and Joseph Crawhall (q.v.) who had a great influence on his artistic career. Studied in Paris 1891. Visited Egypt 1892-6. Married in 1904 and settled near Inverness. Elected ARSA 1902, RSA 1913, member of the RWS 1910. Many of Alexander's watercolours are painted on silk, linen or textured paper. His style reflects the decorative ideas of the Glasgow school and the influence of Japanese art.
Bibl: Who's Who 1906; Caw pp.304, 438-40, 450; Cundall; J. Patterson, *E.A.*, OWS Annual IV 1926; Hardie II pp.207-9 (pl.240).

ALEXANDER, George fl.1843-1857
Greenwich painter of historical and other figure subjects. Exhib. at RA 1843-6 (3) and elsewhere. Titles at RA 'Newhaven Fishwoman', 'Camilla Restores the Ring to Gil Blas', etc.

ALEXANDER, Miss J. fl.1851-1859
London painter of still-life, domestic and historical subjects. Exhib. at RA 1851-3 (3), BI (l) and SS (4). Titles at RA 'The Dead Rabbit', 'My Own Room', etc.

ALEXANDER, John fl.1878
London painter; lived in Balham. Exhib. one picture of fruit at SS in 1878.

ALEXANDER, Miss Marion fl.1887-1893
Painter of domestic subjects; lived at Farnborough. Exhib. at GG, NG and elsewhere.

ALEXANDER, Robert L. RSA RSW 1840-1923
Edinburgh animal painter; father of Edwin Alexander (q.v.), and father-in-law of Alexander Roche (q.v.), who was married to his daughter Jean. Exhib. at RA 1878-88; also at RSA and other Scottish exhibitions. Titles at RA 'Orphans', 'A Collie and Puppies', 'The Happy Mother', etc.

ALEXANDER, William fl.1878-1898
Salisbury painter. Exhib. at RA 1889-98 and elsewhere; mostly views in and around Salisbury.

ALFORD, Agnes fl.1881
London flower painter. Exhib. one picture at SS in 1881.

ALFORD, Leonard C. fl.1885-1904
Southampton painter of seascapes and coastal scenes. Exhib. at RA 1885-1904.
Bibl: Brook-Hart.

ALFRED, Henry Jervis fl.1855
London still-life painter. Exhib. two pictures of fish at SS in 1855.

ALGER, Vivian C. fl.1882-1889
London landscape painter. Exhib. 8 pictures. at RA 1882-9. Titles all scenes in Devon and Cornwall, especially coastal views.
Bibl: Brook-Hart.

ALISON, Miss M. fl.1868-1874
London landscape and topographical painter. Exhib. at RA in 1868 and 1874, also at SS (7). Titles at RA 'Dogana', 'Verona' and 'Swansea Harbour'; at SS mostly Italian views.

***ALKEN, Henry 1785-1851**
Sporting painter and watercolourist; best known of the Alken family of sporting artists. Henry's father, Samuel Alken Snr., of Danish extraction, was a landscape and sporting painter. Henry was born in London and first studied with J.T. Barber, a painter of miniature portraits. The only works ever exhib. by Alken at the RA, in 1801 and 1802, were portrait miniatures. In 1809 he married Maria Gordon in Ipswich. A keen huntsman, Alken showed a real knowledge and love of hunting in his pictures and prints. At first, he produced his hunting prints anonymously, signing them Ben Tally Ho, but it was not long before the secret was out. Although a prolific painter and watercolourist of hunting, coaching and shooting scenes, Alken became well known through his many sporting prints, which were mostly published by Fores. For example, the series 'The Midnight Steeplechase' was very popular, and produced in large numbers. After 1820 the quality of Alken's work declined; it

became dull and repetitive, and he died in poverty in Highgate in 1851. He is known to have had at least two sons, Henry Jnr. and Seffrien, who imitated his style closely. The work of Henry Jnr., who signed H. Alken as well, has never been satisfactorily distinguished from the late work of his father. He probably used the signature H. Alken in order to pass his pictures off as his father's. Seffrien Alken signed S. Alken, and is usually confused with Samuel Alken Snr. Two other Alkens, George and Samuel Jnr., are recorded, but practically nothing is known about them.

Bibl: DNB; Redgrave, Dict.; M. Hardie, *The Coloured Books of H.A.*, Queen CXVIII 1905 p.194; W.S. Sparrow, *H.A.*, 1927; VAM; Paviere, Sporting Painters (pl.l); Hardie III; Maas pp.71-2, 74-5 (pl. p.74); Ormond I p.30.

ALLAN, Mrs. A.F. fl.1866-1870
London still-life painter. Exhib. two pics. at RA in 1867 and 1868, both entitled 'Fruit'. Also exhib. at SS (11). Graves lists a Miss Eliza Mann, later Mrs. Archibald Allan, who may be the same artist.

ALLAN, C. fl.1880
Painter, lived at Hillhead. Recorded by Graves as exhibiting one 'domestic' picture in 1880.

ALLAN, Miss Christina fl.1884-1885
London painter. Exhib. two seapieces at GG 1884-5.

ALLAN, Miss Eliza fl.1863-1865
London painter of fruit. Exhib. at BI and SS.

ALLAN, J. McGregor fl.1854-1856
London portrait painter. Exhib. at RA 1854-6 (5), all portraits, one on enamel.

ALLAN, Patrick fl.1840-1841
Painter of historical subjects; lived in London and Paris. Exhib. at RA and BI.

***ALLAN, Robert Weir RWS RSW 1852-1942**
Glasgow *plein-air* landscape and seascape painter and watercolourist. Subjects mainly landscapes of north-east coast of Scotland, fishing villages and cliffs. Worked first near Glasgow, exhib. at Glasgow Institute in 1873 and at the RA from 1875 onwards. Later went to Paris and worked under Julian and Cabanel. From Paris he sent many *plein-air* landscapes to English exhibitions. Settled in London 1881. Sketched much in Holland, Belgium, France and Italy; toured India 1891-2 and Japan 1907. His seascapes and harbour scenes similar in feeling to those of Colin Hunter (q.v.), but his foreign scenes reflect his Paris training.

Bibl. AJ 1904 p.197; Studio XXIII p.229-37 (monograph with illustrations by Mrs. A. Bell); Caw pp.329-31; VAM; FAS 1924; Hardie III p.193 (pl.229).

***ALLAN, Sir William RA PRSA 1782-1850**
Scottish painter of history and scenes of Russian life. Apprenticed as a coach painter; studied under Graham at the Trustees' Academy with Wilkie, John Burnet and Alexander Fraser (qq.v.). Later he entered the RA Schools in London. In 1805 he went to Russia and spent several years in the Ukraine, travelling to Turkey, Tartary, etc., studying the Cossacks and Circassians, and collecting subjects for many future pictures. In 1814 he returned to Edinburgh and in 1815 exhib. 'Circassian Captives', which was subscribed to by Sir Walter Scott and his friends. Later he painted scenes of Scottish history suggested by Scott's novels, which proved more popular than his Russian subjects. Exhib. at the RA 1803-49. ARA 1825, RA 1835, PRSA 1837. In 1843 he exhib. 'The Battle of Waterloo

from the English Side', bought by the Duke of Wellington. In 1844 he again went to St. Petersburg and there he painted for the Tsar 'Peter the Great Teaching his Subjects the Art of Shipbuilding' (Winter Palace). Also painted portraits. Not only was Allan one of the first to paint oriental subjects, he was also one of the pioneers of Scottish history painting.

Bibl: AJ 1849 p.109; 1850 p.100; 1903 p.53; Clement & Hutton; Redgrave, Dict.; DNB; NPG Cat; Caw *passim* (pl. opp. p.105); Binyon; Irwin, see index; Connoisseur CLXXXVI 1973 pp.88-93; Strong.

ALLARDYCE, Miss Mary R. fl.1891
London painter. Exhib. one picture 'Lenten Fare' at RA 1891.

ALLBON, Charles Frederick ARE 1856-1926
Croydon landscape and seascape painter. Exhib. at RA 1885, 1888, 1892 and SS. Subjects mainly views of the French and Dutch coasts. Also an etcher; elected ARE 1887; membership ceased 1911.

Bibl: Brook-Hart.

ALLCHIN, Harry fl.1885-1904
Landscape painter; lived in London and USA. Exhib. American landscapes at RA 1885-1904.

ALLCHIN, J. Herbert fl.1877-1881
Flower and still-life painter. Exhib. at RA 1877-81 (6) and at SS (6). Titles at RA 'Death and Life', 'Wild Flowers and Butterflies', 'The Finishing Touch', etc. Graves gives addresses in Southall, Hastings and Highbury.

ALLDRIDGE, Miss Emily, Miss Florence Maude, and R.L.
Painters of portraits and figure subjects; all lived at Old Charlton in Kent. R.L. Alldridge exhib. at RA 1866-77, at SS (2) and elsewhere. Titles include portraits of Miss Emily and Miss Florence Maude Alldridge, and a portrait of the picture dealer Martin Colnaghi. Miss Emily and Miss Florence Maude both exhib. only at SS between 1865 and 1879, mostly figure subjects, in watercolours.

ALLEN, Miss Annie C. fl.1881-1883
London painter. Exhib. a portrait and a flowerpiece at SS 1881-3.

ALLEN, Mrs. Eliza fl.1860-1864
Greenwich painter of figure subjects, exhib. at SS 1860-4.

ALLEN, George Maule fl.1880
London painter. Exhib. one topographical watercolour of old buildings in Dijon at SS 1880.

ALLEN, Geraldine Whitacre fl.1890-1893
London painter. Exhib. one picture, a moonlight study, at SS 1890.

ALLEN, H.W. fl.1874-1875
London painter; exhib. one picture, 'Scene in Berkshire', at SS 1873.

ALLEN, James Baylis 1803-1876
A landscape of a stream by him is in Birmingham City AG.

ALLEN, John Whitacre fl.1859-1886
Bath and Cheltenham landscape painter. Exhib at RA in 1864, 1879 and SS. Visited Italy.

ALLEN, Joseph William 1803-1852
Prolific London landscape painter and watercolourist. Drawing Master at the City of London School. Secretary to the Society of

British Artists, and regular exhibitor there (329 works). Also exhib. at RA 1826-33 and BI. Subjects mainly idealised views in North Wales, Cheshire, Yorkshire and other Midland counties. The *Art Journal* of 1852 cites 'The Vale of Clwyd' (1847) as a really fine work, but criticises Allen's work for "unequivocal marks of haste and want of finish".

Bibl: AJ 1852 p.316 (obit.); Redgrave, Dict.; DNB; Cundall; VAM; Hardie II pp.154-5 (pl.140); Brook-Hart.

ALLEN, L. Barbara M. fl.1872-1877
London painter of figure subjects. Exhib. watercolours at SS and elsewhere.

ALLEN, L. Jessie fl.1881-1887
London flower painter. Exhib. at SS only 1881-7.

ALLEN, M. fl.1864
London painter; exhib. two pictures, 'Fresh from the Sea' and a portrait at SS 1864.

ALLEN, Marens fl.1864
London painter; exhib. one picture, 'An Irish Study, Fighting Phil' at SS 1864.

ALLEN, Marie fl.1889
Taunton painter; exhib. two landscapes at SS 1889.

ALLEN, Mrs. O. fl.1873
Painter; lived in Grasmere, Westmorland. Exhib. one watercolour, 'The Gentle Friend' at SS 1873.

ALLEN, Robert fl.1841
Sign painter and amateur artist. A London street scene by him, dated 1841, is in the London Museum (1970 Cat. no. 2).

ALLEN, Thomas William b.1855 fl.1881-1902
Landscape painter, working in London and Surrey. Exhib. at RA 1882-1902 and SS. Subjects mainly in Surrey, Oxfordshire and Wales, or ideal landscapes, e.g. 'At Eventide' (RA 1886).

ALLEN, Captain W. RN fl.1828-1847
London painter of African landscapes; exhib. at RA and SS.

ALLEN, Walter James fl.1859-1861
London painter of genre and figure subjects. Exhib. one picture, 'Reflection' at RA in 1861. 'Preparing Vegetables' was sold at Sotheby's, 7 November 1972.

ALLEN, William Herbert RBA ARCA b.1863 fl.1904-1929
Surrey landscape painter in oil and watercolour. Lived mainly at Farnham. Exhib. at RA 1904-29, SS, RI and elsewhere. Titles at RA 'Near Croydon, Surrey', 'A Forest Clearing', 'The Return of the Flock', etc. Also painted in France and Italy.

ALLFREY, Henry W. fl.1842-1861
Stratford landscape painter. An honorary exhibitor at the RA, where he showed two pictures in 1842 and 1843; also exhib. at BI and SS. Titles at RA 'A Farmhouse' and 'At Buckland on the Moor'.

ALLFREY, W.A. fl.1865
Landscape painter; exhib. two pictures at BI 1865.

ALLIN, J.S.W. fl.1870-1874
London painter of figure subjects. Exhib. at SS only 1870-4.

ALLINGHAM, Miss A. fl.1853
London painter; exhib. one watercolour, 'Study from Nature' at SS 1853.

***ALLINGHAM, Mrs. Helen RWS 1848-1926 (Miss Helen Paterson)**
Watercolour painter of rural scenes, sunny gardens and children. Educated at the Birmingham School of Design and the RA Schools. Strongly influenced by Birket Foster and Frederick Walker (qq.v.). In 1874 she married William Allingham, the Irish poet, thus entering a literary circle where she met Ruskin (q.v.), who became an admirer of her work. In *Art of England* (1884), he linked her with Kate Greenaway (q.v.) and praised her representation of "the gesture, character and humour of charming children in country landscapes". She was elected ARWS in 1875, and member in 1890. Exhib. almost entirely at the OWS (221 works). Now most famous for her watercolours of old English cottages.

Bibl: Clement & Hutton; Clayton II pp.l-5; Ruskin, Academy Notes 1875; J. Ruskin, *Art of England,* 1884; Studio Summer Number 1900; H.B. Huish, *Happy England as Painted by H.A. with Memoir,* 1903; FAS 1886 pp.87, 91, 94, 98, 1901,1913; VAM; Cundall; Hardie III pp.112-13 (pl.34); Maas p. 231; C. Neve, *Mrs. Allingham's Cottage Gardens,* Country Life 155 pp.632-3; Wood, Paradise Lost; Wood, Painted Gardens; Newall; Ina Taylor, *H.A.'s England,* 1900; Christie's, London, Cat. of the Marley Collection of Watercolours by H.A., 19 September 1991.

ALLNUTT, Miss Mabel fl.1891
Windsor landscape painter. Exhib. a view of Eton at SS 1891.

ALLOM, A. fl.1859-1860
London landscape and topographical painter. Exhib. three pictures at SS 1859-60.

ALLOM, Thomas 1804-1872
Architect and topographical watercolourist. Articled to Francis Goodwin. Founder member of RIBA. Produced perspectives for Sir Charles Barry of the new Houses of Parliament and completed the hall in Barry's Highclere, Hampshire. Employed by Virtue & Co. and Heath & Co., he made drawings for *Cumberland and Westmorland, Devonshire and Cornwall, Scotland, France, Constantinople, Asia Minor and China.* He is chiefly known today for his topographical drawings mostly views of buildings. He travelled extensively on the Continent and in the Far East. Exhib. at the RA 1827-71 and SS.

Bibl: AJ 1863 pp.36, 77, 123,162, 205, 228, 250,1872 p.300; Builder 26 October 1872; DNB; Binyon; Redgrave, Dict.; RIBA Drawings Cat. Vol. A; Hardie III p.29 (pl.38).

ALLPORT, Miss C. Lily fl.1891-1900
London painter. Exhib. at RA 1891-1900, landscapes, views of buildings, and figure subjects.

ALLPORT, Harvey fl.1888-1890
London painter. Exhib. landscapes and views on the Thames at RA and SS.

ALLPORT, John fl.1831-1850
London painter of figure subjects. Exhib. at BI and SS, both oils and watercolours. Titles 'Little Flora', etc.

ALLPORT, S. fl.1865
Painter; lived at Padstow, Cornwall. Exhib. one picture 'A Girl with Peacock's Feather' at SS 1865.

ALLSOP, C. fl.1864-1865
London still-life painter. Exhib. four pictures at BI 1864-5.

ALLSOP, J. fl.1857
Birmingham landscape painter. Exhib. one Scottish landscape at SS 1857.

ALLSWORTH, W. fl.1836-1856
London painter of portraits and domestic subjects. Exhib. at RA 1836-56 (10) and BI (2). Titles at RA 'Hopgrounds at Kenfield', 'The Schoolboy at Christmas', and portraits.

ALMA-TADEMA, Anna fl.1885 d.1943
Painter of landscape, classical genre and flowers. Daughter of Alma-Tadema (q.v.). Exhib. at RA 1885-1903, NWS, GG and NG. Usually signed A. Alma-Tadema. Her pictures are painted with great delicacy and poetry, but her reputation has always been overshadowed by that of her father and mother.
Bibl: W.S. Sparrow, *Women Painters of the World*, 1905; Newall.

***ALMA-TADEMA, Lady Laura 1852-1909**
(Miss Laura Epps)
Painter of children (usually in Dutch 17th century costume), portraits in pastel, domestic scenes, classical subjects and small landscapes (generally Italian). Daughter of Dr. George Napoleon Epps and second wife of Alma-Tadema (q.v.). Her sister Mrs. Edmund Gosse and her daughter Anna (qq.v.) also painters. Exhib. at RA from 1873, and GG and NG. Her classical subjects are often confused with those of her husband; she signed L. Alma-Tadema, but did not use opus numbers. In 1878 she was one of the two women artists invited to contribute to the International Exhibition in Paris.
Bibl: Alice Meynell, AJ 1883 pp.345-47 (mono. with pls.); Clayton II p.6.

***ALMA-TADEMA, Sir Lawrence OM RA 1836-1912**
Painter of Greek and Roman subjects, set in scenes of remarkable archaeological and architectural accuracy. His paintings are always recognisable for their brilliant luminosity, and exquisite rendering of marble, silver, gold, bronze and silks. Born in Dronryp, Holland. In 1852 entered the Antwerp Academy, where Louis de Taye, the Professor of Archaeology, much influenced his work. In 1860 became assistant and pupil to Baron Leys. Settled in London 1870. His output was prolific. He numbered all his works with roman numerals, his first work, painted when he was fifteen, being Opus I 'Portrait of my Sister'. His last work, Opus CCCCVIII, 'Preparations', was painted two months before his death. His first picture painted in London was Opus LXXXVI, 'From an Absent One'. In 1906 he was awarded the Royal Gold Medal by the RIBA for his promotion of architecture in painting. His own house in St. John's Wood was designed in the style of a Pompeian villa. He also produced stage designs for Sir Henry Irving's *Coriolanus* 1901 and *Cymbeline* 1896, and for Sir Herbert Beerbohm Tree's *Julius Caesar* and *Hypatia*. Exhib. at the RA from 1869, OWS, GG and NG. He had many followers and imitators, e.g. Edwin Long and J.W. Godward (qq.v.). His wife Laura and his daughter Anna (qq.v.) were also painters, who closely followed his style. Forgeries of his work do exist, many of which are falsely signed and numbered CCCXXXVIII or CCCXXVIII.
Bibl: Art Annual 1886, 1902, 1910; George Ebers Lorenz, *A.-T*, 1886; Percy Cross Standing, *Sir L. A.T.*, 1905; William Gaunt, *Victorian Olympus*, 1952; Reynolds, VP pp. 120,123,180,193 (pl. 89-90); Mario Amaya, *The Roman World of A.-T.*, Apollo December 1962 (with additional bibl.); Mario Amaya, Sunday Times Magazine 18 February 1968; Maas pp.182-3 (pl. pp.182-3); Wood, Pre-Raphaelites; Wood, Olympian Dreamers; Prof. V. Swanson, *A.-T.*, 1977; Prof. V. Swanson, *Biography and Catalogue Raisonée of the Works of A.-T.*, 1990.

ALMGILL, G.T. fl.1877
London painter. Recorded by Graves as exhibiting one 'domestic' picture.

ALMOND, W. Douglas 1866-1916
London genre and historical painter. Member of the Langham Sketching Club. Exhib. at RA from 1893 and at SS. Subjects often of Cavaliers and Roundheads, e.g. 'In Council' (RA 1899).
Bibl: AJ 1895 p.54; Studio XXXII p.286.

ALPENNY, Joseph Samuel 1787-1858
London painter of portraits and historical subjects. Exhib. at RA 1825-53 (9) and at SS (4). Titles at RA: 'Satan Re-enters Paradise', 'Ancient Irish Hunting the Moose Deer', 'From Plutarch's Life of Pyrrhus', and portraits. Lived in Dublin from 1812 to about 1824, where he used the name Alpenny. From 1805-8 he is recorded as J.S. Halfpenny.

ALPORT, Lily fl.1890
London painter. Exhib. one picture, of Rouen Market, at SS 1890.

ALSOP, Frederick fl.1881-1853
Glasgow landscape painter. Exhib. one picture, 'The Moor in March', at RA in 1883.

ALSOP, J.J. RBA fl.1892-1894
London landscape and portrait painter. Exhib. at SS only 1892-4.

ALSTON, Miss Charlotte M. fl.1886-1914
Painter of churches and still-life; lived at Brockley and in London. Exhib. at RA 1887-8, and in 1914; also at SS, NWS and elsewhere. Titles at RA: 'Entrance, St. Erasmus Chapel, Westminster', 'The Oldest Church in London', and 'Christmas Roses'.

ALSTON, Edward Constable fl.1886-1934 d.1939
London painter of portraits and figure subjects. Exhib. at RA 1887-1931, SS, ROI and NEAC. Titles at RA 'Frolic', 'Sunshine', etc., but mainly portraits.

ALTHAUS, Fritz B. fl.1881-1914
London painter of landscape and coastal scenes. Also lived in Exeter and Leeds. Exhib. at RA 1887-1914, SS, NWS, GG and elsewhere. Titles at RA mostly scenes on the coasts of Devon and Cornwall; also views in Wales and the Lake District.
Bibl: Brook-Hart.

AMBROSE, C. fl.1824-1848
London portrait painter. Exhib. at RA 1824-48 (30), BI (2) and SS(49), all portraits. Painted the dramatist, James Sheridan Knowles.
Bibl: Ormond I p.251.

AMBROSINI, J. fl.1878
London painter. Exhib. one picture, 'La Ghirlandia', at SS in 1878.

AMICONI, Bernardo fl.1859-1875
London painter of portraits and domestic subjects. Exhib. at RA 1859-75, BI (2) and SS (3). Titles at RA: 'My Pet', 'La Mascherina Veneziana', 'The First Post', etc., and portraits.

AMOR, Miss E. fl.1870
London painter. Exhib. one picture of flowers at RA in 1870.

AMPHLETT, Miss Kate fl.1878-1890
London landscape painter. Exhib. at SS and RA 1884-9. Titles 'A Swamp'.

AMYOT, Mrs. fl.1879-1890
(Miss Catherine Engelhart)
Painter of figure subjects and portraits; lived mainly at Diss in Norfolk. Exhib. at RA 1879-90 (9), SS (2) and elsewhere. Titles at RA 'Spring Flowers', 'Interesting News', 'Soap Bubbles', etc.

ANCONA, Kate fl.1873-1874
London painter of figure subjects. Exhib. at SS only 1873-4.

ANCRUM, M. fl.1891
Edinburgh landscape painter. Exhib. one picture, 'A Sunny Day on the Moor', at RA in 1891.

ANDERSON, A. fl.1882-1885
Bedford landscape painter. Exhib. at SS and NWS, mainly watercolours.

ANDERSON, Charles Goldsborough 1865-1936
London portrait painter. Born at Tynemouth, Northumberland. Exhib. at RA 1888-1917, SS, ROI and NG. Exhibitions of his work were held at the Grafton Galleries in 1901 and 1904. In 1910 he painted one of the panels for the Royal Exchange. Later he lived at Rustington, Sussex.

ANDERSON, Sir Charles H.J.A., Bt. fl.1864-1870
Painter of coastal scenes. Exhib. at SS 1864-70, all views on the coast of Iceland.
Bibl: Brook-Hart

ANDERSON, David fl.1880-1881
London painter. Exhib. an oil and a watercolour, both of Dutch harbour scenes, at SS 1880-1.

ANDERSON, Edgar fl.1884-1902
London portrait and figure painter. Exhib. at RA 1884-1902 (8). Titles at RA 'Fan and Fancies', 'A Maid of Kent', etc., and portraits.

ANDERSON, George L. fl.1893-1898
Coventry painter. Exhib. figure subjects and scenes in Brittany at RA 1893-8.

ANDERSON, G.W. fl.1826-1852
London landscape painter; son of William Anderson, the marine painter. Exhib. at RA 1828-52 (7), BI (3) and SS (3). Titles at RA 'Near Kilburn', 'At Albury, near Guildford', 'A Boat Adrift', etc.

ANDERSON, J.H. fl.1892
London landscape painter; recorded by Graves as exhibiting one picture in 1892.

ANDERSON, Captain J.W. fl.1857-1865
London painter of shipping scenes. Exhib. at BI (4), SS (2) and elsewhere. Titles at BI 'In Portsmouth Harbour—Morning', 'A Calm, the Solent from the Esplanade, Ryde', also a view in the Fiji Islands.
Bibl: Brook-Hart.

ANDERSON, John fl.1858-1884
Coventry landscape painter. Exhib. at SS, BI and RA 1858-84. Subjects views around Coventry and the Midlands, e.g. 'A Bit of

Warwickshire', 'Green Pastures on the Avon' etc. Another landscape and flower painter called John Anderson exhib. at the RA 1827-39, but neither are well known.

ANDERSON, John F. fl.1879-1882
London painter and watercolourist. Exhib. at SS only 1879-82, all watercolours, mostly harbour scenes of Clovelly, N. Devon.
Bibl: Brook-Hart.

***ANDERSON, John MacVicar 1835-1915**
Architect and painter of topographical subjects, mostly views in London. Exhib. six times at RA 1856-96. A picture of the Houses of Parliament by him is in the London Museum (1970 Cat. no. 3), and a view of Columbia Market belongs to Tower Hamlets Library. Anderson designed the facade of Christie's in King Street, London.
Bibl: *Victorian Panorama*, exhib. at the Alexander Gallery, London, October-November 1976, no. 20.

ANDERSON, John Silvy fl.1886-1890
Dorking painter of figure subjects. Exhib. one picture, 'Sic est Vita', at RA in 1888, also at SS (l) and NWS (4).

ANDERSON, Robert ARSA RSW 1842-1885
Scottish line-engraver; elected ARSA in 1885. About 1880 he turned to painting in oils and watercolour. Exhib. at RA, NWS and RSW. Subjects mostly fishermen, and other figure subjects.
Bibl: Caw p.324.

ANDERSON, S. fl.1855-1865
London painter of domestic subjects. Exhib. at RA in 1863 and 1870; also at BI (3) and SS (8). Titles at RA 'Still Life' and 'Elaine'.

***ANDERSON, Mrs. Sophie 1823-1903**
Genre, landscape and portrait painter. Born in Paris, where she studied under Steuben. Her father being French, her early years were spent in France, but with the outbreak of the 1848 Revolution, she and her family left for America. There she established herself as a successful portrait painter and married an English artist, Walter Anderson (q.v.). In 1854 they came to England, and in 1855 she began to exhibit genre pictures at the RA. While in England she lived in London, Dalston (Cumberland), and Bramley, near Guildford, but around 1871 she moved to Capri because of ill-health. Eventually she returned to England and lived in Falmouth. She is best known for one outstanding work, 'No Walk Today' (Reynolds, VP, on cover), but more pictures by her may well come to light. She exhib. at the RA 1855-96, BI, SS and GG.
Bibl: Clayton II pp.7-9; Reynolds, VP p.113 (pl. 73 and cover); E. Cerio, *The Masque of Capri*, 1957 pp.77-80; Wood, Olympian Dreamers; Wood, Paradise Lost.

ANDERSON, T.W. fl.1839
London landscape painter. Exhib. one picture, 'Kingston-on-Thames' at RA 1839.

***ANDERSON, Walter fl.1856-1886**
London painter of domestic subjects; husband of Sophie Anderson (q.v.). Exhib. at RA in 1867 and 1870; also at BI (2) and SS (13). Titles at RA 'Christmas Eve' and 'Mignon'.

ANDERSON, Will fl.1880-1895
London painter of landscapes and rustic scenes. Exhib. at RA and SS.

ANDERSON, William fl.1856-1893
London landscape and figure painter. Exhib. at RA, SS, NWS and elsewhere. Titles at RA: 'Peasant Girl of Bretagne', 'A Holiday', etc.

ANDRADE, Miss Ellen, Miss J. and Miss Kate L.
London painters of still-life and domestic genre. Miss Ellen and Miss J. exhib. at RA, BI and SS 1849-58; Miss Kate exhib. at RA in 1929 and at SS in 1893.

ANDRE, James Paul Jnr. fl.1823-1867
Prolific London landscape painter. Exhib. at RA 1823-59, BI and SS. Subjects at RA views in Surrey, Kent, Devon and elsewhere.

ANDREUVE, J. fl.1841
London painter; exhib. one picture of fruit at RA in 1841.

ANDREW, C. fl.1849
London painter. Exhib. one picture at RA in 1849 with the interesting title 'A Chartist Orator advocating the Six Points'.

ANDREW, F.W., Jnr. fl.1842
London still-life painter. Exhib. one picture of fruit at SS 1842. His father, F.W. Andrew Snr., was a painter of dead game, fl.1826-7.

ANDREWS, C.W. fl.1865
Dorchester painter; recorded by Graves as exhibiting two pictures of the Philippines in 1865.

ANDREWS, Edward William fl.1860-1897
London landscape and portrait painter. Exhib. at RA 1875-97 (5), BI (1), SS (3), NWS and elsewhere. Titles at RA 'King's Lynn, Moonlight', portraits of John Ruskin and Cardinal Manning (etching).

ANDREWS, George Henry RWS 1816-1898
London landscape painter and watercolourist. Exhib. mostly at OWS; also at RA, BI and SS. Titles at RA 'The Gleaner', 'Somerleyton Hall', 'Northfleet Hope', etc. A watercolour by him is in the Laing AG, Newcastle.
Bibl: Bryan; VAM; Cundall; Hardie III p.80 (pl. 99).

***ANDREWS, Henry fl.1830-1860**
London genre and historical painter. Exhib. at RA 1830-58, BI and SS. Now best known for his imitations and adaptions of Watteau, whom he is also said to have forged. Redgrave says that "he fell into the hands of unscrupulous dealers". Although derivative, his Watteau-style pictures are popular for their decorative appeal.
Bibl: Redgrave, Dict

ANDREWS, James fl.1868
Portrait painter; exhib. one pic. at RA 1868. Lived at Maidenhead, Berkshire.

ANDREWS, John fl.1824-1870
London portrait painter. Exhib. at RA as an Honorary Exhibitor 1825-60, BI (12) and SS (2). Titles at RA all portraits, including one of George Hudson, the railway king (1846), and a few still-life subjects, e.g. 'A Bachelor's Desserts' (1847).

ANDREWS, John fl.1865-1888
Landscape painter. Exhib. at RA, NWS and elsewhere. RA exhibit a view in Wales. Lived in Wimbledon, London.

ANDREWS, R.H. fl.1854-1860
London painter of landscape and still-life. Exhib. one picture at RA in 1854, 'Garden of Somerleyton Hall', and five at BI. Titles at BI 'Goldborough Mill, Yorkshire', 'The Derwent Waters', etc., and still-lifes of fruit.

ANDREWS, T.H. fl.1850
London painter. Exhib. two pictures at BI 1850, in collaboration with Alfred Provis (q.v.).

ANDY, N. fl.1839
Exhib. one picture, 'The Barbican at Plymouth', at RA 1839.

ANELAY, Henry 1817-1883
Landscape painter; lived at Eyre Cottage, Blackheath. Exhib. mainly at SS, showing five works at the RA between 1858 and 1873. Some of the titles are coastal views, e.g. 'Coast near Fairlight' (1872); Ruskin commented on 'Anstey's Cove' (RA 1858) " . . . though not an altogether successful effort, is a most earnest one to render the mingling of transparency with reflection in pure and perfect sea".
Bibl: Ruskin, Academy Notes 1858; Staley p.175; Ormond I p.38.

***ANGELI, Baron Heinrich von 1840-c.1900**
Austrian born painter of portraits and historical subjects. Studied in Vienna and Düsseldorf. At first painted historical scenes, but changed to portrait painting, at which he enjoyed great success in the courts of Europe, particularly in Vienna, St. Petersburg and London. He painted a portrait of Queen Victoria in 1885, which led to other commissions, including one to paint for the Queen a portrait of Stanley, the African explorer. Exhib. six pictures at RA 1874-80, also at GG.
Bibl: See TB.

ANGELL, E. Frank fl.1873-1876
Landscape painter. Exhib. at SS and elsewhere. mostly watercolours. Lived at Bexley, Kent.

ANGELL, Frank fl.1889-1891
London landscape painter. Exhib. at SS, NWS and elsewhere.

ANGELL, Mrs. John b. 1847 fl.1875-1882
Flower painter and watercolourist. Specialised in small studies of fruit, flowers and birds in the manner of W. Henry Hunt, G. Clare and W. Cruickshank (qq.v.). Hunt regarded her as his successor. Exhib. at OWS, NWS, GG and at RA 1876-8. Sister of W.S. Coleman (q.v.).
Bibl: AJ 1884 p. 127; Clayton II p.261; Cundall;VAM: Hardie.

ANGELL, Miss Maude fl.1888-1916
London painter of flowers. Exhib. at RA, SS and NWS. Lived at Hendon, London.

ANGELL, T.W. fl.1848-1852
London landscape painter. Exhib. at RA, BI and SS. Title at RA 'Arnolphe, et voici, etc.'. At the BI he exhibited a scene from Walter Scott's *Wandering Willie*.

ANGUS, Miss Maria L. fl.1887-1910
London painter of domestic subjects. Exhib. at RA 1891-1910, SS, NWS and elsewhere. Titles at RA 'Out of Mischief', 'Playmates', 'An Amber Witch', etc.

ANKCORN, J. fl.1864-1868
London still-life painter. Exhib. at RA 1865-8, BI (8) and SS (5). Titles at RA all birds' nests with flowers, e.g. 'May and Bird's Nest' (1866).

ANNE, Marie fl.1851
Flower painter; exhib. one picture at RA 1851.

***ANSDELL, Richard RA 1815-1885**
Liverpool sporting and animal painter. Began studying painting in 1836; by 1840 he was exhibiting at the RA. Following the vogue for Highland subjects, he painted many Scottish subjects in the popular Landseer manner — stags in glens, moorland scenes, sheep-dipping, cattle, shooting parties, etc. He also painted battles and historical scenes. In 1856 he went to Spain with John Phillip (q.v.), and again in the following year by himself. Phillip and Ansdell collaborated on several Spanish pictures, and from this time many Spanish genre scenes and landscapes appear in Ansdell's work. He is also said to have often collaborated with Thomas Creswick and W.P. Frith (qq.v.). Exhib. at the RA 1840-85 (149 works) and BI. Elected ARA 1861. RA 1870. President of the Liverpool Academy 1845-6. Many of his pictures were engraved and became very popular. His studio sale was held at Christie's, 19 March 1886. Although best known for his Landseer-type works, some of Ansdell's large portrait groups, such as 'The Caledonian Coursing Club' sold at Christie's, 25 April, 1969, show him to have been an artist of considerable ability.
Bibl: Ruskin, Academy Notes 1857; AJ 1860 p.233; 1885 p.192; 1904 p.217; Clement & Hutton; Redgrave, Cent. p.85; Marillier pp.51-5 (pl. opp. p.52); Pavière, Sporting Painters (pl. 2); Maas pp.53, 83, 96; Wood, Panorama; cat. of exhib. at Richard Green and Malcolm Innes Galleries, London, 1985.

ANSELL, Miss Alice M. fl.1892
Landscape painter; lived at Wimbledon, London. Exhib. one picture, 'A Village Street, North Somerset', at SS 1892.

ANSELL, George fl.1879
London landscape; recorded by Graves as exhib. one picture in 1879.

ANTHONY, George Wilfrid 1800-1860
Landscape painter and art critic. Studied under Ralston in Manchester and Barber in Birmingham. Exhib. at RA 1831-2, BI and SS. Became a drawing master, and wrote for the *Guardian*. Cousin of Henry Mark Anthony (q.v.).
Bibl: AJ 1860 p.10 (obit).

***ANTHONY, Henry Mark 1817-1886**
Landscape painter, born in Manchester. Much influenced by the Barbizon painters Corot and Dupré, with whom he studied in Paris and Fontainebleau 1834-40. Later he settled in London where he was in contact with Ford Madox Brown (q.v.), Goodwin and other Pre-Raphaelites. Exhib. at the RA 1837-84, BI and SS. Travelled in France and Spain. As well as landscapes, he painted many small studies of trees, ponds and foliage. Cousin of George Wilfred Anthony (q.v.) .
Bibl T.M. Rees, *Welsh Painters*, 1911; W.M. Rossetti, *Some Reminiscences*, 1906 pp.140-2; Bryan; Clement & Hutton; exhib. cat. of the Leathart Collection, Laing AG, Newcastle, 1968.

ANTROBUS, A. Lizzie fl.1882
Flower painter; lived at New Oscott, Warwickshire. Exhib. one picture of flowers at SS 1882.

ANTROBUS, Edmund G. fl.1876-1877
London landscape painter; recorded by Graves as exhib. two pictures 1876-7.

APPIAN, Adolphe fl.1874-1881
London painter; recorded by Graves as exhib. thirteen works in London, mainly at Dudley Gallery.
Bibl: Brook-Hart.

APPLEBY, Ernest W. fl.1885-1907
London painter of portraits, figure subjects and landscapes. Exhib. at RA 1886-1907, SS, GG and elsewhere. Titles at RA 'Quiet Thoughts', 'Haymakers', 'The Rising Moon', and portraits, including one of Quintin Hogg (1892).

APPLETON, Miss Rosa fl.1888-1902
Manchester landscape painter. Exhib. impressionist-style landscapes in Manchester and Liverpool.

ARBOUIN, S. fl.1875-1877
Landscape painter. Exhib. two landscapes of France at RA 1875 and 1877.

ARBUTHNOT, George fl.1829-1854
London landscape painter. Exhib. two pictures. at RA in 1829 and 1835, but more regularly at BI. Titles at BI 'The Last Load', 'Scene in North Devon', etc., and views in France and on the Rhine.

ARCHER, Archibald fl.1810-1845
London painter of portraits and religious subjects. Exhib. at RA, BI and SS.

ARCHER, C. fl.1873
Birmingham flower painter. Exhib. one picture at SS 1873.

ARCHER, Edward fl.1884-1891
Landscape painter; lived at Great Malvern, Worcestershire. Exhib. at RA, GG, NG and elsewhere.

***ARCHER, James RSA 1823-1904**
Scottish painter of genre, portraits, landscapes and historical scenes (mostly medieval). Studied at the Trustees' Academy in Edinburgh under Sir William Allan (q.v.). At first painted chalk portraits; but in 1849 he exhib. his first historical picture 'The Last Supper' at the RSA. Elected ARSA 1850, RSA 1858. Exhib. at the RA 1840-1904 (108 works), BI and SS. About 1859 he began to paint a series of Arthurian subjects, e.g. 'La Morte d'Arthur', 'Sir Launcelot and Queen Guinevere', etc. which show Pre-Raphaelite influence. In 1862 he settled in London, and turned mainly to sentimental historical scenes and portraits. He was the first Victorian painter to do children's portraits in period costume. Often signed with monogram JA, punningly transfixed by an arrow.
Bibl: AJ 1871 pp. 97-99 (3 plates); Ruskin, Academy Notes 1875; Clement & Hutton; Caw pp.170-1; Maas, p.231 (pl. on p.256); Ormond, see index; Irwin p.306.

ARCHER, Miss Janet fl.1873-1916
London painter of landscape, animals and figure subjects. Also lived near Bushey. Exhib. at RA 1873-1916, SS, NWS and elsewhere. Titles at RA 'An Arab's Head', 'Feathered Friends', 'Port Isaac, Cornwall', etc.

ARCHER, John Wykeham RI 1808-1864
Engraver, watercolourist and antiquary. Born in Newcastle-on-Tyne, and sent to London to study with John Scott, an animal engraver. Worked as an engraver in Newcastle and Edinburgh, before returning to London, where he decided to take up watercolours. Exhib. regularly at NWS 1842-64, eventually becoming a member. He was best known for his topographical watercolours of old buildings, for which he received many commissions. He also illustrated himself several books, e.g. *Vestiges of Old London* 1851. His collection of drawings is now in the British Museum.
Bibl: AJ 1864 p.243 (obit.); Ottley; Binyon; Redgrave, Dict; VAM; DNB; Hardie; Hall.

ARCHER, J.S. fl.1850
Sporting painter. Exhib. one picture of a horse at RA 1850.

ARDEN, Edward fl.1881-1889
Landscape painter; lived at Ambleside in the Lake District. Exhib. at NWS, GG and elsewhere.

ARENDRUP, Madame b.1846 fl.1864-1878
(Miss Edith Courtauld)
Painter of landscape and religious subjects. Exhib. at RA first under her maiden name, and later as Madame Arendrup; also at BI, SS, and elsewhere. Titles at RA 'Daybreak on Mount Calvary', 'Nubian Captives in Egypt', etc., and also religious subjects. Miss Courtauld was the daughter of a partner in D. Courtauld & Co., the crêpe manufacturers, and began to paint at a very early age. She was helped and encouraged by J.R. Herbert and J.E. Hodgson (qq.v.), and had a studio in the garden of G.E. Hering (q.v.). In 1872 she visited Egypt, and in 1873 married Colonel Arendrup, a Danish officer serving in Egypt, who was killed in 1875. Thereafter Madame Arendrup continued to paint mainly in Egypt, exhibiting her work at the Dudley Gallery.
Bibl: Clayton II pp.10-20.

ARGENT, W. fl.1837
London painter; exhib. a view of St. Albans at RA 1837.

ARGLES, Alice fl.1880
Flower painter; lived at Stamford, Lincolnshire. Recorded by Graves as exhibiting one picture.

ARGYLL, George, 8th Duke of fl.1882
Exhib. a landscape at GG 1882. His wife, H.R.H. Princess Louise, was a sculptress and watercolourist, who exhib. regularly at London exhibitions, including RA, NWS, GG and NG.

ARKELL Laura fl.1887
Exhib. one picture at SS 1887; lived at Swindon, Wiltshire.

***ARMFIELD, George fl.1840-1875**
London painter of dogs, especially terriers chasing birds, cats or mice. Exhib. at RA 1840-62, BI and SS. Also painted landscapes, dead game birds and other wild animals. His small dog pictures often passed off as Landseer. Graves says his real name was Smith. An Edward Armfield also painted some similar dog pictures, and may have been related to George Armfield. See also George Armfield Smith.
Bibl: AJ 1859 p.121.

ARMITAGE, Alfred fl.1889-1892
Painter of flowers and animals. Exhib. at RA, SS and NG. Lived at Shipley, Yorkshire.

ARMITAGE, C. fl.1870-1872
London painter of rustic subjects. Exhib. two pictures, one of a French farmyard, at RA in 1870 and 1872.

ARMITAGE, C. Liddall fl.1891
London painter. Exhib. one picture, 'Ebb Tide', at SS in 1891.

ARMITAGE, Miss E. fl.1858
London painter of figure subjects. Exhib. one picture 'Retribution' at RA in 1858.

***ARMITAGE, Edward RA 1817-1896**
London painter of biblical and historical subjects and allegories. Pupil of Paul Delaroche in Paris and assisted him in the decoration of the hemicycle in the Ecole des Beaux-Arts. Won a £300 prize in the Westminster Hall Competition in 1843 for his 'Landing of Julius Caesar'. Executed two frescoes in the Houses of Parliament. In 1845 he won a £200 prize for his cartoon 'The Spirit of Religion'. In 1847 his 'Battle of Meanee' won a £500 prize and was bought by the Queen. Exhib. only at the RA 1848-93. In Rome 1849-51. Painted 'Inkerman' and 'Balaclava' after a visit to the Crimea during the Russian war. Other major works by him are 'Retribution', a large allegory in the Leeds Town Hall, and frescoes in Marylebone Parish Church and the St. Francis Chapel of the Roman Catholic church of St. John in Islington. Elected ARA 1867, RA 1872. His style is similar to that of Edwin Long (q.v.).
Bibl: AJ 1863 pp.177-80, 1896 p.220; Ruskin, Academy Notes 1875. Clement & Hutton; J.P. Richtel, *Pictures & Drawings Selected from the Work of E.A.,* 1897; DNB; T.S.R. Boase, *English Art 1800-1870* pp.210, 215-16, 291 (pl.900); Maas pp.22, 27; Ormond I pp.170, 305; Wood, Olympian Dreamers; Strong.

ARMITAGE, Thomas Liddall fl.1885-1891
London painter of domestic subjects. Exhib. one picture, 'When we were young', at RA 1891.

ARMITAGE, William fl.1848-1853
London painter of biblical subjects. Exhib. two pictures at BI in 1849 and 1852.

ARMITAGE, William J. fl.1889
London landscape painter. Exhib. one picture of Windsor Forest at RA 1889.

ARMOUR, George Denholm 1864-1949
Painter, watercolourist and illustrator of hunting subjects. Studied in Edinburgh at RSA schools; later moved to London and exhib. at RA 1884-1928, RSA and elsewhere. Also worked as an illustrator for *Punch, Tatler* and the *Graphic*. Later settled in Wiltshire, where he became very popular as a painter of horses, dogs and hunting scenes.

ARMSTEAD, Miss Charlotte W. fl.1886-1897
London painter of flowers and architectural subjects. Exhib. three pictures at RA 1886-97. Daughter of H.H. Armstead, the sculptor, and sister of Miss Lottie Armstead (q.v.).

ARMSTEAD, Miss Lottie fl.1885
London flower painter. Daughter of H.H. Armstead, the sculptor, and sister of Charlotte Armstead (q.v.). Exhib. two flower pictures at RA in 1885.

ARMSTRONG, Miss Elizabeth A. see FORBES, Mrs. Stanhope

ARMSTRONG, Miss Emily S. fl.1865-1872
London flower painter; recorded by Graves as exhibiting ten pictures 1865-72.

ARMSTRONG, Miss Fanny fl.1883-1890
Oxford landscape painter. Exhib. one watercolour, 'On the Stour, Canterbury', at SS 1883.

ARMSTRONG, John fl.1879-1882
Landscape painter; lived in Manchester and N. Wales. Exhib. three pictures at RA 1879-1882: 'The Rivulet', 'Autumn' and 'Whitby Harbour'.

***ARMSTRONG, Thomas 1835-1911**
Manchester decorative figure painter. Studied under Ary Scheffer in Paris and was one of the 'Paris Gang' in Du Maurier's novel *Trilby*

with Whistler, Poynter and T.R. Lamont (qq.v.). Unlike the other members of the group, Armstrong remained a lifelong friend of Du Maurier's. Exhib. at the RA 1865-77 and GG. Armstrong's decorative style and subjects similar in feeling to Albert Joseph Moore (q.v.). In addition to his easel pictures, he also painted several decorative schemes for interiors. In 1881 he was appointed Director of Art at the South Kensington Museum, and practically gave up painting.

Bibl: Clement & Hutton; T. Armstrong, A *Memoir*, 1912; Reynolds, VP pp.119, 123-4, 151, 194 (pl. 136); Maas, p.184; Leonée Ormond, *George Du Maurier*, 1969, see Index; Wood, Olympian Dreamers.

ARMYTAGE, Charles fl.1863-1874
London painter of figures and historical subjects, mainly in watercolour. Exhib. at SS and elsewhere.

ARNDT, F. fl.1885
London painter; exhib. one picture, 'A Capri Fruitseller', at RA 1885.

ARNOLD, Mrs. 1787-1867
(Miss Harriet Gouldsmith)
London landscape, portrait and genre painter. Exhib. at RA 1840-54 and BI. Subjects at RA: views around London, on the Thames and in Wales. One of the few 19th century woman painters to gain any distinction in landscape painting.

Bibl: AJ 1863 p.53; Clayton I p.397.

ARNOLD, Mrs. Edwin fl.1874-1885
London painter of still-life and domestic subjects, mostly in watercolour. Exhib. at SS, NWS and elsewhere.

ARNOLD, Harry fl.1877-1890
London painter of domestic subjects. Exhib. two pictures at RA in 1888 and 1889; also SS, NWS and elsewhere. Titles at RA: 'Waiting for Orders' and 'Imperative'.

ARNOTT, McLellan fl.1892
Scottish painter; lived in Dumfries. Exhib. one picture, 'Semiramis', at RA 1892.

ARONSON, Miss Meta fl.1883
London painter; exhib. one picture, 'Dressed for a Walk with Mama', at RA 1883.

ARROWSMITH, H. fl.1855
London painter. Exhib. one picture entitled 'Prosperity — Adversity, the Necessity for Life Insurance' at SS, 1855.

ARROWSMITH, Hannah F. fl.1867
London landscape painter; recorded by Graves as exhibiting one picture in 1867.

ARROWSMITH, H.J. fl.1864-1865
London painter of figure subjects. Exhib. three pictures at SS 1864-5.

ARTHUR, Reginald fl.1881-1896
London portrait and genre painter. Exhib. at RA (9), SS (2) and Walker Gallery. Titles: 'Princess Henry of Pless', 'The Death of Cleopatra', etc. Painted classical subjects in a style similar to Alma-Tadema.

ARTHUR, Robert fl.1879
London painter; recorded by Graves as exhibiting one 'domestic' subject in 1879.

ARTHUR, Miss Winifred fl.1889-1901
Painter of landscapes; lived in London and Liverpool. Exhib. four pictures at RA 1889-1901.

ARUNDALE, Francis Vyvyan Jago 1807-1853
London architect, topographical painter and traveller. Studied with Pugin. Travelled in the Middle East and spent many winters in Rome. Exhib. at RA 1830-52 and BI. Pictures all of buildings, classical ruins, temples, archaeological sites, etc. Published and illustrated several books on architecture. Married to a daughter of Frederick Pickersgill (q.v.).

Bibl: AJ 1854 p.50 (obit.); Redgrave, Dict; Binyon.

ARUNDLE, Miss Kate fl.1866
London landscape painter. Exhib. one picture 'Lane near Barking, Essex' at BI 1866.

ASCROFT, William fl.1858-1886
London landscape painter. Exhib. at RA 1859-86, BI and SS. Titles also include genre scenes, e.g. 'Thou Busy, Busy Bee', 'Is it a Hogarth?', etc.

ASH, Albert Edward fl.1880-1882
Birmingham landscape painter and watercolourist. Exhib. at RA and SS, mostly views on Cannock Chase, Staffordshire.

ASH, Miss Chrissie fl.1889-1899
London painter of figure subjects. Exhib. at RA and SS. Painted some pictures at Newlyn in Cornwall.

ASH, H. fl.1851-1858
London landscape painter. Exhib. three pictures at RA 1851-8, BI and SS. Titles at RA 'Evening', 'View near Oxford' and 'Rochester on the Medway'.

ASH, Thomas Morris fl.1881-1885
Birmingham landscape painter. Exhib. Welsh and other landscapes at SS and elsewhere.

ASHBURNER, G. fl.1881
London landscape painter; recorded by Graves as exhibiting one picture in 1881.

ASHBY, H. fl.1794-1855
London portrait painter. Exhib. regularly at RA 1794-1836, also at BI and SS.

ASHBY, H.P. fl.1835-1865
London landscape painter. Exhib. at RA 1835-65. Subjects all English views, especially around Wimbledon, where Ashby lived.

ASHBY, Robert fl.1855-1856
Recorded by Graves as exhibiting four pictures 1855-6; lived at Brentford, Essex.

ASHE, J.W.L. fl.1866-1884
London painter of coastal scenes. Exhib. at RA 1874-84, SS and elsewhere. Titles at RA all scenes on the Devon and Cornwall coasts.

Bibl: Brook-Hart.

ASHLEY, Alfred fl.1850-1853
London landscape painter; recorded by Graves as exhibiting seven pictures 1850-3.

ASHLEY, F.M. fl.1870-1877
London painter of figure subjects. Exhib. three pictures. at RA 1873-7; titles all of fisherfolk, e.g. 'Beating Nets' and 'At Newlyn, Cornwall'.

ASHLEY, J. fl.1822-1839
London painter of landscape and portraits. Exhib. at RA only 1822-39.

ASHMORE, Charles fl.1858-1870
Birmingham painter of domestic subjects. Exhib. one picture at RA in 1867 — 'Knuckle Down'; also at BI and SS.

ASHTON, Miss E. fl.1839-1840
London flower painter; exhib. three pictures at RA 1839-40.

ASHTON, G.A. fl.1868
London landscape painter. Exhib. one Welsh scene at RA 1868.

ASHTON, G.F. fl.1861-1871
London landscape painter. Exhib. at RA 1861-6, BI and SS. Titles at RA: 'The Time for Reflection', 'Windsor Castle', 'Sunshine and Shadow', etc.

ASHTON, G.R. fl.1874-1877
London animal painter. Exhib. at SS and elsewhere, mostly watercolours.

ASHTON, H. fl.1867-1870
Exhib. two pictures at RA in 1867 and 1870, one of Bombay Cotton Market. Lived at Prestwich.

ASHTON, Julian R. 1851-1942
London genre painter. Exhib. mainly at SS, also RA 1873-8. Titles at RA: 'Mother's Darling', 'Thinner she Might Have Been', etc. Went to Australia where he became a very well-known artist.

ASHWELL, Miss fl.1866
Exhib. two Italian subjects at SS 1866. Lived in London and Dieppe. Daughter of Mrs. Ashwell (q.v.).

ASHWELL, Mrs. fl.1866-1873
Exhib. Italian and other foreign subjects at SS 1866-73. Like her daughter, Miss Ashwell (q.v.), she lived in London, Dieppe and also Bath.

ASHWELL, Ellen fl.1877
London painter of figure subjects; recorded by Graves as exhibiting two pictures in 1877.

ASHWELL, Lawrence Tom fl.1883-1893
London landscape painter. Exhib. four pictures at RA 1889-90; more regularly at SS. Titles at RA: 'Waste Land', 'Low Land', 'On the Arun', etc.

ASHWORTH, Miss Susan A. fl.1874-1880
London painter. Exhib. two watercolours at SS in 1874, one of dead birds, the other a landscape.

ASKEW, Richard J. fl.1885-1887
Exhib. landscape watercolours at SS and NWS. Lived at Shere, near Guildford.

ASPINAL, George S. fl.1881-1885
Dorking landscape painter. Exhib. two pictures at RA 1883-4; also at SS, NWS and elsewhere. Titles at RA: 'The Oak and the Ash', and 'Primrose Time'.

ASPINWALL, Reginald ARCA 1858-1921
Lancaster landscape painter and watercolourist. Exhib. at RA 1884-1908, SS, NWS and elsewhere. Titles at RA: 'Craggy Heights, the Home of the Jackdaws', 'An Old World Town', 'A Romantic Pool on the Eden, Kirkby Stephen', etc.

ASPREY, Amelia fl.1885
Exhib. one picture 'Margaret' at RA 1885. Lived at Merton, London.

ASTON, Charles Reginald RI 1832-1908
Birmingham landscape painter and watercolourist. Exhib. at RA 1862-78, BI, SS and NWS. Subjects at RA: views in Wales, Cornwall and Italy.
Bibl: Brook-Hart.

ASTON, J. fl.1878
London painter; recorded by Graves as exhibiting one picture of 'figures' in 1878.

ASTON, Miss Lilias fl.1865
Birmingham flower painter; recorded by Graves as exhibiting one picture in 1865.

ATCHERLEY, Miss Ethel fl.1895-1897
Exhib. three rustic subjects at RA 1895-7. Lived at Eccles, Lancashire.

ATKINS, Miss Catherine J. fl.1871-c.1922
London genre painter. Exhib. at RA 1877-94, BI, OWS, NWS, GG and NG. Titles at RA: 'The Dowager', 'Happy Thoughts', 'Age is a Time of Peace', etc.
Bibl: The Year's Art 1880-97.

ATKINS, Edward M. fl.1894-1901
Exhib. four pictures and designs for friezes — all flowers — at RA 1894-1901. Listed by Graves as a decorator.

ATKINS, Miss Emmeline fl.1878-1885
London still-life painter. Exhib. one pic. at RA in 1885 — 'Clarissa'; also at SS, NWS and elsewhere.

ATKINSON, Miss Amy B. fl.1890-1916
London painter of domestic subjects. Exhib. at RA, SS and elsewhere. Titles: 'La Pastorella', etc.

ATKINSON, B.T. fl.1856
London landscape painter; exhib. two pictures at BI 1856.

ATKINSON, B.W. fl.1888
Exhib. one picture 'Flowing to the Sea' at RA 1888. Lived at Egremont, Cheshire.

ATKINSON, Charles fl.1879-1881
Exhib. portraits at GG and elsewhere 1879-81. Lived at Datchet, near Windsor.

ATKINSON, George Mounsey fl.1859-1877
London landscape and figure painter. Exhib. one picture at RA in 1859, 'An Arab Guard'; also at BI and SS. Titles at SS mostly of children and other figure subjects.

ATKINSON, George Mounsey Wheatley fl.1806-1884
Irish marine painter. Started life as a ship's carpenter; later held a naval post at Queenstown, Co. Cork. Exhib. at the RHA. A little known but very attractive marine artist.

ATKINSON, Herbert D. fl.1889
Exhib. one picture at SS 1889, entitled 'Relics of the Past'. Lived at Beckenham, Kent.

ATKINSON, J.M. fl.1885
London painter; exhib. one picture, 'The Domestic', at BI 1858.

ATKINSON, James 1780-1852
Persian scholar and amateur artist. Trained as a doctor, and occupied various posts in India and elsewhere in the East. Several pictures by him, including a self-portrait, are in the NPG.
Bibl: Ormond I, see index.

***ATKINSON, John 1863-1924**
Newcastle painter of animals, especially horses. Studied at Newcastle Art School and under Wilson Hepple (q.v.). Exhib. at RA, RSA and elsewhere. Also painted landscapes and beach scenes. After his death an exhibition of his work was held at the Art Gallery, Armstrong College, Newcastle. His watercolours of horse fairs and gypsies are remarkably similar to the early works of Sir A. Munnings.
Bibl: Hall.

ATKINSON, John Gunson fl.1849-1879
Prolific London landscape painter. Exhib. mainly at SS (108 works), also at BI and RA 1854-74. Titles at RA: mostly views in Wales and north of England.

ATKINSON, Miss Kate E. fl.1871-1872
Exhib. four watercolour landscapes at SS 1871-2. Lived in London.

ATKINSON, Miss Mary fl.1833-1839
Painter of birds. Exhib. one watercolour at SS 1833 and one oil at RA 1839. Lived in London.

ATKINSON, Robert 1863-1896
Painter and illustrator. Exhib. two pictures, 'The Chief's Daughter', etc. at RA 1891. Studied in Antwerp. Went to New Zealand and Australia for his health 1885-9. Returned to Leeds, then moved to Newlyn, Cornwall. Died in New Zealand. Works by him are in Leeds AG.

***ATKINSON, W.A. fl.1849-1867**
Little-known London genre and historical painter. Exhib. only a small number of works at the RA (1849-62), BI and SS. Now only known for one exceptional picture, 'The Upturned Barrow' (Reynolds, VS, pl. 65), but more of his work may come to light.
Bibl: Reynolds, VS pp. 26, 85 (pl. 65).

ATTLEE, Miss Della and Miss Kathleen Mabel fl.1886-1897
Dorking painters of flowers. Both exhib. at RA and SS, Miss Della 1886-97, Miss Kathleen 1886-94. Titles: all flowers, mostly azaleas and chrysanthemums.

AUBREY, H. fl.1879
London landscape painter. Exhib. one picture, 'At Set of Sun', at SS 1879.

AULD, John fl.1869-1910
London painter of figure subjects; lived in Blackheath. Exhib. at RA 1879-1910, SS and elsewhere. Titles at RA: 'A Wharf at Greenwich', 'The Little Port', etc.

AULD, Patrick C. fl.1850-1865
London landscape painter. Exhib. at RA 1850-5, BI, SS. Titles at RA: mainly Scottish views, e.g. 'Balmoral Castle', 'Lower Heath Pond, Hampstead'. Two watercolours by him are in Aberdeen AG.

***AUMONIER, James RI 1832-1911**
Painter of quiet pastoral landscapes and animals, in oil and watercolour. Born at Camberwell, London; studied drawing at the Birkbeck Institution, Marlborough House and South Kensington Schools. At first worked as a designer of printed calicoes, but about 1862 took up landscape painting under the influence of Lionel Smythe and W.L. Wyllie (qq.v.). Exhib. at RA from 1870, BI, SS, NWS, GG and NG. Member of the NEAC, ROI, RA. Awarded medals at many international exhibitions.
Bibl: Studio XX 1900 p.141.

AUMONIER, Miss Louisa fl.1868-1900
London flower painter. Exhib. at RA 1885-1900, SS, NWS and GG. Very little known; presumably related to James Aumonier (q.v.).

AUSTIN, Mrs. fl.1835-1838
Bristol portrait painter. Exhib. five portraits at RA in 1835 and 1838, and a watercolour at SS 1835.

AUSTIN, A.E. fl.1870-1871
London landscape painter. Exhib. two watercolours at SS 1870-1.

AUSTIN, Miss Emily fl.1879-1887
London flower painter. Exhib. one picture, 'The Last of the Season', at RA 1887.

AUSTIN, Miss F. Roberts fl.1886
London portrait painter; exhib. one picture at GG 1886. Graves notes that her name may be spelt Austen.

AUSTIN, Hubert J. fl.1887
Lancaster landscape painter. Exhib. one watercolour at NWS 1887.

AUSTIN, William fl.1848
London historical painter. Exhib. one picture of Guy Fawkes at SS 1848.

AUTY, Charles fl.1881-1887
London painter of domestic subjects. Exhib. four watercolours at SS 1881-6; also exhib. at NWS. A picture by him of Bispham Village is in Blackpool AG.

AVELING, H.J. fl.1839-1842
London painter of portraits and other figure subjects. Exhib. five pictures at SS, including one of a cricket match.

AYLING, Albert William RCA fl.1853-1892 d.1905
Landscape and portrait painter; lived in Chester and Liverpool. Exhib. at RA 1853-92, SS, NWS. Subjects: portraits, Welsh landscapes, fruit and occasional genre. Also painted watercolours.

AYLING, F. fl.1878
London portrait painter. Exhib. mainly at RA, also BI and SS, all portraits.

AYLING, J. fl.1823-1842
London portrait painter. Exhib. mainly at RA, also BI and SS, all portraits.

AYLMER, Thomas Brabazon fl.1834-1856
London landscape painter. Exhib. at RA 1838-55, BI, SS. Titles at RA: mostly continental views — Italy, Belgium and Germany.

AYRE, Miss Minnie fl.1886
London flower painter. Exhib. one picture at SS and one at NWS.

AYRES, H.M.E. fl.1873
London flower painter; exhib. one picture of azaleas at SS 1873.

AYRTON, Madame Annie fl.1878-1886
London painter of still-life and figure subjects; also lived in Paris, but continued to exhibit in London, at RA 1879-86 and elsewhere. Titles: 'A Corner of my Studio', 'Ancient Armour and Arms', 'In Possession', etc.

AYRTON, Oliver fl.1888-1889
Exhib. one picture, 'The Spring', at RA 1889 and one at GG. Paris address.

AZILE, B. fl.1861
Recorded by Graves as exhibiting four landscapes in 1861. Lived at Ventnor, Isle of Wight.

B

BABB, Miss Charlotte E. fl.1862-1885
London painter of genre and mythological subjects. Exhib. at BI, SS and elsewhere. Titles at SS 'Tired Out', 1863, and 'On Troy Walls', 1875.

BABB, John Staines fl.1870-1900
London painter of romantic landscapes and literary subjects; decorative artist. Exhib. 1870-1900; at the RA, 1872-1900: titles, 'One, midst the forest, etc.' 1872, and designs for friezes; at SS, 1874-6, and elsewhere.

BABCOCK, W.P. fl.1855
Exhib. 'Repose' at the RA, 1855. No address given.

BABER, J. fl.1839
Baber's 'Skating on the Serpentine', 1839, is in the London Museum. An architect 'J. Baber', fl.1806-12, is recorded in Graves *Dictionary*, but no painter of that name.
Bibl: J. Hayes, *Catalogue of Paintings in the London Museum*, No. 5.

BABINGTON, P. fl.1870-1871
Exhib. 'A Study' at SS, 1870-1. London address.

BACCANI, Miss Italia fl.1885
Exhib. a portrait at GG, 1885. London address.

BACCUNI, E. fl.1857
Exhib. 'Italian Beggars' at the RA, 1857. London address.

BACH, Edward fl.1874-1893
Painter of genre, portraits, fruit and still-life. Worked in Ireland; exhib. from a London address. Exhib at the RA, SS and also at the RHA. Titles at the RA, 'Simplicity', 1876, 'Sweet Seventeen', 1880, etc.

BACH, Franz fl.1880
Exhib. 'Restless Waves' at SS, 1880. London address.

BACH, Guido R. RI fl.1866 d.1905
Portrait and genre painter often of Italian village subjects. Exhib. from 1866, mainly at the RI, of which he was a member, and also at the RA, GG and elsewhere. Titles at the RA 'The Golden Age', 1880, and 'Feathered Friends', 1883.

BACH, William Henry fl.1829-1859
London painter of landscape, mostly subjects in Wales. Exhib. 1829-59, at the RA, SS, BI, NWS and elsewhere.

BACK, W.H. fl.1843-1845
London painter of landscape and coastal scenes who exhib. at SS 1843-5.

BACKHOUSE, Henry fl.1856
Exhib. a landscape at BI in 1856. London address.

BACKHOUSE, J. fl.1855
Exhib. a landscape at BI, 1855. London address.

BACKHOUSE, James Edward 1808-1879
Born at Darlington, Co. Durham, Backhouse became an etcher and painter in watercolours of seascapes, several of them being executed on the County Durham coastline near Sunderland. Exhib. at the NWS from 1886-91. He lived in Sunderland. The Backhouses were a well-known Darlington family.
Bibl: Hall.

BACKHOUSE, Mrs. Margaret b.1818 fl.1846-1882
(Miss Margaret Holden)
London painter of portraits and genre. Daughter of the Rev. H. Augustus Holden, Mrs. Backhouse was born at Summer Hill, near Birmingham. She went to school at Calais, and later went to study art in Paris under M. Troivaux and M. Grenier. On her return to London she went to Sass's Academy and later married. Exhib. from 1846-82 at the RA, SS, and elsewhere. Member of the Society of Lady Artists. Clayton notes that "her favourite subjects are graceful female figures, often beautiful Italian or Swiss girls, picturesque gipsy children, gleaners, beggars and cottagers". Many of her pictures were issued as chromo-lithographs by Messrs. Rowney.
Bibl: Clayton II pp. 21-9.

BACKHOUSE, Miss Mary fl.1869-1880
(Mrs. W.E. Miller)
London painter of portraits and genre. Daughter of Mrs. Margaret Backhouse (q.v.). Exhib. 1869-80, at the RA, SS and elsewhere. Titles at SS, 'In a cloud', 1871, 'Sweet Seventeen' 1880, etc. See also Mrs. W.E. Miller.

BACKSHELL, W. fl.1848
Painter of sporting subjects and genre. Exhib. at SS 1848. Titles 'Lace making' and 'Rustic Study'.
Bibl: Pavière, Sporting Painters.

BACON, D'Arcy fl.1855-1874
London painter of landscape and animal subjects. Exhib. 1855-74 at the RA, BI, SS and elsewhere. Title at the RA, 'Evening in the Highlands', 1855.

BACON, H.D. fl.1861
Exhib. one picture in 1861. Pavière lists him as a sporting painter.
Bibl: Pavière, Sporting Painters.

BACON, H.M. fl.1864
Exhib. an historical subject at BI, 1864. London address.

BACON, Miss H.M. fl.1862
Exhib. two paintings of fruit at BI, 1862. London address

***BACON, John Henry F. ARA 1868-1914**
London domestic and genre painter. Exhib. at RA from 1889. Titles at RA mostly romantic — 'A Confession of Love', etc. Occasionally painted portraits. Sometimes signed J.H.F.B. His best known work is 'The City of London Imperial Volunteers Retum to London from South Africa on Monday 29 October 1900' in the Guildhall, London. His studio sale was held at Christie's 27 April 1914. 'The Coronation of King George V and Queen Mary, 1911' is in Buckingham Palace.
Bibl: Studio XXII, XXIII, XXV (illus.); Wood, Panorama pl.84 ('The Wedding Morning').

BACON, J.P. fl.1865-1867
Exhib.landscapes from 1865-7 at the BI. Stoke-on-Trent address.

BACON, T. fl.1844-1845
Painter of landscapes and architectural subjects; architect. Exhib. 'Ancient Foot Bridge over the Mugnoni Torrent, near the ruined city of Fiesoli, Italy — The first fall of snow', at the RA, 1844, and 'Florence, from the fortress, Belvedere' at the SS, 1845. Florence and London addresses. FSA; FRAS.
Bibl: Cat. of the Trafalgar Galleries, London, *The Victorian Painter Abroad.* 1965, reprd. Nos. 1 and 2.

BACON, W.E. fl.1883
Exhib. 'Woodlands' at the RA, 1883. Address Bettws-y-Coed, N. Wales.

BADCOCK, Miss Isabel fl.1886-1889
Painter of architectural subjects. Exhib. from 1886-9 at SS and NWS. Title at SS, 'Interior: Norton Hall, Stockton on Tees', 1886. Ripon address.

BADCOCK, Miss K.S. fl.1889
Exhib. 'Sketch of Daisy' at SS, 1889. Ripon address.

BADCOCK, Miss Leigh fl.1887-1893
Painter of architectural subjects, landscape and flowers. Exhib. from 1887-93 at SS and NWS. Norwood address.

BADEN-POWELL, Frank Smyth 1850-1933
London painter of landscapes, marines and battle subjects; sculptor; barrister-at-law. Born at Oxford, elder brother of Lord Baden-Powell. Called to the Bar, Inner Temple, 1883. Studied art in Paris — painting under Carolus Duran and sculpture under Rodin. Exhib. from 1880, at the RA, GG, Paris Salons and elsewhere. Titles at the RA, 'Bodekessel, Harz', 1880, 'Trafalgar Refought', 1881, and 'The Admiral's Daughter Outward Bound', 1896. Travelled round the world 1902-3 and again 1908-9. See also F.S. Baden Powell.
Bibl: Who's Who 1908.

BADHAM, Edward Leslie RI ROI RBA 1873-1944
Landscape, coastal and marine painter in oil and watercolour. Born in London, he studied art at Clapham School of Art, South Kensington and the Slade School. For much of his life he lived in St. Leonard's-on-Sea and Hastings, Sussex, and taught at the Hastings School of Art. He worked in and around Hastings and other Sussex coastal towns. Exhib. 1898-1943 at the RA: titles 'Wind and Rain', 1898, 'The Old Mill', 1901. He and his daughter were killed during the war by a bomb from an enemy aircraft.

BAERTSOEN, Albert fl.1890-1891
Exhib. two river scenes at the SS, 1890-1. Titles 'On the Thames' and 'Low Tide'.

BAGGE-SCOTT, Robert 1849-1925
Landscape and marine painter. Born in Norwich. After a career in the Merchant Navy, he resigned his commission so as to concentrate on painting. He painted many scenes in Norfolk and also on the Continent. Exhib. at the RA from 1886. Lived at Norwich and St. Olaves, and was for twenty-five years President of the Norwich Arts Circle. Many of his works are in the Norwich Castle Museum.

BAGSHAW, Joseph Richard RBA 1870-1909
Marine painter, living in London and Whitby, Yorkshire. Exhib. at the RA from 1897 and at SS, of which he was a member.
Bibl: P. Phillips, *The Staithes Group,* 1933.

BAIGENT, R. fl.1843-1846
Winchester landscape painter. Exhib. from 1843-6 at SS, mostly landscapes near Winchester, Hampshire.

BAILDON, W.A . fl.1824-1841
London landscape painter. Exhib. from 1824-41 at the RA, BI and SS.

BAILEY, Albert E. fl.1890-1904
Landscape painter, lived at Northampton and Leicester. Exhib. at the RA from 1890, subjects mainly idyllic and evening landscapes.

BAILEY, Arthur fl.1884-1885
Exhib. two paintings at SS, 1884-5. Titles 'The Lone Shore' and 'A Salmon Pool'. London address.

BAILEY, Miss Elizabeth fl.1862-1874
Painter of genre and portraits. Exhib. from 1862-74 at SS and elsewhere. Titles at SS include 'The Glow-worm's Retreat'. London address.

BAILEY, Henry fl.1879-1907
London landscape and genre painter. Also lived in Chelmsford. Exhibited at RA and SS from 1879. Titles 'The Dart near Staverton', 'Cornfield by the Sea', 'On the Cliffs', etc.

BAILEY, R.H. fl.1848-1876
London landscape painter. Exhib. at SS 1848-76.

BAILEY, William H. fl.1879-1881
Exhib. a view of 'An Old Back Yard' at SS, 1881, and three paintings elsewhere. Cookham address.

BAILLIE, Miss Caroline fl.1872
Exhib. two paintings of flowers at various galleries in London (Graves Dictionary). Brighton address.

BAILWARD, Miss M.B. **fl.1889-1891**
London landscape painter. Exhib. 1889-91 at the RA, SS, NWS, GG and NG.

BAILY, R.H. **fl.1843-1847**
London painter of fruit and landscape. Exhib. at the RA 1843-7. Titles 'Fruit and Flowers', 1845, 'Seale Force between Buttermere and Crummock', 1847, etc.

BAILY, R.M. **fl.1874**
Exhib. one landscape in London in 1874 (Graves Dict.).

BAINBRIDGE, Arthur **fl.1884**
Exhib. two landscapes at the NWS in 1884. Torquay address.

BAINES, B. Cooper **fl.1881**
Exhib. a flower painting in London in 1881. London address. (Graves Dictionary).

BAINES, Henry **1823-1894**
Exhib. a landscape at BI, 1851. London address. A portrait drawing of William Etty, d. 1847, is in King's Lynn Museum and Art Gallery, Norfolk, where Baines worked as a drawing master.
Bibl: Ormond p. 165.

BAIRD, John Foster **fl.1866-1874**
Exhib. landscapes in London, 1866-74. Teddington address. (Graves Dictionary).

BAIRD, Nathaniel Hughes John **ROI** **b.1865 fl.1883-1935**
Painter of landscapes, portraits, pastoral scenes and genre. Born at Yetholm in Roxburghshire; studied art in Edinburgh, London and France. Exhib. from 1883 at the RA, SS and ROI. Titles at the RA include 'Golden Days', and 'The Heart of merry England'. Lived in Dawlish, Exeter, Lewes, Henley and Rodmell, Sussex. Elected ROI in 1897.

BAIRD, William Baptiste **fl.1872-1899**
London domestic genre painter. Born in Chicago; exhibited in Paris, and at the RA 1877-99. Titles at RA mostly family scenes — 'The Cares of a Family', 'The Cottage Door', etc.

BAKER, Alfred **1850-1872**
Birmingham landscape painter, son of S.H. Baker (q.v.). Studied art under his father and at the Birmingham School of Art. Exhibited mainly at Birmingham Society, showing only four works at SS in London. Subjects largely open-air landscapes in the Midlands and N. Wales.
Bibl: Birmingham Cat.

BAKER, Alfred Rawlings **b.1865 fl.1885-1923**
Painter in oil and watercolour of portraits, landscape and coastal scenes. Born in Southampton. Studied at Hartley School of Art in Southampton and in Paris at the Académie Julian. Exhlb. 1885-1923, at the RA (1889-1923), SS and RI. Titles at the RA, 'Fair weather — entrance to Dartmouth Harbour', 1889, 'The Mill at Twilight', 1898, etc. Lived in Southampton and from 1891 in Belfast.

BAKER, Miss Alice E.J. **fl.1876-1882**
Exhib. portraits at the RA and elsewhere from 1876-82. London address.

BAKER, Miss Annette **fl.1890-1898**
(Mrs. W.D. Gloag)
London flower painter. Exhib from 1890-8 at the RA (1893-8), SS and elsewhere.

BAKER, Arthur **fl.1864-1889**
London painter of sporting and cattle subjects in oil and watercolours. Exhib. from 1864-89 at the RA (1867 and 1870), BI, SS and elsewhere. Titles 'Highland Cattle', RA 1867, and 'Breaking cover', SS 1889.

BAKER, Miss Blanche **1844-1929**
Bristol landscape painter. Exhibited at RA 1869-1901 and SS. Titles 'Lingering Twilight', 'The Evening Tide', 'The Forester's Garden', etc.

BAKER, E. **fl.1857-1858**
Landscape painter. Exhib. from 1857-8 at the RA and BI. London and Sudbury addresses. Titles 'On the Stour, near Sudbury' RA, 1858,

BAKER, Miss Evangeline **fl.1889-1893**
London painter of landscape and genre. Exhib. from 1889-93 at SS, titles including 'A Life of Honest Toil', 1891.

BAKER, Miss F. **fl.1840-1841**
Southampton painter of fruit, who exhibited from 1840-1 at SS.

BAKER, Frederick W. **fl.1850-1874**
London painter of landscape. Exhib. from 1850-74 at the RA (1850-68), Bl, SS and elsewhere. Titles include many subjects in N. Wales.

BAKER, Frederick W., Jnr. **fl.1873-1893**
London painter of coastal scenes and landscape, the subjects mainly on the English south coast. Exhib. from 1873-93, at the RA (1881-93), SS, NWS and elsewhere. Titles at the RA mainly of coastal scenes, 'On the Shore, Studland, Dorset', etc.

BAKER, George Arnald **fl.1861-1867**
Painter of 'scriptural' subjects. Exhib. at the BI and SS in 1861 and 1867. Title at SS 'Industry and Idleness'. Chelsea address.

BAKER, G.H. Massy see MASSY-BAKER, G.H.

BAKER, Henry **1849-1875**
Birmingham landscape painter, known as 'Harry' Baker. Eldest son of S.H. Baker (q.v.), and brother of Alfred Baker (q.v.). Studied in his father's studio. Did not exhibit at the RA; only at SS and the Birmingham Society. Subjects mostly landscapes in N. Wales, Devon and Ludlow. Often signed HB in monogram.
Bibl: Birmingham Cat.

BAKER, J. **fl.1841-1851**
Exhib. landscapes and cottage scenes at the SS from 1841-51. Woolwich address.

BAKER, Miss L.H. **fl.1843**
Exhib. a painting of fruit at the RA in 1843. No address given.

***BAKER, Oliver** **RBSA, RCA** **1856-1939**
Birmingham painter and etcher of landscapes and architectural subjects; silver designer. Born in Birmingham, son of Samuel Henry Baker (q.v.). Studied art under his father and at the

Birmingham School of Art. Exhib. from 1875 at the RA, SS, NWS, NG and elsewhere — his subjects all landscapes. Took up etching in 1880, and in 1881 elected a member of the Royal Society of Painter-Etchers and Engravers. Elected a member of the RBSA 1884, and of the RCA 1908. From 1887 he worked mainly in watercolour. He was interested in old buildings and published *The Moated Houses of Warwickshire*. He also designed silver, and much of his work was manufactured by Liberty & Co.

Bibl: Studio XIX 1900 pp.122-9; XX 1901 p.125; XXXII 1904 p.345; Winter No. 1901-2; Summer No. 1902; Who's Who 1908.

BAKER, Richard b.1822 fl.1843-1854
Irish painter of dead game and landscape. Born in England, son of Benjamin Baker, a military surveyor. Exhib. at the RHA from 1843-1854.

Bibl: Pavière, Landscape.

***BAKER, Samuel Henry RBSA 1824-1909**
Birmingham landscape painter and watercolourist. Worked first with a magic lantern slide painter; then studied at the Birmingham School of Design, the Birmingham Society, and with J.P. Pettitt (q.v.). Exhib. from 1848 at the RBSA, of which he became a member in 1868, and later trustee and treasurer. Also exhib. at the RA 1875-96, and at SS. Subjects mainly North Wales and Midlands. Shared Cox's reverence for the Welsh countryside, but employed a stipple technique foreign to Cox's vigorous and free brushwork. Often signed with the initials S.H.B. His three sons, Alfred, Henry and Oliver B. (qq.v.), all artists, and also his brother.

Bibl: Birmingham Cat.

BAKER, Sidney fl.1881-1883
London landscape painter. Exhib from 1881-3 at SS and elsewhere.

BAKER, S.J. fl.1855
Birmingham landscape painter, who exhib. at the RA in 1855.

***BAKER, Thomas 1809-1869**
Midlands landscape painter and watercolourist, known as Baker of Leamington. Exhib. at the RA in 1831, 1847 and 1858, but more frequently at the BI and RBSA. Best-known and probably the most accomplished painter of the numerous Baker family of artists. Subjects mainly landscapes in Warwickshire and the Midlands, with sheep and cattle. His diaries and notes, which contain a complete list of his works, are in the Birmingham City Art Gallery. Usually signed T. BAKER and numbered each picture on the back.

Bibl: Binyon; RBSA Retrospective exhib. cat., 1968.

BAKER, Thomas fl.1872-1882
Painter of fruit. Exhib. 1872-82 at the RA (1882), SS and elsewhere. London and Weymouth addresses.

BAKER, W. fl.1859-1866
London painter of genre, landscape and portraits. Exhib. 1859-66 at the RA (1859-64) and SS. Titles at the RA 'A happy little boy', 1859, and 'Bridge of the Mersey', 1864.

BAKER, W., Jnr. fl.1839
Exhib. 'A Country girl' at the RA in 1839. London address.

BAKER, William fl.1825-1847
London painter of still life. Exhib. at BI and SS 1825-47.

BAKER, W.J. fl.1840-1855
London landscape painter. Exhib. 1840-55 at the RA, BI and SS.

BAKER, W.M. fl.1826-1843
London painter of portraits, genre, still-life and dead game. Exhib. 1826-43 at the RA (1827-33), BI and SS. Also exhib. in Birmingham.

BAKEWELL, Miss Esther M. fl.1889-1891
London painter of landscape and architectural subjects. Exhib. 1889-91 at the RA and SS. Titles at the RA, 'The Court of the Bargello, Florence', 1889, and 'Sunshine and Shade', 1891.

BAKEWELL, Miss H. fl.1877-1893
London flower painter. Exhib. 1877-93 at the NWS and elsewhere.

BALDINI, T. fl.1871
Exhib. 'Connoisseurs' at RA in 1871. No address given.

BALDOCK, Charles E. fl.1900
Painter of sporting subjects. Exhib. 'Hard Pressed — S. Notts. Hounds' at the RA, 1900. Nottingham address.

BALDOCK, James Walsham fl.1867-1887
Worksop animal and sporting painter. Exhib. at SS and NWS. Subjects mainly cows, but also painted horses and hunting scenes in a style derived from J.F. Herring Snr. (q.v.).

Bibl: Pavière, Sporting Painters p.14 (pl.3).

BALDREY, Samuel H. fl.1897-1899
London painter of landscape and coastal scenes. Exhib. 1897-9 at the RA. Titles 'Sand-dunes — Bois des Sapins, Camiers' and 'Fir, Sand, and Ragwort'.

BALDRY, Alfred Lys 1858-1939
Painter in oil and watercolours of landscape and portraits; writer and art critic. Born at Torquay. Educated at Oxford University. Studied art at the RCA and in the studio of Albert Moore for four years. Exhib. from 1885 at SS and elsewhere. Art critic of the *Globe* 1893-1908 and later of the *Birmingham Daily Post*. Author of *Albert Moore: His Life and Works*, 1894; *The Life and Works of Marcus Stone*, 1896, *G.H. Boughton*, 1904, *The Practice of Watercolour Painting*, 1911, etc. The *Studio*, 1906, notes in a review of a current exhibition of his works: "His well-known admiration for the works of Albert Moore manifested itself in some of the figure subjects, as it has often done in his writings". He also worked in pastels and was a member of the Pastel Society. Lived for a time at Marlow, Buckinghamshire.

Bibl: Studio XXXVII 1906 p.154; Who's Who 1908.

BALDRY, Miss Grace fl.1897
Exhib. 'Judith' at the RA, 1897. London address.

BALDRY, Harry fl.1887-1890
London painter of portraits. Exhib. 1887-90 at the RA, NWS and GG.

BALDWIN, Archibald fl.1896-1900
Exhib. landscapes and river scenes at the RA in 1896 and 1900. Manchester and Upper Walmer addresses.

BALDWIN, B. fl.1841-1845
London portrait painter. Exhib. 1842-5 at the RA. A watercolour portrait of Sir James Abbott in Afghan costume, dated 1841, is in the NPG.
Bibl: Ormond p. 1.

BALDWIN, Henry C. fl.1898
Exhib. 'Purple Islands in an opal Sea' at the RA, 1898. London address.

BALDWIN, J. fl.1844
Exhib. 'The Recruits' Departure' at the SS in 1844. London address.

BALDWIN, Samuel fl.1843-1858
Little known Halifax genre painter, who exhibited at SS 1843-58. Almost his only known work is 'Sketching Nature' reprd. in Maas, who notes "he combined a Ruskinian eye for landscape with figure painting".
Bibl: Maas p.238 (pl. on p.244).

BALDWYN, Charles H.C. fl.1887-1905
Worcester painter of birds, rustic genre, landscape, still life and flowers, in oil and watercolour. Exhib. 1887-1905, at the RA, SS and NWS. Titles at the RA 'A Study of Teasels', 1887, 'In Haunts of Bloom and Bird', 1903, etc.

***BALE, Charles Thomas fl.1868-1875**
London still-life painter. Exhib. at the RA in 1872, and at SS. Subjects mainly fruit and flowers, painted in a style derived from George Lance and William Duffield (qq.v.). Also painted figurative subjects, which suggests he may be the same as T.C. Bale (q.v.).

BALE, Edwin RI ROI 1838-1923
London painter of genre, landscape and flowers. Studied at the S. Kensington Schools and at the Academy in Florence. Exhib. from 1867, at the RA (from 1870), NWS, GG and elsewhere. Titles at RA, 'Battledore', 'The Love Letter', etc. A of RI in 1876 and RI in 1879. From 1882 he was art director to Cassell & Co. Ltd., and was the first Chairman of the Imperial Arts League.
Bibl: Who's Who 1908; VAM.

BALE, J.E. fl.1855-1859
Painter of landscape and topographical subjects. Exhib. 1855-9, at the RA, BI and SS, titles mainly interior views of churches and street scenes. Lived in London and Tunbridge Wells, Kent.

BALE, T.C. fl.1868-1873
Exhib. genre subjects at SS 1868-73. Titles 'The Repose', 'The Broken Pitcher', etc. London addresses.

BALFOUR, J. Lawson fl.1892-1899
Painter of genre. Exhib. 1892-9 at SS, NWS and the RA. Titles at the SS, 'Fagged Out' and 'In a Fix'. London and Bangor, Co. Down, addresses.

BALL, Arthur E. fl.1876-1885
Painter and etcher of landscape, genre and flowers, living in Putney and Richmond, Surrey. Brother of W.W. Ball (q.v.). Exhib.1876-85, at the RA (1880-5), SS and elsewhere. Titles at the RA, 'Red House Farm, Godalming', 1884, and 'Sunset — Returning to the Fold', 1885.

BALL, A.J.F. (V.) fl.1872-1873
Exhib. two paintings of genre at SS, 1872-3: titles, 'The Valentine' and 'The First Letter Home'. London address.

BALL, G. Meyer fl.1899
Exhib. 'Mr. B; a portrait' at the RA, 1899. Address Windsor, Berkshire.

BALL, Wilfrid Williams 1853-1917
London landscape and marine painter, etcher and watercolourist; lived in Putney. Exhibited at the RA 1877-1903 (mainly etchings), also at SS, NWS and GG. Many of his paintings and etchings were views on the Thames in the style of Whistler. Also travelled in Holland, Germany, Italy and Egypt.
Bibl: AJ 1905 p.219; Studio XVI p.3 ff. (mono. with illus.); XXXI pp.72-3; Hardie III p.82.

BALLANTYNE, Miss Edith fl.1866-1887
Painter of portraits and genre who lived in London, and from 1884 in Melksham, Wiltshire. Exhib. 1866-84 at the RA, SS and elsewhere, and twice in 1887 at the RSA. Titles at the RA 'The Last New Novel', 1882, and 'Afternoon Tea', 1878.

***BALLANTYNE, John RSA 1815-1897**
Scottish portrait and historical genre painter. Studied in Edinburgh; came to London 1832. Exhib. at the RA 1835-83. Teacher at the Trustees' Academy. Specialised in portraits of artists in their studios. The NPG has one of Sir Edwin Landseer at work on the lions in Trafalgar Square. The whole series was exhib. at H. Graves & Co., Pall Mall, November 1866. Also exhib. at RSA 1831-87. Elected ARSA 1841, RSA 1860.
Bibl: NPG Cat. 1903; Caw pp.230-1; E. Quayle, *Ballantyne the Brave*, 1967; Ormond I see index, II pl.500; Irwin p.306; Wood, Pre-Raphaelites.

BALLARD, Miss Alice E. fl.1897
Exhib. a portrait and 'A Little Ghost' at the RA, 1897. High Barnet address.

BALLARD, Thomas 1836-1908
London genre painter. Exhib. at RA 1865-77, BI and SS. Titles at RA 'Going Marketing', 'Expecting Friends', 'The New Governess', etc.
Bibl: Wood, Panorama p.131 (pl.134).

BALL-HUGHES, Miss Georgina fl.1889
Exhib. a portrait at RA, 1889. Hampstead address.

BALLINGALL, Alexander fl.1883
Edinburgh painter of marines and coastal scenes. Exhib. one genre painting at NWS in 1883. Caw notes: "The marines and shorepieces of Messrs. J.D. Taylor, Andrew Black, John Nesbitt, J.D. Bell, Alexander Ballingall, and one or two more of somewhat similar age and standing, if unaffected in feeling, possess no qualities of technique or emotion calling for comment . . ."
Bibl: Caw p.331.

BALMER, George 1805-1846
Newcastle landscape and marine painter and watercolourist. Worked in North Shields, exhibiting at the Blackett St. Academy in Newcastle. Friend and rival of J.W. Carmichael (q.v.), with whom he collaborated on several pictures. Toured the Continent, visiting Holland, Germany and Switzerland, after which he settled in London. In 1836 he started work on *The Ports, Harbours, Watering Places and Coast Scenery of Great Britain* which contained

engravings of some of his best drawings, but was never completed. The first volume appeared in 1842. He also exhib. rural and architectural subjects 1830-41 at the BI and SS, Balmer's watercolours are often attributed to the better-known and more expensive Charles Bentley (q.v.).
Bibl: AU 1846 pp.280-1 (obit.); Binyon; DNB; Hardie III p.78 (pl. 95); Hall.

BALSHAW, Fred fl.1896-1905
Painter of landscape and genre. Exhib. 1896-1905 at the RA, titles 'Moor and Stream', 1896, and 'A Lancashire Moulding Shop', 1905. Manchester and Bolton addresses.

BALSON, A. fl.1840
Exhib. a view of 'The Bourse at Caen' at the RA, 1840. Limehouse address.

BAMBRIDGE, Arthur L. fl.1891-1893
London portrait painter. Exhib. 1891-3 at the RA and elsewhere.

BAMFORD, Alfred Bennett fl.1880-1913
Painter of architectural subjects, still life and genre, living in Romford, Essex, and London. Exhib. 1880-1913 at the RA, SS, NWS and elsewhere. Titles at the RA, 'Chapel of St. Nicholas, Westminster', 1886, 'Light Refreshment', 1904, etc.

BAMPIANI R. fl.1879
Exhib. 'Algie and Leila' at the RA, 1879. Tenby address.

BANCROFT, Elias Mollineaux RCA fl.1869-1893 d.1924
Manchester landscape painter; also worked in London, exhib. at the RA from 1874. Subjects mainly views in Wales, Germany and Switzerland. President and later Secretary of the Manchester Academy of Fine Arts.
Bibl: Manchester Guardian 23 April 1924 (obit.).

BANES, Frederick Mathias fl.1881
Exhib. 'Simplicity' at the RA, 1881. London address.

BANKS, Miss fl.1865-1869
Painter of genre, who exhib. 1865-9 at the RA. Titles 'At the Turret Window', 1865, 'The Trysting Place', 1867, etc. Address Shepherd's Bush, London.

BANKS, Miss Catherine fl.1869-1874
Exhib. two paintings of flowers and genre at SS, 1869-74: titles 'Edith's Canoe', etc. London address.

BANKS, Edmund G. fl.1889-1890
Exhib. a view 'Near Martello Tower, Rye' at the RA, 1889, and two landscapes at the NWS, 1889-90. London address.

***BANKS, J.O. fl.1856-1873**
London painter of rustic genre. Exhib. at RA 1856-73. Subjects usually pretty girls and children in landscapes.

BANKS, T. fl.1864
Landscape painter who exhib. at SS, 1864. London address.

BANKS, Thomas J. fl.1860-1880
York landscape painter. Exhibited 26 works between 1860 and 1874 at SS and BI. Another York artist, Thomas J. Banks, is also recorded as a landscape painter, and is probably of the same family.

BANKS, William fl.1877-1879
Landscape painter who exhib. 1877-9 at SS. Hammersmith address.

BANKS, William Lawrence RCA FSA fl.1856-1880
Landscape painter, who exhib. 1856-80 at SS and elsewhere. Llanfairpwllgwngyll, Anglesey, address.

BANNATYNE, John James RSW 1836-1911
London landscape painter and watercolourist. Exhib. at the RA 1869-86, also at SS and NWS. Subjects mostly views of Scottish lochs.

BANNER, Joseph fl.1860-1871
Birmingham painter of fruit, genre and birds' nests. Exhib. 1860-71 at BI and SS.

BANNERMAN, Mrs. Frances fl.1888-1891
Painter of genre, living in Great Marlow. Wife of Hamlet Bannerman (q.v.). Exhib. 1888-91 at the RA and SS. Titles at the RA 'Marlow Regatta Course', 1890, and 'Grandmother's Treasures', 1891.

BANNERMAN, Hamlet fl.1879-1891
Painter of landscape and genre, living in London and Great Marlow. Exhib. 1879-91, at the RA (1882-91), SS and elsewhere. Titles at the RA 'The Chestnut Harvest', 1885, and 'A Case for the Hospital', 1889.

BANNISTER, C.E. fl.1864
Exhib. a landscape at BI, 1864. London address.

BARBASON, M. fl.1888
Exhib. a genre painting at SS, 1888. London address.

BARBELLA, C. fl.1878
Exhib. 'La Seduzione' at the RA, 1878, and one elsewhere. Address c/o J.B. Burgess, London.

BARBER, Alfred Richardson fl.1879-1893
Colchester painter of landscape, animals and game. Exhib. 1879-93 at SS and elsewhere. Titles: 'Rabbits and Partridge', 1879, and 'Helping Themselves', 1884.

***BARBER, Charles Burton 1845-1894**
London sporting and animal painter. Exhib. at the RA 1866-93 and SS. Specialised in portraits of dogs, often with children. Painted Queen Victoria with her dogs, and many other royal dogs e.g. 'Fozzy', the Prince of Wales's dog.
Bibl: H. Furniss, *The Works of C.B.B.*, 1896.

BARBER, Charles Vincent 1784-1854
Birmingham landscape painter and watercolourist. Eldest son and pupil of Joseph Barber (1758-1811), the teacher of David Cox. One of the founders of the first Society of Birmingham Artists in 1809, which developed into the Birmingham Academy of Arts, Barber was a friend of David Cox and accompanied him on sketching tours in Wales. By 1818 he was working in Liverpool as a drawing master and was exhibiting at the Liverpool Academy by 1822. He later became its treasurer, secretary and president (1847-53). Exhib. at the RA in 1829 and 1849, also at SS and the OWS.
Bibl: AJ 1854 p.50 (obit.); Hardie II p.192; *Cat. of Early English Watercolours and Drawings in Walker Art Gallery*, Liverpool, 1968.

BARBER, Joseph Moseley fl.1858-1889
Leicester landscape and genre painter. Worked in Birmingham, later in Chelsea. Exhib. at RA 1864-78, also at SS. and BI. Subjects mostly rustic genre 'Granddad's Darling', 'Cottage Pets', etc. Not to be confused with Joseph Vincent Barber (1788-1830) or his father Joseph Barber (1758-1811), teacher of David Cox.
Bibl: AJ 1859 p.121; Roget I pp.331-2.

BARBER, J.S. fl.1840-1857
Exhib. 'Belphoebe finding Timias' at the RA, 1840 and one elsewhere in 1857. No address given. Called "An Honorary Exhibitor" by Graves.

BARBER, Reginald fl.1885-1893
Manchester painter of genre and portraits. Exhib. 1885-93 at the RA, SS and NWS. Titles at the RA 'Weather Wise', 1889, and 'Twixt hope and fear', 1890.

BARBOR, Mrs. G.D. fl.1862-1864
Painter of genre who exhib. 1862-4 at BI and SS. Title at SS 'Pretty Dick', 1862. Chelsea address.

BARCLAY, A. fl.1873
Exhib. a flower painting at SS, 1873 and one elsewhere. London address.

BARCLAY, A.P. fl.1880
Exhib. a landscape painting in London 1880. Kilburn address.

***BARCLAY, Edgar b.1842 fl.1868-1913**
London landscape and genre painter. Studied in Dresden and Rome. Exhib. at the RA from 1869, also at the GG and NG. Subjects usually landscapes or scenes of peasants working in fields, showing the influence of J.F. Millet. Also a friend of Giovanni Costa and the Etruscan group of artists. His unpublished archive is in Swiss Cottage Library.
Bibl: AJ 1894 p.266 illus.; C. Newall, *The Etruscans,* cat. of exhib. at Stoke-on-Trent AG 1989.

BARCLAY, G. fl.1876
Exhib. 'A Dance, Capri' at the RA, 1876. No address given.

BARCLAY, J. Edward fl.1868-1888
London landscape painter. Exhib. 1868-88 at SS and elsewhere — his subjects mostly watercolour views in Italy.

BARCLAY, John Maclaren RSA 1811-1886
Scottish painter of portraits, genre and figure subjects. Born in Perth, and lived there and in Edinburgh. Exhib. 1835-87 at the RSA, titles mostly portraits, but also 'A Gipsy Girl', 1839, and 'Homeward Bound', 1840. Also exhib. at the RA, 1850-75 and SS, 1850-6. ARSA in 1863; RSA 1871; Treasurer of RSA, 1884-6. Caw notes that he "displayed considerable accomplishment, if no distinction".
Bibl: Clement & Hutton; Studio Special Number, RSA, 1907; Caw p.178; Ormond p.5l.

BARCLAY, W. fl.1873-1876
Edinburgh painter of sea pieces and coastal scenes, who exhib. 1873-6 at the RA. Titles 'Evening on the Coast', 1875 and 'A Fresh Breeze', 1876.

BARD fl.1848
Exhib. a portrait in London, 1848. Acton address.

BARDSWELL, Emily fl.1880-1881
Exhib. two landscapes in London, 1880-1. Wimbledon address.

BARENGER, J.R. fl.1853-1855
Painter of architectural subjects, living in Peckham and Camberwell, S. London. Exhib. 1853-5 at the RA and SS. Titles 'Plumstead Church, Kent', RA 1853, and 'View in Epping Forest' (watercolour), SS 1855.

BARFELD, J.C. fl.1894
Exhib. a view of 'St. Peter's Church, Northampton', at the RA, 1894. Leicester address.

BARFORD, Richard fl.1879-1880
Birmingham landscape painter, who exhib. 1879-80 in London.

BARING, Lady Emma fl.1888
London landscape painter who exhib. in 1888 at the NWS.

BARKER, Miss A.E. fl.1858-1870
Portrait painter, who exhib. 1858-70 at the RA, SS and elsewhere. In 1870, Brighton address. Called "An Honorary Exhibitor" by Graves.

BARKER, B. fl.1841
Exhib. two portraits at the RA, 1841. London address.

BARKER, C.F. fl.1845
Exhib. 'A Study from Nature of a French Girl of Marseilles' at SS, 1845. London address.

BARKER, Clarissa fl.1885-1886
Painter of flowers, who exhib. 1885-6 at SS. Dolgelly address.

BARKER, John Joseph fl.1835-1866
Painter of genre and historical subjects. One of the 'Barkers of Bath'. Exhib. 1835-66 at the RA and BI. Titles at the RA 'Beauties of the Court of Charles II', 1835, and 'Reading the Gazette', 1860.
Bibl: VAM.

BARKER, Joseph fl.1843-1848
York painter of animals and rustic genre who exhib. 1843-8 at the RA. Titles 'Cattle — evening' and 'Happy as a Queen'.

BARKER, J.S. fl.1841-1858
London portrait painter, who exhib. 1841-58 at the RA.

BARKER, Miss Lucette E. fl.1853-1874
Painter of portraits, genre and animals, who exhib. 1853-74 at the RA, BI and elsewhere. Lived in Thirsk and London. Titles at the RA 'Dogs' Heads', 1855, and 'Baby', 1860.

BARKER, Miss M.A. fl. 1820-1848
Bath landscape painter, who exhib. 1820-48 at the RA, BI and elsewhere.

BARKER, Miss Marion fl.1889
Exhib. 'Dolly Dunlop' at the RA, 1889. Manchester address.

BARKER, Thomas 1769-1847
Bath landscape painter; one of the "indefatigable family of Barkers of Bath", many of whom were painters. His brother was Benjamin Barker of Bath (1776-1838). Exhib. at the RA and SS, but mostly at the BI. Barker was much influenced by Gainsborough, and their

pictures and drawings are often confused. Also painted sporting pictures.

Bibl: T.M. Rees, *Welsh Painters, etc.*, 1911; Pavière, Sporting Painters p.14; Hardie pp.95-6.

***BARKER, Thomas Jones 1815-1882**
London historical and battle painter. Studied under Horace Vernet in Paris. Exhib. at the RA 1845-76, also at SS and BI. Subjects mainly historical battle scenes, especially of the Napoleonic and Crimean Wars. Also a painter of portraits and sporting subjects.

Bibl: AJ 1878 pp.69-72; 1882 p.159; Clement & Hutton; T.M. Rees, *Welsh Painters*, 1911; Pavière, Sporting Painters p.14; Ormond I see index; Wood. Panorama.

BARKER, W. Bligh fl.1835-1850
London painter of portraits, genre, flowers and topographical subjects. Exhib. 1835-50 at the RA, BI and SS. Titles at the RA include 'Rival Beauties — from the Old and the New World', 1843, and 'Greenwich Hospital, Observatory and "Dreadnought" ',1850.

BARKER, Mrs. W. Bligh fl.1834-1843
London painter of fruit and flowers. Exhib. 1834-43 at the RA and SS.

BARKER, W.D. fl.1870-1880
Landscape painter who lived at Trefriew, Wales. Exhib. 1870-80 at SS and elsewhere — his subjects landscapes in Wales.

***BARKER, Wright RBA fl.1891-1935 d.1941**
Painter of hunting subjects and genre. Exhib. 1891-1935 at the RA, and at SS. Titles at the RA 'In Forest's Depths Unseen', 1891, and 'My Children and their Pets', 1904. Lived at Mansfield, Newark, London and Harrogate. 'Full Cry' sold at Christie's 16 October 1964.

Bibl: Pavière, Sporting Painters; Wood, Olympian Dreamers.

BARKLEY, C.W. fl.1852
Exhib. 'Lane Scene near Newark' at the RA, 1852. Chelsea address.

BARKWORTH, Miss Emma L. fl. 1891
Exhib. a landscape view at NWS, 1891. Tunbridge Wells address.

BARKWORTH, Walter T. fl.1884-1893
Exhib. landscapes in London 1884-93. Dorking address.

***BARLAND, Adam fl.1843-1875**
London landscape painter. Exhib. at the RA 1843-63, and at the BI and SS. Subjects views in England and the Scottish Highlands.

BARLOW, Miss fl.1852-1855
Painter of portraits and genre. Exhib. 1852-5 at the RA and BI. Clapton address.

BARLOW, B.J. fl.1885
Exhib. a watercolour 'Stacking Hay, Ilford' at SS, 1885. Brixton address.

BARLOW, Emily S. fl.1870-1876
Exhib. landscapes in London, 1870-6. Old Charlton address.

BARLOW, Miss Florence E. fl.1878-1888
Painter of birds, genre and flowers. Sister of B.J. Barlow (q.v.) and Hannah Bolton Barlow, sculptor. Exhib. 1878-88 at the RA, SS and elsewhere. Titles at the RA, 'A Young Adventurer', 1884, and 'Canaries', 1885. Brixton address.

BARLOW, John Noble ROI 1861-1917
Painter in oil and watercolour of landscapes, coastal scenes and genre. Born in Manchester; studied in Paris. Exhib. from 1893 at the RA, titles 'Morning after Rain', 'Summer Pastures', etc. Lived at St. Ives in Cornwall where he died.

BARNARD, Frank fl.1871-1883
London landscape painter. Exhib. 1871-83 at the RA, SS and elsewhere. Title at the RA 'Shetland Homes', 1883.

BARNARD, Frederick 1846-1896
London painter of genre, mainly domestic scenes. Studied under Leon Bonnat in Paris. Worked in London, and at Cullercoats, on the coast of Northumberland. Exhib. at the RA 1858-87, and at SS. Worked as illustrator for *Punch, Illustrated London News* and other magazines. Chiefly known for his illustrations reinterpreting the novels of Dickens. His paintings and watercolours are done in bright, pure colours, and usually contain much period detail of Victorian interiors.

Bibl: The Year's Art 1897 p.309; DNB 1908; Reynolds, VS p.90 (pl.77); Hall.

BARNARD, Geoffrey fl.1888-1889
Painter of genre, who exhib. 1888-9 at NG and elsewhere. Dorking address.

BARNARD, George fl.1832-1890
London landscape painter and watercolourist. Pupil of J.D. Harding (q.v.). Exhibited at the RA 1837-73, and at the BI, but more often at SS. Subjects views in Switzerland, Wales, Devon, etc. and some sporting scenes.

Bibl: Roget II p.179.

BARNARD, Gertrude fl.1892-1893
Flower painter, who exhib. 1892-3 at SS and elsewhere. Putney address.

BARNARD, Mrs. H.G. (Elizabeth) fl.1884-1894
London painter of landscape and flowers, who exhib. 1884-94 at the RA, and SS. Titles at the RA: 'A Fir Tree', 1884, and 'Where the Bee Sucks', 1894.

BARNARD, J. Langton b.1853 fl.1876-1902
Painter of genre, landscape and marines. Exhib. 1876-1902, at the RA, SS, NG, NEAC and elsewhere. Titles at the RA, 'Beside the Tumbling Sea', 1885, and 'A New Arrival', 1901. Lived in London, Chertsey and West Drayton.

Bibl: Brook-Hart.

BARNARD, Mrs. J. Langton fl.1881
(Miss Emily Cummins)
Exhib. 'Christmas Roses' at SS, 1881. Virginia Water address.

BARNARD, Mrs. J. Langton (Catherine) fl.1883-1922
Catherine Barnard exhib. flower paintings, marines, landscapes and genre at the RA 1888-1922 and at the SS in 1890. Same addresses as J. Langton Barnard. Kate Barnard is listed separately in SS as exhibiting portraits and genre 1883-4. Same address as J. Langton Barnard. It is unknown if Catherine or Kate Barnard was the same person as Mrs. J. Langton Barnard (Miss Emily Cummins, see

previous entry), the second wife, or another member of the family. Graves Dictionary is at odds with Graves RA Exhibitors and SS for these entries.

BARNARD, Louisa **fl.1871-1873**
Exhib. two landscapes in London, 1871-3. Highbury, London, address.

BARNARD, Mary B. **fl.1894-1899**
Exhib. 'Chrysanthemums' and 'In the Golden Light' at the RA, 1894-9. Norbiton and London addresses.

BARNARD, Mrs. William **fl.1880-1881**
Exhib. 'Viola' (watercolour) and 'A Mitherless Bairn' at SS, 1880-1. Lewisham, London, address.

BARNES, A.W. **fl.1837**
Exhib. a landscape at SS, 1837. London address.

BARNES, E. **fl.1856-1857**
Exhib. 'The Bridge of Sighs' and 'Devotion — a Study' at SS, 1856-7. Birmingham address.

***BARNES, E.C.** **fl.1856-1882**
London painter of domestic scenes and interiors, especially of children. Exhib. mainly at SS, but also at the RA 1856-82 and the BI. His work mainly of two types, small genre and domestic scenes, and larger Frith-type scenes of Victorian life. He also painted some Spanish subjects in the manner of John Phillip and J.B. Burgess (qq.v.).

BARNES, G.E. **fl.1866**
Exhib. 'The Cloisters, Westminster Abbey' at SS, 1866. London address.

BARNES, Miss Isabella **fl.1890-1942 d.1955**
London painter of landscape, portraits and still life subjects. Born in Knightsbridge; studied at Lambeth School of Art and at the RCA. Exhib. 'Copper and Brass Pots, with Drapery' at SS, 1890, and at the RA, 1910, 1918 and 1942; also elsewhere. Lived in Chelsea.

BARNES, James **fl.1870-1901**
Liverpool painter of landscape and genre. Exhib. 1870-1901 at the RA and SS. Titles at the RA 'A Rough Road through the Wood', 1878, and 'A Highland Lassie', 1901.

BARNES, Joseph H. **fl.1867-1887**
London painter of genre, who exhib. 1867-87 at the RA, SS, NWS and elsewhere. Titles at the RA 'The Bouquet', 1868, and 'The Village Doctor', 1882.

BARNES, J.W. **fl.1855**
Exhib. two landscapes in London, 1855. Durham address.

BARNES, Miss Marian L. **fl.1890-1913**
Flower painter, who exhib. 1890-1913 at the RA, SS and NWS. Addresses Lewisham, Blackheath and Margate.

BARNES, Robert ARWS fl.1873-1893
Painter of genre and landscape. Exhib. 1873-93 at the RA and OWS. Titles at the RA 'Little Lady Bountiful', 1873, and 'Mr. Justice Hawkins sums up', 1891. Lived at Berkhamsted, Hertfordshire, and Redhill, Surrey.

BARNES, Samuel John **1847-1901**
Birmingham landscape painter. Studied at the Birmingham School of Art, in London and on the Continent. Specialised in landscape, his favourite sketching ground being the country along Deeside and near Balmoral, Scotland. He enjoyed the patronage of Queen Victoria and Queen Alexandra. Exhib. at the RA, 1884 and 1886 — titles 'The Haunt of the Heron' and 'A Rift in the Clouds'.
Bibl: Birmingham Cat.

BARNES, W. Rodway **fl.1886**
Exhib. a landscape in London, 1886. Worcester address.

BARNETT, James D. **fl.1855-1892**
Landscape painter, working at Crouch End. Exhibited at the RA 1855-72, and at the BI, but mostly at SS. Painted views on the Rhine, in Normandy and Burgundy, and also town views in England.

BARNETT, W. **fl.1848**
Exhib. a painting of 'India' at a gallery in London, 1848. London address.

BARNEY, Joseph W. **fl.1815-1851**
Fruit and flower painter. Son of Joseph Barney of Wolverhampton. Lived at Greenwich, 1817, Westminster 1818 and Southampton 1838. Exhib. 1815-51 at the RA, BI, SS and OWS. Fruit and flower painter to the Queen.

BARNICLE, James **fl.1821-1845**
London painter of landscape and coastal scenes. Exhib. mainly at SS and BI, also at the RA 1821-43. Subjects views on South Coast, Channel Islands, Wales and Scotland.
Bibl: Brook-Hart.

BARNS, G. **fl.1872-1874**
London painter of genre and animals. Exhib 1872-4 at the RA and SS. Title at the RA 'The Pet Sister', 1872.

BARRABLE, George Hamilton **fl.1873-1887**
London painter of genre scenes, mainly interior and domestic subjects. Exhibited at the RA 1875-87, and at SS. Titles at RA 'April Showers', 'The Coquette', 'After the Dance', etc. A painting by H. Barrable and R.P. Staples is in the MCC Gallery at Lord's Cricket Ground, London.

BARRATT, Reginald R. **1861-1917**
London painter of architectural subjects. Educated at King's College. Studied architecture under R. Norman Shaw, and painting in Paris under Bouguereau and Lefèvre. In his early career he worked for the *Graphic* and *Daily Graphic*. He travelled much in the Middle East and painted many subjects representing eastern life and architecture, as well as views in Italy — particularly Venice. He exhib. from 1885 at the RA, NWS and NG, became ARWS in 1901 and RWS in 1913. He was also a Fellow of the Royal Geographical Society.
Bibl: *Old Watercolour Society, 1804-1904*, Studio 1905 Spring, pl.XXXVI; Who's Who 1908; VAM.

BARRATT, Thomas **fl.1852-1893**
Sporting and animal painter, worked at Stockbridge. Exhib. at the RA 1852-93, and the BI and SS. Titles at RA 'The Sick Lamb', etc.

BARRAUD, Allan F. fl.1872-1900
Landscape painter and etcher; lived in Watford. Exhib. at the RA 1873-1900, mostly etchings, and also at SS. Titles at the RA 'A Winter Afternoon', 'Collecting the Flock', 'At the Ford', etc.

BARRAUD, Charles James fl.1871-1893
London landscape painter and watercolourist. Exhib. mainly at SS but also at the RA 1877-94. Titles at RA 'Waiting', 'Close of Day', etc.

BARRAUD, Francis fl.1878 d.1924
London painter of portraits, genre, fruit and sporting subjects. Son of Henry Barraud (q.v.). Exhib. from 1878 at the RA, SS, NWS and elsewhere. Titles at the RA, 'In the midst of Plenty', 1904, ''Tis better to have Loved and Lost', 1907. One of his paintings is at Lord's Cricket Ground, London. He was the painter of the celebrated picture 'His Master's Voice' used on early HMV record labels.
Bibl: Pavière, Sporting Painters.

BARRAUD, Francis P. fl.1877-1891
London painter of architectural subjects. Exhib. 1877-91 at the RA, SS and NWS.

***BARRAUD, Henry 1811-1874**
London portrait, sporting and genre painter, brother of William Barraud (q.v.), with whom he often collaborated on sporting pictures. Exhib. at the RA 1833-59, also at the BI and SS. Subjects mainly historical, e.g. 'Robert Bruce and the Spider', 'The Theory of Gravitation suggested to Sir Isaac Newton by the Fall of an Apple', etc. Henry and William Barraud exhib. joint pictures on which they both worked at the RA 1836-49. These were mostly portraits with horses and dogs, and historical scenes, e.g. 'Border Law', 'The Annual Benediction of the Animals at Rome'. Henry probably painted the figures, William the animals.
Bibl: Sir W. Gilbey, Animal Painters; Pavière, Sporting Painters p.15 (pl.4); Ormond I; E.M. Barraud, Barraud, the Story of a Family, 1967.

***BARRAUD, William 1810-1850**
London sporting painter, brother of Henry Barraud (q.v.), with whom he often collaborated. Pupil of Abraham Cooper. Exhib. at the RA 1829-50, also at the BI and SS. Subjects sporting, portraits with horses and dogs, animals, and some historical. Apart from their separate output, William and Henry Barraud exhib. several joint pictures at the RA between 1836 and 1849 (see Henry Barraud).
Bibl: AJ 1850 p.339, and as for Henry Barraud.

BARRET, George, Jnr. 1767/8-1842
London landscape watercolourist. Son of George Barret RA (1732-1784). He began to exhib. in 1800, and soon became known by his poetic treatment of sunrise, sunset and moonlight effects. He was an early member of the OWS, and exhib. 581 works there; he also exhib. at the RA (1800-2 and 1821), BI, SS and elsewhere. He published Theory and Practice of Watercolour Painting in 1840. Spurious 'Barrets' were painted in hundreds by his nephew (see Webber's Life of James Orrock, 1903, I, p.140). Williams notes, "He exhibited views of Wales and the Thames Valley, but more and more as time went on he specialised in poetically idealised landscapes, often of sunsets, sunrises or other effects of glowing light, and in classical compositions upon Claudian lines. He liked in his later years rich fruity colours, with much purple and orange and he believed that watercolours would not fade if they were put on thickly".
Bibl: Some Letters of G.B.II, OWS XXVI; VAM; A. Bury, G.B. II, Connoisseur CV 1940; Williams; Hardie III pp.92, 233 for full bibl.

BARRET, J.V. fl.1843
Exhib. 'Sunset' and 'Twilight' at the RA in 1843. London address.

BARRETT, C.P. fl.1836-1844
London painter of landscapes and river scenes. Exhib. 1836-44 at the RA and SS. Lived at the same address as J.V. Barret (q.v.), presumably his brother, and exhibited the same subjects 'Sunset' and 'Twilight' at the RA in 1844.

***BARRETT, Jerry 1824-1906**
Brighton historical and genre painter. Exhib. at the RA 1851-83 and at SS. Titles at RA 'Meeting of Queen Victoria with the Royal Family of Orleans', 'Lady Mary Wortley Montague in Turkey', 'Nature and Art', etc. Barrett's two most famous works were 'The Mission of Mercy — Florence Nightingale Receiving the Wounded at Scutari in 1856' and 'Queen Victoria Visiting the Military Hospital at Chatham.' Because of the patriotic feelings aroused by the Crimean War, both these pictures were enormously popular through engravings.
Bibl: AJ 1861 p.191; 1858 p.191; The Year's Art 1907; Reynolds, VP pp.112, 115 (pl.65); Ormond I pp.180, 487; Wood, Panorama.

BARRETT, John fl.1883
Exhib. 'January Sunlight' at the RA, 1883. Plymouth address.

BARRETT, M. fl.1876-1880
London painter of rustic genre. Exhib. 1876-80 at SS and elsewhere. Title, 'Market Morning', 1876.

BARRETT, Mrs. M. fl.1872
(Miss Marianne Foster)
Exhib. 'A portrait' at the RA, 1872. Address Rome, and c/o Mrs. Foster, Camberwell.

BARRETT, Thomas 1845-1924
Nottingham painter of landscape and genre. Exhib. 1883-1909 at the RA, BI and SS. Titles at the RA, 'Early Morning; Counting the Catch', 1887, and 'On the Scar', 1909.
Bibl: P. Phillips, The Staithes Group, 1993.

BARRETT, William fl.1837-1847
Painter of topographical subjects. Lived in Sidmouth, 1837 and London. Exhib. at the RA in 1837 and from 1845-7 at SS.

BARRINGTON, Arthur fl.1882
Exhib. two landscapes in London. 1882. Port Arthur address.

BARRINGTON, W. fl.1874
Exhib. a still life at SS, 1874. Buckingham address.

BARROW, Miss Edith Isabel fl.1887-1926 d.1930
Painter in watercolour of landscapes and flowers. Studied at Goldsmiths' Institute and at S. Kensington. Exhib. 1887-93 at SS, and 1890-1926 at the RA, and also at the NWS. Lived at Lee, Dulwich, and Combe Martin, Devon.

BARROW, Miss Jane fl.1891-1896
London painter of genre and landscape. Exhib. 1891-6 at SS, the RA and elsewhere. Titles, 'Twilight', 1891 SS, and 'Bad News', 1896 RA.

BARROW, W.H. fl.1887
Exhib. three 'sea pieces' in London, 1887. Hastings address.

BARRY, Desmond fl.1888
Exhib. 'A September Evening' at SS, 1888. London address.

BARRY, Dick fl.1883
Exhib. landscape subjects — e.g. 'Close of Day' at SS, 1883. London address.

BARRY, Miss Edith M. fl.1893-1897
Exhib. portraits at the RA, 1893-7. Bushey, Hertfordshire, address.

BARRY, Frederick fl.1826-1860
Painter of marines and coastal scenes, genre, landscape and game subjects. Lived in London, and from 1848 at Cowes, Isle of Wight. Exhib. 1826-60, mostly at SS, but also at the RA and BI.

BARRY, W. Gerard fl.1888
Exhib. 'Time Flies' at the RA, 1888. Ballyadam, Co. Cork, address.

BARSTOW, Montagu fl.1897-1916
Painter of genre. Lived in London and Maidstone. Exhib. 1897-1916 at the RA, titles 'Idle Moments' and 'Autumn's Tribute'.

BARSTOWE, H. fl.1865-1869
Birmingham painter of genre. Exhib. 1865-9 at the RA and SS. Titles at SS 'Reading the Letter', 1865, and 'Bird Nesting', 1869.

BARTAJAGO, E. fl.1881
Exhib. a painting of 'figures' at an unspecified gallery in London, 1881. London address.

BARTER, Gertrude Mary fl.1889
Exhib. a flower painting at SS, 1889. Watford address. This information appears in Graves Dictionary and is not in the RBA Catalogue.

BARTH, C.W. fl.1890
Exhib. a painting of a coastal scene at the GG, 1890. London address.

BARTH, Wilhelm fl.1889
Exhib. 'A Critical Moment' at the RA, 1889. London address.

BARTHOLOMEW, Harry fl.1889-1890
Exhib. two genre paintings at London galleries, 1889-90. London address.

BARTHOLOMEW, Valentine 1799-1879
Prolific London flower and still-life painter and watercolourist. Exhib. mainly at the OWS, of which he was a member; also at the RA 1826-54 and SS. Appointed Flower Painter in Ordinary to the Queen and the Duchess of Kent.
Bibl: AJ 1879 p.109; Roget II pp.245-9; Clement & Hutton.

BARTHOLOMEW, Mrs. Valentine 1800-1862
(Miss Anne Charlotte Fayermann)
London painter of miniature portraits, genre, fruit and flower subjects. Born at Loddon, Norfolk, the daughter of Arnall Fayermann. In 1827 she married Walter Turnbull, composer. At that time she became a miniature painter, and also painted fruit and rustic genre. She also wrote plays and poems. In 1838 she was widowed and in 1840 became the second wife of Valentine Bartholomew (q.v.). Under his influence she came to paint flower subjects. As Miss Fayermann, she exhib. 'The Infant Psyche', and portraits of Swiss and French peasants at the BI, in 1826 and 1827; as Mrs. Walter Turnbull, she exhib. miniature portraits at the RA and SS, 1829-44; and as Mrs. V. Bartholomew she exhib. miniature portraits, genre and fruit subjects at the RA, SS and elsewhere, 1841-62. Member of the Society of Female Artists and of the Society of Watercolour Painters.
Bibl: Clayton I pp.398-400; Roget II pp.247-8; Ormond I pp.125, 378.

BARTLETT, Miss Annie S. fl.1864-1870
London painter of game and fruit. Exhib. 1864-70 at the RA and SS. Titles at the RA: 'Mushrooms', 1866, and 'Dead Birds', 1868.

BARTLETT, Miss J. Hoxie fl.1894
Exhib. a view of 'Glen Sannox, Arran', 1894. Edinburgh address.

BARTLETT, William H. 1858-1932
London painter of domestic scenes and interiors. Not to be confused with William Henry Bartlett (q.v.). Studied under Gérôme in Paris. Exhib. at SS, also at the RA from 1880, and at the GG and NG. As well as genre, painted continental views, and according to Pavière sporting subjects.
Bibl: RA Pictures 1891.

BARTLETT, William Henry 1809-1854
London topographical watercolourist and illustrator. Articled, when fourteen, to John Britton who sent him to make topographical drawings for his *Cathedral Antiquities of Great Britain,* and the *Picturesque Antiquities of English Cities.* About 1830 he visited the Continent, and then Syria, Egypt, Palestine and Arabia; he went four times to America. Nearly a thousand of his drawings — as Hardie notes — "effective as to topography, but slight and uninspiring in workmanship", were engraved in many of his illustrated works such as *Walks about Jerusalem,* 1845; *Pictures from Sicily,* 1852; *The Pilgrim Fathers,* 1853. He exhibited at the RA in 1831 and 1833, and also at the NWS. Not to be confused with William H. Bartlett (q.v.).
Bibl: AJ 1855 pp.24-6; W. Beattie, *Brief Memoir of W.H. Bartlett,* 1855; J. Britton, *A Brief Biography of W.H. Bartlett,* 1855; FAS 1892; Binyon; DNB; Hughes; VAM; Country Life 15 February 1968; Hardie III pp.29-30, (pl.41); A.M. Ross, *W.H.B. Artist, Author and Traveller,* Toronto 1973.

BARTON, Miss C.A. fl.1883
Exhib. a painting of flowers at the GG, 1883. Wincanton address.

BARTON, Miss Eleanor G. fl.1898-1906
Painter of portraits and genre. Exhib. 1898-1906 at the RA. Titles: 'Florrie', 1898, and ' "Sir, I am a true labourer" ', 1906. Wimbledon Park and Old Bushey, Hertfordshire, addresses.

BARTON, J. fl.1854
Exhib. 'a portrait' at the RA, 1854. No address given.

***BARTON, Miss Rose** RWS 1856-1929
London genre and landscape painter in watercolour. Born in Dublin. Exhib. from 1880 at the RA, SS, OWS, NWS, GG and elsewhere. Elected ARWS 1893, RWS 1911.
Bibl: W. Shaw Sparrow, *Women Painters of the World,* 1905 pl.143 ('Almond Blossom in London').

BARTON, Mrs. W. (Matilda M.) fl.1888-1889
Exhib. two portraits at the RA in 1888 and 1889. London address.

BARTSCH, E. fl.1892
Exhib. 'A Rainy day:- Greenwich', at SS, 1892. Greenwich address.

BARWELL, Miss Edith fl.1901
Exhib. 'Deserted' at the RA, 1901. London address.

***BARWELL, Frederick Bacon fl.1855-c.1897**
London genre painter. Friend of J.E. Millais (q.v.), who painted most of 'The Rescue' and other pictures in his studio. Exhib. at the RA 1855-87, and a few pictures at the BI and SS. Subjects mainly small domestic scenes and interiors, but occasionally attempted bigger scenes of Victorian life, such as 'Parting Words — Fenchurch Street Station', his best known work (Reynolds, VS pl.72). Ruskin praised Barwell's 'The London Gazette' (RA 1855) and 'Adopting a Child' (RA 1857), describing the latter as "a well-considered and expressive picture".
Bibl: Ruskin, Academy Notes 1855, 1857; The Year's Art 1880-1897; Reynolds, VS p.88 (pl.72); Ormond I p.328; Wood, Panorama.

BARWELL, Henry George fl.1878-1891
Norwich painter of landscape, who exhib. 1878-91 at SS, NWS, GG and elsewhere.

BARWICK, J. fl.1844-1849
London painter of portraits of huntsmen and horses, often set in landscapes. Exhib. in 1844 and 1849 at the RA. Titles: 'J.S. Perring Esq.' and 'Portraits — the property of Lord Willoughby D'Eresby. (Horses).'
Bibl: Pavière, Sporting Painters.

BASBE, C.J. fl.1849
Painter of a number of cricket portraits. The Gallery at Lord's Cricket Ground, London, has a number of sketches by this artist.
Bibl: Pavière, Sporting Painters.

BASKETT, Charles E. RE fl.1872-1918
Colchester painter of fruit and game subjects, landscapes and coastal scenes; etcher and engraver. Exhib. 1872-1918 at the RA, SS and elsewhere. Titles at the RA: 'On the Marshes — Evening', 1893, and 'An Old Stackyard—Winter', 1895.

BASSETT, George fl.1829-1875
London landscape painter. Exhib. at the RA 1829-32, at the BI in 1865 and at SS, 1865-75.

BASSETT, Miss R. fl.1862
Exhib. 'Study in Richmond Park' at SS, 1862. London address.

BASTABLE, H. fl.1877
Exhib. two landscape subjects set in Surrey at SS, 1877. Address, Witley, Surrey.

BASTIN, A.D. fl.1871-1900
Painter of genre. Exhib. 1871-92 at SS and elsewhere, and at the RA in 1900. Title at the SS: 'The Rescued Fly', 1871. London and West Worthing addresses.

BATCHELOR, Kate fl.1884
Exhib. three flower paintings at unspecified galleries in London, 1884. Bristol address.

BATCHELOR, Miss M.H. fl.1901
Exhib. 'Outdoor Chrysanthemums' at the RA, 1901. Sevenoaks, Kent, address.

BATE, H. Francis NEAC 1853-1950
Painter of genre, landscape and flowers. Educated at Christ's Hospital. Studied art at the RCA and at the Antwerp Academy under Verlat. Exhib. from 1885 at SS, GG, NEAC and elsewhere. Author of *The Naturalistic School of Painting*, 1887. Lived at Hammersmith and Reading, Berkshire.

BATEMAN, B. Arthur fl.1885-1894
Painter of portraits and genre — particularly Cornish subjects. Lived in Reigate, Surrey, 1885, Penzance, 1887 and Newlyn, 1894. Exhib. from 1885-94 at the RA, SS and elsewhere. Titles: 'Day-dreams', 1887 RA, and 'In the Penzance Market Place', SS 1886.

BATEMAN, James 1815-1849
London sporting painter. Exhib. at the RA 1840-8, also at the BI and SS. Subjects hunting, shooting and fishing.
Bibl: AJ 1849 p.161; W. Shaw Sparrow, *Angling in British Art*.

***BATEMAN, Robert 1842-1922**
Very little known minor Pre-Raphaelite painter. Entered RA schools in April 1865. Exhib. six works at RA 1871-89, 14 at the GG, and 10 elsewhere. One of his RA pictures, 'The Pool of Bethesda' (1876) was rediscovered and published by Basil Taylor in *Apollo*. It shows Bateman to have been a very original artist, with a style compounded of Burne-Jones and eclectic study of early Italian Renaissance painters.
Bibl: Basil Taylor, *A Forgotten Pre-Raphaelite*, Apollo, Notes on English Art, August 1966; *The Last Romantics*, cat. of exhib. at the Barbican AG, London, 1989; Amanda Kavanagh, *R.B. a True Victorian;* Apollo September 1989 pp.174-9.

BATEMAN, Samuel fl.1900
Exhib. a view 'Near Greenlands, Henley' at the RA, 1900. Henley address.

***BATES, David 1840-1921**
Midlands landscape painter, worked in Birmingham and Worcester. Exhib. at the RA from 1872, also at SS and the GG. Style and subjects similar to other artists of the Birmingham school, such as Joseph Thors and S.H. Baker (qq.v.). Also made many small oil sketches of hedges and plants, which he usually inscribed and signed on the reverse.

BATES, Edwin fl.1836-1840
London landscape painter who exhib. from 1836-40 at the BI and SS.

BATES, Henry W. fl.1882-1888
Leicester painter of rustic genre, landscape and topographical subjects. Exhib. 1882-8, at the RA, SS, NWS and elsewhere. Titles: 'The Old Church Tower', SS, 1883, and 'A Harvest Supper: the Last Song', RA, 1888.

BATES, Mrs. Jessie F. fl.1892-1896
Exhib. 'Corner of a Studio' at the RA 1896. Malvern address.

BATES, W.E. fl.1847-1872
London marine and seascape painter. Exhib. mainly at SS, but also at the BI and RA 1847-64. Titles at RA: 'On the Beach at Fecamp, Normandy', 'Pegwell Bay', etc.

BATH, W. fl.1840-1851
London landscape painter, who exhib. 1840-51, at the RA, BI and SS.

BATHE, J. fl.1872-1874
London landscape painter, who exhib. 1872-4, at the RA, SS and elsewhere.

BATHGATE, Miss Ellen **fl.1888**
Exhib. 'A Day in June' at the RA, 1888. Edinburgh address. Sister of George Bathgate (q.v.).

BATHGATE, George **fl.1885-1887**
Painter of landscape and genre. Exhib. 1885-7 at the RA and SS. Titles at the RA: 'Seamstress', 1885, and 'Beadstringers, Venice', 1886. Lived in Edinburgh and London.

BATLEY, Miss Marguerite E. **fl.1895-1899**
Painter of portraits, landscape and genre. Exhib. 1895-9 at the RA. Titles: 'Pas seul', 1895, and 'Daybreak', 1897. Bushey, Hertfordshire, and London addresses.

BATLEY, Walter Daniel **b.1850 fl.1875-1919**
Landscape painter in oil and watercolour. Born in Ipswich; studied art at Ipswich and S. Kensington, and also at the RA Schools. Exhib. 1875-1919 at the RA, SS and elsewhere. Titles at the RA: 'Cottage Homes', 1878, and ' "Struggling Moonbeam's Misty Light" ', 1901. Lived at Felixstowe and Ipswich.

BATSON, Rev. A. Wellesley **fl.1890**
Exhib. a landscape subject at the GG, 1890. London address.

BATSON, Frank **fl.1892-1904**
Landscape painter. Lived at Ramsbury, Hungerford and Penzance, Cornwall. Exhib. 1892-1904, at the RA and NWS. Titles at the RA: 'Playing out time in an awkward light', 1901, and 'Autumn at Delft', 1904.

BATSON, H.M. **fl.1874-1875**
Exhib. 'Evening on the Kennett' at SS, 1874, and one elsewhere. Ramsbury, Wiltshire, address.

BATT, Arthur **fl.1879-1892**
Painter of genre. Lived in Romsey, Lyndhurst and Brockenhurst, Hampshire. Exhib. 1879-92, at the RA, SS, GG and elsewhere. Titles at the RA: 'Silent Sympathy', 1887, and 'Gossips', 1889. Was also fond of painting animals, particularly donkeys.

***BATTEN, John Dickson** **1860-1932**
London painter, book illustrator and etcher. Exhib. at the RA 1891-8, and at the GG and NG. Subjects mainly themes from fairy tales or mythology, e.g. 'Thetis Saves the Argonauts from Scylla' (RA 1898). Batten often painted in tempera, and was influenced by late Quattrocento painters such as Crivelli, and also by Burne-Jones.
Bibl: Studio XXIII p.158; XXXV p.295; XXXVIII pp.64, 67; Wood, Pre-Raphaelites.

BATTERSBY, Mrs. **fl.1833-1839**
Painter of portraits and 'character' subjects. Exhib. 1833-9, at the RA and SS. Titles at the RA: 'The Maid of Athens', 1833, and 'Leila', 1839. Termed "An Honorary Exhibitor" by Graves.

BATTY, Edward **fl.1864-1867**
London genre painter. Exhib. 1864-7 at SS. Titles: 'La douce pensée', 1865, etc.

BATTY, R. **fl.1848**
Exhib. two views of waterfalls in Switzerland at the BI, 1848. London address.

BATTY, Lt.-Col. Robert **1789-1848**
Painter of landscape and topographical subjects. Exhib. 1813-48 at the RA — subjects ranging over the world, views in India, Germany, Gibraltar, Holland, etc., painted during his life in the army.
Bibl: AJ 1849.

BAUERLE, Miss Amelia M. see BOWERLEY, Miss Amelia M.

BAUGHTON, H. see BOUGHTON, H.

BAUMANN, Miss A. Hilda **fl.1890**
Exhib. a genre painting at an unspecified gallery in London, 1890. London address.

BAUMANN, Miss Ida **fl.1892**
Exhib. portraits at the RA and elsewhere, 1892. London address.

BAUMER, Lewis Christopher Edward **RI** **1870-1963**
Painter of portraits, still life and genre, in oil, watercolour and pastel; illustrator. Born in London; studied art at the RCA, at St. John's Wood Art School and at the RA Schools. Exhib. from 1892 at the RA, SS and elsewhere. Elected RI, 1921. Member of the Pastel Society. His work was reproduced in *Punch*, the *Tatler* and other magazines. Lived at Henley-on-Thames for some years.

BAUTEBARNE, E. **fl.1849**
Exhib. 'A Portrait of a Lady' at the RA, 1849. London address.

***BAXTER, Charles** **RBA** **1809-1879**
London painter of fancy portraits and charming pretty girls in 'The Keepsake' tradition. Exhib. at the RA 1834-72, but more often at SS. Subjects also included poetic and rustic subjects. Started his career as a bookbinder and miniature painter. Elected member of the Society of British Artists in 1842. His studio sale was held at Christie's, 15 March 1879.
Bibl: AJ 1864 pp.145-7 (biog); 1879 p.73 (obit.); VAM; Maas p.107 (pl.106, 111); Ormond I p.494.

BAXTER, C.J. **fl.1870-1875**
London painter of domestic subjects. Exhib. only at SS (5). 'Visiting a Cottage' was sold at Christie's 2 July 1971.

BAXTER, George **1804-1867**
London painter in watercolours and lithographer of historical and sporting subjects. Exhib. 'Christening of the Prince of Wales at Windsor' at the RA, 1845. One of his paintings is at Lord's Cricket Ground, London.
Bibl: Pavière, Sporting Painters.

BAYES, Alfred Walter **RE** **1832-1909**
London painter of genre, portraits, biblical subjects, landscapes and angling scenes; etcher and engraver. Exhib. 1858-1908 at the RA, BI, SS, NWS and elsewhere; titles at the RA: 'The Village Sadler', 1858, 'Ruth and Naomi', 1863, and 'Anglers of the Wye', 1876. Published English Etchings. 'Day Dreams' is in York AG. Elected ARE 1890; RE 1900.
Bibl: Cat. of the Franco-British Exhibition London 1908, Fine Art Section, No. 1119; York Cat.

BAYES, Walter John **RWS** **1869-1956**
Painter of figure subjects, landscapes and decorations, and illustrator. Born in London, son of A.W. Bayes (q.v.), painter and etcher, and brother of Gilbert Bayes. Studied in the evenings at the

City and Guilds Technical College, Finsbury, 1886-1900, and then at the Westminster School of Art, 1900-2. Exhib. from 1890 at the RA, SS, NWS and elsewhere. Influenced by Sickert, and a founder member of the Camden Town Group, 1911 and the London Group, 1913, resigning in 1915. Art critic of *The Athenaeum*, 1906-16, and also contributed articles to many periodicals. One man show at the Carfax Gallery, 1913. Headmaster of the Westminster School of Art, 1918-34, Lecturer in Perspective, RA from 1929, and Director of Painting, Lancaster School of Arts and Crafts, 1944-9. Author of *The Art of Decorative Painting*, 1927; *Turner, a Speculative Portrait*, 1931, and *A Painter's Baggage*, 1932.
Bibl: Tate Cat.

BAYFELD, Miss Fanny Jane fl.1872-1897
Painter of flowers and fruit. Exhib. 1872-97, at the RA and SS. Lived in Norwich and London.

BAYLISS, Edwin Butler RBSA b.1874 fl. until 1944
Wolverhampton painter of industrial scenes, landscapes and portraits. Born in Wolverhampton. Exhib. at the Royal Birmingham Society of Artists, 1895-1944, at the RA, 1899-1928, at the ROI and in Liverpool. Titles at the RA 'A Bit of Wales', 1899, and 'Blast Furnaces: Evening', 1920. Member of the Royal Birmingham Society of Artists.

BAYLISS, Mrs. Elise fl.1890
Exhib. " 'The Floral Year': Twelve pages from the Floral Year, a work now in preparation for publication by Messrs. Day & Son", at SS, 1890. Wife of Sir Wyke Bayliss (q.v.).

BAYLISS, J.B. fl.1854-1855
Exhib. landscape subjects at SS, 1854-5. Title 'A Sketch of a Village School'. London address.

BAYLISS, J.C. fl.1866-1867 d.1886/7
Exhib. four watercolour landscape subjects at SS, 1866-7. Titles, 'The Wellhorn, from the Pass of the Grand Sheideck', 1866, and 'Bowness, Windermere', 1866. Address, Clapham, London.

BAYLISS, Sir Wyke PRBA FSA 1835-1906
London painter and architect. Exhib. almost only at SS; exhib. at RA in 1865 and 1879. Specialised in Gothic church interiors. Also a prolific writer on art and aesthetics.
Bibl: AJ 1906 p.192.

BAYNE, W. fl.1857
Exhib. 'Oberwesel, on the Rhine' at SS, 1857. London address.

BAYNE, Walter Mcpherson fl.1832-1858
London landscape painter. Exhib. 1832-58 at the BI and SS.

BAYNES, A .H. fl.1879
Exhib. one landscape subject in London, 1879. Oxford address.

BAYNES, Frederick Thomas 1824-1874
London still-life painter and watercolourist. Exhib. at the RA 1833-64, and at SS. Subjects small fruit and flower pieces in the manner of Oliver Clare, and occasional figure subjects.

BAYNES, Robert fl.1853
Exhib. two landscape subjects at BI, 1853. Windsor address.

BAYNES, Thomas Mann fl.1794-1854
London landscape painter and topographical watercolourist;

architect. Brother of James Baynes (1766-1837). Exhib. 1811-32, at the RA, SS and NWS. A few oils are also known. One of his paintings is at Lord's Cricket Ground, London.
Bibl: Pavière, Landscape.

BAYNHAM, T. fl.1842
Exhib. 'Near Wateringbury, Kent' at SS, 1842. Walworth address.

BAYNTON, Henry 1862-1926
Coventry landscape painter; exhib. at Birmingham.

BEACALL, J. fl.1864-1868
Painter of landscape and portraits. Exhib. 1864-8 at the RA and SS. Titles at SS: 'Study of Fern' and 'The Road through the Copse'. London address.

BEACH, Miss Alice fl.1898-1935
London painter of genre, landscape and flowers. Exhib. 1898-1935 at the RA. Titles: 'Tulips', 1898, and 'Baby', 1904. Many of her landscape subjects set in Brittany.

BEACH, Ernest George b.1865 fl. until 1934
Painter in oil, watercolour and pastel of portraits, genre and landscape. Born in London; studied art in London and Paris. Exhib. from 1888-1922 at the RA, SS and elsewhere. Titles at the RA: ' "Goodbye!" Holland', 1898, and 'The Cottage Meadow', 1908. Worked extensively in France, Holland and Belgium. Lived in London and in Dover and Hythe, Kent.

BEADELL, F. fl.1855
Exhib. two Scottish landscape subjects at the RA, 1855. London address.

BEADLE, James Prinsep Barnes 1863-1947
Painter of historical and military subjects, portraits, animals and landscapes. Born in Calcutta, son of Major-General James Pattle Beadle. Studied art at the Slade School under Legros, at the Ecole des Beaux-Arts in Paris under Cabanel, and then in London under G.F. Watts (q.v.). Exhib. from 1879, at the RA, GG, NG and elsewhere, and also at the Paris Salon. Won a bronze medal at the Paris Universal Exhibition of 1889. Represented in several public collections.

BEAL, Miss Annie L. fl.1876-1914
London painter of genre and portraits. Exhib. 1876-1914 at the RA, SS and elsewhere. Titles at the RA, 'A Postman of the Light Blue', 1878, and 'Spring', 1885.

BEALE, Ellen fl.1865
Exhib. a view of 'Old Cottages, Minehead, Somerset', SS, 1865. Sister of Miss Sarah Sophia Beale (q.v.).

BEALE, Miss Sarah Sophia fl.1860-1889
London genre, portrait and marine painter. Exhib. mainly at SS; also at RA 1863-87. Titles at RA: 'The First Violet', 'The Pleasures of Art', 'The Funeral of an Only Child — Normandy', etc. Also wrote books about Paris and French architecture.
Bibl: Brook-Hart.

BEAN, Ainslie H. fl.1870-1886
London painter of landscape and topographical subjects. Exhib. 1870-86 at SS, NWS and elsewhere.

BEARD, Miss Ada fl.1885-1896
London flower painter. Exhib. 1885-96 at the RA.

BEARD, Katherine L. fl.1885-1890
London flower painter. Exhib. 1885-90 at SS and elsewhere.

BEARNE, Edward H. fl.1868-1895
London landscape and rustic genre painter. Exhib. at the RA and SS 1869-95. Views in Devon, Italy and Germany, and rustic genre, e.g. 'The Peasant's Cottage'.

BEARNE, Mrs. Edward see CHARLTON, Miss Catherine

BEATTIE-BROWN, William see BROWN, William Beattie

BEAUCHAMP, Miss M. fl.1878
Exhib. a view of 'Abbot's Hospital, Guildford' at SS, 1878. London address.

BEAUCHAMP, Mary Catherine, Countess fl.1872
Exhib. a portrait at the RA, 1872. London address.

BEAUMONT, Miss A. fl.1873
Exhib. a watercolour of 'Dead Game' at SS, 1873. Liverpool address.

BEAUMONT, Frederick Samuel RI b.1861 fl. to 1922
London painter of portraits and landscape; mural decorator. Born at Lockwood, Huddersfield. Studied art at the RA Schools and at the Académie Julian in Paris. Exhib. 1884-1922 at the RA, SS and elsewhere. A of the Royal British Colonial Society of Artists.

BEAUMONT, Jerold fl.1893
Exhib. a genre painting in London, 1893. London address.

BEAUMONT, W. fl.1832-1854
Painter of landscape and cattle. Exhib. 1832-54 at the BI, SS, NWS and elsewhere. Titles at the SS 'Lane Scene, Kent', 1833, and 'Landscape and Cattle', 1835. Lived at Rochester, Kent, and London.

BEAUX, Miss Cecilia fl.1900
Exhib. a 'Portrait of a Lady' at the RA, 1900. London address.

BEAVIS, C. fl.1840
Exhib. 'Lighting him out' at the BI, 1840. London address.

BEAVIS, Maud fl.1881
Exhib. 'Cacklers' at SS, 1881. London address.

***BEAVIS, Richard RWS 1824-1896**
Prolific painter, in oils and watercolours, of landscape, and especially atmospheric coastal scenes, e.g. 'Fishermen Picking up a Wreck at Sea', 'Threatening Weather', etc., rustic genre, eastern subjects, animals, and military scenes. Born at Exmouth; entered RA Schools 1846; worked as an artist for the firm Messrs. Trollope, upholsterers and decorators, until 1863. With him as designer the firm competed successfully for three international competitions. He exhibited some of these interior designs at the RA in 1855, 1858 and 1860. Later he worked for them only part time. In 1867-8 Beavis lived in Boulogne, visiting Holland. He was influenced by Millet and the Barbizon painters. In 1875 he travelled via Venice and Brindisi to Alexandria, Cairo, Jaffa and Jerusalem, the trip providing him with subject matter for many of his later paintings. In all he exhibited from 1852-96 at the RA, SS, BI, OWS, NWS,

GG, NG, and also on the Continent. Elected A of the Institute, 1867; member 1871; ARWS, 1882; RWS, 1892. His studio sale was held at Christie's 17 February 1897. Painted the ceiling of St. Bride's Church, Fleet St., London.
Bibl: AJ 1877 pp.65-8; 1897 January (obit.); Studio 1905; OWS; Bryan; Brook-Hart p.95 (pl.170).

BEAZLEY fl.1846
Exhib. a portrait of Sir George Pollock at the RA, 1846. No address given.

BECHER, Miss Augusta L. fl.1894
Exhib. ' "Sarah Grand" ' at the RA, 1894. London address.

BECK, John W. fl.1879-1892
Landscape painter. Exhib. 1879-92 at the GG and NG. Merton address. Was for a time Secretary of the GG.

BECKER, Ernest August fl.1849-1859
German painter of portraits and genre. Born in Dresden; settled in London; exhib. 1849-59 at the RA, BI and SS.

BECKER, Harry 1865-1928
Painter of genre, landscape and portraits; etcher and lithographer. Exhib. from 1885 at the RA, SS, NWS and elsewhere. Titles at the RA, 'Sixty miles to London, Joe!', 1889, and 'A Clover Field—Evening', 1897. Lived in London and Colchester.
Bibl: David Thompson, cat. of H.B. exhib., Ipswich Borough Council. 1993.

BECKETT, J. fl.1846-1847
Landscape painter. Exhib. 1846-7 at SS and BI — subjects landscapes near Dorking. Dorking address.

BECKINGHAM, Arthur fl.1881-1912
London painter of historical subjects, landscape and genre. Exhib. 1881-1912, at the RA, SS and elsewhere. Titles at the RA 'Incident in the French Revolution', 1882, and 'A Wandering Musician', 1888.

BECQUET, S. fl.1847
Exhib. a view 'Near Ambleside, Bucks.' at the RA, 1847. No address given.

BEDDOES, Thomas H.W. fl.1896
Exhib. two sea subjects at the RA, 1896. Titles: 'At the Foot of thy Crags, Oh Sea!', and 'The Sound of the Trampling Waves, etc'. London address.

BEDE, Cuthbert fl.1876
Exhib. a view of a church in London, 1876. Oakham address.

BEDERMAN, W. Clive fl.1838
Exhib. 'A Winter Scene, with various Figures' at the RA, 1838. No address given.

BEDFORD, B . fl.1848
Exhib. a biblical subject at SS, 1848. Title, 'The Young Men of the Tribe of Benjamin seizing the Daughters of Shiloh in the Vineyards for Wives'. London address.

BEDFORD, Miss Ella M. fl.1882-1908
London genre and decorative painter. Exhib. at RA 1885-1908, and at SS. Titles at RA: 'Poetry — Design for Decoration', 'A Breton Maid', 'Isabella, the Pot of Basil', etc.

BEDFORD, Francis Donkin b.1864 fl.1892 d.1954
London painter of landscape, topographical subjects and genre. Exhib. 1892-1949 at the RA. Titles: 'Amboise, Salerno', 1892, and 'Peter on Guard', 1912. Possibly a grandson of Francis Bedford (1784-1858).

BEDFORD, Francis William fl.c.1867 d.1904
Architect and topographical painter. Studied in Leeds, then in London, and later in Spain, Sicily and Italy. Began his own practice in Leeds c.1900 and removed to London c.1903 where he died of typhoid fever, 1904. Exhib. 1890-1905 at the RA. Subjects: his own designs and views of buildings in Spain and Italy.

BEDFORD, George 1849-1920
Landscape watercolourist. Studied at the Torquay School of Art and S. Kensington Schools. Headmaster of the Torquay School of Art 1878-1918, and also for many years headmaster of the Newton Abbot Art School. He was examiner to the Royal Drawing Society and lectured on etching and other crafts. There is a watercolour landscape in the VAM.
Bibl: VAM.

BEDFORD, Henry E. fl.1892-1893
Exhib. landscape subjects at SS 1892-3. Richmond, Surrey, address.

BEDFORD, John Bates b.1823 fl.1848-1886
London painter of historical and religious subjects, portraits, flowers and genre. Born in Yorkshire. Exhib. at RA 1848-86, BI, SS and elsewhere. Titles at RA: 'Enid with the Shield of Sir Lancelot', 1861, and 'Curly Locks', 1877. 'The Language of Flowers' was sold at Sotheby's Belgravia 19 October 1971.
Bibl: Clement & Hutton.

BEDINGFELD, Richard T. fl.1889-1894
Exhib. 'Zobeide' and 'In a Hammock' at the RA, 1889-94. London address.

BEDINGFIELD, J. fl.1890
Exhib. ' "Le Modéle s'amuse" ' at the RA, 1890. London address.

BEDWELL, Emily P. fl.1877
Exhib. a still-life subject in London, 1877. Richmond address.

BEEBE, Miss Annie A. fl.1888-1890
Exhib. 'In Disgrace' and 'Lever de Lune' at the RA in 1888 and 1890. London address.

BEEBY, Mrs. Elizabeth K. fl.1868-1872
Painter of portraits, flowers and landscape. Exhib. 1868-72, at SS and elsewhere. Titles at SS, 'Study of flowers with nest', 1868, and 'A Neglected Field —— Addiscombe', 1868. Croydon address.

BEECH, A.J. fl.1888-1889
London flower painter. Exhib. 1888-9 at the RA, SS and NWS.

BEECH, Herbert J.G. fl.1893
Exhib. a portrait of Mrs. Beech at the RA, 1893. Cardiff address.

BEECH, J. fl.1830-1839
Portrait painter. Exhib. 1830-9 at the RA. Lived in Leicester and London.

BEECHAM, John fl.1835-1857
Painter of historical subjects, genre and buildings. Exhib. 1835-57 only at the BI. Titles: 'Perkin Warbeck taking Sanctuary at the Abbey of Beaulieu', 1835, and 'By-gones', 1854. Lived at Cirencester.

BEECHEY, Miss Augusta fl.1870-1872
London still-life painter. Exhib. 1870-2 at SS and elsewhere.

BEECHEY, Miss Frances A. see HOPKINS, Mrs. Edward

BEECHEY, Miss Frederika fl.1870-1874
London painter of landscapes and coastal scenes. Sister of Miss Augusta Beechey (q.v.). Exhib. 1870-4 at SS and elsewhere.

BEECHEY, H. fl.1829-1838
Exhib. 'A View of part of Cyrene, etc.', at the BI, 1829 and 'Mrs. Worthington' at the RA, 1838. London address.

***BEECHEY, Capt. Richard Brydges 1808-1895**
London marine painter; son of Sir William Beechey, the portrait painter. Made the navy his career, and eventually rose to the rank of Admiral. Exhibited at the RA 1832-77, and at the BI and SS. Specialised in rough weather, shipwrecks and storms.
Bibl: Brook-Hart pp.339-40 (pl.182).

BEECHEY, S.R. fl.1859
Exhib. 'The Artist' at the RA, 1859. London address.

BEESTON, Arthur fl.1880-1884
Exhib. a watercolour 'Water Meadows and River Test, Stockbridge, Hants.' at the SS, 1884, and one elsewhere. London address.

BEETHAM, William fl.1834-1853
London portrait painter. Exhib. 1834-53 at the RA and SS.

BEETHOLME, George Law fl.1847-1878
London landscape painter. Exhib. 1847-78 at the RA, BI, SS and elsewhere. Titles at the RA mostly subjects in Scotland.

BEETHOLME, George Law Francis, Jnr. fl.1878-1886
London painter of fruit and landscape. Exhib. 1878-86 at SS.

BEGG, Samuel fl.1886-1891
Exhib. 'Choosing a Model in Paris Atelier', 'Objects d'Atelier', and 'Grand Stand — "Melbourne Cup" ', at the RA, 1886-91. London address.

BEGLEY, Henry fl.1862-1890
Irish landscape painter, living in Dublin and Limerick. Exhib. 1862-70 at the RHA.
Bibl: Strickland I p.54.

BEHR, Miss Julia fl.1870-1885
London painter of portraits and literary subjects. Exhib. 1870-85 at the RA, SS and GG. Titles at SS in 1870 'Marguerite' and a subject from Goethe's Faust.

BEKEN, Miss Annie fl.1898-1920s
London painter and etcher of flowers and genre. Studied art at the RCA. Exhib. 1898-1917 at the RA, and also in the provinces and abroad.

BELCHER, Miss E. Beatrice fl.1885
Exhib. 'Winter Leaves' at the RA, 1885. London address.

BELCHER, F. fl.1874-1879
Exhib. domestic subjects in London, 1874-9. London address.

BELFORD, Miss Kate A. 1871-1887
Painter in watercolour of genre and landscape. Exhib. 1871-87 at SS, NWS and elsewhere. Titles at SS 'A Peep into a Back Kitchen', 1874, and 'Sweet Madoline', 1880. Lived in London and Tunbridge Wells.

BELGRAVE, Dacres J.C. fl.1880-1885
London landscape painter. Exhib. 1880-5, at the RA, SS, NWS, and elsewhere. Titles: 'When March Winds Sleep', RA 1885 and 'Old Chalk Pit, Bury Lodge, Hants.', SS 1880.

BELGRAVE, Percy fl.1880-1896
London painter of landscape and genre. Exhib. 1880-96, at the RA, SS, NWS, GG, NG and elsewhere. Titles at the RA: 'Shades of Evening', 1883 and 'A Quiet Shore', 1894.

BELGRAVE, William fl.1890-1897
London landscape painter. Exhib. 1890-7 at the RA and elsewhere.

BELL, A. fl.1852-1857
London painter of topographical subjects, biblical subjects and genre. Exhib. 1852-7, at the RA and SS. Titles at the RA: 'Hide and Seek', 1853 and 'Little Dalby Hall, Leicestershire', 1856.

BELL, Miss Ada fl.1878-1903
London flower painter and landscapist. Exhib. at the RA 1880-1903 (mostly flowers); also at SS, GG and NWS.

BELL, Alexander Carlyle fl.1866-1891
London landscape painter. Exhib. 1866-91, at the RA, SS, NWS and elsewhere. Subjects often views in Scotland.

BELL, Alfred fl.1890-1895
Exhib. 'In Lorenzi Kirche, Nuremberg' and 'Thun' at the RA in 1890 and 1895. London address.

BELL, A.R. fl.1851-1853
London portrait painter. Exhib. 1851-3 at SS.

BELL, Arthur George RI ROI 1849-1916
London genre and landscape painter in oil and watercolour. Born in the City of London. Studied art at the Slade School and in Paris under Gerome at the École des Beaux Arts. Exhib. at the RA from 1879, and more often at SS. Subjects often of New Forest. Illustrated some books including *Nuremburg* and *Picturesque Brittany*. Lived in London and Southbourne-on-Sea, Hampshire.

BELL, E. fl.1873-1875
Exhib. 'A Studious Boy' and 'A Country Boy' at SS, 1873-5. London address.

BELL, Edward fl.1811-1847
Worcester painter of dead game, fish, still-life, landscapes, rustic genre and historical subjects. Also an engraver and mezzotinter. Exhib. at the RA 1811-47, and at the BI and SS.
Bibl: J.Challoner Smith, *British Mezzotint Portraits*, I 1878 p.55; Binyon.

BELL, Miss Eleanor fl.1874-1885
London painter of genre, historical and literary subjects, portraits and flowers. Exhib. 1874-85 at the RA, SS and elsewhere. Titles at the RA 'Learning her Lesson', 1874, 'Mariana', 1878, and 'Grandmother's Bible', 1882.

BELL, Mrs. Gleadthorpe fl.1859
Exhib. 'A Violet Bank' at SS, 1859. Mansfield, Nottinghamshire, address.

BELL, H. fl.1872
Exhib. 'As the Sun Went Down' at the RA, 1872. Manchester address.

BELL, Miss H.E. fl.1877
Exhib. a painting of fruit in London, 1877. London address.

BELL, Henry J. fl.1894-1907
Edinburgh landscape painter. Exhib. 1894-1907 at the RA.

BELL, Hesketh Davis fl.1849-1872
Exhib. 'Scene in N. Wales' and 'Stormy' at the BI in 1849 and 1852. Also exhib. elsewhere in London. London address.

BELL, Rev. J. fl.1863
Exhib. a 'Portrait of a Girl' at the RA, 1863. London address.

BELL, Miss Jane Campbell fl.1850-1863
London painter of portraits, historical subjects and genre. Exhib. 1850-63 at the RA and SS. Titles at the RA: 'Lucy Ashton and Dame Gourlay', 1855 and 'The Accordion', 1856.

BELL, J.C. fl.1857-1868
Scarborough painter of sporting subjects, game, animals and genre. Exhib. 1857-68 at SS, titles: 'Heron Attacked by Gerfalcons' 1857, and 'After Dinner', 1858.

BELL, John fl.1852-1861
Landscape painter. Exhib. 1852-61, at the RA, BI, SS and elsewhere, subjects mainly views in North Wales and North Italy. Lived at Cheapside, London and Betws-y-Coed, N. Wales.

BELL, John Clement fl.1878-1892
Exhib. landscapes at the RA, NWS and elsewhere, 1878-92. London address. It is possible that this may be the same artist as the J. Clement Bell who exhib. designs for stained glass at the RA, 1925-35, and who died in 1944.

BELL, John Zephaniah 1794-1883/4
Scottish domestic and historical painter. Studied with Archer-Shee, and Gros in Paris. Worked in Edinburgh, Rome, Lisbon, Oporto, and Manchester. Won a prize in the competitions for the Westminster Hall decorations. Exhib. at the RA 1824-61, and at the BI and SS. Subjects: 'Cartoon for Ceiling at Muir House', 'Richard II Giving the Charter to the Goldsmith's Company', 'Circassians reconnoitring Position', etc.

BELL, Miss Lucy Hilda fl.1889-1919
London painter of fruit, flowers, portraits, landscape and coastal scenes. Exhib. 1889-1919, at the RA, SS and NWS. Titles at the RA 'Study of Pomegranates', 1890 and 'Chrysanthemums', 1897.

BELL, Miss Mary A. fl.1894-1929
(Mrs. Eastlake)
Painter of landscape, portraits and genre. Exhib. 1894-1929 at the RA. Titles: 'Moonrise', 1894, and 'Mobilisation Day: French Fisherwomen Watching the Departure of the Fleet', 1917. Lived in St. Ives, Cornwall and Croydon.

BELL, Percy F.H. fl.1887-1892
Exhib. a portrait at the RA, 1887, and topographical scenes in Venice at SS, 1892; also two elsewhere. Hounslow, Middlesex, address.

***BELL, Robert Anning RA 1863-1933**
Figure painter, sculptor of reliefs, illustrator and designer of mosaics and stained glass. Articled to an architect. Studied at the RA schools in 1881 and at Westminster School of Art. Worked in Paris under Aimé Morot and in London with George Frampton, then visited Italy. Exhib. at RA from 1885; elected ARA 1914, RA 1922. Member of NEAC 1892-1902; ARWS 1901; Art Worker's Guild (Master in 1921). Taught at Liverpool University from 1894 and Glasgow School of Art from 1911. Professor of Design at RCA 1918-24. Designed mosaics for Westminster Cathedral. Memorial exhibition at FAS 1934. His wife was Laura Anning Bell (1867-1950), the portraitist.
Bibl Tate Cat.; Studio, see index; Wood, Pre-Raphaelites.

BELL, Robert Clifton fl.1882-1883
Landscape painter. Exhib. 1882-3 at the SS and elsewhere. Lived in East Molesey, Surrey.

BELL, Robert Purves ARSA 1841-1931
Scottish painter of portraits, genre, Moorish subjects, landscape and flowers, in oil and watercolour. Born in Edinburgh, son of Robert Charles Bell, a steel engraver. Studied art at the RSA Schools; exhib. at the RSA from 1863. Became ARSA in 1880. Before 1893 only exhib. once in London, and never at the RA, SS, BI or NWS. Lived in Scotland in Edinburgh, Tayport and Hamilton. Titles at the RSA, 'The Romance', 1868 and 'A Street in Algiers: Moorish Women paying a Marriage Visit', 1875.

BELL, Stuart Henry 1823-1896
Marine painter, worked in Newcastle, Gateshead and Sunderland. Not known to have exhibited, although his pictures were admired by Queen Victoria in 1886. Bell was also a theatrical scenery painter, and impresario. He leased the Theatre Royal, Newcastle, and the Drury Lane, Sunderland, but his theatrical speculations ended in bankruptcy. The Sunderland Art Gallery has a collection of his pictures .
Bibl: Brook-Hart (pl.183); Hall.

BELL, Thomas C. fl.1898
Exhib. 'Dutch Boats' at the RA, 1898. London address.

BELL, W.H. fl.1896
Exhib. 'The Winter Sun: Putney' at the RA, 1896. London address.

BELLAMY, A.S. fl.1868-1874
London painter of fruit and flowers. Exhib. 1868-74 at the RA and SS.

BELLANDI, F. fl.1880
Exhib. one genre painting in London, 1880. London address.

BELLANGER, G. fl.1869
Exhib. 'La Lecture' at the RA, 1869. London address.

BELLAY, Charles R. fl.1871-1879
Exhib. seven paintings of 'figures' in London, 1871-9. Rome address.

BELLEI, Gaetano fl.1882
Exhib. ' "Cara Nonna" ' at the RA, 1882. London address.

BELLHOUSE, Richard Taylor fl.1880-1884
Exhib. topographical subjects at SS, NWS and elsewhere, 1880-4. Bruges and London addresses.

BELLI, Enrico fl.1862-1884
London painter of portraits, Italian subjects and genre. Exhib. 1862-84 at the RA and SS. Titles at SS 'Costume of Naples' 1879 and 'A Fancy Picture', 1884.
Bibl: Ormond I pp.36, 486.

BELLIN, Arthur fl.1877-1888
London painter of marines and coastal scenes. Exhib. 1877-1888 at the RA, SS, GG and elsewhere, his subjects mainly views of the south coast and Channel Islands.

BELLIN, Miss J. fl.1839
Exhib. 'Madonna's Shrine — Subiaco' and 'View in the Forum at Rome' at SS, 1839. No address given.

BELLOC, Miss Emma fl.1895-1900
Exhib. 'In the Harbour — Polperro', and 'An Orphan' at the RA in 1895 and 1900. London address.

BELLOT (BELLOTT), Herbert M. fl.1874-1884
Exhib. 'An Italian Peasant' and 'Gulnare-Vide Arabian Nights' at SS, 1874-5, and 'Out-door Relief' at the RA, 1884. Also one picture at the NWS. London address.

BELLOT, Mrs. Julia Cecilia fl.1884
Exhib. 'Hermione' at the RA, 1884 and elsewhere. Wife of Herbert M. Bellot (q.v.). London address.

BELLOWS, Albert F. fl.1869
Exhib. two landscapes in London, 1869. London address.

BELMONT, Aloysius fl.1898
Exhib. 'In the Market — Tangier' at the RA, 1898. London address.

BELSHAW, Frank fl.1881-1882
Nottingham painter of fish and landscape. Exhib. 1881-2 at the RA and SS. Titles at the SS, 'A Neglected Orchard in Devon', and 'Roach'.

BENDIXEN, Siegfried Detler 1786-1864
Landscape and portrait painter. Born in Russia and settled in London in 1832, where he exhib. at the RA and NWS.

BENECKE, Miss Amy M. fl.1885
Exhib. one landscape at the NWS, 1885. London address.

BENEDICT, R. fl.1856-1862
London painter of genre. Exhib. 18S6-62 at SS. Titles: 'The Milking Field', 1856, and 'The Young Ramblers', 1862.

BENETT, Newton 1854-1914
Landscape painter, in oil and watercolour. Born in London, he was the youngest child of William Benett, a master in the High Court,

and was collaterally descended from Sir Isaac Newton. He devoted himself to art from the age of seventeen. He was a pupil of Paul Naftel, and a friend of Alfred Fripp, Alfred Hunt, Alfred Parsons, Arthur Hughes, G.D. Leslie and other artists. Exhib. from 1875 at the RA, SS, NWS, GG, NG and elsewhere. He worked in the New Forest, and at Lyme Regis, Warborough-on-Thames, and Dorchester.
Bibl: VAM.

BENGA. Ed. W. fl.1892
Exhib. 'On Dartmoor' at SS, 1892. London address.

BENGER, Berenger RCA 1868-1935
Landscape painter in oil and watercolour. Born at Tetbury in Gloucestershire. Studied art under Verlat at the Antwerp Academy. Exhib. from 1884 at the NWS and from 1890 at the RA. Lived at Birkenhead and later at Uckfield, Crowborough and Pulborough in Sussex. Member of the Royal Cambrian Academy.

BENGER, William Edmund fl.1890-1913
Landscape painter. Brother of Berenger Benger (q.v.); lived at Llandudno, N. Wales and at Crowborough and Fittleworth, Sussex. Exhib. 1890-1913 at the RA, SS and NWS.

BENHAM, Miss Jane see HAY, Mrs. Jane

BENHAM, Miss Jessie fl.1887-1893
Exhib. two studies of the sea at the RA, 1887-93, and one elsewhere in London. London address.

BENHAM, Thomas C.S. fl.1878-1922
London painter of landscape, portraits, flowers, sporting and figure subjects. Exhib. at RA, NWS, GG and elsewhere from 1878. Titles at RA 'Poachers', 'Toilers of the Sea', etc.

BENJAMIN, R. fl.1858
Exhib. 'Gipsy Boys playing Cards at Seville' at the RA, 1858. London address.

BENNETT, Alfred fl.1861-1916
Landscape painter. Exhib. 1861-1916 at the RA, BI and SS. Lived in London, and later, in 1916, at Knebworth, Hertfordshire.

***BENNETT, Frank Moss 1874-1953**
London painter of portraits, genre and historical subjects; illustrator. Born at Liverpool. Studied art at St. John's Wood Art School, at the Slade School, and at the RA Schools where he won a gold medal and a travelling scholarship. Exhib. 1898-1928 at the RA. Titles: 'A Book Plate', 1898, 'The Greek Runner Ladas Falling Dead as he goes to Receive his Crown at Olympia', 1900, and 'Gay Birds', 1903. Also exhib. at the RI and Paris Salon. Best known for his Elizabethan subjects, many of which became well-known through calendars and other forms of popular reproduction.

BENNETT, G.R. fl.1877
Exhib. 'A Portrait' at the RA, 1877. London address.

BENNETT, Miss Harriet M. fl.1877-1892
Painter of genre and landscape. Exhib. 1877-92 at the RA, SS, NWS and elsewhere. Titles at the RA 'The Story of "Poor Cock Robin" ' 1891, and 'I Shan't Play!', 1892. Forest Hill address.

BENNETT, Miss Isabel fl.1870-1876
London landscape painter. Exhib. mostly at SS, 1870-6, and once at the RA, in 1874.

BENNETT, J.A. fl.1882
Exhib. 'A Fruit Seller of Tivoli' at the RA, 1882. Manchester address.

BENNETT, J. Lovett fl.1885
Exhib. 'Dragging In on Him' at SS, 1885. Parsonstown, Ireland, address.

BENNETT, Miss Kate fl.1888
Exhib. a genre painting at NWS, 1888. Forest Hill address.

BENNETT, Miss Mary fl.1871-1876
London landscape painter. Exhib. 1871-6 at SS and elsewhere

BENNETT, S.E. fl.1880
Exhib. a painting of 'Figures' in London, 1880. Forest Hill address.

BENNETT, William RI 1811-1871
Landscape painter in watercolour. He is said to have been a pupil of David Cox, "whose style he adopted as the groundwork on which to form his own. A few years ago his drawings bore far greater similarity to those of his master than his later works show; especially in the treatment of foliage " (AJ). Exhib. 1842-71, at the RA, SS, BI, but mostly at the NWS, of which he became A in 1848, and member in 1849. Alfred Williams (q.v.) was his pupil.
Bibl: AJ 1871 p.139 (obit.); Redgrave, Dict.; VAM.

BENNETT, William fl.1878-1887
London landscape painter. Exhib. 1878-87 at SS, NWS and elsewhere.

BENNETT, William B. fl.1900-1913
Painter of genre and landscape. Exhib. 1900-13 at the RA. Titles: 'A Soldier's Daughter', 1900, and 'Echo', 1902. Lived at Bushey, Hertfordshire.

BENNETT, William Mineard c.1778-1858
Exeter portrait painter and miniaturist. Pupil and imitator of Sir Thomas Lawrence. Worked in London and Paris before returning to Exeter in 1844.

BENSON, Charlotte E. 1846-1893
Irish painter of landscapes and marines. Daughter of Dr. C. Benson of Dublin; studied in Dublin. Exhib. at the RHA. Visited India.
Bibl: Strickland I pp.55-6.

BENSON, Eleanor B. fl.1870
Exhib. 'Leonardo da Vinci, from the picture by himself, Uffizi Gallery' at SS, 1870. No address given.

BENSON, Miss H. fl.1875
Exhib. 'Garden Flowers' at the SS, 1875. London address.

BENSON, Miss Henrietta fl.1885
Exhib. a genre painting at NWS, 1885. Hertford address. Sister of Mary K. Benson (q.v.).

BENSON, Miss Mary K. fl.1879-1890
Painter of genre and animals. Exhib. 1879-90, at the RA, SS and elsewhere. Titles at the RA ' "Why thus Longing, etc." ' and 'Kittens', 1884. Lived at Hertford.

BENSON, Miss Nellie fl.1897-1901
London painter of flowers and portraits. Exhib. 1897-1901 at the RA.

BENSTED, J. fl.1828-1847
Painter of game. Exhib. 1828-47 at the RA and SS. Lived in London and Maidstone, Kent.

BENTHAM, A.W. fl.1893
Exhib. a painting of a river subject at the NG, 1893. No address given.

BENTHAM, R.H. fl.1871-1874
Guernsey landscape painter. Exhib. 1871-4 at SS — his subjects views in Guernsey, France and Switzerland.

BENTLEY, Mrs. see SMITH, Miss Lucy Bentley

BENTLEY, Charles 1806-1854
London marine watercolourist. Apprenticed as an engraver to Theodore Fielding and worked with him and his two engraver brothers. Engraved a number of Bonington's watercolours and much influenced by his style. In 1827 set up on his own as an engraver and produced drawings for illustrated publications. Elected A of the OWS 1834, member 1843. Exhib. mainly at OWS 1834-54 (209 works), also at SS and NWS. Did not exhib. at the RA. Subjects generally coast and river scenes, with varying effects of sunset, evening, storm and calm, on the British and Irish coasts, Normandy and the Channel Islands. A lifelong friend of William Callow (q.v.) with whom he made many trips to Normandy and Paris. His studio sale was held at Christie's, 16 April 1855.
Bibl: DNB: Binyon; Roget; F.G. Roe, Walker's Quarterly, I No.3 1920; VAM; Hardie III pp.76-8; Brook-Hart p.93.

BENTLEY Edward fl. from 1866 d.c.1882
Painter of flowers, fruit and landscape. Lived at Bexley Heath, Kent. Exhib. 1866-85 at SS and in 1883 at the RA. Titles at SS, 'The Last Flowers of Autumn', 1866, and 'A Bit from the Hedgerow', 1873. SS notes "died 1882?" and Graves RA "The late" in 1883.

BENTLEY, Joseph Clayton 1809-1851
London landscape painter, watercolourist and engraver. Born in Bradford. Pupil of Robert Brandard the engraver. Exhib. 1833-51 at the BI, 1846-52 at the RA, and at SS. His watercolours often confused with those of Charles Bentley (q.v.).
Bibl: AJ 1851 p.280; 1852 p.15 (obit.); Redgrave, Dict.; VAM; Cundall; DNB; Hughes; Hardie III p.77.

BENTLEY, Joseph Herbert RBA b.1866 fl.1885-1917
Painter of portraits, genre and topographical subjects. Born at Lincoln. Studied at Lincoln School of Art and at the Antwerp Academy. Exhib. at the RA, 1885-1917, and was elected RBA in 1895. Lived in Lincoln and Sheffield. His portrait of Queen Victoria, dated c.1897, is in the Guildhall, Lincoln.
Bibl: Ormond I p.491.

BENTON, George Bernard b.1872 fl.1898-1902
Birmingham painter of historical and literary subjects, landscape and genre. Born in Birmingham, studied at Birmingham College of Arts and Crafts. Exhib. at the RA, 1898-1902. Titles: 'Gareth and Lynette', 1900 and 'The Four Knights of Sussex', 1902. Also at the Royal Birmingham Society of Artists.

BENTON, Mrs. Julia L. (J.) fl.1883-1885
London painter of genre and landscape. Exhib. 1883-5 at the RA and SS. Titles at the RA 'Pot Hooks and Hangers', 1884, and 'Father's Sunday Boots', 1885.

BENTZ, Frederick fl.1877-1885
Painter of genre and landscape. Exhib. 1877-85, at the RA, SS and elsewhere. Titles at the RA: 'Eel Catchers', 1884 and 'Yes or No', 1885. Lived in Edinburgh and Manchester.

BENUZZI, Edwin fl.1888-1889
Exhib. views of Venice at SS, 1888-9. London address.

BENWELL, Mrs. fl.1870-1871
Exhib. landscape views in Italy at SS, 1870-1. Wife of Joseph Austin Benwell (q.v.).

BENWELL, Joseph Austin fl.1865-1886
London painter of landscapes and eastern subjects. Exhib. 1865-86, at the RA, SS, NWS and elsewhere. His subjects were mainly scenes in Egypt, Jerusalem, Mount Sinai, etc.

BERENS, A.H. fl.1888
Exhib. 'The Moonlighters' at the RA, 1888. London address.

BERESFORD, Miss E.M. (C.M.) fl.1865-1885
London painter of genre. Exhib. 1865-85 at SS, NWS and elsewhere. Titles at SS, 'A Grey Beard', 1877 and 'Orange-seller, Rome', 1878. Possibly the same Miss Beresford listed in SS who exhib. there in 1881 from a Rome address. Titles: 'Head of an Italian Boy' and 'A Negro'.

BERESFORD, Miss P. fl.1871-1880
Painter of genre. Exhib. 1871-80 at SS and GG. Titles: 'Study of a Peasant — North Italy', 1872, and 'Venetian Fishermen', 1874. Address, c/o Clifford, 30 Piccadilly. See also E.M. Beresford.

BERGER, Johan fl.1839
Exhib. 'Moonlight in Dublin Bay' and 'Marine view off Dublin, with the Custom House in the Distance' at the BI, 1839.

BERGSON, Miss Mina fl.1885-1888
Painter of portraits and figure subjects. Exhib. 1885-8 at the RA. Titles: 'Beatrice', 1885, and 'Richard, Duke of Gloucester', 1888. London address.

BERKELEY, Harriet fl.1854
Exhib. 'Happy Moments' at the RA, 1854. London address.

BERKELEY, Stanley RE fl.1878-1902 d.1909
London animal, landscape, sporting and historical battle painter. Exhib. at the RA 1881-1902, also at SS and NWS. Titles at RA 'On the Thames', 'For God and the King', 'The Sunken Road of Ohain; an Incident in the Battle of Waterloo'. His wife, Mrs. Edith Berkeley, painted genre and landscapes, and also exhib. at the RA 1884-91.
Bibl: Maas p.206 (reprd. detail from 'For God and the King').

BERKLEY, Miss M. fl.1854
Exhib. 'Innocence' at the BI, 1854. Same London address as Harriet Berkeley (q.v.), so name may be misspelt in Graves BI.

BERNAN, Miss Charlotte A. fl.1884
Exhib. a painting of flowers at the NWS, 1884. No address given.

BERNARD, Miss Margaret fl.1883-1898
Landscape painter. Exhib. 1883-98, at the RA and NWS. Bath and Wimbourne, Dorset, addresses.

BERNASCONI, George H. fl.1861-c.1881
London painter of portraits and genre. Exhib. 1861-6 at the RA, BI and SS. Titles at the RA 'What does she Think of the Open Book?' 1861, and 'The Sea, The Sea', 1863. A portrait of George Dawson, c.1881 is in Birmingham Art Gallery.
Bibl: Birmingham Cat.

BERNAU, Miss Charlotte fl.1887-1907
Portrait painter. Exhib. 1887-1907 at the RA. Lived in London and Whyteleaf, Surrey.

BERRIDGE, William Sidney
Animal painter. Very little known. Probably working c.1880-90. A picture of a tiger was sold at Christie's, December 1968.

BERRY, Miss Maude fl.1880-1885
London portrait painter. Exhib. 1880-5 at the RA and elsewhere.

BERRY-BERRY, Francis fl.1874-1893
London painter of flowers, genre and landscape. Exhib. 1874-93, at the RA, SS, NWS, NG and elsewhere. Titles: 'Our Little Pet', SS 1875, and 'Chrysanthemums', RA 1883.

BERTHA, Julia fl.1881
Exhib. two landscapes at SS, 1881. Cookham, Berkshire, address.

BERTHOUD, H. fl.1846
Exhib. two paintings of game at SS, 1846. London address.

BERTI, G. fl.1835-1839
London painter of literary subjects and Italian genre. Exhib. 1835-9 at the RA and SS. Titles at the RA: ' "The Milanese having Revolted . . . Renzo appears, etc." ', 1835, and 'An Italian Countrywoman Instructing her Child to Read', 1839.

BERTIE, Marion A. fl.1886-1888
London painter of pastoral subjects. Exhib. 1886-8 at the RA and SS. Titles: 'Apple Blossom', SS 1886 and 'Falling Leaf and Fading Tree', RA 1888.

BERTIER, C.A. fl.1886
Exhib. 'Returning from School' at the RA, 1886. London address.

BERTIN, E.F. fl.1872
Exhib. one landscape at SS, 1872. No address given.

BERTIOLI, Frank fl.1871-1889
London painter of genre and figure subjects. Exhib. 1871-89 at the RA, SS and NWS. Titles: 'Ismene', RA 1872, and 'The Morning Paper', SS 1884.

BERTON, E. fl.1880-1881
Painter of genre. Exhib. 1880-1 at SS and elsewhere. Titles: 'A Quiet Corner'. Putney address.

BERTRAM, Miss fl.1867
Exhib. one painting of game at SS, 1867. Address c/o one in London.

BERTRAM, Frederick H. fl.1896-1907
London marine painter. Exhib. 1896-1907 at the RA. Titles: 'The Turn of the Tide', 1896 and 'A Ground Swell', 1899.
Bibl: Brook-Hart p.340.

BERTRAM, Miss Marion fl.1884
Exhib. one painting of 'Figures' at GG, 1884. London address.

BERWICK, C.M. fl.1880
Exhib. one painting of 'Figures' in London, 1880. London address.

BESCH, Miss L. fl.1889
Exhib. one genre painting at the NWS, 1889. London address.

BESNARD, Albert fl.1881-1882
London painter of portraits and genre. Exhib. 1881-2 at the RA.

BESSET, Mrs. Jane M. fl.1846-1856
London painter of genre and historical subjects. Exhib. 1846-56 at the RA, SS and elsewhere. Titles: 'The Reading Lesson', SS 1847, and 'The Age of Innocence', RA 1849.

BESSON, M. fl.1853
Exhib. two paintings of mythological subjects in London, 1853. Manchester address.

BEST, Miss F.G.S. fl.1878-1881
Exhib. a painting of flowers and 'Study of Lamps: St. Mark's, Venice' at SS, 1878-81. Andover, Hampshire, address.

BEST, George Hollings fl.1873-1905
Painter of landscapes and literary subjects. Exhib. 1873-1905, at the RA and elsewhere. Titles at the RA, 'The Haven', 1873, and ' "Nigh upon that hour when the Lone Hern forgets his Melancholy" Tennyson, "Gareth and Lynette" ', 1905. Lived in Streatham and Chichester, Sussex.

BEST, Thomas fl.1834-1839
London painter of genre and portraits. Exhib. 1834-9 at the RA and SS. Titles: 'Miss Cust', RA 1834, and 'Love's Garland', SS 1837.

BESWICK, Frank fl.1881-1883
Chester landscape painter. Exhib. 1881-3 at the RA and NWS.

BETHELL, Miss V.S. fl.1884
Exhib. one landscape at GG, 1884. No address given.

BETTS, Miss Ida 1871-1951
Watercolour painter. Born at Chipperfield in Hertfordshire. Studied art at Bedford and St. Ives. Exhib. 'The Banks of the Yeam' at the RA in 1900, and also at the RI, RBA and Paris Salon. Lived at Abbots Langley, Hertfordshire, at Wilton in Wiltshire and later at Newbury in Berkshire.

BEVAN, J. fl.1846
Exhib. 'A Portrait', at the RA, 1846. London address.

BEVERLEY, J. fl.1838
Exhib. 'Portrait' at the RA, 1838. No address given.

BEVERLEY, William Roxby c. 1811-1889
Landscape painter and watercolourist. Son of William Roxby, an actor and theatrical manager. As a boy Beverley studied with

Clarkson Stanfield, but devoted most of his career to painting and designing stage scenery. Worked in Manchester and London, and was scenic director of Covent Garden 1853-84. In spite of the demands of his work, he found time to paint pictures and watercolours, mainly coastal scenes, especially at Scarborough, Sunderland, Eastbourne and Hastings. He also visited the Lake District, Paris and Switzerland. His output was not large, but Hardie says "there can be no doubt that if there were wider knowledge of his radiant and limpid watercolours, Beverley would have a much higher place than he has hitherto occupied in any history of watercolour".

Bibl: F.L. Emanuel, *W.R.B.*, Walkers Quarterly I No. 21; Clement & Hutton; Binyon; VAM; Hughes; DNB; Hardie II pp.188-9 (pl.182); Hall; Brook-Hart p.92.

BEVERS, Miss Maud fl.1899
Exhib. 'Orchids' at the RA, 1899. Oxford address.

BEVES, Mrs. Helen C. fl.1900
Exhib. 'Patty' at the RA, 1900. London address.

BEWICK, William 1795-1866
Painter of portraits, historical subjects and genre. Born at Hurworth, Co. Durham, Bewick left Northumbria early in life and went to London to become a pupil of Benjamin Robert Haydon, the historical painter. Received a commission to complete a series of drawings of the Elgin Marbles for Goethe. Exhib. at the BI, 1822-48 (historical subjects, 'Jacob meeting Rachel', 1822), at the RA 1839-40 (portraits and historical subjects), and at the SS 1839-41. A period in Darlington, in the 1820s followed, during which he painted portraits, and a short while later he was commissioned by Sir Thomas Lawrence to copy Michelangelo's frescoes in the Sistine Chapel. Bewick remained in Italy for about four years, then returned to London to set up as a portrait painter. Ill health followed and he was obliged to retire to the country, living at Haughton House, Haughton-le-Skerne, Co. Durham, for the last twenty years of his life. He was not related to Thomas Bewick.

Bibl: Thomas Landseer, *The Life of William Bewick*, 1871; Hall pp.17-18; Ormond I pp.52, 243, 251, 293, 295.

BEYERHAUS, E. fl.1857
Exhib. a portrait at the RA, 1857. London address.

BIBBS, Louisa H. fl.1864
Exhib. a still-life at SS, 1864. Worcester address.

BICKLEY, H.M. fl.1883
Exhib. 'A Mountain Road' at SS, 1883. Woking, Surrey, address.

BICKNELL, Mrs. see DESVIGNES, Miss Emily E.

BIDAU, J. fl.1862
Exhib. a watercolour 'Portrait of a Lady' at SS, 1862. London address.

BIDDLE, R.J. fl.1875-1882
London painter of marines and coastal scenes. Exhib. 1875-82 at the RA and SS.

BIDDLECOMBE, Walter fl.1883-1886
Southampton painter of genre and landscape. Exhib. 1883-6, at the RA and SS. Titles, 'The Gleaner', RA 1883, and 'At Eventide: An Ancient Lichgate at Pulborough, Sussex', SS 1886.

BIDDULPH, Miss Edith fl.1892-1893
Exhib. paintings of flowers at the RA and NWS, 1892-3. London address.

BIDDULPH, General Sir Michael A. fl.1890
Exhib. 'A Summer Evening, Biarritz' and 'Looking over the Lolab, Cashmir' at SS, 1890. Exhib. c/o a London address.

BIDOUZ, J. fl.1861
Exhib. 'Portrait of a Lady' at the SS, 1861. London address.

BIELFELD, H. fl.1825-1856
Painter of genre, historical and mythological subjects, landscapes and portraits. Exhib. 1825-56, at the RA, BI and SS. Titles at the RA 'Cupid Borne by Zephyrs', 1848, and 'The Light of the Harem', 1848. Lived in Liverpool, Manchester, Exeter, Devon and London.

BIGG, Charles O. fl.1869-1876
London landscape painter. Exhib. 1869-76 at SS and elsewhere subjects mostly landscapes in Brittany.

BIGLAND, Mary B. fl.1869-1887
Birkenhead landscape painter. Exhib. 1869-87 at the NWS and elsewhere.

BIGLAND, Percy fl.1882-1925 d. 1926
Painter of portraits, genre and landscape. Educated at Sidcot in Somerset and spent some years studying art in Munich. Exhib. at the RA 1882-1925, and also at SS, GG, NG and elsewhere. Lived at Liverpool, London and Beaconsfield, Buckinghamshire. Died in 1926, aged 68.

BIHAN, D.L. fl.1852
Exhib. 'Heath of St. Anne D'Auray, in Brittany, with Peasants returning from Church, after Marriage' at the RA, 1852. London address.

BILBIE, James L. fl.1884
Exhib. two landscapes at the RA, 1884. Nottingham address.

BILLER, A. fl.1868-1871
Exhib. 'French Peasant Girl' and a landscape sketch at the RA, 1868 and 1871. London and Bickley, Kent, addresses.

BILLER, C. fl.1873
Exhib. 'A Lady writing on a Letter' and 'Solitude' at SS, 1873. No address given.

BILLYEALD, Arthur fl.1882-1887
Exhib. landscapes and river scenes at the RA and SS, 1882-7. Catford Bridge address.

BILSTON, S. fl.1843
A prolific painter, in watercolour, of churches and other buildings in Newcastle and Co. Durham, Bilston worked in Northumbria in the mid-19th century.
Bibl: Hall.

BILTON, A. fl.1893
Exhib. a painting of 'Figures' at the NWS, 1893. Gunnersbury address.

BINCKES, Henry Ashby fl.1846
Exhib. 'The Midnight Attack — Boys Bolstering' at the RA, 1846. London address.

BINDLEY, Frank fl.1878-1883
Painter of genre. Exhib. 1878-83 at the RA and SS. Titles at the SS 'Late for School', 1878, and 'Old Love Letters', 1883. Lived in London and Galway.

BINET, V. fl.1886
Exhib. 'September Morning — St. Aubin', at the RA, 1886. London address.

BINFIELD, E.H. fl.1869-1877
Exhib. 'Granada' at the RA, 1869, and six paintings elsewhere in London, 1869-77. London address.

BINFELD, Miss F.D. fl.1873
Exhib. 'Waiting' at the SS, 1873. London address.

BINGHAM, The Hon. A.Y. fl.1878
Exhib. two landscapes at the RA, 1878. Titles: 'Cape Brassey, Straights of Magellan', and 'Sacred Mountain' — inland sea of Japan'. London address.

BINGHAM, W.R. fl.1844
Exhib. 'Twilight from nature — "this treasured hour I sit alone, etc." ' at the RA, 1844. London address.

BINGLEY, James George 1840-1920
Godalming landscape painter. Also lived at Wallington and Midhurst. Exhib. at RA and SS 1871-91. Mainly views of Kent, Surrey and the South Coast. Titles at RA 'A Bit of Old Kent', 'Gathering Primroses', 'The First Brood', etc. Painted in an attractive impressionist style.

BINKS, Thomas A. 1799-1852
Hull marine painter. Painted merchant ships in and around Hull, and also scenes of arctic exploration. Not known to have exhibited in London. Pictures by him are in the Ferens AG and the Maritime Museum in Hull.
Bibl: Brook-Hart p.69 (pl.130).

BINNS, Miss Elizabeth J. fl.1882-1895
Worcester flower painter. Exhib. 1882-95 at the RA and SS.

BINNS, Miss Frances Rachel fl.1880-1886
London painter of landscape and portraits. Exhib. 1880-6 at the RA and SS.

BIRCH, Annie fl.1892
Exhib. 'In Shoreham Harbour' at SS, 1892. London address.

BIRCH, Downard 1827-1897
Landscape painter. Exhib. only five works at the RA (1858-61 and one in 1892) and three at the BI. His early works show interesting Pre-Raphaelite influence, but his output was very small, and he lived for many years in Italy. The AJ says in his obituary that the promise of his early years "was scarcely fulfilled".
Bibl: AJ 1897 p.350 (obit.).

BIRCH, John 1807-1857
Sheffield painter of portraits, landscape and genre. Born at Norton, Derbyshire; he first assisted his father as a file cutter, and then became apprenticed to George Eadon, carver and gilder, for seven years. Then he went to London and studied under H.P. Briggs RA (q.v.). Exhib. 1842-56 at the BI and SS. He was a close friend of Ebenezer Elliott, the corn-law rhymer, and painted many portraits of him. He exhib. a portrait of Elliott among the rocks of Rivilion, Sheffield, 1839, and this attracted great attention. For some years Birch lived in London, making occasional visits to Sheffield, and then he returned home.
Bibl: AJ 1857 p.272 (obit.); Redgrave, Dict.

BIRCH, Lionel fl.1899-1920s
Landscape painter. Exhib. 1899-1916 at the RA, and also at the Royal West of England Academy. Lived at Newlyn, Cornwall and at Whimple and Ottery St. Mary, Devon.

BIRCH, Miss Sarah fl.1884-1898
Painter of genre and portraits. Exhib. 1884-98 at the RA, SS, GG, NG and elsewhere. Titles at the RA 'In a World of her Own', 1885, and 'A French Fisher Girl', 1890. Lived in London and at Brighton.

BIRCHAM, J.B. fl.1837-1838
Exhib. two Shakespearian subjects at BI, 1837-8. London address.

BIRD, Clarance A. fl.1896-1898
Exhib. 'Lydia' and 'Arcadian Shades' at the RA 1896-8. London address.

BIRD, Harrington fl.1870-1893
London painter of sporting subjects and genre. Exhib. 1870-93 at the RA, SS and elsewhere. Titles at the RA 'The Horsepond', 1870, and 'Rivals', 1893.

BIRD, H.D. fl.1846
Exhib. 'Portrait of T. Downing, Esq., with a favourite old Spaniel' at the RA 1846. London address.

BIRD, Miss H.M. fl.1875
Exhib. 'Francesco-Roman Contadino — Study from Life' at SS 1875. Bristol address.

BIRD, Isaac F. fl.1826-1861
Exeter and London portrait painter. Exhib. at RA 1826-59, BI and SS. Titles: all portraits and groups, and 'Study of a Yorkshire Factory Girl' (1840). A portrait group of three girls appeared at Christie's, 15 December 1972, lot 168.

BIRD, Miss Margaret fl.1891-1892
Painter of genre. Exhib. 1891-2 at the RA and SS. Titles at the RA 'The Song of the Shirt', 1891, and 'Orphans', 1892. Lived at Newlyn, Cornwall and Haywards Heath, Sussex.

BIRD, Samuel C. fl.1865-1893
London painter of coastal and genre scenes and dead game. Exhib. at the RA 1866-83, and at the BI and SS. Titles at RA 'Who Killed Cock Robin', 'The Many Twinkling Smile of Ocean', etc.

BIRD, W.D. fl.1840
Exhib. a portrait at SS, 1840. London address.

BIRD, William fl.1897-1919
London portrait painter. Exhib. 1897-1919 at the RA.

BIRKENRUTH, Adolphus 1861-1940
Painter, in oil and watercolour, of landscapes and figure subjects. Born at Grahamstown, S. Africa. Came to England and studied art in London, also in Paris. Exhib. from 1883 at SS, and from 1885 at the RA; also at the NWS, GG and elsewhere.

BIRKETT, B. fl.1865
Exhib. 'La Bonne' at SS, 1865. London address.

BIRKETT, P. fl.1847-1848
Exhib. two portraits at SS, 1847-8. London address.

BIRKMYER, James B. fl.1868-1898
Exeter landscape painter. Exhib. 1868-98 at the RA and SS.

BIRLEY, Ada Kate fl.1880-1881
Birmingham flower painter; exhib. there in 1880-1.

BIRNE, Rix fl.1885-1887
Painter of portraits and genre. Pupil of Whistler. Exhib. 1885-7 at the SS. Titles: 'The Muslin Gown', 1887, etc.

BIRTLES, Henry 1838-1907
Birmingham landscape painter. Also lived in Regent's Park, Hampstead, and Arundel. Exhib. at the RA 1861-78, more often at SS. Titles at RA 'Sheep in the Meadows', 'A Dewy Morning', etc.

BISCHOFF, C.F. fl.1848
Exhib. 'The Secret, Winning the Challenge Cup of the R.T.Y.C. for the Second Time, value 130 guineas, June 8, 1847' at the SS, 1848. London address.

BISHOP, A.S. fl.1874-1889
Nothing is known of this painter and hardly any of his pictures are recorded: a portrait of the 4th Marquess of Salisbury on horseback, signed and dated 1874, is at Hatfield, and a coaching scene 'John Selby's Brighton Coach outside the New White Horse Cellar, Piccadilly', 1889, is at the London Museum.
Bibl: John Hayes, *Cat. of the Oil Paintings in the London Museum,* 1970.

BISHOP (BISHOPP), G. fl.1880-1885
Still-life painter. Exhib. 1880-5 at SS and elsewhere. Lived in London and Horsham, Sussex.

BISHOP, Harry fl.1893-1897
London painter of portraits and landscape. Exhib. 1893-7 at the RA, and elsewhere. Possibly the same painter, H. Bishop, who exhib. 'The Piazza, Venice' at SS, 1890.

BISHOP, Walter Follen 1856-1936
Liverpool landscape painter. Also lived in London and Jersey. Exhib. at RA 1882-1902, more often at SS. Specialised in woodland scenes. Titles at RA 'A Woodland Pool', 'In the Heart of the Forest', etc.

BISHOPP, Miss Patience E. 1853-1929
Exhib. 'Grandfather's Books' at SS, 1891, and 'Cherwell Water Lilies' at the RA, 1906. Ashford, Kent, address. A memorial exhibition of her work was held at the Graham Gallery, 72 New Bond Street, in October 1930.
Bibl: Exhib. cat., Ashford Library Gallery, Kent, March 1989.

BISSCHOP, Christophe fl.1876
Exhib. 'Sharpening a Skate, Friesland' at the RA, 1876. London address.

BISSCHOP, Mrs. Christopher
see SWIFT, Miss Catherine Seaton Forman (Kate)

BIZO, John fl.1839-1879
London painter of portraits and genre. Exhib. at the RA 1839-79, at SS 1847-69, and also at the BI and elsewhere. Titles at RA 'An Attached Couple', 1849, and 'At Church', 1862.

BLACK, A.E. fl.1868
Exhib. 'A Study' at the RA, 1868. London address.

BLACK, Andrew RSW 1850-1916
Glasgow marine and landscape painter. Educated in Glasgow and Paris. He worked for 11 years as a designer and turned to painting full-time in 1877. Exhib. 1883-90 at the RA, and at the NWS. Elected RSW 1884.
Bibl: Caw p.331; Brook-Hart.

***BLACK, Arthur John 1855-1936**
Nottingham landscape and figure painter. Studied in Paris under B. Constant. Exhib. at the RA from 1882, and at the NG. Subjects: mainly romantic landscapes, sometimes with figures. Titles at RA 'Young Fishermen — Wollaton Canal', 'A Fairy Swirl', 'Lobster Fishers'. His coastal scenes show stylistic influence of the Newlyn School. Painted some fairy and fantasy subjects.

BLACK, Edwin fl.1875-1894
London painter of genre and landscape. Exhib. 1875-94, at the RA, SS, NWS and elsewhere. Titles at the RA 'By the Side of the Stream', 1879, and 'A Village Playground in School Hours', 1894.

BLACK, Miss Emma L. fl.1879-1894
(Mrs. J.D.K. Mahomed)
London painter of genre, portraits, flowers and still-life. Exhib. 1879-94 at the RA and SS. Titles at the RA: 'Sweet and Twenty', 1885, and 'Threading Beads', 1894. Became Mrs. Mahomed in 1886.

BLACK, Francis RBA fl. from 1891 d.1939
London painter of landscapes and coastal scenes. Exhib. from 1891 at the RA, SS and elsewhere. Elected RBA, 1895. Also member of the Pastel Society, British Watercolour Society and associate of the Royal College of Art. Principal of the Camden School of Arts and Crafts 1882-1915.

BLACK, G.B. fl.1855
Exhib. one portrait at the RA, 1855. London address.

BLACK, J. fl.1844
Exhib. 'Crossing the Brook' at SS, 1844. No address given.

BLACK, Miss Margaret L. fl.1893
Exhib. 'Beech Leaves' at the RA, 1893. London address.

BLACKALL, J. fl.1862
Exhib. one painting of still-life at the BI, 1862. London address.

BLACKBOURNE, T.F. fl.1876-1881
Painter of genre and historical subjects. Exhib. 1876-81 at the RA and elsewhere. Titles at the RA 'Roman Widow Celebrating an Anniversary', 1878, and 'The "Chip Hat" ', 1881. Rome and London addresses.

BLACKBURN, Arthur fl.1890-1891
Leeds landscape painter. Exhib. 1890-1 at the RA.

BLACKBURN, Mrs. Hugh fl.1850-1875
(Miss Jemima Wedderburn)
Painter of animals and birds. Married to the Professor of Mathematics at Glasgow University. Exhib. only three works at RA, but much admired by Ruskin, who praised her *Illustrations of Scripture* in 1855. See also Miss Jemima Wedderburn.
Bibl: Mary Lutyens, *Millais and the Ruskins,* 1967 p.113; Rob Fairley, *Jemima — The Paintings and Memoirs of a Victorian Lady,* 1988.

BLACKBURN, Samuel fl.1842-1857
Painter of historical subjects and genre. Exhib. at the RA, 1842-54, and at SS, 1854-7. Titles at the RA 'The Earl of Strafford in the Tower, etc.', 1842, and 'Cromwell, Milton and Mary Powell, his Wife', 1854.

BLACKBURNE, E.R. Ireland fl.1891-1901
Painter of landscapes, shooting and sea-shore subjects. Exhib. 1891-1901 at the RA. Lived at Newlyn, Cornwall and Lilliput, Dorset.

BLACKBURNE, Miss Helena fl.1880-1899
London painter of genre, portraits and flowers. Exhib. 1880-99, at the RA (1884-99), SS, NWS and elsewhere. Titles at the RA 'The Dropped Stitch', 1896, and 'Andante con Espressione', 1899.

BLACKBURNE, Lilian G. fl.1875
Exhib. two paintings of figure subjects in London, 1875. London address.

BLACKDEN, Hugh fl.1898
Exhib. 'St. Ives Harbour on a Grey Day' at the RA, 1898. Lelant, Cornwall, address.

BLACKDEN, M.W. fl.1890
Exhib. 'An Episode of the Deluge' at the RA, 1890. London address.

BLACKHAM, J. fl.1867-1874
Birmingham flower painter. Exhib. at the SS 1867-74 and at the RA 1868.

BLACKIE fl.1871
A portrait of C.J. Kean by Blackie was sold at Christie's, 22 July 1871, lot 141.
Bibl: Ormond I p.247.

BLACKLOCK, C. fl.1885-1886
Manchester landscape painter. Exhib. 1885-6 at the RA.

BLACKLOCK, Thomas Bromley 1863-1903
Scottish painter of landscapes and children. Later became a painter of fairy tales, e.g. 'Red Riding Hood', 'Bo-Peep', 'The Fairies' Ring', etc. Studied in Edinburgh, and worked in East Linton and Kirkcudbright. Exhib. at the RA 1901 and 1903.
Bibl: Caw p.406.

BLACKLOCK, William James 1816-1858
London landscape painter. Exhib. at the RA 1836-55, also at the BI and SS. Born in Carlisle, he specialised in landscape views in the north of England, especially in Cumberland. Examples are in Carlisle AG.
Bibl: AJ 1858 p.157; DNB 1908 11 p.591; Redgrave, Dict; Binyon; Carlisle AG, *Exhibition of Cumberland Artists, 1700-1900,* 1971 pp.33-4.

BLACKLOCK, William Kay b.1872 fl.1897-1922
Painter in oil and watercolour of landscape and genre. Born at Sunderland. Studied art at the Royal College of Art. Exhib. at the RA 1897-1918. Lived at Sunderland; London; School of Art, Royal Institution, Edinburgh, 1902-6; Walberswick, Suffolk; St. Ives, Huntingdonshire. In 1922 is recorded as living in Leicester.

BLACKMAN, Walter fl.1878-1895
London painter of landscape, portraits, genre and Venetian subjects. Exhib. 1878-95 at the RA, SS, GG and elsewhere. Titles at the RA 'Crossing the Brook', 1880, and 'Venetian Market Girl', 1895.

BLACKMORE, J. fl.1833-1841
London portrait painter. Exhib. 1833-41 at the RA and SS.

BLACKWOOD, Lady A. fl.1878-1880
Exhib. two landscapes at SS, 1878-80. Address Boxmore, Hertfordshire.

BLADES, Miss Daisy fl.1889-1891
Exhib. two portraits at the RA, 1889-91, one of Princess Victoria of Teck, 1889. London address.

BLAIKLEY, Alexander 1816-1903
London portrait and figure painter. Born in Glasgow. Exhib. at the RA 1842-67 (mainly portraits) and at the BI and SS. At Birmingham AG is 'The First Ragged School, Westminster' 1851.
Bibl: Birmingham Cat; Ormond, I.

BLAIKLEY, Edith S. fl.1880
Exhib. 'Christmas Roses' at SS, 1880. Lived at same London address as Alexander Blaikley (q.v.), so possibly his wife or daughter.

BLAIKLEY, Miss Ruth fl.1865-1874
Exhib. 'The Young Companion' and ' "Who can it be from?" ' at SS, 1865-74. Daughter of Alexander Blaikley (q.v.) and lived at the same London address.

BLAINE, Mrs. Roberton fl.1859-1867
Exhib. 'The Colossi, at Sunrise, Thebes' at the Society of Female Artists ("A work of great power" AJ); and 'A Caravan Approaching Cairo' at the BI, 1867. London address.
Bibl: AJ 1859 p.84.

BLAIR, Andrew fl.1847-1885
Exhib. 'Quoit Players' at the BI, 1847, 'An Errand Girl' at SS, 1848, and one painting at the NWS, 1885. Dunfermline address.

BLAIR, John fl.1885-1888
Exhib. three genre paintings at the NWS, 1885-8. Edinburgh address.

BLAKE, C. fl.1848
Exhib. 'Portrait of an Artist' at SS, 1848. London address.

BLAKE, Leonard fl.1876-1885
London painter of portraits and figure subjects. Exhib. 1876-85 at the RA, NWS and elsewhere.

BLAKELEY, Miss fl.1848
Exhib. 'One of the Houses of England' at SS, 1848. London address.

BLAKELEY, S. fl.1840
Exhib. 'Sea-Shore, Hastings' at the RA, 1840. London address.

BLAKENEY, Miss Charlotte fl.1898-1904
London portrait painter. Exhib. 1898-1904 at the RA.

BLAKESLEY, Miss Alicia fl.1893-1896
Exhib. 'The Back Door' at SS, 1893, and ' "When we were first Acquent" ', at the RA, 1896. London address.

BLAKISTON, Douglas Y. 1810-1870
London painter of portraits, genre and figure subjects. Exhib. 1853-65, 30 works, chiefly portraits, at the RA, BI, SS and elsewhere. Titles at the RA 'A Scene from Scutari Hospital', 1855, and 'The Little Gleaner', 1860. The portrait of the Rev. Hugh Hutton is in Birmingham AG.
Bibl: Birmingham Cat.

BLAKISTON, Miss Evelyn fl.1889-1891
Exhib. two portraits at the RA, 1889-91. London address.

BLAKSLEY, Miss M.C. fl.1847-1848
London painter of biblical subjects. Exhib. 1847-8 at the RA and SS. Titles at the RA: 'Shadrach, Mesheck and Abednego before King Nebuchadnezzar', 1847, and 'The Pilgrim, 1848.

BLAMIRE, W. fl.1843-1844
London painter of landscapes and topographical subjects. Exhib. 1843-4 at the RA and SS.

BLANCKLEY, Mrs. E. fl.1843
Exhib. 'Portrait of a Child' at SS, 1843. London address.

BLAND, Miss Emily Beatrice 1864-1951
Painter of still-life, flowers and landscape. Born in Lincolnshire; studied art at Lincoln School of Art and at the Slade School, 1892-4, under Brown and Tonks. Visited Switzerland. Exhib. at the RA 1890-1950, and with the NEAC from 1897. Member of NEAC, 1926.

BLAND, John H. fl.1860-1872
London painter of landscape and archaeological subjects. Exhib. 1860-72, at the RA, BI, SS and elsewhere. Titles at the RA 'In Pompeii', 1860 and 'Greek Fragments in the Triangular Forum, Pompeii', 1869.

BLANDEN, L. fl.1844
Exhib. a portrait at the RA, 1844. London address.

BLANDY, Miss L.V. fl.1879-1881
London flower painter. Exhib. five paintings at GG 1879-81.

BLEADEN, Miss Mary fl.1853-1884
London painter of portraits, genre and landscape. Exhib. 1853-82, at the RA (1853-73), SS, BI and elsewhere. Titles at SS 'The End of the Holidays' and 'A Gipsy Waif', 1881.

BLENCOWE, S.J. fl.1850-1854
London painter of genre and biblical subjects. Exhib. 14 works at SS, 1850-4. Titles: 'Christ giving Sight to the Blind', 1852, etc.

BLENNER, P. fl.1871
Exhib. 'The Young Squire' at SS 1871. London address.

BLES, David fl.1877
Exhib. one figure subject at GG 1877. London address.

BLEWITT, R. fl.1874-1878
London genre painter. Exhib. 1874-8 at the RA and SS. Titles at the RA 'Among the Mummies', 1874 and ' "From out the Corridors of Time" ', 1878.

BLIGH, E.R. fl.1872-1875
Landscape painter. Lived at Broadstairs, Kent. Exhib. 1872-5 at SS and elsewhere.

BLIGH, Jabez fl.1863-1889
London and Peckham still-life painter. Exhib. at RA 1867-89, also at SS. Titles at RA 'Mushrooms', 'Fungus', 'Nest & Primroses', etc.

BLIND, Rudolph 1850-1916
Painter of religious and genre subjects. Born in Brussels. Studied art at the Slade School and at the RA Schools. Assisted with the decorations at the Vienna Opera House and volunteered for the German Army for the Franco-Prussian war of 1870-1. Settled in London and exhib from 1876 in London. Exhib. once at the RA, 'Azrael' in 1884. Painted a series of pictures illustrating the evils of drink.

***BLINKS, Thomas 1860-1912**
London sporting and animal painter. Exhib. at the RA from 1883, and at SS. Titles at RA mainly hunting scenes and dogs. One of the best Victorian painters of foxhounds.
Bibl: Pavière, Sporting Painters p.19 (pl.5); Wood, Paradise Lost.

BLISS, M. fl.1880
Exhib. one landscape in London, 1880. Sandwich, Kent, address.

BLOCK, L. fl.1879-1893
London painter of fruit and still-life. Exhib. 1879-93, at the RA (1885), SS, NWS and elsewhere.

BLOCKLEY, E. fl.1870
Exhib. 'The Hay Cart' at SS, 1870. London address.

BLOFIELD, Z. fl.1849-1851
Graves Dictionary describes Blofield as a painter of "sea pieces", but titles at SS, 1849-51, are 'Lane Scene near Seven Oaks, Kent', 1849, 'Thames Barge', 1850 and 'Harwich', 1851. London address.

BLOMFIELD, Eardley W. fl.1880-1898
Landscape painter. Exhib. 1880-98, at the RA (1883-96), SS and elsewhere. Lived in London, Mansfield and St. Ives, Cornwall.

BLOOMER, H. Reynolds fl.1879-1890
Landscape painter, possibly American, but living and exhibiting in London 1879-90, at the RA, SS, GG, NG and elsewhere. Titles at the RA 'A Normandy Orchard', 1880, and 'Seeking Shelter', 1883 Graves Dictionary gives his address as New York; also lived for a time in the 1880s at Cookham Dene, Berkshire.

BLORE, Burton fl.1885
Exhib. 'Constance' at SS, 1885. London address.

BLOUNT, Juliane fl.1853
Exhib. a portrait at the RA, 1853. London address.

BLOXHAM, Miss Mary A. fl.1894
Wimbledon flower painter. Exhib. at the RA, 1894.

BLUHM, H. Faber fl.1875-1881
Painter of landscape, genre and figure subjects. Exhib. 1875-81, at the RA, SS and elsewhere. Titles at the RA 'A Spanish Gipsy', 1879, and 'Cross and Crescent', 1880. Lived at Lee.

BLUM, Robert H. fl.1888
Exhib. 'Venetian Laceworkers' at the RA, 1888. Address, c/o Messrs. Tooth, London.

***BLUNDEN, Miss Anna E. 1830-1915**
(Mrs. Martino)
Figure and landscape painter; worked in London and Exeter. Exhib. at the RA 1854-72, but more often at SS. At first a figure painter, she turned to landscape at the encouragement of Ruskin, who admired her pictures 'Past and Present' (1858) and 'God's Gothic' (1859) at the RA. A.W. Hunt and Holman Hunt were also among her admirers, and David Roberts bought one of her pictures. "Mr. Roberts might learn something by that picture, if he would but study it," was Ruskin's comment. She visited Italy, married in Hamburg and settled near Birmingham.
Bibl: Ruskin, Academy Notes 1858, 1859; Clayton II pp.196-226; Staley p.175; Mrs. V. Surtees (ed.) *Sublime and Instructive — Letters from John Ruskin, etc.*, 1972; Wood, Panorama.

BLUNT, Lady Anne fl.1880
Exhib. an 'Egyptian' subject at GG, 1880. London address. Presumably the wife of the writer Wilfred Scawen Blunt.

BLUNT, Arthur Cadogan fl.1890
Exhib. one genre painting at the NWS and one elsewhere. London address.

BLY, J. fl.1863-1867
Exhib. paintings of fruit and mushrooms at SS, 1863-7. Worcester and London addresses.

BOADLE, William B. fl.1874-1901 d.1916
Portrait painter. Exhib. 1874-1901 at the RA and elsewhere. Lived in Liverpool and died in 1916, aged 76.

BOCQUET, E. fl.1817-1849
London painter of landscape, genre and portraits. Exhib. 1817-49, at the RA, BI and SS. Titles at the RA 'The Messenger', 1843, and 'The Mole and Lighthouse, Naples', 1846.

BODDINGTON, Edwin Henry 1836-c.1905
London landscape painter, son of Henry John Boddington (q.v.). Exhib. at the RA 1854-66, but more often at the BI and SS. Subjects: mainly views on the Thames. Boddington developed a very personal and recognisable style. His river scenes are usually painted in a calm evening light, using a range of very dark greens and browns.
Bibl: AJ 1860 p.77; J. Reynolds, *The Williams Family of Painters*, 1975.

***BODDINGTON, Henry John 1811-1865**
London landscape painter. Second son of Edward Williams (q.v.). After his marriage to Clara Boddington in 1832, he used the name Boddington so as not to be confused with other members of the Williams family. Exhib. at the RA 1837-69, at the BI, but mainly at SS where he showed 244 works. Subjects mainly views on the Thames and in Wales. Ruskin praised his pictures for their honesty and true love of countryside.
Bibl: AJ 1865 p.191 (obit.); DNB 1908 11 p.752; Ruskin, *Notes on the SBA*, 1857, 1858; Redgrave, Dict; Illustrated London News 6 March, 1847 (cover); J. Reynolds, *The Williams Family of Painters*, 1975.

BODDY, William James 1832-1911
York painter of landscape, topographical subjects and coastal scenes. Exhib. 1860-90, at the RA, SS, NWS and elsewhere. A work by him is in York A.G.

BODEN, Samuel Standige 1826-1896
London landscape painter. Exhib. 1865-73 at SS and elsewhere. A work by him is in the BM.

***BODICHON, Mme. Eugène 1827-1891**
(Miss Barbara Leigh Smith)
Amateur landscape painter and watercolourist. Wife of a French doctor; travelled widely in Canada, America, France, Spain and N. Africa, painting views wherever she went. Also a famous philanthropist, and one of the founders of Girton College, where some of her pictures hang. Exhib. at RA 1869-72, mainly coastal scenes, e.g. 'Stormy Sea near Hastings'. Much influenced by the Barbizon painters; the French critics called her the "Rosa Bonheur of landscape". Madame Bodichon was a friend of Rossetti, who often stayed at her house in Sussex, Scalands. Rossetti described her as "blessed with large rations of tin, fat, enthusiasm and gold hair". She also knew many of the other Pre-Raphaelites. See also Miss Barbara Leigh Smith.
Bibl: Clayton II pp.167, 374, 38,3; Hester Burton, *Barbara Bodichon*, 1949; Fredeman, see index; Rosalie Glynn Grylls, *Portrait of Rossetti*, see index; Brook-Hart; John Crabbe, *An Artist Divided*, Apollo May 1981; John Crabbe, *Wild Weather in Watercolour*, Country Life 2 March 1989; Newall.

BODILLY, Frank fl.1885-1886
Painter of landscape and genre. Exhib. 1885-6, at the RA and SS. Titles at the RA 'A Quiet Hour', 1886, and 'A Street in Newlyn', 1886. Lived in London and Penzance, Cornwall.

BODKIN, Edwin fl.1874
Exhib. two pictures of rustic genre in London, 1874. Highgate address.

BODKIN, Frederick E. fl.1872-1922
London landscape painter. Exhib. at the RA 1874-1902, and at SS. Subjects poetic landscapes, or views in the south of England. Titles at RA 'Down by the Old Mill Wheel', 'Full Summer Time', 'A Lowland Hill', etc.

BODKIN, R. fl.1875
Exhib. one landscape in London. Highgate address.

BODMER, Karl fl.1877
Exhib. 'View on the Missouri near Fort Leavensworth', at the RA, 1877. Hereford address.

BOEHM, A. William fl.1856-1857
London painter of literary and historical subjects and genre. Exhib. 1856-7 at the BI. Titles: 'The Studio of Sir Joshua Reynolds', and 'The Toilette'.

BOEHM, Wolfgang fl.1850-1869
London painter of portraits and genre. Son of the medallist Joseph Daniel Boehm, and brother of Sir Joseph Edgar Boehm RA, the sculptor. Exhib. 1850-69, at the RA and BI. Titles at the RA portraits and 'The Miser', 1865, and 'Dolce far Niente', 1869.

BOGGIS, J.H. (or M.) fl.1832-1846
Cambridge painter of landscape, game and river subjects. Exhib. 1832-46 at SS.

BOGLE, W. Lockhart fl.1886-1900
Painter of portraits, genre, historical subjects and landscape. Exhib. 1886-94, at the RA, SS, NG and elsewhere. Titles at the RA mainly portraits, but also 'Night Birds', 1886, and 'The 79th at Waterloo', 1893, etc. His portrait of W.M. Thackeray, d.1900, is at Trinity College, Cambridge.
Bibl: Ormond I p.465.

BOHMFIELD, A. fl.1880
Exhib. 'Solitude — Winter Sunset' at the RA, 1880. London address.

BOIS, Miss fl.1861-1867
London painter of landscape and topographical subjects. Exhib. 1861-7 at SS.

BOISRAGON, T.S.G. fl.1879
Exhib. one landscape at GG, 1879. London address.

BOISSEREE, Frederick fl.1876-1877
Exhib. Welsh landscape subjects at SS and elsewhere, 1876-7. Betws-y-Coed address.

BOLINGBROKE, Miss Minna RE fl.1888-c.1930
Painter of landscape, genre, flowers and architectural subjects; etcher. Exhib. 1888-1926, at the RA (1891-1926) and SS. Titles at the RA 'Behind the Plough', 1891, and 'Feeding Time, Picardy', 1904. Came from an old Norfolk family and married the artist C.J. Watson, RE. Elected ARE 1893, RE 1899, and her membership ceased 1930. Lived at Eaton, Norwich and London.

BOLT, Miss Marion fl.1886
Exhib. a flower painting at the NWS, 1886. Sunbury address.

BOLTON, A. fl.1875
Exhib. two landscapes in London, 1875. Brighton address.

BOLTON, Miss Alice fl.1874-1879
London portrait painter. Exhib. 1874-9, at the RA, SS and elsewhere.

BOLTON, Miss Emily fl.1872-1879
London landscape painter. Exhib. 1872-9, at the RA, SS and elsewhere. Titles at the RA 'Autumn and Spring', 1876, and 'Heather', 1878.

BOLTON, John Nunn 1869-1909
Painter of landscapes, portraits and marines, in oil and watercolour. Born in Dublin, the son of Henry E. Bolton, an amateur landscape painter. Studied at the Metropolitan School of Art, Dublin and at the RHA. Exhib. at the RHA. Lived in Warwick for some years, and was Master of the Leamington School of Art.
Bibl: Strickland I pp.70-1.

BOLTON, William Treacher fl.1857-1881
London landscape and flower painter. Exhib. mainly at SS, also at RA 1859-81. Titles at RA 'Apple Blossom', 'A Beech Wood — Surrey', etc.

BOMFORD, L.G. fl.1871-1882
London landscape painter. Exhib. once at the RA, 1873, but mostly at SS and elsewhere, 1871-82.

BONAVIA, George fl.1851-1876
London painter of portraits and romantic genre. Exhib. at RA 1851-74, and at the BI and SS. Genre titles at RA 'A Recluse "For Thee I Panted" ', 'The Heart has Tendrils Like the Vine', etc.

BOND, J. fl.1858
Exhib. one landscape at BI, 1858. Liverpool address.

BOND, Miss J. fl.1875
Exhib. 'Welsh Children Learning to Knit', and 'A Welsh Shepherd's Home' at SS, 1875. Betws-y-Coed address.

BOND, John Lloyd fl.1868-1872
Landscape painter. Exhib. 1868-72 at SS — subjects landscapes in Wales. Betws-y-Coed address.

BOND, L. fl.1871
Exhib. 'Near Llyn Idwal' and 'Snowy Mountains in Mist' at the RA, 1871. Betws-y-Coed address.

BOND, Miss Mildred B. fl.1884-1885
Exhib. three genre paintings in London, 1884-5. Address, British Museum, London.

BOND, Richard Sebastian 1808-1886
Midlands landscape painter; distant relation of W.J.J.C. Bond (q.v.). Born in Liverpool, where he studied with Samuel Austin. Lived at Betws-y-Coed in Wales, where he was friendly with David Cox and W.J. Müller (qq.v.). Exhib. at the RA 1856-72, and at the BI and SS, but chiefly exhibited in Birmingham and the Liverpool Academy, of which he was an associate 1836-42. Subjects mainly coastal scenes and Welsh landscapes.
Bibl: The Year's Art 1887 p.229; Marillier pp.69-70; Birmingham Cat.

BOND, William H. fl.1896-1907
Brighton marine and landscape painter. Exhib. 1896-1907 at the RA. Titles: ' "In the Freshening Morning Breeze; Out into the Open Sea" ' 1896, and 'Sussex, by the Sea', 1904.

***BOND, William Joseph J.C. 1833-1928**
Liverpool landscape painter. Apprenticed to Thomas Griffiths, a picture dealer and restorer. Lived in Caernarvon, then in Central Chambers, South Castle Street, Liverpool. Worked mainly for northern patrons. Exhib. at SS, but only twice at the RA, in 1871 and 1874. Elected associate of Liverpool Academy 1856, member 1859. An eclectic artist — the influences of Davis, Huggins, and especially Turner are visible in his work. His pictures have often been passed off as Turners. Came under Pre-Raphaelite influence in the 1850s. Subjects: landscapes, coastal and harbour scenes, mainly

in Cheshire, Wales and Anglesey. Also fond of painting old buildings. Visited Antwerp.
Bibl: Marillier pp.71-8 (pls. opp. pp.72, 76); Staley p.147; Brook-Hart pp.55-6 (pl.109, colour pl.20).

BONE, Herbert fl.1877-1882
Painter of literary subjects, genre and flowers; designer for tapestry. Exhib. two paintings illustrating Lovelace and Tennyson at the SS in 1877 and 1882; and exhib. 1879-82 at the RA, subjects including two "medieval" designs for the Royal Tapestry Manufactory, Windsor. Lived at Windsor and London.

BONE, Herbert Alfred fl.1874-1892
London painter of genre, medieval-literary subjects, landscape and historical subjects. Exhib. 1874-92, at the RA (1876-99), SS, NWS, GG and elsewhere. Titles at the RA 'The Child's Grave', 1876, 'Hero and Leander', 1885 and 'The Mistress of the Moat', 1898.

BONHAM CARTER, Miss J.H. fl.1868
A portrait drawing of A.H. Clough was exhib. at the South Kensington Museum, 1868 and reprd. in K. Chorley *Arthur Hugh Clough: an Uncommitted Mind,* 1962, frontispiece.
Bibl: Ormond I p.103.

BONLIAN, Miss. A. fl.1873-1874
Exhib. two paintings, of still life and 'currants' at SS, 1873-4. C/o London address.

BONNAR, William RSA 1800-1853
Edinburgh painter of historical and genre scenes, and portraits. Exhib. mainly in Edinburgh; showed only four works at SS. Caw states that his "pastoral pieces and children" were better suited to his talent than his ambitious historical pieces. His genre subjects showed marked Wilkie influence.
Bibl: AJ 1853 p.76; DNB; Caw p.120.

BONNEAU, Miss Florence Mary fl.1871-1920s
(Mrs. F.M. Cockburn)
Painter of flowers, genre and literary subjects. Studied art at Heatherley's. Exhib. from 1871 at the SS, RA and elsewhere. Titles at SS flower subjects and 'A Norman Peasant', 1874, and 'Princess Parizade and the Talking Bird', 1881. Lived in London and at Walberswick, Suffolk.

BONNEY, Charles Henry fl.1888-1892
Landscape painter. Exhib. 1888-92 at the RA and SS. Rugeley address.

BONNOR, Miss A.S. fl.1874-1878
Painter of landscapes and historical subjects. Exhib. 1874-8 at the SS. Title: 'Episode in the Forest of Fontainebleau: XVI Century', 1878. Hereford address.

BONNOR, Miss Rose D. fl.1895-1916
London portrait painter. Exhib. 1895-1916 at the RA.

BONNY CASTLE, H. fl.1873-1875
London painter of genre. Exhib. 'The Sleeping Partner' at SS, 1874, and two paintings elsewhere in London, 1873-5.

BONSER, J. fl.1843-1857
London painter of architectural subjects. Exhib. 1843-57 at the RA, BI and SS.

BOODLE, Walter fl.1891-1908
Bath painter of landscape. Exhib. 1891-1908 at the RA.

BOOKER, A.E. fl.1871-1872
Exhib. 'Chair of Angels' and 'Queen of Sheba's visit to Solomon', 1871-2. London address.

BOOM, A.S. fl.1857
Exhib. 'Emily; a sketch' at the RA, 1857. London address.

BOOSEY, W. fl.1848-1872
London landscape painter. Exhib. 1848-72, at the RA (1854-69), BI, SS and elsewhere. Titles at the RA include many landscapes set in N. Wales.

BOOT, William Henry James RBA RI 1848-1918
London landscape painter. Exhib. mainly at SS, also at RA 1874-1903. Travelled in Germany, France and N. Africa. Titles at RA views in Derbyshire, Surrey, Devon, and on the Continent. Also painted domestic genre and interiors.
Bibl: Reynolds, VS p.37.

BOOTH, Charles fl.1882-1892
London painter of genre. Exhib. 'Idle moments' at the RA, 1892, and at SS and NWS.

BOOTH, Edward C. fl.1856-1864
Leeds landscape painter. Exhib. at the RA 1856-64. Very little known, except that Ruskin admired 'The Roadside Spring' exhib. at the RA in 1856, praising its honesty and attention to detail.
Bibl: J. Ruskin, Academy Notes 1856; Staley p.175.

BOOTH, Miss Elizabeth fl.1879-1885
Flower painter. Exhib. 1879-1885 at the RA and elsewhere. Addresses Florence and Paris.

BOOTH, George fl.1857-1878
London landscape painter. Exhib. 'Summer Time' at the RA, 1857, and five pictures elsewhere in London.

BOOTH, James William RCA 1867-1953
Painter of rustic genre and landscape, in oil and watercolour. Born at Manchester. Exhib. 1896-1935 at the RA. Titles: 'In the Shade of the Trees', 1896, and 'Ploughing', 1898. Lived at Middleton, Manchester, and for many years at Scarborough.
Bibl: P. Phillips, *The Staithes Group,* 1993.

BOOTH, Miss R.E.R fl.1893
Exhib. 'A Grey Day, Cumberland', at the RA, 1893. Folkestone, Kent, address.

BOOTY, Edward fl.1846-1848
Brighton landscape painter. Exhib. 1846-8 at the RA and SS.

BOOTY, Henry R. fl.1882-1883
Exhib. 'The Toad Rock, near Tunbridge Wells', at the RA, 1882, and one painting at SS, 1883. London address.

BOROP, Louis fl.1864-1873
London painter of genre. Exhib. 1864-73, at the SS and elsewhere. Titles at the SS 'A Country Scene', 1864, and 'The Forlorn French Fishergirl', 1866.

BORROW, William H.　**fl.1863-1893**
London marine painter; also lived at Hastings. Exhib. at the RA 1863-90, BI and at SS. Subjects mainly coastal scenes in Devon and Cornwall.
Bibl: Brook-Hart.

BORROWS, Henry　**1884-1889**
Huddersfield flower painter. Exhib. 1884-9 at the RA.

BORSTEL, R.A.　**fl.1891-1917**
Painter of 'Ship' portraits. Known works are the 'Cambrian Prince', 1891, and 'Star of Peru', 1917.
Bibl: Brook-Hart pp.22, 24, pl.58 (reprd).

BORSTONE, H.　**fl.1868**
Exhib. two paintings of fruit at SS, 1868. London address.

BORTHWICK, Alfred Edward　**RSA RBA**　**1871-1955**
Edinburgh painter of portraits, landscape and genre. Born at Scarborough. Studied art at Edinburgh School of Art, at Antwerp, and at Julian's in Paris under Bouguereau and Tony Fleury. Served in the Boer War with the Scottish Sharpshooters, and in the 1914-18 War. Exhib. at the RSA, RA (1895-1924), Paris Salon and elsewhere. Elected ARE 1909, RSW 1910, RBA 1927, ARSA 1928, and RSA 1938.
Bibl: Caw p.432.

BORTHWICK, J.D.　**fl.1860-1870**
London painter of genre and landscape. Exhib. 1860-70 at the RA, BI, SS and elsewhere. Titles at the RA 'Dead Broke', 1862, and 'In Hertfordshire', 1865.

BOSANQUET, J.E.　**fl.1854-1861**
Irish landscape watercolourist, working in Cork. Exhib. at the RHA mostly local views in watercolour. "His work was slovenly and of little merit" (Strickland). His son J. Claude Bosanquet was also a landscape painter.
Bibl: Strickland I p.72.

BOSDET, H.T.　**fl.1876-1885**
Exhib. 'A Portrait' at the RA, 1885, and one painting elsewhere, 1876. London address.

BOSSE, E.　**fl.1855**
Exhib. 'Portrait of a Young Lady' at the RA, 1855. London address.

BOSTOCK, Mrs. Edith　**fl.1863-1868**
London painter of fruit. Wife of John Bostock (q.v.). Exhib. 1863-8 at the RA and elsewhere.

BOSTOCK, John　**fl.1826-1869**
Painter of portraits, genre and fruit. Exhib. 1826-69, at the RA, BI, SS, OWS and elsewhere. Titles at the RA mainly portraits, but include several genre and fruit, 'The Outcast', 1848, and 'Arming for Conquest', 1866. Lived in Manchester and London.
Bibl: AJ 1859 p.171 ('The Spinning Wheel' at the RA); Roget; Ormond I p.160.

BOSWELL, J.　**fl.1838**
Exhib. 'A Seapiece' at the RA, 1838. No address given.

BOSWORTH, Philip A.　**fl.1867-1878**
London landscape painter. Exhib. 1867-78, at the RA (1870-6), SS and elsewhere.

BOTHAMS, Walter　**fl.1882-1914**
Painter of genre and landscape. Exhib. 1882-1914, at the RA, SS and NWS. Titles at the RA 'A Gleam of Sunshine', 1885 and 'Enjoying life', 1887. Lived in London, Salisbury and Malvern.

BOTT, R.T.　**fl.1847-1862**
London painter of portraits, figure subjects and genre. Exhib. 1847-62 at the RA and BI. Titles at the RA ' "My Laddie is Gane" ', 1847, and 'Quintin Matsys showing his celebrated picture to Mandyn, the Artist', 1850. His portrait of Sir Robert Peel is in Birmingham AG.
Bibl: Birmingham Cat.

BOTTOMLEY, Edwin　**fl.1865-1929**
Landscape and animal painter, who worked in Lancashire, Yorkshire and North Wales. Exhibited mainly at the RCA in Manchester.

BOTTOMLEY, John William　**1816-1900**
London sporting and animal painter. Studied in Munich and Dusseldorf. Exhib. at RA 1845-75, and at SS, BI. Titles at RA show that he painted shooting scenes, dogs, deer, sheep and cattle, and a few pure landscapes. Thought to have painted many of the cattle in T. Creswick's (q.v.) landscapes.

BOTTOMLEY, Reginald　**fl.1875-1895**
Painter of genre and figure subjects. Exhib. 1875-95 at the RA, SS and elsewhere. Titles at the RA 'Maternité', 1883, and 'Christ', 1895. Addresses in Paris and Luxembourg.

BOUCHETTE, A.　**fl.1873-1889**
London genre painter. Exhib. 1873-89 at SS. Titles: 'The Housewife', 1873, and 'Kept In', 1888.

***BOUGH, Samuel**　**RSA**　**1822-1878**
Scottish landscape painter. Born in Carlisle, son of a shoemaker. Worked as a theatre scenery painter in Manchester and Glasgow. Encouraged by James Macnee to take up painting. In Glasgow 1848-55; often worked with Alexander Fraser (q.v.) in Cadzow Forest. Moved to Edinburgh, elected ARSA, and in 1875 RSA. Exhib. 15 works at the RA 1856-76. Subjects chiefly Scottish or north of England. His early style is minute and detailed; after 1860, his handling became broader and more confident. Caw praises his "feeling for air and atmosphere and movement, and for broad and scenic effects" but warns that his works are at times "deficient in intimacy of sentiment and depth of feeling". Bough was also a good watercolourist. Often signed SB in monogram.
Bibl: R. Walker, *S.B. & G.P. Chalmers;* Caw pp. 188-90 (pl. opp. p.190); Sidney Gilpin, *S.B.,* 1905; DNB II p.912; Cundall; VAM; Binyon; Maas p.46 (with pl.); Brook-Hart p.91; Irwin pp.360-1.

***BOUGHTON, George Henry**　**RA**　**1833-1905**
London painter of genre, figure subjects, portraits, landscape, sporting pictures and historical scenes. Lived in America, studied in Paris, and came to London in 1862. Exhib. 1863-1904, at the RA, BI, GG and NG. Painted views in England, Scotland, France and Holland. 1879 ARA; RA 1896. Many of his paintings are very decorative, but often the figures tend to become too pretty and the subjects over-sentimental. The single figures, especially, usually portraits of women, often veer too closely to the chocolate-box, e.g. 'Rosemary' and 'Black-eyed Susan'. Ruskin, who did not like Boughton's technique, described it as "executed by a converted crossing sweeper, with his broom after it was worn stumpy". The sale of his studio was held at Christie's, 15 June 1908. Lived at

Broadway, Worcestershire, where he was a friend of E.A. Abbey, F.D. Millet, J.S. Sargent and the other Broadway artists.
Bibl: AJ 1904 p.367; AJ Christmas Annual 1904, full mono. with pls.; Portfolio 1871 p.69; J. Ruskin, Academy Notes 1875.

BOUGHTON, H. fl.1827-1872
London painter of portraits, genre, landscape and biblical and literary subjects. Exhib. 1827-72, at the RA (1830-58), BI (1832-57) and SS (1827-72). Titles at the BI 'Landscape with Sheep', 1832, 'Belshazzar Beholding the Handwriting on the Wall', 1843, and 'Portia', 1847. H. Baughton is listed separately at SS but this must be the same artist.

BOUGHTON, T. fl.1845-1847
Exhib. four paintings of game at SS, 1845-7. Guildford address.

BOULAT (BOWLAT), P. fl.1849
Exhib. 'La Lecture' at SS, 1849. London address.

BOULDERSON, B. fl.1884
Exhib. one landscape in London, 1884. London address.

BOULT, A.S. fl.1815-1853
London painter of sporting subjects, game and landscape. Exhib. 1815-53, at the RA, BI and SS. Titles at the RA 'Pheasant Shooting', 1844, and 'Hayfield', 1847.

BOULT, Francis Cecil fl.1885
Exhib. 'Gone Away' at SS, 1885. Graves Dictionary calls this a sporting subject. London address.

BOULTON, Miss C.B. fl.1884
Exhib. one landscape at NWS, 1884. Totteridge address.

BOURCE, Hans Joseph fl.1870-1877
Painter of marines and genre. Moved from Antwerp to London, c.1876. Exhib. 1870-7 at the RA and elsewhere. Titles at the RA 'Through the Sand', 1870, and 'So Like His Daddy', 1871.
Bibl: Brook-Hart.

BOURCICAULT, W.S. fl.1866
Exhib. 'A Bedouin Arab' at SS, 1866. London address.

BOURDILLON, Frank W. fl.1881-c.1900
Painter of landscape, genre and historical subjects. Exhib. 1881-92, at the RA, SS, GG and elsewhere. Titles at the RA 'A Kentish Homestead', 1882, and 'Aboard the "Revenge", 1591', 1892. Lived in London and Dorking. Worked also for a time in Cornwall and later abandoned painting in order to become a missionary.

BOURGAIN, G. fl.1883
Exhib. 'A Street in Alexandria; after the Bombardment', at the RA, 1883. London address.

BOURGOIN, A. fl.1869
Exhib. 'The Quarrel' at the RA, 1869. London address.

BOURNAN, E.G. fl.1870
Exhib. one landscape in London, 1870. London address.

BOURNE, Edmunda fl.1838-1844
London flower painter. Daughter of painter James Bourne. Exhib. 1838-44, at the RA and SS.
Bibl: Birmingham Cat.

BOURNE, Miss F. fl.1840-1846
London flower painter. Sister of Edmunda Bourne (q.v.). Exhib. 1840-6 at the RA.

BOURNE, John Cooke 1841-1896
London landscape and topographical painter. Exhib. 'Old Houses at Hastings' at the RA, 1863, and also exhib. at SS and NWS. Best known for his illustrations of the Great Western Railway. These are among the finest early drawings of the railway, and several examples are in the Elton Collection. Bourne tried three times, unsuccessfully, to join the NWS.

BOURNE, Samuel c.1840-1920
Nottingham painter of landscape. Exhib. 1880-7 at SS and elsewhere. Titles at SS 'In the Lledr Valley, North Wales', 1880. An example is in Nottingham Museum.

BOUSFIELD, Miss H. Mary fl.1893-1895
Exhib. 'Lilies' and 'Eileen' at the RA in 1893 and 1895. Bedford address.

BOUTERWEK, J. (?) Frederick fl.1840
Exhib. 'Peasantry Returning from Naples to Sorrento' at the RA, 1840. London address.

BOUTFLOWER. C. fl.1871-1878
Exhib; landscape subjects at SS, 1871-8. Lived at Harrogate,

BOUTWOOD, Charles Edward fl.1881-1887
London painter of landscape, genre and portraits. Exhib. 1881-7, at the RA, SS and elsewhere. Titles at the RA 'A Quay-Pool, Cornwall', 1885, and 'Chums', 1885.

BOUVIER, Miss Agnes Rose see NICHOLL, Mrs. Samuel Joseph

BOUVIER, Arthur fl.1875-1876
Belgian painter; born at Brussels. Won a medal at Philadelphia, where he exhib. 'Scene on the Coast of Flanders — Sunrise'. Also exhib. 'Sunset' at the RA, 1875 (from a London address) and 'Breeze on the Scheldt' at the Paris Salon, 1876. Not a member of thc Bouvier family (q.v.).
Bibl: Clement & Hutton.

BOUVIER, Augustus Jules c.1827-1881
London painter, in watercolours, of portraits, genre, figure and biblical subjects. Son of Jules Bouvier (q.v.). Entered the RA Schools in 1841 and afterwards studied in France. Exhib. 1845-81, at the RA (1852-79), BI, SS and elsewhere, but mainly at the NWS. Elected A of the NWS, 1852, member in 1865. "As an artist he struck out for himself an original, if not very elevated, walk in art". (AJ).
Bibl: AJ 1881 p.95 (obit.); Bryan; Cundall; VAM.

BOUVIER, Gustavus Arthur fl.1866-1884
London genre painter. Son of Jules Bouvier (q.v.). Exhib. mainly at SS, also at RA 1869-81. Titles at RA 'The Orange Girl', 'Miss in her Teens', 'A Fisher's Wife', etc.

BOUVIER, Joseph fl.1839-1888
London genre and historical painter. Son of Jules Bouvier (q.v.). Exhib. chiefly at SS, also at BI and RA 1839-56. Titles at RA 'Little Red Riding Hood', 'Cleopatra', 'The Little Romany Maid', etc. Painter of pretty Victorian girls and children in the tradition of Baxter and Birket Foster.

BOUVIER, Jules, Snr. 1800-1867
Painter of genre, figure subjects, literary and biblical subjects. Born in Paris, but came early in life, 1818, to London. He married a Scottish lady, Miss Agnes Chalmers, and remained in England, though often staying for periods in France. Exhib. 1845-65, mainly at SS, but also at the BI and elsewhere. Titles at SS 'Dorothea', 1845, 'The Widow's Mite', 1853, and 'Martha and Mary', 1863. His six children were all artists: Joseph Bouvier, Augustus Jules, Urbain James, Gustavus Arthur, Julia and Agnes Rose (Mrs. Nicholl) (all q.v.). A watercolour 'Girl with Basket of Grapes', 1860, is in VAM.
Bibl: Clayton II p.34; VAM.

BOUVIER, Miss Julia fl.1853-1873
London painter of birds, game and fruit. Eldest daughter of Jules Bouvier (q.v.). Exhib. 1853-73 at SS and elsewhere. "She gave up the practice of art at her marriage, although she had already a good reputation as a painter of birds, her special fancy" (Clayton).
Bibl: Clayton II p.34.

BOUVIER, Urbain James fl.1854-d.1856
London painter of genre and figure subjects. Third son of Jules Bouvier (q.v.). Exhib. 1854-6, at the RA, BI and SS. Titles at SS: 'The Loiterer', 1854, and 'Waiting the Return of the Fishing Boats, Boulogne', 1856. Died at La Chapelle, near Chantilly, after a journey to visit his family who were staying there at the time.
Bibl: Clayton II p.35.

BOUWENS, Mrs. T. (Amata) fl.1891-1897
Painter of portraits and figure subjects. Exhib. 1891-7 at the RA. Titles: 'A Child of the Pantomime', 1891, and 'Shadowy Dreaming Adeline', 1892. Lived in London, Staines and Shepperton.

BOVILL, Percy C. fl.1883-1903
Painter of genre and landscape. Exhib. 1883-1903, at the RA, SS and elsewhere. Titles at the RA ' "The Grey Hooded Even" ', 1883, and 'A Humble Home', 1898. Lived in Chiswick and Cornwall.

BOWDEN, Mrs. Ambrose (Mary) fl.1871-1890
London painter of genre and flowers. Exhib. 1871-90, at the RA, SS and elsewhere. Titles at the RA 'The Bride', 1873, and 'Azaleas', 1885.

BOWDEN, E.J. fl.1875
Exhib. 'Woodland Scenery — Auvergne' at SS, 1875. Paris address.

BOWEN, Eva fl.1882
Exhib. one genre painting in London, 1882. London address.

BOWEN, Hugh fl.1897-1903
Exhib. 'Marcelle', and 'Under the Trees' at the RA, 1897-1903. Same London address as Miss Lota Bowen (q.v.).

BOWEN, Miss Lota fl.1889-1922
London painter of landscape and topographical subjects. Exhib. 1889-1922 at the RA and SS: subjects mainly topographical scenes in Venice, Switzerland, etc.

BOWEN, Owen ROI RCA 1873-1967
Painter in oil and watercolour of landscapes, flowers and still-life. Born in Leeds and educated at Leeds High School. Studied during the evenings at Leeds School of Art under Gilbert Foster and later privately at Foster's studio in Leeds. He worked as a pottery designer, then as a lithographic apprentice; he later turned to painting. Exhib. at the Leeds AG, 1888 and at the RA, 1892-1945. Painted mainly in Yorkshire and formed the Leeds School of Painting, later known as the Owen Bowen School of Painting. Lived for many years at East Keswick, near Leeds. Elected R.Cam.A 1916; ROI 1916; P.R.Cam.A 1947-54.
Bibl: P. Phillips, *The Staithes Group,* 1993.

BOWEN, Ralph fl.1887
Exhib. 'His First Steps — Quimperle. Brittany', at the RA, 1887. Worcester address.

BOWERLEY, Miss Amelia M. fl.1897 d.1916
Etcher and painter and illustrator of figure subjects. Born in London, her surname was originally Bauerlé. Studied art at the RCA, the Slade School and in Munich and Italy. She was trained in etching by Frank Short. Exhib. at the RA 1897-1915. Titles: 'Fairy Tales', 1897, and 'The Depths of the Sea', 1900. Also exhib. in Paris and the U.S.A. Elected A of the Royal Society of Painter-Etchers and Engravers 1900. Worked as an illustrator for a number of magazines, notably the *Yellow Book.* Lived in London.
Bibl: W.S. Sparrow, *Women Painters of the World,* 1905 p.132; Studio XXXIX 1907 p.59.

BOWERS, Albert Edward fl.1875-1893
Landscape painter. Exhib. 1875-93 at the RA, SS, NWS and elsewhere; subjects mainly Sussex landscapes. Lived at Kew and Richmond, Surrey.

BOWERS, H. fl.1852
Exhib. 'A Recollection of Rome, one of the Artist's Models' at SS, 1852. London address.

BOWERS, Stephen fl.1874-1891
Landscape painter. Exhib. 1874-91 at SS and the NWS. Lived at Kew and Richmond, Surrey.

BOWES, Mrs. fl.1868
Exhib. 'Forest Scene in France' at the RA, 1868. No address given.

BOWES, Miss Constance fl.1890
Exhib. 'Study of Roses', at the RA, 1890. Paris address.

BOWKETT, Family of
Several Miss Bowketts are recorded (all q.v.), Miss A., Miss E.M., Miss Jane Maria, Miss Jessie, Miss Kate and Miss Leila (Lily). All are very little known and presumably of the same family.

BOWKETT, Miss A. (or L.) fl.1878
Exhib. 'On the Thames, near Chiswick' at SS, 1873. Lived at 239 East India Road, London.

BOWKETT, Miss E.M. 1837-1891
London landscape painter. Exhib. 1862-7 — mainly views in Sussex — at the RA, BI and SS. Lived at the same address (Folkestone Terrace, East India Road and 243 East India Road) as Miss Jane Maria and Miss Kate Bowkett (qq.v.).

***BOWKETT, Miss Jane Maria 1837-1891**
(Mrs. Charles Stuart)
London painter of domestic scenes, usually of mothers and children. Exhib. mainly at SS, also at RA 1861, 1881 and 1882. Subjects 'Preparing for Dinner', 'Sally in our Alley', etc. Also

often painted seaside subjects, mainly on the south coast. Her husband Charles Stuart (q.v.) was also a painter.

Bibl: Reynolds, VS p.85 (pl.64); Wood, Panorama; J. Foley-Fisher, *The World of J.M.B.*, The Lady 18/25 December 1986.

BOWKETT, Miss Jessie fl.1880-1881
Exhib. 'To Market', and 'Dawdling' at SS, 1880-1, and one painting elsewhere in London. Lived at the same Acton address as Miss Leila Bowkett (q.v.).

BOWKETT, Miss Kate fl.1866-1867
Exhib. 'A Lane near Barking' at the SS, 1866, and 'A Country Lane' at BI, 1867. Lived at the same London addresses as Miss E.M. and Miss Jane Maria Bowkett (qq.v.).

BOWKETT, Miss Leila (Lily) fl.1876-1881
London landscape painter. Exhib. 1876-81 at SS and elsewhere. Lived at the same address — 2 Leamington Villas, Acton — as Miss Jessie Bowkett (q.v.).

BOWLBY, Miss Annie E. fl.1884
Exhib. a painting of 'Churches' at the NWS, 1884. London address.

BOWLER, Miss Annie Elizabeth b.1860 fl.1888-1930
London painter of portraits and genre; miniaturist. Studied at Lambeth School of Art, at the RA Schools and in Paris. Exhib. at the RA 1888-1930, at SS, RI and also in the provinces. Lived at Barnes.

BOWLER, Miss Ellen A. fl.1887-1891
Exhib. three paintings of genre at NWS, 1887-91. London address.

***BOWLER, Henry Alexander 1824-1903**
London landscape and genre painter. Like Redgrave, Dyce, Moody and many other Victorian painters, Bowler devoted most of his life to teaching, and so did not have much time to paint. Headmaster of Stourbridge School of Art 1851-5. Professor of Perspective at the RA 1861-99. Exhib. at the RA 1847-71, mostly landscapes, and a few works at BI, SS and NWS. His best known work is 'The Doubt "Can These Dry Bones Live?" ' an illustration to Tennyson, showing Pre-Raphaelite influence both in subject and style.

Bibl: AJ 1908 p.108; Reynolds, VS pp.17, p.81 (pl.1 'The Doubt'); Maas p.133; Wood, Panorama; Wood, Pre-Raphaelites.

BOWLER, Thomas William fl.1857-1860
Exhib. topographical views of Capetown at the RA and SS, 1857-60. London and Capetown addresses.

BOWLES, Miss E. fl.1851
Exhib. "Study of Fruit and Still Life' at the BI, 1851. Sister of James Bowles (q.v.). London address.

BOWLES, George fl.1857-1869
London painter of landscape, flowers and birds' nests subjects. Exhib. at the RA, 1857-9, at SS, 1857-67, and elsewhere in London. Titles at SS 'Bit of a New Forest Bank', 1859, 'Convolvulus', 1862, and 'Goldfinch's Nest', 1864.

BOWLES, James fl.1852-1873
London painter of genre, portraits and biblical subjects. Exhib. 1852-9, at the RA, BI, SS, and elsewhere. Titles: 'Cottage Cares and Cottage Treasure', RA 1852, and 'Christ Beginneth to Preach', BI 1853. His portrait of Sir W.M. Gomme, d.1873-4 is in the NPG.

Bibl: Ormond I pp.188-9.

BOWLES, J.G. fl.1856
Exhib. one painting 'Cottage on the Woolwich Road' at SS, 1856. Brother of James Bowles (q.v.) and lived at the same address, 27 Clarendon Polygon, St. Pancras.

BOWLEY, C. fl.1857
Exhib. a painting with no title at SS, 1857. No address given.

BOWLEY, Edward O. fl.1843-1870
Birmingham landscape painter. Exhib. at RA, BI, SS and elsewhere. Titles at RA 'Scene in Dauphiny, France' and 'Cornfield near Sutton Coldfield, Warwickshire'. A highland landscape appeared at Sotheby's Belgravia, 2 November 1971.

BOWLEY, Miss May fl.1890-1892
Painter of subjects for decorative panels and wall decoration. Exhib. 1890-2 at the RA. Titles: 'The Danaides', 1890, and ' "Cupid Laid Aside His Brand and Fell Asleep" '. Design for wall decoration, 1892. Lived at Lee, and in London.

BOWMAN, Albert George fl.1880-1908
Landscape painter. Exhib. 1880-1908, principally at the RA, but also at SS and NWS. Titles at RA 'Breaking Clouds', 1888, and ' "How Soft the Music of the Village Bells" ', 1897. Lived at Croydon, Sydenham and West Wickham, Kent.

BOWMAN, Ernest fl.1884-1885
London landscape painter. Exhib. 1884-5 at the RA and elsewhere. Possibly the same artist as H. Ernest Bowman (q.v.) but listed separately in Graves Dictionary and RA.

BOWMAN, H. Ernest fl.1881-1920
London landscape painter. Exhib. 1881-1920, at the RA (1904-20), NWS and elsewhere.

BOWMAN, Thomas G. fl.1866-1867
Exhib. 'Revolt in the Kitchen' at the BI, 1867, and four genre subjects elsewhere in London, 1866-7. London address.

BOWNESS, William 1809-1867
London portrait and genre painter. Mainly self-taught artist. Born in Kendal. Exhib. at RA 1836-63, more often at SS and the BI. Titles at RA 'The Grecian Mother', 'The Fair Falconer', 'Consulting the Glass', etc. Married to the eldest daughter of John H. Wilson (q.v.) the marine painter.

Bibl: AJ 1868 p.34 (obit.); DNB II p.983; Redgrave, Dict.

BOWSER, Miss Rose Maude fl.1886-1889
London flower painter. Exhib. 1886-9, at the RA and NWS.

BOWYER, Miss Ellen fl.1888-1893
London landscape painter. Exhib. 1888-93, at the RA, NWS, GG and NG. Titles at RA 'Early Autumn, Capel Curig', 1888, and 'Tenby, a Corner of the Harbour', 1889.

BOX, Alfred Ashdown fl.1879-1910
Birmingham landscape painter. Exhib. in Birmingham and Manchester 1879-1910. Signed A. Ashdown Box.

***BOXALL, Sir William RA FRS 1800-1879**
London portrait painter of the literary, artistic and ecclesiastical establishment. Exhib. portraits at RA 1818-80, and also religious subjects and landscapes. Also exhib. at BI and SS. Ruskin criticised

his portrait of Mrs. Coleridge (RA 1855) for "excess of delicacy and tenderness". His studio sale was held at Christie's, 8 June 1880.

Bibl: Ruskin, Academy Notes, 1855; DNB II p.995; Ormond I, see Index (p1.231).

***BOYCE, George Price RWS 1826-1897**

Landscape and topographical painter and watercolourist. Educated as an architect, and made many architectural studies on the Continent. In 1849 he met David Cox (q.v.) at Betws-y-coed, who encouraged him to give up architecture for painting. Exhib. at the RA 1853-61, and at SS. Titles at RA 'Edward the Confessor's Chapel, Westminster', 'St. Mark's, Venice', 'At Lynmouth, N. Devon', etc. Exhib. mainly at the OWS (218 works) of which he was A in 1864, member 1877, retired 1893. Friend of D.G. Rossetti (q.v.) and one of the founders of the Hogarth Club. Ruskin praised Boyce's 'At a Farmhouse in Surrey', RA 1858, as "full of truth and sweet feeling". Boyce's Diaries, published by the OWS in 1941, are a valuable source of information on the Pre-Raphaeiites. His studio sale was held at Christie's, 1 July 1897.

Bibl J. Ruskin, Academy Notes, 1858, 1859; A.E. Street, Architectural Review 1899; OWS XIX 1941; Bryan; VAM; Roget; Birmingham Cat: Fredeman, see Index; Hardie III pp.127-9 (pl.191); Staley pp.107-10 et passim (pls. 54a-57b); Cat. of G.P.B. exhib., Tate Gallery, London, 1987; Newall.

BOYCE, H. fl.1819-1848

London painter of landscape. Exhib. 1819-48 at the RA and BI. Titles at RA 'Stonehenge', 1828 and 'Crossing the Brook', 1847. 'An Honorary Exhibitor' at the RA.

BOYCE, Miss Joanna Mary see WELLS, Mrs. H.T.

BOYCE, William Thomas Nicholas 1858-1911

Marine painter and watercolourist, living at South Shields, Co. Durham. Son of a master mariner and shipowner, Boyce became a draper before becoming a professional painter. Did not exhibit in London; he spent much of his life in South Shields and regularly exhibited throughout the N. East. Subjects mainly shipping scenes off the N.E. coast, portraying the sea in a wide range of climatic conditions. Works by him are in the South Shields Public Library and Museum, the Laing AG, Newcastle, and the Sunderland AG. His sons Herbert Walter (1893-1946) and Norman Septimus (1895-1962) were also marine watercolourists.

Bibl: Hall.

BOYD, A. fl.1848

Exhib. 'The Head of the Lake' at the RA, 1848. London address.

BOYD, A. fl.1880

Exhib. 'A Scottish Glen' at the RA, 1880. London address.

BOYD, Miss (?) Agnes S. fl.1873

Exhib. 'Winter on the Thames at Chelsea' at the RA, 1873. Chelsea, London address.

BOYD, Alexander Stuart RSW 1854-1930

Painter and illustrator of street scenes. Worked for Punch and the Graphic. Exhib. at RA and NWS, 1884-7. Used the pseudonym Twym. Emigrated to New Zealand in 1912.

BOYD, Miss Alice fl.1874

Exhib. one figure subject in London, 1874. London address. This may be the Alice Boyd of Penkill Castle, Ayr, the faithful friend of William Bell Scott (q.v.).

BOYD, Dr. D.D. fl.1885

Exhib. a painting of a church at the NWS, 1885. Oxford address.

BOYD, Henry N. fl.1869-1871

Marine painter. Exhib. 1869-71 at the SS and elsewhere. Silverton address.

BOYD, Major fl.1879

Exhib. 'Caves of Elephanta' at SS, 1879. London address.

BOYD, Walter Scott fl.1883-1886

Exhib. 1883-6 at the RA and elsewhere. Titles at RA 'The Great Gallery, Aston Hall', 1883, 'Going to Mass', 1885, and 'Arranging the Catalogue', 1886. Birmingham and Glasgow addresses.

BOYDELL, Creswick fl.1889-1894

Liverpool landscape painter. Exhib. 1889-94 at the RA and SS. Titles at RA ' "The Day Declining into Night" ', 1890 and ' "At the Close of Day, When the Hamlet is Still" ', 1894. A of the RCA.

BOYES, Miss M.L. fl.1866

Exhib. 'View near Rottingdean, Coast of Sussex', at SS, 1866. London address.

BOYLE, George A. fl.1884-1889

Landscape painter. Exhib. 1884-9, at the RA and SS. Titles at RA 'On the River', 1884 and 'At Plaistow, Kent', 1889. Greenwich, Blackheath and Lewisham addresses.

BOYLE, J.M. fl.1855

Exhib. 'Elgiva' at the RA, 1855. No address given.

BOYLE, Lockhart fl.1891

Exhib. one historical subject in London, 1891. London address.

BOYLE, Hon. Mrs. Richard 1825-1916
(Eleanor Vere)

Watercolourist and book illustrator. Wife of the Hon. and Rev. Richard Boyle, Rector of Marston, near Frome, Somerset. During the 1850s and 1860s, she became well known as an illustrator of children's books, e.g. Beauty and the Beast, Story without an End, etc., using only her initials EVB. Her illustrations have considerable period charm and are now much appreciated by collectors. She also exhib. occasionally at GG and elsewhere, 1878-81. After the death of her husband, she moved to Huntercombe, near Henley, and turned to writing and illustrating gardening books. One of these, Days and Hours in a Garden (1884) was a best-seller in its day.

Bibl: M. McGarvie, E.V.B., Frome Historical Research Group, 1982; Newall; Wood, Painted Gardens.

BOYNS, Bessie fl.1891

Exhib. 'Ebbing Tide and Showery Weather' at SS, 1891. St. Just, Cornwall address.

***BOYS, Thomas Shotter NWS 1803-1874**

Watercolourist and lithographer, well known for his architectural views of London and Paris. Worked in Paris with Bonington, where his pupils were Callow and A. Poynter. Also painted landscapes and figure subjects. After the 1840s his career was much affected by illness.

Bibl: For full details see James Roundell, T.S.B., 1974.

***BRABAZON, Hercules Brabazon 1821-1906**

Landscape and still-life watercolourist. Born in Paris. Educated at Harrow and Trinity College, Cambridge, where he read

Mathematics. Studied in Rome for three years, and took lessons from J.H. d'Egville and A.D. Fripp. Travelled with Ruskin and Arthur Severn; toured Spain, Egypt, India, etc. Original member of NEAC. In 1892, Sargent persuaded Brabazon. to exhibit some of his drawings at the Goupil Gallery, as up to then he had practised as an amateur. Since then his rapid, colourful sketches have been popular with collectors.

Bibl: Goupil Gallery exhib. cat. 1892 (Preface by Sargent); AJ 1906, 1907; Studio XXXV pp.95-8; Hardie III p.202; Brook-Hart p.93; cat. of H.B.B. exhib., Chris Beetles Gallery, London, 1989.

BRABY, Newton fl.1898-1907
Painter of portraits, genre and flowers. Exhib. 1898-1907 at the RA. Titles: 'The Last Rose of Summer', 1898 and 'A Remnant', 1900. Lived in London and Teddington.

BRACE, Miss Eleanor fl.1882-1891
Painter of flowers, landscapes and architectural subjects. Exhib. 1882-91, at the RA (1891), SS, NWS and elsewhere. Titles at SS 'Shades of Gold', 1883, 'Primula', 1886, and 'Tomb of Sir Francis Vere, Westminster Abbey', 1889. Lived at Reigate, Brighton and London.

BRACKEN, A. fl.1885
Exhib. 'A Mahometan at Prayer' at the RA, 1885. Florence address.

BRADBURNE, Miss L. fl.1872
Exhib. 'Ned Gillet, Fisherman' and 'Game' at SS, 1872. Northwich address.

BRADBURY, A.A. fl.1879
Exhib. two landscapes in London, 1879. Hanley address.

BRADDON, Paul fl.1880-1893
Topographical painter. Pseudonym for the Hull artist J.L. Crees. Published *Nooks, Corners and Crannies of Old Birmingham*, 1893. Several views of towns and buildings, dated 1880-90, are in Birmingham AG.

Bibl: Birmingham Cat.

BRADEN, Karl fl.1886-1891
Landscape painter. Exhib. at the RA, SS and NWS, 1886-91. Lewes, Sussex, address.

BRADFORD, Miss Harriette fl.1862-1867
London flower painter. Exhib. 1862-7 at the RA and SS.

BRADFORD, Louis King ARHA 1807-1862
Irish painter of landscape and figure subjects, in oil and watercolour. Studied at the Dublin Society's School. Exhib. at the RHA from 1827, and at SS in London in 1854. Elected ARHA, 1855. Lived in Dublin.

Bibl: Strickland I pp.76-7.

BRADLEY, Basil RWS 1842-1904
Landscape and genre painter and watercolourist. Studied at Manchester School of Art. Exhib. mainly at OWS, also SS and RA, 1873-99. Subjects at RA chiefly English and Scottish landscapes, some sporting.

Bibl: Clement & Hutton; Cundall; Pavière, Sporting Painters (pl.7).

BRADLEY, Mrs. E. fl.1865
Exhib. one still-life subject at the SS, 1865. Wife of Edward Bradley (q.v.).

BRADLEY, Edward fl.1824-1867
London landscape and still-life painter. Exhib. at RA, 1824-44, more often at BI and SS. Subjects at RA views in Hampshire, Surrey, Scotland and Italy.

BRADLEY, Miss Gertrude M. fl.1898-1900
Exhib. ' "Right! Away!" ' and 'The Cat-Witch' at the RA, 1898-1900. Bushey and Battersea addresses.

BRADLEY, Gordon fl.1832-1839
London landscape painter. Exhib. 1832-9, at the RA, SS and NWS. Titles at RA 'Sunset', 1834 and 'One of the Old Windmills that stood on Blackheath — Evening', 1839.

BRADLEY, J. fl.1817-1843
London portrait painter. Exhib. 1817-43 at the RA, SS and OWS.

BRADLEY, J. fl.1864
Exhib. 'Study from Nature' at the RA, 1864. London address.

BRADLEY, James fl.1883
Exhib. one landscape in London, 1883. Worcester address.

BRADLEY, John Henry b.1832 fl.1854-1884
Landscape and topographical painter and watercolourist. Pupil of David Cox and James Holland, both of whose influence can be detected in his work. Lived in Leamington and London, and travelled in Italy. Exhib. at RA 1854-79, and at BI and SS. Subjects landscapes, views in Italy, and some flower pieces. His views of Venice similar in style to James Holland.

Bibl: Clement & Hutton.

BRADLEY, Robert 1813-c.1880
Nottingham painter of landscapes and local scenery; for many years landlord of the 'Lord Belper' in Nottingham.

BRADLEY, William 1801-1857
Manchester portrait painter. Exhib. 1823-46 at the RA, BI and SS. His style is at times similar to that of Margaret Carpenter and A.W. Devis, especially his pictures of children. An undeservedly neglected artist, little known outside his native Manchester.

Bibl: Ormond I pp.29, 298, 441.

BRADLEY, William fl.1872-1889
Painter of landscape, river scenes and flowers. Exhib. 1872-89, at the RA, SS, NWS and elsewhere. Titles: 'Gally-y-Gogo, and Trefan — A Sunny Morning in the Ogwen Valley, North Wales', SS, 1873, and 'Primroses' RA, 1880. Lived in London, but from 1875 at Maidenhead, Berkshire. He did not exhib. portraits as stated in Graves Dictionary.

BRADLING, A. fl.1839
Exhib. 'Adam Woodcock' at the BI, 1839. No address given.

BRADSHAW, Florence fl.1889
Exhib. 'Down by the Sea', and ' "The Shadows are Lengthening" ' at SS, 1889. London address.

BRADSHAW, Samuel fl.1869
Exhib. 'A Sketch near Cheltenham' at SS, 1869. Cheltenham address.

BRADSTREET, Miss E. fl.1868
Exhib. one painting of fruit at SS, 1868. London address.

BRAGG, Charles William fl.1855-1857
Birmingham flower painter. Exhib. 1855-7 at the BI and elsewhere.

BRAGG, John fl.1880-1889
Birmingham painter of landscapes and coastal scenes. Probably related to C.W. Bragg.

BRAGGER, Charles fl.1879-1880
London portrait painter. Exhib. 1879-80 at the RA and elsewhere.

BRAIN, Miss Constance fl.1891-1894
London painter of flowers and portraits. Exhib. at the NWS in 1891 and at the RA in 1894.

BRAIN, Miss F. fl.1864-1867
London flower painter. Exhib. 1864-7 at the BI and SS.

BRAIN, H. fl.1865
Exhib. 'May' at the BI, 1865. Stepney Causeway address.

BRAMHALL, H. fl.1844-1859
London landscape painter. Exhib. 1844-59, at the RA and SS. Titles at RA 'Afternoon', 1848 and 'By the Woodside', 1859.

***BRAMLEY, Frank RA 1857-1915**
Genre and portrait painter. Member of the Newlyn School, with Stanhope Forbes and Henry Tuke (q.v.), at Newlyn, Cornwall. Like those of Forbes, Bramley's works combine the social realism of Courbet and Millet, with the *plein-air* landscape of the Barbizon painters. He exhib. at the RA from 1884. Elected ARA 1893, RA 1911. 'A Hopeless Dawn' (RA 1888) bought by the Chantrey Fund and now in the Tate (Reynolds, VP pl.131). One of the founder members of the NEAC; exhib. at GG and NG. After 1897 turned increasingly to portrait painting.
Bibl: Tate Cat.; Reynolds, VP pp.188, 194, 195 (pl.131); Maas pp.249-50; Wood, Panorama.

BRAMPTON, Herbert fl.1896
Exhib. 'Staircase of Palace of the Bargello, Florence' at the RA, 1896. Hanley address.

BRANDARD, Miss Annie Caroline fl.1867-1884
London painter of genre, flowers and landscape. Sister of Robert Brandard (q.v.). Exhib. 1867-84 at the RA and SS. Titles at RA 'Christmas and a Lodging to Let', 1867 and 'Blackberry Brambles', 1884.

BRANDARD, Edward Paxman 1819-1898
Landscape engraver and painter. Brother of Robert Brandard (q.v.). Exhib. 1849-85, at the RA, BI, SS, NWS and elsewhere. Like his brother lived in Birmingham and then came to London.

BRANDARD, Robert 1805-1862
Landscape engraver and watercolourist, brother of E.P. Brandard, an engraver. Their sister Annie Caroline Brandard was also a landscape painter. Robert came to London from Birmingham in 1824, and studied with Edward Goodall (q.v.). Exhib. oils at the RA in 1838, 1842 and 1852, but concentrated on engraving. Employed by Turner, Callcott, Stanfield and others. Engraved plates for Turner's *England* and *English Rivers*.
Bibl: Redgrave, Dict.; DNB II p.1124; Bryan; Binyon; VAM; Cundall; Hughes; Hardie III p.29.

BRANDISH, A. fl.1872-1873
London landscape painter. Exhib. 1872-3 at SS, landscapes set in Worcestershire.

BRANDLING, Henry Charles fl.1850-1881
London painter of genre and portraits. Exhib. 1850-81, at the RA and elsewhere. Titles at RA ' "Hier Verkoopt Men Drank" ' and 'Miss E. Brandling', 1850.

BRANDON, Mrs. fl.1864
Exhib. 'Flowers, Painted on Vellum', at the SS, 1864. London address.

BRANDON, Dolly fl.1891
Exhib. 'End of the Heath' at the SS, 1891. London address.

BRANDON, E. fl.1870
Exhib. 'St. Catherine of Sweden prays over the Body of her Mother, St. Bridget', at the RA, 1870. No address given.

BRANDT, Otto fl.1867
Exhib. three genre subjects at SS, 1867. Exhib. c/o E. Eagles, Sutton Valence, Staplehurst.

BRANEGAN, J.F. fl.1871-1875
London painter of coastal scenes. Exhib. 1871-5 at the RA and SS. Titles at RA 'Morning on the Beach', 1871 and 'Fish Sale — Early Morning', 1875.

BRANGWIN, Noah fl.1851-1856
Painter of rustic genre and landscape. Exhib. 1851-6, at the RA, BI and SS. Titles at BI 'The Young Sportsman's Bag', 1851 and 'Returning from Labour', 1852. Lived at Henley-on-Thames and Wargrave, Berkshire.

BRANGWYN, Sir Frank RA 1867-1956
Painter, watercolourist, etcher and lithographer. At first a self-taught artist; worked under William Morris, then went to sea. Exhib. at the RA from 1885, also at SS, GG and NG. Subjects at RA mainly marines, scenes of life on board ship, and subjects inspired by his travels. At first his colours were grey and subdued; after his return from abroad his style became richer and more colourful. Brangwyn's long career extends well beyond the Victorian period, so for the remainder of his career after this period, see Bibl.
Bibl: P. Macer-Wright, *Brangwyn — a Study of Genius*; Vincent Galloway, *Oils and Murals of Brangwyn*; Walter Shaw-Sparrow, *Frank Brangwyn and his Work*, 1910-1915 (with appendix by Brangwyn of list of paintings, sketches and etchings up to 1914); T.M. Rees, *Welsh Painters, etc.*, 1911; Tate Cat.; Maas p.67; Brook-Hart p.97.

BRANNAN, J. fl.1859
Exhib. 'The Organ Boy' at the RA, 1859. London address.

BRANSCOMBE, Charles H. fl.1891
Exhib. one landscape in London, 1891. Bournemouth address.

BRANSON, Mrs. Juliet fl.1886-1895
London landscape painter. Exhib. 1886-95 at the RA and SS. Titles at RA 'A Picardy Village', 1889 and 'The After Glow', 1895.

BRANSTON, Miss Eva M. fl.1892-1894
Exhib. two landscapes at the RA and one elsewhere, 1892-4. Titles at RA ' "Where Green Trees Whisper, Kissing the Soft Air" ' 1892 and 'The Windmill, Felpham, Sussex', 1894. Lived at Beckenham and London.

BRANWHITE, Charles 1817-1880
Bristol landscape painter and watercolourist. Pupil of William Müller (q.v.). Exhib. mainly at the OWS (265 works); also at RA, 1845-56, and at the BI. Subjects mainly views in the West Country, Wales, Scotland, and on the Thames. His studio sale was held at Christie's on 15 April 1882. Style shows influence of Muller. The AJ says he was particularly noted for his "frost scenes".
Bibl: Ruskin, *Notes on OWCS,* 1857, 1858; AJ 1880 p.208 (obit.); Clement & Hutton.

***BRANWHITE, Charles Brooke 1851-1929**
Bristol landscape painter, in oil and watercolour. Born at Bristol, son of Charles Branwhite (q.v.). Studied art under his father and at the South Kensington School of Art. Exhib. from 1873, at the SS, NWS, RA and elsewhere. Elected a member of the Royal West of England Academy, 1913.

BRANWHITE, Miss Rosa see MÜLLER, Mrs. E.G.

BRAUER, O. fl.1872
Exhib. one figure subject in London, 1872. London address.

BRAYSHAY, W.H. fl.1867
Exhib. 'Gordale Beck, Craven, Yorkshire' at the RA, 1867. Burley-in-Wharfedale, Yorkshire, address.

BREACH, E.R. fl.1868-1886
London painter of sporting subjects, cattle, genre and landscape. Exhib. 1868-86, at the RA (in 1875 only), SS and elsewhere. Titles at SS 'Harvest Time', 1868, 'Highland Cattle — A Coming Storm', 1875 and 'The Twelfth of August — On the Moors', 1878.

BREAKELL, Miss Mary Louise fl.1879-1908
Painter of landscape, genre and flowers. Exhib. 1879-1908, at the RA, SS and elsewhere. Titles at RA 'The Forest Maid', 1879, 'A Garden in France', 1883 and 'A Garden of Larkspurs, Brittany', 1890. Lived in Richmond, Surrey, Prestwick Park, Manchester and London.

***BREAKSPEARE, William A. 1855-1914**
London genre painter. Foundation member of the Birmingham Art Circle. Studied in Paris and influenced by Thomas Couture. Member of the Newlyn School in Cornwall. Exhib. at the RA 1891-1903, and at SS and GG. Subjects mainly genre, or 18th century costume pieces.

BREBANT, Albert fl.1848-1852
Exhib. 'A Village Scene' at the RA, 1848, and four genre subjects elsewhere in London, 1848-52. Liverpool address.

BREBNER, Miss Elizabeth M. fl.1896-1914
London painter of flowers and portraits. Exhib. 1896-1914 at the RA.

BREDBURG, Madame Mina fl.1892
Exhib. a portrait at the NG, 1892. London address.

BRENAN, George fl.1875-1883
Irish painter of landscapes and animals. Brother of James Brenan, RHA (q.v.). Exhib. at RHA 1875-83. "Did not attain much excellence in his art" (Strickland).
Bibl: Strickland I p.77.

BRENAN, James RHA 1837-1907
Art teacher and painter. Born in Dublin. Studied in England, where he assisted Digby Wyatt and Owen Jones with the decoration of the Roman and Pompeian courts at the Great Exhibition. Worked as an art teacher in several English towns, then in Cork 1860-89, and finally became Headmaster of the Metropolitan School of Art in Dublin 1889-1904. Exhib. regularly at RHA from 1862, his subjects usually cottage interiors and scenes of Irish life.
Bibl: Strickland.

BRENAN, James Butler RHA 1825-1889
Cork portrait painter. Son of John Brenan (q.v.). Exhib. at the RHA 1843-86; elected ARHA 1861, RHA 1871. His sitters were mostly local patrons. His brother John J. Brenan painted many of the landscape backgrounds in his works. His portrait of Macaulay, d.1860, is in the Collection of Lady Wise.
Bibl: Strickland I pp.79-80; Ormond I p.290.

BRENAN, John b.c.1796-1865
Irish landscape painter. Born in County Tipperary; studied at the Dublin Society's School; settled in Cork. Exhib. at the RHA, 1826-64. Father of James Butler Brenan (q.v.) and John J. Brenan.
Bibl: Strickland I pp.80-1.

BRENCHARD, A. fl.1892
Exhib. two landscapes at the NG, 1892. London address.

BRENNAN, Edward J. fl.1874-1884
Irish landscape painter. Born in Kilkenny; studied in Paris. Returned to Dublin. Exhib. from 1878 at the RHA. Visited London and the continent, 1884, where he died "from the effects of intemperance".
Bibl: Strickland I p.82.

BRENNAN, Fitzjohn fl.1885-1887
London landscape painter. Exhib. 1885-7 at the RA. Titles: 'Rugged Slopes', 1885, and ' "When the Glow is in the West" ', 1887.

BRENNAN, Michael George 1839-1874
Irish landscape and genre painter. Trained in Dublin and at the RA; settled in Rome. Exhib. at RA 1865-70. Subjects: scenes of Roman life, and Italian views around Capri, Naples and Pompeii.

BRENNIR, Carl fl.1899
Exhib. 'On the Hill at Alkham, Kent' at the RA, 1899. Address, "26 Shakespeare Villa, Notts".

BRERETON, Robert fl.1835-1847
Painter of portraits and genre. Exhib. portraits at the RA, 1841 and 1843, and at the SS, 'The Benevolent Family', 1835 and 'Lace-Makers', 1847. Lived in London and Melton Mowbray.

BRETLAND, Thomas W. 1802-1874
Nottingham animal and sporting painter. Never exhibited in London; travelled round the country working for his patrons, who included the Dukes of Buccleuch and Montrose. As a painter of horses he was competent, if uninspired. Pictures by him are in the Nottingham AG.

BRETT, B. fl.1841-1845
London landscape painter. Exhib. 1841-5, at the RA, BI and SS. Titles at SS 'Sandwich Flats', 1841, and 'Shakespeare Cliff, Storm Passing Off', 1845.

***BRETT, John ARA 1830-1902**

London painter of coastal scenes and landscapes. Attracted the attention of Ruskin with 'The Stonebreaker' at the RA in 1858. Encouraged by Ruskin, Brett visited N. Italy, and painted 'The Val d'Aosta' which he exhibited at the RA in 1859. Ruskin devoted several pages of his *Academy Notes* for that year to praising the picture, although he did comment "it is Mirror's work, not Man's". Under Ruskin's influence, Brett's style developed away from his earlier Pre-Raphaelitism, towards subjects of geological and botanical interest. For the next forty years, Brett exhibited at the RA a succession of highly detailed, geological coast scenes of a rather repetitive formula, but which often show great beauty and observation.

Bibl Ruskin, Academy Notes 1858, 1859, 1875; AJ 1902 p.87; Bate 87ff.; Tate Cat; Ironside & Gere p.45 (pls. 77-9); Reynolds, VS PP.17, 76 (pl.III); Fredeman, see index; Reynolds, VP pp.65, 68, 69, 154, 155; Maas p.63, 67, 133-4 (pls. pp.65; 68, 136, 137); Staley pp.124-37 *et passim* (pls. 68a-73b); Brook-Hart pp.7, 9-10, 56 (pls.41-2); Wood, Pre-Raphaelites, Wood, Paradise Lost; Newall.

BRETT, Miss Rosa 1829-1882

Landscape painter; sister of John Brett (q.v.). Exhib. at RA 1858-81, and occasionally elsewhere. Although really an amateur, she painted many charming studies of fruit, flowers, foliage, and animals, as well as landscapes. See also under Rosarius.

Bibl: Staley p.128, l5l; P.G. Nunn, *R.B.*, Burlington Magazine October 1984 (with illus. and check list).

BREUN, John Ernest RBA 1862-1921

Portrait painter. Second son of John Needham Breun, Duc de Vitry. Educated in London. Studied art at South Kensington and at the RA Schools, 1881-4, where he won a number of prizes and medals. Exhib. from 1879 at the RA, SS, NWS and elsewhere. Elected RBA 1895. Lived in London.

Bibl: Ormond I pp.263, 351.

BREWER, Miss Amy Cobham fl.1893-1896

Painter of literary and imaginative subjects. Exhib. 1893-6 at the RA and NG. Titles at the RA 'Love in Idleness', 1894, and ' "Beware of Goblin Men" ', 1895. Also exhib. at the RA a design in relief for a bronze, 1893. Lived in Bushey, Hertfordshire.

BREWER, Henry Charles RI 1866-1950

Painter in watercolour of landscapes and architectural subjects. Son of H.W. Brewer (q.v.). Studied art at Westminster Art School under Fred Brown. Exhib. at the RA from 1888-1949, and also at the RI, in the provinces and abroad. Elected RI 1914.1899-1902 exhib. decorative paintings at the RA. Lived in London.

BREWER, Henry William fl.1858-1897 d.1903

London painter of churches, details of church interiors and tombs. Exhib. at RA 1858-97 and at SS. Travelled in England, France, Germany and Italy in search of subjects. Style similar to Samuel Prout.

Bibl: AJ 1881 pp.257-61 (illus.).

BREWER, Miss Maude fl.1888-1890

Exhib. three landscapes at NWS, 1888-90. Sevenoaks, Kent, address.

***BREWTNALL, Edward Frederick RWS RBA 1846-1902**

London painter, in oil and watercolour, of genre, landscape and figure subjects. Exhib. from 1868, at the RA, SS, GG and elsewhere, but mainly at the OWS. Titles at RA 'The Model's Luncheon', 1872, 'Cinderella', 1880 and 'On the Embankment', 1899. A of OWS 1875; RWS 1883, RBA 1882; resigned 1886. Also a member of the Institute of Oil Painters.

Bibl: Bryan; VAM .

BRICE, Edward Kington RBSA 1860-1948

Painter of figure subjects and genre. Born at Edgbaston, Birmingham. Studied at the Birmingham School of Art. Exhib. ' "What is it?" ' at the RA, 1893, from a Manchester address. Also exhib. in the provinces. Elected RBSA 1920. Lived near Evesham.

Bibl: Wood, Painted Gardens.

BRICKDALE, Sir Charles Fortescue 1857-1944

Exhib. one landscape at the NWS, 1887. Norwood address. Brother of Eleanor Fortescue-Brickdale (q.v.).

BRICKDALE, Eleanor Fortescue See FORTESCUE-BRICKDALE, Eleanor

***BRIDELL, Frederick Lee 1831-1863**

Landscape painter. Born Southampton. Apprenticed to an art dealer, he travelled round Europe painting copies for him. After visiting Italy, returned to England and settled at Maidenhead. Exhib. at the RA 1851-62, also at the BI and SS. Subjects all continental views,especially Italy. Returned to Rome, where he married Eliza Florence Fox, also a painter (q.v. Bridell Fox). He suffered from poor health, and died of consumption aged 32. His last and best-known picture, 'The Coliseum by Moonlight', exhib. at the International Exhibition in 1862, is a romantic and individual work; had Bridell lived longer he might have become a considerable artist, but his output was too small for him ever to achieve lasting fame. The sale of his studio was held at Christie's on 26 February 1864.

Bibl: AJ 1864 p.12 (obit.); Redgrave, Dict.; DNB 1909 II p.1220; Tate Cat; Reynolds, VP p.155 (pl.III); Maas p.228; John Sweetman, *F.L.B. and Romantic Landscape*, Apollo August 1974.

BRIDGE, Annie fl.1889-1891

Exhib. two flower paintings at SS, 1889-91. Highgate address.

BRIDGE, J. fl.1866-1872

London painter of genre, figure subjects and landscape. Exhib. 1866-72 at the RA and SS. Titles at RA 'A Persian Girl', 1867, and 'The Mountebank's Daughter', 1872.

BRIDGES, James fl.1819-1853

Oxford landscape and portrait painter. Lived at same address as John Bridges (q.v.), so presumably they were brothers. Exhib. at RA 1819-53, and at BI and SS. Subjects: portraits, and landscape views around Oxford, and in Italy and Germany.

***BRIDGES, John fl.1818-1854**

Oxford portrait and genre painter, presumably brother of James Bridges (q.v.). Exhib. at RA 1818-54, also at BI and SS. Subjects: portraits, genre, and some historical and religious scenes. His portrait groups have great period charm, and are full of detail of Victorian interiors.

BRIDGFORD, Thomas RHA 1812-1878

Irish portrait and figure painter. Studied at Dublin Schools, and began to exhibit at RHA in 1827. Elected ARHA 1827. In 1834 went to London, and in 1844 returned to Dublin. RHA 1851.

BRIDGMAN, Frederick Arthur 1847-1927
American landscape and historical painter. Studied with Gerome in Paris. Exhib. at RA 1871-1904. Subjects chiefly views in Egypt, Algeria, N. Africa, and scenes from Egyptian history.
Bibl: AJ 1879 p.155 (with illus.).

BRIDGMAN, G. fl.1880
Exhib. one landscape subject in London, 1880. London address.

BRIDGMAN, J.B. (J.D) fl.1865
Exhib. 'Ancient Bottle found during Excavations at Hackney, with Shells' at SS, 1865. London address.

BRIDGWATER, Mrs. H. Scott fl.1893-1899
(Miss H. May)
Painter of figure and literary subjects. Wife of Henry Scott Bridgwater, engraver. Exhib. 1893-9 at the RA. Titles: ' "Golden Slumbers Kiss Your Eyes" ', 1893 and 'La Source', 1899. Lived at Bushey, Hertfordshire.

***BRIERLY, Sir Oswald Walters RWS 1817-1894**
London marine painter and watercolourist. Decided at an early age to be a marine painter. Studied at Sass's Academy and at naval college in Plymouth. 1841-51 went on his first trip round the world, during which he took an exploratory expedition round the Australian coasts. Went to the Crimea as reporter on naval affairs, after which he was employed as marine painter to the royal family. 1867-8 around the world again in the Duke of Edinburgh's suite. 1868-9 up the Nile with Prince of Wales. Exhib. at RA 1839-71, and at OWS (192 works). In 1874, when Schetky died, Brierly. was appointed Marine Painter to the Queen. Knighted 1885. In his later years, turned to historical naval scenes, many of the Armada and other patriotic themes. Spent much time in Venice, with his friend Edward Goodall (q.v.). A full-scale exhibition of his work was held at the Pall Mall Gallery in 1887.
Bibl: J.L. Roget in AJ 1887 pp.129-34; DNB; Bryan; Cundall; Wilson p.18 (pl.4); Maas p.65 (pl. p.64); Brook-Hart.

BRIGGS, Miss E. Irlam fl.c.1890-1950
Painter of portraits, historical figure subjects, landscape and genre. Studied at Wimbledon Art College, at St. John's Wood Art School, at the RA Schools, and in Paris at the Académie Julian. Exhib. at the RA 1892-1901, and in the provinces. Lived at Parkstone in Dorset for many years.

BRIGGS, Ernest Edward RI RSW 1866-1913
Scottish watercolourist, mainly of landscape and genre subjects. Born at Broughty Ferry, Fife; studied art at the Slade School, 1883-7, after giving up a career in mining engineering for reasons of health. Exhib. from 1889 at the RA, SS and NWS; member of the RI and RSW. A keen fisherman and author of *Angling and Art in Scotland*, 1912; often painted river and fishing subjects. Worked largely in Scotland, favouring the area around Glen Dochart. His output was comparatively small. 'A Flood on the Kew at Earlstown Linn' was a Chantrey purchase, 1913.
Bibl: W. Shaw Sparrow, *Angling in British Art;* Tate Cat.

BRIGGS, Henry Perronet RA 1791-1844
London historical and portrait painter. Studied at RA Schools 1811; in 1813 went to Cambridge. Exhib. at RA, 1814-44 (132) works and at the BI, 1819-35. Elected ARA 1825, RA 1832. After about 1835, he gave up historical painting (mainly subjects from Shakespeare or English history) in favour of portraits. Among his many famous sitters were Charles Kemble, the Duke of Wellington,

and the Earl of Eldon. As with many Victorian portrait painters, his sketches and drawings have more charm and spontaneity than his finished works. As 'Baron Briggs' he was placed first by Thackeray in his 'List of Best Victorian Painters' (Fraser's Magazine 1838). His studio sale was held at Christie's 25-27 April 1844.
Bibl: AU 1844 p.62; Redgrave, Dict., Cent.; Bryan; Binyon; NPG 1907 Cat; Maas pp.22, 110, 215; Ormond I.

BRIGGS, John fl.1889
Exhib. 'October' at the RA, 1889. London address.

BRIGGS, W. fl.1842-1845
London portrait painter. Exhib. 1842-5, eight portraits, at the RA. There is confusion in Graves Dictionary between this W. Briggs and William Keighley Briggs (q.v.). It is possible that they are the same artist.

BRIGGS, William Keighley fl.1849-1860
Portrait painter. Exhib. 1849-60, at the RA, SS and elsewhere. Lived in Leeds and London.

BRIGHT, Miss Beatrice 1861-1940
London painter of portraits and seascapes. Born in London; studied art under Sir Arthur Cope. Exhib. at the RA, 1896-1928, and at the Paris Salon.

BRIGHT, Harry fl.1867-1892
Bird painter, mainly in watercolour. Usually painted robins and wrens in great detail, but occasionally produced free sketches in the manner of E. Alexander. Illustrated several bird books. May be the same artist as another H. Bright, who painted extraordinary pictures of frogs.

***BRIGHT, Henry 1814-1873**
Norwich School landscape painter and watercolourist. Trained as a chemist, and became dispenser at Norwich hospital. Studied with J.B. Crome and John Sell Cotman. Exhib. at RA 1843-76, at the BI, SS, and NWS, of which he was elected a member in 1839. Subjects at RA mainly views in East Anglia, also views in Holland and on the Rhine. After living in London for over 20 years, he retired due to ill-health to Ipswich, where he died. Although better known as a watercolourist, he was also an able painter, working in a style similar to Alfred Vickers and other second generation Norwich painters.
Bibl: AJ 1873 p.327; Redgrave, Dict; DNB 1909 II p.1238; Binyon, F.G. Roe, *H.B. of the Norwich School,* Walker's Quarterly I no.l. 1920; Bryan; VAM; Cundall; Clifford; Maas p.57 (with pl.). H.A.E. Day, *East Anglian Painters,* II p.214-26.

BRIGHT, Henry fl.1884
Exhib. one figure subject at the NWS, 1884. Giggs Hill address.

BRIGHT, Mary fl.1837-1846
London landscape painter. Exhib. 1837-46 at SS. Sister of William Bright, landscape painter, who exhib. 1828-34 at SS, and 1828-30 at the RA.

BRIGHTWELL, G. fl.1877-1881
Exhib. 'A Snug Corner' at SS, 1881 and four paintings elsewhere in London, 1877-81. London address. Called a "landscape" painter in Graves Dictionary.

BRINCKMAN, Lady fl.1848
Exhib. 'Mary Magdalene' at BI, 1848. London address.

BRINDLEY, Charles A. fl.1888-1898
Surbiton painter of genre and portraits. Exhib. 1888-98 at the RA. Titles: 'Her First Born', 1892 and 'His Siesta', 1898.

BRINDLEY, John Angell A. fl.1884-1890
London landscape painter. Exhib. 1884-90, at the RA, SS and NWS. Titles at SS: 'A Grey Day on the Minster Dykes', 1884, and 'Afloat', 1887.

BRINDLEY, Sarah fl.1879
Exhib. 'The Last Load' at SS 1879. London address.

BRINSON, J. Paul RBA fl.1895 d.1927
Landscape painter in watercolour and pastel. Exhib. at the RA 1895-1918, at the RI and elsewhere. Founder and secretary of the British Watercolour Society. Lived at Reading.

BRINTON, Miss Edith D. fl.1885-1900
London painter of genre, portraits, still-life and landscape. Exhib. 1885-1900, at the RA, SS and elsewhere. Titles at RA 'Market Day', 1893 and 'A Grey Afternoon', 1898.

BRISCOE, Claude fl.1872-1873
London painter of genre. Exhib. 1872-3 at SS. Titles: 'In the Library' and 'A Reverie'.

BRISSOT, Frank fl.1879
Exhib. 'Returning Home' at the RA, 1879. London address.

***BRISTOW, Edmund 1787-1876**
Sporting and animal painter. Lived at Windsor, where he was patronised by the Duke of Clarence, later William IV, and other members of the court. Exhib. only seven works at the RA between 1809 and 1829; also exhib. at BI and SS. Painted sporting scenes, animals, portraits, rustic genre and landscapes in a style which belongs more to the era of Morland and Ibbetson than to the Victorian period. He. was a recluse by nature, and disliked patronage so much that he would often refuse to sell his pictures. He died in such complete obscurity at the age of 88 that the Art Journal, writing his obituary, could discover nothing to say about him.
Bibl: AJ 1876 p.148 (obit.); Redgrave, Dict; Pavière, Sporting Painters (pl.7); Maas p.48.

BRISTOW, George L. fl.1883-1887
London landscape painter. Exhib. 1883-7 at the NWS.

BRISTOW, Miss Lily fl.1889-1899
Painter of genre and flowers. Exhib. 1889-99, at the RA, SS and elsewhere. Titles at RA 'The Parting Gleam', 1894 and 'The Girdle', 1899. Lived at Clapham Common and Bushey, Hertfordshire.

BRISTOW, W.H. fl.1834-1840
Exhib. 'The Philosopher' and 'The Orphans' at the BI, 1834, and 'Portrait of a Gentleman' at SS, 1840. London address.

BRISTOWE, Miss Beatrice M. fl.1893-1899
London portrait painter. Exhib. 1893-9 at the RA.

BRITTAN, Charles Edward 1837-1888
Exhib. ' "The Antler'd Monarch of the Waste" ' at SS, 1858. Truro, Cornwall address. Father of a landscape painter of the same name, Charles Edward Brittan, b.1870, who exhib. at the RA 1928-9, and elsewhere, and who lived in Devon and North Wales.

BRITTEN, William Edward Frank 1848-1916
London decorative painter, mainly of Grecian figures. Exhib. at RA 1884-8, but after that mainly at the GG and NG. Titles at RA 'Boy and Dolphin', 'A Frieze', etc. His style shows the influence of Leighton and A.J. Moore. Much encouraged by Leighton, who he helped with part of his frescoes in the Victoria and Albert Museum. Britten also designed two of the mosaic spandrels in the dome of St: Paul's Cathedral.
Bibl: AJ 1883 p.236 (illus.); L. and R. Ormond, *Lord Leighton,* 1975; Wood Olympian Dreamers.

BROADBRIDGE, Miss Alma fl.1879-1894
Painter of genre. Exhib. 1879-94, at the RA, SS and elsewhere. Titles at RA 'An Unequal Match', 1886 and 'Confirmation Day', 1891. Lived in London and Brighton.

BROCAS, Henry, Jnr. b.c.1798-1873
Dublin painter of landscapes and topographical views in Dublin and other parts of Ireland. Fourth son of Henry Brocas Snr. Exhib. at the RHA. Master at the Royal Dublin Society's School, 1838. BM has 'View in Phoenix Park'.
Bibl: Strickland I pp.91-2.

BROCAS, James Henry c.1790-1846
Eldest son of H. Brocas Snr. Studied at Dublin Schools and settled in Cork c.l834. Painted landscapes, portraits and animals.

BROCAS, Samuel Frederick c.1792-1847
Second son of H. Brocas, Senior. Lived in Dublin and painted landscapes in oil and watercolour. Exhib. at RHA 1828-47, and was a member of the Society of Irish Artists.

BROCAS, William RHA c.1794-1868
Third son of H. Brocas, Snr. Exhib. landscapes, figure subjects and portraits at RHA 1828-63. President of the Society of Irish Artists. Elected ARHA 1854, RHA 1860.

BROCK, Charles Edmund RI 1870-1938
Portrait painter and illustrator. Born at Holloway; went to school at Cambridge and studied art under the Cambridge sculptor Henry Wiles. Exhib. at the RA 1897-1906 and also at the RI. Elected RI 1908. Contributed to *Punch* and the *Graphic;* also illustrated Hood's *Comic Poems* 1893, *Gulliver's Travels* 1894 and other works. Lived at Cambridge for many years. His younger brother Henry Matthew Brock RI (1875-1960) was also an illustrator.
Bibl: Ormond I p.269.

BROCK, Miss Ellen fl.1868-1884
Guernsey painter of literary subjects, genre and flowers. Exhib. 1868-84 at SS and elsewhere. Titles at SS 'Mariana in the Moated Grange', 1868 and 'The Industrious Scholar', 1875.

BROCK, Fannie fl.1883
Exhib. 'Primroses' at the SS, 1883. London address.

BROCK, J.S. (J.L.) fl.1853-1862
Exhib. 'An Incident from the Crusade against the Albigenses' at the BI, 1853, and 'Italian Contadini — A Rest by the Way' at SS, 1862. London address.

BROCK, William b.1874 fl.1897-1914
Painter of landscape, genre and portraits. Born at St. John's Wood; studied art at the RA Schools and in Paris at the Ecole des Beaux-

Arts. Exhib. 1897-1914 at the RA. Titles at RA: 'An Orchard Corner in Somersetshire', 1897 and 'Weeds and Waste', 1898. Also exhib. at the Paris Salon. Lived in London, Brondesbury and Woodbridge, Suffolk.

BROCKBANK, Albert Ernest RBA 1862-1958
Liverpool painter of portraits, landscape and pastoral genre. Born at Liverpool. Studied at Liverpool School of Art, in London, and then at Julian in Paris. Exhib. at the principal London galleries from 1886, at the RA 1886-1926, RI and SS. Titles at RA 'The Meadows, Grez', 1886, 'A Dream of Spring', 1893 and 'A Manx Idyll', 1903. President Liverpool Academy of Arts, 1912-24 and also President of the Liver Sketching Club. Represented in several public collections, among them Walker AG, Liverpool and Preston AG.
Bibl: Studio XXIV 1902 p.136; Cat. Walker AG, Liverpool.

BROCKELL, Miss Jeannie F. fl.1883
Exhib. ' "Tyne"; A Portrait Study' at the RA, 1883. London address.

BROCKMAN, Charles Henry Drake fl.1871-1904
Painter of landscape and genre. Exhib. 1871-1904, at the RA, SS, NWS and elsewhere. Titles at RA 'Infant School', 1874 and 'A French Fishing Town', 1892. Lived at Witley, Surrey, in London, and at Bruges, Belgium. Charles, Charles Drake, and Charles H. Brockman, given in Graves RA are the same person.

BROCKMAN, Walter fl.1885
Exhib. two paintings of figure subjects in London, 1885. London address.

BROCKY, Charles 1807-1855
Hungarian painter of portraits and classical figure subjects. Lived in Vienna and Paris in great poverty; brought to London by the collector Munro of Novar. Exhib. at RA 1839-54, also at BI and NWS. Subjects at RA portraits, also 'Psyche', 'Music and Art Instructed and Crowned by Poetry', etc. By the end of his career, he had established himself as a very successful portrait painter, with Queen Victoria among his sitters.
Bibl: Norman Wilkinson, *Sketch of the Life of C.B. the Artist,* 1870; Redgrave, Dict.; Binyon; Ormond I p.345.

BRODIE, A.K. fl.1898
Exhib. 'A Breton Interior' at the RA, 1898. Edinburgh address.

BRODIE, John Lamont fl.1848-1881
London painter of portraits, coastal scenes, landscapes, and historical genre. Exhib. at RA 1848-81. Titles include some Italian scenes, and fishing subjects.

BRODIE, Miss Margaret fl.1874-1875
Exhib. 'Marine Parade, Eastbourne' and 'View of Magdalene Bridge and Tower, Oxford' at SS, 1874-5. London address.

BRODRICK, William fl.1881
Exhib. 'In the Mews' at the RA, 1881. Chudleigh, Devon, address.

BROMET, William fl.1818-1843
London painter of landscape and architectural subjects. Exhib. 1818-43, at the RA, BI and SS. 'An Honorary Exhibitor' at the RA. Address in 1821 Life Guards' Barracks, Knightsbridge.

BROMLEY, C. Shailor fl.1879-1885
London painter of fruit, landscape and coastal subjects. Exhib. 1879-85 at SS: subjects fruit and coastal scenes in Wales.

BROMLEY, Clough W. fl.1870-1904
London landscape and flower painter. Imitator and copyist of George Vicat Cole RA (q.v.), and engraver of some of his works. Exhib. mainly at SS, also at RA from 1872. Titles at RA 'Wild Roses', 'On a London Common', 'Cherry Orchard, Fittleworth', etc.
Bibl: AJ 1894 p.194 (engr. after V. Cole).

BROMLEY, John Mallard RBA fl.1876-1904
Landscape painter; lived in London, Rochford and Saint Ives. Exhib. mainly at SS (92 works), also at RA from 1881. RA subjects: views in Wales, Yorkshire, Derbyshire and Cornwall.

BROMLEY, Valentine Walter 1848-1877
London historical painter and watercolourist. His wife, Alice Louisa Maria Atkinson, was a landscape painter, as was his father, William Bromley III (q.v.). Exhib. at SS and NWS, also at RA 1872-7. Titles at RA 'The False Knight', 'Queen Mab', etc. He was frequently art correspondent of the *Illustrated London News,* and also a prolific book-illustrator. In 1875 he travelled in North America with Lord Dunraven, illustrating his *The Great Divide.* Died suddenly aged only 30.
Bibl: AJ 1877 p.205; Redgrave, Dict.; DNB 1909 II p.1311.

BROMLEY, Walter Louis fl.1866-1882
London painter of genre and landscape. Exhib. 1866-82, at SS and elsewhere. Titles at SS 'Gathering Wild Flowers', 1873 and 'A Potato Lot', 1882.

BROMLEY, William III fl.1835-1888
London historical and genre painter, grandson of William Bromley, the engraver. Exhib. at SS (187 works), the BI, and RA 1844-70. RA titles: 'Preaching of the Covenanters', 'Rural Courtship', 'Jacob and Rachel at the Well', etc.
Bibl: Clement & Hutton; Redgrave, Dict.

BROOK, Mrs. Caroline W. fl.1877-1888
London painter of genre, flowers, landscape and topographical subjects. Exhib. 1877-88, at the RA, SS and elsewhere. Titles at SS 'The Incense Burner', 1884 and 'Miladi Coquette', 1886.

BROOK, Miss Maria Burnham fl.1872-1885
London painter of genre, portraits and figure subjects. Exhib. 1872-85, at the RA, SS and elsewhere. Titles at SS 'Day Dreams', 1873 and 'A Little Better', 1876.

BROOK, Mrs. T. fl.1883
Exhib. 'An Exile from Home' at SS, 1883. Stoke Newington address.

BROOKBANK, W.H. fl.1864-1887
London landscape painter. Exhib. 1864-87, at the BI, SS and NWS. Titles at SS 'Eastbourne Downs from the Pevensey Road', 1864 and 'The Bank of a Moated House', 1883.

BROOKBANK, William fl.1847
Exhib. 'A Magnolia, from the Garden of W. Borru Esq., Henfield, Sussex', at SS, 1847. Brighton address.

BROOKE, Edmund W. fl.1890-1891
Exhib. 'Notre Dame de Paris at Night' and 'Miss — ' at the RA, 1890-1. Paris address.

BROOKE, Edward fl.1846-1878
London landscape painter. Exhib. 1846-78 at the RA. Titles: 'The Old Church', 1846 and 'Harvest Field — Tichborne', 1878. May be the same as Edward Adveno Brooke (q.v.).

BROOKE, Edward Adveno 1821-1910
London painter of landscape, fishing and river subjects. Exhib. 1844-64 at the RA, Bl, SS and elsewhere. Titles at RA: 'A Boy Fishing', 1846, etc. Also illustrated *The Gardens of England* (1856), a large and now very rare book, of which there is a copy in the Linley Library of the Royal Horticultural Society.
Bibl: Wood, *Painted Gardens*.

BROOKE, F. William fl.1886-1891
London landscape painter. Exhib. 1886-91 at SS and NWS. Titles at SS 'A Riverside Inn', 1886 and 'Sunlight and Shadow', 1887.

BROOKE, H. fl.1849
Exhib. 'Forest Scene — Incident among the Wild Tribes of the North American Indians' at the BI, 1849. Hastings address.

BROOKE, J. fl.1840
Exhib. a portrait at the RA, 1840. London address.

BROOKE, John William fl.c.1854 d.1919
Painter of portraits, genre and Algerian subjects. Born at Cleckheaton, Yorkshire; studied under Herkomer at Bushey, also in Paris. Travelled extensively. Exhib. at the RA 1894-1917. Titles: portraits and 'Moorish Quarters, Algiers', 1899. Lived in London and Leeds.

BROOKE, Leonard Leslie 1862-1940
Book illustrator and painter of portraits, genre and landscape. Educated at Birkenhead School; studied art at the RA Schools where he won the Armitage Medal, 1888. Drew illustrations for Andrew Lang's *The Nursery Rhyme Book, The Truth about Old King Cole, Johnny Crow's Party* and other works. Exhib. at the RA, 1887-1919, and at the NWS. Titles at RA 'Bunbury Church, Cheshire', 1887 and 'Grandmother's Chair', 1895. Lived in London.

BROOKE, Percy fl.1898-1906
Landscape painter. Exhib. 1898-1906 at the RA. Titles: 'Tumulus', 1898 and 'The Stream', 1902. Lived at Staithes, Yorkshire, and at Preston and Blackburn, Lancashire.

BROOKE, William fl.1895-1899
Landscape painter. Exhib. 1895-9 at the RA. Titles: 'A Sunlit Bay', 1895 and 'O'er Moor and Fen', 1897. Lived at Saxmundham, Suffolk, and St. Ives.

BROOKE, William Henry ARHA 1772-1860
Irish portrait painter. His grandfather, Robert Brooke, and his father Henry Brooke (1738-1806) were also painters. Studied under H. Drummond. Also an illustrator, in the style of his friend Thomas Stothard.
Bibl: Strickland.

BROOKER, Miss Catherine P. fl.1881-1893
London portrait painter. Exhib. 1881-93, at the RA, SS, NWS and elsewhere.

BROOKER, CommanderE.W. RN fl.1870
Exhib. 'Nibu Karra, Inland Sea, Japan' at SS, 1870. London address.

***BROOKER, Harry 1848-1940**
Painter of domestic genre, especially of children. Exhib. one picture at the RA, and four at SS. His Victorian interiors and figures are full of period charm, and follow the tradition of Webster and F.D. Hardy. His most characteristic works are of children playing in the school rooms of country houses.
Bibl: Wood Panorama; Wood, Paradise Lost.

BROOKER, J. fl.1857
Exhib. 'A Little Too Hot' at the BI, 1857. Bath address.

BROOKES, Warwick 1808-1882
Manchester painter of landscapes and figure subjects. Exhib. locally, and at Manchester Art Treasures Exhibition of 1857. Became member of Manchester Academy in 1868.

BROOKS, Miss F.C. fl.1882
Exhib. one figure subject at GG, 1882.

BROOKS, Frank 1854-1937
Painter in oil and watercolour of portraits and landscape. Born at Salisbury, son of the artist Henry Brooks (1825-1909) and brother of the painter Henry (Harry) Brooks (q.v.). Studied at the Salisbury School of Art and then at Heatherley's School in London. Exhib. from 1880, at the NWS, RA, SS and elsewhere. At first painted portraits in Salisbury and in 1882 received a commission from the States of Guernsey to paint a portrait of the Bailiff for the Royal Court House, which led to many other commissions on the island. Later visited India in 1888 to paint portraits for Indian princes, and again in 1892 when he painted a further 32 portraits of the local and leading British figures. Returned to London in 1896 where he lived for a number of years. In 1900 he visited Berlin and again in 1908. Lived at Lyndhurst, Hampshire.

BROOKS, Henry fl.1876-1891
Salisbury painter of genre. Exhib. 1876-91, at the RA, SS and NWS. Titles at RA 'The Corner of the Fold', 1891 and 'Contentment', 1891. Brother of Frank Brooks (q.v.).

***BROOKS, Henry Jamyn fl.1884-1904**
Portrait painter, who exhibited 1884-1900 at the RA and NG. His best known work is the large 'Private View of the Old Masters' Exhibition, 1888, RA', painted in 1889 (NPG), which is very similar in conception to Frith's 'Private View of the RA, 1881'. In 1904 the Graves' Gallery held an exhib. of 11 of his paintings, including portraits of the King and Queen, and a portrait of Gladstone — said by *The Studio* to be the best thing in the exhibition: "It is very small, but the sensitive handling gives it a distinction lacking in some of the larger paintings." A large picture by him of a polo match hangs in the Hurlingham Club, London.
Bibl: Studio XXXI 1904 p.151; Ormond I p.520.

BROOKS, Miss Maria fl.1869-1890
London portrait painter. Exhib. at RA, 1873-90, and at SS. Titles at RA also include some figure subjects: 'Miss Mischief', 'News of Home', 'A Love Story', etc.
Bibl: Royal Academy Notes, 1877-9.

BROOKS, Samuel fl.1883
Exhib. 'A Gipsy Girl' at the RA, 1883. London address.

***BROOKS, Thomas 1818-1891**
Genre painter, born in Hull. Pupil of H.P. Briggs (q.v.). Exhib. at the RA, 1843-82, and at BI and SS. Painted many pictures of dramas connected with the sea, e.g. 'The Missing Boat', 1869, 'A Story of the Sea', 1871, 'Launching the Lifeboat', 1868. Also sentimental Victorian scenes such as 'The Sister's Grave', 'Consolation', etc. usually involving a wistful heroine. Influenced by the Pre-Raphaelites in the 1850s and 1860s, which was the period of his best works.
Bibl: AJ 1872 p.197ff. (mono. with illus.); Clement & Hutton; Brook-Hart p.68; Wood, Panorama.

BROOKS, W.W. fl.1869
Exhib. 'Children' at the RA, 1869. London address.

BROOME, G.J. fl.1867-1873
London still life painter. Exhib. at RA, SS and elsewhere, all pictures of fruit. A coastal scene 'Off Portsmouth' appeared at Sotheby's Belgravia 21 March 1972.

BROOME, William 1838-1892
Ramsgate marine painter "who recorded a number of ships in the transition from sail to steam". Two of his paintings are in The Old Custom's House, Lymington. Similar paintings which appear to bear the monogram C.A.B. (Brook-Hart pl.133), may also be by this artist. Also some signed J. Broome have been attributed to him.
Bibl: Brook-Hart pp.69, 72, (pls.132, 133).

BROOMFIELD, G.H. fl.1877
Exhib. 'Fruit' at SS, 1877. Camberwell address.

BROOMHEAD, T. fl.1846
Exhib. 'Three Cows in a Landscape' at the BI, 1846. Birmingham address.

BROPHY, A. Finn fl.1876-1898
London painter of figure subjects and paintings on enamel. Exhib. figure subjects in London 1876-7, and enamel paintings at the RA, 1895-8. Titles: 'The Pearl Maiden' and 'Danae'.

BROS, Miss A. fl.1868
Exhib. 'Primulas' at the RA, 1868. London address.

BROS, J. fl.1874
Exhib. two landscape paintings in London, 1874. London address.

BROTHERTON, A.H. fl.1846-1864
London landscape painter. Exhib. at the RA, 1846 and at the BI, 1859-64. Titles at BI 'The Harvest of Indian Corn in the Abruzzi' 1860 and 'Moonrise at Amalfi', 1864.

BROUGHTON, Miss Emily J. fl.1878-1882
London painter of figure subjects and portraits. Exhib. 1878-82 at the RA and SS. Titles at RA 'Study of a Head', 1878 and 'Olivia. "Twelfth Night" ', 1882.

BROWN, Miss Alberta fl.1870-1871
Exhib. two genre paintings in London, 1870-1. London address.

BROWN, Alexander Kellock RSA 1849-1922
Glasgow landscape and flower painter. Exhib. at the RA, 1873-1902, and at SS, NWS, GG and NG. RA titles mostly views in Scotland, the Highlands and the Hebrides.
Bibl: AJ 1901 p.101; 1904 pp.172, 174; 1909 p.153; Caw pp.300-1 (with illus.); Studio 1917-18 p.16.

BROWN, Miss Alice G. fl.1890-1892
Harrow painter of portraits and genre. Exhib. 1890-2 at the RA. Titles: ' "Twice Twelve" ',1890 and 'Day Dreams', 1892.

BROWN, B. fl.1850
Exhib. 'Sleeping Infant' at SS, 1850. London address.

BROWN, Miss Bessie fl.1885
Exhib. one flower painting at the GG, 1885. London address.

BROWN, C.J. fl.1868
Exhib. one genre painting in London, 1868. London address.

BROWN, Catherine Madox b.1850 fl.1869-1872 (Mrs. Frank Hueffer)
Daughter of Ford Madox Brown; sister of Lucy Madox Brown (qq.v.). Worked as studio assistant to her father, before exhibiting on her own at the RA and Dudley Gallery from 1869. She painted figurative subjects and portraits.
Bibl: See under Ford Madox Brown.

BROWN, E. fl.1873
Exhib. two landscape subjects in London, 1873. New Whitby address.

BROWN, Edward RBA b.1869 fl.1893-1930
Painter of landscape and portraits. Born at Ancaster Hall, Lincolnshire. Studied at the Slade School. Exhib. from 1893 at SS, 1906-30 at the RA, and also at the RI. RBA 1904-6. Lived in Bedford.

BROWN, Miss Eleanor fl.1857-1872
London landscape painter. Exhib. at BI and SS. Title: 'Near Dolgelly'. A landscape dated 1859 appeared at Christie's, 15 December 1972.

BROWN, Miss Ella G. fl.1887-1888
Exhib. two paintings of game at the RA, 1887-8. Lytham address.

***BROWN, Ford Madox 1821-1893**
Painter of historical, literary and romantic genre, landscape and biblical subjects. Born in Calais. Studied in Bruges, Ghent and Antwerp, under Baron Wappers 1837-9. In Paris 1841-4. Competed for the Westminster Hall Decorations 1844-5. Visited Rome 1845, where he came under the influence of the German Nazarene painters. Returned to England in 1846. In 1848, D.G. Rossetti wrote him a letter expressing admiration for his work, and shortly afterwards became his pupil. Although never a member of the Pre-Raphaelite brotherhood, Brown was familiar with their aims and ideals, and under their influence painted some of his best works, such as 'Work' and 'The Last of England'. Exhib. at the RA and BI, 1841-67. In his later period, Brown reverted to the historical and romantic subjects of his youth, painted predominantly under the influence of Rossetti, often in watercolour. Although he never achieved the fame or popularity of the Pre-Raphaelites, Brown was the most important artist to be closely associated with them.
Bibl: Ironside & Gere p.22 (pls.7-17); Reynolds, VS pp.3, 18, 65, 66, 75 (pl.32); Reynolds, VP pp.60, 61, 64, 65, 68 (pl.49); Maas pp.88, 124, 125, 131-32, 182, 198, 216 (pls. pp.130, 131, 132, 198, 199); for full bibl. see Fredeman pp.151-3 and index; Staley pp.26-44 *et passim* (pls.lla-17a); Ormond I pp.93, 310; Irwin pp.279-80; Wood, Panorama; Wood, Pre-Raphaelites; Strong; Newall; Wood, Paradise Lost; T. Newman and R. Watkinson, *F.M.B.*, 1991.

BROWN, Frank B. fl.1880
Exhib. one landscape subject in London, 1880. Selkirk address.

***BROWN, Frederick 1851-1941**
Landscape and genre painter, watercolourist and teacher. Studied at the RCA 1868-77 and in Paris under Robert-Fleury and Bougereau 1883. Taught at Westminster School of Art 1877-92, and succeeded Legros as Slade Professor, 1892-1918, during which time he turned out many talented pupils. Exhib. at RA from 1879, and SS. Titles at RA 'Carlyle's Chelsea', 'Candidates for Girton', Rural England', etc. Played large part in the foundation of the NEAC in 1886.
Bibl:AJ 1893 p.29; Studio XXXVII pp.29-32; XLIV pp.136-8; Burlington Mag. LXXXII 1943; Tate Cat.; Recollections by F.B. in *Art Works*, 1930 Nos. 23, 24.

BROWN, G.A. fl.1864
Exhib. 'A Flower Piece' at the RA, 1864. London address.

BROWN, G. Lunell fl.1884
London painter of figure subjects. Exhib. one painting 'The Young Mother' at RA in 1884. A picture of 'Two Ladies on a Beach' appeared at Christie's, 25 July 1975.

BROWN, Colonel G.R. RHA fl.1865-1877
Exhib. 'The Ruskepat Valley in the Himalayahs. The Stream, a Tributary of the River Sutley', and 'Sutley' at SS, 1865 as Capt. Brown, and 'Elephant Battery' at the RA, 1877 as Colonel Brown. London address.

BROWN, G.W. fl.1877
Exhib. one painting of 'Heads' in London, 1877. London address.

BROWN, Mrs. Heitland fl.1885-1886
Painter of miniature portraits (enamel on copper) and genre. Exhib. 1885-6 at SS. Titles there including 'One of the Unemployed', 1886. Lived at Crouch Hill.

BROWN, Miss Helen fl.1883-1903
Flower painter. Exhib. 1883-1903 at the RA and NWS. Forest Gate address.

BROWN, H.L. fl.1876-1877
Exhib. two coastal scenes at SS, 1876-7. London address.

BROWN, J. fl.1856-1858
Exhib. two flower paintings at the RA, 1856-8. London address.

BROWN, J. fl.1873-1874
Exhib. 'Chingford Church' and 'The Willows' at SS, 1873-4. Lower Clapton, London, address.

BROWN, J. Alfred fl.1890
Exhib. 'A Cornish Pasture', at the RA, and 'Growing Shadows' and 'Sea and Sky' at SS, 1890. Bushey, Hertfordshire, address. Probably the same as Sir John Alfred Arnesby Brown (q.v.).

BROWN, J.B., Jnr. fl.1862
Exhib. 'A Summer's Half Holiday' at SS, 1862. London address.

BROWN, J.G. fl.1880-1885
Exhib. 'The Passing Show' and 'Free from Care' at the RA, 1880-5. London address.

BROWN, J. Michael fl.1885-1900
Edinburgh painter of landscape and river scenes. Exhib. 1885-1900, at the RA, SS and NWS. Titles at RA: 'On Leven Links, Fifeshire', 1890 and 'The Mouth of the River', 1893.

BROWN, J. Osborn fl.1869
Exhib. one painting of an interior in London, 1869. London address.

***BROWN, Sir John Alfred Arnesby RA 1866-1955**
Landscape painter. Pupil of Hubert Herkomer (q.v.) and much influenced by the Barbizon and Impressionist landscape painters. Exhib. at RA from 1891. 'Morning' was bought by the Chantrey Bequest in 1901 and is in the Tate Gallery. Most of his work falls outside the Victorian period.
Bibl: Studio 1898 pp.118-22; AJ 1902 p.214; 1903 pp.86, 175;1905 pp.169, 184; Tate Cat.

BROWN, John Crawford ARSA 1805-1867
Scottish painter of landscape, genre and historical subjects. Born at Glasgow, where he began his art studies. He visited Holland, Flanders and Spain and on his return spent several years in London. He then settled for a time in Glasgow and finally moved to Edinburgh. Exhib. at the RSA 1830-65 and posthumously in 1880, and single works in London at the RA, BI, SS and NWS. Titles at RSA: 'Catching Birds with Nets', 1836, 'Fugitives after the Battle of Culloden', 1844, 'A Shepherd's Shieling', 1845, and 'Harvest-Time in the Highlands', 1849. ARSA, 1843.
Bibl: Redgrave, Dict. (under Browne).

BROWN, John Lewis fl.1875
Exhib. 'La Halte en Forêt' at the RA, 1875. Paris address.

BROWN, J.W. 1842-1928
Painter of portraits and genre; designer of stained glass. Born at Newcastle-upon-Tyne, but moved south at an early age. He became acquainted with William Morris and later specialised in the design of stained glass windows, e.g. St. George's Church, Jesmond, Newcastle. He exhib. three genre paintings in London, 1876-8, and some of his works are in the Laing AG, Newcastle.
Bibl: Hall.

BROWN, Mrs. J.W. fl.1856-1876
(Miss Eleanor Fairlam)
London landscape painter. Exhib. 1856-76, at the BI, SS and elsewhere.

BROWN, Lucy Madox 1843-1894
(Mrs. W.M. Rossetti)
Pre-Raphaelite watercolourist. Daughter of Ford Madox Brown (q.v.). Began exhibiting in 1868 at the Dudley Gallery, where she showed most of her work. She only exhib. one picture at the RA — 'The Duet', in 1870. Her best work was 'Romeo & Juliet' exhib. at the Dudley in 1871. Visited Italy 18734. Married William Michael Rossetti, brother of D.G. Rossetti (q.v.) in 1874.
Bibl: Clayton II pp.116-24; DNB; Bate pp.23-3 (pl. opp. p.23); other references see Rossetti, and also Fredeman index.

BROWN, Margaret fl.1881
Exhib. one flower painting in London, 1881. London address.

BROWN, Miss Matilda fl.1822-1839
London flower and fruit painter. Exhib. 1822-39 at the RA and BI.

BROWN, Maynard fl.1878-1902
Painter of genre, landscape and historical subjects. Exhib. 1878-1902, at the RA and elsewhere. Titles at RA 'The Last Look', 1883, 'Zenobia, Queen of Palmyra, taken Prisoner by Aurelian, Emperor of Rome', 1885 and 'Bank Holiday, Hampstead Heath', 1900. Lived in Nottingham and London.

BROWN, Miss Nellie fl.1894-1897
London landscape painter. Exhib. 1894-7 at RA. Titles: 'From Sunny Climes', 1894 and 'From Old Seville', 1897.

BROWN, R.G. fl.1844
Exhib. 'Dead Game' at the RA, 1844.

BROWN, Thomas Austen RI ARSA 1857-1924
Scottish landscape and domestic genre painter. Exhib. at RA 1885-98, and at NWS and GG. Titles at RA 'Sabbath Morning', 'Potato Harvest', 'Hauling Ashore the Sail', etc.
Bibl: Caw p.446; Glasgow Cat.

BROWN, W.E. fl.1879-1881
London painter of topographical subjects. Exhib. 1879-81 at SS and elsewhere. Titles at SS 'Tomb in Old Church, Cheyne Walk, Chelsea', 1879 and 'Queen's College, Oxford: View from Logic Lane', 1881.

BROWN, W.M. fl.1849-1856
Painter of genre and animals. Exhib. 1849-56, at the BI (1852), SS and elsewhere. Titles at SS 'The Grave of the Persecuted', 1850, 'The Doctor's Horse, and the Parson's Horse', 1851 and 'Wandering Thoughts', 1856. Lived in London and Manchester.

BROWN, William Beattie RSA 1831-1909
Edinburgh landscape painter. Born at Haddington in Scotland; educated at Leith High School and studied art at the Trustees' Academy, Edinburgh. Began his artistic career under James Ballantine of Edinburgh, a glass stainer and decorator. Exhib. at the RA 1863-99, all Scottish views, and also at the NWS and elsewhere. Exhib. at RSA 1852-1910; elected ARSA 1871 and RSA 1884. He used a dark palette, painting sombre Highland scenes in-a style similar to Peter Graham (q.v.). Caw notes: "Forty years' contact with Nature has left him contented with a brown world, and a technical method, which takes no account of true detail, natural textures or atmospheric tones. Neither the general tone or colour of his pictures, nor the conventional markings with which he renders mountain corries and foaming torrents, bosky woodlands, and heathery moors, can be said to represent Nature as she is. Yet his art seems to give many people pleasure; he is an RSA, and his are amongst the most popular landscapes of the year."
Bibl: Clement & Hutton; Caw p.298; AJ 1904 p.138; 1909 p.180.

BROWN, William Fulton RSW 1873-1905
Scottish painter, in watercolour, of genre and figure subjects. Born and lived in Glasgow; studied under his uncle, David Fulton and at the Glasgow School of Art. Silver medal, Salzburg, 1904. Exhib. at the RSW. Caw notes: "Drawn with considerable facility, good in tone and agreeable if restrained in colour, and handled expressively and with breadth, his studies of old-world statesmen, or magicians or singing pages, or of the showmen or herds of today were simply and pleasantly designed, admirable in character and good as art. They gave promise of better things to come." He died when only thirty-two.
Bibl: Caw p.429.

BROWNE, Cecil fl.1887
Exhib. one genre painting in London, 1887. London address.

BROWNE, Charles Henry fl.1860-1869
Shrewsbury painter of fruit, flowers, game and figure subjects. Exhib. at the RA, 1865 and the SS 1860-9. Titles at SS 'Primroses and Violets', 1860, 'An Eastern Peasant', 1867 and 'A Reverie', 1869.

BROWNE, E. fl.1853-1860
London landscape painter. Exhib. 1853-60 at the RA. Subjects often scenes in N. Wales.

BROWNE, Miss E. fl.1869-1877
Horsham painter of flowers, landscapes and birds' nests. Exhib. 1869-77, at the RA (1871) and SS. Titles at the SS 'A Forest Glade', 1872, 'A Hedge-Sparrow's Nest', 1872, and 'May', 1877.

BROWNE, E.F. fl.1873
Landscape watercolourist working in the north-east. in the late 19th century. Exhib. 'In Jesmond Dene, Northumberland' at the RA, 1873. Cullercoats address.
Bibl: Hall.

BROWNE, George H. fl.l 836-1885
London painter of landscapes, marines, contemporary genre and occasional historical subjects. Exhib. 1836-85, at the RA, BI and elsewhere, but mostly at SS (62 works). Titles at SS include 'Scudding under Reefed Topsails', 1844, 'Wreck of the "Northern Belle", American ship, off Kingsgate, 7th January 1857, etc', 1857 and 'Troopers on the Look Out', 1869. Lived at Camberwell and Blackheath Hill until 1853 and at Greenwich from 1870.
Bibl: Brook-Hart.

BROWNE, Gordon Frederick RI 1858-1932
Watercolourist and illustrator. Son of H.K. Browne. Elected RI 1896. Illustrated editions of Shakespeare, Scott and Defoe.

BROWNE, Hablot Knight (Phiz) 1815-1892
Artist and book-illustrator, who assumed the pseudonym Phiz. Apprenticed to Finden, the engraver; then started as a painter in watercolour with a young friend; at the same time attended a life school in St. Martin's Lane, where Etty was a fellow-pupil. In 1832 won the Silver Isis medal offered by the Society of Arts for the best illustration of an historical subject. In 1836 he first became associated with Dickens in Dickens's *Sunday as it is by Timothy Sparks*. Later illustrated *Pickwick Papers,* using the pseudonym Nemo for the first two plates, and then Phiz. The association of Browne and Dickens continued through many novels. Exhibited watercolours at the BI and SS. He also painted in oils but these were imperfect technically. Fifteen years before his death he was struck with paralysis, but continued to work.
Bibl: Forster, *Life of Charles Dickens*, III 1874; Clement & Hutton; Fitzpatrick, *Life of Charles Lever,* 1879; F.G. Kitton, *Phiz, A Memoir,* 1882; D.C. Thompson, *Life & Labours* of H.K. Browne, 1884; Bryan; Binyon; DNB III; Ormond I p.143.

BROWNE, Harry E.J. fl.1889-1915
London painter of genre, landscape, and figure subjects. Exhib. 1889-1915, at the RA, SS and elsewhere. Titles at the RA: 'News of HMS "Serpent" ', 1891, 'The Lonely Shore', 1897 and 'Wood Nymphs', 1899.

BROWNE, J.B. fl.1861-1863
Exhib. 'Wild Fowl' at SS, 1861 and 'A Spring evening — the badger leaving his winter quarters' at the RA, 1863. London address.

BROWNE, J. Lennox fl.1868-1901
London painter of landscapes, coastal and river scenes. Exhib. 1868-1901, at the RA (1896 and 1901 only), SS, NWS and elsewhere. Titles at SS 'Early morning — Shiplake Weir', 1869 and 'Hastings — rough weather', 1871.

BROWNE, James Loxham fl.1891-1905
London painter of landscape and genre. Exhib. 1891-1905, at the RA, SS and NWS. Titles at the RA 'Over the heather', 1894 and 'The poachers', 1897. Lived in Hampstead 1892-1905, although a Hethersett address is recorded in Graves Dictionary.

BROWNE, Philip fl.1824-1865
Shrewsbury landscape, sporting and still-life painter. Exhib. at RA 1824-61 (70 works) and SS. Subjects mainly views around Shrewsbury, in Wales and Holland.

BROWNE, Rupert M. fl.1880
Exhib. one landscape subject in London, 1880. Thornton Heath address.

BROWNE, T.D.H. fl.1861-1867
London painter and sculptor of scriptural and historical subjects. Exhib. 1861-7, at the RA, SS and BI. Titles include 'Ishmaelites buying Joseph from his brethren', BI 1863 and 'The Monk of Antioch and the last of the Gladiators', SS 1865.

BROWNE, Thomas Arthur RI RBA 1872-1910
Painter of genre, figure subjects and landscapes; illustrator. Born in Nottingham; left school at the age of 11 and worked in the Nottingham Lace Market. When he was 14 he was apprenticed to a firm of lithographers and there he stayed until he was 21. Came to London in 1895. Exhib. at the RA, 1898-1905. Elected RBA 1898 and RI 1901. Titles at the RA include 'Sunshine and Shadow Spain', 1898 and 'A Volendam Woman', 1901. Exhibited under the name Tom Browne.

BROWNE, Walter fl.1866
Exhib. ' "What a story-teller" ' at SS, 1866. London address.

BROWNING, E. fl.1867-1871
London portrait painter. Exhib. 1867-71 at the RA.
Bibl: Ormond I p.301.

BROWNING, G., Jnr. fl.1848
Exhib. one painting of a coastal scene in London, 1848. London address.

BROWNING, G.F. fl.1854-1873
London portrait painter. Exhib. 1854-73 at the RA.

BROWNING, George fl.1826-1858
London painter of genre, portraits and landscape. Exhib. 1826-58, at the RA, BI, SS and elsewhere. Titles include a number of subjects that seem to show an early interest in social genre, e.g. 'The beggar girl', SS 1827, 'A charity girl', RA 1838, and 'Foundlings', BI 1839.

BROWNING, Robert Barrett 1846-1912
Painter and sculptor; son of Robert and Elizabeth Browning. Studied in Antwerp and Paris. Exhib. at RA, 1878-84, and at GG. Domestic and genre subjects, mostly in Antwerp and Belgium. In his early career he was helped by his parents' friend, Millais (q.v.).

***BROWNLOW, Miss Emma fl.1852-1873**
London domestic genre painter. Worked in Belgium and north France. Exhib. at RA, 1852-67, and at BI and SS. Titles at RA 'Granny's Lesson', 'Repentance and Faith', 'Lullaby', etc. Her father was Secretary of the Thomas Coram Hospital for Children, London, and an interesting group of works by her are still in the collection there (see bibl.). Also exhib. as Mrs. E.B. King, 1868-73.
Bibl: Wood, Panorama.

***BROWNLOW, George Washington 1835-1876**
Painter of figure subjects, especially country scenes and domestic interiors with mothers and children. Exhib. mainly at SS, also at RA and BI, titles 'A Spinning Lesson', etc. Lived in London and Suffolk, but also painted in Ireland and Northumberland, especially at Cullercoats.
Bibl: Wood, Paradise Lost.

BROWNLOW, Stephen b.1828
Painter of landscapes, seascapes and animal studies, who is known to have lived and worked in Northumbria for many years. His studio was for some time in New Bridge Street, Newcastle, close to that of Ralph Hedley and Henry Hetherington Emmerson. His work inscribed S. Brownlow.
Bibl: Hall.

BROWNSCOMBE, Miss Jennie fl.1900
Exhib. 'A Woodland Princess', at the RA, 1900. London address.

BROWNSWORD, Harry A. fl.1889-1892 d.c.1910
Nottingham landscape painter. Exhib. 1889-92 at the RA and SS. Titles at the RA 'A court in Newlyn, Penzance', 1889, and 'In sweet September', 1890. Not to be confused with the sculptor Harold Brownsword (1885-1961).

BRUCE, Mrs. Carmichael fl.1883
London flower painter. Exhib. 'A bit of Autumn', and 'Spring Bouquet', at SS 1883.

BRUCE, Miss Harriet C. fl.1882-1891
Scottish landscape painter. Exhib. 1882-91, at the RA, SS, NWS and elsewhere. Titles: 'Her Majesty's Post Office, Ford, Loch Awe', RA 1887, and 'Early Spring', 1890. Lived at Lochgilphead.

BRUCE, Miss Helen (or Eleanor) fl.1883
London flower painter. Exhib. at the NWS and GG, 1883.

BRUCE, Martin B. fl.1893-1899
London painter of landscape and genre. Exhib. 1893-9, at the RA and SS. Titles: 'Sunlit water', and 'Bathers', SS 1893.

BRUCE, W. Blair fl.1883-1898
Exhib. 'The Pear Orchard', 'Siesta' and 'A Sea-piece' at the RA, 1883-98. Lived at Barbizon and in Paris.

BRUCK-LAJOS, L. fl.1889-1891
Exhib. 'Homeless' and 'Tales of a Wayside Inn', 'The Landlord's Tale' at the RA, 1889-91. London address. Some of his scenes of street life are painted with notable realism and honesty, and present an interesting picture of Victorian city life.

BRUETON, Frederick fl.1897-1909
Painter of portraits, figure subjects and coastal scenes. Exhib. 1897-1909 at the RA. Titles: 'A tribute to the Goddess of Vanity', 1897 and 'Fishing fleet off Brighton preparing to depart', 1903. Lived in Brighton, Bridgwater and Paignton.

BRUGGEMANN, Hans fl.1880
Exhib. 'Evening' at the RA, 1880. London address.

BRUHL, Louis Burleigh RBA 1861-1942
Landscape painter. Born at Baghdad; educated at Vienna. Exhib. from 1889 at SS, and 1891-1928 at the RA. Elected RBA, 1897, A.R.Cam.A 1909, PBWS 1917 and R.Cam.A 1929. President of the Old Dudley Art Society 1905, of the Constable Sketching Club 1912, Member of the BWS, 1914, and of the Liverpool Academy of Arts 1918. Represented in several public collections, e.g. VAM. Lived at Watford and Romford.

**BRUNE, Miss Gertrude R. Prideaux
see PRIDEAUX-BRUNE, Miss Gertrude**

BRUNNER, H. fl.1861
Exhib. 'A garden near Algiers' at the RA, 1861. London address.

BRUNNER, H. Lacost fl.1858-1860
Exhib. 'Fruit' at the RA, 1858, and 'Group of palm trees' at the BI, 1860. London address.

BRUNNING, William Allen fl.1840-1850
London landscape painter. Exhib. at RA 1840-50, and at BI and SS. Exhibited works mainly views on the Thames, in Kent and Normandy, and street scenes.
Bibl: Brook-Hart.

BRUNTON, Arthur D.
Almost completely unknown figure painter. A picture of a widow outside a pawnshop entitled 'Extremity' was sold at Christie's, 28 January 1972, lot 73. Lived at Weighouse, Yorkshire.
Bibl: Wood, Panorama

BRUNTON, E. fl.1857
Exhib. 'Rabbit and partridge' at SS,1857. London address.

BRUTEY, Robert S. fl.1888-1900
Painter of landscapes, coastal and river scenes. Exhib. 1888-1900 at the RA. Titles: 'A quiet shore: Poole Harbour on a showery day', 1888 and 'Evening in the New Forest', 1893. Lived at Teignmouth, Milford-on-Sea and Lee-on-the-Solent.

BRYAN, H. fl.1856
Exhib. 'Corfe Castle' at the BI, 1856. London address.

BRYANS, Herbert William fl.1891
Exhib. 'Street scene, Cairo' at the SS, 1891. Address c/o W. Fitz, Fitzroy Street, London. Also designed stained glass.

BRYANT, H.C. fl.1860-1880
London painter of genre, landscape and animals, especially farmyard and market scenes. Exhib. 1860-80, mainly at SS, but also at the RA and BI. Titles at SS 'The Knife Grinder', 1862, and 'Feeding the Calves', 1874. Also lived at Portsea. His pictures frequently appear at auctions in London.

BRYDALL, Robert fl.1874-c.1906
Glasgow painter of landscape and genre; art historian. Exhib. 1874-1906, at the SS 1874 and RA 1906. Titles at SS 'Wandering thoughts', and 'The Griben Loch-na-Keal, Isle of Mull'. Wrote *History of Art in Scotland*. Noted by Caw, 1908, as being "recently dead".
Bibl: Caw pp.3, 157.

BRYMNER, William fl.1884
Exhib. one painting of birds in London, 1884. London address.

BRYSON, Robert M. fl.1863-1876
London painter of landscape and genre. Exhib. 1863-76 at the RA, SS and elsewhere. Titles at SS 'The Path across the Fields', 1863 and 'The Youthful Ramblers', 1866.

BUCHANAN, George F. fl.1848-1864
London landscape painter. Exhib. 1848-64, at the RA, BI and SS. His subjects almost all scenes in Scotland.

BUCHANAN, Mrs. George F. fl.1865
Exhib. 'Loch Long, Argyllshire' at the RA, 1865.

BUCHANAN, J. fl.1874-1876
London painter of genre, figure subjects and flowers. Exhib. 1874-6, at the RA and SS. Titles at the SS 'Meditation', 1874, and 'Wild Flowers', 1876.

BUCHANAN, J.A. fl.1851-1855
Painter of landscape and genre. Exhib. 1851-5 at the BI. Titles: 'Young Draught Players; the Decisive Move', 1851, and 'The Soldier returned; an Incident in the Last War', 1855. Lived in Glasgow, London and Gourock.

BUCHANAN, James fl.1848-1855
Liverpool painter of genre and figure subjects. Exhib. 1848-55 at the RA and SS. Titles: 'The Debtor and his Child', RA, 1848, and 'Scotch Interior — "The Homely Meal" ', SS, 1849.

BUCHANAN, J.P. fl.1890-1891
Painter of landscape and genre. Exhib. 1890-1 at SS and the NG. Titles at SS 'A Highland washing', and 'An Old Street, Clovelly', 1890. Malvern and Eastbourne addresses.

BUCHANAN, Mrs. Percy fl.1893
Exhib. one landscape at the NG, 1893. No address given.

BUCHANAN, Peter fl.1887-1888
Exhib. 'Rydal Water, Westmorland' and 'By the loch side' at the RA, 1887-8. Putney address.

BUCHEL, Charles A. 1872-1950
German-born portrait painter and theatrical artist. Worked for many years for Herbert Beerbohm Tree, producing posters, programmes and designs. Later became a portrait painter, especially of theatrical figures.
Bibl: Charles Buchel, *Some Famous People I have Painted*, Windsor Magazine, 1938.

BUCHSER, E. fl.1854
Exhib. 'Portraits' at SS, 1854. Scarborough address.

BUCHSER, Frank fl.1877
Exhib. three figure subjects at the GG, 1877. Scarborough address.

BUCK, Miss L. Margaret fl.1892-1893
Exhib. two genre paintings in London, 1892-93. Ipswich address.

BUCK, W. fl.1864
Exhib. 'Still life' at SS, 1864. London address.

BUCKERIDGE, Charles E. fl.1882-1883
London landscape painter. Exhib. 1882-3 at the RA and SS.

BUCKLAND, Arthur Herbert RBA b.1870 fl.1895-1927
Painter of romantic landscape subjects, genre and portraits; illustrator. Born at Taunton; studied art at the Académie Julian in Paris. Exhib. 1895-1927 at the RA and also at the RI, RBA, ROI and Paris Salon. 'Valley of Flowers', RA 1897, was one of his best known works. "Mr. Arthur Buckland's 'Valley of Flowers' is of the order of romantic landscape; a forest glade, in which rhododendrons, along with many coloured wild flowers are conspicuous, being the background for his subject. 'She placed a crown of gold upon my head which bought forgetfulness of all things' — a richly robed knight kneels at the feet of a stately woodland nymph, and if a few discordant notes of colour are struck, there is no lack of spirit and grace in the canvas" (AJ).
Bibl: AJ 1897 pp.176-7 (reprd.)

BUCKLE, S. fl.1849
Exhib. four landscapes in London, 1849. Peterborough address.

BUCKLER, John Chessel 1793-1894
London architectural painter and draughtsman, son of John Buckler, an architect and antiquarian draughtsman. Exhib. at RA 1810-44, also SS and OWS. Mainly views of churches, ruins, and country houses.
Bibl: AJ 1894 p.125; Redgrave, Dict; Binyon; DNB; Bodleian Library, Oxford, *Drawings of Oxford,* by J.C.B. 1951; RIBA Drawings Cat.

BUCKLEY, Arthur fl.1878-1881
Exhib. three landscape subjects in London, 1878-81. Hampton Wick address. Related to Miss H. Blanche Buckley, miniature painter.

BUCKLEY, Charles F. fl.1841-1869
London landscape painter, in oil and watercolour, who exhib. 1841-69 at the BI and SS. VAM has two landscape watercolours, dated 1841, of views in the Lake District.
Bibl: VAM.

BUCKLEY, J.E. fl.1843-1861
London painter of historical subjects. Exhib. 1843-61 at SS. Titles: 'The Happiest Days of Mary, Queen of Scots', 1845 and 'Queen Elizabeth at Kenilworth, July 1575', 1853.

BUCKLEY, R.E. fl.1877
Exhib. 'Fairlaight Glen, Hastings' at SS, 1877. London address.

BUCKLEY, William fl.1840-1845
London painter of landscape and architectural subjects, portraits, genre, religious and historical subjects. Exhib. 1840-5 at SS. Titles: 'Two of the Choir Children', 1840, 'Goodrich Castle', 1841, and 'Holy Family', 1841.

BUCKMAN, Charles fl.1875
Exhib. one landscape subject in London, 1875. Witley address.

BUCKMAN, Edwin ARWS 1841-1930
London watercolour painter of genre and decorative compositions using genre subjects; etcher and engraver. Studied at the Birmingham School of Art, later in Paris and Italy. Exhib. at the principal London galleries from 1866, mainly at the RWS and RA (1870-81). Elected ARWS, 1878. Illustrated for *Once a Week* and was also on the original staff of *The Graphic*. Gave instruction in art to Queen Alexandra and then to the Princess of Wales.
Bibl: Studio XVIII 1900 p.103; Who's Who 1911.

BUCKMASTER, Martin Arnold 1862-1960
Painter of architectural subjects, landscape, still-life and flowers. Studied architecture at the RCA, where he won a travelling scholarship, and in Paris. Exhib. at the principal London galleries from 1890, mainly at the SS, RI and RA. Published several books on architecture. He was senior art master at Tonbridge School.

BUCKNALL, A.H. fl.1887
Exhib. one genre painting in London, 1887. London address.

BUCKNALL, Ernest Pile b.1861 fl.1919
Landscape painter. Born in Liverpool; studied art at Lambeth and South Kensington. Exhib. from 1885 at the RA (1887-1919), SS, NWS, GG and elsewhere. Titles: 'A Forest Road, Hampshire', RA 1887 and 'The End of the Day', RA 1898. Lived at Reigate, Tunbridge Wells, Chelmsford and Bristol.

***BUCKNER, Richard 1812-1883**
London portrait painter. 1820-40 he lived in Rome, where he was friendly with Leighton, and exhibited Italian genre subjects. Returned to London about 1845, and concentrated on portrait painting. Became a very successful painter of elegant and fashionable Victorian ladies. Exhib. at RA 1842-77, also at BI and SS. A sale of his works was held at Christie's, 22 February 1873.
Bibl: AJ 1859 pp.81, 142, 163; 1860 p.80; Binyon; Maas p.212 (pl.p.213); Ormond I; B. Stewart and M. Cutten, *R.B.'s Portraits,* Antique Collector April 1989.

BUCKSTONE, Frederick fl.1857-1874
London landscape painter. Exhib. 1857-74 at the RA, BI and SS. His subjects mainly scenes in North Wales.

BUDGETT, Miss S.E. fl.1883-1884
Exhib. three flower paintings in London, 1883-4. Guildford address.

BÜHLER, E. fl.1889
Exhib. 'The Wetterhorn' at the RA, 1889. London address.

BUKOVAC, B. fl.1890
Exhib. 'Woodbine' at the RA, 1890. London address.

BULEWSKI, L. fl.1855-1860
Exhib. two portraits at the RA, 1855-60. London address.

BULFIELD, Joseph fl.1895-1902
Painter of genre. Exhib. at the RA 'The Last Hour', 1895 and 'Paid Off: Brittany sailors returning home', 1902. Address Finistère, France.

BULGIN, C.F. fl.1855
Exhib. 'The Dutch Lugger' at SS, 1855. No address given.

BULL, Miss Nora fl.1885-1893
Painter of portraits and genre. Exhib. 1885-93 at the RA. Titles of portraits including 'A Quiet Hour', 1893. Lived in Richmond Hill and Wimbledon.

BULL, William Cater fl.1893
Exhib. 'A Misty Evening' at SS, 1893. Streatham address.

BULLAR, Miss Mary fl.1872
Exhib. 'Drawing-room of Fairfax House, Putney' at SS, 1872. Southampton address.

***BULLEID, George Lawrence ARWS 1858-1933**
Painter, in oil and watercolour, of figure and mythological subjects and still-life. Born at Glastonbury, son of a local solicitor. Exhib. at the principal London galleries from 1884, mainly at the RWS, RA (1888-1913), and RI. Elected ARWS 1889. Titles at the RA 'Sacred to Venus', 1888 and 'An offering to Apollo', 1889. The *Studio,* 1906, refers to his quality of "classic charm". Lived in Bath. The Harris Museum and AG, Preston, has a watercolour of flowers. His classical watercolours are similar to those of Henry Ryland, but painted in a more delicate style.
Bibl: Studio 1906 XXXVII, p.348; Who's Who 1911.

BULLEN, Miss Eliza M. fl.1873-1880
London painter of landscapes and flowers. Exhib. 1873-1880 at SS. Titles: 'London Fields', 1873, and 'Winter Flowers', 1877.

BULLEY, Ashburnham H. fl.1841-1851
London painter of animals, game and genre. Exhib. 1841-51 at the RA, BI and SS. Titles: 'Portrait of Vixen, the property of E. Shewell, Esq.,', RA 1846, 'Rabbit-Terriers', SS 1848, and 'The Unlucky Trespasser', BI 1845. Also exhib. an occasional historical subject, e.g. 'A Privy Councillor in the Reign of Charles II', SS 1841.

BULLEY, S. Marshall fl.1899-1905
Exhib. 'Clover' and 'Afternoon on the Eastern Lagoon, Venice' at the RA in 1899 and 1905. Hindhead, Surrey, address.

BULLOCK, Edith fl.1889-1891
Manchester landscape painter. Exhib. 1889-91 at SS. Titles: 'Above the Crafnant Lake: North Wales', 1889, and 'Coast Scene, Anglesea', 1890, and two landscapes elsewhere in London.

BULLOCK, E.E. fl.1848
Exhib. 'The Happy Family' and 'Dead Game' at the BI, 1848. London address.

BULLOCK G.G. fl.1827-1859
London portrait painter. Exhib. at RA 1827-55, also BI and SS. Titles at RA also include some still-life and genre pictures.

BULLPITT, H. fl.1842-1843
Landscape painter. Exhib. 1842-3 at SS. Leyton, Essex, address.

BULMAN, Henry Herbert RBA 1871-1928
Painter in oil and watercolour of portraits, genre and flowers. Born at Carlisle. Exhib. at the RA, 1899-1929, and also at the NEAC, SS, etc. Elected RBA 1916. Member of the Langham Sketching Club. Lived in London.

BUNBURY, T.H. fl.1881
Exhib. one landscape in London, 1881. London address.

***BUNCE, Kate Elizabeth 1858-1927**
Birmingham decorative painter; youngest daughter of John Thackray Bunce, editor of the *Birmingham Post*. Studied at the Birmingham Art School under Edward R. Taylor. Influenced by Rossetti and the later Pre-Raphaelites. Exhib. 1887-1901, four works at RA. Titles at Birmingham include 'Melody' and 'The Keepsake'. Most of her later work altar-pieces and church murals. Elected associate RBSA 1888. Signed KB in monogram. Her sister was Myra Louisa Bunce (q.v.).
Bibl: Birmingham Cat.

BUNCE, Miss Myra Louisa fl.1878-1893
Birmingham landscape painter. Exhib. 1878-93 at the RA, NWS and elswhere. Titles at the RA ' "The Charmed Sunset Lingered" ', 1891 and 'St. Columb Porth, Newquay, Cornwall', 1893. Sister of Kate Elizabeth Bunce (q.v.). Daughter of the editor of the *Birmingham Post*.

***BUNDY, Edgar ARA RI RBA 1862-1922**
London historical and genre painter and watercolourist. As a boy spent much time in the studio of Alfred Stevens; otherwise self-taught. Exhib. at RA from 1881 and at the Paris Salon from 1907. Subjects mainly historical costume pieces. Painted 'The Landings of the Canadians in France 1915', for the Canadian War Memorial.
Bibl: AJ 1897 pp.170, 182; 1900, pp.176, 183; 1905, p.176; 1909 pp.174, 334ff.; Studio Summer No. 1900 p.23; Tate Cat.

BUNDY, Miss Elizabeth E. fl.1851-1858
London painter of genre, landscape and historical subjects — the majority set in France. Exhib. 1851-8, at the BI SS and elsewhere. Titles: 'The Toilette. Clemence Isaure receiving the violets from the Sire de Nesle', BI 1851, and 'A Corner in Dinan', BI 1855.

BUNKELL, Miss Alice fl.1885
Exhib. 'A Reflection' at the RA, 1885. London address.

BUNKER, Joseph fl.1871-1890
Painter of fruit and genre. Exhib. 1871-90, at the RA, NWS and elsewhere. Titles at the RA ' "Full and fair ones, come and buy" ', 1883, and 'Fruit', 1890. Lived at Bath and Tiverton-on-Avon.

BUNNEY, John Wharlton 1828-1882
Painter of landscapes and architectural views. Under the influence of Ruskin, he produced a number of extraordinarily meticulous pictures, especially a view of St. Mark's, Venice, which took him twelve years to paint. He exhib. at RA 1873-81; a memorial exhibition of his work was held at the Fine Art Society in 1883.
Bibl: Staley p.l56-7 (pls. 86a and b); Newall.

BUNNEY, W. fl.1853-1861
London painter of genre, portraits and figure subjects. Exhib. 1853-61, at the RA, BI and SS. Titles at the RA ' "A Foreigner" ', 1854, and 'Shylock', 1855.

BUNTING, Thomas 1851-1928
Aberdeen landscape painter. An example is in Aberdeen AG.

BUOTT, C. fl.1879
Exhib. one landscape in London, 1879. London address.

BURBANK, J.M. fl.1825-1872 d.1873
London animal painter and watercolourist. Exhib. at RA, 1825-47, and at BI, SS and NWS. Travelled in N. America.
Bibl: Cundall p.190.

BURBANK, Miss L. fl.1826-1842
London painter of fruit and flowers, birds and birds' nests. Exhib. 1826-42 at the RA, SS and NWS. Titles at the RA 'Bird's nest', 1831, and 'In memory of a favourite', 1837. Related to J. and J.M. Burbank and lived at the same address.

BURBIDGE, John fl.1862-1880
London painter of landscapes and architectural subjects. Exhib. 1862-80, at the RA, SS and elsewhere. Titles at SS 'Church of St. Lawrence, Nurenberg', and 'View in Glen Nevis, Scotland', 1869.

BURCHAM, Robert Partridge 1812-1894
Painter of fruit, flowers, birds' nests and landscape. Exhib. 1852-72, at the RA, SS and elsewhere. Lived in London and Norwich. Norwich Museum has a painting of fruit.

BURCHETT, Arthur fl.1874-1913
London painter of genre and landscape. Exhib. 1874-1913, at the RA, SS, NWS and elsewhere. Titles at the RA 'Recreation of a Country Person', 1875, and 'Suspense', 1881.

BURCHETT, J.P. fl.1868
Exhib. one figure subject in London, 1868. Address in Graves Dictionary given as South Kensington Museum, so possibly related to Richard Burchett (q.v.), whose address in 1868 was 'Training School, Science and Art, South Kensington.

BURCHETT, Richard 1815-1875
London historical and landscape painter, and teacher. Assistant master at Government School of Design at Somerset House; and later in charge of training art teachers at the Department of Practical

Art. Because of his official duties, he was not able to devote much time to painting. Exhib. five works at the RA, 1847-73. Worked on several decorative schemes, including some in the House of Lords. 'A Scene in the Isle of Wight' (Reynolds, VP pl.103) shows him to have been a landscape painter of considerable ability. It is a pity he did not devote more time to this instead of his now forgotten historical works.

Bibl: AJ 1875 p.232 (obit.); Redgrave, Dict.; DNB; Reynolds, VP pp.152-3 (pl.103); Maas p.228; Staley p.80.

BURD, Laurence fl.1848-1870
Shrewsbury landscape painter. Exhib. in Birmingham 1848-70.

BURDEKIN, Miss Mary L. fl.1898
Exhib. 'Old Mother Hubbard' at the RA, 1898. London address.

BURDER, William Corbett fl.1859
Exhib. 'Pont ar Lledr, North Wales', at the RA, 1859. Clifton address. Illustrated books about Bristol. An example is in the VAM.

BURFORD, R.W. fl.1852
Exhib. 'Fruit', at the BI, 1852. London address.

BURGE, G.H. fl.1855
Exhib. 'A Road through St. Ann's Wood, near Bristol' at SS, 1855. London address.

BURGESS, Miss Adelaide fl.1857-1886
Leamington painter of genre and portraits, probably the daughter of John Burgess Jnr. (1814-74, q.v.). Exhib. 1857-72 at the RA, and also at the Society of Female Artists. The AJ, 1859, writes of her works exhib. there: " 'Old Brocades, or the Sack of Aunt Tabitha's Wardrobe', contains two figures — a young lady who, having dressed in an old brocade, is consulting her glass as to her appearance; and her maid, who is enraptured with the becoming fit of the dress. It is an ambitious work, the drawing is everywhere careful, and the execution, especially that of the background, is unexceptionable. By the same artist there is another drawing from 'The Old Curiosity Shop', equal in quality to the other, but in sentiment much more touching." The VAM has a painting of 'Girls begging', 1886.

Bibl: AJ 1859 p.84; VAM.

BURGESS, Arthur fl.1883-1884
London painter of landscape and genre. Exhib. 1883-4, at SS and elsewhere. Titles at SS 'Egypt', 1883 and 'Consideration', 1883.

BURGESS, Miss Emma fl.1873-1882
Exhib. seven landscape subjects in London, 1873-82. Wigston address.

BURGESS, Miss Florence fl.1885-1890
London portrait and genre painter. Exhib. 1885-90 at the RA, SS and NWS.

BURGESS, Frederick fl.1882-1892
Painter of landscapes and architectural subjects. Exhib. 1882-92, at the RA, SS, NWS and NG. Titles at SS 'Canal, Venice', 1882 and 'October morning, Wimbledon', 1887. Lived in London, Leicester and Malvern.

BURGESS, G.H. fl.1871
Exhib. 'Portrait of a Lady' at SS, 1871. London address.

BURGESS, Miss H. fl.1857-1865
London painter of figure subjects and genre. Exhib. 1857-65 at SS. Titles: 'A Peasant Girl', 1857 and 'Who will buy?', 1865.

BURGESS, H.H. fl.1843-1844
London painter of landscape and architectural subjects. Exhib. 1843-4 at SS. Titles: 'Study of Willows, Battersea', 1843, and 'Ruins of the Abbey of Jumieges, Normandy', 1844.

BURGESS, James Howard 1817-1890
Irish landscape and miniature painter. Exhib. at RHA from 1830. An example is in Ulster Museum.

BURGESS, Miss Jane Amelia fl.1843-1848
London flower painter. Daughter of John Cart Burgess (q.v.). Exhib. 1843-8 at the RA and SS.

BURGESS, John, Jnr. AOWS 1814-1874
Landscape painter. After travelling in Europe, he settled in Leamington and took over a teaching practice. His sister was Jane Amelia Burgess (q.v.).

Bibl: Cundall; Roget; VAM; Hughes; Hardie.

***BURGESS, John Bagnold RA 1830-1897**
Painter of Spanish genre. Son of H.W. Burgess, landscape painter to William IV and grandson of portrait painter William Burgess. Pupil of J.M. Leigh. Exhib. at RA, 1850-96, and at BI and SS. Specialised in Spanish, Gypsy and North African subjects of the type popularised by John Phillip (q.v.), although in his earlier years he painted some charming pure genre pieces. Travelled frequently in Spain with his friend Edwin Long (q.v.). His studio sale was held at Christie's 25 March 1898.

Bibl: Ruskin, Academy Notes 1875; AJ 1880 pp.297-300; 1898, p.31; Clement & Hutton.

BURGESS, John Cart 1798-1863
Landscape and flower painter; son of William Burgess a portrait painter. Exhib. at RA from 1812. He became a drawing master, with pupils among the royal family. Published several books on painting.

Bibl: AJ 1863.

BURGESS, William 1805-1861
Dover painter of coastal scenes, landscape, historical subjects and genre. Exhib. 1838, at the RA, and 1845-56 at SS Titles at SS: 'A Vessel on Shore, near Dover', 1845, and 'Loading Military Baggage in Dover Castle', 1854. Friend of T.S. Cooper, with whom he travelled in France. Settled in Dover as a drawing master.

BURGHERST, Lady Priscilla Anne see WESTMORLAND, Countess of

BURKE, Augustus Nicholas RHA c.1838-1891
Irish painter of landscape, genre and historical subjects, and occasionally portraits. Began his career in London, and from 1863-91 exhibited at the RA, SS and elsewhere. Titles at the RA include views in Ireland, England, Holland, France and Italy. In 1869, settled in Dublin and elected ARHA July 1871, member August 1871. 'The Feast Day of Notre Dame de Tremala, Brittany' is in the Council Room of the RHA, and a 'View of Connemara' in the National Gallery of Ireland. In 1882, after the murder in Phoenix Park of his brother, Thomas Henry Burke, Under-Secretary for Ireland, he left Dublin and settled in London.

Bibl: Strickland; Pavière, Landscape.

BURKE, Harold Arthur RBA 1852-1942
Landscape and portrait painter in oil and watercolour. Born in London. Educated at Cheltenham College and Liège University. Studied art at the RCA, at the RA Schools, and in Paris at the Ecole des Beaux-Arts under Gerome. Exhib. at the principal London galleries from 1890, mainly at the RA and SS. Elected RBA 1899, and VPRBA 1915-19. Lived in London and later at Findon, Sussex.

BURKINSHAW, Samuel fl.1865
Exhib. 'Preparing for School', at the RA, 1865. Liverpool address.

BURKLY, Z. fl.1852
Exhib. 'Portrait' at the SS, 1852. No address given.

BURLEIGH, Charles H.H. fl.1897 d.1956
Painter of landscape, interiors, genre and still-life. Exhib. from 1897-1948 at the RA (early titles: 'Sussex Meadows', 1897, and 'August', 1899), RI, ROI and elsewhere. Lived at Hove, Sussex.

BURLISON, J. fl.1846
Exhib. 'Sorrento, Bay of Naples' and 'Grand Canal, Venice' at the RA, 1846. Lived in London, at the same address as Clement Burlison.

BURMAN, John fl.1886
Exhib. 'Old-fashioned Friends' and 'Fruit; a study' at the RA, 1886. Sutton address.

BURN, Gerald Maurice 1862-1945
Painter in oil and watercolour of marines, battleships (many in dock) and genre. Born in London, studied art at South Kensington, and also in Cologne, Dusseldorf, Antwerp and Paris. Exhib. from 1881 at the principal London galleries, at the RA (1885-1911), SS and elsewhere — portraits of battleships at the RA and genre at SS. Titles at the RA 'The *Boskenna Bay* in dry dock after collision', 1885, and 'Launch of a battleship on the Thames', 1899. Brook-Hart notes he was "a marine artist who recorded some of the 'new' battleships in the full transition from sail to steam at the end of the Cl9". Lived at Amberley, Sussex.
Bibl: Brook-Hart

BURN, Thomas F. fl.1861-1867
Exhib. 'The Only One' at SS, 1861, and two marines at the BI, 1867. London address.

BURNAND, Victor Wyatt RBA 1868-1940
Portrait and landscape painter in oil and watercolour. Born at Poole in Dorset; studied art at the RCA, where he received his diploma in 1898, and in Paris. Exhib. at the RA, 1896-1940, and also at the RBA, RHA, Paris Salon and elsewhere. Illustrated Bunyan's *Pilgrim's Progress* and Hawthorne's *Tanglewood Tales*. Lived in Guildford.

***BURNE-JONES, Sir Edward Coley, Bt. ARA 1833-1898**
Painter, watercolourist, designer and leader of the second phase of the Pre-Raphaelite movement. Born in Birmingham; in 1852 went to Exeter College, Oxford, where he became a friend of William Morris. Intended to enter the Church, but was so impressed by the work of Rossetti that in 1856 he left Oxford, deciding to become a painter instead. He later met Rossetti, and in 1857 they worked together on the Morte d'Arthur wall paintings in the Union Debating Society's Room at Oxford. Went to Italy in 1859; went again in 1862 together with Ruskin. As a partner in the firm of Morris & Co., Burne-Jones produced many designs for stained glass and tapestries. Elected Associate of the OWS in 1864, Member 1868, but resigned in 1870 following criticism of one of his works. Elected ARA 1885, but only exhibited once at the RA in 1886, and resigned his Associateship in 1893. He exhib. five works at the opening exhibition of the Grosvenor Gallery in 1877, which quickly established his reputation as England's most influential artist. Thereafter he exhibited mainly at the GG and NG, also occasionally at the OWS. Created baronet 1894. In the 1880s and 1890s became an international figure — awarded the Legion of Honour, and many other European honours. Burne-Jones's consciously aesthetic and unworldly style, which combined the romanticism of Rossetti with the medievalism of Morris, became steadily more abstract towards the end of his life. Most of his subjects are taken from the Arthurian legends. He rarely painted either in pure oils or watercolours, preferring to experiment with mixed media. He had many pupils and imitators, including Marie Stillman, Frederick Sandys, Simeon Solomon, J.M. Strudwick, T.M. Rooke, J.R. Spencer Stanhope, Charles Fairfax Murray, Evelyn de Morgan and others, who carried his ideas well into the 20th century. The sale of his studio was held at Christie's, 16 and 18 July 1898.
Bibl: Reynolds, VP pp.65, 69, 70, l21, 142 (pls. 46, 51, 52, 57); Hardie III pp.121-3 *et passim* (pls.140-3); Maas pp.135-46 *et passim* (pls. pp.138, 141, 144-5); for full bibl. see Fredeman; David Cecil, *Visionary and Dreamer*, 1969; *Burne-Jones*, exhib. at Sheffield AG, 1971; M. Harrison and B. Waters, *Burne-Jones*, 1973; P. Fitzgerald, *Edward Burne-Jones*, 1975; Apollo, Burne-Jones issue November 1975; Arts Council exhib., *Burne-Jones*, 1975; Wood, Pre-Raphaelites; Wood, Olympian Dreamers; Newall; J. Hartnoll, *The Reproductive Engravings after E.B.-J.*, by C. Newall and J.G. Christian, 1988; E. Casaretti, *The Fatal Meeting* (E.B.-J. and Maria Zambaco), Antique Collector March 1989.

BURNE-JONES, Sir Philip, Bt. 1861-1926
Painter of portraits and topographical views; son of Sir Edward Burne-Jones (q.v.). Educated at Marlborough and University College, Oxford. First exhib. at GG in 1886 with 'An unpainted Masterpiece'. Also exhib. at RA and elsewhere, but mainly at NG, and at Paris Salon of 1900 (a portrait of his father). Among his sitters were Kipling, Watts, Lord Rayleigh and Sir Walter Gilbey. Later in life he gave up painting, and only did drawings and caricatures for his friends.
Bibl: Studio, *A Record of Art in 1898*, p.75; Who's Who 1911 p.289; The Graphic, 28 May 1910; see also under Sir E. Burne-Jones.

BURNET, John FRS 1784-1868
London painter of rural genre and cattle, landscapes and portraits; well known engraver. Exhib. 1808-62, at the RA, BI and SS. Titles at the BI 'The Cottage Door', 1815, 'The Fisherman's Return', 1858, and 'The Gaberlunzie', 1862. Engraved pictures by David Wilkie; pensioned, 1860; wrote treatises on drawing and painting.
Bibl: Ormond I pp.81-2.

BURNETT, Cecil Ross RI 1872-1933
Painter of landscape, genre, portraits and flowers — and especially farm scenes and rural life — in oil, watercolour and pastel. Born at Old Charlton, Kent; studied under Joseph Hill at the Blackheath School of Art from 1888, at the Westminster School of Art, and at the RA Schools from 1892, where he won the Turner Gold Medal, a £50 scholarship, and the first prize for portrait painting. Exhib. at the RA 1896-1929, and also at the RI, ROI, etc.; elected RI 1910. In about 1898 he started the Sidcup School of Art and was headmaster for many years. He lived at Blackheath and at Amberley in Sussex where he worked extensively.

BURNETT, G.R. **fl.1873-1887**
London portrait painter. Exhib. 1873-87, at GG and elsewhere.

BURNETT, William Hickling **fl.1844-1860**
London painter of landscape and architectural subjects. Exhib. 1844-60, at the RA, BI and elsewhere. Titles at the BI 'Part of the Palazzo Farnese, with the back of the fountain of the Mascherone, Rome', 1844 and 'The Cypress Walk, Villa d'Este, Tivoli', 1859. Travelled in Italy, Egypt, Spain and Tangier.

BURNS, Balfour **fl.1884-1890**
Exhib. six landscapes, mostly views on the Isle of Wight, at the RA, 1884-90. Streatham address.

BURNS, Cecil Leonard (Laurence) **1863-1929**
Painter of portraits, mythological figure subjects, genre and flowers. Studied art under Herkomer at Bushey and one of his paintings of that period, 'Phillida and Corydon' is reproduced in an article on 'Professor Herkomer's School' (AJ, 1892). Exhib. at the RA 1888-94, SS 1883-7 and at the NG. Principal of Camberwell School of Arts and Crafts 1897-9, and was Principal of Bombay School of Art 1899-1918.
Bibl: AJ 1892 pp.292-3.

BURNS, Clarence Laurence **fl.1885-1889**
Genre painter. Exhib. 'Loiterers' at the RA, 1888 and eight paintings elsewhere. Upper Tooting address.

BURNS, Robert **ARSA** **1869-1941**
Portrait and figure painter. Studied in London and Paris before returning to Edinburgh. Exhib. at RSA from 1892; elected ARSA 1902. Examples are in Aberdeen AG and the Nat. Gall. of Scotland. His paintings are usually poetic subjects, handled in a consciously decorative style.
Bibl: Caw pp.412-13 (illustration).

BURNSIDE, Miss H. **fl.1859**
Exhib. 'Winter-fruit' at the RA, 1859. Bromley address.

BURR, Alexander Hohenlohe **1835-1899**
Scottish genre and historical painter, brother of John Burr (q.v.). Pupil of John Ballantyne (q.v.) in Edinburgh. Exhib. at RA 1860-88, and at BI, SS, and GG. Titles at RA: 'King Charles I at Exeter', 'Grandad's Delight' and 'Blind Man's Buff', etc. Fond of painting children. Worked on some of the illustrations for an edition of Burns's poems. Many of his works were engraved.
Bibl: AJ 1870 pp.309-11 (Monograph with plates); Clement & Hutton; Caw p.262; Irwin pp.337, 350; Wood, Panorama.

BURR, Mrs. Higford **fl.1839-1876**
(Miss A. Margaretta Scobell)
Painter of topographical subjects. Only daughter of Captain Edward Scobell of Pottair, Penzance. In 1839 she married D. Higford Burr, at that period one of the representatives of the city of Hereford. With her husband she travelled widely, visiting in 1839 Italy, Spain and Portugal, and in the 1840s, Egypt and Asia Minor. In 1846 she published a portfolio of her sketches made on a journey to Egypt in 1844; and many of her drawings were also published by the Arundel Society. Member of the Society of Female Artists; the AJ noted of two architectural subjects exhibited there in 1859, ". . . drawings of exquisite delicacy of colour and execution; rarely do we, in this class of subject, meet with such taste in selection and execution." She did not exhib. at the RA, SS, BI or other leading galleries, but occasionally contributed to amateur exhibitions and sales of pictures for charitable purposes.
Bibl: AJ 1859 p.84; Clayton II pp.408-10.

***BURR, John P.** **RBA ARWS** **1831-1893**
Scottish genre painter, brother of A.H. Burr (q.v.). Studied at Trustees' Academy in Edinburgh. Began by exhib. at RSA, and in 1861 both he and his brother came to London. Exhib. at the RA 1862-82, and at SS and OWS. Subjects at RA mainly domestic scenes with children, similar in style to his brother's. A sale of his works was held at Christie's 23 April 1883.
Bibl: AJ 1869 p.272 (pl.) pp.337-9 (mono. with pls.); Clement & Hutton; Caw p.262; Irwin pp.337, 350 (pl.148).

BURRELL, James **fl.1859-1867**
London painter of landscapes and marines. Exhib. at the RA in 1863 and at the SS 1859-65. His 'Sailing vessels off the Coast in a Fresh Breeze', d.1867 is illustrated in Brook-Hart.
Bibl: Brook-Hart pl.185.

BURRELL, J.E. **fl.1869-1870**
London painter of architectural subjects. Exhib. 1869-70 at SS. Titles: 'Old House at Dinan', 1869 and 'The Choir Aisle, Chartres', 1870.

BURRINGTON, Arthur Alfred **RI** **1856-1924**
Painter of landscapes, genre and flowers. Born at Bridgwater, Somerset; studied at the South Kensington Schools, the Slade School, in Rome under Cipriani, 1878 and in Paris, 1882. Exhib. from 1880 in London, at the RA (1888-1918), SS (from 1883), NG, RI and elsewhere. Elected RI 1896. Lived for a time in the West of England and exhib. at the RWA. Later lived in the South of France. The Victoria AG, Bath, has three works by him.

BURROUGHS, Mrs. **see WARREN, Frances B.**

BURROUGHS, A. Leicester **fl.1881-1916**
London painter of genre, portraits and landscape. Exhib 1881-1916, at the RA, SS, NWS and elsewhere. Titles at RA ' "Full of Wise Saws and Modern Instances" ',1886 and 'In Varying Moods', 1897.

BURROW, Miss C.F. Severn **fl.1899-1903**
London painter of portraits and genre. Exhib. 1899-1903 at the RA. Titles: 'Traveller's Joy', 1899 and 'Rosalys', 1902.

BURROWS, Robert **fl.1851-1856**
Ipswich landscape painter. Exhib. 1851-6 at the RA and BI. Titles at RA 'Scene at Sproughton, near Ipswich', 1851 and 'A Scene on the Banks of the River Orwell', 1855.

BURT, Charles Thomas **1823-1902**
Midlands landscape painter. Born in Wolverhampton. Pupil of Samuel Lines in Birmingham, and also a friend and pupil of David Cox (q.v.), by whose style he was influenced. Exhib. at RA 1850-92, BI, SS and elsewhere. Member of the Birmingham Society of Artists, 1856. Specialised in Highland and moorland landscapes.
Bibl: Birmingham Cat.

BURT, H.A.B. **fl.1878-1880**
Exhib. three flower paintings in London, 1878-80. Wokingham address.

BURTON, Mrs. **fl.1874-1875**
Exhib. three landscapes in London, 1874-5. London address.

BURTON, Mrs. **fl.1890**
Exhib. one painting of 'Buildings' at the NWS, 1890. Birkenhead address.

BURTON, A.F. fl.1875
Exhib. 'Watching for a Bite' at SS, 1875. London address.

BURTON, Arthur P. fl.1894-1914
London painter of mythological figure subjects, landscape, genre and portraits. Exhib. 1894-1914 at the RA. Titles: 'The Nymph of the Bay', 1896 and 'Chalk Cliffs', 1901.

BURTON, F.W. fl.1855-1858
Exhib. two landscape subjects at SS, 1855-8. Hackney and Hoxton addresses.

***BURTON, Sir Frederick William RHA 1816-1900**
Irish landscape painter and watercolourist. Although Director of the National Gallery of Ireland 1874-94, he. still found time to paint portraits, genre and historical scenes, as well as landscapes, which he exhibited at the RA 1842-74, OWS and elsewhere.
Bibl: AJ 1859 p.173; NPG Cat.; VAM; DNB; Cundall; Newall; M. Bourke, *Sir F.W.B.*, Watercolours Magazine Autumn 1987.

BURTON, Henry fl.1883-1884
Exhib. two landscapes at the NWS, 1883-4. London address.

BURTON, J. fl.1848-1858
London portrait painter. Exhib. two portraits at the RA in 1855 and 1858 from the address 68 Newman Street. Also exhib. 'Captain of Invalids — Chelsea Hospital' at SS, 1848 from the same address but incorrectly listed under James Burton, marine painter, fl.1823-44 (q.v.).

BURTON, J. fl.1858
Exhib. 'A Fruit Piece' at SS, 1858. No address given. Possibly the same artist as J. Burton, portrait painter, fl.1848-58, (q.v.).

BURTON, James fl.1823-1844
Painter of marines, coastal scenes, landscapes and architectural subjects. Exhib. at the RA 1823-6, at the BI 1825-44 and at SS 1844. Lived in London and at Brighton. There is a confusion in Graves Dictionary between this James Burton and the J. Burton, portrait painter fl.1848-58 (q.v.).

BURTON, Miss M.R. Hill fl.1891-1896
Painter of genre and landscape. Exhib. 1891-6 at the RA, SS, NG and elsewhere. Titles at SS 'A Painter of Humble Life', 1891 and 'Street Arabs in a Town Park', 1892. Edinburgh and London addresses.

BURTON, T. fl.1838-1847
London painter of portraits, genre and landscape. Exhib. 1838-47 at the RA. Titles: 'The Sacristan', 1842 and 'A Rustic Bridge near Rome', 1843; at SS 1842-3 and at the BI 1842-3. There is a confusion both in Graves Dictionary and SS, where two T. Burtons are listed separately but with the same addresses.

BURTON, William fl.1887
Exhib. ' "Little Bird with Bosom Red, etc" ' and 'The Forgotten Way', 1887. New Barnet address.

BURTON, William Paton 1828-1883
Landscape painter. Born in India, travelled in Egypt and on the Continent. Lived at Witley, and exhib. at RA 1862-83, SS and elsewhere. Titles at RA 'A November Sunset', 'Gloaming', 'The Lone Mill', etc.
Bibl: DNB.

***BURTON, William Shakespeare 1824-1916**
London historical painter. Student at the RA schools. Now solely known for 'The Wounded Cavalier' (Maas pl. p.l56, "one of the finest works ever painted in England under the Pre-Raphaelite influence" (Bate). The picture was at first rejected by the RA Hanging Committee, but noticed by C.W. Cope (q.v.) who withdrew one of his own pictures to make room for it. Hung without artist or title, on the line next to Holman Hunt's 'Scapegoat', the picture caused a sensation at the 1856 Academy, and Ruskin hailed it as "masterly". Dogged by ill-health and lack of recognition, Burton practically abandoned painting during the 1880s and 1890s, but was persuaded to take it up again around 1900. His later works, such as 'The Angel of Death', 'Faithful unto Death', 'The King of Sorrows', 'The World's Gratitude', etc. never fulfilled the expectations of 'The Wounded Cavalier'. Exhib. at RA from 1846.
Bibl: Ruskin, Academy Notes 1856; Bate pp.81-2 (pls. opp. pp.80,82); William Gaunt, *The Lesser Known Pre-Raphaelite Painters,* Apollo Annual 1948 pp.5-9; Maas p.156 (pl. 'The Wounded Cavalier'); Staley p.89 (pl.43b); Strong; Wood, Pre-Raphaelites.

BURY, Viscount fl.1878
Exhib. one painting of 'Nuremberg' in London, 1878. No address given.

BUSCH, Mrs. H.M. fl.1892
Exhib. one landscape at the NWS, 1892. London address.

BUSH, Reginald Edgar James RE 1869-1956
Landscape and genre painter and etcher. Born in Cardiff, son of James Bush, Headmaster of Cardiff School of Science and Art. Studied art at the RCA, and gained the British Institute Scholarship for Engraving, also a travelling scholarship 1893. Visited Paris and Italy. Exhib. at the RA 1895-1936, and internationally. Elected ARE 1898, RE 1917. Principal of Bristol Municipal School of Art 1895-1934 and lived in the city for many years. He specialised in woodland scenes and produced some etchings of New Forest subjects. His wife Flora (née Hyland) was a flower painter.
Bibl: Studio 1901 XXIII pp.15,22; Special Summer No. 1902 pl.13.

BUSHBY, Thomas 1861-1918
Painter of landscape and genre. Born in Eccleshill, Yorkshire; lived in Carlisle. Exhib. 1900-14 at the RA. Titles: 'The Last Stack: Harvesting near Bradford', 1900 and 'The Last Gleam of Day', 1908. Said to have been influenced by Burne-Jones; was also encouraged by the Earl of Carlisle. Travelled in Norway, France, Switzerland, Holland and Italy. Works by him are in Carlisle AG.

BUSK, Miss E.M. fl.1873-1889
London painter of portraits and literary figure subjects. Exhib. 1873-89 at the RA portraits and 'Portia and Lucius', 1885.

BUSK, William fl.1889-1892
Exhib. 'An Old Shepherd, 89 Years of Age', 1889 and 'An Old Breton Peasant', 1892, at the RA. Lived at Horsham and Dorchester.

BUSS, Robert William 1804-1874
London historical, genre and portrait painter. Pupil of George Clint. At first painted theatrical portraits, later turned to historical scenes and humorous genre. Exhib. at RA 1826-55, BI, SS and NWS. Exhib. at House of Lords competition 1844-5. Editor of *The Fine Art Almanack* and English Graphic Satire with etchings by himself.
Bibl: AJ 1874 p.300; 1875 p.178; Redgrave, Dict.; DNB 1908 III p.492; Binyon; Ormond I pp.307-8.

BUSS, Rev. Septimus fl.1854-1859
London landscape painter. Exhib. 1854-9 at the RA, BI, SS and elsewhere, subjects often Welsh landscapes, e.g. 'Village at Bettws-y-coed', BI 1857.

BUSSEY, Reuben 1818-1893
Little-known painter of figures, especially children. 'The Black Knights' — a picture of chimney-sweeps — was sold Christie's, 5 March 1971. Studied in Nottingham under Thomas Barber and John Rawson Walker. After a spell in London, he returned to Nottingham, where he continued to paint local subjects, also scenes from Shakespeare and the Bible. Works by him are in Nottingham Castle Museum.

BUTLAND, G.W. fl.1831-1843
Painter of marines, landscapes and coastal scenes. Exhib. 1831-43 at the RA, BI and SS. Lived in the City of London, Greenhithe, Kent and later in Fulham.
Bibl: Brook-Hart.

***BUTLER, Charles Ernest 1864-c.1918**
London painter of portraits, mythological and other figure subjects, genre and landscapes. Born at St. Leonards-on-Sea, Sussex; studied at St. John's Wood School of Art and at the RA Schools. Exhib. at the RA, 1889-1918. Titles: 'An Episode of the Deluge', 1890, 'St. Thena', 1893 and 'King Arthur', 1903.

BUTLER, E.F. fl.1856
Exhib. 'Gibraltar' and 'No Title' at SS, 1856. Ramsgate address.

***BUTLER, Lady Elizabeth Southerden 1846-1933**
(Miss Elizabeth Thompson)
Painter of patriotic battle scenes and episodes of military life. Sister of Alice Meynell, the poet and essayist, she was brought up mostly abroad, particularly in Italy, and educated by her father. Entered South Kensington Art Schools in 1866; in 1869 she became a pupil of Giuseppe Belucci in Florence, and also studied in Rome. First exhibited at RA in 1873 with 'Missing' and in 1874 she became famous when she exhibited 'The Roll Call' at the RA (full title 'Calling the Roll after an Engagement, Crimea'), which was bought by Queen Victoria. After this she painted almost entirely military subjects, and among her best-known paintings are 'Quatre Bras', 1875 (Melbourne), 'The Remnants of an Army', 1879 (Somerset County Museum), 'The Defence of Rorke's Drift, 1880 (Windsor Castle), and 'Scotland for Ever', 1881 (Leeds AG). Ruskin described 'Quatre Bras' as "Amazon's Work" and as "the first fine pre-Raphaelite picture of battle that we have had". The precision of her painting was prized by the army for its faithful recording of regimental actions and dress, and few artists have equalled her drawing of horses. In 1877 she married Major (afterwards Lieutenant-General Sir) William Francis Butler.
Bibl: AJ 1874 pp.146, 163; 1876 p.190; 1905 p.322; Clayton II p.139; Clement & Hutton; Wilfrid Meynell in the Art Annual 1898; The Studio, *Art in 1898*; Lady Butler, *Letters from the Holy Land*, 1903; Lady Butler, *From Sketchbook and Diary*, 1909; Lady Butler, *An Autobiography*, 1923; Viola Meynell, *Alice Meynell*, 1929; DNB 1931 p.40; Wood, Panorama; cat. of Lady Butler exhib., National Army Museum, 1987.

BUTLER, J. Stacey fl.1899
Exhib. 'The Miller's Home' at the RA, 1899. Danbury, Essex address.

BUTLER, Miss Mary E. fl.1867-1909
London flower painter. Exhib. from 1867, at the RA, SS, NWS and elsewhere. In 1909 living in Natal, South Africa. VAM has two flower paintings.
Bibl: S.H. Pavière, *A Dictionary of Flower, Fruit and Still Life Painters*, 1962-64, Vol. 3, (reprd).

***BUTLER, Mildred Anne ARWS 1858-1941**
Irish painter and watercolourist of genre, landscape and animals. Studied at Westminster School of Art, and with W. Frank Calderon (q.v.). Exhib. at RA 1889-1902, NWS and elsewhere. Elected ARWS 1896. 'The Morning Bath' (RA 1896) was bought for the Chantry Bequest and is in the Tate Gallery. A sale of her work was held at Christie's, 13 October 1981.
Bibl: Tate Cat.; Who's Who 1911 p. 300; Wood, Painted Gardens.

BUTLER, Nina H. fl.1884
(Mrs Thomas Butler)
Exhib. 'Daffodils' at SS, 1884. London address.

BUTLER, Richard fl.1859-1886
Sevenoaks landscape painter. Exhib. at RA 1859-86. Subjects views in the south of England, many of them of Knole Park.

BUTLER, Miss S.A. fl.1890
Exhib. 'Pepita' and 'Jachauerin' at the RA, 1890. Tetbury, Gloucestershire address.

BUTLER, Samuel 1836-1902
Best known for his books (*Erewhon, the Way of All Flesh*, etc.). Butler took up painting after his return from sheep-farming in New Zealand. His first efforts were rather crude, but study with J.M. Leigh improved his style. Exhib. at RA 1869-76. Titles: 'Mr. Heatherley's Holiday', 'Don Quixote', etc.
Bibl: Reynolds, VS pp.89-90 *et passim* (pls. 75-6); Wood, Panorama.

BUTLER, T.W.G. fl.1874
Exhib. 'The Sonnet' at the RA, 1874 and 'Perdita' and 'The Cavalier's Daughter' at SS, 1874. London address.

BUTLER, William, E. fl.1894
Exhib. 'Study of a Head' at the RA, 1894. Bushey address.

BUTT, J. Acton fl.1884-1886
Exhib. three landscapes in London, 1884-6. Birmingham address.

BUTTERFIELD, Clement fl.1896
Exhib. one portrait at the RA, 1896. London address.

BUTTERSWORTH, J.E. fl.1835-1870
Marine painter. Possibly the son of Thomas Buttersworth, fl.1798-1827, marine painter to the East India Company. Brook-Hart notes that his background is little recorded and that he is better appreciated in the U.S.A. where he went in the mid-19th century and had some influence in introducing the English school of painting to that country.
Bibl: Brook-Hart pp.29, 109 (pl.12).

BUTTERWORTH, George fl.1865-1881
Painter of landscape and coastal scenes. Exhib. 1865-81, at the RA, SS, GG and elsewhere, the majority of the subjects at SS being scenes in N. Wales. Lived at Thornton Heath.

BUTTERWORTH, J. fl.1839-1854
London painter of historical and literary subjects. Exhib. 1839-49 at SS, and 1841-54 at BI. Titles at BI 'Margaret of Branksome' 1841, and 'Christmas with her Children, Mercy, and Mr. Greatheart at the Valley of the Shadow of Death', 1854.

BUTTERTON, J. fl.1847
Exhib. 'A Head' at the RA, 1847. London address.

BUTTERTON, Mary fl.1889
Exhib. 'Sketch of Vauxhall, from Albert Embankment' and 'S. Mouth of the Blythe, Southwold', at SS, 1889. London addresss.

BUTTON, Kate fl.1881
Exhib. 'Snowdrops' at SS, 1881. Clevedon, Somerset, address.

BUTTS, Miss Amy fl.1867-1883
(Mme. Giampietri)
Painter of figure subjects. Exhib. once in London in 1867, from a Winchester address, and again in 1883 from a Rome address as Madame Giampietri. Married Chevalier Settino Giampietri. Member of the Society of Lady Artists. See also Mme. Giampietri.

BUTTURA, M. fl.1878
Exhib. 'St. Cassien, Near Cannes' at SS, 1878. London address.

BUXTON, A. fl.1848
Exhib. 'Mrs. Buxton and Children' at the RA, 1848. Address St. Helier, Jersey. Possibly painted a portrait of Sir James Outram (Scottish NPG).
Bibl: Ormond I p.351.

BUXTON, A.J. fl.1827-1844
London painter of figure subjects. Exhib. 1827-44 at SS. Titles: 'Head of an Italian Bandit', 1827 and 'The Falconer', 1844.

BUXTON, Miss Amy L. fl.1893
Exhib. two genre paintings in London, 1893. Wimbledon address.

BUXTON, William Graham- fl.1885-1892
London painter of landscape and coastal scenes. Exhib. 1885-92, at the RA, SS and elsewhere. Titles at SS 'Leigh, Essex, at Low Water', 1885 and 'Nature's Garden', 1892.

BYARD, Miss Florence fl.1890-1891
London flower painter. Exhib. 1890-1 at the RA and elsewhere.

BYARD, Frederick fl.1878-1879
Exhib. ' "Mother's Pet" ', 'Flower Girl' and 'Spare Moments' at SS, 1878-9. London address.

BYGATE, Joseph E. fl.1890
Exhib. 'Durham' at SS, 1890. London address.

BYLES, William Hownsom fl.1872-1916
Painter of landscape, portraits and genre. Exhib. 1872-1916 at the RA. Titles: 'Moonrise Before Sunset in the New Forest', 1896, and 'Au Revoir', 1898. Lived in London and Chichester, Sussex.

BYRNE, Miss Elizabeth fl.1838-1849
London painter of landscapes and architectural subjects. Exhib. 1838-49 at the RA and SS. Titles at RA 'Part of Netley Abbey', 1840 and 'Conway Castle', 1843. Sister of John and Letitia Byrne (qq.v.).

BYRNE, J. fl.1870
Exhib. 'Playmates' at SS, 1870. Manchester address.

BYRNE, John 1786-1847
Landscape painter. Son of William Byrne, an engraver, whose profession he at first followed. Gave this up in favour of landscape painting, and was elected ARWS in 1827. Travelled in France and Italy, but continued to paint subjects in Wales or the Home Counties. His sisters were Elizabeth and Letitia Byrne (qq.v.).

BYRNE, Miss Letitia 1779-1849
London landscape and flower painter. Exhib at RA 1799-1848, mainly views in Derbyshire and Wales. Sister of Elizabeth and John Byrne (qq.v.).

BYRNE, William S. fl.1879-1889
London landscape painter Exhib. 1879-89, at the RA, SS, GG and elsewhere. Titles at RA 'Wild Evening in the New Forest', 1881 and 'Twilight: On the Trent', 1889.

BYWATER, Mrs. fl.1851
Exhib. 'The Little Pet' at SS, 1851. Bermondsey address.

BYWATER, Mrs. Elizabeth fl.1879-1888
London flower painter. Exhib at RA 1879-88, SS and GG.

BYWATER, Miss Katharine D.M. fl.1883-1890
London painter of genre and portraits. Sister-in-law of Mrs. Elizabeth Bywater (q.v.). Exhib. 1883-90 at the RA and SS. Titles at RA' "All My Fancy Dwelt on Nancy" ', 1884 and 'The Gardener's Daughter', 1887.

CA.B. see BROOME, William

***CADENHEAD, James RSA RSW fl.1858-1927**
Scottish landscape painter. Born Aberdeen. Studied at RSA schools, and under Carolus Duran in Paris. Returned to Aberdeen in 1884, and settled in Edinburgh in 1891. Exhib. at RSA, RSW, and at NEAC in London. His early landscapes show French influence, but his later works show Japanese influence in their flat, decorative design. Elected RSW 1893, ARSA 1902, RSA 1921. Founder member of NEAC 1886.
Bibl: Studio X p.67; XXV p.207; XLVIII p.233; Special Number on RSA 1907; Caw.

CADMAN, William E. fl.1854-1856
London landscape painter. Exhib. one picture at SS, 1855.

CADOGAN, Lady Honoria 1813-1904
A more than usually talented amateur watercolourist. Painted interiors of country houses, views of Cowes, the Isle of Wight, Brighton and elsewhere on her travels. Exhib. three works at SS 1869. Lived mainly in London.
Bibl: Huon Mallalieu, Country Life 16 January 1992 pp.48-9.

CADOGAN, Sidney Russell fl.1877-1895
London landscape painter. Exhib. at RA 1877-95 mainly Scottish views. Exhibited 'In Knowle Park' 1877, 'Rohallion, Perthshire' 1884, 'Loch of the Lowes, Dunkeld' 1890. Also exhib. at GG and NG.

CAFE, James Watt b.1857 fl.1877-1897
London painter of churches and church interiors. Lived at the same address as his brother Thomas Watt Cafe (q.v.). Exhib. oils and watercolours at RA, SS, NWS and elsewhere.

CAFE, Thomas, Jnr. fl.1844-1868
London painter of landscape and coastal scenes. Exhib. at RA, SS and elsewhere, in both oil and watercolour.

CAFE, Thomas Smith fl.1816-1840
London painter of landscapes, coastal scenes, and fisherfolk. Exhib. at RA, BI, SS and NWS. Presumably father of Thomas Cafe Jnr. (q.v.).
Bibl: Brook-Hart.

CAFE, Thomas Watt RBA 1856-1925
Educated at King's College, London and at the RA Schools. Exhib. at the RA from 1876 onwards. For some time a member of the Dudley and Cabinet Picture Society, and wrote occasional articles on art subjects in daily press. Graves lists his speciality as 'landscape' but titles include: 'Shrine of Edward the Confessor, Westminster Abbey' 1876, 'Wreaths of Welcome', 'Nydia', 'The Favourite', 'Summer Idleness', 'The Gift', 'Laurels for the Victor', 'The Valley of the Shadow', etc. His pictures are usually classical figures in Graeco-Roman interiors, and show the influence of Alma-Tadema (q.v.). James Cafe, Thomas S. Cafe, and Thomas Cafe Jnr. (qq.v.) were also exhibiting at the same period, and may have been of the same family.
Bibl: Who Was Who 1916-1928.

CAFFIERI, Hector RI RBA 1847-1932
Born in Cheltenham. Landscape painter and watercolourist. Pupil of Bonnat and J. Lefebvre in Paris. Worked in London and Boulogne-sur-Mer. Member of NWS. Painted fishing scenes of English and French ports, flowers, landscapes and some sporting subjects. Exhib. at the RA 1875-1901, and in Paris at the Salon des Société des Artistes Français 1892-3 with 'Attente' and 'Départ des Bateaux de Boulogne'. Typical titles are 'A Fishing Party' and 'Mussel Gatherers'. Exhib. mainly at SS and NWS.
Bibl: Brook-Hart.

***CAFFYN, Walter Wallor fl.1876-d.1898**
Landscape painter; lived in Dorking, Surrey. Exhib. RA 1876-97, and SS. Painted views in Surrey, Sussex and Yorkshire; also painted landscapes for the angling painter H.L. Rolfe (q.v.).
Bibl: Pavière, Landscape (pl.10).

CAHILL, Richard Staunton fl.1853-1889
London painter of figure subjects. Exhib. at RA, BI, SS, NWS and elsewhere. Titles at RA 'An Irish Peasant Boy', 'City Arab', etc.

CAHUSAC, John Arthur FSA c.1802-1866/7
London painter of figure subjects. Exhib. mainly at SS, also at RA, BI, NWS and elsewhere. Titles at RA 'The Stable Boy', 'Flower-Girl', etc. and some still-life pictures.

CALCOTT, J. fl.1861-1862
Portsmouth painter. Exhib. two watercolours of landscapes at SS, 1861-2.

CALDECOTT, Randolph RI 1846-1886
Illustrator and watercolourist. Educated at King's School, Chester, where he took two prizes for drawing from the Science and Art Department, South Kensington. Worked as a bank clerk at Whitchurch, Salop, and later at Manchester, where he studied at the Art School, and from 1868 drew for the local papers. He contributed to *London Society* from 1871 and *Punch* from 1872, in which year he settled in London where he studied at the Slade School. He also drew for the *Graphic* and illustrated numerous books, his children's picture books being published 1878-85 (e.g. *The House that Jack Built* and *John Gilpin).* Exhibited at the RA 1872-85, and at the RI etc. In l882 he became Member of the RI, and in 1880 of the Manchester Academy of Fine Arts. He also made bronze models and terracotta busts. He made his name by his illustrations to Washington Irving's *Old Christmas* 1875 and *Bracebridge Hall* 1876. His world was the "fresh, vigorous scenes of the English squirearchy in manor-house and hunting field" (Hardie), and, in his own words, he studied the "art of leaving out as a science". The BM and VAM own a wide variety of his watercolours, pen drawings and coloured proofs. A studio sale was held after his death, at Christie's 11 June 1886.
Bibl: Redgrave, Cent.; VAM MSS., R.C. letter to Edmund Evans, 1884; H.R. Blackburn, *R.C.,* 1886; C. Phillips, *R.C.,* Gazette des Beaux-Arts XXXIII 1886; *R.C. 's Sketches,* 1890; Bryan; Binyon; Cundall; DNB; VAM; M.G. Davis, *R.C.,* 1946; Hardie III pp.144-5 (pl.170); R.K. Engen, *R.C. Lord of the Nursery,* 1976.

CALDERON, Abelardo Alvarez fl.1880-1896
Peruvian painter of figure subjects. Exhib. in London at RA, SS and elsewhere Titles: 'Afternoon Tea', etc. Also exhib. at Paris Salon and other Paris exhibitions.

***CALDERON, Philip Hermogenes RA 1833-1898**
Painter of domestic and historical scenes and leader of the St. John's Wood Clique. Born in Poitiers; educated by his father, a renegade Spanish priest, who was Professor of Spanish Literature at King's College, London. 1850 entered J.M. Leigh's art school in Newman St. 1851 studied under Picot in Paris. In 1853 he began to exhibit at the RA, and in 1857 made his name with 'Broken Vows' (Tate Gallery). This picture, which shows marked Pre-Raphaelite influence, was engraved in 1859 and became widely popular. In 1867 'Her Most High, Noble and Puissant Grace' won him a medal at the Paris International Exhibition, the only gold medal awarded that year to an English artist. In 1891 his version of the 'The Renunciation of St. Elizabeth of Hungary' (Tate Gallery) gave great offence to Roman Catholics owing to the representation of St. Elizabeth kneeling naked before the altar. After 1870 he turned mainly to portrait painting. 1887 elected Keeper of the RA, and managed the RA Schools. Calderon's success, like that of Millais, was due to his ability to invent and portray an incident in a way which appealed to popular taste. He usually signed with initials P.H.C. For his part in the St. John's Wood Clique, see article by Bevis Hillier listed below.
Bibl: Ruskin, Academy Notes 1858-9; DNB; Bevis Hillier, *The St. John's Wood Clique,* Apollo June 1964; Reynolds, VP pp.111-12, 179, 180, 196 (pl.121); Maas pp.13, 119, 234-5.

CALDERON, William Frank ROI 1865-1943
Painter of portraits, landscapes, figure subjects and sporting pictures. Third son of P.H. Calderon (q.v.). Educated at the Slade School under Professor Le Gros. Founder and Principal of the School of Animal Painting, 1894-1916. He was a regular exhibitor at the RA 1881-1921. His first RA painting, 'Feeding the Hungry', was purchased by Queen Victoria. His principal works are 'John Hampden, Mortally Wounded, Riding from Chalgrove Field', 'Flood', 'Market Day','A Son of the Empire', 'Showing his Paces' (Hamburg), etc., and many portraits. He published *Animal Painting and Anatomy,* 1936.
Bibl: Who Was Who 1941-1950.

CALDWELL, Edmund fl.1880-1921 d.1930
London animal painter. Exhib. at RA, SS, NWS and elsewhere. Later in his career he also produced animal sculptures.

CALKIN, Lance ROI 1859-1936
London portrait painter. Studied at RCA, RA and Slade Schools. Exhib. at RA 1882-1926; also SS, GG, NG, ROI and elsewhere. Among his sitters were King Edward VII, George V, William Logsdail and John Tenniel. A portrait of John Feeney by him is in Birmingham City AG and others are in the NPG.
Bibl: The Connoisseur 1911 p.314; Birmingham Cat; Ormond I pp.76, 391.

CALLAHAN, James E. fl.1895-1898
London painter. Exhib. two pictures at RA in 1895 and 1898, 'Vauxhall, February 1895', and 'Alice in Wonderland'.

CALLARD, J. Percy fl.1882-1889
London painter of landscapes with figures. Exhib. at RA, SS, GG and elsewhere. Titles: 'A Hot Day', etc.

CALLARD, Miss Lottie fl.1883-1892
London painter of figure subjects. Exhib. at RA, SS and elsewhere. Titles: 'The Orange Girl', etc.

CALLAWAY, William Frederick fl.1855-1861
London painter of historical and literary subjects. Exhib. at RA, BI and elsewhere. Titles: 'Taming of the Shrew', etc.

CALLCOTT, A. fl.1856-1864
London painter of landscapes and river scenes. Exhib. both oils and watercolours at BI and SS.

***CALLCOTT, Sir Augustus Wall RA 1779-1884**
Painter of landscapes, seascapes and historical genre. Studied at RA Schools, and with John Hoppner. His first exhibited works mainly portraits. Travelled in Holland, on the Rhine and in Italy. His romantic classical landscapes earned him the title of the English Claude. Exhib. at RA (129 works) and BI. Elected ARA 1806, RA 1810. For many years Keeper of the Royal Collection, for which he was knighted in 1837. Ruskin was of the opinion that Callcott "painted everything tolerably, nothing excellently", but he was very popular and expensive in his lifetime, though his reputation did not last. His best-known works were 'Mouth of the Tyne', 1818, 'Milton Dictating Paradise Lost to his Daughters', 1840, and 'Raphael and his Fornarina', 1837. The sale of his studio was held at Christie's, 8-11 May 1845, and 22 June 1863.
Bibl: AU 1845 p.15 (obit.). AJ 1856 pp.9ff.; 1866 pp.99ff.; 1896 pp.334ff.; Portfolio 1875 pp.161ff.; J. Dafforne, *Pictures by Sir Augustus Wall Callcott,* 1878; Redgrave, Dict.; Roget; Bryan; Cundall; DNB; Hughes; VAM, Reynolds, VP p.12; Hardie II pp.153-4 (pl.139); III pp.272-3; Maas pp.22, 54; Ormond I p.329; Brook-Hart; David Cordingley, *The Marine Paintings of A.W.C.,* Connoisseur 184 1973 pp.98-101.

CALLCOTT, C. fl.1873-1877
London painter of domestic subjects. Exhib. at RA, SS and elsewhere. Titles 'The Cottage Door', etc.

CALLCOTT, J. Stuart fl.1862-1868
London painter of portraits and other subjects. Exhib. at RA and BI. RA titles mostly portraits, but also the occasional still-life or figure subject.

CALLCOTT, William fl.1856-1865
London painter of river and coastal scenes. Exhib. oils and watercolours at BI, SS and elsewhere.

CALLCOTT, William J. fl.1843-1890
London marine painter and of storm and coastal scenes. Titles at RA 'Fishing Craft, Scarborough Harbour' and 'The Breakwater at Gorleston, Great Yarmouth'. Greenwich Maritime Museum has two examples. Exhib. at RA 1844-96, BI, SS, and NWS.

CALLINGHAM, J. fl.1873-1879
Exhib. three watercolours of coastal scenes at SS, 1873-9. Lived at Surbiton.

CALLOW, George D. fl.1858-1873
London landscape painter. Exhib. at SS and BI; only two pictures at the RA. Mostly painted river and coastal scenes. A James W. Callow is also recorded at the same address, 82 Newman Street. He exhib. one picture at the RA in 1860.
Bibl: Brook-Hart pp.63-4 (pl.124).

CALLOW, James W. fl.1860
London painter. Exhib. one picture 'The East Scar and Bay, Whitby' at RA, 1860.
Bibl: Brook-Hart pp.63-4 (pl.125).

***CALLOW, John 1822-1878**
Marine and landscape painter. Pupil of his elder brother William Callow (q.v.) who took him to Paris in 1835 where he studied for several years. In 1844 he returned to England and started up as a landscape painter in watercolours. In 1855 he was appointed Professor of Drawing in the Royal Military Academy at Addiscombe, and six years later he took the post of Sub-Professor of Drawing at Woolwich. Some years later he retired and painted for exhibitions as well as taking pupils. He excelled in marine painting more than landscapes and his brother said that teaching impeded his development. He exhibited yearly at the OWS (352 works), and at RA, BI, SS and NWS.
Bibl: Roget; DNB; Hardie III pp.36, 217, 221 (pl.249); Brook-Hart.

***CALLOW, William RWS 1812-1908**
Painter of landscapes, buildings and sea pieces, mainly in watercolour but some in oil — the Victorian heir of the picturesque, topographical school epitomised by Prout. Articled at the age of 11 to Theodore and Thales Fielding. Went to Paris in 1829, where he worked under Newton Fielding, and later established himself there as a teacher. Thomas Shotter Boys much influenced his style. In 1831 he exhibited 'View of Richmond' at the Salon, and as a result was appointed drawing master to the family of Louis Philippe. From 1838 to 1840 he toured Europe making sketches. He left Paris in 1841 for London, and in 1838 was elected A of the OWS, member in 1848, and secretary 1866-70. He exhibited there about 1,400 works. In 1848 he took to oil painting. In 1855 he left London and settled in Great Missenden where he died. His work became somewhat mannered and after a time ceased to attract. About two years before his death he turned out his portfolios of early works and these sold so well that he held an exhibition of them at the Leicester Galleries in 1907. His studio sale was held at Christie's, 21 March 1910.
Bibl: DNB; Roget; William Callow, *An Autobiography,* ed. H.M. Cundall 1908; Martin Hardie, *William Callow,* OWS XXII 1927; Walker's Quarterly XXII 1927; VAM; Reynolds, VP p.25; Hardie III *passim* (pls.51-4); Maas pp.64, 88, 97-8; Brook-Hart; Jan Reynolds, *W.C.,* Connoisseur February 1978.

CALLWELL (CALWELL), Miss Anette fl.1880-1887
London painter of figures and coastal scenes. Exhib. at RA, SS, GG and elsewhere. Titles: 'In an Irish Bog', etc.

CALOSCI, Arturo fl.1890
Exhib. one picture, 'Idyll', at SS, 1890. London address.

CALTHROP, Claude Andrew 1845-1893
London genre and historical painter. Pupil of John Sparkes. Exhib. at RA 1867-93, BI, SS, and also at the Salon des Société des Artistes Français in Paris, where he lived for a time. Subjects at RA include a few portraits. Ruskin said of his picture 'Getting Better' (RA in 1875) that "it deserves close attention, much praise, and a better place than it at present occupies". He also painted a number of social realist subjects, particularly involving seamstresses.
Bibl: Gazette des Beaux-Arts 1873 II p.248; Ruskin, Academy Notes 1875.

CALTHROP, Mrs. M.A. fl.1877-1883
Painter of flowers. Exhib. at RA and SS. Lived in London and Uppingham.

CALVERT, Charles 1785-1852
Landscape painter. Son of the Duke of Norfolk's agent, also an amateur artist. Worked as a cotton merchant before turning to art. He painted landscapes, and also taught both oils and watercolours. Was a founder of the Royal Manchester Institution, and father-in-law of William Bradley of Manchester (q.v.).

CALVERT, Edith L. fl.1893
London painter. Exhib. two watercolours at SS, 1893.

CALVERT, Edward 1799-1883
Friend and disciple of William Blake and Samuel Palmer and member of the Shoreham Group. Entered the Navy at an early age, but abandoned it to study painting. He studied under James Ball and Ambrose B. Johns at Plymouth, and afterwards moved to London where he worked at the RA Schools. He exhibited at the RA 1825-36, and met Palmer there in 1826, looking "a prosperous stalwart country gentleman redolent of the sea, and in white trousers". During the years of the Shoreham Period 1827-31 he produced a series of remarkable wood-engravings (Arcadian visions), such as 'The Cyder Feast' and 'The Chamber Idyll', and he is best known for these. From then on he painted mainly to please himself, in oil and watercolour, mostly mythological subjects, destroying a great deal and leaving much unfinished. He was greatly interested by Greek Art and the mysticism of a pagan antiquity, and visited Greece, bringing back many studies. He aspired to a "beautiful ideal" and took his subjects from mythology.
Bibl: Redgrave, Cent.; Roget; S. Calvert *Memoir of Edward Calvert,* 1893; Bryan; DNB; E. Calvert, *Ten Spiritual Designs* (H.P. Horne, Brief notice of Edward Calvert), 1913; L. Binyon, *The Followers of William Blake,* 1925; A.J. Finberg, *The Engravings of Edward Calvert,* Print Collector's Quarterly XVII No.2 1930; A. Grigson, *A Cornish Artist E.C.,* West County Magazine 1946; Arts Council, *Samuel Palmer and His Circle,* 1957; R. Lister, *Edward Calvert,* 1962; Reynolds, VP pp.141-2 (pl.94); Hardie II pp.169-71 (pls. 159-60); Maas pp.39, 41-2, 167 (pls. on p.41-2).

CALVERT, Edwin Sherwood RSW 1844-1898
Scottish landscape painter, working mainly in Glasgow. Disciple and follower of Corot. He began by painting coast and fishing scenes, but his later work, much of which was in watercolour, was pastoral in subject and idyllic in character. He often painted in the north of France, in grey and pensive colour schemes, and closely followed Corot in the general balancing of foliage and shepherdesses and sheep. Exhibited at the RA 1878-96, and occasionally at the NG.
Bibl: Caw p.310.

CALVERT, Frederick fl.1827-1844
London painter of shipping and coastal scenes. Exhib. at BI and SS. Also a topographical watercolourist and engraver. Works by him are in the National Maritime Museum, VAM, and the Walker AG, Liverpool.
Bibl: Brook-Hart pp.36-7 (pl.74).

CALVERT, Henry fl.1813-1861
Painter of sporting pictures, born in Manchester. Titles of paintings exhib. at the RA 1826-54 include: 'A Brood Mare', 'The Wynnstay Hunt', 'The Royal Pair of the Jungle'. Although little known, Calvert was a very competent animal painter whose work can be compared, at its best, with H.B. Chalon and R.B. Davies. He worked mainly in Wales.
Bibl: Pavière, Sporting Painters p.24 (pl.9).

CAMERON, Mrs. Campbell fl.1879-1882
London landscape painter. Exhib. two pictures at GG in 1879 and 1882.

***CAMERON, Sir David Young RSA RA RWS RSW 1865-1945**
Scottish painter, watercolourist and etcher. In the 1890s he became famous for his etchings; his early paintings and watercolours are eclectic, and show a variety of influence — Velazquez, Whistler, the Barbizon painters and M. Maris. Later his style matured, and he concentrated on highland landscapes, painted around his home at Kippen. Using romantic and dramatic colour combinations, he tried to express the mystical grandeur of highland scenery. Elected ARWS 1904, RWS 1915; ARA 1911, RA 1920. Also RSA and RSW; knighted 1924.
Bibl: Studio, *The Paintings of Sir D.Y.C.,* 1919; D. Martin, *The Glasgow School of Painting,* 1908; Caw; Who's Who 1911; VAM; D. Meldrum, *Watercolours of the Highlands by D.Y.C.,* Apollo 1929; Caw, *Sir D.Y.C.,* OWS XXVII, Cat. Sir D.Y.C. Centenary Exhibition, Scottish Arts Council 1965; Hardie III pp.65, 211 (pl.245); Irwin, p.373.

CAMERON, Duncan fl.1871-1900
Scottish landscape painter working in Stirling and Edinburgh. Exhib. at RA, 1872-1900, and at SS. Titles at RA 'The Druid Stones in Arran', 'A Harvest Field in Perthshire', 'Glencoe', etc.
Bibl: Caw p.303.

***CAMERON, Hugh RSA RSW 1835-1918**
Scottish painter of genre and portraits. Studied under Scott Lauder in the Trustees' Academy in 1852. His work developed parallel with that of G.P. Chalmers and McTaggart, but has its own individuality, a littler gentler than theirs. Apart from portraits, his favourite subjects were homely genre, especially with an accent on childhood or old age; and some of his early works are painted with Pre-Raphaelite finish. He settled in London 1876-88, but later spent the summers at Largs and the winters in Edinburgh. About 1880, he visited the Riviera and painted, exceptionally, a few Italian subjects. ARSA 1859; RSA 1869; RSW 1878. Edinburgh (National Gallery of Scotland) has several of his best works including 'Going to the Hay', 1858 and 'A Lonely Life', 1873. Exhib. at RA 1871-92.
Bibl: Caw pp.259-61 *et. passim* (pl. opp. p.260); Who Was Who, 1916-1928; Cat. National Gallery of Scotland; Irwin pp.348-9 *et passim* (pl.190).

CAMERON, Miss Julia fl.1880-1891
Painter of flowers and other subjects. Exhib. at SS and NWS.

CAMMELL, Bernard E. fl.1883-1913
London painter of portraits and figure subjects. Exhib. at RA, GG and elsewhere. Titles: 'A Derbyshire Lassie', etc.

CAMP, Isabella fl.1882
Exhib. one watercolour of an Arab at SS, 1882. Lived in Watford.

CAMPANELLA, Miss Catherine fl.1854-1862
Painter of European views. Exhib. scenes in Italy, Germany and Holland at RA, BI and SS. Lived in London.

CAMPBELL, Archibald fl.1865-1868
London painter of domestic scenes. Exhib. at BI and SS. Titles: 'Old Sweethearts', etc.

CAMPBELL, Cecilia Margaret 1791-1857 (Mrs. Nairn)
Irish painter of landscapes and flowers. Daughter of John Henry Campbell, also an artist. Exhib. in Dublin from 1809, also at RHA. In 1826 she married George Nairn, ARHA, an animal painter. She painted in both oil and watercolour, and made wax models of flowers. See also Cecilia Margaret Nairn.

CAMPBELL, Lady Colin fl.1886
Exhib. a sketch of 'Thalassa' at SS, 1886. Lived in London.

CAMPBELL, Mrs. Corbett fl.1888
Exhib. one landscape at GG in 1888. London address.

CAMPBELL, Dewer fl.1865-1873
London painter of fruit. Exhib. at RA, BI and SS. Graves spells his christian name Durar.

CAMPBELL, Hon. Mrs. E. fl.1879
Exhib. one picture 'Head of Brittany Peasant Woman' at SS, 1879. London address.

CAMPBELL, H. fl.1850
Exhib. two figure subjects at SS, 1850. London address.

CAMPBELL, Mrs. H. fl.1872
Exhib. two figure subjects at SS, 1872. Greenwich address.

CAMPBELL, Hay fl.1892-1893
London painter of buildings. Exhib. a view of Edinburgh at SS, 1892.

CAMPBELL, J.A.D. fl.1864
Exhib. one picture of fruit at SS, 1864. London address.

***CAMPBELL, James c.1825/8-1893**
Liverpool genre and landscape painter; strongly influenced by the Pre-Raphaelites in the 1850s. Spent most of his working life in Liverpool; studied at RA schools in 1851. Began exhibiting at Liverpool Academy in 1852, elected Associate 1854, Member 1856. 'Eavesdroppers' noticed by Ruskin at SS in 1856; he praised several of Campbell's later pictures at the SS and RA. Campbell only exhib. twice at the RA, in 1859 and 1863, and 13 works at SS. He was supported mainly by northern patrons, such as John Miller, James Leathart and George Rae. His genre scenes of the 1850s are painted with "minute finish, pale tonality, and Dickensian characterisation" (Bennett), but according to Marillier he lacked "the gift of combining figures with scenery". About 1862 he changed to a broader style painting, and the quality of his work declined. After a period in London, he returned to Liverpool, and was forced to give up painting because of failing eyesight.
Bibl: Ruskin, *Notes on SS,* 1856, 1858; Academy Notes, 1859; Marillier pp.81-4 (pl. opp. p.84); Mary Bennett in the Liverpool AG Bulletin Vol.12 1967; Cat. of the Leathart Collection Exhibition, Laing AG, Newcastle, 1968; Staley p.147; Wood, Panorama; Wood, Paradise Lost.

CAMPBELL, John Hodgson 1855-1927
Newcastle painter of domestic subjects and scenes of north country life. Exhib. at RA and NWS. Titles: 'Daddy's Dinner', etc. Founder member of the Bewick Club and the Pen and Palette Club in Newcastle. A picture by him is in the Laing AG, Newcastle.
Bibl: Hall.

CAMPBELL, Oswald R. fl.1847-1852
London painter of biblical subjects. Exhib. at RA and elsewhere.

CAMPBELL, Samuel fl.1854-1857
London painter of Scottish landscapes. Exhib at RA, BI, SS and elsewhere.

CAMPBELL, Captain T.H. fl.1847-1849
Exhib. biblical and other figure subjects at BI, SS and elsewhere. Titles: 'Study from an Arab Inhabitant of Hyderabad', etc. London address.

CAMPION, George Bryant NWS 1796-1870
London watercolourist; painted landscapes and topographical views. Exhib. at SS, but mainly at NWS, of which he was a member. Lived the latter part of his life in Munich. His pictures often contain soldiers. Usually worked on grey or brown paper, using chalk and watercolour.

CAMPION, Mrs. Howard fl.1880
Exhib. one landscape of Sussex at SS, 1880. London address.

CAMPION, Howard T.S. fl.1876-1883
London landscape painter. Exhib. mainly at SS, also at RA and elsewhere. Subjects mostly views in Northern France and South England. His wife was also a landscape painter, who exhib. one picture at SS in 1880 under the name Mrs. Howard Campion (q.v.).

CAMPION, S.M. fl.1882
Exhib. one landscape, 'On the Aven, Brittany' at RA, 1882. London address.

CAMPOTOSTO, Henry fl.1861-1880 d.1910
Belgian painter of rustic genre; worked in Brussels, and came to London about 1870-1. Exhib. at RA 1871-4 and SS, and at Paris Salon. Titles at RA 'The Happy Mother', 'The Child's Caresses', etc. 'Italian Fisher Children' is in the Leeds AG. Sometimes collaborated with the Belgian painter Eugone Verboeckhoven. His sister Octavia Campotosto was also a painter (q.v).
Bibl: Gazette des Beaux-Arts 1860 p.320; AJ 1871 p.80; 1872 p.156.

CAMPOTOSTO, Octavia fl.1871-1874
London painter of portraits and figure subjects. Sister of Henry Campotosto (q.v.). Exhib. four pictures at RA, 1871-4.

CANE, Herbert Collins fl.1883-1891
London painter of animals. Exhib. at RA and NWS. Titles: 'The Startled Hare', etc.

CANNING, Charlotte, Viscountess 1817-1861
Talented amateur watercolourist. Married Lord Canning in 1835, and was a Lady of the Bedchamber to Queen Victoria, 1842-55. Canning was appointed Viceroy of India in 1855, and Charlotte accompanied him there. She travelled widely in India, painting landscapes and flowers, and died there in 1861. Her sister was Louisa, Marchioness of Waterford (q.v.).
Bibl: A.J.C. Hare, *The Story of Two Noble Lives,* 1872; Country Life 4 April 1957; V. Surtees, *Charlotte Canning,* 1975.

CANNING, Mrs. J. Cater (M.W.) fl.1850-1853
Landscape painter. Lived at Bishop's Stortford, Essex. Exhib. at RA, SS and elsewhere. Subjects mostly Essex views.

CANNING, Miss Mary G. fl.1868
Exhib. one view in the Roman Campagna at RA, 1868. London and Dover addresses.

CANNON, Miss Edith M. fl.1892-1902
Painter of portraits and domestic subjects. Exhib. once at RA in 1902; also elsewhere.

CANTELO, Miss Ellen fl.1859
Exhib. one picture 'Westmill' at SS, 1859.

CANZIANI, Mrs. Starr see STARR, Miss Louisa

CAPARN, W.J. fl.1882-1893
Oundle landscape painter. Exhib. one picture 'At Capel Curig' at SS, 1882.

CAPE, E.J. fl.1879
London landscape painter. Exhib. one picture 'On the Common' at SS, 1879.

CAPES, Miss Mary fl.1881
Recorded by Graves as exhib. one landscape in 1881. London address.

CAPPER, Miss Edith fl.1865-1884
Southampton landscape painter. Exhib. at RA, SS, NWS, GG and elsewhere. Titles: 'Grey Evening', etc.

CAPPER, J.J. fl.1849-1859
London landscape painter. Exhib. at RA only, 1849-59. Subjects include English and Italian views.

CARDON, Claude fl.1892-1915
London painter of domestic subjects. Exhib. at RA and SS. Titles: 'A Family of Three', etc.

CARELLI, Conrad H.R. b.1869 fl.1886-1897
Painter of Egyptian scenes. Exhib. at RA, SS, NWS and NG. Son of Gabriel Carelli (q.v.).

CARELLI, Gabriel 1821-1900
Landscape painter. Son of Raphael Carelli, who was patronised by the Duke of Devonshire. Gabriel settled in England, married an Englishwoman, and took British nationality. Travelled widely in Europe, North Africa, Turkey and Palestine. Exhib. at RA from 1874, and elsewhere. Patronised by Queen Victoria. Consalvo Carelli was his brother, and Conrad H.R. Carelli his son (q.v.).
Bibl: see TB.

CAREY, Miss A.S. fl.1881
Exhib. one picture at GG 1881.

CAREY, Mrs. Charles fl.1869-1872
Recorded by Graves as exhib. seven pictures 1869-72. Guernsey address.

CAREY, Charles W. fl.1882
Exhib. one picture 'Scandal' at SS, 1882.

CAREY, Miss Violet M. fl.1894-1895
London portrait painter. Exhib. two portraits at RA 1894-5.

CARL, C. fl.1857
Exhib. one picture 'Study of a Head' at BI, 1857.

CARLAW, John RSW 1850-1934
Glasgow painter of animals and Scottish landscapes. Studied at Glasgow School of Art. Exhib. at RA, NWS, and elsewhere. Specialised in pictures of horses and dogs, especially around Helensburgh, where he lived. A William Carlaw (1847-89) and Effie Carlaw (fl.1886) are also recorded, presumably part of the same family.
Bibl: Caw p.341.

CARLILL, Stephen Briggs fl.1888-1897 d.1903
Painter of portraits, animals and historical subjects. Exhib. at RA, NWS, and NG. His wife Mrs. S.B. Carlill exhib. portraits and figure subjects at RA, 1895-6. Carlill was master of Hull School of Art. Later he emigrated to South Africa.

CARLINE, George F. RBA 1855-1920
Painter of portraits and rustic genre, especially scenes in gardens. Born in Lincoln. Studied at Heatherley's, also in Paris and Antwerp. Exhib. at RA from 1886, SS, NWS and elsewhere. In 1896 an exhibition of his work was held at Dowdeswell's Gallery entitled 'The Home of our English Wild Flowers'.

CARLINE, H. fl.1849
Exhib. one picture at RA, 1849 — 'The Departure of Young Tobias under the Guidance of the Angel Raphael'.

CARLISLE, 9th Earl of see HOWARD, George

CARLISLE, John fl.1866-1893
London landscape painter. Exhib. mainly at SS, also RA (1881-9) and NWS. Travelled in Italy. Titles at RA 'Glen Cloy, Arran', 'Hayes Common, Kent', etc.

CARLISLE, Miss Mary Helen 1869-1925
London painter of figure subjects. Exhib. at RA only, 1891-1925. Titles: 'After the Ball', etc. Two miniature portraits by her of Queen Victoria are in the NPG.
Bibl: Ormond I pp.477-8, 492.

CARLTON, C. fl.1870-1871
London landscape painter. Exhib. three watercolours at SS, 1870-1.

CARLYLE, Miss Florence fl.1896-1921
Painter of figure subjects, portraits and still-life. Exhib. at RA, 1896-1921. Lived in London and Crowborough, Sussex.

CARMAN, H.A. fl.1867-1873
Painter of fruit and flowers. Exhib. at SS, 1867-73. Lived at Crayford, Kent.

***CARMICHAEL, John Wilson** 1800-1868
Newcastle marine painter. Graves and all later writers mistakenly call him James. Friend and pupil of T.M. Richardson Snr. (q.v.). Exhibited mainly at the Northern Academy of Arts in Blackett Street, Newcastle, which was next door to his studio. Travelled in Holland, Italy, and also in the Baltic. Recorded the Crimean War for *The Illustrated London News*. Also painted landscapes and

watercolours. He coloured the figures and buildings in many of John Dobson's architectural drawings, and also did a series of railway drawings. Lived in London for a time, but retired due to ill-health to Scarborough, where he died. Exhib. at the RA 1835-59, BI and SS. The centenary exhib. of Carmichael's work at the Laing AG, Newcastle 1968, was the most comprehensive devoted to him. The catalogue contains a detailed account of his career. Works by Carmichael can be seen at Greenwich, Newcastle, Gateshead and Sunderland AG. His studio sale was held at Christie's, 24-5 November 1870.

Bibl: AJ 1868 p.128 (obit.); Redgrave, Dict; Cundall; DNB; Hughes VAM; Wilson, *Marine Painters*, pl.7; Cat. of J.W.C. Centenary Exhibition, Laing AG 1968; Hardie III pp.68, 72 (pl.87); Maas p.63; Hall; Ormond I pp.95, 130, 132; Brook-Hart.

CARMICHAEL, H.G. see SCHMALZ, Herbert Gustave

CARMICHAEL, Mrs. M.D.T. fl.1857
London flower painter; exhib. one picture in 1857.

CARON, Miss L. fl.1854-1855
London painter of portraits and figure subjects. Exhib. two pictures at RA, 1854-5.

CARPENTER, A.R. fl.1868-1890
Birmingham landscape painter, in both oil and watercolour, who exhib. there, 1868-90.

CARPENTER, Miss Dora fl.1880-1883
London painter of domestic subjects. Exhib. at RA and SS. Titles: 'A Total Abstainer', etc.

CARPENTER, H. Barrett fl.1890
Liverpool still-life painter. Recorded by Graves as exhib. one picture in 1890.

CARPENTER, J. Lant fl.1886-1892
Derby landscape painter. Exhib. at RA, SS and elsewhere. Subjects all English views.

CARPENTER, Margaret Sarah 1793-1872
Painter of portraits and figure subjects. Born Margaret Geddes in Salisbury. Her first art studies were made from the pictures at Longford Castle, belonging to Lord Radnor. Came to London in 1814, and soon established her reputation as a fashionable portrait painter. Exhib. at RA, 1818-66, BI and SS. In 1817 she married William H. Carpenter, Keeper of Prints and Drawings at the British Museum, and on his death in 1866, Queen Victoria conferred on her a pension of £100 p.a. Her portraits follow in the tradition of Lawrence, but have a more fanciful and feminine character which is particularly noticeable in her portraits of children. Three of her works are in the NPG, including portraits of R.P. Bonington and John Gibson. There are also several 'leaving portraits' by her in the collection at Eton College.

Bibl: AJ 1873 p.6; Clayton I p.386; Redgrave, Dict.; Bryan; W. Shaw Sparrow, *Women Painters of the World*, 1905 pp.60, 66, 96, 100; DNB 1908; Ormond see index.

CARPENTER, Percy fl.1841-1858
London painter of church interiors. Exhib. at RA and BI. Also exhib. views of Gibraltar and Singapore.

CARPENTER, William 1818-1899
Painter of figure subjects, historical and mythological subjects and portraits, who exhibited at the RA 1840-66. He lived in London but after 1862 in Boston, U.S.A. In 1855 he accompanied the Punjab Irregular Force to Afghanistan, and exhibited several eastern subjects as a result of his journey. Titles at the RA include among portraits: 'Thetis Bathing Achilles in the Styx', 'Charles II in Holland before the Restoration'. Son of Margaret Carpenter (q.v.).

Bibl: VAM; Ormond I p.343.

CARPENTIER, Felix fl.1888
Exhib. one picture of flowers at SS, 1888. London address.

CARR, Miss Bessie fl.1883-1890
Painter of portraits and figure subjects. Exhib. at RA and SS. Addresses recorded in London, Worthing and Paris.

CARR, David 1847-1920
Painter of rustic scenes and other figure subjects. Studied under Legros at the Slade School, and also in Paris. Exhib. at RA, SS, NWS, GG, NG and elsewhere. Later he lived at Beer in Devon, where he designed several country houses.

CARR, Ellis fl.1884
Recorded by Graves as exhib. one landscape in 1884. London address.

CARR, Miss Kate fl.1871-1877
London portrait painter. Exhib. at GG and elsewhere, 1871-7.

***CARRICK, John Mulcaster fl.1854-1878**
Landscape painter, and painter of figure subjects who exhibited at the RA 1854-71, and occasionally at BI and SS. Member of the Hogarth Club, which sympathised with Pre-Raphaelite ideas. Little known, except that Ruskin praised his 'The Village Postman', RA 1856 and 'Rydal', RA 1857. Travelled in France, Switzerland and Spain. His pictures are usually small, detailed, and of high quality, but in his later period he painted a number of rather repetitious coastal scenes.

Bibl: Ruskin, Academy Notes 1856-7.

CARRICK, Robert RI c.1829-1904
Painter of genre and landscapes who exhibited at the RA 1853-80, titles including 'A Day in the Fields', 'The Widow's Cares', 'The Cottage Door', 'Saved from the Wreck'. Ruskin admired his 'Thoughts of the Future', RA 1857, and 'Weary Life', RA 1858.

Bibl: AJ 1859 p.162; 1869 p.302; Ruskin, Academy Notes 1857-8.

CARRINGTON, E. fl.1871-1873
London painter. Exhib. a view in Rome and one in Venice at RA in 1871 and 1873.

CARRINGTON, Frances E. fl.1869-1870
Recorded by Graves as exhib. four landscapes, 1869-70. Dunkeld address.

CARRINGTON, James Yates fl.1881-1891 d.1892
Genre and landscape painter who exhibited at the RA 1882-9, titles including 'So Sinks the Day to Eventide', 'Steerage Passengers', 'An Out-patient at King's College Hospital'. Graves Dictionary gives his speciality as animals.

Bibl: AJ 1892 p.224.

CARRINGTON, Louis fl.1874-1888
Landscape painter. Exhib. watercolours at SS, NWS and elsewhere. Views in Wales, Cornwall and elsewhere. Lived at Forest Hill, near London.

CARRINGTON, Mrs. Patty fl.1883-1887
Worcester flower painter. Exhib. three watercolours at NWS, 1883-7.

CARROLL, Colin R. fl.1893
Exhib. one picture 'Seven Thousand Feet above the Sea' at RA, 1893. Liverpool address.

CARRUTHERS, George P. fl.1897-1930
Leeds landscape painter. Exhib. one picture 'A Silvery Morning' at RA, 1897, and again in 1928 and 1930.

CARSE, Alexander fl.1808-1835 d.c.1838
Scottish painter of figure subjects. Went to London in 1812, but returned to Edinburgh about 1820. Exhib. at RA and BI. His subjects were mostly scenes from Scottish life, observed with a racy and realistic humour. They are said to have influenced the young David Wilkie. He also painted subjects from Ramsay and Burns. William Carse, thought to be his son, painted similar subjects in an inferior style.
Bibl: Portfolio 1887 p.90; DNB; Caw p.106; Irwin pp.190-1 *et passim* (pls.73-4)

CARSE, J.H. fl.1860-1862
London landscape painter. Exhib. one picture 'An Old Mill on the Avon near Bathgate' at SS, 1860, and elsewhere.

CARSOE, W. fl.1849-1853
Exhib. a landscape and a biblical subject at BI in 1849 and 1853. London address.

CARSWELL, J. fl.1842-1853
London painter of Scottish landscapes. Exhib. at BI and SS.

CARTE, M. fl.1867
Exhib. one picture 'The Passing Cheer' at BI, 1867.

CARTE, Miss Rose fl.1873-1885
London flower painter. Exhib. two watercolours at SS; also once at GG.

CARTE, Miss Viola fl.1874-1877
London painter of figure subjects. Exhib. twice at RA, in 1875 and 1877, and elsewhere. Titles: 'Betwixt This Mood and That', etc.

CARTER, Miss Austin fl.1862-1873
Painter of literary subjects and portraits. Exhib. mainly at SS, also once at RA, 1868. Exhibits at SS mostly Shakespearian subjects, and mostly in watercolour.

CARTER, Miss B. fl.1856-1859
Exhib. two portraits and one other subject, 'Numa Pompilius Instructed by the Nymph Egeria', at RA in 1856 and 1859. London address.

CARTER, C. fl.1850
Exhib. one picture 'The Young Shepherd' at SS, 1850. London address.

CARTER, Charles fl.1868-1873
Exhib. two watercolours, one of fruit and the other 'The Story Book' at SS, 1868 and 1873.

CARTER, E. fl.1877
Exhib. one watercolour of Henry VII's Chapel, Westminster, at SS 1877.

CARTER, Mrs. E.S. fl.1861-1874
London painter of fruit and flowers. Exhib. at SS and elsewhere mostly watercolours.

CARTER, Emily fl.1880
Recorded by Graves as exhib. one picture of flowers in 1880. Address Wallington, Berkshire.

CARTER, Frank Thomas 1853-1934
Newcastle landscape painter. Exhib. one picture 'Cheviot Moorland' at SS, 1892, also at RA from 1898, and other galleries, including the Paris Salon. Painted mostly in the Lake District.
Bibl: Hall.

CARTER, H. fl.1867
Birmingham landscape painter. Exhib. one picture 'Old Cottage near Llangollen' at SS, 1867 .

CARTER, Henry fl.1866
London animal painter. Exhib. two pictures of rabbits at SS, 1866.

CARTER, Henry Barlow 1803-1867
Painter of coastal scenes, mostly in watercolour. Born in Scarborough but lived mostly in Plymouth. Exhib. at RA, BI, and SS. Some of his large atmospheric watercolours show the influence of Turner. His children included J.N. Carter (q.v.), Vandyke Carter, and possibly Matilda Austin Carter and R.H. Carter (qq.v.), all artists.
Bibl: Binyon; VAM; Cundall; Redgrave; Brook-Hart p.68.

CARTER, Henry William fl.1867-1893
London painter of animals and domestic subjects. Exhib. mainly at SS, also at RA. Titles: 'A Lucky Dog', etc.

CARTER, Hugh RI 1837-1903
London painter and watercolourist, of portraits, domestic genre and other figure subjects. Born in Birmingham. Studied in Düsseldorf under E. von Gebhart. Exhib. at the RA, 1859-1902, but mostly at NWS. Elected ARI 1871, RI 1875. Influenced by the Hague School.
Bibl: Cundall; Studio XXIV 1902 p.267; Ormond I pp.399-40.

CARTER, J.H. fl.1839-1856
London painter of portraits. Exhib. at RA only 1839-56. Painted a portrait of King William IV.
Bibl: Ormond I p.514.

CARTER, J.M. fl.1842-1865
Painter of landscape and still-life. Exhib. at RA, BI and SS. Subjects include views of Gibraltar, scenes in Scotland, and still-life of fruit. Addresses recorded in Gibraltar, London and Monmouth.

CARTER, Joseph Newington 1835-1871
Recorded by Graves as exhib. six coastal scenes, 1857-60. Scarborough address. Son of H.B. Carter (q.v.).
Bibl: Brook-Hart.

CARTER, Miss Mabel fl.1892
Recorded by Graves as exhib. one picture of figures, 1892. Address Bexley, Kent.

CARTER, Miss Matilda Austin fl.1884-1893
London painter of flowers. Exhib. three watercolours at NWS, 1884-93.

CARTER, Miss Mary E. fl.1884
Exhib. one watercolour of flowers at SS, 1884. London address.

CARTER, Richard Harry 1839-1911
Cornish painter of landscape and coastal scenes. Lived in Truro. Exhib. at RA, 1871-1908, SS, NWS, GG and elsewhere. Subjects at RA mostly scenes in Cornwall or Scotland.

CARTER, Robert fl.1874
Exhib. two watercolour landscapes at SS, 1874. Southampton address.

***CARTER, Samuel John 1835-1892**
Norfolk animal and sporting painter. Born in Swaffham, and studied in Norwich. Lived in London and Swaffham. Specialised in sentimental pictures of dogs and puppies. Exhib. at RA, BI, SS, GG. Ruskin, always sentimental about animals, praised Carter's 'The First Taste', RA 1875, as "exemplary in its choice of a moment of supreme puppy felicity as properest time for puppy portraiture". Pictures are in the Tate and Preston AG.
Bibl: Ruskin, Academy Notes 1875.

CARTER, Samuel, Jnr. fl.1880-1888
London landscape painter. Son of Samuel John Carter (q.v.). Exhib. at SS and elsewhere.

CARTER, T.A. fl.1885
Exhib. one picture 'A Canal Scene, December', at SS, 1885. Leamington address.

CARTER, T.W. fl.1847
Exhib. one picture of the interior of the Church of St. Jacques, Liège, Belgium, at RA, 1847. London address.

CARTER, W. fl.1849-1850
London landscape painter. Exhib. one oil at RA, 1849 and one watercolour at SS, 1850.

CARTER, W.J.B. fl.1876-1880
Exhib. a portrait at RA, 1880. London address.

CARTER, William fl.1843-1864
London landscape painter and topographical artist, who exhibited at the RA from 1843-64; in 1843 'Sketch on the Spot of Jacob's Island, Southwark, mentioned by Boz in *Oliver Twist*'.

CARTER, William RBA 1863-1939
Norfolk painter of portraits, animals and still-life. Son of Samuel John Carter (q.v.) and brother of the Egyptologist Howard Carter. Studied at RA schools, and exhib. at RA, 1883-1938, SS, GG, NG and elsewhere. RA exhibits all portraits. Lived mainly at Swaffham in Norfolk, but also in London. Member of the Society of Portrait Painters.
Bibl: The Year's Art 1911 p.460

CARTMILL, E. fl.1858
Exhib. one landscape 'The Footbridge' at SS, 1858. London address.

CARTWRIGHT, Frederick William fl.1854-1889
London painter of landscapes, portraits and rustic genre who exhibited at the RA 1854-89. He lived in London, Brixton and Dulwich and the landscapes he exhibited at the RA were of views in Devon, N. Wales, Hastings and Haslemere. TB also calls him a marine artist.

CARTWRIGHT, Miss Rose fl.1883-1888
London landscape painter. Exhib. at GG and NG.

CARWARDINE, Miss Mary E. fl.1883-1888
London painter of landscape and rustic scenes. Exhib. at SS and NWS, all watercolours. Titles: 'Rural Pleasures', etc.

CARY, Frances Stephen 1808-1880
Genre and historical painter who exhibited at the RA 1837-76, titles including illustrations of scenes from Shakespeare, 'Abelard and Heloise', 'Escape of Eliza', 'St. Valentine's Day', 'The Village Well', etc. A pupil of Henry Sass in Bloomsbury, he also went to the RA Schools and for a short time was in Lawrence's studio. 1829 in Paris and Munich; 1833-5 on foreign travel. In 1842 he took over the management of Sass's art school in Bloomsbury, and is best known for this. This school was modelled on the school of the Carracci in Bologna and many prominent painters went there — Cope, Millais, Rossetti, etc. Through his father, the Rev. Henry Francis Cary (1772-1844), the translator of Dante, he enjoyed much of the literary society of the day. He painted an interesting portrait of Charles and Mary Lamb (NPG). He retired to Abinger Wotton in 1874.
Bibl: AJ 1880 p.108; DNB; Bryan.

CASE, Bertha L. fl.1873
Exhib. two pictures of flowers in 1873. Address Maidstone, Kent.

CASEY, John Archibald fl.1830-1859
London painter of historical subjects. Exhib. at RA, BI and SS. RA titles scenes from Mary Queen of Scots, Joan of Arc, Margaret of Anjou, etc.

CASEY, William Linnaeus 1835-1870
London painter of landscape and figure subjects. Exhib. mostly at SS (mainly watercolours), also RA and BI. Born in Cork. Set up as a drawing master in London, and was Master of the St. Martin's Lane Academy.

CASHEL, Miss Mary fl.1892
Exhib. one interior at NWS, 1892. London address.

CASLEY, William fl.1891
Exhib. one coastal scene at NWS, 1891. Address The Lizard, Cornwall.

CASS, Miss Margaret fl.1890
Exhib. one flower picture in 1890. London address.

CASSELS, William fl.1893
Glasgow landscape painter. Exhib. one picture of a Scottish landscape at RA, 1893.

CASSIDY, John fl.1893
Manchester portrait painter. Exhib. three portraits at NG, 1893.

CASSIE, James RSA RSW 1819-1879
Aberdeen painter of landscapes and coastal scenes. Exhib. at RA 1854-79, BI and SS. Subjects usually calm sea at dawn or sunset, but titles at RA include several domestic genre subjects also. Elected ARSA 1869, RSA 1879. Many of his works are in Aberdeen AG.
Bibl: Caw p.324.

CASTLE, Miss Florence b.1867 fl.1891-1904
London painter of figures and domestic subjects. Exhib. at RA, SS and elsewhere. Titles: 'A Maiden Fair', etc.

CASWALL, Miss A.M. fl.1870-1874
Painter of animals and flowers. Exhib. at RA and SS. Address Binfield, Berkshire.

CATCHPOOL, H. fl.1881
Exhib. one picture 'The Hall Table' at SS, 1881. Address Crouch End.

CATLIN, George fl.1848
Exhib. five pictures of 'figures' in 1848. London address.

CATLOW, George Spawton fl.1884-1900
Leicester landscape painter. Exhib. at RA, 1884-1900, also NWS. RA exhibits include views in Cornwall, the Midlands, and the Channel Islands.

CATTERMOLE, Charles RI RBA 1832-1900
London painter and watercolourist; nephew of George Cattermole (q.v.). He painted historical and other figure subjects in a style similar to that of his uncle, and exhibited mainly at NWS and SS; also a few pictures at RA and BI. Became ARI 1864, RI 1870.
Bibl: Bryan; Cundall; VAM 1908.

***CATTERMOLE, George 1800-1868**
Architectural draughtsman and topographer of the romantic movement, illustrator, and painter of historical genre. Placed about 1814 with John Britton, to study architecture, and began his career as a topographical draughtsman, making illustrations for Britton's *Cathedral Antiquities of Great Britain.* Elected A of the OWS 1822, and Member 1833, but resigned in 1852 when he took up oil painting, although he later returned to the practice of watercolour. Abandoning purely architectural for figure subjects, he became a painter of historical genre, of great spirit and originality. He exhibited 1819-50, 105 works at the RA (1819-27) BI and OWS (97 works). He worked much for publishers, making illustrations for Roscoe's *Wanderings in N. Wales,* the *Waverley Novels,* several of Dickens's novels, a history of the Civil War by his brother Richard, etc. He was a close friend of Dickens and Thackeray, Macready and Maclise. Ruskin *(Modern Painters),* admired him: "The antiquarian feeling of Cattermole is pure, earnest, and natural; and I think his imagination originally vigorous, certainly his fancy, his grasp of momentary passion considerable, his sense of action in the human body vivid and ready". But at the same time Ruskin felt his later work was ruined by a lack of study of nature, and was "tending gradually through exaggeration to caricature". His studio sale was held at Christie's, 8 March 1869.
Bibl: AJ 1857 July; 1868 Sept.; 1870 March; J. Ruskin, *Modern Painters,* I 1843; Redgrave, Cent., Dict.; Clement & Hutton; Roget; Binyon; Cundall, DNB; Hughes; VAM; R. Davies, *George Cattermole,* OWS IX 1932; Hardie III *passim* (pl.113); Ormond I p.40.

CATTERMOLE, Leonardo F.G. fl.1872-1886
London painter of historical subjects, mainly in watercolour. Exhib. at SS, GG and elsewhere. Subjects mostly taken from the Civil War period.

CATTY, A. fl.1854
Exhib. one picture 'The Cousins' at RA, 1854. No address given.

CAUCHOIS, Henri fl.1883-1890
London painter of flowers. Exhib. nine pictures at SS, 1883-90. This is probably Eugène-Henri Cauchois (1850-1911) the French painter of flowers.

CAUDER, A. fl.1853
Exhib. one picture of flowers in 1853. London address.

CAUDRON, J. fl.1864
Exhib. one picture 'La Cuisinière' at RA, 1864. Address near Barnet, Hertfordshire.

CAULFIELD, F.W. fl.1878
Exhib. one picture of flowers, 1878. Address Crowthorn.

CAUNTER, R. fl.1850
Exhib. one picture 'The Boatie Rows' at RA, 1850. Edinburgh address.

CAUTY, Horace Henry 1846-1909
Genre and historical painter who exhibited at the RA from 1870-1904. Titles include: 'The Inspection of the Watch', 'The Vagabond', 'Tramps', 'Little Sunshine', etc. He was Curator of the RA Schools.
Bibl: The Year's Art 1910 p.387; Wood, Paradise Lost.

CAUTY, Horace Robert fl.1870-1893
London landscape painter. A prolific exhibitor at SS, mostly watercolours of English scenery and coastal scenes. Also exhib. at NWS and elsewhere.

CAVELL, John Scott fl.1851-1863
London painter of figure subjects. Exhib. at RA, BI and SS. Titles at RA 'Hassman, the Arab Interpreter', 'A Pillow of Snow', 'Un Peu Fatigué', etc.

CAWKER, L.G. fl.1857-1858
London painter of flowers. Exhib. two pictures at SS, 1857-8.

CAWKER, Miss Maud fl.1896
Exhib. one portrait at RA, 1896. Address Bushey, Hertfordshire.

CAWSE, Miss Clara fl.1841-1867
London painter of portraits and figure subjects. Exhib. at RA, BI and SS. Subjects at RA mostly portraits, also genre, e.g. 'Weary Travellers', and subjects from Dickens. Presumably the daughter of John Cawse (q.v.), as they are recorded at the same address.

CAWSE, John 1779-1862
London painter of portraits, horses, and historical subjects. Exhib. at RA, BI, SS and OWS, 1802-45. His early works were mostly portraits and sketches, as he was kept occupied by teaching. Later he turned to painting portraits of racehorses, and scenes from Shakespeare. He published *The Art of Oil Painting* in 1840.
Bibl: Redgrave, Dict.

CHABOT, A. fl.1841-1846
London painter of landscape and rustic subjects. Exhib. at RA and SS. Titles mostly English views.

CHADBURN, G.H. fl.1891
Exhib. one still-life at SS, 1891. Address Sutton, Surrey.

CHADWICK, Miss Emma L. fl.1890
Exhib. two pictures of domestic subjects in 1890. Paris address.

CHADWICK, Ernest Albert RI b.1876 fl.1900-1939
Birmingham painter of landscapes, gardens and flowers. Exhib. mainly at RBSA, of which he became a member in 1912.
Bibl: Wood, Painted Gardens.

CHADWICK, Henry Daniel fl.1879-1896
London painter of portraits and figure subjects. Exhib. at RA and SS. RA titles 'A Grecian Princess', 'In Cupid's Bonds', etc. and portraits.

CHALK, Miss Hilda fl.1899
Brighton painter; exhib. one picture, 'Sowing', at RA, 1899.

CHALKLEY, H.E. fl.1848
London landscape painter. Exhib. two Essex scenes at SS, 1848.

CHALLENGER, J. fl.1893
Exhib. one landscape of Richmond Park at SS, 1893. Address Twickenham, near London.

CHALLICE, Miss Annie Jane fl.1866-1904
London painter of domestic and historical subjects. Exhib. at RA, SS and elsewhere. Titles: 'Poor but Content', etc. Also exhib. some portraits and still-life.

CHALLIS, Ebenezer fl.1846-1863
London painter of churches and ruins. Exhib. at RA and SS. RA exhibits all views of cathedrals, churches, ruined abbeys, etc. Also engraved pictures for *The Art-Journal* and other publications, after David Roberts, Thomas Allom, W. Turner and others.

CHALLISS, Charles A. fl.1899
Harrow painter; exhib. one picture 'Galley Head, St. Leonard's' at RA, 1899.

***CHALMERS, George Paul RSA RSW 1833-1878**
Painter of domestic genre, portraits and landscapes. The son of the captain of a coasting vessel, and apprenticed to a ship chandler, he eventually came to Edinburgh and at the age of 20 became a student at the Trustees' Academy under R. Scott Lauder. Settling in Edinburgh, he led a quiet and uneventful life in the practice of art, varied by occasional painting trips to Ireland, the Continent, Skye and Glenesk. A of the RSA in 1867, and member in 1871. His genre paintings and portraits are usually of single quiet figures seated in dimly-lit interiors, usually placed in strong light and shade, and are similar to those of R. Scott Lauder. The Scottish National Gallery has several examples e.g. 'A Quiet Cup' (an old woman taking tea), and 'The Tired Devotee' (a child dozing in church).
Bibl: AJ 1897 pp.83-8; 1878 p.124 (obit.); Portfolio 1887 p.189; 1877 p.192; 1880 p.39ff.; A. Gibson and J. Forbes White, *Memories of C.P.C. and the Art of his Times*, 1879; Edward Pinnington, *C.P.C. and the Art of his Times*, 1897; Holmes, *Royal Scottish Academy*, Studio 1907; Caw pp.244-7 (pl. opp. 244); DNB; Irwin pp.344-8 *et passim* (pls.170, 182).

CHALMERS, Mary H. fl.1880
Exhib. one picture 'Telling Fortunes' at SS, 1880. London address.

***CHALON, Alfred Edward RA 1780-1860**
Painter of portraits and of contemporary and historical genre. Younger brother of John James Chalon (q.v.). He was the most fashionable painter of portraits in watercolour — usually about 15 ins. high, and also miniatures on ivory, and was the first to paint Queen Victoria on her accession to the throne, and thereby received the appointment of Portrait Painter to H.M. the Queen. Among his best known subject pictures are 'Hunt the Slipper', 1831; 'John Knox Reproving the Ladies of Queen Mary's Court', 1837; 'Sophia Western', 1857. He was clever at imitating the styles of other painters and particularly Watteau. He also painted a vast number of works in oils, and exhib. at the RA 1801-60. ARA 1812, RA 1816.
Bibl: VAM, MS letters to and from John Constable, 1822-51; Redgrave, Cent., Dict.; AJ 1860 p.337; 1862 p.9 (article by James Dafforne); *Autobiographical Recollections of C.R. Leslie*, ed. Tom Taylor, 2 vols., *passim*, 1865; Roget; Bryan; Binyon; Cundall; Hughes; VAM; A.P. Oppe, *English Drawings at Windsor Castle*, 1950; DNB; Hardie II pp.149 (pl.135); Ormond I see index.

CHALON, Henry Bernard 1770-1849
London sporting and animal painter, and lithographer. Son of Jan Chalon, a Dutch engraver (1738-95). Animal painter at the Prince Regent's Court and to the Duke of York. Mainly painted horses and dogs, in the Ben Marshall/Abraham Cooper tradition. Exhib. at the RA 1792-1847 (198 works), BI and SS.
Bibl: AJ 1849 p.271; Redgrave, Cent.; Pavière, Sporting Painters (pl.9); Ormond I p.40.

***CHALON, John James RA 1778-1854**
Painter of landscape, genre and animals, both in oil and watercolour. Brother of A.E. Chalon (q.v.). Born at Geneva of French parents; came to England in 1789, when his father became French professor at Sandhurst. Entered the RA Schools in 1796. Exhib. 1801-54, 86 works at the RA, 48 at the BI, and 55 at the OWS. Elected ARA 1827, and RA 1841; A of the OWS 1805 and Member 1807-12. In 1816 he exhibited an important work at the RA, 'Napoleon on Board the Bellerophon', and 'The Gravel Pit' at the International Exhibition in 1862, said to be one of his best works. Redgrave, Cent. notes that "in his early days much of his time was given up to teaching, and although he was an exhibitor for fifty years his works are comparatively few". He was a friend of C.R. Leslie who wrote of him that few painters "had so great a range of talent" — he painted landscapes, figure and animal subjects, and marine pictures with equal facility and success. He published in 1820 *Sketches from Parisian Manners*.
Bibl: C.R. Leslie in AJ 1854 p.375; 1855 p.24; Redgrave, Cent., Dict.; Roget; Binyon; Cundall; DNB; Hughes; VAM; Ormond I p.98.

CHAMBERLAIN, W.B. RSW fl.1879-1889
Brighton landscape painter. Exhib. twice at RA, and at NWS and RSW. RA subjects views in Scotland and Italy.

CHAMBERLIN, Mrs. Amy G. fl.1895-1897
Exhib. two pictures 'The Rose Queen' and 'Stella' at RA in 1895 and 1897. London address.

CHAMBERS, Alfred P. fl.1859-1862
London painter of historical and literary subjects. Exhib. at BI, SS and elsewhere. Works include subjects from Shakespeare.

CHAMBERS, Miss Alice May fl.1880-1893
London painter of Egyptian and mythological subjects. Exhib. at RA, NWS, NG and elsewhere. Titles at RA 'A Priestess of Ceres', 'During the Prelude', 'Psyche', etc.

CHAMBERS, Coutts L. fl.1883-1890
London landscape painter. Exhib. at GG only, 1883-90.

CHAMBERS, E. fl.1855
Exhib. one picture 'Signalizing for a Pilot off Dover' at BI, 1855. London address.

CHAMBERS, Frederick fl.1886-1891
London landscape painter. Exhib. once at RA, 1886 and once at SS, 1891.

***CHAMBERS, George RWS 1803-1840**

Marine painter and watercolourist. Born at Whitby, the son of a fisherman. Worked as a sailor until he was 17, when he set up as a house and ship painter. Came to London, and began to practise as a ship painter. Also worked as a scenery painter at the Pavilion Theatre. He was much patronised by naval officers; in 1830 was commissioned by William IV to paint four pictures, which are still in the Royal Collection. Exhib. 1827-40 at RA, BI, SS, OWS and NWS. Elected ARWS 1834, RWS 1835. Both his oils and his watercolours are lively and spirited, and show a real knowledge of ships and the sea.

Bibl: AU 1840 p.186ff. (obit.); AJ 1859 p.332; Portfolio 1888 p.127; *Memoir of G.C.*, 1837; J. Watkins, *Life and Career of G.C.*, 1841; Redgrave, Dict.; Roget; Binyon; Cundall; DNB; Hughes; VAM; Wilson; Hardie III pp.72-5 (pls.89-90); Maas pp.62-3; Brook-Hart p.36 (pl.15).

CHAMBERS, George, Jnr. fl.1848-1862

Marine painter, son of George Chambers (q.v.). Exhib. RA 1850-61, BI and SS. Subjects at RA river and coastal scenes, e.g. 'Lord Mayor's Day', 'Schooner Ashore near Whitby', etc. His work is often confused with that of his father.

Bibl: Brook-Hart p.36 (pl.73).

CHAMBERS, John 1852-1928

Painter and watercolourist; born and worked in North Shields, near Newcastle. Studied in Paris. Painted local views along the Tyne, and local portraits, including one of the painter H.H. Emmerson (q.v.).

Bibl: Hall.

CHAMBERS, Thomas fl.1849-1858

Painter of rustic subjects and coastal scenes. Exhib. at SS only, 1849-58. Addresses London and Scarborough. Due to lack of success, he gave up art for the millinery trade.

Bibl: Brook-Hart.

CHAMBRE, Mrs. fl.1869-1874

London painter of figure subjects. Exhib. three watercolours at SS, 1869-74. Titles: 'The Girl in my Heart', etc.

CHAMPION, Edward C. fl.1870-1883

London painter of domestic subjects. Exhib. at RA and SS. Titles: 'Hide and Seek', etc.

CHAMPION, Mrs. H. fl.1868-1885

London painter of domestic and other figure subjects. Exhib. mainly at SS; also RA and NWS. RA titles 'Meditation','Baby', 'An Italian Girl', etc.

CHAMPION, H.E. fl.1874

Exhib. two studies of heads at SS, 1874. No address given.

CHANCE, Miss Jane fl.1888

Exhib. one portrait in 1888. London address.

CHANCE, Mrs. W. (Julie C.) fl.1896-1898

Painter of cats. Exhib. three pictures at RA, 1896-8. Lived at Frimley, Surrey.

CHANDLER, Miss Rose M. fl.1882-1891

Painter of landscape and figure subjects. Exhib. at SS, NWS and elsewhere, mostly watercolours. Lived at Haslemere, Surrey.

CHANNER, Miss C. Alfreda fl.1876-1892

London painter of interiors and figure subjects, mostly in crayons and watercolour. Exhib. at RA, SS, NWS and elsewhere.

CHANNON, Miss M.E. fl.1858-1865

London painter of flowers. Exhib. at RA once in 1865, also at SS.

CHANT, J. fl.1849

Exhib. one picture of fruit 1849. London address.

CHANTRE, C. fl.1863

Exhib. one picture of fruit at RA, 1863. Clapton address.

CHAPLIN, Mrs. Annie fl.1883

Exhib. one picture 'An Arab Girl' at RA, 1883. London address.

CHAPLIN, Florence fl.1882

Exhib. one picture 'Little Kitty' at SS, 1882. London address.

CHAPLIN, Frank fl.1879

Exhib. one picture of fruit at SS, 1879. Worcester address.

CHAPLIN, Henry fl.1855-1879

Worcester still-life painter. Exhib. at RA, BI and SS. Subjects at RA mostly of fruit

Bibl: AJ 1859 p.122.

CHAPMAN, Abel 1851-1929

Animal painter and illustrator. Born in Sunderland; lived at Houxty, near Wark-on-Tyne. He was a naturalist and writer on animals, and produced many drawings and watercolours to illustrate his own works. Many of his drawings are in the Hancock Museum, Newcastle.

Bibl: Hall.

CHAPMAN, Mrs. Catherine J. fl.1894

Exhib. one picture of flowers at RA, 1894. Address Cheshunt, Hertfordshire.

CHAPMAN, George R. fl.1863-1874

Portrait painter who exhibited at the RA 1863-74. During the early 1860s was associated with Rossetti, Arthur Hughes and Madox Brown.

Bibl: AJ 1895 p.344; Leathart Collection Cat. no.32 1968.

CHAPMAN, H. fl.1823-1841

London landscape painter. Exhib. once at BI and twice at SS.

CHAPMAN, H.W. fl.1855-1856

Exhib. two landscapes 1855-6. London address.

CHAPMAN, J. fl.1855

Exhib. one picture 'Preparing for a Drive' at RA, 1855. Address Slough, Berkshire.

***CHAPMAN, John Watkins fl.1853-1903**

Genre painter and engraver. Exhib. mainly at SS (112 works), also RA 1853-1903, BI and NWS. Subjects at RA include still-lifes of birds and flowers, portrait engravings after Reynolds and Hoppner, and genre scenes, e.g. 'The Mischievous Model', 'Wooed but not Won', etc.

Bibl: BM Cat. of Engraved British Portraits 1908 I pp.174, 228; Wood, Panorama.

CHAPMAN, R.W. fl.1855-1861

Little-known London genre and historical painter. Exhib. at the RA in 1855 and 1856, and also at SS. Titles at RA 'At Length the Tumult Sinks, the Noises Cease', 'The Lollard Discovered'.

Bibl: Reynolds, VP p.116 (pl.77).

CHAPMAN, R. Hamilton fl.1881-1903
Landscape painter. Exhib. at RA, SS, NWS and elsewhere. Lived mainly in Surrey, and many of his RA subjects are views in Surrey, especially Oxshott and Esher.

CHAPMAN, William 1817-1879
A picture of York Minster by Chapman is in the Laing AG, Newcastle (see 1939 Cat. p.129). He was an engraver, who later turned to watercolours and oils of buildings and landscapes.

CHAPPEL, Edouard fl.1892-1903
London painter of still-life, animals and landscape. Exhib. at RA only, 1892-1903. Subjects include views of Mount Edgcumbe, Cornwall.

CHAPPELL, Reuben 1870-1940
Yorkshire ship painter. At first worked in Goole, then moved to Cornwall in 1904. Worked only for private patrons, usually painting ship portraits in watercolour. Exhibitions of his work were held at Bristol AG and at the National Maritime Museum in 1970. Several of his pictures are in Danish museums, also in Hull.

CHAPPELL, William fl.1858-1882
London painter of figure subjects. Exhib. mainly at SS; also RA, BI and elsewhere. Titles: 'The Intercepted Dispatch', etc. and subjects from Goldsmith and Chaucer.

CHAPPELSMITH, J. fl.1842
Exhib. two portraits at RA, 1842. London address.

***CHARLES, James 1851-1906**
Painter at first of portraits, later mainly of landscape and rustic genre. Studied at Heatherley's School, at the RA Schools from 1872, and in Paris at the Académie Julian, where he was influenced by the *plein-air* movement. Exhib. at the RA, 1875-1906, the NG and at the Paris Salon 1897-1905. Member of the NEAC 1886-7, and continued to exhib. there until the end of his life. Visited Italy 1891 and 1905. Memorial exhib. at the Leicester Galleries, 1907. Reynolds, VS., says that he was "one of the first to practise *plein-air* painting in England. His unpretentious and often charming studies of country life in England have never attained the reputation they deserve".
Bibl: AJ 1905 p.185; 1906 p.350; 1907 p.135; 1908 pp.145ff.; Studio XL 1907 pp.43-9; XXXVIII pp.229ff.; XXXIX p.62; Reynolds, VS pp.40, 97 (pl.92); Tate Cat.; Reynolds, VP pp.194, 199 (pl.l 37); Wood, Panorama; Wood, Paradise Lost.

CHARLES, Mrs. R.C. fl.1865
Exhib. one picture 'Isabel' at RA, 1865. London address. Later became the wife of the painter and critic F.G. Stephens (q.v.).

CHARLES, W. fl.1870-1871
Exhib. three watercolour views of the South Coast at SS, 1870-1. London address.

CHARLESWORTH, Miss Alice fl.1896-1903
Portrait painter. Exhib. portraits of children at RA, 1896-1903. Address in Surrey.

CHARLTON, Miss Catherine fl.1878-1890
(Mrs. Edward Bearne)
Landscape painter. Wife of Edward H. Bearne (q.v.). Exhib. at RA, SS, GG and elsewhere. Works at RA mostly views in Switzerland, also some English scenes.

***CHARLTON, John RBA RI ROI 1849-1917**
Born in Bamburgh, Northumberland, Charlton studied at the Newcastle school of art and at South Kensington. Painted portraits, sporting subjects, and battles. Exhib. at the RA 1870-1904, SS, NWS, GG and NG. 'God Save the Queen', RA 1899, a picture of Queen Victoria arriving at St. Paul's for the Diamond Jubilee Service, was commissioned by the Queen herself. In his later years Charlton turned increasingly to military and battle scenes. 'The Women', an unusual genre painting of women struggling to pull a fishing boat from a stormy sea, is in the Laing AG, Newcastle.
Bibl: Hall; Wood, Paradise Lost.

CHARLTON, Miss Louisa fl.1897
Flower painter. Exhib. one picture at RA, 1897. Stoke-on-Trent address.

CHARLTON, William Henry 1846-1918
Newcastle painter of landscape and rustic scenes. Exhib. two pictures at RA in 1889 and 1891, also at RSA and elsewhere. Painted both continental and English views, many of them views on the Northumberland coast. Worked in oil, watercolour, chalks and lithography .
Bibl: Hall.

CHARNOCK, Miss Ellen fl.1852-1861
Exhib. 21 pictures of flowers 1852-61. London address.

CHARRETIE, Mrs. John 1819-1875
(Miss Anna Maria Kenwell)
London painter of portraits, flowers and figure subjects. Forced to take up painting professionally by the ill-health and early death of her husband. Exhib. at RA, BI, SS, and the Society of Lady Artists. Best known for her portraits of children and women; also fond of painting old china, and figure subjects in 18th century dress. Also painted watercolours and miniatures.
Bibl: AJ 1876 p.12 (obit.); Clayton I pp.415-19; G.C. Williamson, *History of British Portrait Miniatures*, 1904 II p.35.

CHARTERIS, Miss fl.1888
Exhib. one picture at GG 1888. London address.

CHARTERIS, Hon. Captain F.W. fl.1876-1883
Landscape painter. Exhib. at NWS and GG. Quidenham address.

CHARTERIS, Lady Louisa fl.1876-1881
London landscape painter. Exhib. 13 pictures at GG only 1876-81.

CHASE, Frank M. fl.1874-1895
London landscape painter. Exhib. at RA, SS, NWS and elsewhere. RA subjects include English views, Italian scenes, and some figure subjects.

CHASE, Miss Jessie fl.1885-1886
Flower painter. Exhib. at NWS and Society of Lady Artists. Address Kilburn, London.

CHASE, John RI 1810-1879
Topographical painter and watercolourist. Pupil of John Constable. Exhib. mostly at NWS, also RA, SS. Specialised in views of churches. Mrs. John Chase also exhibited watercolours at the NWS, 1836-9.
Bibl: AJ 1879 p.73; Clement & Hutton; DNB; Cundall.

CHASE, Miss Marian RI fl.1866-1893 d.1905
London painter and watercolourist of still-life, especially flowers and birds. Daughter and pupil of John Chase (q.v.) Exhib. mainly at NWS, also at RA, SS, GG and Dudley Gallery. Also studied with Miss Margaret Gillies (q.v.), and received encouragement from Henry Warren, G.W. Mote, E.H. Wehnert (qq.v.) and others. Elected RI, 1875. A watercolour of roses is in Aberdeen AG.
Bibl: Clayton II pp.183-5; Sparrow p.130.

CHASE, Powell fl.1893-1904
London painter of literary and other figure subjects. Exhib. at RA and SS. Titles: 'The Lady of Shalott', etc.

CHASEMORE, Archibald fl.1874-1878
London caricaturist, exhibiting under the name Judy. Exhib. seven works at various exhibitions, 1874-8.

CHATTOCK, Richard Samuel RE 1825-1906
Birmingham etcher and landscape painter. Exhib. 1869-91 at the RA — all landscapes — but generally was better known and was very popular as an etcher. He contributed to *The Etcher* (Second Series, folio, dating from 1880), and to *The Portfolio* (from 1873-1884), where his landscapes were liked very much. Some of his best things are his 14 plates of *Views in Wensleydale*, 1872, and he also published a reproduction of Crome's *Woodland Road*, and *Practical Notes on Etching*, 1883.
Bibl: Portfolio III p.81; *Rugby School Register*, 1901 I p.309; Cat. of Modern British Etchers, VAM 1906 p.28; The Times 3 February 1906 p.10; W. Shaw Sparrow, A *Book of British Etching*, 1926 pp. 186-7, 192.

CHAUNCY, Auschar fl.1860-1861
London painter. Exhib. two works, a biblical subject and a scene from Dickens, at BI, 1860-1.

CHAUVIN, A. fl.1851
Exhib. three biblical subjects at RA, 1851. No address given.

CHEADLE, Henry fl.1875-1878
Birmingham landscape painter. Exhib. at SS only, 1875-8. Subjects North Wales and Midlands views. Two of his landscapes are in Birmingham City AG.

CHEESMAN, Thomas Gedge fl.1890-1891
London painter of figure subjects. Exhib. one picture 'After a Stroll' at RA, 1891.

CHEESMAN, William fl.1890-1891 d.1910
Landscape painter. Exhib. two pictures at RA, 1890-1. Address Esher, Surrey.

CHEETHAM, Miss M.E. fl.1868-1870
Painter of figures. Exhib. one picture at RA, 1868 and one at SS, 1870. No address given.

CHEFFINS, Miss Mary fl.1830-1850
Landscape painter. Exhib. at RA, BI and SS. Subjects especially Cumberland and the North of England. Address Hoddesdon, Hertfordshire.

CHESTER, George 1813-1897
Landscape painter. He rejected the Governorship of Sierra Leone, and turned to painting. He was largely self-taught, but was encouraged by Augustus Egg and Ansdell, to whom his wife was related. Through Ansdell he met many of the leading painters, Frith, Elmore, H. O'Neil, John Phillip, Creswick, Bridell and Lee. He exhibited at the RA 1849-89. Titles including: 'Starting for Market', 1853, 'The Woodland Glade', 1861 and 'The Fisherman's Haunt', 1862. His paintings were usually large and in the style of Constable.
Bibl: AJ 1897 p.255; Studio II 1897 pp.100-6 (five illus.).

***CHESTER, George Frederick fl.1861-1889**
London painter of rustic scenes and other flgure subjects. Exhib. at RA, BI and SS. Titles: 'Turf Gatherers', etc. 'The Fish Auction, Brixham', RA 1870, appeared at Parke-Bernet, New York 16 January 1975, lot 211 (illustrated).

CHETTLE, Miss Elizabeth M. fl.1880-1904
Painter of portraits and figure subjects. Exhib. at RA, SS, NG and elsewhere.

CHETWYND, Ida and Kate F. fl.1892
Both exhib. one picture at SS, 1892, 'The Jester in Disgrace' and 'Giovanni'. Recorded at the same address in London, so presumably sisters.

CHEVALIER, Nicholas 1828-1902
Painter of landscapes and topographical views, especially in the Far East. Exhib. at RA 1852-95, SS, and NWS, Works at RA include scenes in China, Tahiti, the Philippines and New Zealand. Also patronised by the Royal Family, and painted pictures for the Queen and the Prince of Wales. For the Queen he painted 'The Marriage of T.R.H. the Duke and Duchess of Edinburgh at the Winter Palace, St. Petersburg', RA 1875.
Bibl: AJ 1879 p.121ff.; Ormond I p.489.

CHEVALIER, Robert Magnus fl.1876-1898
Painter of Egyptian scenes. Exhib. mainly at SS, also at RA, NWS, GG, NG and elsewhere. Titles mostly scenes in Cairo.

CHEYNEY, Miss Lucy M. fl.1837-1868
London painter of flowers. Exhib. at RA and SS.

CHEYNEY, Miss S. Emma fl.1891-1894
Flower painter. Exhib. at RA, SS, NWS and elsewhere. Address Redhill, Surrey.

CHILCOTT, Mrs. J.W. fl.1844
Exhib. one watercolour of shells at SS, 1844. London address.

CHILD, Mrs. fl.1848
Exhib. one untitled picture at SS, 1848.

CHILD, W. fl.1847-1851
London painter of portraits and figure subjects. Exhib. at RA, BI and SS, both oils and watercolours. Mostly portraits of children.

CHILDE, Elias RBA fl.1798-1848
Landscape painter; brother of James Warren Childe, the miniaturist. An enormously prolific exhibitor at the RA, BI and SS, showing nearly 500 works. His subjects were usually landscapes with figures, also river and coastal scenes.
Bibl: Redgrave; VAM Cat. 1907 p.14.

CHILDE, Miss Ellen E. fl.1878
Exhib. one picture 'Study of Colour' at RA, 1878. London address.

CHILDERS, Miss Louise fl.1885
Exhib. two watercolours at NWS, 1885. Graves lists her speciality as buildings. London address.

CHILDERS, Miss Milly fl.1890-1904
London portrait painter. Exhib. at RA, SS and NG.

CHILDS, Miss Agnes fl.1852-1871
London painter of flowers, birds' nests, and still-life. Exhib. watercolours at SS, 1852-71.

CHILDS, Alfred Edward fl.1867-1875
London painter of birds and animals. Exhib. four watercolours at SS, 1867-75.

CHILDS, George fl.1826-1873
Painter of landscapes and rustic genre, and lithographer. Exhib. at the RA 1833-71, 1836 at BI, 1826-73 at SS. Titles at RA 'The Village Coquette', 'The Pride of the Village', 'Shall I Fight or Not'. He drew lithographs for a volume on trees and published A *New Drawing-Book of Figures; The Little Sketch Book; Child's Drawing-Book of Objects; English Landscape Scenery and Woodland Sketches.*

CHILDS, Miss Julia fl.1851-1864
London still-life painter. Exhib. mainly at SS, but also at RA. Painted fruit, flowers, birds and animals, usually in watercolour.

CHILDS-CLARKE, Miss Sophia fl.1889
Exhib. one still-life at RA, 1889. Address Thornerton, Devon.

CHILMAN, Miss Lizzie fl.1856-1864
London flower painter. Exhib. mainly at SS, also one picture at RA in 1857, 'Camellia', and elsewhere. Painted in oil and watercolours, also exhib. a few figure subjects.

CHILTON, E. fl.1869
Exhib. one picture of flowers at SS, 1869. London address.

CHINN, Samuel fl.1833-1845
London painter of portraits and figures. Exhib. at RA and SS. A portrait of the opera singer Mary Ann Wood is in the Guildhall AG.
Bibl: Ormond I p.521.

CHINNERY, George RHA 1774-1852
Portrait, miniature and landscape painter, usually on a small scale. Studied at RA Schools; exhib. at RA 1791-1802. Lived in Dublin 1797-1802. Sailed for Madras 1802 and lived in Calcutta 1807-25. Finally fled to Macao to escape his creditors, and lived there for the rest of his life. Now justly celebrated for his portraits and landscapes of India and China, and for his many studies of Chinese life.
Bibl: For full bibl. see Patrick Conner, *George Chinnery*, 1993.

CHIPP, Herbert fl.1877-1885
London landscape painter. Exhib. watercolours at SS and NWS.

CHISHOLM, Alexander FSA 1792(3)-1847
Scottish painter of historical subjects and portraits. Studied in Edinburgh, and came to London 1818. Exhib. at RA from 1820, also BI, SS and OWS. Many of his subjects were taken from 17th century English history.
Bibl: AU 1847 p.378; 1848 pp.27, 314; Redgrave; Roget; Cundall; DNB; Ormond I p.306.

CHISHOLM, Miss Helen fl.1887
Exhib. one watercolour of a domestic subject at NWS, 1887. Address Haslemere, Surrey.

CHISHOLM, Peter fl.1877-1897
Landscape painter; lived at North Shields, near Newcastle. Exhib. one picture, 'November', at RA, 1897.
Bibl: Hall.

CHISHOLME, Alexander C. fl.1841-1856
London painter of domestic and other figure subjects. Exhib. at RA and BI. RA titles 'Going to School', 'The Letter', etc.

CHISHOLME, R.F. fl.1858-1859
London painter of coast scenes. Exhib. one picture at RA 1858 and one at BI 1859.

CHITTENDEN, T. fl.1845-1864
London painter of portraits and figure subjects Exhib. at RA and BI. Titles: 'A Magdalen', etc.

CHOLMONDELY, R. fl.1856-1867
London portrait painter. Exhib. at RA only. Sitters mostly aristocracy and gentry.

CHOWNE, Gerard 1875-1917
Painter of landscapes, portraits and flowers. Studied at the Slade under Fred Brown, and joined the NEAC. Killed in the First World War.

CHRISTIAN, Miss Clara L. fl.1898-1900
Exhib. flower pictures and 'The Letter' at RA, 1898-1900. London address.

CHRISTIAN, Miss Edward (Eleanor)
An early Victorian miniaturist who also painted portraits in watercolour.

CHRISTIAN, Miss Gertrude fl.1888
Exhib. one watercolour of flowers at NWS, 1888. Address Penzance, Cornwall.

CHRISTIE, Alexander ARSA 1807-1860
Edinburgh painter of portraits and historical subjects. Studied at Trustees' Academy, and briefly in London. Returned to Edinburgh, where he was appointed director of ornamental department of the Trustees' School. Exhib. mostly at RSA; elected ARSA 1848. Exhib. once at RA in 1853, a scene from the life of Luther, also at BI.
Bibl: Portfolio 1887 pp.179ff.; Redgrave.

CHRISTIE, Archibald H. RBA fl.1888-1898
London painter of figures and still-life. Exhib. at RA and elsewhere. Titles: 'Psyche', etc.

CHRISTIE, Ernest fl.1886-1904
Landscape painter. Exhib. at RA and SS. Address Blackheath, near London.

CHRISTIE, F. fl.1874
London landscape painter. Exhib. one watercolour at SS, 1874.

CHRISTIE, F.H. fl.1874-1878
Landscape painter. Exhib. at RA and SS. Address Blackheath, near London.

CHRISTIE, James Elder 1847-1914
Scottish painter of pictures of childhood scenes from Burns, moralising allegories and portraits. Trained at the Art Schools, Paisley and at South Kensington, and won two gold medals at the RA in 1876 and 1877. But then he went to Paris and returning joined the NEAC and "disappointed the prophets by producing

work in the best oposition style". In 1893 he went to Glasgow, but his best work was done before he returned there. Exhib. at RA 1877-1900.

Bibl: David Martin, *The Glasgow School of Painting,* 1902 pp.3-6; Caw p.274; DNB; Who's Who 1912; Studio II 1897 p.121 (reprd. 'Vanity Fair'); Cat. of The Glasgow Boys' Exhibition, Scottish Arts Council, 1968; Irwin.

CHRISTIE, Robert RBA fl.1891-1903
London painter of portraits and figures subjects. Exhib. at RA, SS and elsewhere.

CHRISTIE, Miss Vera fl.1893
Exhib. two portraits in 1893, one at NG. No address given.

CHRISTOPHERS, J.M. fl.1871
Exhib. one watercolour of a Devon landscape at SS, 1871. Address Exeter, Devon.

CHRISTY, Miss Josephine fl.1894-1895
Exhib. two pictures 'Phyllis' and a view of Florence and Fiesole, at RA 1894-5. Address Chelmsford, Essex.

CHURCH, Sir Arthur Herbert KCVO FRS FSA fl.1854-1870
London painter of landscapes and still-life. Exhib. at RA and BI several landscapes of Cornwall. Was Professor of Chemistry to the Royal Academy 1879-1911.

Bibl: Hutchison.

CHURCHER, G P. fl.1886
Exhib. one watercolour of Christchurch, Oxford, at SS, 1886. Oxford address.

CHURCHILL, H. fl.1872
Exhib. one watercolour 'An Arab of Algiers' at SS, 1872. London address.

CHURCHYARD, Thomas 1798-1865
Suffolk landscape painter. Lived in Woodbridge, where he practised as a lawyer. Occasionally visited London, but mostly painted in his native Suffolk, in a style similar to that of Constable, who he may have known. Exhib. in London 1830-3, and in Norwich in 1829 and 1852. He had several children, many of whom were also painters.

Bibl: D. Thomas, *Thomas Churchyard of Woodbridge,* 1966.

CLABBURN, Arthur E. fl.1875-1879
Portrait painter. Exhib. three pictures at RA, 1875-9. Lived in London and Norwich.

CLACK, Richard Augustus fl.1827-1875
London portrait painter. Exhib. at RA, BI and SS. RA exhibits all portraits, and a few landscapes.

CLACK, Thomas 1830-1907
Painter of figure subjects and landscape. Lived in Coventry but then moved to London. Exhib. at RA, and elsewhere. RA subjects mostly domestic genre, also some landscape and portraits. Was Master at the National Art Training School at Marlborough House.

CLACY, Miss Ellen fl.1870-1900
Historical and genre painter. Exhib. 1870-1900 at SS and RA, 1872-1900 at RA. Titles at RA 'The List of Conspirators', 'A Hunted Jewess, France 1610', 'The Letter', etc. 'Will Myers, Ratcatcher and Poacher', RA 1885, is in the Walker AG, Liverpool.

CLAPHAM, James T. fl.1862
Painter of fruit. Exhib. two pictures at SS, 1862. Address Crayford, Kent.

CLAPHAM, Miss Mary fl.1885
Exhib. one picture of moonlight in 1885. London address.

CLARE, Miss fl.1858
Exhib. one picture of flowers at RA, 1858. London address.

CLARE, George 1835-1890
Birmingham fruit and flower painter. Exhib. 1864,1866 and 1867 at RA, also BI and SS. Imitator of William Henry Hunt's small, detailed pictures of fruit, flowers, blossom and birds' nests. The father of Oliver and Vincent Clare (qq.v.). All the Clares frequently painted pairs of pictures, usually one of fruit, the other of flowers.

***CLARE, Oliver 1853-1927**
Painter of fruit and flowers; son of George Clare and brother of Vincent Clare (qq.v.). Exhib. one picture at RA in 1883, two at SS. Like his brother, probably worked mainly in Birmingham. Generally considered to be the best painter of the Clare family.

CLARE, Vincent 1855-1930
Still-life painter; son of George Clare and brother of Oliver Clare (qq.v.). His work is similar to that of the other two Clares, but coarser in quality. He worked in Birmingham, but did not exhibit in London.

CLARIS, F.G. fl.1884
Exhib. one picture 'A Sombre Day' at SS, 1884. London address.

CLARK, B. fl.1875
Exhib. one picture of a grey mare at SS, 1875. London address.

CLARK, C.W. fl.1839-1843
London painter of portraits. Exhib. at RA only, 1839-43.

CLARK, Christopher RI 1875-1942
Painter and illustrator of military and historical subjects. Elected RI, 1905. Published and illustrated several military history books.

CLARK, Dixon fl.1890-1902
Animal painter from Blaydon-on-Tyne. Exhib. at RA from 1890-1902, but worked mostly in the north-east. Subjects usually cattle or sheep in pastoral landscapes, in the style already popularised by T.S. Cooper. Pictures by him are in the Sunderland AG.
Bibl: Hall.

CLARK, Falconer fl.1888-1889
Exhib. two watercolours of domestic subjects at NWS, 1888-9. Address Dorking, Surrey.

CLARK, Francis fl.1853-1865
London painter of figure subjects. Exhib. at RA, BI and SS. RA subjects also include a portrait and still-life.

CLARK, J. Wait fl.1880-1900
Painter of seascapes and coastal scenes; lived at South Shields, Co. Durham. Exhib. one picture, 'Whitley Sands', at RA, 1900.

CLARK, James RI ROI 1858-1943
Painter and watercolourist of religious and other figure subjects, portraits, landscape and flowers. Also book illustrator and designer

of stained glass. Studied at first in Hartlepool, Co. Durham, later in Paris, and settled in London. Exhib. at RA, SS, NWS, and at the NEAC, of which he was a member.

Bibl: Hall

***CLARK, Joseph ROI 1834-1926**
Painter of domestic genre of a tender and affecting nature (usually of children), and a few biblical subjects. Studied at J.M. Leigh's. Exhib. at the RA 1857-1904. Received a medal and award at Philadelphia in 1876 sending there his 'Sick Child' and 'The Bird's Nest'. Among his more important works are 'The Wanderer Restored', 1861, and 'Early Promise'. Graves, Royal Academy, lists him as 'Joseph Clarke'. Uncle of Joseph Benwell Clark (q.v.).

Bibl: AJ 1863 pp.49ff. (reprd. 'The Return of the Runaway', 'The Wanderer Restored', and 'Hagar and Ishmael'); AJ 1859 p.165; 1860 p.78; 1869 p.296; Clement & Hutton; Ruskin, Academy Notes 1875; Who's Who 1912; Wood, Panorama; Wood, Paradise Lost.

CLARK, Joseph Benwell 1857-1938
London painter of rustic subjects. Exhib. at RA, SS, GG and elsewhere. At the RA he exhibited also a portrait of H.S. Tuke (q.v.), a picture copied from Joseph Clark (q.v.), and two military subjects set in Afghanistan painted in collaboration with V.M. Hamilton (q.v.). Together with William Calderon he founded the School of Animal Painting in 1894. Also an illustrator of books and magazines. Born at Cerne Abbas, Dorset, where he is also buried.

CLARK, Miss Mary fl.1844-1848
London painter of figure subjects. Exhib. at RA and SS. Titles: 'Rose Bradwardine', etc. London address.

CLARK, Miss Mary Brodie fl.1889-1902
Painter of fruit and flowers. Exhib. once at RA and SS. Address Brentford, Middlesex.

CLARK, S.J.
Very little-known painter of horses, animals and farmyard scenes, whose works have appeared frequently at auction sales in London and the provinces. His style is similar to that of J.F. Herring, Jnr., but he did not exhibit in London.

Bibl: Annual Art Sales Index 1969-1975.

CLARK, Thomas ARSA 1820-1876
Scottish landscape painter. First exhib. at RSA when 20 years of age. ARSA in 1865. At that period he lived in Edinburgh. Painted both in oil and watercolour: his subjects were chiefly scenes in Scotland, but were sometimes scenes in England as a few years before his death he used to winter in the south. Among his better works are: 'Waiting for the Ferry', 'A Quiet Morning on Loch Awe', 'Spring', 'Summer' and 'The Farm Yard, Woodside, Surrey'. Exhib. at RA 1830-70, BI and SS.

Bibl: AJ 1877 pp.20, 38 (obit.); Clement & Hutton; DNB.

CLARK, W.F. fl.1884-1890
London landscape painter. Exhib. watercolours at SS and NWS. Graves lists him as W.F.C. Clark.

***CLARK, William fl.1827-1870 d.1883**
Painter of ship portraits and shipping scenes; worked in Greenock, near Glasgow. Although he did not exhibit in London, his pictures are remarkably competent, and show a good knowledge of ships and the sea. Pictures by him often appear on the art market, and are deservedly popular. Examples can be seen in the National Maritime Museum and the Walker AG, Liverpool.

Bibl: Brook-Hart p.76 (pls. 23,145).

CLARK, William fl.1860
Worcester landscape painter. Exhib. three watercolours at SS, 1860.

CLARKE, Miss fl.1872
Exhib. a view near Ryde, Isle of Wight at SS, 1872. Address Bromley, Kent.

CLARKE, A.F. Graham fl.1883
Exhib. one landscape in 1883. Address Rhayader, Wales.

CLARKE, A.T. fl.1890-1891
Exhib. one watercolour of a domestic subject at NWS. London address.

CLARKE, Miss Ada fl.1892-1898
Painter of landscapes, figures and flowers. Exhib. once at RA, 1898 'My Model', and twice at SS. Address Blackheath, near London.

CLARKE, Alfred Alexander fl.1851
Exhib. one landscape 'Holford Glen' at RA, 1851. Address Taunton, Devon.

CLARKE, Miss Bethia fl.1892-1893
Painter of landscapes and figures. Exhib. four pictures at SS, 1892-3. Address Eastbourne, Sussex.

CLARKE, C. Macdonald fl.1881
Exhib. one picture 'A Little Village Maid' at RA, 1881. Address Bournemouth, Hampshire.

CLARKE, Caspar fl.1856-1871
Painter of landscapes and rustic scenes. Exhib. at RA, SS, and elsewhere. Addresses London and Rugeley, Staffordshire.

CLARKE, E. fl.1842
London painter; exhib. one picture of fruit at RA, 1842.

CLARKE, Frederick fl.1834-1870
Painter of still-life and historical subjects. Lived in London and Leicester. Exhib. at RA only; exhibits mostly of dead game, but also two historical subjects.

CLARKE, George Frederick fl.1868-1872
London painter of portraits and figures. Exhib. at RA and SS. Titles: 'Music', etc.

Bibl: Ormond I p.110.

CLARKE, George Row fl.1858-1888
Landscape painter. Exhib. at NWS and elsewhere 1858-88, and stood unsuccessfully for membership of NWS in 1871 and 1873. Painted mainly in the Midlands.

CLARKE, Mrs. H. Savile fl.1882-1890
London landscape painter. Exhib. at NWS, GG, NG and Society of Lady Artists.

CLARKE, J. fl.1841
Exhib. one picture of fruit at RA, 1841. London address.

CLARKE, J.R. fl.1861
Exhib. one landscape 'Returning Home - Evening' at SS, 1861. London address.

CLARKE, Jane fl.1833-1843
London painter of landscape and portraits. Exhib. three pictures at RA, 1833-43.

CLARKE, Joseph see CLARK, Joseph

CLARKE, Miss Kate fl.1863-1884
London painter of flowers and landscape. Exhib. once at BI and SS and elsewhere.

CLARKE, L.J. Graham- RCA fl.1879-1887
Landscape painter. Lived near Rhayader, South Wales. Exhib. at RA, SS and elsewhere. RA pictures included English landscapes, and also scenes in France and Morocco.

CLARKE, Miss Mary C. fl.1873
Exhib. one watercolour of Strasburg Cathedral at SS,1873. Address Bromley, Kent.

CLARKE, Miss Minnie E. fl.1892
Exhib. one picture of figures in 1892. Address Bedford Park, London.

CLARKE, Miss Polly fl.1893-1895
Painter of figure subjects and flowers. Exhib. at RA only. Address Bushey, Hertfordshire.

CLARKE, R.(E?) fl.1825-1848
London painter of coastal scenes and landscapes. A regular exhibitor at RA, BI and SS. Titles include many views on the Thames and in Devon.

CLARKE, S. fl.1873
Exhib. one landscape with cattle at SS, 1873. London address.

CLARKE, Samuel Barling fl.1852-1878
Domestic genre painter of humorist themes, titles including 'The Stolen Bite', 'Toothache', 'A Modern Friar Tuck', 'Up in the Clouds, Down in the Dumps', etc. Exhib. at the RA 1854-74, BI and SS.

CLARKE, W.D. fl.1858-1862
Exhib. two watercolour landscapes at SS in 1858 and 1862. London address.

CLARKSON, Jane fl.1840
Exhib. one picture of a street near Rouen at RA, 1840. London address.

CLARKSON, Miss Marion F. fl.1891-1901
London painter of figure subjects. Exhib. at RA, 1891-1901. Titles: 'The Sound of the Tumbrils, Paris, 1793', etc.

CLARKSON, Robert fl.1880-1896
Yorkshire landscape painter. Exhib. at RA and SS. Mostly views in Yorkshire.

CLARKSON, William Herbert RBA 1872-1944
Exhib. one picture 'Cool Evening' at SS, 1893. Address Highgate, London. After 1900 he continued to exhibit regularly at RA and SS.

CLATER, Frederick R. fl.1848-1854
London painter of coastal scenes. Exhib. at RA, BI and SS. Also painted some landscapes.

CLATER, Miss J. fl.1843-1846
(Mrs. T.C. Collingwood)
London painter of literary and other figure subjects. Exhib. at BI and SS, both oils and watercolours. Titles from Scott, Dickens, etc.

CLATER, T.B. fl.1842
Exhib. one picture 'An Easy Conquest' at SS, 1842. Son of Thomas Clater (q.v.).

CLATER, Thomas 1789-1867
Painter of domestic genre and portraits. Exhib. at the RA from 1819-59, in 1819 'The Game of Put or the Cheat Detected'. Titles include: 'Reading the Letter', 'Dressing the Bride', 'Luncheon', 'Scandal!!! Only think!!' 'The Music Lesson'. His paintings were usually of scenes from domestic and provincial life, in a manner based on that of Dutch genre, usually of a quietly humorous character that was easily appreciated at the time. 'A Chief of Gipsies Dividing Spoil with his Tribe' is in the Walker AG, Liverpool.
Bibl: Redgrave, Dict.; DNB; Gentlemen's Magazine new series III p.667.

CLAUDET, Mrs. M.H. fl.1877
Exhib. one watercolour of Amboise, France at SS, 1877. London address.

CLAUSEN, Miss Elenore M. fl.1886-1890
London flower painter. Exhib one picture at SS 1886 and one at GG.

CLAUSEN, Lady (Agnes M.) fl.1882-1884
Painter of figures and domestic subjects. Wife of Sir George Clausen (q.v.). Exhib. at SS and NWS. Titles: 'Lazy Boy', etc.

***CLAUSEN, Sir George RA RWS RI 1852-1944**
Plein-air figure and landscape painter of scenes of rural life, both in oil and watercolour. He also painted portraits, some nudes, town interiors and still-life, and made occasional decorations and engravings. Born in London, the son of a Danish sculptor, he studied at the South Kensington Schools. He visited Holland and Belgium in 1876, exhibiting his first picture at the RA that year: 'High Mass at a Fishing Village on the Zuyder Zee'. He worked under Bouguereau and Tony Robert-Fleury in Paris, but then returned to London and began to paint the life of the agricultural labourer. Strongly influenced by Bastien-Lepage, he worked out of doors and was preoccupied with the effects of light, but at the same time retained solidity of form. He was especially interested in figures seen against the sun. He spent much of his time in Essex sketching agricultural life. His 'Labourers after Dinner', 1884, brought him wide repute, and 'The Girl at the Gate', 1889 was purchased by the Chantrey Bequest (now in the Tate Gallery). He was an original member of the NEAC in 1886 ceasing to exhib. there when elected ARA in 1895. 1904-6 Professor of Painting at the RA Schools; 1908 RA; knighted 1927. He also published *Six Lectures on Painting* 1904 and *Aims and Ideals in Art*, 1906.
Bibl: F.G. Roe, *George Clausen*, OWS XXIII; Who's Who 1912; Dyneley Hussey, *George Clausen* (Contemporary British Artists) 1923 (no work earlier than 1904 reprd.); VAM; DNB pp.1941-50; Tate Cat.; Maas p.250 (pl.p.250); Wood, Panorama; Cat. of Clausen Exhibition Bradford AG 1980; Newall; Wood, Paradise Lost.

CLAXTON, Miss Adelaide and Miss Florence A. fl.1859-1879
London painters, watercolourists and illustrators, both daughters of Marshall Claxton (q.v.). Both exhibited figure subjects at the RA, SS and elsewhere. Miss Adelaide (who become Mrs. George Gordon Turner in 1874) exhib. 1860-76; Miss Florence 1859-79. They collaborated as illustrators for London magazines, e.g. *London Society, Illustrated Times*, etc., specialising in humorous and 'ghost' subjects.
Bibl: Clayton II pp.41-7, 329-30.

CLAXTON, Marshall 1812-1881
Painter of historical and biblical subjects, portraits and scenes in India, Australia, Jerusalem, Egypt, etc. Pupil of John Jackson RA, and also studied at the RA Schools. In 1843 he won a prize at the Cartoon competition at Westminster Hall, for his 'Alfred in the Camp of the Danes'. Due to lack of success he went to Australia in 1850, hoping to sell his own work and that of others and to found a school. He held the first exhibition of paintings in Australia, but had little success, so he went to India where he disposed of most of his paintings. He also visited Egypt and the Holy Land, and in about 1858 returned to England. While in Australia he had received a commission from the Queen to paint a 'General View of the Harbour and City of Sydney', and he also painted a portrait of the last Queen of the Aborigines. His best work was thought to be his 'Sepulchre' which he sent to the International Exhibition of 1862 and later gave to the RA. He exhibited at the RA 1832-76.
Bibl: AJ 1869 p.368; Athenaeum 13 August 1881 p.216 (obit.); Ottley; Bryan; DNB; Ormond I p.360.

CLAY, Alfred Barron fl.1852-1870
London painter of historical subjects and portraits. Exhib. at RA, BI, SS and elsewhere. RA titles include scenes from English and French history, and subjects from Scott and Shakespeare.

CLAY, Sir Arthur Temple Felix, Bt. 1842-1928
Painter of historical and domestic subjects and also of portraits. An amateur painter, educated at Trinity College, Cambridge. Exhib. at the RA 1874-90 and also SS, NWS, GG and NG. Pictures by Clay are in the London Law Courts (Court of Criminal Appeal), the War Office and the London Museum.
Bibl: Who Was Who 1916-1928.

CLAY, G. fl.1846-1860
London landscape painter. Exhib. at RA, BI and SS. RA exhibits mostly scenes in England or Wales.

CLAY, John fl.1837-1856
Ramsgate painter of coastal scenes. Exhib. at RA and SS.

CLAY, Julia M. fl.1880-1881
Exhib. five figure pictures, 1880-1. London address.

CLAYTON, H. fl.1847
Exhib. one picture 'A Dilemma' at RA, 1847. London address.

CLAYTON, J. Essex fl.1871-1885
London painter of domestic subjects, portraits and flowers. Exhib. at RA and SS. Titles: 'Birds of a Feather', etc.

CLAYTON, Captain J.W. fl.1872
Exhib. one landscape, 1872. London address.

CLAYTON, Miss Mary Anna fl.1884-1885
Exhib. three flower pictures, 1884-5. Brighton address.

CLAYTON, W. fl.1857
Exhib. one Scottish landscape at RA, 1857. London address.

CLEAVER, Miss fl.1848
Exhib. five landscapes in 1848. Address Streatham, London.

CLEAVESMITH, Edmund fl.1880-1884
Sheffield landscape painter. Exhib. watercolours at SS and NWS. Views mostly North Wales and the Isle of Man.

CLEGG, S. fl.1852-1853
Exhib. two views of Jersey at RA, 1852-3. No address given.

CLEGHORN, John fl.1840-1881
London landscape painter. Exhib. at RA, BI, SS and elsewhere. Several RA titles were views near Dorking, Surrey.

CLELAND, William H. fl.1892-1895
Landscape painter. Exhib. at RA and NG. Titles: 'A Corner of the Farm', etc. Addresses London and Banstead, Surrey.

CLEMENS, Matt H. fl.1895-1897
Painter of landscape and figures. Exhib. at RA, 1895-7. Lived in London, Bushey and Cornwall.

CLEMENT, C.V. fl.1841
Exhib. one picture 'A Merry Mood of Infancy' at RA, 1841. Address Clapham, London.

CLEMENTS, G.H. fl.1886
Exhib. one watercolour 'Outward Bound' at SS, 1886. London address.

CLEMINSHAW, Miss M. Isabella fl.1891-1904
London painter of coastal scenes. Exhib. at SS 1891-2, and once at RA 1904.

CLEMINSON, Robert fl.1865-1868
Sporting painter. Subjects deer, dead game, dogs, shooting, etc. Exhib. at BI and SS 1865-68.

CLEVERLEY, Charles F.M. fl.1893-1898
London painter of figure subjects. Exhib. at RA, 1893-8. Titles: 'Daydream', etc.

***CLIFFORD, Edward 1844-1907**
Painter of portraits and biblical genre. Born in Bristol, where he first studied. Later moved to RA Schools. Exhib. at RA 1867-92, SS, NWS, GG, NG and elsewhere. All Clifford's RA pictures were conventional Victorian female portraits, but at the GG and elsewhere he showed biblical scenes, such as 'Israelites Gathering Manna' and other genre pieces. His religious pictures show the influence of Holman Hunt. Clifford was himself a religious man, and later in life he worked for the Church Army. A portrait drawing of General Gordon is in the NPG.
Bibl: Ruskin, Academy Notes 1875; Clement & Hutton; The Times 20 September 1907; David Ker Gallery, London, E.C. Exhibition 1990.

CLIFFORD, Edward C. RI RBA 1858-1910
London painter of figure subjects. Exhib. at RA, SS, NWS and elsewhere. Titles: 'Before Her Peers', etc.

CLIFFORD, Henry fl.1866-1884
Exhib. one landscape watercolour at NWS, and one elsewhere. Address Blackheath, London.

CLIFFORD, Henry Charles RBA 1861-1947
Painter of landscapes and village scenes. Born at Greenwich. Studied in Paris and under Bouguereau, Constant and Tony Fleury. Exhib. at RA from 1892, also at SS. Later he lived at Storrington in Sussex. Two of his London scenes are in the London Museum (1970 Cat. nos. 28-9).

CLIFFORD, Maurice fl.1890-1894
London painter of domestic subjects. Exhib. at RA and elsewhere. Titles: 'Idle Moments', etc.

CLIFT, A. fl.1879
Exhib. two watercolour landscapes at SS, 1879. London address.

CLIFT, Stephen fl.1868-1886
Landscape painter. Exhib. at RA, SS and elsewhere, in oil and watercolour. Subjects views in England and Switzerland. Addresses Croydon, Surrey, and Geneva.

CLIFTON, J. fl.1849-1850
Exhib. two landscapes with figures at RA, 1849-50. Titles: 'Buck Washing on Datchet Mead', etc.

CLIFTON, John S. fl.1852-1869
Painter of historical and other figure subjects, much influenced by the Pre-Raphaelite Brotherhood. Exhib. at RA, BI and elsewhere. Oxford and London addresses.
Bibl: Wood, Pre-Raphaelites.

CLIFTON, William fl.1849-1885
London landscape painter. Exhib. at RA, BI and NWS, views around London, the Lake District, etc.

CLINK, Miss Isabel M. fl.1897
Exhib. one picture 'The Khan's Daughter' at RA, 1897. London address.

CLINK, Miss Matilda J. fl.1891
Exhib. one flower picture at RA, 1891. London address.

***CLINT, Alfred 1807-1883**
Son of George Clint, ARA (q.v.). Painter of landscapes, coastal scenes and portraits. President of the Society of British Artists. Exhibited landscapes at the RA for over 40 years, 1829-71. "He could devise fine effects, at times rivalling Danby in the red glow of the sunsets" (Maas). He was also a prolific exhibitor at SS (406 works) and the BI. His studio sale was held at Christie's, 23 February 1884.
Bibl AJ 1854 p.212; 1868 p.92; Redgrave, Dict; Maas p.48 (reprd. p.49, 'Landscape with Mountain and Rocks' VAM); Ormond I p.102; Brook-Hart pp.61-3 (pl.120).

CLINT, George ARA 1770-1854
Portrait painter, engraver and miniature painter. He began his career as a miniature painter and then took up engraving. His studio at 83 Gower Street was the rendezvous of the leading actors of the day, a popularity due to a series of theatrical portraits he painted, e.g. 'W. Farren, Farley and Jones as Lord Ogleby, Canton and Brush in the Comedy *Clandestine Marriage*' 1819. He exhibited at the RA 1802-45, and was elected ARA in 1821, but resigned in 1836 as he was disappointed in never becoming an RA. His son Alfred Clint (q.v.) was also a painter. Many of his portraits are in the NPG.
Bibl: AJ 1854 p.212 (obit.); Redgrave, Dict.; Clement & Hutton; Williamson, *History of Portrait Miniatures*, 1904; DNB; Ormond I see index.

CLINT, Raphael fl.1857-1858
Exhib. two figure studies at SS, 1857-8. London address the same as Alfred Clint (q.v.), so may well have been his son.

CLIQUE, The
Group of early Victorian rebels, consisting of P.H. Calderon, A.L. Egg, John Phillip, Richard Dadd, H.N. O'Neil, and W.P. Frith (all

q.v.). They had no coherent policy, beyond general dissatisfaction with the RA. Flourished during the late 1830s, after which the artists went their very separate ways.

CLIVE, Theophilus fl.1856-1857
London portrait painter. Exhib. three portraits at RA, 1856-7.

CLOTHIER, Robert fl.1842-1873
London miniaturist, and painter of domestic and historical subjects. Exhib. regularly at RA, BI and SS. In addition to portrait miniatures, he exhibited figure subjects, scenes from Shakespeare and other writers, and still-life, both in oil and watercolour.

CLOUD, Mrs. J. Lizzie fl.1873-1878
Painter of domestic subjects. Exhib. at RA, BI and elsewhere. Titles: 'The Connemara Postman', etc. Addresses London and Galway, Ireland.

CLOUGH, Tom 1867-1943
Landscape painter. Exhib. at RA from 1894. Titles: 'Home from the Fields', etc. Addresses Bolton, Lancashire and North Wales.

CLOW, Miss Florence fl.1882-1884
London painter of portraits and flowers. Exhib. at RA, SS and elsewhere.

CLOWES, Miss C. fl.1878
Exhib. one picture 'Spring Flowers' at RA, 1878. Address Loughborough, Leicestershire.

CLOWES, Harriett Mary fl.1847-1861
Painter of landscapes, church interiors and exteriors, in Scotland and on the Rhine.

CLUFF, Elsie M. fl.1891-1897
Exhib. views inside Westminster Abbey at RA and SS. Walthamstow address.

COATES, Miss Kate Belford fl.1890
Exhib. one watercolour at NWS, 1890. London address.

COBB, Alfred F. fl.1878-1889
London landscape painter. Exhib. watercolours at SS and elsewhere; views on the Thames, Devon and Cornwall, etc.

COBB, Edward F. fl.1872
Exhib. two landscapes, 1872. London address.

COBB, T.P. fl.1865
Exhib. one landscape, 1865. London address.

COBBE, H. Bernard fl.1868-1883
London painter of figures and domestic subjects. Exhib. at RA and SS. Titles: 'Hours of Idleness', etc.

***COBBETT, Edward John RBA 1815-1899**
Genre and landscape painter. Trained under the landscape painter, J.W. Allen (q.v.). Exhib. at the RA 1833-80. Titles include 'The Proposal', 1863, 'The Ballad', 1864, 'A Rustic Confabulation', etc. Two of his RA exhibs. were of dead game and angling. At York AG is 'A Welsh Interior', 1856. Of 'Heather Bells', exhib. at SS in 1859, the AJ said: "A company of colliers' daughters with such (!) petticoats for colour and texture, and standing on a piece of hillside

bottom, rich in grasses, and fragrant with the sweet heath-bloom. The figures are made to tell powerfully against the sky and distances."
Bibl: Ottley; AJ 1859 p.141; 1860 p.80; Clement & Hutton; Wood, Panorama; Wood, Paradise Lost.

COBBETT, Miss Phoebe M. fl.1875-1882
London painter of domestic subjects. Exhib. at SS only. Titles: 'My Little Model', etc.

COBBETT, William V.H. fl.1880-1890
Painter of Venetian scenes. Exhib. both oils and watercolours at SS only. Address Richmond, Surrey.

COBLEY, Miss Florence fl.1888-1889
Exhib. two flower pictures, 1888-9. London address.

COCHRANE, Mrs. Helen Lavinia 1868-1946
(Miss Shaw)
Painter of romantic landscapes and Venetian scenes. Studied at Liverpool and Westminster Schools of Art, and in Munich. Later lived in Italy.

COCKBURN, Edwin fl.1837-1868 d.c.1874
London painter of domestic scenes. Exhib. at RA, BI and SS, exhibiting a total of over 60 pictures. RA titles 'The Cottage Fireside', 'Daddy's Coming', etc. A sale of his pictures took place after his death at Foster's Saleroom in London on 18 March 1874.

COCKBURN, Mrs. F.M. see BONNEAU, Miss Florence Mary

COCKBURN, W.A. fl.1850-1852
London landscape painter. Exhib. French and Swiss views at RA and BI.

COCKBURN, William fl.1866
Exhib. one picture of buildings, 1866. No address recorded.

COCKERELL, Miss Christabel A. b.1860 fl.1884-1903
(Lady Frampton)
London painter of portraits and figure subjects. Wife of the sculptor Sir George Frampton. Exhib. at RA and SS. Titles: 'Little Mother',
Bibl: Sparrow p.136.

COCKERELL, Edward A. fl.1883
Exhib. one picture of Lynmouth, Devon, at SS, 1883. London address.

COCKERELL, Samuel Pepys b.1844 fl.1875-1903
Son of Charles Robert Cockerell, the architect. Painter of historical scenes, portraits, mythological and genre pictures, decorative artist, and sculptor. As a sculptor he produced the mural monument to James Stewart Hodgson in Haslemere Church, exhib. at RA 1903, and the decorative reliefs inside and out at Lythe Hill, Haslemere. Exhib. at the RA 1875-1903, SS and GG. Titles at RA 'Pilate Washing his Hands before the People', 'Orpheus and Eurydice', 'Our Lady of the Ruins', etc.
Bibl: Ruskin, Academy Notes 1875; Blackburn, *Academy Notes*, 1882 p.80 n.1624; G. Ulick Browne, Studio XXX 1904 pp.116-22 (sculpture).

COCKERILL, Miss Alice M. fl.1893
Exhib one flower picture at RA, 1893. London address.

COCKING, Edward fl.1830-1848
London still-life painter. Exhib. at RA, BI and SS. Subjects fruit, flowers, birds, etc. and occasional figures.

COCKING, R. fl.1839
Exhib. one picture 'Girl' at RA, 1839. No address given.

COCKRAM, George RI RCA 1861-1950
Liverpool landscape painter in watercolour, especially of mountain and coast scenes. Studied at the Liverpool School of Art, 1884, and in Paris, 1889; then decided to devote himself entirely to painting in watercolour. RCA 1891. Exhib. at the RA 1883-1924. 'Solitude', RA 1892, was purchased by the Chantrey Bequest and is in the Tate Gallery. Elected RI 1913.
Bibl: Tate Cat; RA Pictures 1892 p.153 (reprd. 'Solitude'); Brook-Hart.

COCKRAN, Henrietta fl.1871
Exhib. one landscape, 1871. London address.

COCKRAN, Jessie fl.1875
Fruit painter who exhib. at the Society of Female Artists, 1875.

COCKRELL, Louis fl.1891-1892
Birmingham painter of figure subjects. Exhib. two pictures at RA 1891-2, 'Margaret' and 'Harvest Moon'.

CODINA, Victoriano fl.1878-1883
(Mrs. Langlin)
London painter of domestic and figure subjects. Exhib. under her maiden and married names at RA and SS. Painted Spanish subjects, e.g. 'Spanish Lovers', and also exhibited some sculpture.

COE, E.O. fl.1833-1851
London painter of churches and castles. Exhib. at RA and SS, mainly views of French cathedrals.

COGGIN, Mrs. Jeannie fl.1892
Exhib. one picture of a French town hall at RA, 1892. Wife of Clarence Coggin, architect. London address.

COGILL, Miss Emily fl.1897-1898
Exhib. two landscapes at RA, 1897-8. Address Surbiton, Surrey.

COHEN, Miss Ellen Gertrude fl.1881-1904
London painter of domestic scenes and children. Exhib. at RA, SS, NWS and elsewhere. Titles: 'A Young Rebel', etc. Also a sculptor.

COHEN, Miss Minnie Agnes b.1864 fl.1891-1904
Painter of figures and Dutch scenes. Exhib. at RA, 1891-1904. Her Dutch subjects often painted around Katwyk. Addresses Manchester and London. Worked in oil, pastel and watercolour.

COKE, Alfred Sacheverel fl.1869-1892
London painter of historical subjects. Exhib. at RA, SS and elsewhere. Titles: 'The Daughter of Herodias', etc.
Bibl: Newall.

COLBY, Joseph fl.1851-1886
Painter of genre, portraits, historical and mythological subjects. Exhib. at the RA from 1851, 'Asiatic Indolence', to 1886. In 1860 he exhibited at the BI, 'Olivia': "Not one of these Olivias whom we all know so well — yet a study of rare excellence" (AJ).
Bibl: AJ 1860 p.80.

COLE, Mrs. fl.1824-1840
London painter of fruit and flowers. Exhib. at RA and SS.

COLE, Miss A. fl.1855-1856
Exhib. two portraits at RA, 1855-6. London address.

COLE, Alfred Benjamin fl.1867-1883
London landscape painter. Exhib. at RA, SS and elsewhere. Subjects mostly views in Sussex and Hampshire.

COLE, Miss Blanche Vicat fl.1890-1893
Exhib. three domestic scenes, 1890-3. Presumably a daughter of George Vicat Cole (q.v.).

COLE, Chisholm ARCA fl.1890-1899
Painter of Welsh landscapes. Exhib. at RA, 1890-9. Lived at Llanbedr, Conway.

COLE, E.S. fl.1837-1868
London painter of churches and monuments. Exhib. at RA, SS and elsewhere.

COLE, Miss Ellen fl.1841-1858
London painter of historical, biblical and other figure subjects. Exhib. at RA and SS.

***COLE, George 1810-1883**
Portrait, landscape and animal painter. Self-taught, and began by painting several large canvas advertisements for the proprietor of a travelling circus (tiger hunts, etc., exhib. at Weyhill Fair). This success led him to study animal painting more seriously and he went to Holland to study the Dutch Masters. He devoted himself for some years to animal painting in Portsmouth, exhibiting for the first time in London at the BI in 1840. His 'Don Quixote and Sancho Panza with Rosinante in Don Pedro's Hut' attracted much attention there in 1845. From 1849-82 he exhibited at the RA, turning to landscapes, mainly in Hampshire, Surrey, Cornwall, Wales, Sussex, etc. His son George Vicat Cole (q.v.) was also a landscape painter, and their work is sometimes confused.
Bibl: AJ 1883 p.343; Ottley; Clement & Hutton; DNB; Pavière, Landscape (pl. 12); Wood, Paradise Lost.

***COLE, George Vicat RA 1833-1893**
Landscape painter, eldest son of George Cole (q.v.). Born in Portsmouth; in 1852, he sent his first pictures for exhib. to London to the Society of British Artists. He exhib. at the RA 1853-92 becoming A in 1869, and RA in 1880. His work was highly popular. Maas notes that he "achieved almost the popular success of Leader, and was capable of grand effects — as in 'The Pool of London' ". His subjects were taken from England, Wales and Scotland, but he was especially fond of views along the Thames. His studio sale was held at Christie's, 16 June 1893.
Bibl: AJ 1870 pp.177ff.; 1893 p.33; 1909 p.294, R. Chignell, *Life and Works of Vicat Cole*, 1898; Pavière, Landscape (pl.13); Maas pp.228-9 (pl.229); Wood, Paradise Lost.

COLE, Miss H. fl.1877
Exhib. one bird's nest picture at SS, 1877. London address.

COLE, Sir Henry KCB 1808-1882
Best known as an administrator, reformer and designer, and especially for his work on the 1851 and 1862 Great Exhibitions. He was also an amateur artist, and studied under David Cox. Between 1827 and 1866 he exhibited occasionally at the RA, usually landscape drawings and watercolours. As a designer he produced the well-known 'Summerley's Art Manufactures'. His diaries are in the VAM.
Bibl: DNB; L'Art II p.141; Gazette des Beaux-Arts 1864-67; Hardie II p.195.

COLE, J. Foxcroft fl.1875-1877
Painter of Normandy landscapes. Exhib. at RA and SS. Addresses London and Paris.

COLE, James f1.1856-1885
London painter of figure subjects. Exhib. mainly at SS, also at RA, BI and NWS. RA titles mostly pictures of children.

COLE, James William fl.1849-1882
London painter of domestic subjects and animals. Exhib. a total of 63 pictures at RA, BI and SS. RA pictures mostly of horses and dogs. His only known work is 'A Holiday', RA 1862, a scene at the International Exhibition of 1862 (see bibl.).
Bibl: Wood, Victorian Panorama (pl. 189).

COLE, John H. RCA fl.1870-1892
Landscape painter from Llanbedr, Carnarvonshire. Exhib. at RA 1870-92, and SS. Subjects mainly Welsh landscapes, with children.

COLE, Miss M.M. fl.1871
Exhib. one picture, 'A Wealth of Golden Hair', at SS, 1871. London address.

COLE, Miss Mary Ann fl.1841-1872
London painter of domestic subjects. Exhib. a total of 40 pictures at RA, BI and SS. RA titles mostly genre, e.g.: 'Meditation', 'The Youthful Hairdresser', 'News from the Crimea', etc., and a few portraits.

COLE, Philip Tennyson fl.1878-1889
London painter of portraits and domestic subjects. Exhib. at RA, SS, and NWS. Titles: 'Sunday at Home', etc.

COLE, Reginald Rex Vicat ROI 1870-1940
Landscape painter, son of George Vicat Cole (q.v.). Exhib. at RA from 1896, and elsewhere, mainly views in Sussex and London, and canal scenes. Together with J. Byam Shaw (q.v.) he founded the Byam Shaw and Vicat Cole School of Art.
Bibl: Studio XXI 1901 p.187; XXX 1904 p.248; XLIII 1908 pp.45ff.; R. Chignell, *Life and Works of Vicat Cole*, 1897.

COLE, Solomon fl.1845-1859
Portrait painter. Worked in Worcester and London. Exhib. only at RA, all portraits.

COLE, Thomas William ARCA b.1857 fl.1886-1901
London painter of fruit, flowers and old buildings. Exhib. at RA, SS and elsewhere. Was Headmaster of Ealing Art School.

COLEMAN, A.G. fl.1877
Exhib. one watercolour of a bramble at SS, 1877. London address.

COLEMAN, Charles b.1807 fl.1839-1869
Painter of Italian scenes. Exhib. at RA and elsewhere. Lived in Rome and painted peasant life in the Campagna.
Bibl: The Etruscans, Cat. of Exhibition at Stoke-on-Trent AG 1989.

COLEMAN, Charles Caryl fl.1878-1891
Exhib. Italian scenes at RA, GG, NG and elsewhere. Lived in Rome, and may be the same as Charles Coleman (see above).

COLEMAN, Edward fl.1813-1848 d.1867
Born at Birmingham towards the end of the 18th century; son of James Coleman, a portrait painter. Painter of portraits, dead game

and kindred subjects; he also decorated papier-mâché ware. Exhibited 16 works at the RA, 1813-48, and was a contributor to the RBSA from 1827. Elected Member RBSA, 1826.

Bibl: Birmingham Cat.

COLEMAN, Edward Thomas fl.1849-1877
London landscape painter. Exhib. at RA, BI and SS. RA exhibits all landscapes, and one historical picture of 'Alexander the Great'.

COLEMAN, Frank fl.1885-1892
Bradford painter of figure subjects. Exhib. at RA and SS. Titles: 'A Poor Dinner Table', etc. and some Italian subjects.

COLEMAN, Mrs. Gertrude fl.1881
Exhib. one flower picture at SS, 1881. London address.

COLEMAN, Miss Helen Cordelia see ANGELL, Mrs. John

COLEMAN, Henry fl.1882-1889
Painter of Italian landscapes. Exhib. once at RA, 1889, and elsewhere. Lived in London and Rome.

COLEMAN, Miss Rebecca fl.1867-1879
London painter of domestic and figure subjects. Studied at Heatherley's, then lived in Germany for a number of years, where she gave lessons. Returned in 1866, and exhib. at RA, SS, Dudley Gallery and Society of Lady Artists. Titles: 'In the Studio', etc. Also painted heads on pottery. Sister of W.S. Coleman (q.v.).

Bibl: Clayton II pp.47-67.

***COLEMAN, William Stephen 1829-1904**
London figure painter and illustrator; brother of Miss Rebecca Coleman and Mrs. John Angell (qq.v.). Exhib. at SS and elsewhere. Worked for Minton's Art Pottery and designed many tiles and plates for them. Illustrated many books, including *Natural History Picture Book for Children* 1861, and *Our Garden Friends* 1863-4. Works by him are in Glasgow AG and the VAM. 'A Girl with Parakeets' appeared at Sotheby's Belgravia, 2 November 1971.

Bibl: AJ 1904 p.170-1; Cat. of Glasgow AG 1906; VAM Watercolour Cat. 1908; Cundall; Wood, Paradise Lost.

COLEPEPER, H. fl.1874
Exhib. one Irish landscape at SS, 1874. London address.

COLERIDGE, Lady fl.1864-d.1878
London portrait painter; formerly Mrs. John Duke Coleridge. Exhib. at RA only 1864-78. Among her sitters were William Boxall (q.v.), William Butterfield, and J.H. Newman.

Bibl: Ormond I pp.49, 340.

COLERIDGE, F.G. fl.1866-1891
Berkshire landscape painter. Exhib. mainly at SS, also RA, NWS and elsewhere. Exhibited two pictures only at RA, both views near Mapledurham. SS exhibits all watercolours. Four works by him are in the Laing AG Newcastle (1939 Cat. pp.129-30).

COLERIDGE, Hon. Stephen 1854-1936
London landscape painter. Exhib. at RA and SS. Subjects include English and Scottish views, and some of Venice. Travelled in South America and the East 1879-80. Later wrote many books, e.g. *Memories* 1913.

COLES, Miss Mary fl.1873-1877
Exhib. one picture of mushrooms at SS, 1877. Address Cheltenham, Gloucestershire.

COLES, William C. fl.1881-1897
Painter of landscapes. Exhib. at RA, SS and elsewhere. Addresses Devizes, and Winchester School of Art.

COLKETT, Samuel David 1800/6-1863
Landscape painter, engraver and lithographer of the Norwich School, working both in oil and watercolour. Pupil of James Stark. 1828-36 he lived in London, exhibiting at the RA in 1830 and 1831, but then returned to Norwich as a dealer, restorer and drawing master, where he stayed for seven years before transferring his business to Yarmouth, and eventually, for the last ten years of his life, to Cambridge. His work has often been attributed to Thomas Churchyard (1798-1865), and until recently his water-colours were very scarce. Clifford says he is a more individual watercolourist than has been supposed, especially for his rural scenes "painted very wetly in bright fresh colours. His was a slight talent, but he deserves to be remembered for it rather than as a poor imitator and copyist of Stark and an over-painter of Cotman's canvasses, which is all Dickes could say of him."

Bibl: Dickes, *The Norwich School of Painting*, pp.318, 572; Clifford pp.49, 50, 61, 72, 82, 84 (pls.54b, 55a-b); H.A.E. Day, *East Anglian Painters*, II pp.91-7.

COLKETT, Miss Victoria S. ARPE fl.1859-1893
(Mrs. Harry Hine)
Landscape painter. Exhib. under her maiden name 1859-74, and as Mrs. Harry Hine 1876-93, at RA, BI, SS, NWS and elsewhere. Lived in Cambridge and St. Albans, and painted many views of Cambridge colleges. See also Mrs. Harry Hine.

COLLEY, Andrew fl.1873-1899
Newcastle painter of figure subjects. Exhib. at RA, 1893-9. Titles: 'Pleasures of Life', etc.

Bibl: Hall.

COLLIER, Alexander fl.1870-1882
Landscape painter. Exhib. watercolours of English scenery at SS and elsewhere. Addresses London and Southampton.

COLLIER, Miss Amy fl.1874
Exhib. picture of a dead magpie at SS, 1874. Address Callington, Cornwall.

COLLIER, Arthur Bevan fl.1855-1899
Landscape painter; lived in London and Cornwall. Exhib. at RA 1855-99, BI and SS. Subjects mainly Scottish and Welsh landscapes, also views in Devon and Cornwall. 'Trebarwith, near Tintagel, Cornwall', RA 1872, is in the Birmingham AG.

COLLIER, Bernard C. fl.1878-1887
Painter of coastal scenes and figures. Exhib. oils and watercolours at RA and SS. Lived in London and Canterbury. Son of T.F. Collier (q .v.).

COLLIER, Miss Emily E. fl.1879-1890
Painter of domestic subjects. Exhib. at SS, NWS and elsewhere. Address Shortlands.

***COLLIER, Hon. John 1850-1934**
Painter of portraits, dramatic subject pictures and occasional landscapes. Younger son of the Judge Robert Collier (afterwards first Lord Monkswell). Educated at Heidelberg. Studied art under Poynter at the Slade School, in Paris under J.P. Laurens and in Munich; encouraged by Alma-Tadema and Millais. Exhib. at the

RA from 1874-1934. Published *The Primer of Art* 1882; *A Manual of Oil Painting* 1886; *The Art of Portrait Painting* 1905. One-man exhib. of landscapes at the Leicester Galleries, 1915; retrospective exhib. at Sunderland AG, 1921-2. Titles include: 'The Last Voyage of Henry Hudson', 1881 (Tate Gallery); 'Marriage de Convenance', 1907 and 'A Glass of Wine with Caesar Borgia', 1893, both exhib. at RA Bicentenary Exhibition, 1969. Collier's subject pictures, like those of Orchardson, catered for the vogue for psychological dramas of upper-class life.

Bibl: W.H. Pollock in AJ 1894 pp.65-9; Tate Cat.; W.H. Pollock, *Art Annual* 1914 ('The Last Voyage of Henry Hudson' reprd. p. 19); Ormond I see index; Wood, Olympian Dreamers; Wood, Pre-Raphaelites.

COLLIER, Mrs. John fl.1880-1884
(Marian Huxley)
London painter of portraits, figures and flowers. Wife of the Hon. John Collier (q.v.). Exhib. at RA, SS, and GG. Titles: 'A Coming Tragedian', etc.

COLLIER, Mrs. Mary J. fl.1878-1881
Exhib. five flower pictures, 1878-81. London address.

COLLIER, The Rt. Hon. Sir Robert Porrett 1817-1886
(Lord Monkswell)
Amateur landscape painter; father of the Hon. John Collier (q.v.). He had a distinguished legal career, becoming Attorney-General, Justice of Common Pleas, and Lord Monkswell in 1885. He painted views in the Swiss Alps, which he exhib. at the RA, SS, GG and elsewhere. 'The Jossin Horn' was offered at Sotheby's Belgravia, 9 September 1975, lot 184.

Bibl: DNB; Pyecroft, *Art in Devonshire*, 1883; The Times 28 October 1886; Cat. of Fitzwilliam Museum, Cambridge, 1902; Bryan; Ormond I p.322.

COLLIER, Thomas RI 1840-1891
Landscape watercolourist. Occasionally painted in oils. Attended Manchester School of Art, first exhib. at SS when 23: 'On the Llugwy, N. Wales', 1863. Lived 1864-9 at Betws-y-Coed then in Hampstead. Influenced by David Cox. In the 19th century his work was confused with that of James W. Whittaker (q.v.). Little known about his life and career and under-appreciated until Adrian Bury's monograph in 1944. Hardie calls him "one of the supreme watercolour painters of England". Exhib. four works at the RA 1869 and 1870; and 80 at the RI, of which he was elected A 1870, and Member 1872.

Bibl: Ruskin, Academy Notes 1857; Cundall; VAM; Nettlefold; Adrian Bury, *Thomas Collier,* 1944; Hardie III pp.150-6 (pls. 175-6).

COLLIER, Thomas Frederick fl.1850-1874
London painter of landscapes and still-life. Exhib. at RA and SS, in oils and watercolour. Also exhib. at RHA from 1850, and taught at Cork School of Design. Because of an addiction to drink, he gave up his teaching job, and moved to London. His son was Bernard Collier (q.v.).

COLLING, James Kellaway fl.1844-1883
Norfolk landscape and architectural painter. Published several books on architectural ornament.

COLLINGHAM, G. fl.1880
Exhib. one figure subject 1880. London address.

COLLINGRIDGE, Miss Elizabeth Campbell fl.1864-1873
London painter of figure subjects and landscapes. Studied at Heatherley's and RA Schools. Exhib. at BI and SS. Was also a decorative artist, and painted panels on furniture for several firms.

Bibl: Clayton II pp.334-6.

COLLINGRIDGE, Mrs. John fl.1888
Exhib. one landscape, 1888. Winchmore Hill address.

COLLINGS, Albert H. RBA fl.1893
Exhib. two figure subjects at SS, 1893. London address.

COLLINGS, Charles John 1848-1931
Landscape painter, mainly in watercolour. Exhib. in London until 1910, when he went to Canada. He painted in a broad, strong style, which shows the influence of Cotman.

Bibl: Apollo LIV 1951.

COLLINGS, Robert fl.1883
Exhib. one portrait at SS, 1883. London address.

COLLINGWOOD, A.J. fl.1864
Exhib. one Welsh landscape at SS, 1864. London address.

COLLINGWOOD, Ellen fl.1880
Exhib. one domestic subject, 1880. London address.

COLLINGWOOD, Lilly fl.1882
Exhib. one flower picture, 1882. London address.

COLLINGWOOD, W.J. fl.1875
Liverpool artist. Exhib. one lake scene, 1875.

COLLINGWOOD, William RWS 1819-1903
Landscape painter, mainly in watercolour. Born in Greenwich, son of an architect. Pupil of J.D. Harding and Samuel Prout. Exhib. at RA 1839-60, BI, SS, OWS (732 works) and NWS (108 works). In 1856 Ruskin praised his watercolour of the 'Jungfrau at Sunset' and thereafter Collingwood was chiefly known for his Alpine subjects. Many of his pictures are in Liverpool and its vicinity, where most of his professional life was spent. He was intensely religious, a lay preacher, and member of the Plymouth Brethren. He was a friend of A.W. Hunt (q.v.). Died in Bristol.

Bibl: J. Ruskin, *Notes on the OWS,* 1856; Clement & Hutton; Marillier pp.87-91

COLLINGWOOD, William Gersham 1854-1932
Landscape painter and watercolourist. Son of William Collingwood (q.v.). Studied under his father; went to University College, Oxford, where he met Ruskin. Later studied under Legros at Slade School. In 1881 he became Ruskin's secretary at Brantwood, near Coniston. In 1883 he married and moved to Windermere. Exhib. at RA from 1885, also SS, NWS, GG and elsewhere. He shared Ruskin's historical and geological interests, which are reflected in his works. He was a founder member of the Lake Artists' Society, and President from 1922 until his death in 1932. Author of several books including a *Life of Ruskin* and *Lake District History.*

Bibl: Studio XXIII 1901 p.114; XXXIX 1907 p.66; Marillier pp.90-1; J.S. Dearden and K.G. Thorne, *Ruskin and Coniston,* 1971.

COLLINS, Alfred fl.1851-1882
London landscape painter. Exhib. at RA, BI, SS and elsewhere. RA subjects include several landscapes around Hampstead, Highgate and Kentish Town.

COLLINS, Archibald fl.1876-1893
London painter of figure subjects and still-life. Exhib. at SS and elsewhere. Titles: 'Tender Thoughts', etc.

COLLINS, Charles RBA fl.1867-1903 d.1921
Painter of rustic genre and figure subjects. Dorking address. Exhib. at the RA 1867-1903, SS and NWS. Titles include: 'An English Cottage' 1867, 'When March Winds Blow', and 'His First Attempt' 1903.

***COLLINS, Charles Allston 1828-1873**
Painter of historical genre. Studied at RA schools. Came into contact with the Pre-Raphaelites, and his paintings of the 1850s show their influence, especially 'Convent Thoughts' (Ashmolean) his best-known work. Very friendly with Millais, with whom he made several painting expeditions. Their drawing styles are very similar, and are sometimes confused. Never a facile artist, Collins gave up painting about 1858 to pursue writing. He wrote two novels, two very observant and amusing travel books and periodical essays. His father was William Collins (q.v.), his brother Wilkie Collins, and he was married to a daughter of Dickens, see Mrs. C.E. Perugini. Exhib. at the RA 1847-55, and at BI 1848-9.

Bibl: AJ 1904 pp.281-4 (Smetham & C.A.C); 1859 p.122; 1873 p.177; Ruskin Academy Notes 1855; Forster, *The Life of Charles Dickens*, 1893; Bate pp.79-80 (pls. opp. pp.10, 79); Bryan; DNB; S.M. Ellis, *Wilkie Collins. Le Fanu and others*, 1931; Fredeman, see Index; Reynolds, VP p.68; Maas pp.127, 193; Staley; Wood, Pre-Raphaelites.

COLLINS, D. Lincoln fl.1871-1882
London landscape painter. Exhib. at various exhibitions, 1871-82.

COLLINS, Miss Elizabeth L. fl.1866-1869
London painter of still-life and landscape. Exhib. at SS, 1866-9 in oils and watercolours.

COLLINS, Henry fl.1874
Exhib. one rustic subject, 1874. London address.

COLLINS, Hugh fl.1868-1891
Edinburgh painter of figure subjects. Exhib. at RA and SS. Titles at RA portraits, and 'In Close Pursuit of a Deserter: the 42nd Highlanders'. 'A Christmas Cactus' was offered at Sotheby's Belgravia, 11 January 1972.

COLLINS, James Edgell fl.1841-1875
London portrait painter. Exhib. at RA, BI, SS and elsewhere, all portraits, except for a few figure subjects, e.g. 'A Flower Girl', etc. A portrait by him is in Birmingham City AG.

COLLINS, Miss Jennette fl.1892-1897
Edinburgh painter of domestic subjects. Exhib. three pictures at RA, 1892-7. Titles: 'Sunshine', etc.

COLLINS, Mrs. M. fl.1874-1881
Gravesend painter of figure subjects. Exhib. once at RA, 1876, with 'A Study', also at other various exhibitions.

COLLINS, Miss Maria fl.1889
Exhib. one picture 'An Old Mill, Vichy' at RA, 1889. Edinburgh address.

COLLINS, Miss Mary fl.1895
Exhib. one flower picture at RA, 1895. Epsom address.

COLLINS, R. fl.1860
Exhib. two pictures of fruit at SS, 1860. London address.

COLLINS, Thomas fl.1857-1893
Birmingham flower painter. Exhib. at RA and SS, 1867-73, also in Birmingham.

***COLLINS, William RA 1788-1847**
Painter of landscape, coastal scenes and rustic genre. Although really a pre-Victorian figure, Collins is important because he established the tradition of picturesque rustic landscape carried on by Shayer and many others. Father of C.A. Collins (q.v.) and Wilkie Collins, the novelist. His father, William Collins, was Morland's biographer, and it was from Morland that young William received his first lessons. Entered RA Schools 1807, and began exhibiting in that year. Also exhib. at BI. Elected ARA 1814, RA 1820. In 1822 married a daughter of the Scottish painter Andrew Geddes. Encouraged by his friend D. Wilkie (q.v.) he travelled in Holland and Belgium 1828, Italy 1836-8, Germany 1840. Although Collins's landscapes are contrived, and his figures sentimental, his pictures were enormously popular. His colours are fresh and his technique pleasingly fluid, but many of his pictures have now discoloured because of his use of experimental pigments. His studio sale was held at Christie's, 31 May–5 June 1847. His diaries are in the VAM.

Bibl: AU 1847 p.137; AJ 1855 pp.141-4; 1859 p.44; 1899 p.139ff.; W. Wilkie Collins, *Memoirs of the Life of W.C.*, 1848; Redgrave, Cent. pp.346-50; DNB; Reynolds, VP p.16 (pl.5); Maas pp.54-5; Staley; Ormond I p.112; Brook-Hart.

COLLINS, W.J. fl.1859
Exhib. one picture 'The Artist's Reverie' at RA, 1859. London address.

COLLINS, W.T. fl.1858-1859
Exhib. two coast scenes 1858-9. London address.

COLLINS, W.W. fl.1849
Exhib. one picture 'The Smugglers Refuge' at RA, 1849. London address.

COLLINS, William Wiehe RI 1862-1952
Painter of landscapes, figure and architectural subjects, and naval scenes. Studied at Lambeth School of Art 1884-5, and Académie Julian, 1886-7. Exhib. at RA from 1890, and other London galleries. Elected RI 1898. Served in the Navy in World War I, and illustrated several books. Lived in Wareham, Dorset, and Bridgwater, Somerset.

***COLLINSON, James 1825-1881**
One of the original founder members of the Pre-Raphaelite Brotherhood (q.v.). Fellow student with Holman Hunt and D.G. Rossetti at RA Schools. In 1847 exhib. at RA 'The Charity Boy's Debut', which attracted Rossetti's attention for its painstaking detail, who induced him to become one of the original seven brothers of the PRB. He was engaged to Christina Rossetti 1849-50. In 1851 he exhib. at the Portland Gallery a PRB picture 'An Incident in the Life of St. Elizabeth of Hungary'. He was fiercely Roman Catholic, and after 1851 left the PRB and retired to Stonyhurst. About 1854 he emerged again and resumed the profession of an artist. He confined himself to small subjects of domestic and humorous character, e.g. 'For Sale' and 'To Let', 'Good for a Cold', 'The New Bonnet', and of all the original PRB's his reputation dwindled the most rapidly. However, his paintings are extremely pretty and show his great dexterity in painting objects and the surfaces of materials. "He seems to have been chiefly remarkable for his habit of falling asleep on all occasions, which made him something of a butt among his friends, who treated him with a kind of contemptuous kindness" (Ironside & Gere).

Bibl: DNB; Thomas Bodkin, Apollo XXXI May 1940 pp.128-33; Ironside & Gere p.26; Fredeman (for full bibl.); Maas p.117 (pl.140); Staley; Wood, Pre-Raphaelites; Wood, Paradise Lost.

***COLLINSON, Robert b.1832 fl.1854-1890**
Genre painter who exhib. at the RA 1858-90, titles including 'Stray Rabbits' 1858, 'Summer Ramble' 1880. Also exhib. at BI and

SS. Ruskin praised his 'Sunday Afternoon' at the RA in 1875. 'Ordered on Foreign Service', RA 1864, is in the Ashmolean, Oxford.
Bibl: Ottley; Ruskin, Academy Notes 1875; VAM Cat. I 1907.

COLLINSON, Mrs. Robert (Eliza) fl.1856-1868
London flower painter; wife of Robert Collinson (q.v.). Exhib. at RA and SS.

COLLIS, A.P. fl.1852-1854
Exhib. two landscapes of the Lake District at SS, 1852-4. Lived in Westmorland.

COLLS, Ebenezer fl.1852-1854
London painter of shipping and coastal scenes. Exhib. at BI only. Painted views on the Thames, off Dover, Plymouth and elsewhere.
Bibl: Brook-Hart p.57 (pl.111).

COLLS, Harry fl.1878-1890
London painter of shipping and coastal scenes. Exhib. at RA, SS, GG and elsewhere.
Bibl: Brook-Hart p.343.

COLLS, Richard fl.1831-1855
London still-life painter. Exhib. at RA, BI, SS and elsewhere. Subjects at RA mostly pictures of fruit, and a few landscapes.

COLLUCCI, Z. fl.1860-1861
London portrait painter. Exhib. at RA and SS.

COLLYER, H.H. 1863-1947
Nottingham landscape painter; member of the Nottingham Society of Artists. Particularly painted gardens.

COLLYER, Miss Margaret fl.1897-1903
London painter of figure subjects. Exhib. at RA, 1897-1903. Titles: 'Friend or Foe?', etc.

COLMAN, Samuel fl.1816-1840
Bristol painter of romantic subjects, whose work until recently has mostly been misattributed either to John Martin or Samuel Colman (1832-1890) of the Hudson River School. Colman lived in Bristol, where he exhibited at the Society of Bristol Artists, also at RA in 1839 and 1840. His best known work is 'The Delivery of Israel out of Egypt', Birmingham, which shows his own highly individual treatment of Martinesque themes. Some of his works are also in Bristol AG.
Bibl: The Bristol School of Artists, Bristol 1973 Exhibition Cat. pp.203-9.

COLMAN, S.G. fl.1872
Exhib. one landscape 'On the Avon' at RA, 1872. London address.

COLOMB, Wellington fl.1865-1870
Painter of Irish landscapes. Exhib. at RA, SS and elsewhere. London address.

COLQUHON, Miss Annie T. fl.1893
Exhib. one watercolour at NWS, 1893. Londonderry address.

COLSON, Miss fl.1874
Exhib. two watercolours of landscape at SS, 1874. London address.

COLVILLE, Baron Charles John fl.1876-1878
Exhib. two landscapes in London, 1876-8. London address.

COLVILLE, Miss E. fl.1880-1884
Exhib. one watercolour of flowers at SS, 1884. London address.

COMAN, Mrs. Charlotte B. fl.1879
Exhib. two Dutch landscapes at SS, 1879. Paris address.

COMBER, Miss Mary E. fl.1887
Exhib. one picture of oysters at RA, 1887. Warrington address. Also painted blossoms and mossy banks in the manner of the Clares (qq.v.).

COMBES, Miss Alice H. fl.1885
Exhib. one landscape 1885. London address.

COMBES, Hon. Edward HRI fl.1884-1892
Exhib. Australian views at RA and NWS. Addresses London and Sydney.

COMBES, Mrs. G.E. fl.1885-1887
London flower painter. Exhib. three watercolours at NWS, 1885-7. Probably the same as Grace Emily Combes (q.v.).

COMBES (COOMBES), Miss Grace Emily fl.1879-1882
London painter of flowers and birds. Exhib. at SS only, 1879-82.

COMOLERA, Mme. Melani de fl.1816-1854
London fruit and flower painter; also painted on porcelain and glass. Studied at Sèvres factory 1816-18. Exhib. at the Paris Salon 1817-39. Settled in London, and exhib. at RA 1826-54, BI and SS. Appointed Flower Painter to the Duchess of Clarence, and also to the Queen Dowager.
Bibl: Clayton I p.401.

COMPTON, A. fl.1878-1879
Exhib. two landscapes at SS, 1878-9. Address Epsom, Surrey.

COMPTON, Charles 1828-1884
Genre and historical painter. Born in London; entered RA Schools in 1845. There he met Rossetti, Millais, and other members of the Pre-Raphaelite group, with whom he became friendly. In 1847, he won a silver medal, and exhibited his first picture at the RA 'The Sick Child'. This early promise was not to be fulfilled, as he soon after became a civil servant, and moved to Woolwich, where he was employed by the Ordnance Department of the War Office. In 1860 he married Elizabeth Green. He continued to paint as a hobby, and exhib. 1847-57 at the RA, BI and SS. Titles at RA 'An Incident in the Life of Benjamin West', 'Bunyan in Bedford Gaol AD 1661', etc. He remained a great admirer of Millais, and made many copies of his work, including 'The Huguenot', 'The Black Brunswicker' and 'The Order of Release'. He died in Woolwich in 1884.
Bibl: Mrs. J. Turner (grand-daughter of the artist), Charles Compton, The Army Quarterly July 1971.

COMPTON, E.H. fl.1873
Exhib. one landscape 1873. Address Weston-super-Mare.

***COMPTON, Edward Thomas b.1849 fl.1879-1881**
Landscape painter. A self-taught artist, he first painted English scenery, then travelled to Germany and Switzerland. He became one of the first artists to devote himself to painting the remote and inaccessible heights of the Alps. For this reason he has always been more appreciated in Switzerland than in England. He also travelled in Spain, Corsica, North Africa and Scandinavia. Exhib. at RA, SS,

NWS, GG and elsewhere. Many of his pictures and drawings were used in guide books to the Alps.

Bibl: AJ 1907 p.247; E.W. Bredt, *Die Alpen und ihre Maler*, 1910; Dreyer, *Der Alpinismus und der Deutsch-Osterr Alpenverein*, 1909.

COMPTON, Theodore fl.1866-1874
London flower painter. Exhib. two pictures in London in 1866 and 1874.

CONANT, Amy L.E. fl.1884
Exhib. one watercolour 'A Cottage in Rutland' at SS, 1884. Address Oakham, Rutland.

CONDER, Charles 1868-1909
Painter of landscapes and portraits in oil, best known for his watercolours on silk, usually done as panels for wall decoration or fans. Also a lithographer. Spent early years in India and Australia. Studied art in Melbourne and Sydney. Went to Paris in 1890; after 1897 lived mainly in England. Exhib. at Leicester Galleries, Grafton Gallery, and NEAC. One of the founders of the Society of Twelve. His subjects, like those of Beardsley, are vague and fragile, tinged with *fin de siècle* morbidity and decadence. An exhibition of his work was held at the Graves AG Sheffield in 1967.

Bibl: VAM; Cundall; F.G. Gibson, *Charles Conder*, 1914, J. Rothenstein, *The Life and Death of Conder*, 1938; Hardie III pp.170-1 (pl.200); Maas pp.20, 169, 252 (pls. on pp.252, 255).

CONDER, Miss H. Louise fl.1890-1893
London painter of landscapes and buildings. Exhib. at SS and NWS.

CONDER, Josiah fl.1885
Exhib. three pictures of Japanese temples at RA, 1885. Tokyo address.

CONDER, Roger T. fl.1883
Exhib. one picture of the interior of St. Mark's, Venice at RA, 1883. London address.

CONDY (CUNDY), Nicholas 1799-1857
Landscape painter. Born in Torpoint, Cornwall. Served in the Peninsula War, 1811-18. From 1818 he studied art and became a professional painter in Plymouth. He chiefly produced small watercolours on tinted paper, about 8 by 5ins. which he sold for about 15s. [75p] to one guinea each. Between 1830 and 1845 he exhib. landscapes at the RA, BI and SS. At the RA in 1843 and 1845: 'An interior of an Irish cottage at Ballyboyleboo, Antrim', and 'The Cloisters of Laycock Abbey'. His best known painting 'The Old Hall at Cotehele on a Rent-day' is at Mount Edgcumbe. He published *Cotehele on the Banks of the Tamar, the Ancient Seat of the Rt. Hon. the Earl of Mount-Edgcumbe*, 17 plates with descriptive account.

Bibl: DNB 1908.

CONDY, Nicholas Matthew 1816-1851
Son of Nicholas Condy (q.v.). Marine painter. Became a professor of painting in Plymouth. He exhibited three sea pieces at the RA 1842-5, which gave hopes of his becoming a distinguished artist, but he died prematurely.

Bibl: DNB; Redgrave, Dict; Brook-Hart (pl.186).

CONEY, R.H. fl.1877
Exhib. one picture 'In the Year 1350' at SS, 1877. London address.

CONNAH, J. Douglas fl.1894
Exhib. one picture 'Lost in Reverie' at RA, 1894. London address.

CONNELL, Miss M. Christine fl.1885-1890
London painter of domestic and figure subjects. Exhib. at RA, SS and elsewhere. Titles: 'Little Mischief', etc.

CONNELL, William fl.1876-1877
Exhib. two sea pictures 1876-7. London address.

CONNING, George J. fl.1890
Exhib. one picture 'The Sands, Yarmouth' at RA, 1890. London address.

CONNOLLY, Michael fl.1885-1903
London painter of portraits and figure subjects. Exhib. at RA, 1885-1903. Titles: 'A Veteran', etc.

CONNOP, J.H. fl.1852
London painter of figures and still-life. Exhib. three pictures at BI and SS in 1852. Graves lists his initials as T.H.

***CONOLLY, Miss Ellen fl.1873-1885**
Genre painter. Sister of Francis Conolly, a sculptor, fl.1849-70. Exhib. at RA, SS and elsewhere. Titles at RA 'Darby and Joan' 'Chelsea Pensioners', 'A Village Genius', etc.

CONQUEST, Alfred fl.1880-1890
London landscape painter. Exhib. at RA, SS, GG and elsewhere. Painted views in Cornwall, Essex, and on the northern coast of France. Also exhib. at Paris Salon 1882-3.

Bibl: Brook-Hart.

CONRADE, Alfred Charles 1863-1955
Architectural painter, mainly in watercolour. Studied in Düsseldorf, Paris and Madrid. Travelled in Europe and Japan. His subjects are usually architectural scenes or capriccios, with figures.

CONRADI, Moritz fl.1865-1876
London painter of portraits and domestic genre. Exhib. at RA only. Titles: 'Homewards from Shopping', etc., and portraits.

CONSTABLE, E.P. fl.1879
London landscape painter. Exhib. three landscapes at RA and SS in 1879.

CONSTABLE, G., Jnr. fl.1862
Exhib. one Sussex landscape at BI, 1862. Address Arundel, Sussex.

CONSTABLE, Isabel 1823-1885
 Alfred Abram 1826-1853
 Lionel Bicknell 1828-1884
London painters, children of John Constable. Isabel exhib. two flower pictures at the RA, 1851-2. Alfred Abram exhib. landscapes and coastal scenes at the RA, 1847-53. Lionel Bicknell exhib. landscapes at RA, 1849-55 and BI.

Bibl: For further reference see John Constable literature.

CONSTABLE, S.C. fl.1891
Exhib. one watercolour 'An English Cottage' at SS, 1891. London address.

CONWAY, C.J. fl.1855
Exhib. three landscapes at SS, 1855. London address.

CONWAY, George fl.1854-1871
London landscape painter. Exhib. mainly at SS, also RA and BI. Subjects: Views of the Thames, Essex, North Wales, etc.

COODE, Miss Helen Hoppner fl.1859-1880
London painter of figure subjects. Exhib. mostly at Society of Lady Artists, also RA, BI and SS. Titles: 'The Sermon rehearsed', etc.

COOK, Ambrose B. fl.1886
Exhib. one picture 'The Intruder' at SS, 1886. London address.

COOK, C. fl.1860
Exhib. one still-life of birds and fruit at SS, 1860. London address.

COOK, Charles A. fl.1877-1882
Landscape painter. Exhib. one watercolour of Skye at SS, 1877, also elsewhere. Address Blackheath, London.

COOK, Ebenezer Wake 1843-1926
Landscape watercolour painter, mainly of views of the Thames, in Yorkshire, Venice, Florence and Switzerland. Studied under N. Chevalier and worked in London. Exhib. at the RA 1875-1910, SS and NWS. Titles include: 'Mussel sorters, Conway', 1875, 'The Thames near Great Marlow', 1876, 'Sunset on the Lake of Geneva' 1892, 'The Loggia dei Lanzi, Florence', 1900, 'The Earthly Paradise', 1902. His drawings illustrating 'The Quest of Beauty' and 'Real and Ideal' were exhib. at the FAS, 1903, of which the *Studio* said: "He fails sometimes to bring the many details of his design into proper relation". 'S. Georgio in Venice', 1896 is in Melbourne, and 'The Wye and the Severn from the Windcliff', 1881 and 'The Last Days of the Campanile, Venice', 1906, are both in Sydney.
Bibl: Studio XXVIII p.135.

COOK, Miss Emily Annie fl.1881-1898
London painter of flowers and figure subjects. Exhib. at RA, SS, NWS, GG and elsewhere. RA subjects all flowers, and some genre, e.g. 'Parting is such Sweet Sorrow', etc.

COOK, F.B. fl.1877
Exhib. one picture 'Springtime' at SS, 1877. London address.

COOK, Frederick fl.1878-1891
London landscape painter Exhib. at RA and NWS. Titles include some views of Hampstead and Highgate, near which he lived.

COOK, George Edward fl.1874-1898
London painter of landscapes and rustic subjects. Exhib. at RA, SS, GG, NG and elsewhere. RA titles: 'Feeding Time', 'A Chat by the Way', 'Wargrave Church', etc.

COOK, George Frederick fl.1879-1897
London still-life painter. Exhib mainly at SS, also RA and elsewhere. RA titles flowers, also some genre subjects, 'The Spendthrift's Legacy', 'A Village Fair', etc.

COOK, H. fl.1880-1883
London painter of Venetian scenes. Exhib. once at RA 1881, and at GG.

COOK, Henry 1819-1890
London painter of landscapes, portraits, and battle scenes. Studied under F.R. Say, and at the Academy of St. Luke in Rome. Exhib. at RA, BI, SS and elsewhere. RA titles include some views in Italy, where Cook lived for several years, painting battle scenes for Napoleon III and Victor Emmanuel. Some of these are in the Quirinal Palace, and the Capodimonte Museum in Naples. On his return to London he turned more to landscapes, which he exhibited at the GG. Among his patrons was Queen Victoria.

COOK, Henry S. fl.1890
Exhib. one picture 'The Constitutional' at RA, 1890. London address.

COOK, Herbert Moxon b.1844 fl.1868-1920
Landscape painter. Lived in Manchester, London, and later at Prestatyn, North Wales. Exhib. at RA, SS, NWS and elsewhere. RA subjects mostly views in Wales and Scotland. A work by him is in Manchester AG.

COOK, J.A. fl.1883
Exhib. two portraits at GG, 1883. London address.

COOK, J.B. fl.1859
Exhib. one picture 'A Rustic Bridge, North Wales' at BI, 1859. Leamington address.

COOK, John Thomas fl.1883
Exhib. one picture 'The Stones at Bettws' at RA, 1883. Sheffield address.

COOK, Joshua fl.1838-1848
London painter of still-life and figures. Exhib. at RA, BI and SS. Most of his exhibited works were of birds, also figure subjects, e.g. 'Return from Hawking', 'The Eglinton Tournament', etc. A Joshua Cook Jnr. is also recorded; he exhibited pictures of fruit at the BI and SS 1852-4.

COOK, Miss L.S. fl.1870-1881
Flower painter. Exhib. once at GG, and elsewhere. Address Rochdale, Lancashire.

COOK, Miss Nelly E. fl.1887-1900
London flower painter. Exhib. at RA, SS, and NWS. Also exhib. some figure subjects, e.g. 'Alack and Well a Day, Phillida flouts me', etc.

COOK, Richard ARA 1784-1857
Painter of historical subjects. Studied at RA Schools, and exhib. at RA from 1816. Also a book-illustrator. Elected ARA 1816. His remaining works were sold at Christie's, 1 June 1857.

COOK, S.J. fl.1843
Animal painter. Exhib. one picture of 'Duke, the property of Mrs. Pearl', at RA, 1843. London address.

COOK, Samuel RI 1806-1859
Plymouth watercolourist of landscapes and rustic scenes. He was by profession a painter and glazier, and devoted all his spare time to watercolours. Exhib. mainly at NWS, where he was a member, and once at SS. Many of his works were coast scenes painted around Clovelly and Plymouth.
Bibl: AJ 1861 p.212 (obit.); Redgrave; Cundall; VAM Cat. 1908 p.83.

COOK, Theodore fl.1881-1894
London painter of rustic subjects and portraits. Exhib. at RA, SS and elsewhere. Titles: 'The Village Bakehouse', etc.

COOK, Thomas fl.1886
Exhib. one domestic subject 1886. London address.

COOK, William fl.1877-1879
Plymouth painter of coastal scenes. Exhib. four watercolours of Cornish scenes at SS, 1877-9. Probably son of Samuel Cook (q.v.).

COOKE, Arthur Claude b.1867 fl.1890-1904
Painter of figure subjects. Born in Luton; studied at RA Schools. Exhib. at RA and SS. Titles: 'The Poacher's Wife', etc. Lived in London and Radlett, Hertfordshire.

COOKE, C.H. fl.1885
Exhib. one picture 'Industry' at SS, 1885. London address.

***COOKE, Edward William RA 1811-1880**
Painter of river and coastal scenes in oil and watercolour. Son of George Cooke, an engraver. Because of his detailed knowledge of ships and their rigging, Cooke was employed by the marine painter Clarkson Stanfield (q.v.) to make studies of details of ships for him. Under Stanfield's influence he took up painting in oil, and travelled in France, Scandinavia, Holland and Egypt. Exhib. at RA 1835-79 (129 works), BI and SS. Elected ARA 1851, RA 1863. A sale of his works was held at Christie's, 19 June 1861; his studio sale was 22 May 1880.
Bibl: AJ 1869 p.253; Redgrave, Cent; Ruskin, Academy Notes 1856 pp.57, 58, 75; Clement & Hutton; Hughes; Bryan; Cundall; DNB; VAM; Wilson (pl.10); Maas pp.62-3 (2 pls.); Brook-Hart pp.33, 35 (pls.69-70); John Munday *E.W.C. A Man of His Time*, 1995.

COOKE, Miss Ellen Miller fl.1886-1892
London flower painter. Exhib. at RA, SS and elsewhere.

COOKE, Ernest O. fl.1886
Exhib. one picture from La Fontaine's fables at RA, 1886. London address.

COOKE, George R. fl.1881-1884
Painter of coastal and harbour scenes. Exhib. at SS and elsewhere. Address Clovelly, North Devon.

COOKE, Isaac RBA 1846-1922
Landscape painter and watercolourist. Born at Warrington, Lancashire. Lived at Liscard and Wallasey. Exhib. at RA, SS, NWS and elsewhere. Member of Liverpool Academy, Liverpool Watercolour Society, and RBA 1896-1915. RA pictures mostly views in Wales and the Lake District. Works by him are in the Walker AG Liverpool.
Bibl: Studio XXIV p.137.

COOKE, John fl.1887-1903
London painter of portraits and figure subjects. Exhib. at RA, SS, NG and elsewhere. RA titles 'The Girl in Grey', 'Bathing Nymphs', 'The Kiss of the Dew', etc. Exhib. a portrait of Sargent at the Paris Salon in 1887.
Bibl: Studio Summer No. 1901.

COOKE, Miss L. fl.1884
Exhib. one watercolour of flowers at NWS, 1884. Bath address.

COOK(E), T.A. fl.1838
Exhib. one landscape at SS, 1838. London address.

COOK(E), T.B. fl.1850-1857
Landscape painter. Exhib. at BI and SS, especially views in Warwickshire and Northamptonshire. Lived in London and the Midlands.

COOKE, Thomas Etherington fl.1865-1868
Edinburgh painter of coastal and river scenes. Exhib. at BI and SS. Subjects all Scottish scenes.

COOKE, William Cubitt 1866-1951
Painter of landscape and figure subjects. Apprenticed to a chromo-lithographer at 16. Although mainly self-taught, he studied at Heatherley's and Westminster School of Art. Exhib. at RA and SS. Also an illustrator and contributor to the *Graphic* and *Illustrated London News*. Member of the Langham Sketch Club. Lived in London and later Stroud, Gloucestershire.
Bibl: Who's Who 1912.

COOKE, William Edward
Painter of landscapes and rustic subjects; lived at Loughborough in Leicestershire. Exhib. at RA, SS and elsewhere. RA titles 'The Village Wharf', 'Agricultural Depression; the Rent day', etc.

COOKES, Miss Laura fl.1866
Exhib. one portrait at SS, 1866. Warwick address.

COOKESLEY, Mrs. Margaret Murray- fl.1884-1910 d.1927
London painter of middle eastern subjects, especially Egyptian scenes. Exhib. at RA, NWS and elsewhere. RA titles 'An Arab Cemetery', 'An Eastern Doorway', 'Three Little Wags', etc. Her work is similar to that of other specialists in Egyptian subjects such as Goodall and Edwin Long.

COOLING, John A. fl.1878-1880
Exhib. one chalk drawing of a head at RA, 1880. London address.

COOMBE, Miss L. Ella fl.1887
Exhib. one flower picture 1887. London address.

COOMBES see COMBES

COOP, Hubert RBA 1872-1953
Landscape painter. Exhib. at RA from 1897. Painted in North Wales and other parts of England, especially the West Country.
Bibl: Brook-Hart.

***COOPER, Abraham RA 1787-1868**
London sporting, battle and historical painter. Largely self-taught except for a few lessons from Benjamin Marshall. Employed at 13 by Astley's Circus which was managed by his uncle. He turned his attention at an early age to painting horses, in which he became very proficient. His first picture 'The Battle of Waterloo' was purchased by the Duke of Marlborough from BI in 1816; and in 1817 he was elected ARA for 'The Battle of Marston Moor', his first picture exhib. at the RA. Elected RA 1820. Among his works are 'Rupert's Standard', 'The First Lord Arundel taking a Turkish Standard at the Battle of Strigonium'. 'The Battle of Bosworth Field', 'The Gillies' Departure', etc. 'A Donkey and Spaniel' and 'A Grey Horse at a Stable-door' are in the VAM (both 1818). As a painter of battle-pieces he stands pre-eminent — holding an analogous position to Peter Hess in Germany and Horace Vernet in France. He also painted many of the celebrated racehorses of the day. John Frederick Herring Snr. (q.v.) was one of his pupils, and their painting of horses is very similar. William Barraud (q.v.) also studied with Cooper. In the BM Print Room is a folio volume containing many engravings after Cooper .
Bibl: AJ 1869 p.45; Ruskin, Academy Notes 1856, 1858, Clement & Hutton; DNB; Sparrow *passim* (pl.73), Pavière, Sporting Painters (pl.12); Maas p.74; Ormond I p.115; Strong.

COOPER, Alexander Davis fl.1837-1888
Son of Abraham Cooper, RA (q.v.). London painter of landscape, portraits, genre and scenes from Shakespeare. Exhib. at RA 1837-88, BI and SS. Titles at RA 'Spaniel and Game', 'Milking Time', 'Imogen entering the Cave', 'Abraham Cooper Esq. RA', etc. Mrs. Alexander Davis Cooper (q.v.) was also a painter.
Bibl: Cat. NPG 2 1907 p.91; Ormond I pp.109, 115.

COOPER, Mrs. Alexander Davis fl.1854-1875
London painter of fruit and flowers, and occasional figure subjects. Exhib. at RA 1854-68, BI, SS and elsewhere. Wife of Alexander Davis Cooper (q.v.).

COOPER, Alfred see COOPER, Alfred W.

COOPER, Alfred Heaton 1864-1929
Painter of landscape and still-life. Exhib. at RA, SS, NWS and elsewhere. Lived at Ambleside and painted mainly scenes in the Lake District. Father of Alfred Egerton Cooper (1883-1974) also a painter.

COOPER, Alfred W. fl.1850-1901
London painter of domestic scenes, historical and other figure subjects. Exhib. at RA, BI, SS, NWS and elsewhere. RA titles: 'The Old Chest', 'A Rainy Day', 'The Young Squire', etc.

COOPER, Alick fl.1873-1893
London painter of rustic subjects. Exhib. at RA, SS, NWS and elsewhere, in oil and watercolour. Titles: 'The Keeper's Daughter', etc.

COOPER, Byron 1850-1933
Landscape painter; lived in Manchester and Bowdon. Exhib. at RA, SS and NWS. Painted especially in Surrey and Devon. Most of his RA exhibits have poetic titles: 'Where the golden gorse doth bloom', etc. Also painted evening and moonlight effects. His work is represented in Manchester City AG. Painted a series of landscapes connected with Tennyson.
Bibl: The Year's Art 1912 p.473; M Ridgeway in The Bowden Historical Society Papers.

COOPER, Claude fl.1870
Exhib. one picture of fish 1870. Address Winkfield, Berkshire.

COOPER, Miss Edith A. fl.1885-1889
London portrait painter. Exhib. at RA, GG and elsewhere.

COOPER, Mrs. Emma b.1837 fl.1872-1893
(Miss Wren)
Painter of still-life and figure subjects, mainly in watercolour. Married in 1865, and took up painting professionally about 1865. Exhib. at RA, SS, NWS, Society of Lady Artists and elsewhere. Best known for her watercolours of birds and flowers, which were compared to W.H. Hunt, also for miniatures, and illuminations on vellum. Lived at New Barnet, Hertfordshire.
Bibl: Clayton II pp.264-70.

COOPER, Frederick Charles fl.1844-1868
Painter of historical and other figure subjects. Exhib. at RA, BI and SS. Also went on an archaeological trip to Nineveh with A.H. Layard, and exhibited pictures of the excavations on his return.

COOPER, George fl.1875-1901
London landscape painter. Exhib. at RA, SS and elsewhere. Lived in Putney, and many of his subjects were views of the area, e.g. Wimbledon, Hammersmith, the Thames, etc.

COOPER, Henry M. fl.1842-1872
London painter of historical and other figure subjects. Exhib. at RA, BI, SS and elsewhere. Subjects mostly taken from English history.

COOPER, Miss Lydia fl.1891-1893
London painter of landscapes and portraits. Exhib. one picture at RA, 1891 and two at SS.

COOPER, R. fl.1847
Exhib. one picture 'A Study — Admiration' at SS, 1847. Address Uckfield, Sussex.

COOPER, Robert fl.1850-1874
Landscape painter. Exhib. four pictures at RA 1850-71, and elsewhere. Lived mainly in Sussex.

***COOPER, Thomas George fl.1857-1896**
London painter of landscapes, pastoral scenes and rustic genre. Exhib. at RA 1868-96, BI and NWS. Titles at RA 'Harvest Time in Berkshire', 'Waiting for the Ferry', 'The Golden Age', etc. Son of Thomas Sidney Cooper (q.v.).
Bibl: Ruskin, Academy Notes 1875; Portfolio 1884 p.226; Wood, Panorama.

***COOPER, Thomas Sidney RA 1803-1902**
Animal painter. Encouraged by Abraham Cooper (q.v.), no relative, and Sir Thomas Lawrence. Entered RA Schools. In 1827 became a teacher in Brussels, and friend of the Belgian animal painter Verboeckhoven who greatly influenced his style, as did the Dutch School of the 17th century. In 1831 he settled in London, and first exhib. at SS in 1833. Exhib. 48 pictures at BI 1833-63. 'Landscape and Cattle', RA 1833, was the first of a series of 266 exhibits shown there till 1902, without a break — a record for continuous exhibiting at the Academy. Sheep or cattle were his constant subjects but in 1846 he attempted a large historical painting 'The Defeat of Kellermann's Cuirassiers at Waterloo'. This and 'Hunting Scene', RA 1890, were his only figure studies. Between 1848 and 1856 he painted the cattle in numerous landscapes by Frederick Lee (q.v.), and also the animals in landscapes by Thomas Creswick (q.v.). After about 1870 his commissions were so constant and lucrative that he was tempted to yield to facile repetition of his favourite themes, but the quality and competence of his style only began to decline in the 1890s, by which time he was an old man. His studio sale at Christie's lasted three days, April 12-15, 1902.
Bibl: AJ 1849 pp.336-7; 1861 pp.133-5; 1902 p.125 (obit.); Clement & Hutton; T. Sidney Cooper, *My Life*, 1890, 2 vols; DNB; Maas p.53 (pl. p.50); Wood, Paradise Lost.

COOPER, W. fl.1846-1862
London portrait painter. Exhib. at RA, BI and SS, all portraits or portrait studies. Many of his sitters were clergymen.

COOPER, W. Savage fl.1882-1903
Painter of religious and other figure subjects. Exhib. at RA, SS, NWS and elsewhere. RA titles: 'The Rose Queen', 'Childhood's Sunny Days', etc., and religious subjects.

COOPER, William Sidney fl.1871-1908
Landscape painter, who exhib. from 1871-1908, at RA, 1881-91, and SS. Titles include: 'Springtime; Isle of Wight', 1881, 'The Avon at Ringwood', 1889, 'Twilight on the Thames', 1884. Does not appear to have been related to T.S. Cooper. A 'View on the Thames' is in the Reading Museum.

COPE, Sir Arthur Stockdale RA 1857-1940
Prolific portrait painter. Son of Charles West Cope (q.v.). Painted: Marquis of Hartington, 1889; General Lord Roberts, 1894; Duke of Cambridge, 1897; Lord Kitchener, 1900; Archbishop of Canterbury, 1904; Edward VII, 1907; Prince of Wales, 1912. His treatment could alternate between strong and realistic — Rev. William Rogers 'Hang Theology Rogers' (Studio V 118), and soft, weak, and pretty as in the portrait of Mrs. Joseph Prior Jnr. (RA Pictures, 1891). He exhib. at the RA from 1876.
Bibl: RA Pictures (1891-1907); Studio V p.118; XXIX p.42; XXXV p.43; XLI p.31; XLIV p.43; Ormond I pp.119, 390.

***COPE, Charles West RA 1811-1890**
Painter of historical, literary and biblical subjects; contemporary and historical genre; illustrator and engraver. Studied at Mr. Sass's Art School in Bloomsbury and became a student at the RA in 1828. In 1831 he went to Paris and studied the Venetian pictures in the Louvre. In 1833 he first exhibited at the RA, 'The Golden Age' (he continued to exhibit until 1882), and 1833-5 he travelled in Italy. In 1843 he took part in the competition for the decoration of the Houses of Parliament, and won a prize of £300 for a cartoon of *Trial by Jury,* and in the next year obtained a commission to paint a fresco of 'Edward III investing the Black Prince with the Order of the Garter', which was followed by a second of 'Prince Henry acknowledging the Authority of Judge Gascoigne', and 'Griselda's First Trial of Patience'. ARA in 1843; RA in 1848. He retired in 1883. He is now best remembered for his small cabinet pictures of contemporary genre, especially his sympathetic studies of mothers with children. In 1969 a large number of his watercolours and drawings appeared for sale at Christie's, from the estate of one of Cope's granddaughters.
Bibl: AJ 1859 p.264; 1869 p.177ff. (with pls.); 1890 p.320 (obit.); Ottley; C.H. Cope, *Reminiscences of C.W. Cope RA,* 1891; Richard Redgrave, A *Memoir,* 1891 pp.32, 46, 51-2; Bryan; DNB; T.S.R. Boase, *The Decoration of the New Palace of Westminster;* Journal of the Warburg and Courtauld Institutes 1954 Vol.17 pp.319-58 (figs. 46b, 49d, 50b-c); Reynolds, VP p.36 (pl.21); Hutchison pp.108, 122, 139 (pl.47); Maas pp.28, 216, 238 (pls. pp.217, 241, 243); Ormond I see index; Strong; Newall; Wood, Paradise Lost.

COPE, J.T. fl.1873
Exhib. one picture 'An Ancient' at SS,1873. London address.

COPE, W. Henry fl.1848-1855
London landscape painter. Exhib. once at RA 1855, also at SS (all watercolours) and elsewhere. Subjects views in southern counties, Scotland and France.

COPELAND, A.J. fl.1882
Exhib. one picture 'Old Homestead near Watford' at SS, 1882. Watford address.

COPLAND, Miss L. fl.1842
Exhib. a portrait of two children at RA, 1842. London address.

COPPARD, C. Law fl.1858-1880
Brighton painter of landscapes and domestic scenes. Exhib. mostly at SS, also RA, BI and elsewhere. His RA pictures mostly scenes in Wales, both landscapes, and cottage scenes.

COPPING, Harold 1863-1932
London painter of domestic scenes and figure subjects; also book illustrator. Studied at RA Schools, and won the Landseer Scholarship. Exhib. at RA, SS, NWS and elsewhere. Illustrated many books, including *Pilgrim's Progress* and the *Copping Bible.* Visited Palestine and Egypt to gather material for his religious illustrations; also travelled in Canada.

CORAH, William J. fl.1888
Exhib. one Welsh landscape at RA, 1888. Address Conway, Wales.

CORBAUX, Miss Fanny RI 1812-1883
(Marie Françoise Catherine Doetter)
Miniature portrait painter and biblical critic. Forced to earn her own living at 15, she first won success in 1827 at the Society of Arts, obtaining the large silver medal for an original portrait in miniature; in 1828 the silver Isis medal, and in 1830 the gold medal, again for a miniature portrait. In 1830 she was made an hon. member of the Society of British Artists and for a few years she used to contribute oil pictures to its gallery. Later she turned entirely to miniature painting as it was more immediately lucrative. She was also elected a member of NWS, and hardly ever failed to contribute to its annual exhibitions. She exhib. at the RA 1829-54 — all portraits She designed the illustrations for Moore's *Pearls of the East* 1837 and for *Cousin Natalia's Tales* 1841.
Bibl: Clayton II p.68ff.; DNB.

CORBAUX, Miss Louisa b.1808 fl.1828-1881
London painter, watercolourist and lithographer; sister of Fanny Corbaux (q.v.). Exhib. at RA 1833, 1834 and 1836, SS and NWS. Subjects chiefly children and pet animals, e.g. 'A Child with a Kitten', 'Portrait of a Favourite Cat', 'The Bird's Nest', etc.
Bibl: Clayton II p.70.

CORBET, D. fl.1851
Exhib. one landscape 'In Penshurst Park' at BI, 1851. No address given.

***CORBET, Matthew Ridley ARA 1850-1902**
Landscape and portrait painter. Educated at Cheltenham College, the Slade, under Davis Cooper, and the RA Schools. His first exhibits at the RA were portraits, but apart from a few, from 1883 onwards he painted almost entirely landscape. Pupil, for three years in Rome, of Giovanni Costa, Italian landscape painter, and much influenced by him. Corbet was at his best painting in Italy, and produced the type of poetic-pastoral landscape and a title for a landscape of 1890 suggests the mood he chose to adopt: 'A Land of Fragrance, Quietness, and Trees and Flowers (Keats)', He exhib. at the RA 1875-1902. After 1880 he also sent several works to the GG and later to the NG. ARA 1902. 'Morning Glory', RA 1894, and 'Val D'Arno', 1901, were both bought by the Chantrey Bequest, and are in the Tate Gallery.
Bibl: Bryan; AJ 1902 p.92ff. (reprd: 'Val D'Arno'), p.164 (obit.); Studio XXV 1902 p.133; Mag. of Art XXVI 1902 p.236; DNB; Newall; *The Etruscans,* Cat. of Exhibition at Stoke-on-Trent AG 1989.

CORBET, Mrs. Matthew Ridley (Edith) fl.1891-1903
Painter of figure subjects, and Italian scenes. Born Edith Ellenborough (q.v.), she was first Mrs. Arthur Murch (q.v.), before marrying the painter Matthew Ridley Corbet (q.v.). Exhib. at RA and GG, and like her husband, painted many views in Italy, and studies of Italian life.
Bibl: RA Pictures 1893-6, 1906; *The Etruscans,* Cat. of Exhibition at Stoke-on-Trent AG 1989.

CORBET, Philip fl.1823-1856
Portrait painter. Exhib. frequently at RA 1823-56, and once at BI. Lived in London, and later in Shrewsbury, where he seems to have enjoyed a flourishing country practice.
Bibl: Poole 1912 p.118; Cat. of Engraved British Portraits BM I 1908; Ormond I p.211.

CORBETT, F. fl.1854
Exhib. one landscape with cattle at RA, 1854. London address.

CORBETT, S. Bertha fl.1881
Exhib. one landscape 1881. Address Stockport, Lancashire.

CORBIN, Miss Rosa H. fl.1889
Exhib. one landscape 'Near St. Ives' at RA, 1889. Southampton address.

***CORBOULD, Alfred fl.1831-1875**
London sporting painter. Exhib. at RA 1835-75, BI and SS. Subjects mainly dogs and shooting scenes, with occasional landscapes. Another painter of horses and dogs, Alfred Hitchens Corbould, was working c.1844-63, probably a relation.

CORBOULD, Alfred Chantrey RBA fl.1878-1893
Cartoonist and illustrator. Exhib. drawings for *Punch* at RA, and other drawings at SS, NWS and elsewhere.

CORBOULD, Alfred Hitchens fl.1844-1864
London portrait and animal painter. Exhib. at RA only 1844-64. Exhib. portraits, often with horses, dogs and sporting subjects, e.g. 'On the Moors', etc.

CORBOULD, Aster R.C. fl.1841-1877
Painter of rustic genre, portraits and horses. Exhib. at RA 1850-74, BI and SS. Titles at RA 'The English Farmer', 'Mrs. Craven on her Favourite Mare', 'Madras Hunt', etc.

***CORBOULD, Edward Henry RI 1815-1905**
Watercolour painter. Pupil of Henry Sass, and student at RA Schools. His main work was in watercolour, in which he produced a large number of subjects illustrating literature (chiefly Chaucer, Spenser, and Shakespeare), history, biblical subjects, and daily life. Only a small proportion of his pictures are in oil, e.g. 'The Canterbury Pilgrims', RA 1874. In 1842 his watercolour of 'The Woman Taken in Adultery' was bought by Prince Albert and nine years later he was appointed "instructor of historical painting" to the Royal Family. For 21 years he continued to teach various members of the royal family and many of his best works were acquired by Queen Victoria and Prince Albert and his royal pupils. He also produced a large number of designs for book illustration. Exhib. at the RA 1835-74, BI, SS and NWS (241 works). A large fantasy subject 'The Artist's Dream' is in Bristol AG. Courbauld was the official artist at the Eglinton Tournament in 1839.
Bibl: AJ 1864 p.98 (reprd: 'The Lesson of the Passover'); 1905 pp.286, 379; J. Ruskin, *Notes on NWS*, 1858-9; DNB; Gleeson White; Ormond I p.481; Newall.

CORBOULD, Walter Edward fl.1889-1896
London painter of domestic subjects. Exhib. twice at RA, and at NWS. Titles: 'Inquisitiveness', etc.

CORBOULD-HAYWOOD, Miss Evelyn fl.1887
Exhib. one landscape 1887. London address.

CORBYNPRICE, Frank fl.1882-1883
Exhib. two watercolour landscapes at SS, 1882-3. London address.

CORDEN, William, Jnr. fl.1843-1855
Painter of figure subjects. Son of William Corden, an enamellist. Exhib. at RA 1843-55 and once at BI. Titles: 'Consulting the Oracle' etc.

CORDER, C.E. fl.1873
Exhib. three watercolours of theatrical subjects, all involving Henry Irving, at SS 1873. London address.

CORDER, Miss Rosa fl.1879-1882
London portrait painter. Exhib. once at RA and once at GG. A portrait of E.B. Pusey is in Pusey House, Oxford.
Bibl: Ormond I p.389.

CORDINGLEY, Georges R. fl.1893-1896
Exhib. two coastal scenes, one in France, at RA, 1893-6. London address.

CORELLI, A. fl.1881-1882
Exhib. one picture 'Washerwomen of the Abruzzi, Italy' at RA 1882, and one watercolour at SS. London address.

CORKLING, Miss May fl.1875-1880
Painter of flowers and foliage, and figure subjects. Born in Manchester, and later came to London. Encouraged to take up painting by J.D. Watson (q.v.). Exhib. at RA, GG, Dudley Gallery and elsewhere. Her pictures are mainly studies of leaves, ferns and stones.
Bibl: Clayton II pp.270-2.

CORKRAN, Miss A. fl.1868
Exhib. one landscape 'A Common in Wiltshire' at SS, 1868. No address given.

CORKRAN, Miss Henriette L. fl.1872-1911 d.1911
London painter of figure subjects and portraits in pastel. Exhib. at RA from 1872, and elsewhere. Titles: 'A Little Outcast', etc.

CORNELISSEN, Miss Marie Elizabeth
see LUCAS, Mrs. John Seymour

CORNER, Frank W. d.1928
Northumbrian painter of town and coastal scenes. Examples are in Newcastle and Sunderland AG.

CORNER, George E. fl.1886-1891
London painter of landscape and figure subjects. Exhib. at SS only. Subjects are scenes on the Thames, south of England, northern France, etc.

CORNER, S. fl.1838-1849
London painter of landscape. Exhib. at SS only, all watercolours.

CORNISH, Mrs. Mary fl.1869
Exhib. one picture of fishing boats 1869. London address.

CORNISH, William Permeanus fl.1875-1904
London painter of landscape and figure subjects. Exhib. at RA, SS and NWS. Titles: 'London East', etc.

CORRIE, Miss E.J. fl.1877
Exhib. one picture of dead pheasants at RA, 1877. Exeter address.

CORTISSOS, Charles fl.1872-1875
London painter of fruit. Exhib. once at SS, and elsewhere.

COSBIE, S. fl.1864
Exhib. one picture 'Ravenswood, from the Bride of Lammermoor' at RA, 1864. London address.

COSTA, John da see DA COSTA, John

COSTEKER, Miss Jane O. fl.1886
Exhib. one picture of flowers 1886. Address Eccles, Lancashire.

COSTELLO, Henry fl.1880
Exhib. one figure subject in London, 1880. London address.

COTCHETT, T. fl.1849
Exhib. one flower picture at RA, 1849. London address.

COTESWORTH, Miss Lillias E. fl.1885-1888
Painter of flowers and figure subjects. Exhib. once at RA and SS, also elsewhere. Address Winchester, Hampshire.

COTMAN, Frederick George RI 1850-1920
East Anglian painter of portraits, landscape, genre and historical subjects — both in oil and watercolour — who exhib. at the RA from 1871 onwards. Nephew of John Sell Cotman, being the son of Henry Cotman, John Sell's younger brother. Born and educated at Ipswich, in 1868 entered the RA Schools, where his 'The Death of Eucles' won him the gold medal for historical painting, 1873 (now in Town Hall, Ipswich). His early watercolours were purchased by both Leighton and Watts, and he was engaged by Leighton to assist in painting 'The Daphnephoria', 1876, and by H.T. Wells to do similar work. He at first started as a portrait painter (for example the large portrait group of The Marchioness of Westminster, Lady Theodora Guest and Mr. Guest playing dummy whist), but later also painted landscape and genre. Walker AG has 'One of the Family', and Oldham 'Her Ladyship's First Lesson'. In 1882 he was elected RI.
Bibl: Studio XLVII 1909 pp.167-77 (pls.); Who Was Who 1916-1928;Ormond I p.393.

COTMAN, John Joseph 1814-1878
Landscape watercolourist. Second son of John Sell Cotman. He studied under his father, and after a short stay in London as an aide to his father at King's College School, which did not suit him, he returned to Norwich in 1834. Here he struggled, between bouts of heavy drinking and periods of mental instability, to maintain the paternal teaching practice in Norwich for the rest of his life. Exhib. eight works at the BI, 1852-6, and one in 1853 at the RA. His watercolours are very individual, being freer and more passionate than those of his father or brother, and outstanding for their highly personal range of colour — bright blues and yellows, gold and Indian reds. In his foliage paintings there is a similarity to Samuel Palmer's Shoreham period. Clifford writes: "His range is not wide nor are his drawings all equally successful, but he is one of the most remarkable and least appreciated watercolourists of the third quarter of the century."
Bibl: AJ 1878 p.169 (obit.); Roget; Cundall; DNB; VAM; 'Sprite' (pseudonym), *Norwich Artist Reminiscences*, J.J. Cotman, 1925; A. Batchelor, *Cotman in Normandy*, 1926; Clifford *passim* (pl.VII, figs. 73b, 74, 75 a-b, 76a); Hardie II pp.94, 97 (pls. 82-3); H.A.E. Day, *East Anglian Painters*, III pp.55-70; Brook-Hart .

COTMAN, Miles Edmund 1810-1858
Eldest son of John Sell Cotman (1782-1842), whose work he closely imitated. He started to exhibit at Norwich at the age of 13. Came to London, 1835, and assisted his father as drawing-master at King's College School, succeeding him for a short time after his death. In 1852 he returned to Norfolk, teaching at North Walsham for some years before going to live with his brother in Norwich until his death in 1858. Exhib.1835-56 at the RA, BI and SS. He collaborated very closely with his father, to such an extent that John Sell often put his name to his son's work, so that many drawings of this period cannot with certainty be attributed to Miles or to his father. However his work has its own personal qualities —a decisive line, strong colour and a certain tightness of finish. He worked in both oil and watercolour.
Bibl: Redgrave, Dict; Roget; Binyon; Cundall; DNB; VAM; C.F. Bell, *Miles Edmund Cotman*, Walker's Quarterly 1927; S.D. Kitson, *Life of J. Sell Cotman*, 1937; Clifford *passim* (pls. 69a, 69b, 70a); Hardie II pp.93, 96-7 (pls.80-1) III p.204n; H.A.E. Day, *East Anglian Painters*, III pp.39-54; Brook-Hart pp.64-5 (pl.128).

COTTAM, Miss Ellen fl.1892
Exhib. one picture of flowers at SS, 1892. London address.

COTTON, Henry Robert fl.1871
Exhib. one picture of fruit at SS, 1871. London address.

COTTON, Mrs. Leslie (Mariette) fl.1891-1893
Portrait painter. Exhib. three pictures at RA, and elsewhere. Munich address.

COTTON, W. fl.1834-1843
London painter of domestic subjects and portraits. Exhib. at SS only. Titles: 'A Hearty Lunch', etc.

COTTRELL, Arthur Wellesley fl.1873-1876
Birmingham landscape painter. Exhib. at SS only, 1873-6. Mostly views in Cumberland.

COTTRELL, Henry J. fl.1878-1884
Birmingham painter of architectural subjects. Exhib. in Birmingham 1878-84.

COTTRELL, Wellesley fl.1889-1896
Birmingham landscape painter. Exhib. mainly at NG, also RA. Subjects include several views in Wales.

COUCHMAN, Miss Florence A. fl.1883-1890
London painter of old buildings. Exhib. at RA, SS and NWS, in oil and watercolour.

COUGHTRIE, James B. fl.1863-1881
London painter of domestic subjects. Exhib. once at RA and SS. Titles: 'Dolly's New Frock', etc.

COULDERY, B.A. fl.1862-1877
London painter of animals and landscapes. Lived for a time at same address as H.H. Couldery (q.v.). Exhib. at BI, SS and elsewhere.

COULDERY, C.A. fl.1870-1872
Painter of domestic subjects. Exhib. three pictures at SS, 1870-2. Address Lewisham, Kent.

***COULDERY, Horatio Henry b.1832 fl.1861-1893**
Animal painter. Exhib. at RA 1861-92, BI and SS. Ruskin comments upon 'A Fascinating Tail': "Quite the most skilful piece of minute and Dureresque painting in the exhibition — (it cannot be rightly seen without a lens); — and in its sympathy with kitten nature, down to the most appalling depths thereof, and its tact and sensitiveness to the finest gradations of kittenly meditation and motion,—unsurpassable". Other titles at RA 'The First Mouse', 'The End of a Tail', etc.
Bibl: Ruskin, Academy Notes 1875.

COULDERY, R., Jnr. **fl.1843-1861**
Landscape painter. Exhib. at RA, BI and SS. Lived in Lewisham, like most of the other members of the Couldery family. He may have been the son of H.H. Couldery (q.v.).

COULDERY, Thomas W. **fl.1883-1893**
London painter of domestic and rustic subjects. Exhib. at RA, SS and NWS. Titles: 'Washing Day Tomorrow', etc.

COULON, James **fl.1892**
Exhib. one flower picture at RA, 1892. London address.

COULSON, J. **fl.1864-1867**
London landscape painter. Exhib. four pictures at BI, 1864-7.

COULSON, John **fl.1889**
Exhib. one picture 'Under the Smoke of the Cannons' at SS, 1889. London address.

COULTER, William **fl.1869-1889**
Painter of landscape and still-life. Exhib. at RA, SS, GG and elsewhere. Lived in London and Godalming, Surrey.

COURT, Miss Catherine Payn **fl.1886-1891**
London flower painter. Exhib. two pictures at SS, and elsewhere.

COURTAULD, Miss Edith **see ARENDRUP, Madame**

COUSEN, Charles **fl.1848**
Exhib. one watercolour portrait at SS, 1848. Address Norwood, south London.

COUSEN, John **fl.1863-1864**
Exhib. two landscapes at RA, 1863-4. Address Norwood, south London.

COUSINS, Charles **fl.1877-1879**
London portrait painter. Exhib. five pictures at GG.

COUSINS, T.S. **fl.1862-1873**
Exhib. three pictures at SS, 1862-73, two landscapes and a figure subject. London address.

COUTTS, Hubert Herbert **RI** **fl.1874-1920 d.1921**
Landscape painter working in Ambleside. Exhib. 'Early Summer, near Grasmere, Westmorland' at RA, 1876; and continued to exhib. at RA until 1903, also SS and NWS. Subjects mainly landscapes around the Lake District, also Wales and Scotland.
Bibl: Newall.

COVENTRY, James **fl.1854-1861**
London landscape puinter. Exhib. al RA, BI, SS and elsewhere. Subjects views in Wales, Cumberland and Scotland, etc.

COVENTRY, Robert McGowan **ARSA RSW** **1855-1914**
Scottish painter of landscapes and coastal scenes. Studied at Glasgow School of Art and in Paris. Exhib. at RSA, RSW and at RA. Painted landscapes and coastal scenes, both in Scotland, Holland and Belgium. His work shows the influence of the Hague School, such as Maris, Mesdag and Blommers.
Bibl: Studio XXV 1902 p.209; XXVII 1903 pp.52, 204; XXXVII 1906 p.348; XXXVIII 1906 p.78ff.; XXXIX 1907 p.258; Caw p.332; Who's Who 1912; Cundall; Hardie III p.194.

COWAN, C.A. **fl.1871-1874**
Exhib. three pictures of Venice 1871-4. Address Blackheath, London.

COWAN, Miss Edith C. **fl.1891**
Exhib. one picture 'Elsa' at RA, 1891. London address.

COWAN, Miss Janet D. **fl.1882-1893**
London painter of domestic subjects. Exhib. at SS and elsewhere. Titles: 'An English Homestead', etc.

COWDEROY, William **fl.1858-1885**
London painter of figure subjects. Exhib. at RA, BI, SS and elsewhere, in oil and watercolour. In addition to English subjects, he also painted Arab and Italian figures.

COWELL Edwin, Jnr. **fl.1860-1865**
London landscape painter. Exhib. four pictures at BI, landscapes and a still-life.

COWELL, Miss Emma **fl.1849-1856**
London landscape painter. Exhib. at RA, BI and SS. Subjects all English scenery, especially in East Anglia.

COWELL, G.H. Sydney **fl.1890-1904**
London sculptor and painter. Exhib. mostly sculpture at RA, and paintings of figure subjects at SS and elsewhere, e.g. 'A Cabman's Fare', etc.

COWELL, H.B. **fl.1851-1853**
London landscape painter. Exhib. one picture at RA 1851 and two at BI.

***COWEN, Lionel J.** **RBA** **fl.1869-1888**
London painter of figure subjects and interiors. Exhib. at RA, BI, GG and elsewhere. RA pictures often of women in interiors, with sentimental titles: 'Sweet Memories', 'Recalling the Past', 'Loves Letterbox', etc. 'Sweet Memories' was sold at Christie's, 18 October 1974 (illus. pl. 12).

COWEN, William **1797-1861**
London landscape painter and topographer who exhib. views in Ireland at BI in 1823. Patronised by Earl Fitzwilliam who paid for him to travel in Switzerland and Italy. In 1824 he published a series of six Italian and Swiss views. Exhib. at RA 1823-39, drawing on sketches made during his earlier travels. Visited Corsica 1840 and published a book, with etchings by himself, *Six Weeks in Corsica*, 1848.
Bibl: DNB; Cundall p.200; Bryan

COWIE, Frederick **fl.1845-1870**
London painter of historical subjects. Exhib. mainly at SS, also RA, BI and elsewhere. Many of his subjects were taken from Shakespeare, also from English history.

COWPER Anna **fl.1871-1875**
Exhib. three flower pictures 1871-5. London address.

COWPER, Douglas **fl.1837-1839**
Painter of portraits and historical subjects. Born in Guernsey. Studied at Sass's Academy, where he became friendly with the young Frith. He was a brilliant pupil, and went on to study at the RA schools. A great future was predicted for him, but he was

consumptive and died before reaching 21. He exhibited a few pictures at the RA, BI and SS. Frith, who makes several references to Cowper in his *Autobiography,* also records that Cowper painted a full-length portrait of him.

Bibl: AU 1839 pp.167,183ff.; DNB; W.P. Frith, *My Autobiography and Reminiscences,* 1887-8 see index.

*COWPER, Frank Cadogan RA 1877-1958

Painter of portraits, historical and fantasy scenes; also decorator and watercolourist. Studied at St. John's Wood School; also with Edwin Abbey (q.v.) and J.S. Sargent. Exhib. at RA from 1899 and at RWS. Although his career falls mostly outside the Victorian period, Cowper was strongly influenced by Burne-Jones and Pre-Raphaelitism, and carried its ideas and style well into the 20th century. His 'St. Agnes in Prison' was the last work bought by the Chantrey Bequest. In 1910 he was commissioned by George Howard, Earl of Carlisle (q.v.) to paint six walls in the Houses of Parliament.

Bibl: AJ 1904 p.144; 1905 pp.31ff., 348; Studio XXVII 1903 pp.58-9; XLI 1907 p.61; XLIV 1908 p.75; Who's Who 1912; Record of Art 1912; Times 24 January 1912; Illustrated London News 25 May 1912; Wood, Pre-Raphaelites.

COWPER, M.E. fl.1875

Exhib. one flower picture 1875.

COWPER, Richard fl.1882-1883

Exhib. one landscape watercolour at NWS, and two elsewhere. London address.

COWPER, Thomas fl.1891-1904

London painter of portraits and figure subjects. Exhib. at RA and elsewhere. Titles: 'The Rosy Hours of Youth', etc.

COX, A.H. fl.1842

Exhib. one watercolour of a Shetland pony at SS, 1842. London address.

COX, Albert J. fl.1885-1887

London landscape painter. Exhib. one watercolour 'On the Road to the Farm' at SS 1885, also at NWS.

COX, Alfred Wilson c.1820-c.1888

Nottingham landscape painter. Exhib. at RA, SS and elsewhere. RA titles mostly suggest views in the Midlands. A portrait of the 5th Duke of Newcastle is in Nottingham Castle AG.

Bibl: Ormond I p.338.

COX, Arthur fl.1874-1887

Exhib. one picture 'The Old Shore Grange' at RA 1874, also at SS and elsewhere. Graves lists a C. Arthur Cox of Birkenhead, who is almost certainly the same artist.

COX, Bertram fl.1893

Exhib. one watercolour 'Muriel' at SS, 1893. Address Bedford Park, London.

COX, C.H. fl.1866-1889

Exhib. one picture 'The Chilly Silence of a Winter's Night' at SS, 1879. Also exhib. regularly at NWS, GG and other minor exhibitions in London. Address Birkenhead, Cheshire.

COX, Charles Edward fl.1879-1901

London painter of landscapes and coastal scenes. Exhib. at RA, SS and elsewhere. RA exhibits mostly coastal views, especially on the Thames estuary.

*COX, David, Snr. RWS 1783-1859

Painter of English and Welsh scenery — landscapes, coastal scenes and rustic genre — chiefly in watercolour, but in oils as well; highly prolific. Born in Deritend, Birmingham; son of a whitesmith and worker in small iron wares. Sent at an early age to the evening drawing school of Joseph Barber; later apprenticed to a miniature painter named Fieldler, who committed suicide. He then worked at scene-painting at the Theatre Royal, Birmingham. Went to London in 1804 and absorbed himself in the task of learning to be a painter; received a few lessons in watercolour from John Varley (q.v.). In 1808 he married Mary Ragg and settled in Dulwich, where he supplemented his earnings with teaching. Exhib. in 1809 at the Associated Artists in Watercolours, of which he became President, 1810, and remained member until its collapse, 1812. Elected A of the OWS, 1812, and Member 1812, and exhib. 849 works there 1813-59; 13 works at the RA, 1805-44; exhib. also at the BI, SS, and elsewhere. Appointed drawing master at the Military Academy at Farnham in 1813, but quickly resigned and went to Hereford, 1815, as drawing master at Miss Croucher's School. In 1814 he published his *Treatise on Landscape Painting and Effect in Watercolours,* which made his ideas on painting known to a much wider circle. He also published *Progressive Lessons in Landscape for Young Beginners* 1816 and *The Young Artist's Companion* 1819-21. He lived in Hereford until 1827, when he returned to London. In 1836 Cox made a technical discovery that was to give his work a distinctive character — he started to use a rough textured wrapping paper, made in Dundee, which well suited his rapid strokes and his representation of windswept landscapes with rough atmospheric effects. However, he only ordered a ream and when it was finished was never able to obtain the same quality of paper again. A similar paper today is always known as 'David Cox' paper. From 1812 onwards Cox had occasionally painted in oils, but it was not until 1840 that he began to think of the medium seriously, and then he took lessons from William Müller (q.v.). In 1841 he moved to Harborne, where he died. Member of the Birmingham Society of Artists from 1842, he made many sketching tours in England and Wales, visiting the latter for the first time in 1805. He visited France, Holland and Belgium in 1826, and France again in 1829 and 1832. Cox's early style was hard and dry, based on the work of the topographical painters, e.g. 'Old Westminster' 1805. From about 1820-40 he showed a broader outlook and used broken colour for rendering transient effects, e.g. 'Lancaster Sands', Mellon Collection. After this he produced works which are the most popular today — "large generalized aspects of nature, very vigorous in their touch" (Hardie II), e.g. 'Rhyl Sands'. His works were immensely popular in the 19th century and many of his pupils' paintings were sold as authentic works, often with a fake signature. His studio sale was held at Christie's, 3-5 May 1873.

Bibl: AJ 1860 p.41ff.; 1859 p.211; 1898 p.65ff.; 1909; J. Ruskin, *Modern Painters,* 1843; Redgrave, Cent; N. Neal Solly, *A Memoir of the Life of David Cox,* 1873; F. Wedmore, *David Cox,* Gentleman's Magazine March 1878; W. Hall, *Biography of David Cox,* 1881; G.R. Redgrave, *David Cox and Peter de Wint,* 1891; Roget; A.L. Baldry Studio Summer Number 1903; Studio XXXIV 1905 p.38ff.; Whitworth Wallis, *David Cox Forgeries,* Connoisseur May and July 1905; Binyon; Cundall; DNB; A.J. Finberg, *The Drawings of David Cox,* 1909; Hughes; F. Gordon Roe, *David Cox,* 1924 (contains list of paintings by Cox which may be seen in galleries open to the public); A.P. Oppé, *The Watercolours of Turner, Cox and de Wint,* 1925; VAM; B.S. Long, *David Cox,* OWS X 1933 (with list of works exhib. at OWS); F. Gordon Roe, *Cox the Master,* 1946 (contains an appendix of list of works by David Cox exhib. in London during his lifetime); Sir Trenchard Cox, *David Cox,* 1947, also by him a Birmingham Museum and AG publication on Cox published after 1952; C.A.E. Bunt, *David Cox,* 1949; Williams; Sir Trenchard Cox, *David Cox,* 1954; Hardie II pp.109-209 *et passim* (pls. 183-190); III *passim;* Maas pp.44-6 (pls. pp.45 53); Staley see index.

COX, David, Jnr. ARWS 1809-1885
Only child of David Cox (q.v.). Studied art under his father whose style he imitated in his watercolours. Exhib. 1827-84, three works at the RA, 579 at the OWS, 87 at NWS, and one at SS. Elected A of the NWS, 1841; member 1845; resigned 1846; A of the OWS, 1848. Maas notes that, although he imitated his father, "some of his fairly large landscapes display a certain character and distinction of their own." His studio sale was held at Christie's, 14-15 April 1886.
Bibl: DNB; AJ 1886 p.29 (obit.); Maas p.46.

COX, Everard Morant fl.1878-1885
London painter of domestic subjects. Exhib. twice at RA, and elsewhere. Titles: 'Fatal Fidelity', etc.

COX, Frank E. fl.1870-1894
London landscape painter. Exhib. at RA, SS, NWS, GG and elsewhere. RA titles: 'A Pastoral', 'A Lonely Road', 'Spring in London', etc.

COX, Rev. Sir George W., Bt fl.1888-1889
Exhib. two watercolours at NWS. York address.

COX, H. fl.1873
Exhib. one picture 'A Sussex Rick-Yard' at SS, 1873.

COX, Miss Jane Wells fl.1880-1882
London landscape painter. Exhib. six watercolours at SS and elsewhere; exhibits mostly views in Sussex or East Anglia.

COX, Wilson fl.1881-1884
Nottingham landscape painter. Exhib. three pictures at SS, mostly views in the Midlands.

COXWELL, A.F. fl.1869
Exhib. one picture of ducks, 1869. Address Bracknell, Berkshire.

CRABB, W.A. fl.1829-1859
London flower painter. Exhib. at RA, SS and NWS, mostly of flowers, some of fruit.

CRABB, William 1811-1876
London painter of portraits, religious and other figure subjects. Exhib. at RA, BI, SS and elsewhere. His portraits follow in the tradition of Raeburn. Painted a portrait of General Havelock which was engraved by Sinclair in 1858.
Bibl: Carr; BM Cat. of Engraved British Portraits II 1910 p.467; Ormond I p.218.

CRABBE, Herbert G. fl.1885-1891
Landscape painter. Exhib. at RA, SS and NWS. Lived at Beckenham, Kent, and painted mostly views in Kent and Surrey.

CRACE, John Dibblee 1838-1919
Exhib. views of Egyptian temples, Egyptian scenes, and designs for interior decoration at the RA. He was a member of the famous firm of architects and interior designers Crace & Co., and the son of John Gregory Crace. Hon. Associate of RIBA; FSA; First President of the Institute of British Decorators.
Bibl: The Builder CXVII, 1919 pp.531, 534 (obit.); Who's Who in Architecture 1914; Cat. of the Drawings Collection of the RIBA Vol C-F 1972.

CRACKNELL, Thomas C. fl.1865-1866
Birmingham landscape painter. Exhib. three landscapes at SS, views in Wales and the Midlands.

CRAFT, Percy Robert RCA 1856-1934
London painter of landscape and figure subjects, in oil, watercolour and pastel. Studied at Heatherley's and the Slade, under Poynter and Legros. Exhib. at RA, SS, ROI and elsewhere. Elected RCA 1925.
Bibl: AJ 1889 p.141; Who's Who 1912.

CRAFTON, Richard fl.1877-1882
London landscape painter. Exhib. at SS only, both oils and watercolours. Subjects: English views, coastal and rural scenes.

CRAIG, Alexander fl.1840-1857 d.1878
London portrait and figure painter. Exhib. at RA and BI. At RA he exhibited portraits, including David Livingstone, 1857; at the BI domestic subjects, e.g. 'Infancy and Age'. Spent his early years in Glasgow, where the museum has a portrait of the poet Thomas Campbell by him.
Bibl: Glasgow Museum Cat. 1908 no. 243; Ormond I pp.272, 273.

CRAIG, Frank ROI 1874-1918
Painter of historical and other figure subjects; illustrator. Studied at Lambeth School of Art, Cook's School, Fitzroy Street, and RA schools under E.A. Abbey. Exhib. at RA from 1895, also SS. Worked as an illustrator for several magazines, and also illustrated Kipling's poems. Died in Sintra, Portugal. He painted romantic historical scenes and portraits in the manner of Abbey and F.C. Cowper.
Bibl: AJ 1906 p.381; Studio XXXVIII 1906 pp.4, 11; XLIV 1908 pp.34, 36.

CRAIG, James Stephenson fl.1854-1870
London painter of figures and domestic subjects. Exhib. at RA, BI and SS. Titles: 'The Young Anglers', 'The Gamekeeper's House', etc. and some historical works, e.g. 'Jennie Deans'.

CRAIG, Phillip fl.1887
Exhib. one flower picture at SS, 1887.

CRAIG, Robert Henry see ROSELL, Alexander

CRAIG, William 1829-1875
Irish landscape painter. Studied at Dublin Society, and exhib. at RHA 1847-62. In 1863 he left for America.

CRAISTER, Mrs. Walter fl.1870-1892
Chester painter of still-life. Exhib. at SS, NWS and elsewhere. Subjects fruit, flower and birds, all in watercolour.

CRAMBROOK, W. fl.1824-1862
Landscape painter; lived in Deal, Kent. Exhib. mainly at SS, only occasionally at RA and BI. Subjects mostly views in Wales and Scotland. 'A Moonlight view of Bristol' is in Bristol AG.
Bibl: Brook-Hart.

CRAMP, Viola fl.1875
Exhib. one landscape 1875. London address.

CRAMPTON, James S. fl.1876
Exhib. one landscape 1876. Address Bootle, Lancashire.

CRANBROOK COLONY, The
Group of artists who congregated during the summer at Cranbrook in Kent. Leader was Thomas Webster, (q.v.) who lived in Cranbrook 1856-86. Other followers included F.D. Hardy, A.E. Mulready, G.B. O'Neill, and J.C. Horsley, (all q.v.). Their aim was to paint simple, unaffected scenes of country life, especially children, following both the techniques and the traditions of Wilkie. This group had many imitators, who carried its ideal right through the 19th century, and even into the early 20th century.
Exhib: Wolverhampton AG 1977.

CRANE, Thomas 1808-1859
Painter of portraits and figure subjects, in oil and watercolour. Born in Chester. Studied at RA schools, and then returned to Chester to paint miniatures, including a series of portraits of well-known characters of North Wales. He then moved to Liverpool, where he exhibited at the local Academy, of which he became an Associate 1835, Member 1838. He then moved to London; where he exhib. at the RA, BI and SS. Troubled by ill-health, he returned to Liverpool, but eventually settled in Torquay for 12 years. His more famous son, Walter Crane (q.v.) was born in Liverpool. Thomas moved back to London in 1857, and died there in 1859. He was best known for his sympathetic portraits of women and children, but he also painted other subjects, e.g. 'The Deserted Village', 'The Cobbler' and scenes from *The Vicar of Wakefield*.
Bibl: AJ 1859 p.360 (obit.); Bryan; DNB; Cundall; Marillier pp.92-4; for further references see under Walter Crane.

CRANE, Thomas fl.1890-1900
Landscape painter. Exhib. two pictures at RA. London address.

***CRANE, Walter RWS 1845-1915**
Painter of portraits, figure subjects and landscapes; he also designed numerous illustrations for children's books and other publications, 1863-96, e.g. *Song of Sixpence, The Fairy Ship* 1869, *Baby's Opera* 1877, *Floral Fantasy* 1899; also made many designs for textiles, wallpapers, etc., and executed interior decoration. Born in Liverpool; apprenticed to W.J. Linton, wood engraver in 1859. Influenced by Burne-Jones and the Pre-Raphaelite Brotherhood; associated with William Morris in the Socialist League. His first illustrations appeared in a series of sixpenny toy books between 1864 and 1869. Exhib. from 1862 at the RA, OWS, NWS, GG, etc. Member of the RI 1882-6; elected A of the OWS, 1888, member 1899. Principal of the RCA 1898-9. Signs in monogram with the initials WC and a crane.
Bibl: AJ 1901 p.79ff.; 1902 p.270ff.; etc. (TB for full list); P.G. Konody, *The Art of Walter Crane*, 1902; VAM Press cuttings and MS notes relating to Walter Crane 1903; W. Crane, *An Artist's Reminiscences*, 1907; Cundall; DNB; VAM (book illus. and landscape studies, etc.); Anthony Crane, My *Grandfather, Walter Crane*, Yale University Library Vol. XXXI, no.3 1957; Reynolds, VP pp.65, 69, 70, 71 (pl.54); Hardie III pp.142-3 (pls. 167-8); Maas pp.16, 146, 183 (pl. p.142); Isobel Spencer, *W.C.*, 1975; Wood, Pre-Raphaelites; Wood, Olympian Dreamers; Newall.

CRANSTON, W.A. fl.1878-1879
Exhib. two domestic subjects 1878-9. London address.

***CRANSTONE, Lefevre James fl.1845-1867**
Little-known genre painter. Lived in London and Birmingham. Exhib. at RA 1845-54, BI and SS. Titles at RA 'A Country Fair', 'Waiting at the Station' and 'Cheap Jack'. Cranstone appears to have specialised in Frith-type scenes of Victorian life. Although very little is known of his life or the amount of his output, 'Waiting at the Station' shows that he was a competent and charming artist.
Bibl: Wood, Panorama.

CRANSTOUN, James Hall 1821-1907
Perthshire landscape painter in oil and watercolour. Studied at the Slade. An example is in Dundee AG.

CRAVEN, Hawes fl.1867-1875
London painter of river and coastal scenes. Exhib. seven watercolours at SS 1867-75, including some views on the Thames.

CRAVUN, J. fl.1855
Exhib. one watercolour 'The Village Spring' at SS, 1855. London address.

CRAWFORD, Mrs. fl.1869-1891
(Miss Emily Aldridge)
London painter of figure subjects. Exhib. at RA, SS and elsewhere. Titles: 'A Soldier's Legacy', etc.

CRAWFORD, Ebenezer fl.1858-1873
London painter of historical and domestic subjects. Exhib. at RA, BI, SS and elsewhere. Titles mostly historical subjects from 18th century, e.g. 'Rousseau and Mrs. Garrick at the Play' and some Irish scenes.
Bibl: AJ 1859 p.167.

CRAWFORD, Edmund Thornton RSA 1806-1885
Scottish landscape painter. Studied at Trustees' Academy, Edinburgh. 1831 paid the first of many visits to Holland, to study the painters of the 17th century. Exhib. mostly at the RSA; only once at the RA in 1836. Elected ARSA 1839, RSA 1848. Painted Scottish landscapes, coastal scenes, and harbours. The predominant influence on his style was Dutch — Van de Velde in seascape, and Hobbema in landscape. His work is similar in spirit and period to that of Patrick Nasmyth (q.v.).
Bibl: W. Armstrong in Portfolio 1887 p.178ff.; Caw pp.161-2; DNB; L. Baldry, *Royal Scottish Academy*, Studio 1907 p.7ff.

CRAWFORD, Robert Cree 1842-1924
Glasgow painter of landscapes, seascapes, portraits and flower subjects. Exhib. at RA from 1880, and is represented in Glasgow City AG.
Bibl: Caw; Glasgow Museum Cat. 1908 pp.50-1.

CRAWFORD, Thomas Hamilton RSW fl.1890-1930
Scottish painter of buildings, figure subjects and still-life. Also produced mezzotints. Exhib. at RA from 1891, also RSA and Paris Salon. RA exhibits mostly views of old buildings, e.g. St. Paul's Cathedral, the Charterhouse, etc. Lived in Glasgow and later Berkhamsted, Hertfordshire.

CRAWFORD, William ARSA 1825-1869
Edinburgh portrait painter. Born at Ayr. Studied at Trustees' Academy, Edinburgh, under Sir William Allan. Won a travelling studentship, and spent several years in Rome. On his return he settled in Edinburgh, and conducted the drawing lessons at the Trustees' Academy until 1858. He painted portraits and small subject pictures, and his chalk drawings were especially admired. Exhib. mainly at RSA 1841-80; also at RA 1852-68; ARSA 1860.
Bibl: AJ 1869 p.272 (obit.); Redgrave, Dict; DNB; Cat. of Engraved British Portraits BM 1908 II p.2; Ormond I p.128.

CRAWHALL, Joseph 1821-1896
Amateur artist and illustrator; father of the more famous animal painter of the same name (q.v.). He worked for the family rope business in Newcastle, but in his spare time wrote and illustrated his own books, e.g. 'The Compleatest Angling Booke that ever was writ', 1859. He was also a close friend of Charles Keene, and sent him many sketches and ideas for *Punch;* these drawings are now in Glasgow AG. Was also Secretary of the Newcastle Arts Association.
Bibl: Hall; for further references see under Joseph Crawhall below.

***CRAWHALL, Joseph 1861-1913**
Painter and watercolourist of landscapes and animals. Born Morpeth, Northumberland; studied in London; spent much of his early life in Scotland, where he was closely associated with the Glasgow School. He worked at Brig o' Turk with James Guthrie, E.J. Walton and George Henry (qq.v.). Most of Crawhall's work is in watercolour on silk or linen; his favourite subjects were horses,

dogs, animals and birds. His rapid wash drawings are often compared with Oriental calligraphic art. Crawhall lived many years in Tangier, which he visited with Edwin Alexander (q.v.). Later he settled at Brandsby, Yorkshire. Crawhall's output was small; he exhib. once at the RA 1883; most of his work was bought by a few Scottish collectors.

Bibl: AJ 1905 p.121; 1906 pp.118, 186; 1911 pp.71-6; Studio III p.166ff.; XLVII p.180; LVI p.65; Caw; Cundall; VAM; A.S. Hatrick, *A Painter's Pilgrimage,* 1939; M. Hardie, *J.C.,* OWS XXIII 1945; Adrian Bury, *J.C.,* 1958; Hardie III pp,204-7 (pls. 237-9); Maas pp.85-7 (pls. pp.l9, 84-5); Hall; Irwin see index (pls. 193, 196); Newall; V. Hamilton, *J.C.,* 1990.

CRAWHALL, W. fl.1860-1894
Newcastle painter of landscapes and coastal scenes, possibly related to Joseph Crawhall (q.v.). Exhib. at BI and SS. Also known to have painted a view of St. Nicholas Cathedral, Newcastle.
Bibl: Hall.

CREASEY, Miss Maria fl.1850
Exhib. one portrait at RA 1850. London address.

CREASY, Mrs. fl.1839-1841
Painter of fruit and fish. Exhib. three pictures at SS. Address Tonbridge, Kent.

CREES, J.L. see BRADDON, Paul

CREGEEN, Miss Bertha C. fl.1893-1896
Painter of portraits and figures. Exhib. four pictures at RA 1893-6. Titles: 'Nancy', etc. Address Brockley.

CREGEEN, Miss Emily A. fl.1892-1894
Exhib. two portraits at RA in 1892 and 1894. Lived at Brockley, at same address as Miss Bertha C. Cregeen (q.v.).

CREGEEN, Miss Nesey Isabel fl.1887
Exhib. one landscape 'Evening' at RA, 1887. London address.

CRESSWELL, A.E.B. fl.1861-1866
Landscape painter. Exhib. three watercolours of Scottish scenes at SS. Address Clifton, near Bristol.

CRESSWELL, Miss Henrietta fl.1875-1892
London flower painter. Exhib. both oils and watercolours at RA, SS, NWS, GG and elsewhere.

CRESWELL, J. fl.1857
Exhib. one picture of ducks at RA, 1857. London address.

CRESWICK, Mrs. fl.1865-1867
Exhib. two pictures of fruit at RA in 1865 and 1867. Presumably the wife of Thomas Creswick (q.v.).

CRESWICK, H.G. fl.1855
Exhib. one portrait of a clergyman at RA, 1855.

CRESWICK, Mortimer fl.1889
Liverpool landscape painter. Exhib. one evening landscape at RA, 1889.

***CRESWICK, Thomas RA 1811-1869**
Landscape painter, of a narrow range of scenery chiefly in Wales and the north of England, usually with streams or water. Studied under John Vincent Barber in Birmingham and in 1828 moved to London. Exhib. from 1828, 266 works at the RA, BI, SS, and elsewhere. ARA, 1842; RA, 1851. As his themes were limited in scope he frequently varied his pictures by introducing figures and cattle, painted by his friends, Ansdell, Bottomley, Cooper, Elmore, Frith, Goodall and others. Reynolds notes that he liked to maintain an overall brown tone and that his work stands out by "its integrity and power of construction". His work was a great success and a memorial exhibition was held after his death. He was also favourably criticised by Ruskin in *Modern Painters,* 'On the Truth of Vegetation'. At the London International Exhibition of 1873, 109 of his works were collected together, with a catalogue by T.O. Barlow, RA. He was also a book illustrator. His studio sale was held at Christie's, 6 May 1870.

Bibl: AJ 1856 p.141ff. (mono. with pls.); 1870 p.53 (obit.); 1906 p.333; 1908 p.104; Ruskin, Academy Notes 1855-7; Redgrave, Cent., Dict.; DNB; VAM; Reynolds, VP p.152 (pl.159); Maas p.49 (pl. p.49); Staley.

CRICHTON, N.S. fl.1888-1889
Exhib. three watercolours of churches in France at SS, 1888-9. Lived in Leeds and Bradford.

CRIDDLE, Mrs. Harry RWS 1805-1880
(Miss Mary Ann Alabaster)
London painter and watercolourist of figure subjects and portraits. Studied under Hayter 1824-6, and won several medals. Began to exhibit in 1830, at RA, BI and SS, but especially at OWS, of which she became a member in 1849. Her subjects were portraits, historical scenes, and literary subjects taken from Shakespeare, Milton, Dickens, Tennyson and others. In 1852 she went partly blind, but recovered sufficiently to continue painting. In 1861 she retired to Addlestone, near Chertsey. Several of her works were bought by Baroness Burdett-Coutts.
Bibl: Clayton II pp.704; Roget II pp.337-9.

CRIDLAND, Miss Helen fl.1886-1901
Painter of domestic subjects. Exhib. at RA, SS, NG and elsewhere. Titles: 'A Forced Acquaintance', etc. Address Bushey, Hertfordshire.

CRIGHTON, Hugh Ford fl.1865
Exhib. one portrait at RA, and one picture of a Moorish girl at SS, both in 1865. London address.

CRISP, Miss H. fl.1877-1878
Exhib. two watercolours of Devon landscapes at SS, 1877-8. Address Torquay, Devon.

CRISPE, Miss Leila Constance fl.1885-1887
Exhib. one picture 'Autumn Leaves' at SS 1885, also elsewhere. London address.

CRITTENDEN, Miss Dora E. fl.1884
Exhib. one picture of wallflowers at RA, 1884. London address.

CROCHEZ, T. fl.1850
Exhib. one portrait at RA, 1850. London address.

CROCKER, A.C. fl.1885-1886
Exhib. three watercolours of sea subjects at NWS. Cheshunt address.

CROCKFORD, Miss fl.1845
Exhib. one landscape, a subject from St. Luke, at SS 1845. London address.

CROCKFORD, Miss F. fl.1839
Exhib. one picture of 'Carlsruhe — market day' at RA, 1839. London address.

CROCKFORD, George fl.1835-1865
London landscape painter, honorary exhibitor at the RA 1835-65 — landscape views in Switzerland and Scotland. Also exhib. at BI and SS.
Bibl: VAM

CROFT, Arthur b.1828 fl.1868-1893
London landscape and topographical painter. He travelled widely, to Switzerland, Algeria, the USA and New Zealand, and most of his subjects were taken from these countries. He also painted English and Welsh scenes. Exhib. at RA 1868-93 and elsewhere. An example is in the VAM. Particularly known for his Alpine scenes.

CROFT, John fl.1868-1875
Exhib. two pictures of churches, 1868-75. London address.

CROFT, John Ernest fl. 1868-1873
Painter of rustic scenes and landscape. Exhib. at RA, SS and elsewhere, in oil and watercolour. Lived in London and Tunbridge Wells.

CROFT, Marian fl.1869-1882
London landscape painter. Daughter of John Croft, an ivory carver. Exhib. at SS, Dudley Gallery, and at the Society of Lady Artists, of which she was a member.
Bibl: Clayton II pp.185-6.

***CROFTS, Ernest RA 1847-1911**
Painter of battle pieces and disciple of Meissonier. He chiefly painted the English Civil War, the Napoleonic War and the Franco-Prussian War. Among his more famous works are 'The Evening of the Battle of Waterloo', Walker AG, Liverpool, 'The Morning of Waterloo', 'Napoleon's Last Attack', and 'Charles II at Whiteladies after the Battle of Worcester'. He also achieved success as an illustrator. His studio sale was held at Christie's, 18 December 1911.
Bibl: Clement & Hutton; AJ 1882 p.22; 1893 p.286; 1898 p.180; 1902 p.143; Mag. of Art XIX 1896 p.134; XXII 1898 p.627; DNB.

CROMBIE, Miss Elizabeth E. fl.1890-1894
London flower painter. Exhib. three pictures at RA 1893-4, and one at NWS.

CROME, John Berney 1794-1842
Norwich School landscape painter; eldest son and pupil of John Crome and brother of William Henry Crome (q.v.). In 1816 he visited the Continent with George Vincent. Exhib. at RA, BI and SS, and also at the Norwich Society of Artists, of which he became President in 1819. He painted landscapes, coastal scenes and continental views, but was best known for his moonlight pictures, which are reminiscent of Aert van der Neer. In 1831 he was declared bankrupt, and thereafter the quality of his work declined.
Bibl: AU 1842 p.278; 1843 p.10 (obit.); H.A.E. Day, *East Anglian Painters*, II pp.36-44; for full bibl. of Crome family see D. and T. Clifford, *John Crome*, 1968 pp.285-9.

CROME, Vivian fl.1858-1883
Painter from Norwich, son of William Henry Crome. A painting of 'The White Dog', 1883, was exhib. at the Maas Gallery, May 1969. He exhib. at the RA in 1867 'Zoe', and at the BI in the same year, 'The White Rose' and 'The Sage'. His address is given as 35 Cheyne Walk. Graves Dictionary gives his speciality as "flowers".

CROME, William Henry 1806-1873
Norwich School landscape painter; son of John Crome. Exhib. at BI, SS and elsewhere in London, but mostly at Norwich Society and other East Anglian exhibitions. He painted in a style similar to that of his brother, John Berney Crome (q.v.) but used a characteristic greeny-blue colouring, especially in the distances and foliage of his landscapes.
Bibl: H.A.E. Day, *East Anglian Painters*, II 1968 pp.45-55; for further references see under John Berney Crome.

CROMEK, Thomas Hartley RI 1809-1873
Landscape painter and watercolourist; son of Robert Hartley Cromek, an engraver. Studied under the portrait painter J. Hunter in Wakefield, and with the painter John N. Rhodes (q.v.) in Leeds. From 1830 to 1849 he travelled extensively in Greece and Italy, and was best known for his architectural views in those countries. Exhib. mainly at NWS, also RA and SS.
Bibl: Ottley; Clement & Hutton; Binyon.

CROMER, J.B. fl.1842
Exhib. one Dutch coastal scene at SS, 1842. No address given.

CROMMELIN, Miss M. fl.1870
Exhib. one picture 'Bessie' at RA, 1870. London address.

CROMPTON, James Shaw RI 1853-1916
Painter of figure subjects, mainly in watercolour, but also occasionally in oils. Studied under John Finnie in Liverpool, at the Liverpool Academy, and at Heatherley's in London. Exhib. mainly at NWS, elected RI 1898, but also at RA and SS. Subjects domestic scenes, historical subjects, and also Arab figures. Was President of the Langham Sketching Club.

CROMPTON, John fl.1872-1886
London painter of figure subjects and landscapes. Exhib. at RA, SS and elsewhere. Titles: 'Testing his Gallantry', etc.

CROMPTON, Miss Mildred Roberts fl.1892-1893
Exhib. two watercolours of flowers at NWS 1892-3. London address.

CRONSHAW, James Henry b.1859 fl.1880-1927
Landscape and flower painter. Studied at South Kensington Schools. Was an art master in Accrington, Slough, and Ashton-under-Lyme.

CROOKE, John fl.1890-1898
Landscape painter. Exhib. at RA and GG. Titles: 'Sunlight and Shadow', etc. Lived in London and Newlyn, Cornwall.

CROOKE, W. fl.1878-1879
Exhib. six pictures of churches, 1878-9. London address.

CROOME, C.J. fl.1842-1845
London painter of rustic subjects and animals. Exhib. at SS only. Titles: 'Hauling at Stone Quarry', etc.

CROOME, J.D. fl.1839-1852
London painter of historical and other figure subjects. Exhib. at RA, BI and SS. Titles: 'The Astrologer', scenes from Shakespeare, etc.

CROSBY, William fl.1859-1873
Sunderland painter of domestic subjects. Exhib. at RA and SS. Titles: 'The Mother's Hope', 'Happy Days', etc. Several of his works are in Sunderland Museum. 'The Magic Sailor' appeared at Sotheby's Belgravia, 1 August 1975, lot 53.
Bibl: Hall; Wood, Panorama p.93 (pl.95).

CROSHAW, T. fl.1846
Exhib. one still-life picture at RA, 1846. London address.

CROSLAND, Enoch b.1860 fl.1883-1889
Derbyshire landscape painter. Born in Nottingham, where he studied at the School of Art. Exhib. at RA and SS. Was a member of the Derby Sketching Club.

CROSLEY, Miss Edith A. fl.1880-1884
London painter of domestic subjects and children. Exhib. at RA, SS and elsewhere. Titles: 'Ah! Happy Years, Once more who would not be a boy', etc.

CROSS, John 1819-1861
London painter of historical subjects. Born at Tiverton, Devon, but brought up in St. Quentin, France, where he studied at the local School of Design. Studied also under Picot in Paris. In 1847 he came to London and entered a picture 'Richard Coeur de Lion forgiving Bertrand de Jourdon' for the Westminster Hall Competition. It won a £300 prize, and Cross was encouraged to move with his family to London. This early promise was not to be fulfilled, however, as he was not among those selected to decorate the Houses of Parliament with frescoes. Instead he exhibited a series of ambitious historical works at the RA 1850-8, but few of them found purchasers. He died, a disappointed man, at the age of only 41.
Bibl: AJ 1862 pp.117-19; Ottley; G. Pycroft, *Art in Devonshire*, 1883 p.36ff.; DNB 1908 IV; W.M. Rossetti, *Some Reminiscences*, 1906 p.140.

CROSS, Joseph fl.1890-1892
Preston landscape painter. Exhib. twice at RA, in 1890 and 1892.

CROSS, William fl.1867
Exhib. one landscape 1867. London address.

CROSSE, Edwin Reeve fl.1888-1897
Leeds painter of portraits and figure subjects. Exhib. five pictures at RA 1888-97. Titles: 'Expectancy', etc.

CROSSLAND, James Henry b.1852 fl.1885-1904
Landscape painter. Exhib. at SS from 1885, RA from 1898, and other provincial exhibitions. Lived in Derbyshire, but later moved to the Lake District, where he found most of his subjects. Founder member of Lake Artists' Society, 1904.

CROSSLAND, John Michael 1800-1858
London painter of portraits and figure subjects. Exhib. at RA and SS. Painted several Italian subjects.
Bibl: Ormond I p.438.

CROSTHWAITE, Daniel fl.1833-1845
London portrait painter. Exhib. at RA and SS. Also exhib. two landscapes of the Lake District.

CROUDACE, Mrs. E.H. fl.1852-1869
London painter of domestic and figure subjects. Exhib. mainly at SS, also RA. At RA and SS exhibited pictures of Russian subjects; also portraits, and Italian and Japanese scenes.

CROUGHTON, George fl.1874
Exhib. one watercolour of flowers at SS, 1874. London address.

CROW, Miss Margaret G. fl.1879-1897
London painter of figure subjects. Exhib. at RA, SS and elsewhere. Titles: 'Don't Cry, Baby', etc.

CROWDACE, Mrs. W.A.H. fl.1873
Exhib. one watercolour portrait of a Polish Countess at SS, 1873. London address.

CROWDY, Miss Fanny fl.1859
Exhib. one domestic subject 1859. Address Reading, Berkshire.

CROWDY, Miss Rose fl.1895
Exhib. one study of a head at RA, 1895. Address Torquay, Devon.

***CROWE, Eyre ARA 1824-1910**
Painter of historical subjects, domestic genre, and portraits. Elder brother of J.A. Crowe, who wrote with G.B. Cavalcaselle the *History of Painting in North Italy,* etc. He was a pupil of Paul Delaroche, with whom he went to Rome in 1843, and a life-long friend of Gérôme. He became secretary to Thackeray, who was his cousin, and went with him on a lecture tour to America in 1852. This provided him with the subject of his painting of 'The Sale of Slaves at Richmond, Virginia', exhib. 1861, which was basically a study of negroes and a foretaste of the Civil War. The AJ commented: "However skilfully painted such pictures may be, the subjects do not commend themselves either to the eye or the mind. Neither the colour nor the features of the negro race can be associated with European notions of aesthetic beauty." As befits a pupil of Delaroche the majority of his paintings tend to be themes from history, but occasionally, and only too rarely in his work, are scenes of contemporary social comment — like the Richmond Slaves and a scene from industrial life 'The Dinner Hour, Wigan' 1874, and simple genre scenes like 'The Bench by the Sea'. He exhibited at the RA from 1846, and became ARA in 1875.
Bibl: AJ 1864 pp.205-7; 1868 p.28; 1904 p.166; RA Pictures 1891-6; 1905-7; DNB; Reynolds, VS p.92 (pl.80); Reynolds, VP p.112 (pl.72 'The Bench by the Sea'); Maas p.238; Ormond I; Wood, Panorama.

CROWE, T. fl.1854-1855
London portrait painter. Exhib. five portraits at RA, 1854-5.

***CROWLEY, Nicholas Joseph RHA 1813-1857**
Irish painter of portraits and domestic genre who exhib. at the RA 1835-58. He worked in Dublin and Belfast, coming to London in 1838. Titles at RA 'What's her History?', 'Expectation', 'The First Step', etc.
Bibl: DNB; Redgrave, Dict; Ormond I.

CROWLEY, Walter fl.1874-1875
Exhib. one picture 'Resting' at SS, 1874; also exhib. elsewhere. Manchester address.

CROWQUILL, Alfred see FORRESTER, Alfred Henry

CROWTHER, John fl.1876-1898
London painter of architectural and topographical subjects. Exhib. at RA 1876-98, also at Brighton Royal Pavilion Gallery. Graves lists him as an architect.

CROXFORD, Thomas Swainson fl.1876-1884
Brentford landscape painter. Exhib. at RA, SS and elsewhere. Subjects mainly Cornwall and the Isle of Man.

CROXFORD, William Edwards fl.1871-1896
Landscape painter. Lived at Brentford, Hastings, and in Cornwall. Exhib. at RA, SS and NWS; titles mostly coastal scenes. A Thomas Swainson Croxford is also recorded, presumably a relation, as he also lived in Brentford. He also exhibited landscapes and coastal

scenes especially of Cornwall, at RA, SS and elsewhere (signing sometimes as W. Croxford Edwards, q.v.).

CROYDON, W.J. fl.1858-1864
Windsor landscape painter. Exhib. at RA and BI; subjects mainly scenes in Windsor Forest.

CROZIER, Miss Anne Jane fl.1868-1894
Oxford painter of rustic figure subjects. Exhib. at RA, NWS and elsewhere. Titles: 'The Stackyard', etc.

CROZIER, George RCA fl.1865-1886 d.1914
Landscape painter. Born in Manchester, son of Robert Crozier (q.v.). On Ruskin's advice, he studied Natural Science at Radcliffe Library, Oxford, and produced many scientific drawings. Exhib. at RA from 1866, NWS and elsewhere. Later he lived at Rydal, Westmorland, and Carnforth, Lancashire. Painted in Scotland and Ireland; also travelled in Norway, France, Italy and Greece. His father, Robert Crozier (q.v.) of Manchester, was also a painter.

CROZIER, Robert 1815-1891
London painter of shipping and river scenes. Exhib. at RA, BI and SS, mostly views on the Thames, or at Boulogne.
Bibl: Brook-Hart.

CROZIER, Robert fl.1854-1882
Manchester painter of domestic subjects, portraits and children. Exhib. at RA and SS. Titles: 'A Good little Girl', etc. President of the Manchester Academy, father of George Crozier (q.v.). Also recorded is a Miss Anne Jane Crozier, probably his daughter, who exhib. domestic subjects at the RA, NWS and elsewhere 1868-86.

CRUICKSHANK, Francis fl.1852-1855
Exhib. a portrait and a figure subject at RA in 1852 and 1855. Addresses Edinburgh and London.

CRUICKSHANK, Frederick 1800-1868
Scottish portrait and figure painter. Pupil of Andrew Robertson, a miniaturist. He exhib. at RA and elsewhere from 1822. His work is often found in Scottish country houses.

CRUICKSHANK, William fl.1866-1879
South London painter of genre, still-life, fruit, game and birds. Imitator of W. Henry Hunt (q.v.). Exhib. from 1866-79 at the RA and SS. His works are usually small and highly detailed, and often come in pairs.
Bibl: Maas p.l73 (pl.l72 'Still life with Bird, Bird's Nest and Blossom').

CRUIKSHANK, Miss Dora fl.1884
Exhib. one landscape at NWS, 1884. London address.

CRUIKSHANK, George 1792-1878
Painter, cartoonist and illustrator; son of Isaac Cruikshank, also a cartoonist, and brother of I.R. Cruikshank (q.v.). At first he followed in the traditions of Gillray and Rowlandson, but in the Victorian period he developed his own personal style. He illustrated a great many books, including Dickens's *Sketches by Boz,* but was best known for his cartoons on moral and social themes, such as 'The British Bee Hive', 'London going out of Town', etc. He was also a militant member of the Temperance League, and the evil of drink was the theme of many cartoons, e.g. 'The Bottle' and 'The Drunkard's Children'. He also painted an enormous picture packed with figures entitled 'The Worship of Bacchus'; it was exhibited at

Exeter Hall in 1863, and is now in store at the Tate Gallery.
Bibl: Cat. of the George Cruikshank exhib., Arts Council 1974, contains a good bibl. p.45; for further details see DNB and TB.

CRUIKSHANK, Isaac Robert 1789-1856
Brother of George Cruikshank (q.v.) and eldest son of Isaac Cruikshank. Went to sea before turning to miniature painting and caricature. He also did book illustrations, sometimes together with his brother George, whose reputation has now over-shadowed his own.
Bibl: See under George Cruikshank.

CRUTTWELL, Miss Maud fl.1880-1893
London painter of domestic subjects. Exhib. one picture 'A Doubtful Bargain' at RA 1891, and at other London exhibitions.

CUBLEY, Henry Hadfield fl.1884-1902
Wolverhampton landscape painter. Exhib. at RA, SS and elsewhere. Subjects mainly Scottish and Welsh landscapes.

CUBLEY, W.H. 1816-1896
Newark landscape painter. Exhib. at RA and SS. Subjects mainly Welsh views. Taught art in Newark, where his best known pupil was Sir William Nicholson. Examples are in Nottingham Castle AG.

CUITT, George, the Younger 1779-1854
Yorkshire landscape and topographical painter; son of George Cuitt, the elder (1743-1818). Taught drawing in Richmond, Yorkshire and Chester 1804-20. Then returned to Yorkshire and settled at Masham for the rest of his life. He published several books of north country views. He painted castles, churches and country houses, often for private patrons.

CULL, James Allanson fl.1872-1886
London painter of figure subjects. Exhib. at RA, NWS and elsewhere. Titles: 'The Little Mother', etc.

CULLEN, Isaac fl.1881-1889
London painter of domestic subjects. Exhib. four pictures at RA 1881-9. Titles: 'Her Hobby', etc. Graves Dictionary spells him Cullin. He painted 'The Weighing-In Room at Epsom on Derby Day', an interesting racing subject (formerly collection Trafalgar Galleries, London).

CULLUM, John fl.1833-1849
London painter of domestic and figure subjects. Exhib. at RA, BI, SS and elsewhere. Titles: 'Gipsy going to Market', 'The Young Milkmaid', 'The Antiquary', etc.
Bibl: Binyon.

CULVER, Fred fl.1889-1893
London painter of landscapes and river scenes. Exhib. mainly at SS, also RA and NWS. Painted several views on the Thames.

CUMBERLAND, C. fl.1861
Exhib. one picture 'The Sere and Yellow Leaf' at RA, 1861.

CUMMING, Miss M. fl.1874
Exhib. one flower picture at RA, I 874. London address.

CUMMINS, Miss Emily see BARNARD, Mrs. J.L.

CUNARD, W.S. fl.1890-1893
London landscape painter. Exhib. at SS only, 1890-3. Subjects English and French views.

CUNARD, Mrs. William fl.1890-1893
London landscape painter. Exhib. at SS, and also at RA in 1892, under the name Mrs. Laura Cunard. The titles of her pictures suggest a penchant for autumnal and evening effects.

CUNDELL, C.E. (or E.C.) fl.1860-1869
Exhib. three portraits at RA, 1860-9. London address. A portrait by him of John Phillip (q.v.) is in the Garrick Club, London.
Bibl: Ormond I p.377.

CUNDELL, Henry 1810-1886
London painter of buildings and landscapes. Exhib. at RA only 1838-58. Titles include landscapes in Wales and on the Thames, and views of buildings, mostly in London. His early watercolours are similar to T.S. Boys. An example is in the BM.

CUNDELL, Naomi fl.1883-1884
Exhib. two pictures of fruit and flowers at SS, 1883-4. Address Reading, Berkshire.

CUNLIFFE, D. fl.1826-1855
London painter of portraits, animals, figure subjects and landscape. Exhib. at RA, BI and SS. Titles include a Highland Sword Dance, (a photograph of which is in the Witt Library, London) and a portrait group of officers of the 74th Highlanders. 'A Sortie from Jellalahbad' is in the Somerset County Museum in Taunton.

CUNNINGHAM, Mrs. Georgina fl.1888
Exhib. one picture 'The White Shell' at RA, 1888. London address.

CUNYNGHAME, H. fl.1888
Exhib. one picture of ruins at NG, 1888. No address given.

CURDIE, John fl.1850
Exhib. one view of Culzean Castle, Ayrshire, at SS, 1850. Addresses London and Kilmarnock, Ayr.

CURNOCK, James 1812-1862
Bristol painter of portraits and figure subjects. Exhib. at RA and SS. A number of his works, mostly portraits, are in Bristol AG.

CURNOCK, James Jackson RCA 1839-1891
Bristol landscape painter who exhib. at the RA 1873-89 — all landscapes and chiefly Welsh views. Ruskin highly praised 'The Llugwy at Capel Curig': "I find this to be the most attentive and refined landscape of all here; too subdued in its tone for my own pleasure, but skilful and affectionate in high degree; and one of the few exceptions to my general statement above made; for here is a calm stream patiently studied. The distant woods and hills are all very tender and beautiful." Also exhib. at SS and NWS.
Bibl: Ruskin, Academy Notes 1875; Clement & Hutton.

CURRER, R.W. fl.1865
Exhib. one picture 'The Dame's School' at BI, 1865. London address.

CURREY, Miss Ada fl.1878-1889
Painter of figure subjects and flowers. Exhib. at SS and NWS. Titles: 'Weary Work', etc. Address Weybridge, Surrey.

CURREY, Miss Fanny W. fl.1880-1897
Painter and watercolourist of flowers and gardens. Lived at Lismore, Ireland. Exhib. at RA, SS, NWS, GG, NG and elsewhere.

CURRIE, Miss Jessie fl.1897
Exhib. one picture 'Sunday' at RA, 1897. Address Highgate, London.

CURRIE, Captain R.W. fl.1835-1840
London animal painter. Exhib. at BI and SS, both animals and sporting subjects.

CURRIE, Robert fl.1880-1885
Exhib. one picture of birds at RA, 1885; also exhib. elsewhere. Address Perthshire.

CURRIE, Sidney fl.1892-1930
Birmingham landscape painter. Exhib. regularly at RBSA, also at RA and SS. Painted mainly views in Warwickshire. One picture by him is in Birmingham City AG.

CURTIS, Mrs. fl.1848
London landscape painter. Exhib. at SS only, mainly Welsh views.

CURTIS, George D. fl.1889-1898
Manchester landscape painter. Exhib. at RA and GG. Titles: 'A Quiet Nook', etc.

CURTIS, Miss Isabel C. fl.1850-1856
London painter of figure subjects. Exhib. at RA and SS. Titles: 'Medea', 'Beatrice Cenci', etc.

CURTIS, Miss R.F. fl.1887-1891
London flower painter. Exhib. at SS and NWS.

CURTIS, Ralph Wormeley 1854-1922
Exhib. one picture of Venice at RA, 1890; also once at GG. Addresses London and Paris. Painted a portrait of Browning, which is in the Rucellai collection, Florence.
Bibl: Ormond I p.75.

CURTIS, Sir W., Bt. fl.1862
Exhib. a view of Nice at BI 1862, and one untitled picture at SS. No address given.

CURTOIS, Miss Dering fl.1887-1892
Lincoln painter of rustic scenes and portraits. Exhib. at RA and NG. Titles: 'Sheep Feeding, Lincolnshire', etc.

CUSTARD, A. Marsh fl.1856-1860
Exhib. seven pictures of churches at various minor London shows. Address Yeovil, Somerset.

CUTHBERT, John Spreckley fl.1852-1877
London painter of portraits and figure subjects. Exhib. at RA, BI, SS, GG and elsewhere.

CUTLER, Cecil E.L. fl.1886
Exhib. one watercolour subject from Charles Kingsley at SS, 1886; also elsewhere. Address Putney, London.

CUTLER, Ernest J.H. fl.1887
Exhib. two landscapes, one in Brittany at SS, 1887. London address.

CUTTS, John T. fl.1885
Exhib. one watercolour landscape at NWS 1885. Liverpool address.

D

***DA COSTA, John 1867-1931**
Painter of portraits, landscapes and figure subjects. Studied in Paris and with the Newlyn School in Cornwall. His success in portrait painting encouraged him to visit America in 1905, where he received many commissions, returning there regularly throughout his career. Exhib. at RA, GG, NG and elsewhere both in London and the provinces, also in Europe and the USA. His style, especially in his portraits and figure pictures, reflects the influence of his friend and contemporary, Sargent. An exhibition of his work was held at Leighton House in 1974.
Bibl: Cat. of the John Da Costa exhib., Leighton House, London, November-December 1974 (full bibl. p.12).

DACRE, Miss Susan Isabel fl.1876-1894
Manchester painter of figure subjects. Exhib. at RA 1876-94, and at NG. Titles: 'Marietta', etc.

DADD, Frank RI ROI 1851-1929
Painter and illustrator of romantic historical genre in oils and watercolour. Studied at the RCA and RA schools. Worked for the *London Illustrated News*, 1878-84, and later for *The Graphic*. Exhib. at RA occasionally between 1878 and 1912, titles including: 'Life or Death', 'Teaching the Young Idea how to Shoot'. Member of RI, 1884 and ROI, 1888; also exhib. at the RBA.
Bibl: Tate Cat.

***DADD, Richard 1819-1886**
Painter of fairy and fantasy subjects. Following his youthful ambition to paint "works of the imagination", Dadd studied at the RA schools, and became a member of The Clique with Egg, Phillip, H.N. O'Neil, and Frith. 1842-3 travelled with Sir Thomas Phillips in Italy, Greece, the Middle East, Italy and France. On his return he began to show symptoms of madness which got steadily worse. In 1843 he murdered his father at Cobham, fled abroad, but was soon caught and confined to Bedlam, insane. Spent the rest of his life there and in Broadmoor, where he died. His style underwent a complete metamorphosis from the promising academy work of his youth to the allegorical, surrealistic style for which he is now best known. His intense, crowded, obsessive pictures have the look of embroidery, and are almost unique in Victorian art. To us he is a fascinating psychological phenomenon; to the Victorians he was merely mad. Before 1843 he exhib. only a few works, four at the RA 1839-42, 16 at Suffolk Street.
Bibl: AU 1843 pp.267-71, 295; 1845 p.137; AJ 1864 p.130; Bryan; Binyon; VAM; Cundall; Reynolds, VS pp.10-11, 56 (pl.16); John Ricketts, *Richard Dadd, Bethlem and Broadmoor*, Sotheby's Year Book 1963-4 (with pls.); Reynolds, VP pp.29, 31-2, 141 (pl.18); Hardie III p.129 (pls.153-4); Maas pp.150-2 (2 pls.), David Greysmith, *Richard Dadd*, 1973, Patricia Allderidge, Cat. of Richard Dadd exhib., Tate Gallery 1974; Ormond I pp.247, 377; Irwin; Strong; Newall.

DADD, Stephen T. fl.1879-1892
London painter of domestic scenes. Exhib. once at SS 1855-6, NWS and elsewhere. Title at SS 'A Visiting Acquaintance'.

DADE, Ernest b.1868 fl.1887-1929
Scarborough marine painter. Exhib. 1887-1901 at RA, and at SS. Titles at RA mostly coastal scenes in Yorkshire, or imaginary, e.g. 'Ashore', 'Solitude', 'A Wreck', etc. Lived for a time in Chelsea, where he was associated with the Manresa Road group of artists in the 1880s.

DAE, E. fl.1848
Exhib. four watercolours at SS, 1848. Three were of flowers, the other a copy after Leonardo. Worcester address.

DAFFARN, Miss Alice fl.1886
Exhib. one landscape 1886. Address Haslemere, Surrey.

DAFFARN, William George fl.1872-1904
London painter of genre and landscape who exhib. at the RA from 1872 onwards; also at SS and GG. Titles at RA: 'The Village Maiden', 'The Duck Pond', 'Early one morning', etc.

DAFFORNE, James fl.1837-1845
Landscape painter. Exhib. six paintings at RA, 1837-45. Titles: 'View near Southampton', 'St. Augustine's Gate, Cambridge', etc. Address Clapton, Essex.

DAGNALL, T.W. fl.1824-1836
London painter of landscapes, rustic scenes and seascapes. Exhib. mainly at SS, also RA and BI.
Bibl: Brook-Hart.

DAINTREY, Alice S. fl.1879
Exhib. one still-life, 1879. Address Petworth, Sussex.

DAKIN, Joseph fl.1859-1900
London landscape painter. Exhib. 1859-1900 at RA, BI, SS and elsewhere. Titles: 'An Old Sandpit', 'On Reigate Heath', etc.

DAKIN, Miss Sylvia C. fl.1893
London watercolour painter of landscape. Exhib. three pictures SS 1893. Titles: 'In Fen Country', etc.

***DALBY, David fl.1780-1849**
Sporting painter, lived at York and Leeds. Did not exhib. in London but worked for private patrons, painting racehorses, equestrian portraits, and hunting scenes. Often called Dalby of York because he signed Dalby York. Sometimes copied John Ferneley Snr., by whom he might have been influenced. Many of his pictures are to be found in private houses in Yorkshire.
Bibl: Pavière, Sporting Painters p.30 (pl. 14).

DALBY, John fl.1826-1853
York sporting painter; possibly the son of David Dalby (q.v.). Mostly known for hunting scenes which, like those of David Dalby, are of very good quality.

DALE, Miss Annie fl.1867
Exhib. one painting BI, 1867. Title: 'Off the Cape of Good Hope'.

DALE, Miss Constantia M.M. fl.1898
Exhib. one picture 'Flemish Lacemakers' at RA, 1898. Address Weston-super-Mare, Somerset.

DALE, E. fl.1873
Exhib. two pictures SS, 1873. Titles: 'View near Barmouth' and 'Cader Idris'. London address.

DALE, H. fl.1872
Exhib. one watercolour landscape SS, 1872. Title: 'Scarborough Castle from Scalby Mill'. London address.

DALE, Henry Sheppard ARE 1852-1921
Watercolour painter of landscape and architectural subjects; etcher, engraver. Born in Sheffield; studied in London and Italy. Exhib. RA, SS, NWS and elsewhere. Worked for *The Graphic*, illustrated several books, and produced sets of etchings of Venice and elsewhere.

DALGLEISH, William 1860-1909
Glasgow landscape painter. Exhib. RA and NWS. Titles: 'Across Renfrewshire', etc.

DALLAS, E.W. fl.1839-1853
Painter of Italian scenes. Exhib. RA, BI and SS. Lived Rome and London. Titles: 'Interior of a kitchen of the Ava-Coeli' and 'Interior of wine house near Naples', etc.

D'ALMAINE, William Frederick fl.1846-1864
London painter of figures and still-life. Exhib. RA, BI, SS and elsewhere. Titles: 'A Water Nymph', etc. His pictures show both Nazarene and Pre-Raphaelite influence.

DALMAS, F.E. de St. 1871-1878
Guernsey watercolour landscape painter. Exhib. at SS, 1871-8. Titles: 'Salmon Weir', etc.

D'ALMEIDA, W.B. fl.1885
Exhib. one landscape 1885. London address.

DALTON, E.C. fl.1876-1879
Exhib. one landscape SS 1879 and two elsewhere. Title: 'Walberswick, Suffolk'. London address.

DALTON, Edwin fl.1877
Exhib. one landscape 1877. Old Charlton address.

DALTON, Mrs. M. fl.1879
Exhib. two bird pictures RA, 1879. London address.

DALZIEL
For more information about this numerous family of artists, see catalogue of the Herbert Dalziel sale, Sotheby's Belgravia, 16 May 1978.

DALZIEL, Edward 1817-1905
Engraver, illustrator and painter. Born in Wooler, Northumberland; came to London in 1839 to help his brother George (1815-1902) to found the famous firm of engravers and illustrators, Dalziel Brothers. Edward was mainly an engraver, but he also painted oils and watercolours, which he exhib. at RA, BI and elsewhere 1841-66. Together with his brother George he published in 1901 *The Brothers Dalziel — a record of 50 years' work in conjunction with the most distinguished artists of the period* which is the main source of information about the family.
Bibl: AJ 1902 p.95; 1905 p.159; DNB Supp. 1912; *The Brothers Dalziel...*, 1901; Gleeson White; Hall.

DALZIEL, Edward Gurden 1849-1888
London painter and illustrator. Eldest son of Edward Dalziel (q.v.). Exhib. domestic subjects at RA, SS, NWS and elsewhere. Titles: 'In the Orchard', etc. Illustrated the magazine *Fun*, and also the novels of Dickens and Bunyan.
Bibl: Kitton, *Dickens and his Illustrators*, 1899 p.221; *The Brothers Dalziel...*, 1901; DNB Supp. 1912.

DALZIEL, Gilbert 1853-1930
Painter and engraver, second son of Edward Dalziel (q.v.). Studied in London at South Kensington Schools, and the Slade under Poynter. Worked as engraver for the family firm of Dalziel Brothers, but also painted figure subjects, which he exhibited at the Dudley Gallery, Crystal Palace, and elsewhere.
Bibl: Who's Who 1913.

DALZIEL, Herbert 1853-1941
London painter of figures, flowers, etc; eldest son of Thomas Dalziel (q.v.). Exhib. RA, SS, NWS, GG, NG and elsewhere. Titles: 'Harvest', etc. Studied in Paris 1882-3. Member of NEAC. His studio sale took place at Sotheby's Belgravia, 16 May 1978. The catalogue contains more information about the Dalziel family.

DALZIEL, James B. fl.1851-1908
London landscape painter. Exhib. RA, BI, SS and elsewhere. Titles: 'Trees in Hyde Park', 'Treasure Seekers', etc. No relation of the Dalziel family.

DALZIEL, Owen 1861-1942
London figure painter; second son of Thomas Dalziel (q.v.). Exhib. at RA, SS, NWS, GG and elsewhere. Titles: 'Old Books', etc. and many coastal scenes. A number of his works appeared at auction at Sotheby's Belgravia, 2 November 1971.
Bibl: Brook-Hart.

DALZIEL, Robert 1810-1842
Portrait and landscape painter; son of Alexander Dalziel (1781-1832). Studied in Edinburgh with John Thomson of Duddingston. Later moved to London and exhib. at BI and SS. Portraits by him of his family appear in *The Brothers Dalziel...*, 1901.
Bibl: *The Brothers Dalziel...*, 1901; DNB Supp. 1912; Hall.

DALZIEL, Thomas Bolton Gilchrist Septimus 1823-1906
Painter and illustrator; seventh son of Alexander Dalziel and the youngest member of the family firm of Dalziel Brothers. He was best-known as a book illustrator, but also exhib. landscape, figure subjects and charcoal drawings at RA, BI, SS and elsewhere. Titles: 'Green Pastures', etc.
Bibl: Gleeson White; *The Brothers Dalziel...*, 1901; The Year's Art 1907; DNB Supp. 1912; Hall.

DALZIEL, William 1805-1873
Painter and illustrator; eldest son of Alexander Dalziel. Painted still-life pictures, and also heraldic book decorations, but did not exhibit his work in London.
Bibl: *The Brothers Dalziel...*, 1901; Hall.

DAMIS, J. fl.1879
Exhib. one flower picture at RA in 1879.

DAMPIER, Arthur fl.1866-1875
London landscape painter; exhib. watercolours at SS and elsewhere. Titles: 'At Bramshaw, New Forest', etc.

DANA, William Parsons Winchester 1833-1927
Exhib. one picture at RA 1873, one elsewhere. Title at RA: 'Day Dreams'. Dana was an American-born artist who spent most of his career in Paris.

DANBY, Collinson fl.1866-1870
London watercolour painter of river scenes, landscape and biblical subjects. Exhib. SS. Titles: 'The Pool, London Bridge', etc.

***DANBY, Francis ARA 1793-1861**
Bristol landscape painter, born in Ireland. Studied in Dublin Royal Society Schools, and with the landscape painter James O'Connor (q.v.). Lived in Bristol 1813-23, then moved to London. Exhib. at the RA 1821-60, mostly poetical and imaginary landscapes, especially with effects of sunset or early morning. Also exhibited some religious and historical subjects. In his later years moved to Exmouth, where he concentrated chiefly on mythological subjects, e.g. 'The Departure of Ulysses from Ithaca'. Some of his large and dramatic pictures, such as 'The Delivery of Israel out of Egypt', 1825, were painted in emulation of the work of John Martin. Danby was never made a full RA, which was a great disappointment to him, and led to public criticism of the academy election procedures.
Bibl: AJ 1855 pp.77-80; 1861 p.118; Redgrave, Dict.; DNB; Reynolds, VP pp.15, 142 ('Liensford Lake' pl.9); Arts Council, Danby exhib. Cat. 1961 (many illus.); Hardie II p.47; Maas pp.36-7 (pls. pp.36, 38); Eric Adams, *Francis Danby, Varieties of Poetic Landscape,* 1973; *The Bristol School of Artists,* exhib. Bristol AG 1973.

DANBY, Frederick fl.1849
Exhib. one river scene at BI in 1849. Title: 'A misty morning on the Sands of the Exe'. Exmouth address.

DANBY, Jacob C. (John?) fl.1863-1882
London landscape painter. Exhib. BI and SS. Titles: 'An old shed', etc. In SS records he is listed as John C. Danby.

DANBY, James Francis 1816-1875
Eldest son and pupil of Francis Danby (q.v.), brother of Thomas Danby (q.v.). Exhibited at the RA 1842-76, also at the BI and SS. Painted landscapes in oils and watercolours, chiefly views in Wales, Scotland and on the north-east coast, often scenes of sunrise or sunset "resembling his father's in execution, but not emulating his ideality" (DNB). Travelled in France, Switzerland and north Italy.
Bibl: AJ 1859 pp.142, 171; 1876 p.47; DNB; Brook-Hart p.344 (pl.187).

DANBY, Joseph fl.1854
Exhib. two landscapes of Welsh subjects at BI in 1854. Titles: 'Tantallon Castle', etc. London address.

DANBY, Thomas RWS 1817(18?)-1886
Younger son and pupil of Francis Danby (q.v.), and brother of James Francis Danby (q.v.). Travelled with his brother in France, Switzerland and Italy. In Paris he was much impressed by the landscapes of Claude Lorraine, whose aerial effects he tried to imitate. Exhibited at the RA 1843-82, and also exhibited over 200 watercolours at the RWS. Like his brother's pictures, they were mostly views in Wales, Scotland and Switzerland. Also painted occasional rustic genre subjects, e.g. 'The Shepherd's Home' 1861. Close friend of Paul Falconer Poole (q.v.) with whom he shared a romantic feeling for nature. In his latter years he devoted himself chiefly to watercolour painting. His studio sale was held at Christie's, 17 June 1886.
Bibl: AJ 1886 p.157; DNB; Hardie II p.47.

D'ANCONA, T. (V.) fl.1869-1872
Painter of genre. Exhib. four pictures RA. Titles: 'Does he love me?', etc. London address.

DANFORD, Charles G. fl.1883-1885
Landscape painter who exhib. at NWS. Address Harpenden, Hertfordshire.

DANIEL, C.G. fl.1837
Exhib. one picture at RA in 1837. Title: 'Dead Game'. London address.

DANIEL, P.A. fl.1853-1870
London painter of figures. Exhib RA, BI and SS. Titles: 'A Woman in White', etc.

DANIELL, Rev. Edward Thomas 1804-1842
Amateur landscape painter. Exhib. landscapes of Rome, France, Switzerland and England at RA and BI. Titles: 'View of St. Malo', etc. Brought up in Norfolk, where he was taught drawing by Crome. Also knew John Linnell and Joseph Stannard. Lived for two years as a curate in Norfolk, 1831-3, then moved to London. Joined an expedition to Lycia, and died of fever in Asia Minor.
Bibl: R.I.A. Palgrave, *E.T. Daniell,* 1882; F.R. Beecheno, *E.T.D.,* 1889; W.F. Dickes, *The Norwich School,* 1905; H.L. Mallalieu, *The Norwich School,* 1975.

DANIELL, Frank fl.1889-1903
Exhib. portraits, flower, figure and church subjects at RA. Titles: 'A Bluecoat Boy', etc. Addresses London and Colchester.

DANIELL, Miss S.M. fl.1853
Exhib. one picture BI in 1853. Title: 'Study of a Head'.

DANIELS, Mrs. Amy fl.1889
Exhib. one landscape at RA in 1889. Title: 'A Reminiscence of Sussex'.

***DANIELS, William 1813-1880**
Liverpool portrait, historical and genre painter. Working as an apprentice bricklayer, he developed a talent for modelling portraits in clay. These were seen by Mosses, a local portrait painter, who encouraged him to take up painting. He soon became popular in Liverpool as a portrait painter, and exhibited at the RA in 1840 and 1846. He also painted genre and historical works, many of Shakespearian subjects, e.g. 'The Prisoner of Chillon', 'Shylock', 'Macbeth', 'The Recluse', etc. Daniels' style is vivid and bold, and he was fond of strong chiaroscuro effects of light and shade. Unfortunately, says Marillier "a taste for low life and convivial associations spoilt his chances and destroyed his excellent promise". Several pictures by him are in the Walker AG, Liverpool.
Bibl: Redgrave, Dict.; Marillier pp.95-8 (pl. opp. p.96); Ormond I p.247.

DANSON, George 1799-1881
London painter of landscape, river scenes, etc. Exhib. RA, BI and SS. Titles: 'Study on the Thames', etc. Born in Lancaster. Also a scene painter. Examples are in the VAM.

DANSON, R. fl.1862
Exhib. one horse picture at BI in 1862. London address.

DANSON, Thomas fl.1846-1855
London painter of Swiss landscape, animals and seascape. Exhib. RA, SS. Titles: 'Lake of Thun, Switzerland', etc.

DANYELL, Herbert (Berto) fl.1890-1893
Exhib. two figure paintings at NWS and GG. Florence address.

DAPLYN, A.J. fl.1875-1880
Exhib. two pictures, SS and elsewhere. Title at SS: 'A Holy Place, Brittany'. London address.

DARBON, William fl.1886
Exhib. one ship picture at NWS. Plymouth address.

DARCY, Miss Laura fl.1881-1891
London painter of domestic scenes and landscape in oil and watercolour. Exhib. RA, SS, NWS. Titles: 'The Road to Ruin', etc.

DARLEY, J.F. fl.1886-d.1932
Landscape painter. Exhib. SS and elsewhere. Titles: 'The Old Moat', 'An eviction', etc. Addresses London and Woking, Surrey.

DARLEY, William H. fl.1836-1850
London painter of mainly scriptural subjects. Exhib. RA, BI. Titles: 'Christ bearing the cross', 'Head of St. John the Baptist on a charger', etc.

DARTIGUENAVE, P. fl.1859
Exhib. one picture at RA. Title: 'My Window'. London address.

DARTIGUENAVE, Victor fl.1841-1854
London painter of portraits, landscape and domestic scenes. Exhib. miniatures at RA. Exhib. RA, SS. Titles: 'An Equestrian Lady', 'The Love Token', etc. Painted either miniatures or watercolours.

DARTON, William fl.1887
Exhib. one seascape NWS. Plymouth address.

DARVALL, Charles G. fl.1855
Exhib. one domestic scene. London address.

DARVALL, Frank fl.1881
Exhib. one picture of Venice at GG. London address.

DARVALL, Henry fl.1848-1889
London painter of genre, mythological scenes and landscape in oil and watercolour. After 1869 exhib. only Italian landscape and sea views. Exhib. RA, BI, SS, GG and elsewhere.

DASILVA, H.C. fl.1852
Exhib. one landscape of Wimbledon Park at SS, 1852. London address.

DAUBRAWA, De see DE DAUBRAWA

DAUN, B. fl.1858
Exhib. one picture 'Pandora' at SS, 1858. London address.

DAVENPORT, C. Talbot fl.1892
Exhib. one picture 'A Cloudy Day near Groombridge' at SS, 1892. Address Hawkhurst, Kent.

DAVENPORT, H.D. fl.1845-1846
Exhib. two domestic subjects 'Temperance' and 'Welsh Cottage' at SS, 1845-6. London address.

DAVEY, Florence fl.1881
Exhib. two watercolours of flowers at SS, 1881. Address Horsham, Surrey.

DAVID, Miss Mary R. fl.1866-1877
Exhib. one watercolour of Westminster Abbey at SS, 1866; also twice at other minor exhibitions. London address.

DAVID, R.B. fl.1866
Exhib. one landscape 'A Winter Sunset' at SS, 1866. Bristol address.

DAVIDIS, Miss A.E. fl.1883
Exhib. one landscape at GG and once elsewhere; address Tunbridge Wells, Kent.

DAVIDSON, Alexander RSW 1838-1887
Scottish painter and watercolourist of figures and domestic subjects. Exhib. at RA, SS and elsewhere. Titles: 'Highland Cookery', etc. Lived mainly in Glasgow.
Bibl: Cundall; Caw p.272.

DAVIDSON, Mrs. C.D. fl.1879
Exhib. one picture 'A Scotch Lassie' at SS, 1879; London address.

DAVIDSON, Charles RWS 1820-1902
Painter and watercolourist of landscapes and rustic scenes. Studied under John Absolon (q.v.). Mainly a watercolourist, he exhib. over 800 watercolours at the OWS alone, and 114 at the NWS. He also exhib. some oils at RA, BI, SS and elsewhere. At first a member of NWS, he resigned to join the OWS, of which he became a member in 1858. For many years he lived near Samuel Palmer at Redhill. Hardie notes that his watercolours are not usually signed, and that many have probably been attributed to other artists. Works by him are in the VAM and the Ashmolean, Oxford. His son was Charles Topham Davidson (q.v.).
Bibl: AJ 1859 p.173; VAM Cat. 1908 p.106; Cundall; Hughes; Hardie II p.233 (pl.225).

DAVIDSON, Charles Topham b.1848 fl.1870-1902
Landscape painter, son of the watercolourist Charles Davidson (q.v.). Exhibited at RA 1872-1902 mostly coastal views in Cornwall and Wales. Also exhib. at SS, NWS, GG and elsewhere.

DAVIDSON, George Dutch 1879-1901
Scottish illustrator, working in Dundee about 1899. A memorial exhibition was held in Dundee in l901.
Bibl: Scottish Art Review XIII; Magazine of Art 1904.

DAVIDSON, Miss Jessie Y. fl.1892
Liverpool landscape painter. Exhib. one picture 'In the Shade' at RA, 1892.

DAVIDSON, John fl.1871
Edinburgh landscape painter; exhib. once in London 1871.

DAVIDSON, Thomas fl.1863-1893
London historical genre painter. Exhib. at RA 1863-1903, and at SS. Subjects mostly medieval, but 1894-9 he produced a series of pictures of scenes from the life of Admiral Nelson.

DAVIEL, Leon fl.1893
Exhib. one allegorical portrait at RA, 1893. London address.

DAVIES, Alfred fl.1888-1889
Leicester landscape painter. Exhib. two watercolours at NWS, 1888-9.

DAVIES, C. fl.1845
Exhib. one picture 'The Village Favourite' at RA, 1845. RA catalogue lists as C. Davis.

DAVIES, Edward 1843-1912
Leicester landscape painter and watercolourist. Exhib. at the RA 1880-1904. Chiefly views in Scotland, Wales and the Isle of Man.

DAVIES, G.S. fl.1885
London landscape painter. Exhib. twice at SS, 1885: 'In the New Forest', etc.

DAVIES, George E. fl.1893
Leicester landscape painter. Exhib. two pictures at SS, 1893: 'Street in Newlyn, Cornwall' and 'Stormy Weather'; also at NWS.

DAVIES, James Henry fl.1872-1892
Manchester landscape painter. Exhib. at RA and SS. Titles: 'The Wild Ducks' Haunt', etc., and views in France and Sweden, as well as English scenes.

DAVIES, James Hey RCA b.1844 fl.1875-1891
Manchester landscape painter. Exhib. at SS and elsewhere in London but mainly at RCA and in provinces. Titles: 'Welsh Homestead', etc. A picture by him is in Manchester City AG.

DAVIES, John fl.1819-1853
Landscape painter. In Italy 1820-1. Probably a pupil of the architect George Maddox. Worked in London and Home Counties, and exhib. at RA, 1819-53.

DAVIES, Miss M.I. fl.1893
Exhib. one picture of flowers at SS, 1893. London address.

DAVIES, N.P. see PRESCOTT-DAVIES

***DAVIES, William fl.1890-1910**
Scottish landscape painter. Generally painted highland scenery in Argyllshire, with sheep and cattle. His style is very distinctive, and his effects of cloud and mist are especially good.

DA VINCI, L. fl.1839
Exhib. one picture 'Minnow-Fishing' at BI, 1839. London address.

DAVIS, Alfred fl.1863-1879
Landscape painter. Exhib. English views at BI and SS. Lived in London and Pinner, Middlesex.

DAVIS, Annie fl.1879
Exhib. one alpine view at SS, 1879. London address.

DAVIS, Arthur Alfred fl.1877-1884
London painter of domestic subjects and street scenes. Exhib. at SS. Titles: 'Dust Cart — a London Street', 'Waiting for a Job', etc.

DAVIS, Arthur H. fl.1871-1893
London landscape painter. Exhib. mainly at SS, also once at RA 1872, and elsewhere. Subjects English views, especially Devon and the southern counties.

DAVIS, C.D. fl.1877
Exhib. one Cambridgeshire landscape at SS, 1877. Address Lee, south-east London.

DAVIS, Miss C.L. fl.1877
Exhib. one Welsh landscape in watercolour at SS, 1877; also elsewhere. London address.

DAVIS, Miss Celia 1889-1892
York painter. Exhib. once at RA, 1889: 'Silver and Gold', and once at SS: 'View of York Minster', 1892.

DAVIS, Charles H. fl.1891
Exhib. four landscapes at RA, 1891. Titles: 'The Passing Day', etc. London address.

DAVIS, Mrs. E. fl.1855-1856
Exhib. two still-life pictures at RA, 1855-6. Address Weymouth, Dorset.

***DAVIS, Edward Thompson 1833-1867**
An almost forgotten painter of genre scenes who worked in Worcester and came into prominence when an album of his drawings was sold at Christie's in 1951. He entered the Birmingham School of Design under J. Kyd; exhib. at RA 1854-67. Among his best works are 'On the Way to School', 'Granny's Spectacles', 'Words of Peace'', and 'The Little Peg Top'. His 'A Game of Marbles' was in the 1962 Arts Council exhib. of Victorian Paintings.
Bibl: DNB: Cat. Arts Council Exhibition of Victorian Paintings 1962.

DAVIS, F. fl.1872-1874
Bournemouth landscape painter. Exhib. three pictures at various exhibitions in London 1872-4.

DAVIS, Mrs. F. fl.1875-1876
Exhib. two fruit pictures and one landscape at SS, 1875-6. London address.

DAVIS, Frederick fl.1853-1892
Colchester landscape painter. Exhib. mainly at SS, all watercolours, also RA, BI and elsewhere. Subjects English views, also Welsh and Irish.

DAVIS, Frederick William RI RBA RBSA 1862-1919
Birmingham painter of figure subjects. Studied in Birmingham, Antwerp and Paris. Exhib. at RBSA from 1887, also at RA, SS and NWS. Elected RBA 1892; RBSA 1893; RI 1897. Titles: 'The Life of the Hostel', etc. Also painted historical subjects and murals.

DAVIS, G.G. Markwell fl.1884
Exhib. one figure subject in London, 1884. London address.

DAVIS, H.E. (or H.D.) fl.1862
Exhib. one picture of 'The Great Fire of London 1861' at BI, 1862. London address.

DAVIS, H.N. fl.1860
Exhib. one picture 'A Street in Tivoli' at SS, 1860. London address.

***DAVIS, Henry William Banks RA 1833-1914**
London landscape and animal painter, and occasional sculptor. Exhib. over 100 works at RA 1852-1904, also at BI, SS and NG. His subjects were mostly landscapes with animals in Wales, Scotland and Northern France. In the 1850s and early 1860s he was much influenced by the Pre-Raphaelites, and his works of this period show a high level of observation and detailed technique. Later he broadened his style and turned to larger size works of the Landseer and Rosa Bonheur type. His pictures were immensely popular, and made high prices at auction in his lifetime. Two works were bought by the Chantrey Bequest in 1880 and 1899. Elected ARA 1873; RA 1877.
Bibl: AJ 1901 p.174; Clement & Hutton; Who's Who 1913; RA Pictures, Index 1893-1914.

DAVIS, J. Barnard fl.1890-1904
London landscape painter. Exhib. at RA, SS and NWS. Titles: 'In the Meadows', etc.

DAVIS, J.S. fl.1877
Exhib. one domestic subject, 1877. Address Argenteuil, France.

DAVIS, J. Valentine RBA 1854-1930
Landscape painter. Born in Liverpool, son and pupil of William Davis (q.v.). Studied with Ford Madox Brown and settled in London. Exhib. mostly poetical landscapes at RA 1875-1912, and occasional genre interiors, e.g. 'Five o'clock in the Studio', 1908.
Bibl: Studio 1904 pp.32, 284; Who's Who 1913 p.512; RA Pictures 1905.

DAVIS, John J. fl.1882-1884
London landscape painter. Exhib. at RA, SS and elsewhere. Titles: 'On the Common', etc.

DAVIS, John Phillip (Pope Davis) RBA 1784-1862
London painter of portraits and historical subjects. Exhib. mainly at SS, elected RBA 1839; also RA, BI, NWS and elsewhere. In 1824 he went to Rome where he painted a large work 'The Talbot Family receiving the Benediction of the Pope' from which he got his nickname Pope Davis. He was a friend of B.R. Haydon, and like him, a bitter critic of the RA. Graves incorrectly lists him as exhibiting until 1875.
Bibl: Redgrave, Dict.; Pycroft, *Art in Devonshire*, 1883 p.40; DNB; T.M. Rees, *Welsh Painters*, 1902 p.27; BM Cat. of Engraved British Portraits 1908; Ormond I p.325.

***DAVIS, John Scarlett 1804-1844**
Painter of landscapes, portraits and architectural studies in oils and watercolours. Born the son of a Hereford shoemaker, Davis studied at the RA Schools, and travelled widely on the Continent, where he found most of the subject matter for his works. Because he exhib. few works, mainly at RA 1822-41, Davis is still a neglected and underrated artist today. The brilliance of his watercolours is comparable to the work of Bonington. Specialised in the interiors of buildings, libraries and picture galleries "reproducing the Old Master paintings on their walls with extraordinary fidelity" (Maas).
Bibl: DNB 1908 V (under Davies); Connoisseur 1912 p.215; Hardie II pp.187-8; Maas p.94 ('The Art Gallery of the Farnese Palace, Parma' p.94).

DAVIS, Joseph Lucien RI 1860-1951
Painter and illustrator. Son of the Liverpool artist William Davis (q.v.), was principal social artist for *The Illustrated London News* for twenty years. Later became an art teacher at St. Ignatius College, North London. Exhib. at RA and RI, and abroad. Elected RI 1893.

DAVIS, Miss Kathleen fl.1892-1893
London portrait painter. Exhib. at NG and elsewhere, 1892-3.

DAVIS, Miss Lena M. fl.1891-1892
Exhib. two domestic subjects, 'Old Friends', etc. at SS, 1891-2. London address.

DAVIS, Lucien RI 1860-1941
Son of William Davis of Liverpool and younger brother of J. Valentine Davis (qq.v.). Exhib. at RA 1885-1913. Mostly historical genre, some flower pieces. Worked as illustrator for *The Graphic, The Illustrated London News*, and illustrated books. Titles at RA: 'Musical Chairs', 'The Ghost Story', 'Ping-Pong', etc.
Bibl: Who's Who 1913 p.511; The Year's Art 1913 p.491.

DAVIS, Miss Miriam J. fl.1884-1903
London painter of flowers, fruit and domestic subjects. Exhib. mainly at SS, also RA, GG, NG and elsewhere. Titles: 'A Floral Harvest', 'The Bridal Dress', etc.

***DAVIS, Richard Barrett RBA 1782-1854**
London sporting artist. A competent and prolific painter, Davis exhibited 141 works at SS, as well as a good number at the RA 1802-53 and BI. His father was Huntsman to the Royal Harriers, and George III patronised Davis, as did George IV, William IV, and Victoria. Studied with Sir Francis Bourgeois and Sir William Beechey. Nearly all Davis's pictures are hunting scenes, in a style similar to Cooper and Herring. At his best he can nearly equal the brilliance of Marshall, but he produced a lot of mediocre work.
Bibl: DNB 1908 V; Pavière, Sporting Painters p.31 (pl.14); Ormond I pp.482, 512.

DAVIS, Miss S.J. fl.1870
Exhib. one picture 'Domenico' at SS, 1870. London address.

DAVIS, Stuart G. fl.1893-1904
London painter of figure subjects. Exhib. at RA 1893-1904. Titles: 'Friendly Critics', 'Day Dreams', etc.

DAVIS, T. fl.1852
Exhib. one hunting subject at RA, 1852: 'Hounds Running into a Fox, in a Stone Wall Country'.

DAVIS, T.P. fl.1886
Exhib. one picture 'A Brother Artist' at SS, 1886. Address Igtham, Kent.

DAVIS, Thomas fl.1877-1880
Exhib. three watercolour landscapes at SS, 1877-80. Address Bromley, Kent.

DAVIS, Tyddesley R.T. fl.1831-1857
Brighton painter of sporting subjects. Exhib. at BI only. Titles: 'Dejeuner on Dartmoor', etc.

DAVIS, W.H. fl.1893
Exhib. one picture 'Her Daily Toil' at SS, 1893. Southampton address.

DAVIS, Miss W.J. fl.1883
Exhib. one picture 'Summer's Close and Winter's Dawn' at SS, 1883. London address.

DAVIS, W. Paul fl.1875-1893
London painter of rustic subjects and landscapes. Exhib. at RA, SS and elsewhere. Titles: 'The Village Doctor', etc.

***DAVIS, William 1812-1873**
Liverpool landscape painter. Born Dublin. Studied at Dublin Academy; at first painted portraits. Moved to Liverpool, and joined the Liverpool Academy in 1854. Exhib. at RA 1851-72, mostly landscapes and still-life. Landscape studies usually taken along the Cheshire coasts and in the woods around Wallasey. Helped to organise Pre-Raphaelite exhibitions in Liverpool; friendly with Hunt, Rossetti and Madox Brown. Member of Old Hogarth Club. Madox Brown thought Davis an unlucky and underrated artist. Ruskin wrote Davis a letter of advice, which he never received. Little appreciated in his lifetime, he was kept occupied by a handful of Liverpool patrons, such as Miller and Rae. Several fine Pre-Raphaelite landscapes by him are in the Walker AG Liverpool.
Bibl: AJ 1873 p.177; 1884 p.325; 1903 pp.225, 228; Marillier pp.99-113, 259; Cat. of Leathart Collection, Laing AG Newcastle, 1968; Maas pp.227-8; Staley pp. 139-44 *et passim* (pls. 74a-77b); Wood, Pre-Raphaelites.

DAVIS, William Henry fl.1803-1849
London painter of sporting and animal subjects. Exhib. at RA, BI
and SS. Many of his RA exhibits were commissioned portraits of
horses, dogs, and other favourite animals. Was appointed Animal
Painter to William IV in 1837.
Bibl: BM Cat. of Engraved British Portraits I 1908 p.50.

DAVISON, E. Eleanor fl.1880
Exhib. one flower picture 1880. London address.

DAVISON, H. fl.1868-1877
London topographical painter, especially of churches. Exhib.
watercolours at SS, mostly of churches on the Continent.

DAVISON, Mrs. Munro fl.1897
Exhib. one picture 'Spoils of the Ocean' at RA, 1897.

DAVISON, Miss Nora fl.1881-1905
London painter of landscapes, coastal and river scenes in oil and
watercolour. Exhib. mainly watercolours at SS, also RA, NWS,
GG, NG and elsewhere. Titles: 'Preparing for the Cowes Week',
etc. and many harbour scenes.

DAVISON, William fl.1813-1843
London painter of portraits, figure subjects and landscapes. Exhib.
at RA, BI and SS.

DAWBARN, Mrs. A.G. see WILSON, Miss M.

DAWBARN, Joseph Yelverton fl.1890-1930
Liverpool painter of rustic subjects and landscapes. Exhib. at RA
from 1897, but mainly at Liverpool Academy, of which he was
President 1905-12. His profession was that of barrister.

DAWS, C. fl.1877
Exhib. one picture 'Surrey Cottage' at RA, 1877. Address Dorking,
Surrey.

DAWS, Philip 1873-1879
Dorking landscape painter. Exhib. at RA and SS. Subjects mainly
views in Surrey and Wales.

DAWSON, Alfred fl.1860-1893
Landscape painter and etcher, son of Henry Dawson, younger
brother of Henry Thomas Dawson (qq.v.). Exhib. at RA 1860-89,
mostly pen drawings and etchings. Titles: 'A Page from Gray's
Elegy', 'Leaving the Plough'. Also exhib. at SS and BI.
Bibl: Portfolio 1884 pp.l, 28.

DAWSON, Amy fl.1889-1891
Exhib. three pictures at SS 1889-91, flowers, fruit, and one portrait.
London address.

DAWSON, Mrs. B. fl.1851-1876
(Miss Elizabeth Rumley)
Painter of fruit and flowers, who exhib. as Miss Elizabeth Rumley
1851-8, and as Mrs. B. Dawson 1859-76, at the RA, BI, SS and
elsewhere.

DAWSON, Chester fl.1881
Exhib. one landscape 1881. London address.

***DAWSON, Henry** 1811-1878
Marine and landscape painter. Born in Hull. Lived in Nottingham
until 1844, when he moved to Liverpool. Studied with J.B. Pyne

(q.v.), but mainly self-taught. Exhib. at the Liverpool Academy;
elected Associate 1846, Member 1847. In 1850 he moved to
London. Exhib. at the RA 1838-74, also at BI, SS, the Portland
Gallery. His work, mostly marine and coastal scenes, was not
popular with the RA Hanging Committee, who placed them badly.
He also painted landscapes, and some very large views of London,
e.g. 'The Pool from London Bridge' which made £1,400 at
Christie's in 1876. His two sons Alfred and Henry Thomas Dawson
were also painters (qq.v.).
Bibl: AJ 1879 p.48; Portfolio 1879 p.24; Marillier pp.114-18, 259 (pl. p.116);
DNB; A. Dawson, *The Life of Henry Dawson Landscape Painter*, 1891; Hardie
III p.159; Brook-Hart p.345 (pl.188).

DAWSON, Henry Thomas fl.1860-1878
Marine painter, son of Henry Dawson, and elder brother of Alfred
Dawson (qq.v.). Exhib. at RA 1866-73 and BI 1860-7.
Bibl: Portfolio 1885 p.91; Cat. of Walker AG Liverpool, 1884 p.72 Brook-Hart.

DAWSON, J.C. fl.1863
Exhib. one picture 'Off Douglas, Isle of Man' at BI, 1863. Address
Chiswick, London. Also a son of Henry Dawson (q.v.).
Bibl: Brook-Hart p.345.

DAWSON, Mabel fl.1880-1881
Exhib. two flower pictures 1880-1. London address.

DAWSON, Nelson ARWS RBA RE 1859-1941
Marine painter. Exhib. at RA 1885-93. Subjects mostly of Cornish
Coast. His wife, Edith B. Dawson, was also a painter. After 1895
they abandoned painting for metal and enamel work, which they
studied under Alexander Fisher. From then on they exhib. caskets,
bronze figures, medallions and enamel work together at the RA. In
addition to this, they both continued to exhib. pictures and
watercolours.
Bibl: M.H. Spielmann, *British Sculptors*, 1901 pp.170-1; Studio XXII pp.169-74;
XXVIII p.124; XL pp.182-90; Hardie III pp.83-4; Brook-Hart.

DAWSON, Russell fl.1868-1883
Eton landscape painter. Exhib. once at GG and once elsewhere.

DAWSON, William fl.1830-1864
Exeter painter of landscapes, town scenes, and railway bridges.
Examples are in Exeter Museum.

DAY, Barclay fl.1873-1879
London painter of domestic subjects and flowers. Exhib. at RA and
SS. Titles: 'In Confidence', etc.

DAY, G.F. fl.1850-1869
Leicester painter of rustic subjects. Exhib. at RA and SS. Titles:
'Gleaners Returning', etc.

DAY, H.S. fl.1837-1848
London painter of portraits and historical subjects. Exhib. at RA, BI
and SS. Titles: 'A Knight and a Page', etc.

DAY, Hannah fl.1849
Exhib. one watercolour portrait at SS, 1849. London address.

DAY, William Cave RBA 1862-1924
Painter of portraits, figure subjects and landscapes. Born in
Dewsbury. Took up painting professionaliy in 1890. Exhib. at RA,
SS and elsewhere in London. Studied in Paris and at Herkomer
School in Bushey. Elected RBA 1903. His landscapes were usually
painted in watercolour, and his other subjects in oil. Lived in St.
Ives and Harrogate.
Bibl: Who's Who 1913.

DAYMAN, Francis S. **fl.1884**
Exhib. one watercolour landscape at NWS, 1884. Tiverton, Devon address.

DAYSON, L.J. **fl.1885**
Exhib. one picture of 'Duck and Ducklings' at SS, 1855. London address.

DEACON, Augustus Oakley **1819-1899**
London landscapist, and painter of churches. Exhib. at RA 1841-55, and at SS and BI. Teacher in a school in Derby 1849-61. Titles at RA 'Western Doorway — Tintern Abbey', 'Windsor Castle', 'Stapenhill Ferry, Burton-on-Trent', etc. Works by him are in Derby AG. Later went blind.

DEACON, G.S. **fl.1872-1879**
Southampton painter of figure subjects, portraits and landscapes. Exhib. at RA, SS and elsewhere. Titles: 'Forget Me Not', etc.

DEACON, Henry D. **fl.1880**
Exhib. one picture 'Penrice Castle and Sandhills, Gower' at SS 1880, and one elsewhere. Bristol address.

DEACON, Miss Virginia **fl.1885**
Exhib. one watercolour still-life at NWS, 1885. Eastbourne address.

DEAKIN, Andrew **fl.1856-1857**
Birmingham landscape painter. Exhib. at BI and SS, mainly Welsh scenes.

DEAKIN, Mrs. Jane **fl.1861-1884**
London landscape painter, in oil and watercolour. Exhib. mainly at SS, all watercolours, also RA, NWS, and Society of Lady Artists, of which she was a member. Wife of Peter Deakin (q.v.).

DEAKIN, Peter **fl.1855-1884**
Landscape painter, worked in Harborne, near Birmingham. Moved to Birmingham and later to London. Exhib. at RA 1855-78. Chiefly views in Wales, Worcestershire, and Salop. Friend of David Cox, and later his executor.

DEALY, Miss Jane M. **fl.1879-1903**
(Lady Lewis)
Genre painter, lived in Blackheath. Married Sir Walter Lewis, 1887. Exhib. at RA 1881-1903 genre scenes, mostly studies of children. Titles: 'Mary, Mary, Quite Contrary', 'Watching the Fairies', 'A Wee Bit Doleful', etc. Also illustrated several children's books.
Bibl: W. Shaw Sparrow, *Women Painters of the World*, 1905 p.144; Who's Who 1913 p.1200.

DEAN, Miss **fl.1890**
Exhib. one portrait at GG, 1890. London address.

DEAN, Frank **b.1865 fl.1885-c.1907**
Landscape painter, born Headingley, near Leeds. Studied with Legros at the Slade, and in Paris. Returned to Leeds 1887, and exhib. at RA from then until about 1907. Also travelled in Egypt and the Sudan, which provided him with many subjects. Titles at RA 'On the Sand Dunes', 'A Son of the Soudan', 'Tilling on the Nile Banks', etc.
Bibl: Studio XXXIX 1907 p.164; XLIX 1910 pp.47-51; The Year's Art 1913 p.491.

DEANE, Charles **fl.1815-1851**
London landscape painter. Exhib. at RA 1815-51 and at BI. Chiefly views on the Thames, and around Bristol. Also travelled in Holland, on the Rhine, and the Moselle, painting views.
Bibl: Brook-Hart.

DEANE, Dennis Wood **fl.1841-1868**
Historical genre painter, elder brother of William Wood Deane (q.v.). Exhib. at RA 1841-68, also at BI and SS. Subjects mostly Shakespearian. Also travelled in Spain and Italy, which provided inspiration for some of his genre scenes. Titles at RA 'Don Quixote', 'The Despair of Claudio', 'Van Dyck and Frans Hals', etc.
Bibl: AJ 1859 pp.81, 165, 166; 1860 p.78.

DEANE, Miss Emmeline **fl.1879-1934**
Bath portrait painter and miniaturist. Exhib. five works at RA 1879-92. A portrait by her of Cardinal Newman, dated Edgbaston 1889, is in the NPG.
Bibl: Ormond I p.338 (pl.672).

DEANE, L. **fl.1885**
Exhib. one landscape in watercolour at NWS, 1885. Bath address.

DEANE, William Wood **OWS** **1825-1873**
London architect, painter and watercolourist. Younger brother of Dennis Wood Deane (q.v.). Exhib. at RA 1844-72, at the SS, OWS and NWS. Subjects architectural studies, interiors and landscapes. Travelled in Belgium, France and Italy. Much of his best work done in Spain, travelling with F.W. Topham. Studied watercolours with David Cox. Examples are in the BM and VAM.
Bibl: AJ 1873 p.80 (obit.); Roget II pp.383-6; Hardie III p.21.

DEANES, Edward **fl.1860-1893**
London painter of figure subjects and portraits. Exhib. at RA, BI, SS and elsewhere, sometimes in watercolour. Titles: 'The Dinner Hour', etc.

DEANES, Miss Mary **fl.1870-1871**
Exhib. two pictures of fruit at SS, 1870-1. London address.

DEANS, D. **fl.1871-1872**
London painter of figure subjects. Exhib. six pictures at SS 1871-2, mostly beach scenes at Hastings.

DEAR, Miss Mary E. **fl.1848-1867**
London painter of portraits and figure subjects, especially children. Exhib. at RA and SS. Titles: 'Playfellows', etc.

DEARDEN, A. **fl.1866-1873**
Exhib. once at RA and SS, a portrait, and a cat with kittens. Addresses Stroud, Gloucestershire, and Herefordshire.

DEARE, Miss Margaret **fl.1884-1887**
Exhib. three pictures at SS 1884-7, a watercolour and two sketches. Address Staines.

DEARLE, John **fl.1852-1871**
Landscape painter. Exhib. at RA only 1852-71. Subjects English views, including Wales and the West Country. Lived in Jersey and London.

DEARLE, John Henry **fl. 1853-1891**
Glassmaker, tapestry worker and designer of carpets, textiles, etc. for Morris & Co. Pupil of William Morris. Became partner in the

firm and manager of the works at Merton Abbey. Designed stained glass windows at Glasgow University, Troon Church and Rugby School Chapel. Was responsible for designing many of the wallpapers for Morris & Co. although many have since been attributed to Morris himself.
Bibl: AJ 1905 pp.84-9, 380; 1906, pp.54, 56; Studio XXVIII 1903 pp.40, 119; XLV 1909 pp.13, 24; see also books on William Morris.

DEARMAN, Miss Elizabeth J. **fl.1828-1846**
London landscape painter. Exhib. at RA, BI, SS and NWS. Subjects usually rustic scenes with children. Lived for a time at same address as John Dearman (q.v.), and also collaborated with him on some pictures, so was probably his sister.

***DEARMAN, John** **fl.1824-1856**
Landscape painter, lived in London and Guildford. Exhibited at the RA 1824-56; also a regular exhibitor at SS and BI. Subjects invariably landscapes with cattle, sheep, horses and figures.

DEARMAN, Miss M. **fl.1834-1842**
London painter of landscape, rustic subjects and still-life. Exhib. both oils and watercolours at BI and SS. Lived for a time at same address as John Dearman (q.v.), so may have been his sister.

DEARMER, Thomas **fl.1840-1867**
London landscape painter. Exhib. at RA 1842-66, SS 1840-67, and BI. Views mostly in the south of England, and Wales. Travelled in Wales and Italy.
Bibl: Brook-Hart.

DEAS, Kenneth **fl.1890**
Exhib. sea pictures at GG and elsewhere, 1890. London address.

DEATH, H. **fl.1848**
Exhib. one picture 'A Peasant Girl' at SS, 1848. London address.

DE BERNHARDT, Mrs. **see BOUVIER, Miss Julia**

***DE BREANSKI, Alfred** **1852-1928**
Landscape painter. Exhib. at RA 1872-90 and SS. Specialised in Welsh and Scottish mountain scenery, especially highland lochs at sunset. Also painted views on the Thames. Usually inscribed his pictures with title and date on the reverse. His brother was Gustave de Breanski and his son was Alfred de Breanski Jnr. (qq.v.). He also had another son called Arthur, who only produced a small number of paintings.

DE BREANSKI, Alfred, Jnr. **1877-1957**
Landscape painter, son of Alfred de Breanski (q.v.). Painted landscapes and highland scenes in a style similar to his father's, but rather coarser and broader in the handling. At some point he started using the names Alfred Fontville de Breanski, and signing his works A.F. de Breanski. He also sometimes signed A. Fontville. This has led to considerable confusion, but it is now thought that Alfred Jnr. and Alfred Fontville are the same person. He also painted flowers under the name Gustave Courtier.

DE BREANSKI, Alfred Fontville
see DE BREANSKI, Alfred, Jnr.

DE BREANSKI, Gustave **c.1856-1898**
Painter of landscapes and coastal scenes; brother of Alfred de Breanski (q.v.). Like all the Breanski family, he painted landscapes, highland and river scenes, but he made more of a speciality of coastal scenes, often with fishing boats. His style is much broader and more impressionistic than Alfred.
Bibl: Brook-Hart pp.88-9 (pl.160).

DE BREE, Anthony **fl.1876-1893**
Painter of domestic subjects. Exhib. eight pictures at SS 1876-93, mostly Dutch interiors.

DE BYLANDT, A. **fl.1853-1884**
London landscape painter. Exhib. at RA, BI, SS and elsewhere. Subjects both English and European views.

DE CASTRO, Harry M. **fl.1877-1886**
London landscape painter. Exhib. at RA, SS and elsewhere. Titles: 'Drear November', etc.

DE DAUBRAWA, Henry **fl.1842-1861**
London painter of military subjects. Exhib. at RA, BI, and SS. Also painted other figure subjects.

DEEY, Rev. William **fl.1829-1874**
London painter of figure subjects. Exhib. regularly at RA, BI and SS for nearly forty years. Titles often of children, e.g. 'A Parochial Schoolboy', etc.

DE FEYL, Mme. **fl.1864-1866**
London painter of historical and biblical subjects. Exhib. at RA, BI and SS. Titles: 'Rizpah Mourning for her Sons', etc.

DEFFELL, Miss Justina **fl.1859-1871**
London painter of figure subjects and animals. Exhib. at BI, SS and Society of Lady Artists. Many subjects rustic scenes, e.g. 'A Rustic among the Leaves', etc.

DE FLEURY, J.V. **fl.1847-1868**
London landscape painter. Exhib. at RA 1847-68, at BI and SS. Travelled to Brittany, Switzerland, Venice and north Italy painting views.
Bibl: AJ 1860 p.78; Brook-Hart.

DE FLEURY, W. **fl.1865**
Exhib. one landscape 1865. London address.

DE FORESTIER, Mlle. Alice **fl.1872-1874**
Exhib. six landscapes at various minor exhibs. London address.

DEFRIES, Miss Lily **fl.1886**
Exhib. one portrait at GG 1886. London address.

DEFRIES, Miss Sara **fl.1878-1879**
Exhib. two historical subjects at GG, 1878-9.

DEGRAIN, M. **fl.1873**
Exhib. one picture 'A Homestead in Granada' at SS, 1873. London address.

DEGRAVE, P. **fl.1877**
Exhib. one picture 'The Charity School' at RA, 1877.

DE GROOT, F.A.B. **fl.1851**
Exhib. one picture 'The Anxious Moment' at RA, 1851.

D'EGVILLE, James T. Hervé **c.1806-1880**
Landscape painter. Son of a ballet master. Pupil of A. Pugin. Exhib. over 250 works at NWS, also at RA and BI. Painted English and continental views. Also a drawing master, and teacher of H.B. Brabazon (q.v.).
Bibl: Hardie III p.l3.

DE HOGHTON, Miss fl.1883-1887
Exhib. five portraits at GG, 1883-7. London address.

DE JONG, P. de Josselin fl.1891
Exhib. two portraits 1891.

DE JONGHE, Gustave fl.1875
Exhib. one picture 'The Birthday Wishes' at RA, 1875. London address.

DE KATOW, P. fl.1872-1873
Exhib. three watercolours of military subjects at SS, 1872-3. London address.

DE LA CONDAMINE, E.J. fl.1872-1874
Exhib. two landscapes 1872-4. Address Ryde, Kent.

DE LA CROUÉE, H. fl.1885
Exhib. one watercolour landscape at NWS, 1885. London address.

DE LACY, Charles John fl.1885-1930
Painter of landscapes, coastal scenes and portraits. Born in Sunderland. Studied at Lambeth and South Kensington. Exhib. at RA and SS, in oil and watercolour. Also exhib. in the provinces. Lived in London and Cheam. Often painted views on the Thames, and scenes in the docks.
Bibl: Brook-Hart p.345 (pl. 189).

DE LAFOLLIE, A. fl.1857-1862
London portrait painter. Exhib. three portraits at RA, 1857-62.

DE LA MARE, A. fl.1836-1839
Exhib. one interior at RA 1839, and one watercolour of a scene from Byron's Werner at SS, 1836. London address.

DELAMOTTE, Philip Henry FSA 1820-1889
Painter, illustrator and photographer; son of William Delamotte (q.v.). He was Professor of Drawing at King's College, London, and illustrated several technical books. Exhib. architectural subjects at RA, SS and elsewhere.
Bibl: Roget I p.232; BM Cat. of Drawings II 1900 p.72; H. and A. Gernsheim, *The History of Photography*, 1969.

DELAMOTTE, William Alfred 1775-1863
Landscape painter, watercolourist and lithographer. Born in Weymouth of a French refugee family, he studied at the RA under Benjamin West. Drawing master at Sandhurst Military Academy. Exhib. at RA 1793-1851; also at BI and OWS. Views in Wales, Oxford, on the Thames, Belgium, France, on the Rhine, Switzerland, and north Italy. He also illustrated topographical books, especially about Oxford. His son Philip Henry Delamotte was also an artist and early photographer. Brighton AG has a set of six views of Brighton.
Bibl: Roget I pp.211, 231-2.

DE LATRE fl.1838
Exhib. one picture of a Mare and Foal at BI, 1838.

DE LAUNE, C.D.F. fl.1872
Exhib. one picture 'Hall of Karnac' at RA, 1872. London address.

DELKOP, L.W. fl.1869
Exhib. one landscape in 1869. London address.

DELL, Miss Etheline E. fl.1885-1891
Painter of domestic subjects. Exhib. at RA, SS, NWS and elsewhere. Titles include fairy subjects, e.g. 'There Sleeps Titania', etc. Address New Malden, Surrey.

DELL, John H. 1830-1888
London landscape and rustic genre painter. Exhib. at RA 1853-75, BI 1851-67, and SS. Titles at RA 'A Rustic Nursery', 'A Farmyard Corner' and 'Cottage Cares'. His pictures are usually small and painted with meticulous detail.
Bibl: The Year's Art 1889 p.256; Brook-Hart.

DELMAR, William RBA fl.1823-1856
Canterbury landscape painter. Exhib. over 50 pictures at SS, also RA and BI. Subjects include views in Kent, the Lake District and other parts of England, French scenes, and views of Canterbury Cathedral.

DELOTZ, G.G. fl.1848-1864
London painter of landscape and still-life. Exhib. at RA, BI and SS 1848-64. Painted London views, fruit and flowers.

DE LYONCOURT, Baron Hubard fl.1869-1883
Landscape painter. Exhib. three French landscapes at RA 1873-83; also GG and elsewhere. Subjects mainly river scenes in Brittany. London address.

DEMAIN-HAMMOND, Miss Christine M. and Miss Gertrude C.
see HAMMOND, C. and G.

DE MAINE, Miss A. fl.1884
Exhib. one watercolour landscape at NWS, 1884. Address Skipton, Yorkshire.

DEMAINE, G. fl.1887
Exhib. one landscape at NWS, 1887. Address Skipton, Yorkshire.

DEMANARA, H. fl.1852
Exhib. one portrait at RA, 1852. London address.

D'EMAREST, E. fl.1875
Exhib. one landscape at SS, 1875. Address Guildford, Surrey.

DE MARTINO, Cavalier Edward see MARTINO

***DE MORGAN, Mrs. Evelyn 1855-1919**
(Miss Pickering)
Pre-Raphaelite painter. Pupil of her uncle, J.R. Spencer-Stanhope (q.v.) and wife of the potter William de Morgan (q.v.) whom she married in 1887. Studied at Slade 1873; visited Italy 1875-7. Exhib. mostly at GG and NG. Her pictures, which are often very large, are usually allegories painted in the aesthetic Burne-Jones idiom, but show a distinctly individual manner. She did not sell many works in her lifetime, and most of her output still belongs to the de Morgan Foundation.
Bibl: Studio XIX 1900 pp.220-32; XXVI p.292; LXXIX 1920 pp.28-31; Connoisseur LXIII 1922 p.183ff.; Bate p.115 (pl. opp. p.111); Mrs. A.M.W. Stirling, *William De Morgan and his Wife,* 1922; Cat. of E. de M. Drawings, Hartnoll & Eyre Gallery, London 1970; Wood, Pre-Raphaelites; Wood, Olympian Dreamers; Newall.

DE MORGAN, William 1839-1917
Painter and designer of stained glass, pottery, tiles and ceramics. Began career designing stained glass; later began to make pottery in his own kiln at his house in Cheyne Row, Chelsea. Although not a partner of Morris & Co., de Morgan's works supplied them with

tiles and designs. In 1881 he moved his works to Merton with Morris & Co. De Morgan painted a few Pre-Raphaelite pictures, but did not regard this as a serious side of his output. His wife Evelyn (q.v.), whom he married in 1887, was better known as a painter. As a result of ill-health, and De Morgan's lack of business sense, the factory was closed in 1905, after which he embarked on a very successful career as a novelist.

Bibl: Portfotio 1876 p.114ff.; Studio LXX 1917 p.88; Burlington Magazine XXXI 1917 pp.77 83, 91-7; Connoisseur LXIII 1922 p.183ff.; Mrs. A.M.W. Stirling, *W. De Morgan and his Wife*, 1922; W. Gaunt and M.D.E. Clayton-Stamm, *W. de M.*, 1971; R. Dennis and W.E. Wiltshire, *The Designs of W. de M.*, 1989.

DEMPSEY, Charles W. fl.1880
Exhib. one watercolour 'A Visitor from the Garden' at SS, 1880. London address.

DEMPSTER, Miss Margaret fl.1891-1893
Edinburgh portrait painter. Exhib. once at RA, SS and NG.

DENBY, William fl.1850-1869
London painter of biblical subjects. Exhib. at RA, BI and SS. Titles: 'St. Peter and Rhoda', etc, and some other figure subjects.

DENDY, G. fl.1870
Exhib. three domestic subjects 1870. London address.

DENDY, Walter C. fl.1842-1850
London landscape painter. Exhib. at RA, SS and elsewhere; both English and European views.

DENEW, Richard fl.1827-1858
London painter of Italian subjects. Exhib. mainly at SS, also RA, BI and NWS. Subjects mostly views in Italy, or scenes of Italian life.

DENHAM, John Charles fl.1796-1858
London landscape painter. Exhib. only at RA, showing over 50 pictures between 1796 and 1858, sometimes exhibiting only under the initials J.C.D. Subjects mostly English views, some European, and several foreign views based on sketches made by other artists such as Sir R.K. Porter and Thomas Phillips.

Bibl: Roget I p.98.

DENIS, V. fl.1865
Exhib. two watercolours at SS, 1865: 'Cookham, Berks' and 'Shiplake Church'. London address.

DENISON, J. fl.1882
Exhib. one landscape at GG, 1882.

DENN, A. fl.1877
Exhib. one picture 'Caught in a Shower' at SS, 1877. London address.

DENNING, Stephen Poyntz 1795-1864
London miniaturist and portrait painter. Pupil of J. Wright. Exhib. mainly at RA 1814-52; also BI and SS. Was also a copyist of old masters. In 1821 appointed curator of Dulwich Gallery; died at Dulwich College in 1864. Among his sitters were George Grote and Queen Victoria, painted as a girl in 1823 (Collection Dulwich College).

Bibl: AJ 1864 p.243 and Athenaeum 1864 (obits.); Redgrave, Dict.; Bryan; Ormond I pp.82, 205, 479; II pl. 938; Hardie III p.97 (pl.119).

DENNIS, Miss fl.1866
Exhib. one animal picture 'On Guard' at SS, 1866. London address.

DENNIS, Miss Ada ROI fl.1891-1930
London painter of figure subjects. Exhib. at RA, SS and ROI; elected ROI 1917. Born in Chester, and studied at Académie Julian in Paris. Also painted portraits, landscapes and miniatures.

DENNIS, W.T. (S?) fl.1841-1850
London painter of figure subjects. Exhib. a portrait and a scene from *Dombey and Son* by Dickens at RA; also at SS and elsewhere. In the SS lists he is recorded as W.S. Dennis.

DENNIS, William fl.1834-1849
London still-life painter, especially of fish and game. Exhib. at RA, SS and elsewhere.

DENNISTOUN, William 1838-1884
Exhib. one watercolour landscape at NWS, and two elsewhere; address Capri, Italy. Examples are in Glasgow AG.

DENT, Miss J. fl.1869
Exhib. one watercolour of a bullfinch at SS, 1869. London address.

DENT, Rupert Arthur fl.1884-1890
Animal painter; exhib. at RA, NWS and elsewhere. Titles: 'The Dog of the Future', etc. Lived at Wolverhampton, Edinburgh and Cheltenham.

DENTON, F.W. (W.F.?) fl.1876
Exhib. one landscape 'Twilight over the North Yorkshire Moors' at SS, 1876. London address. Grave's Dictionary lists his initials as W.F., the SS records as F.W.

DENYER, Alfred fl.1882-1893
Bedford landscape painter. Exhib. at SS only 1882-93. Subjects English views, especially of Bedford and Lincoln, both in oil and watercolour.

DE POIX-TYREL, Edmond fl.1862-1874
London landscape painter. Exhib. both oils and watercolours at SS, and once at RA. Subjects mostly views in Wales and the West Country.

DE PONCY, Alfred V. see PONCY

DE PRADES, A.F. fl.1844-1883
London painter of sporting and military subjects. Exhib. at RA, BI and SS. Sometimes collaborated with E.J. Niemann (q.v.). Also painted Spanish and Russian subjects. Although little is known about his career, his work is often seen on the art market, and he must therefore have worked for private patrons. He painted full-length portraits of Lord and Lady Cardigan, which can be seen at Deene Park, Northamptonshire.

DE PRADES, Frank fl.1857-1861
Exhib. two pictures at RA in 1857 and 1861, one a group portrait at Boulogne in 1854, including the Emperor Napoleon and Prince Albert, the other 'A Thirsty Dog'. Also exhib. at SS. London address.

Bibl: Ormond I pp.13, 338, 413.

DE QUERANGAL, Mlle. see QUERANGAL

DERBY, Alfred Thomas 1821-1873
Painter of portraits and historical genre. Son of the watercolour painter William Derby (q.v.). Exhib. at RA 1848-72. BI and SS. Studied at RA Schools. For a few years he painted portraits, in oil, and pictures of scenes from Scott's novels, but his father's ill health made it necessary for him to help him in the production of watercolour copies from Landseer and others. From that time he worked in watercolour, sometimes producing originals, but mostly copies.
Bibl: AJ 1873 p.208; DNB 1908 V.

DERBY, Miss Emma fl.1838
(Mrs. Chatfield)
Exhib. one watercolour 'Edith' at SS, 1838. London address.

DERBY, William 1786-1847
Painter and copyist. Pupil of J. Barber in Birmingham. Came to London 1808. Copied from old masters, and from Landseer. Also painted still-lifes of his own. He was partially paralysed in 1838, and was helped thereafter by his son Alfred Thomas Derby (q.v.).

DERING, Arthur fl.1866-1899
Exhib. a view of Hanover at RA 1889, and one picture 'Black or White' at BI, 1866. Addresses London and Ashford, Kent.

DE ROCKSTRO, J. Sambroke fl.1835-1852
London painter of landscapes and figures. Exhib. at RA and SS. Subjects include views in Northumberland and Scotland.

DE ROVRAY, Fanny Gallandat fl.1848-1850
Exhib. three watercolours of costume subjects, Louis XV period, at SS, 1848-50. London address.

DERRY, Miss E.K. fl.1886
Exhib. one picture 'An Indian Chief' at RA, 1886. Address Malden, Surrey.

DESANGES, Miss A.J. fl.1841-1843
Exhib. two pictures at SS, 1841-3: 'Young Sailors' and 'The Orphan'. London address.

DESANGES, Louis William b.1822 fl.1846-1887
Naturalised Frenchman, born in Bexley. Travelled in France and Italy. Settled in London in 1845. His first pictures were historical, but he turned to the more lucrative business of painting portraits of ladies and children. Exhib. at RA, 1846-87, BI and SS. In 1872 he began to paint contemporary military scenes, and travelled in India. In 1859 many of these were exhib. at an exhibition entitled 'Victorian Cross Gallery' which was later shown at the Crystal Palace.
Bibl: Academy Notes 1877-8; AJ 1864 pp.41-3; Ormond I see index.

DESANGES, Miss Louisa fl.1837
Exhib. one picture 'Coast Scene, at Boulogne' at SS, 1837. London address.

DE SATUR, Edmond Byrne fl.1878-1885
London painter of domestic subjects. Exhib. at RA 1878-85 and elsewhere.

DE SATUR, Mrs. Francis fl.1879-1884
London painter of landscape and rustic subjects. Exhib. six pictures at RA 1879-84. Titles: 'Spring Time', etc. Wife of W.B. de Satur (q.v.)

DESMEDI, T. fl.1847
Exhib. one picture of Rubens in his studio at RA, 1847. Graves RA Exhibitors spells his name Desmed.

DESSURNE, Mark b.1825 fl.1842-1873
Painter of religious, historical and other subjects, and landscapes. Exhib at RA, BI, SS and elsewhere. Lived in Glasgow and London, and his religious and historical pictures show the influence of Sir J. N. Paton (q.v.). His landscapes mostly Scottish views.
Bibl: Bryan; Brook-Hart.

DE ST. DALMAS, F. Emeric fl.1872-1880
Guernsey landscape painter. Exhib. at RA, SS and elsewhere. Titles: 'The Solitary Tree', etc.

DE STEIGER, Mme. Isabel fl.1879-1883
London painter of historical subjects. Exhib at RA, SS and elsewhere. Titles 'Marianne', 'Cleopatra's Deadly Resolve in the Temple of Isis', etc.

DESVIGNES, Miss Emily E. fl.1855-1876
(Mrs. Bicknell)
London painter of sheep and cattle. Exhib. mostly at SS, also RA, 1855-72, and BI. Daughter of Herbert Clayton Desvignes (q.v.). When her father went blind, she was forced to take to the stage to support herself. After achieving some success, she married a Mr. Bicknell and resumed her painting career.
Bibl: Clayton II p.305.

DESVIGNES, Miss F.C. fl.1868
Exhib. one watercolour of a church in Antwerp at SS, 1868. Address Lewisham, Kent.

DESVIGNES, Herbert Clayton fl.1833-1863
London landscape and animal painter. Exhibited at the RA 1833-61, also at BI and SS. Titles: 'Landscape and Cattle', 'A Kentish Farm', etc. His daughter was Emily Desvignes (q.v.) and when Desvignes went blind she had to take to the stage to support him.

DE TEISSIER, H.P. fl.1881
Exhib. two landscapes of mountains 1881. London address.

DE TESSIER, Isabelle Emilie see DUVAL, Marie

DE THANNBERG, Count L. fl.1850-1853
Exhib. two portraits at RA 1850 and 1853, one of the Emperor Napoleon. London address.

DETMOLD, Charles Maurice ARE 1883-1908
Painter and etcher of birds and animals. Twin brother and collaborator with Edward Julian Detmold (q.v.). Exhib. at RI, NWS, etc. In 1900 an exhibition of his work was held at FAS. Elected ARE 1905. Illustrated *Pictures from Birdland* and Kipling's *Jungle Book*.
Bibl: See under E.J. Detmold.

*DETMOLD, Edward Julian ARE 1883-1957
Painter, watercolourist, etcher and aquatinter of animals, birds, flowers, insects and landscapes. Often collaborated with his twin brother C.M. Detmold (q.v.). Exhib. at RA, NWS, etc. Elected ARE, 1905. His works are painted in a naturalistic, highly-coloured, and very detailed style, and many illustrations can be found in the *Studio* (see Bibl). A group of watercolours by him appeared at Christie's, 21 October 1975.
Bibl: AJ 1908 p.186; Studio XXX 1904 p.252; XXXIII 1905 p.79ff.; XXXVIII 1906 p.244ff.; LI 1911 pp.289-97; LVII 1913 p.178; The Artist Engraver 1904 II; Campbell Dodgson in *Die Graph. Kunste,* Vol. 33 Vienna 1916 pp.17-24; Who's Who 1913.

DETMOLD, Henry E. b.1854 1879-1898
Painter of rustic and other figure subjects. Exhib. mainly at SS, also RA, GG and elsewhere. Painted scenes in England, France, Cairo, and North Africa. Worked in Cornwall with the Newlyn School, and was mentioned in an article about the school in the Art Journal in 1889. Probably father of the twins C.M. and E.J. Detmold (qq.v.).
Bibl: AJ 1889 p.140; RA Pictures 1892-3; Leeds City AG 1909 p.25.

DEUTMANN, F. fl.1891
Exhib. one picture, 'River View, Holland', at SS, 1891. Address Lewisham, Kent.

DE VARROC, E. fl.1849
Exhib. one picture, 'A Dog and a Cat', at SS, 1849. Graves Dictionary spells him Varroe.

DE VAUX, A.R. Grant fl.1847-1867
London landscape painter. Exhib. at RA and SS, views in Wales, Scotland and the Lake District.

DE VECK, L. fl.1878
Exhib. one watercolour of fishing boats in Cornwall at SS, 1878. London address.

DE VEGA, Pedro fl.1879-1885
Cambridge painter; exhib. two pictures at RA 1884-5, of the Market Place, Cambridge, and Gloucester Cathedral.

DEVER, Alfred fl.1859-1876
London painter of portraits and figure subjects. Exhib. mostly at RA 1859-76, also at SS. Titles: 'Please Have You Seen Mother?', etc.

***DEVERELL, Walter Howell 1827-1854**
Pre-Raphaelite painter. Born in Charlottesville, U.S.A., where his English father was a schoolmaster. Returned to London with his father in 1829, and studied at Sass's Drawing School, where he became friendly with D.G. Rossetti. From January to May 1851 he and Rossetti shared the studio at 17 Red Lion Square later used by Burne-Jones and Morris. Appointed assistant master at Government School of Design. Although never a member of the Pre-Raphaelite Brotherhood, he was friendly with its members, and influenced by their ideas. After the resignation of Collinson in 1850 he was nominated for membership, but it was never confirmed. His promising career was cut short by illness and poverty, and he died, aged only 27. He exhib.only four works at the RA 1847-53, one at BI 1853, two at SS, and two elsewhere. His best known work is 'The Pet' (Tate Gallery). The rarity of his work has inevitably prevented him from enjoying the reputation he deserves.
Bibl: Bate p.54; Ironside & Gere pp.27-8 (pls.23-4); Fredeman, see index; Reynolds, VS passim (pl.43); Reynolds, VP pp.65, 68; Maas p.133; Staley pp.109-10, Christopher Wood, W. H. Deverell — The Forgotten Pre-Raphaelite, Christie's Review of the Season 1973 pp.56-7; Wood, Pre-Raphaelites.

DE VILLALOBOS, A. fl.1838-1839
Exhib. two portraits at RA 1838-9, one of the Bishop of Cordova. London address.

DE VILLE, Joseph Vickers RBSA 1856-1925
Wolverhampton painter of landscapes and rustic subjects. Exhib. at RA, RBSA, ROI and elsewhere. Elected RBSA 1917. Painted views in Wales and the Midlands, especially Cannock Chase.

DE WALTON, J. fl.1856
Exhib. one military portrait at RA, 1856. London address.

DE WARVILLE, F. Brissot fl.1882
Exhib. one picture, 'Sheep Feeding', at RA, 1882. London address.

DEWE, Miss N. fl.1893
Exhib. one domestic subject 1893. London address.

DE WETTE, Aug. fl.1887
Exhib. one theatrical picture 1887. London address.

DE WILDE, Miss fl.1879
Exhib. one picture, 'Waiting', at SS, 1879. London address.

DEWILDE, G.J. fl.1855-1856
Northampton landscape painter. Exhib. six landscapes in small London exhibitions 1855-6.

DE WINT, Peter 1784-1849
Landscape painter and watercolourist. Only a small part of his working life falls inside the Victorian period. Studied with John Raphael Smith, where he met his life-long friend and future brother-in-law William Hilton. At this period he came under the influence of Varley and Girtin, from whom he imbibed much of his style. His subject matter was almost entirely English, and he was especially fond of Lincoln and the Trent area, the Lake District and Wales. He exhib. mainly at the OWS, also at RA, BI and elsewhere. Elected Associate of the OWS 1810, Member 1811. He developed an exceptionally broad and sweeping style, and is one of the great masters of the art of pure watercolour. He was also an accomplished painter in oil, and this aspect of his output has been very neglected. During his lifetime he received only moderate recognition, and supported himself by giving lessons. His only pupil of any note was Samuel Austin. A notable collection of his works is in the Usher AG, Lincoln. After his death a sale of his works was held at Christie's, 22-28 May 1850.
Bibl: Roget; Redgrave; Hughes; RA 1934; Bryan; Cundall; Willams; Binyon; Hardie II pp.210-2 et passim (pls.197-206); Hardie III p.301 for full list of books and articles.

DEWLING, A. fl.1874
Exhib. one picture, 'Clouds', at SS, 1874. London address.

DIBDIN, Thomas Colman 1810-1893
London landscape painter and watercolourist. A prolific exhibitor at SS, and the Portland Gallery, also RA and BI. Painted landscapes and architectural subjects in England and France in a style similar to Alfred Vickers (q.v.). Forced to give up painting by blindness in 1883. Works by him are in the BM and VAM.
Bibl: Hughes; Cundall; VAM; Binyon; Hardie III pp.30-1 (pl.42).

DICEY, Frank ROI fl.1865-d.1888
London painter of figure subjects. Exhib. at RA, SS, NWS, GG and ROI. Titles: 'A Vision of Spring', etc. Also exhib. at Paris Salon in 1876, 1879, 1882 and 1885.
Bibl: Bryan.

DICKER, Miss Alice M. fl.1888-1889
London painter of figure subjects. Exhib. twice at RA, once at SS, and once elsewhere. Titles: 'Sweet Seventeen', etc.

DICKES, William fl.1843-1881
Exhib. one picture, 'Rachel weeping for her Children', at RA, 1843, and one elsewhere. London address.

DICKINS, Frank fl.1886
Exhib. one picture of grapes at SS, 1886. Address Putney, London.

DICKINS, S.A. fl.1861-1868
Exhib. a figure subject, 'Hesitation', at RA, 1868; also two coastal scenes at BI and SS. London address.
Bibl: Brook-Hart.

DICKINSON, Miss Annie J. fl.1890-1897
Exhib. two pictures at RA in 1890 and 1897: 'A Corner of the Greenhouse' and 'Dutch Pasture Land'. London address.

DICKINSON, Arthur fl.1877-1882
London landscape painter. Exhib. at RA, SS and elsewhere, both in oil and watercolour. Subjects all English views.

DICKINSON, Miss Florence fl.1892
Exhib. two pictures at SS, 1892, a landscape and 'Addison's Tomb, Westminster Abbey'. London address.

DICKINSON, Henry R. fl.1881-1897
Exhib. two landscapes of the south coast at RA in 1881 and 1897. London address.

DICKINSON, J. Reed fl.1867-1881
London painter of figure subjects and landscapes. Exhib. mostly watercolours at SS, also RA and elsewhere. Subjects include domestic scenes, coastal views, figure subjects both English and European.

DICKINSON, John fl.1876-1880
London portrait painter. Exhib. at RA and SS. Subjects all portraits, some figure studies, e.g. 'Sad Thoughts'.

DICKINSON, K. (R.?) fl.1878
Exhib. one landscape 1878. London address.

DICKINSON, Miss Lilian fl.1880-1883
London portrait painter. Exhib. four portraits at RA, 1880-3.

DICKINSON, Lowes Cato 1819-1908
Highly successful portrait painter to the Victorian establishment. Exhibited portraits at the RA, 1848-91. Sitters included many famous politicians, soldiers, dons and aristocrats — Gladstone, General Gordon, etc. His pictures tend to be large and sombre, and mostly in private collections. For these reasons they do not appear on the market frequently.
Bibl: L. Cust, NPG 1902 p.202; W.M. Rossetti, *Some Reminiscences*, 1906 p.139 Staley pp.27, 151; Ormond I see index.

DICKINSON, Walter C. fl.1854
London still-life painter. Exhib. three pictures of birds and fruit at RA and SS.

DICKINSON, William Robert fl.1836-1882
London painter of rustic subjects. Exhib. at RA, SS, GG and elsewhere. For a time he lived in France, and many of his pictures were of French subjects, e.g. 'A Breton Peasant', etc.

***DICKSEE, Sir Frank (Francis Bernard) PRA RI 1853-1928**
Genre and portrait painter. Son and pupil of Thomas Francis Dicksee (q.v.). Exhib. at RA from 1876, achieving success with his picture 'Harmony' in 1877, which was bought by the Chantrey Bequest. His subjects were often romantic genre pictures, e.g. 'The Magic Crystal' in a very personal style compounded of Watts, Burne-Jones and late Pre-Raphaelite influences. He also painted social dramas in the Orchardson manner, e.g. 'Reverie', 1895 and many elegant society portraits. Elected ARA 1881, RA 1891. Although a strong opponent of modernity in art, he was elected PRA in 1924 at the age of 71; Knighted 1925; KCVO 1927.
Bibl: AJ 1897 pp.326-7; 1901 p.160; 1902 p.213; 1904 p.181; 1905 pp.331-2; 1906 p.10; 1908 p.318; 1909 p.167; Art Annual 1905 Christmas Number pp.1-32; Studio XXIII 1901 p.185; RA Pictures 1891-1907; Mag. of Art 1887 p.218; Tate Cat; Reynolds, VP *passim* (pl.59); Hutchison *passim*; Maas p.231 (pl.p.15); Wood, Pre-Raphaelites; A. Kavanagh, *A Post Pre-Raphaelite Sir F.D.*, Country Life 31 January 1985.

DICKSEE, Herbert Thomas RE 1862-1942
Painter of animals and historical genre. Son of Thomas Francis Dicksee (q.v.). Exhib. at RA 1885-1904. Subjects mostly of lions, and other animals, historical genre, and copies after Millais and Frank Dicksee. Titles: 'The Dying Lion', 'After Chevy Chase', 'The Little Gipsy', etc.
Bibl: Studio Summer No.1902; Who's Who 1911.

DICKSEE, John Robert 1817-1905
Painter of portraits and genre scenes. Brother of Thomas Francis Dicksee, uncle of Frank and Herbert Thomas Dicksee (qq.v.). Exhibited at the RA, 1850-1905, and at the BI and SS. Genre titles at RA 'Fluttering the Fan', 'A Dream of Chivalry', 'Sophia Western', etc.
Bibl: Guildhall Cat. 1910; Ormond I see index.

DICKSEE, Miss Margaret Isabel 1858-1903
London painter of historical and domestic subjects; daughter of Thomas Francis Dicksee (q.v.). Exhib. at RA and SS. Titles: 'In Memoriam', 'The Child Handel', etc. Her historical works at the RA were exhibited with long explanatory quotations.
Bibl: AJ 1897 p.65; 1903 p.370; W. Shaw Sparrow, *Women Painters of the World*, 1905; RA Pictures 1890,1892-5.

DICKSEE, Thomas Francis 1819-1895
Painter of portraits and historical genre. Pupil of H.P. Briggs, the portrait painter. Exhib. at RA, 1841-95, BI and SS. Subjects mostly Shakespearian, some historical, some pure genre. Titles: 'Ophelia', 'Crochet Work', 'Lucretia', 'Antigone', etc. Father of Sir Frank, Herbert Thomas and Margaret (qq.v.). Painted numerous pictures of female figures in classical or historical costume.
Bibl: AJ 1872 pp.5-7; 1896 p.31; The Year's Art 1895.

DICKSON, A. fl.1850
Exhib. one portrait at RA, 1850.

DICKSON, Miss Anna fl.1864
Exhib. one picture, 'Vivien', at SS, 1864. London address.

DICKSON, Arthur fl.1878
Exhib. one landscape 1878. London address.

DICKSON, Frank RBA 1862-1936
Landscape painter. Born in Chester; educated in Liverpool. Studied at St. John's Wood Art School and RA Schools. Exhib. at RA, SS and elsewhere. Lived in Upper Norwood, London.

DICKSON, William fl.1881-1904
London landscape painter. Exhib. at RA and SS. Titles: 'The Last of the Sunlight', etc.

DICKSON, William Playfair fl.1897-1902
London painter of portraits and figure subjects. Exhib. at RA 1897-1902. Titles: 'Kitty', etc.

DIEHL, Arthur fl.1889
Exhib. one picture, 'The Quay, Aldeburgh', at RA, 1889. London address.

DIGBY, George fl.1888-1889
Painter of coastal scenes. Exhib. at RA and SS. Titles: 'On the Sands', etc., and some landscapes. Lived in London and Ilfracombe.

DIGHTON, George fl.1857-1871
Painter of figure subjects and views in north France. Exhib. at RA and BI. Titles: 'Elaine and Sir Lancelot', etc.

DIGHTON, William Edward fl.1843-1853
London painter of landscapes and river scenes. Exhib. at RA, BI, SS and elsewhere. Painted in England, Wales and France; also exhib. one picture of the temple of Luxor at Thebes, Egypt.

DILLON, Hon. Mrs. A. (Viscountess Dillon) fl.1848
Exhib. one picture, 'The Thread of Life', at BI, 1848.

DILLON, Frank RI 1823-1909
Topographical painter in oil and watercolour. Pupil of James Holland (q.v.). Like Lewis and Lear, he travelled abroad continually, visiting Spain, Italy, Egypt and the Far East. Exhibited at the RA, 1850-1903, the BI and OWS. Subjects mostly views of temples, ruins, etc. the majority Egyptian. He also painted Moorish interiors in the manner of J.F. Lewis, but not as brilliantly. His studio sale was held at Christie's, 21 January 1911.
Bibl: AJ 1909 p.223; DNB 1901-11; Staley pp.109-10.

DIMES, Frederick fl.1837-1866
London landscape painter. Exhib. at BI, SS and elsewhere; subjects views in England, Wales, Scotland and France; also some Venetian scenes.

DIMMA, Miss Ada C.G. fl.1891-1892
Exhib. two pictures of domestic subjects 1891-2. Clapton address.

DIMSDALE, John fl.1875-1876
Darlington landscape painter. Exhib. twice in London, 1875-6.

DINGLE, Thomas fl.1846-1888
London landscape painter. Exhib. at RA, BI and SS. Painted around London, and in Cornwall.

DINGLE, Thomas, Jnr. fl.1879-1889
Devon landscape painter; son of the above. Exhib. five pictures at SS, 1879-89, in oil and watercolour, mostly scenes in Devon.

DINKEL, J. fl.1840
Exhib. one picture of fossil fish at RA, 1840. London address.

DINSDALE, John fl.1884-1889
London landscape painter. Exhib. twice at NWS, 1884 and 1889.

DITCHFIELD, Arthur 1842-1888
Painter, watercolourist and traveller. Exhibited at the RA, 1866-86, and at BI and SS. Painted views in France, Spain, Germany, Algeria and Egypt.
Bibl: AJ 1908 p.261; *The Etruscans*, Cat. of exhib. at Stoke-on-Trent AG 1989.

DIX, Mrs. fl.1855-1860
London flower painter. Exhib. five watercolours of flowers and fungi at SS, 1855-60.

DIX, Charles Temple fl.1867
Exhib. one landscape of Sark, Channel Islands, at RA, 1867. London address.

DIXCEE, T. fl.1828-1865
London landscape painter. Exhib. at RA, BI and SS. Subjects mostly views in Wales and the West Country.

DIXEY, Frederick Charles fl.1877-1920
London painter of river and coastal scenes. Exhib. once at RA, 1884, also SS, NWS and elsewhere. Later lived at Richmond, Surrey.
Bibl: Brook-Hart.

***DIXON, Alfred fl.1864-1891**
London painter of domestic and other figure subjects. Exhib. at RA, SS and elsewhere. Titles: 'Miles from Home', etc. Also painted historical scenes and flowers. Some of his pictures have a social realist flavour, such as the picture 'Bereaved: Seaham Colliery, 1880', RA 1882, showing women waiting at the pit-head after an accident, and 'Forsaken' a scene in a women's workhouse, (Sunderland AG). Father of Charles E. Dixon (q.v.).

DIXON, Arthur A. fl.1892-1927
Painter of figure subjects. Exhib. at RA and RBA. Titles: 'A Confession', etc. Lived at Berkhamsted.

DIXON, Charles Edward RI 1872-1934
Painter of river, coastal and marine subjects, in oil and watercolour. Son of Alfred Dixon (q.v.). Exhib. at RA, NWS and elsewhere. Elected RI 1900. Worked for *The Graphic* and other periodicals. Best known for his port scenes, especially on the Thames. He was a keen yachtsman, and lived at Itchenor, on the Sussex coast.
Bibl: Brook-Hart pp.97-8 (pls.177-8).

DIXON, Charles Thomas fl.1846-1857
London landscape painter. Exhib. at RA, BI and SS, both in oil and watercolour. Painted views near London, especially at Highgate and Hampstead, and also some coastal scenes.

DIXON, E. fl.1835-1839
London portrait painter. Exhib. at RA, BI and SS. Among his sitters was Captain Marryat, and this portrait is now in the National Maritime Museum, Greenwich.
Bibl: Ormond I p.302.

DIXON, E.H. fl.1847-1859
London landscape painter. Exhib. at RA, BI and SS. Titles: 'Moonlight Effect near Blackheath', etc.

DIXON, Miss Ella Hepworth. fl. 1877-1883
London painter of figure subjects. Exhib. four times at SS, 1877-83. Titles: 'Down the Avenue', etc.

DIXON, Miss Emily fl.1885-1886
Hull flower painter. Exhib. twice at RA and at SS.

DIXON, John fl.1879-1885
Exhib. four watercolours of coastal scenes at SS; also at NWS and elsewhere. Titles: 'Off the Eddystone', etc. Address Surbiton, Surrey.
Bibl: Brook-Hart.

DIXON, Pelham 1859-1898
Painter of river and coastal scenes. Lived in South Shields, Co. Durham, and painted mainly around the mouth of the Tyne. Works by him are in South Shields Library and Museum.
Bibl: Hall.

DIXON, Percy RI 1862-1924
London painter of landscape in watercolour. Exhib. mainly at SS and NWS, also RA. Subjects often highland scenes. Elected RI 1915. Later moved to Bournemouth.

DIXON, W.H. fl.1881
Birmingham landscape painter. Exhib. one Welsh landscape at RA, 1881.

DIXSEE, F.H. fl.1845
Exhib. one portrait of Count de Greci, Chamberlain of Honour to the Pope, at RA, 1845. London address.

DLOFI, K. fl.1849
Exhib. one picture, 'An Upstart', at BI, 1849. London address.

DOANE, C. fl.1835-1851
London painter of portraits and figure subjects. Exhib. mainly at SS, also at RA. Subjects mostly portraits, some genre, e.g. 'La Petite Vendageuse', etc.

DOBBIN, John 1815-1884
Landscape and topographical painter. Exhib. at RA, 1842-75, and also exhibited over 100 works at SS. Travelled in Holland, France, Spain and Germany. Specialised in architectural studies of cathedrals, churches and buildings. Subjects at RA also include some Scottish landscapes. Also painted in the north-east, especially around Darlington.
Bibl: Hall.

DOBELL, Miss Alice fl.1867
Cheltenham flower painter. Exhib. two watercolours at SS, 1867.

DOBELL, Clarence M. fl.1857-1866
London painter of figure subjects. Exhib. at RA, BI and SS. Titles: 'Mistress and Maid', etc. Painted a portrait of the poet Sydney T. Doben.
Bibl: Ormond I p.146.

DOBINSON, W. fl.1864-1865
Carlisle painter. Exhib. one religious subject and an Italian landscape at BI, 1864-5.

DOBRÉE, Edwin de S. fl.1893
Exhib. one landscape, 'Blaydon Hills — Winter', at RA, 1893. Jersey address.

DOBSON, Edmund A. fl.1883-1889
Painter of rustic subjects, in oil and watercolour. Exhib. at RA and SS. Titles: 'The Village Maiden', etc.

***DOBSON, Henry John RSW b.1858 fl.1881-1892**
Scottish genre painter, worked in Edinburgh. Exhib. a few works at RA and SS; mostly exhibited at RSA. Subjects homely scenes of Scottish life. Titles at RA 'The Gloamin', 'The New Toy', 'Burns Grace', etc.
Bibl: Caw p.468; Reynolds,VS (pl.104); Wood; Panorama.

DOBSON, Robert fl.c.1850-1881
Exhib. one landscape at GG, 1881. Address Birkenhead, Cheshire. Painted in Lancashire and Cheshire, in oil and watercolour. Also painted scenes in Liverpool Docks.

***DOBSON, William Charles Thomas RA RWS 1817-1898**
Painter of religious and historical scenes, genre subjects, and portraits. Master of the Society of Arts and School of Design in Birmingham. Exhib. 107 works at RA 1842-94. His genre subjects, mainly of children. Titles at RA include 'Prosperous Days of Job', 'Nursery Tales', 'Christmas Carols', 'Bethlehem'.
Bibl: Clement & Hutton; AJ 1859 p.212; 1860 p.137; 1898 p.94: DNB; Ormond I p.250.

DOCHARTY, Alexander Brownlie 1862-1940
Scottish landscape painter; nephew of James Docharty (q.v.). Exhib. at RA from 1882, also at RSA and elsewhere. He painted the highlands, and other Scottish scenery in a broad and naturalistic style, both winter and summer scenes. Caw describes his pictures as "painted with gusto, but not without refinement, in frank, fresh and harmonious colour, and good in drawing and design".
Bibl: Studio XXXI 1904 p.163; AJ 1909 p.152; Caw p.390.

DOCHARTY, James ARSA 1829-1878
Glasgow landscape painter. Served his apprenticeship as a pattern designer for calico printing. About 1862 he abandoned designing for landscape painting. His studio was in Glasgow and he exhib. at the Edinburgh Academy, the Glasgow Institution, and 13 works at the RA, 1865-77. Elected ARSA, 1877. In the spring of 1876, his health failing, he went to Egypt, through Italy and France, and died shortly after his return. His paintings are all Scottish views, and his style is realistic, natural and truthful to nature. The AJ of 1874 notes: " 'The Fishing Village' and 'The Cuchullin Hills' leave nothing to desire; for James Docherty lays his hand, not metaphorically, like Byron, but materially, upon Nature's elements, and shows us many secrets of her witchery".
Bibl: AJ 1878 p.155; Clement & Hutton; DNB; Caw pp.193-4; Birmingham Cat; Irwin.

DOCKER, Edward fl.1890-1899
Painter of domestic and other figure subjects. Exhib. at RA, 1890-9 and elsewhere. Titles: 'An Old Woman's Pets', etc. Lived in Newlyn, Cornwall, also in France.

DOCKREE, Mark Edwin fl.1856-1890
Landscape painter, exhib. mainly at SS, also at RA. Subjects views in Wales, Surrey and Kent.

DODD, Arthur Charles fl.1878-1890
Tunbridge Wells painter of hunting, animal, landscape and rustic subjects. A prolific exhibitor at SS 1878-91, also at RA, GG and elsewhere. Titles: 'The First Fence', 'Carrying Hay', etc.

DODD, Charles Tattershall 1815-1878
Tunbridge Wells painter of landscape and rustic subjects. Exhib. mostly at BI, 1832-66, also at RA, and once at SS. Titles mainly views in Kent and Sussex, especially of old buildings. Father of C.T. Dodd Jnr.

DODD, Charles Tattershall, Jnr. fl.1892-1904
Tunbridge Wells landscape and figure painter. Exhib. at RA, 1892-1904. Titles: 'Birds and Blossom' and scenes in Holland and northern France.

DODD, Joseph Josiah 1809-1880
Painter of buildings and street scenes. Exhib. at RA and SS. Subjects including several church interiors. Lived in London, Kent and Paris. Examples are in the Grosvenor AG, Chester, and the Manchester AG.

DODD, W. fl.1829-1840
London portrait painter. Exhib. at RA and SS. Subjects all portraits except for one 'Sketch on the Coast of Sunderland'.

DODDS, Annie fl.1865-1866
Newcastle flower painter. Exhib. two pictures at SS 1865-6.

DODDS, John fl.1865-1866
London painter of figure subjects. Exhib. once at BI and twice at SS. Titles: 'A Daughter of Eve', etc.

DODDS, Will. G. fl.1879-1885
Exhib. one picture 'A Sketch near Antwerp' at SS, 1881; also at other small exhibs. London address.

DODGSON, G. fl.1880
Exhib. two landscapes at GG, 1880. London address.

DODGSON, George Haydock OWS 1811-1880
London landscape painter, mainly in watercolour. Born in Liverpool. Worked as a civil engineer in George Stephenson's office, but bad health forced him to give this up for art in 1835. Exhib. at OWS and RI, also RA, BI and SS. Elected Associate of NWS 1842; Member 1847; resigned to join the OWS; ARWS 1848; RWS 1852. Painted landscapes, garden scenes, *fêtes-champêtres*, and later coastal scenes. Noted for his atmospheric effects, achieved by working on wet paper.
Bibl: AJ 1880 p.300 (obit.); Athenaeum 1880 I p.831; Roget; Bryan; Cundall p.206; DNB 1908; VAM; Hardie III pp.160-1 (pl.183).

DODGSON, George P. fl.1867-1868
Exhib. one watercolour, 'Study of a Head', at SS, 1867, and also elsewhere. London address.

DODGSON, Miss Jessie fl.1876-1879
London landscape painter. Exhib. six watercolours at SS, 1876-9, mostly views in Knole Park, and once elsewhere.

DODSLEY, Anne M.J. fl.1872
Exhib. one picture of fruit 1872. London address.

DODSON, George fl.1893
Exhib. one watercolour, 'Old Trawlers, Rye', at SS, 1893. Address Lewisham, Kent.

DODSON, George J. fl.1899
Exhib. one picture, 'Street in Corfe Castle, Dorset', at RA, 1899. London address. May be the same as George Dodson (q.v.).

DOE, Miss Catharine fl.1848-1852
Painter of domestic subjects and children. Exhib. four pictures at SS. Titles: 'Bird-Nesting', etc. Lived in London and Torrington, Devon.

DOGGETT, T. fl.1853
Exhib. one 'Study of a Head' at SS, 1853. London address.

DOIDGE, Miss Sarah A. fl.1859-1885
Landscape painter and watercolourist. Exhib. at RA and SS. Lived in Richmond-on-Thames and N. Wales, and her subjects almost all painted in these areas. Also painted some rustic genre, e.g. 'Spoils of a Truant'.

DOLAN, Philip fl.1867-1877
London painter of fruit and flowers, and rustic subjects. Exhib. at RA, SS and elsewhere. Titles: 'Tired Out', etc., and still-life subjects.

DOLBY, Edwin fl.1863-1877
London painter of church architecture in oil and watercolour. Exhib. mostly at SS, and once at RA. Subjects mainly cathedrals and churches on the Continent.

DOLBY, Edwin Thomas fl.1849-1865
Exhib. one picture of Wells Cathedral at RA, 1849, and five elsewhere. London address. Probably the same as Edwin Dolby (q.v.).

DOLBY, Joshua Edward A. fl.1837-1875
London painter of Italian subjects. Exhib. twice at RA and SS, subjects views of Pompeii, Rome, Amalfi, etc.

DOLLMAN, Herbert P. b.1856 fl.1874-1892
London painter of figure subjects. Born in Brighton; studied West London School of Art. Exhib. at RA, SS, NWS and elsewhere. Titles: 'Stage Struck', 'A Codicil', etc. Also worked as an illustrator for the magazines *Fun* and *Moonshine*, etc.
Bibl: Morning Post 6 March 1909.

***DOLLMAN, John Charles RWS RI ROI 1851-1934**
Historical genre and animal painter. Exhib. at RA, 1872-1904, and at SS. Titles include 'Table d'Hote at a Dogs' Home', 'Your Humble Servant', 'Saint Anthony', 'Kismet'. Also painted dog portraits. Specialised in highly dramatic pictures involving animals.
Bibl: RA Pictures 1892, 1894, 1895, 1905-12.

DOLLOND, W. Anstey fl. 1879-1889
Painter of landscapes and rustic subjects. Exhib. at RA and SS. Titles: 'Touches of Sweet Harmony', etc. Several addresses listed in London, Essex, Hertfordshire and Kent. Also painted neo-classical figures in a style similar to Henry Ryland. Sometimes spelt Dolland.

DOLORES, Mme. fl.1848
Exhib. one picture of 'An Indian Dancing Girl reposing on the Banks of the Ganges' at RA, 1848. London address.

DOMETT, A.N. fl.1879
Exhib. one flower picture at RA, 1879. London address.

DOMETT, Miss Susan C. fl.1864-1877
London painter of domestic subjects. Exhib. at SS and elsewhere, and once at RA. Titles: 'Evening Prayer', etc.

DOMINGO, F. fl.1892
Exhib. two portraits in 1892.

DOMINGUES, J. fl.1874-1875
London painter of landscape and figure subjects. Exhib. mainly at SS, and twice elsewhere, mainly in watercolour. Titles: 'The Finishing Touch', 'Feeding the Ducks', etc. In one of his RA exhibits, the figures were painted by A. Ludovici Jnr. (q.v.).

DOMINY, J.S. fl.1865-1876
Painter of rustic subjects and coast scenes. Exhib. five pictures each at RA and SS. Titles: 'Help by the Wayside', etc. Lived in London and Great Yarmouth, and later moved to York, where he taught at the Government Art School.

DON, C.B. fl.1885-1886
Landscape painter. Exhib. six pictures at SS, 1885-6, mostly views in Essex, some in watercolour.

DONALD, Emily fl.1886
Exhib. one watercolour still-life at SS, 1886. London address.

DONALD, John Milne 1819-1866
Scottish landscape painter. Studied in London, and settled in Glasgow about 1844. He was a naturalist painter in the tradition of McCulloch and Sam Bough (qq.v.), but developed an interesting and highly personal style. He was little appreciated in his lifetime, and is still a most underrated artist. His subjects were mainly the rivers and valleys around Glasgow, but he exhib. only twice at RA and once at BI.
Bibl: Portfolio 1887 p.207; Clement & Hutton; Bryan; Caw; Irwin p.356.

DONALD, Tom fl.1875
Exhib. one landscape of 'Sannox Ford, Arran' at SS, 1875. London address.

DONALD-SMITH, Miss Helen fl.1883-1930
London portrait and landscape painter. Born in Scotland. Studied at Kensington, in Paris and at Herkomer's School at Bushey. Exhib. mostly at Society of Lady Artists, also RA, SS, NWS, GG and NG.

DONALDSON, Andrew 1790-1846
Landscape and architectural painter in oil and watercolour. After an accident in a Glasgow cotton mill, he turned to painting, mostly of village scenes. Examples are in Glasgow AG.

DONALDSON, Andrew Benjamin b.1840 fl.1861-1910
Painter of historical and religious genre, and landscapes. Exhib. at RA, 1862-98, but was a more regular contributor at SS. Titles include 'The Garden of Faith', 'Flight from the Danes', 'The River Dee at Chester'. In some books referred to as Andrew Brown Donaldson. Painted murals on the staircase of the St. Pancras Station Hotel.
Bibl: The Etruscans, Cat. of exhib. at Stoke-on-Trent AG 1989.

DONALDSON, James H. fl.1883-1892
Scarborough still-life painter. Exhib. twice at RA and once at NWS.

DONDERS, Mrs. fl.1890-1891
Exhib. two portraits at NG, 1890-1. Address Dorking, Surrey.

DONE, Miss A.E. fl.1875-1878
Worcester painter of flowers and animals. Exhib. five pictures at SS, 1875-8.

DONKIN, Miss Alice E. fl.1871-1900
Painter of portraits and domestic subjects. Exhib. mainly at RA, 1871-1900, also SS, NWS, GG and NG. Titles: 'Six Bars Rest', etc. Among her sitters was Sir Henry Acland. Lived mainly in Oxford and London. Portraits by her of John Keble and Earl Stanhope are in the NPG.
Bibl: Ormond.

DONKIN, John fl.1880
Exhib. one watercolour of the tower of Ely cathedral at SS, 1880. London address.

DONNE, Benjamin John Merifield 1831-1928
London landscape painter. Exhib. at RA, NWS, GG and NG. Probably the same as J.M. Donne (see below). Several exhibitions of his work were held at Dowdeswell Galleries, London, in the 1880s. Examples are in the BM, and Exeter AG.

DONNE, J.M. fl.1865-1885
London landscape painter. Exhib. at RA, SS, GG and elsewhere. Subjects all views in Italy and the Alps.

DONNE, Walter J. b.1867 fl.1885-1893
Painter of landscapes, rustic subjects and portraits. Studied in Paris at the Ecole des Beaux-Arts, and was later Principal of the Grosvenor Life School. Exhib. at RA, SS, NWS, and NEAC. His impressionistic yet forceful style and his choice of robustly rustic subjects shows the influence of his French training. His pictures resemble those of Clausen, Stott and the Newlyn School.
Bibl: AJ 1899 p.274 ff.; 1906 p.380; 1909 p.285; Studio VII p.40; XXXIX pp.348-9; XLVII p.36; XLVIII pp.53-4; Daily Telegraph 25 October 1909; RA Pictures 1905-13; Cat. of International Fine Arts Exhibition, Rome 1911.

DONOGHUE, J.P fl.1846
Exhib. one picture, 'Belinda's Distress', from the Rape of the Lock at RA, 1846. London address.

DORMAN, J.J. fl.1855-1859
Reading painter of figure subjects. Exhib. twice at RA and SS. Titles: 'My Landlord's Daughter', etc.

DORMAN, S. fl.1857
Exhib. one picture of 'Holt Well' at SS, 1857. Lived in Reading, at the same address as J.J. Dorman.

DORMER, Hon. Louise fl.1891
Exhib. one landscape 1891. London address.

DOROTHEA, Lucy fl.1856
Exhib. one picture 'A Sketch' at RA, 1856.

D'ORSAY, Count Alfred 1801-1852
A celebrated wit and dandy, who established with Lady Blessington one of the most fashionable salons of the day. He was also a talented artist and sculptor, and exhib. at the RA and SS. A great many of his portrait drawings are in the NPG; these are profile drawings of many of the distinguished men of the 1830s and 1840s, but are of interest more for their social and historical value than for artistic merit. At the RA he exhib. portrait busts, including one of the Duke of Wellington. A portrait of D'Orsay by Sir George Hayter is illustrated in volume 2 of this Dictionary.
Bibl: DNB; Ormond I pp.147-9, 557-60, and index.

DORSCHWELLER, H. fl.1837
Exhib. two pictures at RA, 1837: 'A Conversation', and 'Costume of the Time of Louis XI of France'. London address.

DOUBTING, James fl.1868-1881
Bristol landscape painter. Exhib. four pictures of landscapes with animals at SS, and elsewhere.

DOUCET, Lucien fl.1892
Exhib. one portrait 1892.

DOUGAN, A. fl.1867-1868
Exhib. two watercolours of Hastings Cliffs at SS, 1867-8. London address.

DOUGHTY, Eleanor F.M. fl.1889-1893
London flower painter. Exhib. six pictures at SS, 1889-93.

DOUGLAS, Arthur fl.1878
Exhib. one picture of figures 1878. London address.

DOUGLAS, Edward Algernon Stuart fl.1880-1892
Sporting painter. Exhib. at RA only 1880-92, subjects mainly hunting. Lived in Barnes, London.

DOUGLAS, Edwin b.1848 fl.1869-1892
Scottish sporting, animal and genre painter. Imitator and successor of Edwin Landseer. Exhib. at RA, 1869-1900. Titles include: 'The Highland Hearth', 'Mountain Shooting', 'Milking Time — Jersey', 'The Dog in the Manger'. He studied at the RSA School, living in Edinburgh until 1872, when he came to London. He first exhib. at the RSA in 1865.
Bibl: AJ 1885 pp.193, 213; Clement & Hutton; Caw p.340.

DOUGLAS, James fl.1885
Edinburgh landscape painter. Exhib. twice at SS, 1885.

DOUGLAS, John b.1867
Landscape painter in oil and watercolour. Studied at Glasgow School of Art and lived in Ayr.

***DOUGLAS, Sir William Fettes PRSA 1822-1891**
Scottish painter of landscape and historical genre. Took up painting in 1847 after ten years as a bank clerk. Mainly self-taught. Elected RSA 1854. His earliest works mostly portraits, which he soon gave up in favour of genre subjects. After visiting Italy in 1857 he became a keen antiquarian and collector of books, coins, medals, manuscripts, ivories, enamels and antiquities, which he used as accessories in his pictures. Although he painted landscapes and historical scenes, he was most fond of painting interiors of studios, with antiquarians poring over books, manuscripts and other objects. The detail and quality of his still-life painting has often been compared with the Pre-Raphaelites, but being more interested in accessories, his figures are often rather weak and lifeless. Elected Curator of the National Gallery of Scotland 1877-82 and PRSA 1882-91. Exhib. at RA 1862-75. Typical titles: 'The Rosicrucian', 'The Alchemist', 'The Conspirators'. Used the Douglas Heart as his monogram, usually in red.
Bibl: Clement & Hutton; John M. Gray, *Sir William Fettes Douglas PRSA*, 1885; AJ 1891 p.288; Caw pp.172-4; DNB; Hardie III pp.189-90; Irwin pp.305-7 *et passim* (pl.171).

DOUGLAS-HAMILTON, R. fl.1888
Exhib. one picture of figures 1888. London address.

DOUGLASS, Richard fl.1875-1890
London landscape painter. Exhib. mainly at SS, also NWS and GG. Subjects Wales, Cornwall, and the south of England.

D'OUSELEY, Miss Sophia fl.1889
Exhib. one landscape at NWS, 1889. London address.

DOUST, W.H. fl.1859-1880
Painter of shipping and coastal scenes. Exhib. at BI, SS and elsewhere. He painted scenes off the Tyne, the Medway, and other English coasts, including the Channel Islands. His paintings are breezy and effective, but he is still very little known.
Bibl: Brook-Hart p.75 (pl.139).

DOVE, W. fl.1850-1857
London landscape painter. Exhib. three pictures at RA, 1850-7. Titles: 'On the Dart, Devonshire', etc.

DOVERS, Mrs. H.A. fl.1854
Exhib. one picture, 'Betty's Nosegay', at RA, 1854. London address.

DOW, Lumley fl.1893
Exhib. one picture of game 1893. London address.

DOW, Thomas Millie RSW 1848-1919
Scottish painter of landscape, still-life, historical and classical subjects. Born at Dysart, Fifeshire. Studied in Paris under Gerome and Carolus Duran. There he met William Stott (q.v.), whose style was to have an influence on his own. After his return to Scotland he became closely associated with the Glasgow School of painters, before he moved to St. Ives in 1896. His paintings are romantic and allegorical in conception, and usually in pale, atmospheric colours, e.g. 'The Enchanted Wood', 'The Wood Nymph', etc. They also show a typically 'Glasgow School' feeling for abstract, decorative quality. He exhib. mainly in Scotland, but also at SS and GG.
Bibl: AJ 1904 p.49; 1905 p.91; Studio V 1895 p.21ff.; X 1897 p.144ff.; XXXIII 1905 p.171ff.; D. Martin, *The Glasgow School of Painters*, 1902 p.10ff.; Caw p.407ff.; *The Glasgow Boys*, Scottish Arts Council exhib. 1968; Irwin.

DOWIE, Miss Sybil M. fl.1893-1904
Painter of portraits and figure subjects. Exhib. three pictures at RA, 1893-1904: 'Physalis', etc. Lived in Brighton and London.

DOWLEY, C. fl.1833-1851
London painter of rustic subjects and portraits. Exhib. once at RA and three times at SS. Titles: 'The Swing', etc.

DOWLING, R.B. fl.1868
Exhib. one picture, 'Doubts', at RA, 1868. London address.

DOWLING, Robert 1827-1886
Australian painter who lived mostly in London. Exhib. mostly at SS, also RA, BI and elsewhere. Painted portraits, historical and biblical subjects, and also Egyptian scenes. At the RA he exhib. a portrait of the Prince of Wales for the Tasmanian Government. Also painted the Arctic explorer Sir Francis McClintock.
Bibl: AJ 1859 p.171; 1879 p.142; Cat. of the National Gallery Melbourne 1911 pp.164, 181; Ormond II p.291.

***DOWNARD, Ebenezer Newman fl.1849-1889**
London genre and landscape painter. Exhib. at RA 1849-89, also at BI and SS. Also painted biblical scenes and portraits. Some of his landscapes show Pre-Raphaelite influence, particularly of Holman Hunt. Titles at RA 'Gulliver Diverting the Emperor of Lilliput', 'Cheap Jack at a Country Fair', 'The Tethered Goat'.
Bibl: AJ 1883 p.248.

DOWNES, Miss Ada E. fl.1893
Exhib. one picture of Westminster Clock Tower at SS, 1893. London address.

DOWNES, Miss Annabel fl.1885-1890
London painter of portraits and figure subjects. Exhib. at RA, SS, NWS and GG. Titles: 'Rosalie', etc.

DOWNES, Thomas Price fl.1835-1887
London portrait painter, working 1835-87. Exhib. mainly at the RA. He also occasionally painted landscapes, and historical genre. Titles at RA 'Italian Peasant Girls', 'Queen Eleanor Obliging Fair Rosamund to Take Poison', 'Last Moments of Princess Elizabeth'. Later he turned almost entirely to portraits.

DOWNIE, Patrick RSW 1854-1945
Scottish landscape painter, mainly in watercolour. Born at Greenock. Largely self-taught, but studied in Paris. Exhib. mainly at RSA and RSW, but also in London at RA, SS and NWS. Painted views around Glasgow, and especially scenes on the River Clyde, similar to those of James Kay (q.v.).
Bibl: Caw p.334; Brook-Hart p.346 (pl.190).

DOWNING, Charles Palmer fl.1870-1898
London portrait painter. Exhib. mainly at RA, 1872-98, also at SS and elsewhere. Among his sitters was the Duke of Connaught (painted for the Royal Artillery Mess, Aldershot), and other army officers.

DOWNING, Delapoer fl.1885-1902
London painter of domestic subjects. Exhib. at RA, SS and elsewhere. Titles: 'On Tour in the Provinces', 'Tempting', etc.

DOWNS, J. fl.1859
Exhib. one picture 'The Errand Girl' at RA, 1859. London address.

DOWSON, Russell fl.1867-1896
Eton landscape painter. Exhib. at RA, SS, NWS, GG and elsewhere. Painted views in England and France, especially harbour scenes.

DOWTON, C. fl.1849
Exhib. one untitled picture at SS, 1849.

DOYLE, Charles Altamont 1832-1893
Youngest son of the caricaturist John Doyle and brother of Richard Doyle (qq.v.). Entered the Civil Service and spent most of his life in the Edinburgh Office of Works. In his leisure hours he painted many strange fantasies with elves, horses and figures. He also illustrated John Bunyan's *Pilgrim's Progress*. His son was Sir Arthur Conan Doyle.
Bibl: Universal Cat. of Books on Art (VAM 1870) I p.189 (under Bunyan); Maas p.155 (pl.159); Newall; *The Doyle Family,* Cat. of VAM exhib. 1984.

DOYLE, Henry Edward RHA 1827-1892
Irish painter of portraits and religious subjects; also cartoonist. Third son of John Doyle (q.v.). Born in Dublin. Painted religious murals, of which his best known are in the chapel of the Dominican Convent at Cabra, near Dublin, 1864. Elected ARHA 1872, RHA 1874. Director of the National Gallery of Ireland for 23 years. Portraits by him of John Doyle and Cardinal Wiseman are in the NPG; several portraits are also in the National Gallery of Ireland, including Ruskin and Richard Doyle.
Bibl: Strickland I pp.294-6; DNB; Gazette des Beaux-Arts 1882 I p.182ff.; Ormond I pp.150, 341, 518-9 (pls. 279, 1012, 1014); *The Doyle Family,* Cat. of VAM exhib. 1984.

DOYLE, John (H.B.) 1797-1868
Caricaturist and cartoonist, better known as HB, the monogram with which he signed his cartoons. Born in Dublin, where he studied at the Dublin Society's Schools. Came to London about 1822, and at first tried portrait painting. He was not successful in this, and began to do lithographs of prominent public characters of the day. These became popular, and thus Doyle became a cartoonist. Between about 1829 and 1840 he was the leading political cartoonist in London, although his draughtsmanship was rather stiff, and his compositions formal. But his cartoons were always polite and gentlemanly, and never descended to sensationalism or vulgar abuse.
Bibl: AJ 1868 p.47 (obit.); Redgrave, Dict.; Everett, *English Caricaturists,* 1886 pp.238-76; DNB; Binyon; Ormond I see index; *The Doyle Family,* Cat. of VAM exhib. 1984.

***DOYLE, Richard 1824-1883**
Son (with Charles) of John Doyle the well-known caricaturist (qq.v.). Primarily a book illustrator of themes from everyday life and fairy subjects, and painter of a number of highly original fairy pictures. In 1843 he joined the staff of *Punch* and designed the famous cover in 1849. In 1851, after he had left *Punch,* he did some of his first fairyland illustrations for Ruskin's *The King of the Golden River.* He also illustrated Thackeray's *The Newcomes,* Leigh Hunt's *Pot of Honey,* William Allingham's *The Fairy Land,* and many others. He painted both in oil and in watercolour, and exhib. at the RA in 1868 and 1871, and at the GG. Some of his pictures were very large and peopled with hundreds of fairies. He also did landscapes but these were never very popular.
Bibl: Clement & Hutton; DNB; Daria Hambourg, *Richard Doyle,* 1948; Maas pp.155-60 (pls. on pp.16, 156); Ormond I; Rodney Engen, *R.D.,* 1983; *The Doyle Family,* Cat of VAM exhib. 1984; Newall.

DRABBLE, J.D. fl.1880
Exhib. one watercolour of shells, and one of a view of the Isle of Wight at SS, 1880. London address.

DRABBLE, Richard R. fl.1859-1855
Landscape painter. Exhib. mainly at RA, also BI and SS. Subjects views in the Midlands, Wales, Scotland, etc. Lived mainly in London, also in Cheshire and Sevenoaks.

DRAGE, J. Henry fl.1882-1900
Croydon painter of animals and rustic subjects. Exhib. at RA, 1882-1900, NWS, NG and elsewhere. Titles: 'An Exploring Party', etc.

DRAGE, Miss Mildred Frances fl.1885-1892
Landscape painter; lived at Hatfield, Hertfordshire. Exhib. at RA, SS, NG and elsewhere. RA exhibits all Italian views, but also painted English scenes.

DRAKE, W. fl.1861-1877
Exhib. five landscape watercolours at SS, 1861-77. Subjects views in Wales and the West Country. Lived in Hornsey, London.

DRANE, Herbert Cecil fl.1890-1893
Landscape painter; lived at Dorking, Surrey. Exhib. three times at SS, 1892-3, also NG and elsewhere. Titles: 'The Gamekeeper's Home', etc.

DRAPER, Charles F. fl.1871-1887
Painter of landscapes and coastal scenes. Exhib. mainly at SS, usually watercolours, also at NWS. Subjects include views in Jersey and Guernsey, as he lived in Guernsey, but after moving to London he painted English views.

***DRAPER, Herbert James 1864-1920**
Neo-classical painter of mythological and historical genre. Also painted portraits and mural decorations. 'An Episode of the Deluge' at the RA in 1890, won him a gold medal and a travelling scholarship, which he spent in Paris and Rome. 'The Lament for Icarus' was bought by the Chantrey Bequest in 1898. His style is similar in both style and subject matter to that of J.W. Waterhouse. Studied at St. John's Wood School of Art and at the RA Schools from 1884; worked in Paris at the Académie Julian and in Rome 1890-1. Exhib. at the RA from 1887 and elsewhere. Decorated the Nurses' Canteen, Guy's Hospital, 1887, and the ceiling at Drapers' Hall, 1903. Retrospective exhib. at Leicester Galleries 1913.
Bibl: Studio, Art in 1898 p.52; AJ 1898 p.182; 1900 p.184; 1901 pp.165, 179; Sir Claude Phillips, Daily Telegraph 21 March 1913; Who's Who 1913; Tate Cat; Maas p.232 (reprd. 'The Lament for Icarus'); Wood, Pre-Raphaelites; Wood, Olympian Dreamers.

DRAW, Miss Florence fl.1877
Exhib. one picture, 'The Fancy Ball', at RA, 1877. Windsor address.

DRAW, H. fl.1865
Exhib. three domestic subjects at RA, 1865. Titles: 'Cantari', etc. London address.

DRAYTON, Miss L. fl.1864-1868
London landscape painter. Exhib. seven pictures, some watercolours, at SS, 1864-8, and once at BI. Subjects mostly views in Wales.

DRESCH, Augusta M. fl.1854
Exhib. one watercolour, 'Going to the Opera', at SS, 1854. London address.

DRESSER, Arthur fl.1890
Exhib. one picture, 'Absorbed', at RA, 1890. Address Bexley Heath, Kent.

DRESSER, Mrs. Arthur (J.R.) fl.1889
Exhib. one picture, 'Gone', at RA, 1889. Address Bexley Heath, Kent. Wife of Arthur Dresser (q.v.).

DRESSLER, Miss Ada fl.1892-1896
London flower painter. Exhib. twice at RA in 1892 and 1896, and once at SS.

DREW, J.P. fl.1835-1861
London painter of rustic genre and portraits 1835-61. Exhib. 18 works at RA 1835-52; exhib. more frequently at BI and SS. Titles at RA: 'A Cottage Girl', 'Wild Flowers', 'Girl and Rabbits'.
Bibl: Glasgow AG Cat. 1911.

DREW, Miss Mary fl.1880-1901
London painter of portraits and domestic subjects. Exhib. at RA, SS and elsewhere. Titles: 'Half an Hour with the Poets', etc.

DREW, S.J. fl.1865-1867
Exhib. two watercolours of birds' nests and flowers at SS, 1865-7. Address Bexley, Kent.

DROFFIG, Miss J.J. fl.1843
Exhib. one picture, 'Getting Wood', at SS, 1843. London address.

DRUCE, Miss Helen fl.1885-1890
Exhib. one picture, 'Twickenham Ferry', at SS 1890, and three watercolours at SS. London address.

DRUCE, R. fl.1853-1860
Exhib. two scenes of Vienna at RA, 1853-4, and a view of Heidelburg at SS, 1860. London address.

DRUITT, Miss Emily fl.1883-1885
Exhib. one picture, 'The Knight', at SS, 1885, and twice elsewhere. London address.

DRUMMOND, Arthur 1871-1951
Painter of historical and other figure subjects. Born in Bristol, the son of John Drummond, a marine painter. Studied under Alma-Tadema, and also under Constant and Laurens in Paris. Exhib. at RA from 1890. Titles: 'The Last Days of Pompeii', 'The King's Courtship', etc. His Roman and Egyptian scenes are similar to Alma-Tadema, and are often in specially designed frames.
Bibl: Who's Who 1913.

DRUMMOND, E. fl.1869
Exhib. one figure subject 1869. London address.

DRUMMOND, G. fl.1863
Exhib. one portrait, 'A Family Group', at RA, 1863. York address.

DRUMMOND, H. fl.1875-1880
London painter of coastal scenes, and figure subjects. Exhib. mostly at SS, also once at RA and elsewhere. Titles include views off the south coast and Jersey.
Bibl: Brook-Hart.

DRUMMOND, J. Nelson fl.1888-1896
London landscape painter. Exhib. at RA and SS. Titles: 'Eventide', etc., and also sea subjects.

***DRUMMOND, James RSA 1816-1877**
Scottish historical genre painter. Worked in Edinburgh, and exhib. mostly at the RSA. Sent only a few works to the RA, BI and SS. Two of his smaller works, 'Peace' and 'War', exhib. at the BI in 1850, were purchased by Prince Albert. They are now at Osborne and were reproduced in the AJ in 1860 and 1861. Most of his subjects were taken from Scottish history. His great knowledge of Scottish arms, costume and customs enabled him to make his pictures very accurate, but he lacked the ability to breathe dramatic life into his figures and groups. Caw criticises him for this: "If capacity for taking pains would have made a history painter, then Drummond should have been one". In 1868 he was appointed Curator of the Edinburgh National Gallery.
Bibl: AJ 1877 p.336 (obit.); Redgrave, Dict.; DNB; Caw pp.118-19; Irwin p.304.

DRUMMOND, John Murray 1802-1889
Soldier and amateur artist. Studied in Edinburgh under A. Nasmyth (q.v.). Painted for Queen Victoria at Osborne.

DRUMMOND, Julian fl.1854-1892
London painter of portraits and figure subjects. Exhib. at RA and SS. Titles: 'Just Landed", etc.

DRUMMOND, Julian E. fl.1896-1903
Brighton painter of coastal scenes. Exhib. at RA, 1896-1903. Titles: 'A Fish Market', etc.

DRUMMOND, W. fl.1830-1843
London painter of figure subjects. Exhib. at RA, BI and SS. Titles: 'Morning Ablution', etc. and some historical scenes, e.g. 'Roderick Random and Miss Sparkle', etc. Probably the same as William Drummond who painted portraits of Prince Albert and Thackeray (see bibl.).
Bibl: Ormond I pp.10, 15, 464.

DRURY, Miss Ada fl.1891-1892
London flower painter. Exhib. four pictures at NG, 1891-2.

DRYSDALE, J.T. fl.1887-1889
London landscape and figure painter. Exhib. at RA, SS and elsewhere. Titles: 'A Spanish Head', etc.

DRYSDALE, Miss Mary fl.1859-1860
Exhib. two landscapes at SS, 1859-60. Titles: 'At Richmond, Surrey', etc. Lived in Richmond.

DUASSUT, Curtius fl.1889-1903
Landscape painter. Exhib. mainly at SS, also RA, NWS and elsewhere. Subjects all English scenes, especially Sussex and Devon, but often with poetic titles: 'The Golden Hour', etc. Lived in London, Amersham, and near Chelmsford.

DUBASTY, Ad. Henry fl.1853
Exhib. two pictures, 'The Return from Market' and 'The Return from the Wedding', at RA, 1853. London address.

DUBOC, M.A. fl.1828-1842
Greenwich painter of figure subjects. Exhib. at RA, BI and SS. Titles: 'Innocent Pastime', etc., and also some Roman views.

DUBOURG, Mme. Victoria b.1840 fl.1882-1909
Flower painter. Pupil and later wife of the French flower painter H. Fantin-Latour. Exhib. mostly at NWS, also RA, SS, GG and elsewhere. Also exhib. at Paris Society of Artists 1869-1909. Her style is very similar to that of her husband, but she mostly painted under her maiden name. Works by her are in the museums of Rheims, Grenoble, Chateau-Thierry and Luxembourg.
Bibl: W. Shaw Sparrow, *Women Painters of the World*, 1905 p.240.

DUBUFE, Louis Edouard fl.1838-1873
Painter of portraits and figure subjects. Exhib. eight pictures at RA, 1838-73, and once at BI. Titles: 'The Sisters', etc. Lived in Paris and London.

DUBUISSON, Miss fl.1805-1840
London painter of still-life, and occasional portraits. Exhib. regularly at RA, 1805-40, also BI and SS. Subjects fruit, flowers and dead game, mainly birds.

DUCANE, Miss Ella fl.1890-1930
Watercolourist of landscapes, flowers, figures and buildings. Exhib. one landscape watercolour at NWS 1893. Illustrated several A. & C. Black books, especially about flowers and gardens. London address.

DU CHATTEL, F.J. fl.1880
Exhib. two landscapes at GG, 1880.

DUCKETT, Lady (Isabella) fl.1867-1871
Painter of birds and flowers, mainly in watercolours. Studied with Horlor, and a miniaturist called Booth. Exhib. mainly at Society of Lady Artists, also at International Exhibition 1871.
Bibl: Clayton II pp.371-2.

DUDDING, E.B. fl.1876
Exhib. two landscapes 1876. St. Albans address.

DUDGEON, Miss Dorothea fl.1893
Exhib. one picture of fruit at RA, 1893. London address.

DUDGEON, Miss E. fl.1876
Exhib. one picture, 'Lettie', at SS, 1876. Address near Gravesend, Kent.

DUDGEON, Miss Louisa fl.1861-1868
Leicester still-life painter. Exhib. two watercolours of fruit and birds at SS in 1861 and 1867, also elsewhere.

DUDLEY, Ambrose fl.1890-1900
Exhib. three portraits and a religious subject at RA, 1890-1900. London address.

DUDLEY, Arthur fl.1890-1901
London still-life painter. Exhib. at RA, SS and NWS. Subjects fruit, flowers, birds and fish.

DUDLEY, Robert fl.1865-1891
London painter of coastal scenes, historical and topographical subjects. Exhib. regularly at RA, SS, NWS and elsewhere, but is now very little known. Subjects include views off England and France, also scenes in Venice, North Africa and Spain. Also interiors, e.g. 'The Long Gallery, Haddon Hall'.
Bibl: Brook-Hart.

DUDLEY, Robert Charles fl.1853
Exhib. one picture, 'He Sang the Song of the Shirt', at RA, 1853. London address.

DUDLEY, Thomas fl.1879-1910
Hull painter of landscape and coastal scenes. Exhib. in York and elsewhere 1879-1910. Painted in the north-east, Lake District and Cornwall. Also a drawing master. Examples are in the VAM and the Ferens AG Hull.

DUFF, John Robert Keitley RI RE 1862-1938
London painter of landscape and figure subjects, in oil, watercolour and pastel; also etcher. Studied at Slade School under Legros. Exhib. at RA from 1891, also SS, NWS, RE. Elected RI 1913, ARE 1914, RE 1919. Published *Pastel: A Manual for Beginners*. His subjects were usually pastoral and romantic landscapes, e.g. 'Autumn Pasture', etc., especially with effects of dusk and sunset.

DUFF, Miss Margery F. fl.1884
Exhib. one landscape, 'Covesea, Moray Firth', at RA, 1884. London address. Graves in RA Exhibitors spells her Marjory.

DUFFIELD, Miss C.M. fl.1873-1874
Exhib. two pictures of fruit and flowers at SS, 1873-4. London address .

***DUFFIELD, William 1816-1863**
Still-life painter, born in Bath. At first a self-taught artist, Duffield moved to London and studied under George Lance (q.v.). He also studied in Antwerp for two years with Baron Wappers. Eventually returned to Bath. Specialised in fruit, vegetables, meat, and dead game. Occasionally included figures, mostly portraits of his wife and son. Exhib. only a few works at RA and BI, but preferred SS,

where he exhib. 38 works. Died suddenly aged 47 at the height of his powers. His wife, Mary Ann Rosenberg (q.v.), whom he married in 1850, was a flower painter, and they presumably worked together. William L. Duffield (q.v.), a landscape and figure painter, who exhib. very few works, was probably his son.

Bibl: AJ 1863 p.221 (obit.); Redgrave, Dict; Maas p.174.

DUFFIELD, Mrs. William b.1819 fl.1848-1893
(Miss Mary (Anne?) Rosenberg)
Flower painter and watercolourist. Daughter of the painter Thomas Elliot Rosenberg. Married the still-life painter William Duffield in 1850. Exhib. at the RA, 1857-74, BI, NWS, GG and elsewhere. See also Miss Mary (Anne?) Rosenberg.

Bibl: Clayton II pp.172-3; Who's Who 1913.

DUFFIELD, William L. fl.1873-1880
London painter of landscapes and figure subjects. Exhib. at RA, SS and elsewhere. Subjects highland scenes, and a view in Cairo.

DUFFY, Patrick Vincent RHA 1836-1909
Dublin landscape painter. He studied at the schools of the Royal Dublin Society, and while still a student was elected A of the RHA and three months later full member. In 1871 he was elected keeper of the RHA, a post he held until his death. A good example of his art, 'A Wicklow Common', is in the Irish National Gallery. "His pictures are very unequal in merit", notes the DNB.

Bibl: DNB.

DUFOURCQ, A. fl.1830-1844
Exhib. three Roman subjects at RA, 1830-44. Titles: 'View of a Tile Kiln, Rome', etc., also twice at SS. London address.

DU GUE, Mme. fl.1870
Exhib. one study of a fungus at SS, 1870.

DUGUID, Henry G. fl.1831-1860
Edinburgh drawing master and music teacher. Painted landscapes and old buildings.

DUJARDIN, Miss fl.1827-1861
(Mrs. Meers)
London painter of landscapes and river scenes, especially by moonlight. Exhib. at BI and SS under her maiden and married names. Often painted on the Thames. Probably daughter of John Dujardin (q.v.).

DUJARDIN, John fl.1820-1863
London painter of landscapes and seascapes. A prolific exhibitor at the BI and SS, less often at RA, but now very little known. Painted many views on the Thames and the Medway, and on the coasts of Essex and Kent.

Bibl: Brook-Hart.

DUJARDIN, John, Jnr. fl.1837-1858
London painter of figure subjects and coastal scenes. Exhib. at RA, BI and SS. Titles: 'The Mountain Maid', etc. At the BI he exhib. a view of Greenwich painted with James Webb (q.v.).

Bibl: Brook-Hart.

DUKE, W. Medleycott fl.1888
Exhib. one picture of Venice at SS, 1888. London address.

DUKENFIELD, Mrs. fl.1858
Exhib. one figure picture 1858. London address.

***DUKES, Charles fl.1829-1865**
Landscape and rustic genre painter, working in London 1829-65. Although little known, he exhib. over 100 works at the RA, BI and SS. Subjects cottage or country scenes, and views in Wales and Ireland. Titles at RA 'Interior of an Alehouse', 'Country Courtship', 'A Welsh Peasant Girl'. A work by him is in the Burton Collection, York City AG.

Bibl: AJ 1859 pp.80, 121-2.

DUKESELL, Mrs. Eleanor fl.1862
Exhib. four pictures of fruit at SS, 1862. London address.

DU MAURIER, George Louis Palmella Busson 1834-1896
Artist and cartoonist in black and white, and novelist. Born in Paris, where he was educated. Studied chemistry at University College, London, 1851, and art under Gleyre in Paris, 1856-7, and under De Keyser and Van Lerins at Antwerp, 1857-60. Worked at book illustrations in London, 1860. Contributed occasional drawings to *Punch* in 1860 and joined the staff in 1864 as successor to John Leech and began literary contributions in verse and prose in 1865. Illustrated stories for *Cornhill Magazine*, 1863-83. He published, in the first instance serially, in *Harper's Magazine*, three novels, *Peter Ibbotson*, 1891, *Trilby*, 1894, and *The Martian*, 1896. Trilby was a transcript of his own experiences in the Quartier Latin during his year in Gleyre's studio and contains portraits of T.R. Lamont, Thomas Armstrong and Poynter. It was dramatised and produced at the Haymarket in 1895. His drawings for *Punch* chiefly satirised middle-class society in the spirit of Thackeray, and especially the aesthetic movement.

Bibl: DNB supp. II; Leonee Ormond, *G. Du M.*, 1969, with full bibl.; Staley pp.92-3, 134; Wood, Olympian Dreamers.

DUN, John fl.1872-1884
Edinburgh landscape painter. Exhib. three Scottish scenes at RA 1872-84. Titles: 'Where the Red Deer Drink', etc.

DUNBAR, P. fl.1869-1877
London painter of Scottish landscapes. Exhib. seven pictures at SS 1871-7, and once at RA.

DUNBAR, Lady (Sophia) fl.1863-1875 d.1909
Landscape and topographical watercolourist. Wife of Sir Archibald Dunbar Bt. (m.1840). First exhib. at Society of Female Artists in 1863, later at RA, RSA and elsewhere. She was an energetic traveller, and made drawings and sketches in Algiers, Corsica, Spain, and the South of France. In Algiers she met Mme. Bodichon (q.v.) who became a great friend, and an influence on her style. In Seville she met and travelled with E.W. Cooke and John Phillip (qq.v.).

Bibl: Clayton II pp.373-93.

DUNBAR, W. fl.1834-1845
Exhib. two pictures at SS, and one at NWS. Titles: 'Still Life' and 'King's Somborne Church, Hants', both watercolours. Address Andover, Hampshire.

DUNBAR, W.J. fl.1845
Exhib. one watercolour of Stonehenge at SS, 1845. London address.

DUNBAR, W.N. fl.1839
Exhib. four pictures at SS, two views near Rome, and two biblical subjects. Lived in London and Rome.

DUNCAN, Alexander fl.1853-1862
London painter of figure subjects and children. Exhib. at BI, SS and elsewhere. Titles: 'The Orange Seller', etc.

DUNCAN, Allan fl.1854-1887
London painter of landscapes and seascapes; son of Edward Duncan (q.v.). A prolific exhibitor at RA, SS, NWS and elsewhere. Subjects English scenes, especially views on the Thames and the English coasts, also landscapes in Wales. Most of his 41 exhibits at SS were watercolours.
Bibl: Clement & Hutton.

DUNCAN, Miss C. fl.1859
Exhib. one picture, 'A Study from Nature', at RA, 1859.

DUNCAN, E.G. fl.1892
Exhib. one figure picture at NG, 1892. London address.

***DUNCAN, Edward RWS 1803-1882**
London marine painter and watercolourist. Began his career as a copyist and engraver in the studio of Robert and William Havell. Set up his own engraving business, working mainly for Fores of Piccadilly on sporting subjects and for William Huggins on shipping subjects. After marrying Huggins's daughter, he branched out as a marine painter. Most of his marine works are in fact coastal and port scenes, as Duncan did not have enough knowledge of the sea to paint pure marine pictures. He also continued to paint landscapes and animals. Although he exhib. about 40 works at the RA, BI and SS, he was a far more frequent exhibitor at the OWS and NWS, where he exhibited over 500 watercolours and drawings. A prolific, competent, if uninspired artist. Hardie rates him as "a painstaking, skilful painter of a class below Stanfield, Chambers and Bentley".
Bibl: AJ 1882 p.159; 1883 p.400; Hardie III pp.75-6; Maas pp.48, 64; Brook-Hart p.93 (colour pl.28).

DUNCAN, Miss Emily fl.1880-1904
London painter of flowers and figure subjects. Exhib. at RA and SS. Titles: 'A Boathouse on the River', etc.

DUNCAN, Miss Fanny fl.1876-1889
Painter of landscapes and figure subjects. Exhib. at RA 1876-89 and elsewhere. Titles: 'Ploughing', 'Apres le Déjeuner', etc. Lived in Manchester and Paris.

DUNCAN, J.E. fl.1875
Exhib. one watercolour, 'Banks of the Itchen, Southampton', at SS, 1875. Southampton address.

DUNCAN, John McKirdy RSA RSW 1866-1945
Scottish painter of landscape, genre and historical subjects, in oil, tempera and watercolour; also mural decorator and stained glass designer. Studied in London, Antwerp and Düsseldorf; exhib. at RA from 1893. Elected ARSA 1910, RSA 1923, RSW 1930.
Bibl: Caw pp.412-13; Irwin passim (pl.204).

DUNCAN, Lawrence fl.1860-1891
London painter of landscapes and rustic scenes. Exhib. mainly at RA 1861-90, also SS and elsewhere. Titles: 'Music by the Sea', etc. Often painted in Brittany. Son of Edward Duncan (q.v.).

DUNCAN, Thomas ARA RSA 1807-1845
Scottish historical and portrait painter. Studied at Trustees' Academy in Edinburgh under William Allan. Exhib. at RA 1836-46; elected ARA and RSA 1843; in 1846 headmaster of the Trustees' Academy. Took his subjects mostly from Scottish history, especially the '45 Rebellion. Although his style and subjects are typical of his period, Duncan painted with remarkable freedom of technique, and strong sense of colour. His promising career was cut short by his early death at the age of 38.
Bibl: AU 1847 p.380; Portfolio 1887 p.179; Redgrave, Dict.; Caw pp.110-12; Ormond I pp.113, 128; Irwin pp.213-15 et passim (pl.91).

DUNCAN, Walter ARWS 1851-1932
London painter and watercolourist; son of Edward Duncan (q.v.). Exhib. prolifically at OWS, also RA, SS, NWS, GG, NG and elsewhere. Subjects mostly coastal scenes and seascapes, but also poetic and historical, e.g. 'Undine's Farewell', 'Jephthah's Daughter', etc. Elected ARWS, but according to Hardie left the Society "under a cloud".
Bibl: Clement & Hutton; Hardie p.76.

DUNCUMB, Miss E. fl.1829-1843
Painter of fruit and flowers. Exhib. at RA, SS and NWS. Lived at West Ham, Essex.

DUNDAS, Miss Agnes fl.1863-1873
London painter of dogs, birds, still-life and other animal subjects. Exhib. at RA, BI, SS and elsewhere. For a time a prolific artist, exhibiting over fifty pictures in only ten years.

DUNDAS, James fl.1846-1868
Painted landscapes and figure studies in England and on the Continent 1846-68.

DUNDEE, Captain fl.1818-1854
Landscape painter. An honorary exhibitor at the RA, where he showed five pictures, views in England, France and Germany. Recorded as living in Augsburg.

DUNLOP, Miss Wallace fl.1871
Exhib. one domestic subject, 1871. London address.

DUNN, Miss Constance fl.1883-1884
Exhib. one picture of roses at SS, 1883-4. London address.

DUNN, Miss Edith see HUME, Mrs. T.O.

DUNN, Henry Treffry 1838-1899
Pre-Raphaelite painter, and studio assistant to D.G. Rossetti (q.v.) for 20 years. Born in Truro, Cornwall. Studied at Heatherley's. Recommended as assistant to Rossetti by Howell. Produced replicas, and also assisted Rossetti on many of his pictures. When Rossetti became ill and lived mostly out of London, Dunn became his general factotum at Cheyne Walk. After Rossetti's death, Dunn's career ran downhill into poverty and alcoholism, but he was rescued by the charitable Clara Watts-Dunton, who looked after him at The Pines in Putney, as she had previously looked after Swinburne. Although Dunn is mentioned in most books on Rossetti, the most complete account of his career is Life with Rossetti by Gale Pedrick.
Bibl: Gale Pedrick, Life with Rossetti, 1964; Fredeman, see index; see also references in Rossetti literature.

DUNN, John fl.1872
Exhib. one domestic subject 1872. London address.

DUNNE, Isaac fl.1881
Birmingham landscape painter. Exhib. three pictures in London in 1881.

DUNNING, Miss Agnes fl.1890
Exhib. one picture of poppies at SS, 1890. Address Streatham, London.

DUNNING, John Thomson RBA 1851-1931
Painter of landscapes and figure subjects. Born in Middlesbrough; studied at Heatherley's and in Exeter. Settled and exhib. at RA, SS and NWS. Titles: 'Early Spring', etc. Elected RBA 1899.

DU NOYER, George Victor 1817-1869
Topographical draughtsman. Exhib. at RHA 1841-63. Worked for the Ordnance Survey, the Geological Survey, and also taught drawing.

DUNSMORE, John Ward fl.1884-1888
Painter of figure subjects. Exhib. at SS and elsewhere. Titles: 'A Perplexing Point', etc., and some historical subjects. Lived at Blackheath, London.

DUPEUX, Joseph fl.1835-1839
London painter of interiors. Exhib. at RA and SS. Subjects all interiors or ruins.

DUPPA, Bryan Edward fl.1832-1853
London portrait painter. Exhib. at RA, BI and SS. Also painted some figure subjects, e.g. 'The Sketch Book'. Painted Landseer and Sir John Bowring (see bibl.).
Bibl: Ormond I pp.47, 257.

DUPRÉ, Mrs. S. fl.1843
Exhib. one picture, 'An Infant Bacchus', at BI 1843. London address. Probably the same as Miss S. Dupuy (q.v.).

DUPUIS, Philippe Felix fl.1874-1882
London portrait painter. Exhib. at RA, SS and GG. Among his sitters was Lord Leighton. Also exhib. one military subject.

DUPUY, Miss S. fl.1847
Exhib. one picture, 'Evening', at BI 1847. Probably the same as Mrs. S. Dupré (q.v.).

DURAND, Godfrey fl.1873-1877
Exhib. one watercolour of 'The Siege of Paris' 1871 at SS 1873, also elsewhere. London address.

D'URBAN, William fl.1886-1888
Exhib. one landscape, 'The Way to the Wood', at SS 1888, also at NC and elsewhere. Lived at Bushey, Hertfordshire.

DURELL, A.C. fl.1882
Exhib. one fruit picture 1882. London address.

DURELL, Miss Amy fl.1889-1890
Exhib. one portrait at RA, 1890. London address.

DURHAM, Mrs. C.B. fl.1868-1870
Flower painter, wife of Cornelius B. Durham, a miniaturist. Exhib. two watercolours of orchids at SS.

DURHAM, C.J. fl.1859-1880
London painter of figure subjects. Exhib. mainly at SS, also once at RA, and elsewhere. Titles: 'Day Dreams', etc.

DURHAM, Miss Mary Edith 1863-1944
London painter of portraits, figure subjects and animals; also an illustrator. Studied at RA schools. Exhib. at RA, NWS, and ROI. Titles: 'The Decrees of Fate', etc. Also travelled widely, and published several books about the Balkans.

DURNFORD, F. Andrew fl.1836-1886
London painter of river and coastal scenes. Exhib. regularly at RA, BI, SS and elsewhere. Painted off the coasts of England, France and Holland.
Bibl: Brook-Hart.

DURNFORD, Miss Lucy fl.1858-1859
Exhib. two pictures of fruit, flowers and birds at SS, 1858-9. London address.

DURRANI, B. fl.1880
Exhib. one portrait at RA, 1880. Address Streatham, London.

DURRANT, Miss G. fl.1866
Exhib. one picture of a pug dog at RA, 1866. Address Newbury, Berkshire.

DUTHIE, Spottiswoode fl.1892-1912
Exhib. two domestic subjects at SS 1892, one entitled 'Meditation'. Also exhib. figurative subjects at RA, SS and RSA. Lived at Udney, Aberdeenshire.

DUTHOIT, Miss Elizabeth Emma fl.1885
Exhib. one landscape at NWS, 1885. London address.

DUTHOIT, J. fl.1874
Exhib. one landscape, 'At Sevenoaks, Kent', at RA, 1874. London address.

DUTTON, John Frederick Harrison fl.1893-1909
Chester painter of portraits and figure subjects. Exh. at RA, RCA and elsewhere.

DUTTON, Miss Mary Martha see PEARSON, Mrs. Charles

DUTTON, Thomas Goldsworth fl.1845-1879 d.1891
London painter of shipping scenes and ship portraits; also lithographer. Exhib. at SS only 1858-79. Subjects often the coasts of Devon and Cornwall.
Bibl: Brook-Hart p.19 (pl.49).

DUTTON, W.E. fl.1854-1857
London painter of figure subjects. Exhib. once at RA and twice at BI. Titles: 'The Babes in the Wood', etc.

DUTURCQ, Mme. fl.1872
Exhib. one watercolour of flowers at SS 1872. London address. Presumably wife of T. Duturcq.

DUTURCQ, T. fl.1872
Exhib. one picture, 'Sea-Fog, Boulogne', at SS, 1872. London address.

DUVAL, A. fl.1873
Exhib. one still-life picture at SS, 1873. London address.

DUVAL, Charles Allen 1808-1872
Portrait and historical genre painter, born in Ireland, worked mainly in Manchester. Exhib. 20 works at RA 1836-72, mostly portraits, also some religious and historical genre. Titles: 'Columbus in

Chains', 'The Dedication of Samuel to the Lord', 'Moonlight on the Sea'. Did several group portraits — one containing one hundred portraits of the leading Wesleyans in the U.K., another is of the chief members of the Anti-Corn Law League. One of his best known works is 'The Ruined Gamester', which was engraved and became so popular that a cartoon in *Punch*, caricaturing Sir Robert Peel, was drawn from it.

Bibl: Redgrave, Dict; DNB; Ormond I.

DUVAL, E. fl.1857-1869
Exhib. one picture, 'After a Storm', at RA 1869, and two views near Albano at BI. London address.

DUVAL, Edward J. fl.1876-1901
Manchester painter of seascapes, coast scenes and landscapes. Exhib. at RA, SS and elsewhere. Titles: 'Where Wave Meets Wave', etc.

DUVAL, J.C.A. fl.1826-1856
London painter of coastal scenes. A regular exhibitor at RA, BI, SS and elsewhere. Painted off the Thames, Kent, Yorkshire, and in France.
Bibl: Brook-Hart.

DUVAL, John fl.1834-1881
Ipswich animal and sporting painter, working 1834-81. Exhib. 77 works, 49 of them at the SS. Titles at RA 'Lambing Time', 'Shooting Pony and Setters', 'The Master's Cob'.
Bibl: H.A.E. Day, *East Anglian Painters*, I pp.153-67.

DUVAL, Marie fl.c.1874
(Isabelle Emilie De Tessier)
Cartoonist and illustrator. Her real name was De Tessier, and the name Marie Duval only a *nom de plume*. Her profession was that of actress, but she also drew caricatures for various journals, and also humorous drawings for books.
Bibl: Clayton II pp.330-3.

DUVALL, John 1816-1892
Ipswich painter of landscapes, sporting and rustic subjects. Exhib. at RA and BI, but more often at SS. Titles: 'The Keeper's Daughter', etc. His style and subject-matter are similar to the other Ipswich painters E.R. and Thomas Smythe.
Bibl: H.A.E. Day, *East Anglian Painters*, I pp.155-67.

DUVALL, Thomas George fl.1840-1879
London historical and landscape painter. Exhib. at RA, SS and elsewhere. Titles: 'The Charity of King Canute the Great', etc., and other figure subjects, 'Cottage Industry', etc.

DYASON, E.H. fl.1885-1886
Exhib. three watercolour landscapes at SS 1885-6. Titles: 'The Path through the Woods', etc. Address Worthing, Sussex.
Bibl: Brook-Hart p.79 (pl.151).

DYCE, J. Stirling fl.1884-1891
Landscape painter. Exhib. five pictures at RA 1884-91. Subjects views in Scotland or France. Lived in Paris, Henley and London.

***DYCE, William RA HRSA 1806-1864**
Scottish painter and decorator. Son of an Aberdeen doctor, he studied art against his father's will. Sir Thomas Lawrence was so impressed with his talent that he persuaded Dyce to take up painting professionally. He made several trips to Rome, where he was deeply impressed with the aims and ideals of the Nazarenes Overbeck and Cornelius, and also by Italian Renaissance painting. These influences persisted throughout his career. He painted portraits and religious subjects, and several fresco cycles in the

House of Lords, Lambeth Palace, Buckingham Palace, Osborne House, and several churches. He was one of the few artists to sympathise with the Pre-Raphaelites. His own works, such as 'Pegwell Bay', and 'Titian's First Essay in Colour' show PRB influence in the realistic detail and bright colours. The latter picture drew praise from Ruskin in 1857: "Well done, Mr. Dyce! and many times well done!" As he was kept busy by public duties in Government Schools, he did not exhibit a great many pictures. Most were exhibited at the RA and RSA and some at the BI. His style is highly individual, a blend of Nazarene and Pre-Raphaelite ideas, and is always characterised by an innate religious feeling. His studio sale was held at Christie's, 5 May 1865.

Bibl: AJ 1860 p.293; 1864 pp.90, 113, 153, 320, 321; 1865 pp.333-4; Redgrave, Cent; DNB: Caw pp.128-35 (pl.l.p.132);Dyce Centenary exhib., Aberdeen AG 1964; Reynolds, VS pp.23, 66-7 (pl.33); Reynolds, VP pp.37-8 *et passim* (pls.31-2); Fredeman see index; Maas pp.25-6 *et passim* (pls. pp.25, 135-6, 237); Staley pp.162-9 *et passim* (pls. 90a-96b); Ormond I p.165: Irwin pp.244-62, 317-18 *et passim* (pls. IV, 223-8, figs. 6,10); Strong; Wood, Pre-Raphaelites.

DYER, Charles G. fl.1880
Exhib. one picture, 'The Student', at RA, 1880. Munich address.

DYER, Miss Gertrude M. fl.1891-1893
Exhib. two watercolours of flowers at NWS, 1891-3. Address Leatherhead, Surrey.

DYER, Lowell fl.1890
Exhib. one interior at GG, 1890. Address St. Ives, Cornwall.

DYER, Wilson fl.1852-1855
Manchester painter of figure subjects. Exhib. three times at BI and once at SS. Titles: 'The Sleepy Boy', 'Mariana', etc.

DYKE, Miss Eleanor Hart- fl.1867-1892
Exhib. three landscapes at NWS, and once elsewhere 1867-92. Address Eynsford.

DYKE, R.H. fl.1856-1867
London painter of coastal scenes and landscapes. Exhib. three pictures at BI and two at SS. Titles: 'Sea-Shore, Bognor', etc.
Bibl: Brook-Hart.

EAGLE, W. fl.1866
Exhib. one picture, 'The Stolen Kiss', at the BI, 1866. London address.

EAGLES, Edmund fl.1851-1877
Painted genre and literary subjects. Exhib. at RA 1851-75, including a scene from Hamlet and 'Mischievous'. London address.

EAGLES, Rev. John 1783-1855
An amateur painter of landscape as well as a connoisseur of art. Exhib. various landscapes at the BI, 1814-52. He was not permitted to join the OWS, because he was an amateur. He lived in Bristol, and was a member of Danby's Sketching Club.
Bibl: Roget I p.435; Redgrave, Dict. p.135; J. Fawcett, *The Rise of English Provincial Art*, 1974 pp.185-6; *The Bristol School of Artists*, Cat. of exhib., Bristol AG, pp.243-9.

EALES, Miss M. fl.1877
Exhib. a portrait of Lady Magdalen Yorke at the RA, 1877. London address.

EAMONSON, S. fl.1852-1857
Exhib. two landscapes at the RA in 1855 and 1857. Homerton, Cambridgeshire, address.

EARL, F. see EARLE, F.

***EARL, George 1824-1908**
London sporting and animal painter. Exhib. at RA 1857-83, also at the BI and SS. Titles at RA 'Deer Stalkers Returning', 'Polo Match at Hurlingham', 'Finding the Stag', 'Grouse Driving on Bowes Moor, Yorkshire'. Also painted two outstanding railway platform pictures, 'King's Cross — Going North' and 'Perth Station — Coming South', now in the Railway Museum, York. His daughter Maud Earl (q.v.) was also an animal painter, as was his brother Thomas William and his son Thomas Percy (qq.v.).

***EARL, Miss Maud 1863-1943**
London animal painter; specialised in sentimental or dramatised pictures of dogs. Exhib. at the RA 1884-1901, and once at SS. Titles at RA 'Old Benchers', 'The Dog of War', 'Dogs of Death', etc. Painted Queen Victoria's and Edward VII's dogs, and many pedigree and prize-winning dogs. Her work very popular through engravings. Twelve of her compositions were engraved in 1908 for 'The Sportman's Year'. Her father was George Earl (q.v.) the sporting painter.
Bibl: Who's Who 1914.

EARL, Thomas Percy 1874-1947
Painter of racehorses, and other animals. Usually signed his pictures T.P. Earl, or T. Earl. A member of the Earl family of artists.

EARL, Thomas William fl.1836-1885
London animal painter; specialised in dogs and rabbits. Exhibited at the RA 1840-80, also at the BI and SS, where he exhibited over 100 works. Titles at RA 'Cat and Dog Life', 'The Dream of the Hound', 'The Rabbit Family', etc. Occasionally painted the animals in Henry Bright's landscapes. Brother of George Earl (q.v.).

EARL, William Robert fl.1823-1867
London landscape painter. Exhib. at RA 1823-54, but more frequently at the BI and SS. Subjects mainly views of Sussex, the Isle of Wight, and other places on the English coast. Also travelled in Germany and along the Rhine.
Bibl: Brook-Hart.

EARLE, Augustus fl.1806-1838
Painter of historical subjects, landscapes and marine subjects. Exhib. at the RA, 1806-38, including 'Divine Service as it is usually performed on Board a British Frigate at Sea'. London address.
Bibl: Redgrave, Dict. p.135; Bunyon; Bryan.

EARLE, Mrs. C.W. (Maria Theresa) fl.1878-1880
Exhib. six landscapes 1878-80. London address. This is possibly the author of *Pot-Pourri from a Surrey Garden*, a very popular book in its day.

EARLE, Charles RI 1832-1893
London landscape painter and watercolourist. Exhib. at RA 1857-90, also at SS and NWS. Subjects mainly views in England and Wales; also travelled in Germany and Italy. Elected RI 1882.

EARLE, F. fl.1839
Exhib. two pictures: 'Portrait of a Spaniel, the property of Greville Berkeley, Esq.', and a study of an old woman, at the RA in 1839. London address.

EARLE, J.H. fl.1842-1845
Exhib. five pictures at SS, 1842-4, including 'A Monk at his Devotions' and 'View in Normandy'. London address.

EARLE, Miss Kate fl.1887-1903
Painted country genre and coastal scenes. Exhib. five times at SS, 1887-94, including 'Waiting for the Tide'' and 'The Gardener's Daughter'. Kensington, London, address.

EARLES, Chester fl.1842-1863
London portrait painter. Also painted literary subjects from Spencer, Shakespeare and Keats, and genre scenes. Exhib. 56 works at the RA, 1844-63, and 56 at SS, 1842-63. London address.

EARNSHAW, Mrs. Mary Harriot fl.1888-1896
Exhib. three pictures, including a pastel: 'Two Kitties', and a watercolour: 'An Amusing Story', at SS 1888-9. London address.

EARP, Henry 1831-1914
Landscape and animal painter. Exhib. four landscapes at SS 1871-2. Brighton address. Other members of the Brighton family of Earps who painted include Frederick Earp (1828-1914), Edwin Earp (active c.1900), George Earp (active c.1874), Vernon Earp (active c.1900), and William Henry Earp. All were prolific painters of landscapes and coastal scenes.

***EAST, Sir Alfred RA RI PRBA RPE 1849-1913**
Landscape painter and watercolourist. Born Kettering, Northamptonshire. Studied at Glasgow School of Art, then in Paris under Tony Fleury and Bougereau. Settled in London about 1883. One of the earliest members of the Society of Painters-Etchers. Elected ARA 1899 President of the RBA 1906, knighted 1910, RA 1913. Exhib. at RA from 1883, also at BI and NWS. Travelled in Japan, France, Spain, Italy and Morocco. Landscape style much influenced by the Barbizon painters, Corot, Daubigny and Rousseau, particularly in his use of distinctive pale browns and greens. His landscapes are generally romantic and idealised, but carefully composed, as East believed in applying the principles of decorative design to landscape. In his day East enjoyed a great reputation, but since his death has been completely neglected. Recently there have been signs of a revival of interest in his work. Many of his works can be seen in Kettering AG.
Bibl: Who's Who 1913; Chronique des Arts 1913 p.225 (obit.); Studio VII 1896 pp.133-42; XXXVII, pp.96-102; and General Index; Hardie III p.163; VAM; Connoisseur XXXVII 1913 p.186ff.; RA Pictures 1891-1913.
Exhib: London, Nico Jungmann Gallery 1911.

EAST, Mary fl.1873
Exhib. two watercolours, 'A Dead Duck' and 'Wild Flowers and Nest', at SS, 1873-4. Newcastle, Northumberland, address.

EAST, William H. fl.1891
Exhib. one picture, 'Meditation', at the RA in 1891. Dover, Kent, address.

EASTLAKE, Mrs. see BELL, Miss Mary A.

EASTLAKE, Caroline H. fl.1868-1873
Exhib. flower paintings, 1868-73. Plymouth address.

EASTLAKE, Charles Herbert RBA fl.1889-c.1930
Landscape painter. Studied in Antwerp and Paris. Exhib. at the RA, 1892-1900, and SS, 1889-92. Worked in France and England. Lived in Balham, London.
Bibl: Studio XXXVI p.72; XXXVIII pp.119-24.

***EASTLAKE, Sir Charles Lock PRA 1793-1865**
Painter of biblical scenes, Italian genre, historical genre and portraits; writer and critic. Born Plymouth; studied under Prout and at RA schools. Returned to Plymouth as portrait painter, his most famous sitter being Napoleon, who was brought into port on the *Bellerophon*. Settled in Rome 1818-30, where he painted many of his best works, e.g. 'Pilgrims Arriving in Sight of Rome', 1828. Elected ARA 1827, RA 1830. Exhib. RA 1823-55, also BI. After his return to London in 1830, official duties gradually forced him to give up painting. He was secretary to the Royal Commission for the Decoration of the Houses of Parliament, PRA 1850, and from 1855-65 Director of the Nat. Gall. Eastlake's biblical and historical works tend to be rather dry and academic; his Italian genre subjects are undoubtedly his best. Dubbed 'Archbishop Eastlake' he ranked sixth in Thackeray's Order of Merit (*Fraser's Magazine*, 1838). His studio sale was held at Christie's, 14 December 1868. Manuscripts relating to this artist are held by the VAM.
Bibl: Lady Eastlake, *A Memoir of Sir Charles L. Eastlake*, 1870 (a contribution to Eastlake, Sir Charles Lock, contributions to the literature of the Fine Arts); W. Cosmo Monkhouse, *Pictures by Sir Ch. L. Eastlake*, with a biographical sketch 1875; DNB; Redgrave, Dict., Cent.; AJ 1855 p.277ff.; 1866, p.60 (obit.); Reynolds, VP pp.35, 37, 38, 61, 119, 151; Staley pp.2, 3; D. Robertson, *Sir C.E. and the Victorian Art World*, 1978.
Exhib: London, Drake's Little Gallery c.1925; Plymouth, City AG 1965.

EASTLAKE, Miss Elizabeth R. fl.1874-1888
Exhib. one picture, 'The Thoughts of Youth are long, long Thoughts', at the RA, 1883. Plymouth, Devon, address.

EASTLAKE, W. fl.1870-1877
Exhib. two landscapes, 'On Roborough Downs, Devon' and 'A Hayfield', at the RA in 1872 and 1877. Devon address.

EASTWOOD, Francis H. fl.1875-1902
Watercolourist of landscape and architectural subjects. Exhib. RA, 1878-1902, and SS, 1875-85, including 'On the Uplands', 'Florence from San Miniato' and 'A Street in Algiers'. London address.

EASTWOOD, Walter 1867-1943
Lancashire painter. Lived at Lytham St. Annes, where he was first President of the Art Society.

EATON, Miss Ellen M.M. fl.1897-1950
Exhib. a picture, 'Steamer on the Medway', at the RA in 1897. The main body of her work is later in date. Kensington, London, address.

EATON, G.C.
Painted a portrait of Alfred Stevens.
Bibl: Ormond I p.431; K.R. Towndrow, *Alfred Stevens*, see index (pl. of Alfred Stevens facing p.214).

EATON, George fl.1862-1870
Exhib. two landscapes, 'The Plumstead Marshes' and 'The Confluence of the Bure and the Yare, Great Yarmouth', at the RA in 1867 and 1868, and two others at SS in 1862 and 1870. Norwich address.

EATON, Stephen O. fl.1889
Exhib. three landscapes, 'Hampstead', 'Down by the Riverside' and 'Poppies', at the RA in 1889. London address.

EATON, W.P. fl.1884
Exhib. one picture in 1884. Weymouth, Dorset, address.

EBNER, Lewis F. (or Lewis) fl.1888-1890
Exhib. one picture, 'Fire in a Village', at the RA in 1890; also exhib. twice at the GG. London address.

EBURNE, Miss Emma see OLIVER, Mrs. William

ECCLES, J. Evans fl.1881-1883
Exhib. one picture, 'Zingaretna', at the RA in 1883, and two landscapes at SS in 1881. Chelsea, London, address.

EDDINGTON, William Charles fl.1861-1865
Landscape watercolourist. Frequently drew the scenery of the Welsh mountains. Exhib. at the RA, 1861-81, and SS, 1862-75. 'Near Dinas Crag on the Holyhead Road, North Wales' is in VAM.

EDDIS, Eden Upton 1812-1901
Portrait painter; worked in London, and after 1886 at Shalford, near Guildford. Exhib. over 100 works at the RA between 1834 and 1883; also a few at BI and SS. Painted occasional landscapes and biblical scenes. Among his many sitters were Sir Francis Chantrey, Lord Macaulay, Lord Coleridge, and many other public figures of the day. Many of his portraits were engraved.
Bibl: Bryan; Waagen, *Galleries and Cabinets of Art in Great Britain* I p.144ff.; BM Cat. of Engraved British Portraits, I-III; NPG Cat. II 1902; DNB 2 Supp. I p.545; Ormond.

EDDISON, Sam fl.1891-1892
Exhib. two portraits at the RA in 1891 and 1892. Leeds address.

EDELSTEN, Miss A.J. fl.1878
Exhib. a watercolour, 'Autumn Leaves and Berries', at SS in 1878. London address.

EDEN, Sir William, Bt. 1849-1915
Distinguished amateur watercolourist who worked in Egypt, India, Japan and America as well as in England. Exhib. at the Paris Salon, and in London, at the Goupil, New English and Old Dudley galleries, and at the NWS of which he became president. He was provoked by James McNeill Whistler (q.v.) and, having accused Whistler of libel, became involved in the court case which Whistler was to describe in *The Baronet and the Butterfly*. Eden lived at Windlestone, Co. Durham, where he was a noted landowner and sportsman.
Bibl: J.A. McN. Whistler, *Eden versus Whistler, the Baronet and the Butterfly: A Valentine with a Verdict*, Paris, 1899; Sir Timothy Eden, Bt., *The Tribulations of a Baronet* (Sir William Eden), 1933, reprd. in paperback 1990; AJ 1905 p.120; 1906 p.286; 1908 pp.220, 223; Who's Who 1914; Hall p.29.

EDEN, William fl.1866-1898
Landscape painter; worked in Liverpool, and later in London. Exhib. RA, SS and NWS. Subjects all English views, but appears

to have travelled in Germany. Titles at RA 'Flatford Mill', 'Staffordshire Uplands', 'Walberswick Pier'. Often confused with the watercolourist Sir Wllliam Eden. His son William Denis Eden was also a painter (q.v.).

EDEN, William Denis 1878-1949
Painter of genre and historical subjects. Studied under F.G. Stephens. Later attended the RA Schools. Exhib. at RA, 1900-3, including 'The Prioress's Tale' and ' "He who Defers His Work From Day to Day" ', etc. The son of William Eden (q.v.). London address.

EDGAR, James H. fl.1860-1870
Liverpool portrait and genre painter. Exhib. a small number of pictures at the RA, BI and SS. Title at the BI 'The Spinning Wheel — a Galway Interior'. 'The Wreath Maker" sold Sotheby's, 23 May 1973.

EDGELOW, Alice Maud fl.1889
Exhib. a picture of a head in 1889. London address.

EDGINGTON, E.W. fl.1887-1888
Exhib. a landscape, 'A Winter Afternoon', at the RA in 1888, and two landscapes at SS in 1887-8. London address.

EDGINGTON-WILLIAMS, Miss E.
see WILLAMS, Edgington-, Miss E.

EDINGER, W.H. fl.1892
Exhib. one landscape at the NWS in 1892. Wanstead address.

EDMONDS, Miss Anna Maria fl.1867
(Mrs. William Collings Lubis Guerin)
Exhib. one painting, 'The Lumberer's Shanty', at the RA in 1867. Lived in Rome. See also Mrs. Guerin.

EDMONDS, Mrs. C. (E.) fl.1900
Exhib. one landscape, 'Cottages — St. Minver, North Cornwall', at the RA in 1900. Exeter, Devon, address.

EDMONDS, E.M. fl.1872-1893
Exhib. three landscape watercolours at SS, 1872-4, and also at the NG. Kendal address.

EDMONDS, F.W. fl.1845
Exhib. one picture, 'The Image Dealer', at the RA in 1845.

EDMONDS, Miss Lilian fl.1896-1903
Exhib. at the RA, 1896-1903, subjects including 'Portrait of the Artist' and 'Vauxhall Bridge — Evening'. London address.

EDMONDSON, Robert Holt fl.1870-1885
Exhib. two landscapes, 'Signs of Winter' and 'Off the Coast of Donegal', at the RA in 1870 and 1885. Manchester address.

EDMONSTON, Samuel 1825-1906
Scottish painter of landscapes, seascapes, portraits and scenes of Scottish life, usually humerous or pathetic. Exhib. at RSA, and RA in 1862 and 1864. Lived in Edinburgh, where he studied as the RSA schools under Sir W. Allan and Thomas Duncan. 'The Volunteers' was sold at Christie's, 24 October 1974, lot 68.
Bibl: Clement & Hutton.

EDRINGTON, Miss Amy fl.1898-1901
Exhib. a portrait and a picture called 'Kitty' at the RA in 1898 and 1901. Fulham, London, address.

EDSON, Allan fl.1886
Exhib. two landscapes at the RA and two watercolours, including a view in Yellowstone Park, at SS, in 1886. Maida Vale, London, address.

EDWARD, Albert fl.1885-1886
Exhib. two views of Venice at the NWS in 1885-6. London address.

EDWARD, Alfred S. RBA 1852-1915
Painter of landscapes, seascapes and coastal scenes, mostly of Scotland. Exhib. at the RA, 1879-1900, including 'The Cold Grey Sea' and 'A Lone Shore', and at SS, 1876-94. Lived at Puckeridge, Cambridgeshire.
Bibl: AJ 1903 pp.286-7; Who's Who 1914; Brook-Hart.

EDWARD, C. fl.1884
Exhib. two paintings, 'Winter Fuel' and 'A Cambridgeshire Farmyard', at the RA in 1884. London address.

EDWARDS, Lieutenant
Made a watercolour portrait drawing of Sir Charles James Napier (reprd. R. Lawrence, *Charles Napier*, 1952, facing p.109).
Bibl: Ormond.

EDWARDS, A. fl.1874-1876
Exhib. two landscapes at SS, 1874-6. London address.

EDWARDS, Miss A.G. fl.1893
Exhib. one painting of fruit at the NWS in 1893. London address.

EDWARDS, Miss Amelia B. fl.1858-1863
Exhib. three watercolours, 'A Campagna Landscape', 'View of Venice', and 'View in North Wales', at SS, 1858-60. London address. Manuscripts relating to this artist are held at the VAM.

EDWARDS, Miss Catherine Adelaide see SPARKES, Mrs. J.

EDWARDS, Miss E.E. fl.1868
Exhib. one portrait at the RA in 1868. London address.

EDWARDS, Edwin 1823-1879
Landscape painter and etcher; lived in Sunbury and London. Exhib. RA 1861-79. Subjects mainly views in the south of England, especially Devon and Cornwall. Under the influence of Legros, Whistler, Fantin and Jacquemart he turned mainly to etching. Press cuttings relating to this artist are held at VAM.
Bibl: Beraldi, *Graveurs du 19 siècle*, VI 1886; Tate Cat.; Portfolio 1872.

EDWARDS, Ellin H. fl.1879-1880
Exhib. one still-life painting at SS, 1879-80. London address.

EDWARDS, F. fl.1868-1869
Exhib. two pictures, 'Nell Gwynne' and 'The Student', at SS in 1868 and 1869. Camden Town, London, address.

EDWARDS, G.H. fl.1837-1847
Painter of landscape and churches. Exhib. at the RA, 1837-46, two views of Westminster Abbey and one of Crowland Abbey. Exhib. four times at SS, 1840-7.

EDWARDS, George Hay fl.1900
Exhib. one picture, 'View of Richmond, Yorkshire', at the RA in 1900. London address.

EDWARDS, George Henry fl.1883-1900
Exhib. at the RA, 1896-1900 and at SS, 1883-93, subjects including 'The Spirit of the Marsh', 'St. Valentine's Day' and 'A Wood Nymph'. London address.
Bibl: Studio XXXII p.288.

EDWARDS, James fl.1868
Exhib. two landscapes in 1868. Lived in Nottingham. 'Robbers' Mill, Nottingham' is in the VAM.

EDWARDS, Miss Jessie A. fl.1864-1879
Watercolourist. Titles include: 'War Tidings', 'Puritan Pleasures', 'Caught in the Lane' and 'A Tempting Bait'. Exhib. 17 times at SS, 1864-79. Chelsea, London, address.

EDWARDS, Kate J. fl.1879
Exhib. one watercolour, 'Caught', at SS in 1879. Fulham, London, address.

EDWARDS, Miss Louisa fl.1884-1886
Exhib. four paintings at SS, 1884-6, two of which were of flowers. South Kensington, London, address.

EDWARDS, Miss Marian fl.1875-1877
Exhib. two pictures at RA: 'On the Common, Leytonstone', 1876 and 'On the Common', 1877. Leytonstone address.

EDWARDS, Miss Mary Ellen see STAPLES, Mrs. John C.

EDWARDS, Miss Mia fl.1893-1900
(Mrs. A. Brown)
Exhib. five paintings at the RA, 1893-1900, including: 'Once upon a Time', 'In the Wood' and 'Midsummer Morning'. Abergavenny, Wales, address.

EDWARDS, T.W. fl.1847
Exhib. one painting, 'View of the West Front of Lichfield Cathedral', at the RA in 1847. London address.

EDWARDS, W. fl.1860
Exhib. one picture, 'Benfleet Church, Essex' at the BI in 1860. London address.

EDWARDS, W.H. fl.1793-1850
London flower painter. Exhib. at the RA, 1793-1841, and at SS, 1840-4.
Bibl: W.H. Edwards, *The Young Artist's Guide to Flower Drawing, and Painting in Watercolours*, London, 1820.

EDWARDS, Mrs. W.H. fl.1847
Exhib. a painting, 'Fruit', at the RA and a watercolour, 'Fruit and Flowers from Nature', at SS, both in 1847.

EDWARDS, W. Croxford fl.1874-1878
Painter of landscapes, seascapes and coastal scenes. Exhib. mainly at SS 1872-6 (sometimes signing as W.E. Croxford), e.g. 'Fishing Smacks — North Sea' and 'On the Beach — Hastings'. Once, in 1878 at the RA. Lived at Brentford, Hastings, and finally at Newquay in Cornwall. See also W.E. Croxford.
Bibl: Brook Hart.

EDWIN, Horace fl.1874-1882
Exhib. in 1881 'A Quiet Cup of Tea', and in 1882 'Puzzled', both at the RA. He exhib. a landscape painting at SS.

EDWIN, Mrs. Mary fl.1891-1892
Exhib. two paintings of fruit in 1891-2. Lived in Norwood, South London.

EEDES, R. fl.1852
Exhib. one portrait at the RA in 1852. Lived in Warwick.

EGERTON, Miss A. fl.1859
Exhib. one portrait at the RA in 1859.

EGERTON, Daniel Thomas RBA fl.1824-d.1842
Engraver and watercolourist of landscape, topography and architectural subjects. He was a founder member of the RBA, where he exhib. from 1824. Exhib. 1837-9 a number of his paintings done in Mexico and, in 1840, a view of Niagara. He was murdered in Mexico in 1842. His Mexican subjects are now highly prized by collectors there.
Bibl: Redgrave, Dict. p.139; Bryan II; Prideaux, *Aquatint Engraving*, 1909 pp.361, 393; Connoisseur XXXV p.95.

EGERTON, John C. fl.1899
Exhib. a portrait at the RA in 1899. Bath address.

EGERTON, Will. fl.1880-1881
Exhib. twice at SS, a landscape watercolour in 1880 and a landscape, 'Summer Afternoon: Surrey', in 1881. London address.

***EGG, Augustus Leopold RA 1816-1863**
London historical genre painter. The son of a rich gunsmith, Egg studied at Sass's and the RA schools. In the 1840s and 1850s was a member of The Clique with J. Phillip, Dadd, H.N. O'Neil, and Frith (all q.v.). Elected ARA 1849, RA 1861. Subjects taken from English history and literature, especially Shakespeare, Scott and Le Sage. This was a genre which had already been popularised by Leslie and Newton, but Egg's technique was more robust and colourful, and his treatment less sentimental. In his later period Egg was influenced by the Pre-Raphaelites, to whom he gave advice and encouragement. 'The Travelling Companions' painted in 1862 shows an awareness of Pre-Raphaelite techniques, and an interest in painting scenes of contemporary life. Owing to poor health, Egg was forced to live abroad much of his life. He travelled in France and Italy, and died aged 47 in Algiers. The sale of his studio was held at Christies, 18 May 1863.
Bibl: AU 1847 p.312; AJ 1863 p.87 (obit.); DNB; Reynolds, VS pp.3, 10, 11, 18, 56 , 77-8 (pls. 48-50); Reynolds, VP pp. 29, 31, 32, 62, 66, 142 (pls. 16 ('The Travelling Companions'), 27); Maas pp. 13,133 (reprd. 'Past and Present', No.3, and Scene from 'The Winter's Tale'); Staley pp. l38, 172; Ormond; Wood, Panorama; Strong; Wood, Pre-Raphaelites.

EGGAR, Miss Catherine A. fl.1886
Exhib. one painting at the NWS in 1886. London address.

EGGINTON, Wycliffe RI 1875-1951
Landscape painter, mainly in watercolour. Painted in Ireland and England, especially on Dartmoor, in a style similar to that of Tom Collier. Exhib. from 1910; elected RI 1912.
Exhib: London, FAS 1933, 1934, 1935, 1938.

***EGLEY, William Maw 1826-1916**
London historical genre painter. Son of William Egley (1798-1870) the miniaturist. Exhib. at the RA 1843-98, also at the BI and SS. Egley's work can be divided into three phases. In the first period,

which lasted from about 1843 until 1855, he painted literary illustrations mainly taken from Molière and Shakespeare. In 1855 Egley turned to painting scenes of contemporary life. The fact that he was a friend of Frith, and painted several backgrounds in his pictures, must obviously have influenced his style in this direction. The works of this period, which lasted only until about 1862, are undoubtedly Egley's best, and are now the most sought after. In his last period, Egley turned to 18th century costume and historical pieces in the manner of Marcus Stone. Egley was a slow worker but in his diaries, which are in the VAM, he lists over 1,000 paintings done between 1840 and 1910. Like many successful Victorian artists who lived too long, Egley's work is of very uneven quality. Manuscripts relating to various members of the Egley family are held at the VAM.

Bibl: Reynolds, VS pp.25, 85 ('Omnibus Life in London' pl. 66); Reynolds, VP pp.96, 109, 111 (pl. 63); Egley's MSS diaries and lists VAM; Maas pp.104, 239; Ormond; Wood, Panorama; Wood, Pre-Raphaelites; Wood, Paradise Lost.

EGLINGTON, James T. fl.1835-1859
Liverpool painter of genre and landscape. Exhib. twice at the RA, 1847 and 1856; twice at SS in 1859; three times at BI, including in 1857, 'He dreamt he lived in Marble Halls'. Associate of Liverpool Academy 1835; Member 1837; Secretary 1847-56. The Walker AG possesses 'The Entry into London of Richard II and Bolingbroke'
Bibl: Marillier.

EGLINGTON, Samuel fl.1830-1856
Liverpool painter of landscape, still-life and genre. Exhib. mainly at the BI, including 'Grouse' and 'Foraging Party across the Border', 1841-55, and twice, in 1837 and 1853, at the RA. Associate of Liverpool Academy 1832; Member 1842; President 1845. 'Serious Thoughts About Emigration' was sold at Sotheby's, Belgravia, 19 October 1971.
Bibl: Marillier.

EGNER, Miss Maria fl.1888
Exhib. one picture, 'Hungarian Farmyard', at the RA in 1888. London address.

EGVILLE, D. see D'EGVILLE

EHRKE, Julius fl.1889-1890
Exhib. two landscapes, the second a view from Malvern, at the RA in 1889 and 1890. Address in Malvern, Worcestershire.

EILOART, Miss E.G. fl.1859-1862
Flower painter. Exhib. 'Greenhouse gatherings', at the RA in 1860, and four other paintings at SS in 1859-61. London address.

ELAND, John Shenton 1872-1933
Portrait painter. Studied at the RA schools from 1893. First exhib. at the RA in 1896.
Bibl: Who's Who 1914.

ELCOCK, George A. fl.1876-1892
Painter of country scenes and rustic genre. Exhib. at SS, 1877-92, including 'A Cottage Door', and 'Winter Fare'. London address.

ELDER, Charles 1821-1851
Painter of literary, biblical and genre subjects. Exhib. at the RA. 1845-52, scenes from Spencer, Coleridge and Shakespeare, and at SS, 1846-51. London address.
Bibl: Redgrave, Dict. p.141.

ELEN, Philip West fl.1838-1872
London landscape painter. Exhib. RA 1839-72, also at the BI and SS. Subjects mainly views in Yorkshire and North Wales.

ELEY, Miss Mary fl.1874-1890
Painted watercolour portraits and genre subjects. Exhib. at the RA, 1880-97, subjects such as 'Envy' and 'Preparing the Hookah', and at the SS, 1874-88. London address.

ELFORD, Sir William, Bt. fl.1774-1837
Amateur landscape painter. Exhib. at the RA for the last time in 1837. Address in Plympton.
Bibl: DNB; Redgrave p.141; Binyon II.

ELGIE, Howard fl.1875-1881
Landscape painter. Exhib. SS. Maida Vale, London, address.

***ELGOOD, George Samuel RI ROI NWS 1851-1943**
A watercolourist of landscape and architectural subjects. He specialised in the painting of English and Italian gardens. Exhib. mainly at the NWS. He spent several months of each year in Italy. For works illustrated by, see card cat. at VAM. His best known book is *Some English Gardens* written together with Gertrude Jekyll (1904).
Bibl: Studio V pp.51-5; XIII pp.108-11; XIX pp.121, 124-6; XXV pp.119-25; XXXI pp.209-15; XLIII p.142; Summer No. 1900 p.29; AJ 1906 pp.307-11, Who's Who 1914; Hardie III p.114; Hall p.29; Wood, Painted Gardens; Newall.

ELIAS, Alfred fl.1885-1903
Landscape painter. Worked in France as well as southern England. Exhib. at the RA, SS and NG. Tunbridge Wells, Kent, address.

ELIAS, Miss Annette fl.1881-1904
Painted landscapes and country subjects. Exhib. at the RA. Member of the Society of Lady Artists. London address.

ELIAS, Miss Emily fl.1884-1901
(Mrs. Alfred Elias)
Exhib. four pictures at the RA, two landscapes, a portrait and a work entitled 'Phoebe'. Paris and Tunbridge Wells, Kent, addresses.

ELIOT, Granville fl.1891
Exhib. one picture, 'Hauling up Crab Pots', at the RA in 1891. Horsham, Surrey, address.

ELLENBOROUGH, Miss Edith fl.1871
Spelt Edenborough in the Suffolk Street list. Exhib. a study of head at SS in 1871. London address. See also Mrs. M.R. Corbet and Mrs. A. Murch.

ELLENOR, Laura K. fl.1893
Exhib. two paintings, 'The Angler's Hobby' and 'Chrysanthemums', at SS in 1893. Address in Tooting, London.

ELLERBY, Thomas fl. 1821-1857
London portrait and genre painter. Exhib. at the RA 1821-57, also at the BI, and occasionally SS. Apart from official portraits, titles at the RA include 'An Italian Female', 'A Spanish Lady', 'A Roman Woman Selling Flowers'. Many of his portraits were engraved.

ELLERBY, William Alfred fl.1886-1892
Graves lists two artists Ellerby and Elleby. Lived near Ashbourne in Derbyshire. Painted landscapes and country genre paintings which were exhib. at the RA, 1888-92, and at SS.

ELLESON, G. fl.1857
Exhib. a portrait of an officer at the RA in 1857.

ELLIOT, George fl.c.1853
An inmate of Bensham Asylum, near Gateshead, County Durham, Elliot is known for only one work, an architectural fantasy entitled 'The City of God'. This drawing was sold at Sotheby's Belgravia saleroom on 1 February 1972 (66) for £160, and it formerly hung in the bar of a public house called the Davy Inn in Wallsend. A self-portrait, also a pen and wash drawing, is in the possession of Gateshead Public Library.
Bibl: Clarence R. Walton in The Gateshed Post 11 June 1954; Bevis Hillier in The Times 22 January 1972; Hall p.29.

ELLIOT, James fl.1882-1897
Spelt Elliott in Graves Dictionary. Manchester painter of North Wales landscape. Exhib. at the RA from 1884.

ELLIOT, Richard fl.1879-1893
Painted landscape and country genre subjects. Exhib. 26 paintings at the RA and 33 at SS. Lived at Wymondham, Norfolk.

ELLIOTT, Charles fl.1876
Exhib. two paintings in 1876. London address.

ELLIOTT, Frank fl.1884
Exhib. one picture, 'Fairies We!', at the RA in 1884. London address.

ELLIOTT, James fl.1848-1873
London painter of landscape and fruit. Exhib. at the RA and SS.

ELLIOTT, Miss Rebecca fl.1878
Exhib. 'Grapes and Chrysanthemums' at SS in 1878-9. Address in Chelsea, London.

***ELLIOTT, Robinson 1814-1894**
Newcastle painter of genre, religious scenes, portraits and landscapes. Exhib. at RA 1844-81, BI, SS, NWS and elsewhere. Titles at RA 'Children in the Wood', etc. and several views in Northumberland and around South Shields. He also painted some charming pictures of children. 'In School' is in the Sunderland AG.
Bibl: Hall.

ELLIS, Miss Alice Blanche fl.1876-1883
Flower painter. Exhib. at SS. Address in Hereford.

ELLIS, Arthur 1856-1918
Painter of landscape, portraits, genre and architectural subjects. Exhib. at the RA and SS. Address in Highgate, London.
Bibl: Who's Who 1914; AJ 1906 p.158.

ELLIS, Bert fl.1890-1892
Painted seascapes and landscapes in oil and watercolour. Exhib. SS. London address.

ELLIS, C. Wynn fl.1880-1904
Painter of portraits and genre subjects such as 'The Birthday Present' and 'Home Again'. Exhib. at the RA. London address.

ELLIS, Miss E.G. fl.1875
Exhib. one picture, 'Old Town, Folkestone', at SS in 1875. London address.

ELLIS, Mrs. Edith Kingdon- fl.1897
Exhib. a portrait of the Dean of Peterborough at the RA in 1897. Address in Peterborough, Northamptonshire.

***ELLIS, Edwin 1841-1895**
London marine and landscape painter. Born in Nottingham, where he first worked in a lace factory. Studied under Henry Dawson (q.v.) and settled in London in the 1860s. Exhib. at RA, but more often at SS, where he showed nearly 100 works. Subjects mostly coastal views in Yorkshire, Wales and Cornwall. His rich colouring and broad technique similar to the late style of Charles Napier Hemy (q.v.). In 1893 a comprehensive exhibition of his work was held at the Nottingham Museum.
Bibl: AJ 1895 pp.84, 191; Manchester Cat.; Brook-Hart.

ELLIS, Edwin John fl.1870-1888
Exhib. one picture, 'A dance', at the RA in 1888. London address.

ELLIS, Ernest G. fl.1899
Exhib. one picture, 'Edith', at the RA in 1899. Address in Hackney, London.

ELLIS, H. fl.1851
Exhib. one picture, 'A View in Richmond Park', at the RA in 1851. London address.

ELLIS, John fl.1884
Exhib. one landscape watercolour at SS in 1884. Address in Clovelly, Devon.

ELLIS, Paul H. fl.1883-1891
Painted flowers and landscapes. Exhib. mainly at SS. Birmingham address.

ELLIS, Mrs. T.H. fl.1871
Flower painter. Exhib. 'Spring Flowers' and 'Our Last Doves' at SS in 1871 and 1872. Address in Tulse Hill, London.

ELLIS, T.J. fl.1872-1877
Painted landscapes and genre. Exhib. at SS. Address in Kensington, London.

ELLIS, Thomas fl.1842-1856
Painted flowers and fruit. Exhib. twice at the RA and once at SS. Address in Peckham, London.

ELLIS, Tristram J. ARE 1844-1922
London landscape painter and watercolourist. At first an engineer on the District and Metropolitan railway, Ellis studied under Bonnat in Paris, and travelled widely, visiting Cyprus, Asia Minor, Egypt and the Middle East. His travels in these countries furnished him with the subject matter of most of his pictures and drawings, which he exhibited at the RA, NWS and GG.
Bibl: Who's Who 1914; Portfolio 1879 p.144; Studio Summer Number 1902; AJ 1884 (illus.).

ELLIS, William fl.1863-1864
Exhib. two landscapes at SS in 1863 and 1864. Birmingham address.

ELLISON, Miss Edith fl.1884-1890
Painted portraits. Five works were exhib. at the RA, 1884-8, and two at the GG. London address.

ELLSON, John fl.1833-1852
Painted dogs. Exhib. 'The Favourite Dog's Head' at SS in 1852. South London address.

***ELMORE, Alfred W.** RA 1815-1881
London genre and historical genre painter. Born Clonakilty, Cork; came to London at the age of 12. After learning to draw from the sculptures in the British Museum, Elmore entered the RA schools in 1832. In 1834, aged only 19, he exhibited his first picture at the RA 'Subject from an Old Play'. From 1833-9 he lived mainly in Paris; in 1840 he studied in Munich, and then settled in Rome until 1842. After his return he was elected ARA 1845, and RA 1857. Elmore exhib. at RA 1834-80, and also at the BI and SS. His exhibited works were almost all subjects from English, French or Italian history, and Shakespeare. Only occasionally did he attempt scenes of modern life, such as 'On the Brink' in 1865 which scored a great success with the public. These few contemporary works are now much more sought after than Elmore's historical pictures. Elmore was also an excellent watercolourist, compared by Hardie to Bonington and Delacroix. Of his historical works Hardie says "Elmore's romantic medievalism is sometimes sentimental but never cheap... it reveals a sincere emotional quality." Redgrave also praised his pictures as being "varied in idea, and exceedingly well thought out and composed". A sale of his studio was held at Christie's, 5 May 1883.
Bibl: AJ 1857 p.113; 1865 p.68; 1866 pp.172, 204; 1881 p.95; Portfolio 1881 pp.54, 104. Redgrave, Cent.; Strickland I; Reynolds, VP pp.32, 64, 110-1 ('On the Brink' pl.61); Hardie II, pp.186-7 (pls.177, 178); Staley; Ormond; Wood, Panorama; Wood, Olympian Dreamers.

ELMORE, Miss Edith fl.1877-1887
Painted flowers. Exhib. at the RA and SS. Address in Kensington, London.

ELMORE, Miss Fanny fl.1861
Exhib. one picture, 'Fruit', at SS in 1861. Address in Tunbridge Wells, Kent.

ELMORE, Frances Mary fl.1872
Exhib. one picture, 'Fruit', in 1872. London address.

ELMORE, Richard fl.1852-1885
Painted landscapes in Surrey and Kent and country genre subjects, which were exhib. at the RA, SS and BI. Address in Croydon, Surrey.
Bibl: AJ 1859 p.83.

ELMORE, T.J. fl.1848-1849
Exhib. two landscapes, one of the Campagna the other of Orvieto, at the RA in 1848 and 1849. London address.

ELMORE, T.W. fl.1863
Exhib. one picture, 'On the Road to Hurst Wood, near Tunbridge Wells' at the RA in 1863. Address in Tunbridge Wells, Kent.

ELPHINSTONE, Archibald H. RBA 1865-1936
Painted coastal landscapes. His watercolour, 'The Thames', was exhib. at SS 1893-4. From 1894-1904 he exhib. at the RA. London address.
Bibl: AJ 1905 p.385; 1909 p.157; Connoisseur XXX, p.67.

ELRINGTON, H.H. fl.1848
Exhib. 'Roman Monument at Treves' at the RA in 1848. London address.

***ELSLEY, Arthur John** 1861-1952
Painted portraits and domestic genre subjects such as 'Castles in the Air', 'Don't' and 'Divided Affection'. These were exhib. at the RA. He was fond of sentimental pictures of children, similar to those of Frederick Morgan (q.v.). Many of these were engraved, or used for advertisements.

ELSLEY, J. fl.1845
Exhib. 'A Group of Horses' at the BI in 1845.

ELTON, A.H. fl.1852
Exhib. one picture, 'Sunset View at Leghorn' at the RA in 1852. Bristol address.

ELTON, Miss K. fl.1872
Exhib. one picture, 'Dolly', at SS in 1872. Address in Clifton, near Bristol.

ELTON, Samuel Averill 1827-1886
Painted the landscape of Durham, North Yorkshire and the Lake District. Exhib. two landscapes at the RA and two at SS. Became professor at the School of Art, Darlington, Country Durham.
Bibl: Hall.

ELWELL, Frederick William RA ROI 1870-1958
Yorkshire painter of figurative subjects, portraits and interiors. Lived in Beverly, near Hull, where he painted most of his work. Studied at Lincoln, Antwerp, and the Académie Julian in Paris. Exhib. at the Paris Salon from 1894, and the RA from 1895. Elected ARA 1931, RA 1938. Elwell had a robust, realistic style, and enjoyed recording Yorkshire life. He also became a successful portrait painter, and painted George V in 1932. An exhibition of his work was held at the Ferens Art Gallery in Hull in 1993, with a good catalogue (see Bibl.). In 1914 he married Mary Bishop, also a noted painter of figure subjects and interiors.
Bibl: Wendy Loncaster, *Fred Elwell RA*, Hull City Museum and AG 1993; Wood, Paradise Lost.

ELWES, F.C. fl.1871
In the Suffolk Street lists his initials are given as W.C. Exhib. one watercolour landscape of Southam, Gloucestershire, at SS in 1871. Address in South Kensington, London.

ELWES, Robert 1819-1878
Painted landscapes in Norway which were exhib. at the BI and at SS. Travelled all over the world making sketches and watercolours as he went. An exhibition of these was held at the King's Lynn Festival in 1979. Elwes lived at Cougham, near King's Lynn.

EMANUEL, Frank Lewis 1865-1948
Painted landscape, interiors and architectural subjects. Studied at the Slade and first exhib. at the RA and Paris Salon in 1886. Address in Kensington, London.
Bibl: Studio VIII p.43; XVIII pp.85-90; XXX p.346ff.; AJ 1906 p.384.

EMBE von der KER see VON DER EMBE, K.

EMERIS, Miss Frances fl.1889
Exhib. one picture at the NWS in 1889. Address in Gloucestershire.

EMERSON, C.E. fl.1866-1881
London landscape watercolourist. Exhib. Lakeland and Highland scenes at the RA.

EMERSON, William fl.1817-1843
Painted portraits and domestic genre subjects which were exhib. at the RA and occasionally at the BI. London address.

EMERSON, William fl.1870-1901
Painted landscapes and views of buildings mainly in India. Exhib. at the RA. London address.

EMMAURE, Miss J. fl.1873
Exhib. one landscape in 1873. London address.

***EMMERSON, Henry Hetherington 1831-1895**
Newcastle genre painter. Born in Chester-le-Street, Co. Durham, Emmerson studied in Newcastle with William Bell Scott. Except for occasional visits to London, he lived in and around Newcastle all his life, at Ebchester, Bywell, Whickham, Morpeth, and finally Cullercoats, where he died. Between 1851 and 1893 he exhibited 54 works at the RA. Subjects mainly scenes of country life in his native Northumberland. Titles at RA 'The Maid of Derwent', 'Gamekeeper's Daughter — Twilight', 'The Calf Yard'. Emmerson once enjoyed a great reputation in the north-east, but is now very little known. His works may be seen in the York AG, and the Laing AG in Newcastle, and in many family collections in the north. He also illustrated children's books. One of his patrons was the 1st Lord Armstrong. For works illustrated by, see Card Cat. at VAM.
Bibl: The Year's Art 1896 p.297; AJ 1859 p.166; Cat. of Laing AG, Newcastle; M. Girouard, *Entertaining Victorian Royalty*, Country Life 4 December 1969; Hall; Staley p.160; Ormond.

EMMERSON, W.H. fl.1859-1863
Exhib. 'The Coquette' and 'Waits for the Bark that never can Return' at the BI in 1859. Address in London.

***EMMS, John 1843-1912**
London sporting and animal painter. Also lived in Lyndhurst, Hampshire. Exhib. at RA 1866-1903, also at BI, SS and the NWS. Titles at RA 'The Bird's Nester', 'Clumber Kennels', 'Digging Out'. Emms particularly specialised in painting foxhounds.
Bibl: Wood, Paradise Lost.

EMSLEY, Walter fl.1896-1900
Exhib. three country scenes at the RA in 1896, 1899 and 1900. Address in Bushey, Hertfordshire.

***EMSLIE, Alfred Edward ARWS b.1848 fl.1867-1889**
London genre and portrait painter. Son of John Emslie, an engraver, and brother of John Phillips Emslie (q.v.). His wife, Rosalie Emslie, a well-known miniaturist. Emslie exhib. at the RA 1869-97, also at SS and the Grosvenor Galleries; he also showed watercolours at OWS, NWS and NG. Titles at RA include 'Binding Sail After a Gale', 'Early Spring', 'Lead Kindly Light', 'Love Amongst the Roses'. Travelled in Japan. In his later years turned increasingly to portrait painting. 'Dinner at Haddo House' is in the NPG.
Bibl: AJ 1900 p.l92; Studio XX pp.47, 48; XXXII; p.l53ff.; Reynolds, VP p.193 (pl.133); Ormond; Wood Panorama.

EMSLIE, John Phillipps 1839-1913
Painted genre subjects in watercolour. Exhib. mainly at SS. Titles include: 'Thinking of Father', 'Still Learning' and 'A Pleasant Letter'. Trained at the Working Men's College. His drawing 'The Sir Paul Pindar Tavern' is in the VAM. London address.
Bibl: Fincham, *Art and Engraving of England*, 1897.

ENDERBY, Samuel G. fl.1886-1904
London painter of genre and portraits. Exhib. 11 times at the RA.

ENFIELD, Henry b.1849 fl.1904
Painted seascapes and coastal landscapes. Exhib. at the RA ten times and at the SS twice. Studied under Carolus-Duran in Paris. Address in Nottingham.
Bibl: Drebler, Kunstjahrbuch, 1914; Katal; Mittlgn d. Kstlers.

ENFIELD, Mrs. William
Pupil and imitator of J.B. Pyne in Nottingham. Wife of William Enfield, Town Clerk of Nottingham 1845-70.

ENGELHART, Miss Catherine see AMYOT, Mrs.

ENGLAND, W. fl.1874
Exhib. a painting called 'Ruth' at SS in 1874. London address.

ENGLEFIELD, Arthur b.1855 fl.1904
Painter of genre, landscape and portraits. Exhib. nine times at the RA. Address in St. Albans.

ENOCK, Arthur Henry fl.1869-1910
Birmingham landscape watercolourist who exhib. five times with the NWS. At first he was a self-taught artist, studying in Wales in his holidays. He exhib. in Birmingham 1869-1910, and about 1890 he moved to Devon, where he was known as "the artist of the Dart". Noted for effects of mist and sunlight.

***ENSOR, Mrs. Mary fl.1871-1874**
Very little known painter of birds and flowers; lived at Birkenhead, Cheshire. Exhib. seven works at SS, but not known to have exhib. elsewhere. Her pictures are usually small, colourful and highly detailed renderings of birds and flowers, in the tradition of Hunt, Clare and Cruickshank.

ENTHOVEN, Miss Julia fl.1889
Painted flowers. Exhib. 'Poppies' at RA in 1889. Address in Sydenham, London.

EPINETTE, Marie fl.1881
Exhib. one portrait at the RA in 1881. London address.

EPPS, E. fl.1874-1880
Painted landscapes one of which was exhib. at SS in 1875-6. London address.

EPPS, Miss Emily fl.1874
Exhib. 'My doll's Picnic' at the RA in 1874. London address. Probably the same as E. Epps (see above).

EPPS, Miss Laura T. see ALMA-TADEMA, Lady

EPPS, N. fl.1872-1874
Painted genre subjects of which 'At Townshend House' was exhib. at the RA in 1872. Address in Birkenhead, near Liverpool.

EPPS, Miss Nellie see GOSSE, Mrs. Edmund

ERCOLI, Signor Alcide Carlo fl.1857-1866
Spelt Ercole in Graves Royal Academy lists. Painted portraits, including that of the Marchioness of Northampton, which were exhib. at the RA. London address.
Bibl: AJ 1859 p.167.

ERIC, F. fl.1863-1864
Exhib. 'A Christmas Present' at the BI in 1864 and two other pictures at SS in 1863-4. London address.

ERICHSON, Miss Nelly fl.1882-1897
Spelt Erichsen in Graves Dictionary. Painted country genre and landscapes and exhib. at the RA and SS. Address in Tooting, London.

ERRINGTON, Isabella fl.1846-1850
A painter of landscape, portraits and coastal genre from North Shields, Northumberland. Exhib. twice at SS in 1846, including 'A Boy Carrying Bait, from Life'. Also exhib. at the Carlisle Athenaeum.
Bibl: Hall.

ERSKINE, Miss Edith E. fl.1886-1887
Exhib. two paintings, 'Chrysanthemums' and 'The Old Man's Corner', at the RA in 1886 and 1887. London address.

ERSKINE, W.C.C. fl.1879
Edinburgh landscape painter. Exhib. 'A Glen in Winter' at the RA in 1879.

ERTZ, Edward Frederick RBA 1862-1954
Born in America he settled in England c.1900. In 1900 he exhib. 'The Fisherman's Son' and 'Lighting Up Time' at the RA. The main body of his work was painted later.
Bibl: Martin, *Nos Peintres et Sculpteurs*, II; American Art Annual X; Studio XXVI p.170ff.; XXXVI p.60ff.; Who's Who 1914.

ERWOOD, A. fl.1860-1869
A London painter of genre subjects. Exhib. 'The Rejected Picture', RA 1861 and 'Home for the Holidays', SS 1861.

ESCAZENA, J.M. fl.1841-1848
Spelt Escarzena in Graves Dictionary. Painted views of houses and interiors. London address.

ESCOMBE, Miss Anne fl.1869-1875
Exhib. three landscapes at the RA, 1869-75. Address in Guildford, Surrey.

ESCOMBE, Miss Jane fl.1869-1877
Exhib. three paintings, 'Drapery', 'Wharf on the Wey' and 'An Etcher Biting', at the RA, 1869-77. Address in Guildford, Surrey.

ESSEX, Richard Hamilton OWS 1802-1855
A London architect who also made watercolour drawings of buildings, chiefly English churches and cathedrals. These were exhib. at the OWS to which he was elected in 1823 and from which he resigned in 1837. Exhib. also at RA and SS. His drawing 'The Choir of Ely Cathedral' is in the VAM.
Bibl: Redgrave, Dict. p.144; Roget I p.495; Cundall p.208.

ESTALL, William Charles 1857-1897
Manchester landscape painter. Worked in Brittany as well as England. Specialised in painting evening mists and moonlight. Exhib. at the RA and SS.
Bibl: Studio XII p.73ff.; Cundall p.208; Hardie III p.158, (illus. 172).

ESTCOURT, Miss F.J. fl.1892
Exhib. a figurative picture in 1892. Address in Bushey, Hertfordshire.

ESTRIDGE, Rev. Loraine fl.1891
Exhib. three landscapes at the NG in 1891.

ETHELSON, Edmund fl.1890
Spelt Ethelston in Suffolk Street lists. Exhib. 'A Street Singer' at SS in 1890. Address in Kensington, London.

ETHERINGTON, Miss Lilian M. fl.1884-1901
Painted genre of which 'Kept In' and 'An Idle Boy' were exhib. at the RA in 1885 and 1899, and 'The Diver's Courtship' at SS in 1888-9. Address in Kensington, London.

ETHOVER, T. fl.1877
Exhib. a view in Rome at the RA in 1877. London address.

ETHRIDGE, H.A. fl.1882
Exhib. a landscape watercolour of Den-y-Banc at SS in 1882. London address .

***ETTY, William RA 1787-1849**
Painter of classical and historical subjects. Born in York, the son of a baker, Redgrave says that "he demonstrated his love for art very early by defacing every plain surface." After a strict Methodist schooling, he worked as a printer's apprentice 1798-1805. In 1807 he entered the RA schools, and in 1808 studied under Lawrence. Success was slow in coming to Etty; only in 1811 did the RA finally accept one of his works, and it was not until 1821, with 'Cleopatra's arrival in Sicily', that "one morning, he woke famous" (Leslie). Lived in Rome 1821-3. Elected ARA 1824, RA 1828. Between 1811 and 1850 he exhib. 138 works at the RA, as well as a good number at the BI. Etty devoted himself to the painting of the female nude, and was a familiar figure at the RA life classes all his life. His luscious, sensual sketches of female nudes frequently scandalised the Victorian public, but his large-scale machines in the manner of Rubens, Titian and Veronese were more acceptable. Etty's subjects were mostly episodes from classical or mythological history, as these enabled him to use the maximum number of female nude figures. In 1848 he retired to his native York, where he died. The same year, an exhibition of his work was held at the Society of Arts. In May 1850 Christie's sold the remaining sketches and drawings in his studio for over £5,000. Manuscripts relating to Etty are held by the VAM.
Bibl: A. Gilchrist, *Life of W.E.*, 1844; W.C. Monkhouse, *Pictures by W.E.*, 1874; W. Gaunt, *E. and the Nude*, 1943; Dennis Farr, *W.E.*, 1958; Redgrave, Cent. pp.257-62; Reynolds, VP. pp.13, 119 (pl.4); AJ 1849 pp.13, 37-40 (autobiog.), p.378 (obit.); DNB; Maas pp.166-7; Ormond; Brian J. Bailey, *William Etty's Nudes*, 1974; D. Farr, *An Etty Sketchbook*, Connoisseur August 1963; Roger Bell, *The RSA Etty Exhibition of 1849*, RSA Journal July 1990.
Exhib: London, Society of Arts 1849; London, Brook Street AG 1938; London, Adams Gallery 1946; York, Corporation AG and Museum 1949; Great Britain Arts Council 1955; Rye AG 1974.

EVANS, Adam fl.1894
Exhib. a painting of 'Chrysanthemums' at the RA in 1894. London address.

EVANS, Amy fl.1880
Exhib. a watercolour of apple blossom at SS in 1880-1. South London address.

EVANS, Bernard Walter RI RBA 1848-1922
Born in Birmingham and lived in London. Studied painting under Samuel Lines and Edward Watson. He painted landscapes in oil and watercolour, and most frequently depicted scenes of the Midlands and North Wales. He exhib. at the RA 13 times from 1870, and at SS 68 times.
Bibl: Studio Special Summer No. 1900; Who's Who 1914.

EVANS, Mrs. Bernard fl.1888-1889
Exhib. a country genre subject at SS 1888-9. London address.

EVANS, E.H. fl.1838-1839
Exhib. at the RA 'Still Life' and 'Portrait of a Brother' in 1838 and 1839. Address in Taunton, Somerset.

EVANS, Edward fl.1857-1872
Painted watercolour landscapes, mostly of North Wales. Exhib. 11 times at SS. Address in Bayswater, London.

EVANS, Edmund William b.1858 fl.1897
A London engraver who produced illustrated books. He was also a watercolourist. As a young man he was a friend of Myles Birket Foster (q.v.). Exhib. a number of drawings, including a series of the Thames in London, at SS. Works engraved: See Card Cat. at VAM.
Bibl: M. Hardie, *English Coloured Books*, 1906 pp.266-82; Hardie III p.141; Edmund Evans, *The Reminiscences of E.E.*, Oxford 1967.

EVANS, Mrs. Fred M. fl.1870-1881
Painted fruit.

EVANS, Frederick M. fl.1886-1928
Painted genre of which 'A Message for Nurse' and 'Offer of Marriage' were exhib. at the RA in 1892. Address in Highbury, North London, and later in Penzance, Cornwall.

EVANS, G. fl.1842
Exhib. a portrait at the RA in 1842. London address.
Bibl: BM Cat. of Engraved British Portraits IV p.271; Ormond I p.466.

EVANS, G.H. fl.1840
Exhib. a portrait of a man at SS in 1840. London address.

EVANS, Helena M. fl.1891-1893
Exhib. one picture, 'Nell Gwynne's Garden', at SS in 1891. Address in Carmarthen, Wales.

EVANS, Herbert Davies fl.1883-1884
Exhib. paintings of flowers at SS in 1883 and 1884. London address.

EVANS, Herbert E. fl.1893-1900
Exhib. two paintings of fruit at the RA in 1893 and 1896, and one landscape, 'On the Avon', in 1900. London address.

EVANS, J.W. fl.1874
Exhib. a watercolour called 'Repairing Damages' at SS in 1874.

EVANS, John fl.1841-1891
A London watercolourist. Exhib. English landscapes at SS 1849-50. In the 1870s and 1880s exhib. views of Venice at SS and, on one occasion in 1888, at the RA.

EVANS, Miss Kate fl.1884
Exhib. one painting, 'A Bunch of Cowslips', at the RA in 1884. Address in Norwood, South London.

EVANS, Miss Lena M. fl.1890
Exhib. one painting, 'Pansies', at SS in 1890. London address.

EVANS, M.E. fl.1885
Exhib. one painting, 'A Grey Day in Weymouth Harbour' at SS in 1885. Address in Winchester, Hampshire.

EVANS, Miss Marjorie RSW fl.1892-1895
Exhib. two paintings of roses at the RA in 1892 and 1895. Address in Richmond, London.

EVANS, Richard 1784-1871
A London painter of portraits, including those of the King of Haiti, the Turkish Ambassador, George Bradshaw and Harriet Martineau, and of occasional literary subjects. Exhib. RA and BI.
Bibl: DNB; Rowinsky Lex. Dun. Portratisten, 1886ff. I p.539 1 n. 2; IV p.663; Bryan II; Ormond I pp.49, 303; II pl. 78.

EVANS, Samuel Thomas George RWS 1829-1904
Son of William Evans of Eton, he was the third of four generations of Evans to be drawing master at Eton College. He held the post 1854-1903. He exhib. his landscape watercolours, which often included rivers, 228 times with the RWS and seven times at the RA.
Bibl: AJ 1905 p.34; Clement & Hutton I p.242; Roget II p.211; Hardie II p.209.

EVANS, Dr. Sebastian fl.1878-1881
Exhib. one painting, a subject from Milton, at the RA in 1881. Address in Dulwich, London.

EVANS, Wilfred fl.1880-1890
Watercolourist from Clapton in London. Exhib. five drawings of Westminster Abbey at SS.

EVANS, Wilfred Muir fl.1888-1902
Portraitist from Bushey in Hertfordshire who exhib. four works at RA and one at the NG.

EVANS, William, of Eton RSW 1798-1877
Born and educated at Eton College, in 1818 he succeeded his father, Samuel Evans, as drawing master at Eton. He was the second of four generations of his family to hold this post. As a landscape watercolourist his style was close to that of David Cox. He painted in Scotland and along the Thames and exhib. 264 works at the OWS.
Bibl: Ottley; AJ 1878 p.76; Redgrave, Dict. p.146; Clement & Hutton I p.242; Roget I pp.529-30; II pp.209-11; Rees, *Welsh Painters, etc.*, 1912 p.47; Hardie II p.209.

EVANS, William, of Bristol ARWS 1809-1858
Known as 'Evans of Bristol' or 'Welsh Evans'. Exhib. his large watercolours, generally of the Welsh or Italian landscape, at the RWS, of which he became an associate in 1845. London address.
Bibl: AJ 1859 p.135; Ottley; Redgrave, Dict. p.146; Clement & Hutton I p.242; Roget II pp.295-6; Binyon II; Rees, *Welsh Painters, etc.*, 1912 p.46; Hardie II p.209.

EVANS, William E. fl.1889-1897
London painter of domestic genre. Subjects exhib. at the RA between 1889-97 include ' "Won't you Buy?" ' and 'Helping Mother'.

EVELYN, Miss Edith M. fl.1886-1893
(Miss Evelyn Lucas)
London portraitist. Subjects exhib. at RA 1886-9 include several of children.

EVERARD, J. c.1870-1890
Marine painter
Bibl: Brook-Hart.

EVERETT, Edwin W. fl.1880-1884
A watercolourist who exhib. six drawings of country genre at SS.

EVERETT, Frederic **fl.1882-1890**
Exhib. two paintings, 'Solitude' and 'Before the Heat of the Day', at the RA in 1890. Address in Erith, Kent.

EVERITT, Allen Edward **1824-1882**
Birmingham watercolourist who exhib. at the RA and SS. He made drawings of buildings and interiors.
Bibl: AJ 1882 p.224; DNB XVIII p.88; Chronique des Arts 1882 p.187.

EVERITT, Edward **fl.1819-1865**
Birmingham landscape watercolourist. Exhib. lakeland and other scenes at the RA, SS and elsewhere. Exhib. less frequently in his later career.

EVERSHED, Dr. Arthur **RPE** **1836-1919**
London landscape painter and etcher. Pupil of Alfred Clint. Exhib. at RA 1857-1900, also at SS and OWS. Subjects mainly views on the Thames or of southern England; also travelled in Italy.
Bibl: Beraldi, *Graveurs du 19 siècle* VI 1887; Who's Who 1914 p.666.

EVES, Reginald Granville **RA ROI RI RP** **1876-1941**
Born in London. He studied at the Slade under Brown, Legros and Tonks. His first exhibited work was 'Waiting', at the RA in 1901. The main body of his work is later in date.
Bibl: Adrian Bury, *The Art of Reginald E., RA*, Leigh-on-Sea, 1940.
Exhib: London, Knoedler & Co. 1935; London, Royal Society of British Artists Galleries 1947.

EWART, W. **fl.1846-1863**
London portrait and landscape painter. Exhib. four portraits at the RA, 1846-50, and five paintings of rural genre, such as 'The Tired Vagrant', at BI, 1847-63.

EWBANK, John Wilson **RSA** **1779-1847**
Scottish landscape and seascape painter. Born in Gateshead, Ewbank worked for a house painter named Coulson. Later he moved to Edinburgh and studied with Alexander Nasmyth. His technique and subject matter strongly influenced by the Dutch 17th century, particularly Van der Velde. His best work is from his early years, as after about 1810 his style deteriorated badly. Elected RSA, 1823. Died in Edinburgh in great poverty. For works illustrated by, see Card Cat. at VAM.
Bibl: Caw p.160ff., 322; AU 1848 p.51; Hall; Brook-Hart.

EWBANK, T. John **RSA** **fl.1826-1862**
Edinburgh painter of country genre. Exhib. 'Waiting for the Boat' at BI in 1862. Also exhib. at the RA and SS.

EYLES, Charles **fl.1881-1899**
London landscape painter. Exhib. eight works at RA and nine at SS.

EYRE, Lady Alice **fl.1886**
London painter. Exhib. two figurative paintings at the GG in 1886.

EYRE, James **b.1802 fl.1837**
Derbyshire landscape painter. Exhib. BI and SS.
Bibl: Redgrave, Dict. p.147.

EYRE, John **RBA** **fl.1877-1904 d.1927**
Painter of landscape and genre. Exhib. at RA, RBA, RI and Paris Salon.

EYRES, Miss Emily **fl.1899-1904**
Exhib. 'A Bachelor' at the RA in 1899. London address.

EYRES, John W. **fl.1887-1889**
Landscape painter. Exhib. five works at RA 1887-9. Address in Walton-on-Thames.

FACON, E. **fl.1846**
Exhib. one picture, a landscape in Monmouthshire, at the RA in 1846. Address in London.

FAED, H. **fl.1875**
Exhib. one picture, 'Une Napolitaine', at the RA in 1875.

FAED, James, Snr. **1821-1911**
Scottish landscape and figure painter. Brother of John and Thomas Faed (qq.v.). Exhib. in London and Edinburgh from 1855. His son was James Faed Jnr. (q.v.).

FAED, James, Jnr **1857-1920**
Exhib. paintings of animals and landscapes at the RA from 1880. Also exhib. at the RSA. Address in Edinburgh.
Bibl: Clement & Hutton; Irwin pp.300-2.

***FAED, John** **RSA** **1820-1902**
Scottish genre and historical painter. Elder brother of Thomas Faed (q.v.). Exhib. at the RA 1855-93, and at SS. At first a miniature painter in Galloway, Faed settled in Edinburgh about 1841. Elected ARSA 1847, RSA 1851. Joined his brother in London 1862-80, and then retired to his native village. His subjects included historical and biblical genre, as well as domestic and Highland scenes. Many of his and Thomas's compositions were engraved by the third brother, James Faed. Prior to his retirement from London in 1880, a sale of his works was held at Christie's, 11 June 1880.
Bibl: AJ 1871 pp.237-9 (biog.); Clement & Hutton; Caw p.166; DNB 2 Supp. II 1912; Irwin; M. McKerrow, *The Faeds,* 1982.

FAED, John Francis **fl.1882-1892**
Painter of ships and seascapes. He was the son of Thomas Faed. Exhib. at the RA 1883-92 including 'At the Mercy of the Waves', and at SS in 1882-3. Address in St. John's Wood, London.
Bibl: Brook-Hart.

FAED, Miss S. **fl.1866-1868**
Exhib. three pictures, including 'The Country Lass', at the RA 1866-8. Lived at Gatehouse in Scotland.

***FAED, Thomas** **RA HRSA** **1826-1900**
Scottish painter of domestic genre and Highland scenes. Younger brother of John Faed (q.v.). Born in Burley Mill, Kircudbrightshire. Studied with his brother John in Edinburgh, and then with Sir

William Allan and Thomas Duncan. Elected ARSA 1849. Settled in London 1852. In 1855 he established his popularity with 'The Mitherless Bairn' which became widely known through engravings. Elected ARA 1859, RA 1864. Exhib. nearly 100 works at the RA between 1851 and 1893. Subjects mainly sentimental scenes of Scottish peasant life — e.g. 'Cottage Piety' 1851, 'Highland Mary' 1856, 'My Ain Fireside' 1859 — or pretty Highland girls. Sometimes collaborated with J.F. Herring, Snr. (q.v.).

Bibl: AJ 1871 pp.1-3; Mag. of Art 1878 p.92ff.; Clement & Hutton; Caw pp.164-6 (pl. 'The End of the Day'); Ormond; Irwin; Wood, Panorama; M. McKerrow, *The Faeds*, 1892.

FAED, William C. fl.1881-1889
Exhib. three paintings, including 'I Dreamt I Dwelt in Marble Halls', at the RA, 1884-9, and two at SS, 1881-5. Edinburgh address.

FAGAN, Louis Alexander 1845-1903
Diplomat, art critic and amateur painter. Worked in the BM Print Room. Drew portraits, including those of Richard Cobden and Sir Charles Napier.

Bibl: Ormond.

FAGNANI, Guiseppe (Joseph) 1819-1873
Painted portraits, including those of John Bright and Richard Cobden.

Bibl: Ormond.

FAHEY, Edward Henry RI 1844-1907
Watercolourist of landscape, portraits and genre. Worked in Italy and France as well as in England. Exhib. 127 times at the NWS, 38 times at the RA and seven times at SS. Address in London. Son of James Fahey (q.v.).

Bibl: Clement & Hutton; Newall.

FAHEY, James RI NWS 1804-1885
Watercolourist of portraits, landscapes and architectural subjects. Studied painting in Munich and Paris. Exhib. 485 times at the NWS and 16 times at the RA. Address in London.

Bibl: Ottley; Clement & Hutton; Binyon II; Bryan; DNB.

FAHEY, Miss Palacia Emma see ALABASTER, Mrs. Henry

FAIRBAIRN, Miss Hilda fl.1893
Studied painting at the Herkomer School at Bushey. Exhib. three genre paintings, including 'These Pretty Babes, with Hand in Hand, went wandering up and down', at the RA 1896-1903. Address in London. For works illustrated by, see Card Cat. at VAM.

FAIRBAIRN, Thomas RSW 1820-1884
Landscape watercolourist. Exhib. seven drawings of Scottish landscape at SS, 1865-72. 'Woman with a Sickle in a Field', signed and dated 1855, was sold at Christie's, 6 May 1970. Address in Hamilton, Scotland.

Bibl: Caw p.303.

FAIRER, Charles G. fl.1872-1876
Exhib. three paintings of flowers, 1872-6. London address.

FAIRFAX, A. fl.1881
Exhib. one portrait at the GG in 1881. Manchester address.

FAIRLAM, Miss Eleanor see BROWN, Mrs. J.W.

FAIRLESS, Thomas Kerr 1825-1853
Landscape painter, born in Hexham, Northumberland. Studied for a time under Bewick's pupil, Nicholson, a wood engraver, at Newcastle. Came to London and practised landscape painting. From 1848-51 he exhib. landscapes at the RA, and also at BI and SS. "His works were executed in a broad and vigorous manner, with a fine idea of colour and exquisite feeling for the beauties of country scenery, gathered during the summer days among the woods and pastures of England". He also painted sea views and shipping.

Bibl: AJ 1853 p.215 (obit.); DNB; Redgrave, Dict.; Hall.

FAIRLIE, John fl.1845
Exhib. one picture, 'A Cool Retreat', at the RA, in 1845.

FAIRLIE, William J. fl.1850s-1860s
Carlisle landscape painter who painted views in the Lake District, and exhibited at the RA in 1853, 1855 1857 and 1865. Subjects Lake District, or country around Carlisle.

FAIRMAN, Miss Frances L. 1836-1923
Animal painter. Exhib. twice at the RA, including 'The Platter Clean; portraits of three Japanese Dogs', 1897-9, and once at SS, in 1893. Address in London. Member of the Society of Lady Artists.

Bibl: Kunstchron. NF IX 1898 p.250; Evening News 24 February 1910.

FALCON, Miss Maud fl.1888-1890
Exhib. two flower paintings at the GG 1888-90. London address.

FALDONBURN, P. fl.1857
Was exhibiting in 1857. Lived in London.

FALKENER, Edward 1814-1896
An architect who also made drawings of buildings. Studied at the RA schools. Exhib. at the RA, 1840-73, including many drawings of the remains at Pompeii and of buildings in the Middle East. Address in London.

Bibl: DNB Supp. II p.199.

FALKNER, Miss Annie L. fl.1893
Exhib. a landscape painting at SS in 1893-4. Address in Bedford.

FALKNER, Miss Mary G. fl.1899
Exhib. one painting, entitled 'Found', at the RA in 1899.

FALL, Miss E.M. fl.1855-1856
Exhib. two paintings at SS, 1855-6, and on 'A Welsh Grange', at BI in 1855. Address in Brixton, London.

FALL, George c.1848-1925
York topographer who also painted portraits in oil. Also painted in Co. Durham. Examples are in York AG.

FALLON, Miss Sarah W.M. fl.1888-1895
Exhib. five paintings at SS, 1888-94, and one, 'Mending Nets', at the RA. Address in Croydon, Surrey.

FALLON, W.A. fl.1839-1840
Exhib. two portraits at the RA in 1839 and 1840. London address.

FALLOWES, William fl.1870-1900
Painter and watercolourist. Lived in Bridlington, Yorkshire.

FALLS, R. **fl.1893**
Exhib. a view of Gibraltar at SS in 1893. Address in London.

FANE, General Walter **CB** **fl.1859-1884**
Watercolourist. Exhib. at SS a drawing of two native officers and a sergeant of the First Punjab Infantry Regiment, and drawing of Indian Temples. London address.

FANNER, Miss Alice Maude **1865-1930**
(Mrs. Taite)
Studied at the Slade Schools. Exhib. five landscape paintings at the RA from 1897. Address in Chiswick, near London.
Bibl: W. Shaw Sparrow, *Women Painters of the World*, 1905; Studio LIV p.317; LX p.305.

FANNER, Henry George **fl.1854-1884**
Worked in oil, crayons and watercolour. Did portraits, including in 1876 one of the Duchess of Edinburgh, and genre subjects such as 'What did he Mean?' Exhib. at the RA and SS. Address in London.

FARGUES, Mrs. **fl.1845-1852**
Exhib. three landscapes of the Devon coast at SS, 1845-52, and once at the RA. London address.

***FARMER, Mrs. Alexander** **fl.1855-1867**
Genre and still-life painter, wife of Alexander Farmer, whose sister Emily was also a watercolourist. Lived at Porchester, Hampshire. Exhib. at RA 1855-67, also at BI and SS. Titles at RA 'A Bird's Nest', 'An Anxious Hour', 'The Remedy Worse than the Disease', etc. Mrs. Farmer, like Sophie Anderson and many other minor female painters of the Victorian period, produced a small body of extremely competent pictures.
Bibl: Wood, Panorama; Wood, Paradise Lost.

FARMER, Corrall **fl.1893**
Exhib. a landscape in 1893. Address in New Billingham.

FARMER, Emily **RI** **1826-1905**
Painter of figure subjects, especially children. Pupil of her brother Alexander Farmer (d.1869), she was at first a miniaturist. Exhib. at RA and NWS. Elected to NWS 1854.

FARMER, F.W. **fl.1866**
Exhib. two portraits at SS in 1866. Address in London.

FARMER, F.W. **fl.1866**
Painted marines, coastal landscapes and views in the Channel Islands. Exhib. at SS, 1870-8. London address.

FARMER, Mrs. Fanny see FARMER, Mrs. Alexander

FARMER, Henry **fl.1865**
Exhib. a figurative painting in 1865. London address.

FARMER, Miss Mary **fl.1886**
Exhib. a landscape in 1886. Lived in Poole, Dorset.

FARNUM, H. Cyrus **fl.1896**
Exhib. at view of the Piccola Piazza Anna Capri at the RA in 1896. Address in Paris.

FARQUHAR, R.T. **fl.1873-1874**
Landscape watercolourist. Exhib. views of the Lake District at SS, 1873-4. Address in Grasmere.

***FARQUHARSON, David** **ARA ARSA RSW** **1840-1907**
Scottish landscape painter. Born in Blairgowrie, Perthshire, and lived there until he came to Edinburgh about 1872. He was, to a great extent, a self-taught artist. Exhibited at the RSA for the first time in 1868, and in 1882 was elected A, but in 1886 he settled in London until 1894. He then removed to Sennen Cove, Cornwall, but often revisited Scotland. His landscapes attracted considerable attention and led to his election as ARA in 1905 at the age of 66. He exhibited at the RA 1877-1904. He painted the Highland hills and moors and peat mosses, river valleys and views in England and Holland, in all sorts of atmospheric conditions, in a tonal palette reminiscent of early Corot.
Bibl: DNB; Caw pp.306-7; AJ 1907 pp.197, 283, 360; 1908 p.231; Studio XXXVIII p.10; RA Pictures 1891-6,1906-8.

***FARQUHARSON, Joseph** **RA** **1846-1935**
Scottish landscape painter, noted for winter subjects, especially snowstorms, snowy landscapes and winter woods. He occasionally painted Oriental mosques and eastern market places, social and rustic genre, and portraits. Born in Edinburgh, he studied first under Peter Graham, RA, then at the Board of Manufacture School in Edinburgh, and the Life School at the RSA. In 1859 he first exhib. at the RSA; he exhib. at the RA from 1873 onwards, and was elected ARA in 1900. In 1880 he studied in Paris under Carolus Duran. In 1885 he visited Egypt. Sickert wrote an essay comparing him to Courbet, and preferring Farquharson: "Farquharson's extraordinary virtuosity has been developed by experience, but it arises certainly from the fact that he is thinking of telling his story. The arrest of the fox in the snow of the picture called 'Supper Time' is a breathless moment. The subject is the very *raison d'etre* of the picture. Bloomsbury will perhaps tell you that it is wrong to paint a live fox. Fortunately the writ of Bloomsbury does not run in the North of Scotland." Not related to David Farquharson (q.v.). An exhibition of his work was held at the FAS in March 1887.
Bibl: AJ 1890 p.158; 1893 p.153 (mono.); 1905 p.175; Studio Art in 1898, Index; RA Pictures 1905-8, 1910-12; Caw p.306; The Globe 5 August 1908; W.M. Sinclair, *The Art of J.F.*, Art Annual Christmas-Number 1912; Connoisseur XXXVI pp.59ff.; W.R. Sickert, *A Free House*, ed. Osbert Sitwell 1947 pp.204-6 (essay first published with the title 'Snow Piece and Palette-Knife', in the Daily Telegraph 7 April 1926); Irwin.

FARR, Miss Henrietta **fl.1877-1879**
Exhib. four paintings, including 'Consideration', 'Her Mind, the music breathing from her face', and a watercolour drawing of an old barn at SS, 1877-9. London address.

FARRAN, Miss Lulu **fl.1887-1892**
Exhib. a portrait at the RA in 1887 and four other pictures at the NWS. London address.

FARREN, Robert B. **b.1832 fl.1889**
Painted landscapes in Scotland and East Anglia. Also painted a subject from Cymbeline and a portrait of Adam Sedgwick. Exhib. 16 times at the RA. Address in Cambridge.
Bibl: Ormond.

FARRER, Thomas Charles **1839-1891**
Landscape painter. Exhib. 25 times at the GG, nine times at the RA, including views of Rochester, Cromer and Medmenham Abbey, and nine times at SS. Lived in Notting Hill, London.
Bibl: AJ 1871 p.127; Zeitschr f. bild-Kunst 1871; Beibl. p.134; Clement & Hutton; Champlin-Perkins, *Cyclopedia of Painting*, II 1888.

FARRIER, Robert 1796-1879
Painter of genre and portraits who exhib. at the RA 1818-59, titles including 'The Prophecy — You'll Marry a Rich Young Lady'. Often painted school children. His sister Charlotte was a miniaturist.

FARROW, William John fl.1890-1893
Exhib. three paintings, 'The Firstborn', 'Book Companions' and 'First Come, First Served', at SS, 1891-4.

FARWELL, Miss fl.1856-1861
Exhib. four paintings, including 'The Invalid' and 'St. Valentine's Day', at RA, 1856-61 and one, 'The Lesson', at the BI. Lived at St. Martin's, Liscard.

FAULKNER, Benjamin Rawlinson 1787-1849
London portrait painter. Exhib. 64 times at the RA, almost all portraits. Also exhib. 32 times at SS. Address in Leicester Square, London.
Bibl: AJ 1850 p.94; Bryan; BI, *A Century of Loan Exhibitions* I 1913; BM Cat. of Engraved British Portraits I, II and III; Ormond.

FAULKNER, C. fl.1874
Exhib. a landscape watercolour at SS 1874-5. Address in Fareham, Hampshire.

FAULKNER, John RHA c.1830-1888
Irish painter of landscapes and seascapes, in oil and watercolour. Exhib. one picture, 'The Home of the Red Deer', at the RA in 1865. Address in Dublin. Elected RHA 1861. In 1870 he was expelled from the RHA, and left Dublin for America. Later he returned to London.
Bibl: Strickland.

FAULKNER, Miss Mary fl.1838-1842
Exhib. five works at the RA, 1838-42, three of which were portraits of children and the fifth of which was entitled, 'Releasing the Little Favourite "It will never Return"'. Address in London.

FAULKNER, Robert fl.1847-1849
Exhib. portraits in oil, pastel and watercolour at the SS, 1849-62, and once at the RA in 1847. Son of Benjamin Rawlinson Faulkner (q.v.). Address in London.

FAUNCE, Mrs. fl.1872-1873
Exhib. a landscape watercolour at SS in 1872-3.

FAUNTHORPE, Mrs. fl.1874
Exhib. two flower paintings in 1874. Lived in Wandsworth, London.

FAUNTLEROY, Mrs. C.S. fl.1881
Exhib. one picture, 'Iridescent Grass and Flowers' at SS in 1881. Lived in Devon.

FAUVELLE, Henry fl.1877
Exhib. one picture, 'A Retreat for the Aged — Grey Friars Hospital, Coventry', at the RA in 1877. Address in Kentish Town, London.

FAWINKEL, Magdalen von see VON FAWINKEL, Magdalen

FAWKES, Col. Lionel Grimston 1849-1931
An amateur portrait painter.
Bibl: Ormond.

FAYE, F. fl.1837
Exhib. one landscape, a view in Normandy, at the RA in 1837.

**FAYERMANN, Miss Anne Charlotte
see BARTHOLOMEW, Mrs. Valentine**

FEAD, H.J. fl.1862
Exhib. one landscape, 'A Home sketch upon the Rhine', at SS in 1862. London address.

FEARNLEY, Thomas fl.1837-1838
Exhib. paintings of the landscapes of Norway, Austria and Switzerland at the BI, the RA and SS in 1837-8. Address in London.

FEARNSMITH, George fl.1871
Exhib. a landscape in 1871. London address.

FEENEY, Patrick M. RBSA fl.1867-1911
Painter of landscapes and coastal scenes. Exhib. at the RA three times, 1888-1903, including 'An Iron Coast and Angry Waves'. Also exhib. with the RBSA from 1867. Lived in Birmingham and later in London.

FEENEY, William Peregrine fl.1880-1896
Painted East Anglian and Thames side landscapes. Exhib. 11 times at SS and three times at the RA. London address.

FELL, C. fl.1872
Exhib. one portrait of a boy at the RA in 1872. Address in Ambleside.

FELL, Herbert Granville 1872-1951
Painter of genre and religious themes and writer on art. Exhib. at the RA from 1892. Studied at Heatherley's School and abroad. Lived in London.
Bibl: Studio II pp.154, 164; IV p.l9; Vl p.193; VIII p.167; XII p.71; XIII p.71; XV pp.192, 211; XXIII p.274; XXIV p.250; LVI p.46; Winter Number 1900 p.70; Summer Number 1901 p.95; Sketchley, *English Book Illustrations of Today*, 1903, pp.25, 26, 126; Who's Who 1914; Cedric Chivers, *Books in Beautiful Bindings,* Bath.

FELL, W.H. fl.1878
Exhib. a landscape at SS 1878-9. Address in Sydenham.

FELLOWES, Arthur fl.1869
Exhib. a landscape in 1869. London address. Emigrated to British Columbia, Canada.

FELLOWES-PRYNNE see PRYNNE

FELTON, Lydia M. 1890-1892
Exhib. four times at SS, 1890-2, including 'Armour' and 'Oriental Head'. London address.

FENDER, Miss Maggie F. fl.1891
Exhib. two landscapes at the RA in 1891, 'St. Abb's Head' and 'A Summer Sea'. Address in Ayton.

FENN, Miss A.S. Manville fl.1883-1885
Exhib. four times at SS 1883-5 including a scene from *Bleak House* and a picture entitled 'Here's Nurse Coming'. Member of the Society of Lady Artists. Address in Chiswick, London.

FENN, G. fl.1839
Exhib. a painting of dogs at the RA in 1839.

FENN, William Wilthieu **fl.1848-d.1906**
Landscape and coastal landscape watercolourist. Exhib. at the RA, 1848-65, including views on the Sussex, Dorset and Devon coasts. Also exhib. at SS, BI and elsewhere. Address in London.
Bibl: AJ 1860 p.77; 1907 p.36; Portfolio 1886 p.24; Brook-Hart

FENNELL, John Greville **1807-1885**
Painted landscapes in Scotland, on the Thames, and, on one occasion, in California. Studied at Sass's School. Exhib. at SS, 1851-72. Address in Staines, Middlesex. A keen fisherman, and often painted fishing subjects. Friend of Phil Browne, Dickens and Thackeray.
Bibl: Ottley; DNB XVIII.

FENNELL, Miss Louisa **1847-1930**
Painted landscapes and views of buildings in watercolour. Worked in Rome. Exhib. at SS, 1876-82. Lived in Wakefield, Yorkshire, where there are examples of her work in the museum.

FENNER, Charles **fl.1858-1866**
Painted landscape, country genre and animals. Exhib. at the BI, 1861-6, including 'What, Misty Rover?' and 'Our Young Keeper. A Cumberland Interior'. Lived at Hampton Wick.

FENNER, J. **fl.1838**
Exhib. 'A view on the Thames' at the RA in 1838. London address.

FENOULET, W. **fl.1836-1839**
Exhib. two landscapes, one of the Val d'Aosta and another of the Thames, at the RA in 1839. Address in London.

FENTON, Miss Annie Grace **fl.1875-1885**
Genre painter. Exhib. at the RA, 1877-85, including 'The Mouth with steady sweetness set', 'An English girl three hundred years ago' and 'Where is another sweet as my sweet', etc. Address in Notting Hill, London.

FENTON, Enos **fl.1832-1860**
Exhib. five landscape watercolours at SS, 1832-41. Address in London.

FENTON, Eva R. **fl.1876**
Exhib a genre painting in 1876. London address.

FENTON, F. **fl.1859**
Exhib. two paintings at SS in 1859, a view in the Forest of Arden and a scene from *As You Like It*. Address in London.

FENTON, Roger **fl.1849-1851**
Exhib. at the RA, 1849-51, including an illustration to Tennyson's *The May Queen*. Address in London.

FENTON, Miss Rose M. **fl.1877-1885**
Exhib. twice at the RA, 'A Rose but one, none other rose had I' and a portrait of Mrs. Roger Fenton, 1877 and 1885. Address in London.

FERGUS, Robert **fl.1882**
Exhib. one picture, 'On the Bank of the Pond', at SS in 1882. Address in London.

FERGUSON, Mrs., of Raith
A watercolour portrait by her of Lady Stirling-Maxwell is in the Scottish NPG.
Bibl: Ormond; Irwin.

FERGUSON, Mrs. A. **fl.1881**
(Miss Edith Marrable)
Exhib. a portrait at the GG in 1881. Member of the Society of Lady Artists. Address in Kirkcaldy. See also Miss E. Marrable.

FERGUSON, Eleanor **fl.1884**
Exhib. one picture, 'Fallen Apples', at SS in 1884. London address.

FERGUSON, J. Knox **fl.1886-1887**
Exhib. two pictures at the RA, 'Chatterton: Morning of the 25th August, 1770' and 'Rashleigh and Francis Osbaldiston' in 1886 and 1887. Lived in Edinburgh.

FERGUSON, J.W. **fl. late 19th century**
Painted coastal scenes on the Durham and Northumbrian coast. His 'Entrance to Sunderland Harbour' is in the Sunderland Art Gallery.
Bibl: Hall.

FERGUSON, James **fl.1817-1857**
Landscape painter. Exhib. at the RA, BI and SS. Most of his paintings are of the landscape of Scotland. James Orrock was his pupil. Addresses in Edinburgh and London.
Bibl: Hardie III p.159.

FERGUSON, James M. **fl.1867-1882**
Watercolour painter of landscapes, country scenes and trees. Exhib. at the RA, 1867-77, including 'Glen Fallach' and 'The Beech and the Holly Bush', and at the SS, 1874-82. Address in London.

FERGUSON, Jane **fl.1882**
Exhib. a picture in 1882. Address in London.

FERGUSON, T.R. **fl.1867**
Exhib. a picture of fruit in 1867. Address in London.

FERGUSON, W. **fl.1892**
Exhib. one picture, 'Daffodils', at the RA in 1892. Address in Edinburgh.

FERGUSON, William J. **fl.1849-1886**
Landscape painter. Specialised in trees, buildings and the Italian Lakes. Worked in London and Cheltenham.

FERNELEY, C.N. **fl.1851**
Exhib. a view on the Lancashire coast at the RA in 1851. Lived in Melton Mowbray.

FERNELEY, Claude Lorraine **1822-1891**
Melton Mowbray sporting painter; son of John Ferneley Snr. (q.v.), by his first wife Sarah. Exhib. only one picture of horses at the RA in 1868. Painted horse portraits and hunting scenes for local patrons in a style similar to his father's. Works by him can be seen in the Leicester AG.
Bibl: Strickland; Guy Paget, *Sporting Pictures of England*, 1945; Guy Paget, *The Melton Mowbray of John Ferneley*, 1931; W. Shaw-Sparrow, *A Book of Sporting Painters*; Ormond.

FERNELEY, John, Jnr. **c.1815-1862**
Melton Mowbray sporting painter, eldest son of John Ferneley Snr. (q.v.), by his first wife Sarah. Very little is known of his life, except that he worked in Manchester, York, and died in Leeds. His work is often confused with his father's, and they probably collaborated on many pictures. John Jnr. usually signed John Ferneley, and his

father J. Ferneley, but the son's work is noticeably coarser and less competent than his father's.

Bibl: Guy Paget, *The Melton Mowbray of John Ferneley*, 1931; W. Shaw-Sparrow, *A Book of SportingPainters*; Sparrow p.193.

***FERNELEY, John E., Snr. 1782-1860**
Melton Mowbray sporting painter. Born at Thrussington, Leicestershire, the son of a wheelwright. Worked for his father until he was 21, painting only in his spare time, and occasionally painting panels on coaches and waggons. Encouraged by the Duke of Rutland and other local patrons, he was sent to London to study under Ben Marshall. Worked in Dover and Ireland, before settling in Melton Mowbray. Married Sarah Kettle in 1809, by whom she had four sons, including John Jnr. and Claude Lorraine (qq.v.), who both became painters. Sarah died in 1836; Ferneley married Ann Allan, who died in 1853. Although Ferneley exhibited at the RA, BI and SS, he worked mostly for private patrons. Within the patterns laid down by the current Marshall-Herring tradition, he developed a very recognisable personal style.

Bibl: Guy Paget, *The Melton Mowbray of John Ferneley*, 1931; W. Shaw-Sparrow, *A Book of Sporting Painters*; Sparrow pp.9, 179, 180, 181, 185-94, 216, 217, 234 (pl.59); Pavière, *Sporting Painters*; Maas p.72 (pl. p.71); Ormond; Irwin. Exhib: Leicester Museum and AG 1960.

FERRARI, Giuseppe fl.1877-1883
Exhib. 'A Street in Tunis' at the RA in 1877. Address in Chudleigh, Devon.

FERREIRA, Gustavus Adolphus fl.1845-1856
Painter of landscape and country scenes. Exhib. at the RA six times, all Devon scenes, and at the BI and SS. Addresses in Devon and London.

FERRER, V. fl.1876
Exhib. 'The Yard of a Spanish Country House' at SS in 1876-7. Address in Valencia, Spain.

FERREY B.
Painted in watercolour. He was a pupil of A.C. Pugin.

Bibl: Hardie III p.13.

FERRIER, George Stratton RI RSW RE fl.1872-d.1912
Scottish etcher and painter of ships and coastal landscapes. Exhib. four times at the RA. Address in Edinburgh.

Bibl: Caw p.303; Who's Who 1912.

FERRIER, James fl.1873
Exhib. one landscape, 'In Glen Cannick', at the RA in 1873. Address in Edinburgh.

FERRIS, E. fl.1875-1889
Painter of landscapes and country scenes in oil and watercolour. Exhib. 13 times at SS including 'The Cornfield, Essex', 'At the Cottage Door' and 'The Veteran'. Address in London.

FERRY, C.E. fl.1875
Exhib. one landscape, 'A Smart Shower — On the Chelmer', at SS in 1875-6. Address in Stoke Newington, London.

FEYEN-PERRIN see PERRIN, A.F.

FFITCH, G.S. fl.1839-1847
Exhib. at the RA, 1839-47, including portraits and genre paintings. London address.

FFOULKES, Charles J. fl.1897-1901
Exhib. at the RA, 1897-1901, three paintings of the story of St. George and one entitled 'Vanity'. Address in Rye, Kent.

FICHARD, Baron de fl.1877
Exhib. a view of Venice in 1877. Address in Baden-Baden, Germany.

FICKLIN, Alfred fl.1865-1889
Exhib. five pictures, including one of fruit and three landscapes, at SS, 1865-90. Also exhib. at the BI. Address in Kingston-upon-Thames, near London.

FICKLIN, George fl.1865-1885
Exhib. seven paintings of landscape in Wiltshire, Devon and Cornwall at SS, 1865-85. Address in Pimlico, London.

FICKLIN, R. fl.1863
Exhib. a painting of fruit at the BI in 1863. Address in London.

FIDLER, Gideon M. 1857-1942
Genre painter. Exhib. at the RA from 1890 including 'Our Tame Pigeon', 'Playing Pigs' and 'A Queen upon her Throne'. Also exhib. at SS and the NWS. Lived near Salisbury, Wiltshire.

FIDLER, Harry RI RBA fl.1891-d.1935
Painter of genre and country scenes. Studied at the Herkomer School at Bushey. Exhib. at the RA from 1891 including 'A Fruitful Land' and ' "Hark! Hark! The Dogs do Bark!" '. Also exhib. at the NEAC and the Paris Salon. Lived near Andover, Hampshire.

FIELD, Dora fl.1874-1879
Exhib. three genre pictures, 1874-9. Address in Leamington, Worcestershire.

FIELD, Edwin Wilkins 1804-1871
Solicitor and amateur painter. Set up a drawing class at Harp Alley School. Exhib . a picture of boats in 1865. Sketched on the Isle of Wight and the Thames with George Fripp and others. Was legal adviser to the OWS. Drowned in a boating accident.

FIELD, Miss Frances A. fl.1882-1889
Exhib. at the RA 'Primroses' and 'June Roses' in 1882 and 1883. Also exhib. at SS and NWS. Address in Oxford.

FIELD, Freke fl.1890-1894
Exhib. at the RA, 'Le Matin' and 'L'Attente' in 1890 and 1892, and a portrait in 1894. Lived near Ham, Surrey.

FIELD, John M. 1771-1841
Portrait and landscape painter. Often painted on to plaster of Paris and also made landscapes *à la silhouette*. Exhib. 43 works at the RA 1800-36. Address in London.

Bibl: Rowinsky, *Lex. Russ. Portrastiche* 1886 I p.226; Binyon; Nevill Jackson, *The History of Silhouettes*, 1911 p.93.

FIELD, Mrs. Mary F. fl.1869-1893
Painted genre subjects. Exhib. at the RA from 1892 including 'A Little Cottage Beauty' and 'Heirlooms'. Exhib. once at SS in 1890. Lived in Hampstead, London.

FIELD, Miss Nora fl.1889
Exhib. a landscape in 1889. London address.

FIELD, Walter ARWS 1837-1901
Landscape and country genre painter. Exhib. mainly at the NWS
but also at the RA. Worked in the Thames Valley and on
Hampstead Heath. Lived in Hampstead, London.
Bibl: DNB; F. de Böticher, *Malerw. 19 Jahrh,* 1891 I.

FIELDER, Henry fl.1872-1885
Landscape watercolourist. Worked in Surrey and made many
drawings of Box Hill and the River Mole. Exhib. at SS. Lived in
Dorking, Surrey.

FIELDER, Mrs. J.N. fl.1857
Exhib. one picture, 'Horse Play', at the RA in 1857. Address in
Boulogne, France.

FIELDER, R.W. fl.1877
Exhib. a landscape watercolour at SS in 1877. Lived at Dorking,
Surrey.

***FIELDING, Anthony Vandyke Copley 1787-1855**
Marine and landscape painter in watercolour and oil. Second son of
Nathan Theodore Fielding. Studied under his father and John
Varley. In 1810 he began to exhibit at the RWS, where he exhib.
most during his career, often sending 40 or 50 a year. He became a
full member of this society in 1813, secretary in 1813 and president
from 1831 to his death. He exhib. only 17 paintings — all oils — at
the RA 1811-42, landscapes and views of buildings. He was one of
the most fashionable drawing masters of his day. In 1824 he was
awarded a medal at the Paris Salon, with Constable and Bonington.
His best subjects were views of the Sussex Downs, but also storm
scenes at sea, and drawings of lake and mountain scenery in
Scotland, Wales and the north of England. He also painted a few
Italian scenes, but these were from the sketches of others. He never
went abroad. He was championed by Ruskin: "No man has ever
given, with the same flashing freedom, the race of a running tide
under a stiff breeze, nor caught, with the same grace and precision,
the curvature of the breaking wave, arrested or accelerated by the
wind" (*Modern Painters*). Many of his watercolours have faded,
because of the use of indigo. For works illustrated by, see Card Cat.
at VAM.
Bibl: DNB; S.C.K. Smith OWS III 1925; Roget; Redgrave Dict., Cat.; AJ 1855
p.108 (obit.); 1906, pp.298-9; Burlington Mag. XIX 1911 pp.331-2; Ruskin,
Modern Painters, see Index; Binyon; VAM Cat. of Oil Paintings, 1907; A.L.
Baldry, *The Wallace Collection,* 1904 pp.117, 119; Maas p.64; Hardie III *passim;*
Staley; Brook-Hart; Irwin.

FIELDING, Edward fl.1877
Exhib. a landscape watercolour, of Langdale Pikes, at SS in 1877.
Address in London.

FIELDING, Miss Eliza M. fl.1848-1856
Exhib. at BI two pictures, 'A Connemara Peasant' and 'The
Holidays', 1855 and 1856. Also exhib. once at the RA and once at
SS. Address in London.

FIELDING, N. fl.1851
Exhib. 12 sporting pictures in 1851. Address in London.

FIELDING, Newton Smith Limbird 1799-1856
Youngest son of N.T. Fielding, and brother of Copley Fielding
(q.v.). Ran the family engraving business in Paris, until the
Revolution of 1830, when he returned to London. After working
with his brothers Thales and Theodore (qq.v.), he returned to Paris,
where he enjoyed an extensive teaching practice. His best known
works are farmyard scenes and wild animals.

FIELDING, Thales AOWS 1793-1837
Landscape painter. Brother of Copley Fielding (q.v.) Exhib. at the
RA, BI, SS and OWS until 1837. London address.
Bibl: DNB XVIII p.426; Redgrave, Dict.; Roget; *Journal of Eugène Delacroix,*
1893-5; Binyon; Cat. of watercolour paintings VAM II 1908; Gazette des Beaux-
Arts 1912 II pp.269-70; Hardie.

FIELDING, Theodore Henry Adolphus 1781-1851
Painted watercolours. He was the eldest brother of Copley Fielding
(q.v.). He taught drawing at the Military College at Addiscombe.
He lived near Croydon, Surrey. He published a 'Treatise on the
Ancient and Modern Practice of Painting in Oil and Watercolours'.
Bibl: Redgrave, Dict.; Roget; Hardie.

FIGGINS, Vincent fl.1838-1848
Painted landscapes. Exhib. at SS, 1842-3 and at the RA, 1838-43,
including views of Hemel Hempstead and Watford. Address in
London.
Bibl: Printing Historical Society, Facsimiles of Printing Types, 1967.

FILBY, S.H. fl.1864-1865
Painted coastal landscapes. Exhib. at the BI, 1864-5, views of the
Kent coast. Lived in Hammersmith, London.

***FILDES, Sir Samuel Luke RA 1843-1927**
Painter of genre and portraits. Born in Liverpool. Fildes studied
first at a local Mechanics Institute. After eight years at Warrington
School of Art, he came to London in 1863 to study at the South
Kensington schools. Fildes then worked for several years as an
illustrator on magazines such as *Once a Week* and *The Graphic.*
Through a recommendation from J.E. Millais, he was
commissioned by Dickens to illustrate his last novel, *Edwin Drood.*
In the 1870s Fildes turned from illustration to painting; and in 1874
his large picture of 'Applicants for Admission to a Casual Ward'
brought him fame overnight. The picture, which is now in the Royal
Holloway College, was praised for its Dickensian realism, honesty
and lack of affectation. Fildes's subsequent output was of three
types: firstly, social documentary subjects, such as 'The Widower'
(1876) and 'The Doctor' (1891) which became enormously popular
through engravings; secondly, Venetian genre scenes, such as
'Venetians' (1885) and 'An Alfresco Toilet' (1889), painted in a
style similar to Van Haanen, Eugene de Blaas and Henry Woods
(q.v. — Fildes's brother-in-law); thirdly, portraits. It was as a
portrait painter that Fildes found the fame and fortune he so
earnestly pursued. In 1894 he painted the Princess of Wales, which
led to a series of royal commissions, including the state portraits of
Edward VII in 1902, and George V in 1912. Fildes was elected
ARA 1879, RA 1887, and knighted 1906. The fullest account of his
life is the biography published by his son. His studio sale was held
at Christie's, 24 June 1927. Manuscripts relating to Fildes are held
at the VAM.
Bibl: Clement & Hutton; AJ 1877 p.168; 1895 pp.179, 181; 1897, pp.168, 338ff.;
1898 pp.167, 177; 1900 p.177; 1901 p.180; 1902 p.184, 1909 p.166; Art Annual
1895 pp.1-32 (mono. with pls.); Who's Who 1914; Reynolds, VS pp.27, 28-30,
33, 40, 94-5 (pls. 84, 85); Reynolds, VP pp.15, 120, 141, 180; L.V. Fildes, *Luke
Fildes RA. A Victorian Painter,* 1968; Maas pp.237-8 (pl. p.239); Ormond; Irwin;
Wood Panorama; Wood, Paradise Lost.

FILDES, Mrs. Samuel Luke fl.1875-1884
(Miss Fanny Woods)
Exhib. three paintings at the RA, 1878-83, 'Peeling Potatoes', 'A
Berkshire Cottage' and 'The New Gown'. Wife of the painter, Luke
Fildes (q.v.). Lived in Melbury Road, London.
Bibl: Clement & Hutton; L.V. Fildes, *Luke Fildes RA. A Victorian Painter,* 1968.

FILIDEI, A. fl.1863
Exhib. one painting, 'The Country of the Italian Campagna', at the RA in 1863. Address at Eldersham, Staffordshire.

FILKIN, G. Griffin fl.1873-1882
Birmingham painter of landscapes, and coastal scenes.

FILL, W. fl.1853
Exhib. one landscape, a view on the Wye, at SS in 1853 .

FILLANS, G. fl.1838-1840
Exhib. two portraits at the RA in 1838 and 1840. Also exhib. two pictures, entitled 'Covenanter reading the Scriptures' and 'Jennie Deans on her road to London', at the BI. Address in London.

FINBERG, Alexander Joseph fl.1888
Exhib. a painting at the NWS in 1888. Address in Clapton.

FINCH, Francis Oliver 1802-1862
Landscape watercolour painter. Worked for five years under John Varley, and became an associate of the Society of Painters in Watercolours in 1822 and a member in 1827. He exhib. at the RA 1817-1832. He painted many views of Scottish and English landscapes in "rather stilted classical compositions, using the 'hot' colours which affected watercolour painting at the time" (Maas).
Bibl: Mrs. Eliza Finch, *Memorials of F.O. Finch*, 1865; Redgrave, Dict.; Roget; DNB; VAM Cat. of Oil Paintings 1907; Watercolour Paintings 1908; Binyon; AJ 1862, p.207 (obit.); 1893, p.44; Maas p.44; Hardie II pp.171-2 (pls.161-2); Raymond Lister, *Edward Calvert* (including appendix *On the Late Francis Oliver Finch, as a painter*), 1962.

FINDLEY, Mrs. Edith A. fl.1885-1890
Exhib. at SS watercolours called 'February' and 'The Studio'. Exhib. at the RA 'A Mountain Path, New Zealand'. Lived in Hampstead, London.

FINK, Philip fl.1862-1867
Painted genre scenes. Exhib. at the BI, including 'Home Sweet Home' and 'Two Old Friends', and at the RA and SS. Address in London.

FINLAY, A. fl.1840-1848
Painted landscapes. Worked in England and Ireland. Exhib. at the RA, including views in Shropshire and County Wicklow, and once at SS. Lived in Lambeth, London.

FINLAY, Alexander fl.1879-1881
Exhib. two paintings at the RA, 'The Harbour, Kemaquhair' and ' "When ye were Sleeping on your Pillows, etc." ' in 1879 and 1881 Address in Glasgow.

FINLAY, K.J. fl.1855-1873
Painted coastal genre subjects and coastal landscapes. Exhib. four times at the RA. Address in London.

FINLAYSON, Alfred fl.1860-1881
Painted fruit and flowers. Exhib. 36 times at SS. Also exhib. at the RA and the BI.

FINLINSON, Miss Edith M. fl.1897-1899
Exhib. three paintings at the RA, two portraits and a work called ' "The Thoughts of Youth are long, long Thoughts" '. Address in South Godstone.

FINN, Herbert John b.1861 fl.1886-1901
Exhib. country genre subjects and views of buildings. Studied in Paris under Bougereau. Exhib. at SS, 1886-93, including 'A Kentish Watermill', and at the RA in 1901. Address in Deal, Kent.
Bibl: AJ 1900 p.33; 1901 p.381; 1902 p.172; 1903 p.159; Evening Standard 8 June 1908; The Times 22 November 1912; Who's Who 1914.
Exhib: London, St. James's Hall 1902; London, 108 New Bond Street 1905; French Gallery 1934.

FINNEMORE, Joseph RBA RI 1860-1939
Painted genre, literary subjects and the royal family. Exhib. at the RA from 1891, including 'H.R.H. The Prince of Wales Shooting at Sandringham' and 'The Pick-pocket' from John Gay's *Trivia*, and at SS, including 'When the King shall enjoy His own again' and 'Breton fish wife'. Elected RI 1898. Address in London. .
Bibl: Who's Who 1914.

FINNEY, Mrs. Virginia fl.1887-1893
Exhib. twice at the RA, ' "Ma io veggio or la tua mente, etc." ' and a portrait. London address.

FINNIE, John 1829-1907
Liverpool landscape painter, engraver and etcher. Born Aberdeen. Worked in Newcastle, where he met W. Bell Scott in London 1853-6. He then became Headmaster of the Mechanics Institute and School of Art in Liverpool, and held the post until 1896. Finnie, whose landscapes were broad and naturalistic in style, was also a mezzotinter and etcher. He exhib. at the RA 1861-1902, BI, SS and the Paris Salon, where he once received honourable mention.
Bibl: AJ 1907; Studio VII p.167; XXIV p.36; XXVIII p.208; XLII p.148; Art in 1898 66; Summer No. 1902; Marillier pp.119-21 (pl. opp. p.120); DNB.

FIRMINGER, Rev. Thomas Augustus Charles 1812-1884
Painted landscapes, architecture and ruins. Exhib. 68 times at the NWS. Also exhib. at the RA, including 'Native Boats, Gowhatti, Assam', and at the BI. Lived at Edmonton, and later in India. Elected NWS in 1834, but retired in 1844 on entering the church.
Bibl: Cundall p.210.

FISCHER, C. fl.1890
Exhib. a landscape in 1890. Address in Bushey, Hertfordshire.

FISCHER, Henry fl.1881
Exhib. a black paper work in 1881. London address.

FISCHER, John George Paul 1786-1875
Came to England in 1810, and painted miniatures for the royal family. A portrait drawing by him of W.H. Hunt is in the BM. Exhib. at the RA and elsewhere 1817-52, and occasionally painted landscapes.
Bibl: Ormond.

FISCHER, P. fl.1871
Exhib. at the RA in 1871 a drawing of the North Terrace at Windsor Castle. London address.

FISHER, Mrs. fl.1859
Exhib. a genre painting in 1859. London address.

FISHER, Alfred Hugh ARE 1867-1945
Painted landscapes, seascapes, townscapes and country genre subjects. Exhib. at the RA from 1887 including 'The Orchard Pump', 'Gray's Inn' and 'St. Martin's Church from the Portico of the National Gallery', and at SS, 1889-91. Address in London.

FISHER, Alfred Thomas b.1861 fl. up to 1924
Landscape painter. Lived in Cardiff, and was Secretary of the South Wales Art Society, 1913-24.

FISHER, Miss Amy E. fl.1866-1885
Painted genre and townscapes in watercolour. Exhib. at the RA, 1866-85, including 'Covent Garden', 'At a Fountain' and 'In the Campo SS Giovanni e Paolo, Venice', and at SS, 1866-84. London address.

FISHER, Arthur E. fl.1891-1900
Exhib. three paintings at the RA, 1891-1900, 'Returning from Market', 'Rose's Garden' and 'Ponies — Frosty Morning'. London address.

FISHER, Miss Beatrice fl.1889-1893
Painted portraits and genre subjects. Exhib. at SS, 1890-1. London address.

FISHER, Ben RCA VP fl.1886 d.1939
Exhib. a landscape at the RA in 1886. Lived in North Wales.

FISHER, Charles fl.1881-1890
Exhib. two views of Clovelly, Devon, at SS, 1881-3. Also exhib. once at the RA. London address.

FISHER, Daniel fl.1875-1890
Painted landscapes and coastal and country subjects. Exhib. at SS, 1875-85, and at the RA, 1882-4, including 'Landing Herrings at Whitby Pier, Yorkshire'. London address.

FISHER, E.J. fl.1836-1853
Painted portraits. Exhib. at the RA, 1848-51, including a portrait of John Kinnersley Hooper, Lord Mayor of London, and at SS, 1848-53. London address.

FISHER, Miss Edith fl.1899
Exhib. 'Sand Pits, Dawes Heath' at the RA in 1899. Address in Weybridge, Surrey.

FISHER, Miss Elizabeth A. fl.1886
Exhib. one picture, 'Petunias', at the RA, and another, 'From Bad to Worse', at SS. Lived at Addlestone, Surrey.

FISHER, Miss Ellen fl.1865-1866
Exhib. two still-lifes in 1865-6. London address.

FISHER, Frederick fl.1875
Exhib. a portrait in 1875. Address in Addlestone, Surrey.

FISHER, George P. fl.1899
Exhib. one picture, 'The Last Gleam of Sunshine', in 1899. Address in Fulham, London.

FISHER, H.M. fl.1883
Exhib. a landscape painting in 1883. London address.

FISHER, Miss Helena fl.1891-1903
Painted animals. Exhib. at the RA from 1891 including 'Rabbits', 'Love's Young Dream', 'Young Rabbits' and 'A Mighty Hunter'. Address in Addlestone, Surrey.

FISHER, Horace fl.1882-1903
Painted genre in Italianate settings. Exhib. at the RA from 1882, including 'A Moment's Rest: A Venetian Interior' and 'La Filatrice' and at SS, 1882-6, including 'At Caioggia'. Address in Herne Hill, Surrey .

FISHER, J. fl.1856
Exhib. 'On the Jersey Coast' at SS in 1856. Address in Wargrave, Berkshire.

FISHER, J.H. Vignoles fl.1884-c.1920
Landscape watercolourist. Exhib. at the RA from 1884, including views of Brittany, the Stour Valley and the Mendips, and at SS, 1884-91. Addresses in London and Lewes, Sussex.

FISHER, Miss Janet fl.1897-1902
Exhib. genre subjects at the RA from 1897, including 'At the Well', ' "I Ply my Spinning Wheel" ' and 'Through Dutch Meadows'. Address in Burton-upon-Trent, Staffordshire.

FISHER, Joseph 1796-1890
Oxford topographical painter. Was first Keeper of the University Galleries in 1844. Also copied early Turners.

FISHER, Joshua b.1859 fl. up to 1918
Liverpool landscape and figure painter. Pupil of J. Finnie (q.v.) at the Liverpool School of Art. President of the Liverpool Sketching Club in 1918.

FISHER, Miss Laura M. fl.1896-1903
Painted genre subjects. Exhib. at the RA from 1896 including 'Oranges and Lemons', ' "What O'Clock?" ' and 'Idleness'. Address in Hornsey, London.

FISHER, Miss M.J. fl.1858-1866
Painted landscapes. Exhib. four times at the RA, 1858-63, and four times at SS, 1859-63, including 'Near Boyne Hill' and 'Cliefden Woods'. Address in Wargrave, Berkshire.

FISHER, Maud Horman see HORMAN-FISHER

FISHER, Percy Harland b.1867 fl. from 1882
Painted genre and animals. Exhib. at the RA from 1890 including 'The King of Hearts', 'The Cock of the Walk' and 'A Family Removing'. Address in Herne Hill, London.

FISHER, Samuel Melton RA RWA PS 1860-1939
Painter of portraits, figurative subjects and genre in Italianate settings. Exhib. at the RA from 1878 including 'Una Vecchia', 'Venetian Costume Makers' and portraits of Mrs. Val Prinsep and the daughters of Sir Oswald Mosley, Bart. Also exhib. at SS and GG. Lived at Herne Hill, London.
Bibl: A.L. Baldry in Studio, XLII p. 173; Studio XXIX, XLII, XLIV, LIII; AJ 1901 and 1904; Connoisseur XXXVI pp.268, 272; Paris Salon, Soc. d'Art Français 1909; Venice Esp. Internaz. 1897, 1901, 1903, 1909; Pittsburgh Carnegie Inst. exhib. 1907.

FISHER, William 1817-1895
Irish painter of portraits, genre and historical subjects. Exhib. at the RA, 1840-84, including portraits of the Duke of Cambridge and Robert Browning, and at the BI, 1842-67, including 'The Toilet', 'Triumph of Venus' and 'Carnival at Venice'. London address.
Bibl: Strickland; BM Cat. of Engraved British Portraits I, III, IV; Ormond.

***FISHER, William Mark RA 1841-1923**
Landscape painter, considered by George Moore in 1893 to be "our greatest living landscape painter". Born in Boston, USA. Studied at the Lowell Institute, Boston, and under George Innes. Started as a genre and portrait painter. Went to Paris about 1861; studied under Gleyre and was influenced by Corot. Returned to Boston, but not finding success, came to England in 1872. Exhib. at the RA, from 1872. ARA 1911; RA 1919. Member of NEAC. He chiefly painted landscapes. Manuscripts relating to Fisher are held at the VAM.
Bibl: Who's Who in America VII; Clement & Hutton; George Moore, *Modern Painting,* 1900 pp.249-51; AJ 1910 pp.15-20; 1896 p.97; 1900; 1905; 1908; Studio II pp.23, 30, 35, 44, 47, 58; Burlington Mag. XII pp.278, 286; Connoisseur XXIX p.56; RA Pictures 1905-13; VAM MSS: Letters to H.M. Cundall from M.F. with biog. inform. 1878; V. Lines, *Mark Fisher and Margaret Fisher Prout,* 1966; VAM; Wood, Paradise Lost.
Exhib: London, Beaux-Arts Gallery 1938; London, Royal Soc. of Painters in Watercolour, Memorial exhib. 1966.

FISK, William 1796-1872
Painter of portraits and historical subjects. Exhib. at the RA, 1818-48, including 'The Coronation of Robert the Bruce', 'Leonardo Expiring in the Arms of Francis I' and 'The Trial of Charles I in Westminster Hall', at SS, 1828-38, including a sketch for 'The Introduction of Christianity into England' and at the BI, 1830-46. London address.
Bibl: AJ 1873 p.6; Redgrave; Clement & Hutton, DNB; BM Cat. of Engraved British Portraits; Ormond.

***FISK, William Henry 1827-1884**
Painted landscapes and historical subjects. Son of William Fisk (q.v.). Exhib. at the RA, 1850-73, including 'Fugitives Escaping form the Massacre of Glencoe' and scenes from the history of the French Revolution, at SS, 1846-62, and at BI, 1856-63. His most remarkable picture is 'The Secret', illustrated in volume 2 of this Dictionary. London address.
Bibl: Bryan II; DNB; Redgrave, Dict.

FITCH, Walter fl.1848
Exhib. a landscape in 1848.

FITHIAN, Miss Edith fl.1894
Exhib. a portrait of a lady at the RA in 1894. Address in Bushey, Hertfordshire.

FITZ, William fl.1880-1891
Exhib. twice at the RA, 'The Gallery, Hampton Court Palace' and 'Windsor Castle' in 1885 and 1890, and at SS three times 1880-1. London address.

FITZADAM, A. fl.1853
Exhib. one picture, 'Oh! So Tired!', at SS in 1853. London address.

FITZCOOK, A. fl.1853-1864
Exhib. twice at the BI, 1853-64, 'Beware!' and 'The Ploughman's Midday Meal'. London address.

FITZCOOK, Henry b.1824 fl. to 1898
Painted literary and biblical subjects. Also worked as an illustrator. Exhib. at SS 1853-72, including 'Don Quixote and Sancho Panza waiting for Sunrise' and 'Jacob and Rachel at the Well', and at the RA four times, 1846-98, including 'Hark! Hark! The Lark at Heaven's Gate Sings!' and 'The Marriage at Cana'. London address.
Bibl: Ottley.

FITZGERALD, Lady fl.1893
Exhib. a study for a painting at the NG in 1893.

FITZGERALD, Claude J. fl.1893
Exhib. a still-life in 1893. Address in Chiswick, London.

FITZGERALD, Edith fl.1869
Exhib. a genre subject in 1869. London address.

FITZGERALD, Edward 1809-1883
Made a portrait drawing of Tennyson.
Bibl: Ormond.

FITZGERALD, F. fl.1848-1858
Exhib. at the BI in 1848 'Custom of the Roman Shepherds before Christmas', and at the RA in 1858 'Summertime'. Address in Bayswater, London.

FITZGERALD, Miss Florence fl.1887-1900
Painter and sculptress. Exhib. at the RA, 1887-1900, including 'By the Meadow Brook' and 'Where the Wild Flowers grow' and at SS, 1884-93. London address.

FITZGERALD, Frederick R. fl.c.1897
Painter of coastal and marine subjects. Lived in Cheltenham. Visited Norway, and exhib. in Birmingham in 1897.

FITZGERALD, H. fl.1846
Exhib. one painting, 'The Fight', at SS in 1846. Address in Newington.

FITZGERALD, H. Jane fl.1851
Exhib. one painting, 'Contentment', at the RA in 1851. London address.

FITZGERALD, James fl.1850
Exhib. 'Highland Flowers' at the RA in 1850. London address.

***FITZGERALD, John Anster 1832-1906**
Painter of fairy scenes and dreams (sleeping people surrounded by goblins) — all highly imaginative works. Very little is known of his life and only very few of his paintings exist. Four of his best are reproduced in Maas, 'The Captive Dreamer', 'The Chase of the White Mice', 'The Dream', and 'Standing Nude'. He is known to have belonged to the Maddox Street Sketching Club, and he exhib. at the RA 1845-1902, the last title being 'Alice in Wonderland', 1902. Works by him can be seen in the Guildhall, London, and the Walker AG, Liverpool. Also a watercolourist.
Bibl: AJ 1859 pp.82, 121, 141, 162; 1860 p.80; Index Printsellers' Assoc. 1912; Maas pp.153-4 (pls. pp.154-5, 159, 166); B. Phillpotts, *Fairy Paintings,* 1978.

FITZGERALD, Miss K. fl.1864-1866
Exhib. three watercolours, 'Apple Blossom', 'Wild Berries' and 'Apple Blossom and Chaffinch's Nest', at SS, 1864-6. London address.

FITZGERALD, Michael 1875-1885
Exhib. twice at the RA, 1883-5, 'In Winter Quarters: Old Soldiers at the Royal Kilmainham Hospital, Dublin' and 'Members of the Commons' and once at SS, 'The Little Fishes', in 1875-6. London address.

FITZGERALD, Percy Hetherington 1829 or 1834-1925
A portrait drawing by him, of Charles Waterton, is in the NPG.
Bibl: Ormond.

FITZHENRY, S. fl.1840
Exhib. 'A Diligence' at SS in 1840. Address in Chelsea, London.

FITZJAMES, Miss Anna Maria fl.1852-1876
Painted fruit. Exhib. nine times at SS and four times at the RA, including 'Greengages and Grapes' and 'Apple and Damsons'. Pupil of William Henry Hunt (q.v.). Member of the Society of Lady Artists.
Bibl: Clayton; Roget.

FITZJOHN, E. fl.1884
Exhib. 'Tranquility' at SS in 1874. Address in Hampstead, London.

FITZ-MARSHALL, see MARSHALL, J. Fitz

FITZPATRICK, Arthur fl.1862-1868
Painted genre subjects. Exhib. mainly at SS, 1862-8, including 'Sign the Petition', 'The Smile and the Frown' and 'The Governante and her Charge'. Also exhib. at the RA in 1868, and the BI, 1863-7. London address.

FITZPATRICK, Edmund ARHA fl.1848-1870
Irish genre painter. Painted subjects from Irish life. Exhib. mainly at SS, 1856-70, including 'Till the Heart is sick and the Brain Benumbed', 'The Poor Scholar' and 'A Tipperary Peasant'. Also exhib. once at the BI in 1867. Address in Chelsea, London.
Bibl: Strickland.

FLACK, Charles fl.1891-1892
Exhib. three times at the RA including, in 1892, a portrait and a painting entitled 'A Keen Politician'. Address in Bushey, Hertfordshire.

FLACK, Miss Edith Mary fl.1887-1889
Exhib. at the RA in 1889 an interior of the Henry VII Chapel at Westminster Abbey, and at SS in 1887-8, an interior of St. Erasmus's Chapel at Westminster Abbey. London address.

FLACK, Thomas 1771-1844
Landscape painter in oil and watercolour, who worked mainly on the Continent.

FLANDERS, French fl.1856-1857
Exhib. a painting, 'At Seville', at the BI in 1857. 'A Pipe at Lunchtime' was sold at Christie's, 15 December 1972. Address in Islington, London.

FLEETWOOD, S. fl.1862
Exhib. a painting 'On the Lake of Lucerne' at SS in 1862. London address.

FLEMING, Miss Le see LE FLEMING

FLEMING, John B. RSW 1792-1845
Scottish painter of landscapes, and especially lochs, of which he painted a series for Swan's *Scottish Lochs* in 1834. Lived in Greenock.

FLEMING, W. b.1804 fl.1842
Painted interiors. Exhib. one picture, 'Dutch Interior: A Peasant Girl looking out', at the RA in 1842. Address in Leiden, Holland.
Bibl: Immerzeel, *Levens en Werken*, 1842.

FLEMING, W.B. fl.1873-1875
Exhib. three paintings, 'Fruit', 'Food for Taste' and 'Dead Game and Fruit', at SS, 1873-5. Address in Croydon, Surrey.

FLEMMING, Miss Leila fl.1899
Exhib. one picture, 'Morning Grass', at the RA in 1899. Lived near Bath.

FLEMWELL, George Jackson 1865-1928
Genre painter. Studied under W.P. Frith (q.v.) and at the Antwerp Academy. Exhib. at the RA from 1892, including 'Une Question Embarrassante' and 'Patience'. Lived in Antwerp and later in Australia and England.

FLÈRE, Herbert H. fl.1893
Exhib. a genre painting in 1893. London address.

FLETCHER, Miss fl.1838
Exhib. one 'View from Nature', at the RA in 1838.

FLETCHER, Arthur fl.1859
Exhib. 'The Pond in the Paddock' at the RA in 1859. Address in Hornsey, London.

FLETCHER, C.J. fl.1836-1837
Exhib. at SS, 1836-7, including 'The Pensive Thought'. London address.

FLETCHER, Clelia Lega fl.1862
Exhib. two watercolours at SS in 1862, one of them entitled 'Bit of Rock, Bangor'. London address.

FLETCHER, Edith Croft fl.1876
Exhib. a landscape in 1876. Lived at Windermere.

FLETCHER, Evelyn fl.1880
Exhib. a watercolour, 'Rue du Marchi', at SS in 1880. Lived at Hampton Court.

FLETCHER, Flitcroft fl.1882-1886
Exhib. at the RA, 1882-6, including 'A Lonely Pool' and 'Winter in the Fens'. Address in Croydon, Surrey.

FLETCHER, Frank Morley 1866-1949
Painter of portraits and figurative subjects and graphic artist. Studied in Paris at the Atelier Cormon. Exhib. at the RA, 1892-3, a portrait and a work entitled 'The Shadow of Death'. The greater part of his work is later in date. Eventually he settled in California.
Bibl: Singer Kstlerlex; Studio XXI 1901 p.96; Les Arts 1912 no.121 p.25; 1913 no.139 p.32.

FLETCHER, Mrs. Grace fl.1888
Exhib. a 'Study of Grapes' at the RA in 1888. Address in Paris.

FLETCHER, H. Murray fl.1883-1902
Exhib. three watercolours at SS, 1883-4, 'Early Spring', 'A River Scene' and 'A Pool in the Forest'. Later exhib. at the RA. Address in Stoke Newington, London.

FLETCHER, J.H. fl.1889
Exhib. 'Wash Day' at the RA in 1889. Address in Nottingham.

FLETCHER, Miss Margaret fl.1886
Exhib. one picture, called 'Nancy', at the RA in 1886. Address in Oxford.

FLETCHER, William Teulon Blandford 1858-1936
Landscape and genre painter. Exhib. in London from 1879. He was a member of the Newlyn Group. An exhibition of his work was

held at the Maas Gallery, London, in June 1975 (see Bibl:) with a brief catalogue. 'Evicted' (1887) is in Queensland AG Australia.

Bibl: Maas Gallery, London, *Blandford Fletcher*, June 1975; Wood, Paradise Lost.

FLETCHER-WATSON, P. RBA 1842-1907
Painter of architectural subjects. Worked in Australia and was Founder and President of the Australian Academy. Exhib. at the RA. Lived at Paignton, Devon.

FLEURS, Henry J. fl.1847-1874
Painted portraits and genre subjects. Exhib. at the RA, 1847-74, including 'The Queen's Shilling', 'Monks of St. Bernhard's Abbey finding a relic of Bosworth' and several portraits. Lived in Marlborough, Wiltshire, where he was drawing master.

FLEURY De see DE FLEURY

FLEURY, R. fl.1841-1846
Exhib. two paintings at the RA, 'The Miser' and 'Flemish Painter's Study' in 1841 and 1846.

FLEUSS, Oswald fl.1890
Designed and painted stained glass. Exhib. at the RA from 1890. Address in Hammersmith, London.

FLICK, R. fl.1842
Exhib. one picture, 'Asleep and Awake', at the BI in 1842. Address in Bloomsbury, London.

FLINT, Savile Lumley William fl.1880-1895
Painted landscape. Exhib. at SS, 1880-8, including several views of the Thames, and at the RA, 1882-92, including 'On the Ebb Tide' and 'Kew Bridge'. London address.

FLOCKTON, F. fl.1867-1876
Painted watercolours of birds and their nests. Exhib. at SS, 1866-75, including 'Chaffinch's Nest, Birds and Honeysuckle', and at the RA in 1869 and 1876, including 'Nest and small Birds'. Address in Pangbourne, Berkshire.

FLOOD, A.J. fl.1859-1862
Painted landscape watercolours. Exhib. at SS, 1860-2, including views in Surrey and 'By the Side of the Wood', and at the RA, 1859-62, including 'A Bundle of Sticks'. Address in Chelsea, London.

FLOR, Ferdinand 1793-1881
His portrait of Queen Adelaide was in the collection of the Earl of Shrewsbury.

Bibl: Ormond.

FLORENCE, Mrs. Mary NEAC 1857-1954
Painted frescoes, figure subjects and landscapes. Studied at the Slade. Exhib. at the RA and NEAC. Lived at Marlow, Buckinghamshire.

FLOUD, Miss M.C.F. fl.1860
Exhib. two landscapes in 1860. Address in Exeter, Devon.

FLOWER, Charles Edwin BWS NSA b.1871 fl.1900
Painted landscapes and, later in his career, architectural subjects. Exhib. at the RA from 1899, including 'At Low Tide' and 'Mont

Orgeuil Castle, Jersey'. Addresses at Balham, London and Wallingford, Oxfordshire.

FLOWER, Clement fl.1899-1901
Exhib. twice at the RA, a portrait and 'A National Sunday League Concert in the Holborn Union' in 1899 and 1901. Address in Bushey, Hertfordshire.

FLOWER, Mrs. E. Wickham fl.1872-1873
Exhib. two paintings of flowers in 1872-3. Address in Croydon, Surrey.

FLOWER, Edgar fl.1890
Exhib. a view of Tremezzo on Lake Como at SS in 1890. Lived in Stratford-upon-Avon.

FLOWER, John 1793-1861
Leicester topographical painter. Pupil of de Wint in London. Painted all over England, in a style similar to that of his master. His daughter Elizabeth painted in a similar style.

FLOWER, Marmaduke C. William fl.1873-d.1910
Painter of portraits, landscape and genre. He was H. von Herkomer's first assistant. Exhib. from 1878 at the RA, including 'Winter's Ending: Old Aqueduct, Meanwood', 'The Old Farmstead' and portraits. Lived at Bushey, Hertfordshire, and in Leeds, Yorkshire.

Bibl: Building News 1910 II p.509.

FLOWER, Noel fl.1898-1904
Exhib. portraits at the RA from 1898. Address in Holland Park, London.

FLOYD, Harry fl.1884-1890
Painted portraits, genre and country scenes. Exhib. three pictures at the RA, 1884-90, 'A Moorhen's Haunt, Sussex, with Beachy Head in the Distance', 'Enough and to Spare' and 'La Comtesse de la Rochette'. Address in Eastbourne, Sussex.

Bibl: American Art Annual 1898-1903.

FOGGO, George 1793-1869
Painter of literary, historical and biblical subjects as well as landscapes. Also worked as a lithographer. Exhib. mainly at SS, 1834-64, including 'The Historical Painter', 'The Monk finding Edward III abandoned in His Last Moments' and 'The Relief of Lucknow'. Also exhib. at the RA, 1819-52, including 'Harrow, from Hampstead Heath' and 'Christ Healing the Sick Woman in the Temple'. London address.

Bibl: AJ 1860 p.372; 1869 p.360; Redgrave, Dict.; DNB; BM Cat. of Engraved British Portraits II pp.548, 712.
Exhib: London, Maddox Street Gallery, *Messrs J. and G. Foggo's Grand Historical Painting Representing the People of Parga Burying Their Dead*, 1819.

FOGGO, James 1790-1860
Painted literary, biblical and historical subjects. He was the brother of George Foggo (q.v.). Exhib. mainly at SS, 1834-58, including 'Bishop Grosteste, in his last illness, foretells the fate of Simon de Montfort' and 'The Forget-me-not'. Also exhib. at the RA, 1816-52. London address.

Bibl: Redgrave, Dict.
Exhib: See G. Foggo above.

FOLEY, Charles Vandeleur fl.1852-d.1868
Irish painter. Exhib. at the RA, 'A Brown Study' and 'Boy's Head' in 1856 and 1860, and at the BI, 'A Study from Nature' and 'A Reverie' in 1852 and 1860. London address.
Bibl: Strickland.

FOLEY, G.C.E. fl.1869-1873
Exhib. twice at SS in 1869-73 including 'Queen of the May'. London address.

FOLEY, H.W. fl.1872
Exhib. 'Going to the Wars — the Goodbye at the Door' at SS in 1872. Address in Dalston, London.

FOLEY, Joseph B. fl.1863-1877
Painted seascapes and shipping. Exhib. mainly at SS, 1863-77, including 'Towing a Disabled Ship into Ramsgate', 'Off Heligoland' and 'Unsettled Weather'. Also exhib. at the BI, 1863-4. Address in Hackney, London.
Bibl: Brook-Hart.

FOLI, Mme. Rosita fl.1885
Exhib. a genre subject in 1885. London address.

FOLINGSBY, George Frederick 1828-1891
Irish painter of portraits and historical subjects. Exhib. twice at the RA, 'The First Lesson' and 'Lady Jane Grey's Victory over Bishop Gardiner' in 1869 and 1871. Address in Munich, Germany.
Bibl: Senbert Kstlerex, *Dioskuren* 1868, 1869, 1872; Kunstchron XIV 1879 p.528; Botticher, *Malerwerke* 19 Jahrh 1891; Strickland.

FOLKARD, B. fl.1872-1873
Exhib. 'Silver and Gold' at SS in 1872-3.

FOLKARD, Miss Elizabeth F. fl.1876-1884
Painted genre subjects in watercolour. Exhib. at the RA, 1877-81, including 'A Favourite Corner' and 'For thy sake, Tobacco, I would do anything but die', and at SS, 1878-85, including 'My Little Model' and 'Tearful Thoughts'. Lived in Bayswater, London.

FOLKARD, Miss Julia Bracewell 1849-1933
Painter of portraits and genre subjects. Studied at South Kensington and at the RA Schools. Exhib. mainly at the RA from 1873 'Souvenir de Venise', 'Drink to me only with thine eyes', 'How to be Happy though Single' and 'The Lady of the Lilies'. Also exhib. at SS, 1873-82. Member of the Society of Lady Artists. Address in Bayswater, London.

FOLKS, F.C. fl.1852
Exhib. one picture, 'A Nook on the Coast', at the BI in 1852. London address.

FONTANA, V. fl.1877
Exhib. a figurative painting in 1877. London address.

FONTANESSI, A. fl.1866-1872
Exhib. four paintings at the RA in 1866, including 'A Watering Place' and 'Mary's Hens'. London address.

FONTVILLE, A. fl.1893
Exhib. one painting, 'Exmoor', at SS in 1893. London address.

FOOT, F. fl.1857-1867
Landscape painter. Worked in Devon and frequently painted the River Dart and Dartmoor. Exhib. six times at the RA, seven times at SS, and seven times at the BI. Lived at Ashburton, Devon.

FOOT, William Yates fl.1880
Exhib. a watercolour entitled 'Cornfield — Berkshire' at SS in 1880. Address in Wallingford.

FOOTE, Edward K. fl.1898
Exhib. 'Waiting at the Mosque Door' at the RA in 1898. London address.

FOOTTIT, F. fl.1873
Exhib. 'December — Derbyshire' at the RA in 1873. Address in Denmark Hill, London.

FORBES, Charles Stuart 1856-1926
His portrait of Robert Browning is in the collection of the Contessa Rucellai, Florence.
Bibl: Ormond.

FORBES, H. fl.1862
Exhib. a landscape at SS in 1862.

FORBES, James G. b.1800 fl. to 1857
Exhib. at the BI, 1855-7, including 'Interview between Henry IV and his son Prince Hal'. Also exhib. at the RA on one occasion. London address.

FORBES, Patrick Lewis fl.1893
Exhib. a landscape at the NWS in 1893. London address.

***FORBES, Stanhope Alexander RA 1857-1947**
Painter of realist genre, frequently in the open air, historical subjects and landscapes. Born in Dublin. Studied at Lambeth School of Art, the RA Schools, 1874-8, and for two years in Paris under Bonnat. Influenced by Bastien-Lepage; painted in Brittany with La Thangue (q.v.) 1880. Settled in Cornwall, 1884 and became a leading member of the Newlyn School. Foundation member of the NEAC, 1886. Began exhibiting at the RA in 1878, ARA 1892, RA 1910. Married Elizabeth Armstrong, ARWS painter, in 1889, and founded with her the Newlyn School of Art 1899. (See Mrs. Stanhope Forbes below). Most of his paintings are large, realistic scenes of life in the fishing villages of Cornwall, painted in a robust *plein-air* style, using the muted colours so typical of Bastien-Lepage and his followers. His best known work is the Courbet-like 'The Health of the Bride' in the Tate Gallery.
Bibl: L. Birch, *Stanhope A. Forbes and Eliz. S. Forbes*, 1906; C.L. Hind, *The Art of S.A. Forbes*, AJ Christmas No.1911; W. Meynell in AJ 1892 pp.65-9; 1889 pp.98-101; Studio XXIII 1901 pp.81-8; also XXVI, XXIX, XXXII, XXXV, XLI, XLIX, LIII, LXIII; RA Pictures 1891-1914; Who's Who 1914 p.725; Tate Cat.; Wood, Panorama; Wood, Paradise Lost; Caroline Fox, *S.F. and the Newlyn School*, 1993.

***FORBES, Mrs. Stanhope ARWS 1859-1912**
(Miss Elizabeth Armstrong)
Painter of rustic genre; wife of Stanhope Alexander Forbes (q.v.), who she married in 1889. Exhib. at RA from 1883, SS, NWS, GG, NG and NEAC. Her style and subjects very similar to those of her husband. She also exhib. flower pieces and a few etchings. Founded the Newlyn Art School with her husband in 1899.
Bibl: AJ 1889; 1896; 1904 p.382ff.; Studio IV 1894 pp.186-92; XVIII 1900 pp.25-34; XXIII 1901 pp.81-8; also XXVI, XXXVIII, XLIV, LVI; Studio, *A Record of Art in 1898*, Special Number; Who's Who 1912-13; also see under Stanhope Alexander Forbes.

FORBES-ROBERTSON see ROBERTSON, E.J.F.

FORD, B. fl.1887-1888
Exhib. a watercolour of Barnes High Street and an interior view of one of the chapels at Westminster Abbey at SS in 1887 and 1888-9. Address in Chelsea, London.

FORD, Miss Emily S. fl.1889
Exhib. a figurative painting at the GG in 1889. Address in Leeds.

FORD, F. fl.1852-1860
Painted views in towns and architecture. Exhib. ten times at the RA, 1852-60, including several views of towns in Belgium and northern France. London address.

FORD, F.J. fl.1845-1853
Painted views in towns and architecture. Exhib. five times at the RA including views in towns in Brittany and Belgium, and ten times at SS. London address.

FORD, Miss Harriet fl.1890-1892
Exhib. a portrait at SS in 1892. Addresses in St. Ives, Cornwall, and San Gimignano, Italy.

FORD, Henry Justice 1860-1941
Illustrator of children's books, and also a painter (though weak) in oils of romantic and historical subjects. Friend of Burne-Jones. His most famous series of designs were the volumes of *Fairy Tales and True Stories (Blue, Red, Green, Pink, Grey, Yellow, Violet etc.)*, edited by Andrew Lang for Longmans. He also illustrated *Aesop's Fables*, 1888, and *The Arabian Nights' Entertainment*, 1898, and many others. He exhib. at the RA 1892-1903; and an exhibition of his watercolours — chiefly for *The Yellow Fairy Book*, 1894 — was held at the FAS in May, 1895. Sketchley says that he "represents (with J.D. Batten and H.R. Millar) the modern art of fairy-tale illustration at its best", and Gleeson-White notes that he was "a prime favourite with the small people". For works illustrated by Ford, see VAM Card Cat.
Bibl: AJ 1899; 1900; 1901; 1905; Studio Special Winter Number 1897; Gleeson-White, *Children's Illustrated Books*, p.46; R.E.D. Sketchley, *English Book Illustration of Today*, 1903 pp.109, 110, 165.

FORD, J.A. fl.1893
Exhib. a portrait at the RA in 1893. Address in Edinburgh.
Bibl: Caw p.290.

FORD, R. Onslow fl.1897-1901
Exhib. at the RA from 1897, including portraits and landscapes. London address.

FORD, Wolfram Onslow fl.1897-1904
Exhib. at the RA from 1897, including portraits, still-life, landscapes and a picture of Joan of Arc. London address.
Bibl: AJ 1899 pp.174, 176; 1900 p.180; 1902 p.60; Bate p.114; Evening Standard 24 June 1910.

FORES, Miss Mary H. fl.1888
Exhib. 'A Reverie' at the RA in 1888. London address.

FOREST, H. fl.c.1880
Painted yachts
Bibl: Brook-Hart pl.192.

FORESTIER, A. fl.1882-1883
Exhib. 'The Washing Day' at SS in 1882-3. Address in Penge, south London.

FORESTIER, Mlle. Alice de see DE FORESTIER

FORMILLI, C. fl.1887
Exhib. two landscapes at the GC in 1887. Address in Rome.

FORMILLI, T.G. Cesare fl.1894-1903
Exhib. at the RA from 1894, including designs for schemes of decoration and genre paintings. London address.

FORREST, A. fl.1858
Exhib. one painting, 'Returning with Wood', at SS in 1858. Address in Greenhithe, Kent.
Bibl: Caw p.467.

FORREST, Archibald Stevenson 1869-1963
Painted landscapes. Studied at Edinburgh Art School. Exhib. in London from 1893. Address in Sussex.

FORREST, W.S. fl.1840-1866
Painted horses, dogs and game. Exhib. mainly at SS, 1840-6, including 'A Grey Hunter, Snowden', and 'Rabbit and Woodcock'. Also exhib. at the RA and BI. Address in Greenhithe, Kent.

FORRESTER, Alfred Henry 1804-1872
Cartoonist and illustrator. Collaborated with his brother Alfred Henry Forrester, a writer, using the joint pen-name of Alfred Crowquill. Exhib. a few pen and ink sketches at the RA. Contributed to *Punch, Illustrated London News*, Chambers' *Book of Days;* and published many humorous books written and illustrated by himself. Also illustrated many of his brother's books, and others such as Cuthbert Bede's *Fairy Tales*, 1858, Albert R. Smith's *Beauty and the Beast*, 1843, etc. Manuscripts relating to this artist are held at the VAM.
Bibl: DNB; Everitt, *English Caricaturists*, 1893 pp.368-71, 410; BM Cat. of Engraved British Portraits II p.237; III p.434; IV p.98.

FORSHALL, Francis S. Hyde fl.1893
Exhib. at the RA, 1893-9, including a self-portrait and a painting entitled 'November'. London address.

FORSTER, C. fl.1828-1847
Painted portraits. Exhib. at the RA, 1828-47, including portraits of Mr. Anderson of the Theatre Royal and Samuel Prout, FSA. London address.

FORSTER, C.F., Snr. fl.1846
Exhib. four watercolours at SS including 'The Children in the Wood' and 'Happy Thoughts'. London address.

FORSTER, Charles, Jnr. fl.1835-1876
Painted watercolours of country genre and subjects from Dickens. Also painted portrait miniatures. Exhib. mainly at SS including 'The Gipsies' and 'Kate Nickleby sitting to Miss La Greevy for her portrait'. Also exhib. at the RA. London address.

FORSTER, Miss Emily fl.1840
Exhib. a painting 'Group of Flowers' at the RA in 1840. London address.

FORSTER, F.V. fl.1847
Exhib. one watercolour, 'The Italian Boy', at SS in 1847. Address in London.

FORSTER, Miss J. fl.1862
Exhib. one landscape of Gwynant Falls, at the RA in 1862. Address near Trowbridge, Wiltshire.

FORSTER, Joseph Wilson fl.1889-1893
Painted portraits and religious subjects. Exhib. at the RA including portraits of Rev. Charles Voysey and J. Gilbert Baker, Esq., Keeper of the Herbarium, Royal Botanic Gardens, Kew, and of 'The Vision of the Sangrael'. Address in London.

FORSTER, Miss Mary see LOFTHOUSE, Mrs.

FORSTER, P. fl.1845-1858
Painted rural genre subjects. Exhib. at the RA, 'The Leading Hound' and at the BI, 'Minnow-fishing on the Tweed'. Addresses in the north of England and Berwickshire.

FORSTER, Miss Selina fl.1857-1858
Exhib. three times at the RA, 1857-8, including 'Inez' and 'Reading the Household Words', and twice at the BI in 1858. Address in London.

FORSTER, T.B.W. fl.1859-1886
Painted landscapes and architecture. Exhib. at the RA, 1859-86, including views in North Wales, Wiltshire and the area of Grenoble in France. Also exhib. at SS. Address near Chippenham, Wiltshire.
Bibl: Roget II p.426.

FORSYTH, Adam fl.1889-1892
Exhib. one painting, 'Evening', at the RA in 1892. Also exhib. at the NWS. Address in Harlesden, London.

FORSYTH, W. fl.1834-1838
Exhib. a watercolour of flowers at SS in 1838. London address.

FORTESCUE, William B. RWA RBSA fl.1880-1901 d.1924
Painted genre subjects, including many related to ships and boats. Exhib. at the RA from 1887, including 'The Larboard Light' and 'Harvest Festival in a Cornish Fishing Village'. Also exhib. at SS. Address in St. Ives, Cornwall.

***FORTESCUE-BRICKDALE, Eleanor RWS 1872-1945**
Book illustrator and painter, in oil and watercolour, of homely genre, historical and imaginative subjects. Educated at Crystal Palace School of Art and the RA Schools. In 1896 she won a £40 prize for a design for the decoration of a public building — a decorative lunette 'Spring' for one of the lunettes in the RA Dining Room. She first exhib. at the RA in 1896 and onwards. Member of the Royal Society of Painters in Watercolours. Amongst books she illustrated are: *Poems by Tennyson*, 1905 (Bell Endymion series); Browning, *Pippa Passes* and *Men and Women*, 1908; Browning, *Dramatis Personae* and *Dramatic Romances and Lyrics,* 1909; Tennyson, *Idylls of the King,* 1911; W.M. Canton, *Story of St. Elizabeth of Hungary,* 1912; *Book of Old English Songs and Ballads,* 1915; *Eleanor Fortescue Brickdale's Golden Book of Famous Women,* 1919 ; *The Sweet and Touching Tale of Fleure and Blanchfleure,* 1922; *Carols,* 1925; Palgrave, *Golden Treasury of Songs and Lyrics,* 1925; Calthorp, *A Diary of an Eighteenth Century Garden,* 1926. Her paintings are in the Walker AG, Liverpool, also Birmingham, Leeds, etc; she also designed stained glass windows for Bristol Cathedral, Brixham etc.
Bibl: AJ 1905 p.387 (pl.); Studio XIII pp.103-8; XXIII pp.31-44; W.S. Sparrow, *Women Painters of the World,* 1905 p.73;Who Was Who 1941-50; Hartnoll & Eyre Ltd. Cat. III; Ashmolean Museum, Oxford, E.F.B. exhib. 1972; Wood, Pre-Raphaelites; Wood, Painted Gardens; Newall.

FORTIE, John fl.1847
Exhib. one painting, 'The Old Shepherd — scene near Pentland Hills', at the RA in 1847. Address in Edinburgh.

FORTT, Frederick RBA fl.1848-1861
Painted biblical, literary and architectural subjects. The setting is almost invariably italianate. Exhib. at SS, 1849-54, including scenes from *Othello* and views in Rome. Also exhib. at the RA in 1848 and at the BI, 1853-61. Address in Bath.

FORTYE, W.H. fl.1875-1886
Exhib. five times at the NWS, 1875-86. Address in London.

FOSBROOKE, Leonard fl.1884-1892
Painted landscapes. Exhib. at the RA, including 'Leafless Trees' and 'Horner Bridge, Somerset'. Also exhib. at the NWS. Address in Ashby-de-la-Zouch.

FOSKEY, Harry fl.1896-1901
Exhib. four times at the RA, 1896-1901, including 'In the Days of Roses' and 'Sweet Labour'. Address in Chelsea, London.

FOSTER, Miss Amy H. see LEATHER, Mrs. R.K.

FOSTER, Arthur J. fl.1880-1904
Painted marines, coastal scenes and portraits. Exhib. at the RA, 1885-1904, including portraits and a self-portrait, and works entitled 'Harbour at Low Tide' and 'French Fishing Boats in Torquay Harbour'. Address in London.

FOSTER, Miss C.E. fl.1871-1876
Exhib. three watercolours at SS, 1871-6, including 'A Glass of Flowers' and 'November's Sky is Chill and Drear'. Address in Hitchin, Hertfordshire.

FOSTER, Miss Dorothea fl.1900-1903
Exhib. at the RA, 1900-3, including 'Ileene' in 1900. Address in Leeds, Yorkshire.

FOSTER, Miss F.E. fl.1871-1879
Painted watercolours of flowers, birds and birds' nests. Exhib. 21 times at SS, including 'Poor Birdie' and 'Linnet's nest and Apple Blossom'. Address in Hitchin, Hertfordshire.

FOSTER, Frederick fl.1867-1876
Painted landscapes and rural genre. Exhib. at SS 16 times, 1867-77, including 'Waiting for Somebody', 'Watercress Gatherers' and 'On the Lea, near Higham'. London address.

FOSTER, George Sherwood fl.1898-1904
Painted landscapes. Exhib. at the RA from 1898, including 'A Fresh Breeze' and 'A Winter Evening — Aberdovey'. Address in Birmingham.

FOSTER, Gilbert 1855-1906
Painted landscapes and rural genre. Exhib. at the RA from 1895, including 'The Grey of the Gloaming' and 'Summer Snow'. Address in Leeds.
Bibl: Studio XXX 1904 p.155; AJ 1906 p.286.

FOSTER, Helen fl.1879-1880
Exhib. three landscapes at SS, 1879-80, including 'The Streamlet'. London address.

FOSTER, Herbert Wilson fl.1870-1899
Painted genre and country genre subjects. Exhib. at the RA, 1873-99, including 'The Village Rivals' and 'A Peasant Proprietor'. Also exhib. at the NWS. Address in Stoke-on-Trent, Staffordshire.

FOSTER, Miss Marianne see BARRETT, Mrs. M.

***FOSTER, Myles Birket RWS 1825-1899**
Painter, chiefly in watercolour, of landscape and of rustic scenes in Surrey and elsewhere, peopled with children and milkmaids; illustrator and engraver. Born in North Shields; came to London when he was five, and apprenticed when about 16 to Ebenezer Landells, a leading wood engraver who had been a pupil of Bewick. There he first cut blocks and then produced drawings of topical scenes and current events for *Punch*, *The Illustrated London News* and other magazines. He was then employed as a draughtsman under Henry Vizetelly and illustrated Longfellow's *Evangeline* and Rogers's *Italy*. In 1846 he set up on his own, illustrating books and producing illustrations for *The Illustrated London News*. About 1859 he turned to painting chiefly in watercolours. Elected A of the OWS in 1860, RWS 1862; and from that date contributed some 400 drawings to its exhibitions. Also exhib. at the RA 1859-81. In 1852, 1853 and 1861 he travelled about the Continent, chiefly up the Rhine, making many colour sketches and pencil studies; in 1866 he went abroad again, and in 1868 visited Venice with W.Q. Orchardson and Fred Walker, who was a very close friend. He also made many later visits to Italy — largely on the commission from Charles Seeley to make 50 Venice drawings for £5,000. In 1863 he built a house at Witley, near Godalming, and it is for his watercolours of the Surrey countryside that he is best known today. Hardie notes: "As a painter, he worked with meticulous finish and with astounding technical skill. At his best he showed a fine sense of composition and command of colour. Under all the rather sugary surface of sentiment and prettiness lies a hard core of sound and honest craftsmanship. We may deplore the sentiment, but we shall be narrow-minded if we fail to respect the artistry". Manuscripts relating to this artist are held at the VAM. For works illustrated by him see Card Cat. at VAM.
Bibl: AJ 1871 p.157ff.; 1863 p.10ff.; AJ Christmas No.1890, M.B. Huish, *Birket Foster, his life and work*; Portfolio 1891 p.192ff.; J. Pennell, *Modern Book Illustrators*, 1895; Studio 1902 English Watercolour; Bryan; Cundall; H.M. Cundall, *Birket Foster*, 1906; DNB; W.R. Sickert, *Fathers and Sons*, The Art News 7 April 1910; Hughes; VAM; L. Glasson, *Birket Foster*, OWS XI 1933; Reynolds, VP pp.156, 173 (pl.113); Hardie III pp.109-12 *et passim* (pl.133); Maas p.231 (pl.p.230); Ormond; Hall; Staley; Jan Reynolds, *B.F.*, 1984; Wood, Paradise Lost; Wood, Painted Gardens; Newall.

FOSTER, Sarah F. fl.1876
Exhib. one painting of flowers in 1876. Address in Burton Overy.

FOSTER, Sybilla C. fl.1881
Exhib. one painting, 'Will it Mend?' at the SS in 1881. Address in London.

FOSTER, Walter H.W. fl.1861-1888
Painted landscapes, which frequently include views of rivers, and occasional imaginary landscapes from literary sources. Exhib. 69 times at SS. Also exhib. 13 times, from 1861, at the RA, including 'The Forest of Arden', 'He drew a dial from his Poke (*As You Like It*)' and 'Otter Hunting on the River Lowther'. London address.

FOSTER, Mrs. Walter H.W. (Kate E.) fl.1882-1889
Exhib. three landscapes at SS, 1882-9, including 'A Sussex Cornfield'. Address in London.

FOSTER, William 1853-1924
Painter of landscapes and interiors, still-life and genre in watercolour, and illustrator in black and white. Second son of Myles Birket Foster (q.v.); followed his father's methods in painting, and exhib. at the RA from 1872 onwards. He was a fellow of the Zoological Society and supplied colour illustrations to several books on birds.
Bibl: Hardie III p.112.

FOSTER, William Gilbert RBA 1855-1906
Painter of landscape and rustic genre, who for a long time lived and worked in Leeds. Born in Manchester, son of a Birkenhead portrait painter. He studied under his father and worked with him until 1876, when he first exhib. at the RA from a Leeds address. He exhib.1876-1906 at the RA, SS and elsewhere. He is listed under William Gilbert Foster (1876-93) and Gilbert Foster (1895-1904) in Graves Dictionary. Titles at the RA include 'Eventide', 'The Girl with the Geese', and 'Driving the Ducks'. For some years he was art master at Leeds Grammar School. Two of his works are in Leeds AG, and one in Hull. He painted in oil, watercolour and charcoal. RBA in 1893. For works illustrated by, see Card Cat. at the VAM.
Bibl: AJ 1906 p.286; Studio XXX 1904 p.155; RA Pictures 1892, 1895, 1898, 1900, 1901, 1903; Cat. of Leeds City AG 1909; P. Phillips, *The Staithes Group*, 1993.

FOSTER, William John fl.1885
Exhib. one painting of a bird at the GG in 1885. London address.

FOSTER, Wilson fl.1889
Exhib. twice at the RA in 1889, 'Innocence and Mischief' and 'After the Day's Work is Done'. Address in Stoke-on-Trent, Staffordshire.

FOTHERGILL, C.W. fl.1900
Exhib. one painting, a view of Park House, Smarden, at the RA of 1900. Address in Cranbrook, Kent.

FOTHERGILL, Charles fl.1880-1884
Exhib. three watercolours at SS, 1880-4, including 'The Mouth of the Dart', and 'Hulks in Portsmouth Harbour'. Address in London.
Bibl: Brook-Hart.

FOTHERGILL, George Algernon b.1868
Drew and painted country scenes including hunting and other field sports.
Bibl: Hall.
Exhib: London, Walker's Gallery 1938.

FOTHERSGILL, S. fl.1853
Exhib. one watercolour, 'Fish Lock at Dinsdale on the Tees', at SS in 1853. Address in Darlington, County Durham.

FOULGER, Howson Rutherford fl.1890
Exhib. one painting, 'This Year, Next Year, Sometime, Never!', at the RA in 1890. London address.

FOURMOIS, F. fl.1848
Exhib. one landscape painting in 1848. Address in Brussels.

FOWELL, M. fl.1873-1874
Exhib. two paintings 'The Love Letter' and 'The Look Out', at SS 1873-4. Address in London.

FOWINKEL, von see VON FOWINKEL

FOWKE, F.R. fl.1884
Exhib. a painting at the NWS in 1884. Address in London.

FOWLER, B. RCA fl.1892
Exhib. one painting, 'Evening', at the RA in 1892. Address in North Wales.

FOWLER, Daniel 1810-1894
Painted watercolour landscapes and views of buildings. Exhib. principally at SS, 16 times 1836-42, including 'Vale of Llangollen — Sunset' and 'Bolton Priory, Yorkshire'. Address in London. Died in Canada.

FOWLER, Mrs. E. Miller fl.1895-1900
Exhib. two flower paintings at the RA in 1895 and 1900. Address in Hereford.

FOWLER, Howard fl.1880-1891
Painted landscape watercolours. Exhib. principally at SS, 1882-5, including 'The Moor-hen's playground' and 'After a Dry Summer'. Also exhib. at the RA and the NWS. Address in Staines, Berkshire.

FOWLER, J. fl.1872
Exhib. one painting, 'View from tunnel on District Railway, etc.' at the RA in 1872. Address in London.

FOWLER, Miss Martha fl.1866-1880
Exhib. nine landscapes, 1866-80. Address in Southampton.

FOWLER, Miss Mary Lemon fl.1871
(Mrs. S.E. Waller)
Exhib. one genre painting in 1871. Address in Gloucester. See also Mrs. S.E. Waller.

FOWLER, Munro fl.1884-1888
Painted flowers and landscapes. Exhib. four times at SS, 1884-8 including 'Chrysanthemums' and 'Meran, S.Tyrol' London address.

FOWLER, Miss R.J. fl.1881-1882
Exhib. one watercolour, 'Summer Roses', at SS in 1881-2. Address in Woodford, Essex.

***FOWLER, Robert RWS 1853-1926**
Liverpool decorative painter, of myth and allegory — figures treated decoratively in pale colours, in the style of Albert Moore, Leighton and Fernand Khnopff. Also influenced by Japanese artists. Born in Anstruther, he studied in London, but moved to Liverpool, where his chief work was done. He stayed there until 1904, when he returned to London. His studio in Liverpool was a chief centre for artistic life. His work at first was chiefly in watercolour, the subjects from classic myth or romantic poetry. Later he worked in oils, in which he was more successful. In 1902 he started in landscape painting. He exhib. at the RA 1876-1903. In 1891 became a member of the RI. He also designed posters — some for the Walker AG.
Bibl: Who's Who 1914; Caw pp.355, 407-11; RA Pictures 1897-1913; Studio IX 1897 pp.85-98 (with many illus.); XXXII 1904 p.161; Art in 1898; Summer No.1900 p.35; Ormond.

FOWLER, Walter fl.1887-1902
Painted landscapes. Exhib. at the RA from 1888, including 'Across Hampstead Heath' and 'Near Southwold', and at the BI from 1888 including 'In the Valley of the Stour' Address in Richmond, Surrey.
Bibl: Studio XXX 1904 pp.30, 40; XXXIX 1907 p.247; Connoisseur XXVIII 1910 p.204; XXX 1911 p.68.

FOWLER, William 1796-1880
Painted portraits. Two portraits of Queen Victoria by him are recorded.
Bibl: Ormond.

FOWLER,William II RBA fl.1825-1867
Landscape and architectural painter. Also painted game. His subjects frequently include views of picturesque buildings in France, Germany, England and Italy. Exhib. 72 times at the BI, 1825-67; 72 times at SS, 1826-57; and 23 times at the RA, 1829-52. 'The Fish Stall at Covent Garden' was sold at Sotheby's Belgravia, 20 June 1972.

FOWLES, A.W. of Ryde fl.1840-1860
Little known marine painter, born on the Isle of Wight. Not known to have exhib. in London, so presumably he worked entirely for local patrons. Pictures by Fowles are in the Bury AG, Ryde Town Hall, and the Maritime Museum, Greenwich. Often painted naval reviews and other events around Plymouth and the Isle of Wight.
Bibl: AJ 1876 p.30; Wilson p.35; Brook-Hart pl.178A.

FOWLKES, Clater fl.1852
Exhib. a genre subject in 1852. London address.

FOX, A.W.T. fl.1850
Exhib. a painting called 'The Wreath' at SS in 1850. Address in Edgeley.

FOX, Augustus H. fl.1841-1849
Exhib. three times at the RA, 1841-9, including ' "We Make Woe Wanton with this Fond Delay" ' and 'Learning the Harvest Song'. Address in London.

FOX, Bridell fl.1867-1874
Exhib. three portraits at the RA, 1867-74. This is probably the wife of F.L. Bridell (q.v.).

FOX, Mrs. Caroline fl.1892
Exhib. a landscape painting of 'Uyn Idwall' at SS in 1892. Address in St. Leonards-on-Sea.

FOX, Charles James fl.1883-1904
Painted landscapes and country scenes. Exhib. at the RA from 1884, including 'Harrow on the Hill from Hampstead Heath' and 'Stepping Stones on the Lledr, North Wales'. Also exhib. at BI and NWS. Address in London.
Bibl: Hardie III p.3.

FOX, Edward fl.1813-1854
Painter of landscape and country genre. Exhib. at the RA, 1813-51, including many views in Sussex. Also exhib. at BI, SS and OWS. Address in London.
Bibl: T. Fawcett, *The Rise of English Provincial Art*, p.41.

FOX, Edward fl.1880
Exhib. two landscape watercolours at SS. Address in London.

FOX, Eman fl.1895
Exhib. a painting, 'Portrait of my Cousin', at the RA in 1895. London address.

FOX, Ernest R. fl.1886-1901
Painted landscapes and architectural subjects. Exhib. at the RA, 1887-1901, including 'Blazing July' and 'Littlecote'. Address in Strood, Kent.

FOX, George fl.1873-1889
Painted genre subjects. Exhib. 19 times at SS, 1873-89, including 'The Night before the Trial' and 'Preparing for the Worst'. Address in London. Specialised in legal subjects.

FOX, Henry Charles RBA b.1860 fl.1879-1913
London landscape painter exhibiting at the RA, 1880-1902, SS and NWS.

FOX, John Shirley fl.1890-1902
Exhib. portrait paintings at the RA from 1890. Address in South London.
Bibl: Connoisseur XXXI 1911 p.187; Who's Who 1914.

FOX, Nicholas Percy fl.1892-1901
Exhib. at the RA from 1892, including 'When the Sun is Low'. Also exhib. at the NWS. Address in London.

FOX, R. fl.1867
Exhib. a painting of fruit at the RA in 1867. London address.

FOX, Robert b.1810 fl. to 1868
London painter of genre and eastern portraits, who exhib. at the RA from 1853. Titles: 'Head of a Hindoo', 'As She Looked in the Glass', 'After the Opera', etc.
Bibl: Strickland.

FOX, W. fl.1864
Exhib. one painting, 'On Wimbledon Common', at the RA in 1864. Address in London.

FOX, W.T. fl.1862-1867
Exhib. landscapes and paintings of fruit at the BI, 1862-7. Address in Fulham, London.

FOY, William 1791-1861
Irish painter of portraits and genre subjects. Exhib. at the RA, including portraits and other titles such as 'Boy Blowing Bubbles' and 'Intrusion upon the Toilet'. Also exhib. at BI and SS. London address.
Bibl: Strickland.

FRADELLE, Henry Joseph c.1778-1865
Painter of literary subject matter and scenes from plays. He also painted historical subjects. Exhib. mainly at the BI, 1817-49, including 'Ivanhoe', 'Raphael and La Fornarina' and 'Othello and Desdemona'. Also exhib. at the RA, 1817-55. Born in France, he lived in London.
Bibl: Schorns Kunstblatt 1822 p.237; 1823 p.104; 1825 p.277; Ottley; Dussieux, Art Français à L'Etr. 1876; Redgrave, Dict.; Bellier-Auvray, Dict. Gen. I 1882; Cat. of the Pictures in the Shakespeare Mem. at Stratford 1896; BM Cat. of Engraved British Portraits 1910 p.176; BM Cat. of Drawings II 1900; Ormond.

***FRAMPTON, Edward Reginald ROI RBA 1872-1923**
Painter and sculptor of religious subjects in a highly decorative art-nouveau style. Exhib. at the RA from 1895, including 'As the Sun Goes Down' in 1898. Later in his career he was responsible for schemes of decoration in a number of churches.
Bibl: Studio XXXVI 1906 pp.346-50; LVIII 1913 p.28; LXII 1914 p.173; AJ 1907 pp.289-96; 1909 p.175; Paris Salon Cats. 1910-15; Who's Who 1914; Wood, Pre-Raphaelites.

FRANCE, Charles fl.1881-1889
Exhib. two landscapes at the RA, 1888-9, including 'On the Wharf late Autumn'. Address in Skipton, Yorkshire.

FRANCES, Miss E. fl.1857-1859
Exhib. a painting, 'Pour deux Sous', at the RA in 1857. Also exhib. a painting of fruit at the BI in 1859. Address in London.

FRANCES, H.E. fl.1851-1875
Painted country scenes and genre. Exhib. at the BI, 1851-65, including 'A Memory of a Ball' and 'Papa's Slippers'. Also exhib. at the RA, 1851-8. Address in London.

FRANCES, Miss S. fl.1859
Exhib. a painting entitled 'Amy' at the RA in 1859. London address.

FRANCIA, Count Alexandi T. 1820-1884
Painter of coastal landscapes. Exhib. at the BI, 1856-74, including 'The Entrance to the Thames' and 'Irish Peasants, Coasts of Kerry'. Also exhib. at the RA, 1841-67. Born in Calais. Addresses in London and Brussels.
Bibl: Journal des Beaux-Arts Brussels 1878, 1884; Hippert u. Linnig, Peintra-Grav. holl. et belge. 1879; Bellier-Auvray Dict. Gen. I 1882; F. v. Botticher, Malerwerke d.19 Jahrh I 1899; La Renaissance Brussels IV pp.114, 118; VIII p.170; Brook-Hart.

FRANCIS, Miss Eleanor fl.1889
Exhib. one painting, 'Christmas Roses', at the RA in 1889. Address in Southsea.

FRANCIS, Miss Eva fl.1889-1903
Painted flowers. Exhib. at the RA from 1889, including 'Old-fashioned flowers' and 'Clematis'. Also exhib. at the NWS. Address in Southsea.

FRANCIS, John Deffett 1815-1901
Exhib. six times at the BI, 1837-60, including 'Strand' and 'Autumn — Scotland — Evening'. Exhib. once at the RA in 1846. Address in London.
Bibl: T.M. Rees, Welsh Painters, 1912 p.47; BM Cat. of Engraved British Portraits II p.162; III pp.356, 434; IV p.355; Ormond.

FRANCIS, Miss M. fl.1852
Exhib. one watercolour, 'Dead Wood Pigeon', at SS in 1852. Address in Hampstead, London.

FRANCIS, Miss M. fl.1884-1886
Exhib. two landscape paintings, 1884-6. Address in London.

FRANCIS, S.D. fl.1867
Exhib. a painting entitled 'This is the Maiden all Forlorn that Milked the Cow with a Crumpled Horn' at the BI in 1867. London address.

FRANCIS, Thomas E. fl.1900-1904
Exhib. at the RA from 1900, including 'Fruit Trees'. Address in London.

FRANCIS, W.T. fl.1844
Exhib. two paintings at the RA in 1844, 'L'Allegro ed il Penseroso' and 'Scene in Chevening Park'. London address.

FRANCK, Mrs. G.A. fl.1892-1894
Exhib. at SS, 1892-4, including ' "For a Score of Sweet Little Summers or So?" ' and 'In the Gloaming'. London address.

FRANCK, Miss Helen fl.1885-1900
Painter of flowers, fruit and landscape. Exhib. at the RA from 1885, including 'Bulrushes', 'Hemlock and Poppies' and 'Clearing up after Rain'. Also exhib. at SS, 1888-93. London address.

FRANK, Mrs. Alberta fl.1877
Exhib. a view in Boulogne sur Mer. France, at SS in 1877. London address. See also Brown, Miss Alberta.
Bibl: Clayton II p.181.

FRANK, Mrs. Ellen fl.1899-1904
Exhib. at the RA from 1899, including 'Before the Break' and 'These Bright and glorious things'. Address in London.

FRANKLIN, George fl.1825-1847
Painted landscapes, portraits and genre subjects. Exhib. at the RA, 1825-45, including 'View in Venice'. Also exhib. at the BI, 1828-47, including 'St. Katharine's Fare or Charcoal and Chestnuts'. Address in London.

FRANKLIN, J. fl.1830-1868
Painter of genre, portraits and literary subjects. Exhib. at the RA, 1832-61, including 'The Struggle for the Standard', at the BI, 1830-59, including a scene from *Bombastes Furioso*, and at SS, 1832-68. London address.

FRANKLIN, Matilda fl.1883
Exhib. a watercolour landscape, 'The Cottages on the Cliff', at SS in 1883. Address in Harlington.

FRANKS, B. fl.1876-1877
Exhib. twice at SS, 1876-7, 'An old Mill, South Devon' and 'Hampstead Heath'. Address in London.

FRASER, A. fl.1851
Exhib. one painting, 'On Holmwood Common', at the BI in 1857. Address in London.

FRASER, A. Anderson 1861-1904
Exhib. three watercolours at SS, titles including 'Arthur's Seat, from Musselbro'. Address in London.

FRASER, Miss Agnes fl.1881-1887
Exhib. two genre paintings at the NWS, 1881-7. Address in London.

***FRASER, Alexander, Jnr. RSA 1828-1899**
Landscape painter, son of Alexander George Fraser (q.v.). He studied at the Trustees' Academy. Until 1857, a year before he was elected ARSA (RSA 1862), his subjects were principally Scottish, but in that year he visited Wales, and for some time Welsh landscape engaged him. But he returned to paint some of his finest pictures in Scotland in Cadzow Forest and on Loch Lomond. During 1868-9 he painted in Surrey, and for the last fifteen years of his life, in Scotland. He exhib. at the RA from 1869-85. He especially liked summer and high noon in the forest and resembled the PRB in the attention he gave to detail.
Bibl: DNB; Caw p.190ff. (reprd. opp. p.192 'On the Avon – Haymaking time'); AJ 1904 pp.375-9; 1906 p.154ff.; 1873 p.101; Portfolio 1887 p.208; Armstrong, *Scottish Painters*, 1888; Irwin.

FRASER, Alexander George, Snr. ARSA 1786-1865
Painter of domestic and historical genre. Assistant to Wilkie, and for about 20 years he is said to have painted the still-life and accessories in Wilkie's paintings. He exhib. at the RA 1810-48, and in 1842 his 'Naaman cured of the Leprosy' obtained the premium at the BI for the best picture of the year. In taste, and subject his paintings were very like Wilkie's, and in the fashionable brown-

tone. Caw says that "most of his pictures deal with social or convivial situations conceived in the spirit of comedy".
Bibl: AJ 1865 p.125; Gentleman's Magazine 1865 XVIII p.652; Portfolio 1887 p.109; DNB; Caw p.104ff. (reprd. opp.p.104, 'Tam and the Smith'); Cunningham, *Life of Sir David Wilkie*; Irwin.

FRASER, Alice fl.1891
Exhib. one painting, 'A Study', at SS in 1891. Address in Stevenage, Hertfordshire.

FRASER, Miss Annie fl.1866-1867
Exhib. two paintings, a portrait and another entitled 'Infanta Clara', at the RA, 1866-7. London address.

FRASER, Arthur Anderson 1861-1904
Landscape watercolourist. Member of the Fraser family of artists (see R.W. Fraser). Lived and worked mainly around St. Ives, Huntingdon.

FRASER, F. fl.1876-1877
Exhib. twice at SS, 1876-7, 'Father's Dinner' and 'On the Conway North Wales'. Address in Sutton, Surrey.

FRASER, Miss Florence fl.1880-1884
Exhib. twice at SS, 1880-4, including 'In at one Ear and Out at the Other'. London address.

FRASER, Francis Arthur 1846-1920
Painted landscapes and genre subjects. Exhib. 11 times at SS, 1867-83, including 'Morning on the Moor' and 'The Keeper's Son'. Also exhib. four times at the RA, 1873-8. Address in London. Brother of R.W. Fraser (q.v.).

FRASER, Garden William see GARDEN, William Fraser

FRASER, George Gordon 1859-1895
Painted landscapes. Exhib. eight times at the RA 1884-93, including 'Cliefden Woods' and 'Larne Loch. County Antrim'. Also exhib. once at the GG. Address in Bedford.

FRASER, J.S. fl.1883
Exhib. a genre subject at the NWS in 1883. Address in Edinburgh.

FRASER, John RBA b.1858
London marine painter. Exhib. at the RA, 1879-93, also at the SS and NWS. Titles at the RA 'North Sea Herring Boats', 'Anchovy Boats in the Straits of Gibraltar', etc. Several works by Fraser are in the Greenwich Maritime Museum.
Bibl: Wilson p.36; Brook-Hart pl.6.

FRASER, John A. fl.1889
Exhib. one painting, 'A bit of Loch Awe between the Showers', at the RA in 1889. Address in London.

FRASER, John P. fl.1864-1884
Painted genre subjects, particularly Scottish genre. Exhib. at the RA 11 times, 1864-84, titles including 'Aberdeen Fisherwomen waiting for the Low Tide'. Also exhib. four times at the BI, 1864-7, and seven times at SS, 1865-75. London address.

FRASER, Patrick Allan fl.1852-d.1890
Exhib. four paintings at the RA, 1852-78, titles including 'The Romp' and 'Monk Architects'. Address in Arbroath, Scotland.
Bibl: Studio XXIV 1902 p.65; Chas. Holme, *Royal Scottish Academy*, Studio 1907 p.IX; Irwin.

FRASER, Robert Winchester 1848-1906
Bedford landscape painter who exhib. from 1876-92 at the RA. Subjects mostly views in the South of England. Titles: 'It was on an April Morning', 'Honey Hill, Bedford', 'Near Pickhurst, Kent', etc. Other members of the Fraser family include William Garden Fraser (who also used the name W.F. Garden), George Gordon Fraser, Arthur Anderson Fraser and Francis Arthur Fraser (qq.v.) and Gilbert Baird Fraser. His son was also a watercolourist and signed himself Robert Winter.
Bibl: Charles Lane, *The Frasers*, Watercolours Magazine Winter 1989.

FRATELLI, T. fl.1876
Exhib. a painting of cows in 1876. Address in London.

FRAZER, Miss fl.1866
Exhib. a portrait in 1866. Address in Lynmouth, Devon.

FRAZER, Charles E. fl.1881
Exhib. a painting, entitled 'Edith', at the RA in 1881. Address in London.

FRAZER, Hugh RHA 1826-1861
Irish painter of landscape and genre subjects. Exhib. at the Dublin Academy. Also exhib. twice at the BI in 1832 and 1841, 'Solitude' and 'The Sombre Mood', and twice at SS.
Bibl: Strickland.

FRAZER, William Miller RSA PSSA 1864-1961
Scottish landscape painter. First exhib. at the RA in 1892, 'A Woodland in March'. Studied art at the RSA. Addresses in Bridge of Erne, Scotland, and Edinburgh.
Bibl: AJ 1903 p.284; Studio XLIV pp.230, 232; LVIII p.66; LXV p.102; Caw p.391; Who's Who 1914.

FREAKE, Mrs. fl.1879-1881
Exhib. two marine subjects, 1879-81. Address in London.

FREDERICKS, J. fl.1856
Exhib. four landscapes in 1856. Address in London.

FREDERICS, A. fl.1877
Exhib. a watercolour study of a head at SS in 1877. Address in London.

FREELING, K.T. fl.1857
Exhib. one painting at the RA in 1857 entitled 'Girl with a Love Bird'.

FREEMAN, Henry fl.1874
Exhib. a landscape in 1874. Address in Liverpool.

FREEMAN, Miss Mary Winefride fl.1886-1904
Painted portraits, historical and genre subjects in watercolour. Exhib. from 1886 at the NWS and NG. Also exhib. from 1895 at the RA, titles including 'The Red Shoes' and 'The Dedication of St. Edward the Confessor'. London address.

FREEMAN, Miss Pauline fl.1869
Exhib. a watercolour of camellias at SS in 1869. Address in London.

FREEMAN, William, Jnr. fl.1860
Exhib. one painting, 'River scene — early morning', at the RA in 1860. Address in Norwich, Norfolk.

FREEMAN, William Henry fl.1840
Exhib. one painting, 'Une Parisienne — a Relic of the Revolution', at the RA in 1840. Lived in Paris.
Bibl: Gazette des Beaux-Arts XI 1861 p.551; Nagler, Monogr. V 1879; Bellier-Auvray, *Dict. Gén.*, 1882; Béraldi, *Les Grav. du 19 siècle*, 1885.

FREEMAN, William Philip Barnes 1813-1897
Norfolk painter and watercolourist. Lived in Norwich. Exhib. one watercolour, 'Breydon Water — A Calm', at SS in 1862. Pupil of J.S. Cotman and J.B. Ladbroke and member of the Norwich Amateur Club.

FREER, Mrs. John see STAPLES, Mrs. J.C.

FREEZOR, Mrs. fl.1866
Exhib. a painting of fruit at the BI in 1866. Address in London.

FREEZOR, George Augustus fl.1861-1879
Genre and portrait painter. Lived in London. Exhib. at RA, 1861-8, and once at BI and SS. Subjects at RA mostly female portraits, of the keepsake type. A work by him is in the Graves AG, Sheffield.

FRENCH, Miss Annie 1873-1965
Scottish painter of architectural views and figurative subjects. Exhib. five times at SS 1864-6, including 'St. Saviour's Church, Jersey'. Also exhib. twice at the BI. Best known for her art nouveau illustrations in pen, ink and watercolour. Address in London.
Bibl: Studio XXIV p.205; XXX p.114; XXXIV p.262; XXXVIII p.164; XLII p.146; LVIII p.228; Art et Decoration 1907 I p.193; Caw p.417; Chas. Holme, *Pen, Pencil and Chalk*, Studio 1911 p.8.

FRENCH, Henry fl.1872-1875
Exhib. three times at SS 1872-5, including 'A Quiet Pipe'. Address in London.

FRENCH, P.C. fl.1885
Exhib. a watercolour entitled 'Field Sports' at SS in 1885. Address in Dublin.

FRERE, Augusta fl.1871
Exhib. one landscape in 1871. Address in London .

FREW, Alexander fl.1890-d.1908
Exhib. two landscapes, 'Sundown in the Tropics' and 'A Summer Evening', at the RA in 1890. Address in Glasgow.
Bibl: Caw p.333; Brook-Hart

FREYBURG, Frank P. fl.1893-1903
Painted country scenes. Exhib. at the RA from 1893, titles including 'Jogging Home' and 'Ere the Winter Storms Begin'. Address in Hassocks.
Bibl: Ormond I p.446.

FRIEDENSON, Arthur A. 1872-1955
Painted landscapes, often coastal landscapes. Studied painting in Paris and Antwerp. Exhib. at the RA from 1889, titles including 'Down to the Sea' and 'By Wood and Meadow to the Sea'. Lived in Yorkshire and Dorset.
Bibl: P. Phillips, *The Staithes Group*, 1993.

FRIEDLANDER, N. fl.1844
Exhib. one painting, 'Flight of the Polish Refugees', at the RA in 1844. Address in Stockholm.

FRIEND, J.S. fl.1839-1843
Painted literary subjects. Exhib. five times at the RA, 1839-43, including two scenes from *Faerie Queene* and a painting entitled 'Believe and thou shalt be Saved'. Address in London.

FRIER, Harry c.1849-1919
Painted landscape watercolours. Studied in Paris. Lived in Somerset.

FRIESE, R. fl.1879
Exhib. three paintings of animals in 1879. Address in London.

FRIGOUT, Mrs. Julie fl.1885-1889
Painted landscapes. Exhib. eight times at SS, 1885-9, titles including 'Rainy Weather — Cookham' and 'The Poppy Field'. Also exhib. once, in 1889, at the RA. London address.

FRIPP, Alfred Downing RWS 1822-1895
Born in Bristol, the younger brother of George Arthur Fripp (q.v.). At the age of 18 he went to London, and studied at the BM and RA. Like his brother he exhib. regularly at the RWS from 1844, when he sent his 'Poacher's Hut'. His early works were British and Irish landscapes and rustic genre. Then in 1850 he went to Rome, and from then to 1854 his subjects were Italian — views and studies of peasants. After his return to England he again reverted to Welsh and English scenes and genre. He exhib. at the RA in 1848, 'Sad Memories'.
Bibl: See under George Arthur Fripp.

FRIPP, Charles Edwin ARWS 1854-1906
Painted military subjects in watercolour. Worked as a correspondent for *The Graphic* during the Boer War. Exhib. 23 times at the RWS. Also exhib. twice at the RA, 'The Last Stand at Isandihula' and 'The Attack on General Sir John McNeill's Forces near Suakim' in 1885 and 1886. London address.,
Bibl: Roget II p.267; Mireux, *Dict. des Ventes d'Art*, III 1911; Newall.

FRIPP, Constance L. 1862-1892
Painted landscapes in watercolours. Exhib. seven times at SS, 1862-92, including 'Beech Trees, New Forest' and 'The Bridge at Beddgelert, North Wales'. Also exhib. at the RA in 1887. Lived in Southampton.

FRIPP, G.E. fl.1854
Exhib. one painting, 'Shiplake Mill on the Thames', at the RA in 1854. Address in Bristol.

FRIPP, George Arthur RWS 1813-1896
Landscape painter, mainly in watercolour, but also occasionally in oil. Born in Bristol and taught by James Baker Pyne, and Samuel Jackson. In 1834 he made a foreign tour — through Germany to Venice — with his Bristol friend W.J. Muller. In 1841 he came to London, and was elected A of the RWS in that year, and Member in 1845. He exhib. there regularly and at the RA in 1838, 1843, 1844 and 1848. In 1860 he was commissioned by the Queen to visit Balmoral to make sketches of it and the neighbourhood —and these were added to the Royal Collection. His landscapes were highly regarded, and met with a ready sale. His subjects were mainly: river scenes of the Thames, foreign scenery, rustic and agricultural subjects, ruined castles and scenes on the Isles of Skye and Sark, and elsewhere in the North. Manuscripts relating to Fripp are held at the VAM.
Bibl: AJ 1877 February; Roget II pp.264-8 (George) pp.291-3 (Alfred); DNB; H.S. Thompson, *G.A. and A.D. Fripp*, Walker's Quarterly XXV, XXVI 1928; Clement & Hutton.

FRIPP, Innes fl.1893-1904
Painted genre subjects and designed stained glass. Exhib. at the RA from 1893, titles including 'The Forum, Pompeii' and 'The Gentle Art'. Address in London.

FRIPP, J.W. fl.1893
Exhib. a landscape at the NG in 1893.

FRIPP, Tom fl.1890-1892
Painted landscapes and genre subjects. Exhib. at SS, 1890-2, titles including 'Calabrian Girl' and 'Walberswick'. London address.

FRISTON, David Henry fl.1853-1869
Painted genre subjects. Exhib. at the RA 14 times, 1853-69, titles including 'The Peep-Show' and 'Varnished and Dated, in Commemoration of his 100th Birthday'. Also exhib. six times at the BI, 1854-67, and once at SS. Address in London.

FRISWELL, Harry P. Hain- fl.1882-1895
Painted landscapes. Exhib. six times at the RA, 1887-95, titles including 'A Day in Early Summer' and 'Morning Mist', and seven times at SS, 1881-92. Address in Bexley Heath, Kent.
Bibl: Who'sWho 1914.

FRISWELL, Mrs. J. (Emma) fl.1852-1862
Painted portraits, genre subjects and flowers. Exhib. three times at the RA, 1852-5, including 'Indolence' and 'Camellias and Azaleas', seven times at SS, 1852-62, and four times at the BI, 1853-9. London address.

***FRITH, William Powell** RA 1819-1909
Painter of historical genre and scenes of Victorian life. Born near Ripon, Yorkshire, Frith was forced by ambitious parents to take up painting against his will. Studied at Sass's Academy and RA Schools. Elected ARA 1845, RA 1852. During the 1840s a member of The Clique, with Richard Dadd, A.L. Egg, H.N. O'Neil, and John Phillip (all q.v.). Early subjects all historical and literary scenes, the subjects being taken from such sources as Shakespeare, Molière, Scott, Goldsmith, Dickens and Sterne. In his autobiography Frith claims that he was always "strongly drawn towards illustration of modern life." It was not, however, until the Pre-Raphaelites had made modern genre acceptable that Frith tried his hand at this type of subject. A visit to Ramsgate in 1851 gave him the idea for his first panorama of Victorian life, 'Ramsgate Sands', exhibited at RA 1854. The picture was an enormous success, and was bought by Queen Victoria. Encouraged by this, Frith went on to paint a succession of similar panoramas, for which he is now best known — 'Derby Day' (1858), 'The Railway Station' (1862), 'The Salon d'Or, Homburg' (1871), 'Private View Day at the Royal Academy' (1883). He also painted several moralistic series such as 'The Road to Ruin' (1878), and 'The Race for Wealth' (1880). In addition to these, he continued to paint historical and sentimental subjects, becoming steadily more repetitive, his colours growing thinner and dryer. Frith exhib. at the RA for 60 years, from 1840-1902, and also at the BI and SS. A self-portrait is in the MacDonald Collection at Aberdeen AG. A sale of works from his own collection was held at Christie's, 14 June 1884. Manuscripts relating to Frith are held at the VAM.
Bibl: W.P. Frith, *My Autobiography and Reminiscences,* 1888; The Times 4 November 1901 (obit.); AU 1849; AJ 1910 p.14 (obit.); AJ 1854 p.161; 1856 p.237ff.; 1858 pp.93, 161; 1864 p.64; 1854 pp.157, 167; 1866 p.116; 1867 pp.137, 172; 1878 p.166; Clement & Hutton; DNB 2 Supp II 1912; Jonathan Mayne, Cat. of Frith exhib., Whitechapel AG 1951; Reynolds, VS pp.4, 8, 10 11-13, 18, 23, 24, 56, 57-62, 78 (pls. 18, 19, 20, 21, 22, 23, 25-7); Reynolds, VP pp.29, 32-4, 95,

96, 111, 113, 117, 123, 141, 173 (pls.23-5); Maas pp.110-13 (pls. pp.112. 113, 114, 118); Staley; Ormond; Brook-Hart; Irwin; Wood, Panorama; Strong; J. Maas, *The Prince of Wales' Wedding — The Story of a Picture*, 1977; Wood, Paradise Lost.
Exhib: London, Whitechapel AG 1951; Harrogate, Corporation AG 1951.

FRITZ, W. fl.1880
Exhib. a painting of a head in 1880. Address in London.

FROGGATT, T. fl.1838-1850
Painted landscapes, marines and interiors in watercolour. Exhib. ten times at SS, 1838-50, including 'Coast Scene — Shanklin, Isle of Wight' and 'Interior of a Boat-house'. Also exhib. once at the RA in 1846. London address.

FROLICH, F. fl.1890
Exhib. one painting, 'Benighted', at the RA in 1890. London address.

FROST, Miss H. fl.1858-1861
Painted studies from nature. Exhib. six times at SS, 1858-61, including 'A Hedge Sparrow's Nest'. Address in Porchester, Hampshire.

FROST, Miss Louisa fl.1853-1856
Exhib. twice at the RA. Titles: 'The Chancel of St. Stephen's Church, Westminster' and a painting entitled 'Sara', in 1853 and 1856. London address.

FROST, Miss Minnie P. fl.1892-1893
Exhib. a painting entitled 'Fiddle and I' at SS in 1892-3. Address in London.

FROST, R. fl.1882
Exhib. a painting entitled 'Mabel' at the RA in 1882. Address in London.

***FROST, William Edward RA 1810-1877**
Painter of portraits, mythological and historical subjects. He was an early protégé of Etty's, and there is a reflection of Etty's style in his work. In 1829 he became a student at the RA, and exhib. there from 1836 to 1878, and was awarded the gold medal in 1839 for his 'Prometheus Bound by Force and Strength'. In 1843 he won a £200 prize in the Houses of Parliament competition for 'Una alarmed by the Fauns and Satyrs'. These successes led him to leave portraiture for subjects of a sylvan and bacchanalian character, drawn chiefly from Spenser and Milton. 'Diana and her Nymphs surprised by Actaeon' led to his election as an Associate in 1846. 'Una', from Spenser's Faene Queen was bought by Queen Victoria in 1847. He became an RA in 1870, his diploma work being a 'Nymph and Cupid'. Ilis studio sale was held at Christie's on March 14, 1878.
Bibl: Sandby, *History of the RA* 1862 pp.ll, 219ff.; AJ 1849 p.184; 1856 p.4; 1857 p.5ff.; 1858 p.4; 1866 p.76; 1877 pp.234, 280; DNB; Maas p.168; Ormond.

FROWD, Thomas T.J. fl.1847-1864
Painted the landscape of the Thames Valley. Exhib. 32 times at SS, including several views of Windsor, 12 times at the BI, and nine times at the RA, including 'Landscape near Ascot' and 'The Footbridge'. Address in Windsor, Berkshire.

FRY, H. Windsor see WINDSOR-FRY

FRY, Lewis George, RBA RWA 1860-1933
Painted landscapes. First exhib. at the RA in 1896 with 'The Building of the New House'. Studied at the Slade. Address in London.

FRY, Roger NEAC 1866-1934
Painter of still-lifes and landscape. Influential critic and writer on art. Studied in Paris. Worked under Sickert from 1893. The greater part of his work is later in date.
Bibl: Howard Hannay, *Roger Fry and Other Essays*, 1937; Virginia Woolf, *Roger Fry: A Biography*, 1940; Solomon Fishman, *The Interpretation of Art*, 1963; Quentin Bell, *Roger Fry: An Inaugural Lecture*, 1964; Roger Fry, *Letters of Roger Fry*, 1972.
Exhib: London, Independent Gallery 1923; Great Britain Arts Council 1952; London, Courtauld Institute of Art, *The Fry Collection* 1958; University of Nottingham (with the Arts Council) l966; Rye AG, *Artists of Bloomsbury* 1967.

FRY, Mrs. Samuel fl.1880-1883
(Miss Caroline Nottidge)
Exhib. four times at the RA, 1880-3, including 'A Venetian Senator' and 'Inclined to be Obstinate'. Address in London.

FRY, William Arthur b.1865
Painter of landscapes, marines and portraits. Born in Yorkshire, he lived in County Down, Northern Ireland.

FRYER, E.L. fl.1866
Exhib. twice at the BI, a view of St. Mark's, Venice, and a view of Netley Abbey, in 1866. Also exhib. once, a view on the Grand Canal, Venice, at SS in 1866. Address in London.

FRYER, Edward H. fl.1834-1843
Painted landscapes and architecture, usually in an Italianate setting. Exhib. nine times at the RA, 1835-9, including 'Campo Vaccino, Rome — Morning' and 'Falls of Tivoli', six times at the BI, 1837-41, and three times at SS, 1836-43. London address.
Bibl: T. Fawcett, *The Rise of English Provincial Art*, p.16.

FRYER, H. fl.1874-1875
Exhib. twice at SS, a painting entitled 'Shades of Evening' and a view in Guernsey, in 1874 and 1875-6. London address.

FRYER, Rose fl.1882
Exhib. a painting of Venice in 1882. Address in London.

FUDGE, J. fl.1815-1846
Painted views of churches and historical buildings, and views in towns. Exhib. at the RA 25 times including views of Westminster Abbey, Tintern Abbey and Rievaulx Abbey. Address in London.

FUGE, James fl.1832-1838
Exhib. three watercolours at SS, 1834-8, including a view in Salisbury and another of Mont St. Michel. Also exhib. at the BI and the NWS. Address in London.

FUGE, W.H. fl.1849-1866
Painted genre subjects. Exhib. at the RA, 1852-63, including 'A Letter from Australia' and 'Draw Me'. Also exhib. at SS and BI. Address in Essex.

FUIDGE, Edwin fl.1854
Exhib. two landscapes in 1854. Address in Fareham, Surrey.

FULCHER, Miss Norah fl.1898
Exhib. a portrait of a man at the RA in 1898. Address in London.

FULLAGER, Miss H. fl.1839
Painted watercolour copies after the old masters. Exhib. three times in 1839 at SS. Address in Stoke Newington.

FULLER, Miss Edith fl.1893
Exhib. a genre painting at the NG in 1893. Address in Croydon, Surrey.

FULLER, Edmund G. fl.1893-1904
Exhib. 14 times at the RA, 1894-1904. Titles: 'Sun-kissed Foam' and 'Cornwall's Iron-Bound Coast', etc. Address in St. Ives, Cornwall.
Bibl: Brook-Hart.

FULLER, Miss Florence A. fl.1897-1904
First exhib. at the RA in 1897 with 'Summer Reverie'.

FULLER, Horace fl.1874-1884
Painted watercolour landscapes and country scenes. Exhib. at SS nine times, 1875-81, including several views of the Hampshire Coast. London address.

FULLER, S.P. fl.1863-1867
Exhib. three times at SS, 1863-7, including an illustration to Tennyson's *Maud.* London address.

FULLERTON, Mrs. Elizabeth S. fl.1890-1893
Painted flowers. Exhib. two painting of rhododendrons at the RA in 1890 and 1892. Address in Paisley, Scotland.

***FULLEYLOVE, John RI 1847-1908**
Leicester painter of landscape and views of buildings in Greece, Rome, Venice, Jerusalem, etc., and genre. Also a book illustrator for A. & C. Black. A friend of Thomas Collier (q.v.). He exhib. in London 1871-1904, at the RA (1873-1904), SS, and at the RI, and other galleries.
Bibl: Studio VII p.77ff.; XXV p.l99, Summer Number 1900; Sketchley, *English Book Illustration of Today,* 1903; DNB.
Exhib: London, 1 Langham Chambers 1907 and 1908.

FULLWOOD, Albert Henry b.1863 fl. to 1904
First exhib. landscape paintings of South Africa at the RA in 1901. London address. Possibly brother of John Fullwood (q.v.).
Bibl: Studio XVIII p.275; XIX p.291; XLVI p.45; Art et Décoration 1907 II December p.2.

FULLWOOD, Charles fl.1888-1889
Exhib. a view on the River Severn at SS in 1888-9. Also copied paintings. London address.
Bibl: Ormond I.

FULLWOOD, John RBA RI fl.1881-d.1931
Landscape painter and etcher. Exhib. at the RA from 1883 including several views of the Thames. Also exhib. at SS from 1888. Lived in Twickenham, Middlesex. Possibly brother of Albert Henry Fullwood (q.v.).
Bibl: AJ 1886 pp.321, 336; 1893, p.305; 1895 p.257; 1896 pp.369-73; 1902 p.238.

FULTON, David RSW 1848-1930
Exhib. once at the RA, 'Arran from the Bute Shore, Kyles of Bute', in 1884. Address in Glasgow.
Bibl: Caw p.284; Muther, *Gesch. der Engl. Maler,* 1903 p.380; F. v. Ostini, *Die Gall. Th. Knorr in Munchen,* 1901 pp.132, 137; V. Pica, *L'Arte. Mond. a Venezia nel 1899,* p.30.

FURKEN, H. fl.1838
Exhib. one painting, an interior scene, at the RA in 1838. Address in Brussels.

FURLONG, Miss Marianne M. fl.1891-1894
Painted flowers. Exhib. twice at SS in 1891. London address.

FURNESS, Algerton fl.1856-1858
Exhib. one landscape, a scene near Hornsey, at the RA in 1856. Also exhib. two landscapes in 1856 and 1858 at the BI. London address.

FURNISS, Harry fl.1854-1925
Irish portrait draughtsman and caricaturist. His drawings of John Bright and Thomas Carlyle are in the NPG. For works illustrated by, see Card Cat. at VAM.
Bibl: Portfolio 1887 p.126; AJ 1894 p.192; 1896 pp.128, 158; Singer, *English Book Illustration of Today,* 1903; Singer, *Kunstlerex Nächstr.,* 1906; BM Cat. of Engraved British Portraits I p.141; Who's Who 1914; Ormond; *Harry Furniss's Joke Academy* (W. Allan), Connoisseur CLXXXIII no.735 p.l .

FURNISS, Miss Mary fl.1900-1904
First exhib. at the RA in 1900 with 'A Surrey Shepherd'. Address in Epsom, Surrey.

FURSE, Charles A. fl.1891
Exhib. four portraits in 1891.

FURSE, Charles Wellington ARA 1868-1904
Painter of portraits and figure subjects, influenced by Whistler and Sargent; lecturer and writer on art. His brother was the sculptor John H.M. Furse. Studied at the Slade School under Legros, 1884, in Paris at the Académie Julian, and at the Westminster School of Art under Fred Brown. Exhib. at the RA from 1888; NEAC and NG from 1891; member of NEAC 1892. Painted decorations in the Town Hall, Liverpool, 1899-1901. ARA 1904. Died of tuberculosis. Memorial exhibition at the Burlington Fine Arts Club, 1906. 'The Return from the Ride', 1902, and 'Diana of the Uplands', 1903-4, are in the Tate Gallery.
Bibl: AJ 1893 p.158; 1904 pp.79, 182, 189, 381, 396; 1905 pp.43, 353; 1906 p.37; 1908 pp.144, 146; 1909 p.82 (pls.); Studio I pp.33, 124; VI p.215 (pls.); LXII 1914 pp.96, 102; LXV 1915 pp.128, 204; Mag. of Art 1904 p.438; Burlington Fine Arts Club, D.S. MacColl, *Illustrated Memoir of Charles Wellington Furse ARA,* 1908; DNB. Supp. II; Illustrated London News 1914 Vol. 145 p.65 (pl.); Dame Katharine Furse, *Hearts and Pomegranates,* 1940; Tate Cat.; Ormond.

FURSE, Thomas fl.c.1840
His portrait of Cardinal Wiseman is in the English College at Rome.
Bibl: Ormond I p.519.

FURSE, W.H. fl.1831-1850
Painted religious subjects and Italianate genre subjects. Exhib. at the RA, 1842-50, including 'Peter the Hermit' and 'Joseph and Mary arriving in Bethlehem'. Also exhib. at the BI, 1831-44. Lived in Rome.
Bibl: Muller, Kunstlerlex, 1857 II.

FUSSELL, Alexander fl.1838-1881
Exhib. at the RA, 1839-52, including portraits and genre subjects. Also at SS, 1854-76, and including landscape. Address in London.
Bibl: Nagler, Monogr. I no.546.

FUSSELL, Frederick Ralph fl.1843-1858
Exhib. twice at the BI, 'Still Life' and 'Morning', in 1843 and 1847. Also exhib. one portrait at the RA in 1858. Address in Nottingham.

FUSSELL, Joseph 1818-1912
Painted religious subjects and country scenes as well as marines. Exhib. at the RA, 1821-44, including 'Landscape and Cattle' and 'Christ raising Jairus's Daughter'. Also exhib. at the BI, 1822-45. Address in London.
Bibl: Brook-Hart.

FÜSSLI, W. fl.1874
Exhib. two portraits at the RA in 1874. Address in Munich, Germany.

FYFE, William B.C. fl.1865-1882
Painted historical and genre subjects, and portraits. Exhib. at the RA, 1866-82, including 'The Fisherman's Daughter' and 'The Raid of Ruthven; An Incident in the Life of James VI of Scotland'. Also exhib. at SS and the BI. London address.

GABRIEL, C. Wallis fl.1882
Exhib. one painting, 'An Absent Friend', at the RA in 1882. Address in Bath.

GADE, William R. fl.1878
Exhib. two paintings at the RA, 'Old Jim' and 'Happy Old Age', in 1878. London address.

GADSBY, James fl.1872-1875
Exhib. a watercolour entitled 'Presents for the Hospital' at SS in 1874-5. London address.

***GADSBY, William Hippon RBA 1844-1924**
Painter of domestic subjects and children. Studied at Heatherley's and at the RA schools, where he was influenced by Millais. Studied on the Continent, in Rome and Venice in 1870. Exhib. at RA, BI and SS, and at his death was the oldest member of the RBA. Best known for his many delightful pictures of children. In 1922 he painted a watercolour of a child's head for the Queen's Dolls' House.
Bibl: Ormond.

GAIR, Gillies fl.1872-1874
Exhib. three portraits at the RA, 1872-4, and a painting entitled 'Scottish Interior' at SS in 1873-4.

GALBRAITH, W.C. fl.1866-1870
Painted landscape watercolours. Exhib. nine works at SS, mostly views in Northumberland. Address in North Shields, Northumberland.

GALE, Frances fl.1877-1885
Exhib. a painting entitled 'Thistle' at the RA in 1885. London address.

GALE, R.L. RBA fl.1832-1841
Painted landscape watercolours. Exhib. at SS, 1836-40, including views in Italy, Germany and Switzerland. Also exhib. twice at the RA including 'Irish Cabin' in 1841. London address.

***GALE, William 1823-1909**
London painter of historical and biblical genre. Also painted portraits, mythological subjects, and scenes of life in the Orient. Student of the RA schools. Travelled in Italy 1851, Syria 1862, Palestine 1867, and Algeria 1876-7. Exhib. at RA, 1844-93, BI, and SS. A work by him is in Glasgow AG. In his early period he also painted several charming genre scenes in Pre-Raphaelite style. A typical one of this type is in the Tate.
Bibl: J. Dafforne in AJ 1869 p.373ff. (mono. with illus.); 1859 pp.162, 163,166; Clement & Hutton.

GALES, Henry fl.1868
Painted a group portrait of the Cabinet of the Earl of Derby. This was lent by Baroness Kinloss to the exhib. *The Victorian Era*, 1897.
Bibl: Ormond.

GALLIMORE, Samuel fl.1861-1893
Exhib. five works at the RA, 1861-93, including a portrait of the Rt. Hon. W.E. Gladstone, M.P., and a painting entitled 'The Haunt of the Mallard'. Also exhib. once at SS and once at the NWS. London address.

***GALLON, Robert 1845-1925**
London landscape painter, who exhib. 1868-1903 in London, at the RA (32) 1873-1903, and at the BI (27), titles being generally landscapes in England, Wales and Scotland. Painted in realistic style similar to B.W. Leader and Vicat Cole.
Bibl: Brook-Hart; Wood, Paradise Lost.

GALLON, Robert Samuel Ennis fl.1830-1868
London genre and portrait painter, and lithographer. Father of Robert Gallon (q.v.). Exhib. at RA 1830-68, BI and SS. In 1847 he drew a lithograph portrait of the opera singer Marietta Alboni.
Bibl: BM Cat. of Engraved British Portraits 1906 IV p.287.

GALLOWAY, E. fl.1847
Exhib. one painting, entitled 'Shipping off Sheerness', at the RA in 1847. London address.

GALPIN, William Dixon fl.1883-1887
Exhib. three times at the RA, 1883-7, including 'An English Flower' and 'Beatrice: A Portrait'. Also exhib. a painting entitled 'Past and Present' at the SS in 1883. Address in Roehampton.

GALSWORTHY, Gordon C. fl.1893-1912
Exhib. two works at SS in 1893, 'Boys Fishing' and 'An Old Garden'. Exhib. at the RA from 1899, including a work entitled 'A Summer Morning'. Address in Sussex.

GALSWORTHY, W.H. fl.1847-1856
Painted landscapes, coastal landscapes and marine subjects, many of which are set in Devon and Cornwall. Exhib. two works at the RA, in 1847 and 1850. Exhib. eight works at the BI, 1847-54, including 'Plymouth Sound — Ships Hove To' and 'A Devonshire Lane'. Also exhib. five times at SS, 1847-56. London address.

GALTON, Miss Ada fl. from 1899
First exhib. at the RA in 1899, a painting entitled 'A Moor Road Yorkshire'. Address in South London.

GAMBARDELLA, Spiridione fl.1842-1864
Painted genre, portraits and figurative scenes. Exhib. four times, 1842-50, including 'London Beggars'. Exhib. at the BI, 1842-50, including 'Aspiration' and 'The Music Grinders'. Painted a portrait of Carlyle.
Bibl: BM Cat. of Engraved British Portraits II p.23: Ormond.

GAMMAGE, Miss Emma fl.1865-1868
Exhib. three times at the BI, 1865-7, including 'Some of Flora's Gems'. Also exhib. three times at SS, 1866-8, including 'Spring Flowers' and 'Geraniums'. Address in Liverpool.

GANDY, Mrs. Ada fl.1898
Exhib. a portrait at the RA in 1898. London address.

GANDY, Herbert fl.1879 d.c.1920
Painted landscapes, genre and literary subjects. Exhib. at the RA from 1879 including 'Men Were Deceivers Ever' and 'The Viking's Homecoming'. Also exhib. at SS, 1879-83. London address.
Bibl: Gazette des Beaux-Arts 1879 II p.368.

GANDY, T. fl.1848-1859
Painted portraits. Exhib. seven works at the RA, 1848-59, including portraits of the Dean of Exeter and his daughters. London address.

GANDY, Walton fl.1893
Exhib. a watercolour view of the golf links at Littlehampton at SS in 1893-4. London address.

GANGALEN, Van see VAN GANGALEN

GANT, James Y. fl.1827-1841
Painted landscapes, principally in Devon. Exhib. 13 works at the BI, 1828-41, including 'Evening, Pen Roy Castle, Devonshire' and 'Nosworthy Bridge, on the Plym'. Exhib. 13 works at the RA, 1827-40, including 'Morning — Going up the Needles — Deck of a Portsmouth Lighter'. Lived in Plymouth, Devon.
Bibl: Brook-Hart.

GANTHONEY, R. fl.1872-1873
Exhib. a watercolour entitled 'Sawpits, Richmond Park' at SS in 1872-3. Address in Richmond, London.

GANZ, Henry F.W. fl.1883-1904
An etcher who also exhib. paintings, at the RA from 1891 and also at the GG. London address.
Bibl: Studio XXVI p.216; XXXI p.151; XXXII p.242.

GARBUT, Joseph (Putty) fl.1870-1900
Painted portraits and genre subjects, marines and landscapes. He was a glazier by trade and lived in South Shields, County Durham. Represented in the South Shields Museum.
Bibl: Hall.

GARDEN, Miss Louisa E. fl.1879
Exhib. a watercolour entitled 'Moonlight: Margate' at SS in 1879. London address.

***GARDEN, William Fraser 1856-1921**
Landscape watercolourist. Exhib. at the RA, including 'The Path Through the Woods' and 'A Fen Village', 1882-90. Address in Bedford. His real name was Garden William Fraser, but he changed it to Garden. Brother of Robert Winchester Fraser and the other artists of the Fraser family. W.F. Garden was undoubtedly the most remarkable artist of the Fraser family. His watercolours of the fens and its buildings are unsurpassed in their detail, clarity, and stillness.
Bibl: Newall; Wood, Paradise Lost; Charles Lane, The Frasers, Watercolours Magazine Winter 1989.

GARDINER, Miss E. fl.1841
Exhib. two watercolours at SS in 1841, 'Coast Scene, Worthing' and 'Glastonbury Abbey'.

GARDNER, C. fl.1853-1856
Exhib. three seascapes at the BI, 1855-6, and a painting entitled 'The Wrecked' at the RA in 1853. Address in Kilburn, London.
Bibl: Brook-Hart.

GARDNER, Edwin C. fl.1867-1888
Painted landscapes and literary subjects in oil and watercolour. Exhib. 11 works at SS, 1867-84, including scenes from A Midsummer Night's Dream. Also exhib. three works at the RA, 1884-6, including 'Shaving Hop-poles' and 'Spring Lamb'. London address.

GARDNER, Emma E. fl.1875
Exhib. a landscape in 1875. London address.

GARDNER, G. fl.1884-1885
Exhib. twice at SS, 1884-5, 'Strawberries and Grapes' and 'Choice Fruit'. London address.

GARDNER, J.L. fl.1880-1888
Painted landscapes. Exhib. five works at the RA, 1880-8, including 'Michaelmasstide' and 'Among the Water Lilies'. Also exhib. twice at SS. London address.

GARDNER, Lord fl.1887-1890
Exhib. five landscapes at the NWS, 1887-90. Address in Dorking, Surrey.

GARDNER, Mabel fl.1878-1879
Exhib. a flower painting in 1878-9. Address in Cheltenham, Gloucestershire.

GARDNER, Sidney fl. from 1899
Exhib. two works at the RA, 'Field Flowers' and 'The Seabank, Skegness', in 1899 and 1900. London address.

GARDNER, William Biscombe c.1847-1919
Engraver and landscape painter. Exhib. 32 works at the RA, 1878-1900, mostly engravings but also including landscapes in the south of England. Also exhib. from 1874, at the NWS, and GG and the NG. London address.
Bibl: A. Hayden, Chats on Old Prints, 1909 p.125.

***GARLAND, Charles Trevor 1855-1906**
London painter of genre and children, portraits and landscape, who exhib. 1874-1901, at the RA (19), and from 1875-1901 at the BI (19). Titles include 'In Heart-thrilling Meditation Lost', 'Sunny Days', 'Good-bye Sweetheart' (in 1885 and 1901). The AJ illustrates 'The Rivals' — children in Cromwellian costume. Lived in Newlyn, Cornwall.
Bibl: AJ 1884 p.264 (pl.).

***GARLAND, Henry fl.1854-1890**
Painter of landscape and genre. Lived in Winchester and London. Exhib. at RA, 1854-90, BI and SS. Works by him are in Leicester, York and Sunderland AG. Also recorded as living in Winchester are T. Valentine, Valentine Thomas and William Garland, all painters of domestic genre. Graves's Dictionary lists T. Valentine, Valentine Thomas (q.v.) and T.W. Garland separately, but it seems probable that they are all the same artist.

***GARLAND, Valentine Thomas fl.1884-1903**
Painter of animals; lived in Winchester and London. Exhib. at RA from 1868, SS and NWS. Titles at RA 'Forty Winks', 'A British Workman', 'The Sunshine of Life', etc. Graves's Dictionary also lists a T. Valentine and a T.W. Garland; these are both probably mistakes for Valentine Thomas.

GARLAND, William fl.1857 d.1882
Painted landscapes and genre. Exhib. 10 works at SS, 1868-75, including: 'Fairy', 'An Old Lock — St. Catherine's, Winchester' and 'Young Rabbits'. Also exhib. four works at the RA, 1857-73. Address in Winchester, Hampshire.
Bibl: The Year's Art 1883 p.228.

GARMAN, Miss Mabel fl.1900
Exhib. one work, a study of an Arab's head, at the RA in 1900. Address in Birmingham.

GARNETT, Alfred Payne fl. from 1896
First exhib. at the RA in 1896, a work entitled 'The Old Quarry'. Address in Bushey, Hertfordshire.

GARNETT, Miss Ruth fl. from 1893
Exhib. at the RA from 1893 titles including ' "Who So Happy as I?" ' and 'Waiting for Father's Bus'. London address.

GARNHAM, G.R. fl.1878
Exhib. two Sussex landscapes at the RA in 1878. London address.

GARRATT, Agnes M. fl.1891-1892
Exhib. a watercolour entitled 'Hilary' at SS in 1891-2. Address in Walthamstow, London.

GARRATT, Arthur P. fl. from 1899
First exhib. at the RA in 1899, a work entitled ' "To Be Merry, Let's Now Take Our Time, While We're In Our Prime." ' In 1900 he exhib. at the RA a painting entitled 'Wounded Men at Wynberg, South Africa'. Address in Chiswick, London.

GARRATT, Eliza fl.1872
Exhib. a still-life in 1872. Address in Putney, London.

GARRAWAY, Edward fl.1875-1878
Exhib. two watercolours at SS, entitled 'A Shilling an Hour' and 'Now Then!', in 1875 and 1876. London address.

GARRAWAY, George Hervey b.1846 fl. to 1929
Painted country genre subjects and portraits. Studied at Heatherley's School and at the Ecole des Beaux Arts. Exhib. four works at the RA, 1872-91, including 'The Breton Beggars' and 'A Liverpool Street'. Also exhib. four works at SS, 1870-82, including 'A Breton Religious Procession'. The Walker AG possesses his painting 'The Florentine Poet'. Addresses in Liverpool and Florence, Italy.

GARRER, J. fl.1876
Exhib. one painting at SS in 1876, entitled 'An Italian House in Rome'. London address.

GARRIE, R. fl.1865
Exhib. one painting, entitled 'Moorland', at the RA in 1865. London address.

GARROD, Edith fl.1878-1880
Exhib. two figurative paintings, 1878-80. London address.

GARSTIN, Norman 1855-1926
Painted genre and exotic scenes in oil and watercolour. Exhib. at the RA from 1883 including 'In a Weary Land' and 'The Piece of Silver that was Lost'. Also exhib. at SS, 1882-89, including 'Trouble' and 'His Latest Bride'. Born in County Clare, Ireland. Lived at Penzance, Cornwall.
Bibl: A. Meynell in AJ 1889 p.140; Studio XXXI 1904 p.74; XLVI 1909 p.227; XLVII p.117; LVI 1912 p.65.

GARTHWAITE, William fl.1860-1889
Painted marines. A painting of his, dated 1889 and entitled 'The Burning of the American Packet *Ocean Monarch* off Great Ormshed, 1848', was sold at auction in April 1974.
Bibl: Brook-Hart.

GARVEY, Miss Clara fl.1887-1892
Exhib. two paintings, 'An Old Man's Friends' and 'Primulas', at the RA in 1887 and 1889. Address in Dulwich, London.

GARVIE, Thomas Bowman b.1859 fl.1886-1903
Painted portraits, biblical, genre and Italianate subjects and rustic scenes. Studied at Calderon's School, the RA schools and the Académie Julian. Exhib. at the RA, 1886-1903, including 'By the Waters of Babylon', 'Quiet Consolation' and several portraits. Also exhib. twice at SS. There was a loan exhibition of his work at the Laing AG, Newcastle-upon-Tyne, in 1934. He is represented in the Laing and Sunderland AG. Travelled and painted in Italy. Lived at Morpeth, and later Rothbury, Northumberland.
Bibl: Hall.

GASCOIGNE, Mrs. General fl.1871
Exhib. one painting, entitled 'Threading the Needle: A Study from Nature', at the RA in 1871.

GASCOYNE, George RPE 1862-1933
Painted landscape, genre and literary subjects. Studied at the Slade School. Exhib. at the RA from 1884 titles including 'The Knife Grinder', 'The Good Samaritan' and 'The Miry Beasts Retreating frae the Plough — Burns'. Lived at Aldbourne, Wiltshire.
Bibl: Portfolio 1893 p.197; Studio LXIII p.144.

GASH, Walter Bonner 1869-1928
Painted portraits, figures and landscapes. Studied at Lincoln School of Art and in Antwerp. Exhib. at the RA from 1896, including 'Studying the New Woman' and 'Selling Flowers'. Born in Lincoln. Lived at Kettering, Northamptonshire.

GASKELL, George Arthur fl.1871-1900
Painted figurative and genre subjects. Exhib. 10 works at the RA, 1871-1900, including 'A Young Archer' and ' "See My Kitties!" ' Also exhib. at SS, 1872-93. London address.

GASKIN, Arthur Joseph ARE RBSA 1862-1928
Painter and etcher of portraits, figures and still-lifes. Studied at Birmingham School of Art. Exhib. twice at the RA, ' "For Those in Peril on the Sea" ' and 'Spring' in 1889 and 1891. Born in Birmingham. Lived in Warwickshire and later at Chipping Camden, Gloucestershire.
Bibl: Studio LXIV p.25; XXIII pp.155-8; XXVI pp.295-9; XLII p.210; LVIII p.63; LXI pp.293-301; LXX p.18; Bate; Sketchley, *English Book Illustration*, 1903.

GASS, John B. fl.1880-1891
Painted architectural subjects. Exhib. three works at the RA, 1880-91, including 'The Tower of the Church of St. Jean, Maastricht'. Address in Bolton, Lancashire.

GASSIOT, H. fl.1877-1878
Exhib. three genre paintings in 1877-8. London address.

GAST, Bertram fl.1888-1892
Painted watercolour landscapes. Exhib. five works at the RA including 'An Evening Sketch near Marlow'. Also exhib. at SS, 1889-91, including several other Thames Valley landscapes. London address.

GAST, Frank fl.1891-1892
Exhib. three works at the RA, 1891-6, including a portrait and 'Digging Potatoes'. London address.

GASTINEAU, Henry G. c.1791-1876
Landscape and topographical watercolourist, his work "technically accomplished but not particularly original" (Hardie). Student at the RA; began his career as an engraver but soon gave this up, first starting painting in oils, and then turning exclusively to watercolour. Exhib. 26 works at the RA, 1812-30; elected A. of the OWS, 1821, and Member, 1823, exhibited 1,310 drawings there, 1818-75; also three works at the BI, 1816, 1819, 1841. Spent much time in teaching. From 1833 many of his drawings were engraved for books on English topography. He was one of the last artists to work in the old school of picturesque topography and his landscapes are mainly stock picturesque subjects in England, Scotland and Wales. He also visited Belgium, Switzerland, the Italian Lakes, and after 1838 painted a number of subjects in Ireland, notably the coast of Antrim. 'Near Trim, Co. Meath', VAM. For works illustrated by see Card Cat. at the VAM.
Bibl: AJ 1876 p.106 (obit.); Builder 1876 p.108; Redgrave, Dict; The Year's Art 1885; Roget; Cundall; DNB; Hughes; VAM; Hardie III pp.40, 150, 160 (fig.182).

GASTINEAU, Miss Maria G. fl.1855-1889 d.1890
Landscape watercolourist. Daughter of H.G. Gastineau (q.v.). Member of the Society of Lady Artists.

GAUBERT, George Frederick fl.1829-1861
Painter of marines, coastal landscapes and shipping. Exhib. 28 works at the RA, 1829-61, including numerous views of both the French and English Channel coasts and ports. Also exhib. five works at SS. He lived in Boulogne-sur-Mer and later in Islington, London.
Bibl: Brook-Hart.

GAUCI, Paul fl.1834-1863
Painted landscape. Also made portrait lithographs. Exhib. four works at the RA, 1845-63, including two scenes in Windsor Great Park. Also exhib. once at the BI and twice at SS. London address.
Bibl: BM Cat. of Engraved British Portraits I p.12; II pp.134, 169, 271; III pp.79, 169, 409, 618; IV pp.162, 338, 431.

GAUGAIN, Mrs. Anne fl.1838-1847
Painted fruit. Exhib. five works at the BI, 1838-47, including three entitled 'Fruit and Flowers' and one 'Dick having a Frolic among the Grapes'. London address.

GAUGAIN, Philip A. fl.1783-1847
Painted portraits and genre subjects. Exhib. 12 portraits at the RA, 1808-42. Exhib. seven paintings, including 'Girl Listening to a Singing Bird', at the BI, 1809-39. Address in Chelsea, London.

GAULD, David RSA **1865-1936**
Glasgow painter of cattle and landscape, decorative portraits and allegorical subjects. Apprenticed to a Glasgow lithographer; first attracted attention through a series of clever pen drawings illustrating stories and verses, which appeared in the *Glasgow Weekly Citizen* in the late 1880s. He then turned to designing stained glass. As a painter he produced paintings of wood-nymphs, dryads or girls loitering by streams or wandering in summer woodlands, and also decorative portraits of girls' heads with flowers or wavering leaves as a setting. But he first made his mark as a painter of cattle and landscape, and developed into a specialist in painting Ayrshire calves. Gauld himself said that the two main influences on his work were Rossetti and James Maris.
Bibl: AJ 1909 p.153; Studio XXV p.207 (pl.); XXIX p.298; XXXI p.163; LXIII p.117; LXVI pp.103, 105; Martin, *The Glasgow School of Painting,* 1902 p.14ff.; Caw pp.442, 450-1; Irwin.

GAULTIER, A.T. or M. fl.1860-1861
Exhib. a painting, entitled 'Fruit', at the BI in 1860. Address in Hammersmith, London.

GAUNT, Thomas Edward fl.1876-1884
Painted genre. Exhib. 11 works at SS, 1876-84, including 'A Little Girl', 'My Little Model' and 'My Pet and I'. Also exhib. three works at the RA, 1877-83. London address.
Bibl: BM Cat. of Engraved British Portraits II 1910 p.555; III 1912 p.589.

GAUNTLETT, Miss Gertrude E. fl.1866-1880
Painted genre subjects in watercolour. Exhib. 13 works at SS including 'Vis a Vis', 'Olivia' and 'The Seamy Side'. Also exhib. once at the RA in 1880. Address in Clapham, London.

GAUTHIER, A. fl.1881
Exhib. a landscape in 1881, London address.

GAVEY, Miss Edith fl.1901
Exhib. a painting entitled 'Anemones' in 1901. Address in Hampton Wick.

GAVEY, R.E. fl.1828-1839
Exhib. four works, including 'The Widow' and 'Fête Champêtre', at the BI, 1828-34. Also exhib. four watercolours at SS, 1828-39, including a scene from *Ivanhoe*. London address.

GAVIN, Malcolm ARSA RP **b.1874**
Painted portraits. Studied at South Kensington and at the RA schools. Lived in Edinburgh and London.

GAVIN, Robert RSA **fl.1855-1871**
Exhib. five works at the RA, 1855-71, including 'Feckless Fanny', 'La Mulatresse' and a study of an American slave girl. Address in Edinburgh.
Bibl: DNB; AJ 1866 p.12; Bryan; Caw.

GAY, G. fl.1877-1880
Exhib. twice at the RA, 'After the War' and 'The First Steps', in 1877 and 1880. London address.

GAY, Miss Susan Elizabeth fl.1874-1876
Exhib. twice at the RA, 'Sea Cave' and 'Old Orchard' in 1874 and 1876. Address in Croydon, Surrey.

GAYLER, Mrs. Ellen fl.1891
Exhib. at the RA from 1891, including 'Love's Watch Keeping', 'Rosebuds' and 'The Fairy's Step'. Address in Bristol.

GAYTON, Miss Anna M. fl.1874-1893
Painted portraits. Also a sculptress. Exhib. nine works at the RA, 1890-9. Address in Much Hadham, Hertfordshire.

GEAR, A. Handel fl.1877-1894
Exhib. one painting, entitled 'A Whiff of the Sea' at SS in 1879-80. London address.

GEAUSSENT, Mrs. George F. fl.1890
Exhib. a painting of flowers in 1890. London address.

GEBSATTEL, Baroness S. fl.1893
Exhib. a painting entitled 'Modèle à contre-coeur' at the RA in 1893. Address in Munich.

GEDDES, Andrew ARA 1783-1844
Scottish portrait painter. Also occasionally undertook historical and biblical subjects. Exhib. 100 works, mostly portraits, at the RA, 1806-45. Also exhib. 28 studies, genre subjects and landscapes at the BI, 1818-42. London address. His studio sale was held at Christie's, 8-12 April 1845.
Bibl: Mrs. Geddes, *Memoir of the late A.G.*, 1844; Art Union 1844 pp.148, 291; Laing, *Etchings by Wilkie and G.*, 1875; Redgrave; Hamerton, *Etchings and Etchers;* DNB; The English Illustrated Magazine 1884 p.160; Portfolio 1887 p.110; Slater, *Engravings and Their Value*, 1900; Caw; Cat. of the Geddes Exhib. Edinburgh 1921; C. Dodgson, *The Etchings of . . . and A.G.*, London 1936; BM Cat. of Engraved British Portraits; Ormond; Irwin.

GEDDES, Ewan RSW fl.1891-d.1935
Painted watercolour landscapes. Exhib. two works, 'A Scotch Interior' and 'A Group of Trees', and at the RA in 1891 and 1892. Also exhib. in Scotland. Lived in Edinburgh.
Bibl: Studio XXVIII p.52; LXIII p.117; LXVII p.262.

GEE (JEE), David 1793-1871
Coventry painter who painted battles, landscapes, town views and portraits. He worked in Coventry from 1815 to 1868, and there are examples in Coventry AG.

GEE, Miss Lucy fl. from 1897
Exhib. at the RA from 1897 including ' "A Contented Mind is a Continual Feast" ' and 'The Master of the House'. Address in Bletchley, Buckinghamshire.

GEERE, J.W.H. fl.1858-1867
Exhib. six landscape paintings of Kent and the Wye Valley at the BI, 1858-67. London address.

GEGAN, J.J. fl.1844-1860
Exhib. eight landscapes, all Kentish views, at SS, 1844-60. Also exhib. 'At Bridborough, Tunbridge' at the RA in 1848. Address in Maidstone, Kent.

GEIKIE, Miss Lucy fl. from 1901
First exhib. at the RA in 1901 with 'The End of the Day'. London address.

GEISLER (GIESLER), C. fl.1858
Exhib. a view of Glen Urquhart on Loch Ness at SS in 1858. London address.

GELDER, J. fl.1865
Exhib. one painting, 'Lane Scene — Beverley, Yorkshire', at the RA in 1865.

GELLER, Miss Angelina fl.1865-1866
Exhib. two watercolours, entitled 'Favourites' and 'Fruit' at the RA in 1865 and 1866. London address.

GELLER, W. Henry fl.1848-1849
Exhib. one painting, 'A Group of Flowers', at the RA in 1849. London address.

GEMMELL, Miss Marion
Painted portraits. Has been confused with Miss Mary Gemmell (q.v.).

GEMMELL, Miss Mary fl.1883-1894
Painted flowers. Exhib. at the RA, 1883-94, including ' "Pleasures are like Poppies Spread" '. London address.

GENDALL, John 1790-1865
Topographer, landscape painter and engraver. Born on Exe Island, Exeter, he became servant to Mr. White of Exeter. Recommended by White to Sir J. Soane, he was introduced by Soane to Ackermann who employed him for some years as a draughtsman, lithographer and manager. Among works which Gendall himself illustrated were 'Picturesque Views of the Seine', 1821, and 'Views of County Seats', 1823-8. He exhib. at the RA 1818-63, all landscapes in Devon.
Bibl: Redgrave, Dict; G. Pycroft, *Art in Devonshire*, 1883; Binyon; Cundall; DNB; VAM; Prideaux, *Aquatint Engraving*, 1909 pp.375, 377; Hardie III p.28 (fig.36).

GENOTIN, Frederick fl.1866
Exhib. a painting, entitled 'Three Fishers', at the RA in 1866. Also exhib. a painting entitled 'Christmas' at SS in 1866. Address in Edinburgh.

GENTLE, E. c.1880-1900
Painted views on the English south coast.
Bibl: Brook-Hart (pl. 194).

GEOFFROI, Harry fl.1884-1885
Exhib. a watercolour entitled 'A Grey Morning: Prussia Cove, Mount's Bay' at SS in 1884-5. Address in Penzance, Cornwall.

GEOFFROY, Jean fl.1890
Exhib. one painting, 'Un Lavabo', at the RA in 1890. London address.

GEORGE, Sir Ernest RA RE PRIBA 1839-1922
Principally an architect but also an amateur watercolourist and etcher. Painted views in Belgium, France, Italy and London. Lived in London.
Bibl: Portfolio 1874 p.71; 1875 p.60; 1876 p.136; 1877 p.176; 1881 p.121; 1882 p.101; 1887 p.247; Studio I p.217; VII p.147; AJ 1910 p.97; Who's Who 1914.

GEORGE, Miss Esther H. fl. from 1892
Exhib. at the RA from 1896 including 'The Old Parish Clerk' and 'The Pensioner's Rest'. Address in Bushey, Hertfordshire.

GEORGE, F.W.
See G.F. Watts, who, for some reason, assumed this name for the RA exhibition of 1858.

GEORGE, J. fl.1825-1838
Exhib. at SS, 1829-32, including 'Rustic Toilet', 'Solitude' and 'H.R.H. The Late Duke of York'. Also exhib. at the RA. London address.

GEORGE, S.G. fl.1874
Exhib. a painting of a church in 1874. London address.

GEORGE, St. see ST. GEORGE, J.

GEORGE, T. fl.1829-1838
Exhib. at the RA, 1829-38, three portraits and two other figurative paintings. London address.
Bibl: BM Cat. of Engraved British Portraits II 1910 p.478.

GEORGE, W. fl.1847-1848
Exhib. three times at SS including paintings entitled 'Landscape South Wales' and 'A Nibble' in 1847 and 1848. Also exhib. at the RA and BI. London address.

GEORGE, W. Pettit fl.1852-1854
Exhib. nine times at SS, 1852-64, including landscapes in the north of England, the Lake District and Wales. Address in Grasmere, Westmorland.

GEORGES, Charles E. RBA fl.1893
Exhib. a watercolour entitled 'Harvesting: Wiltshire' at SS in 1893-4. London address.

GERARDIN, D. De La Place fl.1868-1879
Exhib. six times at SS, 1868-79, including landscapes and views in Essex. London address.

GERE, Charles March RA RWS RBSA NEAC 1869-1957
Painter of landscapes, portraits and figurative subjects. Also an illustrator. Exhib. one painting, 'The Chair of Idris', at the RA in 1890 Also exhib. six times at the NG. Lived at Painswick, Gloucestershire.
Bibl: Studio LIX pp.87-94; XLII p.218; LV p.224; LVI p.144; LVII p.317; LX p.303; LXVI p.277; Connoisseur XXXIX p.204; Sketchley, *English Book Illustration*, 1903.
Exhib: Gloucester, Wheatstone Hall 1963.

GERNION, E.D. fl.1853
Exhib. one painting, entitled 'Evening with Cattle' at the RA in 1853.

GETHIN, Percy Francis 1874-1916
Painter and etcher of architectural subjects. Studied at the RCA, Westminster School of Art and in the Atelier Colarossi. Born in Sligo, Ireland. Later lived in London, and was killed in the First World War.

GHENT, Peter RCA 1856-1911
Painted landscapes, mostly in North Wales. Exhib. 22 works at the RA, 1879-96, including 'A Misty Morning in the Ogwen Valley, North Wales' and 'Mussel Gatherers — Coast of Anglesea'. Also exhib. three times at SS. There are two of his landscapes in the Walker AG. Address in Liverpool.
Bibl: The Building News 1911 p.294.

GIACHI, F. fl.1888-1889
Exhib. two genre paintings in 1888-9. London address.

GIAMPIETRI, Mme. fl.1883
(Miss Amy Butts)
Exhib. a figurative painting in 1883. Married to the Italian painter Settimio Giampietri. Lived in Rome. See also Miss Amy Butts.

GIBB, Phelan 1870-1948
Painter of architectural subjects. Studied in Newcastle-upon-Tyne, Paris, Antwerp and Munich. Born in Northumberland. Lived in Paris.

***GIBB, Robert RSA 1845-1932**
Painter of romantic, historical and military subjects, who became famous for his painting 'The Thin Red Line' (an infantry line facing a cavalry charge). His earlier paintings are more romantic, eg. 'Death of Marmion', 1873; 'The Bridge of Sighs', 1877; in 1878 he started upon military themes: 'Comrades', 'The Retreat from Moscow', and in 1881, 'The Thin Red Line' which was a great success at the RSA. He painted especially the infantry. He exhib. five works only at the RA, 1882-93. He also painted portraits. His elder brother was William Gibb (1839-1929), watercolourist and lithographer, who painted with great clarity — relics, goldsmith's work, etc. — his work being the counterpart of Jacquemart's etchings in France.
Bibl: AJ 1897 p.25ff. (with pls.); Studio LXV p.204; Caw pp.214, 266-7, 289, 474, 480 (fig. opp. p.266); Who's Who 1914; Hardie III p.195.
Exhib: London, Morris's Gallery, *The Guards at Waterloo, Hougomont, 1815*, 1903.

GIBB, William 1839-1929
Painted watercolours of objects of art. He was the elder brother of Robert Gibb, RSA. Born in Scotland. Lived in London.
Bibl: Hardie III.

GIBBINS, H.J. fl.1871-1872
Exhib. once at the RA, 'Boulogne — Low Water', in 1871. Also exhib. once at SS. Address in Dulwich, London.

GIBBS, Miss Beatrice fl.1888-1896
Painted figurative subjects. Exhib. six times at the RA, 1888-96, including 'The Dancing Girl' and ' "Righteousness and Peace have Kissed each Other." ' London address.

GIBBS, Charles fl.1878-1899
Painted landscapes, mainly in Surrey. Exhib. 23 works at SS, 1877-94, including many views on the Rivers Mole and Ouse. Also exhib. 12 times at the RA, 1878-99, including 'An Old Water-Mill near Shere, Surrey' and 'Evening in the Wood, Dorking'. Address in Dorking, Surrey.

GIBBS, F.J. fl.1854-1858
Exhib. one painting, entitled 'Disappointed', at the RA in 1854. Exhib. four works at BI, 1854-8, including 'Dogs After a Rat' and 'Not to be Caught'. London address.

GIBBS, Henry fl.1865-1901
Painter of portraits, landscapes and coastal landscapes. Exhib. 29 works at the RA, 1876-1901, titles including 'Cornish Cliffs', 'Granite Rocks near Land's End' and 'Low Tide in the Mouth of the River'. Amongst the remainder were many portraits. Also exhib. at SS, 1877-80, including 'A Mulatto'. London address.

GIBBS, J.W. fl.1874
Exhib. two watercolours at SS in 1874, 'Battle Abbey — South Aisle' and 'St. Joseph's Chapel, Glastonbury'. London address.

GIBBS, James fl.1840-1841
Exhib. twice at the RA, 'Railway Bridge over the Thames at Battersea' and a view of Cape Finisterre, in 1840 and 1841. London address.

GIBBS, James Walter 1854-1906
West country painter. Born in Bath. Lived in Dorchester. Died in Swanage.

GIBBS, Miss Mary fl.1860-1878
Painted figurative and genre subjects. Exhib. five works at SS, 1862-78, including 'The Lace Maker' and 'Guilty'. Also exhib. twice, in 1860 and 1866, at the RA. Address in Brentford, London.

GIBBS, Percy William fl.1894-1925
Painted landscape. Studied at the RA Schools. Exhib. at the RA for the first time in 1894 with ' "When the Daylight Blends with the Pensive Shadows on Evening's Breast." ' Exhib. eight works at the RA before 1901. Lived at East Molesey, Surrey.
Bibl: The Evening Standard 22 April 1912.

GIBBS, Reginald fl.1889
Exhib. a landscape in 1889. Address in Topsham, Devon.

GIBBS, S.H. fl.1849
Exhib. one painting, 'The Return from the Fair', at the BI in 1849. London address.

GIBBS, Thomas Binney b.1870
Portrait and landscape painter. Studied at Liverpool School of Art. Born in Darlington. Lived in London.

GIBERNE, Edgar fl.1872-1888
Painted figurative and genre subjects. Exhib. four works at the RA, 1876-8, including 'Parson Chowne — from Blackmore's *Maid of Sker*' and 'Little Miss Muffet'. Also exhib. three works at SS, 1875-85. Address in Epsom, Surrey.

GIBERNE, Miss Maria fl.1832-1851
Painted portraits of Cardinals Newman and Wiseman.
Bibl: Ormond.

GIBLETT, J. fl.1846
Exhib. a portrait of a young lady at the RA in 1846. London address.

GIBSON, David Cooke 1827-1856
Scottish portrait and genre painter. Exhib. five works at the RA, 1855-7, titles including 'Rustic Education' and 'The Little Stranger'. London address.
Bibl: DNB; D.C. Gibson, *The Struggles of a Young Artist: Being a Memoir of David C. Gibson, by a Brother Artist* (W. MacDuff), 1858.

GIBSON, Miss Edith fl.1882-1886
Exhib. two works at SS, 1882-5, entitled 'A Child's Posy' and 'A Brown Study'. Also exhib. once, 'Parting Summer', at the RA in 1886. London address.

GIBSON, Miss Edith M. fl.1885-1891
Exhib. two works at SS, entitled ' "There was a Soft and Pensive Grace, A Cast of Thought upon his Face" — Scott' and 'Pansies', in 1885 and 1893. Also exhib. one work, 'Curable Cases Only', at the RA in 1891. London address.

GIBSON, G. fl.1837-1838
Exhib. three landscapes at the RA, 1837-8. Also exhib. a watercolour of a group of dock leaves and a lane scene at SS in 1837 and 1838. London address.

GIBSON, G.M. fl.1876
Exhib. a portrait in 1876. London address.

GIBSON, John 1790-1854
Painter and glass stainer. Born on Tyneside, Northumberland.
Bibl: Hall.

GIBSON, Joseph J. fl.1877-1887
Exhib. three watercolours, 'The Sewing Lesson', 'Snipe' and 'Camellias', at SS, 1877-9. Also exhib. a portrait miniature at the RA. Addresses in Cork, Ireland and London.

GIBSON, Joseph Vincent fl.1861-1888
Painted portraits, genre and figurative subjects. Exhib. six works at the RA, 1862-88, titles including 'The Parting Gift', 'Carrying off the Palm' and 'A Busy Little Bee'. Also exhib. once at SS in 1865 and once at the BI in 1864. London address.
Bibl: AJ 1861 p.228.

GIBSON, Thomas 1810-1843
Painted the landscape and architecture of the North of England. Exhib. from 1834 at the Northern Academy. Exhib. four works at SS in 1841, including 'View of Askham Hall, Westmorland', 'View of Brougham Castle, Westmorland' and 'View on Windermere, Westmorland'. Born in North Shields, Northumberland. He lived in Newcastle, Carlisle and London.
Bibl: Hall.

GIBSON, William Alfred 1866-1931
Landscape painter. Exhib. two works at the RA, 'In the Forest of Dean near Stainton' and 'Harrowing', in 1898 and 1899. Born and lived in Glasgow.
Bibl: Studio XXIX p.296; XXXIX pp.352, 353; XLIII pp.138, 319, 323; LII pp.320, 321; LVII pp.156, 159; LX p.151; LXIII p.116; LXXII p.118; AJ 1905 p.226; Caw.

GIBSON, William Sidney 1814-1871
Painted watercolours of coastal scenes and landscapes after his retirement as Registrar of the Newcastle-upon-Tyne Court of Bankruptcy in 1869. Represented in the Laing AG, Newcastle.
Bibl: Hall.

GIBSONE, George c.1763-1846
Made over 7,000 watercolour drawings of sea shells. These were bought by public subscription in 1890 and presented to Newcastle-upon-Tyne Central library. Lived in Newcastle, Northumberland.
Bibl: Hall.

GIDDENS, George fl.1879-1885
Exhib. eight works at SS, 1879-85, including 'A Marshy Nook', 'The Swallow-haunted Pool' and 'A Forest Road, Fontainebleau'. London address.

GIFFORD, Augustus Edward fl.c.1850
Headmaster of Coventry School of Art in about 1850; painted local views.

GIFFORD, E.A. fl.1837-1876
Painted genre and figurative subjects. Exhib. 16 works at SS, 1837-73, titles including 'Life in a Cottage' and 'Homely Joys'. Also exhib. six works at the RA, 1842-70, including a portrait and a work entitled 'Fountain of Temperance. "Pride of the Vale!" —Coleridge'. Also exhib. six works at the BI, 1838-65. London address.

GIFFORD, Hon. Edward Scott fl.1865
Exhib. a coastal scene in 1865. London address.

GIFFORD, F. **fl.1854**
Exhib. 'A Young Naturalist' at the RA in 1854. Address in Exmouth, Devon.

GILBERT, Mrs. **fl.1865**
Exhib. a painting entitled 'Rocks at Bettws-y-Coed' at the RA in 1865. Address in Worcester.

GILBERT, Annie Laurie **c.1848-1941**
Painted topographical views in and around Nottingham, and landscapes in other parts of England and Wales. Daughter of Isaac Charles Gilbert (c.1816-c.1890) a Nottingham architect, and amateur painter.

***GILBERT, Arthur** **1819-1895**
London landscape painter, who exhib. 1836-94 at the RA (48), 1842-94 at the BI (51), and at SS (111). Titles at the RA include river scenes, moonlight and twilight scenes (and from 1874 a few Egyptian landscapes). Like Henry J. Boddington (q.v.) A.G. Williams changed his name to Arthur Gilbert, to avoid confusion with other members of the Williams family. He was the fourth son of Edward Williams (q.v.).
Bibl: *The Williams Family*, exhib. at N.R. Omell Gallery, London, April 1971; Jan Reynolds, *The Williams Family of Painters*, 1975.

GILBERT, Mrs. E. **fl.1843**
Exhib. a 'Portrait of her Daughter' at the RA in 1843. London address.

GILBERT, Miss Ellen **fl.1863-1891**
Watercolourist of nature studies, genre and literary subjects. Exhib. 55 times at SS including subjects from Richardson, Wordsworth and Shakespeare. Address in Blackheath, South London. Probably a relation of Sir John Gilbert (q.v.).

GILBERT, Frederick **fl. 1862-1877**
Exhib. twelve works at SS, 1862-83, including military subjects and subjects from Shakespeare and Tennyson. Address in Blackheath, South London.

GILBERT, Mrs. G.M. **fl.1856**
Exhib. a 'Sketch in Hampstead Fields' at the RA in 1856.

GILBERT, Horace Walter **b.1855 fl.1873-1885**
Landscape painter. Son of Arthur Gilbert (q.v.); brother of Kate Gilbert (q.v.). Exhib. five works at the RA, 1873-85, including 'Kittiwakes' and ' "How Pleasant the Life of a Bird Must Be!" ' Also exhib. three times at SS. Address in Limpsfield, Surrey.
Bibl: Jan Reynolds, *The Williams Family of Painters*, 1975 p.30.

GILBERT, J.M. **fl.1825-1855**
Painted marines and coastal landscapes. Exhib. two works at the RA in 1825 and 1855, the latter entitled 'Fort Victoria, Sconce Point, Near Yarmouth, Isle of Wight'. Also exhib. at SS and the BI. Frequently painted views of the area of Lymington, Hampshire, in which town he lived.
Bibl: Brook-Hart pl.146.

***GILBERT, Sir John** **RA PRWS** **1817-1897**
Painter and watercolourist of historical genre, successor to the sentimental and romantic tradition of George Cattermole (q.v.). In 1836 he gave up his career as an estate agent to take up painting. At first he worked mainly as an illustrator, at which he was immensely prolific. He illustrated about 150 books, and contributed nearly 30,000 illustrations to *The Illustrated London News*. After 1851 he devoted himself mainly to watercolours. Elected Associate of OWS 1852, Member 1854, President 1871. Knighted 1872, and elected ARA, RA 1876. Gilbert exhib. oils at the RA, 1838-97, and at BI and SS, but his oil paintings fall far short of his watercolours in quality. In spite of the enormous bulk of his output, his works display an extraordinary facility and fertility of pictorial invention. For works illustrated by, see Card Cat. at the VAM.
Bibl: J. Ruskin, *Notes on the OWS*, 1856; Roget; Binyon; Cundall; DNB; VAM; R. Davies, *Sir John Gilbert*, OWS Vol.X; Richard Ormond, Country Life 18, 25 August 1966; Hardie III pp.94-6 (pls. 115-16); Maas p.232; Ormond; Newall.

GILBERT, John Graham **RSA** **1794-1866**
Glasgow portrait, biblical, and genre painter. Born John Graham. Studied at RA schools; travelled in Italy for two years. Settled first in Edinburgh, and after 1834, in Glasgow. Exhib. at RA 1844-64. President of the West of Scotland Academy, and one of the founders of the Glasgow Art Institute. His portraits follow the tradition of Raeburn. He also painted biblical and genre scenes, which show the influence of the Italian Old Masters, of which he was a notable collector.
Bibl: Portfolio 1887 p.139; DNB; AJ 1886 p.217; Redgrave, Dict; Caw pp.85-7 (pl. opp. p.86); Ormond.

GILBERT, Joseph Francis **1792-1855**
Painted landscape. Exhib. six works at the RA, 1813-46, including 'The Rustic Traveller Crossing the Stile' and 'An Overshot Mill'. Exhib. 13 works at SS, 1828-50. Address in Chichester, Sussex.
Bibl: AJ 1855 p.305; DNB XXXI; Redgrave, Dict.

GILBERT, Josiah **1814-1892**
Portrait painter in pastel. Also an illustrator. Specialised in painting children. Exhib. 34 works at the RA, 1847-65, the majority portraits of children. Also exhib. 15 works at SS, 1837-41. London address.
Bibl: The Year's Art 1893 p.278; Cust, NPG, 1901; Cat. of the Nottingham AG 1913 p.54; OWS Club X 1932; Ormond.

GILBERT, Miss Kate **b.1843 fl.c.1885-1888**
(Mrs. Hughes)
Exhib. one work entitled 'Noon in the Essex Marshes' at SS in 1885. Address in Croydon, Surrey. Daughter of Arthur Gilbert and sister of Horace Walter Gilbert (qq.v.).
Bibl: Jan Reynolds, *The Williams Family of Painters*, 1975 p.30.

GILBERT, Miss Minnie F.W. **fl.1889**
Exhib. a painting of fruit at the RA in 1889. Address in Exeter, Devon.

GILBERT, Miss O.P.
Genre painter, living in Blackheath, who exhib. 1862-91 at SS.

GILBERT, Varnee **fl.1888**
Exhib. a portrait at SS in 1888. London address.

GILBERT, W.J. **fl.1851**
Exhib. a figurative painting in 1851. Address in Halesworth, Suffolk.

GILBERT, William H. **fl.1888**
Exhib. a portrait at SS in 1888-9. His portrait of Sir Richard Owen is in the Lancaster Museum and AG. London address.
Bibl: Ormond.

GILCHRIST, Herbert H. fl.1876-1896
Exhib. six works at the RA, 1880-96, including 'A Game of Nine-Pins in New England' and 'The Entrance of Cleopatra into Tarsus'. London address.

GILCHRIST, Miss J.A. fl.1885-1888
Exhib. three landscapes at the NWS, 1885-8. Address in Sidmouth, Devon.

GILCHRIST, Philip Thomson 1865-1956
Painted marines and landscapes. First exhib. at the RA in 1900 with 'The Fairy Tree'. Studied at the Manchester Academy of Fine Arts. Lived near Lancaster.
Bibl: Studio XLIV p.230; XLVII p.57; Who's Who 1914.

GILES, Edith fl.1891
Exhib. one work entitled 'Old Shoreham' at SS in 1891. London address.

GILES, Major Godfrey Douglas 1857-1923
Newmarket painter of horses, military scenes, and battles. Born in India. Served with army in India, Afghanistan and Egypt. Studied in Paris with Carolus Duran. Exhib. at RA 1884-8 and elsewhere.
Bibl: AJ 1901 p.38; Who's Who 1914; Frederic Gordon Roe, *Lesser Nineteenth Century Horse Painters*, 1953; Ormond.

***GILES, James William RSA 1801-1870**
Aberdeen landscape, sporting and animal painter. Specialised in angling scenes, and pictures of fish, as well as in studies of deer in Highland landscapes. Also painted a series of views of Scottish castles. Travelled in Italy. Exhib. mainly at BI and SS, only twice at RA in 1830 and 1854. Many of his works are in the Aberdeen AG.
Bibl: AJ 1870 p.343; Caw pp.146, 198; DNB XXI 1890; Irwin.

GILES, John Alfred fl.1849-1862
Exhib. five times at the RA, 1849-62, including 'The Young Mechanician — A Boy Taking a Clock to Pieces' and 'Sweets in Captivity'. London address.

GILES, John West fl.1830-1864
Exhib. nine works at SS, 1832-44, including 'Portrait of an Ox' and 'Grouse-Shooting in North Wales'. Also exhib. six works at the RA, 1830-48, including 'Sabine Shepherds with Their Wolf Dogs'. Address in Aberdeen.

GILES, Mary fl.1870
Exhib. a painting entitled 'Maud' at SS in 1870. London address.

GILES, R.H. fl.1826-1876
Gravesend painter of portraits and figure subjects.

GILES, William b.1872
Painter and etcher of landscapes and birds. Studied at the RCA and in Paris. Exhib. twice at the RA in 1899 and 1900, the former a study of a dog. Born and lived in Reading, Berkshire.
Bibl: Studio XLIX p.294; LVIII pp.137, 288-93; LXX p.104; Les Arts 1912 no.121 p.29; no.124 pp.22, 26, 29; 1913 no. 139 p.29; C. Salaman, *Modern Colour Print of Original Design*, 1920 p.14.

GILKS, Thomas fl.1859-1875
Exhib. a watercolour entitled 'Among the Beeches — Autumn' at SS in 1870. London address.

GILL, Captain fl.1834-1840
Exhib. three works at the RA, 1834-40, including 'A Tuda, or Inhabitant of the Summit of the Neilgherry Hills, in the Southern Peninsula of India'.

GILL, E.W. fl.1843-1868
Painted still-lifes, particularly dead game. Exhib. 11 works at the RA, 1843-55, including 'Dead Partridge' and 'Dead Teal'. Also exhib. at the BI, 1854-5, and SS, in 1852. Address in Hereford.
Bibl: Ormond.

GILL, Edmund 1820-1894
London landscape painter. Often mistakenly called Edward Gill. Lived in Ludlow and Hereford. In 1841 met David Cox (q.v.) in Birmingham, whose work had a lasting influence on him. Exhib. at RA, 1842-86, BI and SS. Subjects mainly Wales and Scotland. Especially fond of painting waterfalls, which earned him the nickname of Waterfall Gill.
Bibl: AJ 1874 p.41ff. (mono. with pls.); Binyon.

GILL, Edward fl.1842-1872
Painted waterfalls (as did the artist with whom he is often confused, Edmund Gill (q.v.)) and marines. In 1867 he exhib. a work entitled 'Storm on a Rocky Coast: Wreck of a Merchant Vessel' at the RA. He exhib. many times at the RA, the BI and SS.
Bibl: Brook-Hart.

GILL, F.H. fl.1838-1842
Painted landscapes. Exhib. 14 works at SS, 1838-42, including views in Holland and the Thames valley. London address.

GILL, F.T. fl.1847
Exhib. one work entitled 'Breaking Cover' at the BI in 1847. London address.

GILL, Harry P. fl.1881-1889
Exhib. three watercolours at SS, 1881-2, including 'Battersea Bridge: Tide Running Down' and 'Cleopatra's Needle'. London address.

GILL, J.S. fl.1847-1862
Exhib. one work at the RA, 'The Temple of Victory Apteros at Athens', in 1847. Also exhib. once at the BI in 1861 and twice at SS, 1847 and 1862. London address.

GILL, R.A. fl.1872-1885
Painted watercolours of landscape and buildings. Exhib. seven works at SS, 1872-81, including: 'Bleak House, Broadstairs' and 'A Berkshire Cottage'. Also exhib. twice, in 1872 and 1883, at the RA. London address.

GILL, Thomas Watson 1854-1934
Amateur painter of animals and landscape. Worked as a bricklayer. Lived in Chester.

GILL, W.H. fl.1871-1872
Exhib. one watercolour, of Sandown, Isle of Wight, at SS in 1871. Address in Eltham, London.

GILL, W.W. fl.1854-1867
Ludlow landscape painter who exhib. 1854-67 at the BI (5), and SS (4). Titles at the BI are mostly of topographical views of castles.

GILL, William fl.1826-1869
Portrait and genre painter, living in London and Leamington, who exhib. 1826-69 at the RA (18), 1827-54 at the BI (22), and at SS

(46). Titles at the RA 'Listening to the Violin', 'Blowing Bubbles', etc. Gill's work, like that of Webster and the Cranbrook Colony (qq.v.), was a continuation of the genre tradition of David Wilkie.

GILLARD, William fl.1856
Exhib. one work, entitled 'A Ride in the Fields', at the RA in 1856. Address in Liverpool.
Bibl: Strickland.

GILLETT, Miss C. fl.1859
Exhib. one painting, 'A Bunch of White Grapes', at the RA in 1859. Address near Chippenham, Wiltshire.

GILLETT, Edward Frank RI 1874-1927
Painted landscapes and sporting subjects. Worked as a clerk at Lloyd's in the City until 1896 when he took up art by working as an illustrator. Lived in Norfolk and Suffolk.

GILLETT, G. fl.1862-1871
Exhib. seven works at the BI, 1862-7, mostly Norwegian landscape paintings. Address in Melton Mowbray, Leicestershire.

GILLETT, William J. fl.1878-1884
Exhib. two watercolours, one a view in Venice, the other of Guildford, Surrey, at SS, 1884-5. London address.

GILLI, Alberto Masso fl.1875-1887
Exhib. one work, ' "Tentation" — "Surge, Comede, Carnes Plurimas" ', at the RA in 1887. Address in Rome.

GILLIES, Miss Margaret RWS 1803-1887
Painter of genre and miniature portraits. Niece of Lord Gillies, an Edinburgh judge, and brought up by him in an artistic and literary society, meeting Sir Walter Scott, Jeffrey and Lord Eldon. Then she resolved to try to be an artist in London, and received instruction from Frederick Cruickshank in miniature painting. Before she was 24, she was commissioned to paint a miniature of Wordsworth, and she also painted Dickens, and 1832-61 contributed portraits to the RA. In 1851 she went to Paris and studied under Ary Scheffer. On her return she exhib. from time to time portraits in oil, but soon turned exclusively to painting in watercolour, usually domestic, romantic or sentimental subjects, and it is on these that her chief distinction rests. In 1852 became an A of the OWS and was a constant exhibitor there till her death. Hardie illustrates a charming watercolour, 'June in the Country', signed MG.
Bibl: Clayton II p.87ff.; The Times 26 July 1887; Mary Howitt, *An Autobiography*, 1889 ii; Roget; Cundall; DNB; VAM; BM Cat. of Drawings II 1900; BM Cat. of Engraved British Portraits II 1910 p.670; III 1912 p.178; IV 1914 p.542; Hardie III pp.l99-1 (fig.124); Ormond.

GILLMAN, Gustave fl.1878-1881
Exhib. six views of buildings, 1878-81. Address in Lee.

GILMAN, Harold John Wilde 1876-1919
Painter of figure subjects, portraits, interiors and landscapes. Studied at the Slade School from 1897. He was greatly influenced by post-Impressionism. The main body of his oeuvre is post-Victorian.
Bibl: Fairfax Hall, *Paintings and Drawings by Harold Gilman and Charles Ginner in the Collection of Edward Le Bas,* 1965.
Exhib: London, Tooth's Gallery 1934; Lefèvre Gallery 1943, 1948; Great Britain Arts Council 1954.

GILMOUR, Miss fl.1869
Exhib. a study of a head at SS in 1869. London address.

GILOSSI, G. fl.1882
Exhib. two works, entitled: 'Spring' and 'With Verdure Clad', at SS, 1882-4. Address in Slough, Berkshire.

GILROY, John W. fl.1898
Exhib. one painting 'Trawler Resting', at the RA in 1898. Address in Newcastle-upon-Tyne, Northumberland.

GINGELL, Mrs. M.E. fl.1851
Exhib. a watercolour of geraniums at SS. Address on the Isle of Wight.

GINNETT, Louis ROI 1875-1946
Painted portraits and interiors. Studied in Paris and London. Noted for his charming studies of elegant Edwardian ladies. Lived in Sussex.

GIRADOT, C.E. fl.1874
Exhib. one work, entitled ' "Bring them to Mamma!" ', at SS in 1871. London address.

GIRADOT, Jean Edine fl.1841
Exhib. at the RA in 1841. London address.

GIRARDIN, Mme. P. fl.1851
Exhib. one drawing of a flower at the RA in 1851. London address.

GIRARDOT, Alfred C. fl.1877
Exhib. one work, entitled 'A Bit of Rough Nature' at SS in 1877. London address.

GIRARDOT, Ernest Gustave RBA fl.1860-1893
Painted portraits, genre and literary subjects. Exhib. 76 works at SS, 1748-88, almost all of which are genre subjects. Titles include: ' "Am I Sharp Enough?" ', 'Taking Your Likeness' and ' "What Shall I Say?" ' Also exhib. 18 works at the RA including portraits and scenes from *The School for Scandal* and *The Vicar of Wakefield*. Also exhib. at the BI. Painted a portrait of Tennyson. London address.
Bibl: Ormond.

GIRDLESTONE, Lucy fl.1886
Exhib. two works, entitled 'Chrysanthemums' and 'Irises' at SS in 1886. Address in Sunningdale, Berkshire.

GIRLING, Edmund 1796-1871
Landscape painter and etcher. Worked in Gurney's Bank, Norfolk, with Frederick Crome. Brother of Richard Girling.

GIRLING, Richard 1799-1863
Exhib. one work, entitled 'Lane Scene, near Caistor' at the RA in 1858. Also an etcher. Brother of Edmund Girling.
Bibl: J. Reeve, *Ms. Notices of Norfolk Artists,* BM.

GIRVIN, Charles W. fl.1873-1874
Exhib. five watercolours at SS, 1873-4, titles including 'The First Show' and 'The Road across the Moor'. Address in Birkenhead, near Liverpool.

GITTINS, Miss Edith fl.1868-1887
Exhib. three paintings of buildings at the RA, 1868-79. Lived in Leicester. Represented in the Leicester Museum.

GLASCOTT, S. fl.1833-1852
Painted river and coastal landscapes. Exhib. 16 works, some of them watercolours, at SS, 1833-52, including views in the Wye

valley and on the Yorkshire coast. Also exhib. once at the RA and once at the BI. Address in Brighton, Surrey.

GLASGOW, Alexander fl.1859-1884
Painted portraits and genre subjects. Exhib. 14 portraits and a painting entitled 'Going Home to Fight for their Country' at the RA, 1859-82. Exhib. 16 works at SS, 1859-84, including 'Dressing the Model' and 'Singing for his Bath'. London address.

GLASGOW, Edwin 1874-1955
Painted landscape. He worked as an educational inspector in Newcastle and painted many views in Northumberland. Later he became a keeper of the Nat. Gall. He was born in Liverpool and lived in Newcastle and London.
Bibl: Hall.

GLASIER, Annie fl.1872
Exhib. a genre painting in 1872. Address in Teddington, Middlesex.

GLASIER, Miss Florence E. fl.1866-1873
Exhib. two works at SS in 1867 and 1868, the latter entitled 'No Sound nor Motion of a Living Thing the Stillness Breaks'. Address in Hampton Wick, Middlesex.

GLASKETT, S. fl.1864
Exhib. one work, entitled 'Prayer', at the BI in 1864. London address.

GLASS, James William 1825-1857
American military and portrait painter who exhib. at the RA 1848-55, at the BI, and at SS. In 1845 he became a pupil of Huntington in New York, going to London in 1847 where he studied and painted for some years. He returned to America in 1856. His 'Last Return from Duty', an equestrian portrait of the Duke of Wellington, first brought him to the public's notice in England. It was bought by Lord Ellesmere and a duplicate was ordered by the Queen. Among his works are 'The Battle of Naseby', 'The Royal Standard' and 'Puritan and Cavalier'. He was particularly good at drawing horses. Graves Royal Academy Exhibitors lists two exhibits of 1847 and 1859 as being by a J. Glass of Edinburgh, but this is probably a different artist.
Bibl: Tuckerman, *Book of the Artists*, 1867 p.421; Clement & Hutton.

GLASS, John Hamilton ARSA 1820-1885
Scottish painter of portraits, horses and landscapes. Elected ARSA, 1849, and exhib. at RA in 1847 and 1859. Then emigrated to Australia, and gave up painting.
Bibl: Caw p.340.

GLAZEBROOK, Hugh de Twenebrokes 1855-1937
Painter of portraits and occasional genre subjects. Studied at South Kensington under Poynter, and in Paris. Exhib. principally at the RA from 1885. The majority of the 28 portraits he exhib. at the RA were of women. Also exhib. four times at the GG. Lived in London.
Bibl: Studio LVI p.127; LXV p.279; Connoisseur XXXIII p.158; Who's Who 1914.

GLEADALL, W.C. fl.1851-1865
Exhib. five works at the RA, 1851-64, including 'Scene near Barnet' and 'A Rustic'. Also exhib. a painting entitled 'The Belle of the age' at the BI in 1865. London address.

GLENDENING, Alfred, Jnr. RBA 1861-1907
London landscape and genre painter, son of A.A. Glendening (q.v.). Exhib. at RA 1881-1904 and SS. His picture of 'Haymaking'

(RA 1898) was bought by the Chantrey Bequest. Later worked as a theatrical scenery painter. His style is more impressionistic than that of his father.
Bibl: Wood, Paradise Lost.

***GLENDENING, Alfred Augustus fl.1861-1903**
London landscape painter, who began life as a railway clerk. Exhib. at RA, 1865-1903, BI and SS. Subjects include views on the Thames, in the southern counties, Wales and Scotland. His son and pupil was Alfred Glendening Jnr. (q.v.). Both painted broadly realistic landscapes, in a style similar to that of Alfred de Breanski.
Bibl: Pavière, Landscape (pl.24).

GLENNIE, Arthur RWS 1803-1890
Exhib. 410 works at the OWS, 1837-90. Pupil of S. Prout (q,v.). Lived in London. Died in Rome.
Bibl: Roget.

GLENNIE, George F. fl.1861-1882
London landscape painter who exhib. 1861-82, at the RA 1861-74 (6), at SS (10), elsewhere (75).

GLENNY, William J. fl.1868-1874
Exhib. seven landscapes, 1868-74. Address in Wandsworth, London.

GLINDON, Paul fl.1879
Exhib. a country genre subject in 1879. London address.

***GLINDONI, Henry Gillard RBA ARWS 1852-1913**
London painter of historical and figure subjects. At first worked in the theatre, helping his grandfather who was a scene-painter. Also worked for various photographers, including Blanchards, colouring prints and painting on porcelain. Studied at the Working Mens' College and the Castle Street School of Art. Exhib. at RA, SS and OWS, where his costume pieces set in the 17th and 18th centuries gained success. Settled at Chadwell Heath, near Dagenham, where he died. His diary and papers are preserved in Dagenham Public Library.
Bibl: John O'Leary, *H. Gillard Glindoni — a Forgotten Essex Artist,* The Essex Review pp.100-2 (date unknown).

GLOAG, H. fl.1893
Exhib. a portrait in 1893.

***GLOAG, Miss Isobel Lilian ROI NWS 1865-1917**
Painted portraits, literary, classical and genre subjects. Studied at the St. John's Wood School, at the Slade and at South Kensington. Exhib. at the RA from 1893 including 'Isabella and the Pot of Basil', 'Rosamunde "The Queen This Threade did Gette" ' and 'Rapanzel: From a Poem by William Morris'. Lived in London. A picture by her was sold at Sotheby's Belgravia, 11 April 1972.
Bibl: J. Greig, Mag. of Art 1902; Studio LXV, LXVI, LXVII; RA Pictures 1915.

GLOAG, J.L. fl.1890-1893
Exhib. two works at SS in 1890 and 1893, entitled 'Sunflowers' and 'Babette'. London address.

GLOAG, Mrs. W.D. see BAKER, Miss Annette

GLOSSOP, G.P.P. fl.1850
Exhib. a landscape, 'On the Konig-See near Salzburg' at the RA in 1850. Address in Isleworth.

GLOVER, Miss Emily fl.1871-1876
Exhib. ten works, 1871-6. Address in Derby.

GLOVER, Miss Hannah fl.1884
Exhib. a genre painting in 1884. Address in Croydon, Surrey.

GOATLEY, John fl.1831-1839
Exhib. seven landscape paintings at the RA, 1831-9. Also exhib. once at SS. London address.

GOBLE, Warwick fl.1893 d.1943
Painted figurative subjects. Also an illustrator. Exhib. one work, 'A Doorway in Algiers', at the RA in 1893. Lived in Richmond, near London.
Bibl: AJ 1898 p.303; Studio XXXVIII p.182; Connoisseur XXIX p.61.

GODARD, E.H. fl.1880
Exhib. two genre paintings in 1880. London address.

GODART, Thomas fl.1852-1861
Exhib. a view of Addison's Walk, Magdalen College, Oxford, at the BI in 1852, and a watercolour of 'Fruit' at SS in 1861. London address.

GODBOLD, Samuel Berry fl.1842-1875
Painter of miniatures, portraits and figure subjects. Exhib. regularly at RA and SS, and also at BI. Also painted landscapes and Irish country scenes.

GODDARD, A.G. fl.1843-1850
Exhib. three works, including a view of Addison Gardens on the Holland Park Estate, at the RA, 1843-50. London address.

GODDARD, Charles fl.1853
Exhib. two watercolours at SS in 1853, 'A Study from Nature' and 'An Oyster Boy'. Address in Hastings, Kent.

GODDARD, Miss Eliza fl.1897
Exhib. a work entitled 'Roses' at the RA in 1897. Address in Christchurch, Hampshire.

GODDARD, G.H. fl.1837-1844
Exhib. three watercolours at SS, 1843-4, including 'A Cactus'. Also exhib. once at the RA. London address.

GODDARD, George Bouverie 1832-1886
Sporting and animal painter. Born in Salisbury. Received no training, but came to London in 1849 and spent about two years making studies of animal life at the Zoological Gardens. During this time he supported himself mainly by drawing sporting subjects for *Punch* and other periodicals. He then returned to Salisbury, where he received many commissions, but finding his sphere of work too limited, he settled in London in 1857. He began to exhib. at the RA in 1856 with 'Hunters' and continued to exhib. until 1886. His first work of note was 'The Tournament' in 1870. In 1875 he exhib. a large picture, 14ft. long, representing 'Lord Wolverton's Bloodhounds', which was highly praised in Whyte-Melville's *Riding Recollections*. In 1879 he sent in 'The Struggle for Existence' which is now in the Walker AG, Liverpool.
Bibl: AJ 1886 p.158 (obit.); The Times 18 and 29 March 1886; DNB.

GODDARD, J. Bedloe fl.1875-1893
Exhib. five landscapes, three of them watercolours, at SS, 1875-93. Titles include: 'The Priory Church, — Christchurch, Hants — Early Morning' and 'Ruins of Norman House and Castle Keep, Christchurch'. Address in Christchurch, Hampshire.

GODDARD, James fl.1800-1855
London flower painter who exhib. at the RA 1800-55, and also at BI and SS. His brother, J. Goddard, was a miniature painter, who exhib. at the RA 1811-42.

GODDARD, Miss K. fl.1860
Exhib. a watercolour of primroses at SS in 1860. London address.

GODDARD, William Charles fl.1885
Exhib. one landscape at the NWS in 1885. London address.

GODET, Julius fl.1844-1884
London landscape painter who exhib. from 1844-4, at the RA (16) 1852-76, at the BI (40), and at SS (51).

GODFREY, Miss Adelaide A. fl.1848
Exhib. a landscape entitled 'Scene on the Ayr at Barskumming' at the RA in 1848.

GODFREY, Miss L.M. (Ellen) fl.1882
Exhib. a self-portrait at the RA in 1882. Address in Cambridge.

GODFREY, Miss M.A. fl.1855
Exhib. a work entitled 'The Bird's Nest' at the RA in 1855. London address.

GODGIFT, J. fl.1898
Exhib. one work, entitled 'Waiting-Place of the Jews, Jerusalem'. Address in Cairo.

GODSALL, Miss Mary fl.1872-1892
Painted figurative and genre subjects. Exhib. at SS, 1872-80, including 'Highland Mary', 'Inez' and 'My Great Grandmother'. Also exhib. three times at the RA, 1879-96, including ' "Give a Dog a Bad Name and Hang Him" '. London address.

GODSELL, Miss Mary E. fl.1884-1897
Exhib. four times at the RA, 1884-93, including 'The Last of the Season' and 'Crowded Out'. Also exhib. at the NWS. Address in Stroud, Gloucestershire.

***GODWARD, John William RBA 1861-1922**
London painter of classical genre scenes; exhib. at RA from 1887 and SS. Subjects usually pretty girls wearing filmy robes, reclining in marble interiors, e.g. 'A Pompeian Bath', etc. Developed his own very personal variation on the Alma-Tadema theme.
Bibl: Wood, Olympian Dreamers.

GODWIN, Gurth fl.1875-1877
Exhib. three genre paintings, 1875-7. London address.

GODWIN, Miss fl.1847
Exhib. a painting of King John's Cup at the RA in 1847.

GODWIN, J. Arthur fl.1892-1893
Exhib. three landscapes at SS, 1892-3, including 'On Sunderland Point' and 'St. Martin's Summer'. Address in Bradford, Yorkshire.

GODWIN, James fl.1846-d.1876
Painted genre and figurative subjects and scenes from Shakespeare. Exhib. three works, all Shakespearian, at the RA, 1846-51. Also exhib. ten works at SS, 1847-50, including 'Returning from the

Vineyard' and 'The Village Schoolmaster Arguing with the Parson'. London address.

Bibl: AJ 1876 p.106; Bryan.

GOEBEL, C. fl.1870

Exhib. a work entitled 'Two Sisters' at the RA in 1870. London address.

GOEPEL, James S. fl.1867

Exhib. a landscape entitled 'Near Farnham Royal, Bucks' at SS in 1867. Address in Chelsea, London.

***GOETZE, Sigismund Christian Hubert 1866-1939**

Painted portraits, religious and historical subjects and murals. Studied at the Slade and RA Schools. Exhib. from 1888 at the RA including 11 portraits, the majority of them children, a Saint Sebastian, and 'Soul's Struggle with Sin' and 'Girlhood Awakening to Love'. Also exhib. once at GG. Lived in London.

Bibl: Who's Who 1914; S. Goetze, *Mural Decorations at the Foreign Office, Descriptive Account by the Artist*, 1921.
Exhib: London, Royal Society of British Artists' Gallery 1948.

GOFF, Frederick E.J. 1855-1931

London topographical painter, mostly in watercolour. Exhib. at RA in 1900, and NWS. Best known for his small watercolour views of London, which catch the mood of the late Victorian city.

GOFF, Colonel Robert Charles RPE 1837-1922

Painted and etched landscape. Exhib. at the RA, 1870-90, including views of the English coasts and of Venice. Also exhib. five times at SS, 1871-85. Born in Ireland. Retired from the Coldstream Guards in 1878. Subsequently lived in Hove, Sussex, Florence and Switzerland .

Bibl: Studio 1894 pp.41-5; XLVI p.288; Wedmore, *Etching in England*, 1895 p.117; Mag. of Art 1904 pp.318-23; Cat. of the Beardsley-Garrido-Goff exhib., Brighton 1914.
Exhib: London, Rembrandt Gallery 1896; Walker's Gallery 1934.

GOFFEY, Harry 1871-1951

Painted portraits and landscapes. Also produced etchings and mezzotints. Studied at Liverpool School of Art and under Herkomer at Bushey. Lived at Berkhamsted, Hertfordshire.

***GOGIN, Charles 1844-1931**

Painted genre and figurative subjects especially pictures of children. Also portraits and landscape. Exhib. 14 works at the RA, 1874-94, including a scene from *Twelfth Night* and paintings entitled 'Tea Without Scandal' and 'After Waterloo'. Also exhib. three works at SS, 1876-86. Illustrated books for the author Samuel Butler. London address.

GOGIN, Mrs. Charles (Alma) fl.1895-1898

Exhib. two works, entitled 'Little Sunshine' and ' "What Shall I Say?" ' at the RA in 1895 and 1898. Address in Shoreham, Sussex.

GOLDIE, Charles fl.1858-1879

London painter of genre and historical subjects, who exhib. at the RA 1858-79, titles including 'Joan of Arc', 'The Trial of St. Perpetua', 'Louis XVII and the Sparrows in the Temple'. In 1859 he exhib. 'The Monk Felix' (a single figure of a monk) upon which the AJ commented "A figure picture without a face is usually considered an impossibility; yet this is one". He also exhib. at the BI (6) and SS (11).

Bibl: AJ 1859 pp.81, 166-7.

GOLDIE, Lancelot Lyttleton b.1872

Painted architectural subjects. Also produced etchings. Born in Derbyshire. Lived in Bath.

GOLDINGHAM, James A. fl.1870-1881

Exhib. six works at the RA, 1871-81, including 'A Bite', 'Le Chef and ' "Till I Found Him Lying Murdered Where He Wooed Me Long Ago." ' Also exhib. twice at SS, 1878-9. London address.

GOLDSMID, C. fl.1884

Exhib. one work, entitled 'Head of a Highwayman' at SS in 1884-5. London address.

GOLDSMITH, Miss Georgina S. fl.1869-1870

Exhib. two watercolours and another work at SS 1869-71. The two watercolours are of landscapes in Surrey and Jersey and the third painting is of a Sussex landscape. Address in south London.

GOLDSMITH, Walter H. fl.1880-1898

Landscape painter, living in Maidenhead, who exhib. 1880-98 at the RA (15), and at SS (24).

GOLDTHWAIT, Harold fl. from 1898

Exhib. landscape paintings at the RA from 1898. The majority of the works are of views in the south of England. Address in south London.

GOLE, Alfred fl.1861

Exhib. a landscape in 1861. London address.

GOLLINS, Ormond Edwin b.1870

Painted landscape watercolours. Born in Shrewsbury. Lived in Birmingham.

GOMPERTZ, E. fl.1836-1837

Exhib. two watercolours, one entitled 'A Chelsea Pensioner', at SS in 1836 and 1837. Also exhib. a 'Sketch from Nature in Kensington Gardens' at the RA in 1837. London address.

GOMPERTZ, G. fl.1827-1843

Exhib. five watercolours at SS, 1833-8, including a drawing of a 'Monument in the Western Part of the Nave at Durham Cathedral'. Exhib. six works at the RA, 1830-43, including 'The Country Public House' and 'Deaf as a Post'. London address.

GONNE, Mrs. Anne b.1816 fl.1840-1853

Flower painter, wife of an Irish engraver Henry Gonne. Exhib. frequently at the RHA, and was also a drawing teacher. Also modelled wax flowers.

GOOCH, Edward fl.1898

Exhib. a painting entitled 'The Passing of Elaine' at the RA in 1898. Address in Liverpool.

GOOCH, James fl.1819-1837

Painted landscape, animals and country scenes. Exhib. at SS, 1824-37, including, in 1837, 'A View near the Telegraph, Coomb Wood, Surrey, Seat of the Earl of Liverpool'. London address. Also exhib. at the BI, 1819-33. Address in Norfolk, Norwich.

Bibl: Ormond.

GOOCH, Miss Mary Ann fl.1853-1877

Exhib. four works, including two landscapes, a painting of fruit and a painting of primroses with a Greenfinch's nest at the BI, 1858-60. Also exhib. once at the RA in 1853 and once at SS in 1853. Address in Richmond, London.

GOOCH, Miss Matilda fl.1860
Exhib. sixteen 16 of landscapes, flowers and dead birds at SS, 1857-77. Titles include 'Dead Chaffinch and Nest' and 'A Fatal Shot'. London address.

GOOCH, R.A.C. fl.1845-1871
Exhib. eight works at SS, 1851-72, including 'Fop's Head' and 'Waiting for the Word of Command'. Also exhib. four times at the BI, 1845-65, and twice at the RA, 1851-67. London address.

GOOD, Clements 1810-1896
Danish consul in Hull, and an amateur painter. Painted local views and shipping subjects.

***GOOD, Thomas Sword 1789-1872**
Berwick painter of domestic genre. Pupil of D. Wilkie (q.v.). Exhib. at RA 1820-33, BI 1823-34, and SS. Fond of painting fisherfolk and coastal scenes around Berwick. In 1830 he inherited a legacy, and soon after gave up painting.
Bibl: AJ 1852 p.94; 1901 p.293; Redgrave, Dict.; DNB XXII; Poynter, The National Gallery 1899-1900 III; Hall.

GOODALL, Edward 1795-1870
Painted and engraved landscapes. Exhib. at the RA 1822-3; at SS 1824-36, and at the BI 1823-41, including views in Pembroke. London address.
Bibl: DNB XXII; AJ 1854-69, 1870; Clement & Hutton; Hayden, Chats on Old Prints, 1909.

GOODALL, Edward Alfred RWS 1819-1908
London painter and watercolourist of continental views and battle scenes. Son of Edward Goodall, an engraver, and brother of Frederick Goodall (qq.v.). Accompanied the Schomburgh Guiana Boundary Expedition in 1841; in 1854 visited the Crimea as artist for The Illustrated London News. Travelled in Morocco, Spain, Portugal and Italy. Exhib. at RA 1841-84, BI, SS and OWS. Elected Associate 1858, Member 1864 OWS. Hardie calls him Edward Angelo Goodall. His studio sale was held at Christie's, 30 November 1908.
Bibl: AJ 1859 p.173; 1908 p.187; Redgrave, Dict.; Clement & Hutton; Roget; Cundall; VAM; Hardie III p.164 (pl.195).

GOODALL, Edward Angelo see GOODALL, Edward Alfred

GOODALL, Miss Eliza fl.1846-1854
(Mrs. Wild)
Painted country genre scenes. Exhib. ten works at the RA 1846-55, 'A Farm House Kitchen' and 'Blackberry Gatherers'. Also exhib. six works at the BI 1847-53, and once at SS in 1848. London address.

GOODALL, Florence fl.1892
Exhib. a painting entitled 'Relics' at SS in 1892. London address.

***GOODALL, Frederick RA 1822-1904**
London painter of landscapes, genre and Egyptian subjects. Son of Edward Goodall, an engraver, and brother of Edward Alfred Goodall (qq.v.). Won a silver medal at the Society of Arts in 1837, at the age of 14. In 1843 he toured Ireland with F.W. Topham (q.v.). His early works are mainly genre and peasant scenes in the Wilkie tradition, but later he specialised in views of Egypt, scenes of Egyptian life, and biblical genre. Elected ARA 1852, RA 1863. Two of his sons, Frederick Trevelyan and Herbert Goodall (qq.v.), were painters. At the height of his career, he was earning over £10,000 a year, but later his fortunes declined, and he was declared bankrupt in 1902.
Bibl: AJ 1850 p.213 (autobiog.); 1855 p.109ff. (biog.); 1850 p.167; 1862 p.46; 1895 p.216; 1904 pp.301-3; Ruskin, Academy Notes 1859, 1875; Roget; Clement & Hutton, Binyon; Reminiscences of Frederick Goodall, 1902; Cundall; VAM; Reynolds, VP pp.111, 144, 180 (pls.67, 98); Hardie III p.164, Maas pp.97, 155, 184 (pl. pp.97, 160); Staley; Ormond; J. Maas, Gambart, 1976; Strong.

GOODALL, Frederick Trevelyan fl.1868-1871
Son of Frederick Goodall (q.v.). Painted portraits and figurative subjects. Exhib. 17 times at the RA, 1868-71, including eight portraits and paintings entitled 'The Return of Ulysses' and 'The Little Puritan'. London address.
Bibl: AJ 1871 p.166; Redgrave, Dict.; DNB XXII

GOODALL, Herbert fl.1890-d.1907
Son of Frederick Goodall (q.v.). Exhib. six works at SS, 1890-3, including 'A Neglected Corner' and 'A Neapolitan'. London address.
Bibl: AJ 1907 p.360.

GOODALL, Howard 1850-1874
Exhib. two works, entitled 'Nydia, in the House of Glaucis' and 'Capri Girls Winnowing', at the RA in 1870 and 1873. London address.
Bibl: DNB; AJ 1874 p.80.

GOODALL, John Edward fl.1877-1891
Painted country genre scenes. Exhib. 15 works at SS, 1876-89, including 'Gathering Peat in Hampshire'. Also exhib. seven works at the RA, 1877-1901, including 'The Little Bretonne' and 'Say Au Revoir But Not Good Bye'. London address.
Bibl: Portfolio 1887 p.166.

GOODALL, Thomas F. 1856/7-1944
London painter of landscapes, coastal scenes and rustic genre. Not apparently related to the other Goodalls. Exhib. at RA 1879-1901, SS, GG and NG. A picture by him is in the Walker AG, Liverpool. Collaborated with the photographer P.H. Emerson in the publication of Life and Landscape on the Norfolk Broads, and also other books.

GOODALL, Walter RWS 1830-1889
Exhib. two portraits and a study from nature at the RA in 1852. Exhib. 156 works at the OWS. London address.
Bibl: DNB; Roget; Hardie.

GOODCHILD, Miss Emily fl.1890-1897
Exhib. five works at the RA, 1890-7, including 'Peonies', 'Ophirie Roses' and three portraits. London address.

GOODE, Miss Louise see JOPLING, Mrs. J.M.

GOODE, W. fl.1854
Exhib. a genre painting in 1854. London address.

GOODE, W.E. fl.1845-1866
Exhib. four paintings, titles including 'Otter Hunting', 'Boys Ferreting Rabbits' and 'Otter Hounds', at the BI, 1854-66. Also exhib. four times at SS, 1845-7. London address.

GOODEN, James Chisholm fl.1835-1875
Marine and landscape painter. Friend and sketching companion of W.J. Müller (q.v.) on trips down the Thames and elsewhere. He painted landscapes but was chiefly interested in marine subjects, and compiled the Thames and Medway Admiralty Surveys, 1864. Hardie notes that "he drew boats with much skill and his sketches

made among the tidal waters of estuaries have considerable charm". He exhib. 1835-65, at the RA (3) 1835-46, at the BI (9) and at SS (17).

Bibl: Roget II pp.234-7, 314; VAM; Hardie III pp.59-60, 62, 81 (fig. 77); Brook-Hart.

GOODERSON, Emily fl.1860
Exhib. a work at SS in 1860. London address.

GOODERSON, Mrs. T. fl.1855
Exhib. a painting entitled 'Crochetting' at the RA in 1855. London address.

GOODERSON, Thomas Youngman fl.1846-1860
Portrait and genre painter, who exhib. l846-60 at the RA (21), at the BI (14), and at SS (24).

Bibl: AJ 1859 p.167; Ormond.

GOODHALL, Miss Mary C. fl.1887-1895
Exhib. two works at the RA, paintings entitled 'Still Life', and 'Edie', in 1887 and 1895. London address.

GOODIER, Arthur fl.1870-1883
Painted landscape watercolours and views of buildings. Exhib. 13 works at SS, 1870-84, including views in Highgate, Hampstead and Essex. London address.

GOODMAN, Mrs. L. 1812-1906
(Miss Julia Salaman)
London painter of portraits and occasional figurative subjects. Exhib. 15 works, the majority of which are portraits, at SS, 1836-89. Exhib. seven portraits at the RA, 1838-63, and two paintings, entitled 'A Young Cottager' and 'Don Juan', at the RA in 1837 and 1848. Member of the Society of Lady Artists.

Bibl: DNB; AJ 1907 p.64.

GOODMAN, Miss Maude fl.1874-1901
(Mrs. Scanes)
London painter of genre and humorous pictures of children. Exhib. at RA, 1874-1901, BI, NWS and GG;. Titles: 'A Little Coquette', 'Don't Tell', 'Like this, Grannie', etc. For works illustrated by, see Card Cat. at VAM.

Bibl: AJ 1889 p.200; RA Pictures 1892, 1893.

GOODMAN, Robert Gwelo b.1871
South African painter who exhib. at the RA from 1898 including 'Pale Queen of Night' and 'One Summer's Day; so Cool, so Bright, so Fair'. London address.

Bibl: Who's Who 1914; Connoisseur XXXVII p.190; Studio XXXIV p.68; XXXVIII p.162; XLVI p.57; LI p.232; LIII p.305; LV p.129; LX p.146; LXII p.301; LXIII pp.140, 260; LXVI p.74; LXVIII p.40.

GOODMAN, Thomas Warner fl.1854
Exhib. a painting entitled 'In Nubibus' at the RA in 1854. London address.

GOODMAN, Walter b.1838 fl.1859-1890
Exhib. three portraits at the RA, 1872-88, including that of the Chinese Minister at the Court of St. James. Also exhib. two paintings entitled 'Doctoring the Cane' and 'Bible Stories' at the BI in 1859 and 1861. London address.

GOODRICH, James B. fl.1853-1858
Exhib. seven paintings of the Devon landscape at the RA, 1853-8. Address in Topsham, Devon.

GOODRICH, Jerome fl.1829-1859
Painted portraits, biblical and historical subjects. Exhib. three portraits at the RA, 1829-42. Exhib. six works, including 'Queen Berengaria soliciting Richard Coeur de Lion to Spare the Life of the Earl of Huntingdon', at the BI, 1843-59. Also exhib. three works at SS. London address.

Bibl: Ormond.

***GOODWIN, Albert RWS 1845-1932**
Painter in oils and watercolour of landscapes, and of biblical, allegorical and imaginative subjects. Ardent follower of J.M.W. Turner. First exhib. at the RA in 1860, aged 15, with an oil painting 'Under the Hedge'. For a short time in the early 1860s, was a pupil of Arthur Hughes and Ford Madox Brown (qq.v.), and was introduced by the former to Ruskin who took him on a trip to Italy in 1872, with Arthur Severn, and employed him to copy objects. He travelled widely in Europe, India, Egypt and the South Sea Islands. In 1871 he was elected A of the OWS, and in 1881 a full Member. He paid great attention to effects of light and atmosphere, and Hardie notes that "he can be counted as one of those who have successfully dealt with twilight and sunset." He experimented with methods of sponging and stippling and was one of the first to use a pen-line in combination with watercolour wash. His early work was at first in oil, but later was almost entirely in watercolour. Reynolds writes that "he painted in a comparable stippling manner [to Birket Foster], but reached a higher plane of poetry, even a hint of mystery". Often signed AG (in monogram).

Bibl: W.M. Rossetti in Portfolio 1870 p.118; 1886 p.124; Studio XLIX 1910 pp.84-97; XXXI 1904 p.252ff.; XXXV p.155; Redgrave, Dict.; Bryan; Caw; DNB; VAM; *The Diary of Albert Goodwin*, 1934; Reynolds, VP pp.173, 177 (fig.169); Cat. of Paintings by A. Goodwin, RWS, Seal Galleries, Seal, Kent, June 1968; The Leathart Collection Cat., exhib. at Laing AG, Newcastle, 1968; Hardie III pp.162-3 (fig.188); Maas pp.230-1; Staley; Newall; C. Beetles, *A.G.*, 1986.
Exhib: Birmingham, Museum and AG 1926; London, Walker's Gallery 1961; London, Albany Gallery 1967; Rye, AG 1968; Guildford, Guildford House 1972; RWS 1986.

GOODWIN, Miss F.W. fl.1842-1843
Exhib. three works, including 'The Favourite Cat' and 'The Head of a Scotch Terrier', at SS, 1842-3. Address in Kings Lynn, Norfolk.

GOODWIN, Frank A. 1848-c.1873
Exhib. seven landscapes, 1867-73. London address. Youngest brother of Albert Goodwin (q.v.).

GOODWIN, Harry fl.1867-1902 d.1932
Maidstone landscape and genre painter who exhib. 1867-1902, at the RA (15) 1868-1902, SS (27), and NWS (17). Titles at the RA include 'Arundel Castle', 'The First Spring Day', 'Venice in June', and 'Old Servants of the State'.

GOODWIN, Mrs. Harry fl.1873-1893
(Miss Kate Malleson)
Painted landscapes. Exhib. at the RA, 1873-93, including landscapes in Normandy, Cornwall and Scotland. Exhib. once at SS. Address in Croydon, Surrey. See also Katherine Malleson.

GOODWIN, J.C. fl.1839
Exhib. a painting entitled 'A Bark Coming Out of Harbour' at the RA in 1839.

GOODWIN, Mrs. L. fl.1837
Exhib. a self-portrait at the RA in 1837.

GOODWIN, Sydney 1867-1944
Painted landscapes, often featuring views or coasts, and usually with figures.

GOODWIN, T.A. fl.1867
Exhib. a watercolour entitled 'Fulham Fields' at SS in 1867. London address.

GOODWIN, W.S. fl.1870-1877 d.1916
Exhib. 11 works at SS, 1873-7, including landscapes and views in Hampshire and views in the Middle East. Nephew of Albert Goodwin (q.v.). Address in Southampton, Hampshire.

GOODY, Miss Florence P. fl.1888-c.1920
Painted genre subjects. Exhib. three works, including 'The Luxury of Laziness' and 'A Maiden All Forlorn', at SS, 1888-92. Also exhib. one work, entitled 'Two little Gossips', at the RA in 1891. Lived at Lewisham, Kent.

GORDON, Alexander fl.1891-1898
Exhib. four works at the RA, 1891-8, including 'The Blacksmith' and 'Forgetting the World'. Also exhib. two works, including 'The Cooper's Shop' at SS, 1891-2. Address in Taunton, Somerset.

GORDON, G. fl.1821-1840
Exhib. two portraits at the RA in 1821 and 1840, the latter a portrait of a young lady. London address.

GORDON, G.C. fl.1856-1858
Exhib. four works at SS, 1856-8, including two views in Caernarvon and one near Edinburgh. London address.

GORDON, H.P. fl.1874
Exhib. a painting of animals in 1874. London address.

GORDON, Hilda May 1874-1972
Painted landscapes and figurative subjects in watercolour. Travelled in the Middle and Far East.

***GORDON, Sir John Watson RA PRSA 1788-1864**
Scottish portrait painter. Studied at Trustees' Academy. At first he attempted genre and historical subjects, but soon discovered that his talent was for portrait painting. His early style was closely modelled on Raeburn, a friend as well as teacher. After Raeburn's death he assumed the mantle of leading Scottish portrait painter. A prolific worker, he exhib. 123 works at the RA, and many more at the RSA. Elected ARA 1841, RA 1851, PRSA 1850. Later he evolved a more personal style, and was a great admirer of Velazquez. "His portraiture, whatever it lacks in brilliance, is simple, sincere, and, at its best, gravely beautiful" (Caw).
Bibl: AJ 1850 p.373; 1864 p.215; 1903 pp.301-4; Portfolio 1887 p.138ff.; Studio see index; Redgrave, Dict.; Bryan; DNB; Caw pp.80-3 et passim (pl.p.82); BM Cat. of Engraved British Portraits VI 1925 p.489; Reynolds, VP; Maas.

GORDON, R.G. fl.1890
Exhib. a view in Norway at the NWS in 1890. Address in Canterbury, Kent.

GORDON, Robert James RBA fl.1871-1893
London genre painter who exhib. 1871-93 at SS (88) and the RA (22), titles including 'Souvenirs', 'Pet Parrot', 'Lady Teazle', and 'Good-night'.

GORDON, Samuel fl.1900
Exhib. a painting entitled 'Birch and Bracken' at the RA in 1900. London address.

GORDON, Mrs. T. fl.1870-1871
Exhib. three landscapes, all views of Loch Awe, at SS 1870-1.

GORDON, William fl.1833-1858
Painted landscapes, usually coastal landscapes. Exhib. eight works at SS, 1833-6. Exhib. two works, views of the Firth of Forth and of Pakefield on the Suffolk coast. Also exhib. once, a painting entitled 'Leigh Shrimpers Going Out' at the BI in 1858. London address.

GORE, Elizabeth M. fl.1875-1877
Exhib. five genre paintings, 1875-7. London address.

GORE, William Henry RBA fl.1880-c.1920
Painted landscapes and genre subjects. Exhib. 29 works at the RA, 1882-1900, including 'It was a Lover and His Lass' and 'In the Gloaming'. Also exhib. 21 works at SS, 1880-94, including ' "Midst the Tall Crested Water Reeds, Whispering their Lullaby" '. Lived at Newbury, Berkshire.

GORMAN, Ernest Hamilton b.1869
Exhib. in Lancashire. Lived at Hoylake, Cheshire.

GORST, Mrs. H.C. fl.1890-1892
Exhib. two works, entitled 'Chrysanthemums' and 'Yum Yum', at SS in 1890 and 1892. Address in Cheshire.

GORSTIN, Miss A. fl.1856
Exhib. a work entitled 'Mountain Tarn' at the BI in 1856. London address.

GORTON, C. fl.1848-1849
Exhib. two works, entitled 'Camellias and Fruit' and 'Fruit', at the BI in 1848 and 1849. London address.

GOSLING, Miss Jessie W. fl.1897
Exhib. two works, entitled 'Blood Oranges' and 'Grapes', at the RA in 1897. Address in Braintree, Essex.

***GOSLING, William W. RBA 1824-1883**
London painter of landscape and rustic genre who exhib. 1849-83, at the RA (13) 1851-83, at the BI (23), and at SS (176). Member of the Society of British Artists. Titles at the RA include 'Grandad — a Rustic Incident', 'On the Thames', and 'A Hot Day in the Harvest Field'. The AJ (1873) commented: "By William Gosling is a landscape of remarkable power, when we look back and consider his earlier performance. It is entitled 'Harvest Time at Hennerton' [SS 1873] and shows a field of corn already yielding to sickle. The expanse of golden grain is bounded by a dense wood; and altogether the work is so much superior to others that have preceded it, that this artist must be estimated among those who have greatly advanced."
Bibl: AJ May 1873; Clement & Hutton; Bryan.

GOSNELL, Duncan H. fl.1884-1885
Painted landscapes. Exhib. ten works at the RA, 1884-1901, including 'Rook Scaring' and 'A Grey Haying'. Address in Surrey.

GOSSE, Mrs. Edmund fl.1879-1890
(Miss Nellie Epps)
She was a pupil of Ford Madox Brown (q.v.). Exhib. one work, a landscape in Northumberland at SS in 1882-3. Also exhib. 17 times at the GG. London address.
Bibl: Clayton.

GOSSE, W. fl.1814-1839
Exhib. two portraits at the RA in 1814 and 1839. London address.

GOSSET, M.C. fl.1876-1877
Exhib. three genre paintings, 1876-7. London address.

***GOTCH, Thomas Cooper RBA RI 1854-1931**
Painter of portraits, landscape and allegorical and realistic genre. Studied at Heatherley's School; the École des Beaux Arts, Antwerp; the Slade School, and in Paris under J.P. Laurens. Visited Australia in 1883. Lived first in London, then settled in 1887 at Newlyn, Cornwall, where he belonged to the Newlyn School of *plein-air* painters. Exhib. at the RA from 1880, and at SS, OWS, NWS, GG, NG, Munich, Paris and Chicago. Original member of NEAC 1886, RBA 1885, RI 1912. Founder of the Royal British Colonial Society of Artists, 1887 and President 1913-28. Retrospective exhibition at the Laing AG, Newcastle, 1910. Chantrey Purchase, 'Alleluia', 1896. His earlier work was naturalistic in the style of the Newlyn School. After his visit to Italy in 1891, he turned to more symbolistic and allegorical subjects, and a more decorative treatment, for example, as seen in 'Alleluia'. Manuscripts relating to Gotch are held by the VAM.
Bibl: AJ 1889 p.138; 1902 p.211; 1903 p.167; 1905 p.356; Studio XIII pp.73-182 (monograph); XXVI p.38; XLII p.55; Studio Summer Number, *Art in 1898*; Portfolio 1888 p.103; Tate Cat.; Wood, Pre-Raphaelites.

GOTCH, Mrs. Thomas Cooper fl.1890-1895
(Miss C.B. Yates)
Exhib. six paintings at the RA, 1890-5, including 'A Cosy Couple' and 'Motherhood'. Address in Newlyn, Cornwall. See also Miss C.B. Yates.

GOTT, John William fl.1882-1891
Exhib. a painting entitled 'Finished' at the RA in 1883. Also exhib. a Welsh landscape at SS in 1891. London address.

GOTTEFRIED, A. fl.1872
Exhib. one work, entitled 'The Petition', at SS in 1872. London address.

GOTTSCHALK, Miss Blanche fl.1890-1902
Exhib. with the NWS in 1890-3. London address.

GOTZENBERG, F. fl.1855-1857
Exhib. a double portrait and a view of Congregation House, Oxford, at the RA in 1855 and 1856. Also exhib. once at SS in 1856 and twice at the BI in 1855 and 1857. London address.

GOULD, Alexander Carruthers RBA RWA 1870-1948
Painted landscapes and marines. Also an illustrator. Exhib. two works, 'London Twilight' and 'Baggy Point, North Devon', at SS in 1892 and 1893. Son of Sir Francis Carruthers Gould (q.v.). Born in Essex. Lived at Porlock, Somerset.
Bibl: Studio LXI p.140; Connoisseur XXXIX p.40; Who's Who 1919.

GOULD, Miss C. fl.1855-1856
Exhib. three watercolours, entitled 'Preparing for Market', 'The Trap' and 'The Early Scholar' at SS, 1855-6. Address in Stockwell, London.

GOULD, Sir Francis Carruthers 1844-1925
Caricaturist and illustrator. Also produced landscape drawings of Normandy and Brittany. Exhib. two paintings of animals in 1876-7. Lived at Porlock, Somerset.
Bibl: Sir Francis Gould, *Cartoons of the Campaign,* 1895; The Westminster Cartoons 1896-1903; Political Caricatures 1903-6; Studio XXIII p.199; XXXVIII p.248; Mag. of Art 1903 p.396; Political Caricatures 1905 p.104; Cartoons from the Westminster Gazette 1906.

GOULD, H. fl.1877
Exhib. a painting of shipping in 1877. London address.

GOULDSMITH, Edmund RBA RWA 1852-1932
Painted coastal landscapes and marines. Also painted portraits. Studied at the Bristol Government School of Art and at the RA Schools. Exhib. at the RA, 1891-1901, including a 'Grey Day off Scarborough' and 'Sundown off Sea'. Also exhib. four works at SS, 1877-93. Travelled in Australia and New Zealand. Lived in Bath and Bristol.
Bibl: Who's Who 1914; Brook-Hart.

GOULDSMITH, Miss Harriett 1786-1863
(Mrs. Arnold)
London landscape painter. Exhib. up to 1839 as Miss Harriett Gouldsmith, thereafter under her married name of Arnold (q.v.).

GOURLIE, Miss Edith fl.1883-1885
Exhib. one work, entitled 'A Fair Librarian' at the RA in 1884. London address.

GOURSAT, Georges 1863-1934
Made a watercolour portrait of Sir Edwin Landseer.
Bibl: Ormond.

GOVAN, Miss Mary M. fl.1899
Exhib. a work entitled 'The Letter' at the RA in 1899. Address in Edinburgh.

GOVER, Miss Mary Edith fl.1886-1888
Exhib. a watercolour study of rhododendrons at SS in 1886. Also exhib. a work entitled 'Haunted Houses, Colorado, U.S.A.' at the RA in 1888. Address in Hampstead, London.

GOVETT, W.R. fl.1846
Made a portrait drawing of Sir William Molesworth.
Bibl: Ormond.

***GOW, Andrew Carrick RA RI 1848-1920**
Painter of historical and military subjects, genre and portraits. Exhib. at the RA from 1867 onwards, and at SS (3), NWS (48), and GG (1). Titles at the RA 'The Tumult in the House of Commons March 2nd, 1629', 1877, 'Algerian Gossip', 1886, and Washington's Farewell to the Army', 1902, etc. Elected ARA 1880, RA 1890. Ruskin wrote of 'Loot, 1797': "It is an entirely fine picture of its class, representing an ordinary fact of war as it must occur without any false sentiment or vulgar accent. Highly skilful throughout, keenly seen, well painted." A large picture of Queen Victoria at St. Paul's Cathedral on Diamond Jubilee Day is in the Guildhall AG.
Bibl: Ruskin, Academy Notes 1875; Clement & Hutton; RA Pictures 1891ff.; Who's Who 1914; Wood, Panorama.

GOW, Charles fl.1844-1872
Exhib. seven portraits at the RA, 1844-72. Also exhib. one watercolour portrait at SS in 1853. London address.
Bibl: Ormond.

GOW, David fl.1886-1888
Exhib. five landscape paintings, 1886-8. London address.

GOW, James RBA fl.1852-1885
Painter of genre and historical subjects who exhib. 1852-84, at the BI (5) and at SS (60). Member of Society of British Artists. Titles at the RA 'Rehearsing the School Task', 'Preparing the Ark for the Infant Moses', and 'A Volunteer for Cromwell', etc.

GOW, James F. Macintosh fl.1890-1898
Exhib. six landscapes, mostly views in Scotland, at the RA, 1890-8. Address in Edinburgh.

***GOW, Miss Mary L. RI 1851-1929**
(Mrs. Hall)
Painted genre subjects in oil and watercolour, especially pictures of girls. Sister of Andrew Carrick Gow (q.v.). Studied at Heatherley's School. Exhib. 18 works a SS, 1869-80, including 'Something Important' and 'Mending Dolly's Frock'. Also exhib. six works at the RA, 1873-85, and 36 at the NWS. London address. Resigned from NWS in 1903, and married the painter S.P. Hall (q.v.). For works illustrated by, see Card Cat. at VAM.
Bibl: Clayton; Studio LI p.232; LXIII p.216.

GOWANS, George Russell RSW 1843-1924
Scottish landscape painter. Studied at Aberdeen Art School and at the Académie Julian in Paris. Exhib. four paintings at the RA, including 'Evening' and 'Afternoon, Aberdeen Links'. Also exhib. once at SS and once at the NWS. Born and lived at Aberdeen.
Bibl: Caw.

GOWERS, W.R. fl.1888
Exhib. one work, entitled 'Anchor Boat at Walberswick', at the RA 1888. London address.

GRACE, Alfred Fitzwalter RBA 1844-1903
Landscape and portrait painter. Studied art at Heatherley's and the RA Schools, where he won the Turner gold medal. Exhib. from 1865, at the RA from 1867, at the BI (6), SS (81), NWS (10), GG (5) and NG (3). Member of the Society of British Artists. He lived at Steyning, Sussex, and his landscapes were particularly views of the South Downs. His portraits were often miniatures. Author of *A Course of Landscape Painting in Oils*, 1881. Friend of J.M. Whistler. His wife was Emily M. Grace, an enamel painter, who exhib. portraits at the RA 1881-8.
Bibl: AJ 1904 p.381.

GRACE, Miss Frances Lily fl.1876-1889
Painted figurative subjects. Exhib. 14 works, including ' "O Blessed Seclusion from a Jarring World!" ' and 'Still Achieving still Pursuing', at SS, 1876-86. Also exhib. three works at the RA 1881-94. Address in Brighton, Sussex.

GRACE, Miss Harriette Edith fl.1877-1891
Painted portraits, landscapes and nature. Exhib. 16 works, including studies of dahlias, apples and springtide blossom. Also exhib. 11 works, including portraits and still-lifes, at the RA, 1881-1900. Address in Brighton, Sussex.

GRACE, James Edward RBA 1851-1908
Landscape painter and illustrator, who exhib. 1871-1903; at the RA 1876-1903, at SS (158), at NWS (14), at GG (16) and at NG (16). Member of the Society of British Artists.
Bibl: Cundall p.215.

GRACE, Mrs. James E. fl.1881-1893
Exhib. one work, entitled 'A Mill Street', at SS in 1881. Address Godalming, Surrey.

GRACE, Miss L.A. fl.1874-1875
Exhib. a watercolour entitled 'Priscilla' at SS in 1874-5. London address.

GRÄEF, Professor Gustave fl.1880-1884
Exhib. five portraits at the RA, 1881-4. Addresses in London and Berlin.

GRAEFLE, Albert 1807-1889
Exhib. one painting, entitled 'The Triumph of Hermann; After the Battle in the Teutoberg Forest', at the RA in 1851. Painted a portrait of Queen Victoria as a widow in 1864. Address in Paris.
Bibl: Ormond; Wood, Panorama.

GRAHAM, C. fl.1841-1850
Exhib. four watercolour portraits and a view of Kingston at SS, 1841-50. Also exhib. a view of Nevsky Prospect, St. Petersburg, and a work entitled 'Inauguration of the Column erected to the Memory of the Late Emperor Alexander in the Great Square, St. Petersburg', in 1844 and 1846. London address.

GRAHAM, Miss C. fl.1868
Exhib. a painting entitled 'Adeline. "Like a Lily, which the Sun Looks Through" ' at the RA in 1868.

GRAHAM, Miss Florence E. fl.1882-1891
Exhib. four works, including 'An Eastern Flora' and 'Sympathy', at the RA, 1883-98. London address.

GRAHAM, Miss J. fl.1883
Exhib. a landscape at the GG in 1883. London address.

GRAHAM, James Hunter- fl.1889-1893
Exhib. three works, including 'The Twilight Moon' and 'Coming up with the Mails', at the RA, 1889-93. Address in Brighton, Sussex.

GRAHAM, Miss Jean Douglas fl.1890-1892
Exhib. a painting entitled 'A Little Royalist' at SS, 1892-3. Also exhib. three works at the NWS. London address.

GRAHAM, Norman fl.1900
Exhib. a painting entitled 'On the Surrey Downs' at the RA in 1900. Address in Guildford, Surrey.

***GRAHAM, Peter RA 1836-1921**
Scottish painter of landscapes and coastal scenes. Pupil of the naturalistic school of R.S. Lauder in Edinburgh. Leapt to fame in 1866 with his first picture at the RA, 'A Spate', but his later work did not fulfil his early promise. In spite of this his desolate moorland scenes and stormy coastal scenes remained very popular. Exhib. at RA 1866-1904. Elected ARA 1877, RA 1881. Titles: 'After Rain', 'Seagirt Crags', 'Lonely Sea-cliffs Where the Gannet Finds a Home', etc.
Bibl: Portfolio 1887 November; Mag. of Art II p.144; AJ Christmas Art Annual 1899; Caw pp.255-6 (pl.opp. p.254).

***GRAHAM, Thomas Alexander Ferguson HRSA 1840-1906**
Scottish painter of fishing and country life, and later of portraits. Entered the Trustees' Academy in 1855, and soon took a prominent place in the brilliant group trained by R.S. Lauder — Orchardson, Pettie, Chalmers and McTaggart. He began to exhib. at the RSA in 1859, but in 1863 he joined Orchardson and Pettie in London. He spent more time abroad than his associates: in 1860 he went to Paris with McTaggart and Pettie and in 1862 visited Brittany. In 1864 he was in Venice, and in 1885 in Morocco where he painted 'Kismet' and other oriental subjects. But the wild west coast of Scotland, and

the Fifeshire fishing villages were his favourite sketching grounds. 'A Young Bohemian', 1864 (National Gallery of Scotland) is an example of his early work, and shows the influence of the Pre-Raphaelites, especially Millais, which is in his work of the 1860s. He exhib. at the RA 1863-1904. Hon.Member of the RSA in 1883. He was exceptionally handsome and was the model for the angry husband in 'The First Cloud', and also appears in Pettie's 'The Jacobites'. Reynolds notes that "although of a finer sensibility than his fellow students in Edinburgh, he did not achieve the same official successes. Yet, as 'The Landing Stage' shows, he was capable of combining the observation of human emotion with a purely painterly approach to its physical setting."

Bibl: AJ 1873 p.208 (pl.); 1874 p.356 (pl.); 1901 p.92 (pl.); 1902 p.216 (pl.); 1907 p.36 (obit.); Studio XL p.87 (pls.); Portfolio 1887 p.233; 1896 No. 14 p.6 (pl.); VAM Cat. of Oil Paintings 1907; Caw pp.244, 258-9, 479; DNB; Reynolds, VP pp.193, 194 (pl.128); Maas p.252 (fig. 253).

GRAHAM, Mrs. W.J. (Josephine) fl.1883-1884
Exhib. three paintings of flowers at the NWS, 1883-4. London address.

GRAHAM-BUXTON, W. see BUXTON, W. Graham-

GRAHAM-CLARKE, L.J. see CLARKE, L.J. Graham-

GRAHAM-ROBERTSON, Walford
see ROBERTSON, Walford Graham-

GRAHAM-YOOLL, Miss fl.1887
Exhib. a genre painting at the GG in 1887. Address in Edinburgh.

GRAHAME, A.B. fl.1871-1876
Exhib. 11 paintings at SS, 1873-6, including 'Gathering Flowers', 'The Afternoon Nap' and 'The Gamesters'. Also exhib. three works at the RA, 1871-6. London address.

GRAHAME, James B. fl.1866-1880
Exhib. four paintings, including 'An Old Shed on the River' and 'Herding Sheep', at SS, 1877-80. Also exhib. seven paintings including 'Hope on the Horizon' and 'Trying the Costume' at the RA, 1866-75. London address.

GRAHAME, John B. fl.1866-1876
Painted landscapes and genre subjects. Exhib. 16 works at SS, 1871-6, including 'Free Traders', 'The Last Gleam' and 'The Old Woman's Corner'. Also exhib. twice at the RA in 1878 and 1879. Address in Edinburgh.

GRAINGER, Edward fl.1889-1890
Exhib. three works, including 'Near the Sea' and 'Nature's Carpet', 1889-97. Address in Dudley, Worcestershire.

GRAMPIETRI, Mme. Sellimo fl.1884-1890
Painted views of buildings in watercolour. Exhib. at SS, 1884-90, including interior views of Westminster Abbey and of the Doge's Palace, Venice.

GRANBY, Marchioness of see LINDSAY, Miss Violet

GRANT, Miss Alice fl.1879-1904
Painted portraits and fruits. Exhib. 28 works, 18 portraits and eight still-lifes, at the RA, 1885-90. Also exhib. six works at SS, 1879-89. London address. Member of the Society of Lady Artists.
Bibl: AJ 1893.

GRANT, Aug. R. fl.1838-1840
Exhib. two paintings, 'The Brook' and 'Lane Scene near Ripon', at the RA in 1838 and 1839.

GRANT, Carleton fl.1892-1893
Exhib. ten works, all landscapes of the Thames Valley or North Wales, at the RA, 1892-7. Address in Eton, Berkshire.

GRANT, Charles fl.1825-1839
Painted portraits. Exhib. 15 portraits at the RA, 1825-39. Also exhib. one portrait at the BI in 1829. London address. Later he probably went to India.
Bibl: Ormond.

GRANT, Miss Emily fl.1854-1855
Exhib. two works, a 'Woodland Scene' and a study from nature, at SS 1854 and 1855.

***GRANT, Sir Francis PRA 1803-1878**
Painter of portraits and hunting scenes. Born the younger son of the laird of Kilgraston, Perthshire, Grant at first painted as an amateur. In the 1830s he took up painting as a profession. His social connections and flattering portrait style ensured a quick success, and in 1840 his portrait of Queen Victoria and Melbourne riding in Windsor Park made him the most fashionable portrait painter of the day. Among his other sitters were Palmerston, Macaulay, and Landseer. His wife was a niece of the Duke of Rutland, and he spent much time painting around Melton Mowbray. His pictures of the Melton Hunt became well-known through engravings. Exhib. at RA 1834-79, BI and SS. Elected ARA 1842, RA 1851, PRA 1866. His studio sale was held at Christie's, 28 March 1879.
Bibl: Portfolio 1887 p.139ff.; AJ 1878 p.232; Redgrave, Dict., 1878 Supp; Caw pp.176-7; DNB XXII p.386; Country Life CXI p.152, H.C. Smith, *Sir Francis Grant's Quorn Masterpiece;* John Steegman. *Sir F.G. PRA,* Apollo June 1964; Reynolds, VP pp.94, 173 (pl.171); Maas pp.72-3, 213, 215 (pls. pp.73, 218); Ormond.

GRANT, Henry fl.1872-1888
Exhib. six works, including 'Study of Vermin' and 'Expectation', at SS, 1872-80. Also exhib. three works, a landscape, a portrait and a work entitled 'Deeply Interested', at the RA, 1876-88. London address.
Bibl: Ormond.

GRANT, Lewis fl.1901
Exhib. a work entitled 'The Teazle' at the RA in 1901. Address in Bushey, Hertfordshire.

GRANT, Miss Mary Isabella fl.1870-1893
Painted landscape watercolours, usually of Devon. Exhib. 47 works at SS, 1870-81, including many drawings of landscapes in Devon, and others of Wiltshire and Yorkshire. Also exhib. at the NWS. Address in Cullompton, Devon.

GRANT, W. fl.1847-1854
Exhib. three works, 'Fruit and China', 'On the Medway, near Rochester' and 'Misty Morning, Dover', at the BI in 1831.

GRANT, W.A. fl. 1862-1864
Exhib. four works, two landscapes and two views in Sevenoaks, Kent, at the BI, 1862-4. Also exhib. one work, 'Winter Sunset', at the RA in 1862. London address.

***GRANT, William James 1829-1866**
London historical genre painter. Studied at RA Schools. Exhib. at RA 1847-66 and BI. Titles: 'The Last Trial of Madam Palissy', 'A Legend of the White Rose', 'Katherine Parr', etc. His works showed considerable talent, but his career was cut short when he died at the age of 37.
Bibl: AJ 1864 pp.233-5; 1866 p.217 (obit.); Redgrave, Dict.

GRANVILLE, Captain R.C. fl.1879
Exhib. a 'Scene on the Lake of Geneva' at SS in 1879. London address.

GRAPES, Mrs. Elizabeth c.1860-c.1932
Hull painter of landscape in oil and watercolour. Emigrated to Australia later in life.

GRAVELY, Percy fl.1886-1892
Exhib. 'In the Marshes near Rye' at SS in 1886/7. Address in Bushey, Hertfordshire .

GRAVES, C.R. fl.1858
Exhib. 'A Brig Driving Ashore, After a Collision' at SS in 1858. Address in Hastings, Kent.

GRAVES, Charles A. fl.1873-1884
Exhib. a painting entitled 'Moonlit Sea' at the RA in 1884. Also exhib. 'Beckley Church, Sussex — Winter' at SS in 1873. Address in St. Leonard's, Sussex.

GRAVES, Frederick Percy fl.1858-1872
Painted rivers and mountain landscapes of north Wales. Exhib. 25 works at SS, 1859-72, including numerous drawings of the River Conway. Also exhib. six works at the RA. London address.
Bibl: Ormond.

GRAVES, Hon. Henry Richard fl.1846-1881
Portrait painter who exhib. at the RA 1846-81. His sitters included many of the aristocracy, and he also painted several members of the royal family, Princess Louise and Princess Beatrice, by Royal Command.
Bibl: Cat. Exhibition Portrait Miniatures, London 1865; BM Cat. of Engraved British Portraits II p.168; III p.587; Cat. Military Prints, London 1914 (T.H. Parker Bros); Ormond.

GRAVIER, Florence fl.1879
Exhib. a figurative work in 1879. London address.

GRAY, Mrs. fl.1844-1857
Exhib. three portraits at the RA, 1844-57. London address.

GRAY, Miss Alice fl.1891-1892
Exhib. two works, entitled 'Grinding Corn' and a portrait, at the RA in 1891 and 1892. Also exhib. 'A Hand-loom Weaver' at SS in 1891. Address in Edinburgh.

GRAY, Curwen fl.1862-1871
Painted genre subjects. Exhib. seven works, including 'A Lesson on the Bagpipes' and 'A Mountain Belle', at SS, 1862-71. Also exhib. two works at the BI in 1865 and 1866. Address in Woodford, Essex.

GRAY, Mrs. Curwen fl.1864-1875
(Miss Kate Newenham)
Exhib. eight works, including an illustration to Southey's *Battle of Blenheim*, at SS, 1864-75. Also exhib. a painting entitled 'Grandpa's Wig' at the BI in 1865. Address in Woodford, Essex.

GRAY, F. fl.1852
Exhib. a work entitled 'The Last Two for a Penny' at the RA in 1852. London address.

GRAY, George fl.1874-1879
Exhib. seven Scottish landscapes at SS, 1874-9. Address in Kirkcaldy, Scotland.
Bibl: Caw.

GRAY, H. Barnard fl.1844-1871
Landscape and sporting painter who exhib. 1844-71, at the BI, RA 1845-63, at SS and elsewhere. Titles at the RA include, in 1850, 'The Britannia Tubular Bridge across the Menai Straits', from sketches made on the spot.
Bibl: AJ 1859 pp.121, 171.

GRAY, Herbert fl.1901
Exhib. a painting entitled 'Eventide' at the RA in 1901. London address.

GRAY, J. fl.1863-1872
Exhib. seven watercolours of fruit at SS, 1863-72. London address.

GRAY, J., Jnr. fl.1866-1867
Exhib. a painting entitled 'Little Teddy' at SS in 1866. London address.

GRAY, Miss Jessie D. fl.1892
Exhib. a painting entitled 'A Little Maid' at the RA in 1892. London address.

GRAY, John fl.1839-1842
Exhib. seven works, including landscapes in Wales and Devon, at SS, 1840-2. Also exhib. 'The Flight Into Egypt' in 1839 at the RA. London address.

GRAY, John fl.1885-1904
Painted portraits, landscapes and flowers. Exhib. at the RA up to 1904 including landscapes of the South of England and portraits of the artist and his wife. Also exhib. at SS, 1890-4, including 'Anemones' and 'A Pond in Surrey'. Address in Chiswick, London.

GRAY, Miss L. fl.1874-1875
Exhib. three works, including 'A French Peasant' and 'The Invalid' at SS, 1874-5. Address in Tunbridge Wells, Kent.

GRAY, Miss Millicent Etheldreda fl.1899-1911
Painted portraits and figurative subjects. Studied at the Cope and Nicol School and at the RA Schools. Exhib. at the RA from 1899 including 'Royden Water Splash, New Forest'. London address.
Bibl: The Gentlewoman 17 June 1911.

GRAY, Miss Monica F. fl.1900
Exhib. a painting entitled 'Hook Heath, Surrey' at the RA of 1900.

GRAY, Paul fl.1867
Exhib. three watercolours, entitled 'The Nosegay', 'The Sonata' and 'The Despatch' at SS in 1867.

GRAY, Paul Mary 1842-1866
Irish painter and illustrator. Exhib. at RHA 1861-3, then came to London, where he worked as an illustrator for *Punch* and other periodicals. For works illustrated by, see Card Cat. at the VAM.
Bibl: Strickland.

GRAY, Ronald RWS NEAC 1868-1951
Painted landscape and figures. Studied at the Westminster School of Art and at the Académie Julian. Exhib. ten portraits, 1891-2.

GRAY, S. fl.1883-1884
Exhib. a work entitled 'Old Companions' at SS in 1883-4. London address.

GRAY, T.W. fl.1827-1851
Exhib. 'Villagers Returning from the Fair' at the RA in 1831. Also exhib. at the BI and SS. Address in Salisbury, Wiltshire.

GRAY, Thomas fl.1859-1869
Painted genre subjects. Exhib. at the RA, including 'A Pet Rabbit' and 'The Bookworm', 1859-69. Also exhib. eleven works at SS, 1859-74. London address.

GRAY, Thomas fl.1881-1902
Exhib. six works, including 'The Halt' and 'The Advance Guard', at SS, 1881-93. Also exhib. twice at the RA 1899-1902. Address in Chiswick, London.

GRAY, Tom fl.1866-1887
Exhib. one work, entitled 'The Monk's Homily', at the BI in 1866. London address.

GRAY, William fl.1835-1883
Sculptor and landscape painter. Exhib. landscapes of the Isle of Wight and South Coast at the RA. Also exhib. at the BI 1848-60, and at SS. London address.
Bibl: BM Cat. of Engraved British Portraits p.465.

GRAYSON, W.T. fl.1868-1871
Exhib. a watercolour, 'In Llanberis Pass, North Wales' at SS in 1868. London address.

GREATA, Mme. fl.1858-1860
Exhib. five works at SS, 1858-60, portraits in pastel and watercolour and works in watercolour entitled 'The First Team' and 'Playmates'. London address.

GREAVES, Henry fl.1873
Exhib. a work in 1873. This is probably Harry Greaves (1850-1900), the brother of Walter (q.v.) and one-time friend of J.A.M. Whistler (q.v.). Lived in Chelsea, London.
Bibl: See under Walter Greaves.

GREAVES, Mabel fl.1876
Exhib. a genre subject in 1876. Address in Leamington Spa, Warwickshire .

***GREAVES, Walter 1846-1930**
Painter of landscape and river scenes. Son of a Chelsea boat-builder who used to ferry Turner across the river; Walter and his brother Harry also performed this service for J.A.M. Whistler (q.v.), and in about 1863 became his unpaid studio assistants and pupils. They adored Whistler, accompanied him where he went, imitated his dress and manner, made the frames for his canvases, bought his materials and prepared his colours. Walter said: "He taught us to paint, and we taught him the waterman's jerk." Most of Greaves's paintings were imitations of Whistler's, but his remark "To Mr. Whistler a boat is always a tone, to us it was always a boat" shows that he recognised their difference in outlook. His reputation was established by an exhibition at the Goupil Gallery in 1911. In 1922 he was admitted to the Charterhouse, where he died.
Bibl: Studio LIII 1911 pp.65, 144-8, pls; E.R. and J. Pennell, *The Life of James McNeill Whistler*, 1908 pp.l, 88, 106-8, 126, 137, 138, 164, 165, 168, 171, 175-6, 179, 185, 188, 204; Cat. Toledo Museum 1914; W.R. Sickert, *A Free House*, 1947 pp.28-32 (essay first appeared in The New Age 15 June 1911); Reynolds, VS pp.101-2 (fig.103); Maas, p.247; Ormond; Tom Pocock, *Chelsea Reach*.
Exhib: London, Goupil Gallery 1922; London, Leighton House 1967; London, Chelsea Library 1968; London, Parkin Gallery 1974.

GREAVES, William fl.1885-1920
Leeds landscape painter, who exhib. 1885-1920 at the RA — landscapes and woodland scenes, some in Sherwood Forest.

GREEN, Alfred H. fl.1844-1862
Painted country genre subjects. Exhib. at the BI in 1862 two paintings of poultry and animals and a work entitled 'The First Effort in Art'. Also exhib. four works, including 'Please, I've come for Milk', at SS, 1844-61, and once at the RA, in 1861. Address in Birmingham.

GREEN, Arthur fl.1879
Exhib. a genre subject in 1879. London address.

GREEN, Benjamin Richard NWS 1808-1876
Watercolour painter and illustrator. Son of James Green, the portrait painter. Studied at the RA schools, and painted both figures and landscapes, mostly in watercolour. 1834 elected member of the Institute of Painters in Watercolours. He was also employed as a teacher and lecturer. Exhib. at the RA 1837-58 (all miniature portraits), NWS (243), and SS (38). In 1829 he published a numismatic atlas of ancient history, executed in lithography; he also published works on perspective, a lecture on ancient coins, and a series of heads from the antique. For works illustrated by, see Card Cat. at the VAM
Bibl: AJ 1877 p.20; Arnold's Magazine of Fine Arts I 1833 p.532; Redgrave, Dict.; VAM Univ. Cat. of Books on Art 1870; Bryan; DNB; BM Cat. of English Book Sales 1915; Ormond.

GREEN, Miss Blanche fl.1870-1871
Exhib. four watercolours at SS, 1870-1, including 'To Meet, To Know, To Love and Then to Part, is the Sad Tale of Every Human Heart'. London address.

GREEN, C.B. fl.1853
Exhib. a 'Sketch from Nature' at the RA in 1853. London address.

***GREEN, Charles RI 1840-1898**
Watercolour painter of genre and historical subjects, and illustrator. Starting under Whymper, he worked for *Once a Week* and other periodicals, and became one of the most successful of the black and white draughtsmen of his time, especially in his illustrations to Dickens. Some of these were turned into watercolours (e.g. 'Little Nell,' VAM, Hardie, fig. 163). As a watercolour painter he became A of the RI in 1864 and Member in 1867. He exhib. 1862-83 at the RA, all genre titles — 'The Rivals', 'The Letter Bag', 'Ruin', and The Girl I left Behind me', and at NWS (150). (His elder brother was H. Towneley Green (1836-99), who also drew in black and white and painted in watercolour. A of RI in 1875, Member in 1879.) A sale of both their works was held at Christie's, 13 January l900. For works illustrated by, see Card Cat. at the VAM.
Bibl: AJ 1873 p.141; 1908 pp.90-1; Studio XXXII, p.286 (pl.); Bryan; Cundall; Gleeson White; VAM Cat. of Watercolour Paintings II 1908; Hardie III pp.82, 96,140, 152 (fig. 163); Newall.

GREEN, David Gould RI 1854-1917
Landscape watercolourist, who exhib. 1879-98 at the RA, and also at SS (40), NWS (15), GG (4) and NG (1). Brother of N.E. Green (q.v.).

GREEN, E.F. fl.1824-1851
Painted portraits, literary and exotic subjects. Exhib. 20 works at SS, 1828-44, including portraits, scenes in Greece and Albania, and illustrations to *The Arabian Nights*. Exhib. 21 works at the BI, 1828-49, including scenes in Italy, Greece, Persia and India. Also exhib. 14 works at the RA, 1824-51. London address.
Bibl: Cat. of Paintings etc. in India Office 1914.

GREEN, Mrs. E. Goodwin fl.1886
Exhib. a painting of flowers in 1886. Address in Maidstone, Kent.

GREEN, George Pycock Everett fl.1841-1873
Portrait painter. Exhib. 20 works, all portraits, at the RA, 1841-73. Exhib. nine figurative subjects, including 'Shylock' and 'Little Red Riding Hood', at the BI, 1845-62. Also exhib. 12 works, including several landscapes, at SS, 1841-73. London address.
Bibl: Ormond.

GREEN, H. Vaughan fl.1884-1886
Exhib. three watercolours, entitled 'Low Water', 'A Lancashire Moss' and 'Marshland Meadows', at SS, 1884-6. Address in Preston, Lancashire.

GREEN, Henry Towneley RI 1836-1899
Painter, watercolourist and illustrator. Exhib. from 1855 at RA, NWS and elsewhere. His brother was Charles Green (q.v.).

GREEN, Miss Isabella fl.1873-1875
Exhib. a painting, entitled 'Primulas', at the RA in 1875. Address in Knutsford, Cheshire.

GREEN, Josiah fl.1862-1868
Exhib. three works at the BI, including 'A Study from Italy' and 'The Sham Fight', 1862-6. Also exhib. twice, in 1862 and 1866, at SS, and once in 1868, 'Spring's Gatherings', at the RA. Addresses in London and Birmingham.

GREEN, Miss L.J. fl.1830-1845
Exhib. six historical subjects in watercolour at SS, including a portrait of Lady Jane Grey, 1830-45. London address.

GREEN, Miss M. Helen fl.1884-1887
Exhib. three paintings of flowers at the RA, 1884-7. London address.

GREEN, Miss Mabel fl.1880-1893
Exhib. five landscapes, including a view on Exmoor and another on the Yorkshire Moors, at the RA, 1884-96. Also exhib. four works, including a painting of flowers, at SS, 1880-2. London address.

GREEN, Miss Mary C. fl.1890-1891
Exhib. a work entitled 'St. Paul's at Sunrise' at the RA in 1890. Also exhib. once at the NWS. London address.

GREEN, Nathaniel Everett 1833(?)-1899
Painted landscapes, buildings and interiors. Exhib. 24 works, the majority watercolour landscapes of Ireland and Scotland, at SS, 1855-82. Exhib. 18 works, including views in Ireland and Scotland and interiors at Gawthorpe Hall, at the RA 1857-85. London address.
Bibl: Bryan.

GREEN, P. fl.1873
Exhib. two watercolours, one a view of Saint's Bay, Guernsey, at SS in 1873. Address in Guernsey.

GREEN, Mrs. R. fl.1846-1848
Copied old masters. Also exhib. a painting entitled 'The Infant Saviour' at SS in 1848. Address in Eltham, Kent.

GREEN, Richard Crafton b.1848 fl. to 1929
Exhib. genre and figurative subjects. Also painted flowers. Studied at Heatherley's School. Exhib. 26 works including 'Early Training', 'Fantasie' and 'No Better than a Gipsy Maid'. Also exhib. from 1890 at the RA including landscapes and flower paintings. Born at Stansted, Essex, lived in Essex.

GREEN, W.P. fl.1865
Exhib. a work entitled 'Shady Lane, Warwickshire' at SS in 1865. Address in Birmingham.

GREENAWAY, F.W. fl.1864
Exhib. one watercolour, entitled 'Dumpton Gap, Ramsgate, at SS in 1864. Address in Greenwich, near London.

***GREENAWAY, Miss Kate RI RWS 1846-1901**
Drew and painted children and made illustrations for childrens' books. Studied at Islington School of Art, Heatherley's and the Slade. Exhib. 11 watercolours at the SS, 1870-76, including 'Little Miss', 'The Milk Maid' and 'Buttercups'. Also exhib. seven works, all drawings of children, at the RA, 1877-95. Her first attempt at illustrating her own text for children, *Under the Window*, was a great success in 1879. Lived in London. For works illustrated by, see Card Cat. at the VAM.
Bibl: Mag. of Art 1902 p.118; Bryan; AJ 1902; Gazette des Beaux-Arts 1910; M.S. Spielmann, *Kate Greenaway*, 1910; Hardie; Maas; M.J. Pressler, *A Verie Brief Historie of the Lives and Works of Five Illustrators of Bookes for Little Masters and Misses...*, Chicago c.1965; K. Greenaway, *The Kate Greenaway Treasury*, 1968; R.K. Engen, *Kate Greenaway*, 1976; Newall.

GREENBANK, Arthur fl.1888-1893
Painted figurative subjects. Exhib. at the RA seven works, including 'The Victor', 'Pandora' and 'Elsie', 1890-9. also exhib. at SS, 1892-4. London address.

GREENE, Alice fl.1883-1886
Exhib. four works, including 'An Old Corner in Quimperle' and 'A Summer Tangle', at SS, 1883-6. Address in Richmond, Surrey.

GREENE, Miss Mary Charlotte 1860-1951
Painted landscape. Studied at the St. John's Wood School of Art and at the RA Schools. Born in Essex, she later lived in Cambridgeshire. President of the Cambridge Drawing Society. Examples are in the Fitzwilliam Museum, Cambridge.

GREENE, Richard Massy fl.1875
Exhib. a work entitled 'An Old Blade' at SS in 1875. London address.

GREENER, J. fl.1811-1838
Exhib. paintings of fruit, shells and flowers at the RA, 1811-35, and at SS, three works, 1836-8. London address.

GREENFIELD, E. Latham fl.1886
Exhib. a painting entitled 'In the Forest' at SS in 1886, London address.

GREENFIELD, Mrs. Latham fl.1883-1885
Exhib. two paintings, entitled 'Christmas Roses' and 'Poppies', at SS in 1883 and 1885/6. Address in Richmond, Surrey.

GREENHILL, Miss M.E. fl.1873-1885
Exhib. four works including 'Behind the Scenes at Drury Lane' and 'Little Peasant Girl', at SS, 1873-9. Also exhib. two works, 'An Old Pensioner' and 'Tantalization' at the RA in 1878 and 1885. London address.

GREENISH, Miss Florence E. fl.1880-1886
Exhib. a watercolour entitled 'After Sunset: Venice' at SS in 1883. Also exhib. a work entitled 'Evening' at the RA in 1884. Address in Northampton.

GREENLEES, Miss Georgina Mossman fl.1878-1880
Exhib. two works, entitled 'A Corner of the Forest, Inverary' and 'A Bye Path — Corrie, Arran' at the RA in 1878 and 1880. Address in Glasgow.

GREENLEES, Robert M. RSW fl.1873-1877
Exhib. four paintings, a landscape, two nature studies and a portrait of the Governor of Barataria, at the RA, 1873-7. Address in Glasgow.
Bibl: Caw; Cat. of Pictures in the Glasgow AG and Museum 1911.

GREENOUGH, G. fl.1879
Exhib. a portrait in 1879. Address in Rome.

GREENOUGH, J. fl.1830-1838
Exhib. a landscape near Islington and a self-portrait at the RA in 1838. Address in Islington, London.

GREENSLADE, James Thomas fl.1887
Exhib. a painting entitled 'Lace Workers, Ghent' at the RA in 1887. Address in Walthamstow, London.

GREENWOOD, Miss Beatrice fl.1892-1893
Exhib. two works, entitled 'Evening' and 'A Quiet Corner' at SS, 1892 and 1892/3. Address in Willesden, London.

GREENWOOD, Colin H. fl.1869-1881
Landscape watercolourist. Exhib. 28 works at SS, including numerous views in North Wales and others in south-east England, 1869-81. Also exhib. eight works, all views either in North Wales or Sussex, at the RA, 1872-7. London address.

GREENWOOD, F. fl.1840-1845
Painted landscapes and coastal landscapes. Exhib. three works at the BI, two views of the Channel coasts and a 'Souvenir of the South of France', 1843-5. Also exhib. three works at SS, 1840-4, and once at the RA, in 1840. London address.

GREENWOOD, Miss Isabella fl.1864-1875
Exhib. one work, entitled 'Dead Grouse', at the BI in 1864, and another, 'Dead Sparrow', at SS, 1874/5. London address.

GREGG, Thomas Henry fl.1824-1872
Painted portraits and figurative subjects. Exhib. 17 works, mostly portraits, at the RA, 1834-72. Also exhib. six works, including a 'Christ and His Disciples' and 'The Pets', at SS, 1824-48. Also exhib. three works at the BI, 1835-52. Address in Cambridge.

GREGORY, Charles 1810-1896
Marine watercolourist. Painted a great many ship portraits and yachts for members of the Royal Yacht Squadron. Exhib. two works, 'On the Shore at East Cowes' and 'Fruit', at SS in 1848 and 1849. Address in Cowes, Hampshire.
Bibl: Brook-Hart.

GREGORY, Charles RWS 1850-1920
Painter of genre and historical subjects who exhib. 1877-97 at the RA, and at SS (11), and OWS (94). Titles at the RA 'Pensive Thoughts', 'The Conversion of Ancient Britons', and 'England, Home and Baby', etc.
Bibl: AJ 1882 p.80 (pl.); Portfolio 1887 p.248.

GREGORY, Miss Edith M. fl.1885-1893
Exhib. three works, 'Cecilia', 'Portrait of a Lady' and 'The Shipper's Daughter', at the RA, 1888-97. London address.

***GREGORY, Edward John RA RI 1850-1909**
Illustrator and painter of genre and portraits. Born in Southampton. Entered the drawing office of the P & O Steamship Co., but decided to become an artist, met Herkomer and came to London in 1869. Studied at the RCA and later at the RA Schools. Was employed on decorations at the VAM and from 1871-5 worked for *The Graphic*. Exhib. at the RI (A 1871, Member 1876, PRI 1898-1909), NWS (55), GG (14), and at the RA from 1875 (ARA 1879, RA 1898). Visited the Continent and in 1882 stayed in Italy. 'Marooned', 1887, is in the Tate Gallery. His most famous work is 'Boulter's Lock: Sunday Afternoon', 1898, which obtained for him his election as RA (now Lady Lever AG, Port Sunlight). Manuscripts relating to Gregory are held at the VAM.
Bibl: AJ 1895 p.176; 1897 p.162; 1905 p.259; 1908 p.292; 1909 p.255; Studio XXXII 1904 p.61; XLIII p.311; XLVIII p.87ff.; Mag. of Art VII p.353; Gazette des Beaux-Arts 1878 II pp.314, 644, 727; 1879; II pp.372, 374; Portfolio 1878 p.161; 1883 p.64, RA Pictures 1891-5, 1897-1901, 1905, 1907-8; DNB; Reynolds, VS pp.105-6, (fig. 110); Tate Cat.; Wood, Panorama; Newall. Exhib: Jeremy Maas Gallery, *Theme and Variation: Boulter's Lock by Edward Gregory, RA* 1970.

GREGORY, George 1849-1938
Painted marines. Son of Charles Gregory 1810-96 (q.v.). He did not exhib. in London. He lived and worked on the Isle of Wight. He made occasional journeys abroad.
Bibl: Brook-Hart (pls.179-81).

GREGORY, Miss J. fl.1873
Exhib. a painting of flowers in 1873. London address.

GREGORY, Miss Mary F. fl.1870-1874
Exhib. five landscape watercolours, including views in the Cotswolds, near Hastings and on the Thames, at SS, 1872-4. Also exhib. a work entitled 'The Blue Jay of India' at the RA in 1870. London address.

***GREIFFENHAGEN, Maurice William RA 1862-1931**
Painter and illustrator. Studied at RA schools. Began to exhib. at RA in 1884, also SS and elsewhere. Titles at RA mostly portraits, also allegorical figures in late Pre-Raphaelite style, e.g. 'An Idyll', 'The Mermaid', 'The Judgement of Paris', etc. He was also a prolific illustrator, best known for his illustrations of the novels of Rider Haggard. He also worked for such magazines as *The Lady's Pictorial* and *The Daily Chronicle*. After about 1900 he turned increasingly to portrait painting. In 1906 he taught at the Arts School in Glasgow. Between 1901 and 1912 he exhib. at many of

the big international exhibitions, in Munich, Venice, Pittsburgh, etc. For works illustrated by, see Card Cat. at the VAM.

Bibl: AJ 1890 p.150; 1894 pp.225ff.; Studio IX pp.235ff.; LXIII pp.131, 260; LXVIII pp.40, 122; LXIX p.71; J. Pennell, *Modern Illustration*, 1895; R. Sketchley, *English Book Illustration of Today*, 1903; Who's Who 1921.

GREIG, E.S. fl.1866-1868
Exhib. eight landscapes and figurative paintings including 'Boat Building' and 'On the South Coast'. Also exhib. once at the RA, in 1866, and once at the BI, in 1866. Address in Bristol. A work entitled 'Cottage Interior with a Small Boy Playing a Whistle' was sold at Sotheby's Belgravia, 23 November 1971.

GREIG, George M. fl.1851-1866 d.1867
Exhib. three works, interior views of Holyrood Palace and 51 Albemarle Street, at the RA in 1865. Addresses in Edinburgh and London.

Bibl: Redgrave, Dict.

GREIG, James RBA 1861-1941
Scottish painter of town scenes and figures. Painted some Arab subjects. Also worked as an illustrator. Born in Arbroath. Lived in London.

Bibl: Caw; Who's Who 1921.

GREIG, John Russell b.1870
Scottish painter of portraits, figures and landscape. Studied at Gray's School of Art, Aberdeen and at the RSA in Edinburgh. Lived in Aberdeen and taught at Gray's School.

Bibl: Studio XXXVIII 1906 p.119; Caw.

GREPPI, A. fl.1860-1861
Exhib. two views of Venice and a painting entitled 'Michael Angelo's Visit to Venice' at the BI in 1861. Also exhib. once at the RA in 1860 and twice at SS in 1860. London address.

GRESLEY, Frank 1855-1936
Painted landscape, particularly views of the Trent Valley. Son of James Stephen Gresley (q.v.). Born and died in Derby.

GRESLEY, James Stephen 1829-1908
Exhib. two watercolours (landscapes in Wales and Scotland) at SS in 1867 and 1880. Also exhib. once at the NWS. He was the first of three generations of Derbyshire painters. Address in Derby.

GRESLEY, Miss W.M. fl.1886
Exhib. a genre work at the NWS in 1886. Address in Litchfield, Staffordshire.

GREVILLE, R.K. HRSA fl.1844-1852
Exhib. three landscapes, one Scottish, one Welsh and one entitled 'Strath Africk', at the RA, 1844-52. Also exhib. two landscapes at SS in 1847. Address in Edinburgh.

GREY, Alfred RHA fl.1873-c.1920
Irish painter of cattle and landscapes. Exhib. three works, including 'Cattle: Howth, Co. Dublin' and two landscapes, at the RA, 1873-86. Lived in Dublin.

GREY, Miss Edith F. fl.1890-1904
Painted flowers, fruit and portraits. Exhib. 13 works at the RA between 1891 and 1904 including 'Yellow Chrysanthemums', 'Cherries' and three portraits. Also exhib. three works at the NWS. Address in Newcastle-upon-Tyne, Northumberland.

GREY, J. fl.1858
Exhib. two works, including 'The Discussion', at the BI in 1858. Also exhib. a work entitled 'Si Prego, O Madre Pia, etc.' at the RA in 1858. London address.

GREY, James RHA fl.1873-1875
Exhib. two works, entitled 'Pat Humphrey's Pride' and The First Touch', at the RA in 1873 and 1875. Address in Dublin.

GREY, Mrs. Jane Willis fl.1884-1896
Painted genre subjects in watercolour. Exhib. 19 works at SS, 1882-94, including 'Heavily Loaded' and 'Fine Feathers Make Fine Birds'. Also exhib. five works at SS, 1884-96, including 'Two Little Conservatives' and 'Here they Come!' London address.

GREY, John fl.1890-1892
Exhib. three portraits, 1890-2. Address in Thursby, Cumberland.

GREYSMITH, Ralph Granville 1874-1953
Studied at the Brighton School of Art and at the Académie Julian. Born in Manchester. Lived in Ealing, near London.

GRIBBLE, Bernard Finegan RBC 1873-1962
Painted ships and shipboard scenes. Studied at the South Kensington schools. Exhib. 20 works at the RA between 1891 and 1904, including 'The Burning of the Mentmore', 'Assisting a Disabled Ship' and 'The Pirate's Prize'. Lived in London and later at Parkstone, Dorset.

Bibl: The Artist XXVII 1900 pp.252-7; Who's Who 1921; Brook-Hart.

GRIBBLE, Mrs. Nora fl.1883-1886
Exhib. two works at the NWS, 1883-6. London address.

GRIER, Edmund Wyly b.1862 fl. to 1895
Painted portraits and figurative subjects. Pupil of Bouguereau in Paris. Exhib. six works, including three portraits and paintings entitled 'Bereft' and 'A Difficult Passage', at the RA, 1886-95. Also exhib. a painting and a sculpture at SS in 1886 and 1887. Brother of Louis Monro Grier (q.v.). Born in Melbourne, Australia. Lived in London.

Bibl: Poole I 1912; The American Art Annual 1900.

GRIER, J.J. fl.1877-1879
Exhib. six works, 1877-9. Address in Greenock, Scotland.

GRIER, Louis Monro RBA fl.1864-1920
Painted river and coastal landscapes. Exhib. seven landscapes, titles including 'A Golden Autumn Eventide' and Light Lingers on the Lowland', at the RA 1888-1904. Also exhib. two works at SS in 1886 and 1887. He was the brother of Edmund Wyly Grier (q.v.). Born in Melbourne, Australia, lived at St. Ives, Cornwall.

Bibl: AJ 1907 p.198; SpringExhibition, Rochdale, 1913.

GRIERSON, C. fl.1863-1871
Painted genre and figurative subjects. Exhib. seven works at SS, including 'The Valentine' and 'Minnie', 1863-71. Also exhib. six works at the BI, 1863-6. London address.

GRIERSON, Mrs. C. fl.1864-1875
Painted genre subjects. Exhib. 12 works at SS, 1864-75, including 'Saved', 'Carolina' and 'Pleasing Reflection'. London address.

GRIERSON, Miss C.G. fl.1874
Exhib. a watercolour of a dead partridge at SS in 1874. Address in Dublin.

GRIERSON, Charles MacIver RI PS 1864-1939
Painted genre and figurative subjects. Studied at the Westminster School of Art. Exhib. eight works at the RA between 1887 and 1904, titles including 'A Game of Marbles', 'An Ancient Dame' and 'An Old Man's Dream'. Also exhib. three times at SS, 1885-93, and 18 times at the NWS. Born in Queenstown, Ireland. Lived in London.

GRIESBACH, Mrs. Charles fl.1856-1863
Exhib. three works, comprising two still-lifes and an 'Interior of an Old Kitchen, near Marlow', at SS, 1856-63. Also exhib. two works, entitled 'Lisette' and 'Heartsease' at the RA in 1856 and 1863. London address.

GRIESBACH, Charles Frederick William fl.1848-1856
Painted watercolour landscapes and genre subjects. Exhib. three landscapes, including 'On the Derwent', at SS, 1854-6. Also exhib. two works, including 'Do You Like Butter?', at the BI in 1849 and 1851. Also exhib. once at the RA in 1848. London address .

GRIEVE, Alec SSA fl.1891-d.1933
Painted portraits and landscape. Studied in the Académie Colarossi in Paris. Exhib. a view of Manis Castle, near Dundee, at the RA in 1891. Born in Dundee. Lived at Tayport, Fifeshire.

GRIEVE, F.J. fl.1877
Exhib. two landscapes in 1877. London address.

GRIEVE, Miss J.E. fl.1855-1873
Painted flowers. Exhib. seven works including 'Chrysanthemums', 'Pelargoniums' and 'Azaleas', at the RA 1855-9. London address.

GRIEVÉ, J.G. fl.1877
Exhib. a view of Rotterdam in 1877. Address in Paris.

GRIEVE, Miss M.A. fl.1856-1859
Exhib. three works, entitled 'Josette', 'A Reverie' and 'The Invalid', at the RA, 1856-9. London address.

GRIEVE, R. fl.1838
Exhib. an Argyllshire landscape at the RA in 1838. London address.

GRIEVE, Thomas 1799-1882
Member of a family of scene painters at Covent Garden. In 1839 he became principal painter there, but later moved to Drury Lane. He produced many successful panoramas, together with W. Telbin and J. Absolon, and later with his son Thomas Walford Grieve. He occasionally exhib. landscapes at the RA.

GRIEVE, William fl.1826-1839
Painted landscapes and views of architecture. Exhib. at the RA, 1826-39, including views of Dover Castle, Tonbridge Castle and The Royal Palace, Dresden. London address. He was the younger brother of Thomas Grieve (q.v.) and also worked as a scene painter at Covent Garden, Drury Lane, and the Royal Opera House.

GRIFFEN, Anna fl.1888-1890
Exhib. a watercolour portrait and a pastel study at SS in 1890. London address.

GRIFFIN, J.C. Heyness fl.1886
Exhib. a landscape at the NWS in 1886. London address.
Bibl: Cat. Cape Town AG 1903.

GRIFFIN, Miss J.L. fl.1885
Exhib. a painting entitled 'A Labour of Love' at the RA in 1885. London address.

GRIFFIN, William fl.1826-1839
Painted marines, lived in Hull, Yorkshire. According to the Ferens AG's publication *Old Hull Artists* (quoted by Brook-Hart) his work is "quaint and pleasing ... but largely derivative".
Bibl: Brook-Hart (pl.131).

GRIFFITH, Agnes fl.1886
Exhib. a painting of apple blossom at SS in 1886. Address in Surrey.

GRIFFITH, Miss Kate fl.1879-1885
Painted watercolours of birds, flowers and fruit. Exhib. six works, including four still-lifes of dead birds, at SS, 1879-82. Also exhib. four works, including 'Bull Finch and Blue Tit' and 'Kingfishers' at the RA, 1880-5. Address in Winchfield.

GRIFFITH, M. fl.1877
Exhib. a watercolour entitled 'The Wetterhorn' at SS in 1877. London address.

GRIFFITH, Mary fl.1881-1892
Exhib. a watercolour entitled 'On Barden Moor, Yorkshire' at SS in 1881. London address.

GRIFFITH, William fl.1875-1883
Exhib. three works, including 'Roses and Ferns' and two views in Venice, at SS, 1882-3. Also exhib. two works, entitled 'At the Spring' and 'Waiting' at the RA in 1878 and 1882. London address.

GRIFFITHS, Arthur fl.1872-1877
Painted ships and landscapes. Exhib. seven works at the RA, 1872-6, including 'Dismantled Ships in Chatham Dockyard' and 'A Kentish Cornfield'. Address in Chatham, Kent.

GRIFFITHS, Miss Gwenny WIAC b.1867 fl.1892
Painted portraits. Studied at the Slade School and the Académie Julian. Exhib. a painting entitled 'Madame Chrysantheme' at SS, 1892-3. Born in Swansea, Wales. Lived in London.

GRIFFITHS, John 1837-1918
Painted landscapes and scenes in India. Exhib. 19 works at the RA 1869-1904 including 'Street Scene, Bombay', 'A Rohilla Sentinel', 'Bunjari Women (The Gipsies of India)' and 'Head of an Old Snake-Charmer'. Address in Bombay, India.

GRIFFITHS, Tom fl.1871-1904
Landscape painter. Exhib. 29 works between 1871 and 1904, including views in the North of England and Sussex. Also exhib. 22 works at SS, 1871-82, including numerous views of Robin Hood's Bay and elsewhere in Yorkshire. Address in Leeds, Yorkshire.

GRIFFITHS, W.T. fl.1878
Exhib. a painting entitled 'A Bit of Old Yarmouth' at the RA in 1878. Address in Ipswich, Suffolk.

GRIGG, F.R. fl.1890-1892
Exhib. three works, including 'The Library' and 'An Arab Fruit Seller', at SS, 1890-2. London address.

GRIMMOND, William fl.1887-1891
Exhib. three works, including 'A Scotch Police Court' and 'Our Father' at the RA, 1887-91. Address in Glasgow.

GRIMSHAW, Arthur 1868-1913
Very little-known son of J. Atkinson Grimshaw (q.v.). Painted moon-light scenes and winter landscapes in his father's style, but without the same technical mastery or poetic feeling. Not known to have exhib. in London. With the revival of interest in J. Atkinson Grimshaw, Arthur's work now occasionally appears on the London art market. He probably only painted around 1890-1900; he was also a composer, and organist at the Roman Catholic Church in Leeds.

GRIMSHAW, Atkinson see GRIMSHAW, John Atkinson

GRIMSHAW, Mrs. Eva M. fl.1888
Exhib. a painting entitled 'On the Devon Coast' at the RA in 1888. London address.

***GRIMSHAW, John Atkinson 1836-1893**
Leeds painter of landscapes, town views and dockyards, especially at sunset or by moonlight. Born the son of an ex-policeman, Grimshaw first began painting while working as a clerk for the Great Northern Railway. He encountered bitter opposition from his parents, but after his marriage in 1858 to Theodosia Hubbarde, a cousin of T.S. Cooper (q.v.), he was able to devote himself to painting. At first he painted landscape in a strongly Pre-Raphaelite style, similar to that of his fellow Leeds artist, J.W. Inchbold (q.v.). By 1870, he was successful enought to rent Knostrop Old Hall, a 17th century mansion near Temple Newsam, which features in many of his pictures. Later in the 1870s he built a house near Scarborough, and in the 1880s rented a studio in Chelsea. Grimshaw painted mostly for private patrons, and exhib. only five works at the RA 1874-6, and one at the GG. The towns and docks that he painted most frequently were Glasgow, Liverpool, Leeds, Scarborough, Whitby and London. Grimshaw's style and subject matter changed little during his career; he strove constantly to perfect his own very individual vision. He was interested in photography, and sometimes used a camera obscura to project outlines on to canvas, enabling him to repeat compositions several times. He also mixed sand and other ingredients with his paint to get the effects he wanted. Although he established no school, Grimshaw's pictures were forged and imitated in his lifetime, notably by Wilfred Jenkins and H. Meegan. Although his moonlit town views are his most popular works, he also painted landscapes, portraits, interiors, fairy pictures and neo-classical subjects. During his early period he signed J.A. Grimshaw but c.1867 dropped the John, and signed himself Atkinson Grimshaw. He usually signed his pictures on the front and the reverse, inscribed with the title. Two of his sons, Arthur and Louis, were also painters (qq.v.).
Bibl: Reynolds, VP p.155 (pl.99), Cat. of the Grimshaw exhib., Ferres Gallery 1964; Maas pp.202-3, 229-30 (pls. pp.204, 205, 229); J. Abdy, *A.G.*, 1970: Staley; Brook-Hart; G.R. Phillips, *The Biography of J.A. Grimshaw*, 1972; Wood, Olympian Dreamers; Wood, Pre-Raphaelites; Wood, Painted Gardens; Alex Robertson, *A.G.*, 1988.
Exhib: London, Ferrers Gallery 1970; London, Alexander Gallery 1976; London, Richard Green Gallery 1990, cat. by C. Wood.

***GRIMSHAW, Louis H. 1870-1943(?)**
Son of J. Atkinson Grimshaw (q.v.). Painted moonlight town views in his father's style. Collaborated with his father on many pictures, Atkinson painting the sky and backgrounds, and Louis the figures. In 1905 Louis gave up painting for good, and became a cartographer for the *Manchester Guardian*. His work is consequently very rare. Most of his pictures are views of London, which were commissioned by a dealer called Jackson, but he also painted in other towns. About 1902 he painted a series of views of London, as it was decorated for the Coronation of Edward VII.
Bibl: See under J.A. Grimshaw.

GRIMSHAW, W.H. Murphy fl.1886-1893
Painted landscapes. Exhib. six works, including three winter landscapes, at the RA, 1886-96. Also exhib. three works, including 'After the Snow Storm', at SS, 1886-92. London address.

GRIMSHAWE, Thomas fl.1853-1864
Exhib. three works, comprising a landscape and two paintings entitled 'They are Coming' and 'The Favoured Galloway — My First Lesson', at the RA, 1853-64. Address in Derby.

GRIMSTONE, Edward fl.1837-1879
Painted portraits, animals and genre subjects. Exhib. 15 works, including nine portraits and works entitled 'The Death of Grafton, A Celebrated Bloodhound' and 'My White Mouse', at the RA, 1837-79. Also exhib. 13 works at SS, 1838-54, and three at the BI, 1842-62. London address.
Bibl: Ormond.

GRIMSTONE, Mary fl.1881
Exhib. a painting of flowers in 1881. London address.

GRINDLING, Miss Alice G. fl.1893
Exhib. a painting entitled 'Stella' at the RA in 1893. London address.

GRISET, Ernest Henry 1844-1907
Exhib. two works, entitled 'With the Long Gallop which can Tire the Hound's Deep Hate and the Hunter's Fire' and 'In Sight', at SS in 1871-2. London address. For works illustrated by, see Card Cat. at VAM.
Bibl: AJ XIV 1875 p.151; Binyon; Ormond; Lionel Lambourne, *Anthropo-morphic Quirks — The Work of Ernest Griset*, Country Life 6 January 1977 pp.26-8.

GRISET, H.D. fl.1868-1874
Exhib. four works, including 'La Siesta' and 'Under the Porch', at SS, 1871-5. London address.

GRISPINI, Filippo fl.1863
Exhib. two portraits at the RA in 1863. London address.

GRITTEN, Henry fl.1835-1849
London landscape and topographical painter who exhib. 1835-49, at the RA 1835-45, and also at BI (30) and SS (14).

GRÖNE, Ferdinand E. fl.1888-1904
Painted landscapes, river landscapes and figures. Exhib. 13 works at SS, including 'The Farmer's Daughter' and 'The Harvest Field'. Also exhib. eight works at the RA between 1888 and 1903, including an 'Afternoon Fishing' and 'Thistle Down'. Address in Colchester, Essex.

GRÖNLAND, Theude fl.1849-1867
Painted fruit and flowers. Exhib. 16 works, all paintings of fruit and flowers, at the RA, 1849-67. Also exhib. six works at the BI, 1857-67, and once at SS in 1867. Addresses in Paris and London.

GROOM, A.H. fl.1863-1872
Painted landscapes in watercolour. Exhib. ten works, including views of various rivers in Yorkshire and Hertfordshire, and of mills. Also exhib. two works at the RA in 1867 and 1868. London address.

GROOM, Charles W. fl.1889-1893
Exhib. five works at the RA, 1889-95, including 'The Cottage by the Moor' and 'Evening'. Also exhib. two works, 'A Showery Day' and 'Departing Light' at SS in 1892 and 1893. Address in Carshalton, Surrey.

GROOM, Edward fl.1858-1860
Exhib. three watercolours, including 'Forty Winks' and 'A Willing Gossip' at SS, 1859-60. London address.

GROOM, J. fl.1851-1858
Painted landscapes. Exhib. eight works at the RA, including 'Heath Scene — Summer Evening' and 'The Sands near Winville'. London address.

GROOM, Richard fl.1869-1874
Exhib. three views of buildings, including the Palazzo Vecchio, Florence, and Santa Maria della Spina, Pisa, at the RA in 1869, and a view of a Persian palace at the RA in 1874. London address.

GROOME, William H.C. fl.1881-1892
Painted landscapes and genre subjects. Exhib. eight works at the RA, 1886-1901, including ' "Weer on Airth is it?" ' and 'The Old Net Maker'. Exhib. nine works at SS, 1881-7, including ' "The Best of Friends Must Part" ' and 'We are Seven'. London address.

GROSE, Miss Annie fl.1877
Exhib. a painting entitled 'Uninhabitated Houses' at the RA in 1877. London address.

GROSE, Miss Millicent S. fl.1879-1890
Painted landscapes and Breton genre subjects. Exhib. 14 works at SS, 1879-85, including 'On the Aven, Finisterre', 'Breton Interior' and 'Choosing the Wedding Apron'. Exhib. once, 'Primroses', at the RA in 1882. Addresses in London and Oxford. Member of the Society of Lady Artists.

GROSSE, Professor fl.1886
Exhib. two portraits at the GG in 1886. Address in Dresden, Germany.

GROSSMITH, W. Weedon 1854-1919
Painted genre and figure subjects. Also a writer and actor. Studied at the Slade and RA Schools. Exhib. 13 works at SS, 1872-85, including 'A Domestic Martyr' and 'A Good Little Girl'. Exhib. nine works at the RA, 1879-87, including 'Marjorie - "There is a Garden in her Face" '. London address. Better known as the author of *The Diary of a Nobody*.
Bibl: AJ 1905 p.349; Who's Who 1914.

GROVE, J.A. fl.1838
Exhib. a view of Wouldham Church at the RA in 1838. London address.

GROVER, A.H. fl.1858
Exhib. a landscape in 1858. London address.

GROVER, Miss Jane Elizabeth fl.1841-1859
Exhib. four works, including 'The Flemish Market Women' and 'The Credulous Girl' at the RA, 1841-59. London address.

GROVER, Miss Louisa E. fl.1840-1863
Painted historical subjects and genre. Exhib. four works at the BI, 1851-63, including 'Completing her Toilette' and 'Threading Grandmother's Needle'. Also exhib. at SS, 1842-51, including 'Lady Jane Grey Imploring Mercy of Queen Mary for Lord Dudley'. Addresses in Ghent, Belgium and London.

GROVER, T. fl.1840
Exhib. a painting entitled 'Revels in Flanders on the Eve of St. Nicholas' at the RA in 1840. London address.

GROVES, C. fl.1856-1864
Painted landscape watercolours. Exhib. 12 drawings, the majority views in Surrey, Sussex and Hampshire, at SS, 1856-64. London address.

GROVES, Miss L. fl.1882
Exhib. a river landscape in 1882. London address.

GROVES, Miss Mary fl.1884-1904
Painted landscapes and genre subjects. Exhib. six works at SS, 1886-93, including 'Hickling Broad', 'A Maiden Fair' and 'Love Story'. Also exhib. six works at the RA between 1885 and 1904. London address.

GROVES, Robert E. fl.1887-d.c.1944
Painted marines and coastal landscapes. Exhib. five works at the RA, 1893-1903, including two of the coasts of Iona. Also exhib. two watercolours at SS and eight at the NWS. Lived at Lymington, Hampshire.
Bibl: Brook-Hart.

GROVES, Thomas fl.1881-1889
Exhib. two works at the RA: 'Old Oaks — Bradgate Park, Leicestershire' and 'On the Lincolnshire Coast' in 1881 and 1889. Also exhib. one work at SS in 1883, and eight at the NWS. Address in Leicester.

GRUBBE, Laurence Carrington fl.1893
Exhib. a work entitled 'A Game of Draughts' at the RA in 1893. London address.

GRÜDER, James fl.1867
Exhib. a portrait at the RA in 1867. Address in Dresden, Germany.

**GRUNDY, Sir Cuthbert Cartwright 1846-1946
RR Cam. A RI RWA RBC VPRCA FSA**
Landscape and figure painter. Exhib. seven landscapes and coastal landscapes, 1888-1900, including 'Moorland and Sky', 'Meeting the Boats' and 'The Haunted Pool'. He was the joint founder of the Grundy AG in Blackpool. Lived at Ambleside and in Blackpool.
Bibl: Who's Who 1921.

GRUNDY, J.R.G. RCA fl.1880-1893
Brother of Sir Cuthbert Grundy (q.v.). Exhib. two landscapes 'A Quiet Afternoon' and 'A Lonely Shore' at the RA in 1880 and 1890. Address in Blackpool, Lancashire.

**GUERIN, Mrs William Collings Lubis fl.1873-1888
(Miss Anna Maria Edmonds)**
Painted flowers and birds in watercolour. Exhib. 11 works at SS, 1873-82, including 'French Partridge' and 'Ragged Robins'. Exhib. 11 works at the RA, 1875-88, including 'The Mourners of Tom Tit'. Member of Society of Lady Artists. London address. See also Anna Maria Edmonds.

GUEST, Miss Agnes W. fl. 1890-1893
Exhib. one work, entitled 'Near London Bridge', at SS in 1893. London address.

GUEST, Douglas fl.1803-1839
A painter of mythological and historical subjects. The main body of his oeuvre is pre-Victorian. However, he exhib. at the RA and at SS until 1838 and at the BI until 1839. His last exhib. painting was 'Phaeton Driving the Chariot of the Sun'. London address.
Bibl: Ormond.

GUEST, H. fl.1849-1853
Exhib. three works, comprising a view of the coast at Dover and two portraits, at the RA, 1849-53. London address.

GUIDI, G. fl.1875
Exhib. a painting entitled 'Domestic Life in Pompeii' at SS in 1875/6. London address.

GUILLOD, Miss Bessie fl.1876-1893
Painted flowers. Exhib. five works at SS, 1876-89, and once, 'Daffodils', at the RA in 1886. London address.

GUILLOD, Thomas Walker fl.1839-1860
Painted portraits, landscapes and views of buildings. Exhib. ten works, the majority of which were portraits, at the RA, 1839-59. Exhib. 16 works at SS, 1839-55, including landscapes, portraits and still-lifes. Also exhib. six works at the BI, 1845-60. London address.

GUINNESS, Miss Elizabeth S. fl.1873-1900
Painted figurative subjects and genre. Exhib. ten works at SS 1875-83, including ' "May I Come In?" ' and 'Spinsters in Brittany'. Exhib. eight works at the RA, 1874-87, including two portraits and a work entitled 'The Sleeping Beauty'. London address.

GULICH, John Percival RI 1865-1899
Illustrator, etcher and caricaturist who drew for *The Graphic*. Elected RI in 1897. Died of typhoid.

GULLAND, Miss Elizabeth fl.1866 d.1934
Painted portraits and figurative subjects. Also made engravings. Studied in Edinburgh and under Herkomer at Bushey. Exhib. 11 works at the RA, 1887-1903, including engravings and works entitled 'Honeysuckle', 'Girl with a Wreath' and 'Fantasy'. Born in Edinburgh. Lived at Bushey, Hertfordshire.
Bibl: Davenport, *Mezzotints* 1904; BM Cat. of Engraved British Portraits IV.

GULLY, John fl.1871
Exhib. one painting, 'Mount Cook and the Southern Alps: West Coast of New Zealand', at the RA in 1871.

GULSTON, A.G. fl.1883
Exhib. a landscape at the GG in 1883.

GULSTON, Miss J. fl.1859
Exhib. a work entitled 'Iron Armour' at SS in 1859. London address.

GUMMERY, H. fl.1862-1879
Exhib. paintings of fruit and fruit and flowers, as well as 'Welsh Fisherman's Cottage', at SS, 1862-79. Address in Worcester.

GUNDRY, Arthur fl.1866-1868
Exhib. four works, titles including 'Setting to Work' and 'Cinderella', at the RA, 1866-8. Also exhib. two works at SS in 1868. London address.

GUNDRY, Thomas fl.1891
Exhib. a work entitled 'In Training' at the RA in 1891. London address.

GUNN, A. fl.1849-1871
Painted genre scenes. Exhib. six works at SS, 1852-71, including 'Reduced Circumstances' and 'An Irish Piper'. Exhib. four works at the BI, 1849-54, including 'Reading the Scriptures'. Also exhib. three works at the RA. London address.

GUNN, Frederick G.T. fl.1892-1895
Exhib. four landscapes, titles including 'Landscape — Midlothian' and 'Cleaning Up', at the RA, 1891-5. Address in Edinburgh.

GUNNING, Frank fl.1874
Exhib. a portrait in 1874. London address.

GUNNIS, Louis J. fl.1887-1897
Exhib. five works at the RA, 1887-97, titles including 'Cain' and 'Remorse'. London address.

GUNSTON, W. fl.1867-1875
Exhib. four works at SS, 1867-75, including ' "Where's Dicky Gone?" ' and 'Widow and Fatherless'. London address.

GURDEN, Lovel fl.1889
Exhib. a work entitled 'A Fireside Study' at SS in 1889. London address. This could perhaps be Lovell Gurden Dalziel (1864-1949), one of the Dalziel family.

GURENSTONE, T. fl.1853
Exhib. two portrait watercolours at SS in 1853. London address.

GURNEY, Ernest T. fl.1900
Exhib. a painting, entitled 'The Plough', at the RA in 1900. London address.

GUSH, Frederick fl.1847-1866
Painted portraits and figurative subjects. Exhib. nine portraits at the RA, 1847-66. Exhib. six works, including 'La Neapolitana' and 'The Rosebud' at SS, 1848-52. Also exhib. once at the BI in 1851. London address.

GUSH, William fl.1833-1874
Portrait painter, whose portraits were painted in the "keepsake" tradition — "aptly named" (Maas). He exhib. at the RA 1833-74, titles including 'A Portrait — when She Speaks, her Soul is Shining through her Earnest Face', 1858, and at the BI (4), and SS (2). His female types are very similar to those of Charles Baxter (q.v.).
Bibl: BM Cat. of Engraved British Portraits 1908ff. I-IV *passim*; Cat. Art Museum, Nottingham 1913 p.59; Maas p.108 (fig.109); Ormond.

GUTHRIE, Miss E. fl.1849-1855
Exhib: a portrait in chalk, a watercolour portrait and work entitled 'Mischief' at SS, 1849-55. London address.

***GUTHRIE, Sir James** PRSA HRA RSW 1859-1930
Glasgow landscape and portrait painter. Gave up law in 1877 to take up painting. Met John Pettie (q.v.) and other Scottish painters in London 1879. After a visit to Paris in 1882, his work was strongly influenced by the *plein-air* ideas of Bastien-Lepage. Returning to

Scotland, Guthrie continued to paint landscapes, together with George Henry, Crawhall (qq.v.), and others of the Glasgow School. In 1885 he took up portrait painting, at which he was very successful. President of Glasgow Art Club 1896-8, ARSA 1888, RSA 1892, PRSA 1902-19, Knighted 1903. Member of NEAC and RSW.
Bibl: AJ 1894, 1903, 1909, 1911; Studio LIV 1912; Connoisseur LXXXVI 1930; *The Glasgow Boys*, Scottish Arts Council exhib. 1968.

GUTHRIE, James Joshua 1874-1952
Painter, illustrator, author and poet. Born at Glasgow. Lived at Bognor in Sussex.
Bibl: Cat. of the Loan Exhibition *Modern Illustrations* 1901; Sketchley, *English Book Illustrations of Today,* 1903; J.J. Guthrie, *Last Bookplates* 1929.

GUTHRIE, John fl.1882
Exhib. a work entitled 'Blowing Fresh' at the RA in 1882. Address in Glasgow.

GUTHRIE, W.D. fl.1881-1882
Exhib. three watercolours, including 'Cherry Bloom' and 'Cottages: Witley, Surrey' at SS in 1881-2. Also exhib. once at the RA, 1881. London address.

GUY, J.W. fl.1849
Exhib. a view entitled 'Coast near Folkestone' at the BI in 1849. London address.

GUYARD, H. fl.1871
Exhib. a portrait in 1871. Address in Barmouth, Merionethshire.

GWATKIN, Joshua Reynolds fl.1832-1851
Painted portraits. Exhib. six portraits at the RA, 1832-51. Exhib. four portraits and a work entitled 'Jewish Doctors' at SS, 1832-4. London address.
Bibl: Cat. of Engraved British Portraits BM II 1910 p.271.

GWATKIN, Stewart Beauchamp fl.1883-1893
Exhib. eight works at SS, 1888-93, including two still-lifes and works entitled 'My Private Secretary', 'A Child of Gentleness' and 'Daily Toil'. London address.

GYFFORD, S. fl.1837
Exhib. a view of a house near Tunbridge Wells, Kent, at the RA in 1837. London address.

GYNGELL, Albert E. fl.1874-1891
Exhib. six landscapes, including views in North Wales and on the Severn, at the RA, 1874-91. Address in Worcester.

GYNGELL, Edmund fl.1893
Exhib. two portraits at the RA in 1893. Address in Bushey, Hertfordshire.

*HAAG, Carl RWS 1820-1915
Painter and watercolourist of landscapes, portraits and eastern subjects. Born at Erlangen, Bavaria. Studied Nuremberg and

Munich. Worked in Brussels as miniature painter. Came to England 1847. Continued to paint miniature portraits, but in 1853 painted Swiss views, and then worked at Balmoral on two large pictures of stag-shooting and highland scenes for Victoria and Albert. In 1854 he visited Dalmatia and Montenegro and 1858-60 travelled in Egypt and the Middle East, with Frederick Goodall (q.v.). His pictures of eastern subjects brought him fame and prosperity. Elected ARWS 1850, RWS 1853. Exhib. at RA 1849-81, BI and OWS.
Bibl: AJ 1883 p.71; Portfolio 1878 p.81; 1882 p.224; 1885 p.245;Mag.of Art 1889 (biog. with pls.); Roget; VAM; Hardie III pp.67, 164; Ormond; Irwin; D. Millar, *Queen Victoria's Life in the Highlands,* 1985.

HACCOU, Johannes Cornelis 1798-1839
Exhib. two winter landscapes at SS in 1835 and 1836. He was Dutch by birth but lived and died in London. Pupil of J.H. Koekkoek, father of the Koekkoek family of artists. Painted landscapes, seascapes and moonlight scenes.

*HACKER, Arthur RA 1858-1919
Painter of portraits, genre and historical scenes. Studied at RA Schools and with Bonnat in Paris. Exhib. at RA from 1878, BI, GG and NG. His early works were mostly genre scenes, e.g. 'Her Daughter's Legacy', but he soon became a very popular society portrait painter, to which he devoted most of his energies. He continued to paint occasional romantic genre subjects, such as 'Circe', 'Leaf Drift', etc., and views of London by night. His picture of 'The Annunciation' (RA 1892) was bought by the Chantrey Bequest.
Bibl: Studio XXIX p.45; XXXII p.39; XXXVIII p.16; XLI p.43; XLIII p.26; XLIV pp.33, 39; XLVI pp.175-82; LXVIII pp.40, 50; Connoisseur XXVIII p.207; XXXVI p.58; Tate Cat; Maas; Wood, Olympian Dreamers.

HACKING, E. fl.1877
Exhib. a landscape in 1877. Address in Liverpool.

HACKING, Frederick Sidney b.1873
Painted landscapes. Studied in Preston and at the RCA. Born at Darwen, Lancashire. Lived at Mexborough, Yorkshire.

HACKSTOUN, William 1855-1921
Landscape and topographical painter. Trained as an architect in Glasgow. His watercolours attracted the attention of Ruskin and he studied with him. Painted mostly in Perthshire, Edinburgh and Kent. Lived in London and Glasgow. Examples are in Glasgow AG and the National Gallery of Scotland.

HACON, Jessie fl.1886
Exhib. a watercolour drawing of the tomb of Henry III in Westminster Abbey at SS in 1886. London address.

HADDAN, Percy fl.1900
First exhib. at the RA in 1900 with 'Ploughing in the Fens'. London address.

HADDEN, Miss Nellie fl.1885-c.1920
Painted genre subjects and miniatures. Exhib. two works, 'Cave Canem' and 'Relations' at SS, 1888-9 and 1892. Lived at Sunningdale, Berkshire.

HADDO, Lord George fl.1845-1849
(Later 5th Earl of Aberdeen)
Exhib. two works, a landscape and a view of Kilchurn Castle, Loch Awe, at the RA in 1845 and 1849.

HADDON, Arthur Lumley fl.1866-1893
Watercolourist. Exhib. 13 works at SS, 1867-76, including views on the Thames and of Sonning Church and works entitled 'Returning after Pleasure' and 'Early Boys'. Also exhib. two works at the RA. London address.

HADDON, Arthur Trevor RBA 1864-1941
Painter and watercolourist of landscape and country genre. Studied at the Slade School and in Madrid. Also under Herkomer. Exhib. 12 works at SS, 1883-90, including 'A Country Hack', 'The Cabbage Garden' and 'Berkshire Meadows'. Also exhib. at the RA, including views in Spain and portraits, and at the NWS. Travelled in North and South America. Lived in London, Cambridge and, for a time, Rome.

HADDON, Wilberforce fl.1880-1882
Exhib. two watercolours of Breton subjects at SS in 1880-1. Also exhib. a view of St. Michael's Bay, Cornwall, at the RA in 1882. Address in Wanstead, Essex.

HADFIELD, Charles A. fl.1881-1892
Exhib. two works at SS in 1881-2 and 1892-3. Also exhib. 'A Syrian Arab' at the RA in 1882. London address.

HADGIE, A. fl.1851-1852
Exhib. a view of the ruins of the Temple of the Sun, Baalbek at SS in 1851, and a landscape with the Nile at the BI in 1852.

HADLEY, E.A. fl.1864
Exhib. a work entitled 'Crom Llan, North Wales' at the RA in 1864. London address.

HADLEY, W.H. fl.1874-1876
Exhib. two works, 'A Trout Stream' and 'Moorland in October' at the RA in 1876. Address in Liverpool.

HAELIN (HACLIN), A. fl.1855
Exhib. a fruit piece at the RA in 1855. London address.

HAGARTY, Miss Mary S. fl.1885-c.1930
Landscape watercolourist. Exhib. at the RA from 1885, including views on the Wye and the Severn and views on the East Anglian coast. Also exhib. ten works at the NWS and two at SS. Lived in Liverpool and, from 1896, in London. Sister of Parker Hagarty (q.v.).

HAGARTY, Parker ARCA 1859-1934
Landscape, portrait and figurative painter. Studied at the Liverpool School of Art and at the Académie Julian. Exhib. at the RA from 1884, including views in Wales and East Anglia, and country scenes. Also exhib. a watercolour and another work at SS in 1890. Founder Member of the South Wales Art Society. Elected R.Cam.A. in 1900. Born in Canada. Lived in Liverpool and Cardiff. Brother of Mary Hagarty (q.v.).

HAGHE, Mrs. L. fl.1880
Exhib. a painting entitled 'Primula' at the RA in 1880. London address.

HAGHE, Louis HPRI 1806-1885
Painter and watercolourist of continental views and historical genre. Born Tournai, Belgium. His right hand was deformed, and he worked with his left. Studied lithography; came to London and worked for Day & Son, who published lithographs for David Roberts. From 1840-52 Haghe published many volumes of his own lithographs, all topographical views. After 1852 he devoted himself completely to watercolours. Exhib. at BI and NWS; President of NWS 1873-84. His favourite subjects were scenes in the old towns of Belgium and Germany, and cathedral interiors. His brother Charles (d.1888) was a lithographer, and they worked together. For works lithographed by, see Card Cat. at VAM.
Bibl: AJ 1859 pp.l3ff.; Redgrave, Cent.; Binyon; Cundall; DNB; Hughes; Hardie III p.93 (pl.114); Ormond; Irwin.

HAGREEN, Henry Browne 1831-1912
Watercolourist. Exhib. two works entitled 'The Knife Boy' and 'My Own Studio at Ipswich' at SS in 1853 and 1854. Also exhib. one work at the RA in 1856. Address in Ipswich, Suffolk.
Bibl: VAM Cat. 1908; Daily Telegraph 10 December 1912.

HAGREEN, H.W. Owen fl.1883-1914
Exhib. two landscapes, one entitled 'After Rain — Harlech Marsh' at the RA in 1884 and 1885. London address. Art Master at Wellington College after Raymond Tucker (q.v.).

HAGUE, J. Edward Homerville fl.1885-1903
Sculptor who also exhib. paintings. For example at SS in 1891-2, 'Waiting at Boulter's Lock'. London address.

HAGUE, J. Houghton b. 1842 fl. to 1886
Landscape and figure painter. Studied at Manchester School of Art. Exhib. four works at the RA, 1874-86, including 'The Ornithologist' and 'Mending Old Wounds'. Address in Oldham, Lancashire.

HAGUE, Joshua Anderson RI RBA PRCA 1850-1916
Landscape painter and watercolourist. Studied at Manchester Art School. Lived mostly in North Wales, exhib. at RA from 1873, SS, NWS, GG and NG. President of the Royal Cambrian Academy. Hague's landscapes, which are similar in feeling to those of J. Aumonier (q.v.), are quiet, pastoral scenes, painted in a broad technique. His works can be seen in Manchester and Liverpool AGs.
Bibl: AJ 1895 p.284.

HAHNEL, A. fl.1870-1871
Exhib. a work entitled 'Blackberry Blossom' at SS 1870-1

HAIG, Axel Herman RPE 1835-1921
Etcher and painter of urban and architectural views in London, Italy, Germany and Spain. Exhib. at the RA, 1870-94; SS, 1869-80 and at the NWS. Worked as an architectural perspectivist for several architects, including William Burges. Manuscripts relating to Haig are held at VAM. Born in Gotland, Sweden. He changed his name to Haig from Hagg. Lived in London and Haslemere, Surrey.
Bibl: AJ 1892; E.A. Armstrong, *A.H. Haig*, 1906; Wedmore, *Etching in England,*1895; American Art News 1921; J.M. Crook and C. Lennox-Boyd, *A.H. Haig,* 1984.
Exhib: London, Rembrandt Gallery 1881, 1899?, 1901?, 1905.

HAIG, Miss E. Cotton fl.1891-1897
Exhib. at the RA, 1891-7, including miniature portraits and 'Winter's Children'. Address in Edinburgh.

HAIG, Miss M.C. fl.1873-1874
Exhib. a work entitled 'Apples and Grapes' at SS in 1873-4. London address.

HAILEY, George fl.1866
Exhib. two landscapes in 1866. London address.

HAINES, Miss Agnes Eliza fl.1887
Exhib. a painting of fish in 1887. London address.

HAINES, Miss Clara fl.1896
Exhib. a work entitled 'A Study; Head of a Man' at the RA in 1896. London address.

HAINES, Robert J. fl.1888-1903
Landscape painter. Exhib. three works, 'Oyster Shells', 'St. Étienne, Caen' and 'Cloud and Sunshine — Segovia' at the RA, 1888-1903. Address in Oxford.

HAINES, W. fl.1854-1864
Exhib. four works, including cottage interiors in Kent and Sussex, at the BI, 1856-60. Also exhib. once at SS and once at the RA. London address.

HAINES, William 1778-1848
Painted watercolour portraits. Amongst his sitters was the 5th Earl Stanhope.
Bibl: Ormond.

***HAINES. William Henry** 1812-1884
London genre painter. At first a picture restorer, Haines exhib. genre scenes, landscapes and views of London and Venice at the RA, 1848-81, BI and SS. He often used the pseudonym William Henry. He is also known to have painted views of Venice in the manner of Canaletto and Guardi, which were passed off as originals.
Bibl: VAM; Cundall.

HAINS, Vincent fl.1881-1882
Exhib. two works, 'Reading the News' and 'A Dry Job' at SS in 1881 and 1882. London address.

HAINSSELIN, Henry fl.1843-1853
Painted figurative subjects and genre. Exhib. 20 works at the RA, 1843-53, including 'An Old Sailor, aged 90, supposed to be the only survivor of Keppel's Action' and 'In Search of Fortune'. Also exhib. once, 'Ragged School Students', at the BI in 1852. Born in Devonport, Devon, lived in London.

HAINSWORTH, Thomas b.1873
Painted in oil and watercolour. Born and lived in Halifax, Yorkshire.

HAIR, Thomas H. fl.1838-1849
Northumbrian painter of towns, landscapes and industrial subjects. He made a series of views of Northumbrian coal mines, which he etched and published as 'Sketches of the Coalmines in Northumberland and Durham' in 1839. Exhib. in London at the RA, 1841-9; at the BI, 1842-9, and at SS, 1838-43. Hair is represented in the Laing AG and the collection of Newcastle University.
Bibl: Binyon 1910; Hall.

HAITÉ, George Charles RBA RI 1855-1924
Painter, illustrator and writer. Son of a designer, Haité was a self-taught artist. Exhib. first at the Crystal Palace, later at RA, 1883-1904, BI and NWS. Exhib. works mainly English landscapes, and Moroccan scenes. Later he became first President of the London Sketch Club and the Institute of Decorators and Designers. He designed the cover of the *Strand Magazine*.
Bibl: Studio XXV pp.193ff.; XXX pp.21ff.
Exhib: London, 118 New Bond Street, *One Hundred Lilliputian Pictures in Oil*, c.1900.

HAITE, W. fl.1849
Exhib. one work, entitled 'The Mountain Nymph' at SS in 1849. London address.

HAKE, Miss Mary Lilly fl.1888-1889
Exhib. three paintings of flowers at the NWS, 1888-9. London address.

HAKES, J.A. fl.c.1871
His signed painting 'The Sailing Ship *Northfleet*' was in The Old Customs House, Lymington, Hampshire.
Bibl: Brook-Hart pl.56.

HAKEWILL, Frederick Charles fl.1827-1841
Exhib. three works at the BI, 1831-41, and two at SS in 1827 and 1832. Also exhib. once, a Madonna and Infant Christ, at the RA in 1829. London address. Son of James Hakewill (q.v.) and a member of the Hakewill family of painters and architects.
Bibl: Art Union 1843; Redgrave, Dict.; DNB XXIV.

HAKEWILL, James 1778-1843
Painted landscapes and architecture. He was the second son of John Hakewill, father of F.C.Hakewill (q.v.) and husband of Maria C. Hakewill (q.v.).
Bibl: Art Union 1843; Redgrave, Dict.; DNB XXIV.

HAKEWILL, Mrs. James (Maria C.) fl.1808-1838 d.1842
Painted portraits and figures, particularly children's heads. Exhib. 45 works at the BI, 1808-38. Also exhib. 37 works, the majority portraits, at the RA, 1808-38, and 16 works at SS, 1827-34. London address. Wife of James Hakewill (q.v.).
Bibl: See under James Hakewill.

HAKING, Miss Hilda B. fl.1894
Exhib. a work entitled 'Anemones' at the RA in 1894. London address.

HALDANE, Miss Mary fl.1881-1892
Painted marines and landscapes, the majority featuring ponds or rivers. Exhib. 23 works at SS, 1881-92, including views on the Sussex coast and Norfolk Broads. Also exhib. one work entitled 'The Streamlet' at the RA in 1882. Address in Milford, Surrey.

HALE, Bernard fl.1868
Exhib. a landscape in 1868. Address in Bridlington Quay, Yorkshire.

HALE, Miss E. Thomas fl. from 1898
Exhib. at the RA from 1898 including ' "Her Cheek was Glowing, etc." ' London address.

***HALE, Edward Matthew** 1852-1924
Genre painter; lived in London and Godalming. Studied in Paris, 1873-5 with Cabanel and Carolus-Duran. In 1877-8 worked as war artist for *The Illustrated London News* with the Russian Army, and later in Afghanistan. Most of his genre scenes are of army life, or the sea. Two works are in Leeds AG. Exhib. at RA, SS, GG, NG and elsewhere. Also painted classical subjects in the manner of Alma-Tadema and Poynter.
Bibl: Wood, Olympian Dreamers.

HALE, George Ernest b.1861
Painted marines. Born at Eastbourne, Sussex. Lived at Felixstowe, Suffolk.

HALE, John Howard RBA 1863-1955
Painted portraits and landscapes. Studied at the RCA and at Westminster School of Art. He was Instructor and Director of the Blackheath School of Arts and Crafts, 1887-1928. Born and lived in Farnham, Surrey.

HALE, Miss M.B. fl.1878-1881
Exhib. a watercolour painting of daisies at SS in 1879 and a painting 'Gladiola and Clematis' at the RA in 1880. Address in Bath.

HALE, William Matthew RWS 1837-1929
Painter and watercolourist of landscape and seascape. Pupil of J.D. Harding (q.v.) and William Collingwood Smith (q.v.). Exhib. at RA 1869-96, SS and OWS. Elected RWS 1871. Subjects: England, Scotland, Norway and Spain.
Bibl: Hardie III; Brook-Hart.

HALES, T. fl.1864
Exhib. two works, 'On the Look Out' and 'After Work' at SS in 1864. Address in Lowestoft, Suffolk.

HALEY, Henry J. fl. from 1901
Painter and silversmith. Exhib. at the RA from 1901, including 'A Reflection'. London address.

HALEY, Herbert fl.1893
Exhib. two paintings of poppies and chrysanthemums, at the RA in 1893 and 1894. Address in Bradford, Yorkshire.

HALFNIGHT, Richard William 1855-1925
Sunderland landscape painter. Worked for a time in London, exhibiting landscapes and Thames views at the RA, 1884-9, SS and NWS. Later moved to Newcastle. Two works are in Sunderland AG.
Bibl: Cat. of Sunderland AG 1908; Hall.

HALFORD, Miss Constance fl.1892
Exhib. at the RA from 1892, including 'Grey Day: Porlock' and 'Kate-a-Whimsies; a portrait'. London address.
Bibl: Studio XXXVII; XXXIX.

HALFORD, Miss Jane Charlotte fl.c.1900-1935
Painted watercolour landscapes. Born in Leeds, Yorkshire. Lived in Leicester and was a member of the Leicester Society of Artists.

HALFPENNY, John C. fl.1885-1893
Painted landscapes and country genre. Exhib. at the RA, 1891-8, including 'Surrey Heath' and 'A Sunny Farmyard'. Also exhib. at SS, 1885-93, including 'At the Cottage Door' and at the NWS. Addresses in Liverpool and London.

HALHED, Miss Harriet fl. from 1890
Exhib. four works, including a portrait and 'A little Lamb, Here I am' at SS, 1891-4. Exhib. at the RA from 1890, including 'The Apple', 'To My Ladye' and 'Sweet Pea; Head of a Girl'. Born in Australia. Lived in London and Canterbury, Kent.

HALL, Miss fl.1847
Exhib. a painting of flowers in 1847. London address.

HALL, Mrs. Ann Ashley fl.1874
Painter of Venetian and coastal scenes; lived at Bilston, Staffordshire. Exhib. a painting of fishing-boats in 1874. London address. Also exhib. in Birmingham.

HALL, Annie fl.1884-1886
Exhib. two works, 'Entrance to the Jerusalem Chamber' and 'Convocation' at SS in 1884 and 1886. London address.

HALL, Arthur W. fl.1872
Exhib. a painting of fruit in 1872. London address.

HALL, C.H. fl.1867-1870
Exhib. five watercolours, including landscapes and a view of Hatfield House at SS, 1867-70. Address in Marlow, Buckinghamshire.

HALL, Miss C.L. fl.1878
Exhib. a watercolour view of Arundel Park at SS in 1878. Address in Petworth, Sussex.

HALL, Charlotte fl.1856
Exhib. a portrait at SS in 1856. London address.

HALL, Lady Edna Clarke b.1879
(Miss Waugh)
Painted figurative subjects in watercolour. Studied at the Slade School and won a scholarship in 1897. Exhib. at home and abroad, including the NEAC, from 1901. Born at Shipbourne, Kent. Lived in Essex.

HALL, Fanny R. fl.1830-1837
Painted portraits and figurative subjects. Exhib. ten works at the BI, 1834-7; three works at the RA, 1836-7, and three works at SS, 1830-7. London address.

***HALL, Frederick 1860-1948**
Painter of landscape and rustic genre. Studied at Lincoln School of Art and at Antwerp under Verlat. From 1883-98 he was a member of the Newlyn School in Cornwall, with Stanhope Forbes and F. Bramley (qq.v.), etc. His pictures show identification with their ideas about social realism and *plein-air* painting, but Hall also pandered to the popular taste for storytelling pictures, e.g. 'The Result of High Living', RA, 1892. Exhib. at RA from 1887, SS, GG and NG. Also exhib. in Paris and Venice. Hall was also known for his caricature drawings.
Bibl: AJ 1889 p.102; 1890 p.365; 1891 pp.25ff.; 1905 p.356; Cat. of Leeds AG 1909.
Exhib: London, Meryon Galleries 1912; London, Fry Gallery 1975.

HALL, George Henry A. fl.1867
Exhib. a view of Fladbury Mill, on the Avon, Worcestershire, at the RA in 1867. London address.

HALL, George Lowthian 1825-1888
Painted watercolour landscapes and coastal scenes. His works show the influence of Turner. Exhib. eight watercolours at SS, 1856-62, including views in Hastings and Wales. Exhib. seven works at the RA, 1856-75, including views in Rio de Janeiro and Ireland. Exhib. primarily at the Portland and Dudley Galleries.
Bibl BM Cat. 1900; VAM Cat. 1908; Brook-Hart pl.p.196.

HALL, Gilbert fl.1858-1875
Painted landscapes. Exhib. five works at SS, 1871-5, including 'Dovedale' and 'Ferry Boat on the Thames near Mapledurham'. Exhib. three works, including two views in North Wales, at the BI, 1858-60. Exhib. twice at the RA in 1871 and 1872. London address.

***HALL, Harry fl.1838-1886**

Sporting painter; worked in London and Newmarket. Exhib. at RA, 1838-64, BI and SS. Painted racehorses, hunters and occasional sporting scenes, in a style similar to J.F. Herring Snr. (q.v.).

Bibl: Pavière, *Sporting Painters* p.45 (pl.18); BM Cat. of Engraved British Portraits; Maas; Ormond.

HALL, J. fl.1890

Exhib. one work entitled 'A Quiet Corner' at SS in 1890. Address in Brighton, Sussex.

HALL, James 1797-1854

Scottish amateur painter. A friend of D. Wilkie. Painted portraits and landscapes. Exhib. eight works, including a portrait of the Duke of Wellington and the view from Burns's Monument in Ayrshire, at the RA, 1835-53. Also exhib. seven landscapes at the BI, 1850-4. London address.

Bibl: DNB XXIV.

HALL, Miss Jessie fl.1893 d.1915

Watercolourist. Exhib. a watercolour entitled ' "Why Cannot Friends Agree to Differ?" ' at SS in 1893-4. Also exhib. two works at the NWS. Address in Croydon, Surrey.

HALL, John George 1835-1921

Hull painter and decorator. Painted local scenes in oil and watercolour.

HALL, Joseph Compton RBA 1863-1937

Painted landscape watercolours. Member of the Langham Sketching Club. Born in Cork, Ireland, and lived in Littlington, Sussex.

HALL, Lindsay Bernard NEAC 1859-1935

Painted portraits and genre. Studied at South Kensington, also in Antwerp and Munich. Exhib. seven works, including 'The Trysting Place', 'A Reverie' and portraits, at the RA, 1883-91. Exhib. five works at SS, 1882-9. He was an original member of the NEAC. Lived in London and Australia.

Bibl: Cat. National Gallery, NSW, Australia, 1906; Studio LXXXI; Who's Who 1921.

HALL, Miss Mary B. fl.1886

Exhib. a painting of wallflowers at the RA in 1886. Address in Worthing, Sussex.

HALL, North fl.1888-1889

Exhib. a genre painting at the NWS in 1888-9. London address.

HALL, Oliver ARPE 1869-1957

Painter and etcher of landscapes. Studied at the RCA. Exhib. three landscapes, including views in Cumberland and Somerset, at SS, 1890-1. Also exhib. at the RA, 1890-7, and twice at the NWS. Born in London. He was a friend of Daniel Alexander Williamson (q.v.). Lived in Pulborough, Sussex, and Ulverston, Lancashire.

Bibl: Wedmore, *Etching in England*, 1895; AJ 1896 p.43; 1904 p.89; Studio XL 1907.
Exhib: London, Barbizon House 1933, 1934; Fine Art Society 1936; Barbizon House 1940.

HALL, R.H. fl.1866

Exhib. a work entitled 'New Rothsay' at the BI in 1866. Address in Lee.

HALL, Richard fl.1799-1837

Painted landscapes and country genre. Exhib. at the RA, 1799-37. Also exhib. three landscapes at the BI. 1819-37. London address.

***HALL, Sydney Prior 1842-1922**

Painted portraits, including portraits of the royal family, and historical subjects. Also worked as an illustrator. Exhib. at the RA from 1875, including portraits of Indian officers and the Prince of Wales at Baroda, 'The Marriage of H.R.H. the Duke of Connaught K.G.' and 'Mr. Gladstone Playing his Evening Game of Backgammon'. Also exhib. 14 works at the GG. Accompanied the Prince of Wales on his visit to India, and many of his Indian sketches are at Osborne, Isle of Wight. Born at Newmarket, Cambridgeshire. Lived in London. For works illustrated by, see Card Cat. at VAM.

Bibl: AJ 1905; Cat. of Paintings in the India Office, London, 1914; Ormond.

***HALL, Thomas P. fl.1837-1867**

London genre and historical painter. Exhib. at RA, 1854-67, BI 1837-67, and SS. Titles: 'Cavalier and Puritan', 'Dean Swift and the Peasant,' etc. A genre scene of children picnicking was in Agnew's exhib. of Victorian Painting, 1961.

Bibl: Smith, *Recollection of the British Institution*, 1860.

HALL, W.E. fl.1866

Exhib. a painting of a snowstorm in 1866. London address.

HALL, W. Honywill fl.1874-1891

Painted landscape. Exhib. 30 works at SS, 1874-91, including views in Devon, Dorset and on the Thames. Exhib. four works at the RA, 1878-90, including 'From the Weir, Marlow'. London address.

HALL, Mrs. W. Honywill fl.1878-1884

Exhib. five works, including three watercolour views on the Thames and a view in South Wales, at SS, 1879-82. London address. Wife of W. Honywill H. (q.v.).

HALL, W.T. fl.1823-1858

Painted landscapes and country scenes. Exhib. 18 works at the RA, 1823-57, including many views in Essex, also in Kent and Surrey. Also exhib. a Kentish landscape at SS in 1858. London address.

HALL, William fl.1859-1885

Painted landscapes, usually including rivers. Exhib. eight works, including views on the rivers Ribble, Brathay and Hodder, at the RA, 1876-81. Exhib. seven landscapes, mostly watercolours, at SS, 1859-86. His view of Bolton-le-Sands, signed and dated 1854, was sold at Christie's, 2 July 1971. Lived in Birmingham.

HALL, William Henry fl.1859 d.1880

Painted landscape watercolours. Exhib. 13 works, the majority views in North Wales, at SS, 1871-85. Also exhib. once, in 1859, at the BI, and once, in 1883, at the RA. Address in Birmingham.

***HALLÉ, Charles Edward 1846-1914**

Painter of portraits and decorative figure compositions. Son of Charles Hallé, the musician. Pupil of Baron Marochetti and L. von Mottez. Exhib. at RA, 1866-82, mostly portraits; in 1877 he joined the group of artists of the 'Secession' at the newly-founded Grosvenor Gallery. After 1887 he was also involved with the New Gallery. A close friend of Burne-Jones, Watts, Herkomer and Alma-Tadema, Hallé was more important as an organiser; his own

paintings are inspired by the aesthetic style of Burne-Jones. After the 1880s he exhib. entirely at the GG and NG.

Bibl: C. E. Hallé, *Notes from a Painter's Life*, 1908.

HALLÉ, Miss Elinor fl.1881-1887
Her drawing of Cardinal Newman is in the Royal Collection. Exhib. a bronze medal at the RA in 1887.

Bibl: Ormond.

HALLÉ, Samuel Baruch 1824-1889
Painted genre subjects. Exhib. 32 works at the BI, 1856-67, including 'Going to the Ball', 'A Young Lady at her Devotions', 'Good Morning, Mother!' and ' "My Darling" '. Exhib. 22 works at the RA, 1847-68, and 15 at SS, 1858-68. Addresses in Frankfurt and London.

HALLETT, W.H. fl.1854
Exhib. 'A Misty Morning, with Gipsies Crossing a Brook' at the BI in 1854. Address in Exmouth, Devon.

HALLEWELL, Colonel Edmund Gilling 1822-1869
Soldier and amateur typographer. A set of views of the Bermudas was sold at Sotheby's in 1990. Exhib. two views of Niagara Falls and another of a Welsh hill at SS, 1850-1. Also exhib. a view in Canada at the BI in 1851 and a view in Malta in 1853. Address in Stroud, Gloucestershire.

***HALLIDAY, Michael Frederick 1822-1869**
Amateur painter. Son of a naval captain. Held an official post in the House of Lords, and late in life began to take an interest in painting. Exhib. at RA, 1853-66, and occasionally elsewhere. He painted landscapes, views in the Crimea, genre and Italian scenes. Shared a studio for a time with Holman Hunt (see Bibl.). His best known work is 'The Measure for the Wedding Ring' which was formerly in the collection of Evelyn Waugh.

Bibl: AJ 1869 p.272; Redgrave, Dict.; DNB; Diana Holman Hunt, *My Grandfather, His Wives and Loves*, 1969, see index; Staley; Wood, Pre-Raphaelites.

HALLOWES, Sidney M. fl. from 1900
Exhib. at the RA from 1900 including 'The Turn of the Plough' and 'Southborne Cliffs, Hampshire'. London address.

***HALLWARD, Reginald F. 1858-1948**
Painter, illustrator, decorator and designer of stained glass. Exhib. a painting entitled 'The Waning Moon' at SS in 1883-4. Also exhib. designs for book covers and embroidery, etc. at the RA, 1888-95. Studied at the Slade School and the RCA. Lived in Merionethshire.

Bibl: Cat. of Reginald Hallward exhib., Christopher Wood Gallery, London, May 1984.

HALPEN, M. Francis fl.1845-1868
London genre and landscape painter. Exhib. at RA, 1845-57, and BI. Graves lists a W.F. Halpen, a G.F. Halpen, an F. Halpen and an F.H. Halpen, but it seems probable that these all refer to the same artist. Several of his RA pictures were unfinished sketches.

***HALSWELLE, Keeley RI ARSA 1832-1891**
Genre and landscape painter. At first worked as an illustrator, for *The Illustrated London News,* and for the Edinburgh publisher Nelson. He exhib. at the RSA, and was elected ARSA in 1866. Many of the pictures of this early period were scenes of fishing life at Newhaven. In 1868 he went on the first of his visits to Rome,

which was to provide him with Italian subjects for many years. Typical titles at the RA were 'Contadine in St. Peter's Rome', 'A Roman Fruit Girl', 'Lo Sposalizio', etc. In the 1880s he abandoned figure paintings, and turned almost entirely to highland landscapes and views on the Thames. Exhib. at RA, 1862-91, SS, NWS, GG and NG.

Bibl: AJ 1879 pp.49-52; 1884 p.59ff.; 1891 p.192; 1893 p.132; Portfolio 1884 p.24; Mag. of Art IV p.406; Clement & Hutton; Cundall; DNB 1890; Gleeson White pp.45, 127, 140.

HAM, Miss Ada J. fl.1885-1887
Painted flowers. Exhib. five works, including 'Christmas Roses', 'Azaleas' and 'Oranges and Daffodils', at the RA, 1885-7. London address.

HAMAND, Louis Arthur b.1873
Painted watercolours. Born at Knowle, Warwickshire. Lived in Great Malvern, Worcestershire.

HAMBRIDGE, Alice fl.1901
Her drawing of Tennyson was exhib. at the Tennyson Centenary Exhib. in 1909.

Bibl: Ormond.

HAMER, J. fl.1861
Painted landscapes. Exhib. at SS, 15 works including views in Syria, Wales, Switzerland and Scotland, 1861-8. Also exhib. four works, including two views of the 'Fox' on her expedition into Arctic Regions, at the RA, 1861-5. London address.

HAMER, John fl.1890-1891
Exhib. two views in York at SS in 1890-1 and 1891-2. London address.

HAMERTON, Phillip Gilbert HFRPE fl.1867-1869
Etcher and author. Exhib. at RA and elsewhere.

HAMERTON, Robert Jacob RBA fl.1831-1858
Irish painter of figurative scenes, country genre and rustic subjects. Exhib. 48 works at SS, 1831-58, including 'Young Ramblers', 'Returning from Market' and 'The Irish Mother'. Also exhib. 11 works at the BI, 1831-47, and seven at the RA, 1832-57. London address.

Bibl: Strickland; BM Cat. of Engraved British Portraits.

HAMILL, E. fl.1842-1859
Exhib. three works, including 'Lane in Wiltshire' and 'View of Eton College', at SS, 1842-51. London address.

HAMILTON, Andrew (Alexander) fl.1854-1875
Exhib. ten coastal views at SS, 1871-5, several of them views off the Isle of Wight. Also exhib. once, in 1859, at the RA. London address.

HAMILTON, Miss Augusta D. fl.1896
Exhib. a portrait at the RA in 1896. London address.

HAMILTON, Charles fl.1831-1867
Painter of genre, oriental scenes, and sporting subjects. Exhib. at RA, 1831-8, BI and SS. Titles: 'The Egyptian Emir', 'Arabs Migrating', 'The Kensworth Harriers', etc. Hamilton lived in London, and at Kensworth, Hertfordshire.

HAMILTON, Cuthbert d.1928
Vorticist and member of the Camden Town Group. London address.

HAMILTON, E. fl.1842
Exhib. a painting of 'Old Houses' at the RA in 1842. Address in London.

HAMILTON, E.B. fl.1874
Exhib. a watercolour of azaleas at SS in 1874.

HAMILTON, Rev. J. fl.1851
Exhib. a landscape in 1851. London address.

HAMILTON, J.C. fl.1887
Exhib. a landscape at the NWS in 1887. Address in Bushey, Hertfordshire .

HAMILTON, James ARSA 1853-1894
Scottish genre painter. Exhib. a painting entitled 'On the Alert' at the RA in 1892. Address in Edinburgh.
Bibl: AJ 1895 p.60; Studio 1907 p.IX; Caw.

HAMILTON, James Whitelaw RSA RSW 1860-1932
Scottish landscape painter. Studied in Glasgow and with Dagnan-Bouveret and Aimé Morot in Paris. Exhib. one work 'At Greenwich' at the RA in 1885. Also exhib. in Scotland and abroad. Won a Gold Medal at the Munich International Exhib., 1897. Born in Glasgow. Lived at Helensburgh, Dumbartonshire.
Bibl: Studio XXIV p.120; XXXVII p.110; XLII p.133; LX p.9, LXII pp.140, 146; LXVI p.272; LXVII p.261; LXXXIII p.30; D. Martin, *The Glasgow School of Painters*, 1902; Caw; Brook-Hart; Irwin.

HAMILTON, Miss Kathleen fl.1885
Exhib. a genre subject in 1885. London address.

HAMILTON, Thomas T. fl.1886
Exhib. 'Moonlight and Snow on the Killeries, Connemara' at the RA in 1886. London address.

HAMILTON, Vereker Monteith fl.1886-1914
Painter of military scenes, mainly of the Afghan and Napoleonic Wars. Exhib. at RA, 1886-1914, and GG. His wife Mrs. Lilian Hamilton, a sculptress, also exhib. at RA from 1889.

HAMILTON, William E. fl.1874
Exhib. a painting of horses in 1874. London address.

HAMMERSLEY, James Astbury 1815-1869
Manchester landscape painter. Pupil of J.B. Pyne. Born in Burslem, Staffordshire. Lived mainly at Nottingham, where he was teacher in the local Art School. Exhib. at RA, 1846-8, BI and SS. Works are in the Manchester AG, and the Royal Collection. Hammersley's work, with its pale and delicate colouring, plainly shows the influence of Turner and Pyne. About 1848 he was commissioned by Prince Albert to paint his birthplace, Rosenau.
Bibl: DNB; Manchester AG Cat. 1910.

HAMMETT, A.A. fl.1865
Exhib. two landscapes in 1865. London address.

HAMMOND, Miss Christine M. Demain fl.1886-1893
Painted figurative subjects and genre. Exhib. six works, including 'A Blue Stocking' and 'Great Grandmother's Flirtation', at the RA, 1886-94. Also exhib. two works at SS, 1886-90, and nine works at the NWS. London address.

HAMMOND, Miss Gertrude E. Demain RI 1862-1953
Painted portraits and genre. Exhib. eight works, including works entitled 'Baffled' and 'A Reading from Plato' and portraits, at the RA, 1886-1903. Also exhib. three watercolours, including 'Rain, Rain Go Away. Come Again Another Day' and 'Il y a Toujours un Autre' at SS, 1887-9. London address.
Bibl: Sparrow.

HAMMOND, John Royal Canadian Academician fl.1886-1890
Exhib. four works, including 'Evening' and 'On the Seashore', at the RA, 1886-90. Address in New Brunswick.

HAMMOND, Thomas W. fl.1890
Exhib. at the RA from 1890. Titles include: 'Willows', 'Showery Weather' and 'After Rain', and views of the Yorkshire and Northumberland coast are recorded. Address in Nottingham.

HAMMOND-SPENCER, Miss Helen 1873-1955
Painted landscapes, coastal scenes and flowers. Born in Jersey, lived in London.

HAMPTON, Herbert 1862-1929
Painter and sculptor. Studied at Lambeth, Westminster, and the Slade, also in Paris. London address.
Bibl Studio XLIII 1908 p.313; Ormond.

HANBURY, Miss Ada fl.1875-1887
Painted flowers and, on occasions, fish. Exhib. five works at the RA, 1875-81, including 'Cod and Red Gurnet' and 'Japanese Lilies and Clematis'. Also exhib. once at SS, in 1877, and two works at the NWS. Address in Peckham, London.

HANBURY, Blanche fl.1876-1887
Painted landscapes and flowers in watercolour. Exhib. 11 works at SS, 1876-84, including 'Beech Glade in Knole Park', 'Chrysanthemums' and 'On the Avon'. Also exhib. two works at the RA, in 1881 and 1882, and two works at the NWS. London address.

HANCOCK, Albany 1806-1873
Drew and painted flowers, fruit and fish. He abandoned attempts to become a lawyer in favour of an interest in natural history. He was particularly interested in conchology and he became co-author and illustrator of a monograph on the subject. The Hancock Natural History Museum, in Newcastle-upon-Tyne, was named after him and his brother John Hancock (q.v.). Lived in Newcastle.
Bibl: Hall.

HANCOCK, C. fl.1873-1874
Exhib. three works at the RA, 1873-4, 'The Way to the Village', 'In the Path to the Warren' and 'Attack and Defence'. London address.

HANCOCK, C.S. fl.1869
Exhib. a work entitled 'The Mower' at the RA in 1869. London address.

HANCOCK, Charles 1795-1868
Sporting and animal painter; worked at Marlborough, Reading and Tattersall's in London. Exhib. at RA, 1819-47, BI, SS and NWS. Pictures usually small in scale, and of horses, dogs and sporting scenes. Also very occasional portraits and rustic genre scenes.
Bibl: BM Cat. of Engraved British Portraits.

HANCOCK, Miss E.J. fl.1876
Exhib. a painting entitled 'Azaleas' at SS in 1876. London address.

HANCOCK, H.F. fl.1880-1881
Exhib. three landscapes, 1880-1. London address.

HANCOCK, John 1808-1890
Taxidermist, painter and lithographer of natural history. He was the author of *Catalogue of the Birds of Northumberland and Durham*, published in 1874. The Hancock Natural History Museum in Newcastle-upon-Tyne was named after him and his brother Albany Hancock (q.v.). Lived in Newcastle.
Bibl: Hall.

HANCOCK, Miss Mildred L. fl.1890-1893
Exhib. a work, entitled ' " Tell Me What It's All About" ', at the RA in 1892. Exhib. another work, entitled 'Bridge of Sighs', at SS in 1892. Also exhib. once at the NWS.

HANCOCK, Samuel Harry d.1932
Painted landscapes and portraits. Founder and President of the Ilford Art Society. Lived in Ilford, Essex.

HANDLEY, J.W.H. fl.1827-1846
Exhib. at the RA, nine portraits and two coastal scenes, 1827-41. Also exhib. two works, the second a view of a fire in Bridge Town, Barbados, at SS in 1845 and 1846. London address.

HANDLEY-READ, Edward Harry RBA 1869-1935
Painted portraits and landscapes. Studied at Westminster and at the RA Schools. Painted in France and the Low Countries. Born in London. Lived at Storrington, Sussex.
Bibl: Studio LXVII p.124; LXVIII p.118; Special No., *The War*, p.41.

HANDS, A.W. fl.1871
Exhib. five works, all drawings of buildings or details of architecture in Venice, at the RA in 1871. London address.

HANDS, Miss Lydia fl.1874-1875
Exhib. two watercolours, including an interior view of Westminster Abbey, at SS in 1874-5 and 1875. London address.

HANDSWORTH, W.T.M. fl.1888
Exhib. a painting of shipping at the NWS in 1888. London address.

HANHART fl.1848
Exhib. a portrait at the RA in 1848.

HANHART, Henry A.F. fl.1875
Exhib. two watercolours, 'Hurdle-making' and 'Farm Yard — Feeding Ducks', at SS, in 1875 and 1876-7. London address.

HANHART, Michael fl.1870-1900
Painted landscape and rustic genre subjects. Exhib. 13 works, including 'Early Morning — Going to Work' and 'Evening on the Hills', at SS, 1871-83. Also exhib. five works, including 'The Village Post Office', at the RA, 1876-1900. London address.

HANKES, J.F. fl.1838-1859
London genre, historical and biblical painter. Exhib. at RA, 1838-59, BI and SS.

HANKINS, George fl.1879-1882
Painted landscape. Exhib. nine works, including views at Winchelsea and Broadstairs in Sussex and one entitled 'At Stamford Hill: Dust Heaps', at SS, 1879-82. London address.

HANLEY, Edgar fl.1878-1883
Painted portraits and genre subjects. Exhib. 22 works, including 'Where the Oranges Ripen', ' "Shy" ' and portraits, at the RA, 1878-83. Also exhib. five works, including 'Incident at the Carnival at Naples' at SS, 1878-81. London address.

HANN, Walter fl.1859-1904
Painted landscape and architecture. Also painted stage scenery. Exhib. seven works, including views in London and an interior of Rochester Castle, at SS, 1879-82. Exhib. three works, including 'Foul Play; Original Design for the River Scene in *Romany Rye*' at the RA, 1883-1904. London address.

HANNAFORD, Charles E. RBA 1863-1955
Painted watercolour landscapes. Studied in Paris and under Stanhope Forbes. Lived in London and Norfolk.

HANNAH, Robert 1812-1909
London historical and genre painter. Born Creetown, Kirkcudbright. Exhib at RA, 1842-70, BI and SS. Also exhib. in Liverpool and Rome. Titles: 'The New Frock', 'The Countess of Nithsdale Petitioning George I', 'Sisters of Charity', etc. Also painted portraits. Works are in the VAM, and Glasgow AG. Two works by him were in the collection of Charles Dickens.
Bibl: VAM 1907 Cat.; Glasgow AG Cat. 1911; Ormond.

HANNAY, E.W.D. fl.1874
Exhib. three genre paintings in 1874. Address in Dorking, Surrey.

HANNAY, Mrs. Elliot (Alice M.) fl.1877-1882
Exhib. six genre works, 1877-82. Address in Dorking, Surrey.

HANNAY, Walter fl.1843-1851
Exhib. a work, 'On the Shore at Cardiff', at SS in 1843. Exhib. a landscape in Kircudbrightshire at the BI in 1851. London address.

HANSARD, Miss Freda fl.1899
Exhib. at the RA trom 1899 including 'Medusa Turning a Shepherd into Stone' and 'Rival Charms'. London address.

HANSEN, Hans RSW 1853-1947
Painted landscapes and townscapes in Italy, Scotland, Scandinavia and Holland. Exhib. at the RA from 1876 including 'Entrance to Glasgow Station' and 'Evening — Dordrecht'. Also exhib. at SS, three works, 1892-4. Born and educated in Edinburgh. Address in Essex.

HANSEN, Theo Brooke fl.1896
Exhib. two works, 'Old Age' and 'Fatiguée', at the RA in 1896. London address.

HANSEN-BAY, Mrs. Celia b.1875
Painted portraits, landscapes and watercolours. Studied at the RCA. Born in London. Lived in Derbyshire.

HANSOM, J.T. fl.1869-1872
Exhib. two watercolours, 'In Cathedral, Noyon' and 'On the Coast', at SS in 1869 and 1872. London address.

HANSON, Albert J. fl.1892-1893
Painted landscape. Exhib. 15 works, the majority views in New South Wales, at SS, 1892-4. Also exhib. a view 'On the New South Wales Coast, near Sydney' at the RA in 1893. London address.
Bibl: Studio LXI pp.47, 50.

221

HANSON, J. fl.1853-1856
Exhib. two watercolour portraits at SS in 1856. London address.

HARBUTT, W. fl.1873-1874
Exhib. a watercolour, 'Jersey Hillside and Cottage', at SS, 1873-4.

***HARCOURT, George RA RP 1869-1947**
Scottish painter of portraits and figurative subjects. Studied under Herkomer. Exhib. at the RA from 1893 including 'Psyche "Farewell O Fairest Lord!" ' and 'Goodbye! The 3rd Battalion Grenadier Guards Leaving Waterloo Station, October 21st, 1899'. His portrait of Michael Faraday is in the collection of the Institution of Electrical Engineers. Born in Dumbartonshire. Lived at Bushey, Hertfordshire.
Bibl: Studio XXIV p.66; XLVII p.42; L p.l9; LXVIII p.l12; LXX p.160; Caw; Ormond.

HARCOURT, Mrs. George (Mary L.) fl. from 1899
Exhib. at the RA from 1899 including 'Early Spring' and 'Baby: A Portrait'. Wife of George Harcourt (q.v.). Address in Bushey, Hertfordshire.

HARDCASTLE, Miss Charlotte fl.1852-1866
Painted flowers and birds in watercolour. Exhib. 12 works, including 'From my Brother's Garden' and 'A Peep in A Wood', at SS, 1852-62. Exhib. nine works, including 'Snipes' and 'Dead Birds', at the RA, 1855-66. Also exhib. four works at the BI, 1857-65. London address.

HARDEN, Edmund Harris fl.1851-1880
London painter of historical and biblical genre. Exhib. mainly at SS 1851-80, also at RA 1851-9, and BI 1851-62. Works also include some pure genre scenes and studies of heads.
Bibl: Brook-Hart.

HARDESS, Miss Maria A. fl.1867-1869
Exhib. three works, including 'Holly-berries' and 'Fruit', at SS, 1867-9. London address.

HARDIE, Charles Martin RSA 1858-1916
Scottish painter of portraits, figurative subjects and landscapes. Studied at the RSA Life School in Edinburgh. Exhib. at the RA, 1885-1903, including 'A Country Dancing School', 'The Deaf Postillion' and portraits. Also exhib. once at the NWS. His nephew was Martin Hardie RI, the watercolourist and writer. Address in Edinburgh.
Bibl Caw; Hardie.

HARDING, Charles fl.1822-1847
Painted portraits and figurative subjects. Exhib. at the RA, 1822-47, including portraits of the Duke of Norfolk and the Hon. Daniel Webster of the United States Senate. Exhib. five works at SS, 1824-5, and three works, including 'A Sailor Singing at the Alehouse Door', at the BI, 1823-4. London address.
Bibl: Ormond

HARDING, Edward J. 1804-1870
Cork portrait painter, in oil, watercolour and pen and ink. Also a miniaturist.

HARDING, Frank fl.1885-1890
Exhib. five works, including 'A Game of Five Stones', 'Hide and Seek: The Chest' and 'An Interval for Refreshment', at SS, 1885-90. Address in Clapton.

HARDING, George Perfect fl.1802-1847 d.1853
Miniaturist and portrait copyist. Son of Sylvester Harding, 1745-1809. Exhib. at RA 1802-40. Painted series of portraits of Deans of Westminster, Princes of Wales, and many other historical portraits.

***HARDING, James Duffield OWS 1797-1863**
Landscape and topographical painter, mainly in watercolours, but also in oils; engraver and lithographer. Received 10 or 15 lessons in watercolours from S. Prout; in 1816 or 1818 gained the Society of Arts Medal for an original landscape. Apprenticed to John Pye, the engraver. Exhib. in London 1811-64, at the RA 1811-58, at BI, SS, OWS (143 works); became an A of the OWS in 1820; Member 1821; resigned in 1846 to become a candidate for the RA, as a painter in oil, but failed, and was re-elected, 1856. He was a small exhibitor as he spent much time in teaching lithography. He was a pioneer in the movement for art instruction in schools and for the training of art masters. Published many books on teaching drawing — all supporting direct observation of nature rather than tricks (for details of his publications see Roget II pp.178-87.) He taught Ruskin, among others, and when the first volume of *Modern Painters* appeared in 1843, many of Harding's old pupils recognised his lessons "on skies", "on water", "on mountains", etc., and especially his theory that tree-drawing should be based upon the laws of tree growth. Ruskin said that, next to Turner, Harding was "unquestionably the greatest master of foliage in Europe". Visited Italy, 1824; went frequently to the Continent after that date; visited Verona, Venice and Mantua with Ruskin in September 1845. His illustrations in the *Landscape Annual* (he supplied 24 lithographs for each of the three volumes, 1832-4, two dealing with Italy, one with France), made him one of the best-known artists of his day. His studio sales were held at Christie's, May 1864 and May 1865. For works illustrated by him, see Card Cat. at VAM.
Bibl: AJ 1864 p.39ff. (obit.); J. Ruskin, *Modern Painters*, Vols. I-V, 1843-60, Index, *passim;* Ottley; Redgrave, Cent.; Ruskin, Academy Notes 1875; VAM, *Universal Catalogue of Books on Art*, Supp. 1877; Redgrave, Dict.; The Portfolio 1880 pp.29ff.; J. Ruskin, *Praeterita*, 1885-9 II chp. VII; Roget I, II; Binyon; Cundall; DNB; Hughes; VAM; F.J. Nettlefold Collection Catalogues 1933-8; H. Lemaitre, *Le Paysage Anglais a l'Aquarelle*, 1760-1851, 1954; Hardie III pp.24-7 *passim (*pls. pp.32-4); Maas, p.55; Staley; Brook-Hart.

HARDING, Miss Mary E. fl.1880-1903
Painted flowers and figurative subjects. Exhib. 24 works, including 'Portrait of a Boy', 'An Old Irish Woman' and 'Foxgloves', at the RA, 1880-1903. London address.

HARDINGE, The Rt. Hon. Viscount 1822-1894
Painted landscapes, including various battlefields, and buildings. Exhib. 19 works, including 'Hever Castle', 'Mouth of the Seine near Havre' and 'Blenheim Park', at the RA, 1851-76. Exhib. 14 works, including views in the Crimea, at the BI, 1851-67. Also exhib. four works at SS, 1849-79. Born in London. Died at South Park, Penshurst.
Bibl: DNB II p.389; Ormond.

HARDMAN, Miss Minnie J. fl. from 1900
Exhib. at the RA from 1900, titles including 'Wilfred' and 'Hush-a-Bye'. Address in Northaw, Hertfordshire.

HARDMAN, Mrs. Thomas (Emma L.) fl.c.1885-c.1935
Painted landscapes and flowers. Exhib. seven works, including 'The Way Through the Salt Marshes' and 'A Bunch of Buttercups', at SS, 1889-93. Also exhib. five works, including 'When Other Flowers are Gone', at the RA, 1888-1903. Address in Potter's Bar, Hertfordshire.

HARDMAN, Thomas Hawthorn **fl.1885-1893**
Painted landscapes and rustic scenes. Exhib. 12 works, including
'A Wet October Day: The River Mole at Hertford' and 'In a
Hertfordshire Sheepfold', at SS, 1885-93. Also exhib. five works,
including 'The Life of the Fields' and 'Rabbiting', at the RA, 1889-
95. Address in Potter's Bar, Hertfordshire.

HARDS, Charles G. **fl.1883-1891**
Painted genre subjects. Exhib. nine works, including 'Bubbles' and
' "Do you Like Butter?" ' at the RA, 1886-9. Also exhib. three
works at SS, 1883-6, and four works at the NWS. London address.

HARDWICK, John Jessop **ARWS** **1832-1917**
Painter and watercolourist of fruit and flowers in the manner of
William Henry Hunt (q.v.). Like Hunt, he was praised and
encouraged by Ruskin. Worked as illustrator for *The Illustrated
London News* 1858. Exhib. at RA, SS, OWS (172 works) and GG.
Bibl: Studio LXX p.88 (obit.); Hardie III p.109 (pl. p.180).

HARDWICK, William Noble **RI** **1805-1865**
Painter and watercolourist of landscapes, usually on a small scale.
Exhib. mainly at NWS (member 1834), also RA 1830-58, BI and
SS. After 1838 lived in Bath.
Bibl VAM 1908 Cat II.

HARDY, Albert **fl.1865-1888**
Exhib. a work entitled 'Shanklin Chine, Isle of Wight' at SS, 1865.
Also exhib. two works at the NWS. London address.

HARDY, David **fl.1855-1870**
Painted rustic genre and country subjects. Exhib. 20 works,
including 'Return from Market', 'Rustic Courtship' and 'Waiting
for a Bite', at SS, 1862-70. Also exhib. six works 'The Reaper's
Luncheon' and 'The Last Drop', at the BI, 1855-65, and one work
at the RA, in 1855. Address in Bath.

HARDY, Mrs. Deric. **see SMALL, Miss Florence**

***HARDY, Dudley** **RBA** **1866-1922**
Painter, watercolourist and illustrator, born in Sheffield. Studied first
with his father T.B. Hardy (q.v.), then in Düsseldorf, Antwerp and
Paris. Began exhibiting at the RA in 1884, but his first notable
success was 'Tramps in Trafalgar Square at Dawn'. Hardy also
worked as an illustrator and cartoonist for many magazines,
including *The Pictorial World, The Lady's Pictorial, The Sketch,
Black and White*, etc. He did fashion drawings, and his cartoons of
cockney humour became widely popular. He also designed theatre
posters. In addition to all this, Hardy still found time to exhibit at the
RA, SS, NWS and GG. His output was varied, and included biblical
scenes, oriental views, landscape and seascape, and genre, in both oil
and watercolour. For works illustrated by, See Card Cat. at VAM.
Bibl AJ 1897 p.353-7; Studio XXX 1904 p.42ff.; XLVIII 1910 p.236; LVIII 1913
p.56, LXIX 1917 p.98, Fincham, *Art and Engraving of Britain*, 1897; Sketchley,
English Book Illustration, 1903 p.93; A.E. Johnson, *D. Hardy*, 1909; Who's Who
1914.
Exhib: London, 21 Haymarket 1892; Black and White Gallery 1901.

HARDY, F. **fl.1875**
Exhib. a genre subject at the RA in 1875. London address.

***HARDY, Frederick Daniel** **1826-1911**
Painter of genre scenes, especially interiors with children. Son of a
musician. Studied under Thomas Webster (q.v.). Exhib. at RA
1851-98, and BI 1851-6. Member of the Cranbrook Colony in Kent,

with Webster, A.E. Mulready, G.B. O'Neill and J.C. Horsley (all
q.v.). His studio was in Webster's house in Cranbrook. Like
Webster, Hardy painted humorous scenes of children, usually in
detailed Victorian interiors, but his range of subjects sometimes
included drawing-room scenes and portraits. He lived in Cranbrook
1854-75, and died there.
Bibl: AJ 1875 p.73ff. (biog. with pls.); Mag. of Art 1889; Ottley; DNB 2nd Supp.
1912; Reynolds, VS pp.54, 67 (pl.11); Reynolds, VP pp.36, 58 (pls. 28-9); Maas
p.234; Wood, Panorama; Cat. of Cranbrook Colony exhib., Wolverhampton AG,
1977; C. Neve, *Painters who went to the Weald* (F.D. Hardy and the Cranbrook
Colony), Country Life 24 March 1977; Wood, Paradise Lost.

HARDY, George **1822-1909**
Painter of figure subjects, especially domestic scenes with children.
Brother of F.D. Hardy (q.v.). Their subjects are similar, although
George's works tend to be smaller, and are often on panel. He
exhib. at RA 1846-92, BI and SS.

***HARDY, Heywood** **ARWS RPE** **1842-1933**
Painter and watercolourist of animals, sporting subjects, and genre.
Studied in Bristol, settled in London 1870. Exhib. at RA, BI, SS,
OWS, GG and NG. Some of Hardy's animal studies are very sensi-
tive, but he also painted genre pieces, in 18th century costume, often
of people riding. Collaborated with Frank Walton. Among his many
patrons were the Sitwells of Renishaw. Painted a series of religious
scenes of the life of Christ for Clymping Church, Sussex, 1909.
Bibl: AJ 1875 p.296; Portfolio 1881 p.57; 1885 pp.194ff.; Pavière, Sporting
Painters p.46 (pls. 19, 20); Wood, Paradise Lost.

HARDY, James, Snr. **1801-1879**
Painted portraits, and watercolour landscapes and townscapes.
Exhib. ten works, including a portrait of Lord George Lennox on a
favourite pony, and sketches in the Lake District and London, at the
RA, 1832-57. Exhib. ten works, including 'The Old Market Place,
Guernsey' and 'A Sketch of Hampstead', at SS, 1842-67. London
address.
Bibl: BM Cat. of Engraved British Portraits I pp.119, 293.

HARDY, James, Jnr. **RI** **1832-1889**
Bristol painter and watercolourist. Exhib. at RA 1862-86, BI, SS,
and NWS (Member 1877), subjects landscapes with rustic figures,
hunting scenes, and still-life. Now best known for his pictures of
dogs with game. Sales of his work were held at Christie's, March
1878, and after his death 4 April 1889.
Bibl: Cundall p.218; Pavière, Sporting Painters p.46 (pl. 21).

HARDY, John Forbes **fl.1847-1874**
Painted landscape and views of buildings. Exhib. 19 works,
including views in Avignon, North Wales and on the Rhine, at the
RA, 1847-60. Exhib. ten works, mostly landscapes, at the BI, 1847-67.
Also exhib. nine works, mostly views in Wales, at SS, 1847-63.
London address.

HARDY, Miss Margaret E. **fl.1893**
Exhib. a view of the studio of Thomas Webster, RA, at SS in
1893/4. Address in Sissinghurst, Kent.

HARDY, Miss Nina **fl.1890-1893**
Exhib. at the RA from 1891 including 'When the Cat's Away the
Mice Will Play' and portraits. Also exhib. at the NG and the GG.
London address.

HARDY, Norman H. **fl.1891-1900**
Exhib. at the RA including 'Solomon Island Head-Hunter', 'For the
Term of Their Natural Lives' and 'Robbery Under Arms', 1891-
1900. London address.

HARDY, Paul fl.1890
Exhib. two works, 'H.M. King Henry VIII visits Sir Thomas More at Chelsea' and another, at the RA in 1890 and 1899. Address in Bexley Heath.

***HARDY, Thomas Bush RBA 1842-1897**
Marine painter and watercolourist; born in Sheffield. Travelled in Holland and Italy. Exhib. at SS 1871-97 (elected RBA 1884), RA and NWS. Hardy's prolific coastal scenes, painted in fresh and vivid colours, achieved enormous popularity. His later work tended to become hasty and repetitive, which is perhaps why his reputation is much smaller today. His son Dudley Hardy (q.v.) was a painter and illustrator.
Bibl: Studio 1919, British Marine Painting, pp.30, 77; Bryan; Binyon; Cundall; VAM; Hardie III p.82 (pl. 107); Maas; Brook-Hart pls.85-6.

HARDY, W.H. fl.1868-1893
Exhib. three works, views in Surrey and Kent and on the Isle of Skye, at SS, 1868-93. Address in Finchley Common, near London.

HARDY, W.J. fl.1854-1856
Exhib. two watercolours, views of Newark Castle on the River Clyde and of Scarborough, at SS, in 1854 and 1856. London address.
Bibl: Binyon

HARDY, William Wells fl.1818-1856
Painted flowers, fruit and landscapes. Exhib. 14 works, including eight paintings of flowers and two landscapes in Surrey, at the RA 1818-56. Also exhib. one work a watercolour landscape, at SS in 1855. London address.

HARE, Augustus John Cuthbert 1834-1903
Although best-known as an author of biographies and guide books, Hare was also a competent watercolourist. His works are mostly topographical, and often used to illustrate his own books.
Bibl: A.J.C. Hare, The Story of My Life.
Exhib: London, Albany Gallery 1973.

HARE, G.W. fl.1846
Exhib. a work entitled 'Fisher Children' at SS in 1846. London address.

HARE, Julius RCA 1859-1932
Painted portraits and landscape. Studied at South Kensington and elsewhere. Exhib. two works, 'Day Fades and the Peasants Turn to Home' and 'The Last Bright Beams of Glorious Day', at the RA in 1887 and 1889. Exhib. one work in 1888-9. Born in Dublin. Lived at Conway, North Wales.

HARE, Miss Margaret Lily fl.1887
Exhib. one work, a painting of flowers, at the NWS in 1887. Address in Exeter, Devon.

HARE, St. George RI ROI 1857-1933
Painter of genre, portraits (particularly group portraits of children), historical pictures exploiting the nude, and fluffy Edwardian 'keepsake' beauties. Born and studied in Limerick under N.A. Brophy, the son of an Englishman; came to London in 1875 and entered the RCA. In 1882 and 1883 exhib. at the Dudley Gallery; 1883 and 1884 at SS, and in 1884 for the first time at the RA with 'The Little Mother'. In 1885 at the RA, 'Natural Instincts' (a study of a child before a looking glass), achieved immediate popularity. In 1890 at the RA he exhib. his first important painting of the nude — 'The Victory of Faith' (a white skinned girl and a young negress sleeping side by side in a cell below the arena). Other titles include 'The Death of Attila', 'Miserere Domine', and 'The Adieu'. He painted in oil, watercolour and pastel. A large group of his works is at Stourhead House, Wiltshire.
Bibl: AJ 1908 pp.345-9 (with pls.); Studio XXII 1901 p.45; XXXV 1905 p.68; XXXVIII 1906 p.15; XLIV 1908 p53; LXVI 1916 p.40; RA Pictures 1902-4-6-8 (pls.); Who Was Who 1929-40.

HARFORD, Alfred fl.1886
Exhib. a landscape in 1886. Address in Bristol.

HARFORD, W. fl.1874-1878
Exhib. eight watercolour landscapes, including views in Jersey, Northumberland and in the West Country. London address.

HARGITT, Edward RI 1835-1895
Scottish landscape painter, born in Edinburgh and a pupil of Horatio MacCulloch. He exhib. 1852-93, at the RA (1853-81), at BI, SS, NWS (255), and elsewhere. He was elected an associate of the RI in 1867 and member in 1871. Hardie thinks his 'Leixlip on the Liffey, Nr. Dublin' (VAM) extremely good — "like a Harpignies, it has breadth and subtle refinement in its low-toned scheme of grey and green." He was also well-known as an ornithologist.
Bibl: Ottley; Bryan; Binyon; Cundall; VAM; Hardie III 163 (pl. 190).

HARGRAVE, Frank H. fl.1880-1886
Exhib. two works, 'A Bridle-road near Knaresborough' and 'Autumn-tide', at the RA in 1885 and 1886. Address in Knaresborough, Yorkshire. Imitated the moonlight scenes of J. Atkinson Grimshaw (qq.v.). One of these, dated 1880, was in the Alexander Gallery's Grimshaw Exhibition in London 1976, catalogue no. 39 (Hargrave misspelt Hargreaves).

HARGRAVE, William Wallace fl.1859
Exhib. two landscapes in 1859. Address in York.

HARGREAVES, Henry fl.1883
Exhib. a work entitled 'A Bit of Devonshire' at SS in 1883. London address.

HARKE, Miss Evelyn fl.1899-1914
Exhib. two works including 'Two's Company, Three's None', at the RA in 1899. London address.

HARKER, Joseph Cunningham 1855-1927
Painted panoramic views. Worked in London, where he was apprenticed to T.W. Hall, a scene painter. Also worked in Glasgow. Dublin and the U.S.A. Member of the London Sketching Club.

HARLAND, T.W. fl.1832-1854
Painted portraits. Exhib. 17 portraits, including that of Mr. H. Holl, of the Haymarket Theatre, at the RA, 1882-54. London address.
Bibl: Ormond.

HARLEY, George 1791-1871
Drawing master. Worked in many parts of England; painted landscapes and views. Exhib. a watercolour of Rochester at SS in 1865. London address. His watercolour view of Fulham Church and Putney Old Bridge is in the VAM.
Bibl: DNB XXIV p.396; Binyon; VAM Cat.; Studio XLIX p.128.

HARLEY, Henry fl.1891
Exhib. a marine painting in 1891. London address.

HARLEY, Herbert E. fl.1884-1901
Painted figurative and genre subjects. Exhib. 12 works, including 'A bit of the British Museum' and 'The Lady of the Lake', at the RA, 1890-1901. Exhib. five works, including 'Remnants of the Estate' and 'Another Light on the Subject', at SS, 1884-7. London address.

HARLEY, R. fl.1856-1865
Exhib. three works, 'Devotion', 'The Seamstress' and 'A Study', at the RA, 1856-65. London address.

HARLEY, Vincent H. fl.1890-1891
Exhib. three genre works, 1890-1. London address.

HARLIN, Miss Kate fl.1888
Exhib. a work entitled 'A City Maiden' at the RA in 1888. Address in Birmingham.

HARLING, William Owen fl.1849-1878
Painted portraits and figurative subjects. Exhib. 27 works, including 11 portraits and works entitled 'A Monk's Parlour, Bay of Naples' and 'Choir Practice', at the RA, 1849-77. Exhib. four works, including 'Bunyan in Prison' and 'A Brown Study', at the BI, 1861-5, and two works at SS, 1878-9. Lived in Chester, Cheshire.
Bibl: AJ 1876 p.287

HARLOWE, G. fl.1841
Exhib. a painting entitled 'A Monk' at the RA in 1841.

HARMAN, Ruth fl.1887
Exhib. a watercolour entitled 'Their Last Resting Place' at SS in 1887-8. London address.

HARMAR, Fairlie NEAC 1876-1945
(Viscountess Harberton)
Painted portraits, figurative subjects and landscapes. Studied at the Slade School. Born in Weymouth. Lived in London.
Exhib: London, Leger Gallery 1938; 1945; Royal Society of British Artists 1949.

HARMS, Miss Edith M. fl.1900
Exhib. a painting entitled 'A Halt by the Wayside' at the RA in 1900. Address in Horsham, Surrey.

HARMSWORTH, J. fl.1861-1879
Exhib. four works, including 'Departure of the Great Eastern from Deptford' and 'Lambeth Church Palace', at SS, 1861-79. London address.

HARPER, Miss Cecily T. fl.1886-1896
Painted churches. Exhib. six works, including views of St. Saviour's, Southwark, St. Bartholomew-the-Great, West Smithfield, and Westminster Abbey, at SS, 1886-94. Exhib. two views in Westminster Abbey at the RA in 1891 and 1896. London address.

HARPER, Claudius fl.1882-1898
Painted views of ancient buildings. Exhib. five works including 'Alkestis — A Fragment from one of the Columns of the Temple of Artemis at Ephesus' at the RA, 1883-98. Also exhib. five works at the NG. London address.

HARPER, E. fl.1859-1860
Exhib. three works, including 'A Dutchman in Difficulty' and 'A Mill on the Lancashire Coast', at the BI in 1859-60. Address in York.

HARPER, Edward Steel, Snr. RBSA b.1854 fl.1880-1919
Painted figurative subjects, genre and landscape. Exhib. 16 works, including 'The Missing Boat in Sight' and 'Great Expectations' at the RA, 1885-1901. Also exhib. once at the NWS and at exhibitions in the Midlands. Taught at Birmingham School of Art, and was art critic for the *Birmingham Post*. Father of E.S. Harper, Jnr. (q.v.).

HARPER, Edward Steel, Jnr. 1878-1951
Birmingham landscape painter. Son of E.S. Harper (q.v.). Art Master at Wolverhampton Grammar School. Exhib. mainly at RBSA.

HARPER, F.G. fl.1884-1885
Exhib. a watercolour of flowers at SS in 1884-5. London address.

HARPER, Gertrude fl.1889
Exhib. a watercolour of daisies and dahlias at SS in 1886-7. London address.

HARPER, H.C. fl.1876-1881
Exhib. four portraits, 1876-81. London address.

HARPER, Henry Andrew 1835-1900
London landscape and genre painter who exhib. 1858-93, at the RA 1865-88, at SS, NWS, GG, and elsewhere. From 1873 onwards he began to exhib. landscapes of views in Jerusalem, Mount Sinai, Dead Sea, and Cairo. Two of his watercolours are in the Wallace Collection. Agnews held an exhibition of his Near Eastern views in 1872.
Bibl: Wallace Collection Cat. 1908.

HARPER, J.R. fl.1877
Exhib. a work entitled 'Weariness' at the RA in 1877. London address.

HARPER, Thomas fl.1836-1875
Exhib. four works, all marines or coastal landscapes off Northumberland, at SS, 1856-75. Also exhib. two Northumbrian landscapes at the RA in 1840. Address in Newcastle-upon-Tyne, Northumberland. Represented in the Laing AG, Newcastle.
Bibl: Hall.

HARRADEN, Richard Bankes 1778-1862
Son of the Cambridge painter Richard Harraden (1756-1838), with whom he collaborated on views in and around Cambridge, and topographical prints. Member of the RBA, 1824-49.

HARRAND, Miss Lucie fl.1900
Exhib. a painting entitled 'My Sister' at the RA in 1900. London address.

HARRIETT, Miss fl.1853
Exhib. a sketch at the RA in 1853. London address.

HARRINGTON, A. fl.1871-1875
Painted marines and views on the Thames. Exhib. 11 works at SS, 1871-5, including 'Fishing Boats on Hastings Beach', 'Mackerel Fishing' and 'A Summer's Night on the Thames, near Twickenham'. London address.
Bibl: Brook-Hart.

HARRINGTON, Charles 1865-1943
Sussex landscape painter in the Cox-Collier tradition. His work is in the VAM, Hove, Eastbourne and other museums.
Exhib: London, Walker's Gallery 1954.

HARRINGTON, E. fl.1876
Exhib. a landscape in 1876. Address in Burnham, Buckinghamshire.

HARRIOTT, W.H. RBA fl.1811-1837
Watercolourist who painted landscape and views of buildings. Pupil of Samuel Prout. Exhib. 42 works at SS, 1824-37, including views in Italy, Switzerland and France. Also exhib. 11 works at the BI, 1821-7, and four works at the RA, 1811-37. London address.
Bibl: Portfolio 1897 p.78; Binyon 1900.

HARRIS, Mrs. fl.1847-1872
(Miss Frances Rosenberg)
Exhib. three works, 'Imogen Sleeping', 'The Careful Mother' and 'Idle Thoughts' at the RA in 1848. Exhib. 139 works at the NWS. London address. See also Frances Rosenberg.

HARRIS, Mrs. A. fl.1878
Exhib. a genre subject in 1878. Address in Kirkby Lonsdale, Westmorland.

HARRIS, Alfred, Jnr. fl.1865-1868
Exhib. five landscapes, 1865-8. Address in Bingley, Yorkshire.

HARRIS, Lady Alice fl.1893
Exhib. a work entitled 'The Mountain Witch' at the RA in 1893. Address in Ascot, Berkshire.

HARRIS, Arthur fl.1892
Exhib. a work entitled 'St. Andrew's from Tent's Muir' at the RA in 1892. Address in Newport-on-Tay, Fife.

HARRIS, Edwin RBSA 1855-1906
Painted portraits, genre, figurative subjects and coastal scenes. Exhib. 13 works, including 'The Wood Cutter's Daughter', 'A Village Idyll' and 'Between "Yes" and "No" ' at the RA, 1882-1904. Also exhib. a landscape at SS in 1891. Lived in Birmingham, and later at Newlyn, Cornwall.

HARRIS, Frederick fl.1881-1892
Exhib. two works, 'The Lady Shrine, Lincoln Cathedral' and 'Dessert', at the RA in 1881 and 1892. Addresses in Lincoln and Stafford.

HARRIS, Frederick G. fl.1868
Exhib. three watercolours, 'The Corner of the Wood', 'Feeding Ducks' and 'The Stile', at SS in 1868. London address.

HARRIS, George fl.1858-1881
Painted portraits and genre. Exhib. six works, including three portraits and works entitled 'Thinking of Home' and 'The Corsair Chief', at the RA, 1858-81. Also exhib. three works at SS, 1858-60. Address in Foots Cray.

HARRIS, George Walter fl.1864-1893
Painter of fruit who exhib. at the RA 1864-93, at SS, and elsewhere.
Bibl: Guildhall Cat.

HARRIS, Henry Alfred b.1871
Painted landscape and figurative subjects. Studied at Hammersmith School of Art. Lived in London.

HARRIS, Henry Hotham RBSA b.c.1805 d.1865
Painted landscapes. Also a lithographer. Exhib. 16 works, including watercolour views in Cornwall, Wales and Yorkshire, at SS, 1826-77. Exhib. five works at the RA, 1826-40, and five works at the BI, 1827-52. He lived in Birmingham and was a member of the Birmingham Society of Artists; Secretary 1852-9.

HARRIS, Miss Isabella M. fl. from 1898
Exhib. two flower paintings, 'Poppies' and 'Rhododendrons', at the RA in 1898 and 1903. Address in St. Alban's, Hertfordshire.

HARRIS, James 1810-1887
Swansea marine painter. Exhib. at BI and SS. His painting, 'Wreck on the Mumbles', is in the Norwich Museum.
Bibl: Wilson p.40 (pl.15); Brook-Hart.

HARRIS, Sir James C. HRI 1831-1904
Exhib. a view of the Valley of Lauterbrunner and the Jungfrau at the RA in 1883. Lived in Nice, France.

HARRIS, John, II 1791-1873
Painted portraits and figurative subjects. Also a lithographer. Exhib. 15 works, including portraits and works entitled 'The Vows to Which her Lips had Sworn Assent' and 'Long Did She Gaze and Silently upon the Slumbering Maid', at the RA, 1822-51. Also exhib. four works at SS, 1845-8, and four works at the BI, 1845-59. His father John Harris I was also a painter. Lived in London.
Bibl: DNB XXV; BM Cat. of Engraved British Portraits 1908, 1910, 1912, 1914; Times Literary Supplement 23 January 1919.

HARRIS, Maude E. fl.1883-1892
Exhib. two watercolours, 'Fungi' and 'Orchid, Trichopilia Suavis', at SS in 1883 and 1884. Also exhib. once at the NWS. London address.

HARRIS, Miss Maude M. fl.1890
Exhib. a work entitled 'A Summer Morning: Trawlers at Anchor' at SS in 1890. London address.

HARRIS, Robert 1849-1919
Painted figurative subjects. Studied under Legros in London and von Bonnat in Paris. Exhib. two works, 'A Quiet Corner for Work' and 'Harmony', at SS in 1882-3 and 1887. Exhib. once, a work entitled 'Head of a Monk', at the RA in 1883. Born in Caernarvon. Lived in Montreal, Canada. He was President of the Royal Canadian Academy. His painting 'The Fathers of the Confederation' is in the NG, Ottawa.
Bibl: American Art Annual I 1898; Studio LXX p.39; Ottawa, National Gallery of Canada, *Where are These Works by Robert Harris?*, 1973.
Exhib: Ottawa, National Gallery of Canada 1973-4.

HARRIS, William E. fl.1883-1891
Exhib. three works, all views in North Wales, at SS, 1883-4. Exhib. three works, 'Harvest Time, Boveney Lock, on the Thames', 'Welsh Meadow Weeds' and 'A Rick Yard — Dorney Court Farm, near Eton', at the RA, 1889-91. Lived in Birmingham.

HARRISON, Alexander ROI fl.1885-1896
Exhib. four works, including 'Moonrise', 'A Rainy Street' and 'The Great Mirror', at the RA, 1888-96. Exhib. three works, including 'Study: Bathing Scene' and 'Surf' at SS, 1885-8. Address in Paris.

HARRISON, Miss Anna Maria fl.1846
Exhib. a painting of a glass of flowers at the RA in 1846. London address.

HARRISON, Arthur RBSA d.1922
Painted architectural subjects. Lived at Moseley, Birmingham.

HARRISON, Bernard fl. from 1893
Landscape painter. Exhib. in Paris from 1893. Born in London. Lived in Paris. Son of the painter Frederick Harrison (q.v.).
Bibl: Daily Telegraph 11 February 1910; Studio LIII 1911 p.154; American Art News XX 1922 p.7.
Exhib: London, Cooling Gallery 1937.

HARRISON, Brook fl.1885
Exhib. a work entitled 'Newhaven' at SS in 1885. Address in Shoreham, Kent.

HARRISON, Charles Harmony 1842-1902
Painted the landscape of the Norfolk Broads in watercolour. Exhib. two drawings at the NWS, but mostly exhib. in Norfolk. He painted from a houseboat which he shared with his friend S.J. Batchelder (q.v.) Born in Great Yarmouth. Lived in Norfolk.
Bibl: A.H. Patterson and C.H. Smith. *Charles H. Harrison,* 1903; Country Life CLVII March 1975.

HARRISON, Darent fl.1897-1900
Exhib. three portraits and a view in Montreuil-sur-Mer at the RA, 1897-1900. London address.

HARRISON, Miss Emily H. fl.1892-1893
Exhib. two paintings of flowers, 1892-3. London address.

HARRISON, Miss Emily M. fl.1870-1871
Exhib. two views of sea shores, 1870-1. London address.

HARRISON, Miss Emma Florence fl.1887-1891
Exhib. three works, 'Bank's Alley, Tewkesbury', ' "Where Now Should Such a Child be Sought" ' and 'Bahdie' at the RA, 1887-91. London address.

HARRISON, F.E. fl.1862-1867
Exhib. three works, entitled 'Strawberries', 'Geraniums' and 'Spring Flower', at the RA, 1862-7. London address.

HARRISON, Miss Fanny fl.1870-1871
Exhib. a watercolour of blackberries at SS in 1871. London address.

HARRISON, Frederick fl.1846-1878
Exhib. five works, including 'Marlborough College' and 'Pip, Joe and the Convicts Crossing the Marshes' (from *Great Expectations),* at the BI, 1846-63. Exhib. five works, including 'Volunteers Returning from Firing' and 'Confederate Cavalry in a Foray', at the RA, 1861-7. London address. His son, Bernard Harrison (q.v.) lived and worked in Paris.

HARRISON, G.J. fl.1875-1876
Exhib. two works, views in Lynton, Devon, at SS in 1875-6. London address.

HARRISON, George RCA fl.1867-1880
Painted landscape. Exhib. eight works, mostly watercolours of North Wales, at SS, 1867-80. Address in Betws-y-Coed, Caernarvonshire.

HARRISON, Mrs. George fl.1886
Exhib. a study at the GG in 1886. London address.

HARRISON, George Henry AOWS 1816-1846
Landscape and genre painter. Born in Liverpool where his mother Mary P. Harrison (q.v.) was a flower painter. They moved to Denbighshire and then, when he was 14, Harrison came to London. He started by making anatomical and other medical drawings, and in studying anatomy at the Hunterian School in Windmill Street. Later Constable became his friend and continually encouraged him to study nature. He specialised in landscape, often with luxuriant foliage, and practising as a teacher, he always preferred to teach in the open air. He exhib. at the RA 1840-6, and also at BI, SS and OWS. Titles at RA include 'The Days when we went Gypsying', 'The First Born', 'Lane Scene', etc.
Bibl: AU 1847 p.44 (obit.); Clayton I pp.411-3; American Art Review II fig. 1 1881 p.174; Roget; Bryan; VAM Cat. II 1908; BM Cat. of Engraved British Portraits II 1910 p.10; Ormond.

HARRISON, George L. fl.1878-1904
Painted genre and rustic scenes. Exhib. at the RA from 1882 including 'Disturbed', 'Going to Pasture' and 'After a Long Day's Work'. Also exhib. two works at SS, ' "What A Day We're Having" ' and 'Innocents Abroad', 1881-2 and 1888-4. London address.

HARRISON, Gerald E. fl.1890-1892
Painted portraits and figurative subjects. Exhib. two works, 'The Sparrowhawk' and ' "Them's My Sentiments" ' at SS in 1890 and 1892 . Lived in Brighton, Sussex.

HARRISON, Harriet
Flower painter. Daughter of Mary P. Harrison and sister of G.H. Harrison (qq.v.). Hon. Member of the Society of Female Artists.

HARRISON, Henry fl.1867
Exhib. one landscape in 1867. Address in Plaistow.

HARRISON, J. fl.1827-1865
Painted portraits and views of buildings. Exhib. at the RA. London address.

HARRISON, J. fl.1845-1865
Little-known York portrait painter and miniaturist. Exhib. a few pictures at the RA between 1846 and 1856, but worked mostly in the north. A portrait of a girl dated 1845, sold by Christie's, 11 July 1969, shows him to be an artist of considerable charm and talent.

HARRISON, J.B. fl.1867-1872
Exhib. four portraits, including one of the Bishop of Hereford at the RA, 1867-72. Made a portrait drawing of David Livingstone. London address.
Bibl: Ormond.

HARRISON, J.C. fl.1882-1891
Painted genre and coastal subjects in watercolour. Exhib. 13 works, including 'Mending Nets', 'Toiler of the Sea' and 'Domestic Duties'. Also exhib. two works at the RA, 1883 and 1884, and 14 works at the NWS. London address.

HARRISON, John fl.1801-1852
Painter of portraits and buildings as well as mythological, genre and figurative subjects. Exhib. at the BI, 1808-52, including 'The Toilet Deranged, or Infant Vanity', 'The Age of Innocence' and 'A Rose

of York'. Exhib. at SS, 1827-50, including views of Canterbury and portraits. Supposedly exhib. 40 works at the RA. London address.

Bibl: BM Cat. of Engraved British Portraits I; Hardie III.

HARRISON, Joseph S. fl.1889-1893
Exhib. two works, 'The Warren, Chailey' and 'The Upper Street, Shere', at the RA in 1889 and 1892. London address.

HARRISON, Lawrence Alexander 1867-1937
Painted portraits. Exhib. in public very rarely. Lived in London.

HARRISON, M. fl.1858
Exhib. a painting entitled 'A Peep into the Wood' at the RA in 1858. London address.

HARRISON, M.E. fl.1875
Exhib. a painting of flowers in 1875. London address.

HARRISON, Miss Margaret S. fl.1894
Exhib. a work entitled 'Latent Possibilities' at the RA in 1894. Address in Lee.

HARRISON, Miss Maria ARWS fl.1845-1893
Painted fruit and flowers. Exhib. 439 works at the NWS. Exhib. nine works, including five paintings of fruit and flowers and views of Lake Windermere, at SS, 1848-59. Exhib. seven works, including ' "O Flower de Luce, Bloom On" ' and 'A Basket of Old-Fashioned Cabbage Roses'. London address. She was a member of the Harrison family of painters, a sister of George Henry Harrison (q.v.).

Bibl: See under George Henry Harrison.

HARRISON, Mrs. Mary P. 1788-1875
(Miss Mary P. Rossiter)
Fruit and flower painter, "one of the most graceful of modern times" (Clayton). Born in Liverpool; married in 1814; her husband lost most of his money 15 years later, and with 12 children to support, she turned to painting. Moved to London where she joined some friends in establishing a new Society of Painters in Watercolours (the Institute) of which she remained a member till her death. In France, during the reign of Louis Philippe, when she met George Sand and many celebrities, she was much sought after and called the 'Rose and Primrose' painter. In 1862 she painted 'The History of a Primrose', in three compartments: 'Infancy', 'Second Maturity' and 'Decay'. Exhib. 1833-75, at the RA, BI, SS and NWS (322 works). Two of her paintings are in the Walker AG, Liverpool, and in her lifetime two of her works were purchased by the Queen. Her four children, William Frederick, George Henry, Maria and Harriet, were also painters (all q.v.).

Bibl: See under George Henry Harrison.

HARRISON, Miss Sarah Cecilia b.1863 fl.1889-1902
Painted portraits. Studied at the Slade School under Legros. Exhib. 11 works at the RA, 1889-1902, and once at the NG. Born in County Down, Ireland. Lived in Dublin.

Bibl: Studio XXXVII 1906 p.352; LXIV p.288; LXV p.281.

HARRISON, Miss Theodora fl.1890-1894
Exhib. two works, 'Green and Grey' and 'A Street in St. Ives' at SS in 1890 and 1893-4, and a work entitled 'Dawn' at the RA in 1890. London address.

HARRISON, Thomas Erat fl.1875-1895
Painted figurative works. Also a sculptor. Exhib. 15 works, including sculpture and book-plates and paintings entitled 'Alecto' and 'The Sorceress', at the RA, 1875-95. London address.

Bibl: Fincham, Art and Engraving etc. of Book-plates, 1897.

HARRISON, William A.D. fl.1896
Exhib. two portraits of girls at the RA in 1896. London address.

HARRISON, William Frederick 1814-1880
Eldest son of the flower painter Mary P. Harrison (q.v.). Lived near Fishguard in South Wales. Worked in a bank, and exhib. marine subjects at RA, Dudley Gallery and elsewhere.

Bibl: See under George Henry Harrison.

HARROWAY, Henry G. fl.1889
Exhib. two works, 'Pinner Church' and 'A Bend in the Stream', at SS in 1889. London address.

HART, Mrs. Anne E. fl.1886-1887
Exhib. a painting entitled ' "Only a Face at the Window" ' at the RA in 1887. Also exhib. two works at the NWS. Address in Anerley.

HART, Conway Weston fl.1849
Exhib. a work entitled 'The Little Fife-player' at the BI in 1849. London address.

HART, Miss Elizabeth fl. from 1898
Exhib. two works, 'A Pastoral' and 'Rough Pasture', at the RA in 1898 and 1899. Address in Bushey, Hertfordshire.

HART, H. fl.1841-1846
Exhib. three works, including 'The Antiquary's Visit to Edie Ochiltree in Prison', at SS, 1845-6, and two works, including an interior view of the Basilica San Lorenzo in Rome, at the RA, 1841-3. London address.

HART, Herman fl.1877-1883
Exhib. three works at SS, 1879-84, including 'Rosamund's Bower: Westerhanger, Kent' and two other views in Kent. London address.

HART, Horace S. fl.1887-1889
Exhib. two works, 'Study of a Dutch Peasant' and 'Sunday Afternoon in Holland', at the RA in 1887, and two works at SS, 1888 and 1889. London address.

HART, J. Lawrence fl.1887-1890 d.1907
Exhib. a work entitled 'The Golden Fringe on the Moors' at SS in 1890. Address in Rugby, Warwickshire. Later became a hermit at Morfa Nevin.

HART, James Turpin 1835-1899
Painted genre and rustic scenes. Studied at Nottingham Art School. Exhib. 12 works at the BI, 1856-66, including 'Gleaner's Pastime', 'Going to School in a Fog' and 'The Hay Field'. Also exhib. four works at the RA, 1856-62, and one at SS in 1864. Stylistically close to Mulready. Lived in Nottingham where he taught at the Art School. Represented in the Nottingham AG.

Bibl: Nottingham AG Cat. 1913 p.60.

HART, Mrs. P. fl.1881
Exhib. a figurative painting in 1881. London address.

***HART, Solomon Alexander RA 1806-1881**
Painter of historical and biblical genre, and portraits. Born in Plymouth. Came to London in 1820 with his father, a Jewish goldsmith. At first a miniaturist, then began to exhib. paintings at the BI and SS. Encouraged by success, Hart went on to paint many large and ambitious historical canvases. Many of his works were

painted on a huge scale, which partly accounts for the neglect into which they have now fallen. He also painted many official portraits, and views of Italian churches. Exhib. at RA, 1826-81, BI and SS. Elected ARA 1836, RA 1840. In 1855 he succeeded Leslie as teacher of painting at the RA Schools, and later became Librarian. After his death two sales of his works were held at Christie's, 29 July 1881, and 2 August 1881.

Bibl: AJ 1881 p.223; Studio 1916, Shakespeare in Pictorial Art, Spring Number; Ottley; Ruskin, Academy Notes 1857, 1858; A. Brodie, *Reminiscences of A.S. Hart RA*, 1882; G. Pycroft, *Art in Devonshire*, 1883; Cundall p.219; Ormond.

HART, Thomas FSA fl.1865-1880 d.1886
Painted marines and coastal views in watercolour. Exhib. three works, including 'Shipwrecked Mariners Watching the Breaking Up of Their Vessel by the Flowing Tide' and 'Carting Seaweed at Polpier, Lizard', at the RA, 1872-3. Also exhib. two works at the GG. Address Lizard, Cornwall.

Bibl: Brook-Hart pl.198.

HART, W. fl.1845
Exhib. an historical painting in 1845. London address.

HARTE, Miss Margaret K. fl.1879-1889
Exhib. three works, entitled 'Child and Goat', 'Little Rudy' and 'Die Grossmutter', at the RA, 1879-89. Address in Blandford, Dorset.

HARTLAND, Henry Albert 1840-1893
Irish landscape watercolourist. Self-taught. Exhib. 21 works, including views in Connemara, King's County and County Mayo, and works entitled 'Mountain and Lake in Ireland' and 'The Brown Bog of Allen', at the RA, 1869-89. Exhib. 13 works, views in Ireland and Wales, at SS, 1868-89. Address in Cork. Died in Liverpool.

Bibl: Bryan III; Strickland.

HARTLEY, Alfred RBA ARPE 1855-1933
Painter of landscape and genre, etcher, in line and aquatint, and portrait painter of considerable success. Pupil of Sir Frank Short and C.J. Watson, etcher; studied at South Kensington Art Schools and at Professor Brown's class at Westminster Art School, with Frampton and Anning Bell as fellow pupils. Exhib. from 1885 onwards at the RA, SS, NWS, GG, NG and elsewhere. Between 1889 and 1899 he painted many notable portraits, amongst them portraits of Lord Randolph Churchill, Lord Russell of Killowen and the Prime Minister. Titles at RA include: 'Spring', 'Maternity', 'Hen and Chicks', 'Wayfarers', 'Twilight'; he also did decorative paintings, e.g. Studio, 1901, 'A Decorative Panel for a Rosewood Piano, a Pastoral Scene'.

Bibl: Studio XXIII p.22; XXVIII p.61; LXIV 1915 p.99ff.; LXVII pp.115, 252; LXX 1917 pp.55, 111; Special Numbers; Art in 1898; Summer Number 1902; Die Graph, Kste XXI 1898 p.48ff.; Cat. exhib. Carnegie Institute, Pittsburgh 1907, 1911-13; Holme, *Modern Etching*, 1913; Salaman, *Modern Woodcuts*, 1919. Exhib: London, Colnaghi's 1935.

HARTLEY, Mrs. Alfred (Nora) fl. from 1897
Exhib. at the RA from 1897 including 'A Mother of Eight' and 'Windfalls'. London address.

HARTLEY, Miss E.A. fl.1871
Exhib. a painting of fruit at the RA in 1871. Address in Boston, Lincolnshire.

HARTLEY, Richard fl.1890 d.1921
Painted landscape. Exhib. three works, 'A Yorkshire Moor', 'The Stream Through the Meadow' and 'The Calm Before the Storm', at

the RA, 1890-2. Lived in Liverpool. He was a member of the Liverpool Academy of Arts.

Bibl Studio XLII 1908 p.148; The Year's Art 1922 p.312.

HARTLEY, Thomas fl.1820-1860
Painter of genre and portraits who exhib. from 1820-60, at the RA 1821-59, at the BI, SS and OWS. Titles at RA include 'Portrait of a Lady', 'A Girl at Embroidery', 'Memory, Thy Pleasure Most We Feel when Most Alone'. In the BM is an engraving of a portrait of William Lockwood (engr. 1836).

Bibl: BM Cat. of Engraved British Portraits III 1912 p.82.

HARTMANN, Christian fl.1847
Exhib. a work entitled 'A Charitable Action; Sketched from Nature' at the RA in 1847. London address.

HARTMANN, Karl 1818-1857
Painted two watercolour portraits of Jane Carlyle. These are now in Carlyle's House, London.

Bibl: Ormond.

HARTNELL, Nathaniel fl.1829-1864
Painted figurative works and landscape. Also a lithographer. Exhib. ten works, including 'A Boy Doing His Studies' and 'A View near Ewell', at SS, 1831-56, and ten works, including ' "Why are you Wandering Here, Fair Maid? The Sage Looked Grave, the Maiden Glum" ' at the RA, 1831-53. London address.

HARTRICK, Archibald Standish RWS NEAC 1864/5-1950
Scottish painter and lithographer of figurative subjects and landscapes. Studied at the Slade School, 1884-5, and in Paris under Boulanger and Cormon. Exhib. two works, 'November in Finisterre' and 'A Cork Cutter', at SS, 1887-8, and seven works, including 'The Undiscovered Country' and 'Suburban Spring', at the RA, 1892-9. Met Gauguin at Pont-Aven in 1886. He was on the staff of various newspapers from 1890. Born in India. He was educated in Scotland and lived in Gloucestershire and London.

Bibl: Studio XLIV p.140; LXI pp.6, 13; LXVII p.184; Special Numbers 1898, 1900-1, 1917, 1919; R.E.D. Sketchley, *English Book Illustration of Today*, 1903; Caw; Who's Who 1922; Apollo XXIV 1936; A.S. Hartrick, A *Painter's Pilgrimage Through Fifty Years*, 1939. Exhib: London, Rembrandt Gallery 1938; Great Britain Arts Council 1951.

HARTRY, E. fl.1883-1888
Exhib. a painting entitled 'Net Menders: Finisterre' at SS at 1883-4. Address in Southampton, Hampshire.

HARVEY, Douglas S. fl.1859
Exhib. a work entitled 'The High Tor, Matlock' at the BI in 1859. London address.

HARVEY, E. fl.1859
Exhib. a work entitled 'A By-way' at the BI in 1859, and another entitled 'After the Brawl' at SS in 1859. London address.

HARVEY, George ANA 1800-1878
An associate of the National Academy of America, but born in England. Painted portraits, landscapes, flowers and miniatures, exhibiting at the RA, 1832-78, and SS, 1869-77. Titles include: 'Wise and Foolish Builders', 'Gleaning near Sittingbourne, Kent', and river scenes on the Thames. London address.

***HARVEY, Sir George PRSA 1806-1876**
Scottish painter of genre, scenes of Scottish history, and landscape. Studied at Trustees' Academy in Edinburgh (1823) under Sir

William Allan. Elected ARSA 1826, RSA 1829. Harvey established his reputation with a number of patriotic scenes from Scottish history, which appealed to the taste of the day. Many of them depicted scenes during the Covenant period. Owing to his use of bitumen, many of these works are now obscured. When painting genre, observing the everyday life of the people, Harvey's work could be much more spontaneous and charming. He was also a masterful painter of Scottish landscape — "he realized the pensive charm and pastoral melancholy of the Highland straths and the Lowland hills with an insight and sympathy which make recollection of his landscapes a precious possession" (Caw). On the death of Sir John Watson Gordon (q.v.) elected PRSA, knighted 1867. Exhib. at RA, BI and SS, but mostly at Scottish Academy.

Bibl: AJ 1850 p.341; 1858 pp.73-5; 1876 (obit.); 1904 p.392; Portfolio 1887 p.152; A.L. Simpson, *Harvey's Celebrated Paintings*, 1870; Redgrave, Dict; W.D. McKay, *The Scottish School of Painting*, 1906; Caw see index (pl. opp. p.150); DNB XXV; Ormond; Irwin pl.149.

HARVEY, Miss H.M. fl.1886
Exhib. a still-life at SS in 1886. London address.

HARVEY, Harold C. 1874-1921
Painted landscape and portraits. Studied in Paris at the Académie Julian under Constant and J.-P. Laurens. Exhib. at the RA from 1898 including 'In a Cornish Cottage' and 'The Milkmaid'. Lived at Newlyn, Cornwall.

Bibl: Studio XLVII 1909 pp.116, 117; LXXXIV 1922 p.54; Wood, Paradise Lost.

HARVEY, J.K. fl.1858
Exhib. a painting of flowers at the RA in 1858. London address.

HARVEY, John Rathbone RBSA d.1933
Painted portraits, genre and pastoral subjects. Studied at the Slade School. Lived in Birmingham.

HARVEY, William 1796-1866
An illustrator who also painted in oil and watercolour. He was apprenticed to Thomas Bewick, and in 1817 he moved from Newcastle-upon-Tyne, the place of his birth, to London, to study under Benjamin Robert Haydon and Sir Charles Bell. His fellow student was Edwin Landseer. Died in Richmond, Surrey. For works illustrated and engraved by, see Card Cats. at the VAM.

Bibl: AJ 1866 p.89; Redgrave, Dict.; DNB XXV; Burlington Mag. II 1903 pp.298, 306; BM Cat. of Engraved British Portraits II 1910; Hall.

HARVEYMORE, A. fl.1868
Exhib. a view of 'The Point, near Walton-on-the-Naze', at the RA, in 1868. London address.

HARWOOD, Edward b.1814 fl.1844-1872
Irish painter of genre and historical subjects. Elder brother of J.J. Harwood (q.v.). Originally in business with his father as a housepainter, but became a painter, first of portraits and landscapes, and moved to Dublin where he studied in the Dublin Society's School. Exhib. at the RHA 1844-8, such subjects as 'Study of a Girl Reading', 'Conrad and Gulnare', 'The Pet', etc. He went to London c.1851 and exhib. 'A Winter Scene at Rugby School, Football' at the RA in 1859 (the only time he exhib. there). He was then living at Rugby and was still there in 1872.

Bibl: Strickland.

HARWOOD, Henry fl.1892-1902
Painted landscape. Exhib. four works, including 'The Radiant Morn' and 'In the Land of Amphion', at SS, 1892-4. Exhib. at the RA from 1894 including 'The Brow of the Hill', 'Hill and Dale' and 'The Bridle Path'. Address near Bradford, Yorkshire.

HARWOOD, John James 1816-1872
Irish painter of portraits, genre and historical subjects. Born in Clonmell, he appears to have studied in Italy; but was following his profession in Clonmell in 1836. He was in London in 1839, and in Bath 1841-4. For the rest of his life he lived in London, visiting Ireland occasionally. Exhib. in London 1839-71, at the RA 1840-71, BI, SS and elsewhere; and at the RHA in 1836, 1842, 1844, 1847-8, 1850, 1853, 1856, 1858 — portraits, genre and historical subjects, e.g. 'Francesca and Paolo of Rimini', 1853, and 'Children Feeding the Birds', 1845. The National Gallery of Ireland has two portraits by him, 'Field-Marshal Gough', 1851 and 'Samuel Lover', 1856.

Bibl: Strickland; Ormond.

HARWOOD, Robert 1830-living 1879
Painter of landscape, portraits and genre. Younger brother of J.J. and Edward Harwood (qq.v.). Lived with his brothers at Clonmell and afterwards at 2 Percy Street, London. Exhib.1855-79, at the RA 1855-76, BI, SS and elsewhere, chiefly Welsh landscapes; and at the RHA in 1856 and 1858.

Bibl: Strickland.

HASELER, W. fl.1859-1860
Exhib. three works, 'The Road over the Downs', 'Cattle in the Meadows' and 'The Sands at Burnham, after the Gale of October, 1859', at SS, 1859-60. Address in Bath.

HASELTINE, J.P. fl.1870
Exhib. three works, views of houses, at the RA in 1870.

HASKEW, J.T. fl.1840
Exhib. two works, 'Landscape and Waterfall' and 'Coast Scene with Figures', at SS in 1840. London address.

HASLAM, W.D. fl.1871-1881
Exhib. three works, 'Reverie', 'Feeding the Swans' and 'A Marble Player', at SS, 1871-4, and a work entitled 'Solitude' at the RA in 1873. London address.

HASLEGRAVE, Miss Adelaide L. fl.1901
Exhib. a work entitled 'In the Sunny South' at the RA in 1901. London address.

HASLEHURST, Ernest William RI RBA RWA RBC 1866-1949
Painted landscape in watercolour. Studied at the Slade School. Exhib. two works, 'An Old Well, Sark' and 'La Grande Grêve', at SS in 1888 and 1889, and a work entitled 'Shadows' at the RA in 1901. Member of the Langham Sketching Club and President of the Midland Sketch Club. Born in Walthamstow. Lived in London. For works illustrated by, see Card Cat. at the VAM.

Bibl: Pictures of the Year 1914

HASLEM, John 1808-1884
Derby porcelain painter, who also exhib. watercolour portraits at RA, SS and elsewhere. Also worked in oil, and painted enamel portraits for the royal family.

HASMER, Miss H. fl.1857
Exhib. a work depicting a scene from the *Life of Beatrice Cenci* at the RA in 1857. Address in Rome.

HASSALL, John RI RWA 1868-1948
Painter, illustrator and poster designer. Began as a farmer in Manitoba. Studied art in Antwerp and Paris. Exhib. three works, 'Temporary Insanity', 'Birds of Prey' and 'One Who Knows the Law — *Much Ado About Nothing*' at the RA, 1894-1901. Member of the London Sketch Club. London address. For works illustrated by, see Card Cat. at VAM.
Bibl: *Pen, Pencil and Brush, Hassall, his Book*, London; Studio XXIII p.52; XXVIII p.200; XXX p.26; XXXVI p.199; XXXIX p.60; XLVIII p.237; LVIII p.57; LX p.306; LXVIII p.245; LXIV p.281; Studio Special Number 1911.

HASSAM, Alfred fl.1865-1897
Painted figurative subjects in watercolour. Exhib. eight works, including 'An Old Fisherman' and 'An Abyssinian Negro', at SS, 1865-8, and four works, 'Young Blood' and 'A Young Roman', at the RA, 1865-8. London address. Also wrote a book on Arabic in 1897.

HASSELL, Edward RBA fl.1830-d. 1852
Painter and watercolourist; son of John Hassell, also a watercolourist and engraver. Exhib. regularly at SS; elected RBA 1841, and later became secretary. Also exhib. at RA and BI. Painted landscapes and interiors of Gothic churches and buildings.
Bibl: Redgrave, Dict.; DNB XXV under John Hassell; BM Cat. of Drawings by British Artists 1900 II.

HASTIE, Miss Grace H. fl.1874-1903
London fruit and flower painter who exhib. 1874-1903, at the RA 1878-1903, at SS, NWS, GG, NG and elsewhere. A Member of Society of Lady Artists.

HASTINGS, Edward fl.1804-1861
Portrait and landscape painter. Exhib. 47 works, the majority of Northumbrian personalities, at the RA, 1804-27. Also exhib. at the BI, including views of Bamburgh Castle, and at SS. He continued to work and exhib. in the north-east until 1861. Represented in the Laing AG. Lived in County Durham.
Bibl: BM Cat. of Engraved British Portraits I-IV; Hall; Ormond.

HASTINGS, Ethel fl.1887-1888
Exhib. a work entitled 'A Fireside Story' at SS in 1887-8. London address.

HASTINGS, George fl.1869-1875
Painted landscape. Exhib. eight works, views in North Wales and the West Country, at the RA, 1869-75, and five works, including 'A Hazy Morning, North Wales' and 'Where the Rushes Like to Grow', at SS, 1869-71. Address in Bristol.

HASTINGS, Miss Kate Gardiner fl.1885-1888
Exhib. four works, 'Wild Rose', 'My May' and two portraits, at the RA, 1885-8. Also exhib. at the GG and NG. London address.

HASTLING, Miss Annie E. fl.1882-1893
Exhib. a work entitled 'Forbidden Fruit' at the RA in 1882. Also exhib. at the NWS. Address in Sheffield, Yorkshire.

HASWELL, Dr. John 1855-1925
Painted marines. Worked in the north-east. Exhib. at the RA from 1907.
Bibl: Hall.

HATCH, Miss Ethel C. SWA fl.1894-1896
Exhib. two works, entitled 'Clare' and 'Phyllis' at the RA in 1894 and 1896. Studied at the Slade School under Tonks, Brown and Steer. London address.
Exhib: London, Godfrey Barclay 1938.

HATCHETT, J.C. fl.1856
Exhib. a work entitled 'Ferry on the Ouse' at SS in 1856. London address.

HATHERELL, William RI ROI RWA 1855-1928
Painted figurative, historical and literary subjects. Also worked as an illustrator. Exhib. at the RA from 1879, including 'Grave Alice', 'Far From the Madding Crowd' and 'John Ridd's Second Meeting with Lorna Doone'. Also exhib. three works, 'At Odds', 'A Girl of the 16th Century' and 'A Bit of Old Noyon', at SS, 1879-83. Member of the Langham Sketching Club. London address.
Bibl: AJ 1885; RA Pictures 1877-1902; Studio LVII 1913 p.264; Special Spring Number 1916.

HATTON, Miss Helen Howard fl.1879-1894
Painted flowers and figurative subjects. Exhib. seven works, including portraits and works entitled 'Poppyheads and Hemlock' and 'Love if thy Tresses be so Dark', at the RA, 1885-94. Exhib. six works, including 'Shelling Peas' and 'A Pert French Maid', at SS, 1879-88. London address.

HATTON, Richard George ARCA 1865-1926
Painted portraits, genre and landscape. Trained at the School of Art in Birmingham. In 1890 he became an art master at Armstrong College, Newcastle-upon-Tyne. Later he became Director of the King Edward VII School of Art, Newcastle. The Hatton Gallery, Newcastle University, was named after him.
Bibl: Hall.

HAUGHTON, Benjamin 1865-1924
Painted landscape. Studied painting under Herkomer. Exhib. at the RA from 1893 including 'The Deserted Garden', 'The Babes in the Wood' and 'Queen of the Night'. Lived at Dawlish, and later near Barnstaple, Devon.

HAUSSELIN, H. fl.1849
Exhib. two untitled works at the BI in 1849. London address.

HAVELL, Alfred Charles fl.1878-1884
Painted horses and figurative subjects. Exhib. two works, 'Reverie' and 'An Idyll', at the RA in 1878 and 1884. London address.
Bibl: Frederic Gordon Roe, *Lesser Nineteenth Century Horse Painters*, British Racehorse VIII v. 1953.

HAVELL, Charles Richards fl.1858-1866
Painted landscape and country subjects. Exhib. four works, including 'The Little Watercress Girl', 'Watering the Team' and 'The Gleaners', at the BI, 1858-66. Also exhib. once at the RA in 1862, and once at SS in 1864. Address in Reading, Berkshire.
Bibl: Wood, Panorama p.159 (pl.167).

HAVELL, Edmund, Jnr. 1819-1894
Genre and portrait painter; son of Edmund Snr. a landscape painter, and nephew of William Havell (q.v.). Lived in Reading, 1835-42, and London. Exhib. at RA, 1835-95, BI and SS. Also a lithographer, mainly of portraits. Titles at RA also mainly portraits, and some genre, e.g. 'Spring Flowers', 'Italian Boy', 'Crochet', etc. He visited the United States and exhibited in Philadelphia.
Bibl: Cat. of William Havell exhib., Reading Museum, 1970.

HAVELL, Edwin fl.1868
Made a portrait drawing of Sir James Scarlett. This is now in the Townley Hall AG, Burnley.
Bibl: Ormond.

HAVELL, H. fl.1849
Exhib. 'Prospero, Miranda and Ariel — from *The Tempest*' at the RA in 1849. Address in Cheltenham.

HAVELL, William RWS 1782-1857
Painted landscape in oil and watercolour, according to Maas: "Somewhat in the manner of early Constable. They are distinctly his own, but the colouring tends to monotony." Exhib. at RA 1804-57, SS and RWS. Brother of Edmund Havell Snr. and uncle of Edmund Havell Jnr. (q.v.). His studio sale was held at Christie's, 24 May 1858.
Bibl: Maas; F. Owen, *W.H.*, Connoisseur February 1978.

HAVERFIELD, J.T. fl.1870-1871
Painted landscape. Exhib. four works, including 'A Bit on the Moors, near Klin' and 'A Stretch of the Bass Rock', at SS, 1870-2, and one work, 'A November Day in the Pass at Leny, Scotland', at the RA in 1871. Address in Callander, Perthshire.

HAVERS, Miss Alice Mary 1850-1890
(Mrs. Frederick Morgan)
Genre and landscape painter. Born in Norfolk; married Frederick Morgan (q.v.) in 1872. Studied at the South Kensington Schools, and became a clever and popular painter. Exhib. 1872-89, at the RA, 1873-89, SS, the Paris Salon and elsewhere, titles at the RA including 'A Knotty Subject', 'A Montevidean Carnival', 'Goosey, Goosey Gander' and 'Peasant Girls, Varengeville'. She was a member of the Society of Lady Artists. 'Blanchisseuses' is in the Walker AG, Liverpool, and 'The Annunciation' in the Norwich Castle Museum. For works illustrated by, see Card Cat. at VAM.
Bibl: H. Blackburn, *Academy Notes,* 1875 p.34; 1876 pp.53, 55, 65; 1877-83; The Portfolio 1890; Art Chronicle p.XX; Bryan (under Morgan); W. Shaw-Sparrow *Women Painters of the World,* 1905 ('Blanchisseuses').

HAVERS, Val fl. from 1898
Exhib. at the RA from 1898, including works entitled ' "Within the Branching Shade of Reverie" ' — (D.G. Rossetti) and 'The Quest of Fair Ladies'. London address.
Bibl: The Year's Art 1913 p.436.

***HAVERTY, Joseph Patrick RHA 1794-1864**
Irish portrait painter and lithographer. Exhib. 17 works including 'Father Matthew, receiving a Repentent Pledge-Breaker — A Portrait from Life', and portraits, at the RA, 1835-57. Exhib. eight works, including a portrait of Cardinal Wiseman, at SS, 1851-8. His work 'Limerick Piper' is in the National Gallery, Dublin. Born in Galway, Ireland. Died in Dublin.
Bibl: Strickland; Ormond; Wood, Panorama.

HAVILAND, Miss Harriet M. fl.1864
Exhib. a painting of roses and a painting of flowers at the BI in 1864. Address in Bridgwater, Somerset.

HAVILL, Frederick fl.1849-d.1884
Painted portraits and figurative subjects. Exhib. 11 works, including portraits and works entitled 'Subtle, Deep and Far Reaching are the Meditations of the Jesuit' and 'The Advocate', at the RA, 1849-74. Also exhib. four works, including three portraits, at SS, 1867-70. Lived in Cheltenham. His portrait of David Livingstone is in the NPG.
Bibl: Ormond.

HAWEIS, M. fl.1875
Exhib. a portrait in 1875. London address.

HAWES, Arthur G. fl.1890-1891
Exhib. a painting, 'Among the Reeds, Beccles', at SS in 1891. London address.

HAWKER, Miss Florence fl.1889
Exhib. a genre subject at the NWS in 1889. London address.

HAWKER, Miss Margarita E. fl.1891
Exhib. a painting of flowers at the NWS in 1891. London address.

HAWKES, Miss Clara M. fl.1884-1894
Exhib. two works, 'Study of a Head' and 'A Poem', at the RA in 1886 and 1894, and a work entitled 'Relics of the Past' at SS, in 1884. London address.

HAWKES, Mrs. E.A. fl.1852-1854
Exhib. two works, entitled 'The Exile's Mother' and 'The Reader', at the BI in 1852 and 1853, and a portrait at the RA. London address.

HAWKES, F. fl.1844-1845
Exhib. two landscapes, one on the Thames near Reading, the other near Weston-Super-Mare, at SS in 1844 and 1845. Address in Reading, Berkshire.

HAWKES, Joseph fl.1839
Exhib. a painting entitled 'The Village Belle' at the RA in 1839. London address.

HAWKINS, Miss Agnes M. fl.1872-1876
Exhib. a watercolour entitled 'The Duet' at SS in 1872-3. London address.

HAWKINS, Miss Amy fl.1892
Exhib. a genre subject at the NWS in 1892. London address.

HAWKINS, Benjamin Waterhouse fl.1832-1841
Painted animals and portraits. Also a lithographer. Exhib. 15 works, including portraits and works entitled 'My Aunt's Darling' and 'The Honey-moon, A Scene in the Zoological Gardens, Regent's Park', at SS, 1832-41. Exhib. five works at the RA, 1833-40, and four works, including 'A Lap Dog', 'Carriage Horses' and 'Carp', at the BI, 1833-6. London address. For works illustrated by, see Card Cat. at VAM.
Bibl: BM Cat. of Engraved British Portraits I p.184; II p.582.

HAWKINS, Henry RBA fl.1820-1881
Portrait painter. Also painted dogs, landscapes and views of buildings. Exhib. 200 works at SS, eight at the RA, and two at the BI. London address.

HAWKINS, J. fl.1879
Exhib. a portrait of a lady at the RA in 1879. London address.

HAWKINS, Miss Jane fl.1871-1874
Painted figurative subjects. Exhib. nine works, the majority watercolours, titles including 'The Village Belle', 'The Sybil' and 'Une Paysanne', at SS, 1871-5. London address.

HAWKINS, Louis (Welden?) fl.1880-d.1910
Exhib. two works, 'By the Wayside' and 'Keston Common', at SS in 1880 and 1881, and one work at the NWS. This is probably Louis Welden Hawkins, a German-born painter of English parents. Lived in Paris, and died there in 1910, and belongs to the French School. Later he painted female figures and nudes in symbolist style.

HAWKINS, Mrs. W.H. (Louisa) fl.1839-1868
Painted portraits. Exhib. 20 works at the RA, 1839-68, and 11 portraits and paintings of flowers in watercolour, at SS, 1839-47. London address.
Bibl: BM Cat. of Engraved British Portraits IV pp.319, 346.

HAWKSLEY, Arthur 1842-1915
Painted landscape and architecture. Exhib. five works, including two watercolours of churches in Cornwall, at SS, 1877-83, and four works, including a view of the Nottingham waterworks, and works entitled 'Frog's Hole, Sussex' and 'An Old Posting Yard, Surrey'. Born in Nottingham. Lived in London.

HAWKSLEY, Miss Florence fl.1881
Exhib. a work entitled 'An Old German Woman' at the RA in 1881. London address.

***HAWKSWORTH, William Thomas Martin RI RBA 1853-1935**
Painted landscape, townscapes and architectural subjects in watercolour. Exhib. 25 works, including many views in the London docks and views in Canterbury, at SS, 1881-94. Exhib. 11 works, including 'Becket's Corner', 'River Scene on the Medway' and 'Street Scene, Canterbury', at the RA, 1885-95. Lived at Herne Bay, Kent, and in London.
Bibl: Studio Special Number, British Marine Painting, 1919 pp.33, 125.
Exhib: London, Walker's Galleries 1937.

HAWORTH, Miss E.F. fl.1844-1855
Exhib. two portraits, one of the daughter of the Dean of Exeter, at the RA, 1844-5. London address.

HAWTHORN, C.M. (or C.J.) fl.1833-1844
Painted landscapes and marines. Exhib. five works, including 'Scene at Northfleet, Kent', and 'Shower Clearing Off — from Nature', at SS, 1832-45. Also exhib. two works at the BI in 1833. London address.
Bibl: Brook-Hart.

HAWTHORN, E.D. fl.1858-1862
Exhib. two works, 'The Holly and Ivy Girl' and 'Happy Thoughts' at the BI in 1858 and 1862. London address.

HAY, F.B. fl.1859-1862
Supposed to have exhib. seven historical works at the RA, 1859-62. London address.

HAY, G.J. fl.1857
Exhib. a work entitled 'Bakehouse and Ovens, Pompeii' at the BI in 1857. London address.

HAY, George H. 1831-1913
Exhib. a work, 'The Bass Rock', at the RA in 1867. Studied at the Trustees' Academy. His work, 'Caleb Balberstone's Ruse' is in the Scottish National Gallery. Born in Leith. Died in Edinburgh.
Bibl: AJ 1898 pp.367-70; Caw; Cat. National Gallery Edinburgh 1920 p.358ff.

HAY, J. Macpherson fl.1893
Exhib. a landscape in 1893. London address.

HAY, James fl.1887-c.1920
Exhib. two genre subjects at the NWS. Address in Edinburgh.

HAY, James Hamilton LG 1874-1916
Painted and engraved landscapes and marines. Exhib. two works at the RA in 1900: 'Moonrise, Conway Valley' and 'Dock Buildings, Liverpool'. He was a friend of Augustus John. Lived in Liverpool until 1912 when he removed to London to exhib. with the Camden Town Group.
Bibl: AJ 1905 p.260; Studio XXXVII 1906 p.345ff.; LXIII 1915 p.217ff.; LXIV 1915 p.140; LXVI 1916 p.214.
Exhib: Liverpool, Walker AG 1973.

HAY, Mrs. Jane fl.1859
(Miss Jane Benham)
Exhib. two landscapes in 1859 which were commented on by Ruskin in Academy Notes.

HAY, Peter Alexander RI RSW RBC 1866-1952
Painted portraits and figurative subjects. Studied at the RSA Schools and at the Académie Julian. Exhib. at the RA from 1892 including 'The Foolish Virgins', 'Twenty Years After' and 'Wedded'. Also exhib. two works at SS in 1893. Born in Edinburgh. Lived in London.
Bibl: Caw.

HAY, Thomas Marjoribanks RSW 1862-1921
Painted landscapes and coastal scenes in watercolour. Exhib. three works, 'The Old Mill' 'Glen Strae, Argyllshire' and 'The Old Brig o' Ayr' at the RA in 1891-3. His watercolour, 'Crinlarich' is in the Manchester City AG.
Bibl: Caw; Holmes, Sketching Grounds, Studio Special Number 1909; Hardie III pl.224.

HAY, William Hardie b.1859
Painted landscapes. Studied at Glasgow School of Art and in Paris. Lived in Glasgow and was a member of the Glasgow Art Club.

HAY, William M. fl.1852-1881
London painter of portraits, genre and biblical scenes. Exhib. at RA, 1855-77, BI and SS. Titles at RA mostly portraits; also some genre, e.g. 'A Funny Story', 'A Pleasing Story', etc.
Bibl: AJ 1860 p.80; Wood, Panorama.

HAY, William Robert b.1886
Painted and etched landscape subjects. Studied at Westminster and Chelsea. London address.

HAYCOCK, Augustus Edmonds fl.1882-1885
Exhib. three works, 'Study of an Indian Adjutant', 'Dangerous Ground' and 'A Nubian', at the RA, 1883-4. Exhib. two works at SS, 1882-3. London address.

HAYCOCK, G.B. fl.1862-1868
Painted dead birds and fruit. Occasionally combined on works with J.T. Lucas. Exhib. 12 works, including 'Dead Chaffinch and Fruit', 'Dead Wood Pigeon' and 'A Fatal Swoop', at the BI, 1863-7. Exhib. 11 works at the RA, 1862-8. Also exhib. nine works, including ' "What d'ye Lack?" ' (jointly with J.T. Lucas (q.v.)), at SS, 1862-8. London address.

HAYCOCK, Washington fl.1862-1864
Exhib. five works, including 'Fine Feathers Make Fine Birds' and 'French Partridge and Missel Thrush', at SS, 1862-4. London address.

HAYDEN, Fred b.1874
Painted landscape. Exhib. chiefly in the Midlands. Lived in Worcester and was a member of Worcester Art Club.

***HAYDON, Benjamin Robert 1786-1846**
Painter of large-scale historical subjects, and genre. Born Plymouth; came to London 1804. Worked for Hoare, Northcote and Fuseli, and studied at RA Schools, where he befriended Wilkie. His first picture, 'The Flight into Egypt', was bought by Thomas Hope for 100 guineas in 1806. Haydon was deeply impressed by the Elgin marbles, which he studied at Elgin's house in Park Lane. Inspired by the idea of promoting historical painting in England, he produced a series of huge and grandiose canvases — 'Judgement of Solomon' 1814, 'Christ's Entry into Jerusalem' 1820, 'The Raising of Lazarus' 1823, etc. Unfortunately his technique was inadequate to cope with the scope of his ambitions. A turbulent and quarrelsome character, Haydon alienated clients by failing to complete compositions, and antagonised the Academy and his critics by his scathing attacks on them through pamphlets. He was imprisoned for debt three times. Bitterly disappointed by his failure to win any of the Westminster Hall competitions, he organised in 1846 an exhibition of his own work at the Egyptian Hall in Piccadilly. It was a complete failure, and Haydon committed suicide on 22 June of the same year. He also painted a number of popular genre works, such as 'Mock Election', and 'Chairing the Member', for which he is now best remembered. He exhib. at the RA, BI, SS (of which he was one of the first supporters when founded in 1823) and OWS. His diaries are among the best ever written by an English artist. The most recent edition was published by Hutchinson in 1990, as *Neglected Genius — The Diaries of B.R.H.* (ed. John Joliffe).

Bibl: AU 1846 p.235ff. (obit.); Mag. of Art IV pp.250, 501; T. Taylor, *Life and Art of B.R.H.*, 1853; *Correspondence and Table Talk of B.R.H.*, ed. L.W. Haydon 1876; Redgrave, Dict.; DNB XXV p.283ff.; E. George, *The Life and Death of B.R.H.*, 1948 (2nd ed.) 1967; Boase see index (pl.63); Maas; Ormond; Irwin; references in literary biographies of Hazlitt, Lamb, Scott, Reynolds, Keats, Wordsworth, Southey, etc.

HAYES, Arthur fl.1880-1893
Exhib. 'Leaving their Mother' at SS, 1880-1, and 'Eve' at the RA in 1883. London address.

HAYES, Claude RI ROI 1852-1922
Landscape and portrait painter. Born in Dublin; son of Edwin Hayes (q.v.). He ran away to sea, serving on *The Golden Fleece,* one of the transports used in the Abyssinian Expedition of 1867-8. Spent a year in America; studied art at Heatherley's School and for three years at the RA Schools, and at Antwerp, under Verlat. Exhib. from 1876 at the RA, and also at SS, NWS, GG, NG, and elsewhere. He first practised as a portrait painter in oil, but soon abandoned portraiture for landscape, first in oil and then in watercolour as his favourite medium. In 1884 he first exhibited at the RI, of which he was elected member, 1886. He worked in Hampshire, meeting James Aumonier, and in Surrey with William Charles Estall whose sister he married. He was influenced by Cox and Thomas Collier. Hardie writes: "Maintaining worthily and without imitation their breezy, open-air distance with able indication of form and colour values. His transparent use of fresh and untroubled colour allowed the sparkle of white paper to play its part in the general scheme. He has never quite received the recognition which he deserves."

Bibl: Studio XXXIII 1905 pp.290-7 (pls.); LXVII 1916 pp.79-90 (pls.); RA Pictures 1896-1908, 1912 pp. 14, 15; Holme, Sketching Ground, Studio Special Number 1909 p.23ff. (pls); VAM; E.P. Reynolds, Walker's Quarterly VII (describing palette and method of work); Hardie III pp.156, 157-9 (p1.178); Brook-Hart; John Lello, *C.H.,* Watercolours Magazine Winter 1992.

HAYES, Miss E. Irene fl.1898
Exhib. a work entitled ' "Pity the Sorrows of a Poor Old Man" ' at the RA in 1898. Address in Southport, Lancashire.

HAYES, Miss Edith Caroline b.1860 fl.1889-1897
Studied at St. John's Wood Art School and at the RA Schools. Exhib. two works, 'At Newlyn' and 'The Guitar', at the RA in 1889 and 1897. Also exhib. at the NG. Lived in Marlow, Buckinghamshire.

HAYES, Edward RHA 1797-1864
Irish portrait painter and miniaturist. Trained under Alpenny in the Royal Dublin Society's Drawing School. Also a miniaturist and teacher. Exhib. at RHA, 1831-63. Elected ARHA 1856, RHA 1861. Father of M.A. Hayes (q.v.).
Bibl: Strickland.

***HAYES, Edwin RHA RI ROI 1820-1904**
Marine painter, principally in watercolour, but also in oil. Born in Bristol, he exhib. prolifically, at the RA 1855-1904, at BI, SS, NWS, GG, NG and elsewhere, and made his name by his marine subjects. He became an Associate of the NWS (RI) in 1860 and Member in 1863. He was also a Member of the Royal Hibernian Academy and of the Institute of Oil Painters. His 'St. Malo' 1862 (Bethnal Green Museum) is a typical work. His studio sale was held at Christie's, 21 January 1905. Father of Claude Hayes (q.v.) Manuscripts relating to Hayes are held at VAM.
Bibl: VAM Mss: 47 letters to H.M. Cundall, 1850-1912; RA Pictures 1891-1904 (pls.); Poynter, National Gallery of British Art 1900 I; DNB Supp. II 1912; Benezit II 1913; Marine Painting, Studio Special Number 1919; VAM; Hardie pp.157, 159; Maas; Brook-Hart pl.43.

HAYES, Frederick William ARCA 1848-1918
Painted landscapes and marines. His work is sometimes comparable to that of John Brett (q.v.). Exhib. 17 works, including 'Sunset on the Formby Sand Hills', 'Her Last Berth' and 'A Solitary Fisher', at the RA, 1872-91. Exhib. four works, views in North Wales, at SS, 1872-89. Lived in or near Liverpool until about 1880, when he removed to London. Founder of the Liverpool Watercolour Society.
Bibl: Brook-Hart pls.29a, 158 and 159; Hardie III pl.179.

HAYES, George RCA fl.1855-1875
Painted landscapes. Exhib. four watercolours, entitled 'Sunday in Wales' and 'The Pass of Glencoe', at SS, 1861-71, and three works, 'A Welsh Churchyard', 'A Flood' and 'Skirts of a Forest', at the RA, 1855-75. Lived in Manchester.

HAYES, Miss Gertrude Ellen ARE SWA 1872-1956
Painted and etched architectural subjects. Exhib. at the RA from 1896, including 'A Geisha' and 'Washing Sheds, Avranches'. Studied at the RCA. Member of the Coventry and Warwickshire Society of Artists. Lived at Kenilworth, Warwickshire and later in Nottingham.

HAYES, Henry fl.1900
Exhib. one work, entitled 'Kept In', at the RA in 1900. Address in Ilford, Essex.

HAYES, Henry Edgar fl.1879-1886
Exhib. three works, 'Meditation', 'Contemplation' and 'Lunch for an Epicure', at SS, 1879-86. Address in Camberwell, Kent.

HAYES, J. Percy fl.1900
Exhib. two genre subjects in 1890. Address in Chiswick, London.

HAYES, J.W. fl.1838-1845
Exhib. two works, 'Little Red Riding Hood' and a scene from the *Vicar of Wakefield,* at the BI in 1838 and 1844, and 'Sappho' at the RA in 1845. London address.

HAYES, John 1786-1866
London painter of portraits and historical genre. Exhib. at RA and BI, 1814-51. Specialised in portraits of military and naval officers. Later turned to historical genre. Also a lithographer. Many of his own portraits were engraved. His portrait of Agnes Strickland is in the NPG.
Bibl: DNB XXV 1891; BM Cat. of Engraved British Portraits; India Office Cat. of Paintings 1914; Ormond pl.873.

HAYES, John fl. from 1897
Exhib. at the RA in 1897 and 1902, work entitled 'Nature's Gifts' and 'Autumn Gatherings'. London address.

HAYES, Michael Angelo RHA 1820-1877
Irish painter of military subjects. Exhib. two watercolours, 'The Videttes — 16th Lancers in India' and 'The Soldier and the Citizen' at SS in 1845. Exhib. 'H.M. 3rd Dragoon Guards taking the Principal Sikh Battery at Moodkee' at the RA in 1847. Also exhib. 35 works at the NWS. Born in Waterford, Ireland, son of Edward Hayes (q.v.). Lived in Dublin and London. Died in Dublin.
Bibl: Redgrave, Dict.; AJ 1878 pp.76, 108; DNB XXV p.292; Strickland; National Army Museum, London, *The Costume of the 46th Regiment by Michael Angelo Hayes*, 1972.

HAYES, S.J. fl.1880
Exhib. a work entitled 'The Road By the Brook' at SS in 1880. Address in Camberwell, London.

HAYES, W.B. fl.1885-1892
Exhib. a work entitled 'October Afternoon' at the RA in 1885. Address in Barnes, London.

***HAYLLAR, Miss Edith 1860-1948**
Still-life and genre painter; sister of Jessica, Kate and Mary Hayllar, all daughters of James Hayllar (all q.v.). Exhib. at RA, 1882-97, SS and elsewhere. Titles at RA 'The Sportsman's Luncheon', 'The First of October', 'Five O'Clock Tea', etc. Her pictures are similar to those of her sister Jessica. Both found their subjects in the day-to-day life of the household of their family home, Castle Priory, Wallingford, Berkshire, then a small village by the Thames. Her pictures have great charm and naturalness of observation, recording in an exact but unpretentious way the life of a Victorian middle-class family.
Bibl: Christopher Wood, *The Artistic Family Hayllar*, The Connoisseur April-May 1974; Wood, Panorama; Wood, Paradise Lost.

***HAYLLAR, James RBA 1829-1920**
Painter of portraits, figure subjects and landscapes. Studied with F.S. Cary (q.v.) and at RA Schools. Travelled in Italy 1851-3. Exhib. at RA, 1850-98, BI, but mostly at SS, of which he was a member. At first he painted mainly portraits, but in 1866 he took up subjects of children, achieving his first success with 'Miss Lily's Carriage stops the Way'. From this time he continued to paint a great many subjects involving children and pretty girls. In 1875 he rented Castle Priory, a large house at Wallingford, on the Thames, and he painted many of his pictures there, often depicting scenes of village life. Four of his daughters, Jessica, Edith, Mary and Kate (qq.v.), were also talented artists, exhibiting alongside their father at the RA. A study of the work of James Hayllar and his daughters was published by the author in *The Connoisseur* April-May 1974.
Bibl: Ottley, Clement & Hutton; BM Cat. of Engraved British Portraits IV 1914 p.8; Reynolds, VS pp.21, 83 (pl.60); Christopher Wood, *The Artistic Family Hayllar*, The Connoisseur April-May 1974; Ormond; Wood, Paradise Lost.

***HAYLLAR, Jessica 1858-1940**
Painter of figure subjects, especially children, and flowers. Eldest daughter of James Hayllar. Studied under her father, and began to exhibit in 1879. Exhib. at RA, 1880-1915, and at many other exhibitions. Her best works, painted between 1885 and 1900, are nearly all quiet domestic scenes of everyday life at her father's house, Castle Priory. Both her figures and interiors are observed with great naturalness and charm; her models were mostly members of her family, or locals from the village. About 1900 she was crippled by an accident, and thereafter painted only flower pictures, especially azaleas.
Bibl: Christopher Wood, *The Artistic Family Hayllar*, The Connoisseur April-May 1974.

HAYLLAR, Miss Kate fl.1883-1898
Painter of flowers and still-life. Daughter of James Hayllar (q.v.). Exhib. 12 works, including 'The Old Brocaded Gown', 'Sunflowers and Hollyhocks' and 'A Thing of Beauty is a Joy for Ever', at the RA, 1885-98. Also exhib. six watercolours, titles including 'Tommy's School Hamper' and 'From the Sunny South', at SS, 1883-9. About 1900 she gave up painting and became a nurse.
Bibl: See under Jessica Hayllar.

HAYLLAR, Miss Mary fl.1880-1885
(Mrs. H.W. Wells)
Painted flowers, figurative subjects and landscapes. Daughter of James Hayllar (q.v.). Exhib. 15 works, including 'Tiffin', 'Last of the Season' and 'Great Expectations', at SS, 1880-5, also exhib. five works, including 'For a Good Boy' and 'Helping Gardener' at the RA, 1880-5. After her marriage she gave up painting except to do miniatures of children. See also Mrs. H.W. Wells.
Bibl: See under Jessica Hayllar.

HAYMANN, G. fl.1877-1878
Exhib. a work 'On the Nile — Cairo' at SS in 1877-8.

HAYNES, Adeline fl.1879-1880
Exhib. a work entitled 'Heartsease' at SS in 1879-80.

HAYNES, Arthur S. fl.1887-1900
Painted architecture. Exhib. seven works, including views of houses and works entitled 'Gathering Flithers on the Yorkshire Coast' and 'Through the Stubbles', at the RA, 1887-1900. Exhib. two coastal views and a view of Venice at SS, 1890-1. London address.

HAYNES, Edward Travanyon fl.1867-1885
Painted portraits and figurative subjects. Exhib. at the RA, 1868-85, including portraits and work entitled 'Dido "The Moon Shines Bright" ' and 'Calypso Deserted by Ulysses'. Also exhib. two works, including an Italian landscape, at SS, 1873-82, and one at the BI in 1867. His portrait of Admiral Sir Astley Cooper is in the Greenwich Naval College. London address.

HAYNES, Frederick fl.c.1860-1880
A signed work 'Sailing Vessels off Dover' has been recorded.
Bibl: Brook-Hart pl.155.

HAYNES, H. fl.1843
Exhib. a work entitled 'A Pond at Harlow, Essex' at the RA in 1843. London address.

***HAYNES, John William fl.1852-1882**
London genre painter. Exhib. at RA, 1852-67, BI, SS. Titles at RA 'Kept In', 'A Little Entanglement', 'Tuning the Fiddle', etc. Lived in Cambridge and London. 'The First, the Only One' is in York AG.
Bibl: AJ 1864; City of York AG Cat.; Reynolds, VS p.84 (pl.61).

HAYNES-WILLIAM, John see WILLIAMS, John Haynes

HAYS, Miss Beatrice fl.1888-1893
Exhib. three works, 'The Studio Corner', 'Chrysanthemums' and 'Temptation', at the RA, 1890-3, and two works, one entitled 'Christmas Pleasures', at SS, 1888-91/2. Address in Surrey.

HAYTER, Angelo Cohen fl.1848-1852
Painted portraits and figurative subjects. Exhib. five works at the RA, 1850-2, and four works, including 'Neapolitan Peasants near the Tomb of Virgil' and 'The Portico of the National Gallery', at the BI. 1848-51. London address.

HAYTER, Miss Edith C. fl.1890
Exhib. a landscape at the NG in 1890. London address.

***HAYTER, Sir George 1792-1871**
Painter of portraits and historical genre; son of Charles Hayter, also a portrait painter and miniaturist. Studied at RA Schools. In 1815 awarded a premium of 200 guineas by the British Institution. Appointed the same year painter of miniatures to Princess Charlotte and the Prince of Saxe-Coburg. Studied in Italy, 1815-18. In 1825 his picture of the 'Trial of Lord William Russell' became widely known through engraving. He is best known today for his large portrait groups, such as the 'Trial of Queen Caroline' and 'The Meeting of the First Reformed Parliament'. In Italy again 1826-31. On the accession of Queen Victoria in 1837, he was appointed her portrait and history painter. He painted a large picture of her Coronation, and in 1836 her state portrait, for which he was knighted in 1842. He exhib. at the RA, 1809-38, his portrait of Victoria being his last exhibited work. Thereafter he enjoyed a lucrative practice as a fashionable portrait painter. His younger brother John (q.v.) was also a painter. Sir George's studio sale was held at Christie's, 19 April 1871.
Bibl: Sir George Hayter, *A Descriptive Catalogue of the Picture of the Interior of the British House of Commons in 1833*, 1844; AJ 1871 p.79 (obit.); 1879 p.180; 1902 p.192; Redgrave, Dict; DNB XXV; L. Cust, NPG. Cat. II; BM Cat. of Engraved British Portraits I-IV; Boase pp.164, 209, 315 (pl 62b); Reynolds, VP p.12; Maas pp.23, 213; Ormond.
Exhib: London, Cauty's Great Rooms 1823; London, Egyptian Hall 1843.

HAYTER, John 1800-1891
London portrait and genre painter; younger brother of Sir George Hayter (q.v.). Exhib. at RA, 1815-79, BI and SS. At the RA he exhib. mostly portraits; at the BI mostly historical genre scenes. His portrait sketches and drawings were popular, and many were engraved. For works illustrated by, see Card Cat. at VAM.
Bibl: DNB XXV; BM Cat. of Engraved British Portraits I-IV *passim*; Studio 1916, Shakespeare in Pictorial Art, Spring Special Number; Ormond.

HAYWARD, Mrs. A.F.W. fl.1901-1902
(Miss Edith Burrows)
Exhib. two works: 'A Distant View of Winchester' and 'Langport', at the RA in 1901 and 1902. Address in Winchester, Hampshire. Presumably wife of A.F.W. Hayward (q.v.).

HAYWARD, Albert fl.1862-1885
Exhib. six works, including 'The Heron's Haunt', 'By the Shore a Plot of Ground' and 'The Haunted Mill', at the RA, 1862-85. London address.

HAYWARD, Alfred Frederick William b.1856 fl.1880-1904
Painted portraits and flowers. Exhib. 29 works, including numerous paintings of azaleas, roses and chrysanthemums, at the RA from 1880. Born in Canada. Came to England in 1875 and studied at the West London Art Schools. Lived in London.

HAYWARD, Alfred Robert ARWS RP NEAC 1875-1971
Painted landscapes, portraits and mural decorations. Studied at the RCA and at the Slade, 1891-7. Born in London.
Bibl: Studio XXXIX p.346; XLIV pp.41, 141; XLVIII p.229; XLIX p.139; LII p.222; LIII p.122; LIV p.144; LVIII p.138; LXIII p.140; Connoisseur XXIX p.5l; XXXII p.69; XXXIV p.193; XXXVIII p.56; XXXIX p.204; LXI p.116.

HAYWARD, Miss Emily L. fl.1887
Exhib. a work entitled 'Kenneth, Gwendoline and Hugh' at the RA in 1887. London address. Her portrait of the Rev. F.D. Maurice is in London Guildhall.

HAYWARD, J.M. fl.1872
Exhib. a landscape in 1872. Address in Sidmouth, Devon.

HAYWARD, Jane Mary 1825-1894
Painted a portrait of the Rev. F.D. Maurice in 1853-4 which is now in the NPG.
Bibl: Ormond pl.617.

HAYWARD (Haywood), M. fl.1870-1872
Exhib. four watercolours, titles including 'Breakfasting Out', 'The Wedding Present' and 'Comfort in Cold Weather', at SS, 1870-2. London address.

HAYWARD, Miss Mary fl.1867-1874
Painted flowers and still-lifes. Exhib. eight works, including 'A Winter Study', 'Lily of the Valley' and 'In a Somersetshire Wood', at SS, 1867-74. London address.

HAYWOOD, Mrs. Mordan (Emma) fl.1884-1886
Exhib. two views of churches at the NWS in 1884-6. Address in Gipsy Hill.

HEAD, Arthur William b.1861 fl.1886-1893
Painted landscapes, still-lifes and flowers. Exhib. three works: 'Sketch near Whitby', 'The Reedy Pool' and 'Tender Thoughts', at the RA, 1888-93, and two works, 'The South Bay, Seaston, Yorkshire', and 'A Grey Day on the Moors', at SS, 1886-93. Studied at the RCA. Lived in London.

HEAD, B.G. fl.1867-1888
Painted genre and landscapes. Exhib. 31 works, including 'Making Hay While the Sun Shines' and 'The Trysting Place', at SS, 1867-89. Exhib. nine works, including 'Holy Thoughts', 'Little Poachers' and 'In Burnham Beeches', at the RA, 1868-88. London address.

HEAD, Edward Joseph b.1863 fl.1889-1903
Painted figures, landscape and still-life. Studied at the Regent Street Polytechnic and the Scarborough School of Art. Exhib. at the RA from 1889, including 'The Cambridge Fens', 'The Last Load of Hay' and 'A Cornfield by the Sea', and two works at SS, in 1893, 'A Breezy Day' and 'A Summer Day'. Lived in London and Scarborough, Yorkshire.

HEAD, T.J. fl.1895
Exhib. one work entitled 'Tween Gloaming and the Mirk' at the RA in 1895. Address in Surrey.

HEADLAND, Miss Margaret fl.1887-1891
Exhib. three still-lifes and a painting of chrysanthemums at the RA, 1887-91. London address.

HEADLEY, Lorenzo RBSA b.1860
Painted flowers and gardens. Exhib. chiefly in the Midlands from 1888. Lived at Bromsgrove and was a member of Birmingham Art Circle.

HEALEY, C.E.H. fl.1890
Exhib. a work entitled 'Before the Gale' at SS in 1890. London address.

HEALEY, G.R. fl.1840-1852
Painted genre and figurative subjects. Exhib. 19 works, including 'Sketch of a Jew', 'A Scene from *The Tempest*' and ' "Who at Her Trysting Place, Her Rustic Swain Awaits" ' at SS, 1840-52. Exhib. six works, including an illustration to Schiller, at the RA, 1845-51, and three works at the BI, 1849-51. London address.

HEALY, George Peter Alexander 1808-1904
Painted portraits, including one of Joseph Hume.
Bibl: Ormond.

HEAPHY, Archibald C. fl.1870-1889
Exhib. two works, 'Giving to Drink' and 'Care Can Never Touch the Soul, Who Deeply Drinks of Wine' at SS in l870-1 and 1881-2. Address in Wokingham, Berkshire.

HEAPHY, Miss Elizabeth see MURRAY, Mrs. Henry John

HEAPHY, G. fl.1874-1875
Exhib. a work entitled 'Masaniello' at SS in 1874-5. London address.

HEAPHY, Miss Theodosia fl.1883-1885
Exhib. four works, including 'Flowers of the Fall', 'My Fondest Friend' and 'A Westphalian Peasant', at SS, 1883-5. London address.

***HEAPHY, Thomas Frank 1813-1873**
Painter of portraits, and historical and genre subjects. Eldest son of Thomas Heaphy (1775-1835), watercolour painter. Started as a portrait painter in watercolour, and for many years enjoyed an extensive patronage but branched off into the painting of subject pictures in oil. Exhib. at the RA 1831-73, and at the BI, but mostly at SS (68 works). In 1850 exhib. his first subject picture at the RA, 'The Infant Pan Educated by the Wood Nymphs'. Among his most successful works which followed were 'Catherine and Bianca', 1853; a series of peasant girls of various countries, 1859-62; 'Lord Burleigh showing his Peasant Bride her New Home', 1865. In 1867 he exhib. at SBA (SS), 'General Fairfax and his Daughter pursued by the Royal Troops', and in that year was elected a member of the society. He spent many years in an investigation of the traditional likeness of Christ, and published his research in the AJ in 1861 in a series of eight articles. After his death these were reissued in a volume, *The Likeness of Christ,* edited by Wyke Bayliss, 1880. Drawings and oil sketches for this work are in the BM. He travelled widely to do this, and especially spent much time in Rome. In 1844 he was commissioned to paint an altarpiece for the Protestant church at Malta, and he also executed one for a church at Toronto, Canada. At an early period Heaphy assumed the additional name Frank, to distinguish his work from his father's, but dropped it before 1850.
Bibl: AJ 1873 p.308; Athenaeum No. 2390 16 August 1873; Redgrave, Dict.; Roget; Binyon; Cat. VAM 1907; DNB; H. Hubbard OWS XXVI 1948; Hardie III pp.99-100; Ormond.

HEARD, Miss B. fl.1858-1860
Exhib. two paintings of flowers at the BI in 1858 and a work entitled 'Amusing Grandmother' at SS in 1860. London address.

HEARD, Joseph 1799-1859
Painter of ships and shipping scenes. Lived in Liverpool, London and Whitehaven, and exhib. at the Carlisle Academy in 1827. His pictures are realistic and truthful, and are now sought after by collectors of marine pictures. Several of his works are in the National Maritime Museum and the Walker AG, Liverpool. He died in Liverpool.
Bibl: Brook-Hart pl.50.

HEARD, Nathaniel b.1872
Painted landscapes and figures. Studied at the RCA until 1898. Lived in London.

HEARN, R.H. fl.1866-1871
Exhib. four works, two views on the Rance river, one on the Voise river and one entitled 'Sunset', at the RA, 1866-71. Address in Paris.

HEATH, A.H. fl.1854-1855
Exhib. three works, including 'Effie Deans Sentenced to Die' at SS, in 1855, and another 'The Princess Ida, discovering that she too has a Heart' at the BI in 1854. Address in Tonbridge, Kent.

HEATH, Charles 1785-1848
Engraver and illustrator. Son of the engraver James Heath. Best known as the promoter of the Keepsake Annuals.

HEATH, Ernest Dudley fl.1886-c.1930
Painted figurative subjects. Exhib. six works, including 'The Last Rose of Summer', 'As in a Looking-Glass' and 'The White Kitten', at the RA, 1892-1900, and one work, 'Bookseller's Row', at SS in 1893. Signed his paintings Dudley Heath. London address.

HEATH, Frank Gascoigne 1873-1936
Painted landscapes and figurative subjects. Studied at South Kensington, Croydon, Westminster, Antwerp and Bushey. Lived at St. Buryan, Cornwall.

HEATH, Miss Margaret A. fl.1886-c.1920
Painted portraits, genre and figurative subjects. Exhib. 12 works, including 'Her Own Sweet Thoughts for Company', 'The Magic Whistle' and portraits, at the RA, 1889-1900. Also exhib. seven works at the NWS. London address.

HEATH, Miss S.F. fl.1871
Exhib. a watercolour entitled 'Rest Under a Walnut Tree' at SS in 1871. Address in Tonbridge, Kent.

HEATH, Thomas Edward fl.1879-1880
Exhib. a watercolour entitled 'A Stormy Morning in Bracelet Bay, Mumbles', at SS in 1879-80. Address near Cardiff.

HEATH, Thomas Hastead fl. from 1901
Exhib. at the RA from 1901, including a portrait. Address in Cardiff.

HEATH, W. fl.1850-1851
Exhib. two landscapes, both views in Hebden Bridge, Yorkshire, at the RA in 1850 and 1851. Address in Halifax, Yorkshire.

HEATH, William 1795-1840
Painter and engraver. He favoured military and Shakespearian subjects.
Bibl: Redgrave, Dict.; G. Everitt, *English Caricaturists,* 1893; *Shakespeare in Pictorial Art,* Studio Special Spring Number 1916.

HEATH, William H.H. fl.1829-1847
Exhib. five works, including a scene on the river Medway, near Tonbridge, and a view of the Broad Water, near Tonbridge, at SS, 1829-47. Also exhib. a work entitled 'Girl and Dog' at the BI in 1837. Address in Tonbridge, Kent.

HEATHCOTE, Mrs. fl.1877-1878
(Miss Grace Hussey)
Exhib. three landscapes, 1877-8. Address in Salisbury, Wiltshire. See also Grace Hussey.

HEATHCOTE, Mrs. Evelyn fl.1883-1888
Exhib. three landscapes at the NWS, 1883-8. Address in Winchester, Hampshire.

HEATHCOTE, F. fl.1879
Exhib. one work, entitled 'Harvesting', at SS in 1879. London address.

HEATHCOTE, Miss M. fl.1867-1880
Exhib. three Alpine views in 1867-80. Address in Borrowdale, Cumberland.

HEATHCOTE, W.C. fl.1871-1872
Exhib. four watercolours, two of them of Tollymore Park, County Down, and another, a view on the Lynn in North Devon, at SS, 1871-2. London address.

HEATHERLEY, Thomas fl.1858-1887
Painted genre and figurative subjects. Exhib. three works, 'Poor Charlie's Birthday', 'The Dull Book' and 'After the Battle', at the BI, 1858-66. Also exhib. two works at SS, 1868-72, and one 'Princess Elizabeth in the Tower', at the RA, in 1871. London address. Best known as the founder of Heatherley's Academy, and principal from 1860 until his retirement in 1887. Many famous Victorian artists studied there.
Bibl: C Neve, *London Art School in Search of a Home*, Country Life 17 August 1978 pp.448-50.

HEATHERWELL, W. fl.1881
Exhib. a figurative work in 1881. London address.

HEATLIE, William 1848-1892
Painter of landscapes and buildings in oil and watercolour. Lived at Melrose, on the Scottish borders, and painted mostly in that area. Illustrated *The Monks of Melrose* by the Rev. W.G. Allan.

HEATON, A. fl.1867
Exhib. a view of a house at the RA in 1867.

HEATON, John fl.1884-1889
Exhib. a work, 'Windsor From the Home Park', at SS in 1885. Also exhib. five works at the NWS. Address in Datchet, Buckinghamshire.

HEATON, Monica fl.1880-1881
Exhib. two works, a portrait of a woman and a work entitled 'A Study from the Antique' at the RA in 1881. London address.

HEAVYSIDE, John Smith fl.1838 d.1864
Exhib. two landscapes at SS in 1839, and a work, 'An Indian Beggar', at the BI, 1838. Born in Stockton-upon-Tees. Died in London.
Bibl: Hall.

HEDGER, F. fl.1854
Exhib. a work entitled 'Solitude Disturbed' at the RA in 1854. London address.

HEDLEY, Johnson d.1914
Painted landscapes and marines in oil and watercolour. He was the vice-president of the Stanfield Art Society, Sunderland, and a member of the Bewick Club, Newcastle. He is represented in the Sunderland AG. Lived in Sunderland, County Durham. Brother of Ralph Hedley (q.v.).
Bibl: Hall.

***HEDLEY, Ralph 1851-1913**
Newcastle genre painter. Born Richmond, Yorkshire. Studied at Newcastle Art School. President of Bewick Club and Northumbrian Art Institute. Exhib. at RA from 1879. The subjects of his pictures are usually scenes of the working life of ordinary people in his native north-east. Sailors, labourers, recruits, veterans feature most often, usually observed in a gently humorous way. His work can be seen in Sunderland and in the Laing AG, Newcastle.
Bibl: AJ 1904 p.308; RA Pictures 1892-1900, 1905, 1907, 1913; Cat. Sunderland AG 1908; Who's Who 1913, 1914; The Year's Art 1914 p.445; Hall; Ormond; Cat. of R.H. exhib., Laing AG, Newcastle, 1990.

HEGG, Mme. Teresa RI fl.1872-1893
(Mlle. de Lauderset)
Flower painter. Exhib. 30 watercolours at NWS, and also at Society of Lady Painters.

HEINE, E. fl.1863
Exhib. a painting of flowers at the RA in 1863. London address.

HEITLAND, Mrs. H. fl.1889-1893
Is supposed to have exhib. portraits at SS and the NWS and elsewhere. Address in Crouch Hill.

HEITLAND, J. fl.1873
Exhib. a figurative work at the NWS in 1873. Address in Crouch End.

HELCKÉ, Arnold fl.1865-1898
Guernsey landscape and seascape painter. Exhib. at RA, SS, NWS, GG and NG. Subjects mostly views on the English and French coasts. Also exhib. in Paris at the Société des Artistes Français, 1894-8.
Bibl: RA Pictures 1891; VAM 1907 Cat.; Brook-Hart pl.115.

HELCKÉ, Miss Laura fl.1890
Exhib. a painting of flowers in 1890. Address in Bournemouth, Hampshire.

HELMICH, A.
Made a portrait drawing of the 1st Baron Lawrence.
Bibl: Ormond.

HELMORE, Rev. Thomas fl.1885
Exhib. a landscape at the NWS in 1885. London address.

HELY, E.R. fl.1850
Exhib. a view of the Gap of Dunloe, Killarney, at the BI in 1850. London address.

HEMINGWAY, A. fl.1884
Exhib. a view of the south transept of Westminster Abbey at the RA in 1884. Address in Roehampton.

HEMMING, Miss Fanny fl.1885
Exhib. a view of Wroxham Bridge on the Norfolk Broads at the RA in 1885. London address.

HEMMING, Mrs. W.B. (Serena L.) fl.1851-1878
Painted figurative and architectural subjects in Normandy and East Anglia. Exhib. nine works, including 'A Normandy Fish Girl', and views in Beauvais and Brussels at SS, 1851-78. Also exhib. five works at the RA, 1856-9, and five works, including views in Boulogne and Honfleur, at the BI, 1857-9. London address.

HEMSLEY, Walter Howard fl.1868-1871
Exhib. two watercolour studies of fruit at SS in 1868 and 1870-1. London address.

***HEMSLEY, William RBA b.1819 fl.1848-1893**
London genre painter. Son of an architect. At first Hemsley followed his father's profession, teaching himself painting in his spare time. Travelled in Germany and Holland. Exhib. at RA, BI, and especially at SS, of which he was a member, later vice-president. Hemsley's genre scenes of everyday life, which are usually painted on a small scale, follow the gentle tradition of T. Webster and F.D. Hardy (qq.v.). He was, like them, fond of painting children at play.
Bibl: AJ 1853 p.85; 1866 p.178; Ottley; Clement & Hutton; Wood, Paradise Lost.

HEMY, Bernard Benedict fl.1875-1910 d.1913
North Shields marine painter, little known outside the north-east. Brother of Charles Hemy (q.v.). Exhib only two pictures in London, at SS in 1875-7. Also exhib. in Northumberland. Lived in North Shields, Northumberland.
Bibl: Hall; Brook-Hart pl.89.

***HEMY, Charles Napier RA RWS 1841-1917**
Painter and watercolourist of landscape and seascape; brother of Bernard and Thomas Hemy (qq.v.). Studied at Newcastle Art School. Worked on church decoration in Newcastle and Lyons, France. In 1863 he began to exhibit in London. In this early period he painted coastal scenes showing strong Pre-Raphaelite influence, particularly in the detailed painting of rocks. It is these works which are most admired today. Hemy then studied with Baron Leys in Antwerp, and under his influence began to paint historical scenes, mostly in 16th century costume. About 1880, Hemy turned to marine painting, to which he was to devote the rest of his career. Settling in Falmouth, where he died, he spent much time sailing. His marine and coastal scenes of this period, painted in a broad swirling style, show that he had an intimate knowledge and love of the sea. Exhib. at RA from 1865, also at BI, SS, OWS, NWS, GG and NG.
Bibl: AJ 1881 pp.225-7; 1901; 1905; 1907; Studio LXXII 1918 p.73 (obit.); 1919 British Marine Painting, Special Number; RA Pictures 1894-1903, 1906-8, 1910-15; Poynter, National Gallery of British Art 1900 II; Wilson p.41 (pl.16); Maas pp.67, 194 (pls. p.193); Hall; Staley pls. 89a, 161; Brook-Hart, pls. 87, 88; Cat. of C.N.H. exhib. Laing AG, Newcastle, 1984.

HEMY, M.W. (or W.M.) fl.1868
Exhib. a view of Venice in 1868. London address.

HEMY, Thomas Marie Madawaska 1852-1937
North Shields marine painter, brother of Bernard and Charles Hemy (qq.v.). Studied in Newcastle and under Verlat in Antwerp. Exhib. at RA from 1873; also at SS, NWS and GG. Fond of painting shipwrecks. His work can be seen at Sunderland AG and the Laing AG, Newcastle.
Bibl: The Graphic, Pictures of the Year 1914 pp.10, 167; Sunderland AG Cat.1908 p.11; Hall; Brook-Hart.

HENDERSON, Miss A. fl.1853-1861
Exhib. four works, including 'The Village Pump' and 'Reflection', at the BI, 1853-61. Also exhib. a work at SS in 1856. London address.

HENDERSON, A. (or H.) fl.1888
Exhib. a landscape at the NWS in 1888. London address.

HENDERSON, Arthur Edward RBA 1870-1956
An architect who also painted architectural subjects. Lived in Turkey from 1896 and took part in the British Excavations at Ephesus. Lived in London and later at Crawley Down, Sussex.

HENDERSON, Miss C. fl.1850-1854
Painted landscapes and buildings. Exhib. four works, including views in Hertfordshire and Cornwall, at SS, 1850-3, and three works, including a view of Hendon Church, at the BI, 1851-4. London address.

***HENDERSON, Charles Cooper 1803-1877**
Little known painter of coaching scenes in oils and watercolours. Exhib. only twice in London, at the RA in 1840 and 1848. Worked entirely for private patrons. Like J.C. Maggs (q.v.) Henderson carried on the coaching tradition of Pollard long after coaches had begun to disappear from English roads. Many of his pictures were engraved by Fores and Ackermann. As a boy Henderson first studied law, and then took lessons from Samuel Prout (q.v.).
Bibl: DNB XXV 1891 p.396; Maas p.75 (pl.).

HENDERSON, Colonel E. RE fl.1865
Exhib. a view of Cairo in 1865. London address.

HENDERSON, John 1754-1845
Scottish theatre and landscape painter. Born in Glasgow. Died in Dublin.
Bibl: Strickland.

HENDERSON, John 1860-1924
Scottish painter of landscapes. Exhib. at the RSA. Lived in Glasgow. Represented in the Glasgow AG. Son of Joseph Henderson and brother of Joseph Morris Henderson (qq.v.).
Bibl: AJ 1901 p.102; Studio XXV 1902 p.207; Caw.

HENDERSON, John Morris fl.1892-1893
Exhib. at the RA from 1893, including 'Hayfield', 'Cows at Pasture' and 'Stacking Hay'. Address in Glasgow. This is probably one of the sons of Joseph Henderson (q.v.).

HENDERSON, Joseph RSW 1832-1908
Scottish painter of landscapes and Scottish country and coastal scenes. Studied at the Glasgow School of Art. Exhib. 20 works at the RA, 1871-86, including 'Fishing Boats Going Out', 'Morning after a Storm – Carting Seaweed' and 'Haymaking in the Highlands'. Also exhib. four works at SS, 1882-4. Born at Stanley, Perthshire. Lived in Glasgow from 1852. His work shows the influence of McTaggart (q.v.). Father of John and Joseph Morris Henderson (qq.v.).
Bibl: DNB; AJ 1898 p.370; Caw; Brook-Hart.

HENDERSON, Joseph Morris RSA 1863-1936
Scottish painter of landscapes. Studied at Glasgow School of Art. Exhib. chiefly in Scotland. Lived in Glasgow and Busby, Lanarkshire. He was the son of Joseph Henderson and the brother of John Henderson (qq.v.).
Bibl: Caw; AJ 1909 p.153.

HENDERSON, R. fl.1854
Exhib. a watercolour entitled 'The Afternoon Nap' at the RA in 1854. London address. This may be the miniaturist Robert Henderson (1826-1904).

HENDERSON, W.S.P. fl.1836-1874
London genre and portrait painter who exhib. 1836-74, at the RA, 1839-63, at BI and SS, titles at the RA including 'The Last Look of Home', 'A Cottage Scullery', etc.

HENDERSON, Mrs. William fl.1816-1841
Painted mythological, biblical and literary subjects. Exhib. 11 works, including 'Prospero and Miranda', and 'Pekuah Waiting for her Ransom, "She was Weary of Expectation" ' at the RA, 1816-41. Exhib. eight works at the BI, 1817-31, and two works at SS, 1827-9. London address.

HENDERSON, William fl.1817-1848
Painted fruit and fish. Exhib. four works, including 'Lobster', 'Fruit Piece from Nature' and a view on the Surrey Canal at SS, 1824-48. Also exhib. three works at the RA, 1817-25. London address.

HENDERSON, William fl.1874-1892
Painted landscapes and figurative subjects. Exhib. nine works including 'Autumn Ploughing in Bucks', 'Out in the Snow' and 'The March Past', at SS, 1874-93. Address in Whitby, Yorkshire.

HENDLEY, G.E. fl.1886
Exhib. a work entitled 'Returning from the Orchard' at SS in 1886. London address.

HENDRIE, Robert fl.1867-1868
Exhib. a work entitled 'Cub-Hunting — noon; Lullingstone' at the RA in 1867. London address.

HENDRIX, J. Louis fl.1870
Exhib. a scriptural subject in 1870. Address in Antwerp.

HENDRY, George E. fl.1901
Exhib. a work entitled 'Autumn Leaves' at the RA in 1901. London address.

HENKLEY, Henry fl.1886
Exhib. an architectural subject in 1886. London address.

HENLEY, A.W. fl.1880-1881
Exhib. a landscape at the GG in 1880-1. London address.

HENLEY, J. fl.1836-1843
Exhib. two works, one a portrait of a boy with a rabbit, at SS, in 1836 and 1837. Also exhib. a work at the BI in 1838 and another at the RA in 1843. London address.

HENLEY, Lionel Charles RBA c.1843-1893
Genre painter who exhib. 1862-93 at the RA, 1862-88, at BI, and SS (124), titles at the RA including 'Private and Confidential', 'A Vexed Question', etc. He studied first in Düsseldorf and exhib. in Magdebourg before returning to Lodon. A painting by him is in Leeds AG.
Bibl: D. Du Maurier, *The Young George Du Maurier*, 1951; L. Ormond, *George Du Maurier*, 1969.

HENLEY, W.B. fl.1854-1856
Exhib. three landscapes, at Yardley, Worcestershire, at King's Norton, and on a river near Birmingham, at the BI, 1854-6. Address in Birmingham.

HENNESSY, William John ROI PS NA 1839-c.1920
Irishman who painted landscapes in America, England and France, and figurative subjects. Exhib. 16 works, including views in New England, Long Island and Normandy, at the RA, 1871-82. Also exhib. at the GG and elsewhere. Born in County Kilkenny, Ireland. Lived in America until 1870, when he moved to London. For works illustrated by, see Card Cat. at VAM.
Bibl: Clement & Hutton; Champlin and Perkins, *Cyclopaedia of Painters*, 1888.

HENNIKER, Miss Annie L. fl. from 1897
Exhib. at the RA from 1897 including 'Confidences', 'Sweet Hopes that Come with Spring' and 'Trysting'. Address in Tooting, London.

HENRI, Lucien fl.1887
Exhib. a work entitled 'Stenocarpus and Strelitza' at the RA in 1887. Address in Sydney, Australia.

HENRY, Barclay fl.1899
Exhib. a work entitled 'The Flowing Tide' at the RA in 1899. Address in New Brunswick.

HENRY, Francis A. fl.1883-1887
Exhib. two works, 'A Devonshire Mill' and 'Line of Coast, Sark', at the RA in 1883 and 1887, and a view on the Northumberland coast at SS in 1883. London address.

***HENRY, George RSA RA RSW 1858/60?-1943**
Glasgow school landscape and decorative painter. Studied at Glasgow School of Art. Met Sir James Guthrie, J. Crawhall Jnr. and E.A. Walton (all q.v.), with whom he worked at Brig O'Turk and Roseneath, and later at Eyemouth and Cockburnspath. Began to exhib. at Glasgow Institute in 1882. In 1895 he met E.A. Hornel (q.v.). The two painters found their ideas so *en rapport* that they shared a studio, and produced two large works together — 'The Druids' and 'The Star in the East'. The former was very successful at the GG in 1890. In 1892 Henry was sent abroad to convalesce, and he and Hornel visited Japan together. This had a great effect on Henry's work, and he painted many Japanese subjects on his return, striving constantly for pleasing decorative effects. Member of the NEAC, 1887. President of Glasgow Art Club, 1901-2. Elected ARSA 1892, RSA 1902, ARA 1907, RA 1920.
Bibl: Studio XXIV p.117; XXXI p.3ff., p.95ff.; LXVIII p.73ff., p.95ff.; LXXXIII p.33; AJ 1904-7; 1909; D. Martin, *Glasgow School of Painting* 1902; Caw pp.399-404; George Buchanan, The Scottish Art Review Vol.7 No.4; *The Glasgow Boys* Scottish Arts Council exhib. 1968; Irwin pls.l99, 202-3.

HENRY, James Levin 1855-c.1904
Landscape painter who exhib. 1877 at the RA, SS, NWS, GG and elsewhere. *The Studio*, 1908, wrote regarding 'A West Coast Harbour', and 'Breezy Lowlands' — "they are particularly remarkable for their power and interest, their sense of atmosphere and regard for beauty."
Bibl: Studio Special Number, Art in 1898; Studio LXIV 1908 p.36; Manchester City AG, *Handbook to thePermanent Collection*, 1910; Athenaeum 1920 I p.375.

HENRY, Paul RHA 1876-1958
Painted portraits and landscapes. Studied at Belfast School of Art and Paris under Whistler and J.P. Laurens. Lived in County Wicklow, Ireland.

HENRY, William see HAINES, William Henry

HENSHALL, J. fl.1848-1863
Painted architecture. Exhib. 15 works, including views in Dieppe, Rouen, York, Coventry and Abbeville, at the BI, 1853-63. Also exhib. five works at the RA, 1844-63, and two works at SS, in 1863. London address.

***HENSHALL, John Henry RWS 1856-1928**
Painter of genre and historical subjects, in oil and watercolour, the latter often very large, the subjects highly dramatic and full of sentiment. Educated at South Kensington Schools and RA Schools. Exhib. from 1879 at the RA, SS, RSW, Salon and elsewhere. ARWS 1883; RWS 1897. His works include 'Adam Bede', 1894, 'The Stool of Repentance', 1895 (a naughty girl sitting on a high stool), 'Her Daughter's Legacy', 1897 (a grandmother holding her daughter's child, and comparing youth with old age). His paintings were purchased by Birmingham, Leeds, Hull, Manchester, Bristol, Preston and Blackpool, for permanent collections.
Bibl: AJ 1894 p.123; 1895 p.61; 1897 p.104; RA Pictures, 1897, 1901, 1908, 1910, 1912; Benezit II 1913; Who's Who 1922; Wood, Panorama; Newall.

***HENSHAW, Frederick Henry 1807-1891**
Birmingham landscape painter. Pupil of J.V. Barber. Influenced by Turner. Travelled in Germany, Switzerland and Italy, 1837-40. Exhib. in London, 1829-64, at RA, BI, and SS; also at Birmingham Society of Artists. Apart from occasional continental views, his work is mostly English landscape, painted in the Midlands, Wales or Scotland. Works by him are in Birmingham and Glasgow AG. Occasionally collaborated with an artist called R.J. Hammond.
Bibl: The Portfolio 1891; Art Chronicle p.XXIV.

HENSLEY, Mrs. P. (Marie) fl.1897-1902
Exhib. two paintings of violets at the RA in 1897 and 1902. London address.

HENSMAN, Frank H. fl.1890
Exhib. a work entitled 'Where the Pheasants Feed — Windsor Forest' at the RA in 1890. Address in Windsor, Berkshire.

HENSMAN, Miss Rosa Fryer fl.1886-1893
Painted genre subjects. Exhib. five works, including 'So Heavy', 'La Toilette de Dimanche' and 'Disillusioned', at SS, 1886-94. London address.

HENTON, George W. Moore 1861-1924
Painted architectural subjects. Studied at the Leicester School of Art. Exhib. at the RA from 1884, including 'Peterborough Cathedral', 'The Long Walk, Eton College' and 'Brewer's Yard, Eton College'. Also exhib. ten works at the NWS. Born, educated and lived in Leicester. He was a member of the Leicester Society of Artists.

***HENZELL, Isaac fl.1854-1875**
London genre painter. Exhib. 1854-75 at RA, BI, and especially SS. Also a landscape painter. Works by him are in Reading, Sheffield and York AGs. Known to have collaborated with Henry Bright of Norwich (q.v.). Subjects usually rustic scenes with children and pretty girls.
Bibl: AJ 1859 pp.141-3.

HEPBURN, Mrs. Blanche fl.1891
Exhib. a genre subject in 1891. London address.

HEPPER, G. fl.1866-1868
Exhib. three works, 'Uncle Charlie's Favourites', 'Aunt Peggie's Pets' and 'The Old Coachman', at the BI, 1866-7. Also exhib. two works at SS in 1866 and 1868. London address.

HEPPLE, John Wilson 1886-1939
Painted animals and genre subjects. Learnt to paint under instruction from his father Wilson Hepple (q.v.). Taught art at the Armstrong Technical School, Newcastle-upon-Tyne.
Bibl: Hall.

HEPPLE, Wilson 1854-1937
Northumbrian painter of animals, especially kittens, sporting scenes, and genre subjects. He also painted scenes of local interest such as 'Last of the Old Tyne Bridge' and 'King Edward VII's visit to Newcastle'. He was a founder member of the Bewick Club in Newcastle and exhib. there. Lived in Acklington, Northumberland. Represented in the Laing AG.
Bibl: Hall.

HEPWORTH, Walter fl.1885-1886
Exhib. two works, a watercolour entitled 'A Sunny Afternoon' and 'Ready', at SS in 1885-6 and 1886-7. Also exhib. a work entitled 'A Suffolk Common' at the RA in 1885. London address.

HERALD, James Watterson 1859-1914
Painted landscapes and coastal views in watercolour. Studied at Dundee, Edinburgh and at Herkomer's School at Bushey. Influenced by the work of Arthur Melville and Japanese art. Lived in London until 1901, when he moved to Arbroath, Angus.
Bibl: Hardie III pl.235.

HERBERT, Alfred fl.1843-1860 d.1861
Southend marine painter and watercolourist. Exhib. at RA, 1844-60, BI and SS. Subjects mainly coastal scenes of East Anglia, Devon, Kent, Holland and France. Works can be seen at Beecroft AG, Southend.
Bibl: AJ 1861 p.56; Redgrave, Dict.; DNB XXV 1891 p.168; Wilson p.41 (pl.16); Brook-Hart.

HERBERT, Arthur John 1834-1856
Exhib. two works, 'Don Quixote's First Impulse to Lead the Life of a Knight Errant' and 'Philip IV of Spain Knighting Velazquez', at the RA in 1855 and 1856. London address. Brother of Cyril Wiseman H. (q.v.) and Wilfred Vincent H. (q.v.).
Bibl: Redgrave, Dict.; AJ 1882 p.256; DNB XXVI p.172; Ottley.

HERBERT, Cyril Wiseman 1834-1856
Exhib. five works, including 'Homeward After Labour', 'An Idyll' and 'On the Hill-tops', at the RA, 1870-5. London address. Brother of Arthur Herbert and Wilfred Herbert (qq.v.).
Bibl: See under Arthur John Herbert and John Rogers Herbert.

HERBERT, Frank fl.1857-1866
Exhib. a work entitled, 'Far Far Away' at the RA in 1866, and a portrait at the RA in 1857. London address.

***HERBERT, John Rogers RA HRI 1810-1890**
Painter of portraits, historical genre, biblical scenes and landscape. Studied at RA schools, 1826-8. At first a painter of portraits, which he began to exhib. at the RA in 1830. He then tried his hand at romantic genre. His picture 'The Rendezvous' was engraved for one of the Keepsake books. Following a visit to Italy, he painted many Italian historical subjects. A keen admirer of Pugin, Herbert was converted to Catholicism about 1840. Thereafter his subjects were predominantly biblical, although he continued to paint some charming landscapes and genre scenes. Herbert's biblical scenes tend to be dry and academic, and show familiarity with the work of

Dyce and the Nazarenes. His picture of 'Our Saviour Subject to his Parents at Nazareth' (Guildhall AG exhib. in 1847), seems to anticipate Millais's 'Christ in the House of his Parents', painted three years later, but Herbert used far more conventional Italian-style figures. Exhib. at RA, BI and SS; elected ARA, 1841, RA, 1846. His sons Arthur John, Cyril Wiseman and Wilfred Vincent were painters (all q.v.).

Bibl: AJ 1865 p.162; T. Smith, *Recollections of the BI,* 1860; Redgrave, Cent.; W. Sandby, *History of the RA,* 1862 II; Ottley; DNB XXVI 1891; BM Cat. of Engraved British Portraits II-IV; Studio, Shakespeare in Pictorial Art, Special Spring Number 1916; Reynolds, VS pp.63, 67 (pl.28); Reynolds, VP pp.38, 58, 64 (pl.30); Maas pp.16, 28 (pl. p.28); Ormond; Strong.

HERBERT, Richard fl.1892-1893
Exhib. two works, 'Arundel' and 'A Surrey Thatch', at SS in 1892 and 1893-4. Address in Leatherhead, Surrey.

HERBERT, Sydney 1854-1914
Exhib. a work, 'Sunset, Conway Bay', at SS in 1865. Born in Worcestershire. Lived in Cheltenham, where he taught at the Ladies College. His work, 'A Dream of Ancient Athens' is in the Leeds City AG.

Bibl: Notes and Queries II Series IX 1914 p.380.

HERBERT, T. fl.1868-1870
Exhib. six watercolours, including 'Shades of Evening', 'Poplars at Wargrave' and 'The Close of Day', at SS, 1868-70. Address in West Malvern, Herefordshire.

HERBERT, Wilfred Vincent fl.1863-1891
Painted biblical and historical subjects, and portraits. Exhib. 27 works, including 'St. Martin of Tours', 'Captives from Britain in the Arena of the Flavian Amphitheatre' and 'Runnymede near Windsor', at the RA, 1863-91. Brother of Cyril and Arthur Herbert (qq.v.).

Bibl: Ormond; also see under Arthur John Herbert and John Rogers Herbert.

HERBERTE, E.B. fl.c.1870-1880
With the revival of interest in sporting pictures, works by Herberte now frequently appear on the art market, although practically nothing is known of his career. He never exhib. in London, painting hunting scenes for private patrons. His pictures are usually painted in pairs, or sets of three or four.

Bibl: Pavière, Sporting Painters p.48 (pl.23).

HERDMAN, Miss Maud fl.1891-1895
Exhib. six portraits at the RA, 1891-5. Address in County Tyrone, Ireland.

*HERDMAN, Robert RSA RSW 1829-1888
Scottish painter of genre and historical subjects, portraits, landscape and flowers. Born at Rattray, Perthshire, where his father was parish minister, he was educated in theology at St. Andrews. A good Greek scholar, he retained a love for classics throughout his life. However, he left university; exhib. for the first time at the RSA in 1850, and in 1852 entered the Trustees' Academy as a pupil under Scott Lauder. In 1854 he won the Keith Prize for the best historical work by a student in the exhib., and visited Italy the following year. Elected ARSA in 1858; RSA in 1863. Some of his early paintings illustrated biblical subjects, but after his return from a visit to the continent in 1855 which supplied him with several Italian subjects, e.g. his diploma work 'La Culla', 1864, his source of inspiration became Scottish, history and song: often patriotic

subjects like 'After the Battle', 1870 Edinburgh, showing a severely wounded soldier with his family. He also did portraits, e.g. 'Lady Shand', 1867 Edinburgh, and single figures, often Scottish peasant girls. He did some charming work in watercolour, and many of the holiday sketches of wildflowers, boulders and seashores, made in Arran, are very beautiful. Caw remarks that, in his oils, his chief defects were "a want of solidity and richness of impasto, and a certain greasiness of touch". He was certainly the best educated and most highly cultured man of his group.

Bibl: AJ 1873 p.376; W.D. McKay, *Scottish School of Painting,* 1906; Studio Special Number RSA 1907 XLI (pls.); Caw pp. 60,174-6, 204, 233, 475, 478; DNB; Ormond; Strong.

HERDMAN, Robert Duddingstone ARSA 1863-1922
Painted portraits and genre subjects. Studied at the RSA Schools and subsequently travelled in France, Spain and Holland. Exhib. mainly in Scotland, but also, from 1888, at the RA, titles including 'The Heaven of Childhood's Eyes', 'I sent my Love a Letter' and portraits. Also exhib. in Paris, Munich and Vienna. He was the second son of Robert Herdman (q.v.). Lived in Edinburgh.

Bibl: Studio XLII p.64; XLIV p.232; Connoisseur XXXVIII p.72; The Year's Art 1923; Irwin pl.150.

HERDMAN, William Gawin 1805-1882
Liverpool landscape and topographical painter. Best known for his topographical studies of Liverpool and the surrounding area, such as 'Pictorial Relics of Ancient Liverpool' published in 1843 and 1856. Joined Liverpool Academy in 1836. Following a quarrel with the Academy in 1857 over the annual award to Millais for his 'Blind Girl', Herdman left and set up a rival society, the Institution of Fine Arts. He exhib. landscapes at the RA, 1834-61, mostly views around the Liverpool area. He also wrote essays and pamphlets on a wide variety of subjects, including curvilinear perspective, and *Hymns and Ancient Melodies,* and published a book of poems.

Bibl: Walker AG Liverpool 1884 Cat.; Marillier pp.136-42 (pl.opp.p.136); DNB XXVI.

HEREFORD, E. fl.1884-1888
Exhib. two views of Venice at the NWS, 1884-8. Address in Greenock, near Glasgow.

HERFORD, Miss A. Laura fl.1861-1869
Painted figurative subjects. Exhib. six works, including 'An Evening Study', 'Thoughtful' and 'Brother and Sister' at the RA, 1861-7, and six works, including 'Convalescent' and 'Viva Garibaldi', at SS,

*HERING, George Edwards 1805-1879
London landscape painter. Son of a bookbinder. Studied in Munich 1829. Travelled in Switzerland with his patron, Lord Erskine, and then studied two more years in Venice. After further travels in the Levant, he came to Rome, where he met John Paget, a publisher of travel books, for whom he worked on many illustrations. After seven years' absence, Hering returned to London in 1836, and became a regular exhibitor at the RA, BI and SS. For his subjects, he drew mostly on his travel sketches made on the continent and in the Middle East. His pictures are often small in scale, but painted with a delicate feeling for light and atmosphere. His wife was also a landscape painter (q.v.). After Hering's death, two sales of his works were held at Christie's, 7 May 1880 and 25 April 1881.

Bibl: AJ 1861 pp.73-5; 1880 p.83 (obit.); DNB XXVI p.244.

HERING, Mrs. George Edwards fl.1840-1858
Painted landscape and buildings. Exhib. six works, including 'The Church of the Salute, Venice' and 'Evening — A Sketch in the Isle of Arran', at the RA, 1840-58, and three works, a view near Spezzia and two views in the Highlands, at SS, 1853-5. London address. Wife of George Hering (q.v.).

HERIOT, George 1766-1844
Amateur watercolourist.
Bibl: Hardie III pl.275.

HERKLOTS, Rev. Gerard Andreas fl.1878
Exhib. two works, a view on the coast of Cornwall and a watercolour view on the Isle of Arran, at SS, 1878 and 1893. London address.

HERKOMER, Miss Bertha fl.1889-1890
Exhib. two paintings of flowers in 1889-90. Address in Watford, Hertfordshire.

HERKOMER, Herman G. ROI b.1863 fl.1884-1893
Anglo-American painter of portraits. Exhib. at the RA from 1886 including portraits of Hubert Herkomer and H.R.H. the Duke of Cambridge. Also exhib. various sketches and figurative subjects at SS, 1884-7. Born in Cleveland, Ohio. Lived in London and Bushey, Hertfordshire.
Bibl: AJ 1888 p.128.

***HERKOMER, Sir Hubert von RA RWS CVO 1849-1914**
Painter of social realism, portraits, historical subjects and landscapes; engraver. Born at Waal, Bavaria; son of a woodcarver, who settled in Southampton, 1857. Entered South Kensington Schools in 1866 where he studied under Fildes (q.v.); influenced by Frederick Walker (q.v.). From 1869 he received an income from *The Graphic* for engravings. Exhib. from 1869 at the RA, SS, OWS, RI, GG, NG and elsewhere. He first achieved great success with 'The Last Muster, Sunday at the Royal Hospital, Chelsea', 1875, which was bought for £1,200 by the Lady Lever Gallery. Among his outstanding social-genre paintings are 'Found', 1885, Tate Gallery, 'Hard Times', 1885, Manchester, 'On Strike', 1891, RA Diploma. As a portrait painter he had a very extensive clientele, his portraits including those of Wagner, Ruskin, Lord Kelvin and Lord Kitchener. He also made a speciality of large portrait groups, somewhat reminiscent of 17th century Holland, e.g. 'The Chapel of the Charterhouse', RA 1889, 'The Council of the RA', 1908 and 'The Firm of Friedrich Krupp', 1914. He composed music and wrote some operas, acted and designed stage scenery, even living to design sets for the cinema. He founded and directed the School of Art at Bushey, 1883-1904; Slade Professor of Fine Arts at Oxford, 1885-94; member of the Institute of Painters in watercolours, 1871; ARA, 1879; RA, 1890; ARWS, 1893; RWS, 1894; CVO, 1890; knighted, 1907; raised to noble rank by the Emperor of Germany in 1899, and afterwards assumed the prefix von. Wrote an autobiography and on etching, etc. Maas writes: "Herkomer claimed to have learned in England that 'truth in art should be enhanced by sentiment'."
Bibl: For full bibl. and list of paintings and publications see TB 1925. Selected Bibl: AJ 1870 p.86; Studio XXIX 1903 pp.60, 63; L 1910 p.15; LVI 1912 p.17; Ludwig Pietsch, *Herkomer,* 1901; A.L. Baldry, *Hubert Von Herkomer RA, a Study and a Biography,* containing a list of his works to 1901, 1902; Sir H. von Herkomer, *My School and My Gospel,* 1908; Sir H. von Herkomer, *The Herkomers* 2 vols. 1910-11; Who's Who 1913; DNB 1912-21; J. Saxon Mills, *Life and Letters of Sir Hubert Herkomer, A Study in Struggle and Success,* 1923; Reynolds, VS pp.27, 30-1, 96-7, 105 (pl.91); Maas p.237 (pl.239); Ormond; Peter Ferriday, *Hubert von Herkomer,* Country Life 25 January and 1 February 1973; Wood, Panorama; Cat. of Herkomer exhib. at Watford AG 1982; Newall; Wood, Paradise Lost.

HERKOMER, Lorenz, Snr. fl.1872 d.1887
German woodcarver; exhib. a figurative work in 1872. He was the father of Hubert von Herkomer (q.v.). He settled in Southampton in 1857 and died in Bushey in 1877.

HERMAN, R.W. fl.1847
Exhib. a work entitled 'Old Manor House on the Cliffs near Margate', at the BI in 1847. London address.

HERMANN, H. fl.1858-1859
Exhib. five works, including 'Her First Service', 'The Organ Player' and two portraits at the RA in 1858-9. London address.

HERMSTIN, O. fl.1880
Exhib. a work entitled 'The Old Battlefield' at the RA in 1880.

HERN(E), Charles Edward 1848-1894
Painted townscapes, marines and views of buildings. Exhib. six works, including views in Langham Place and of Westminster Abbey, at SS, 1887-93, and five works, including views in the London Docks and the East End, at the RA, 1884-93. London address. Taught members of the royal family, including the Princess Royal.

HÉROULT, Mrs. fl.1838
Exhib. a work, a view on the Dyle, at the RA in 1838. London address.

HÉROULT, H. (or M.) fl.1838
Exhib. two works 'A Promenade in Meudon' and 'A Fair at Rouen' at SS in 1838. London address.

HERRICK, William Salter fl.1852-1880
Painted portraits and scenes from Shakespeare. Exhib. 33 works, the majority portraits but also including 'The Gipsy Fortune Teller from *The Vicar of Wakefield',* 'Portia "Have Mercy Jew" ' and 'Ophelia "Sweet Bells Jangling out of Tune" ' at the RA, 1852-80. Also exhib. seven works at the BI, 1857-67. London address.
Bibl: Illustrated Cat. of Pictures Shakespeare Memorial at Stratford-upon-Avon, 1896; BM Cat. of Engraved British Portraits 1910; Ormond.

HERRIES, H. fl.1855
Exhib. a work entitled 'First Day from Cairo to Suez — Losing Sight of the Valley of the Nile', at the RA in 1855.

HERRIES, H.C. fl.1865-1873
Exhib. a watercolour entitled, 'A Cloudy Morning', at SS in 1867. Also exhib. elsewhere. London address.

HERRING, Benjamin, Snr. 1806-1830
Animal and sporting painter; brother of J.F. Herring Snr. (q.v.). Did not exhib. in London. Painted hunting scenes, racehorses, and horse fairs. Very often confused with Benjamin Herring Jnr. (q.v.). His style is similar, but not as good as J.F. Herring and Harry Hall.
Bibl: Sparrow; Pavière, Sporting Artists p.48 (pl.23 — the picture illus. is dated 1867, and must therefore be by Benjamin Herring Jnr.)

HERRING, Benjamin, Jnr. 1830-1871
Painter of animals, sporting scenes and rustic genre. Lived in Tonbridge. Son of J.F. Herring Snr. (q.v.), and often confused with Benjamin Herring Snr. (q.v.). Exhib. at BI and SS, 1861-3. It is possible that many of the forged J.F. Herring farmyard scenes now in circulation are by Benjamin Herring, Jnr.

HERRING, Charles fl.1842
Exhib. a study from nature at SS in 1842. Address in Camberwell. He was a son of J.F. Herring Snr. (q.v.).

***HERRING, John Frederick, Snr.** 1795-1865
Sporting and animal painter. At first a sign and coach painter. Worked as stable boy and coachman in Yorkshire until, with the help of patrons, he was able to study with Abraham Cooper (q.v.). Exhib. at RA, 1818-46, and BI, but mostly at SS (82 works) of which he was a member, 1841-52. Herring became a popular painter of racehorses. For many years he painted the winners of the Derby and the St. Leger, as well as many other famous horses and jockeys of the day. He also painted many charming small-scale studies of rabbits, ducks, goats, birds, and other animals. Towards the end of his career he turned increasingly to repetitious farmyard scenes, which were much copied and imitated by his son J.F. Herring, Jnr. (q.v.). He had two other sons, Benjamin Jnr. and Charles (qq.v.) who died aged 28. Many of Herring's works were engraved. He held the appointment of animal painter to the Duchess of Kent. Sometimes collaborated with Thomas Faed (q.v.). A picture by both artists is in the City of York AG. Herring's studio sale was held at Christie's, 3 February 1866.
Bibl: AJ 1865 pp.172, 328 (obit.); *Memoir of J.F.H.,* Sheffield 1848; Redgrave, Dict.; Bryan; DNB XXVI p.258ff.; Guy Paget, *Sporting Pictures of England;* Sporting Magazine Vol. 6; Sparrow, see Index (pls.76, 83); Pavière, *Sporting Painters* p.49; Maas pp.74, 78, 82 (pl. p.78); Ormond; Oliver Beckett, *J.F. Herring and Sons,* 1981.

HERRING, Mrs. John Frederick fl.1852-1866
Exhib. a portrait of children at the RA in 1852 and a work entitled 'The Old Lodge', at SS in 1866. She was a member of the Society of Lady Artists. London address.

***HERRING, John Frederick, Jnr.** fl.1860-1875 d.1907
Sporting and animal painter and watercolourist. Son and imitator of J.F. Herring Snr. (q.v.). Exhib. mainly at SS (53 works), also at RA and BI. Herring Jnr. is said to have quarrelled with his father, and although a competent artist, he devoted his career to copying and imitation of his father's work, particularly farmyard scenes. As both painters used the same name and initials, their work is constantly confused. Herring Jnr.'s style is much coarser, and became more so as he got older.
Bibl: AJ 1907 pp.160, 251, 360; Sparrow, pp.222-3; Oliver Beckett, *J.F. Herring and Sons,* 1981; Wood, Paradise Lost.

HERRINGTON, Fred W. fl.1882-1890
Exhib. a painting of a dead pigeon at SS in 1882-3. London address.

HERTFORD, Mrs. A. fl.1863-1868
Painted figurative subjects. Exhib. five watercolours, including, 'Stepping Westward', 'The Hop Picker' and 'The Gipsy Girl', at SS, 1863-8. Also exhib. four works, including 'Gipsy Mother and Child' and 'Autumn Mist Clouds — Malvern', at the BI, 1863-5. Address in West Malvern, Herefordshire.

HERVÉ, A. fl.1841-1843
Exhib. three portraits at the RA, 1841-3. London address.

HERVIEU, August fl.1819-1858
Painted portraits, mythological and literary subjects. Exhib. 31 works, including 'Miss Agnes Strickland, Historian of the Queens of England' and 'L'Amour "Qui que tu sois" Voltaire'. Also exhib. 13 works, including portraits and genre subjects, at SS, 1827-49, and three works, 'The Apotheosis of Byron', 'Fresh Eggs' and 'Contentement passe Richesse', at the BI, 1825-47. London address.
Bibl: BM Cat. of Engraved British Portraits 1908; Ormond.

HERVY, Leslie fl.1893-1894
Exhib. a watercolour of chrysanthemums at SS in 1893-4. Address in Bedford.

HESELTINE, Arthur fl.1879-1880
Exhib. three landscapes in 1879-80. London address.

HESKETH, Richard 1867-1919
Newcastle landscape painter. Exhib. locally.
Bibl: Hall.

HETHERINGTON, Ivystan fl.1875-1904
Painted landscapes. Exhib. 19 works, including 'Sunny Devon', 'September "Flushed Autumn's Sunny Days Flew By" ' and 'When Autumn Wreathes its Spell Around the Year', at the RA, 1877-1900. Also exhib. four works at SS, 1877-9. London address.

HEUSS, F. fl.1842-1844
Exhib. portraits of the Duke and Duchess of Cambridge and another, at the RA, 1842-4. Address in Germanny.

HEUSS, M.
Painted a portrait of the Marquis of Normanby. Ormond suggests this painter is the same as Eduard von Heuss (1808-80).
Bibl: Ormond.

HEWETSON, Miss Edith fl.1893
Exhib. a landscape in 1893. London address.

HEWETSON, Edward fl.1889
Exhib. a landscape, 'Aberlour, Croix des Gardes, Cannes, France', at the RA in 1889. Address in Cannes, France.

HEWETT, Miss Mabel fl. from 1898
Painted fruit. Exhib. at the RA from 1898 including 'Apples', 'Lemons and Marguerites' and 'Prospects of Punch'. London address.

HEWETT, Sir Prescott Gardiner FRS HRWS 1812-1891
Eminent surgeon, collector, and amateur painter. Exhib. 16 landscape watercolours at the OWS and four landscapes at the GG. His watercolour of Newquay Bay, Cornwall is in the Tate Gallery. London address.
Bibl: DNB; Roget; Cundall; VAM Cat.

HEWETT, Miss Sarah F. fl.1851-1883
Exhib. a watercolour, entitled 'Catch Me', at SS in 1854, and another 'Hop Picking at Sevenoaks, Kent' at the RA in 1857. Address in Leamington, Warwickshire.
Bibl: AJ 1859 p.84.

HEWINS, Alfred J. fl.1891
Exhib. a work 'A Peep into Shropshire' at the RA in 1891. Address in Wolverhampton, Staffordshire.

HEWIT, Forrest RBA 1870-1956
Painted figurative subjects and landscapes. Studied under T.C Dugdale and Walter Sickert. Lived at Wilmslow, Cheshire.

HEWITT, Alice J. fl.1888
Exhib. a work 'Isaac of York — *Ivanhoe*' at SS in 1888. Address in St. Leonards, Sussex.

HEWITT, H. fl.1845-1870
Painted landscapes. Exhib. eight works, including 'Mill near Bristol' and 'Clearing after Stormy Weather, Backwell Downs near Bristol', at the BI, 1845-54. Also exhib. four works, including Welsh landscape watercolours, at SS, 1851-70, and two works at the RA in 1850. Address in Bristol.

HEWITT, Henry George RBA fl.1884-1907
Painted landscape. Exhib. three works, including 'Apple Blossoms' and 'The Last Pages', at SS, 1884-92, and at the RA from 1889, including 'Season of Mists and Mellow Fruitfulness' and 'The Dying Flame of Day'. London address.

HEWKLEY, Henry fl.1890-1893
Exhib. two works, 'In the Parc Royal, Brussels' and 'Papendrecht near Dordrecht', at the RA in 1890 and 1899, and two works, views in Palmer's Green, at SS, 1893-4. London address.

HEWLETT, Arthur L. fl.1889-1893
Exhib. two works, 'Long Thrown Shadows' and a portrait, at the RA in 1889 and 1893. Address in Bushey, Hertfordshire.

HEYDENDHALL, C. fl.1881
Exhib. a landscape in 1881. London address.

HEYWOOD, Tom fl.1880
Exhib. a genre work in 1880. Address in Oldham, Lancashire.

HEYWORTH, Richard ROI b.1862 fl.1890
Painted coastal landscapes. Studied under Benjamin Constant and David Davies. Exhib. a landscape in 1890. Also exhib. Paris Salon. Lived in Charlton Kings, Gloucestershire.

HIAKTAKE, Y. fl.1876
Exhib. one work, a view near Yokohama, Japan, at the RA in 1876. London address.

HICKIN, George fl.1858-1877
Painted landscapes and birds. Exhib. 24 works, including 'Turkeys and Fowls', 'On the River Clwyd, near St. Asaph' and 'A Foraging Party', at SS, 1851-92. Also exhib. seven works, mostly still-lifes of dead game, at the RA, 1858-62, and six works at the BI, 1858-62. Lived in Greenwich, Liverpool and Cheshire.

HICKIN, George Arthur fl.1880
Exhib. a view of Glyder Fawr, North Wales, at the RA in 1880. Address in Birmingham. Perhaps the same as George Hickin (q.v.).

HICKMAN, Miss Evelyn fl.1891
Exhib. a work entitled 'Summer' at the RA in 1891. Address in St. Leonards, Sussex.

HICKS, Albert S. fl.1885
Exhib. a work entitled 'The Labourer's Home' at the RA in 1885. Address in Sydenham, Kent.

***HICKS, George Elgar RBA 1824-1914**
London painter of genre, portraits and scenes of Victorian life. Studied to be a doctor, but changed to painting, entering RA Schools in 1844. Exhib. 1848-1905 at RA, BI, SS and GG. The success of 'Dividend Day at the Bank of England', 1859, led Hicks to attempt more scenes of contemporary life, such as 'The General Post Office at One Minute to Six', 1860, and 'Billingsgate Market',

1861, in the colourful style of Frith. These brought Hicks great popularity, but he turned later to portraits, and biblical and historical genre. As a society portrait painter, Hicks was much in demand, but his work in this field has none of the charm or quality of his genre scenes of the 1860s. His importance as a painter of modern-life subjects has yet to be sufficiently recognised.
Bibl: AJ 1872 pp.97-9; Clement & Hutton; Reynolds, VS pp.8, 13-14, 88-9 (pls. 73-4); Reynolds, VP III; Maas pp. 117, 119, 121; Wood, Panorama *passim* (pls. 2, 31, 57, 81, 82, 108, 151, 180, 199 and cover), Cat. of G.E.H. exhib., Geffrye Museum, London, 1983.

HICKS, George Matthew fl.1854-1856
Painted landscapes. Exhib. three works, 'The Falls of the Ackarn', 'Rain Clearing Off — Kilchurn Castle, Loch Awe' and 'Lake of the Four Cantons', at the RA, 1854-5. Also exhib. two works, two views in Scotland, at the BI in 1856, and one work, at SS in 1854. Address in Ostend.

HICKS, Jane fl.1837-1839
Exhib. five works, including 'View at Newdigate, Surrey', 'View near Cromer' and 'In Epping Forest', at SS, 1837-9. London address.

HICKS, Julian fl.1865
Exhib. one work, 'Westminster Bridge, 1859', at the BI in 1865. London address.

HICKS, Lilburne NWS fl.1830 d.1861
Painted figurative, mainly Shakespearian subjects. Exhib. ten works, including 'Ophelia', 'Juliet in Her Balcony' and 'Death of Geffroi Rudel, the Pilgrim of Love', at the RA, 1830-44. Also exhib. six works including 'The Awakened Brigand', 'A River Nymph' and 'A Trumpeteer', at SS, 1831-44, and two works at the BI, 1831-8. London address.
Bibl: Holme, Royal Institute of Painters in Watercolour, Studio VIII 1906; Cundall.

HICKS, Miss Mary fl.1890-1891
Exhib. a work, 'A Ptarmigan', at SS in 1890-1. Address in Colchester, Essex.

HICKS, Miss Minnie J. fl.1892
Exhib. a work, 'Partridges', at SS in 1892-3, and another, 'A Peep into the Past', at the RA in 1892. Address in Hendon, London.

HICKSON, Miss Annie W. fl.1886-1891
Painted flowers. Exhib. two works, 'Orchids and Cineraria' and 'Roses', at the RA in 1886 and 1891, and one at the NWS. London address.

HICKSON, Miss Margaret R. fl.1879-c.1922
Painted country genre and figurative subjects. Exhib. seven works, including 'A Shady Lane', 'Among the Grass' and 'Evening in Florence', at the RA, 1882-1900. Exhib. seven works, including 'Waiting Her Turn in the Procession: Corpus Christi Festival', at SS, 1879-90. Also exhib. at the NWS and the NG. Lived at Wallasey, Cheshire.

HIGGINS, Miss C. fl.1873-1882
Exhib. three views in Venice at SS, 1873-81, and one work, entitled 'Cottage Interior, near Amalfi', at the RA in 1882. Address in Rome.

HIGGINS, Miss Elsie fl.1899-1901
Exhib. three works, a portrait and works entitled, 'Summertime' and 'The Rompers', at the RA, 1899-1901. Address in Rye, Sussex.

HIGGINS, Reginald Edward RBA ROI 1877-1933
Painted portraits and decorative schemes. Studied at the St. John's Wood Art School and at the RA Schools. Exhib. portraits at the RA from 1900. Lived in London.

HIGGINS, V. fl.1838
Exhib. a view of cottages at Two Waters, Hertfordshire, at the RA in 1838.

HIGGINS, Wayman fl.1862-1863
Exhib. two works, 'Lane Scene' and 'A Lane near Lansdowne', at SS in 1862 and 1863, and a view of the Old Bath Road, near Wick, at the RA in 1862. Address in Wick, near Bath.

HIGGINS, William A.A. fl.1891-1893
Exhib. four works, including 'Evening on the Yorkshire Scaur' and 'After Glow — Yorkshire Coast', at the RA, 1891-7. Address in Birmingham.

HIGGINSON, Miss May fl.1888-1892
Painted flowers. Exhib. three works, including roses and azaleas, at the RA, 1889-94, and three works at SS, 1888-9. Address in Torquay, Devon.

HIGGS, Miss Madeleine fl.1886
Exhib. a still-life at the RA in 1886. Address in Barnet, Hertfordshire.

HIGNETT, George fl.1879-1887
Birmingham landscape painter; exhib. there 1879-87.

HILDER, P. John fl.1829-1839
Painted country scenes and genre. Exhib. 14 works, including 'An Old Mill at Chipstead, Surrey', 'A Cottage Scene' and 'The Gleaner's Repast', at the BI, 1830-9. Exhib. 14 works at SS, 1829-39, and nine works, including scenes in Kent and the Thames Valley. London address. Probably the brother of Richard H. Hilder (q.v.).

***HILDER, Richard H. fl.1836-1851**
London landscape painter. Exhib. 1836-51 at RA, BI and SS. Four drawings by him are in the BM. Perhaps brother of P. John Hilder (q.v.), also a landscape painter, who lived at the same address. Subjects at RA mainly views in Kent and Sussex.

HILDITCH, George 1803-1857
Prolific London landscape painter who exhib.1823-56, at the RA, BI and SS. Bryan writes: "His style is original, with much of the power and truth to nature of Patrick Nasmyth, but pictures painted by him during a visit to France in 1836 have been mistaken for the works of Bonington." The subjects were selected chiefly from Richmond and its vicinity, North and South Wales, France and Germany.
Bibl: Bryan.

HILDITCH, Richard H. fl.1823-1865
Landscape painter who exhib. 1823-65, at the RA, BI and SS. Brother of George Hilditch (q.v.). Subjects Wales, the Thames, and Warwickshire. Also travelled on the Rhine and in Italy.

HILES, 'Bartram' Frederick John RWA 1872-1927
Painted landscapes, marines and coastal views in watercolour. Lost both his arms when a boy in a street accident. Learnt to paint by holding a brush between his teeth. Studied at the Bristol School of Art and South Kensington. Exhib. a watercolour entitled 'Evening — Venice', at the RA in 1893-4. Lived in Clifton near Bristol.
Bibl: Hardie III.

HILES, George fl.1892
Exhib. a work entitled 'A Gathering Storm', at the RA in 1892. Address in Stoke Newington.

HILES, Henry Edward b.1857 fl.1888-1898
Painted landscapes. Studied in Paris at La Grande Chaumière and in the studio of E. Philips Fox. Exhib. three works, 'Old Houses, Bidston', 'Bishop Wilson's School, Binton, Cheshire' and 'Sea Pinks', at the RA, 1888-98. Born in Cheshire. Lived in Banbury, Oxfordshire. He was a member of the Liverpool Academy of Arts.

HILL, A.C.E. fl.1888-1893
Exhib. two works, 'Detling Hills' and 'Hayricks', at SS, 1888-92. London address.

HILL, Arthur RBA fl.1858-1893
Painter of landscape, genre and portraits, working in Nottingham and London. Exhib.1858-93, at SS, at the RA, 1864-93, at BI and elsewhere. Titles at the RA include 'Oak in Bradgate Park', 'Mariana', 'Andromeda' and 'The Foolish Virgins'. Painted female neoclassical figures in the style of Alma-Tadema.

HILL, D.H. fl.1868-1871
Painted marines. Exhib. four works, including 'On the Coast', 'Hastings — Sunset' and 'Fishing by Moonlight', at SS, 1868-71. Also exhib. one work, 'Fishing Boats' at the RA in 1869. London address.

HILL, David Octavius RSA 1802-1870
Scottish painter of portraits and landscape, who subsequently became known as one of the outstanding portrait photographers of the 19th century. Born in Perth, he studied under Andrew Wilson at Edinburgh School of Art. He was Secretary to the Society of Artists in Edinburgh for eight years, before in 1838 it became the RSA, and occupied the post till his death. In 1841 he published *The Land of Burns,* a series of 60 illustrations engraved from his oil landscapes, and these became very well known. He first adopted photography to paint a large group portrait containing no less than 474 likenesses, called 'The Signing of the Deed of Demission' (to commemorate the first general assembly of the new congregation of ministers who had withdrawn from the established Presbyterian Church of Scotland). This was begun in 1843 and completed in 1865, and is now in the Free Church Assembly Hall, Edinburgh. Together with the chemist and photographer Robert Adamson, he began in 1843 to take calotype photographs of each person to appear in the painting, and at the same time opened a photographic business with Adamson, photographing many of the eminent Scots of the day, and often exhibiting these calotypes alongside his landscapes at the RSA (e.g. in 1844, 1845 and 1846). After the retirement of his partner in 1847, Hill returned to painting. He exhib. 1832-68, at the RA 1852-68, BI, SS and elsewhere. He also helped in founding the National Gallery of Scotland, 1850. In 1846 he published a series of calotype views of St. Andrews. In the 19th century Hill's photographs were favourably compared with the work of earlier masters — Reynolds, Rembrandt and Murillo — and the painter Clarkson Stanfield, who Ruskin called "the great English realist", found them superior to the work of Rembrandt.
Bibl: AJ 1869 pp.317-19; 1870 p.203 (obit.); Redgrave, Dict; Clement & Hutton; Portfolio 1887 p.135; Ch. Holme, RSA, The Studio p.XLI (pl.); BM Cat. of Engraved British Portraits 1908 II p.178; IV p.239; Caw pp.93, 145-6; DNB; Heinrich Schwarz, *David Octavius Hill,* 1932, and in Art Quarterly, Winter 1958; Aaron Scharf, *Art and Photography,* 1968 pp.27, 29-31, 59, 260; Maas p.191; Staley; Irwin pl.152.

HILL, Miss Ellen G. fl.1864-1893
Painted portraits and figurative subjects. Exhib. 12 works, including 'Oh Dear! What Can the Matter Be?', 'Waiting for the Sedan Chair' and portraits, at the RA, 1873-93. Also exhib. two works, 'Storming the Castle' and 'Back from Fishing, Cornwall', at the BI in 1864 and 1865, and one work, at SS in 1866. London address.
Bibl: Clayton; Ormond.

HILL, F.
Copied a portrait by J.R. Herbert of A.W.N. Pugin (1815-1852). The copy is in the Royal Institute of British Architects.
Bibl: Ormond.

HILL, Fanny fl.1879
Exhib. a painting of flowers in 1879. Address in Leamington Spa, Warwickshire.

HILL, Mrs. Henry fl.1847
Exhib. a work, 'An Old Elm Tree in Hyde Park', at the BI in 1847. London address.

HILL, J.B. fl.1839-1850
Exhib. two works, 'Abbot Lichfield's Chapel' and 'Distant View of London', at the RA in 1839 and 1845. Also exhib. two works at SS, 1849-50, and another, 'Fishing Boys on the Coast', at the BI in 1848. Address in Birmingham.

HILL, Mrs. J. Gray (C.E.) fl.1888-1889
Exhib. four views of buildings at the GG, 1888-9. Address in Birkenhead, Cheshire.

HILL, James fl.1875
Exhib. a painting entitled 'Holme Bridge' at SS in 1875-6. London address.

***HILL, James John RBA 1811-1882**
Painter of landscape, rustic genre and portraits. Born in Birmingham, where he studied. Came to London 1839. Exhib. mainly at SS. Elected RBA, 1842. Also exhib. at RA, 1845-68, and BI. His patroness was Lady Burdett-Coutts, for whom he painted many portraits, animal and dog studies. Hill also painted a few fantasy works, but his later work has a tendency to repeat the same formula — pretty smiling peasant girls, either singly or in groups, with landscape backgrounds. Visited Ireland frequently. Hill's pictures were often reproduced lithographically for *The Illustrated London News*. Sometimes painted figures for Henry Bright (q.v.).
Bibl DNB XXVI 1891; Bryan; BM Cat. of Engraved British Portraits III p.526.

HILL, James Stevens RI ROI 1854-1921
Painted landscapes. Studied at the RA Schools. Exhib. 31 works, including views in Suffolk and Hampshire, at SS, 1880-91. Exhib. 18 works, including 'Meadows near Southwold', 'The Season of Mist and Rain' and views in Dorset, at the RA, 1880-1900. Born in Exeter. Lived in London.
Bibl: *A Record of Art in 1898*, Studio; AJ 1905 p.402; Studio LXVI 1915 pp.204-8.

HILL. John Henry fl.1865-1879
Exhib. two watercolours, a view on the river Hackensack and a view of a cottage in North Wales, at SS in 1865 and 1879. London address.

HILL, Justus fl.1879-1898
Painted country scenes and figurative subjects. Exhib. 13 works at the RA, 1884-98, titles including, 'Old Farm House', 'The Artist's Colour Box' and 'After a Mouse'. Also exhib. two works, 'Sketch in Hampstead' and 'The Brooklet', at SS in 1879-80 and 1885-6. London address.

HILL, Miss Kate fl.1845-1873
Exhib. six watercolours, titles including 'A View at East Grinstead', 'A Greek Priest' and 'A Hole in the Wall', at SS, 1845-73. London address.

HILL, Miss L.M. fl.1852-1854
Exhib. two works, 'Interior of a Study' and 'A Sketch in the Marche aux Fleurs, Brussels', at the BI in 1852 and 1854. Also exhib. one work, 'The Spirits of the Clerk's Two Sons appearing to their Mother on Christmas Night, from *Border Minstrelsy*' at the RA in 1852, and another at SS in 1851. London address.

HILL, Leonard Raven fl.1885-1898
An illustrator and painter of figurative subjects. Exhib. six works, including 'Toil and Peril in Ancient Britain', 'Hagar and Ishmael' and 'Fruit Seller, Tangiers', at SS, 1887-90. Exhib. three works, which possibly are illustrations, at the RA, 1889-98. Also exhib. at the NWS and GG. London address.

HILL, Nathaniel RHA fl.1886-1893
Irish genre painter. Exhib. four figurative works, 1886-93. Lived in Dublin.

HILL, Miss Nora fl.1867
Exhib. a view of a church in 1867. London address.

HILL, R. (or W.R.) fl.1863
Exhib. a work entitled 'The Bridesmaid' at SS in 1863. London address.

HILL, Rowland Henry 1873-1952
Painted landscapes and country genre scenes. Studied at Halifax and Bradford Schools of Art, and at the Herkomer School in Bushey. Exhib. at the RA from 1897, including 'Primrose Gatherers', 'Blackberry Gathering', 'Faggot-Gatherers' and 'Homeward'. Born in Halifax, Yorkshire. Lived at Hinderwell, Yorkshire.
Bibl: P. Phillips, *The Staithes Group*, 1993.

HILL, Thomas 1852-1926
Painted portraits, genre and landscape. Exhib. nine works, including landscapes, at SS 1871-81, and 19 works, including 'A Chelsea Celebrity', 'Grandfather's Clock', 'The Mariner' and portraits, at the RA, 1880-1903. London address.

HILL, William Robert fl.1859-1884
Exhib. four works, 'Windsor Castle, Sunset', 'Moonlight on the River Medway', 'The Houses of Parliament from the Bishop's Walk' and 'Folkestone Harbour', at the BI, 1859-62. London address.

HILLARD, S. fl.1847
Exhib. one work, 'Joan of Arc Preparing for Her Mission', which was accompanied by a quotation from Schiller, at the BI in 1847. London address.

HILLIARD, Constance fl.1877
Exhib. a painting of flowers in 1877. Address in Uxbridge, London.

HILLIARD, Lawrence fl.1876-1887

Exhib. seven still-life paintings at the NWS, 1876-87. Address in Uxbridge, London.

HILLIER, H.D.

Little-known painter whose works appear in the salerooms. He painted highland landscapes; two of these were sold at Christie's, 15 December 1972.

HILLIER, Miss Harriet C. fl.1850-1857

Exhib. seven watercolours, including 'Sister of Mercy', 'Little Red Riding Hood', 'The Flower Girl' and portraits, at SS, 1850-7. London address.

***HILLINGFORD, Robert Alexander** 1825-1904

Painter of historical genre. Born in London. Studied in Düsseldorf, Munich and at home. After marrying an Italian model, Hillingford spent many years in Italy, painting scenes of Italian life. In 1864, after 16 years absence, Hillingford returned to London, where he exhib. 1864-93 at the RA, BI and SS. Abandoning his early Italian subjects, he turned to historical genre, and battle scenes, especially of the Napoleonic Wars. He also painted some typical fancy-dress genre pieces, mostly in 17th century costume, which reflect his Munich training. Works by him are in Glasgow and Sheffield AG.

Bibl: AJ 1871 pp.213-15; 1908 p.350; L'Art XLII 1890 pp.212-13; Clement & Hutton; Blackburn, RA Notes 1881-3; RA Pictures 1893, 1895, 1898-1902; F. Gordon Roe, *The Hillingford Saga*, Connoisseur September 1975.

HILLS, George Macdonald fl.1860

Exhib. one work, a view of Wiston Church, near Steyning, at the RA in 1860. London address.

HILLS, Robert OWS 1769-1844

Painted landscapes and animals. Exhib. 44 works, including landscapes in Kent and the Lake District and paintings of cattle, donkeys, sheep and deer. Exhib. 600 works at the OWS. London address.

Bibl: Redgrave, Cent.; Redgrave, Dict.; Roget; DNB XXXVI 1891 p.431ff.; Cundall, VAM Cat.; Maas; Walker's Quarterly III 1923; Burlington Mag. LXXXVI February 1945; OWS Club XXV 1947; Connoisseur CL 1962; Country Life 25 July 1968.

HILLS, Mrs. W. fl.1870

Exhib. a watercolour study of a sleeping child at SS in 1870. Address in Leyton, London.

HILL-SNOWE, Miss Lilly fl.1880-1885

Exhib. one work, ' "Go Where Glory Waits Thee" — Moore', at the RA in 1885. London address.

HILLYARD, J.W. fl.1833-1861

Painted landscapes and country scenes. Exhib. seven works, including 'Crossing the Moor', 'Creeping Jenny' and 'Plough Teams, Homeward', at SS, 1835-61. Also exhib. one work at the BI in 1833. London address.

HILTON, Henry fl.1880-1883

Painted landscapes. Exhib. four works, 'A Sunny Day on the Moors', 'The Old Mill', 'Gleams of Sunlight' and a landscape in North Wales, at the RA, 1880-3, and another landscape in North Wales at SS in 1880-1. Address near Conway, North Wales.

HILTON, Miss Marie E. fl.1889

Exhib. a still-life at the RA in 1889. London address.

HILTON, William RA 1786-1839

Painted mythological, historical and biblical subjects. Exhib. at the RA 1803-38, and at the BI 1808-39. His last exhib. work at the RA in 1838, and at SS in 1839, was 'Herod, Mocked by the Wise Man'. Son of William Hilton Snr. (1752-1822). Born in Lincoln.

Bibl: DNB XXVI; Redgrave, Cent.; Redgrave, Dict.; AJ 1855 pp.253-5; 1899 p.118; L. Cust, NPG 1900; BM Cat. of Engraved British Portraits 1908; further bibl. in TB; Maas; Staley; Ormond.

HIME, Harry fl.1887-1892

Exhib. five works, including 'Evening Glow', 'The Rosy Clouds of Evening' and 'Counting the Flock', at the RA, 1887-95. Address in Liverpool.

Bibl AJ 1904 p.221.

HINCHCLIFF, W. fl.1872-1873

Exhib. a watercolour view of a lane in Beckenham, Kent, at SS, 1872-3. London address.

HINCHLEY, Mrs. Edith Mary RMS SWA b.1870

Painted portraits and miniatures. Studied at the RCA until 1895. Lived in London.

HINCHLIFF, C.H. fl.1877-1878

Exhib. a watercolour view of 'La Maison de La Madeleine, Dinan', at SS in 1877-8. Address in Dinan, Brittany.

HINCHLIFF, Woodbine K. fl.1895-1911

Painted figurative subjects and country scenes. Exhib. at the RA from 1895, including 'Faithful Friends', 'The Rose Legend of St. Elizabeth of Hungary' and 'Bramble Blossom'. Address in Bushey, Hertfordshire.

HINCHLIFFE, Major C.H. fl.1889

Exhib. two landscapes at the NWS in 1889. Address in Instow.

HINCHLIFFE, Richard George PRCA 1868-1942

Painted portraits, figurative subjects and landscapes. Studied at Liverpool School of Art, the Slade, the Académie Julian in Paris, and in Munich. Lived in Liverpool.

HINCKS, S.C. fl.1858-1867

Painted animals and sporting subjects. Exhib. seven works, including 'The Cover Side', 'Deer Stalking in the Highlands' and 'Pet Fawns', at the BI, 1858-67. Also exhib. two works at SS in 1858 and 1867. Address in Bagshot, Surrey.

HIND, Ellen Mary fl.1887-1900

Exhib. a painting of primroses at the RA in 1900. London address.

HIND, Frank fl.1885-1903

Painted landscapes and townscapes. Exhib. 17 works, including views in Venice, Holland and the Balearic Islands, at SS, 1885-8, and at the RA from 1887, including views in Venice, Seville, Granada and elsewhere. Address in Leamington Spa, Warwickshire.

HIND, Miss M.A. fl.1845

Exhib. one work, entitled 'Fruit etc. from Nature', at SS in 1845. London address.

HIND, Miss P. fl.1844-1845

Exhib. two works, 'Young Mischief and 'Flowers, Fruit, etc.', at the RA in 1844 and 1845, and another, at SS in 1845. London address.

HINDE, Mrs. B.L. fl.1875
Fruit and flower painter who exhib. at Society of Female Artists in 1875.

HINDLEY, Godfrey C. fl. 1876-1903
Painted figurative and genre subjects. Exhib. at the RA from 1876, including 'Certes, He was a Most Engaging Wight', 'After the Duel' and ' "Will He Come?" '. Exhib. at SS, nine works, 1877-81, including ' "He Was a Veray Parfitt Gentil Knight" ' in 1880-1. London address. His work 'A Chapter of Accidents' is in the Sunderland AG.

HINDLEY, Miss Helen M. fl. from 1901
Exhib. at the RA from 1901, including 'Impromptu', in 1901. London address.

HINE, Miss Esther fl.1885
Exhib. a study at the NWS in 1885. London address.

HINE, Harry T. RI ROI NWS 1845-1941
Painted landscapes and churches in watercolour. Exhib. ten works, including landscapes in Essex and Sussex and views of St. Albans Abbey, and Durham and Lincoln Cathedrals, at the RA, 1873-97, and two watercolours, 'Sea Coast, Sussex' and 'Between Amalfi and Salerno', at SS in 1875-6 and 1884-5. Exhib. 130 works at the NWS. Studied at Accrington School of Art, at the RCA and at the Académie Julian. Lived at Kingston, London. Son of Henry George Hine and brother of William Egerton Hine (qq.v.).
Bibl: Holme, *Royal Inst. of Painters in Watercolour*, Studio 1906 p.IX.

HINE, Mrs. Harry ARPE 1840-1926
(Miss Victoria S. Colkett)
Painted and etched landscapes. Exhib. two works, both views of houses, at SS in 1882 and 1889. Also exhib. 12 works at NWS. She was the wife of Harry Hine (q.v.) and daughter of S.D. Colkett (q.v.). Born in Norwich. Lived at Botesdale, Suffolk. Also painted views of Oxford and Cambridge colleges. See also Miss Victoria S. Colkett.
Bibl: AJ 1893 p.63.

HINE, Henry George VPRI 1811-1895
Painted watercolours of landscape, mainly of Sussex and Northumberland, buildings and figurative subjects. Exhib. 12 works, including 'Stranded Merchantmen', 'The Picts Wall in Carrfield Crags, Northumberland' and 'Dilston Castle, Northumberland', at SS, 1833-56, and eight works, including 'Wrecks on the Beach at Brighton', at the RA, 1830-61. Father of Harry and William Egerton Hine (qq.v.). Born in Brighton, Sussex. Died in London.
Bibl: Illustrated London News 1868; Mag. of Art 1893; DNB 1901; AJ 1895 p.160; 1905 p.192; Bryan; Cundall; Early English Watercolour Drawings, Studio Special Number pp.30, 41, 48; Brook-Hart; Newall.

HINE, Mary E. fl.1873
Exhib. a figurative subject in 1873. London address.

HINE, Mrs. W.E. fl.1889
Exhib. a landscape at the NWS in 1889. Address in Dorking, Surrey. Presumably the wife of William Egerton Hine (q.v.).

HINE, William Egerton fl.1873 d.1926
Painted landscape watercolours. Exhib. eight works, including 'Knockholt, Kent', 'A Backwater at Wargrave' and 'In the Vale of Pickering, Yorkshire', at SS, 1876-83, and four works, including

'On the Mole', 'Weeds' and 'Sunlight and Sand', at the RA, 1873-1901. He was Art Master at Harrow School, 1892-1922. Son of Henry George Hine and brother of Harry Hine (qq.v.).

HINES, Frederick fl.1875-1897
London landscape painter who exhib. 1875-97, at the RA 1879-97, at SS, NWS, GG and elsewhere. Titles at the RA include 'Silver Birches', 'The Reapers', 'The Woodland Solitude'. Brother of Theodore Hines (q.v.).

HINES, Theodore fl.1876-1889
London landscape painter who exhib. 1876-89, at the RA 1880-9, SS, GG and elsewhere. Brother of Frederick Hines (q.v.) Titles at the RA include 'Spring', 'Lingering Light', and 'Gloaming'.

HINLEY, Alfred fl.1890
Exhib. a work entitled 'An Old House, Broadway, Worcestershire', at the RA in 1890. Address in Birmingham.

HINSON, Miss Ethel Brooke fl.1886-1891
Exhib. four works, including 'A Spanish Student', 'Relics of the Past' and 'A Meditative Lassie', at the RA, 1886-91. Address in Beckingham, Nottinghamshire.

HIPKINS, Miss Edith fl.1879-1898
Painted fruit. Exhib. seven works, including 'Apricots', 'Blue Beard's Wives' and ' "Pellucid Grapes Without One Seed" — Christina Rossetti', at SS, 1879-85, and five works, including ' "With Thy Sweet Fingers" ' and ' "Hickory Dickory Dock" ', at the RA, 1883-98. London address.

HIPSLEY, John Henry fl.1882-1892
Exhib. two watercolours, 'Japanese Chrysanthemums' and 'Gloire de Dijon Roses', at SS in 1882 and 1891-2. Address in Woodford, Essex.

HIPWOOD, Miss Sarah fl.1868-1869
Exhib. two works, 'Spring' and 'Fruit', at SS in 1868 and 1869. London address.

HIRD, W. fl.1867
Exhib. a painting of apple blossoms at the BI in 1867. London address.

HISCOX, George Dunberton 1840-1901
Painted landscapes in watercolour. Studied at Bristol School of Art. Exhib. 18 works at SS, 1879-94, including views in Windsor and Eton and on the Thames, and 19 works at the RA, 1884-99, including 'A Grey Morning on the Cornish Coast near St. Mawes' and 'The Haunt of Wild Fowl'. Born near Wells, Norfolk. Lived in Windsor, Berkshire.

HISCOX, Laura M. fl.1880-1884
Exhib. six watercolours, including 'A Farmyard' and 'Autumn Gleaning', at SS, 1880-5. Address in Slough, Buckinghamshire.

HISLOP, Andrew fl.1889
Exhib. a view of Cathcart Castle at the RA in 1889. Address in Glasgow.

HITCH, J. fl.1874
Exhib. a watercolour entitled 'From Pelham Woods, Ventnor' at SS in 1874.

HITCH, N. fl.1884
Exhib. a portrait at the RA in 1884. London address.

HITCHCOCK, Arthur fl.1884
Exhib. a watercolour entitled 'A Quiet Corner' at SS in 1884. London address.

HITCHCOCK, Miss Kate fl.1885-1891
Exhib. two works, 'El Bandido' and 'Washing Day', at the RA in 1885 and 1886, and one work, 'Pity', at SS in 1890-1. London address.

HITCHCOCK, S. fl.1882
Exhib. a landscape in 1882. London address.

HITCHENS, Alfred b.1861 fl.1889-1902
Painted portraits, figurative subjects and landscapes. Studied at South Kensington and at the Académie Julian, Paris, and in Rome. Exhib. ten works at the RA, including 'Love Awakening the Soul', 'Galatea by the Spring of Acis' and 'Mermaids', 1889-1902. Also exhib. at the GG. London address.

HITCHINGS, Miss Henrietta C. fl.1856-1858
Exhib. three works, 'Sea Coast', 'The Reed Sparrow's Nest' and 'A Harvest Field', at SS, 1856-8, and two works, 'The Lock at Shiplake, Berkshire' and 'A Willow Bordered Stream, Berkshire' at the RA in 1856 and 1857. Address in Wargrave, Berkshire.

HITCHINGS, J. fl.1860-1870
Painted watercolours of country subjects and landscapes. Exhib. 16 works, including views in Banbury, and works entitled 'The Harvest Moon', 'The Ruined Mill', 'The Mid-day Meal' and 'Sunny Hours'. London address.

HITCHINS, John fl.1865-1874
Exhib. a work entitled 'Sunset After Rain' at the RA in 1866. London address.

HITCHINS, John B. fl.1873-1876
Painted marines. Exhib. four works including 'Shipwreck on a Lee Shore', 'The Sinking of the Northfleet' and 'Fishing Boats off Cape Race, Newfoundland', at SS, 1873-7. London address.

HIXON, James Thompson ANWS 1836-1868
Painted figurative subjects. Exhib. five works, including 'The Night March', 'Devotion' and 'The Connoisseur', at the BI, 1857-62, and five works, including 'The Letter' and 'An Arab Boy', at SS, 1858-61. Lived in London. Died in Capri of consumption shortly after his election as ANWS.
Bibl: Illustrated London News 1868; Redgrave, Dict.; Binyon.

HIXON, William J. fl.1825-1857
Painted animals. Exhib. 13 works, including studies of cows, sheep, goats and donkeys, and portraits of prize-winning dogs and oxen. Exhib. ten works, including paintings of animals and works entitled 'Oliver Cromwell on Horseback' and 'Interior of a Farrier's Shop', at the BI, 1825-57, and four works at the RA, 1827-56. London address.

HOARE, Rev. Arthur M. fl.1871-1872
Exhib. a watercolour entitled 'Sand Carts at Budehaven, Cornwall' at the RA in 1872. Address in Southampton, Hampshire.

HOARE, George T. fl.1888-1891
Exhib. two works, 'The Mill Pond' and 'A Reach on the Upper Thames', at the RA in 1888-9. Address in Slough, Buckinghamshire.

HOARE, Sir Richard Colt, Bt. FRS FSA 1758-1838
Amateur watercolourist, traveller and historian. He illustrated his own works, which include *History of Wiltshire* and *Classical Tour Through Italy and Sicily*. There exists at Stourhead, where he lived, a catalogue of his oeuvres as a draughtsman. His younger half-brother, Peter Richard Hoare (1772-1849) also produced drawings of the West Country.
Bibl: Hardie III pl.269.

HOBBS, Miss Katie fl.1889-1892
Exhib. five works, 'Marigolds', 'A Wharf in Bristol' and 'Wild Scottish Roses', at SS, 1889-92. Address in Bourton-on-the-Water, Gloucestershire.

HOBDEN, Frank RBA fl.1879-c.1930
Painted genre and figurative subjects. Exhib. 14 works, some of them watercolours, including 'At the Door of the Harem', 'The Little Mermaid' and 'Amusing the Invalid', at SS, 1883-9. Also exhib. seven works, including ' "Who is it?" ', 'A Last Look' and 'In the Frigidarium', at the RA, 1886-1901. Lived at South Benfleet, Essex.

HOBKIRK, Stuart fl. from 1897
Exhib. at the RA from 1897 including 'In the Shade', 'Fishing Luggers returning Home' and several views of the Paris flower market. Address in St. Ives, Cornwall.

HOBLEY, Edward G. fl.1893 d.1916
Painted genre subjects and landscapes. Exhib. four works, including 'Boy and Goat', 'Shaft of light' and 'After the Day's Toil', at the RA, 1893-1900. He taught art in Penrith. His work 'Shaft of Light' is now in the Walker AG, Liverpool.

HOBSON, Miss Alice Mary RI 1860-1954
Painted landscape watercolours. Studied under James Orrock, John Fulleylove and Wilmot Pilsbury. Exhib. 27 works at the NWS. Painted in Switzerland, Germany, Italy, Corsica, Egypt and Basutoland. Lived in Cornwall.
Bibl: Sparrow.

HOBSON, Cecil James RI 1874-1915
Painted landscape watercolours. Lived in London.

HOBSON, Miss Ellen M. fl.1884
Exhib. a landscape in 1884. London address.

HOBSON, F.W. fl.1891
Exhib. a view of the Via dei Cavalieri at SS in 1891.

HOBSON, G. fl.1862
Exhib. a watercolour landscape near Bitton, Gloucestershire, at SS in 1862. Address in Bath.

HOBSON, Henry E. fl.1857-1866
Painted genre subjects. Exhib. a work entitled 'The Ivy Wreath' at the RA in 1857, and two works, 'The Woodman's Daughter' and 'The Heather Bell', at the BI in 1863 and 1866. His watercolour 'A Country Girl' is in the VAM. Lived in Bath. He was the son of Henry Hobson, a Bath engraver, and his wife was a daughter of J. Hardy, Snr. (q.v.).

HOBSON, Victor 1863-1889
Painted portraits and landscapes. Lived in Darlington, County Durham.
Bibl: Hall.

HOCK, Daniel b.1858 fl.1890-1893
Painted historical and genre subjects. Exhib. two works, 'Carina' and 'The Little Harper', at the RA in 1890 and 1893. Born in Vienna. Lived in London.

HODDER, Albert fl.1872-1890
Painted marines and coastal landscapes. Exhib. nine works, including 'Fishing Boats on the South Coast', 'A Grey Day on the Yorkshire Coast' and 'A Fishing Village on the Northumberland Coast' at the RA, 1877-95. Addresses in London and Worcester.
Bibl: Brook-Hart.

HODDER, Mrs. Albert (Charlotte) fl.1883
Exhib. a study of irises at the RA in 1883. Address in Worcester.

HODGE, Miss E.G. fl.1886-1887
Exhib. three paintings of flowers, 1886-7. London address.

HODGE, Miss Ina fl.1888-1889
Exhib. a painting of peonies at the RA in 1888 and a painting of roses at SS in 1888-9. London address.

HODGES, E. fl.1844-1846
Painted coastal landscapes. Exhib. six works, including 'Coast Scene — a Breeze', 'Coast Scene — a Squall' and 'Coast Scene — Calm Morning', at SS, 1844-6. London address.
Bibl: Brook-Hart.

HODGES, Ernest fl.1888-1893
Exhib. a work entitled 'Leigh Green' at the RA in 1890. Address in Groombridge, Sussex.

HODGES, Miss Florence M. fl.1890
Exhib. a study of a door in Henry VII's Chapel, Westminster Abbey, at the RA in 1890. London address.

HODGES, J. Sydney Willis 1829-1900
Painted portraits. Exhib. 35 works, almost all portraits, at the RA, 1854-93. Exhib. eight works, including landscapes and genre subjects, titles including 'Comforts for the Crimea', 'The Opera' and 'The Lady of Shalott', at the BI, 1856-63. Born in Worthing, Sussex. Lived in London.
Bibl: Bryan; BM Cat. of Engraved British Portraits III; Ormond.

HODGES, Miss Mary Anne E. fl. 1851-1852
Exhib. two works, 'Study of a Head' and 'Reading Made Easy', at the RA in 1851 and 1852. London address.

HODGES, W.J. fl.1853
Exhib. a sketch at the BI in 1853. London address.

HODGETTS, Thos. fl.1801-1846
Painted and engraved landscapes and portraits. Exhib. 11 works, including portraits, at SS, 1824-46, and two works, 'A Study from Nature' and 'A View near Harrow', at the BI in 1824 and 1825. London address.
Bibl: A. Whitman, *Masters of Mezzotint,* 1898; BM Cat. of Engraved British Portraits; Connoisseur Extra No. 1906 p.131.

HODGKINS, Miss Frances 1869-1947
Painted landscapes, figurative subjects and still-lifes. Born and brought up in New Zealand. Studied at Dunedin Art School. Arrived in Europe in 1901. Taught art in Paris. Settled in England in 1914.

HODGKINS, Thomas F. fl.1835 d.1903
Irishman who painted landscapes. Exhib. eight works, including 'Deep Mill near Great Missenden, Buckinghamshire', and 'Landscape near Aylesbury', at SS, 1835-53. Also exhib. four works at the BI, 1836-54, and three works at SS, 1836-9. Born in Dublin. Died in Maidstone, Kent.
Bibl: Strickland.

HODGSON, David 1798-1864
Painted townscapes and architecture. Exhib. at the BI, 1822-64, including many views of Norwich and others of Chester. Also exhib. views in Norwich, Ely and Chester at SS, and one work at the RA. Address in Norwich, Norfolk.
Bibl: Redgrave, Dict.; W.F. Dickes, *Norwich School of Painters;* Burlington Mag. VII 1905 p.237.

HODGSON, Mrs. Dora fl.1885
Exhib. a painting of fruit in 1885. London address.

HODGSON, George 1847-1921
Exhib. a work entitled, 'Seville Oranges' at the RA in 1886. Address in Nottingham. Member of Nottingham Society of Artists, and painted mainly in watercolour.

HODGSON, J. fl.1874
Exhib. one work, 'The Chalk Mill', at the RA, and a sketch at SS, both in 1874. Address in Bury St. Edmunds, Suffolk.

***HODGSON, John Evan RA HFRPE 1831-1895**
Painter of genre, landscape, historical and eastern subjects. Born in London, he spent his early youth in Russia; educated at Rugby and afterwards began a commercial career in London. Then he entered the RA Schools in 1853. Exhib. 1856-93, at the RA, BI, SS, and elsewhere. From 1856-68 he exhib. at the RA historical or domestic scenes, e.g., 'Canvassing for a Vote', 1858, 'The Patriot's Wife', 1859, 'Margaret Roper in Holbein's Studio', 1860. In 1868 he visited Africa — Tunis, Tangier, Algiers and Morocco, and from that time his works were almost exclusively eastern in subject matter, e.g. 'An Arab Story Teller'. Elected ARA 1872, RA 1879, his Diploma painting being 'A Shipwrecked Sailor Waiting for a Sail'. He was Librarian and Professor of Painting at the RA from 1882-95, and with Fred. A. Eaton wrote *The Royal Academy and its Members,* 1768-1830, 1905. Hodgson was a member of the St. John's Wood Clique (see Bibl.), whose members painted a series of frescoes in his house.
Bibl: AJ 1895 p.256 (obit.); Portfolio 1871 pp.17-19; *Gazette des Beaux-Arts* 1873 II p.348; H. Blackburn, *Academy Notes,* 1876 pp.13, 24; Clement & Hutton; The Year's Art 1896 p.297; Bryan; BM Cat. of Engraved British Portraits IV 1914 p.386; Hutchinson pp.137, 143, 232, 233; Bevis Hillier, *The St. John's Wood Clique,* Apollo June 1964; Wood, Panorama, p.245 (pl.261); Wood, Paradise Lost.

HODGSON, John James 1871-1905
Painted landscapes and still-lifes. Lived and worked in Carlisle and was associated with the Nutter family. An exhibition of his work was held at the Carlisle AG in 1970.

HODGSON, W. fl.1838-1841
Painted animals. Exhib. three works, two portraits of horses and one of a dog, at the RA, 1838-41. London address.

HODGSON, Walker fl.1890s
Little-known artist and illustrator. Reputedly led a bohemian life, so almost nothing is definitely known about him. In the 1890s he produced a large set of portraits, mostly in pen and grey wash, of leading artists of the day.
Exhib: London, Christopher Wood Gallery 1984.

HODGSON, William Scott b.1864
Painted landscapes. Self-taught artist. Exhib. at the RA and in the provinces. Lived at Whitby, Yorkshire.

HODSON, Edward fl.1849-1881
Birmingham painter of landscapes and coastal scenes; exhib. in Birmingham, 1849-81.

HODSON, Sir George Frederick, Bt. 1806-1888
Irish amateur painter. Exhib. a view of the Pontine Marshes and the Circean Promontory, from Velletri, at the RA in 1838. Also exhib. at the Dublin Academy. Exhib. at RHA from 1827, and was made an honorary member in 1871.
Bibl: Strickland.

HODSON, Samuel John RWS RBA RCA 1836-1908
Landscape and architectural painter, and lithographer. Studied at RA Schools. Exhib. 1858-1906 at RA, BI, SS and OWS. Subjects mainly romantic views of buildings in Italy, Spain, Germany, Belgium and Switzerland, both in oil and watercolour. Elected ARWS 1882, RWS 1890; secretary of RI. Hodson worked for *The Graphic* as colour lithographer, engraving many well-known pictures by Millais, Leighton, Fildes and others.
Bibl: AJ 1901 pp.207-12; Cundall pp.159, 221; The Year's Art 1909 p.406; BM Cat. of Engraved British Portraits V 27.

HODSON, T. fl.1865
Exhib. two works, 'The Bramble Gatherers' and 'An Early Visitor', a SS in 1865. London address.

HOFFCAUER, F. fl.1872
Exhib. two works, 'Mary Stuart's Monument in Westminster Abbey' and 'The Last Five Days at Pompeii', at the RA in 1872. London address.

HOFFMAN, H.W. fl.1878-1880
Exhib. a watercolour of a footbridge on the river Blyth at SS in 1880. London address.

HOFLAND, Thomas Christopher RBA 1777-1843
Painted landscapes, especially mountainous landscape. Exhib. 118 works at SS 1824-43; 141 at the BI 1810-43, and 72 at the RA 1798-1842. Amongst those exhib. at the BI are many views of the Lake District, the Scottish Highlands and Dovedale. He also painted houses, amongst which group there are frequent views of 'White Knights, seat of the Duke of Marlborough'. Address in Kew, near London, where he often painted views along the Thames. In 1840 he spent nine months in Italy, making sketches for his patron Lord Egremont.

HOFLAND, Thomas Richard 1816-1876
Exhib. two works, 'Castello Latri, near Castel a Mari' and 'Salerno', at the BI in 1844 and 1845. Address in Richmond, near London. Son of T.C. Hofland (q.v.). Was a drawing master. Travelled in America and elsewhere.
Bibl: AJ 1876.

HOGARTH, T.C. fl.1859
Exhib. a work entitled, 'Ancient Well of an Old Manor House near Mount Orgueil Castle, Jersey', at the BI in 1859. Lived in Edinburgh and London.
Bibl: BM Cat. of Engraved British Portraits.

HOGG, Archibald W. fl.1895
Exhib. a work entitled 'A Lowland Stream' at the RA in 1895. Address in Edinburgh.

HOGG, J. fl.1841-1844
Exhib. two portraits and a view of an Indian woman standing at a fountain, at SS, 1841-4. London address.

HOGLEY, Stephen E. fl.1874-1881
Exhib. a watercolour of Glen Finlas, Perthshire and a work entitled 'Going South', at SS in 1874 and 1881. Address in Holmfirth, Yorkshire.

HOLD, Abel fl.1849-1871
Yorkshire painter of birds. Exhib. 16 works, including 'Wild Ducks, from Nature', 'Red Grouse, Woodcock and Plover' and 'Pheasants, Hare, Partridge, Woodcock, Snipe, etc.', at the RA, 1849-71. Also exhib. a work at SS, and another at the BI. Address in Barnsley, Yorkshire.

HOLDEN, Professor Albert William 1848-1932
Painted historical, religious and genre subjects. Studied at the RA Schools. Exhib. eleven works, including, 'Zuleika', 'Capture of Col. Blood and Recovery of the Stolen Regalia', which is now in the National Gallery, Sydney, and 'An Artful Card', at SS, 1881-94. Exhib. four works, including 'The Annunciation' and a portrait, at the RA, 1838-1901. London address.

HOLDEN, C. fl.c.1874
Made a sketch portrait, after a photograph by Downey, of Tennyson.
Bibl: Ormond.

HOLDEN, E. fl.1840-1846
Exhib. seven works, including landscapes on the Thames and in North Wales, and a painting of a falcon, at SS, 1840-6. London address.

HOLDEN, J. fl.1843
Exhib. a painting of camellias at the RA in 1843. London address.

HOLDEN, Miss Louisa Jane fl.1840-1843
Exhib. six works, including portraits and works entitled, 'Weaving Sweet Fancies' and 'Head of an Italian Girl Returning from the Vintage at Sunset'. London address.

HOLDEN, Miss Margaret see BACKHOUSE, Mrs. Margaret

HOLDEN, S. fl.1845-1847
Exhib. four works, three paintings of flowers and one portrait, at the RA, 1845-57. Address in Greenwich, London.

HOLDER, Miss Charlotte fl.1857-1860
Exhib. a work entitled, 'Repose' at SS in 1860. Address in Isleworth, Middlesex.

***HOLDER, Edward Henry fl.1864-1917**
Yorkshire landscape painter. Born in Scarborough. Exhib. 1864-93 at SS, also at RA, 1872-3. Subjects mainly coastal views in Yorkshire. Lived in London and Reigate, and then visited South

Africa, where he carried out many commissions. In 1917 he exhib. a view of the Victoria Falls on the Zambesi at the RA. Several of his works are in York AG.

Bibl: City of York AG 1907 Cat. p.53 (new Cat. now published).

HOLDER, Edwin fl.1856-1864
Painted landscapes in Scotland and the North of England. Exhib. nine works, including 'The Orphan Family', 'The Passing Storm' and 'Denizens of the Mountains' at SS, 1856-64. Address in Isleworth, Middlesex. Settled in Yorkshire c.1860.

Bibl: Yorkshire Gazette 6 October 1860.

HOLDER, H.W., Snr. fl.1876
Exhib. two views on the Yorkshire coast near Scarborough at SS, 1876 and 1876/7. Address in Scarborough, Yorkshire.

HOLDICH, W. Whyte- fl.1878-1887
Exhib. five works, landscapes in Wales, Yorkshire and Devon, at SS, 1878-86. Address in Bexley, Kent.

HOLDING, Henry James G. 1833-1872
Painted marines, landscapes and Tudor scenes. Exhib. six landscapes, 1867-70. Address in Manchester. Brother of the illustrator Frederick Holding (1817-74).

Bibl: AJ 1872 p.255; Redgrave, Dict.; DNB XXVII 1891 p.122.

HOLDING, John fl.1877-1880
Exhib. three landscapes, a view in Aberdeenshire and two watercolours, at SS in 1877. Address in Manchester.

HOLE, Miss Alice fl.1886
Exhib. a view in the gardens of the Villa d'Este at the RA in 1886. Address in Maidenhead, Berkshire.

HOLE, William Brassey RSA RSW RPE 1846-1917
Scotsman who painted and etched landscapes. Studied at the RA Schools. Exhib. in London from 1873. His own paintings are of genre subjects, titles including 'An Assignation', 'Sheep-shearing in the Cheviots' and ' "If Thou Hadst Known!" ' and were exhib. at the RA. Born in Salisbury. Died in Edinburgh.

Bibl: Portfolio 1881, 1892; AJ 1882, 1897, 1902; Mag. of Art 1902; Sketchley, *Book Illustration of Today*, 1903; Caw; Irwin.

HOLGATE, J. fl.1887
Exhib. a sea-piece at the NWS in 1887. London address.

HOLGATE, Thomas W. fl. from 1899
Studied at the RA from 1899, including 'Study of a Female Head' and 'A Friar of Orders Grey', at the RA. London address.

HOLIDAY, H.G. fl.1855-1863
Exhib. four works, two landscapes in Wales, an illustration to Tennyson's *Dora*, and 'The Lady of Shalott', at SS, 1857-63. Also exhib. a landscape at the BI in 1855. Address in Isleworth, Middlesex.

***HOLIDAY, Henry 1839-1927**
Painter of historical genre; also illustrator, glassmaker, enamellist and sculptor. Studied at Leigh's Academy, and RA Schools. Now best known for his 'Dante and Beatrice' exhib. at GG in 1883, and now in the Walker AG, Liverpool. In 1861, under the influence of Burne-Jones, Holiday began to design stained glass for Powell &

Sons. In 1890 he founded in Hampstead his own glassworks, which produced stained glass, mosaics, enamels, and sacerdotal objects. Exhib. at the RA from 1858, mainly cartoons and stained glass, although he did continue to paint occasional figure subjects, e.g. 'Terpsichore', 'Cleopatra', 'Sleep', etc. in the Pre-Raphaelite style, and portraits. As an illustrator, Holiday is best known for his work on Lewis Carroll's *The Hunting of the Snark*.

Bibl: Studio XXXIV 1905 p.304; XLVI 1909 p.106; LXX 1817 p.131; Studio Year Book of Decorative Art 1909 p.55; AJ 1859 p.169; 1884 p.5; 1890 p.31; 1901 p.121; 1904 p.23; 1906 pp.20-5; 1908 p.83; H. Holiday, *Reminiscences of My Life*, 1914; Reynolds, VP pp.65, 69, 71, 72, 85, 92 (pl.55); Maas p.231; Staley; Wood, Olympian Dreamers; *The Etruscans*, Cat. of exhib., Stoke-on-Trent AG 1989.

***HOLL, Frank RA ARWS 1845-1888**
Painter of portraits and genre, and illustrator. Son of Francis Holl, an engraver. Studied at RA Schools 1860; won Gold Medal 1863. Began to exhibit at RA in 1864. In 1868 scored his first success with 'The Lord Gave and the Lord hath Taken Away'. For this he was awarded the Travelling Prize, which he spent in Italy 1869. In 1870 'No Tidings from the Sea' was bought by Queen Victoria. In genre painting, Holl's preference was for dramatic social realism. Most of his illustrations for *The Graphic* were scenes of working class life. His best known picture of this type is 'Newgate — Committed for Trial', exhib. at the RA in 1878. Holl was elected ARA 1878, RA 1882. Exhib. at RA 1864-88, and GG, and occasionally BI, SS and NG. In 1877 Holl began to paint portraits, launching himself on a career which made him one of the most popular and one of the best of all Victorian portrait painters. His portraits are painted in strong black and brown tones, with dramatic chiaroscuro, showing the influence of Dutch 17th century painting, especially the work of Rembrandt. Among Holl's sitters were Millais, John Bright, Joseph Chamberlain, Gladstone, Pierpont Morgan, the Duke of Cambridge and the Prince of Wales. In 1888 Holl fell ill on a visit to Spain, and died later the same year, aged 43.

Bibl: AJ 1876 pp.9-12; 1889 pp.53-9; Portfolio 1888 p.183ff.; DNB XXVII 1891; Roget; Poynter NG Cat. 1900; BM Cat. of Engraved British Portraits I-XI; A.M. Reynolds, *The Life and Works of F.H.*, 1912; India Office Cat. 1914 p.41; Reynolds, VS pp.27-8, 33, 40, 93 (pl.83); Reynolds, VP pp.37, 173, 180; Maas, pp.213, 223, 237; Ormond; Wood, Panorama; Wood, Paradise Lost.

HOLL, Mrs. Frank fl.1881-1882
Painted watercolours of flowers. Exhib. six works, including 'Chrysanthemums', 'Primula' and 'Jonquils and Narcissus', at SS, 1881-2. London address.

HOLLAMS, Miss F. Mabel fl.1897-1912
Exhib. four works, including 'Sunday at Home' and 'Destined for the Fair', at the RA, 1897-1900. Address in Tonbridge, Kent.

HOLLAND, Miss Ada R. fl.1888-1902
Painted portraits and genre subjects. Exhib. at the RA, from 1892, portraits and a work entitled 'A Child of Happiness'. Exhib. five works, including ' "Which Way Next?" ', 'A Long, Long Way' and 'Delighted and Delightful', at SS, 1888-92. London address.

HOLLAND, Mrs. Charlotte F. fl.1882-1885
Exhib. two works, 'Spring' and a view on the south coast, at SS in 1882 and 1882/3. London address.

HOLLAND, F. fl.1868
Exhib. a work entitled 'Expectation' at the RA in 1868. London address.

HOLLAND, G. fl.1839-1841
Painted marines and shipping. Exhib. nine works, including 'View from Weston-Super-Mare, in the Bristol Channel' and 'A Brig Wrecked on the West Coast of Ireland', at SS, 1839-41. London address.
Bibl: Brook-Hart.

HOLLAND, Gertrude fl.1875
Exhib. a view of a church in 1875. London address.

HOLLAND, Henry fl.1878-1890
Exhib. a work entitled 'Love's Old Sweet Story' at the RA in 1890. Also exhib. two works at the NWS. London address.

HOLLAND, Henry T. fl.1885
Exhib. a watercolour drawing of a Spaniard at SS in 1885/6. London address.

***HOLLAND, James RWS 1799-1870**
Painter and watercolourist of landscapes and continental views, especially Venice. Born Burslem, Staffordshire. Taught by his mother, who painted flowers on porcelain. Came to London 1819. At first concentrated on flower painting, but changed gradually to landscape. In 1831 he went to France on the first of many tours he was to make all over Europe, gathering enough material to last a lifetime. Holland's early watercolours, much influenced by Bonington, are among the finest in the tradition of Victorian continental view painting, comparable to, sometimes even better than, Callow, Prout, Harding or Roberts. After about 1840, Holland's style began to decline. Like so many Victorian artists, he found it more profitable to turn out romantic, colourful views of Venice. These pictures still enjoy popularity, and are not without merit, but they represent a decline when compared with Holland's earlier work. Exhib. at RA 1824-65, BI, SS (108 works), OWS (194 works) and NWS. Elected ARWS 1835, RWS 1857. Member of SBA 1842-8. His studio sale was held at Christie's, 26 May 1870.
Bibl: AJ 1870 p.104 (obit.); Portfolio 1892 p.211; Connoisseur 1913 p.105; 1914 pp.76, 82; Studio Spring Number 1915; Winter Number 1922-3; Ottley; Redgrave, Dict; Roget; Binyon; Cundall; DNB XXVII 1891 p.146; Hughes; VAM; H. Stokes, *J.H.*, Walker's Quarterly XXIII 1927; R. Davies, *J.H.*, OWS VII 1930; Reynolds, VP p.25; M. Tonkin, *The Life of J.H.*, OWS XLII 1967; Hardie III pp.31-5 and Index (pls.47-59); Maas pp.88, 98 (pls. p.98); Brook-Hart.

HOLLAND, John, Snr. fl.1831-1879
Nottingham landscape painter. Exhib. landscapes and coastal scenes at SS, 1831-79, and BI, 1865-6. Usually signed J. Holland, and his works are sometimes passed off as James Holland (q.v.). Works by him are in the Nottingham AG. His son John Holland Jnr. (1830-86) was also a landscape and portrait painter.

HOLLAND, L.G. d.1893
Made sketch drawings, including one of Tennyson. His sketchbooks are in the NPG.
Bibl: Ormond.

HOLLAND, Philip fl.1850-1856
Painted watercolour still-lifes of birds, fruits, flowers and game. Exhib. 49 works at SS, 1850-86, and eight works, including 'Dead Birds — Bullfinch and Chaffinch' and 'Cluster of Damsons and Apples', at the RA, 1853-66. London address.

HOLLAND, Philip Sidney 1855-1891
Painter of genre and historical subjects, who exhib. 1877-84, at the RA, SS, NWS and elsewhere. Titles at the RA include 'Music of the Past', and 'The Trial of a Noble Family Before the Blood Council, Antwerp, 1567'. One of his paintings is at Norwich AG.

HOLLAND, Samuel 1807-1887
Nottingham picture dealer and painter of landscapes and seascapes. Probably brother of John Holland Snr. (q.v.). His son Samuel Holland Jnr. (c.1835-95) was also a painter.

HOLLAND, Sebastopol S. fl.1877-1890
Exhib. three landscapes, 'Snow-Capped Idwal', 'The Foggy Thames' and 'Compass Point, Bude', at the RA, 1890-5. Also exhib. a view of Tintagel Castle at SS in 1878. Address in Nottingham.

HOLLAND, Thomas J.B. fl.1881
Exhib. a painting of the Old Neptune Inn, Ipswich, at the RA in 1881. London address.

HOLLIDAY, Edward fl.1879-1884
Painted still-lifes and genre subjects. Exhib. 33 works at SS, 1879-85, and at the RA, including 'Dead Game', 'A Homely Shelf' and 'Found Dead', 1879-84. Address in Croydon, Surrey.

HOLLIDAY, Lily fl.1879-1884
Painted flowers and birds' nests. Exhib. 14 works, including 'Hedgesparrow's Nest', 'Lilies and Nasturtiums' and 'Chaffinch's Nest and Roses', at SS, 1879-84. Address in Croydon, Surrey.

HOLLIDGE, J. (or T.) fl.1872
Exhib. two views of churches in 1872. London address.

HOLLINGDALE, Horatio R. RBA fl.1881-1899
London landscape painter who exhib. 1881-99, mostly at SS (55 works), and also at the RA and elsewhere.

HOLLINGDALE, Richard fl.1850-1899
Genre and portrait painter working in Stroud, Kent, who exhib. 1850-99, at the RA 1854-99, BI and SS. Titles at the RA mainly portraits, and 'The Sister's Entreaty', and 'Let me Tell your Fortune, Fair Ladies'.
Bibl: Ormond.

HOLLINGS, G. Seymour fl.1865-1871
Painted watercolours of mountain landscape. Exhib. eight works, including views in Devon and North Wales, at SS, 1867-70. Exhib. a view of Clovelly at the BI in 1866, and another Welsh landscape at the RA in 1867. London address.

HOLLINGSWORTH, Thomas fl.1857-1885
Painted figurative subjects. Exhib. three works, 'An Arab of Mocha', 'Italian Peasant Woman' and 'The Fair Student', at the BI in 1858-60. Also exhib. two works, 'Little Girl with a Book' and 'Making Patchwork', at SS, 1857-75, and another at the RA in 1858. His work 'Blind Beggar and His Daughter' was sold at Sotheby's Belgravia, 23 November 1971. Lived in London.

HOLLINS, John ARA 1798-1855
Painter of portraits, historical and genre subjects, and occasional landscapes. Born in Birmingham, where his father was a glass painter. Exhib. two portraits at the RA in 1819, three more in 1821, and settled in London in 1822, painting portraits in oil, and occasionally in miniature. From 1825-7 he travelled in Italy and on

his return resumed his practice as portrait painter, though he also painted numerous historical subjects from the works of Shakespeare, Goethe and other writers. Later in life he also painted landscape and genre. Occasionally he painted group portraits: 'A Consultation Previous to an Aerial Voyage from London to Weiburg in Nassau on Nov. 7th 1836' (showing many noted people of the day), and 'Salmon-fishing on Loch Awe', 1854, with F.R. Lee, RA, another celebrated group portrait. He was elected ARA in 1842.

Bibl: Ottley; Redgrave, Dict; L. Cust, NPG II 1902 p.70; DNB; VAM; BM Cat. of Engraved British Portraits V 1922 p.87; Ormond.

HOLLIS, Charles T. fl.1881-1882
Exhib. a work entitled 'In the Wild Woods of St. Leonard's, Windsor' at the RA in 1882. Address in Windsor, Berkshire.

HOLLIS, Thomas 1818-1843
Landscape painter. Son of George Hollis (1793-1842) an etcher and topographer. Studied with H.W. Pickersgill and at RA Schools. Painted many landscapes around Dulwich.

HOLLOWAY, Charles Edward RI 1838-1897
Landscape and marine painter, engraver and lithographer. Born at Christchurch, Hampshire. Fellow pupil of Fred Walker, Charles Green and Sir J.D. Linton at Leigh's Studio in Newman Street; subsequently associated with William Morris till 1866 in the production of stained glass. Then, devoting himself entirely to painting, he exhib. 1866-94, at the RA 1867-94, SS, NWS (70 works), GG and elsewhere, showing many paintings of the Fen district, the Thames, and Suffolk and Essex coasts. At the RA he exhib. mainly topographical views, and his speciality is listed as 'churches' in Graves Dictionary. Hardie notes that "his watercolours show his acceptance of the Impressionist outlook and also a kinship with Whistler in their suave and subtle colouring". Elected A of the RI in 1875, member in 1879.

Bibl: AJ 1896 (pl.p.12); 1897 p.127 (obit.); Studio 1906 (pl. X); Bryan; Cundall; VAM; Studio Special Number, *British Marine Painting,* 1919 p.28 (pl.p.68); Hardie III pp.82, 84 (pl.p.106).

HOLLOWAY, George fl.1842-d.1843
Exhib. four portraits at SS, in 1842, and another at the RA in 1843. Born in Christchurch, Hampshire. Lived in London.

Bibl: The Art Union 1843 p.244.

HOLLOWAY, J. fl.1864
Exhib. three works, 'A Summer's Afternoon', 'Repose' and 'Evening' at the BI, 1864-5. London address.

HOLLOWAY, L. fl.1857-1865
Painted portraits and figurative subjects. Exhib. eight works, including portraits and works entitled 'Pity the Sorrows of a Poor Old Man' and 'Girl and Dog', at the RA, 1857-61. Also exhib. two portraits at SS, and a work entitled 'A Hop Wreath' at the BI. London address.

HOLLYER, Christopher C. fl.1867-1872
Exhib. a work entitled 'A Quiet Nook' and an etched portrait at the RA, 1867-72. London address.

HOLLYER, Miss Eva fl.1891-1898
Exhib. three works, 'Expectation', 'A Tiff' and 'The Course of Love Never Did Run Smooth', at SS, 1891-3. Also exhib. three works, 'Hurt', 'Happy' and 'Spring' at the RA, 1891-8. Address in Cheshire.

HOLLYER, F. fl.1881
Is supposed to have exhib. a work in 1881. London address.

HOLMAN HUNT, William see HUNT, William Holman

HOLME, William fl.1833-1849
Painted portraits and figurative subjects. Exhib. five works, including portraits and a work entitled 'Going to Work', at SS, 1845-7. Exhib. three works, 'The Little Flower Girl', 'Content' and 'A Study', at the BI, 1833-49, and two portraits at the RA, in 1839 and 1842. London address.

HOLMES, Miss fl.1834-1843
Exhib. a painting of fish at the RA in 1843. London address.

HOLMES, B. fl.1876-1877
Exhib. two landscapes, one of a pool in Epping Forest, the other a view on the river Arun, Sussex, at SS in 1876 and 1877. Address in Leytonstone, Essex. This is probably the same artist as Basil Holmes.

HOLMES, Basil fl.1844-1850
Painted landscapes and occasional figurative subjects. Exhib. nine works, several of them views on the Thames, and a painting of a girl reading, at SS, 1844-7. Also exhib. six landscapes at the BI, 1845-57, and two landscapes at the RA, in 1844 and 1850. London address.

HOLMES, Sir Charles John VPRWS NEAC 1868-1936
Painter and etcher of landscape. Art historian and editor of *The Burlington Magazine.* Exhib. with the NEAC from 1900. Born in Preston, Lancashire. Lived in London. Slade Professor 1904-10, Director of the Nat. Gall. 1916.

Bibl: Malcolm C. Salaman, *The Watercolours of C.J. Holmes,* Studio 1921; C.H. Collins Baker, *Sir C. Holmes,* Contemporary British Artists Series (with further bibl.), 1924.

HOLMES, E.N. fl.1860-1871
Exhib. a view of the Members' Private Staircase in the House of Commons at the BI in 1860, and a view in the Members' Cloak Room: 'A Meeting of the Reformers, 1867', at the RA in 1871. London address.

HOLMES, Edward RBA fl.1841-1891
Landscape, marine and portrait painter, who exhib. 1841-91, mostly at SS (159 works), and also at the RA 1855-91, and BI 1847-67. Titles at the RA include 'Going to Market', 'The Prawn Fishers', 'In the New Forest' and 'The End of the Year'.

HOLMES, Miss Emily R. fl.1898
Exhib. a work entitled 'Juno's Herd Boy' at the RA in 1898. Address in Penzance, Cornwall.

HOLMES, George Augustus RBA fl.1852-1911
Painter of genre who exhib. 1852-1909, at the RA 1852-1900, BI, GG, Paris Salon 1906, 1910-11, elsewhere, but mostly at SS (110 works). Titles at the RA include 'Isabella-Vide', 'Orlando Furioso', 'Feeding Time' and 'Forty Winks'.

HOLMES, H. fl.1840-1852
Painted figurative subjects. Exhib. ten works including 'A Warrior', 'Hassan' and portraits of figures from the plays of Shakespeare, at SS, 1840-7. Also exhib. two works at the BI, 1847-8, and one, 'The Parting Gift', at the RA, in 1852. Address in Leeds, Yorkshire.

HOLMES, James 1777-1860

Painter of genre, portraits and miniatures, engraver and lithographer. Apprenticed to an engraver; after that turned to painting in watercolour. Elected member of OWS, 1813, exhibiting 'Hot Porridge' and 'The Married Man'. 1819 exhib. two miniatures at the RA and at about the same time started to paint oils. In 1821 he ceased to be a member of the OWS, and actively worked to establish the Society of British Artists who held their first exhibition at SS in 1824. He became a member in 1829 and a constant exhibitor, chiefly in miniatures up to 1850 when he resigned. In the latter part of his career he became a fashionable miniature painter, and had many distinguished sitters — amongst them Byron. He varied his portraits with genre, liking the plain humour and pathos of domestic scenes, as is seen from such titles quoted above. His genial character and musical talents gained him the personal friendship of George IV and his 'Michaelmas Dinner' of 1817 was bought by the King. He was also a popular teacher. Hardie quotes Gilchrist's statement that Blake was indebted to Holmes and to Richter for "a greater fullness and depth of colour in his drawings than he, bred in the old school of slight tints, had hardly thought could have developed in watercolour art". In all, he exhib. at SS (142 works), RA 1798-1849, BI, OWS, NWS and elsewhere.

Bibl: A full list of his paintings, portraits and engravings is in TB (ed. 1923); A. Gilchrist, *Life of William Blake*, I 1863 p.247; Redgrave, Cent., Dict; Roget I, II; A.T.Storey, *James Holmes and John Varley*, 1894; G.C.Williamson, *History of Portrait Miniatures*, 1904 I (pls.p.188); BM Cat. of Engraved British Portraits I 1908 pp.132, 313; II 1910 pp.62, 246. 315; III 1912 pp.230, 431, 582; IV 1914 pp.24, 338, 400, 489; Cundall; DNB; Connoisseur 30 1911 (pls.p.251); Hughes; Hardie II pp.120, 152-3; Ormond.

HOLMES, James, Jnr. fl.1836-1859

Painted portraits and watercolours. Exhib. 20 works, including watercolour portraits, works entitled 'The Orphan', 'The Doubtful Shilling' and 'The Maid of the Mill', at SS, 1838-59. Also exhib. three works at the RA 1839-48, and one work, 'The Reaper's Daughter', at the BI in 1854. London address.

HOLMES, R. Sheriton fl.1879-1881

Painted watercolour scenes on the river Tyne in the late 19th century. His painting, 'Old Coal Shipping Staithes near Wallsend', of 1879, is in the Laing AG, Newcastle-upon-Tyne, Northumberland.

Bibl: Hall.

HOLMES, Miss Rhoda fl.1881

Exhib. two works, 'Mendicant Monks Collecting Elemosina for Christmas — Venice' and a watercolour of Santa Maria delle Salute, at the RA and at SS, in 1881. London address.

HOLMES, Sir Richard Rivington FSA fl.1872-1891

Archaeologist and watercolourist. Exhib. five works, landscapes in Abyssinia and Italy, at the RA, 1874-8. Also exhib. at the GG and the NG. Address in Windsor Castle, Berkshire.

Bibl: Who's Who 1911; Binyon.

HOLMES, Miss Sophia fl.1886-1891

Exhib. a painting of daffodils at SS in 1890/1, and another, of weeds, at the RA in 1889. Address in Dublin.

HOLMES, W. fl.1848

Exhib. a work entitled 'Enjoyment', at SS in 1848.

HOLROYD, Lady fl.1894
(Miss Fannie Fetherstonhaugh Macpherson)

Exhib. a portrait at the RA in 1894. London address. She was the wife of Sir Charles Holroyd (q.v.).

HOLROYD, Sir Charles RPE 1861-1917

Painted and etched architectural, figurative and landscape subjects. Studied at the Slade, where he subsequently taught. Exhib. eight works, including 'Fisherman Painting a Sail', 'Death of Torrigiano' and 'The Satyr King', at the RA 1885-95. Also exhib. at the NWS and GG. Travelled in Italy 1888-97. Became the first Keeper of the Tate Gallery and a Director of the Nat. Gall. Born in Leeds, Yorkshire. Lived in London.

Bibl: Wedmore, *Etching in England,* 1895; Studio XXIII p.14; XLVIII pp.216, 218; LXXII p.155; Summer Numbers 1902, 1913, 1917; AJ 1901 p.254; 1902 p.272; 1908 p.69; 1909 p.126; A.L. Baldry, *The Paintings and Etchings of Sir Charles H.,* Studio XXX; Connoisseur January 1919; further bibl. in TB.

HOLROYD, Mrs. F.F. fl.1892

Exhib. a portrait at the Nat. Gall. in 1892. London address.

HOLROYD, T. fl.1860-1878

Painted landscapes and buildings, the majority in Italy. Exhib. nine works, including views in Gennazzano, near Rome, and views in Capri, at the RA 1860-78. Also exhib. six works, also including views in Italy, at SS 1862-75. London address.

HOLST, Lauritz fl.1878-1902

Painted marines and shipping. Exhib. ten works at the RA, 1878-1902, titles including: 'Derelict: Morning After the Storm', 'Ice-Bound' and 'After Trafalgar'. Lived in Scarborough, Yorkshire, until 1888, when he moved to London.

Bibl: Brook-Hart.

*HOLST, Theodore von 1810-1844

Painter of figure and fantasy subjects. Son of a music teacher of Livonian descent. Studied at the BM and at the RA Schools under Fuseli, by whom he was much influenced. Holst's work was admired by the youthful Rossetti in the 1840s.

Bibl: Max Browne, *The Romantic Art of T. von Holst,* Cat. of exhib., Cheltenham AG 1994.

HOLT, Miss A.H. fl.1853-1856
(Mrs. Jackson)

Painted still-life watercolours of birds and fruit. Exhib. six works at SS 1853-6, titles including 'Dead Bird and Nest', 'Wood Pigeon' and 'Fruit'. London address. See also Mrs. Jackson.

HOLT, E.F. fl.1850-1865

Painted mythological, biblical, historical and genre subjects. Exhib. 36 works at SS 1850-65, titles including 'Tydides Listening to the Counsels of Nestor', 'But Brightest Vision Deck Thy Tranquil Bed' and 'La Circassians'. Exhib. 12 works at the BI, 1853-60, including 'Joan of Arc on the Eve of Her Execution', 'Cupid and Psyche' and 'The Flower Girl'. Exhib. seven works at the RA 1854-8, including 'Bacchante Reposing' and 'Prometheus Chained'. London address.

HOLT, Mrs. E.F. fl.1857

Exhib. a study from nature at SS in 1857. London address.

HOLT, J. fl.1828-1863

Painted landscape. Also a sculptor. Exhib. 17 works, including 'Ruins of the Monastery of St. Leonard near the Pont de Briques', 'Shipwreck' and landscapes. Also exhib. two works, the second an illustration to a passage from the Book of Proverbs, at the RA in 1828 and 1845. London address.

HOLT, Miss Mary Ann **fl.1863-1868**
Exhib. two watercolours, 'Summer Flowers' and 'Lily, Pine-apple etc.' at SS in 1868. London address.

HOLTE, A.B. **fl.1875**
Exhib. a work entitled 'Ash-Tree Pool' at SS in 1875. London address.

HOLTE, Frank A. **fl.1867-1869**
Exhib. a work entitled 'Dinas Craig, North Wales' at the RA in 1869. London address.

HOLYOAKE, Rowland **fl.1880-1907**
Painter of genre, portraits, landscapes and interiors. Son of William Holyoake (q.v.). Exhib. 1880-1907, at the RA 1884-1907, SS, NWS, GG, and elsewhere, titles at the RA including 'For the Banquet' (*Hamlet*, III, 4), 'Shall I Wear a White Rose?' His interiors show the influence of the Aesthetic movement.
Bibl: RA Pictures 1905.

***HOLYOAKE, William** **RBA** **1834-1894**
Genre and historical painter. Member of the RBA where he exhibited 53 works; Vice P of the RBA for many years, and was in that position when Whistler was elected for his brief career as President. Also exhib. at the RA 1865-85, and at BI 1858-67. Twice the Curator of one of the Academy Schools. Among his best known works are 'The Sanctuary' (which now hangs in one of the Chapels of Westminster Abbey), 'The Home at Nazareth', and 'The Broken Vow'. Reynolds, VS, illustrates 'In the Front Row at the Opera', comparing the ladies to Rossetti's 'stunners'.
Bibl: AJ 1894 p.95 (obit.); H. Blackburn, *Academy Notes*, 1877, 1878 (pls); BM Cat. of Engraved British Portraits I 1908 p.70; Glasgow AG Cat. 1911 (Biography); Reynolds, VS p.91 fig.70; Wood, Panorama.

HOMAN, Miss Gertrude **fl.1886-1905**
Painted portraits and figurative subjects. Exhib. 17 works, including 'Peg Woffington Criticized in the Place of her Portrait', 'Nine Points of the Law' and 'Sally in our Alley', at the RA, 1889-1902. Exhib. eight works, including a scene from *As You Like* It, at SS, 1886-92. London address.

HOME, Gordon **fl.1900**
Exhib. a view of Millmead, Guildford, at the RA in 1900. Address in Epsom, Surrey.
Bibl: Studio 1909 pp.185-93; 1912 p.310.

HOME, Robert **b.1865**
Painted portraits and landscape. Born in Edinburgh. Lived in Fife.

HOMFRAY, J. **fl.1824-1843**
Painted landscapes. Exhib. seven works, including 'A View on the Coast of Wales', 'View on the Aqueda' and a watercolour, 'The Mumbles, Swansea Bay', at SS 1824-42. Exhib. three works, 'Caerphili Castle', 'Mill near Boulogne' and 'Llandaff Castle', at the RA 1825-43. London address.

HONE, Nathaniel II **RHA** **1831-1917**
Irish landscape painter. Studied under Couture. Exhib. a study from nature at the RA in 1869. Born and died in Dublin. Lived for a while in Paris. He was the great-nephew of Nathaniel Hone I (1718-84).
Bibl: AJ 1909 p.91; Studio LXIV p.288; Thomas Bodkin, *Four Irish Landscape Painters*, 1920.

HONEYMAN, John **fl.1879-1880**
Scottish architect and engineer. Exhib. two works, a view at Skipness, Argyllshire, and church at North Mechiston, Edinburgh, at the RA in 1879 and 1880. Address in Glasgow.
Bibl: Who's Who 1914.

HOOD, Agnes J. **fl.1888**
Exhib. a work entitled 'Tea-Time: Portrait' at SS in 1888. London address.

HOOD, Hon. Albert **fl.1874-1878**
Painted portraits and figurative subjects. Exhib. four works, including 'Child with a Dead Rabbit', 'A Boulogne Fish Girl' and 'La Vie est Dure', at SS, 1874-5. Also exhib. two portraits at the RA in 1874 and 1878. London address.

HOOD, George Percy Jacomb-
see JACOMB-HOOD, George Percy

HOOD, Thomas **fl.1849**
Exhib. a view of Harrow, from the north-east, at the RA in 1849.

HOODLESS, William Henry **1841-1902**
Cumberland painter. Studied under Sam Bough. Born at Wigton, Cumberland.

HOOK, Allan J. **b.1853 fl. to 1896**
Painted genre, coastal and rustic subjects. Exhib. 28 works, including 'A Sheep-run by the Sea', 'Winnowing Gleanings', 'A Fine Day for Mackerel' and 'Salvage after a Fog: Swimming Cattle from a Wreck'. Address in Farnham, Surrey. Brother of Bryan Hook (q.v.).
Bibl: Portfolio 1888 pp.38, 41, 105.

HOOK, Bryan **fl.1879-1900**
Painted landscape and coastal subjects. Exhib. 40 works at the RA 1879-1900, titles including 'A Peasant Proprietor', 'Just Before the Gloamings', 'Gathering Eggs on the Cliffs of Lundy' and 'Venice from the Lido'. Address in Farnham, Surrey.
Bibl: AJ 1884 pp.193-6; Portfolio 1888 pp.40, 105; RA Pictures 1893/6 p.99; Brook-Hart.

***HOOK, James Clarke** **RA HFRPE** **1819-1907**
Painter of coastal scenes and seascapes, historical genre and landscape. Studied with the portrait painter John Jackson, and in 1836 at RA Schools. In 1839 he made his debut at the RA with 'The Hard Task'. 1844 won Gold Medal in Houses of Parliament Competition. 1845 won three year travelling prize, which he spent in France and Italy. He was much influenced by the rich colours of the great Venetian painters. On his return he settled down to a series of historical scenes, mostly from literary sources, and rustic genre. In 1859 the success of 'Luff Boy!' at the RA — it was much praised by Ruskin — encouraged him to turn to coastal scenes and seascapes, for which he is now best known. Elected RA 1860. Exhib. at RA 1839-1902, BI and occasionally elsewhere. Hook's brisk style and rich colours succeed admirably in capturing the effects of wind and sunshine by the sea.
Bibl: AJ 1856 pp.41, 44; 1907 p.187; 1908 pp.58, 59, 61; Portfolio 1871 p.181ff.; Ruskin, Academy Notes, 1855 pp.57-9, 75; W. Sandby, *History of the RA*, 1862; F.G. Dumas, Biog. of Mod. Artists 1882-4; A.H. Palmer, *J.C.H.*, 1888; F.G. Stephens, *J.C.H. His Life and Work*, 1890; DNB 2nd Supp. 1912 p.293ff.; Reynolds, VP pp.94, 152, 153 (pl.105); Maas p.66 (pl.p.68); Ormond; Brook-Hart pls.105, 106.

HOOK, Samuel fl.1882-1887
Exhib. a watercolour view of the moon above Betws-y-Coed at SS in 1882. Also exhib. a work at the NWS. London address.

HOOKE, Richard 1823-1887
Irish portrait painter. Exhib. a portrait of 'The Late Marquis of Devonshire', at the RA in 1872. Address in Manchester.
Bibl: Strickland.

HOOKER, Ayerst fl.1894
Painted a copy of T.C. Thompson's portrait of William Buckland which, until it was destroyed during the Second World War, hung in the Deanery, Westminster Abbey.
Bibl: Ormond.

HOOLE, William fl.1861
Exhib. a landscape in 1861. London address.

HOOPER, Miss fl.1842-1843
Exhib. two works, 'Hamlet' and 'View in the Tyrol', at SS in 1842 and 1843. London address.

HOOPER, Alfred William fl.1873-1881
Exhib. two works, a view in the Boboli Gardens, Florence, and a view in Jerusalem, at the RA in 1876 and 1877, and a watercolour of the tomb of the Duke of Somerset in Wimborne Minster, Dorset, at SS in 1873. London address.

HOOPER, J. fl.1877-1878
Exhib. three views on Hampstead Heath and one near Chipperfield, Hertfordshire, at SS, 1877-8. London address.

HOOPER, John Horace fl.1877-1899
Painted landscapes. Exhib. six works, including views in Mapledurham, Pangbourne and Sonning, at the RA, 1885-99. He painted in a broad, realistic style, similar to that of H.J. Kinnaird; he must also have been a prolific artist, as his works often appear in salerooms. London address.

HOOPER, Luther 1849-1932
Painted landscapes and churches, and country subjects. Exhib. six works, including a view in Devon and works entitled 'Morning Grey' and 'Twilight', at SS, 1870-82. Exhib. five works, including views of Nayland and East Bergholt churches in Suffolk and works entitled 'A Shepherd Boy's Pastime' and 'The Bird-Scarer's Breakfast', at the RA, 1879-91. Address in Stoke Newington, London.
Bibl: AJ 1906 pp.238, 339; 1911 pp.47, 83; Studio Year Book 1921.

HOOPER, Miss Margaret L. fl.1877-1892
Exhib. four works, two portraits and works entitled 'On the Threshold' and 'Omar Khayyam and the Angel', at the RA, 1884-87. London address.

HOOPER, Miss Miriam Mabel b.1872
Watercolour landscape painter. Studied at Croydon School of Art and under Tatton Winter. Lived at Redhill, Surrey.

HOOPER, W. Cuthbert fl.1880
Is supposed to have exhib. a landscape in 1880. Address in Odiham, Hampshire.

HOOPER, William G. fl.1870-1898
Painted figurative and rustic subjects. Exhib. five works, including 'Gleaners', 'A Suffolk Pastoral' and 'Wayside Fruit', at the RA 1883-98. Also exhib. four works, all watercolours, at SS 1870-9. London address.

HOOTON, Mary T. fl.1874
Exhib. a painting of flowers in 1874. Address in Croydon, Surrey.

HOPE, Mrs. fl.1892-1893
Exhib. three genre works at the NG. London address.

HOPE, G. fl.1854
Exhib. a painting entitled 'Slumber' at the RA in 1854. London address.

HOPE, J.B. fl.1844-1845
Exhib. two works, a 'Distant View of Windsor', at SS in 1844, and a view on the coast of Sussex, at the BI in 1845. London address.

HOPE, Robert RSA 1869-1936
Scottish painter of portraits, genre and landscape. Studied at the Edinburgh School of Design and at the RSA Life School. Lived in Edinburgh.
Bibl: Caw; Who's Who; Studio XLII p.63; L p.233; LVII pp.54, 57; LXXIII p.74; Ch. Holmes, *Sketching Grounds*, Studio 1909 pp.82, 84.

HOPE, William Henry fl.1874-1890
Exhib. three works, 'The Coming Storm', 'When the Wind Blows' and another, at SS 1889-90. Address in Croydon, Surrey.

HOPKINS, Miss fl.1862-1864
Exhib. two watercolours, 'Autumn' and 'Camellias', at SS, in 1862 and 1863. Address in Worcester. This is possibly Miss Hannah Hopkins.

***HOPKINS, Arthur RWS RBC 1848-1930**
Painted portraits and figurative subjects especially country scenes in the style of H. Allingham. Studied at the RA Schools. Exhib. at the RA from 1875, titles including 'The Mowers', 'The Apple Loft', 'All Hands to the Capstan' and portraits. Also exhib. 106 works at the OWS. Also worked as an illustrator. Lived in London. Brother of Everard Hopkins (q.v.) and of Gerard Manley Hopkins the poet.
Bibl: Who's Who; AJ 1899 p.193; 1908 p.38; Studio LXXXIII 1922 p.315; Wood, Paradise Lost; further bibl. in TB.

HOPKINS, Mrs. Edward fl.1860-1891
(Miss Frances A. Beechey)
Painted landscapes in Canada. Exhib. 12 works, including 'Canoe Travelling in the Backwoods of Canada', 'Relics of the Primeval Forest, Canada' and 'Autumn on the St. Lawrence', at the RA 1869-1902. Also exhib. four works at SS. London address.

HOPKINS, Everard 1860-1928
Painted and made illustrations. Studied at the Slade. Exhib. five works at the NWS in 1884-5. London address. Brother of Arthur Hopkins (q.v.).

HOPKINS, Miss Hannah H. fl.1871-1879
Painted rustic subjects. Exhib. six works, including 'An English Home: Grey Twilight', 'Changing the Pasture' and 'The Fall of the Leaf', at the RA 1873-7. Also exhib. two works 'Feeding the Chickens' and 'The Old Barn' at SS in 1873. Address in Odiham, Hampshire. Daughter of William H. Hopkins (q.v.).

HOPKINS, M.R. fl.1880
Exhib. a drawing in 1880. Address in Oxford.

HOPKINS, W. fl. 1846-1870
Painted landscape watercolours. Exhib. 24 works, the majority views in Normandy and Brittany, and works entitled 'L'Attente du Retour', 'La Femme du Pecheur' and 'Rustic Lovers, Brittany', at SS, 1846-70. Exhib. one work at the BI. London address.

HOPKINS, William H. fl.1853-1890 d.1892
Landscape, animal and sporting painter. Exhib. at BI from 1853, and RA from 1858, and SS. Became a popular painter of horses, hounds, and hunting scenes, e.g. 'Her Majesty's Buckhounds', 1877. Sometimes collaborated with Edmund Havell Jnr. (q.v.) who painted figures. Hopkins's daughter Hannah exhib. genre scenes at RA, 1873-7
Bibl: Chronicle des Arts 1892 p.270.

HOPKINSON, Miss Anne E. fl.1877-1887
Painted flowers. Exhib. five watercolours, including 'Apple Blossom and Bird's Nest', 'Azaleas' and 'Autumn', at SS, 1877-84. Also exhib. two works, 'Spring Flowers' and 'Azaleas', at the RA, in 1886 and 1887, and two works at the NWS. Awarded a gold medal by the Society of Female Artists in 1879. Address in Forest Hill

HOPLEY, Charles fl.1869
Exhib. a pastel portrait of Sir Richard Owen at the RA in 1869. This is now in the Royal College of Surgeons.

***HOPLEY, Edward William John 1816-1869**
Painter of genre, portraits, and in particular historical, allegorical and fairy subjects. He originally studied medicine, but later turned to art, gaining popularity as a painter of domestic genre and portraits. He first exhib. at the BI in 1845 'Love Not', and at the RA in 1851 with 'Psyche'. The subjects of some of his paintings were very diverse and strange: 1853 BI, 'Puck and Moth, Two Treatments', two small and very highly finished pictures, proposing to contrast the spirit of Pre-Raphaelism with that of Post-Raphaelism. The conceptions are ingenious and worked out with incomparable nicety. 1855 RA, 'A Primrose from England'; 1859 'The Birth of a Pyramid', the result of considerable archaeological research. He also invented a trigonometrical system of facial measurement for the use of artists. Much of his life was passed in Lewes.
Bibl: AJ 1853 p.88; 1869 pp.159, 216 (obit.); DNB XXVII 1891 p.340; Maas p.155 (pl.158); Staley pls.39, 82; B. Phillpotts, *Fairy Paintings*, 1978.

HOPPER, Charles W. fl.1893-1902
Exhib. six works, including 'At Overstrand', 'Sunset Over the Marsh', 'Sheep Washing near Christchurch' and 'Bluebells', at the RA 1893-1902. London address.

HOPPER, Cuthbert fl.1880
Exhib. a view on Linchmere, Hampshire, at the RA in 1880. Address in Odiham, Hampshire.

HOPWOOD, Henry Silkstone RWS 1860-1914
Painted genre and country subjects. Studied at the Manchester School of Art, under Bouguereau at the Académie Julian and in Antwerp. Exhib. nine works, including 'Her Daily Bread', 'Bringing in the Stragglers' and 'Pig Market, Brittany', at the RA, 1893-1902. Address in Manchester.
Bibl: Studio XXVII pp.295-7; XL pp.234-6; XLI pp.27-33; LIV p.219; LXIII p.220; AJ 1906 p.187; 1907 p.186; 1909 pp.27-30; Who's Who 1913; Connoisseur XL 1914; P. Phillips, *The Staithes Group*, 1993.

***HORLOR, George W. fl.1849-1891**
Animal and sporting painter. Worked in Cheltenham, Birmingham and Brentford. Exhib. at RA, BI, and SS. Specialised in shooting scenes in the Highlands, e.g. 'A Day's Sport in Perthshire', 1856, 'Denizens of the Moors', 1866, etc., painted in a bright, cheerful style.
Bibl: AJ 1859 pp.81, 122, 143, 167; 1860 p.79.

HORLOR, Joseph fl.1834-1866
Landscape and coastal painter. Worked in Bath and Bristol. Exhib. at BI and SS 1834-66. Subjects mostly Welsh landscapes and coastal scenes. Two works by him are in Bristol AG.
Bibl: Building News 1910 II p.490; Brook-Hart pls.105, 106.

HORMAN-FISHER, Maud fl.1876-1881
Exhib. 20 works, 1876-81. London address.

HORN, J.B. fl.1858-1860
Exhib. three works, 'Off Folkestone', 'Fishingboats off the South Foreland' and 'Entrance to Calais Harbour', at SS, 1858-60. Address in Folkestone, Kent.

HORNBROOK, T.L. 1780-1850
Plymouth marine painter to Duchess of Kent and Queen Victoria. Exhib. at RA 1836-45 and SS. Very little known, but his work shows a developed feeling for light and colour, particularly in his pictures of ships in calm water.
Bibl: Wilson p.44 (pl.17); Brook-Hart.

HORNCASTLE, Miss Jane A. fl.1863-1869
Painted still-lifes and figurative subjects. Exhib. five works, including 'A Group of Autumn Roses' and 'A Robin's Nest', at SS 1863-7. Also exhib. one work, a study from life, at the RA in 1868. London address.

HORNE, Herbert Percy fl.1864-1889
Landscape painter. Visited Italy with F.C. Shields in 1889. Also an art historian and collector.

***HORNEL, Ernest Atkinson 1864-1933**
Glasgow school genre and decorative painter. Born in Australia, but lived mostly in Kirkcudbright. Studied at Trustees' Academy, Edinburgh, and in Antwerp under Verlat. The works of this early period show strong Belgian influence; mostly landscapes with figures in the manner of Maris or Mauve. Through his long friendship with George Henry (q.v.), Hornel moved towards a more colourful, decorative style. Hornel's association with Henry, which lasted about ten years, produced a series of pictures which are regarded as the essence of the Glasgow school. Using low-keyed palettes, both tried to escape subject and local colour, concentrating on purely decorative colour arrangements. After Hornel's Japanese paintings of 1893-4, his work declined in quality, becoming sentimental, repetitive, and over-sweetly coloured.
Bibl: AJ 1894 pp.76, 78; 1905 p.352; 1906 p.383; 1909 p.95; Studio, see Index 1901-14; Connoisseur 1911 p. 216; 1913 p. 111; RA Pictures 1910-15; D. Martin, *The Glasgow School of Painting*, 1902 p.30ff.; Caw pp.400-3 (pl. opp. p.402); Who's Who; *The Glasgow Boys*, Scottish Arts Council exhib., 1968; Maas; Irwin pls.201, 203.

HORNER, John fl.1876-1891
Exhib. four works, 'Dagenham Water', 'Contentment', 'Manton, near Marlborough' and 'La Rue de Sleen, Antwerp', at SS, 1881-6. London address.

HORNIMAN, John fl.1889
Exhib. a portrait in 1889. London address.

HORNUNG, T. fl.1838-1839
Exhib. three works, 'A Scholar Too Many', 'Calvin on his Death-bed' and 'Catherine de Medici Orders the Execution of Admiral de Coligny,' at the RA, 1838-9. London address.

HORRAK, T. fl.1858-1862
Painted figurative subjects and portraits. Exhib. eight works, including 'Expectation', 'Italian Peasants' and portraits, at the RA, 1858-62. London address.

HORSFALL, Ernest fl.1891-1893
Exhib. a work entitled 'A Pillar of the Church', at SS, in 1891/2. London address.

HORSLEY, Charles RBA 1848-1921
Painted landscape. Studied at Manchester School of Art. Exhib. five landscapes, 1877-93. Lived in London.

HORSLEY, Gerald Callcott fl.1862-1904
An architect who also exhib. views of architecture. Exhib. at the RA from 1882 including views of tombs, sculpture, architectural details and mosaics, in Italy and England. London address. Son of J.C. Horsley (q.v.).

HORSLEY, Hopkins Horsley Hobday 1807-1890
Birmingham landscape painter, worked in London, Birmingham, and Sutton Coldfield. Exhib. in London, 1832-66 at RA, BI and SS. Subjects Staffordshire, Devonshire, Wales, the Swiss Alps and North Italy.

***HORSLEY, John Callcott RA 1817-1903**
Historical genre painter. Nephew of Sir A.W. Callcott (q.v.) and brother-in-law of the engineer Brunel. Studied at RA Schools. His first RA picture in 1839, 'Rent Day at Haddon Hall in the Days of Queen Elizabeth', launched him on a long and successful career. Exhib. at RA 1839-96, and BI. Painted mostly historical subjects, but in the 1850s and 1860s he turned to contemporary subjects, usually "scenes of flirtation set in the countryside" (Reynolds) such as 'Showing a Preference' or 'Blossom Time'. The recipe for these pictures was described by a contemporary as "sunshine and pretty women". Was also a member of the Cranbrook Colony in Kent, with Thomas Webster, A.E. Mulready, G.B. O'Neill and F.D. Hardy (all q.v.). From 1875-90 he was rector of the RA, where his prudish objections to the use of nude models earned him the nickname of Clothes-Horsley. He was the organiser of the first RA Old Master Winter Exhibitions. A keen musician, he was a friend of Mendelssohn-Bartoldy; he also contributed drawings to *Punch* for another friend, John Leech.
Bibl: AJ 1857 pp.181-4; Ottley; Ruskin, Academy Notes 1856-8; Sandby, *History of the RA*, 1862; Blackburn, *RA Notes*, 1875-83; RA Pictures 1891-3 p.96; J.C. Horsley, *Recollections of an R.A.*, 1903; DNB 2nd Supp. 1912 p.304; Studio, *Shakespeare in Pictorial Art*, Spring Number 1916; Reynolds, VS pp.54-5, 70 (pls.12-13); Reynolds, VP pp.36, 62, 64, 66 (pls.22, 26); Maas pp.27, 28, 164, 232-3 (pls.p.232); Ormond; Wood, Panorama; Strong; Wood, Paradise Lost.

HORSLEY, Walter Charles b.1855 fl.1875-1904
Painted portraits and exotic subjects. Exhib. at the RA, from 1875 including subjects set in Egypt, Turkey and India. Also exhib. a watercolour, 'A Present to the Harem', at SS in 1879-80. London address. Son of J.C. Horsley (q.v.).
Bibl: AJ 1885 pp.357-68; Ormond.

HORTON, Miss Etty fl.1892-1903
Exhib. two works, 'A Bit of Old Chelsea' and 'Interior of St. Mark's, Venice', at the RA in 1893 and 1903, and two works at SS. London address.

HORTON, George 1859-1950
Watercolourist of shipping subjects and Dutch coastal scenes. Exhib. a view of the Fish Quay, North Shields, at the RA 1896. One-man exhibitions of his work were held in The Hague and in Rotterdam. Lived in South Shields, County Durham, until 1918, when he moved to London. Represented in the Laing AG and Shipley AG. He developed a very individual and impressionistic watercolour style.
Bibl: Hall.

HORTON, Miss Sarah Elizabeth Roberts BWS b.1865 fl.1893
Painted portraits. Also made book illustrations. Studied at Bushey under Herkomer. Exhib. a view of a church at SS 1890-1. Born in Australia. Lived in Bath.

HORTON, Westley fl.1874-1875
Painter of animals and rustic scenes, who was recorded in Birmingham in 1874-5. His work is similar in mood to Birket Foster and Helen Allingham.

HORWICK, Emanuel Henry fl.1886-1890
Exhib. five works at the NWS and one at the GG.

HORWITZ, B. fl.1874-1885
Exhib. five watercolours at SS, 1874-85, titles including 'Boar Hunt', 'Forest Scene, Hants' and 'Rural Scene' at SS, 1874-85. London address.

HORWITZ, Emanuel Henry fl.1888-1891
Exhib. two watercolours, 'Reflections' and 'Firelight Fancies', at SS, 1888-92. London address.

HORWITZ, Herbert A. fl.1892-1904
Painted portraits and figurative subjects. Exhib. at the RA from 1892, including portraits and works entitled 'Devotion' and 'The Nightingale'. Also exhib. a work entitled 'Venetian Girl' at SS in 1892. London address.

HOSKIN, Richard fl.1900
Exhib. two works, 'Ploughing on the Borders of Dartmoor' and 'Twins', at the RA in 1900. Address in Plymouth, Devon.

HOSKYN, Mary G. fl.1879
Exhib. a watercolour still-life at SS in 1879. London address.

HOSSACK, J. fl.1865
Exhib. a watercolour study at SS in 1865. London address

***HOUGH, William B. fl.1857-1894**
Painter of still-life and birds' nests. Exhib. 1857-94, at the RA, BI, SS, NWS and elsewhere. Worked at Coventry and subsequently for many years in London. Imitator of William Henry Hunt, closely following his painting of flowers and fruit, especially plums. He is represented (amongst other places) at Glasgow AG.
Bibl: Cundall; VAM; Hardie III pp.102, 109, 114; Maas.

***HOUGHTON, Arthur Boyd 1836-1875**
Book illustrator and painter of contemporary genre, both in oil and watercolour. Studied at Leigh's Art School, and became known for his brilliant illustrations to Dalziel's *Arabian Nights*, 1865, *Don Quixote*, 1866, *A Round of Days*, 1866, and for the many drawings he supplied to *The Graphic, Fun* and other serials. He exhib. 1859-74, at the RA 1861-72, BI, SS, OWS and elsewhere. He travelled to India, and to America (for *The Graphic*, making sketches of Shaker customs), and these trips supplied him with a taste for the exotic as

is seen in such subjects as 'The Transformation of King Beder' and 'The Return of Hiawatha', 1871, VAM, both watercolours, and rich in colour. His oil paintings were chiefly of contemporary genre and "reveal a refreshingly undoctrinaire approach to the everyday scenes of home life, and give a much less tragic view of Victorian domesticity than might be gleaned solely from Hunt's 'The Awakening Conscience' or Egg's 'Past and Present' " (Reynolds, VP). But his fame depends mainly upon his designs for books and he was outstanding in this field, even among his brilliant contemporaries of the 1860s. Elected A of the OWS in 1871. His studio sale was held at Christie's, 17 March 1876.

Bibl: AJ 1876 p.47 (obit.); Redgrave, Dict; Roget II; L. Housman, *Arthur Boyd Houghton. A Selection from his Work,* 1896; Gleeson White; VAM, Cat. of exhib. of Modern Illustrators, 1901; Binyon; Cundall; DNB; A. Hayden, *Chats on Old Prints,* 1909; Burlington Mag. XL 1922 p.203; Studio Special Number, *Drawings in Pen,* 1922; Studio Special Winter Number, *British Book Illustrators,* 1923-4 p.22ff.; Print Collector's Quarterly X No. 1 1923 February; No. 2 1923 April; VAM: Reynolds, VP pp.109, 114 (figs. pp.97, 100); Hardie III pp.139-40 (pl.162); Maas p.235, fig.p.116; Wood, Panorama; Cat. of A.B.H. exhib., VAM 1975.

HOUGHTON, Georgiana fl.1871-1882
An exhibition of her 'Spirit Drawings in Watercolour' was held at the New British Gallery, London, 22 May 1871. She also published books on spiritualist subjects.

HOUGHTON, John W. fl.1876-1879
Exhib. four genre works in 1876-9. London address.

HOUGHTON, M.P. fl.1875-1877
Exhib. a view of St. Asaph, North Wales, at the RA in 1875. London address.

HOULTON, J.T. fl.1842-1863
Exhib. three works, 'A Magdalen', 'A Fruit Girl' and 'Reflection', at the RA 1842-63.

HOUSEMAN, Miss Edith Giffard ASWA b.1875
Painted landscape. Studied under Claude Hayes, Frank Calderon and Walter Donne. Lived in Petworth, Sussex.

HOUSSOULLIER, W. fl.1844-1845
Exhib. two works, 'Fountain of Youth' and 'Bacchus Triumphant', at the RA in 1844 and 1845. Address in Paris.

HOUSTON, Donald
A picture by this unrecorded artist, 'Begging for a Crust' was sold at Christie's, 2 July 1971.

HOUSTON, George RSA RI RSW 1869-1947
Scottish painter and etcher of landscapes and marines. Worked in Ayrshire and Argyllshire. Lived at Dalry and in Glasgow.

Bibl: Studio XXXVIII pp.164, 169; XXXIX p.155; LXIII p.116; LXXII p.118; Special Winter Number 1917; AJ 1908 p.128; Caw; further bibl. in TB.

HOUSTON, H. fl.1841-1842
Exhib. two landscapes at the RA in 1841 and 1842. London address.

HOUSTON, J.P. fl.1836-1838
Exhib. four works, including 'The Idler' and 'Landscape and Scotch Herd Girl', at SS, 1836-8, and two works, 'Don Quixote in his Study' and another, at the BI, 1836 and 1837. London address.

*HOUSTON, John Adam RSA RI 1812-1884
Scottish historical genre painter and watercolourist. Studied in Edinburgh, Paris and Germany. Returned to Edinburgh, elected ARSA 1841, RSA 1844. In 1858 moved to London, where he remained for the rest of his career. Exhib. at RA 1841-77, BI, SS and NWS. His treatment of historical scenes was romantic and imaginative rather than historically accurate, and he was especially fond of scenes from the Civil War period.

Bibl: AJ 1869 pp.69-71; Portfolio 1887 p.136; The Year's Art 1885 p.229; Clement & Hutton; Caw p.119; Ormond.

HOUSTON, John Rennie McKenzie RSW 1856-1932
Painted figurative subjects and interiors. Exhib. in Scotland. Elected RSW in 1889. Lived at Rutherglen, Scotland.

HOVENDEN, Thomas 1840-1895
Irish-American painter of genre, landscapes and portraits. Exhib. one work, 'The First Cloud', at SS in 1880. Born in Dunmanway, Ireland. Died in Norristown, Penn.

Bibl: Champlin-Perkins, *Cyclop. of Painters etc.,* II 1888. Clement & Hutton; Studio Special Number Summer 1902; S. Isham, *History of American Painting,* 1905; Strickland; further bibl. in TB.

HOW, F. Douglas fl.1889
Exhib. a landscape at the NWS. Address in Wakefield, Yorkshire.

HOW, Miss Julia Beatrice 1867-1932
Painted figurative subjects. Studied under Herkomer at Bushey and in Paris at the Académie Delacluse. Exhib. in France and at the RA. Lived in France.

Bibl: W. Shaw Sparrow, *Women Painters of the World,* 1905; Art et Décoration XXXIV pp.115-20; Studio LXII p.318.

HOWARD, C. fl.1864
Exhib. a view of Callender, near Kilmahog turnpike, at SS in 1864. London address.

HOWARD, Miss Catherine fl.1888-1890
Exhib. a painting of rhododendrons at the RA in 1888 and two works, 'Lewes' and 'A Cornish Village', at SS in 1889 and 1890. London address.

HOWARD, Charles T. fl.1897
Exhib. a work entitled 'This Month's Magazine', at the RA in 1897. Address in Grantham, Lincolnshire.

HOWARD, E. Stirling fl.1834-1870
Painted landscape. Exhib. three works, views of Rivelin Dale, Eggleston Abbey and a bridge in Yorkshire, at SS 1834-71, and two works, 'Out of the Currant at Ruswarp' and 'Sylvia's Home', at the RA in 1869 and 1870. Address in Sheffield, Yorkshire. Represented in the VAM.

HOWARD, Miss Elizabeth H. fl.1856-1881
Exhib. a still-life of fruit at the BI in 1856. Address in Hemel Hempstead, Hertfordshire.

HOWARD, Francis 1874-1954
Painted portraits and genre subjects. Studied art in Paris, London and at Bushey. Wrote on art. Lived in London.

HOWARD, Frank 1805-1866
Painted portraits and literary, historical and biblical subjects. Exhib. 43 works at the RA 1825-46, titles including 'Othello and Desdemona', 'Country Wedding in the time of Henry V', 'A

Midshipman' and 'The Rescue of Cymbeline'. Also exhib. 26 works at the BI 1824-46, and nine works at SS. London address. Son of Henry Howard, RA (q.v.).

Bibl: AJ 1866 p.286; Redgrave, Dict; Ormond.

***HOWARD, George, 9th Earl of Carlisle HRWS 1843-1911**
Amateur painter and watercolourist. His London house at 1 Palace Green was built by Philip Webb, and decorated by Morris and Burne-Jones. Studied at South Kensington School of Art under Costa and Legros. In 1868 he began to exhibit at the GG, which he continued to do until 1910, also at the NG. His narrative pictures and watercolours were much influenced by the Pre-Raphaelites, who were mostly personal friends. The Howards had a wide circle of literary and artistic friends, which included Morris, Burne-Jones, Arthur Hughes, Crane, Leighton, Tennyson, Browning, and many other leading figures of the day, who all stayed with them at Naworth Castle in Cumberland. Howard was also widely travelled, and made continual sketches and watercolours wherever he went. In 1889, he inherited the title of 9th Earl of Carlisle. For 30 years he was Chairman of the Trustees of the Nat. Gall. In 1968 an exhibition of Howard's work was held at Carlisle AG. Paintings by Howard hang at Castle Howard, Yorkshire, and at Kelmscott Manor.

Bibl: BM Cat. of Engraved British Portraits I, IV; DNB 2nd Supp. 1912; Cat. George Howard exhib., Carlisle AG 1968; also many contemporary biographical references; Staley; Newall; V. Surtees, *The Artist and the Autocrat*, 1988; *The Etruscans*, Cat. of exhib., Stoke-on-Trent AG 1989.

HOWARD, H.T. fl.1889
Exhib. two works, 'Lewes' and 'A Cornish Village', at SS in 1889 and 1890. London address.

HOWARD, H. Wickham fl.1890-1892
Exhib. a landscape at the NG in 1890-2. Address in Chiswick London.

HOWARD, Henry RA 1769-1847
Neo-classical painter of portraits, mythological, biblical and historical subjects. Exhib. 259 works at the RA 1794-1847, 72 works at the BI 1806-44, and two works at SS. Amongst his later works exhib. at the RA were 'Daedelus and Icarus', 'The British Flag Borne by Zephyrs Across the Ocean', 'Hebrew Exiles' and 'Aaron Staying the Plague'. Addresses in Rome and London. Father of Frank Howard (q.v.).

Bibl: Sandby, History of the RA 1862 pp.329-31; Redgrave, Cent., Dict; DNB; Bryan; Index to Waagen 1912; BM Cat. of Engraved British Portraits.

HOWARD, Henry fl.1880-1897
Painted landscapes. Exhib. four works, three of them landscapes in Northern Italy, at the RA 1889-97. Also exhib. four works, including 'On the Edge of the Pool, Stanklyn' and 'A Golden Stone for Winds to Mock at', at SS 1880-2. Address in Kidderminster, Worcestershire.

HOWARD, J. fl.1880
Exhib. a landscape in 1880. London address.

HOWARD, Marion fl.1879
Exhib. a genre work in 1879. London address.

HOWARD, Vernon 1840-1902
Painted landscapes and country scenes. Exhib. 11 works, some of them watercolours, at SS 1864-78, titles including 'Farm-yard —

Summer', 'Bonchurch, Isle of Wight' and 'A Country Road, near Boston, Lincolnshire'. Exhib. four works, two of them views on the Lincolnshire coast, at the RA 1884-1902. Addresses in Boston, Lincolnshire and Kidderminster, Worcestershire. Represented in VAM and Nottingham AG.

Bibl: Brook-Hart.

HOWARD, William
His work, 'A View of a Riverside Village' was sold at Sotheby's Belgravia, 20 June 1972.

HOWARTH, Albany E. ARE 1872-1936
Etcher, lithographer and watercolourist, of landscapes and architectural subjects. Worked in England, Italy and France. Lived in Hutton, Essex.

Bibl: AJ 1909 p.143; Studio LVIII 1913 p.122.

HOWARTH, F.A. fl.1884
Exhib. a watercolour of an arch and staircase in the Old Palace Croydon. Address in Croydon, Surrey.

HOWE, B.A. fl.1844-1857
Exhib. three works, 'The Surprise', 'The Pigeon Fancier' and 'The Favourites', at SS in 1844-57. London address.

HOWE, F.N. fl.1875
Exhib. a landscape in 1875. Address in Southsea, Hampshire.

HOWE, H. fl.1862
Exhib. a watercolour view of an old cottage at Folking, Sussex, at SS in 1862. Address in Isleworth.

HOWELL, Miss Constance E. fl.1878-1882
Exhib. three watercolours, 'Wallflowers', 'Roses' and 'On the Look-Out', at SS 1878-82. London address.

HOWELL, Samuel fl.1829-1854
Painted portraits. Exhib. 33 works, the majority portraits but also including 'The Rose', 'The Day Dream' and 'The Flower Gathering', at SS 1828-47. Also exhib. ten portraits and a work entitled 'The Gipsy Queen', at the RA 1829-54. London address.

Bibl: BM Cat. of Engraved British Portraits; Ormond.

HOWELL, Sydney fl.1841-1851
Exhib. a view of Southwicke House, Hampshire, at the RA in 1841. London address.

HOWELLS, Howard fl.1901
Exhib. a work entitled 'Grey and Gold' at the RA in 1901. Address in Lydney, Gloucestershire.

HOWELLS, Leonard T. fl.1901
Exhib. a work entitled 'A Bit of the Welsh Coast' at the RA in 1901. Address in Lydney, Gloucestershire.

HOWELLS, T.C.F. fl.1873-1878
Exhib. two watercolours, 'Old House Tops — Soho' and 'Pickett's Farm, South End, Hampstead', at SS 1873-6. London address.

HOWES, F. fl.1850
Exhib. a work, an illustration to Tennyson, at the BI in 1850. London address.

HOWES, T. **fl.1866**
Exhib. a study at the RA in 1866. London address.

HOWEY, John William **1873-1938**
Painted landscapes, marines and portraits. Born in West Hartlepool, County Durham. Represented in the Gray AG, West Hartlepool.
Bibl: Hall; P. Phillips, *The Staithes Group*, 1993.

HOWGATE, William Arthur **fl.1884-1904**
Painted landscapes and coastal scenes. Exhib. 13 works, 'The Crofter's Plot, near Coldingham Shore', 'Launching the Lifeboat' and 'Bamboro' Castle', at the RA 1884-1904. Also exhib. nine works, all landscapes, at SS 1886-92. Address in Leeds, Yorkshire.

HOWITT, Miss Anna Mary **fl.1854-1855**
Exhib. a work entitled 'The Castaway' at the RA in 1855. London address.

HOWSE, F. **fl.1846-1849**
Exhib. four works, 'Henry II and Thomas à Becket', 'Jacob Refusing to Send Benjamin down into Egypt', and portraits, at the RA 1846-9. London address.

HOWSE, Frederick D. **fl.1884-1893**
Exhib. five works, including 'Harvest Time — Capri', 'Memories', 'The Grave Has Eloquence' and 'Hours of Idleness', at the RA 1887-93. London address.

HOWSE, George **NWS** **fl.1830-d.1860**
Painted landscape and buildings. Exhib. 26 works at the RA 1830-58, including views on the rivers Thames and Rhine. Also exhib. at the BI and SS, and 531 works at the NWS. Elected NWS 1834. London address.
Bibl: Redgrave, Dict.; Cundall.

HOWSE, Miss Kate **fl.1881**
Exhib. a work entitled 'Through the Looking Glass', at the RA in 1881. London address.

HOYER, Edward **fl.c.1870-1890**
His painting 'Shipping in the Channel', is reproduced in Brook-Hart.
Bibl: Brook-Hart (pl.p.201).

***HOYOLL, Philipp** **b.1816 fl.1836-1875**
Genre painter, miniaturist and lithographer. Born in Breslau; studied at Düsseldorf Academy 1834-9. Exhib. at Berlin Academy 1836-46. About 1864 moved to London, where he exhib. 1864-75 at the RA, BI and SS. His subjects genre scenes, especially of children, and occasional portraits.
Bibl: F. van Boetticher, Malerwerke der 19. Jahrh. I p.2 1895; R. Wiegmann, Düsseldorf Academy Cats. 1856 p.234; E. Hintze, Schles. Miniaturmaler d.19 Breslau 1904 p.149.

HOYTE, Mrs. Lucy **fl.1893**
Exhib. an 'Autumn Study' at SS at 1893-4. London address.

HUARD, Frans **fl.1872-1879**
Painted figurative subjects. Exhib. four works at the RA, 1873-8, including 'Othello "Make all the Money Thou Canst" ', 'The Bravo' and 'Recollections'. Exhib. 12 works, including 'The Bandit', 'Much Ado About Nothing — Act 1, Scene 1', and 'Homeless' at SS 1872-7. London address.

HUARD, Louis **fl.1857-1872**
Exhib. two works, 'The Wager' and 'The Corn Flowers', at the BI in 1857. London address.

HUBARD, Henri **fl.1867-1869**
Painted landscapes. Exhib. three works, 'Between Brussels and Waterloo', 'Sunday Afternoon, Parham Park, Sussex' and 'On the Banks of the River Scheldt, near Ghent', at the RA 1867-8. Also exhib. two landscapes at SS in 1869. London address.

HUBBARD, B. **fl.1839-1864**
Painted animals and portraits. Exhib. seven works, spaniels and ponies as well as portraits, at the RA 1839-64. Address in Louth, Lincolnshire.

HUBBARD, G.A. **fl.1865**
Exhib. four watercolours, still-lifes of flowers and birds' nests, at SS in 1865. Address in Bexley Heath.

HUBBARD, J. **fl.1867**
Exhib. a work entitled 'From Night 'Till Morn', at the RA in 1867. London address.

HUBBARD, W. **fl.1837-1868**
Painted flowers and buildings. Exhib. four works, a view of Bexley Heath Church and another of a cottage in Bexley Heath, and two paintings of flowers, at SS 1837-68. Also exhib. a painting of geraniums and a chaffinch's nest at the BI in 1867. Address in Crayford, Kent.

HUBERT, V. **fl.1871**
Exhib. a sketch between Portsmouth and Ryde at SS in 1871-2. Address in Ryde, Isle of Wight.

HUCKS, Miss H.M. **fl.1880**
Exhib. a watercolour entitled 'A Summer Gathering' at SS in 1880. Address in Hertford.

HUDJON, J.
Painted marines. Lived in Sunderland, County Durham. Represented in the Shipley AG.
Bibl: Hall.

HUDSON, Albert Wilfred **b.1874**
Painted landscapes. Studied at the Académie Julian. Exhib. at the RA, the Paris Salon and in the provinces. Born at Bingley, Yorkshire. Lived in Bushey, Hertfordshire.

HUDSON, Benjamin **fl.1852-1853**
Painted portraits. Exhib. four works at the RA 1852-3, and two portraits at SS in 1852. London address.
Bibl: BM Cat. of Engraved British Portraits II.

HUDSON, Charles **fl.1848-1874**
Exhib. three works, views of Albury Church, Guildford, and the Hotel de Sens, Paris, at the RA 1848-71. Also exhib. a watercolour of the Conventual Buildings of St. Martin, Tours, at SS in 1874. London address.

HUDSON, Miss Edith H. **fl.1888-1889**
Exhib. two works, 'The White Cottage' and 'Schooners', at the RA in 1871. Address in Bradford, Yorkshire.

HUDSON, Henry fl.1898
Exhib. a still-life at the RA in 1898. Address in Sherborne, Dorset.

HUDSON, Henry John fl.1881-1910
Painted portraits and figurative subjects. Exhib. at the RA from 1881, titles including 'Finishing Touches', 'Ophelia', 'Yseult of Ireland' and portraits. Also exhib. one work, 'Will he Come?', at SS in 1888-9. London address.

HUDSON, J. fl.19th century
Painted marines in oil and watercolour. Lived and worked in Sunderland, County Durham.
Bibl: Hall

HUDSON, Robert, Jnr. fl.1873 d.1884
Exhib. three works, 'The Rail, the Road and the River, near Matlock', 'Late Autumn' and 'Bolton Abbey', at SS 1873-80. Also exhib. a work entitled 'Companions in Age' at the RA in 1877. Address in Sheffield, Yorkshire.
Bibl: The Year's Art 1885 p.229.

HUDSON, William fl.1837-1844
Painted buildings and architectural details. Exhib. seven works including 'Gateway to Ancient Palace of the Duc de Guise at Calais', 'George IV's Tower, Windsor Castle' and 'Town Hall and Market at Epsom', at the RA 1837-44. London address.
Bibl: Ormond.

HUE, C.B. fl.1857-1863
Painted marines and shipping. Exhib. ten works, including 'Broadstairs Hovellers, going out to the Goodwin Sands', 'Off the Foreland, Studland Bay, Dorset' and 'A Fine Night for Crossing the Channel', at SS 1857-63. Exhib. five works, all marines or views of boats, at the BI 1858-62, and two works at the RA in 1857. London address.
Bibl: Brook-Hart.

HUE, Miss E. fl.1861-1871
Painted landscapes. Exhib. seven works, including views in North Wales, the Lake District and on the Lake of Geneva at SS 1861-71. London address.

HUEFFER, Mrs. Frank see BROWN, Miss Catherine Madox

HUFFAM, Miss M. fl.1874
Exhib. a drawing illustrating *Armfeld* at the RA in 1874. Address in Bath.

HUGARD fl.1848
Exhib. a view in Chamonix at the RA in 1848. London address.

HUGGINS, Miss Anna fl.1854-1855
Exhib. three still-lifes of game at the RA, 1854-5. She was the sister of William Huggins (q.v.). Address in Liverpool.

HUGGINS, J.M., Jnr. fl.1827-1842
Painted shipping. Exhib. four works, including 'French Boats entering Ramsgate Harbour' and 'Dutch Boat off Dogger Bank' at SS 1826-30. Also exhib. a landscape at the BI in 1842. London address.

HUGGINS, Samuel
A brother of William Huggins (q.v.) who also painted.

HUGGINS, Sarah
Was a member of the Liverpool Academy. She was a sister of William Huggins (q.v.). Lived in Liverpool.

*HUGGINS, William 1820-1884
Liverpool animal and landscape painter. Studied at Mechanics Institute, where he won a prize aged 15 for a historical subject. His devotion to animals soon began to show itself; he studied them at the Zoo, and kept a house full of pets. In 1847 he became an associate of the Liverpool Academy, and in 1850 a member. He also exhib. at RA, 1842-75, BI and SS. Apart from his pure animal pictures — lions, horses, donkeys, poultry, etc., Huggins also painted historical subjects involving animals, such as 'David in the Lion's Den' and 'Una and the Lion', portraits and landscapes. He developed a very individual technique, painting with pale, transparent colours over a white ground. In 1861 he moved to Chester, and in 1876 took a house at Bettws-y-Coed. He later returned to Chester, where he died. Anna and Sarah Huggins (qq.v.) were his sisters, and Samuel Huggins (q.v.) his brother.
Bibl AJ 1904 pp.219-21; Connoisseur 1913 p.150; Bryan; Marillier pp.143-53 (pls.opp.pp.146, 150); DNB 1891 p.159; Cat. of Walker AG Liverpool; Reynolds, VP p.66; Hardie III pp.73, 75; Maas pp.81-2 (pls.pp.81-2).

HUGGINS, William John 1781-1845
London marine painter. Served at sea with the East India Company. Exhib. at RA, 1817-44, BI and SS. Painted merchantmen and warships, and naval actions. 1834 appointed marine painter to William IV. The compositions of Huggins's pictures are mostly conventional, but painted in a clear, pleasing style. A large group of his works can be seen at the Greenwich Maritime Museum.
Bibl: Redgrave, Dict; DNB 1891 p.159; Cat. of Royal Gallery, Hampton Court, 1898; Wilson p.44 (pl.18); Maas p.63 (pl.p.65); Brook-Hart (pl.8)

HUGHES, Miss fl.1860
Exhib. an interior view of All Saints, Boyn Hill, Maidenhead at the RA in 1860. Address in Suffolk.

HUGHES, Mrs. fl.1843
Exhib. a painting of flowers at SS in 1843. London address.

HUGHES, A. 1805-1838
Engraver and painter of genre subjects. Exhib. a painting of cattle at the RA in 1831, and a Dutch Winter Scene at the BI in 1842. Born in Devon. Died in Dresden, Germany.

HUGHES, Miss Alice fl.1890-1899
Exhib. 'A Corner' and 'A Study' at SS 1890-2, and a work entitled ' "1799" Portrait of a Lady', at the RA in 1899. Address near Newport, Isle of Wight.

HUGHES, Miss Amy fl.1881-1882
Exhib. a genre subject at the GG in 1881-2. Address in Wallington.

*HUGHES, Arthur 1832-1915
Pre-Raphaelite painter and illustrator. Studied under Alfred Stevens. Entered RA Schools 1847; began exhibiting at RA 1849. About 1850 converted to Pre-Raphaelitism by reading *The Germ*. Met Holman Hunt, Rossetti, Madox Brown, and later Millais. In 1852 he exhib. his first major Pre-Raphaelite picture 'Ophelia'. Throughout the 1850s and 1860s Hughes continued to produce a series of delicately poetic pictures, which hover on "the knife-edge between sentiment and sentimentality" (Fredeman) but are always redeemed by their brilliant colour and microscopic detail. Some of

the best known are 'Home from the Sea', 'The Long Engagement', 'The Tryst' and 'April Love', which Ruskin thought "exquisite in every way". In 1857 he worked with other Pre-Raphaelites on the frescoes in the Oxford Union. He was also a member of the Hogarth Club. About 1858, Hughes retired to live with his family in the suburbs of London. Being of a quiet and retiring nature, very little is known of his later career. After about 1870 his work lost its impetus, and cannot be compared with his earlier brilliance. Hughes illustrated Allingham's *Music Master* and many other novels, children's books and periodicals. Exhib. at RA, GG and NG. After his death a sale of his works took place at Christie's, 21 November 1921.

Bibl: For detailed bibl. see Fredeman index; other useful references: AJ 1904 pp.237-8; Studio LXVII 1916 p.56; LXXII p.69; Portfolio 1870 p.132ff.; L'Art LIX 1894 p.399ff.; Burlington Mag. XXVIII 1915-16 pp.204ff. (obit.); Ruskin, Academy Notes 1856, 1858-9; H. Blackburn, *Academy Notes,* 1879-83; Bate p.71ff. (pls opp.pp.71, 72); DNB Supp. II pp.275-6; Forrest Reid, *Illustrations of the Sixties,* 1928 pp.83-95; Ironside & Gere pp.41-4 figs. 9-10 (pls.63-70); Reynolds, VS pp.79-81 (pls.52-4); Reynolds, VP pp.65, 67-70, 112 (pl.53); Maas pp.135, 230 (pls.pp.133, 134, 136); Staley (pls. 42a, 42b, 84-6); Irwin; Wood, Panorama; R. Mander, *The Tryst Unravelled,* Apollo March 1964; Cat. of A.H. Exhibition, National Gallery of Wales and Leighton House, London, 1971; Wood, Pre-Raphaelites; Wood, Paradise Lost.

HUGHES, Arthur Foord b.1856 fl.1878-c.1927
Painted landscapes and country scenes. Exhib. 13 works, including 'Gleaning', 'On the Stour, Canterbury' and 'At Rest —Low Tide', at the RA 1878-1902. Also exhib. two works at SS 1890-2. Address near Newport, Isle of Wight.
Bibl: Wood, Paradise Lost.

HUGHES, Edmund fl.1879
Exhib. a landscape in 1879. London address.

HUGHES, Edward 1832-1908
London genre and portrait painter; son of George Hughes (q.v.). Exhib. at RA 1847-84, BI, SS and GC. Titles at RA 'Ruinous Prices', 'The First Tooth', 'After Confession', etc., also some portraits and historical scenes.
Bibl: AJ 1859 pp.83, 170; DNB 2nd Supp. 1912 p.319ff.; Ormond.

***HUGHES, Edward Robert RWS 1851-1914**
London historical genre painter. Studied at RA Schools, also with Holman Hunt, and his uncle Arthur Hughes (q.v.). Exhib. at RA 1870-98, BI, OWS, GG and at International Exhibitions in Venice, Munich and Düsseldorf. ARWS 1891, RWS 1895. Painted mainly romantic genre, with subjects drawn from Boccaccio and novels. Hughes was a friend of Holman Hunt, and in his later years often worked as his assistant.
Bibl: F.W. Gibson in E.A. Seeman's *Meister der Farbe,* 1904 I p.55; Studio 1914 pp.57, 214; references in Holman Hunt literature; *The Last Romantics,* Cat. of Exhibition at the Barbican AG 1989.

HUGHES, Edwin fl.1872-1892
Little-known London genre painter. Exhib. at RA 1872-92. Subjects usually children, domestic scenes or sentimental genre, painted on a small scale.

HUGHES, Miss F.L. fl.1884
Exhib. a painting of fish at the NWS in 1884. London address.

HUGHES, George fl.1813-1858
Landscape painter; father of Edward Hughes (q.v.). Exhib. at RA 1813-58, BI and SS. Mostly views around London, and some portraits.

HUGHES, George fl. from 1900
Exhib. at the RA from 1900 including 'Silver and Gold' and 'In the Old Homeland'. Address in Liverpool.

HUGHES, George Frederick fl.1873-1879
Exhib. four works, all views on the Thames, at SS 1873-9. London address.

HUGHES, Godfrey fl.1891-1893
Exhib. two landscapes at the NG 1891-3. Address in Kew, near London.

HUGHES, Harry fl.1898
Exhib. a work entitled 'A Corner of the Studio' at the RA in 1898. London address.

HUGHES, Henry Harold fl.1892
Exhib. a view of the Bar Gate, Southampton at the RA in 1892. Address in Bangor, Caernarvon.

HUGHES, Hugh 1790-1863
Welshman who painted landscapes. Exhib. six works, including 'The Minas Bridge, North Wales', 'Falls of Helygog' and 'Flowers' at SS, 1827-51. Exhib. four works at the BI 1827-51. London address.
Bibl: DNB 1891; Rees, *Welsh Painters,* 1912; Chatto, *A Treatise of Wood Engraving,* 1861.

HUGHES, John 1790-1857
Painted landscapes. Exhib. seven works, including views in Highgate, St. John's Wood, and on Primrose Hill, at the BI, 1819-25. Exhib. seven works at SS 1826-38, and five works, including a view in Windsor Great Park, at the RA 1827-36. London address. Also an etcher and sculptor.
Bibl: Rees, *Welsh Painters,* 1912; DNB 1891.

HUGHES, John Joseph fl.1838-1867 d.c.1909
Painted landscapes. Exhib. 22 works, including views in North Wales and the Midlands, at SS 1853-66. Exhib. ten works including 'Lakeland Scene' at the BI 1859-67, and four works, including views in Warwickshire, Borrowdale and in Dolgelly, at the RA 1855-65. Address in Birmingham.

HUGHES, Leonard RCA fl.1889-c.1930
Painted portraits. Exhib. two portraits at the RA in 1889 and 1894. Address in Holywell, Flintshire.

HUGHES, Miss Mary fl.1891
Exhib. a figurative work at the NWS in 1891. Address in Brentford, London.

HUGHES, Nathan fl.1849-1870
Exhib. a work entitled 'Rubens painting a Portrait of His Second Wife' at the BI in 1849, and a work entitled 'Shoeing a Horse in France' at SS in 1870. London address. In the *Pall Mall Gazette* of 18 October 1886, Hughes wrote an article highly critical of Lord Leighton and the Royal Academy, and blaming them for his being reduced to living in the Lambeth Workhouse.
Bibl: F. Boase, *Modern English Biography,* 1892-1921 (repr. 1965); R. and L. Ormond, *Lord Leighton,* 1975 p.115-16.

HUGHES, Mrs. Philippa Swinnerton 1824-1917
Painted two portraits of her father, Robert Lucas de Pearsall, one a copy of the other. The first, of 1849, is in the Benedictine Abbey of Einsiedeln in Switzerland. The second is in the NPG.
Bibl: Ormond (pl.720).

HUGHES, R.E. fl.1872
Exhib two watercolours, one entitled 'My Pet' and another untitled but accompanied by the lines 'The North Wind Doth Blow, And We Shall Have Snow; And What Will Robin do Then, Poor Thing!' London address.

HUGHES, Robert Morson 1873-1953
Painted landscapes and marines. Studied at Lambeth School of Art and at South London Technical Art School. Lived at St. Buryan, Cornwall.

HUGHES, S.J. fl.1837
Exhib. a scene near Hampstead at the RA in 1837. London address.

HUGHES, T.J. fl.1851-1865
Painted portraits and figurative subjects. Exhib. ten works, the majority portraits, at the RA 1851-60. Also exhib. two works, a portrait and 'Pride of the Village', at SS 1854-7, and a work at the BI in 1853. London address. Probably the same painter as Thomas John Hughes (q.v.).

***HUGHES, Talbot ROI PS 1869-1942**
Painted genre, figurative and theatrical subjects. Exhib. at the RA 1871-1903, titles including 'Fruitful Boughs', 'The End of the Game', 'In Dire Peril' and 'The Road of Love'. Also exhib. at the GG, and at SS. Son of the still-life painter William Hughes and brother of H. Hughes-Stanton (qq.v.). Lived in London and later at Osmington, near Weymouth, Dorset.
Bibl: Mag. of Art 1902; AJ 1904; Studio XXXI, XXXVIII; RA Pictures 1899 and 1903; Who's Who 1924.

HUGHES, Thomas John fl.1879-1892
Painted genre subjects. Exhib. eight works, including 'A Much-Prized Family', 'It's for Papa' and 'Merry Thoughts Make a Laughing Face', at SS, 1879-89. London address. Probably the same painter as T.J. Hughes (q.v.).
Bibl: Wood, Panorama p.134 (pl.140).

HUGHES, Vernon fl.1852-1855
Painted literary and historical subjects. Exhib. five works, including 'A Soldier of the Commonwealth', 'The Temptation of St. Anthony' and 'Manfred Seeing the Witch of the Alps', at the RA 1852-4. Also exhib. four works, including 'A Belle of the 18th Century' and 'The Rape of the Lock', at the BI 1853-5. London address.

HUGHES, W.C. fl.1880
Exhib. a landscape in 1880. Address in Scarborough, Yorkshire.

HUGHES, W.H. fl.1877-1880
Exhib. six drawings, 1877-80. London address.

HUGHES, William 1842-1901
Still-life painter; father of Sir Herbert Hughes-Stanton (q.v.). Pupil of George Lance and William Henry Hunt (q.v.). Lived in London and Brighton. Exhib. at RA 1866-1901, BI, SS and GG. Titles at RA 'The Baron's Dessert', 'For the Feast of the Tournament', etc. His major work was a set of five large bird pictures for the hall of Lord Calthorpe's house in Grosvenor Square. A work by him is in Hull Museum.
Bibl: Bryan.

HUGHES, William W., Jnr. fl.1830-1853
Painted landscape watercolours. Exhib. 11 works, almost all either views in North Wales or around Shrewsbury, at SS 1830-53. Also exhib. seven works, views of Cader Idris, Festiniog and Windsor Castle , at the RA 1830-49 , and two works at the BI in 1851. London address.

HUGHES-STANTON, Sir Herbert Edwin Pelham RA PRWS 1870-1937
Landscape painter, son of William Hughes (q.v.). Self-taught, except for lessons from his father, and study of the old masters. In 1886 he began to exhibit at the GG, where he exhib. most of his work. He also exhib. at RA, RWS, NG and the Institute of Painters in Oil. Rather like his contemporary, Sir Alfred East (q.v.), Hughes-Stanton's landscapes are a romantic reinterpretation of the great English landscape tradition of the 18th and 19th centuries. His style and colours, however, were quite individual, and show more continental influence. Elected RA 1920, RWS 1921, although he had been PRWS since 1915. Knighted 1923. Hughes-Stanton's work enjoyed a big reputation in his day, but is now sadly out of fashion. His pictures are to be found in many museums in England; also in Rome, Florence, Barcelona, Buenos Aires, Tokyo and Australia.
Bibl: AJ 1910 pp.77-82; 1904 p.271; 1906 p.180; 1907 p.373; 1908 p.171; 1909 p.285; Studio XLII 1908 p.269ff.; International Studio XXXIII 1908 p.269ff.; RA Pictures 1907-8, 1910-15; Who's Who 1924.

HUGUET, C. fl.1872
Exhib. a painting of a storm at SS in 1872-3. London address.

HUIBER, J.D. fl.1875
Exhib. six charcoal drawings in 1875.

HULK, Abraham, Snr. 1813-1897
Painter of Dutch marines and coastal views. Pupil of the portrait painter J.A. Daiwaille. Later studied at the Amsterdam Academy. Visited the USA, where he held exhibitions of his work. Exhib. three works, including two views on the Dutch coast, at the RA 1876-90. Settled in London in 1870. His son, also called Abraham (q.v.), was also a marine artist.
Bibl: Brook-Hart (pls. 17, 83, 84); further bibl. in TB.

HULK, Abraham, Jnr. fl.1876-1898
Painted landscapes. Exhib. 15 works, including views in Netley, Witley, Albury, St. George's Hill, Reigate and Dorking, all in Surrey, at SS 1875-92. Exhib. 24 works, including views in Holland, Germany and in the South of England, at the RA 1888-98. Address in Dorking, Surrey. Son of the marine painter Abraham Hulk, Snr. (q.v.).
Bibl: Brook-Hart.

HULK, William Frederick fl.1875-1906
Landscape and animal painter. Exhib. at RA 1876-98, SS and NWS. Lived at Shere, near Guildford, and painted mainly in Surrey. Subjects rustic landscapes with cattle and sheep.

HULL, Miss Clementina M. fl.1866-1904
Painted flowers and genre subjects. Exhib. at the RA from 1889, including 'Between the Showers', 'At Mischief Again' and 'Yet Still the Face of Heaven Was Grey'. Also exhib. four watercolours, including 'Azaleas', 'Daisies' and 'Evening: Study in a Wood', at SS 1867-89. London address.

HULL, Edward fl.1860-1877
Painter of landscapes and figures; also illustrator. Not to be confused with another Edward Hull, a lithographer and topographical draughtsman, working from 1820-34. Both may be relations of William Hull (q.v.).

HULL, George fl.1877-1886
Exhib. landscapes at the NWS in 1877-86. Address in Leicester.

HULL, Miss Mary A. fl.1877-1887
Exhib. a painting of gooseberries and currants at the RA in 1877. Also exhib. three works at the NWS. Address in Leicester.

HULL, William 1820-1880
Painted landscapes and still-life. Exhib. eight works, views in North Wales and the Lake District, at the RA 1858-77, and three works, all watercolours, at SS 1867-74. Born in Graffham, Huntingdonshire. Died in Rydal. Best known for his fruit and flower pieces in the style of William Henry Hunt (q.v.).
Bibl: DNB XXVIII; Portfolio 1886 pp.15-21; 1887 pp.35, 77, 97, 113, 195, 127; Hardie III.

HULLAH, Miss Caroline E. fl.1863-1867
Exhib. two works, 'At Tournament' and 'Tame Dormouse', at the RA in 1863 and 1865. London address.

HULME, Miss Alice L. fl.1877-1890
Painted flowers. Exhib. three works, 'Christmas Roses', 'Azaleas and Narcissus' and 'Winter Flowers', at the RA 1886-90. Address in Kew, London.

HULME, E. fl.1840-1854
Exhib. three works, 'View at Battersea', 'Netley Abbey' and 'Mackerel Fishing, Coast of Devon — Moon Rising', at the RA 1845-54 Also exhib. four works, including 'Elijah Fed by the Ravens', at SS 1840-3, and two works at the BI in 1843 and 1844. London address.

***HULME, Frederick William 1816-1884**
Landscape painter. Born Swinton, Yorkshire. Taught by his mother, who was a painter on porcelain. 1841 exhib. at Birmingham Academy. 1844 came to London, and worked as an illustrator and engraver. Exhib. at RA, 1852-84, and BI. Subjects mostly Wales and Surrey. Also painted idyllic landscapes, with rustic figures and animals. Hulme's style is usually clear and fresh, similar in colouring to W. Shayer and T. Creswick (qq.v.).
Bibl: AJ 1858 pp.101-3; Studio Spring Number 1915 p.26; Ottley; Wood, Paradise Lost.

HULME, Robert C. fl.1862-1876
Exhib. a work entitled 'A Gipsy Encampment — Barnes Common' at the RA in 1862, and a view of an old Kentish foot-bridge at SS in 1876. Address near Sevenoaks, Kent.

HULME, T.O. fl.1865-1867
Exhib. two works, 'Morning Among the Hills' and 'In the Vale of Llangollen', at the BI in 1865 and 1867. London address. This is probably the same painter as T.O. Hume (q.v.).

HULTON, Everard fl.1882
Exhib. a view of Whitby at the RA in 1882. London address.

HULTON, William fl.1882 d.1921
Painted landscapes. Exhib. six works, including 'A Bright Day: Coast of France', 'Going to the Tryst' and 'At Rest', at SS 1884-5. Exhib. five works, including 'A Grey Day in Pont Aven' and 'Campo SS. Giovanni e Paolo, Venice', at the RA 1882-9. London address. Died in Venice.
Bibl: The Year's Art 1922 p.312.

HUME, J. Henry 1858-1881
Painter of landscapes, genre, portraits and flowers. Brother of Thomas O. Hume (q.v.). Exhib. 1875-81 at the RA, SS and elsewhere, titles at the RA including, 'Students Day at the NG', and

'Harvest Weather'. He died aged 23, "a young artist of promise — though chiefly a landscape painter, he had lately turned his studies with success to figure and portrait painting, showing a rich and refined feeling for colour" (AJ).
Bibl: AJ 1881 p.192 (obit.).

HUME, Robert fl.1891-1903
Edinburgh painter of landscape and rustic genre who exhib. 1891-1903 at the RA, SS and NWS. Titles at the RA include 'Midday', 'The Harvest is Come' and 'In the Land of Macgregor'. From 1894 he lived in London.

HUME, T.H. fl.1878
Exhib. a landscape in 1878. Address in Sutton, Surrey.

HUME, Thomas O. fl.1864-1893
Landscape painter who exhib. 1864-93, at the RA 1871-93, at BI, SS and elsewhere. Brother of J. Henry Hume (q.v.).

HUME, Mrs. T.O. fl.1862-1892
(Miss Edith Dunn)
Painter of genre — often fishing scenes — who exhib. under her maiden name Miss Edith Dunn, from 1862-7, at the BI and SS, and as Mrs. T.O. Hume 1870-92, at the RA 1874-92, SS, NWS, GG and elsewhere. Titles at the RA include 'Fishing on the Old Pier Head', 'Ripening Corn', 'Distant Thoughts' and 'Mending Nets'.
Bibl: H. Blackburn, Academy Notes, 1883 (pl.).

HUMPHREY, Edward J. fl.1872-1889
Painted landscapes and figurative subjects. Exhib. 13 works, including 'Touchstone and Corin', 'Fresh Herrings' and 'Crocksford Mill' at the RA 1872-85. Exhib. seven works, including 'Welsh Interior', 'Antoinette' and 'On the Way', at SS 1872-85. London address.

HUMPHREYS, F.W. fl.1858
Exhib. a work 'Near Pen Machno', at the BI in 1858. Address in Birmingham.

HUMPHREYS, Miss Jane K. fl.1865-1886
Painted genre and figurative subjects. Exhib. three works, including 'Rachel Weeping for her Children' and 'Field Flowers', at the RA, 1871-6. Exhib. seven works, including 'Neapolitan Peasant Girl', 'Our Minister' and 'Number One in the Old Parish Church' at SS, 1865-86. London address.

HUMPHRIS, William H. fl.1881-1899
Painted genre and figurative subjects. Exhib. six works, including 'A Love Token', 'A Cup-Bearer', 'Heirlooms' and 'Undeniable Proof', at SS 1881-91. Exhib. five works at the RA 1891-9, including 'Memories', 'Debutantes' and 'An Idle Singer'. Address in Falmouth.

HUMPHRY, C. fl.1878-1880
Exhib. five works, including 'Feeding Time', 'Make Haste!', 'Connubial Bliss' and 'Domestic Quarrels', the latter two watercolours, at SS 1878-80. London address.

HUMPHRY, Miss K. Maude fl.1883-1891
Exhib. a work entitled 'My Solace', at SS in 1883, and a portrait at the RA in 1891. London address.

HUNDLEY, Philip fl.1869-1880
Painted landscapes and country subjects. Exhib. 16 works, mostly watercolours, titles including 'The Cottage Door', 'First at the Rendez-vous' and 'The Squire's Lunch', at SS 1870-80. London address.

HUNN, Thomas H. 1857-1928
Painted landscapes, gardens, buildings and portraits. Exhib. 13 watercolours, including 'Valley of the Wey: From the Fir Wood near Unstead', 'An Old Stone Bridge' and 'October Morning:River Arun', at SS 1880-90. Exhib. at the RA from 1878, including views at Sutton Place, Guildford, and elsewhere in Surrey, Sussex and Essex. London address; also lived in Wallingford.
Bibl: Ormond; Wood, Painted Gardens.

HUNT, A. fl.1852-1853
Exhib. three works, 'P for Puss', 'The Picture Bible' and 'Uncle Tom and Eva', at SS 1852-3. London address.

HUNT, Alfred fl.1870-1874
Exhib. three works, 'A River View', 'A Wood-pigeon just Shot' and 'Fishing Boats Picking up Waifs and Strays After a Storm', at SS, 1870-4. Address in Reading, Berkshire.
Bibl: Brook-Hart.

***HUNT, Alfred William RWS 1830-1896**
Liverpool landscape painter and watercolourist. Studied at Oxford where he won the Newdigate Prize for English Verse in 1851. From 1853 until 1861 he was a Fellow at Oxford; in 1861 he married and decided to devote his career to art. Elected Associate of Liverpool Academy 1854; Member 1856. Exhib. at RA 1854-88. OWS (334 works) and elsewhere. Came to London 1862. ARWS 1862, RWS 1864. Hunt's watercolours, which combined Pre-Raphaelite detail with admiration for Turner, were highly praised by Ruskin. He painted in Scotland, the Lakes, and the Thames valley, but was especially fond of North Wales and Whitby. He also travelled in France and Switzerland. His daughter was Violet Hunt, author of *The Wife of Rossetti*, and other books. Hunt's work is often compared with that of Albert Goodwin (q.v.).
Bibl: AJ 1896 p.220 (obit.); 1897 p.93ff.; 1903 p.226ff.; Portfolio 1876 p 155ff.; 1884 p.44; Studio Winter Number 1917-18 p.23; Ruskin, Academy Notes 1856 pp.57, 59, 75; DNB 2nd Supp. III 1901; Marillier pp.156-68; Cundall; VAM; Hardie III pp l61-2 (pl 187); Staley pls. 78b, 79a, 145-7; Newall.

HUNT, Andrew 1790-1861
Painted landscapes and figurative subjects. Exhib. two works, 'Children Playing at Jink-Stones' and 'The Butterfly', at the RA 1852-6. Address in Liverpool. He was the father of Alfred William Hunt (q.v.). His work 'The North Shore, or Estuary of the Mersey' is in the Walker AG.
Bibl: DNB XXVIII; Marillier; Staley.

HUNT, Arthur Acland fl.1863-1902
Painted portraits, figurative subjects and landscapes. Exhib. 19 works including works entitled 'An Old Salt' and 'Chums at Work', views on Sark, and portraits, at the RA 1865-1902. Exhib. 22 works, including a subject from Fortunes of Nigel and works entitled, 'The Lavender Girl', 'Music Hath Charms' and 'Driving a Bargain', at SS 1863-78. Also exhib. at the BI and NWS.

HUNT, Cecil Arthur RWS 1873-1965
Painted landscapes. Watercolours by him are in the Leeds City AG and the VAM ('The Cadini Dolomites'). Born in Torquay, Devon. Lived in London .
Bibl: Athenaeum 1919 II; Burlington Mag. XLIV; Studio LXVI p.204; LXXXV p.286; Who's Who 1924, OWS Club XXXVII 1963.

***HUNT, Charles 1829-1900**
Painter of contemporary genre, often humorous, and historical subjects. Exhib. at the RA 1862-73, BI and SS. Titles at the RA include 'Vocal and Instrumental', 'My Macbeth' and 'Make Way for the Grand Jury'. He is singled out by Reynolds (VP) who illustrates 'In the Museum' as by one of those "unknown artists who painted modern life in the 1850s and attained a standard of achievement which ensures their continuing interest". Now best known for his Irish cottage scenes, and many pictures of children's games.
Bibl: Reynolds, VP pp.113, 116 (pl.108); Wood, Panorama.

HUNT, Clyde du V. fl.1898
Exhib. a painting of a girl milking a goat at the RA in 1898. London address.

HUNT, E. Aubrey 1855-1922
Painted landscapes and country subjects. Exhib. 45 works, including views in Holland, Brittany, Normandy, Venice and the South of England, at SS 1879-88. Exhib. 18 works, including 'Passing Showers', 'Venetian Boys at Play' and 'Threshing Corn in the East', at the RA 1881-1902. Also exhib. at the NG and GG. Born near Boston, Massachusetts. Lived and died in Hastings, Sussex.

***HUNT, Edgar 1876-1955**
Painter of farmyard scenes and animals; probably a son of Charles Hunt and a brother of Walter Hunt (qq.v.). He painted in a meticulous, realistic style, which is very recognisable, and hardly changed at all throughout his career. His pictures are now avidly collected, especially in the Midlands where he lived. He is best known for his pictures of chickens, but also painted other birds, donkeys, goats and ponies.

HUNT, Miss Emily fl.1856-1862
Exhib. two works, 'The Shy Damsel' and 'Jealous Jenie', at the RA in 1861 and 1862, and two watercolours at SS in 1859 and 1860. London address.

HUNT, Mrs. Emma C.W. fl.1884
Exhib. four works, 'Roses', 'Winter Roses', 'Azaleas' and 'Roses', at the RA 1884-9. London address.

HUNT, Miss Eva E. fl.1885-1893
Painted flowers. Exhib. 18 works, including 'Primula', 'Narcissus and Carnations' and 'Chrysanthemums', at SS, 1885-94. Exhib. six works, five paintings of flowers and one work entitled, 'A Norwich Marsh', at the RA 1887-97. London address.

HUNT, George fl.1855
Exhib. a work in 1855. London address.

HUNT, George Henry fl.1878
Exhib. a view of a house in Warwickshire at the RA in 1878. London address.

HUNT, Gerard Leigh fl. from 1894
Exhib. at the RA from 1894, including portraits and a work entitled 'Sweet Nancy'. London address.

HUNT, Herbert S. fl.1893
Painted portraits and genre. Exhib. a work entitled 'La Petite Cuisiniere' at SS in 1893-4. Lived in London and in Concarneau, Brittany.
Bibl: Studio XXXIII p.176.

HUNT, Miss Maria fl.1856-1866
Painted still-lifes. Exhib. four works, including 'Fruit and Game', 'Fruit and Ferns' and 'Fruit, Game and Misletoe', at the RA 1855-6. Also exhib. a work entitled 'A Christmas Hamper' at SS in 1866. Address in Liverpool.

HUNT, Millson fl.c.1875-1900
Painted marines. His painting 'Coastal Scene with Fishing Vessels', in the Old Customs House, Lymington, Hampshire, is reproduced in Brook-Hart .
Bibl: Brook-Hart (pl.200).

HUNT, T. Greenwood fl.1873-1878
Exhib. two group portraits of children and a work entitled 'Profit and Loss', at the RA, 1875-8. Addresses in Chelmsford, Essex, and London.

HUNT, Thomas VP RSW ARSA 1854-1929
Painted genre subjects and landscapes. Studied at the Leeds and Glasgow Art Schools, in Scotland and in Paris. Exhib. 11 works, including 'Repose', 'Unsold, Returning from the Fair', 'Rates and Taxes' and 'The Kirk Beadle', at the RA 1881-1904. Also exhib. at the NWS. Lived in Glasgow.
Bibl: AJ 1898 p.158, Studio LXIII p.115; LXIV p.203; LXIX p.98; LXXXIV p.13; Caw; Who's Who 1924.

***HUNT, Walter** 1860-1941
Animal painter; son of Charles Hunt and brother of Edgar Hunt (qq.v.). Painted farmyard scenes in a style similar to Edgar, especially barn interiors with donkeys and calves. Exhib. at RA 1881 onwards, titles including 'Best of Friends', 'Twins', etc. 'Dog in the Manger', RA 1885, was bought by the Chantrey Bequest.
Bibl: Mag. of Art 1901 p.433; Poynter, *The Nat. Gall.*, III 1900; RA Pictures 1891, 1901.

HUNT, William fl.1889-1896
Painted landscapes. Exhib. nine works, including 'A Bright November Day', 'Out of the World's Way' and 'A Stormy Sunset', at the RA 1890-6. Exhib. five works, including ''Twixt Grey and Gold' and 'Morning Mist', at SS 1889-94. London address.

***HUNT, William Henry** OWS 1790-1864
Painter and watercolourist of fruit and flowers, rustic genre, and landscapes. Sometimes referred to as Bird's Nest Hunt or Hedgerow Hunt. Although primarily a watercolourist, Hunt's works influenced many Victorian painters, as well as watercolourists. Because of a deformity in his legs which made it difficult for him to walk, Hunt's parents decided on an artistic career for him, and placed him with John Varley. In 1807 he began to exhibit oils at the RA; in 1808 entered RA Schools. Elected ARWS 1824, RWS 1826. His early work mostly landscapes, rustic genre or architectural studies, much influenced by Varley. About 1827 he began to paint fruit and flowers, and candlelight scenes. His technique also changed. Using bodycolour, he developed an individual method of hatching and stippling over a white ground, similar to that of Myles Birket Foster (q.v.). These pretty, enamel-like watercolours became enormously popular, and were also much admired by Ruskin. Hunt had a host of imitators, among whom were William Cruickshank, William Hough, William Hull, T.F. Collier, J. Sherrin, J.J. Hardwick and George and Vincent Clare (all q.v.). Hunt's studio sale was held at Christie's, 16 May 1864.
Bibl: Fraser's Mag. October 1865; AJ 1895 pp.12-14; Portfolio 1888 pp.196-8; 1891 pp.9-16; Mag. of Art XXII 1898 pp.503-5, Studio XXXVII 1906 pp.192, 194; Studio Special Numbers 1919, Winter 1922-3; Connoisseur XXXIX 1914 pp.78, 80. 82; Ottley; Redgrave, Cent., Dict.; Ruskin, *Notes on S. Prout and W.H.H.*, 1879; Roget; DNB 1891 p.281ff.; Bryan; Binyon; Cundall; Hughes; VAM; F.G. Stephens, *W.H.H.*, OWS XII 1936; Reynolds, VP pp.94, 173 (pl.120); Hardie III pp.104-9 and Index (pls.125-8, 130); Maas pp.108, 171-3, 246 (pls. pp.109, 110, 172, 208); Staley; Ormond; Sir John Witt, *W.H.H.*, 1982; Newall.

***HUNT, William Holman** ARSA RWS OM 1827-1910
Pre-Raphaelite painter. Born in London, son of a warehouse manager. Against the wishes of his family, studied painting under Henry Rogers, a portrait painter, and copied at the Nat. Gall. and BM. Entered RA Schools, 1844, and met Millais (q.v.) who became his greatest friend. Later met Rossetti (q.v.) and through him Ford Madox Brown (q.v.). In 1848-9, Hunt, Millais and Rossetti, together with W.M. Rossetti, James Collinson (q.v.), F.G. Stephens and Thomas Woolner, formed the Pre-Raphaelite Brotherhood. In revolt against the Academy and its teaching, they aimed to paint nature with complete fidelity, combined with noble ideas. During the following years, Hunt painted some of his best-known works, such as 'The Hireling Shepherd', 'Valentine Rescuing Sylvia', 'The Light of the World', and 'The Awakening Conscience'. In 1854 he visited the Holy Land, where he painted 'The Scapegoat'. Visited the Middle East again in 1869 and 1873 to find the exact historical and archeological backgrounds for his religious pictures. Of all the Pre-Raphaelites, Hunt was the only one who remained faithful to its original principles. He exhib. at the RA 1846-74, OWS 1869-1903, GG and NG. Elected RWS 1869. Hunt's large pictures tend to be over-elaborate and crowded with detail, but he was also a masterly watercolourist. Awarded OM 1905. Buried in St. Paul's Cathedral.
Bibl: Full Bibl. see Fredeman pp.133-8 and Index; other references: Reynolds, VP pp.62-6, 69-71 and index (pls. 39-41); Hardie III pp.54, 115-16, 118, 123, 125 (pls. 147-8); Mary Bennett, Cat. of H.H. exhib., Walker AG 1969; Maas pp.124, 126-8 (pls. 124, 127, 128, 129, 218); Diana Holman Hunt, *My Grandfather, His Wives and Loves*, 1969; Staley (pls. 1a, 1b, 5, 19b, 26-37. 50a); Ormond; Irwin; Wood, Panorama; Wood, Pre-Raphaelites; Wood, Paradise Lost; A.C. Amor, *W.H.H. The True Pre-Raphaelite*, 1989.

HUNT, William H. Thurlow fl.1883-1885
Exhib. five works, including 'Coast of Finnisterre', 'Playmates' and 'The Piazza at Capri', at SS 1883-5, and four works, including a portrait and a work entitled 'Mia Bella Capri' at the RA 1883-5. London address. A studio interior was exhib. at the Alexander Gallery, London, in an exhibition entitled 'Victorian Panorama', in October 1976 (cat. No.ll).

HUNT, William Howes 1806-1879
Great Yarmouth painter of beach scenes and fishing boats. Examples are in the BM, Norwich and Great Yarmouth Library.

HUNTER, A. fl.1841
Exhib. a work entitled 'Sunday Evening — The Curate' at the RA in 1841. London address.

HUNTER, Miss Ada fl.1886-1893
Exhib. at the RA 1886-98, titles including 'After the Victory', 'The Little Bridesmaid' and portraits. Also exhib. at the NWS. London address.

HUNTER, Miss Blanche F. fl.1889-1890
Exhib. a work entitled 'For Eye and Palette' at the RA in 1889. Also exhib. two works at the NWS. London address.

***HUNTER, Colin** ARA RI RSW 1841-1904
Scottish painter of seascapes and coastal scenes. Born in Glasgow. Studied with J. M. Donald (q.v.) as a landscape painter, but in the 1860s took to seascape painting, on which his reputation is

founded. Exhib. at RA 1868-1903, NG and elsewhere. ARA 1884. Moved to London 1872. In 1873 'Trawlers waiting for Darkness' was his first major success, and in 1879 'Their Only Harvest' was bought by the Chantrey Bequest. Hunter's pictures capture the moods of the sea rather than its purely visual effects. Although not technically as good a painter as J.C. Hook or C.N. Hemy (qq.v.) Hunter's strong greeny-black colours and evening skies can be remarkably effective. Most of his pictures were painted on the west coast or in the Hebrides. His studio sale was held at Christie's, 8 April 1905. Father of John Young Hunter (q.v.).

Bibl: AJ 1885 pp.117-20; Portfolio 1887 p.209; Studio, *British Marine Painting*, No 1919 pp.29, 73; H. Blackburn, *Academy Notes*, 1876 p.62; Caw pp.324-6 (pl. opp.p.324); DNB 2nd Supp. II 1912 p.328; RA Pictures 1893-6, 1901; Brook-Hart pl.104.

HUNTER, Miss Elizabeth fl.1853-1883
Painted genre and figurative subjects. Exhib. 17 works, including 'Too Much at a Time, Billy!', 'The Jam Pot — A Question of Preserves' and 'A Friendly Pipe'. Exhib. 11 works, including 'Oh Dear! What Can the Matter Be?' and 'The Farmyard "Those Noisy Pigs!" ' at the RA 1855-83. Also exhib. at the BI. London address.

***HUNTER, George Sherwood RBA fl.1855-1893**
Aberdeen painter of landscape and genre — mostly fishing scenes. Exhib. 1855-93, mostly at SS, but also at the RA 1882-98. In 1887 he moved to London, and in 1898 to Newlyn, Penzance. In 1898 he exhib. at the RA 'Jubilee Procession in a Cornish Village, June 1897'. Also painted in Spain and Italy. A group of his works were sold at Christie's, 25 July 1975.

HUNTER, John fl.1840
Exhib. a view of Mont Bilghi, Lucerne, at SS in 1840. London address.

HUNTER, John Kelso 1802-1873
Exhib. a self-portrait at the RA in 1847. Born in Ayrshire. Lived near Glasgow.
Bibl: DNB XXVIII.

HUNTER, John Young 1874-1955
Painted genre and historical subjects, portraits and landscape. Studied at the RA Schools. Exhib. at the RA from 1895. Titles include 'All in a Garden Fair', 'My Lady's Garden', 'Rings and Things and Fine Array', 'Forest Lovers' and portraits. Lived in London. Settled in the USA in 1913. Died at Taos, New Mexico. Son of Colin Hunter (q.v.).
Bibl: Bate; Studio XXVIII p.271; Caw.

HUNTER, Mrs. John Young (Mary Ethel) 1878-1936
Painted portraits and flowers. Studied at Newlyn. Cornwall. Exhib. at the RA from 1900, titles including 'The Denial', 'The Duke's High Dame' and 'Joy and the Labourer'. Lived at Ripon, Yorkshire. Wife of John Young Hunter.(q.v.).
Bibl: See under John Young Hunter.

HUNTER, Mason ARSA RSW 1854-1921
Painted landscapes and coastal views. Studied at the Edinburgh School of Design, also in Paris and at Barbizon. Exhib. seven works, Scottish landscapes, at the RA 1889-95. Also exhib. a watercolour, 'Under the Cliffs, Goldingham', at SS in 1881, and four works at the NWS. Born at Broxburn, Linlithgowshire. Lived in Edinburgh.
Bibl: Studio XXVII p.155; XLII p.63; XLVII p.224; LXIV p.60; LXVII p.58; LXVIII p. 125; LXXIII p.74; Caw; The Year's Art 1922; Brook-Hart.

HUNTER, Stephen W. fl.1901
Exhib. a work entitled 'Middle Watch', at the RA in 1901. London address.

HUNTINGDON, Francis H. fl.1849-1878
Painted landscapes. Exhib. 29 works, including watercolours of the Dorset countryside and views in Devon, Surrey and North Wales, at SS 1851-78. Exhib. 16 works, including views in Devon, Cornwall and Norfolk. Exhib. nine works, including views in Scotland, at the RA 1851-94. Address in Ipswich, Suffolk.

HUNTINGTON, G. fl.1847
Exhib. a painting of a man-of-war at anchor at the RA in 1847. London address.

HUNTLEY, W. fl.1835-1850
Exhib. three works, 'A Turkish Lady', 'Study from an Indian' and 'Head of a Female', at SS 1835-50. Exhib. two works at the BI 1847-50, and one, 'Girl and Bird', at the RA in 1846. London address.

HURDLE, E.H. fl.1851-1855
Exhib. two works, a view on the Thames and one of Topsham, Devon, at the RA 1851-5. Address in Topsham, Devon.

HURD-WOOD, J. fl.1881
Exhib. two landscapes in 1881. Address in Leatherhead, Surrey.

HURLSTONE, F.B., Jnr. fl.1857-1869
Painted figurative subjects in watercolour. Exhib. nine works, including 'La Contadina', 'Wayfarers' and 'Gossip at the Fountain', at SS 1857-69, and a portrait at the RA in 1858. London address.
Bibl: DNB; Siret, *Dict. des Peintres*, 1883.

HURLSTONE, Frederick Yeates 1801-1869
Portrait and historical painter. Entered RA Schools 1820, and in 1823 won the gold medal for his 'Archangel Michael and Satan Contending for the Body of Moses'. Studied also under Beechey, Lawrence and Haydon. Exhib. at the RA 1821-45, and at the BI 1821-46, but mainly at the SBA (SS 326 works), of which he became Member 1831, and President 1835-69. His later works, which were much inferior to his earlier ones, consisted mainly of Spanish and Italian rustic and fancy subjects; the outcome of several visits to Italy, Spain and Morocco made 1835-54. He was very successful as a portrait painter. He was always much opposed to the constitution and management of the RA. Ruskin writes in *Academy Notes,* on his painting 'A Fisherman's Daughter of Mola di Gaeta' exhib. SBA in 1858: "Is it too late for Mr. Hurlstone to recover himself? He might have been a noble painter. Bad and coarse as it is, that bright fish is the best piece of mere painting in all the rooms . . ."
Bibl: AJ 1869 pp.216, 271 (obit.); 1870 p.86; Ottley; Ruskin, Academy Notes 1875; Redgrave, Dict.; Bryan; DNB; BM Cat. of Engraved British Portraits II pp.41, 593; IV p.455.

HURLSTONE, Mrs. Jane fl.1846-1856 d.1858
(Miss Coral)
Painted portraits and figurative subjects. Wife of F.Y.Hurlstone (q.v.). Exhib. 23 works, many of them watercolours, including 'A Greek Boy', 'I Won't Be Washed' and 'One of the Friends of Italy', at SS 1846-56. Also exhib. six portraits at the RA 1846-50. London address.

HURRY, Miss Agnes **fl. from 1901**
Exhib. portraits at the RA from 1901. London address.

HURST, Hal (Henry William Lowe) **RI RBA HRMS 1865-1938**
Painted and etched genre subjects and portraits. Worked as an illustrator in America. Studied at the Académie Julian and at the RA Schools. Exhib. at the RA from 1896, titles including 'The Siren', 'Faith', 'An Encore' and portraits. Lived in London.
Bibl: AJ 1898 p.198; The Ladies' Field 24 October 1903; The Standard 21 February 1908; Connoisseur XXX p.67.

HURT, Mrs. Louis B. **fl.1886**
Exhib. a landscape, 'In Glen Shiel, Rosshire', at SS in 1886. Address in Ashbourne, Derbyshire.

HURT, Louis Bosworth **1856-1929**
Derbyshire landscape painter. Exhib. at RA 1881-1901 and SS. Subjects mostly Highland scenes with cattle. Titles at RA 'In a Northern Glen', 'The Silence of the Woods', 'By Peaceful Loch and Mist-wreathed Hill', etc. A work by Hurt is in Reading Museum.

HURTON, C.F. **fl.1865**
Exhib. a painting of flowers in 1865. Address in Stoke, Staffordshire.

HUSKINSSON, H.L. **see HUSKISSON, Robert**

HUSKISSON, L. **fl.1839-1859**
Painted landscapes and country subjects. Exhib. 12 works, including 'A Country Fair', 'Itinerant Performers' and 'Rabbit Shooting', at the RA 1839-59. Exhib. five works, including 'The Impertinent Intruder' and 'The Chess Players', at the BI 1851-8. London address.

***HUSKISSON, Robert** **fl.1832-d.1854**
Painter of genre, fairy pictures and portraits. Born in Langar, near Nottingham, and worked in Nottingham and then in London. TB equates him with H. Huskisson, a Nottingham portrait painter who exhib. at the RA in 1832, and who had a considerable reputation as a portrait painter in Nottingham. As R. Huskisson he exhib. at the RA, BI and SS 1838-54, genre and fairy subjects, e.g. 'The Midsummer Night's Fairies, There Sleeps Titania', etc., 1847, and 'Titania's Elves Robbing the Squirrel's Nest', 1854. He illustrated Mrs. S.C. Hall's *Midsummer Eve: A Fairy Tale of Love,* 1848, and Maas illustrates the frontispiece of this (Maas, p.159). Frith describes meeting him and concedes that he "had painted some original pictures of considerable merit," although "he was a very common man, entirely uneducated. I doubt if he could read or write; the very tone of his voice was dreadful." It is possible that he was related to L. Huskisson, who exhib. at the RA 1839-59, and who lived at the same address in London as he did, 39 Penton Place.
Bibl: NB especially entry in TB; AU 1847; 1848 X (pl.); William Powell Frith, *My Autobiography and Reminiscences,* 2 vols., 1887; City of Nottingham Art Museum Cat.1913 p.66; Maas pp.160-1 (pls. pp.159, 161); B. Phillpotts, *Fairy Paintings,* 1978.

HUSON, Thomas **RI RPE** **1844-1920**
Liverpool painter of landscape and genre, and engraver. Born and worked in Liverpool, and from c.1907 in Bala, North Wales. Exhib. 1871-89 at the RA, SS, NWS, GG and elsewhere. In 1903 he exhib. 'A Midsummer Day' at the Walker AG and was referred to by *The Studio* as "another landscape painter held in high esteem". His wife also painted landscapes and exhib. at SS 1877-8.
Bibl: AJ 1904 p.221 (pl.); 1905 p.353 (pl.); 1907 p.373 (pl.); 1909 p.335; The Studio XXVIII 1903 pp.207-8 (pl.); XXXIX 1907 pp. 66-8 (pl.); The Studio Summer Number 1902, *Modern Etching* (pls.); Cundall p.172; The Year's Art 1921 p.344.

HUSON, Mrs. Thomas **fl.1877-1879**
Exhib. two works, 'Near Lancaster' and 'A November Study', at SS 1877-9. Address in Liverpool. She was the wife of Thomas Huson (q.v. for bibl.).

HUSSEY, Miss Agnes **fl.1877-1887**
Exhib. a watercolour entitled 'The Month of Roses', at SS in 1881-2. Address in Salisbury, Wiltshire. She was the daughter of Henrietta Hussey (q.v.).

HUSSEY, Grace **fl.1876-1877**
(Mrs. Heathcote)
Exhib. three landscapes, 1876-7. She was the daughter of Henrietta Hussey (q.v.). Address in Salisbury, Wiltshire. See also Mrs. Heathcote.

HUSSEY, Henrietta **1819-1899**
(Miss Grove)
Painted landscapes. Exhib. four landscapes 1876-7. Address in Salisbury, Wiltshire. She was a member of the Society of Lady Artists. Grace and Agnes Hussey were her daughters. She was married to James Hussey.
Bibl: Clayton.

HUTCHINGS, J. **fl.1849-1893**
Painted historical subjects and landscapes. Exhib. five works, including 'The First Regal Endowment of the Anglican Church by King Ethelbert', 'Sir John Falstaff Hacking His Sword' and 'The Fox and Fowl', at the BI 1850-6. Exhib. one work, 'Morning', at the RA, and another 'The Court-yard, Moreton Old Hall, Cheshire' at SS. Address in Towcester, Oxfordshire.

HUTCHINSON, E.L. **fl.1880-1882**
Exhib. a watercolour study of an old man at SS in 1882. London address.

HUTCHINSON, F.J. **fl.1837-1839**
Exhib. a work, 'The Vision of Eliphaz', at the RA in 1837. London address.

HUTCHINSON, George **fl.1884-1887**
Exhib. two works, 'Fairy' and 'Meditation', at the RA in 1885-7. London address.

HUTCHINSON, George W.C. **fl.1875-1889**
Exhib. three works, 'Multiplication is Vexation', 'Fact and Fiction' and 'Charity', at the RA 1882-9, and four works, including 'Apple Gleaners at Rest', 'A Devon Cider-cellar' and 'A Mackerel Boat', at SS.

HUTCHINSON, Mrs. Jane P. **fl.1882-1883**
Exhib. a watercolour of 'Crossleaved Heath, Hindhead' at SS in 1883. London address.

HUTCHINSON, P. **fl.1871**
Exhib. a view of the Kisnah Viaduct on the Great India Railway at the RA in 1871. London address.

HUTCHINSON, W. Henry Florio **fl.1843-1861**
Exhib. two works, a view of Abingdon Abbey and a work entitled 'Doorga Pooja, Hindoo Festival', at SS in 1859. Address near Abingdon, Berkshire.

HUTCHISON, John **1833-1910**
Scottish portrait painter. Studied at the Trustees' Academy, Edinburgh. Lived in Edinburgh.
Bibl: AJ 1859 p.112; Clement & Hutton; The Royal Scottish Academy, Studio Special Number 1907; further bibl. in TB.

***HUTCHISON, Robert Gemmell RSA RSW 1855-1936**
Scottish genre and portrait painter. Born in Edinburgh where he studied at the Board of Manufacturers School of Art. Began to exhibit at RSA 1879, RA 1880, and GG. Using a broad and vigorous style, Hutchison painted children, sailors, workmen, homely domestic scenes and landscapes. His work shows influence of Dutch painters such as Israels and Blommers, and is anti-sentimental, literal and realistic. Elected RSW 1895, ARSA 1901, RSA 1911.
Bibl: AJ 1900 pp.321-6; Who's Who 1924; Studio 1913 pp.134, 136; 1915 p.103; Caw pp.427-8; Hardie III p.193.

HUTTON, Alfred fl.1884-1886
Exhib. five landscapes at the NWS in 1884-6. London address.

HUTTON, R. fl.1884
Exhib. a view of Luccombe, Isle of Wight, at SS in 1884. London address.

HUTTON, T.G. fl.1895
Exhib. a work entitled 'A Peep on the River Derwent, County Durham', at the RA in 1895. Address in Newcastle-upon-Tyne, Northumberland.

HUTTON, Thomas S. c.1875-1935
Northumbrian landscape watercolour painter. Sometimes imitated T.M. Richardson Jnr (q.v.). Exhib. two works, a view of St. Abb's Head, and a work entitled 'The Glories of Departing Day — Needles Eye, N.B.', at the RA in 1898 and 1899. Address in Secombe, Devon. He was a prolific artist, and his works are often to be found in the north-east.
Bibl: Hall.

HUTTON, Walter C. Stritch fl.1890-1892
Exhib. at the RA from 1890, including 'The Golden Hour', 'A Sheltered Valley' and portraits. London address.

HUTTULA, Richard C. fl.1866-1887
Painted landscapes and country subjects in watercolour. Exhib. 28 works, including views in the New Forest and on the south coast, at SS 1867-86. London address.

HUXLEY, Miss Nettie fl.1885-1888
Exhib. two works, 'Beauty and the Beast' and 'Caught Napping', at the RA in 1887 and 1888. London address.

HUYBERS, John fl.1887-1888
Exhib. two street views at SS in 1887-8. London address.

HYDE, F. fl.1851
Exhib. a view of a church at Gravesend at the RA in 1851.

HYDE, Frank fl.1872-1885
Painted portraits and genre. Exhib. five works, including 'Little Samuel', 'A Portrait', 'The Greek Slave' and portraits, at the RA 1872-85. London address.

HYDE, Henry James fl.1883-1892
Exhib. a work entitled 'The Nearest Way Home', at SS in 1885-6. London address.

HYDE, Mrs. Richard (Elizabeth L.) fl.1893-1896
Is supposed to have exhib. a genre subject at SS in 1893-6. London address.

HYDE, William fl.1889-1891
Exhib. four works, including 'An Autumn Evening', 'Light and Shade' and 'Winchelsea Rocks', at the RA 1889-91. London address.
Bibl: Sketchley, *English Book Illustration of Today*, 1903; Studio XXVIII 1906.

HYDE-POWNALL, George 1876-1932
Painter of evocative London street scenes, often at night. Although very little is known of his career, he painted very attractive usually small, pictures of London at night, which are in the tradition of Grimshaw and Whistler, but are painted in a more impressionistic style. He also worked in Australia, and examples by him are in Melbourne City Council.

HYSLOP, Theo. B. fl.1901
Exhib. a view 'Near Ventnor', at the RA in 1901. London address.

HYTCHE, Miss Kezia fl.1885-1893
Exhib. a painting of flowers at the RA in 1887, and four works, including 'Easter Trifles' and 'A Sluggish Stream', at SS 1885-94. London address.

I'ANSON, Charles fl.1875-1905
Painted landscapes, which often include rivers. Exhib. 17 works, including watercolours, at SS 1875-94, and 20 works, including views in Hampshire, Sussex, Yorkshire and Scotland, at the RA. London address.

I'ANSON, F. fl.1833-1877
Painted portraits. Exhib. three portraits at SS 1833-7, and a portrait and a work entitled 'The Pet Rabbit', at the RA 1833-6. London address.

IBBERSON, Herbert G. fl. from 1898
Painted architectural views. Exhib. four works, views in Hunstanton, Norfolk and Dinan, France, at the RA 1898-1901. London address.

ICHENHAUSER, Mrs. Natalie fl.1889-1894
Exhib. a portrait of a man at the RA in 1894. London address.

IFOLD, Frederick fl.1846-1867
Painted literary subjects, marines and landscapes. Exhib. eight works, including subjects from Shakespeare and Spencer, and landscapes, at SS 1846-66. Also exhib. five works, including landscapes, at Ryde and on the Isle of Wight, at the BI 1847-66, and four works at the RA 1847-67. London address.
Bibl: Brook-Hart pl.202; Wood, Panorama pl.206.

ILLIDGE, Thomas Henry 1799-1851
Painted portraits. Exhib. 14 works at the RA 1842-51. Exhib. 13 works, including a portrait of 'James Montgomery, author of *The World Before the Flood*' at SS 1843-51. Born in Birmingham. Died in London.
Bibl: AJ 1851 p.182; Redgrave, Dict.; DNB 1891; BM Cat. of Engraved British Portraits; Ormond.

INCE, Charles Percy RI RBA 1875-1952
Painted landscapes in oil and watercolour. Studied under H.G. Moon (q.v.). Lived at Purley, Surrey, Bognor, Sussex, and Purbrook in Hampshire.

INCE, Howard fl.1882-1904
Architect who also painted views of architecture. Exhib. a view of a street in Viterbo at the RA in 1883. London address.

***INCE, Joseph Murray 1806-1859**
Landscape, marine and architectural painter, both in oil and watercolour. Born in Presteign, Radnorshire; pupil of David Cox in Hereford in 1823, and remained with him for three years before coming to London in 1826. Exhib. 1826-58, at the RA 1826-47, BI, SS (137 works), NWS and elsewhere. He painted pleasing landscapes on a small scale, such as 'Coasting Vessels, with Harbour', 1836 VAM, and in 1832 was living at Cambridge, where he made many drawings of architectural subjects. Returned to Presteign c.1835 where he lived till his death. "His smaller works are the best, being well drawn and coloured" (VAM). VAM has three watercolours, BM five, National Gallery in Dublin one.
Bibl: Redgrave, Dict.; Studio 1902, English Watercolour; Bryan; Binyon; Cundall; DNB; Williams; Hardie III p.19 (pl.26).

***INCHBOLD, John William 1830-1888**
Landscape painter, who as a young man was influenced by the Pre-Raphaelites, and painted landscapes according to their principles. Born at Leeds; came to London and entered, as a draughtsman, the lithographic works of Day & Haghe; about 1847 studied watercolour painting under Louis Haghe, and in 1847 entered the RA Schools. Exhib. at SS in 1849 and 1850, at the BI 1854 and 30 works at the RA 1851-85. 'The Moorland', RA 1855, painted in illustration of a famous passage in *Locksley Hall,* was highly praised in *Academy Notes* by Ruskin, who singled out his work for attention and acted as his host in Switzerland in 1857. Ruskin also bought his 'White Doe of Rylstone'. His best known works are probably 'The Jungfrau', 1857, 'On the Lake of Thun', 1860, 'Tintagel', 1862, 'Gordale Scar', 1876. In his later years, which were spent largely abroad, especially in Spain and Italy, he gradually abandoned the minuteness of his earlier work for a freer style, but the poetic feeling in his art remained. A year or two before his death he returned from Algeria with a large collection of sketches. Through Ruskin he met Rossetti and members of the Pre-Raphaelite circle, and was a friend of Coventry Patmore and Swinburne, who wrote him a beautiful funeral ode. Other admirers and supporters were Tennyson, Browning, Lord Houghton, Sir Henry Thompson and Dr. Russell Reynolds. He also was a poet, and published a volume of sonnets, *Annus Amoris,* in 1877.
Bibl: AJ 1871 p.264; Portfolio 1874 p.180; 1876 p.186; 1879 p.187; J.Ruskin, Academy Notes 1875; Athenaeum 4 February 1888; E.J. Poynter, *The National Gallery,* III 1900; Bryan; DNB; VAM; Reynolds, VP pp.154-5, 177 (pl.p.164); Leathart Collection Cat. 1968 Laing AG Newcastle; Maas p.227 (pl.p.226); Staley (with pls.); Wood, Pre-Raphaelites; Newall; C. Newall, Cat. of Inchbold exhib., Leeds City AG 1993.

INCHBOLD, Stanley b.1856 fl.1884-1921
Exhib. a work entitled 'Low Tide at Whitby' at SS in 1892-3. Studied under Herkomer at Bushey, Hertfordshire. Travelled in North America, the Middle East and Europe. Lived at Brading, Isle of Wight.

INDERMAUR, J.G. fl.1842-1847
Exhib. four works, titles including 'Lorenzo and Jessica — *Merchant of Venice'* and 'The Love Letter', at the RA, 1842-7, and a watercolour of children at SS in 1847. London address.

INGALL, John Spence 1850-1836
Exhib. a sea piece at the NWS in 1892. Address in Barnsley, Yorkshire.

INGES, George Scott b.1874
Painter and lithographer. Studied art at the RCA. Received his diploma in 1899. Address in Leicester.

INGLE, J. Lee fl.1872-1874
Exhib. a work entitled 'A Dangerous Coast, Mumbles, near Swansea' at the SS in 1874. London address.

INGLE, Miss Leura fl.1896
Exhib. 'A Study: Head of a Boy' at the RA in 1896. London address.

INGLEFIELD, Rear-Admiral E.A. fl.1851-1870
Royal Naval Officer who painted marines and views of shipping. Exhib. eight watercolours, titles including 'Her Majesty's Ships *Phoenix* and *Talbot* driven on shore by the ice in Barrow Straights', and 'Diplomacy in Action', at SS, 1852-70. Also exhib. five naval subjects at the RA, 1851-68. London address.
Bibl: Brook-Hart.

INGLIS, J. Johnstone RHA fl.1890-1902
Painted landscapes. Exhib. 13 works, the majority highland scenes, but also including views in North Wales and Ireland. London address.

INGLIS, Miss Jane fl.1859 d.1916
Painter of fruit and flowers, landscapes, and genre who exhib.1859-1905 at the RA, BI, SS, NWS and elsewhere, and in 1891 at the Paris Salon. Titles at the RA include 'Bird's Nest', 'A Milanese Girl', 'All on a Summer's Day'.
Bibl: RA Cat. 1905.

INGPEN, A.W. fl.1830-1838
Painted horses and sporting scenes. Exhib. eight works, including 'Portrait of Forester, a favourite Carriage Horse' and 'Portrait of Emerald, a Hunter', at the RA. Also exhib. six works at SS and two at the BI. Address in Canterbury, Kent.

INGRAM, Archibald B. fl.1881-1887
Exhib. a watercolour entitled 'Night: Gravesend', at SS in 1887. London address.

INGRAM, Miss E.J. fl.1864-1866
Exhib. two works, 'Herne's Oak, blown down 31st August 1863' and 'Where the Primroses Grow', at the BI. Address in Frogmore.

INGRAM, Margaret K. fl.1883-1884
Exhib. two Venetian views at SS, 1883-4. London address.

INGRAM, William Ayerst RBA RI ROI 1855-1913
Landscape painter. Born in Glasgow, the son of the Rev. G.S. Ingram; pupil of J. Steeple and A.W. Weedon. He was a considerable traveller; exhib. from 1880 at the RA, SS (80 works), NWS at the Goupil Gallery, 1886, Fine Art Society 1888 and 1902, Dowdeswell Gallery 1911 and 1914. He was elected Member of the RBA in 1883, of the RI in 1907, ROI in 1906, and in 1888 President of the Royal British Colonial Society of Artists. Hardie writes: "Much of his work was in oil, but his watercolour drawings of subjects found on the coast and the open sea have a quiet, though not impressive accomplishment, but are lacking in bite and personality."
Bibl: RA Cat.1905 pp.7, 12; Who's Who 1913; 1914; VAM; Hardie III p.82 (pl.105); Brook-Hart pl.203.

INMAN, Marshall Nisbet fl.1876
Exhib. a landscape in 1876. London address.

INNES, Miss Alice fl.1869-1870
Exhib. two watercolours of flowers at SS, 1869-70. London address.

INNES, Henry P. fl.1897-1899
Exhib. two works, entitled 'The Three Witches in Macbeth' and 'Paul and Florence Dombey', at the RA, 1897-9. London address.

INNES, James Archibald fl.1866-1870
Painter of figure subjects. Exhib. six watercolours at SS 1866-70, titles 'The Victor's Wreath', etc.

INSKIP, John Henry RBA fl.1886-1910 d.1947
Scarborough painter of landscapes and interiors, who from 1886 onwards was a constant exhibitor at the RA, SS and elsewhere; Hon. Member of the Old Cheltenham FAS; and an occasional writer on art criticism. The Pannett Gallery, Whitby, has 'The Mill at Canterbury', and Rochdale AG two oils, 'Walmer' and 'Whitstable'.
Bibl: RA Cat. 1905 pp.7, 9, 11, 12; Who Was Who 1941-50.

INSKIPP, James 1790-1868
Painter of landscape, genre, portraits and game. Originally employed in the commissariat service, from which he retired with a pension and adopted painting as a profession for the remainder of his life. He began with landscapes, then turned to small subject pictures, and with less success to portraits. His pictures were admired at the time and some were engraved. Drew a series of illustrations for Sir Harris Nicholas's edition of Izaak Walton's *Compleat Angler,* 1833-6. In 1838 he published a series of engravings from his drawings, *Studies of Heads from Nature.* Exhib. 1816-64 at the RA, BI (83), SS and elsewhere, titles at the RA including 'Boy with Fruit', 'Père la Chaise', 'Market Girls'. He lived the latter part of his life in Godalming.
Bibl: Redgrave, Dict.; DNB; Connoisseur XXXIX 1914 pp.117ff.

IRELAND, James fl.1885-c.1925
Exhib. five works, including 'Pilferers', 'The Sail-Maker' and 'Landed', at the RA 1885-96. Also exhib. three works at the NWS. Address in Liverpool.

IRELAND, Thomas fl.1881-1903
Landscape painter who exhib. 1881-1903, at the RA, SS, NWS, GG, NG and elsewhere. T. Tayler Ireland (q.v.), landscape painter, who exhib. at the RA in 1896 and 1902, has the same address as the above.

IRELAND, Thomas Tayler fl.1880-c.1927
Painted landscapes in oil and watercolour. Exhib. two works, including 'A Berkshire Lock', at the RA in 1896. London address.

IRVINE, Miss fl.1863-1871
Exhib. five landscapes in Sussex, Scotland and Wales at SS, 1865-6. She was a member of the Society of Lady Artists. London address.

IRVINE, E. fl.1871
Exhib. a view near Crawley, Sussex, at SS in 1871. London address.

IRVINE, James 1833-1899
Scottish portrait painter. Born and educated at Menmuir, Forfarshire. Pupil of Colvin Smith, the painter, at Brechin; subsequently studied at the Edinburgh Academy and was afterwards employed by Mr. Carnegy-Arbuthnott of Balnamoon to paint portraits of the old retainers on his estate. Practised as a portrait painter for some years at Arbroath and then moved to Montrose. After a period of hard struggle he became recognised as one of the best portrait painters in Scotland, and received numerous commissions. He was a close friend of George Paul Chalmers (q.v.). Exhib. at the RA in 1882 and 1884. He also painted some landscapes.
Bibl. Cat. of the Scottish National Portrait Gallery 1889; Caw p.289; DNB.

IRVINE, John 1805-1888
Scottish portrait and genre painter. Exhib. 29 works at the RA 1787-1842. Also exhib. two works, subjects taken from Sir Walter Scott, at SS, and two works at the BI. London address.
Bibl: Ormond.

IRVING, J. Thwaite fl.1888-1893
Exhib. three landscapes, 'Winter', 'A Pastoral' and 'Winter Loading', at SS 1889-92. Also exhib. at the RA, NWS, GG, and NG. Address in Witley, Surrey.

IRVING, William 1866-1943
Painted portraits, genre and landscapes. Exhib. two works, 'Ducks and Darlings' and 'Happy Days', at the RA 1898-1901. Studied in Newcastle-upon-Tyne under William Cosens Way (q.v.) and at the Académie Julian. Worked as an illustrator for the *Newcastle Chronicle.* His most famous work was 'Blaydon Races — A Study from Life', exhib. in 1903. Born in Cumberland. Died in Jesmond, Northumberland. Member of the Bewick Club.
Bibl: Hall.

IRWIN, Miss Annie L. fl.1886-1890
Exhib. a painting of chrysanthemums at the RA in 1890. Address in Sunderland, County Durham.
Bibl: Hall.

IRWIN, Clara fl.1891-1916
Irish painter of street scenes. Lived in Dublin and Carnagh.

IRWIN, Miss Madelaine fl.1888-1901
Exhib. ten works, titles including 'A Mouse', 'Old King', 'My Tailor' and 'A Little Scrub', at the RA. Address in Colchester, Essex.

ISAAC, John 1836-1913
Little known landscape painter.

ISAACS, Miss Esther S. fl.1885-1890
Exhib. one work entitled 'On the Watch', at the RA in 1890. London address.

ISBELL, W.G.R. fl.1886
Exhib. a scene near Fairlight, Hastings, at SS in 1886. Address in St. Leonard's, Sussex.

IVALL, D.J. fl.1855-1860
Exhib. four works, including 'The Market Place at Dieppe', 'Chiffonniers de Paris' and 'Once a Week', at the RA 1855-60. Addresses in Paris and London.

IVER, R.H. fl.1871
Exhib. a landscape in 1871. London address.

IVEY, Miss Marion Teresa fl.1884-1888
Exhib. two works, a portrait and a work entitled ' "And the Syrians had Brought away a Captive out of the Land of Israel, a Little Maid" ', at the RA 1884-5. Also exhib. at the NWS and at SS. Address in the Tower of London.

IZANT, Herbert fl.1880-1898
Exhib. five watercolours, including 'Faust and Marguerite' and 'A By-lane, Surrey', at SS 1880-2. Exhib. four works at the RA 1886-98. Address in Thornton Heath.

IZARD, Miss Edith A. fl.1884-1890
Exhib. a work entitled 'Sans Mère' at the RA in 1890, and 'Crofter Home in Skye' at SS in 1884. London address.

IZARD, Edwin fl.1880-1885
Painted landscapes. Exhib. 12 works, including 'Cottages at Bury', 'The Silver Strands of Connemara' and 'Mouth of the Seine', at SS 1880-5. Also exhib. at the RA. London address.

IZARD, Miss Gertrude M. fl.1890-1891
Exhib. two works, 'Autumn Favourites', 'Chrysanthemums', at SS. London address.

JACK, Miss Patti fl.1884
Exhib. a work entitled 'On the Moors, Galloway' at the RA in 1884. Address in St. Andrews, Fifeshire.

JACK, Richard RA RI RP 1866-1952
Painted portraits and figurative subjects, interiors and landscapes. Studied at the York School of Art and at the RCA, also at the Académie Julian and the Atelier Colarossi. Exhib. 25 works at the RA 1893-1904, titles including 'Happiness', 'The Remorse of Cain' and portraits. Born in Sunderland, County Durham. Died in Canada. Represented in the Laing AG and the Shipley AG.
Bibl: Who's Who; Mag. of Art 1904 pp.105-11; AJ 1905 p.31; Studio XLI p.53; Fine Arts Journal XXXI p.290; Hall.

JACKER, B. fl.1842
Exhib. a work entitled 'Marguerite, Goethe's *Faust*' at the RA in 1842. London address.

JACKMAN, Miss Kate fl.1889-1890
Exhib. two genre subjects 1889-90. London address.

JACKMAN, P. fl.1867-1870
Exhib. three works, including 'Fisherman's Wife' and 'Early Training', at the RA 1867-70. London address.

JACKSON, Mrs. fl.1857-1861
(Miss A.H. Holt)
Exhib. three watercolours, including one of wood pigeons, at SS 1857-61. London address. See also Miss A.H. Holt.

JACKSON, Albert Edward 1873-1952
Illustrator and painter in oil and watercolour. Studied at the Camden School of Art. Exhib. a work entitled 'Heaven's Gift' at the RA in 1901. Lived in Berkhamsted, Hertfordshire. He was a member of the East Sussex Arts Club.

JACKSON, Arthur fl.1890
Exhib. a view of a church at the NWS in 1890. London address.

JACKSON, Miss Caroline F. fl.1847-1848
Exhib. two works at SS 1847-8, and another, entitled 'Prima Donna', at the RA in 1847. London address.

JACKSON, E. fl.1876
Exhib. a work entitled 'London Suburb' at SS in 1876. London address.

JACKSON, E. Jeaffreson fl.1884-1887
Exhib. three works, including 'View from the guard room of Churchyard, Mont St. Michel, Normandy', at the RA 1884-7. London address.

JACKSON, Miss Emily E. fl.1883-1884
Exhib. three works, including 'A Hampshire Cottage' and 'A Ferry at Norwich', at the RA 1883-4, and one work, 'On the Wensum, Norwich', at SS in 1884. London address.

JACKSON, Miss Emily F. fl.1878-1884
Flower painter, exhibiting 1878-84 at the RA and SS.

JACKSON, Miss Emily M. fl.1870
Exhib. two genre subjects in 1870. London address.

JACKSON, Emma fl.1873
Exhib. two views on the coasts of Jersey at SS in 1873. Address in St. Servin.

JACKSON, Miss Evelyn fl.1898
Exhib. a work entitled 'Spring' at the RA in 1898. London address.

JACKSON, Francis Ernest ARA 1872-1945
Painted figurative subjects, portraits, landscapes and architecture. Also a lithographer. Studied in Paris at the Académie Julian and at the Ecole des Beaux Arts. Later taught at the Central School, the RA Schools and at the Byam Shaw School. Born in Huddersfield, Yorkshire.
Bibl: Studio XVIII p.282ff.; XXXI p.134ff.; LXVI pp.6, 16; LXVII p.185; LXXXIII p.98; Studio Special Number 1919; Gazette des Beaux-Arts 1911 II p.46; *Notes from the Sketch Books of F. Ernest Jackson*, Oxford 1947. Exhib: London, Beaux-Arts Gallery, *Memorial Exhib. of the Paintings, Drawings and Lithographs of the Late F. Ernest Jackson* 1946; Byam Shaw School, *E. Jackson* 1955.

JACKSON, Rev. Frederick C. fl.1868-1884
Painted marines and coastal landscapes. Exhib. six watercolours, including '*The Irish Lady* — off Land's End, Cornwall' and 'North Coast of Cornwall, near Newquay', at SS 1868-73. Also exhib. two marines at the RA 1878-84. Address in Cornwall.
Bibl: Brook-Hart.

JACKSON, Frederick Hamilton RBA 1848-1923
London painter of genre, historical subjects and landscape; illustrator; designer. Student and first class medallist at the RA Schools. Exhib. from 1870 at the RA 1875-92, SS, NWS, GG, NG

and elsewhere, the subjects decorative and Pre-Raphaelite in inspiration, e.g. 'The Lady of Shalott' and illustrations for Morris's *Earthly Paradise;* also sketches for stained glass and mural paintings. Master of Antique School at the Slade School, under Poynter and Legros. Founder of the Chiswick School of Art in 1880 with E.S. Burchett. Member of the Art Workers' Guild 1887. He gave special attention to decoration and design, writing and lecturing also on technical and archaeological subjects; also specialised in ecclesiastical decoration, including the mosaic in the east end of St. Bartholomew's, Brighton, and the apse of St. Basil's, Deritend, Birmingham. His publications include: *Handbooks for the Designer and Craftsman; Intarsia and Marquetry; Mural Decoration; True Stories of the Condottieri, A Little Guide to Sicily; The Shores of the Adriatic; Rambles in the Pyrenees.*

Bibl: BM Cat. Loan Exhib. of Modern Illustrations 1901; RA Cats. 1907-9, 1916, 1919; Who's Who 1924.

JACKSON, Frederick William RBA 1859-1918

Landscape and marine painter. Born at Middleton Junction, Oldham; studied at the Oldham School of Art and the Manchester Academy, and although called a 'Manchester' painter (where he often exhib.) he worked principally in Hinderwell, Yorkshire. He also studied under J. Lefebvre and Boulanger in Paris, and travelled in Italy and Morocco. Exhib. from 1880 at the RA, SS and elsewhere, titles at the RA including mainly landscapes, and 'Gossip', 'The Haven under the Hill', 'Sunny Days', etc. His watercolour sketches are very atmospheric with a great sense of breadth and light, e.g. 'Early Morning, Florence, 1910'. He also did decorative sketches for tiles, etc. His works are in Bradford AG and Manchester City AG.

Bibl: Studio XXX 1904 p.66; XLIV 1908 p.228 (pls.); XLVII 1909 p.59; L 1910 pp.229 (pls.), 230; VAM; Pavière, Landscape; Brook-Hart; P. Phillips, *The Staithes Group*, 1993.

JACKSON, G. fl.1844

Exhib. a painting of dead game at the RA in 1844. London address.

JACKSON; Miss Helen fl.1884-d.1911

Painted genre and figurative subjects. Also illustrated children's books. Exhib. seven works, titles including 'Sweet As English Air Could Make Her' and 'A Child of Our Grandmother Eve', at the RA 1885-1904. Also exhib. three watercolours at SS 1884-6. London address. For works illustrated by see Card Cat. at VAM.

Bibl: AJ 1911 p.322.

JACKSON, Herbert P.M. fl.1891-1901

Exhib. three portraits at the RA, 1895-1901. London address.

JACKSON, James Eyre fl.1876-1886

Exhib. four works, including two landscapes and a view of the Flower Pot Inn, Ashton, Berkshire, at the RA 1877-84, and four works, including two watercolours at SS 1876-86. Addresses in Salford, Lancashire, and Heathfield, Sussex.

JACKSON, John 1801-1848

An engraver and occasional painter. He was an apprentice of Thomas Bewick in Northumberland. Born at Ovingham, Northumberland. Moved to London to work under William Harvey. He was the brother of Mason Jackson (q.v.). For works illustrated by see Card Cat. at VAM.

Bibl: DNB XXIX p.98ff.; Hall.

JACKSON, John fl.1856-1871

Exhib. a watercolour entitled 'Harvest Time, Watford' at SS in 1871. London address.

JACKSON, John Richardson 1819-1877

An engraving of his portrait of Sir Hugh Gough was published in 1842.

Bibl: Ormond.

JACKSON, Joseph 1858-1922

Little-known Preston painter.

JACKSON, L. fl.1885-1886

Exhib. two works, entitled 'Moorland' and 'The Outskirts of a Forest', at SS in 1885-6. London address.

JACKSON, Louis W. fl.1878-1879

Exhib. a chalk drawing entitled 'Euphrosyne' at the RA in 1878. London address.

JACKSON, M. fl.1868-1869

Exhib. two watercolours, entitled 'After Curfew' and 'To the Rescue' at SS 1868-9. London address.

JACKSON, Miss Marion E.

Exhib. a portrait study at the RA in 1894. London address.

JACKSON, Mason 1819-1903

Painted landscape. Also an illustrator. Exhib. two landscapes, a view on the Isle of Wight and a view of Warkworth Castle, Northumberland, at the RA 1858-9. Born in Ovingham, Northumberland. He was the brother and pupil of John Jackson (q.v.).

Bibl: DNB 1912; BM Cat. of Engraved British Portraits.

JACKSON, Mulgrave Phipps B. fl.1850-1857

Painted landscape and figurative subjects. Exhib. five watercolours, including 'Innocence' and 'Day's Decline', at SS 1852-7. Also exhib. three works at the RA 1852-4, and two works, including 'Relics of the Commonwealth', at the BI 1850-1. London address.

JACKSON, Samuel AOWS 1794-1869

Landscape painter. Exhib. a work entitled 'Twilight — The Wounded Knight' at the BI in 1828, and 49 works at the OWS. Born in Bristol. He was the father of Samuel Phillips Jackson. (q.v.).

Bibl: AJ 1870 p.53; Redgrave, Dict.; Roget; DNB 1892; Binyon; Maas.

*JACKSON, Samuel Phillips RWS 1830-1904

Landscape and marine painter. Born in Bristol, son and pupil of Samuel Jackson (q.v.), landscape watercolour painter. In 1851 his 'Dismantled Ship off the Welsh Coast' was shown at the BI, where he exhib. 1851-7; at the RA 1852-81. His earlier works, mainly in oils were chiefly Devon and Cornish coast scenes and won the praise of Ruskin. In 1856 Ruskin wrote on "Two very interesting Studies of Sea — the breaking of the low waves in 167 is as true as can be; and both pictures are delicate and earnest in perception of phenomena of sea and sky. The land is bad, in both." Elected A of the RWS (OWS) in 1853, and after this confined himself mainly to watercolour, contributing annually to their exhibitions; elected Member in 1876. In 1856 he moved to Streatley-on-Thames, and subsequently to Henley, and after this he chiefly painted views of the Thames, intermixed with inland scenes in Wales. He was interested in effects of sunlight, and skilful at handling grey mist and clouds. Hardie notes that "his work shows clean handling, and a pleasant feeling for moist and hazy atmosphere."

Bibl: AJ 1904 p.103 (obit.); Studio 1905 Spring Number, The 'Old' Watercolour Society; Ruskin, Academy Notes 1856; Roget II pp.379-81; Cundall; DNB Supp. II 1912; VAM; Hardie III pp.161, 164 (pl.185); Brook-Hart.

JACKSON, Sir Thomas Graham RA FSA 1835-1924
An architect who also exhib. views of buildings at the RA 1873-1904. Subjects include 'Bell Tower, Christchurch, Oxford', 'Trinity College, Oxford' and 'St. John's Church, Hampstead'. London address. His own numerous books on architectural history are listed in TB.
Bibl. AJ 1892 p.94; Who's Who 1924; The Times 9 January 1925; *Recollections of Thomas Graham Jackson, RA,* arranged and edited by B.H. Jackson, 1950.

JACKSON, W.G.G. fl.1876
Exhib. a 'Profile Head' at the RA in 1876. Address in Penge, London.

JACKSON, Walter fl.1874
Exhib. a genre subject in 1874. London address.

JACOB, Miss Edith fl.1888-c.1925
West Country flower painter, chiefly in watercolour. Exhib. five paintings of flowers at the NWS. Lived at Clifton, near Bristol.

JACOB, Julius fl.1845-1854
Painted portraits, which occasionally include animals. Exhib. 16 works, the majority portraits of children, and also including a view of Loch Katrine, at the RA 1845-54. London address. He was a member of the Royal Society of Fine Artists in Paris.

JACOBS, E. fl.1859
Exhib. 'A Bathing Girl' at the RA in 1859. London address.

JACOBS, J.F. fl.1884
Exhib. a painting of gorse blossom at SS in 1884. London address.

JACOBS, John fl.1816-1864
Painted landscapes, buildings and rustic subjects. Exhib. 16 works at SS titles including 'The Remains of Old London Bridge' and 'The Road-side Inn'. Also exhib. eight works at the BI and seven, including 'Fallow Deer' and 'The Abbey Church, Bath', at the RA. London address.

JACOBS, John Emmanuel fl.1882-1898
Painted landscapes and rustic subjects. Exhib. 15 works at SS, titles including 'The Silent Pool', 'Loiteress' and 'Punting'. Also exhib. eight works at the RA. London address.
Bibl: Who's Who 1924; National Gallery of N.S.W. III. Cat., Sydney, 1906.

JACOBSON, Miss S.H. fl.1875
Exhib. a painting of wild roses at SS in 1875. London address.

***JACOMB-HOOD, George Percy MVO RBA RE 1857-1929**
Painter of portraits, genre and historical subjects; illustrator; etcher; sculptor. Born at Redhill; son of an engineer and director of the London, Brighton and South Coast Railway. Educated at Tonbridge School. Won a scholarship at the Slade School; studied also under J.P. Laurens in Paris. Exhib. from 1877 at the RA, SS, GG, NG, Paris Salon and elsewhere. Original member of NEAC; member of the RBA, and of the Society of Portrait Painters but later resigned his membership. Member also of the ROI, Vice-President of the Royal British Colonial Society of Artists, and served on the Council of the Royal Society of Painter-Etchers. Worked for *The Graphic,* which sent him to Greece, 1896; to Delhi for the Durbar, 1902; on the Indian Tour of the Prince and Princess of Wales, 1905; and on King George V's tour of India in 1911, when he was a member of his personal staff. MVO 1912. Painted portraits in India and in England, and subject pictures. Exhib. two bronzes at the RA in 1891.
Bibl: For full bibl. see TB; Portfolio 1881 pp.l, 37, 76, 92; 1882 p.85; 1883 p.56; 1888 pp.64, 189; RA Pictures 1893 p.97; 1900 pp.2, 5, 10, 11; Who's Who 1924; G.P. Jacomb-Hood, *With Brush and Pencil,* 1925 (reminiscences); Birmingham Cat. Supp.II 1939.
Exhib: London, Walker's Gallery, Memorial Exhib. of Works by the Late G.P. Jacomb-Hood 1934.

JACQUET, Miss Cecilia fl.1889-1893
Supposed to have exhib. two landscapes at SS. London address.

JAGGER, Wilson fl.1900
Exhib. a still-life group at the RA in 1900. Address in Cardiff.

JALFON, A.J. fl.1846
Exhib. a view in Cumberland at SS. London address.

JAMES, Alfred Percy fl. from 1901
Exhib. two works, 'The Good Shepherd' and 'The Five Foolish Virgins', at the RA in 1901 and 1904. Address in Lee, Kent.

JAMES, Arthur C. fl.1888-1889
Exhib. four landscapes at the NWS 1888-9. Address in Eton, Berkshire.

JAMES, C. fl.1881-1882
Exhib. two works, 'Summer' and 'Winter', at SS in 1881-2. London address.

JAMES, Charles Stanfield fl.1854-1862
Painted landscapes. Exhib. four watercolours, including 'Stepping Stones, Bettws-y-Coed' and 'Hurstmonceaux Castle', at SS 1856-62, and three works, two of them North Wales landscapes, at the RA 1854-6. London address.

***JAMES, David fl.1881-1892**
Marine painter. Exhib. at RA 1881-92, and elsewhere. Like Henry Moore (q.v.), James was more interested in pure studies of the sea, rather than topographical coastal views. He was especially good at painting waves. Much of his work was done on the coast of Cornwall. Titles at RA 'A North Cornish Breaker', 'An Atlantic Roll', etc.
Bibl: Wilson p.46 (pl.18); Brook-Hart (colour pl. p.5).

JAMES, Miss Dora fl.1897
Exhib. a work entitled 'Yvonne' at the RA in 1897. London address.

JAMES, Miss Edith Augusta 1857-1898
Painted flowers and portraits. Studied in Paris under Chaplin. Exhib. four works, including three paintings of roses, at the RA 1886-96, and two works, 'Autumn Roses' and 'Primulas', at SS 1883-4. Born in Eton, Berkshire. Died in Tunbridge Wells, Kent.
Bibl: VAM.

JAMES, F.E. fl.1887
Exhib. a watercolour, entitled 'A Tidal Mill', at SS in 1887. London address. This is probably the same painter as Francis Edward James (q.v.).

JAMES, Francis fl.1832-1845
Painted views in Florence and Venice. Exhib. four works, including three views of the Ponte Vecchio, at the RA. Also exhib. twice at SS and once at the BI. Lived in London and Florence.

JAMES, Francis Edward RWS RBA NEAC 1849-1920
Painted landscapes, seascapes and skies, in watercolour. Exhib. 17 works, including 'On the Thames', 'Blue Sea — Scilly Isles' and 'Scotland: November Colour', at SS. Lived in Hastings, Sussex and later at Torrington, North Devon.
Bibl: Studio XII pp.259-66; XXXVII pp.190-5; LX p.90; AJ 1901 pp.249-52; Connoisseur LVIII p.116; LX p.184.

JAMES, Frank James fl.1888-1890
Exhib. two works, 'Floodtime' and 'Sand Links; Northumberland', at the RA, and three works, including 'Meadow Sweet', at SS. London address.

JAMES, H. James fl.1889
Is supposed to have exhib. a landscape at the RA in 1889. London address.

JAMES, Harry E. fl.1888-1902
Painted landscapes and boats. Exhib. six works, including 'The Last of the Ebb' and 'Cornish Cottages', at the RA 1888-1902, and two studies of boats at SS in 1890. London address.

JAMES, J. Dearman fl.1864
Exhib. a painting of two sheep dogs at the BI in 1864. London address.

JAMES, Miss M. fl.1873-1878
Exhib. four watercolours, including 'Nasturtiums' and 'Juliet', at SS. London address.

JAMES, P. fl.1874
Exhib. two works, 'The Orange Girl' and 'Topsyturvy', at SS in 1874. London address.

JAMES, R. fl.1841-1851
Exhib. four works, including 'Pensive Moments' and 'Schoolboys Taking Stock', at the RA, and one, 'The Wanderer and his Friends', at SS. London address.

JAMES, Richard S. fl.1860-1900
Painter of genre who exhib. 1860-1900 at the RA, BI, SS, and elsewhere, titles at the RA including 'He Sang of all Sweet Things', 'Dutch Courtship' and 'The Opening Rose'.

JAMES, S. fl.1879-1890
Exhib. two watercolours, 'Before Moving' and 'A Buttercup Field', at SS, and a view of Purbeck Meadows at the RA in 1890. London address.

**JAMES, Sir Walter Charles, Bt. 1816-1893
(1st Lord Northbourne)**
Exhib. five works, including 'Beech and Oak Trees from Penshurst Park; A Sketch' and 'A Sketch of Sunset', at the RA, and two works, including 'The Arrival of Lord Hardinge at Penshurst, AD 1848', at the BI.
Bibl: *The Etruscans*, Cat. of exhib. at Stoke-on-Trent AG 1989.

JAMES, Hon. Walter John RBA RE 1869-1932
Painted and etched landscape. Exhib. at the RA from 1897 including 'Northumberland Hills', 'In Umbria', and 'A Redesdale Landscape'. Son of Lord Northbourne (see above). Lived at Eastry, Kent and Otterburn, Northumberland.
Bibl: Studio LII p.289; LIV pp.103-10; LV p.223; LXIV p.181; LXX p.69; Burlington Mag. XXX p.32; Who's Who (as Ld. Northbourne) 1924.

JAMESON, Miss Georgina fl.1896
Exhib. a still-life at the RA in 1896. London address.

JAMESON, Middleton fl.1877-d.1919
Painted figurative subjects. Exhib. at the RA from 1887 titles including 'Toilers of the Sea' and 'Cupid and Psyche'. Also exhib. two landscapes at SS in 1877. London address.

JAMESON, Miss Rosa fl.1885-1894
Exhib. five works, titles including 'A Home Among the Flowers', 'Poached Eggs' and 'A Mere Bagatelle', at the RA 1885-94. Also exhib. at SS and NWS. London address.

JAMESON, William fl.1871
Exhib. a river scene in 1871. London address.

JAMIESON, Alexander ROI 1873-1937
Painted portraits, landscapes and townscapes. Studied at the Haldane Academy, Glasgow. Won a scholarship to study in Paris in 1898. Lived at Weston-Turville, Buckinghamshire.
Bibl: Studio XXXVII pp.29ff., 67ff.; LI pp.274-82; AJ 1907 p.232; 1911 pp.274-82; Caw; Who's Who 1924.
Exhib: London, Royal Institute Galleries, Memorial Exhibition 1938; Hazlitt Gallery, *Alexander J., and his Wife Biddy Macdonald* 1970.

JAMISON, Mrs. Archer or Arthur (Isabel) fl.1877-1896
Painted flowers. Exhib. five works, including 'Bird's Foot Trefoil' and 'Marsh Marigold', at the RA 1883-96. Also Exhib. at SS and NWS. Address in St. Helen's, Lancashire.

JAMISON, Miss Sarah fl.1890
Exhib. a flower painting at the NWS in 1890. Address in Belfast.

JANNOCH, Miss Vera fl. from 1898
Painted flowers. Exhib. four works, including 'Violets' and 'Cornflowers', at the RA 1898-1904. Address in King's Lynn, Norfolk.

JANSEN, Fritz fl.1883-1885
Exhib. a portrait at the RA in 1883. Also exhib. at the NWS. London address.

JANSEN, P.J. fl.1882
Exhib. a figurative subject in 1882. London address.

JANSEN, Theodore fl.1855
Painted a portrait of the 1st Baron Clyde in 1855.
Bibl: Ormond.

JAQUES, Jules fl.1882-1883
Exhib. two works, including a view on Mitcham Common, at SS in 1882/3. London address.

JARDINE, Mrs. James fl.1891
Exhib. a landscape at the NWS in 1891. London address.

JARMAN, Henry T. fl.1900-1904
Exhib. three works, including 'The Osier Bed' and 'The Bathing Place', at the RA, 1900-4. London address.

JARVIS, George fl.1874-1890
Painted genre and figurative subjects. Exhib. nine works, including 'Neapolitan Girl', 'As Happy as a King' and ' "Is Life Worth Living?" ' at SS. Also exhib. three works at the RA. London address.

JARVIS, Henry C. 1867-1955
Painted watercolour landscapes. Studied at Goldsmiths' College School of Art. Lived at Sevenoaks, Kent.

JARVIS, Matthew fl.1879-1887
Exhib. two watercolour views of Venice at SS 1879-80. Also exhib. a view near Raby, Cheshire at the RA in 1884. Address in Liverpool.

JAY, Miss Carrie fl.1880-1884
Exhib. two works, 'A Peep in the Woods' and 'Willow Marsh', at SS. London address.

JAY, Hamilton fl.1875-1904
Painted landscapes and flowers. Exhib. 21 works, including 'Chrysanthemums', 'The Old Churchyard' and a watercolour, 'The Corner of the Harvest Field', at SS. Also exhib. eight works at the RA 1880-1904. London address.

JAY, J.A.B. fl.1878-1880
Exhib. two works, 'On the Road Home' and ' "Ware Hare, Challenger!" ' at the RA. London address.

JAY, J. Isabella Lee fl.1873-1896
Exhib. three watercolours, of fruit, flowers and Magdalen Tower, Oxford, at SS, and a view of the Screen in St. David's Cathedral, South Wales, at the RA. London address.
Bibl: Connoisseur XLVII p.178

JAY, J.W. fl.1868
Exhib. a study at SS in 1868. London address.

JAY, William Samuel RBA 1843-1933
Landscape painter who exhib. 1873-1913 at the RA, SS, GG, NG, and elsewhere, titles at the RA including 'A Rich Corner', 'Cutting Rushes in Surrey', 'Old Boats. Dieppe'. Nottingham AG has one of his paintings of an autumn wood, 'At the Fall of Leaf, Arundel Park, Sussex', 1883.
Bibl: RA Cats. 1905, 1913; Nottingham Museum and AG Cat. 1913 pp.67, 70 (pl.).

JAYNE, Charles fl.1838-1879
Painted landscape. Exhib. 12 works, including views in Australia and on the River Trent and the Trent Canal, at the BI. Exhib. ten works, including 'Kelham Park on the Trent' and the 'River Orwell, Ipswich', at the RA. Also exhib. eight works at SS. London address. He was the husband of Mary Jayne (q.v.).

JAYNE, Mrs. Charles (Mary) fl.1846-1878
Landscape painter who exhib. 1846-78, at the RA 1846-64, BI and SS. She was the wife of the landscape painter Charles Jayne (q.v.).

JEAURON, Philippe Auguste fl.1851
Exhib. a 'Flight Into Egypt' at the RA in 1851.

JEAYES, Miss J. fl.1872
Exhib. a watercolour entitled 'The Deserted Home' at SS in 1872. London address.

JEEVES, Louie fl.1884
Exhib. a study of a head at SS in 1884. Address in Hitchin, Hertfordshire.

JEFFCOCK, Charles Augustine Castleford b.1872
Painted landscapes. Studied at Heatherley's. Born at Wolstanton, Staffordshire. Lived on the Isle of Wight.

JEFFERIES, J. fl.1862
Exhib. a view of the bed of the Esk, near Whitby, at SS in 1862. London address.

JEFFERSON, Charles George 1831-1902
Painted marines and landscapes with rivers. Exhib. at the Glasgow Institute of Fine Arts, the Scottish Royal Academy and at the first exhibition of the South Shields Art Club in 1892. Represented in the South Shields Public Library and Museum. Born and lived in South Shields, County Durham.
Bibl: Hall.

JEFFERY, Miss Anna fl.1890
Painted flowers. Exhib. two works, including 'Chrysanthemums', at SS, and one work 'Larkspurs', at the RA. Address in Haywards Heath, Sussex.

JEFFERY, C. fl.1877
Exhib. a view in Bengal in 1877. London address.

JEFFERY, Emmanuel 1806-1874
Exeter landscape painter. Exhib. three Devonshire landscapes, including views of Exmouth and Dartmoor, at the RA 1840-2. Examples are in Exeter Museum.

JEFFERYS, Bertha fl.1890
Exhib. a painting of wallflowers at SS in 1890. London address.

JEFFRAY, A. Edgar fl.1833-1848
Painted landscape and figurative subjects. Exhib. five works, including 'An Israelite', 'Near Llanberis, North Wales' and 'Evening — Leyton Marshes', at the RA. Also exhib. two works at the BI and three at SS. London address. Probably the brother of James and Richard Jeffray (qq.v.).

JEFFRAY, James fl.1854-1855
Painted landscapes, which often include cattle. Exhib. seven works, including 'Landscape and Cattle — Hackney Marshes' and 'An Outlet of the Thames, with Cattle — Wargrave', at the RA. Also exhib. four works at SS and two at the BI. London address. Probably the brother of A. Edgar and Richard Jeffray (qq.v.).

JEFFRAY, Richard fl.1835-1854
Painted mythological and figurative subjects. Exhib. 11 works, including 'Achilles and Thetis' and 'Eve at the Fountain', at the RA. Also exhib. seven works, including 'The Golden Age' and 'Mother and Child', at the BI, and four works at SS. London address. Probably the brother of A. Edgar and James Jeffray (qq.v.).

JEFFREY, Miss E.C. fl.1881
Exhib. a watercolour entitled 'Alba Fontana' at SS in 1881. Address in Rome.

JEFFREY, James Hunter b.1874
Landscape painter. Studied at the Belfast School of Art, and at the RCA, where he received his diploma in 1906. Exhib. at the RHA and elsewhere in Ireland, titles including 'Black Rocks at Portrush' and 'Summer Heat'. Born in County Antrim, Ireland. Lived in Belfast.

JEKYLL, Miss fl.1865
Exhib. a work, entitled 'Cheeky, 64 Reg.t., a Native of Cawnpore', at the RA in 1865. Address in Guildford, Surrey.

JELLEY, James Valentine RBSA fl.1885-1942
Landscape and flower painter, working in Birmingham and Hampton in Arden, Warwickshire, who exhib. at the RA, NWS and GG 1885-1918. 'River Scene' and 'The Lily Garden' are in Birmingham AG.
Bibl: Brook-Hart (pl.204).

JELLICOE, John F. fl.1865-1888
Exhib. a watercolour entitled 'Mischief' at SS in 1887-8. London address.

JENKIN, William fl.1870-1877
Exhib. four landscapes in 1870-7. Address in Warrington, Lancashire.

JENKINS, Miss Anne fl.1876-1885
Painted flowers. Exhib. ten works, including 'Azaleas', 'Oleander Blossom' and 'Roses', at the RA. Exhib. 12 flower paintings, all watercolours, at SS. London address.

JENKINS, Arthur Henry b.1871
Painted figurative subjects and landscapes. Studied at Edinburgh College of Art and in Paris. Lived at Bathampton and later near Marlborough, Wiltshire.
Exhib: London, Beaux-Arts Gallery 1938.

JENKINS, Miss Blanche fl.1872-1915
Painted genre and figurative subjects. Exhib. 32 works at the RA, titles including 'Merry Christmas Time', 'A Little Sailor Boy' and 'A Little Coquette', 1873-1904. Also exhib. 18 works, including watercolours and paintings of flowers, at SS 1872-86. London address. She was a member of the Society of Lady Artists.

JENKINS, C.S. fl.1871
Exhib. a landscape in 1871. London address.

JENKINS, David C. fl.1884-1892
Painted landscape and rustic subjects. Exhib. six works, including 'The Village Wheelwright's Yard' and two views of the River Trent in Nottinghamshire, at the RA 1885-91. Also exhib. a landscape at SS in 1892. Addresses in London, Nottingham and Liverpool.

JENKINS, Emily Vaughan fl.1890-1891
Exhib. a work entitled 'Poet's Corner' at SS in 1890-1. Address in Oxford.

JENKINS, H. fl.1854-1872
Painted townscapes. Exhib. watercolour views of towns, including, Antwerp and Dinan, at SS. Also exhib. views in Rouen and Abbeville at the RA. London address.

JENKINS, Joseph John RWS 1811-1885
Engraver and watercolour painter of domestic genre and single figures. Son of an engraver; engraved many portraits and illustrations for the annuals, e.g. *The Keepsake,* Heath's *Book of Beauty,* etc. Later he turned to watercolour, and exhib.1829-81, at the RA (once only 1841), BI, SS, OWS (273 works), NWS (61) and elsewhere. In 1842 he was elected A of the NWS and Member in

1843. In 1847 he joined the OWS, and became A in 1849, Member in 1850. He was its Secretary for ten years from 1854 and was a constant exhibitor; he was the first to introduce the system of private press views at picture exhibitions. He devoted the remainder of his life to collecting material for a history of the OWS and its members, and this was completed in 1891 by J.L. Roget. His studio sale was held at Christie's, 1 March 1886. Manuscripts relating to this artist are held at the VAM.
Bibl: See TB for list of his works; Roget II; Reading Museum and AG Cat. 1903 p.37; DNB; BM Cat. of Engraved British Portraits I 1908 pp.31, 70, 221, 249, 300, 330, 339, 475, 541; II 1910 pp.63, 104, 254, 376, 474, 528, 584, 603, 630; III 1912 pp.65, 86, 277, 428, 440, 586; IV 1914 pp.182, 234, 443, 469; T.M. Rees, *Welsh Painters,* 1912; Cat. National Gallery of Ireland, Dublin, 1920 p.173; VAM.

***JENKINS, Wilfred**
Very little-known painter, whose dates are not known, and who did not exhibit in London. He painted moonlight street and dock scenes in imitation of the better-known J. Atkinson Grimshaw (q.v.), and for this reason his work is now beginning to arouse interest.
Bibl: Cat. of AG exhib., Alexander Gallery, London, 1976.

JENKINSON, Miss Charlotte fl.1874-1889
Exhib. a landscape in 1874. Address in Farnham, Surrey.

JENNENS, Luke fl.1880-1897
Exhib. three works, including 'Cavaliers and Roundheads' and 'Doubt and Desire', at the RA. London address.

JENNENS, W. fl.1872
Exhib. a painting of animals in 1872. London address.

JENNER, G.P. fl.1834-1840
Painted historical and literary subjects. Exhib. five works, including 'The Trial of Rebecca' from *Ivanhoe,* and 'The Mournful Obsequies of the Valiant Raymond Berenger', from *The Betrothed,* at the RA 1834-40. London address.

JENNER, Isaac Walter c.1836-d. aft. 1883
Marine painter. Born in Godalming, Surrey, or Seaford, Sussex. Served in the Royal Navy. Lived in Brighton from 1865. Exhib. one work, 'Sunset on the Beach, Brighton', at the RA in 1874. In 1883 he emigrated to Brisbane, Australia, where he was instrumental in the founding of the Queensland Art Society and the Queensland National Gallery.

JENNINGS, Miss E. fl.1837
Exhib. a watercolour of horses at SS in 1837. London address.

JENNINGS, E. fl.1879
Painted a portrait of Cardinal Newman, from a photograph, in 1879.
Bibl: Ormond.

JENNINGS, Edward fl.1865-1888
Painted landscape. Exhib. 11 works, including views in the Lake District and views of shipping, at the RA 1869-88. Exhib. nine watercolours, including landscapes in Cornwall, Wales and the Lake District. London address.

JENNINGS, Edward W. fl.1885
Exhib. a view of doorway in a church in Lisieux at the RA in 1885. Address in Swansea, Glamorgan.

JENNINGS, Emma M. fl.1880-1881
Exhib. a watercolour study of Italian architecture. with the tomb of Cardinal Zeno at SS in 1880-1. London address.

JENNINGS, Reginald George 1872-1930
Painted portraits, figurative subjects, miniatures and landscapes. Studied at Westminster School of Art. Lived in London and in Siena, Italy

JENNONS, Luke fl.1880-1881
Is supposed to have exhib. two genre subjects at the RA. London address.

JENSEN, Christian Albrecht 1792-1870
His portrait of Sir John Herschel is in the Royal Society, London.
Bibl: Ormond.

JENSEN, Edvard Michael fl.1864-1867
Exhib. two Danish landscapes, and one Swedish, at the BI 1864-71. Born in Copenhagen, he came to London in 1863.

JENSEN, Theodor fl.1854-1864
Painted figurative subjects. Exhib. seven subjects, including 'A Bacchante' and 'The Fair Fruit Gatherer', at the BI. Also exhib. five works, including 'H.R.H. The Prince of Wales represented in the Robes of the Star of India', at the RA. Also exhib. two works at SS. London address.

JEPHSON, Mrs. Alfred (Harriet J.) fl.1884-1889
Exhib. a watercolour entitled 'Templum Urbis' at SS in 1884/5. Also exhib. at the NWS and GG. Address in Cowes, Isle of Wight.

JEROME, Miss Ambrosini fl.1840-1871
Portrait painter to the Duchess of Kent 1843, and also of landscape, genre and historical subjects. Exhib. 1840-71, at the RA 1840-62, BI, SS and elsewhere, titles at the RA including 'Sir John Falstaff and Mrs. Ford', 'Contemplation', and 'Cupid Defeated'.

JERVIS, Edward de Rosen fl.1890-1891
Exhib. two views in Venice at SS. Address in Sidmouth, Devon.

JERVOIS, W.D. RE fl.1847
Exhib. a watercolour landscape of 'Kaffirland' at SS in 1847. London address.

JERVOUS, A. fl.1875
Is supposed to have exhib. a landscape at SS in 1875. Address in Bridgwater, Somerset.

JESSE, George R. fl.1872-1874
Exhib. a work entitled 'An Aged Trunk' at the RA in 1874. Address in Macclesfield, Cheshire.

JESSOP, Ernest Maurice fl.1883-1890
Exhib. three works, including 'Meditation' and 'The Ruin', at the RA 1883-90. London address.

JESSOP, J. fl.1867-1868
Exhib. two watercolours of fruit, the first including melon, apricots and grapes; the second, peaches and grapes, at SS. Address in Croydon, Surrey.

JEVONS, Arthur fl.1876-1877
Exhib. two landscapes in 1876-7. Address in Lyndhurst, Hampshire.

JEVONS, G.W. fl.1894-1896
Exhib. two works, 'Evening' and 'A Cornish Lane' at the RA. Address in Cornwall.

JEVONS, Miss Mary C. fl.1880-1886
Exhib. a landscape at the NWS. London address.

JOASS, John J. b.1868 fl.1897
An architect who exhib. views of buildings. Exhib. two works, the first a view of the choir of San Vitale, Ravenna, at SS 1896-7. London address.
Bibl: See TB.

JOBBINS, William H. fl.1872-1886
Painted landscape and views of Venice. Exhib. four works, including views of St. Mark's, Venice, at the RA 1878-82. Also exhib. two watercolour landscapes in Worcestershire at SS 1872-3. Address in Nottingham. Went to Venice about 1880, and then to India.

JOBLING, Isa 1851-1926
(Miss Isa Thompson)
Painted landscapes, country subjects and portraits. Exhib. at the RA from 1892. Wife of Robert Jobling (q.v.). See also Miss Isa Thompson.
Bibl: Hall; Cat. of Isa and Robert Jobling Exhibition, Laing AG, Newcastle, 1992; P. Phillips, *The Staithes Group,* 1993.

***JOBLING, Robert 1841-1923**
Painter of river and marine subjects, and genre, working in Newcastle-on-Tyne. Born in Newcastle; his father a glass-maker, he worked in the same trade until he was 16, and attended evening classes at the Newcastle School of Art under W. Cosens-Way. In 1899 he held a successful exhibition, and then turned entirely to painting. He exhib. in London from 1878 at SS, and from 1883 at the RA. He illustrated Wilson's *Tales of the Borders.* In 1910 elected P of the Bewick Club. An exhibition of his work was held at King's College, Newcastle, 6 March 1923. The AJ wrote of his work, "Jobling looks upon the sea when it is blue or grey, or when little wisps of white are fringing the processional waves; he looks upon the people with a poetic and sensitive eye, in their less intense moments . . . a group of sailors gossiping by the side of a boat or on the headland . . ."
Bibl: AJ 1904 pp.306 (pl.), 308; RA Cats. 1905, 1911, 1912; Laing AG Cat. of Watercolours, Newcastle-on-Tyne, 1939, pp.112-13; Hall; Brook-Hart; Cat. of Isa and Robert Jobling Exhibition, Laing AG, Newcastle, 1992; P. Phillips, *The Staithes Group,* 1993.

JOBSON, Henry fl.1873-1877
Exhib. a painting of roses at SS in 1873-4. London address.

JOEL, H.B. c.1880-1905
Painted coastal scenes and landscapes. Brook-Hart reproduces one of his watercolours. Sometimes mis-catalogued as A.J. Boel or Noel, because of his complicated signature.
Bibl: Brook-Hart (pl.205).

JOHNS, Miss fl.1859
Exhib. a watercolour of a bird's nest at SS in 1859. Address in Rickmansworth, Hertfordshire.

JOHNS, A. fl.1842
Exhib. a study at the RA in 1842. London address.

JOHNS, Ambrose Bowden 1776-1858
Painted landscape. Exhib. 13 works, the majority landscapes in Devon and including views on the Rivers Plym and Laing, at the RA;

also exhib. four works at SS and three at the BI. Address in Plymouth, Devon.

Bibl: AJ 1859 pp.29, 45; Redgrave, Dict.; Pycroft, *Art in Devonshire*, 1883; Bryan.

JOHNS, J.W. fl.1854

Exhib. a portrait at the RA in 1854. London address.

JOHNSON, A. fl.1851

Exhib. a work entitled 'The Two Favourites' at the RA in 1851.

JOHNSON, Mrs. A.H. or A.K. (Bertha J.) fl.1878-1882

Exhib. three works, two portraits and a work entitled 'China', at the RA 1878-82. Address in Oxford.

JOHNSON, Miss Adeline fl.1867-1872

Exhib. a watercolour of spring flowers at SS in 1868. London address.

JOHNSON, Alfred fl.1881-1886

Exhib. three landscapes and a watercolour view of the grave of Charles Dickens in Westminster Abbey at SS. London address.

JOHNSON, Alfred George b.c.1820 fl.1846-1850

Irish painter. Trained at Royal Dublin Schools; exhib. at RHA 1846-50, and later worked at Ordnance Survey.

JOHNSON, Alfred J. fl.1875-1887

Painted landscape and genre subjects. Exhib. six works, including 'A Day Dream', 'The Cottage Door' and ' "Phil" ' at the RA. Exhib. seven works, the majority watercolours, at SS. London address.

JOHNSON, Mrs. Basil fl.1893-1897
(Miss Bessie Percival)

Painted landscape and genre subjects. Exhib. seven works, including 'My Mantelpiece', 'A May Morning' and views in Algiers, at the RA 1893-7. Her copy of W.W. Ouless's portrait of Cardinal Newman is at Trinity College, Oxford. Address in Rugby, Warwickshire. See also Miss Bessie Percival.

Bibl: Ormond.

Exhib: London, Walker's Gallery, *Watercolours of Rome, Switzerland, the Riviera, etc.* 1933.

JOHNSON, C. fl.1871-1874

Exhib. three works, including 'Spring Memories' and 'Flower Girl', at the RA 1871-4. London address.

JOHNSON, C.R. fl.1880

Exhib. 'An Irish Hill-side' at SS in 1880. London address.

JOHNSON, Charles Edward RI ROI 1832-1913

Landscape painter. Born in Stockport; studied at the RA Schools; began his career as an artist in Edinburgh, moving to London in 1864. He conducted a school for landscape painting at Richmond. Exhibited from 1855 at the RA, BI, SS, NWS, GG, NG and elsewhere. His best known pictures are 'Glencoe, Ben Nevis in Winter', 'The Wye and the Severn', 'Gurth the Swineherd' (Tate Gallery, Chantrey Bequest in 1879), 'Fingal's Cave' and 'The Timber Wagon'. His paintings are in the Tate Gallery and in Rochdale, Derby and Sheffield AG.

Bibl: AJ 1896 pp.170, 180; 1897 pp.172, 175; 1900 pp.173, 182; Studio LVIII 1913 p.224 (obit.); 1914 p.XXII (list of works); RA Pictures 1891-1903, 1905-7, 1910-12; RA Cats., 1905, 1907, 1909-12; Poynter, National Gallery III 1909 p.176 (pls.); Who's Who 1913; VAM; Sale Cat. 1927 12-13 December at Sheen of watercolours by C.E.J. (with prices); Brook-Hart.

JOHNSON, Cyrus RI 1848-1925

Miniature portrait painter, and also painter of genre and landscape. Educated at Perse Grammar School, Cambridge. First exhib. at the RA 1871-4 as C. Johnson, genre and landscape, and then from 1877 onwards at the RA — all miniature portraits, in which field he had considerable success. His sitters included Sir John Duckworth, R. Neville Granville, Rt. Hon. Edward Gibson, Lord Ebury, etc. He was also a member of the ROI.

Bibl: RA Cats. 1905, 1909, 1912, 1917; Who's Who 1924.

JOHNSON, Eastwood fl.1873-1878

Exhib. a work entitled 'Bo-Peep' at the RA in 1873. Address in Liverpool.

***JOHNSON, Edward Killingworth RWS 1825-1923**

Landscape and genre painter. Born in Stratford-le-Bow; self-taught and copied at the Langham Life School. Exhib. from 1846, at the RA (1846, 1858 and 1862), SS, OWS (176 works) and elsewhere, titles at the RA including 'Afternoon', 'A River Party' and 'Mending a Pen'. A of RWS 1866, and RWS 1876. He lived in London until 1871 when he moved to north Essex. His 'The Anxious Mother' 1876, was purchased by Birket Foster. His work was very popular in America, and amongst others he exhib. 'The Rival Florists' in New York 1873, 'A Study' at Philadelphia 1876, and 'Intruders' in New York 1876, of which the AJ said ". . . it has been received with expressions of the highest praise . . . its aim is so high and its motive so charming that it commands admiration in spite of any mere defect."

Bibl: AJ 1876 p.210; Illustrated London News 1868; Clement & Hutton; The Year's Art 1897; Cundall pp.158, 255.

JOHNSON, Ernest Borough RI RP RBA ROI 1867-1949

Painted portraits, figurative subjects and landscapes. Studied at the Slade and under Herkomer in Bushey. Exhib. in London from 1886, and abroad. Later he became professor of Fine Arts, Bedford College. Husband of the artist Esther George (q.v.). Lived in London.

Bibl: Studio XIII pp.3-12; XXVI p.297; XXXIII p.260; LXXXVIII p.130ff.; Studio Special Number 1911; AJ 1892 pp.291-2; Who's Who 1924.

JOHNSON, Mrs. F.V. fl.1855-1872

Exhib. two works, 'Beech Trees' and 'On the Look Out', at the RA, 1855-64, and three works at SS, in 1872. London address.

JOHNSON, Miss Fanny fl.1838

Exhib. a work entitled 'Paysans in Normandy' at the RA in 1838. London address.

JOHNSON, G.F. Waldo fl.1894

Exhib. a work 'In the Meadows' at the RA in 1894. Address in Stamford Bridge.

JOHNSON, Mrs. H. fl.1844

Exhib. a view of Harlaxton Hall at the RA in 1844 and a painting of flowers at SS in 1845. London address.

JOHNSON, Harry John RI 1826-1884

Landscape painter. Born in Birmingham, eldest son of an artist, W.B. Johnson; studied at the Birmingham Society of Arts, under Samuel Lines, and after 1843 under William Müller (q.v.), whom he accompanied to the Levant on the Lycian expedition, 1843-4. Three volumes of sketches exist made in Lycia. On his return he worked in the Clipstone St. Studio in Müller's company. He was also a close friend of David Cox and went on sketching expeditions

with him to Wales. He exhib. 1845-80 at the RA, BI, SS and NWS and is listed in Graves (Royal Academy, Dictionary), as Harry and Harry John Johnson. Elected A of the RI in 1868, RI 1870. Hardie notes: "Both in pencil and colour work, Johnson retained the influence of Cox, but still more than that of Müller throughout his life. He was an admirable draughtsman; his studies of boats in particular have high merit; and his sketches in general have a force and vitality not always displayed in his exhibition pieces." His studio sale was held at Christie's, 5 March 1885.

Bibl: Roget; Bryan; Binyon III 1902; Cundall pp.170, 225; DNB; VAM; Hardie II p.209 (pls. 195-6); Ormond; Brook-Hart.

JOHNSON, Miss Helen Mary fl.1865-1881
Painted figurative subjects, marines and landscapes. Exhib. six works, including 'Maiden Meditation', 'Among the Hills' and a watercolour 'Fishing Boats Going Out — Early Morning', at SS. Also exhib. three works at the BI. London address.

JOHNSON, Henry fl.1824-1847
Painted portraits and figurative subjects and studies. Exhib. 12 works, the majority portraits, at the RA. Also exhib. 12 works at SS, and nine at the BI, including 'Head of a Jewish Rabbi' and 'An Oriental Traveller'. London address.

JOHNSON, Herbert 1848-1906
Painted landscapes, figurative subjects and genre. Exhib. 11 works, including Tiger Shooting in the Terai, containing portraits of the Prince of Wales and others', at the RA. Also exhib. 16 works at SS, titles including 'The Eve of St. Valentine', 'A Calabrian' and watercolours. London address. For works illustrated by, see Card Cat. at VAM.

Bibl: AJ 1885 p.253;VAM Cat. Loan Exhibition of Modern Illustrators 1901.

JOHNSON, J .C. fl.1870
Supposed to have exhib. a landscape at SS. Address in Charlton.

JOHNSON, John RCA fl.1876-1878
Exhib. three landscapes in 1876-8. Address in Trefrew.

JOHNSON, Louisa fl.1865
Supposed to have exhib. a painting of fruit at SS in 1865. London address.

JOHNSON, Miss Louisa H. Kate fl.1894-1896
Exhib. two paintings of flowers, 'Peonies' and 'Spring Flowers', at the RA in 1894 and 1896. Address in Carrington, Nottinghamshire.

JOHNSON, Miss Mabel fl.1889
Exhib. a landscape at the NWS in 1889. London address.

JOHNSON, Nancy J. fl.1845-1848
Exhib. a watercolour view near Ephesus at SS in 1848 and a view of Makri, in Asia Minor, at the BI in 1845. London address.

JOHNSON, Mrs. Patty fl.1877-1904
(Miss Pattie Townsend)
Nuneaton painter of landscape and genre, who exhib. 1877-1904, at the RA 1881-1904, SS, NWS and elsewhere, 1877-92 under her maiden name, and from 1897 onwards under Johnson. Titles at the RA include 'An Old Footbridge', 1881, 'The Children's Hour', 1900, and 'When Work Begins', 1904.

JOHNSON, Robert J. fl.1862-1887
Painted churches. Exhib. six works, including two interior views in Westminster Abbey and views of churches in Newcastle-upon-Tyne, at the RA. London address.

JOHNSON, Robin H. fl.1871-1880
Painted landscape. Exhib. seven works, all landscape studies, at SS, 1871-81, and three works, views near Arundel, on Wimbledon Common and in Picardy, France, at the RA. London address.

JOHNSON, Thomas Croshaw fl.1852-1880
Painted landscape and architecture. Exhib. 33 works, including watercolours, of landscape in Germany, France, Scotland and several views of Knowle Park, at SS. Also exhib. three landscapes at the RA and seven works, landscapes and views of buildings, at the BI. London address.

JOHNSON, W. fl.1864
Exhib. a view of Sark, near Guernsey, at the BI in 1864. Address in St. Saviour's, Jersey.

JOHNSON, W. Noel fl.1892
Exhib. a work entitled 'The Close of the Winter's Day' at SS. Address in Bowden, Cheshire.

JOHNSON, Will fl.1889
Exhib. a view on Summerton Broad, Norfolk, at the RA in 1889. Address in Bradford, Yorkshire.

JOHNSON, Captain Willes J. RN fl.1828-1841
Exhib. three works, including 'Heavy Weather Come On; or a Convoy on a Lee Shore' and 'Second Position of the Queen Charlotte, off the Mole-head at Algiers', at the RA.

Bibl: Brook-Hart.

*JOHNSTON, Alexander 1815-1891
Scottish historical, genre and portrait painter. Born in Edinburgh, son of an architect. Student of the Trustees' Academy 1831-4; came to London with an introduction to Sir David Wilkie; entered the RA Schools under W. Hilton in 1836. Exhib. 1836-86 at the RA, BI and SS, and a little in Scotland. At the RA in 1839 his picture 'The Mother's Grave' attracted good notices. In 1841 he exhib. his first historical painting, 'The Interview of the Regent Murray with Mary Queen of Scots', which was bought by the Edinburgh Art Union. Many of his works won premiums, and in 1845 his 'Archbishop Tillotson Administering the Sacrament to Lord William Russell in the Tower', was bought by Mr. Vernon for the Vernon Gallery and is now in the Tate. Caw notes that "his pictures, sometimes of the affections, and occasionally historical, are conceived in a somewhat similar spirit to those of Sir George Harvey. Austere and grave in feeling, and dwelling upon the pathos of life, his pictures, amongst which one may name 'The Mother's Grave', 'The Coventer's Marriage', and 'The Last Sacrament of Lord William Russell', are marked by sound drawing and expressive composition."

Bibl: AJ 1857 p.57; 1862 p.108; 1863 p.236; 1865 p.336; Ottley; Caw p.120; DNB; Irwin.

JOHNSTON, Frederick fl.1855-1868
Painted genre subjects. Exhib. 11 works, including 'The Quiet Time of Life', 'Feeding Baby' and 'Spilt Milk', at SS. Exhib. ten works, including 'Rustic Courtship' and 'Anxious Parents', at the BI, and three works, including 'The Photograph', at the RA. London address.

JOHNSTON, Rev. George Liddell 1817-1902
Made drawings of grotesque imaginary subjects. The great part of his work was bound in a single sketchbook, made in 1892, while he was on holiday in Italy. This was exhib. at the Stone Gallery,

Newcastle-upon-Tyne in 1970. Johnston was born in Sunderland, Co. Durham, and lived in Exeter and in Vienna, where he was a clergyman in the British Embassy.

Bibl: Hall.

Exhib: London, Hartnoll and Eyre, *An Exhibition of My Stray Thoughts and Odd Notions Set Down by the Reverend George Liddell Johnston*, 1969; Newcastle, Stone Gallery 1970.

JOHNSTON, Sir Harry Hamilton GCMG KCB HRWS fl.1879-1903

Painted animals. Exhib. eight works, including 'The Pets of an Eastern Palace: A Tunisian Study', 'A Dead Gazelle' and 'Crocodiles and Waterbirds on the Shores of an African Lake', at the RA. Address in Camberwell.

Bibl: Sir H.H.J., *The Story of My Life*, 1923; Who's Who 1924.

JOHNSTON, Henry NWS fl.1834-1858

Exhib. three works, including 'A Venda in the Orgao Mountains' and 'Fishwives of Dieppe after a Gale — Faith, Hope and Charity', at the RA. Also exhib.34 works at the NWS. London address.

Bibl: Cundall.

JOHNSTON, Henry H. fl.1875-1882

Probably the same artist as Sir Harry Hamilton Johnston (q.v.).

JOHNSTON, Philip Mainwaring fl.1885

Exhib. a view of a Norman doorway, Clymping Church, at the RA in 1885. London address.

JOHNSTON, William Borthwick RSA 1804-1868

Scottish painter of historical and genre subjects, and landscapes. Exhib. eight historical subjects in 1848-53. Address in Edinburgh.

Bibl: AJ 1868 p.157; DNB 1892; Irwin.

JOHNSTONE, Mrs. Couzens fl.1835-1859

Painted portraits. Exhib. 13 portraits and a work entitled 'The Cottage Girl' at the RA.

JOHNSTONE, Mrs. David fl.1846-1847
(Miss M.A. Wheeler)

Exhib. three portraits at the RA. London address.

JOHNSTONE, George Whitton RSA RSW 1849-1901

Edinburgh landscape painter. Born in Glamis, Forfarshire, and came to Edinburgh as a cabinet-maker; became a pupil at the RSA's Life School, and during this period did genre and portraits. First exhib. at the RSA in 1872, and regularly afterwards; ARSA 1883; Member 1895; RSW; exhib. at the RA 1885-92. He painted mainly landscapes, many in Eskdale and Annandale, seaside scenes, streams and rivers. He also went to France and painted in the Fontainebleau forest. In his later years his paintings became more generalised — foliage and composition becoming more reminiscent of Corot. Caw notes a certain mannerism of touch, with results in a "rough hewn and unpleasantly marked surface".

Bibl: AJ 1899 pp.146-9 (pls.); Caw p.302.

JOHNSTONE, Henry fl.1835-1853

Probably the same artist as Henry Johnston (q.v.).

JOHNSTONE, Henry John RBA fl.1881-1900

Painted figurative and genre subjects. Exhib. 14 watercolours, including 'Good for Nothing', 'A Maiden's Thoughts' and ' "My Face is My Fortune, Sir", She Said', at SS. Exhib. 18 works, including 'Idle Hands' and 'The Lass that Loves a Sailor', at the RA. Painted in a minutely detailed style similar to C.E. Wilson (q.v.). Address in Marlow, Buckinghamshire.

JOHNSTONE, J. Nicholson fl.1883-1897

Painted views of architecture. Exhib. seven works, including views in Yeovil, Somerset and Southampton, at the RA. London address.

JOLLEY, Martin Gwilt- b.1859 fl.1904

Painted figurative and genre subjects, and landscapes. Exhib. 24 works at the RA, titles including 'In Memory of a Mother's Love', 'A Trespasser' and ' "Si o No?" '. Also exhib. 11 works at SS, including views in Italy and Cornwall. London address.

Bibl: AJ 1904 p.358.

JOLLY, Miss Fanny C. fl.1856-1879

Painted flowers, landscapes and genre subjects. Exhib. six works at the RA, titles including 'In a Copse', 'In Robin Hood's Bay' and views near Whitby. Also exhib. nine watercolours at SS, including 'Girl, with Bird Cage' and 'Almost Gained'. Address in Bath.

JONES, Mrs. fl.1852

Exhib. a watercolour entitled 'Deeside, Aberdeenshire', at SS in 1852.

JONES, A. fl.1839

Exhib. a 'Landscape near Laeken, with Cattle', at the BI in 1839. London address.

JONES, Adolphe Robert 1806-1874

Exhib. an 'Interior of a Stable, with Cattle, Fowls, Figures, etc.' at the BI. Born in Brussels.

JONES, Captain Adrian 1845-1938

An army veterinary officer who studied art under C.B. Birch, ARA, and exhib. sculpture and paintings in London from 1884. Lived in London.

Bibl: M.H. Spielmann, *British Sculptors of Today: Rees; Memoirs of a Soldier Artist*, with a foreword by Lt.Gen. Lord Baden-Powell, 1933.

JONES, Agnes fl.1893-1894

Exhib. two watercolours, 'Early Morning in the Dordogne' and 'The Emanuel Almshouses, Westminster', at SS. London address.

JONES, Alfred Garth fl. from 1900

Exhib. three works, including 'Youth and Death', at the RA 1900-1. London address. For works illustrated by, see VAM Card Cat.

JONES, Anna M. fl.1868-1870

Exhib. a work, entitled 'Moulin, Huet Lane, Guernsey', at the RA in 1868. Address in Guernsey.

JONES, The Rev. Calvert Richard c.1804-1877

Painted marines and figurative subjects. Amongst his works are a number of views of H.M. Ships. He was also a pioneer of calotype photography. He was ordained and became rector of Longhor, near Swansea, in 1829. An exhibition of his work was held at the National Museum of Wales and elsewhere in 1973.

Bibl: Brook-Hart pl.206.

Exhib: Colchester, The Minories 1974.

JONES, Champion fl.1878-1892

Painted landscapes, marines and rustic subjects. Exhib. nine works, including 'Fishing Boats on the River Yare' and 'Loading Hay — Essex Coast', at the RA. Also exhib. 16 works, including watercolours, of landscapes in the south-east of England. London address.

Bibl: Brook-Hart.

***JONES, Charles RCA 1836-1892**
London painter of animals — sheep, cattle and deer in landscape settings. Of Welsh extraction, born near Cardiff. He was well known as an animal painter — generally known as Sheep Jones for his skilful painting of sheep — and exhib. 1860-91, at the RA 1861-83, BI, SS, NWS and elsewhere. Member of the RCA, and c.1890 awarded a gold medal at the Crystal Palace.

Bibl: AJ 1892 p.288; The Year's Art 1893 p.278; Cat. National AG, Sydney 1906 (biography); Cat. Preston AG 1907; T.M. Rees, *Welsh Painters*, 1912 p.77. Exhib: Balham, Heathercroft 1911.

JONES, Miss Constance Flood fl.1890
Exhib. a genre subject at the GG in 1890. London address.

JONES, Conway Lloyd fl.1871-1881
Painted landscape watercolours. Exhib. eight watercolours, including 'View near Wimborne' and 'Lynmouth Shore', at SS. Address in Wimborne, Dorset.

JONES, Mrs. D. (Viola) fl.1893
Exhib. a portrait of a girl at the RA in 1893. London address.

JONES, Dan Rowland ARCA b.1875
Painter, etcher and sculptor. Studied at London School of Art, at the RCA and in Paris at the Académie Julian. Lived in Aberystwyth, Cardigan.

JONES, David fl.1891
Exhib. a work 'Between the Showers' at the RA. Address in Dudley, Worcestershire.

JONES, Miss E.C. fl.1887
Exhib. a figurative subject in 1887. Address in Harrow, London.

JONES, Edward fl.1833-1849
Painted coastal scenes and shipping. Exhib. 11 works, including 'Dover Lugger Making for Port' and 'Trawl-boat Running into Harbour', at SS. Also exhib. three works, including 'Coast Scene, Ireland', at the BI, and one work at the RA. London address.

JONES, Sir Edward Coley Burne -
see BURNE-JONES, Sir Edward Coley

JONES, Miss Emma E. fl.1823-1837
(Mme. Soyer)
Painted figures and animals. Exhib. twenty six works, including, in 1837, 'A Gleaner' and 'Children with Flowers', at the BI. Also exhib. up to 1837 at the RA and, up to 1828 at SS. London address. See also Mme. Soyer.

JONES, Ernest Yarrow b.1872
Sculptor and painter in oil and watercolour. Studied at Westminster and South Kensington, also in Paris. Born in Liverpool. Lived at Hythe, Kent, and in Paris.

JONES, Miss Frances M. fl.1882-1885
Exhib. seven works, including 'On the Edge of the Wood', 'The Convent Garden' and 'The New Dress', at SS. London address.

JONES, Francis E. fl.1880
Exhib. a view of St. Peter's Church, Carmarthen, at the RA in 1880. London address.

JONES, Frederick fl.1867-1885
Exhib. a view from the village of Borth, near Portmadoc, North Wales, at the RA in 1885. London address.

JONES, G. Smetham- fl.1888-1889
Exhib. a work entitled 'Not a Moment to Lose' at the RA in 1888, and 'Disaster' at SS in 1888/9. London address.

JONES, George RA 1786-1869
Painter of battlepieces and military subjects, portraits, genre historical subjects and views of towns. Born in London, son of John Jones, mezzotint engraver. Studied at the RA Schools in 1801, but his studies were considerably interrupted by his military ardour; he served in the Peninsular War, and in 1815 formed part of the army of occupation in Paris. When he resumed his career, his pictures were chiefly of a military character, and he painted many representations of the battles in the Peninsula and at Waterloo. In 1820 his picture of Waterloo with Wellington leading the British Advance was awarded the BI premium of 100 guineas (Chelsea Hospital), and another Battle of Waterloo again in 1822. Another of his well known works was 'Nelson Boarding the San Josef at the Battle of Cape St. Vincent' (Greenwich Hospital). He also painted historical events, such as 'The Prince Regent Received by the University and City of Oxford, June 1814', views of continental cities, e.g. 'Orleans' and 'Rotterdam', and in his later years did a great number of drawings in sepia and chalk of biblical and poetical subjects, and depicted the battles of the Sikh and Crimean Wars. Exhib. 1803-70 at the RA (221 works), BI, SS, and OWS; 1822 ARA; 1924 RA; 1834-40 Librarian of the RA; 1840-50 Keeper of the RA. While Keeper he visited many foreign schools to see what improvements could be made, and it was on his recommendation that the draped living model was set in the Painting School. He was a close friend of Chantrey and Turner, and in 1849 published *Recollections of Sir Francis Chantrey*. He prided himself that he bore a certain resemblance to the Duke of Wellington, for whom he was said to have been once mistaken. This story, when repeated to the Great Duke, drew from him the remark that he had never been mistaken for Mr. Jones. The BM has many of his watercolours, and 11 volumes of academic studies, bequeathed by him.

Bibl: A list of his works is given in TB; AJ 1869 p.336 (obit.); 1903 p.372ff. (pls.), Ottley; Redgrave, Dict.; Binyon; DNB; L. Cust, NPG Cat. II; T.M. Rees, *Welsh Painters*, 1912 p.84; T.H. Parker, Cat. of Military Prints 1914 No.2141; Hutchison; Ormond.

JONES, George Kingston- fl.1896-1899
Exhib. three works, including 'On Caister Sands' and 'Southwold, from Walberswick', at the RA, 1896-9. London address.

JONES, George W. fl.1885
Exhib. a work entitled 'Hetty Sorrel' at the RA in 1885. London address.

JONES, H.E. fl.1882-1883
Exhib. four works, including 'Changing Pastures', 'A Country Lane, with Sheep' and 'Alarmed', at SS 1882-3. Address in Brentford, London.

JONES, H. Thaddeus fl.1883-1884
Exhib. three works, portraits of the Duke and Duchess of Teck, and a worked entitled 'A Wine Carrier', at the RA. He was an associate of the RHA. London address.

JONES, Harry C. fl.1891-1893
Exhib. three works, including 'A Household Confidante' and 'Making Friends', at the RA 1891-3. Address in Epsom, Surrey.

JONES, Sir Horace 1819-1887
An architect who also exhib. views of buildings, including 'Holborn Valley Viaduct', 'Metropolitan Meat Market' and a view in Fécamp, at the RA. London address.

Bibl: T.M. Rees, *Welsh Painters*, 1912.

JONES, Miss J.G.E. fl.1859
Exhib. two watercolours, views in Rouen and Tewkesbury, at SS. Address in Gloucester.

JONES, J. Rock fl.1840-1896
Northumbrian draughtsman. Influenced by David Cox, T.M. Richardson and Copley Fielding (qq.v.). He was a founder member of the Newcastle Life School (which became the Bewick Club). Exhib. three Northumbrian landscapes at the Carlisle AG 1896 exhibition of the work of living artists. Born on the Isle of Man. Moved to Newcastle with his father, who was a portrait painter, in 1840.
Bibl: Hall.

JONES, Miss Jessie H. fl.1901
Exhib. a study at the RA in 1901. Address in Wolverhampton, Staffordshire.

JONES, Joseph fl.1881
Exhib. a landscape in 1881. Address in Ashby-de-la-Zouch, Leicestershire.

JONES, Josiah Clinton RCA 1848-1936
Painted country subjects, landscapes and marines. Studied at Liverpool School of Art from about 1873. Worked principally in North Wales, where he settled in 1885. Exhib. in London and in the provinces. Exhib. five works, including 'An Old Fashioned Garden' and 'The Lengthening Shadows of a Winter Day', at the RA 1885-1902. Also exhib. once at the NWS. Elected RCA in 1885 and to the Liverpool Academy of Arts in 1901. Born in Staffordshire. Lived in Liverpool and in Conway, Caernarvon.

JONES, Miss Laura Edwards fl.1882-1902
Exhib. three works, including 'A Quiet Spot' and 'Kindlings', at the RA and two at SS. London address.

JONES, Miss Lily fl.1891
Exhib. a painting of chrysanthemums at the RA in 1891. Address in Sutton Coldfield, Warwickshire.

JONES, Lionel J. fl.1892-1894
Exhib. 'A Morning Mist — Blackfriars' at the RA in 1894, and a work at the NWS. London address.

JONES, Miss Louie Johnson b.1856 fl.c.1880-1910
Animal painter. Studied at Calderon's School of Animal Painting, and St. John's Wood School. Painted a large frieze of horses at Cheadle Royal, Cheshire. Exhibitions of her work were held by Colnaghis.
Bibl: T.M. Rees, *Welsh Painters*, 1912.

JONES, Miss M.F. fl.1885
Exhib. a work entitled 'Suppertime' at the RA in 1885. London address.

JONES, Miss Martha J. fl.1828-1861
Painted genre subjects. Exhib. six works, including 'A Letter from Home', 'A Sunday Walk' and 'The Question, "Cavalier or Roundhead" ' at the RA. Also exhib. at SS, and a scene from *Cymbeline* at the BI. London address.

JONES, Miss Mary Helen fl.1883-1885
Exhib. a study of a head in 1885. London address.

JONES, Miss Mary K. fl.1845-1863
Painted flowers. Exhib. four works, including 'For Dessert' and 'Peonies', at the BI. Exhib. two works at the RA and two works at SS. London address.

JONES, Miss Maud Raphael fl.1889-1900
Painted landscape and country subjects. Exhib. at the RA 1889-1900, titles including 'Pulling Turnips, Yorkshire: A November Afternoon', 'Harvest on the Hill', 'Yorkshire Oats' and 'Where Washburn joins Wharfe'. Address in Birmingham.

JONES, Owen Carter 1809-1874
An architect and decorator who exhib. views of architecture. Exhib. a number of interior views in the Palace of the Alhambra at the RA. London address.
Bibl: AJ 1874 pp.211, 285; DNB 1892; T.M. Rees, *Welsh Painters*, 1912; Binyon; VAM Cat.; Irwin.

JONES, R. fl.c.1839
His painting of Charles James Mathews was reproduced in a lithograph in Dickens's *Life of Charles James Mathews*, 1879.

JONES, R.J. Cornewall fl.1886
Exhib. a view of the church of St. Nicholas, Boulogne-sur-Mer at the RA. Address in Ryde, Isle of Wight.

JONES, Reginald T. 1857-1904
Painted boats, coastal scenes and landscape in watercolour. Exhib. 16 works at the RA 1884-1904, titles including 'After Summer Rains', 'Autumn Mist' and 'View from Macugnaga'. Exhib. 13 works at SS, including 'Shunting at Whitstable' and 'Farm on the Marsh'. London address. Examples are in Wakefield AG.
Bibl: Studio XXX pp.33, 42; LXVII p.51.

JONES, Richard fl.1810-1844
Exhib. three works, including a rural scene and a river scene, at SS 1833-44. London address.

JONES, S. Maurice RCA 1852-1932
Painted landscape. Exhib. in London and the provinces, principally at the R. Cam. A. Born at Mochdre, Denbighshire. Died in Llandudno, Caernarvonshire.
Bibl: T.M. Rees, *Welsh Painters*, 1912.

JONES, Samuel John Egbert fl.1820-1845
Painted animals, figurative subjects and landscapes. Exhib. 14 works at the BI 1824-45, including views of water mills in Derbyshire and Kent, and 19 works, all prior to 1837, at SS. Also exhib. 14 works, including 'The Lesson "Delightful Task," ' and 'Born to Good Luck', at the RA. London address.
Bibl: Strickland.

JONES, T. Hampson fl.1876-1903
Painted landscapes and views in Venice. Exhib. 24 works at the RA 1876-1903, titles including 'Near Barmouth — A Sunny Morning', 'The Medway at Rochester' and 'Canal in Venice — Evening'. Also exhib. at the NWS and the GG. Address in Liverpool.

JONES, T. Harry fl.1880-1882
Exhib. a work 'On the Sands: Concarneau' at SS in 1881-2. Address in Concarneau, France.

JONES, T.W. fl.1832-1871
Painted portraits and biblical subjects. Exhib. nine works at the RA, including portraits and a scene from Samuel, and five works, including 'The Call of Samuel' and 'Afraid to Pass the Gypsies', at the BI. Also exhib. two works at SS. London address.

JONES, Theodore fl.1879-1889
Painted landscape watercolours. Exhib. 11 watercolours at SS, including views on Hampstead Heath, and views on the Essex marshes and at Southwold and Walberswick in Suffolk. Exhib. four works, views in Yarmouth, Walberswick and Harrow. London address.

JONES, Sir Thomas Alfred PRHA 1823-1893
Dublin portrait painter. After studying at the schools of the R. Dublin Society and the RHA, he entered Trinity College in 1842, but left without taking his degree and in 1846 went abroad. In 1849 he returned to Dublin, and became a painter of portraits and figures, exhibiting at the RHA in 1849, 1851 and 1856. His early works were small figure subjects, most of them drawings in watercolour and pastel, for which he found a ready sale; but he finally confined himself to portrait painting in oil, in which he achieved success; and after the death of Catterton Smith, he had almost a monopoly of portrait painting in Ireland. 1861 elected a Member of RHA, and was P from 1869 till his death. 1880 he was knighted. Exhib. at the RA 1872-9. Strickland writes: "His oil portraits are numerous, nearly everyone of note for many years sat to him; but his art was commonplace, and though his pictures satisfied his sitters as faithful likenesses, they are poorly painted, mechanical in execution, and without any artistic merit."
Bibl: Strickland; VAM; Ormond.

JONES, Thomas J. fl.1901-1935
Painted figurative subjects, landscapes and views of buildings. Studied at the RCA and received his diploma in 1902. Exhib. at the RA from 1901, including views in North Devon. Born in Bideford, Devon. Lived in Tunbridge Wells, Kent, and was Principal of the Tunbridge Wells School of Arts and Crafts.

JONES, Victor T. fl.1894
Exhib. a view of a cottage on the Isle of Wight at the RA in 1894. London address.

JONES, Viola fl.1881
Exhib. a drawing in crayons in 1881. London address.

JONES, W. fl.1853
Exhib. a view in Canterbury, showing one of the towers of the Cathedral, at SS in 1853. London address.

JONES, W.H.H. fl.1845-1878
Painted landscape and views in the South of England. Exhib. ten works at the RA, including 'A Barley Field at Goring, Oxon', 'The Thames at Moulsford' and 'A Moated Manor House in Wilts'. Exhib. six landscapes, mostly watercolours, at SS. London address.

JONES, Mrs. W.H.H. fl.1843
Exhib. a view of Reculver, Kent, at the RA in 1843. London address.

JONES, William fl.1818-1860
Painted portraits. Exhib. at the RA 1818-53 including portraits and, in 1853, 'Head of a Welsh Bard'. London address. Also painted scenes from Welsh history.
Bibl: T.M. Rees *Welsh Painters,* 1912.

JONES, William E. fl.1849-1871
Bristol landscape painter who exhib. 1849-71 at the RA, BI and SS. Member of the Bristol Academy of Arts. Pavière illustrates his 'Panorama of the Thames from Richmond Hill'.
Bibl: Pavière, Landscape, pl.39.

JONES-PARRY, Thomas P. fl.1884-1888
Exhib. three landscapes at the NWS. Address in Wrexham, Denbigh.

***JOPLING, Mrs. J.M.** RBA 1843-1933
(Mrs. Frank Romer, née Miss Louise Goode)
Painter of portraits, genre and landscape. Born in Manchester; at 17 she married Frank Romer, who in 1865 was appointed private secretary to Baron Rothschild in Paris. The Baroness discovered her talent and advised her to take lessons with M. Charles Chaplin, which she did, 1867-8, exhibiting two small red chalk drawings of heads at the Salon. In 1869 her husband lost his appointment and died in 1873. In 1874 she married Mr. Jopling, watercolour painter. She exhib. as Romer 1870-3 at the RA, and as Jopling from 1874 onwards, at the RA, SS, NWS, GG (32 works) and elsewhere. She was the first woman to be elected RBA. Her portrait of Samuel Smiles is in the NPG. A list of her best known pictures is given in Clayton — they are mainly portraits.
Bibl: Clayton II p.107; Clement & Hutton; RA Pictures 1891 p.98, 1892 p.136; 1894 p.72; 1896 p.158; 1897; 1902-3; W.S. Sparrow, *Women Painters of the World,* 1905; Mrs. Jopling, *Twenty Years of My Life,* 1925.

JOPLING, Joseph Middleton RI 1831-1884
Painter of historical subjects, genre, still-life, flowers, portraits and landscape. Son of a clerk in the Horse Guards; occupied for some years a position similar to that of his father; was self-taught as an artist. Exhib. 1848-84 at the RA, SS, NWS (126), GG, and elsewhere. RI in 1859; resigned in 1876. Director of the Fine Art Section at the Philadelphia International Exhibition. An active volunteer and won the Queen's Prize for rifle shooting at Wimbledon in 1861. Close friend of J.E. Millais. His studio sale was held at Christie's, 12 February 1885.
Bibl: Clement & Hutton; Walker AG Cat. 1884; Bryan; Binyon; VAM.

JORDAN, Miss fl.1849-1850
Exhib. a painting of autumn fruit at SS in 1849, and a painting entitled 'Buy My Primroses' at the BI in 1850. London address.

JOSEPH, Mrs. Delissa 1864-1940
(Miss Lily Solomon)
Painted portraits, landscapes and interiors. Studied at the RCA and the Ridley Art School. Exhib.portraits 1891-3, and a work entitled 'Light and Shadow' at the RA in 1904. Lived in London. She was the sister of the painter Solomon J. Solomon (q.v.).

JOSEPH, F.B. fl.1873
Exhib. a landscape near Anvers, France, at SS in 1873. London address.

JOSEPH, George Francis ARA 1764-1846
Painted portraits, mythological and literary subjects. Exhib. 146 works at the RA 1788-1846. His last works include portraits and 'May "For Thee, Sweet Month" '. Also exhib.14 works at the BI 1806-34. London address.
Bibl: DNB XXX; BM Cat. of Engraved British Portraits; Cat. of the National Gallery of Ireland, Dublin, 1920; Ormond.

JOSI, Charles RBA fl.1827-1851
London painter of sporting and animal subjects, and landscape. Exhib. 1827-51 at the RA 1838-47, BI and SS.
Bibl: Pavière, Sporting Painters p.54.

JOWERS, Alfred fl.1875
Exhib. a landscape in 1875. London address.

JOY, Arthur RHA c.1808-1838
Irish painter of landscapes, historical and figure subjects. Exhib. a work entitled 'Welsh Peasant Girl' at the BI in 1838. London address. Studied under R.L. West, RHA, in Dublin, also in Paris and Holland. Elected ARHA 1836, RHA 1837.
Bibl: Strickland.

JOY, Miss Caroline fl.1845-1855
Exhib. two portraits, one of a little girl at the RA, in 1845 and 1855. London address.

***JOY, George William 1844-1925**
Irish painter of highly dramatic historical subjects, genre and portraits. Brother of Albert Bruce Joy, RHA (sculptor). Educated at South Kensington and RA Schools. In 1868 he went to Paris where he studied under Jalabert, who had been a pupil of Delaroche. In 1878 he exhib. 'Laodameia' at the RA — his first serious picture, which was singled out for praise. In 1881 his 'Joan of Arc' was sold on opening day. His range extended from military and patriotic subjects to the nude, including historical subjects (eg. 'The King's Drum shall Never be Beaten for Rebels', Russell Cotes Museum, Bournemouth) and genre. He is now best known for 'The Bayswater Omnibus' (1895, in the London Museum), a delightful genre painting which shows an attempt at social realism in the way the different social types of passenger are contrasted on the bus. He exhib. from 1872 at the RA, SS and elsewhere.
Bibl: AJ 1900 pp.17-23 (pls.); Studio LXVI 1915 p.195 (pls.); *The Work of George William Joy*, with autobiographical sketch, 1904; RA Pictures 1892-5, 1897-9, 1905-6, 1908, 1910, 1913; RA Cats. 1905, 1907-8, 1910, 1913-14; Reynolds, VS pp.25, 95 (pl.86); Maas pp.232, 239 (pl.240); Wood, Panorama.

JOY, Jessie fl.1843-1869
Painted literary and historical subjects, and landscapes. Exhib. five works, including 'Lady Jane Grey', 'Dolly Varden Dressing for the Ball, from *Barnaby Rudge*' and 'Imelda', at the BI. Also exhib. 11 works at SS, including 'Little Nell and her Grandfather'. Also exhib. six works at the RA 1843-59. Address in Richmond, Yorkshire.

JOY, John Cantiloe see JOY, William

JOY, Miss M.E. fl.1866-1867
Exhib. a work entitled 'Long I Looked out for the Lad She Bore' from *Jean Ingelow*, at the RA in 1866, and another entitled 'The Cyanus' at the BI in 1867. London address.

JOY, R. fl.1864
Exhib. a work entitled 'The Fisherman' at SS in 1864. London address.

***JOY, Thomas Musgrove 1812-1866**
Painter of portraits, historical, genre and sporting subjects. Born in Boughton Monchelsea, Kent; studied under Samuel Drummond, ARA. Exhib. 1831-67, at the RA (an honorary exhibitor 1831-64), BI, SS, and NWS. Patronised by Lord Panmure, who placed John Phillip (q.v.) with him as a pupil. In 1841 he was commissioned by the Queen to paint portraits of the Prince and Princess of Wales. He was best known for his subject pictures, e.g. 'Le Bourgeois Gentilhomme', 'A Medical Consultation' and 'Prayer'. In 1864 he painted 'The Meeting of the Subscribers to Tattersall's before the Races', which contained portraits of the most noted patrons of the Turf. His studio sale was held at Christie's, 18 June 1866.
Bibl: AJ 1866 p.240 (obit.); Redgrave, Dict; DNB; Cat. of York AG; BM Cat. of Engraved British Portraits II 1910 p.235: Pavière, Sporting Painters; 1965; Ormond; Irwin; Wood, Panorama.

JOY, William 1803-1867
 John Cantiloe 1806-1866
Marine painters. William was born in Yarmouth; John in Chichester. Most of their pictures and drawings were joint productions. About 1832 they moved to Portsmouth, where they were employed by the Government to make drawings of various types of fishing boats. Later they worked in London and Chichester. William exhib. at RA in 1824 and 1832, BI and SS, John at SS 1826-7. Works by them are in Birmingham, Sheffield, Norwich and VAM.
Bibl: Wilson p.47 (pl.19); Hardie III; Maas; Brook-Hart pl.16.

JOYCE, Miss Annie G. fl.1900
Exhib. a work entitled 'After Supper' at the RA in 1900. Address in Worcestershire.

JOYCE, Miss Mary fl.1880-1893
Painted flowers. Exhib. three works, including 'Little Goldlocks' and 'Bulrushes', at the RA, and five works at SS, including 'Expectation' and 'Pelargoniums'. South London address.

JOYNER, M. fl.1837-1868
Exhib. three works, including 'Morning on the Mountains' and 'The Twins', at SS. Also exhib. two works, 'Moonlight' and 'Morning', at the RA, and one work, at the BI. London address.

JUDKIN, Rev. Thomas James 1788-1871
Painted landscape. Exhib. 22 works at the RA, as an honorary exhibitor, titles including 'Gateway Reading: Painted on the Spot', 'On the Fleet: Painted out of Doors' and 'Cottages at Selborne, at which Village Flourished the Celebrated Naturalist the Rev. Gilbert White'. Also exhib. 17 works at SS and four at the BI. Address in Southgate. A friend of Constable, whose funeral service he conducted.
Bibl: Bryan; Binyon.

JULIAN, Ernest Roderick Eluse b.1872
Painted portraits and landscapes in oil and watercolour. Studied at the Central School of Arts and Crafts, in the William Morris Studios, and at the RCA. Born in London. Lived in Bournemouth, Hampshire.

JULIAN, M. fl.1870-1871
Exhib. two paintings of sheep at SS. London address.

JULYAN, Miss Mary E. fl.1863-1866
Exhib. two works, 'The Prisoner' and 'Fruit', at the RA and 'Azaleas' and 'Roses' at SS. London address.

JUMP, R. fl.1842
Exhib. two paintings of shipping at the BI. London address.

JUNES, C. fl.1847
Exhib. an interior view of St. Peter's Church, Cornhill at the RA.

JUNGMAN, N.W. fl.1897
Exhib. a view of the Cloisters at Westminster Abbey at the RA. London address.

JUNGMAN, Nico RBA 1872-1935
Painted landscapes, townscapes, coastal scenes, portraits and genre. Also an illustrator. Studied art in Amsterdam. Exhib. in London and on the Continent. Born in Amsterdam. Moved to London in the 1890s and became a British subject.
Bibl: Studio XIII pp.25-30; XVI p.123ff.; XXVIII p.44; XXXIX p.156ff.; LXXIII pp.90-9; The Artist XXXI pp.144-6; Mag. of Art 1902 pp.301-5.

JUPP, George Herbert BWS b.1869 fl.1895-1900
Painted landscapes and country subjects. Exhib. nine works at the RA 1895-1900, titles including 'The Minnow Catcher', 'A Prayer for Those at Sea' and 'The Story of the Wreck'. Born in London. Address in Bray, Berkshire.
Bibl: Daily Graphic 16 September 1911.

JURY, Julius b.1821 fl. to 1864
Painted figurative subjects. Exhib. four works, including 'A German Timber', 'Ladies Preparing to Bathe' and 'The Trysting Stile', at the BI. Exhib. four works, including 'My Own Darling', at SS, and one work at the RA. Lived in London.

JUSTYNE, Percy William 1812-1883
Painted historical subjects, portraits and landscapes. Exhib. two interiors containing armour at SS, and one work, 'Scene on the Alps by Moonlight', at the RA. London address. Also an illustrator. Worked in Granada 1841-8.
Bibl: DNB XXX; BM Cat. of Engraved British Portraits.

***JUTSUM, Henry 1816-1869**
Landscape painter. Born in London; educated in Devon. In 1839, became a pupil of James Stark. Exhib. 1836-69, at the RA 1836-68, BI, SS, NWS and elsewhere. For some time he devoted himself to watercolour, and in 1843 was elected a member of the NWS. However, he preferred to paint in oil and in 1848 resigned his membership, afterwards painting mainly in oil. His works are always much admired: 'The Noonday Walk' is in the Royal Collection and was engraved for the AJ, and 'The Foot Bridge' is at the VAM. Many of his works were sold at Christie's, 17 April 1882; his studio sale was also held there 19 February 1870.
Bibl: AJ 1859 p.269 (monograph with pls.); 1869 p.117 (obit.); Ruskin, Academy Notes; Redgrave, Dict.; DNB; VAM; Pavière, Landscape (pl.40).

KAPPARDAKI, S. fl.1887
Exhib. a portrait of 'His Excellency J. Gennadius, the Greek Minister' at the RA. London address.

KARPEN, Miss R. fl.1868
Exhib. a landscape in North Wales at SS in 1868. London address.

KATES, A.H. fl.1849
Exhib. a view in Westminster Abbey at the RA in 1849. London address.

KAULBACH, E. fl.1853-1857
Exhib. four portraits at the RA 1853-7. London address.

KAVANAGH, Joseph M. RHA fl.1886-1888
Irish painter. Exhib. two works, 'A Hallowed Spot' and 'Soul-soothing Art', at the RA 1886-8. Address in Dublin.
Bibl: Studio XXV p.210; LXIV p.288.

KAY, Archibald RSW RSA RBC 1860-1935
Scottish landscape painter Exhib. 14 works at the RA, 1890-1903, titles including 'Pine Trees at Carradale, Mull of Kintyre', 'Harvest at Kilrenny, Fife' and 'Lowlanders; on Loch Tay, Perthshire'. Exhib. mainly in Scotland. Studied in Glasgow under Robert Greenlees. Also in Paris at the Académie Julian. He was president of the Glasgow Art Club. He was born and lived in Glasgow and is represented in the Glasgow City AG ('The Rhymer's Glen').
Bibl: Caw; AJ 1909 pp.152, 154; Studio XXV p.208; XXIX p.295; LXVIII p.125; LXXXVII p.266ff.; Who's Who 1924.

KAY, James RSA RSW 1858-1942
Scottish painter of marines and shipping, landscapes, street and continental scenes. Painted in Scotland, France and Holland. Studied at the Glasgow School of Art. Exhib. three works at the RA 1889-1904, including 'Towing into Harbour on the Clyde' and 'From Foreign Lands'. Lived in Glasgow and Whistlefield, Dumbartonshire. Represented in the Glasgow, Leeds, Bradford and Stirling AGs.
Bibl: Caw; Studio XXVII p.348; XXVIII p.52; XXXIX p.258; Who's Who 1924; Hardie III; Brook-Hart.
Exhib: London, Connell & Son's Gallery 1935.

KAY, Richard fl.1883
Exhib. a view of St. Brelade's Bay, Jersey, at SS in 1883/4. Address in Hastings, Sussex.

KEARNAN, Thomas NWS fl.1821-1850
Watercolourist and engraver. Exhib. two London views at the RA and a landscape on the River Lune at SS. Also exhib. 25 works at the NWS. London address. Elected NWS 1837.
Bibl: Cundall.

KEARNEY, William Henry 1800-1858
Painter and watercolourist of landscapes, genre and portraits. Exhib. in London 1823-58, mainly at NWS (170 works) of which he was a founder member and later Vice President; also at RA and SS. Unlike most of his contemporaries, Kearney continued to paint water colours in the traditional eighteenth century style, scorning the use of bodycolour. His studio sale was held at Christie's, 30 March 1859.
Bibl: AJ 1858 p.253 (obit.); DNB XXX 1892; Cat. National Gallery of Ireland 1920 p.173.

KEARSLEY, Miss Harriet fl.1824-1858 d.1881
London portrait and genre painter. Exhib. 1824-58 at RA, BI and SS. Apart from portraits, her genre subjects include titles such as 'Florentine Peasant Woman', 'A Woman of Antwerp' and 'A Woman of Sorrento'. Also a copyist of old masters.

KEATING, Mrs. fl.1863
Exhib. two paintings of terriers at the BI in 1863. She was a member of the Society of Lady Artists. Address in Ventnor, Isle of Wight.

KEATINGE, Mrs. R.H. (Julia A.) fl.1884-1888
Exhib. three works, including 'Porte Dauphine, Fontainebleau' and 'The Gardener's Daughter', at the RA. London address.

KEELEY, John RBSA 1849-1930
Painted landscape watercolours. Studied in Birmingham. Exhib. two landscapes, 'An October Day on the Avon' and 'A Breezy Day', at SS. Also exhib. eight works at the NWS. Exhib. more than 300 works at the RBSA from 1872. Lived and died in Birmingham.
Bibl: AJ 1905 p.356.

KEELING, Miss Agnes fl.1878
Exhib. a painting of 'Almond Blossom' at the RA in 1878. Address in Sydenham, Kent.

KEELING, Miss Gertrude fl.1896
Exhib. a view of tombs in Westminster Abbey at the RA in 1896. London address.

KEELING, William fl.1891-1904
Painted coastal scenes. Exhib. five works, including 'Gorey Castle, Jersey', 'Sand Hills, Harlech' and 'The Harbour, St. Mary's Scilly', at the RA 1891-1904. Address in Sheffield, Yorkshire.

KEELING, William Knight RI 1807-1886
Painted portraits and genre subjects. Exhib. a work entitled 'The Reproof' at the BI in 1842 and a scene from *As You Like It* at the RA in 1855. Also exhib. 60 works at the NWS. Address in Manchester.
Bibl: AU 1842 p.58; DNB XXX p.301.

KEEN, Arthur fl. from 1883
Painted views of architecture. Exhib. ten works at the RA, 1883-1904, including 'Chateau de Blois', 'A House at Walmer' and 'A House in Hampstead'. London address.
Bibl: A. Keen, *Sketches of Oxted and Limpsfield*, 1935-7.

KEENE, Alfred fl.1854-1866
Painted landscapes. Exhib. seven works at SS, titles including 'Hunshaw Mill near Bideford', 'Ashford near Barnstaple' and 'Hollystreet Mill, Devonshire', the latter two watercolours. Address in Bath, Somerset.

KEENE, Alfred John 'Jack' 1864-1930
Painted landscape watercolours. Exhib. two works, 'After the Winter' and 'A Morning Breeze, Guernsey', at SS 1892-3. He was a founder member of the Derby Sketching Club. Brother of the artist William Caxton Keene (q.v.). Lived and died in Derby.

KEENE, Charles Samuel 1823-1891
Cartoonist and illustrator, best known for his work in *Punch*. Also worked on *Illustrated London News, Once a Week*, and many books, such as Reade's *The Cloister and the Hearth*. Member of the Langham Sketching Club. Nearly all Keene's work was done in pen and ink, a technique of which he was complete master. He produced few watercolours and no oil paintings to speak of, but his genius and importance as a recorder of the period qualifies him for inclusion in any Victorian dictionary. For works illustrated by, see VAM Card Cat.
Bibl: AJ 1891 p.92ff.; Studio, see Index 1902-22; G.S. Layard, *The Life and Letters of C.S.K.*, 1892-3; S.W.L. Lindsay, *C.K.*, 1934; F.L. Emmanuel, *C.K.*, 1935; D. Hudson, *C.K.*, 1947; Binyon; Cundall; DNB XXX 1892 p.302ff.; Hardie III pp.148-9 (pls.173-4); Maas; Ormond; Irwin.
Exhib: Manchester, City AG 1932; Ottawa, National Gallery of Canada 1935; London, Colnaghi's 1947; Leicester Galleries 1952; Great Britain, Arts Council 1952; Cape Town, National Gallery of South Africa 1952; London, Leicester Galleries 1966; London, Fine Art Society 1969; Centenary Exhibition (with Cat.) Christie's 1991.

KEENE, Elmer fl.1895
Exhib. a view in Burniston Bay, Yorkshire, at the RA in 1895. Address in Leicester.

KEENE, Henry E. fl.1866-1876
Exhib. five landscapes in 1866-76. London address.

KEENE, J.B. fl.1848
Exhib. a painting of a 'Woodman' at SS in 1848. London address.

KEENE, William Caxton 1855-1910
Painted landscapes in oil and watercolour. Studied at South Kensington. Exhib. 11 watercolours at SS, titles including 'Caernarvon Castle: The Morning Sun' and 'On the Canal between Derby and Nottingham'. Exhib. six works, including engravings, at the RA; views in Derbyshire. Brother of Alfred John Keene (q.v.). Born in Derby. Died in London.

KEENS, A.W. fl.1855-1864
Exhib. two works, 'Fruit piece' and 'Chloe', at the BI in 1855, and a domestic scene at SS in 1864. London address.

KEENS, H.L. fl.1822-1859
Painted flowers. Exhib. eight works at the RA, including several paintings of flowers and works entitled 'The Female Dilettante' and 'The Reverie'. Exhib. eight works, the majority paintings of flowers, at SS, and five works at the BI. London address.

KEESON, A. fl.1847
Exhib. a work entitled 'The Temptation' at the BI in 1847. London address.

KEILOR, Miss Bertha fl.1896
Exhib. a work 'Off Lowestoft' at the RA in 1896. London address.

KEITH, Alexander fl.1846-1862
Exhib. two works, 'Juvenile Friends' and a portrait, at the RA; two works, 'Feeding-time' and a Scottish landscape, at the BI, and two works at SS. London address.

KEITH, Allan fl.1880
Exhib. a landscape in 1880. London address.

KEITH, Mrs. L.M. see PARSONS, Miss Letitia Margaret

KELL, Ellen fl.1877
Exhib. a watercolour of wallflowers at SS in 1877. London address.

KELL, J.S. fl.1868
Exhib. a watercolour entitled 'Cottage Scene, Hampstead' at SS in 1868. London address.

KELL, Thomas fl.1880
Exhib. two views of Swansea harbour at the RA in 1880. London address.

KELL, W.F. (or F.W.) fl.1875-1877
Exhib. a view of the Thames at Pangbourne and a watercolour view of a sunset on Woking Common at SS. London address.

KELLER, Miss B. fl.1877-1878
Exhib. a watercolour study at SS. Address in Spilsby, Lincolnshire.

KELLY, H. fl.1879
Exhib. a watercolour entitled 'A Garland from God's Acre' at SS. Address in Northamptonshire.

KELLY, John fl.1886
Exhib. a view of St. James's, Spanish Place, at the RA. London address.

KELLY, Robert George 1822-1910
Painted Irish and Scottish landscapes. Exhib. five works at the RA, including views in Kircudbrightshire and Wigtownshire. Exhib. portraits and landscapes at SS and three works, including 'An Ejectment in Ireland', at BI. Father of Robert George Talbot Kelly (q.v.). Born in Dublin. Died in Chester, Cheshire.
Bibl: Strickland.

***KELLY, Robert George Talbot RI RBA RBC 1861-1934**
Painted landscapes and figurative subjects in Egypt and Morocco. Exhib. 12 works, including a number of views in Cairo and works entitled 'The Shadow of the Great Rock in the Weary Land' and 'A Fishing Village in the Delta', at SS. Exhib. six works at the RA, 1888-1901, including a view of the Pyramids. Also painted in Burma, Iceland, Italy and France. Born in Birkenhead, the son of Robert George Kelly (q.v.). Lived in London.
Bibl: Connoisseur LXIX p.183ff.; Who's Who 1926.

KELLY, Tom fl.1888-1893
Exhib. ten landscapes at the NG 1888-93. Address in Newmarket, Suffolk.

KELSEY, Frank fl.1887-1923
Painted shipping and coastal, harbour and river scenes. Also painted flowers. Exhib. seven works at the RA 1887-1904, including 'The White Ship', and nine works at SS, including 'Barges at Chelsea', 'Still Lagoon', 'At Anchor' and 'The Lighthouse'. London address.
Bibl: Brook-Hart.

KEMM, Robert fl.1874-1885
London genre painter. Exhib. 13 works at SS between 1874 and 1885. Specialised in Spanish subjects in imitation of John Phillip and J.B. Burgess (qq.v.). 'Sleeping Priest' is in the Sunderland AG.
Bibl: Cat. of Sunderland AG 1905 p.6.

KEMP, A. fl.1865
Exhib. a work entitled 'Hallowed Ground' at SS in 1865. London address.

KEMP, Amy K.P. fl.1889-1890
Exhib. two works, 'The Marshes, Rye' and 'The Harbour, Polperro', at SS. London address.

KEMP, Mrs. Davidson (A.) fl.1867-1870
Exhib. two works, 'Al Pozzo' and 'Envy, Hatred and All Uncharitableness', at SS, and 'Thoughts of Home' at the RA. London address.

KEMP, Georgie W. fl.1886
Exhib. a painting of flowers at the NWS in 1886.

KEMP, John fl.1868-1876
Exhib. three watercolours, including 'The Fisherman's Return' and 'The Mourne Mountains from Greenmore', at SS. Address in Gloucester, where he taught at the Art School.
Bibl: VAM Cat.

KEMPE, Miss Harriet fl.1867-1892
London genre painter. Exhib. at RA, SS and elsewhere. Her pictures are mostly humorous. Titles at RA 'Return from the Ramble', 'The Cottage Door', 'The Torn Frock', etc.

KEMPLAY, Charles H. fl.1872
Exhib. a view of the Pont de Napoleon St. Sauveur, Hautes-Pyrénées at the RA in 1872. London address.

KEMPSON, Frederick R. fl.1861-1893
Painted views of buildings. Exhib. five works, four views of buildings in Herefordshire and one in Glamorgan, at the RA 1861-93. Address in Hereford.

KEMPSON, Miss M. Freeman fl.1868-1884
Painted watercolours of mountain landscapes. Exhib. 22 works at SS, including views of Snowdon and elsewhere in North Wales, the Isle of Skye and the Lake District. Address in Croydon, Surrey. She was a member of the Society of Lady Artists.

KEMPTHORNE, S. fl.1833-1840
An architect who also exhib. a view of Florence and a view of Rome at the RA. London address.

KEMP-WELCH, Miss Edith M. fl. from 1898
Painted portraits. Exhib. nine works at the RA 1898-1904, the majority portraits but also including a landscape on the Kentish Downs. Address in Bushey, Hertfordshire. She was the sister of L.E. Kemp-Welch (q.v.).

***KEMP-WELCH, Miss Lucy Elizabeth RI ROI RBA RCA 1869-1958**
Painted horses and country subjects. Studied under Herkomer at Bushey. Exhib. four works at the RA 1895-1904, including 'Gipsy Horse-drovers', 'Summer Drought: in the New Forest', 'Horse Bathing in the Sea' and 'Ploughing on the South Coast'. She took over Herkomer's School in Bushey in 1905. She was the sister of E.M. Kemp-Welch (q.v.).
Bibl: Who's Who; G.J. Poynter. *The National Gallery,* 1900; Sparrow; David Messum, *Lucy Kemp-Welch,* 1976.
Exhib: London, Arlington Gallery 1934, 1938.

KENDALL, Henry E. fl.1799-1843
An architect who exhib. views of buildings at the RA 1799-1843, including 'Conservatory at Wimpole Hall, the seat of the Earl of Hardwicke'. London address. He was the father of Henry Edward Kendall (q.v.).

KENDALL, Henry Edward c.1805-1885
An architect who exhib. views of buildings at the RA 1827-62, including 'Composition "A Vast Metropolis with Glistening Spires"' and 'Mansion in the Old English Style'. London address. He was the son of Henry E.Kendall (q.v.).
Bibl: Reynolds, VP.

KENDALL, J.G. fl.1843-1862
Painted landscape watercolours in Italy, France, Wales and England. Exhib. six works at the RA; 14 works at the BI, including

views in Venice, around Lake Maggiore and in Normandy, and 14 works at SS, including views at Knole Park and Cobham Park and coastal views in Normandy, Brittany and Norfolk. London address.

KENDRICK, Matthew RHA 1797-1874
Irish painter of coastal scenes and harbours. Exhib. three works at SS, including views in Fécamp and of the harbour at Scarborough, and three works at the BI and one at the RA. Born in Dublin. Died in London.

Bibl: Strickland; National Gallery of Ireland Cat., Dublin, 1920.

KENNEDY, Charles Napier 1852-1898
Painter of portraits, genre and mythological scenes. Studied at the Slade School, and at University College under E.J. Poynter (q.v.) who was to influence his work. Exhib. in London 1872-94 at RA, SS, GG, NG and elsewhere. At first exhib. mostly portraits and domestic scenes; later he turned to mythological and imaginative subjects, which he exhib. at the GG and NG. Typical titles 'Boy and Dryad', 'Neptune', 'Peace', etc. Works by Kennedy are in many provincial museums, including Leeds, Sheffield, Liverpool and Manchester. His wife was also a painter (q.v.).

Bibl: AJ 1890 pl.30; 1892 p.188; Strickland I.

KENNEDY, Mrs. Charles Napier fl.1886-1893
(Miss Lucy Marwood)
Exhib. three genre subjects at the NWS and six genre subjects at the NG. London address.

Bibl: See under Charles Napier Kennedy.

KENNEDY, David fl.1895
Exhib. a view of a garden pavilion on the edge of a lake at the RA in 1895. London address.

KENNEDY, Edward Sherard fl.1863-1890
London genre painter. Exhib. at RA, SS, NWS and elsewhere; also at the Paris Salon in 1880. Titles at RA include some historical genre: 'Louis XI, his One Good Deed', 'The Wolf in the Fold', 'Darby and Joan', etc. His wife was also a painter (q.v.).

KENNEDY, Mrs. Edward Sherard fl.1880-1893
(Miss Florence Laing)
Painted genre subjects. Exhib. four works, including 'Thinking it Over' and 'Love Me, Love My Dog', at the RA 1885-93. Also exhib. 'Autumnal Tints' at SS. London address. She was the wife of Edward Sherard Kennedy (q.v.).

KENNEDY, G. fl.1866
Exhib. a work entitled 'Up the Carnival' at the BI in 1866. London address.

KENNEDY, G.P. fl.1843-1851
An architect who exhib. views of buildings at the RA 1843-51, including 'Temple of Theseus, Athens' and 'View of Drummond Castle and Garden'. London address.

KENNEDY, H. Arthur fl.1875
Exhib. a mythological subject in 1875. London address.

KENNEDY, John fl.c.1855
Scottish landscape painter. Master of Dundee School of Art for a time. Examples are in VAM and National Gallery of Scotland.

KENNEDY, Joseph fl.1861-1888
Painted figurative and country subjects. Exhib. nine works at SS, including 'The Lay Brother' and 'The Crow-Boy's Dinner', both watercolours; four works at the RA, including 'Comfortable Quarters' and 'A Sketch in the Skullery', and one work at the BI. London address.

KENNEDY, S. fl.1868
Exhib. a view of a mansion near Leeds at the RA in 1868.

KENNEDY, Mrs. Sara fl.1897
Exhib. a work entitled 'Squally Weather' at the RA in 1897. London address.

KENNEDY, William 1860-1918
Painted landscape and genre subjects. Studied in Paris. Exhib. a work entitled 'Waiting to Mount Guard' at the RA, and three works at the GG. Worked in Stirling and Glasgow, and in the South of England. Represented in the Glasgow AG.

Bibl: D. Martin, *The Glasgow School of Painting,* 1902.

KENNEDY, William Denholm 1813-1865
Scottish history, genre and landscape painter. Born in Dumfries; came to London in 1830. Friend and pupil of William Etty (q.v.). Entered RA schools 1833. Won Gold Medal for historical painting 1835. Travelled in Italy 1840-2. Exhib. from 1833 at RA, BI and SS. At first a painter of historical scenes, Kennedy changed after his Italian journey to Italian genre and historical subjects. He also painted literary subjects from Byron, Spenser, Tasso, etc., domestic scenes, and landscape. His studio sale was held at Christie's, 10 and 11 July 1865.

Bibl: AJ 1865 p.235 (obit.); Redgrave, Dict.; DNB XX 1892 p.437; Bryan; Caw p.120; Cat. of National Gallery of Ireland 1920 p.64; Ormond.

KENNELL, W.H. fl.1872-1880
Painted watercolour still-lifes. Exhib. five works at SS, including 'An Entomological Corner', 'A Corner in the Studio' and 'Chrysanthemums'. London address.

KENNEY, Miss M.T. fl.1837-1840
Exhib. two portraits, the second of Miss Ellen Tree as Ginevra in the *Legend of Florence,* at the RA. Also exhib. a watercolour sketch at SS. London address.

*KENNINGTON, Thomas Benjamin RBA NEAC 1856-1916
London portrait and genre painter. Member of the SBA and also the Royal Institute of Painters in Oil. Exhib. 1880-1916 at the RA, also at SS, NWS and GG. Also exhib. at international exhibitions in Paris and Rome. Most of Kennington's subjects are scenes of upper-class life, especially mothers and children. Like John Collier (q.v.) he also painted psychological dramas of society life, with titles like 'Disillusioned'.

Bibl: AJ 1893 p.66; Connoisseur XLII 1915 p.253; RA Pictures 1891, 1893-5, 1897-1903,1905-16; Poynter, The Nat. Gall. III; Maas.

KENNION, Charles John 1789-1853
Landscape painter; son of Edward Kennion (1743-1790). Exhib. regularly at RA 1804-53, also at SS and elsewhere, subjects mostly views in his native Wales.

Bibl: Bryan; T.M. Rees *Welsh Painters,* 1912.

KENT, Miss Ethel A. fl.1896
Exhib. a portrait at the RA in 1896. Address in Margate, Kent.

KENWORTHY, Miss Esther fl.1881-1882
Exhib. two views of wallflowers at the RA and a watercolour of Marigolds at SS. London address.

KENWORTHY, John Dalzell ARCA 1858-1954
Painted portraits and landscapes. Exhib. in London, at the R.Cam. A. and in Liverpool. Worked in England, Scotland and France. Born and died in Whitehaven, Cumberland. Lived at St. Bees, Cumberland.

KENYON, Hon. E.F. fl.1879
Exhib. a work entitled 'Pillars of the House' at the RA, 1879. London address.

KENYON, George fl.1893-1896
Exhib. four views of buildings, including houses in Yorkshire, Suffolk and Lancashire. London address.

KER, W.A. fl.1874-1878
Exhib. a watercolour entitled 'The Politician' at SS. London address.

KERNOT, Mrs. James H. fl.1855-1856
Exhib. two oriental scenes in 1855-6. London address.

KERNS, Miss Miriam fl. 1874-1879
Exhib. four genre subjects, including 'Now Baby, Love Mamma' and 'It Takes Two to Make a Quarrel' at SS. London address.

KERR, Charles Henry Malcolm RBA 1858-1907
Painted portraits, landscapes and country subjects. Studied at the RA schools and at the Académie Julian. Exhib. 27 works at the RA 1884-1904, including 'Wargrave Church', 'The Oldest Inhabitant', 'An Academy Picture' and portraits. Exhib. 13 works at SS, including views in Whitby. Lived in London. His self-portrait is in the Tate Gallery.
Bibl: Tate Gallery Cat.; Cat. of the Works of Art belonging to the Corporation of London 1910; Ormond.

KERR, Frederick James b.1853
Painted landscapes. Studied at the Swansea School of Art and at the RCA. Exhib. in London and in the provinces. Lived at Barry, Glamorgan.

KERR, George Cochrane fl.1873-1906
London marine and seascape painter. Exhib. 1873-93 at RA, SS and NWS. Titles at RA 'The Cliffs of Dover', 'The Busy Thames', 'Greyhounds of the British Navy', etc.
Bibl: Brook-Hart.

KERR, Henry Wright RSA RSW 1857-1936
Painted portraits and figurative subjects in watercolour. Studied at the RSA Schools, Edinburgh. Exhib. six works, including 'His Day at the Plate', 'The Wearing of the Green' and 'Preparing for an Argument', at the RA. Worked in Scotland and Holland. He was influenced by Israels. Born and lived in Edinburgh.

KERR, Miss Margaret fl.1877
Exhib. three watercolours, including 'Grandmother's Pets' and 'A Highland Lassie', at SS. London address.

KERR, Robert 1823-1904
An architect who exhib. views of buildings, including Bearwood House, Berkshire, and the Berlin Parliament House, at the RA. London address.
Bibl: DNB 1912.

KERR, T. fl.1850
Exhib. a work entitled 'Irish Peat Gatherer' at the RA in 1850. London address.

KERR-LAWSON, James 1865-1939
Painted landscapes and portraits. Mural decorator and lithographer. Studied in Rome and Paris. Exhib. a work entitled 'Rigging the Model' at SS in 1890. Born in Anstruther, Fifeshire. Lived in Canada, Italy and London. Works by him were sold at Christie's, 21 July 1978.
Bibl: BM Cat. of Engraved British Portraits.
Exhib: London, Beaux-Arts Gallery 1948.

KERRY, William L. fl.1865-1881
Painted landscapes. Exhib. four works at the RA, including views in Borrowdale, Glyder Fawr and Formby, Lancashire. Also exhib. a Welsh landscape at SS. Address in Liverpool.

KERSEY, Miss A.M. fl.1830-1846
Exhib. a work entitled 'The Day after the Fair' at SS. Address in Framlingham, Suffolk.

KERSHAW, Miss Agnes fl.1898
Exhib. a work entitled 'Waiting' at the RA. Address in Sheffield, Yorkshire.

KESSISOGLU, Miss Esther fl.1891-1892
Exhib. two works, 'Anemones' and 'China Asters', at SS. London address.

KESWICK, William fl.1887
Exhib. a landscape in 1887.

KETCHLEE, Miss Nellie M. fl.1891-1892
Exhib. two works, 'Arrears of Correspondence' and 'Don't be Afraid', at SS. Address in Wadhurst, Sussex.

KETTLE, Sir Rupert Alfred 1817-1894
Lawyer and amateur painter. Exhib. one work, 'The Burial of Saul', at the BI in 1864, and another at the NWS. Address in Wolverhampton, Staffordshire.
Bibl: DNB; VAM.

KETTLEWELL, John William fl.1866
Exhib. a watercolour, 'Apple Blossom, Chaffinch and Nest' at SS. Address near Leeds, Yorkshire.

***KEYL, Friedrich Wilhelm 1823-1871**
Painted landscapes, animals and country subjects. Exhib. 42 works at the RA, titles including 'Donkey and Foal', 'Malvern Hills', 'Chewing the Cud' and 'Chinese Lap Dog, the property of Her Majesty'. Also exhib. 34 works, almost all paintings of animals, at the BI. Born in Frankfurt. Died in London. Pupil of Landseer, who introduced him to the royal family, for whom he painted many animal pictures.
Bibl: Redgrave, Dict; Wood, Paradise Lost.

KEYS, Miss Frances M. fl.1856-1877
Painted landscape watercolours. Exhib. 36 works, including views in Surrey and Devon. Also exhib. three works at the RA, including 'The Holly Tree Inn' and 'On the Addington Hills, Surrey'. Address in Mitcham, Surrey.

KEYS, G.F. fl.1889-1893
Painted landscapes. Exhib. four works, including 'Dreary Dartmoor' and 'In the Cuckmere Valley, Sussex', at SS, and two works, views on Guernsey and in the New Forest, at the RA. London address.

KEYS, George Scott fl.1856-1875
Painted landscape watercolours. Exhib. 24 works, including views in North Wales and works entitled 'The Stream', 'The Abandoned Road' and 'On the Hill Tops', at SS. Also exhib. one North Wales landscape at the RA. London address.

KIBBLER, W. Ambrose fl.1891
Exhib. a landscape at the NWS in 1891. London address.

KIDD, Joseph Bartholomew 1808-1889
Scottish landscape painter. Pupil of John Thomson of Duddington. One of the original ARSAs, becoming RSA in 1829. In 1836 he moved to London, and resigned from the RSA in 1838. He painted highland scenes and portraits, and became a drawing master at Greenwich.

KIDD, William RSA 1790-1863
Scottish genre painter. Studied under J. Howe, an animal painter, but was more influenced by the work of David Wilkie and Alexander Carse (qq.v.). Came to London and between 1817 and 1853 exhib. at RA, BI and SS. In 1849 he was elected HRSA and thereafter began to exhibit most of his work in Edinburgh. His scenes of Scottish life, pathetic or humorous, are in the Wilkie tradition, e.g. 'The Highland Reel', 1842, 'The Cottar's Saturday Night', 1845, and 'The Jolly Beggars', 1846. He also painted animals, portraits and still-life. Although a prolific and talented artist, Kidd was "quite unable to manage his worldly affairs" (Redgrave) and lived in continual poverty. Towards the end of his life he was supported by an Academy pension and the charity of his friends .
Bibl: Portfolio 1878 p.151ff.; Redgrave, Dict.; DNB XXXI 1892 p.95;Caw.

KIDDIER, William 1859-1934
Painted landscapes. Exhib. in London, at the RSA, the RHA and in the provinces. Lived in Nottingham.

KIDNER, William fl.1878-1888
Exhib. two paintings of banks at the RA. London address.

KIDSON, H.E. fl.1887-1888
Painted portraits and landscapes. Exhib. two landscapes at the NWS. Address in Liverpool. Represented in the Walker AG.

***KILBURNE, George Goodwin RI RBA 1839-1924**
London genre painter, watercolourist and engraver. Studied for five years with the Dalziel brothers, the engravers and illustrators. 1863 began to exhibit at RA. Elected member of NWS 1866. Exhib. at RA 1863-1918, SS, NWS, GG and elsewhere. Kilburne's work is mostly genre set in 17th century costume. Many of his pictures became popular through prints. His work is in the Walker AG Liverpool, and the Sheffield AG. Kilburne also painted many charming scenes of Victorian life. His son George Kilburne Jnr. (1863-1938) painted historical and domestic subjects in a very similar style and their work is often confused.
Bibl: Connoisseur LXX 1924 p.58 (obit.); Wood, Panorama; Wood, Paradise Lost.

KILBURNE, Miss S.E. fl.1871
Exhib. a watercolour entitled 'No Thoroughfare' at SS in 1871. Address in Hawkhurst, Kent.

KILLICK, T. fl.1864
Exhib. two works, 'Bird's Nest and Fruit' and 'A Dead Partridge', at the RA. Address in Petworth, Sussex.

KILPIN, Legh M. fl.1886-1896
Exhib. two works, 'A Cottage Corner' and 'A Well Discussed Subject', at the RA. London address.

KILVERT, Rev. Edward
Made a portrait drawing of Edward Bouverie Pusey which is reproduced in H.P. Liddon's *The Life of Edward Bouverie Pusey*.

KILVINGTON, George 1858-1913
Painted landscape, often including buildings. Born at Hartlepool, County Durham. Lived and worked in Northumbria.
Bibl: Hall.

***KINDON, Miss Mary Evelina fl.1879-1918**
Painter of domestic genre portraits and landscapes. Lived in Croydon and Watford. Exhib. at RA 1879-1918, SS, NWS, and also at the Paris Salon of the Société des Artistes Français 1904-14. Titles at RA 'Free Seats', 'A Cosy Party', 'The Song Went to her Heart', etc. Often painted mothers and children, and seems to have been fond of painting girls in white dresses.

KING, Miss Bertha fl.1900
Exhib. a painting of wild parsley at the RA in 1900. Address in Shoreham, Kent.

KING, Charles Robert Baker fl.1885-1895
Exhib. three views of churches, including one in Southwark, London, and another in Ceylon, at the RA 1885-95. London address.

KING, Mrs. E. Brownlow see BROWNLOW, Miss Emma

KING, Edward fl.c.1900-1930
Painted landscapes and rivers. Lived at East Molesey, Surrey.

KING, Edward R. fl.1884-1904
Painted figurative and country subjects. Exhib. 21 works at the RA, including 'Blessed are they that Give to the Poor', 'The Haymaker' and 'Milking Time', 1888-1904. Also exhib. four works, two village scenes, a portrait and a view in the King's Road, Chelsea, at the RA. Address in Petersfield, Hampshire.

KING, Miss Elizabeth Thomson fl.1883-1901
Painted portraits and figurative subjects. Exhib. three portraits at the RA 1883-1901, and four works, including 'Fishing Boats: Venice' and 'Capuchin Monk', both watercolours, at SS. Also exhib. two works at the NWS. London address.

KING, Miss Ethel Slade fl.1884-1896
Painted portraits. Exhib. 24, the majority portraits, but also including 'The Creation of Eve', at the RA 1884-96. London address.

KING, F.H. fl.1873
Exhib. a work entitled 'From Our Back Door' at SS in 1873. London address.

KING, Frank G.W. fl.1893-1900
Exhib. a work 'When Autumn Leaves are Falling' at SS in 1893-4. London address.

KING, Fred fl.1889-1891
Exhib. a work entitled 'Roadside Pasture' at SS in 1891-2. Address in Lambourne, Berkshire.

KING, H.B. fl.1874-1875
Exhib. a watercolour of the Mosque of Kait Bey, Cairo, at SS, 1874-5. Address in Norwich, Norfolk.

***KING, Haynes RBA 1831-1904**
London genre and landscape painter. Born in Barbados. Came to London in 1854. Studied at Leigh's Academy. In 1857 began to exhibit at SS, of which he became a member in 1864. Also exhib. at RA 1860-1904, BI and NWS. King shared a house with Thomas Faed (q.v.), who had a considerable influence on his style. Later he lived with Henry John Yeend King (q.v.) who was no relation. His genre scenes are usually cottage interiors with figures, in the manner of Faed, e.g. 'The Lace Maker', 'Jealousy and Flirtation', etc. He also painted landscapes and coastal scenes. Works by King are in the VAM, Bethnal Green Museum, and Leeds AG.
Bibl: AJ 1904 p.272; DNB 2nd Supp. II p.401; H. Blackburn, *English Art in 1884,* p.288, RA Pictures 1892, 1893, 1896; Academy Notes 1879, 1880, 1881; The Times 21 May 1904; Reynolds, VP (pl.132).

KING, Henry fl.1839-1846
Painted flowers and landscapes. Exhib. six works at SS, titles including 'Flowers', 'Fruit' and 'On the Llanberis side of Snowdon' Also exhib. a 'Lane Scene' at the BI. London address.

***KING, Henry John Yeend RBA VPRI ROI 1855-1924**
London landscape and rustic genre painter. Worked for three years in a glassworks. Studied under William Bromley (q.v.), and also with Bonnat and Cormon in Paris. Exhib. 1874-1924 at RA, SS, NWS, GG, RI 1886, later VP. Elected RBA 1879, RI 1886, later VP. Also member of Royal Institute of Oil Painters. In 1898 his picture of 'Milking Time' was bought by the Tate Gallery. Yeend King was a typical late Victorian painter of rustic genre, often garden scenes with pretty girls, but his robust *plein air* technique and bold colours reflect his Paris training. Works by him are in the Tate, the Walker AG, Reading, Rochdale and Sheffield Galleries. He was married to the sister of Robert Gallon's (q.v.) wife.
Bibl: AJ 1897 p.374; 1898 p.182; RA Pictures 1892-5, 1897-1904, 1906-8, 1910-15; Cat. International Exhibition, Rome, 1911; Who's Who 1924; Wood, Paradise Lost.

KING, J.W. fl.1838-1853
Painted portraits, many of them of children. Exhib. ten works at the RA, including 'The Infant Chief', 'The Sick Child' and 'The First Prayer'. Also exhib. six works at SS and six works at the BI. London address.

KING, J. Arthur fl.1876-1885
Exhib. two works, 'Hark! How the Sacred Calm that Breathes Around' and 'Newnham', at the RA, and two works, 'The Justice' and 'Two-a-Penny', at SS. London address.

KING, Miss Jesse Marion 1875-1949 (Mrs. Taylor)
Scottish illustrator, most of whose work falls outside the Victorian period. She illustrated many books, and produced pen and ink drawings of fairy-tale princesses in a very personal decorative style, derived from Beardsley and others.
Bibl: Cedric Chivers, *Books in Beautiful Bindings,* Bath c.1910.

KING, John 1788-1847
Painter of biblical and historical genre, and portraits. Exhib. at RA 1821-84, BI 1814-45, and SS. Worked in London, and also in Bristol where he painted several religious works for churches, as well as portraits of local notables.
Bibl: AU 1847 p.413 (obit.); Redgrave, Dict.; DNB XXXI 1892 p.141, Cust NPG II 1902 p.161; Ormond.

KING, John Baragwanath 1864-1939
Painted landscapes. Trained as an engineer before becoming a painter. Exhib. in London and Paris. Lived at St. Austell, Cornwall.

KING, Captain John Duncan 1789-1863
Landscape painter. Entered the army in 1806, and served in France, Spain and Portugal. After the peace of 1815 turned to painting. Exhib. at RA 1824-58, BI and SS. Studied with Horace Vernet in Paris 1824. Subjects mostly views in Germany, Spain, Portugal and Ireland. Also known to have copied Claude Lorraine. After 1852 lived at Windsor as a 'Military Knight'.
Bibl: AJ 1863 p.198 (obit.); Redgrave, Dict.; DNB XXXI 1892 p.141.

KING, John Lockwood fl.1880
Exhib. a view of Tiffin's School, Kingston-upon-Thames at the RA in 1880. London address.

KING, John W. fl.1893
Exhib. a work entitled 'The Smithy', at SS in 1893. London address.

KING, Miss Katherine fl.1869
Exhib. a painting of game in 1869. London address.

KING, Miss Lydia B. fl.1886-1890
Exhib. two works, ' "Maiden with the Meek Brown Hair" ' and 'Roses', at the RA, and a watercolour of poppies at SS. London address.

KING, Thomas R. fl.1839-1846
Painted watercolour landscapes. Exhib. 15 works at SS, titles including 'Ramsgate Pier and Royal Harbour', 'Eton from the Thames' and 'Ulcombe Church, near Sutton Valence, Kent'. London address.

KING, Mrs. Thomas R. fl.1848
Exhib. two watercolours, 'A Scene from Eugène Aram' and 'Near Newbury, Berkshire', at SS. London address.

***KING, William Gunning- 1859-1940**
Painted figurative subjects. Exhib. 16 works at the RA, including 'Strawberry Gatherers', 'The Love Letter' and 'An Interrupted Elopement'. Exhib. four works, including 'The Young Cavalier' and 'Feeding Pigeons', at SS. Lived near Petersfield, Hampshire.
Bibl: Wood, Paradise Lost.

KING, William Joseph ARBSA b.1857
Painted landscapes and marines. Exhib. at the RBSA 1885-1943, also at the R. Cam. A. and RSA. Titles include 'Harvest near the Sea' and 'Evening at Anglesey'. Lived in Birmingham.

KINGDON, Walter fl.1879
Exhib. a work entitled 'A Pompeian' at the RA in 1879 and another at the GG. London address.

KING-SALTER, P. fl.1877
Exhib. a work entitled 'The Captain's Boots' at the RA in 1877 and another at the GG. Address in Rome.

KINGSBURY, T.U. fl.1874-1878
Painted coastal landscapes. Exhib. seven works at SS, including 'The Goodwin', 'On the Beach near Hastings — Mist clearing off' and 'Driving Ashore — A Sketch on the West Coast of Ireland'. London address.

KINGSLEY, Miss Lydia fl.1890-1896
Painted still-lifes. Exhib. four works at the RA, including 'Dead Birds' and 'Purple Plums'. Also exhib. one work at SS and three at the NWS. London address.

KINGSTON, Gertrude A. fl.1887-1888
Exhib. a work entitled 'Rosa' at SS in 1887-8. London address.

KINGSTON, James A. fl.1890
Exhib. a view of a mountain stream, Ogwen, North Wales, at SS in 1890. London address.

KINGSTON, Miss S. fl.1843
Painted watercolour still-lifes. Exhib. four watercolours at SS, including 'Bird and Grapes' and 'A Study from a Garden Wall'. Also exhib. a painting of flowers at the RA. London address.

KINNAIRD, F.B.S. fl.1865-1875
Exhib. two works, 'Fondly Gazing' and 'The Reverie', at the BI. London address.

KINNAIRD, F.G. fl.1864-1881
Painted figurative and country subjects. Exhib. 12 works at SS, including 'The Sea-side Belle', 'Going to the Masquerade' and 'Grandfather's Luggers'. Also exhib. a work at the BI and another at the RA. London address.

***KINNAIRD, Henry John fl.1880-c.1920**
Painted landscapes and river scenes. Exhib. nine works at the RA, including 'The Tow-path near Henley', 'The Thames near Pangbourne' and 'The Old Mill, Burnham, Essex'. Exhib. eight works at SS, including 'Near Epinet, on the Seine' and 'On the River Lea, Essex'. Lived at Ringmer, near Lewes, Sussex. Painted in a broad, naturalistic style, at times similar to J. Horace Hooper (q.v.).

KINNAIRD, T.J. fl.1874
Exhib. two works, 'Only a Penny a Bunch' and 'The Mountain Spring' at the RA. London address.

KINNEAR, James fl.1880-1892
Painted landscapes. Exhib. four works at the RA, including 'March', 'The Year's Decline' and 'The Opening Year'. Also exhib. a work at the NWS. Address in Edinburgh.

KINNEBROOK, W.A. fl.1843-1863
Painted landscapes and views of architecture. Exhib. six works at the RA, including views in the Lake District and Norfolk, and views in Westminster Abbey. Exhib. seven works, including 'Dancing Girls Reposing' and 'On the Beach, Ryde, Isle of Wight', at SS, and one work at the BI. London address.

KINSETT, J. fl.1848
Exhib. a work 'Reminiscences of Italy' at the RA in 1848. London address.

KINSLEY, Albert RI RBA RCA 1852-1945
Painted landscapes in oil and watercolour. Exhib. 21 works at the RA 1882-1901, titles including 'Down by the Running Brook',

'An Old Farmstead' and 'On the Fringe of the Moor'. Exhib. 45 works at SS 1881-94, titles including 'Decline of the Year', 'A Wooded Slope' and 'Hoar Frost in the Woods'. Also exhib at the NWS and the GG. Born in Hull, Yorkshire. Moved to live in London in 1876.
Bibl: AJ 1896 p.158; 1900 p.185; Leeds City AG Cat. 1909; Who's Who 1926.

KINTON, Miss Florence fl.1884
Exhib. a work entitled 'Bobbie' at the RA in 1884. Address in Malvern, Worcestershire.

KIRBY, Edmund fl.1877-1896
Exhib. five views of buildings, four of them churches in Cheshire and also Duncombe Park, near York, at the RA. Address in Liverpool.

KIRBY, J.R. fl.1877-1878
Exhib. four marines, 1877-8. London address.

KIRK, C. fl.1850
Exhib. a view of Eastwell Hall, the seat of the Earl of Winchester, at the RA in 1850. Address in Sleaford, Lincolnshire.

KIRKALDY, D. fl.1861
Exhib. a work entitled 'Naval Architecture; Royal Mail Steamship *Persia'* at the RA in 1861. Address in Glasgow.

KIRKBY, Thomas fl.1796-1847
Painted portraits and occasional figurative subjects. Exhib. 43 works at the RA 1796-1846. The great majority of the later works were portraits. Also exhib. 12 landscapes and figurative subjects at the BI 1808-47, titles including 'Gipsies: a Night Piece' and 'Purse Bay on Ullswater'. Addresses in London and Lichfield, Staffordshire.
Bibl: Poole 1912-15; BM Cat. of Engraved British Portraits.

KIRKPATRICK, Miss Ethel fl.1891-c.1941
Painted landscapes and marines. Also made woodcuts. Exhib. 11 works, including some watercolours, at SS, titles including 'A Summer Haze' and 'Becalmed'. Also exhib. six works, including 'Moonrise', 'Phyllis' and 'Day Dreams', at the RA 1895-1904. Studied at the RA Schools, at the Central School of Arts and Crafts and at the Académie Julian. Born in Jersey. Lived at Harrow, Middlesex. Sister of Ida Kirkpatrick (q.v.).
Bibl: Studio XXXVI p.156; LVIII p.296ff.

KIRKPATRICK, Miss Ida Marion fl.1888-c.1935
Painted coastal scenes and landscapes in watercolour. Studied at the Royal Female School of Art and at the Académie Julian in Paris. Exhib. 12 works at SS, titles including 'When Evening Cometh On', 'The Pier Lamp', 'The Gladstone' and 'A Cornish Quay'. Also exhib. in the provinces. Born in Jersey. Lived at Harrow, Middlesex. She was the sister of Ethel Kirkpatrick (q.v.).
Bibl: See under Ethel Kirkpatrick.

***KIRKPATRICK, Joseph b.1872 fl.1898-1928**
Landscape painter, watercolourist and engraver. Born in Liverpool, where he studied at the School of Art under John Finnie (q.v.); also studied at the Académie Julian in Paris under Bouguereau and Gabriel Ferrier. Exhib. at RA 1898-1928 and elsewhere. Two works by him are in the Walker AG Liverpool.
Bibl: Connoisseur XLV p.187; Wood, Paradise Lost.

KIRKPATRICK, Miss Lily fl.1897-1898
Exhib. three works, including 'Mother and Child' and 'A Quiet Hour', at the RA 1897-8. Address in St. Ives, Cornwall.

KIRKPATRICK, W. fl.1841
Exhib. two landscapes at SS in 1841. London address.

KIRKUP, Seymour Stocker 1788-1880
Amateur artist and connoisseur. Studied at RA schools. Made portrait drawings, including those of John Gibson and Joseph Severn. Lived in Italy.
Bibl: Ormond.

KIRWAN, William Bourke b.c.1814 fl.1836-1846
Landscape painter of rustic scenes in the Morland vein, who exhib. in Dublin and London 1836-46.

KISTE, Adolph b.1812 fl.1840
Exhib. three works, two pastel portraits and a view of St. Anthony's Chapel, Edinburgh, at SS. Born in Hamburg. Lived in London.

KISTE, J.A. fl.1844-1846
Exhib. two works, including a scene in Glencoe, at the RA. Address in Plymouth, Devon.

KITCHEN, Miss E.M. fl.1850-1852
Painted still-life watercolours. Exhib. four watercolours at SS, including 'Flowers and Fruit from Nature' and 'Flowers and Grapes'. London address.

KITCHEN, T.S. fl.1833-1852
London landscape painter. Exhib. 1833-52 at RA, BI and SS. Mostly views on the Thames, or in Kent and Essex.

KITSELL, Thomas R. fl.1898
Exhib. two works, views of the Plymouth Citadel and the Soldiers and Sailors Institute, Devonport, at the RA. Address in Plymouth, Devon.

KITSON, Miss Catherine M. fl.1886-1892
Exhib. a work entitled 'Kismet' at the RA and a watercolour entitled 'Eschscholtzia' at SS. London address.

KITSON, Robert L. fl.1890-1891
Exhib. three works, 'Un Rendez-vous', 'Drummer' and 'An Amateur Critic', at the RA. Address in Huddersfield, Yorkshire.

KITTON, Frederick George fl.1886-1887
Painter of London views; exhib. at Norwich Art Circle in 1886-7. Also illustrated the works of Dickens.
Bibl: Anon, *F.K. a Memoir*, 1895.

KLEIN, Miss A. fl.1887
Exhib. a painting of roses at the RA in 1887. London address.

KNAGGS, Miss Nancy fl.1887-1893
Painted coastal subjects and marines. Exhib. three watercolours, two of them views in Whitby, at SS, and 'A Squall, deep lowering, blots the Southern Sky' at the RA. London address.

KNAPPING, Miss Edith M. fl.1877-1878
Exhib. a work, entitled 'The Twins', at the RA in 1877. Address in Blackheath, London.

KNAPPING, Miss Margaret Helen fl.1876-d.1935
Painted flowers and landscapes. Studied under E. Aubrey Hunt, in England, France and Belgium. Exhib. 13 works at SS, including 'Bowl of Roses', 'Azaleas' and 'Parma Violets and Acacia'. Also exhib. three works, a painting of azaleas and two landscapes in Cornwall, at the RA 1880-1904. Lived in London, also at St. Ives in Cornwall, and was a member of the St. Ives Society of Artists.

KNEEN, E.W. b.1866
Painted landscapes. Exhib. chiefly in Lancashire. Born in Liverpool. Lived at Hale, Liverpool, and was a member of the Liver Sketching Club.

KNEEN, William RBA NEAC 1862-1921
Painted landscapes. Studied under Frederick Brown (q.v.). Exhib. a view of the beach at Southend at SS and two works, 'A Negro' and 'Rustic Beauty' at the RA. Born on the Isle of Man. Lived at Richmond, Surrey.
Bibl: Who's Who 1921; The Year's Art 1922 p.312.

KNELL, Adolphus
Painted marines. Brook-Hart suggests that he was the son of W.A. Knell (q.v.).
Bibl: Brook-Hart pls. 98 and 99.

***KNELL, William Adolphus c.1805-1875**
London marine painter, probably father of William Callcott Knell (q.v.). Exhib. mainly at BI 1825-67, also at RA 1825-66, and SS. Most of his subjects are views on the English coast; he also painted the French, Belgian and Dutch coasts. In 1847 his 'Destruction of Toulon 1793' won a 2nd prize in Westminster Hall competitions. For Queen Victoria he painted 'The Landing of Prince Albert at Dover' and The Review of the Fleet at Spithead'. He also illustrated a book on naval history. Works by Knell are in the National Gallery, Edinburgh, Derby and York AGs.
Bibl: AU 1847 p.269; AJ 1857 p.269; 1860 p.80; Redgrave, Dict.; Bryan; DNB XXXI 1892 p.240; S.T. Prideaux. *Aquatint Engraving*, 1919 pp.152, 376; Wilson p.49 (pl.20); Brook-Hart pl.97.

KNELL, William Callcott fl.1848-1879
London marine painter, probably son of William Adolphus Knell (q.v.). Exhib. 1848-65 at RA, BI and SS. His output was smaller than that of his father, and of poorer quality.
Bibl: Wilson p.49 (pl.20); Brook-Hart pl.18.

KNEWSTUB, Walter John 1831-1906
Genre painter and watercolourist. Met D.G. Rossetti in 1862 and became his first studio assistant. Through Rossetti met Ford Madox Brown, W.M. Rossetti (qq.v.) and Theodore Watts-Dunton. Worked on 12 frescoes in Manchester Town Hall 1878-93. Exhib. 1865-81 at RA and SS. In his early days he also did humorous drawings and caricatures. His daughter married William Rothenstein.
Bibl Studio XXXVIII 1906 p.238 (obit.); W.M. Rossetti, *Some Reminiscences*, III 1906; John Rothenstein, *W.J.K.*, Artwork Vol.IV 1930 p.87; references in Rossetti literature.

KNEWSTUB, W. Holmes fl.1881-1884
Exhib: three landscapes in 1881-4. London address.

KNIGHT, Miss Adah fl.1893
Painted figurative subjects. Exhib. at the RA from 1893, titles including 'A Little Girl', 'A Game of Chess', 'Pansey' and portraits. Address in Gloucester.

KNIGHT, Adam fl.1892-d.1931
Painted landscape watercolours. Exhib. a view of the Pass of Achray at SS, and two works, 'Snowdon — Early Spring' and 'A Road between two Hamlets' at the RA 1899-1900. Also exhib. at the R. Cam. A., RWA and in Liverpool. Lived at West Bridgford, Nottinghamshire.

KNIGHT, Alfred E. fl.1879
Exhib. a painting of fruit at SS. London address.

KNIGHT, Arthur W. fl.1900
Exhib. a view in Cortina at the RA in 1900. London address.

KNIGHT, C. fl.1892
Is supposed to have exhib. a landscape at the RA in 1892. Address in Chester, Cheshire.

KNIGHT, C.J. fl.1844
Exhib. a view of a pulpit in a church in Wolverhampton at the RA in 1844. London address.

KNIGHT, Charles Neil b.1865 fl.1899
Painted genre subjects. Studied in Paris at the Académie Julian. Exhib. two works, 'The Captive' and a landscape at SS, and two works, 'A Sister of St. Vincent de Paul' and 'Polynices', at the RA. Also exhib. in Liverpool. Lived in Bath, Somerset. He was the secretary of the Bath Society of Artists.
Bibl: Poole 1925.

KNIGHT, Charles Parsons 1829-1897
Bristol landscape and marine painter. At an early age was making drawings of ships in Bristol harbour. Went to sea as a sailor, and on his return studied at the Bristol Academy. Exhib. in London, 1857-95 at RA, BI, SS and NG. Subjects coastal landscapes, and studies of sea and sky. Several of his works are in Bristol AG.
Bibl: Bryan; Poynter, Nat. Gall. Cat. III; Studio Special Number 1919, *British Marine Painting*, pp.28 65; Bristol AG Cat. 1910; Brook-Hart.

KNIGHT, Miss Clara RCA c.1861-1899
(Mrs. Beswick)
Painted trees and landscapes, largely in watercolour. Studied at Manchester School of Art. Exhib. six works, including 'Autumn Mist', 'Last Leaves' and 'October on the Thames', at the RA, and seven works, including 'Young Birch Trees' and 'In the Wood', at SS. Lived in London and Deganwy, North Wales. She was the daughter of Joseph Knight, RI, (q.v.) and the wife of Frank Beswick.

KNIGHT, Frederick George fl.1877-1892
An architect who also exhib. views of buildings at the RA 1877-92, including 'Christchurch Priory Church, Hampshire' and 'Houses in Cadogan Gardens'. London address.

KNIGHT, G.J. fl.1878
Exhib. a landscape in 1878. London address.

KNIGHT, Harold RA ROI RP 1874-1961
Painted portraits, shipping, interiors and coastal subjects. Studied at the Nottingham School of Art, at the RCA, and in Paris under Laurens and Constant. Exhib. ten works at the RA 1896-1904, including 'The Last Cable', 'Toilers of the Deep' and 'Unloading Herrings'. Born in Nottingham. Lived at Staithes, Yorkshire, in Holland, Newlyn, Cornwall and finally in Colwall, Herefordshire. Married to Laura Knight (q.v.).
Bibl: *The Art of Harold and Laura Knight,* Studio LVII p.183ff.; P. Phillips, *The Staithes Group,* 1993.

KNIGHT, Henry Hull fl.1863-1877
Exhib. four works, including 'Lynmouth Harbour, Low Water', 'Absent Thoughts' and 'Aylesford on the Medway', at SS. London address.

KNIGHT, James P. fl.1849-1867
Exhib. two works, including a painting of fruit, at the BI and two works, both landscapes, at SS. London address.

KNIGHT, John Baverstock 1788-1859
Amateur and connoisseur. Painted landscapes in oil and watercolour, also etchings and miniatures. An exhibition of his work was held at the Goupil Gallery, London, in 1908. A sale of his works and furniture was held by Baker & Ensor in 1859.
Bibl: Rev. F. Knight, *J.B.K.,* 1908; D.S. MacColl, Burlington Mag. May 1919; Dorset Year Book XXI 1925.

KNIGHT, John Prescott RA 1803-1881
London portrait and genre painter. Born in Stafford, son of an actor. Studied at Sass's Academy, and with George Clint. Exhib. at RA 1824-78 (227 works), BI and SS. Elected ARA 1836, RA 1844. Member of RA Council, and later Professor of Perspective and Secretary. Knight painted many of the leading men of the Victorian age, many large portrait groups, and institutional portraits. His genre pictures were usually of literary subjects, or rustic scenes, smugglers, etc. Many of his portraits were engraved. His wife (q.v.) was a genre painter. His studio sale was held at Christie's, 2 July 1881.
Bibl: AJ 1849 p.209; 1881 p.159 (obit.); W. Sandby, *History of the RA,* 1861 II; Bryan; Poynter, Nat. Gall. Cat. 1899 III; Poole II 1925; BM Cat. of Engraved British Portraits III-V; L. Cust, NPG Cat. 1901 II; Hutchison, see index (pl.29); Ormond; Stafford Historical and Civic Society, *John Prescott Knight: A Catalogue,* 1971.

KNIGHT, Mrs. John Prescott fl.1832-1837
Painted still-lifes and figurative subjects. Exhib. three works, including 'The Dressing Table', at the BI; three works, including 'A Cabinet Picture' at SS, and two works at the RA. London address.

KNIGHT, John William Buxton RBA RCA RE 1843-1908
Landscape painter and watercolourist. Although his father William Knight was a landscape painter, Buxton Knight was virtually self-taught. Painted in the woods and parks around Sevenoaks, Kent. Exhib. at RA 1861-1907, SS, GG, NG and NEAC. Also at Berlin and Paris Internationals. Knight's landscapes are a fusion between the English landscape tradition of Constable, Cox and de Wint, and the techniques of the Barbizon School. One of his finest works 'December Landscape' was bought by the Tate Gallery in 1908.
Bibl: Mag. of Fine Arts II 1906 pp.159-68; Studio XLII 1908 pp.278-92; AJ 1907 p.43; 1908 p.120; Burlington Mag. XXXI 1917 p.9; Connoisseur LVIII 1924 p.47; The Year's Art 1909 p.406; RA Pictures 1892-1907; Cundall; Morning Post 17 February 1908.
Exhib: London, St. George's Gallery, *Paintings and Drawings Illustrative of the Life-work of J.W. Buxton-Knight* 1899.

KNIGHT, Joseph RI RCA ARPE 1837-1909
Manchester landscape painter. Self-taught artist. Exhib. in London 1861-1908 at RA, NWS, GG and elsewhere. Exhib. mainly at Society of Painters and Etchers, and in Manchester. Subjects usually rather sombre Welsh landscapes, with titles such as 'Cloud and Crag', 'Conway Marsh', etc. 'A Tidal River' was bought by the Tate Gallery in 1877. Father of Clara Knight (q.v.).
Bibl: AJ 1909 p.94 (obit.); RA Pictures 1897, 1905, 1908; Poynter, Nat. Gall. III 1900.

KNIGHT, Joseph b.1870
Painted landscapes. Studied in Paris. Born in Bolton, Lancashire. Lived in Bury, Lancashire. He was the headmaster of Bury School of Art.

KNIGHT, Dame Laura RA RWS 1877-1970
Painter and watercolourist. Born Laura Johnson in Derbyshire; studied at Nottingham School of Art. Married Harold Knight (q.v.) also a painter, in 1903, and together they joined the Staithes Group in Yorkshire. Later they moved to Newlyn in Cornwall. Dame Laura's output was varied, but she loved to paint and draw the circus, the ballet, and the theatre. She also painted figures and landscape in a breezy and colourful impressionist style. Elected ARWS 1919, RWS 1928, ARA 1927, RA 1936, the first woman RA since the 18th century. Wrote two autobiographical works *Oil Paint and Grease Paint* 1936, and *The Magic of a Line* 1965.
Bibl: For full bibl. see Caroline Fox, *Dame Laura Knight*, 1988; P. Phillips, *The Staithes Group*, 1993.

KNIGHT, Mary fl.1871-1876
Exhib. two watercolour views of Knole in Kent at SS. Address in Sevenoaks, Kent.

KNIGHT, Paul fl.1883-1891
Exhib. two paintings, 'Hard Up' and 'Pandy Mill', and an engraving at the RA. Also exhib. a landscape at SS. London address.

KNIGHT, Valentine fl.1871
Exhib. a landscape in 1871. Address in Folkestone, Kent.

KNIGHT, W.F. fl.1841
Exhib. a view of the Church of the Crucifixion, St. Miniato, Florence, at the RA in 1841. London address.

KNIGHT, W.S. fl.1860-1861
Exhib. two views at Knole Park at SS. Address in Sevenoaks, Kent.

KNIGHT, William fl.1807-1845
An architect who exhib. views of buildings at the RA, 1807-45, including Knole Park, Kent and the cathedral in Barcelona. Addresses in London and Sevenoaks, Kent.

KNIGHT, William fl.1829-1846
Painted landscapes. Exhib. 15 works at SS, some of them watercolours, subjects including 'Landscape with Gipsies', 'Beeches, Knole Park' and 'Rochester Castle, Kent'. Address in Chelmsford, Essex.

KNIGHT, William b.1871
Painted landscapes and genre subjects. Studied at the Leicester School of Art and at Heatherley's. Exhib. in London, the provinces and abroad, titles including 'Midnight Pastoral' and 'Silvery Morning'. Lived in Leicester. Taught at the Leicester School of Art.

KNIGHT, William George fl.1896-d.1938
Painted portraits and landscapes. Studied at the RCA and in Paris. Exhib. two portraits and a landscape, 'Evening — Avranches', at the RA 1896-1901. Address in Weston-Super-Mare, Somerset.
Bibl: Who's Who 1924.

***KNIGHT, William Henry 1823-1863**
Genre painter. Gave up career as a solicitor to become a painter; came to London in 1845, and entered RA schools. At first a portrait painter. Exhib. at RA 1846-62, BI and SS. Later turned to humorous and pathetic genre scenes, usually of children. His pictures are mostly of small size. Some of his best works were 'Boys Snowballing', 1853, 'The Young Naturalist', 1857, and 'The Lost Change', 1859.
Bibl: AJ 1861 p.l95; 1863 pp.113-15; 1865 p.240; Redgrave, Dict.; Wood, Paradise Lost.

KNIGHT, William Henry b.1859
Painted portraits and genre subjects. Studied at Birmingham Municipal School of Art, at the RCA and in Paris and Italy. Exhib. in London and the provinces. Born in Birmingham, he was headmaster of Northampton School of Art and later Principal of Penzance School of Art.

KNOECHL, Hans fl.1894
Exhib. a work entitled 'The Favourite Song', at the RA in 1894. London address.

KNOTHE, Alice fl.1873
Exhib. a figurative subject in 1873. Address in Dresden, Germany.

KNOWLES, Davidson RBA fl.1879-1896
London genre painter. Exhib. mainly at SS, where he was a member; also at RA and elsewhere. Titles at RA include 'My Mother', 'The Tea Girl', 'Private and Confidential', etc.

KNOWLES, Frederick J. b.1874
Painted landscape and figurative subjects. Studied at the Cavendish School of Art. Exhib. in London, at the R. Cam. A. and in the provinces. Born in Manchester. Lived near Oswestry, Salop.

KNOWLES, G. fl.1845-1848
Exhib. three views of monuments in Athens, including the Parthenon and the Temple of Minerva, at the RA. London address.

KNOWLES, G.T. fl.1853
Exhib. a view of the ruins of St. Martin le Grande, Dover at the BI. Address in Dover, Kent.

***KNOWLES, George Sheridan RI RBA ROI RCA 1863-1931**
London genre painter and watercolourist. Exhib. 1885-93 at RA, SS and NWS, and at RCA in Manchester. Subjects mostly sentimental genre scenes set in the middle ages, the 18th century, or the Empire. Titles at RA 'The Wounded Knight', 'The Love Letter', 'Home Again', etc. Works by Knowles are in Oldham and Nottingham AGs.
Bibl: AJ 1901 p.l17; RA Pictures 1891-2, 1894-8, 1903-7, 1914-15; Cundall p.173.

KNOWLES, James Thomas fl.1843-1860
Exhib. four views of buildings, including Silverton Park, Devon, and the Grosvenor Hotel, Victoria Station, at the RA. London address.

KNOWLES, Miss Juliet fl.1888
Exhib. a painting of apples and plums at the RA. Also exhib. a work at the NWS. Address in Manchester.

KNOWLES, William Pitcairn fl.1882-1892
Painted landscapes. Exhib. five works at SS, including 'The Haven Houses near Christchurch' and 'Morning: On the Swale'. Also exhib. two works at the RA, five at the NWS, and two at the NG. Address in Christchurch, Hampshire.

KNOX, Archibald 1864-1933
Landscape painter and teacher. Founder of the Knox Guild of Design and Crafts, and lived in Douglas, Isle of Man, from 1895.
Bibl: Winifred Tuckfield, *Archibald Knox*, 1963.

KNOX, B.D. fl.1873-1878
Exhib. three works, including 'A Ship on Fire in the Downs' and 'A Ground Swell off Ushant', at the RA. Address in Caversham, Kent.
Bibl: Brook-Hart.

KNOX, George James 1810-1897
Painted landscape watercolours. Exhib. 20 watercolours at SS, including views on the Isle of Wight, Lundy Island and views on the Thames. Also exhib. nine works, including 'View near Perigeux' and 'On the Thames near Putney', at the RA. London address. Examples are in Capetown AG.

KNOX, John 1778-1845
Scottish landscape painter. Pupil of Alexander Nasmyth (q.v.). Exhib. six works at the BI, including 'Fall of Bonnington on the Clyde' and 'Glencoe, Scotland'. Also exhib. at RA and SS, all views in Scotland and the Lake District. Knox was the subject of a special exhibition in Glasgow (see bibl.) which has helped to stimulate more interest in his work.
Bibl: Caw; Glasgow AG Cat. 1911; *John Knox* Cat. of Exhibition Glasgow AG 1974; Irwin.

KNOX, T. fl.1849
Exhib. a view of Derwentwater at the RA. Addresses in London and Keswick, Cumberland.

KOBERWEIN, Georg see TERRELL, Mrs. Georgina

KOBERWEIN, Mrs. Georgina F.
see TERRELL, Mrs. Georgina

KOBERWEIN, Miss Rosa see TERRELL, Mrs. Georgina

KOE, Miss Hilda fl.1895-1901
Exhib. two works 'Vintage Design for Decoration' and 'Goblin Market' at the RA. London address.

KOE, Lawrence E. fl.1888-1904
Painted and sculpted portraits. Exhib. 15 portraits, in sculpture and painting, at the RA 1891-1904. Address in Brighton, Sussex.

KOE, Winifred fl.1888
Exhib. a painting of anemones at SS. London address.

KOELMAN, J. fl.1858
Exhib. a portrait at the RA in 1858. Address in Rome.

KOLLER, R. fl.1857
Exhib. a work 'Driving Cattle to the Alp near Hasle' at the RA.

KONSTAM, Miss Gertrude A. fl.1883-1885
Exhib. two genre subjects 1883-5. London address.

KORTRIGHT, Henry Somers RBA 1870-1942
Painted landscapes and portraits. Studied at the Lambeth School of Art and under Herkomer. Exhib. seven works at the RA 1899-1904, titles including 'Memories', 'Summer Flower' and 'The Peaceful Hour'. Lived in London and at Bexhill, Sussex.
Bibl: Who's Who 1924.

KOSTER, E. fl.1857-1859
Exhib. a Dutch coastal scene at the RA. London address.

KOVÀSCHI, John fl.1854
Exhib. a genre subject in 1854. London address.

KOZANECHI, L. fl.1838-1848
Exhib. three works, a portrait and two still-lifes of game, at the RA. London address.

KRAFTMEIER, Miss Marta fl.1899-1901
Exhib. three portraits at the RA. London address.

KRICHELDORF, Carl fl.1892-1900
Painted figurative and architectural subjects. Exhib. nine works, including 'The Love Letter' and 'Staircase of an old Manor House, Doughton, Gloucestershire' at the RA 1892-1900. Also exhib. two works at SS. Address in Tetbury, Gloucestershire.

KUMMINGS, Richard fl.1876
Exhib. three drawings in 1876. Address in Scarborough, Yorkshire.

KÜMPEL, William fl.1855-1879
Painted landscapes, historical and literary subjects. Exhib. seven works at the RA, including 'Margaret from *Faust*', 'Disappointment' and 'An Incident in the life of Otto I, Emperor of Germany'. Also exhib. a work at SS and another at the BI. London address.

'KYD'
Nom d'artiste of Joseph Clayton Clarke who made a series of watercolours of Dickens's characters, which was published in 1889.

KYD, James fl.1855-1875
Painted rustic and highland subjects. Exhib. nine works at SS, including 'Highland Boy Fishing', 'Spinning Wool in a Highland Shepherd's Cottage' and 'Thoughts of Early Days'. Also exhib. six works at the BI and two at the RA. Addresses in Worcester and London.

KYLBERG, Regina fl.1884-1885
Exhib. four watercolours, views in Rome and Naples and a painting of 15th century costume, at SS. London address.

L

LABY, Alexander fl.1864-1866
Exhib. a biblical subject and two scenes in Brittany at SS 1864-6. London address.

LACEY, W.S. fl.1827-1838
London landscape painter. Exhib. at RA and SS, in oils and watercolour. Subjects: English views, and Tivoli, Italy.

LACK, J. fl.1855-1865
Exhib. one picture at RA 1855, and one at BI 1865, of Beggar Children and a landscape. Address Preston, Lancashire.

LACOSTE, H.B. fl.1860
Exhib. flowers at RA and SS in 1860. London address.

LACRETELLE, Jean Edouard 1817-1900
London painter of portraits and figure subjects. Exhib. 25 pictures at RA; also SS and elsewhere. Also lived for a time in Paris, where he exhib. at the Salon 1841-81. Worked in oil, watercolour and gouache; also painted historical and mythological subjects. Died in Paris.
Bibl: BM Cat. of Engraved British Portraits IV 1914 p.298.

LADBROOKE, Frederick fl.1860-1864
Bury St. Edmunds painter of rustic subjects. Exhib. four pictures at SS, including 'The Errand Boy'. Youngest son of Robert Ladbrooke, and brother of Henry and John Berney Ladbrooke (qq.v.).

LADBROOKE, Henry 1800-1870
Norfolk landscape painter. Second son of Robert Ladbrooke (q.v.). Lived in King's Lynn and Walsham, Norfolk. Exhib. mostly at Norwich Societies, also at BI and SS, all views in East Anglia.
Bibl: See under Robert and John Berney Ladbrooke.

LADBROOKE, John Berney 1803-1879
Norwich School landscape painter and lithographer. Third son of Robert Ladbrooke (q.v.). Said to have been the pupil of his uncle John Crome, although Clifford thinks this unlikely as the Cromes and Ladbrookes quarrelled when he was 12. Exhib. from 1821-72, at the RA 1821-2, 1843, BI and SS. He was largely an oil painter, but did produce several watercolours.
Bibl: DNB; Clifford pp.22-3, 44, 73, 75 (pls.62b-63b); Pavière, Landscape; Maas p.56 (pl.); H.A.E. Day East Anglian Painters, II pp.142-58; Hardie.

LADBROOKE, Robert 1770-1842
Norwich School painter of landscapes and portraits. Brother-in-law of John Crome, with whom he founded the Norwich Society of Artists in 1805. About 1811 he quarrelled with Crome, and set up a rival society. He exhib. regularly at both societies, usually Norfolk landscapes and coastal scenes. He also exhib. in London at RA 1809-16 and Bl. His career falls mostly outside the Victorian period, but his style was continued by his sons, Henry, John Berney and Frederick Ladbrooke (qq.v.).
Bibl: DNB; W.E. Dickes, The Norwich School, 1905; Bryan; BM Cat. of Engraved British Portraits III 1912; Clifford; H.A.E. Day, East Anglian Painters, II; Cundall; Williams; Redgrave Dict; Hardie.

***LADELL, Edward 1821-1886**
Still-life painter. Lived in Colchester, Essex. Exhib. at RA l856-86, BI and SS. Ladell's pictures are always easily recognisable, as he used the same props over and over again — fruit, flowers, and sometimes a bird's nest, a casket, or carved mug and other objects, on a marble ledge draped with an oriental rug. Although Ladell is now very popular, and his work frequently comes on the market, practically nothing is known of his life. His wife, Ellen Ladell, also painted in a style almost identical to her husband's. She usually signed with her full name, whereas Edward used the EL monogram back-to-back. They must undoubtedly have collaborated on many pictures. Works by Ladell are in Sheffield and Reading AGs.
Bibl: Maas p.174 (with pl.); Frank Lewis, Edward Ladell 1821-1866, 1976.

LADELL, Ellen see LADELL, Edward

LAFAYE, Prosper 1806-1883
Exhib. one picture of Louis XIV's bedroom at Versailles at the BI, 1843. Also painted Victoria and Albert in the Indian Pavilion of the Great Exhibition (VAM). Lived mainly in Paris where he exhib. 1831-80.
Bibl: Benezit; Wood, Panorama; for full bibl. see TB.

LA FOLLIE, Yves Adolphe Marie de 1830-1896
Exhib. a portrait of Archbishop Manning at RA 1868; London address. Also exhib. at Paris Salon 1869-80.
Bibl: Bellier-Auvray, Dictionnaire Général, 1882.

LAIDLAW, H. Giuseppe fl.1885
Exhib. one landscape of Wimbledon Common at SS, 1885. London address.

LAIDLAY, Miss Lucy fl.1891-1892
Flower painter; exhib. twice in London 1891-2. Wimborne address.

LAIDLAY, William James 1846-1912
Landscape painter. Studied in Paris 1879-85 with Carolus Duran and Bouguereau. Exhib. at the Société des Artistes Français in Paris 1880-1912, also at RA, SS, GG and NG. One of the founders of the NEAC, about which he wrote a book, The Origin and First Two Years of the New English Art Club. Laidlay was one of the strongest opponents of the RA. His pictures show French Impressionist influence.
Bibl: AJ 1890 p.156; 1907 p.154; Caw p.308; Who's Who 1913; Maas p.248.

LAIDLER, Miss fl.1838
Painted a portrait of Grace Darling in 1838.
Bibl: Ormond.

LAING, Frank ARPE b.1862 fl.1892-1907
Painter and etcher of landscapes and architectural subjects. Exhib. at RA and RE. Elected ARPE 1892, resigned 1907. Lived in Kirkaldy, Scotland, and also in Spain.
Bibl: Caw; Gazette des Beaux-Arts 1899 I p.65ff.

LAING, Miss Georgina fl.1898-1901
Liverpool painter. Exhib. twice at RA, 1898 and 1901, a landscape and a portrait.

LAING, Miss Isabella fl.1868-1872
Painter of fruit and flowers. Exhib. at RA, SS and elsewhere. Address Twickenham.

LAING, James Garden RSW 1852-1915
Glasgow painter of landscapes, architectural views and church interiors, mostly in watercolour. Exhib. at RA from 1883, SS, NWS and OWS. Painted in Scotland, also in Holland. Much influenced by the Hague School of Painters, and especially Bosboom.
Bibl: Caw pp.392-3; Studio XXVIII 1903 p.202ff.; XXXVII 1906 p.350; LXI 1914 p.320ff.; LXVII 1916 p.262; Morning Post, London, 18 April 1910.

LAING, William Wardlaw fl.1873-1898
Liverpool painter of landscapes and rustic subjects. Exhib. at RA, 1873-98, SS, NWS, OWS. Titles: 'A Ferny Glade', etc.
Bibl: Studio XLII 1908 p.148.

LAIRD, Alicia H. fl.1846-1865
Painter of scenes of Scottish life, who exhib. at the Society of Female Artists and elsewhere 1846-65. Examples are in Hove Library, Sussex.

LAIT, Edward fl.1865-1869
Exhib. four watercolour landscapes at SS 1865-9. London address. Perhaps the same as Edward Beecham Lait, recorded in Mallalieu's Dictionary of British Watercolour Artists.

LAJOS, L. Bruck- see BRUCK-LAJOS

LAKE, Miss Gertrude fl.1893-1903
Manchester painter. Exhib. once at RA in 1903 with 'A Normandy Farmyard', and once at NWS.

LALONE, A. fl.1842
Exhib. one picture, 'Un Malheur', at SS 1842. London address.

LAMB, Miss H. fl.1872
Exhib. one picture, 'Babette', at SS 1872. London address.

LAMB, Henry fl.1834-1861
Landscape painter. Exhib. once at BI in 1861, with a view of Derwentwater; also at NWS and elsewhere. Address Malvern, Worcestershire.

LAMBERT, Clement 1855-1925
Brighton painter of landscapes, shore scenes and genre. Exhib. from 1880, at the RA from 1882, SS, NWS, GG, NG and elsewhere. Titles at the RA 'Ebb Tide', 1882, 'The Hayfield', 'A Wayside Chat', etc. For many years he was on the Brighton Fine Art Committee.
Bibl: Connoisseur LXXI 1925 p.180 (obit.).

LAMBERT, E.F. fl.1823-1846
London painter of portraits and historical subjects. Exhib. at RA and SS; subjects mostly from English history and literature of the 17th and 18th centuries, e.g. 'Burke's Dinner with Barry'.
Bibl: BM Cat. of Engraved British Portraits II 1910.

LAMBERT, Edwin J. fl.1877-1904
London painter of buildings and landscape. Exhib. at RA, SS and elsewhere.

LAMBERT, J.W. fl.1822-1851
Painter of horses, dogs, sporting and rustic subjects. Exhib. at RA, BI and SS. Lived mostly at Carshalton, Surrey, and painted in that area.

LAMMINI, Miss fl.1886
Exhib. one watercolour of iris at SS, 1886. London address.

LAMOND, Miss fl.1886
Exhib. one sea piece in 1878. Hampton Wick address.

***LAMONT, Thomas Reynolds ARWS 1826-1898**
Scottish genre painter and watercolourist. Studied in Paris with George Du Maurier, E.J. Poynter, Thomas Armstrong and Whistler (qq.v.). Du Maurier used Lamont as model for the character of the Laird in his novel *Trilby,* which he wrote many years later. Lamont also appears in some du Maurier cartoons. Also studied in Spain. Exhib. only four works at the RA, and after 1880, lived a quiet life in St. John's Wood, and on his estates near Greenock in Scotland. He continued to exhib. watercolours at the OWS. Little is known of Lamont's later career, and it seems probable that he gave up painting seriously in the 1880s.
Bibl: Cundall, p.229; Leonee Ormond, *George Du Maurier,* 1969, see index; Wood, Panorama pp.112-13.

LANCASTER, Mrs. fl.1840
Exhib. a 'Landscape near Windsor' at BI 1840. London address.

LANCASTER, Alfred Dobrée fl.1863-1904 d.1909
London painter of figure subjects. Exhib. mainly at RA, also BI, SS and elsewhere. Titles: 'A Summer Guest' etc.

LANCASTER, Hume RBA fl.1836-1849 d.1850
Painter of marine subjects and coastal views, especially of Dutch scenery. Born in Erith in Kent; in 1841 became a member of the SBA. Exhib. 1836-49 at the RA, BI and SS. the AJ notes: "Had circumstances permitted him the free exercise of his talents, he would doubtless have reached considerable eminence . . . but it is painful to know that a man of education, and of unquestionable ability in his profession, should from domestic troubles, have been compeled to pass the prime of his life in obscurity and to paint for picture-dealers at prices barely sufficient to afford him subsistence . . ." Not to be confused with Rev. Richard Hume Lancaster (1773-1853), landscape painter, who was an hon. exhibitor at the RA 1800-27.
Bibl: AJ 1850 p.240 (obit.); Brook-Hart.

LANCASTER, John fl.1882-1884
London landscape painter. Exhib. three pictures at SS 1882-4.

LANCE, Miss E. fl.1859-1861
Exhib. three pictures of fruit at RA 1859-61. Presumably a daughter of George Lance (q.v.) as they are recorded at the same address.

LANCE, Miss Eveline fl.1891-1893
Exhib. watercolour landscapes at SS and NWS. London address.

***LANCE, George 1802-1864**
Still-life painter. Studied under B.R. Haydon (q.v.). Exhib. in London 1824-64, mainly at BI (135 works), also RA, SS and NWS. Also exhib. regularly at the Liverpool Academy, of which he was an honorary member. In 1836 he won the Liverpool prize for a historical picture, 'Melancthon's First Misgivings of the Church of Rome'. In addition to his many fruit and still-life pictures, Lance also painted occasional historical genre scenes. His favourite pupil and imitator was William Duffield (q.v.). After Lance's death a sale of his works was held at Christie's, 27 May 1873.
Bibl: AJ 1857 p.305ff.; 1864 p.242 (obit.); Redgrave, Dict; Marillier p.169; Reynolds, VP pp.173, 178 (pl.119); Maas pp.23, 174; Ormond.

LANCE, W.B. fl.1882
Exhib. one watercolour 'My Own Fireside' at SS 1882. Chiswick address.

LANCE, William fl.1887
Exhib. one domestic subject in 1887. London address.

LANCE, Wilmot fl.1893
Exhib. two pictures of flowers at SS, 1893. Ipswich address.

LANCON, A. fl.1880
Exhib. three domestic subjects in 1880. Address in Hastings, Kent.

LANDELLS, Robert Thomas 1833-1877
Illustrator, military and ceremonial painter, and special war correspondent. Eldest son of Ebenezer Landells 1808-60, wood engraver and originator of *Punch.* Educated principally in France and afterwards studied in London. In 1856 sent by the *Illustrated London News* as special artist to the Crimea, and contributed some illustrations of the close of the campaign. After the peace he was sent to Moscow for the coronation of Tsar Alexander II, and

contributed illustrations of the ceremony. He was present as artist throughout the war between Prussia and Denmark in 1863, and again in the war between Austria and Prussia in 1866, when he was attached to the staff of the Crown Prince of Prussia. In 1870, on the outbreak of the Franco-Prussian war, he was again attached to the staff of the Crown Prince. His war sketches were always much admired. He was also successful as a painter, and exhib. 1863-76 at SS (45 works), and elsewhere, but not at the RA. He was employed by Queen Victoria to paint memorial pictures of various ceremonials which she attended.

Bibl: Redgrave, Dict.; DNB.

LANDER, Alice fl.1859-1860
Exhib. three figure subjects in London 1859-60. London address.

LANDER, Henry Longley fl.1864-1887
Landscape painter who exhib. in London 1864-87, at the RA (1867-81), BI, SS, NWS and elsewhere. Titles at RA: 'Spring', 'Streatley on Thames', 'Beda Fell, Cumberland', etc.

LANDER, Mrs. Mary E. fl.1854-1857
Exhib. three pictures at SS 1854-7. Address Fareham, Hampshire.

LANDER, Wills fl.1887-1891
London landscape painter. Exhib. at RA, SS, NG and elsewhere. Titles: 'In a Kentish Farmyard', etc.

LANDOR, G. Dick fl.1848
Exhib. two landscapes in 1848. Edinburgh address.

*LANDSEER, Charles RA 1799-1879
Genre and historical painter, elder brother of Edwin Landseer (q.v.). Studied with his father John Landseer, an engraver; with B.R. Haydon (q.v.) and at RA schools. Exhib. at RA 1828-79, BI and SS. Elected ARA 1837, RA 1845. Keeper of the RA 1851-73. Subjects mainly of a semi-historical nature, e.g. 'The Eve of the Battle of Edgehill', 'Queen Margaret of Anjou and the Robber of Hexham', 'The Death of Edward III', etc. The AJ says of his works that they are "distinguished by careful execution, appropriate accessories and costumes, rather than by striking effects and grandeur of character." His studio sale was at Christie's, 14 April 1880.

Bibl: AJ 1879 p.217 (obit.); DNB XXXII; BM Cat. of Engraved British Portraits VI 1925; Ormond.

*LANDSEER, Sir Edwin Henry RA 1802-1873
London sporting, animal and portrait painter, and sculptor. Son of John Landseer, an engraver. As a boy, Landseer was fond of drawing animals; entered RA schools at 14. Encouraged by B.R. Haydon, he studied dissection and anatomy to perfect his knowledge of animals. Elected ARA 1826, RA 1831. In 1834 paid first of many visits to Highlands, with C.R. Leslie (q.v.). His many pictures of Highland animals and sporting scenes helped to establish the vogue for Scottish subjects. Queen Victoria was a great admirer of Landseer's work. She owned a large number, and also commissioned him to paint her dogs. Also painted portraits, and designed sculpture; commissioned to model the bronze lions in Trafalgar Square. Exhib. 1815-73 at RA, BI, SS and OWS. Knighted 1850. Among his best known works are 'The Old Shepherd's Chief Mourner', 'Dignity and Impudence', 'Monarch of the Glen' and 'The Stag at Bay'. Enormous numbers of engravings were made after his works, which greatly increased their popularity. Although a brilliant painter of animals, Landseer

pandered to the Victorian taste for monkey pictures, comical dogs, and excessive sentiment. For this reason some of his pictures find little favour today, but his sketches and drawings are much appreciated for their wonderful observation and superb brushwork. Landseer's last years were marred by depression and illness. In 1865 he was offered the Presidency of the RA, but refused. In 1874 an exhibition of his work was held at Burlington House, and another in 1961. After his death, his studio sale was held at Christie's, 8 May 1874.

Bibl: AJ 1873 p.326ff. (obit.); 1874 p.55ff.; 1875-7 see index; 1879 pp.178, 201, 245 1905 p.59; 1908 p.248; Portfolio 1871 p.165ff.; 1876 p.18ff.; 1885 p.32, 1872 p.127; 1873 p.144; C.S. Mann, *The Works of E.L.*, 1843; A. Graves, *Cat. of the Works of the Late Sir E.L.*, 1876; F.G. Stephens, *Sir E.L.*, 1880; F.G. Stephens, *Life and Works of Sir E.L.*, 1881; C. Monkhouse, *E.L. Works Illustrated by Sketches from the Collection of Her Majesty*, 1888; J.A. Manson, *Sir E.L.*, 1902; L. Scott, *Sir E.L.*, 1904; A. Chester, *The Art of E.L.*, 1920; J. Ruskin, *Modern Painters;* J. Ruskin, Academy Notes 1856-8; Redgrave, Dict.; Roget; Binyon; Cundall; DNB XXXII; Hughes; VAM, Pavière, Sporting Painters (pl.26); Reynolds, VP pp.14-15, 61, 173 (pl.8); Maas pp.79-81, 89; Irwin; Hardie; Ormond; Staley; Wood, Panorama; Campbell Lennie, *Landseer the Victorian Paragon*, 1976; Sarah Tytler, *Landseer's Dogs and Their Stories*, 1877; I.B. Hill, *Landseer; An Illustrated Life of Sir E.L.*, 1973; R. Ormond, Cat. of Landseer exhib., Tate Gallery, London 1981; Newall.

Exhib: London, Royal Academy of Arts 1874, 1961; Tate Gallery 1981.

LANDSEER, Miss Emma see McKENZIE, Mrs. D.

LANDSEER, George c.1834-1876
London painter of portraits and figure subjects. Son of Thomas Landseer ARA, the engraver. Exhib. at RA, BI and SS, including subjects from Wordsworth, Spenser and the Bible. Went to India where he continued to paint portraits and watercolour views of Kashmir and northern India, returning in 1870.

Bibl: AJ 1876 p.254 (obit.); Ormond.

LANDSEER, Miss Jessica 1807-1880
Painter, etcher and miniaturist. Sister of Sir Edwin Landseer (q.v.) for whom she kept house for most of his life. She painted landscapes, portraits and animals, and exhib. at the RA, BI, SS and OWS. She made etchings, and sometimes copies of Edwin's works, and also painted miniatures of children. Although talented, she was "a meek, amiable little body who looked after her brother's house in a very quiet and unostentatious way" (Graves), and was overshadowed by the fame of Sir Edwin.

Bibl: DNB; BM Cat. of Engraved British Portraits III 1912; Campbell Lennie, *Landseer the Victorian Paragon*, 1976.

LANE, Albert fl.1856-1872
Landscape painter; lived at Barnstaple, north Devon. Exhib. mainly at SS 1856-66, but also at RA and BI. Subjects mostly views in Devon, Wales and Surrey.

LANE, Rev. Charlton George c.1840-c.1892
Exhib. three watercolours at SS 1868-73; two pastoral scenes and a view of the Alhambra, Granada. Address Little Gaddesden, Hertfordshire, where he was vicar, and also librarian to Lord Brownlow at Ashridge, Hertfordshire. Also painted in Venice.

LANE, Miss Clara S. fl.1856-1859
Exhib. five figure subjects at RA 1856-9. Titles: 'The Country', 'The Town', etc. London address. Also a portrait painter. For works illustrated by, see VAM Card Cat.

Bibl: Ormond.

LANE, Miss E. fl.1865-1868
Exhib. six flower pictures 1865-8. London address.

LANE, G.A. fl.1837
Exhib. a pair of views of Hampstead and Hendon at SS 1837. London address.

LANE, H. fl.1868-1870
Exhib. four pictures of flowers and fruit at SS 1868-70. Address Bexley Heath, Kent.

LANE, J. fl.1851
Exhib. two biblical subjects at BI 1851. London address.

LANE, Samuel 1780-1859
Suffolk portrait painter. Born in King's Lynn, died in Ipswich. He was deaf and partially dumb from childhood. Studied under Joseph Farington, and afterwards under Sir Thomas Lawrence, who employed him as one of his chief assistants. Friend of Constable. Exhib. 1804-57 at the RA (217 works), and at BI and SS. He built up a very successful practice and many of his portraits were engraved. Among his works are Lord George Bentinck (NPG), Admiral Lord Saumarez (United Services Club), and Captain Murray (VAM).
Bibl: Redgrave, Dict.; DNB; Cat. of Scottish National Portrait Gallery, Edinburgh, 1889, BM Cat. of Engraved British Portraits VI Index p.510; Cat Dulwich 1914; Poole II 1925 No.44 (pl. IV); Ormond.

LANE, Miss Sarah H. fl.1843-1872
London painter of portraits and figure subjects. Exhib. at RA, BI and SS.Titles: 'Meditation', etc.

LANG, J. fl.1849-1852
Exhib. four watercolour landscapes at SS 1849-52, mostly views in the West Country. London address.

LANGDALE, Marmaduke A. fl.1864-1904 d.1905
Landscape painter, working in Staines and Brighton. Studied at the RA schools, and in his third year won the Turner Gold Medal. Exhib. 1864-1904, at the RA 1866-1904, BI, SS and elsewhere. He worked in north Wales, south Wales, north Devon and finally settled in Brighton. His favourite medium was oil, but he sometimes used watercolour and pen and ink. *The Studio* considered his best picture to be 'The Wye near Tintern Abbey', and commented, "He may well be remembered as one who strove sincerely after the simplicity of the everyday of nature."
Bibl: Studio XXXVII 1906 pp.163-4, (pls.).

LANGDON, E. fl.1846-1848
Exhib. three landscapes at RA 1846-8, all views near London.

LANGHAM, Hon. Mrs. E. (G?) fl.1879-1882
Exhib. one landscape at GG and one elsewhere in 1879 and 1882; London address.

LANGL, H. fl.1845-1850
Exhib. three pictures of animals at RA in 1845 and 1850, subjects dog, sheep, and horses. London address.

LANGLANDS, George Nasmyth fl.1890-1896
Edinburgh landscape painter. Exhib. six pictures at RA 1890-6. Titles: 'Golden Autumn', etc.

LANGLEY, C.D.
Nothing is known of this artist except two charming Victorian portraits which were sold at Christie's, 7 November 1969.

LANGLEY, R. fl.1834-1845
London painter of fruit and rustic scenes. Exhib. five pictures at RA, BI and SS.

***LANGLEY, Walter RI 1852-1922**
Genre painter. Born in Birmingham. Studied at South Kensington Art School 1873-5. After his return to Birmingham, devoted himself more to watercolours. In 1882 settled in Newlyn, Cornwall, and became part of the Newlyn School, which included Stanhope Forbes, Frank Bramley (qq.v.) and others. Exhib. in London 1890-1919 at RA, SS and NWS. Elected RI 1883. Subjects mostly scenes of fisherfolk and life in fishing villages.
Bibl: AJ 1889 p.137ff.; RA Pictures 1892-6; Newall.

LANGLIN, Mrs. see CODINA, Victoriano

LANGLOIS, C., Jnr. fl.1835-1849
London painter of portraits and figure subjects. Exhib. 15 pictures at RA and SS. Titles: 'The Book of Pictures', etc.

LANGLOIS, Mark W. fl.1862-1873
London painter of fruit and sea pictures. Exhib. 14 pictures at RA, SS and elsewhere, some in watercolour. Also painted figure subjects.

LANGLOIS de SENS, C. 1757-1845
London painter of portraits. Exhib. 12 portraits at RA 1831-41. Born in France, where he exhib. at the Paris Salon 1806-36. Thieme-Becker lists him as Langlois de Sezanne. His son was C. Langlois, Jnr.

LANGSHAW, J. fl.1865
Exhib. one watercolour at SS in 1865, a view in south Wales. Bristol address.

LANKESTER, Arthur fl.1858-1865
Exhib. four pictures of domestic subjects at RA and BI. Titles: 'Peace after War', etc. London address.

***LAPORTE, George Henry 1799-1873**
Animal and sporting painter. Son of John Laporte. (1761-1839) also an artist. Exhib. RA 1821-50, BI, SS and NWS. Animal painter to the Duke of Cumberland, later King of Hanover. He painted hunting scenes, dogs and equestrian portraits. Worked in Hanover, where some of his pictures can be found in museums. His sister Mary Ann Laporte was also an artist, who exhib. 1813-45 at BI, RA, NWS, etc.
Bibl: AJ 1859 p.175; 1874 p.26; Redgrave, Dict.; DNB; Cundall; Pavière, Sporting Painters p.57 (pl.26); Wood, Panorama.

LAPORTE, Miss Mary Ann fl.1813-1845
London painter of portraits and figure subjects. Exhib. mainly at NWS, also RA and BI. Often painted children. Sister of G.H. Laporte (q.v.) and son of John Laporte, an engraver.
Bibl: See under G.H. Laporte.

LAPWORTH, William E. fl.1891
Exhib. one landscape watercolour at NWS 1891. London address.

***LARA, Georgina fl.1862-1871**
Painter of farmyard scenes. Exhib. once at BI, 16 works at SS. Nothing is known about her life, but she painted naive farmyard and village scenes. Her works are sometimes attributed to William

Shayer (q.v.), a much superior artist, who painted similar subjects. Lara's work can often be recognised because of her tendency to put large numbers of small, doll-like figures into her canvases. Was for a time mistakenly known as George Lara. Another artist who signed Edwina Lara is thought to be the same person.

LARBALESTIER, P. fl.1857
Exhib. one landscape of Brittany at RA 1857. Jersey address.

LARIS, F.G. fl.1883
Exhib. one picture of 'Wild Grasses' at SS 1883. No address recorded.

LARK, Tremayne fl.1882-1885
Exhib. three domestic subjects at RA and SS. Titles: 'Pastime', etc. London address.

LARKINS, F. fl.1835-1847
Exhib. two landscapes at SS in 1835 and 1847. London address.

LARSON, Virginia fl.1880
Exhib. one picture 'Ante-chamber in the Palace of the Colonna, Rome' at SS 1880. London address.

LASCELLES, Thomas W. fl.1885-1891
Painter and etcher of figure subjects, usually children. Exhib. eight works at RA and SS. Titles: 'The Little Angler', etc. Lived at Cookham, Berkshire.

LASCH, E. fl.1870
Exhib. one figure subject in 1870. London address.

LATHAM, Miss Frances A. fl.1861
Exhib. one watercolour of Keswick at SS 1861. London address.

LATHAM, Francis P. fl.1889
Exhib. one watercolour at NWS 1889. London address.

***LA THANGUE, Henry Herbert RA 1859-1929**
Painter of landscape and scenes of rustic life. Studied at South Kensington, Lambeth and RA schools. Won Gold Medal 1879, and studied with J.L. Gerome in Paris for three years. While in Paris he came more under the influence of the Barbizon and *plein-air* painters, such as Bastien-Lepage and Dagnan-Bouveret. On his return to London exhib. at RA, SS, GG and NG; also at Institute of Painters in Oils, and NEAC. Lived at Bosham, Surrey. La Thangue was a friend of Stanhope Forbes (q.v.), and was in sympathy with the aims and ideals of the Newlyn School in Cornwall. His subjects tended to be farm workers and country life, rather than fisherfolk. 'The Last Furrow' is in Oldham AG.
Bibl: AJ 1893 pp.169-75; Studio IX 1897 p.167ff. (monograph with pls. by George Thomson); Wood, Panorama; pp.106-8; Wood, Paradise Lost.

LATILLA, Eugenio H. RBA 1800-1859
Painter of portraits, genre, landscape and historical subjects. Son of an Italian living in England. He worked 1828-42 in London, 1842 in Rome, 1847-8 in Florence, 1849 in London, and then in America where he died. Exhib. 1828-59 in London, at the RA 1829-37, BI, and SS. RBA in 1838. Among his portraits are those of R. Godson, D. Harvey, D. O'Connell and Queen Victoria.
Bibl: Redgrave, Dict.; BM Cat. of Engraved British Portraits 1908-25; Ormond.

LATILLA, F.Z. fl.1839-1840
Exhib. three figure subjects at SS 1839-40, two of Italian peasants. London address.

LATOIX, Gaspard fl.1883-1903
Painter of landscapes and figures. Exhib. at RA and SS. Titles: 'Kenilworth Castle', etc. and also pictures of North American Indians. Lived mostly in Leamington.

LATZARUS, Miss Edith M. fl.1890-1896
Exhib. five pictures at RA and SS 1890-6, mostly flowers, but also figures, and a church interior. London address.

LAUBER, Adolph fl.1870-1879
Exhib. five pictures at RA and SS 1870-9, mostly flowers, also figures, e.g. 'An Old Man's Head', etc.

LAUDER, Charles James RSW fl.1890-d.1920
Painter of architectural subjects. Son of a portrait painter, James Thompson Lauder. Studied in Glasgow. Settled in London and began to exhibit at SS in 1890. Painted along the Thames, also in Italy, where he travelled often, to Venice in particular. Later returned to Scotland, residing at Thornton Hall, Lanarkshire.
Bibl: Caw p.334; Connoisseur LVIII 1920 p.54.
Exhib: London, M. Silva White, *Watercolour Drawings of Venice by C.J.L.* c.1910.

LAUDER, James Eckford RSA 1811-1869
Edinburgh painter of genre and historical subjects, and landscape. Younger brother of Robert Scott Lauder (q.v.). Pupil at the Trustees' Academy under Sir William Allan, RA, and Thomas Duncan, ARA 1830-3; 1834-8 in Rome with his brother; on his return settled in Edinburgh. In 1847 his paintings 'Wisdom' and 'The Parable of Forgiveness' gained the £200 premium in the Westminster Hall competition. Elected ARSA 1839; RSA 1846; exhib. in London 1841-58, RA 1841-6, BI, SS and elsewhere. Among his more important paintings are 'Baillie Duncan McWheeble at Breakfast', 1854 (bequeathed to the National Gallery of Scotland), 'The Parable of the Ten Virgins', 1855, and 'Hagar', 1857, which Caw notes has the faults and good qualities of his average performance. From about 1857 he turned to painting landscape, hoping he would be more successful than he had been with figure subjects. However, he was not more successful and "the result was indifference, which led to carelessness, and, finally, to absolute neglect by the public: this hastened his end" (AJ). Caw, however, notes that he was a finer draughtsman than his brother and praises 'Baillie McWheeble' as a "most admirable piece of painting" in the Dutch tradition. He did not fulfil his early promise. 'The Parable of Forgiveness' is in the Walker AG, Liverpool.
Bibl: AJ 1869 p.157 (obit.); Portfolio 1887 p.153; Redgrave, Dict.; Caw p.118; DNB; Irwin.

LAUDER, Robert Scott RSA 1803-1869
Scottish painter of historical and biblical genre. Pupil of Sir William Allan (q.v.). Studied in Italy for five years, where he existed by painting portraits. Returned to London 1838; exhib. at RA and BI. In 1852 appointed Master of the Trustees' Academy in Edinburgh. Lauder was a popular and successful teacher, and under his guidance the Academy produced many of its best pupils. The subjects of his own pictures are mostly drawn from Scott and the Bible. His historical scenes, such as 'The Trial of Effie Deans' are generally more effective than his religious works, which tend to be large and theatrical. His wife was a daughter of the amateur artist, the Rev. John Thompson of Duddingston.
Bibl: AJ 1850 p.12ff.; 1869 p.176 (obit.); 1898 pp.339-43, 367-71; Redgrave, Dict.; Caw pp.115-17 and index (pl. opp. p.116); Irwin; Ormond.

LAUDERSET, Mlle. de see HEGG, Mme. Teresa

LAUNDY, George Albert fl.1878-1893
London landscape painter. Exhib. once at RA and NWS, and elsewhere. London address.

LAURENCE, H. fl.1872
Exhib. one portrait at SS 1872. London address.

LAURENCE, Samuel 1812-1884
London portrait painter. Exhib. at RA 1836-82, SS and elsewhere, mostly chalk drawings. Several pictures and drawings by him are in the NPG, London. His works are sometimes mistakenly attributed to Sir Thomas Lawrence, PRA.
Bibl: DNB XXXII; BM Cat. of Engraved British Portraits VI 1925; Ormond.

LAURENCE, Sydney M. fl.1890
Exhib. two Venetian scenes at SS 1890. Address St. Ives, Cornwall.

LAVERS, Arthur E. fl.1882
Exhib. one landscape at SS 1882. London address.

LAVERTY, A. Sorel fl.1881-1886
Exhib. six pictures of flowers at SS 1881-6. Address Ryde, Isle of Wight.

***LAVERY, Sir John RSA RA RHA 1856-1941**
Scottish portrait, genre and landscape painter. Studied in Glasgow, London and Paris (under Bouguereau). Returned to Glasgow, where he was a friend of many of the Glasgow School artists including James Guthrie (q.v.). In 1888 he painted the official picture of the Queen's State Visit to Glasgow. This led to more commissions, and in the 1890s he moved to London, where he became a highly fashionable portrait painter. Painted several official pictures, such as 'The Arrival of the German Delegates on the HMS Queen Elizabeth 1918'. One of his best known pictures was 'The Prime Minister at Lossiemouth 1933' (Ramsay MacDonald). Also painted genre scenes and landscapes in a characteristically broad and fluid style, similar to the early work of Munnings. Exhib. at RA, SS, GG, NEAC, in Scotland, and at many European academies. Elected ARSA 1892, RSA 1896, ARA 1911, RA 1921. Knighted 1918, Vice President of the International Society of Sculptors, Painters and Gravers. Lavery had a studio in Tangier where he usually spent the winter every year.
Bibl: AJ 1904 pp.6-11 (A.C.R. Carter); 1908 pp.3-6; Studio XXVII 1903 pp.3-13, 110-20 (J.S. Little); XLV 1909 pp.171-81 (S. Brinton); Apollo II 1925; D. Martin, *The Glasgow School of Painting*, 1902; Caw pp.376-9 (pl. opp. p.378); W.S. Sparrow, *J.L. and his Work*, 1911; J. Lavery, *The Life of a Painter*, 1940; *British Artists at the Front. Part II: Sir John Lavery*, 1918; Belfast Municipal AG and Museum; *Sir John Lavery Coll. of Paintings*, illustrated Cat. 1929; Irwin; Ormond; Wood, Panorama; Newall.
Exhib: London, Nico Jungmann Gallery 1911; London, Leicester Galleries Memorial Exhib. 1941; Belfast Municipal AG and Museum 1951; Scottish Arts Council, *The Glasgow Boys*, Cat. of the Scottish Arts' Council exhib. 1968; Fine Art Society, London, and Ulster Museum 1984-5 with Cat.

LAW, Miss Annie fl.1876-1878
Landscape painter. Exhib. only at SS 1876-8, all watercolours. Subjects views all over British Isles, and Venice.

LAW, Miss Beatrice fl.1884-1888
London landscape painter. Exhib. six watercolours at SS 1884-8, mostly English views, one of Venice.

LAW, David RBA RPE 1831-1901
Landscape painter and etcher. Born in Edinburgh; apprenticed early to George Aikman, steel engraver; 1845 admitted to the Trustees'

Academy where he studied under Alexander Christie (q.v.) and Elmslie Dallas until 1850. He became a 'hill' engraver in the ordnance survey office, Southampton, and it was not until 20 years later that he resigned and became a painter. He was one of the founders of the RS of Painter-Etchers in 1881. Exhib. from 1869, at the RA 1873-99, SS, NWS and elsewhere. His plates after Turner and Corot and some modern landscape painters had many admirers, and during 1875-90 were in great demand (when reproductive etching was in high fashion). His best and most vital etched work was done from watercolours by himself.
Bibl: AJ 1902 p.85 (obit.); Portfolio 1879 p.193ff. (with pls.); 1880 p.93; 1883; 1884; 1902 p.85ff. (obit. with pls.); Bryan; DNB 2nd Supp.

LAW, Edward fl.1860-1883
London landscape painter. Exhib. mainly at SS, also RA and elsewhere. Titles: 'In a Miller's Orchard', etc., and some views in Wales.

LAW, Ernest fl.1891-1893
Exhib. three pictures at SS 1891-3, two harbour scenes and one figure subject. London address.

LAW, Mrs. W. fl.1854-1862
Exhib. six pictures of fruit and flowers at RA and BI. London address.

LAW, William fl.1860-1874
London painter of landscape and still-life. Exhib. at RA, BI, SS and elsewhere.

LAWFORD, Edgar C. fl.1876-1893
Exhib. two pictures at RA, and three elsewhere. Titles: 'A Greengrocer's Shop, Kingston', etc. London address.

LAWFORD, Mrs. Rowland fl.1866-1882
London flower painter. Exhib. twice at SS in 1867, also elsewhere, usually in watercolour.

LAWLESS, Matthew James 1837-1864
Pre-Raphaelite painter and illustrator. Born Dublin. Studied under several teachers, including Henry N. O'Neil (q.v.). Exhib. at RA and SS. His early works are mostly domestic scenes in the manner of O'Neil, but 'The Sick Call', RA 1863, is a work of remarkable power. Had Lawless not died of consumption at the age of 27, he might have produced some first-rate Pre-Raphaelite paintings. He is best known for the illustrations he produced for *Once a Week* and other magazines. As an illustrator Lawless was compared with Millais during his own lifetime. For works illustrated by see Card Cat. at VAM.
Bibl: Studio, British Book Illustration, Winter Number 1923/4 p.77; XC 1925 p.56; Bate pp.83-4 (pls. opp. p.84); Strickland II; DNB; Gleeson White pp.162-3, and index (several pls.).

LAWLOR, Uniacke James fl.1854-1876
Exhib. four portraits and figure subjects at RA, BI and SS. London address.

LAWLOR, W.J. fl.1874-1875
Exhib. two figure subjects at SS 1874-5. London address.

LAWRANCE, Bringhurst B. fl.1877-1884
Animal painter. Exhib. once at SS 1881, and twice elsewhere. Titles: 'The Rats' Enemies', etc. London address.

LAWRANCE, T. fl.1850-1855
Exhib. three figure subjects at BI 1850-5. Titles: 'Mariana', etc. London address.

LAWRENCE, Miss Edith M. fl.1884-1886
London flower painter. Exhib. only at SS, and once elsewhere.

LAWRENCE, Georgina fl. 1886-1888
Exhib. two pictures at SS 1886-8, one still-life and one figure subject. London address.

LAWRENCE, Henry fl.1871-1884
London painter of figure subjects. Exhib. mainly at SS, also at RA and elsewhere. Titles: 'A Greek Girl', etc.

LAWRENCE, J. fl.1842
Exhib. two watercolour portraits at SS 1842. London address.

LAWRENCE, John C. fl.1871-1888
London painter of figure subjects. Exhib. mainly at SS, also RA, GG and elsewhere. Titles: 'Mournful Moments', etc.

LAWRENCE, Leonard E. fl.1880
Exhib. one picture at SS 1880, and three elsewhere. London address.

LAWSON, Alexander fl.1890-1903
Wolverhampton landscape painter. Exhib. mainly at RA. Titles include views in Wales, Staffordshire, Scotland and coastal scenes.

***LAWSON, Cecil Gordon 1851-1882**
Landscape painter and watercolourist. Born in Shropshire of Scottish parents. Came to London in 1861 with his father William Lawson, who was a portrait painter. At first painted small, detailed studies of fruit and flowers in the manner of William Henry Hunt (q.v.). Exhib. 1869-82 at RA, SS and GG. Scored his first notable success with 'The Minister's Garden' in 1878 at the opening of the GG. Lawson's death four years later at the age of 31 cut short his promising career. What few pictures he did paint show him to be an artist "singularly sensitive to the grandeur and bold rhythm of nature" (Hardie). Many critics would still agree with Caw that "he remains one of the greatest landscape painters of his century". His wife, Constance (q.v.) was a flower painter.
Bibl: AJ 1882 p.232ff. (obit.); 1895 p.282; 1908 p.122; 1909 p.102; Mag. of Art No. 158 December 1893; Studio LXVI 1916 p.240; 1923 p.261; *Early English Watercolours by the Great Masters,* Special Number 1919 p.48; E.W. Gosse, *Lawson, A Memoir,* 1883; Redgrave, Cent.; DNB XXXII 1892; Caw pp.314-16 (pl. opp. p.314); Binyon; Cundall; Reynolds, VP p.155 (pl.110); Hardie III pp.188-9 (pl.221); Maas p.228

LAWSON, Mrs. Cecil fl.1880-1892
(Miss Constance B. Philip)
Flower painter, wife of Cecil Gordon Lawson (q.v.). A regular exhibitor, 1880-92, of flower pictures, both in oil and watercolour, at the RA, SS, NWS, GG, NG and elsewhere.
Bibl: See under C.G. Lawson.

LAWSON, David Arthur fl.1851-1864
London painter of figure subjects. Exhib. seven pictures at RA, BI and SS, and others elsewhere. Titles: 'An Old Vegetarian', etc.

LAWSON, E. fl.1877
Exhib. one picture of tulips at SS 1877. London address.

LAWSON, Edith M. fl.1891
Exhib. one interior at SS 1891. London address.

LAWSON, Francis Wilfred 1842-1935
Painter of genre and allegories, portraits and landscapes; illustrator. Elder brother of Cecil Gordon Lawson (q.v.). Born in Shropshire; began as a designer for periodicals, especially *The Graphic;* exhib. 1867-87, at the RA 1867-84, SS, GG, Dudley Gallery and elsewhere. Caw notes that he attained considerable distinction as a painter of allegories and of incidents in the life of poor city children, treated with a touch of symbolism which makes them homilies, e.g. 'Imprisoned Spring; Children of the Great City', 1877. He is represented at the Walker AG, Liverpool.
Bibl: Caw p.313; John Denison Champlin and Charles C. Perkins, *Cyclopedia of Painters and Painting,* 1913 III (noted as 'Living').

LAWSON, John 1868-1909
Scottish landscape painter of highland and Welsh scenes. One of his Welsh landscapes is in Glasgow AG.
Bibl: AJ 1909 p.352.

LAWSON, John fl.1893
Exhib. one landscape at NWS 1893. Sheffield address.

LAWSON, Lizzie fl.1881
(Lizzie Mack)
Exhib. one domestic subject 1881.

LAWSON, Miss M.S. fl.1831-1840
Exhib. four portraits and one figure subject at SS 1831-40. Address Bexley Heath, Kent.

LAWSON, Miss Marion fl.1886
Exhib. one figure subject in 1886. Address Tooting.

LAWSON, William fl.1819-1864
Painter of rustic scenes and portraits. Exhib. mostly at SS, also RA and BI. Titles: 'Cottage Children', etc. Lived in Edinburgh and London. Father of Cecil Gordon Lawson (q.v.).

LAWSON, Mrs. William fl.1852-1888
(Miss Elizabeth Stone)
London painter of figure subjects and flowers. Exhib. at SS, GG, and NG. Titles: 'The Fortune Teller', etc. See also Miss Elizabeth Stone.

LAYTON, Mrs. E.M. fl.1872-1875
Exhib. two watercolour still-life pictures at SS 1872 and 1875. London addresses.

LAYTON, F.W. fl.1873
Exhib. three pictures of dead birds at SS 1873. London address.

LAYTON, H.B. fl.1867
Exhib. one picture 'A Creek on the Thames near Kingston' at RA 1867. Address Richmond, Surrey.

LEA, Mrs. fl.1842
Exhib. one watercolour of flowers at SS 1842.

LEA, Miss Anna see MERRITT, Mrs. Henry

LEA, E. fl.1829-1842
London painter of figures. Exhib. at RA, BI and SS, subjects usually of children, or allegorical, e.g. 'A Wizard Summoning the Spirits of the Elements', etc.

LEA, H. fl.1863-1877
Exhib. one coastal scene each at RA, BI and SS. London address.

LEACHMAN, J. fl.1848-1850
Exhib. six landscapes at RA and SS 1848-50. London address.

LEADBITTER, Miss S.M. fl.1857-1874
Exhib. six watercolours at SS 1857-74, mostly portraits, one of flowers. London address.

***LEADER, Benjamin Williams RA 1831-1923**
Worcester landscape painter. Born Benjamin Williams, but added the surname Leader to distinguish himself from the Williams family of artists, to whom he was not related. Exhib. at RA 1857-1922, BI, SS and at Birmingham Society of Artists. Subjects usually set in Scotland or the Midlands, but he was especially fond of the landscape around Betwys-y-Coed, Wales. Leader's early pictures show some Pre-Raphaelite influence, but he later developed a broader, more naturalistic style, which was enormously successful. His best known picture is 'February Fill-Dyke' (Birmingham AG) which has been described as the equivalent in landscape painting of 'The Light of the World' in religious painting, or of 'Bubbles' in popular art. Although repetitive, Leader's works have always been admired for their literalness and 'truth to Nature'.
Bibl: AJ 1871 pp.45-7; 1893 pp.96-9; 1901-1905 see index; L. Lusk *B.W.L.*, Christmas Annual 1901 (part of AJ); Connoisseur LXVI 1923 p.53 (obit.); Studio 1916 pp.88-5; 1923 p.219ff. (obit.); M. Rees, *Welsh Painters*, 1912; Reynolds, VP p.155 (pl.112); Maas p.228 (pl. p.228); Staley; Frank Lewis, *B.W.L. RA.*, 1971; Wood, Paradise Lost; Wood, Painted Gardens.
Exhib: Cradley, Worcestershire, Lower Nupend Gallery 1971.

LEADER, Mrs. Benjamin Williams fl.1878-1885
(Miss Mary Eastlake)
Flower painter. Wife of B.W. Leader (q.v.). Exhib. four pictures at RA 1878-85, and once elsewhere.

LEAHY, Edward Daniel 1797-1875
Painter of portraits, and historical and marine subjects, e.g. the Battles of the Nile and Trafalgar. He studied at the Dublin Society's School, and was working and exhibiting in Dublin 1815-27. He then moved to London and exhib. 1820-53 at the RA, BI and SS. He mostly exhib. portraits at the RA, but also historical subjects, e.g., 'Mary Queen of Scot's Escape from Lochleven Castle', 1837 and 'Lady Jane Grey, Summoned to her Execution', 1844. Both the Duke of Sussex and the Marquis of Bristol sat to him, and his sitters also included many prominent Irishmen. He painted marines both in England and Ireland. Between 1837 and 1843 he lived in Italy, and in Rome painted a portrait of John Gibson, RA. After his return he exhib. a few Italian subjects. His portrait of Father Mathew, the 'Apostle of Temperance' is in the NPG.
Bibl: Redgrave, Dict.; DNB; Strickland; Wilson; Ormond.

LEAK, W. fl.1838
Exhib. a self-portrait at RA 1838. London address.

LEAKEY, James 1775-1865
Exeter landscape painter. Exhib. 12 pictures at RA, landscapes in the West Country, also portraits and figure subjects. Also painted a portrait of the engraver Samuel Cousins, which is in the NPG (see bibl.).
Bibl: AJ 1865 p.125 (obit.); G. Pycroft, *Art in Devonshire*, 1883; G.C. Williamson, *History of Portrait Miniatures*, 1906; BM Cat. of Engraved British Portraits III 1912; Ormond pl.214.

LEAR, Charles Hutton 1818-1903
London painter of historical, biblical and other figure subjects. Exhib. at RA, BI and SS, subjects Shakespeare, Keats, etc. After 1852 Lear gave up painting except as a pastime, but he made a number of sketches of his fellow artists, which are now in the NPG (see bibl.).
Bibl: R. Ormond, *Victorian Student's Secret Portraits*, Country Life 1967 pp.288-9; Ormond pp.561-2.

***LEAR, Edward 1812-1888**
Topographical watercolourist, one of the best watercolour painters of the 19th century; landscape painter also in oils, illustrator, author and traveller. Lear was the youngest of 21 children, his father a stockbroker who lived in Holloway. In 1831 he found employment at the Zoological Gardens as a draughtsman, and in 1832 published the *Family of the Psittacidae*, one of the earliest collections of coloured ornithological drawings made in England. From 1832-6 he worked at Knowsley for the 13th Earl of Derby, and for him illustrated the above work; the bird portion of Lord Derby's *The Knowsley Menagerie*, 1846; and for his children, *The Book of Nonsense*, first edition 1846. There, too, he met many of his aristocratic friends, and in 1846 came to give drawing lessons to Queen Victoria. From 1837 onwards he never again permanently lived in England: from 1837-41 he wintered in Rome. He worked throughout Italy, and later travelled to Corsica, Malta, Greece 1849, Turkey, the Ionian Isles, Egypt, Jerusalem, Corfu, Syria, etc. From 1864-70 Lear spent his winters in Nice, Malta, Egypt and Cannes, till finally he settled at San Remo where he died. In 1873-5 he went to India and Ceylon for Lord Northbrook. Amongst other books he published *Journals of a Landscape Painter in Greece and Albania* 1851, and *In Southern Calabria* 1852. He exhib. from 1836 at SS, and 1850-73 at the RA, and also at the BI, GG and elsewhere. His output of work was enormous: his 'topographies' were always done in pencil on site, and were often scribbled over with colour notes and dated. They were then inked in in sepia and brush-washed with colour in the winter evenings. His oil paintings were mainly done 1840-53. Hardie notes that Lear carried on through the Victorian period the tradition of watercolour drawing as exemplified in the work of Francis Towne. He comments: "Turner alone had the same zest for life, the same infinite capacity for work, but Turner, though he did try his hand at poetry, could not write nonsense verse. 'Topographies' these drawings are, but they possess something more. Lear set down observantly, rightly, rhythmically, the facts of life and nature, without any high flight of poetry or imagination."
Bibl: DNB; VAM; A. Davidson, *Edward Lear*, 1938; Reynolds, VP pp.12, 154 (pl.162); Hardie III pp.43, 63-7, 187 (pls. 78-81); Maas pp.38, 79, 84-5, 99-100, 184, 193 (pls. pp.99, 100, 108); Vivien Noakes, *Edward Lear: the Life of a Wanderer*, 1968 (for full bibl. and for a list of his own published works); Staley; E. Kelen, *Mr. Nonsense; A Life of Edward Lear*, 1973; Susan Hyman, *E.L.'s Birds*, 1980; Wood, Pre-Raphaelites; Susan Hyman, *E.L. in the Levant*, 1988; Ruth Pitman, *E.L.'s Tennyson*, 1988; V. Noakes, *The Painter E.L.*, 1991.
Exhib: London, 112 Piccadilly 1912; Tunbridge Wells, Craddock & Barnard's Gallery 1937; London, Fine Art Society 1938; Redfern Gallery 1942; Adams Gallery 1946, 1947; Walker's Gallery 1950, 1951; Great Britain, Arts Council 1958; Worcester, U.S.A., 1968; Washington, U.S.A., 1971-2; Liverpool, Walker AG 1975; London Royal Academy 1985 with Cat.

LEAR, J.M. fl.1871-1872
Exhib. four domestic subjects 1871-2. Bath address.

LEARMOUTH, Alexander fl.1858-1859
Exhib. three landscapes at BI and SS. London address.

LEATHEM, W.J. fl.1840-1855
Brighton painter of shipping subjects. Exhib. 13 works at RA, also at BI and SS. Usually painted ships in a breeze or heavy weather, also ships on the Atlantic run.
Bibl: Brook-Hart p.82 (pl. 153).

LEATHER, Mrs. R.K. fl.1886-1893
(Miss Amy H. Foster)
Teignmouth landscape painter. Exhib. at SS, NWS, GG and NG, mostly under her maiden name.

LEATHER, Walter E. fl.1867-1868
Exhib. one flower picture at RA 1868, and once elsewhere. London address.

LEAVERS, Miss Lucy A. fl.1887-1898
Nottingham painter of domestic subjects. Exhib. at RA 1887-98. Titles: 'At Play', etc.

LE BAS, Miss fl.1839
Exhib. one watercolour portrait at SS 1839. Guernsey address.

LE BRETON, Miss Rosa fl.1865
Exhib. one domestic subject 1865.

LE CAPELAIN, John 1814-1848
Jersey painter of shipping and coastal scenes. Exhib. once at SS and once at NWS. Painted views in Jersey and the coast of France. For Queen Victoria he painted an album of views in Jersey, and another of views in the Isle of Wight. Many of his works are in the St. Helier Museum, and one is in the British Museum. For works illustrated by, see VAM Card Cat.
Bibl: Redgrave, Dict.; DNB; Binyon.

LECHE, Randal fl.1861-1863
Chester landscape painter. Exhib. at RA and SS, subjects mainly views in Wales.

LECKY, Miss S. fl.1878
Exhib. one figure picture in 1878. London address.

LEDGER, Miss M. fl.1855
Exhib. one watercolour of flowers at SS 1855. London address.

LEDIARD, H. fl.1850
Exhib. one portrait at RA 1850. London address.

LEDSAM, M. fl.1879-1880
Exhib. two sea pieces 1879-80. Address Norwood, London.

LEE, Miss fl.1844-1845
Exhib. two flower pictures at RA 1844-5. London address.

LEE, Miss A. fl.1897
Exhib. one picture 'Water Seller — Venice' at RA 1897. London address.

LEE, Annie fl.1891
Exhib. one picture of roses at SS 1891. London address.

LEE, Barnard H. fl.1865
Exhib. one picture, a scene from Lytton's 'The Last of the Barons' at BI 1865. London address.

LEE, David T. fl.1863-1889
Painter of figure subjects. Exhib. at RA, BI, SS, NWS, GG and elsewhere. Painted several Egyptian and Italian subjects. Lived in London and Birmingham.

LEE, Emily fl.1882-1883
Exhib. one landscape at SS 1882, and one at NWS. Address Leatherhead, Surrey.

***LEE, Frederick Richard RA 1798-1879**
Landscape, seascape and still-life painter. Lived mostly in Barnstaple, Devon, his birthplace. As a young man served in the Army, but resigned his commission due to ill-health. Entered RA Schools 1818. Elected ARA 1834, RA 1838. Exhib. at RA 1824-70, BI and SS. Subjects mostly views in Devon, also Scotland. Like Shayer, Creswick and Witherington (qq.v.), Lee was a popular painter of idealised landscape and sentimental rustic genre. He often collaborated with the animal painter T.S. Cooper and sometimes with Landseer (qq.v.). Retired from the RA 1872; died in S. Africa.
Bibl: AJ 1879 p.184 (obit.); 1908 p.376; W. Sandby, *History of the RA,* 1862; Ottley; G. Pycroft, *Art in Devonshire,* 1883; DNB XXXII 1892; E.J. Poynter; Nat.Gall. Cat. III 1900; Maas pp.53, 226 (2 pls. p.51); Staley; Wood, Paradise Lost.

LEE, Sir George fl.1846
Exhib. one picture 'Harbour of Marseilles' at RA 1846.

LEE, J. fl. 1840
Exhib. one picture 'Water Mill' at RA 1840. London address.

LEE, J.J. see LEE, John fl.1850-1860

LEE, James N. fl.1873-1891
London painter of figure subjects. Exhib. at RA, SS, NWS and elsewhere. Titles: 'Mother's Coming', etc. and some animal subjects.

LEE, James R. fl.1864-1872
London landscape painter. Exhib. seven pictures at RA, BI and SS. Titles: 'Heath Gathering', etc.

***LEE, John fl.1850-1860**
Little known Liverpool Pre-Raphaelite painter. Exhib. at SS in 1860 and 1861. Graves lists a J.J. Lee under the same address who exhib. at RA 1863-7 and who is probably the same as John Lee. His works are rare, but are "striking testimony to the triumph of Pre-Raphaelitism in the provinces" (Maas).
Bibl: Maas p.237 (pl. p.238); Staley; Wood, Panorama.

LEE, John fl.1891
Exhib. one picture, 'Cynthia', at SS 1891. London address.

LEE, John Ingle fl.1868-1891
London painter of figure subjects. Exhib. at RA, SS and elsewhere. Titles: 'Holiday Afternoon', etc.

LEE, Miss Louisa E. fl.1870-1874
Exhib. two landscapes in 1870 and 1874. London address.

LEE, Miss M.L. Gwendoline fl.1892
Exhib. one figure subject 1892. London address.

LEE, Mrs. R. fl.1843
Exhib. one picture of flowers at RA 1843. London address.

LEE, Rachael fl.1882
Exhib. one picture of flowers at SS 1882. Address Putney, London.

LEE, Sydney Williams fl.1879-1888
London painter of literary and other figure subjects. Exhib. 15 pictures at RA, SS and elsewhere. Titles: 'The Bachelor', etc., and scenes from Byron and *Guy Mannering*.

LEE, William NWS 1810-1865
Painter of rustic genre, often English or French figures in coastal scenes, and mainly in watercolour. Member and Secretary of the Langham Sketching Club, All Souls' Place, for many years. Exhib. 1844-55, at the RA 1844-54, SS, NWS (91 works); A of RI 1845; RI 1848. 'French Fisherwomen' is in the VAM.
Bibl: AJ 1865 p.139 (obit.); Redgrave, Dict.; DNB; VAM.

***LEECH, John** 1817-1864
Illustrator and caricaturist. At first studied medicine, but abandoned it for art. Contributed his first cartoon for *Punch* in 1847, and was a regular contributor to this and many other magazines. His best known illustrations were those he did for the novels of Surtees. Most of Leech's work was done in pen and ink; he occasionally used watercolour and gouache, but rarely oils. His drawings and cartoons present a charming panorama of Victorian life, observed with gentle wit, although his jokes at the expense of the lower classes are regarded as bad taste by our more democratic age. His studio sale was held at Christie's, 25 April 1865.
Bibl: AJ 1864 p.373 (obit.); Quarterly Review Appr. 1865; North Brit. Review March 1865; J. Brown, *J.L. and other Essays*, 1882; F..B. Kitton, *J.L. Artist and Humorist*, 1883; W.P. Frith, *Leech, Life and Work*, 1891; DNB XXXII 1892; Everitt, *English Caricature*, 1893; Bryan; Reynolds, VS p.31; Maas p.70 (pl. p.190); Leonée Ormond, *George Du Maurier*, 1969 see index; Ormond; J.N.P. Watson, *Jorrocks & Co. Truly Drawn* (J.L. in the Hunting Field), Country Life 20 January 1977.

***LEE-HANKEY, William** RWS RI ROI RE 1869-1952
Painter and etcher of landscapes, figure subjects, and harbour scenes. Born in Chester; studied there and in Paris. Exhib. in London from 1893, at RA, OWS, NWS, ROI and elsewhere. Lived in France and painted many of his pictures there. Won many medals, and his work is represented in collections both in England and abroad.
Bibl: Studio XXXVI 1906 p.291, also XXX, XXXVIII, XLII, LXI; Who's Who in Art 1927; for further bibl. see TB.
Exhib: London, Walker's Gallery, 1954.

LEEKEY, G.G. fl.1847-1850
London painter of landscapes and figure subjects. Exhib. seven pictures at RA and BI. Titles: 'The Painter's Favourites', etc.

***LEES, Charles** RSA 1800-1880
Scottish portrait, landscape and genre painter. Born Cupar, Fifeshire. Pupil of Raeburn. After a six month visit to Rome, he returned to Edinburgh, where he passed the rest of his career. Elected RSA 1830. As well as portraits, Lees painted many charming scenes of Scottish life, landscapes, and sporting scenes. He is best known for his skating scenes. Treasurer of the RSA.
Bibl: AJ 1880 p.172; DNB XXXII; Caw p.120; Wood, Panorama pp.184, 195-6; Wood, Paradise Lost.

LEES, F.J. fl.1865-1866
Exhib. one portrait at RA 1866, and one elsewhere. London address.

LEES, Miss H.E. Ida ARBA fl.1891-d.1928
Landscape painter. Exhib. at RA from 1891, also SS and elsewhere. Elected ARBA 1925. Specialised in moonlight and night scenes. Lived at Ryde, Isle of Wight, and later Kingston-by-Sea, Sussex.

LEES, J.H. fl.1870
Exhib. two landscapes at SS 1870.

LEESE, Spencer fl.1882
Exhib. one picture of Wargrave Church at SS 1882. London address.

LEESMITH, Miss Mary Lascelles fl.1893-1897
Exhib. three portraits at RA 1893-7. Address Bushey, Hertfordshire.

LE FANU, G.B. fl.1878-1885
London landscape painter. Exhib. at RA, SS, NWS and elsewhere. Titles: 'A Devonshire Trout Stream', etc.

LEFEBVRE, Charles fl.1891
Exhib. one picture 'Twilight in the Desert' at RA 1891. London address.

LE FLEMING, Miss Mildred fl.1884-1891
Exhib. three watercolour landscapes at NWS 1884-91. Address Ambleside, Cumbria.

LEFROY, Miss C.E. fl.1866-1867
Exhib. two landscapes at SS 1866-7. Address Thornton Heath, Surrey.

LEFTWICH, G. fl.1851-1853
Exhib. five landscapes at RA, BI and SS, mostly views in Wales or the Lake District. London address.

LEFTWICH, G.R. fl.1875-1880
Exhib. two domestic subjects 1875 and 1880. London address.

LEFTWICH, H.T. fl.1848-1874
Exhib. seven landscapes at RA, BI and SS, subjects mainly Wales and the Lake District, also south of England, and northern France. London address.

LEGGE, Arthur RBA fl.1886-c.1921
Landscape painter. Exhib. at RA, SS and NWS. Lived at Doncaster and later in Essex. Head of the West Ham School of Arts and Crafts.

LEGGE, M.C. fl. 1880
Exhib. one landscape 1880. London address.

LEGGETT, Alexander fl.1860-1870
Scottish painter of rustic and coastal scenes. Exhib. once at RA in 1860 with 'Study of a Fishergirl on the East Coast of Scotland', and once at SS 1870. Edinburgh address. His pictures of country girls are similar to those of P. F. Poole (q.v.).

LEGROS, Professor Alphonse RE 1837-1911
Painter of portraits, landscape, genre and historical subjects; etcher; lithographer; sculptor; medal designer; teacher. Born in Dijon; apprenticed to a builder and decorator. In 1851 he moved to Paris, where he worked as a scene-painter; studied at the École des Beaux-Arts, and under Lecoq de Boisbaudran. Exhib. at the Salon

from 1857, where a profile portrait attracted Champfleury's attention and led him to be drawn into the group of so-called 'Realists', and he appears in Fantin-Latour's portrait group 'Hommage a Delacroix'. In 1859 he exhib. 'Angelus' which led Baudelaire to call him a "religious painter gifted with the sincerity of the Old Masters". Encouraged by Whistler that he might find work in London, Legros came to England in 1863. A few years later he was appointed Teacher of Etching at the South Kensington School of Art, and in 1876 Professor of Fine Art at the Slade School, University College, London, a post which he held until 1892, having considerable influence on many of the students he taught. Exhib. 1864-89, at the RA 1864-82, GG, NG and elsewhere, paintings, etchings and medals. One of the founders of the Royal Society of Painter Etchers and Engravers. Much of his work outside his classroom continued to bear traces of the rebellious romanticism of his youth, e.g. his etchings from Edgar Allan Poe, the 'Bonhomme Misère', and 'La Mort du Vagabond'. In his later years, after 1892, he etched 'Le Triomphe de la Mort', and idylls of fishermen by willow-lined streams, labourers in the fields and rustic scenes in France and Spain.

Bibl: For full bibl. see TB; selected bibl. only: AJ 1897 pp.105-8, 213-16; Studio XXVII 1913 pp.245-67 (pls.); XXIX 1903 pp.3-22; L. Benedicte, *Alphonse Legros*, 1900 Paris; *L'Oeuvre Gravé et Lithogr. de Alphonse Legros*, 1904 Paris; Burlington Mag. XX 1911-12 p.273ff.; DNB 2nd Supp; M. Salaman, *Alphonse Legros*, 1926; VAM; Irwin; Ormond.
Exhib: London, Rembrandt Gallery c.1885; London, National Gallery of British Art 1912; London, Taranman Gallery, 1974, 1975.

LEHMANN, Henri fl.1863-1866
Exhib. four portraits at RA 1863-6. London and Paris addresses.

LEHMANN, Rudolf 1819-1905
German painter of portraits, historical and genre subjects. Born at Ottensen, Hamburg, son of Leo Lehmann, portrait painter. In 1837 he went to Paris where he studied under his brother Heinrich Lehmann, later professor at the École des Beaux-Arts. From Paris he went to Munich, studying under Kaulbach and Cornelius, and in 1838 joined his brother in Rome. First visited London in 1850; lived in Italy 1856-66, mostly in Rome. In 1861 he married in London, and in 1866 settled there. Exhib. from 1851 at the RA, GG, NG and elsewhere. He painted four portraits of Browning, who became a close friend. In his later years he mainly did portraiture (e.g. Lord Revelstoke, Earl Beauchamp, and Miss Emily Davies, Girton College, one of his best), but also other paintings, e.g. 'Undine', 1890 and 'Cromwell at Ripley Castle', 1892.

Bibl: For full bibl. see TB; AJ 1873 pp.169-72; 1893 p.260; 1905 p.385; Rudolf Lehmann, *An Artist's Reminiscences*, 1894; R.C. Lehmann, *Memories of Half a Century*, 1908; DNB 2nd Supp.; Ormond.

LEIGH, Miss Clara Maria see POPE, Mrs. Alexander

LEIGH, George Leonard ARBSA 1857-1942
Landscape painter. Exhib. at RBSA from 1881, and RA from 1900. Secretary of the Midlands Arts Club, member of the Birmingham Art Circle, and elected ARBSA 1919. Lived near Birmingham.

LEIGH, H.G. fl.1872
Exhib. one landscape 'On the Lynn, North Devon' at RA 1872. London address.

LEIGH, James Matthews 1808-1860
Painter of historical subjects and portraits; teacher. Son of Samuel Leigh, well-known publisher and bookseller in the Strand. Studied under William Etty (his only pupil), in 1828. Exhib. 1825-49, at the RA 1828-49, BI and SS, often scriptural subjects, e.g. 'The Trial of Rebecca', 1840. He was also an author and in 1838 published an historical play 'Cromwell', and 'The Rhenish Album'. He was better known as a teacher, starting the well-known painting school in Newman Street, which was very well attended and a rival to the school run by Henry Sass. Although he did not exhibit in his later years, he often sketched the subjects set for his students, the subjects often being scenes from Scott and Shakespeare. Many hundreds of these sketches, with his paintings and watercolours, were sold after his death at his studio sale at Christie's, 25 June 1860.

Bibl: AJ 1860 p.200 (obit.); Redgrave, Dict.; DNB.

LEIGH, Roger fl. 1878-1887
Exhib. two landscapes at SS in 1878 and 1887 and two elsewhere. Subjects views in France and Holland. Address Barham Court, Kent.

LEIGH, Miss Rose J. fl.1887-1902
Landscape painter. Exhib. at RA and SS. Titles: 'By the Lake — Autumn', etc. Address Ireland, Antwerp and London.
Exhib: London, 175 New Bond Street 1896.

LEIGHTON, Charles Blair fl.1843-1855
Portrait painter. Exhib. both portraits and figure subjects at RA, BI and SS. Father of Edmund Blair Leighton (q.v.). Lived in London and Kingsland. His portrait of Joseph Hume is in the NPG.
Bibl: Ormond.

*LEIGHTON, Edmund Blair 1853-1922
Historical genre painter. Son of Charles Blair Leighton (q.v.). E.B. Leighton exhib. at RA 1878-1920, SS and elsewhere. Typical titles: 'The Dying Copernicus', 'Un Gage d'Amour', 'Romola', etc. 'Lady Godiva' is in the Leeds AG. His pictures of elegant ladies in landscapes or interiors have a similar kind of charm to those of Tissot.
Bibl: AJ 1895 p.176; 1896 p.175; 1897 pp.173, 205; 1900 pp.133-8; 1901 p.181; 1902 pp.206, 380; 1903 p.168; Connoisseur LXIV 1922 p.125 (obit.); The Year's Art 1923 p.339.

*LEIGHTON, Frederic PRA RWS HRCA HRSW
(Baron Leighton of Stretton) 1830-1896
Painter of historical and mythological subjects, and leader of the Victorian neo-classical painters. Born Scarborough, Yorkshire, the son of a doctor. Studied under various teachers in Florence and Rome, including the German Nazarene Steinle. In 1855 his first RA picture, 'Cimabue's Celebrated Madonna Carried in Procession through the Streets of Florence', was bought by Queen Victoria for £600, thus launching him on a long and successful career. In the 1860s Leighton turned away from medieval and biblical subjects towards classical themes. It is for these Hellenic subjects that he is now best known. Among his best works are 'Flaming June', 'The Garden of the Hesperides' and 'The Daphnephoria'. Leighton made nude studies and draped studies of each figure in his pictures, and also figure sketches of the whole composition. These drawings and sketches are often more admired than his finished pictures. Exhib. at RA 1855-96, SS, OWS, GG and elsewhere. Elected ARA 1864, RA 1868, PRA 1878. Although conscious of his own limitations as a painter, Leighton was by the end of his life a pillar of the Victorian art establishment. He was knighted in 1878, made a baronet 1886, and raised to the peerage in 1896, just before his death. He is the only English artist to have been accorded this honour. His house in Holland Park Road is now a museum with a

permanent exhibition of his pictures and drawings. After his death sales of his pictures were held at Christie's, 11, 13 July 1896.

Bibl: Main biographies: Mrs. A. Lang, *Sir F.L. Life and Works*, 1884; E. Rhys, *Sir F.L.*, 1895; 1900; G.C. Williamson, *Fred Lord L.*, 1902; Alice Corkran, *Leighton*, 1904; Mrs. R. Barrington, *The Life and Works of F.L.*, 1906; E. Staley, *Lord L.*, 1906; A.L. Baldry, *L.*, 1908; R. and L. Ormond, *Lord Leighton*, 1975; C. Newall, *The Art of Lord Leighton*, 1990.
Other references: Ruskin, Academy Notes 1855, 1875; Sir W. Bayliss, *Five Great Painters of the Victorian Era*, 1902; RA Exhibition 1897; DNB Supp.III 1901 p.88ff.; Encyclopedia Britannica XVI 1911; Roget; Bryan; Binyon; Cundall; VAM; W. Gaunt, *Victorian Olympus*, 1952; Reynolds, VP pp.117-19 *et passim* (pls. 78-80, 87); Hutchinson pp.136-7; Maas pp.178-81 (pls. pp.176-181, 185); Michael Levey, Sunday Times Colour Supplement, 2 November 1969; Ormond; Staley; Wood, Panorama; Ormond, *Leighton's Frescoes in the V & A Museum*, 1975; Wood, Olympian Dreamers.

LEIGHTON, John FSA 1822-1912

London book illustrator and publisher, who used the pseudonym Luke Limner. Under this name he exhib. a design for the stained glass windows of St. George's Hall, Liverpool, at RA 1854.

Bibl: For full bibl. and list of illustrated books see TB.

LEIGHTON, John fl.1889

Exhib. two Dutch scenes at SS 1889. London address.

LEIGHTON, Miss Sarah fl.1883

Exhib. one watercolour of flowers at NWS 1883. London address.

LEITCH R., Jnr. fl.1845-1854

London landscape painter. Exhib. five pictures at BI and SS, views in Holland and on the Thames. Probably a younger brother of Richard P. Leitch (q.v.).

LEITCH, Richard Principal fl.1844-1862

London painter of river and coastal scenes, in oil and watercolour. Exhib. at RA and SS, subjects mainly views on the Thames or the coasts of Holland and France. Probably brother of W.L. Leitch (q.v.).

Bibl: Hardie III p.186; Brook-Hart p.352.

LEITCH, William Leighton 1804-1883

Landscape painter and watercolourist. Born in Glasgow. Became scene painter at Glasgow Theatre Royal. Came to London and worked as scene painter with Clarkson Stanfield, David Roberts (qq.v.) and others. Studied in Italy. Exhib. at RA 1833-61, BI, SS and NWS. Elected RI 1862; Vice-President for many years. Teacher of watercolour painting to Queen Victoria and many other members of the royal family. Although at times superficial and cluttered, his work is "characterised by thorough observation, nicety of touch, and supreme competence" (Hardie). After his death two sales of his works were held at Christie's, 13 March, 17 April 1884.

Bibl: AJ 1884 p.127; Portfolio 1883 p.145; A. MacGeorge, *Memoir of W.L.*, 1884; Bryan; Binyon; Caw pp.155-6; Cundall; DNB XXXIII; Hughes; VAM; Hardie III p.186 (pls. 216-17); Irwin.

*LE JEUNE, Henry ARA 1819-1904

London genre painter. Studied at RA schools. Exhib. at RA 1840-94, BI and SS. Subjects historical genre, country scenes, and pictures of children. In 1845 became Drawing Master at RA, and in 1848 Curator. Elected ARA 1863. Works by Le Jeune are in Manchester and Salford AG. Titles at RA 'Field Flowers', 'Tickled with a Straw', 'Little Bo-Peep'. In the 1840s and 1850s he painted some historical and biblical subjects, but later abandoned these in favour of more commercial genre themes.

Bibl: AJ 1858 p.265ff.; 1904 p.381.

LEKEGIAN, Gabriel fl.1883-1885

Exhib. three Turkish subjects at RA 1883-5. Addresses Manchester and Constantinople.

LE LATROUWER, A. fl.1867

Exhib. one picture of a farm near Antwerp at BI 1867. London address.

LE MAISTRE, Francis William Synge ROI
b.1859 fl.1888-1921

Painter of landscapes and seascapes. Exhib. at RA, SS, ROI and elsewhere. Elected ROI 1921. Lived at St. Brelades, Jersey.

LEMAN, Miss Alicia J. fl.1891

Exhib. one picture, 'Spotting a Winner', at RA 1891. London address.

LEMAN, Robert 1799-1863

Amateur landscape painter, and pupil of J.S. Cotman. Member of the Norwich Amateur Club in the 1830s, and exhib. at the Norwich Society. Friend and patron of many of the Norfolk School of painters.

LEMANN, Miss E.A. fl.1878

Exhib. one landscape at SS 1878. Address near Bath.

LEMASLE, Miss fl.1853

Exhib. one picture of ducks 1853. London address.

LEMON, Alfred D. fl.1838-1867

London painter of historical and figure subjects. Exhib. 12 pictures at BI and SS. Titles: 'The Sorceress', etc.

LEMON, Arthur 1850-1912

Painter of genre, particularly Italian pastoral scenes. Born on the Isle of Man, he spent his youth in Rome; was for ten years a cowboy in California, where he made studies of Indians. Returning to Europe, studied under Carolus Duran in Paris. Lived in England and Italy. Exhib. at the RA, GG, NG and elsewhere from 1878-1902. Titles at the RA include: 'Cattle in the Roman Campagna', 'A Sussex Ox Team', 'Milking Time', etc. A memorial exhibition was held at the Goupil Gallery 1913. 'An Encampment' is in the Tate Gallery (Chantrey Purchase).

Bibl: Cat. Cape Town AG 1903 p.25 (with pls.); *Der Cicerone* V 1913 p.216; *The Standard* V 19 February 1913; Tate Cat.; *The Etruscans*, Cat. of exhib., Stoke-on-Trent AG 1989.

LEMON, Mrs. Arthur (Blanche) fl.1880-1890

Exhib. one picture, 'Gathering Reeds', at RA 1888; also four at GG and elsewhere. Wife of Arthur Lemon (q.v.).

LENDRUM, Miss Florence fl.1893-1900

Exhib. three figure subjects at RA 1893-1900. Titles: 'Clear and Cool', etc. Address Huddersfield, Yorkshire.

LENOX, Miss A. fl.1877

Exhib. one watercolour 'Wandering Thoughts' at SS 1877; London address.

LEONARD, John Henry 1834-1904

Landscape and architectural painter. Born in Patrington, Holderness. 1849-60 lived in York where he was engaged in architectural and lithographic drawing. He was a pupil there of

William Moore, father of Albert Joseph, Edwin, Henry, John Collingham and William Moore Jnr. (qq.v.). Close friend of Henry Moore throughout his life, and influenced by his interest in atmospheric effects. Moved to Newcastle; in 1862 settled in London. At first did architectural drawing for R.H. & Digby Wyatt, but afterwards devoted himself to painting only, landscapes and architectural subjects, mostly in watercolour, but also in oils. The architectural precision and topographical subject matter, however, always remained in his work. Exhib. 1865-81, at the RA 1868-81, SS, Dudley Gallery and elsewhere. From 1886-1904 he was Professor of Landscape Painting at Queen's College, Harley Street. He travelled in France, Holland and Belgium.

Bibl: AJ 1909 pp.84-6 (monograph with pls.).

LE PETIT, Ferdinand fl.1882-1897
Exhib. three animal pictures at RA 1882-97, subjects rabbits and robins. London address.

LE PETTIT, H. fl.1874-1882
Exhib. three domestic subjects at SS 1874-82. Titles: 'A Drop for Pussy', etc. London address.

LE RESCHE, S. fl.1864
Exhib. one picture, 'Cain', at RA 1864. London address.

LE ROHO, H.L. fl.1842-1846
Exhib. seven pictures at RA and SS, subjects landscapes, portraits and churches. Address Clapham, London.

LEROY, Miss H.F. fl.1872-1883
Exhib. two domestic subjects at SS in 1872 and 1883. Titles: 'Day Dreams', etc. London address.

LERRY, William fl.1863
Exhib. one winter landscape at SS 1863. Address Aston, near Birmingham.

LESAGE, Miss Clara fl.1892
Exhib. one picture of buildings 1892. London address.

LESLIE, Mrs. fl.1871
Exhib. one landscape 1871. London address.

LESLIE, Charles fl.1835-1863
Landscape painter, lived in Wimbledon, London. Exhib. at RA 1856-62, BI, SS and elsewhere. Subjects usually Scottish or Welsh moorland scenes. Titles at RA 'A Shower Passing the Welsh Hills', 'The Crags of Cader Idris', 'Upper Leke', etc.

***LESLIE, Charles Robert RA 1794-1859**
Painter of historical genre. Father of Robert and George Dunlop Leslie (qq.v.). In 1800 his parents went to live in Philadelphia. Studied with George Sully. Came to London and studied at RA schools. 1817 visited Brussels and Paris. Exhib. at RA 1813-59 and BI. Elected ARA 1825, RA 1826. Leslie painted historical and humorous genre in the manner of Wilkie and Mulready (qq.v.). His sources were taken from a wide range of authors — Cervantes, Shakespeare, Swift, Addison, Molière, etc. One of his most popular works was 'Roger de Coverley Going to Church'. Leslie was a friend of Walter Scott, and illustrated many of the Waverley Novels. From 1847 to 1852 was Professor of the RA. For Queen Victoria he painted 'Queen Victoria Receiving the Sacrament' and 'The Christening of the Princess Royal'. Leslie was a great friend of John Constable, and their letters are an important source of

information about Constable's life and character. Manuscripts, including letters from Constable, are held at the VAM.

Bibl: AJ 1856 pp.73-5, 105-7; 1859 p.187 (obit.); 1902 pp.144-8; *Autobiographical Recollections*, 1860; Redgrave, Dict. and Cent., J. Dafforne, *Pictures by Leslie*, 1875; Bryan; Binyon; Cundall; DNB; J. Constable, *The Letters of John Constable and C.R.L.*, 1931; Studio Spring Number 1916; *Shakespeare in Pictorial Art*; Dunlap, *History of Arts and Design in the US*, 1918; Reynolds, VP pp.13, 94, 117 (pl.6); Maas p.109 (pl. p.120); Ormond; Staley; Wood, *Panorama*; Strong.

***LESLIE, George Dunlop RA 1835-1921**
Landscape and genre painter; son of C.R. Leslie (q.v.). Studied under his father, and at RA schools. Exhib. at RA from 1857, BI, SS, GG, NG and elsewhere. After a brief period of Pre-Raphaelitism, Leslie turned to landscapes with children and girls, especially views on the Thames. Titles at RA 'Whispering Leaves', 'The Lily Pond' and also some historical works, e.g. 'The War Summons 1485', 'Lucy and Puck', etc. For a time Leslie lived in St. John's Wood and was a member of the St. John's Wood Clique (q.v. and see bibl.), until he moved to Wallingford.

Bibl: Portfolio 1894 p.42; RA Pictures 1893-6; Studio LXXXI 1921 p.155 (obit.); Connoisseur LIX 1921 p.244; Clement & Hutton; Bate p.90 (pl.opp.); G.D. Leslie, *The Inner Life of the Royal Academy*, 1914; Bevis Hillier, *The St. John's Wood Clique*, Apollo June 1964; Reynolds, VP pp.13, 26,179,195.

LESLIE, H.H. fl.1850
Exhib. one picture, 'Contentment', at BI 1850. London address.

LESLIE, Harry fl.1871-1881
London painter of figure subjects. Exhib. occasionally at RA, SS and GG, but mostly at smaller exhibitions. Titles: 'Good Morning', etc. Lived in Southampton.

LESLIE, Harry C. fl.1868-1874
Exhib. three pictures at SS 1873-4, but mostly at smaller exhibitions. Subjects landscapes and figures. London address.

LESLIE, Sir John, Bt. 1822-1916
Exhib. six portraits at GG 1877-83. London address. Probably also exhib. as John Leslie 1853-67. Pupil of K.F. Sohn in Dusseldorf.

Bibl: American Art News XIV 1916 No.17 p.4 (obit.).

LESLIE, John fl.1853-1867
London painter of portraits and figure subjects. Exhib. at RA, BI and SS. Probably same as Sir John Leslie (q.v.).

LESLIE, Robert C. fl.1843-1887
Painter of marine views, portraits and genre. Eldest son of Charles R. Leslie and younger brother of George D. Leslie (qq.v.). Made a speciality of marine subjects, and for many years had a studio in Southampton; exhib. 1843-87 at the RA, BI, SS, Dudley Gallery and elsewhere. Among titles at the RA are 'The Great Horseshoe Fall, Niagara, Canada', 'Robinson Crusoe Visits the Spanish Wreck', and 'A Last Shot at the Spanish Armada in the North Sea'. Tom Taylor, in *English Painters of the Present Day*, 1870, wrote: "All that Robert Leslie has executed of this kind (sailor life, shipping and the sea), has shown a genuine love and pure feeling for Nature, a thorough mastery of the technical elements of his subjects, and a consistency in all parts of his pictures such as in this particular walk of art only exact knowledge can secure. These qualities give a distinctive value and interest to Robert Leslie's pictures, which as yet (1870) have hardly the recognition their merit entitles them to." Leslie was also the author of several works on nautical subjects.

Bibl: AJ 1902 p.148; Clement & Hutton; Brook-Hart.

LE SOUEF, Miss Jessie fl.1866

Exhib. one picture of plants at RA 1866. Address Wanstead, Essex.

LESSORE, Jules RBA RI 1849-1892

Painter of landscape, portraits, genre and architectural subjects. Son of Emile Aubert Lessore 1805-76, Parisian painter, lithographer and engraver. Born in Paris; pupil of his father and of F.J. Barrias. Worked principally in England; exhib. 1879-92, at the RA 1885-90, SS, NWS, GG and elsewhere; at the Paris Salon from 1864-77. Became a member of the RI in 1888.

Bibl: Cundall; VAM; Pavière, Landscape.
Exhib: London, Beaux-Arts Gallery 1943

LESTER, G. or T. fl.1864-1865

Exhib. three figure subjects at SS 1864-5, 'The Flower Girl', etc. London address.

LESWELL, Emily fl.1855

Exhib. one watercolour, 'The Angel of the Flowers', at SS 1855. Dublin address.

LE TALL, Charles McL. fl.1883-1886

Exhib. two landscape studies at RA in 1884 and 1886, and two elsewhere. London address.

LETHABY, William Richard 1857-1931

Although best known as an architect, Lethaby was also a painter and watercolourist. He exhib. architectural subjects at the RA from 1881, and also painted landscapes in watercolour. Manuscripts relating to Lethaby are held at the VAM.

Bibl: William Richard L., *Architecture, Nature and Magic,* 1928; Robert W.S. Weir, *William Richard L.,* 1932; London, RIBA, *William Richard L., A Bibliography of his Literary Works,* 1950; London County Council (Central School), *W.R.L. 1857-1931,* 1957.
Exhib: London, Tate Gallery 1932.

LETHERBROW, John Henry fl.1877-1881

Exhib. five historical subjects 1877-81. Brother of T. Leatherbrow (q.v.). Manchester address

LETHERBROW, Thomas b.1825

Manchester landscape painter, brother of J.H. Letherbrow (q.v.). Also a book illustrator.

LETTS, Miss E.F. fl.1878

Exhib. one picture, 'A Day Dream', at SS 1878. London address.

LEVACK, John fl.1856-1857

Exhib. two pictures at SS 1856-7, subjects Scottish and Irish figures. Lived at Airdrie, Scotland.

LEVESON, Miss Dorothy fl.1896

Exhib. five portraits at RA in 1896. London address.

LEVESON, Miss Mary E. fl.1899

Exhib. one portrait at RA 1899. London address.

LEVICK, Richard fl.1898

Exhib. one picture, 'Brittany Peasant Girl', at RA, 1898. Address St. Ives, Cornwall.

***LEVIN, Phoebus** fl.1836-1878

Portrait and genre painter. Born in Berlin, where he studied 1836-44, and exhib. until 1868. In Rome 1845-7, and London 1855-78, where he exhib. mainly at SS, also RA and BI. His best known picture is 'The Dancing Platform at Cremorne Gardens' in the London Museum.

Bibl: Maas p.117 (pl.p.118); Ormond; Wood; Panorama.

LEVIN, Miss Victoria fl.1869-1886

Exhib. domestic subjects regularly at the SS only, mainly in watercolour. Lived in London, at the same address as Phoebus Levin, so was presumably his daughter.

LEVITT, L.C. fl.1867

Exhib. one watercolour 'Young Wheat' at SS 1867. Manchester address.

LEVY, Miss Julia M. fl.1883-1888

Exhib. four domestic subjects at RA 1883-6. Titles: 'Matching a Tint', etc.; also once at GG, and elsewhere. London address.

LEVY, Miss Netta fl.1898

Exhib. one picture of flowers at RA 1898. London address.

LEWIN, Stephen fl.1890-c.1910

London painter of historical scenes. Exhib. at RA from 1902, and elsewhere. Subjects mostly dramatic scenes set in 17th century costume, similar to those of Edgar Bundy (q.v.). Two of his pictures are in Sheffield AG.

LEWIS, A. fl.1886

Exhib. one landscape at NWS 1886. London address.

LEWIS, Miss Anne Madeline fl.1880-1922

Flower painter. Exhib. at RA, SS and elsewhere, in oil and watercolours. Address Sevenoaks, Kent. Lived in France for a time, and also painted landscapes and architectural subjects.

LEWIS, Arthur James 1824-1901

London painter of landscape and portraits, who exhib. 1848-93, at the RA 1848-85, BI, GG, NG and elsewhere. Titles at the RA include 'Far Away on the Hills — Scene in Arran', 1881.

LEWIS, Avery fl.1899

Exhib. one picture, 'The Garden of Pan', at RA 1899. Address Rye, Kent.

LEWIS, C.H. fl.1841-1843

Exhib. three figure subjects at SS 1841-3. Titles: 'Study of a Gipsy', etc. London address.

LEWIS, C.W. Mansel RPE fl.1872-1922

Welsh painter of domestic and rustic scenes; also etcher. Exhib. at RA from 1878, and also at RPE, to which he was elected in 1881. Lived at Llanelly, Carmarthenshire.

***LEWIS, Charles James** RI 1830-1892

Painter of landscape, small domestic subjects, rustic genre, and angling scenes. He was an industrious and rapid artist and his work was very popular. Exhib. 1852-93, at the RA 1853-90, BI, SS, NWS (72 works), GG, NG, and elsewhere (187 works). Elected RI in 1882. The AJ, 1869, reproduces 'The Mill-Door', and comments "We are pleased to meet with something which breaks the monotony of what is ordinarily set before us ... both in the subject and its treatment we have an attractive work: the introduction of the mother and her children gives animation to the scene, while they do not appear forced in for the sake of effect; they express only a domestic incident natural enough in their daily life."

Bibl: AJ 1869 p.244 (pl.); DNB; Pavière, Sporting Painters; Wood, Paradise Lost.

LEWIS, Miss Eveleen fl.1870-1893

London landscape painter. Exhib. watercolours only at SS 1870-93. Subjects views in the south of England, Scotland and elsewhere.

LEWIS, F.C. fl.1870
Exhib. one picture of the Bazaar in Baghdad at SS 1870. Not the same as Frederick Christian Lewis (q.v.).

LEWIS, Miss Florence E. fl.1881
Exhib. one picture of flowers at RA 1881. London address. Also exhib. at the International Exhibition, and in the provinces. Later worked for Doultons decorating pottery with flowers and birds.
Bibl: Clayton II p.283.

LEWIS, Frederick Christian 1779-1856
Engraver and landscape painter, in oil and watercolour. Brother of George R. Lewis (q.v.) and father of John F. Lewis and F.C. Lewis, Jnr. (qq.v.). He held the appointment of Engraver of Drawings to Princess Charlotte, Prince Leopold, George IV, William IV and Queen Victoria. He did the aquatint work for some of Girtin's *Views of Paris* and for Turner's first experimental plate in the *Liber Studiorum*. He engraved many of T. Lawrence's crayon portraits. He engraved his own drawings in *Picturesque Scenery of the River Dart*, 1821, *Scenery of the Tamar and Tavy*, 1823 and *Scenery of the Exe*, 1827. He was also a painter of some merit and exhib. 1802-53 at the RA, BI and SS, and watercolours at the OWS from 1814-20.
Bibl: AJ 1857 p.61; 1875 p.279; 1880 p.300; 1910 pp.93-5; Dibdin, *Bibliographical Decameron*, 1817 ii p.520; Gentleman's Magazine 1857 i p.251; Redgrave, Dict.; Roget; Bryan; Binyon; DNB; BM Cat. of Engraved British Portraits 1908-25 VI pp.514, 644ff.; S.T. Prideaux, *Aquatint Engraving*, 1909 pp.366, 398ff.; T.M. Rees, *Welsh Painters*, 1912; Hughes; Connoisseur XXXVII 1913 p.2; XLVI 1916 pp.102, 115; Print Collector's Quarterly XII 1925 p.383; XIII 1926 pp.53, 56, 60, 62; VAM; Walker's Monthly May 1929; Hardie III p.48; Ormond.

LEWIS, Frederick Christian, Jnr. 1813-1875
Painter of portraits, figure subjects, and Indian scenes. Youngest son of Frederick Christian Lewis (q.v.). Pupil of Thomas Lawrence. Visited Persia about 1836-8, and a volume of Persian sketches is in a private collection in London. About 1840 he went to India, where he remained for many years, and is often referred to as Indian Lewis. His pictures were often engraved by his father.
Bibl: Evan Cotton, *Frederick Christian L. A Victorian Artist in the East* (from *Bengal, Past and Present* XLIV 1932); see also under F.C. Lewis.

LEWIS, George Lennard RBA 1826-1913
Landscape and architectural painter, who exhib. 1848-98 at the RA, BI, SS, NWS, GG, NG and elsewhere. Painted views and buildings in England, France and Portugal. Second son of George Robert Lewis (q.v.).
Bibl: T.M. Rees, *Welsh Painters*, 1912.

LEWIS, George Robert 1782-1871
Painter of landscape, portraits, and figure subjects including many scenes of pilgrimages, e.g. 'Pilgrimage to the Monastery of Goetweig, near Vienna', 1820. Younger brother of Frederick Christian Lewis (q.v.). Studied under Fuseli at the RA schools. Worked with his brother, in aquatint on Chamberlaine's *Original Designs of the Most Celebrated Masters* and Ottley's *Italian School of Design*. Exhib. 1805-17, at the RA 1820-59, BI, SS, NWS and elsewhere. In 1818 accompanied Dr. Dibdin as draughtsman on his continental journey, and drew and engraved the illustrations for Dibdin's *Bibliographical andl Picturesque Tour through France and Germany*, 1821. He also published many engraved books on different subjects.
Bibl: See under Frederick Christian Lewis; DNB.

LEWIS, Lady Jane M. RI fl.1879-d.1939
(Miss Jane M. Dealy)
Figure painter and illustrator of children's books. Exhib. from 1879; elected RI 1887. Married Sir Walter Lewis in 1887. Lived in Blackheath. See also Miss Jane M. Dealy.

LEWIS, Miss Janet fl.1891
Exhib. one landscape at NWS 1891. London address.

LEWIS, John fl.1842-1848
Exhib. two landscapes at RA in 1842 and 1848, one a Swiss scene. London address.

***LEWIS, John Frederick** RA HRSA 1805-1876
Painter and watercolourist of animals, landscape, and genre, especially Spanish and oriental subjects. Lewis was born into an artistic family; both his father Frederick Christian Lewis and his uncle George Robert Lewis (qq.v.) were artists. As a boy he studied animals with Edwin Landseer (q.v.). In 1820 he began to exhib. at the BI, and in 1821 at the RA. His early works mostly animal subjects. About 1825 he turned to watercolours, elected ARWS 1827, RWS 1829. 1827 visited Switzerland and Italy; 1832-4 in Spain. In 1835 published *Sketches and Drawings of the Alhambra* with lithographs by J.D. Harding (q.v.), and other books of Spanish views. 1837 visited Paris, 1838-40 settled in Rome. From Rome Lewis set out for Greece and the Middle East, arriving in Cairo in 1841, where he remained for ten years. From 1841 to 1850 he did not exhib. in London, but in 1850 his watercolour 'The Hareem', created a sensation. Ruskin praised it as "faultlessly marvellous" and hailed Lewis as a leading Pre-Raphaelite. Although Lewis used similar technical methods to the Pre-Raphaelite Brotherhood painters, he was never associated with them. Elected PRWS 1855, but resigned in 1858 to take up oil-painting again. ARA 1859, RA 1865. In both his oils and his watercolours, Lewis was a meticulous craftsman, combining to a remarkable degree detailed observation, jewelled colour, and effects of light. An exhibition of his work was held at the RA in 1934. After his death, a sale of his studio was held at Christie's, 4 May 1877.
Bibl: AJ 1858 pp.41-3; 1876 p.329; 1891 pp.323, 325. 327; 1908 p.293; Portfolio 1892 pp.89-97, 125; Connoisseur LVI 1920 pp.202, 220; LXV 1923 pp.46, 48; LXXI 1925 pp.169, 174; Redgrave. Cent., Dict.; Ruskin, Academy Notes 1855-8; Roget; DNB XXXIII 1893; Ruskin, *Modern Painters*, 1898 V p.177; Bate pp.91-2 (pl. opp. p.92); Binyon; Cundall; Hughes; VAM; R. Davies, *J.F.L.*, OWS III 1926; H. Stokes, *J.F L.*, Walker's Quarterly XXVIII 1929; Reynolds, VP pp.12, 143-4, 156 (pls. 95, 97); Hardie III pp.48-55 (pls. 65-9); Maas pp.91-3 (pls. pp.90, 92, 93); Irwin; Ormond; M.I. Wilson, *A Man Who Loved Beasts*, 1976; Newall.
Exhib: London, RA 1934; Newcastle-upon-Tyne, Laing AG 1971.

LEWIS, John Hardwicke 1840-1927
London painter of landscapes and rustic figure subjects. A regular exhibitor at the RA, SS and elsewhere. Subjects include views in England, Europe and California; also some portraits. Son of Frederick Christian Lewis Jnr. A watercolour by him is in the VAM. An exhibition of his work was held at Walker's Gallery in London in May 1929.
Bibl: See under Frederick Christian Lewis Jnr.
Exhib: London, 118 New Bond Street, 1901; Walker's Gallery 1929.

LEWIS, Mrs. Lennard fl.1878-1879
Exhib. four watercolours of buildings in Brittany at SS 1878-9. London address. Wife of George Lennard Lewis (q.v.).

LEWIS, Miss M.A. fl.1877-1880
Exhib. three watercolours at SS 1877-80, flowers and landscapes. London address.

LEWIS, Miss Madeleine fl.1898
Exhib. two landscapes at RA 1898. London address.

LEWIS, R. fl.1877
Exhib. one watercolour landscape at SS 1877. London address.

LEWIS, Richard Jeffreys RBA fl.1843-1851
London painter of historical and other figure subjects. Exhib. at RA, BI and SS. Titles: 'The Widow', etc., and two scenes from the life of Mozart. Elected RBA 1848.

LEWIS, Shelton fl.1875-1880
Exhib. landscapes at RA, SS and elsewhere. Titles: 'A Wiltshire Farmhouse', etc. Address Henley, Berkshire.

LEWIS, Miss Sylvia C. fl.1890-1891
Exhib. two landscapes at SS 1890-1. London address.

LEWIS, Thomas fl.1835-1852
London portrait painter. Exhib. at RA and BI, but mostly at SS. Occasionally painted figure subjects and flowers. Painted a portrait of the poet Thomas Hood.
Bibl: Ormond.

LEWIS, Tom Noyes fl.1898-1904
London landscape painter. Exhib. three pictures at the RA, 1898-1904.

LEWIS, William fl.1870
Exhib. one picture 'Sighing for Liberty' at SS 1870.

LEY, George William fl.1849-1851
Exhib. three figure subjects at RA and BI, mostly of Welsh girls. Brighton address.

LEYCESTER, R. Neville fl.1883
Exhib. two pictures of fruit at SS 1883. London address.

LEYDE , Otto Theodore RSA RSW 1835-1897
Painter of portraits; engraver. Prussian by birth, he was born in Wehlau; as a youth he came to Edinburgh where he was employed as a lithographic artist; then he devoted himself to painting. Began to exhibit at the RSA in 1859, in London 1877-88, at the RA and elsewhere. ARSA 1870; RSA 1880. He was a member of the Council of the RSA and Librarian for some years.
Bibl: AJ 1897 p.iv (obit.); BM Cat. of Engraved British Portraits 1908-25 VI pp.515, 645.

LIBERTY, Miss Octavia fl.1881-1882
Exhib. two pictures of flowers at GG 1881-2. Nottingham address.

LIDDELL, H. fl.1888
Exhib. one landscape 1888. London address.

LIDDELL, J.D. fl.c.1900
Northumbrian painter of shipping and coastal subjects.
Bibl: Hall.

LIDDELL, T. Hodgson RBA 1860-1925
London landscape painter. Born in Edinburgh, where he also studied art. Exhib. at RA from 1887 and at SS. Visited China and brought back a collection of watercolours which were shown at the Fine Art Society in 1909. Also travelled in many other countries, and published a book on China in 1909.
Bibl: Brook-Hart p.75 (pl. 140); listed as J.H. Liddell Who's Who 1924; Connoisseur LXXII p.181ff.; LXXIII p.57ff.
Exhib: London, Fine Art Society 1909; London, 5 Warwick Studios c.1910.

LIDDELL, Tom fl.1886
Exhib. one figure subject 1886. London address.

LIDDELL, Miss Violet fl.1887
Exhib. one portrait at GG 1887.

***LIDDERDALE, Charles Sillem RBA 1831-1895**
London genre painter. Exhib. 1851-93 at RA, BI and SS. Subjects mostly single figures in landscapes, especially pretty farm girls; pictures often of small size. Titles at RA 'A Chelsea Pensioner', 'Threading Granny's Needle', 'Foul Play', etc.
Bibl: AJ 1859 p.165; 1868 p.278; Wood, Paradise Lost.

LIGHTBODY, Robert fl.1888
Exhib. one landscape at NWS 1888. Liverpool address.

LIGHTON, Sir Christopher Robert, Bt. fl.1891
Exhib. one shipping picture at NWS 1891. Brighton address.

LILLEY, Albert E.V. fl.1892-1940
Painter of landscapes, architectural subjects and flowers. Exhib. mainly at RBSA, also at RA from 1898. Painted in Belgium and Holland. Teacher at Wolverhampton School of Art. Lived at Dudley and later Sheffield.

LILLEY, Miss Elizabeth A. fl.1885-1902
London painter of figure subjects. Exhib. at RA and SS. Titles; 'The Garland', etc.

LILLEY, H. fl.1843
Exhib. one portrait at RA 1843.

LILLEY, John fl.1832-1846
London painter of portraits and figure subjects. Exhib. portraits only at the RA 1834-46, mostly military, including 'The Duke of Wellington as Lord Warden of the Cinque Ports', for the Corporation of Dover, 1837. Exhib. figure subjects at BI and SS. Titles: 'The Gleaner', etc.
Bibl: BM Cat. of Engraved British Portraits I 1908; Cat. of Paintings in the India Office, London, 1914; Ormond.

LILLIE, Charles T. fl.1882
Exhib. two flower pictures at SS 1882. London address.

LILLIE, Robert fl.1893
Exhib. one coastal subject 1893. Address Dulwich, London.

LILLINGSTON, G.B.P. fl.1871-1899
Painter of landscapes and figure subjects. Exhib. twice at RA in 1878 and 1899, more regularly at SS and elsewhere. Painted in Devon and Cornwall. Lived in London, Leamington and Penzance.

LILLINGSTONE, Juliana fl.1866
Exhib. one landscape 1866. Torquay address.

LIMBREY, Miss M.D. fl.1858-1859
Exhib. six domestic subjects 1858-9. Address Barnes, London.

LIMNER, Luke see LEIGHTON, John, FSA

LIN, Clifton fl.1884-1887
London painter of flowers and figure subjects. Exhib. mostly at SS, also GG. Subjects mostly flowers, occasionally figures, e.g. 'Jeanne la Bretonne', etc.

LINDEN, E.V.D. fl.1881
Exhib. one picture 'Looking Out' at RA 1881. London address. Graves Dictionary lists him as a sculptor.

LINDEN, G. fl. 1890-1891
Exhib. two sea pieces 1890-1. Address Chiswick, London.

LINDER, Miss P. fl.1885
Exhib. one picture 'Meditation' at RA 1885. London address.

LINDNER, G.M. fl.1869
Exhib. one landscape 1869. Birmingham address.

LINDNER, Mrs. Gussie fl.1900
Exhib. one landscape at RA 1900. Address St. Ives, Cornwall.

LINDNER, Peter Moffat ROI RWS 1852-1949
Landscape and marine painter, working in London and St. Ives. Studied at the Slade and Heatherley's School. Exhib. from 1880 at the RA, from 1881 SS, NWS, GG, NG, NEAC and elsewhere. His paintings are in museums in Barcelona, Bradford, Brighton, Cheltenham, Dublin, Hull, Liverpool (Walker AG), Oldham and Wellington, NZ. His watercolours — notably those reproduced in the Studio — are liquid and atmospheric in their effects, especially those of Venice.
Bibl: Studio XXXII 1904 pp.160, 185-90, (pls.); XLIV pp.511, 76; XLVII pp.56 (pl.); LIX (pl.); LX pp.139, 140 (pl.), 141; LXVIII pp.54-5; LXXXIX pp.285-6 (pl.); Special Summer Number 1900; Special Summer Number 1919; The Athenaeum 1920 II p.185; Who Was Who 1941-50.
Exhib: London, Rembrandt Gallery.

LINDSAY, Lady RI 1844-1912
(Blanche Fitzroy)
Painter of figure subjects. Wife of Sir Coutts Lindsay (q.v.) with whom she founded the Grosvenor Gallery. She was a regular exhibitor at the GG and the NWS, and later at the NG.
Bibl: See under Sir Coutts Lindsay.

LINDSAY, Sir Coutts, Bt. RI 1824-1913
Painter and watercolourist. Exhib. at RA 1862-75, NWS, GG and elsewhere. Titles mostly portraits, or portrait studies, e.g. 'The String of Pearls', etc. His most important work was the ceiling of a room in Dorchester House. As an artist, he was not particularly distinguished, but he is best remembered today for his role in the founding of the Grosvenor Gallery in 1877. Throughout the 1880s it was the focus of the aesthetic movement, patronised by Burne-Jones and many avant-garde artists, satirised by Du Maurier and Gilbert and Sullivan – "greenery-yallery-Grosvenor-Gallery", etc. His wife Blanche (q.v.) was also a painter and writer, and it was their separation which led to the closing of the Grosvenor in 1890, and the founding of the rival New Gallery.
Bibl: Who's Who 1912-14; Champlin-Perkins, Cyclop. of Painters etc, 1888 III; C.E. Halle, Notes from a Painter's Life, 1909; Louise Jopling, Twenty Years of My Life, 1925; J Comyns Carr, Some Eminent Victorians, 1908 V. Surtees, Sir Coutts Lindsay, 1993.

LINDSAY, Hon. Mrs. Lloyd fl.1878
(Lady Wantage)
Exhib. one interior at GG 1878.

LINDSAY, Mrs. Ruth fl.1882
Exhib. one fruit picture 1882. Address Rugeley, Staffordshire.

LINDSAY, Thomas NWS 1793-1861
Landscape painter in watercolour, whose speciality was Welsh scenery. Born in London, he worked first at Bow Road, Mile End, then at Greenwich, and settled at Cusop, Hay, nr. Brecon. He was one of the earliest members of the NWS, and 1833-61 exhib. 347 works there; also exhibited at SS. In his obituary, the AJ commented: "His pictures, the majority of which were representations of Welsh scenery, were pleasing, but not of a high character; his colouring was feeble and unimpressive, and his manipulation wanted firmness; he belonged, in fact, to a school of art which had passed away."
Bibl: AJ 1859 p.175; 1861 p.76 (obit.); Redgrave, Dict.; VAM.

LINDSAY, Thomas M. fl.1893-1901
Rugby painter of coastal scenes and landscapes, mostly in Cornwall. Exhib. at RA and NWS. Worked at Rugby Art Museum.

LINDSAY, Miss Violet fl.1879-1893 d.1937
(Marchioness of Granby and Duchess of Rutland).
Portrait painter. A relation of Sir Coutts Lindsay (q.v.), and a regular exhibitor at the GG, and also the NG. Also exhib. at RA 1892-3, including a portrait of the Speaker of the House of Commons. She was the mother of Lady Diana Cooper. Made a number of interesting portrait drawings of her contemporaries. See also Mrs. Henry Manners and Rutland, Duchess of.
Bibl: Sparrow; AJ 1906 p.37; BM Cat. of Engraved British Portraits; see also under Sir Coutts Lindsay.

LINES, Henry Harris RBSA 1801-1889
Birmingham landscape and architectural painter, eldest son of Samuel Lines, also a painter. Exhib. at RA 1818-46, BI, SS and at Birmingham Society of Artists, of which he was a member (RBSA). Awarded Silver Medal at SS. Subjects mostly Warwickshire landscapes, and views on the Welsh borders. About 1830 settled near Worcester as a teacher. Several works by him are in the Birmingham AG.
Bibl: Cat. of National Gallery of Art, VAM II; Birmingham Cat.; G. Potter, A Provincial from Birmingham: Some Account of the Life and Times of H.H.L. Artist and Archaeologist, 1969.

LINGARD, Henry fl.1884
Exhib. one Normandy landscape at RA 1884. London address.

LINGEMAN, J. fl.1874
Exhib. one domestic subject 1874. London address.

LINGFORD, T.J. fl.1843
Exhib. one picture of fruit at SS 1843. London address.

LINGHAM, G. fl.1840
Exhib. one picture 'A Study' at BI 1840. London address.

LINGWOOD, Edward J. fl.1884-1904
Suffolk landscape painter. Exhib. mainly at RA 1885-1904, also SS and elsewhere. Subjects mostly Suffolk scenes. Lived at Needham Market and Saxmundham.

LINN, David fl.1847-1862
London landscape painter. Exhib. at BI, SS, once at RA, and elsewhere. Subjects views in Devon, Surrey and Wales.

LINNELL, James Thomas 1820-1905
Landscape painter, second son of John Linnell (q.v.). Lived in London, later at Redhill, Surrey. Exhib. at RA 1850-88. Subjects mainly landscapes with farm-workers or children. His style is similar to his father's, but usually more brightly-coloured and broader. Works by him are in Rochdale, Manchester and Sheffield AGs. In the 1850s he painted some religious subjects, but after this devoted himself entirely to landscape.
Bibl: AJ 1872 p.250ff.; H. Blackburn, Academy Notes, 1877; Clement & Hutton.

***LINNELL John 1792-1882**

Landscape painter. Son of James Linnell, a carver and gilder. Pupil of John Varley, together with William Henry Hunt and W. Mulready (qq.v.). Under the patronage of Benjamin West, entered RA schools 1805. At first painted portraits and watercolours. Member of OWS from 1810 till 1820, when he resigned in order to concentrate on landscape painting. Exhib. at RA 1807-82, BI and OWS. Lived in Hampstead; then Porchester Terrace; in 1852 retired to Redhill, Surrey, where he lived surrounded by his large family for the rest of his life. Linnell was a friend and patron of Blake, and also father-in-law of Samuel Palmer (q.v.). He was strongly religious, and his landscapes are imbued with a feeling of the grandeur of nature. His subjects were mostly of country life in Surrey, painted in a distinctive brown tone, with masses of fleecy white clouds. Among his best known works are 'The Last Gleam Before the Storm', 'The Timber Waggon' and 'Barley Harvest'. Linnell was proposed as an ARA, but withdrew his name, and would never consent to submitting it again. Three of his sons, John Jnr., James Thomas, and William (qq.v.), were painters.

Bibl: AJ 1850 p.230; 1851 p.272; 1859 p.105ff.; 1862 p.216; 1865 p.208; 1882 pp.261-4, 293-6 (F G Stephens); 1883 pp.37-40; 1892 pp.301-5; 1893 p.43; Portfolio 1872 pp.45-8; 1882 p.61; 1883 p.41; Smith, *Recollections of the British Institution,* 1860; Redgrave, Cent.; A.T. Story, *The Life of J.L.,* 1892; Roget; Bryan; Binyon; Cundall; VAM; Hughes; DNB XXXIII; Studio, *Early English Watercolours by the Great Masters,* 1919 pp.43-4; OWS Annual 1924-5; Reynolds, VP p.16 (pls. 13-15); Hardie II pp.l56-7 (pls. 156-8); Maas pp.42-4 (pls. 42-3); Ormond; Staley; Wood, *Paradise Lost*; David Linnell, *Blake, Palmer, Linnell & Co.* 1994.
Exhib: London, Colnaghi's 1973; Cambridge, Fitzwilliam Museum 1982-3.

LINNELL, John, Jnr. fl.1858

Exhib. one picture of flowers at RA 1858. Son of John Linnell (q.v.).

LINNELL, Miss Mary fl.1868-1869

Exhib. two watercolour landscapes at SS 1868-9; presumably a daughter of John Linnell (q.v.).

LINNELL, Thomas G. fl.1864-1884

Landscape painter, presumably related to the Linnell family, as he also lived at Redhill. Exhib. at RA 1865-84. Titles: 'The Old Oak', 'Summer Foliage', 'The Bridle Path', etc.

LINNELL, William 1826-1906

Landscape and rustic genre painter, eldest son of John Linnell (q.v.). Exhib. at RA 1851-91. Subjects rustic landscapes in similar vein to his father's, e.g. 'Summer Crops', 'Through the Barley', 'Return from Labour', etc. Visited Italy, and painted some Italian genre scenes. William Linnell did not marry, and lived near his father's house at Redhill, Surrey. Works by him are in Sheffield, Manchester and Salford AGs. After his death his collection of pictures was sold at Christie's, 27 May 1910.

Bibl: H. Blackburn, *Academy Notes,* 1875 p.31; 1877; Clement & Hutton.

LINNIG, W. fl.1863-1875

Exhib. two domestic subjects at RA in 1863 and 1875. London address.

LINSLEY, W. fl.1880-1900

Unrecorded painter of coastal scenes whose works are often seen in the saleroom.

Bibl: Brook-Hart p.353 (pl.207).

LINTON, J. fl.1814-1854

London painter of fruit and flowers. A regular exhibitor at RA 1814-54, also occasionally at SS.

LINTON, J. Gilbert fl.1872

Exhib. one figure subject 1872. Bristol address.

***LINTON, Sir James Dromgole PRI HRSW 1840-1916**

Painter of figure subjects in watercolour; portraits and historical pictures in oil; lithographer. Pupil at J.M. Leigh's Art School, and exhib. from 1863 onwards, at the RA from 1865, SS, NWS (104 works), GG, NG, Dudley Gallery and elsewhere. In his early years he made many drawings for *The Graphic;* became an Associate of the NWS in 1867; RI 1870; PRI 1884-98, 1909-16; knighted in 1885. Hardie writes: "In his work he was a little laboured and heavy handed following Cattermole in a dull and encyclopaedic fashion, but without any of Cattermole's 'curiosa felicitas'. He painted figure subjects and liked colour in costume and rich stuffs, but the costume was fancy dress." His studio sale was held at Christie's, 19 January 1917.

Bibl: AJ 1891 pp.57-62; 1904 p.192; l905 p.l91; The Studio XXXVIII 1906 p.16; LX 1914 p.141; LXIX p.67; Special Number, *Art in 1898;* Special Summer Number 1900; The Portfolio 1885 p.43; 1893 pp.224-31; Chesneau, *Artistes Anglais Contemporains,* Paris, 1887; Roget; Connoisseur XXXVI 1913 p.108; XXXIX 1914 p.81 (pl.), p.84; XLII 1915 pp.59, 251; 1916 p.59; 1917 p.54ff.; VAM; Hardie III pp.82, 96.

LINTON, James W.R. fl.1890-1893

Exhib. domestic subjects at NWS and elsewhere. London address.

***LINTON, William RBA 1791-1876**

Landscape painter. Born in Liverpool, where at the age of 16 he was placed in a merchant's office. He painted landscapes in the Lake District and copied pictures by Richard Wilson, and eventually made art his profession and settled in London. He took an active part in founding the SBA in 1824. Exhib. 1817-71, at the RA 1817-59, BI, SS (101 works), OWS, and NWS. Early in his career his subjects were taken from scenery in England, especially that in the vicinity of the lakes; but later he turned to classical landscapes, and it was here that he made his reputation. Many are treated ideally, e.g. 'Embarkation of the Greeks for the Trojan War', 'Venus and Aeneas', many literally, e.g. 'The Temple of Jupiter, Athens', 'Temple of Paestum'; some also are of scenery in Italy, Sicily and Calabria. In 1853 he published *Ancient and Modern Colours, from the Earliest Periods to the Present Time, with their Chemical and Artistical Properties;* and in 1857 *Scenery of Greece and its Islands,* illustrated by 50 engravings. After his retirement in 1865, a sale of his works was held at Christie's, 28 April 1865.

Bibl: AJ 1850 p.252; 1858 pp.9-11; 1876 pp.329-30 (obit.); Redgrave, Dict.; Binyon; Cundall; DNB; Connoisseur LXVIII 1924; VAM.
Exhib: London, 7 Lodge Place 1842.

LINTZ, Ernest fl.1875-1891

London painter of domestic subjects. Exhib. at RA, SS, GG and elsewhere. Titles: 'Puzzled', etc.

LINZELL, John J. fl.1881

Exhib. one landscape 1881. Address Tottenham, London.

LION, Mrs. Flora ROI 1876-1958

Painter of portraits, figure subjects and landscapes. Studied in London and Paris. Began to exhib. at RA in 1900 with 'The Lady of Shalott'. Elected ROI 1909. Married in 1915, and her husband adopted her name.

Bibl: Who's Who; Salaman, *Modern Woodcuts,* etc.; Studio Special Number 1919; Studio XXXVIII 1906 p.248; also LVIII, LXXXIII-LXXXIV; Connoisseur XXVIII 1910 p.314; XLII 1915 p.180; LVII 1920 pp.114-15; LIX 1921 pp.115, 121; LXVI 1923 p.182; Art News XXIV 1925-6 No.5 p.l.
Exhib: London, Fine Art Society 1937; Knoedler's 1940.

LISSMORE, Charles　**fl.1883**
Exhib. two sea pictures 1883. London address.

LISTER, Hon. Beatrix　**fl.1881**
Exhib. one flower picture at GG 1881.

LISTER, E.M.　**fl.1882**
Exhib. one flower picture at SS 1882. Address Leytonstone.

LISTER, George　**fl.1881-1882**
Exhib. two pictures at SS 1881-2, 'Among the Flowers', etc. London address.

LISTON, J.　**fl.1846-1848**
Exhib. four landscapes at RA and SS, including Italian and Scottish scenes. London address.

LITTLE, Miss Emily　**fl.1888-1900**
Exhib. two portraits and a figure subject at RA. London address.

LITTLE, George Leon　**b.1862 fl.1884-1902**
Exhib. seven pictures at SS, portraits and landscapes, including a portrait of H. Rider Haggard. Also exhib. two landscapes at RA 1900 and 1902. London address.
Bibl: AJ 1894 p.171; Studio XXXVII p.157.
Exhib: London, 26 Emperor's Gate 1903.

LITTLE, Robert W.　**RWS RSW**　**1854-1944**
Scottish painter of landscapes and genre, interiors and flowers, closely related to the Glasgow School in the decorative quality of his work. Also a lithographer. Born in Greenock, son of a shipowner; educated at Glasgow University. Studied at the RSA Schools 1876-81, worked at the British Academy in Rome, and under Dagnan-Bouveret in Paris, 1886. He was elected RSW 1886; A of the RWS 1892; RWS 1899, VP 1913; hon. retired member 1933. He exhib. from 1885 at the RA, OWS, GG and elsewhere from 1885, and settled in London in 1890. He painted both in oil and watercolour, and his work presents considerable variety; at first studies of interiors and groups of flowers, then Italian subjects — hill towns in Italy, domestic genre with titles like 'Renunciation' and 'Yours Faithfully', and latterly, landscapes. Caw notes that his work is "marked by a certain romanticism of sentiment and by a pleasing mingling of decorative quality and of classic balance and restraint in design".
Bibl: Studio XXIII 1901 p.48; XLI 1907 pp.172-80; LV 1912 pp.189, 190 (pls.) Summer Number 1900; Winter Number 1917-18, pl. X 28; M.B. Huish, *British Watercolour Art*, 1904; Caw pp.387-8; Hardie III p.194.

LITTLE, Walter　**fl.1864-1878**
Painter of landscapes and rustic scenes. Exhib. mainly at SS, also once at RA in 1872, and elsewhere. Titles: 'Helping Grandmama', etc. Lived in Bexley Heath, and elsewhere.

LITTLER, Joseph　**fl.1885**
Exhib. one watercolour of Barnaby Rudge at SS 1885.

LITTLER, William Farran　**fl.1887-1892**
Exhib. one portrait at RA 1892, and once elsewhere. London address.

LITTLETON, Lucy Ann　**fl.1878**
Painter who lived in Bridport, Dorset. Exhib. a view in the Lake District in Glasgow in 1878.

LITTLEWOOD, James　**fl.1887**
Exhib. one picture of flowers at SS 1887. London address.

LIVENS, Miss Dora B.　**fl.1892-1893**
Exhib. four pictures at SS 1892-3, titles mostly Italian subjects: 'An Italian Dancing Girl', etc. Lived at the same address in Croydon, Surrey, as Horace Mann Livens (q.v.), so presumably his sister.

LIVENS, Horace Mann　**1862-1936**
Painter of landscapes, figure subjects, town scenes, flowers and poultry. Studied at Croydon School of Art, and later in Antwerp under Verlat, where he became friendly with Van Gogh who suggested he also study in Paris. Exhib. at the RA from 1890, also SS, NWS and elsewhere. For works illustrated by, see VAM Card Cat.
Bibl: AJ 1905 p.225; 1909 pp.321-6; Studio LVII p.148; LX p.95.

LIVESAY, F.　**fl.1869-1881**
Landscape painter. Exhib. mainly at SS, also twice at RA, and elsewhere. Painted in Scotland, the Isle of Wight, and in Europe. Lived in the Isle of Wight, Portsmouth and elsewhere.

LIVESAY, Miss Rose M.　**fl.1897**
Exhib. two designs for mural decoration at RA, 1897. Titles: 'Winter' and 'Autumn'. London address.

LIVETT, Louis Charles　**fl.1866-1873**
Exhib. once at RA 1868 and once at SS 1873, but mostly at smaller exhibitions. Titles mostly figure subjects. Lived in Manchester and London.

LLEWELLYN, Sir Samuel Henry William　**PRA RBA RI 1858-1941**
Painter of portraits and landscapes. Born in Cirencester, Gloucestershire. Studied under Poynter at the RCA, and in Paris under J. Lefebvre and G. Ferrier. Exhib. from 1884 at the RA, and also at SS, NWS, GG, NG and elsewhere. Member NEAC 1887-9; RBA, RI. Painted the state portrait of Queen Mary, 1910. ARA 1912, RA 1920, PRA 1928-38; KCVO 1918; GCVO 1931.
Bibl: M.H. Dixon, *The Portraits of Mr. W. Llewellyn*, from The Lady's Realm 1906; AJ 1906 p.181; Studio XXXIX p.150; XLI p.52; XLII p.131; RA Pictures 1891 p.59; 1893 p.30; 1894 p.115; 1895 p.8; 1896 p.147; Poole III 1925; Who's Who 1927; Tate Cat.; Hutchison. Exhib: London, 14 Aubrey Walk c.1900.

LLEWELYN, Miss E.　**fl.1877**
Exhib. one picture of flowers at RA 1877. London address.

LLEWELYN, J.D.　**fl.1874**
Exhib. one picture of flowers at SS 1874. London address.

LLOYD, Andrew　**fl.1881**
Exhib. one picture, 'Old Houses on the Lyn', at SS 1881. London address. An A. Lloyd also exhib. two pictures at SS in 1878, perhaps the same artist.

LLOYD, E.　**fl.1861**
Exhib. one picture of sheep at RA 1861. Address Ellesmere, Salop.

LLOYD, E.G.　**fl.1843-1845**
Exhib. three landscapes at RA. London address.

LLOYD, Miss Edith　**fl.1893**
Exhib. one picture of flowers at NWS 1893. London address.

LLOYD, Miss Ethel A. fl.1893-1899
Exhib. seven portraits and figure subjects at RA 1898-9; also exhib. elsewhere. Addresses London and Isle of Wight.

LLOYD, G.W. fl.1870-1871
Exhib. two views of buildings in India at RA 1870-1. London address.

LLOYD, Mrs. H. fl.1850-1853
Exhib. four flower pictures at SS. London address.

LLOYD, Harriette fl.1862
Exhib. one untitled picture at SS 1862. London address.

LLOYD, J. Andrew fl.1888-1891
Exhib. one landscape at RA 1888, also once at GG, and elsewhere. London address.

LLOYD, John H. fl.1830-1866
Landscape painter. Exhib. mainly at BI, also RA and SS. Painted mostly in Wales, also around London. Graves's Dictionary also lists a John Lloyd, but this appears to be the same as John H. Lloyd.

LLOYD, Miss M. fl.1862-1863
Exhib. three flower pictures at RA and BI. London address.

LLOYD, Robert Malcolm fl.1879-1899
Painter of landscape and coastal scenes, living at Catford Bridge and in London, who exhib. 1879-99, at the RA 1881-99, SS, NWS and elsewhere. Titles at the RA include 'Coast of Cornwall' and 'A Squally Evening'.

***LLOYD, Thomas James** RWS 1849-1910
Painter, principally of landscape, but also of genre and marine subjects. Living in London, Walmer Beach and Yapton, Sussex. Exhib. from 1870 at the RA, 1871-1910 SS, OWS (83 works), and elsewhere. AJ 1877 August: "In 'Pastoral' (RA 1877) the lighting up of the hill beyond is remarkably like nature, and 'Nearly Home' is very faithful to rural circumstances, as well as natural fact . . . This artist is making rapid strides, and bids fair to become one of our great landscape-painters."
Bibl: AJ 1877 August; Clement & Hutton; Wilson.

LLOYD, W. Stuart RBA fl.1875-1929
Landscape and marine painter, who exhib. from 1875 at the RA, SS (117 works), NWS, GG and elsewhere, titles at the RA including 'Autumn Morning' and 'Salmon Fishing: Christchurch Bay'. Lived in Brighton.
Bibl: RA Pictures, 1893, 1894.

LLOYD, Mrs. Watkins fl.1877
Exhib. one landscape 1877. London address.

LLOYD-JONES, C. fl.1871-1876
Exhib. two watercolour landscapes at SS 1871 and 1876. Address Wimborne.

LLOYD-JONES, Miss Lydia fl.1898
Exhib. one picture 'In Brixham Harbour' at RA, 1898. London address.

LLOYDS, F. fl.1858-1861
Exhib. three pictures, one each at RA, BI and SS, all street or harbour scenes. London address. Also painted a portrait of Charles Kean.
Bibl: Ormond.

LLUELLYN, Mrs. fl.1889
Exhib. two sea pieces 1889. London address.

***LOBLEY, James** 1828-1888
Painter of domestic genre and other figure subjects; lived in Brighouse, near Bradford. Exhib. at RA 1865-7, SS and elsewhere. Although he painted a few pictures in detailed Pre-Raphaelite style, the majority of Lobley's works are humorous genre in the manner of Thomas Webster and F.D. Hardy (qq.v.). Most of his subjects are scenes in church, e.g. 'Little Nell Leaving the Church', 'I Believe', 'A Village Choir', etc. An exhib. of Lobley's work was held at Bradford Art Gallery in 1983.
Bibl: Reynolds, VS p.86 (pl.68); Birmingham Cat.; Wood, Panorama; Cat. of James Lobley exhib., Bradford AG, 1983; Wood, Paradise Lost.

LOCH, Miss Alice Helen fl.1882-1888
Exhib. four landscapes at SS and NWS. London address.

LOCK, A.H. fl.1874-1875
Exhib. two pictures of birds 1874-5. London address.

LOCK, Frederick William fl.1845-1871
London painter of portraits and figure subjects. Exhib. nine pictures, mostly watercolours, at RA and SS. Titles: 'A Little Gipsy', etc. Painted a portrait of Sir James Outram.
Bibl: Ormond.

LOCK, T. Roe fl.1866-1867
Exhib. two watercolours, both views in Devon, at SS 1866-7. Address Lynton, north Devon.

LOCKER, John fl.1862-1875
London painter of domestic scenes; exhib. mostly at SS, also RA and BI. Titles: 'The Sempstress', etc.

***LOCKHART, William Ewart** RSA ARWS RSW 1846-1900
Painter of genre, landscapes, Spanish subjects, Scottish historical subjects and portraits. Born at Eglesfield, Annan, Dumfriesshire, his father, a small farmer, sent him at the age of 15 to study art in Edinburgh, under J.B. Macdonald, RSA (q.v.). In 1863 he was sent to Australia for his health. On his return he settled in Edinburgh, and in 1867, much stimulated by the influence of John Phillip's latest pictures, made the first of his journeys to Spain. Here he found material for some of his best works, subjects such as the 'Muleteer's Departure', 1871, 'Orange Harvest, Majorca', 1876, the 'Swine Herd', 1885, and the 'Church Lottery in Spain', 1886, which are marked by much bravura of execution and brilliance of colour. He also found subjects in the literature and romantic history of Spain, illustrating several incidents in *Don Quixote* and *Gil Blas* and the story of El Cid. Episodes in Scottish history were another source of inspiration. In 1871 he was elected ARSA, and in 1878 RSA; 1878 ARWS, and for some years RSW. He exhib. 1873-99 at the RA, OWS and GG. In 1887 he was commissioned by Queen Victoria to record on a large canvas 'The Jubilee Ceremony at Westminster Abbey' (Windsor Castle), and after this he remained in London and devoted himself principally to portraiture. Hardie notes that although he was successful in oil painting, his work in watercolour was more subtle and distinguished: "It shows genuine feeling for open-air effects, a good pictorial sense, expressive drawing, both in landscape and figures, and an informal, breezy directness which connects him with Sam Bough."
Bibl: Portfolio 1878 pp.84, 132, 148, 164, 190; 1883 p.226; 1887 p.228; RA Pictures 1891-6; Bryan; Caw pp.264-6; Cundall; Hardie III pp.174, 190. Exhib: London, Waterloo House 1887.

LOCKING, E. fl.1847
Exhib. one picture 'The Pedlar' at RA 1847. London address.

LOCKING, Kate fl.1881-1882
Exhib. three figure subjects, all watercolours, at SS. Titles: 'At the Well', etc. Address Chertsey, Surrey.

LOCKING, Miss Nora fl.1882-1891
London painter of domestic subjects. Exhib. five pictures at RA and SS, and three elsewhere. Titles: 'Reflections', etc., also some flower pieces.

LOCKING, R. fl.1846
Exhib. one picture 'Tending Goats' at RA 1846. No address recorded.

LOCKYER, Florence A. fl.1886
Exhib. one watercolour of a coastal scene at SS 1886. London address.

LOCKYER, J.M. fl.1849
Exhib. one picture of a Church in Perugia at RA 1849. London address.

LOCKYER, S.B. fl.1855
Exhib. two domestic subjects 1855. London address.

LODDER, Captain Charles A. fl.1874-1882
Edinburgh painter of shipping and coastal scenes. Exhib. eight works at SS 1874-81, and two elsewhere. Titles: 'Bass Rock', etc.
Bibl: Brook-Hart.

LODER, James fl.1820-1857
Sporting painter, known as Loder of Bath. Did not exhibit in London, but was well known in his day as a local painter of horses and sporting groups. Some of his pictures were aquatinted by G. Hunt.
Bibl: Pavière, Sporting Painters p.59 (pl.27).

LODGE, Edward Howitt fl.1890-1893
London landscape painter. Exhib. six pictures at RA, SS, NWS and elsewhere, subjects mostly river and coastal scenes.

LODGE, Miss Florence F. fl.1889
Exhib. one flower picture at RA 1889. Address Lee.

***LODGE, George Edward** 1860-1954
Painter of birds and animals, in oil, tempera, and watercolour. A friend of the bird painter Archibald Thorburn (q.v.), whose work is similar in style. Exhib. at RA from 1881, also SS and elsewhere. Lodge was also a naturalist, and portrayed animals with real understanding. He lived most of his life at Hawk House, Camberley, Surrey.
Exhib: London, Rembrandt Gallery 1920; Stevens and Brown Gallery 1937; Rowland Ward, 1948.

LODGE, Reginald B. fl.1881-1890
Landscape painter and etcher. Exhib. seven pictures at RA, SS and elsewhere. His etchings were landscapes after J. MacWhirter and W.B. Gardner (qq.v.).

LOFTHOUSE, Mrs. ARSW 1853-1885
(Miss Mary Forster)
Landscape painter, mainly in watercolour. Exhib. under her maiden name at RA, OWS, NWS and elsewhere, and then under her married name only at OWS. Subjects English and Welsh views, also France. lived in Walton-on-Thames. Daughter of T.B.W. Forster (q.v.), a Wiltshire landscape painter. Married S.H.S. Lofthouse, a barrister.

LOFTHOUSE, S.H.S. fl.1874
Exhib. one winter landscape watercolour at SS 1874, and three pictures elsewhere. London address.

LOFTUS, Lady Anna
Amateur painter, mostly landscapes in watercolours, usually views in England or on the Rhine. Exhib. at Society of Lady Artists.
Bibl: Clayton II pp.345-6.

LOGAN, R.F. fl.1883
Exhib. one sea piece at NWS 1883. Edinburgh address.

LOGSDAIL, Miss Marian fl.1886-1909
(Mrs. Richard Bell)
Painter of figures and street scenes. Sister of William Logsdail (q.v.). Lived in Lincoln. Exhib. at RA from 1886, subjects mostly views in Lincoln or Venice.

***LOGSDAIL, William** 1859-1944
Landscape and genre painter. Born in Lincoln, where he studied at the Art School under E.R. Taylor (q.v.). Also studied in Antwerp, together with his friend, Frank Bramley (q.v.) who was also from Lincoln. Exhib. at RA from 1877, SS, GG, NG and elsewhere. Although not a member of the Newlyn School, his *plein-air* style and rustic subjects show that he was influenced by their ideas. Logsdail achieved his greatest success with his large, realistic London scenes, such as 'The Ninth of November — Lord Mayor's Day' and 'St. Martins in the Fields 1888' (bought by the Chantrey Bequest for £600). He also painted similar panoramas in Venice, and landscapes in France and Italy.
Bibl: AJ 1892 p.321ff.; 1903 p.95; Wood, Panorama pp.151, 153, 159; MSS of an autobiography by Logsdail is in the possession of the artist's family; Cats. of Logsdail exhibs., Usher AG, Lincoln, 1952, 1994.
Exhib: Lincoln, Usher AG 1952, 1994.

LOMAS, J.L. fl.1862-1874
Exhib. two pictures at SS in 1862 and 1874. Titles: 'The Loose Tooth', etc. Birmingham address.

LOMAS, William fl.1877-1889
London painter of figure subjects. Exhib. ten pictures at RA, SS and elsewhere. Titles: 'Music', etc.

LOMAX, Arthur fl.1875
Exhib. one landscape 1875. Liverpool address.

LOMAX, J. O'Bryen fl.1853-1880
Painter of shipping and coastal scenes. Exhib. mostly at SS, also RA and elsewhere, subjects views on South Coast, the West Coast and Ireland.
Bibl: Brook-Hart.

***LOMAX, John Arthur RBA** 1857-1923
Genre painter. Born in Manchester. Studied at Munich Academy. Exhib. mainly at SS, also at RA from 1880. Subjects mostly historical genre of the 17th and 18th centuries, especially of the Civil War period, often with a dramatic or sentimental theme. Titles at the RA 'Thoughts of Christmas', 'An Old Master', 'A Flaw in the Title', etc. Also painted interiors.
Bibl: AJ 1903 p.27ff.; RA Pictures 1892-6; Reynolds, VP p.179.

LOMAX, John Chadwick fl.1889-1891
Exhib. three Venetian scenes at RA 1889-91. London address.

LOMAX, L. fl.1883
Exhib. two watercolour views on the Thames at SS 1883. London address.

LOMID, T. fl.1844-1845
Exhib. three landscapes at RA 1844-5, all river scenes in Norfolk. Norwich address.

LONG, A. fl.1843-1847
Cambridge landscape painter. Exhib. seven works at RA and BI, all scenes around Cambridge.

LONG, E.W. fl.1851-1855
Exhib. eight pictures at RA, BI and SS, mostly figure subjects, e.g. 'Repose', etc. London address.

***LONG, Edwin RA 1829-1891**
Painter of portraits, historical and biblical genre. Born in Bath. Pupil of John Phillip (q.v.). At first Long painted Spanish subjects in the manner of his teacher Phillip, but achieved fame and fortune with large biblical and historical pictures, especially of Egyptian subjects. His style, which derives from Alma-Tadema, is similar to that of Edward Armitage (q.v.). In 1875 his large work 'The Babylonian Marriage Market' created a sensation at the RA and was sold for 7,000 guineas. In 1882 it was sold at Christie's for 6,300 guineas, the Victorian saleroom record for the work of any living English artist. This and Long's flair for choosing popular subjects enabled him to charge very high prices for his pictures. Exhib. at RA 1855-91, BI and SS. Elected ARA 1875, RA 1881. After his death, Long's reputation did not last, and his works find little favour today. A large group of his works are in the Russell-Cotes Museum, Bournemouth.
Bibl: AJ 1891 p.222 (obit.); 1908 p.175ff.; 1911 p.88; DNB XXXIV 1893; L. Cust, NPG Cat. II 1902; Bryan; Richard Quick, *The Life and Works of E.L.*, 1931 repr. 1970; P.H. Ditchfield, *The City Companies of London*, 1904 p.292; G. Reitlinger, *The Economics of Taste*, 1961 pp.159-60 (pl. opp. p.149); Maas p.184 (pl.p.184); Ormond; Wood, Olympian Dreamers.
Exhib: London, Lawrence Gallery 1885; Bournemouth, Russell-Cotes AG, *The Life and Works of Edwin Long, RA*, 1931.

LONG, Miss Emily L. fl.1890-1894
Exhib. three pictures at RA and SS, landscapes and rustic subjects. London address.

LONG, H. fl.1874
Exhib. one watercolour view on the Thames at SS 1874. Address Hackney, London.

LONG, John O. RSW fl.1868-1882
Landscape painter, working in London, who exhib. 1868-82, at the RA 1872-82, SS and elsewhere. Titles at the RA include 'Crofters' Homes in the Hebrides' and 'Tarbert, Loch Fyne'.

LONG, Lady Mary 1789-1875
Amateur painter and watercolourist, who painted landscapes and copies (see Clayton for further information).
Bibl: Clayton I pp.404-5.

LONG, Rose H. fl.1872
Exhib. one picture of buildings 1872. London address.

LONG, William fl.1821-1855
London painter of historical subjects, genre and portraits, who exhib. 1821-55 at the RA, BI and SS. Titles at the RA include: 'The Vision of Joseph', 'Orpheus and Eurydice' and 'A Domestic Scene in the Park at Sunset'.
Bibl: Binyon.

LONGBOTTOM, Robert I. fl.1830-1845
London painter of animals and sporting subjects. A regular exhibitor at RA, BI, SS and NWS, subjects horses, dogs and Welsh scenes.

LONGHURST, F.G. fl.1869-1877
Exhib. five landscape watercolours at SS. London address.

LONGMAN, Charlotte fl.1879
Exhib. one landscape 1879. Address Farnborough Hill.

LONGMAN, Eleanor D. fl.1879-1880
Exhib. one watercolour of flowers at SS 1880, and twice elsewhere. London address.

LONGMORE, W.S. fl.1875-1879
Exhib. three architectural subjects at RA 1877-9, a fishing scene at SS 1876, and four pictures elsewhere. Address Walthamstow, Essex.

LONGSDON, David fl.1865-1901
Landscape painter. Exhib. occasionally at RA, SS and GG, but mostly at smaller exhibitions. Lived at Forest Hill and in London.

LONGSHAW, Frank W. ARCA fl.1885
Exhib. one watercolour of a Welsh scene at SS 1885. Address Conway, Wales.

LONGSTAFF, Sir John 1862-1941
Australian portrait painter. Studied at Melbourne Art Schools and in Paris. Exhib. at the Paris Salon, and at the RA from 1891. Knighted in 1928. Lived in London and East Melbourne.
Bibl: AJ 1908 p.94; Studio XXII 1901 pp.210, 259; XXVI 1906 p.87; N. Murdoch, *Portrait in Youth of Sir J.L. 1861-1941*, 1948.

LONGSTAFFE, Edgar fl.1885-1889
Landscape painter. Exhib. only six pictures at RA 1885-9, but was a prolific painter of landscapes and woodland scenes. His works are often seen in the salerooms, but has remained unknown until now because he only signed with a monogram.

LONSDALE, R.T. fl.1826-1849
Painter of landscape, portraits, genre and historical subjects. Son of James Lonsdale, 1777-1839, portrait painter. Exhib. 1826-49, at the RA 1826-46, BI, SS. Titles at the RA include 'The Curiosity Shop' and 'A Visit from the Nurse'.

LORAINE, Nevison Arthur RBA fl.1889-1903
Painter of rustic subjects. Exhib. mainly at SS, also RA and elsewhere. Titles: 'The Blacksmith's Bench', etc. Address Chiswick, London.

LORD, John fl.1834-1855
Miniature painter; also painted figure subjects. Exhib. at RA, BI and SS. Titles: 'The Lacemaker', etc. Lived in Liverpool and London. Another John Lord (1835-72) is recorded in Strickland; possibly this may be the same artist.

LORD, Stanhope fl.1883
Exhib. one untitled work at SS 1883. London address.

LORIMER, Alfred fl.1878
Exhib. one landscape 1878. London address.

***LORIMER, John Henry RSA RSW RWS 1856-1936**
Painter of portraits and contemporary genre, particularly the "more refined and cultured side of modern society" (Caw). Born in Edinburgh, son of Professor James Lorimer, LL D, and brother of the architect Sir Robert Lorimer; studied at the RSA under McTaggart and Chalmers (qq.v.), and in Paris under Carolus Duran, 1884. Travelled in Spain 1877, Italy 1882, and Algiers 1891. Exhib. at the RSA from 1873 and at the RA from 1878. ARSA 1882; RSA 1900; RPE; ARWS. In his early years he concentrated on portraiture, and flower painting and on the study of tone; later he won distinction as a painter of contemporary genre — mainly scenes of Scottish middle-class home life, e.g. 'Winding Wool', 1890, 'Grandmother's Birthday — Saying Grace', 1893 and 'The Flight of the Swallows', 1907. 'The Ordination of the Elders in a Scottish Kirk', 1891, was a scene in a country kirk and Caw calls it "one of the most national pictures ever painted". He was always much concerned with the effects of light, and his interiors especially, both in oils and watercolours, are luminous and transparent. His work was popular in France and in exhibitions abroad came to be associated with the members of the Glasgow School — Sir James Guthrie, Sir John Lavery, Joseph Crawhall, etc.
Bibl: AJ 1893 p.308; 1895 pp.321-4; 1908 p.127; Studio XXXIV p.270; LXVIII p.125; Portfolio 1893 pp.104, 118, 153; The Artist 1899 p.113ff.; Caw pp.346, 362, 420-3, 450, 481 (pl. opp. p.422); A. Dayot, *La Peinture Anglaise*, 1908 pp..275, 281ff. (with pls.); Who's Who 1924; Tate Cat; Hardie III p.209 (pl.243); Wood, Painted Gardens.

LOTHIAN, G. fl.1846
Exhib. one Highland scene at BI 1846. London address.

LOTT, Frederick Tully fl.1852-1879
Jersey painter of landscapes and coastal scenes. Exhib. regularly at SS, also at BI. Painted in England, Jersey and France.

LOUD, Arthur Bertram RCA 1863-1931
Painter of portraits, landscapes and figure subjects. Son of Charles Jones (q.v.) but changed his name from A.B.L. Jones to A.B. Loud. Studied at RA Schools and at Académie Julian in Paris. Exhib. at the RA from 1884. Elected RCA 1890.

LOUDAN, William Mouat 1868-1925
Portrait and genre painter. Born in London, of Scottish parentage. Educated at Dulwich College. Studied at the RA Schools, where he won the gold medal, and finally the travelling studentship. Studied also in Paris, under Bouguereau. Exhib. from 1880 at the RA, SS, GG, NG and elsewhere. Member of the Art Workers' Guild, and the National Portrait Society. 'The Red Cloak' is in Birmingham AG. In his later years he devoted himself almost entirely to portraiture.
Bibl: Who Was Who 1916-28; Ormond.

LOUND, Thomas 1802-1861
Norwich landscape painter, both in oil and watercolour; engraver. Born to a brewer's business; studied under J.S. Cotman, and became known as a successful landscape painter. He was never a member of the Norwich Society, but exhib. at Norwich from his eighteenth year until 1833, and in London from 1846-57, at the RA 1846-55, and BI. Clifford notes that he was an eclectic, there being considerable variety in his work, it often appearing like Cotman, Henry Bright or Cox (by whom he was much influenced). After Cotman and Bright he was the most prolific watercolourist of the Norwich School.
Bibl: Redgrave, Dict; Cundall; DNB; Dickes, *The Norwich School of Painting*, pp.575-83 (pls.); Studio Special Number, *Norwich School*, 1920 p.LXXVIIIff.; Clifford pp.48-9, 52, 61, 72, 75, 77 (pls.60a-62a); Hardie II pp.62, 70 (pl.61); H.A.E. Day, *East Anglian Painters* III pp.71-90.

LOVATTI, Signor Augusto fl.1888
Exhib. one landscape at NG 1888. London address.

LOVEGROVE, H. fl.1829-1844
Landscape painter. Exhib. mainly at SS, also at RA and BI. Painted in Berkshire and Buckinghamshire. Lived at High Wycombe and Brighton.

LOVEGROVE, J. fl.1850
Exhib. one picture of a farm at SS 1850. London address.

LOVELL, Charles Edward fl.1890-1892
Exhib. one figure subject at NG and two elsewhere. London address.

LOVELL, Miss Elizabeth M. fl.1883-1884
Exhib. a picture of flowers at SS 1883, and one at NWS. London address.

LOVELL, Robert S. fl.1889-1890
Exhib. two portraits at RA, one a chalk drawing. London address.

LOVER, Samuel RHA 1797-1868
Irish painter, miniaturist, illustrator, songwriter and novelist. Exhib. at RHA from 1826. Elected ARHA 1828, RHA 1829. Moved to London in 1835, where he painted miniatures, until his sight began to deteriorate about 1844. He then turned mainly to painting landscapes, which he exhib. at the RA 1851-62, and the RHA. Retired to Jersey for the last four years of his life.
Bibl: Strickland; B. Bernard, *The Life of Samuel Lover RHA*, 1874.

LOVERING, Miss Ida fl.1881-1903
London painter of figure subjects and portraits. Exhib. at RA from 1881, SS, NWS, and Society of Lady Painters. Her portraits mostly of children. A niece of Alfred and Henry Tidey (qq.v.). Examples are in Brighton AG.
Exhib: London, Lyceum Club, *Pastel Portraits by Ida Lovering . . .*, 1913.

LOW, Charles RBA fl.1870-1902
Landscape painter, living in Hungerford and Witley, Surrey, who exhib. 1870-1902, at the RA 1885-1902, SS and NWS. Titles at the RA include 'Cinerarias' and 'A Farmyard Corner'.

LOW, Charlotte E. fl.1880
Exhib. one picture of flowers at SS 1880. London address.

***LOWCOCK, Charles Frederick RBA fl.1878-1922**
Genre painter. Exhib. at RA 1878-1904, SS and elsewhere. Titles at RA 'In the Temple', 'The Lost Chord', 'A Love Letter', etc. Lowcock painted a number of very interesting interiors as well as pictures of prettily dressed girls in interiors or gardens.

LOWE, Miss fl.1848
Exhib. one flower picture at SS, 1848. London address.

LOWE, Arthur fl.1900
Exhib. one picture 'October' at RA, 1900. Nottingham address.
Exhib: London, New Burlington Galleries, *Beauty of the Midlands*, 1936.

LOWE, Edward S. fl.1893
Exhib. one landscape 'A Babbling Brook' at RA, 1893. Address Wanstead.

LOWE, Miss Ella fl.1889
Exhib. one flower picture at RA, 1889. Address Wimbledon, London.

LOWE, G.E. fl.1885
Exhib. one landscape at SS, 1885. Address Harlech, Wales.

LOWE, Miss Mary C. fl.1888-1896
Exhib. two domestic subjects at RA, and one elsewhere. Titles: 'Last Stage of All', etc. Lived in Abbot's Bromley, Staffordshire, and Royston, Hertfordshire.

LOWE, S.L. fl.1849
Exhib. one picture of flowers at RA, 1849. London address.

LOWE, W.D. fl.1872
Exhib. one landscape, 1872. Address Llantwith, Wales.

LOWENTHAL, Miss Bertha fl.1888-1920
London painter of flowers and architectural scenes. Exhib. at RA, SS, NWS and elsewhere; subjects often views of Westminster Abbey.

LOWENTHAL, E. fl.1865-1881
Exhib. six Italian figure subjects at RA, including a portrait of John Gibson, the sculptor. Rome address.
Bibl: Ormond.

LOWES, J.H. fl.1861-1862
Exhib. two landscapes at BI 1861-2. London address.

LOWNDES, Miss Mary fl.1884-1886
Exhib. one view in Pont-Aven at SS 1886, and once elsewhere. London address.

LOWRY, Matilda fl.1804-1855
(Mrs. Heming)
Painter of landscapes, miniatures and portraits. Daughter of Wilson Lowry (1762-1824), an engraver. Won a gold medal from the Society of Arts in 1804, and exhib. 1808-55 . Worked mostly in watercolour.

LUARD, John Dalbiac 1830-1860
Exhib. four historical subjects at RA, including 'A Welcome Arrival', 1857, an interesting scene in the Crimea, which is now in the National Army Museum. Friend of Millais, with whom he shared lodgings for a time. His father Col. Luard (1790-1875) was an amateur artist.
Bibl: J.G. Millais, *Life and Letters of Sir J.E. Millais*, 1899 I pp.243, 291; Redgrave, Dict; AJ 1861 p.118 (obit.); Wood, Panorama pp.230-1, pl.244.

LUARD, Miss L. fl.1899
Exhib. one picture of flowers at RA 1899. Address Witham, Essex.

LUBBERS, H. fl.1882
Exhib. one picture of the Danish coast at RA 1882. London address.

LUCAS, Miss A.M. fl.1875
Exhib. one landscape 1875. Address Hitchin, Hertfordshire.

LUCAS, A.P. fl.1896
Exhib. one study at RA 1896. Paris address.

***LUCAS, Albert Durer 1828-1918**
Flower painter; son of the sculptor Richard Cockle Lucas. Exhib. in London 1859-78 at BI, SS and elsewhere. Painted small, detailed studies of flowers and foliage, sometimes with butterflies and other insects. In 1910 he caused a sensation by revealing that his father was the real author of a bust of Flora which had recently been bought by the Berlin Museum as a Leonardo.
Bibl: Burlington Mag. XVII 1910 pp.178, 181.

LUCAS, Arthur fl.1881-1893
London landscape painter. Exhib. only once at RA 1883, mainly at NG, GG and NWS.

LUCAS, Bernard J. fl.1885-1891
Exhib. eight landscapes at GG, and two at NG. Address Tooting, London.

LUCAS, C. fl.1875
Exhib. three pictures of flowers at SS, 1875. Address Croydon, Surrey.

***LUCAS, Edward George Handel 1861-1936**
Painter of still-life, landscape and figure subjects. Exhib. at RA, 1879-99, SS, GG and elsewhere. Best known for his meticulous still-life pictures with moralistic titles, e.g. 'Dust Crowns All', 'Foes in the Guise of Friends', etc., which bear an extraordinary resemblance to the work of the American still-life painter William Harnett. Lucas lived in Croydon, and later in Brighton. In his later years he suffered poverty and neglect, and his reputation was only revived when his pictures began to appear at London auctions in 1972.
Bibl: Geraldine Norman, *Blowing the Dust off a Forgotten Pre-Impressionist*, The Times 10 June 1972.

LUCAS, Miss Evelyn see EVELYN, Miss Edith

LUCAS, Miss Florence fl.1892
Exhib. one landscape at NWS 1892. Address Acton, London.

LUCAS, George fl.1863-1899
Landscape painter who exhib. 1863-99, at the RA 1871-99, SS, NW, GG, and elsewhere. In Bristol AG is 'A Surrey Cornfield'.

LUCAS, Miss Hannah fl.1888
Exhib. one picture of a church at SS 1888. London address.

LUCAS, Mrs. Jeanie fl.1873
Exhib. two pictures of fruit and birds at SS 1873. London address.

LUCAS, John 1807-1874
London portrait painter and engraver. At first studied mezzotint engraving under S.W. Reynolds. Exhib. at RA 1828-74, BI and SS. Lucas built up an enormously successful practice as a fashionable portrait painter. Among his sitters were the Prince Consort and the Duke of Wellington. Most of Lucas's works are large, similar in style to Richard Buckner (q.v.), and are still mostly in possession of the families for whom they were painted. A full list of Lucas's sitters is in his biography by his son Arthur Lucas (see bibl.). His studio sale was held at Christie's, 25 February 1875.
Bibl: AJ 1874 p.212 (obit.); Redgrave, Dict; DNB XXXIV; Arthur Lucas, *J.L. Portrait Painter*, 1910; BM Cat. of Engraved British Portraits VI 1925 pp.516, 647; Ormond.

***LUCAS, John Seymour RA RI 1849-1923**
London genre painter, nephew of John Lucas (q.v.). Exhib. 1867-93 at RA, SS, NWS and elsewhere. Subjects mostly genre scenes set in 17th and 18th century costume, or episodes in English history. His wife Marie (q.v.) was also a painter. In addition to his genre

work, Lucas also painted portraits. Manuscripts relating to Lucas are held at the VAM.

Bibl: AJ 1887 pp.65-9; 1905 p.170; 1908 p.107ff., 338; Christmas Number 1908 pp.1-32 (60 illus.); Connoisseur LXVI 1923 p.114ff. (obit.); Who's Who 1913, 1924; BM Cat. of Engraved British Portraits VI 1925 p.516; Maas p.240 (pl. on p.243).

LUCAS, Mrs. John Seymour 1855-1921
(Miss Marie Elizabeth Cornelissen)
Painter of portraits, genre and domestic subjects, especially children. Born in Paris; studied there and in London and Germany. Married J.S. Lucas in 1877. Exhib. at RA, SS, NWS and elsewhere from 1873. Titles: 'The Ruler of the Manor', etc. Also illustrated children's books.

Bibl: Connoisseur LXII 1922 p.49 (obit.); see also under J.S. Lucas.

LUCAS, John Templeton 1836-1880
Landscape and genre painter. Son of John Lucas, portrait painter, 1807-74 (q.v.). Exhib. 1859-76, at the RA 1861-75, BI, SS and elsewhere, titles at the RA including 'The Spinning Wheel, N. Wales', and 'The Fairy at Home'. York AG has 'Not Sold Yet'. He also published a farce, *Browne the Martyr,* which was performed at the Royal Court Theatre, and a little volume of fairy tales, *Prince Ubbely Bubble's New Story Book,* 1871.

Bibl: DNB; Wood, Paradise Lost.

LUCAS, Mrs. John Templeton fl.1867
Exhib. one picture of fruit at BI 1867. London address. Wife of John Templeton Lucas (q.v.).

LUCAS, Miss Lancaster fl.1890-1893
Exhib. one figure subject at GG and one elsewhere. London address. Probably the same as Miss May Lancaster Lucas (q.v.).

LUCAS, Miss Mary fl.1877
Exhib. one picture of fruit at SS 1877. London address.

LUCAS, May Lancaster fl.1888-1910
Exhib. six portraits and figure subjects at RA 1891-1910. London address. Also exhib. in Paris Salons 1888-1910.

LUCAS, Ralph W. fl.1821-1852
Painter of landscape, portraits, and occasionally genre, working in Greenwich and Blackheath, who exhib. 1821-52 at the RA, BI, SS and NWS. RA titles 'View of Canterbury', 'Landscape — Evening', 'Sunset', etc. and views in Wales and Scotland.

LUCAS, Mrs. Ralph W. fl.1846
Exhib. one picture of a cactus at RA 1846. Lived in Greenwich. Wife of Ralph W. Lucas (q.v.).

LUCAS, S. Bright fl.1883-1891
Exhib. two landscapes at SS 1883-4, and one at NWS. London address.

LUCAS, Samuel 1805-1870
London landscape painter. Exhib. at RA, BI and SS, subjects Wales, Holland, etc. Lucas was an amateur, and also painted birds and flowers, sometimes in watercolour. Many members of his family painted, including his son Samuel Jnr., and his wife Matilda, née Holmes.

Bibl: DNB; Cundall; BM Cat. of Drawings by British Artists 1902; Walker's Quarterly p.27.

LUCAS, William 1840-1895
Watercolour painter of portraits and figure subjects, who exhib. 1856-80, at the RA 1856-74, BI, SS, NWS (100 works), and elsewhere. Early in his career he showed great promise, was elected an associate of the 'New' Society in 1864, but resigned in 1882 when it moved to the Piccadilly Institute. However his career was marred by an early physical breakdown; and for many years he practised lithography. The AJ notes that his father was the well-known portrait painter (John Lucas, q.v.), his cousin the ARA (John Seymour Lucas, q.v.), and his brother the art publisher.

Bibl: AJ 1895 p.191 (obit.); The Year's Art 1904 p.114; Cundall.

LUCY, Mrs. Anne fl. 1843-1847
(Miss Anne Bishop)
Exhib. two figure subjects at RA in 1843 and 1847, one of Robert Burns and Highland Mary. London address.

LUCY, Charles 1814-1873
Painter of historical subjects, and portraits. Born in Hereford; studied at the École des Beaux-Arts under Paul Delaroche; returned to London and studied at the RA schools. He settled at Barbizon, near Fontainebleau, where he stayed for about 16 years, painting large historical pictures from English, and especially Puritan, history. Exhib. 1834-73, at the RA 1838-73, BI, SS, NWS and elsewhere. He won prizes at the Westminster Hall competitions in 1844, 1845 and 1847. Many of his works were purchased for public institutions in America. He was commissioned by Sir Joshua Walmesley to paint a series of portraits of eminent men, including Oliver Cromwell, Nelson, Bright, Cobden, Gladstone, etc., and these were bequeathed to the VAM. His studio sale was held at Christie's, 4, 5 March 1875.

Bibl: AJ 1873 p.208 (obit.); Redgrave, Dict.; Clement & Hutton; Bryan; Binyon; DNB; Ormond; Staley; W.M. Rossetti, Some Reminiscences, 1906 pp.138-9.

LUCY, Charles Hampden fl.1869-1894
London painter of landscapes and rustic subjects. Exhib. mainly at SS, also RA and elsewhere. Titles: 'Pet among Pets', etc.

LUCY, Edward Falkland fl.1884-d.1908
London landscape painter. Exhib. at RA, NWS, NG and elsewhere. Titles: 'Homewards', etc.

Bibl: The Year's Art 1909 p.407.

LUCY, Hubert A. fl.1874
Exhib. two figure subjects, in watercolour, at SS in 1874. Titles: 'Bribery not Corruption', etc. London address.

LUDBY, Max RI RBA 1858-1943
Cookham painter of landscapes and genre; engraver. Studied from 1882-4 in Antwerp, exhib. from 1879 at the RA, SS, NWS, GG and elsewhere; exhib. 'From Oxford to Greenwich', a series of 82 watercolours at Dowdeswells, 1893, and 'Some Sketches of Venice', a series of 60 watercolours at Dickinson and Fosters, 1897. Some of his noted paintings were 'A Berkshire Common', RA 1888, 'One of the Flock', RI 1891 and 'An Old Shepherd', RI 1893. RI in 1891.

Bibl: Who Was Who 1941-50.

LUDLOW, Henry Stephen (Hal) b.1861 fl.1880-1903
London painter of landscapes, rustic scenes, and fishing subjects. Exhib. at RA from 1888, NWS and elsewhere. Worked for the *Illustrated London News* and *The Sketch.*

LUDLOW, W. fl.1852
Exhib. one picture 'A Village Church' at RA 1852.

LUDOVICI, Albert RBA 1820-1894
Genre painter. Exhib. mainly at SS (224 works), also at RA 1854-89, BI, NWS, GG and elsewhere. Father of Albert Ludovici, Jnr. (q.v.) and like him, lived mainly in Paris. Titles at RA: 'An American Jewess', 'Lorelei', 'A Bit from Normandy', etc.
Exhib: London, Little Art Rooms 1919.

***LUDOVICI, Albert, Jnr. RBA 1852-1932**
Genre painter; son of Albert Ludovici (q.v.). Exhib. mainly at SS (147 works) also at RA 1880-97, NWS, GG and elsewhere. Ludovici fell under the spell of Whistler (q.v.) while the latter was President of the RBA. His pictures show Whistler's influence, particularly his London scenes, which are painted in a delicately Impressionistic style. Like his father, Ludovici lived mostly in Paris, and his pictures of London life do reflect something of the Parisian boulevard gaiety of the period. Titles at the RA 'Dreamland', 'A Victim of Fashion', 'The Park', 'The Grey Lady', etc. Ludovici was also a member of the International Society of Painters, Sculptors and Engravers.
Bibl: Studio XXXV p.238; XXXXVI p.350ff.; LXIII p.140; LXVIII p.54; NPG Illustrated List 1928.

LUDWIG, E. fl.1847
Exhib. one picture of 'The Last Supper' at SS 1847. London address.

LUKER, Miss fl.1868
Exhib. one picture of game at SS 1868. London address. Presumably a daughter of William Luker (q.v.) as they are recorded at the same address.

LUKER, A. fl.1885
Exhib. one picture of rocks on the Scilly Isles at RA 1885. Address Merton, London.

LUKER, Mrs. Ada fl.1865-1900
Landscape painter; wife of William Luker (q.v.). Exhib. mainly at SS, also RA. Titles: 'A Rest in the Wood', etc.

LUKER, Gilham fl.1869
Exhib. two landscapes 1869. London address.

LUKER, William fl.1851-1889
Painter of portraits, genre, animals and landscapes, working in London and Faringdon, who exhib. 1851-89, at the RA 1852-89, BI, SS (127 works), and elsewhere. Titles at the RA include 'Deerstalkers, Portraits of a Gentleman, his Son and Attendants, with Favourite Pony and Deer Hound', 1851.

LUKER, William, Jnr. RBA b.1867 fl.1886-1892
Painter of genre, portraits and landscape; illustrator. Son of William Luker (q.v.). Exhib. 1886-92 at the RA, SS, NW and elsewhere, titles at the RA including 'Pleading Guilty' and 'A Rest in the Wood'.

LUMLEY, A. Fairfax fl.1881
Exhib. two domestic subjects 1881. London address.

LUMLEY, Augustus Savile fl.1856-1880
London genre and portrait painter. Exhib. at RA 1856-80, BI and SS. Exhib. works mostly portraits; occasional genre scenes, e.g. 'Le Rendezvous', etc.

***LUND, Niels Moeller RI ROI ARE 1863-1916**
Painter of landscapes, portraits and town scenes. Born in Denmark. Studied at RA schools and Académie Julian. Exhib. at RA from 1887. Titles: 'Breaking Mists', etc. Painted in Scotland and Northumberland, and several of his works are in the Laing AG, Newcastle. His highland landscapes tend to be large and dark, similar to those of Peter Graham (q.v.).
Bibl: AJ 1900 p.180; 1903 p.167; 1904 pp.187, 307; 1905 pp.166, 170; Connoisseur XLIV 1916 p.178; XLVII 1917 p.228; Studio LXIII p.218; LXIV p.181ff.; LXVII pp.120, 245, 247; LXVIII p.iii (obit.); Hall; Wood, Panorama.

LUNDGREN, Egron Sellif 1815-1875
Painter and watercolourist of figure subjects and Middle Eastern scenes. Exhib. 93 works at OWS, but only two at RA in 1862. Born in Stockholm; studied in Paris under Cogniet. Travelled in Spain, Italy and India. Works by him are in the VAM, and in several Swedish museums.
Bibl: G. Nordensvan, E. Lundgren, 1906; K. Asplund, E. Lundgren, 1915; Roget; DNB; Ormond; Staley.
Exhib: Stockholm, National Museum 1953.

LUNTLEY, James fl.1851-1858
Exhib. seven portraits at RA and BI. London address.
Bibl: VAM British Pictures Cat. 1908; Ormond.

LUPTON, Miss Edith fl.1871-1893
London flower painter. Exhib. mostly at SS, also RA and elsewhere.

LUPTON, Nevil Oliver b.1828 fl.1851-1877
Painter of landscapes and genre. Youngest son of Thomas Goff Lupton, engraver and miniature painter, 1791-1873. Exhib. 1851-77 at the RA, BI, SS, Portland Gallery and elsewhere, the majority silvan landscapes and rustic genre, e.g. at the RA, 'A Favourite Walk of the Poet Coleridge at Highgate'. The AJ says of 'Brewhurst Mill, Sussex', BI 1860, "Foliage is the principal feature here, and it is painted with a view to the identity of the different trees that are brought into the essay."
Bibl: AJ 1859 pp.121-2, 163; 1860 p.79; Binyon; Cat. York AG 1907; Ormond.

***LUSCOMBE, Henry Andrews b.1820 fl.1845-1865**
Plymouth marine painter and watercolourist. Exhib. at RA 1845-65. Subjects mainly shipping scenes around Plymouth, or modern naval incidents. Luscombe was one of the first artists to paint steam warships, and to record the events of Victorian naval history.
Bibl: G. Pycroft, Art in Devonshire, 1883 p.89; Wilson p.52 (pl.22); Brook-Hart pl. 208.

LUTWIDGE, C.R.F. fl.1865-1870
Exhib. two pictures of ruins in 1865 and 1870. Address Tunbridge Wells, Kent.

LUTYENS, Charles Augustus Henry 1829-1915
London painter of portraits, animals and hunting scenes. Exhib. at RA 1861-1903, BI, SS and GG. Titles: 'Hog Hunting', 'Doncaster Derby Winner 1873', 'Major Browne and Northumberland Hounds', etc. Father of Sir Edwin Lutyens (q.v.).
Exhib: London, St. Martin's Gallery 1962

LUTYENS, Sir Edwin Landseer PRA 1869-1944
Although more famous as an architect, Lutyens was also a painter, as was his father Charles Lutyens (q.v.). Exhib. at RA and elsewhere from 1890. Elected ARA 1913, RA 1920, PRA 1938-44. Knighted in 1918.
Bibl: R. Lutyens, Sir Edwin L., 1942; The Lutyens Memorial 1950; R. Lutyens, Six Great Architects, 1959; Victorian Society, Seven Victorian Architects, 1976.

LUTYENS, F.M. fl.1889-1891
Exhib. one domestic subject at GG and once elsewhere. London

LUXMOORE, Arthur C.H. FSA fl.1854-1886
London painter and sculptor. Exhib. figure subjects and architectural subjects at RA, SS, GG and elsewhere. Titles: 'The Best Mouse Trap' and some 18th century historical scenes.

LUXMOORE, C.N. fl.1868
Exhib. pen and ink sketches at RA 1868. Torquay address.

LUXMOORE, Mrs. Kate F. fl.1875-1880
Exhib. five figure subjects 1875-80. London address. Wife of Arthur C.H. Luxmoore (q.v.).

LUXMOORE, Miss Myra E. 1851-1919
London painter of portraits and figure subjects. Exhib. at RA, SS and elsewhere. Titles: 'Too Late', etc.

LYDON, Alexander Francis 1836-1917
Exhib. one farmyard scene at RA 1861. Address Great Driffield, Yorkshire. Also listed as Frank A. Lydon. For works illustrated by, see VAM Card Cat.
Bibl: Print Collector's Quarterly XII 1925 p.342.

LYLE, Byron fl.1887
Exhib. one domestic subject 1887. London address

LYLE, Thomas B. fl.1887
Exhib. one picture 'A Lesson in Charity' at RA 1887. London address.

LYNCH, Albert b.1851 fl.1890-1893
Exhib. one portrait 1893. Born in Peru of an Irish family. Studied and lived, mainly in Paris, where he painted figurative subjects.
Bibl: Studio XXVII 1903 p.60ff.

LYNDON, Herbert fl.1879-1922
London landscape painter, who exhib. from 1879 at the RA, BI, NWS, GG and elsewhere, titles at the RA including 'On the Wye', 'In the Birch Wood' and 'Harbingers of Weather'.

LYNN, John fl.1826-1838
London; painter of shipping and coastal scenes. Exhib. 14 pictures at BI and SS, mostly views off the South Coast. Lynn is a rare artist, but according to Brook-Hart, his works are of "an exceptionally high quality."
Bibl: Brook-Hart pp.37, 66 (pl. 75 and frontispiece).

LYON, Miss A. fl.1885
Exhib. one picture of dogs' heads at RA 1885. London address.

LYON, Miss C.E. fl.1872
Exhib. one figure subject 1872. Address Leamington.

LYON, Charles E. fl.1889
Exhib. one picture of flowers at RA 1889. London address.

LYON, Miss E.F. fl.1885
Exhib. one picture 'The Long Vacation' at SS 1885. London address.

LYON, George P. fl.1885
Exhib. one Scottish landscape at RA 1885. Glasgow address.

LYON, Lucy S. fl.1888
Exhib. one picture of flowers at SS 1888. London address.

LYONCOURT, Baron de, see DE LYONCOURT

LYONS, Thomas fl.1867
Exhib. one fruit picture 1867. London address.

LYSTER, Richard fl.1857 d.1863
Exhib. one scene from *Nicholas Nickleby* at RA 1857. Address Cork, Ireland.
Bibl: Strickland.

MAC, M', Mc, Mac are all treated as Mac. The next letter in the name determines the position of the entry

MAC, Robert F. fl.1867-1870
Exhib. two works at SS, two works 'South Heath, Hampstead' and 'A Study on the Caledonian Canal' at the BI, and one work 'Cockmoor' at the RA. London address.

McADAM, Walter RSW 1866-1935
Painted landscapes. Exhib. at the RA, in the provinces and abroad. Titles include: 'Flowers of the Meadow' and 'October Glow'. Born and lived in Glasgow.
Bibl: Who's Who 1924.

MACALLISTER, A.D. fl.1854
Exhib. one work 'Paring Potatoes' at the RA. London address.

MACALLUM, John Thomas Hamilton RI RSW 1841-1896
Scottish painter of coastal and fishing scenes. Studied RA schools. Exhib. at RA 1869-96, SS, NWS, GG, NG and elsewhere. like Colin Hunter (q.v.) he found most of his subjects on the west coast of Scotland. He also travelled in Italy. His pictures are usually sunny and cheerful, and the figures slightly sentimental. As a painter of the sea, Macallum achieved technical mastery, but his works have an emotional superficiality which prevented him from achieving the first rank.
Bibl: AJ 1880 p.149ff.; Portfolio 1870 p.150; 1887 p.211; 1890 p.184; Bryan; Caw pp.327-9 (pl. opp. p.326); Brook-Hart.

MacARTHUR, Miss Blanche F. fl.1870-1888
London genre painter. Exhib. at RA 1870-83, but more regularly at SS and elsewhere. Titles at RA 'The Spinner's Daydream', 'Footsteps', 'Shy', etc.

MacARTHUR, Charles M. fl.1873-1876
Exhib. four watercolours, including 'The Val de Cloist, Chamonix', 'A Yorkshire Stream' and 'Old Matlock on the Derwent' at SS, and two works at the RA. London address. Examples are in Accrington and Nottingham museums.

MACARTHUR, Lindsay G. fl.1890-c.1930
Painted landscapes and country genre subjects. Exhib. 14 works, including 'The Firth of Lorne', 'Carting Peats' and 'The Hill Quarry' at the RA 1893-1904. Addresses in Argyllshire and Gloucestershire. Represented in the Glasgow AG.

MacARTHUR, Miss Mary fl.1872-1888
Painted landscape and figurative subjects. Exhib. ten works, including 'Holywell Beach, Sussex' and 'A Studious Lad' at SS, and three works at the RA. London address.

MACARTNEY, Carlile Henry Hayes 1842-1924
London landscape painter. Exhib. at RA 1874-97, and occasionally elsewhere. Titles at RA 'Kew Bridge', 'A Track over the Moor', 'In the Yorkshire Dales', etc. Painted in Devon and Cornwall; also travelled in France and Italy. Occasionally painted portraits.
Bibl: Art News XXIV 1925-6 No. 27 p.3.

MACAULAY, Miss Kate RSW fl.1872-1884
Scottish painter of coastal scenes. Exhib. at SS, RA 1881-3, and elsewhere. Lived in Wales. Titles at RA 'Scotch Herring Trawlers', 'A Sea Cliff', 'A Corner of the Quay', etc.
Bibl: Brook-Hart.

McBEAN, Miss M.E. fl.1856-1859
Exhib. two works, a portrait and 'Lost in the Woods' at the RA. London address.

MacBEAN, Major-General W. Forbes fl.1880
Exhib. a landscape in 1880. Address in Dinan, France.

MACBETH, James 1847-1891
London landscape painter. Exhib. at RA 1872-84, SS, NWS, GG and elsewhere. Painted mostly around London, and in the Scottish Highlands.
Bibl: Clement & Hutton.

MACBETH, L. fl.1886
Exhib. a portrait at the RA in 1886. Address in Edinburgh.

MACBETH, Norman RSA 1821-1888
Scottish portrait painter. Studied engraving in Glasgow; later studied at RA schools and in Paris. Worked in his native Greenock, then Glasgow, and after 1861 in Edinburgh. Exhib. at RA 1837-86, but enjoyed a more lucrative practice in Scotland. Although prolific and competent, his work is mostly "conventional and completely undistinguished" (Caw). He was the father of R.W. and Henry Macbeth-Raeburn (qq.v.).
Bibl: Portfolio 1886 p.25; 1887 p.233; Clement & Hutton; Caw pp.176, 178; DNB; Ormond.

***MACBETH, Robert Walker RA RI RPE RWS 1848-1910**
Painter of pastoral landscapes and rustic genre. Son of Norman Macbeth (q.v.). Studied in London, and worked for *The Graphic*. Influenced by G.H. Mason, and Frederick Walker (qq.v.). Exhib. at RA from 1871, OWS, GG, NG and elsewhere. Elected ARA 1883. Macbeth's realistic scenes of country life, which he painted mostly in Lincolnshire or Somerset, are compared by Caw to the novels of Thomas Hardy. He was also an accomplished watercolourist and etcher.
Bibl: AJ 1883 p.296; 1893 p.28; 1897 p.324; 1900 pp.289-92; 1908 p.12; Portfolio 1881 p.21; 1883 p.64; 1884 p.224; 1887 p.233; Wedmore, *Etching in England,* 1895 p.152ff.; Studio Special Number 1917, *Graphic Arts of Great Britain,* pp.123, 132; Caw pp.277-9; VAM Supp; Hardie III p.l90; Wood, Paradise Lost; Newall.

MACBETH-RAEBURN, Henry RA RE 1860-1947
Painted flowers and figurative subjects. Studied at the RSA Schools and at the Académie Julian. Exhib. at the RA from 1881, titles including 'Chrysanthemums', 'Belle' and 'Waiting a Change in the Tide'. Also made engravings after works by Millais, Stone and G.W. Joy. Addresses in Edinburgh, Berkshire and Essex. He was the son of Norman Macbeth (q.v.).
Bibl: Portfolio 1886 p.25; 1891 p.61; 1892 p.16; AJ 1888 p.33; 1889 p.129; 1892 p.161; Connoisseur LXIII 1922 p.16ff.; LXV 1923 p.173; LXXII 1925 p.110; LXXXII 1928 p.191.
Exhib: London, Grave's Galleries 1933.

MacBRIDE, Alexander RSW RI 1859-1955
Painted landscape watercolours. Studied at the Glasgow School of Art and at the Académie Julian. Exhib. four landscapes at the NWS. Exhib. principally in Scotland. He was President of the Glasgow Art Club. Born and lived in Cathcart near Glasgow.
Bibl: AJ 1901 p.159; Studio XXVI 1902 p.54; XXXVII 1906 p.349ff.; Who's Who 1924.

MacBRIDE, William fl.1890-1894
Exhib. three works at the RA, including 'Brown October' and 'Under the Greenwood'. Address in Glasgow.

McCALL, Gertrude S. fl.1887
Exhib. studies of strawberries and cherries at SS in 1887. Address in Leicestershire .

M'CALL, William fl.1818-1837
Painted portraits. Exhib. 25 works, the majority portraits but also including 'King Lear and Cordelia' and 'The Devotee' at the RA. Also exhib. 19 works at the BI and six at SS. London address.

***McCALLUM, Andrew 1821-1902**
Landscape painter. Born in Nottingham, where he studied at the Government School under J.A. Hammersley (q.v.). Studied in London at Government School of Design. 1851 took teaching post in Manchester, then at Stourbridge School. Travelled in Italy 1853-8, after which he began to devote himself seriously to landscape. Exhib. at RA 1850-86, BI, SS and elsewhere. Continued to travel in Italy, Switzerland and Egypt. Was particularly known for his painting of trees in a highly detailed Pre-Raphaelite style.
Bibl: AJ 1877 pp.321-4; 1908 p.17; Clement & Hutton; DNB Supp. II 1912; Wood, Pre-Raphaelites.

McCALMONT, Miss Ethel E. fl.1883
Exhib. a work entitled 'Spring' at the RA. Address at Hampton Court, near London.

McCALMONT, H.B. fl.1881
Exhib. a watercolour view of San Giorgio Maggiore, Venice, at SS. Address in Hampton Court, near London.

McCARTY, W.W. fl.1877
Exhib. a watercolour of Blarney Castle at SS. London address.

McCAUL, G.J. fl.1874
Exhib. a watercolour landscape at SS.

McCAUL, Miss Meta W. fl.1884
Exhib. a watercolour of fishing smacks at SS. Address in Chislehurst, near London.

McCAUSLAND, Miss Charlotte Katherine fl.1881-1904
Painted portraits and figurative subjects. Exhib. ten works at SS and seven at the RA 1886-1904, titles including 'Father's Socks' and 'A Horny-handed son of Toil'. London address.

McCLEERY, Robert C. fl.1887-1892
Exhib. four landscapes at the NWS. London address.

McCLOSKY, A. Binford fl.1893
Exhib. a work entitled 'California Roses' at SS. Address in Paris.

M'CLOSKY, William J. fl.1892-1893
Exhib. a work, entitled 'Song', at SS and a work at the NWS. London address.

McCLOY, Samuel 1831-1904
Painted Irish country genre and figurative subjects. Exhib. nine works at SS titles including 'Under Its Boughs All Mossed with Age' and 'Dull — No News', some of these watercolours. Also exhib. one work 'The Haunt of Meditation' at the RA. Born in Lisburn and lived in Waterford, Ireland. Died in London. Represented in the VAM and in the Belfast Museum. His wife E.L. McCloy, nee Harris, painted children's heads.
Bibl: Strickland.

McCLYMONT, John I. fl.1893-1895
Exhib. two works 'Left in Charge' and 'Spinning', at the RA. Address in Edinburgh.

MacCOLL, Dugald Sutherland NEAC 1859-1948
Painted landscapes and buildings. Studied at the Westminster School of Art and at the Slade. Also an art critic and lecturer. London address. Founder of the National Art Collections Fund; Keeper of the National Gallery 1906-11, and of the Wallace Collection 1911-24.
Bibl: AJ 1896 p.147ff.; 1906 pp.63, 155, 246; Studio XIII 1898 p.232; LXV p.186; Connoisseur LI 1918 pp.175, 179, 239; LX 1921 p.120; Burlington Mag. XII p.157ff.; Irwin.

***McCORMICK, Arthur David** RI 1860-1943
Painted landscapes and figurative subjects, and African and Indian subjects. Studied at the RCA. Exhib. ten works at the RA 1889-1904, titles including 'A Dead World', 'Sakar, India — Moonlight' and 'A Hunter's Shrine — Central Caucasus'. Also exhib. nine works at SS. Published *An Artist in the Himalayas* in 1895. Born at Coleraine, Ireland. Lived in London.
Bibl: Connoisseur XXVIII 1910 p.314; LI 1918 p.110; LXIII 1922 p.112; LXVI 1923 p.50; Who's Who 1924.

McCRACKEN, Miss Katherine ASWA 1844-c.1930
Painted landscapes. Studied under Sir James Linton (q.v.). Exhib. 13 landscapes at GG. Also an illustrator. Address in Blackheath near London.

McCROSSAN, Miss Mary RBA fl.1898-d.1934
Painted landscapes, marines and coastal views. Studied at the Liverpool School of Art and at the Académie Julian. Exhib. three works, including 'White Gigs' and 'St. Ives Harbour' at the RA. Born in Liverpool. Lived in London and at St. Ives, Cornwall. Represented Walker AG, Liverpool.
Bibl: Athenaeum XXXII 1923 p.590.

McCULLOCH, George fl.1859-1901
Painter of historical genre and sculptor. Exhib. at RA 1859-1901, SS and elsewhere. Titles at RA 'Love Shaping his Bow', 'The Story of Cain', 'The Saving of Andromeda', etc. Also exhib. allegorical statues and reliefs, e.g. 'Higher and Still Higher', etc., RA 1867.

***MacCULLOCH, Horatio** RSA 1805-1867
Scottish landscape painter. Born in Glasgow. Studied under John Knox with Macnee and W.L. Leitch (qq.v.). Elected ARSA 1834, RSA 1838, after which he settled in Edinburgh. Exhib. mostly at RSA; showed only two pictures at RA in 1843. His preference for grand highland subjects reflects the influence of John Thomson of Duddingston, but his detailed technique is more akin to the Dutch 17th century style. His work was very popular, and influenced a whole generation of Scottish landscape painters, such as John Fleming, Arthur Perigal, and J. Milne Donald (qq.v.). Although an important figure in Scottish painting, his technique and colours were often unable to match the grandeur of his subjects. One of his pupils was Edward Hargitt (q.v.).
Bibl: AU 1847 p.380; AJ 1867 p.187ff. (obit.); Portfolio 1887 p.135ff., 207; Redgrave, Dict.; A. Fraser, *Scottish Landscape, The Works of H.M.*, 1872; Caw pp.143-5 and index (pl. opp. p. l44); DNB; Cundall; Hardie III pp.187-8 (pl.213); Ormond; Irwin.

MacCULLOCH, James RBA RSW fl.1872-d.1915
Landscape painter. Exhib. in London 1872-93 mostly at SS, also RA and NWS. Mostly highland subjects, e.g. 'River Ewe, Ross-shire', 'Loch Alsh from the Isle of Skye'.

MACDONALD, Miss A. fl.1870-1878
London landscape painter. Exhib. at SS 1870-8. Painted on the Thames, the Wye and in Sussex, Devon and Ireland.

McDONALD, Alexander 1839-1921
Painted portraits. Exhib. five portraits, including one of the Earl of Lichfleld, at the RA 1893-1904. London address.
Bibl: Poole 1912-25; The Year's Art 1922 p.313; Ormond.

MACDONALD, Alfred fl.1868-1903
Painted landscapes. Exhib. seven works, including 'Under the Jungfrau', 'Durham After Rain' and 'The Road to the Farm' at the RA, 1868-1903. Address in Oxford.

MACDONALD, C. fl.1857
Exhib. a work entitled 'The Stolen View' at the RA. London address.

MACDONALD, Daniel (or McDANIEL) 1821-1853
Exhib. a portrait at the RA and four works, titles including'An Irish Peasant Family Discovering the Blight of Their Store' and 'The Gun of Distress' at the BI. Lived in Cork, Ireland and in London.
Bibl: Strickland; Ormond.

MACDONALD, Miss Frances 1874-1921
Painted portraits and figurative subjects. Wife of J.L. Herbert MacNair (q.v.). She was a member of the Glasgow Group.
Bibl: Joseph W. Gleeson White, *Some Glasgow Designers and their Work;* Studio 1897-8; Irwin.

MacDONALD, Miss H.M. fl.1873
Exhib. a portrait at the RA in 1873. London address.

McDONALD, John fl.1843-1848
Exhib. two Scottish views at the RA. London address.

MacDONALD, John Blake RSA 1829-1901
Scottish historical genre and landscape painter. Exhib. at RA 1866-76, but more often at RSA. His historical subjects were mostly from the Jacobite period. In later life gave up figure painting for landscape. Elected ARSA 1862, RSA 1877. His work was of a conventional type, and he used the dark colours and chiaroscuro effects of Lauder and his pupils.
Bibl: Bryan; Caw pp.262, 264.

McDONALD, Miss Madeline M. fl.1896-1903
Painted portraits and figurative subjects. Exhib. five works at the RA 1896-1903, titles including 'Day Dreams' and 'Maisie' and portraits. London address.

MACDONALD, Murray fl.1889-1910
Edinburgh landscape painter. Exhib. at RSA 1889-1910.

MACDONALD, William fl.1848
Exhib. a scene in Antrim at SS. London address.

MACDONALD, William Alister fl.1884-1893
Painted watercolour views of London. Exhib. two watercolour views of the Thames in London at SS and two works including 'Her Palaces and Towers' at the RA. London address.
Bibl: E.B. Chancellor, *London Recalled*, 1937.
Exhib: London, Arlington Gallery 1935, 1936; Walker's Gallery, *Watercolours and Drawings of Old London Previous to 1914*, W.A. Macdonald, 1942.

McDONNELL, James d.1911
An amateur painter of landscapes and animals. Exhib. at the RHA from 1875. Lived in Dublin.

McDOUGAL, John RCA fl.1877-c.1941
Liverpool painter of landscapes and coastal scenes. Exhib. at RA 1877-1903, SS, NWS and elsewhere. Painted views in Wales, Cornwall, Devon and elsewhere, and also ideal landscapes, e.g. 'A Midsummer Day', 'When the Tide Flows in', 'The Tranquil Light of Rosy Morn', etc. Works by him are in Blackburn and Liverpool AG.
Bibl: AJ 1907 p.373; Brook-Hart.

MACDOUGALL, Allan fl.1851-1853
Exhib. three landscapes 1851-3. Address in Glasgow.

McDOUGALL, Miss Lily M.M. 1875-1958
Painted still-lifes in oil and watercolour. Exhib. at the RSA and RSW. Represented in Glasgow AG.

MACDOUGALL, Norman M. fl.1874-c.1927
Painted landscapes and figurative subjects. Exhib. eight works, including 'French Peasant Girl' and 'A Pool Where Lilies Grow', at the RA. Also exhib. 12 watercolours at SS, including 'Olivia' and 'A Silent Streamlet'. Addresses in Glasgow and London.

MACDOUGALL, William Brown NEAC fl.1887 d.1936
Painted landscapes and figurative subjects. Also an illustrator, etcher and engraver. Studied at the Académie Julian and under Bouguereau. Exhib. RA, RSA, NEAC, and Paris Salon. Born in Glasgow. Lived in Essex.

***MacDUFF, William fl.1844-1876**
London genre painter. Exhib. at RA 1844-66, BI and SS. Titles at RA 'The Doubtful Purchaser', 'A Country Auction', 'Rest by the Wayside', etc. His best-known picture is 'Shaftesbury, or Lost and Found', RA 1863, which was in the Arts Council Exhibition of Victorian Paintings, and is now in the Museum of London.
Bibl: Reynolds, VS p.84 (pl.63); Victorian Paintings, Arts Council exhib., No. 42, 1962; Wood, Panorama.

M'EMLYN, Miss fl.1861
Exhib. a genre subject in 1861. London address.

McEVOY, Mrs. Mary 1870-1941
(Miss Mary Edwards)
Painted portraits, flowers and interiors. Studied at the Slade. Exhib. at the NEAC from 1900. Married the painter Ambrose McEvoy in 1902. Born in Freshwood, Somerset. Lived in Somerset and London.
Exhibitions: London, Knoedler's 1933, 1936.

McEVOY, William fl.1858-1880
Painted Irish and Welsh landscapes. Exhib. six works, including views of the Lledr Valley, North Wales, and the Long Range, Killarney, at SS. Also exhib. at the RHA. Lived in Dublin and London.
Bibl: Strickland.

McEWAN, Charles fl.1885-1890
Exhib. two works, 'September in Surrey' and 'The Village Street', at the RA, and one work at SS. Address in Glasgow.

McEWAN, Tom RSW 1846-1914
Painted genre subjects and interiors in watercolour. Exhib. a work entitled 'They Shall Be Comforted' at the RA in 1887. Address in Helensburgh, Dumbartonshire. Represented in the Glasgow AG.
Bibl: AJ 1896 pp.15-19; Caw.

McFADDEN, A. fl.1872
Exhib. a watercolour 'Summer Afternoon — Clovelly Bay, North Devon' at SS. Address in Southampton.

McFADDEN, Frank G. fl.1878-1892
Exhib. two views of Southampton and one of Winchester, at the RA. Address in Southampton.

McFADDEN, Rowland fl.1874-1879
Exhib. two landscapes, 1874-9. Address in Southampton.

McFALL, C. Haldane fl.1891-1894
Exhib. two works, 'A Marriage in High Life, Sierra Leone' and 'British Zouaves Checking French Attack at Dawn, Warina, December, 1893', at the RA. London address.

MACFARLANE, J.L. fl.1863-1868
Painted fruit and flowers. Exhib. four works at the RA, five at SS and two at the BI. London address.

MacFARREN, J.J. fl.1839-1846
Landscape painter. Exhib. mainly at SS, also at RA 1840-6 and BI. Titles at RA English landscapes, also Italian views and genre, e.g. 'Casa Nassini, near Lodi' and 'Il Doppomezzogiorno'.

MACFEE, John fl.1887
Exhib. a work at the NWS in 1887. London address.

McGAW, John Thoburn RI RBA 1872-1952
Watercolourist. Exhib. RA, RI, RBA, RWA, RCA and elsewhere. Born in New South Wales, Australia. Lived at Horsham, Sussex.

McGEEHAN, Miss Jessie fl.1901
Exhib. a work entitled 'The Victorian Era' at the RA in 1901. Address in Glasgow.

***MACGEORGE, William Stewart RSA 1861-1931**
Painted landscape, portraits and figurative subjects. Studied at the Royal Institution Art School in Edinburgh, and at the Antwerp Academy. Exhib. three works, including 'In the Valley of the Dee' and 'Among the Wild Hyacinths' at the RA. Address in Edinburgh.
Bibl: Studio LXVI p.251ff.; Caw; Connoisseur XXXVI 1913 p.272.

McGHIE, John b.1867 fl.1893
Painted coastal scenes, figurative subjects and portraits. Also an etcher. Studied at the Glasgow School of Art, at the RA Schools and at the Académie Julian. Exhib. three works including 'A Hand Loom Weaver' and 'The Sword Dance', at the RA. Lived in Glasgow. He was president of the Glasgow Society of Etchers.

McGIBBON, Alexander fl.1891
Exhib. a view of the Palais de Justice in Rouen at the RA. Address in Glasgow.

McGILL, Mrs. W.M. (Fanny) fl.1888
Exhib. a work entitled 'The Wren's Nest, Dudley' at the RA. Address in Richmond, near London.

McGILL, William Murdoch fl.1867-1877
Exhib. three works including 'Solitude and Duck Weed' and 'The Wren's Nest — Dudley', at the SS. London address.

MACGILLIVRAY, James Pittendrigh RSA 1856-1938
Portrait sculptor who was also a painter. Studied at the Edinburgh School of Art. Exhib. mainly in Scotland. Born in Aberdeenshire. Lived in Glasgow and Edinburgh.
Bibl:M.H.Spielmann, *Brit. Sculpt. of Today*, 1901; Caw; AJ 1897 p.241; 1898 p.73, Connoisseur XLI 1915 p.113 XLIII 1915 p.113; LI 1918 p.179; LXIII 1922 p.122; Studio LXV 1915 p.102; LXX 1917 p.132ff.; LXXX 1920 p.18; Irwin. Exhib: Glasgow, Alex, Reid & Lefèvre 1927.

MACGOUR, Miss Hannah C. Preston fl.1893-1895
Exhib. two works, one an illustration to a line from Tennyson, the other entitled 'The Day's Work Done', at the RA. Address in Edinburgh.

MACGREGOR, Archie G. fl.1884 d.1910
Sculptor and painter of Old Testament subjects. Exhib. 14 works, including sculpture and paintings entitled 'The Fallen Archangel' and 'Desolation. Illustration to *Descent of Ishtar'*, at the RA. London address.
Bibl: Studio XLVIII 1910 p.306ff.

MacGREGOR, Miss Jessie fl.1872-1904 d.1919
Liverpool genre and historical painter. Moved to London c.1879. Exhib. at RA 1872-1904, and occasionally elsewhere. Titles at RA 'The Gardener's Daughter', 'The Wail of the Valkyrs', 'King Edward the Sixth', 'The Nun', etc. and some portraits.
Bibl: Academy Notes 1879-82; Cat. Walker AG Liverpool 1927 p.123.

McGREGOR, Robert RSA 1848-1922
Scottish painter of pastoral landscape and rustic genre. Worked as an illustrator for Nelson's in Edinburgh before taking up painting. Exhib. mainly at RSA, also RA 1878-1904 and elsewhere. Elected ARSA 1882, RSA 1889. MacGregor's *plein-air* style and his preference for rustic subjects show an affinity with such Dutch artists as Mauve and Israels, although he did not study outside Scotland.
Bibl: AJ 1903 p.124; Studio LXVIII 1916 p.123; LXXXV 1923 p.106ff.; Connoisseur LXV 1923 p.108; Caw pp.283-4 (pl. opp. p.282).

MCGREGOR, Miss Sarah fl.1869-1885
Painted watercolours of flowers. Exhib. seven works, including paintings of azaleas and wild flowers, at SS. London address.

MacGREGOR, William York RSA RSW NEAC 1855-1923
Scottish landscape painter. Son of a Glasgow shipbuilder. Studied under James Docharty (q.v.), and later under Legros (q.v.) at the Slade School. At first his landscapes were of a conventional type, but under the influence of his friend James Paterson (q.v.), who had

studied in Paris, he began to develop a broader, more robust style. His ideas were quickly taken up by other young Glasgow artists, and for this reason MacGregor is traditionally regarded as the father of the Glasgow School. From 1888-90 he went to South Africa because of ill-health. After his return, his style again changed, tending towards sombre colours, and an almost abstract concern for solid form. He exhib. mainly in Scotland, or at International Shows. Elected member of RSW 1885, NEAC 1892, ARSA 1898, RSA 1921.
Bibl: AJ 1898 p.47; 1904 p.172; Studio LXXXIX 1925 p.89ff.; CXII 1926 pp.53, 55; Connoisseur LXVIII 1924 p.55; Who's Who; D. Martin, *The Glasgow School of Painting*, 1902 pp.42-4; A. Dayot, *La Peinture Anglaise*, 1908; Caw pp.380-2 (pl. opp. p.380); *The Glasgow Boys*, Scottish Arts Council, 1968; Irwin

McGUINNESS, W. Bingham RHA fl.1882-c.1929
Painted landscape. Exhib. ten landscapes at the NWS. Also exhib. at the RHA and RI. Addresses in Dublin and London.

McHEATH, Charlotte D. fl.1870-1871
Exhib. two genre subjects in 1870-1. London address.

MACHELL, Reginald fl.1881-1893
Painted flowers and figurative subjects. Exhib. eight works, including 'Peonies' and 'An Hour of Peace and Happiness', at SS, and five works, including portraits, at the RA. London address.

MacIAN, Ronald Robert ARSA 1803-1856
Scottish painter of historical genre. Although quite a good actor, he gave up the stage about 1840 to devote himself to painting. Exhib. at RA 1836-47, BI and SS. Painted episodes from Scottish history, and incidents illustrative of highland courage and character. His wife Fanny (q.v.) was also a painter. Redgrave gives his names as Robert Roland.
Bibl: AJ 1857 p.62ff. (obit.); Redgrave, Dict.; Caw p.120.

MacIAN, Mrs. Ronald Robert (Fanny) fl.1835-1852
Genre painter, wife of R.R. MacIan (q.v.). For many years a teacher in the Government School of Design. Exhib. at RA 1836-47, BI and SS. The sources of her pictures were mostly historical or literary, e.g. 'The Little Sick Scholar', 'Nell and the Widow', 'The Slave's Dream', etc.
Bibl: See under R.R. MacIan.

McILWAINE, John Bedell Stanford RHA 1857-1945
Irish landscape painter. Studied at the RHA. Exhib. two landscapes in County Wicklow at SS. Born in Dublin. Addresses at Caledon in County Tyrone and in County Dublin.

McINNES, Alexander fl.1848-1853
Painted highland subjects. Exhib. five works including 'Visiting the Bothie', 'Jamie's Return' and 'Highland Industry', at the BI. Also exhib. three works, including a view of the house in which Turner died at the RA, and two works at SS. London address.

McINNES, Miss Ellen fl.1854-1865
Exhib. four works, including 'A Present from the Gardener' and 'Nonpareil, from the Royal Botanic Society, Regent's Park', at the BI, and two works at SS. London address.

***McINNES, Robert** 1801-1886
Scottish genre painter. Exhib. at RA 1841-66, BI and elsewhere. Painted both highland and Italian scenes, usually of a conventionally picturesque type, e.g. 'Fiore dal Carnivale', 'The Highland Girl', 'The Sunday School', etc. Also occasionally painted portraits and historical scenes. A work by him is in Glasgow AG.
Bibl: AJ 1859 p.170; Caw p.120; Ormond.

McINNES, S. fl.1849-1852
Is supposed to have exhib. two historical subjects at the RA.
London address.

MACINTOSH, Colin M. fl.1882
Exhib. three landscapes in 1882. London address.

MACINTOSH, John Macintosh RBA 1847-1913
London landscape painter. Exhib. mainly at SS, also at RA 1880-
1901, NWS and GG. Titles at RA include views in the south of
England, and also some ideal landscapes, e.g. 'Spring', 'Eventide',
'December Evening', etc.
Bibl: Who's Who 1913.

MACINTYRE, Mrs. fl.1841-1854
(Mrs. Denis Dighton)
Exhib. three works, including studies of apples and flowers, at the
RA. She was appointed painter of fruit and flowers to Queen
Adelaide. Address at Kilburn Priory.

McINTYRE, James fl.1867-1898
Painted figurative subjects. Exhib. six works, including 'Adrift', 'You
Naughty Boy!' and 'Jack O'Lantern', at the RA, and six works,
including 'Spilt Milk' and 'Touch Me Not', at SS. London address.

McINTYRE, John H. fl.1896-1904
Exhib. two works, 'Winter Woodlands' and 'Old and Broken', at
the RA. London address.

McINTYRE, Joseph Wrightson fl.1866-1888
Painter of coastal scenes and seascapes. Exhib. at RA 1871-88, BI and
mostly at SS. Titles indicate mostly stormy subjects, e.g. 'A Gleam of
Hope', 'A Wild Night on Goodwin Sands', 'Bridlington Quay', etc.
Bibl: Brook-Hart.

McINTYRE, Robert Finlay fl.1892-1897
Exhib. three works, including 'Druid Oak: Kent' and 'Sennen
Cove, Cornwall', at SS, and two works at the RA. London address.

MACIRONE, Miss Cecilia A. fl.1855-1859
Exhib. two works, 'San Guiseppe' and 'A Group of Hollyhocks', at
the BI, 'Un Pifaro' at the RA, and 'A Scene at the Seat of the War',
at SS. London address.

MACIRONE, Miss Emily fl.1846-1878
London genre and portrait painter. Exhib. at SS most often; also at
RA 1846-73 and elsewhere. Titles at RA 'Nell in the Churchyard',
'The New Playmate', 'Love and Labour', etc., and some French
and Italian genre subjects.

MACKAY, Mrs. Barbara fl.1891
Exhib. a portrait in 1891.

MACKAY, Charles b.1868
Painted landscape watercolours. Studied at the Glasgow School of
Art and at the Académie Delecluse. Exhib. at the RSA. Lived in
Glasgow.

McKAY, David B. see ROFFE, William John

MACKAY, Father Edward
Painted portraits. He was a pupil of H.P. Briggs. A portrait of Pugin
in the NPG has been attributed to him.
Bibl: Ormond.

McKAY, Miss G. fl.1886
May have exhib. at the NWS in 1886. London address.

McKAY, Miss Rose fl.1892-1899
Exhib. two works, 'Study of a Head' and 'The Fortune Teller', at
SS. London address.

MACKAY, T.W. fl.1826-1853
Painted portraits and figurative subjects. Exhib. six works, including
The Spanish Guardroom', 'Andromeda' and portraits, at the RA.
Exhib. ten works at SS and seven at the BI, including 'Ophelia', 'A
Monk Reading to the Brotherhood' and 'The Toilet'. London address.

***McKAY, Thomas fl.1893-1912**
Liverpool watercolourist of landscapes and country scenes, painted
in a delicate impressionist style. Exhib. in Liverpool and at the RA.
Bibl: Wood, Paradise Lost.

***McKAY, William Darling RSA 1844-1924**
Painted landscape and genre subjects. Studied at the Trustees'
Academy in Edinburgh. Born at Gifford, East Lothian, and lived in
Edinburgh. Represented in the Glasgow AG.
Bibl: Caw; Irwin; Wood, Panorama p.159 (pl.166); Wood, Paradise Lost.

McKECHNIE, Alexander Balfour RSW 1860-1930
Painted landscapes and oriental subjects in oil and watercolour.
Studied at Glasgow School of Art. Born at Paisley near Glasgow.
Lived in Renfrewshire.

MACKEI, B. Jessop fl.1889
Exhib. a study entitled 'A Tribute to Scopon' and a work entitled
'Rain and Mist' at SS. London address.

MACKELLAR, Duncan RSW 1849-1908
Painted genre subjects, often in historical settings. Exhib. two
works, 'A Tragedy', painted in combination with A.K. Brown, and
'A Yeoman's Daughter' at the RA. Also exhib. at the NWS and the
GG. Born in Inverary, Argyll. Lived in Glasgow.
Bibl: Studio XXVIII 1903 pp.50, 137; Caw; Cat. Glasgow AG 1911 p.134.

McKENNY, R. fl.1843
Exhib. two Welsh scenes at the RA. London address.

MACKENZIE, Lady fl.1875
Exhib. a genre subject in 1875 London address.

MACKENZIE, Alexander Marshall ARSA b.1848 fl.1888
An architect who exhib. a landscape, a view of Loch Luichart,
Ross, and views of buildings at the RA. Address in Aberdeen.
Bibl: Redgrave, Dict.; Who's Who.

McKENZIE, Mrs. D. fl.1845-1860
(Miss Emma Landseer)
Animal painter. Exhib. eight works (three of them as Miss
Landseer), including 'A Forest Encounter', 'Looking In' and 'A
Mischievous Dog', at the BI. Also exhib. two works at the RA. She
was the youngest sister of Sir Edwin Landseer (q.v.). She outlived
all her brothers and sisters, and inherited most of Edwin's fortune.
Bibl: See under Sir Edwin Landseer.

MACKENZIE, Miss E. fl.1857
Exhib. a work entitled 'Nino' at the RA. London address.

MACKENZIE, Mrs. E. Phillipe **fl.1866-1868**
Painted figurative subjects in watercolour. Exhib. six watercolours at SS, titles including 'Give Me a Bite' and 'Unpaid Nurses'. Address in Oxfordshire.

MACKENZIE, Frank J. **fl.1891-1893**
Painted landscapes and marines. Exhib. three works, including 'Early Morning — Waiting for the Tide Off the Coast of Flanders', at the RA, and three works, including 'On the Brow of the Hill', at SS. Address in Godalming, Surrey.

MACKENZIE, Frederick **OWS** **1787-1854**
Painted views of buildings. Exhib. 92 works at the OWS. Also exhib. once at the RA and once at SS. Address in Romford, Essex. Mainly an architectural and topographical draughtsman.
Bibl: DNB XXXV; Roget; Prideaux, *Aquatint Engraving*, 1908; Cundall, Hardie III.

MACKENZIE, George **fl.1833-1844**
Painted landscape and views of buildings. Exhib. seven works at the RA including 'View of St. Alban's Church' and two landscapes, and six watercolours at SS. London address.

MACKENZIE, H.A.O. **fl.1891**
Exhib. a work entitled 'A Quiet Day — The National Gallery' at SS. London address.

MACKENZIE, J.M. **fl.1846**
Exhib. a work entitled 'Innocence' at the RA. London address.

MACKENZIE, James Hamilton **ARSA RSW ARE** **1875-1926**
Painted and etched architectural subjects. Studied at the Glasgow School of Art and in France and Italy. Born and lived in Glasgow. He was the president of the Glasgow Art Club.

MACKENZIE, James M. **fl.1882**
Exhib. a river scene in 1882. Address in Woodside.

MACKENZIE, James Wilson **fl.1888-1890**
Exhib. three works at SS, 'Thoughts of Bygone Days', 'Resting' and a portrait. Address in Liverpool.

MACKENZIE, John D. **fl.1886-1891**
Exhib. three works, including 'Prince Arthur and the Friends of Intemperance' and a subject from E. Allan Poe, at the RA. Address in Newlyn, Cornwall.

MACKENZIE, Kenneth **fl.1884-1899**
Landscape painter. Exhib. at RA l885-99, and elsewhere. Lived in Wales, and after about 1892 in Scotland. Subjects mostly highland scenes, e.g. 'The Home of the Heather', 'Snipe Land', 'Wild Grouse', etc.

MACKENZIE, M.H. **fl.1877**
Exhib. two works, one entitled 'Portia', at SS. London address.

MACKENZIE, Miss S.A. Muir **fl.1871-1877**
Exhib. four works 'Sehnsucht', 'The Yellow Gown', etc. at the RA. London address.

MACKENZIE, William G. **fl.1894-1897**
Exhib. three works, two portraits and a work entitled 'My New Shoes!', at the RA. London address.

McKEWAN, David Hall **1816-1873**
Landscape painter and watercolourist. Exhib. at RA l837-53, BI, SS and NWS (498 works). Elected RI 1848 Painted in Wales, Scotland,

Ireland and Kent. Published *Lessons on Trees in Watercolours*. His studio sale was held at Christie's, 6, 7 March 1874
Bibl: Redgrave, Dict.; DNB.

McKEWEN, M.W. **fl.1872-1875**
Painted watercolour landscapes. Exhib. 18 works, the majority views in and around Tichborne, Hampshire, and on the Brent, near Hendon. London address.

MACKEY, J. **fl.1845**
Exhib. a study of a head at the RA. London address.

MACKIE, Miss Annie **fl.1887-1893**
Painted flowers. Exhib. four works, including three paintings of chrysanthemums, at the RA. London address.

MACKIE, Charles Hodge **RSA RSW SSA** **1862-1920**
Painted landscapes, portraits and murals in oil and watercolour. Studied at the RSA Schools. Exhib. five works, including 'Sandy Pastures', 'The Winnower' and 'Folding Sheep at Gloaming', at the RA. Address in Edinburgh.
Bibl: AJ 1900 p.287; Caw; Studio LVIII p.66; 137 p.295ff.; LXVIII pp.61, 122, 125; LXX p.107; Irwin; P. Phillips, *The Staithes Group*, 1993.

MACKINLAY, Thomas **fl.1863-1870**
Painted portraits and figurative subjects. Exhib. three portraits and works entitled 'The First Lesson' and 'Making the Wedding Dress', at the RA. London address.

McKINNON, Finlay **fl.1891-1893**
Exhib. two landscapes at the NWS. London address.

MACKINTOSH, Mrs. Margaret **RSW** **fl.c.1900-1940**
(Miss Macdonald)
Watercolourist. Studied at Glasgow School of Art. Exhib. on the Continent. Married to Charles Rennie Mackintosh. Born in Staffordshire .
Bibl: J.W.G. White, *Some Glasgow Designers*, Studio 1897-8.
Exhib: Glasgow, McLellan Galleries 1933; Edinburgh, Festival Society 1968.

MACKLIN, Thomas Eyre **RBA** **1867-1943**
Painted figurative subjects, portraits and landscapes in watercolour. Also a sculptor and illustrator. Studied at the RA schools. Exhib. 16 works at the RA 1889-1903, titles including 'From the Sunny South', 'A Bend of the Tees' and portraits. Born in Newcastle-upon Tyne. Lived in Northumberland, London and France. For works illustrated by, see VAM Card Cat.
Bibl: Hall.

MACKRETH, Harriet F.S. **1828-1842**
Painted portraits. Exhib. 23 works at the RA including portraits of the architect John Dobson and the engineer Wm. Chapman. She painted miniatures as well as full-size portraits. Lived in Newcastle-upon-Tyne.
Bibl: Hall.

MACKRETH, Robert **fl. early 19th century**
Painted, engraved and lithographed landscape subjects. Lived in Newcastle-upon-Tyne. Made illustrations for Hodgson's *History* of Northumberland.
Bibl: Hall.

MACKWORTH, Audley **fl.1884-1890**
Painted biblical subjects. Exhib. seven works, including 'Hard-won Gains', 'Christ Calming the Sea' and 'Cloud Chariots' at the RA. London address.

MACKWORTH, Miss T. **fl.1886**
Exhib. a portrait at the NWS in 1886. London address.

McLACHLAN, Miss Aileen M. **fl.1885-1893**
Exhib. eight portraits 1885-93. London address.

McLACHLAN, Miss H. **fl.1881-1882**
Exhib. two works, one a still-life of fruit, at SS. London address.

McLACHLAN, H. **fl.1886**
Exhib. a figurative subject in 1886. London address.

McLACHLAN, Thomas Hope **ROI** **1845-1897**
Landscape painter. Born in Darlington of Scottish parents. Studied for the bar, and in 1878 gave up the law for painting, encouraged by J. Pettie (q.v.) and others. Exhib. at RA 1877-97 GG, NG and elsewhere. His landscapes are romantic and moody, showing the influence of G.H. Mason and C.G. Lawson (qq.v.), but his technique remained rather amateurish. His figures are usually solemn peasant workers of the Millet type; his theme the unity of Man and Nature.
Bibl: AJ 1897 p.191; Mag. of Art 1903 p.117ff.; Studio XXXIX 1907 p.134ff.; DNB; Caw pp.316-18; Hill.

McLAREN, C. **fl.1871**
Exhib. a work entitled 'Gipsy Cottages, Seville' at the RA. London address.

MACLAREN, John Stewart **b.1860 fl.1903**
Painted landscapes, figurative and architectural, including Spanish, subjects. Studied at the RSA Schools and in Paris. Exhib. five works, including 'A Spanish Patio' and 'Torre de la Vela, Granada, Spain' at the RA. Also exhib. two works at SS. Born and lived in Edinburgh. He was a member of the Scottish Arts Club.

MACLAREN, Thomas **fl.1885-1892**
Painted views of buildings. Exhib. nine works at the RA including views of S. Carlo theatre, Naples, the pulpit of Siena Cathedral and Croscombe Church, Somerset. London address.

MacLAREN, Walter **fl.1869-1893**
Genre painter. Lived for a time in Capri, where he painted many scenes of Capri life and landscape. Exhib. at RA 1869-1904, GG, NG and elsewhere. Titles at RA 'A Capri Mother', 'Capri Life — the Embroiderers', 'Scene in an Orange Garden', etc.

MACLAUGHLIN, Frances **fl.1878**
Exhib. a view of a church in 1878. Address in Worcestershire or Gloucestershire.

McLAURIN, Duncan **RSW** **1849-1921**
Painted landscapes and cattle. Studied at Glasgow School of Design and at Heatherley's. Exhib. chiefly in Scotland. Represented in the Glasgow AG. Lived at Helensburgh, Dumbarton.

McLEA, Duncan Fraser **1841-1916**
Painted marines and landscapes in oil and watercolour. Worked in north-east England and Scotland. Lived at South Shields, County Durham. He was President of the South Shields Art Club.
Bibl: Hall.

MACLEAN, Alexander **VP RBA** **1867-1940**
Painted landscapes, marines and figurative subjects. Exhib. ten works, including 'A Roman Girl' and 'The Wane of an Autumn Day' at the RA and four works, including 'Two a Penny' and 'On the Sandwich River' at SS. London address.
Bibl: DNB XXXV; AJ 1878 p.16.
Exhib: London, The Cottage, Holland Park Road, c.1908.

MACLEAN, Hector **fl.1880**
Exhib. a watercolour entitled 'A Sussex Lane' at SS. Address in Brighton, Sussex.

MacLEAN, Sara **fl.1880s**
Painter of Cornish coastal scenes and still-lifes. An example is in Portsmouth City Museum.

MACLEAY, Kenneth **ARSA** **1802-1878**
Scottish portrait and figure painter. Entered Trustees' Academy in 1822. An original ARSA in 1826, resigning and being re-elected in 1829. At first a miniaturist, he turned to larger portraits as a result of competition from photography. He painted a series of drawings of highland costume for Queen Victoria, and published *Highlanders of Scotland* in 1870.

MACLEAY, Macneil **ARSA** **fl.1839**
Exhib. a landscape, a 'View Near the Head of Loch Eil, Invernesshire' at the RA. Address in Edinburgh. His brother was Kenneth Macleay (q.v.).

McLELLAN, Alexander Matheson **RSW RBA** **1872-1957**
Painted portraits and figurative subjects. Studied at the RA schools and at the École des Beaux-Arts. Worked in Paris, London, Manchester and for many years in Glasgow.

McLEOD, G. **fl.1856**
Exhib. a work entitled 'Poor Dicky' at the RA. London address.

MacLEOD, Miss Jessie **fl.1845-1875**
London genre painter. Exhib. at RA 1848-74, BI and SS. Titles at RA 'A Village Genius', 'Sunny Hours', 'At the Church Door', and also some German scenes.

***MACLISE, Daniel** **RA** **1806-1870**
Irish portrait and historical painter. Born in Cork, where he studied at the local Academy. Came to London 1827; entered RA Schools 1828. At first he made a living by portraits, but soon turned to historical genre. Exhib. at RA 1829-70, BI and SS. Elected ARA 1835, RA 1840. His historical scenes were usually based on popular literary sources, such as *The Vicar of Wakefield, Gil Blas,* Shakespeare, etc . He also painted some ambitious historical scenes such as 'The Marriage of Strongbow and Eva', 'Here Nelson Fell', etc. In the House of Lords he painted two frescoes, 'Spirit of Justice' and 'Spirit of Chivalry', and later his two best known historical scenes, 'The Death of Nelson' and 'The Meeting of Wellington and Blucher'. Worn out by these immense commissions, which he completed in 1864, he produced very little in the last years of his life. He also illustrated several books. His studio sale was held at Christie's, 24 June 1870.
Bibl: AJ 1870 p.181ff. (obit.); Connoisseur LXIV 1922 pp.120, 123; LXXIV pp.30, 33; LXXV p.186; J. Ruskin, Academy Notes 1855, 1857; Redgrave, Dict., Cent., J. Dafforne, *Pictures by D.M.;* W.J. O'Driscoll, A Memoir of D.M., 1872; Caw; DNB; Strickland; Reynolds, VS pp.57, 67 (pl.17); Boase index; Reynolds, VP *passim*; Maas pp.24-5 (pl. p.26); Ormond; Irwin; Cat. of Arts Council exhib., 1972; R. Ormond, *D.M. —A Major Figurative Painter,* Connoisseur 1972; John Turpin, *German Influence on D.M.,* Apollo February 1973; Strong.
Exhib: Great Britain, Arts Council 1972.

MACLURE, Andrew fl.1857-1881
Painted landscapes and coastal scenes. Exhib. six works, including 'Venice', 'Storm at Brighton, November 1875' and 'Eastbourne' at the RA. London address.

MacMANUS, Henry RHA 1810-1878
Irish historical and genre painter. Began to exhib. at RHA in 1835. Elected ARHA 1838, RHA 1858. Worked in London 1837-44, Glasgow 1845-9, then returned to Dublin. Appointed Headmaster of Dublin School of Design. Also exhib. at RA 1839-41, BI and OWS. Painted historical scenes, and also scenes of Irish life, e.g. 'May Day at Finglas, Dublin' and 'Rory O'More'. Also worked as book illustrator. Professor of painting at RHA 1873-8.
Bibl: AJ 1878 p.156 (obit.); Strickland.

McMARA, H. fl.1855
Exhib. two works, 'Eel Stall' and 'Cottage Griefs' at SS. London address.

MacMASTER, James RBA RSW 1856-1913
Scottish landscape painter and watercolourist. Exhib. mainly at SS, and at RA 1885-97, NWS, RSA and RSW. Subjects highland views and coastal scenes. Titles at RA 'At Anstruther, Fife, NB', 'Off to the Fishing Ground', 'Out on the Deep', etc.

McMICHAEL, Mrs. W. fl.1844-1849
Exhib. a composition at SS. Address at Bridgenorth, Shropshire.

McMILLAN, Miss Emmeline S.A. fl.1885-1892
Exhib. two works, 'Mariana' and 'A Surrey Cottage' at the RA. Also exhib. three works at the NWS. London address.

McMILLAN, Hamilton J. fl.1896
Exhib. a painting of a tinker's camp at Roseneath at the RA. Address in Dunbarton.

McMINN, J.K. fl.1871-1873
Exhib. a watercolour of a camellia and another work at SS. London address .

MACNAB, John fl.1855-1890
Exhib. a view near Edinburgh at the RA. London address.

MACNAB, Peter RBA fl.1864-1892 d.1900
London landscape and rustic genre painter. Exhib. mainly at SS, also RA 1868-92, NWS and elsewhere. Titles at RA 'Coming Through the Rye', 'Amid the Ripening Corn', 'The Smuggler's Wife', etc. Painted in Brittany and Spain.

McNAB, Robert Allan b.1865
Barrister and amateur landscape painter. Born and lived in Preston, Lancashire, and generally painted in the Lake District.

MACNAIR, J.L. Herbert fl.c.1890-1940
Painted portraits and figurative subjects. His wife, Frances Macdonald (q.v.) was a painter. Member of the Glasgow Group.
Bibl: Joseph W. Gleeson White, *Some Glasgow Designers,* Studio 1897-8; Irwin.

McNALLY, Irvine fl.1870-1880
Painter of military subjects working in the 1870s and 1880s.

MACNAMARA, F.A. fl.1840-1850
Exhib. a portrait of three sisters and a work entitled 'A Rough Style'. London address.

***MACNEE, Sir Daniel PRSA 1806-1882**
Scottish portrait painter. Born Fintry, Stirlingshire. Studied in Glasgow under John Knox, together with MacCulloch and W.L. Leitch (qq.v.). Worked for an engraver in Edinburgh, while studying at the Trustees' Academy. In 1832 returned to Glasgow, where he quickly established himself as a portrait painter. Elected RSA 1829. Exhib. at RA 1832-81 and at RSA. After the death of Watson Gordon in 1864, and Graham Gilbert in 1866, Macnee became the leading Scottish portrait painter of the day. Elected PRSA 1876. As a portrait painter he has been described as "an understudy of Raeburn". His best work was done between 1845 and 1860.
Bibl: Portfolio 1887 p.139; Caw pp.177-8 and index; DNB; Ormond; Irwin.

MACNEE, Robert Russell fl.1892-d.1952
Painted landscapes and figurative subjects. Exhib. a work entitled 'An Evening in October' at the RA. Also exhib. at the RSA, and Paris Salon. Born at Dunbartonshire. Lived in Angus.

MacNICOL, Miss Bessie 1869-1904
(Mrs. Alexander Frew)
Painted portraits, genre and landscapes. Exhib. a work entitled 'Fifeshire Interior' at the RA. Represented in the Glasgow AG. Lived in Glasgow and was married to the painter Alexander Frew (q.v.).
Bibl: Studio XXVIII 1903 pp.135,137; AJ 1904 pp.48, 270; 1905 p.226; Caw.

MacNIVEN, D.P. fl.1881-1883
Exhib. two works, one of them, a watercolour, entitled 'At Rest' at SS. London address.

MacNIVEN, John RSW fl.1889-1894
Exhib. four works, including 'The Closing Struggle: Glasgow Regatta', 'The Clyde at Pointhouse' and 'Arran from the Shores of Jura' at the RA. Address in Glasgow.

McNIVEN, Lt.-Col. Thomas William Ogilvie fl.1846-1870
Exhib. two watercolours 'Porto Farrajo, Elba' and 'The Ruins at Paestum' at SS. London address. Also did topographical scenes and military subjects.

McPHEARSON, J. fl.1833-1839
Painted marines, coastal scenes and river landscapes. Exhib. 11 works, including some watercolours, at SS; three works at the BI, titles including 'Boats in a Fresh Breeze' and 'Coast Scene, Unloading Cargo', and one 'River Scene' at the RA. London address.

MACPHERSON, Miss Barbara H. fl.1882-1885
Painted watercolours depicting seasonal and country subjects. Exhib. four works at SS, titles including 'Sheep: Drinking and Changing Pastures' and 'Early Spring'. London address.

MACPHERSON, John fl.1865-1884
Painted river and coastal landscapes in watercolour. Exhib. 12 works at SS, titles including 'Moonlight on the River Wey', 'Bait Gatherers, Portobello Sands' and 'Autumn Floods in Essex'. London address. His son Douglas Macpherson, b.1871, was an illustrator.

MACPHERSON, Miss Margaret Campbell fl.1897
Studied under Courtois. Also exhib. in Paris. Exhib. a work entitled 'Day Dreams' at the RA. Born in Canada. Lived in Edinburgh.

MACPHERSON, Robert 1811-1872
Painter and photographer. Painted Roman and Italian scenes. A campagna landscape dated 1842 was sold at Christie's, 6 March 1970. About 1851 he gave up painting for photography, and became well-known for his Roman views.
Bibl: H. Gernsheim, *The History of Photography,* 1969.

McPHIRSON, J.R. fl.1849
Exhib. 'A View from Villa Mattei, at Rome' at the RA.

MacQUOID, Percy Thomas RI 1852-1925
Genre painter and watercolourist; son of T.R. MacQuoid (q.v.). Exhib. at RA 1875-87, SS, NWS, GG and elsewhere. Titles at RA 'Not for you', 'The Eve of the Battle of Salamis', 'Horses Bathing'. Also worked as a furniture designer and decorator.
Bibl: Country Life 28 March 1925.

MacQUOID, Thomas Robert RI 1820-1912
Architectural painter, watercolourist and illustrator. Exhib. at RA 1838-94, SS, NWS and elsewhere. Painted buildings in England, France and Spain, and occasional Spanish genre scenes. Also worked as an illustrator for *The Graphic* and *The Illustrated London News*. For works illustrated by, see VAM Card Cat.
Bibl: Who's Who 1911; Ormond.

MACRAE, L.C. fl.1898
Exhib. two works, 'A Homestead in Pas de Calais' and 'In Her Cottage Garden' at the RA. London address.

MacRAE, Mary fl.1893-1894
Exhib. a work entitled 'A Jovial Monk' at SS. London address.

MacRORY, Miss Anna A. fl.1900
Exhib. a work entitled 'Idle Dreams' at the RA. Address in Florence, Italy.

McSWINEY, Eugene Joseph ARWS b.1866 fl.1904
Painted portraits and landscapes. Exhib. two works, 'Eventide' and 'In Sheltered Vale' at the RA 1897-1904. Also exhib. at the RHA. Born in Cork, Ireland. Lived in London.

***McTAGGART, Sir William RSA RSW 1835-1910**
Scottish painter of landscape and coastal scenes. Born in Aros, on the Atlantic coast of Scotland, whose "seas and sands made him a painter" (Hardie). Studied under Lauder at Trustees' Academy 1852-9, where his fellow pupils included Orchardson, MacWhirter, Tom Graham and J. Pettie (qq.v.). Exhib. at RSA from 1853, and RA from 1866. Elected ARSA 1859, RSA 1870. McTaggart's swirling and brilliant style, and his rendering of effects of light and atmosphere, were similar to that of the French Impressionists, although it was not until the 1890s that he saw his first Monet. He was also a brilliant watercolourist, but after 1889 he painted mainly in oils. "Even Turner has not excelled him in his knowledge of the swift movement, the scudding foam and spray, the changing light and colour of the sea" (Hardie). His work remained comparatively unknown outside Scotland until the exhibition at the Tate in 1935, which was followed by exhibitions at the National Gallery in Edinburgh in 1935 and Manchester in 1937.
Bibl: AJ 1894 pp.243-6; Studio LXVII 1909 pp.83-93, Burlington Mag. XXXII 1918 p.227ff.; Connoisseur L 1918 p.106ff.; Caw pp.248-54 and index (2 pls.); J.L. Caw, W. *McT.*, 1917; D. Fincham, W. *McT.*, 1935; Cat. Fine Art Society McT. exhib., 1967; Hardie III pp.195-8 (pl. 230); Brook-Hart (pl.103); Irwin; H. Harvey Wood, W. *MacTaggart*, 1974.
Exhib: London, Tate Gallery 1935; Edinburgh, National Gallery of Scotland 1935; Manchester, City AG 1937; Great Britain, Arts Council 1954; Arts Council, *Four Scottish Painters*, 1963; London, Fine Art Society 1967; Edinburgh, Scottish Arts Council 1968; London, Fine Art Society, *The McTaggarts' McTaggarts*, 1974; Conway, Royal Cambrian Academy of Art 1975; Royal Scottish Academy, 1989.

MacVEAL, R. fl.1847
Exhib. a view near Petworth, Sussex, at the RA. London address.

MacWHIRTER, Miss Agnes Eliza b.1837 fl.1867-1879
Exhib. three works, including 'Old Books, Lamplight' and 'The Poison Chalice' at the RA. London address. Sister of John MacWhirter. (q.v.). Her still-life pictures are generally small and minutely painted. Moved to London about 1870.

***MacWHIRTER, John RA HRSA RI RE 1839-1911**
Scottish landscape painter. Born in Edinburgh. Elected ARSA 1867, but left Edinburgh soon after to settle in London. Exhib. at RA 1865-1904, NWS, GG and elsewhere. Elected ARA 1879, RA 1894. MacWhirter's preference was for peaceful and poetic landscapes. At first he attempted Pre-Raphaelite detail, but later abandoned this for a broader style. Travelled widely in Europe and America, and in the Alps, France and Italy.
Bibl: AJ 1879-1911 *passim*; M.H. Spielman, *The Art of J. MacW.*, 1904; W.M. Sinclair, *The Life and Work of J. MacW.*, AJ Christmas Annual 1903; Caw pp.256-8 and index (pl. opp. p.256); DNB; Who's Who 1911; J. MacWhirter, *Sketches from Nature,* intro. by Mrs. MacW., 1923; Hardie III p.199 (pl. 232); Irwin.
Exhib: London, Fine Art Society 1901; London, Leicester Gallery 1910, 1911.

MADDEN, Wyndham fl.1870-1871
Exhib. two landscapes in 1870-1. London address.

MADDISON, John fl.1896-1901
Painted still-lifes. Exhib. five works, including 'Brown Jar and Onion' and 'Crabs and Willow-pattern Plate' at the RA. Address in Middlesbrough, Yorkshire.

MADDOX, George RBA 1760-1843
Architect who painted buildings and antiquities. Exhib. 42 works at SS including views of tombs on the Appian Way and of aqueducts and ruins. Also exhib. architectural studies at the RA until 1819. London address.
Bibl: The Art Union V 1843 p.296; Redgrave, Dict.

MADDOX, Richard Willes fl.1873-1904
Painted country subjects and historical subjects. Exhib. 13 works at the RA 1888-1904, including 'Some Winter Birds', 'Medea' and 'Dolce fa Niente'. Also exhib. four works, including a watercolour 'The Home of the Water Rat' at SS. London address.

MADDOX, Willis 1813-1853
Painter of portraits, historical, allegorical and religious subjects. Born in Bath, where he was patronised by William Beckford. Exhib. 13 works at the RA (also at BI) including 'Objects of Vertu, the Property of William Beckford', 'Snake Catchers of Syria', etc. Painted the Turkish Ambassador, which led to an invitation to Constantinople to paint the Sultan. While there he painted a number of Turkish portraits and subject pictures, and died in Pera, near Constantinople. His name is sometimes spelt Willes Maddox.
Bibl: AJ 1853 p.311; Redgrave, Dict.

MADOT, Adolphus M. fl.1852-1864
Painted Shakespearian and other literary subjects. Studied at the RA schools. Exhib. eight works at the RA, titles including 'Such was Francesca' and works from *Hamlet* and *Romeo and Juliet* Also exhib. six works at SS and four at the BI, including a scene from *Macbeth*. London address.
Bibl: AJ 1861 p.148; Bryan.

MADOT, Miss A.E. fl.1859
Exhib. a study at the RA. London address.

MADOX BROWN, Ford see BROWN, Ford Madox

MAES, H. fl.1878
Exhib. one work 'A Deserted Home' at SS. London address.

***MAGGS, John Charles 1819-1896**
Bath coaching painter. Ran a school of painting in Bath, at his studio in 34 Gay Street. Although he never exhib. in London, he was widely patronised by lovers of coaching, including Queen Victoria. Like Charles Cooper Henderson (q.v.) he carried the tradition of coaching painting well into the railway age. He was particularly fond of painting coaches in snow.
Bibl: Pavière, Sporting Painters p.61 (pl. 28).

MAGILL, L. fl.1891
Exhib. a work entitled 'Tired Out' at SS. London address.

MAGNES, Isidore fl.1849-1852
Is supposed to have exhib. two portraits at the RA. London address.

MAGNIAC, The Hon. Mrs. fl.1875
Exhib. a watercolour view of the Castle of Chillon, Lake of Geneva at SS. Address in Bedford.

MAGNUS, Miss Emma fl.1884-1901
Painted figurative subjects and still-lifes. Exhib. six works, including 'Natives' and portraits, at the RA, and ten works, including 'Preparing for a Days Fishing', 'A Dish of Fruit' and a scene from *The Merchant of Venice,* at SS. Address in Manchester. She was the sister of Rose Magnus (q.v.).

MAGNUS, Miss Rose fl.1884-1893
Painted flowers. Exhib. 19 works, including paintings of 'Field Flowers', 'Pansies' and 'Violets', at SS. Address in Manchester. She was the sister of Emma Magnus (q.v.).

MAGNUSSEN, Christian Karl 1821-1896
His painting of 'The Marriage of Princess Helena' is in the Royal Collection.
Bibl: Ormond.

MAGOR, M.A. fl.1878
Exhib. two landscapes in 1878. London address.

MAGRATH, William 1838-1918
Painted landscapes and country subjects. Exhib. six works, including 'Something Towards the Rent' and ' "Shule Aroon", An Old Irish Song' at the RA, and five works, four of them watercolour views in Sussex and Kent, at SS. Born in Ireland. Lived in Washington D.C.
Bibl: Clement & Hutton.

MAGUÉS, J. fl.1849-1852
Exhib. two works at the RA; a portrait and a double-portrait of the King and Queen of Holland.
Bibl: Ormond.

MAGUIRE, Miss Adelaide Agnes 1852-1876
Painted figurative and country subjects. Exhib. four works, including 'Learning to Sew' at the RA, and two watercolours 'Looking over the Hedge' and 'November', at SS. She was the daughter of T.H. Maguire (q.v.). She was influenced by the PRB and Birket Foster (q.v.). She was a member of the Society of Lady Artists.
Bibl: Strickland; Hardie III; Clayton I p.420ff.

MAGUIRE, Miss Bertha fl.1883-1904
Exhib. seven flower paintings at the NWS. Also exhib. four works, including 'Japanese Anemones' and 'Honeysuckle', at the RA. London address. She was the daughter of T.H. Maguire (q.v).
Bibl: See under T.H. Maguire.

MAGUIRE, Miss Helena J. 1860-1909
Painted children and animals in watercolour. Exhib. 13 works at the RA 1881-1902 including 'Out of Danger', 'Left Behind' and 'A Swimming Lesson'. Also exhib. four watercolours at SS and 21 works at the NWS. London address. She was the daughter of T.H. Maguire (q.v.).
Bibl: Strickland.

MAGUIRE, Henry Calton 1790-1854
A painter and writer from Cavan, Ireland. He was editor of *The Connoisseur.*
Bibl: Strickland.

MAGUIRE, Sidney Calton
Was one of the Maguire family of painters, the children of T.H. Maguire (q.v.).

MAGUIRE, Thomas Herbert 1821-1895
Portrait, genre, and historical painter, and lithographer. Exhib. at RA 1846-87, BI and SS. As well as genre scenes, he exhib. many portrait lithographs at the RA. He was lithographer to Queen Victoria. Later he turned to portraits in vitrified enamel. His daughter, Adelaide (q.v.), was a promising genre and landscape painter. Bertha, Helena and Sidney (qq.v.), who also lived at 6 Blomfield Crescent, were his children, and all also painted.
Bibl: AJ 1876 p.48 (obit.); Strickland.

MAGUIRE, William Henry fl.c.1830-1840
An artist who painted in Belfast, c.1830-40.
Bibl: Strickland.

MAHOMED, H. fl.1837
Exhib. a work entitled 'The Christmas Present' at the RA. Address in Brighton, Sussex.

MAHOMED, Mrs. J.D.K. see BLACK, Miss Emma L.

MAHONEY, James ARHA NWS c.1810-1879
Painted figurative subjects. Exhib. six works, including 'The Smoke on the Sky', 'Now Then, Lazy!' and 'Rivals', at the RA. Exhib. ten works at the NWS. London address.
Bibl: Strickland; Hardie III.

MAIKS, G. fl.1878-1879
Exhib. a study of a head at SS. London address.

MAILE, Alfred fl.1871-1889
Painted landscapes and buildings. Exhib. five works, including 'Christchurch, Oxford' and 'Dinan; A Showery Day', at the RA. Also exhib. two watercolours at SS and one work at the GG. Address in Ambleside, Westmoreland.

MAISEY, Thomas PNWS 1787-1840
Painted landscape and views of buildings. Exhib. six works, including views in Kent and Surrey and at Dromana, Ireland. Also exhib. at the RA until 1828, and at the NWS. London address. He was President of the NWS.
Bibl: Cundall.

MAITLAND, Captain Alexander Fuller fl.1887-1904
Painted coastal subjects and marines. Exhib. 13 works, including
'Colliers Warping Out', 'Distant View of Portland' and 'Down
Channel', at the RA. Address in Belfast.
Bibl: Brook-Hart.

MAITLAND, J.E. fl.1882
Exhib. a river scene in 1882. London address.

MAITLAND, Paul Fordyce 1869-1909
Painted landscapes and townscapes. Studied at the RCA and under
Th. Roussel. He was influenced by Whistler. Exhib. two works, 'At
Low Tide' and 'In Chelsea', at SS. Born in Chatham, Kent. Lived
in London.
Bibl: Studio XXXV 1905 p.237; XCVI 1928 p.134ff.; AJ 1907 p.282; Daily
Graphic 23 March 1912; Connoisseur LX 1921 p.182; Burlington Mag. XL 1922
p.203; Apollo VII 1928 p.295; Maas.
Exhib: London, Leicester Galleries 1948, 1952, 1962; Fine Art Society 1994.

MAJOR, Miss Charlotte see WYLLIE, Mrs. C.

MAJOR, H.L. fl.1868
Exhib. a watercolour of fruit at SS. London address.

MAJOR, Henry A. fl.1859-1873
Painted still-lifes. Exhib. six works, including 'A White Dog
Striving to Drink from a Pitcher' and 'Grapes, Plums and a Wasp',
at SS. London address.

MAJOR, Mrs. R.H. fl.1848
Exhib. a portrait of an infant at SS. London address.

MAJOR, W. fl.1873
Exhib. a work entitled 'My Son' at the RA. London address.

MAJOR, W. Wreford fl.1878-1879
Exhib. two portraits at the GG.

MAKIN, J.R. fl.1878
Exhib. a genre subject in 1878. Address in Manchester.

MALAPEAU, E. fl.1871
Painted birds in watercolour. Exhib. four works, including 'Cocks
and Hens' and 'The Ducks and Tortoise — fable', at SS. London
address.

MALCOLM, Miss Beatrice fl.1892
Exhib. a figurative subject in 1892. London address.

MALCOLM, J. fl.1862
Exhib. a work, 'Going over the Stile', at the RA. London address.

MALCOLM, Miss L. fl.1870
Exhib. two works, 'Fruit' and 'An Anglo-Greek Girl', at SS.
London address.

MALCOLM, R. fl.1874-1879
Exhib. a work 'Coast of Normandy', at the RA and a watercolour,
'Marine Sketches' and a work 'Fishing Smack — Rye', at SS.
Address in Broadstairs, Kent.

MALEMPRÈ, Leo fl.1887-1901
Painted portraits and figurative subjects. Exhib. at the RA,
including five portraits and works entitled 'The Story', 'My First
Earrings' and 'A Venetian Fruit Seller'. London address.

MALIPHANT, William 1862- fl.1893
Welsh painter of landscape and genre subjects. Studied at the
Westminster School of Art. Exhib. two works, 'The Rising Moon'
and 'An Autumn Morning in the Clearing', at the RA, and three
watercolours at SS. Born at Brynmawr. Brought up in
Pennsylvania. Lived in London.
Bibl: Rees, *Welsh Painters*, 1912.

MALKIN, Miss fl.1846-1849
Exhib. a watercolour study of nature and another work at SS.
London address.

MALKIN, A.C. fl.1843-1855
Painted landscape, particularly mountainous and lakeland. Exhib.
eight works including views in the Lake District and Snowdonia at
SS and three works, including two views on the Thames, at the BI.
London address.

MALLESON, Katherine fl.1870-1873
(Mrs. Harry Goodwin)
Exhib. eight landscapes 1870-3. Address in Croydon, Surrey. See
also Mrs. Harry Goodwin.

MALLET, Harriette fl.1882
Exhib. a painting of flowers in 1882. London address.

MALLOWS, Charles Edward fl.1888-1897
An architect who exhib. views of buildings. Exhib. 16 works at the
RA including 'Cloisters, Gloucester Cathedral', 'Gloucester — The
Deanery from the Garden' and 'Flamboyant Gates, Albi Cathedral'.
London address.

MALROY, D. Florence fl.1857-1860
Exhib. a painting of Joan of Arc at the RA and 'Sappho' at the BI.
London address.

MAMINGER, A. fl.1856
Exhib. a work entitled 'My Novel' at the BI. London address.

***MANDER, William Henry fl.c.1880-1922**
Birmingham landscape painter. Did not exhib. in London. Painted
views in the Midlands and North Wales in a style similar to the late
manner of B.W. Leader (q.v.). He was a prolific artist, and his
works often appear in the salerooms.

MANFRED, H. fl.1855
Exhib. two watercolours, one a view of Stoke near Exeter, at SS.
London address.

MANGIARELLI, N. fl.1878
Exhib. a landscape in 1878. London address.

MANGLES, Alice fl.1881
Exhib. a painting of heather in 1881. Address in Tongham.

MANLEY, C. Macdonald fl.1884-1889
Exhib. two works, a watercolour 'The Nook of Milborne Court' and
a work entitled 'The Waters are Out', at SS. London address.

MANLEY, George P. fl.1848-1859
Painted historical and North American subjects. Exhib. ten works at
the RA, titles including 'An Incident in the Life of Lady Jane Grey'
and 'The Medicine Man Performing his Medicines over a Dying
Chief'. Also exhib. two works at SS. London address.

MANLEY, H.B. fl.1863-1868
Painted flowers and fruit. Exhib. one work, of apples and grapes, at the RA, and two watercolours at SS. London address.

MANLY, Miss Alice Elfrida 1846-c.1923
London landscape painter. Exhib. 1872-93 at RA, SS, NWS and elsewhere. In addition to landscapes, also painted flowers and portraits. Her sister Eleanor (q.v.) was also a painter.
Bibl: Clayton II pp.189-91.

MANLY, Miss Eleanor E. fl.1875-1898
Painted genre subjects of children. Exhib. 11 works including 'A Regular Tease', 'Open the Door Please!' and 'Oh! Look at the Darling!', at the RA. Also exhib. seven works, including watercolours, at SS. She was the sister of Alice Manly (q.v.). London address.

MANLY, Mrs. Sarah fl.1887-1892
Exhib. a painting of camellias at the RA. London address.

MANN, Alexander ROI 1853-1908
Scottish landscape and genre painter. Born in Glasgow. Pupil of Carolus Duran. Exhib. 1883-93 at RA, SS and elsewhere. His picture of 'A Bead Stringer, Venice' was one of the first Glasgow pictures to be noticed at the Paris Salon in 1884. He painted genre scenes in Italy, France, and Morocco, and settled in London in the mid-1890s. His landscapes show a refined feeling for atmosphere, and a taste for subdued colours. Works by him are in Glasgow, Liverpool and Nottingham AGs.
Bibl: Studio XLVI 1909 pp.300-5; Who's Who 1908; Caw pp.384-5; Fine Art Society, London, Cat. of A.M. exhib., 1983.

MANN, Edward fl.1857-1870
Painted children and genre subjects. Exhib. eight works, including 'Father's Coming' and 'Village Gossips', at SS. Also exhib. one work, 'Heave Ho!' at the RA. London address.

MANN, Miss Florence fl.1885-1886
Painted portraits and flowers. Exhib. two portraits and a work entitled 'Chloe' at the RA and four works, including 'Nasturtiums', at SS. Address in Edinburgh.

MANN, Frank W. fl.1888-1893
Exhib. three works, 'Foiled', 'The Mendicant' and 'Strayed', at the RA. London address.

***MANN, Harrington RP RE NEAC 1864-1937**
Portrait painter. Also painted marines and historical subjects. Studied in Glasgow, at the Slade and in Paris. Exhib. 22 works at the RA 1885-1904 including 'Ulysses Unbinding the Sea Nymph's Veil', 'The Attack of the Macdonalds at Killiecrankie, 1689', and portraits. Moved from Glasgow to London in 1900. His reputation as a portraitist extended to the United States and he maintained a house in New York.
Bibl: F.N. Newbery, *The Glasgow School of Painting*, 1902; Studio XXIX 1903 p.118; XLI pp.32, 49, 144; XLIV p.77; XLVII p.99; LVII p.143; Harrington Mann, *The Paintings of Mr. Harrington Mann*, 1907; Caw; Who's Who; Connoisseur XXXVIII 1914 pp.131, 135; Poole III 1925; Irwin.
Exhib: London, Knoedler's 1934.

***MANN, Joshua Hargrave Sams fl.1849-1884**
London genre painter. Exhib. mainly at SS (128 works) where he was a member; also at RA, BI and elsewhere. Titles at RA subjects from Byron, Coleridge, Tennyson and Milton, some portraits, and other genre, e.g. 'Wayfarers', 'Hark, Hark the Lark', 'In Time of War', etc. Painted in France and Spain. After his death two studio sales were held at Christie's, 7, 25 May 1886.
Bibl: AJ 1859 pp.82, 168ff.; 1866 p.232; 1873 p.168; 1879 p.104; Wood, Panorama; Wood, Paradise Lost.

MANN, Mabel M. fl.1885
Exhib. a work entitled 'March Daffodils' at SS. London address.

MANN, Robert fl.1869-1892
Birmingham landscape painter in oil and watercolour. Exhib. there 1869-92.

MANN, W.H. fl.1881
Exhib. a landscape at the GG. London address.

MANNERS, Mrs. Henry fl.1883-1886
(Marchioness of Granby and Duchess of Rutland)
Exhib. a portrait at the RA and eight works at the GG 1883-6. Also exhib. as Miss Violet Lindsay and as the Duchess of Rutland (qq.v.).

MANNERS, William RBA fl.1889-c.1910
Painted landscape. Exhib. three works at the RA, 'The Sun's Last Gleam', 'Homewards' and 'Among the Yorkshire Hills'. Also exhib. eight works at SS. Address in Bradford, Yorkshire.

MANNFELD, Conrad fl.1878-1893
Painted flowers and landscape. Exhib. five works at SS, including 'Among the Lilies' and 'Sunshine', and two works at the RA, 'A Lowland Valley' and 'Radishes'. London address.

MANNIN, Mrs. M. fl.1851-d.1864
Her watercolour portrait of Sir Henry Havelock is in the collection of the Havelock Estate.
Bibl: Ormond.

MANNING, Miss Eliza F. fl.1879-1889
Exhib. two works 'Trespassers' and a portrait at the RA, and one work at the NWS. Address in Surbiton, near London. For works illustrated by, see VAM Card Cat.

MANNING, M.R. fl.1892
Exhib. a study of flowers at SS. Address in Dublin.

MANNING, Michael P. fl.1862
Exhib. a view of St. Olive's, Ramsay, Isle of Man, at the RA.

MANNING, R.H. fl.1841-1842
Exhib. two works, views of Lake Como and the Bay of Palermo, at the RA. London address.

MANNING, William Westley RBA ROI ARE 1868-1954
Painted landscape. Also made etchings and aquatints. Studied at the Académie Julian. Exhib. a work entitled 'Flood Time, Normandy' and a pastel entitled 'Normandy Peasant Girl' at SS. London address.
Bibl: Who's Who; Burlington Mag. XLIV 1924 p.54.
Exhib: London, Colnaghi's, *The Aquatints of W. Westley Manning*, 1929; Walker's Gallery 1947.

MANSON, George 1850-1876
Painted landscape and figurative subjects; also an etcher. Exhib. a work entitled 'Bertha' at the RA. Born in Edinburgh. Died in Lympstone, Devon.
Bibl: Portfolio 1880 p.187ff.; 1887 p.229; Caw; Hardie III.

MANTON, Miss Elizabeth fl.1868-1878
Exhib. genre subjects in watercolour. Exhib. five watercolours at SS, including 'Pleasant Thoughts', 'Will He Come?' and 'Sweet Seventeen'. London address.

MANTON, G. Grenville RBA fl.1878 d.1932
London portrait painter. Exhib. at RA 1880-99, SS and elsewhere. Also some allegorical portraits, e.g. 'Cinderella', 'Dawn', etc. Also an illustrator. Lived in Hertfordshire.

MANWARING, G.R. fl.1845
Exhib. three watercolours, including 'View in Devonshire' and 'Ellen from *The Lady of the Lake*, at SS. Also exhib. a subject from *Ivanhoe* at the RA. London address.

MAPLESTONE, Mrs. Florence Elizabeth fl.1868-1885
Painted literary and historical subjects in watercolour. Exhib. 17 works, including subjects from Shakespeare, Tennyson, Longfellow and Scott, and various subjects from 17th century English history, at SS. London address. She was the wife of Henry Maplestone (q.v.).

MAPLESTONE, Henry NWS 1819-1884
Painted landscapes and country subjects in watercolour. Exhib. 11 works including 'Cottage Scene near Windsor' and 'On the Thames near Pangbourne'. Also exhib. 349 works at the NWS. London address. Florence Elizabeth Maplestone (q.v.) was his wife.
Bibl: Connoisseur LXXI 1925 pp.164-6.

MAPPING, Helen fl.1875
Fruit and flower painter. Exhib. with the Society of Female Artists in 1875.

MARCH, Edward fl.1862-1867
Exhib. three works, 'Twilight on Whitby Sands', 'Moorland Thicket, Yorkshire' and a work entitled by a line from Wordsworth, at the RA. Also exhib. one work at the BI. Address in Leeds, Yorkshire.

MARES, Miss E.J. fl.1854
Exhib. a view of Glen Cairn at the RA. London address.

MARES, Henry fl.1833-1851
Sculptor and painter. Exhib. a view of the Trevi Fountain at the RA. London address.

MARGETSON Mrs. W.H. b.1860 fl.1904
(Miss Helen Howard Hatton)
Painted figurative subjects in watercolour. Studied at the RA Schools and in Paris. Exhib. two works 'The Moon and I' and 'The First Violets', at the RA in 1895 and 1904. Lived at Wallingford-on-Thames, Berkshire. Her husband William Henry Margetson (q.v.) was a painter. See also Miss Helen Howard Hatton.

***MARGETSON, William Henry RI ROI 1861-1940**
Painted portraits, literary and figurative subjects. Studied at South Kensington and at the RA Schools. Exhib. 34 works at the RA 1885-1904 including 'The Tryst', 'Cleopatra', 'Pygmalion' and 'The Wonders of the Shore'. Exhib. two works at SS. Lived at Wallingford, Berkshire. Helen Howard Margetson (q.v.) was his wife.
Bibl: Connoisseur LXI 1921 p.231; Ormond.

MARGETTS, Miss Ada fl.1861-1862
Painted still-lifes. Exhib. three works, including 'Live Lobsters' and 'A Peep into the Gardener's Shed' at the RA. Also exhib. three works at the BI and two at SS. Address in Oxford.

MARGETTS, Mrs. Mary NWS fl.1841-d.1886
Painted flowers. Exhib. a painting of a vase of flowers at the RA. Exhib. 124 works at the NWS. London address.
Bibl: AJ 1859 p.176; Cundall.

MARGITSON, Mrs. Maria fl.1857-1864
Painted fruit. Exhib. nine still-lifes of fruit at SS and one at BI. Address in Norwich, Norfolk.

MARICHAL, Peter fl.1870
Exhib. a figurative subject in 1870. London address.

MARIUS de MARIA fl.1887
Exhib. two landscapes at GG. Address in Rome.

MARK, E.W. fl.1843
Exhib. two works, 'The Poultry Cross, Salisbury' and a portrait, at the RA. London address.

MARKES, Albert Ernest 1865-1901
Painted marines in watercolour. Worked on the east coast and in Belgium and Holland. Moved from Cornwall to London.
Bibl: Hardie III; Brook-Hart pl.209.

MARKS, Miss Anne fl.1893-1900
Exhib. two works, 'Sweet Seventeen' and 'A Study' at the RA. London address. For works illustrated by, see VAM Card Cat.

MARKS, Barnett Samuel RCA 1827-1916
Welsh portrait painter. Born in Cardiff; moved to London about 1867. Exhib. at RA 1859-91, and occasionally elsewhere. Also painted some genre, e.g. 'Listening to a Fairy Tale', 'A Rabbi Reading', 'A Jewish Bibliophile', etc.
Bibl: Rees, *Welsh Painters*, 1912.

MARKS, Edmund fl.1841-1869
Painted landscapes and coastal views. Exhib. seven works, including views on the Dorset and Sussex coast, at the RA, and two works, including 'Nature and Art', at the BI. London address.

MARKS, Miss Florence fl.1889-1904
Exhib. two works at the RA, a portrait and a scene from *The Clandestine Marriage,* 1889-1904. London address.

***MARKS, George fl.1876-c.1922**
Landscape painter. Lived at Penge. Exhib. RA 1878-1904, SS, NWS and elsewhere. Painted mainly in Kent, Surrey and the southern coast. Many of his pictures have idealised titles, e.g. 'Solitude', 'Autumn Glow', 'A Gleam of Sunshine', etc.
Bibl: Wood, Paradise Lost; Newall.

MARKS, Mrs. H.S. fl.1898-1900
(Miss Mary Harriet Kempe)
Exhib. three works, including 'The Young Nurse' and 'A School Girl', at the RA. London address. See also Miss Harriet Kempe.

***MARKS, Henry Stacy RA RWS HRCA HRPE 1829-1898**
London genre painter and watercolourist and illustrator. Pupil of J.M. Leigh, and Picot in Paris, 1851-3. Exhib. at RA 1853-97, BI, SS, OWS, GG and elsewhere. Elected ARA 1870, RA 1878. Most of his genre was either literary, especially Shakespearian, or historical, and often humorous, e.g. 'Toothache in the Middle Ages'. Later Marks turned mainly to painting animals, which he did with sympathy, accuracy, and lack of sentiment. He was one of the founders of the St. John's Wood Clique (q.v.), and a notorious practical joker. Ruskin reproved him for "that faculty" which, he



said, impeded his progress as an artist. His studio sale was held at Christie's, 25-26 March 1898.

Bibl: AJ 1870 pp.361-3; 1898 p.94; Bryan; DNB Supp. III 1901 p.140; Cundall p.234; Bevis Hillier, *The St. John's Wood Clique,* Apollo June 1964; Reynolds, VP pp.179-80 (pl.123); Maas p.82 (pl.p.86).

MARKS, J.G. fl.1866-1874
Exhib. nine genre subjects 1866-74. Address in Mitcham.

MARLOWE, Miss Florence fl.1873-1888
Painted still-lifes and genre subjects. Exhib. five works, including still-lifes and a work entitled 'I Wish I had the Key', at SS, and one work at the RA. Address in Sutton, near London.

MARNY, Paul 1829-1914
Painted landscapes and marines in watercolour. Exhib. a landscape in Saumur-sur-Loire, France, at the RA. Born in Paris. Lived in Belfast and, from 1860, at Scarborough, Yorkshire.

MAROLDA, Emilio fl.1882-1883
Exhib. a view of 'Gorey Pier, Jersey, at Daybreak with The French Boat' at SS. London address.

MARPLES, George ARE 1869-1939
Painted birds. He was also an etcher. Studied at Derby School of Art, at the RCA and in Paris. Exhib. in London and abroad. Lived at Sway, Hampshire.

MARQUIS, James Richard RHA fl.1862-d.1885
Exhib. two works, 'Hove-to in a Gale' and 'Coast Scene — Sunset', at the RA, and one work at SS. Address in Dublin.

Bibl: Strickland; Brook-Hart.

MARR, J.W. Hamilton ARCA fl.1846-1888
Graphic artist who exhib. a landscape at the GG. Lived in Birmingham. Sophie Marr (q.v.) was his wife.

MARR, Mrs. J.W. Hamilton (Sophie) fl.1892
Exhib. two paintings of flowers in 1892. Address in Kingswood, Gloucestershire. Wife of J.W.H Marr (q.v.).

MARRABLE, Miss Edith fl.1878-1882
(Mrs. A. Ferguson)
Exhib. four paintings of flowers 1878-82. London address. She was a member of the Society of Lady Artists. See also Mrs. A. Ferguson.

MARRABLE, Mrs. PSWA fl.1864-d.1916
(Miss Madeline Frances Cockburn)
Painted watercolour landscapes in Italy, Switzerland and Ireland. Exhib. nine works at the RA, and seven watercolours, including 'Speke Hall, Lancashire', 'A Side Street in Siena, Italy' and 'The Meeting of the Waters, Tollamore Park, County Down', at SS. Painted Edward VII and other members of the royal family. Wife of Frederick Marrable, a London architect. She was President of the Society of Lady Artists.

Bibl: Clayton; Redgrave, Dict.

MARRIOTT, Frederick RE RBC 1860-1941
Painted figurative subjects, landscape and architectural. Also an engraver. Studied at the School of Art, Coalbrookdale, and at the RCA. Exhib. ten works including 'The Artist's Wife', 'The Enchantress' and 'Through the Woods to Fairy Land', at the RA, 1891-1904. London address.

Bibl: Studio XXXI 1904 pp.338, 541ff.; XLIX p.290; L p.60; LXII p.310; LXX p.107; Cat. Walker AG, Liverpool, 1927.

MARRS, Mrs. fl.1871
Exhib. two watercolours, 'Dog Roses' and 'Spring', at SS. London address.

MARSH, Arthur Hardwick ARWS RBA 1842-1909
London genre painter and watercolourist. Exhib. at OWS (108 works) RA, SS and elsewhere. Titles at RA 'The Harpischord', 'The Salmon Fishers', 'Shrimpers', etc. Painted many scenes of fishing life on the Northumberland coast, at Whitby, Cullercoats and Tynemouth.

Bibl: AJ 1884 pp.85, 87; 1893 p.29; 1904 p.305; The Year's Art 1910 p.388 (obit.); Hall.

MARSH, Charles Edward RBA fl.1872-c.1922
Painted portraits and genre subjects. Exhib. in London from 1872. Lived in London.

MARSH, Charles F. fl.1892-1893
Exhib. one work, 'A Crack Shot', at the RA, and one work, 'Silver Morn', at SS. Address in East Grinstead, Sussex.

MARSH, Miss Emily F. fl.1893
Exhib. a painting of roses at SS. London address.

MARSH, Miss J. fl.1875
Exhib. a painting of pelargoniums at SS. London address.

MARSHALL, Miss C. fl.1876
Exhib. an interior view of a house in Hampstead. London address.

MARSHALL, Charles 1806-1890
London landscape painter; father of R.A.K. Marshall (q.v.). Worked in the theatre, painting scenery, decorations and panoramas. Later turned to landscape painting. Exhib. at SS (149 works), RA, BI, NWS and elsewhere, 1828-84. Painted mostly in Wales. His son, Charles, Jnr. was also a landscape painter (q.v.).

Bibl: Connoisseur LXXII 1925 pp.245, 249; Clement & Hutton; Hardie III p.29; Brook-Hart.

MARSHALL, Charles, Jnr. fl.1864-1886
Painted landscapes in the west country. Exhib. four works at SS, including views in Worcestershire and Gloucestershire. Exhib. two works at the RA and two works at the BI; also exhib. at SS and elsewhere. Addresses in Coventry, Warwickshire and London.

MARSHALL, Charles Edward RBA fl.1872-1903
London portrait and genre painter. Exhib. 1872-1903 at SS, RA and elsewhere. Titles at RA 'The Old Pump', 'A Cavalier', 'Love in her Eyes sits Playing', etc.

MARSHALL, D. fl.1836-1837
Exhib. three works, one entitled 'Shakespeare's Cliff' and two Scottish landscapes at SS. London address.

MARSHALL, F. fl.1876
Exhib. a painting of a hedge-sparrow's nest at SS. Address in Croydon, Surrey.

MARSHALL, F.J. fl.1848
Exhib. a watercolour entitled 'The Cobbler' at SS.

MARSHALL, Henry J. fl.1880
Exhib. a work entitled 'Pensive Thoughts' at SS. London address.

***MARSHALL, Herbert Menzies RWS RE 1841-1913**
London topographical painter and watercolourist, and architect. Pupil of the French architect Questel. Professor of landscape painting at Queen's College, London. Exhib. 1871-93 at OWS (277 works), RA, SS and elsewhere. Produced several series of topographical watercolours, e.g. 'The Scenery of London', 'Cathedral Cities of France'.
Bibl: Studio LVIII 1913 p.222ff.; Special Number 1909, *Sketching Grounds,* pp.231-8; Daily Telegraph 7 June 1910; Who's Who 1913-14; VAM; Hardie III p.163 (pl.193).
Exhib: London, Fine Art Society 1886; London, Abbey Gallery 1935.

MARSHALL, J.D. fl.1846-1860
Painted historical subjects. Exhib. five works, including 'Tasso and the Three Leonoras' and 'Lady Jane Grey and her Tutor' at the RA. Also exhib. three works, including 'Sir Walter Raleigh' at the BI. London address. He was possibly the brother of John Marshall (q.v.).

MARSHALL, J. Fitz RBA 1859-1932
Croydon painter of landscapes, animals and flowers. Probably the son of John Marshall (q.v.). Exhib. at RA 1883-1903, SS, GG, NG and elsewhere. Titles at RA: 'Chestnut Boughs', 'During the Sermon — the Choirmaster's Terrier', 'A Challenge', etc. Best known for his pictures of dogs in interiors.
Bibl: Who's Who 1913.

MARSHALL, J. Miller RWA fl.1885-c.1925
Painted coastal and river scenes, and townscapes. Exhib. four works, including 'On Cromer Sands' and 'The Fish Wharf, Brixham Harbour' at the RA. Also exhib. a work entitled 'North Lancashire' at SS. He was the son of Peter Paul Marshall (q.v.). He was a member of Norwich Art Circle from its inception in 1885. Lived in Norwich and in Devon.

MARSHALL, John fl.1840-1896
Painted figurative subjects, animals and still-lifes. Exhib. 18 works at SS, including 'The Gleaner', 'Terrier and Rabbit' and 'Fruit from Nature'. Exhib. 20 works at the RA, including *The Curate,* a famous Steeplechaser' and various paintings of fruit. London address. He was possibly the father of J. Fitz Marshall (q.v.) and the brother of J.D. Marshall (qq.v.).

MARSHALL, Peter Paul 1830-1900
Liverpool genre painter. Born in Edinburgh. By profession an engineer; painted only in his spare time. While working in Liverpool became friendly with many artists there, and fell under the influence of the Pre-Raphaelites. Exhib. at Liverpool Academy. Settled in London where, through Madox Brown, he became a partner in William Morris's firm Morris, Marshall, Faulkner & Co. in 1861. He never played a very active role and resigned in 1875. Exhib. only once at RA in 1877, and occasionally elsewhere in London. He was the father of J. Miller Marshall (q.v.).
Bibl: Marillier pp.170-3; Singer, *Der Prae-Raphaelitismus in England,* 1912 p.124.

MARSHALL, Mrs. Philippa fl.1868-1880
Exhib. two watercolours, 'Old-Fashioned Flowers' and 'Roses on our Wall', at SS. Address in Exeter, Devon.

MARSHALL, R. fl.1877
Exhib. a painting of Suffolk ducks at SS. Address in Oxford.

***MARSHALL, Roberto Angelo Kittermaster 1849-c.1923**
London landscape painter; son and pupil of Charles Marshall (q.v.). Exhib. at RA 1867-1902, SS, NWS and elsewhere. Painted in Sussex, Gloucestershire and especially Hampshire.
Bibl: Clement & Hutton; Wood, Paradise Lost.

MARSHALL, Mrs. Rose fl.1879-1890
Leeds flower painter. Exhib. 1879-80 at RA, SS, GG and elsewhere. Titles at RA include some genre subjects, e.g. 'The Year's at the Spring', etc.

***MARSHALL, Thomas Falcon 1818-1878**
Liverpool genre painter. Began exhibiting at Liverpool Academy in 1836. Elected Associate 1843, Member 1846. Exhib.at RA 1839-78, BI and SS. He was a versatile and prolific painter, and an admirer of W.P. Frith (q.v.). His subjects included rustic scenes, cottage interiors, farmyard scenes and also historical genre drawn from Goldsmith, Thomson, Byron and others.
Bibl: AJ 1878 p.169 (obit.); Redgrave, Dict.; Marillier pp.174-6; Cundall p.234; Reynolds, VP p.113 (pl. 75); Wood, Paradise Lost.

MARSHALL, Thomas Mervyn Bouchier fl.1855-1858
Painted figurative and theatrical subjects. Exhib. nine works at the RA, titles including 'Francesca', 'Scene from the Last Act of Marmion' and 'Mr. Vandenhoff as Shylock'. Also exhib. a work at the BI. London address.

MARSHALL, Miss Wilhelmina fl.1890-1891
Exhib. two works, 'A Bretonne' and 'The Lady of Shalott' at the RA. London address.

MARSHALL, William Elstob fl.1859-1881
Painted animals and rustic subjects. Exhib. 18 works, some of them watercolours, at SS, titles including 'Ferreting Rabbits', 'Spaniel's Head' and 'Gathering Peat, Invernesshire'. Also exhib. eight works at the RA and five works at the BI. London address. Probably a son of T.F. Marshall (q.v.).

MARSHAM, Miss fl.1852
Exhib. two watercolours at SS, 'Geraniums' and 'Flower Piece'. London address.

MARSHMAN, J. fl.1876
Exhib. a painting of a bull-fight in 1876. Address in Bangor, Caernarvon.

MARSON, Thomas E. fl.1899-1900
Exhib. two works, 'Spring Time' and 'Evening', at the RA. Address in Rugby, Warwickshire.

MARSTON, F.R.W. fl.1891
Exhib. an historical subject in 1891.

MARSTON, Miss Mabel G. fl.1885-1903
Painted flowers. Exhib. eight works at SS, titles including 'Fresh from the Flowers' and 'Pleasant and Sweet, in the Month of May'. Exhib. seven works at the RA, including 'Violets' and 'Emblems of Spring'. London address.

MART, Frank Griffiths fl.1892-1904
Exhib. eight works at the RA 1894-1904, titles including 'A Northern Suburb' and 'St. Helier's Bay, Jersey'. Also exhib. a work at the NWS. London address.

MARTEN, Elliot H. fl.1886
Exhib. a work entitled 'Autumn Leaves' at the RA. Address in Hawick, Scotland.

MARTEN, W.J. fl.1874-1887
Exhib. two genre subjects 1874-6. Possibly also exhib. a work at the GG in 1887. Address in Rome.

MARTENS, Henry fl.1828-1854 d.1860
London military painter and watercolourist. Exhib. 1828-54 at BI and SS. Subjects mostly episodes from Victorian military history. Also did many drawings of military uniforms for Ackermann's *Costumes of the Indian Army*, 1846, and *Costumes of the British Army in 1855*, 1858.
Bibl: Connoisseur XL 1914 p.143; Print Collectors' Quarterly XIII p.62.

MARTIN, Ambrose NWS fl.1830-1844
Painted marines and landscapes. Exhib. six works at SS, titles including 'A Sea Piece — Vessels Going Before the Wind' and 'Rochester, from the Coach and Horses Hill'. Also exhib. three works at the RA and two works at the BI. London address.

MARTIN, Anson A. fl.1840-1861
Painter of coaching and hunting scenes, and other sporting subjects. May possibly have collaborated with C. Cooper Henderson (q.v.). Did not exhib. in London; presumably worked entirely for private patrons.
Bibl: Pavière, Sporting Painters p.62 (pl. 30).

MARTIN, C.H. fl.1838-1858
Painted marines, coastal landscapes and landscapes. Exhib. 12 works at the RA, including views of Carisbrooke, Conway and Dumbarton Castles. Also exhib. 11 watercolours at SS including views on the Isle of Wight coast. London address.
Bibl: Brook-Hart.

MARTIN, Charles 1820-1906
London portrait painter; son of John Martin (q.v.). Exhib. at RA 1836-96, BI, SS and NWS. A portrait of Turner is in the NPG and several drawings in the BM. A portrait of his father on his death-bed is in the Laing AG, Newcastle.
Bibl: Binyon; The Year's Art 1907 (obit.); see also under John Martin; Ormond.

MARTIN, D.W. fl.1867-1872
Exhib. three oriental subjects 1867-72. London address.

MARTIN, David fl.1892
Exhib. a landscape at the NWS. Address in Glasgow.

MARTIN, Mrs. Edith E. b.1875
Painted landscapes and figurative subjects. Studied at Croydon School of Art, at the Yellow Door School and in Germany. Exhib. in London and North America. Lived in London and at Swanborough, Sussex.

MARTIN, Edward fl.1845-1861
Painted landscapes. Exhib. ten works at SS, including 'Swanbourne Lake' and 'A Scene on the Bank of the Arun'. Also exhib. four works at the BI including 'The Wood Nymph's Hymn to the Rising Sun'. Address in Worthing, Surrey.

MARTIN, Miss Eliza fl.1863-1868
Painted figurative subjects. Exhib. five works at the RA, including 'Thine Eyes, Blue Tenderness, Thy Long Fair Hair — Byron' and 'At the Carnival'. London address.

MARTIN, Miss Ethel b.1873
(Mrs. Friedlander)
Studied at Sevenoaks and in Paris under Deschamps. Exhib. three works, a landscape on Sark and two views in Caudebec at the RA. Born in Sevenoaks, Kent. Lived in London.

MARTIN, Mrs. Florence fl.1876-1892
Painted figurative subjects. Exhib. 15 works at SS, titles including 'Poor Humanity', 'The Authoress' and 'The Novel Reader'. Also exhib. four works at the RA. London address.
Exhib: London, Arthur Jeffress Gallery 1962.

MARTIN, Captain George Mathew fl.1860
Portrait drawing of Sir Mark Cubbon and Sir Patrick Grant by Martin are in the NPG.
Bibl: Ormond.

MARTIN, Henry fl.1870-1894
Painter of coastal landscapes and scenes of fishing life. Exhib. at RA 1874-94, SS and elsewhere. Titles at RA 'The Sail Mender', 'Newlyn Quay', 'Mending the Old Buoy', etc. Lived at Newlyn, Cornwall, and at other villages on the Cornish coast, and was almost certainly associated with the Newlyn School. Also visited Venice.
Bibl: Brook-Hart.

MARTIN, Henry Harrison fl.1847-1882
Genre painter. Exhib. mainly at SS, 56 works, also at RA 1852-79, and BI. Titles at RA include some historical genre from Scott and Sheridan. Also visited Spain and painted some Spanish scenes, e.g. 'At the Bull Fight', 'La Gitana', etc.

MARTIN, J. fl.1845
Exhib. a study from nature at the RA.

MARTIN, J.W. fl.1847
Exhib. two works 'Fish' and 'Dead Game' at SS. London address.

***MARTIN, John 1789-1854**
Painter of historical and biblical scenes, and landscape. Born at Eastland Ends, a cottage near Haydon Bridge, Northumberland. Apprenticed to a coach painter in Newcastle, but ran away to study painting with an Italian, Boniface Musso. 1806 came to London, and at first worked as a china painter. Began exhibiting at the RA in 1811. His grandiose biblical scenes soon began to catch the popular imagination, and 'Belshazzar's Feast', which made him famous, became through engravings one of the most popular pictures of the age. Exhib. at RA 1811-52, BI, SS, NWS and elsewhere. He continued to paint similar subjects, such as 'The Plains of Heaven', 'The Great Day of his Wrath', 'The Last Judgement', which were scorned by Ruskin and the critics, but enjoyed enormous popular appeal. Although his technique and colouring were sometimes deficient, he had an undoubted ability to convey a sense of awe-inspiring grandeur, which has often been compared to the methods of modern epic films. He was also a watercolourist, and book illustrator. Even today, he is often referred to as Mad Martin, a sobriquet which he does not deserve. It arises from confusion with his brother Jonathan, who was insane, and earned considerable notoriety by trying to burn down York Minster.
Bibl: AJ 1909 p.20; The Artist XXX 1901 pp.189-97 (E.W. Cooke); J. Ruskin, *Modern Painters*; Redgrave, Cent, Dict.; Binyon; Cundall; DNB; VAM; Smith, *Recollections of the British Institution*, 1908; Mary L. Pendred, *J.M Painter, his life and times*, New York 1924; T. Balston, *J.M.*, 1947; Reynolds, VP p.15 (pl. 10); Hardie II p.46 (pls. 31-3); Maas pp.34-5 (pls. pp.35, 37); Cat. of J.M. exhib., Laing AG Newcastle 1970; Hall; Ormond; W. Feaver, *The Art of John Martin*, 1975.
Exhib: Newcastle-upon-Tyne, Hatton Gallery 1951; London, Whitechapel AG 1953; Newcastle-upon-Tyne, Laing AG 1970; London, Alexander Postan Fine Art, *J.M., Master of the Mezzotint*, 1974; Hazlitt, Gooden & Fox 1975; Christopher Mendez 1976.

MARTIN, John F. fl.1837-1851
Painted portraits and figurative subjects in watercolour. Exhib. 19 works at SS, titles including 'Nymph at her Toilette', 'Tickling Him Up' and portraits. Also exhib. two works at the BI. London address.

MARTIN, John H. fl.1871-1889
Exhib. two works, 'On the Sands, Whitby' and 'Newlyn, near Penzance', at the RA and two works at SS. London address.

MARTIN, L. fl.1851-1859
Painted landscapes. Exhib. four works, including 'Evening on Wimbledon Common' and 'View on the Thames' at the RA. Also exhib. a work at the BI and another at SS. London address.

MARTIN, Miss Mary D. fl.1875-1882
Exhib. two works, 'In the Wood' and 'Plover' at the RA. Also exhib. a watercolour at SS. London address.

MARTIN, P. fl.1869
Exhib. an alpine view in 1869. London address.

MARTIN, R. fl.1826-1838
Painted landscapes, animals and figurative subjects. Exhib. 21 works at SS, including 'A Scene near Waverley' and 'View near Highgate'. Also exhib. two works at the RA and another at the BI. London address.

MARTIN, R.T. fl.1844-1846
Painted landscapes and figurative subjects. Exhib. three works at SS including 'Minster, Isle of Thanet' and 'Shakespeare Cliff, Dover Showing the Railway and Entrance to the Tunnel'. Also exhib. two works at the BI. London address.

MARTIN, Sylvester fl.1870-1899
Sporting artist who lived at Handsworth, near Birmingham. Exhib. there 1870-99. Often painted pairs and sets of small hunting and coaching scenes.

MARTIN, T. fl.1839
Exhib. 'Sir Walter Scott Reading the Ms. of *The Lady of the Lake*' at the RA. London address.

MARTIN, W.R. fl.1847
Exhib. a work entitled 'Prayer' at the BI. London address.

MARTIN, Y.F. fl.1845
Is supposed to have exhib. two portraits at SS. London address.

MARTINEAU, Mrs. Basil fl.1873-1902
(Miss Clara Fell)
Painted figurative subjects, portraits and flowers. Exhib. seven portraits at the RA, and four works at SS including 'Only a Penny a Bunch' and 'A Westmoreland Lassie'. London address.
Bibl: Ormond.

MARTINEAU, Miss Edith ARWS 1842-1909
Landscape, genre and portrait painter and watercolourist. Exhib. at RA 1870-90, SS, OWS, NWS, GG and elsewhere. Titles at RA 'A Doubtful Passage', 'Oranges', 'Touching the Strings', etc. and several portraits.
Bibl: AJ 1909.

MARTINEAU, Miss Gertrude fl.1862-1894
Genre and animal painter. Exhib. at RA 1862-94, SS, NWS and elsewhere. Titles at RA mostly animals, e.g. 'Do Doggies Gang to Heaven?', 'Master and Pupil', 'Naughty', etc.

***MARTINEAU, Robert Braithwaite 1826-1869**
Pre-Raphaelite painter. Educated at University College School. Studied law 1842-6. No doubt encouraged by his mother, Elizabeth Batty, who was a talented amateur watercolourist, he gave up law and entered the RA Schools. Became a friend and pupil of Holman Hunt (q.v.) and worked in his studio c.1851-2. After Hunt's first trip to the Middle East, Martineau, Hunt and Michael Halliday (q.v.) shared a studio at 14 Claverton Street, Pimlico. Martineau began to exhib. at the RA in 1852 with 'Kit's Writing Lesson', Tate Gallery. This was followed by 'Katherine and Petruccio', 1855, 'The Last Chapter', 1863, and other genre and historical scenes. By far his best, and his most successful work was 'The Last Day in the Old Home', shown at the International Exhibition of 1862. Hunt and Martineau continued to share a studio until 1865, when Martineau married Maria Wheeler. His death in 1869 at the age of only 43 prevented him from fulfilling the promise of 'The Last Day in the Old Home'. At his death he was still working on the large 'Christians and Christians' in the Walker AG, Liverpool.
Bibl: AJ 1869 p.117 (obit.); Athenaeum 20 February 1869 p.281 (obit.) Connoisseur LXII 1922 p.117; CX 1942 pp.97-101, Burlington Mag. XLIII 1923 p.312; Studio LXXXVII 1924 p.207ff. (by Helen Martineau. the artist's daughter); CXLIII 1947 pp.78-9; Redgrave, Dict.; DNB; Bate pp.75, 81ff.; Ironside & Gere p.27 (pl. 22); Reynolds, VS pp.3, 17, 21, 75-6 (pls. 45-6); Fredeman, see index; Reynolds, VP pp.65, 68-9; Maas p.121; Diana Holman Hunt, *My Grandfather, His Wives and Loves*, 1969 see index; Wood, Panorama; Wood, Pre-Raphaelites.

MARTINETTI, A. fl.1880
Exhib. a work entitled 'Reciting an Ode on Mamma's Birthday' at SS. London address.

MARTINO, Del Don fl.1874-1879
Exhib. two works, 'Easter in S. Marco, Venice' and 'Church of St. Anthony, Padua', at the RA. London address.

MARTINO, Cavalier Edward de 1838-1912
Painted marines. Exhib. four views of shipping at the GG. Became Marine Painter in Ordinary to HM Queen Victoria. Born in Naples. Died in London.
Bibl: The Year's Art 1913 p.436; Connoisseur LXXIII 1925 p.180ff.

MARTINO, Mrs. see BLUNDEN, Miss Anna

MARTYN, Dora fl.1884-1886
Exhib. two works 'Out of Work' and 'A Quiet Haven' at SS. Address in Kimbolton, Huntingdonshire.

MARTYN, Miss Ethel King ARPE RE fl.1886-c.1923
Painted portraits and figurative subjects. Also an etcher. Exhib. 11 works at the RA including 'He Descended into Hell', 'The Prodigal Son' and portraits. London address.
Bibl: Studio XXVIII 1903 p.291.

MARTYN, Greville fl.1886
Exhib. a work entitled 'The Cowherd' at SS. London address.

MARTYR, J. Greville fl.1887
Exhib. a work entitled 'The Herdsboy' at the RA. London address.

MARVIN, Philip J. fl.1875-1888
Painted and drew views of buildings. Exhib. 13 works, including 'Campanile of Pistoia Duomo', 'Old House, Strasbourg' and a view of a church in Verona. Address in Ryde, Isle of Wight.

MASCALL, Christopher Mark 1846-1933
Painted landscapes. Pupil of John Moore. Lived in Suffolk.

MASEY, Francis fl.1887-1889
Exhib. three works, including 'West Doorway, S. Stefano, Florence' at the RA. London address.

MASON, Alfred William 1848-1933
Painted landscape and genre subjects. Studied at St. Martin's School of Art and at the RCA. Exhib. two works 'A Gleaner' and 'Evening' at the RA. London address.

MASON, Blossom fl.1881-1885
Exhib. two works 'A Branch from the Orchard' and 'A Cottage Posy' at SS. London address.

MASON, David fl.1866
Exhib. two works 'A Calm Day' and 'On the Forth, at Sunset' at SS. London address.

MASON, E.F. fl.1848
Exhib. two works including 'Peasant Woman of Sarasenesca' at SS. Address in Birmingham.

MASON, Edith fl.1879-1880
Exhib. two genre subjects 1879-80. London address.

MASON, Miss Edith M. 1897-1902
Exhib. five works, three portraits and works entitled 'Memories' and 'An Essex Farmer'. London address.

MASON, Miss Eleanor fl.1864-1865
Exhib. two works 'Autumnal Flowers' and 'Homes of the Houseless' at the BI, and one work at the RA. London address.

MASON, Miss Emily Florence b.1870
Painted portraits and oriental subjects. Exhib. in London. Born in Birmingham. Lived in Croydon, Surrey.

MASON, Ernold A. fl.1883
Exhib. a work entitled 'Day Dreams' at the RA. London address.

MASON, Frank Henry RI RBA 1876-1965
Marine painter and watercolourist. Also an etcher, illustrator and poster designer. Professionally he was a sailor and an engineer. Exhib. at the RA. Born in County Durham. Travelled extensively. Lived in Yorkshire.
Bibl: Who's Who; The Graphic 4 December 1909 p.770; Studio XC 1925 p.178; Hall; Brook-Hart (pl.176); P. Phillips, *The Staithes Group,* 1993.
Exhib: London, Sporting Gallery 1939; London, National Maritime Museum 1973.

MASON, George Finch 1850-1915
Painted sporting subjects. Exhib. five subjects 1874-6. London address. Also a prolific book illustrator.

***MASON, George Heming** ARA 1818-1872
Painter of landscapes and pastoral scenes. Born Witley, Staffordshire. Studied to be a doctor. In 1844 visited France,

Germany, Switzerland and Italy, settling in Rome for several years, where he decided to take up painting as a profession. Exhib. at RA 1857-72. ARA 1869. In 1858 he returned to England. He painted both Italian views, mainly in the Campagna, and English landscapes. His English scenes are romantic and poetic in feeling; he delighted especially in effects of mist, sunset and moonlight. His influence on other romantic landscape painters was considerable. He died of heart disease, aged 54. His studio sale was held at Christie's, 15 February 1873.
Bibl: AJ 1872 p.300 (obit.); 1883 p.43ff., p.108ff., p.185ff. (Alice Meynell); Portfolio 1871 pp.113-17; 1873 pp.40-3; 1880 p.132; 1887 pp.65, 164; Redgrave, Cent., Dict.; Clement & Hutton; Cundall; DNB; L. and R. Ormond, *Lord Leighton,* 1975; S. Reynolds, *G.H.M. and the Idealised Landscape,* Apollo February 1981; *The Etruscans,* Cat. of exhib., Stoke-on-Trent AG 1989.
Exhib: London, Fine Art Society 1982; Stoke-on-Trent AG 1989.

MASON, Mrs. H. fl.1855-1865
Exhib. two watercolours 'The Excursion' and 'The Cottage Door' at SS. London address.

MASON, M. Morton fl.1875-1877
Exhib. three landscapes 1875-7. Address in East Retford, Nottinghamshire.

MASON, Miss M. Watts fl.1893
Exhib. a figurative subject in 1893. London address.

MASON, Miss Mary fl.1869-1891
Exhib. seven works at SS, titles including 'Sketch of Cliffs — Moonlight', 'A Little Neapolitan' and 'In the Guard Room'. London address.

MASON, Miles B. fl.1877-1886
Painted rustic subjects. Exhib. 12 works at SS including 'A Hertfordshire Homestead', 'On the Grand Junction Canal' and 'Binding the Last Sheaf'. Also exhib. one work at the RA. London

MASON, R.H. fl.1857-1859
Exhib. eight still-lifes 1857-9. London address.

MASON, S. fl.1872-1875
Painted landscapes. Exhib. six works at SS, titles including 'Near Cobham Wood' and 'Fern Gatherers, Surrey Hills' and one work at the RA. London address.

MASON, William Henry fl.1858-1885
Marine painter. Lived at Chichester and Worthing. Exhib. at RA 1863-88, BI, SS and elsewhere. Titles at RA 'Spithead', 'After a Gale — Seaford Bay', 'Ironclads at Spithead', etc.
Bibl: Brook-Hart.

MASQUERIER, John James 1778-1855
Painted portraits and historical subjects. Exhib. 71 works at the RA, the great majority portraits. Exhib. 18 works at the BI, including 'Escape of Charles II from Brighton, after the Battle of Worcester'. Represented in the NPG. Born in London. Died in Brighton, Sussex.
Bibl: DNB XXXVII (with further bibl.); Connoisseur XXXV pp.79, 106; L p.119; LVI pp.68, 107, 124; LVII pp.31, 177; LX pp.211, 213, 218, 221; LXII p.183; LXIV p.183; LXV p.56; BM Cat. of Engraved British Portraits; Ormond.

MASSET, Ernest fl.1879-1880
Exhib. three marines in 1879-80. London address.

MASSEY, Frederick fl.1893
Exhib. a watercolour entitled 'The Missing Boats' at SS. Address in Penrhyn, Cornwall.

MASSEY, Mrs. Gertrude 1868-1957
(Miss Seth)
Painted portraits and landscapes. Exhib. in London and Paris. She was married to Henry Gibbs Massey (q.v.). Born in London.

MASSEY, Henry Gibbs ARE 1860-1934
Painted genre subjects. Also an etcher. Studied at Bushey, Hertfordshire, and in Paris. Exhib. four works at the RA including 'Bad News' and 'Desperate', and two watercolours at SS. Also exhib. ten works at the NWS. London address.

MASSEY, Joseph 1850-1921
A painter who lived in Dudley, Worcestershire.

MASSY, E. Martin fl.1888-1895
Painted landscapes. Exhib. four works at SS including 'A Devonshire Cliff-path' and 'Autumn Mists on the Trent' and one work at the RA. Address near Derby.

MASSY-BAKER, G.H. fl.1891
Exhib. a portrait in 1891. London address.

MASTERS, Edward fl.1869
Exhib. a work entitled 'Sunset on Woking Common' at SS. Address in Woking, Surrey. Both Edward and Thomas Masters painted landscapes and farmyard scenes in a style similar to Georgina Lara (q.v.). Little is known about either artist, but their work frequently appears at auctions.

MASTERS, Henry fl.1876-1879
Landscape painter. Exhib. five watercolours, including views in North Wales and the Lake District at SS. Address in Southampton, Hampshire.

MASTERS, Thomas fl.c.1870-1880
Landscape painter. Painted small country scenes with figures in a style similar to Georgina Lara (q.v.). Little is known about Edward (q.v.) or Thomas Masters, but their work is now often seen in auctions.

MASTERS, W. fl.1866
Exhib. a view on the Thames at SS. London address.

MASTIN, John fl.1898
Exhib. a scene near Reading at the RA. Address in Sheffield, Yorkshire.

MATESDORF, T. fl.1886
Exhib. a portrait at the RA. London address.

MATHER, John Robert b.1845 fl.1862-1873
Newcastle marine painter. Exhib. 13 works at SS 1862-73. Emigrated to Australia in 1878 and became Curator of the Melbourne Museum in 1893.
Bibl: Hall.

MATHEWES, Miss Blanche fl.1888-1893
Painted French country subjects. Exhib. five works at the RA, titles including 'A Rural Spot in Picardy' and 'Breton Child'. Address in Surrey.

MATHEWS, Miss Adele fl.1864-1868
Exhib. six watercolours at SS, including 'Sketch of a Child's Head', 'Paysanne Normande' and 'The Finishing Touches'. London address.

MATHEWS, Mrs. F.C. fl.1880-1892
Exhib. a work entitled 'Beech Trees — Early Autumn in the New Forest' at SS. Also exhib. four works at the NWS. London address.

MATHEWS, John Chester fl.1884-1888
Exhib. a painting of horses at the GG. London address.

MATHEWS, Mrs. Lydia B. fl.1900
Exhib. a work entitled 'Sweet Peas' at the RA. London address.

MATHEWS, M.A.A. fl.1857-1862
Painted still-lifes. Exhib. five works, including 'Hollyhocks', 'Pheasants' and 'Woodcocks' at the BI. Also exhib. one work at the RA. Address in Oxford.

MATHEWS, Miss Minnie fl.1886-1887
Exhib. two works 'Doorway of the Chapel of St. Erasmus, Westminster' and 'Arbutus' at the RA. London address.

MATKIN, Sarah fl.c.1870
Follower and perhaps pupil of J. Stannard (q.v.).

MATKIN, Miss Susanna fl.1884
Exhib. a landscape at the NWS. Address in Stamford, Lincolnshire.

MATTALIA, James fl.1862-1866
Exhib. four works at the BI including 'The Love Letter' and 'The Mother's Idol' at the BI. London address.

MATTHEW, T. fl.1840
Exhib. a view in the Broad Street, Reading, at the RA. London address.

MATTHEWS, E. fl.1878
Exhib. two landscapes in 1878. London address.

MATTHEWS, Miss Edith fl.1901
Exhib. a work entitled 'Sadie' at the RA. London address.

MATTHEWS, J.C. fl.1886-1887
Exhib. two works including a portrait of a horse, at SS. London address.

MATTHEWS, James
Sussex painter working towards the end of the 19th century in a style similar to Helen Allingham (q.v.).

MATTHEWS, Joseph fl.1869-1881
Painted landscapes and trees. Exhib. five watercolours at SS including 'Burnham Beeches — November' and 'Fairley Heath — Ewhurst Firs in the Distance'. London address.

MATTHEWS, Miss Julia B. RI fl.1893-d.1948
(Mrs. Ivimey)
Painted genre subjects. Exhib. a work entitled 'A Story of Balaclava told by one of the Survivors' at SS. Addresses in Richmond, Surrey, and in Newquay, Cornwall.

MATTHEWS, R.A. fl.1891
Exhib. a work entitled 'Autumn Spoils' at SS. Address in Earls Colne, Essex.

MATTHEWS, William 1821-1905
Painted portraits. Exhib. a drawing in 1876. London address. Born in Bristol. Died in Washington, DC.
Bibl: Fielding, *Dictionary of American Painters*, 1926.

MATTHISON, William fl.1874-c.1922
Painted rustic and coastal subjects. Exhib. 17 works, some of them watercolours, at SS, titles including 'An Angler's Haunt', 'An East Coast Fishing Town' and 'Sunset at the Pier Steps, Whitby'. Address in Banbury, Oxfordshire.

MAUD, W.T. 1865-1903
War artist and illustrator. Worked for *The Graphic*. Exhib. a portrait at the RA. Lived in Brighton, Sussex. Died in Aden.
Bibl: Bryan; Poole 1925.

MAUGHAM, J. fl.1862
Exhib. a view of a waterfall at the RA.

MAUGHAN, Miss fl.1861
Exhib. a landscape at the RA.

MAUGHAN, James Humphrey Morland 1817-1853
Amateur artist who lived in Northumberland until 1844, when he moved to Maidstone, Kent. An example of his work is illustrated in a letter to *Country Life* 22 May 1969.

MAULE, Henry fl.1849-1860
Painted landscapes and still-lifes. Exhib. four works at the BI, 'Enfield Mill', 'Interior of a Larder', 'Greenwich' and 'Bromley, Kent'. Also exhib. four works at SS and three at the RA. London address.

MAULE, James fl.1835-1863
Lewisham marine painter. Exhib. 1835-63 at RA, BI and SS. Titles at RA 'Portsmouth Harbour', 'View of Holland', 'Off Dover', etc.
Bibl: Brook-Hart.

MAULEY, J. fl.1844
Is supposed to have exhib. two marines at SS. London address.

MAULL, C. fl.1839
Exhib. a marine entitled 'A Stiff Breeze' at the RA.

MAUND, George C. fl.1853-1871
Painted landscapes and gardens. Exhib. eight watercolours, including 'A Tree at Hampstead', 'Hampstead Priory' and 'Lane at Hendon' at SS, and three works at the RA. London address.
Bibl: Wood, Painted Gardens.

MAUNDRELL, Charles Gilder b.1860 fl.1922
Painted French landscapes and subjects. Studied under Gerome in Paris. Exhib. nine works at the RA including 'A Peasant Proprietor' and 'The Marne near Paris'. Also exhib. three works at SS and eight at NWS and in Paris. Lived in London.

MAUR, W.C. fl.1881
Exhib. two works 'The Weir, Mapledurham' and a watercolour entitled 'Lamia' at SS. London address.

MAVROGORDATO, Alexander J. fl.1892-1903
Painted buildings and townscapes. Exhib. 16 works at the RA 1892-1903, including views in Lincoln, Coventry, Perugia and Venice. London address.

MAW, John Hornby fl.1840-1848
Amateur watercolourist. Exhib. six works at the RA, including four interior views of his house in Hastings. He was a well-known collector, and friend of many artists, including Wiliam Henry Hunt (q.v.). Address in Hastings, Sussex.

MAWE, Miss Annie L. fl.1891-1893
Exhib. a watercolour of the west door of St. Etienne-le-Vieux, Caen, at SS. Address in Chislehurst, near London.

MAWE, G. fl.1843
Exhib. a portrait of an officer at the RA.

MAWLEY, George 1838-1873
London landscape painter and watercolourist. Exhib. 1858-72 at RA, SS and elsewhere. Painted on the Thames, in Yorkshire and elsewhere. Exhib. most of his watercolours at the Dudley Gallery.
Bibl: Redgrave, Dict.

MAWSON, Miss Elizabeth Cameron 1849-1939
Flower painter; lived at Gateshead, near Newcastle. Exhib. 1877-92 at RA, SS, NWS and elsewhere. Also painted genre scenes, e.g. 'An Illustrious Ancestor', 'A Reverie', etc.
Bibl: Hall.

MAXIE, Paul fl.1869
Exhib. a painting of an animal in 1869. London address.

MAXIMOS, Mrs. fl.1887
Exhib. a portrait in pastels at the RA. London address.

MAXSE, Mrs. fl.1890
Exhib. two views of Malaga in 1890. London address.

MAXWELL, Miss H.C. fl.1837-1839
Exhib. two works, a view in Caen, Normandy and a work entitled 'A Winter Morning' at the RA, and another work at SS. London address.

MAXWELL, Hamilton RSW 1830-1923
Painted landscapes and architectural subjects. Exhib. a landscape near Loch Lomond at the RA and a watercolour entitled 'The Old Gean Tree, Luss' at SS. Travelled in Australia and India. Painted full-time from 1881. Lived and exhib. in Scotland. He was the President of the Glasgow Arts Club.

MAXWELL, R. fl.1840-1841
Exhib. two works 'Scene near a Farm' and 'Trees in Richmond Park' at the RA, and two works at SS. London address.

MAY, A.S. fl.1887-1897
Exhib. a work entitled 'A Winter Sea at Dawn' at the RA. Also exhib. a work at SS. London address.

MAY, A.W. fl.1875-1878
Painted landscape. Exhib. six works at the RA, titles including 'Late Autumn', 'The Meuse in Summer' and 'A Bend in the River'. London address.

MAY, Alfred fl.1900
Exhib. a work entitled 'The Mill' at the RA. London address.

MAY, Arthur Dampier fl.1872-1900
Genre and portrait painter. Exhib. at RA 1876-1900, SS, NWS, GG and elsewhere. Most of his exhib. portraits were of children. He also painted genre scenes, e.g. 'The Children's Hour', 'A Little Bridesmaid', 'The Lord's Prayer', etc.
Bibl: Poole III 1925 p.145.

MAY, Arthur Powell fl.1875-1893
Landscape painter. Possibly the brother of Arthur Dampier May (q.v.), as both have Lee addresses. Exhib. 1875-93, at the RA in 1876, SS, NWS, and elsewhere. At the RA he exhib. a landscape, 'At Zennor, Cornwall, Gurnard's Head in the Distance'.

MAY, Mrs. Frank (Clementina) fl.1884-1892
Exhib. two works, 'Street in St. Ives' and 'Old China' at SS. Address in Elstree, Hertfordshire.

MAY, Miss Gertrude Brooke fl.1887-1893
Painted fruit and flowers. Exhib. two works, 'Oranges and Violets' and 'Roses', at the RA, and three watercolours at SS. Also exhib. three works at GG and two at the NG. London address.

MAY, Mrs. Gisborne fl.1845-1848
Painted buildings and landscape. Exhib. nine works at the RA, titles including 'Chingford Church, Essex' and 'Snowden'. London address.

MAY, Miss H. see BRIDGWATER, Mrs. H. Scott

MAY, H. Goulton fl.1886-1887
Exhib. a work entitled 'A Quiet Corner' at SS and two works at the NWS. London address.

MAY, James fl.1860-1866
Painted genre subjects. Exhib. nine works at SS including 'The Fisher's Daughter', 'The Favourite Puppy' and 'Beg for It', and one at the RA. Address in Edinburgh.

MAY, Miss Kate fl.1877-1883
Painted flowers and figurative subjects. Exhib. four works at the RA, including 'Friends through All the Year' and 'Daffodils', and two works at SS. Addresses in London and Dunster, Somerset.

MAY, Miss Margery fl.1879-1885
Exhib. a work, 'Carting Turnips', at the RA. London address.

MAY, Philip William (Phil) RI 1864-1903
Caricaturist. At the age of 12 he became a scene-painter at Leeds, and joined a travelling theatre company. Later he worked as an illustrator in London, also in Australia 1885-8, and Paris. He joined Punch in 1895; elected RI 1897. He worked mostly in pen, ink and wash, in a lively and expressive style. Many of his best cartoons are of cheeky London street urchins.
Bibl: J. Thorpe, *Phil May*, 1932; AJ 1903; Apollo LXXVI December 1962; J. Thorpe, *Phil May*, 1948; Frederick Gordon Roe, *Phil May*, 1955. Exhib: London, Fine Art Society 1969.

MAY, R. fl.1852
Exhib. a work entitled 'The Farmer's Boy' at the RA. London address.

MAY, Walter William RI 1831-1896
Marine painter and watercolourist. Exhib. 1859-93 at NWS (281 works), RA, BI, SS and elsewhere. Painted coastal and shipping scenes in England, France and Holland. A work by him is in the Norwich Museum.
Bibl: Cundall p.235; National Gallery of Ireland Catalogue of Pictures etc. 1920 p.177; Brook-Hart.

MAY, William Charles 1853-1931
Painted genre subjects. Also a portrait sculptor. Studied at the RA Schools and in Paris. Exhib. in London from 1875 Lived in London.
Bibl: AJ 1883 p.304.

MAY, William Holmes RPE fl.1880-1881
Painted and etched landscape subjects. Exhib. a watercolour, 'At the Foot of Leith Hill' at SS. Address in Merton, Surrey.

MAYE, Henry Thomas fl.1854-1867
Exhib. three works, 'A Free Gift', 'The Wreath' and 'Domestic Pursuits', at the RA, and two works at SS. London address.

MAYER, Mrs. fl.1893
Exhib. a figurative subject in 1893. London address. See also Miss Millicent Phelps.

MAYER, A. fl.1865
Exhib. a view of the Thames from Hungerford Bridge at the RA. London address.

MAYER, Arminius fl.1825-d.1847
Painted portraits. Exhib. eight works, all portraits, at the RA. Also exhib. five works at SS, including 'A Madonna', 'Pensiveness' and 'Interior of a Stable'. London address.
Bibl: Ormond.

MAYES, William Edward 1861-1952
Painted landscape watercolours. Painted the Norfolk Broads. Lived in Norfolk and was a founder member of the Great Yarmouth and Gorlaston Art Societies.

MAYHEW, G.W. fl.1839
Exhib. a view of the Ship Torbay Tavern, near Greenwich Pier at the RA. London address.

MAYLORD, James fl.1881
A flower picture, dated 1881, appeared at Christie's, 11 July 1970.

MAYNARD, Harriette fl.1885
Exhib. a work illustrating a line from Keats at SS. London address.

MAYNE, Arthur Jocelyn RHA c.1837-1893
Painted landscape. Studied and exhib. at the RHA. Lived in Dublin where he taught drawing.
Bibl: Strickland.

MAYO, Miss M. fl.1873
Exhib. a view of a building in 1873. Address in Winchester, Hampshire.

MAYOR, Mrs. Hannah 1871-1947
Painted flowers. Studied at the Royal Female School of Art and at Westminster. She was married to the artist W.F. Mayor (q.v.). Exhib. in London, where she lived.
Bibl: P. Phillips, *The Staithes Group*, 1993.

MAYOR, William Frederick 1865 or 1868-1916
Painted landscape and country subjects in watercolour. Studied painting at the RCA and in Paris. Exhib. 11 works at the RA, titles including 'The Forge', 'Charcoal Burner' and 'Boys Playing Cricket'. Also exhib. five works, two of them watercolours, at SS. Influenced by F. Brangwyn (q.v.), with whom he shared a studio. Born near Ripon, Yorkshire. Died in London.
Bibl: The Artist 1899 p.92ff.; Apollo IX p.259; Hardie III; P. Phillips, *The Staithes Group*, 1993.

MAZZONI, A. fl.1875
Exhib. a painting of flowers in 1875. London address.

MEAD, Miss Mary P. fl.1877-1883
Painted landscape watercolours. Exhib. six watercolours at SS, titles including 'Heavy and Dank with Autumn Vapour' and 'A Wiltshire Cottage'. London address.

MEAD, Miss Rose fl.1896-1899
Exhib. four subjects at the RA, including 'Cuisine en Bohème' and 'My Mother'. Address in Bury St. Edmunds, Suffolk.

MEAD, T. fl.1867-1868
Exhib. four watercolours at SS, including 'The Brook and the Bridle Path' and 'The Cross Roads Ale House'. London address.

MEADE, Arthur ROI 1863-c.1947
Painted West Country landscape. Exhib. 35 works at the RA 1888-1904, including 'Studland, Dorset', 'In Hardy's Country — Egdon Heath', 'Old Mill on the Frome' and 'Wessex Hills and Heather'. Addresses in London and St. Ives, Cornwall.

***MEADOWS, Arthur Joseph 1843-1907**
Painter of coastal scenes. Exhib. mostly at SS, also at RA 1863-72, and BI. Painted harbours and coastal scenes in England, France and Holland. He was the father of Gordon Arthur Meadows, the brother of James Edwin Meadows and the son of James Meadows Snr. (qq.v.).
Bibl: Wilson, p.54 (pl.23); Brook-Hart (pls.93, 94).

MEADOWS, Edwin L. fl.1854-1872
London landscape painter. Exhib. at RA 1858-67, BI and mostly SS. Titles at RA 'Near Dorking, Surrey', 'A Shady Pool', 'In Epping Forest — Evening', etc.
Bibl: Brook-Hart (pl.96).

MEADOWS, Gordon Arthur b.1868
Painted landscape, including views, in watercolour. He was the son of Arthur Joseph Meadows (q.v.).

MEADOWS, J.M. fl.1849
Exhib. a view of an old mill in Devon at SS. London address.

MEADOWS, James, Snr. 1798-1864
Painted marines. Exhib. at the RA and elsewhere in London. Father of A.J., J.E. and W. Meadows (qq.v.). Also a miniaturist.
Bibl: Brook-Hart (pl.92).

***MEADOWS, James Edwin 1828-1888**
London landscape painter. Exhib. at RA 1854-72, BI, SS and elsewhere. Titles at RA include views in Essex, Kent, Sussex, Surrey, the Isle of Wight, etc. and some coastal scenes. Son of James Meadows Snr. (q.v.).
Bibl: Rees, *Welsh Painters*, 1912; Brook-Hart (pl.92).

MEADOWS, Joseph Kenny 1790-1874
Portraitist, illustrator and caricaturist. Exhib. four portraits, including one of Miss Ellen Tree, of the Theatre Royal, Covent Garden, at SS. Born in Cardiganshire. Died in London.
Bibl: Chatto, *A Treatise on Wood Engraving*, 1861; AJ 1874 p.306; Redgrave, Dict.; Everitt, *English Caricaturists*, 1893; Mag. of Art June 1896; Rees, *Welsh Painters*, 1912; Connoisseur LXXXIII 1929 p.15; BM Cat. of Engraved British Portraits.

MEADOWS, K. fl.1845-1853
Is supposed to have exhib. two dramatic subjects at the RA. London address.

MEADOWS, William fl.1870-1895
Painted Venetian scenes. He did not exhib. in London. He was the third son of James Meadows Snr. (q.v.).
Bibl Brook-Hart (pl 95).

MEAKIN, Miss Mary L. fl.1843-1862
Painted portraits and fruit. Exhib. 11 works at the RA including 'The Golden Drop', 'Windfalls', 'Demand and Supply' and portraits. London address.

MEARNS, A. fl.1855-1864
Painted dogs. Exhib. four works at the BI, including 'Pointers', 'Clumber Spaniels' and 'An Interior', and two works at SS. Address in Faversham, Kent.

MEARNS, Miss Fanny fl.1870-1881
Painted landscapes and figurative subjects. Exhib. 13 works, some of them watercolours, at SS, titles including 'The Gloaming' and 'A Rest by the Way'. Also exhib. five works at the RA. London address.

MEARNS, Miss Lois fl.1864-1880
Painted figurative subjects. Exhib. 14 works, some of them watercolours, at SS, titles including 'From *The Vicar of Wakefield*', 'A Difficult Passage' and 'Divided Attention'. Also exhib. two works at the RA. London address.

MEARS, George fl.1870-1895
Very little-known marine painter. Lived in Brighton and painted shipping scenes off the south coast. Works by him are in Folkestone AG and Greenwich Maritime Museum.
Bibl: Wilson p.54 (pl.24); Brook-Hart (pl.54).

MEASHAM, Henry RCA 1844-1922
Manchester landscape and portrait painter. Exhib. 1867-83 at RA and elsewhere. Titles at RA mostly portraits, and some genre, e.g. 'An Italian Shepherd', 'Fruit for Winter', 'An Old Basket Maker', etc. Works by him are in Manchester and Salford AG.

MEASOM, William F. fl.1899-1902
Exhib. four works including three harvest time subjects at the RA. London address.

MEASON, W. fl.1837-1853
Exhib. two works, a portrait and a work entitled 'The Meeting' at the RA. Address in Exeter, Devon.

MEASOR, W. fl.1837-1864
Painted portraits and landscapes. Exhib. nine portraits at the RA, eight works at SS, including watercolours of Burnham Beeches. Also exhib. a painting of 'Cain' at the BI. London address.

MEASOR, W.B.M. fl.1854-1872
Painted portraits. Exhib. eight portraits including one of E. Welby Pugin at the RA. London address.
Bibl: Ormond.

MEDLAND, J.G. fl.1875-1877
Painted flowers and fruit. Exhib. six works at SS including 'Poppies' and 'French Pippins'. London address.

MEDLAND, John fl.1875-1902
Exhib. three works 'Nature and Art' and two views of buildings at the RA, and a watercolour view in a town in Normandy at SS. London address.

MEDLYCOTT, The Rev. Sir Hubert J., Bt. 1841-1920
Landscape and architectural painter. Lived in Somerset. Exhib. 1878-93 at SS, NWS, GG and elsewhere.
Bibl: Court Journal 22 February 1908.
Exhib: London, 108 Cambridge Street 1899.

MEDWIN, Leslie fl.1892
Exhib. a landscape in 1892. London address.

MEEGAN, Walter fl.c.1890-1900
Painter of moonlight scenes, in imitation of J. Atkinson Grimshaw (q.v.). He was an itinerant artist and worked in the north of England. Reputed to have moved from inn to inn, paying his bills by presenting the landlord with a painting.

MEEK, Mrs. M.A. fl.1832-1837
Painted landscapes. Exhib. eight works at SS including 'Culloden Moor' and 'The Blackberry Gatherers'. Also exhib. three works at the BI and one at the RA. London address.

MEERS, Mrs. see DUJARDIN, Miss

MEGGISON, J.T. fl.1869
Exhib. a work entitled 'The First Day of the Season' at SS. Address in Durham.

MEGSON, Arthur fl.1865-1867
Exhib. a work entitled 'Autumn Gathering' at the RA. Address in Bradford, Yorkshire, where he kept an art shop. He often painted flowers and birds' nests in the manner of William Henry Hunt (q.v.).

MEIN, Miss Margaret J. fl.1885-1891
Exhib. a painting of primroses at SS and a study at the RA. Address in Edinburgh.

MELBY, Wilhelm fl.1853-1868
Painted marines, shipping and coastal subjects. Exhib. 15 works at the BI, including views on the Norwegian coast and of shipping around Land's End and on the west coast of Scotland. Also exhib. 11 works at the RA and four at SS. London address.
Bibl: Brook-Hart (pls.112, 113).

MELDRUM, Thomas fl.1886-1891
Exhib. six works including 'The Maid of the Mill', 'Dittsam Ferry' and 'By the Hedgerow' at the RA. Address in Nottingham.

MELLING, Henry fl.1829-1853
Painted genre subjects. Also an engraver. Exhib. three works at the BI including 'The Standard Combat' and two works at the RA. London address.

MELLOR, Everett Watson 1878-1965
Landscape painter; son of William Mellor (q.v.). Painted in a very similar style to his father and their work is sometimes confused. Signs his works E.W. Mellor.

***MELLOR, William 1851-1931**
Yorkshire landscape painter. He did not exhib. in London but his works appear frequently on the market. His subjects are usually landscapes in North Wales or the West Country. Mellor was born in Barnsley and lived mostly in Yorkshire. He worked in Ilkley, Scarborough and Harrogate, where he died. His works can be confused with those of his son E.W. Mellor (q.v.).

MELVILLE, Alexander fl.1846-1868
Painter of portraits and genre who exhib. from 1846-68 at the RA, BI and SS, titles at the RA including 'Portrait of a Lady', 1846, and 'Meditation', 1847.
Bibl: Ormond.

MELVILLE, Mrs. Alexander fl.1854-1868
(Eliza Anne Smallbone)
Painter of genre and portraits who exhib. 'Morning Post' at the RA in 1854 under the name Smallbone, and under the name Melville from 1862-8 at the RA, BI and SS, all portraits.

***MELVILLE, Arthur RWS ARSA RSW 1855-1904**
Scottish painter and watercolourist of eastern subjects. Entered RSA schools 1875. Studied in Paris 1878. Travelled in the Middle East 1881-3. By 1884 he was back in Scotland, and his arrival lent impetus to the newly-formed Glasgow School movement. Exhib. at RA 1878-96, OWS, NWS, GG, etc. RWS 1889, after which he settled in London. It was still the East to which he turned for inspiration — Egypt, Algeria, Morocco and Spain — "wherever he found scenes of vivid life, and of colour in motion" (Hardie). He developed a brilliant and quite individual impressionistic style, which has had many imitators, but few rivals. Among those influenced by Melville are F. Brangwyn, H. Brabazon (qq.v.) and several Scottish watercolourists.
Bibl: AJ 1904 pp.336, 381 (obit.); Studio XXXVII 1906 pp.284-93; XLII 1908 pp.143-5; LXXXII 1921 pp.227, 251, 257; LXXXIII 1922 pp.132-5; Caw; Cundall; VAM; R. Fedden. *A.M. OWS*, 1923; A.E. Mackay, *A.M.*, 1951; Hardie III pp.199-203 (pls.231, 233); Irwin; Newall.

MELVILLE, Harden Sidney fl.1837-1881
London genre and landscape painter. Exhib. at RA 1837-65, BI and SS. Titles at RA 'A Horse', 'Dinner Time' and 'Toast for Papa', etc., and some animal studies.
Bibl: Binyon III; Ormond.

MELVILLE, Henry fl.1826-1841
Painted rustic genre subjects. Exhib. 21 works at SS, titles including 'The Stable Door', 'The Woodman' and 'Mill at Hartings'. Also exhib. 'Interior of the House of Lords, on the event of H.M. the Queen Opening her First Parliament' at the RA. London address.

MELVILLE, Miss Pattie fl.1868-1869
(Mrs. E.A. Pettitt)
Exhib. three works 'Expectation', 'The Bells' and 'Winter' at SS. See also Mrs. E.A. Pettitt.

MELVILLE, W. fl.1851-1861
Exhib. a work entitled 'A Rabbi' at the BI. London address.
Bibl: Ormond.

MENCIE, M. fl.1873
Is supposed to have exhib. a painting of a bird at SS. Address in Preston, Lancashire.

MENDHAM, Miss Edith fl.1888
Exhib. an historical subject at the NWS. Address in Clifton, Somerset.

MENDHAM, Robert fl.1821-1858
Exhib. four works, including 'The Affectionate Dog' and 'The Miser' at the BI, and two portraits at the RA. Addresses in London and Eye, Suffolk.

***MENPES, Mortimer RI RBA RE 1855-1938**
Painter, watercolourist, and etcher. Born in Australia. Pupil and follower of Whistler. Exhib. at RA 1880-1900, SS, NWS, GG and elsewhere, including NEAC. Painted street and market scenes in Brittany, Tangier, India and Japan, and also genre scenes, e.g. 'The Village Smithy', 'Washing Day', 'Sunday Morning', etc. His broad delicate colours and choice of subjects both reflect the influence of Whistler and the Japanese style. Also exhib. etchings at the RA, some after Old Masters; illustrated travel books.
Bibl: AJ 1881 p.352; Connoisseur XXX 1914 p.289; Who's Who; Wedmore, *Etching in England*, 1895 pp.144-7; Hind, A *Short History of Engraving*, 1911; Irwin.
Exhib: London, Adam & Charles Black 1903 (?).

MENZIES, John fl.1864-1892
Painted fruit and landscape. Exhib. four landscapes, including a view of Barnard Castle and views in the highlands, at the RA, and two watercolour still-lifes of fruit at SS. Address in Wakefield, Yorkshire.

MENZIES, Mrs. John (Maria) fl.1880-1885
Exhib. three works including 'On the Coast near Aberdeen' and 'On the Moor — Trossachs' at the RA. Also exhib. three works at the NWS. Address in Hull, Yorkshire.

MENZIES, Miss Maria fl.1886
Exhib. a landscape at the NWS. Address in Hull, Yorkshire.

MENZIES, William A. fl.1886-1902
Painted figurative subjects and portraits. Exhib. 16 works at the RA including 'Before the Masters of the Art', 'On a Charitable Errand' and 'The Vicar's Story'. Also exhib. work at SS and the NWS. London address.
Bibl: Poole II 1924.

MEO, Gaetano fl.1875-1893
Painted landscapes. Exhib. seven works, three landscapes in north Devon and views in Hampstead at SS, and one work, 'Sketch on Hampstead Heath', at the RA. London address.

MERCER, Fletcher J. 1861-1922
Studied painting at Whistler's School in Paris, and at the Slade. Exhib. with the NEAC. Born in Gainsborough, Lincolnshire.

MERCER, Frederick RBSA fl.1871-c.1929
Painted landscapes and coastal scenes in watercolour. Exhib. six watercolours at SS including 'Farm near Tamworth, Staffordshire' and 'Barmouth from the Sands'. Also exhib. four works at the NWS. Address in Birmingham.

MERCIER, Major Charles 1834-after 1893
Exhib. a portrait at the RA. Amongst his sitters as a portraitist were Disraeli and Lord Napier. Born in Surrey. Lived in Manchester.
Bibl: Ormond.

MERCIER, Miss Ruth fl.1885-1902
Exhib. three paintings of flowers at the RA. Also exhib. one work at the NWS and two works at the GG. Address in Cannes, France.

MEREDITH, William b.1851 fl.1874
Exhib. two landscapes in 1873-4. Address in Manchester. Represented in the Manchester City AG.
Bibl: *Handbook to the Permanent Collection,* Manchester City AG 1910.

MEREDYTH, William b.1851
Landscape painter who studied at Manchester School of Art.

MERIFIELD, J. or T. fl.1875-1876
Exhib. a watercolour of the Temple of Vesta, Rome, at SS. London address.

MERIGNAN, Miss A. fl.1866
Exhib. a figurative subject in 1866. London address.

MERLIN, C.E.P. fl.1880
Exhib. a painting of a Greek peasant in Megara at the RA. Address in Athens.

MERRICK, Mrs. Emily M. fl.1879-1893
Painted figurative and genre subjects. Exhib. ten works including portraits at the RA, and exhib. 13 works at SS including 'Getting Better', 'Sweet Seventeen' and 'A Child of the Vineyards'. London address.

MERRIFIELD, Mrs. fl.1851
Exhib. two watercolour portraits at SS. Address in Brighton, Sussex.

MERRITT, Henry 1822-1877
Painter, restorer and bookseller. Born in Oxford. Died in London. Anna Lea Merritt (q.v.) was his wife.
Bibl: AJ 1877 p.309f.

***MERRITT, Mrs. Henry (Anna Lea) 1844-1930**
Portrait and genre painter. Born in Philadelphia. Her husband Henry Merritt (q.v.) was also a painter. Exhib. at RA 1878-93, GG and NG. Subjects mostly portraits, also genre. Her best known work is the much ridiculed 'Love Locked Out' in the Tate Gallery. After her husband's death in 1877 she was known as Mrs. Anna Lea Merritt.
Bibl: Henry Merritt, *Art Criticism and Romance,* 1879; Who's Who; M. Fielding, *Dictionary of American Painters,* 1926; W. Shaw-Sparrow, *Women Painters of the World,* 1905; *Love Locked Out — The Memoirs of A.L.M.*, Boston Museum 1983; Wood, Olympian Dreamers.

MERRITT, Thomas Light fl.1847 d.1870
Exhib. a painting of flowers at the RA. Address in Maidstone, Kent. Also a poet.

MERRITT, William J. fl.1888-1890
Painted marines and shipping. Exhib. five works at the RA including 'Manx Fishing-Boats' and 'Port St. Mary, Isle of Man Bay', and three works at SS including 'Punt Fishing' at SS. London address.
Bibl: Brook-Hart.

MERRY, Godfrey fl.1883-1903
Painted landscapes and figurative subjects. Exhib. eight works at SS including 'A Son of the Desert', 'An Ancient Inhabitant' and 'Italy in London'. Also exhib. four works at the RA 1886-1903. London address.

METCALFE, Mrs. Anne fl.1845-1849
Exhib. a work entitled 'Meditation' at the RA and 'The Virgin' at SS. London address.

METCALFE, Gerald F. fl.1894-1902
Painted portraits. Exhib. 11 works at the RA including seven portraits and works entitled 'Pan' and 'Forests Ancient as the Hills'. London address.

METCALFE, W. fl.1861
Painted landscapes. Exhib. a work at the RA 'Scene on the St. Mary River between Lakes Huron and Superior' and three landscapes including two in Canada at SS. London address.

***METEYARD, Sidney Harold RBSA 1868-1947**
Painter in oil, watercolour and tempera; designer of stained glass. Studied at Birmingham School of Art under Edward R. Taylor (q.v.). Associate of RBSA 1902, Member 1908. Exhib. at RA, Birmingham, Liverpool and the Paris Salon. Illustrated Longfellow's *Golden Legend,* and designed a stained glass window for St. Saviour's, Scarborough. All his work shows a strong influence of Burne-Jones; examples can be seen in Birmingham AG.
Bibl: Studio I 1893 pp.237-40; Cat. of Symbolists; Wood, Pre-Raphaelites; Wood, Olympian Dreamers.
Exhib: London, Piccadilly Gallery 1970.

METHEUN, Cathcart W. fl.1884
Exhib. a landscape at the NWS.

MEULEN, F.P.J. fl.1880
Exhib. a genre subject at the GG.

MEUTE, C. fl.1881
Exhib. a figurative subject in 1881. London address.

MEYER, Adolph Campbell 1866-1919
Painted landscapes. Exhib. nine works at the RA 1891-1903, including 'The Bend of the River', 'A Summer Evening' and 'Harvest Time'. Address in New Brighton.
Bibl: Studio Summer Number 1902.

MEYER, Miss Beatrice fl.1873-1893
London historical painter. Exhib. 1873-93, mainly at SS, also RA, NWS and elsewhere. Only exhib. once at the RA in 1888 with a picture entitled 'The Betrothal'.

MEYER, Miss Constance fl.1866-1882
Exhib. 23 paintings of flowers 1866-82. London address.

MEYER, F.W. fl.1869-c.1922
Painter of shipping and coastal scenes. Lived in Putney. Exhib. at RA 1869-92, SS and elsewhere. Painted the English coasts and Brittany. Also painted landscapes, mostly in Wales.
Bibl: Brook-Hart (pl. 210).

MEYER, Frederick John fl.1826-1844
Painted portraits. Exhib. 22 portraits at the RA and 42 works at SS. Also exhib. three works 'The Village Lass', 'A Study' and 'The Gleaner' at the BI. London address.
Bibl: Ormond.

MEYER, Henry Hoppner c.1782-1847
Portraitist who ceased to exhib. in 1834.
Bibl: Ormond.

MEYER, Jean Georges fl.1863
Exhib. a work entitled 'Maternal Joy' at the RA. Addresses in Berlin and London.

MEYER, Miss Julia fl.1893-1903
Exhib. a painting of flowers in 1893. London address.

MEYER, Miss Margaret fl.1872-1886
Exhib. a painting of chrysanthemums at the RA and 'A Leisure Hour' at SS. London address.

MEYER, Mary H. fl.1868-1885
Exhib. 16 flower paintings 1868-85. London address.

MEYERHEIM, Robert Gustav RI 1847-1920
German landscape painter; one of a family of Danzig artists. Studied under H. Gude and Oswald Achenbach. Settled in England in 1876, and exhib. 1875-93 at RA, SS and NWS. Lived in London, later moved to near Horsham, Surrey. Painted English landscapes and farming scenes; also visited Holland. An exhibition of his works entitled 'The Soul of the Countryside' was held at the Carroll Gallery in 1913.
Bibl: Connoisseur XXXVI 1913 pp.132-3.

MAYERN HOHENBERG, L. von 1815-1865
His drawing of Prince Albert is in the collection of the Royal Society of Arts.

MEYRICK, Arthur fl.c.1895-1925
Painted watercolour landscapes and coastal views. Lived at Hartfield, Sussex.

MEYRICK, Miss Myra fl.1889-1891
Exhib. a view of the Old Town, Algiers, at the RA and three works at the NWS. Address in Blickling Aylsham, Norfolk.

MEYWICK, Miss fl.1837
Painted landscape watercolours. Exhib. six watercolours 'Sandsfoot Castle, near Weymouth' and 'Fishing-boats on the Beach at Brighton' at SS. London address.

MICHAEL, Frederick Howard fl.1892-1903
Painted figurative subjects and portraits. Exhib. 12 works at the RA including four portraits and works entitled 'A Grecian Holiday', 'Titania' and a landscape. London address.

MICHAEL, L.H. fl.1845-1856
Painted landscapes, buildings and figurative subjects. Exhib. 12 watercolours at SS including 'A Scotch Fishwoman', 'The Black Mount, Glencoe' and 'Interior of an Old Church at Etampes'. Also exhib. eight works at the RA. London address.

MICHAEL, W.A. fl.1853-1892
Exhib. a watercolour view of Ben Nevis and Loch Eil at SS. London address.

MICHAELSON, Assur fl.1895
Exhib. a work entitled 'At the End of a Luckless Day' at the RA. London address.

MICHELIN, M.J. fl.1850-1851
Exhib. two works including a still-life at the RA. Address in Paris.

MICHIE, J. fl.1870-1875
Exhib. figurative subjects and landscapes. Exhib. three works at the RA including 'Whistling Aloud to Keep his Courage Up'. Exhib. 12 works at SS including 'On the Sands, Newhaven', 'A Maiden's Reverie' and 'A Tiresome Beau'. London address.

MICHIE, James Coutts ARSA SSA 1861-1919
Scottish landscape and portrait painter. Born in Aberdeen. Studied in Edinburgh, Rome and Paris (under Carolus Duran). Settled in

London about 1890. Exhib. 1889-93 at RA, SS, GG, etc. ARSA 1893. Member of Aberdeen Art Society and the Society of Scottish Artists. Subjects usually peaceful rural scenes. Works by him are in the Aberdeen AG and the Walker AG Liverpool. He was a good friend of the collector, George McCulloch, and after McCulloch's death in 1909, he married Mrs. McCulloch. His sister, Miss M. Coutts Michie (q.v.), was a flower painter.

Bibl: AJ 1902 pp.290-3; 1905 p.122; 1907 p.164; Studio XXXVIII 1906 pp.15, 16, 21; Art in 1898, Special Number; Connoisseur LVI 1920 p.126; Caw pp.311-12.

MICHIE, John D. fl.1864
Exhib. a work 'Kilmeny in the Fairy Glen' at the RA. Address in Edinburgh.

MICHIE, Miss M. Coutts fl.1892
Exhib. a work entitled 'Autumn Flowers' at the RA. Address in Aberdeen. She was sister to James Coutts Michie (q.v.).

MICHOLLS, Miss A. fl.1872-1877
Exhib. two works including 'An Old Soldier' at the RA, and two watercolours 'On the Loire' and 'Labour' at SS. Address in Manchester.

MICOCCI, Guiseppe fl.1887
Exhib. a mountain landscape at the GG. London address.

MIDDLETON, Miss Fanny fl.1884-1887
Exhib. a watercolour entitled 'On the Towpath, near Marlow' at SS. Address in York.

MIDDLETON, J.T. fl.1855-1856
Exhib. three domestic genre subjects 1855-6. London address.

MIDDLETON, James Godsell fl.1826-1872
Portrait and genre painter. Exhib. at RA 1827-72, BI and SS. Also painted historical genre, 'Scene from Old Mortality', 'Jennie Deans', 'Nell Gwynn and Charles II', etc. His self-portrait is in the Pitti Palace, Florence.

Bibl: Cat. of Paintings etc. in the India Office, London, 1914 p.83; BM Cat. of Engraved British Portraits VI p.520; Ormond.

MIDDLETON, James Raeburn b.1855 fl.1904
Painted oriental subjects and portraits. Exhib. four works including 'Evening Prayer at a Burmese Pagoda' and 'At the Gateway of the Governor's Palace' at the RA, and one work, a view of Tangier, at SS. Address in Glasgow.

***MIDDLETON, John 1828-1856**
Norwich School landscape painter. Studied under Crome, J.B. Ladbroke and Alfred Stannard (qq.v.). Worked together with Henry Bright and Thomas Lound (qq.v.). Educated in Norwich; visited London 1847-48. Exhib. at RA 1847-55 and BI 1847-55. He painted rustic scenes of the Norwich type and occasionally collaborated with the animal painter H.B. Willis (q.v.). Hardie describes his watercolours as "unusually fresh and vigorous". Works by him are in Norwich Castle Museum.

Bibl: AJ 1857 p.62; Redgrave, Dict.; Cundall; W.F. Dickes, *The Norwich School of Painters,* 1905; VAM; DNB; Clifford; Hardie II p.71 (pls. 66-7); H.A.E. Day, *East Anglian Painters,* III pp.105-21.

MIDDLETON, Miss Katherine fl.1890-1891
Exhib. two works 'Shere, Surrey' and 'Wimbledon Common' at SS. London address.

MIDDLETON, Miss Mary E. fl.1884-1892
Exhib. a view of the common, Ashdown, Sussex, at the RA and two watercolours 'In an Orchard' and 'Elm Trees, near Goring' at SS. Address in York.

MIDFORTH, Charles Henry fl.1884-1891
Exhib. five works including 'Pigeons', 'Evening Silence' and 'The Morning Bath' at the RA, and one work at SS. London address.

MIDGLEY, J.H. fl.1880
Exhib. a landscape in 1880. Address in Surbiton, near London.

MIDGLEY, William RBSA ARCA fl.1899-d.1933
Painted portraits, landscapes and coastal views. Exhib. a painting entitled 'Kiss Me Quick' at the RA. Address in Birmingham.

***MIDWOOD, William Henry fl.1867-1871**
Little known genre painter, working in London in the 1860s and 1870s. Although Midwood's work appears quite often on the art market, he only appears to have exhib. two works at SS between 1867 and 1871. His subjects are domestic scenes, sometimes humorous.

Bibl: Wood, Paradise Lost.

MILBANKE, Mark Richard 1875-1927
Painted portraits. Exhib. seven portraits, including that of the Master of the Essex Staghounds at the RA. Also exhib. RHA, RWA and in Liverpool. Lived in London.

Bibl: The Tatler No. 442 15 December 1909; The Year's Art 1928 p.360.

MILDMAY, C. St. John fl.1880
Exhib. two watercolour views of Venice at SS. London address.

MILDMAY, Walter St. John fl.1899
Exhib. a work entitled 'Who's Coming?' at the RA. Address in Compton, Surrey.

MILEHAM, Harry Robert NSA 1873-1957
Painted biblical and historical subjects. Studied at Lambeth Art School and at the RA schools. Exhib. five works at the RA 1896-1935, including 'The Finding of Moses' and 'Rachel by the Well'. Member of the Art Workers' Guild. Painted a series of pictures of the life of King Alfred, as well as subjects from Chaucer and Shakespeare. Painted a number of altarpieces for churches and also designed stained glass. Address in Hove, Sussex.

MILES, Mrs. fl.1860
Is supposed to have exhib. a figurative subject at SS. London address.

MILES, Miss Annie Stewart fl.1888-1894
Painted flowers. Exhib. five works at the RA including 'A Student's Lunch' and 'Yellow and White Poppies' and two works at SS. London address.

MILES, Arthur fl.1851-1880
Painter of portraits and genre, who exhib. 1851-80, at the RA 1851-72, BI and SS (77 works). Titles at the RA mostly include portraits (some in chalk) and also 'The Lost Kitten' and 'Trying his First Composition'. One of his portraits is in the NPG.

Bibl: NPG Illustrated List 1928.

MILES, C. fl.1838-1843
Exhib. two works including a view of the Erechtheum at the RA. London address.

MILES, G. Frank (George Francis) 1852-1891
Portrait, genre and marine painter. Exhib. 1874-87 at RA and GG. Specialised in female portraits. RA titles: 'An Evening on Lough Muck, Connemara', 'Sea-Dreams', 'Sweet Doing Nothing', etc.
Bibl: DNB; Bryan; F. Harris, *My Life*, 1926 p.428ff.

MILES, Miss Helen Jane Arundel b.c.1840 fl.1861-1878
Painted figurative subjects and landscapes. Exhib. 11 works including some watercolours at SS, including a scene from *Hamlet*, 'The Fisherman' and 'The Two Peacocks of Bedfont'. London address.

MILES, Leonidas Clint fl.1860-1883
Landscape and architectural painter. Exhib. 1858-83 at SS, BI and RA. Titles at RA views of London, e.g. 'Charing Cross from Trafalgar Square' and landscapes, e.g. 'Moonrise', etc.

MILES, T.G.H. fl.1874-1881
Painted landscapes and flowers. Exhib. 11 works at SS including 'Cornfield', 'A Back-water on the Thames' and 'Primulas'. London address.

***MILES, Thomas Rose fl.1869-1888**
Painter of landscapes and coastal scenes. Exhib. at RA 1877-88, and SS. Titles at RA 'Peel Harbour, Isle of Man', 'Daybreak during a Gale', 'Launch of the Lifeboat', etc.
Bibl: Brook-Hart pls.6a, 44.

MILES, W. fl.1841
Exhib. a work entitled 'A Yeomanry Charger' at the BI. Address near Exeter, Devon.

MILL, J. fl.1855
Exhib. a work entitled 'A Sunny Evening' at the BI. Address in Bath, Somerset.

***MILLAIS, Sir John Everett, Bt. PRA HRI HRCA 1829-1896**
Painter, watercolourist and illustrator. Came to London from Jersey with his parents in 1837. Entered Sass's School 1838; RA schools 1840. Exhib. his first work at the RA in 1846 at the age of 16. Won several prizes, including the Gold Medal for historical painting in 1847. While at the RA schools formed a lasting friendship with Holman Hunt (q.v.). Together with Hunt and D.G. Rossetti (q.v.) he founded the Pre-Raphaelite Brotherhood in 1848-9. By far the most accomplished painter of the Brotherhood, he produced most of its memorable masterpieces, such as 'Lorenzo and Isabella', 'Christ in the House of his Parents', 'Ophelia', 'Mariana', 'The Blind Girl', etc. His work was reviled by the critics, until Ruskin came to the rescue in 1851. In 1853 he was elected ARA, effectively dissolving the PRB. In the same year he went on the ill-fated trip to Scotland with John and Effie Ruskin, who he was to marry in 1855. About this time, he began to turn away from Pre-Raphaelite ideas, towards a more popular style. 'The Black Brunswicker' of 1860 marks a new departure in this direction. From then on he produced a succession of popular works which earned him greater success than any other English painter. Typical works of this period are 'Bubbles', 'Cherry Ripe', 'The North-West Passage', 'The Boyhood of Raleigh', 'Yeoman of the Guard', etc. He also became a fashionable society portrait painter, numbering Gladstone, Tennyson and Carlyle among his many famous sitters. By the 1880s his income was estimated at £30,000 a year. He also produced many fine illustrations for magazines such as *Good Words, Once a Week*, etc., and many books. Exhib. at RA 1846-96, BI, NWS, GG and NG and elsewhere. RA 1863. In 1885 he became the first English artist to be made a Baronet. PRA 1896, but died a few months later. Although his late work is regarded by most critics as inferior to his great Pre-Raphaelite pictures, perhaps Ruskin's judgement was more just . . . "whether he is good one year, or bad, he is always the most powerful of them all." Exhibitions of his work were held at the RA in 1898 and 1967. After his death three sales were held at Christie's, of his own work, engravings after them, and his private collection, on 1 May 1897, 21 March 1898 and 2 July 1898.
Bibl: Main Biographies: J.G. Millais, *Life and Letters of J.E.M.*, 1899; A.L. Baldry, *Sir J.E.M.*, 1899; J.E. Reid, *Sir J.E.M.*, 1909; G. Millais, *Sir J.E.M.*, 1979. Other references: Bryan; Binyon; Cundall; DNB; VAM; Bate; Ironside & Gere; Fredeman (for full bibliog.); Reynolds, VP pp.62-4 *et passim* (pls.40, 42); Mary Lutyens, *Millais and the Ruskins*, 1967; Cat. of the Millais exhib., RA 1967; Hardie III pp.124-5 (pls.144-6); Maas pp.127-8 *et passim* (pls. pp.125, 126, 128, 139, 149, 212, 214); Ormond; Irwin; Wood, Panorama; M. Lutyens, *Millais' Portrait of Ruskin*, Apollo April 1967; Strong; Wood, Pre-Raphaelites.

MILLAIS, John Guille 1865-1931
Painted animals and birds. Travelled very widely and published many natural history books. Lived at Horsham, Sussex. He was the fourth son of Sir J.E. Millais (q.v.).
Bibl: Who's Who; Sketchley, *English Book Illustrators of Today* 1903.

MILLAIS, William Henry 1828-1899
Landscape painter and watercolourist; brother of Sir J.E. Millais (q.v.). Exhib. 1853-92 at RA, NWS and elsewhere. Titles at RA 'Beddington Park, Surrey', 'Sea View, Isle of Wight', 'Bamburgh Castle', etc. He and John are known to have collaborated on a few pictures, mostly in the 1850s. William Henry lacked both the talent and energy of his brother, and his reputation has been unfairly eclipsed by the other's fame.
Bibl: Bryan; Newall; for further references see under J.E. Millais.

MILLAR, James H.C. fl.1884-1903
Painted coastal scenes and subjects. Exhib. five works at the RA including 'A Weather-Worn Coast — That Mighty Surge that Ebbs and Swells, *Scott*' and 'The Otter's Haunt; a Rock Study'. London address.

MILLARD, Charles S. fl.1866-1889
Exhib. two watercolours of Scottish landscapes at SS. Also exhib. three works at the NWS. London address. Represented in the VAM.
Bibl: VAM Cat.; Hardie III.

MILLARD, Miss E. fl.1893
Exhib. a work entitled 'Tomb of the Founder, St. Bartholomew's' at SS. London address.

MILLARD, Fred RBA b.1857 fl.1893
Genre painter. Lived at Newlyn, Cornwall; presumably associated with the Newlyn school. Exhib. mainly at SS, also RA 1885-8 and elsewhere. Titles at RA 'The Convalescent', 'Bad News', 'Walls Have Ears'.

MILLARD, Walter J.N. **fl.1881-1904**
Painted views of buildings. Exhib. nine works at the RA 1881-1904, including 'Ponte di Castello Vecchio, Verona' and 'An Artist's Home'. London address.

MILLER, Alexander G. **fl.1895**
Exhib. a work entitled 'Shifting Sand and Stable Rock' at the RA. London address.

MILLER, Miss Alice **fl.1884-1896**
Painted country subjects. Exhib. seven works at SS including 'A Village Common' and 'Mud Banks'. London address.

MILLER, Charles S. **fl.1883-1891**
Painted rivers and coastal views. Exhib. seven works at the RA including 'Off the Essex Coast', 'Looking Up the Medway' and 'Lulworth Cove, Dorset'. Exhib. 15 works at SS. London address.
Bibl: Brook-Hart.

MILLER, E.J. **fl.1891**
Exhib. a landscape at the NWS. London address.

MILLER, Frederick **fl.1880-1892**
Exhib. a work entitled 'The St. Vincent, Portsmouth Harbour' at the RA. Address in Brighton, Sussex.

MILLER, George **fl.1827-1853**
Exhib. two works 'The Fall of the Angels' and 'Old Mill at Jersey' at SS. Address in Bath, Somerset.

MILLER, George W. **fl.1890-1896**
Painted flowers. Exhib. five works including 'Tulips and Narcissus' and 'Coal Barges at Sandwich' at SS, and two works at the RA. Address in Chislehurst.

MILLER, Harrison **fl.1891-1892**
Exhib. two works including 'The Milkman and the Maid' at the RA, and three works including 'Cat and Dog Life' and 'The Ferry in Flood-time' at SS. Address in Abingdon, Berkshire.

MILLER, Miss Henrietta **fl.1884-1889**
Exhib. two works, paintings of daffodils and narcissi, at the RA, and two watercolours of chrysanthemums at SS. Also exhib. two works at the NWS and one work at the GG. She was a member of the Society of Lady Artists.

MILLER, J. **fl.1846-1864**
Painted portraits and figurative subjects. Exhib. four portraits at the RA, three works including 'A Jester' and 'Isabel' at the BI, and two works at SS. London address.

MILLER, John **fl.1876-1890**
Exhib. three works including 'Summer time on the Ayrshire Coast' and 'The Lobster-fishers' at the RA. Address in Glasgow.

MILLER, John Douglas **fl.1869-1903**
An engraver who also exhib. watercolours at SS. Exhib. eight watercolours at SS including 'Oranges', 'Doves and Mopsy'. London address.
Bibl: BM Cat. of Engraved British Portraits.

MILLER, Mrs. Mary **fl.1896**
Exhib. a portrait at the RA. London address.

MILLER, Philip Homan **ARHA** **fl.1877 d.1928**
Irish painter of genre, portraits and literary subjects, who exhib. 1877-1903, at the RA 1879-1903, SS and elsewhere. Titles at the RA include 'A Punjab Water-bottle', 'The Old Armchair' and 'Mariana in the Moated Grange', 1903. He became ARHA in 1890. Sophia Miller (q.v.) was his wife.
Bibl: Strickland.

MILLER, Miss Sarah Alice **fl.1880-1888**
Painted country subjects. Exhib. eight works at SS including 'May — Breath and Bloom of Spring', 'A Household God' and 'The Poppy Field'. Address in Bishop's Stortford, Hertfordshire.

MILLER, Sophia **fl.1892-1894**
Painted flowers. Exhib. five works including 'Pansies', 'Primulas' and 'Christmas Roses' at the RA. She was the wife of Philip Homan Miller (q.v.). London address.

MILLER, T. Harrison **fl.1889-1891**
Exhib. three works in 1889-91. Address in Abingdon, Berkshire.

MILLER, W. **fl.1837-1838**
Exhib. two nature studies at the RA. London address.

MILLER, Mrs. W.E. **fl.1883-1893**
(Miss Mary Backhouse)
Exhib. four paintings of girls at the RA. She was the wife of William E. Miller (q.v.). London address. See also Miss Mary Backhouse.

MILLER, W.H. **fl.1836-1851**
Painted coastal scenes. Exhib. ten works at SS including 'Off Sheerness', 'Folkestone Pier' and 'Aldborough, Suffolk'. London address.

MILLER, William **1796-1882**
Engraver and watercolourist, who lived at Millerfield, near Edinburgh. An honorary member of the RSA. Examples are in Glasgow AG.

MILLER, William Edwards **fl.1873-1903**
London portrait painter. Exhib. 1873-1903 at RA, SS and elsewhere. Painted occasional figure subjects, e.g. 'A Little Royalist', 'A Girl's Head', etc. His wife Mrs. W.E. Miller (q.v.) was also a painter.
Bibl: Poole III 1925; Ormond.

MILLER, William G. **fl.1892-1901**
Exhib. three works, 'An Anxious Moment', 'Shy', and 'In the Autumn', at the RA. London address.

MILLET, Francis David **1846-1912**
American painter of genre, portraits and frescoes; also illustrator, medallist and travel writer. Pupil of J. van Lerius and N. de Keyser in Antwerp. Although American, he worked and exhib. frequently in London. Exhib. at RA from 1879, NG and elsewhere. Subjects mostly interiors with figures in vaguely historical costume. 'Between Two Fires', RA 1892, was bought by the Chantrey Bequest. Died in the sinking of the *Titanic*.
Bibl: AJ 1893 p.27; Clement & Hutton; M. Fielding, *Dictionary of American Painting*, 1926; Who's Who in America VI 1910-11; American Art Annual X 1913 p.79 (obit.); C.H. Caffin, *Story of American Painting*, 1905; S. Isham, *American Painting*, 1905.

MILLICHAP, G.T. fl.1845-1846
Exhib. a scene from Shakespeare's *The Tempest* at the RA and a work illustrating a line from Spencer at SS. London address.

MILLINGTON, James Heath 1799-1872
Irish portrait painter and miniaturist. Born in Cork. Lived mostly in Cork and Dublin. Exhib. at RA 1831-70, BI and SS. Painted some figure subjects, e.g. 'The Choice of Hercules', 'A Study of Moonlight', 'A Magdalene', etc. Was for a short time Curator of the School of Painting at the RA.
Bibl: Strickland; Redgrave, Dict.; DNB; Ormond.

***MILLNER, William Edward** 1849-1895
Genre and animal painter. Lived and worked all his life in Gainsborough, Lincolnshire. His father William (1818-70) was also a local artist and teacher. Exhib. at RA 1869-96, BI and SS. Titles at RA mostly rustic genre, e.g. 'Labourers', 'Unyoking', 'Ploughing — Lincolnshire'. He also painted animals, especially horses. A number of his pictures can be seen in the Gainsborough Old Hall Museum. 'A Wayside Gossip' signed and dated 1873, is in the Tate Gallery.
Bibl: Wood, Paradise Lost.

MILLONS, Captain Thomas b.1859
Painted marines and architectural subjects. Exhib. in London and Australia.

MILLS, Arthur W. fl.1899
Exhib. a work entitled 'So Near and Yet So Far' at the RA. London address.

MILLS, Miss E. fl.1875
Exhib. a view of the Foco Valley, S. Remo at the RA. London address. She was a member of the Society of Lady Artists.

MILLS, Edward fl.1890-1899
Painted Middle Eastern subjects. Exhib. four works at the RA including 'The Lebanon, with Goats' and a scene in Cairo. London address.

MILLS, Fred. C. fl.1884-1891
Exhib. two works, a portrait and a painting of a boy's head at the RA. London address.

MILLS, John fl.1801-1837
Painted figurative subjects. Exhib. six works at the RA 1801-31, and five works at the BI 1828-37, the last of these entitled 'Welsh Cottage'. London address.
Bibl: BM Cat. of Engraved British Portraits VI.

MILLS, Miss Louie fl.1889
Exhib. a moonlit scene at the NWS. London address.

MILLS, S.F. fl.1858-1882
Painter of genre, landscape, interiors and architectural subjects. Exhib. 1858-82, at the RA 1858-80, SS and elsewhere, titles at the RA including 'A Centenarian', 'Lighting Up', 'Granny's Lesson', and 'Mending Nets'. For some time he was a master at the Metropolitan School of Art, Spitalfields. Three of his watercolours are in the VAM.
Bibl: VAM.

MILLS, T.F. fl.1867
Exhib. a work entitled 'In the Suds' at the BI. London address.

MILLS, William fl.1883-1888
Painted landscape. Exhib. two works 'A Quarry Pool' and 'A September Afternoon' at the RA, and two works at SS. Address in Birmingham.

MILLSON, Frederick fl.1885-1888
Exhib. two works 'A Winter Morning' and 'Lion Brewery' at SS, and one work at the RA. London address.

MILNE, Ada E. fl.1879-1882
Exhib. a watercolour 'On the Thames' at SS. London address.

MILNE, H.D. fl.1875-1881
Painted still-lifes. Exhib. four works, incorporating birds' nests, fruit and flowers, at SS. Address in Crayford, Kent.

MILNE, Joseph 1861-1911
Painted landscape. Exhib. six works, including 'Tay Backwater', 'Crossing the Moor' and 'Twixt the Gloaming and the Mirk', at the RA. Address in Edinburgh.
Bibl: The Year's Art 1916 p.426.

MILNE, William 1873-1951
Painted landscapes in watercolour. Studied under Robert Ventress, the Newcastle painter and frame-maker. He was a part-time painter who lived and exhib. in the north-east.
Bibl: Hall.

MILNER, Miss Elizabeth Eleanor fl.1887-d.1953
Painted animals and birds. Also a portrait engraver. Studied at Lambeth School of Art, at the St. John's Wood Art School, at the RA Schools and at Bushey. Exhib. six works at the RA, including 'Finches', 'Tits' and 'Sacrificed to Art', and engravings after works by Landseer. Born at Stockton-upon-Tees, Durham. Lived at Bushey, Hertfordshire.

MILNER, Frederick RBC RWA fl.1887-d.1939
Painted rivers and coasts. Studied at Wakefield and Doncaster Art Schools. Exhib. 12 works at the RA, 1892-1903, including 'Low Tide on the Bar', 'The Pool Below the Hatch' and 'On the Great Ouse'. Addresses in Cheltenham, Gloucestershire and St. Ives, Cornwall.

MILNER-KITE, J. fl.1884-1892
Painted Mediterranean subjects. Exhib. seven works at SS, including 'After the Day's Work: Donkeys, Tangier' and 'A Spanish Patio'. Studied and lived in Paris.

MILNES, Miss Annie fl.1892-1893
Exhib. a work entitled 'One of These Little Ones' at the RA. Address in Bradford, Yorkshire.

MILNES, William Henry RBA ARE 1865-1957
Painted landscape and buildings. Studied in Antwerp and at the RCA. Exhib. six works at the RA, 1898-1902, including 'Approach to a Yorkshire Village' and 'A Norfolk Bridge'. Taught at Walthamstow and Coventry schools of art. Born at Wakefield, Yorkshire. Lived near Colchester, Essex.

MILO, T. fl.1842
Exhib. a portrait in 1842. London address.

MILSTED, Frisby fl.1896
Exhib. a work entitled 'Love's Prisoner' at the RA. London address.

MILWARD, Miss Clementina fl.1893
Exhib. a landscape in 1893. London address.

MILWARD, Mary fl.1879-1880
Exhib. a watercolour 'Deep in the Wood' at SS. Address in Farnham, Surrey.

MINASI, James Anthony 1776-1865
Painted and engraved portraits. Exhib. 17 works at the RA, mostly portraits including one of 'Master Minasi — Artist to the King of Naples'. London address.
Bibl: Hind, *A Short History of Engraving,* 1911; BM Cat. of Engraved British Portraits; Print Collector's Quarterly XIV 1927 p.240.

MINCHIN, Hamilton fl.1882-1883
Exhib. a still-life at SS. London address.

MINNS, Miss Fanny M. fl.1890
Exhib. two paintings of flowers at SS. Address in Newport, Isle of Wight. For works illustrated by, see VAM Card Cat.

MINÔT, Edwin (or Edward) fl.1864-1875
Painted landscape and still-lifes. Exhib. five works at SS, including 'Near Sandown, Isle of Wight' and 'The Woods at Highgate', and three works at the BI, including 'Eggs and Bacon'. London address.

MINS, C. fl.1833-1840
Painted marines, coastal views and landscapes around London. Exhib. four works at the RA; ten works at SS, including 'Distant View of Highgate Tunnel', and five works at the BI, including 'A Distant View of Calais' and 'Boulogne sur Mer'. London address.
Bibl: Brook-Hart.

MINSHALL, Miss M.W. fl.1886
Exhib. a landscape at the NWS. Address in Oswestry, Salop.

MINSHULL, R.T. fl.1866-1885
Liverpool genre painter. Exhib. at RA 1874-85, SS and elsewhere. Titles at RA mostly of children: 'Baby's New Frock', 'Nursing Dolly', etc. and occasional landscapes, 'The Hay Harvest', etc.

MITAN, Miss A. fl.1840-1842
Exhib. a landscape at the BI and four works, including views in Surrey and Kent, at SS. London address.

MITAN, Samuel 1786-1843
Exhib. a watercolour showing the storming of Seringapatam in the East Indies at SS. London address. His brother James was an artist.
Bibl: Redgrave, Dict.; DNB.

MITCHELL, Alfred fl.1894-1904
Painted marines. Exhib. five works at the RA including 'Lion Head and Old Lizard Head' and 'Atlantic Swell, Scilly'. Address in Plymouth, Devon.
Bibl: Brook-Hart.

MITCHELL, Arnold Bidlake fl.1885-1904
An architect who exhib. views of buildings. Exhib. 45 works at the RA 1885-1904, including 'The Western Front, Wells Cathedral' 'The Nave, Châlons-sur-Marne' and 'Selby Abbey, from S.E.'. London address.

MITCHELL, Arthur Croft b.1872
Painted landscape and figurative subjects. Studied at the Slade School. London address.

MITCHELL, Charles William fl.1876-1893
Newcastle genre painter. Exhib. at RA 1876-89, GG and NG. Titles at RA portraits and some genre, e.g. 'A Duet', 'Egyptian Dancing Girl', 'Avide', etc. Works by him are in the Laing AG, Newcastle. His family were Newcastle engineers and shipbuilders, and lived at Pallinsburn, Northumberland .
Bibl: Hall.

MITCHELL, E. fl.1852
Painted rivers and landscape. Exhib. three works at the RA, including a view on the River Ouse; four works at SS, including views on the Rivers Lodden and Thames, and two works at the BI. London address.

MITCHELL, Miss Emily fl.1872-1892
Exhib. five works at SS, including 'The Departure' and 'A Tiny Londoner', and a work at the RA. London address.

MITCHELL, Ernest Gabriel RBSA b.1859
Painted landscape. Exhib. with the RBSA from 1879. Born near Birmingham. Lived at Hockley Heath, Warwickshire.

MITCHELL, J. Edgar 1871-1922
Painted landscape and figurative subjects. Lived and worked in Newcastle-upon-Tyne.
Bibl: Hall.

MITCHELL, Mrs. James B. fl.1879-1887
Exhib. two paintings of flowers at the RA. Also exhib. seven works at the GG. London address.

MITCHELL, James B. fl.1883
Exhib. a portrait at the NWS. London address.

MITCHELL, John Campbell RSA 1865-1922
Painted landscape and marines. Exhib. four works, including views on the River Dee near Aberdeen and a view near Balmoral, at the RA 1884-1904. Also exhib. at the RSA. Born in Argyll. Lived in Midlothian.
Bibl: Studio XXXII 1904 p.166; XLIX 1910 p.229; LXXX 1920 p.l9; AJ 1904 pp.284, 300; Caw; Connoisseur LXII 1922 p.241ff.; LXVII 1923 p.120; The Year's Art 1923 p.339; Westminster Gazette 21 April 1910.

MITCHELL, Miss M.D. fl.1876-1882
Exhib. paintings of chrysanthemums, primroses and violets at SS. London address.

MITCHELL, M.L. fl.1870
Exhib. a work entitled 'The Letter' at the RA. London address.

MITCHELL, Percy fl.1886
Exhib. a landscape in 1886. London address.

MITCHELL, Philip RI NWS 1814-1896
Painted marines and landscape. Exhib. 338 works at the NWS. Address in Plymouth, Devon.
Bibl: G. Pycroft, *Art in Devonshire,* 1883; Cundall.

MITCHELL, Tom fl.1888
Exhib. a landscape in 1888. Address in Bradford, Yorkshire.

MITCHELL, William Frederick c.1845-1914
Portsmouth ship painter; mainly used watercolour. Painted ships which visited Portsmouth, mainly on commission for naval officers. Numbered all his works, up to about 3,500.
Bibl: Brook-Hart pls.53a, 53b.

MOBERLY, Alfred fl.c.1887-1905
Painted landscape, rivers and flowers. Exhib. a painting of flowers in 1882. Address in Hythe, Kent.

MOBERLY, Mrs. H.G. (Mariquita J.) RI BWS NSA fl.1855-1903
Painted figurative subjects, animals and landscape. Studied art in Germany and under Carolus-Duran in Paris. Exhib. 15 works at the RA 1885-1903, including 'A Maiden of the Primrose League' and 'Nut-brown Hair'. Also exhib. five works at SS, and eight works at the NWS. Born at Deptford, Wiltshire. Lived at Mitcham, Surrey.

MOCATTA, D. fl.1831-1847
Painted views of buildings. Exhib. 13 works at the RA, 1831-47, including views of buildings on the Roman Forum, Rome and of buildings in London. London address.

MOCATTA, Miss L. fl.1889
Exhib. a painting of flowers in 1889. London address.

MOCATTA, Maria fl.1883
Exhib. a genre subject in 1883. London address.

MOCATTA, Rebecca fl.1882-1890
Exhib. two works, 'Polly' and 'A Sketch from Life' at SS. London address.

MOFFAT, Arthur Elwell fl.1886-1890
Painted landscape. Exhib. three works, including 'The Dee at Banchory near Aberdeen' and 'At Gullane', at the RA, and three works at the NWS. Address in Edinburgh.

MOGFORD, Henry fl.1837-1846
Painted views of buildings. Exhib. five watercolours at SS, including 'Remains of the Chateau of Plessis-les-Tours at Tours, France'. Exhib. four works at the RA, including views in Tours and Orleans. London address.

***MOGFORD, John RI 1821-1885**
Painter and watercolourist of coastal scenes. Born in London, of a Devonshire family. Studied at Government School of Design at Somerset House. Married a daughter of Francis Danby (q.v.). Exhib. at RA 1846-81, BI, SS, NWS (292 works), GG and elsewhere. Associate of RI 1866, member 1867. Specialised in painting rocks and cliffs; his work is sometimes similar in feeling to that of John Brett (q.v.). His studio sale was held at Christie's, 25 February 1886.
Bibl: AJ 1885 p.382; Bryan; Cundall; DNB; VAM; Hardie III p.81 (pl.102); Brook-Hart.

MOGFORD, Thomas 1800-1868
Exeter portrait, genre and landscape painter. Exhib. at RA 1838-54, BI and SS. Genre titles mostly country scenes, e.g. 'Rustic Boy', 'The Love Letter', etc. Was well-known in Devonshire as a portrait painter. Also painted some highly detailed Pre-Raphaelite landscapes, mostly views in his native county. The obituary of the

Art *Journal* states that although his early promise was not fulfilled, he left a small number of works which "for exquisite feeling in execution and truthfulness of effect, have rarely been equalled".
Bibl: AJ 1868 p.158; G. Pycroft, *Art in Devonshire*, Exeter 1883; Ormond.

MOIR, Ellen fl.1871-1881
Exhib. two paintings of animals 1871-81. Address in Edinburgh.

MOIRA, Gerald Edward PROI VPRWS RWA NPS 1867-1959
Painted landscape, portraits and figurative subjects. He was also a decorator. Studied at the RA Schools and in Paris. Later taught art in Edinburgh. Exhib. 14 works at the RA including portraits and 'Victory', 'The King's Daughter' and a work illustrating a line from D.G. Rossetti. Born in London. Lived in Middlesex. His paintings are in a late, romantic Pre-Raphaelite style, like those of F. Cadogan Cowper and J. Byam Shaw (qq.v.).
Bibl: Bate; Studio XII 1898 pp.223-38; XXII p.197; XL pp.24-34; XLI pp.32, 44; XLIX p.49; LX pp.222-5; LXXXV p.269; AJ 1900 pp.331-6; 1907 pp.93-6; H. Watkins, *The Art of Gerald M.*, 1923; Who's Who; further bibl. in TB.
Exhib: London, Little Art Rooms 1923.

MOISAND, Maurice fl.1894-1896
Exhib. four works at the RA, including 'En Visite' and 'Friends at Tea'. Address in Paris.

MOLE, Miss Clara fl.1886-1887
Exhib. three paintings of birds at the NWS. London address.

***MOLE, John Henry VPRI 1814-1886**
Landscape painter and watercolourist. Born in Alnwick, Northumberland. Worked as a clerk in solicitor's office in Newcastle, but gave it up for miniature painting. He exhib. miniatures at the RA 1845, 1846, 1879. Later he turned to landscape, particularly in watercolour, and exhib. at NWS (679 works), BI, SS, GG and elsewhere. Associate of the RI, member 1848, and Vice-President 1884. His studio sale was held at Christie's, 1 February 1887.
Bibl: AJ 1859 p.175; 1887 p.63; Bryan; Cundall; Laing AG Newcastle, Cat. of Permanent Collection of Watercolour Drawings, 1939; Hall.

MOLINEUX, E. fl.1874
Exhib. a work entitled 'Autumn Gatherings' at SS. London address.

MOLINEUX, M. fl.1888
Exhib. a work entitled 'Harbingers of Spring' at the RA. London address.

MOLLEA, J.F. (or MOLLER, F.) fl.1841-1873
Painted portraits. Exhib. 15 works, including portraits of members of the Danish Royal Family, at the RA. He was a member of the Danish Royal Academy of Fine Arts. London address.

MOLONEY, William fl.1846-1856
Painted portraits in Limerick, Ireland.
Bibl: Strickland.

MOLONY, C. fl.1870
Exhib. three works, including 'Juana — A Spanish Gipsy', at SS. London address.

MOLROY, F. fl.1853
Exhib. a work entitled 'The Dangerous Guide' at the BI. London address.

MOLTINO, Francis fl.1847-1867
Painter of coastal scenes, who exhib. 1847-67, at the RA. 1848-55, BI and SS; titles at the RA including 'Early Morning, Waiting for the Tide', 1850, 'View of the Thames, Battersea Old Mill', 1851 and 'Morning on Burgh Flats', 1853.
Bibl: Brook-Hart.

MOLYNEUX, Edward fl.1899-1904
Painted Himalayan landscape. Exhib. six works at the RA, 1899-1904, including 'A Himalayan Glacier' and 'A Kashmir Glen'. London address.

MONCLAR, Count Ripert fl.1837
Made a portrait drawing of Robert Browning.
Bibl: Ormond.

MONCRIEFF, Colonel Alexander fl.1883
Exhib. a landscape at the NWS. London address.

MONGER, J. fl.1832-1845
Painted still-lifes. Exhib. seven paintings of dead game. London address.

MONGRÈDIEN, Miss J. fl.1887
Exhib. a painting of heads in 1887. London address.

MONK, William RE 1863-1937
Painted landscape and architecture. Also an etcher. Exhib. 17 works at the RA 1894-1904, including numerous views in Hampstead. Studied at Antwerp. Later worked in Venice and New York. London address.
Bibl: AJ 1903 pp.321-26; 1905 p.158; 1906 p.38: Studio XXXIV 1905 pp.31-7; LXIII 1914 p.247ff.; further bibl. in TB.
Exhib: London, Walker's Gallery 1938.

MONKHOUSE, Cosmo (William C.) 1840-1901
Writer on art and amateur painter.
Bibl: Bryan III; AJ 1902 p.72.

MONKHOUSE, Miss Mary F. fl.1884-1891
Exhib. two works, 'Boy's Head' and 'The Blackberry Gatherers', at the RA. Address in Manchester.

MONKSWELL, Lord see COLLIER, The Rt. Hon. Sir Robert

MONRO, A.B. fl.1842-1847
Exhib. two works, 'Coast Scene — A Stormy Afternoon' and 'Lochgrange Castle, Arran', at the RA. Address in Edinburgh.

MONRO, C.C. fl.1872-1885
Exhib. 'A Bit of Common' at the RA, and a watercolour, 'A View of Eastbourne: Hastings in the Distance', at SS. London address.

MONRO, Charles C. Binning fl.1874-1890
Painted marines and landscapes. Exhib. ten works at the RA including 'The Silent Tide', 'Moorland Pastures' and 'A Wet Day on the East Coast'. London address.
Bibl: Brook-Hart.

MONRO, J.C. fl.1866-d.1889
Painted figurative and rustic subjects. Exhib. five works, including 'The Day of Rest' and 'Limpet Gatherers',at the RA. Also exhib. 12 works at SS, including 'Weary', 'Truant' and 'A Highland Funeral'. London address.
Bibl: The Year's Art 1890 p.229.

MONTAGU, Miss Ellen fl.1888
Exhib. a work entitled 'Maria' at the RA. London address.

MONTAGUE, Mrs. fl.1871
Exhib. a still-life in 1871. London address.

***MONTAGUE, Alfred fl.1836-1870 d.1883**
Painter of landscapes, town views and coastal scenes. Exhib. at RA 1836-70, BI, SS (156 works) and elsewhere. Painted landscapes and coastal scenes in England, Holland and France His town views in northern France and Belgium are similar to those of Henry (Henri) Schafer (q.v.).
Bibl: Brook-Hart pls.27, 156.

MONTAGUE, Alice L. fl.1869
Exhib. two paintings of flowers in 1869. Address in Dover, Kent.

MONTAGUE, Arthur fl.1872-1875
Painted landscape. Exhib. five works at SS including 'Pope's Villa on the Thames' and 'Clover-field at Chertsey'. Address near Reading, Berkshire.
Bibl: Brook-Hart.

MONTAGUE, Clifford fl.1883-1900
Birmingham painter of landscapes and coastal scenes. Exhib. in Birmingham from 1887, including English and French subjects.

MONTAGUE, Miss Ellen fl.1837-1849
Painted landscape and rustic subjects. Exhib. five works, including 'The Water-Cress Girl' and 'The Gleaner', at SS, and a landscape at the RA. Addresses in London and Windsor, Berkshire.

MONTAGUE, H. fl.1806-1861
Palnted figurative subjects. Exhib. 12 works at the BI including 'Looking at the Procession', 'Hope Deferred' and the 'Bride of Lammamoor'. Also exhib. eight works at the RA and nine at SS. London address.

MONTAGUE, H. Irving fl.1873-1883
Painted townscapes and scenes from the Russo-Turkish War. Exhib. nine works at SS including 'Old Street, Dinan' and 'A Turkish Reconaissance near Plevna'. London address.

MONTAIGNE, William John fl.1839-1889 d.1902
Painter of historical subjects, portraits, landscapes, and some coastal scenes of Southwold and Porthleven. Pupil of the RA Schools at the same time as Millais. Exhib. 1839-89, at the RA 1841-89, BI, SS and elsewhere, titles at the RA including 'Portrait of a Lady', 'How Queen Elizabeth Passed her Last Days', 'Farm Buildings at Ewelme, Oxon' and 'Jacobite Prisoners'.
Bibl: Bryan; Wilson.

MONTALBA, A.R. fl.1884
Exhib. two works, 'A Tomb in Italy' and a work illustrating a line from Byron, at the BI. Also exhib. landscapes at the RA and SS. London address.

MONTALBA, Anthony fl.1875-1881
Exhib. three works, 'Castle Gandolfo, Summer Residence of the Pope', 'Near Venice' and 'Fusina', at the RA. London address.

***MONTALBA, Miss Clara RWS 1842-1929**
Landscape, topographical and marine painter, principally of Venetian subjects. Sister of Ellen and Hilda, painters (qq.v.) and of Henrietta, sculptor. Born in Cheltenham; studied for four years in

Paris under Eugène Isabey. Travelled in France and especially Normandy. However, she felt most at home in Venice and lived there for many years, her principal works being paintings, in oil and watercolour, of interiors and exteriors of churches, shipping and views in Venice. Exhib. from 1866 at the RA, BI, SS, OWS (86 works), GG, NG and elsewhere, her more important works at the RA being 'San Marco' 1882, 'King Carnival' 1886, and 'The Port of Amsterdam'. A of OWS 1884; RWS 1892; she also belonged to various continental art institutions including the Accademia di Belle Arti, Venice. The AJ said of her work: " 'Il Guardino Publico' stands foremost among the few redeeming features of the exhibition (OWS). In delicate perception of natural beauty the picture suggests the example of Corot. Like the great Frenchman, Miss Montalba strives to interpret the sadder moods of Nature — when the wind moves the water a little mournfully, and the outlines of the objects become uncertain in the filmy air."

Bibl: AJ January 1874; Clayton II pp.226-7 (Ellen p.258); Clement & Hutton; Portfolio 1882 p.156; Connoisseur LXXXIV 1929 p.263 (obit.); Who Was Who 1929-1940.

MONTALBA, Miss Ellen fl.1868-1902
Painter of portraits, landscape and genre, working in London and Venice. Younger sister of Clara (q.v.). Born in Bath; studied at the South Kensington Schools. Exhib. 1868-1902, at the RA 1872-1902, SS and elsewhere, titles at the RA including 'Spring', 1872, 'H.R.H. the Princess Louise', 1882, and 'A Posy from the Rialto', 1891. She travelled in France a good deal, but, like her sisters, preferred Venice and the scope its subjects gave her splendid colouring. Her life-size portraits were also painted with considerable power. She also occasionally drew illustrations for magazines.

Bibl: See under Clara Montalba.

MONTALBA, Miss Hilda fl.1873-1903 d.1919
Painter of landscape and genre, particularly scenes in Venice. Sister of Clara (q.v.). Exhib. 1873-1903, at the RA from 1876-1903, SS, GG, NG and elsewhere, titles at the RA including 'Early Spring', 1876, and 'Venetian Boy Unloading a Market Boat', 1880. Worked in London and Venice.

MONTALBA, R. fl.1848
Exhib. two rustic subjects at the RA. London address.

MONTBARD, Georges fl.1880-1903
Painted Middle Eastern subjects and landscape. Exhib. six works at SS, including 'In the Park of Longleat' and 'Ploughing in Kaleley', and three works at the RA, including 'The Slipper Bazaar, Cairo' and 'Un Fauconnier au Maroci. London address.

MONTEFIORE, E.B. Stanley fl.1872-1890
Painted figurative and rustic subjects. Exhib. ten works at the RA, including 'Lost Love', 'The Village Smith' and 'War's Alarms'. London address.

MONTFORT, H. fl.1845
Exhib. a work entitled 'The Pirates of the Archipelago' at the RA. London address.

MONTGOMERY, J. fl.1878
Exhib. a landscape in 1878. Address in Richmond, near London.

MONTGOMERY, Robert E.M. fl.1870-1892
Exhib. four works, including 'Summer — Flemish Scenery' and 'A Wavebeaten Rock, North Coast of Ireland', at the RA. Address in Antwerp, Belgium.

MONTGOMERY, Miss V.A. fl. late 19th century
Landscape painter; pupil of J.W. Ferguson and N.E. Green (qq.v.). Exhib. regularly in the late 19th century at the Royal Amateurs' Art Exhibition in London, and in Edinburgh and Perth.

MONTMORENCY, Miss Lily de fl.1898
Exhib. a work entitled 'Spring' at the RA. London address.

MONTROSE, R.F. fl.1871-1872
Exhib. three landscapes, one on Hampstead Heath, at SS, and a work entitled 'Salvator Rosa amongst the Brigands', at the RA. London address.

MOODY, Edward G. fl.1876-1890
Exhib. a work entitled 'The Twins — Epping Forest' at the RA, and 'Margarita' at SS. London address.

*MOODY, Miss Fannie SWA b.1861 fl.1885-1897
(Mrs. Gilbert King)
London animal painter, especially of dogs. Daughter of F.W. Moody (q.v.). Pupil of J.T. Nettleship (q.v.). Exhib. at RA 1888-97, SS and elsewhere. Titles at RA all rather whimsical scenes of animal behaviour, e.g. 'Professional Jealousy', 'A Question of Privilege', etc. She lived at 34, Lupus Street, Pimlico, where she knew Rossetti, Hunt, Stephens, Annie Miller and others. She was a member of the Society of Lady Artists.

Bibl: RA Pictures 1893, 1895; The Artist November 1899 pp.121-30; Diana Holman Hunt, My Grandfather, His Wives and Loves, 1969 p.247.

*MOODY, Francis Wollaston 1824-1886
London genre and portrait painter. Exhib. at RA 1850-77, BI and SS. Instructor in decorative art at the South Kensington Museum (now VAM), where he painted several ceilings and lunettes. He also designed mosaics there and at the Bethnal Green Museum. He lived for a time in Pimlico where he knew Holman Hunt's model, Annie Miller. His best-known picture is 'A Scene in Chelsea Gardens', RA 1858, in which the Chelsea pensioner portrayed is Annie Miller's father.

Bibl: Reynolds, VS pp. 17, 82 (pl.56); Diana Holman Hunt, My Grandfather, His Wives and Loves, 1969 pp.176, 188, 247.

MOODY, Miss Mary fl.1877-1878
Exhib. two works, 'Fruit', and a watercolour, 'Beech Trunks', at SS. London address.

MOON, C.T. fl.1837-1849
Painter of landscapes and coastal scenes in England and Italy, near Sorrento. Exhib. 1837-49 at the RA, BI and SS.

MOON, Henry George 1857-1905
Painted landscape. Exhib. eight watercolours at SS including 'Near High Beech, Essex', 'Sketch at Ponders End, Essex' and 'Sewardstone Green, Essex'. Exhib. nine works at the RA, landscapes in Essex and Hertfordshire, and flowers. Represented in the Glasgow AG. London address.

Bibl: The Daily Chronicle 23 January 1908; The Evening Standard 9 October 1912.

MOON, William H.B. fl.1889
Exhib. a painting of oranges at the RA. Address in Scarborough, Yorkshire.

MOONY, Robert James Enraght RBA 1879-1946
Painted landscape. Studied at the Académie Julian. Exhib. in London and the USA. Born at Athlone, Ireland. Lived at Mount Hawke, Cornwall.

MOORAT, E.S. fl.1876
Exhib. a 'Sunset' at SS in 1876. London address.

MOORE, Miss fl.1859
Exhib. a watercolour at SS. London address.

MOORE, Miss Agnes E.C. fl.1881-1885
Exhib. paintings of flowers at the NWS and the GG. London address.

MOORE, A. Harvey fl.1874-1903 d.1905
Landscape and marine painter, living in Putney and Leigh, Essex, who exhib. 1874-1903, at the RA from 1876-1903, SS, NG and elsewhere. One of his works is in the City AG Manchester: 'The Thames off Yantlett Creek, Kent'.
Bibl: The Year's Art 1906 p.362; Brook-Hart.

MOORE, Mrs. A.Harvey (Florence) fl.1898-1904
Exhib. three works at the RA 1898-1904, including 'Early Morning on a Mediterranean Shore'. She was the wife of A. Harvey Moore (q.v.). Address in Leigh-on-Sea, Essex.

***MOORE, Albert Joseph ARWS 1841-1893**
Neo-classical painter. Son of William Moore (1790-1851) (q.v.), and brother of Henry Moore RA (q.v.). Exhib. at RA 1857-93, SS, OWS, GG, NG and elsewhere. After a brief period of Pre-Raphaelitism, he began to exhibit classical subjects in the 1860s. His later work consists entirely of single Grecian figures, or groups of figures, carefully posed in an elaborate design. His prime interest was not subject-matter, but colour. Whistler admired, and was probably influenced by, Moore's "genuine feeling for the juxtaposition and interrelation of colour" (Reynolds). In his exploration of colour relationships he would often repeat compositions, using different colour schemes. The titles of his pictures reveal his lack of interest in subject or anecdote, e.g. 'Beads', 'Apples', 'The Dreamers', 'A Sofa', etc. As a monogram he used the Greek anthemion, which could be incorporated into the design of his pictures. This may well have given Whistler the idea of using his butterfly monogram. Like Leighton, Moore made careful studies and drawings for every figure in his pictures, first nude, then draped. He also made several colour sketches for each picture, and would sometimes complete these later, which accounts for the existence of many versions of the same composition.
Bibl: AJ 1881 p.160ff.; 1895 p.48ff.; 1903 p.33ff. (A.L. Baldry); 1904 p.143ff.; 1909 p.236; Portfolio 1870 pp.4-6; Studio III 1894 pp.3ff., 46ff.; XXXI 1904 p.345ff.; LXII 1914 p.130ff.; Winter Number 1923/4, British Book Illustration; F. Wedmore, *Studies in English Art*, 1880; A.L. Baldry, *A.M., His Life and Works*, 1894; DNB; Bryan; Reynolds, VP pp.121-2 (pls.82-4); Maas p.187 (pls.pp.186, 187, 203); *Albert Moore and his Contemporaries*, Cat. of exhib., Laing AG, Newcastle, 1972; Wood, Olympian Dreamers; Newall.

MOORE, Alfred J. Howell fl.1899-1904
Exhib. six works, including 'Molly' and 'On the Hill Side', at the RA. Address in Walthamstow, near London.

MOORE, Miss Anne Osborne fl.1889-1890
Exhib. a painting of 'French Peonies' at the RA. London address.

MOORE, Anthony John 1852-1915
Painted and etched marines and river scenes. Born near Sunderland. Worked as a violin maker and painted as an amateur.
Bibl: Hall.

MOORE, Barlow fl.1863-1891
Painted shipping. Exhib. two works at the BI, 'On the Medway; Shrimpers Drying Gear' and 'Thames Barges', and two works at

SS. London address. Was painter to the Royal Thames Yacht Club.
Bibl: Portfolio 1890 pp.5, 10, 33, 112, 114, 117, 234; Brook-Hart pl.211.

MOORE, Bertha fl.1890
Exhib. a painting of sweet peas at SS. London address.

MOORE, Claude T. Stanfield 1853-1901
Painter of landscapes and seascapes. Exhib. a work entitled 'Beating Up Thames' at SS. Represented in the Nottingham AG. Born in Nottingham. He painted river and coastal scenes, especially on the Thames.

MOORE, Edwin 1813-1893
Watercolour painter, mainly of topographical and architectural subjects. Eldest son of William Moore (1790-1851) (q.v.), by his first wife. Born in Birmingham. Studied watercolours under David Cox and Samuel Prout (qq.v.). Exhib. 1855-85, at the RA 1855-73, NWS and elsewhere. Employed for many years as a watercolour teacher at York, especially by the Society of Friends in their schools there, from whom he received a pension after 57 years work. Two of his works are in the Walker AG, Liverpool (Cat. 1927 131).
Bibl: Bryan; DNB.

MOORE, Ernest b.1865 fl.1903
Painted portraits and country subjects. Studied in London and Paris. Exhib. a cottage interior at Fontainebleau at SS. Born in Barnsley, Yorkshire. Lived in London.

MOORE, F. fl.1841
Exhib. a work entitled 'Cornfield, Isle of Wight' at SS. London address.

MOORE, George Belton 1805-1875
Painter of topographical and architectural subjects. Pupil of A.C. Pugin. Exhib. 1830-70, at the RA 1830-59, BI, SS and elsewhere; at the RA chiefly pictures of foreign scenery; and his last work to be hung there was 'Monument of Lord Norris, Westminster Abbey', 1859. For some time he was Drawing Master at the Royal Military Academy, Woolwich, and at University College, London. He published two treatises, *Perspective, its Principles and Practice*, 1850, and *The Principles of Colour applied to Decorative Art*, 1851.
Bibl: AJ 1876 p.47; Redgrave, Dict.; DNB; Hardie III p.13.

MOORE, H. Wilkinson fl.1882-1890
Exhib. views of buildings at the RA, including 'Lincoln College' and 'Somerville Hall'. Address in Oxford.

***MOORE, Henry RA RWS 1831-1895**
Marine painter and watercolourist. Son of William Moore (1790-1851) (q.v.) and elder brother of Albert Joseph Moore (q.v.). Studied under his father; at the York School of Design; and at RA schools. At first painted landscapes and rural scenes, which show Pre-Raphaelite influence, but about 1857 turned to marine painting, for which he is best known. Exhib. at RA 1853-95, BI, SS (174 works), OWS, GG, NG and elsewhere. ARWS 1876, RWS 1880, ARA 1885, RA 1893. Moore has often been described as an imitator of J.C. Hook (q.v.), but although his colours are similar, his paintings of the sea for its own sake are quite different in approach from Hook's coastal scenes with figures. Moore was one of the first painters to try and observe accurately the movement and moods of the sea. In his search for accuracy his technique became more fluid, and his colours more impressionistic. The artist closest to him in

technique and ideas is the Scottish painter, William MacTaggart (q.v.). In the 1880s and 1890s Moore was regarded as one of England's most important artists, and his work was exhib. throughout Europe.

Bibl: AJ 1881 p.160ff.; 1895 pp.280, 282; 1904 p.143ff.; 1905 pp.159, 160; 1908 p.352; 1909 p.92; Portfolio 1887 p.126; 1890 pp.88, 110; Studio Special Number, *British Marine Painting*, 1919 p.15ff.; F. Maclean, *H.M.*, 1905; Bryan; DNB; VAM; Cundall; Reynolds, VP pp.153-4 (pl. 104); Hardie III p.81 (pl.104); Maas pp.67-8 (pl. p.67); Brook-Hart pl.40.

MOORE, J. fl.1853
Exhib. three works, 'A Peep into the Woods', and two watercolours. London address.

MOORE, Miss J. fl.1856
Exhib. a portrait at the RA. London address.

MOORE, J.G. fl.1856
Exhib. a portrait of children at the RA. London address.

MOORE, James Hon. RHA 1819-1883
A Belfast surgeon who exhib. genre subjects and sketches from nature at the RHA.
Bibl: Strickland.

MOORE, James fl.1890
Exhib. a painting of bathers at the RA. Address in Sheffield, Yorkshire.

MOORE, Miss Jennie fl.1877-1900
Painter of domestic genre and scriptural subjects, who exhib. 1877-1900 at the RA, SS, NWS, NG and elsewhere. Titles at the RA 'Delilah' and 'Dreams', 1877, 'Sad Thoughts', 1879, 'Homeless Ragged and Tanned', 1880, and 'Mary, the Mother of Jesus', 1900.

MOORE, John fl.1831-1837
Exhib. three portraits at the RA 1831-7. London address.

MOORE, John, of Ipswich 1820-1902
East Anglian painter of landscapes and coastal scenes. Worked at first in Woodbridge, but moved to Ipswich about 1850. Became a member of the Ipswich Art Club in 1875, and exhib. 332 works there. Painted in the style of Constable and Churchyard in an attractive, but sometimes slightly heavy style. His work is usually signed.
Bibl: H.A.E. Day, *East Anglian Painters*, I pp.171-91 (many illus.); Brook-Hart pl.76.

MOORE, John Collingham 1829-1880
Painter of portraits, landscapes and genre. Born at Gainsborough, the eldest son of William Moore (1790-1851) (q.v.) by his second wife, and brother of Albert, Edwin and Henry (qq.v.). Entered RA schools in 1850, and up to 1857 he was occupied in portrait painting. In 1858 he went to Rome, and painted many views of the Roman Campagna, mostly in watercolour. Many of these were exhib. at the Dudley Gallery, e.g. 'Olive-trees near Tivoli' and 'The Shady Sadness of a Vale', which were simple and poetic in their treatment. In Rome in 1858 he met and became influenced by George H. Mason (q.v.). After 1872 Moore turned his attention chiefly to portraits of children, and often with extreme sublety of colour and childish expression. He exhib. 1852-81, at the RA from 1852-80, BI, Dudley Gallery, GG and elsewhere.
Bibl: AJ 1880 p.348 (obit.); L'Art XXII 1880 p.144; Bryan; DNB; VAM; *The Etruscans*, Cat. of exhib., Stoke-on-Trent AG 1989.

MOORE, John W. fl.1898
Exhib. a work 'At Mont St. Michel' at the RA. Address in Birmingham.

MOORE, Miss Madeleine fl.1887
Exhib. a painting of flowers at the NWS. Address in Eastbourne, Sussex.

MOORE, Miss Madena fl.1879-1881
Exhib. four works, including 'Tired Fingers' and 'O Rare Pale Margaret — Tennyson', at the RA and two works, including a watercolour entitled 'A Quiet Puff' at SS. London address.

MOORE, Morris fl.1843-1844
Painted portraits and figurative subjects. Exhib. seven works at the RA including 'Beatrice' and 'Il Condottiere'. Also exhib. three works at the BI and two at SS. London address. He was living in Perugia, Italy, in 1851.

MOORE, Sidney fl.1879-1900
Landscape painter who exhib. 1879-1900, at the RA from 1883-1900, SS (41 works) and elsewhere. Titles at the RA 'Among the Birches', 1883, 'Coming thro' the Rye', 1889, and 'Near Pulborough', 1900.

MOORE, Thomas Cooper 1827-1901
Self-taught landscape painter. Lived in Nottingham. Father of Claude T.S. Moore (q.v.).

MOORE, W. fl.1830-1856
Exhib. four watercolours including 'Village near the foot of Burnham Hill, near Dunkeld, Perthshire' and 'A Peep up the Gill' at SS. Address in York.

MOORE, William 1790-1851
York portrait painter. Father of Albert Joseph, Edwin, Henry, John Collingham and William Moore, Jnr. (all qq.v.). Painted portraits in oils, watercolours and pastel for local patrons.
Bibl: Bryan; DNB; Hardie III.

MOORE, William, Jnr. 1817-1909
Landscape painter, son of William Moore (1790-1851) (q.v.) of York. Exhib. at RA 1855-6l, NWS and elsewhere. Painted in Yorkshire, the Lake District, Scotland and Switzerland.

MOORE, William J. fl.1885-1892
Exhib. three works at the RA, including 'A Morning Gossip' and 'Elsie'. London, address.

MORAN, John P. d.1901
Studied at the RHA, at South Kensington, in Paris and finally in Rome. Returned to Ireland to teach art.
Bibl: Strickland.

MORAND, Pierre fl.1842
Made portrait drawings of Charles Dickens.
Bibl: Ormond.

MORANT, Charles Harbord fl.1886-1893
Exhib. an interior view of a Swiss kitchen at the RA. London address.

MORBY, Kate fl.1871
Exhib. a painting of flowers in 1871. London address.

MORBY, Walter fl.1875-1889
Painted landscapes. Exhib. 16 works at SS including 'The Beach at Southwold', 'On the Welsh Cliffs' and 'Wayside Pasturage', and two works at the RA. London address.

MORDAUNT, F. b.1801 fl.1845
Painted portraits and genre subjects. Studied at the RA schools. Exhib. 'A Woman Bathing' at the BI, 'The Little Sower' at SS and a study at the RA. London address.

MORDECAI, Joseph b.1851 fl.1873-1899
London painter of portraits, genre and literary subjects. Studied at Heatherley's and at the RA schools. Exhib. 1873-99, at the RA, SS and elsewhere, titles including 'A Nubian', 1873, and 'Day Dreams', 1888. One of his works, in the Leeds City AG, 'The Minstrel's Curse', depicts a King who murdered a minstrel's son, and one is in the Corporation of London AG.
Bibl: Cat. of Leeds City AG 1909; Cat. of Corporation of London AG 1910.

MORELL, D'Arcy fl.1877-1880
Exhib. 'A French Farmstead — Winter' at the RA and 'A Deserted Harbour' at SS. Address in Calais, France.

MORELL, L. fl.1840
Exhib. two landscapes, one Scottish, at SS.

MORELLE, John P. fl.1884-1886
Exhib. a watercolour entitled 'Eye' at SS, and a work entitled 'French Peasant Girl', at the RA. London address.

MORELLI, Mariano fl.1872
Exhib. a copy in 1872.

***MORGAN, Alfred fl.1862-1904**
Painter of still-life, dead game, fruit and flowers, genre, portraits, landscapes, historical and scriptural subjects. Exhib. 1862-1904, at the RA 1864-1904, BI, SS, GG and elsewhere, titles at the RA including 'The Young Pretender', 1864, 'A Dead Pheasant', 1867, 'Baby's Nosegay', 1873, and 'Return of the Prodigal Son', 1902. Two of his paintings 'Cat and Dead Pigeons' and 'Part of the Ruins of Whitby Abbey' are in the VAM. Also in the VAM is a reduced copy made by the artist of W. Etty's 'Youth at the Prow and Pleasure at the Helm'. His son Alfred Kedington Morgan (q.v.) was also a painter.
Bibl: VAM Cat. of Oil Paintings 1907; Wood, Panorama.

MORGAN, Alfred George fl.1896-1902
Painted still-lifes. Exhib. eight works at the RA, including 'Fresh from the Garden' and 'Apples and Tomatoes', and one work at SS. London address.

MORGAN, Alfred Kedington ARE 1868-1928
Painted and etched landscapes and portraits. Studied at the RCA. Exhib. two works including 'The Dove Holes, Dovedale, Derbyshire', at the RA 1899-1902. He was the son of Alfred Morgan (q.v.) and married the painter Gertrude Hayes (q.v.).

MORGAN, Charles fl.1885-1889
Painted coastal scenes. Exhib. four works at SS, including 'On the Cornish Coast' and 'Robin Hood's Bay'. Address in Birmingham.

MORGAN, Charles W. fl.1872-1879
Exhib. five figurative subjects 1872-9. Address in Evesham, Worcestershire.

MORGAN, E.P. fl.1883
Exhib. a watercolour 'The Sources of the Visp', at SS. London address.

MORGAN, Frank Somerville fl.1883-1888
Exhib. three works including two watercolours, 'Picture Books' and 'Old Cronies', at SS. London address.

***MORGAN, Frederick ROI 1847-1927**
Painter of child life, domestic genre, animals and portraits, who exhibited from 1865 at the RA, BI, SS, NWS, GG and elsewhere. Titles at the RA 'Just Caught', 1868, 'The Doll's Tea Party', 1874, 'An Apple Gathering', 1880, and 'H.M. Queen Alexandra, Her Grandchildren and Dogs', 1902 (dogs by T. Blinks). Morgan's paintings of children were very popular and often reproduced. His works are in Leeds and Sheffield AGs, and in the Walker AG, Liverpool. He was the son of John Morgan (q.v.), and the husband of Alice Havers (q.v.).
Bibl: Connoisseur LXXVIII 1927 p.104; The Year's Art 1928 p.360; Reynolds, VP p.12; Pavière, Sporting Painters.

MORGAN, Mrs. Frederick see HAVERS, Miss Alice Mary

MORGAN, H. fl.1877
Exhib. a work entitled 'All Gone!' at the RA. Address in Guildford, Surrey.

MORGAN, Henry fl.1849
Amateur landscapist. Lived in Cork, Ireland.
Bibl: Strickland II.

MORGAN, Jane 1832-1899
Painter and sculptress. Trained in Cork and Dublin. Later lived in the USA.
Bibl: Strickland.

***MORGAN, John RBA 1823-1886**
Genre painter. Exhib. at SS (114 works), RA 1852-86 and BI. Many of his pictures are of children, e.g. 'The Young Politician', 'Ginger Beer', 'Marbles', in the manner of Thomas Webster (q.v.). He also painted historical and biblical genre. Works by him are in the VAM, the Walker AG, Liverpool, and the Guildhall. His studio sale was held at Christie's, 1 March 1887. He was the father of Frederick Morgan (q.v.).
Bibl: Wood, Paradise Lost.

MORGAN, Miss Kate fl.1886-1899
Painted figurative subjects. Exhib. eight works at the RA including 'A Modern Italian', 'Irene', 'A Slave Market' and portraits. London address.

MORGAN, M.L. fl.1888
Exhib. a landscape at the NWS. London address.

MORGAN, Miss Mary E.T. fl.1896
Exhib. a work entitled 'Reverie' at the RA. Address in Sutton, Surrey.

MORGAN, Mrs. Mary Vernon RBSA fl.1880-c.1930
Painted flowers, landscapes and fruit. Exhib. 16 works including 'Waterside Weeds', 'Flowers of the Sea Cliff' and 'Arums', at SS, and eight works at the RA. Also exhib. in Birmingham and abroad. Daughter of W.H. Vernon (q.v.). Lived in Birmingham.

MORGAN, Matthew Somerville 1839-1890
Anglo-American painter of genre and decorative subjects. Exhib. five works including 'Boathouse, Southampton', 'Algiers from the North' and 'The Rose of England' at SS, and two works at the BI. Born in London. Died in New York.
Bibl: Clement & Hutton; Fielding, *Dictionary of American Painting,* 1926.

MORGAN, Owen B. fl.1898-1901
Exhib. two works 'Evening' and 'Evening Star' at the RA. London address.

MORGAN, S. fl.1892
His portrait of Lady Sydney Morgan (1783-1859) was exhib. in 1892.
Bibl: Ormond.

MORGAN, Mrs. S. Louisa fl.1883
Exhib. a portrait at the RA. Address in Manchester. London address.

MORGAN, T.H. fl.1877
Exhib. a watercolour of Egglestone Hall, Yorkshire, at SS. Address in Budleigh Salterton, Devon.

MORGAN, Walter Jenks RBA RBSA 1847-1924
Painter of genre; illustrator. Born at Bilston; educated at Sir Robert Peel's School, Tamworth. Came to Birmingham, and apprenticed to Thomas Underwood, lithographer; studied also at the Birmingham School of Art and at the Birmingham Society of Artists; won a scholarship at the former which enabled him to study for three years at South Kensington. Painted in oils and watercolours and produced numerous drawings for book and magazine illustration; worked for *The Graphic, The Illustrated London News,* and Cassell & Co. Exhib. from 1876, at the RA from 1879, SS, NWS and elsewhere, titles at the RA including 'A Bit of Scandal, Algiers', 1879, 'A Fishermaid', 1882 and 'Going to the Hayfield', 1883. RBA 1884; RBSA 1890. President of the Birmingham Art Circle and of the Midland Arts Club.
Bibl: Birmingham Cat.

MORGAN, William James fl.1847-1856
Painted landscapes. Lived and worked in Cork, Ireland. On one occasion exhib. at the RHA.
Bibl: Strickland.

MORGEN, Miss Kate fl.1894
Exhib. a work entitled 'Sweet Seventeen' at the RA. Address at Bingham, Nottinghamshire. This may be the same artist as Kate Morgan (q.v.).

MORICE, Miss A.A. fl.1871-1885
Painted landscapes. Exhib. eight watercolours at SS including 'Lynmouth from the Beach', 'Cottage Interior at Brenchley' and 'The Copse in Spring', and two works at the RA. Address in Brenchley, Kent.

MORIN, Edmond 1824-1882
Made portrait drawings of Tennyson, c.1856.
Bibl: Ormond.

MORIN, Edward NWS fl.1858-1878
Exhib.23 genre subjects at the NWS. Address in Paris.

MORISON, Douglas 1810-1846 (DNB 1814-1847)
Topographical watercolour painter and lithographer. Studied drawing under Frederick Tayler, and practised chiefly in watercolours. Principally an architectural painter, but he also painted several views in Scotland. A of RI in 1836, but resigned in 1838. A of OWS in 1844. He also practised in lithography, and published *The Eglinton Tournament; Views of Haddon Hall,* 1842; *Views of the Ducal Palaces of Saxe-Coburg and Gotha,* 1846 (with notes and suggestions from the Prince Consort). He made some sketches for the Queen at Windsor and received several medals in recognition of his art. Exhib. 1836-46, at the RA from 1836-41, OWS and NWS, titles at the RA including 'Melrose', 1836, 'Haddon Hall' and Chatsworth', 1841.
Bibl: Roget; Bryan; Cundall; DNB.

MORISON, J.A. fl.1879
Exhib. a genre subject in 1879. London address.

MORLAND, James Smith fl.1877 d.1921
Painted landscapes. Exhib. seven works at the RA including 'Sunshine and Shower' and landscapes in South Africa. Address in Liverpool. Represented in the Glasgow AG.
Bibl: Studio Special Winter Number 1916-17 pp.118, 127; The Year's Art 1922 p.313.

MORLEY, George fl.1832-1863
Animal painter, who exhib. 1832-63 at the RA and BI. He was employed by Queen Victoria and Prince Albert to paint portraits of their horses and dogs, and was also employed by other members of the royal family, and by officers to paint pictures of their chargers. Three of his works were in the Hutchinson Sporting Gallery.
Bibl: Pavière, Sporting Painters; Maas p.78.

MORLEY, H.W. fl.1837-1853
Painted landscapes. Exhib. seven works at SS including 'Landscape and Cattle' and views on the Thames. London address.

MORLEY, Henry 1869-1937
Painted and etched landscapes. Studied at Nottingham School of Art and at the Académie Julian. Exhib. in London and abroad. Member of the Glasgow Art Club. Born in Nottingham. Lived at St. Ninian's, Stirling.
Bibl: Caw.

MORLEY, Miss Ida fl.1900-1904
Exhib. two works, the first 'Knockhundred Row, Midhurst', at the RA 1900-4. London address.

MORLEY, Mrs. Ida R. fl.1897-1899
Exhib. four works at the RA including 'Muse of the Lyre, Illume My Dream!' and 'The Old Farm Corner'. London address.

***MORLEY, Robert RBA 1857-1941**
Painter of animal subjects, landscapes, genre and historical subjects. Lived in Frensham, Surrey and Stroud, Gloucestershire. Son of Professor Henry Morley, LLD. Educated at the Slade School under Poynter and Legros, and afterwards at Munich and Rome. Was Slade Scholar and Painting Medallist. Exhib. from 1879, at the RA from 1884, SS and elsewhere. At first he largely exhib. figure subjects but after 1888 turned to animal painting and landscape. RBA 1889; Hon. Sec. RBA and subsequently Hon. Treasurer 1890-6. In 1921 he exhib. at the Society of Animal Painters "half a dozen 'anecdotes' rendered with his wonted taste for the whimsicalities of animal life!"; and in 1922 at the SBA 'The Manor Farm 1693' — "a sincere record of a charming stone-built house".
Bibl: Connoisseur LVIII 1920 p.238; LX 1921 p.118; LXIII 1922 pp.117, 243; Who Was Who 1941-1950; Pavière, Sporting Painters.

MORLEY, T.W. 1859-1925
Painted landscapes and coastal scenes in watercolour. Worked on the south coast and in northern France.

MORLEY, W.S. fl.1845
Exhib. a painting of a retriever at the RA.

MORNEWICK, Charles Augustus, Snr. fl.1826-1875
Dover marine painter, father of Charles Augustus Mornewick Jnr. (q.v.). Exhib. at RA. Subjects mostly shipping off the south coast.
Bibl: Ormond.

MORNEWICK, Charles Augustus, Jnr. fl.1836-1874
Dover marine painter, son of Charles Augustus Mornewick Snr. (q.v.). Exhib. at RA 1836-74, BI and SS. Subjects often storms or shipwrecks. Painted in England and abroad.
Bibl: Brook-Hart.

MORNEWICK, Henry Claude fl.1827-1846
Dover marine painter, related to Charles Augustus Mornewick (q.v.). Exhib. once at RA in 1846, 'Fresh Gale off Dover', and once at Bl and SS.
Bibl: Brook-Hart.

MORRELL, Miss C.M.B. fl.1855-1874
Painted animals and figurative subjects. Exhib. 14 works at the RA including 'In Sweet Content Our Days are Spent', 'Himalaya Rabbits', and 'The Mother's Grave'. Address in Malden, Essex.

MORRELL, R.J. fl.1839
Exhib. *Fuss,* a portrait of a Skye Terrier' at the RA and another study of a dog at SS. London address.

MORRIS, Alfred fl.1853-1873
Deptford painter of genre, landscape and sporting subjects, who exhib. 1853-73, at the RA 1866 and 1870, BI, SS and elsewhere. His RA exhibits were landscapes.

MORRIS, Miss Alice fl.1886
Exhib. two paintings of flowers at the NWS. Address in Manchester.

MORRIS, Andrew fl.1887
Exhib. two works, 'On the Itchen, Southampton' and 'Christchurch from the Ferry', at the RA. Address in Southampton, Hampshire.

MORRIS, Charles Greville RBA b.1861 fl.1886-1894
Manchester landscape painter. Born in Lancashire, studied in Paris under M.M. Bollinger, Collin and Courtois. Exhib. 1886-94 at the RA and elsewhere, all landscapes. Titles include: 'Winter in Finistère',1887, 'Thistledown', 1889, and 'Evening, Cornwall', 1890. He lived in St. Ives after 1892. One of his paintings, 'Marshland', is in the City AG, Manchester.
Bibl: RA Pictures 1893 p.142; City AG Manchester Cat. 1910.

MORRIS, Ebenezer Butler fl.1833-1863
Painter of historical and mythological subjects, portraits and genre, who exhib. 1833-63 at the RA, BI and SS. Titles at the RA 'Horatius Returning in Triumph after his Victory over the Curiatii', 1838, 'Apollo and the Muses', 1848, 'Maternal Affection', 1841, and 'John Knox and Mary, Queen of Scotland', 1852.
Bibl: Thomas Smith, *Recollections of the B.I.,* 1860 pp.112, 121-2; Ormond.

MORRIS, Miss Helena fl.1890
Exhib. a painting of a church at the NWS. London address.

MORRIS, Henry fl.1838-1844
Exhib. two works, 'View of Civita Castellana' and 'Landscape with Cattle and Figures', at SS. London address.

MORRIS, J. fl.1873-1877
Exhib. two works, 'Plums — from Nature' and 'East Cliff — Hastings', at SS. London address.

MORRIS, J.C. fl.1851-1863
Painter of landscapes, genre and animals, working in Greenwich and Deptford, who exhib. 1851-63, at the RA from 1851-62, BI, SS and elsewhere. Titles at the RA 'A Sketch on the Mountains, Argyllshire', 1856, and 'A Runaway at the Wrong Door', 1862. He was a pupil of T. Sidney Cooper (q.v.). One of his paintings 'Sheep', 1859, is in Birmingham AG.

MORRIS, J.W. fl.1866-1867
Exhib. three works including 'Left at Home' and 'The Pet'. London address.

MORRIS, M. fl.1845
Exhib. a study for a cattle piece at the BI. London address.

MORRIS, Mrs. Mittie fl.1883-1894
Exhib. a watercolour of the 'Old Inn Yard, near Pulborough, Sussex' at SS. London address.

MORRIS, Oliver fl.1866-1892
Exhib. 'The Kingfisher's Haunt' at the RA and a watercolour 'Wickham, Gloucestershire', at the SS. London address.

MORRIS, Oliver fl.1866-1895
London landscape painter; later worked in Edinburgh.

***MORRIS, Philip Richard ARA 1838-1902**
Painter of genre and portraits. Born at Davenport. Entered RA schools 1855. He won two silver medals, and in 1858 the gold medal for a biblical picture 'The Good Samaritan'. Awarded a Travelling Studentship; visited France and Italy. Exhib. at RA 1858-1901, BI, SS, GG and elsewhere. Painted both historical and biblical genre, and also domestic scenes. Later he turned almost entirely to portrait painting. Retired as an RA in 1900.
Bibl: AJ 1868 p.200; 1872 pp.161-3; 1902 p.231; Mag. of Art 1902 p.423ff.; RA Pictures 1891-5; Bryan; DNB; E. Chesneau, *Art Anglais Contemporain,* 1887; Champlin and Perkins, *Cyclopaedia of Painters,* 1888; A. Dayot, *La Peinture Anglaise,* 1908.

MORRIS, R. fl.1830-1844
Painted landscapes. Exhib. eight works at SS, including 'Scene near Shrewsbury', 'Sketch in Windsor Forest' and 'Rustic Bridge', two works at the RA and three at the BI. London address.

MORRIS, R. fl.1863
Exhib. a painting of dead game at the BI. London address.

MORRIS, W. fl.1866
Exhib. a study in 1866. London address.

MORRIS, William Bright ROI 1844-1896
Genre and portrait painter. Pupil of William Muckley (q.v.) in Manchester. Exhib. at RA 1869-1900, GG, NG and elsewhere. Travelled in Italy and Spain, and painted mostly Spanish or Italian genre scenes. He lived for a time in Capri and Granada. The AJ 1894 describes him as "par excellence the painter of the patio".
Bibl: AJ 1875 p 180; 1894 p.283; Academy Notes 1876,1878-81 ; Cat. of AG Manchester 1894 p.82; Ormond.

MORRIS, W. Walker fl.1850-1867
Painter of genre and sporting subjects, who worked in Greenwich and Deptford at the same address as J.C. Morris (q.v.). Exhib. 1850-67 at the RA, BI and SS. Titles at the RA 'The Task', 1850, 'The Match Seller', 1851, and 'The Pets', 1854.

MORRISH, Sydney S. fl.1852-1894
London painter of genre, landscape and portraits, who exhib. 1852-94 at the RA, BI and SS. Titles at the RA 'Fruit', 1852, 'A Welsh Interior', 1862, 'Reading to Grandmother', 1867, 'Homeless', 1872, and 'Harvesting in S. Devon', 1892.
Bibl: G. Pycroft, *Art in Devonshire*, 1883 p.97.

MORRISH, W.S. 1844-1917
Painted landscapes. Exhib. 11 watercolours at SS including views in Devon and Switzerland. Also exhib. three works including 'A Moorland Stream' and 'Dartmoor' at the RA. Son of Sydney S. Morrish (q.v.).
Bibl: G. Pycroft, *Art in Devonshire*, 1883.

MORRISON, Miss fl.1858
Exhib. a watercolour landscape at SS. London address.

MORRISON, Kenneth MacIver LG fl.1900-1930
Studied in Paris at Julian's and Colarossi's. Exhib. three works, 'The Red Gown', 'The Young Ensign' and 'The Musical Box', at the RA 1900-3. Born in Surrey. Lived in Paris and in London.
Exhib: London, Little Art Rooms 1920; Beaux-Arts Gallery 1938.

MORRISON, R. fl.1844-1857
Painted portraits and figurative subjects. Exhib. ten works at the RA including five portraits and five works at SS including 'Tanka Boat-girls of Macao — Evening'. London address.

MORRISON, Robert Edward RCA 1852-1925
Liverpool painter of portraits and genre. Born in Peel, Isle of Man. Member of the RCA and Liverpool Academy. Exhib. from 1883, at the RA from 1884, SS, NWS and at many local exhibitions. The portraits listed and illustrated in *The Studio* are 'The Mayor of Birkenhead', 1915, and other portraits of professional men. His works are in the Walker AG, Liverpool, and Queen's College, Oxford.
Bibl: Studio XXIV 1902 p.136 (pl.); XXVIII 1903 p.209 (pl.), p.210; LXIII 1915 p.218; LXVI 1916 p.214; Poole II 1925 p.137; Cat. Walker AG, Liverpool, 1927.

MORRISON, W.W. fl.1877-1885
Exhib. a work entitled 'Going to the Senate' at SS. Address in Hanwell.

MORROW, Albert George 1863-1927
Painted figurative subjects. Also an illustrator. Studied at the RCA. Exhib. nine works at the RA 1890-1904, including 'The Story of the Little Mermaid' and 'The Man in the Street'. Born at Comber, County Down. Lived in Sussex.
Bibl: Who's Who.

MORTEN, Mrs. J. Wells fl.1887
Exhib. a landscape at the NWS. London address.

MORTEN, Thomas 1836-1866
Painted historical and genre subjects. Also an illustrator. Exhib. five works at the RA including 'A Scene from Kenilworth' and 'Conquered but not Subdued', five works at SS including 'The Assassination of Rizzio' and two works at the BI. London address.
Bibl: AJ 1866 p.184ff.; Gleeson White; DNB.

MORTIMER, G. fl.1848
Exhib. a view of Chepstow Castle at the RA. London address.

MORTIMER, G.A. fl.1847
Exhib. a work entitled 'Returning Home' at SS. London address.

MORTIMER, Thomas
Painter of coastal scenes in the style of T.B. Hardy (q.v.).

MORTLOCK, Miss Ethel fl.1878-1904
Painted portraits. Exhib. 29 works at the RA 1878-1904, including those of HRH The Duke of Madrid, the Earl of Ashburnham and the Duchess of Wellington. She was a pupil of W. Orchardson (q.v.). Born in Cambridge.
Bibl: Ormond.

MORTON, Andrew 1802-1845
Portrait painter. Born in Newcastle-on-Tyne, son of Joseph Morton, master mariner, and elder brother of Thomas Morton (1813-49) the surgeon. Studied at the RA schools, gaining a silver medal in 1821. Exhib. 1821-45 at the RA, BI and SS. His art was entirely confined to portraiture, in which his style resembled that of Sir Thomas Lawrence. He had a large practice and many distinguished sitters. In the NPG are, amongst others, portraits of Sir James Cockburn, Marianna, Lady Cockburn and Marianna Augusta, Lady Hamilton; in Greenwich Hospital is a portrait of William IV.
Bibl: Redgrave, Dict.; Capetown AG Cat. 1903-17; DNB; Hall; Ormond.

MORTON, Edgar fl.1885-1886
Exhib. two landscapes at Capri and Amalfi at SS. London address.

MORTON, George fl.1879-1904
London painter of genre and portraits, who exhib. 1879-1904, at the RA 1884-1904, SS, NWS, GG and elsewhere. Titles at the RA 'The New Curate's First Audience', 1885, 'A Vegetarian', 1892, and 'Rivals', 1897.

MORTON, Thomas Corsan 1859 or 1869-1928
Painted landscapes. Studied at Glasgow School of Art, at the Slade School and in Paris. Exhib. a 'Woodland Pastoral' at SS. Also exhib. in Scotland. From 1908 he was Keeper of the National Gallery of Scotland. Lived in Glasgow, Edinburgh, and at Kirkcaldy.
Bibl: Martin, *The Glasgow School of Painting*, 1902; Studio XXXI 1904 pp.159, 163; Caw; Irwin.

MORTON, William fl.1862-1889
Exhib. two landscapes 1869-76. Address in Manchester. Also painted portraits.

MOSCHELES, Felix Stone 1833-1917
Jewish portrait and genre painter; son of the composer Ignaz Moscheles. Studied under Jacob van Lerius, at the Antwerp Academy, where he met his friend George Du Maurier (q.v.) Moscheles wrote a book about these early years —*In Bohemia with George Du Maurier*. He often featured in Du Maurier's cartoons. It was through him that Du Maurier became interested in hypnotism. Worked as a portrait painter in Paris; came to London in 1861. Built up a successful portrait practice in London, and also painted sentimental genre scenes. Worked in Leipzig; also travelled in Spain and Algiers.
Bibl: Chronicle des Arts 1917-19 p.84; Connoisseur LXX 1924 p.117; LXXVI 1926 p.63; Champlin-Perkins, *Cyclopaedia of Painters*, 1888; Leonée Ormond, *George Du Maurier*, 1969 (index); Ormond.

MOSELEY, Henry fl.1842-1866
Painted portraits. Exhib. 24 portraits at the RA including those of Mrs. Mortimer Sackville-West and Sir Harry Smith, late Governor-General of the Cape of Good Hope. Also exhib. six works at SS. His wife, Maria A. Challon, was also a painter. Lived in London.
Bibl: AJ 1859 p.167; Cat. of Paintings etc. in the India Office, London, 1914; Ormond.

MOSELEY, R.S. fl.1862-1893
Painter of genre and animals, who exhib. 1862-83, at the RA 1863-80, BI, SS and elsewhere. Titles at the RA 'Mutual Benefit', 1863, ' "If the Dog is Awake — why, the Shepherd may Sleep" ', 1870, and 'The Dog of the Alps', 1879.

MOSER, Robert James fl.1871-1893
Painted landscapes. Exhib. five works, all views on the south coast, at the RA. London address.

MOSLEY, L. fl.1859
Exhib. two genre subjects in 1859. Address in Stoke upon Trent, Staffordshire.

MOSS, Henry William fl.c.1900-1930
Painted landscapes. Studied at Dublin Metropolitan School of Art, at Newlyn in Cornwall and at Heatherley's. Exhib. at the RHA. He was a member of the Watercolour Society of Ireland and President of the Dublin Sketching Club. Lived at Howth, County Dublin.

MOSS, John H.B. fl.1892
Exhib. a study at the RA. Address in Gloucester.

MOSSES, W.J. fl.1876
Exhib. a watercolour entitled 'Salmon Fishing Station on the Forth' at SS. Address in Stoke Newington.

MOSSMAN, David 1825-1901
Painter of landscapes, figure subjects and miniatures. Exhib. at RA 1853-88, also SS 1857-90 and NWS. Born in Newcastle, where the Laing AG has examples.

MOSSMAN, W.H. fl.1838-1840
Exhib. two works, including 'Waterloo Bridge during the late Frost', at SS. London address.

***MOSTYN, Tom E. ROI RWA RCA 1864-1930**
Painted figurative and genre subjects and landscapes. Studied at the Manchester Academy of Fine Arts and at Bushey. Exhib. 13 works at the RA 1891-1904, including 'The Torrent', 'Miss Muffet' and 'Castles in the Air'. He was the son of Edward Mostyn, who was also a painter. Born in Liverpool. Lived in London and Torquay, Devon. Mostyn had a very distinctive and strong impressionist style, and his work has been somewhat unfairly neglected.
Exhib: London, Cooling Gallery 1933.

***MOTE, George William 1832-1909**
Landscape painter. A self-taught artist, he worked as gardener and caretaker to Sir Thomas Phillipps, the great manuscript collector, at Middle Hill, near Broadway, Worcestershire. His early pictures, mostly of the house and gardens at Middle Hill, are painted in a remarkably direct and evocative primitive style. He was fond of the device of painting a landscape through an open window. Later he became a full time artist, and exhib. at the RA 1857-73, BI, SS and elsewhere. He painted views in Surrey, Sussex and Wales, and occasional houses and gardens. His style became more accomplished but "he had lost some of the original intensity of his vision" (Maas). After 1877 he stopped exhibiting, and the quality of his work began to decline.
Bibl: AJ 1909 p.94 (obit.); Maas p.229 (pl. p.229); Wood, Paradise Lost.

MOTE, J.H.
His pencil drawing copy of a self-portrait by William Etty is in the York AG.
Bibl: Ormond.

MOTE, W.H., Jnr. fl.1855
Exhib. a sketch from life at SS. London address. He was possibly the son of W.H. Mote, a steel-engraver in London c. 1850.

MOTHANS, Alfred fl.1883
Exhib. a landscape at the NWS. London address.

MOTT, Edwin fl.1872-1877
Exhib. four works including 'Hush!' and 'The Key of the Tower' at SS. London address.

MOTT, J. fl.1854
Exhib. 'Sketches from Nature' at the RA and at SS. London address.

MOTT, J.N. fl.1845
Exhib. a portrait at the RA. London address.

MOTT, Miss Laura fl.1892-1898
Exhib. two portraits at the RA. London address.

MOTT, R.S. fl.1871-1872
Exhib. two watercolours of sheep and cattle at SS. London address.

MOTTRAM, A. fl.1886
Exhib. a landscape at the NWS. London address.

MOTTRAM, Charles Sim RBA fl.1876-1903
Painter of coastal scenes, who exhib. 1876-1903, at the RA 1881-1903, SS, NWS and elsewhere. Titles at the RA 'A Cornish Sea', 1888, 'Gathering Clouds', 1887, and 'A Stiff Breeze off Godrevy, St. Ives', 1903.
Bibl: Brook-Hart pl.212.

MOTTRAM, J.M. fl.1888
Exhib. a painting of birds at the NWS. London address.

MOULD, J.W. fl.1848
Exhib. a view of a stone barn at Thornhill Old Hall, Yorkshire, at the RA. London address.

MOULTING, George fl.1847-1857
Painted portraits. Exhib. 15 watercolours at SS, including 11 portraits and works entitled 'The Wreath' and 'Fancy Sketch'. Also exhib. two portraits at the RA. London address.

MOULTRAY, J. Douglas fl.1870-1872
Exhib. two highland landscapes at the RA. Address in Edinburgh.

MOUNCEY, William 1852-1901
Scottish landscape painter represented in the Glasgow AG. Born in Kircudbright.
Bibl: AJ 1901 p.102; Studio XXVII 1903 p.135; XXXI 1904 p.163; XLV 1909 pp.96-103; Caw.

MOUNSEY, R.K. fl.1857
Exhib. two domestic genre subjects in 1887. London address.

MOUNTAIN, William fl.1881-1883
Exhib. two works 'A Venetian' and 'In the Pass of Leni' at SS. London address.

MOUNTFORD, Ernest Chesmer 1844-1922
Painted genre subjects. Also an illustrator and poster designer. Exhib. at the RBSA. Lived in Birmingham.

MOUQUE, A. fl.1838-1844
Painted cattle. Exhib. five works, all landscapes with cattle, at SS. London address.

MOURANT, E. fl.1883
Exhib. a landscape at the NWS. London address.

MOXON, John fl.1880s
Exhib. two watercolours 'Yorkshire Fieldworkers' and a view in France at SS. Address in Edinburgh.

MOYES, F. fl.1881
Exhib. 'Evening in Normandy' at SS. London address.

MOYNAN, Richard Thomas 1856-1906
Painted portraits and genre subjects. Studied at the RHA, Dublin and in Antwerp and Paris. Born, lived and died in Dublin.
Bibl: Studio XXV 1902 p.209; Strickland.

MUCKLEY, Arthur Fairfax fl.1886-1891
Exhib. three works, a portrait, 'Those Days We Went a Gipsying' and 'Grim's Goblins' at the RA, and a watercolour at SS. London address.

MUCKLEY, Louis Fairfax- fl.1887-1901
Painted genre subjects. Also an illustrator. Exhib. four works including 'The Weird Lady', 'A Sainted Maiden' and 'Phaeton's Sisters', at the RA. Address in Stourbridge, Worcestershire.
Bibl: Studio IV 1894 p.146ff.; Bate; Sketchley, *English Book-Illustration of Today,* 1903; Cedric Chivers, *Books in Beautiful Bindings,* c.1910.

***MUCKLEY, William Jabez RBA 1837-1905**
Flower and still-life painter. Born in Audnam, Worcestershire. Studied in Birmingham, London and Paris. Exhib. at RA 1858-1904, BI, SS, NWS, GG and elsewhere. Worked as a teacher at the Government Schools in Wolverhampton and Manchester. His pictures are mostly large, showy vases of flowers, set in sumptuous interiors. Also painted occasional interiors with children, usually in watercolour.
Bibl: RA Pictures 1892-3, 1895-6, Handbook to the Permanent Collection Manchester City AG 1910.

MUDGE, Alfred fl.1862-1877
Exhib. three works including 'Holiday in the Woods' and 'Evangeline' at the BI, and one work at the RA. Address in Richmond, near London.

MUHEIM, J. fl.1859
Exhib. a landscape in the Canton of Uri at the RA. Address in Switzerland.

MÜHLENFELDT, Mrs. Louisa S. fl.1846-1865
Painted flowers and fruit. Exhib. five still-lifes at the RA, 11 at the BI and 11 at SS. Included among the works exhib. at SS were 'The Visit to the Hermit', 'A Study of Fruit and Flowers from Nature' and a watercolour view of Roslyn Castle. London address.

MUHRMAN, Henry fl.1884-1890
Painted landscapes and figurative subjects. Exhib. eight works, five of them watercolours, at SS including 'Peasant Children Returning from School', 'Sunset After Rain' and 'The Roundhouse, Evening'. London address.

MUIR, Miss Agnes fl.1879
Exhib. 'A Shelf in a Farm-house Kitchen' at the RA. London address.

MUIR, David fl.1884-1888
Exhib. 'In the Twilight Deep and Silent' at the RA, and a watercolour view on the Scottish coast at SS. London address.

MUIR, H. fl.1857
Exhib. a view on the Esk at SS. London address.

MUIR, Miss Jessie fl.1884
Exhib. a view of a church at the NWS. London address.

MUIR, W. Temple fl.1887-1899
Exhib. three works, including 'A Path through the Birchwood — Winter' and 'Old Lock on the Kennet', at the RA. Address in Burnham, Buckinghamshire.

MUIRHEAD, Charles fl.1886-1904
Painted landscapes. Exhib. ten works at the RA 1886-1904, titles including 'At St. Erth', 'Marsh Lands' and 'Harvest Time'. Address in Liverpool.

**MUIRHEAD, David Thomson ARA ARWS NEAC
1867-1930**
Painted landscapes, buildings and figurative subjects. Studied at the RSA Schools, Edinburgh, and at Westminster School of Art. Born in Edinburgh. He moved to London in 1894.
Bibl: Who's Who; Caw; AJ 1909 pp.40-5; Studio LVII 1913 pp.97-106; LXII pp.96, 100; LXIV p.138; LXV p.180; LXVI p.287; LXVIII pp. 55, 118; LXIX p.116; Connoisseur XLIV 1916 p.55; L p.116; LV p.98; LXI p.54; LXII p.110; LXVIII p.113; Burlington Mag. XLVII 1925 p.XXXI; Apollo VII 1928 p.195; Hardie III.
Exhib: London, Rembrandt Gallery 1933.

MUIRHEAD, John RSW RBA 1863-1927
Painted landscapes. Also an etcher and illustrator. Studied at the Board of Manufacturer's School in Edinburgh. Exhib. eight works at the RA including 'On the Spey' and 'Port Antibes'. Also exhib. at the RSA and in London and abroad. Worked on the Continent. Born in Edinburgh. Lived in London and Houghton, Huntingdonshire.
Bibl: Who's Who; The Year's Art 1928 p.360; Studio LXVI p.206; Connoisseur XXVIII p.204; XLVIII p.56; LI p.56; LII p.232; LX p.117; LXII p.47.

MUIRHEAD, L. fl. 1877-1884
Exhib. a work illustrating a line from Shelley at the RA, and two works at the NWS. Address in Tetsford, Oxfordshire.

MULCAHY, Jeremiah Hodges ARHA fl.1842 d.1889
Irish landscapist. Exhib. a landscape including a view of Limerick and part of the River Shannon at SS. Address in Limerick.
Bibl: Strickland.

MULLARD, Joseph Albert b.1868
Painted landscapes and portraits. Studied in Bradford, London and Paris. Lived in London and at Godalming, Surrey.

MÜLLER, Professor Carl fl.1872-1889
Painted and sculpted portraits and religious subjects. Exhib. seven works including a portrait and two paintings of the Virgin and Child at the RA. Also exhib. three works at the GG. Address in Düsseldorf, Germany.

MÜLLER, Daniel fl.1863-1878
Painted landscapes and figurative subjects. Exhib. four landscapes with cows at the RA, four works at the BI including 'Our Mutual Friends' and 'Members of the Temperance Society', and 16 works at SS including 'A Shady Pool', 'A Passing Train' and 'A Water Party'. London address.

MÜLLER, Mrs. E.G. fl.1861-1867
(Miss Rosa Branwhite)
Painted landscapes. Exhib. three works, two landscapes in North Wales and one in North Devon at SS. Address in Bristol. She was the wife of Edmund Gustavus Müller (q.v.).

MÜLLER, Edmund Gustavus fl.1836-1871
Painted landscapes. Exhib. 11 works at SS including two views of Venice and landscapes in North Wales, some of them in watercolour. Address in Bristol. His Venetian views are attractive, and similar to those of W.J. Müller (q.v.), his elder brother.

MÜLLER, Robert Antoine fl.1872-1881
Painted portraits. Exhib. seven works at the RA including portraits of the children of HRH the Duke of Edinburgh and 'The Invention of Gunpowder'. Also exhib. three works at SS. London address.
Bibl: Poole I 1912.

***MÜLLER, William James 1812-1845**
Painter and watercolourist. Born in Bristol, the son of a Prussian refugee. As a young man Müller was apprenticed to J.B. Pyne (q.v.) but the indentures were cancelled after two years. He painted in and around Bristol; visited Wales 1833. 1834-5 travelled up the Rhine to Switzerland, Venice, Florence and Rome. He made many drawings and sketches on his travels, which he later worked up into finished paintings. He was especially enthralled by Venice of which he painted many of his best pictures. 1838-9 visited Greece, Egypt, Malta and Naples. 1839 moved to London. became member of Clipstone Street Society. 1840 visited northern France. 1843-4 Turkey with an archaeological expedition. Developed a heart condition and died aged only 33 in 1845. A sale of his works was held at Christie's, 1-3 April 1846. Müller exhib. at RA 1833-45, BI and SS. His style in both oil and watercolour was rapid, accurate and confident. "He does not often rise to the heights of creative intuition, but for sheer vitality and lucid expression he has rarely been surpassed" (Hardie). He is now best known for his Venetian and Middle Eastern scenes.
Bibl: AJ 1850 p.344; 1864 p.293ff.; 1895 p.154ff.; 1909 p.274; Connoisseur XXXVI 1913 p.101ff.; N.N. Solly, *Memoir of W.J.M.*, 1875; Redgrave, Dict., Cent.; Roget; Bryan; Binyon; Cundall; DNB; Hughes; VAM; *A Letter from W.J.M.*, OWS XXV 1947; Hardie III pp.55-63 (pls.71-4); Maas pp.94-5 (pls. pp.48, 94, 174); Ormond; Cat. of Müller exhib., Bristol AG 1991.
Exhib: Birmingham 1896; London, RA 1934; Bristol 1962, 1991.

MULLIN, Henry 1811-1872
Painted portraits. Also made copies. Worked in the South of Ireland.
Bibl: Strickland.

MULLINS, T.P. fl.1881
Exhib. two works, 'A Path through the Woods' and 'At Hampstead', at SS. London address.

MULOCK, Frederick Charles fl.1888-c.1933
Painted figurative subjects. Exhib. nine works, including 'The Lost Chord', 'The Babes in the Wood' and 'The Poacher', at the RA. London address.
Exhib: London, Royal Society of Painters in Watercolours 1933.

***MULREADY, Augustus E. fl.1863-c.1886**
Genre painter, and member of the Cranbrook Colony, with Webster, F.D. Hardy, J.C. Horsley and G.B. O'Neill (qq.v.). Exhib. at RA 1863-80. Painted London street scenes, especially of street urchins, flower-sellers and children. Titles at RA 'Uncared For', 'Stop my Hat', 'A Little Creditor', etc. One of the few artists to record without too much sentiment the everyday street scenes of Victorian life. As Mulready died c.1886, works in a similar style after this date are probably by his son, A.E. Mulready Jnr.
Bibl: Reynolds, VP pp.37, 95, 195 (pl. 34); Maas p.234 (pl. p.255).

MULREADY, John fl.1831-1843
Painted portraits. Exhib. seven works at the RA, all portraits, and three works, including 'The Study' and 'Domestic Poultry', at the BI. London address.

MULREADY, Michael 1808-1889
Painted portraits. Exhib. 21 works at the RA, 18 of them portraits, including one of William Mulready, RA (q.v.), and works entitled 'Christmas Eve' and 'The Fortune Teller'. London address.
Bibl: Ormond.

MULREADY, P.A. fl.1827-1855
Painted portraits and figurative subjects. Exhib. 13 works at the RA including 'Looking over the Portfolio' and 'The Cottage Door'. Also exhib. three works at SS and one at the BI. London address.
Bibl: Ormond.

***MULREADY, William RA 1786-1863**
Genre painter. Born at Ennis, County Clare, Ireland, the son of a leather breeches maker. Moved to Dublin, then London. Showing a precocious talent for drawing, he entered the RA schools in 1800 at the age of 14. At first he attempted historical genre and landscape, without success. In 1807 he turned to Wilkie-style genre scenes, drawing inspiration from the Dutch masters of the 17th century. Meanwhile he supported his family by teaching, and painting theatrical scenery. He married a sister of John Varley, but they later separated. His first major success was 'The Fight Interrupted' at the RA 1816. This picture, now in the VAM, of a vicar stopping a fight between two boys, clearly shows the influence of Wilkie and Webster in style and subject. Its success set the course of Mulready's career. ARA 1815, RA 1816. Exhib. at RA 1804-62, BI and SS. Later he developed a more personal technique, using a white ground and pure, luminous colours, anticipating the methods of the Pre-Raphaelites. Typical of his late style are 'Burchell and Sophia in the Hayfield' (Lord Northbrook Collection) and 'Choosing the Wedding Dress (VAM) of which Ruskin wrote they "remain in my mind as standards of English effort in rivalship with the best masters of Holland". One of his sons, William Mulready Jnr. (q.v.) was also a painter. His wife, Miss Elizabeth Varley, exhib. landscapes at the RA, BI and OWS 1811-19. His studio sale was held at Christie's, 28 April 1864.
Bibl: AJ 1863 pp.166, 181, 210; 1864 p.65ff., p.130ff.; 1876 p.136; Portfolio 1887 pp.23, 85-90, 119-25 (F.G. Stephens); Redgrave, Dict., Cent.; J. Ruskin, *Modern Painters;* also Academy Notes 1846-7, 1857, 1859; F.G. Stephens, *Memorials of W.M.*, 1867; J. Dafforne, *Pictures and Biographical Sketch of W.M.*, 1872; Roget; Binyon; Cundall; DNB; Strickland; VAM; Reynolds, VS see index; W.M. exhib., Cat., Bristol AG 1964; Reynolds, VP pp.12, 14, 37, 60 (pls. 2-3); Hardie II p.69

et passim; Maas pp.107, 168 (pls. p.106, 167); Ormond; Irwin; VAM, Cat. of the Drawings of William Mulready; K.M. Heleniak, *W.M.*, 1980; M. Pointon, Cat. of W.M. exhib., VAM, 1986-7.
Exhib: Bristol, Museum and AG 1964, 1969; London, VAM 1972, 1986-7.

MULREADY, William, Jnr. b.1805 fl.1831-1842

Painter of dead game, son of William Mulready (q.v.). Exhib. at RA 1835-42, BI and SS.

MULVANY, George Francis ARHA 1809-1869

Painted portraits and figurative subjects. Studied at the RHA. Exhib. two works 'Infant Bacchus' and 'Various Attractions — A Scene in the Louvre' at the RA. Son of Thomas Mulvany (q.v.). Became a Director of the National Gallery of Ireland.

Bibl: AJ 1869 p.117; Redgrave, Dict.; DNB 1894 p.39; Bryan III; Strickland; Cat. National Gallery of Ireland, Dublin, 1920; Ormond.

MULVANY, Thomas James 1779-1845

Irish landscape and figure painter. Father of George Francis Mulvany (q.v.). He was keeper of the RHA.

Bibl: Redgrave, Dict.; DNB 1894 p.39; Bryan; Strickland II 1913.

MUMFORD, Robert T. fl.1897

Exhib. a work entitled 'A Meal by the Wayside' at the RA. Address in Dover, Kent.

MUMMERY, Horace A. 1867-1951

Painted landscapes. Exhib. ten works at SS including 'The Hour of Rest', 'The Fading Glory of the Day' and a watercolour, 'The Sugar Loaf Mountain, Breconshire'. Also exhib. one work at the RA and another at the NWS. Admirer and follower of Turner. London address.

MUMMERY, J. Howard fl.1875-1878

Exhib. three works including 'Bude Sands' and 'On the West Coast of Brittany' at SS. London address.

MUMMERY, S. fl.1877

Exhib. two watercolours 'Out in the Fields' and 'Monuments in Verona' at SS. Address in Dover, Kent.

MUNBY, H.R. fl.1846-1847

Exhib. four works including 'Scone Palace', 'Edinburgh, from the South' and 'The Mansion House, London', at the RA. London address.

MUNDELL, J. c.1850-1870

Painted landscapes, river scenes and coastal views. It has been suggested that J. Mundell was a pseudonym of John James Wilson (q.v.).

Bibl: Brook-Hart pls. 127, 213.

MUNN, George Frederick RBA 1852-1907

American landscape and flower painter; sculptor. Born in Utica, New York. First studied under Charles Calverly, the sculptor, and later at the National Academy, New York. He came to England and entered the South Kensington Schools, where he received a gold medal, the first awarded to an American, for a model in clay of the Farnese Hercules. At the RA schools he received a silver medal for a life drawing; subsequently he was in the studio of George F. Watts (q.v.) in 1876. He painted and sketched in Brittany, and exhib. 1875-86, at the RA 1877-86, SS, GG and elsewhere. Titles at the RA include 'Wallflowers', 1877, 'A Grey Day, Brittany',

1878, 'The Story of the Church', 1884, and 'On the Kennet', 1886. His flower paintings, especially, were much admired for their minute detail.

Bibl: Clement & Hutton; American Art Annual 6 1907-8 p.112; M. Fielding, *Dictionary of American Painting*, 1926.

MUNN, W.A. fl.1852

Exhib. a coastal view at the RA.

MUNNS, Henry Turner 1832-1898

Painted portraits, genre subjects and landscapes. Exhib. eight works at the RA including eight portraits, and works entitled 'Drawing Timber in the Vale of Dovey' and 'The Pleasure of Art'. Exhib. ten works including portraits, and two works at the BI. Address in Birmingham.

MUNNS, John Bernard RBSA NSA 1869-1942

Painted portraits and landscapes. Studied at Birmingham School of Art and Graphic School. Exhib. in Birmingham, Paris and London. Member of the Birmingham Art Circle. He was the son of Henry Turner Munns (q.v.). Born and lived in Birmingham.

MUNRO, Mrs. Campbell (Henrietta M.) fl.1878-1888

Exhib. two portraits at the RA. London address.

MUNRO, Charlotte fl.1870

Exhib. a study of a girl's head at SS.

MUNRO, Hugh 1873-1928

Painted landscapes and genre. Exhib. at the RSA. Born and lived in Glasgow. His wife Mabel Victoria (née Elliot) RSW (1884-1960) who married, secondly, W.S. MacGeorge (q.v.).

MUNRO, J. Calder fl.1860-1861

Exhib. two domestic genre subjects. Address in Cheltenham, Gloucestershire.

MURA, Frank fl.1897-1904

Painted landscapes. Exhib. five works at the RA including 'The Reed-Cutter', 'On Hampstead Heath' and 'Fishing Boats on the Niemen'. London address.

MURA, Mrs. Frank (Charlotte) fl.1894-1902

Exhib. four works at the RA 1894-1902, titles including 'An Idyll — Who Can Light on a Happier Shore?', 'Truants' and 'When the Cat's Away, the Mice Will Play'. London address.

MURCH, Arthur fl.1850-1851

Painted views in Rome and the Campagna. Exhib. three works including two views in Tivoli at the BI, and a view of the Doria Palace at the RA. Husband of Edith Murch (q.v.), and friend of Lord Leighton. Address in Bath, Somerset.

MURCH, Mrs. Arthur (Edith) 1850-1920

Exhib. twenty two figurative subjects at the GG and six at the NG. Address in Rome. Born Edith Ellenborough (q.v.). Married first Arthur Murch (q.v.) and secondly, in 1891, M.R. Corbet (q.v.).

MURDOCH, W.G. Burn- 1891-1903

Exhib. a portrait and a work entitled 'After the Theatre' at the RA. Address in Edinburgh.

MURPHY, Edward Henry ARHA c.1796-1841
Painted flowers and still-life. Exhib. in Dublin where he lived and taught art.
Bibl: Strickland.

MURPHY, John Ross 1827-1892
Painted marines. His early life was spent at sea. He took up painting seriously when he became a pupil of W. Clarkson Stanfield (q.v.). Exhib. at the RHA and in Liverpool.
Bibl: Strickland.

MURPHY, S.J.
A picture of 'The Little Seamstress' appeared at Christie's, 11 July 1969.

MURRAY, Alexander Henry Hallam 1854-1934
Painted townscapes and buildings in watercolour. Studied at the Slade. Exhib. 17 works at the RA 1884-1904, including views in Segovia, Toledo, Rome, Venice, Berne and Würzburg. Also exhib. two landscape watercolours at SS. Travelled very widely. He was author and illustrator of a number of books. Born in London. Lived in Hythe, Kent. For works illustrated by, see VAM Card Cat.

MURRAY, C.S. fl.1855
Exhib. a river scene in 1855. London address.

***MURRAY, Charles Fairfax 1849-1919**
Pre-Raphaelite painter. Worked for Morris & Co. Sent to Italy by Ruskin to copy Old Masters. His style and subject matter are strongly imbued with the spirit of the Italian Renaissance, but with the additional overtones of Burne-Jones and Rossetti. Exhib. mainly at GG, also NG, RA in 1867 and 1871, and elsewhere. His output was not large, as he devoted most of his time to collecting. His drawings collection was famous; part of it was bought by Pierpoint Morgan; Birmingham, the Fitzwilliam and other museums were left the remainder. His own paintings can be seen in Birmingham and the Walker AG, Liverpool. For works illustrated by, see VAM Card Cat.
Bibl: Bate.

***MURRAY, Sir David RA HRSA RSW RI 1849-1933**
Scottish landscape painter. Born in Glasgow. Spent 11 years in business before taking up painting. ARSA 1881; moved to London 1882. ARA 1891, RA 1905. Exhib. at RA from 1875, OWS, NWS, GG, RSA and elsewhere. His landscapes are realistic and painted in a broad and vigorous style. Up to 1886 he painted in Scotland, but after that he found his subjects mostly in the south of England and the Continent. 'In the Country of Constable', RA 1903, was bought by the Chantrey Bequest. At his death he left a bequest to the RA to encourage landscape painters.
Bibl: AJ 1892 pp.144-8; 1895 p.98 (pls.); Caw pp.304-6 (pl. p.304); Brook-Hart. Exhib: London, 1 Langham Chambers 1934.

MURRAY, E. fl.1880
Exhib. a work entitled 'A Spanish Breakfast Party' at the RA. London address.

MURRAY, Lady Edith fl.1880
Exhib. a watercolour view of a town in Belgium at SS. London address.

MURRAY, Mrs. Eliza Dundas fl.1859-1861
Exhib. 'The Outcast' at the RA and a watercolour view of the lighthouse at Sunderland at SS. London address.

MURRAY, Miss Elizabeth Emily fl.1888-1890
Exhib. two works at the NWS. She was a friend and pupil of John Ruskin (q.v.).
Bibl: Guide to an Exhibition of Drawings BM 1912.

MURRAY, Ethel fl.1883-1884
Exhib. a work entitled 'Reverie' at SS. London address.

MURRAY, Miss Florence E. fl.1890
Exhib. a view of the Palace of Westminster at SS. London address.

MURRAY, Frank fl.1876-1899
London landscape and decorative painter, who exhib. 1876-99, at the RA 1879-99, SS, NWS and elsewhere. Titles at the RA include 'Shipman's Land, E. London', 1879, 'A Dry Dock on the Thames', 1885, and 'Section, Decorative Frieze for Board Room, P & O Company', 1899.
Bibl: Brook-Hart pl.214.

MURRAY, George 1875-1933
Portrait painter represented in the Glasgow AG.

MURRAY, George fl. 1899-1904
Painted figurative subjects. Exhib. 13 works at the RA 1899-1904, including 'The Death of Ladas', 'Abraham and Isaac' and 'The Meadow Stream'. London address.
Bibl: Studio XXII 1901 p.119; XXV 1902 pp.28, 39.

MURRAY, H. fl.1850-1860
Painted historical subjects. Exhib. two works, 'Milton Reading to Cromwell' and 'Molière Rehearsing' at the BI, and a work entitled 'Giorgione' at SS. London address.

MURRAY, Mrs. Henry John 1815-1882
(Miss Elizabeth Heaphy)
Painter of portraits, genre and oriental subjects. Daughter of Thomas Heaphy (q.v.). Studied under her father, and taken by him to Rome where she drew from the antique, and attracted the attention and encouragement of Horace Vernet. In about 1835, when her father died, she left England for Malta to execute some commissions for Queen Adelaide. Her own book, *Sixteen Years of an Artist's Life,* gives an account of her career until some time after her marriage to Henry John Murray in 1846. He was then British Consul at Gibraltar and Mrs. Murray accompanied him as he moved to Tangiers and Constantinople. In Turkey she made sketches in the slave markets, and painted portraits of the various members of the foreign embassies, and in Greece she painted portraits of the King and Queen. They then moved to America where she became very well known; she had many pupils and Clayton notes that "she may be said to have practically introduced watercolour painting of the modern school into the United States". She exhib. in London as Miss Heaphy 1834-43 at the RA (portraits); and as Mrs. Murray 1846-82, at the RA 1846 and 1847, SS, NWS (52 works), GG and elsewhere. RI in 1861. Among her best pictures are 'The Eleventh Hour', 'A Spanish Letter Writer', 'The Best in the Market, Rome', 'Spanish Bolero Dancer', 'Ave Maria' and 'The White Rose'. Among her best portraits are ones of the Duke of Cambridge, Prince Demidoff and Garibaldi, who was a personal friend. 'Just Awake' was her diploma picture at the RI.
Bibl: AJ 1859 p.84; Gazette des Beaux-Arts II 1859 p.179; VI p.106; Elizabeth Murray, *Sixteen Years of an Artist's Life;* Clayton II pp.111-16; Clement & Hutton; Bryan; Williamson, *History of Portrait Miniatures,* I 1904 p.199; VAM.

MURRAY, John Reid 1861-1906
Painted landscapes. Studied in Edinburgh, Glasgow and Antwerp. Exhib. a work entitled 'September' at the RA. Represented in the Glasgow AG. Born in Helensburgh, Dunbarton. Died in Prestwick, Lancashire.
Bibl: D Martin, *The Glasgow School of Painting,* 1902; Caw; Cat. Glasgow AG 1911.

MURRAY, Miss Maria fl.1852-1881
Exhib. four works at the RA including 'Orange Blossoms', 'Waiting for the Carriage' and 'Which Hand Will You Have?' Also exhib. two watercolours, 'The Age of Poetry' and 'Jealousy', at SS. London address.

MURRAY, W. Bazett fl.1871-1875
Exhib. a work entitled 'Peasantry Nearing Paris, September 1870' at the RA. London address.

MURRAY, W. Hay fl.1880-1896
Exhib. four works at the RA, including 'Sandrock, Hastings' and 'Hazlehurst, Hastings', at the RA. Address in Hastings, Sussex.

MURRAY, William Grant 1877-1950
Painted landscapes. Studied at Edinburgh School of Art, the RCA and in Paris. Exhib. four works at the RA 1901-03, including 'My Sister' and 'Childhood'. Born at Portsoy, Banff. Lived in Swansea, Glamorgan.
Exhib: Cardiff, National Museum of Wales 1943.

MUSCHAMP, Francis fl .1865-1881
Painted landscapes. Exhib. 15 works at SS including views in North Wales and on the Wye, and scenes from Ben Johnson's play *The Fox.* Also exhib. three landscapes at the BI. London address.

***MUSCHAMP, F. Sydney RBA fl.1870-1903 d.1929**
London painter of genre and historical and mythological subjects, who exhib. 1870-1903, at the RA 1884-1903, SS and elsewhere. Titles at the RA include 'Scene from *The Merchant of Venice*', 1884, 'The Winning of the Golden Fleece', 1894, and 'Circe', 1897. His classical subjects are similar to those of Alma-Tadema.
Bibl: Wood, Panorama.

MUSGRAVE, Miss fl.1891-1892
Exhib. a painting of clematis at SS. Address in Sidmouth, Devon.

MUSGRAVE, G.A. fl.1877
Exhib. a drawing in 1877. London address.

MUSGRAVE, Harry fl.1884-1903
Painted marines and shipping. Exhib. 15 works at the RA including 'A Breezy Day in Mid Channel', 'Near the Lizard, Cornwall' and 'Off the Needles'. London address.
Bibl: Brook-Hart.

MUSGRAVE, Thomas M. fl.1844-1862
London still-life painter, who exhib. 1844-62, at the RA in 1848 and 1853, BI and SS.

MUSGRAVE, William fl.1841-1847
Painted portraits. Exhib. two works, a portrait and a sketch of children at the RA. Address in Edinburgh.

MUSPRATT, R.F.L. fl.1872
Exhib. a view of the cloisters at S. Giovanni, Palermo, at the RA Address in Flintshire.

MUSTO, Frederick fl.1900
Exhib. a view in Yorkshire at the RA. Address in Leeds.

MUSURUS, P. fl.1858
Exhib. a self-portrait at SS. London address.

***MUTRIE, Miss Annie Feray 1826-1893**
Flower and fruit painter. Born in Manchester and studied at the Manchester School of Design under George Wallis. Exhib.1852-82 at the RA, BI and elsewhere. The truthfulness of her painting (and her sister's) was much admired by Ruskin, who continually praised her work: "All these flower paintings are remarkable for very lovely, pure, and yet unobtrusive colour —perfectly tender and yet luscious, and a richness of petal texture that seems absolutely scented. The arrangement is always graceful — the backgrounds sometimes too faint. I wish this very accomplished artist would paint some banks of flowers in wild country, just as they grow, as she appears slightly in danger of falling into too artificial methods of grouping" (Academy Notes, 1855).
Bibl: J. Ruskin, Academy Notes 1855, 1856, 1857, 1858; Portfolio 1886 p.43; 1893, Art Chronicle p.XXIII; Clayton II p.289; Clement & Hutton.

MUTRIE, Miss Martha Darley 1824-1885
Flower painter. Elder sister of Miss Annie Feray Mutrie (q.v.). Also studied under George Wallis at the Manchester School of Design, and had a similarly successful career as her sister. Exhib. 1853-84, at the RA 1853-78, BI, NWS and elsewhere.
Bibl: See under Miss A.F. Mutrie.

MYALL, H.A. fl.1835-1838
Exhib. three works, including 'The Old Bachelor' and 'The Watchful Smuggler', at SS.

MYERS, G. fl.1853
Exhib. a view of the interior of the medieval court at the Great Exhibition, 1851. London address.

MYERS, John fl.1883-1886
Exhib. 'The Parish Priest' and two studies at the RA. London address.

MYLNE, H. fl.1866
Exhib. a study of a head at the RA. London address.

MYLNE, Robert fl.1845
Exhib. a view of San Clemente, Rome. London address.

MYLNE, Mrs. Robert Williams fl.1867
Exhib. a portrait at the RA. London address.

NAEGELY, Henry fl.1879-1893
Exhib. two works, one entitled 'The Edge of a Cornfield', at the RA. London address.

NAFTEL, Miss Isabel fl.1870-1873
Exhib. four works at the RA including a portrait of the Dowager Duchess of St. Albans and works entitled 'The Letter' and 'The

Little Model'. Presumably she was the daughter of Paul Jacob Naftel and his second wife, Isabel (qq.v.). Address in Guernsey.

Bibl: See under Paul Jacob Naftel.

NAFTEL, Miss Maude ARWS 1856-1890

London painter of flowers and landscape. Daughter of Paul Jacob Naftel (q.v.) by his second wife, and sister of Isabel Naftel (q.v.). Studied at the Slade School and under Carolus Duran in Paris. Exhib. 1875-89, at the RA, OWS, NWS, GG, NG, and elsewhere. Titles at the RA are mostly flower subjects, for which she was well known, and 'An Autumn Garden' and 'Sand Dunes near Boulogne'. ARWS in 1887. She published a book on *Flowers and How to Paint Them*.

Bibl: See under Paul Jacob Naftel.

NAFTEL, Mrs. P.J. fl.1857-1891
(Miss Isabel Oakley)

Guernsey painter of genre, landscape, flowers and portraits. Second wife of P.J. Naftel (q.v.), and youngest daughter of Octavius Oakley (q.v.). Exhib. 1857-91, at the RA 1862-89, SS, NWS, GG, NG and elsewhere, titles at the RA including 'A Little Red Riding Hood', 1862, 'Musing', 1869, and 'A Sark Cottage', 1885.

Bibl: See under Paul Jacob Naftel.

*NAFTEL, Paul Jacob RWS 1817-1891

Guernsey painter of landscape. Born in Guernsey and lived the early part of his life there. Although he was self-taught, he was appointed Professor of Drawing at Elizabeth College. Settled in England in 1870 where he practised as a drawing master, and among his pupils was Kate Prentice (q.v.). He exhib. 1850-91, prolifically at the OWS (689 works), and also at GG. A member of the OWS in 1856; RWS 1859. His subjects were, in his earlier days, the scenery of the Channel Islands, and later views in Britain and Italy. He also made designs to illustrate Ansted and Latham's book *The Channel Islands*, 1862. His second wife was Isabel (q.v.). His works are in the VAM, Reading and Cardiff Museums. His studio sale was held at Christie's, 6 April 1892. For works, illustrated by, see VAM card cat.

Bibl: AJ 1891 p.352; J. Ruskin, Academy Notes 1856-9; Clement & Hutton; The Year's Art 1892 p.288; Cundall; DNB; VAM. S. Furniss and T. Booth, *P.J. Naftel*, 1991; T. Booth, *Naftel — a Truly Gifted Artist*, Watercolour Magazine April 1992.

NAIRN, Anne Langley fl.1844-1847

Painted landscape. Exhib. at the RHA 1844-7. Lived in Co. Fermanagh. She was the daughter of George Nairn (q.v.).

Bibl: Strickland.

NAIRN, Cecilia Margaret 1791-1857

Painted landscape. Exhib. at the RHA, 1826-47. She was the wife of George Nairn (q.v.).

Bibl: Strickland.

NAIRN, George ARHA 1799-1850

Painted portraits, landscape and animals. He was a regular exhibitor at the RHA 1826-49.

Bibl: Strickland.

NAIRN, James M. 1859-1904

Painted landscape and portraits. He was a pupil of R. Greenlees and W.Y. McGregor (qq.v.). Born in Glasgow. From 1889 he lived in New Zealand. Represented in the Glasgow AG and the museum in Wellington, New Zealand.

Bibl: Carr; *The Art of the British Overseas*, Studio Winter Number 1916-17 p.86ff.
Exhib: Auckland, New Zealand, 1964.

NAISH, J. fl.1872

Exhib. an interior view of Speke Hall, Lancashire at the RA.

*NAISH, John George 1824-1905

Painter of genre, classical figures and nymphs, etc., landscape and marine subjects, working in Midhurst, Ilfracombe and London. Studied at the RA Schools and exhib. 1843-93 at the RA, BI, SS and elsewhere. From 1850-1 he studied in Paris, Bruges and Antwerp. In about 1860 he altered the style of his paintings, leaving the ideal and classical figures, eg. 'The Water Nymph's Hymn to the Rising Sun', RA 1849, for marine subjects, mostly set on the Devonshire and Cornish coasts, e.g. 'A Summer Sea — Scilly Islands', RA 1860. The AJ 1875 noted "Certainly there was no truer or finer combination of land and ocean among the pictures of that year than the view of the town ('Ilfracombe', RA 1870) in which the painter had been resident for some time"; it afterwards gained a gold medal at the Crystal Palace. The Walker AG, Liverpool has some of his works. He also painted occasional fairy subjects in his early period.

Bibl: Clement & Hutton

NALDER, James H. fl.1853-1881

Painter of genre and portraits, living in London and Wantage, who exhib. 1853-81, at the RA 1856, 1858 and 1868, BI, SS and elsewhere. Titles at the RA include 'Portrait of a Lady' and 'A Pleasure Party on the Celebrated Shell Beach at Herm, a Little Island in the Channel', 1858.

NANCE, Robert M. fl.1895

Exhib. three works at the RA including 'Old Bowers' and 'Study of a Rustic'. Address in Bushey, Hertfordshire.

NANKIVELL, Miss Helen L. fl.1892-1893

Exhib. three works at SS including watercolour views of Walberswick Church, Suffolk, and St. Bartholomew the Great, Smithfield. London address.

NAPIER, Mrs. Eva fl.1885-1889

Exhib. a work entitled 'A Quiet Corner, Skye' at SS. London address.

NAPIER, J. Macvicar fl. 1889-1890

Exhib. two works, 'On the Firth of Clyde' and 'The Wild West Shore', at the RA. Address in Gourock, Renfrewshire.

NAPIER, John James fl.1856-1876

London painter of portraits, who exhib. 1856-76 at the RA and BI. The AJ comments on 'The Hon. Sir Samuel Cunard Bt. RA', 1859: "A life sized figure, seated, with a head and features full of vigorous intelligence".

Bibl: AJ 1859 p.168; Ormond.

NAPIER OF MAGDALA, Lady fl.1889-1898

Exhib. two landscapes, 1889-98. London address.

NAPIER, General Sir William Francis Patrick 1785-1860

Soldier, historian and amateur painter. Exhib. a sculpture, and a painting entitled 'Juan and Haidee', at the RA.

Bibl: Ormond.

NAPPER, Harry fl.1890-1897

Exhib. two works, 'The Thames near Kew' and 'Wet Sands', at SS. London address.

NARIL, C. or O. fl.1876
Exhib. a painting of the Battle of Victoria at the RA.

NASH, Frederick 1782-1856
Watercolour painter of architectural subjects and landscapes; architectural draughtsman; engraver and lithographer. Born in Lambeth, the son of a builder. Studied architectural drawing under Thomas Malton II; at the RA Schools from 1801; was occasionally employed by Sir R. Smirke, RA, the architect. For the first ten years he was almost fully occupied in supplying architectural drawings to be engraved in his own publications or in books issued by Britton and Ackermann. Exhib. 1799-1856, at the RA 1799-1847, BI, SS, OWS (472 works) and elsewhere. Member of OWS 1810; resigned in 1812, re-elected 1824. Member of the Associated Artists in Watercolours, 1809. In 1807 he was appointed architectural draughtsman to the Society of Antiquaries. Turner called Nash the finest architectural painter of his day. He did not, however, only paint buildings. He accompanied De Wint on sketching excursions, eg. to Lincoln in 1810, and travelled much in France, Switzerland and Germany. His usual practice when sketching was to make three drawings of his subject, at morning, midday and evening. He also continued to paint elaborate church interiors at Westminster, Durham, Windsor and elsewhere. Amongst others, he illustrated Ackermann's *History of Westminster Abbey,* 1810, and T. Pennant's *History of London,* 1805, and his own published works include *A Series of Views, Interior and Exterior of the Collegiate Chapel of St. George at Windsor,* 1805, *Twelve Views of the Antiquities of London,* 1805-10, and *Picturesque Views of the City of Paris and its Environs,* 1823. His studio sale was held at Christie's, 15 May 1857.
Bibl: AJ 1 857 pp.31, 61 (obit.) ; Redgrave, Dict; Roget; Binyon: Cundall; DNB (for full list of published works); Hughes; S.T. Prideaux, *Aquatint Engraving,* 1909; VAM; Hardie III pp.12, 16-17 (pl.20); Ormond.

NASH, Mrs. J.N. (Laura E.) fl.1872-1874
Exhib. three genre subjects 1872-4. Address in Guernsey.

NASH, J.O. fl.1897
Exhib. a view in Cornwall at the RA. Address in Plymouth, Devon.

***NASH, Joseph 1808-1878**
Topographical and architectural painter, architectural draughtsman and lithographer. Born at Great Marlow; son of a clergyman who kept a school at Croydon. Pupil of Augustus C. Pugin, under whom he became a skilful draughtsman especially in Gothic architecture, and with whom he went to Paris in 1829 to make drawings for *Paris and its Environs,* 1830. He early practised lithography and lithographed the plates in Pugin's *Views Illustrative of Examples of Gothic Architecture,* 1830. He also illustrated novels and books of poetry, and between 1834 and 1848 did plates for *The Keepsake* and other Annuals. Exhib. 1831-79, at the RA in 1863 and 1871, BI, OWS (276 works) and NWS, also six drawings at the Paris Exhibition of 185S, when he was awarded an honourable mention. AOWS in 1834; RWS 1842. His exhibits at the OWS were architectural subjects, mixed with designs from Shakespeare, Scott and Cervantes. His most typical works were nearly always the grand interiors of Tudor or Elizabethan mansions peopled with figures in bright costume. Knole, Hampton Court and Speke Hall were buildings he often depicted. His published works include *Architecture of the Middle Ages,* 1838 (25 lithographs), *The Mansions of England in the Olden Time,* 1839-49 (four sets of 26 lithographs), *Scotland Delineated,* 1847-54, and *Views of Windsor Castle,* 1848.
Bibl: AJ 1879 p.73 (obit.); Roget; Binyon; Cundall; DNB; Hughes; Studio Special Spring Number 1915, *Old English Mansions;* VAM; Hardie III pp.93-4 (pl.118); Brook-Hart; Ormond.

NASH, Joseph, Jnr. RI fl.1859-1893 d.1922
London marine painter. Only son of Joseph Nash (q.v.). RI in 1886. Exhib. 1859-93, at the RA 1877-85, SS, NWS and elsewhere, titles at the RA including 'On the Sands "Hold On" ', 1878, and 'The Fisherman's Hospital, Gt. Yarmouth', 1885.
Bibl: DNB.

NASMYTH, Alexander RBA 1758-1840
Scottish landscape painter. Exhib. 18 works at the BI including 'Rosslyn Castle' and 'Tantalon Castle', and nine works at the RA, the majority views in the neighbourhood of Edinburgh. Address in Edinburgh. He was the father of all the Nasmyths listed below.
Bibl: Art Union 1840 p.71: AJ 1882 p.208ff.; Bryan; Caw; Hardie; Irwin; Staley; J.C.B. Cooksey, *A.N.,* 1991.
Exhib: Eccles, Monk's Hall Museum, *Alexander Nasmyth and his Family,* 1973 (with. Cat.).

NASMYTH, Miss Anne G. b.1798 fl.1829-1838
Painted landscape. Exhib. 11 works at SS including 'View near Norwood' and 'Scene near Loch Katrine', and four works at the BI, including views in Scotland and near Rome. Addresses in London and Edinburgh. She was the daughter of Alexander Nasmyth (q.v.).

NASMYTH, Miss Barbara b.1790 fl.1854-1866
Painted landscape. Exhib. seven works at SS including views in Ayrshire, Perthshire and near Edinburgh. London address. She was the daughter of Alexander Nasmyth (q.v.).

NASMYTH, Miss Charlotte b.1804 fl. to 1866
Painted landscape. Exhib. 31 works at SS, including views in the Home Counties, North Wales and Scotland. Also exhib. at the RA and the BI. Addresses in Manchester and London. She was the daughter of Alexander Nasmyth (q.v.).
Bibl: Irwin.

NASMYTH, Miss Elizabeth b.1793 fl.1838-1866
Exhib. a view near Edinburgh at the BI. London address. She was the daughter of Alexander Nasmyth (q.v.).

NASMYTH, Miss Jane b.1788 fl. to 1866
Painted landscape. Exhib. 11 works at SS including Scottish landscapes and views in the Home Counties. Also exhib. five works at the BI. Address in Edinburgh. She was the daughter of Alexander Nasmyth (q.v.).
Bibl: Irwin.

NASMYTH, Miss Margaret b.1791 fl.1841-1865
Painted landscape. Exhib. 11 works at SS including views in Edinburgh and Northumberland. Address near Manchester. She was the daughter of Alexander Nasmyth (q.v.).

***NASMYTH, Patrick 1787-1831**
Landscape painter. Eldest of the eleven children of the Scottish landscape painter Alexander Nasmyth (q.v.). Studied under his father, and came to London in 1807. Although his subject matter was usually found in the countryside around London, his style was modelled on the Dutch 17th century artists, especially Hobbema. His landscapes are pleasing and conventional, and achieved considerable success in their day. He exhib. at the RA, BI, and SS, and was one of the founder members of the RBA. Nasmyth's works were forged in his own lifetime, and many of his brothers and sisters were also painters, which has led to much confusion about

the family and their work. His studio sale was held at Christie's, 18 June 1831.

Bibl: AJ 1908 p.36; Connoisseur XXXV 1913 p.75ff.; LIII 1919 p.40; LXXIII 1925 pp.30, 51; Whitehall Review April 1910 p.22ff.; Portfolio 1887 p.143; Bryan; DNB; Caw pp.l57-9 (pl. opp. p.l58); Hardie; Irwin; Staley.

NATHAN, Adelaide A. Burnett fl. 1883-1886
Exhib. four works at SS, titles including 'I'm Coming!', 'A Nondescript Girl Doing Nothing' and 'Who'll Pick it Up?'. London address.

NATHAN, Annette M. fl.1881-1886
Exhib. three works at SS including 'Waiting for a Customer' and 'An Albanian'. London address.

NATHAN, Mrs. Estelle fl.1898-1900
Exhib. two works, a portrait and a work entitled 'The Coal Heavers', at the RA. London address.

NATHAN, Miss Fanny fl.1892-1897
Exhib. two works at the RA, 'In Morocco' and 'In the Pyrenees'. Address in Richmond, Surrey.

NATTRESS, George fl.1866-1888
Painted landscape, flowers and views of buildings. Exhib. 22 works at the RA including 'In the Orchard', 'Whitby Abbey' and 'Entrance to Haddon Hall'. Also exhib. at the NWS. London address.

NAUGHTEN, Miss Elizabeth fl.1867-1882
Exhib. two works at SS, 'Near Loch Luichart' and 'The Sluice'. London address.

NAVONE, Edoardo fl.1891
Exhib. a work entitled 'Interessante Notizia' at the RA. London address.

NAYLOR, Miss Marie J. fl.1883-1904
Painted fruit and figurative subjects. Exhib. nine works at SS including 'Grapes', 'From Egypt' and 'Waiting for the Postman'. Exhib. 12 works at the RA including 'Blanche', 'Portrait of the Artist' and 'Planning Mischief'. London address.

NEAGLE, John 1799-1865
Painted portraits. His portrait of Mary Ann Wood is in the Pennsylvania Academy of Arts.
Bibl: Ormond.

NEALE, Edward fl.1858-1881
Painted game and landscape. Exhib. six works at the BI and nine works at SS, including 'Peregrine Falcon and Mallard', 'Mountain Fox Catching Ptarmigan' and 'An October Snow-Storm on the Moors'. London address.

NEALE, Edward J. fl.1886-1889
Exhib. four works, including 'Fleecy Clouds' and 'Sunset and Solitude', at SS. London address.

NEALE, George Hall 1863-1940
Painted portraits and figurative subjects. Studied at the Liverpool School of Art and at the Académie Julian. Exhib. 11 works at the RA including 'One Man's Loss is Another Man's Gain' and 'Syrinx'. Lived in Liverpool and was President of the Liverpool Academy of Arts.

NEALE, J. fl.1846
Exhib. a work entitled 'Dos-à-dos' at the RA. London address.

NEALE, John Preston 1780-1847
Painter of topographical and architectural subjects, insects, flowers and fruit; architectural draughtsman. His earliest works were drawings of insects, flowers and fruit (exhib. some of these at the RA 1797-1803). He met John Varley (q.v.) in 1796, who became a life-long friend, and together they published The Picturesque Cabinet of Nature, No. I, 1796 (Neale etched and coloured the plates, Varley drew the landscapes; No. 2 never appeared). For a time he was a clerk in the Post Office, but eventually resigned. His works were now topographical landscapes and to give them greater truth he studied architecture; some were in oil, but mostly they were in pen tinted with watercolour. He travelled through Great Britain making drawings of country seats and churches, which were later published. His most famous published works include History and Antiquities of the Abbey Church of St. Peter, Westminster, 1823 (text by E.W. Brayley), Views of the Seats of Noblemen and Gentlemen in England, Wales, Scotland and Ireland (1st series 6 vols., 1824; 2nd series 5 vols., 1824-9). He exhib. 1797-1844 at the RA, BI, SS and OWS.
Bibl: Gentleman's Magazine 1847 pp.ii, 667; Redgrave, Dict; Roget; J.H. Salter, Engravings and their Value, 1900; Bryan; Binyon; DNB (for list of Neale's topographical publications); S.T. Prideaux, Aquatint Engraving, 1909, pp.367, 460.

NEAVE, Sir Richard Digby, Bt. 1793-1868
Painted landscape. Exhib. 'A Scene in the New Forest' at the RA and another landscape at SS.
Bibl: Burlington Mag. XXVI pp.114. 116.

NEEDHAM, Lieut.-Col. fl.1880
Exhib. a landscape at the GG. London address.

NEEDHAM, Jonathan fl.1858-1870
Exhib. 29 landscapes 1858-70. London address.

NEEDHAM, Joseph G. fl.1860-1874
Exhib. two works, views at Henley-upon-Thames and on the East Lynn River, at the BI. London address.

NEILSON, E. fl.1883
Exhib. a still-life at SS. London address.

NELSON, Mrs. D. fl.1856
Exhib. a portrait at the RA.

NELSON, Harold Edward Hughes b.1871
Painter of figurative subjects and illustrator. Studied at Lambeth School of Art and at the Central School. Exhib. in London. Born in Dorchester, Dorset. Lived in London.
Bibl: Studio VII p.93ff.; VIII p.226; XXIV p.63; LXIII p.148; LXXIII p.67; LXXXI p.19; LXXXIII p.96.

NELSON, Miss S.R. fl.1846-1847
Exhib. two watercolours, 'A Peasant Girl' and 'Industry Rewarded', at SS. London address.

NELSON, William J. fl.1879-1883
Exhib. 'The Close of an Autumn Day' at SS, and 'Eastern Comfort' at the RA. London address.

NERUDA, L. Norman fl.1886
Exhib. a figurative subject at the GG.

NESBITT, Miss Fannie M. fl.1881-1885
Exhib. a work entitled 'A Peep Over the Distance' at SS. London address.

NESBITT, Miss Frances E. 1864-1934
Painted landscapes and townscapes. Exhib. 17 works, some of them watercolours, at SS, titles including 'The Fish Corner, Whitby', 'Waiting for the Tide, Venice' and 'An Old-Fashioned Garden'. Born at King's Langley, Hertfordshire. Lived in London.

NESBITT, John 1831-1904
Edinburgh landscape and marine painter, who exhib. 1870-1888 at the RA. Titles include: 'After a Gale', 1870 and 'Looking East from the Roundell, Gullane', 1888. Caw writes: "The marines and shore-pieces of Messrs. J.D. Taylor, Andrew Black, John Nesbitt, J.D. Bell, Alexander Ballingall, and one or two more of somewhat similar age and standing, if unaffected in feeling, possess no qualities of technique or emotion calling for comment . . ." One of his works is in Glasgow AG.
Bibl: Caw p.331; Brook-Hart.

NESBITT, Sidney fl.1872-1878
Exhib. two watercolours at SS, including 'The Bridge, Eynsford' and 'The Old Farm'. Also exhib. one work at the RA. London address.

NESFIELD, William Andrews RWS 1793-1881
Painter of landscape — chiefly waterfalls — and marines, in watercolour; landscape gardener. Son of the rector of Brancepeth, Durham; educated at Winchester, Trinity College, Cambridge and Woolwich. Entered the army in 1809, served in the Peninsular War and in Canada, and retired in 1816. He took up painting in watercolour — landscapes — and became well known for his paintings of waterfalls. Ruskin speaks of him as "Nesfield of the radiant cataract". He exhib. 1823-51 at the OWS (91 works), the subjects being chiefly waterfalls in North and South Wales, Yorkshire and Scotland. In 1852 he retired from the OWS and took up the profession of landscape gardening. He helped to lay out several London parks, notably St. James's and Kew Gardens, and also planned gardens for leading house owners, such as at Trentham, Alnwick and Arundel Castle. He was the father of the architect William E. Nesfield.
Bibl: J. Ruskin, *Modern Painters*, I 1843; II 1846; Roget; Binyon; Cundall; DNB; Hughes; VAM; A. Bury, *William Andrews Nesfield*, OWS XXVII; Hardie III p.28 (pl.37); Hall.

NETHERWOOD, Arthur RCA fl.1895-d.1930
Painted landscape. Exhib. three works, including 'Conway Quay After Rain' and 'Ploughing on a Breezy Day' at the RA. Born in Huddersfield, Yorkshire. Lived near Shrewsbury, Salop.

***NETTLESHIP, John Trivett 1841-1902**
Painter of animals and genre; illustrator; author. Born in Kettering; went to the Cathedral School, Durham; entered his father's solicitor's office; then he entered Heatherley's and the Slade School. His early work is in black and white, and often biblical scenes. He illustrated his friend Arthur W.E. O'Shaughnessy's *An Epic of Women*, 1870, and Mrs. A. Cholmondeley's *Emblems*, 1875. He did many sporting activities; boxed, and accompanied Sir Henry Cotton on a mountaineering expedition to the Alps. He then

became an animal painter and studied at the Zoological Gardens. Exhib. 1871-1901, at the RA 1874-1901, SS, NWS, GG, NG and elsewhere. In 1880 he was invited to India by the Gaekwar of Baroda, for whom he painted a cheetah hunt, 'The Last Leap but One', RA 1881, as well as an equestrian portrait. In his later years he also used pastel. He was also an author and published *Essays on Robert Browning's Poetry*, 1868 (three editions, 3rd in 1895), and *George Morland and the Evolution from him of some Later Painters*, 1898. Nettleship often painted animals in other people's pictures; for example, he did the pigeons in Henry Holiday's 'Dante and Beatrice'. His eldest daughter married Augustus John.
Bibl: Mag. of Art 1903 pp.75-9; DNB 2nd supp; Sir Henry Cotton, *Indian and Home Memories*, 1911.

NEÜMANS, Alphonse fl.1873-1889
Painted figurative subjects. Exhib. three works including 'The Critics' and 'The Sister of Charity', at the RA. Also exhib. two works at SS. Address in Scarborough, Yorkshire.

NEUMEGEN, Miss Florence A. fl.1901
Exhib. a work entitled 'Mother and Babe' at the RA. London address.

NEUSTEIN, A.S. fl.1848
Exhib. two works, 'On the Elbe' and 'Evening' at the RA. London address.

NEVE, A. Aug. fl.1888-1903
Exhib. two works, 'Reflections' and 'Across the Southern Sea', at the RA. London address.

NEVE, William West fl.1887-1902
An architect who exhib. townscapes and views of houses in London and Scotland, and a work entitled 'View from the Pont des Moulins, Strasbourg', at the RA. London address.

NEVINS, W. Probyn- fl.1885
Exhib. a genre subject in 1885. London address.

NEW, Miss E. fl.1864
Is supposed to have exhib. a portrait at the RA. Address in Munster.

NEW, Edmund Hart 1871-1931
Architect, illustrator and painter of landscapes, coastal scenes, portraits and figure subjects. Studied under E.R. Taylor and A.L. Gaskin at Birmingham School of Art, and exhib. in Birmingham 1890-1923. Lived mainly in Oxford.

NEWBERY, Francis H. RWA 1855-1946
Painted figurative subjects. Studied at Bridport Art School and at the RCA. Exhib. four works at the RA, including 'A Summer Day' and 'The Village Inn', and one work at SS. Director of Glasgow School of Art from 1885. Born at Membury, Devon. Lived in Glasgow and later at Corfe Castle, Dorset.
Bibl: Who's Who; AJ 1906 pp.73, 264; 1909 p.152; Studio LXIII p.115; LXV p.100; LXVI p.101; LXXVII p.263; LXXVIII p.54; LXIX pp.94; LXXIX p.98; LXXX p.18ff.; LXXXIII p.34; Irwin.

NEWBERY, Miss Maud fl.1892
Exhib. a painting of apples at the RA. London address.

NEWBOLD, Miss Annie fl.1892
Exhib. a landscape in 1892. London address.

NEWBOLT, Sir Francis George ARE 1863-1940
Painted landscape. He was both a lawyer and a scientist, and painted in his spare time. Studied at the Slade School and at Oxford. Exhib. six works at the RA 1897-1904, including 'Home-coming Rooks, Suffolk' and 'The Hundred River'. He published books on art history. Born at Bilston, Staffordshire. Lived in London and at Aylesbeare, Devon.

NEWBOLT, J. fl.1868
Exhib. a view entitled 'Rome from Monte Mario, with Sir George Beaumont's Pine' at the RA. London address.

NEWBY, Alfred T. fl.1885-1890
Exhib. two landscapes at the NWS. Address in Leicester.

NEWCOMBE, Miss Bertha fl.1876-1904
Painted landscape and figurative subjects. Exhib. 11 works at the RA, including 'Cecile' and 'Fragrant Posies', and eight works at SS, including 'A Suffolk Cottage' and 'A Cowslip Field'. She was a member of the Society of Lady Artists. Address in Croydon, Surrey.

NEWCOMBE, Frederick Clive 1847-1894
Liverpool landscape painter, chiefly in watercolour. His real name was Frederick Harrison Suker, and he adopted his pseudonym to distinguish him from his father John Suker and brother Arthur Suker (q.v.), also painters. Studied at the Mount Street School of Art under John Finnie. Exhib. at the Liverpool Academy from 1867, and at the RA 1875-87. His 'The Head of a Highland Glen', RA 1875, attracted the notice of Ruskin who described it as "the best study of torrent, including distant and near water, that I find in the rooms". Newcombe's earliest sketching-ground was at Bettws-y-Coed, and he afterwards worked in Scotland, Warwickshire, Devonshire and the Lake District. The last was his favourite, and in 1880 he made Keswick his headquarters. He died at Coniston.
Bibl: AJ 1894 p.125; J .Ruskin, Academy Notes 1875; Bryan.

NEWCOMEN, Mrs. Olive fl.1862-1872
Painted animals and rustic subjects. Exhib. eight works at the RA, including 'Clumber Spaniel's Head and Teal' and 'Cart-Horses Watering', and four works at SS, including 'Wild Duck and Lobster'. London address.

NEWELL, Hugh b.1830 fl.1861
Irish-American who painted genre subjects. Studied in Antwerp and Paris. Exhib. three works at SS, and one work, an illustration to a line from Longfellow, at the RA. Born in Belfast.
Bibl: Clement & Hutton; M. Fielding, *Dictionary of American Painting*.

NEWENHAM, Frederick 1807-1859
Painter of portraits and historical subjects. Born in Co. Cork; early in life he went to London where he painted portraits and historical subjects. In 1842 he was selected to paint a portrait of Queen Victoria for the Junior United Service Club, and also a companion portrait of the Prince Consort. Subsequently he became a fashionable painter of ladies' portraits. He exhib. at the RA 1838-55 — mostly portraits, and at the BI 1842-52 — subject pictures, many very large in size. Titles include: 'Arming for Battle' 1841, 'Jenny's Lament', 1849, 'Cromwell Dictating to Milton', 1850, and 'Princess Elizabeth Examined by the Council', 1852. One of his historical paintings is in Salford Museum.
Bibl: Gentleman's Magazine 1859 I p.548; Redgrave, Dict; DNB; Strickland; Ormond.

NEWENHAM, Robert O'Callaghan 1770-1849
Painted landscape. He was Superintendant of Barracks in Ireland. During his tours of inspection he made topographical drawings. These were published by Ackermann.
Bibl: Strickland.

NEWEY, Harry Foster RBSA 1858-1933
Painted landscape and genre. Studied in Birmingham, where he lived and exhib.

NEWHOUSE, Charles B. fl.1830-1840
Painter of coaching subjects in oil and watercolour.

NEWILL, Miss Mary J. 1860-1947
Painted landscape and coastal views. Worked in the Midlands and exhib. at the RBSA from 1884. She was a member of the Birmingham Group. Lived in Edgbaston, Warwickshire.

NEWMAN, Miss Catherine M. fl.1886-1897
Painted flowers. Exhib. two works, 'Wallflowers' and 'Irish Pods', at the RA. Also exhib. a work at SS. London address.

NEWMAN, Miss E. fl.1862-1863
Exhib. two works, 'Fruit' and 'Pomegranate and Grapes' at the RA. London address.

NEWMAN, E.E. fl.1871
Exhib. a painting of flowers in 1871. London address.

NEWMAN, John FSA 1786-1859
An architect and archaeologist who exhib. views of buildings at the RA. His first exhib. at the RA was a view of an antique temple in Rome. London address.
Bibl: Redgrave, Dict.; DNB.

NEWMAN, Philip Harry RBA 1840-1927
Painted historical and classical subjects. Studied in London and Paris. Exhib. in London from 1872, mainly at the RA. Member of the Langham Sketch Club. Lived in London and near Towcester, Northamptonshire.
Bibl: Who's Who; The Year's Art 1928 p.361.

NEWMAN, Samuel J. fl.1876-1886
Exhib. views of buildings at the RA including one of Winchester Cathedral and one of a house in Northamptonshire. Address in Southampton, Hampshire.

NEWMANS, H.
Very little known artist who seems to have imitated the moonlight harbour scenes of J. Atkinson Grimshaw (q.v.).

NEWMARCH, Strafford fl.1866-1874
Painted landscapes. Exhib. one work, 'A Trout Stream', at the BI, 'A Surrey Farmyard' at the RA and four works at SS, including 'The Wayside Shrine' and 'A Sketch in Petersham'. London address.

NEWMEGEN, Florence A. fl.1893
Exhib. 'A Summer Sketch' at SS. London address.

NEWNHAM, Miss Margaret fl.1864-1865
Painted fruit. Exhib. 'Grapes and Peaches, from Thomony, France' at the BI and a painting of grapes at the RA. London address.

NEWNUM, T.E. fl.1846
Exhib. a view of Fooden Gill, Yorkshire, at SS. Address in York.

NEWTON, A.H. fl.1851-1856
Exhib. three works at SS including a watercolour of 'Mount St. Catherine, near Rouen'. Also exhib. 'On the Banks of the Thames' at the RA. London address.

NEWTON, Alfred Pizzey (Pizzi) RWS 1830-1883
Landscape painter, especially of mountain scenery, and mainly in watercolour. Born at Rayleigh, Essex; self-taught. His earliest works were painted in the highlands of Scotland, and obtained the patronage of Queen Victoria when he was painting scenery near Inverlochy Castle. She selected him to paint a picture as a wedding present for the Princess Royal in 1858, and he also contributed some sketches for the royal album of drawings. Exhib. 1855-83, at the RA 1855-81, SS and especially at the OWS (249 works). He travelled in Italy 1862, and Greece 1882. Ruskin wrote on 'View in Argyllshire', OWS 1858: "Let Mr. Newton but draw all the four sides of Ben Nevis as he has done this one, and nobody need ever go to the mountain again for the mere sake of seeing what it is like." The VAM holds manuscripts relating to Newton.
Bibl: J. Ruskin, Academy Notes 1858, 1859; Portfolio 1870 p.147; 1883 p.225; The Year's Art 1884 p.217; Roget; Bryan; Cundall; DNB; VAM; Zoe Earle Newton, *Reminiscences of the Work of the Late Alfred Pizzi Newton, RWS*, c.1940.

NEWTON, Ann Mary (Lady Charles J.) 1832-1866
Painter of portraits, topographical landscapes and antiquities. Born in Rome, daughter of Joseph Severn (q.v.), then English Consul. Pupil of her father and George Richmond (q.v.), who lent her some of his portraits to copy and employed her for the same purpose. When she was 23 she went to Paris and studied under Ary Scheffer. While there she painted a watercolour portrait of the Countess of Elgin, which was much admired and gained her numerous commissions on her return to England, including some from the Queen. Exhib. RA 1852-6 as Miss Mary Severn, and 1864-5 as Ann Mary Newton. She married (Sir) Charles Newton, keeper of Classical Antiquities at the BM, and afterwards made drawings of the antiquities in the BM for her husband's books and lectures, and made many sketches accompanying him in Greece and Asia Minor.
Bibl: AJ 1866 p.100; Redgrave, Dict.; Clayton I p.410; Bryan; DNB; S. Birkenhead, *Illustrious Friends*, 1965 see index; Ormond.

NEWTON, Charles M. fl.1889-1899
Exhib. five works at the RA including 'Allies or Rivals' and 'Correspondence'. London address.

NEWTON, G. fl.1850-1859
Painted portraits and figurative subjects in watercolour. Exhib. eight works at SS including portraits and a scene from *Romeo and Juliet*. Also exhib. two landscapes at the RA and a work at the BI. Addresses in London and Durham.

NEWTON, G.H. fl.1858-1871
Painted landscape watercolours. Exhib. 14 watercolours at SS including views on the rivers Greta, Browney and Tees, and works entitled 'Cock Mill, near Whitby' and 'Brignall Banks, Rokeby'. Address in Durham.

NEWTON, H. NWS fl.1837-1839
Exhib. 22 figurative subjects at the NWS. London address.

NEWTON, Henry fl.1847-1854
An Englishman who settled in Dublin and who exhib. between 1847 and 1853. Some of his watercolours are in the collection of the National Gallery of Ireland.
Bibl: Strickland; Ormond.

***NEWTON, John Edward RI fl.1835-1891**
Liverpool painter of fruit and landscapes, who exhib. RA 1862-81, BI, SS, NWS and elsewhere. Titles at the RA include 'Inspection of the Morning's Sport', 1862, 'The Dragon-fly's Haunt', 1863, and 'Early Spring, Sowing Mangold', 1870. From 1856 to 1867 he lived in Liverpool, where he was a member of the Academy. In this period he painted in a highly detailed Pre-Raphaelite style, but after moving to London he changed to a broader style. An interesting example of his Pre-Raphaelite style, 'Mill on the Alleyne River, near Gresford, Denbighshire', is in the Walker AG, Liverpool.
Bibl: Cundall p.240; *The Taste of Yesterday*, Cat. of exhib., Walker AG, Liverpool, 1970 No. 66 (with pl.); Staley pl.80a.

NEWTON, John Orr fl.1835-1843
Exhib. figurative and genre subjects at the RHA 1835-43. Address in Newtown, Mountkennedy.

NIAS, J.M. fl.1878-1879
Exhib. two works, 'Brighton Beach' and 'Sunset and Moonrise', at SS. Address in Brighton, Sussex.

***NIBBS, Richard Henry c.1816-1893**
London and Brighton painter of marines, landscapes, genre and battles. He lived in Brighton, painting numerous views in Sussex as well as scenes in France and Holland. In 1843 he painted a picture of Queen Victoria landing at Brighton. Exhib. 1841-89, at the RA 1841-88, BI, SS and elsewhere, titles at the RA including 'Battles of Trafalgar and Nile', 1849, 'Newhaven Harbour, Sussex' and 'Brigantine Dropping out of Port'. The AJ wrote on 'Early Morning on the Coast, Bosham, Sussex', BI 1860: "The subject looks infinitely Dutch; it is difficult to believe that on the Sussex coast there is anything so primitive."
Bibl: AJ 1860 p.79; Binyon; VAM; Wilson; Brook-Hart pls. 71, 72; Ormond; *Richard Henry Nibbs, 1816-93*, Cat. of exhib., Brighton Polytechnic 1974.

NICHOL, Miss Bessie fl.1890
Exhib. 'The Angler's Haunt' at the RA and 'Gossips' at SS. London address.

NICHOL, Edwin 1855-1923
London landscape painter, who exhib. 1876-1900, at the RA 1879-1900, SS and elsewhere. Titles at the RA include 'When the Summer Sun is Hot', 1886, and 'The Mill Stream', 1900.

NICHOL, H.W. fl.1848
Exhib. a portrait at the RA. London address.

NICHOLAS, Miss F. fl.1841-1855
Painted landscape watercolours. Exhib. five watercolours at SS including 'White Horse Hill, Norwood, Surrey' and 'Sheep Kensington Gardens'. Address in Norwood, Surrey.

***NICHOLL, Andrew RHA 1804-1866**
Irish landscape painter and illustrator. Born in Belfast, son of a boot-maker; apprenticed to a printer. Studied in London and subsequently worked in Dublin, where he exhib. in 1832 and was elected A of RHA in 1837; RHA 1860. In 1840 he settled in London. Exhib. 1832-67, at the RA 1832-54, BI, SS, NWS and elsewhere, titles at the RA including 'Giant's Causeway', 1845, and 'The Fort of Colombo, Ceylon', 1849. In 1849 he went to Colombo as teacher of painting and drawing at the Colombo Academy. After living again in London, Belfast and Dublin, he finally returned to London. Some of his drawings were engraved and lithographed,

and he also wrote some articles and poetry. Now well-known for his watercolours of wild flowers. William, his brother (q.v.), was also a landscape painter, and a Member of the Association of Artists at Belfast.

Bibl: Binyon; Cundall; Strickland; VAM.

**NICHOLL, Mrs. Samuel Joseph b.1842 fl.1860-1892
(Miss Agnes Rose Bouvier)**
London painter of genre and flowers. Born in London, the youngest of a family of six, all artists. Her father was French, and the family travelled a good deal abroad. She first exhib. in 1860 in Birmingham, 'Sticks for Granny', the painting gaining several commissions for her. In 1868 she visited Germany and Venice. In 1874 she married the architect Samuel Joseph Nicholl. She exhib. as Agnes Rose Bouvier 1866-74, at the RA 1871-4, SS and elsewhere, and as Mrs. S.J. Nicholl 1874-92, at the RA 1876-84, SS, NWS and elsewhere. Titles at the RA 'Carry Me', 1871, 'Buttercups and Daisies', 1872, 'My Lady Carried Love within her Eyes', 1884. She always painted in watercolour, her favourite subjects being young rustic girls and children, painted from the living model.

Bibl: Clayton II p.34.

NICHOLL, William 1794-1840
Painted landscapes in watercolour. He was the brother of Andrew Nicholl (q.v.).

Bibl: Strickland.

NICHOLLS fl.1838
Exhib. a painting of a trout at the RA. Address in Farnham, Surrey.

NICHOLLS, Miss A. fl.1877
Exhib. a landscape in 1877. London address.

NICHOLLS, Charles fl.1857-1862
Exhib. three works including 'Mama's Pet' and 'Flora' at the BI and two works at the RA. Lived in Dublin.

***NICHOLLS, Charles Wynne RHA 1831-1903**
London painter of genre, historical subjects and landscapes. Born in Dublin; studied at the Royal Dublin Society's Schools and at the RHA, and began to exhib. in 1859. A of RHA 1861; RHA 1869. Left Ireland in 1864 and lived in London, but continued to exhib. regularly in Dublin. Exhib. in London 1855-86, at the RA 1866-81, BI, SS and elsewhere. Titles at the RA 'The Tomb of Grace Darling', 1866, 'Lilies', 1878, and 'Relics of Trafalgar', 1881. He always found a ready sale for his pictures. His 'The Tomb of Grace Darling' was engraved for the AJ in 1872.

Bibl: Strickland; Wood, Panorama p.190 (pl. 203).

NICHOLLS, H. fl.1857-1858
Exhib. a still-life at SS and a painting of fruit at the BI. Address in Leamington Spa, Warwickshire.

NICHOLLS, Rhoda Holmes fl.1884
Exhib. a view of a staircase in Venice at the RA. She was the wife of the American painter Burr H. Nicholls. She was born in Coventry, Warwickshire.

Bibl: Field, *Dictionary of American Painting.*

NICHOLS, Miss fl.1865
Is supposed to have exhib. a genre subject at SS. London address.

NICHOLS, Alfred fl.1866
Exhib. a landscape in 1866. London address. Taught for a time at Bristol School of Art.

NICHOLS, Miss Catherine Maude RPE 1848-1923
Painted and engraved landscapes. Exhib. 13 works at the RA including some dry points, the majority views near Norwich and on the Norfolk Broads. Also exhib. six works at SS including 'The Towing Path' and 'A Rough Sea'. Address in Norwich, Norfolk.

NICHOLS, G.A. fl.1840
Exhib. a watercolour study of spaniel puppies at SS. London address.

NICHOLS, Miss Mary Anne fl.1839-1850
Painted flowers, portraits and landscapes. Exhib. 37 works, many of them watercolours, at SS, including landscapes in the vicinity of London and genre subjects. Exhib. 12 works including ten portraits at the RA. London address.

NICHOLS, W.P. fl.1885
Exhib. two landscapes at the NWS. Address in Devizes, Wiltshire.

NICHOLSON, Alexander fl.1871-1884
Painted landscape watercolours. Exhib. six watercolours at SS including 'At Caterham, Surrey', 'A Devon Bridge at Peter Tavey, Dartmoor' and 'On the Mole at Betchworth'. Address in Caterham, Surrey.

NICHOLSON, Miss Alice M. fl.1884-1888
Exhib. two works 'Herrings' and 'Brambles' at the RA, and two works at SS. Addresses in London and Newcastle-upon-Tyne.

Bibl: Hall.

NICHOLSON, Ellen M. fl.1847
Exhib. a painting of Hagar and Ishmael at the BI. London address.

NICHOLSON, Miss Emily fl.1842-1869
Painted landscapes and views of houses. Exhib.12 works at the RA including 'An Oat Field', 'In Teesdale, Durham' and views of Bolton Castle and Knole. Also exhib. 19 watercolours at SS including views on the rivers Thames and Trent and scenes in Yorkshire and the Lake District. London address.

NICHOLSON, John M. fl.1880-1885
Exhib. landscapes at the GG and the NWS. Address in Douglas, Isle of Man.

NICHOLSON, Richard E. fl.1882-1888
Exhib. 'Pigeons and Partridges' at the RA. Address in Halifax, Yorkshire.

NICHOLSON, Lady Sarah Elizabeth fl.1880
Exhib. a work entitled 'A Little Cavalier' at the RA. Address in Totteridge, Hertfordshire.

NICHOLSON, William RSA 1784-1844
Painted portraits. Exhib. at the RA 1808-22, including a portrait of Thomas Bewick. Also painted Sir Walter Scott. Born in Ovingham, Northumberland. Lived in Edinburgh from 1820.

Bibl: Hall; Ormond.

**NICHOLSON, Mrs. William 1871-1918
(Miss Mabel Pryde)**
Studied painting at Bushey. She was the sister of James Pryde and the wife of William N.P. Nicholson (qq.v.). A memorial exhibition of her works was held at the Goupil Gallery, London, in 1920.

NICHOLSON, Sir William Newzam Prior NPS 1872-1949
Painter of portraits, still-lifes and landscapes. Studied at Bushey and in Paris at the Académie Julian. Represented in many public collections. Born at Newark-upon-Trent. Died at Blewbury, Berkshire. For works illustrated, see VAM Card Cat.
Bibl: Studio XII pp.177-83; XXXVII pp.107-10; XLVII p.94; LIII pp.3-11; LXVIII p.53; LXX p.74; LXXXI p.23; LXXXII pp.256, 269; LXXXIV p.73; XCIII p.42ff.; AJ 1900 pp.72-7; 1904 p.51; 1905 p.141; 1906 pp.34, 86; 1908 p.71; 1909 pp.157, 193ff.; Connoisseur XXXVIII p.136; XLIII p.231; XLIV p.233; XLV pp.180, 183; L p.236; LI p.179; LII p.169; LIV p.174; LVI p.253; LIX p.49; LXVI p.249; LXVII p.l73; LXXVI p.l27; LXXIX p.63; Marguerite Steen, *William Nicholson*, 1943; Lilian Browse, *William Nicholson* (Cat. Raisonné), 1956.
Exhib: London, *Company of the Butterfly*, 1900; Nottingham Museum and AG 1933; Manchester City AG 1933; London, Beaux-Arts Gallery 1933; London, Barbizon House 1934; London, Leicester Galleries 1936; Leicester Galleries 1938; Beaux-Arts Gallery 1939; London, Nat. Gall. 1942; London, Roland, Browse & Delbanco 1945; Great Britain, Arts Council, 1947; Roland, Browse & Delbanco 1948; Roland, Browse & Delbanco 1951; London, Marlborough Fine Art Ltd. 1967; London, Folio Fine Art Ltd. 1967; Aldeburgh, Suffolk, 1972; London, William Weston Gallery 1976.

NICKSON, Miss F.K. fl.1886
Exhib. a work entitled 'The Potting Shed' at SS. London address.

***NICOL, Erskine RSA ARA 1825-1904**
Scottish painter of genre, often of a humorous character. Born at Leith. House-painter's apprentice; attended the Trustees' Academy 1938; went to Ireland 1846; received appointment in Dublin, and, during four years' residence there, found the material for a long series of paintings on the humorous side of Irish life. After he had settled in London in 1862 he still made a yearly journey to Ireland to study his subjects at first hand. Later when he could not travel so far he painted Scottish genre instead, at Pitlochry. ARSA 1855; RSA 1859; ARA 1868. Exhib. in London from 1851 at the RA and BI. After 1885 he lived in retirement, living in Scotland and at Feltham, Middlesex, where he died.
Bibl: AJ 1870 pp.65-7; 1893 p.301; 1904 p.170; Ruskin, Academy Notes 1875; Portfolio 1879 p.61ff.; 1887 p.227; Caw; DNB; Bulletin Worcester Art Museum XVII 1926 p.28; VAM; Reynolds, VS p.64 (pl.30); Maas pp.116-17; Irwin; Wood, Panorama; Wood, Paradise Lost.

NICOL, Erskine E. fl.1890 d.1926
Painted landscapes and figurative subjects. Exhib. six works at the RA including 'A Dewy Morn' and 'The Noonday Rest'. Address in Colinton, Midlothian. He was the son of Erskine Nicol (q.v.).

***NICOL, John Watson fl.1876-1924 d.1926**
London painter of genre, historical subjects and portraits. Son of Erskine Nicol (q.v.). Follower of J. Pettie (q.v.). Exhib. 1876-1924 at the RA and elsewhere, titles at the RA including 'A Young Cavalier', 1877, 'Before Culloden', 1882, and 'Westward Ho!', 1901. The AJ 1884 illustrates 'Lochaber No More', the tragedy of a Highlander who has to leave his shepherd's life; and 1906 illustrates a brushwork drawing of an Arts and Crafts design, based on the tulip, for a book cover. Sheffield Museum has 'For Better, for Worse' (Rob Roy and the Bailie).
Bibl: AJ 1884 p.348 (pl.288); 1906 pl.150; Gazette des Beaux-Arts 1879 II p.371; Caw p.272; Wood, Panorama.

***NICOL, William W. fl.1848-1864**
Genre painter. Lived in Worcester, Cheltenham, and later London. Exhib. at RA 1855-64, BI and elsewhere. Titles at RA 'The Recruit', 'Jack in the Box', 'He Doubts', etc.
Bibl: AJ 1859 p.168.

NICOLSON, John P. fl.1891-1894
Painted landscapes. Exhib. seven landscapes at the RA, including 'Old Mill on the Tyne' and 'Charcoal Burning — Forest of Fontainebleau', and two river scenes at SS. Address in Leith, Midlothian.

***NIEMANN, Edmund John 1813-1876**
Painter of landscapes, angling subjects and marines. Born at Islington, his father being German. Employed as a young man at Lloyds, but after 1839 he devoted himself to art, and settled at High Wycombe where he worked incessantly out of doors. Exhib. 1844-72, at the RA, BI (1845-67), SS and elsewhere. He returned to London in 1848 for the foundation of the Free Exhibition held in the Chinese Gallery at Hyde Park Corner. Later in 1850 this became the Portland Gallery, Regent Street, of which he became Secretary. His paintings, often very large, illustrate every phase of nature. He often painted the scenery of the Thames and of the Swale near Richmond in Yorkshire. His son Edward H. Niemann (q.v.) closely imitated his style, and their work is often confused.
Bibl: AJ 1876 p.203; 1877 pp.201-4 (mono. with pls.); G.H. Shepherd, *Critical Catalogue of Some of the Principal Pictures Painted by Edmund John Niemann*, 1890; DNB; VAM; Wilson; Pavière, Sporting Painters; Pavière, Landscape (pl.53); Brook-Hart.

NIEMANN, Edward H. fl.1863-1867
London landscape painter. Son of Edmund John Niemann (q.v.). Exhib. two landscapes at the BI in 1863 and 1867. A landscape 'Near Maidstone, Kent' is in Birmingham AG. His style is very similar to that of his father, but coarser and broader in colour.

NIEUWERHUYS, E. fl.1868
Exhib. two works, 'In for a Shower' and 'A Gallop', at the RA. London address.

NIGHTINGALE, Frederick C. fl.1865-1885
An amateur landscape painter, working in Wimbledon, who exhib. 1865-85 at various galleries (not known). The VAM has a watercolour 'San Biagio, Venice', 1868.
Bibl: VAM.

NIGHTINGALE, Mrs. L.C. (Agnes) fl.1881-1885
Exhib. two works, 'Through the Wood' and 'Apple Blossom', at the RA and a painting of azaleas at SS. London address.

NIGHTINGALE, Leonard Charles fl.1880-1904
Painted figurative subjects. Exhib. 20 works at the RA 1880-1904, titles including 'No Alternative', 'A Wayside Chat' and 'Youth and Springtime'. Also exhib. eight works at SS including 'Treasure Trove' and 'Gossips'. London address.

***NIGHTINGALE, Robert 1815-1895**
Painter of sporting subjects, landscapes, still-life and portraits working in Malden. Exhib. 1847-74, at the RA and SS, titles at the RA including 'Portrait of a Lady', 1847, 'A Walk Round the Shrubberies', 1860, and 'Fruit', 1874. Nightingale painted many series of horse portraits for private patrons.

NILLETT, W. fl.1867
Exhib. a watercolour of St. Stephen's, Vienna, from the West Entrance, at SS. Address in Lewisham.

NINEHAM, Henry 1793-1874
Painted marines and shipping. A member of the Norwich School. Also exhib. at Norwich 1816-31, and painted views of the city.
Bibl: Brook-Hart.

NISBET, Miss Frances E. fl.1886
Exhib. a genre subject in 1886. London address.

NISBET, H. fl.1885
Exhib. a watercolour entitled 'The Last of the Spanish Armada' at SS. London address.

NISBET, Mrs. M.H. fl.1908
Battersea painter of genre and imaginative subjects, not listed in Graves, Dictionary or Royal Academy. Two of her paintings, dated 1908, were exhib. at the Maas Gallery 1969.

NISBET, Margaret D. 1863-1935
Painter of portraits, miniatures and landscapes. Studied in Edinburgh, Dresden and Paris. Perhaps a sister of R.B. Nisbet (q.v.).

NISBET, Pollok Sinclair ARSA RWS 1848-1922
Edinburgh painter of landscapes, architectural subjects and coast scenes. Brother of R.B. Nisbet (q.v.). Exhib. in London at the RA in 1871 and 1884. ARSA in 1892. He travelled abroad — working in Italy, Spain, Morocco, Tunis and Algeria. His loch and glen pieces are rather formally handled and conventionally composed, and his best and most characteristic works are his paintings of market places, mosques and palaces in Morocco and Spain.
Bibl: Charles Holme, *RSA*, 1907; Caw p.298.

NISBET, Robert Buchan RSA RBA RWS RI 1857-1942
Scottish landscape watercolour painter. Born in Edinburgh, son of a house painter. At first apprenticed in a shipping office, but took up painting in 1880; joined his brother Pollock Nisbet (q.v.), in Venice, and then studied in Edinburgh at the Board of Manufacturers' School and the RSA Life Class 1882-5, and in Paris under Bouguereau. Exhib. at the RSA from 1880; ARSA 1893, RSA 1902; and from 1888 at the RA, SS, OWS, NWS, GG and elsewhere. RWS 1887, RI 1892-1907. Founder member 1892 and second P of the Society of Scottish Artists. Hon-member of the Royal Belgian Watercolour Society. His work was always popular and much appreciated abroad. Hardie notes that his work was "similar to De Wint in broad contrasts of light and shade and in depth of low-toned masses, but his method was much less direct and spontaneous. Some of his small sketches are fresh and fluent but in larger work he was tempted into rubbing and scrubbing his colour". Manuscripts relating to Robert Buchan N. are held by the VAM.
Bibl: Studio XXVII 1903 p.135; XXXVII p.349; LVIII p.66; LXIV p.60; LXV p.102; LXVI p.106; LXVII pp.58, 258; LXVIII p.125ff.; LXIX p.98; LXX p.44; VAM MSS Eleven letters to F.C.Torrey 1899-1909; Charles Holme, *RSA*, 1907 pl.XXX; Caw pp.312-13; Studio Winter Number 1917-18, *The Development of British Landscape Painting in Watercolour;* VAM: Tate Cat; Hardie III p.191 (pl.225).

NISBETT, Miss Ethel C. fl.1884-1893
Painted flowers. Exhib. eight works at the RA, including 'Azaleas', 'Almond Blossom' and 'Marsh Marigolds'. Also exhib. five watercolours, four of flowers and one a view at Westminster Abbey, at SS. London address.

NISBETT, J.S. fl.1871
Is supposed to have exhib. a landscape at the RA. Address in Edinburgh.

NISBETT, M. fl.1843
Exhib. two interiors with cart-horses and sheep at the RA and a scene near a farm in Cambridgeshire at the BI. London address.

NIVEN, David P.M. fl.1880
Exhib. 'A Sandy Hillock' at SS. London address.

NIXON, Mrs. fl.1865
Exhib. two watercolours, 'Quinces and Grapes' and 'May and Eglantine', at SS. Address in Tonbridge, Kent.

NIXON, J.F. fl.1864
Exhib. a watercolour of fruit at SS. Address in Tonbridge, Kent.

NIXON, James Henry 1808-c.1850
London painter of genre and historical and scriptural subjects. Pupil of John Martin (q.v.), history painter. Exhib. 1830-47 at the RA, BI and SS, titles including 'Ingress Hall, Greenhithe, Kent', 1838, 'A French Peasant', 1844, and 'The Convent', 1847. 'Queen Victoria's Progress to Guildhall on 9th November 1837', exhib. RA 1838, is in the Guildhall AG.
Bibl: Guildhall AG Cat. 1968 p.17 (pl.23); Ormond.

NIXON, Marian fl.1876-1877
Exhib. three genre subjects 1876-7. London address.

NIXON, Miss Minna fl.1897-1904
Exhib. three works, including 'Winter Blooms' and 'A Bruges Canal', at the RA 1897-1904. London address.

NIXON, William Charles c.1813-1878
Exhib. figurative subjects at the RHA 1844-5. Also painted portraits and worked as a restorer and picture dealer. Born in Dublin, he returned there from Belfast in 1840.
Bibl: Strickland.

NOA, Mme. Jessie fl.1858-1866
Painted figurative subjects and portraits. Exhib. seven watercolours at SS including 'Contentment' and portraits, and two works at the RA, a portrait and a work entitled 'Ida'. London address.

NOAKES, Charles G. fl.1885-1888
Exhib. two paintings of flowers at the NWS. Address in Sydenham.

NOAKES, James fl.1871-1872
Exhib. a watercolour view 'On the Lyn, N. Devon' at SS. London address.

NOBLE, Miss Charlotte M. fl.1871-1892
London painter of domestic genre, who exhib. 1871-92 at SS (41 works).

NOBLE, Edwin fl.1899-1904
Exhib. three works at the RA 1899-1904, including 'The Old Black Mare' and 'The Book Case'. London address.

NOBLE, F.W. fl.1880
Exhib. a work entitled 'Morning on the Thames' at SS. London address.

NOBLE, Miss Florence K. fl.1898-1904
Exhib. two works at the RA 1898-1904, 'Fowls' and 'Our Pussy'. London address.

NOBLE, G.J.L. fl.1825-1840
Painted portraits and figurative subjects. Exhib. 13 works at SS, nine works at the RA and two at the BI. Amongst his later works were 'L'Allegro (from Milton)' and 'Eurydice' as well as portraits. London address.

NOBLE, James RBA 1797-1879
London painter of genre and landscape who exhib. 1829-78, at the RA 1829-55, BI and SS (156 works). Titles at the RA include 'The Truant', 1837, 'Dressed for the Masquerade', 1839, and 'Thoughtful Moments', 1855. For many years he was a member and Treasurer of the RBA. The AJ noted he was "chiefly a painter of figure subjects of a genre character, but he occasionally produced landscapes, principally views of Italian scenery in and about the Roman States . . . one of his best works is 'Rembrandt Painting his Father's Portrait' (SS 1875)".
Bibl: AJ 1879 p.156 (obit., called John).

***NOBLE, James Campbell RSA 1846-1913**
Scottish painter of landscape, portraits and rustic genre. Studied at the RSA Schools under Chalmers and McTaggart (qq.v.), and much influenced by the former. He began with rustic genre — dark cottage interiors, or idylls of country life painted out of doors. But once elected ARSA (1879; RSA 1892) he abandoned genre for landscape, scenes of shipping, rivers and ports, and pictures on the Medway, Tyne, Seine and Clyde. In the early 1880s he went to live at Coldingham and painted the rocky coast of Berwickshire. In 1900 he revisited Holland, and after that his most characteristic works were of Dutch waterways. He exhib. at the RA 1880-96.
Bibl: Studio XLIV 1908 p.232; LVIII 1913 p.66; Charles Holme, *RSA*, 1907; Caw pp.309-10 (pl.310); The Year's Art 1914 p.445.

***NOBLE, John Sargent RBA 1848-1896**
London animal and sporting painter. Studied at the RA Schools and was a pupil of Landseer. Exhib. 1866-95, at the RA 1871-95, SS and elsewhere, titles at the RA including 'Otter Hounds', 1876, 'Royal Captives', 1888, and 'Trusty Friends', 1890. The AJ illustrates 'Unwelcome Visitors': "a family of donkeys receive a group of geese, of whom one is evidently inclined to become impertinent." Especially known for his pictures of dogs.
Bibl: AJ 1895 p.220 (pl.); Pavière, Sporting Painters; Wood, Paradise Lost.

NOBLE, Miss Marion fl.1884
Exhib. a work entitled 'The Cottage Door' at the RA. London address.

NOBLE, R. fl.1841-1842
Exhib. two portraits, one of them of an eastern traveller, at the RA. London address.

NOBLE, R.P. fl.1836-1861
London landscape painter, who exhib. 1836-61, at the RA 1836-60, BI, SS and elsewhere. Titles at the RA — all landscape: 'An Old House near Guildford', 1844, and 'A Mill by the Conway River', 1853. Two of his watercolours are in Birmingham AG and the National Gallery.

NOBLE, R.S. fl.1852
Is supposed to have exhib. a landscape at the RA. London address.

NOBLE, Robert RSA 1857-1917
Scottish landscape and genre painter. Born in Edinburgh; studied under his cousin James Campbell Noble (q.v.), at the Trustees' School and the RSA Life Class 1879-84, sharing the Keith Prize in 1882. He first attracted notice by a number of large cottage interiors with figures, deep-toned in their contrasting effects of light and shade, but about 1880, after studying in Paris under Carolus Duran, he turned to landscape, a development confirmed when he moved to East Linton, East Lothian. He exhib. at the RSA from 1877; ARSA 1892, RSA 1903; and at the RA, GG, NG and elsewhere

from 1889. He was a foundation member and first P of the Society of Scottish Artists 1892. Caw writes that "the scenery of his choice is a combination of sylvan and pastoral, and preferably the tree-fringed meadows, variously wooded watersides, rocky linns and foliage . . . embowered water-mills of the Haddingtonshire Tyne near East Linton, . . . and in the later eighties, under the influence of Monticelli, whose art was so admirably represented in the Edinburgh Exhibition of 1886, he produced a series of pictures with brilliantly costumed figures amongst the blaze of the Tynninghame rhododendrons in full bloom". He is represented at the Tate Gallery by 'Dirleton Church, E. Lothian', 1912. His work is also in the National Gallery, Edinburgh. After his death a sale of his collection and his own works was held at Christie's, 7 December 1917.
Bibl: AJ 1890 p.159; Studio LVIII 1913 p.66; LXIV 1915 p.60; LXV 1915 p.100ff.; LXVIII 1916 p.125; LXX 1917 p.44; LXXIII 1918 p.73; XCII 1926 p.53; Charles Holme, *RSA*, 1907; Caw pp.310-1; Charles Holme, *Sketching Grounds*, 1909 pp.71-6, 81; Connoisseur LV 1919 p.99; Tate Cat.

NOBLE, Robert Heysham RBA fl.1821-1861
London painter of landscape and coastal scenes, who exhib. 1821-61 at the RA 1821-3, BI and SS. He specialised in coastal scenes, many executed at Hastings and in Lancashire.
Bibl: Wilson.

NOBLETT, Henry John b.1812 fl.1844
Painted landscape. Exhib. in London and Dublin. Born and lived in Cork.
Bibl: Strickland.

NONNEN, Annie fl.1861-1864
Exhib. an interior view of a Swedish soldier's hut at the RA. Address in Gothenburg, Sweden.

NORBURY, Edwin Arthur RCA 1849-1918
Painted genre subjects. Also an illustrator. Exhib. a work entitled 'Love Among the Cabbages' at the RA. Also exhib. a work at the NWS. Born in Liverpool.

NORBURY, Miss M.A. fl.1889-1890
Exhib. two works, one a view of Westminster Abbey, at SS. London address.

NORBURY, Richard RCA 1815-1886
Liverpool painter of portraits and historical subjects; illustrator; engraver; sculptor. Born in Macclesfield; held successively the posts of assistant master to the Schools of Design at Somerset House and liverpool. P of the Liverpool Watercolour Society. Member of the Liverpool and Cambrian Academies. Painted a large number of portraits, and was also much involved in decorative design and book illustration. Exhib. 1852-78 at the RA, SS and elsewhere, titles at the RA including 'St. John and the Virgin Mary Returning from the Crucifixion', 1853, and 'Caractacus Leaving Britain a Prisoner', 1860. One of his paintings is in the Walker AG, Liverpool.
Bibl: Bryan.

NORIE, Frank V.
Painted romantic scenes, often Mediterranean or North African. Possibly a relative of Orlando Norie (q.v.).

NORIE, Orlando 1832-1901
London painter of battles, who exhib. 1876-89 at the RA in 1882 and 1884, NWS and elsewhere. Titles at the RA 'Battle of Ulundi', 1882, and 'Tel-el-Kebeer', 1884. He also did many watercolour studies of military uniforms.

NORIE, R. fl.1846
Exhib. a view on the River Meuse at the RA. Address in Edinburgh.
Bibl: Caw.

NORIS, R. fl.1844
Exhib. a landscape at the BI. Address in Edinburgh.

NORMAN, Mrs. Caroline H. fl.1874-1891
Painted flowers and birds. Exhib. nine works at the RA including 'Rhododendrons' and 'Lapwing and Plover', and three watercolours at SS. Address in Devonport, Devon.

NORMAN, Miss G. fl.1887
Exhib. a landscape in 1887. London address.

NORMAN, George Parsons 1840-1914
Painted landscape, particularly the landscape of the Norfolk Broads. Exhib. three works, including landscapes at Rottingdean, Sussex and at Beccles, Suffolk, at SS. Lived at Lowestoft, Suffolk, and also in Norwich.

NORMAN, H.T. fl.1874
Exhib. a work entitled 'The Cottage in the Lane' at SS. London address.

NORMAN, Philip FSA c.1843-1931
London landscape painter, who exhib. 1876-1904, at the RA 1877-1904, SS, NWS, GG, NG and elsewhere, titles at the RA including 'The Thames at Rotherhithe', 1881, and 'The Red Cow Inn and Dr. Burney's House, Hammersmith Road', 1904. The VAM has a collection of his drawings of old London.
Bibl: VAM.

NORMAN, W.T. fl.1834-1843
Painted landscape. Exhib. five works, including views in Italy and on Dartmoor, at the BI. Also exhib. two views near Rome at the RA and two views on Dartmoor at SS. Address in Devonport, Devon.

NORMAND, Ernest 1857-1923
Painter of historical subjects, genre and portraits, living in Upper Norwood and London. Studied at the RA Schools 1880-3, under J. Pettie (q.v.), and in Paris under Constant and Lefebvre in 1890. Exhib. from 1881 onwards at the RA, NG and elsewhere, titles at the RA including 'A Study of Eastern Colour', 1882, 'Pygmalion and Galatea', 1886, and 'Mordecai Refusing to do Reverence to Hamon', 1892. His paintings are in Bristol, Oldham, Southport and Sunderland AGs. His wife Henrietta (née Rae) was also a painter (q.v.).
Bibl: See under Mrs. Ernest Normand.

***NORMAND, Mrs. Ernest 1859-1928**
(Miss Henrietta Rae)
Painter of classical and literary subjects, portraits and genre. Married Ernest Normand (q.v.) in 1884. Began to study art at the age of 13, and was a pupil at Heatherley's and at the RA Schools. Medallist at Paris and Chicago Universal Exhibitions. Exhib. from 1881 at the RA, GG, NG and elsewhere. Her principal paintings are: 'Ariadne', 1885, 'Ophelia', 1890 (Liverpool, Walker AG), 'Flowers Plucked and Cast Aside', 1892, 'Sir Richard Whittington and his Charities', 1900 (fresco for the Royal Exchange), 'Portrait of Lady Tenterden and Echo', 1906, 'Hylas and the Water Nymphs', 1910, etc.
Bibl: AJ 1901 pp.137-41, 302-7; Mag. of Art 1901 p.134ff.; A. Fish, *Henrietta Rae*, 1906; Who Was Who 1916-28; Wood, Olympian Dreamers.

NORRIS, Miss fl.1841-1842
Exhib. two watercolours, including 'The Maid of Judah', at SS. London address.

NORRIS, Miss Helen Bramwell fl.1893
Exhib. a painting of flowers in 1893. London address.

NORRIS, Hugh L. fl.1882-1904
Painted landscape and country subjects. Exhib. 13 works at the RA 1890-1904, titles including 'Washing Day, Newlyn' and 'Maldon, Essex', and four works at the NWS. London address.

NORRIS, T. fl.1838
Exhib. a street view at the RA.

NORRIS, William ARCA b.1857 fl.1893
Painted scriptural subjects, landscape and country subjects. Studied at Gloucester School of Art and at the RCA. Exhib. four works at the RA, including 'Twilight Gleaners Returning Home'. Exhib. elsewhere titles including 'Feed My Lambs' and 'The Early Morning Breakfast'. Born in Gloucester. Lived in London.

NORRIS, William Foxley fl.1884-1887
Exhib. two watercolours, including 'Below Sonning', at SS and one work at the RA. Addresses in Eton, Berkshire, and in Oxford.

NORSWORTHY, W. fl.1839
Exhib. a view of Gloucester Square, London, at the RA. London address.

NORTH, Arthur William fl.1886-1887
Exhib. two works, 'Pilchard Carriers Returning from Their Work' and 'All-fours', at the RA. Address in Penzance, Cornwall.

***NORTH, John William ARA RWS 1842-1924**
Painter of landscape and genre; illustrator and wood-engraver. Born at Walham Green. Studied at the Marlborough House School of Art; apprenticed to J.W. Whymper (q.v.) as a wood-engraver in 1860, working with Frederick Walker, G. Pinwell and Charles Green (qq.v.). An intimate friend of F. Walker (q.v.), whose art he influenced and who sometimes drew figures in North's paintings. R.W. Macbeth, A.B. Houghton and Cecil Lawson (qq.v.) belonged to the same group of artists. 1862-6 employed by the Dalziel Bros. and his landscapes may be seen in *Wayside Posies*, 1867, and other publications of this period. Drew illustrations for *Once a Week*, *Good Words*, *The Sunday Magazine*, etc. Exhib. from 1865, at the RA from 1869, OWS, GG, NG and elsewhere. 1871 A of OWS; 1883 RWS; 1893 ARA. Member of the Royal West of England Academy. From 1868 he lived at Halsway Farm, Washford, Somerset. He travelled to Algiers with Walker. Hardie notes that his landscapes reveal "an almost scientific search for detail in the tangled luxuriance of orchard and copse. He was interested in effects of light, and his method to expess shimmering atmosphere can be compared to 'pointillisme'." He preferred landscape to figures, and was inclined to avoid them, sometimes inducing Walker to put one in for him. He spent years of his life in the unremunerative commercial venture of producing a pure linen OW paper.
Bibl: J. Pennell, *Modern Illustrators*, 1895; R.D. Sketchley, *English Book Illustration of Today*, 1903; The Studio Winter Number, *British Book Illustrations*, 1923-4 p.27ff., p.82; Apollo I 1925 p.126; Connoisseur LXXI 1925 p.112; VAM; Gleeson White; H. Alexander, *John William North*, OWS V 1927; Hardie I p.27n; III pp.137-8 (pl.158) *et passim*; Maas p.235 (pl.235); Staley; Wood, Paradise Lost; Newall.

NORTH, Lucy E. fl.1870-1871
Exhib. a watercolour of an old Sussex cottage at SS. London address.

NORTH, Marianne 1830-1890
Painted flowers. Pupil of Val Bartholomew (q.v.). Exhib. a work entitled 'Serra des Orgaos' at the RA.
Bibl: Mag. of Art 1882 p.22; AJ 1890 p.320; The Year's Art 1891 p.260; DNB 1895 p.41.

NORTH, R.P. fl.1856-1858
Exhib. three paintings of fruit at the BI. London address.

NORTON, Arthur William fl.1882-1886
Painted figurative subjects. Exhib. five works at SS including 'A Word with Dickie-bird' and 'Rejected Generosity'. Address in Antwerp.

NORTON, Benjamin Cam fl.1862
Sheffield landscape painter who exhib. two paintings at the BI in 1862: 'Shades of Evening, Waiting for the Drover' and 'The Random Shot'. He also painted horse portraits, and other sporting subjects, working for private patrons in the Midlands.

NORTON, Charles William RI RCA ARWA 1870-1946
Painted landscape and figurative subjects. Studied at the Regent Street Polytechnic and at the Académie Julian. Born at Beverley, Yorkshire. Lived and died in Cheam, Surrey.

NORTON, Miss F.M. fl.1898
Exhib. a work entitled 'L'Ennui' at the RA. London address.

NORTON, H. fl.1853-1858
Painted landscape and figurative subjects. Exhib. six works at the RA including portraits and 'In a Field near Harrow'. Also exhib. two works at the BI and two works at SS. London address.

NORTON, Miss Sarah fl.1853-1854
Painted country genre. Exhib. two works at the BI, 'Gypsy' and 'Cottager's Daughter', and one work at SS. London address.

NORWOOD, Arthur Harding fl.1889-1893
Exhib. four works, including 'Moonrise' and 'A Sussex Hayfield', at SS. London address.

NOTT, Miss Isabel C. Pyke- fl. 1891-1903
Painted figurative subjects, which possibly are miniatures. Exhib. ten works at the RA, including 'A Reverie', 'Circe' and 'Zaza'. London address.

NOTT, James S. Pyke- fl.1897
Exhib. a portrait of Mrs. Pyke-Nott at the RA. London address.

NOTTINGHAM, Miss E. fl.1856-1861
Exhib. two landscapes, both views of Hayes Common, Kent, at the RA. London address.

NOTTINGHAM, Robert A., Jnr. fl.1853-1875
Painted landscape watercolours. Exhib. 29 watercolours, the majority views in Surrey and Kent, at SS. Also exhib. views at the RA and one at the BI. Address in Camberwell, later Bowness in the Lake District.

NOVELLO, Miss E.A. fl.1868
Her portrait of Richard Cobden was exhib. at the South Kensington Museum in 1868.
Bibl: Ormond.

NOVRA, Henry fl.1870-1876
Exhib. four works at SS, including 'Meditation' and 'An Early Christian Martyr'. London address.

NOWELL, Arthur Trevithan RI RP 1862-1940
Painter of portraits, landscape, genre and literary subjects. Educated at Dudley and Bury Grammar Schools; Manchester School of Arts, and the RA Schools where he won Gold Medals in Landscape and Historical Painting. Travelled throughout the Continent. Lived in Runcorn and London. Exhib. from 1881 at the RA, NWS, NG, RS of Portrait Painters, and elsewhere, titles at the RA including 'Quiet Pleasures', 1881, 'Flora and Zephyr', 1903, and 'Isabella and the Pot of Basil', 1904. He exhib. 'Pandora' at the NWS in 1917, which was noted by *The Connoisseur*: "Mr. A.T. Nowell's 'Pandora' introduced us to a classically draped figure set in an environment of statuary and marble such as Alma Tadema often painted. Mr. Nowell's art is, however, more personal than that of the great Anglo-Dutch painter, and in the resonant blue of the draperies, accentuated by the contrast of the white sunlit stonework, he has struck an individual note, which makes the work interesting as a colour scheme as well as for its finished technique and archaeological detail."
Bibl: Connoisseur XXXIX 1914 p.274; XLVIII 1917 p.55; XLIX 1917 p.172; LXVI 1923 p.46; Burlington Mag. XXXIX 1923 p.312; American Art News 20 1921-2 No. 9 p.9; No. 15 p.5; 21 1922-3 No. 33 p.1; Art News 22 1923-4 No. 9 p.6; 24 No. 1925-6 No. 10 p.1; Who Was Who 1929-40.

NOWLAN, Miss Carlotta RMS fl.1885-d.1929
Painted flowers and figurative subjects. Exhib. eight works at the RA 1885-1900, including 'Yellow Roses' and 'Doris'. She was the daughter of Frank Nowlan (q.v.). Lived in Sutton, Surrey.
Bibl: Connoisseur XLIX p.240.

NOWLAN, Frank c.1835-1919
Painter of genre and portraits. Born in County Dublin; came to London in 1857 and studied at Leigh's School, where he became a friend of Frederick Walker (q.v.). Nowlan's portrait by Walker (1858) is at the BM. He afterwards studied from the life at the Langham School of Art. He painted in oil and watercolour and occasionally in enamel; he also painted some miniatures and had a considerable reputation as a restorer of miniatures. He was employed by Queen Victoria, Edward VII, and other members of the royal family. He exhib. 1866-1918, at the RA 1873-8, SS, Royal Society of Miniature Painters, and elsewhere, titles at the RA including 'Our Beauty', 1873, 'An Interesting Story', 1876, and 'Art Critics', 1878. He devoted much time to the invention and patenting of unforgeable cheques. Two watercolours, 'Lady Wearing a Lace Veil and Holding a Fan' and 'Head of a Girl Wearing a Yellow Headdress', are in the VAM.
Bibl: VAM.

NOY, Mrs. R. fl.1871
Exhib. a painting of black grapes at SS. Address in Norwich, Norfolk.

NOYES, Miss Dora fl.1883-1903
Painter of genre, landscapes and portraits, working in London, Salisbury and Torquay, who exhib. 1883-1903 at the RA, SS, NWS, GG and NG. Titles at the RA include 'An Old Fatalist', 1883, 'Sea Poppies', 1889, and 'Two at a Stile', 1894.
Exhib: London, Wertheim Gallery 1939.

NOYES, Henry James fl.1873-1874
Exhib. 'Head of a Fransiscan Monk' at the RA and two paintings of roses at SS. Address in Shrewsbury, Salop.

NOYES, Miss Mary fl.1883-1888
Exhib. four watercolours, including 'A Lone Woman' and 'A Quiet Corner', at SS. London address.

NOYES, Miss Theodora fl.1887
Exhib. a work entitled 'Noonday' at the RA. London address.

NOYES-LEWIS, Tom see LEWIS

NUITZ, A. fl.1847
Exhib. a work entitled 'Un Buveur' at the RA. London address.

NUNN, J.W. fl.1865
Exhib. a painting of fruit at SS. London address.

NURSEY, Claude Lorraine 1820-1873
Landscape and marine painter. Born in Woodbridge, Suffolk. After practising for a short time as a landscape painter at Ipswich, he went through a course of training in the Central School of Design, Somerset House, and in 1846 was appointed Master of the Leeds School of Design. While there he superintended the establishment of a similar school at Bradford. In 1849 he moved to the Belfast School, until about 1855 when he transferred to the School at Norwich. While in Belfast he was successful in interesting the local manufacturers in the subject of industrial art. For some time he was Secretary of the Norwich Fine Arts Association. Exhib. 1844-71 at the BI and SS, and at the RHA in 1853 and 1854. He painted a picture of the local Volunteers on the rifle-range on Mousehold Heath, Norwich, containing portraits of the officers.
Bibl: Strickland; Pavière, Landscape.

NUTTER, J. fl.1864-1865
Painted children. Exhib. three works at SS including 'Happy Days' and 'The Piper's Son', and one work at the RA. Address in Bristol.

NUTTER, Miss Katherine M. fl.1883-1890
Painted flowers. Exhib. five works at the RA, including 'Chrysanthemums', 'Azaleas' and 'Wallflowers', and one work at SS. London address.

NUTTER, Matthew Ellis 1797-1862
Carlisle painter of landscapes, portraits and topographical subjects, especially of Carlisle. First Secretary of the Carlisle Society, founded 1822, and also an art teacher. Father of W.H. Nutter (q.v.).

NUTTER, William Henry 1821-1872
Landscape painter; son of M.E. Nutter (q.v.). Worked with his father as a drawing master, and also painted topographical subjects in a similar style. Travelled in Belgium and France, and died in Spain. Examples of both father and son are in Carlisle AG.

NYE, George F. fl.1839-1843
Painted figurative subjects and landscapes in watercolour. Exhib. ten watercolours at SS, titles including 'Portrait of a Lady in Costume' and 'Sketch of the Thames'. London address.

OAKES, A. fl.1872
Exhib. a view of Criccieth Castle at SS. Address in Matlock, Derbyshire.

OAKES, Frederick G. fl.1866-1869
Exhib. three works at SS, titles including 'A Patriarchal Court of Justice' and 'Happy Days', and one work at the BI. London address.

OAKES, H.F. fl.1841-1847
Exhib. two works, 'Faustus in Meditation' and 'An Old Curiosity Shop', at the BI. London address.

***OAKES, John Wright ARA 1820-1887**
Liverpool landscape painter. Began to exhib. at Liverpool Academy in 1839; at BI 1847 and at RA 1848. Elected Associate of Liverpool Academy 1847; Secretary 1853-5. Moved to London in 1859. Exhib. at RA 1848-88, BI, SS, NWS and elsewhere. He mostly painted in North Wales; also made a tour of Switzerland. His landscapes are naturalistic, in the tradition of Leader and George Vicat Cole (qq.v.), but he often attempted Turneresque effects of light and sky. ARA 1876.
Bibl: AJ 1879 pp.193-6; 1887 p.287 (obit.); Portfolio 1887 p.186 (obit.); Bryan; DNB; Marillier pp.182-8 (pl.p.186); Maas; Brook-Hart pl.215; Staley.

OAKESHOTT, George J. fl.1887
Exhib. a sketch of the lectern in Siena Cathedral and a view in Padua at the RA. London address.

OAKLEY, A. fl.1893
Exhib. a watercolour entitled 'A Game of Chess' at SS. London address.

OAKLEY, Miss Agnes fl.1854-1856 d.1866
Painted game and roses in watercolour. Exhib. five watercolours at SS including 'Study of Roses' and 'Ptarmigan and Grey Men'. London address. Sister of Maria and daughter of Octavius Oakley (qq.v.).

OAKLEY, B. fl.1859
Exhib. three works, including 'Married and Happy' and 'Single, Lone and Miserable', at SS. London address.

OAKLEY, Miss Isabel see NAFTEL, Mrs. P.J.

OAKLEY, Miss Maria L. fl.1854-1865
Painted flowers and fruit. Exhib. five watercolours at SS including 'Study in a Garden' and 'Study of Camelias'. London address. Sister of Agnes and daughter of Octavius Oakley (qq.v.).

OAKLEY, Octavius RWS 1800-1867
Derbyshire portrait and rustic painter, mainly in watercolour. Worked for a dock manufacturer near Leeds, and gradually built up a reputation as a portrait artist. Worked in Leamington, then settled in Derby. Among his many aristocratic patrons were the Duke of Devonshire and Sir George Sitwell of Renishaw. Exhib. at RA 1826-60, OWS and elsewhere. Came to London about 1841; ARWS 1842, RWS 1844. In addition to portraits, he painted many landscapes with rustic figures and gipsies, which earned him the nickname of Gipsy Oakley. His studio sale was held at Christie's, 11, 12 March 1869. His daughters Agnes, Isabel and Maria (qq.v.) also painted.
Bibl: Redgrave, Dict; Roget; Bryan; Cundall; VAM; Hardie III pp.97-8 (pl.123); Ormond.

OAKLEY, William Harold fl.1881-1888
Exhib. three views of houses and a work entitled 'An Old Cart' at the RA, and one work at SS. London address.

OBBARD, Miss C. fl.1867
Exhib. a painting of apple blossoms at the RA. London address.

O'BRIEN (or O'BRINE), T. fl.1864-1866
Painted landscape. Exhib. five works, including 'Evening View in North Wales' and 'Early Morning, Pen Thorn', at SS, and two works at the BI. London address.

O'BRIEN, William Dermod PRHA 1865-1945
Painted portraits, landscape, genre and animals. Studied at the Antwerp Academy, at the Académie Julian and the Slade. Exhib. a portrait at the RA. Born at Foynes, County Limerick. Lived in London and later in Dublin.
Bibl: Who's Who; Studio XXXV p.77ff.; LXII p.304; LXIV p.288; Lennox Robinson, *Pallette and Plough, A Pen and Ink Drawing of Dermod O'Brien, PRHA*, Dublin, 1948.

O'CONNOR, A. fl.1846-1871
Exhib. a work 'On The Avon at Clifton' at SS. London address.

O'CONNOR, James Arthur NWS 1792-1841
Painted landscape. Self-taught artist. Exhib. 21 works at the RA 1822-40, including views in Ireland; 39 works at SS 1829-38, including 'The Broken Bridge' and 'A Scene in the Mountains', and 18 works at the BI 1823-39. Born in Dublin. Died in London. His landscapes are classical and idealised, and he is sometimes referred to as the Irish Claude.
Bibl: Art Union 1841; DNB; Strickland; Thos. Bodkin, *Four Irish Landscape Painters*, 1920; Maas.

***O'CONNOR, John RI RHA 1830-1889**
Irish topographical painter and watercolourist. Worked in Belfast and Dublin as a painter of theatrical scenery. Came to London 1848, and was principal scene-painter at Drury Lane and the Haymarket 1863-78. About 1855 he began to paint topographical views, which he exhib. at RA 1857-88, BI, SS, NWS, GG and elsewhere. He travelled in Germany, Italy, Spain and India, painting towns and buildings. Now best-known for his many views of London. For works illustrated by, see VAM Card Cat.
Bibl: DNB; Cundall; Strickland; Wood, Panorama p.143 (pl.148).

O'CONNOR, W.H. fl.1859-1865
Painted literary and biblical subjects. Exhib. four works at the RA, including a scene from Dante's *Paradiso* and works entitled 'Olivia' and 'A Priestess of Vesta'. Exhib. one work at SS. London address.

O'CONOR, Roderic 1860-1940
Painted landscape, portraits and still-lifes. Studied in London, Antwerp and in Paris under Carolus-Duran. Worked in France and for a time joined the circle around Gauguin at Pont-Aven. Born at Roscommon, Ireland. Died in Maine-et-Loire, France.
Exhib: London, Roland, Browse & Delbanco 1956, 1957, 1961, 1964.

ODDIE, Arthur C. fl.1875
Exhib. a figurative subject in 1875. London address.

ODDY, Henry Raphael fl.1883-1904
Painted landscape and rustic subjects. Exhib. five works at the RA, 1888-1904, titles including 'The Hills of Appin' and 'The Stonebreaker'. Address in Halifax, Yorkshire.

O'DONOGHUE, J. fl.1846
Exhib. a work entitled 'The Judgement of the Flowers' at SS. London address.

O'DRISCOLL, Alexander fl.c.1844
Painted scenes from Irish political life which were published in England. He was probably a native of Cork.
Bibl: Strickland.

OEINOMO, A. fl.1867
Exhib. a study from nature at the RA. Address in Manchester.

OFFER, F.R. c.1860-1890
Painted marines and coastal scenes, the majority seem to be views on the South Coast. No record of his having exhib.
Bibl: Brook-Hart pl.216.

OFFOR, Miss Beatrice fl.1887-1904
Painted figurative subjects. Exhib. nine works at the RA, 1887-1904, titles including 'Sappho', 'Cassandra' and 'The Snake Charmer'. Address in Sydenham.
Bibl: W. Shaw-Sparrow, *Women Painters of the World*, 1905 p.160.

OFFORD, Miss Gertrude E.W. c.1880-1950
Painted flowers. Exhib. seven works at the RA 1894-1903, including 'Poppies' and 'Peonies'. Address in Norwich.

OFFORD, John J. fl.1886
Exhib. a work entitled 'Fallen Foes' at the RA. London address.

OFFORD, Miss Mary H. fl.1886-1900
Exhib. two works 'The Hedgerow' and 'Sweet Williams' at the RA. London address.

OGDEN, Miss Jane fl.1879-1882
Painted flowers. Exhib. five works at the RA, including 'Primroses' and 'Yellow Azaleas', and two works, including a watercolour, at SS. London address.

OGG, Henry Alexander fl.1844-1846
Painted landscapes and portraits. Exhib. three works, all views in the vicinity of London, at SS. London address.

OGILVIE, Frank S. fl.1870-1925
Painted portraits and figurative subjects. Exhib. eight works at the RA, including ' "Really Now!" ', 'A Leader of Women' and portraits, and five works at SS. Lived at North Shields, Northumberland and exhib. at the Bewick Club.
Bibl: Hall.

OGILVIE, Frederick D. fl.1875-1886
North Shields marine painter. Exhib. two works at SS, and occasionally elsewhere.
Bibl: Hall.

OGILVIE, J.D. fl.1885
Exhib. a work entitled 'In the Hermitage Glen' at the RA. Address in Edinburgh.

OGILVY, James S. fl.1893
Exhib. a landscape at the NG. London address.

OGLE, John Connell fl.1844-1864
Painted shipping, coastal landscapes and views of ports. Exhib. five works at the RA, including 'Troops Embarking' and views in Corfu, seven works at the BI and seven works, some of them watercolours, at SS. London address.
Bibl: Brook-Hart.

O'GRADY, Miss A.B. **fl.1851-1852**
Exhib. two works at SS including 'A Domestic Scene in the Time of Charles I'. London address.

O'HAGAN, Mrs. Harriett **fl.1854**
(Miss Osborne)
Exhib. a portrait at the RA. Born in Dublin. Lived in London.

O'HARA, Miss Helen **fl.1884-1893**
Exhib. 13 works at the NWS. She was a member of the Society of Lady Artists. Address in Portstewart.

O'KELLY, Aloysius C. **b.1853 fl.1876-1892**
Genre and landscape painter. Born in Dublin. Studied under Bonnat and Gerome in Paris. Lived in London and New York. Exhib. at RA 1876-91, SS, NWS and elsewhere. Painted genre scenes in Ireland and Brittany, but after 1886 all his pictures at the RA were Egyptian views and Arab genre.
Bibl: M Fielding, *Dictionary of American Painters*, 1926; American Art Annual.

OLAFSON, B. **fl.1882**
Exhib. a work entitled 'On a Cold Winter's Evening' at SS. London address.

OLDACRE, R. Samuel **fl.1900**
Exhib. a view of a church at the RA. Address in Birmingham.

OLDAKER, Francis A. **fl.1882**
Exhib. a view on the river Llugwy at SS. Address in Epsom, Surrey.

OLDFIELD, J. Reffitt- **fl.1891-1892**
Exhib. five landscapes at the NG. London address.

OLDFIELD, John Edwin **fl.1825-1854**
Exhib. two landscapes at the RA and a view of Lowther Castle at SS. London address. Painted mainly architectural and topographical subjects in England and Europe.

OLDHAM, G.R. **fl.1854-1857**
Exhib. six watercolours at SS, including 'Viaduct at Stoney Stratford', 'The Task Achieved' and 'Wild Flowers'. Address in Chipping Norton, Oxfordshire.

OLDING, L. **fl.1852-1863**
Painted genre and figurative subjects. Exhib. four works at SS, including 'Children Watching a Rabbit' and 'The Little Seamstress', and one work at the BI. London address.

OLDMEADOW, F.A. **fl.1840-1851**
Bushey sporting painter. Exhib. at RA 1840-51. Titles at RA mostly horse portraits. Worked for the Duke of Westminster at Moor Park.

OLDMEADOW, J.C. **fl.1841-1849**
Exhib. two works at the BI, views of Eton College and Windsor Castle, and one work, a view of Moor Park House, at the RA. Address in Bushey, Hertfordshire. Possibly the same as F.A. Oldmeadow (q.v.).

OLIPHANT, Francis Wilson **1818-1859**
Painted figurative and historical subjects. Studied in Edinburgh. Exhib. five works, including 'Dying Interview of John of Gaunt with Richard II' and 'Coming Home — The Prodigal Son', at the RA. Born in Newcastle-upon-Tyne. Died in Rome. His style was much influenced by the Nazarenes and William Dyce.
Bibl: DNB p.42.

OLIVER, Miss **fl.1867**
Exhib. three watercolours, 'Wild Flowers', 'Dead Robins' and 'Apples', at SS. Address in Watford, Hertfordshire.

OLIVER, Rev. A. **fl.1880**
Exhib. a landscape in 1880. London address.

OLIVER, Archer James **ARA** **1774-1842**
Portrait and figurative painter who exhib. 210 works at the RA and 62 at the BI until 1842. Amongst his later exhib. works are 'Jupiter and Leda', 'Abraham and Isaac' and portraits.
Bibl: DNB p.42; AJ 1899 p.310; BM Cat. of Engraved British Portraits; Ormond.

OLIVER, C.F. **fl.1868**
Exhib. a work entitled 'Flora' at SS. London address.

OLIVER, Mrs. C.N. **fl.1866-1868**
Exhib. three watercolours of flowers, including 'Spring Lilacs' and 'Autumn Fadings and Spring Refreshings', at SS. London address.

OLIVER, F. **fl.1853-1856**
Painted architecture. Exhib. four works, including views in Florence, Rome and Venice, at the RA. London address.

OLIVER, Isaac **fl.1824-1853**
Painted game. Exhib. 12 works at SS including 'A Pair of Teals' and 'Wood Pigeon and Partridge'. London address.

OLIVER, Madge **1875-1924**
Painted landscapes and interiors. Studied at the Slade School. Subsequently lived and worked in the South of France. Born in Knaresborough, Yorkshire. Died in Corsica.

OLIVER, Robert Dudley **1883-1899**
London portrait and genre painter. Exhib. at RA 1883-99. Genre titles at RA: 'The Chatelaine', 'House and Studio, Holland Park', etc.

OLIVER, T. **fl.1868-1869**
Exhib. two highland landscapes at SS. London address.

OLIVER, Thomas **1792-1858**
Made architectural drawings. Many of his views in Newcastle and Durham were published. Born at Jedburgh, Roxburghshire. Later lived in Newcastle-upon-Tyne.
Bibl: Hall.

OLIVER, W. Redivivus **fl.1861-1862**
Exhib. two watercolours, 'Rydal Water, Westmoreland' and 'Ben Voilich from Rob Roy's Cave', at SS. Address in Watford, Hertfordshire.

***OLIVER, William** **RI** **1804-1853**
Landscape painter and watercolourist. Exhib. at RA 1835-53, BI, SS, NWS and elsewhere. Painted views in England, France, Italy and Switzerland; especially fond of the Pyrenees. Works by him are in the VAM, Sheffield and Sunderland AGs. His wife Emma (q.v.) was also a painter.
Bibl: Redgrave, Dict.; DNB.

OLIVER, Mrs. William **RI** **1819-1885**
(Miss Emma Eburne)
Landscape painter and watercolourist. Pupil of her husband William (q.v.) who she married in 1840. Like him, she painted

views in England and on the Continent. Exhib. at RA 1842-68, BI, SS, NWS and elsewhere. After the death of her husband in 1853, she married John Sedgwick.

Bibl: See under William Oliver.

OLIVER, William fl.1867-1882
Painted genre and figurative subjects, mostly half-length figures of girls. Exhib. 15 works at the RA, titles including 'A Thing of Beauty is a Joy for Ever' and 'A Love Test'. Also exhib. one work at the BI and another at SS. London address.

OLIVIER, Herbert Arnould RI RP RE RBC 1861-1952
Painted figurative subjects, genre and portraits. Studied at the RA Schools. Exhib. 55 works at the RA 1883-1904, including views in Italy, portraits and works entitled 'The Passion Flower', 'Hampshire Yew-trees' and 'The King's Flowers'. Also exhib. at the NWS, GG and NG. Born at Battle, Sussex. Lived in London. Died in Hayling Island, Hampshire.

Bibl: Who's Who; Poole 1912-15; Studio LXV p.129; LXVI p.214; LXVIII p.117; LXXXIV p.13.

***OLSSON, Julius RA RBA PROI RWA NEAC 1864-1942**
Painter of coastal scenes and landscapes. Born in London; his father was Swedish, his mother English. Exhib. at RA from 1890, SS, GG, NEAC and elsewhere. Most of his works are coastal scenes and sea studies in the late impressionistic style of Henry Moore (q.v.).

Bibl: AJ 1905 p.356; 1907 p.194; 1909 p.268; Studio see index 1909-15; Connoisseur see index 1915-24; Who's Who; Brook-Hart.
Exhib: London, Walker's Galleries 1935.

O'MAHONEY, Miss Florence fl.1877-1885
Exhib. a work entitled 'Benedictine Monks at Vespers, Perugia' at the RA, and another at SS. London address.

O'MALLEY, James c.1816-1888
Exhib. portraits and scenes of peasant life at the RHA from 1840. Also painted religious works. Born in Newport, Co. Mayo. He was for some years in America, working as a portraitist. He later lived in Galway and Mayo.

Bibl: Strickland.

O'MEARA, Frank 1853-1888
Painted landscape and figurative subjects. Studied in France. Exhib. two landscapes at the GG. Born in Carlow, Ireland.

Bibl: Caw; T.M., Frank O'Meara, or the Artist of Collingwood, 1876.

O'NEIL, Miss C.S. fl.1859-1864
Painted flowers. Exhib. four works, all flower paintings, at the RA. London address.

O'NEIL, F. fl.1839
Exhib. a landscape at the RA.

***O'NEIL, Henry Nelson ARA 1817-1880**
Historical genre painter. Born in St. Petersburg. Friend and fellow-student of Alfred Elmore (q.v.) with whom he travelled in Italy. As a young man he was a member of The Clique (q.v.) and his ambition was to paint incidents to strike the feelings. Most of his work was historical and literary genre, but he scored his greatest success with a contemporary scene, 'Eastward Ho! August 1857', RA 1857, followed by 'Home Again', RA 1859, showing British troops departing for India to quell the Indian Mutiny, and returning home. Exhib. at RA 1838-79, BI and SS. ARA 1879. None of his later works achieved the same success as 'Eastward Ho!'. Although a clever and sociable man, his contemporaries felt that his talents were so varied as to prevent him becoming a first-rate artist. His studio sale was held at Christie's, 18 June 1880.

Bibl: AJ 1864 p.40; 1880 p.171 (obit.); Redgrave, Cent; F. van Boetticher, Malerwerke des 19 Jahrh, 1898; Bryan; DNB; Reynolds, VS passim (pls. 69-70); Reynolds, VP pp.29, 31, 37 (pl.17); Maas pp.13, 97, 104, 115-16 (pl.p.115); Derek Hudson, Billiards at the Garrick in 1869, Connoisseur December 1969; Irwin; Ormond; Wood, Panorama pls.239, 245-6.

***O'NEILL, George Bernard 1828-1917**
Genre painter. Born in Dublin. Exhib. at the RA from 1847. Although little is known of his life, he was a prolific and charming painter of small genre scenes, often of children. His style has an affinity with those of Thomas Webster and F.D. Hardy (qq.v.); he was associated with both artists in The Cranbrook Colony (q.v.). One of his best-known works is 'Public Opinion', RA 1863, now in the Leeds City AG. Manuscripts relating to this artist are held by VAM.

Bibl: AJ 1864 p.260 (pl.); Reynolds, VS pp.54, 67 (pl.34); Reynolds, VP pp.36-7 (pl.33); Maas p.234; Ormond; Wood, Panorama pls.63, 216, 241, 254; Cranbrook Colony exhib., Wolverhampton AG, 1977.

O'NEILL, Henry 1798-1880
Landscape painter. Exhib. at the RHA from 1835. He also painted contemporary political subjects and views of Irish antiquities. Born in Clonmel. Lived in Dublin.

Bibl: Strickland.

O'NEILL, J.G. fl.1874
Exhib. a coastal landscape in Australia at SS. London address.

ONION, E.J. fl.1832-1852
Painted figurative and genre subjects. Exhib. ten works at the BI, including 'The Captive Herald' and 'Marbles', and eight works at SS, including 'Boys Blowing Bubbles'. Also exhib. three works including a self-portrait at the RA. London address.

OPIE, Edward 1810-1894
Genre painter. Great-nephew of the portrait painter John Opie. Pupil of H.P. Briggs (q.v.). Worked mainly in London and Plymouth. Exhib. at RA 1839-86, and once at SS. Subjects mostly rustic genre, some historical genre (Civil War period) and portraits.

Bibl: Connoisseur LXXXIV 1929 pp.164-71 (Recollections by E. Opie); Ormond.

ORAM, Miss fl.1836-1839
Painted genre and figurative subjects. Exhib. eight works at SS including 'The Expected Letter' and 'Peeping Over the Shoulder'. London address.

ORCHARD, Miss A.G. fl.1892
Exhib. a work in 1892. London address.

ORCHARD, J. fl.1847-1848
Painted historical and literary subjects. Exhib. two works, 'Helena and Hermia' and a study at the RA, and two works, 'Flight of Becket from England' and 'Balfour and Bothwell', at SS. London address.

ORCHARDSON, Charles M.Q. d.1917
Painted landscape, portraits and figurative subjects. Exhib. 15 works at the RA 1896-1904, including 'Sheila', 'Fruit Stall' and 'A Maid of Norfolk'. He was presumably the son of Sir W.Q. Orchardson (q.v.). Died of wounds 26 April 1917.

***ORCHARDSON, Sir William Quiller RA 1832-1910**
Scottish genre painter. Born in Edinburgh. Pupil of R.S. Lauder. Among his fellow-pupils were John Pettie and T. Graham (qq.v.) with whom he later shared lodgings in London. Came to London in 1862. Exhib. at RA from 1863, and at BI, GG, NG and elsewhere. ARA 1868, RA 1877. At first he painted historical genre, choosing subjects mainly from Shakespeare and Scott. Later he turned to psychological dramas of upper-class life, such as 'Le Mariage de Convenance' and 'The First Cloud', for which he is now best known. His grouping of figures, and feeling for the value of empty spaces, gives his pictures a theatrical air. His technique was equally refined and distinctive. He used deliberately muted colours — mostly yellow and brown — "as harmonious as the wrong side of an old tapestry" (Chesneau). He was also a distinguished portrait painter, and illustrator. He worked mainly for the magazine *Good Words*. His studio sale was held at Christie's, 27 May 1910.
Bibl: AJ 1867 p.212; 1870 p.233ff.; 1894 p.33ff.; W. Armstrong, *The Art of W.Q.O.* (Portfolio Mono.), 1895 repr. 1904; Stanley Little, *Life and Works of W.Q.O.*, Art Annual 1897; Hilda Orchardson Gray, *The Life of Sir W.Q.O.*, 1930; DNB 2nd Supp; Caw pp.236-40 (2 pls.); Reynolds, VS *passim* (pls. 87-90); Reynolds, VP *passim* (pls.127, 130); Maas *passim* (pls.pp.l9, 245-6); Irwin; Ormond; Wood, Panorama.
Exhib: Edinburgh, Scottish Arts Council 1972.

ORCZY, Baroness Emmuska b.1865 fl.1894
Author who also painted figurative subjects. Exhib. four works at the RA, including 'A Herald of Spring' and 'The Jolly Young Waterman'. Also exhib. three works at SS. Born in Budapest. Lived in London.

O'REILLY, Joseph ARHA d.1893
Painted landscape and figurative subjects. Studied at the RHA School and showed great promise. He died of consumption at an early age.
Bibl: Strickland.

ORMONDE, Leonard fl.c.1880-1920
Painted portraits, figurative subjects and landscapes.

ORMSBY, V. fl.1870-1886
Painted rustic and genre subjects. Exhib. 12 works at the RA including 'Notice to Quit' and 'Seaside Enjoyment'. London address.

ORPEN, Richard Francis Caulfield RHA 1863-1938
Architect who painted in watercolour. He was the elder brother of Sir William Orchardson. (q.v.). Born at Blackrock, County Dublin. Lived in Dublin.

***ORPEN, Sir William Newenham Montague 1878-1931 RA RWS RHA RI NEAC**
Painter of portraits and genre subjects. Studied at Dublin Metropolitan School of Art and at the Slade. First exhib. with the NEAC in 1900. Born at Stillorgan, County Dublin. Lived in London.
Bibl: AJ 1904 p.28; 1905 p.136; 1907 pp.30, 43; 1908 p.30ff.; 1909 pp.17-24; Studio 1906 p.26; 1907 p.306; 1909 pp.96, 181ff., 254; 1910 p.18; 1913 pp.151, 239; 1914 p.223; 1915 p.87ff.; 1916 pp.38, 49; 1917 pp.95, 110; 1918 p.137; 1921 pp.27, 187;1926 p.359ff.; Apollo III 1926 p.4; IV 1926 pp.123-5; VII 1928 p.239; VIII 1928 p.239; XIV 1931 pp.249-300; Connoisseur L 1918 pp.175, 237; LXIX 1924 p.109ff.; J. Laver, *Portraits in Oil and Vinegar*, 1925; Who's Who; The Times 1 October 1931; Poole; The New York Times 11 October 1931; Exhib. Cat. Royal Academy of Arts 1932; Maas; Bruce Arnold, *Orpen*, 1981.
Exhib: London, 1913; Birmingham, Museum and AG 1933; London, Rembrandt Gallery 1933; Manchester City AG 1933; Rye AG 1968.

ORPHEUS, V. fl.1892
Exhib. a view of the Old Town Hall, Bosham, at SS. London address.

ORR, J.N.J. fl.1843
Exhib. two works at the RA and a work entitled 'The United Kingdom' at SS. London address.

ORR, Monro Scott b.1874
Painted and etched figurative subjects. Also an illustrator. Studied at Glasgow School of Art. Lived in Glasgow.
Bibl: AJ 1900 p.310ff.; Studio XXIX 1903 p.215ff.; Caw.

ORR, Patrick William b.1865 fl.1893
Exhib. a work entitled 'Madame X' at the RA. Address in Glasgow.

ORR, Stewart RSW 1872-c.1945
Painted landscape. Studied at the Glasgow School of Art. Born in Glasgow. Lived at Corrie, Isle of Arran.
Exhib: London, Connell & Sons Gallery 1935, 1937.

ORRIDGE, Miss Caroline E. fl.1890
Exhib. a work entitled 'A Retrospect' at SS. London address.

ORROCK, James RI 1829-1913
Landscape painter and watercolourist. Born in Edinburgh. Qualified as a dentist, and practised in Nottingham. Worked at Nottingham School of Design, and later studied under James Ferguson, John Burgess, Stewart Smith and W.L. Leitch (q.v.). Came to London 1866. Associate RI 1871, member 1875. Exhib. at RA 1858-82, SS, NWS, GG, NG and elsewhere. He was a great admirer of David Cox (q.v.), and his style and subject matter both reflect this. He was also a keen collector, writer and lecturer.
Bibl: Mag. of Art 1904 pp.161-7; Studio XXX 1904 p.360ff.; *Light and Watercolours, A* Series of Letters by J.O. to The Times 1887; J. Webber, *J.O. Painter Connoisseur Collector*, 1904; Caw; Who's Who 1913-14; VAM; Hardie III pp.159-60 (pl.181).
Exhib: London, Fine Art Society 1893.

ORTMANNS, Auguste fl.1865-1871
Exhib. a landscape of the forest of Fontainebleau at the RA and another at SS. London address.

***OSBORN, Emily Mary b.1834 fl.1851-1908**
Genre painter. Daughter of a London clergyman. Studied at Dickinson's Academy in Maddox Street, first under John Mogford (q.v.), later under J.M. Leigh (q.v.). Exhib. at RA 1851-93, BI, SS, GG, NG and elsewhere. Her pictures mostly genre, sometimes historical, often of children. The theme of many of her pictures is the damsel in distress. A typical example is 'Nameless and Friendless', for which there is a preparatory drawing, falsely signed Millais, in the Ashmolean, Oxford.
Bibl: AJ 1864 p.261ff.; 1868 p.148; H.A. Muller, Biog. *Kunsterlexicon d. Gegenw.*, 1884; Maas p.121 (pl. p.121 'Nameless and Friendless'); Wood, Panorama pls.103, 112.

***OSBORNE, Walter Frederick RHA 1859-1903**
Irish landscape and portrait painter, son of William Osborne (q.v.). Studied at the RHA, and at the Antwerp Academy under Verlat. Up to 1884 he signed himself Frederick Osborne, but after 1885 changed it to Walter F. Osborne. Began exhibiting at RHA in 1877. Spent his summers sketching in England, or on the Continent. Exhib. at RA 1886-1903. 'Life in the Streets, Hard Times', a pastel of 1892, was bought by the Chantrey Bequest. In the 1890s he turned mainly to portraiture. The current revival of Irish painting has led to a renewed interest in Osborne.
Bibl: DNB; Strickland II p.201 (with a list of main works); Thomas Bodkin, *Four Irish Landscape Painters,* Dublin 1920; Cat. of Pictures etc. National Gallery of Ireland 1920; Maas.

OSBORNE, William **RHA** **1823-1901**
Animal and portrait painter. Father of Walter Frederick Osborne (q.v.). Entered RHA as a student in 1845. Exhib. mainly at RHA. ARHA 1854, RHA 1868. Painted animals, especially dogs, and hunting groups.
Bibl: Strickland II pp.207-8.

OSCROFT, Samuel William **1834-1924**
Nottingham landscape painter and watercolourist. Exhib. at RA 1885-9, SS, NWS and elsewhere. Titles at RA 'Rye from the Marsh', 'Crab Boats on the Coast, S. Devon', 'At Eventide it shall be Light'. Several views by him are in the Nottingham AG.
Bibl: Connoisseur LXXI 1925 p.187.

OSGOOD, J. **fl.1834-1845**
Painted landscape and genre subjects. Exhib. 20 works at SS including 'The Cottage Grace', 'The Cowherd' and landscapes in Wales and Berkshire. Address in Newbury, Berkshire.

OSGOOD, S.S. **1808-1885**
Painted a portrait of Harriet Martineau.
Bibl: Ormond.

OSMOND, John **fl.1881**
Exhib. a work entitled 'The Winter' at SS. Address in Lee.

OSPOVAT, Henry **1877-1909**
Russian illustrator whose family settled in Manchester. His illustrations reflect the influence of the Pre-Raphaelites and C.S. Ricketts (q.v.). A memorial exhib. was held at the Baillie Gallery in 1909.

OSSANI, Alessandro **fl.1857-1888**
Portrait and genre painter. Exhib. at RA 1860-88, SS, GG and elsewhere. Most of his RA pictures were portraits with occasional genre scenes, e.g. 'Italian Flower Girl', 'The Gleaner', etc.
Bibl: Ormond.

OSTELL, Miss Mary M. **fl.1893**
Exhib. a painting of genre at the NWS. London address.

OSWALD, Frank **fl.1857-1874**
Painted seascapes and landscapes. Exhib. 15 works, some of them watercolours, at SS, including 'On the Essex Coast', 'Off Boulogne From the Pier' and 'Chipstead Church, Surrey'. Address in Croydon, Surrey.
Bibl: Brook-Hart.

OSWALD, John H. **fl.1871-1899**
Painted landscape. Exhib. seven works at the RA including 'Glenfinlas — October' and 'Rouen — Morning'. Address in Edinburgh. Also painted town scenes.

OTTEWELL, Benjamin John **HRI** **fl.1885-c.1930 d.1937**
Painted landscape. Exhib. four works at the RA including 'Mid Gorse and Fen' and 'The Birch Encircled Pool'. Also exhib. at SS, NWS, GG and NG. Lived in Bath, Somerset.

OTTLEY, Emily **fl.1856-1860**
Painted in a style similar to G. Pyne (q.v.), in Wales, London and Paris.

OTWAY, J. **fl.1888**
Exhib. a figurative subject at the GG. Address in Waterford, Ireland.

OULESS, Philip J. **1817-1885**
Painted portraits of ships and yachts. Did not exhib. in London. Lived in Jersey.
Bibl: Brook-Hart

OULESS, Walter William **RA** **1848-1933**
Portrait painter. Born St. Helier, Jersey. Studied at RA Schools 1865-9. Exhib. at RA from 1869. ARA 1877, RA 1881. A prolific and competent artist, but not an inspired one, he nonetheless built up an enormously successful practice as a portrait painter in late Victorian and Edwardian society.
Bibl Clement & Hutton; L. Cust, NPG Cat. 1901; BM Cat of Engraved British Portraits VI 1925 p.525; Poole 1912-25; Ormond.

OULETT, Jesse J. **fl.1887**
Exhib. a genre subject in 1887. London address.

OUSEY, Buckley **1851-1889**
Painted portraits, landscape and genre. Studied in Antwerp. Exhib. a work entitled 'Low Margin of the Sea' at the RA and 'Gossips' at SS. Address in Conway, Caernarvonshire.

OVENDEN, F.W. **fl.1834-1843**
Painted coastal landscape and marines. Exhib. six works at SS including 'Walmer Beach, Kent' and 'North Deal, Kent', and one work, 'Shore Scene' at the RA. London address.
Bibl: Brook-Hart.

OVERBURY, Miss L. **fl.1874**
Exhib. a watercolour of chrysanthemums at SS. London address.

OVEREND, William Heysham **1851-1898**
London marine painter. Worked for *The Illustrated London News*. Exhib. at RA 1872-98, SS and elsewhere.
Bibl: American Art Annual 1898 p.36; The Year's Art 1899 p.336; Portfolio 1890 p.7; Cundall p.242.

OVERWEG, Miss Lily **fl.1897-1898**
Exhib. two works, 'Madamoiselle B.' and 'Violets', at the RA. Address in Paris.

OWEN, A.C. **fl.1868**
Exhib. a watercolour entitled 'Early Spring' at SS. Address in Oxford.

OWEN, Rev. Edward Pryce **1788-1863**
Painted landscape and biblical subjects. Exhib. eight works at the BI including 'A Welsh Cottage' and 'The Prodigal'. Also exhib. four works at SS. London address.
Bibl: AJ 1865 pp.77, 80; DNB; Rees, *Welsh Painters*, 1912.

OWEN, James **fl.c.1880-1920**
Painted landscape, particularly views of Eastbourne, mostly in watercolour. Address in Eastbourne, Sussex.

OWTRAM, Robert L. **fl.1892-1901**
Painted portraits and figurative subjects. Exhib. seven works at the RA including portraits and works entitled 'Scraps' and 'A Vagabond'. London address.

OYSTON, George **fl.1891**
Exhib. a landscape at the NWS. London address.

P

PACE, Percy Currall fl.1897-c.1920
Painted landscape, portraits and still-life. Studied at the Antwerp Academy. Exhib. three works at the RA 1897-1903, including 'Chestnuts' and 'The Farmer's Daughter'. Also exhib. in the provinces. Born at Sutton, Surrey. Lived in Steyning, Sussex.

PACK, Faithful Christopher 1759-1840
Painted landscape, figurative subjects and portraits. Studied in Reynolds's studio. Exhib. ten works at the RA 1786-1840, including portraits, landscapes in Ireland and a work entitled 'Contemplation', and 11 works at the BI 1825-39. Also attempted to teach painting and drawing. Born in Norwich, Norfolk. Lived in Liverpool, Dublin and London.
Bibl: Strickland; The Walpole Society VI 1917-18 pp.79, 81, 93; The Times 6 May 1932.

PACKARD, E. fl.1877-1880
Exhib. two genre subjects, 1877-80. Address in Ipswich, Suffolk.

PADDAY, Charles M. RI fl.1889-c.1947
Painted coastal landscapes and landscapes. Exhib. 15 works at the RA 1890-1904, including 'A Baltic Timber Port', 'Marooned' and 'Back from the Indies', and six works at SS. Lived at Hayling Island, Hampshire, and later at Cuckfield, Sussex.
Bibl: AJ 1906 p.168.

PADGETT, John fl.1828-1839
Painted views and landscape. Exhib. four works at SS including 'Abergavenny' and 'View of the Farm, Kentish Town'. London address.

PADGETT, William 1851-1904
Landscape painter; lived in London, Hampton and Twickenham. Exhib. at RA 1881-98, SS, GG, NG and elsewhere. Titles at RA 'Winter on the Marsh', 'The Old Mill', 'In Flanders', etc.

PADLEY, J.W. fl.1842
Painted marines. Exhib. three works at SS including 'A Ship under Close-reefed Topsails' and 'Scene near the Nass Sand'. Address in Swansea, Glamorgan.

PADMORE, William Pinder fl.1843
Exhib. two works, including a view of Magdalen College Tower, at the RA. London address.

PADWICK, H.C. fl.1889
Is supposed to have exhib. a landscape at SS in 1889. London address.

PAE, William fl. late 19th century
Painted landscape and possibly marines. Lived in Gateshead, County Durham, and produced paintings of local topography.
Bibl: Hall.

PAGE, G. fl.1833-1851
Painted and sculpted figurative subjects. Amongst the paintings exhib. at SS were 'Reconciliation' and 'The Soldier's Return'. Also exhib. at the RA and the BI. London address.

PAGE, G.R. fl.1834-1838
Exhib. three works, including 'An Albanian Chief' and 'Sketch — Oliver Cromwell', at SS. London address.

PAGE, George Gordon fl.1864-1880
Exhib. two works, views of bridges in Dublin and York, at the RA. London address.

PAGE, H. Flood fl.1858-1865
Painted landscape and rustic subjects. Exhib. 17 works at the BI including Italian and German subjects and works entitled 'The Morning Errand' and 'A Campaign Story'. Also exhib. three works at the RA and three works at SS. London address.

PAGE, H.R. fl.1875-1878
Exhib. two works, 'Street in Swanage' and 'Ye Red Ladye', at SS. London address.

PAGE, Henry Maurice fl.1878-1890
Landscape and animal painter. Lived in London and Croydon. Exhib. at RA 1879-90, but mostly at SS (54 works). Titles at RA suggest he painted birds and still-life, e.g. 'Sport from Loch and Moor', 'Winged', 'On the Flight', etc.

PAGE, Robert fl.1880-1890
Painter of rustic genre. Lived at Great Claxton, Essex. Exhib. at RA 1881-9, SS and elsewhere. Titles at RA 'The Old Hedger', 'Noonday Rest', 'Essex Calves', etc., and some historical scenes.

PAGE, T fl.1851-1863
Exhib. views of bridges, including bridges in London, Windsor, York and Constantinople, at the RA. London address.

PAGE, William 1794-1872
Painted landscape and views of ancient architecture. Exhib. 19 works at the RA, including landscapes in Wales and views of the Parthenon and of buildings in Constantinople. London address.
Bibl: Country Life 26 September 1968 (letters).

PAGE, William 1811-1885
His portrait of Robert Browning is in the collection of Baylor University, Texas.
Bibl: Ormond.

PAGET, Miss Elise fl.1877-1888
Painted townscapes and figurative subjects in watercolour. Exhib. ten works at SS including 'Maid of Athens' and views in the City of London. Also exhib. two works, including a view in Trafalgar Square, at the RA. Address in Pinner, London.

PAGET, Mrs. H.M. fl.1883-1884
Exhib. figurative subjects at the GG. London address. She was the wife of Henry Marriott Paget (q.v.).

PAGET, Henry Marriott RBA 1856-1936
Painter and illustrator. Exhib. at RA 1879-94, SS, GG and elsewhere. Most of his RA exhibits were portraits, or historical subjects, e.g. 'Enid and Geraint', 'Circe', etc. He illustrated the

works of Dickens. Some of his portraits are at Oxford University. His brothers Sidney and Walter (qq.v.) were also illustrators. His wife was also a painter (q.v.).

Bibl: Sketchley, *English Book Illustration of Today,* 1903; Poole 1912.

PAGET, L. fl.1897

His watercolour portrait of Sir Charles James Napier was exhib. in the *Victorian Era Exhibition* in 1897.

Bibl: Ormond.

PAGET, Sidney Edward 1860-1908

Painter and illustrator. Exhib. at RA 1879-1903, SS and elsewhere. Titles at RA mostly portraits, and some genre, e.g. 'Under the Hill', 'Shadows on the Path', 'Outcast', etc. Among the books he illustrated were the works of Scott and C. Doyle. A picture of 'Lancelot and Elaine', RA 1891, is in the Bristol AG. His brothers Henry Marriott and Walter Paget (qq.v.) were also illustrators.

Bibl: Sketchley, *English Book Illustration of Today,* 1903; Ormond.

PAGET, Walter fl.1878-1888

Exhib. three works at the RA and two watercolours, 'The Mill Wheel' and 'Oaks' at SS. London address. He was the brother of Henry Marriott and Sidney Edward Paget (qq.v.).

PAGLIANO, M. fl.1880

Exhib. a landscape in 1880. London address.

PAICE, George fl.1878-1900

Sporting and animal painter; lived in Croydon. Exhib. at RA 1881-97, SS and elsewhere. Painted many small portraits of horses and dogs in landscapes, most of which are still in English private collections.

PAIN, Robert Tucker fl.1863-1877

Landscape painter. Exhib. at RA 1866-76, BI and SS and elsewhere. Titles at RA include views in Wales, Scotland and Switzerland. A watercolour by him is in the VAM. Pain was also an accomplished photographer, and a collection of his work can be seen at the Camberley Museum, Surrey.

PAINE, Miss Edith A. fl.1883-1885

Exhib. two landscapes at the GG. London address.

PAINE, J.D. fl.1828-1843

Exhib. designs for and views of buildings at the RA, including a view of St. Petersburg railway station, a view of a bridge across the river Leith and 'Lighthouse on the Goodwin Sands'. London address.

PAIRPOINT, Miss Nellie M. fl.1897-1904

Exhib. two works at the RA 1897-1904, the first entitled 'Village Smithy, Horses'. London address.

PAKINGTON, Hon. Herbert Perrott Murray fl.1888-1892
(Lord Hampton)

Exhib. three works at the RA, including 'Bocca d'Arno' and 'Wild October'. London address.

PALIN, W. Long fl.1881

Exhib. a figurative subject in 1881. Address in Stifford.

PALIN, William Mainwaring RBA 1862-1947

Painter and decorator. Born at Hanley, Staffordshire, son of the engraver William Palin. Worked for five years with Josiah Wedgwood & Sons, then studied at the RCA. Also studied in Italy and Paris. Exhib. at RA 1889-1904, SS and NWS. Painted portraits, landscapes and also genre, e.g. 'Orphans', 'Reflections', 'A Summer Afternoon', etc. Among his decoration commissions were

the MacEwan Hall of Edinburgh University, and St. Clements Church, Bradford.

Bibl: AJ 1896 p.234-6; Studio LXVI 1916 p.206; Who's Who.

PALISADES, W.Z.G. fl.1863

Exhib. two works, a scene from *Much Ado About Nothing* and 'The Troubadour', at the BI. London address.

PALMER, A. Herbert

His portrait drawing of Samuel Palmer is the frontispiece to his book *The Life and Letters of Samuel Palmer.*

Bibl: Ormond.

PALMER, Miss Charity fl.1852-1859

Painted game, fruit and flowers. Exhib. eight watercolours, including 'Piebald and White Pheasants' and 'The Goliah Plums', and four works at the RA. London address.

PALMER, Miss Charlotte E. fl.1877

Exhib. a work entitled 'The Hayfield' at the RA and a watercolour at SS. Address in Odiham, Hampshire.

PALMER, G.H. fl.1876-1888

Exhib. a watercolour view on the River Llugwy at SS. London address.

PALMER, Miss Gertrude fl.1884

Exhib. a work entitled 'The Edge of the Wood' at SS. Address in Wolverhampton, Staffordshire.

PALMER, H. fl.1828-1877

Exhib. three works at the RA, including a view of the Abbey Gate, Reading. London address.

*PALMER, Harold Sutton RBA RI 1854-1933

Landscape painter and watercolourist. Born in Plymouth. Exhib. at RA from 1870, SS, NWS and elsewhere. Many of his landscapes were painted in Surrey. The mood of his scenes is always peaceful and idyllic, perhaps a little artificial. "It is a pleasing but a conscious and sophisticated art, depending upon recipe and very skilful technique" (Hardie).

Bibl: Connoisseur LVI 1920 p.262ff.; LXIII 1922 p.186; LXV 1923 p.238; Studio LXXXIII 1922 p.348; Holme, *Sketching Grounds,* Studio Special Number 1909 pp.15, 17; Who's Who; VAM; Morning Post 16 March 1909; Hardie III p.234 (pl.228).

Exhib: London, Vicars Brothers' Galleries 1934; London, Fine Art Society 1934.

PALMER, James Lynwood d.1941

Sporting artist. Born in Lincolnshire. A self-taught artist, he worked only for private patrons, including George V, and did not exhibit his work. He painted horses, dogs, hunting and coaching subjects.

PALMER, John fl.1877-1887

Exhib. a watercolour of a chaffinch's nest at SS. London address.

*PALMER, Samuel RWS 1805-1881

Painter of pastoral landscapes, illustrator and etcher, and most important follower of William Blake (1757-1827). Son of a bookseller, he was very precocious and at an early age read the Bible and Milton and studied Latin. In 1819, at the age of 14, he exhib. two landscapes at the BI and three at the RA. By 1822 he had met Stothard, John Linnell, John Varley and Mulready (qq.v.), and through Linnell met Blake in 1824. Palmer was much influenced by Blake's mystic visionary teaching, and especially by his illustrations to Dr. R.J. Thornton's *Virgil's Eclogues,* 1820-1:

"They are visions of little dells, and nooks, and corners of Paradise; models of the exquisitest pitch of intense poetry." He first visited Shoreham in Kent in 1825-6 and settled there in 1827. Frequent visitors to his "valley of vision" were George Richmond, Edward Calvert, Henry Walter and Francis Oliver Finch (qq.v.), who called themselves The Ancients (because of their interest in the ancient poets and painters, e.g. Virgil and Milton). In his Shoreham Period, 1826-35, Palmer painted landscapes charged with Christian symbolism — depicting sheep and shepherds, sunsets, moons, clouds and hills, abundant harvests and the rounded blossoming trees of Shoreham, often illustrating some text of pastoral life taken from Virgil, Milton or Shakespeare. In their directness, blazing colour and lack of literal representation, the works of these years were far in advance of their time, and only came to be fully appreciated in 1925 with the publication of Laurence Binyon's *The Followers of William Blake,* and with the Palmer exhibition held at the VAM in 1926. This "primitive and infantine feeling" (his own words) for landscape began to fade c.1822; in 1835 he settled in London; in 1837 he married Hannah, daughter of John Linnell (qq.v.) and afterwards spent two years in Italy. There he painted a series of careful drawings, ranging from studies of trees (which were especially admired by Ruskin), to panoramic views of Rome and Florence. He returned to London in 1839 where he lived until 1861, when he moved to Reigate and in 1862 to Redhill. Exhib. 57 works at the RA 1819-73; 20 at the BI 1819-53; ten at SS; and 178 at the OWS. A of the OWS 1843, Member 1854. He exhib. Italian subjects and after 1854 drawings of pastoral scenery in Great Britain. He now made his living by teaching and by highly-wrought exhibition landscapes, gorgeously coloured and sentimental in their appeal. His last period began in the 1850s when he abandoned transparent colour and worked with an impasto of opaque colour on a board prepared with a wash of Chinese white, giving an effect of rich oil painting, very bright and rich in tone. More similar, however, to his Shoreham Period are his monochrome drawings illustrating Virgil and Milton, and at the time of his death he was working on an English metrical version of Virgil's *Eclogues,* illustrated with his own designs. Manuscripts relating to the artist are held by VAM. For works illustrated by, see VAM Card Cat.

Bibl: AJ 1881 p.223; 1893 p.44; Portfolio 1876 pp.60-4, 90; 1884 p.31ff., 145ff.; 1887 p.28ff; 1891 pp.255-60; Connoisseur XLIV 1916 p.177ff.; LXXVIII 1927 p.125ff.; Apollo II 1925 p.305; V 1927 p.82ff.; John Ruskin, *Modern Painters,* 1846; Redgrave, Cent; Roget; Alfred Herbert Palmer, *The Life and Letters of S.P., Painter and Etcher,* London, 1892; Cundall; DNB; Hughes; VAM; Williams; L. Binyon, *The Followers of William Blake,* 1925; *S.P. and other Disciples of William Blake,* VAM 1926; M. Hardie, *S.P.,* OWS IV 1927; G. Grigson, *S.P., The Visionary Years,* 1947; R. Melville, *S.P.,* 1956; *S.P. and his Circle — The Shoreham Period,* Arts Council 1957; *Paintings and Drawings by S.P.,* Ashmolean Museum, Oxford 1960; *S.P.'s Sketch Book,* 1824, introduced by M. Butlin, 1962; Reynolds, VP pp.141-2 (pl.24); Edward Malins, *S.P.'s Italian Honeymoon,* London 1968; Hardie (pls.lll), *passim;* Carlos Peacock, *S.P.: Shoreham and After,* 1968; Maas (pls.39, 40); Raymond Lister, *S.P. and his Etchings,* 1969; Lord David Cecil, *Visionary and Dreamer: Two Poetic Painters, S.P. and Edward Burne-Jones,* 1969; Charles Dickens, *Pictures from Italy,* 1973; Staley; R. Lister, *S.P. A Biography.* 1974 (revised 1988); Ormond; James Sellars. *S.P.,* 1974; Newall.
Exhib: London, VAM 1926; New York, Durlacher Bros. Gallery 1949; Arts Council 1957; Oxford, Ashmolean Museum, 1960; Princeton University 1971.

PALMER, Mrs. Samuel fl.1840-1842
(Miss Hannah Linnell)

Painted landscape and views in Italy. Exhib. five works, views in Tivoli and in Naples, at the RA, and three works at the BI. She was the daughter of John Linnell and the wife of Samuel Palmer (qq.v.).

PALMER, Mrs. W.J. fl.1872-1879

Painted flowers in watercolour. Exhib. nine watercolours, including 'Wild Roses', 'Tulips' and 'Primroses', at SS. London address.

PALMER, William fl.1869-1889

Exhib. two works, 'A Meadow in Derbyshire' and 'Scene on the Tees', at the RA. London address.

PALMER, William James fl.1858-1888

Landscape and genre painter. Exhib. RA 1868-85, SS, NWS and elsewhere. Titles at RA 'Northumberland Moors', 'Monte Leone and the Simplon Pass' and genre subjects from Tennyson and Wordsworth. For works engraved by, see VAM Card Cat.

PANNINI, N. fl.1858

Exhib. a work entitled 'Job and his Three Friends' at the RA. Address in Rome.

PANTON, Alexander fl.1861-1888

Landscape painter. Exhib. at SS (69 works) also RA 1866-88 and BI. RA pictures mostly views in Kent and Surrey.

PAOLETTI, Antonio Silvio fl.1881-1891

Painted figurative subjects. Exhib. four works at the RA including 'Melon Eaters' and 'The Antique Seller', and one work 'Return from Fishing' at SS. London address. Subjects mainly Venetian scenes.

PAPWORTH, C. fl.1802-1844

Exhib. three works at the RA 1802-7.

PAPWORTH, F. fl.1845

Is supposed to have exhib. a painting of Vesuvius in 1845. London address.

PARALTA, Francisco fl.1881

Exhib. a figurative subject in 1881. London address.

PARAVEY, Mlle. Marie A.H. fl.1850

Exhib. a painting of flowers at the RA. Address in Grasville, France.

PARIS, Miss fl.1850

Exhib. a view of Hatfield House at the RA.

PARIS, T.C. fl.1855-1856

Exhib. two works, 'The Haunted Heath' and 'The Road to the Farm', at the RA. London address.

PARIS, Walter fl.1849-1891

Topographical painter and watercolourist. Exhib. at RA in 1849 and 1877, SS, NWS, and elsewhere. Painted views in England, Jersey, France, Venice, and India. Eight watercolours by him are in the VAM. He should not be confused with Walter Paris (1842-1906), an architect and watercolourist who studied in London and later emigrated to the USA.
Bibl: VAM Cat. of Watercolours 1908.

PARK, G .H. fl.1876

Exhib. a landscape in 1876. London address.

PARK, Henry 1816-1871

Painted animals and figurative subjects. Exhib. four works, paintings of cattle and sheep, at the RA, and three works at SS, including 'The Death Struggle' and 'The Amateur's Rehearsal'. Born in Bath. Died in Bristol .
Bibl: AJ 1859 p.348.

PARK, James Chalmers **b.1858**
Watercolourist and etcher of British game birds. Studied at Leeds
College of Art. Exhib. in London and Yorkshire. Born at Wetherby,
Yorkshire. Lived in Leeds, Yorkshire.

PARK, Stuart **1862-1933**
Glasgow flower painter. At first painted in his spare time, but in
1888 took up art professionally. Specialised in painting carefully
arranged bouquets of roses, lilies, orchids and azaleas. He
developed a very individual technique, using thick and rapid
strokes against a dark background, suggesting rather than defining
the texture and colour of flowers. He worked only in Scotland, and
did not exhib. in London.

Bibl: Studio XXIX 1903 p.296; XXXI 1904 pp.67, 163; XXXVII 1906 p.200;
Connoisseur XXXVII 1913 p.121; D. Martin, *The Glasgow School of Painting*,
1902; Caw pp.499-50; *The Glasgow Boys*, Scottish Arts Council 1968; Irwin.

PARKE, R. **fl.1876**
Exhib. a still-life in 1876. London address.

PARKER, A.M. **fl.1839-1840**
Exhib. a landscape with cattle at the RA and a watercolour at SS.
Address in Nottingham.

PARKER, Miss Ellen Grace **fl.1875-1893**
London flower and genre painter; lived in St. John's Wood. Exhib.
at SS, RA 1878-93, and elsewhere. Titles at RA flowers and genre
scenes, e.g. 'Schoolboys Bathing', 'An Art Student's Holiday', 'Up
the River', etc.

PARKER, Miss F. **fl.1849-1859**
Exhib. a watercolour entitled 'The Besom Maker' at SS. London
address.

PARKER, Frederick **fl.1833-1847**
Landscape and topographical painter. Exhib. at SS, RA 1845-7, and
BI. Titles at RA all of castles, e.g. 'Stirling Castle', 'Edinburgh
Castle', 'Castle of Marksburg', etc.

PARKER, Frederick H.A. **RBA** **fl.1881-1904**
Landscape and genre painter. Exhib. at SS, and RA 1886-1904.
Genre scenes mostly of children, e.g. 'The Millers Little Maid', 'A
Truant', 'A Girl in White', etc.

PARKER, Harold **1873-1962**
Sculptor and painter of portraits and figurative subjects. Studied at
the Art School, Brisbane, and at the City and Guilds School, until
1902. Exhib. in London and Australia. Born at Aylesbury,
Buckinghamshire. At an early age went to Australia. Returned to
London in 1896.

Bibl: Who's Who; Studio LVIII 1913 p.207; LXII 1914 p.209; Connoisseur XL
1914 p.233ff.; XLIV 1916 p.211; XLVI 1916 pp.102, 105; XLVIII 1917 p.114.

***PARKER, Henry H.** **1858-1930**
Little-known Midlands landscape painter working in the last
quarter of the 19th century. He did not exhib. in London, but his
works now appear frequently at auction. He painted mostly views
on the Thames, in Surrey, Kent and Wales, in a style similar to the
late work of B.W. Leader (q.v.).

***PARKER, Henry Perlee** **HRSA** **1795-1873**
Genre and portrait painter. Known as Smuggler Parker, because he
specialised in pictures of smugglers. Born in Devonport, Cornwall;
son of Robert Parker, a painter, carver and gilder. In 1814 he
married and set up as a portrait painter in Plymouth. 1815 moved to
Newcastle, where he soon established himself as a painter of
portraits and local subjects. Exhib. at RA 1817-59, BI, SS, NWS,
and at many exhibitions in Newcastle. He was a member of the
Northumberland Institution for the Promotion of the Fine Arts; and
co-founder with T.M. Richardson Snr. (q.v.), of the Northern
Academy of Arts. About 1826 he first began to paint smuggling
subjects. His best known work was 'The Rescue of the Forfarshire
Steam Packet' by Grace Darling and her father. Other local subjects
include 'The Opening of the Grainger Market', 'Eccentric
Characters of Newcastle on Tyne', etc. Moved to Sheffield 1841-5,
where he was a drawing master at Wesley College. In 1845 he
moved to London where he later died in poverty. His beach scenes
have a remarkable similarity to those of William Shayer (q.v.). He
also painted a number of interesting scenes of mining and pitmen.

Bibl: Bryan; Richard Welford, *Men of Mark Twixt Tyne and Tweed*, 1895 III;
N.A. Johnson, *H.P.P.*, Newcastle Life September 1969; Cat. of H.P.P. exhib.,
Laing AG, Newcastle, 1969-70; Hall; Ormond.

PARKER, J .B. **fl.1867**
Exhib. three works at SS, including 'One for his Knob' and a
watercolour entitled 'Italian Peasants'. London address.

PARKER, J.C. **fl.1868**
Exhib. two views on the coast of Normandy at SS. Address in
Folkestone, Kent.

PARKER, John **RWS RBSA** **1839-1915**
Landscape and genre painter, mostly in watercolour. Born and
studied in Birmingham. Exhib. at OWS (185 works), RA from
1871, SS, GG, NG and elsewhere. Lived in St. John's Wood. Titles
at RA 'The River, Hurley, Bucks', 'Sheep Marking', 'Little Nell's
Garden', etc.

Bibl: Studio LXVII 1916 p.254; Who's Who.

PARKER, Miss Louise **fl.1892-1893**
Exhib. two works, 'Thoughts' and 'A Daughter of Toil', at SS.
London address.

PARKER, Miss Nevillia **fl.1881-1888**
Exhib. two views on the Gower Coast, Ireland, at SS and one work
entitled 'Left on the Rocks' at the RA. London address.

PARKER, Miss Phoebe **fl.1885-1886**
Exhib. two works, 'Study in an Old Barn' and 'Relics of the Past',
at the RA. Address in Clitheroe, Lancashire.

PARKER, R.H. **fl.1848-1858**
Exhib. three works, including 'The Itinerant Pan-maker' and
'Entrance of the Port of Tyne, Northumberland', at SS, and one
work at the RA. Address in Sheffield, Yorkshire.

PARKER, Miss Sybil C. **fl.1872-1893**
Painted figurative subjects. Exhib. seven works at the RA,
including 'A Family Party' and 'Too Long a Swim', and one
drawing at SS. Address in Clitheroe, Lancashire.

PARKER, T. **fl.1867-1868**
Exhib. two works, 'The End Justifies the Means' and a study, at the
RA, and one work at SS. London address.

PARKER, Miss V. **fl.1875**
Exhib. a work entitled 'Clio' at SS. London address.

PARKES, Miss S. fl.1876
Exhib. a painting of cottages in Berkshire at the RA. London address.

PARKES, William Theodore fl.1870-1904 d.c.1908
Son of Isaac Parkes, a Dublin medallist. At first worked as a medallist and designer, but after his father's death in 1870, he turned to painting landscape and figure subjects. Exhib. at RHA 1875-83. About 1883 he moved to London, where he worked as artist and journalist.

PARKINSON, Miss Amelia fl.1872-1873
Exhib. two paintings of flowers at SS. London address.

PARKINSON, John W. fl.1880
Exhib. a work entitled 'Just in Time' at the RA. Address in Portsmouth, Hampshire.

PARKINSON, William fl.1883-1895
Painted landscape and genre subjects. Exhib. six works at the RA, including 'Whims and Fancies' and 'Prenez Garde!', and three works at SS. London address.

PARKINSON, William Edward 1871-1927
Painted landscape in watercolour. Also a sculptor. Studied at Chester School of Art and at the RCA. Exhib. in London, the provinces, and in Paris. Born in Chester, Cheshire. Lived in York.

PARKINSON, William H. fl.1892-1898
Painted landscape and marines. Exhib. seven works at the RA including 'A Bit of Bolton Woods', 'Red Nab Sand-dunes' and 'Toilers of the Sea'. Address in Bradford, Yorkshire.

PARKMAN, Alfred Edward b.1852 fl. to 1930
Bristol topographical painter; son of Henry Spurrier Parkman (q.v.).

PARKMAN, Ernest 1856-1921
Bristol painter of town scenes in the West of England. Son of H.S. and brother of A.E. Parkman (qq.v.).

PARKMAN, Henry Spurrier 1814-1864
Painted portraits. Exhib. eight works at the RA, portraits and a work entitled 'Italian Boy with Mice', and one work at SS. Address in Bristol. His sons Alfred Edward and Ernest were also painters (qq.v.).
Bibl: Ormond.

PARKYN, John Herbert RWA b.1864 fl.1884-1903
Painted flowers and genre. Studied at the Clifton School of Art, at the RCA and in Paris at the Académie Julian. Exhib. six works at the RA 1884-1903, including 'Roses' and 'Purple Iris'. Born in Cumberland. For 11 years he was Head of Hull School of Art. Later lived in Galloway.

PARKYN, William Samuel ARCA ARWA SMA PS 1875-1949
Painted marines and landscape. Studied at the Blackburn School and under Louis Grier at St. Ives, Cornwall. Exhib. RA, RI, RCA, RWA, RHA, and in the provinces. Member of St. Ives Art Society and of the London Sketch Club. Born in Blackheath, London. Lived at the Lizard, Cornwall.

PARLBY, James fl.1870-1873
Painter of landscape and figure subjects. Exhib. at SS 1870-73. Lived in Hastings and London, and painted views in Sussex and Scotland.

PARMINTER, G. fl.1848
Exhib. a view in Salisbury at the RA. London address.

PARNELL, Mrs. A. fl.1874
Exhib. 'A German Girl' at SS. Address in Dublin.

PARNELL, A.M. fl.1874
Exhib. two works 'Household Cares' and 'Peep o'Day' at SS. Address in Dublin

PARR, A.H. fl.1876
Exhib. a work entitled 'Returning from Market' at the RA. London address.

PARR, Sam fl.1890
Exhib. a work entitled 'A Grey Day in the Midlands' at the RA. Address in Nottingham.

***PARRIS, Edmund Thomas 1793-1873**
Portrait, genre and landscape painter and architect. Exhib. at RA 1816-74, BI, SS and NWS. Painted a panorama of London for the Coliseum 1824-9. In 1843 his picture of 'Joseph of Arimathea Converting the Jews' won a prize in the Westminster Hall competition. He also painted large pictures of the coronation of Queen Victoria, and the funeral of the Duke of Wellington, both of which were engraved. Between 1853 and 1856 he worked on the restoration of Thornhill's frescoes in the dome of St. Paul's Cathedral. In 1832 he was appointed Historical Painter to Queen Adelaide.
Bibl AJ 1874 p.45; Connoisseur IV 1902 p.205; DNB; Bryan; Roget; *Shakespeare in Pictorial Art*, Studio Special Spring Number 1916; BM Cat. of Engraved British Portraits 1908-25; Maas; Ormond.

PARRIS, Miss Mary Ann fl.1845-1869
Painted flowers and fruit. Exhib. four works at the RA, including three paintings of fruit; two works at the BI and one at SS. London address.

PARROTT, H. fl.1852
Exhib. a view on the River Don, Yorkshire, at the RA. Address in Nottingham.

PARROTT, Samuel 1797-1876
Painted landscape. Exhib. four works at the RA, including three views in Derbyshire, and three works at SS. Address in Nottingham. He was a pupil of Henry Dawson (q.v.), and they later went on sketching tours together. Examples are in Nottingham AG.

***PARROTT, William 1813-1869**
Topographical painter and watercolourist, and lithographer. Exhib. at RA 1835-63, BI, SS and elsewhere. Visited Paris 1842-3, Rome 1845. Published a set of lithographs, *Paris et ses Environs* He is now best known for his Italian views, especially of Rome.
Bibl: *Londoners Then and Now*, Studio Special Number 1920 p.133; Hardie III pp.20-1 (pl.30); Wood, Panorama p.121.

PARRY, A. fl.1850-1865
Exhib. 'Cattle Reposing' at the RA. London address.

PARRY, C. fl.1843
Exhib. a view of St. Albans Abbey at SS. Address in St. Albans, Hertfordshire.

PARRY, Charles James 1824-1894
Painted landscape. Exhib. five works at the RA including 'Ogwen, North Wales', 'In Glencoe' and 'The Edge of the Forest', and one work at SS. London address. His son, Charles James II, was also a painter.

PARRY, David Henry 1793-1826
Exhib. two works, 'The Fading of the Day' and 'An English Lane', at the RA. London address.

PARRY, E. Gambier fl.1898-1899
Exhib. three works, including a view of the Stour estuary, at the RA. Address at Goring-on-Thames, Oxon.

PARRY, James 1805-1871
Manchester painter of portraits and landscapes. Son of Joseph Parry (1744-1826), also a Manchester artist. Exhib. at Royal Manchester Institution 1827-56. His elder brother D.H. Parry and his nephew C.J. Parry (qq.v.) were also painters.

PARRY, John fl.1867-1868
Exhib. three landscapes 1867-8. London address.

PARRY, Thomas Gambier 1816-1888
Collector, watercolourist and painter of frescoes. Developed his own method of spirit fresco, which was copied by both Leighton and Ford Madox Brown (qq.v.). Examples of Parry's frescoes can be seen in the cathedrals of Ely and Gloucester, Tewkesbury Abbey, and in the church which he built on his own estate at Highnam Court, Gloucestershire. His collection of early Italian paintings is now in the Courtauld Institute, London. He was the father of the composer Sir Hubert Parry.
Bibl: DNB Bryan; BM Cat. of Engraved British Portraits; The Fine Art Quarterly Review 1863 pp.20, 197; Portfolio 1886 p.164; 1888 p.224; Burlington Mag. 1903 p.117; further bibliography VAM; Cat. of T.G. Parry exhib., Courtauld Institute, London, 1922.

PARSONS, Miss fl.1857
Exhib. a portrait at the RA. London address.

***PARSONS, Alfred William RA RI PRWS 1847-1920**
Landscape painter and watercolourist, and illustrator. Worked as a post office clerk, while studying at South Kensington Art School, after which he took up painting professionally. Exhib. at RA from 1871, and at SS, NWS, GG, NG and elsewhere. ARA 1897, RA 1911. 'When Nature Painted all Things Gay', RA 1887, was bought by the Chantrey Bequest. In addition to his realistic pastoral scenes and landscapes, he also specialised in painting gardens, and plants. Illustrated *The Genus Rosa* by Miss Ellen Wilmott (1914). Lived in Broadway, Worcestershire.
Bibl: AJ 1890 pp.162, 188; 1911 pp.170, 174; Studio XVI 1909 pp.149-56; Connoisseur XXXVIII 1914 p.66ff.; LVI 1920 p.251ff.; DNB; Who was Who 1916-28; H. Fincham, *Artists and Engravers of Book Plates,* 1897; R.E.D. Sketchley, *English Book Illustrators of Today,* 1903; Hardie III pp.96. 163; Maas; Wood, Painted Gardens.

PARSONS, Arthur Wilde RWA 1854-1931
Painted landscape and marines. Exhib. five works at SS, including 'Wandsworth Common — Early Autumn' and 'Trawlers in the North Sea', and six works at the RA, including 'Homeward Bound' and 'Abandoned'. Lived at Redland, Bristol.
Bibl: Brook-Hart pl.218.

***PARSONS, Miss Beatrice E. 1869-1955**
Flower and garden painter. Studied at the RA Schools. Exhib. at RA 1889-99. Titles: 'Chrysanthemums', 'Autumn', 'Spring', etc. She specialised in pictures of old English gardens. Particularly known for her colourful pictures of borders in summer. Worked mainly for private patrons in England, France and North Africa, but also exhib. at the Dowdeswell and Greatorex Galleries in London. Lived at Watford, Hertfordshire.
Bibl: Wood, Painted Gardens.

PARSONS, Miss E. fl.1886
Possibly exhib. at GG in 1886. Address in Frome, Somerset.

PARSONS, Mrs. G. fl.1869
Exhib. a watercolour view of a Cornish mill at SS. Address in Cornwall.

PARSONS, Miss H. fl.1853-1854
Exhib. two watercolours at SS, a landscape on the Isle of Man and 'The Last Rose of Summer'. London address.

PARSONS, Herbert fl.1874
Exhib. a genre subject in 1874. Address in Lewisham.

PARSONS, J.V.R. fl.1900-1904
Exhib. three works at the RA 19004, including 'An Unexpected Return'. Address in Liverpool.

PARSONS, John R. c.1826-1909
Painted portraits. Exhib. seven works at the RA including 'Portrait of an Octogenarian' and portraits. London address.
Bibl: BM Cat. of Engraved British Portraits; AJ 1909 p.94; The Year's Art 1910 p.389.

PARSONS, John W. RBA RMS SSA 1859-1937
Painted marines, landscape and portraits. Studied at the RSA Schools and under Paul Delance. Exhib. from 1892. Lived at Pulborough, Sussex.
Bibl: Who's Who 1914.

PARSONS, Miss Letitia Margaret fl.1877-1913
(Mrs. Keith)
Flower painter. Lived at Frome, Somerset. Exhib. at RA 1879-87, GG and NG. Titles at RA 'A Winter Bouquet', 'Daffodils', 'Flowers and Berries', etc.
Bibl: Ormond.

PARTING, Miss Florence fl.1883
Exhib. a genre subject in 1883. London address.

PARTINGTON, John H.E. 1843-1899
Painter of genre, portraits and marine subjects, working in Stockport and Ramsey, Isle of Man. Born in Manchester and died in Oakfield, California. Exhib. 1873-88, at the RA 1873-86, NWS and GG, titles at the RA including 'Shetland Turf Gatherers', 1873, 'Hard Weather', 1875 — called by Ruskin "highly moral", 'The Smuggler's Yarn', 1880, and 'A Ramsey Wrecker', 1884. A portrait of W.A. Turner is in the City AG, Manchester.
Bibl: Ruskin, Academy Notes.

***PARTON, Ernest ROI 1845-1933**
American landscape painter. Born in Hudson, New York; younger brother of Arthur Parton, in whose studio he spent two winters, receiving no other regular art instruction. In 1873 he came to England, where he settled, exhibiting from 1874, at the RA from 1875, SS, NWS, GG, NG and elsewhere. He also lived in France

and travelled in Switzerland and Italy. In 1879 his large landscape 'The Waning of the Year', RA 1879, was purchased for the Tate Gallery by the Chantrey Bequest, and in the same year 'Woodland Home' was purchased for the Walker AG, Liverpool.

Bibl: AJ 1892 pp.353-7 (mono.); Clement & Hutton; Who Was Who 1929-40; Pavière, Landscape.

PARTRIDGE, Miss Annie St. John RI RBA fl.1888-d.1936
Painted landscape and figures. Exhib. in London and abroad. Exhib. a painting of flowers at the NWS. London address.

PARTRIDGE, Charlotte P. fl.1847-1853
Exhib. from the same address as Ellen Partridge (q.v.).

PARTRIDGE, Miss Ellen fl.1844-1893
Painted portraits. Exhib. 23 works at the RA, some of them miniatures. Also exhib. a painting of fruit at the BI. She was a member of the Society of Lady Artists. Lived in London.

***PARTRIDGE, John 1790-1872**
Portrait painter. Pupil of Thomas Phillips. Exhib. RA 1815-46, and BI. Partridge was a successful society portrait painter. In 1842 he exhib. portraits of Prince Albert and Queen Victoria, and the following year was appointed Portrait Painter Extraordinary to Her Majesty and HRH Prince Albert. His position as Court Painter was eclipsed by the arrival of Winterhalter.

Bibl: AJ 1902 p.145; South Kensington Museum, Cat. of 3rd Exhib. of National Portraits 1868; Redgrave, Dict.; DNB; L. Cust., *The NPG*, 1902; BM Cat. of Drawings by British Artists 1902; BM Cat. of Engraved British Portraits 1908-25 VI p.526; Poole 1912-15; Ormond.

PARTRIDGE, Sir John Bernard 1861-1945
Punch cartoonist and book illustrator. Nephew of John Partridge (q.v.). At first an actor, then a stained-glass and decorative painter. Joined Punch in 1891. RI 1896-1906.

PASCOE, William fl.1842-1844
Landscape painter, working in London and Plymouth, who exhib. 1842-4, at the RA 1842 and 1843, BI and SS, titles at the RA including 'View on the Caddiver River, Dartmoor, Devon', 1842.

PASH, Miss Florence fl.1892-1905
(Mrs. Humphrey)
Painted genre subjects. Exhib. 12 works at SS including 'The Disputed Point', 'A Parting Glance' and 'Good News', and nine works at the RA 1892-1903. London address.

PASLEY, M. fl.1868
Exhib. a watercolour landscape of Perthshire at SS. London address.

PASLEY, Miss Nancy A. Sabine fl.1886-1892
Exhib. a work entitled 'A Kitchen Window' at SS. London address.

PASMORE, Daniel, Snr. fl.1829-1865
Genre and portrait painter, presumably the father of Daniel Pasmore Jnr. (q.v.). Exhib. at RA 1829-65, and elsewhere. Titles at RA mostly historical genre and portraits, e.g. 'The Happy Days of Anne Boleyn', etc. Four pictures by Daniel Pasmore Snr. or Jnr., are in York AG.

PASMORE, Daniel, Jnr. fl.1829-1891
Genre and portrait painter, son of David Pasmore (q.v.). Exhib. mostly at SS (86 works), also at RA 1829-34, BI and NWS. Titles at RA 'The Juvenile Architects', 'Boys Blowing Bubbles', 'Contemplation', etc.

PASMORE, Emily fl.1881-1884
Painted flowers and fruit. Exhib. four works, including ' "Oft I Gather Flowerets Gay" ' and 'A Branch of Plums', at SS. London address.

PASMORE, F.G., Jnr. fl.1875-1884
Painted genre subjects. Exhib. 15 at SS, titles including 'Making a Fair Bargain', 'Striking for Wages' and 'An Artful Trick'. London address.

PASMORE, John fl.1830-1845
Animal and still-life painter. Exhib. at RA 1831-45, BI and SS. Titles at RA 'Still Life', 'Sheep', 'Portrait of a Highland Sheepdog', etc.

***PASMORE, John F. fl.1841-1866**
Painter of rustic genre, animals and still-life. Exhib. at RA 1842-62, BI, SS and elsewhere. Titles at RA 'The Cattle Shed', 'The Farmer's Boy', 'A Farm Yard', etc. His wife Mrs. J.F. Pasmore was also a painter (q.v.).

PASMORE, Mrs. John F. fl.1861-1878
Painted domestic subjects. Exhib. 1861-78 at the RA, BI and SS. Wife of John F. Pasmore (q.v.).

PASQUIER, James Abbott fl.1851-1872
Painted portraits and genre subjects. Exhib. six works at the RA, portraits and works entitled 'A Cool Reception' and 'Taking A Mean Advantage'. Also exhib. two watercolours and another work at SS. London address. He was probably a relation of E.J. Pasquier, NWS, fl.1822-34.

PASSEY, Charles Henry fl.1870-1885
Exhib. three landscapes, in Derbyshire and Cumberland, at SS. London address. Often painted cornfields and harvesting scenes.

PASSINGHAM, Miss Leila A. fl.1895
Exhib. a portrait at the RA. London address.

PATALANO, Enrico fl.1890
Exhib. a portrait at the RA. London address.

PATERSON, Alexander Nisbet ARSA RSW 1862-1947
Architect who painted watercolours. Studied at the École des Beaux-Arts, Paris. Exhib. an interior view of the Baptistry in Florence at the RA. Lived at Helensburgh, Dumbartonshire.

Bibl: Who's Who; Studio LXVI 1916 pp.117, 268ff.

PATERSON, Miss Caroline fl.1878-1892
(Mrs. S. Sharpe)
Exhib. three works at the NWS. London address. Sister of Helen Allingham (q.v.).

PATERSON, Emily Murray RSW SWA 1855-1934
Painted landscape and flowers. Exhib. two works, 'A Summer Afternoon' and 'On the Sandhills, Boulogne', at SS. She travelled extensively on the Continent. Born in Edinburgh. Lived in London.

Bibl: AJ 1907 p.275; Studio LXII 1914 p.236; LXV 1915 p.105; LXVII 1916 p.59; LXX 1917 p.44; Who's Who; Caw; Walker's Monthly November 1930 No. 35; Hardie pl.236.
Exhib: London, Walker's Galleries 1935.

PATERSON, George M. fl.1881-1886
Exhib. two works, 'The Old Fisherman's Favourites' and 'Marshal Keith's Last Battle, Hochkirch, 1758', at the RA. Address in Edinburgh.

PATERSON, Miss Helen see ALLINGHAM Mrs. Helen

***PATERSON, James PRSW RSA RWS 1854-1932**
Scottish landscape painter and watercolourist. Son of a cloth manufacturer. Worked as clerk for four years before taking up painting. Studied in Paris under Jacquesson de la Chevreuse and J.P. Laurens. On his return, he became a leading member of the Glasgow School, together with his lifelong friend and sketching companion, W.Y. Macgregor (q.v.). In 1884 he married and settled near Moniaive, Dumfriesshire, where he found the best type of landscape for his quiet, pastoral paintings, which show the romantic influence of Corot and the Barbizon School. He exhib. at the RA from 1879, also RSA, SS, GG. NEAC, etc. Titles at the RA 'Windy Trees', 'The Old Mill', etc.
Bibl: AJ 1894 pp.77, 79; 1905 pp.184, 352ff.; 1906 p.186; 1907 p.187; 1908 p.28; Studio LXIII 1915 p.112ff., also indexed 1903-18; Art News XXX 1932 No.20 p.12; D. Martin, *The Glasgow School of Painting*, 1902; Caw pp.382-3 (pl.p.382); *The Glasgow Boys*, Scottish Arts Council 1968; Hardie pl.226; Irwin; Ormond; OWS Annual X 1932-3, *J.P.*
Exhib: London, Belgrave Gallery, *The Paterson Family*, 1977.

PATERSON, Stirling fl.1893-1894
Exhib. two works, 'A Quiet Morning' and 'Waiting for the Tide', at the RA. Address in Edinburgh.

PATERSON, W. fl.1900
Exhib. a landscape in Rosshire at the RA. London address.

PATERSON, W. Richard fl.1823-1841
Painted landscapes and townscapes. Exhib. seven works at the RA, including 'Cottages near Deal, Kent' and 'The Old Entrance into Sandwich, Kent', and six works at the BI, including views in Kent and London. London address.

PATEY, Miss Ethel J. fl.1891-1892
Exhib. three portraits at SS, one of which was a pastel drawing. London address.

PATMORE, Miss Bertha G. fl.1876-1903
Figure and landscape painter, working in Hastings and Lymington, Hampshire, who exhib. at the RA 1876-1903, titles including 'Portion of a Survey of Westmorland, Natural Scale', 1876, and 'Love in a Mist', 1880.

PATON, Frank 1856-1909
Painter of genre and animals; illustrator; working in London and Gravesend; exhib. 1872-90, at the RA 1878-90, SS and elsewhere, titles at the RA including 'Puss in Boots', 1880 and 'A Happy Family', 1890.
Bibl: The Year's Art 1910.

PATON, Hugh ARPE 1853-1927
Self-taught painter and etcher. Exhib. 'A Spring Morning' at SS. Address in Manchester.
Bibl: Studio LVII 1913 p.15; Who's Who; Who Was Who 1916-28.

***PATON, Sir Joseph Noel RSA 1821-1901**
Painter of historical, religious, mythical and allegorical subjects. Born at Dunfermline. Studied at RA Schools 1843; met Millais (q.v.), who remained a life-long friend. Won prizes in Westminster Hall competitions 1845 and 1847. Although he sympathised with the aims of the Pre-Raphaelite Brotherhood, he never became a member because of his return to Scotland. Exhib. at RA 1856-83; mostly at RSA. ARSA 1847, RSA 1850. Appointed H.M. Limner for Scotland and knighted 1866. A man of wide learning and culture, the subjects of his pictures were drawn from an equally wide range of sources. Perhaps his most original works were his paintings of fairies, such as 'Oberon and Titania' and 'The Fairy Raid'. He also painted a few pictures of contemporary life. His technique was laborious and Pre-Raphaelite in detail, but he was primarily a painter of the intellect, and cared more for ideas than techniques. After 1870 he began to devote himself to religious works, moving towards a cold and academic style, often compared to the Nazarenes. The sketches for these late works — usually in brown monochrome — are often livelier and more interesting than the finished picture. He also published books of poetry. His brother, Waller Hugh Paton (q.v.) was also a painter. For works illustrated by, see VAM Card Cat.
Bibl: AJ 1861 p.119; 1863 p.64; 1866 p.140; 1869 pp.1-3; 1881 pp.78-80; 1895 pp.97-128; 1902 pp.70-2; Mag. of Art III 1880 pp.1-6; L'Art LIX 1894 p.386ff.; LXI 1902 p.30; Ruskin, Academy Notes 1856, 1858; Bate p.71ff.; Bryan; Caw pp.167-70 (pl. p.68); Fredeman section p.53 *et passim*; Maas p.152 (pls.pp.152-3, 231); Irwin; Staley pls. 45, 90; Ormond; Wood, Panorama; M.H. Noel-Paton *Tales of a Grand-Daughter* (privately printed 1970); Wood, Pre-Raphaelites; M.H. Noel-Paton and J.P. Campbell, *Sir J.N.P.*, 1990.
Exhib: Edinburgh, Scottish Arts Council 1967.

PATON, Ronald Noel fl.1895
Painted portraits. Exhib. a portrait of his father Sir Noel Paton (q.v.) at the RA. Address in Edinburgh. For works illustrated by, see VAM Card Cat.
Bibl: AJ 1895 p.127.

***PATON, Waller Hugh RSA RSW 1828-1895**
Scottish landscape painter. Born in Wooers-Alley, Dunfermline. At first he assisted his father who was a damask designer. In 1848 he became interested in landscape painting, and had lessons in watercolour from John Houston RSA (q.v.). A of RSA 1857; RSA 1865; exhib. there annually 1851-95, and at the RA 1860-80. In 1858 he joined his brother Sir Noel Paton (q.v.) in illustrating Ayton's *Lays of the Scottish Cavaliers*, 1863. From 1859 he lived in Edinburgh; 1860 he stayed in London; 1861 and 1868 he toured the Continent. In 1862 he was commissioned by Queen Victoria to make a drawing of Holyrood Palace. FSA of Scotland 1869; RSW 1878. He was the first Scottish painter to paint a picture throughout in the open air, and most of his subjects were the hill scenery of Perthshire, Aberdeenshire, and especially Arran, generally at sunset. His prevailing colour effect was the purple of the northern sunset, and in his earlier work, his close study of detail is almost Pre-Raphaelite, as in 'The Raven's Hollow'. Paton's work was always very popular with the general public, but Caw notes that his later pictures are mannered and lack the fresh observation and detail of the earlier ones. His Diploma work 'Lamlash Bay' is in the National Gallery, Edinburgh. Paton made a watercolour sketch of all his paintings and several albums of these are preserved in the Paton family. For works illustrated by, see VAM Card Cat.
Bibl: AJ 1895 p.169 (obit.); Bryan; Caw pp.194-5; DNB; Irwin; Staley.

PATRICK, J. Rutherford fl.1891
Exhib. a work entitled 'Through Wind and Rain' at the RA. Address in Preston Kirk.

PATRY, Edward RBA 1856-1940
London painter of portraits and genre. Educated at Rugby, and at the South Kensington Schools where he studied under Sir Edward Poynter 1879-82; also worked in the studio of Herr Frisch, court

painter, in Darmstadt. Exhib. from 1880, at the RA from 1883, SS and elsewhere; exhib. at the Paris Salon, 1909 Gold Medal, Brussels International Exhibition, 1910 diploma, first class medal, portrait purchased by Belgian Government for the Musée Moderne, Brussels. Principal works include 'Pleading', 'Mandolinata', 'A Daughter of Eve', Portrait Panel of Sir Richard Glyn, Royal Exchange 1922, and Antony Gibbs, Royal Exchange 1926.

Bibl Connoisseur LXXVI 1926 p.266 pl.265; Who Was Who 1929-40.

PATTEN, Alfred Fowler RBA 1829-1888
Genre painter; son of the portrait painter George Patten (q.v.). Exhib. at RA 1850-78, BI and SS (118 works). Painted historical genre, oriental subjects, and country scenes. Titles at RA 'Hamlet and Ophelia', 'The Fair Persian Tempting the Sheikh with Wine', 'May Day', etc.

Bibl: Clement & Hutton.

PATTEN, Edmund fl.1838-1842
Painted shipping. Exhib. 11 works, the majority watercolours, at SS, including 'East India Docks — Ships Dismantled' and 'Bay of Biscay — Homeward Bound', and two works at the RA. London address.

Bibl: Brook-Hart.

PATTEN, George ARA 1801-1865
Painter of portraits, and of historical, mythological and scriptural subjects. Son of William Patten, a miniature painter; taught painting by his father. Entered RA Schools 1816, and chiefly practised miniature painting until 1828, when he again entered the RA Schools to become proficient in oil painting, which he adopted in 1830. In 1837 he went to Italy, and was elected ARA. In 1840 he went to Germany to paint a portrait of Prince Albert, RA 1840, who subsequently appointed him Painter-in-Ordinary. From this he gained a considerable patronage in presentation portraits, e.g. Richard Cobden, Lord Francis Egerton and Paganini, exhib. 1833. He also painted mythological and scriptural subjects, e.g. 'A Nymph and Child', 1831, 'Bacchus and Io', 1836, and 'The Destruction of Idolatry in England', 1849. Many of these were also exhib. at the BI. Of this type of painting —"the ideal" — the AJ commented: "Several of these are painted on a scale too large for the artist's powers to carry out successfully: Mr. Patten evidently aimed at Etty's manner, and though his flesh painting of the nude, or semi-nude figure, was fairly good, it cannot for an instant be brought into comparison with that of Etty." He exhib. 131 works at the RA 1819-64, and 16 at the BI 1832-44. His studio sale was held at Christie's, 18 January 1867.

Bibl: AJ 1865 p.139; W. Sandby, *The History of the R. Academy of Arts,* 1862; Redgrave, Dict.; DNB; BM Cat. of Engraved British Portraits 1908-25 VI p.527; Emporium LXXIII 1931 p.299; Ormond.

PATTEN, Leonard fl.1889
Exhib. 'Under a Midday Sun' at the RA. London address.

PATTEN, William, Jnr. d.1843
Painted a portrait of Joseph Hume.

Bibl: Ormond.

PATTERSON, Miss Catherine P. fl.1887-1890
Exhib. three works at the NWS. London address.

PATTERSON, G. fl.1877
Exhib. a view 'In the Lledr Valley' at SS. Address in Birmingham.

PATTERSON, H. fl.1840-1851
Exhib. two portraits at the RA. London address.

Bibl: Ormond.

PATTERSON, Stirling fl.1893
Is supposed to have exhib. a genre subject at the RA. Address in Edinburgh.

PATTISON, Anne R. fl.1876
Exhib. a view of a church in 1876. Address in Hastings, Sussex.

PATTISON, Carl fl.1880-1884
Painted marines. Exhib. two works 'Early Morn on the Swedish Coast' and 'Eve on the Cornish Coast' at SS, and a work at the RA. Address in Düsseldorf, Germany.

PATTISON, Charles T. or J. fl.1883
Exhib. two landscapes in 1883. London address.

PATTISON, Edgar L. b.1872
Painted and etched landscapes and architectural subjects. Studied at Lambeth School of Art. London address.

PATTISON, J. fl.1854
Exhib. a view on the Lea, near Waltham Abbey, at the RA. London address.

PATTISON, Robert T. fl.1855-1864
Painted landscapes and figurative subjects. Exhib. three works at the RA, including 'The Banks of the Ayr', and two works at the BI, including 'Italian Girl at a Well'. Also exhib. a watercolour still-life at SS. London address.

PATTISON, W.R.S. fl.1854-1857
Exhib. a view of a bridge in Devon at SS. London address.

PAUL, A.L. fl.1882-1885
Painted landscape watercolours. Exhib. six works at SS including 'Low Tide' and 'West Quay, Greenock'. London address.

PAUL, Clara fl.1880
Exhib. a watercolour of Bude Harbour, Cornwall, at SS. Address in Leicester.

PAUL, Miss Florence fl.1886-1889
Exhib. a work entitled 'Before the Moon is Up' at SS. Address in Waltham Cross, Hertfordshire.

PAUL, J-B.
His portrait of Sir W.M. Gomm was engraved.

Bibl: Ormond.

PAUL, J.G. fl.1880-1884
Exhib. three works, 'Dumbarton Castle, on the Clyde' and 'Among the Herring Fleet' at SS. London address.

PAUL, Sir John Dean, Bt. 1802-1868
Painted landscapes and views of buildings. Exhib. 20 works at the RA, the last of these being a view of East Permard, Somerset, in winter. He worked in his family's bank, which went bankrupt in 1855.

PAUL, Joseph 1804-1887
Norwich landscape painter, and imitator of John Crome. His son John Paul was also a painter, of horses and hunting scenes.

Bibl: H.A.E. Day, *East Anglian Painters,* II pp.237-42.

PAUL, Maclean fl.1889
Exhib. a genre subject at the NWS. London address.

PAUL, Paul RBA **1865-1937**
Painted landscapes and portraits. Studied under Herkomer. Exhib. two works at the RA 1901-4, the first entitled 'The Road through the Meadows'. Born in Istanbul, of Greek parents. Lived in Bushey, Hertfordshire, and in London.
Bibl: P. Phillips, *The Staithes Group*, 1993.

PAUL, Peter fl.1859
Exhib. a work entitled 'on the Grass' at the RA. Address in Bushey, Hertfordshire.

PAUL, Robert
Robert Paul, and sometimes J. Paul are artists to whom imitations of Crome and Canaletto are often attributed by dealers and auctioneers. It has been fairly conclusively proved both artists are fictitious.
Bibl: Miklos Rajnai, *Robert Paul, the Non-Existent Painter*, Apollo, April 1968.

PAUL, Robert Boyd fl.1857-1876
Painter of portraits and genre. Exhib. 1857-76, at the RA 1859 and 1863, BI, SS and elsewhere. Titles at the RA 'A Portrait' and 'Dinner Preparations'.

PAULL, Miss Edith C. fl.1889-1890
Exhib. two works 'The Harbour Edge, Isle of Marben' and 'Homer Row, Marylebone' at SS. London address.

PAULL, Roland W. fl.1887-1904
Painted views of architecture and church furnishings. Exhib. 11 works at the RA 1887-1904, including views of St. Alban's Abbey and Wells Cathedral. London address.

PAULSON, Mrs. Anna fl.1838-1857
Mansfield painter of fruit, vegetables, etc., who exhib. 1838-57, at BI 1850, SS and elsewhere (31 works).

PAULSON, F. fl.1877-1878
Exhib. two portraits at the RA. London address.

PAVY, Eugène fl.1878-1887
Painted landscapes and figurative subjects. Exhib. eight works at SS, including 'A Montenegrin Soldier' and 'Lynmouth, North Devon', and four works at the RA, including 'A Turkish Bazaar'. London address. He was the brother of Philip Pavy (q.v.).

PAVY, Philip fl.1878-1881
Painted figurative subjects. Exhib. 23 works at SS including many Middle Eastern subjects such as 'A Kurd Soldier' and 'On the Banks of the Nile'. Also exhib. four works at the RA. London address. He was the brother of Eugène Pavy (q.v.).

PAWLE, F.C. fl.1858-1862
Painted watercolour landscapes. Exhib. six watercolours at SS including 'Glade in Gatton Park' and 'The Shore at Whitby'. Address in Reigate, Surrey.

PAWLEY, James fl.1854-1869
Exhib. three works, studies from life, at the BI and at SS, and a painting of the Tedworth Hunt at the RA. London address.

PAYNE, A.F. fl.1858
Exhib. etchings and a work entitled 'The Burial of the Lord of Rosslyn' at the RA. Address in Newark, Nottinghamshire.

PAYNE, Arthur Charles fl.1881
Exhib. a drawing in 1881. London address.

PAYNE, B. fl.1875
Exhib. a painting of oranges and lemons at SS. London address.

PAYNE, Miss C. fl.1864
Exhib. a portrait at the RA. Address in Leipzig.

PAYNE, E.J. fl.1845-1848
Exhib. three works at the RA including views of Tintern and Melrose Abbeys. London address.

PAYNE, Edward fl.1877-1879
Exhib. three drawings 1877-9. Address in Cardiff.

PAYNE, Miss Florence fl.1885-1886
Exhib. a painting of narcissi and wallflowers at the RA. Address in Oxford.

PAYNE, H. Ada fl.1881-1885
Exhib. three works at SS including two watercolours, of poppies and of a farmhouse in Sussex. London address.

PAYNE, Henry A. RWS **1868-1940**
Painted landscapes and figurative subjects. Studied at the Birmingham School of Art. Exhib. a work entitled 'The Witch Lady' at the RA. Taught at the Birmingham School of Art. He was a founder member of the Birmingham Group. Born in Birmingham. Lived in Amberley, Gloucestershire.
Bibl: Bate; Who s Who; Studio XXIX 1903 p.25ff.; XXXV 1905 p.296; LXI 1914 p.128ff.; LXVIII 1916 p.138; LXXX 1920 pp.43-8; LXXXII 1921 p.222; Connoisseur XLIV 1916 p.251; LXIV 1922 p.192; LXVI 1923 p.50; LXVII 1923 p.244.

PAYNE, W. fl.1850
Exhib. a portrait at the RA. London address.

PAYNE, W.R., Jnr. fl.1802-1845
Exhib. a work at the RA and a watercolour view on the River Oder at SS. London address.

PAYTON, Joseph fl.1861-1870
Warwick painter of domestic genre who exhib. 1861-70, at the RA 1861-5, BI and elsewhere. Titles at the RA 'Skating at Chantilly', 1861, 'The Anonymous Letter', 1865, and 'The Morning of the Duel', 1865.

PAZOLT, Alfred J. fl.1901
Exhib. a work entitled 'The Rain Squall' at the RA. Address in St. Ives, Cornwall.

PEACAN, John Philip fl.1880-1891
Exhib. three works, including a landscape in France, at SS, and a landscape in County Dublin, at the RA. Address in County Galway.

PEACOCK, Miss Emma fl.1845-1846
Painted architecture. Exhib. three works at the RA including views of York Minster and Orléans Cathedral. Address in Brighton, Sussex.

***PEACOCK, Ralph 1868-1946**

Painter of portraits, especially of children, and landscape; illustrator. Born in Wood Green, London. In 1882 he entered South Lambeth Art School, for some years working there twice a week in the evening, meanwhile studying for the Civil Service. John Pettie (q.v.), however, suggested that he should take up painting as a profession, so he went to St. John's Wood Art School, and finally to the RA schools in 1887, where he won a gold medal and the Creswick Prize. Exhib. from 1888 at the RA, SS, GG and elsewhere. From 1890 he illustrated books and taught at St. John's Wood Art School. He won a gold medal at Vienna in 1898, and a bronze medal at the Paris Exhibition Universelle in 1900. 'Ethel', Chantrey Purchase 1898, and 'The Sisters', 1900, are in the Tate Gallery.

Bibl AJ 1898 p.178; 1900 pls. 182, 165; Studio XXI 1902 pp.3-15 (mono. by W. Shaw-Sparrow); XXIII 1901 p.119; XXIX 1903 p.48; XXXVIII 1906 p.4; LVIII 1913 p.205; LXVIII 1916 pp.40, 53; Who Was Who 1941-50, Tate Cat. Exhib: London, Barbizon House 1935.

PEAKE, F. fl.1844-1846

Exhib. two portraits at the RA and 'A Flower Girl' at SS. London address.

PEAKE, John N. fl.1853-1861

Painted figurative subjects. Exhib. six works at SS including 'The Artist's Studio' and 'The Interpreter'. Also exhib. two works at the RA and two works at the BI. London address.

PEARCE, Arthur E. fl.1882-1901

Exhib. 'Evening on the Stour' at SS, and two works at the NWS. London address.

PEARCE, Miss Blanche D. fl.1888

Exhib. a painting of almond blossom at the RA. London address.

PEARCE, Charles Maresco NEAC LG 1874-1964

Painted architectural subjects. Studied at the Chelsea Art School. Lived in London and at Graffham, Sussex. He was the son of Maresco Pearce (q.v.).

Bibl: Studio XLVII 1909 p.184; LXVIII 1916 p.118; LXXXIX 1925 p.155, XCV 1928 pp.172-8; Burlington Mag. XXXII 1918 p.206; XXXVIII 1920-1 p.48; Connoisseur LIX 1921 p.51ff.; LXVIII 1924 p.113; LXXIX 1927 p.125; Who's Who 1929. Exhib: London, Wildenstein and Co. 1962.

PEARCE, Christina fl.1889

Exhib. a genre subject in 1889. Address in Cheltenham, Gloucestershire.

PEARCE, Elizabeth fl.1889

Exhib. two works 'Resting' and 'Donna Dolores' at SS. London address.

PEARCE, Maresco fl.1858-1860

Exhib. a work, 'Cromwell at Woodstock', at the RA, and another, 'Expectation', at SS. London address. He was the father of Charles Maresco Pearce (q.v.).

PEARCE, S. Tring fl.1878-1895

Exhib. a watercolour entitled 'In the Service of Bluff King Hal' at SS. London address.

PEARCE, Stephen 1819-1904

Portrait and equestrian painter. Born in London. Trained at Sass's Academy and the RA schools, 1840, and in 1841 became a pupil of Sir Martin Archer Shee (q.v.). From 1842-6 he acted as amanuensis to Charles Lever, and afterwards visited Italy. Exhib. 1837-85, at the RA 1839-85 (92 works), BI, SS and GG. He was attached to the Queen's Mews, and paintings by him of favourite horses in the Royal Mews were exhib. at the RA in 1839 and 1841. In 1851 he completed 'The Arctic Council Discussing a Plan of Search for Sir John Franklin', containing portraits of Back, Beechey, Bird, Parry, Richardson, Ross, Sabine and others, RA 1853. He was widely known as a painter of equestrian presentation portraits and groups, most important of which is 'Coursing at Ashdown Park', 1869 (containing 60 equestrian portraits). He retired from active work in 1888. His studio sale was held at Christie's, 5 February 1886.

Bibl: L. Cust, NPG Cat. 1901; Stephen Pearce, *Memories of the Past,* 1903 (19 pls. and a list of subjects painted); DNB 2nd Supp; BM Cat. of Engraved British Portraits 1908-25 VI p.527; Pavière, Sporting Painters pl. 34; Brook-Hart; Ormond.

PEARCE, William T. fl.1884-1897

Exhib. three portraits at the RA. London address.

PEARD, Miss Frances M. fl.1888-1891

Exhib. three landscapes at the NWS. Address in Torquay, Devon.

PEARS, Miss Augusta fl.1893

Exhib. a painting of flowers at the NG.

PEARS, Charles ROI 1873-1958

Painted marines. Born at Pontefract. Lived in London and at St. Mawes, Cornwall. Represented in the Imperial War Museum.

Bibl: Brook-Hart.

PEARSALL, Henry W. fl.1824-1861

Painter of landscapes and genre, working in London, Bath and Cheltenham, who exhib. 1824-61, at the RA 1832-59, BI, SS, NWS and elsewhere. Titles at the RA include 'An Interior from Nature', 1832, 'An Alehouse Kitchen', 1847, and 'Gleaners', 1851.

PEARSE, Alfred fl.1877-d.1933

Painted figurative subjects. Also was a graphic artist. Exhib. 'A Sketch' at SS. London address.

PEARSE, Miss F. Mabelle fl.1892-1896

Exhib. a painting of chrysanthemums at SS and a work entitled 'The Lost Fairy' at the RA. London address.

PEARSON

His drawing of John Murray II (1808-92) is in the collection of John Murray.

Bibl: Ormond.

PEARSON, Blanche A. fl.1892

Exhib. 'A Winter Study' at SS. London address.

PEARSON, Mrs. Charles RBA fl.1821-1842
(Miss Mary Martha Dutton)

Painted portraits and figurative subjects. Exhib.31 portraits at the RA; 37 portraits and figurative studies at SS, and 15 works at the BI, titles including 'Hark at the Pretty Birds, Mamma!' and 'It is like Papa.' London address.

PEARSON, Cornelius 1805-1891

Landscape and topographical painter; engraver. Born at Boston, Lincolnshire. Came to London at an early age, and apprenticed to an engraver. Then began to paint, mainly in watercolour. Exhib. 145 works at SS 1843-79, four at the RA 1845-72, also at the NWS and elsewhere. One of the oldest members of the Langham Sketching Club. Two watercolour views in Wales are in the VAM. Often signed in monogram C.P.

Bibl: Portfolio 1891; Art Chronicle p.XXVI; Bryan; VAM.

PEARSON, H.J.S. fl.1844
Exhib. two views in Blackheath, London, at the RA. London address.

PEARSON, Harry John RBA 1872-1933
Painted children. President of the Langham Sketch Club. Lived and exhib. in London.

PEARSON, John fl.1876-1890
Painted watercolour landscapes. Exhib. eight watercolours at SS including views in Perthshire and North Wales, and two works at the RA, 'On the Yorkshire Moors' and 'Moorland Road'. Address in Huddersfield, Yorkshire.

PEARSON, Miss Mary A. fl.1899
Exhib. a portrait at the RA. London address.

PEARSON, Robert fl.1896
Exhib. a work entitled 'Old Oaks' at the RA. Address in Scarborough, Yorkshire.

PEASE, Miss E.R.E. fl.1846
Exhib. a watercolour of flowers at SS. London address.

PEASE, Claude Edward 1874-1952
An amateur painter of landscapes in watercolour. Lived in Darlington, County Durham.

PECK, Robert fl.1874
Exhib. a landscape in 1874. Address in S. London.

PECKHAM, R.F. fl.1877
Exhib. two genre subjects in 1877. Address in Paris.

PECKITT, T. fl.1881-1888
Exhib. two works at SS and two works 'Students at the British Museum' and 'North Aisle, Westminster Abbey' at the RA. London address.

PEDDER, John RI 1850-1929
Landscape painter and watercolourist. Exhib. at RA 1875-1912, SS, NWS, GG and elsewhere. Lived in Liverpool, and also near Maidenhead. Titles at RA 'Conway', 'Water-Lilies near Cookham' and 'A Hillside Frolic', etc.

PEDLEY, J.L. fl.1845-1875
An architect who exhib. views of architecture and furnishings, including views in Westminster Abbey, as well as original designs at the RA. London address.

PEEL, Miss Amy fl.1876-1884
Landscape painter; lived in Walthamstow, Essex. Exhib. 22 works at SS between 1876 and 1884.

PEEL, Annie fl.1882
Exhib. a flower piece in 1882. Address in Clitheroe, Lancashire.

PEEL, Archibald R. fl.1864-1866
Painted landscapes. Exhib. four works at the BI including 'The River Luss, Loch Lomond' and a view of Kelso Abbey at SS. London address.

PEEL, Miss C. Bertha fl.1883-1884
Exhib. two landscapes at the NWS. Address in Clitheroe, Lancashire.

PEEL, Miss Florence fl.1857-1869
(Mrs. Hewitt)
Painted still-lifes with flowers. Exhib. three works at the RA including 'The Christmas Hamper' and 'Magnolia', and three works including two watercolours. Also exhib. one work at the BI. She was a member of the Society of Lady Artists. Address in Cork, Ireland.

PEEL, Miss J. Maud fl.1878-1885
Exhib. two works 'Peach Blossoms' and 'In the Garden' at the RA, and three works including two watercolours of carnations at SS. Address in Clitheroe, Lancashire.

***PEEL, James RBA 1811-1906**
Landscape painter. Exhib. mostly at SS (248 works), also RA 1843-88, BI and elsewhere. A prolific painter of English views, in the north-eastern counties, the Lake District, North Wales and also in other parts of England. His naturalistic style and colouring similar to B.W. Leader (q.v.).
Bibl: AJ 1906 pp.96, 134; DNB 2nd Supp. III 1912; Hall.

***PEELE, John Thomas RBA 1822-1897**
Painter of genre, landscape and portraits. Born at Peterborough. At the age of 12 emigrated to America with his parents. Settled in Buffalo where he began painting. Studied in New York; then worked in Albany for two years as a portrait painter. Returned to New York, and elected member of the National Academy of Design. About 1851 came to London, where he remained, except for stays in Liverpool and the Isle of Man. Exhib. at SS (161 works), also at RA 1852-91 and BI. His genre subjects often of children. One of his works, 'The Children in the Wood', was bought by Prince Albert. He also had many patrons in America, including Frederick Church, the landscape painter.
Bibl: AJ 1856 p.136; 1876 pp.109-12 (mono. with pls.); Clement & Hutton; Wood, Panorama p.97.

PEERS, Miss Jane Miller fl.1865-1866
Exhib. two views of buildings 1865-6. Address in Torquay, Devon.

PEGGS, Wallace fl.1889
Exhib. a painting of fungus at the NWS. London address.

PEGRAM, Frederick RI 1870-1937
Painted genre. Also an etcher and illustrator. Exhib. from 1889. London address.
Bibl: R.E.D. Sketchley, *English Book Illustration of Today*, 1903; Studio LXXXI 1921 p.21.
Exhib: London, Fine Art Society 1938.

PELEGRIN, Manuel José fl. late 19th century
Painted landscapes and marines. Probably of Spanish extraction, he lived and worked in Northumberland. His address was in Newbrough, near Hexham.
Bibl: Hall.

PELHAM, Emily fl.1867-1879
Exhib. four works at SS including 'On the Dart' and 'Her First Admirer'. Address in Liverpool.

PELHAM, James II 1800-1874
Miniaturist and painter of portraits and small genre subjects. Son of James Pelham, (d.c.1850), also a miniaturist but not equal to his son in ability. He travelled much, painting portraits of notable persons, especially in Bath and Cheltenham. He was appointed painter to the Princess Charlotte and had many distinguished sitters. He exhib. in

London 1832-68, at the RA 1832, 1836 and 1837, SS and elsewhere. In or before 1846 he settled in Liverpool, and exhib. from that year at the Liverpool Academy, becoming a member in 1851, and in 1854-5 Secretary. After 1854 he stopped exhibiting portraits and turned to domestic genre, usually on a small scale, in 1855, 1859 and 1867. From 1858 there is confusion with his son who began to exhib. in Liverpool in that year.

Bibl: Bryan; Cat. Walker AG, Liverpool, 1927.

PELHAM, James III 1840-1906
Painter of landscapes, genre and angling subjects, in watercolour. Son of James Pelham II (q.v.). Born in Saffron Walden, lived in Liverpool. Began to exhib. at the Liverpool Academy in 1858, and in London 1865-81, at the RA in 1880, GG and elsewhere. Succeeded his father as Secretary of the Liverpool Academy in 1867.

Bibl: See under James Pelham II.

PELHAM, O. fl.1848
Exhib. two views of the Bay of Dundalk at SS. London address.

PELHAM, Miss R. fl.1852
Exhib. a painting of armour at the BI. London address.

PELHAM, Thomas Kent fl 1860-1891
London genre painter, who exhib. 1860-91, at the RA 1863-91, BI, SS and elsewhere, titles at the RA including 'Domestic Beauties', 1864, 'A Cornish Mussel-gatherer', 1874, and 'A Serious Question', 1886. Cardiff Museum and AG has 'Basque Fisherman'.

PELISSIER, F.S. fl.1886-1889
Exhib. three works including 'Willows on the Ouse, Bucks' and 'A Cornfield, Bucks', at SS. London address.

PELLEGRINI, Carlo (Ape) 1839-1889
Caricaturist and illustrator. Worked on *Vanity Fair*. Exhib. a portrait at the RA and ten works at the GG. Born in Capua. Came to London in 1864 and subsequently died there.

Bibl: BM Cat. of Engraved British Portraits; Ormond; Vanity Fair Exhibition, NPG 1976.

PELLEGRINI, R. fl.1893
Exhib. a watercolour view in Seville at SS. London address.

PELLETIER, A. fl.1816-1847
London painter of flowers, fruit and birds, who exhib. 1816-47 at the RA and OWS, titles at the RA including 'A Study of Peaches', 1816, 'Foreign Birds', 1822, and 'Gold Pheasant', 1830.

PEMBER, A. fl.1855
Exhib. a landscape in 1855.

PEMBER, Miss Winifred fl.1898
Exhib. two portraits at the RA. London address.

PEMBERTON, Miss Sophia T. fl.1897-1904
Exhib. five works at the RA 1897-1904 including 'Daffodils' and 'Little Boy Blue'. London address.

PEMBERTON, Mrs. Wykeham Leigh fl.1885
Exhib. a landscape at the GG. London address.

PEMEL (or PEMELL), J. fl.1838-1851
Painter of portraits, genre, landscape and historical subjects, working in Canterbury and London. Exhib. 1838-51 at the RA 1841-51, BI and SS, titles at the RA including 'Child Praying', 1841 and 'Mr. Hills of Guy's Hospital', 1843 Four landscape watercolours are in the VAM.

Bibl: VAM.

PENFOLD, Frank C. fl.1880-1883
Exhib. a work entitled 'Waiting for Father' at SS. Address in Finistère, France.

***PENLEY, Aaron Edwin RI 1807-1870**
Landscape and portrait watercolourist. Exhib. mostly at NWS (309 works), also at RA 1835-69, BI and SS. RI 1838; resigned 1856. In 1851 he was appointed drawing master of Addiscombe East India College. He was also drawing master at Woolwich Military Academy, and watercolour painter to William IV and Queen Adelaide. He was later teacher to Prince Arthur. His subjects were mostly landscape and rustic genre. He was the author of several books on watercolour painting. His studio sale was held at Christie's, 23 April 1870.

Bibl: AJ 1870 p.71; Connoisseur LIX 1912 p.210; Redgrave, Dict.; Binyon; Cundall; DNB; Hughes; VAM; Hardie III p.217; Ormond.

PENLEY, Edwin A. fl.1853-1872
Landscape watercolourist. Very little known — presumed to be son of Aaron Edwin Penley (q.v.). Exhib. 11 works at SS and seven at other exhibitions.

PENNELL, Eugene H. fl.1882-1890
Exhib. three works at the RA including 'Gorlaston Jetty, Norfolk' and 'On the Medway', and one work at SS. London address.

Bibl: The Year's Art 1897 p.399.

PENNIALL, Arthur fl.1874-1876
Exhib. four works at SS including 'Very Busy' and 'The Broken Window'. London address.

PENNINGTON, Harper b.1854
His portrait of Robert Browning is in the collection of Contessa Rucellai.

Bibl: Ormond.

PENNINGTON, Miss S. fl.1840
Exhib. a portrait at the RA. London address.

PENNY, G. fl.1851
Exhib. a 'Scene in Hadley Wood' at SS. London address.

PENNY, William Daniel 1834-1924
Painted marines. Exhib. in Hull 1881-1900. He was a member of the Hull School and is represnted in the Ferens AG, Kingston-upon-Hull.

Bibl: Brook-Hart (pl.22).

PENROSE, Francis Cranmer 1817-1903
Painted views of buildings. Exhib. 14 works at the RA including views of Lincoln and St. Paul's Cathedrals and of the Acropolis. Born near Lincoln. Lived and died in London.

Bibl: AJ 1903 p.370; DNB Supp. III 1912; The Times 4 January 1932.

PENROSE, James Doyle RHA c.1862-1932
Painted portraits, historical subjects and landscapes. Studied at South Kensington, at St. John's Wood and the RA Schools. Exhib. ten works at the RA 1889-1904 including 'Iduna's Apples' and 'Lady Jane Beaufort and King James I of Scotland'. Born in Michelstown, County Dublin. Lived near Watford, Hertfordshire. Sir Roland Penrose was his son.
Bibl: Who's Who; RA Pictures 1896 p.192; The Art News XXX 1932 p.12; The Times 4 January 1932.

PENSON, Frederick T. fl.1891-1892
Exhib. two works at the RA including 'Zephyr Carrying Psyche in his Arms' at the RA. Address in Stoke-on-Trent, Staffordshire.

PENSON, James 1814-1907
Devonshire landscape painter. Son of a doctor; also a drawing master. Examples are in Exeter Museum.

PENSON, Richard Kyrke RI 1805-1886
Architect and painter of architectural subjects and coastal scenes, working in Ferryside. Exhib. 1836-72, at the RA 1836-59, SS, NWS (134 works) and elsewhere. Titles at the RA include 'Coast Scene', 1836, 'Château Gaillard', 1839, and in 1858 'Penywarr, Aberystwyth', 'View of the Church at Wrexham' and views of lime-kilns in Carmarthenshire.
Bibl: Cundall; T.M. Rees, *Welsh Painters, Engravers, Sculptors*, 1912.

PENSON, T.M. fl.1836-1857
Painted landscapes. Exhib. five works at the RA including three landscapes in North Wales. Address in Oswestry, Salop.

PENSTONE, Edward fl.1871-1896
London painter of landscapes and genre, who exhib. 1871-96, at the RA 1877, 1894 and 1896, SS and elsewhere, titles at the RA including 'The Approach of Spring', 1877, and 'Canterbury Cathedral by Moonlight', 1896.

PENSTONE, John Jewell fl.1835-1895
Painted portraits and figures. Exhib. five works at the RA including portraits and works entitled 'The Saxon Bride' and 'The Man of Sorrows' and three works at SS. London address.
Bibl: BM Cat. of Engraved British Portraits; Ormond.

PENTREATH, R.T. fl.1844-1861
Painter of portraits, landscapes and marine subjects, working in Penzance and London. Exhib. 1844-61 at the RA and SS, titles at the RA including 'View of the Mount's Bay, Cornwall', 1845 and 'Fisher People Waiting the Return of the Fishing Boats', 1856.
Bibl: Brook-Hart.

***PEPLOE, Samuel John RSA 1871-1935**
Painted still-lifes, landscapes and figurative subjects. Studied at the Trustees' School, Edinburgh, at the RSA Life Class and in Paris. Exhib. at the RSA from 1901. Lived in Edinburgh.
Bibl: Studio XXX 1904 pp.161, 346, 348; LXI 1914 p.232; LXX 1917 p.43; LXXX 1920 p.18; LXXVII 1924 p.63ff.; XCIII 1927 p.119ff.; CI 1931 pp.103-8; AJ 1909 pp.25-7; Connoisseur LI 1918 p.179; Apollo XI 1930 p.69; XII 1930 p.241; XIII 1931 pp.240-2; Caw; Standard 19 February 1912; Stanley Cursiter, *Peploe: An Intimate Memoir of an Artist and of his Work*, London, 1947; T.J. Honeyman, *Three Scottish Colourists: S.J. Peploe, F.C.B. Cadell and Leslie Hunter*, Edinburgh, 1950; Irwin.
Exhib: London, Lefèvre Gallery 1926, 1939, 1948; Great Britain, Arts Council 1953; Edinburgh, Scottish Arts Council 1970.

PEPPERCORN, Arthur Douglas 1847-1924
Landscape painter in oils and watercolours, often called "our English Corot". Born in London. Studied at the École des Beaux-Arts in Paris

in 1870 under Gérôme, by whom he was little influenced. Met, however, Corot and the painters of the Barbizon School, to whose work his own bears a great resemblance, both in subject matter and technique. Exhib. from 1869 at the RA, SS and elsewhere; also held one-man shows at the Goupil Galleries. Member of the International Society of Sculptors, Painters and Gravers. Friend of Matthew Maris (1839-1917), the Dutch landscape and genre painter, who greatly admired Peppercorn's work. Early in his career Peppercorn chiefly painted woodland scenes; later he also painted marine subjects. In 1926 a memorial exhibition of his work was held at the Leicester Galleries.
Bibl: AJ 1896 pp.201-5; 1904 p.194; 1905 pp.91, 94, 143; Studio XXI 1901 pp.77-85; LVII 1913 pp.150-8, 214; LXV 1915 p.110; XCII 1926 p.347; Special Number, *Art in 1898;* Burlington Mag. XXXII 1918 p.206; VAM.

PERCIVAL, Miss Bessie fl.1885-1891
(Mrs. Basil Johnson)
Painted landscapes and genre subjects. Exhib. five works at the RA in-cluding 'Wallflowers' and 'Etna from Taormina'. Address in Oxford. See also Mrs. Basil Johnson.

PERCIVAL, H. fl.1880s
A marine painter working in the 1880s.

PERCY, Miss Amy Dora fl.1884
Exhib. two watercolours 'Fish Street, Clovelly' and 'Autumn's Soft Shadowy Days', and another work at SS, and a landscape in Cornwall at the RA. Address in Sutton, Surrey.

PERCY, Miss Emily fl.1868-1872
Painted historical subjects. Exhib. four watercolours at SS including 'Elaine' and 'Anne Boleyn and Jane Seymour, an illustration to a line from *Lives of the Queens of England*'. London address.

PERCY, Herbert S. fl.1880-1900
Painted landscapes. Exhib. eight works at SS including 'A Rill from a Mountain Tarn' and 'The Days that are no More'. Address in Sutton, Surrey.

PERCY, J.C. fl.1855
Exhib. two views on the Thames at the RA. London address.

PERCY, Mrs. Lilian Snow fl.1886-1888
Exhib. a still-life at SS. London address.

***PERCY, Sidney Richard 1821-1886**
Landscape painter. Although a member of the Williams family (see under Boddington, Gilbert and Williams) he used the name Percy to distinguish himself from them. Exhib. at RA 1842-86, BI, SS and elsewhere. He painted in Devon, Yorkshire, the Lake District and Skye, but mostly in North Wales. His pictures are always competent and pleasing, though he tended to repeat certain formulas. His colours are bright and meticulous, and noticeably similar to those of his relative, Edwin Boddington (q.v.). His studio sale was held at Christie's, 27 November 1886.
Bibl: AJ 1859 pp.121, 122, 163; Gazette des Beaux-Arts IV 1863 pp.40, 42; Bryan; T.M. Rees, *Welsh Painters*, 1912; Pavière, Landscape; Jan Williams, *The Williams Family of Painters*, 1975.

PERCY, William 1820-1903
Manchester portrait painter, who exhib. 1854-79 at the RA and elsewhere. He was a pupil of William Bradley, a leading Manchester portrait painter. He was a close friend of the Lancashire poet Edwin Waugh, and his portrait of Waugh, together with his own self-portrait, are in the Manchester City AG. Percy practised throughout his life in Manchester as a portrait painter.
Bibl: Cat. of the Permanent Collection, City of Manchester AG, 1910.

PEREIRA, Ferdinand fl.1874
Exhib. a landscape in 1874. London address.

PERIGAL, Arthur, Jnr. RSW RSA 1816-1884
Scottish landscape painter; son of Arthur Perigal Snr. a historical and portrait painter. Exhib. at RA 1861-84, BI, SS and RSA. Titles at RA all Scottish landscapes. RSA 1868; appointed Treasurer 1880. Caw, perhaps unfairly, describes his "harsh and unsympathetic Highland panoramas" as "so much inferior McCulloch".
Bibl: AJ 1884 p.224; Redgrave, Dict. (Perigal Snr.); Bryan; Caw p.146.

PERKIN, Mrs. Isabelle Lilian 1860-1943
(Miss Isabelle Bebb)
Exhib. three works, two paintings of flowers and a work entitled 'Silver and Gold' at the RA. Later she concentrated on painting cats. Address in Tiverton, Devon.

PERKINS, Arthur E. fl.1889-1895
Painted views of buildings. Exhib. five works at the RA including 'The Meat Market — Ypres, Belgium' and two views in Holland. London address.

PERKINS, George fl.1880-1885
Exhib. a work entitled 'The Morning After the Storm' at the RA and another at SS. Address in Manchester.

PERKINS, J. fl.1850-1852
Exhib. three works at SS, a work illustrating a line from Coleridge, a portrait and 'The Lily of the Valley', and a painting of 'Gleaners' at the BI. Address in Oxford.

PERMAN, Louisa E. fl.1899-d.1921
(Mrs. Torrance)
Painted flowers. Exhib. three works at the RA 1899-1904, including 'A Sweet Rose on an Alien Bed'. Represented in the Glasgow AG. Lived in Glasgow.
Bibl: Studio XXVIII 1903 p.136; New York Herald 26 March 1908; Caw; The Year's Art 1922 p.313.

PERMAN, W.A. fl.1836-1837
Exhib. two paintings of flowers at the RA. London address.

PERNA, Charles fl.1896-1898
Exhib. views in Italy. Exhib. five works at the RA including views in Genoa and Palermo. London address.

PERRIN, Alfred Feyen- RCA fl.1860-1911
Painted landscape. Exhib. at the RBSA from 1860. Exhib. three works at SS including 'A Mountain Road — North Wales' and 'Hoeing Turnips' and one work at the RA. Lived in Birmingham and in Wales.

PERRIN, Mrs. Ida Southwell b.1860 fl.1892
(Miss Ida S. Robins)
Painted landscapes and figurative subjects. Exhib. two works at the RA, a portrait and 'Hay-time' and two works at SS. Became manager of the De Morgan pottery works at Bushey Heath. Born in London. Lived in London. See also Miss Ida S. Robins.

PERRIN, Miss Mary fl.1897-1903
Exhib. four works at the RA 1897-1903 including ' "Hark! Now I hear them!" ' from *The Tempest* and 'The Prefect's Daughter'. Address in County Dublin.

PERRING, W. fl.1852-1853
Exhib. three portraits at the RA. London address.

PERRY, Alfred fl.1847-1881
Painter of landscapes, animals and genre, who exhib. 1847-81, at the RA 1847-78, BI, SS and elsewhere. After 1858 he often painted subjects in the Roman campagna and around Naples. Titles at the RA include 'Arundel Castle', 1847, 'The Village Common', 1852, 'Roman Pack Horses', 1858, and 'Neapolitan Fishing Boat Running in for Naples', 1870. In the VAM is 'A Bull of the Roman Campagna', 1868.
Bibl: VAM.

PERRY, Miss Alice B. fl.1890
Exhib. 'In Meadows Green and Lush' at the RA. London address.

PERRY, H. fl.1810-1848
Painted portraits and views of buildings. Exhib. eight works at the RA 1810-25. London address.

PERRY, J.C. RBA fl.1823-1843
Painted shipping and landscapes. Exhib. ten works at the RA including 'A Homeward Bound Indiaman', 19 works at SS including views in the environs of London and paintings of ships. Also exhib. three works at the BI. London address.

PERRY, William J. fl.1870-1871
Exhib. two works 'Expectation' and a watercolour view at Pompeii at SS. London address.

PERTZ, Miss Anna J. fl.1880-1897
Painted figurative subjects and still-lifes. Exhib. eight works at the RA including 'The Slave Girl' and 'After the Tarantella'. London address.

***PERUGINI, Charles Edward 1839-1918**
Genre and portrait painter. Born in Naples. Came to London 1863. Exhib. at RA from 1863, BI, SS, NG and elsewhere. Titles at RA 'A Cup of Tea', 'A Siesta', 'Silken Tresses', etc. His pictures are mostly of elegant ladies in interiors, sometimes with a romantic or humorous theme. Perugini was given encouragement and financial help by Lord Leighton, and may have worked for a time as his studio assistant. His wife Mrs. Charles Edward Perugini (q.v.) was also a painter.
Bibl: AJ 1876 p.360; 1882 p.43 (pl. p.l); Connoisseur LXXXIV 1929 p.60 (obit. Mrs. C.E.P.); The Times 5 October 1929; Clement & Hutton; Who Was Who 1916-1928; Wood, Panorama; p.110 (pl. 111); Wood, Olympian Dreamers; Wood, Paradise Lost.

***PERUGINI, Mrs. Charles Edward 1839-1929**
(Miss Kate Dickens)
Genre and portrait painter. Daughter of Charles Dickens. Married to Charles Allston Collins (q.v.) 1860-73, then married Charles Edward Perugini (q.v.). Exhib. at RA from 1877, SS, NWS, GG, NG and elsewhere. Titles at RA 'Little Nell', 'Mollie's Ball Dress', 'Flossie', etc., and some portraits. She was the model for the girl in 'The Black Brunswicker' by Millais, and was also painted by Millais in 1880.
Bibl: See under Charles Edward Perugini; also Gladys Cox, *Chelsea Memories of Mrs. Perugini,* Chambers Journal 1925-30.

PESSINA, G.D. fl.1848-1866
Exhib. a portrait, a view inside Milan Cathedral and another work, at the RA. London address.

PETERS, William fl.1895-1897
Exhib. two works 'Running the Gauntlet' and 'A Bouquet' at the RA. London address.

***PETHER, Henry fl.1828-1865**

Painter of landscapes, especially by moonlight. Probably the son of Sebastian Pether (q.v.). Exhib. at RA 1828-62, BI and SS. Painted moonlight scenes along the Thames, other English views, and also Venice.

Bibl: Redgrave, Dict.; Bryan; DNB; Maas pp.49, 51 (pl. p.55); Brook-Hart.

PETHER, Sebastian 1790-1844

Painter of landscapes and moonlight scenes. Son of Abraham Pether 1756-1812. Exhib. at RA 1812-26, BI and SS. In addition to moonlight scenes, he also painted fires and other destructive effects of nature, e.g. 'Destruction of a City by a Volcano', RA 1826, and 'A Caravan Passing the Desert Overtaken by a Sandstorm', RA 1826. His pictures are sometimes confused with those of his son Henry (q.v.) if not signed. Sebastian's colours are in general harder and more metallic, in the Dutch manner, whereas Henry's are warmer and brown in tone.

Bibl: AU VI 1844 p.144 (obit.); Redgrave, Dict.; Bryan; DNB; Maas pp.49-51.

PETHERICK, Edith M. fl.1889

Is supposed to have exhib. a landscape at SS. London address.

PETHERICK, Horace William 1839-1919

Painted biblical subjects. Exhib. three works at SS including 'Samuel Anointing Saul' and three works at the RA including 'Happy Hours' and 'Caught at Last'. London address. For works illustrated by, see VAM Card Cat.

Bibl: Fincham, *Art and Engraving of Book Plates,* 1897: Cat. NPG 1928.

PETHYBRIDGE, J. Ley fl.1889-1893

Exhib. four works at SS including 'A Day of Rest' and 'Fish-washing, Polperro', and two works at the RA. Address in Launceston, Cornwall.

PETO, Morton K. fl.1881-1884

Exhib. a work entitled 'A Half Holiday at the Dutch Shippers' at the RA. Address in Pinner, London. Also painted landscapes.

PETRIE, Miss Elizabeth C. fl.1879-1890

Painted townscapes and views of architecture. Exhib. 11 works at SS, the majority watercolours, and including views in Venice and Rome and at Chartres. London address.

PETRIE, George PRHA 1790-1866

Landscape painter. Studied in the Dublin Society's School. Made extensive sketching tours throughout Ireland and had many of his views published. Exhib. at the RHA from 1826, the year of its opening, and on one occasion at the RA. He contributed much to the artistic life of Dublin, the city in which he was born and where he always lived.

Bibl: Strickland.

PETRIE, S. Graham RI ROI 1859-1940

Painted views in Italy. Studied architecture and painting under Fred. Brown and in Paris. Exhib. eight works at the RA 1893-1903, including four views in Venice and five works at SS. London address.

PETTAFOR, Charles R. fl.1862-1900

Landscape painter, living in Eltham and Greenwich, who exhib. 1862-1900, at the RA 1870-1900, BI, SS, NWS and elsewhere, titles at the RA including 'On the Arun', 1870, and 'Autumn Sunrise, Connemara', 1900.

***PETTIE, John RA 1839-1893**

Scottish historical painter. Aged 16 studied at Trustees' Academy, Edinburgh. There he met W. MacTaggart (q.v.) a lifelong friend; also Tom Graham and W.Q. Orchardson (qq.v.), with whom he later shared a studio in London. Began to exhib. at RA in 1860. Moved to London 1862. Worked as illustrator for *Good Words.* Exhib. at RA, BI, SS, GG and elsewhere. ARA 1866, RA 1873. His historical scenes were of many periods — medieval, the Civil War, and the 18th century. His interpretations were always dramatic and imaginative, sometimes a little theatrical. Caw compares his work to the novels of Dumas. He especially liked military episodes, e.g. 'A Drumhead Court Martial', etc. His style was equally vigorous; in power and richness of texture it shows the influence of Van Dyck and Rubens. After 1870 he experimented with chiaroscuro effects, and turned more to portrait painting, often depicting his sitters in historical costume. His studio sale was held at Christie's, 26 May 1893 and his own collection was sold 27 May 1893. Manuscripts relating to this artist are held by the VAM. For works illustrated by, see VAM Card Cat.

Bibl: AJ 1869 pp.265-7; 1893 pp.206-10; 1907 pp.97-116; Bryan; Caw pp.240-3 *et passim* (pl. p.242); M. Hardie, *J.P.,* 1908; Reynolds, VS pp.36, 95; Reynolds, VP pp.12, 193, 194; Hardie pp.198-9; Maas p.244; Irwin.

PETTIE, Marion fl.1874

Exhib. a painting of flowers in 1874. London address.

PETTITT, Alfred fl.1856-1871

Birmingham landscape painter. Exhib. at BI, SS and elsewhere. Titles at BI 'A Cumberland Cottage', 'A Mountain Stream'.

PETTITT, Charles fl.1855-1859

Landscape painter. Exhib. at BI, SS and elsewhere. Titles at BI 'Cottage near Keswick' and 'A Peep at Nature, North Wales'.

Bibl: Cat. of York AG 1907.

PETTITT, Mrs. E.A. fl.1870
(Miss Pattie Melville)

Exhib. a landscape at SS. See also Miss Pattie Melville.

PETTITT, Edwin Alfred 1840-1912

Landscape painter. Exhib. at RA 1858-1880, BI, SS and elsewhere. Titles at RA include views in Cumberland, North Wales and Switzerland.

Bibl: The Year's Art 1913 p.437 (obit.).

PETTITT, George fl.1857-1862

Landscape painter. Exhib. at RA in 1858, BI and elsewhere. Titles at BI 'Langdale Pikes', 'Buttermere', 'A Cumberland Lake' and views in North Italy. He was particularly fond of painting lakes.

Bibl: AJ 1858 pp.78, 80; 1859 pp.81, 121; 1861 p.71.

PETTITT, Miss Jenny fl.1869

Exhib. a watercolour view near Dover at SS. Addresses in London and Switzerland.

***PETTITT, Joseph Paul fl.1845-1880 d.1882**

Birmingham landscape painter. Exhib. at RA 1849-53, BI and mostly at SS (104 works). Titles at RA include views in England, on the Thames, in the Alps and Savoy.

Bibl: The Year's Art 1883 p.229; Bryan.

PETTITT, P. fl.1862-1864

Exhib. four works at SS including 'Feeding the Fowls' and 'Mother's First Care'. London address.

PETTITTSON, C.J. fl.1852
Exhib. two works, 'A Cottage near Patterdale' and 'A Cumbrian Village', at SS. London address.

PETTY, W.R. fl.1886-1899
Exhib. two works, 'Tender Chords' and 'The World Went Very Well Then', at the RA, and five works at the NWS. London address.

PEUCKERT, Edward A. fl.1893-1894
Exhib. three works including two views in Norfolk at the RA. London address.

PFACHLER, Emil H. fl.1853-1856
Painted landscapes. Exhib. five watercolours at SS including views in Italy, Germany and Switzerland. London address.

PFEIFFER, Mrs. J. Emily fl.1876-1882
Exhib. three paintings of flowers at the RA. London address.

PHELPS, Miss Millicent fl.1890-1896
Painted portraits and figures. Exhib. nine works at the RA including 'Sybil', 'A Scherzo' and portraits. London address. See also Mrs. Mayer.

PHENEY, Richard fl.1855-1858
Exhib. a watercolour landscape near Medmenham at SS. London address.

PHILIP, Miss Constance B. see LAWSON, Mrs. Cecil

PHILLIMORE, Lady fl.1881
Exhib. a river landscape in 1881. London address.

PHILLIMORE, G. or B.J. fl.1855-1865
Painted still-lifes and figures. Exhib. five works at the BI including two still-lifes of fruit and flowers and 'A Study of a Head of a Bedfordshire Peasant Girl', and one work at SS. Address at Woburn, Bedfordshire.

PHILLIMORE, Reginald P. b.1855 fl.1891
Painted and etched architectural subjects. Exhib. a view in Edinburgh at the RA. Lived in North Berwick, East Lothian.

PHILLIP, Colin Bent RWS 1855-1932
Scottish landscape painter, principally a watercolourist. Son of John Phillip, RA (q.v.); studied drawing for a short period at Lambeth School of Art, and at Edinburgh; also studied under David Farquharson (q.v.). Exhib. in London at the RA, OWS and GG from 1882. RWS 1886. His watercolours are almost entirely of Highland scenery. Caw notes that "he is perhaps more draughtsman than painter, and his landscapes often large in size are marked by careful and learned drawing of mountain form and structure, rather than by justness of tone, fullness of colour, or fineness of atmospheric relationship and effect."
Bibl: Caw p.308; Who Was Who 1929-40; Pavière, Landscape.

***PHILLIP, John RA 1817-1867**
Scottish genre painter. Sometimes known as Spanish Phillip because of his success in painting Spanish subjects. Born in Aberdeen. Apprenticed to a local house painter, and later to a portrait painter. In 1834 he ran away to London as a stowaway on a boat. He spent an entire day at the RA exhib. which fired him with enthusiasm to become a painter. In 1836 a gift of £50 from Lord Panmure enabled him to study, first under T.M. Joy (q.v.), later at RA Schools, where he became a member of The Clique (q.v.). In 1839 he returned to Aberdeen, but continued to exhib. at RA, RSA and BI. 1846 returned to London. Visited Spain three times, 1851, 1856, 1860. On his second trip he travelled with Richard Ansdell (q.v.). After this he turned away from the Scottish genre subjects of his earlier, Wilkie-inspired period, and concentrated on colourful Spanish scenes. In 1866 he visited Florence and Rome. Exhib. at RA 1838-67, BI, SS and RSA. ARA 1857, RA 1859. He was one of the most naturally facile of all Victorian painters. His style is firm, broad and confident; his colours strong and luminous. The subject matter of his pictures is usually simple and straightforward, although his Spanish scenes at times have a picture postcard flavour. His oil sketches are painted with surprising freedom of brushwork, and look as if they could have been painted fifty years later. His son Colin Bent Phillip (q.v.) was also a painter. His studio sale was held at Christie's, 31 May 1867.
Bibl: AJ 1859 p.132; 1867 p.127ff.; (obit.); James Dafforne, *Pictures by John Phillip, RA*, London, 1877; Portfolio 1887 p.157ff., 175ff. (W. Armstrong); Connoisseur XXXVIII 1914 p.123; Ruskin, Academy Notes 1856, 1859; Bryan; DNB; Caw pp.179-84 (pl. p.182); Reynolds, VS pp.10, 11, 56, 62 (pl.24); Reynolds, VP pp.12, 29, 31, 40 (pls.19-20); Cat. J.P. exhib., Aberdeen AG 1967 (with full bibl.); Maas pp.95-6 *et passim* (pls. p.96-7); Irwin; Ormond; Wood, Panorama (pls. 92, 94).
Exhib: Aberdeen AG 1967.

PHILLIPP, J.P. fl.1842-1845
Painted figurative and historical subjects. Exhib. five works at the RA including 'Innocence' and 'Bruce about to Receive the Sacrament on the Morning Previous to the Battle of Bannockburn', four works at SS and two works at the BI. London address.

PHILLIPS, A.M. fl.1873-1880
Painted landscapes and country subjects. Exhib. 16 works at SS including 'Lynmouth, the Bay etc.', 'Sparrow's Nest and Lichen' and 'In Norbury Park, near Dorking'. Address in Denmark Hill, London.

PHILLIPS, Alfred fl.1872-1904
Painted genre subjects. Exhib. 11 works at the RA including 'Fuel for the Camp', 'Opportunity Makes the Thief' and 'A Friend in Need', and six works at SS. London address.

PHILLIPS, Arthur fl.1889
Exhib. a painting of poppies at the RA. Address in Nottingham.

PHILLIPS, Blackburne fl.1872
Exhib. a view in Billingsgate in 1872. London address.

PHILLIPS, Charles Bannerman 1848-1931
Painted landscape and architecture. Taught at Winchester College. Painted in Hampshire and Surrey.

PHILLIPS, Charles Gustav Louis 1863-1944
Painter of topographical scenes in Dundee, Scotland.

PHILLIPS, Miss Emily R. fl.1855-1866
Exhib. two works including 'A Novel Reader' at SS. London address.

PHILLIPS, F.A. fl.1869-1877
Exhib. four portraits at the RA. London address.

PHILLIPS, G. fl.1865
Exhib. an allegorical subject in 1865. London address.

PHILLIPS, Giles Firman 1780-1867

London landscape painter in watercolour. Became a member of the RI in 1831, but resigned a few years later. Exhib. 1830-66, at the RA 1831-58, BI, SS, NWS and elsewhere. He published *Principles of Effect and Colour, as applicable to Landscape Painting*, 1833 (three edns.), *Theory and Practice of Painting in Watercolours*, 1838, and *A Practical Treatise on Drawing and on Painting in Watercolours*, 1839.

Bibl: Redgrave, Dict.; Cundall; DNB; VAM; BM Cat. of Engraved British Portraits IV 1914 pp.101, 552; Brook-Hart.

PHILLIPS, H.S. fl.1874

Exhib. a work entitled 'Fern Gatherers' at SS. Address in St. Leonard's on Sea, Sussex.

PHILLIPS, Miss Harriet fl.1854-1855

Exhib. a work entitled 'A Highland Lassie' at SS and another work at the RA. London address.

PHILLIPS, Miss Helen fl.1890-1898

Exhib. two works 'Bruce's Castle, Tarbert, Loch Fyne' and 'Barges at Putney Bridge' at SS. London address.

PHILLIPS, Henry Wyndham 1820-1868

Portrait painter. Younger son and pupil of Thomas Phillips, RA (q.v.). Exhib. 1838-68 at the RA, BI and elsewhere. Between 1845 and 1849 he painted a few scriptural subjects which he exhib. at the BI, but his works were chiefly portraits, e.g. Charles Kean as Louis XI (for the Garrick Club), Dr. William Prout and Robert Stephenson. He was a Captain in the Artists' Volunteer Corps, and for 13 years the energetic secretary of the Artists' General Benevolent Institution. His studio sale was held at Christie's, 8-10 April 1869.

Bibl: AJ 1869 p.29; DNB; Rev. T.M. Rees, *Welsh Painters*, 1912; Cat. of Engraved British Portraits VI 1925 p.528; Ormond.

PHILLIPS, J.H. fl.1858-1867

Painted landscape. Exhib. five works at SS including 'Mountain Torrent' and 'A Lane near Wimbledon', two works at the BI and two works at the RA including 'On the Bank of the Yarrow' and 'The Trophies of Spring'. London address.

PHILLIPS, J.W. fl.1857-1865

Exhib. a work entitled 'The Smoker' at the RA. London address.

PHILLIPS, John fl.1832-1837

Exhib. five works at SS including 'The State Overseer' and 'Waiting the Return'. London address.

PHILLIPS, Lawrence Barnett ARE 1842-1922

A watchmaker who took up painting and etching in 1882. Born and lived in London.

Bibl: Portfolio 1875 p.124; Studio 1902; LXXXIII 1922 p.272; Connoisseur LXIII 1922 p.119; LXV 1923 p.54; Who Was Who 1916-28.

PHILLIPS, Miss M.A. fl.1872

Exhib. a watercolour of geraniums at SS. London address.

PHILLIPS, Miss Mariquita J. fl.1881-1882

Exhib. a genre subject in 1881-2. Address in Epsom, Surrey.

PHILLIPS, Philip fl.1826-d.1864

London painter of panoramas, architectural subjects and landscapes, who exhib. 1826-65, at the RA 1841-59, BI and SS. He was the only pupil of W. Clarkson Stanfield (q.v.); his wife was the painter Elizabeth Phillips (q.v.). He painted an enormous panorama of the Ganges, from Calcutta to the Himalayas, and one which commemorated the Queen's visit to Ireland, and in these was often helped by his wife. Titles at the RA include 'The Vale of Keswick, Cumberland, looking towards Causay and Grisdale Pikes', 1844, 'Panoramic view of Zurich, Switzerland, from the Katzen Bastei', 1854, and 'The Bayan Tower', 1857.

Bibl: See under Mrs. Philip Phillips.

PHILLIPS, Mrs. Philip fl.1832-1878
(Miss Elizabeth Rous)

London painter of landscape, architectural subjects, the exteriors and interiors of churches and ruins, still-life, flowers and fruit. Her father was Lt. James Rous, an amateur artist who had worked at the Battle of Waterloo. Her husband was Philip Phillips (q.v.), and it was his enthusiasm that made her take up painting. She often helped him in his panoramas, and they always went on sketching tours together. She exhib. 1832-78, at the RA 1844-55, BI, SS and elsewhere, and was best known for her still-life pictures, her views of churches and landscapes of Rhenish scenery. One of her most important watercolours was 'The Dutch Collection' (still-life of Dutch ware), which was hung on the line at the RA 1852.

Bibl: Clayton II pp.230-4.

PHILLIPS, Thomas RA 1770-1845

Portrait painter. Exhib. 341 works, the great majority portraits, at the RA 1792-1846. He was the father of Henry Wyndham Phillips (q.v.). Born at Dudley, Warwickshire. Lived in London.

Bibl: DNB; Art Union 1845 p.138; AJ 1895 p.254ff.; L. Cust, *The NPG*, 1902; Rees; Bryan; Poole 1912-25; Connoisseur LVII 1920 p.39ff.; LXVII 1923 p.248; LXVIII 1924 p.159; BM Cat. of Engraved British Portraits; William Roberts, *Art Monographs*, III, London 1921-3; Maas; Irwin; Ormond.

PHILLIPS, William fl.1890-1891

Exhib. four works at SS including 'The Mouth of the Severn' and 'Near Chichester'. London address.

PHILLOTT, Miss Constance ARWS 1842-1931

Painter of genre, historical subjects, portraits, landscape and classical subjects, who exhib. 1864-1904, at the RA 1868-81, SS, RWS, GG, NG and elsewhere. Titles at the RA include 'In Wotton Woods', 1868, 'Waterbearers', 1878, and 'Owen Glendower's Parliament House, Dolgelly', 1873. Shaw Sparrow illustrates 'The Herdsman of Admetus' — a classical-pastoral subject — exhib. at the RWS in 1904. She was a cousin of William De Morgan (q.v.)

Bibl: W. Shaw Sparrow, *Women Painters of the World*, 1905 (pl.138).

PHILP, James George RI 1816-1885

Painter of landscape and coastal scenes. Born in Falmouth. Exhib. 1848-85, at the RA 1848-53, SS, NWS (347 works) and elsewhere. He painted almost entirely in Devon and Cornwall, chiefly coastal scenes. He first exhib. two landscapes in oil at the RA, but afterwards his work was almost entirely in watercolour. RI 1856.

Bibl: Bryan; Cundall; Wilson; Brook-Hart.

PHIPPS, H. fl.1872

His painting of Charles John Kean as *Richard III* was in the Dublin Exhibition, 1872.

Bibl: Ormond.

PHIPPS, J. fl.1838
Exhib. a view in Abbeville at SS and another work at the RA. London address.

PHIPSON, Edward Arthur 'Evacustes' 1854-1931
Prolific topographical artist who worked in England and North France. In the 1890s he lived in Birmingham.

PHIZ see BROWNE, Hablot Knight

PHOENIX, George 1863-1935
Painted portraits and genre. Studied at the Birmingham School of Art. Exhib. five works at the RA 1889-1904 including 'The Orphan' and 'Their Useful Toil'. Represented in the Wolverhampton AG. Lived in Wolverhampton, Staffordshire.
Bibl: Who's Who; Studio XXXI 1904 pp.71-2; Connoisseur LXXI 1925 p.55; Poole 1925.

PHYSICK, Robert RBA fl.1859-1866
Animal painter, who exhib. 1859-66, at the RA 1859-64, BI and SS, titles at the RA including 'Forbidden Fruit', 1859, and 'Rabbits', 1864.

PHYSICK, T. fl.1847-1881
Exhib. three works, 'Italian Coast Scene' and two paintings of animals at the RA, and seven works at SS including 'Dog and Magpie' and 'Pigeons'. London address.

PHYSICK, W. fl.1849
Exhib. a coastal scene at the BI. London address.

PICARD, F. fl.1844
Exhib. a view of a building in Auvergne at the RA. London address.

PICKARD, Miss Louise NEAC WIAC 1865-1928
Painted landscape, portraits and still-life. Studied at the Slade School and later in Paris. Worked in London and in the South of France. Born in Hull. Lived in London.
Bibl: Artwork IV 1928 p.221ff.

PICKEN, J. fl.1844
Exhib. a view of the Merchant Tailor's Hall, Threadneedle Street, at the RA. London address.

PICKEN, Thomas fl.1846-1875
Painted landscape and country subjects in watercolour. Exhib. ten watercolours at SS including 'A Boulogne Girl', 'On the Wye, near Symond's Gate' and 'Give Me a Bit', and one view in Devon at the RA. London address.

PICKERING, Charles fl.1886
Exhib. a martial subject at the NWS. London address.

PICKERING, Miss Evelyn see DE MORGAN, Mrs. Evelyn

PICKERING, Ferdinand fl.1831-1882
Painter of genre and historical subjects, who exhib. 1831-82, at the RA 1841-78, BI and SS. Titles at the RA include 'A Visit to Vandyck', 1841, 'The Escape of Prince Rasselas', 1845, 'Scene from the Maya Ballad of Cuncoh and Pixan', 1846, 'A Syrian Girl', 1870, 'Thinking it Over', 1877.

PICKERING, Joseph Langsdale RBA ROI 1845-1912
Painted landscape, country subjects and rustic genre. Exhib. 40 works at the RA 1874-1904 including 'The Iris Pool', 'For the London Market', 'Poaching' and landscapes in the south of England, and 34 works at SS. Worked as a civil engineer in Peru. Born near Wakefield, Yorkshire. Died in London.
Bibl: J. Ruskin, Academy Notes 1876, 1879-83; Studio, Art in 1898; XXXVIII 1906 pp.16, 23, 96-103; AJ 1906 pp.182, 183; Who's Who 1912.

***PICKERSGILL, Frederick Richard RA 1820-1900**
Historical genre painter; son of R. Pickersgill, nephew of H.W. Pickersgill (q.v.). Pupil of his uncle W.F. Witherington (q.v.). Exhib. at RA 1839-75 and BI. Subjects at RA mythological, biblical and literary — especially Shakespeare and Spencer. ARA 1847, RA 1857. He was influenced by William Etty (q.v.) and shared his taste for grand historical subjects in emulation of Titian and the great painters of 16th century Venice.
Bibl: AJ 1850 p.108; 1855 pp.233-6; 1852; 1863; 1864; 1869 (pls.); 1901 p.63; Portfolio 1887 p.106; The Year's Art 1901 p.311 (obit.); DNB; Bryan; Maas; Strong.

PICKERSGILL, Henry Hall 1812-1861
Historical genre and portrait painter; son of Henry William Pickersgill (q.v.). Studied in Holland; travelled in Italy and Russia. Exhib. at RA 1834-61 and BI. Titles at RA include Italian and Russian scenes, historical genre, especially Shakespeare, and later mostly portraits. His wife Jane Pickersgill (q.v.) was also a painter, and exhib. still-life and genre at the RA and BI 1848-63. Pictures by Henry Hall Pickersgill are in the VAM and Salford Museum. His studio sale was held at Christie's, 24 April 1861.
Bibl: AJ 1861 p.76;DNB.

PICKERSGILL, Mrs. Henry Hall (Jane) fl.1848-1863
Painted fruit and figures. Exhib. seven works at the RA including 'Fruit' and genre subjects. London address. She was the wife of Henry Hall Pickersgill (q.v.).

PICKERSGILL, Henry William RA 1782-1875
Portrait painter; father of H.H. Pickersgill, brother of R. Pickersgill (qq.v.). Pupil of George Arnald. Throughout his long life he was a very prolific painter, exhibiting 384 works at the RA 1806-72, and 26 at the BI. His sitters came from a wide variety of professions — theatrical, legal, religious, military and political; he was also patronised by the aristocracy, usually for presentation portraits. He occasionally painted historical genre. ARA 1822, RA 1826. His studio sale was held at Christie's, 16 July 1875.
Bibl: AJ 1850 p.75; 1875 p.231; 1903 p.374; Connoisseur XLI 1915 p.52; LXX 1924 p.177; W. Sandby, History of the RA, 1862; E.J. Poynter, The Nat. Gall., 1900; L. Cust, The NPG, 1902; Bryan; DNB; BM Cat. of Engraved British Portraits VI 1925 p.529; Poole 1925; Maas; Ormond.

PICKERSGILL, Richard fl.1818-1853
Marine and landscape painter; brother of H.W. Pickersgill and father of F.R. Pickersgill (qq.v.). Exhib. at RA 1818-45, BI, SS and NWS. Subjects: landscapes, coastal scenes and contemporary naval incidents.
Bibl: AJ 1855 p.233; Brook-Hart.

PICKERSGILL, Miss Rose M. fl.1889
Exhib. 'A Head' at the RA. Address in Hayes, Middlesex.

PICKETT, Miss Mary S. fl.1892-1899
Painted genre and figurative subjects. Exhib. five works at the RA including 'Forty Winks' and 'Little Nell in the Old Church', and two works at the NWS. Address in South London.

PICKLER, Adolph fl.1881
Exhib. a scriptural subject in 1881. Address in Munich.

PICKNELL, William Lamb RBA 1853/4-1897
Landscape and marine painter. Born in Boston, Massachusetts. Pupil of George Inness in Rome 1874-6 and of Gérôme in Paris. Painted in Brittany for several years under Robert Wylie. Awarded honourable mention, Paris Salon, 1880. Exhib. in London 1877-90, at the RA, SS and elsewhere, and has a London address during that time. Titles at the RA include 'Breton Peasant Girl Feeding Ducks, Pont Aven, Brittany', 1877, 'Unloading Fish', 1884, 'Brockenhurst Road', 1885, and 'A Toiler of the Sea', 1887. Member of the Society of American Artists; elected A Member of National Academy of Design; RBA. Represented by 'The Road to Concarneau', 1880, in the Corcoran AG, Washington.
Bibl: Gazette des Beaux-Arts 1880 II p.66; L'Art LVII 1894 p.170ff.; American Art Annual I 1898 p.333 (pl.); III 1900 p.203 (pl.); Mantle Fielding, *Dictionary of American Painters, Sculptors and Engravers*, 1965 .

PIDDING, Henry James RBA 1797-1864
Painter of humorous subjects from domestic life, and still-life. Born in Cornwall. Pupil of A. Aglio. Exhib. 1818-64, at the RA 1818-55, BI and SS (177 works). Attained some note by his paintings of humorous subjects. RBA 1843. The AJ notes 'Massa Out, Sambo Very Dry' (a negro helping himself to a wine decanter), 'The Fair Penitent' (a negro seated in the stocks) and 'The Battle of the Nile' (two ancient Greenwich pensioners discussing the battle) as being the best of his works. About 1860 he tried to make a sensation with a larger painting, 'The Gaming Rooms at Homburg'. In 1836 he etched a series of six humorous illustrations to *The Rival Demons,* an anonymous poem. He was also well known as a painter of fish. 'The Enthusiast' is in Leicester AG.
Bibl: AJ 1864 p.243; Ottley; Redgrave, Dict.; DNB.

PIDGEON, Henry Clark RI 1807-1880
Painter of landscape and architectural subjects, and portraits; engraver and lithographer; antiquary. He intended originally to enter the church but he then adopted art as a profession, practising as an artist and teacher in London. 1847 became Professor of Drawing at the Liverpool Institute, and drew many local scenes and antiquities. Member of Liverpool Academy in 1847, Secretary 1850, and exhib. regularly there. Joined Joseph Mayer and Abraham Hume in 1848 in founding the Historic Society of Lancashire and Cheshire, and contributed many etchings and lithographs to the Society's publications. RI 1861.
Bibl: AJ 1859 p.176; American Art Review I 1880 p.555; Marillier; DNB.

PIENNE, Georges fl.1891-1892
Exhib. three works at the RA, all landscapes including a beach scene in North Wales. London address.

PIERCY, Frederick fl.1848-1882
London painter of portraits, landscape and genre, who exhib. 1848-82, at the RA 1848-80 and SS, titles at the RA including 'A Portrait', 1848, 'A Garden Gate near that of Osborne', 1857, and 'Coaxing a Puppy to Swim', 1859. Possibly the same person or related to Frederick Hawkins Piercy, sculptor, who also lived at 534 Caledonian Road, in 1880, and exhib. at the RA in 1880.

PIERREPONT, Miss C. Constance fl.1877-1879
Exhib. two watercolours including a painting of rhododendrons at SS. London address.

PIFFARD, Harold H. fl.1895-1899
Painted military and costume subjects. Exhib. four works at the RA including 'The Last Review: Napoleon at St. Helena in 1820' and 'The Last of the Garrison'. London address.

PIGGOTT, John fl.1859-1882
Exhib. a work entitled 'Dread Winter' at the RA and another landscape at the BI. Address in Leamington Spa, Warwickshire.

PIGOT, R. St. Ledger fl.1864-1871
Painted figurative subjects. Exhib. seven works at SS including 'Only Once a Year' and 'The Models', and one work at the RA. London address.

PIGOTT, Charles fl.1888-1893
Painted landscape. Exhib. three works at SS including views of Whitby and Sherwood Forest. Address in Sheffield, Yorkshire.

PIGOTT, W.H. c.1810-1901
Exhib. four works at the RA including 'Blackmail', 'Welsh Mountaineers' and 'Field Workers' and two watercolours at SS. Address in Sheffield, Yorkshire.
Bibl: Cat. Sheffield City AG 1908.

PIKE, Miss A.G. fl.1889
Exhib. three works including 'A Quiet Corner' and 'A Gloomy Day' at SS. London address.

PIKE, Clement E. fl.1880-1884
Exhib. a work entitled 'The Stick Gatherers' at SS. Address in Loughborough, Leicestershire.

PIKE, Joseph fl.1888-1890
Exhib. two coastal views in Somerset and two landscapes in Surrey at SS and a view on the Thames at the RA. London address.

PIKE, N.H. fl.1889
Exhib. a work entitled ' 'Twas in the Merry Month of May' at the RA. London address.

PIKE, Sidney fl.1880-1901
Painter of landscape and genre, living in Taplow, Christchurch and London, who exhib. 1880-1901, at the RA 1885-1901, SS, and elsewhere, titles at the RA including 'The Shepherd's Wife', 1885, 'Tipped with Golden Light', 1889, 'April Showers', 1892, and 'Fading into Night', 1901.

PIKE, William Henry RBA 1846-1908
Plymouth landscape painter, who exhib. 1874-93, at the RA in 1874 and 1888, SS (60 works), NWS and elsewhere. Titles at the RA 'King Arthur's Castle, Tintagel', 1874 and 'Old Impressions', 1888.
Bibl: G. Pycroft, *Art in Devonshire*, 1883 p.105.

PILCHARD, J. fl.1873
Exhib. two paintings of horses at SS. London address.

PILCHER, Charles Westland 1870-1943
Painted marines. Studied medicine. Born and lived in Boston, Lincolnshire.

PILKINGTON, F.M.M. fl.1891
Exhib. a landscape at the NWS. London address.

PILKINGTON, H. fl.1839-1856
London painter of genre, portraits, animals, landscape and interiors, who exhib. 1839-56, at the RA 1839-55 and BI, titles at the RA including 'Sportsman's Pets', 1839, 'Donkey and Sheep' Outskirts of a Common', 1846, 'Reading the News', 1853.

PILKINGTON, Thomas b.1862
Landscape painter. Studied at Gravesend School of Art, and exhib. at South Kensington and elsewhere.

PILL, Martha fl.1884-1885
Exhib. two watercolours at SS, coastal scenes at Perran Porth. Address in Lewisham.

PILLE, William fl.1875-1880
Exhib. a view in Wales at SS. London address.

PILLEAU, F. Startin fl.1882-1892
Exhib. nine views of churches at the NWS. London address.

PILLEAU, Lt.Col. H.E. (or G.) fl.1892-1893
Exhib. two landscapes at the NWS. Address in Brighton, Sussex. Probably the same as Henry Pilleau (q.v.).

PILLEAU, Henry RI ROI 1813-1899
London landscape painter, in oil and watercolour. Educated at Westminster School; entered the Army Medical Corps, where he spent many years and became Deputy Inspector-General of Hospitals. On his retirement he devoted himself exclusively to art, his favourite painting grounds being Venice and the East. Exhib. 1850-80 at the RA, and also at the BI, SS, NWS (76 works), and elsewhere (172 works). RI 1882. He died in Brighton.
Bibl: Cundall p.244; VAM.

PILSBURY, Miss Elizabeth fl.1879-1881
Exhib. four works at the RA including 'The Duck Pond' and 'Farm Sheds'. Address in Leicester.

PILSBURY, Harry Clifford b.1870
Painted portraits and landscape. He was the son of Wilmot Pilsbury (q.v.). Born and lived in London.

***PILSBURY, Wilmot RWS 1840-1908**
Painter of landscape and domestic genre. Born in Cannock Chase, Staffordshire. Studied at Birmingham School of Art and the South Kensington Schools; pupil of J.W. Walker (q.v.). Became Headmaster of the Leicester School of Art. Exhib. 1866, at the RA from 1872, SS, OWS (230 works), GG and elsewhere, titles at the RA including 'Near the Farm', 1872, 'Catching Minnows', 1873, 'Stokesay Castle', 1878, and 'Ploughing Time', 1896. A memorial exhibition of his work was held at the FAS in 1908, of which *The Studio* wrote: ". . . a regard for detail in itself, expressed with a feminine but not very sensitive touch, and little regard for the effect in general. Mr. Pilsbury's was a conventional art with a precedent in the work of Mrs. Allingham, and a great deal of its charm — a charm arising out of pleasant subjects; and a love of the English countryside so strong that it impels towards sympathetic expression."
Bibl: Studio XXVIII 1903 p.135; XLIV 1908 p.142; Cundall p.244; Cat. Norwich Castle Museum 1909; Pavière, Landscape; Newall.

PIMLOTT, E. Philip ARE fl.1894-1900s
Exhib. a view of a public house in Devon at the RA. Primarily an etcher. London address.

PIMM, William Edwin 1863-1952
Exhib. four works at SS including 'On the Watch' and 'Kittens at Play', and two works at the RA. Also painted portraits and miniatures. London address.

PINCOTT, W.H. 1863-1952
Exhib. a work entitled 'The Suppliant' at the RA. London address.

PINKERTON, W.E. fl.1885
Exhib. two works, views in Antwerp and Dordrecht, at the RA. London address.

PINSLEY, A. fl.1859
Exhib. a coastal scene at Ilfracombe at the BI. London address.

PINTO, J.J. de Souza fl.1882
Exhib. a portrait at the RA. London address.

***PINWELL, George John RWS 1842-1875**
Illustrator and engraver; painter in watercolour of genre and historical subjects. Born at High Wycombe; studied at St. Martin's Lane School and at Heatherleys. In 1863 began his professional career by designing and drawing on wood, chiefly for the Dalziel Brothers, whom he assisted in the production of *Arabian Nights' Entertainments* and Goldsmith's *The Vicar of Wakefield*, 1864. Together with Frederick Walker, John W. North (qq.v.) and others he illustrated *A Round of Days*, 1866, R. Buchanan's *Ballad Stories of the Affections*, 1866, *Wayside Posies*, 1867, and Jean Ingelow's *Poems*, 1867. Exhib. 1865-75 at the Dudley Gallery and OWS, of which he was A in 1869, Member in 1870. He died of consumption. Hardie notes that "one may set him beside Charles Keene as one of the greatest of British draughtsmen". An exhibition of his works was held at the Deschamps Gallery in February 1876. His studio sale was held at Christie's, 16 March 1876. For works illustrated by, see VAM Card Cat.
Bibl: AJ 1864 p.326; 1875 p.365; 1876 p.151; 1901 p.321; 1903 p.228; 1905 p.145; Redgrave, Cent., Dict.; Roget II pp.396-9; Gleeson White; G.C. Williamson, *C.J.P. and His Works*, 1900; Bryan; Binyon; Cundall; DNB; Studio Special Number, *Graphic Arts of Great Britain*, 1917 VI p.18; Studio Spring Number, *Drawings in Pen*, 1922 p.115; Studio LXXXIII 1922 p.240; Connoisseur LXII 1922 p.236; LXV 1923 p.72; LXIX 1924 pp.165, 183; LXXII 1925 p.55; Studio Winter Number, *British Book Illustration*, 1923-4 pp.22, 60; *Print Collector's Quarterly* X 1923 pp.108, 130; XI 1924 pp.162-89; Hardie III pp.138-9 (pls.159-60); Maas p.235 (pl.234); Mag. of Art 1901 p.550; Staley; Newall.

PIO, A. fl.1860
Exhib. a work entitled 'Esmeralda' at the RA. London address.

PIPER, Miss Elizabeth ARE ARWA fl.c.1890-1940
Painted and etched landscape and architectural subjects. Studied at Clifton School of Art, at the RCA and in Belgium and Paris. Exhib. three works at the RA including 'A Lowering Evening on the Thames' and 'The Bedroom in which Shakespeare was Born'. Lived at Stanmore, Middlesex.

PIPER, Herbert William fl.1871-1889
London painter of portraits, landscape and genre, who exhib. 1871-89, at the RA 1873-8, SS and elsewhere, titles at the RA including 'Mrs. William Playfair', 1873, 'Springtime', 1874, and 'Primroses', 1878.

PIRIE, Sir George PRSA HRA 1863-1946
Painted animals and birds. Studied in Paris under Boulanger and Lefebvre at the Académie Julian. Exhib. four works including 'His First Brood' and 'Rabbits' at the RA. Represented in several public collections. Born in Campbeltown, Argyllshire. Lived in Glasgow.
Bibl: D. Martin, *The Glasgow School of Painting*, 1902; Caw; AJ 1907 p.364; Studio LXIII 1915 p.115.

PISSARRO, Lucien NEAC 1863-1944
Painter of landscapes and townscapes in oil and watercolour. Wood engraver and designer and printer of books. Born and educated in France. Studied art under his father Camille. Settled in London in 1890 and became a naturalised Briton in 1916. Represented in many public collections.
Bibl: Connoisseur II 1902 p.127ff.; LIX 1921 p.5lff.; Studio XLVIII 1910 p.303; LVIII 1913 pp.61, 292, 299; LX 1914 p.304; LXI 1914 pp.276ff., 279ff.; LXV 1915 p.182; LXVI 1916 p.277; LXVIII 1916 p.117; LXIX 1917 p.57ff.; LXX 1917 p.107; LXXXIX 1925 pp.5, 7; XCVI 1928 p.225; Apollo VII 1928 p.95; VIII 1928 p.87; Who's Who; Lucien Pissarro, *Notes on The Eragny Press,* 1957; Paul Gachet, *Lettres Impressionistes,* 1957; W.S. Meadmore, *Lucien Pissarro; Un Coeur Simple,* 1962; Maas; further Bibl. in TB.
Exhib: London, Leicester Galleries 1934, 1936, 1943, 1946, 1950, 1962, 1973; Manchester City AG 1935; Belfast, Municipal AG and Museum 1936; New York, Carroll Carstairs Gallery 1944; Great Britain, Arts Council 1950?; London, Matthiesen Gallery 1950; Arts Council 1963.

PITCAIRN, Miss Constance fl.1881-1896
Exhib. three works 'Chrysanthemums', 'A Cottage Home' and a portrait, and a watercolour at SS. London address.

PITCHER, W.H. fl.1880
Exhib. a genre subject in 1880. London address.

PITCHER, William John Charles RI 1858-1925
Painted landscape in watercolour. Born in Northfleet, Kent. Lived and died in London.
Bibl: Who s Who 1924; Who was Who 1916-28; Connoisseur LXXI 1925 p.247.

PITMAN, Miss Edith H. fl.1887
Exhib. a landscape in 1887. Address in Solihull, Warwickshire.

PITMAN, Miss Janetta R.A. c.1850-c.1910
Painter of genre, still-life and flowers, living in Basford, near Nottingham, who exhib. 1880-1901, at the RA, SS, NWS, GG and elsewhere. Titles at the RA include 'Dead Wood-pigeon', 1880, 'Christmas Bills', 1882, and 'White Peonies', 1900.

PITMAN, Miss Rosie M.M. fl.1894-1897
Painted figurative subjects. Exhib. seven works at the RA including six illustrations to *Undine.* London address.
Bibl: Sketchley, *English Book Illustration of Today,* 1903.

PITT, Douglas Fox- fl.1893-d.1923
Exhib. a landscape at the NWS. London address. Died in Brighton, Sussex.
Bibl: Who's Who 1914; Studio LXV 1915 p.182; LXVI 1916 p.277ff.; Burlington Mag. XXVIII 1915 p.164.

PITT, Thomas Henry fl.1827-1852
London landscape painter, who exhib. 1827-52, at the RA 1839-48, BI and SS, titles at the RA including 'Dunmow Church, Essex', 1839, and 'Abbeville', 1842.

***PITT, William fl.1853-1890**
Birmingham landscape painter. Exhib. at RA 1863-80, BI and elsewhere, but mostly at SS. He painted English views, especially in Devon and Cornwall.
Bibl: AJ 1859 p.142; Cat. of the National Gallery of British Art, VAM 1908.

PITTAR, I.J. fl.1845-1856
Painter of portraits, genre and historical subjects, living in London and Brighton, who exhib. 1845-56, at the RA 1845-51, BI and elsewhere, titles at the RA being mostly portraits and 'Don Juan and Haidee', 1851.

PITTARD, Charles William fl.1878-1904
Painter of genre and still-life, living in Brixton, Streatham and Twickenham, who exhib. 1878-1904, at the RA 1881-1904, and SS. Titles at the RA include 'Faint Heart and Fair Lady', 1881, 'The Quarrel', 1884, 'Roses', 1891, and 'Sleep', 1904.

PITTARO, Charles fl.1881
Exhib. a sporting subject in 1881. London address.

PITTATORE, Michel Angelo fl.1862-1872
Exhib. a portrait at the RA. London address.
Bibl: L. Cust, The NPG, 1902; Ormond.

PITTMAN, Osmund ROI 1874-1958
Painted landscape. Studied at the RCA and at the RA Schools. Exhib. four works at the RA 1901-4, including 'A Stream through the Meadows' and 'Cumulus Clouds over a Fen Land'. Born and lived in London.

PITTS, Mrs. fl.1864
Exhib. a watercolour entitled 'Dead before Sunshine Comes' at SS. London address.

PITTS, Frederick fl.1856-1882
Painted flowers and country subjects. Exhib. three paintings of 'Wild Herbage' at the RA, six works at SS, including 'The Gamekeeper's Return' and an illustration to Goldsmith's *The Deserted Village,* and two works at the BI. London address.

PITTS, Marcus W. fl.1887
Exhib. a genre subject in 1887. London address.

PLACE, Miss Rosa fl.1859-1868
Painted still-lifes. Exhib. six works at the RA including 'My Garden on the Rock' and 'May and Bird's Nest', and three watercolours of fruit at SS. London address.

PLANT-HOLLINS, H. fl.1891
Exhib. two works, 'Poppies' and 'The Faggot-Gatherers', at SS. Address in Milford, Surrey.

PLASS, A.F. fl.1850
Exhib. a portrait at the RA. London address.

PLASTOW, A.B. (or C.B.) fl.1844-1848
Exhib. two works, 'Hampstead Heath' and 'A Mill, North Wales', at the RA. London address.

PLATT, Miss Emily fl.1832-1838
Painted portraits and country subjects. Exhib. five works at the RA, including 'A Market Cart' and 'Landscape, Windsor', and six works at SS. London address.

PLATT, Henry fl.1825-1865
London painter of rustic genre, landscape and coastal scenes, who exhib. 1825-65, at the RA 1825-63, BI, SS and NWS, titles at the RA including 'Cattle and Landscape', 1825, and 'Coast Scene', 1863. Wilson notes that he was a "painter of rural scenes, but specialised in beach scenes with children, shrimpers, etc. Few of his views are localised but inland scenes were unusual".
Bibl: Wilson.

PLATT, Samuel fl.1803-1837
Painted fruit and portraits. Exhib. 14 works, including 13 portraits, at the RA 1803-35, 16 works at the BI, the majority still-lifes of fruit 1821-37, and six works at SS. London address.

PLAYER, F. de Ponte fl.1873-1881
Marine painter, living in Ventnor and London, who exhib. 1873-81 at the RA, SS and elsewhere, titles at the RA including 'Unloading: near Paignton, S. Devon', 1877.

PLAYER, William H. fl.1858-1884
Landscape painter, living in Ventnor and London, who exhib. 1858-84, at the RA 1863 and 1884, BI, SS, NWS and elsewhere, titles at the RA being 'The Nearest Way to the Village — Scene in the Isle of Wight', 1863 and 'A Watery Moon', 1884.
Bibl: Trafalgar Galleries, *The Victorian Painter Abroad*, London 1965 (pl.17); Pavière, Landscape.

PLAYFAIR, James Charles fl.1865-1876
Painted figurative and genre subjects. Exhib. four works, including 'Ione: *Last Days of Pompeii*' and 'The Toilet', at the RA, and seven works at SS including watercolours entitled 'Contemplation' and 'Yes or No?' London address.

PLEWS, Miss Helen M. fl.1887-1904
Exhib. three works at the RA 1899-1904, including 'A Day of Cloud and Wind and Rain', at the RA, and two works at the NWS. London address.

PLIMPTON, Miss Constance E. fl.1882-1900
(Mrs. Constance Smith)
London painter of domestic genre, flowers and portraits, who exhib. as Miss Plimpton 1882-93 at the RA, SS, NWS and elsewhere, and as Mrs. Smith 1897-1900 at the RA. Titles include: 'Two Pets', 1888, 'Sweet Violets', 1893 and 'A Silver King', 1900.

PLIMPTON, G.R. fl.1834-1838
Exhib. a view of Croxden Abbey, Staffordshire, at the RA, and two works at SS. London address.

PLOSZEZYNSKI, N. fl.1850
Exhib. a portrait at the RA. London address.

PLOWDEN, Miss Edith R. fl.1885-1889
Exhib. a work entitled 'Bambino' at the RA and a view in the Forest of Fontainebleau at SS. London address.

PLOWDEN, Trevor Chichele fl.1870-1880
Pupil and follower of George Chinnery (q.v.). Painted Indian subjects.

PLUM, R.B. fl.1874-1886
Exhib. a view on the Wye at the RA. Also painted animals. Address in Worcester.

PLUMMER, H.L. fl.1837-1845
Painted portraits and figurative subjects. Exhib. 11 works at the RA, including 'Mischief', 'The Invalid' and portraits, and three works at SS. London address.

PLUMPTON, A.W. fl.1874
Exhib. an ink drawing in 1874. Address in Merton.

POATE, R. fl.1845-1869
Exhib. three works, 'The Sailor's Return, or Jack at Home', 'Harvest Time' and a portrait, at SS, and one work at the BI. Address in Portsmouth, Hampshire.

POCKELS, Miss C. fl.1869
Exhib. a work entitled 'A German Peasant Girl' at the RA. London address.

POCKLINGTON, F.C. fl.1879-1884
Exhib. two landscapes at the GG. London address.

POCOCK, A. fl.1841
Exhib. a view of Carisbrook Castle on the Isle of Wight at the RA.

POCOCK, H. fl.1875
Exhib. a watercolour view on the River Nene at SS. London address.

POCOCK, Henry Childe RBA 1854-1934
Painted genre, portraits and historical subjects. Studied under J.J. Jenkins (q.v.), at St. Martin's School of Art and at Heatherley's. Exhib. five works at SS including 'Reckoning Up', 'An Interesting Story' and 'Disinherited', and two works at the RA. Born at East Grinstead, Sussex. Lived in London.
Bibl: Who's Who 1929.

POCOCK, Innes fl.1852
Exhib. a painting of hounds at the BI. London address.

POCOCK, J. fl.1850-1860
Exhib. three works at SS, including 'The Brook' and 'Fox Hunting', and one work at the RA. London address.

POCOCK, Lexden Lewis 1850-1919
Genre and landscape painter. Born in London, son of Lewis Pocock, FSA. Studied under E.J. Poynter (q.v.) at the Slade School, where he won a prize and a silver medal; and later at the RA Schools, where he was awarded a silver medal for drawing from the life. Subsequently he studied and taught for two years at Rome. He was a Member of the Council of the Dudley Art Society, and exhib. from 1872, at the RA from 1875, SS, NWS and elsewhere. Titles at the RA include 'After Rain', 1875, 'Claude Lorraine's Villa on the Tiber', 1879 and 'The Microscope, "Consider the lilies" ', 1904.
Bibl: VAM.

PODDARD, J. fl.1847
Exhib. a portrait at the RA.

POHLMANN, Miss Charlotte fl.1888-1893
Exhib. a work entitled 'A Dutchman' at the RA. Address in Nottingham.

POINGDESTRE, Charles H. fl.1849-1901 d.1905
Painter of Italian landscape and genre. He was for many years the President of the British Academy in Rome. Exhib. at RA 1850-1901, BI, SS, NWS, GG, NG and elsewhere. His subjects all of Rome, the Campagna and Italian rustic life, e.g. 'In the Pontine Marshes', 'Poultry Market, Rome', 'A Steep Road at the Marble Quarries, Carrara', etc. He spent periods of his life in England and Jersey, and painted English landscapes.
Bibl: The Year's Art 1906 (obit.); L'Art LXIV 1905 p.547.

POINGDESTRE, W.W. fl.1856
Exhib. a work entitled 'Roman Drovers' at the BI. London address.

POINTER, G. Henry fl.1896-1899
Exhib. four works, including a portrait and 'Industrious' and 'A Chelsea Pensioner', at the RA. London address.

POINTER, R.M. **fl.1851**
Exhib. a work entitled 'Norma' at the BI. London address.

POLE, T.G. **fl.1839-1843**
Painted marines and shipping. Exhib. four works at SS, including 'Wreck on the Coast of Ireland' and 'Bantry Bay, Ireland', and one work at the RA. London address.

POLEHALT, Emily **fl.1872**
Exhib. a river scene in 1872. London address.

POLLARD, A. Read **fl.1884-1885**
Exhib. two genre subjects 1884-5. Address in Worthing, Sussex.

POLLARD, F. **fl.1837-1839**
Exhib. three works at SS, a landscape, a view in Sussex and a watercolour view of Tintern Abbey. Address in Brighton, Sussex.

***POLLARD, James** **1792-1867**
Painter of coaching and sporting subjects; engraver. Son and pupil of Robert Pollard (1755-1838), an engraver and publisher. Also received much help and advice from Thomas Bewick. In 1820 began to paint coaching scenes, and 1821 exhib. a large work at the RA, 'North Country Mails at the Peacock, Islington'. By 1825 he was successful enough to leave his father, marry, and set up on his own. Exhib. a few works at RA, BI and SS, but worked mainly for dealers and private patrons. In 1840 both his wife and his youngest daughter died. This was a blow from which he never fully recovered, and his later work shows evidence of decline. Although now best known for coaching subjects, he also painted racing, hunting, steeplechasing, shooting and fishing scenes. He was never a technically accomplished artist, but his work is valued for its historical accuracy, in evoking the spirit of the coaching age. He produced many prints, which were engraved by himself, his father, R. Havell, J. Harris and others.
Bibl: Connoisseur LI 1918 pp.15-22; XC 1932 pp.371, 409, 410; Print Collector's Quarterly XII 1925 pp.173-5, 180; XVII 1930 pp.169-95; Oude Kunst IV 1918-19 pp.124-6; Studio Special Number 1920, *Londoners Then and Now;* Apollo VII 1928 pp.158-61, 164; W. Gilbey, *Animal Painters in England,* 1900; W. Gilbey, *Early Carriages and Roads,* 1903; Sparrow; N.C. Selway, *J.P.,* 1965 (with cat. of complete works); Pavière, Sporting Painters p.70 (pl.34); Maas pp.71, 74 (pl.74).

POLLARD, Miss Kattern **fl.1892-1893**
Painted figurative subjects. Exhib. five works at SS including 'A Favourite Corner' and 'Silence Crowns Sweet Harmony'. Address in Hitchin, Hertfordshire.

POLLARD, Miss Remira **fl.1887-1896**
Exhib. three works at the RA, including 'Red and Ripe' and 'First Fruits of Autumn', and one work at SS. London address.

POLLARD, S.G. **fl.1864-1877**
Genre painter, living in London and Taunton, who exhib. 1864-77, at the RA 1864-74, BI, SS and elsewhere, titles at the RA including 'Tired', 1864, 'The Invalid's Friend,' 1866 and ' "She Sails Well" ', 1874.

POLLEN, John Hungerford **1820-1902**
Architect and painter. Exhib. 13 domestic subjects at the GG London address.
Bibl: *The Visitor's Guide to Oxford,* 1897; VAM Cat. 1908; DNB; Anne Pollen, *John Hungerford P.,* 1912.

***POLLENTINE, Alfred** **fl.1861-1880**
Painter of Venetian scenes. Exhib. 1861-80 at BI and SS. Also recorded are R.J. and W.H. Pollentine (qq.v.). They were probably all related, but nothing is known of them. Alfred, who painted in an impressionistic style, also painted some English coastal views.

POLLENTINE, R.J. **fl.1852-1862**
Painted landscape and animals. Exhib. three works at the RA, including a landscape in Northumberland and a painting of a spaniel, two works at the BI and four works at SS, including two views in Wales. London address.

POLLENTINE, W.H. **fl.1847-1850**
Exhib. two paintings of shipping at the RA, and a view off the Sussex coast at the BI. London address.
Bibl: Brook-Hart.

POLLEXFEN, J. **fl.1882**
Exhib. a painting of flowers at SS. London address.

POLLITT, Albert **fl.c.1889-1920**
Landscape painter working in the Midlands and Wales. His style is in the Cox tradition. Examples are in Manchester AG.

POLLOCK, Miss Beatrice M. **fl.1896**
Exhib. 'A Sussex Common' at the RA. London address.

POLLOCK, Sir Frederick, Bt. **1815-1874**
Exhib. a landscape in 1866. Served in the Royal Engineers and sketched in many parts of the world. London address.

POLLOCK, Maurice **fl.1882-1889**
Exhib. a landscape in the New Forest at the RA and another at SS. Also exhib. at the GG and at the NG. London address.

POLTER, Miss E. **fl.1860**
Exhib. a portrait at the BI. London address.

PONCY, Alfred Vevier de **fl.1871-1890**
Painter of landscape and genre, living in Balham and London, who exhib. 1871-90, at the RA 1877-90, SS and elsewhere, titles at the RA including 'A Severe Winter', 1877, 'The Flock', 1879 and 'Landscape and Cattle in Repose', 1890.

PONDER, James R. **fl.1881-1884**
Exhib. a work illustrating a line from Sir Walter Scott at the RA and another work at SS. Address in London.

PONSFORD, John **c.1790-1870**
Painted portraits. Studied in Rome. Exhib. four portraits at the RA, five works, including four portraits, at SS and one work, entitled 'Il Viaggiatore', at the BI. Born in Modbury, Devon. Lived in Plymouth and London.
Bibl: G. Pycroft, *Art in Devonshire,* Exeter 1883; BM Cat. of Engraved British Portraits.

PONSONBY, Hon. Gerald **fl.1867**
Exhib. a landscape in 1867. London address.

PONTIN, George **fl.1898-1904**
Exhib. four works at the RA, 1898-1904, including 'Brigantine Discharging Coals: River Arun' and 'Langston Harbour'. Address in Arundel, Sussex.
Bibl: Brook-Hart.

POOLE, Christopher fl.1882-1891
Landscape painter, living in Poole and Teignmouth, who exhib. 1882-91, at the RA 1889 and 1891, SS, NWS and elsewhere, titles at the RA being 'St. Servan', 1889 and 'Ye Olde Cannon Inne', 1891.

POOLE, Frederick Victor fl.1890-1901
Painted portraits and figurative subjects. He was a pupil of Fred Brown (q.v.). Exhib. three works, including 'The Anxious Mother' and *Isabella* — Keats', at the RA. Born in Southampton. He later lived in Chicago.
Bibl: M. Fielding, *Dictionary of American Painters.*

POOLE, James 1804-1886
Little-known landscape painter. Did not exhib. in London, but his works now appear at auction quite often. Usually painted mountain and moorland scenery, often in Wales and Scotland.
Bibl: The Year's Art 1887 p.230.

***POOLE, Paul Falconer RA RI 1807-1879**
Painter of historical subjects, genre and portraits. Born in Bristol, the son of a grocer, and as an artist was almost entirely self-taught. When only 20 he became involved in a scandal in which Francis Danby was also concerned. Poole probably lived with Danby's wife in about 1830, and Danby eloped to Geneva with Poole's wife. Poole ultimately married Danby's widow after her husband's death in 1861. Exhib. at the RA 1830-79, and also at BI, SS and NWS. ARA in 1846; RA 1861; RI 1878. In 1843 he attracted much attention by his highly dramatic 'Solomon Eagle Exhorting the People to Repentance During the Plague of London', and in 1847 won a prize of £300 in the Houses of Parliament Competition for 'Edward III's Generosity to the People of Calais'. Reynolds, VP notes that many of his paintings are routine, like those of smiling country girls with their children posed against the rocky streams of the West Country, and that "he needed to accumulate reserves of concentration and feeling to produce his most impressive canvases", e.g. 'The Last Scene in Lear', 1858 and 'The Vision of Ezekiel', 1875. Ruskin especially admired the latter; ". . . there is, as there has always been in Mr. Poole's work, some acknowledgment of a supernatural influence in physical phenomena, which gives a nobler character to this storm-painting than can belong to any merely literal study of the elements." An exhib. of his works was held at the RA in 1884. His studio sale was held at Christie's, 8 May 1880.
Bibl: Ruskin, Academy Notes 1858, 1875; AJ 1859 pp.41-3; 1864 p.320; 1865 p.364; 1866 p.212; 1879 p.263; 1908 p.289; Redgrave, Cent.; Clement & Hutton; Portfolio 1879 p.189; 1882 p.165; 1883 p.225; 1884 p.43; Binyon III; DNB; Reynolds, VP p.142 (pl.147); Maas pp.37-8.

POOLE, Samuel b.1870 fl.1903
Painted landscape, country subjects and genre. Studied at Heatherley's. Exhib. eight works at the RA, including 'The Maid of the Mill', 'Afternoon Tea' and 'After Church', and three landscapes at SS. Born in London. Lived in Bath, Somerset.
Bibl: Cedric Chivers, *Books in Beautiful Bindings*, Bath c.1940.

POOLE, William fl.1826-1838
Painted figures. Exhib. 12 works at SS including 'Hamlet: A Study from an Actor', 'The Weary Traveller' and portraits. London address. For works illustrated by, see VAM Card Cat.

POOLE, William fl.1854
Exhib. four interiors in 1854. Address in Sheffield, Yorkshire.

POPE, Mrs. Alexander fl.1796-d.1838
(Miss Clara Maria Leigh and Mrs. Francis Wheatley)
Painter of rustic genre, portraits and fruit and flowers. Daughter of Jared Leigh; married Francis Wheatley. From 1796-1807 she exhib. as Mrs. Francis Wheatley at the RA and BI, first miniatures, and then rustic subjects with figures of children, e.g. 'Little Red Riding Hood'. In 1801 Wheatley died, and in 1807 she married the actor Alexander Pope. From 1808-38 she exhib. as Mrs. A. Pope at the RA, BI and SS, at first rustic genre, but from 1817 entirely studies of fruit and flowers. She had a great reputation for her groups of flowers, and for a long time she was employed as an illustrator by Mr. Curtis, the botanical publisher. She also had many pupils, among them Princess Sophia of Gloucester.
Bibl: AU 1839 p.23; Clayton I p.401; Redgrave, Dict.; DNB.

POPE, Arthur Edward fl.1884-1885
Exhib. two works 1884-5. London address.

POPE, F. George fl.1856
Exhib. a work entitled 'Morning Prayer' at SS. London address.

***POPE, Gustave fl.1852-c.1910**
London genre, historical and portrait painter who exhib. 1852-95, at the RA 1854-95, BI, SS and elsewhere, titles at the RA including portraits and 'The Noble Substitute', 1854, 'The Orphan's Refuge', 1861 and 'Andromache Feeding Hector's Horses', 1883. The AJ engraved 'Accident or Design', a bashful youth approaching a young girl sketching, in historical costume. In 1910 'A Rainy Day' was given to Bristol AG.
Bibl: AJ 1872 (pl.p.112); Building News 1910 II p.490; Wood Panorama p.49 (pl.42).

POPE, Henry Martin 1843-1908
Painted landscape and rustic subjects, in oil and watercolour. Studied under Edward Watson, and H.H. Lines (q.v.) and Samuel Lines. Exhib. five watercolours at SS including views in Worcestershire and Warwickshire. Exhib. 290 works at the RBSA from 1865. He was a founder member of the Birmingham Art Circle. Born in Birmingham.

POPHAM, M. fl.1865
A picture of a child asleep in a harvest field, signed and dated 1865, was in the collection of the late Sir David Scott. Apart from this example, he seems to be unrecorded.

POPKIN, G.P. fl.1850-1859
Painted Welsh landscape and rustic subjects. Exhib. 15 watercolours at SS including 'Morning Mists Clearing off Idwal', 'Waiting for the Miller' and 'A Village Clerk's School — Among the Welsh Hills', and six Welsh subjects at the RA. Address in the Vale of Llanwrst, Wales.

PORTAELS, E. fl.1870
Exhib. a work entitled 'Souvenir d'Orient' at the RA. London address.

PORTAELS, T. fl.1869
Exhib. a scriptural subject at the RA. London address.

PORTER, Alfred T. fl.1882-1896
Exhib. four works at the RA, including 'The Pied Piper of Hamelin' and 'Habet!' London address.

PORTER, Mrs. C.K. fl.1895
Exhib. a design for a Christmas card at the RA. London address.

PORTER, Daniel fl.1888-1901
Painted portraits and genre subjects. Exhib. nine works at the RA, including portraits and works entitled 'Meditation' and 'A Collection of Curios', and eight works, including 'Getting Ready for the Party' and 'Frosted, but Kindly', at SS. London address.

PORTER, Edward P. fl.1892-1900
Exhib. a coaching scene in 1892. London address.

PORTER, Miss Ethel C. fl.1895-1901
Exhib. four works at the RA including 'An Old-fashioned Girl' and three portraits. London address.

PORTER, Frank fl.1893
Exhib. two works, 'Winter' and 'The Valley of the Severn', at the RA. London address.

PORTER, Miss Ida fl.1885-1886
Exhib. a watercolour of wallflowers at SS and another work at the NWS. London address.

PORTER, John fl.1824-1870
Painted landscape and historical and scriptural subjects. Exhib. four works at the RA including 'Haagar and Ishmael' and 'Margaret of Scotland', two works at the BI and ten works at SS including views near Folkestone, Kent, and elsewhere in the South of England. London address.

PORTER, Miss M.C. fl.1859
Exhib. an interior of the Temple Church at the RA. London address.

PORTER, Miss Maud fl.1888-1903
Painted portraits. Exhib. 23 works at the RA 1888-1903, including 'Glad, but not flushed with Gladness, Since Joys Go By' and 18 portraits. London address.
Bibl: The Year's Art 1909.

PORTER, Percy C. fl.1880-1887
Painted landscape. Exhib. five works, all but one watercolours, at SS, including 'Early Autumn', 'A Tarn at the Cheviots' and 'A Wooded Bank'. London address.

PORTER, Sir Robert Ker 1777-1842
Painted landscape and scenes of battle. He was a traveller and diplomat. Trained at the Royal Academy Schools. Exhib. at the RA 1792-1805. Born in Durham.
Bibl: Hall; Irwin.

PORTEUS, Edgar fl.1868-1878
London painter of domestic genre, who exhib. 1868-78, at SS and elsewhere, and at the RA in 1873. Titles at the RA 'Bad Times', 'Good Times'.

POSTLETHWAITE, Miss Elinor b.1866 fl.1889-1903
Born in Cumberland. Studied at Calderon's and at Westminster. Made colour woodcuts. Exhib. four works at the RA 1889-1903, including 'Orchids' and 'It is not Linen you are Wearing Out, But Human Creatures' Lives,' and three works at SS, including a painting of hawthorns. Addresses in South Devon and London.

POTCHETT, Miss Caroline H. fl.1862-1881
Landscape painter, living in Great Ponton, who exhib. 1862-81 at SS.

POTCHETT, Miss Emily fl.1869-1880
London landscape painter who exhib. 1869-80 at SS.

POTT, Charles L. fl.1888-1890
Exhib. two works, 'Sunset below Pangbourne Bridge' and 'The Weir Pool', at SS. London address.

***POTT, Laslett John RBA 1837-1898**
Painter of historical genre. Born in Newark, Nottinghamshire. Studied under Alexander Johnston (q.v.). Exhib. at RA 1860-97, and SS. His historical scenes were based on real and imaginary events, usually of the 17th century and 18th century. Typical titles 'Charles I Leaving Westminster Hall after his Trial', 'Dismissal of Cardinal Wolsey', 'His Highness in Disgrace', 'The Ruling Passion', 'The Jester's Story', etc. He also painted scenes of the Napoleonic Wars.
Bibl: AJ 1869 p.68; 1873 p.264; 1875 p.151; 1877 pp.257-60: Clement & Hutton; American Art Annual 1898 p.40.

POTTEN, Miss fl.1875
Exhib. a painting of Orleans plums at SS. London address.

POTTEN, Christopher fl.1875-1880
Painted landscape. Exhib. a view on the Downs near Eastbourne at the RA and three landscapes at SS. London address.

POTTER, Arthur fl.1882-1892
Exhib. three works at the RA, 'Playmates', 'A Basket of Mischief' and 'An Intruder', and three works at SS. London address.

POTTER, Charles RCA fl.1867-1892
Landscape painter, living in Oldham and Tallybont, Conway, who exhib. 1867-92, at the RA 1871-92, NWS, GG and elsewhere. Titles at the RA include 'The Grave of Taliesin, the Welsh Bard', 1871, 'Street of the Tombs, Pompeii', 1874 and 'Early Spring Welsh Pastoral', 1892.

POTTER, Miss Emily fl.1854-1861
Exhib. a work entitled 'Mignon' at the RA and two works at the BI. London address.

***POTTER Frank Huddlestone RBA 1845-1887**
Genre painter. His father was a solicitor, his uncle Cipriano Potter, a well-known composer, sometime President of the Royal Academy of Music. Some years after leaving school, Potter entered Heatherley's and then the RA Schools. He then went to Antwerp but returned to London in a few months. Exhib. at the RA in 1870, 1871 and 1882; from 1871-85 at SS, and became a RBA in 1877. Potter's work did not meet with the recognition it deserved in his lifetime. A 'Quiet Corner' was exhib. at the GG in 1887, and attracted much notice, but unfortunately he died on the opening day of the exhib. A memorial exhib. of his work was held at SS in 1887, and many of his paintings were bought by Samuel Butler, who had been a fellow student at Heatherley's. 'Little Dormouse' and 'Girl Resting at a Piano' are in the Tate Gallery.
Bibl: Studio LXIV p.234 (pl.); LXXII p.148 (pl.); Bryan; Studio Year Book 1920 p.57 (pl.); Reynolds, VS pp.41, 100 (pl.95).

POTTER, Helen Beatrix 1866-1943
(Mrs. Heelis)
The author of children's books, including *The Tale of Peter Rabbit*. She illustrated her own books and also made landscape watercolours. She was self-taught as an artist.
Bibl: Hardie (pl.169); Jane Quinby, *Beatrix Potter: A Bibliographical Check List*, New York 1954; Anne Carroll Moore, *The Art of Beatrix Potter*, London 1955; *The Journal of Beatrix Potter, 1881-97*, London 1966; Margaret Lane, *The Tale of Beatrix Potter: A Biography*, London 1968; The National Book League, *The Linden Collection of the Works and Drawings of Beatrix Potter*, London 1971.
Exhib: London, National Book League 1966; VAM 1972; National Book League 1971; Tate Gallery 1987 (with cat.).

POTTER, Percy C. fl.1885
Exhib. a watercolour entitled 'Low Tide at Lyme Regis' at SS.

POTTER, R.H. fl.1845-1865
An architect who also exhib. views of buildings, including buildings in Kent, Gloucestershire and France, at the RA. London address.

POTTER, Sydney fl.1883-1890
Exhib. three works, 'The Waning of the Year', 'Some of Nature's Gifts' and 'The Last of the Season', at the RA, and three works at SS. London address.

POTTER, Tennant fl.1897
Exhib. a work entitled 'Mercy' at the RA. Address in Egremont, Cheshire.

POTTER, Walter B. fl.1894-1903
Painted landscape. Exhib. 13 works at the RA, 1894-1903, including landscapes in the Highlands. London address.

POTTINGER, H. fl.1872
Exhib. two watercolours, views of Norway and Devon, at SS. London address.

POTTS, George B. fl.1833-1860
London landscape painter who exhib. 1833-60, at the RA 1835-60, BI and SS, titles at the RA including 'Banstead Downs', 1835, 'Evening near the Thames', 1842 and 'The River from Greenwich Park', 1860.

POTTS, John Joseph 1844-1933
Painted landscape in watercolour. Painted in Wales and the North East. Lived and exhib. in Newcastle-upon-Tyne. He was a founder member of the Bewick Club.
Bibl: Hall.

POULSON fl.1846
Exhib. a painting of flowers at the RA.

POULTER, Harry fl.1887-1893
Exhib. five works at the RA, including 'The Village Fishmonger' and 'The Midharbour, Greenock'. London address.

POULTER, J.A. fl.1850-1860
Painted landscape. Exhib. four works, landscapes near Bolton, Yorkshire and in Dulwich, at SS, four works at the BI and three works at the RA. London address.

POULTER, Marian fl.1862
Exhib. a work entitled 'Autumn' at SS. Address in Dover, Kent.

POULTON, Miss A. fl.1868-1869
Exhib. two paintings of fruit at SS. London address.

POULTON, Elizabeth fl.1847
Is supposed to have exhib. a work at SS. London address.

POULTON, George fl.1846-1856
Painted still-life and landscape. Exhib. 12 works at SS including paintings of flowers, fruit and works entitled 'The Angler' and 'A Quiet Assembly', and four works at the RA. London address. Brother of James Poulton (q.v.).

POULTON, James fl.1844-1859
Painter of still-life and game, living in Homerton and Dalston, who exhib. 1844-59 at the RA, BI and SS, titles at the RA including 'Pigeons', 1844, 'The Harem Lily', 1847 and 'Game', 1859. He was the brother of George Poulton (q.v.).

POUNCETT, R. fl.1840
Exhib. a street scene in Palermo at the RA.

POWELL, Alfred fl.1870-1901
London landscape painter, who exhib. 1870-1901 at the RA, SS, NWS and elsewhere, titles at the RA including 'A Cattle Path on the Greta, Yorks', 1870, 'A Summer Morning, Ullswater', 1872 and 'St. Michael's Mount', 1901. One of his watercolours is in the VAM.

POWELL, Mrs. Alfred fl.1883-1889
Exhib. a watercolour of chrysanthemums at SS. London address.

POWELL, Alfred H. fl.1890-c.1922
Painted landscape and architectural subjects in watercolour. Exhib. at the RA from 1890. Lived in Guildford, Surrey, and later in Cirencester, Gloucestershire.

POWELL, C. fl.1883-1884
Exhib. a watercolour entitled 'Carfay' at SS. Address in Monmouth.

POWELL, Miss C.J. fl.1874-1877
Exhib. two paintings of apple blossom and wild roses at the RA. Address in Charlton, Gloucestershire.

POWELL, David fl.1866-1867
Exhib. two landscapes 1866-7. London address.

POWELL, E.W. fl.1857-1860
Exhib. seven genre subjects 1857-60. London address.

POWELL, Miss E. Ffolliott fl.1887-1893
Exhib. three works, 'A Leisure Hour', 'Before Martyrdom' and 'Waiting for the Artist', at the RA. London address.

POWELL, Sir Francis RWS PRSW 1833-1914
Watercolour painter of landscape and coastal scenes. Born at Pendleton, Manchester, the son of a merchant. Studied at the Manchester School of Art. Exhib. at the OWS from 1856, became A in 1867, RWS 1876. In 1878 he was one of the founders at Glasgow of the Royal Scottish Watercolour Society, and was its first President. Knighted 1893. His watercolours were mostly marine and lake views. Died at Dunoon. Hardie: "His own example as an admirable painter of sea subjects, coupled with his enthusiasm, tact and personal charm, did much to advance the development of watercolour in Scotland."
Bibl: Studio LXIII 1915 p.220; LXVII p.256; Caw pp.211, 334; Who Was Who 1897-1915; VAM; Hardie III pp.82, 174-5 (pl.103); Brook-Hart.

POWELL, Frank fl.1855-1864
Painted landscape. Exhib. three works at the RA, two works at the BI and five watercolours at SS, including 'Balachulish', 'Fallen Rock' and 'Sunset at Sea'. Address in Manchester.

POWELL, Frank Smyth Baden- 1850-1933
Exhib. two works, 'Oaks in Sherwood Forest' and 'The Spencer Bruck, Lucerne', at the RA. Also exhib. under the name Baden-Powell (q.v.). London address.
Bibl: Who's Who 1908.

POWELL, Frederick Atkinson fl.1882-1884
Painted buildings and townscapes. Exhib. four watercolours at SS, views of Regensburg, Verona and Venice. London address.

POWELL, Hugh Peter fl.1867-1868
Painted landscape and riverscapes. Exhib. five works at SS including views in Wales and the Lake District. Also exhib. four works at the BI and two works at the RA. London address.

POWELL, Mrs. J. fl.1875-1876
Exhib. two works, 'Near Cheshunt' and 'On the Wye, near Haddon', at SS. London address.

POWELL, James C. fl.1882
Exhib. a landscape in 1882. London address.

POWELL, Joseph Rubens fl.1835-1871
London painter of portraits, genre and classical subjects, who exhib. 1835-71, at the RA 1835-58, BI, SS and elsewhere, titles at the RA including 'The Golden Age', 1850, 'Innocence' and 'Cupid Disarmed', 1855. He also painted copies of works by Claude Lorraine (for Lord Normanton), Greuze and Reynolds, which were mistaken for the originals by Dr. Waagen in *Galleries and Cabinets of Art in Great Britain*.
Bibl: Fine Arts Quarterly Review II 1864 pp.201-2.

POWELL, Leonard M. fl.1882-1903
Painted landscape. Exhib. seven works at the RA, including two views on the River Avon and another on the River Lea, and two watercolours at SS. London address.
Bibl: Daily Citizen 9 January 1913.

POWELL, P. fl.1826-1854
Painter of landscape and marine subjects, genre and portraits, living in Clapham, Brighton and London, who exhib. 1826-54, at the RA 1839-54, BI, SS and NWS, titles at the RA including 'Lake Scenes at Aix in Savoy — Morning', 1839, 'East Cliff, Hastings', 1850 and 'Lucy', 1853. He worked much abroad but also on the coasts of Kent and Sussex.
Bibl: Wilson; Brook-Hart.

POWELL, Richard fl.1853
Exhib. a work entitled 'Love's Visit' at the BI. London address.

POWELL, Samuel K. fl.1884
Exhib. a watercolour entitled 'The Bannerman' at SS. London address.

POWELL, Captain W.W. fl.1861
Exhib. a view of Algiers at the BI. London address.

POWER, Henry H. fl.1900-1901
Exhib. two works, 'Sunshine and Shadow' and 'Apple Harvest, Devon', at the RA. Address near Exeter, Devon.

POWER, J. fl.1841-1842
Exhib. two works, views on the Lakes Como and Geneva, at SS. London address.

POWER, Miss Lucy fl.1892-1898
Exhib. two portraits and a view of the parish church, Whitby, at the RA, and a work entitled 'Memories' at SS. London address.

POWER, R. fl.1839
Exhib. an illustration to Tasso at SS. Addresses in London and Warwickshire.

POWLES, Lewis Charles RBA 1860-1942
Painted landscape and portraits. Exhib. four works, two portraits and two views in Italy, at the RA. Lived in Rye, Sussex. Represented in the galleries of Hull and Huddersfield.
Bibl: Who's Who.

POWNALL, Miss fl.1874
Exhib. a work entitled 'Il Mabrouka' at the RA. London address.

POYNER, William H. fl.1852-1878
Painted portraits and figurative subjects. Exhib. five works, including two portraits and works entitled 'Child at Croché Work' and 'Returning from Church', at the RA, four works at SS and five works at the BI, including 'Out for a Walk with My Kitten'. London address.

POYNTER, Ambrose 1796-1886
Architect and painter. Pupil of T.S. Boys (q.v.). In Paris with R.P. Bonington, 1832. One of the founders of the RIBA 1834. Painted landscapes, still-life, and topographical subjects. About 1860 his eyesight failed. Father of Sir E.J. Poynter (q.v.).
Bibl: H.M. Poynter, *The Drawings of Ambrose Poynter*, 1931.

***POYNTER, Sir Edward John, Bt. PRA RWS 1836-1919**
Neo-classical painter. Son of Ambrose Poynter (q.v.). Born in Paris. Visited Italy in 1853, where he met the young Frederic Leighton (q.v.), and was much influenced by his neo-classical ideas. Returned to London and studied with Leigh and W.C.T. Dobson (q.v.), and also at RA Schools. In 1856 he entered Gleyre's Studio in Paris. From 1856-59 lived mainly in Paris, where he met Du Maurier, T.R. Lamont, T. Armstrong and Whistler (qq.v.), all of whom were to feature later in Du Maurier's novel *Trilby*. Returned to London 1860. Appointed Slade Professor and later Director of Art at the South Kensington Museum. Exhib. at RA from 1861, and at BI, OWS, GG, NG and elsewhere. Scored his first major success with 'Israel in Egypt', RA 1867. Later he turned more to Greek and Roman subjects, e.g. 'A Visit to Aesculapius', 'Psyche in the Temple of Love', etc. He also painted many smaller scenes of Roman or Greek life, mostly figures in marble interiors similar to those of Alma-Tadema. ARA 1869, RA 1876, PRA 1896-1918. Director of the National Gallery 1894-1906. Poynter was a strictly academic artist, who believed in study of the life model, and made studies for every figure in his pictures. He was also an illustrator, medallist, designer of tiles, and painter of wall decorations. His studio sale was held at Christie's, 19 January 1920. Manuscripts relating to this artist are held by VAM. For works by, see VAM Card Cat.
Bibl: AJ 1877 pp.17-19; 1903 pp.187-192; Studio VII 1896 pp.3-15; XXX 1904 p.252ff.; LXXII 1918 p.89ff.; Connoisseur XXXVI 1913 p.56; LV 1919 pp.51-2; LXIV 1922 pp.55-6; Athenaeum 1919 II p.691 (obit.); Ruskin, Academy Notes; Roget; DNB; VAM; A. Margaux, *The Art of E.J.P.*, 1905; M. Bell, *The Drawings of E.J.P.*, 1906; L. Forrer, *Biog. Dict. of Medallists*, 1909 p.4; Who Was Who 1916-28; W. Gaunt, *Victorian Olympus*, 1952; Reynolds, VP pp.119-21 *et passim* (pls. 85, 86, 88); Hutchison, see index; Maas pp.183-4 *et passim* (pls.pp.183, 184, 186): L. Ormond, *George Du Maurier*, 1969 see index; Staley; Wood, Olympian Dreamers; Newall; A. Inglis, *Sir E.J.P. and the Earl of Wharncliffe's Billiard Room*, Apollo October 1987.
Exhib: Sydney AG of NSW, 1975, *Victorian Olympians*.

POYNTER, James fl.1880
Exhib. two still-lifes in 1880. London address.

POYSER, T.J. fl.1862
Exhib. a work entitled 'Gone Away' at the RA. Address in Liverpool.

PRADILLA, J. fl.1877
Exhib. three watercolours, including two Spanish views, at SS.

PRAETORIUS, Charles J. fl.1888-1904
Exhib. six works at the RA, 1888-1904, including 'Chrysanthemums' and 'The Piazza di Spagna' at the RA. London address.

PRAGA, Alfred RBA 1867-1949
Painted portraits and genre subjects. Also a miniaturist. Studied at South Kensington, Antwerp and Paris. Exhib. three genre subjects at the NWS. Born in Liverpool. Lived in London.
Bibl: Williamson, *History of Portrait Miniatures*, 1904; Who's Who 1924.

PRATER, Ernest fl.1897-1904
Exhib. four works at the RA 1897-1904, including 'A Dash from a Scrimmage' and 'Nelson Wounded at the Nile'. Address in Stoke Newington.

PRATER, T. fl.1855
Exhib. two works, 'A Lane Scene in Kent' and 'Low Water, above Putney. November', at SS. London address.

PRATER, William fl.1873
Exhib. a watercolour entitled 'A Reverie' at SS. London address.

PRATT, A.J. Epps fl.1874-1879
Painted landscape. Exhib. three works, including two watercolours, 'Ryde Sands, Isle of Wight' and 'Hide and Seek of an August Evening', at SS, and one work at the RA. London address.

PRATT, Claude b.1860 fl.1887-1892 d.c.1935
Birmingham genre painter and watercolourist; son of Jonathan Pratt (q.v.). Exhib. only two works at NWS; worked mainly in Birmingham and the Midlands. Subjects mainly rustic genre.

PRATT, Edward fl.1880
Exhib. a work entitled 'Premeditating' at the RA. Address in Edinburgh.

PRATT, Hilton L., Jnr. fl.1867-1873
Painted landscape. Exhib. 'Derwentwater from Barrow' at SS and another work at the RA. Address in Stoke-on-Trent, Staffordshire. Represented in the Derby AG.

PRATT, John fl.1882-1897
Leeds flower and still-life painter. Exhib. at RA 1882-97. Titles: 'Paeonies', 'A Corner of the Larder', 'A Reverie', etc.

PRATT, Jonathan 1835-1911
Birmingham genre painter. Exhib. at RA 1871-1903, SS and elsewhere. Titles at RA 'Where's Grandpa?', 'A Devonshire Cottage', 'A Breton Cottage', etc. A work is in Bristol AG. Also painted interiors. His son Claude Pratt (q.v.) was also a painter.
Bibl: AJ 1905 p.356.

PRATT, Ralph fl.1881-1893
Leeds still-life painter. Exhib. at RA 1881-93. Titles: 'Study of Lemons', 'Dessert', 'Lemons and Jar', etc. Probably the father of John Pratt (q.v.) as they both had the same address, 49 Portland Crescent, Leeds. A work is in Leeds AG.

PRATT, William 1855-c.1897
Painted country subjects, landscape and marines. Studied at the Glasgow School of Art and at the Académie Julian. Exhib. five works at the RA including 'Wreck of the *Juno*', 'The Way to the Fold' and 'Salmon Fishers'. Lived at Lenzie, near Glasgow. Represented in the Gallery of Modern Art, Venice.
Bibl: Studio XXXVIII 1906 p.347ff.; Caw.

PRATTEN, Mrs. fl.1875
Exhib. a painting of flowers in 1875. Address in Haslemere, Surrey.

**PREINDLSBERGER, Miss Marianne
see STOKES, Mrs. Adrian**

PRENDERGAST, George fl.1872-1876
Exhib. two works, 'Picnicking on the Cliffs' and 'The Esplanade, Southend', at SS. London address.

PRENTICE, Andrew N. fl.1892-1904
Painted items of architecture. Exhib. 17 works at the RA, 1892-1904, including views of buildings in Spain and Glasgow as well as of Cavanham Hall, Sussex. London address.

PRENTICE, John R
Brook-Hart reproduces a work by this painter of marines.
Bibl: Brook-Hart (pl.50).

PRENTICE, Miss Kate 1845-1911
Painted landscape. Self-taught painter. Exhib. two landscapes at the NWS and one at GG. Born at Stowmarket, Suffolk. Lived in London. Represented in VAM.

PRENTIS, Edward RBA 1797-1854
Painter of contemporary domestic genre, humorous, pathetic and sentimental, which gained considerable temporary popularity. Born in Monmouth. Exhib. at the first exhibition of the SBA (founded in 1825), and sent all his subsequent pictures there, until 1850. Exhib. at the RA in 1823. Maas likens the theme of 'The Sick Bed' (Glasgow) to Luke Fildes's 'The Doctor' painted later in the century. The AJ quotes what appeared in a daily paper after his death: "His collected works would furnish a striking pictorial epitome for all that is most to be admired and most to be deplored in the hearths and homes of England." He also contributed illustrations to Layard's *Monuments of Nineveh* (1849 fol.).
Bibl: AJ 1855 p.108; Redgrave, Dict; DNB; Reynolds, VS p.55 (pl.14); Maas p.119.

PRE-RAPHAELITE BROTHERHOOD
Association of young artists formed 1848-9 by D.G. Rossetti, J.E. Millais and Holman Hunt (qq.v.). Other members were W.M. Rossetti, James Collinson (q.v.), F.G. Stephens (q.v.) and Thomas Woolner. Although there were many friends and associates on the fringe of the group, e.g. F.M. Brown, W. Deverell, Arthur Hughes, C.A. Collins (qq.v.), etc., there were only these original seven members. Collinson resigned in 1850, and the Brotherhood was virtually dissolved by 1853. The literature of the movement and its members is enormous; the best bibliography is W.B. Fredeman, *Pre-Raphaelitism, a Bibliocritical Study,* 1965.

PRESCOTT, Charles Barrow Clarke NSA 1870-1932
Painted portraits, landscape and genre. Studied at St. John's Wood School and at the Académie Julian. Travelled in America, Africa and the Middle East. Born at Wilmslow, Cheshire. Lived in London.

PRESCOTT, C. Trevor fl.1895
Exhib. a work entitled 'Endymion' at the RA. Address in Liverpool.

PRESCOTT, H.P. fl.1847-1848
Exhib. a work entitled 'The Idler' at the RA, and two works at SS, 'An Irish Peasant' and 'A Negro'. London address.

PRESCOTT-DAVIES, Norman FRS fl.1880-1900
Miniaturist, portrait and figure painter. Worked in London and Isleworth 1880-1900.
Bibl: Wood, Olympian Dreamers.

PRESTON, A.C. fl.1888
Exhib. a landscape at the NWS. Address in Chester.

PRESTON, Mrs. H.J. fl. 1855-1867
Painted figurative subjects. Exhib. six works at the RA, including 'Four Friends', 'The Sandstone Waggon' and 'Forgotten'. London address.

PRESTON, Josephine fl.1888
Exhib. a study of pigeons at SS. London address.

PRESTON, R. fl.1842
Exhib. a 'Moonlight Composition' at the RA and 'Moonlight — A Scene in Derbyshire' at SS. London address.

PRESTON, Thomas fl.1826-1850
Painted portraits and animals. Also a copyist. Exhib. nine works at the RA 1828-36, and 18 works at SS 1826-50, amongst the later of these being several paintings of cows. London address.

PRETTY, Edward 1792-1865
Exhib. two watercolours, 'Firelight' and 'Moonlight', at SS. Address in Northampton. Taught drawing at Rugby School till 1855.
Bibl: Gentlemen's Magazine October 1865.

PRICE, Alice fl.1881
Exhib. a work entitled 'A Reverie' at SS. Address in Stoke Newington.

PRICE, Miss Blackwood fl.1890
Exhib. a portrait at the GG.

PRICE, Edward fl.1823-1854
Painted mountain landscape. Student and assistant to John Glover. Exhib. seven works at the BI, including views in North Wales and Dovedale, seven works at SS, including views in Norway, Scotland and North Wales, and three works at the RA. Addresses in London and Lichfield, Staffordshire.
Bibl: Roget.

PRICE, Frank Corbyn b.1862 fl.1897
Landscape painter, living in London and Billingshurst, who exhib. 1888-97 at the RA, SS and NWS, titles at the RA including 'Coming Winter', 1888, 'Pulborough, Sussex', 1890 and 'A Passing Shower', 1897. His wife (q.v.) was a painter of domestic genre.

PRICE, Mrs. Frank Corbyn fl.1890-1897
(Miss Lydia Jemima Jeal)
Painted flowers and genre subjects. Exhib. six works at the RA, including 'Expectant', 'Dolls' and 'Michaelmas Daisies'. London address.

PRICE, Frederick G. fl.1862-1863
Painted landscapes and figures. Exhib. four works at SS, including two watercolours, 'Spring Twilight' and 'Viola', and one work at the BI. Address in Romford, Essex.

PRICE, Miss Grace fl.1861-1862
Exhib. two watercolours of 'A Study from Nature' and 'Winter Fruit' at SS. Address in Charlton, Kent.

PRICE, James fl.1842-1876
Landscape painter, living in Old Charlton, Kent, and Blackheath, who exhib. 1842-76, at the RA 1842-75, BI, SS and elsewhere, titles at the RA including 'Scene in a Wood', 1842 and 'Scene in Sussex', 1875.

PRICE, Julius Mendès 1857-1924
Painted figurative subjects. Studied in Brussels and at the École des Beaux-Arts. Exhib. five works at the RA, including 'A Fish Auction' and 'The Weary Road across Siberia', and four works at SS. Travelled in the Far East and Asia and wrote and illustrated books describing his experiences. Born and lived in London.
Bibl: Who Was Who 1916-28.

PRICE, T.E. fl.1847-1859
Exhib. two works, 'The Sword and Distaff' and 'Italian Sisters' at SS, and one work at the BI. London address.

PRICE, William Frederick fl.1878-1881
Exhib. a watercolour of 'The Old Manor House' at SS and 'A Hazy Morn' at the RA. Address in Liverpool. Represented in the Norwich Gallery. For works illustrated by, see VAM Card Cat.

PRICE, William Lake 1810-1891
Painter chiefly of architectural subjects, but also of portraits, historical subjects and landscapes; architect; illustrator, etcher and lithographer. Grandson of Dr. Price, chaplain to George IV, and of Sir James Lake, Bt. Articled to Augustus C. Pugin; after studying under De Wint, he abandoned architecture for painting. Travelled extensively on the Continent. Exhib. 1828-52, principally at the OWS, and also at NWS, RA 1828-32, and elsewhere. A of OWS 1837; resigned 1852. He illustrated *Interiors and Exteriors of Venice*, 1843, S.C. Hall's *Baronial Halls of England, I*, 1843. *The Keepsake*, 1845-6, and he published a manual on photography in 1858. Living at Blackheath in 1891.
Bibl: Roget II; Cundall; *Old English Mansions* Studio Spring Number 1915; Cat. of National Gallery of Ireland, Dublin, 1920 p.185; VAM; Hardie.

PRICHARD, W.S. fl.1874-1882
Exhib. three watercolours, including two views near Torquay, at SS. London address.

PRIDEAUX-BRUNE, Miss Gertrude R. fl.1878-1893
Exhib. a marine off the Cornish coast at the RA. London address.

PRIEST, Alfred 1810-1850
Painter mainly of marines and coastal scenes in Norfolk, and also of landscapes in Norfolk, Derbyshire, on the Wye and at Oxford; one of the last of the Norwich School. Also an etcher and lithographer. A pupil of Henry Nineham, from whom he acquired his skill in etching, and later of James Stark. Exhib. in London 1833-47, at the RA 1833-45, BI and SS. He had moved to London in the early 1830s but returned to Norwich in 1848. Most of his known work is in oils, and Clifford notes that he has seen only two

watercolours certainly by him, both in Norwich Castle. "They are best described as clumsy romanticized 'Miles Edmunds' lit by a slightly unexpected cinema-organ sky." He is said to have taken to brandy in his later years, and probably did very little work.

Bibl: W.F.Dickes, *The Norwich School of Painting*, 1905; H.M. Cundall, *The Norwich School*, 1920 (pl.80); Studio Special Number; Clifford pp.61, 73 (pl.67b); Wilson; Brook-Hart.

PRIEST, Alfred RP 1874-1929
Painted portraits. Studied at the RA Schools and at the Académie Julian. Exhib. from 1898. Born at Harborne. Lived in London.

PRIEST, Miss E.A. fl.1848
Exhib. a view at Lynmouth, North Devon at SS. London address.

PRIESTMAN, Arnold RBA 1854-1925
Landscape painter, working in Bradford,who exhib. 1833-c.1908, at the RA 1887-1902, SS, GG and NG. Titles at the RA include 'A Grey Day near Conway', 1887, 'On the River Blyth', 1893 and 'On the Maas', 1902. The AJ reproduced "the spacious Walberswick" exhib. at the NG in 1908. His paintings are in Leeds and Rochdale AGs.

Bibl: AJ 1908 p.179 (pl.178).

***PRIESTMAN, Bertram RA ROI NEAC 1868-1951**
Painter of cattle and lush pastoral life, landscape and coastal scenes. Born in Bradford, Yorkshire; came to London in 1888; exhib. from 1889 at the RA, SS, GG, NG and elsewhere, titles at the RA including 'In Dock for Repairs', 1890, 'Ebb-tide', 1898 and 'The River Meadow', 1900. He was much travelled in Holland and France, and many of his paintings were made there. Member of NEAC 1897; ARA 1916; RA 1923; Associate of International Society of Sculptors, Painters and Gravers, 1900. His paintings are in galleries in Bradford, Leeds, Birmingham and throughout England.

Bibl: AJ 1907 pp.179-84, 185; 1898 p.31; 1899 pp.199, 203; 1900 p.184; 1901 p.184; 1904 p.206; 1905 p.19; Studio XIV 1898 pp.77-98 (mono. with pls.); XXIX 1903 p.297; XXXI 1904 p.346; XXXIV 1905 p.162; XXXVI 1906 p.261; Who Was Who 1951-60.

PRINGLE, Miss Agnes fl.1884-1893
Painted figurative subjects. Studied under William Cosens Way and at the RA Schools. Exhib. five works at the RA including 'A Wee Scotch Lassie' and 'Venetian Girl' and two works at SS. London address.

Bibl: Hall.

PRINGLE, John Quinton 1864-1925
Painted portraits, still-lifes and landscape. Lived in Glasgow and is represented in the Glasgow AG.

Bibl: Brook-Hart.

PRINGLE, John William Graham fl.1867-1879
London landscape painter who exhib. 1867-79 at the BI, SS and elsewhere. Title at the BI: 'Near Ryde'.

PRINGLE Miss Lydia fl.1893
Exhib. a portrait at SS. London address.

***PRINSEP, Valentine Cameron RA 1838-1904**
Painter of portraits, historical subjects and genre, influenced by Pre-Raphaelitism and Lord Leighton (q.v.). Born in Calcutta, son of an Indian civil servant. Educated at Haileybury. A close friendship with G.F. Watts (q.v.) encouraged him to turn to painting instead of the Civil Service, and at first he studied under Watts. He met D.G.

Rossetti (q.v.), and became influenced by Pre-Raphaelitism, but soon came under the influence of Leighton, to whose work his own has a close similarity. Assisted in the decoration of the Oxford Union, 1857. Worked in Paris in the studio of Gleyre, 1859. There Whistler, Poynter and Du Maurier (qq.v.) were his fellow students, and he was the model for Taffy in *Trilby*. He then went to Italy with Burne-Jones (q.v.) and met Browning in Rome, 1859-60. He exhib. annually at the RA from 1862-1904, and also at SS, GG, NG and elsewhere. In 1876 he was commissioned by the Indian Government to paint the historical durbar held by Lord Lytton to proclaim Queen Victoria Empress of India. This resulted in the large canvas 'At the Golden Gate', 1882, and also a number of smaller works on eastern subjects. ARA 1878; RA 1894; Professor of Painting from 1901. Prinsep was extremely versatile, socially gifted and, after his marriage to Florence Leyland, very rich. He published an account of his visit to India, *Imperial India; an Artist's Journal*, 1879; he also wrote two plays, and two novels, *Virginie*, 1890, and *Abibal the Tsourian*, 1893.

Bibl: AJ 1894 p.221; 1905 p.33; Framley Steelcraft, *Mr. Val C. Prinsep R.A.*, Strand Magazine XII December 1896 pp.603-15; Bate p.90 (pl.90); Mrs. Orr, *Life of Robert Browning*, 1908 p.224ff.; DNB 2nd supp; Connoisseur XXXVI 1913 pp.151-2; *The Art of Val. C. Prinsep*, Windsor Magazine XXXIX April 1914 pp.613-28; Fredeman Index; Maas; Staley; Ormond; Wood, Olympian Dreamers.

PRINSEP, William fl.1850
Exhib. a work entitled 'Calcutta' at the RA.

PRINSEP, William Haldimand fl.1856
Exhib. a work entitled 'Part of the City of Morocco' at the RA. London address.

PRIOLO, Paolo fl.1857-1887
Painted historical, literary, biblical and mythological subjects as well as genre and Italianate subjects. The majority are watercolours. Exhib. 35 works at SS including 'The Sicilian Vesper', 'The Death of Galbina' and 'Raphael and the Fornarina' and seven works at the RA. Addresses in Rome and Edinburgh. For works illustrated by, see VAM Card Cat.

PRIOR, William Henry 1812-1882
Painted landscape. Exhib. two works at the RA, one at the BI, and 14 at SS, including views in Surrey and Kent and on the Rhine. Some of these are watercolours. London address.

Bibl: Binyon; Brook-Hart (pl.219).

PRITCHARD, Edward F.D. 1809-1905
Marine, landscape and architectural painter, living in Bristol and London, who exhib. 1852-73, at the RA 1852-63, BI, SS and elsewhere. Titles at the RA include 'Winter in Belgium', 1852 and 'Portland Island from the beach at Sandsfoot Castle, Portland Bay', 1863. In 1859 he exhibited at the BI 'Antwerp, Sunset' of which the AJ said: "This view is taken from the upper quays, whence is obtained a perspective view of the river front of the city, with its most important buildings. The sunset glow is satisfactorily sustained throughout the picture."

Bibl: AJ 1859 p.81; Brook-Hart.

PRITCHARD, Miss Mary E. fl.1893-1895
Exhib. 'Tulips', 'Apples and Nuts' and 'Fruit', at the RA and 'Gladioli' at SS. London address.

PRITCHARD, Thomas fl.1866-1877
Painted mountain landscapes. Exhib. eight work at the RA including two views in Ross-shire, also views in Switzerland and the Pyrenees. London address.

PRITCHETT, Miss fl.1871

Exhib. a watercolour at SS. London address.

***PRITCHETT, Edward fl.1828-1864**

Painter of Venetian scenes. Exhib. at RA 1828-49, BI and SS. Nearly all his pictures were of Venice, but he did exhib. occasional English views. Although practically nothing is known of his life, his Venetian pictures are now attracting attention. They are painted in a lively manner similar to James Holland (q.v.), and at times are almost impressionistic.

Bibl: Hughes; Hardie III p.31 (pl.45); Maas.

PRITCHETT, Robert Taylor FSA 1828-1907

Painted landscape and continental rustic scenes. Exhib. four works at the RA including 'Interior in Brittany — Pancake Making' and 'Fish Buyers on the Beach — Scheveningen', and one work at SS. He visited India and painted there. London address.

Bibl: DNB; AJ 1868 p.69; 1869 p.119; 1870 p.27; Cat. Glasgow AG 1911; Hardie.

PRITCHETT, S. fl.1858

Exhib. two views in Clovelly, Devon, at the RA.

PRITT, Henry fl.1888

Exhib. a landscape at the NWS. Address in Preston, Lancashire.

PRITT, Thomas fl.1861-1864

Painted landscape and country subjects. Exhib. seven works at SS, including two scenes on the River Hodder, Yorkshire, and four works at the BI, including three landscapes with cattle. London address.

PRITTIE, Edward ARHA 1851-1882

Painted figurative subjects. Studied at the Brussels Academy. Exhib. at the RHA and once, in the year after his death, at the RA, 'Beatrice Cenci and Lucrezia Petroni, her Step-mother'. An accomplished man whose work was interrupted by ill health. He lived in Dublin.

Bibl: Strickland.

PROCTOR, Adam Edwin RI ROI RBA 1864-1913

Painter of genre and landscape, living in Brixton and Guildford. Studied at Lambeth School of Art, afterwards at Langham Life Class, and under Professor Fred Brown (q.v.) at Westminster School of Art. Exhib. from 1882 at SS, and from 1888 at the RA, where titles include 'The Shrimper', 1888, 'The Morning Catch', 1895 and 'Market Morning', 1904. He also painted in Algeria, Holland, etc. Hon. Sec. RBA 1895-9; RBA 1889; RI 1908; ROI 1906.

Bibl: Who Was Who 1897-1916.

PROCTOR, Albert fl.1896-1897

Exhib. two works, 'Fishing Boats Ashore' and 'The Port of Liverpool', at the RA. Address in Liverpool.

PROCTOR, Jessy fl.1869

Exhib. a still-life in 1869. London address.

PROCTOR, John fl.1879-1883

Exhib. four works, including 'A Shady Lane, near Bromley, Kent' and 'High and Dry', at the RA. London address.

PROCTOR, Miss M.A. fl.1858-1859

Exhib. a work entitled 'Spring' at the RA. London address.

PROCTOR, William fl.1836-1854

Painted watercolour portraits. Exhib. six works at SS, five of them portraits, three at the RA, including 'Trying a New Tune' and one at the BI. London address.

PROFAZE, Mrs. Annie fl.1870-1872

Exhib. three works, including 'Maiden Meditation' and 'Sweet Seventeen', at SS. London address.

PROSCHWITZKY, Frank fl.1883-1889

Exhib. two works, 'Still-life' and 'Pensive', at the RA. London address.

PROSSER, George Frederick fl.1826-1871

London watercolourist of landscape and topographical views. A work by him is in the Hampshire Record Office. His works have appeared at London auctions between 1983 and 1990.

PROTHERO, Rev. Canon G. fl.1888

Exhib. a painting of 'The Lake, Llandrindod' at SS. London address.

PROUDFOOT, William 1822-1901

Scottish painter. Educated at Perth Academy, and travelled in Italy. Examples are in Dundee AG.

PROUT, Agnes fl.1869

Exhib. a watercolour study of a seashore at SS. London address.

PROUT, Miss Edith Mary 1862-1927

Painted marines. Self-taught painter. Exhib. at SWA and RBSA. Lived at Newquay, Cornwall.

PROUT, John Skinner RI 1806-1876

Watercolour landscape painter. Nephew of Samuel Prout (q.v.). Born at Plymouth; mainly self-taught, but followed his uncle in choice of subject. As a young man he went to Australia, staying at Sydney and Hobart. Friend of W.J. Müller (q.v.) and with him made sketches for *Antiquities of Bristol*. Member of a Sketching Club formed by Müller and Samuel Jackson, William West and T. Rowbotham (qq.v.). Exhib. 1838-76 at the NWS and elsewhere. RI in 1838; re-elected (because of his stay abroad) A in 1849, RI in 1862. Hardie notes that "he followed his uncle in manner of composition and in picturesque, crumbling handling of architecture in foreign towns, but had neither the power of drawing nor his eye for colour. In texture and tint he is far more woolly than Samuel Prout." His studio sale was held at Christie's, 26 February 1877.

Bibl: AJ 1876 p.330 (obit.); Redgrave, Dict; Roget; Bryan; Binyon; Cundall; DNB; Hughes; VAM; Connoisseur LXXXIV 1929 pp.191, 194; Hardie III pp.11-12 (pl.8).

PROUT, Mary fl.1869

Exhib. a watercolour study of a sea-shore at SS. London address.

PROUT, Mrs. Millicent Margaret Fisher 1875-1963
ARA RWS ROI RWA NEAC WIAC

Painted landscape, cattle, figurative subjects and flowers. She studied under her father Mark Fisher, RA, and at the Slade. Born in London. Lived on the south coast.

***PROUT, Samuel 1783-1852**

Topographical watercolourist and painter of architectural subjects. Born in Norfolk; educated at Plymouth Grammar School, where a fellow pupil was B.R. Haydon (q.v.), through whom Prout, at the

age of 18, met John Britton the antiquary. Employed by Britton to make drawings of local architecture but his work proved unsatisfactory. In 1802 he went to London to live with Britton for two years and studied the work of Turner, Girtin and Cozens. In 1803-4 commissioned by Britton to make drawings for his *Beauties of England and Wales* in Cambridge, Essex and Wiltshire. In 1805 ill health made him return home, but in 1808 he returned to London where he sold his work to London dealers, and in 1810 became a member of the Associated Artists in Watercolours. After 1811 he lived in Stockwell, where he taught, one of his first pupils being J.D. Harding (q.v.). In 1813 he published *Rudiments of Landscape in Progressive Studies*, the first of his drawing books for the use of beginners; between 1813 and 1844 he issued 18 publications. Until 1818 he exhib. drawings of West Country scenes and architecture, coastal scenes and shipping; in all he exhib. 28 works at the RA 1803-27; eight at the BI 1809-18; 60 elsewhere; and 560 at the OWS, of which he was elected a member in 1819. In 1819 he first visited the Continent, and found his metier in painting the picturesque architecture of old continental towns. For the rest of his life he constantly produced views of the streets, market places and crowds of old French towns, which became immensely popular. In 1822 and 1823 he added views in Belgium and Germany, and in 1824 first visited Italy. His sketches of Venice also provided him with a constant source of material.

His drawings are undated, but from 1820 onwards there is a change from an earlier simplicity and sombre tones to his more mannered later style, which is distinguished by his use of a crinkled and intricate line to outline objects and buildings. Prout did all his watercolour work and outlining indoors over an outdoor pencil drawing. These pencil studies always remained in his possession, and the sale of his work at Sotheby's in 1852 consisted almost entirely of them. Prout's mannerism and lack of true observation have now been recognised, and his work today has none of the popularity it had in the late 19th century. Ruskin, however, had nothing but praise for him: "We owe to Prout, I believe, the first perception, and certainly the only existing expression, of precisely the characters which were wanting to old art; of that feeling which results from the influence, among the noble lines of architecture, of the rent and the rust, the fissure, the lichen and the weed . . . There *is no* stone drawing, no vitality of architecture like Prout's" (*Modern Painters* I vii p.31). His studio sale was held at Sotheby's, 19-22 May 1852. For works illustrated by, see VAM Card Cat.

Bibl: AJ 1849 p.76; 1852 p.75 (obit.); 1857 p.337; Art Union 1872; J. Ruskin, *Modern Painters, passim*, Academy Notes *passim* and *Notes on S.P. and Hunt*, 1879; Redgrave, Dict., Cent.; Roget; Binyon; Cundall pp.86, 246; DNB; Hughes; Connoisseur XXXIX 1914 pp.75, 78, 142; XLIII 1915 pp.59, 62; LXV 1923 pp.83, 86; LXVI 1923 p.74; LXVII 1924 p.72; C.E. Hughes, *S.P.*, OWS VI; J.G. Roe, *Some Letters of S.P.*, OWS XXIV; Studio Special Winter Number 1914-15 pp.1-26; E.G. Halton, *The Life and Art of S.P.*; J. Quigley, *Prout and Roberts*, 1926; VAM; A. Neumeyer, *An Unknown Collection of English Watercolours at Mills College*, 1941; Williams; Hardie III pp.4-11 *et passim* (pls.5-7); Maas; Irwin; Staley.

PROUT, Samuel Gillespie 1822-1911
An amateur painter. He was the only son of Samuel Prout (q.v.) and a friend of Ruskin, W. Hunt, B.R. Haydon (qq.v.) and others.
Bibl: Hardie.

PROVAN, Miss Elizabeth G. fl.1884-1892
Exhib. four paintings of flowers at the RA. Address in Glasgow.

***PROVIS, Alfred** fl.1843-1886
Domestic genre painter. Exhib. at RA 1846-76, BI, SS and elsewhere. He specialised in small, detailed interiors of cottages and farmhouses, with women and children doing household chores. His pictures are usually small, and predominantly brown in colour, his style and subject matter shows affinity to T. Webster and the Cranbrook Colony (qq.v.). Works by him are in the VAM and Aberdeen AG.
Bibl: AJ 1859 p.81; 1860 p.78; City of Nottingham AG Cat. 1913.

PRYCE, Thomas Edward fl.1882-1900
Painted views of architecture. Exhib. eight works at the RA including views in Montgomeryshire, Oswestry and Barmouth. London address.

PRYDE, James Ferrier 1866-1941
Painted figurative and architectural subjects. Studied at the RSA Schools and in Paris under Bouguereau. Designed posters with his brother-in-law William N.P. Nicholson (q.v.). Born in Edinburgh. Lived in London.
Bibl: Studio XXIII 1901 p.102ff.; LXIV 1915 p.233; LXVIII 1916 p.54; LXIX 1917 p.109; Caw; Apollo XII 1930 pp.351-8; Derek Hudson, *James Pryde*, London 1949; Maas.
Exhib: London, Leicester Galleries 1933; Great Britain Arts Council 1949.

PRYNNE, Edward A. Fellowes- RBA 1854-1921
Painted portraits and genre subjects. Studied in London, Antwerp, Florence and Paris. Exhib. four works, two designs for panel decorations and one stained glass design plus 'The Desire of All Nations', at the RA. London address.
Bibl: Bate; Who Was Who 1916-28.

PRYTERCH, Thomas b.1864 fl.1901
Painted architecture. Studied at the Slade School. Exhib. a view of a monument in Wroxester church at the RA. Address in Wroxester Shrewsbury, Salop.
Bibl: Rees, *Welsh Painters*, 1912.

PUCKLE, Miss Ethel M. fl.1885
Exhib. a painting of christmas roses at the RA. Address in Sutton, Surrey.

PUDDICK, J.E. fl.1851
Exhib. 'On the Road near Sandgate' at the BI. London address.

PUGHE, Miss Buddig Anwylini b.1857
Painted landscape and portraits. Also a miniaturist. Studied at the Liverpool School of Art, also in Paris and Rome. Painted in France, Spain and Italy. Member of the Liverpool Academy of Arts. Born and lived at Aberdovey, Merionethshire.
Bibl: Studio XXIV 1902 p.137; LXVII 1916 p.266; Rees, *Welsh Painters*, 1912.

PUGIN, Peter Paul fl.1871-1879
An architect who painted landscape. Exhib. seven works at SS including 'Hay Field at Borth, N. Wales' and 'At Broadstairs', and one work, 'Below Bridge', at the RA. London address. Manuscripts relating to him are held at VAM.

PULLEN, T.W. fl.1832-1842
An architect who exhib. several views of buildings at the RA including 'Mosque at Agra' and 'Interior of Holy Cross Abbey, Killarney'. London address.

PULLER, John Anthony fl.1821-1867
Landscape and genre painter. Exhib. at RA 1821-62, BI and SS. At first painted mostly landscape, and views on the Thames. Later turned increasingly to rustic genre, e.g. 'The Sailor's Return', 'Cottage Children', 'The Gipsy's Tent', etc. Many of his compositions were used by George Baxter (q.v.) in his books of Baxter prints. Often painted small pairs of pictures, sometimes oval or circular in shape.

PULVERMACHER, Miss Anna fl.1882-1887
Painted figures. Exhib. three works at SS including 'Alice in Wonderland' and 'Maiden Meditations', and two works at the RA. London address.

PURCELL, Mrs. M.C. fl.1880
Exhib. a view in Eastbourne at SS. London address.

PURCELL, P.V. fl.1846-1850
Painted landscape. Exhib. five works at the RA, including views near Bexley, and a sketch at Wimbledon at SS. Address in Merton.

PURCHAS, Thomas J. fl.1879-1891
Painted landscape. Exhib. four works at the RA including 'Above the Lock' and 'Across the Common' and 'A Bend of the River' at SS. London address.

PURCHASE, Alfred fl.1874-1889
Exhib. one work, 'Serpentine Rocks', at the RA, and another at SS. Address in Fishguard, Wales.
Bibl: Brook-Hart.

PURDAY, Miss Sarah T. fl.1845-1847
Exhib. two portraits at the RA and one at SS. London address.

PURKIS, Miss A.B. fl.1875
Exhib. a watercolour entitled 'Dorothea' at SS. London address.

PURSER, Miss Sarah H. RHA 1848-1943
Painted portraits. Exhib. two portraits at the RA. Founded Friends of the National Collections of Ireland. Lived in Dublin.
Bibl: Studio XXIII 1901 p.125; XXVIII 1903 p.291; LXIV 1915 p.288; LXVIII 1916 p.283.

PURTON, Cecil P. fl.1871-1876
Exhib. a landscape at SS. Address in Bridgnorth, Salop.

PURVES, Miss C.J. fl.1881-1885
Exhib. two paintings of flowers at the GG. London address.

PUTT, Miss Hilda fl.1898
Exhib. a work entitled 'The Good Book' at the RA. Address in Newcastle-upon-Tyne.

PYBUS, H. fl.1839
Exhib. four works, including two watercolours of game at SS. London address.

PYBUS, W. fl.1836-1839
Exhib. two works at SS, including a portrait. Also exhib. at the BI. London address.

PYE, Miss A. fl.1859
Exhib. a work entitled 'Waiting for a Customer' at the BI. London address.

PYE, William fl.1881-1899
Painted marines and coastal landscape. Exhib. 13 works at SS including 'A Quiet Evening: Dorset Coast', 'A Study in Weymouth Harbour' and 'West Coast of Portland', and three works at the RA. Address in Weymouth, Dorset.

PYKE, Mary fl.1888
Exhib. a painting of a courtyard at the GG. London address.

PYNE, Miss Annie C. fl.1886-1892
Exhib. five works at SS, including two watercolours of chrysanthemums and 'A Bit on the Heath', and eight works at the NWS. London address.

PYNE, Charles b.1842 fl.1861-1880
Landscape painter. Exhib. mainly at SS, once at RA in 1864, and occasionally elsewhere. Title of RA picture: 'Windsor Castle from Romney Island'. A watercolour by him is in the VAM.
Bibl: Cat. of National Gallery of British Art VAM 1908.

PYNE, Charles Claude 1802-1878
Landscape, genre and architectural painter. Exhib. two pictures at RA in 1839, and one at BI in 1836. RA titles: 'Hall at Bridgefoot, Surrey' and 'Back of Abbots Hospital, Guildford'.
Bibl: Bryan; Cundall p.247; Cat. of National Gallery of British Art VAM 1908.

PYNE, Miss Eva E. fl.1886-1893
Painted landscape and flowers. Exhib. eight works at SS including 'Primulas' and 'In the Meadow'. London address.

PYNE, George ARWS 1800-1884
Landscape, architectural and genre painter, mostly in watercolour. Particularly known for views of Oxford colleges. Son of William Henry Pyne; son-in-law of John Varley (q.v.). Exhib. at OWS, and SS, ARWS 1827-43. He wrote several books on drawing and perspective. Works by him are in the National Gallery, Dublin, and the VAM.
Bibl: Connoisseur LIV 1919 p.52; Roget; Cat. of the National Gallery of British Art VAM 1908.

***PYNE, James Baker RBA 1800-1870**
Landscape painter and watercolourist. Born in Bristol, where he worked as a self-taught local artist up to the age of 35. While in Bristol he gave painting lessons to W.J. Müller (q.v.). Moved to London 1835. Exhib. at RA 1836-55, BI, SS (206 works) and NWS. Member of RBA 1841, later Vice-President. In his early period he painted views and scenery around Bristol, but after 1835 he travelled in Italy and on the Continent, gathering material to work up into finished pictures. He was an admirer and imitator of Turner; his dramatic effects and use of pale yellow tones distinctly reflect Turner's influence. He was a methodical artist, and numbered as well as dated all his oil paintings. The MSS of his *Picture Memoranda is* in the VAM. His studio sale was held at Christie's, 25 February 1871.
Bibl: AJ 1849 p.212; 1856 pp.205-8; 1870 p.276; Connoisseur LVI 1920 p.225; LXXXIII 1929 pp.331, 371; Studio LXXXIII 1922 pp.239-40; Studio Special Number 1919, *British Marine Painting*; Studio Special Number 1919, *Early English Watercolours by the Gt. Masters*; Studio Special Number Winter 1922-3, *Masters of Watercolour Painting*; Redgrave Dict., Cent.; Roget; Binyon; Cundall; DNB; Hughes; VAM; Reynolds, VP pp.16, 28 (pl.l2); Hardie III pp.55-6 (pls.75-6); Maas pp.34, 44.

PYNE, Thomas RI RBA 1843-1935
Landscape painter and watercolourist; son and pupil of J.B.Pyne (q.v.). Exhib. at RA 1874-93, SS (110 works) NWS and elsewhere. Titles at RA all English landscapes, and a few continental, e.g. 'Interior of Andernach', 'A Venetian Courtyard', etc.
Bibl: Who's Who 1914, 1924; The Year's Art 1928 p.515.

PYNE, W.B. fl.1878-1879
Exhib. three watercolours, including views in Marlow and Cookham Dene, at SS. London address.

QUARTREMAINE, G. William 1858-1930
Exhib. two paintings of game 1881-2. Address in Stratford-upon-Avon, Warwickshire. Examples are in Coventry AG.

QUERANGAL, Mlle. Y. De fl.1876
Exhib. a work entitled 'Saxifrage' at SS. London address.

QUESTED, George R. fl.1895-1899
Exhib. bookplates, illustrations to Tennyson and a work entitled 'Fame and Death', at the RA. London address.

QUICK, Miss Edith P. fl.1900
Exhib. a work entitled 'On the Shore at Rye' at the RA. Address in Guildford, Surrey.

QUICK, Richard fl.1884-1886
Exhib. two works, 'Bavarian Blacksmith' and 'After Dinner', at SS. London address.

QUILTER, Harry 1851-1907
Art critic, writer, collector and amateur artist. Exhib. 11 landscapes 1884-92. Also exhib. at Dudley Gallery in 1894 and 1908. Among his many books was *Preferences in Art, Life and Literature,* 1892. His art criticism frequently aroused the hostility of Whistler, whose house in Chelsea, White House, he bought in 1879.
Bibl: DNB 2nd Supp.

QUINNELL, Cecil Watson RBA RMS 1868-1932
Painted portraits, miniatures and figurative subjects. Born and educated in India. Trained for an army career. Resigned his commission in 1890, at which time he took up painting.
Bibl: Who's Who; G.C. Williamson, *History of Portrait Miniatures,* 1904; Connoisseur XC 1932 p.346.

QUINSAC, Charles fl.1878
Exhib. three charcoal drawings in 1878. Address in Liverpool.

QUINTON, Alfred Robert fl.1853-1902
Landscape painter. Exhib. mainly at SS, also at RA 1879-1902, NWS and elsewhere. In 1902 he illustrated two articles in the *Art Journal* on the Wye Valley and Wharfedale.
Bibl: AJ 1902 p.37ff., p.233ff.; The Standard V 11 April 1910.

RABEUF, Hippolyte fl.1893
Exhib. a work entitled 'The Carpet Mender' at the RA. London address.

RACHEL, Mme. fl.1886
Exhib. a figurative subject at the NWS. Address in Milan.

RACKHAM, Arthur VPRWS 1867-1939
Illustrator of fantastic tales and children's books, in black and white and watercolour. Entered the Lambeth School of Art in 1884, where fellow students were Charles Ricketts, Leonard Raven-Hill (qq.v.) and Thomas Sturge Moore; particularly influenced by the former. At the same time, 1885-92, worked as a clerk in an insurance office. From 1884 contributed illustrations to the cheaper illustrated papers, e.g. *Scraps, Pall Mall Budget,* and in 1892 joined the staff of *The Westminster Budget,* his drawings forming a remarkable record of life and the well-known personalities of the 1890s. From 1893 he became increasingly occupied with book illustrations; two of his early books were *The Ingoldsby Legends,* 1898 (revised ed.1907) and Charles and Mary Lamb's *Tales from Shakespeare,* 1899 (revised ed.1909); however, he became famous with *Grimm's Fairy Tales,* 1900 (revised ed.1909), *Rip Van Winkle,* 1905 and an exhib. held at the Leicester Galleries in 1905. Hardie notes that in these books he showed "the full measure of his exquisite fancy and fertility of imagination coupled with unusual technique and a rare quality of line and tone". He also illustrated, among many others, J.M. Barrie's *Peter Pan* in *Kensington Gardens,* 1906; Shakespeare's A *Midsummer Night's Dream,* 1908; Swift's *Gulliver's Travels,* 1909; Hans Andersen's *Fairy Tales,* 1932; and Kenneth Grahame's *The Wind in the Willows,* 1940. He also exhib. many watercolour landscapes, not conceived as book illustrations, at the OWS, NWS and RA from 1888, and became ARWS in 1902, RWS in 1908. His collected works were shown in 1912 at the Société Nationale des Beaux-Arts, Paris, of which he was elected an Associate. Master of the Art Workers' Guild, 1919. Designed the scenery and costumes for *Hansel and Gretel,* Cambridge Theatre, 1934. A memorial exhib. was held at the Leicester Galleries in 1939. For works illustrated by, see VAM Card Cat.
Bibl: Derek Hudson, *Arthur Rackham: His Life and Work,* 1960, repr. 1974, (contains full bibl. and list of books and periodicals Rackham illus.); Hardie III pp.147-8 (pl.171); Jennifer Phillips, *The Arthur Rackham Collection in the University of Texas,* Austin 1971; Fred Gettings, *Arthur Rackham,* 1975. Exhib: London, Leicester Galleries, 1935.

RACKHAM, W. Leslie 1864-1944
Painted landscape and marines. in watercolour. He lived in Norfolk and specialised in views of the Norfolk Broads.

RADCLIFF, Miss Anna fl.1841-1842
Exhib. four landscapes at SS and a view near Dover at the RA. Address in Dover, Kent.

RADCLIFFE, Radcliffe W. fl.1875-1895
Landscape painter. Lived at Dorking and Petersfield. Exhib. at RA 1879-95, SS, NWS, GG and elsewhere. Titles at RA 'December', 'After the Storm', 'A Lonely Shore', etc. and some rustic genre, e.g. 'Feeding Poultry', etc.

RADCLYFFE, Charles Walter 1817-1903
Birmingham landscape painter; son of William Radclyffe, an engraver. Exhib. at RA 1849-81, BI, SS, NWS and elsewhere. Titles at RA 'The Path Through the Wood', 'Sketch from Nature', etc. A watercolour by him is in the VAM.
Bibl: Bryan; DNB.

RADCLYFFE, William, Jnr. **1813-1846**
Painted portraits. Exhib. two paintings of fruit at SS and two portraits at the RA. Born in Birmingham. Died in London. He was the son of William Radclyffe (1796-1855), and the brother of Charles Walter Radclyffe (q.v.). His portrait of David Cox is in the NPG.
Bibl: Ormond.

RADFORD, Edward **ARWS** **1831-1920**
Genre painter and watercolourist. Exhib. at RA 1867-90, SS, OWS and elsewhere. Titles at RA mostly military subjects, e.g. 'From the Camp', 'Pour l'Honneur', etc. Specialised in highly detailed watercolours of interiors, usually with a female figure.

RADFORD, James **fl.1841-1859**
Landscape painter. Exhib. at RA 1841-59, BI and SS. Titles at RA include views in Yorkshire, North Wales and the Thames; also some Italian views.

RAE, Cecil W. **fl.1889-1893**
Is supposed to have exhib. two portraits at the RA. London address.

RAE, Miss Henrietta **see NORMAND, Mrs. Ernest**

RAE, Miss Iso **fl.1891-1893**
Exhib. a work entitled 'A Wet Market Day' at SS. London address.

RAE, Miss Mary **fl.1879-1887**
Exhib. a work entitled 'Monica: A Portrait' at the RA, and another work at the NWS. London address.

RAFFEL, Charles **fl.1872-1874**
Exhib. two works, 'Solitude' and 'Morning Hour', at the RA, 1874, and a landscape in 1872. London address.

RAFTER, H. **fl.1856**
Exhib. a sporting subject in 1856. Address in Coventry, Warwickshire.

RAGGIN, Miss E. **fl.1858**
Exhib. a work entitled 'Sunset' at the RA. London address. Also spelt Raggi in the RA Catalogue.

RAGGIO, Guiseppe **fl.1877-1878**
Exhib. a work entitled 'Mandra di Cavalli' at SS. London address.

RAGON, Adolphe **fl.1872-d.1924**
London marine painter. Pupil of Lionel B. Constable (q.v.). Exhib. at RA from 1877, SS, NWS and elsewhere. Titles at the RA 'In the Channel', 'Rochester by Moonlight' and other harbour and coastal scenes. Lived in the area of Willesden and Cricklewood, and later retired to Felsted, Essex.
Bibl: Connoisseur LXX 1924 pp.57ff., p.116 (obit.); Brook-Hart.

RAHE, Charles T. **fl.1867**
Exhib. a landscape in 1867. London address.

RAILTON, F.J. **fl.1846-1866**
London landscape painter; lived in Chelsea. Exhib. at RA 1847-63, BI and SS. Titles at RA 'An English Village', 'A Woodland Cottage', 'The Port of London', etc., and views in Surrey and Kent.

RAILTON, William **fl.1829-d.1877**
Exhib. views of buildings, including Ripon Cathedral, houses in Leicestershire and Lincolnshire, and a view of the Nelson Column, Trafalgar Square, at the RA. London address.
Bibl: AJ 1878 p.16; DNB XLVII 1896.

RAIMBACH, David Wilkie **1820-1895**
Painted portraits. Exhib. 17 works at the RA, 16 of them portraits, possibly miniatures, and six works at SS, including a scene from *Romeo and Juliet*. Born in London. Died in Birmingham. He was the son of the miniaturist Abraham Raimbach, 1776-1843. His daughter, Emma Harriet (q.v.) was also a painter. David Wilkie (q.v.) was his godfather. A David L. Raimbach is also recorded as working in Birmingham 1895-1901, presumably another member of the family.
Bibl: DNB; BM Cat. of Engraved British Portraits; Strickland.

RAIMBACH, Emma Harriet **1810-c.1882**
She was the painter daughter of David Wilkie Raimbach (q.v.).
Bibl: Ormond.

RAINBOW, W.C. **fl.1883**
Exhib. a landscape at the NWS. London address.

RAINCOCK, Miss Sophia **1808-1890**
Painted figurative subjects. Exhib. five works at SS including 'A Girl with Pigeons' and 'Group in a Church Porch', and two works at the RA. Address in Rome.

RAINEY, H. William **RI** **1852-1936**
Genre and landscape painter, and watercolourist. Studied RA Schools. Exhib. at RA from 1878, SS, NWS and elsewhere. Titles at the RA 'The Mill House', 'The Widower', 'A Dutch Auction', etc. Works by him are in Leeds AG and the National Gallery, Melbourne. For works illustrated by, see VAM Card Cat.
Bibl: Who's Who 1924.

RAINFORD, E. **fl.1850-1864**
Painted Shakespearian and Italianate subjects. Exhib. three works at the RA, including a scene from *Cymbeline* and three works at the BI, including 'Hotspur and the Courtier' and 'Group of Olive Trees, Coast of Sicily'. London address.

RAINGER, Gus. **fl.1871**
Exhib. a work entitled 'The Titmouse' at SS. London address. This is probably the same as W.A. Rainger (see below).

RAINGER, William Augustus **fl.1866**
Exhib. two works, 'The Coming Shower, with Cobham Hall in the Distance' and 'The Young Angler', at SS. London address.

RAJON, A. **fl.1890**
Is supposed to have exhib. a painting of shipping at the RA. London address.

RALFE, Mrs. E. **fl.1892**
Exhib. two works, 'A Surrey Cornfield' and 'Spring Time' at SS. London address.

RALLI, H. **fl.1882-1883**
Exhib. two genre subjects at the GG. London address.

RALSTON, William **1848-1911**
Illustrator and author. Exhib. four works 1875-81. Born in Dumbarton. Died in Glasgow.
Bibl: Caw; The Year's Art 1912 p.426.

RAM, Miss Jane A. **fl.1892-1900**
Painted flowers and figurative subjects. Also sculpted. Exhib. five works at the RA including 'A Corner in the Bazaar' and 'Delphinium', and two works, probably sculptures, at SS. London address.

RAMIE, C.W. fl.1885-1888
Exhib. three works, including 'Backwater; Ripley, Surrey' and 'Study in Coombe Wood', at the RA, and three works at SS. Address in New Malden, Surrey.

RAMIÉ, Marian fl.1886
Exhib. two paintings of flowers at SS. Address in New Malden, Surrey.

RAMSAY, David b.1869
Painted landscape watercolours. Studied at Glasgow School of Art. Born at Ayr. Lived in Greenock, Renfrewshire, where he was art master at the academy.

RAMSAY, Miss Eleanor fl.1898-1902
Exhib. two works, 'Ploughing' and 'A London Sunset', at the RA. London address.

RAMSAY, Miss F.L. fl.1890-1893
Exhib. two paintings of flowers, 1890-3. Address in Beaumaris.

RAMSAY, James 1786-1854
Portrait, historical and genre painter. Exhib. at RA 1803-54, BI and SS. Many of his patrons were from Newcastle and the north-east, and after 1846 he settled in Newcastle, where he died. Among his many sitters were Thomas Bewick and Earl Grey; most of his portraits were members of northern landowning families.
Bibl: Connoisseur XLIX 1917 p.85ff.; Print Collector's Quarterly 12 1925 p.184; DNB; BM Cat. of Engraved British Portraits VI 1925 p.532ff.; Ormond; Hall.

RAMSDEN, Thomas fl.1883-1893
Painted figurative subjects and landscape. Exhib. seven works at SS including 'Cattle: Evening', 'Looking South, Robin Hood's Bay' and 'Junior Clerks', and a painting of peonies at the RA. Address in Leeds, Yorkshire.

RAMSEY, George S. fl.1896-1903
Painted landscape. Exhib. three views in the Lledr Valley and two other landscapes at the RA. Address in Buxton, Derbyshire.

RAMSEY, J. fl.1887
Exhib. a work entitled 'Twilight in Rio Harbour' at SS. London address.

RAND, J. fl.1840
Exhib. a portrait of Mrs. Stevenson, 'The Lady of the American Minister', at the RA. London address.
Bibl: BM Cat. of Engraved British Portraits.

RANDAL, Charles fl.1892
Exhib. two works, 'Steps to the River' and 'Estelle', at the RA. London address.

RANDAL, Frank fl.1887-1901
Exhib. two landscapes in France and a view on the Grand Canal, Venice, at the RA. London address.
Bibl: Staley pls. 87a, 87b.

RANDALL, John fl.1864-1874
Exhib. three watercolours, 'Leisure', 'After-Thoughts' and 'Dessert', at SS. London address.

RANDALL, Richard J. fl.1895
Exhib. a work entitled 'The Old Mill' at the RA. Address in Hertford.

RANDELL, James fl.1849-1864
Painted landscape. Exhib. seven works at the RA, including 'A Scene on the Conway, North Wales' and 'The Val d'Aosta, Piedmont', and five works, including three views in Norway, at the BI. London address.

RANDLE, Florence fl.1879-1880
Exhib. two paintings of birds 1879-80. Address in Plymouth, Devon.

RANDOLPH, Edmund fl.1875
Exhib. a landscape in 1875. London address.

RANDS, Miss Sarah E. fl.1896-1902
Painted figurative subjects. Exhib. four works at the RA including a portrait and works entitled 'The Nursery Window' and 'A Question of Taste'. Address in Northampton.

RANGER, Miss fl.1847
Exhib. paintings of the head of Christ and the head of Ruth at the BI. London address.

RANKIN, A. Scott fl.1892
Exhib. a work entitled 'The Crofter's Cow' at the RA. Address in Edinburgh.

RANKIN, Mary fl.1880
Exhib. two figurative subjects in 1880. London address.

***RANKLEY, Alfred 1819-1872**
Genre and historical painter. Pupil of RA Schools. Exhib. at RA 1841-71, BI and SS. Painted historical genre; often from Scott and Johnson, and domestic scenes, e.g. 'The Lonely Hearth', 'The Evening Sun', etc. His best known work is 'Old Schoolfellows', RA 1854, which shows "that clarity of anecdote and simplicity of moral appeal which was the strength as well as the limitation of mid-Victorian subject painting" (Reynolds). His studio sale was held at Christie's, 3 February 1873.
Bibl: AJ 1873 p.44; Redgrave, Dict.; DNB; Reynolds, VP pp.110-11 ('Old Schoolfellows' pl.62); Wood, Panorama; Wood, Paradise Lost.

RANSOM, George fl.1899-1904
Painted rural subjects. Exhib. four works, including a painting of flowers and works entitled 'The Way to the Village' and 'An Old Farm Pond', at the RA. Address in Farnham, Surrey.

RANWELL, W. fl.1830-1843
Exhib. two landscapes at the RA, and one, a view in Borrowdale, Cumberland, at SS. Address in Woolwich, Kent.

RAPER, Miss Anne fl.1838
Exhib. a view on the Rhine at the RA, a sketch in a forest at the BI, and a work entitled 'Early Morning' at SS. London address.

RAPHAEL, Mrs. Arthur (Mary F.) fl.1889-1915
Painted portraits, landscape and genre subjects. Exhib. seven portraits 1889-93. Also painted large historical and romantic subjects. London address.
Bibl: RA Pictures 1896 p.134; AJ 1899 pp.257-9; 1905 p.132; Daily Graphic 12 July 1912.

RAPHAEL, W. fl.1877-1878
Exhib. a painting of game and still-life at SS. Address in Manchester.

RASELL, Robert fl.1868-1880
Exhib. three works, 'The Boat Builders', 'Evening Grey' and a watercolour entitled 'On the Arun', at SS. Address near Chichester, Sussex.

RASINELLI, Robert fl.1881
Exhib. a landscape in 1881. Address in Rome.

RASSANO, C. fl.1878
Exhib. a landscape in 1878. Address in Paris.

RATH, B. fl.1862
Is supposed to have exhib. a landscape in 1862.

RATHBONE, Harold Steward 1858-1929
Exhib. six portraits at the GG. Address in Liverpool. Founder of the Della Robbia pottery in Birkenhead.

RATHJENS, William 1842-1882
Painted flowers. Exhib. two paintings of flowers at the RA. Address in Withington.
Bibl: The Year's Art 1883 p.229.

RATTRAY, Alexander Wellwood RSW ARSA 1849-1902
Scottish landscape painter and watercolourist. Lived mostly in Glasgow. Exhib. at RA 1883-98, GG, RSA, RSW and elsewhere. Subjects almost entirely Scottish scenes. Typical RA titles 'In the Heart of the Highlands', 'Summer Evening, Isle of Arran', etc. Caw writes of his works ". . . forceful rather than robust, and . . . attracted attention more from their size and a certain peculiarity in colour than from any deeper qualities".
Bibl: Who Was Who 1897-1915, 1929; The Year's Art 1903 p.317; Caw p.303.

RAUDNITZ, Albert fl.1883
Exhib. a portrait at the RA and a work entitled 'Yard in a Small South German Town' at SS. London address.

RAUH, W. fl.1839
Exhib. a work entitled 'The Covetous Boy' at the BI, and another figurative subject at the RA. London address.

RAVEN, Jane A. fl.1868-1878
Exhib. five landscapes 1868-78.

***RAVEN, John Samuel** 1829-1877
Landscape painter; son of Thomas Raven, an amateur watercolourist. Exhib. at RA 1849-77, BI, SS and elsewhere. RA titles mostly views in Sussex, Wales and Scotland. Also visited Switzerland. A self-taught artist, he was influenced by Constable's visions of English countryside, and also by Pre-Raphaelite techniques.
Bibl: AJ 1874 p.212; 1877 p.309 (obit.); Redgrave, Dict; Staley; Wood, Paradise Lost.

RAVEN-HILL, Leonard see HILL, Leonard Raven

RAVENHILL, Miss Anna fl.1878-1884
Exhib. three watercolour views in Westminster Abbey at SS. London address.

RAVENHILL, Miss Margaret F. fl. 1880-1900
Exhib. two watercolours, one a view of Bath Abbey, at SS. London address.

RAVENSCROFT, P. fl.1871
Exhib. a landscape in 1871. London address.

RAVENSHAW, Miss Edith L. fl.1896
Exhib. a view of the Sound of Iona at the RA. London address.

RAWDON, J. Dawson fl.1842
Exhib. a view of S. Donato in Murano at the RA.

RAWLE, John Samuel fl.1870-1887
Landscape painter and watercolourist. Teacher at the Government School of Design, Nottingham. Exhib. at RA 1870-87, SS, NWS and elsewhere. Titles at RA 'Evening', 'A Home in Surrey', 'The Village of Ross, Berwickshire', etc., and coastal scenes.

RAWLENCE, Frederick A. fl.1886-1904
Exhib. a study in 1886. Address in Salisbury, Wiltshire.

RAWLINGS, Ada fl.1881
Exhib. a watercolour entitled 'Summer Glories' at SS. London address.

RAWLINGS, Alfred 1855-1939
Painted landscape and flowers in oil and watercolour. Born in London. Lived in Reading, Berkshire. For works illustrated by, see VAM Card Cat.

RAWLINGS, J. fl.1855-1861
Exhib. a work entitled 'The Cottage Door' at the RA. London address.

RAWLINGS, W. fl.1863
Exhib. a painting of the head of an Arab at SS. London address.

RAWLINS, E.S. fl.1867
Exhib. a work entitled 'At the Foot of Cader Idris' at the BI. London address.

RAWNSLEY, Mrs. Edith fl.1882-1884
Exhib. a work entitled 'A Bit of Helvellyn' at the RA. Address in Ambleside, Westmoreland.

RAWSTORNE, Edward fl.1865-1899
Painted landscape. Exhib. two works, a view on the Thames near Isleworth and a landscape on Jersey, at the RA, and four works at SS. London address.

RAY, John b.1815
Painted portraits. Lived in Sunderland, County Durham. Represented Sunderland AG.
Bibl: Hall.

RAY, W. David fl.1883-1885
Exhib. three works, including 'An Orchard Solitude' and 'Bordering the Woods', at SS. London address.

RAYMENT, Robert fl.1875-1885
Exhib. two views, near Hastings and Margate, at SS. London address.

RAYNER, Miss Frances fl.1861
(Mrs. Coppinger)
Exhib. a watercolour view of a church in Antwerp at SS. Address in Brighton, Sussex. Daughter of Samuel Rayner (q.v.).

***RAYNER, Miss Louise J. 1832-1924**
Architectural and topographical painter and watercolourist. Daughter of Samuel Rayner (q.v.). Exhib. at RA 1852-86, BI, SS, NWS and elsewhere. She painted churches, church interiors, old buildings, town views in England, Wales and northern France. Best known of the Rayner family of artists.
Bibl: Clayton I p.383ff.; see also under Samuel Rayner; Ormond.

RAYNER, Miss Margaret fl.1866-1890
Exhib. two watercolours, and another work, all views of architecture. Address in St. Leonard's on Sea, Sussex. She was a member of the Society of Lady Artists. A daughter of Samuel Rayner (q.v.).

RAYNER, Miss Nancy OWS fl.1848-1855
Exhib. three works, two portraits of children and a work entitled 'The Italian Mendicant', at the RA, and 15 works at the OWS. London address. A daughter of Samuel Rayner (q.v.).

RAYNER, Richard M. fl.1861-1869
Painted buildings. Exhib. four works at SS, including 'Kingston Harbour, Looking towards Brighton' and 'Kenilworth'. Address in Hove, Brighton. Son of Samuel Rayner (q.v.).

RAYNER, Mrs. Rosa fl.1885
Exhib. a work entitled 'Arbutus' at the RA. London address.

RAYNER, Miss Rose fl.1854-1866
Exhib. three works at the RA, including 'Miss Cathy' and 'Divided Attention', and a portrait and a watercolour at SS. London address. Daughter of Samuel Rayner (q.v.) but gave up painting very early in her career.

RAYNER, Samuel A. fl.1821-1872 d.1874
Architectural painter and watercolourist. Exhib. at RA 1821-64, BI, SS, OWS and elsewhere. Titles at RA mostly English cathedrals and abbeys. His five daughters, Frances, Louise, Margaret, Nancy and Rose, and his son Richard (qq.v.) were all painters.
Bibl: Roget; Bryan; Cundall; DNB.

RAZE, E. fl.1855
Exhib. a painting of flowers in 1855. London address.

REA, Cecil William ROI 1861-1935
Painted portraits and figurative subjects. Studied in Paris and at the RA Schools. Exhib. nine works at the RA, 1890-1904, including 'Fairy Tales', 'A Nymph' and 'In Arcady'. His wife, Constance Halford was a sculptress. Born and lived in London.
Bibl: AJ 1901 p.62; 1909 p.283; Studio XXXIX 1907 p.155; Who's Who 1924.

READ, Charles Carter fl.1890-1902
Painted landscape and foliage. Exhib. three works at the RA including 'Autumn on the Avon' and 'Aspen Poplars', and four works at SS. Address in Birmingham.

READ, David Charles 1790-1851
Painted landscape and rustic subjects. Exhib. seven works at the BI, including 'Barley Rick: Storm' and 'View near Salisbury', six works at SS, and one work entitled 'Boys and Sheep' at the RA. Address in Salisbury, Wiltshire. Represented in the Ashmolean Museum, Oxford.
Bibl: D.C. Read, *A Cat. of Engravings after his Own Designs*, Salisbury 1832; Redgrave, Dict; DNB 1896; Hind, *A Short History of Engraving*, 1911; BM Cat. of Engraved British Portraits.

READ, Edward H. fl.1890-1897
Painted landscape. Exhib. four works at SS, including 'On the Old Quay' and 'On the Marshes'. London address.

READ, G.A. fl.1876
Exhib. a painting of fruit at the RA. Address in Nottingham.

READ, Henry fl.1875-1877
Exhib. two watercolours, 'Abraham of Cleeve' and 'Bell Ringers', at SS. London address.

READ, Herbert fl.1886
Exhib. a view of houses at Barnes Common at the RA. London address.

READ, J. fl.1856-1863
Painted genre subjects. Exhib. four works at the RA, including 'Indolence' and 'A Lover of Art', one work at the BI and five works at SS. London address.

READ, Miss Mary fl.1849-1850
Painted portraits. Exhib. four works, all portraits, at the RA, and three genre subjects, at the BI. London address.

READ, Samuel RWS 1815/16-1883
Architectural painter and watercolourist. Pupil of W. Collingwood Smith (q.v.). Exhib. at RA 1843-72, SS, OWS (212 works) and elsewhere. Painted churches, cathedrals, castles and buildings in England, France and Holland. His studio sale was held at Christie's, 29 February 1884.
Bibl: Portfolio 1883 p.145; Roget; Bryan; Binyon; Cundall; DNB; VAM; Hardie II p.233.

READ, Thomas Buchanan 1822-1872
Painted portraits of Robert Browning and Elizabeth Barrett Browning.
Bibl: Ormond.

READING, Miss C.R. fl.1874
Exhib. two watercolours of fruit at SS. London address.

READING, Mrs. E.C. fl.1874
Exhib. a portrait study at SS.

READING, J., Snr.
Painted a portrait of Charles Dickens.
Bibl: Ormond.

READSHAW, Miss Emily S. fl.1883
Exhib. a painting of wild flowers at the RA. Address in Düsseldorf, Germany.

READY, A. fl.1874-1876
Painted landscape. Exhib. five works at SS, including 'Wreck Ashore Moonlight' and 'Wind and Wave'. London address.

READY, H. J. fl.1845
Exhib. two landscapes at the RA. London address.

READY, William James Durant 1823-1873
Painted marines and coastal subjects. Exhib. three works at the BI, 'Gorlestone Pier, Suffolk', 'Dirty Weather Clearing Off' and 'Coast Scene near Harwich', two subjects at the RA and one watercolour at SS. For some reason his works are signed W.F. Ready. Born in London. Died in Brighton, Sussex.
Bibl: Redgrave, Dict.; DNB 1896; Cundall p.248; Brook-Hart.

REASON, Miss Florence fl.1883-1903

Painted figurative and genre subjects. Exhib. ten works at the RA including 'The Snow Queen', 'Where the Bee Sucks', 'Conspirators' and a scene illustrating a passage in the diary of Samuel Pepys. Also exhib. one work at SS and two at the NWS. London address.

REASON, Robert G. fl. 1897-1902

Painted townscapes and architecture. Exhib. four works at the RA, 1897-1902, including 'An Arch of the Ponte Vecchio, Florence' and 'A Street in Perugia'. Address in St. Ives, Cornwall.

REAY, John fl.1838-1900

Painted a portrait of Grace Darling.
Bibl: Ormond.

RECKITT, Francis William c.1859-1932

Painted landscape. Exhib. five works at the RA, including 'Rough Pasture' and 'A West Country Homestead'. Lived in Rickmansworth, Hertfordshire.

REDDIE, Arthur W.L. fl.1876-1885

Painted flowers and landscape. Exhib. four works, two paintings of flowers and views in Kent and at Barmouth, at the RA, and one work at SS. London address.

REDFARN, W.B. fl.1869-1870

Exhib. a work entitled 'The Stag Defiant' at SS. Address in Cambridge.

REDFERN, Richard fl.1873-1889

Painted landscape. Exhib. six works, including views in the Lake District, at the RA. London address.

REDFORD, George fl.1850-1885

Exhib. a portrait at SS and a work entitled 'Joe Stone's Well in Ombersley Wood' at the BI. Address in Worcester.

REDGATE, Arthur William fl.1886-1901

Nottingham landscape painter. Exhib. at RA from 1886, and SS. He painted the countryside of his native Midlands. Most of his pictures are rustic figures, or farm-workers; he only occasionally painted pure landscape. Titles at RA 'Haymakers', 'The Squire's Daughter', 'A Tea Garden', etc.

REDGRAVE, Miss Evelyn Leslie fl.1872-1888

Landscape painter and watercolourist; daughter of Richard Redgrave (q.v.). Exhib. at RA 1876-87, SS, NWS and elsewhere. Titles at RA indicate she specialised in painting old buildings, e.g. 'The Seat of the Evelyns at Wotton', 'A Bit of Old Kensington', etc. Titles also include farmyard scenes and rustic landscapes.

REDGRAVE, Miss Frances M. fl.1864-1882

Rustic genre painter; daughter of Richard Redgrave (q.v.). Exhib. at RA 1864-82, BI and SS. Titles at RA 'The Whortleberry Gatherer', 'The Keepers', 'The Breadwinner's Return', etc. She wrote a biography of her father in 1891.

REDGRAVE, Gilbert Richard fl.c.1870-1880

Although an architect, he produced some watercolours remarkable for their Pre-Raphaelite detail and colouring. Eldest son of Richard Redgrave (q.v.).

REDGRAVE, J. Fraser fl.1843-1849

Exhib. two works, 'Evening near Penshurst' and 'Going to Market', at SS, and one work at the BI. London address.

***REDGRAVE, Richard RA 1804-1888**

Genre and landscape painter. Entered RA Schools 1826. At first painted historical genre in 18th century costume, but in the 1840s he was among the first to turn to social subjects in contemporary dress, e.g. 'The Seamstress', 'Bad News from the Sea', 'The Governess', etc. Exhib. at RA 1825-83, BI, SS and elsewhere. Elected ARA 1840, RA 1851. His numerous official duties curtailed his output of paintings. He was first keeper of paintings at the South Kensington Museum; took over from Dyce on the national art education project; was Inspector of the Queen's Pictures; and co-author with his brother Samuel of *A Century of Painting,* still a valuable book on English art. The only time he could paint was in the summer at his country house, so his later work is mostly landscape, painted in an intensely brilliant pre-Raphaelite style. For works illustrated by, see VAM Card Cat.
Bibl: AJ 1850 pp.48-9 (autobiog.); 1859 pp.205-7; 1889 p.61; Connoisseur LXXXVIII 1931 p.60, Ruskin, Academy Notes 1855, 1856, 1859; F.M. Redgrave, *Richard R. A Memoir,* 1891; Bryan; Binyon; DNB; The National Gallery of British Art, VAM Cat. of Oil Paintings 1907; Reynolds, VS pp.10, 11, 53 (pl.10); Reynolds, VP pp.91-2, 151-2 (pls.100, 102); Maas pp.113-14 (pls.pp.114, 119); Ormond; Staley; Irwin; Wood, Panorama pls.115, 127, 128, 132-3, 141, 236; Wood, Pre-Raphaelites; Wood, Paradise Lost; Newall; Cat. of Redgrave exhib., VAM and Yale AG, 1988.

REDGRAVE, Mrs. Richard fl.1865

Exhib. a landscape in 1865. London address.

REDMAYNE, Mrs. Nessy J. fl.1894-1896

Painted portraits and genre subjects. Exhib. five works at the RA, including portraits, a self-portrait and a work entitled 'Steps and Stairs'. London address.

REDMORE, E.K. c.1860-1939

Painted marines. He was the son of the marine artist Henry Redmore (q.v.).
Bibl: Brook-Hart pls. 21, 117.

***REDMORE, Henry 1820-1887**

Hull marine painter. Exhib. only two pictures at RA in 1868, 'Fishing Ground in the North Sea' and 'A Calm on the Humber'. Although he worked entirely locally, he attained a high level of competence. His subjects were mostly on the Humber and the Yorkshire coast. He also worked in other parts of England, and probably visited the Continent. The influence of Dutch 17th century painting is apparent in his work, and also that of William Anderson and John Ward (q.v.), both of whom worked in Hull. One of his sons, E.K. Redmore, was also a marine painter (q.v.).
Bibl: Wilson (pl.31); O. & P. Johnson Ltd., London, Cat. of Redmore exhib., March-April 1971; Brook-Hart pl.116.

REDRUP, Sidney fl.1887

Exhib. a work entitled 'Oh! What a Surprise!' at the RA. Address in Windsor, Berkshire.

REDWORTH, William Josiah PS b.1873

Painted landscape. Worked in oil, watercolour and pastel. Studied at Chelsea Art School. Born and lived in Slough, Buckinghamshire.

REED, C.T. fl.1874-1880

Exhib. a view of an old mill at SS. London address.

REED, Edward fl.1890

Exhib. an historical subject at the NG. London address.

REED, Edward Tennyson fl.1885-1892

An illustrator. Exhib. nine historical subjects at the NG. London address.
Bibl: E.T. Reed, *Pre-historic Peeps, from Punch,* 1896.

REED, J. fl.1839-1862
Painted figurative and historical subjects. Exhib. six works at the RA, including 'Giorgione at his Studies' and 'The Tired Model', and one work at SS. London address.

REED, Joseph Charles NWS 1822-1877
Landscape painter, mainly in watercolour. Exhib. once at the RA in 1874, SS and NWS (186 works). Painted views all over England, Wales and Scotland. His works were often large and elaborate; the AJ describes them as "clever but showy".
Bibl: AJ 1878 p.16 (obit.); Cundall p.248; DNB.

REED, Miss Kate fl.1873-1882
Painted birds, flowers and figurative subjects in watercolour. Exhib. nine watercolours at SS including 'Dead Chaffinch', 'Marie' and 'Flowers'. Address in Tunbridge Wells, Kent.

REED, Miss Mary fl.1879-1892
Painted landscape and still-lifes. Exhib. nine works, some of them watercolours, at SS, including 'A Grey Day, Devonshire' and 'A Cornish Nest'. London address.

REED, W.T. fl.1875-1881
Painted landscapes and riverscapes in the Midlands and North Wales. Exhib. 25 works at SS including many views on the River Trent and views in Derbyshire and Yorkshire. Address in Bakewell, Derbyshire.

REEKERS, H. fl.1847
Exhib. a painting of fruit and flowers at the BI. London address.

REES, John fl.1852-1879
Landscape painter. Exhib. mainly at SS; also at BI, and at RA in 1856 and 1868, and elsewhere. Titles at RA 'Spring Flowers' and 'St. George's Hill, Surrey'.

REES, Miss M.R. fl.1865-1872
Exhib. two paintings of fruit at SS and a painting of flowers at the RA. London address.

REEVE, Miss fl.1856
Exhib. a portrait of a dog at the RA.

REEVE, A.W. fl.1831-1848
Painted landscape. Exhib. two works, 'Dover Castle' and 'Hayfield near Margate', at the RA, and four works and an engraving at SS. London address. Represented in the Norwich Castle Museum.
Bibl: Prideaux, *Aquatint Engraving*, 1909.

REEVE, Miss Alice fl.1878-1881
Exhib. a watercolour entitled 'The Valentine' at SS. London address.

REEVE, Hope fl.1879
Exhib. a watercolour view of the Lanarkshire Hills at SS. London address.

REEVE, J. fl.1857
Exhib. a painting of cattle in 1857. London address.

REEVE, R.G. fl.1844-1848
Painted flowers. Exhib. eight works, the majority watercolours of flowers, and two engravings, at SS, and one painting of camellias at the RA. Addresses in Dorking, Surrey and London.
Bibl: Prideaux, *Aquatint Engraving*, 1909; Connoisseur LXXXII 1928 pp.159, 187: Apollo VII 1928 pp.160-3.

REEVES, E. fl.1843
Exhib. a portrait of a lady at SS. London address.

REEVES, E.B. fl.1846
Exhib. a work entitled 'Bringing Up by Hand' at the RA. London address.

REEVES, George H. fl.1882-1884
Painted trees. Exhib. two works, 'Willows' and 'Queen Adelaide Oaks', and a watercolour at SS. Addresses in Leicester and Cheshire.

REEVES, Miss Mary fl.1871-1887
Exhib. two watercolours, one a view of Bantry Bay, at SS, and three works at the NWS. Address in Cork, Ireland.

REID, Archibald David ARSA RSW 1844-1908
Aberdeen landscape painter; brother of Sir George Reid (q.v.), and of Samuel Reid (q.v.), also a landscape painter. Studied at RSA and in Paris. Exhib. at RA from 1872, RSA and RSW. Titles: 'On The Sands', 'A Lone Shore', 'A Yorkshire Moor', etc. In spite of his training, the predominant influence on his work was the Dutch School, as is shown by his subdued tones and grey atmospheric colouring. His subjects were mostly Scottish coastal scenes; he also travelled in Holland, France and Spain.
Bibl: DNB; Who Was Who 1897-1915; Caw p.301ff.

REID, Edith M. fl.1873-1880
Exhib. two watercolours, 'The Day Has Passed unto the Land of Dreams' and 'A Cosy Corner' at SS, and another work at the RA. London address.

REID, Miss Flora Macdonald fl. 1879-c.1929
Scottish genre painter; sister and pupil of John Robertson Reid (q.v.). Exhib. at RA from 1881, SS, GG, NG and elsewhere. Titles at RA 'Our Cinderella', 'The Miller's Frau', 'A Dutch Fishwife', 'Gossips', etc. Works by her are in Leeds, Liverpool, Manchester and Rochdale AGs. Her style is very similar to her brother's. "Her subjects are often drawn from continental market-places, the bargaining or gossiping groups supplying incidental interest, and the black, blue and white costumes, the sunlit houses and shadow chequered pavements, the green trees and the canvas booths scope for her favourite colour-scheme, in which a blueness of tone predominates" (Caw).
Bibl: Caw p.283.

***REID, Sir George** PRSA HRSW 1841-1913
Scottish portrait painter and illustrator. Brother of Archibald David and Samuel Reid (qq.v.). Studied in Edinburgh, Utrecht and Paris. Exhib. at RA from 1877, and at RSA. His vivid and assured style quickly attracted notice, and he soon established himself as Scotland's leading portrait painter. ARSA 1870, RSA 1877. Moved from Aberdeen to Edinburgh in 1884; PRSA and knighted 1891. Retired 1902. "His work tells in virtue of vividness of characterisation, power of expression, and simplicity of design" (Caw). His colours are usually silvery and atmospheric. Among his sitters were most of the distinguished Scotsmen of his day. He also painted landscapes, and drew for illustrations.
Bibl: AJ 1882 pp.361-5; Studio LV 1912 pp.169-78; Sketchley, *English Book Illustration of Today*, 1903; The Royal Scottish Academy 1826-1907, The Studio 1907 Special Number; Caw pp.286-9 *et passim* (pl.p.288); Poole 1912-25; Ormond.

REID, George Ogilvy RSA 1851-1928
Scottish historical genre painter. Born in Leith. Worked as an engraver for ten years before turning completely to painting. Exhib. at RSA from 1872, RA from 1887. ARSA 1888, RSA 1898. Subjects mostly scenes of 18th century social life, e.g. 'The New Laird', 'A Literary Clique', or historical incidents, e.g. 'After Killiecrankie', 'The Prince's Flight', etc. He also painted occasional Wilkie type scenes of homely life.
Bibl: AJ 1893 p.151; 1903 p.123; Studio XLIII 1908 pp.134, 137; Caw pp.271-2 (pl.p.272); Ormond.

***REID, John Robertson RI ROI 1851-1926**
Scottish painter of genre, landscape and coastal scenes. Brother of Flora M. Reid (q.v.). Pupil of G.P. Chalmers and W. MacTaggart (qq.v.). Exhib. at RA from 1877. Painted scenes of rural life, e.g. 'Toil and Pleasure' (Chantrey Bequest 1879), 'A Country Cricket Match, Sussex', etc. and fisherfolk, e.g. 'The Waterman's Wife', 'The Boatman's Lass', 'Pilchard Fishers, Cornwall', etc. Although the content of these pictures is often sentimental, his style is remarkably robust and vigorous, as one might expect from a pupil of MacTaggart. In the 1880s his style began to change. His handling became coarser and more mannered, and his subjects over-dramatic, e.g. 'Shipwreck', 'The Smugglers', etc., but even in this period he was still capable of an occasional brilliant work. Although he lived in England, he knew the Glasgow Boys, and made a notable contribution to the development of the Glasgow School. Several works are in the VAM.
Bibl: AJ 1884 pp.265-8; Connoisseur LXXIV 1926 p.250; R. Muther, *Gesch. d Malerei im 19 Jahr.*, 1893; Caw pp.281-3 *et passim;* Hardie III p.192 (pl.227); Brook-Hart; Wood, Panorama (pl. 194); Wood, Paradise Lost.
Exhib: Fine Art Society 1899.

REID, Miss Lizzie fl.1882-1893
Painter of domestic genre. Graves lists her at the same address as Miss Flora M. Reid (q.v.) so presumably her sister. Exhib. mostly at SS, also RA in 1884 and 1886, GG, NG and elsewhere. Titles at RA 'Over the Sea', 'The Music Lesson'.

REID, Miss Marion fl.1889-1894
Exhib. three works at the RA including 'A Song of Spring' and 'Watching Angels'. London address.

REID, Robert Payton ARSA 1859-1945
Painter and illustrator. Studied at the RSA School, in Munich and in Paris. Born in Edinburgh. Lived in North Queensferry, Fifeshire, and later in Edinburgh.

REID, Samuel 1854-1919
Painted figurative and country subjects. Exhib. eight works at the RA including 'A Woodland Stream', 'Perthshire Pastures' and 'Help!' He was also a poet and an author. His collected poems, *Pansies and Folly-Bells,* were published in 1892. He was the younger brother of Sir George Reid (q.v.). Lived in Glasgow, and later at Chorley Wood, Hertfordshire.
Bibl: Who Was Who 1916-28.

REID, Stephen RBA 1873-1948
Painted portraits, historical and classical subjects. Studied at Gray's School of Art, Aberdeen, and at the RSA Schools. Exhib. three works at the RA including 'The Song' and 'Sanctuary: The Traitor's Children'. Born in Aberdeen. Lived in London. Represented in the museums of Reading and Gloucester.
Bibl: AJ 1898 p.271ff.; Who's Who; R.E.D. Sketchley, *English Book Illustration of Today,* 1903; Connoisseur XXXIX 1914 pp.135, 138; XLVIII 1917 pp.110, 114, 115; LI 1918 pp.109, 111; LXIII 1922 p.112; LXIV 1922 p.252; LXX 1924 p.184.

REID, W. fl.1865-1875
Painted coastal scenes. Exhib. four watercolours at SS including 'On the Yorkshire Coast' and 'Whitby'. London address.

REILLY, Fred fl.1890
Exhib. a landscape in 1890. London address.

REILLY, John Lewis fl.1857-1866
Painted portraits and historical subjects. Exhib. seven portraits, including that of the Bishop of Jamaica, at the RA, four portraits at SS and one work, 'A Roman Matron' at the BI. Lived in London. Travelled to Rome in 1863-4.

REILLY, Nora Prowse fl.1889-1895
Exhib. a work entitled 'A Neglected Garden' at SS and one work at NWS. Studied in Paris. Also worked and exhib. in France and India. London address.

REINAGLE, Baron von fl.1854
Exhib. three portraits at SS. London address.

REINAGLE, Miss H. fl.1824-1862
Painted landscape. Exhib. ten works at the BI including views on the Thames, and three works at SS including a view of the Malvern Hills. London address.

REINAGLE, H. fl.1848
Exhib. two works, a scene on Ham Common and 'A Wooded Scene, painted with R.R. Reinagle, R.A.', at SS. London address.

REINAGLE, Ramsay Richard RA 1775-1862
Painter of landscape, portraits and sporting subjects. Exhib. at the RA (244 works) 1788-1857, amongst his last works including views in the Lake District and other mountainous landscapes and portraits, including that of the inventor of the *Improved System of Logarithms.* Also exhib. 51 works at the BI, the majority pure landscape, and 67 works at the OWS. London address. Represented in the Fitzwilliam Museum, Cambridge, NPG, VAM and the Nottingham AG.
Bibl: Sandby, *History of the RA of Arts,* 1862; AJ 1863 p.16; 1903 p.333ff.; Redgrave, Dict.; Roget; DNB 1896; Bryan; BM Cat. of Engraved British Portraits; Hardie pl.93; Ormond.

REJLANDER, Oscar Gustave 1813-1875
Painter and photographer. Exhib. four works at the RA including 'Oh Yes! Oh Yes! Oh Yes!' and 'His First Cup'. London address. At first he used photography as an aid to painting, but then took up photography full-time, and is now better known as a photographer. He created remarkable allegorical compositions, using several negatives, the most famous being 'The Two Ways of Life'.
Bibl: H. and E. Gernsheim, *The History of Photography,* 1969.

REMDÉ, F. fl.1854
Exhib. a painting of a child with dogs at the RA. He was appointed painter to the Grand Duke of Saxe-Weimar.

RENARD, Edward fl.1879-1896
Painted landscape. Exhib. five watercolours at SS including 'Burford Bridge, Boxhill' and 'Ragwork and Sorrow', and three works at the RA, one a view of Scarborough Castle. Address in Saltaire, Yorkshire.

RENDALL, Arthur D. fl.1889-1904
Painted landscape and figurative subjects. Exhib. six works at the RA including 'Relic of Imperial Rome', 'The Cavalier's Last Masquerade' and 'Now Comes Still Evening On'. London address.

RENDALL, Bessie fl.1896-1904
Exhib. two portraits at the RA 1896-1904. London address.

RENDELL, Joseph Frederick Percy ARCA 1872-1955
Painted marines, landscape and figurative subjects. Studied under Walter Wallis and Julius Olsson (q.v.). Exhib. in London and at the Paris Salon. Born and lived in Croydon, Surrey.

RENNY, Miss M. fl.1872-1873
Exhib. three landscapes 1872-3. London address.

RENOUF, Mrs. fl.1883
Exhib. two works, the second entitled 'A South Tyrol Interior' at SS. London address.

RENOUX, M. fl.1841
Exhib. two works, 'Meditation' and 'The Astrologer of the 16th Century', at the RA. London address.

RENSHAW, Alice fl.1881
Exhib. a watercolour entitled 'Stella' at SS. London address.

RENTON, John fl.1799-1841
Painter of portraits, figurative subjects and landscape. Exhib. 34 works at the RA 1799-1839, amongst the last of these being 'A Westmoreland Beck' and 'Portrait of the author of *Pleasures of Remembrance*'. Also exhib. ten works at the BI, the last in 1832. London address.

RENTON, Miss Lizzie fl.1875-1879
Painted figurative subjects. Exhib. four works, two of them watercolours, at SS, titles including 'Golden Hours' and a scene from *She Stoops to Conquer*. London address.

REVILL, W.H. fl.1868-1870
Painted poultry. Exhib. five works, including 'Cocks and Hens' and 'A Farm House Corner', at SS. London address.

REVILLE, H. Whittaker fl.1881-1903
Exhib. two works, 'A Rat for Bob' and 'The Day of Rest', at SS. London address.

REW, Charles Henry fl. 1878-1884
Painted views of buildings. Exhib. four views of houses in Abbeville, Beauvais, and elsewhere in France. London address.

REW, E. fl.1865
Exhib. a work entitled 'A Catalan Gentleman' at the RA.

REYE, H. fl.1874-1878
Exhib. nine landscapes 1874-8. Address in Paris.

REYMANN, Teodoro fl.1872-1874
Exhib. four watercolours, including 'The Convent Kitchen' and 'Sketch in Rome', at SS. London address.

REYNOLDS, Apollonia fl.1882
Exhib. a watercolour entitled 'Old China' at SS. Address in Guildford, Surrey.

REYNOLDS, Misa Clara fl.1892
Exhib. a work entitled 'A Chimney Corner' at SS. London address.

REYNOLDS, Frank fl.1860-d.1895
Painted country subjects. Exhib. two works at the BI, 'The Gleaner' and 'The New Broom', and two works at SS including a scene from *Twelfth Night*. Addresses in Bedford and London. Possibly the same as the Frank Reynolds who worked in Dublin (q.v.), but not to be confused with the well-known Punch illustrator Frank Reynolds, RI, 1876-1953.
Bibl: Who's Who; Studio XXX 1904 p.42; LIV 1912 p.254ff.; LVIII 1913 p.56; LXXXIX 1925 p.303ff.; AJ 1906 p.107; Connoisseur XXXVII 1913 p.266ff.; 1913 p.75; LXIV 1922 p.264.

REYNOLDS, Frank fl.1860-d.1895
Painted portraits. Studied at the RA Schools. Moved to Dublin in 1860, where he became an established portrait painter. Exhib. at the RHA 1860-75. In his last years he lived in both Scarborough and Brighton. He was the son of Samuel William Reynolds Jnr. (q.v.).
Bibl: Strickland.

REYNOLDS, Frederick George 1828-1921
Landscape painter. Exhib. at RA from 1864, SS and elsewhere. Titles at RA: 'Stacking Hay', 'A Quiet Nook', 'Solitude', etc.
Bibl: The Year's Art 1922 p.313 (obit.); E.A. Vidler, *F.C. Reynolds*, 1923.

REYNOLDS, G.S. fl.1835-1848
Painted figurative, country subjects and fruit. Exhib. four works, including 'The Fortune Teller in the Campagna of Rome' and 'Jersey Cattle Returning from Pasture' at the BI, and nine works including paintings of fruit at SS. He or his wife (q.v.) exhib. five similar subjects at the RA. London address.

REYNOLDS, Mrs. G.S. fl.1835-1848
Graves lists Mrs. G.S. Reynolds, presumably the wife of G.S. Reynolds (q.v.), as an exhibitor at the RA.

REYNOLDS, J. fl.1830-1860
Painted landscape. Exhib. ten works, the majority watercolours, at SS including 'Petersham Sandpits, near Richmond', 'Stanford Mill, Worcestershire' and 'Beeches, Bridgewater Park, Herts', and one work at the RA. London address.

REYNOLDS, Miss M.E. fl.1852
Exhib. a work entitled 'Scene in Westmoreland — Girl and Pony' at the RA. Address in Ambleside, Westmoreland.

REYNOLDS, R. fl.1854-1855
Exhib. two works 'Christ and the Woman of Samaria' and 'A Sister of Mercy' at the BI. London address.

REYNOLDS, Samuel William, Jnr. 1794-1872
Painted portraits and figurative subjects. Exhib. 39 works, all but one portraits, at the RA 1820-45, and five works at the BI including 'Fatal Affection' and 'The Pets'. London address. He was the son of the painter Samuel William Reynolds, 1773-1835, and father of the portrait painter Frank Reynolds (q.v.).
Bibl: DNB 1896; Bryan; BM Cat. of Engraved British Portraits; Poole 1925; Ormond.

REYNOLDS, W. fl.1859
Exhib. two works at the RA including 'The Early Bird that Catches the Worm'. London address.

REYNOLDS, Walter see REYNOLDS, Warwick

REYNOLDS, Warwick fl.1859-1885
Landscape painter. Exhib. at RA 1879-84, SS, NWS and elsewhere. Titles at RA 'Hills near Reigate', 'Brook at Edmonton', etc. and views near Enfield where he lived. Sometimes recorded as Walter Reynolds. Brother of F.G. Reynolds (q.v.).

REYNOLDS-STEPHENS, Sir Wiliiam Ernest 1862-1943
Sculptor and painter of genre and literary subjects. Exhib. two watercolours at SS, an illustration to a line from Walter Scott and a work entitled 'Within the Convents Lonely Walls', and 12 works at the RA. Exhib. exclusively as a sculptor from 1894. Born of British parents in Detroit, U.S.A. Lived in London. His painting 'A Royal Game' is in the Tate Gallery.
Bibl: Who's Who; AJ 1888 p.217; 1900 pp.9-11; 1903 pp.275-9; 1904 p.190; 1908 p.253; Studio XVII 1899 pp.75-85; XXVIII 1903 p.37; XXX 1904 pp.295-302; XXXII 1904 p.159; XXXIV 1905 pp.3-15; XXXV 1905 p.41; XXXVIII 1906 pp.14, 16, 23; XLVII 1909 p.44; L 1910 p.4; LXIII 1915 pp.16-19; LXVI 1916 p.281; LXVIII 1916 p.40; LXXXIII 1922 p.308; The Year's Art 1928 pp.67, 518; Wood, Olympian Dreamers.

REZIA, Felice A. fl.1866-1902
Painted landscapes in Italy and France. Exhib. three works at the BI, two views at Como, Italy and a landscape near Rouen, and four works at SS, landscapes near Rouen and Genoa. Also painted some views in London. London address.

RHEAD, George Wooliscroft RPE 1855-1920
Painted and drew flowers and figures. He was also an etcher. Exhib. nine works at the RA, titles including 'Study of a Poppy', 'Magnolia Grandiflora' and 'Cartoon for an Altarpiece'. Also exhib. five watercolours at SS. London address. For works iliustrated by, see VAM Card Cat.
Bibl: Who's Who; Portfolio 1885, 1886, 1889, 1890, 1892; AJ 1903 pp.246-9; 1911 p.183ff.; Connoisseur LIII 1919 p.230; LVIII 1920 pp.75-82; Studio LXVI 1916 p.138; LXXIX 1920 p.150; Who Was Who 1916-28; The Year's Art 1921 p.45.

RHEAM, Henry Meynell 1859-1920
Painted landscape and figurative subjects in a romantic, late Pre-Raphaelite style. Exhib. ten works at the RA including 'When the Wind Bloweth in from the Sea' and 'Crabbed Age and Youth Cannot Live Together', and another work at SS. Also exhib. three works at the NWS. Address in Birkenhead, Cheshire.
Bibl: Who's Who 1914; Who Was Who 1916-28.

RHODES, F.R. fl.1841-1843
Painted landscape. Exhib. five works at the RA including 'Pheasant Shooting' and a view of Haddon Hall, Derbyshire, and one work at the BI. Address in Handsworth, Staffordshire.

RHODES, H. fl.1869-1871
Exhib. one work 'A Piper' at the RA and a watercolour of almond blossom at SS. London address.

RHODES, H. Douglas fl.1885
Exhib. a watercolour of Wargrave Church at SS. London address.

RHODES, Henry J. fl.1869-1882
Painted flowers and figures. Exhib. four works at the RA including 'Mary! Call the Cattle Home!' and 'An Oatfield', and two works at SS. London address. For works illustrated by, see VAM Card Cat.

RHODES, John fl.1832-1843
Painted portraits. Exhib. nine works at the RA 1832-43 including portraits and figurative subjects. Also exhib. four works at the BI. London address.

RHODES, John Nicholas 1809-1842
Painted animals and genre subjects. Exhib. two works at the RA, two works at SS and four works at the BI including 'Which is the Tallest?' and 'Horses and Donkeys'. London address. Son and pupil of Joseph Rhodes, 1782-1854, of Leeds. He painted a portrait of Baron Macaulay.
Bibl: W.H. Thorp, J.N. Rhodes, 1904; Ormond.

RHYS, Oliver fl.1876-1893
Landscape and genre painter. Exhib. at RA 1880-93, SS, GG and elsewhere. Titles at RA 'Hampstead', 'A Venetian', 'The Dawn of Vanity', etc.
Bibl: AJ 1908 p.316; Academy Notes 1880.

RIBBLESDALE, Thomas, 4th Baron fl.1892
Exhib. a sporting subject at the NG. London address.

RICCI, H. fl.1878
Exhib. a portrait at the GG.

RICE, Frederick A. fl.1893
Exhib. a study of a head. London address.

RICH, Alfred William NEAC 1856-1921
Painted landscape watercolours. Studied at the Westminster School of Art and at the Slade School. Exhib. at the NEAC from 1896. He was much influenced by Peter de Wint. He was the author of Water-colour Painting, published in 1918. Born in Gravely, Sussex. Lived in London and Croydon, Surrey. Died in Tewkesbury, Gloucestershire. Represented: Tate Gallery: VAM; Walker AG, Liverpool, Fitzwilliam Museum, Cambridge.
Bibl: Studio XXV 1902 p.51ff.; LXIII 1915 p.215ff.; LXVI 1916 pp.3ff., 205, 277; LXXIII 1918 p.102; XCI 1926 p.274; Studio Special Number 1917-18 and 1921; AJ 1906 p.368ff.; 1907 pp.149-52; 1908 pp.92, 149; The Standard 16 March 1908; The Times 12 April 1910 and 3 February 1912; Burlington Mag. XXXII 1918 p.206; XL 1922 p.154; LV 1929 pl.11; Connoisseur L 1918 p.57ff.; LXI 1921 p.238; LXII 1922 p.110; Hardie.
Exhib: London, NEAC 1908; Hove, Museum and AG 1933; London, Walker's Gallery 1961.

RICH, Anthony fl.1854
Exhib. three landscapes in 1854. London address.

RICH, Frederick W. fl.1866-1867
Exhib. two landscapes 1866-7. London address.

RICH, William George fl.1876-1884
Painted landscape and genre subjects. Exhib. eight works at SS including 'Sketch at Totnes, Devon', 'Cautious Steps' and 'Old Farmstead near Margate', and one work at the RA. Address in Brentford, Essex.

RICHARD, R. fl.1865
Exhib. a view in Durham. Address in Warwick.

RICHARDS, Miss Aimée G. fl.1893-1894
Exhib. two works, 'Medusa's Hair' and 'A Knight of the Bath', at the RA. London address.

RICHARDS, Albert F. 1859-1944
Painted landscape watercolours. Born at Bridport, Dorset. Lived in Sunderland, County Durham, and painted local scenes. Represented in Sunderland AG.
Bibl: Hall.

RICHARDS, Miss Alice S. fl.1892-1893
Exhib. two works, 'The Relics of an Old Soldier' and 'Old Servants', at SS. London address.

RICHARDS, Miss Anna fl.1898-1902
Painted biblical and figurative subjects. Exhib. four works at the RA, an illustration to a line from the Gospel according to St. Matthew and portraits. London address.

RICHARDS, Charles fl.1854-1857
Painter of animals and rustic genre. Exhib. at RA 1854-57, BI, SS and elsewhere. Titles at RA 'Study of Sheep and Lambs', 'The Bristol Market Woman', 'The Little Cleaner', etc. Lived at Keynsham, near Bath.

RICHARDS, Miss Emma Gaggiotti 1825-1912
Painted portraits and figures. Exhib. eight works at the RA including portraits and a work entitled 'Faith' which was in the collection of Queen Victoria. London address.
Bibl: Ormond.

RICHARDS, Miss Fanny fl.1897
Exhib. a work entitled 'Blossoms and Seeds' at the RA. London address.

RICHARDS, Frank RBA fl.1892-1925
Watercolour painter of landscapes and figurative subjects. Exhib. two works, a view of a church in Hampshire and a work entitled 'Spring and Winter', at the RA. Address in Newlyn, Cornwall.

RICHARDS, George fl.1855-1883
Exhib. a work entitled 'The Suppliant' at the RA and a work entitled 'Meditation' at the BI. London address.

RICHARDS, H. fl.1858
Exhib. a view of the Prince of Wales' Tower at the BI. London address.

RICHARDS, Miss Helena fl.1892
Exhib. a view in St. Ives, Cornwall, at SS. London address.

RICHARDS, Henry fl.1857-1858
Exhib. two views, landscapes at Herne Bay and on Jersey, at the BI. London address.

RICHARDS, J. or T. fl.1837
Exhib. three works including 'A French Labourer and his Friend' at SS. London address.

RICHARDS, Richard Peter 1840-1877
Painted landscapes, mostly incorporating rivers in a style similar to that of B.W. Leader (q.v.). Exhib. 11 works at the RA including views on the Rivers Ribble, Calder and Wharfe, and works entitled 'The Little Truant', 'Gold and Silver' and 'The Glistening River'. Also exhib. three watercolours at SS and one at the BI. Born and lived in Liverpool. Died in Pisa, Italy. Represented in the Walker AG, Liverpool.
Bibl: Marillier.

RICHARDS, W. fl.1838-1841
Exhib. three watercolours, two still-lifes of game and one painting of a parrot, at SS. London address.

RICHARDS, W.S. fl.1871
Exhib. a work entitled 'The Lone Trees; Coast of Jersey' at the RA.

RICHARDS, William Trost fl.1879
A London marine painter. Exhib. a Cornish coastal scene at SS 1879.
Bibl: H.S. Morris, *Masterpieces of the Sea*, 1912.

RICHARDSON, Miss Agnes E. fl.1896
Exhib. two works, one a landscape on Dartmoor and another entitled 'Rough Pasture' at the RA. Address in Lelant, Cornwall.

RICHARDSON, Arthur 1865-1928
Painted watercolour seascapes and river scenes. Exhib. three works 'A Groyne at Leigh, Essex', 'Ryton Church' and 'River Flowing to the Sea!' at the RA. Lived in Northumberland and painted local scenes. He was a member of the Northumberland Richardson family. Represented in the Laing AG, Newcastle.
Bibl: Hall.

RICHARDSON, Charles 1829-1908
Landscape painter and watercolourist. Son of T.M. Richardson Snr. (q.v.). Exhib. at RA from 1855, BI, NWS and elsewhere. Subjects mostly scenes around Newcastle, or landscapes in Yorkshire and Cumberland. About 1873 he moved to London and later to Hampshire. Several works by him are in the Laing AG, Newcastle.
Bibl: Roget II p.283.

RICHARDSON, Mrs. Charles fl.1846
Painted landscape. Exhib. a view in Borrowdale at the RA. She was the wife of Charles Richardson (q.v.), one of the Northumberland Richardsons.
Bibl: Hall.

RICHARDSON, Charles E. fl.1897-1904
Painted genre subjects. Exhib. eight works at the RA 1897-1904, including 'Memories' and 'Cracked'. Address in Yarm, Yorkshire.

RICHARDSON, Charles James 1806-1871
Painted views of architecture and interiors. Exhib. 17 works at the RA including views of the Chapel Royal, St. James's, Holland House, Sutton Place and elsewhere. London address.
Bibl: DNB; AJ 1872 p.48; Charles James Richardson (ed.), *General Description of Sir John Soane's Museum*, Studio Special Spring Number 1915 pp.11, 33.

RICHARDSON, Miss Edith b.1867 fl.1900
Painted landscape and animals. Studied at Armstrong College, Newcastle-upon-Tyne. Exhib. three works including 'The Boy and the Winds' and 'White Butterflies' at the RA. Born in Newcastle. Lived in Hertford.
Bibl: Hall.

RICHARDSON, Edward M. ANWS 1810-1874
Landscape painter and watercolourist. Son of T.M. Richardson Snr. (q.v.). Exhib. at RA in 1856 and 1858, but mostly at NWS (187 works) of which he became an associate in 1859. Painted landscapes in England, Scotland and Europe, in a picturesque style similar to that of his brother T.M. Richardson Jnr. (q.v.). Works by him are in the VAM and the Laing AG, Newcastle. A sale of his watercolours was held at Christie's, 19 February 1864; his studio sale was also held there, 25 May 1875.
Bibl: Cundall; C.B. Stevenson, Cat. of the Permanent Collection of Watercolour Drawings, Laing AG 1939; Hall.

RICHARDSON, Ellen fl.1891
Exhib. a work entitled 'Armour' at SS. London address.

RICHARDSON, Esdaile fl.1884
Exhib. a marine in 1884. Address in Lewes, Sussex.

RICHARDSON, F.W. fl.1877-1883
Exhib. three views of buildings, Hurstmonceaux Castle, Kenilworth Castle and the Beauchamp Chapel, Warwick, at the RA. London address.

RICHARDSON, Frederic Stuart RSW RI ROI RWA RBC 1855-1934
Landscape and genre painter. Lived at Sandy, Bedfordshire. Exhib. at RA from 1885, SS, NWS and presumably at RSW, of which he was a member. Titles at RA mostly coastal scenes and fisherfolk, as well as landscapes. Painted in England, Scotland, Ireland, Holland and also Venice. Titles: 'The Herring Fleet, Carradale', 'The Morning Catch', 'The First Snow of Winter', etc.
Bibl: P. Phillips, *The Staithes Group*, 1993.

RICHARDSON, G.C. fl.1877
Exhib. an interior view of a church in Scandinavia. London address.

RICHARDSON, George 1808-1840
Newcastle landscape painter and watercolourist. Eldest son of T.M. Richardson Snr. (q.v.). Exhib. at BI 1828-33 and NWS. Subjects mostly landscapes around Newcastle, in Durham and Yorkshire. Together with his brother, T.M. Richardson Jnr. (q.v.), he opened a drawing Academy at 53 Blackett Street, Newcastle. Died of consumption at an early age. Works by him are in the Laing AG, Newcastle.
Bibl: C.B. Stevenson, Cat. of the Permanent Collection of Watercolour Drawings, Laing AG, Newcastle, 1939; Hall.

RICHARDSON, Harry L. fl.1900-1901
Exhib. two works at the RA, the first entitled 'Yorick, the Parson, on his old Horse'. London address.

RICHARDSON, Henry Burdon c.1811-1874
Landscape painter and watercolourist. Son of T.M. Richardson Snr. (q.v.) by his second marriage. Lived with his brother Charles Richardson (q.v.) at 20 Ridley Place, Newcastle, where he gave painting lessons. Exhib. at RA 1828-61, SS and elsewhere. Painted views in England, Scotland and Europe. In 1848 he painted a series of watercolour views of the Roman Wall for Dr. John Collingwood Bruce; these are now in the Laing AG, Newcastle.
Bibl: C.B. Stevenson, Cat. of the Permanent Collection. of Watercolour Drawings, Laing AG, Newcastle, 1939; Hall.

RICHARDSON, J.T. fl.1900
Exhib. a work entitled 'Eventide' at the RA. Address in Etaples, France.

RICHARDSON, John Isaac RI 1836-1913
Landscape and genre painter, and watercolourist. Son of T.M. Richardson Snr. (q.v.). According to Graves, began to exhib. at RA in 1846 at the age of ten. Also exhib. at BI, SS, NWS and elsewhere. Titles at RA 'A Girl of Sorrento', 'Scotch Herd Girls', 'A Northumberland Straw-Yard', etc.
Bibl: Who Was Who 1897-1915, 1929; Hall.

RICHARDSON, R. Esdaile fl.1897
Exhib. a work entitled 'The Hour of the Sunset' at the RA. Address in Brading, Isle of Wight.

RICHARDSON, Ralph J. fl.1900
Exhib. an illustration to *Colonel Botcherby, M.F.H.* at the RA. London address.

***RICHARDSON, Thomas Miles, Snr. 1784-1848**
Newcastle landscape painter and watercolourist. Worked as a cabinet-maker until 1806, when he became Master of St. Andrews School. Exhib. at RA 1814-45, BI, SS, OWS and NWS. His subjects mostly views in the north-east. He also painted continental scenes, but these were worked up from drawings made by others. His watercolours show admiration for David Cox, but the figures in his pictures are often similar to those of William Shayer (q.v.). With Thomas Bewick and others he organised in 1822 the first Fine Art Exhibition in the north of England; he also helped to found the Northern Academy of Arts. His works have always enjoyed a wide reputation in the north-east. An exhib. of his work was held at the Laing AG, Newcastle, in 1906. Many of his sons were painters, including Thomas Miles Jnr., Charles, Edward, George, Henry Burdon and John (qq.v.).
Bibl: AU 1847 p.389; 1848 p.195 (obit.); Studio LXVII 1916 pp.251, 253; *Memorials of Old Newcastle-upon-Tyne with a Sketch of the Artist's Life*, 1880; R. Welford, *Art and Archaeology: the Three Richardsons*, 1906; C.B. Stevenson, Cat. of the Permanent Collection of Watercolour Drawings, Laing AG, Newcastle, 1939; Roget; Cundall; DNB; VAM; Hardie II p.230 (pl. 218); Brook-Hart; Hall; Irwin; T.M.R. and the Newcastle exhib. Cat., Laing AG, Newcastle-on-Tyne, 1984.

RICHARDSON, Thomas Miles, Jnr. RSA RWS 1813-1890
Landscape painter, mostly in watercolour. Son of T.M. Richardson Snr. (q.v.). At first worked with his father in Newcastle. Exhib. at RA 1837-48, BI, SS and OWS (702 works). ARWS 1843, RWS 1851. After his marriage in 1845 he settled in London. His subjects were mostly views in Scotland, later in Italy and Switzerland. He liked panoramic effects, and often used long narrow sheets of paper for this reason. He tended to overdo the use of bodycolour, giving some of his watercolours an unnatural, mannered look. His best works are his highland sketches, rather than his elaborate exhibition pieces. A sale of his 'Sketches from Nature' was held at Christie's, 9 May 1862. His studio sale was also at Christie's, 16 June 1890.
Bibl: J. Ruskin, *Notes on the OWS*, 1857; Roget; Cundall; VAM; C.B. Stevenson, Cat. of the Permanent Collection of Watercolour Drawings, Laing AG, Newcastle, 1939; Hardie II pp.230-1 (pl. 219); Hall.

RICHARDSON, William fl.1842-1877
Landscape and architectural painter. Exhib. at RA 1842-69, BI, SS and elsewhere. Titles at RA 'The Interior of Bolton Abbey', 'The Weald of Kent', 'Roslyn Chapel', etc. There was also a William Dudley Richardson, 1862-1929, recorded as painting architectural subjects.

RICHARSON, J.V. fl.1846
Exhib. two views in Oxford at the RA. Address in Oxford.

RICHARSON, R. fl.1890
Exhib. a landscape at the NWS. Address in Sidmouth, Devon.

***RICHMOND, George RA 1809-1896**
Portrait painter and watercolourist. Son of Thomas Richmond Snr., brother of Thomas Richmond Jnr. (q.v.). Father of Sir William Blake Richmond (q.v.). Studied at RA schools where he formed a lifelong friendship with Samuel Palmer (q.v.). Together with Palmer and Edward Calvert (q.v.) he was part of the group of Blake's followers called The Ancients. His early work shows strong Blake influence, but after Blake's death in 1827 the demands of making a living forced him to turn to portrait painting in miniatures, chalks and oils. He eventually became a leading portrait painter of his day. Exhib. at RA 1825-84, BI, SS. ARA 1857, RA 1866. His ideal of portraiture was "the truth lovingly told".
Bibl: AJ 1896 p.153 (obit.); Connoisseur XXXIII 1912 p.158; LII 1918 p.116; LXX 1924 p.117; LXXI 1925 p.55; LXXVII 1926 p.116; LXXVII 1927 p.49ff.; Print Collector's Quarterly XVII 1930 p.353ff.; XVIII 1931 p.199ff.; Redgrave, Cent.; Bryan; Roget; Cundall; DNB; VAM; R.L. Binyon, *The Followers of William Blake*, 1925; A.M.W. Stirling, *The Richmond Papers*, 1926; Hardie III pp.98-9 (pl.120); Maas pp.88, 216; Ormond; Raymond Lister, *G.R.*, 1981; also see references in Samuel Palmer bibliography.

RICHMOND, James C. fl.1856-1878
Exhib. a landscape in New Zealand at the RA. London address.

RICHMOND, Julia fl.1866
Exhib. two paintings of flowers in 1866. London address.

***RICHMOND, Thomas, Jnr.** 1802-1874
Portrait painter and miniaturist. Son of Thomas Richmond Snr.; brother of George Richmond (q.v.). Pupil of his father and of RA Schools. 1841 visited Rome, where he met Ruskin. Exhib. at RA 1822-53, and SS. A portrait of Charles Darwin by him is in the Cambridge Medical Schools.
Bibl: Bryan.

***RICHMOND, Sir William Blake** RA 1842-1921
Painter, sculptor and medallist; son of George Richmond (q.v.). Entered RA Schools in 1857 after some early coaching from Ruskin. Began to exhib. at RA in 1861, and from the first established himself as a successful portrait painter. After the death of his first wife in 1864 he went to Italy, where he met Leighton and Giovanni Costa, both of whom had a great influence on his art. 'Procession in Honour of Bacchus', RA 1869, a large neo-classical piece, clearly shows a debt to Leighton's great 'Cimabue' picture. After his return from Italy, he married again, and settled in a house in Hammersmith. Although his ambition was to paint big neo-classical scenes, he still kept up a large portrait practice. Among his sitters were Browning, Darwin, Pater, Gladstone and Bismarck. Exhib. at RA from 1861, BI, GG (119 works), NG and elsewhere. ARA 1888, RA 1895. Manuscripts relating to Richmond are held at the VAM.
Bibl: AJ 1890 pp.193-8, 236-9; 1901 p.125ff.; 1904 p.373ff.; AJ Summer Number and Christmas Art Annual 1902; Mag. of Art 1901 pp.145ff., 197ff.; Der Cicerone VI 1914 p.297ff.; Connoisseur LIX 1921 p.240ff. (obit.); LXXI 1925 p.50; LXXVII 1927 p.49ff.; A.M.W. Stirling, *The Richmond Papers*, 1926; W. Gaunt, *Victorian Olympus*, 1952; Fredeman; Hutchison; Maas pp.184-7 (pl. p.219); Ormond; Staley; Wood, Olympian Dreamers; *The Etruscans,* Cat. of exhib., Stoke-on-Trent AG 1989.

RICHTER, H. fl.1878
Exhib. a study at the GG.

RICHTER, Henry James OWS 1772-1857
Painted portraits and biblical subjects, also landscapes. Exhib. 20 works at the RA including 'The Dedication of the Infant Samuel', 'A Bacchante', portraits and a work entitled 'The Brute of a Husband'. Also exhib. four works at the BI, three works at SS and 88 works at the OWS. London address. For works illustrated by, see VAM Card Cat.
Bibl: DNB; AJ 1857 p.162; Redgrave, Dict.; Roget; Binyon; BM Cat. of Engraved British Portraits; Hardie; Staley.

RICHTER, Herbert Davis RI RSW ROI RBA RBC PS 1874-1955
Painted still-lifes, architectural subjects, interiors and figures. Studied at Lambeth and London Schools of Art under Brangwyn and J.M. Swan. Exhib. in London and the provinces. Published books on painting. Born in Brighton, Sussex. Lived in London.
Bibl: Who's Who; Studio LX 1914 pp.90, 222, 225, 226; LXV 1915 p.114; LXVI 1916 p.206; LXVII 1916 p.252; LXVIII 1916 p.54; LXXXI 1921 p.216; LXXXIII 1922 p.41; LXXXV 1923 pp.27, 31, 162; LXXXIX 1925 pp.331, 339; XCII 1926 p.87; Athenaeum 1919 p.1158; 1920 p.837; Connoisseur LXII 1922 p.237; Herbert Granville Fell, *The Art of H. Davis Richter, RI, ROI, RBC*, 1935.

RICHTER, M. fl.1851
Exhib. two paintings of dead game at the RA. London address.

RICKARDS, T.W. fl.1876
Exhib. a work entitled 'Our Cliffs' at SS. London address.

RICKATSON, Octavius RBA fl.1877-1893
Landscape painter. Exhib. at RA 1880-93, SS, NWS, GG, NG and elsewhere. Titles at RA 'A Quiet Spot', 'Little Bo-Peep', 'Coming Twilight', etc.

RICKETTS, Miss C. fl.1866-1867
Exhib. two works 'Simplicity' and 'Please Buy a Bouquet' at the BI. London address.

RICKETTS, Charles Robert fl.1868-1874
Painted marines and shipping. Exhib. seven works at the RA including 'Billingsgate, 1873; Before Demolition', 'Breakers Ahead' and 'The Bass Rock', and three works at SS. London address.
Bibl: Brook-Hart.

***RICKETTS, Charles de Sousy** RA 1866-1931
Painted figurative subjects, architecture and still-life. Studied at Lambeth School of Art from 1882. He was a friend of Charles Shannon (q.v.). He was also a sculptor, wood-engraver, theatrical designer and writer on art. Born in Geneva. Lived in London.
Bibl: Studio XLVIII 1910 pp.259-66; LXXXIX 1926 p.415ff.; Apollo I 1925 pp.329-34; XIV 1931 p.300; Connoisseur LXXXVIII 1931 p.350; Charles Holmes, *Charles Ricketts*, 1932; Who's Who; T.S. Moore, C.R., 1933; D. Sutton, *A Neglected Virtuoso — C.R. and his Achievements,* Apollo February 1966; Dr. J.G.P. Delaney, *C.R. A Biography*, 1990.

RICKETTS, William C. fl. 1900-1903
Exhib. two works, 'Mushrooms' and 'Wild Roses', at the RA. Address in Worcester.

RICKS, James fl.1868-1877
Painted figurative and genre subjects. Exhib. eight works at the RA including 'Weary', 'Little Friends' and 'The Book Worm', and 11 works at SS including 'Black and Tan' and 'After the Duel'. London address.

RICOZZI, A. fl.1846
Exhib. a work at the RA. Address in Milan.

RIDDEL, James ARSA RSW SSA 1857-1928
Painted landscape, portraits and genre. Exhib. three works at the RA including 'A Sunny Bank in Winter' and 'Passing Showers'. Born in Glasgow. Lived in Balerne, Midlothian. He was a member of the Glasgow Art Club.

RIDDELL, Lady Buchanan fl.1885
Exhib. a coastal scene at the NWS. London address.

RIDDELL, Wdem. fl.1878
Exhib. a work entitled 'A Deserted Cottage' at SS. Address in Lynmouth, Devon.

RIDDETT, Leonard Charles fl.1893
Exhib. a watercolour view of Ferrara at SS. London address.

RIDEOUT, Philip H. fl.c.1900
Painted sporting subjects and coaching scenes. His pictures are usually small, often pairs, or sets of three or four.

RIDER, H. fl.1899
Exhib. a work entitled 'A Bit of Old Hunstanton' at the RA. Address in Leeds, Yorkshire.

RIDER, John fl.1842-1849
Painted landscape. Exhib. eight works at the RA, two works at the BI and ten watercolours at SS including views in North Wales, London and the environs of London. London address.

RIDER, Urban fl.1883-1886
Exhib. four landscapes at the NWS. Address in Dover, Kent.

RIDER, William fl.1824-1849
Painted landscape and country subjects. Exhib. 16 works at the BI including scenes on the Thames and Leam, and landscapes in Devon and elsewhere in the south of England. Also exhib. six works at the RA including 'Sheep Reposing' and 'Bisham Abbey on the Thames'. Addresses in Leamington, Warwickshire, and London.

RIDGEWAY, Miss E. fl.1874
Exhib. a painting of camellias at SS. Address in North Wales.

RIDLEY, Miss Annie fl. 1864-1870
Exhib. a work entitled 'The Bouquet' at the BI and another at SS. London address.

RIDLEY, Matthew White 1837-1888
Landscape, genre and portrait painter. Born in Newcastle-on-Tyne. Pupil of Smirke, Dobson and the RA Schools. Exhib. at RA 1862-88, BI, SS and elsewhere. Painted landscapes, portraits and occasional scenes of Victorian life in the manner of Frith.
Bibl: AJ 1859 p.142; Portfolio 1873 p.81ff.; Connoisseur LXXIV 1926 p.251; Bryan; Hall; V. Gatty, *Artist's Fruitful Friendship*, Country Life 7 March 1974.

RIDLEY, W. fl.1844
Exhib. a view on the Thames near Gravesend at the RA. London address.

RIGAUD, Stephen Francis Dutilh OWS 1777-1861
Painted figurative and genre subjects, and literary subjects. Exhib. 38 works at the RA 1798-1848 including scenes from *The Iliad*, Spenser and The Bible. His last exhib. at the RA was entitled 'The Studious Little Girl'. Also exhib. 23 works at the BI, the last being biblical subjects, six works at SS and 50 at the OWS. London address. Represented in the VAM.
Bibl: Redgrave, Dict.; Roget; Cundall; The Walpole Society VI 1917-18 p.96ff.; BM Cat. of Engraved British Portraits.

RIGBY, Mrs. fl.1867
Exhib. a watercolour entitled 'Sunset, North Devon' at SS. Address in Esher, Surrey.

RIGBY, Cuthbert ARWS 1850-1935
Landscape painter and watercolourist. Born in Liverpool. Pupil of W.J. Bishop. Exhib. at RA from 1875, but mostly at OWS. Titles at RA nearly all views in Cumberland. Works by him are in the VAM and Norwich Museum.
Bibl: AJ 1908 p.342; Who's Who 1924.

RIGBYE, Harriette fl.1879
Exhib. a landscape in 1879. Address in Ambleside, Westmoreland.

RIGG, Alfred fl.1895-1897
Painted country subjects. Exhib. six works, including 'The Approach of Night' and 'The Duck Pond'. Address in Bradford, Yorkshire.

RIGG, Arthur H fl.1888-1891
Exhib. a work entitled 'Winter Fuel' at the RA and another entitled 'Hill and Dale' at SS. Address in Bradford, Yorkshire.

RIGG, Ernest Higgins 1868-1947
Painted genre subjects. Exhib. seven works at the RA 1897-1904, including 'Where There's Life There's Hope' and 'Reading to Granny'. Address in Hinderwell, Yorkshire.
Bibl: P. Phillips, *The Staithes Group*, 1993.

RIGG, Jane fl.1853
Exhib. a watercolour view of the Banqueting Hall, Kenilworth, at SS. Address in Leamington Spa, Warwickshire.

RILEY, Thomas fl.1878-1892
Painter and etcher. Lived in Chelsea, London. Exhib. both pictures and etchings at RA from 1880, SS, NWS, GG, NG and elsewhere. Titles at RA mostly genre scenes, e.g. 'Expectant Curiosity' 'Jealousy', 'At the Garden Wall', etc.
Bibl: AJ 1883 p.88; Portfolio 1882 pp.25, 212;1883 p.25.

RILEY, W. fl.1847
Painted figurative subjects. Exhib. seven works at SS including an Italianate subject and works entitled 'A Red Republican in 1849' and 'Thy Will Be Done', and single works at both the RA and the BI. London address.

RIMER, Mrs. Louisa Serena fl.1855-1875
London flower painter, who exhib. 1855-75, at the RA 1856-74, BI, SS and elsewhere.

RIMER, William fl.1845-1888
Painted genre and literary subjects. Exhib. six works at the RA, including 'Scene from the Castle of Indolence' and scenes from Tennyson's *Princess*, six works at the BI, including 'The Ascension' and 'Deeply Interesting', and 12 works at SS. London address.

RIMINGTON, Mrs. Alexander fl.c.1900-1950
(Miss Evelyn Jane Whyley)
Painted landscape watercolours. Exhib. in London. Lived in London and later in Cholsey, Berkshire. She was the wife of Alexander Rimington (q.v.).

RIMINGTON, Alexander Wallace ARPE RBA c.1854-1918
Painted and etched landscapes and townscapes. Studied in London and Paris. Exhib. 25 works at the RA, 1880-1902, including landscapes in Ireland and Austria and views in Seville, Verona and Dresden. Lived in Weston-Super-Mare, Somerset, and later in London. Author of *Colour-Music*. Represented in the VAM.
Bibl: AJ 1873 pp.33ff., 65ff., 129ff., 161ff., 225ff., 233ff., 257ff., 289ff., 301ff., 321ff., 353ff.

RIPLEY, R.R. fl.1856-1879
Painted landscape. Exhib. two works, 'The Spring in the Wood' and 'A South Coast Scene, painted with B. Herring', at the RA, and four works, amongst them views in Borrowdale, at SS. London address.

RIPPER, Charles b.1864
Painter and etcher. Studied at the RCA. Born in Devonport, Devon. Lived at Lancaster and was Headmaster of the School of Art, Storey Institute, Lancaster.

***RIPPINGILLE, Edward Villiers 1798-1859**
Genre painter, born in King's Lynn, Norfolk. He was self-taught and first practised in Bristol. Exhib. at the RA, SS and BI 1813-57. His subjects were taken from English rural life until he visited Italy in 1837, when for some years his inspiration was Italian, e.g. 'Father and Son; Studies from Calabrian Shepherds', 1838 RA, and 'An English Servant Attacked by Robbers near Rome', 1840 RA. In 1841 he paid a second visit to Italy. In 1843 he won one of the prizes in the Westminster Cartoon Competition. He lectured on art and claimed to be the first to advocate the formation of Schools of Design; he edited *The Artist and Amateur's Magazine.* He died suddenly at Swan Village railway station, Staffordshire. Painted a series of six pictures entitled 'The Progress of Intemperance' of which one, 'The Invitation to Drink', is in the Walker AG, Liverpool.
Bibl: Redgrave, Dict.; Bryan; VAM; *The Bristol School of Artists,* Cat. of exhib., Bristol AG 1973.

RIPPINGILLE, T. fl.1849
Exhib. a work entitled 'The Young Student' at SS. London address.

RISCHGITZ, Alice fl.1880-1898
Exhib. two landscapes 1880-2. London address.

RISCHGITZ, Miss Mary fl.1882-1903
Painted flowers. Exhib. seven works, six paintings of flowers and one still-life, at the RA, and nine works at SS. London address.

RITCHIE, Charles E. fl.1898-1899
Exhib. three works, including 'Flowers of Finisterre' and 'A Suffolk Landscape' at SS. London address.

RITCHIE, Eleanora fl.1880
Exhib. a watercolour entitled 'Dear Lady Disdain' at SS. London address.

***RITCHIE, John fl.1858-1875**
Genre painter. Exhib. at RA 1858-75, BI and SS. Most of his RA pictures were imaginary genre scenes set in 16th or 17th century costume, e.g., 'The Strolling Players', 'The Young King James VI at Church', 'Rogues in Bond', etc. His best known work is 'A Summer Day in Hyde Park' in the London Museum. He painted a number of other large London scenes of this type.
Bibl: Wood, Panorama pls. 187, 188.

RITCHIE, Robert fl.1847
Exhib. a church interior at the RA. London address.

RITSON, J. fl.1855-1859
Exhib. two works 'A Coast Scene, The Fish Auction' and 'Pont-y-Garth' at the BI. London address.

RITTER, Louis fl.1881-1884
Exhib. a work entitled 'Olivia' at the RA. London address.

RIVAZ, Claude F. fl.1895
Exhib. a work entitled 'Absinthe' at the RA. London address.

RIVERS, Leopold RBA 1850-1905
Landscape painter, who exhib. at the NWS and SS from 1873, RBA in 1890 and at the RA 1873-1904. He was the son and pupil of William Joseph Rivers (exhib. 1843-55 at the RA and BI). 'Stormy Weather', 1892, Tate Gallery, was a Chantrey Purchase.
Bibl: L'Art LXIV 1905 p.452; The Year's Art 1906 p.362; Tate Cat.; Brook-Hart.

RIVERS, R. Godfrey fl.1879-1884
Exhib. a work entitled 'Towards Italy from Mentone' at the RA and a watercolour at SS. Address in Brighton, Sussex.

RIVERS, William Joseph fl.1843-1855
Exhib. five works at the BI including 'Dead Game', 'Waiting the Fisherman's Return' and 'The Pet Rabbit', and a sculpture, and one work at the RA. London address.

RIVIERE, Miss Annette L. fl.1870-1887
Painted genre and figurative subjects. Exhib. six works at the RA including 'Slow and Steady Wins the Race' and 'Ready for a Bath', and one work at the NWS. Address in Oxford.

***RIVIERE, Briton RA RE 1840-1920**
Genre and animal painter. Son of William Riviere (q.v.). Pupil of his father and of J. Pettie and W. Orchardson (qq.v.). Exhib. at RA from 1858, BI, SS, GG and elsewhere. ARA 1878, RA 1880. His knowledge and love of animals was based on sound anatomical study, and frequent visits to London Zoo. He usually incorporated animals in all his genre and historical scenes; especially lions, birds, dogs and other domestic pets. His pictures of dogs are often humorous, but nearly always sentimental; they appealed to the dog-loving public and were widely reproduced through engravings. His works are in most British museums. 'Beyond Man's Footsteps', RA 1894, was bought by the Chantrey Bequest. Manuscripts relating to Riviere are held at VAM.
Bibl: Portfolio 1892 pp.61-6, 77-83; Connoisseur LVII 1920 p.119ff.; Studio LXXIX 1920 p.149; W. Armstrong, *B.R. His Life and Work,* Art Annual 1891; DNB; Maas LXXXII (pl.p.83); Ormond; Wood, Olympian Dreamers.

RIVIERE, Mrs. Briton fl.1868-1872
(Miss Mary Alice Dobell)
Exhib. three works, 'A Bit of Spring', 'Fungi' and 'Cup Moss', at the RA. Address in Bromley, London.

RIVIERE, Daniel Valentine 1780-1854
Painted portraits and figurative subjects. Possibly primarily a miniaturist. Exhib. 13 works at the RA including portraits, which were possibly miniatures, and works entitled 'Devotion' and 'The Turkish Love Letter'. London address. He was the father of Henry Parsons Riviere and William Riviere (qq.v.) and the miniature flower painter Miss F. Riviere.

RIVIERE, Henry Parsons ARWS 1811-1888
Genre, landscape and portrait painter, mostly in watercolour. Brother of William Riviere (q.v.). His father Daniel Valentine Riviere (q.v.) was also a painter. Exhib. at RA 1835-71, BI, SS, OWS (299 works) and NWS. He lived in Rome 1865-84, and most of his works are of Italian genre and landscape. Several watercolours by him are in the VAM.

RIVIERE, Hugh Goldwin RP 1869-1956
Painted portraits and literary subjects. Studied at the RA Schools. Exhib. 32 works at the RA 1893-1904, including portraits and subjects illustrating lines from C. Rossetti and Tennyson. Lived in London and later at Midhurst, Sussex. He was the son of Briton Riviere (q.v.).

RIVIERE, Mrs. W. fl.1871
Exhib. three watercolours, 'Apricots', 'Bunch of Plums' and 'Mushrooms', at SS. London address.

RIVIERE, William 1806-1876
Genre and portrait painter. Brother of Henry Parsons Riviere (q.v.) and father of Briton Riviere (q.v.). Exhib. at RA 1826-60, BI and SS. From 1849 to 1859 he was teacher of drawing at Cheltenham College; then settled in Oxford.
Bibl: AJ 1877 p.38; Connoisseur LXXI 1925 p.50; Redgrave, Dict.; Poole 1925; BM Cat. of Engraved British Portraits 1925.

RIXON, Miss Laura fl.1886
Exhib. a painting of a basket of damsons at SS. London address.

RIXON, William Augustus RBA fl.1880-1891
Painted landscapes and country subjects. Exhib. 18 water-colours at SS including 'An Oatfield', 'A Mountain Torrent' and 'The Thames at Stone House', and six works at the RA including 'Going to be Wet' and 'Felled Timber'. Address near Maidenhead, Berkshire.

RIZAS, W.A. fl.1878-1889
Exhib. a work entitled 'Idle Boys' at SS and five works at the NWS. London address.

ROBART, V. fl.1851
Exhib. a portrait at the RA. London address.

ROBB, G.M. fl.1860-1881
Painter of landscape and genre, living in Chingford and Manningtree, who exhib. 1860-81, at the RA 1861-81, BI, SS and elsewhere, titles at the RA including 'Rocks near Ryde', 1861, 'Gleaners', 1868 and 'A May Evening', 1873.

ROBB, William George 1872-1940
Painted landscape and figurative subjects. Studied at Aberdeen Art School and in Paris under Bougereau and Aman-Jean. Exhib. two works 'Autumn' and 'Afternoon in Autumn' at the RA. Born in Ilfracombe, Devon. Lived in London.
Bibl: Who's Who; Athenaeum 1920-1 p.548.
Exhib: London, Fine Art Society, *Lyrical Paintings by W.G. Robb*, 1933.

ROBBINS, Miss Anna fl.1867
Exhib. a watercolour of a bird's nest at SS. Address near Thetford, Norfolk.

ROBBINSON, Mrs. Margaret fl.1854-1870
London painter of genre and historical subjects, who exhib. 1854-70 at the RA and SS, titles at the RA including ' "Wae's me for Prince Charlie" ', 1854, 'What We Still See in Chelsea Gardens', 1860 and 'A Venetian Girl', 1870.

ROBERT fl.1849
Exhib. a portrait at the RA. London address.

ROBERT, Mlle. Caroline fl.1886
Exhib. a work entitled 'A Shady Corner in the Garden' at the RA. Address in Sutton, Surrey.

ROBERT, M. fl.1849
Exhib. two subjects at SS. London address.

ROBERTON, Alfred J. fl.1884-1886
Painted landscape. Exhib. five works including two views on the Thames and works entitled 'Autumn' and 'Summer' at SS. London address.

ROBERTS, Mrs. fl.1851
Exhib. a work at the RA. London address.

ROBERTS, A. fl.1854
Exhib. 'The Holy Family' at the RA. London address.

ROBERTS, Annie fl.1874-1881
Painted landscape and rustic subjects in watercolour. Exhib. ten watercolours at SS including 'The Village Shop' and 'The Farm on the Hill'. London address.

ROBERTS, Benjamin fl.1847-1872
Painter of fruit and genre, living in Chislehurst and London, who exhib. 1847-72, at the RA 1851-72, BI and SS, titles at the RA including 'Gipsy Boy', 1851 and 'Prince of Wales's Plums', 1866.

ROBERTS, Mrs. Chandler fl.1855-1885
Exhib. three watercolours of flowers including camellias and waterlilies at SS. London address.

ROBERTS, Cyril RBA PS 1871-1949
Painted portraits in oil and pastel, and landscapes in watercolour. Studied at South Kensington, at the Slade and in Paris. Born near London. Lived in London.

***ROBERTS, David RA 1796-1864**
Painter of architectural subjects, prolific both in oil and watercolour, often called the Scottish Canaletto. Born at Stockbridge, near Edinburgh, the son of a shoemaker. Apprenticed for seven years to a house painter, much of his spare time being occupied in sketching local architectural monuments. At the age of 21, he joined a travelling circus as a scene-painter, visiting Carlisle, Newcastle, Hull and York. With this experience he was engaged to paint scenery for the Edinburgh Pantheon, the Theatre Royal, Glasgow and then for the Theatre Royal, Edinburgh. In 1822 he was engaged as a scene-painter at Drury Lane Theatre, and settled in London. Also working at Drury Lane was Robert's friend W. Clarkson Stanfield (q.v.), and their joint work won reputation for both. On the formation of the SBA in 1823, Roberts became its Vice-President, and President in 1830, gradually abandoning scene-painting for architectural subjects. In 1827, he was entirely responsible for designing the sets for the first London production of Mozart's *Il Seraglio*. He exhib. at the RA 1826-64, at the BI 1825-59, and at SS. ARA 1838; RA 1841. In 1829 elected an honorary member of the RSA. Owing to his high position in the world of art he was made one of the Commissioners for the Great Exhibition of 1851. He travelled widely on the Continent; 1831 in France; 1832-3 he spent a considerable time in Spain and at Tangier; 1838-9 he visited Egypt and the Holy Land, making sketches sufficient to keep him working for ten years; in 1851 and 1853 he toured Italy. Hardie notes that "he became one of the best known of the later topographers, and the results of his many journeys exist not only in oil-paintings and watercolours, but in the form of coloured reproductions which were highly popular and brought him a considerable fortune." Some of Roberts's most pleasing and lively works were done before 1840; his drawings done in the East are monotonous in their uniform scheme of grey, red, brown and yellow. Ruskin praises his endurance, his exquisite drawings and his statement of facts, but says that among his sketches he saw "no single instance of a down-right study; of a study in which the real hues and shades of sky and earth had been honestly realised or attempted — nor were there, on the other hand, any of these invaluable blotted five minutes works which record the unity of some simple and magnificant impressions". Among his publications are *Picturesque Sketches in Spain during the Years 1832 and 1833;* and *Views in the Holy Land, Syria, Idumea, Arabia, Egypt and Nubia,* published in six volumes, 1842-9, the plates all in chromo-lithography. His studio sale was held at Christie's, 13 May 1865. Another sale of his estate took place on 7 April 1881.
Bibl: AJ 1858 p.201; 1865 p.43; 1867 p.21; J. Ruskin, *Modern Painters*, II p.i Chap. vii; Ruskin, Academy Notes; VAM MSS Letter to W.H. Dixon 1864; James Ballantine, *The Life of D.R. RA*, 1866; Redgrave, Cent., Dict.; Portfolio 1887 pp.45, 136-7; Bryan; Binyon; Caw pp.153-5; Cundall; DNB; Hughes; Connoisseur LI 1918 pp.51, 59; LXVIII 1924 p.48; LXIX 1924 p.195; LXXXVI 1930 pp.402, 406; J. Quigley, *D.R.*, Walker's Quarterly X 1922; J. Quigley, *Prout*

and Roberts, 1926, VAM; A.G. Reynolds, *British Artists Abroad, V: Roberts in Spain, etc.* Geographical Magazine XXI 1949; M. Hardie, *D.R.,* OWS 1947; Hardie III pp.179-83 *et passim* (pls.208-12); Maas p.95 (pls.pp.95, 107, 207); Ormond; Staley; Irwin; H. Guiterman and B. Llewellyn, Cat. of D.R. exhib., Barbican AG, London, 1986.

ROBERTS, E. fl.1867
Exhib. a watercolour view of a cottage in Sevenoaks at SS. London address.

ROBERTS, Edwin Thomas 1840-1917
London painter of genre, who exhib. 1862-86 at SS (46 works) and the RA 1882 and 1884, titles at the RA being 'The Professor', 1882, 'The Dishonoured Bill', 1884 and ' "Polly, What's the Time" ', 1884. He was the son of Thomas E. Roberts (q.v).

ROBERTS, Ellis William RP 1860-1930
Painted portraits. Studied at the Wedgwood Institute, Burslem, and at the Minton Memorial Art School, Stoke-on-Trent, at the RCA and in Paris at the Académie Julian. Exhib. in London from 1886. Born at Burslem, Staffordshire. Lived in London. Died in Brighton, Sussex.
Bibl: AJ 1899 pp.321-5; Connoisseur XXXIX 1914 p.274; LXXXVI 1930 p.338; Who's Who 1930; Apollo XVII 1933 p.96.

ROBERTS, Elsie fl.1882
Exhib. a painting of flowers in 1882. Address in Sheffield, Yorkshire.

ROBERTS, Mrs. Etienne fl.1892-1893
Exhib. a painting of roses at SS. London address.

ROBERTS, F.A. fl.1859-1866
Painted genre subjects in watercolour. Exhib. 12 watercolours at SS including 'Forty Winks', 'Evening Toilet' and 'A Timely Stitch'. London address.

ROBERTS, F.M. fl.1878
Exhib. a figurative subject in 1878. London address.

ROBERTS, F.W.B. fl.1865
Exhib. a landscape at the BI. Address in Horsmonden, Kent.

ROBERTS, Frederick fl.1848-1849
Painted landscape watercolours. Exhib. four works at SS, three views in North Wales and one in Devon. Address in Haverhill, Suffolk.

ROBERTS, G. fl.1843-1853
Painted buildings. Exhib. four works at the RA, including views in Basingstoke and near Malvern. London address.

***ROBERTS, H. Larpent fl.1863-1873 d.c.1890**
London landscape and flower painter, exhib. at RA 1863-6, BI and SS. Titles at RA 'The Word of God, a Parable', 'The Bread of Man', 'The Sweet Story of Old'. He exhib. very few works, but his flower pieces are of good Pre-Raphaelite detail and quality.

***ROBERTS, Henry Benjamin RI RBA 1832-1915**
Genre painter, a close follower of the work of William Henry Hunt (q.v.). Born in Liverpool, son of the landscape painter and house-decorator Benjamin Roberts. Became a member of the Liverpool Academy in 1859; exhib. in London 1859-80, at the RA 1859-75,

BI, SS, NWS (64 works), and elsewhere; was a member of the RI 1867-84. He worked in oil and watercolour, and typical of his work is 'The Dull Blade', a study of an old barber sharpening his scissors, while a small boy is sitting with a sheet round his neck waiting to have his hair cut, everything in the shop being observed with great minuteness. He also did many single figure studies in watercolour, modelled closely on Hunt's work, e.g. 'The Sermon'. Marillier remarks that if one of these figure studies were hung as a pair to one of Hunt's, it would be difficult to tell which was which, especially in the minuteness of stippling.
Bibl: Marillier pp.200-2 (pl.202); VAM; Hardie III pp.113-14 (pl.135).

ROBERTS, Henry William fl.1885-1886
Exhib. two landscapes at the NWS. Address in Leicester.

ROBERTS, Herbert H. fl.1869-1887
Exhib. three works at the RA including 'The Hour Before Twilight' and 'The Evening of Life' at the RA. Address in Thorpe, Norwich.

ROBERTS, James fl.1858-1876
Painted landscape. Exhib. eight works at SS including views in North Wales and Cumberland, one work at the BI, and one at SS. Address in Leeds, Yorkshire.

ROBERTS, John Lewis fl.1831-1864
A marine artist resident in Hull.
Bibl: Brook-Hart.

ROBERTS, Miss Katherine M. fl.1900-1901
Exhib. two works, including 'The Sister', at the RA. Address in Liverpool. For works illustrated by, see VAM Card Cat.

ROBERTS, Miss Lavinia fl.1864-1867
Exhib. four works at SS, including 'The Gipsy' and 'Wild Flowers'. London address.

ROBERTS, Miss Louisa fl.1851-1869
Painted figurative subjects. Exhib. eight works, the majority watercolours, at SS, all but one portraits, and two works at the RA. London address.

ROBERTS, Miss Marion fl.1885-1886
Exhib. a watercolour view of the entrance to the chapel of St. Erasmus at SS, and two works at the NWS. London address.

ROBERTS, R.R. fl.1850-1857
Painted watercolour views of landscape and buildings. Exhib. 22 works at SS including views of Windsor Castle, Hardwicke Hall and Bolton Abbey, and landscapes in North Wales, Yorkshire and Northumberland. London address.

ROBERTS, Sir Randal Howland, Bt. fl.1865
Exhib. a work entitled 'A Fresh Breeze' at the RA.

ROBERTS, Robert fl.1843
Exhib. a view of Snowdon at the RA. London address.

ROBERTS, Miss S. fl.1851
Exhib. two watercolours, including 'Windsor Castle from the Forest', at SS. Address in Haverhill, Suffolk.

***ROBERTS, Thomas Edward RBA 1820-1902**
London painter of genre, portraits and historical subjects; engraver. Exhib. 1850-1901, at the RA 1851-1901, SS (127 works) and elsewhere, titles at the RA including ' "He Loves Me — He Loves Me Not" ', 1851 and 'Basking — a Corner in the Alhambra', 1884. In 1859 Roberts exhib. 'The Opinion of the Press' (No. 173) at SS, a painting showing a young artist much discouraged by a bad review. Ruskin noted it, saying "The two works are interesting . . . for their fidelity of light and shade. The sentiment of No.173 is well and graphically expressed to warn young painters against attaching too much importance to press criticism as an influence on their fortune." And it led him to a sermon on "Do your work well and kindly, and no enemy can harm you."
Bibl: AJ 1859 pp.141, 142; Ruskin, Academy Notes; Ottley; Wood, Panorama pl.218.

ROBERTS, Thomas William 1856-1931
Painted genre subjects. Born in Dorchester, Dorset. Went to Australia in 1869. Subsequently exhib. Australian subjects in London. Represented in the National AG, Sydney.
Bibl: Studio Special Winter Number 1916-17 p.38; Connoisseur LXVII 1923 p.117; Who's Who 1930.

ROBERTS, W. fl.1877
Exhib. a watercolour view in Rouen at SS. London address.

ROBERTS, W.T.B. ARPE fl.1880
Exhib. a landscape in France at the RA. Address in Winchester, Hampshire.

ROBERTS, Winifred Russell fl.1893
Exhib. two watercolours, including a view of Loch Earn, Perthshire, at SS. London address.

ROBERTSON, Alfred J. fl.1883
Exhib. a landscape view near Dorking at SS. London address.

ROBERTSON, Arthur ARPE b.1850 fl.1905
Painted views of buildings. Exhib. 21 works at SS, the majority watercolours, including views of buildings in Rome and Venice, and nine works at the RA 1883-1903, views of buildings and works entitled 'The Wise Virgins' and 'Not Learned, Save in Gracious Household Ways'. London address.
Bibl: H.W. Fincham, Art and Engraving of Book Plates, 1897; A.M. Hind, History of Engraving and Etching, 1911; Studio Special Summer Number 1902.

ROBERTSON, C. Kay fl.1892-1902
Exhib. three works at the RA, two portraits and a work entitled 'A Veteran of Waterloo', at the RA. Address in Edinburgh.

ROBERTSON, Charles ARWS RPE 1844-1891
Painter of landscape and genre, especially Middle Eastern subjects; engraver; living in Aix-en-Provence, Walton-on-Thames, and Godalming, Surrey, who exhib. 1863-92, at the RA 1863-85, SS, OWS (103 works), NWS and elsewhere. Titles at the RA include 'Bonffasik, Algeria', 1863, 'The Wall of Wailing, Jerusalem', 1877 and 'The Ebbing Tide, Porlock', 1883.
Bibl: The Year's Art 1892 p.288.

ROBERTSON, David M. ARSA fl.1892
Exhib. a work entitled 'A Lift by the Way, Connemara' at the RA. Address in Douglas, Isle of Man.

ROBERTSON, Eric J. Forbes- fl.1885-1891
Exhib. five works at SS including 'A Grey Day', 'The Halfway House' and 'A Maiden of Finisterre', and two works at the RA. London address.

ROBERTSON, George Edward b.1864 fl.1904
Painted landscape, and figurative and Shakespearian subjects. Studied at St. Martin's School of Art. Exhib. 20 works at the RA 1885-1904, including 'In the Meadows, East Bergholt', 'Calling Home the Cows', and subjects from King Lear, Julius Caesar and Othello. Also exhib. three genre subjects at SS. London address. He was the son of William Robertson, also a painter.

ROBERTSON, Henry fl.1882-1894
Exhib. three works, including 'Mackerel Market, Lowestoft' and 'An Essex Creek', at the RA. Address in Ipswich, Suffolk.

ROBERTSON, Henry Robert RPE RMS 1839-1921
London painter of landscape, rustic genre and portraits; etcher and engraver. Exhib. 1861, at the RA from 1869, BI, SS, NWS, GG and elsewhere, titles at the RA including 'The Tatler', 1869, 'A Ferry on the Upper Thames', 1875 and 'Her Own Gleanings', 1904. His published works include The Art of Etching Explained and Illustrated, 1883, The Art of Painting on China, 1884, The Art of Pen and Ink Drawing, 1886, Life on the Upper Thames, 1875 (a series of river scenes and rustic genre first published in the AJ 1873-4), Plants We Play With, 1915, and More Plants We Play With, 1920. His painting 'Winter' is in Sheffield AG.
Bibl: AJ 1873 pp.13-15, 73-5, 141-3, 205-7; 1874 pp.17-20, 69-72, 141-4, 193-5, 233-6, 261-4, 301-4; A.M. Hind, History of Engraving and Etching, 1923 pp.387, 397; Who Was Who 1916-28; British Museum, General Catalogue of Printed Books, 1963.

ROBERTSON, J.R. fl.1866
Exhib. a work entitled 'L' Aspirant' at the RA. London address.

ROBERTSON, John Ewart 1820-1879
Painted portraits. Exhib. 13 portraits at the RA and four works at the RA, including 'Cupid Armed' and 'The Larder Window'. Addresses in Liverpool and Kelso, Roxburghshire. Represented in the Walker AG, Liverpool.
Bibl: Marillier.

ROBERTSON, Sir Johnston Forbes- 1853-1937
Painted portraits, including those of actors and theatrical subjects. Exhib. eight portraits at the RA, including more of Ellen Terry and 'Mrs. Rousby in the Character of Mary Stuart'. Also exhib. 12 works at the GG and one at the NG. London address. His portrait of Samuel Phelps is in the collection of the Garrick Club.
Bibl: Ormond.

ROBERTSON, Kay fl.1892
Is supposed to have exhib. a figurative subject at the RA. Address in Edinburgh.

ROBERTSON, L. Roy fl.1866
Exhib. two works, 'The Mandolin Player' and 'The Miser', at the BI. London address.

ROBERTSON, Percy ARPE 1868-1934
Painted and etched landscape. Exhib. 13 works at the RA 1890-1904 including 'A Wet Day, Whitby', 'In East Anglia' and 'The Castle Rocks, Lynton'. Born at Bellagio, Italy. Lived in London. He was the son of Charles Robertson, RWS.
Bibl: AJ 1889 p.333; 1890 p.129; 1891 p.193; 1892 p.257; 1898 p.321; 1899 p.304; 1905 p.104; 1908 p.353; 1909 p.193; A.M. Hind, The History of Engraving and Etching, 1911; Studio Special Number Winter 1915-16 pp.70, 79, 130, 139, 163, 191.

ROBERTSON, Robert Cowan 1863-1910
Scotsman who painted marines and landscape. Born in Glasgow. Died in London. Represented in the City AG Leeds.
Bibl: Caw; The Year's Art 1911 p.416.

ROBERTSON, S. fl.1855-1856
Exhib. two genre subjects 1855-6. London address.

ROBERTSON, Tom ROI 1850-1947
Painted landscape, townscapes and marines. Exhib. nine works at the RA 1889-1901 including 'A Grey Day on the Clyde off Greenock', 'Moonrise on the Tay' and 'Venice'. Also exhib. six works, three of them marines, at SS. Studied at Glasgow School of Art and in Paris under Benjamin Constant. Worked on the Continent and in North Africa. Born in Glasgow. Lived in London and, later, in Eastbourne, Sussex. Represented in the Luxembourg Museum, Paris.
Bibl: Studio XXXII 1904 p.238; AJ 1907 p.44; 1908 p.221; Caw; Studio Special Number 1919 pp.32 90.

ROBERTSON, Victor J. fl.1892-1903
Painted figurative subjects. Exhib. eight works at the RA 1892-1903 including 'The Priestess of the Pythian Apollo' and 'Paola and Francesca'. London address.

ROBERTSON, W.S. fl.1851-1855
Painted figurative subjects. Exhib. five works at the RA including 'The Hop Picker' and 'The Idler'. London address.

ROBERTSON, Walford Graham- RP RBA ROI 1867-1948
Painted portraits and landscape. Also an illustrator. Exhib. 12 portraits at the NG. Studied at South Kensington and under Albert Moore (q.v.). He was the author of several books and plays. Born and lived in London and later in Witley, Surrey. Painted portraits and sketches of many famous figures of the Edwardian age, and his autobiography is a useful source for the period.
Bibl: AJ 1893 p.146; 1900 p.381; 1905 p.388; 1906 p.106; Studio, Art in 1898; Bate; Studio XXXVI 1906 pp.99-107; XLIV 1908 p.51; Studio Special Number 1923-4 pp.38, 142ff.; Connoisseur LX 1921 p.60; Who's Who 1930; W. Graham-Robertson, *Time Was*, 1931.

ROBINS, Mrs. A. fl.1879
Exhib. a portrait at the RA. London address.

ROBINS, B. fl.1871-1872
Exhib. a work entitled 'The Patchwork Quilt' at SS. London address.

ROBINS, Miss D.E. fl.1856-1858
Exhib. six figurative subjects 1856-8. Address in Brighton, Sussex.

ROBINS, Miss Gertrude M. fl.1887
Exhib. a work entitled 'Maude' at the RA. London address.

ROBINS H. fl.c.1870-1880
Painted marines. One of his works 'Wreck of *H.MS. Eurydice* towed into Portsmouth Harbour, September 1st, 1878', was sold at Christie's, 26 April 1974.
Bibl: Brook-Hart pl. 220.

ROBINS, Miss Ida S. fl.1884-1886
Painted figurative subjects. Exhib. five works at the RA including 'Miriam', 'La Signora' and 'Azaleas'. London address.

ROBINS, Miss J.E. fl.1861-1863
Exhib. three works at the RA, two portraits and a work entitled 'Spring Trophies'. London address.

ROBINS, Matthew fl.1858
Possibly exhib. a work in 1858. London address.

***ROBINS, Thomas Sewell 1814-1880**
Painter and watercolourist of marine subjects and landscapes. Exhib. at RA 1829-74, BI, SS and NWS. Member of NWS 1839; resigned 1866. "At his best, Robins was a highly accomplished painter of marine subjects, and conveyed a vivid sense of atmospheric effect" (Hardie). Examples of his work are in the VAM and Bethnal Green Museum. A sale of his works was held at Christie's, 19 February 1859. On his retirement from the RI, another sale took place at Christie's, 17 April 1866; after his death two studio sales were held on 25 February 1881 and 23 February 1882.
Bibl: Portfolio 1890 p.54; Bryan; Cundall; VAM; Wilson; Hardie III pp.78-9 (pl. 96); Brook-Hart.

ROBINSON, Miss Annie Louisa
see SWYNNERTON, Mrs. Joseph William

ROBINSON, Arthur fl.1878-1879
Exhib. a landscape at the RA and a work entitled 'Evening' at SS. Addresses in London and Bishop's Waltham, Hampshire.

ROBINSON, Arthur P. fl.1890
Exhib. a work entitled 'A Calm December Morning' at the RA. London address.

ROBINSON, C. fl.1869-1884
Exhib. a study of a head at the RA. London address.

ROBINSON, Charles RI 1870-1937
Watercolourist and illustrator. Studied at the RA schools, at Highbury School of Art, at the West London School of Art and at Heatherley's. Exhib. four works, two illustrations to *King Longbeard*, a book plate and a mural decoration at the RA. Lived in London and at Chesham, Buckinghamshire. He was the brother of William Heath Robinson. Manuscripts relating to this artist are held at VAM.
Bibl: Studio V 1895 pp.146-9; VI 1896 p.l91; IX 1897 pp.74, 217ff.; XVIII 1900 pp.2, 214; XXV 1902 pp.156, 291; LIV 1912 p.255; LXIII 1915 pp.148, 153; LXVI 1916 pp.176-85; R.E.D. Sketchley, *English Book Illustration of Today*, 1903; Connoisseur XLIV 1916 p.109ff.

ROBINSON, Charles F. ARPE fl.1874-1915
Landscape painter and engraver, living in London and Rainham, who exhib. 1874-90, at the RA 1876-82, SS, NWS and elsewhere, titles at the RA including 'On the Thames at Moulsford', 1876, 'The Village at Leigh', 1881 and 'Nature's Mirror', 1882. He was an ARPE from 1890-6. One of his watercolours is in the VAM.
Bibl: VAM.

ROBINSON, Douglas F. 1864-1929
Painted landscape and bathing scenes. Exhib. five works at the RA including 'A Breezy Day' and 'Bathers', and three watercolours at SS. Address in Paris.
Bibl: Who's Who 1924.
Exhib: London, Fine Art Society 1935.

ROBINSON, E. fl.1852
Exhib. a view of Haddon Hall at the RA. London address.

ROBINSON, E. fl.1890

Exhib. an illustration to a line from Longfellow at the RA. London address.

ROBINSON, Miss E. Julia fl.1869-1893

Exhib. ten landscapes at the NWS and two at the GG. Address in Dorking, Surrey.

ROBINSON, Miss Edith Brearey fl.1889-1894

Painted landscape. Exhib. three works at the RA including 'Evening on a Welsh Estuary' and 'A Garden by the River', and three works including 'Binding the Sheaves' and a painting of chrysanthemums at SS, and four works at the NWS. Address in Scarborough, Yorkshire.

ROBINSON, Edward fl.1826-1838

Painted landscape and buildings. Exhib. eight works at the BI including 'Rustic Bridge over the Wye' and 'View from a Lane under Tintagel Castle', six works at the RA including views in Italy, and one sea piece at the RA. London address. Represented in VAM.

ROBINSON, Edward W. 1824-1883

London landscape painter who exhib. 1859-76, at the RA in 1859, 1872-5, SS and elsewhere, titles at the RA including 'Evening', 1859, 'Valley of the Ticino, St. Gothard, Switzerland', 1873 and 'The Village of Shottery, near Stratford-on-Avon', 1875. A watercolour of Salisbury Cathedral is in the VAM.

Bibl: VAM.

ROBINSON, Francis 1830-1886

Painted landscape. He was a tailor who attended art classes at the Mechanic's Institute, Durham. He was much patronised as a landscapist by the gentry and industrialists of the north-east. He was born, lived and died in Durham.

Bibl: Hall.

*ROBINSON, Frederick Cayley ARA RWS RBA ROI 1862-1927

Painter of idyllic scenes and domestic interiors, decorator and illustrator, influenced by Puvis de Chavannes, Burne-Jones and the Italian Quattrocento. Born at Brentford, Middlesex. Studied at the St. John's Wood School of Art, and then at the RA Schools; lived on a yacht painting realistic sea pictures 1888-90. Studied at the Académie Julian in Paris 1890-2. The influence of Puvis de Chavannes, and that of Fra Angelico after a visit to Florence in 1898, caused him to adopt a more decorative manner. Professor of Figure Composition and Decoration at Glasgow School of Art 1914-24. Exhib. from 1877 at SS, becoming RBA 1888, and at the RA from 1895. ARA 1921, RWS 1919. Member of NEAC 1912. First one-man exhib. at the Carfax Gallery, 1908. Designed décor and costumes for Maeterlinck's *Blue Bird*, Haymarket Theatre, 1909; painted a series of mural panels for Middlesex Hospital, 1910-14. Designed posters for the London, Midland and Scottish Railway. Illustrated *The Book of Genesis*, 1914. He was experimental in technique, particularly in different forms of tempera, and his membership of the Tempera Society connected him with the Birmingham Group of Painters and Craftsmen. Charlotte Gere notes that the quietism and brooding quality of his pictures has much in common with the Cotswold artists, Joseph Southall, Frederick Griggs, Arthur Gaskin and Henry Payne.

Bibl: AJ 1902 p.387; 1903 p.96; 1904 p.205; 1906 p.379; 1907 pp.379, 381; 1909 p.174; Studio XIX 1900 p.46ff.; XXXI 1904 pp.235-41; XXXVIII 1906 p.62; XLIX 1910 pp.204-13; LVII 1913 p.145; LXII 1914 p.176; LXV 1915 p.181; LXXXIII 1922 pp.293-9; LXXXV 1923 pp.132, 269; Bate; Who Was Who 1916-28; Connoisseur XLII 1915 p.253; XLIX 1917 p.238; LXIII 1922 pp.109,

112; LXV 1923 p.170; LXVII 1923 p.242; LXXII 1925 p.126; LXXVII 1927 p.125; Apollo VII 1928 p.145; IX 1929 p.118; XI 1930 p.65; Charles Johnson, *English Painting*, 1932; Tate Cat.; Maas pp.231-2; Charlotte Gere, *The Earthly Paradise, F. Cayley Robinson, F.L. Griggs and the Painter-Craftsmen of The Birmingham Group*, FAS exhib. Cat. 1969.

ROBINSON, Miss G. fl.1879

Exhib. a painting of kingfishers and larks at the RA. Address in Chichester, Sussex.

ROBINSON, George Crosland fl.1882-1901

Painted landscape and figurative and genre subjects. Exhib. nine works at the RA including 'Don't Look at Me, Look at the Dog!', 'Folkestone Harbour' and portraits, and two works at SS. Addresses in London and Paris.

ROBINSON, George Finlay fl.1841-1900

Newcastle engraver and landscape painter. He was an admirer of J.H. Mole (q.v.) and painted local landscapes in a similar style.

ROBINSON, H.P. fl.1852

Exhib. a view on the Teine near Ludlow at the RA. London address.

ROBINSON, H. Walter fl.1889-1904

Exhib. a landscape at the NWS. London address.

ROBINSON, Henry Harewood fl.1884-1896

Painted rustic subjects and landscape. Exhib. 12 works at the RA including 'Waiting for the Auction', 'At a Devon Farm' and 'Between the Wood and the Sea', and eight views in Cornwall and Brittany at SS. Addresses in Concarneau, France, and London. His wife was also a painter (q.v.).

ROBINSON, Mrs. Henry Harewood fl.1888-1901 (Miss W. D. Webb)

Painted fishing and rustic subjects. Exhib. 12 works at the RA including 'The Net Menders', 'A Volunteer for the Lifeboat' and 'At a Breton Farm'. Address in St. Ives, Cornwall. Her husband was Henry Harewood Robinson (q.v.).

Bibl: Brook-Hart.

ROBINSON, J. fl.1845

Exhib. a view on the Derwent at the BI. Address in Newcastle-upon-Tyne.

Bibl: Hall.

ROBINSON, J. Carleton fl.1865

Exhib. three landscapes in 1865. Address in Clifton, Yorkshire.

ROBINSON, J.E.H. fl.1805-1841

Painted portraits and landscape. Exhib. 46 works at the RA 1805-41, the later including portraits and views of Cardiff Castle, Chepstow Castle and Brancepeth Castle. Also exhib. nine works, the majority watercolours, at SS and 12 works at the BI. London address.

ROBINSON, J.H. fl.1875-1876

Exhib. two works 'Stranded' and 'Sand Getting — near Bude' at SS. Address in Godalming, Surrey.

ROBINSON, John fl.1848-1885

Painted architecture. Exhib five works at the RA including views of buildings in Ely, Venice and London. London address.

ROBINSON, John fl.1867-1880
Exhib. 12 paintings of flowers 1867-80. London address.

ROBINSON, Sir John Charles CB FSA RPE 1824-1913
Painted and etched landscape. Studied art in Paris. Worked on the Continent. Exhib. seven works at the RA, including 'In the Merry Month of May. View in Sherwood Forest', and landscapes on Skye and in Cornwall, and two works at the GG. He was head of Hanley Art School, Superintendent of South Kensington and surveyor of the Queen's Pictures, holding the latter post for 20 years. Born in Nottingham. Died in Swanage, Dorset.
Bibl: Who Was Who 1897-1915; Who's Who 1913; AJ 1906 p.62; Studio XXXVI 1906 pp.301-7; Connoisseur XXXV 1913 p.178; further bibl. relating to his work as an engraver in TB.

ROBINSON, Joseph fl.1862-1874
Painted flowers and figures. Exhib. eight works at the RA, including still-lifes and works entitled 'Chanson d'Amour' and 'La Toilette', two works at the BI and two watercolours at SS. London address.

ROBINSON, Joseph fl.1882-1883
Exhib. a landscape at the NWS. London address.

ROBINSON, Miss Mabel Catherine ARE b.1875
(Mrs. Barnes)
Painted and etched landscape. Studied at Lambeth Art School and at the RA schools. Born and lived in London.
Bibl: Studio XXV 1902 p.38; Who's Who 1930.

***ROBINSON, Matthias fl.1856-1884**
Genre painter; lived in Chelsea. Exhib. mostly at SS, also at RA 1856-63, BI and elsewhere. Most of his pictures are of children. Although not known to have been associated with the Cranbrook Colony, his work shows the influence of Thomas Webster and F.D. Hardy (qq.v.).

ROBINSON, Miss Nellie fl.1889
Exhib. a Welsh landscape at SS. Address in Scarborough, Yorkshire.

ROBINSON, T. fl.1899-1900
Exhib. two works, 'H.M.S. Edgar in a Storm, February, 1899' and 'Rough Sea — H.M.S. Powerful', at the RA. London address.

ROBINSON, Walter fl.1898-1901
Painted landscape. Exhib. five works at the RA including 'Early Spring', 'In the Valley' and 'A Water-Mill'. London address.

ROBINSON, William 1835-1895
Manchester landscape painter, who exhib. 1884-89 at the RA and NWS.

ROBINSON, William fl.1884-1889
Exhib. a view of Monte Carlo at the RA. Address in Manchester.

ROBINSON, William A. fl.1842-1863
Painted rustic subjects. Exhib. 14 works at the RA including 'The Literary Bore', 'The Young Anglers' and 'Happy Rustics', ten works at SS including 'An Italian Music Lesson' and 'Girl with Buttercups', and one work at SS. Also exhib. at the RHA.
Bibl: Strickland.

ROBJOHNS, F. fl.1865
Exhib. a landscape in 1865. Address in Tavistock, Devon.

ROBLES, J. fl.1871
Exhib. a subject at the RA.

ROBOTHAM, Miss Frances C. fl.1893
Exhib. a work entitled 'Roxana' at the RA. London address.

ROBSON, Miss Gertrude fl.1893
Exhib. three views of Westminster Abbey at SS. London address.

ROBSON, Miss Henrietta fl.1872-1881
Exhib. two still-lifes containing Christmas roses at the RA. Address in New Brighton.

ROBSON, Miss J.S. fl.1873
Exhib. a watercolour of winter roses and jasmine at SS. Address in Ripon, Yorkshire.

ROBSON, Thomas 1798-1871
Painted portraits and genre subjects. A pupil of Sir Thomas Lawrence. Represented in the Museum of Warrington, the town where he was born.
Bibl: AJ 1871 p.293.

ROBSON, Thomas fl.1803-1844
Painted portraits. Exhib. 21 portraits at the RA 1803-44, four works at the BI including a landscape and a 'Fête Champêtre', and one work at SS. London address.

ROBSON, W.F. fl.1876
Exhib. a landscape in 1876. London address.

ROBY, John fl.1838
Exhib. a 'Meadow Scene, near Pond Street, Hampstead' at the RA.

ROCHDALE, A. fl.1888
Exhib. a flower piece in 1888. London address.

ROCHE, Alexander Ignatius RSA 1861-1921
Painted portraits, figurative subjects and landscape. Studied at Glasgow School of Art and in Paris under Boulanger, Gerôme and Levebvre. Exhib. nine works at the RA including 'Shepherdess', 'The Window Seat' and 'Prue', and three works at the GG. Born in Glasgow. In 1897 he moved to Edinburgh. Represented in the Walker AG, Liverpool and the Modern AG, Dublin.
Bibl: AJ 1894 p.78; 1904 p.236; Studio, Art in 1898; Mag. of Art 1901 p.134ff.; Studio XXV 1902 p.204; XXVII 1906 pp.25, 203-14; XLIII 1908 p.135; LX 1914 p.150; LXIX 1917 p.98; LXXII 1918 p.117; LXXXI 1921 p.201; D. Martin, The Glasgow School of Painting, 1902; Royal Scottish Academy, Studio 1907; Caw; The Year's Art 1922; Irwin pl.205.

ROCHE, Thomas S. fl.1861-1869
Painted landscape and coastal scenes. Exhib. seven works at SS including 'On the Medway', 'A Light Breeze on the Thames' and 'On the Coast, Gower, South Wales'. London address.

ROCHEFORT, Countess of fl.1851
Exhib. a portrait at the RA.

RODEN, William Thomas 1817-1892
Painted portraits. Exhib. eight works at the RA including a portrait of Lord Palmerston, four works at SS including 'The Letter', and two works at the BI. Address in Birmingham.
Bibl: Portfolio 1893; DNB p.49; Bryan; BM Cat. of Engraved British Portraits; Poole 1925; Ormond.

RODGERS, Joseph fl.1889
Exhib. a work entitled 'The Day is Far Spent' at the RA. Address in Newark, Nottinghamshire.

ROE, Clarence Henry 1850-1909
Little-known painter of highland landscapes. Did not exhibit in London. Son of Robert Henry Roe (q.v.), who painted similar subjects.

ROE, Frederic RI RBC 1864-1947
Genre and historical painter and watercolourist; stepbrother of Robert Henry Roe (q.v.). Usually known as Fred Roe. Exhib. at RA from 1877 and elsewhere. His pictures are usually historical scenes set in period costume. He also painted portraits and illustrated books on old oak furniture.
Bibl: AJ 1893 p.160; Connoisseur see Index 1913-32, Studio LXVIII 1916 p.40; LXXXIII 1922 p.302; Who's Who; RA Pictures 1891ff.

ROE, Miss Henrietta A. fl.1880
Exhib. a work entitled 'Chloe' at the RA.

ROE, Richard Manleverer fl.1880-1881
Exhib. three watercolours, one of a view in Kent, the others Belgian townscapes, at SS. London address.

ROE, Robert Ernest fl.1868-1875
Painted coastal subjects. Exhib. four works at SS including 'Scarborough Castle' and 'Stone Point, Walton-on-Naze'. Addresses in London and Cambridge. He was probably the son of Robert Henry Roe (q v.).
Bibl: Brook-Hart pl.142.

ROE, Robert Henry 1822-1905
Painter of highland landscapes and animals. Father of Clarence Henry Roe and stepbrother of Fred Roe (qq.v.). Exhib. at RA 1852-68, BI and SS. Titles at RA all highland scenes and Landseer-style deer.
Bibl: Connoisseur LXIII 1922 p.232; Smith, *Recollections of the BI*, 1860 p.125ff.

ROE, W.J. fl.1853
Is supposed to have exhib. a landscape at the BI. London address.

ROE, Walter Herbert fl.1882-1893
Genre painter. Exhib. mostly at SS, also at RA 1885-93, NWS and elsewhere. Titles at RA 'Waiting', 'La Petite Bonne', 'The Pet of the Laundry', etc.

ROËHN, A. fl.1844
Exhib. a painting of Teniers at work at the BI. London address.

ROELOSS, W. fl.1880
Exhib. three rustic subjects at the GG.

ROFFE, Alfred F. fl.1872-1883
Exhib. six landscapes 1872-83. London address.

ROFFE, William John (David B. McKay) fl.1845-1889
Painter of landscapes and coastal scenes. One of a family of engravers and printers. Exhib. at RA 1845-89, BI, SS, GG and elsewhere. Titles at RA 'Moorland Scene — Twilight', 'Robinson Crusoe Bringing Stores from the Wreck', 'Caught in the Squall', etc. Between 1871 and 1877 he used the pseudonym David B. McKay, and exhib. under this name at the RA and SS.

ROGATEWIER, B.A. fl.1853
Exhib. a painting of cattle at SS. London address.

ROGERS, Arthur Lee fl.1885-1888
Painted landscape. Exhib. eight works at the RA including 'Birch Trees at Upper Pond, Burnham' and three views in Sherwood Forest, and a watercolour study of birches at SS. Address in Liverpool.

ROGERS, Miss E.F. fl.1859
Exhib. a landscape in 1859. London address.

ROGERS, Edward James b.1872
Painted portraits and landscape. Studied at Heatherley's. Born in London. Lived in Glenbrook, County Cork.

ROGERS, Miss Gina J. fl.1886-1888
Exhib. two landscapes at the NWS. London address.

ROGERS, H. fl.1835-1837
Exhib. two portraits at the RA. London address.

ROGERS, J. fl.1838-1864
Painted genre and rustic subjects. Exhib. six works at SS including 'Going to the Fair', 'Fresh from the Spring' and 'The Gleaner', and three works at the RA. London address.

ROGERS, James Edward ARHA 1838-1896
Painter of landscapes, architectural and marine subjects; architect; illustrator. Born in Dublin. By profession an architect, but devoted much of his time to watercolours, mainly of architectural and marine subjects. First exhib. at the RHA in 1870 and for many years afterwards. ARHA 1871. Moved to London in 1876, exhib. 1876-93, at the RA 1881-4, NWS, and elsewhere. Several books were illustrated from his drawings. As an architect he designed the Carmichael School of Medicine in North Brunswick Street, Dublin. 'A Street in Limburg' is in the National Gallery of Ireland. For works illustrated by, see VAM Card Cat.
Bibl: Strickland.

ROGERS, Mrs. Jane Masters fl.1847-1870
London portrait painter, who exhib. 1847-70 at the RA, BI and SS.
Bibl: Ormond.

ROGERS, Miss Kate fl.1884-1885
Exhib. a watercolour of pansies at SS. London address.

ROGERS, Miss M. fl.1876-1879
Painted flowers. Exhib. two works at the RA, including 'Firstborn of the Roses', and two works at SS, including watercolours of lilies and honeysuckle. London address.

ROGERS, M.J. fl.1872
Exhib. a painting of fruit in 1872. Address in Thame, Oxfordshire.

ROGERS, Philip Hutchings 1786/94-1853
Marine and landscape painter. Born at Plymouth and educated at Plymouth Grammar School under John Bidlake, where a fellow pupil was Benjamin Robert Haydon (q.v.). Encouraged to study art by Bidlake who sent him to study in London, maintaining him for several years at his own expense. Rogers returned to Plymouth and painted views of Mount Edgcumbe and Plymouth Sound, painting chiefly wide expanses of water under sunlight or golden haze in

imitation of Claude. Many of these are at Saltram House. Exhib. 1808-51 at the RA, BI, SS, NWS and elsewhere. Etched 12 plates for Noel Thomas Carrington's *Dartmoor,* 1826. After living abroad for some years, he died at Lichtenthal near Baden-Baden.

Bibl: Gentleman's Magazine 1853 II p.424; Athenaeum 1853, 30 July; Smith, *Recollections of the BI,* 1860 p.76; G. Pycroft, *Art in Devonshire,* 1883; Bryan; DNB; Brook-Hart.

ROGERS, W.P. fl.1825-1867
Painted still-lifes and country subjects. Exhib. five works at the BI including studies from nature and works entitled 'Cottages at the Foot of Rochester Castle'. Also exhib. one work at the RA and two fishing scenes at SS. London address.

ROGERS, William P. fl.1842-1872
Painted landscape. Exhib. at the RHA 1848-72, including two 'Scenes in the County of Wexford'. Studied at the Dublin Society's School.

Bibl: Strickland.

ROGET, John Lewis fl.1867-1877
Exhib. 30 landscapes 1867-77. London address.

ROGIER, Jean M. fl.1884-1903
Painted landscape and buildings. Exhib. eight works at the RA, including 'Under the Cliff', 'Gathering Scarlet Runners' and views in the British Museum and of the residence of Cecil Rhodes. Address in Hastings, Kent.

ROHDEN, T. fl.1854
Exhib. 'The Adoration of the Magi' at the RA.

ROLFE, Mrs. A.F. fl.1866
Is supposed to have exhib. a sporting subject at SS. London address.

ROLFE, Alexander F. fl.1839-1871
Painter of landscape, still-life and sporting subjects, especially fishing. Exhib. mostly at SS, and at BI. Titles at BI 'First Woodcock of the Season', 'Salmon Fishing on the Usk, South Wales', 'Dead Game', etc. Presumably related to Henry Leonidas Rolfe (q.v.). Sometimes collaborated with J.F. Herring Snr. (q.v.).

ROLFE, Edmund fl.1830-1847
Painted still-lifes of game and vegetables. Exhib. six works at the BI, including 'Fish and Vegetables' and 'Getting Ready for Market', five works at SS, including 'Wood Pigeons and Widgeon' and other still-lifes. Also exhib. two works at the RA. London address.

ROLFE, F. fl.1849-1853
Painted fishing scenes. Exhib. four works at SS, including 'Salmon Pool on the Usk (A Good Morning's Sport)' and 'River Scenes — The Angler's Luncheon', and two works at the BI. London address.

ROLFE, Frederick d.1913
The author of *Hadrian VII, The Desire and Pursuit of the Whole* and other works. At certain stages during the 1880s and 1890s he spent much of his time painting. His subjects were generally religious, often commissioned as church furnishings. He also styled himself as Baron Corvo and Fr. Austin.

Bibl: A.J.A. Symons, *The Quest for Corvo,* 1952.

*ROLFE, Henry Leonidas fl.1847-1881
Painter of fishing subjects. Exhib. at RA 1847-74, BI, SS and elsewhere. Titles mostly still-lifes of fish and fishing-tackle, set in landscapes or by rivers. Also recorded are Alexander F. Rolfe and F. Rolfe (qq.v.), who lived for a time at the same address as Henry Leonidas Rolfe.

Bibl: Clement & Hutton; David Barr, *Limner of Scaly Portraits,* Country Life 16 February 1978 pp.404-6.

ROLFE, Miss Julia L. fl.1875
Exhib. 'On the Welsh Coast' at SS. London address.

ROLL fl.1893
Exhib. two portraits in 1893.

ROLLASTON, W.A. fl.1884-1887
Exhib. two landscapes 1884-7. Address in Birmingham.

ROLLER, George Conrad b.1856 fl.1904
Painted portraits and horses. Studied at Lambeth and in Paris. Exhib. three works, one engraving, a portrait and a work entitled 'My Thought Was Other-Where', at the RA. Born near Gainsborough, Lincolnshire. Travelled widely. Served in the army during both the Boer War and the Great War. Lived in London and Basingstoke, Hampshire.

ROLLER, George R. RPE fl.1887-1892
Exhib. four works at SS including 'Play Up, Surrey', 'Light and Shade' and 'The Art Critic'. London address.

ROLLER, Mrs. Nettie Huxley fl.1891-1893
Exhib. two genre subjects at the NG. London address.

ROLLESTON, Miss Lucy fl.1888
Exhib. a genre subject in 1888. London address.

ROLLINSON, Sunderland fl.1901
Exhib. a work entitled 'As You Like It' at the RA. London address.

ROLLS, Miss Florence fl.1888-1889
Exhib. a portrait at the RA. Address in Caterham, Surrey.

ROLLS, M.S. fl.1839
Exhib. a scene from *Romeo and Juliet* at the RA, and a scene from *Macbeth* and another work at SS.

ROLT, Charles fl.1845-1867
Painter of portraits, landscape, mythological and biblical subjects, living in Merton and London, who exhib. 1845-67, at the RA 1846-66, BI and SS. Titles at the RA include 'Scene from Comus', 1847, 'Sappho Watching the Departure of Phaon', 1852 and 'Christ and the Syrophoenician Woman', 1859.

ROLT, Vivian RBA 1874-1933
Painted landscape. Studied at the Slade School, at St. John's Wood School, at Bushey and at Heatherley's School. Exhib. four works at the RA, three of them landscapes in Sussex. Born at Stow-on-the-Wold, Gloucester. Lived at Watersfield, near Pulborough, Sussex.

ROMER, Mrs. Frank see JOPLING, Mrs. J.M.

ROMER, T. fl.1853
Exhib. a coast scene on the Isle of Thanet at the BI. London address.

ROMER, William fl.1855
Exhib. a work entitled 'Father's Dinner' at the RA. London address.

ROMILLY, Mme. d'Ausse fl.1828-1837
Exhib. three works, two figurative subjects and a work entitled 'The Prisoner of Chillon', at the RA. London address.

ROMILLY, G.T. fl.1852-1875
Painted landscape and genre subjects. Exhib. ten works, six of them watercolours, at SS, including subjects entitled 'The Mother's Right Hand' and 'Contentment and Regret' and landscapes, and one work at the RA. London address.

ROMILLY, W. 1799-1855
Amateur landscapist. Exhib. two landscapes at the RA. London address.

ROODS, Thomas fl.1833-1867
London painter of portraits (often group portraits), and genre, who exhib. 1833-67, at the RA 1834-67, BI, SS and elsewhere. Titles at the RA include 'A Girl Selecting a Nosegay', 1834, 'A Kentish Hop-garden', 1844, 'The Return from Coursing; Portraits of Thomas Sherwin Esq., and Family', 1844 and 'Mr. Alderman Finnis, Sheriff of London for 1849', 1850.

ROOFF, W.A. fl.1879
Exhib. a painting of azaleas and primulas at SS. London address.

ROOK, O. fl.1867
Is supposed to have exhib. two landscapes at the BI. London address.

ROOKE, Bernard fl. 1879-1888
Exhib. four works at the RA, including 'Waiting', 'Early Roses' and 'A Follower of the Mahdi', and one work at SS. Address in Sittingbourne, Kent.

ROOKE, Henri fl.1895
Exhib. a subject at the RA. Address in Paris.

ROOKE, Herbert Kerr RBA 1872-1944
Painted marines. Designed posters. Studied at South Kensington and at the Slade School. Exhib. four works at the RA 1898-1904, including 'Lulworth Cove', 'The Cathedral Rocks, Mullion' and 'Her Late Majesty Queen Victoria's Last Voyage'. London address.
Bibl: Who's Who.

***ROOKE, Thomas Matthews RWS 1842-1942**
Painter of architectural subjects, biblical subjects, portraits and landscape, closely associated in his younger days with Ruskin, Burne-Jones (qq.v.) and William Morris, and much influenced by them. Began in an Army Agent's Office; then attended classes at the RCA, and RA Schools. Aged 29 he applied for a vacancy as designer in William Morris's firm, and was appointed assistant to Burne-Jones, with whom he worked for many years. In 1878 Ruskin was searching for artists to make drawings of cathedrals and other ancient buildings on the Continent, and Burne-Jones recommended Rooke, saying ". . . also there is a very high place in Heaven waiting for him, and *He Doesn't Know It*". As a result up till 1893 Rooke spent half of his time working for Ruskin abroad. The drawings were given by Ruskin to the Ruskin Museum at Sheffield. For the next 15 years he continued to make similar drawings for the Society for the Preservation of Pictorial Records of Ancient Works of Art, and these are in the Birmingham AG. In 1891 he was elected ARWS, RWS 1903; he had exhib. since 1871, at the RA from 1876, OWS, NWS, GG, NG and elsewhere. Hardie notes that "he both knew and loved the buildings which he portrayed, and he never varied from the painstaking exactness which had very properly won Ruskin's approval". In his early days he had also painted biblical subjects in the Pre-Raphaelite tradition, and adopted the manner of painting several compositions of successive scenes of the same story, which were designed to be placed in one frame.
Bibl: AJ 1880 p.172; Gazette des Beaux-Arts 1877 II p.294; 1879 II p.370; Ruskin, Academy Notes 1877-82; Bate p.114 (pl. facing p.114); William White, *Principles of Art as Illustrated by Examples in the Ruskin Museum at Sheffield;* extracts from letters to Sir S. Cockerell OWS XXI; Birmingham Cat.; Who Was Who 1941-50; Hardie III pp.129-30 (pl.152); Staley pls. 87c, 88a; Wood, Pre-Raphaelites.
Exhib: London, Hartnoll & Eyre 1972.

ROOM, Henry 1802-1850
Portrait painter. Born at Birmingham, of a leading evangelical family; studied at the drawing school conducted by Joseph and J.V. Barber. In 1826 he was one of the members of the short-lived Birmingham Society of Artists which was formed for establishing an exhib. of original works of art and included the artist-members of the Society of Arts. Went to London 1830. Exhib. in London from 1826-48, at the RA, BI and SS. He painted a portrait of Thomas Clarkson for the central Negro Emancipation Committee, and also two groups of 'Interview of Queen Adelaide with the Madagascar Princes at Windsor' and 'The Caffre Chiefs' Examination before the House of Commons Committee'. Many of his portraits were engraved in the *Evangelical Magazine*.
Bibl AJ 1850 p.339; Gentleman's Magazine 1850 II p.449; Redgrave, Dict.; DNB; BM Cat. of Engraved British Portraits 1925 p.543; Birmingham Cat.; Ormond.

ROOS, Eva b.1872 fl.1904
(Mrs. S.H. Vedder)
Painted portraits and figurative subjects, mostly of children. Exhib. five works at the RA including 'A Little Convalescent', 'The Necklace' and 'The Hoop Race'. Studied in Paris at the Académies Colarossi and Delecluze. London address.

ROOS, W. 1808-1878
Painted portraits and historical subjects. He was awarded a prize for his work 'The Death of Owen Glyndwr' at the Llangollen National Eisteddford of 1858. He was born, lived and died at Amlwch, Wales.
Bibl: Rees.

ROOTS, Miss Gertrude fl.1898
Exhib. a work entitled 'A Drink by the Way' at the RA. Address in Canterbury, Kent.

ROPE, George Thomas 1846-1929
Painted landscape and animals. Exhib. three works at the RA, including 'Field Mice' and 'Evening — Early Spring', and one work at SS. Also exhib. at the Ipswich Art Society. He generally worked in Essex and Suffolk, and also on the Continent. He influenced Alfred Munnings. Born at Blaxhall, Suffolk. Address in Wickham Market, Suffolk.
Bibl: H.A.E. Day, *East Anglian Painters*, I.

ROPER, A.F. fl.1841-1846
Exhib. two portraits and 'Lamplight Study — An Old Man Lighting his Pipe' at the RA. London address.

ROPER, Cecil B. fl.1888-1890
Painted views of buildings. Exhib. six works at the RA, including buildings in Oxford, Halifax and London. Address in Halifax, Yorkshire.

RORKE, Miss E. fl.1874
Exhib. a genre subject in 1874. London address.

ROSARIUS, fl.1858-1862
Exhib. three works, 'The Hay Loft', 'Thistles' and 'Fox Gloves' at the RA. Address in Dublin. See also Miss Rosa Brett.

ROSCOE, S.G.William 1852-c.1922
London landscape painter, who exhib. 1874-88, at the RA 1880-3, SS, NWS and elsewhere, titles at the RA including 'On the Exe, Devon', 1880 and 'Richmond Bridge, Surrey', 1883.

ROSE, Miss H. Ethel fl.1877-1890
Peckham painter of portraits and genre, who exhib. 1877-90, at the RA 1885-8, SS, NWS and elsewhere, titles at the RA including 'The Sensitive Plant', 1885 and 'A Knotty Question', 1888.

ROSE, H. Randolph fl.1880-1901
London painter of landscape, portraits and genre, who exhib. 1880-1901, at the RA 1885-1901, SS, NWS, GG, NG and elsewhere, titles at the RA including 'Roscoff, Brittany', 1885, 'A Dancing Girl, Algiers', 1897, and 'Franciscans at Prayer, Redentore, Venice', 1900.

ROSE, Richard H. fl.1869-1889
Painted genre and figurative subjects. Exhib. ten works, eight of them watercolours, at SS, titles including 'The Begging Friar', 'His Lonely Hearth' and 'The Cup that Cheers'. London address.

ROSE, Robert Traill b.1863
Painted landscape and figurative subjects. Studied at Edinburgh School of Art. Exhib. in Scotland and on the Continent. Illustrated several books. Born in Newcastle-upon-Tyne. Lived at Tweedsmuir, Peebles.

ROSE, William S. 1810-1873
Landscape and genre painter, working exclusively in oil, who painted chiefly the rural scenery of the Home Counties. Lived in St. Mary Cray, Kent; Wargrave; Foot's Cray, Kent, and Edenbridge. Exhib. 1845-75, at the RA 1853-75, BI, SS and elsewhere, titles at the RA including 'Kentish Heath Scene', 1853, 'A Rustic Village', 1863 and 'Water Mill, Ashdown Forest', 1875. The AJ noted in his obituary: "His pictures — small landscapes painted with taste and feeling, from the pleasant scenery of Kent and Sussex — were seen almost annually in the Academy and BI."
Bibl: AJ 1859 pp.82, 122, 171; 1873 p.208; Redgrave, Dict.

ROSELL, Alexander 1859-1922
Painter of figurative subjects, mainly domestic interiors. Lived in Brighton. His real name was Robert Henry Craig, and he used Rosell as a pseudonym.

ROSELLO, Francisco fl.1896
Exhib. a landscape at the RA. London address.

ROSENBERG, Charles, Jnr. fl.1844-1848
Painted landscape and figurative subjects. Exhib. three works at the RA, two works at the BI and five works at SS, including landscapes and works entitled 'Happy Thoughts' and 'The Welsh Girl'. London address.

ROSENBERG, Mrs. F. fl.1857
Exhib. a portrait at the RA. Address in Leamington Spa, Warwickshire.

ROSENBERG, Miss Frances Elizabeth Louisa (Fanny?) fl.1845 (Mrs. Harris)
Exhib. a painting of hollyhocks at the RA. Address in Bath, Somerset. She was the sister of George Frederick Rosenberg (q.v.). See also Mrs. Harris.

ROSENBERG, George Frederick OWS 1825-1870
Painted landscape and still-life. Exhib. one painting of fish at the RA, and 230 works at the OWS. Address in Bath, Somerset. He was one of a large family of painters, including: his father, Elliott (1790-1835); his sisters, Frances Elizabeth Louisa and Mary (qq.v.), and his daughters, Ethel J. and Gertrude Mary (d.1912). Represented in VAM.
Bibl: Redgrave, Dict.; Roget; DNB 1897.

ROSENBERG, Miss H.B. fl.1836-1837
Exhib. a painting of rhododendrons at the RA and a watercolour at SS. London address.

ROSENBERG, Miss Mary (Anne?) fl.1848-1849 (Mrs. William Duffield)
Exhib. four watercolour painting of flowers at SS. Address in Bath, Somerset. She was the sister of George Frederick Rosenberg (q.v.). See also Mrs. William Duffield.

ROSENBERG, T. fl.1829-1844
Exhib. a painting of a head at the BI.

ROSENTHAL, S. fl.1865-1868
Exhib. two portraits at the RA. London address.
Bibl: BM Cat. of Engraved British Portraits.

ROSHER, Mrs. G.B. fl.1881-1893
Painted figurative subjects. Exhib. six works at the RA, including 'The Last of the Summer' and 'The Destroying Angel', and five works at SS, including 'It Won't Do!' and 'Little Mischief'. London address.

ROSKELL, Nicholas R. 1837-1911
Painted genre and historical subjects. Exhib. eight works at the RA including 'Lycaon Imploring Achilles to Spare his Life' and a work entitled 'He Died for his Country'. London address. Later he studied in Antwerp and changed to painting landscape in a more impressionist style.
Bibl: Ormond.

ROSS, A.H. fl.1884
Is supposed to have exhib. a landscape at the RA. London address.

ROSS, Miss Christina Paterson RSW 1843-1906
Painted country subjects in watercolour. Exhib. three works at SS, including 'A Village Circulating Library' and 'The Sentry', both watercolours, and two works at the RA. Address in Edinburgh. She was the daughter of Robert Thorburn Ross (q.v.).
Bibl: The Year's Art 1907 p.380; Studio XXXIX 1907 p.258.

ROSS, J. fl.1878-1883
Exhib. a work entitled 'Well Content' at SS. London address.

ROSS, Mrs. Jane fl.1880-1900
Painted landscape and figurative subjects. Exhib. two works at the RA and five works at SS, including 'A Trastevere Model', 'Olivia' and a landscape. London address.

ROSS, Joseph Thorburn ARSA 1849-1903

Painted landscape, portraits and genre. Exhib. five works at the RA, including 'The Evening Concert at Venice' and 'The Bass Rock'. He was the son of Robert Thorburn Ross, and the brother of Christina Paterson Ross (qq.v.). Born in Berwick-upon-Tweed. Died in Edinburgh. Represented in the National Gallery, Edinburgh.

Bibl: DNB; AJ 1900 p.287; Cundall.

ROSS, Mrs. Madge fl.1891-1892

Exhib. two portraits at the RA. London address.

ROSS, Mary fl.1840

Exhib. a painting of a camellia at the RA. London address.

*ROSS, Robert Thorburn RSA 1816-1876

Scottish genre and portrait painter. Pupil of G. Simson, and Sir W. Allen. Worked firstly in Glasgow; moved to Berwick 1842; Edinburgh 1852. Exhib. mostly at RSA, also RA 1871-9, and SS. Elected ARSA and RSA 1869. Painted homely scenes of Scottish life, in the manner of the Faeds and Erskine Nicol (qq.v.), but without their technical accomplishment or humour. Caw praises especially his watercolours and sketches. His son Joseph Thorburn Ross and his daughter Christine Paterson Ross (qq.v.) were also painters.

Bibl: AJ 1871 pp.281-3; 1876 p.295 (obit.); 1900 p.287; Studio XXXIX 1907 p.258; Caw p.166; Cundall.

ROSS, W., Jnr. fl.1816-1854

Painted portraits and rustic subjects. Exhib. 14 works at the RA, all portraits; five works at SS and 11 works at the BI, including 'Cottage Girl', 'The Finding of Oedipus' and 'The Lay-brother'. London address.

ROSS, Sir William Charles RA 1794-1860

Miniature portrait painter, and also painter of historical, classical and biblical subjects in oils. Son of William Ross, a miniature painter and teacher of drawing (exhib. at the RA 1809-25); his mother, Maria Ross, was a portrait painter (exhib. at the RA in 1833). In 1808 he entered the RA Schools, and won numerous prizes; he also received seven premiums at the Society of Arts between 1807 and 1821. He exhib. at the RA 1809-59 (304 works), at first oils of a historical, classical and biblical character. In 1814 he became assistant to Andrew Robertson, an eminent miniature painter, and he abandoned historical painting for miniatures. He soon had a large practice in the highest circles: in 1837 the Queen and Duchess of Kent sat to him, and later, Queen Adelaide, Prince Albert, the royal children and various members of the royal families of France, Belgium, Portugal and Saxe-Coburg. ARA 1838; RA 1843; knighted 1842. In 1843 he won a premium of £100 at the Westminster Hall Competition for the cartoon 'The Angel Raphael Discussing with Adam'. He continued to hold the first place among miniature painters until 1857, when he was struck with paralysis. An exhib. of miniatures by him was held at the Society of Arts in 1860, and in June 1860 his remaining works were sold at Christie's. Reynolds notes that "it was his especial gift to catch his sitters at their most genial and agreeable, and his miniatures of Prince Albert, Melbourne and Louis Philippe rank among the most attractive and effective portraits of their epoch."

Bibl: AJ 1849 p.76; 1860 p.72; AU 1839 p.85; Gentleman's Magazine 1860 I p.513; Sandby, History of the Royal Academy, 1862 II pp.171-4; Redgrave, Dict.; Clement & Hutton; J.J. Foster, British Miniature Painters, 1898; G.C. Williamson, History of Portrait Miniatures, 1904; Binyon; Caw p.90; DNB; Connoisseur XXXI 1911 pp.210, 261; LV 1919 pp.93-4; LXI 1921 p.177; LXIII 1922 p.99; LXIV 1922 p.56; LXV 1923 pp.46, 48; Burlington Mag. XXXIX 1921 p.314; XL 1922; Ormond; Irwin.

*ROSSETTI, Dante Gabriel Charles 1828-1882

Pre-Raphaelite painter and poet. His father, Gabriel Rossetti, was an Italian refugee and Professor of Italian at King's College, where Rossetti first studied 1837-42. Entered RA Schools 1845. Pupil of Ford Madox Brown for a few months in 1848, after which he shared a studio with Holman Hunt. Together with Hunt and Millais, Rossetti played a leading role in the formation of the Pre-Raphaelite Brotherhood (q.v.) 1848-9. Toured France with Hunt 1849. In 1850 he met Elizabeth Siddal (q.v.), who became his favourite model, his mistress, and later, in 1860, his wife. Although Rossetti was the driving force behind the PRB, he only contributed two oil paintings to this first phase of the movement — 'The Girlhood of Mary The Virgin' and 'Ecce Ancilla Domini'. Because of the furore aroused by the paintings of the PRB, he never exhib. his pictures in public again, preferring to sell through agents, such as the disreputable C.A. Howell, or direct to collectors. From this period until about 1864 he preferred to work in watercolour, although as Hardie writes "neither oil nor watercolour were pliant and malleable materials in his hands. He was wrestling with refractory substances, and perhaps for that very reason his work has the intensity and inner glow so often lacking in the painter who attains a surface of superficial ease." He always considered himself primarily a poet (as was his sister Christina). The subjects of his works in the 1850s were mostly taken from Dante or Morte d'Arthur, and Elizabeth Siddal appears in practically all of them. In 1857-8 he worked on the Oxford Union frescoes with Burne-Jones and William Morris, both of whom became his disciples, thus generating the second phase of the Pre-Raphaelite movement. In 1862, after the tragic death of his wife from an overdose of laudanum, he moved to Tudor House, 16 Cheyne Walk, which he shared with his brother, William Michael Rossetti, Swinburne, Meredith, and numerous pets. He turned back to oil painting, concentrating on allegorical female portraits, or groups of females, with titles like 'La Donna della Fiamma', 'Proserpine', 'Venus Verticordia', 'Pandora', etc. Although he used several models, the same facial type, languid and sensual, features in all of them. His most famous model, and the one most associated with the Rossetti image, was Jane Morris, wife of William Morris. From 1871-4 he and Morris shared Kelmscott Manor in Oxfordshire. Rossetti began to suffer mental disturbance, and became increasingly dependent on chloral. The quality of his work declined, but he was still successful enough to employ studio assistants, first W.J. Knewstub and later Henry Treffry Dunn (qq.v.). Burne-Jones and Morris both thought that Rossetti's best work was done before 1860, and many modern critics agree with this. But the influence of his ideas and his personality, transmitted through Burne-Jones and his many followers, remained a potent feature of English painting even into the early 20th century. His studio sale was held at Christie's, 12 May 1883. For works illustrated by, see VAM Card Cat.

Bibl: For full bibl. see Fredeman Sections 22-34 et passim.
Main Biographies: W.M. Rossetti, D.G.R. his family letters, 1895; F.M. Hueffer, R. A Critical Essay, 1902; H.C. Marillier, R., 1904 (still the standard work); P.J. Toynbee, Chronological List of Paintings from Dante by D.G.R., 1912; Sir M. Beerbohm, R. and his Circle, 1922; Evelyn Waugh, R. his Life and Work, 1928; H.M.R. Angeli, D.G.R., 1949; R. Glynn Grylls (Lady Mander), Portrait of R., 1964; G.H. Fleming, R. and the PRB, 1967; V. Surtees, The Paintings and Drawings of D.G.R. A Catalogue Raisonné, 1970; D. Sonstroem, R. and 'The Fair Lady', 1970; G.H. Fleming, That Ne'er Shall Meet Again, 1971; Marina Henderson, D.G.R., 1973; A.I. Grieve, The Art of D.G.R., 1973; John Nicoll, D.G.R., 1975; A.C. Faxon, D.G.R., 1989.
Other bibl. references: Binyon; VAM; Cundall; DNB; Bate; Ironside & Gere; Reynolds, VP pp.60-1, 64-5 et passim (pls.36-8); Maas pp.124-6 et passim (pls. pp.138, 141-3, 200); Hardie III pp.118-21 et passim (pls. 136-9); Ormond; Staley; Irwin; Wood, Panorama pl. 144; Wood, Pre-Raphaelites; Newall.
Exhib: Newcastle-upon-Tyne, Laing AG 1971; London, RA 1973; Yale, Gallery of Fine Arts 1976; Bunkamura Museum, Tokyo, Japan, 1991; Ashmolean Museum, Oxford, Drawings by D.G.R. of Elizabeth Siddal, 1991.

ROSSETTI, Mrs. William Michael
see BROWN, Miss Lucy Madox

***ROSSI, Alexander M. fl.1870-1903**
Painter of genre and portraits, living in Preston and London, who exhib. 1870-1903, at the RA 1871-1903, SS (47 works), NWS and elsewhere. Titles at the RA include 'A Family Group', 1871, 'Caught in the Tide', 1889 and 'Their Morning Bath', 1900. Painted many charming domestic scenes, often of children, sometimes quite large. Also painted beach scenes.
Bibl: Wood, Paradise Lost.

ROSSI, Miss Mary H. fl. 1894
Exhib. a work entitled 'Jealousy' at the RA. London address.

ROSSI, Mrs. S.A. fl.1874-1875
Exhib. a work entitled 'In the Greenhouse' and 'In Training' at SS. London address.

ROSSITER, Mrs. A.M. fl.1845
Exhib. a painting of primroses at the RA. London address.

***ROSSITER, Charles b.1827 fl.1852-1890**
Genre painter. Exhib. at RA 1859-90, BI, SS and elsewhere. Titles at RA 'Sad Memories', 'Rival Anglers', 'Quiet Enjoyment', etc. His wife Mrs. Charles Rossiter (q.v.) was also a painter. His best-known work is 'To Brighton and Back for 3/6' in Birmingham City AG.
Bibl: Clement & Hutton; Birmingham Cat.; Wood, Panorama pl.223.

ROSSITER, Mrs. Charles fl.1858-1892
(Miss Frances Sears)
Genre painter and watercolourist. Studied under Leigh of Newman Street, and Charles Rossiter (q.v.) who she married in 1860. Exhib. first at Liverpool Academy in 1862, later at RA, BI, SS, NWS and elsewhere. Her subjects were mostly sentimental domestic scenes, but in 1866 she began to exhib. paintings and watercolours of birds, which later became her speciality.
Bibl: Clayton II pp.316-18.

ROSSITER, Frances A. fl.1888
Exhib. a painting of birds at SS. London address.

ROSSITER, Henry fl.1885
Exhib. a landscape at the NWS. London address.

ROSSITER, Miss Mary P. see HARRISON, Mrs. Mary P.

ROSSITER, Walter PS b.1871
Painted landscape and architecture in watercolour. Exhib. in London and Paris. Founded the Coventry and Warwickshire Society of Artists. Born in Bath, Somerset. Lived in Bromley, Kent.

ROTHENSTEIN, Sir William NEAC 1872-1945
Painted and etched portraits, figurative subjects and landscape. Studied at the Slade School and at the Académie Julian. Travelled widely. Became an Official War Artist 1914-18. Born in Bradford, Yorkshire. Lived in London 1895-1912, and subsequently in Stroud, Gloucestershire. His memoirs, *Men and Memories,* were published in 1931. His brother, Albert Daniel, changed his name to Rutherstone.
Bibl: AJ 1896 p.41ff.; 1901 pp.190-1; 1905 pp.144, 287; 1906 p.355; Studio XL 1907 p.224; XLVII 1909 p.185; LXIV 1915 p.197; LXVII 1916 p.140ff.; LXVIII 1916 p.l18; XCI 1926 p.306; XCII 1926 p.60; XCIV 1927 pp.155, 196; Who's Who; H.W., *William Rothenstein,* 1923; J. Laver, *Portraits in Oil and Vinegar,* 1927; Apollo VI 1927 pp.91, 114, 118; IX 1929 p.392; BM Cat. of Engraved British Portraits.
Exhib: Berlin, Edward Schulte 1902; London, Alpine Club Gallery 1921; Agnew's 1935; Leicester Galleries 1938; Birkenhead, Williamson AG 1939; Sheffield, Graves AG 1939; London, Leicester Galleries 1942; Nicholson Gallery 1943; Leicester Galleries 1946; Tate Gallery 1950; Gloucester, City Museum and AG 1965-6; Carlisle, Museum and AG 1971; Bradford, City AG and Museums 1972.

ROTHWELL, Richard RHA 1800-1868
Painter of portraits and genre. Born in Athlone, Ireland; trained in Dublin where he worked for a few years. RHA 1826; soon afterwards moved to London where he became Sir Thomas Lawrence's chief assistant. When Lawrence died, Rothwell was entrusted with the completion of his commissions and could have succeeded to his practice, but he was unable to sustain the reputation of his early works, painted in Lawrence's manner. He exhib. 1830-63, at the RA 1830-62, BI, SS and elsewhere. Amongst others, he painted portraits of the Duchess of Kent, the Prince of Leiningen, Viscount Beresford and William Huskisson. In c.1846 he returned to Dublin, where, having resigned in 1837, he was re-elected RHA 1847. From 1849-54 he was again in London, and then went to Leamington. The last years of his life were spent in Paris, and then in Rome, where he died. Three of his genre paintings 'The Little Roamer', 'Novitiate Mendicant' and 'The Very Picture of Idleness', RA 1842, are in the VAM. His portraits of Huskisson and Viscount Beresford are in the NPG.
Bibl: AJ 1868 p.245 (obit.); 1872 p.271; Redgrave, Dict.; Bryan; DNB; BM Cat. of Engraved British Portraits; Strickland; Ormond.

ROTHWELL, S.R. fl.1871
Is supposed to have exhib. an architectural view at the RA. Address in Manchester.

ROTHWELL, Selim Botton 1815-1881
Painted and etched views of buildings. Exhib. five works at the RA, including views in Verona, Brunswick and Florence. Address in Manchester.
Bibl: The Year's Art 1882.

ROTHWELL, T. fl.1875-1877
Exhib. three landscapes, 1875-7. Address in Torquay, Devon.

ROTTA, Silvio G. fl.1881
Exhib. a view of a weir at the RA. Address in Liverpool.

ROUGERON, E. fl.1880
Exhib. a figurative subject in 1880. London address.

ROUGHTON, Mrs. E.M. fl.1889-1893
Painted landscape and architecture. Exhib. five works at SS, including a landscape and views in Gray's Inn. London address.

ROUND, Cecil M. fl.1884-1898
Painted landscape and country subjects. Exhib. eight works at the RA, including 'The Patter of the Whirlwind' and 'The Woodman's House', and four works at SS, including 'Like Flames Upon An Altar Shine the Sheaves'. London address.

ROUS, Bart fl.1869-1879
Exhib. a work entitled 'Devonshire Cottage' at SS and a genre subject at the RA. London address.

ROUS, Miss Elizabeth see PHILLIPS, Mrs. Philip

ROUSE, C. fl.1877
Exhib. a watercolour sketch at Rouen at SS. Address in Birmingham.

451

ROUSE, F.B. fl.1874-1884
Exhib. four watercolours at SS, landscapes and a work entitled 'The Height of Cockneydome'. London address.

ROUSE, Fred J.C.V. fl. 1888-1893
Painted landscape. Exhib. nine works at the RA, including 'An Apple Orchard', 'Autumn's Last Days' and 'A Stream', and six works at SS. London address.

ROUSE, Robert William Arthur RBA fl.1882-c.1929
Landscape painter, living in London and Brixton, who exhib. 1882-1929, at the RA 1883-98, SS, NWS and elsewhere, titles at the RA including 'Far from the Busy Hum of Men', 1883, 'In the Month of May', 1889 and 'Afternoon, August', 1898.

ROUSSEL, Theodore Casimir RBA ARE 1847-1926
Painted and etched portraits, genre subjects and landscape. Exhib. six works at SS, including a portrait of Mortimer Menpes and a work entitled 'The Bathers'. Born at Lorient, Brittany. He fought in the Franco-Prussian War. After 1870 he moved to London where he became a friend of Whistler (q.v.). He was President of the Society of Graver-Printers in Colour. Lived and died in St. Leonards-on-Sea, Sussex.
Bibl: AJ 1896 p.41ff.; 1902 p.154; 1907 p.349; 1909 pp.181-6; Connoisseur XXXV 1913 p.190; LVIII 1920 p.178; LXV 1923 p.111; LXXIX 1927 pp.186ff., 258; XC 1932 p.126; Frank Rutter, *Theo. Roussel*, 1926; Apollo VI 1927 p.234. Exhib: London, Chenil Gallery 1908; Goupil Gallery 1927.

ROUSSOFF, Alexandre N. fl.1880-1888
Painted Venetian subjects. Exhib. five works at the RA including 'Street Bargaining — Venice' and 'Tottering Steps'. London address.

ROUTH, Mrs. R.S. Arden fl.1870
Painted Devonshire landscapes. Exhib. a view in the Valley of the Rocks at the RA and two views near Lynton at SS. Address in Lynton, Devon.

ROUTLEDGE, Miss Emily fl.1870-1874
Exhib. two paintings of roses and another work at SS. London address.

ROWAN, Alexander fl.1852-1859
Painted historical and biblical subjects. Exhib. two works, one a scene from *King John,* at the RA, and nine works at the BI including 'The Warrior's Rest' and 'John the Baptist'. London address.

ROWAN, William G. fl.1891-1894
Exhib. three views of churches in Glasgow at the RA. Address in Glasgow.

ROWAT, James fl.1892
Exhib. a view in Glasgow cathedral at the RA. Address in Glasgow.

ROWBOTHAM, Charles Edmund 1856-1921
Landscape painter, who exhib. 1877-88 at SS, NWS and elsewhere. He was the eldest son of T.C.L. Rowbotham (q.v.) and during the later years of his father's career often painted the figures in his landscapes. His 'Clifton Bridge' (watercolour) is in Cardiff AG. Like his father, he used a great deal of body colour in his watercolours, giving them an unnaturally bright and colourful appearance.
Bibl: John Ramm, *C.R. and his Family,* Antique Collector August 1988; see also under T.C. L. Rowbotham.

ROWBOTHAM, Miss E. fl.1852-1855
Exhib. five watercolour portraits or figure studies at SS. London address.

ROWBOTHAM, Claude Hamilton 1864-1949
Watercolourist of Italian lakes and English landscape, especially on the Thames. Son of T.C.L. Rowbotham and brother of Charles (qq.v.). Exhib.at Dudley Gallery; held one-man shows at the Doré Gallery and Walker's Galleries.
Bibl: See under T.C.L. Rowbotham.

***ROWBOTHAM, Thomas Charles Leeson RI 1823-1875**
Landscape painter in watercolour; engraver and lithographer. Son of Thomas Leeson Rowbotham (1783-1853), also a painter of landscape, marines and coastal scenery. Pupil of his father. His first serious work was done in 1847 on a sketching tour of Wales. Exhib. 1840-75, at the RA 1840 and 1848, SS, NWS (464 works) and elsewhere. In 1848 he became A of the RI, and RI in 1851. He succeeded his father as Professor of Drawing at the Royal Naval School, New Cross, collaborated with him in *The Art of Painting in Watercolours,* and illustrated his father's *The Art of Sketching from Nature.* In his later years his love of sunny effects led him to restrict himself to Italian subjects, especially those of sea or lake, although he had never been in Italy. Ruskin praised his work, and in 1858 said he had the making of a good landscape painter, in spite of his "artificialness". In 1875 he published small volumes of *English Lake Scenery* and *Picturesque Scottish Scenery,* and a series of chromolithographic *Views of Wicklow and Killarney,* with descriptive text by the Rev. W.J. Loftie. He published many other chromolithographs; a series entitled *T.L. Rowbotham's Sketch Book* was issued after his death. A sale of his 'Sketches in Watercolours' was held at Christie's, 8 July 1863; his studio sale was also held there 21 April 1876.
Bibl: For Father and Son: AJ 1875 p.280; Ruskin, Academy Notes (NWS reviews); Redgrave, Dict.; Roget; Bryan; Binyon; Cundall; DNB; Hughes; Strickland; VAM; Hardie III pp.12, 57; J. King, *The Rowbotham Family,* Watercolours Magazine Winter 1993.

ROWDEN, Miss Jessie fl.1891
Exhib. a landscape at the NWS. Address in Oxford.

ROWDEN, Thomas 1842-1926
A self-taught landscape painter, who exhib. from 1884. He painted in Dartmoor, Cornwall and the highlands.

ROWE, Miss A.M. fl.1855
Exhib. an Irish landscape at the RA. London address.

ROWE, Miss Edith d'Oyley fl.1889-1892
Exhib. a painting of poppies at SS and three works at the NWS. London address.

***ROWE, Ernest Arthur 1863-1922**
Painter of landscapes and gardens, mainly in watercolour, living in Lambeth and Tunbridge Wells, who exhib. 1885 at the RA, SS, NWS, NG and elsewhere, titles at the RA including 'Memories of the Past', 1885, 'A Winter's Tale', 1891 and 'Kale Pots and Cherry Blossom', 1893. He had a one-man show of his watercolours at the Greatorex Galleries, Grafton Street, in 1921, of which *The Connoisseur* commented: "Mr. E.A. Rowe arranged an attractive exhibition of watercolours in his accustomed metier. His drawings of old-world gardens are always pleasing, and evince marked sincerity of purpose. Dealing in detail rather than in broad effects,

he sometimes permits himself to be carried away by a comprehensive observation of minutiae, with the result that a few of his more laboured studies lack reticence and become spotty in construction and coloration. An artist should be judged by his best works, however, and in such a sensitively rendered and varied sketch as 'A Quiet Corner — Villa Borghese, Rome', the dross was eliminated, leaving pure quality behind." A watercolour 'The Villa d'Este, Tivoli' is in the City of Birmingham Museum and AG.

Bibl: Connoisseur LIX 1921 p.248; American Art News X 1922 No.20 p.6; Wood, Painted Gardens; Newall.

ROWE, George 1797-1864
Painter and lithographer who worked in Exeter, Sussex, Cheltenham, and also in Australia 1852-9. He painted landscapes and coastal views.

ROWE, George James fl.1830-1862 d.1883
Landscape painter, living in Woodbridge and London, who exhib. 1830-62, at the RA 1830-54, BI and SS, titles at the RA including 'On the Woodbridge River', 1844 and 'Suburban Study Bayswater', 1854.

Bibl: The Year's Art 1884 p.217.

ROWE, Miss Gertrude fl.1896
Exhib. a view of the harbour at St. Ives at the RA. Address in Cornwall.

ROWE, Sidney Grant ROI 1861-1928
Landscape painter, living in London and Warlingham. Son of Charles J. Rowe, lyric author. Studied at the St. Martin's School of Art; exhib. at SS, NWS and elsewhere from 1877 and at the RA from 1882. Titles at the RA include 'Cloudy Day', 1882 and 'Solitude', 1896.

Bibl: Who Was Who 1916-28; Pavière, Landscape.

ROWE, Tom Trythall b.1856 fl.1882-1899
Landscape painter living in London, Cookham Dene and Rotherham, who exhib. 1882-99 at the RA, SS, NWS and elsewhere, titles at the RA including 'Old Battersea Bridge', 1882 and 'Field Flowers', 1899. In Nottingham Museum and AG is 'Evening Glow'.

ROWE, William, Jnr. fl.1900
Exhib. 'A Weedy Corner' at the RA. London address.

ROWE, William J. Monkhouse fl.1882-1891
Exhib. three works, 'Homewards', 'Pegasus' and 'Au Revoir', at the RA. London address.

ROWLETT, G. fl.1847
Exhib. a painting of Shylock from *The Merchant of Venice* at the BI. London address.

ROWLEY, E. fl.1858-1859
Painted landscapes. Exhib. four works at the RA, including two scenes on the Thames. London address.

ROWLEY, E.S. fl.1859-1875
London landscape painter, who exhib. 1859-75, at the RA 1862-72, SS and BI, titles at the RA including 'A Shady Place — Fin Glen, Campsie, Scotland', 1862 and 'A Peep Down a Trout Stream, near Brecon, S. Wales', 1872.

ROWLEY, Miss Elizabeth fl.1852-1859
Edmonton genre painter, who exhib. 1852-9, at the RA 1852, 1853 and 1856. BI, SS and elsewhere, titles at the RA including 'Laura', 1852 and 'Sortie le Bal', 1856.

ROWLEY, Mrs. Francis fl.1893
Exhib. a portrait at the NG. London address.

ROWLEY, H. fl.1861-1862
Exhib. two works, 'Rural Scenery' and 'Ruth and Naomi', at the RA, and another at SS. London address.

ROWLEY, The Hon. Hugh fl.1866
Exhib. a work 'Letters Composing the Word *Juliana,* entwined, Surrounded by Flowers and the Arts' at the RA. London address.

ROWLSTONE, F. fl.1824-1841
Painted landscape, figurative and nocturnal subjects. Exhib. 20 works at SS, including 'An Effect of Candlelight', 'Girl and Mackerel' and 'View in Dovedale', seven works at the BI, and one work, 'A Boy with a Turnip Lantern', at the RA. London address.

ROWSELL, Rev. T. Norman fl.1889-1890
Exhib. two landscapes at the NWS. Address in Eltham, London.

ROWSTORNE, Edwin fl.1891
Exhib. a work entitled 'Feeding Time: An Anxious Moment' at the RA. London address.

ROXBY, C.W. fl.1875-1890
Painted landscape. Exhib. 23 works, some of them watercolours, at SS, including 'Rest By The Way', 'At the Cottage Door, Brittany' and 'The Edge of the Common', and landscapes in Dorset, Hampshire and Suffolk. London address.

ROY, Eugene Armand fl.1848-1859
Exhib. 'A Calm Morning' at the RA, and a 'View of Venice' at SS. London address.

ROYAL, Miss Elizabeth L. fl.1865-1871
(Mrs. John Surtees)
Exhib. two watercolour studies at SS. London address. Wife of the painter John Surtees (q.v.).

ROYLE, Herbert 1870-1958
Painted landscape. Studied under J. Buxton Knight. Exhib. three landscapes, including 'A Welsh Hillside' and Eventide — November', at the RA. Also exhib. elsewhere in London and abroad. Born in Manchester. Lived near Ilkley, Yorkshire.

RUBIO, G.G. fl.1861
Exhib. a subject at the RA. Address in Geneva.

RUCKLE, T.C. fl.1839-1840
Exhib. two works, 'Selling a Diamond to a Jew' and 'Friendly Conversation in a Country Alehouse', at the BI, and two works at the RA. Addresses in London and Baltimore, USA.

RUDD, Miss Agnes J. fl.1888-1926
Painted landscape. Exhib. eight works at the RA, including 'Moor and Sea', 'A Summer's Day, Rye, 1891' and 'Evening, Richmond, Yorkshire'. Address in Bournemouth, Hampshire.

RUDGE, Mrs. fl.1872-1873
Exhib. a work entitled 'My Pet' at SS. Address in Godalming, Surrey.

RUDGE, Bradford 1805-1885
Bedford landscape painter and lithographer, who exhib. 1840-83, at the RA 1840-72, SS and elsewhere, titles at the RA including 'In the Grounds of Ampthill Park, Beds', 1864 and 'A Peep at the

Mwthoc; the Arrans in the Distance', 1872. In 1859 he exhib. at the Portland Gallery 'Yew Tree in Lorton Vale, Cumberland', of which the AJ said ". . . the tree is certainly most skilfully painted, but it stands alone, a melancholy spot in the picture, entirely unsupported by any shred of sympathizing shade."
Bibl: AJ 1859 p.l22; BM Cat. of Engraved British Portraits I 1908 p.476.

RUFF, George, Snr. fl.1877-1886
Painted landscape and marines. Exhib. seven watercolours at SS, including 'Broadstairs with the North Foreland Lighthouse' and 'The Kitchen Garden', and two works, 'Wreck of the *Ida* of Glasgow at Brighton, January 6th, 1877' and 'Old Houses at Lewes'. Address in Brighton, Sussex.

RUFF, George, Jnr. fl.1879-1880
Exhib. three works, including two Sussex landscapes, at SS. London address.

RUFFO, Mme. fl.1875-1876
Exhib. two genre subjects 1875-6. London address.

RUFFORD, Mrs. fl.1881
Exhib. two drawings in 1881. London address.

RUGGLES, W.H. fl.1833-1846
Exhib. two works, a portrait and a painting of a hunter, at the RA. Address in Lewisham.

RUL, Henry fl.1888-1890
Exhib. three works, including 'The Lake' and 'Autumn Leaves', at the RA. Address in Antwerp, Belgium.

RUMBALL, T. fl.1871
Exhib. a work entitled 'The Campos Bridge, in the Brazils', at the RA. London address.

RUMBLE, Frederick fl.1850-1879
Exhib. ten views of churches 1850-79. London address.

RUMLEY, Miss Elizabeth see DAWSON, Mrs. B.

RUNCIMAN, Charles fl.1825-1867
Painted landscape, literary and figurative subjects. Exhib. 25 works at the BI, including 'Elijah Fed by an Angel', 'Richard and Kate Going to the Fair' and 'Viola, from *Twelfth Night*'. Also exhib. 17 works at the RA, including views in Kent and Berkshire, and on the Rhine, and 16 works at SS. London address.
Bibl: AJ 1859 p.l21.

RUSHER, R. Eaton fl.1886-1889
Is supposed to have exhib. a work at SS. London address.

RUSHTON, Alfred Josiah b.1864 fl.1881
Painted landscape and genre subjects. Studied at Birmingham School of Art and at the RCA. Exhib. ten works, some of them watercolours, at SS, including 'Do I Like Butter?', 'At Winchcombe' and 'A Gloucestershire Gable', and a portrait at the RA. Born at Worcester. Lived at West Hartlepool, County Durham.

RUSHTON, George Herbert RI RBA fl.1880-1925
Painted landscape and decorations. Exhib. a work entitled 'The Widow' at the RA. Born in Birmingham. Lived in Newcastle-upon-Tyne until 1906, after which he spent much of his time on the Continent. Represented Laing AG, Newcastle.
Bibl: Hall.

RUSHTON, Miss Kate A. fl.1892
Exhib. a painting of chrysanthemums at SS. London address.

RUSHWORTH, W. fl.1872-1874
Exhib. three works, 'Tynemouth Priory, Northumberland', 'View of St. Albans' and 'Dryburgh Abbey', at the RA. London address.

***RUSKIN, John HRWS 1819-1900**
Writer, critic and artist. The most influential critic of the Victorian age. Born in London, the only child of a wealthy sherry merchant. Educated at Christ Church, Oxford; won the Newdigate prize 1839. In 1840 he met Turner (q.v.), whose work he greatly admired. In 1843 he published the first volume of *Modern Painters,* begun as a defence and justification of Turner, but expanded into a general survey of art. Among his other books were *The Seven Lamps of Architecture,* 1849 and *The Stones of Venice,* 1851-3, both illustrated by himself. The great success of these works established his position as England's leading writer on art, and enabled him to wield more authority than any other critic before or since. Rede Lecturer at Cambridge 1867; Slade Professor of Art at Oxford 1869-84. From 1848 to 1854 he was married to Effie Gray, who left him to marry Millais (q.v.). Ruskin was himself a talented watercolourist and draughtsman, and studied under Copley Fielding and J.D. Harding (qq.v.). Exhib. at OWS 1873-84; HRWS 1873. His drawings reflect his analytical and scientific approach to art. They are mostly of architectural details, or studies of rocks, mountains, and plants. In painting he always insisted on minutely detailed observation of nature, and it was this aspect of the Pre-Raphaelite movement which led him to intervene in their defence in 1851. It also attracted him to artists like John Brett (q.v.), who shared his scientific and geological interests. Late in life he became increasingly interested in social reform. He also began to suffer from mental illness, which made him increasingly eccentric and unreliable as a critic, and led to the notorious Whistler trial of 1878. Retired to Brantwood, Coniston, in the Lake District, where he died. For his opinions on Victorian painters, a good source is his *Academy Notes.* The best complete edition of his works is Cook and Wedderburn 1901-12, but several good anthologies have been published more recently .
Bibl: For full bibl. see Fredeman Section 45.
Main Biographies: W.G. Collingwood, *The Life and Works of J.R.,* 1893; C.E. Godspeed & Co., Cat. of Paintings, Drawings etc. of J.R., 1931; R.A. Wilenski, *J.R.,* 1933; J.H. Whitehouse, *R. The Painter and his Works at Bembridge,* 1938; P. Quennell, *J.R.,* 1949; J. Evans, *J.R.,* l954; M. Lutyens, *Millais and the Ruskins,* 1967; A. Severn, *The Professor —Arthur Severn's Memoir of J.R.,* 1967; Paul H. Walton, *The Drawings of John R.,* 1972; Mary Lutyens, *The Ruskins and the Grays,* 1972.
Other references: Roget; Binyon; Cundall; Hughes; VAM; DNB; *Ruskin and his Circle,* Arts Council exhib. 1964; Hardie II pp.43-5 (pls.29-30); Maas *passim* (pls. pp.15, 226, 228); Staley (pls.21b, 68b); Irwin; Wood, Panorama; Wood, Pre-Raphaelites; Newall; *Ruskin and his Circle,* exhib. at Maas Gallery, London, 1991; for further recent bibl: see VAM subject catalogue.

RUSSELL, Lady Arthur fl.1867-d.1910
Painted a portrait of Sarah Austin, which is in the NPG.
Bibl: Ormond.

RUSSELL, Sir B.F., Bt. fl.1848
Exhib. a work entitled 'A Farmyard — Commotion' at the RA.

RUSSELL, Miss Bertha A. fl.1888-1893
Exhib. two works, 'Relics of a Bygone Age' and 'A Schoolboy's Treasures', at the RA. London address.

RUSSELL, C.J.W. **fl.1848**
Exhib. a view of the Chappell Viaduct on the Colchester and Stour Valley Railway at the RA. Address in Ipswich, Suffolk.

RUSSELL, Charles **RHA** **1852-1910**
Painted portraits and marines. Exhib. at the RHA from 1878. Also exhib. a work entitled 'A Rival in the Studio' at the RA. He was the son of the Scottish artist John Russell and was born in Dumbarton. He lived and died in Dublin.
Bibl: Strickland.

RUSSELL, Edwin **fl.1898**
Exhib. 'A Maid of Kent' at the RA. London address.

RUSSELL, Edwin Wensley **fl.1855-1878**
London painter of portraits, genre and historical subjects, who exhib. 1855-78, at the RA, BI, SS and elsewhere, titles at the RA including 'Consolation', 1855, 'The Rose Seller of Andalusia', 1869 and 'Forbidden Fruit', 1876. The AJ noted of his 'Ave Maria', RA 1859: "A study of a girl at Vespers, painted with firmness and very appropriately circumstanced." A 'Portrait of Miss Nancy Hargreaves' and a watercolour are in Blackburn Museum.
Bibl: AJ 1859 p.167.

RUSSELL, Miss Elizabeth M. **fl.1849-1850**
Painted flowers. Exhib. four watercolours at SS. Address in Guildford, Surrey.

RUSSELL, Frederick **fl.1847**
Exhib. a view of the old Grammar School in Ipswich at the RA. Address in Ipswich, Suffolk.

RUSSELL, H.A. **fl.1851-1852**
Exhib. two works, 'Italian Greyhound' and 'An Orange Boy', at the RA. London address.

RUSSELL, James **fl.1878-1887**
Exhib. two paintings of flowers 1878-87. Address in Bath, Somerset.

RUSSELL, Miss Janette Catherine **fl.1868-1894**
Painted figurative subjects and flowers. Exhib. six works at the RA, including 'Witchcraft', 'As They Grew' and portraits, and five watercolours, including paintings of hawthorn, at SS. Address in Surbiton, Surrey.

RUSSELL, Miss Juliana **fl.1865-1877**
Exhib. 15 genre subjects 1865-77. Address in Surbiton, Surrey.

RUSSELL, Miss M. **fl.1901**
Exhib. a work entitled 'Low Tide — Millside' at the RA. Address in Ravenglass, Cumberland.

RUSSELL, Norman Scott **fl.1869**
Exhib. a portrait in 1869. London address.

RUSSELL, S. **fl.1840**
Exhib. a work entitled 'A Member of the University of Oxford in his Boating Dress' at the RA. London address.

RUSSELL, S. **fl.1874**
Exhib. a portrait at the RA. London address.

RUSSELL, W. **fl.1834-1843**
Painted landscape and views of buildings. Exhib. 11 watercolours at SS including views of Netley Abbey and views in Normandy and Brittany, and two works at the RA. London address.

RUSSELL, Wallace **fl.1889**
Exhib. a work entitled 'Tribe of the Wandering Foot' at the RA. Address in Glasgow.

RUSSELL, Sir Walter Westley **RA RWS NEAC** **1867-1949**
Painted portraits, landscape and genre. Studied at Westminster School of Art under Fred Brown (q.v.). Exhib. five works at the RA 1891-1904, including 'The Pierrots', 'Tea Time' and a portrait. Exhib. with the NEAC from 1893. Assistant Professor at the Slade School 1895-1927. Keeper of the RA 1927-42. As a landscapist mainly worked in Yorkshire, Norfolk and Sussex. Born at Epping, Essex. Died in London. Represented in the Tate Gallery and in the Municipal Gallery of Modern Art, Dublin.
Bibl: AJ 1906 pp.73, 74; 1909 pp.128, 289; Studio XLVII 1909 pp.252, 258; L 1910 pp.171, 178; LVII 1913 p.146; LIX 1913 p.133; LXIII 1915 pp.34, 140; LXV 1915 pp.110, 179ff., 281; LXVI 1916 p.277; LXIX 1917 p.116; LXXIX 1920 p.148; LXXXIII 1922 pp.80, 88; LXXXV 1923 p.24; XCII 1926 .60; Who's Who; Hardie.

RUST, Miss Beatrice Agnes **fl.1883-1893**
London painter of portraits and genre, who exhib. 1883-93, at the RA 1883-92, SS, NWS and elsewhere, titles at the RA including 'An Artist's Model', 1886, 'Sad News', 1887 and 'Sweet Flowers', 1892.

RUSTON, George **fl.1891**
Exhib. a landscape at the NWS. London address.

RUTER, Franz **fl.1886**
Exhib. a Venetian view at the GG.

RUTLAND, Charles, 6th Duke of **fl.1872**
Exhib. 'An Autumn Evening' at the RA. Address Belvoir Castle, Leicestershire.

RUTLAND, Marion Margaret Violet, Duchess of **1856-1937**
Painted portraits and watercolours. Also a sculptor. Exhib. in London, and America and France. She was a member of the Leicester Society of Artists. Born at Wigan, Lancashire. Address Beauvoir Castle, Leicestershire. Died in London. See also Miss Violet Lindsay.
Bibl: Who's Who; Connoisseur LXXII 1925 p.188; Art News XXIV 1925-6 p.11; Apollo XVIII 1932 pp.40, 41; BM Cat. of Engraved British Portraits.

RUTLEDGE, William **fl.1881-1897**
Exhib. two works, 'Blarney' and 'Hay-makers', at SS. Address in Sunderland, County Durham. His portrait of Walt Whitman is in the Sunderland Museum.

RUTSON, J. **fl.1868-1875**
Painted landscape. Exhib. 15 works at SS, including views in Devon, Yorkshire, Brecon and North Wales. Address in Thirsk, Yorkshire.

RUTTER, Edward **fl.1877-1882**
Exhib. three watercolours at SS, including 'On the Beach, Clovelly' and 'October'. London address.

RUTTER, Thomas William **b. 1874**
Painted, engraved and etched landscape. Born near Richmond, Yorkshire. Lived in Northampton.

RUTTY, J. fl.1839
Exhib. a view of the Great Western Railway, Wharncliffe Viaduct at Hanwell at the RA. London address.

RYALL, Henry Thomas 1811-1867
Painted genre subjects. Exhib. three works, 'A Reverie', 'The Pets' and 'The Crochet Lesson' at the RA, and one work at SS. Ryall is better known as an engraver. Born in Frome, Somerset. Died in Cookham, Berkshire.
Bibl: AJ 1867 p.249ff.; BM Cat. of Engraved British Portraits.

RYAN, Charles J. fl.1885-1892
Painted landscape and flowers. Exhib. two works, a view on Stanmore Common and a study, at the RA. Address in Bushey, Hertfordshire. Represented in VAM.

RYAN, Claude fl.1874-1883
Painted flowers and landscape. Exhib. eight watercolours at SS including 'Basket of Flowers', 'A Quiet Corner on the Upper Thames' and 'A Berkshire Homestead'. London address.

RYAN, F. or T.E. fl.1879
Exhib. a watercolour view of Chioggia boats on the Riva degli Schiavoni, Venice, at SS. London address.

RYAN, H. fl.1869
Exhib. a work entitled 'A Lost Pet' at the RA. Address in Kingstown, Ireland .

RYAN, H.S. fl.1854
Is supposed to have exhib. a figurative subject at the RA. London address.

RYDER, Miss Emily S. fl.1866-1874
Painted figurative subjects. Exhib. eight works, some of them watercolours, at SS, including 'Is It So?' and 'Thoughts of the Fatherland', and two works at the BI. London address.

RYDER, Miss Harriet E. fl.1892-1893
Exhib. two genre subjects 1892-3. Address in Lee.

***RYLAND, Henry RI 1856-1924**
Painter, watercolourist, decorator and designer. Exhib. at RA from 1890, also NWS, GG, NG and elsewhere. Ryland's style is a combination of Alma-Tadema and Albert Moore (q.v.), and at times very similar to J.W. Godward (all q.v.). His usual subject is young women in classical draperies on marble terraces. Typical RA titles are 'The Spirit of May', 'Tryst', 'Summer Music', etc.
Bibl: AJ 1895 p.153; Studio, *A Record of Art in 1898*, p.70; XXXV 1905 p.294; Bate p.119; R.E.D. Sketchley, *English Book Illustration of Today*, 1903; H.W. Singer, *Pre-Raphaelitismus in England*, 1912; Who Was Who 1916-28; R. Mudie-Smith, *The Art of H.R.*, Cassells Magazine No. 194 pp.49-57; Wood, Olympian Dreamers.

RYLAND, William fl.1884
Exhib. 'A Calm Day' at SS. Address in Sheffield, Yorkshire.

RYLE, Arthur Johnston RBA 1857-1915
London landscape painter. Third son of the Bishop of Liverpool. Educated at Eton and New College, Oxford. Exhib. 1889-1903, at the RA 1891-1903, SS and NG, titles at the RA including 'Torish, Helmsdale', 1891 and 'Harbour and Hillside', 1903.
Bibl: Who Was Who 1897-1915.

RYLEY, Jane fl.1854-1865
Painted flowers and country subjects. Exhib. five works at SS, including 'A Reaper of Alsace' and 'A Basket of Flowers', and four works at the BI. Also exhib. one work at the RA entitled 'Ye Dwell Beside Our Paths and Houses'. London address.

RYMER, C.W. fl.1875
Exhib. a genre subject in 1875. London address.

RYMER, Chadwick Francis fl.1843-1848
Painted landscape. Exhib. three watercolours at SS, views in the environs of London, and two paintings of cattle, at the RA. London address.

RYMER, J.W. fl.1854-1855
Exhib. two works, 'A Peep at the Moon' and 'A Glimpse of the French Coast from Sandgate', at the BI. London address.

RYND, Miss Edith fl.1892-1893
Exhib. three views of churches at the NWS. Address in Oxford.

RYOTT, W. fl.c.1860-1880
Painted landscape. His works 'Wooded Landscape with Figure' and 'View of Jesmond Dene' are in the Shipley AG, Gateshead. Lived on Tyneside.
Bibl: Hall.

S

SACHE, F. fl.1869-1872
Exhib. 'A Cornfield in South Devonshire' at the RA and another landscape at SS. London address.

SACHSE, Edward J. fl.1884-1897
Painted landscape. Exhib. ten works at the RA including views in Norwood, South London, and Suffolk, and three watercolours at SS. London address.

SADLER, George fl.1878-1883
Exhib. six works at SS, titles including 'Evening' and 'The Fifth Player', both watercolours, and 'Interested' and 'Serious Work'. London address.

SADLER, Miss Kate fl.1878-1893
Flower painter and watercolourist; lived at Horsham, Sussex. Exhib. at RA 1880-9, SS, NWS and elsewhere. Titles at RA mostly of azaleas and chrysanthemums.

SADLER, Thomas fl.1878-1886
Exhib. three works, including 'The Postboy' and 'The Farmer's Daughter', at SS and a study at the RA. London address.

***SADLER, Walter Dendy RBA 1854-1923**
Genre painter. Studied at Heatherley's Art School in London, and with W. Simmler in Düsseldorf. Exhib. at RA from 1873, also at SS, GG; and elsewhere. His subjects were mostly costume pieces of

the 18th or early-19th century period, often with humorous or sentimental themes, e.g. 'Scandal and Tea', 'A Meeting of Creditors', 'An Offer of Marriage', etc. About 1896 he moved to Hemingford Grey, near St. Ives, Huntingdon, where he died. His pictures were very popular and much reproduced through engravings. Works by him are in the Tate, Liverpool, Manchester and Rochdale galleries.

Bibl: AJ 1885 p.72; 1895 pp.193-9 (F.G. Stephens); Art News XXII 1923/4 No.6 p.6 (obit.); Connoisseur LXVIII 1923 p.52ff.; LXX 1925 p.50; RA Pictures 1891-6, etc.

SADLER, William fl.1889
Exhib. a study of a head at the RA. London address.

SAINSBURY, Everton 1849-1885
London genre painter. Exhib. at RA 1878-85, SS, GG and elsewhere. Titles at RA 'The Latest News', 'Superstition', 'A Glimpse of the Unknown' (child in the East End of London seeing butterflies for the first time), etc.

Bibl: Year's Art 1886 p.224; Academy Notes 1880, 1883.

SAINSBURY, Miss Grace E. fl.1889-1904
Painted landscape and country subjects. Exhib. nine works at the RA 1891-1904, including 'By the Margin of the River' and 'Joy in the Meadows', and four works at SS. London address.

SAINSBURY, Miss Maria Tuke fl.1889-1894
Painted flowers. Exhib. two works at the RA including 'Flowers are Lovely: Love is Flower-like'. London address. See also Miss Maria Tuke.

SAINSBURY, S. Fox fl.1888-1897
Exhib. two works including 'To the Fish Sheds' at SS. London address.

ST. CLAIR, A. fl.1873
Exhib. one work 'Setting Out' at SS. London address.

ST. GEORGE, J. fl.1843-1847
Painted landscape. Exhib. three landscapes at SS, two works at the BI, and two works, scenes in Kensington Gardens and Saxony, at the RA. London address.

ST. JOHN, Georgina fl.1873
Exhib. a watercolour view in Devon at SS. Address in Windsor, Berkshire.

ST. JOHN, R. fl.1855-1856
Exhib. three watercolours, including two views in the highlands, at SS. Address in Oxford.

ST. JOHN'S WOOD CLIQUE
Group of artists who lived in St. John's Wood during the 1860s and 1870s, consisting of P.H. Calderon, W.F. Yeames, G.D. Leslie, H. Stacy Marks, J.E. Hodgson, G.A. Storey and D.W. Wynfield (all qq.v.). They held weekly meeting at each other's houses, to make drawings and discuss them.

Bibl: G.A. Storey, *Sketches from Memory*, 1899; Bevis Hillier, *The St. John's Wood Clique*, Apollo June 1964.

ST. MARTIN, Yves Grenier de fl.1858
Exhib. a work at the BI. London address.

ST. MAUR, John fl.1880
Exhib. a genre subject in 1880. London address.

SAINTON, Charles Prosper RI 1861-1914
Painted landscape and portraits. Studied at the Slade, and in Florence and Paris. Exhib. five subjects at the RA including 'Lost in Thought' and 'The Rag-Pickers Home in Paris'. London address. Died in New York.

Bibl: Who Was Who 1897-1915; American Art News No.10 p.4; Connoisseur LXXIII 1925 p.56.

SALABERT, Firmin fl.1836-1845
Painted portraits and figurative subjects. Exhib. 16 works at the RA, the majority portraits, and including one of an artist aged 106 years. He was a pupil of Ingres. He lived in both London and Paris.

Bibl: BM Cat. of Engraved British Portraits VI 1925.

SALANSON, Miss Eugenie fl.1892
Exhib. a painting of a fisher girl at the RA. London address.

SALISBURY, Francis (Frank) Owen RI ROI RP 1874-1962
Painted portraits, historical, ceremonial and literary subjects. Studied at Heatherley's, at the RA schools, and in Italy, Germany and France. Exhib. 12 works at the RA 1899-1904, including 'Reflections', 'Hamlet and the King' and an illustration to a scene from Spencer. Lived in London. Also painted a number of royal portraits and royal occasions, mainly for George V and VI. A number of historical paintings by him are in the Houses of Parliament.

Bibl: Who's Who; Connoisseur XXVIII pp.204, 314; XLVIII p.113; XLIX p.172; LI p.109; LVII p.113; LX p.112; Studio LXII p.182; LXV p.128; LXVIII p.117; Art News XXI p.10; XXIII p.8; XXIV p.l; XXV p.9; Apollo IX p.396; X p.60; Benjamin A. Barker, *The Art of Frank O.S.*, 1936; *F.O.S., Portrait and Pageant: Kings, Presidents and People*, 1944.

Exhib: London, Royal Inst. Galleries, *Portraits and Pageants*, 1953.

SALLITT, Miss Lily fl.1891
Exhib. a painting of thistledown at the RA. Address in Yorkshire.

SALMON, E. fl.1866
Exhib. two paintings, including 'A Normandy Kitchen' and a bronze, at SS. London address.

SALMON, Miss Helen R. fl.1884-1890
Painted figurative subjects. Exhib. six works at the RA including 'In the Conservatory' and 'Patchwork'. Address in Glasgow.

SALMON, J. fl.1849-1868
Exhib. a marine in 1868. London address.

SALMON, J.E. fl.1865-1876
Painted landscape. Exhib. six works at the BI including 'Morning on the Thames' and 'Evening in Surrey'. London address.

SALMON, J.F. fl.1838-1873
Painted landscape. Exhib. a view near Ryde, Kent at the RA. London address.

SALMON, John Cuthbert RCA 1844-1917
Liverpool landscape painter. Exhib. at RA from 1878, NWS and elsewhere. Like many Liverpool artists, he spnt most of his time painting in North Wales. Titles at the RA all Welsh views, except for an occasional Scottish scene.

Bibl: Who Was Who 1916-28; VAM; Cat. of Watercolours 1908.

SALMON, W.R.D. fl.1851-1857
Painted landscape. Exhib. five works at the RA including 'Study after a Shower' and four works at SS. Address in Glamorgan.

SALOMANS, F. FSBA fl.1880
Exhib. a Venetian subject at the GG.

SALOMANS, M. fl.1871
Exhib. a view in Rome in 1871. London address.

SALOMONS, Edward fl.1874-d.1906
Painted architecture. Exhib. views of buildings in Manchester, Venice and Antwerp at the RA. London address.

SALOMONS, Miss J.R. fl.1867
Exhib. two works 'Study of Teal' and 'Monthly Roses' at the BI, and one work at the RA. London address.

SALSBURY, Robert fl.1878-1890
Painted landscape and nature subjects. Exhib. nine works at SS including 'A Reedy Pool', 'An Inlet to Wroxham Broad' and 'Early Primroses', and one work at the RA. London address.

SALT, S.A. fl.1879
Exhib. a work entitled 'A Dull Day' at SS. London address.

SALTER, Mrs. fl.1879
Exhib. a work entitled 'The Miniature' at SS. London address.

SALTER, Miss Anne G. fl.1869-1885
Is supposed to have exhib. two still-lifes at SS. Address in Leamington, Worcestershire. A Miss Emily K. Salter, who exhib. in Birmingham 1879-81, may be her sister.

SALTER, J. fl.1848-1875
Painted landscape and country subjects. Exhib. 21 works at SS including views of rivers, buildings and landscape, in Devon and Cornwall. Also exhib. two works at the RA. London address. He may be the same as John William Salter, a Torquay artist recorded in Mallalieu.

SALTER, Mrs. M.F. fl.1842-1857
Painted figurative subjects. Exhib. three works at the RA, two works at the BI, including 'A Young Bacchante' and 'The Discovery'. London address.

SALTER, William RBA 1804-1875
Historical and portrait painter. Studied under James Northcote 1822-7; travelled in Italy, spending some years in Florence; returned to London 1833. Exhib. at RA 1825-45 and BI, but mainly at SS (101 works) of which he was Vice-President. Painted portraits, historical genre, and Graves also mentions 'mythological'. His best known picture is 'The Waterloo Banquet', which was engraved.
Bibl: Clement & Hutton; Redgrave:, Dict.; DNB; Poole 1925; BM Cat. of Engraved British Portraits 1925; Ormond.

SALTER, William Philip fl.1847-1851
Painted portraits and figurative subjects. Exhib. four works at the RA including three portraits, one work at the BI, and an historical subject at SS. London address.

SALTFLEET, Frank 1860-1937
Painted landscape and marines in watercolour. Exhib. a landscape at the NWS. Address in Sheffield, Yorkshire.

SALTMER, Miss Florence A. fl.1882-1900
Genre and landscape painter. Exhib. at RA 1886-1900, SS, NWS, GG and elsewhere. Titles at RA mostly rustic genre, e.g. 'The Reapers' Lunch', 'The Old Farm', 'Village Gossip', etc.

SALTONSTALL, J.W. BWS b.1873
Studied at Halifax, Blackpool and Preston Schools of Art. Exhib. at the BWS and elsewhere. Lived near Halifax, Yorkshire.

SALVIN, Miss fl.1869
Exhib. a view near Lynchmere, Sussex, at the RA. Address in Haslemere, Surrey.

SAMBOURNE, Edward Linley 1844-1910
Designer and illustrator; worked for many years for *Punch* producing illustrations and cartoons. Exhib. from 1885 at the RA, mainly cartoons for *Punch,* and from 1875 elsewhere. Elizabeth Aslin notes that, unlike Du Maurier, Sambourne worked "almost entirely from imagination, producing what were described as quaint and fanciful drawings with captions so brief that the editors of *Punch* sometimes provided explanations for their less quick-witted readers", and that from 1877 his political cartoons and fanciful drawings often had an aesthetic note. He designed and painted doors and woodwork, as can be seen at his own house at 18 Stafford Terrace, London, 1874, which is one of the most perfect examples of an aesthetic interior and now a museum. He also illustrated books, e.g. Charles Kingsley's *Water Babies*, 1886, and Lord Brabourne's *Friends and Foes from Fairyland,* 1886.
Bibl: AJ 1886 p.31ff.; The Year's Art 1911 p.416; J. Pennell, *Die Modern Illustrator,* 1895; Elizabeth Aslin, *The Aesthetic Movement,* 1969 p.114 (pls. 49, 58, 68, fig.6); Ormond; L. Ormond, *E.L.S.,* 19th Century Magazine Autumn 1978.

SAMBROKE DE ROCKSTRO, J. fl.1846
Exhib. a landscape at the RA. London address.

SAMMONS, John Coulson 1818-c.1878
Exhib. a sketch for a picture of the interior of the church of Upwell St. Peter, Norfolk. Also exhib. 'A Streamlet' at SS, where he is listed as J.E. Sammon. Vicar of various parishes in Suffolk and Nottinghamshire. Address in Wisbech, Cambridgeshire.

SAMPSON, Herbert fl.1879
Exhib. two works 'A Medley' and 'Modern Ornaments' at SS. London address.

SAMPSON, James Henry fl.1869-1879
London painter of coastal and shipping scenes. Exhib. mostly at SS, also at RA 1870-9 and elsewhere. Titles at RA 'Trawling', 'The Restless Sea', 'Spratting', etc.
Bibl: Brook-Hart

SAMPSON, L. fl.1889-1890
Exhib. two landscapes 1889-90. London address.

SAMPSON, Thomas fl.1838-1856
Portrait and genre painter. Exhib. at RA 1838-53, BI, SS and elsewhere. At first exhib. portrait miniatures at the RA, but later turned to landscape and historical genre.

SAMWORTH, Miss Joanna fl.1867-1881
Exhib. eight works, the majority ink drawings, at the RA including 'Fir Trees', 'Study of Moonlight' and 'A Cottage Nosegay'. She was a pupil of H. Scheffer and Rosa Bonheur. Born in Hastings, Sussex.
Bibl: E.C. Clayton, *English Female Artists,* 1876.

SANCROFT, D.A. fl.1869
Exhib. two watercolours, 'Low Water' and 'Lake and Mountain' at SS. London address.

SANDEMAN, Mrs. B. (Mary) fl.1884-1886
Exhib. three works at the RA including 'Afghan Trophies' and ''Twas a Fat Oyster — Live in Peace — Adieu'. London address.

SANDERCOCK, Henry Ardmore fl.1867-1883
Painted landscape. Exhib. nine works at the RA including views on the Devon and Cornwall coasts, and seven watercolours entitled 'King Arthur's Castle' and 'On the Torridge, North Devon', at SS. Address in Bideford, Devon.
Bibl: Brook-Hart.

SANDERS, Mrs. fl.1838
Exhib. 'The Saviour' at the RA.

SANDERS, Miss Ellen fl.1866-1880
Exhib 'On the River Severn' at the BI and a watercolour view in one work at the RA. Also exhib. at RBSA 1866-80. London address.

SANDERS, H. fl.1812-1855
Exhib. 'On the River Severn' at the BI and a watercolour view in Hampstead at SS. London address.

SANDERS, Miss Mariane fl.1859-1886
Birmingham painter of flowers, landscapes and portraits. Exhib. 31 works at the RBSA.

SANDERS, T.H. fl.1855-1862
Painted figurative subjects. Exhib. three works at the BI including a painting of King Alfred burning the cakes. Also exhib. two works at the RA. Address in Worcester.

SANDERS, T. Hale fl.1874-1898
Painted landscapes and river scenes. Exhib. ten works at the RA including 'The River Thames from London Bridge' and 'The City in the Sea', and 12 works, some of them watercolours, at SS including 'Lying off Butler's Wharf' and 'Waiting to be Docked'. London address.
Bibl: Brook-Hart.

SANDERS, W. fl.1826-1838
Painted game and figurative subjects. Exhib. 23 works, the majority watercolours, at SS including 'Brace of Partridge' and 'Returning from Shrimping'. London address.

SANDERS, Walter G. fl.1882-1901
London flower painter. Exhib. at RA from 1884, SS and elsewhere. Titles at RA mostly of roses; also some of still-life.

SANDERSON, John fl.1890-1891
Exhib. two works, including 'Quay Side. Whitby', at SS. Address in Lincoln.

SANDERSON, Julia J. fl.1881-1882
Exhib. four works including 'In the Study' and 'A Highland Fireside' at SS. London address.

SANDERSON, Miss S.M. fl.1891
Exhib. 'Evening after Rain' at the RA. London address.

SANDERSON-WELLS, John Sanderson RI 1872-1955
Painted sporting subjects and portraits. Studied at the Slade and at the Académie Julian. Lived in London. His hunting scenes are particularly lively and colourful, similar to the late work of Heywood Hardy and George Wright (qq.v.). See also Wells, John Sanderson.

SANDS, A. fl.1859
Exhib. a work entitled 'A Quiet Half-hour with The Times' at the BI. Address in Norwich.

SANDS, Henry H. fl.1883-1899
Birmingham painter of landscapes and local views. Exhib. at RBSA.

SANDYS, Anthony 1806-1883
Painted marines. Lived in Norwich.
Bibl: Brook-Hart.

***SANDYS, Anthony Frederick Augustus 1829-1904**
Pre-Raphaelite painter, portraitist, and illustrator. Born in Norwich. His father was a minor Norwich School painter. Studied at RA Schools under George Richmond (q.v.) and Samuel Lawrence, who taught him to draw in chalks. Began to exhib. at RA in 1851. His first work to attract notice was 'The Nightmare', a print satirising Millais's picture 'Sir Isumbras at the Ford'. As a result of this he met Rossetti, Swinburne, and others, and became a member of Pre-Raphaelite circles. His work falls into three distinct categories. Firstly, his oil paintings. These are mostly female heads or half lengths of the Rossetti type, with titles like 'Fair Rosamund', 'La Belle Ysonde', etc. He was capable of more dramatic, individual works, such as 'Medea' and 'Morgan le Fay'. He also painted some portraits in oils, which, with their extraordinary fidelity and high finish, have often been compared with Holbein. Secondly, his portrait drawings. These were mostly done in pale colours on light blue paper. In female portraits, he often added a background of lilies, iris or other flowers, which give them an art nouveau appearance. Thirdly, his woodcuts and illustrations. It was in this field that he made his most important contribution to the Pre-Raphaelite Brotherhood movement. He worked for *The Cornhill, Once a Week, Good Words, The Argosy* and many other magazines, and illustrated poems by Swinburne and Christina Rossetti. His illustrations are a unique blend of Pre-Raphaelite subjects and an almost Dürer-like precision. After about 1880, he began to devote himself more and more to chalk portraits. Exhib. at RA 1851-86, BI and GG. Both his sister Emma (q.v.) and his daughter Winifred were artists.
Bibl: AJ 1884 pp.75-8; 1904 p.270 (obit.); 1905 p.81ff.; 1909 pp.149-51; Studio XXXIII 1905 pp.3-16; Winter Number 1923-4 p.20ff., 52ff.; The Artist Special Winter No. 1896 (Esther Wood); Pall Mall Magazine XVI November 1898 pp.328-38; Print Collector's Quarterly VII 1917 pp.201-16; Apollo II 1925 p.258ff.; Bryan; Bate; DNB; Gleeson White; Fredeman (with full bibl.); T. Crombie, *Some Portraits by F.S.*, Apollo November 65; Reynolds, VP pp.65, 70, 71 (pl.47); Maas pp.144, 217 (pls. pp.146, 218, 219); Staley pls.48a, b, c, 49a, 93; Ormond; Wood, Panorama, Wood, Pre-Raphaelites; Newall.
Exhib: Brighton Public AG, *F.S. 1829-1904*, 1974.

SANDYS, Miss Emma fl.1868-1874
Painted portraits and figurative subjects. Exhib. five works at the RA including 'Enid' and 'Undine' and a portrait of the Duchess of St. Albans. Address in Norwich. Sister of A. Frederick Sandys (q.v.).

SANDYS, S. fl.1835-1839
Exhib. two views on the River Dart and one near Dinant-sur-Meuse at the RA.

SANFORD, Miss S. Ellen fl.1887-c.1927
Painted animals and birds, and genre subjects, in watercolour. Exhib. five genre subjects at the NWS. London address.

SANG, Frederick J. fl.1877-1901
Painted landscape and townscapes. Exhib. nine works at the RA including 'View on the Canal near Gournay' and 'The River from the Pier, Limehouse', and five watercolours at SS. London address.
Bibl: Brook-Hart.

SANI, A. fl.1873
Exhib. one work at SS.

SANSOM, L. Charles fl.1870-1871
Exhib. three works, two of them watercolours, at SS including 'Day and Night' and 'Rest After Hay-making'. London address.

SANT, George RBA fl.1856-1877
London landscape painter. Presumed to be the brother of James Sant (q.v.). Exhib. at RA 1858-77, BI, SS and elsewhere. Subjects mostly Welsh views, with the figures often painted by James Sant.
Bibl: See under James Sant.

SANT, H.R. fl.1891
Exhib. a river scene in 1891. London address.

***SANT, James RA 1820-1916**
Portrait painter. Pupil of John Varley and A.W. Callcott (qq.v.). Exhib. at RA 1840-1904. ARA 1861, RA 1869. Appointed portrait painter to the Queen 1872. Retired from RA in 1914. He was an immensely prolific portrait painter; he also painted allegorical female figures, and genre subjects. As a portrait painter he enjoyed the patronage of many noble and landed families. Portraits by him can still be seen in many English country houses. George Sant (q.v.) was probably his brother.
Bibl: Studio LXVIII 1916 p.176ff. (obit.); Clement & Hutton; Who Was Who 1916-28; BM Cat. of Engraved British Portraits VI 1925; Reynolds, VP p.193 (pl.134); Maas pp.215-16, 244-5 (pls. p.215, 247); Ormond; Wood, Panorama.

SANTER, W. fl.1845-1849
Painted marines. Exhib. four works at SS including 'Pilot and Fishing Boat off Folkestone' and 'An Indiaman Shortening Sail'. London address.

SANTLEY, Edith fl.1879
Exhib. a sketch at SS. London address.

SARGEANT, John fl.1824-1839
Painted figurative subjects. Exhib. seven works at the RA including 'The Happy Hit', 'An Orange Girl' and 'Scene from *Old Mortality* by Sir Walter Scott', five works at the BI and nine works at SS. London address.
Bibl: BM Cat. of Engraved British Portraits.

SARGENT, Frederick fl.1880-d.1899
Painter of figure subjects, miniatures and Venetian scenes. A series of drawings of MPs was exhib. at Tooth's Gallery in 1951.

SARGENT, H. Garton fl.1889-1890
Exhib. two works 'Folkestone Harbour' and 'Interior of a Barn' at the RA. London address.

***SARGENT, John Singer RA 1856-1925**
Painter and watercolourist. Born in Florence; son of a retired Philadelphia doctor. As a boy he travelled widely in Europe with his parents. Studied in Rome, Florence, and finally with Carolus-Duran in Paris 1874. First exhib. at Paris Salon 1878. Visited Spain, where he was much impressed by the work of Velazquez. In 1882 his picture of flamenco dancers 'El Jaleo' was picture of the year at the Salon. He followed this in 1884 with the sensational portrait of Madame Gautreau. In 1886 he settled in London at 33 Tite Street. The following year 'Carnation Lily Lily Rose' was a great success at the RA. But it was as a portrait painter that he was to make his greatest contribution to English painting. By about 1890 he was beginning to establish himself as a fashionable portraitist; by the turn of the century he was acclaimed as England's greatest portrait painter since Lawrence. Between about 1890 and 1907, he produced many masterly portraits, which present a penetrating record of late Victorian and Edwardian society. About 1907 he began to refuse portrait commissions, and thereafter did only charcoal portraits. He also visited the United States regularly to fulfil commissions for portraits. He also was occupied after 1890 on a series of mural decorations for Boston Public Library and Museum. In addition to his portraits, he was also a prolific painter of landscape, figures, town scenes, and topographical sketches done on his frequent travels in Europe, North Africa and the Middle East. Later he turned increasingly to watercolour. Exhib. at RA from 1882, GG and NG. ARA 1894, RA 1897. A sale of his studio was held at Christie's, 24 and 27 July 1925.
Bibl: Main Biographies: Mrs. Meynell, *The Work of J.S.S.*, 1903; W.H. Downes, *J.S.S.*, 1925; A. Stokes, *J.S.S.*, OWS III 1925; E. Charteris, *J.S.S.*, 1925; M. Hardie, *J.S.S.*, 1930; C.M. Mount, *J.S.S.*, 1957; Richard Ormond, *Sargent*, 1970 (with bibl.); D.F. Hoopes, *Sargent Watercolours*, 1971; Carter Ratcliff, *J.S.S.*, New York 1982; Stanley Olsen, *J.S.S. His Portrait*, 1986; Trevor Fairbrother, *J.S.S. and America*, New York 1986; S. Olsen, W. Adelson and R. Ormond, *S. at Broadway — The Impressionist Years*, 1986.
Other References: AJ 1888 pp.65-9; 1911 pp.1-10; Studio XIX 1900 pp.3-21, 107-19; XC 1925 pp.79-87, 162; Hughes; VAM; Caw; Cundall; Reynolds, VP pp.31, 173, 194 (pl.116); Hardie III pp.168-70 (pls.198-9); Maas *passim* (pls. p.222-3); Irwin; Wood; Wood, Panorama; H. Honour and J. Fleming, *The Venetian Hours of Henry James Whistler and Sargent*, 1991.
Exhib: Chicago, Art Institute, *S., Whistler and Mary Cassatt*, 1954; Paris, Centre Culturel Americain, *J.S.S.*, 1963; Washington, Corcoran Gallery of Art, *The Private World of J.S.S.*, 1964; New York, Metropolitan Museum, *J.S.S.*, 1972; Leeds 1979; New York, Whitney Museum 1987; New York, Coe Kerr Gallery 1980.

SARJANT, G.R. fl.1811-1849
Painted landscape and architecture. Exhib. 15 works at the RA including 'View of Winchester' and 'Interior of St. James's Church, Piccadilly', two works at SS and four works at the BI. London address.

SARJENT, Miss Emily fl.1845-1864
Painted figurative subjects. Exhib. nine works at the RA including portraits and works entitled 'The Unwilling Sitter' and 'My Own Dear Pussy!', and seven works, the majority watercolours, at SS. London address.

SARTORIS, E.J. fl. 1879
Exhib. a portrait at the GG. London address.

SASS, Henry 1788-1844
Painted figurative subjects and portraits. Exhib. 84 works at the RA. During the last decade of his career these were almost exclusively portraits. Also exhib. eight works at the BI and three works at SS. London address. Founded the famous Sass's Academy in Bloomsbury, where many Victorian artists studied.
Bibl: DNB; The Art Union 1844 p.332; BM Cat. of Engraved British Portraits.

SASSOON, Alfred fl.1890
Exhib. a genre subject in 1890. London address.

SASSOON, Mrs. Alfred (Theresa) **fl.1889**
Exhib. a work entitled 'The Hours' at the RA. Address in Brenchley, Kent.

SATCHWELL, Theodore **fl.1883-1890**
Exhib. four works at SS, including 'Haymaking' and 'Return of the Fishing Fleet', and two works at the RA. London address.

SATTERLEY, J.T. **fl.1848**
Exhib. two works including a painting of game at the RA. Address in Sevenoaks, Kent.

SAUBER, Robert **RBA** **b.1868 fl.1888-1904**
Genre and portrait painter and illustrator. Born in London of a German father; grandson of Charles Hancock (q.v.). Studied at the Académie Julian. Exhib. at RA from 1889, SS and elsewhere. Titles at RA portraits and genre, e.g. 'Unwelcome Guests', 'An Evening Stroll', 'Mammon', etc.
Bibl: AJ 1899 pp.1-6; Who's Who; Sketchley, *English Book Illustration of Today*, 1903.

SAULE, P. Graves **fl.1872**
Exhib. two landscapes in 1872. Address in Plymouth, Devon.

SAULSON, Mme. **fl.1873**
Exhib. a work entitled 'The Basket-Maker' at SS. London address.

SAUNDERS, Charles L. **fl.1881-1901 d.1915**
Painted landscape. Exhib. seven works at the RA including 'A Pool on the Moor' and 'An Autumn Flood — Dartmoor'. Address near Conway, North Wales.

SAUNDERS, G. **fl.1846**
Exhib. a work entitled 'Divine Providence — Night' at the RA. London address.

SAUNDERS, W.A. **fl.1848**
Exhib. three works including two views near Sevenoaks, Kent.

SAUTER, Professor George **1866-1937**
Painted portraits. Studied at the Munich Royal Academy. Exhib. a portrait at the RA. Born in Bavaria. Lived in London 1895-1915.

SAVAGE, James Henry **fl.1837-1853**
Painted figurative and literary subjects. Exhib. five works at the BI including 'Italian Condottiere of the 16th Century', two subjects from *The Arabian Nights* and one from *A Sentimental Journey*. Also exhib. four works at SS and one at the RA. London address.
Bibl: Thomas Smith, *Recollections of the BI*, 1860.

SAVAGE, Reginald **fl.1886-1890**
Exhib. two watercolours at SS including 'Miracle of the Roses' and one work at the RA. London address.

SAVIDGE, Joseph T. **fl.1900**
Exhib. a painting of fruit at the RA. Address in Newington.

SAVILL, Miss Edith **fl.1880-1883**
Painted figurative subjects. Exhib. four works including 'A Young Widow' and 'Who Goes There?' at the RA and four works including two watercolours at SS. London address.

SAVILL, Miss Gertrude May **fl.1891-1893**
Exhib. two portraits at the RA. Address in Brighton, Sussex.

SAVILLE, Miss Josephine **fl.1863-1885**
Painted landscape and figurative subjects. Exhib. six works at SS including 'Summer' and 'Little Emily' and three works at the RA. Address in Colchester, Essex.

SAVILLE, W. **fl.1862-1867**
Painted landscape. Exhib. six works at the BI including 'Kentish Sheep' and 'On the Cliffs near Dover'. Address in Dover, Kent.

SAWYER, Miss Amy **fl.1887-1904**
Painted figurative and country subjects. Exhib. 11 works at the RA including 'The Girl Who Got Lost in the Toadstool Country' and 'The Love that Flies Away'. Address in Croydon, Surrey.

SAWYER, Mrs. Ethel **fl.1898-1900**
Exhib. two works 'Baby Eric' and a portrait at the RA. Address in Watford, Hertfordshire.

SAWYER, F. **fl.1841**
Exhib. 'The Orator Demosthenes' at the RA. Address in Bristol.

SAWYER, R.D. **fl.1886**
Exhib. a view of the mouth of the Seine near Honfleur at the RA. Address in Paris.

SAXON, George **fl.1875-1885**
Exhib. a painting of gladioli at the RA and another work at SS. Address in Bruton, Somerset.

SAXONI, C. **fl.1846**
Painted Parisian subjects. Exhib. four works at the RA including 'The Butter Market, Paris' and 'Le Marché des Innocents'. London address.

SAY, Frederick Richard **fl.1825-1854**
Portrait painter. Son of William Say, an engraver. Exhib. at RA 1826-54, BI and SS. Among his sitters were Earl Grey, the Duke of Saxe-Coburg and Gotha, and Prince Albert.
Bibl: DNB; Bryan; BM Cat. of Engraved British Portraits VI 1925; Poole III 1925; Cat. of Paintings etc. in the India Office London 1914; Ormond.

SAYER, Charles E. **fl.1895-1903**
Exhib. a work entitled 'Long Meadow, Goring' at the RA. London address.

SAYER, George **fl.1835-1848**
Painted portraits. Exhib. three portraits at the RA and one at SS. London address.
Bibl: BM Cat. of Engraved British Portraits.

SAYER, Miss Jessie C. **fl.1887-1892**
Exhib. 'Fresh Cut Roses' at the RA. Address in Brockley, Somerset.

SAYER, Lawrence **fl.1878**
Exhib. a painting of a church in 1878. London address.

SAYERS, E.C. **fl.1845-1853**
Painted architecture. Exhib. two works at the BI including 'Tomb of Henry V, Westminster Abbey' and three works at the RA including 'Caistor Castle, Norfolk' and 'The Garden and its Fountain'. London address.

SAYERS, Reuben Thomas William 1815-1888
London painter of portraits, genre and biblical subjects. Exhib.
1841-67, at the RA 1845-63, BI and SS, titles at the RA including
portraits and 'The Two Pets', 1845, 'Asleep and Awake', 1846 and
'Childhood', 1863. Bryan notes that some churches possess his
paintings of religious subjects. Salford AG has one of his portraits.
Bibl: Thomas Smith, *Recollections of the BI*, 1860 pp.118, 127; Courier de l'Art
1883 p.352; The Year's Art 1889 p.256; Athenaeum 27 October 1988 (obit.);
Bryan; BM Cat. of Engraved British Portraits I 1908 pp.173-4.

SCAMPTON, Miss Mary fl.1879-1882
Exhib. four paintings of flowers at SS. Address in Coventry,
Warwickshire.

SCANDRETT, Thomas 1797-1870
Architectural draughtsman. Exhib. mostly at SS, also RA 1825-60
and BI. Except for a few architectural designs, his drawings were
mostly of churches, both in England and on the Continent.
Bibl: Redgrave, Dict.

SCANES, Miss Agnes fl.1880-1893
Painted flowers. Exhib. five works at SS including 'Primula', 'The
Baby' and 'Spring Flowers'. Also exhib. at the NWS. London
address.

SCANES, Edwin L. fl.1885-1893
Painted genre subjects. Exhib. three works at the SS, including 'A
Brown Study' and 'L'Ancien Regime', and two works at the RA.
London address.

SCANLAN, Robert Richard fl.1832-d.1876
Irish portrait, genre and animal painter. Exhib. at RA 1837-59, BI,
SS and elsewhere. Titles at RA mostly horse and dog portraits; also
some historical genre scenes.
Bibl: Strickland II; BM Cat. of Engraved British Portraits VI 1925; Ormond.

SCANNELL, Miss Edith M.S. fl.1870-1903
Genre painter. Exhib. at RA 1870-1903, SS and elsewhere. Titles at
RA 'In the Schoolroom', 'The Torn Frock', 'Hard Lines', etc. and
a few portraits of children.

SCAPPA, Miss fl.1874-1875
Exhib. four landscapes 1874-5. Address in Hastings, Kent.

SCAPPA, E.C. fl.1872-1880
Is supposed to have exhib. two works at SS. London address.

SCAPPA, G.A. fl.1867-1886
Painter of landscape and coastal scenes. Exhib. at RA 1869-74, SS
and elsewhere. Titles at RA mostly views on the Thames at
Wapping and Limehouse.

***SCHAFER, Henry (Henri) d.c.1900**
Little-known painter, probably of French birth, working around the
end of the 19th century. He painted only town scenes and buildings
in the area of northern France and Belgium, in a style resembling
that of Alfred Montague (q.v.). Lived in Islington and increasingly
painted pot-boilers as he fell into debt.

SCHAFER, Henry Thomas RBA fl.1873-1915
Genre painter and sculptor. Exhib. both pictures and sculpture at
RA from 1875, SS, NWS, GG, and elsewhere. Titles at RA
'Sisters', 'The Bride'. 'A Faithful Friend', etc. Not to be confused
with the painter of town scenes, Henry Schafer (q.v.).

SCHALANDER, F.W. fl.1868
Exhib. two watercolours. including a view in Scania, at SS. London
address.

SCHARF, George NWS 1788-1860
Painted townscapes and figurative subjects. Exhib. 28 works at the
RA including views of Somerset House, Covent Garden Market
and the new London Bridge. Born in Mainburg, Germany. Lived
and died in London. Father of Sir George Scharf (q.v.).
Bibl: DNB; Bryan; AJ 1860 p.372; Studio Special Number 1920, *Londoners Then
and Now*; Connoisseur LXXXIII 1929 p151.

SCHARF, Sir George KCB FSA 1820-1895
Painted archaeological subjects. Exhib. six works at the RA
including views at Xanthus, and two works at the BI including 'The
Lycian Expedition at Myra'. He was Director of the NPG and was
knighted in 1895.
Bibl: DNB; Bryan; Ormond .

SCHARPF, Joseph fl.1892-1893
Painted landscape. Exhib. ten works at SS including 'Winter on the
Bavarian Lowlands' and 'The North Foreland'. Address in
Broadstairs, Kent.

SCHEFFER, Hendrick fl.1839
Exhib. two works 'A Protestant Preacher' and 'Le Souvenir' at the
RA. London address.

SCHELL, Miss Lily fl.1880-1885
Painted figurative subjects. Exhib. a work entitled 'Jealousy' at the
RA and five works at SS. Address in Brighton, Sussex.

SCHENCK, Mrs. Agnes fl.1880-1884
Painted flowers. Exhib. five works at SS including 'Pansies' and
'Chrysanthemums'. London address.

SCHENCK, J. fl.1859
Exhib. a work entitled 'Paris in Portugal' at the RA. London
address.

SCHENLEY, Hermione fl.1885
Exhib. a watercolour entitled 'Old Curiosities' at SS. London
address.

***SCHETKY, John Christian 1778-1874**
Marine painter, watercolourist and teacher. Born in Edinburgh.
Studied under Alexander Nasmyth (q.v.). In 1801 visited Paris and
Rome. 1808 appointed teacher of drawing at the Royal Military
College, Sandhurst; 1811 teacher at Royal Naval College,
Portsmouth; 1836 teacher at East India College, Addiscombe.
Exhib. at RA 1805-72, BI, SS, OWS and elsewhere. Painted ships,
naval incidents both old and contemporary. In 1844 he was
appointed Marine Painter in Ordinary to Queen Victoria. His
brother John Alexander (1785-1824), an army surgeon, was also an
amateur painter of landscapes and military subjects. Graves lists a
J.T. Schetky, but this is a misprint for J.C.Schetky. His studio sale
was held at Christie's, 26 February 1875.
Bibl: AJ 1874 p.80; 1877 p.160; Redgrave, Dict.; S.F.L. Schetky, *Ninety Years of
Work and Play*, 1877; Roget; Binyon; Caw; Cundall; Wilson pl.33; Hardie III
pp.220-1; Maas p.63; Brook-Hart pl.48; Irwin.

SCHICK, P. fl.1853-1854
Exhib. four portraits at the RA. Address in Hastings, Kent.

SCHILLER, H. Carl fl.1844-1867
Exhib. two portraits at the RA and two portrait watercolours at SS. London address.

SCHIRMACHER, Miss M. Dora fl. 1885-1889
Exhib. two works, 'A Summer's Day' and 'A Welsh Lane'. Address in Liverpool .

SCHJERFBECK, Miss H. fl.1887-1889
Exhib. three domestic subjects 1887-1889. Address in St. Ives, Cornwall.

SCHLOESSER, Carl Bernhard 1832-1914
Painted figurative and historical subjects. Exhib. 35 works at the RA including 'Arrest of Louis XVI at Varennes', 'Beethoven' and 'Her New Dress'. Born in Darmstadt, Germany. Lived in Paris and Rome and, finally, in London. Represented in the museums of Darmstadt and Liverpool.
Bibl: The Year's Art 1914 p.579.

SCHLOESSER, Miss Maud fl.1901
Exhib. a work entitled 'Near Norbury' at the RA. Address in Great Bookham, Surrey.
Exhib: London, 92 New Bond Street, 1905.

SCHMÄCK, Miss Emily fl.1837-1845
Painted figurative subjects. Exhib. 20 works at the RA including 'A Young Lady Preparing for a Fancy Ball' and 'Alice and her Child from *Ernest Maltravers*'. Also exhib. eight works at the BI and one work at SS. London address.

***SCHMALZ, Herbert Gustave 1857-1935**
London painter of genre, portraits and of oriental and biblical subjects. Exhib. from 1879 at the RA, GG, NG and elsewhere, titles at the RA including 'Light and Shade', 1879, 'Sir Galahad', 1881, 'Widowed', 1887, and 'The Daughters of Judah in Babylon', 1892. In 1890 he visited Jerusalem and the Holy Land, where he painted many landscapes and collected material for such biblical works as 'The Return from Calvary'. This journey, 'A Painter's Pilgrimage', is published in the AJ with many plates. He changed his name to Carmichael on 11 November 1918. He signed his flower paintings Angelico.
Bibl: AJ 1893 pp.97-102, 337-42; T. Blakemoore, *The Art of Herbert Schmalz*, 1911; The Graphic 13 January 1912 p.48 (2 pls.); Hall; Wood, Olympian Dreamers.

SCHMIDT, Edward Allan- fl.1868-1877
Exhib. three works at the RA including 'The Hunting Companion' and 'A Trick Too Many'. London address.

SCHMITT, Guido Philipp 1834-1922
Is supposed to have exhib. three genre subjects at the RA. London address.
Bibl: Ormond.

SCHNABEL, Marie fl.1888-1889
Exhib. two works, 'A Daughter of Eve' and 'The Vesper Hour', at SS. London address.

SCHOBINGER, Mme. de fl.1859
(Miss Burdon)
Exhib. four genre subjects in 1859. London address.

SCHOEFT, A. fl.1859-1860
Exhib. a portrait and a view in Venice at the RA. London address.

SCHOFIELD, John William RI RBA RBC fl.1899 d.1944
Painted portraits, landscape and figurative subjects. Studied at the Westminster School of Art and in Paris under Bougereau and Lefebvre. Exhib. 14 works at the RA 1889-1904 including 'Study of Cottages, Interlaken', 'Spring Vapours, N. Devon' and 'Olive'. Lived in London and Devon.

SCHOFIELD, Kershaw fl.1900-1902
Exhib. three works at the RA including 'Green and Gold' and 'Washing Day'. Address in Bradford, Yorkshire.

SCHOLDERER, Otto 1834-1902
German painter of genre, still-life and portraits. Born in Frankfurt where he studied at the State Institute under J.D. Passavant and Jak. Becker, 1849-52 He spent 28 years in England, 1871-99, living in Putney and London, and exhib. 1871-96, at the RA 1875-96, SS, GG and elsewhere. He also had spent some time in Paris where he was friendly with and much influenced by Fantin-Latour, Manet and Leibl. He returned to Frankfurt in 1899, where he died. Titles at the RA include 'Heron and Ducks', 1875, 'Man with Peacocks', 1888, 'At the Fishmonger's', 1892 and 'The Little Flower-seller', 1896. 'Man with Hares' is in Sheffield AG .
Bibl: Fr. Herbert, *Otto Scholderer*, 1934 (for full bibl.); Pavière, Sporting Painters; see TB for fuller bibl.

SCHONBERG, John fl.1895
Exhib. two works including 'Japanese Soldiers in a Snow-Storm' at the RA. London address.

SCHOPIN, M. fl.1877
Exhib. a mythological subject at SS. London address.

SCHOTEL, P.T. fl.1844
Exhib. a view on the coast of Holland at SS. Address in Taunton, Somerset.

SCHOTT, Cecil fl.1887
Exhib. a study for a picture at the RA. London address.

SCHRÖDER, Hubert ARE fl.c.1890-1930
Painted and etched landscape. Exhib. eight works at the RA 1894-1904 including 'A Sussex Farm' and 'Walberswick'. London address.

SCHRÖDER, Walter G. fl.1890-1904
Painted landscape. Exhib. five works at the RA including 'By the Wayside' and 'The Sentinels of the Night', and seven works at SS. Address in Chester, Cheshire.

SCHROESTER, Adeline fl.1877
Exhib. a painting of roses at the RA.

SCHULHOF, Miss S. Edith fl.1891-1892
Exhib. a study at SS. London address.

SCHULTZ, Robert Weir fl.1885-1904
Architect who painted views of archaeological and architectural subjects. Exhib. 11 works at the RA including studies of mosaics in Athens and views in London. London address.

SCHUMACHER, Bernard fl.1897-1898
Exhib. three works, including 'Mortlake Brewery' and 'The Workshop', at the RA. London address.

SCHUTZE, A. fl.1884
Exhib. 'An Old Hand-loom at Anvers' at SS. Address in Southampton.

SCHWARTZE, Miss Theresa fl.1885
Exhib. a work entitled 'Musa' at the RA and another at SS. London address.

SCHWEIGER, Hans fl.1884
Exhib. two works at the GG in 1884. London address.

SCHWEINFURTH, Dr. G. fl.1877
Exhib. two African subjects in 1877. London address.

SCLATER, E. fl.1865-1871
Exhib. two marines at SS. Address in Dover, Kent.

SCLATER-BOOTH, Miss fl.1881-1884
Exhib. three portraits at the GG. London address.

SCOLES, J.J. 1798-1863
Painted architecture. Exhib. ten works at the RA including views at Prior Park near Bath. London address.

SCORER, Frederick fl.1895-1903
Painted middle eastern subjects. Exhib. four works at the RA including 'Afterglow at Assouan' and 'Theban Mountains'. Address in Edenbridge, Kent.

SCORER, George O. fl.1894-1904
Painted views of buildings. Exhib. 11 works at the RA 1894-1904, including 'Keeper's Lodge and Dairy'. These were possibly architect's drawings. London address.

SCORGONI, T. fl.1883
Exhib. a pastel entitled 'The Friend of the Family' at the RA. London address.

SCOTT, A. fl.1856
Exhib. a watercolour view on the Clyde at SS. London address.

SCOTT, Miss Ada fl.1900
Exhib. a view of 'The Old Hospital, Rye' at the RA. Address in Ventnor, Isle of Wight.

SCOTT, Miss Alice M. fl.1880-1889
Painted literary subjects. Exhib. seven works at the RA including subjects from Tennyson, Shelley and Keats, and a portrait. London address.

SCOTT, Mrs. Alma fl.1888
Exhib. a painting of roses at the RA. London address.

SCOTT, Miss Amy fl.1860-1891
Painted landscape and genre subjects. Exhib. five watercolours at SS including 'Old Cottages, Midhurst' and 'The Rye-field'. Also exhib. three works including 'A Christmas Present' at the RA. London address.

SCOTT, B.F. fl.1833-1849
Exhib. a view of Mont Blanc at SS and a Welsh landscape at the RA. London address.

SCOTT, Bessie D. fl.1879-1881
Exhib. two landscapes 1879-81. London address.

SCOTT, Miss Catherine fl.1867-1888
Exhib. a watercolour view of Cranleigh Common at SS. London address.

***SCOTT, David RSA 1806-1849**
Scottish historical painter. Born in Edinburgh, the son of Robert Scott an engraver; brother of William Bell Scott (q.v.). Studied under his father and at Trustees' Academy. Visited Italy 1832-4. Settled in Edinburgh 1834. Like B.R. Haydon and Maclise in England, Scott tried in Scotland to revive the tradition of grand historical painting. His subjects were usually biblical or mythological, e.g. 'Cain', 'Sappho', 'Philoctetes left in the Isle of Lemnos', etc., or sometimes historical, e.g. 'The Traitors' Gate'. His works are romantic and mystical, "they breathe a particular intellectual and spiritual atmosphere, and hence, whatever their defects, they possess a life and . . . interest of their own" (Caw). He exhib. mostly at RSA, at RA only twice — in 1840 and 1845. ARSA 1830, RSA 1835. Unfortunately his work met with little response from the public, and he died disappointed. In addition to his painting, he was a powerful illustrator, best known for his work on *The Ancient Mariner* and *Pilgrim's Progress*.
Bibl: AJ 1849 p.144; Portfolio 1887 p.153ff.; W.B. Scott, *Memoir of D.S.,* 1850; J.M. Gray, *D.S. and his Works,* 1884; Artwork IV 1928 p.250ff.; Redgrave, Dict.; DNB; Fredeman; Reynolds, VP pp.13, 17 (pl.7); Maas p.24 (pl.); Staley; Ormond; Irwin pls.129-34.

SCOTT, E. fl.1839
Is supposed to have exhib. a marine at SS. Address in Dover, Kent.

SCOTT, Miss Edith fl.1882
Exhib. a subject at SS in 1882. London address.

SCOTT, Elizabeth Dundas fl.1877-1878
Exhib. four landscapes 1877-8. London address.

SCOTT, Miss Emily fl.1826-1855
Painter of miniature portraits, living in Brighton and London, at 14 Maddox Street. Exhib. 1826-55, at the RA 1836-55, and SS, all miniature portraits.
Bibl: Ormond.

SCOTT, Miss Emily Anne fl.1825-1855
(Mrs. Seymour)
Painter of miniature portraits, living in London at Park Village East, and from 1855 in Manchester. Exhib.1825-55, at the RA 1844-55, and SS, all miniature portraits. May be the same as Emily Scott, but Graves (Royal Academy Exhibitors) lists them separately.

SCOTT, Esther P. fl.1893
Exhib. a watercolour entitled 'Evening off Harwich' at SS. London address.

SCOTT, Miss Fanny C. fl.1868-1871
Exhib. two watercolour paintings of fruit at SS and a work entitled 'Waiting for a Shot' at the RA. London address.

SCOTT, G. fl.1835-1847
Painted landscape and figurative subjects. Exhib. 13 works at SS including 'A Piping Boy' and 'A Girl at a Window' and five works at the BI including four views of Allan Water. London address.

SCOTT, G. fl.1860
Exhib. a mythological subject at the BI. London address.

SCOTT, H.L. fl.1881
Exhib. four street scenes at the GG. Address in Paris.

SCOTT, H.T. fl.1863
Exhib. a work entitled 'Friends from the North' at the BI. London address.

SCOTT, Henrietta S. fl.1891
Exhib. a work entitled 'Warning Light' at SS. London address.

SCOTT, J. fl.1850-1873
Ship painter. Painted mostly ship portraits, some of which can be see at Greenwich Maritime Museum. Often painted ships at the mouth of the River Tyne. This is almost certainly John Scott (1802-1885, q.v.).
Bibl: Wilson pl. 33.

SCOTT, J. fl.1863
Exhib. a work entitled 'Spring Flowers' at the RA. London address

SCOTT, J.B. fl.1871
Exhib. 'A River Scene, North Devon' at SS. London address.

SCOTT, Miss J.E. fl.1863-1867
Painted portraits. Exhib. five portraits and portrait studies at the RA. London address.

SCOTT, J.J. fl.1863-1864
Exhib. two works, 'Gipsy Encampment' and 'Monday Morning', at the BI. London address.

SCOTT, James fl.1821-1844
Painted portraits and copies, which are possibly miniatures. Exhib. 18 works at the RA including portraits, 11 works at SS, including 'The Two Pets' and 'Contemplating a Cruise', and three works at the BI. London address.

SCOTT, James R. fl.1854-1871
Painted marines and coastal landscapes. Exhib. three works at the BI, 'Lynmouth', 'Looe Harbour' and 'Entrance to Looe Harbour'. Also exhib. three works at SS and one work at the RA. London address.
Bibl: Brook-Hart.

SCOTT, James V. fl.1877-1889
Exhib. three Scottish landscapes at the RA. Also exhib. ten works at the NWS. Address in Edinburgh.

SCOTT, John 1802-1885
Painter of marines and landscape. Studied painting under Carmichael. He remained all his life in the region of Newcastle-upon-Tyne. Represented in the Shipley AG, Gateshead. May be the same as J. Scott (fl.1850-1873, q.v.).
Bibl: Hall.

SCOTT, John RI RBA 1850-1919
London painter of genre and of historical and literary subjects. Exhib. 1862-1904, at the RA 1872-1904, BI, SS, NWS, GG, NG and elsewhere, titles at the RA including 'Coming from Mass', 1872, 'An Incident from *The Marsh King's Daughter*', 1884 and 'Cinderella and her Fairy God-mother', 1900.

SCOTT, John Douglas fl.1871-1881
Painted Scottish landscape. Exhib. three works at the RA, including two views in Ross-shire, and four works at SS. Lived in Edinburgh. Represented in the Sunderland AG.
Bibl: Hall.

SCOTT, John Henderson 1829-1886
Painted landscape watercolours. Also exhib. views of architecture. Exhib. three works at the RA and four watercolours at SS including 'View of Stroud from Farm Hill, Gloucestershire' and 'Wargrave, near Henley on Thames'. Address in Brighton, Sussex. Son of William H.S. Scott (q.v.).

SCOTT, Miss Katharine fl.1872-1892
Streatham painter of flowers and game, who exhib. 1872-92, at the RA 1879-90, SS, NWS and elsewhere. Titles at the RA include 'Scarlet Primula', 1879, and 'Dead Birds', 1887.

SCOTT, Laurence fl.1883-1898
Cheltenham painter of landscape, genre and flowers, who exhib. 1883-98 at the RA, SS and elsewhere, titles at the RA including 'The Kitchen Garden', 1888, 'De Profundis', 1893 and 'Hydrangeas', 1898.

SCOTT, M . fl.1854
Exhib. a portrait at the RA. London address.

SCOTT, Mary fl.1823-1859
(Mrs. Brookbank)
Painter of flowers and children, usually in watercolour. Daughter of William H.S. Scott and sister of John Henderson Scott (qq.v.). AOWS 1823, resigned 1837.

SCOTT, Mrs. Nora fl.1876
Exhib. a painting of camels in 1876. London address.

SCOTT, Miss R.C. fl.1871-1875
Exhib. four watercolours at SS including 'Bramber Castle — Sunset' and 'A Christmas Hamper'. London address.

SCOTT, Richard fl.1883
Exhib. a landscape at the NWS. Address in Beulah Hill, London.

SCOTT, Robert Bagge fl.1886-1896
Painted marines and coastal subjects. Exhib. eight works at the RA including 'On Netherland's Windy Water' and 'The Wind in the Willows'. Lived in Norwich, and is represented in the Castle Museum, Norwich.

SCOTT, Septimus E. fl. 1900-1904
Painted country subjects. Exhib. ten works at the RA, 1900-4, including 'A Market Garden' and 'Whitby'. London address.

SCOTT, Thomas RSA RSW 1854-1927
Painted landscape and townscapes in watercolour. Studied at the RSA Life Classes. Worked widely abroad. Born and lived in Selkirk, Scotland. Well-known for his robust border landscapes.
Bibl: AJ 1907 pp.17-21; Caw; Holme, *Sketching Grounds,* Studio Special Number 1909; The Year's Art 1928 p.361.

SCOTT, Thomas John
Norwich landscape painter working at the end of the 19th century. Vice-President of the Norwich Art Circle.

SCOTT, Walter fl.1831-1853
London painter of portraits and genre, living in Park Village East and therefore possibly the brother of Miss Emily Anne Scott (q.v.). Exhib. 1831-53, at the RA 1841-53, and SS, titles at the RA including portraits and 'In Maiden Meditation Fancy Free', 1848, 'The Scrap-book', 1851 and 'Isabel', 1853.
Bibl: Hall.

SCOTT, Walter fl.1877-1878

Exhib. three landscapes 1877-8. London address. He is probably Walter Scott (1851-1925) a Coventry landscape painter recorded in Mallalieu. Later became Headmaster of Norwich Art School.

SCOTT, William RPE 1848-1914

Painted and etched townscapes and views of architecture. Exhib. ten works at the RA including views in Venice and London, and three works, one of them a watercolour, at SS. London address.

Bibl: Who Was Who 1916-28; Studio XXII 1906 pp.113-17.

*SCOTT, William Bell 1811-1890

Pre-Raphaelite painter, watercolourist, illustrator and poet. Son of Robert Scott, an Edinburgh engraver; brother of David Scott (q.v.). Studied under his father, and at Trustees' Academy. 1837 came to London. Entered for Westminster Hall Competition. This led in 1843 to his appointment as master of the Government School of Design in Newcastle. In 1847 the young Rossetti wrote to Scott, praising one of his poems. They became friends, and Scott contributed poems to *The Germ*. While in Newcastle, he executed his best-known pictures. These are the series depicting the History of Northumbria painted for the Inner Hall of Wallington Hall, the Northumberland seat of the Trevelyan family. He painted another series called 'The King's Quhair' for Miss Alice Boyd of Penkill Castle, Ayr. The Pre-Raphaelite style did not come easily to Scott, and his oil paintings are often laboured in detail, and harsh in colour. His subjects, although well chosen and historically accurate, are often sentimentally superficial. In the medium of watercolour he was usually more effective. While in Newcastle he helped James Leathart of Low Fell to form his remarkable Pre-Raphaelite collection. He returned to London in 1858. Exhib. at RA 1842-69, BI, SS and elsewhere.

Bibl: W.B. Scott, *Autobiographical Notes etc.* 1892; Blackwood's Magazine CLIII February 1893 pp.229-35; DNB; Bryan; Bate; Caw pp.171-2; Windsor Magazine XL September 1914 pp.413-28; R. Ironside in Architectural Review XCII December 1942 pp.147-9; Ironside & Gere; Maas; Fredeman Section 56 *et passim* (with full bibl.); Staley; Hall; Ormond; Irwin; Wood, Panorama; W.E. Fredeman, *The Penkill Letters: A PR Gazette,* Manchester, John Rylands Library Bulletin, 1967; Frank Graham (ed.), *Scenes from Northumbrian History: The Mural Paintings at Wallington Hall,* 1972; Raleigh Trevelyan, *W.B. Scott and Wallington,* 1977; Raleigh Trevelyan, *A Pre-Raphaelite Circle,* 1978; Wood, Pre-Raphaelites; Newall.

SCOTT, William Henry Stothard AOWS 1783-1850

Brighton landscape painter, mainly in watercolour, who exhib. 1810-55, at the RA 1810-33, BI, SS, and prolifically at the OWS (229 works). He was first elected A of the OWS in 1810, and then re-elected in 1820. His home was Brighton, "Whence", says Redgrave, "he seldom strayed abroad". His subjects were the scenery and cottages of Sussex and Surrey, views in the north of France, on the rivers Meuse and Moselle, and in the Pyrenees, and several views in Edinburgh. Father of Mary and John Henderson Scott (qq.v.).

Bibl: Redgrave, Dict; Roget.

SCOTT, William Wallace 1819-1905

Painter of miniature portraits, who lived for a time at the same address in London, Park Village East, as the painters Miss Emily Anne Scott (q.v.) and Walter Scott (fl.1831-1853, q.v.). He exhib. in London 1841-59 at the RA, BI and SS — all portraits including one of Thomas Webster, RA (RA 1853). After 1859 he is said to have moved to New York, where he worked for many years and where he died.

Bibl: American Art Annual VI 1907-8 p.115 (obit.); Mantle Fielding, *Dictionary of American Painters, Sculptors and Engravers,* 1965; Ormond.

SCRIVEN, H. fl.1845-1849

Exhib. two works at the RA including a view near Croydon. London address.

SCROPE, William 1772-1852

Painted landscape. Exhib. 19 works at the BI including views in Italy and six works at the RA including views in Scotland. London address.

Bibl: Redgrave, Dict; AJ 1852 p.286; DNB.

SCRUTON, Victor fl.1880-1884

Birmingham painter of landscapes and buildings.

SCULL, W.D. fl.1886

Exhib. a watercolour entitled 'Creatures That Live But a Day' at SS. London address.

SCULLY, Harold fl.1887-d.1935

Exhib. three landscapes, two of them views in France, at the RA, and three landscapes at the NWS. Address in Cork, Ireland.

SEABROOK, Miss Grace fl.1872-1874

Exhib. two works, entitled 'Barbara' and a watercolour, 'Babette', at SS. London address.

SEAFORTH, Charles Henry b.1801 d. after 1853

Marine painter. Recorded as being admitted to the RA Schools in 1823 at the age of 22. He was a prolific marine artist painting every kind of craft, and also executed many coastal scenes. Lived from 1852 in Naples. Exhib. 1825-53, at the RA 1827-53, BI and SS, titles at the RA including 'Shipping Vessels of Different Rates Performing Various Evolutions', 1829, 'H.M's ships Vanguard and Royal Frederick off Cobreta Point, working into Gibraltar Bay Sunshine', 1837 and 'The Great Western', 1838.

Bibl: Wilson p.71; Brook-Hart.

SEALY, Allen Culpeper fl.1873-1886

London painter of landscape and genre, who exhib. 1873-86, at the RA 1875-86, SS, and elsewhere, titles at the RA including 'Rushy Point, Tresca, Sicily', 1875, 'Tramps, Hazley Heath, Hants', 1879 and 'Life on the Ocean Wave', 1886.

SEARCH, R.D. fl.1875-1877

Exhib. a work entitled 'A London Garden' at the RA. London address.

SEARE, S. fl.1852

Exhib. a work entitled 'A Quiet Spot' at the RA. London address.

SEARLE, A.H. fl.1888

Exhib. a work entitled 'Our Indian Possessions' at SS. London address.

SEARLE, Miss E.E. fl.1897

Exhib. an interior view in a church in Antwerp at the RA. London address.

SEARLE, F. fl.1877

Exhib. a watercolour of plums at SS. London address.

SEARS, Francis b.1873

Painted landscapes, marines and figurative subjects in watercolour. Studied at the Birmingham School of Art. Exhib. at the RBSA from 1907. Born and lived in Birmingham.

SEARS, L. fl.1854
Exhib. a landscape on the Isle of Wight at the RA.

SEATON, Miss A.E. fl.1886
Exhib. a painting of shells at the GG. Address in Sheffield, Yorkshire.

SEATON, C. fl.1858
Exhib. a sketch at SS. London address.

SEAWELL, S. fl.1847-1851
Painted landscape. Exhib. two works, views in Reigate and near Farnham in Surrey, at the RA, and two watercolour landscapes at SS. London address.

SEBBERS, L.H. fl.1849-1854
Painted figurative and religious subjects. Exhib. eight works at the RA including portraits, religious subjects and works entitled 'The Villa d'Este, Tivoli' and 'Shepherd in the Campagna of Rome'. London address.

SEBBON, R. fl.1845
Exhib. a work entitled 'Suspicion Haunts the Guilty Mind' at SS. Address in Liverpool.

SECCOMBE, Colonel F.S., Royal Artillery fl.1876-1885
Painted military subjects. Exhib. nine works at the RA including 'The 5th Fusiliers at El Bodon', 'The Colours of the Grenadier Guards at the Battle of Inkerman' and 'The Fight at the Barrier, Inkerman', the latter two watercolours. Address Tilbury, Essex.

SEDDING, Edmund H. fl.1886-1892
Exhib. four works at the RA, including two views in London. London address.

SEDDON, Fanny fl.1869-1874
Exhib. four landscapes 1869-74. London address.

SEDDON, John Pollard 1827-1906
Architect and graphic artist. Painted views of architecture. Exhib. 26 works at the RA, the majority probably architectural drawings but also including views of Lambeth Palace Chapel and of a church interior in Reims. London address.
Bibl: Who Was Who; Staley.

SEDDON, Miss M. fl.1896
Exhib. two portraits at the RA. London address.

***SEDDON, Thomas B. 1821-1856**
Pre-Raphaelite painter. Son of a cabinet maker; brother of architect John Pollard Seddon (q.v.). 1841 visited Paris; 1850 Barbizon; 1852/3 Dinan. In 1853-4 he accompanied Holman Hunt (q.v.) on his first trip to the Holy Land. In 1856 he returned to Cairo, where he died. His works are remarkable for their minute fidelity to the external facts of landscape, but owing to his early death his output was small. He exhib. only six works at the RA, between 1852 and 1856. After his death an exhib. of his work was held at the Society of Arts, 1857, at which Ruskin delivered a speech (see bibl.).
Bibl: AJ 1857 p.62 (obit.); L'Art I 1875 pp.256-62, 272-6; J. Ruskin, *Speech on T.S.,* Journal of the Society of Arts V May 1857 pp.360-2; *Memoirs and Letters of T.S., Artist,* by his brother J.P.S. 1858; DNB; Poynter, Nat. Gall. III 1900; Reynolds, VP p.12 (pl.108); Fredeman Section 57 *et passim* (with full bibl); Maas pp.90, 133 (pl.p.91); Staley; Wood, Pre-Raphaelites; Newall.

SEDGEFIELD, Miss Isabel M. fl.1889-1891
Painted flowers. Exhib. four paintings of flowers at SS and another at the RA. London address.

SEDGWICK, Mrs. John see OLIVER, Mrs. William

SEELEY, Miss E.L. fl.1873-1875
Exhib. three works at the RA, including 'Pastime in the Jungle' and 'Nobody's Dog'. London address.

SEELEY, R. fl.1876
Exhib. two works at SS, including a view in Westmoreland, and another at the RA. Address in Kingston-upon-Thames.

SEIN, Mangul fl.1859
Exhib. a double portrait in watercolour at SS.

SELB, Orpheus Victor W. fl.1889-1898
Exhib. a view in Antwerp at the RA. Address near Chichester, Sussex.

SELBY, Prideaux John 1788-1867
An ornithologist who made drawings of birds. These were engraved. Born at Alnwick, Northumberland.

SELBY, T. fl.1853
Exhib. a view of a Norman arch and staircase at the BI. Address in Canterbury, Kent.

SELL, Charles fl.1880
Exhib. a work entitled 'After a Skirmish' at the RA. London address.

SELLAR, Charles A. RSW fl.1888-d.1926
Exhib. two works, a portrait and a view in Fifeshire, at the RA. Address in Edinburgh. Also lived in Perth. An example is in Dundee

SELLON, William fl.1876-1877
Exhib. two works at the RA, 'Hard Times' and 'Strangers Yet'. Address in Twyford, Berkshire.

SELLS, V.P. fl.1851-1865
London painter of landscape and architectural subjects (mainly church interiors), who exhib. 1852-65 at the RA and SS. Titles at the RA include 'S. Transept, Rouen Cathedral', 1851, 'Druidical Remains at Gorey, Jersey', 1855 and 'Evening on the Coast', 1859.

***SELOUS, Henry Courtney 1811-1890**
London painter of genre, portraits, landscape, and historical and literary subjects — especially scenes from Shakespeare; lithographer, illustrator and author. Son of George Slous (fl.1791-1839), painter of genre, portraits, landscape and miniatures. Pupil of John Martin (q.v.). Entered RA Schools c.1818. Exhib. under the name Slous 1818-31, at the RA 1818-28, BI and SS, titles at the RA including 'Portrait of a Favourite Cat', 1818 and 'A Boar Hunt', 1820. In 1837 he altered the spelling of his name to Selous. Exhib. as Selous 1838-85, at the RA and BI, titles at the RA including 'Sea Coast and Figures — View near Holland', 1839, 'A Scene at Holyrood, 1566', 1854, and 'Katharine and Petruchio's Wedding Supper', 1870. 1843 won a £200 premium in the Westminster Hall Cartoon Competition. He produced illustrations for the Art Union of London, and illustrated many books, including *Outlines to*

Shakespeare's Tempest, 1836 (12 pls.), Bunyan's *The Pilgrim's Progress,* 1844, C. Kingsley's *Hereward the Wake,* 1869, and Cassell's *Illustrated Shakespeare,* 1864. He wrote and illustrated several children's books, e.g. *Granny's Story-Box,* 1858 and *Eleanor's Governess,* 1867 and also produced children's books under the pseudonyms Aunt Cae and Kay Spen. His painting 'The Great Exhibition in Hyde Park, London; the Opening by H.M. Queen Victoria on 1st May, 1851', 1851-2, is in the VAM.

Bibl Bryan; VAM; BM Cat. of Engraved British Portraits VI 1925; BM General Cat. of Printed Books 1964; Reynolds, VP p.36; Maas p.28; Ormond; Wood, Panorama.

SELOUS, Miss J. fl.1861
Exhib. a work entitled 'Hetty's Toilet' at SS. London address.

SEMBACH, A. fl.1876-1878
Exhib. three works at SS including 'Young Jessica' and 'Late Afternoon on the Thames', and a view on the Maas at the RA. London address.

SENGA fl.1872
Exhib. a portrait at SS. Address in Devon.

SENIOR, E.N. fl.1848
Exhib. a work entitled 'The Ancient School Mistress' at SS. London address.

SENIOR, Mark 1864-1927
Painted landscape, rustic and coastal subjects. Studied at the Slade School. Exhib. 14 works at the RA titles including 'Pastures by the Sea', 'Her Frugal Meal', 'Preparing Bait' and 'Homewards'. He was a friend of Tonks, Fred Brown and Wilson Steer (qq.v.). Born at Dewsbury. Lived in Leeds, and is represented in the Leeds City AG.

Bibl: Studio LXIX 1917 p.115; P. Phillips, *TheStaithes Group,* 1993.

SENTIES, T. fl.1852-1858
Portrait painter living in London, who exhib. 1852-8 at the RA and SS. TB mentions a Pierre Asthasie Théodore Senties, a Dieppe painter of portraits and religious subjects, born in 1801; this may be the same painter, although no mention is made of his having been in England.

SEPHTON, George Harcourt fl.1885-1902
Painted rustic and genre subjects. Exhib. eight works at the RA including 'The Village Forge', 'Hop Picking in Kent' and 'Ducklings', and two works at SS. London address.

SEPHYEL, Professor fl.1876
Exhib. a work entitled 'The Batchelor' at SS. London address.

SERLE, Miss H. fl.1874
Exhib. a painting of fruit at SS. London address.

SETCHEL, Miss Elizabeth fl.1832-1844
Painted portraits and figurative subjects. Exhib. six works at the RA, all of them portraits, two works at SS, including 'A Cottager', and one work at the BI. London address.

SETCHEL, Miss Sarah RI 1803-1894
Painter of portraits, genre and landscape. Awarded a premium by the Society of Arts in 1829; exhib. 1831-67 at the RA 1831-40, SS and NWS; became a member of the RI in 1841, but resigned in 1886. 'The Momentous Question' exhib. at the NWS in 1842, now

in VAM, established her reputation and became very popular. The question asked by the girl is "Will you remain faithful to me and die, or shall I marry your brother and thus preserve your life?" (Crabbe's *Tales of the Hall* Book XXI). Titles at the RA are mainly portraits, and also 'Fanny', 1831, 'Sketch of a Cottager', 1832 and 'Study of a Gentleman Reading', 1840

Bibl: VAM; Roget.

SETON, Charles C. fl.1881-1894
London painter of landscape, genre and historical and literary subjects. Exhib. from 1881-94 at the RA, SS, GG and elsewhere, titles at the RA including 'The Third Age, "And then the lover etc" ', 1883, 'The Unconverted Cavalier', 1884, and 'A Mill on the Teme', 1894.

SETON, Ernest Thompson 1860-1946
Painted animals. Studied at the Ontario College of Art, the RA Schools, and in Paris. Born in South Shields, County Durham. Spent his childhood in Canada. Subsequently lived in the USA. Born Ernest Evan Thompson.

Bibl: Hall.

SETTLE, William Frederick 1821-1897
Hull marine painter, a pupil and cousin of John Ward (q.v.) Moved to London in 1863, where his patrons included Queen Victoria. Exhib. a view on the Dutch coast at the BI, 1867.

Bibl: Brook-Hart pl.82.

SEVERN, Miss Ann Mary fl.1852-1856
Exhib. three works at the RA including 'The Twins'. London address. Also see Ann Mary Newton.

***SEVERN, Joseph 1793-1879**
Historical and portrait painter. Studied at RA Schools 1813-19. Won Gold Medal for historical painting in 1819. Accompanied John Keats to Rome in 1820 and was present when he died in 1821. In Rome Severn's popularity as a personality and as an artist earned him a very successful practice as a portrait painter. He stayed there until 1841, when he returned to London. In 1860 he was appointed British Consul in Rome, and lived there till his death in 1879. Exhib. at RA 1819-57, BI, OWS and elsewhere. Works by him are in the NPG and the VAM. Three of his children were also painters, Joseph A.P., Walter and Ann Mary (qq.v.).

Bibl W. Sharp, *The Life and Letters of J.S.,* 1892; DNB; Bryan; Cundall; Roget; VAM; Connoisseur LXXXVII 1931 p.261; Lady Birkenhead, *Against Oblivion, the Life of J.S.,* 1943; H E. Rollins, *The Keats Circle,* 1948; Lady Birkenhead, *Illustrious Friends, the Story of J.S. and his Son Arthur,* 1965; Maas pp.23, 28; Ormond; Strong.

SEVERN, Joseph Arthur Palliser RI ROI 1842-1931
Landscape and marine painter, mainly in watercolour. Son of Joseph Severn (q.v.). In 1871 he married Ruskin's (q.v.) niece, Joan Ruskin Agnew. He was influenced by Ruskin's ideas, and in 1872 visited Italy with him, and Albert Goodwin (q.v.). Exhib. at RA 1863-96, NWS, GG, but mostly at Dudley Gallery, of which his brother Walter (q.v.) was President and founder. A work by him is in the Walker AG, Liverpool.

Bibl: Connoisseur LXXXVII 1931 p.261; Lady Birkenhead, *Illustrious Friends, the Story of J.S. and his Son Arthur,* 1965; Maas pp.23, 230-1; Irwin.
Exhib: London, Fine Art Society 1892, 1899, 1901; London, Leicester Galleries 1906, 1911.

SEVERN, Miss Mary see NEWTON, Ann Mary and SEVERN, Ann Mary

SEVERN, Walter RCA **1830-1904**
Landscape painter, mainly in watercolour. Eldest son of Joseph Severn (q.v.). Exhib. at RA only twice, in 1853 and 1855, both times with pictures of deer; also at SS and GG. In 1865 he was one of the founders of the Dudley Gallery, and from then on exhib. most of his work there. Later he became its President.
Bibl: DNB 2nd supp III p.293; Who Was Who 1897-1915; Lady Birkenhead, *Illustrious Friends, the Story of J.S. and his Son Arthur*, 1965.

SEWARD, Mrs. Edwin (Edith Jessie) **fl.1889-1891**
Exhib. two works, including 'A Grey Day, Bristol Channel', at the RA. Address in Cardiff.

SEWARD, Edwin RCA FRIBA **fl.1890**
An architect who exhib. 'A Portal in Barcelona' at the RA. Founder of the South Wales Art Society. Born at Yeovil, Somerset, lived in Cardiff, and later in Weymouth, Dorset.

SEWELL, G.H. **fl.1875**
Exhib. a Venetian subject in 1875. Address in Rome.

SEXTIE, William A. **fl.1848**
Exhib. a portrait of a horse at the RA. Address in Marlborough, Wiltshire. He painted racehorses and racing scenes in a style similar to Harry Hall.

SEYFFARTH, Mrs. see **SHARPE, Miss Louisa**

SEYMOUR, Mrs. see **SCOTT, Miss Emily Anne**

SEYMOUR, George L. **fl.1876-1888**
Exhib. a study of a horse at SS. Also exhib. one work at the NWS and elsewhere. London address.

SEYMOUR, Miss Harriette Anne **b.1830 fl.1866**
Painted landscape and marines. A member of the Society of Lady Artists. Exhib. a view of Canterbury Cathedral. Born in Markbury, Somerset. Lived in London.
Bibl: Clayton.

SEYMOUR, J. Sidney **fl.1877-1878**
Exhib. two watercolours, 'A Quiet River' and 'Autumn', at SS. London address.

SEYMOUR, Miss T.D. **fl.1867**
Exhib. a nocturnal subject in 1867. London address.

SEYMOUR, Walter **fl.1873-1896**
Painted landscape. Exhib. five subjects at the RA, including 'The Last Load' and 'Miss Ellen Terry as Lady Macbeth', and four watercolours at SS including 'A Fisherman's Daughter' and 'In the Duddon Valley, Cumberland'. London address.

SHACKLETON, William **1872-1933**
Painter, watercolourist and designer. Studied in London, Paris and Italy. His paintings show a very personal style; a blend of art nouveau design and surrealist fantasy, but they are little seen or appreciated today. A work by him is in the Tate Gallery.
Bibl: Studio LXIII 1915 p.215; 1915 p.186; LXVII 1916 p.58; LXX 1917 p.43; LXXXIII 1922 pp.17-22; Art News XXXI 1932-3 No.20 p.8; H.W. Fincham, *Art and Engr. of Book Plates*, 1897; Who's Who.

***SHALDERS, George** **1826-1873**
Landscape painter and watercolourist. Lived in Portsmouth and London. Exhib. at RA 1848-62, BI, SS and NWS. Subjects mostly summery views in Wales, Ireland and Surrey, and occasionally on the Continent. His work is conventional but attractive, and shows affinities with two other artists from the south-west, William Shayer and F.R. Lee (qq.v.). His best works are his early landscapes showing Pre-Raphaelite influence. Works by him are in the Walker AG and the VAM. A benefit sale for his children was held at Christie's, 9 March 1874; this was a mixed sale and contained only four works by Shalders.
Bibl: AJ 1873 p.80; Redgrave, Dict.; DNB; Cundall p.255; Wood, Paradise Lost; Newall.

SHAND, Miss Christine R. **fl.1899-1900**
Painted flowers. Exhib. three works at the RA including 'Azaleas' and 'Spring Flowers'. Address in Newcastle-upon-Tyne.

SHANKS, William Somerville RSA RSW **1864-1951**
Painted portraits, interiors and still-lifes. Turned to painting from a career as an industrial designer. Studied art at the Glasgow School. Born at Gourock, Renfrewshire. Lived in Glasgow and Stirling.
Bibl: Who Was Who 1897-1915; Who's Who 1915.

***SHANNON, Charles Hazelwood** RA ARPE **1863-1937**
Painter of figure subjects and portraits; illustrator and lithographer connoisseur. Born at Quarrington, Lincolnshire. Studied wood engraving at the Lambeth School of Art, 1882, where he met Charles Ricketts (q.v.). Ricketts and Shannon, nicknamed Orchid and Marigold by Oscar Wilde, became life-long companions and collaborators and lived together until Ricketts's death in 1931. First they worked at illustration: Shannon drew for Quilter's *Universal Review* and for Oscar Wilde's *A House of Pomegranates* 1891 (4 pls; mainly illustrated by Ricketts). They wanted to control all the circumstances of book production, and their joint enterprise produced *Daphnis and Chloe*, 1893, *Hero and Leander*, 1894, and five numbers of *The Dial*, 1889-97 (with the help of the poets John Gray and Thomas Sturge Moore), to which Shannon contributed a number of lithographs. He then turned to painting — producing large canvases in oils (many worked out from his lithograph designs), portraits and self-portraits. Such works include 'A Wounded Amazon', 1896, the self-portrait 'The Man in the Black Shirt', 1897, 'Tibullus in the House of Delia', 1898 (containing portraits of himself, Ricketts, Lucien Pissarro (q.v.) and Sturge Moore), 'Mrs. Dowdall', 1899 ('The Lady with the Cyclamen'), 'The Bath of Venus', 1898-1904 and 'The Romantic Landscape', 1904. From 1904 to 1919 he returned to lithography, producing 46 catalogued prints. Exhib. at the GG 1885-99, the International Society (of which he later became VP) 1898-1919, NEAC 1897-1900, SS, NG and the RA from 1885, ARA 1911; RA 1920; member of the National Society of Portrait Painters, and A of the Société Nationale des Beaux-Arts, Paris. First one-man exhib. at the Leicester Galleries, 1907. Incapacitated after a fall from a ladder in 1929, he lived until 1937, not really recognising his friends. The greater part of the art collection he and Ricketts had formed was left to the Fitzwilliam Museum, Cambridge.
Bibl: AJ 1902 pp.43-6; C. Ricketts, *A Catalogue of Mr. Shannon's Lithographs*, 1902; Campbell Dodgson, *C.S.'s Art*, Die Graph Künste XXVI 1903 pp.73-85; T.M. Wood, *The Lithographs of C.H.S.*, Studio XXXIII 1905 pp.26-34; C. Ricketts, *L'Art et Les Artistes*, X 1909-10 pp.206-19; George Derry, *The Lithographs of C.S. with a Catalogue of Lithographs issued between 1904 and 1918*, 1920; "Tis", C.S. ARA (Masters of Modern Art, list of works up to 1919) 1920; Print Collector's Quarterly VIII 1921 pp.275-6; XI 1924 pp.217-8; XII 1925 p.60; XIV 1927 p.203ff.; E.B. George, *C.S.*, (Contemporary British Artists) p.294; DNB 1931-40; Tate Cat; Hardie III pp.147, 170-1.

***SHANNON, Sir James Jebusa** RA RBA RHA **1862-1923**
Painter of figure subjects and society portraits, considered by some to rival J.S. Sargent (q.v.). Born at Auburn, New York, USA, of

Irish parents. Came to London, aged 16, in 1878 and studied at the RCA under Poynter (q.v.), 1878-91, receiving the Gold Medal for figure painting. Exhib. at the RA 1881-1922, and also at GG, SS, NG and elsewhere; foundation member of NEAC 1886; first one-man exhib. at the FAS 1896. ARA 1897; RA 1909; President of the RP 1910-23; knighted 1922; memorial exhib. at the Leicester Galleries 1923, and included in the RA Late Members' exhib. 1928. Several of his portraits won him awards, and his subject picture 'The Flower Girl', RA 1901, was bought by the Chantrey Bequest for the Tate Gallery.

Bibl: AJ 1901 pp.41-5; S. Isham, *The History of American Painting*, 1905; The Art News, N.Y., XXI 1922-3 No. 22 p.8; American Art Annual XX 1923 p.265; Connoisseur LXV 1923 p.243ff.; Studio LXXXV 1923 p.220; Who Was Who 1916-28; Apollo XVII 1933 p.96ff. (pls.); Tate Cat.; Maas p.223; Ormond. Exhib: London, Nico Jungmann Gallery, 1911.

SHAPLAND, Mrs A.F. Terrell (Ellen) fl.1883-1890
Exhib. four works at the RA including 'Whiting' and 'Iris' at the RA. Address in Brighton, Sussex.

SHAPLAND, John fl.1901-d.1929
Painted figurative subjects. Exhib. three works at the RA, including 'Paradise Lost' and 'Fairy-led'. Address in Exeter, Devon. He was the Principal of Exeter School of Art 1899-1913.

SHARLAND, Miss L.A. fl.1876
Exhib. a subject at SS. London address.

SHARP, Miss fl.1869
Exhib. a view of a church in 1869. London address.

SHARP, Arthur William fl.1875
Exhib. an Essex landscape at the RA. London address.

SHARP, Miss Dorothea RBA ROI VPSWA 1874-1955
Painted landscape and figurative subjects. Studied at the Regent Street Polytechnic and in Paris. Exhib. three works at the RA 1901-4, including 'Playmates'. Lived in London, also in Blewbury, Berkshire, and St. Ives, Cornwall.

Bibl: Who's Who 1935; Connoisseur LI 1918 p.56; Apollo XVII 1933 p.285. Exhib: London, Connell & Sons Gallery, 1933.

SHARP, Edward fl.1857-1859
Exhib. a view of Haddon Hall at the RA. London address.

SHARP, Miss M.A. fl.1883-1885
Exhib. five architectural subjects at the GG. Address in Reading Berkshire.

SHARPE Family (Charlotte, Eliza, Louisa, Mary Anne)
The four daughters of William Sharpe, a Birmingham engraver, were all painters of miniature portraits and subjects, and all prominent members of the OWS. The eldest, Charlotte, married a Captain Morris in 1821 and died in 1849. The second Eliza (1795/6-1874) was unmarried and exhib. 1817-69 at the RA and OWS (87 works). The third, Louisa (1798-1843), was the most prolific and gifted of the sisters. She exhib. miniature portraits at the RA 1817-29 when she was elected a member of the OWS. After 1829 she exhib. at the OWS until 1842 where her exquisitely finished costume pieces were a great attraction. Popular works were 'Brunetta, from Addison', 1832, 'The Good Offer' 1835, 'Constancy and Inconstancy' 1840, 'Alarm in the Night', 1841 and 'The Fortune Teller', 1842, and many of her domestic and sentimental scenes were engraved in *The Keepsake* and other

Annuals. On her marriage in 1834 to Dr. Waldemar Seyffarth, she went to live in Dresden, where her husband was settled as a professor. The youngest, Mary Anne, was unmarried and died in 1867. She exhib. at the RA and BI from 1819.

Bibl: Clayton I pp.379-82; Roget I pp.547-8; II pp.206-7.

SHARPE, Miss Charlotte d.1849
One of the Sharpe family of painters (q.v.).

SHARPE, Miss E. fl.1867
Exhib. a work entitled 'Love, Money and Cunning' at the RA. London address.

SHARPE, Miss E.A. fl.1889
Exhib. a painting of flowers at the NWS. Address in Dover, Kent.

SHARPE, Edmund MA FRIBA 1809-1877
An architect and engineer. Exhib. a view of a church in France at the RA. Born in Knutsford, Cheshire. Died in Mailand.

Bibl: Redgrave, Dict.; DNB; AJ 1877 p.235.

SHARPE, Eliza OWS c.1795-1874
One of the Sharpe family of painters (q.v.).

Bibl: Ormond.

SHARPE, Miss F. fl.1867
Exhib. a work entitled 'Margaret' at the RA. London address.

SHARPE, G.W. fl.1865-1868
Painted landscape and still-lifes. Exhib. three works at the RA including 'Peacock's Feathers' and 'Thinking it Over', three works at SS, all still-lifes, and three works at the BI. London address.

SHARPE, J.B. fl.1861-1876
Painted marines and landscapes. Exhib. seven watercolours at SS including 'The Thames at Battersea', 'Fishing Boats off Hastings' and 'A Surrey Lane'. London address.

SHARPE, J.C. fl.1842
Exhib. two views of a church in Turnham Green at the RA. London address.

SHARPE, J.F. fl.1826-1838
Painted portraits. Exhib. 30 works at the RA 1826-38, all portraits, and 19 works at SS. Lived in London and Southampton.

SHARPE, Miss Louisa 1798-1843
(Mrs. Seyffarth)
The most prolific and talented member of the Sharpe family of painters (q.v.).

Bibl: Ormond.

SHARPE, Miss Mary fl.1865-1880
Painted figurative subjects. Exhib. five works at the RA, including 'The Little School-girl' and 'Girl with a Hoop'. London address.

SHARPE, Miss Mary Anne 1802-1867
The youngest member of the Sharpe family of painters (q.v.).

SHARPE, William fl.1861-1879
Painted figurative and genre subjects. Exhib. 16 watercolours at SS, titles including 'Good Advice', 'The Doll' and 'Refreshment'. London address.

SHAW, A. fl.1826-1839

Painted townscapes and views of architecture. Exhib. eight works at the BI including views in Naples, Rome and Venice. Also exhib. five works at the RA, again the majority Italian subjects, and two works at SS. London address.

SHAW, A. Winter fl.1891-1901

Exhib. two works at the RA, including 'It was but a Summer Shower', and two works at SS, including 'Idlers'. London address.

SHAW, Charles E. fl.1884-1892

Exhib. three works at the RA, including 'When the Sun Sinks to Rest', and one work, 'Acorn Gatherers', at SS. Address in Preston, Lancashire.

SHAW, Frederick fl.1876-d.1923

Painted landscape and rustic subjects. Exhib. four works at the RA including 'At Sefton Lancashire — Evening' and 'Betty with the Milking Pail'. Address in Liverpool. Member of the Liverpool Academy of Arts.

SHAW, G. fl.1859-1862

Exhib. three watercolour still-lifes of fruit at SS. London address.

SHAW, Henry 1800-1873

Exhib. four works at the RA including an interior view of York Minster. Born in London. Died in Broxbourne, Hertfordshire.

Bibl: Ottley; Redgrave, Dict.; DNB; AJ 1873 p.231; Cundall.

SHAW, Hugh George fl.1873-1889

Genre painter, living in Stratford-on-Avon, who exhib. 1873-89, at the RA 1874 and 1875, BI and elsewhere. Titles at the RA including 'The Poacher', 1874 and 'Possession Nine-Tenths of the Law', 1875.

SHAW, J. fl.1851-1853

Exhib. two works, 'Fencing the Corn' and 'The Woodman's Home', at SS. London address.

SHAW, J., Jnr. fl.1825-1846

Exhib. nine views of buildings at the RA including two views of Eton College Chapel. London address.

*SHAW, John Byam ARWS RI 1872-1919

Pre-Raphaelite painter, decorator and illustrator. Studied at the RA Schools, where he won several awards. Began to exhib. at RA in 1893. His works are mostly large and elaborate compositions, painted in the late Pre-Raphaelite style of J.W. Waterhouse, F. Cadogan Cowper (qq.v.), etc., although Shaw's work also shows a lyrical art nouveau influence. His subjects are sometimes taken from Rossetti poems, e.g. 'Rose Marie', 'The Blessed Damozel', 'Circle-Wise Sit They', 'Love's Baubles', etc. He painted in pure pigments, which even now gives his pictures a startlingly bright appearance. Faithful to his academic training, he made careful studies for all the figures in his pictures; his drawings are similar in style to those of Leighton and Poynter (qq.v.). In 1910 he painted 'The Entry of Queen Mary with Princess Elizabeth into London' in the House of Lords. He also illustrated Browning, Boccaccio, *Old King Cole's Book of Nursery Rhymes, The Cloister and the Hearth,* and many other books.

Bibl: Studio II 1894 p.136ff.; X 1897 pp.109-21; XVI 1902 p.136; The Artist March 1907 p.159ff.; Mag. of Art 1903 pp.l-4; Connoisseur XLIV 1915 p.42; XLVII 1917 p.56; LIII 1919 p.110; LXVIII 1924 p.236; XCI 1933 p.189ff.; Burlington Mag. XXX 1917 p.84; Apollo V 1927 p.105; XVI 1932 p.196; R.E.D. Sketchley, *English Book Illustration of Today,* 1903; DNB; Who Was Who 1916-28; Bate, R.V. Cole, *The Art and Life of B.S.,* 1932; P. Skipwith, *Byam Shaw: A Pictorial Story Teller,* Connoisseur CXCI 1976; Wood, Pre-Raphaelites; Newall.

SHAW, Joshua, of Bath 1776-1861

Painted landscape. Exhib. 22 works at the BI 1810-41, amongst the last of these being 'American Forest Scenery' and 'Tintern Abbey'. Also exhib. up to 1814 at the RA. This artist apparently emigrated to North America. He was born in Bellingborough, Lincolnshire, and died in New Jersey, USA. He lived in Bath, Somerset, between 1802 and 1817.

Bibl: Bryan; M. Fielding, *Dictionary of American Artists.*

SHAW, Miss Mary Helen fl.1896-1904

Painted flowers. Exhib. nine works at the RA, 1896-1904, including 'What Shall the Summer Bring?' and 'Peonies'. Address in Beverley, Yorkshire.

SHAW, W.R.B. fl.1839-1846

Exhib. four works at the RA including 'The Beggar Man' and two views near Merthyr Tydfil. London address.

SHAW, Walter James 1851-1933

Painter of coastal scenes and landscape, living in Salcombe, Devon, who exhib. 1878-1904 at the RA and elsewhere, titles at the RA including 'The Storm', 'The Ebb-tide on the Bar', 1880 and 'Salcombe Bar', 1904. Bristol AG has 'Bantham Sands' and 'Salcombe Bar in Bad Weather'.

Bibl: Brook-Hart.

SHAW, William F. fl.1875

Exhib. a landscape in 1875. London address.

SHAW, Winter fl.1895-1899

Painted landscape. Exhib. three works at the RA including 'Beneath the Sky that Burning August Gives'. Address in Beckenham, Kent.

SHAYER, Charles Waller 1826-1914

Very little-known Southampton painter. Exhib. only once in London, at SS in 1879. Painted landscapes and sporting scenes. Presumably related to William Shayer (q.v.).

*SHAYER, William 1787-1879

Landscape and animal painter. A self-taught artist, he lived in Southampton, and painted mostly in Hampshire and the New Forest. His work falls into two distinct categories; firstly, woodland scenes with gypsies, rustic figures and animals, and secondly, beach or coastal scenes with boats and fisherfolk. He was a prolific artist, and tended to repeat certain formulae. Exhib. mostly at SS (338 works), also at RA 1820-43, and BI. His work is in many English provincial museums. He sometimes collaborated with Edward Charles Williams (q.v.). His son William J. Shayer (q.v.) was also a painter.

Bibl: AJ 1880 p.84 (obit.); Mag. of Art 1901 p.330; Connoisseur LXVII 1923 pp.126, 176; LXXIV 1926 pp.130, 184; Apollo VIII 1920 pp.316, 266; IX 1929 pp.211, 215; XV 1932 p.139ff.; XVIII 1933 pp.l9, 44; Pavière, Landscape pl.66; Ottley; Maas p.53 (pl.p.52); Brook-Hart; Wood, Panorama; Wood, Paradise Lost; B. Stuart and M. Cutten, *The Life of W.S. Senior,* Hampshire Magazine December 1979; B. Stewart and M. Cutten, *The Shayer Family of Painters,* 1981.

SHAYER, William Joseph 1811-1892
Animal and landscape painter; son and imitator of William Shayer (q.v.). Exhib. at RA in 1858 and 1885, BI and SS. His pictures are often confused with his father's, as they undoubtedly worked together, and both signed W. Shayer. A work by Shayer Jnr. is in Glasgow AG.
Bibl: Brook-Hart.

SHEAF, H.S. fl.1847
Exhib. a portrait at the RA. London address.

SHEARD, Professor Thomas Frederick Mason RBA 1866-1921
Painted portraits, figurative subjects and landscape. Studied in Paris under Courtois and Lefebvre. Exhib. 14 works at the RA 1891-1903, including 'An Autumn Day in the Allotments', 'Arab Women Preparing for the Midday Meal' and 'Life's Dawn and Setting'. Also exhib. one work at SS. Born in Oxford. Lived at East Hendred, Berkshire. Died in London.
Bibl: Studio XXXII 1904 p.296; Who Was Who; Connoisseur XLIV 1916 p.116; LXI 1921 p.238; Poole 1925.

SHEARER, James Elliott b.1858 fl.1896
Painted landscape. Exhib. a view in Rome at the RA. Born in Stirling. Lived in Edinburgh.

***SHEE, Sir Martin Archer PRA 1769-1850**
Portrait painter. Studied at the Drawing School, Dublin, and at the RA Schools. At first painted historical subjects and portraits of actors. Subsequently he painted members of the Royal Family including the Queen. He was also the author of several books. In 1830, after the death of Lawrence, he became PRA. Most of Shee's work is pre-Victorian, and was in fact regarded as old-fashioned by early Victorians, as he carried on the traditions of the Lawrence portrait style. Born in Dublin, died in Brighton. Represented in the NPG.
Bibl: AJ 1849 p.12; 1850 p.297; Connoisseur LVIII 1920 pp.297-300; Apollo IX 1929 p.138; M.A. Shee, *The Life of Sir Martin Archer-Shee*, 1860; Redgrave, Cent., Dict.; DNB; Strickland; Irwin; Ormond.

SHEEHAN, Charles A. fl.1898
Exhib. a work entitled 'The Mystic City' at the RA. London address.

SHEFFIELD, George 1839-1892
Painted landscape. Exhib. six works at the RA including 'Lindon Common' and 'View in the Island of Sark'. Also exhib. 'A Cheshire Lane' at SS. Addresses in Manchester and Cheshire.
Bibl: DNB; Portfolio 1892 p.XXIV; Yorkshire Post 14 September 1912; Connoisseur LXXXVIII 1931 pp.392, 393.
Exhib: London, Faculty of Arts 1932; Warrington Museum 1935.

SHEFFIELD, Margaret A. fl.1887-1890
Painted flowers and landscape. Exhib. two works at the RA, 'A Dyke in the Fens' and 'A Croyland Wash', and nine works at SS including 'Meadows in Kent', 'Primula' and 'Harvest in Lincolnshire'. London address.

SHEFFIELD, Miss Mary J. fl.1887-1897
Painted flowers. Exhib. seven works at the RA, including 'Primula', 'Roses' and 'Thistledown', and 14 works at SS. London address.

SHEFFIELD, T. Percy fl.1883
Exhib. a work entitled 'Birch Tree and Gorse Land' at the RA. Address in Farnham, Surrey.

SHEIL, Edward RHA 1834-1869
Exhib. 'The Day Before Sending to the Exhibition' at SS, and 'Gethsemanie' at the RA. Born at Coleraine. Lived and died in Cork.
Bibl: Strickland.

SHELDON, Alfred fl.1844-1865
Exhib. two works, 'Fruit from Nature' and 'Harvest on the Cotswold', at the BI, and three works at SS. Address in Winchfield, Hampshire.

SHELLEY, Arthur 1841-1902
Landscape painter. Exhib. at RA and elsewhere 1875-88. Lived in London and Plymouth before settling in Torquay. His brother, John William Shelley (1838-70) was an amateur watercolourist.

SHELLEY, Frank fl.1900
Exhib. a portrait at the RA. London address.

SHELLEY, Frederick b.1865 fl.1904
Painted landscape. Studied at Manley School of Art, at the RCA, and abroad. Exhib. five works at the RA 1890-1904, including 'A Devonshire Orchard' and 'The Fringe of Dartmoor'. London address.

SHELLEY, Henry fl.1853-1862
Exhib. two works at the BI, 'Faith' and a subject including Henry IV of France. Also exhib. a portrait at the RA. Address in Dunkirk, France.

SHELLSHEAR, Miss Alicia J. fl.1873-1887
Painted figurative subjects. Exhib. four works at the RA including 'Purity' and 'Portia — from *The Merchant of Venice*', and a watercolour and two chalk drawings at SS. London address.

SHELLY, Arthur 1841-1902
Landscape painter, living in London, Plymouth and Torquay, who exhib. 1875-88, at the RA 1881-8, SS, NWS and elsewhere, titles at the RA including 'Study at Trachsellauinen, Lauterbrunnen', 1881 and 'Winter Sunset on the Thames', 1888. Born in Yarmouth; died in Torquay. One of his paintings is in the Norwich Castle Museum.

SHELTON, Sidney fl.1881-1889
Exhib. two works, 'Autumnal Leaves' and 'Near Sevenoaks', at the RA, and two works at SS. London address.

SHEPARD, Ernest Howard 1879-1976
Book illustrator and painter. Studied at Heatherley's and at the RCA. Exhib. four works at the RA 1901-4, a portrait, a landscape and works entitled 'They Toil Not Neither Do They Spin' and 'Followers'. Shepard was the illustrator of A.A. Milne's books. Two volumes of autobiography have been published: *Drawn from Memory* and *Drawn from Life*. Lived in Lodsworth, Sussex, for many years.
Exhib: London, Sporting Gallery 1933; VAM 1969.

SHEPARD, Mrs. H.D. (Jessie) fl.1888
Exhib. a still-life at the RA. London address.

SHEPHARD, Eric A. fl.1886
Exhib. a 'Scene in Surrey' at the RA. Address in Torquay, Devon.

SHEPHARD, Henry Dunkin　fl.1885-1891
London painter of genre and architectural subjects, who exhib. 1885-91 at the RA, SS, NWS and GG. Titles at the RA including 'In a German Church', 1885, 'The Last of his Race', 1886, and 'A Chorister', 1891.

SHEPHEARD, Lewis Henry　fl.1844-1875
Painted landscape. Exhib. eight works at SS including 'Scotch Fir Study from Nature', 'Beech Trees near Summing Hill' and a view on the Rhine. London address.

SHEPHERD, Fanny　fl.1863
Exhib. a painting of fruit at SS. Address in Manchester.

***SHEPHERD, George Sidney**　RI　1784-1862
Watercolour painter of landscape, rustic genre, and also topographical subjects. It was formerly thought that he was the son and pupil of George Shepherd, who is recorded as working up to about 1842. It now appears that they are the same artist. George Sidney studied at the RA schools and exhib. 1800-58 at the RA, BI, SS, OWS and NWS. RI 1831. He chiefly painted rural scenery, and views in Surrey and Sussex, into which he introduced pleasing groups of figures. He also engraved prints after other artists' works, and in 1814-15 published a set of *Vignette Designs*, drawn by himself and etched by G.M. Brighty. Sometime about 1830, he turned to topographical views of London, for which he is now best known, and it is these views that are generally signed G.S. Shepherd. He also produced illustrations for C. Clarke's *Architectura Ecclesiastica Londini*, and W.H. Ireland's *England's Topographer*. There is still some confusion about his exact dates of birth and death.
Bibl: Redgrave, Dict.; Binyon; Cundall; DNB; BM Cat. of Engraved British Portraits II 1910 p.186; VAM; Hardie III p.15 (pl.14): J.F.C. Phillips, *Shepherd's London*, 1976 (later revised).

SHEPHERD, George Walwyn　1804-1852
Watercolour landscape painter. Eldest son of George Sidney Shepherd (q.v.). Travelled much on the Continent, and in 1838 married an Italian lady at Florence. Exhib. 1836-51 at the RA, sending in chiefly views in France and Italy and studies of trees, titles including 'The Cedar Pine: view near Spoleto; a drawing in pencil', 1839, 'Ash-trees in the forest of Fontainebleau', 1834 and 'On the Lake of Geneva, near Vaud', 1846.
Bibl: See under G.S. Shepherd.

SHEPHERD, Miss Julianna Charlotte　fl.1868-1870
Exhib. two paintings of flowers and one of fruit at SS. Address in Manchester.

SHEPHERD, S.　fl.1875
Exhib. a landscape in Surrey at SS. London address.

SHEPHERD, Thomas Hosmer　1792-1864
Watercolour painter of topographical views of streets and old buildings in London. Apparently brother of George Sidney Shepherd (q.v.). Exhib. four landscapes at SS 1831-2. He made many drawings of London and in 1827-31 collaborated in the production of several topographical works. Frederick Crace (1779-1859), employed him to make watercolours of old buildings in London before they were demolished; many of these are in the BM.
Bibl: Redgrave, Dict; Cundall; DNB; Hardie III p.15 (pls.15-16).

SHEPHERD, W.A.　fl.1847-1852
Painted landscape. Exhib. five works at SS including 'Dover Harbour' and 'Old Cottage, Hoddesdon, Herts'. Address in Hoddesdon, Hertfordshire.

SHEPHERD, William James Affleck　1867-1946
Painted and illustrated animal subjects. Joined the staff of *Punch* in 1893. Lived at Chalwood, Surrey, and later near Cirencester, Gloucestershire.

SHEPPARD, Miss Charlotte Lillian　fl.1884-d.1925
Painted animals in watercolour. Exhib. at the RBA. Also exhib. a study of a dog at SS. London address.

SHEPPARD, Herbert C.　fl.1890
Painted landscape. Exhib. four works at the RA including 'Twilight on the Sandhills, Glamorganshire' and 'Snow and Smoke'. Address in Bridgend.

SHEPPARD, Miss M.R.　fl.1842-1843
Exhib. four religious subjects in watercolour at SS. Address in Bridgenorth, Salop.

SHEPPARD, Philip　1838-1895
Painted landscape. Exhib. three works at the RA, a view in Cornwall and two in North Wales, and three watercolours at SS. Address near Bath, Somerset. Went blind at the age of 30. Represented in the VAM.
Bibl: Redgrave, Dict; DNB; BM Cat. of Engraved British Portraits.

SHEPPERSON, Claude Allin　ARA ARWS ARE　1867-1921
Painted and etched landscape and figurative subjects. Studied in Paris and London after abandoning a legal career. Born at Beckenham, Kent. Lived in London.
Bibl: AJ 1898 pp.269-71; Studio XXX 1914 p.21; LXX 1917 p.63; LXXIII 1918 p.70; LXXXIII 1922 p.156; Connoisseur XLVII 1917 p.173; LXII 1922 pp.114, 236; further bibl. in TB.

SHERATON, J. Ritson　fl.1860-1862
Exhib. two works, 'The Royal Charter, as she appeared when Breaking Up, on the morning of the Wreck' and 'Crossing the Mountains'. Address in Bangor, North Wales.

SHERATON, T.　fl.1840-1846
Painted figurative subjects. Exhib. three works at the RA, 'Making a Present', 'The Pawnbroker' and a portrait, one work at the BI and a subject from *Paradise Lost* at SS. London address.

SHERBORN, G.F.　fl.1853-1855
Painted landscape. Exhib. two works at the BI, both views in Middlesex, and one view at SS. Address in Brentford, London.

SHERIDAN, Harry　fl.1857
Exhib. a view on the Aar at the RA. Represented in the VAM. Address in Whitehaven, Cumberland.

SHERLEY, Miss C.　fl.1842-1849
Painted genre and figurative subjects. Exhib. 16 works at SS including 'The Sick Mother', 'Returning from the Vintage' and 'The Grandfather's Tale', and a portrait at the RA. London address.

SHERLING, J.　fl.1849
Exhib. a portrait at the RA. London address.

SHERLOCK, John A.　fl.1892
Exhib. a work entitled 'Book-keeping' at SS. London address.

SHERRARD, Miss Florence E.　fl.1884-1894
Painted portraits and figurative subjects. Exhib. eight works at the RA including portraits and works entitled 'The Convalescent' and 'After the First Communion', and seven works at SS. London address.

SHERRIFF, Miss Annie **fl.1885-1888**
Exhib. a painting of Christmas roses at SS. London address.

SHERRIFF, G. Vincent **fl.1875-1877**
Exhib. a landscape at the RA. Address in Liverpool.

***SHERRIN, Daniel 1870-1942**
Little-known landscape painter working around the turn of the century. Although he does not seem to have exhib. in London, his pictures are frequently seen on the market. They are usually imitations of the late style of B.W. Leader (q.v.). He also painted pictures of sailing ships, very similar to those of T.J. Somerscales (q.v.) and early Montague Dawson. Son of John Sherrin (q.v.).
Bibl: Brook-Hart pl.157.

***SHERRIN, John RI 1819-1896**
Still-life and animal painter, mainly in watercolour. Pupil of William Henry Hunt (q.v.). Exhib. at RA 1859-94, SS, NWS and elsewhere. Works by him are in the VAM. Father of Daniel Sherrin. (q.v.).
Bibl: Roget; Cundall.

SHERWIN, Mrs. Kate **fl.1896**
Exhib. a view of a mill at the RA. London address.

***SHIELDS, Frederic James ARWS 1833-1911**
Manchester Pre-Raphaelite painter, watercolourist and decorator. First impressed by the works of the Pre-Raphaelite Brotherhood, which he saw at the Manchester Art Treasures Exhibition in 1857. Later became a close friend of Rossetti and Ford Madox Brown (qq.v.). Painted mostly in watercolour, which he exhib. at the OWS. ARWS 1865. His work is realistic and mostly religious, more akin to Holman Hunt (q.v.) than any of the other Pre-Raphaelites. He was also a fine illustrator, and mural decorator. His two major commissions were the Chapel of Eaton Hall, home of the Grosvenor family, and the Chapel of the Ascension in the Bayswater Road, London, now destroyed.
Bibl: Portfolio 1883 p.184; 1884 pp.134-7; 1887 p.116; AJ 1902 pp.337-43; Building News 1911 p.312 (obit.); Gleeson White; H.E. Scudder, *An English Interpreter,* Atlantic Monthly L October 1882 pp.464-75; H.C. Ewart, *F.S. An Autobiography* (Toilers in Art), 1891; C. Rowley, *F.S.,* 1911; E. Mills, *Life and Letters of F.J.S.,* 1912; Bate; DNB; Fredeman section LVIII *et passim* (with full bibl.); Hardie III pp.128-9; Hall; P. Ferriday, *F.S. Agonistes,* Country Life 31 May 1979; Wood, Pre-Raphaelites; Wood, Paradise Lost; Newall.
Exhib: Manchester, City AG 1907.

SHIELDS, Harry G. RBA 1859-1935
Painter of winter landscapes. Exhib. six works at the RA including 'Winter in the Woods', 'December, Bleak and Drear' and 'Woodland Silver', and 15 similar subjects at SS. Born near Perth. Lived at St. Andrew's, Fife.

SHIELDS, Henry **fl.1890-1891**
Exhib. two coastal landscapes at SS. Address in Glasgow.

SHIELS, William RSA 1785-1857
Scottish painter of animals and domestic genre of the Wilkie (q.v.) type, and also of mythological subjects. Born in Berwickshire, little is known of his life; he became a member of the Scottish Academy at its formation in 1826, and exhib. in London 1808-52 at the RA, BI and SS. Titles at the RA include 'Ulysses and Laertes', 1808, 'Interior of a Scottish Fisherman's Cottage', 1851 and 'Preparing for a Visitor', 1852.
Bibl: Redgrave, Dict.; Caw p.198; BM Cat. of Engraved British Portraits III 1912 p.105.

SHINDLER, Miss Florence A. **fl.1888**
Exhib. a view of the entrance to the Duke of Richmond's Tomb, Westminster Abbey, at the RA. London address.

***SHIPHAM, Benjamin 1806-1872**
Landscape painter, born in Nottingham, who exhib. 1852-72 at the RA, BI, SS and elsewhere, titles at the RA including 'Midland Scenery near Nottingham', 1852. Pavière reproduces 'Harvesting, Nottingham Castle'. His paintings are in Glasgow and Nottingham AGs.
Bibl: Pavière, Landscape (pl.67).

SHIPWAY, J. **fl.1857**
Exhib. two works including 'An Italian Villa' at the RA. Address in Great Malvern, Worcestershire.

SHIPWRIGHT, Miss Emily A. **fl.1893-1904**
Exhib. a still-life at SS. London address.

SHIRLEY, Mrs. Arthur **fl.1859-1866**
Exhib. a study of horses at the BI.

SHIRLEY, Miss Elizabeth **fl.1890-1891**
Exhib. three paintings of flowers at the NWS. London address.

SHIRLEY, Henry **fl.1843-1870**
London painter of genre and landscape who exhib. 1843-70, at the RA 1844-59, BI and SS, titles at the RA including 'The Babes in the Wood', 1844, 'Sunset — Gipsies Preparing for a Revel', 1847 and 'Sunshine on the Lake', 1855. One of his paintings is in Glasgow AG.

SHIRLEY-FOX, Mrs. Ada R. **fl.1888-c.1940**
(Miss Ada R. Holland)
Painted portraits and figurative subjects. Studied in Paris under Carolus Duran. She was the wife of John Shirley-Fox (q.v.). Lived in Bath, Somerset. See also Miss Ada R. Holland.

SHIRLEY-FOX, John Shirley RBA c.1867-1939
Portrait painter. Studied at the École des Beaux Arts under Gerome. Exhib. at the Paris Salon from 1883 and at the RA. Lived in London and Bath. See also under John Shirley Fox.

SHIRREFF, John **fl.1890-1898**
Exhib. four works at the RA including 'Saturday Night' and 'A Scotch Interior'. Address in Aberdeen.

SHOOSMITH, Thurston Laidlaw RBA 1865-1933
Painted landscape watercolours as an amateur. Exhib. a landscape at the NWS and four works at the RA including views in Northamptonshire and Normandy. Address in Northampton.
Bibl: Studio XXXIII 1905 pp.227-32; XXXVII 1906 p.153; XLII 1908; LXIII 1915 p.114; LXVI 1916 p.206; LXVII 1916 p.252; The Year's Art 1928.

SHORE, B.E. **fl.1893-1894**
Exhib. 'The Fringe of a Salt Marsh' at SS. London address.

SHORE, Capt. the Hon. Frederick William John **fl.1883-1888**
Exhib. two works at the RA,'A Peep of the Galleries, Gibraltar' and 'The Bone of Contention, Morocco', and one work at SS. London address.

SHORE, The Hon. Henry W. RN fl.1883-1884
Exhib. two landscapes at the NWS. London address.

SHORE, Robert S. RHA fl.1896 d.1931
Painted marines and landscape. Exhib. two works 'A Grey Day on the River' and 'From Foreign Parts' at the RA. Address in Dublin.

SHORT, F.J. fl.1871-1876
Exhib. a work entitled 'A Fresh Breeze' at SS. Address in Ramsgate, Kent.

SHORT, Sir Frank RA RI PRE 1857-1945
Painted and engraved landscape. Studied at South Kensington and Westminster after abandoning a career as an engineer. Exhib. in London from 1874. Important in the development of etching and engraving techniques. Born at Stourbridge, Worcestershire. Lived in London and at Seaford, Sussex.
Bibl: A large bibl. dealing with his work as a graphic artist is in TB.
Exhib: Brighton, Public AGs, A *Memorial Exhib. of the Work of Sir Frank Short,* 1946.

SHORT, Frederick Golden fl.1885-1892
Landscape painter, living in Lyndhurst, Hampshire, who exhib. 1885-92, at the RA 1887-92, SS, NWS and elsewhere, titles at the RA including 'By the Thames, Limehouse', 1887 and 'Shadows of Departing Day', 1892.

SHORT, Obadiah 1803-1886
Norwich landscape painter in the Crome tradition. Examples are in Norwich Castle Museum.

SHORT, Percy fl.1888-1894
Painted children. Exhib. four works including 'Study of a Child's Head' and 'Innocence' at the RA and one work at SS. London address .

SHORT, Richard RCA 1841-1916
Cardiff painter of coastal scenes and landscape, working in South Wales. Exhib. from 1882 at the RA, SS, GG and elsewhere, titles at the RA including 'Penarth Head', 1882 and 'East Wind, Cardiff', 1900. His work is represented at the National Museum of Wales, Cardiff.
Bibl: Wilson; Brook-Hart.

SHORT, W.J. fl.1836-1845
Painted views of buildings. Exhib. nine works at the RA, including 'At Gloucester' and 'Old Houses in Lambeth Old Town', and two architectural subjects at SS. London address.

SHORTHOUSE, Arthur Charles RBSA 1870-1953
Painted portraits and genre subjects. Studied at Birmingham School of Art and at the RBSA. Exhib. a work entitled 'Happy Times' at the RA. Exhib. at the RBSA from 1892. Lived in Moseley, Birmingham.

SHORTHOUSE, Miss Stella H. fl.1887-1888
Exhib. two paintings of flowers at the RA. Address in Croydon, Surrey.

SHOTTEN, J. fl.1863
Exhib. a portrait at the RA.

SHOTTON, James fl.19th century
Painted landscape and portraits. Also a copyist. Lived in North Shields, Northumberland. Worked on the Northumbrian coast.
Bibl: Hall.

SHOUBRIDGE, W. fl.1831-1853
Painted architectural subjects. Exhib. six works at the RA including 'Forum at Rome', 'The Piazzetta, Venice' and a subject from *Childe Harold*. Also exhib. three views in Italy at the BI and a watercolour at SS. London address.

SHOUBRIDGE, Mrs. W. fl.1870
Exhib. a work entitled 'Florence' at the RA. London address.

SHOUBRIDGE, William fl.1875-1877
Exhib. seven genre subjects 1875-7. Address in Teddington, London.

SHOUT, Robert Howard fl.1845-1849
Painted views of architecture. Exhib. six works at the RA including 'Approach to a Marine Palace' and 'Wimborne Minster, Dorsetshire'. London address.

SHOVERS, E. fl.1847
Exhib. a view of a monument at the RA.

SHRAPNEL, N.H.S. fl.1849-1850
Painted game. Exhib. three works at SS including 'A Couple of Teal, from Nature' and 'Partridges', and two works at the BI. Address in Gosport, Hampshire.

SHRAPNELL, E.S. fl.1860
Exhib. 'A Widgeon and a Plover' at SS. Address near Southampton, Hampshire.

SHRIMPTON, Miss Ada M. fl.1889-1904
Painted flowers and figurative subjects. Exhib. ten works at the RA including 'Pansies', 'The Wood Sprite' and works entitled 'Sulky Sue' and 'Now I'm Father'. London address.

SHRING, Margaret S. fl.1880
Exhib. a landscape in 1880. Address in Uppingham, Rutland.

SHRUBSOLE, W.G. fl.1881-d.1889
Painted landscape. Exhib. five works at the RA including 'The Ramparts of Idwal' and 'A Gusty Morning at Idwal'. Born in Maidstone, Kent. Died in Manchester.

SHUBROOK, Miss Emma L. fl.1887
Exhib. a 'Sketch on the Marshes: Mersea Island, Essex' at SS. London address.

SHUBROOK, Miss Laura A. fl.1889-1898
Painted flowers. Exhib. ten works at SS including 'Red and White Chrysanthemums' and 'Anemones' and five works, all paintings of flowers at the RA. London address. Her sister Minnie J. Shubrook was also a painter (q.v.).

SHUBROOK, Miss Minnie J. fl.1885-1899
London painter of portraits, genre and flowers, who exhib. from 1885-99, at the RA, SS, NWS and elsewhere, titles at the RA including 'Grace', 1885, 'Christmas Roses', 1889 and 'A City Luncheon', 1892. Her sister Laura A. Shubrook was also a painter (q.v.).

***SHUCKARD, Frederick P. fl.1868-1901**
Genre and flower painter. Exhib. at RA 1870-1901, SS and elsewhere. Titles at RA 'Returning with the Spoils', 'A Little Friend', etc., and some flower pictures.

SHULDHAM, E.B. fl.1864-1889

Painted flowers. Exhib. five works at SS, including 'Dog Daisies and Crimson Clover' and 'Autumn's Last Flowers', and one work at the BI. London address.

SHURY, G.W. fl.1833-1838

Exhib. a watercolour view in Boulogne-sur-Mer at SS and four works at the NWS. London address.

SHUTE, Mrs. fl.1886-1888

Exhib. two portraits at the NWS and a work at the GG. London address.

SIBLEY, Charles fl.1826-1847

London painter of genre, still-life and portraits, who exhib. 1826-47 at the RA, BI and SS, titles at the RA including 'Dead Game', 1826, 'Female Reading', 1835 and 'The Suppliant', 1839.

Bibl: BM Cat. of Engraved British Portraits; Pavière, Sporting Painters.

SIBLEY, Frederick T. RCA fl.1879-1893

Exhib. 'A Lonely Shore' at the RA and one work at the NG. London address.

SIBLEY, G. fl.1844

Exhib. an interior view in a chapel in the Auvergne at the RA. London address.

SIBLEY, R.S. fl.1838-1839

Exhib. two works at the RA, one of these an interior view of St. Peters. London address.

SICCAMA, R.R. fl.1856

Exhib. 'Sunset off Gravesend' at the RA. London address.

SICHEL, Ernest Leopold 1862-1941

Painted portraits, figurative subjects and still-lifes. Studied at the Slade School. Exhib. at the RA from 1885. Born in Bradford, of German descent.

SICKERT, Bernhard NEAC 1862-1932

Painted landscape, still-lifes and interiors. Exhib. nine works at SS including 'A Neighbourly Chat', 'The Toy Arcade, Dieppe' and 'Strawberries and Cream', and one work at the RA. He devoted himself to painting from 1885. Influenced by his father O.A. Sickert, his brother W.R. Sickert and Whistler (qq.v.). Born in Munich. Came to London with his family. Lived in London. Died in Buckinghamshire.

Bibl: Studio XLIV 1908 p.141; LXV 1915 p.182; Connoisseur LV 1919 p.54; Art News XXX 1931-2 No. 40 p.8.
Exhib. London, Leicester Galleries 1953.

SICKERT, Oswald Adalbert 1828-1885

Danish landscape painter and illustrator. Exhib. two works at the RA, 'Morthoe, Coast of Devon' and 'Evenings on the Hills in North Devon', and a scene from *As You Like It* at the BI. London address. He was the father of Walter Richard and Bernhard Sickert (qq.v.).

*SICKERT, Walter Richard RA PRBA NEAC ARE 1860-1942

Impressionist painter. Born in Munich, the son of Oswald Adalbert Sickert (q.v.). Came to England with his parents 1868. Studied to be an actor, then switched to Slade School 1881. Became a pupil of Whistler (q.v.), and helped to print his etchings. 1883 took Whistler's picture 'Portrait of my Mother' to Paris, where he met Degas, who was to have an important influence on his work. From 1887 to about 1899 he painted a series of theatre and music-hall interiors, especially of the Old Bedford. At first exhib. at SS 1884-8; then NEAC 1888-1912. Lived in Dieppe 1899-1905. His later work falls outside the Victorian period. After his return to England in 1905, he was leader of the Camden Town Group 1907-14. He painted street scenes, interiors, genre and portraits, and also did illustrations, but recognition of his work did not come until fairly late. ARA 1924, RA 1934.

Bibl: Main Biographies: Virginia Woolf, *W.S. A Conversation*, 1934; W.H. Stephenson, *The Man and his Art*, 1940; R. Emmons, *The Life and Opinions of W.R.S.*, 1941; O. Sitwell, *A Character Sketch of W.R.S.*, Orion II 1945; W.R.S., *A Free House, The Writings of W.R.S.*, 1947; A. Bertram, *S.*, 1955; Lilian Browse, *S.*, 1960 (with bibl.); Sir J. Rothenstein, *W.R.S.*, 1961; M. Lilly, *S.*, 1971; Wendy Baron, *Sickert*, 1973; Denys Sutton, *W.S.: A Biography*, 1976; Richard Shone, *W.S.*, 1988.
Other references: AJ 1909 pp.297-301; Studio XCVII 1929 pp.336-40; C 1930 pp.292, 319-24; CIII 1932 pp.266-72; Burlington Mag. XXXIII 1918 pp.203, 206ff.; XXXIV 1919 p.80ff.; XXXVII 1920 p.52ff.; Connoisseur LXV 1923 p.235ff.; LXXXIV 1929 p.125ff.; Apollo II 1930 pp.227, 295-300; XIII 1931 pp.344-7; Artwork IV 1928; VI 1936; Reynolds, VP; Maas; Irwin; Wood, Panorama.
Exhib: London, Saville Gallery 1930; Cooling Gallery 1933; Agnew's 1933; Fine Art Society 1934; Beaux-Arts Gallery 1935; Leicester Galleries 1936; Adam Bros. Gallery 1937; Beaux-Arts 1937; Redfern Gallery 1937; Leicester 1938; Brook Street Gallery 1939; Beaux-Arts 1939; Leicester 1940; Redfern 1940; New York, American British Art Center 1941; London, Leicester Galleries 1941; Nat. Gall. 1941; Leicester 1942; Roland, Browse, Delbanco 1946; Leicester 1946; Roland, Browse, Delbanco 1948; Arts Council 1949; Beaux-Arts 1949; Leicester 1950; Roland, Browse, Delbanco 1950, 1951; Islington Public Libraries 1951; Arts Council 1953; Dieppe Museum 1954; Sheffield, Graves AG 1957; Roland, Browse, Delbanco 1957; Roland, Browse, Delbanco 1960; Agnew's 1960; Arts Council 1960; Roland, Browse, Delbanco 1963; Arts Council 1964; Hull University 1968; Islington Central Library 1970; Roland, Browse, Delbanco 1970; Agnew's 1972; Parkin Gallery 1974; Arts Council, *Late Sickert*, 1982; Perth, AG of Western Australia, *The Drawings of W.S.*, 1979; London, Royal Academy 1992.

*SIDDAL, Elizabeth Eleanor 1834-1862
(Mrs. D.G. Rossetti)

Discovered by W.H. Deverell (q.v.) working in a milliner's shop. Quickly established herself as Rossetti's favourite model and mistress, although they did not marry until 1860. She was the inspiration for many of Rossetti's works of the 1850s, and featured in several other Pre-Raphaelite paintings, notably Millais's 'Ophelia' and Hunt's 'Two Gentlemen of Verona'. While living with Rossetti she produced a small number of drawings and poems of her own, interesting but mostly very derivative echoes of Rossetti. Ruskin was an admirer of her work, and agreed to buy her complete output. Works by her can be seen in the Fitzwilliam Museum, Cambridge, the Tate and the Ashmolean. On 10 February 1862 she was found dead from an overdose of laudanum. A verdict of accidental death was returned, but the possibility of suicide has never been completely disproved. In her coffin Rossetti laid the manuscripts of all his poems, but he was persuaded a few years later to have them exhumed.

Bibl: Violet Hunt, *The Wife of Rossetti*, 1932; D. Sonstroem, *Rossetti and the Fair Lady*, 1970; in addition see Fredeman; further references: Staley; Wood, Panorama; Wood, Pre-Raphaelites; Jan Marsh, Cat. of E.S. exhib., Ruskin Gallery, Sheffield, 1991.

SIDEBOTTAM, A. fl.1851

Painted portraits. Exhib. two portrait watercolours at SS and one work at the RA. London address.

SIDES, Miss Hilda Mary b.1871

Painted landscape watercolours. Studied in London, Dresden and Paris. Born and lived in London.

SIDLEY, Albert fl.1881
Exhib. a watercolour in North Wales at SS. London address.

***SIDLEY, Samuel RBA ARCA 1829-1896**
Painter of portraits, and occasionally of genre and literary subjects. Born in York. First studied painting at the Manchester School of Art; subsequently entered the RA Schools. Exhib.1855-95, at the RA, BI, SS, GG and elsewhere, titles at the RA including 'The Ancient Mariner', 1855, 'Companions in Mischief', 1864 and 'Civil War', 1865. He became chiefly known as a successful portrait painter, and gained frequent commissions for official and presentation portraits. Among these were portraits of Professor Fawcett, Bishop Colenso (NPG), Lady Brassey and the Duke and Duchess of Buckingham. He also painted some subject pictures, e.g. 'Alice in Wonderland' and 'The Challenge', which were engraved and became popular.
Bibl: Chronicle des Arts 1896 p.251ff.; L. Cust, NPG Cat. II 1902 (pls.); DNB; BM Cat. of Engraved British Portraits VI 1925 p.99.

SIDNEY, Herbert 1858-1923
Painted portraits and historical subjects. Studied at the RA Schools, in Antwerp and in Paris under Gérôme and at the École des Beaux-Arts. Exhib. two works at the RA including 'A Mother and Daughter Perishing in the Destruction of Pompeii'. He was born Sidney Herbert Adams. Lived in London.
Bibl: Who's Who; Who Was Who; Morning Post 17 December 1908.

SIGMUND, Benjamin D. fl.1880-1903
Maidenhead painter of genre and landscape, mostly in watercolour, who exhib. 1880-1903, at the RA 1881-1903, SS, NWS and elsewhere, titles at the RA including 'Tranquillity', 1881, 'On Exmoor, near Lynton', 1886, 'By Willowy Streams', 1888 and 'The Orchard Gate', 1897. Also painted gardens.

SILBURN, A. fl.1873-1885
Exhib. three works at the RA, including 'Grey Friars, Canterbury' and 'Hammersmith Mall', and one work 'Prison at the Hague' at SS. London address.

SILLAVAN, George fl.1872
Exhib. a drawing in 1872. Address in Manchester.

SILLEM, Charles fl.1883-1889
Painted animals and game. Exhib. three works at the RA, including 'Rough Terrier and Rats' and 'A Poacher's Bag', and three works at SS. London address.

SILLETT, James 1764-1840
Painted game, flowers and fruit. Exhib. 43 works at the RA 1796-1837, amongst the last of these 'Hawk and Prey' and 'A Flower Piece'. London address.
Bibl: DNB; W.F. Dickes, The Norwich School, 1905; Cundall.

SILVESTER, Miss H.H. fl.1839
Exhib. a watercolour sketch at SS. Address in Windsor, Berkshire.

SIM, James fl.1870-1893
London painter of landscape and genre, who exhib. 1870-93, at the RA, SS and NWS, titles at the RA including 'The Suspicious Letter', 1870, 'The Return from the Baptism, Mentone', 1873 and 'The Nightingale's Grove, Lake Lecco', 1886.

SIM, William fl.1855
Exhib. two works including 'Residence in Ireland' at the RA. London address.

SIMKIN, J. fl.1875-1876
Exhib. two paintings of fruit at SS. London address.

SIMKIN, Miss L. fl.1877
Exhib. a watercolour of 'The Norman Keep — Scarborough Castle' at SS. London address.

SIMKIN, Richard 1840-1926
Military artist who worked in Aldershot. A prolific painter of military uniforms and parades. Also painted recruiting posters and illustrations for the Army and Navy Gazette.

SIMKINSON, Francis G. fl.1865-1868
Exhib. five landscapes 1865-8. London address.

SIMMONDS, Thomas C. fl.1881
Exhib. a view in Clovelly at the RA. Address in Derby.

SIMMONS, A.J. fl.1853-1860
Painted figurative subjects. Exhib. seven works at the RA including 'Winning the Gloves' and 'The Inquiry — Left his Home'. Also exhib. five works at SS including subjects from She Stoops to Conquer and two works at the BI. London address.

SIMMONS, C. fl.1857
Exhib. a work entitled 'The Discovery' at SS. London address.

SIMMONS, Edward Emerson 1852-1932
Painted figurative subjects and landscapes. Exhib. five works at the RA, including 'A Roman Matron' and 'Coast of Cornwall', and three works at SS. Address in St. Ives, Cornwall.

SIMMONS, Mrs. E.E. (Vesta S.) fl.1889-1890
Exhib. a figurative subject at the GG. Address at St. Ives, Cornwall.

SIMMONS, H.P. fl.1861-1865
Painted figurative subjects. Exhib. four works at the RA including 'A Passing Thought' and 'By the Window'. London address.

SIMMONS, J. Deane fl.1882-1889
Painter of landscape and rustic genre, living in Holmbury St. Mary, Dorking, Henley-on-Thames and London. Exhib. 1882-9, at the RA 1883-9, SS, NWS and elsewhere, titles at the RA including 'Before the Leaf', 1883, 'The Merry May-time', 1886 and 'A Rustic Flirtation', 1889.

SIMMONS, W. St. Clair fl.1878-1899
London painter of portraits, landscape and genre, who exhib. 1878-99, at the RA 1880-99, SS, NWS, NG and elsewhere, titles at the RA including 'Backwater, Ostend', 1880, 'The Time of Primroses', 1882, 'Iris; Portrait of a Lady', 1896 and 'Blackberry Gatherers', 1896.

SIMMS, A.G. fl.1859-1873
London painter of genre and sporting subjects, who exhib. 1859-73, at the RA 1859-65, BI, SS and elsewhere, titles at the RA including 'Repose', 1859, 'The Culprit', 1860 and 'Rather More Free than Welcome', 1865.

SIMMS, C. fl.1895
Exhib. 'Moonrise, After-glow, Mist' at the RA. London address.

SIMMS, C. Nares fl.1878
Exhib. a landscape at the GG.

SIMMS, G.H. fl.1864-1865
Exhib. a watercolour entitled 'Hurdle-making, Hampton Down' at SS and a Devonshire landscape at the BI. Address in Bath, Somerset.

SIMON, Miss Eva fl.1892
Exhib. a subject in 1892. London address.

SIMONAU, George NWS fl.1859-1870
Exhib. 21 landscapes at the NWS. Address in Brussels.

SIMONEAU, François fl.1818-1860
Painted portraits. Exhib. 18 works at the RA 1818-60, including 'Portrait of a Polish Jew', 'A Specimen of Nelson's Invincibles Pensioned Off', and portraits, and four works at the BI. London address.

SIMONS, Marcius fl.1891
Exhib. a work entitled 'Crushed Hopes' at the RA. Address in Northampton.

SIMONSON, Miss Anna fl.1895-1898
Exhib. three works including 'Study of Flowers' and a portrait at the RA. London address.

SIMPSON, Miss Agnes fl.1827-1848
London painter of miniature portraits, who exhib. 1827-48 at the RA and SS.

SIMPSON, Alice M. fl.1885
Exhib. a watercolour of sunflowers at SS. London address.

SIMPSON, Charles fl.1833-1847
London painter of landscape, genre and coastal scenes, who exhib. 1833-47, at the RA 1835-45, BI, SS and NWS. Titles at the RA include 'A Sea-piece', 1835, 'Portuguese Boys', 1838 and 'The Break-up of a Fishing Boat off Margate', 1845. Not to be confused with Charles Walter Simpson (q.v.).

SIMPSON, Charles Walter b.1885 fl.1897-1938
Painted marines, animals, sporting scenes and portraits. First exhib. at the RA in 1897 with two works 'The Pedlar' and 'A Winter's Day'. Born in Camberley, Surrey. Lived in Bushey, Hertfordshire.
Bibl: Studio LXV 1915 pp.128, 212; LXXXI 1921 pp.91-5; Connoisseur LII 1918 p.232; LXXIV 1926 p.60; LXXVI 1926 p.63; Apollo VII 1928 p.43; Who's Who in Art.
Exhib: London, Fine Art Society 1934.

SIMPSON, Miss Eugenie fl.1883-1888
Painted flowers. Exhib. seven works at the RA including 'In Memoriam', 'Japanese Chrysanthemums' and 'Trophies of a Morning's Sport', and two works at SS. London address.

SIMPSON, George G. fl.1883-1885
Exhib. two studies, one in red chalk at the RA. London address.

SIMPSON, H. Hardey fl.1885-1888
Exhib. two works, 'Left at Home' and a portrait of a huntsman, at the RA and two works at SS. Address in Bowden, Cheshire.

SIMPSON, Harry B. fl.1886-1888
Exhib. two works at the RA including 'Childe Roland to the Dark Tower Came'. London address.

SIMPSON, Henry 1853-1921
London painter of genre, who exhib. from 1875, at the RA from 1878, SS, NWS, GG and elsewhere, titles at the RA including 'A Pilgrim', 1878, 'Waiting for the Boats, Scheveningen', 1884 and 'From his Soldier Boy', 1886. Born in Nacton. In April 1910 there was an exhibition of his work at the Leicester Galleries, watercolours of landscapes, architectural and oriental subjects.
Bibl: Daily Telegraph 21 April 1910; The Year's Art 1922 p.314.

SIMPSON, J.H. fl.1877
Exhib. a work entitled 'Just Caught It' at the RA.

SIMPSON, John 1782-1847
Painted portraits. Exhib. 126 works, the vast majority portraits, at the RA. Also exhib. 15 works at the BI including 'Rural Amusement', 'An Old Earth-stopper' and 'Itinerant Musician', and 11 works at SS. London address.
Bibl: Redgrave, Dict.; DNB; AJ 1853; Bryan; Burlington Mag. 1906 p.116; BM Cat. of Engraved British Portraits; W.T. Whitley, *Art in England, 1821-1937*, 1930; Ormond.

SIMPSON, John W. fl.1878-1904
Painted views of buildings. Exhib. nine works at the RA 1878-1904 including 'The Norman Tower, Bury St. Edmunds' and 'The Roedean School'. London address.

SIMPSON, Mrs. Katharine fl.1892-1893
Painted coastal subjects. Exhib. three works at SS including 'Fishing Boats in Port' and 'Herrings for Sale'. Address in Whitby, Yorkshire.

SIMPSON, Miss Margaret H.A. fl.1881-1890
Painted genre subjects. Exhib. seven works at SS including 'A Very Black View to Take' and 'This is the Maiden All Forlorn'. London address.

SIMPSON, Philip fl.1824-1837
Painted portraits and figurative subjects. Exhib. 14 works at the RA including 'The Young Piper', 'Boys with a Monkey' and portraits, nine works at the BI and nine works at SS. London address. Represented in the VAM.
Bibl: Redgrave, Dict.; Bryan; BM Cat. of Engraved British Portraits; Ormond.

SIMPSON, Miss R. fl.1875
Exhib. a work entitled 'Mid-day Meal' at SS. London address.

SIMPSON, Miss Sophia fl.1862-1863
Exhib. a work entitled 'Maud' at the BI, a work entitled 'Lizzie' at the RA and another work at SS. London address.

SIMPSON, Thomas fl.1887-1891
Painted landscape. Exhib. two works, a view on the Arun and a work entitled 'The Time of Sweet Serenity When Colour Glows' at the RA, and four watercolours, including views in Walberswick, Suffolk, at SS.

SIMPSON, W.B. fl.1838-1840
Painted ships. Exhib. a view of the steamship *The Royal Victoria*, and an interior view of another ship, at the RA. London address.

SIMPSON, W.H. fl.1866-1886
Landscape painter, living in Farnham and Malmesbury, who exhib. 1866-86, at the RA 1874-8, SS and elsewhere, titles at the RA including 'A Sunny Day in March', 1874 and 'Burnham Beeches — Winter', 1878.

SIMPSON, William RI 1823-1899
Painter of topographical and architectural subjects, chiefly in watercolour; war artist; illustrator and engraver of contemporary events. Born in Glasgow, intended to become an engineer, but in

1839 apprenticed to a Glasgow firm of lithographers; 1851 came to London and employed by Day & Son. Sent to the Crimean War by Colnaghi to make sketches, and was thus one of the first war artists. After the war he was attached to the Duke of Newcastle's party which explored Circassia. From 1859 to 1862 he travelled in India, Kashmir and Tibet making architectural and archaeological sketches. In 1866 he joined *The Illustrated London News,* for which he attended the marriage of the Tsarevich (Alexander III) at St. Petersburg, and followed the operations of Lord Napier's Magdala expedition and the Franco-German War. He also visited China for the Emperor's marriage, recorded the Prince of Wales's Indian Tour 1875-6, and accompanied the Afghan expedition 1878-9. His last long journey was in 1884 when he was with the Afghan Boundary Commission at Penjdeh, and the latter years of his life were spent completing the series of watercolour drawings 'Glasgow in the Forties' (from sketches made in his youth), acquired by Glasgow AG in 1898. Exhib. from 1874 at SS and NWS. A of RI in 1874; RI 1879. His published works include: *The Seat of War in the East* (81 lithographs from his drawings), 1855; Brackenbury's *Campaign in the Crimea,* 1855, and *India Ancient and Modern.* Hardie notes that "Simpson's work, like that of Roberts, was spirited and dextrous. Much of what he produced in colour (his output in pencil and wash was prodigious) was in the nature of a tinted sketch, but his more thoughtful work, as in some of the watercolours made in India and Egypt, has considerable merit."

Bibl: AJ 1866 p.258; Clement & Hutton; W. Simpson, *Autobiography,* 1903; Cundall; Who Was Who 1897-1915; VAM; Hardie III pp.96, 186-7 (pls.218-19); Maas p.97; Ormond; Irwin pl.166; Wood, Panorama.
Exhib: London, 6 Gate Street, 1869.

*SIMS, Charles RA RWS 1873-1928

Painter and illustrator. Studied at National Art Training School, South Kensington, 1891 in Paris at Académie Julian, 1893 RA Schools. In 1903 he returned to Paris, where he worked under Baschet. Exhib. at RA from 1893, BI, SS and elsewhere. Titles include portraits, mostly of mothers and children, landscapes and allegories, e.g. 'In Elysium', 'Water Babies', 'A Fairy Wooing', etc. ARA 1908, RA 1915. In 1921 he learnt aquatinting, and subsequently produced many prints and illustrations. He was Keeper of the RA from 1920 to 1926, but resigned as a result of mental illness. In 1928 he committed suicide. Works by him are in the Tate Gallery, St. Stephen's Hall, Leeds, and Liverpool AG.

Bibl: *C.S. Picture Making: Technique and Inspiration,* with a critical survey of his work and life by Alan Sims, New Art Library, 2nd series (reviewed in Studio CVIII 1934 p.309ff.); AJ 1905, 1908, 1911 (see pls.); Artwork IV 1928 pp.218, 219ff.; The Art News 1923-7; Connoisseur 1914-26; Studio XCI 1907 pp.89-98; 1909-22 see index; Who Was Who 1916-28, 1929.
Exhib: London, Fine Art Society 1925.

SIMS, Frederick fl.1859

Exhib. a work entitled 'A Naughty Child' at the RA. London address.

SIMS, Frederick Thomas fl.1859-1860

Exhib. two works including 'Noon' at the BI. London address.

SIMS, G. NWS fl.1829-d.1840

Painted landscape. Exhib. 15 works at the BI including views in Derbyshire, Yorkshire and France. Also exhib. 11 landscapes at the RA and 33 works at SS. London address.

Bibl: Cundall.

SIMS, William fl.1821-1867

Painted portraits, figurative subjects and landscape. Exhib. 25 works at the RA, the majority portraits, but also including a landscape and still-lifes, and seven works at the BI including a view on the Wye at Monmouth and two scenes at Ilfracombe. London address.

SIMS, William Percy fl.1848

Exhib. a view of a church at the RA. London address.

SIMSON, J. fl.1845

Exhib. 'A Study from Nature in the Dutch Style' at the BI.

SIMSON, T. fl.1896

Exhib. 'In the Glade' at the RA. Address in Liss, Hampshire.

SIMSON, William RSA 1800-1847

Scottish painter of landscape, portraits and historical genre. Born in Dundee. At first painted landscapes and coastal scenes near Edinburgh. 1827 visited Low Countries. 1834-5 visited Italy. 1838 settled in London. After this he turned mainly to historical genre from English and Italian history, e.g. 'Cimabue and Giotto', 'The Murder of the Princes in the Tower', etc. He also painted portraits, and occasional sporting subjects. Exhib. at RA 1830-47, BI, SS and RSA. RSA 1830. Works by him are in the National Gallery of Scotland. His two brothers were also painters, George (1791-1862) a portraitist, and David (d.1874).

Bibl: AU 1847 p.353 (obit.); Studio Special Number, *The RSA,* 1907 pp.vii, xiv; Redgrave, Dict.; Ottley; Bryan; DNB; VAM; Caw pp.156-7, 483; M.H. Grant, *Old English Landscape Painters,* p.385ff. (pls.); Ormond; Irwin.

SINCLAIR, Alexander Gordon ARSA 1859-1930

Painted landscape and portraits. Lived in Edinburgh.

SINCLAIR, John fl.1872-c.1922

Liverpool landscape painter, who exhib. 1872-90, at the RA in 1874, 1879 and 1888, SS, NWS and elsewhere, titles at the RA including 'Mountain Solitude', 1874 and 'A Cheshire Hayfield', 1888.

SINCLAIR, Max fl. late 19th century

Landscape painter working in the late 19th century. Painted landscapes in Scotland and North Wales, and probably lived in Liverpool.

SINDICI, Mrs. Francesca Stuart fl.1892-1893

Exhib. two works at the RA, the second of these entitled 'It might have Been Napoleon — Wellington, 1847'. London address.

SINGER, W.H. fl.1875

Exhib. two street scenes in 1875. Address in Frome, Somerset.

SINGLETON, Henry 1766-1839

Painted historical, religious and literary subjects as well as occasional figurative subjects and portraits. Also an illustrator and graphic artist. He exhib. 285 works at the RA, the last of these including scenes from *Macbeth* and *Romeo and Juliet* and a work entitled 'The Distressed Father' in 1839. Also exhib. 157 works at the BI 1806-39. London address.

Bibl: Redgrave, Dict.; DNB; BM Cat. of Engraved British Portraits; Connoisseur XL p.155; XLIII p.66; XLVI p.124; XLIX p.250; LXX pp.197, 217; LXXV p.197; LXXVIII pp.41, 57; Apollo VIII p.64.

SINNETT, Miss Sophia fl.1853-1858

Painted landscapes, country subjects and genre subjects. Exhib. five works at SS including 'The Picture Book' and 'Fields about to be Broken Up for Building, near Kentish Town'. Also exhib. four works at the RA and two works at the BI. Address in Southampton.

SINTRAM, H.S.R. fl.1880
Exhib. a rustic subject at the GG. London address.

SINTZENICH, Gustav fl.1809-1838
Painted game and still-life. Exhib. eight works at the RA and ten watercolours at SS including 'An Interior' and 'Hatton Castle, Cheshire'. London address.

SINTZENICH, Gustavus Ellinthorpe fl.1844-1866
London painter of genre, portraits, biblical and literary subjects, who exhib. 1844-66, at the RA 1844-56, BI, SS and elsewhere. Titles at the RA include 'The Grandfather's Visit', 1844, 'Lefevre, the First French Reformer, Preaches the Reformation to Margaret of Valois', 1851, 'Rosalind Reading Orlando's Sonnet', 1854 and 'Mary and Martha Mourning at the Tomb of Lazarus', 1856.

SISSMORE, Charles fl.1885-1887
Exhib. a work entitled 'Showery Arran' at the RA. London address.

SITWELL, Captain H. fl.1868
Exhib. a work entitled 'A Signal of Distress — Bad Weather in the Channel' at SS. London address.

SIVIER, G. fl.1852-1865
Painted portraits and country subjects. Exhib. five works at the RA, three portraits and works entitled 'Fruits' and 'An Ear of Wheat', and four works at the BI. London address.

SKEAPING, John fl.1889-1939
Painted landscape and figurative subjects. Studied at Liverpool School of Art. Born in Liverpool. Lived at Prescott, Lancashire.

SKEATS, Frank G. fl.1876-1887
Exhib. three watercolours at SS, 'Owen Glendwr's Old Parliament House', 'A Field of Oats' and 'The Platform, Southampton'. Address in Southampton.

SKEATS, Leonard Frank 1874-1943
Painted portraits and figurative subjects. Studied art at Hartley University College School of Art, Southampton, and in Paris at the Académie Julian. Exhib. three works including 'The New Brother: Hospital of St. Cross, Winchester' and 'The Casualty List' at the RA. Born in Southampton. Lived in Bath, Somerset.
Bibl: Who's Who in Art 1934.

SKEATS, Thomas fl.1875-1882
Painted landscape and flowers in watercolour. Exhib. 13 watercolours at SS including 'Old Mill and Pond, Carisbrooke', 'Spring Flowers' and 'A Neglected Path'. Address in Southampton.

SKELTON, Joseph fl.1888-1893
Exhib. a work entitled 'A Forgotten Author' at the RA and one work at the NWS. Address in Hinckley, Leicestershire.

SKELTON, Percival fl.1850-1861
Exhib. three works at the RA, including 'Gipsy Encampment' and 'Market Day', and one work at SS. South London address.

SKIDMORE, Miss Harriet fl.1875-1890
Painted landscape. Exhib. six works at SS including 'Local Deposits', 'Traces of Decay' and 'A Sketch at Alnmouth', and one work at the RA. London address.

SKILBECK, Clement O. fl.1884-1901
Exhib. three works at the RA, including 'The Lady of Shalott' and 'St. Christopher', and a painting of poppies at SS. London address.

SKILL, Frederick John RI 1824-1881
London painter of landscape and rustic genre; illustrator and engraver. Trained as a steel engraver. Exhib. 1858-81, at the RA 1858-76, SS, GG, elsewhere, and especially at the NWS (176 works). A in 1871, RI in 1876; also exhib. frequently in Paris. Drew portraits for the *London Journal*, and illustrations for *Cassell's Family Paper* 1860-1. He spent several years at Venice, where some of his best sketches were produced. The AJ noted in his obituary: "Endued with a fine feeling for colour, he was to treat his subjects in a delightfully delicate manner. He was, however, insufficiently appreciated by the mass of buyers, and less gifted men giving him the go-by, he died, we understand more from a broken heart than aught else." Two of his best works are in the VAM.
Bibl: AJ 1881 p.160 (obit.); Bryan; L. Cust, NPG II 1902 p.110ff.; VAM.

SKILLETT, S.D. fl.1845-1856
Painted marines. Exhib. eight works at the RA including 'The Abandoned Ship', 'Admiral Drake Entering Plymouth Sound after his Voyage around the World' and 'A Fine Morning in Winter, on the Thames'. Also exhib. four works at the BI and three works at SS. London address.
Bibl: Brook-Hart.

SKILLINGTON, G. fl.1838-1841
Painted landscape and animals. Exhib. four works at SS, including two watercolours entitled 'Cart Horses' and 'Landscape and Cattle', and one work at the RA. London address.

SKINNER, Edward F. fl.1888-1891
Exhib. two works 'January' and 'Near South Walsham, Norfolk' at the RA, and two works at SS. London address.

SKINNER, Miss V.M. fl.1870
Exhib. a watercolour of a dead thrush at SS. Address in Saxmundham, Suffolk.

SKIPWORTH, Arthur Henry fl.1889-1903
Painted views of churches and church furnishings. Exhib. 31 works at the RA 1889-1903 including views of churches in Sheffield, Walton-le-Dale and Cockington. London address.

***SKIPWORTH, Frank Markham ROI RP 1854-1929**
Chelsea painter of genre, portraits and historical subjects, who exhib. 1882-1916, at the RA from 1883, SS, NWS, GG, NG and elsewhere. Titles at the RA include 'A Dangerous Conspirator', 1883, ' "Keep Still While I Make you Pretty, Dear" ', 'She Loves a Sailor', 1892 and 'Satisfaction', 1903. His portrait of Field Marshal Roberts is in the Walker AG, Liverpool.

SKOTTOWE, Charles b.1793 fl.1842
Painted portraits and figurative subjects. Exhib. six works including five portraits at the RA, and five works at the BI including 'My Lady's Dog' and 'An Italian Boy'. London address.
Bibl: Ormond.

SLACK, Miss M.E. fl.1871-1875
Painted figurative subjects. Exhib. five watercolours at SS including 'Normandy Peasant Girl' and 'Two a Penny', and one work at the RA. London address.

SLADER, Samuel Ernest fl.1876-1879
Exhib. a painting of mushrooms and a watercolour at SS. South London address.

SLATER, C.H. fl.1867
Exhib. a watercolour of plums at SS. Address in Manchester.

SLATER, J. Atwood fl.1883-1902
Painted views of architecture. Exhib. eight works at the RA including views of Salisbury and Albi cathedrals. London address.

SLATER, J.T. fl.1873
Exhib. watercolour views at Tenby and of Chepstow Castle at SS. London address.

SLATER, John Falconar 1857-1937
Landscape and rustic genre painter. Lived at Forest Hall, Northumberland, and in Newcastle. Exhib. at RA from 1889, but has always been better known in the north-east. Titles at RA: 'Going to Market', 'A Fresh Breeze', 'Fleeting Sunshine in the Vale', etc., and some coastal scenes. Painted in a very broad impressionistic style.
Bibl: Hall.

SLATER, Walter James RCA 1845-1923
Manchester landscape painter who exhib. 1877-90, at the RA and NWS, titles at the RA including 'Autumn', 1877, 'Edge of the Marsh', 1880, 'A Sussex Pastoral', 1886 and 'The Arun at Burpham', 1890.

SLATER, William fl.1856-1859
Exhib. four architectural views including one of the choir of Sherborne Abbey. London address.

SLEAP, Joseph Axe 1808-1859
Exhib. six river scenes 1858-9. London address.

SLEIGH, Bernard RBSA 1872-1954
Painted figurative subjects. Also a mural decorator, wood engraver and designer of stained glass. Studied at Birmingham School of Art. Exhib. at the RBSA from 1898. Also exhib. at the RA and abroad. Born in Birmingham. Lived at Edgbaston, Birmingham.
Bibl: Studio XXIII pp.161-3; XXXV pp.238-91; LXXXVII p.94; Studio Special Number 1917 pp.146, 156.

SLEIGH, John fl.1841-1872
Painted landscape. Exhib. three works at SS including 'Knockhalt Beeches' and a watercolour 'In Penshurst Park', and one work at the RA. London address.

SLINGER, F.J. fl.1858-1867
Painted figurative subjects. Exhib. four works at the BI including 'The Gardener's Boy' and 'An English Rose', and three works at the RA. London address.

SLOANE, Miss Mary Anne fl.1889-d.1961
Painted and etched landscape, portraits and figurative subjects. Studied under Herkomer at Bushey and at the RCA. Exhib. three works at SS including 'Anchors, Walberswick' and 'The Early Morning led out the Morning Day'. Born in Leicester. Lived in Endersby, Leicestershire.
Bibl: Who's Who in Art 1934.

SLOCOMBE, Alfred RCA fl.1862-1887
Painted and etched landscape and still-life. Exhib. six works at the RA, at least two of them etchings. Also exhib. five watercolours at SS including 'Convolvulus' and 'Treasures of the Seashore' and two works at the BI. London address.

SLOCOMBE, Frederick Albert RPE b.1847 fl.1866-c.1920
Landscape and genre painter, and etcher. Lived in Cricklewood and Hendon, London. Exhib. at RA 1866-1916, SS, NWS and elsewhere. Titles at RA include landscapes and coastal scenes in England and Wales, and rustic genre: 'A Dark-eyed Maiden', 'Thoughts of Love', 'Meditation', etc. Apart from his own etchings, he made etchings after paintings by J. Farquharson, A. Parsons, B.W. Leader (qq.v.) and others. His brother Charles Philip Slocombe (1832-1895) was also an etcher and watercolourist. Edward C. Slocombe (fl.1873-1904) and Alfred Slocombe (fl.1865-86), presumably all of the same family, were also both etchers and members of the RPE.
Bibl: AJ 1879, 1882-9, 1895 (see pls.); Portfolio 1885, 1889, 1891; A.M. Hind, A Short History of Engraving and Etching, 1911.

SLOCOMBE, Shirley Charles Llewellyn fl.1887-1904
Painted portraits. Exhib. seven works at the RA 1893-1904. London address.

SLOUS, George fl.1791-1839
Painted landscape, figurative and historical subjects. Exhib. 65 works at the RA 1791-1839, the last of these being 'A Venetian Lady of the 16th Century', 'The Boudoir' and 'The Pet Squirrel'. Also exhib. nine works at the BI 1818-37 and one work at SS. Apparently this artist changed his name to Selous in 1837. London address. He was the father of Henry Courtney Selous (q.v.).

SLOUS, Henry Courtney see SELOUS, Henry Courtney

SLUCE, J.A. fl.1833-1837
Painted portraits. Exhib. five portraits at the RA and two works, a portrait and a work entitled 'Temptation', at SS. London address.
Bibl: BM Cat. of Engraved British Portraits.

SMALL, David 1846-1927
Painter of small views of old Glasgow where he lived. Member of the Glasgow Art Club and also worked as a photographer in Dundee.

SMALL, Miss Florence PS c.1860-1933
(Mrs. Deric Hardy)
Painter of genre, flowers and fairy-tale subjects, living in Nottingham and from 1894 at Gloucester Road, Regent's Park. In 1893 she married. Exhib. 1881-1901 at the RA, SS and elsewhere, titles at the RA including 'Rosaria', 1881, 'Between the Lights', 1893, 'Fortunée and the Enchanted Prince', 1895 and 'A Nymph', 1901.

SMALL, William RI HRSA 1843-1929
Painter, watercolourist and illustrator. Pupil of RSA. Moved to London 1865. Exhib. at RA 1869-1900, NWS, GG and elsewhere. Titles at RA: 'The Woodlands', 'Waiting for Tide', 'Water Polo', etc. 'The Last March', RA 1887, was bought by the Chantrey Bequest. As an illustrator he worked for Once a Week, Good Words, The Graphic, Harpers, etc., and illustrated several books. Works by him are in Leicester, Liverpool and Manchester AGs.
Bibl: Clement & Hutton; J. Pennell, Modern Illustration, 1895; Gleeson White; Caw pp.292-4; A. Hayden, Chats on Old Prints, 1909; Hardie III p.96.

SMALLBONE, Eliza Anne see MELVILLE, Mrs. Alexander

***SMALLFIELD, Frederick ARWS 1829-1915**
Genre painter and watercolourist. Pupil of RA schools. Exhib. at RA 1849-86, BI, SS, OWS (425 works), NWS, GG and elsewhere. Titles at RA: 'Entering the Garden', 'A Christmas Invitation', 'The Old Apple Room', etc.; also some flower pieces and historical scenes from Shakespeare. In the Manchester City AG is a charming Pre-Raphaelite work 'Young Love'.
Bibl: AJ 1883 p.336 (pl.); Maas p.119 (pl. p.238); Wood, Panorama; Wood, Paradise Lost.

SMALLFIELD, Philip C. fl.1882-1903
Painted animals and figurative subjects. Exhib. six works at the RA including 'A Good Mouser', 'Leading Strings' and 'A Red Letter Day — Portrait', and two works at SS. London address.

SMALLFIELD, Miss Rosalind C. fl.1901
Exhib. a work entitled 'The Cloisters, Pump Court' at the RA. London address.

SMALLWOOD, C. fl.1873
Exhib. a work entitled 'Sketch in my Garden — Via Brera, Milan' at SS. London address.

SMART, Charles J. fl.1867-1891
Exhib. two watercolours at SS, the second of these 'Holly branch and Bottles'. Address in Burnham, Buckinghamshire.

SMART, John fl.1791-1850
Painted portraits and landscape. Exhib. two portraits at the RA and six works at SS including portraits and a scene from *The Winter's Tale,* also three landscapes, views on the Orwell, at the BI. Addresses in Ipswich and London.

SMART, John RSA RBA RSW 1838-1899
Scottish landscape painter. Born in Leith. Pupil of H. McCulloch (q.v.). Exhib. at RA 1870-99, SS, NWS, GG, RSA, RSW and elsewhere. He devoted himself to painting the life and scenery of the highlands. "If coarse in handling and wanting in subtlety of feeling, they are simple and effective in design, vivid in effect and powerful in execution, and breathe an ardent passion for the landscape of his native land" (Caw). His best work was done 1870-90. ARSA 1871, RSA 1877. Founder member of RSW.
Bibl: Clement & Hutton; Bryan; Caw pp.297-8; Who Was Who 1897-1915.

SMART, R. fl.1855-1856
Exhib. three works, 'The Rejected Picture', 'A View in Wiltshire' and 'After the Storm', at the BI. London address.

SMART, T. fl.1835-1855
London painter of historical subjects, genre and portraits, who exhib. 1835-55 at the RA, BI and SS, titles at the RA including 'Sir John Ramony's Spurs being Struck off Previous to his Execution', 1836, 'Au Revoir', 1842 and 'One of the Effects of Punch', 1852.

SMARTLEY, H. fl.1839-1845
Exhib. two works entitled 'Negro Emancipation' and 'The Calamity of La Rocque' at SS. London address.

SMEETON, A. Williams fl.1855-1860
Painted landscape watercolours. Exhib. seven watercolours at SS including 'Sunset on the Sea—Sussex Coast' and 'On the Coast of Jersey'. London address.

SMEETON, J. fl.1838-1856
Painted children and animals. Exhib. seven works at SS, including 'Boy and Dog' and 'The Sexton', and one work at the BI. Address in Leamington Spa, Warwickshire.

***SMETHAM, James 1821-1889**
Painter of portraits, imaginative landscapes, literary, poetical and biblical subjects; etcher; essayist. Son of a Wesleyan minister, Smetham remained all his life a devout member of that sect. He began by painting portraits in Shropshire; came to London in 1843 and studied at the RA Schools. When commercial photography destroyed this means of livelihood, he became drawing master at the Wesleyan Normal College, Westminster, in 1851. Exhib. 1851-76, at the RA 1851-69, BI, SS and elsewhere. The last 12 years of his life were darkened by madness, to which religious melancholia and a sense of failure and disappointment undoubtedly contributed. His mind was continually distracted between art and literature which prevented his success, and after 1869 his paintings were all rejected by the RA. Ruskin and Rossetti (qq.v.) were both his friends, and thought highly of his work, but he attained no reputation outside his own small circle. Smetham passed through a phase of Pre-Raphaelitism in the 1850s, e.g. 'Naboth's Vineyard', 1856 (Tate Gallery), and his close friendship with Rossetti in the 1860s, 1863-c.1868, is also reflected in his work. He is more remembered today for his critical articles and letters, and for his essay on Blake, first published in the *Quarterly Review* in 1868 (reprinted as an appendix to the second edition of Gilchrist's *Life of Blake* 1880), which was one of the first to establish Blake's true importance.
Bibl: AJ 1904 pp.281-4, *J.S. and C. Allston Collins;* Sara Smetham and William Davies ed., *The Literary Works of J.S.,* 1893; Ford Madox Hueffer, *Ford Madox Brown,* 1896 p.289; H.C. Marillier, *D.G. Rossetti,* 1899 pp.82, 189; Bryan; William Beardmore, *J.S. Painter, Poet and Essayist,* 1906; DNB; VAM Annual Review 1932 p.29; M.H. Grant, *Old English Landscape Painters,* 1935 pp.233, 286; Geoffrey Grigson, *J.S.,* Cornhill Magazine No.976 Autumn 1948 pp.332-46; Ironside & Gere pp.25-6; Fredeman section 60 and Index; Reynolds, VP pp.62, 142 (pl.145); Maas pp.42, 44, 67, 133 (pls.66-7); Staley, with pls.; E. and J. Stevens, *J.S. and F. Danby,* 1974.

SMIRKE, Miss Dorothy fl.1901
Exhib. a painting of the Queen's bedroom, Hampton Court, at the RA. Address in Teddington, near London.

SMITH, Miss fl.1842
Exhib. a painting of fruit at the BI. Address in Sheffield, Yorkshire.

SMITH, A. fl.1837-1838
Exhib. a work entitled 'Girl and a Dog' at the BI. Address in Stourhead, Wiltshire.

SMITH, A.B. fl.1870-1872
Exhib. three works at SS, including 'A Study of Ferns' and 'Entrance to Plymouth Sounds — Moonlight', both watercolours. Address in Devonport, Devon.

SMITH, Albert C. fl.1889
Exhib. two works 'Old Bridge and Toll House, Sandwich' and 'When Twilight Comes' at the RA. London address.

SMITH, Albert D. fl.1888-1891
Painted architectural subjects. Exhib. five works at the RA including views of Christ Church, Oxford, and Norwich and Canterbury cathedrals. London address.

SMITH, Alexander Munro 1860-1933

Painted portraits and figurative subjects. Studied at the Glasgow School of Art. Exhib. at the RSA, RSW and in Liverpool. Born at Falkirk. Lived in London and Edinburgh.

SMITH, Mrs. Alfred fl.1837-1844

Exhib. two paintings of flowers at the RA.

SMITH, Alfred fl.1843-1872

Painted architectural subjects. Exhib. 12 works at the RA including views of churches at Dore, Herefordshire, and of a building in Bury St. Edmunds. London address.

SMITH, Miss Anna Leigh fl.1876-1886

Exhib. oriental subjects at the NWS and at the GG. Address in Algiers.

SMITH, Miss Annie fl.1874-1880

Exhib. a landscape at the RA and a work entitled 'Give Us This Day Our Daily Bread' at SS. Address in Royston, Hertfordshire.

SMITH, Arthur fl.1874-1885

Painted landscape. Exhib. 13 works at SS, including 'The Constitutional', 'Evening on the Somersetshire Village' and 'Nature's Carpet', and two works at the RA. London address.

SMITH, Arthur Reginald RWS RSW 1871-1934

Painted landscape and figurative subjects in watercolour. Studied at Keighley School of Art. Exhib. at the RA and elsewhere. Worked in England and France. Born at Skipton in Craven, Yorkshire. Lived at Grassington, Yorkshire. Drowned in the River Wharfe, near Bolton Abbey.

SMITH, Miss Barbara Leigh fl.1850-1856

Painted landscape. Exhib. eight works at the RA including 'View near Tremadoc, North Wales' and 'A Hot Day at Windermere'. Also exhib. a painting of ferns and foxgloves at the BI and a watercolour at SS. London address. See also Mme. Bodichon.

SMITH, Bernard E. fl.1878-1886

Painted architectural subjects. Exhib. 12 works at the RA including views of buildings in Gibraltar, Lubeck and Granada. London address.

SMITH, Miss Bessy N.W. fl.1898

Exhib. a portrait at the RA. Address in Florence, Italy.

SMITH, Miss C. fl.1875

Exhib. a watercolour entitled 'A Field Study' at SS. Address in South London.

SMITH, C. Christopher fl.1888

Exhib. a view on the River Ouse, York at the RA. Address in Brockley, Somerset.

SMITH, C. Dowton fl.1842-1854

Painter of marine subjects, who specialised in shipping incidents on the Thames and Medway. Exhib. 1842-54, at the RA 1843-54 BI and SS, titles at the RA including 'Fishing Smack Coming Up the Medway' and 'Fishing Lugger off Hastings'. His brother C.W. Smith was resident with him.
Bibl: Wilson; Brook-Hart.

SMITH, C.M. fl.1847

Exhib. two works at SS, 'A Landscape' and 'Evening'. London address.

SMITH, C.M. fl.1881

Exhib. a painting of birds in 1881. Address in Watford, Hertfordshire.

SMITH, C. Welby fl.1839-1885

Painted marines and landscape. Exhib. seven works at SS including 'Fishing Boats — Morning' and 'A Weir near Lingfield, Surrey' and a view on the River Mole, Dorking, at the RA. London address.

SMITH, C. William fl.1861

Exhib. three marines in 1861. London address.
Bibl: Brook-Hart.

SMITH, Campbell L. fl.1901-1904

Exhib. four works at the RA 1901-4, including 'The Twa Corbies', 'The Conversion of St. Hubert' and 'The Farm Girl'. London address.

***SMITH, Carlton Alfred RI RBA ROI 1853-1946**

Genre painter and watercolourist. Exhib. mostly at SS (158 works), NWS, also at RA from 1879 and elsewhere. Titles at RA mostly domestic scenes, e.g. 'First Steps', 'Home', 'Firelight Glow', etc. Works by him are in the VAM, Sunderland AG and the National Gallery, Melbourne. His wife, Mrs. Carlton A. Smith (q.v.), was also a painter.
Bibl: Wood, Paradise Lost; Newall.

SMITH, Mrs. Carlton A. fl.1883-1898

Painted marines and coastal subjects. Exhib. 16 works at SS, including 'Unloading', 'By the Sea' and 'Carting Seaweed', and one work at the RA. London address.

SMITH, Mrs. Caroline fl.1832-1869

London painter of genre and portraits, who exhib. 1832-69, at the RA 1851-69, BI and SS, titles at the RA including 'Roman Peasant-boy', 1851 and 'Henry Warren Esq., President of the Institute of Painters in Watercolours', 1869.

SMITH, Miss Catherine b.1874 fl.1900

Painted and etched landscape and figurative subjects. Studied at the RCA and in Italy. Exhib. three works at the RA including 'On the Thames' and 'St. William's College'. London address.

SMITH, Chadwell fl.1886-1896

Exhib. three works at the RA including 'A Tow Out' and 'Low Tide'. Address in Rye, Sussex.

SMITH, Charles fl.1857-1908

Landscape painter, living in London, Greenwich, Putney and Richmond, who exhib. 1857-1908, at the RA, BI, SS (145 works), NWS and elsewhere. Titles at the RA include 'The Castle of Chillon, Geneva', 1857 and 'The Swale near Richmond, Yorks', 1872.

SMITH, Charles S. fl.1885

Exhib. 'A Corner in Lisieux' at the RA. Address in Reading, Berkshire.

SMITH, Miss Clifford S. fl.1832-1851

Painted figurative and genre subjects. Exhib. 12 watercolours at SS including portraits, and works entitled 'The Rustic Toilette' and 'The Welsh Girl', and six works at the RA. London address.

SMITH, Coke fl.1881
Exhib. two historical subjects at the GG.

SMITH, Colvin RSA 1795-1875
Scottish portrait painter. Studied at RA Schools and visited Italy. In 1827 he set up as a portrait painter in Raeburn's old studio in Edinburgh. Although an average portrait painter, he achieved a large practice and reputation by following the traditions of Raeburn and Watson Gordon. Exhib. at RSA, RA 1843-71, BI and SS. RSA 1829.
Bibl: AJ 1875 p.304 (obit.); Redgrave, Dict.; Bryan; DNB; Caw p.88; Poole; BM Cat. of Engraved British Portraits VI 1925 p.550; R.C.M. Colvin-Smith, *The Life and Works of Colvin Smith,* 1939; Ormond; Irwin.

SMITH, Mrs. Constance see PLIMPTON, Miss Constance E.

SMITH, David Murray RWS 1865-1952
Painted landscape. Studied at the Edinburgh School of Art and at the RSA. Exhib. at the principal galleries from 1893. Exhib. two views on the River Tweed at SS. Born in Edinburgh. Moved to London in 1893. Much later lived in Thame, Oxfordshire.
Exhib: London, Walker's Gallery 1954.

SMITH, E. fl.1827-1875
Painted flowers and landscape. Exhib. seven works at SS including 'Composition of Flowers', 'Guess My Name' and 'Church Ledges, Scilly Islands'. London address.

SMITH, Mrs. E.S. fl.1860
Exhib. a watercolour entitled 'Nest and Daisies' at SS. London address.

SMITH, Miss E. Toulmin fl.1868-1872
Painted still-lifes and genre subjects. Exhib. six watercolours at SS including 'The Garden Paling', 'Disturbed at Breakfast' and 'Primulas'. London address.

SMITH, Miss Edith Heckstall fl.1884-1890
Painted figurative and genre subjects. Exhib. five works at SS including 'Toil and Trouble' and 'An Old Time Keeper', and four works at the RA. Address in Beckenham, Kent.

SMITH, Edward fl.1875-1876
Exhib. three landscapes 1875- 6. Address in Capri, Italy.

SMITH, Edward Blount fl.1877-1898 d.1899
London landscape painter who exhib. 1877-98, at the RA 1886-98, SS, NWS, GG, NG and elsewhere, titles at the RA including 'River Meadows', 1886, 'Battersea', 1897, and 'The Red Forest', 1898.

SMITH, Miss Eliza A. fl.1865-1867
Exhib. a painting of fruit at the BI. London address.

SMITH, Miss Emily fl.1856-1861
Painted genre and country subjects. Exhib. three works at SS including 'The Sailor Boy's Early Dream' and 'The Fisherman's Children' and two works at the RA. Address in Dublin.

SMITH, Ernest fl.1869-1890
Painted landscape. Exhib. six works at the RA including 'A Rural Road', 'The Old Roman Road near Tivoli' and 'Rye Mill, Sussex', and two works at SS. Address in Haslemere, Sussex.

SMITH, F. Denner fl.1901
Exhib. a landscape in Norfolk at the RA. Address in London.

SMITH, Mrs. F.G. fl.1869
Exhib. a figurative subject in 1869. London address.

SMITH, F. Hargreaves fl.1897
Exhib. a painting of a tortoiseshell cat at the RA. Address in Liverpool.

SMITH, F.M. Bell- fl.1888
Exhib. a landscape in the Rocky Mountains at the RA and another at SS. Address in Ontario, Canada.

SMITH, F.R. fl.1881
Exhib. a landscape in 1881. London address.

SMITH, F.S. fl.1847
Exhib. two works 'Interior, Frascati' and 'Charity' at the RA. London address.

SMITH, Fred. H. fl.1896
Exhib. a work entitled 'In a Wash House' at the RA. London address.

SMITH, Miss Frederica J. fl.1862-1863
Exhib. three works including two watercolours of fruit at SS. London address.

SMITH, Frederick fl.1873-1876
Exhib. a work entitled 'A Wet Night in the Streets' at the RA. London address.

SMITH, G.F. fl.1871
Exhib. two works, 'Under the Moonbeams' and 'An Evening Party', at the RA. London address.

SMITH, G.H. fl.1825-1837
Painted landscape and architectural views. Exhib. 14 works at the RA including 'Fishing' and 'A Park Entrance in Venetian Style'. London address.

SMITH, G.J. fl.1839-1841
Painted game. Exhib. two works at the BI, including 'Dead Game' and 'Dead Peewit and Snipes', and two works at SS including 'Rival Cocks'. London address.

SMITH, G.J. fl.1866
Exhib. 'Job's Humiliation' at the RA. Address in Wardwick, Derby.

SMITH, G.R. fl.1847-1873
Exhib. three works at the RA including 'And as the Father Hath Done' and 'The Artist's Assistant'. London address.

SMITH, Garden Grant RSW 1860-1913
Painted landscape. Exhib. five works at SS including 'By the Seashore' and a watercolour entitled 'A Roadside'. Address in Edinburgh.
Bibl: Who's Who.

***SMITH, George 1829-1901**
Genre painter. Pupil of RA Schools and C.W. Cope (q.v.). Exhib. at RA 1848-87, BI, SS, NWS and elsewhere. He painted domestic scenes, often of children, in the manner of Thomas Webster and F.D. Hardy (qq.v.). Titles at RA: 'A Game at Marbles', 'A Cottage

Fireside', 'The New Boy', etc. Works by him are in the VAM, Nottingham and Rochdale AGs.

Bibl: AJ 1863 p.126 (pl.); 1867 p.112 (pl.); The Year's Art 1902 p.319; Clement & Hutton; Bryan; Reynolds, VS p.56 (pl.15); Wood, Panorama pls. 63, 124, 133, 182; Wood, Paradise Lost.

SMITH, George RSA 1870-1934

Painted animals and landscape. Studied in Edinburgh and Antwerp. Exhib. at the RSA, RA and abroad. Born in Mid-Calder, Midlothian. Lived in Edinburgh.

SMITH, George Armfield fl.1836-1839

Painted animals. Exhib. five works at the RA, including 'Fox Prowling' and 'Portraits of Horses and Dogs', two works at the BI and one work at SS. London address. Changed his name in 1840 to George Armfield (q.v.).

SMITH, George E. fl.1874-1903

Exhib. a watercolour 'On the Cornish Coast' at SS. London address.

SMITH, George Fearn 1835-1926

Painted landscape and figurative subjects in watercolour. Studied at the RA Schools, in Paris and in Rome. Born, lived and died in Derby. He was President of the Derby Sketching Club.

SMITH, George G. fl.1894

Exhib. a portrait at the RA. London address.

SMITH, Mrs. Graham fl.1891-1892

Exhib. three portraits at the NG. London address.

SMITH, Mrs. H. Clarendon NWS fl.1858-1877

Exhib. 29 genre subjects at the NWS. London address.

SMITH, H.G. fl.1839-1856

Camden Town painter of portraits and genre who exhib. 1839-56 at the RA, titles being mainly portraits and also 'Preparing for the Fête', 1845 and 'The Mountain Violet', 1856.

SMITH, H.J. fl.1838

Exhib. a street scene in Guernsey at SS. London address.

SMITH, Hannah 1797-1867

Norwich flower and portrait painter; probably a pupil of James Sillett (q.v.).

SMITH, Harry fl.1869

Exhib. a work entitled 'Sion — Inundation of the Rhone' at SS. Address in Greenhithe, Kent.

SMITH, Harry F. fl.1886

Exhib. a watercolour, 'A Summer's Evening on the Lea', at SS.

SMITH, Hely Augustus Morton RBA RBC 1862-1941

Painted marines and shipping, also portraits and flowers. Studied at Lincoln School of Art and at the Antwerp Academy. Exhib. eight works at the RA including 'A Norwegian Barque', 'The Breezy Shore' and 'A Noisy Crew', and one work at SS. Worked widely abroad. Born at Warnbrook, Dorset. Lived in London.

Bibl: Studio Special Number, British Marine Painting, 1919; Who's Who in Art 1934; Brook-Hart.

SMITH, Henry Smith fl.1825-1844

London painter of genre, portraits and historical subjects, who exhib. 1825-44, at the RA 1828-44, BI and SS, titles at the RA including 'The Shipwrecked Mariner', 1838, 'Spenser in his Study', 1839 and 'The Schoolmistress', 1844.

SMITH, Herbert Luther 1809-1869

Painter of portraits, historical and biblical subjects. Younger son of Anker Smith, ARA. Exhib. 1830-54, at the RA 1831-54, BI and SS, titles at the RA being mainly portraits and 'The Bodleian Picture-gallery', 1838, 'Ruth and Naomi', 1842 and 'Jonah's Impatience Reproved', 1845. His portrait of Sir Walter Raleigh is in Oriel College, Oxford.

Bibl: Redgrave, Dict.; Poole II 1925 p.80; BM Cat. of Engraved British Portraits VI 1925.

SMITH, Hugh Bellingham fl.1891-1893

Painted figurative subjects and landscape. Exhib. six works at the SS, including 'In the Stubble', 'The Young Mother' and 'The River Mole', and two works at the RA. London address.

SMITH, Miss J. fl.1824-1839

Exhib. paintings of landscape at the BI and at the RA and a watercolour of a dog at SS. London address.

SMITH, J. Bell see SMITH, James Bennett H.

SMITH, J. Clifford C. fl.1868-1872

Exhib. two works 'Ferny Bank in the West' and 'Holy Street Mill, Devonshire' at the RA. London address.

SMITH, J. Moyr fl.1874-1894

Exhib. four works including 'End of a Drawing Room', 'A Phrygian Chant' and a subject from Macbeth. London address.

SMITH, J.P. fl.1878

Exhib. a view of a church in 1878. Address in Canterbury, Kent.

SMITH, J.S. fl.1851

Exhib. three works, two views in Italy and a work entitled 'The Mill', at the RA. London address.

SMITH, James Bennett H. fl.1830-1847

London painter of genre, portraits and flowers, who exhib. 1830-47, at the RA, BI, SS and elsewhere, titles at the RA being mostly portraits, and also 'Flowers from Nature', 1830, 'The First Essay', 1844 and 'A Girl of Normandy', 1847. Graves, Royal Academy Exhibitors, notes: "This painter appears in my Dictionary as J. Bell Smith, in error. It is clear that J.B. and J.B.H. Smith are one man, and neither name appears in the catalogues after 1847."

SMITH, James Burrell fl.1850-1881

Landscape painter and watercolourist. Exhib. only at SS 1850-81. Lived mainly at Alnwick, Northumberland. He painted landscape views in many parts of England, but was most fond of painting streams and waterfalls, sometimes with anglers in the foreground.

Bibl: Pavière, Landscape pl. 68; Hall.

SMITH, James MacLaren fl.1873-1876

Painted figurative subjects and illustrations. Exhib. seven works at the RA, including 'The Green Parlour at Dome Lodge, Putney' and 'The Breithorn and Kleinmatterhorn in the Evening' and a number of illustrations to The Pearl Fountain, and three works at SS. London address.

SMITH, James Whittet fl.1859-1886

London painter of landscape who exhib. 1859-86, at the RA 1862-86, SS, NWS and elsewhere, titles at the RA including 'Edinburgh

from Inch Colme', 1862, 'The Mer de Glace, Chamonix', 1875, 'Mont Blanc at Sunset', 1877 and 'The Turn of the Tide at Sloughden, Suffolk', 1880.

SMITH, James William fl.1864-1867
Exhib. three works including 'Pledging Mary's Health' and 'The Pet Rabbit' at SS. London address.

SMITH, James William Garrett fl.1878-1887
London landscape painter who exhib. 1878-87, at the RA 1882-7, SS, NWS and GG, titles at the RA including 'The Old Quay at Haughden, Suffolk', 1882 and 'The Roseg Glacier at Sunrise', 1887.

SMITH, John fl.1854-1876
Painted landscape. Exhib. three works at the BI, including 'Dovedale, Derbyshire' and 'Falls of the Swallow in the Valley of the Llugwy', and two works at SS. London address.

SMITH, John (of Roker) 1841-1917
Painted marines. Worked in and around Sunderland. Represented in Shipley AG, Gateshead.
Bibl: Hall.

***SMITH, John Brandon 1848-1884**
London landscape painter who exhib. 1859-84, at the RA 1860-74, BI and SS, titles at the RA including 'View in Surrey', 1860, 'On the Lledr', 1867 and 'Caldron Linn, Perthshire', 1874. Mainly known for his pictures of rivers and waterfalls which have been confused in the past with the work of James Burrell Smith (q.v.).

SMITH, John Henry fl.1852-1893
Painter of genre, landscape and animals, living in London, Brixton and South Lambeth, who exhib. 1852-93 at the RA, BI, SS and elsewhere. Titles at the RA include 'Where the Shoe Pinches', 1882 and 'A Book is the Best Solitary Companion in the World', 1885. Two of his paintings were painted with Miss C.E. Plimpton (q.v.), 'The Audience', 1892 and 'Idle Summer Time', 1893.

SMITH, Miss Julia Cecilia fl.1872-1880
Painted figures and flowers. Exhib. 12 works at SS including 'The Lass of Gowrie', 'Cat Worship' and 'The Garden of Roses', some of these watercolours. London address.

SMITH, Kate Alice fl.1879
Exhib. a watercolour of chrysanthemums at SS. London address.

SMITH, L. fl.1849
Exhib. three works at the RA including 'The Model Returned to her Home in the Country, Rome'. London address.

SMITH, Mrs. L. Graham fl.1897-1901
Exhib. two portraits at the RA. London address.

SMITH, Miss Lucy Bentley fl.1879-1904
Painted figurative and genre subjects. Exhib. 13 works at the RA, including 'The Rabbit on the Wall', 'Pansies for Thoughts' and 'Inez', and four works at SS. Address in Devonport, Devon.

SMITH, M. fl.1848-1849
Exhib. three works, views at Chiswick, Llanrhidran Sands and Caswall Bay, at the BI. London address.

SMITH, Miller RBA fl.1885-c.1920
Painted landscape and genre subjects. Also an engraver. Studied at Manchester School of Art, at Heatherley's and in Antwerp and

Paris. Exhib. five works at the RA including 'The Shepherd's Cave' and 'Passing Shadows'. Born in Manchester. Lived in Campden, Gloucestershire.

SMITH, Noël fl.1889-1900
Painted landscape. Exhib. five works at the RA including 'Mill on the Bure', 'A Suffolk Mill' and 'The Stour Valley, Hampshire'. London address.

SMITH, Miss Olive Wheeler- fl.1878-1883
Painted flowers. Exhib. two watercolours at SS entitled 'Red, White and Blue' and 'Daisies and Poppy', and two works at the RA. Address in Addiscombe, Surrey.

SMITH, P. fl.1844
Exhib. 'A Roadside Public House' at the RA. London address.

SMITH, Mrs. Percy fl.1869
Exhib. three ink drawings in 1869. London address.

SMITH, Mrs. R. Beatrice L. fl.1896-1904
Exhib. three works at the RA including 'Old Mill, Lamberhurst' and 'Spring Time'. London address.

SMITH, Mrs. R. Catterson fl.1882
Exhib. a painting of flowers in 1882. London address.

SMITH, R. Chipchase fl.1866-1888
Exhib. three landscapes at the NWS. Address in Streatham, London.

SMITH, Reginald RWA ARCA c.1870-1926
Painted marines and coastal landscapes. Exhib. 12 works at the RA including 'The Rocky Coast of Pembroke', 'An Iron Coast and Angry Waves — Tennyson' and 'Sea Mists — Spanish Head, Isle of Man'. Address in Clifton, Bristol.
Bibl: Who's Who; Who Was Who; Connoisseur LVII p.50; LXVII p.119; LXXV p.50; Burlington Mag. XXXIX p.250; Chas. Johnson, *English Painting,* 1932.

SMITH, Robert Catterson fl.1880-1890
Painted woodland landscapes. Exhib. seven works at the RA, including 'In the Green Heart of a Wood' and 'Dreaming of Puff-puffs', and six works at SS, including 'Brambles' and 'Alone but not Lonely'. London address.

SMITH, Rosa fl.1893
Exhib. a work entitled 'Kitchen Utensils' at SS. Address in Croydon,

SMITH, Miss Rosa M. fl.1883-1893
Painted flowers. Exhib. five works at SS, including 'Chrysanthemums' and 'Pansies', and one work, 'A Penny for Your Thoughts', at the RA. London address.

SMITH, S.G. fl.1846
Exhib. one work 'Galatea' at the BI. London address.

SMITH, S. Theobald fl.1863-1891
Painted landscape. Exhib. three works at SS including two views near Bettws-y-Coed, and one work at the BI. London address.

SMITH, Samuel Mountjoy fl.1823-1859
London painter of marine subjects, landscape, portraits, genre and animals, who exhib. 1823-59, at the RA in 1831 and 1836, BI, SS

and elsewhere. Titles at the RA include 'A Lion and Lioness Reposing', 1831, and 'Robinson Crusoe', 1836 and, at the BI, 'Fishing Boats on the Beach at Hastings'.

Bibl: BM Cat. of Engraved British Portraits II 1910 p.658; Wilson.

SMITH, Miss Sarah Burrell fl.1873-1877
Exhib. three watercolours at SS including 'Aberystwith Castle' and 'Beachy Head, Eastbourne'. London address.

SMITH, Stephen fl.1882
Exhib. a landscape at the NWS. Address in South London.

SMITH, Stephen Catterson, Snr. PRHA 1806-1872
Portrait painter. Born in Yorkshire. Studied at RA Schools and in Paris. Worked in Londonderry 1839-45; 1845 moved to Dublin. President of RHA 1859-66. Director of National Gallery of Ireland 1868. Exhib. mostly at RHA, occasionally in London at RA 1830-58 and BI. He painted many well-known Irishmen and members of the Irish aristocracy. His son, Stephen Catterson Smith Jnr. (q.v.) was also a painter, and his wife, Anne Wyke, a miniaturist.

Bibl: AJ 1872 p.204; DNB; Bryan; Strickland, Poole 1912; BM Cat. of Engraved British Portraits VI 1925 p.551.

SMITH, Stephen Catterson, Jnr. RHA 1849-1912
Son and pupil of Stephen Catterson Smith Snr. (q.v.). Also painted portraits. Did not exhib. in London; only in Ireland. Secretary of RHA for 20 years.

Bibl: See under S.C. Smith, Snr.; Ormond.

SMITH, Stuart fl.1858
Exhib. one work 'Bay of Naples' at the BI. London address.

SMITH, Sydney fl.1852-1867
Painted landscape and country subjects. Exhib. three works at SS, including 'Barges Waiting for the Evening Tide' and 'Fern Gatherers', and five works at the RA including 'Off the Lido, Venice' and 'Work in the Kitchen'. London address.

SMITH, T.B. fl.1859
Exhib. two landscapes, one a view near Hindhead, Surrey, at SS. London address.

SMITH, T.L. fl.1850
Exhib. three works at the RA including 'Temple of Tivoli' and 'Aqueduct'. London address.

SMITH, T.S. fl.1869
Exhib. 'A Fellah of Kinneh' at the RA. London address.

SMITH, Miss T.W. fl.1865
Exhib. a painting of geraniums at the RA. London address.

SMITH, Thomas Tayler fl.1868-1874
Exhib. two views of buildings in Nice at the RA. London address.

SMITH, Tom fl.1882-1885
Exhib. a view of the harbour at Sark at SS. London address.

SMITH, W. fl.1830-1851
Painted portraits. Exhib. nine works at the RA including portraits and works entitled 'A Native of Bengal' and 'Scene near Woodcote'. London address.

SMITH, W. fl.1843
Exhib. a painting of cattle in a landscape at the RA. London address.

SMITH, Mrs. W. fl.1858-1860
Painted rural subjects. Exhib. two works, 'The First Quarter's Wages' and 'A Blackberry Gatherer', at SS, a subject illustrating a line from *Wordsworth* at the RA and another work at the BI.

SMITH, Mrs. W. fl.1859
Exhib. a landscape in 1859. London address.

SMITH, W.A. fl.1885-1892
Exhib. two works 'On the French Coast' and 'Near the New Forest' at SS. London address.

SMITH, W. Armfield fl.1832-1861
Portrait painter who exhib. 1832-61, at the RA 1832 49, SS and elsewhere. Brother of George Armfield Smith (q.v.), who changed his name to George Armfield in 1840.

SMITH, W. Prior fl.1843-1858
Painted landscape. Exhib. eight works at the RA including 'View of Harrow from Hampstead', 'Meadfort Sands' and 'Erith Reach, Low Water', and nine watercolours at SS including views on the River Dart and in the Weald of Kent. London address.

SMITH, W.T. fl.1857
Exhib. a work entitled 'Ma Belle' at SS. Address in Brighton, Sussex.

SMITH, W. Thomas fl.1895-1901
Exhib. four works at the RA including 'They Forged the Last Link with Their Lives — *H.M.S. Erebus*' and 'The Veteran'. London address.

SMITH, Wells fl.1870-1875
Painted rural and rustic genre subjects. Exhib. 16 works at SS including 'The Scarecrow', 'Father's Dinner' and 'Threading Granny's Needle'. London address.

SMITH, William fl.1813-1859
Painter of animals, portraits and landscape, living in London and Newport, Shropshire. Exhib. 1813-59 at the RA, BI, SS and OWS, titles at the RA including 'Portrait of Mr. William Drury, a Shropshire Yeoman and his Pony Ben', 1840, 'A Loiterer and Rabbit Catchers', 1848 and 'Severn Fish', 1849. Graves, Dictionary, incorrectly divides up his work between W. Smith (1841-59) and William Smith (1813-47).

Bibl: Poole I 1912; II 1915.

SMITH, William Bassett- fl.1887
Exhib. a view of Rouen cathedral at the RA. London address.

SMITH, William Collingwood RWS 1815-1887
Landscape painter and watercolourist. Born in Greenwich. Received some lessons from J.D. Harding (q.v.). At first painted in oils, but later became purely a watercolourist. Exhib. at RA 1836-55, BI, SS and OWS. Graves lists over 1,000 exhibits at the OWS, but Roget says that it was nearer 2,000. ARWS 1843, RWS 1849; Treasurer 1854-79. Painted extensively in the British Isles and Europe, especially in Italy. Was also a popular drawing-master. "His own work is marked by breadth of effect, firmness of drawing and precision of touch" (Hardie). His studio sale was held at Christie's, 3 March 1888.

Bibl: AJ 1887 p.160; Roget; Bryan; Binyon; Cundall; VAM; Hardie II p.233 (pl.224); Brook-Hart.

SMITH, William H. fl.1863-1880
London painter of studies of fruit, who exhib.1863-80, at the RA 1863-72, BI, SS and elsewhere.

SMITH, William H. Seth- fl.1892
Exhib. architectural views. Exhib. three views at the RA including a view in Seville. London address.

SMITH, William Harding Collingwood RBA 1848-1922
Painter of genre and historical subjects, and of landscape; collector. Son and pupil of William Collingwood Smith (q.v.), deriving his second name from J.D. Harding (q.v.) who had been his father's friend and instructor. Exhib. from 1868 at SS, NWS and elsewhere, and at the RA from 1870, titles at the RA including 'Making Advances', 1873, 'King Charles at Cothele on the Tamar', 1873 and 'A Dilettante', 1876. RBA in 1894. *The Connoisseur* notes that he "inherited his father's gift for watercolour, and many of his drawings were executed in the neighbourhood of Chichester. In his earlier days he executed some subject pictures but had abandoned this field many years before his death". He was also a discriminating collector of Japanese, Egyptian, Babylonian and Persian antiquities.
Bibl: Connoisseur LXII 1922 p.112ff. (obit.).

SMITH, William J. fl.1837-1855
Exhib. views of architecture. Exhib. eight works at the RA including 'A Young Favourite' and views in Rome, Rouen and Constantinople. Also exhib. five works at the BI. London address.

SMITHERS, Collier fl.1892-1897
Exhib. three works at the RA, two portraits including one of Norman Shaw, and a work entitled 'A Sea Witch'. London address.

SMITHERS, H. fl.1849
Exhib. 'Dead Game' at the BI. Address in Eton, Berkshire.

SMITHETT, Agnes L. or J. fl.1893
Exhib. 'Fish Street, Clovelly' at SS. London address.

SMITHYES, Arthur W. or U. fl.1883
Exhib. a landscape in 1883. London address.

SMYTH, C. fl.1874
Exhib. 'The last Hours of Queen Elizabeth' at the RA. Address in Brighton, Sussex.

SMYTH, Coke fl.1842-1867
Painted figurative subjects. Exhib. nine works at the BI, including 'Cavalier reading Don Quixote', 'Crossing the Sands' and 'Not Unexpected'. Also exhib. four works at the RA and three works at SS. London address.

SMYTH, Edward fl.1819-1844
Painted flowers and portraits. Exhib. 17 works at the RA, including 'Flowers in a Vase', 'The Villager's Handkerchief Opened, or Wild Flowers' and portraits, and ten works at SS. London address.

SMYTH, Emily R. fl.1850-1874
Painted landscape. Exhib. five works at the RA including 'View in the Calne Valley at Chappel, Essex' and 'Favourite Hounds'. Also exhib. four works at the BI including 'Pony and Boy' and 'The Village Blacksmith'. Address in Bury St. Edmunds, Suffolk.

SMYTH, H. fl.1845
Exhib. a 'View near Bakewell, Derbyshire' at SS and a 'View on the River Usk' at the RA. Address near Nottingham.

SMYTH, Thomas fl.1854-1862
Painted animals and rustic subjects. Exhib. 17 works at SS including 'The Roadside Inn', 'The Tinkers' and 'Keeper's Pony', and three works at the RA. Address in Ipswich, Suffolk. Probably the same as Thomas Smythe (q.v.).

SMYTH, Walter Montague 1863-1965
Painted landscape. Took up painting after abandoning a military career. Studied art in Italy and Holland. Exhib. 11 works at SS including views in Northumberland and views on the coast of Holland, amongst these watercolours. Also exhib. eight works at the RA 1894-1904 including 'A Fen Water Gate' and 'The Village, Southwold'. Travelled widely. Born and lived in London.

SMYTHE, D. fl.1863
Is supposed to have exhib. a genre subject in 1863. London address.

***SMYTHE, Edward Robert 1810-1899**
Ipswich landscape painter. Son of a bank manager. Lived and worked in East Anglia; painted landscapes and coastal scenes, with figures and animals. Exhib. 1850-61 at RA, BI and SS. Graves and other dictionaries list him incorrectly as Emily R. Smythe. Brother of Thomas Smythe (q.v.).
Bibl: Wilson pl.35; Pavière. Landscape pl.69; *The Smythes of Ipswich*, exhib. at Lowndes Lodge Gallery, London, 1964; H.A.E. Day, *East Anglian Painters*, I pp.113-51.
Exhib: London, Lowndes Lodge Gallery 1972; 1986.

SMYTHE, Leslie E.B. fl.1863-1867
Painted landscape. Exhib. four works at SS including views in North Wales and Devonshire. London address.

***SMYTHE, Lionel Percy RA RWS RI ROI 1839-1918**
Painter of landscape and rustic genre. Educated at King's College School, studied at Heatherley's Art School. Exhib. from 1860, at the RA from 1863, BI, SS, OWS, NWS and elsewhere. RI from 1880-90, ROI 1883-6; ARWS 1892; RWS 1894; ARA 1898; RA 1911. In 1889 'Germinal' was purchased by the Chantrey Bequest for the Tate Gallery. Smythe lived principally at Wimereux where he died, and the French peasant girls and countryside round Wimereux and Ambleteuse figure in much of his work. Hardie notes that "his landscapes and episodes of rural life, painted with great purity of delicate colour, are poetic and refined. The outdoor figures are surrounded by shimmering light and air, e.g. 'Under the Greenwood Tree' " (VAM).
Bibl: AJ 1904 pp.223-8; Studio XLIX 1910 pp.171-85; Connoisseur XXXVIII 1914 p.67; LV 1919 p.163; LVI 1920 p.220; LXVIII 1924 p.57ff.; Studio Special Winter Number 1917-18 pl.XII; R.M. Whitlaw, *Lionel Percy Smythe*, OWS I 1923; F.W. Stokes, *List of Works Exhibited by L.P.S. in the OWS's Club*, I 1923-4 pp.69-78; Rosa M. Whitlaw and W.L. Wyllie, *L.P.S. His Life and Work*, 1924; VAM; Hardie III pp. 140-1 (pl.164); Brook-Hart; Newall.

SMYTHE, Miss Minnie fl.1896-d.1955
Painted rural subjects and flowers in watercolour. Exhib. seven works at the RA including 'Ducks', 'Pear Blossom' and 'St. Martin's Summer'. Born in London, the daughter of Lionel Smythe (q.v.). Educated in France. Lived in London.

SMYTHE, Richard b.1863
Portraitist, etcher and engraver. Studied at the Manchester School of Art. Born at Cromford, Derbyshire. Lived in Middlesex.
Bibl: BM Cat. of Engraved British Portraits.

***SMYTHE, Thomas 1825-1907**
Ipswich landscape painter. Brother of Edward Robert Smythe (q.v.). Like him, painted landscapes and coastal scenes with animals and figures. Worked in East Anglia and exhib. there; also painted good winter landscapes.
Bibl: Pavière, Landscape p.121; *The Smythes of Ipswich*, exhib. at Lowndes Lodge Gallery, London, 1964; H.A.E. Day, *East Anglian Painters*, I pp.193-207. Exhib: London, Lowndes Lodge Gallery 1972.

SMYTHSON, Marcus H. fl.1877-1884
Exhib. a work entitled 'Under Consideration' at the RA. London address.

SNAPE Martin fl.1874-1901
Gosport painter of birds, animals and landscape, who exhib. 1874-1901 at the RA, SS, GG and elsewhere, titles at the RA including 'The Gamekeeper's Museum', 1883, 'The Ferret Hutch', 1894 and 'Gosport Fair', 1897.
Bibl: Pavière, Sporting Painters.

***SNAPE, William H. fl.1885-1892**
Painter of interiors with figures. Exhib. four works at the RA including 'Porphyrogenita' and a study of a cat. Address in Gosport, Hampshire.
Bibl: Wood, Paradise Lost.

SNARD, Mrs. T.G. fl.1848-1849
Exhib. a view on the River Colne, Colchester, at the RA. Address in Bishops Stortford, Hertfordshire.

SNELL, G. fl.1844
Exhib. a view in Caen at the RA. London address.

SNELL, James Herbert ROI 1861-1935
London landscape painter who exhib. from 1879, at the RA from 1880, SS, NWS, GG, NG and elsewhere, titles at the RA including 'Signs of Winter', 1880, 'Woodland and Solitudes', 1882 and 'An Old Time Garden', 1902. Studied at Heatherley's and in Paris and Amsterdam.
Bibl: Pavière, Landscape.

SNELL, Miss Mary fl.1901
Exhib. a painting of tulips at the RA. Address in Needham Market, Suffolk.

SNEYD, Miss Sarah M. fl.1895
Exhib. 'In Richmond Park' at the RA. London address.

SNOSWELL, W.T. fl.1846
Exhib. an interior view of a church at the RA.

SNOW, Helena fl.1879
Exhib. a painting of fruit at SS. London address.

SNOWMAN, Isaac b.1874 fl.1893-1904
Painted portraits and genre subjects. Worked in Palestine. Exhib. 18 works at the RA 1893-1904 including 'Tales of a Grandfather', 'The Wailing Wall, Jerusalem' and portraits. London address.
Bibl: BM Cat. of Engraved British Portraits.

SOADY, B. fl.1840
Exhib. a landscape at the RA.

SODEN, John Edward fl.1861-1887
London genre painter. Exhib. at RA 1861-68, BI and SS (64 works). Titles at RA 'Quizzing the Neighbours', 'The Odd Change' and 'Well I Never', etc.
Bibl: Cat. of Paintings, Drexel Institute, Philadelphia, 1935.

SODEN, Miss Susannah fl.1866-1890
Painted flowers and fruit. Exhib. four works including three paintings of azaleas at the RA, and four works at SS. Born at Broenston, Northamptonshire. Lived in London.
Bibl: Clayton.

SOILLEUX, Frederick fl.1870-1871
Exhib. a portrait and a painting of fruit and flowers at SS. London address.

SOLLY, Miss Evelyn W. fl.1897-1903
Exhib. four works at the RA 1897-1903 including 'The Babes in the Wood' and 'The Judgement of Paris'. Address in Bushey, Hertfordshire.

SOLLY, N. Neale fl.1866-1894
Birmingham painter of flowers, landscape and gardens. Exhib. a landscape at the NWS and at RBSA.

SOLLY, Samuel fl.1869-1871
Exhib. two works, 'The Old Man, Coniston' and 'The Frying Pan, Cadgwith, Cornwall', at the RA. London address.

***SOLOMON, Abraham 1824-1862**
Painter of historical and contemporary genre. Elder brother of Rebecca and Simeon Solomon (qq.v.). Studied at Sass's Academy and RA schools. Exhib. at RA 1841-62, BI and SS. At first painted 18th century historical genre, taking his subjects from Scott, Sterne, Molière, Goldsmith, etc. In 1854 he turned to contemporary genre and exhib. at the RA two railway subjects: '1st Class — The Meeting' and '2nd Class — The Parting'. These were an enormous success and widely reproduced through engravings. He went on to paint other subjects of this type such as 'Waiting for the Verdict', 1857 and 'The Acquittal', 1859, which were also very popular. In 1861 he married, but owing to heart trouble he was advised to go abroad. In 1862 he died in Biarritz on the same day as the Academy elected him an ARA. His studio sale was held at Christie's, 14 March 1863.
Bibl: AJ 1862 pp.73-5; 1863 p.29; Apollo XXIII 1936 p.241ff.; Bryan; Bate; DNB; Jewish Lexicon IV 2 1930; Reynolds, VS, VP pl.66; Maas p.238; Lionel Lambourne, *Jewish Historical Society of England*, XXI 1968 pp.274-86; Wood, Panorama, see index; *The Solomon Family*, Cat. of exhib., the Geffrye Museum, London, 1985.

SOLOMON, J.W. fl.1827-1849
Genre and portrait painter. Exhib. at RA 1828-49, BI and SS. Titles at RA 'The Young Rover', 'The Present', 'La Promenade', etc. and also some portraits and historical genre from Milton and Shakespeare.

***SOLOMON, Miss Rebecca 1832-1886**
Historical genre painter. Sister of Abraham and Simeon Solomon (qq.v.). Studied at Spitalfields School of Design, and with her brother Abraham. Exhib. at RA 1852-69, BI, SS and elsewhere. Her early works are genre scenes similar to her brother's, e.g. 'Peg Woffington', 'Fugitive Royalists', 'The Arrest of a Deserter', etc. She also helped several artists to produce studio replicas, including Millais, Frith, Phillip and T. Faed. A copy of Phillips's 'Marriage

of the Princess Royal' by her is in the Royal Collection. During the 1860s she visited France and Italy. Before her brother Simeon's downfall they moved in artistic circles together, but after 1871 she seems to have shared in his disgrace. She exhib. nothing after 1869 and her later years are blanketed in complete obscurity. The DNB says that "she developed like Simeon an errant nature and came to disaster". Her death in 1886 was also due to alcoholism.

Bibl: DNB; Clayton II p.129; Daphne Du Maurier, *The Young George Du Maurier,* 1951 see index; Lord Baldwin, *The MacDonald Sisters,* 1962, see index; C. Wood in Christie's Review of the Year 1968-9 pp.55-7; *The Solomon Family,* Cat. of exhib., the Geffrye Museum, London, 1985; see also references under Simeon Solomon.

*SOLOMON, Simeon 1840-1905

Pre-Raphaelite painter and illustrator. Younger brother of Abraham and Rebecca Solomon (qq.v.). Entered RA schools 1855. First major exhib. at RA was 'The Mother of Moses' in 1860. Exhib. at RA 1858-72, SS, GG, NG and elsewhere. A precocious and brilliant artist, he produced most of his best work in the 1860s. It includes illustrations for Dalziel's Bible and many drawings of Jewish life and ritual. During this time he met Rossetti, Burne-Jones, Pater, Swinburne and others of the Pre-Raphaelite circle, all of whom greatly admired his work. He illustrated books for Swinburne, but the corrupting influence of the poet is generally thought to have hastened his moral and artistic decline. In 1873 he was arrested for homosexual offences and became a complete social outlaw. Both his family and his fellow-artists deserted him and he was forced to live a pathetically bohemian life, mostly in St. Giles Workhouse, Holborn. To relieve his poverty he produced large numbers of drawings and pastels, mostly of mythological and biblical figures. Some of these are weak and repetitive, "virtually a parody of the yearning intensity of the movement" (Reynolds), but they were nonetheless popular in the 1880s and 1890s, especially in the decoration of undergraduate rooms in Oxford. His death in 1905 was due to chronic alcoholism.

Bibl: AJ 1906 p.311ff.; Connoisseur LVI 1920 pp.220, 224; Bate; Binyon; Cundall; DNB; VAM; S. Solomon, *A Vision of Love Revealed in Sleep,* 1871; A Swinburne, *S.S.,* in the Bibelot XIV 1908, T.E. Welby, *The Victorian Romantics,* 1929; B. Falk, *Five Years Dead etc.,* 1937; J.E Ford, *S.S.,* 1964; Fredeman Section 61 *et passim* (with full bibl.); Reynolds, VP p.71 (pl.58); Hardie III pp.126-7 (pl.151); Maas p.146 (pl.143); L. Lambourne, *Jewish Historical Society of England,* XXI 1968 pp.274-86; Wood, Pre-Raphaelites; Wood, Olympian Dreamers; *The Solomon Family,* Cat. of exhib., the Geffrye Museum, London, 1985; S. Reynolds, *The Vision of S.S.,* 1984.
Exhib: Baillie Gallery 1905; New York, Durlacher Gallery 1966.

*SOLOMON, Solomon Joseph RA PRBA 1860-1927

Portrait and genre painter. Studied at RA schools, Munich Academy and under Cabanel at the Beaux-Arts, Paris. Exhib. at RA from 1881, SS, NG and elsewhere. Painted mostly portraits, but also mythological and biblical scenes, e.g. 'Ruth', 'Niobe', 'The Birth of Love', etc. These are often large and dramatic, but his attempts to portray emotion tend to be forced and theatrical. Elected ARA, RA 1906, PRBA 1919. Works by him are in the Walker AG, Liverpool, Preston and Leeds AGs.

Bibl: AJ 1905 pp.165, 174; 1907 p.29; 1908 p.167; Studio VIII 1896 pp.3-11; Connoisseur LXXIX 1927 p.58; O.S. Phillips, *S.J.S.,* Apollo XVIII 1933 p.196ff.; Ormond; Wood, Panorama pl.36; Wood, Olympian Dreamers.

SOMERSCALES, John fl.1893-1898

Exhib. two works, the second a view on the River Flesk, Killarney, at the RA. Address in Hull, Yorkshire.

SOMERSCALES, Thomas, Jnr. fl.1900-1903

Exhib. three works at the RA including 'The Llugwy, near Bettws' and 'A Valley in North Wales'. Address in Hull, Yorkshire.

*SOMERSCALES, Thomas Jacques 1842-1927

Marine painter. Born in Hull. Teacher in the Navy. In 1865 he was put ashore in Chile because of ill-health. He remained in Chile until 1892, and while there took up painting. Returned to England and exhib. at RA from 1893. 'Off Valparaiso' was bought by the Chantrey Bequest. His pictures are mostly of sailing ships at sea and are often similar to those of the better-known Montague Dawson. Works by him are in Hull, Greenwich and the Tate Gallery.

Bibl: Mag. of Art 1902 pp.241-6; Studio Special Number 1919, *British Marine Painting,* pp.31, 82ff.; Connoisseur LXXIX 1927 p.127; RA Pictures 1893-1901, 1903-06, 1908, l911; Wilson p.73 (pl.36); Brook-Hart.

SOMERSET, Frank fl.1878-1883

Exhib. two works, 'Medea' and a scene from *The Tempest,* at the RA and one work at SS. Addresses in London and Newbury, Berkshire.

SOMERSET, Miss J. fl.1888

Exhib. 'A Devonshire Cottage' at the RA and one work at SS. London address.

SOMERSET, Richard Gay VPRCA ROI 1848-1928

Landscape painter living in Manchester, Hulme and Bettws-y-Coed. Exhib. from 1871, at the RA from 1876, SS, GG, NG and elsewhere, and in 1927 at the RCA, ROI and the Walker AG, Liverpool. Titles at the RA include 'The First Day of January', 1876, 'An Olive Grove in Winter, Isola di Capri', 1884 and 'Falls on the Conway', 1902. Vice-President of the RCA. Paintings are in Manchester City AG and Rochdale AG.

Bibl: The Year's Art 1928 p.532.

SOMERVILLE, Charles b.1870

Painted landscapes and portraits. Born at Falkirk, Stirlingshire. Lived at Ashford, Middlesex. Founder of the Doncaster Art Club.

SOMMERS, Otto fl.1875-1877

Painted landscape. Exhib. eight works at SS including 'Seeking Shelter from the Storm' and landscapes in Austria, Germany and the Pyrenees. London address.

SOORD, Alfred Usher 1868-1915

Painted landscape and figurative subjects. Exhib. 19 works at SS 1893-1904, including portraits and views at St. Oswyth, Essex, and at Wastwater, Cumberland. Address in Bushey, Hertfordshire.

Bibl: Studio XXVI p.57; XXXIII p.170; The Year's Art 1916 p.445; BM Cat. of Engraved British Portraits.

SOPER, George RE 1870-1942

Painted landscape and military subjects. Also a graphic artist. Exhib. three works at the RA, including 'Now Fades the Glimmering Landscape on the Sight' and 'The Native Cavalry Charge', and three works at SS. Born in London. Lived in Welwyn, Hertfordshire.

Bibl: Who's Who in Art; Connoisseur LV p.182; LXV p.173; Studio LXXX pp.96-9; :LXXXI p.155; LXXXV pp.262-4; The Artwork IV p.l9.

SOPER, Thomas James fl.1836-1890

Landscape painter. Exhib. at RA 1836-82, BI, SS, NWS and elsewhere. Painted around London and on the Thames, in Devon, Wales and other parts of the British Isles.

Bibl: AJ 1859 p.121; Pavière, Landscape pl.70.

SOPWITH, Thomas 1803-1879

An engineer who exhib. drawings of buildings in Northumberland.

SORBY, Thomas Charles fl.1856-1864
Exhib. three works including two views of churches at the RA. London address.

SORENJEN, C.F. fl.1855
Exhib. a scene on the coast of Holland at the RA. Address in Paris. This may be the Danish artist, Carl Frederick Sorensen (1818-1879).

SORRELL, T. fl.1854
Exhib. a watercolour 'At Canterbury' at SS. London address.

SOTHEBY, Hans W. fl.1873
Exhib. a watercolour view of a sunset on the River Tiber and a view from Lynton, Devon, at SS. London address.

SOTHERN, Miss Fanny fl.1871-1875
Painted flowers and genre subjects. Exhib. five works at SS including watercolours of chrysanthemums and a work entitled 'The First Loss', and two works at the RA. London address.

SOULTERN, A.C. fl.1871-1873
Exhib. two works including 'The Disappointment' at SS. London address.

SOUTH fl.1852
Exhib. a work entitled 'The Drover' at the BI.

***SOUTHALL, Joseph Edward RWS RBSA NEAC 1861-1944**
Painted historical and mythological subjects and landscape. Exhib. three works at the RA 1895-7 including 'Cinderella' and 'Man in a Fez'. His mature works show the influence of the Italian Primitives. Born in Nottingham. Lived in Birmingham. Founder of the Society of Painters in Tempera, 1900.
Bibl: Who's Who; Who's Who in Art; Studio IV p.199; XXIII pp.156, 158, 162, 164; XXVI p.255; XXVIII pp.35, 118; XXXII p.158; XXXVIII pp.16, 19; XLIX p.142; LVII p.279; LIX p.131, LX pp.302, 304; LXV p.185; LXXIX p.7; LXXXIII p.155; LXXXV p.97; XCI p.202; Connoisseur XLVI p.251; Apollo III p.184; VII p.245; IX p.317.
Exhib: Birmingham, Museum and AG, 1945, 1980.

SOUTHBY, Claudia fl.1869-1874
Exhib. a watercolour of oleanders and lilies at SS. London address.

SOUTHERN, J.M. fl.1879-1892
Liverpool landscape painter who exhib. 1879-92, at the RA 1879-82 and GG, titles at the RA including 'A Welsh Moorland in Autumn', 1879 and 'The Shallows of a Welsh River', 1882.

SOUTHGATE, Miss Elsie fl.1878-1887
Painted rustic subjects. Exhib. three views, two of them of scenes in Suffolk, at the RA, and five watercolours at SS including 'A Haystack' and 'A Quiet Moment'. London address.

SOUTHGATE, Frank RBA 1872-1916
Painted birds in watercolour. Born and lived in Norfolk. Killed in action in the Great War.

SOUTHWELL, W.H. fl.1870
Exhib. a work entitled 'Sulks' at the RA. London address.

SOUTHWICK, Alfred b.1875
Newcastle sculptor and painter. Studied at Armstrong College, Newcastle-upon-Tyne and in London.
Bibl: Who's Who in Art.

SOUTTEN, A. Camille fl.1873-1874
Exhib. two works, one entitled 'The Lover's Tiff' at SS. London

SOWDEN, John 1838-1926
Painted landscape and still-lifes. Pupil of William Henry Hunt (q.v.). Exhib. five works at the RA including 'May Blossom and Nest' and 'Whitby from Larpool'. Address in Bradford, Yorkshire.
Bibl: Connoisseur LXXIV p.189.

***SOWERBY, John George fl.1876-1914**
Landscape painter, living in Gateshead, Colchester and Abingdon, Berkshire, who exhib. 1876-1914, at the RA from 1879, and elsewhere. Titles at the RA include 'Twilight', 1879, 'The Erring Burn', 1897 and 'The Avon', 1904. His watercolour landscapes show distinct Pre-Raphaelite influence. His daughter Millicent Sowerby (1879-1967) was also a talented painter and book illustrator.
Bibl: Hall.

**SOYER, Mme. 1813-1842
(Miss Emma E. Jones)**
Painted portraits and figurative subjects. Exhib.12 works at the BI including 'Italian Boys', 'The Crockery Vendor' and 'Savoyards Resting'. Also exhib. two works at the RA and eight works at SS. London address. See also Miss Emma E. Jones.
Bibl: Clayton; Redgrave, Dict.; DNB; BM Cat. of Engraved British Portraits.

SPACKMAN, Miss Mary A. fl.1892
Exhib. a painting of daffodils at the RA. London address.

SPAIN, John Henry fl.1889-1892
Exhib. a view of Browning's grave and an interior view in Westminster Abbey at SS, and another work at the RA. London address.

SPALDING, C.B. fl.1840-1849
Sporting and animal painter, lived in Reading, Brighton and London. Exhib. five pictures at RA 1840-9. Three of these were of horses, the others 'The Battle of Aliwal' and 'A Forester'.

SPANTON, W.S. fl.1867-1868
Exhib. two portraits at the RA. Addresses in London and Bury St. Edmunds .

**SPARKES, Mrs. John b.1842 fl.1866-1891
(Miss Catherine Adelaide Edwards)**
Genre painter and illustrator. Pupil of Lambeth and RA schools and also of John O'Connor. In 1868 she married John Sparkes (q.v.). Exhib. at RA in 1866 and 1868 under her maiden name; 1870-90 as Mrs. Sparkes, also at NWS, GG and Dudley Gallery. She illustrated several books and also worked as a tile painter and designer for Lambeth Pottery, of which her husband was the director.
Bibl: Clayton II pp.130-2.

SPARKES, John Charles Lewis fl.1856-d.1907
Artist and director of the Lambeth Pottery. Studied under P.J. Naftel (q.v.), at Leigh's and the RA Schools. Taught at Marlborough House and South Kensington. His wife was also an artist (q.v.).

SPARTALI, Miss Marie see STILLMAN, Mrs. William

SPEAR, E.F. fl.1873
Exhib. a genre subject in 1873.

SPEED, Harold RP 1872-1957
Painted mythological subjects, landscapes and portraits. Studied at the RA schools after abandoning a career as an architect. Exhib. 20 works at the RA 1893-1904, including 'A Derbyshire Trout Stream', 'The Medusa Head' and portraits. Also exhib. two works at SS. Lived at Watlington, Oxfordshire, and in London.
Bibl: Who's Who in Art; Who's Who; Studio XV pp.151-68; XXXVIII pp.8, 14, 23; XLIV p.42; L pp.9, 26; LXVIII pp.40, 117; LXXXIII p.45; LXXXVII pp.304, 307; LXXXVIII pp.97, 99; AJ 1905 pp.174, 175, 183; Connoisseur XXVIII p.207; XXXIX p.276; XLII p.178; XLV p.120; LVI p.59; LXV p.234. Exhib: London, Fine Art Society 1938.

SPEED, Miss Katherine G. fl.1888-1898
Exhib. a genre subject at the GG. London address.

SPEED, Lancelot 1860-1931
Painted coastal scenes in watercolour. Also an illustrator. Lived in north London and later at Southend-on-Sea, Essex.

SPENCE, Charles James 1848-1905
An amateur etcher and watercolourist of landscape subjects. He lived in North Shields, Northumberland, and worked in the northeast. Represented in the Laing AG, Newcastle-upon-Tyne.
Bibl: Hall.

SPENCE, Ernest fl.1884-1902
Painted landscape and genre subjects. Exhib. nine works at the RA including 'Solitude', 'Circe' and 'The River Wey'. London addresss.
Bibl: The Year's Art 1909.

SPENCE, F. fl.1891
Exhib. a painting of fruit at the NWS. London address.

SPENCE, Harry RBA 1860-1928
Painted portraits and landscape. Studied in Glasgow, London and Paris. Exhib. three works at the RA 1895-1903, including 'On the Normandy Coast' and 'Moonrise'. Born in London of Scottish parents. Represented in Glasgow AG.
Bibl: D. Martin, The Glasgow School, 1902; Caw; Who's Who.

SPENCE, Henry fl.1884
Exhib. a work entitled 'Highland Cornfield' at SS. Address in Bushey, Hertfordshire.

SPENCE, Robert RE 1871-1964
Etched and painted historical subjects and landscapes. Studied at the Newcastle School of Art, the Slade School and in Paris. Born in Tynemouth, Northumberland, the son of Charles James Spence (q.v.). Lived in London.
Bibl: Who's Who in Art; Studio XXIII p.22; LXX p.68; AJ 1904 p.308; 1910 p.332; Connoisseur LIX p.174.

***SPENCE, Thomas Ralph 1855-1903**
Painted landscape and historical subjects. Exhib. 11 works at the RA including 'A Breezy Morning', 'The Sleeping Beauty' and 'The Surrender of Capua, 210 B.C.' Also exhib. at the GG and at the NG. He was responsible for the decorative paintings in Manchester Cathedral. His more ambitious classical subjects owe their inspiration to Alma-Tadema. London address.
Bibl: Hall; Wood, Olympian Dreamers.

SPENCELAYH, Charles HRBSA RMS VPBWS 1865-1958
Painted portraits, figurative and genre subjects. Studied at the RCA and in Paris. Also an etcher and miniaturist. Famous especially for his cluttered interiors with old men, painted in great detail. Born at Rochester, Kent. Died at Northampton.
Bibl: Who's Who in Art; Who's Who; Studio LXXII p.77; Connoisseur LXIX p.180; XC p.55.

SPENCER, Augustus 1860-1924
Painter and art teacher. Studied at Keighley School of Art and at the RCA. He was later headmaster of Coalbrookdale School of Art and Leicester School of Art, and Principal of the RCA.

SPENCER, Miss Blanche fl.1879-1888
Painted figurative subjects. Exhib. six works at SS including 'Joe' from Bleak House, 'Egyptian Minstrels' and 'Old Cottages, near Highgate'. London address.

SPENCER, C. Neame fl.1897
Exhib. a work entitled 'Pastoral' at the RA. Address in Beckenham, Kent.

SPENCER, Fred fl.1900-1904
Painted still-lifes. Exhib. 11 works at the RA 1900-4 including 'Apples and Grapes' and 'Old Books to Read'. London address.

SPENCER, Harry fl.1882
Exhib. a landscape in 1882. London address.

SPENCER, John S. fl.1835-1863
Painted figurative and theatrical subjects. Exhib. six works at the BI including 'A Spanish Bandit', 'The Parting Admonition' and 'Othello, Desdemona and Iago', six works at SS and one work at the RA. Lived in London and Birmingham, where he exhib. at RBSA.

SPENCER, R.B. fl.1840-1870
Marine painter. Did not exhib. in London but worked for private patrons. Painted ship-portraits and naval battles.
Bibl: Wilson pl.36; Brook-Hart.

***SPENCER-STANHOPE, John Roddam 1829-1908**
Pre-Raphaelite painter. Pupil of G.F. Watts (q.v.). Exhib. at RA from 1859, NWS, GG, NG and elsewhere. Subjects usually mythological or allegorical. Although deriving inspiration from Burne-Jones, Stanhope evolved a very personal Pre-Raphaelite style, more similar to that of J.M. Strudwick (q.v.). He painted frescoes in the Anglican Church, Florence, Marlborough School Chapel, and the Union at Oxford. In 1880 he moved permanently to Florence. After his death an exhib. of his work was held at the Carfax Gallery in 1909, with a catalogue by William De Morgan (q.v.). He was uncle and also teacher of Evelyn De Morgan (q.v.). Works by him are in the Liverpool, Manchester and Tate Galleries.
Bibl: AJ 1909 p.158 (pls.155, 159); Studio XXXV 1905 p.293; XLVIII 1910 p.20; Clement & Hutton; Bate; Morning Post 11 March 1909; A.M.W. Stirling, A Painter of Dreams: The Life of R.S.S. Pre-Raphaelite, 1916; Fredeman; Reynolds, VP p.69; Maas p.146 (pl. p.144); Wood, Pre-Raphaelites; Wood, Olympian Dreamers.

SPENDER, Mrs. fl.1861
Exhib. a painting of flowers in 1861. London address.

SPENDER, Miss C. fl.1862-1864
Exhib. two works, 'The Present' and 'The Pride of the Village', at the BI, and a work at SS. London address.

SPENLOVE, Frank Spenlove RCA RBA RI ROI 1868-1933
Landscape and rustic genre painter. Studied in London, Paris and Antwerp. Exhib. at RA from 1887, SS, NWS and elsewhere. His landscapes were often painted in Kent, Suffolk or Holland. In 1896 he founded the Spenlove School of Modern Art, known as the

Yellow Door School, at Beckenham in Kent. Works by him are in the Guildhall, Bristol, Doncaster, Glasgow, Hull, Liverpool, Manchester, Newcastle, Newmarket and Rochdale AGs, and also in the Luxembourg Museum and the Hotel de Ville, Paris.

Bibl: AJ 1895 p.159; 1901 p.l91; 1904 p.196; 1905 pp.300, 385; 1906 p.269; 1907 p.186; Studio see Indexes Vols. XXVII, XXIX, XLI, XLIII, LXIII, LXVI; Connoisseur XLII 1915 p.59ff.; XCI 1933 p.409; Art News XXXI 1932/3 No.36 p.8; Who's Who 1924.

SPERLING, J.W. fl.1845-1848
Exhib. a painting of a stallion and two portraits at the RA. London address.

SPICER, Charles fl.1885-1888
Exhib. a work entitled 'The Unstopped Drain' at the RA. London address.

***SPIERS, Benjamin Walter fl.1875-1893**
London genre painter who exhib. 1875-93, at the RA 1876-91, SS, NWS and elsewhere, titles at the RA including ' "Crack'd Bargains from Brokers, Cheap Keepsakes from Friends" ', 1876, 'The Old Bookstall', 1880 and 'A Visit to Wardour St.', 1890. Specialised in highly detailed interiors, cluttered with books and other objects, usually painted in watercolour.

Bibl: Christopher Wood, *Knicknacks and Silly Old Books,* Country Life 10 June 1993 pp.124-5.

SPIERS, Miss Bessie J. fl.1884-1893
Painted landscape. Exhib. three works at the RA including 'Autumn near Reigate' and 'A Tidal Creek, Sussex', and three works at SS. Also exhib. 12 works at the NWS. She was a member of the Society of Lady Artists. London address.

SPIERS, Miss Charlotte H. fl.1873-1901
London landscape painter who exhib. 1873-1901, at the RA in 1881, 1897 and 1901, SS, NWS, GG and elsewhere, titles at the RA including 'On the Wye', 1881 and 'In the Marshes, Kessingland', 1901.

SPIERS, E.J. fl.1852-1853
Exhib. two landscapes 1852-3.

SPIERS, Richard Phené FSA 1838-1916
Painted views of architecture. Exhib. 98 works at the RA including views of buildings in Rouen, Nuremberg, Pisa, Paris and Athens. Exhib. 21 watercolours of buildings at SS. Born in Oxford. Lived in London.

Bibl: DNB; AJ 1906 p.62.

SPILLER, W.H. fl.1884-1886
Exhib. three still-lifes 1884-6. London address.

SPILLMAN, William fl.1853-1861
Painted figurative subjects. Exhib. five watercolours at SS including 'Study of a Monk' and 'Spanish Figures' and one work at the BI. London address.

SPINDLER, J.G.H. fl.1895
Exhib. a mountainous landscape at the RA. Address in Dundee.

***SPINKS, Thomas fl.1872-1880**
Landscape painter. Exhib. 1872-80 at the RA and SS. Painted Welsh scenery in a style reminiscent of B.W. Leader and W.H. Mander (qq.v.).

Bibl: Pavière, Landscape pl.71.

SPIRIDON, G.S. fl.1871
Exhib. a painting of a dead porcupine. London address.

SPITTLE, William M. RBA RBSA 1858-1917
Painted genre subjects and still-life. Studied at the Birmingham School of Art. Exhib. two works, 'Homeless' and 'An Offering', at the RA. Lived in Birmingham and principally exhib. there.

SPLINDLER, Walter E. fl.1892-1896
Exhib. four works at the RA including a portrait of Sarah Bernhardt. Address in Paris.

SPONG, Miss Annie E. fl.1896-1904
Painted portraits. Exhib. six portraits at the RA. London address.

SPONG, Walter Brookes fl.1881-1903
Painted landscape. Exhib. seven works at the RA including views in Spain, Portugal and the Middle East. London address.

SPOONER, Charles fl.1891-1904
Painted views of architecture. Exhib. views of churches and houses in Essex and Suffolk. London address.

SPOONER, J.S. fl.1854-1874
Exhib. two Welsh landscapes at the RA and one at the BI. Address in Llanrwst, Denbigh.

SPRAGUE, Miss Edith fl.1883-1903
Painted portraits and genre subjects. Exhib. 24 works at the RA 1887-1903, including portraits and works entitled 'Strewn with Faint Blooms like Bridal Chamber Floors' and 'Violet Wearing'. Also exhib. two views of buildings at SS. London address.

SPREAD, William RPE fl.1880-1889 d.1909
London painter of landscape and architectural subjects; engraver. Pupil of Charles Verlat in Antwerp. Exhib. 1880-9, at the RA., SS, GG and elsewhere, titles at the RA including 'A Shop, Dinan, Brittany', 1880 and 'A Street in Bruges', 1889.

Bibl: *Le Blanc Manuel de L'Amat. d'Est.,* 3 1888; The Year's Art 1910 p.389.

SPREAT, William fl.1841-1848
Painted landscape. Exhib. eight works at the BI, including 'Scene on the R. Webber, Dartmoor', 'Brook Scene at Chudleigh' and 'Ogwell Mill', and three works at SS. Address in Exeter. Represented in the York City AG.

SPRECK, Miss B.A. fl.1860
Exhib. a watercolour sketch at SS. London address.

SPRINCK, Leon fl.1893
Exhib. a portrait at the RA. London address.

SPRINGETT, Louis C. fl.1879
Exhib. a river scene in 1879.

SPROSSE, Carl fl.1852-1853
Painted views of Venice. Exhib. three watercolours, all views in Venice, at SS, and two works at the RA. London address.

SPRY, William fl.1832-1847
London painter of fruit and flowers who exhib. 1832-47, at the RA 1834-47, BI, SS and NWS.

SPURLING, Miss Alys fl.1891
Exhib. a figurative subject at the NWS. Address in Kelvedon, Essex.

SPURLING, Miss Celia fl.1896-1900
Exhib. a view of Dieppe as well as two subjects in stained glass at the RA. London address.

SPURLING, Jack 1871-1933
Painted marines. In his early life he had been to sea and subsequently specialised in painting old clipper ships. Lived in London.

SPURR, Gertrude E. fl.1888-1889
Exhib. three works at SS including 'Christmas Roses'. London address.

SQUIRE, Miss Alice RI 1840-1936
London painter of genre and landscape who exhib. 1864-94, at the RA 1873-94, SS, NWS, GG and elsewhere, titles at the RA including 'Windfalls', 1873, 'A Country Lass', 1885 and 'The Cuckoo's Voice', 1893. Member of the Society of Lady Artists. Sister of Miss Emma Squire (q.v.).

SQUIRE, Miss Emma fl.1862-1901
London painter of genre and still-life who exhib. 1862-1901, at the RA 1872-1901, SS and elsewhere, titles at the RA including 'Hoping for the "Yes" Word', 1872, 'Meeting an Old Friend', 1877 and 'Singing the Psalms of David', 1901. Sister of Miss Alice Squire (q.v.).

SQUIRE, Miss Helen fl.1891-1898
Exhib. three works at the RA including 'A Little Bookworm'. London address.

SQUIRE, John fl.1867-1896
Landscape painter, living in Ross, Herefordshire, Swansea and London. Exhib. 1867-96, at the RA 1873-96, SS (50 works), NWS and elsewhere, titles at the RA including 'Watergate Bay, Cornwall', 1873 and 'Coombe Park Water, Exmoor', 1896.

SQUIRES, H. fl.1864-1875
Stratford flower painter who exhib. from 1864-75, at the RA 1865 and 1868, BI, SS and elsewhere.

SRIEVE, A.R. fl.1837
Exhib. 'The Cottage on the Moor' at the RA. London address.

STABB, Mrs. H. Sparke (Janetta) fl.1893-1897
Exhib. two views in Terracina, Italy, and a landscape at the NWS. Address in Liphook, Hampshire.

STABLE, Miss Fanny fl.1877-1897
Painted landscape. Exhib. five works at the RA, including two landscapes in the Pas de Calais, and four works at SS, including 'Across the Marsh' and 'Doubtful Weather'. London address.

STABLE, Harold K. fl.1901
Exhib. 'The River' at the RA. London address.

STABLES, Miss T.G. fl.1880-1884
Painted landscape. Exhib. two works at the RA, 'A Lincolnshire Pool' and 'Crummock Water', and four watercolours at SS. Address in Ambleside, Westmoreland.

STACEY, H.E. fl.1872
Exhib. a watercolour view in Chagford, Devon, at SS. London address.

STACEY, Walter S. RBA ROI 1846-1929
Painter of landscape, genre and historical subjects; decorative designer and illustrator; living in Clapham and Hampstead. Exhib. from 1871, at the RA from 1872, SS, NWS and elsewhere, titles at the RA including 'The Old Family Pew', 1873, 'Memorial Window, Christ Church, Hampstead', 1898 and 'The Verger's Corner', 1904. He was Vice-President of the Dudley Society. 'Summer Holidays', a coastal scene, exhib. at the Dudley Society 1906, is reproduced in the AJ.
Bibl: AJ 1906 p.379 (pl.); Connoisseur LXVII 1923 p.119ff.; LXXXIV 1929 p.313.

STACKE, E.G. fl.1849
Exhib. a portrait at the RA.

STACKPOOLE, Miss Mary Constance fl.1887-1893
Exhib. five works at the RA including 'Chrysanthemums' and 'A Difficult Problem'. London address.

STADE, Miss H. fl.1868
Exhib. a painting of flowers at the RA. London address.

STAFFORD, John Phillips 1851-1899
Exhib. three works at the RA including 'Two Heads are Not Always Better than One'. London address.

STAFFORD, T.W. fl.1840-1841
Exhib. two Scottish landscapes at the RA and a view of Lake Windermere at the BI. London address.

STAINES, E., Jnr. fl.1844-1847
Exhib. four watercolours at SS including views in Cornwall and Dumfriesshire. London address.

STAINES, F.W. fl.1828-1846
Painted landscape. Exhib. 11 works at the RA including views on the Italian coast. London address.

STAINES, P.H. fl.1869
Exhib. a painting of animals in 1869. London address.

STAINTON, George fl.1860-1890
Painted marines. Influenced by the Dutch School.
Bibl Brook-Hart pl.134.

STAITE, Miss Harriet fl.1897
Exhib. 'A Spring Day' at the RA. London address.

STAKEMAN, A. fl.1883
Exhib. a landscape at the NWS. London address.

STALLARD, Mrs. Constance Louisa b.1870
Studied at South Kensington School of Art. Exhib. at the RA, PS, SWA and in the provinces. Born in County Dublin. Lived in London.

STAMFORD, A. fl.1851-1863
Painted landscape. Exhib. 12 works at SS including 'Lake Ullswater', 'Morecombe Bay' and 'Sharpness Point', and five works at the BI including views on Hampstead Heath. London address.

STAMFORD, G. fl.1838
Exhib. a view of Penrhyn Castle at the RA. London address.

STAMP, Ernest ARE 1869-1942
Painted and engraved portraits. Studied under Herkomer. Exhib. at the RA from 1892. Born in Yorkshire.
Bibl: Who's Who in Art; Portfolio 1892 p.219; BM Cat. of Engraved British Portraits.

STAMPA, George Loraine 1875-1951
Painted portraits and figurative subjects. Also an illustrator. Studied at Heatherley's and at the RA schools. Exhib. a figurative study at the RA. Born in Istanbul. Lived in London. He was a member of the Langham Sketching Club.
Bibl: Who's Who in Art; Connoisseur LXI p.254; Studio LXXXII p.240.

STAMPS, Walter J. fl.1901
Exhib. a work entitled 'The Brook' at the RA. London address.

STANDFUST, G.B. fl.1844
Exhib. a work entitled 'Tan, the property of the Hon. Jerald Dillon' at the RA. London address.

STANDISH, W. fl.1859
Exhib. 'Standish, Winner of the Great St. Leger Stakes at Doncaster, 1858' at the BI. London address.

STANDLEY, C.P. fl.1844
Exhib. a watercolour of a subject from *James of the Hill* at SS. London address.

STANDRING, Arthur fl.1885
Exhib. a North Wales landscape at the RA. Address in Manchester.

STANESBY, Alexander fl.1848-1854
Painted portraits. Exhib. eight works at the RA, including a portrait of William Powell Frith (q.v.), and three works, two watercolours and a chalk drawing at SS. London address.
Bibl: Ormond.

STANESBY, John Tatham fl.1833-1834
Exhib. a watercolour copy of a portrait of Richard II and five pen drawings at SS. London address.

STANESBY, Joshua fl.1821-1854
Painted portraits and figurative subjects. Exhib. 11 works at the RA including portraits and works entitled 'A Chelsea Pensioner' and 'An Aged Sempstress'. Also exhib. three works at the BI and three works at SS. London address.

STANESBY, Samuel fl.1850-1853
Exhib. two portraits at SS and a portrait and a painting of fowls at the RA. London address.

STANFIELD, C. fl.1890-1892
Exhib. two works 'A Sunny Day in October' and 'Farnham Common' at the RA. Address in Leeds, Yorkshire.

***STANFIELD, George Clarkson 1828-1878**
Painter of continental scenes; son of W. Clarkson Stanfield (q.v.). Exhib. at RA 1844-76, BI and elsewhere. Painted views in northern France, Holland, Germany, Switzerland and Italy; especially the Rhine and the Italian lakes. Occasionally painted English coastal views. Although he painted in a distinct and individual style, his works are sometimes confused with those of his father. He usually signed George Stanfield or G.C. Stanfield whereas his father usually signed C. Stanfield RA.
Bibl: See under Clarkson Stanfield.

***STANFIELD, (William) Clarkson RA 1793-1867**
Marine painter in oil and watercolour. Born in Sunderland. Entered merchant navy 1808; later pressed into the navy; discharged after an injury 1818. At first worked as a scenery-painter in theatres in London and Edinburgh, where he met his great friend David Roberts (q.v.). Began to exhib. easel pictures, and gave up scene painting in 1834. A close friend of Dickens, he produced much of the scenery for his private theatricals at Tavistock House. Exhib. at RA 1827-67, BI and SS. ARA 1832, RA 1835. Painted shipping, coastal and river scenes, both in England and the Continent, in a straightforward, realistic style. He was commissioned by William IV to paint 'The Opening of New London Bridge' and 'Portsmouth Harbour'. Probably his finest work was 'The Battle of Trafalgar', 1863, painted for the United Services Club in Pall Mall, and still in their possession. His studio sale was held at Christie's, 8 May 1868. His son George Clarkson Stanfield (q.v.) was also a painter.
Bibl: AJ 1857 pp.137-9; 1859 p.112; 1867 p.171; 1878 p.136; Gentleman's Magazine 4 July 1867; Studio Special Number, *British Marine Painting*, 1919; Studio Special Number, *Early English Watercolours by the Great Masters*, 1919; Apollo VII 1928 p.25; Connoisseur pls. in vols. 47-8, 63-4, 68, 71, 87; Ruskin, *Modern Painters I*; J. Dafforne, *C.S.*, 1873; C. Dickens, *The Story of a Great Friendship*, 1918 (letters); Redgrave, Dict., Cent.; Bryan; Binyon; Cundall; DNB; Hughes; VAM; Wilson pl.37; Pavière, Landscape pl.72; Hardie III pp.69-70 *et passim* (pls.85-6); Maas pp.61-2 *et passim* (pls. p.60-1); Hall; Ormond; Brook-Hart pl.68; Irwin; F.S. Richardson, *C.S.*, O.W.C.S. Annual XLIX p.30.
Exhib: London, Corporation AG 1967; Tyne and Wear Museums 1979, with Cat.

STANHOPE, G. fl.1861
Exhib. a subject from *Rob Roy* at the BI. London address.

STANIER, Henry fl.1847-1884 d.1892
Genre and flower painter. Lived in Birmingham but was for a time Vice-Consul in Granada, Spain. Exhib. at SS 1860-64. Painted historical genre, flowers and Spanish views. Exhib. mainly at RBSA. Also travelled in France, North Africa and Greece.

STANILAND, A.J. fl.1865
Exhib. a work entitled 'Little Nellie' at the BI. London address.

STANILAND, Charles Joseph RI 1838-1916
Painter of genre and historical subjects; illustrator. Born at Kingston-upon-Hull; studied at Birmingham School of Art, Heatherley's, South Kensington Schools, and the RA schools in 1861. He drew illustrations for *The Illustrated London News* and for *The Graphic*. Exhib. from 1861, at the RA from 1863, BI, SS, NWS (62 works) and elsewhere, titles at the RA including 'Fugitives for Conscience Sake', 1877 and 'The Relief of Leyden 1574', 1881. A of the RI 1875, RI 1879, resigned 1890, ROI 1883-96. The AJ illustrates a historical costume piece 'Henry III of France and the Dutch Envoys', 1884. The VAM has two watercolours: 'Stormy', 1880, two monks standing in a road, the one rebuking the other, and 'Scene near the Coast, with a Group round a Knife-grinder', 1877.
Bibl: AJ 1884 p.136 (pl.); Who's Who 1911; VAM; Wood, Paradise Lost.

STANILAND, G.S. fl.1858
Exhib. a work entitled 'Near Douglas Head' at the BI. London address.

STANLEY, Lady fl.1892-1903
(Miss Dorothy Tennant)
Painted figurative subjects. Exhib. four works at the RA including a portrait and works entitled 'The Bather' and 'The Forsaken Nymph'. London address. See also Miss Dorothy Tennant.

STANLEY, Archer fl.1847-1877
Landscape and architectural painter. Son of Caleb Robert Stanley (q.v.), landscape and architectural painter, and brother of Charles H. Stanley (q.v.). Exhib. 1847-77, at the RA 1847-71, SS and elsewhere, titles at the RA including 'Study of Beech Trees in Knowle Park', 1847 and 'Approaching Storm in the Highlands', 1853.

STANLEY, C.P. fl.1844
Exhib. a portrait and a street scene in Rome at the RA. London address.

STANLEY, C.W. fl.1848
Exhib. a portrait at the RA. London address.

***STANLEY, Caleb Robert** 1795-1868
Landscape painter and watercolourist. Father of Archer Stanley and Charles H. Stanley (qq.v.). Honorary Exhibitor at RA 1816-63, mainly exhib. at BI (87 works), SS, OWS, NWS. etc. Many of his works are topographical views of towns in England, Scotland, France, Holland and Germany. Works by him are in the VAM and the National Gallery, Dublin. His studio sale was held at Christie's, 19 March 1869.
Bibl: AJ 1868 p.73; Redgrave, Dict.; Bryan; Cundall; VAM Cats. 1907-8; M.H. Grant, *English Landscape Painters*, 1925 p.311; Pavière. Landscape pl.73.

STANLEY, Charles H. fl.1824-1860
Exhib. landscapes and genre at RA 1824-58, BI and SS. Son of Caleb Robert Stanley (q.v.).

STANLEY, Mrs. H.M. see STANLEY, Lady

STANLEY, Harold John 1817-1867
Exhib. three works at the RA including 'The Widow' and 'Doing Business', and works at SS and the BI. Born in Lincoln. Died in Munich, Germany.
Bibl: Bryan.

STANLEY, Miss Kate fl.1879-1893
Exhib. four works at SS including 'Near Chilham, Kent' and 'Thawing'. London address.

STANLEY, Miss M. fl.1875-1877
Exhib. a work entitled 'A Puritan Girl' at SS. London address.

STANLEY, Miss Sara fl.1895-1902
Exhib. two works, both views in Venice, at the RA. London address.

STANMORE, H. fl.1864-1868
Painted landscape and views of Italy. Exhib. three watercolours at SS, including 'Derwentwater' and 'Campagna di Roma', and two works at the RA. London address.

STANNARD, Miss A. fl.1859
Exhib. 'French Partridges' at the RA and 'The Mallard' at the BI. Address in Norwich.

STANNARD, Mrs. A.G. fl.1855
Exhib. two paintings of game at SS. London address.

STANNARD, Alexander Molyneux 1878-1975
Bedford landscape painter. Son of Henry Stannard and younger brother of Henry J.S. Stannard (qq.v.) whose style he followed.

***STANNARD, Alfred** 1806-1889
Norwich landscape and marine painter. Brother and pupil of Joseph Stannard (1797-1830); father of Alfred George Stannard and Eloise Harriet Stannard (qq.v.). Exhib. at BI 1826-60 and SS. Titles at BI mostly views around Norwich and some on the coast near Yarmouth. Works by him are in Norwich Museum.
Bibl: Studio Special Number 1920, *Norwich School*, pl.69; Connoisseur LXVI 1923 pp.129, 178; LXVII 1923 pp.164, 176; DNB; The Year's Art 1890 p.229; W.F. Dickes, *The Norwich School of Painting*, 1905 pp.534-9; Pavière, Landscape pl.74; H.A.E. Day, *East Anglian Painters*, III pp.177-89; Ormond.

STANNARD, Alfred George 1828-1885
Norwich landscape painter. Son of Alfred Stannard and brother of Eloise Harriet Stannard (qq.v.). Exhib. at RA 1856-9, BI and SS. Titles at RA 'The Village Brook', 'Woodlands', 'A Sunny Afternoon', etc. Works by him are in Norwich Museum.
Bibl: W.F. Dickes, *The Norwich School of Painting*, 1905 p.539ff.; M.H. Grant, *English Landscape Painters*, 1925 pp.196, 237; H.A.E. Day, *East Anglian Painters*, III pp.191-205; Brook-Hart.

***STANNARD, Miss Eloise Harriet** fl.1852-1893
Norwich still-life painter. Eldest daughter of Alfred Stannard and sister of Alfred George Stannard (qq.v.). Exhib. pictures of fruit and flowers at RA 1856-93, BI, SS and elsewhere. Three works by her are in Norwich Museum. Member of the Society of Lady Artists. Her pictures of fruit are often compared to those of George Lance (q.v.) who was an admirer of her work. Sometimes confused with Emily Stannard (q.v.).
Bibl: AJ 1859 p.170; W.F. Dickes, *The Norwich School of Painting*, III 1969 pp.207-21 .

STANNARD, Emily 1803-1885
(Miss Emily Coppin)
Still-life painter. Born Emily Coppin, she married Joseph Stannard in 1826. After his death in 1830 she continued to be known as Mrs. Joseph Stannard. Exhib. four works at BI 1832-3, otherwise exhib. mainly in her native Norwich. She painted meticulous fruit and flower pieces, in a traditional Dutch style.
Bibl: H.A.E. Day, *East Anglian Painters*, III pp.223-33.

STANNARD, Emily 1875-1907
Bedford landscape painter. Daughter of Henry Stannard (q.v.). Exhib. at RA 1900-3, but died prematurely.

STANNARD, Henry RBA 1844-1920
Bedford landscape and sporting artist. Son of John Stannard (q.v.) and father of Henry J. S., Alexander M., Emily, Lilian and Ivy Stannard (qq.v). Founded the Bedford Academy of Arts in 1887. exhib. at RA 1902-15 and at SS and Dudley Gallery.

***STANNARD, Henry John Sylvester** RBA RSA 1870-1951
Bedford landscape painter. Son of Henry Stannard (q.v.). Painted landscape and rustic subjects. Exhib. 15 works at the RA including 'The Old Homestead', 'The Trees Began to Whisper' and 'The Trysting Lane'. Also exhib. eight works at SS. Studied at South Kensington. Address in Flitwick, Bedfordshire. His most characteristic works are cottage and village scenes painted in the tradition of Birket Foster.
Bibl: Anthony J. Lester, *H.J.S. Stannard RBA, RSA, His Life, Work and Family*, Antique Finder September 1976; A.J. Lester, *The Stannard Family*, 1983; Wood, *Painted Gardens*.

STANNARD, Ivy 1881-1968
(Mrs. Horn)
Bedford landscape painter. Daughter of Henry Stannard (q.v.). Ran the Bedford Academy of Art for many years and exhib. twice at RA in 1912 and 1916.

STANNARD, John 1794-1882
Bedfordshire painter of landscapes and wall-decorations. Father of Henry Stannard (q.v.).

STANNARD, Lilian 1877-1944
(Mrs. Silas)
Painter of garden scenes, usually in watercolour, in a style similar to that of her brother Henry John Sylvester Stannard (q.v.). Exhib. at RA 1902-30, and RI.
Bibl: See under H.J.S. Stannard.

STANNARD, Theresa Sylvester 1898-1947
(Mrs. Dyer)
Bedford painter of garden scenes and flowers, usually in watercolour. Daughter of Henry J.S. Stannard (q.v.). Exhib. at RA, RI and Society of Women Artists.
Bibl: See under H.J.S. Stannard.

STANNARD, William John fl.1848
Exhib. a watercolour of cottages near Ipswich at SS.

STANNUS, Anthony Carey fl.1862-1903
London painter of genre, marines and landscapes, who exhib. 1862-1903, at the RA 1863-1903, BI, SS, GG and elsewhere, titles at the RA including 'A Young Skipper', 1863, 'View of the City of Mexico', 1868 and 'Evening on the Dogger Bank', 1902. He painted several watercolours (in VAM) of offices and houses at the South Kensington Museum, dated 1863, e.g. 'Lord Talbot's house, used for Male Schools and Barracks', and 'Refreshment Room, erected by the Commissioners of the Exhibition in 1851'.
Bibl: The Year's Art 1911 p.537; VAM.

STANNUS, Caroline fl.1883
Exhib. a watercolour of gladioli at SS. London address.

STANNUS, Hugh Hutton 1840-1908
Painted architectural subjects. Exhib. at the RA in 1886.
Bibl: Portfolio 1884 p.223.

STANTON, Elizabeth fl.1879
Exhib. a watercolour entitled 'Ninetta' at SS. London address.

STANTON, George Clark ARSA 1832-1894
Exhib. a watercolour entitled 'Out for a Ramble' at SS. Address in Edinburgh. Painted figurative subjects, and was also a sculptor.

STANTON, Miss Rose Emily 1838-1908
Painted animals and still-life. Exhib. seven works at the RA including 'Hedgehog and her Young' and 'Plums in Danger'. Address in Stroud, Gloucestershire.

STANTON, Miss Sandys fl.1893
Exhib. a painting of flowers at the NWS. Address in Leicester.

STANTON, Miss Sarah fl.1843-1848
Painted figurative subjects. Exhib. three works at the RA including 'Contemplation' and 'She is Far From the Land — Moore's *Melodies*', three works at SS and one work at the BI. London address.

STAPLE, J. fl.1839
Exhib. a painting of fruit at SS. Address in Chatham, Kent.

STAPLES, John C. fl.1876-1880
Exhib. six landscapes 1876-80. Address in Hedingham.

STAPLES, Mrs. John C. b.1839 fl.1862-1908
(Miss Mary Ellen Edwards; Mrs. Freer)
Painter and illustrator. Exhib. at RA 1862-1908 under her maiden name, and later under both married names; also exhib. at BI, SS and elsewhere. Titles at RA mostly romantic genre, e.g. 'The Last Kiss', 'The First Romance', 'Our Village Beauty', etc. She also illustrated many books and priodicals, including *Good Words, Cornhill Magazine, The Graphic, The Illustrated London News,* etc. In 1866 she married John Freer, who died in 1869. In 1872 she married John Staples. Her main works are listed in Clayton (see bibl.).
Bibl: Clayton II pp.75-80; W. Shaw-Sparrow, *Women Painters of the World,* 1905; Gleeson White, see index.

***STAPLES, Sir Robert Ponsonby, 12th Bt. 1853-1943**
Irish painter of portraits, genre and landscape, living in Cookstown, Co. Tyrone. Studied at the Louvain Academy of Fine Arts 1885-70; under Portaels in Brussels 1872-4; at Dresden 1867; visited Paris 1869, Australia 1879-80. Exhib. from 1875 at the RA, SS, GG and elsewhere. Served as Art Master at the People's Palace, Mile End Road, 1897; Member Union International des Beaux-Arts; the Belfast Art Society. Works include: 'Guilty or Not Guilty?' 1883, 'The Emperor's Farewell: The Dying Emperor Wilhelm I',1888, 'The Last Shot for the Queen's Prize — Wimbledon', 1887 (Worthing Municipal Gallery), 'Mr. Gladstone Introducing the Home Rule Bill, 13th Feb. 1893', portraits of Mr. Labouchère, J. McNeill Whistler and A.C. Swinburne (NPG); the Queen and Edward VII; and two triptychs, illustrating 'Shipbuilding' for New City Hall, Belfast. A collection of his works was sold at Phillips, 11 June 1991.
Bibl: BM Cat. of Engraved British Portraits VI 1925 p.552; Who Was Who 1941-50; *Drawings by Sir R.P.S.,* Cat. of exhib. David Messum Gallery, London, 1991.

STAPLETON, Mrs. George fl.1880-1885
Exhib. a still-life at the NWS. London address.

STAPLETON, W. fl.1845-1857
Exhib. four watercolours including views on the River Dove and on the Isle of Wight at SS. London address.

STAPYLTON, H.E.E. fl.1856
Exhib. a work entitled 'The Peace of Evening' at the RA.

STARK, Mrs. A.J. (R. Isabella) fl.1880-1889
Exhib. a still-life at the NWS. London address.

STARK, Arthur James 1831-1902
Landscape and animal painter. Son of James Stark (q.v.). Pupil of his father, also of Edmund Bristow (q.v.) and RA schools. In 1874 studied with F.W. Keyl (q.v.), animal painter to Queen Victoria. Exhib. at RA 1848-83, BI, SS, NWS and elsewhere. His pictures are usually rustic scenes with farm workers and animals. He lived in Windsor and London, but in 1886 moved to Nutfield, Surrey, where he died. Works by him are in Norwich, Glasgow, VAM and BM.
Bibl: AJ 1859 pp.82, 168; Cundall; DNB; W.F. Dickes, *The Norwich School of Painting,* 1905 p.492ff.; VAM Cat. 1907-8; H.A.E. Day, *East Anglian Painters,* II pp.78-90.

STARK, F.M. fl.1892-1893
Exhib. two works, 'Messmates' and 'Sorrento Lane', at SS. Address in Chagford, Devon.

STARK, Mrs. Flora M. fl.1896-1897
Exhib. two works, 'Trying on the Communion Veil' and 'Moonlight and Lamplight — Asolo', at the RA. Address in Torquay, Devon.

***STARK, James 1794-1859**
Norwich landscape painter and watercolourist. Born in Norwich. Studied with John Crome (q.v.) 1811-14. Exhib. at Norwich Society, of which he became a member. Entered RA schools 1817. Exhib. mostly at BI (136 works), also RA 1831-59, SS, OWS, NWS and elsewhere. His style owes much to his master, Crome. Like him, he painted English landscapes, with animals and rustic figures. Due to illness he returned to Norwich for 12 years, returning finally to London in 1830. His son Arthur James Stark (q.v.) was also a painter.
Bibl: AJ 1850 p.182; 1859 p.135; Portfolio 1897 pp.23-4, 37, 42, 46; 93; Studio Special Number 1920, *The Norwich School*, pp.53-7; W.F. Dickes, *The Norwich School of Painting*, 1905; Redgrave, Dict., Cent.; Roget; Bryan; Binyon; Cundall; DNB; VAM; Pavière, Landscape pl.75, Clifford; Hardie II p.68 *et passim* (pls. 55-6); Maas p.57 (pl. p.55); H.A.E. Day, *East Anglian Painters*, II pp.56-77; Ormond; Brook-Hart.
Exhib: Norwich, *Works of the late James Stark*, 1887.

STARK, James Arthur
Painted landscape, mainly in watercolour. Son of Arthur James Stark (q.v.). Lived in Norfolk and London.

STARK, Mrs. Rose Isabella
(Miss Fassett Kent)
Painted landscape, portraits and still-life. Wife of Arthur James Stark (q.v.).

STARKEY, William Henry fl.1867-1909
Birmingham painter of fruit, landscape and coastal scenes. Exhib. 87 pictures at RBSA. His wife also exhib. there 1874-9. under the name Mrs. W.H. Starkey, painting similar subjects.

STARKIE, Miss Edyth fl.1893-1899
Exhib. four works at the RA including 'Miss M.D.', 'Lilla' and 'St. Cecilia'. London address.

STARLING, Albert fl.1878-1922
Genre, marine and portrait painter, living in Sutton, Surrey. Exhib. from 1878, at the RA from 1884, SS, NWS and elsewhere, and still exhibiting in 1922. Titles at the RA include 'Student Days', 1885, 'Saved from the Sea', 1888 and 'Called to the Lifeboat', 1891. Represented in the Walker AG, Liverpool.
Bibl: RA Pictures 1892 p.92 (pl.); The Year's Art 1923 p.528.

STARLING, Miss Marion A. fl.1883
Exhib.'A Little China Pot with Ferns' at the RA. Address in Brighton, Sussex.

STARR, Miss Louisa 1845-1909
(Mme. Canziani)
Painter of portraits and figure subjects. Exhib. at RA, SS, NWS, GG and the Society of Lady Artists, both as Miss Starr and Mme. Canziani.
Bibl: AJ 1871 p.l00; Clayton II pp.133-5; W. Shaw-Sparrow, *Women Painters of the World*, 1905; The Year's Art 1910 p.389; *Royal Academy Pictures Illustrated* 1893-6; Ormond.

STARR, Sidney RBA NEAC 1857-1925
Painter of genre, portraits, landscape and decorative subjects. Born in Kingston-upon-Hull, Yorkshire, died in New York. Exhib. 1872-89, at the RA 1882-6, SS, NWS, GG and elsewhere, titles at the RA including 'George Wilkinson MA', 1882, 'Sketch, the Fan', 1885

and 'Finchley Road, N.W.', 1886. Awarded bronze medal, Universal Exposition, Paris, 1889. Later he moved to New York. His decorative works include mural decorations for Grace Chapel, New York and 24 figures in the Congressional Library, Washington, D.C.
Bibl: AJ 1890 p.154 (pl.); BM Cat. of Engraved British Portraits IV 1914 p.476; American Art Annual XXII 1925 p.304; Studio XCII 1926 p.42; M. Fielding, *Dictionary of American Painters, Sculptors and Engravers*, 1965.

STATHAM, Henry Heathcote 1839-1924
An architect who exhib. architectural views and designs at the RA 1872-1904 including 'West Front, Tewkesbury Abbey' and 'St. Paul's Cathedral'. Address in Liverpool.

STAYNES, Percy Angelo RI ROI 1875-1953
Painter, illustrator and designer. Studied at Manchester School of Art, at the RCA and at the Académie Julian.

STEAD, Frederick b.1863 fl.1892-1903
Landscape and genre painter. Exhib. at RA 1892-1903. Titles: 'Shades of Evening', 'The Magic Crystal', 'The Princess and the Frog', etc. He lived at Bradford and works by him are in the Museum there, and at Preston AG.
Bibl: AJ 1893 p.157; Who's Who in Art.

STEADMAN, J.T. fl.1887-1891
Exhib. three works at SS including 'Interior of a Farmhouse' and 'Off the Limestone Rocks, Port St. Mary'. Address in Liverpool.

STEAVENSON, C.H. fl. late 19th century
Painted landscape watercolours. Lived and worked in Gateshead, Co. Durham.
Bibl: Hall.

STEBBING, Mrs. G. fl.1861
Exhib. a work entitled 'Maidenhood' at the RA. London address.

STEDMAN, W. fl.1858
Exhib. two works at SS. London address.

STEEDMAN, Amy fl.1856
Exhib. two watercolour still-lifes of fruit at SS. London address.

STEEDMAN, Charles fl.1826-1858
Painter of genre and landscape and coastal scenes chiefly in Scotland and the Isle of Wight. Exhib. 1826-58, at the RA 1826-55, BI and SS, titles at the RA including 'Coast Scene, Forfarshire', 1846, 'A Fish Girl', 1847 and 'The Hay Binder', 1853.
Bibl Wilson; Brook-Hart.

STEEL, John Sydney 1863-1900
Painted game and sporting subjects. Studied at the Slade School. Exhib. six subjects at the RA including 'Hunting the Irish Elk' and 'Dead Teal', and five subjects at SS. Born and lived in Perth.

STEELE, Adeline fl.1847
Exhib. one work 'A Hunter in the Illinois' at the RA. Address in St. Louis, U.S.A.

STEELE, J.S. fl.1858
Exhib. a view of Beddington House, Surrey, in watercolour at SS. Address in Reigate, Surrey.

STEELE, Miss Mary E. fl.1868-1874
Exhib. a work entitled 'Mischief' at SS. Address in Reigate, Surrey.

STEELL, David George ARSA 1856-1930
Painted animals and sporting subjects. Exhib. 'Sporting Dogs' at the RA. Son of Gourlay Steell (q.v.). Studied at Edinburgh School of Art and at the RSA. Lived in Edinburgh.

***STEELL, Gourlay RSA 1819-1894**
Scottish animal painter. Son of John Steell, an Edinburgh engraver, and brother of Sir John Steell, a sculptor. Studied at Trustees' Academy and with R.S. Lauder (q.v.). Exhib. at RA 1865-80, RSA 1832-94. ARSA 1846, RSA 1859. Appointed painter to the Highland and Agricultural Society, and also Animal Painter for Scotland by Queen Victoria, after the death of Landseer in 1873. This prestige ensured him a virtual monopoly of animal and sporting commissions in Scotland. He also painted genre and historical scenes.
Bibl: AJ 1893 p.125; DNB; Caw pp.198-9; Irwin.

STEEN, Miss Annie fl.1890-1915
Birmingham painter of landscape, portraits and figure subjects. Exhib. 45 works at RBSA.

STEEPLE, Miss Georgiana fl.1863-1874
Birmingham painter of landscapes and rustic scenes. Probably a sister of John Steeple (q.v.). Exhib. 47 works at RBSA.

STEEPLE, John RI RBSA fl.1846-d.1887
Painter of landscape and coastal scenes, living in Birmingham and London, who exhib. 1852-86, at the RA 1852-79, SS, NWS and elsewhere. Titles at the RA include 'The Ford — a Scene on the Dee', 1852, 'Mountain and Moorland, N. Wales', 1874 and 'Curfew', 1879. In the VAM is a watercolour 'Squally Weather on the Welsh Coast'. RBSA in 1862.
Bibl: VAM; Birmingham Cat.; Wilson.

STEER, Miss Fanny fl.1833-1842
Painted landscape watercolours. Exhib. 25 works at SS including views in Malvern and on the Malvern Hills. May be the same as Miss Fanny Steers (q.v.).

STEER, Henry Reynolds RI RMS 1858-1928
Landscape and genre painter and watercolourist. Pupil of Heatherley's 1879-88. At first a lithographer; turned later to oils and then watercolours. He painted literary and historical genre, especially scenes from Dickens, Sheridan and Pepys; also landscape. Exhib. mainly at NWS, also RA 1888-95, SS and elsewhere. Works by him are in Liverpool and Leicester AGs.
Bibl: Connoisseur LXXXVII 1931 p.141; Cundall; Who Was Who 1916-28, 1929.

STEER, P. fl.1854
Exhib. a landscape in 1854.

***STEER, Philip Wilson OM NEAC 1860-1942**
Painter of landscape, genre and portraits. Born in Birkenhead, Cheshire. Studied at Gloucester School of Art under John Kemp. Entered Académie Julian, Paris, 1882. Returned to London 1884. During this period he painted coastal and beach scenes with figures, mainly at Walberswick and on the French coast. These are generally considered to be his best works, and are among the most interesting Impressionist paintings produced by an English artist. In 1886 Steer joined the newly-formed NEAC, where he continued to exhib. for many years. Also exhib. at RA from 1883, SS and GG. Contributed to London Impressionists exhib. at Goupil Gallery in 1889. One-man show at Goupil Gallery 1894. After 1900 he turned increasingly to landscape painting. He rarely travelled abroad, preferring to make annual sketching tours of various parts of England, especially Yorkshire. Although Impressionist in technique, his work of this period can be seen as a continuation of the English landscape tradition of Constable and Turner. Steer was teacher of painting at the Slade School for nearly 40 years. His studio sale was held at Christie's, 16-17 July 1942.
Bibl: AJ 1906 pp.231-6; Burlington Mag. XV 1909 pp.225-7; Studio XXIV 1902 pp.263-6; XXXVIII 1906 pp.225-7; XLVI 1909 pp.259-66; also see indexes to vols. LIII, LIV, LXI, LXV and C; Apollo IV 1926 pp.28-31; XXI 1935 pp.290-2; Artwork V 1929 pp.3-22; VAM; Who's Who; Who's Who in Art 1934; R. Ironside, *P.W.S.*, 1943; D.S. MacColl, *P.W.S.*, 1945 (with Cat. of works); Arts Council exhib. Cat. 1960; Reynolds, VP pp.194-5 (pl. 135); Maas pp.250-2 (pls. pp.169, 171, 25l); Irwin; Bruce Laughton, *P.W.S., 1860-1942*, 1971.
Exhib: London, Barbizon House 1934; 1935; Palser Gallery 1937; Barbizon House 1937, 1939; Fine Art Society 1942; Great Britain, Council for the Encouragement of Music and the Arts 1943-4; London, National Gallery 1943; Tate Gallery 1943; Leeds, Temple Newsham 1944; London, Adams Gallery 1949; Birkenhead, Williamson Art Gallery l951; Great Britain, Arts Council, 1960; London, Fine Art Society 1968.

STEERS, A. fl.1837
Exhib. a portrait of the Marquess of Chandos at the RA. Address in High Wycombe, Buckinghamshire.

STEERS, Miss Fanny fl.1846-1860 d.1861
London landscape painter, who exhib. 1846-60 at the NWS (59 works), of which she was a member. Also exhib. in Birmingham.
Bibl: Cundall.

STEFFELAAR, Nico fl.1885
Exhib. three works at SS including 'Maternal Delight' and 'Will you come on my Lap'. London address.

STEIL, Henry fl.1836-1838
Exhib. two works at SS, 'The Guardian' and 'The Dying Saxon', and three works at the BI. London address.

STEIN, Miss Lillie fl.1900-1903
Exhib. a painting of chrysanthemums and another at the RA. London address.

STEIN, Robert fl.1813-1843
Painted landscape and castles. Exhib. five works at SS including views of Tintern Abbey and Windsor Castle, five works at the BI including views of Roslin and Chepstow Castles, and three landscapes at the RA. Address in Edinburgh.

STEINMETZ, John Henry fl.1840-1884
Exhib. two views in Rome, one a view of St. Peters, at the RA. London address.

STENT, Frederick Warburton fl.1846
Exhib. a view of Milan Cathedral at the RA. London address.

***STEPHANOFF, Francis Philip 1790-1860**
Painter of genre, historical, biblical and literary subjects, both in oil and watercolour; illustrator; architectural draughtsman. Son of Fileter N. Stephanoff, a Russian painter of portraits and stage scenery, who had settled in London. Entered the RA schools in 1801; exhib. 1807-45 at the RA, BI, SS, OWS and elsewhere, titles at the RA including 'Answering an Advertisement — Wanted a respectable female, as housekeeper to a middle aged gentleman of serious and domestic habits', RA 1841 (now in Glasgow AG). His

best works were 'The Trial of Algernon Sidney', 'Cranmer Revoking his Recantation' and 'The Reconciliation'. He furnished most of the costume portraits for George Naylor's sumptuous work on the *Coronation of George IV* (now in VAM), and obtained a premium of £100 at the Westminster Hall Competition in 1843 for a scene from Milton's *Comus.* Both he and his brother James Stephanoff (q.v.) were men of learning as well as artists, and were considered "two of the best dilettante violins of the day". They worked as architectural draughtsmen in close association with A.C. Pugin and C. Wild, and were among the illustrators of Pyne's *Royal Residences,* 1819. They also contributed humorous and sentimental subjects to the popular annuals of the period — the *Literary Souvenir, Forget-Me-Not, The Keepsake* and others.

Bibl: AJ 1860; 1902 pp.193-4; Ottley; Redgrave, Dict.; Roget; Burlington Mag. VII 1905 p.265; Binyon; Cundall; DNB; VAM; BM Cat. of Engraved British Portraits VI p.552; The BM Quarterly VIII 1933-4 p.140 (with pls.); IX 1934-5 p.104; Reynolds, VS p.52 (fig. 9 Francis); Hardie III p.l6 (pl.18 James, pl.19 Francis); Wood, Panorama p.133 (pl.136).

STEPHANOFF, James 1788-1874

Painter of historical, biblical and literary subjects, exclusively in watercolour; illustrator; architectural draughtsman. Elder brother of Francis Philip Stephanoff (q.v.). Trained for a short time from 1801 at the RA schools; exhib. 1810-59, at the RA 1812-49, BI, SS, OWS (245 works) and elsewhere. Became a member of the OWS in 1819 and retired in 1861 owing to ill-health. He was one of the founders of the Sketching Society. In 1830 he was appointed Historical Painter in Watercolours to William IV. He also contributed to Naylor's *Coronation of George IV. His* subjects, like those of his brother, were largely taken from the Bible, from legends and from the poets, and he excelled in the representation of public ceremonies and historical incidents which required the skilful grouping of large numbers of figures .

Bibl: See under F.P. Stephanoff; Ormond.

STEPHANY, L. fl.1861-1862

Exhib. two works 'Foggy Day, Ostend' and 'On the Stour' at the BI. London address.

STEPHENS, C. fl.1859

Exhib. a work entitled 'Nant Mill' at the BI. London address.

STEPHENS, C.V. 1840-1879

Painted landscape. Exhib. three works at the BI and four works including views in Wales and Hampstead at the RA. London address.

STEPHENS, Miss E. fl.1839-1844

Painted landscape and figurative subjects. Exhib. eight works at SS including 'Sketch from the Spaniard's, Hampstead' and 'The Bridal Toilet'. London address.

STEPHENS, Miss Emily H. fl.1880-1893

Exhib. two rustic subjects at the GG. London address.

*STEPHENS, Frederick George 1828-1907

Critic, writer and painter; member of the Pre-Raphaelite Brotherhood. Stephens and W.M. Rossetti were the two non-artistic members, but Stephens did make a few attempts at painting between 1848 and 1850. He exhib. at the RA in 1852 and 1854, both portraits. Most of his works are in the Tate Gallery. He wrote for *The Germ,* and devoted the rest of his life to art criticism. He was art editor of *The Athenaeum* for over 40 years, and wrote many

catalogues and monographs on artists, including W. Mulready, Alma-Tadema, Landseer and Samuel Palmer (qq.v.).

Bibl: AJ 1907 p.158; Athenaeum 1907 No. 4142; J.B. Manson, *F.G.S. and the Pre-Raphaelite Brothers,* 1920; Basil Taylor, *F.G.S. and PRB,* Architectural Review CIV October 1948 pp.171-8; R.Glynn Grylls, *The Correspondence of F.G.S.,* Times Literary Supplement No. 2875-6; Fredeman Section 39 and index for full bibl.; Reynolds, VP; Maas; Staley.

STEPHENS, Miss Helen E. fl.1892

Exhib. a portrait at SS. London address.

STEPHENS, Miss Lettice fl.1890-1892

Exhib. a watercolour view on the Thames and another work at SS. Address in Beckenham, Kent.

STEPHENS, O.L. fl.1872

Exhib. two works, 'Declining Years' and 'Golden Plover', at SS. London address.

STEPHENSON, G. fl.1845

Exhib. a Welsh landscape watercolour at SS. London address.

STEPHENSON, Miss Isabel H. fl.1883-1887

Painted flowers. Exhib. six works at SS including 'Orchids and Azaleas' and 'Daffodils'. London address.

STEPHENSON, Mrs. P.A.F. fl.1896-1899

Exhib. two works, 'A Buddhist Monastery in the High Himalayas' and 'In a Berkshire Garden', at the RA. Address in Fermoy.

STEPHENSON, Willie RCA fl.1896-d.1938

Painted landscape. Exhib. five works at the RA 1896-1901 including 'Sunlight and Shade' and 'The Ruined Castle of the Summit'. Studied at Huddersfield Technical College and at South Kensington. Member of the Liverpool Academy of Arts. Lived in Llandudno and later at Wem, Salop.

STERLING, E.C. fl.1867-1877

Exhib. three works, including a portrait and a view of the Nile Valley at the RA. London address.

STERLING, Miss Frances fl.1894-1899

Painted genre subjects. Exhib. four works at the RA 1894-9 including 'Simultaneous Chess' and 'Grandmama's Picture Book'. London address.

STERLING, Miss Helen fl.1870-1882

Painted figures and flowers. Exhib. 'A Cornish Girl' at the RA and three paintings of flowers, two of them watercolours, at SS. London address.

STERN, Marcus fl.1865

Exhib. a watercolour entitled 'A Lady of Queen Elizabeth's Time' at SS. London address.

STERN, Miss Sophie T. fl.1894-1896

Exhib. three works at the RA 1894-6, including 'Lamplight Impression' and 'Audine'. Address in Brighton, Sussex.

STERNDALE, O.J. fl.1875-1881

Painted landscape. Exhib. three works at SS including 'The High Tor, Matlock' and 'In Chatsworth Woods'. Address in Bakewell, Derbyshire.

STERRY, Ida S. fl.1892
Exhib. a view in Croydon at SS. Address in Croydon, Surrey.

STERRY, John Ashby- fl.1858-1892
Exhib. a work entitled 'Bound for the Sea' at the BI. London address.

STEUART, Miss Alice M. Gow- fl.1887-1900
Exhib. two works, 'Head of a Sailor' and 'Forsaken', at the RA. London address.

STEVENS, Albert fl.1872-1902
London landscape painter. Exhib. mainly at SS, also RA 1877-1902, NWS, GG and elsewhere. Titles at RA include English views, also Switzerland and Italy.

STEVENS, Mrs. Albert fl.1889-1894
(Miss Mary Draper)
Painted animals and landscape. Exhib. five works at the RA 1889-94, including 'How I Wonder What You Are' and 'An Alpine Meadow'. London address.

***STEVENS, Alfred George 1817-1875**
Painter, sculptor, decorator and architectural designer — one of the greatest of all English craftsmen and designers. Born in Blandford, the son of a house painter. In 1833 some friends subscribed to send him to Italy where he lived for nine years, studying and copying. In Rome he studied under Thorwaldsen. After his return to England he worked 1845-7 at the Government School of Design, Somerset House. In 1850 he moved to Sheffield to work as designer for Hoole & Robson, a firm of metal-workers. Stevens was primarily a designer and decorator — among the houses where he worked were Dorchester House, Harewood House and Deysbrook Hall. He produced very few oil paintings, mostly portraits, but many of his drawings, watercolour plans and designs, and bronze models survive. He was a superb draughtsman, and his nude studies in red chalk are among the finest of their kind in English art. Exhib. sculpture at the RA in 1874 and 1876 only. His most famous commission was the Wellington Monument in St. Paul's Cathedral, on which he began work in 1858, which was unfinished at his death. The long years of struggle with unsympathetic officials and the financial hardship which this commission involved eventually undermined his health, causing his tragic early death. The monument was completed to his designs by pupils — among them Hugh Stannus (q.v.) and James Gamble. An exhib. of his work was held at the Tate Gallery in 1950. (Alfred Stevens should not be confused with the Belgian painter of coastal scenes and interiors, Alfred Stevens, whose dates are 1823-1906.)
Bibl: L'Art 1880 (article by W. Armstrong, published as book 1881); Portfolio 1890 pp.127-32; AJ 1875 p.232 (obit.); 1902 p. 385ff.; 1903 p.340ff.; Burlington Mag. XIV 1908-9 pp.266-77; Architectural Review 1903, 1911; Redgrave, Dict.; Bryan; Binyon; DNB; VAM; Reynolds, VS p.87 (pl.71); Hardie III p.128 (pl.155); Maas p.168 et passim (pls. pp.12, 13, 171, 211, 213); Ormond; Susan Beattie, Cat. of A.S. exhib., VAM 1975 (with further bibl.); Strong; K.R. Towndrow, A. Stevens (no date).

STEVENS, Frederick fl.1878
Exhib. a drawing in 1878. London address.

STEVENS, George fl.1810-1865
Still-life and animal painter. Exhib. at SS (246 works), also RA 1810-61, and BI. Titles at RA include still-life pictures of game and fruit; also animal pictures, especially horses and cats.

STEVENS, John RSA 1793-1868
Scottish genre and portrait painter. Born at Ayr; studied at the RA Schools, where he obtained two silver medals in 1818. After

practising portraiture for a time at Ayr he went to Italy, where he spent the chief part of his artistic career. Foundation member of the RSA. He exhib. in London 1815-64, at the RA 1815-57, BI and SS, titles at the RA including 'Italian Costume', 1823, 'Capuchin Friar', 1834 and 'Portrait of a Lady of Quality', 1851. 'The Standard-Bearer' is in the National Gallery, Edinburgh. He died in Edinburgh after a railway accident in France. The AJ says of his 'Scene at Bethlehem — the Infant Jesus Sleeping Watched over by an Angel' SS 1859: "The treatment and tone of the picture seem to be suggestive of the Bolognese School."
Bibl: AJ 1859 p.141; Redgrave, Dict.; Bryan; BM Cat. of Engraved British Portraits II 1910 pp.409, 658; Ormond.

STEVENS, Joseph Herbert b.1847 fl.1900
Exhib. two landscapes including one in North Wales, at the RA. Address in Liverpool.

STEVENS, Miss Kate fl.1891-1898
Painted flowers. Exhib. four works at the RA including 'Daffodils' and 'Fire-Coloured Azaleas'. Address in Derby.

STEVENS, P.H. fl.1849
Exhib. one work 'Hudibras's Epistle to the Widow' at the BI. Address in Eton, Berkshire.

STEVENS, Miss Susanna fl.1887
Exhib. a portrait at the GG.

STEVENS, Thomas fl.1891-1893
Exhib. 'Moonlight — A Sheepfold' at the RA and 'After Harvest' at SS. Address in Thames Ditton.

STEVENS, Walter Rupert fl.1874-1891
London landscape painter, who exhib. 1874-91, at the RA 1885-91, SS, NWS, NG and elsewhere, titles at the RA including 'A Surrey Common', 1885, 'A Sussex Hayfield', 1889 and 'March', 1891.

STEVENS, William K. fl.1877-1902
Painted landscape and figurative subjects. Exhib. nine works at the RA including 'Golden October', 'After the Storm' and 'Two's Company', and eight works at SS. London address.

STEVENSON, Ida fl.1891
Exhib. a view of Santa Croce, Florence, at SS. London address.

STEVENSON, Robert Alan Mowbray 1847-1900
Painted landscape and country subjects. Exhib. five works at the RA including 'Wood Alley in December' and 'Smelt Fishers on the Seine'. Born in Edinburgh. Died in Chiswick, London. An influential critic and art historian.
Bibl: DNB; Who Was Who 1897-1915; R.A.M. Stevenson, The Art of Velazquez, revised edition with a biographical study of the author, 1962.

STEVENSON, Robert Macaulay RSW 1860-1952
Painted landscape including moonlight scenes in the style of Corot. Exhib. two works, 'Golden Days' and a landscape, at the RA. Address in Glasgow.
Bibl: P. Bate, The Work of R.M. Stevenson, Studio XXII 1901; D. Martin, The Glasgow School, 1902; Caw; Studio XXXI 1904 p.64; XXXII 1904 pp.162, 163; XXXIV 1904 pp.343, 345; XLIII 1908 p.322; LIX 1913 p.229; LX 1914 p.151; LXVI 1916 p.215; Irwin.

STEVENSON, T. or F.W. fl.1880
Exhib. a genre subject in 1880. Address in Iver, Buckinghamshire.

STEVENSON, Walter Grant fl.1876-1883
Painted figurative subjects. Exhib. five works, including 'Picking Up a Living', 'At Home' and a statuette at SS, and three works at the RA. London address.

STEVENSON, William Grant RSA 1849-1919
Sculptor; painter of animal subjects. Brother of David Watson Stevenson (1842-1904), sculptor. Studied at the Royal Institution, Edinburgh and at the RSA Life School. ARSA 1885; RSA 1896. His important works in sculpture were the statues of Robert Burns at Kilmarnock, Denver and Chicago, and the statue of Sir W. Wallace in Duthie Park, Aberdeen, 1883. The AJ, however, considered "his best work has been modelled in silver and on a small scale", e.g. 'The Return of the Spies with the Grapes of Esheol' for the Marquis of Bute. Caw said of his paintings: "He has painted incidents amongst puppies and poultry with obvious humour but in a hard and uninteresting style, and cold and unsympathetic colour." He exhib. 1874-95 at the RA, BI and elsewhere.
Bibl: AJ 1885 p.335 (pl.); 1898 pp.72, 128 (pl.); Caw p.340; Who Was Who 1916-28.

STEWARD, H.S.R. fl.1881
Exhib. two figurative subjects at the GG. London address.

STEWART, Allan 1865-1951
Painted figurative and military subjects. Exhib. eight works at the RA 1892-1900, including 'Prince Charlie's Last Look at Scotland', 'The Distribution of the Royal Maundy Money' and 'The Charge of the 21st Lancers at Omdurman'. Studied at the RSA schools. Lived in Kenley, Surrey, and in Dalry, Kirkcudbrightshire.
Bibl: Who's Who 1936; Caw

STEWART, Miss Amy fl.1889-1898
Painted figurative subjects. Exhib. three works, 'Mabel', 'Au Revoir' and 'Violet Violée', at the RA and two works at SS. London address.

STEWART, Charles Edward fl.1890-c.1930
Painted rustic and historical subjects. Exhib. 17 works at the RA 1890-1904 including 'Every Dog Has His Day', 'Gipsy Ponies' and 'Crossing the Ford'. Studied at the RA schools and at the Académie Julian. Born in Glasgow. Lived at Little Kimble, Buckinghamshire.

STEWART, Miss Dora M. fl.1882-1887
Painted flowers. Exhib. five watercolours at SS including 'African Marigolds' and 'Primroses'. London address.

STEWART, Miss Eunice fl.1884
Exhib. a watercolour entitled 'Pigeon Nook' at SS. London address.

STEWART, Miss Florence fl.1884-1886
Exhib. a painting of azaleas at the RA. London address.

STEWART, George fl.1851-1885
London painter of landscape and architectural subjects who exhib. 1851-85, at the RA 1851-84, SS and elsewhere, titles at the RA including 'Rochester Cathedral', 1851, 'A River Scene', 1860 and 'Harvest Time, Rustington, Sussex', 1884.

STEWART, George A. fl.1874
Exhib. 'A Nook on the Thames' at the RA and a view at Kingston upon Thames at SS. London address.

STEWART, H.W. fl.1847
Exhib. a work entitled 'Summer' at the RA.

STEWART, Miss Helen F. fl.1899
Exhib. a work entitled 'The Last Gleam' at the RA. Address in Bushey, Hertfordshire.

STEWART, Hope James fl.1834-1865 d.1881
Scottish painter of portraits, figurative and historical subjects. Exhib. eight works, the majority portraits, at SS and five works including 'Cimabue Discovering the Early Genius of Giotto' at the BI. London address.
Bibl: Ormond.

STEWART, J.A. fl.1864
Exhib. one work 'Going Harvesting' at the BI. Address in Dundee, Angus.

STEWART, J.E. fl.1846
Exhib. views of Bamburgh and Alnwick Castles at the RA and a view in Northumberland at SS. London address.

STEWART, J.G. fl.1844
Exhib. a painting of flowers at the RA. London address.

STEWART, James RSA 1791-1863
Engraver; painter of portraits, landscape and genre. Born in Edinburgh, articled to Robert Scott, the engraver; also studied drawing in the Trustees' Academy and became a very able line engraver. He engraved many of Sir William Allan's (q.v.) paintings, e.g. 'Circassian Captives', 1820 and 'The Murder of Archbishop Sharpe', 1824 and later Sir David Wilkie's (q.v.), e.g. 'The Penny Wedding'. He became a foundation member of the RSA in 1826. In 1830 he moved to London. In 1833, due to lack of money, he emigrated to Cape Colony where he settled as a farmer, but within a year lost everything through the outbreak of the Kaffir War. He then went to live in Somerset, Cape Colony, where he taught and painted portraits. He died in the Colony. He exhib. in London 1825-61, at the RA 1825-59, BI and SS (148 works). Throughout this period London addresses are given in Graves, Royal Academy Exhibitors. Titles at the RA include 'Hop Picking near Gravesend', 1850, 'Sunset', 1854 and 'Sheridan Knowles Esq.', 1858.
Bibl: AJ 1863 p.165; Redgrave, Dict.; DNB; Fine Arts Quarterly Review II 1864 p.209; *Le Blanc Manual de l'Amat d'est.*, III 1888; Print Collector's Quarterly XVI 1929 p.273; Ormond.

STEWART, James Lawson fl.1883-1889
Painted views of London, usually large watercolours. Exhib. two works at the RA, 'Quilp's Yard' and 'Jacob's Island, Rotherhithe', and one work at SS. London address.

STEWART, James Malcolm 1829-1916
Scottish painter of portraits and marines. Exhib. 'Our Iron-Bound Shore' at the RA and 'A Lonely Shore' at SS. Represented Glasgow AG.
Bibl: Poole 1925.

STEWART, John RBA b.1800 fl.1828-1865
Scottish painter of figurative and rustic subjects and landscapes. Exhib. 20 works at SS including 'Fisherman's Welcome', 'Hop Picking' and 'The Last of the Wreck'. Also exhib. four works at the RA and three works at the BI. London address.
Bibl: John Pye, *Patronage of British Art*, 1845; BM Cat. of Drawings by British Artists.

STEWART, R. fl.1900
Exhib. a work entitled 'Sea Wrack' at the RA. London address.

STICKS, A.J. fl. late 19th century
Painted landscape watercolours. Worked for a firm of stained glass manufacturers in Newcastle-upon-Tyne.
Bibl: Hall.

STICKS, George Blackie 1843-1938
Painted landscape. Studied painting under William Bell Scott (q.v.). Born in Newcastle-upon-Tyne. Worked in the north-east and Scotland. Was the best known of the Sticks family of painters, see also A.J. Sticks and Harry Sticks (qq.v.). Represented Shipley AG, Gateshead.
Bibl: Hall.

STICKS, George Edward fl. late 19th century
The son of G.B. Sticks (q.v.). His subject matter and style was similar to that of his father.
Bibl: Hall.

STICKS, Harry d.1938
Landscape painter in oil and watercolour. Son of G.B. Sticks (q.v.) whose style he followed. Generally painted on a small scale. Brother of G.E. Sticks (q.v.).

STICKS, William fl.late 19th century
A brother of G.B. Sticks (q.v.) who also worked for William Wailes, the Newcastle stained glass manufacturer. Instructed in art by William Bell Scott (q.v.).
Bibl: Hall.

STIFFE, C.E. fl.1882-1890
Exhib. three works, including 'A Relic of Algiers' and 'A Cabbage Field in Surrey', at the RA. London address.

STIFFE, John Gilbee fl.1872-1888
Exhib. two works, 'Evening' and 'On the Thames, near Sonning', at SS, and 'Pool on the Lledr, North Wales' at the RA. London address.

STIGAND, Miss Helen M. fl.1868-1882
Painted landscape. Exhib. ten works at SS, the majority watercolours, including views in Italy and Switzerland, and five works at the RA including 'Beeches in Knowle Park, Kent' and 'More Glorious in thy Ruin than thy Pride'. London address.

STIKEMAN, Miss Annie fl.1882-1884
Exhib. two watercolours, 'Sunflowers' and 'Cottage Flowers', at SS. London address.

STILLMAN, Miss Lisa R. fl.1888-1894
Exhib. 19 portraits at the NG. London address.

***STILLMAN, Mrs. William J.** 1844-1927
(Miss Marie Spartali)
Pre-Raphaelite painter. Pupil of Ford Madox Brown (q.v.). Used as model by Rossetti. Exhib. at RA 1870-7, SS, NWS, but more frequently at GG and NG. Her style shows a combination of Pre-Raphaelite influences, but mostly that of Rossetti. She married the American journalist William J. Stillman, also a member of the Rossetti circle.
Bibl: Portfolio 1870 p.118ff.; Studio XXX 1904 p.254ff.; Clement & Hutton; W.M. Rossetti, *English Painters of the Present Day,* 1871; Clayton II pp.135-7; Bate p.112 (2 pls.); Fredeman; Reynolds, VP pp.16, 152; Maas p.146 (pl. p.145); Wood, Pre-Raphaelites; J.G. Christian, *M. Spartali, Pre-Raphaelite Beauty,* Antique Collector March 1984.

STILWELL, J., Jnr. fl.1849-1855
Painted landscape. Exhib. four works at the BI, two of them views on Leith Hill, Surrey, two works at SS, including a portrait of a cow, and 'A Favourite Dog' at the RA. London address.

STIRLING, John 1820-1871
Aberdeen painter of portraits and genre, fairy tale and literary subjects, and subjects in Morocco. After 1855 his addresses vary between London and Aberdeen. 1868-9 he visited Morocco. He exhib. in London 1852-71, at the RA and BI, titles at the RA including 'The Princess and the Seven Dwarfs', 1859 and 'Ablution; Scene in Morocco', 1870. Ruskin noted 'Scottish Presbyterians, in a Country Parish Church — the Sermon', RA 1855: "A very noticeable picture, showing careful study and good discrimination of expression. But the painter cannot yet do all he wants to do; he should try to work more delicately, and not attempt so much at once."
Bibl: J. Ruskin, Academy Notes 1855; G.M. Fraser, Aberdeen Journal 7 July 1934.

STIRLING, Miss Nina fl.1885-1888
Painted flowers. Exhib. 'Chrysanthemums' and 'Roses' at SS and two works at the RA. London address.

STIRLING, William fl.1885-1894
Exhib. eight architectural views and designs at the RA including 'Temple of Mithras' and 'Gardener's Cottage, East Burnham Park'. London address.

STJERNSTEDTS, Mme. S fl.1882
Exhib. a view in Sweden at the RA. London address.

STOCK, Miss Edith A. fl.1880-1903
Painted flowers and landscape. Exhib. four paintings of roses at the RA and three works including a Swiss landscape at SS. London address.

STOCK, Edward fl.1834-1842
Painted landscape. Exhib. 13 works at SS including 'French Coast Scene', 'Blackwall, from the Entrance to the West India Docks' and 'The Old Hulk'. London address.

STOCK, Francis R. fl.1875-1884
London painter of fruit and genre who exhib. 1875-84 at the RA, SS and elsewhere, titles at the RA including 'Apples', 1875, 'A Foundling', 1877 and 'St. Valentine's Day', 1882.

***STOCK, Henry John** RI ROI 1853-1930
London painter of genre, portraits and imaginative subjects who exhib. from 1874 at the RA, NWS, GG and elsewhere. Titles at the RA include 'Good and Evil Spirits Fighting for Man's Soul', 1882, 'Death Turning away from the Innocence of a Child', 1894 and 'The Red Apple' and 'Listening to Brahms', 1901. Studied at the RA Schools. RI 1880. Hon. Member of the Society of Miniaturists. *Connoisseur* said in his obituary: "Mr. Stock's Watts-like compositions were well-known features at the RI exhibitions."
Bibl: BM Cat. of Engraved British Portraits VI 1925 p.552; Connoisseur LXXXVII 1931 p.61; Who Was Who 1929-40.

STOCKDALE, C.W. fl.1860-1867
Exhib. two works, views of Wells Cathedral and in Venice at the RA. London address.

STOCKDALE, F.C. **fl.1852-1854**
Exhib. two works, views of Longleat and Howley Hall at the RA. Address in Torquay, Devon.

STOCKER, Miss Florence A. **fl.1885-1886**
Exhib. two landscapes at the NWS. Address in Maidenhead, Berkshire.

STOCKS, Arthur **RI** **1846-1889**
Cenre and portrait painter. Son of Lumb Stocks the famous Victorian engraver. Studied with his father and at RA Schools. Exhib. at RA 1867-89, BI, SS, NWS and elsewhere. Elected RI 1882. Titles at RA often sentimental or humorous, e.g. 'Her Sweetest Flower', 'On the Sick List', 'Saved from the Snow', etc. A portrait of his father is in the Macdonald Collection, Aberdeen AG, and two works are in the Walker AG, Liverpool. His brothers, Bernard and Walter F. Stocks (qq.v.), were painters.
Bibl: AJ 1889 p.364; DNB; Bryan; Cundall.

STOCKS, Bernard O. **fl.1881-1890**
Exhib. three works, 'A Plover', 'Young Haddock' and a copy, at the RA. London address. He was the brother of Arthur and Walter Stocks (qq.v.).

STOCKS, Miss Katherine M. **fl.1877-d.1891**
Painted flowers. Exhib. six works at the RA including 'Primulas', 'Carnations' and 'Azaleas'. London address. She was the daughter of Lumb Stocks the famous Victorian enraver.

STOCKS, R. Bremner **fl.1885**
Exhib. a portrait at the GG.

STOCKS, Walter Fryer **1843-1915**
Landscape, topographical and still-life painter. Son of Lumb Stocks, the engraver, and brother of Arthur and Bernard Stocks (qq.v.). Exhib. at RA 1862-1903, BI, SS, NWS and elsewhere. Titles at RA include landscape views in many parts of England, views of castles, towns and old buildings, and still-life. Two watercolours by him are in the VAM.
Bibl: DNB LIV 1898 p.393; VAM 1908 Cat. of Watercolours; Pavière, Landscape pl.77.

STODDART, Miss Frances **fl.1837-1840**
Painted landscape. Exhib. three works at the RA including views of Dunkeld Abbey and of the Vale of Comrie. Address in Edinburgh.
Bibl: AJ 1859; Gazette des Beaux-Arts VI 1860 p.106.

STOHWASSER, Miss Rosina **fl.1882-1884**
Exhib. an architectural subject at the NWS. London address.

STOKELD, James **1827-1877**
Painted genre subjects. Exhib. three works at SS and one work entitled 'Whispering Sweet Nothings' at the RA. Born in Sunderland, Co. Durham. Represented in the Sunderland AG.
Bibl: Hall.

STOKES, Miss **fl.1838**
Exhib. a watercolour view 'On the Glen of the Dog Leap, County Londonderry, Ireland'. London Address.

STOKES, Mrs. Adrian **1855-1927**
(Miss Marianne Preindlsberger)
Painter of genre, biblical subjects and portraits in a semi-decorative style very similar to that of Arthur Gaskin, J. Southall (qq.v.) and the Birmingham Group of Artists. Born in Southern Austria, she studied in Munich under Lindenschmidt, worked in France, and later came to England where she married Adrian Stokes (q.v.) in 1884. Exhib. from 1883 at the RA, SS, GG, NG and elsewhere. Two of her best known works are 'St. Elizabeth Spinning for the Poor' and 'Little Brother and Little Sister'. She often painted in gesso and tempera, using a bought preparation known as Schoenfield's tempera, upon an unpolished ground, producing almost the appearance of fresco on a rough plaster wall.
Bibl: AJ 1900 pp.193-8; Studio XXIII 1901 p.157 (pl. 'Little Brother and Little Sister'); XLIII 1908 p.82 (pl.); XLVII 1909 p.54 (pl.); Mag. of Art 1901 pp.241-6; Shaw Sparrow, *Women Painters of the World*, 1905 (2 pls.), Connoisseur LXI 1921 p.177; LXIII 1922 p.112; LXVI 1923 p.50; LXXIX 1927 p.127 (obit.).

***STOKES, Adrian Scott** **RA VPRWS NEAC** **1854-1935**
Painter of landscape, portraits, genre, historical and literary subjects. Born at Southport; brother of Leonard Aloysius Scott Stokes (1858-1925), the architect; studied at the RA Schools 1872-75, and in Paris under Dagnan-Bouveret 1885-6. Exhib. at the RA from 1876, and also at SS, OWS, NWS, GG, NG and elsewhere; member of NEAC 1887. ARA 1910, RA 1919; VP of RWS 1933. Painted in Britain, Spain, France, Italy, Austria and Holland. Married the Austrian painter Marianne Preindlsberger (see Mrs. Adrian Stokes) in 1884 and first exhib. with her at the FAS in 1900. Author of *Hungary*, 1909, and *Landscape Painting*, 1925. The Tate Gallery has 'Uplands and Sky', 1888, and 'Autumn in the Mountains', 1903, both Chantrey Purchases.
Bibl: W. Meynell, *Mr. and Mrs. Adrian Stokes*, AJ 1900 pp.193-8 (pls.); Tate Cat.; Adrian Stokes, *Inside Out*, 1947; *The Image in Form*, 1972; *A Game that Must be Lost*, 1973.
Exhib: London, Marlborough Gallery 1965; 1968.

STOKES, Folliott **fl.1892-1902**
Exhib. three works at SS including 'Poor Land' and 'Grey Weather'. Address in St. Ives, Cornwall.

STOKES, G. **fl.1827-1851**
Painted views of architecture. Exhib. ten works at the RA including 'Portion of Westbourne Terrace', 'Porch at the End of Westminster Abbey' and 'On the Lynn, Devon'. London address.

STOKES, G.H. **fl.1854-1864**
Exhib. three works at the RA including an interior view of the Crystal Palace at Sydenham. London address.

STOKES, George Vernon **RBA** **1873-1954**
Painted landscape and animal subjects. Worked in oil, watercolour and pastel. Also an etcher. Lived near Carlisle. Died in Kent.

STOKES, H. **fl.1876**
Exhib. a watercolour landscape at SS. London address.

STOKES, J. **fl.1846-1863**
Painted landscape. Exhib. 21 works at the BI including views in Shropshire and Northumberland. Also exhib. two landscapes at the RA. London address.

STOKES, W.P. **fl.1855**
Exhib. a work entitled 'The Mendicant' at the BI. Address in Hook, Hampshire.

STONE, Mrs. **fl.1845-1846**
(Miss Mary Mulready Leckie)
Exhib. two portraits of girls at the RA.

STONE, Miss Ada fl.1879-1904
Exhib. three works at SS including 'Still life' and 'Cinderella'. London address.

STONE, Coutts fl.1843-1881
Painted views of architecture. Exhib. seven works at the RA including views in Venice and Padua. London address.

STONE, Eleanor fl.1866
Exhib. a landscape in 1866. London address.

STONE, Miss Elizabeth fl.1852-1853
(Mrs. William Lawson)
Painted still-life. Exhib. watercolours of dahlias and primroses at SS. Address in Brighton, Sussex. See also Mrs. William Lawson.

STONE, Miss Ellen fl.1870-1878
Exhib. two works entitled 'The Map of the War' and 'Discouragement' at the RA. London address. She was the daughter of Frank Stone (q.v.).
Bibl: Clayton.

***STONE, Frank ARA 1800-1859**
Painter of historical genre and portraits, and illustrator. Born in Manchester. Began to study art at the age of 24. Came to London 1831. At first concentrated on watercolours but later turned to oil painting. ARWS 1837, RWS 1843, resigned 1847. ARA 1851. Exhib. at RA 1837-60, BI, SS and OWS. Subjects mostly sentimental genre, in historical costume, e.g. 'The Last Appeal', 'The Tryst', 'The Course of True Love', etc. Stone was a specialist in the type of Keepsake beauty. Both he and his son Marcus Stone (q.v.) were friends of Dickens
Bibl: AJ 1856 pp.333-6; 1860 p.9 (obit.); Connoisseur LXII 1922 p.175; Redgrave, Dict.; Roget; DNB; W. Sandby, *History of the RA*, 1862; Reynolds, VS, VP *passim* (pl.74); Maas pp.107, 239 (pl.p.109); Ormond.

STONE, Henry fl.1838-1886
Painted views of architecture. Exhib. nine works at the RA including views of Winchester and Lyons Cathedrals. London address.

***STONE, Marcus RA 1840-1921**
Historical genre painter and illustrator. Son and pupil of Frank Stone (q.v.). Exhib. at RA from 1858 and elsewhere. ARA 1876, RA 1886. Mainly painted genre scenes set in 18th century or Empire costume. The themes are usually dramatic, sentimental, or sometimes humorous. RA titles: 'Rejected', 'The First Love Letter', 'A Stolen Kiss', etc. 'Il y a Toujours un Autre' (RA 1882) was bought by the Chantrey Bequest for £800. In his own day Stone's pictures were much admired and fetched high prices. He illustrated *Our Mutual Friend* for Dickens and worked for *Cornhill Magazine*. Works by him are in many English museums.
Bibl: AJ 1869 pp.33-5; 1885 pp.68-72; 1895 p.217ff.; Connoisseur LX 1921 p.59ff.; Clement & Hutton; R Muther, *Ges. d.Malerie in 19th C*, 1893-4; F.V. Boetticher, *Malerwerke d. 19th C*, 1901 p.845ff.; Reynolds, VP pp.112, 180; Maas p.239 (pl. p.242); Wood, Paradise Lost.

STONE, W. Henry fl.1867
Exhib. a genre subject in 1867. Address in Coventry.

STONE, William fl.1865-1878
Birmingham painter of rustic scenes and figure subjects. Exhib. a work entitled 'The Critic' at the RA and another work at SS. London address.

STONEHOUSE, Charles fl.1833-1865
London painter of genre, portraits, historical, literary and biblical subjects; engraver. Exhib. 1833-65 at the RA, BI and SS. Titles at the RA include 'Mary Queen of Scots Forced into Signing the Resignation of the Crown', 1843, 'Our Saviour Reproving Martha', 1846 and 'Jersey Peasant Girl at a Fountain', 1849.
Bibl: BM Cat. of Engraved British Portraits II 1910 pp.170, 190.

STONES, Miss Emily R. fl.1882-c.1922
Painted flowers and country subjects in watercolour. Exhib. 11 watercolours at SS including 'A Quiet Pool', 'Double Daffodils' and 'The Vicar's Orchard', and three works at the RA. London address.

STONEY, Charles B. fl.1879-1893
Painter of landscape, flowers, portraits and architectural subjects, living in London, Malmesbury, Newton Abbot and Parkstone, Dorset. Exhib. 1879-93, at the RA 1881-93, SS, NG and elsewhere, titles at the RA including 'Anemones', 1881, 'Malmesbury Steeple', 1884 and 'Brixham Trawlers', 1890.

STONEY, T. Butler fl.1899-1900
Exhib. two works, 'The Test at Longparish' and 'The Voyage of St. Patrick', at the RA. London address.

STOPFORD, Robert Lowe 1813-1898
Painted marines and landscape watercolours. Born in Dublin. Died in Cork. Father of W.H. Stopford (q.v.). Exhib. at RHA 1858-84. Worked for *The Illustrated London News* as correspondent for southern Ireland.

STOPFORD, William Henry 1842-1890
Painted landscape. Son of R.L. Stopford (q.v.). Exhib. a work entitled 'On the Top of Great Orme's Head' at the RA and two watercolours at SS. Born in Cork, Ireland. Died in Halifax, Yorkshire. He was head of the Halifax School of Art.
Bibl: Strickland.

STORCK, W.B. fl.1858
Exhib. a work entitled 'Desdemona Cometh' at SS. London address.

STORER, Louisa fl.1816-1843
Painted flowers. Exhib. ten still-lifes of flowers and fruit at the RA. London address.

***STOREY, George Adolphus RA 1834-1919**
Genre and portrait painter. Pupil of J.L. Dulong. Exhib. at RA from 1852, BI, SS, NWS and elsewhere. His early works are Pre-Raphaelite in feeling, but he later turned to portraits and more conventional genre, e.g. 'Rosy Cheeks', 'Lesson of Love', 'The Love Letter', etc., and historical genre. Storey lived in St. John's Wood and was a member of the St. John's Wood Clique (q.v.) until he moved to Hampstead. ARA 1875. In 1899 he published his autobiography, a valuable source of information about the Clique.
Bibl: AJ 1875 pp.173-6; Tatler No. 369 v.22.7 1908 p.92ff.; Clement & Hutton; Bate p.90 (with pl); G.A. Storey, *Sketches from Memory*, 1899; Bevis Hillier, *The St. John's Wood Clique*, Apollo June 1964.

STOREY, John 1827-1877 (or 1828-1888)
Painted views and townscapes. Exhib. three works at SS including 'Brinkburn Priory' and 'Tynemouth Priory Ruins'. Represented in the Sunderland AG. Studied under T.M. Richardson Snr. (q.v.). Born and lived in Newcastle-upon-Tyne. Died in Harrogate, Yorkshire.
Bibl: Hall.

STORMONT, Howard Gull fl.1884-1903

Painted landscape and industrial scenes. Exhib. five works at SS including 'Morgan's Steelworks' and a view at Bray-on-Thames. Address in Brighton, Sussex.

STORMONT, Mrs. Howard Gull (Mary) fl.1899-1902

Painted rustic subjects. Exhib. six works at the RA 1899-1902, including 'A Wayside Inn' and 'Pasture, Studland Bay'. Address in Rye, Sussex.

STORR, Milton fl.1890-1891

Exhib. a view in Dordrecht at the RA and a view in Holland at SS. Address in Haslemere, Surrey.

STORTENBEKER, P. fl.1880

Exhib. a landscape at the GG.

STORY, Miss Blanche fl.1881-1888

Exhib. nine paintings of flowers at the GG.

STORY, Julian fl.1882-1897

Painted portraits. Exhib. four portraits including one of the Prince of Wales, at the RA, and 13 works at the GG. Address in Rome. This may be the American painter Julian Russell Story (1857-1919). See TB.

STORY, Miss Mary S. fl.1880-1886

Exhib. two paintings of gardenias and Parma violets at the RA. Address in Nottingham.

STOTHARD, Robert Thomas FSA fl.1821-1865

Painted portraits and figurative subjects. Exhib. 18 works at the RA 1821-57, the majority portraits, possibly miniatures, also including 'The Feast of Peacocks' and 'March of the May Garlands, Isle of Wight', and two works at the BI. London address.

Bibl: BM Cat. of Engraved British Portraits; Ormond.

***STOTT, Edward ARA NEAC 1859-1918**

Painter of landscape and rustic genre. Born in Rochdale. Studied in Paris under Carolus-Duran and Cabanel. Came under the influence of Bastien-Lepage and also Millet. On his return to England he lived at Evesham, Worcestershire, and later Amberley, Sussex. Following the example of Millet he painted scenes of everyday life in the country, in a *plein air* style similar to that of Clausen and La Thangue (q.v.). He made careful studies for all the figures and animals in his pictures, usually in chalk. Exhib. at RA from 1883, GG, NG, NEAC and elsewhere. ARA 1906.

Bibl: AJ 1889 pp.294-8 (A.C.R. Carter); Studio VI 1896 pp.70-83 (J.S. Little); LV 1921 pp.1-10; Mag. of Art 1901 p.28ff.; Who Was Who 1916-28; Maas p.253 (pl. p.254); Fine Art Society, London, Cat. of William Stott and Edward Stott exhib. 1976.

STOTT, John fl.1881

Exhib. a figurative subject at GG. Address in Paris.

***STOTT, William (of Oldham) RBA 1857-1900**

Landscape and figure painter. Born Oldham, near Manchester; called Stott of Oldham to avoid confusion with Edward Stott (q.v.). Went to study in Paris 1879. Worked in the studio of J.L. Gérôme, and exhib. with success at the Paris Salons of 1881 and 1882. Returned to London and exhib. at RA 1882-99, SS, GG, NG and elsewhere. Painted landscapes, mountain scenery, portraits, and also ideal figure compositions in the style of Gérôme, e.g. 'Diana, Twilight and Dawn', 'The Awakening of the Spirit of the Rose', etc. Works by him are in Glasgow and the Walker AG,

Liverpool. 'The Bathing Place', RA 1891, one of his best works, is in the New Pinakothek, Munich. His portraits and interiors contain echoes of Whistler and Manet.

Bibl: AJ 1900 p.124; Studio IV 1894 pp.1-15 (R.A.M. Stevenson); Mag. of Art 1902 p.81ff.; Maas p.253 (pl. p.257); Irwin; Fine Art Society, London, Cat. of William Stott and Edward Stott exhib. 1976.

STOW, W.C. fl.1829-1843

Painted views of architecture. Exhib. five works at the RA including two views of buildings in Genoa. London address.

STOWERS, T. Gordon fl.1873-1894

Painted portraits. Exhib. three portraits at the RA including those of Sir Francis Grant and G.F. Watts (qq.v.), and three works at SS including works entitled 'A Remnant of Olden Times, Shrewsbury' and 'The Fading Year'. London address.

Bibl: Ormond.

STRACHAN, Arthur Claude 1865-1932

Painted landscape and cottages, mainly in watercolour. Exhib. four works at the RA including two landscapes in North Wales. Studied in Liverpool. Born in Edinburgh. Lived in Minehead, Somerset.

Bibl: Who's Who in Art 1934.

STRACHAN, Douglas HRSA 1875-1950

Painted portraits and figurative subjects. Also a decorator and designer of stained glass. Studied at the RSA Schools. Born in Aberdeen. Lived in Midlothian.

Bibl: Who's Who 1929; Irwin; A.C. Russell, *Stained Windows of Douglas Strachan*, 1972.

STRACHEY, Henry b.1863 fl.1888-1894

Painted landscape and country subjects. Exhib. eight works at the RA including 'The Village Sawpit', 'Autumn in Somerset' and 'Morning on the Downs'. Studied at the Slade School. Lived at Clutton, Somerset.

Bibl: Who's Who in Art 1934.

STRAFFORD, George fl.1842-1845

Painted French townscapes. Exhib. three works at the RA including views in Faugères and Mont St. Michel, and one work at the BI. London address.

Bibl: BM Cat. of Engraved British Portraits.

STRAHAN, Bland fl.1879

Exhib. a portrait head in 1879. London address.

STRANG, Ian RE 1886-1952

Etched and drew architectural and figurative subjects. Studied at the Slade School and at the Académie Julian. He was the son of William Strang (q.v.). Lived at Bletchley, Buckinghamshire.

Bibl Athenaeum 1920 I p.420; Connoisseur LVII 1920 p.52; LVIII 1920 p.124; Studio LXI 1914 p.143; XCIII 1927 pp.258, 259; XCVI 1928 pp.172, 177; Who's Who in Art 1934; Apollo IV 1926 p.168; VII 1928 p.196; VIII 1928 p.306; X 1929 pp.121, 178.

Exhib: London, Leicester Galleries 1936, 1952.

STRANG, William RA RE 1859-1929

Scottish painter and etcher of portraits and figurative subjects. Amongst his earlier exhibs. at the RA are portraits and works entitled 'The Sieve Mender', 'A Good Joke' and 'Girls Bathing'. Studied at the Slade School. Born at Dumbarton. Lived in London. Died in Bournemouth.

Bibl: *The Art of William Strang*, AJ 1910; H. Furst, *The Paintings of William Strang*, Studio LXXXI 1921 pp.171-7; further bibl. relating to Strang's career as a graphic artist in TB.

STRANGE, Albert fl.1878-1897
Painter of genre, landscape and coastal scenes, living in Maidstone and Scarborough. Exhib. 1878-97, at the RA 1881-97, SS, NWS and elsewhere. Titles at the RA include: 'Deserted', 1882, 'Moonrise and Sea Mist, St. Valery', 1886 and 'A Fisherman's Haven', 1897.
Bibl: Brook-Hart.

STRAPP, M. George fl.1886
Exhib. a work entitled 'Old Aquaintances' at SS. London address.

STRATH, B. fl.1866
Exhib. two works at SS: 'Above Putney Bridge' and 'Loch Long'. London address.

STRATHAM, Miss fl.1837-1838
Exhib. two works at the RA, the second a 'Sketch near Gosport'.

STRATTON, Arthur fl.1900-1901
Exhib. two works at the RA, the second a 'House on the Thames'. Address in Liverpool.

STRATTON, Fred fl.1901-1904
Exhib. two works at the RA, the first entitled 'Changing Pastures'. Address in Amberley, Sussex.

STRATTON, Miss Helen fl.1892-1904
Exhib. two works, 'Chums' and 'On the Waveney', at SS. London address.

STREATER, Henry William fl.1851-1858
Painted architecture and landscape. Exhib. ten works at the BI including 'The Hall at Penshurst Place', 'At Studland' and 'Snowdon'. Also exhib. three works at SS. London address.

STREATFIELD, Granville E. fl.1899-1900
Exhib. two views of houses at the RA. London address.

STREATFIELD, James Philip S. fl.1901-1904
Exhib. three works at the RA 1901-4, 'The Close of a Summer's Day', 'Worn Out' and 'My Sister'. London address.

STREATFIELD, Thomas Edward Champion fl.1874
Exhib. two works at the RA, the former a 'Church at Woodford, Essex'. London address.

STRECKER, J. fl.1880
Exhib. a work entitled 'In the Clouds' at the RA. London address.

STREET, Georgina A. fl.1858-1861
Painted fruit and flowers in watercolour. Exhib. five watercolours at SS including 'Fruit and Flowers' and 'A Snow Storm, Poor Robin Meditating on Mortality', and one work at the RA. London address.

STREET, Miss Kate fl.1880-c.1922
London painter of birds and flowers, who exhib. 1880-1902 at the RA, SS, NWS and elsewhere, titles at the RA including 'Wren and Nest', 1880, 'Dividing the Spoil', 1885, 'Found Dead', 1891 and 'Clematis', 1901.

STREETER, Miss Rosalie Ethel fl.1893
Exhib. a still-life in 1893. Address in Brighton, Sussex.

STRETCH, Matt fl.1872-1874
Exhib. three genre subjects 1872-4. London address.

STRETTON, Miss Hesba D. fl.1884-1886
Exhib. a painting of azaleas at the RA and a watercolour view of the crypt of Mont St. Michel at SS. London address.

STRETTON, Philip Eustace fl.1884-c.1919
London painter of animals, sporting subjects and genre who exhib. 1884-1904 at the RA, SS and elsewhere, titles at the RA including 'Disturbed', 1884, 'The Apple of Discord', 1889 and 'The Pet of the Kennel', 1901.
Bibl: Pavière, Sporting Painters.

STRICKLAND, Miss Frances fl.1830-1852
Exhib. 'Reptiles from Nature' at the RA and two works at SS. Address in Cracombe, Worcestershire.

STRIDE, P. fl.1872-1877
Painted genre subjects. Exhib. four works at SS including 'The Letter' and 'Simplicity'. London address.

STRONG, C.E. fl.1851-1856
Painted marines and shipping. Exhib. four works at the RA including 'River Craft Beating Up Gravesend Reach' and 'A Brig Running into Dartmouth Harbour', and four works at the BI. Address in Gravesend, Kent.
Bibl: Brook-Hart.

STRONG, H. fl.1840
Exhib. two landscapes at SS. Address in Ilfracombe, Devon.

STRONG, J. fl.1888
Exhib. a river landscape at the NWS. London address.

STROUD, Miss H.M. fl.1892
Exhib. one work 'Grey Day: Near Rye' at SS. Address in Bushey, Hertfordshire.

***STRUDWICK, John Melhuish 1849-1937**
Pre-Raphaelite painter. Studied at South Kensington and RA Schools where he met with very little success. He then worked as a studio assistant for Spencer-Stanhope and Burne-Jones (qq.v.). This gave his work the direction which it needed, and he evolved a very personal Pre-Raphaelite style. His subjects were derived mainly from Burne-Jones — mythological and allegorical figures — with poetic titles, e.g. 'The Ramparts of God's House', 'The Gentle Music of a Bygone Day', 'Golden Strings', 'Elaine', etc., but his technique was quite different. He painted in a flat linear style, with great attention to detail, especially in the draperies and accessories, using rich and glowing colours. The effect is sometimes rather lifeless and static, but always highly decorative. Exhib. mostly at GG and NG, also at RA, SS and elsewhere. George Bernard Shaw wrote an article on Strudwick for the *Art Journal* of 1891 (see bibl.) in which he wrote "transcendent expressiveness is the moving quality in all Strudwick's works and persons who are sensitive to it will take almost as a matter of course the charm of the architecture, the bits of landscape, the elaborately beautiful foliage, the ornamental accessories of all sorts, which would distinguish them even in a gallery of early Italian paintings."
Bibl: AJ 1891 p.97ff. (G.B. Shaw); Who's Who 1929; Who's Who in Art 1934: Bate pp.112-14 (3 pls.); Maas p.146; Wood, Pre-Raphaelites; Wood, Olympian Dreamers.

STRUDWICK, William fl.1863-1879
Exhib. a work entitled 'The Moorhen's Home' at SS. London address.

STRUTT, Alfred William RCA RBC ARE 1856-1924
Animal, genre and portrait painter. Son and pupil of William Strutt (q.v.). Born Tanaraki, New Zealand. Studied at South Kensington School. Exhib. at RA from 1879, SS, NWS and elsewhere. Titles at RA 'Her First Litter', 'The King's Pillow', 'Oliver Asks for More', etc. Accompanied Edward VII on a hunting trip to Scandinavia.
Bibl: Connoisseur LXVIII 1924 p.243 (obit.); Who Was Who 1916-29; Cat. of *The Strutt Family* exhib., Carlisle City AG 1970.

STRUTT, Arthur Edward b.1862 fl.1886-1900
Exhib. three landscapes at the NWS and two works, 'At the Edge of the Wood' and 'The Dawn of Spring', at the RA. Address in Gravesend, Kent.

STRUTT, Arthur John 1819-1888
Landscape painter. Son of Jacob George Strutt (q.v.). Exhib. 'The Grotto of Egeria near Rome' at the RA. Lived in Rome and generally painted views and scenes in the Campagna.
Bibl: The Year's Art 1889 p.256.

STRUTT, Jacob George 1784-1867
Landscape and portrait painter. Travelled in Austria, Switzerland and Italy, returned to England 1851. Exhib. at RA 1819-58, BI and SS. Painted portraits, Italian views and landscapes, especially woods and forests. He also illustrated books on trees, such as *Sylvia Britannica* 1822.
Bibl: DNB; Bryan.

STRUTT, Miss Rosa J. fl.1884
Painted flowers and animals. Exhib. a landscape in 1884. She was the daughter of William Strutt (q.v.).

***STRUTT, William RBA 1825-1915**
Genre, animal and portrait painter. Son of William Thomas Strutt (1777-1850) a miniaturist, and father of Alfred William Strutt (q.v.). Studied at the Beaux-Arts in Paris where he developed an early interest in animal painting. Went to Australia in 1850 where he produced his *Australian Journal* and the *Illustrated Australian Magazine*. He also made studies of Australian life which are among the earliest records of the colonial days. Visited New Zealand 1856 and returned to England 1862. Exhib. at RA from 1865, BI, SS and elsewhere. He painted genre and religious subjects, but his best works were his sympathetic studies and drawings of animals. His daughter Rosa Strutt (q.v.) was also an animal and flower painter.
Bibl: Connoisseur XLI 1915 p.170 (obit.); Cat. National Gallery Melbourne, Australia; Cat. of *The Strutt Family* exhib., Carlisle City AG 1970; Mrs. H. Curnow, *The Life and Art of W.S.*, 1980 (publ. in New Zealand by Alister Taylor); Cat. of W.S. exhib., AG of New South Wales, Australia, 1981 (with full bibl.).

STUART, Miss fl.1849-1855
Painted fruit. Exhib. six fruit pieces at the BI and two watercolours at SS. London address.

STUART, A. fl.1827-1841
Painted portraits. Exhib. three portraits at the RA and a work entitled 'The Absent' at the BI London address. Also worked in Mysore, India.

STUART, A. Burnett fl.1884-1895
Painted buildings. Exhib. two works at the NWS and a view in Peking at the RA. Address in Wells, Somerset.

STUART, Amy fl.1893
Is supposed to have exhib. at SS in 1893.

STUART, C.E. Gordon fl.1888-1890
Exhib. 'The Professor' at SS. London address.

STUART, Charles fl.1854-1868
Painter of fruit, still-life and landscape, living in Stepney and Gravesend, who exhib. 1854-67 at the BI and from 1859-68 at the RA. Titles at the RA include: 'Fruit', 1859, 'The Baron's Dessert', 1861 and 'Parian Vase and Fruit', 1862. Hls wife was Miss J.M. Bowkett (q.v.) the genre painter. In Graves's Dictionary he and Charles Stuart (q.v.) are amalgamated under one name with the dates 1854-93. This leads to confusion in other dictionaries.

STUART, Charles FSA fl.1880-1904
London painter of landscape and marine subjects who exhib. 1880-1904 at the RA, titles including 'The Summit of Cader Idris, N. Wales', 1880 and ' "Break, break, break at the foot of thy crags, O sea!" (Tennyson)', 1884. Paintings by him are in Derby and Sunderland AGs.
Bibl: Academy Notes 1882; RA Pictures 1893-6.

STUART, Mrs. Charles see BOWKETT, Miss J.M.

STUART, Ernest fl.1889-1903
Exhib. 'A Misty Morning on the North Sea' at SS. London address.
Bibl: Brook-Hart.

STUART, Miss F. fl.1851-1856
Exhib. two paintings of fruit at the RA. London address.

STUART, Miss G.E. fl.1848-1855
Exhib. a painting of fruit at the RA. London address.
Bibl: Brook-Hart.

STUART, J.A. fl.1869
Exhib. an alpine landscape in watercolour at SS.

STUART, J.E. fl.1876
Exhib. a fruit piece and 'A Hazy Morning, Brighton', the latter a watercolour, at SS. London address.

STUART, L. fl.1876-1878
Painted riverscapes. Exhib. four works at SS including 'Dawn on Dartmoor' and 'The Tranquil Thames'. Address at Southsea, Hampshire.

STUART, Hon. Miss Louisa see WATERFORD, Marchioness of

STUART, W.E.D. fl.1846-1858
Still-life painter. Lived in Stepney, London. Exhib. mainly at BI and SS, also RA 1846-58. Titles mostly fruit and flowers and occasional genre, e.g. 'The Gondola-night', 'Their Majesties the Emperor and Empress of Lilliput' and 'The Thames off Limehouse', etc.
Bibl: Brook-Hart pl. 114.

STUART, William fl.1848-1867
Painted marines. Exhib. 16 works at the BI including 'Lord Howe's Action — The Glorious First of June, 1794' and 'Launching the Life Boat'. Also exhib. four works at SS and two works at the RA. London address.
Bibl: Brook-Hart.

STUART, Mrs. William fl.1853-1863
Exhib. two works 'This Pig Went to Market' and 'The Mother's Hope' at SS and one work at the BI. London address.

STUBBS, George ARA fl.1837-1860
Painted landscapes and marines. Exhib. 24 works at SS including 'Old Houses at Salisbury', 'On the Meuse' and 'The Warder's Daughter'. Included amongst these are some watercolours. Also exhib. eight works at the RA, including 'Lashed Close to a Drifted Mast' and 'The Fisherman's Cart', and three works at the BI. Addresses in Boulogne, France, and London.
Bibl: Brook-Hart.

STUBBS, J. Woodhouse fl.1875-d.c.1908
Painted flowers. Exhib. four works at the RA including 'Pansies' and 'Gloire de Dijon Roses'. Address in Sunderland, Co. Durham. Represented in the Sunderland AG.
Bibl: Hall.

STUBBS, Ralph R. fl.1856-1873
Painted marines and shipping. Exhib. ten works at SS including 'Mouth of the Humber', 'Woodland Scene' and 'Off Robin Hood's Bay'. Also exhib. three works at the RA and two works at the BI. Address in Hull, Yorkshire.
Bibl: Brook-Hart pl. 221.

STUBBS, Samuel fl.1867-1870
Exhib. 'A Shipwreck' at the BI and 'Off the Dutch Coast' at SS. London address.

STUCHLIK, Camill fl.1890
Exhib. one work entitled 'Girl Reading' at the RA. Address in Prague.

STUCKEY, George 1822-1872
Exhib. a portrait at the RA and two portraits at SS. London address.
Bibl: Ormond.

STUDD, Arthur Haythorne 1863-1919
Painted landscape and figurative subjects. Studied at the Slade School and at the Académie Julian. Influenced by Gauguin whom he met in Brittany in 1890. Later Studd worked in Tahiti. Born in Leicestershire. Lived and died in London.
Exhib: London, Baillie Gallery 1906; Alpine Club Gallery c.1925; Anthony d'Offay Gallery, *The English Friends of Paul Gauguin*, 1966.

STUDDERT, Rev. G. fl.1891-1893
Exhib. three landscapes 1891-3. Address in Colchester, Essex.

STUMP, Samuel John c.1783-1863
Miniaturist and landscape painter. Member of the Sketching Society. Studied at the RA schools and exhib. at the RA 1802-45, also BI, SS and the Oil and Watercolour Society. Painted many portraits of stage personalities.

STURDEE, Percy fl.1885-1902
Painted figurative subjects. Exhib. four works at the RA 1886-1902, including 'A Lesson in Sculpture' and 'A Cup of Tea at the Priest's House, Japan', and one work at SS. London address.

STURGE, F. William fl.1878-1908
Landscape and coastal painter. Lived in Gloucester and exhib. at Birmingham 1878-81. Painted in Cornwall and the Channel Islands. Exhib. Egyptian views at the Modern Gallery in 1908.

STURGEON, Miss Kate fl.1882-1895
Painted figurative and genre subjects. Exhib. eight watercolours at SS, including 'The Road to School' and 'The Country Cousin', and five works at the RA including 'In Fancy Dress' and 'Violets'. London address.

STURGESS, John fl.1875-1884
Little known sporting and animal painter. Exhib. at SS and elsewhere.

STURTEVANT, Charles T. fl.1866
Exhib. three works, 'St. Cecilia' and two paintings of fruit, at the BI. London address.

STUTELY, Charles fl.1843-1857
Exhib. two interior views of St. Martin in the Fields at the RA. London address.

STYLE, Jane M. fl.1879
Exhib. a work entitled 'The Sacristan' at SS. Address in Liverpool.

SUCH, Joseph fl.1866-1875
Birmingham painter of flowers and landscapes. Exhib. at RBSA.

SUCH, William Thomas fl.1847-1857
Sutton Coldfield landscape painter. Exhib. 'A Snow Piece' and 'An Autumnal Scene' at the BI and another work at the RA. Also exhib. at RBSA.

SUCHLOWSKI, I. fl.1866
Exhib. a view of the French army in Poland in 1812 at SS. London address.

SUDDARDS, Frank fl.1884
Exhib. a painting of flowers at the NWS. Address in Bournemouth, Hampshire.

SUGARS, Miss Fanny fl.1889-1903
Painted flowers and figures. Exhib. five works at the RA including 'Pansies' and 'The Letter'. Address in Manchester.

SUGGATE, F.W. fl.1878-1882
Exhib. 'The Old Dyke' and 'Azaleas' at the RA and another work at SS. London address.

SUHRLANDT, C. fl.1884
Exhib. 'Russian Huntsmen in a Snowstorm' at SS. London address.

SUHRLANDT, R. fl.1840-1854
Exhib. three works including 'Our Saviour' and 'Galileo in Prison' at the RA.

SUKER, Arthur b.1857 fl.1886
Landscape painter. Brother of F.C. Newcombe (q.v.). Exhib. 'By the Western Sea' at the RA. Lived in Liverpool and Devonshire and painted in Wales, the Lake District, the Channel Islands and the Isle of Man.

SUKER, Frederick Harrison
see NEWCOMBE, Frederick Clive

SULLIVAN, Edmund Joseph RWS ARE 1869-1933
Painted figurative subjects in watercolour. Also an illustrator and engraver. Born in London. Educated in Hastings. Lived and died in London.
Bibl: Who's Who 1929; *The Old Watercolour Society*, Studio 1905; further bibl. on Sullivan's work as a graphic artist in TB; J. Thorpe, *E.J. Sullivan*, 1948; E.J. Sullivan, *The Kaiser's Garland*, 1915.

SULLIVAN, James F. fl.1875-1877
Exhib. five caricatures 1875-7. London address.

SULLIVAN, M. fl.1870
Exhib. 'The Black Shed and Cattle Pond' at the RA. London address.

SULLIVAN, William Holmes RCA fl.1870-d.1908
Exhib. a work entitled 'O'er the Dreams of Sages' at the RA. Address in Liverpool. Represented in the Walker AG Liverpool.

SUMMERBELL, L. fl.1879
Exhib. a portrait at the RA. London address.

SUMMERS, John 1896-1969
Painted landscape and marines in watercolour. Lived and worked in Sunderland, Co. Durham.

SUMNER, G. Heywood Maunoir fl.1878-1881
Exhib. two works at the RA, 'Wind and Rain, near Bruges' and an etching. London address.

SUMNER, Margaret L. fl.1882
Exhib. a landscape in 1882. London address.

SUMPTER, H. fl.1816-1847
Painted still-lifes of fish, vegetables and fruit. Exhib. ten still-lifes at the RA, 19 works at the BI and 16 works at SS. London address.
Bibl: Bryan.

SURGEY, J.B. fl.1851-1883
Painter of landscape, genre and architectural subjects, living in London, Chigwell, Essex, Cranford Bridge, Middlesex, and Bridge Bourton, Dorset. Exhib. 1851-83, at the RA 1852-83, BI, SS and elsewhere, titles at the RA including 'Leaving the Temple Church', 1852, 'The House that Jack Built, on the Coast of Suffolk', 1864 and 'A Rustic Relic, New Forest', 1883.

SURTEES, Mrs. fl.1873-1888
Painted watercolour landscapes. Exhib. 12 watercolours at SS including views at Capel Curig and on the rivers Lledr and Conway. London address.

SURTEES, John 1819-1915
Landscape and rustic genre painter. Lived in London and Newcastle and later Cannes. Exhib. at RA 1849-89, BI, SS and elsewhere. Painted landscapes in North Wales, Scotland and elsewhere, and also rustic genre. Works by him are in Cardiff, Sunderland and the Laing AG Newcastle. His wife, Elizabeth Royal (q.v.), was also a painter.
Bibl: AJ 1904 pp.106, 108, 310; Cat. of Permanent Collection of Watercolours, Laing AG, Newcastle, 1939; Hall.

SUTCLIFFE, Miss B. fl.1871-1875
Exhib. two watercolours 'Spring' and 'Daisy' at SS. London address.

SUTCLIFFE, Miss Hariette F.A. fl.1881-c.1922
Hampstead painter of genre and portraits who exhib. 1881-1907, at the RA 1881-99 and elsewhere. Titles at the RA include 'After the Bath', 1891, 'As Rosy as a Pippin', 1895 and 'Beauty and the Beast', 1899.

SUTCLIFFE, Miss Heather fl.1896
(Mrs. C.H. Thompson)
Exhib. a portrait at the RA. Address in Whitby, Yorkshire.

SUTCLIFFE, John fl.1853-1856
Exhib. two works, 'The Steppin' Stones' and a subject from Southey's *Battle of Blenheim*, at the RA. London address.

SUTCLIFFE, Lester RCA fl.1880-c.1930
Painted landscape and marines. Exhib. seven watercolours at SS including 'Left by the Tide' and 'Lynmouth, Devon', and 11 works at the RA including 'A Busy Morning, Whitby' and 'Windward Tide'. Address in Leeds, Yorkshire.
Bibl: The Year's Art 1928 p.536.

SUTCLIFFE, Mrs. Lester T. fl.1893-1904
(Miss Elizabeth Trevor)
Painted flowers. Exhib. nine works at the RA 1893-1904 including 'Wallflowers and Daffodils' and 'Heralds of Spring'. Address in Whitby, Yorkshire.

SUTCLIFFE, Thomas ANWS 1828-1871
Watercolour painter of landscape, marines and still-life. Born in Yorkshire, studied at the RA schools. Exhib. in London 1856-71, at the RA (only one work in 1856) and NWS (109 works), titles at the NWS including 'Early Spring', 1857 and 'A Study in Winter, Adel Moor', 1858. A of the NWS 1857. Watercolours by him are in the VAM, Leeds AG and the Ferens AG, Hull. In his obituary the AJ said: "His pictures are not of the highest order; but they gained as they merited, attention from their truthfulness and poetic feeling. Mr. Sutcliffe was a native of Yorkshire and lived many years in the neighbourhood of Leeds and latterly at Whitby." Father of the Whitby photographer, Frank Meadow Sutcliffe.
Bibl: Ruskin, Academy Notes (NWS 1857, 1858); AJ 1872 p.48 (obit.); Redgrave, Dict.; Cundall p.260; Cat. of City AG, Leeds, 1909; VAM; Wilson.

SUTHERLAND, Miss Fanny fl.1876-1886
London painter of portraits, interiors and topographical subjects who exhib. 1876-86, at the RA 1877-83, NWS and elsewhere. Titles at the RA include 'A Corner of the Study, Hardwick Hall', 1879 and 'A Stately Home of England', 1881.

SUTHERLAND, George Mowbray fl.1861-1866
Exhib. 'Home Sweet Home' at the RA. London address.

SUTHERLAND, Miss Jane fl.1847-1852
Painted literary subjects. Exhib. two works at the RA, 'Rosalind and Celia' from *As You Like It* and 'The Lady's Dream', and two works at SS. London address.

SUTHERS, Leghe 1856-1924
Painted genre and figurative subjects. Exhib. 11 works at the RA including 'Venetian Red', 'A Pound a Leg' and 'Romanies'. Studied in Antwerp, and worked in Brittany with Stanhope Forbes (q.v.). A minor member of the Newlyn School. Address in Southport, Lancashire.
Bibl: C. Fox and F. Greenacre, *Painting in Newlyn 1880-1930*, Barbican AG, London, 1985.

SUTHERS, W. fl.1878-1887
Painted flowers and landscape. Exhib. five works at the RA including two paintings of chrysanthemums and 12 watercolours at SS including 'Wallflowers', 'Old Battersea Bridge' and 'Chelsea Pensioner's Garden'. London address.

SUTRO, Mrs. Esther Stella fl.1885-1931
(Miss Esther S. Isaacs)
Exhib. 'An Old Garden, Sussex' at the RA. London address. See also Miss Esther S. Isaacs.
Bibl: Who's Who in Art 1934; Studio LXVII 1916 p.5l; XCIII 1927 p.353; Apollo V 1927 p.96; IX 1929 p.192.

SUTTILL, Miss Ada P. fl.1889-1890
Exhib. two works 'Iris, Berries and Teazles' and 'Malmaison Roses' at the RA. Address in Bridport, Devon.

SUTTON, G.M. fl.1875
Exhib. a still-life at SS. Address in Worcester. Also exhib. once at RBSA.

SUTTON, J. fl.1876-1890
Painted landscape. Exhib. eight works at the RA including 'A Berkshire Lane' and 'Old Farm Buildings'. Address in Edinburgh.

SUTTON, T. fl.1868
Exhib. a work entitled 'A Quiet Fish' at the RA.

SVOBODA, Alexander fl.1870-1871
Painted Middle Eastern landscape. Exhib. four works at SS including 'Smyrna' and 'Ephesus'. London address.

SWAFFIELD, Helena M. fl.1891-1902
Painted figurative subjects. Exhib. nine works at the RA including 'Sweet and Twenty' and 'Peeling Potatoes' and three works at SS. Address in Sevenoaks, Kent.

SWAIN, Edward (Ned) RPE 1847-1902
Painted and etched landscape. Exhib. six works at the RA, including 'Winter; a Leafless Fig Tree, South Africa' and 'The Stour, Surrey', and ten works at SS. London address.

SWAINE, John Barak fl.1837
Exhib. a work entitled 'Dying Student' at the BI. London address.

SWAINSTON, Miss Laura fl.1870-1894
Exhib. three works including 'A Toiler of the Fields' and 'Adversity' at the RA. Address in Sunderland, Co. Durham.
Bibl: Hall.

SWALLOW, Miss Jane F. fl.1864-1869
Painted flowers. Exhib. five watercolours at SS including 'Crocuses' and one work at the RA. London address.

SWALLOW, John Charles fl.1855-1876
Painted still-life. Exhib. four works at SS, including 'Tulips', 'The Palace of the Stuarts, York' and 'Old Water Mill', and three works at the RA. Address in Leeds, Yorkshire.

SWAN, Mrs. fl. 1888-1891
Exhib. a genre subject at the GG and another two at the NG. London address.

SWAN, Miss Alice Macallan RWS 1864-1939
Painted flowers, landscape and figurative subjects. Exhib. 12 works at the RA including 'Azaleas', 'Harmony and White and Gold' and

'Harbingers of Spring'. Born at Worcester. Died in London.
Bibl: Who's Who 1930; Studio LIV 1912 p.219; Charles Holme (ed.), The Old Watercolour Society 1804-1904, 1905.

SWAN, Cuthbert Edmund 1870-1931
Painted animals, especially tigers, leopards, etc. Exhib. six works at the RA including 'At the Pool — Twilight' and 'Puma and Cubs'. Born in Ireland. Lived in London. Worked in India.

SWAN, Edwin b.1873 fl.1896-1902
Portraitist. Exhib. four works, two portraits and two landscapes, at the RA. Studied at the Académie Julian. Born in Ireland. Lived in London.

SWAN, Miss Emily R. fl.1893
Exhib. 'Nannie' and 'White Chrysanthemums' at SS and one work at the RA. London address.

***SWAN, John Macallan RA RWS 1847-1910**
Animal painter and sculptor. Studied at Lambeth School of Art and RA schools. Studied in Paris with Gérôme and the sculptor Frémiet. Also much influenced by Barye. Exhib. at RA from 1878. In 1889 'The Prodigal Son' was bought by the Chantrey Bequest. Also exhib. at GG, NG and elsewhere. ARA 1894, RA 1905. He is best known for his superb studies of lions, leopards and tigers, executed in rapid pen and wash drawings, pastels, oils or in bronze. He also painted landscapes and allegorical figure subjects, but his true vocation was to paint wild animals.
Bibl: AJ 1894 pp.17-22 (R.A.M. Stevenson); Studio II 1897 pp.236-42; XXII 1901 pp.75-86, 151-61 (A.L. Baldry); M.H. Spielman, British Sculpture and Sculptors of Today, 1901; DNB; Maas p.82 (with pl.).

SWAN, Miss Mary E. fl.1890-1894
Exhib. two works including 'Oranges and Lemons' at the RA. Address in Bromley, Kent.

SWANDALE, George fl.1824-1844
Painted portraits and figurative subjects. Exhib. four works at the RA, portraits and 'A Child with Fruit' and four works at SS. London address.
Bibl: BM Cat. of Engraved British Portraits.

SWANWICK, Joseph Harold RI ROI RCA 1866-1929
Painted figurative and rustic subjects. Exhib. 15 works at the RA 1889-1904, including 'The Last Load', 'Her Kitten' and 'The Drinking Trough', and five works at SS. Studied in Liverpool, London and the Académie Julian. Born at Middlewich. Lived at Wilmington, East Sussex.
Bibl: Studio XXIV 1902 p.l36; Who's Who 1924; Connoisseur LXXXIII 1929 p.380.

SWARBRECK, Samuel Dukinfield fl.1839-1863
London painter of architectural subjects and interiors, who exhib. 1852-63, at the RA 1852-62, BI, SS and elsewhere. Titles at the RA include: 'Bedroom of Mary Queen of Scots, Holyrood Palace', 1856, 'Watergate Row, Chester', 1854 and 'Interior of St. John's Church, Chester', 1856. The AJ said of 'Rosslyn Chapel' (Portland Gallery 1859): "one of the best pictures of this famous relic that we remember to have seen".
Bibl: AJ 1859 p.122.

SWEET, Ada M. fl.1889-1891
Exhib. two works at SS including 'Wandering Thoughts' at SS. London address.

SWEETING, John fl.1879
Exhib. a work entitled 'Peep' at SS. Address in Worthing, Sussex.

SWEETING, R.G. fl.1845-1856
Painted rustic subjects. Exhib. four works at the RA, including 'Beggars, Dinan' and 'German Mendicants', and three works at the BI. Address in Weymouth, Dorset.

SWIFT, Clement N. fl.1878-1880
Exhib. five genre subjects 1878-80. Address in France.

SWIFT, Edmund fl.1866-1868
Painted figurative subjects. Exhib. four works at SS, including 'The Evening Prayer' and 'The Hermit's Tale', and one work at the BI. Address in Liverpool.

SWIFT, Miss Catherine Seaton Forman (Kate) fl.1855-1868 (Mrs. Christopher Bisschop)
Painted figurative and rustic subjects. Exhib. eight works at the BI, including 'Flemish Peasant', 'The Wedding of a Dutch Fisherman' and 'Industry Better than Gold', ten works at SS, including 'Hesitation' and 'The Village Sadler', and five works at the RA. London address. Her sisters Georgina and Louise (qq.v.) were painters.

SWIFT, Miss Georgina fl.1855-1874
Painted figurative and genre subjects. Exhib. 13 works at SS including 'The Basket Maker', 'Preparing for Market' and 'The Pillar Post'. Also exhib. four works at the RA and one work at the BI. She was a member of the Society of Lady Artists. Sister of Catherine and Louise Swift (qq.v.).
Bibl: Clayton.

SWIFT, John Warkup 1815-1869
Painted marines and coastal scenes. Lived in Newcastle-upon-Tyne and worked largely in the north-east.
Bibl: Hall; Brook-Hart pls.143-4.

SWIFT, Miss Louise B. fl.1868
Exhib. a portrait at the RA. London address. Presumably the sister of Catherine and Georgina Swift (qq.v.).

SWIFT, Mrs. W.B. (E.H.) fl.1835-1859
Painted portraits and figurative subjects. Exhib. ten works at the RA, including 'Contemplation' and portraits, and two works at SS. London address.

SWINBURNE, T.H. fl.1855-1856
Exhib. 'My Hand and Sword Defend this Word' at the RA and two works at SS. London address.

SWINDEN, Elsie C. fl.1879-1899
Birmingham painter of fruit, flowers and landscapes. Exhib. at RBSA 1879-99.

SWINDEN, Selina Annie fl.1881-1886
Birmingham painter of flowers and landscape. Sister of Elsie C. Swinden (q.v.).

SWINGLER, John Frank fl.1886-1900
London painter of still-life, flowers, fruit and fish, who exhib. 1886-1900 at the RA, SS and elsewhere, titles at the RA including 'Roses', 1887, 'Herrings and Smelts', 1891 and 'Lemons and Nuts', 1899.

SWINNERTON, J. fl.1839-1851
Exhib. three watercolours including a view on the Thames at SS. London address.

SWINSON, Edward S. fl.1893-1902
Painted portraits. Exhib. seven works at the RA including five portraits and 'A Daughter of Eve'. London address.

SWINSTEAD, Alfred H. fl.1874-1897
Painted figurative subjects. Exhib. seven works at the RA, including 'In the Garden' and 'Boats at Lyme Regis', and one work at SS. London address.

SWINSTEAD, Charles Hillyard 1850-1921
Painted rustic scenes and figure subjects. Exhib. six works at SS including 'The Pike's Haunt' and 'A Quiet Retreat'. Also exhib. two works at the BI and one work at the RA. London address.

SWINSTEAD, Eliza L. (?J.) fl.1881
Exhib. 'Chrysanthemums' and 'Roses' at SS. Address in Dalston, Cumberland .

SWINSTEAD, Frank Hillyard RBA 1862-1937
Painted landscape, genre and portraits. Exhib. a work entitled 'Preparing for the Regatta' at the RA. Studied at the North London School of Art, at the RCA and at the Académie Julian. Born and lived in London.

***SWINSTEAD, George Hillyard RBA RI 1860-1926**
Painter of portraits, genre and coastal scenes. Fourth son of Charles Swinstead, landscape painter, and brother of Alfred Hillyard Swinstead who exhib. 1874-97 at the RA. Exhib. from 1877 at SS and elsewhere, and from 1882 at the RA. RI in 1908. Entered RA Schools in 1881 and in 1882 exhib. for the first time at the RA with 'By Appointment'. Although for many years his principal work consisted of portraits and genre, he also devoted much time to coastal scenes, and latterly exhib. little else (for these see Nettlefold Collection). 'When Trumpets Call, then Homes are Broken', RA 1883, is in Sheffield AG. He also belonged to the Painter Stainers' Company and was author of *My Old-World Garden* and *How I Made it in a London Suburb*.
Bibl: Connoisseur LXXIV 1926 p.189 (obit.); Who Was Who 1916-28; Wilson; Ormond.

SWINTON, James Rannie 1816-1888
Scottish portrait painter, one of the most fashionable of his day. In 1838 he was allowed to train as an artist, and in Edinburgh was much encouraged by Sir William Allan and Sir John Watson Gordon (qq.v.), and worked in the latter's studio. Studied at the Trustees' Academy; in April 1839 went to London; in 1840 entered the RA schools and also went to Italy where he remained for about three years, visiting Spain. At Rome he found many sitters and laid the foundation of his subsequent popularity as a painter of the fashionable beauties of his day. On his return to London he settled in Berners Street and soon had a thriving practice. His portraits are chiefly life-sized boldly executed crayon drawings, although many of them were completed subsequently in oils. One of his best-known paintings was the large portrait group of the three beautiful Sheridan sisters, the Countess of Dufferin, the Hon. Mrs. Norton and the Duchess of Somerset. He also drew and painted the portraits of eminent men with great success, among them being Louis-Napoleon (Napoleon III), Lord Stratford de Redcliffe, the Duke of Argyll and others. He exhib.1844-74 at the RA, BI and SS — all portraits. Built a large house and studio in St. George's Drive, Pimlico, which still survives.
Bibl: Bryan; DNB; BM Cat. of Engraved British Portraits VI 1925 pp.554, 692; Ormond.

SWIRE, John fl.1883-1887
Exhib. a watercolour at SS and another work at the NWS. Address in Wakefield, Yorkshire.

***SWYNNERTON, Mrs. Joseph William** ARA 1844-1933
(Miss Annie Louisa Robinson)
Painter of allegorical and symbolical pictures of Italy, portraits and pictures of children. Born at Kersal, near Manchester, daughter of a Manchester solicitor; studied at the Manchester School of Art, Paris and Rome, exhib. at the RA from 1879, and also at GG, NG and elsewhere. Married Joseph Swynnerton, a Manx sculptor, in Rome 1883. Lived for the most part in Rome until the death of her husband in 1910. Influenced by G.F. Watts (q.v.), and her work also shows affinities with the French Impressionists. ARA 1922, being the first woman to receive academic honours since 1768, when Angelica Kauffman and Mary Moser became foundation members of the RA. Died at Hayling Island. Sargent bought and gave 'The Oreads' to the Tate Gallery, and three of her paintings were bought by the Chantrey Bequest for the Tate: 'New Risen Hope', 1924, 'The Convalescent', 1929 and 'Dame Millicent Fawcett', 1930.
Bibl: AJ 1908 p.174 (pl.); W. Shaw-Sparrow, *Women Painters of the World,* 1905 p.71; Connoisseur L 1918 p.51; LIV 1919 p.173; LXVI 1923 p.112; LXXII 1925 p.126; XCIII 1934 p.59; American Art News XX 1922 No. 27 p.5; XXI 1922-3 No. 10 p.3; No. 11 p.5; The Art News XXII 1923-4 No. 2 p.3; No. 21 p.8; XXXII 1933-4 No. 4 p.10; Studio LXXXV 1923 p.44; Birmingham Cat.

SYDDALL, Joseph fl.1898-1904
Exhib. three portraits at the RA. Address in Chesterfield, Yorkshire.

SYDNAS, A. fl.1868
Exhib. a study at the RA. Address in Norwich, Norfolk.

SYDNEY, John fl.1893
Exhib. a genre subject in 1893. London address.

SYER, H.R. fl.1874-1879
Painted marines and landscape. Exhib. 13 works some of them watercolours at SS including 'Off Deal', 'An Old Mill, Bettws-y-Coed' and 'Near Tremadoc'. London address. Probably a relation of John Syer (q.v.).

SYER, James fl.1867-1878
Painter of coastal scenes. Son of John Syer (q.v.). Exhib. mainly at SS, also at RA 1872-3. Titles: 'An Autumn Day on the Cornish Coast', etc.
Bibl: Brook-Hart.

***SYER, John** RI 1815-1885
Landscape painter. Father of James Syer (q.v.). Studied with J. Fisher, a miniaturist in Bristol. Exhib. at RA 1846-75, BI, SS, NWS, GG and elsewhere. Painted landscapes and coastal scenes with figures, often in Devon and Wales. Works by him are in Bristol, Leeds, Leicester and Sheffield AGs. His studio sale was held at Christie's, 22 March 1886.
Bibl Bryan; Cundall; Wilson pl.38; Pavière, Landscape pl.78; Brook-Hart.

SYER, John C. c.1846-1913
Marine painter. Son of John Syer (q.v.). Served in the navy until 1870 when he settled in Whitby. Exhib. marine pictures in York and Bristol.

SYKES, A. Bernard fl.1893
Exhib. a work entitled 'Death Releasing a Prisoner' at SS. London address.

SYKES, George b.1863 fl.1900-1904
Exhib. two works including 'The Old Path Through the Wood' at the RA. Address in Huddersfield, Yorkshire. Son of Peace Sykes, also a landscape painter.

SYKES, Godfrey 1824-1866
Painter of landscapes and rustic buildings. Studied in Sheffield. Came to London where he was involved in designing the Horticultural Gardens at South Kensington.
Bibl: AJ 1866.

SYKES, Henry RBA fl.1877-1895
Painter of landscape and genre, who exhib. 1877-95, at the RA, SS, NWS, NG and elsewhere, titles at the RA including 'In Fixby Park, Yorks', 1877, 'Summer Roses', 1887 and 'Idlers', 1889. One of his paintings is in Cardiff Museum. Probably a brother of Peace Sykes (q.v.).

SYKES, John Guttridge b.1866
Painted landscapes and marines in watercolour. Studied at Sheffield School of Art. Born in Sheffield. Lived in Newlyn, Cornwall.

SYKES, Miss Lilian fl.1888-1889
Exhib. two works at the NWS. Address in Croydon, Surrey.

SYKES, Peace fl.1872-1890
Painted landscape. Exhib. five works at the RA, all landscapes in Yorkshire, and two works at SS. Address in Huddersfield, Yorkshire. Father of George Sykes (q.v.).

SYLVA, Van Damme- fl.1885
Exhib. two works including 'Cattle and Landscape' at SS. London address.

SYLVESTER, C.J. fl.1846-1849
Painted landscape. Exhib. seven works at the RA including views on the rivers Thames and Wye. London address.

SYLVESTER, John Henry fl.1876-1891
Painted figurative subjects. Exhib. eight works at SS including 'Adeline', 'Blue-bell' and 'A Madonna of the Chairs', and three works at the RA. London address.

SYMES, Mrs. fl.1847
Exhib. 'Fruit' at the RA.

SYMINGTON, D.L. fl.1891
Exhib. a work entitled 'St. Anthony's Light' at SS. London address.

SYMON, Elizabeth fl.1864-1866
Exhib. a watercolour view of Dunrobin Castle at SS. London address.

SYMONDS, Henry T. fl.1868-1881
Birmingham flower painter. Exhib. at RBSA.

SYMONDS, William Robert RP 1851-1934
Portrait painter. Born in Yoxford, Suffolk; in the 1920s living in Brook Green. Studied in London and Antwerp. Exhib. from 1876 at the RA, GG, NG and elsewhere. His portraits are in the Wallace Collection (Sir Richard Wallace); Army Medical School (4); Queen's College, Belfast; Town Hall, Ipswich; Royal Victoria Hospital, Netley; Oriel College, Magdalen College and Pembroke College, Oxford.
Bibl: Austin Chester, *The Art of Mr. W.R.S.,* Windsor Magazine 1910 No. 184 pp.577-92; Supplement to The Graphic 1 January 1913; Poole III 1925 p.342; The Year's Art 1928.

***SYMONS, William Christian RBA 1845-1911**
Decorative designer and painter in oil and watercolour of portraits, genre, landscape, still-life, flowers and historical subjects. Sent at an early age to Lambeth School of Art, and in 1866 entered the RA schools. Exhib. from 1865, at the RA from 1869, SS, NWS, GG, NEAC, ROI and elsewhere; titles at the RA include 'Lily', 1869, 'Studies for Decoration', 'Diana Hunting' and 'The Triumph of Bacchus', 1878, 'Margaret of Anjou and the Robber of Hexham', 1882 and 'The Young Electricians', 1898. In 1870 became a Roman Catholic and began his long connection with the firm of Lavers, Barraud & Westlake for whom he designed stained glass. RBA in 1881 but resigned with Whistler in 1888. Acted as Secretary to the celebrated dinner organised in honour of Whistler on 1 May 1899. From 1899 executed mosaic decorations at Westminster Cathedral (Holy Souls' Chapel; outer wall left transept, rood, altar mosaic, crypt) which were unfairly criticised at the time for their over-emphasis of pictorial illusion. Worked at Newlyn in Cornwall for some time, though not a member of that school. In later life he lived almost entirely in Sussex. He was better known as a decorative designer than as a painter; he executed the spandrels at St. Botolph's Bishopsgate, and one of his best oils is 'The Convalescent Connoisseur' in Dublin Municipal AG. His flower pieces were also particularly good. Symons was obviously influenced by Sargent and Brabazon, but preserved his own individuality and did not allow his art to be influenced by Whistler. A posthumous exhib. of his paintings and watercolours was held at the Goupil Gallery in 1912. In the Mappin AG, Sheffield, are 'In Hora Mortis' and 'Home from the War'.
Bibl: AJ 1909 p.28 (pl.); The Times 5 February 1912; The Morning Post 6 February 1912; The Standard 6 February 1912; DNB 2nd Supp. 1913; Cat. of W.C. Symons exhib., Hastings AG and elsewhere 1994.

SYNGE, Edward Millington 1860-1913
Painted rustic continental subjects. Exhib. eight works at the RA 1899-1904 including 'Tyrolese Cottages' and 'Low Tide at Pont Aven'. Also an etcher. In 1908 he married Miss F. Molony, also an artist. Address in Weybridge, Surrey.

TABATIER, V. fl.1877
Exhib. two landscapes in 1877. Address in Nice, France.

TAFE, W.A. fl.1877
Exhib. two works, the first a watercolour view on the Lea, near Chingford, at SS. London address.

TAFFS, Charles H. fl.1896-1898
Exhib. three works at the RA including 'Summer Song' and 'Outside Only'. London address.

TAGORE, Miss B.B. fl.1874
Exhib. a watercolour entitled 'The Hindoo Goddess' at SS. London address.

TAIT, Miss Adela Seton- fl.1897-1900
Exhib. three paintings of flowers at the RA. Address in Lee.

TAIT, George Hope 1861-1943
Decorative artist. Studied at Edinburgh School of Art. Lived at Galashiels, Selkirkshire.

TAIT, J. fl.1862
Exhib. a view of St. Paul's Cathedral. London address.

TAIT, Mrs. M.A. fl.1839-1846
Painted landscape. Exhib. three works at the RA, all landscapes, and three works at the BI including 'Mountainous Scene' and 'Moonlight'. London address.

***TAIT, Robert S. fl.1845-1875**
London portrait and genre painter. Exhib. at RA 1845-75 and once at BI. Titles at RA mostly portraits and occasional Italian genre subjects, e.g. 'Florentine Boy', 1865, 'The Future Still Hides in it Gladness and Sorrow', 1866, etc. His best-known work is 'Thomas and Jane Carlyle in the Drawing Room of their House in Cheyne Row' which hangs in Carlyle House, Cheyne Row, London.
Bibl: AJ 1859 pp.165, 169; BM Cat. of Engraved British Portraits VI 1925 p.554; Reynolds, VP p.79 (pl.IV); Ormond.

TALBOT, George Quartus Pine 1853-1888
Exhib. four works at the RA including studies of armour and lamps. Born in Bridgwater. Died in Grasmere, Westmoreland.
Bibl: Portfolio 1887 pp.205, 226; AJ 1888 p.224.

TALBOT, Lionel A. fl.1900
Exhib. a work entitled 'Awake! Awake!' at the RA. London address.

TALFOURD, Field 1815-1874
Painter of portraits and landscape, and occasionally of genre. Born at Reading, the younger brother of Mr. Justice Talfourd. Exhib. 1845-74, at the RA 1845-73, BI and elsewhere. His works were chiefly portraits but from 1865-73 he also exhib. landscapes. Other titles at the RA include: 'A Roman Peasant', 1859 and 'The Fisher Boys', 1870. His portrait of Elizabeth Barrett Browning and Robert Browning, 1859, is in the NPG. The AJ noted that "as a painter of portraits and landscapes he obtained considerable reputation."
Bibl: AJ 1874 p.154 (obit.); Bryan; Cat. NPG II 1902 p.289; BM Cat. of Engraved British Portraits VI 1925; Ormond.

TALMAGE, Algernon Mayon RA ROI RWA ARE 1871-1939
Painted landscape, figurative subjects and animals. Exhib. a work entitled 'Harbour Lights' at SS. Studied under Herkomer (q.v.) and in St. Ives, Cornwall. Born in Oxfordshire. Lived in St. Ives and later in London. Died in Hampshire.
Bibl Studio XLII 1908 pp.188-93; XLVI 1909 pp.23-30; L 1910 p.12; LXV 1915 p.110; LXVIII 1916 p.54; LXXXIII 1922 p.264; LXXXIV 1922 p.13; XCIII 1927 p.48; Athenaeum 1920 I p.772; Connoisseur LXVIII 1924 p.235; LXIX 1924 p.113; Who's Who in Art 1934; Who's Who 1936.

TAMBURINI fl.1882
Exhib. a figurative subject in 1882. Address in Chichester, Sussex.

TAMLIN, J. fl.1883
Exhib. 'A Study' at SS. London address.

TANNER, A. fl.1844-1850
Painted landscape. Exhib. six works at SS including 'Fishing Boats, Lower Seine' and 'View of Mont Blanc', both watercolours. London address.

TANNOCK, James 1784-1863
Painted portraits. Exhib. 46 works at the RA 1813-41, the great majority portraits. The great part of his output is pre-Victorian. London address.
Bibl: DNB; Bryan; BM Cat. of Engraved British Portraits.

TANQUERAY, Alice F. fl.1886
Exhib. a work entitled 'Turkish Delight' at SS. London address.

TAPP, Miss C. fl.1889
Exhib. a view of a church at the NWS. Address in Shortlands.

TAPSON, Mary Alice fl.1876-1880
Exhib. four genre subjects 1876-80. London address.

TARGETT, Thomas G. fl.1869
Exhib. a painting of game in 1869. Address in Salisbury, Wiltshire.

TARNER, Miss G. fl.1896
Exhib. a portrait at the RA. London address.

TARRANT, Percy fl.1883-1904
Painted figurative and genre subjects. Exhib. 15 works at the RA 1883-1904, titles including 'Home from the Fields', 'Making a Gentleman of Him' and 'A Pair of Grandfathers'. London address.

TARRY, Miss Alice fl.1890-1896
(Mrs. Frederick Goodall)
Painted figurative and genre subjects. Exhib. six works at the RA including 'In Granny's Chair' and 'The Brother's Kiss'. London address.

TASKER, Edward
Chester painter of local views. Brother of William Tasker (q.v.). Examples are in the Grosvenor Museum, Chester.

TASKER, Miss Helen fl.1840-1843
Exhib. paintings of flowers at the RA and SS.

TASKER, William 1808-1852
Chester painter of sporting scenes and views. Exhib. two works at the RA, the former a view of SS. Giovanni e Paolo, Rome.

TATE, T.F. fl.1850
Exhib. 'The Way Over the Brook' at the RA. London address.

TATHAM, Frederick 1805-1878
Painter of miniatures, portraits and figure subjects; also a sculptor. Son of Charles Heathcote Tatham (1772-1842) an architect. A friend, disciple and biographer of William Blake. Brother-in-law of George Richmond (q.v.) who eloped with his sister. Exhib. 1825-54.
Bibl: L. Binyon, Followers of William Blake, 1926.

TATHAM, Miss Helen S. fl.1878-1891
Painted landscape. Exhib. three works at SS including 'Pandy Oak, near Bettws-y-Coed' and 'Evening — on the Thames above Pangbourne', both watercolours, and one work at the RA. Address in Shanklin, Isle of Wight.

TATTERSALL, Miss Lily fl.1896
Exhib. a painting of grapes and oranges at the RA. London address.

TATTNALL, Miss Diana W. fl.1897
Exhib. a work entitled 'Hayfield' at the RA. Address in Ryde, Isle of Wight.

TAUBMAN, Frank Mowbray b.1868
Painted portraits and landscape. Also a sculptor. Studied at the Académie Julian and at the Ecole des Beaux-Arts, Brussels. Born and lived in London.
Bibl: Apollo VIII 1928 p.86; Who's Who 1936; Who's Who in Art 1934; Ormond.

TAUNCE de LAUNE, C. de L. fl.1872
Exhib. a work in 1872. London address.

TAUNTON, William fl.1853-1875
Painted landscape. Exhib. seven works at SS including 'Skirts of a Common' and 'Near Sunsford, Devon', and one work at the RA. London address. Also lived in Worcester and exhib. at RBSA.

TAXE, Theobald fl.1865-1867
Painted figurative subjects and animals. Exhib. six works at the BI including 'My Cat and My Neighbour's Cat' and 'Fanny Waiting for Sugar', and one work at the RA. London address.

***TAYLER, Albert Chevallier RBC 1862-1925**
Genre and portrait painter. Studied at Heatherley's and the RA; also in Paris. Exhib. at the Paris Salon 1891. Lived for 12 years in Newlyn, Cornwall, before settling in London. Exhib. at RA from 1884, SS and elsewhere. His output was varied and included historical genre, interiors with or without figures, genre and portraits. Later he turned more to portrait painting. Works by him are in Birmingham, Bristol, Liverpool and Preston AGs. Portraits by him are in the Imperial War Museum, the Guildhall, the Devonshire Club and elsewhere.
Bibl: Studio XXII 1901 p.49; Connoisseur LXXIV 1926 p.127; RA Pictures 1893-1915; Who's Who 1924; Who Was Who 1916-28 pp.16-28.

TAYLER, Edward RMS 1828-1906
Painter of miniature portraits and figure studies; "the father of present-day miniature painters" (AJ 1906). Exhib. from 1849 at the RA, SS, NWS, GG, NG and elsewhere. Hon. Treasurer and one of the founders of the Royal Society of Miniature Painters, and an exhibitor at the RA for more than three decades, Tayler was the connecting link between the days of Sir William Ross (q.v.) and the new school.
Bibl: AJ 1906 p.120 (obit.); Studio XXXVII 1906 p.158; The Year's Art 1907 p.380; Connoisseur LXIV 1922 pp.93, 121; Ormond.

TAYLER, Miss Ida R. fl.1884-1893
Painted rustic and figurative subjects and landscapes. Exhib. 17 works at SS including 'A Busy Day', 'Old and New Putney Bridges' and 'A Fireside Song'. Exhib. nine works at the RA. London address. Her sister Minna Tayler (q.v.) was also a painter.

***TAYLER, John Frederick PRWS 1802-1889**
Painter of sporting subjects, landscapes with figures and animals (chiefly Scottish) and illustrations of past times, some of them scenes in the Waverley Novels; lithographer and etcher. Born at Boreham Wood, Hertfordshire. Educated both at Eton and Harrow; studied art at Sass's Academy, the RA Schools, in Paris under Horace Vernet and in Rome; shared a studio with Bonington for a time in Paris, c.1826. Exhib. 1830-89, at the RA 1830-65 (five works), BI, and OWS (528 works), of which he became A in 1831, Member in 1834, and President 1858-71. Awarded gold medals at the Paris Exhibition of 1855, in Bavaria 1859 and Vienna 1872. Member of the Etching Club. After Paris he soon became known as a watercolour painter of sporting and pastoral scenes, and appears

to have added figures and animal life to the paintings of several of his contemporaries, notably those of George Barret (q.v.) with whom he collaborated between 1834-6 on a dozen pictures. Tayler was a frequent guest at country houses in Scotland and often had aristocratic pupils. Queen Victoria purchased several of his pictures, which are now in the Royal Collection. Tayler handled watercolour with free fluid strokes which he seems to have derived from Cox, and Ruskin compares them. Ruskin was an early admirer of Tayler, and in the first volume of *Modern Painters,* says: "There are few drawings of the present day that involve greater sensations of power than those of Frederick Tayler. Every dash tells and the quantity of effect obtained is enormous in proportion to the apparent means. But the effect obtained is not complete. Brilliant, beautiful and right as a sketch, the work is still far from perfection as a drawing." However, he was becoming more critical by the 1850s. *Academy Notes* 1858, on 'Highland Gillie, with Dogs and Black Game': "It is not Presidential work, Mr. Tayler, you know as well as I that it is not right, and you know better than I, how much you could do with that facile hand of yours if you chose . . . " Many examples of his work are in the VAM, BM and in the Dixon Bequest, Bethnal Green Museum.

Bibl: Ruskin, *Modern Painters I*, 1843 p.24; Academy Notes (OWS 1856, 1858); AJ 1858 pp.120, 329-31; 1863 p.174; 1889 p.275; Gazette des Beaux-Arts XXI 1866 p.74; XXIII 1867 p.356; Redgrave, Cent.; Clement & Hutton; Roget; Bryan; Binyon; Cundall; DNB; Hughes; VAM; Williams; Pavière, Sporting Painters; Maas pp.48, 84; Hardie III pp.85, 91-2, 95 (fig.112).

TAYLER, Miss Kate fl.1885-1893
Exhib. two works at the RA, 'A Brittany Girl' and 'Chestnut Blossoms', and two works at the NWS. London address.

TAYLER, Miss Minna fl.1884-1902
Painted figurative and genre subjects. Exhib. 17 works at the RA including 'Must not be Disturbed', 'The Old Beach, Sandwich' and 'A Studio Reflection', and six works at SS including two Italian views. London address. Her sister Ida Tayler (q.v.) was also a painter.

TAYLER, Miss Nina fl.1890
Exhib. a landscape at the NWS. London address.

TAYLER, Norman E. ARWS b.1843 fl.1863-1915
Painter of genre, landscape and flowers. Second son of J. Frederick Tayler (q.v.). Studied at the RA Schools and gained the first medal for drawing from life. Worked in Rome. Exhib. from 1863, chiefly at the OWS (90 works), and also at the RA, BI, SS and elsewhere, titles at the RA including 'Girl with Oranges', 1863, 'Contadini Returning from Rome', 1870 and 'An Anxious Moment', 1882. ARWS 1878-1915. The VAM has one watercolour, 'Country Girl with a Basket of Eggs, Crossing a Ditch, and a Youth Offering Help', 1878.
Bibl: Clement & Hutton; Roget II p.215; VAM.

TAYLER, T. fl.1840
Exhib. a portrait at the RA. London address.

TAYLOR, Miss Ada E. fl.1876-1881
Exhib. 'Ophelia' at the RA and a painting of fruit at SS. London address.

TAYLOR, Alfred fl.1879-1886
Painted landscape and rustic subjects. Exhib. eight works at the RA including 'The Woodstack' and 'Fuel Gatherers', and six works at SS including 'Counting the Flock' and 'Autumn: Near Epping, Essex'. London address.

TAYLOR, Alfred Henry fl.1832-1867 d.1868
London painter of portraits and genre who exhib. 1832-67, at the RA 1832-63, BI, SS, NWS (107 works) and elsewhere. Titles at the RA are mostly portraits but also include 'Design for Westminster Hospital', 1832, 'Reading the News', 1843 and 'Gathering Blackberries', 1851. Member of the NWS.
Bibl: Cundall; BM Cat. of Engraved British Portraits III 1912 p.307; Ormond.

TAYLOR, Sir Andrew Thomas b.1850 fl.1875-1881
Painted architectural subjects. Exhib. five works at the RA including 'Tower of the Church of St. Jacques, Dieppe' and 'Roslin Chapel'. London address.
Bibl: Who's Who in Art 1934; Who's Who 1936.

TAYLOR, C.A. fl.1844
Exhib. two works at the RA, 'Medora' and 'Shakespeare and the Hostess'. London address.

TAYLOR, Charles fl.1836-1871
London painter of marines and historical subjects who specialised in stormy coastal scenes at Brighton, Deal and Yarmouth. Exhib. 1836-71 at the RA and SS, titles at the RA including 'Brighton at Flood-tide', 1843, 'Annabel Bloundel on the Eve of Departing from her Father's House with the Earl of Rochester', 1843 and 'Towing the Life-boat out of Gorleston Harbour', 1871.
Bibl: Brook-Hart.

TAYLOR, Charles, Jnr. fl.1841-1883
London marine painter, son of Charles Taylor (q.v.). Exhib. 1841-80, at the RA 1846-9, BI, SS, NWS and elsewhere, titles at the RA including 'Vessels off Chapman's Head Beacon — Waiting for Ebb Tide', 1847 and 'In Chelsea Reach — Showery Day', 1849. Cape Town AG has one of his marines.
Bibl: Cat. South African AG, Cape Town 1903 p.33; Brook-Hart.

TAYLOR, Charles T. fl.1901
Exhib. a view of a tavern at the RA. Address in Oldham, Lancashire.

TAYLOR, Miss Charlotte fl.1874-1884
Exhib. two still-lifes at the NWS. London address.

TAYLOR, Edward Ingram fl.1881-1897
Painted landscape and made designs for stained glass. Exhib. seven works at the RA including 'A Bridge over Avon', 'On a Surrey Common' and 'Malham Dale', and window designs. London address.

TAYLOR, Edward J. fl.1881-1891
Painted landscape. Exhib. seven watercolours at SS including 'Becky Falls, S. Devon' and 'A Kentish Common'. London address.

TAYLOR, Edward J. Bernard fl.1891-1912
Painted landscape. Exhib. four works at the RA including 'In the Meadows' and 'A Breezy Upland'. Also exhib. at RBSA including Venetian scenes, portraits and figure subjects. Address in Birmingham

TAYLOR, Edward R. RBSA 1838-1912
Painter of portraits, genre, landscape, coastal scenes, biblical and architectural subjects; potter. Born at Hanley; son of a manufacturer of earthenware, with whom he worked as a youth, but afterwards

entered the Burslem School of Art for training as an art teacher. Studied also at the RCA. Appointed first headmaster of the Lincoln School of Art in 1863. Headmaster of the Birmingham Municipal School of Art 1876-1903. Amongst his pupils were W. Logsdail, Frank Bramley, Fred Hall, Walter Langley, W.J. Wainwright, Jelley, Edwin Harris, Skipworth and Breakspeare (all q.v.). For 13 years in succession the Birmingham School obtained the largest number of awards, and was the first to teach arts and crafts. Was the technical expert for art and technological teaching in the Technical Education scheme of the L.C.C. Exhib. from 1861, at the RA from 1865, BI, SS, NWS, GG, NG and elsewhere, titles at the RA including 'Knitting', 1867, 'The Village Well', 1879, 'On the Look-out for her Boat', 1893 and 'The Four Evangelists and Twelve Apostles at Cleeve Prior', 1896. Elected RBSA in 1879. Gold medallist in 1879 for the best figure picture exhib. at the Crystal Palace Gallery. From 1898 made pottery of rich and delicate colouring. Published *Elementary Art Teaching and Drawing* and *Design for Beginners*.

Bibl Who was Who 1897-1916; Birmingham Cat.

TAYLOR, Edwin RBSA fl.1858-1884
Landscape painter. Exhib. four landscapes 1860-72. Address in Birmingham where he also exhib. 1858-84.

TAYLOR, Emma fl.1865
Exhib. a watercolour study at SS. Address in Ipswich, Suffolk.

TAYLOR, Ernest Archibald 1874-1952
Scottish painter of landscape. Also an architect, decorator and engraver. Exhib. a watercolour study of flowers at SS. Born at Greenock. Lived at Kirkcudbright. Married to the artist Jessie M. King (q.v.).

Bibl: Studio XXIV 1902 p.186; XXVI 1902 pp.99, 102-4; XXXIII 1905 p.215; LIX 1913 pp.206-18; LXVI 1916 p.106; LXXXIII 1922 p.34; LXXXIX 1925 pp. 160-4; Studio Year Book 1907; *The Development of British Landscape Art in Watercolour*, Studio Special Winter Number 1917-18; *British Watercolour Painting of Today*, Studio Special Winter Number 1921.

TAYLOR, Miss Etty fl.1888-1910
Exhib. works entitled 'Wind' and 'Yorkshire Coast — Evening' at SS. Address in Birmingham. Also exhib. at RBSA.

TAYLOR, Frank S. fl.1898
Exhib. a view of an hotel on the Isle of Wight at the RA. London address.

TAYLOR, Frederick RI 1875-1963
Landscape and architectural painter. Studied at the Académie Julian and at Goldsmith's College. Born and lived in London.

TAYLOR, G. Hart fl.1879-1880
Exhib. a watercolour view in South Africa. Address in Cornwall.

TAYLOR, Harry fl.1839-1870
Painted portraits and figurative subjects. Exhib. 12 works at SS including 'The Revenge' and 'The First Care', and portraits. London address.

TAYLOR, Henry King fl.1857-1869
London painter of shipping and coastal scenes. Exhib. at RA 1859-64, BI, SS and elsewhere. Titles at RA include 'The Passing Storm', 'The Ramsgate Lifeboat', 'Dutch Shipping', etc.

Bibl: Wilson p.76 (pl.38); Brook-Hart pl.19.

TAYLOR, Mrs. Herbert (Annie) fl.1854-1856
Exhib. 'A Spanish Lady at Mass' at SS. London address.

TAYLOR, J. fl.1863-1865
Exhib. a painting of grapes and a work entitled 'The Wanderer' at the RA. Address in Plumstead.

TAYLOR, J., Jnr. fl.1833-1842
Painted views of architecture. Exhib. 15 works at the RA including 'Hurstmonceaux Castle' and architectural designs. London address.

TAYLOR, J.F. fl.1830-1840
Exhib. two works at the RA including 'A Spanish Bull Fight', and two works at SS. London address.

TAYLOR, J. Fraser fl.1884
Exhib. two rustic subjects at GG.

TAYLOR, Miss J.T. fl.1860
Exhib. a view in St. Mary's Church, Ware, at the RA. Address in Hertford.

TAYLOR, J. Wyckliffe fl.1880-1886
Exhib. a painting of a lioness at the RA. London address.

TAYLOR, Miss Jane fl.1872-1874
Painted still-lifes. Exhib. three works at SS including 'Holly and Christmas Roses' and 'Sparrow's Nest and Apple Blossom', both watercolours. Address in Rye, Sussex.

TAYLOR, John (Old Taylor) fl.1778-1838
Painted mythological and literary subjects. Exhib. 42 subjects at the RA, the last of these in 1824. Exhib. 27 works at the BI, the last, in 1838, was entitled 'Psyche Arising from the Infernal Regions'. London address.

TAYLOR, John fl.1863-1876
Painted landscape. Exhib. four works at the RA including 'A Devonshire Lane' and 'A Mountain Brook, North Wales'. Address in Bettws-y-Coed, North Wales.

TAYLOR, John D. fl.1884-1888
Painted landscape. Exhib. four works at the RA including 'By the Burnside' and 'The First of Winter's Snow, Ben Lomond'. Address in Glasgow.

Bibl: Caw.

TAYLOR, Joseph fl.1848-1902
Exhib. three works including 'Christ Church Meadows, Oxford' and 'View in Old Charlton, Kent' at the RA. Address in Oxford.

TAYLOR, Joshua fl.1846-1877
Painted landscape and figurative subjects. Exhib. 12 works at the RA including 'The Rest at the Stile', 'On the Sea and Along the Shore' and 'Morning Prayer', and six works at SS including views on the Rivers Conway, Exe and Dart. London address.

TAYLOR, Leonard Campbell RA ROI RP 1874-1969
Painted figurative subjects and interiors. Exhib. ten works at the RA 1899-1904 including 'The Sentinel', 'The Last to Leave' and 'The Bargain'. Studied at the Ruskin School, at the St. John's Wood School and at the RA Schools. Born in Oxford. Lived in London.

Bibl: C.G.E. Bunt, *L.C. Taylor, RA*, 1949.

TAYLOR, Miss Lizzie fl.1879-1897
Exhib. three works including two views in Aston Hall at the RA. Address in Birmingham. Also exhib. at RBSA 1879-97.

TAYLOR, Luke RE 1876-1916
Painted and etched landscape and engraved reproductions of contemporary paintings. Exhib. nine works at the RA including 'A Sunlit Corner' and 'A Sinking Sun and an Ebbing Tide'. Studied at the RCA. Lived at Dartford and was killed in action in 1916.
Bibl: AJ 1903 p.274; Studio XLIII 1908 pp.213, 218; LXVIII 1916 p.111; Who's Who 1914; Who Was Who 1916; Connoisseur XLVII 1917 p.228.

TAYLOR, Nora fl.1881
Exhib. a watercolour view near St. Ives, Cornwall, at SS. London address.

TAYLOR, Miss Pauline fl.1868-1869
Painted still-lifes. Exhib. four watercolours at the RA including 'Chaffinch' and 'Shells'. Address in Southport, Lancashire.

TAYLOR, S. fl.1807-1849
Painted figurative subjects. Exhib. four works at the BI including 'The Bride' and 'A Highlander', and six works at SS. London address.

TAYLOR, Miss S.M. Louisa fl.1867-1884
Exhib. three works at SS including 'Hark!' and 'A Lost Chord', and a work at the RA. Address in Oxford.

TAYLOR, Samuel C. fl.1897
Exhib. a still-life at the RA. Address in Belfast.

TAYLOR, Stephen fl.1817-1849
Painter of dead game, animals and portraits, living in Winchester, Oxford and London. Exhib.1817-49, at the RA, BI and SS, titles at the RA including 'The Tiger Cat Pouncing upon an Indian Pheasant', 1828, 'Mandarin, a Chinese Drake; Painted at the Zoological Gardens', 1832 and ' "Love me, Love my Dog!" ', 1849.
Bibl: Pavière, Sporting Painters.

TAYLOR, Tom fl.1883-1898
Painted genre subjects. Exhib. 12 works at SS, the majority watercolours, including 'A Leisure Hour', 'The Right Card to Play' and 'Kisses for Grand-Dad'. Also exhib. six works at the RA. London address.

TAYLOR, W.B. fl.1820-1855
Painted landscape. Exhib. four works at the RA including 'Nymphs Bathing' and a view of Norham Castle, and a view of British artillery in action at SS. London address.

TAYLOR, Walter LG 1860-1943
Painted buildings and landscape in watercolour. Exhib. a work entitled 'Duckling' at the RA. Travelled and worked in Italy and France. Born in Leeds. Died in London. A friend of W.R. Sickert (q.v.) with whom he worked in France and Italy. A one-man show was held at the Grafton Gallery in 1911.
Exhib: London, Mayor Gallery 1935; Leicester Galleries 1944.

TAYLOR, William fl.1812-1859
Painted landscape and figurative subjects. Exhib. 20 works at the RA including 'Frolic and Fright', 'The Lesson' and 'A Brace of Partridges', and seven works at SS including 'The Nurse' and 'Fair Rosamond'. London address.

TAYLOR, William Benjamin Sarsfield 1781-1850
Painter of landscape, battle-pieces, genre, literary, historical and architectural subjects; etcher and engraver; art writer and critic. Born in Dublin, son of John McKinley Taylor (fl.1765-1819), engraver. Pupil at the Dublin Society's Schools in 1800, and exhib. there from 1801. Joined the Commissariat Department and served in the Peninsula, being present at the Siege of San Sebastian in 1813. Exhib. at the RHA from 1826. At some time before that date he moved to London where he lived for the rest of his life. Exhib. 1829-47 at the RA, BI, SS and NWS, titles at the RA including 'Opening of the Cloisters of St. Stephen's Chapel, Westminster, by Henry VIII and Queen Catherine of Aragon', 1837, 'Admiral Nelson's Flag-ship *Vanguard* as seen at Break of Day in June 1798 nearly Dismasted in a Gale', 1839 and 'An Afghan Chief Alarmed by the Cries of a Night Raven', 1847. He was a Member of the RI 1831-3. In the latter part of his life he was Curator of the St. Martin's Lane Academy. He never attained any distinction as an artist and is better known as an art writer and critic. He contributed to the *Morning Chronicle,* and besides his *History of the University of Dublin* (1845, 9 pls., publ. 1819), published a translation of Mérimée's *Art of Painting in Oil and Fresco,* 1839, *A Manual of Fresco and Encaustic Painting,* 1843 and *The Origin, Progress and Present Condition of the Fine Arts in Great Britain and Ireland* (2 vols., 1841).
Bibl: AJ 1851 p.44; Redgrave, Dict.; Universal Cat. of Books on Art, South Kensington 1870; Cundall; DNB; Strickland; Ormond; Brook-Hart.

TEAPE, James S. fl.1897-1901
Exhib. two portraits at the RA. Address in Kingsland.

TEASDALE, John 1848-1926
Painted architectural subjects. Exhib. three landscapes 1877-8. Studied at Newcastle School of Art and at the RCA. Born at Newcastle-upon-Tyne. Taught art and worked in the north-east.
Bibl: Hall.

TEASDALE, Kenneth J.M. fl.1900
Exhib. a work entitled 'The Sheepfold' at the RA. Address in Cranleigh, Surrey.

TEASDALE, Percy Morton RCA 1870-1961
Painted portraits, landscapes and figurative subjects. Exhib. six works at the RA 1894-1904 including 'Under a Spell', 'Firelight' and 'Ready'. Studied under Herkomer and at the Académie Julian. Lived at Bushey, Hertfordshire.
Bibl: Who's Who in Art 1934; P. Phillips, *The Staithes Group,* 1993.

TEBBITT, Miss Gertrude fl.1890-1902
Exhib. a painting of an animal in 1890 and a view of the Villa Borghese and a portrait 1901-2 at the RA. London address.

TEBBITT, Henri fl.1882-1884
Exhib. 'Wet Weather' at the RA, and 'Perch on the Feed' at SS. Address in Surrey.

TEBBY, Arthur Kemp fl.1882-1899
Painted landscape. Exhib. seven works at SS including 'Broadstairs', 'An Old Plough' and 'The Roman Baths, Bath', and three works at the RA. London address.

TEBBY, Leighton fl.1885-1888
Painted landscape. Exhib. three works at SS including 'A Yorkshire Hill-side Home' and 'Evening', and one work at the RA. London address.

TEDDER, M. fl.1885-1891
Exhib. three landscapes at the NWS. Address in Woking, Surrey.

TEED, Mrs. Frank L. fl.1893
Exhib. a flower piece at the NWS. London address.

TEERING, Sir R.F., Bt. fl.1876
Exhib. three landscapes in 1876. Address in Chichester, Sussex.

TEESDALE, C. fl.1883-1886
Exhib. four landscapes at the NWS. London address.

TELBIN, Henry fl.1866
Exhib. three watercolours including views in Ireland and Damascus at SS. London address.

TELBIN, Miss Mary fl.1884
Exhib. a figurative subject in 1884. London address.

TELBIN, W.T., Jnr. fl.1866-1881
Painted landscape. Exhib. five works at SS including 'Bray Head, Co. Wicklow' and 'At the Lizard', the first a watercolour. London address.

TELBIN, William NWS 1815-1873
One of the best-known Victorian stage designers. Also painted landscape and buildings. Exhib. six works at the BI including 'The Alhambra, Granada', 'Dovedale, Derbyshire' and views of Venice, three views at SS and one view at the RA. London address. His son William Lewis Telbin (q.v.) was also a painter.
Bibl: AJ 1859 p.176; 1866 p.332; 1874 p.45; Bryan; Cundall; Mag. of Art 1902 pp.371, 499; The Times 12 December 1931.

TELBIN, William Lewis 1846-1931
Exhib. a view in the Tyrol at SS. London address. He was the son of William Telbin (q.v.).

TELFER, Mrs. C. (?C.) fl.1892
Exhib. a painting of dahlias at SS. London address.

TELFER, W.D. fl.1845-1847
Painted historical subjects. Exhib. three works at the RA including 'The Defiance of Douglas' and 'The Baron's Hand'. London address.

TEMPLE, Captain fl.1867
Exhib. a landscape in 1867. Address in Guernsey.

TEMPLE, Alfred George FSA fl.1881-1890
Exhib. two works including a view of Snowdon at the RA, and a watercolour at SS. London address.

TEMPLE, E. fl.1862-1874
Painted landscape. Exhib. 12 works at SS including 'A Pic-nic in the Woods' and 'A Surrey Cornfield', the second a watercolour. London address.

TEMPLE, Robert Scott fl.1874-1900
Scottish landscape painter, living in Edinburgh, London and Lammas, Norfolk. Exhib. 1874-1900, at the RA 1879-1900 and SS, titles at the RA including 'Among the Pentland Hills', 1879, 'Day's Requiem', 1877 and 'A Kentish Sandpit', 1896.

TEMPLETON, John Samuelson (Samuel) fl.1819-1857
Lithographic artist, and painter of portraits and landscape. Born in Dublin and attended the Dublin Society's Drawing School in 1819. Early in life he went to London, and exhib. landscapes at the RA from 1830-3, titles including 'Christ Church Cathedral' 1830 and 'The Quarries, Hill of Howth', 1832. 1841-57 he exhib. portraits. He also exhib. at the BI and SS. He was, however, chiefly employed as a lithographer and reproduced a number of portraits after pictures and drawings by other artists. His name does not occur after 1857. Among his lithographs are 'Lord Palmerston, after W.C. Ross ARA', 'Sir P.B.V. Broke, after W.C. Ross ARA', and 'The American Ship "Edward", wrecked on the North Bull in Nov. 1825', drawn and lithographed by Templeton.
Bibl: Strickland; Print Collector's Quarterly XVIII 1931 p.237; BM Cat. of Engraved British Portraits VI 1925.

TENISON, Miss Nell fl.1893-1902
Exhib. a painting of poppies at SS. London address.

TENISON, William fl.1873
Exhib. an Italian landscape in 1873. London address.

TENISWOOD, George F. fl.1856-1876
London painter of landscape and marine subjects, who exhib. 1856-76, at the RA 1863-74, BI, SS and elsewhere. Titles at the RA include 'The Curfew Hour', 1863, 'Stonehenge — Early Morning', 1866, and 'The Stranded Wreck — Cloudy Moonlight', 1868. Nearly all the titles are of twilight or moonlight subjects.
Bibl: BM Cat. of Engraved British Portraits II 1910 p.378.

TENKATE, Herman fl.1872-1876
Exhib. a watercolour entitled 'The Little Gardeners' at SS. London address.

***TENNANT, Miss Dorothy fl.1879-1909 d.1926**
(Lady Stanley)
Genre painter and illustrator. Studied at Slade School, and with Henner in Paris. Married the African explorer Sir Henry Stanley in 1890. Exhib. at RA from 1886, GG, NG and elsewhere. Titles at RA include 'An Arab Dance', 'A Load of Care', 'The Forsaken Nymph', etc. She illustrated *London Street Arabs,* 1890, and Stanley's autobiography. A work by her is in Sheffield AG. See also Lady Stanley.
Bibl: The Nat. Gall. (ed. E.J. Poynter) 1899-1900 III p.266ff.; Who's Who 1924; Who Was Who 1916-29; BM Cat. of Engraved British Portraits IV 1914 p.177.

***TENNANT, John F. 1796-1872**
Painter of genre, landscape and coastal scenes. Mostly self-taught, although he did receive lessons from William Anderson. At first he painted historical genre subjects, mostly taken from Walter Scott, but soon turned to landscape, for which he is better known. Exhib. mostly at SS, where he became a member in 1842; also at RA, 1820-67, BI and NWS. He lived for a long time in Devon and Wales. Now best known for his river and coastal scenes, painted in a clear and colourful style.
Bibl: AJ 1873 p.177 (obit); Redgrave, Dict; Clement & Hutton; Pavière, Landscape pl.79.

TENNANT, Mrs. R.N. fl.1852
Exhib. 'A Boy's Head' and 'A Fawn's Head' at the RA.

TENNICK, W.G. fl.1877
Exhib. two landscapes in 1877. London address.

TENNIEL, Sir John RI 1820-1914
Painter, illustrator and cartoonist. Practically self-taught in art; exhib. 1835-80 at the RA, SS, NWS and elsewhere. Titles at the RA include cartoons and illustrations of literary works, e.g. 'The Expulsion from Eden', from Milton. Won a premium in the Westminster Hall Competition of 1845. RI in 1874. Knighted in 1893. From 1851-1901 he was on the staff of *Punch*, for which he drew nearly all the principal cartoons. He also illustrated many books including Lewis Carroll's *Alice in Wonderland* and *Alice Through the Looking Glass*.

Bibl: AJ 1882 pp.13-16; Clement & Hutton; G. Everitt, *English Caricaturists*, 1893; M.H. Spielmann, *The History of Punch*, 1895, and *The First Fifty Years of Punch*, 1900; R.E.D. Sketchley, *English Book Illustration of Today*, 1903; Connoisseur XXXVIII 1914 p.259ff.; XL 1914 p.173; Who Was Who 1897-1915; Burlington Mag. XXX 1917 pp.31, 123; *Graphic Arts of Great Britain*, Studio Special Number 1917 pp.6, 24 (pl.); DNB 1912-21; *Drawings in Pen*, Studio Spring Number 1922 p.128; *British Book Illustration*, Studio Winter Number 1923-4 pp.30ff., 95 (pl.); The Art News XXIV 1925-6 No. 7 p.7 (pl.); VAM; Frances Sarzano, *Sir J.T.*, 1948; Irwin; R. Engen, *Sir J.T.*, 1992.
Exhib: Manchester, City AG 1932; Ottawa, National Gallery of Canada 1935.

TENNISON, W. fl.1873
Exhib. two Italian landscapes at SS.

TENNYSON, J. fl.1865
Exhib. a view of Snowdon at the BI. London address.

TERRELL, Mrs Georgina fl.1876-1903
(Miss G.F. Koberwein)
London painter of still-life, portraits, genre and fruit, who exhib. 1876-8 as Miss G. Koberwein, at the RA, SS and elsewhere, and from 1879-1903 as Mrs. Terrell, at the RA, SS, NWS and elsewhere. Titles at the RA include 'Stella', 1879, and 'Sweet Memories', 1887, but mostly portraits in the later years. She was the daughter of Georg Koberwein (1820-76), a Viennese portrait painter, who settled in London and exhib. portraits 1859-76 at the RA, BI, SS and elsewhere. Her sister was Miss Rosa Koberwein (fl.1876-85), who exhib. for those years at the RA, 1876-82 SS, NWS, GG and elsewhere, mostly portraits and genre, e.g. 'In Maiden Meditation, Fancy Free', RA 1878.

TERRELL, R.H. fl.1855
Exhib. a portrait at the RA.

TERRIS, John RSW RI 1865-1914
Painted landscape. Exhib. three works, including views on the Isle of Arran and near Stirling at the RA. Address in Glasgow.
Bibl: Connoisseur XXXIX 1914 p.39.

TERRITT, J. fl.1845
Exhib. 'A Luncheon' at SS. Address in Taunton, Somerset.

TERRY, Miss Agnes D. fl.1900
Exhib. a work entitled 'The Old Lace Maker' at the RA. London address.

TERRY, Elizabeth fl.1846-1853
Exhib. two works at the RA, one of them a view in Bath. London address.

***TERRY, Henry M. fl.1879-1920**
Painter of genre and literary subjects, and occasionally gardens, living in Brixton and Tetsworth, who exhib. 1879-94, at the RA 1880-94, SS, NWS, NG and elsewhere. Titles at the RA include

'Land of my Birth, I Think of Thee Still', 1880, 'An Old Dame', 1886 and 'An Old Garden Gay and Trim', 1894. The VAM has a watercolour 'A Half-caste, Wearing a Striped Turban and Dress', 1879 which is attributed to another artist, Henry J. Terry (1818-80, not listed in Graves, Dictionary or RA Exhibitors), who was born in England and studied in Switzerland under Calame, many of whose works he lithographed. He took part in many exhibs. in Switzerland and died in Lausanne (VAM).
Bibl: Wood, Painted Gardens.

TERRY, J. fl.1865
Said to have exhib. a work in 1865.

TERRY, Miss Jane fl.1856
Exhib. a sketch from nature at the RA. London address.

TERRY, Joseph Alfred RBA 1872-1939
Painted landscape and genre. Studied at York and in Paris. Born in York, lived in Yorkshire.
Bibl: Who's Who in Art 1934; P. Phillips, *The Staithes Group*, 1993.

TERRY, W.F. fl.1864-1873
Painted landscape. Exhib. six works at SS, including 'Lane Scene at Knockholt, Kent', and 'Trees, Tooting Common', both watercolours, and one work at the BI. London address.

TESTELIN, A.J. fl.1867-1874
Painted figurative subjects. Exhib. four works at SS including 'Stop Thief' and 'A German Girl Knitting'. London address.

THACKER, Samuel T. fl.1886-1888
Exhib. two works entitled 'Breezy Day' at SS. London address.

THACKERAY, Lance fl.1901 d.1916
Painted genre and sporting subjects. Exhib. two works at the RA, the first entitled 'The Flower Girl'. London address.
Bibl: Who's Who 1914; Who Was Who 1916-28, 1929; Studio XXX 1904 pp.26, 41, 42; AJ 1906 p.103.

THADDEUS, Henry Jones- RHA 1860-1929
Portraitist. Exhib. a subject from the Life of King Arthur at SS, and four works at SS. Studied at Heatherley's and at the Académie Julian. Born at Cork, Ireland. Died at Ryde, Isle of Wight.
Bibl: Who's Who 1929; Studio XXV 1902 p.209; Connoisseur LXXXIV 1929 p.60; BM Cat. of Engraved British Portraits; Ormond.

THAGARDH, P. fl.1892
Exhib. a landscape in 1892. London address.

THANNENBERG, Count L. de fl.1852
Exhib. a watercolour portrait at SS. London address.

THATCHER, C.F. fl.1816-1846
Painted portraits, figurative subjects and landscapes. Exhib. 39 works at the RA 1816-46, the later of these including portraits, views in North Wales and 'A Girl Gathering Mushrooms'. Also exhib. 14 works at the BI, the last in 1835, and one work at SS. London address.

THEAKER, Harry George RBA 1873-1954
Painted landscape. Also a decorative and stained-glass painter. Studied at Burslem School of Art, at the RCA and in Italy. Born at Wolstanton, Staffordshire. Lived in London.

THELWALL, J.A. fl.1883-1886
Painted figurative subjects. Exhib. four works at the RA including 'An Art Nursery' and 'Studio Gossip', and one work at SS. Address in East Molsley, Surrey and in London.

THELWALL, Weymouth Birkbeck fl.1867-1868
Is supposed to have exhib. a landscape 1867-8. London address.

THEOBALD, Henry ANWS fl.1845-1851
Exhib. two works, 'The Refreshing Draught' and 'The Monk', at the RA. London address. Elected ANWS, 1847.

THEOBALD, S.S. fl.1885-1886
Exhib. three landscapes at the NWS. London address.

THESIGER, Ernest 1879-1961
Watercolourist and actor. Studied at the Slade School. His autobiography, *Practically True,* was published in 1927.

THEWENETI, J. fl.1860-1876
Exhib. two landscapes at SS. London address.

THIEDE, Edwin Adolf fl.1882-1900
Painted portraits and figurative subjects. Exhib. seven works at the RA including 'An Academy Model' and 'Hop Picking, Kent' and portraits. Address in Lewisham, Kent.

THIENON, L. fl.1852
Exhib. a view of the ruins of Holyrood Chapel at the RA.

THIÉRON, L. fl.1837
Exhib. a view of London at the RA. London address.

THIMM, Franz fl.1850-1852
Exhib. two views in Prussia at the RA. London address.

THIRTLE, John fl.1898
Exhib. 'A Study in Brown Madder' at the RA. Address in Ewell, Surrey.

THOM, James Crawford 1835-1898
Painter of landscape, rustic genre and portraits. Born in New York, son of James Thom, sculptor. Studied at the National Academy of Design in New York, and first exhib. there in 1857. Also studied under Edward Frere in Paris, to whose works his own bear a close resemblance in style. Exhib. 1864-73 at the RA, BI, SS, and the French Gallery, Pall Mall, and elsewhere, sending his first picture to the RA, 'Returning from the Wood — Winter', from Ecouen. Other titles at the RA include ' "Hush-a-Bye" ', 1866 and 'The Monk's Walk', 1873. 1866-c.1874 he was living in Brentford. He also exhib. at the Boston Athenaeum and the Pennsylvania Academy. Died at Atlantic Highlands. The AJ reproduces 'The Grandfather's Grave' showing an old Frenchwoman and a child kneeling by a grave.
Bibl: AJ 1874 p.248 (pl.); Clement & Hutton; American Art Annual 1898 p.31 (obit.); Fielding, *Dictionary of American Painters.*

THOMAS, Miss fl.1841-1842
Exhib. two works, 'The Cottager' and 'Mill at Ashford, Derbyshire', at the RA.

THOMAS, Mrs. fl.1858-1861
Exhib. four works at the RA including 'Foreigners that Agree with Natives' and 'Luncheon Time'. London address.

THOMAS, Annie H. fl.1883-1889
Exhib. three works at SS including two views in Cornwall. London address.

THOMAS, Clifton (Clinton) fl.1884
Exhib. a work entitled 'After Sunset' at the RA. Address in Salisbury, Wiltshire.

THOMAS, Miss D.H. fl.1878-1892
Exhib. a painting of game at the NWS. Address in Llandudno, Caernarvon.

THOMAS, Dudley fl.1881
Exhib. two landscapes at SS. London address.

THOMAS, Miss E. fl.1869
Exhib. 'The Rest by the Way' at SS. London address.

THOMAS, Edgar Herbert fl.1888
Exhib. a portrait in 1888. Address in Cardiff.

THOMAS, F.D. fl.1882
Exhib. two landscapes in 1882. London address.

THOMAS, Miss Fanny E. fl.1880
Exhib. a watercolour entitled 'Ready for the Sickle, Sark' at SS. Address in Shortlands, Kent.

THOMAS, Florence Elizabeth see WILLIAMS, Alfred Walter

THOMAS, Francis Inigo ARPE fl.1893-1902
A landscape architect who painted landscape and views of buildings. Exhib. seven works at the RA including 'Playing Fields, Eton College', London address.

THOMAS, George A. fl.1885
Exhib. a work entitled 'The Home of the Moorhen' at the RA. Address in Hildenborough.

THOMAS, George Grosvenor RSW PS 1856-1923
Painted landscape. Exhib. 'Evening' at the RA. Born in Sydney, Australia. Educated in England.

THOMAS, George Housman 1824-1868
Painter of ceremonial subjects and group portraits (largely commissioned by the Royal Family), genre and contemporary history; illustrator and wood engraver. Began his career in Paris as a wood engraver, after studying under G.W. Bonner, the engraver; went to New York for two years to draw illustrations for a newspaper; designed American banknotes; returned to Europe, was in Rome during its siege by the French and sent drawings of the operations to *The Illustrated London News;* subsequently joined its staff on settling in London. Exhib. 1851-68, at the RA, 1854-68, BI and elsewhere, works at the RA including 'Garibaldi at the Siege of Rome 1849', 1854, 'Ball at the Camp, Boulogne', 1856 and 'The Queen and the Prince Consort at Aldershot 1859', 1866. He also continued to work as an illustrator, and among the books he drew for are *Uncle Tom's Cabin* and *The Child's History of England.* He later painted many pictures of ceremonies, group portraits and marriages for Queen Victoria, e.g. 'The Presentation of Medals for Service in the Crimea by the Queen 1855', 1858, 'The Review on the Champ de Mars', 1859 and 'The Coronation of the King of Prussia', 1863. Many of his works are in the Library at Windsor Castle.
Bibl: AJ 1868 p.181 (obit.); 1869 p.183; *In Memoriam George Housman Thomas Artist. A Collection of Engravings from his Drawings on Wood,* 1869; Redgrave, Dict; Bryan; VAM; Print Collector's Quarterly XXIII 1936 p.181; Ormond. Exhib: London, Lawrence Gallery 1869.

THOMAS, J.L. fl.1855-1869
Painted landscape. Exhib. six works at SS including 'On the Surrey Hills — Autumn' and 'In Knowle Park, Kent', and four works at the RA. London address.

THOMAS, M. fl.1853
Exhib. a painting of fruit at the RA.

THOMAS, M.F. fl.1872
Exhib. a landscape in 1872. London address.

THOMAS, Miss Margaret fl. from 1868 d.1929
Portrait painter and sculptress; writer. Born in Croydon; her parents emigrated to Australia, where she began to study sculpture under Charles Summers. Returned to England in 1868; entered the South Kensington Schools for ten months; spent two and a half years in Rome; on her return she studied at the RA Schools for two years where she gained a silver medal. Exhib. 1868-80, at the RA 1868-77, SS and elsewhere. Marble busts by her of Fielding, Jacob, Fox and Summers are in Shire Hall, Taunton, and a bust of Richard Jefferies is in Salisbury Cathedral. She lived in Letchworth, and travelled in Italy, Spain, Sicily, Egypt, Syria, Denmark, etc. She published *A Hero of the Workshop*, 1880; *Poems in Australian Poets* and *Century of Australian Song*, 1888; *A Scamper through Spain and Tangier*, 1892; *Two Years in Palestine and Syria*, 1899; *Denmark, Past and Present*, 1901; *How to Judge Pictures*, 1906; *A Painter's Pastime*, 1908; *How to Understand Sculpture*, 1911; and *Friendship, Poems in Memoriam*, 1927.
Bibl: Clayton II p.259;Who Was Who 1929-40; Ormond.
Exhib: London, Leicester Galleries 1949, 1950; Canaletto Gallery 1961; Wildenstein 1962.

THOMAS, Mary fl.1878
Exhib. a landscape in 1878. London address.

THOMAS, Miss P. Elizabeth F. fl.1900
Exhib. a 'Portrait by Lamplight' at the RA. Address in Tymaston, Surrey.

THOMAS, Percy RPE 1846-1922
Etcher, and painter of portraits, landscape, genre and architectural subjects. Son of Sergeant Thomas, an early patron of Whistler, and brother of Edmund Thomas, art dealer, and Ralph Thomas, painter, solicitor and author. Educated at the RA Schools. One of the earliest friends and first pupil of J.A.M. Whistler (q.v.), from whom he learnt etching. Learnt printing from Augusta Délâtre, whom his father had brought over from Paris to print Whistler's etchings. Exhib. at the RA from 1867, mainly etchings, but also 'On Strike', 1879, 'Sir Paul Pindar's House, Bishopsgate St.', 1882, 'Relics', 1886 (reprd. RA Cat. 1886), and 'A Parting Request', 1892. Also exhib. at SS and elsewhere. Contributed to *English Etchings*; etched the portrait of Whistler for Ralph Thomas's *Catalogue of Whistler's Etchings*, 1874; etched, for the *Art Union*, 'Windmill' by John Crome, and a series of *The Temple, London* (text by Canon Ainger).
Bibl: Portfolio 1876 p.156 (pls.); Wedmore, *Etching in England*, 1895 p.160 (pl.); E.R. and J. Pennell, *The Life of James McNeill Whistler*, 1908 I pp.86, 152-3, 182, 184, 199; Hind, *A Short History of Engraving*, 1911; Who Was Who 1916-28; BM Cat. of Engraved British Portraits VI 1925 pp.555, 694; Connoisseur LXXVII 1927 p.125.

THOMAS, Richard Strickland RN 1787-1853
Portsmouth marine painter. Painted ships, naval actions and historical events. Exhib. three pictures at RA 183942. Titles at RA include 'Trafalgar, after the Close of the Action', 'The Battle of Navarino', etc. A number of his works are in the Greenwich Maritime Museum.
Bibl: Wilson p.77 (pl.39); Brook-Hart.

THOMAS, Mrs. Sybil fl.1897
Exhib. a portrait at the RA. London address.

THOMAS, Sydney fl.1867-1868
Exhib. two landscapes 1867-8. London address.

THOMAS, Thomas Henry RCA 1839-1915
Painted portraits. Designer and illustrator. Studied at Bristol School of Art, at Carey's, Bloomsbury and at the RA Schools. Born in Pontypool. Lived in London and later in Cardiff.
Bibl: T.M. Rees, *Welsh Painters*, 1912.

THOMAS, W. fl.1838-1862
Exhib. a view on the Thames at SS, and a work entitled 'A Sailor Boy' at the BI. Address in Hampton, Middlesex.

THOMAS, W. Murray fl.1891
Exhib. two marines at SS. Address in Cobham. Surrey.

THOMAS, William Barton 1877-1947
Painted landscape. Born at Boston, Lincolnshire.

***THOMAS, William Cave** b.1820 fl.1838-1884
Painter of genre, historical, literary and biblical subjects; etcher and author. Moved on the outer fringes of the Pre-Raphaelite Brotherhood in its early years. Studied at the RA Schools in 1838; in 1840 went to Munich to see the work of Cornelius and the Nazarenes. Entered the Munich Academy of Art, and worked under Hess on the frescoes in the Basilica. Returned to England in 1842. In 1843 won a premium of £100 at the Westminster Hall Competition for 'St. Augustine Preaching to the Saxons', and later, in the third exhib. at Westminster Hall, £400 for a cartoon of 'Justice'. Exhib. 1843-84, at the RA 1843-62, BI, NWS and elsewhere. Titles at the RA include 'A Guardian Angel: Infancy', 1843, 'Canute Listening to the Monks of Ely', 1857 and 'Petrarch's First Sight of Laura', 1861. From c.1849-50 he was associated with Thomas Seddon and Ford Madox Brown (qq.v.) in a scheme for teaching drawing and design to artisans. He proposed a list of titles for *The Germ*, and is generally credited with the one used. He published *Pre-Raphaelitism Tested by the Principles of Christianity: An Introduction to Christian Idealism*, 1860 (reviewed AJ 1861 p.100) which Fredeman notes "seeks to examine the movement as purely a religious phenomenon and to identify Pre-Raphaelitism with moral and ethical values rather than with artistic ones". His altarpiece, 'The Diffusion of Gifts', 1867, "in Early Renaissance style" (Pevsner, London II) is in Christ Church, Cosway Street, St. Marylebone.
Bibl: AJ 1869 pp.217-19 (pls.); Ottley; Portfolio 1871 pp.149-53; Clement & Hutton; VAM; Fredeman p.10 4.1; 66.7; Raymond Watkinson *Pre-Raphaelite Art and Design*, 1970 pp.137, 140.

THOMAS, William F. fl.1901
Exhib. a view of Walberswick at the RA. Address in Southwold, Suffolk.

THOMAS, William Luson RI 1830-1900
Wood engraver and watercolourist. Founded *The Graphic* as an illustrated weekly newspaper in 1869, and invited Holl and Fildes, together with Herkomer, Pinwell and Walker, to contribute to its illustrations. Also engraved for the *Daily Graphic*, worked in Paris, Rome and New York. As a painter, exhib. 1860-89 at SS, NWS (173 works) and elsewhere, but not at the RA.
Bibl: The Year's Art 1894. 1901; Cundall; BM Cat. of Engraved British Portraits VI 1925 p.694; Reynolds, VS p.27.

THOMPSON, Alfred fl.1863-1876
Painted figurative subjects. Exhib. five works at the RA including works entitled 'The Plague-Ridden, AD 1665' and 'Embroidery', and four works at SS, including 'A Revolt in Japan' and 'The Picture She Likes Best'. London address.

THOMPSON, Baylis fl.1855-1856
Exhib. four landscapes 1855-6. London address.

THOMPSON, C.H. fl.1894
Exhib. a portrait at the RA. Address in Bushey, Hertfordshire.

THOMPSON, Mrs. Christiana fl.1879
Exhib. a work entitled 'Sunshine' at the RA. London address.

THOMPSON, E. fl.1845
Exhib. a portrait at the RA. London address.

THOMPSON, E. fl.1877
Exhib. a work entitled 'Weary' at SS. Address in Birmingham.

THOMPSON, E.H. fl.1871-1872
Painted landscape. Exhib. four works at SS including 'Near Capel Curig, North Wales'. London address.

THOMPSON, Elizabeth
see BUTLER, Lady Elizabeth Southerden

THOMPSON, Frank fl.1875-d.1926
Exhib. two works at SS, 'Old Mill near Darlington' and 'Barnard Castle Market Place'. London address.
Bibl: Hall.

THOMPSON, G. fl.1810-1839
Exhib. two works at the RA, the second a study from nature. London address.

THOMPSON, G.A. fl.1851
Exhib. a work entitled 'Cottage Scene from Nature' at the RA. Address in Guildford, Surrey.

THOMPSON, G.B. fl.1873
Exhib. a watercolour view on the River Lyn, Devon, at SS. London address.

THOMPSON, G.H. fl.1879-1885
Exhib. two views near Southampton at the RA. Address in Southampton.

THOMPSON, G. Ivan fl.1876
Exhib. three landscapes in 1876 London address.

THOMPSON, Gabriel fl.1889-1897
Painted portraits. Exhib. five works at the RA including three portraits and 'Wood Nymph'. Address in Munich.

THOMPSON, George fl.1892
Exhib. a portrait at the NG. London address.

THOMPSON, George Douglas fl.1836-1838
Exhib. two works, 'Astrophobia' and a portrait at SS, and one work at the BI. London address.

THOMPSON, H. fl.1846
Exhib. a watercolour painting of flowers at SS. Address in Waltham Abbey, Essex.

THOMPSON, H. Raymond fl.1892-1904
Painted figurative subjects. Exhib. six works at the RA 1892-1904 including 'The Joy of Youth' and 'The Poetry of Homer'. London address.

THOMPSON, Harry S. fl.1876-1899
Exhib. a work entitled 'A Northern Calf-yard' at SS. Address in Birmingham. Exhib. at RBSA 1876-90.

THOMPSON, Sir Henry 1820-1904
Leading surgeon; pioneer of cremation; an authority on diet; student of astronomy; man of letters; collector of china; amateur painter of landscapes and still-life. For his career in medicine and his other versatile interests see DNB. Born in Framlingham, Suffolk; his mother was Susannah Medley, daughter of Samuel Medley, the artist. Studied under Alfred Elmore RA and Sir L. Alma-Tadema RA (qq.v.); exhib. 1865-1901 at the RA, GG and elsewhere, and also at the Paris Salon. Titles at the RA include 'The Chrysalis', 1865, 'A Japanese Group', 1872 and 'Bellagio — Summer Morning Haze from Caddennabbia, Lake Como', 1901. He was an eminent collector of Nanking china, and published A *Catalogue of White and Blue Nanking Porcelain,* 1878, illustrated by himself and J.M. Whistler (q.v.). He was also a famous host — remembered for his 'octaves' — dinners of eight courses for eight people at eight o'clock.
Bibl: DNB II Supp. 3 1912; Ormond.

THOMPSON, Miss Isa 1851-1926
(Mrs. R. Jobling)
Painted rustic and figurative subjects. Exhib. five works at the RA including 'Fisher-Folk' and 'The Crofter's Harvest', and nine works at SS, including 'Winter and Rough Weather' and 'Cleaning the Hooks'. Address in Newcastle-upon-Tyne. See also Isa Jobling.

***THOMPSON, Jacob 1806-1879**
Landscape, portrait and genre painter. Born in Penrith, Cumberland, and usually known as Thompson of Penrith. Pupil of RA Schools. Exhib. at RA 1831-66, BI and SS. About 1845 or 1846 he returned to Hackthorpe in Cumberland, where he lived for the rest of his life. He painted landscapes, sometimes with rustic figures, mostly depicting the scenery of Cumberland and Westmorland; also portraits, and animals. He also painted two altarpieces for the Church of St. Andrew's in Penrith.
Bibl: Portfolio 1882 p.164; DNB LVI 1898; Llewellin Jewitt, *Life and Works of J.T.,* 1882; BM Cat. of Engraved British Portraits VI 1925 p.555; Pavière, Landscape Painters pl.80; Wood, Panorama pp.161-4 (pls.170, 173), Wood, Paradise Lost; Wood, Painted Gardens.

THOMPSON, James fl.1855
Exhib. two views in Athens in 1855. London address.

THOMPSON, James Robert fl.1808-1843
Painted landscape and views of architecture. Also made architectural designs. Exhib. 27 works at the RA including 'Ruins of Elgin Cathedral' and 'Design for the Nelson Monument'. The majority of his works are pre-Victorian. London address.

THOMPSON, Miss Kate fl.1874-1883
Painted genre subjects. Exhib. four works at the RA including 'Lovely and Gentle, but Distressed' and 'In a Vineyard near Como', and one work at the GG. London address.

THOMPSON, Miss Margaret fl.1871-1893
Painted figurative subjects. Exhib. 17 works, about half of them watercolours, at SS. Titles including 'Italian Girl', 'A Rainy Afternoon' and 'Wild Briar'. London address.

THOMPSON, Mark 1812-1875
Exhib. two landscapes, one a view on the River Tees, at the BI. Address in Sunderland, County Durham. Painted topographical views, including country houses, in the north-east.
Bibl: Hall.

THOMPSON, Matt. Raine fl.1881
Exhib. 'A Sketch at Elstree' at the RA. London address.

THOMPSON, Nelly fl.1888
Exhib. two works at SS entitled 'La Pensive'. London address.

THOMPSON, R.A. fl.1848-1852
Exhib. three works at the BI including two views on the River Brent. London address.

THOMPSON, Stanley b.1876 fl.1899-1900
Painted portraits and figurative subjects. Exhib. two works at the RA, the first 'A Grey Day on the Wear'. Studied at Sunderland School of Art and at the RCA. Born in Sunderland, lived in Middleton-in-Teesdale, County Durham.

THOMPSON, T.W. fl.1857-1864
Exhib. two works at SS, the first entitled 'Clearing Off'. London address.

THOMPSON, Thomas Clement RHA 1778-1857
Painter of portraits, and also occasionally of genre, biblical subjects, scenes from Shakespeare, and landscape. Born probably in Belfast; attended the Dublin Society's Schools in 1796, and after his course started as a miniature painter in Belfast and Dublin. After 1803 he confined himself to portrait painting in oil. In 1810 he settled in Dublin where he had a good practice; in 1817 he went to London. On the foundation of the RHA in 1823, he was elected one of the original members and exhib. there until 1854. Exhib. in London 1816-57 at the RA, BI and SS. In about 1848 he went to Cheltenham where he remained for the rest of his life. Thompson appears to have had a good practice and had many distinguished people as sitters. Strickland notes that "his portraits are carefully done, the drapery well painted, but the drawing, especially in the arms of his female figures, is defective and his flesh painting raw and unpleasant." His self-portrait in the National Gallery, Dublin shows him, palette in hand, before an easel on which is his portrait of George IV. His portraits include Thomas Campbell the poet, 1833; George IV, 1826; Duke of York, 1825 (RH School, Phoenix Park) and the 'Embarkation of George IV from Kingstown', RA 1845 (a large picture begun in 1821, flnished 1826, containing numerous portraits, Royal Dublin Society).
Bibl: Redgrave Dict; Strickland; BM Cat. of Engraved British Portraits VI 1925 p.555; Ormond.

THOMPSON, Wilfred H. fl.1884-1894
Hampstead painter of historical subjects, genre and landscape, who exhib. l884-94, at the RA 1887-94, SS, NWS and elsewhere. Titles at the RA include 'In Deal Marshes', 1887, 'Dante and Virgil in the Limbo of the Unbaptised', 1891 and 'Prayer; the Church of St. Maria in Ara Coeli, Rome', 1893.

THOMPSON, William fl.1891
Exhib. two portraits in 1891.

THOMSON, Miss A.E. fl.1884-1886
Exhib. two paintings of flowers at SS. Address in Newstead.

THOMSON, Mrs. Adam fl.1850
Exhib. a portrait of the manufacturer of the first English clock at the RA. London address.

THOMSON, Miss Bessie fl.1884-1886
Exhib. three watercolours of flowers at SS. London address.

THOMSON, E. Gertrude fl.1875-1881
Exhib. nine figurative subjects 1875-81. Address in Manchester.

THOMSON, George NEAC 1860-1939
Painted landscapes. Exhib. three works at the RA, 'A Fairy Tale', 'A Study in Silver Point' and a portrait, and two London views at SS. Studied at the RA Schools. Born at Towie, Aberdeenshire. Lived in France, where he died.
Bibl: Irwin.

THOMSON, Gordon fl.1878
Exhib. two works, 'Sweet Hearting' and 'Kept Waiting', at the RA. London address.

THOMSON, Hugh 1860-1920
Painted figurative subjects in watercolour. Also an illustrator. Born in Coleraine. Died in London.
Bibl: For a bibl. relating to his work as an illustrator, see TB.
Exhib: Belfast, Municipal AG 1935.

THOMSON, J. fl.1891-1893
Painted landscape. Exhib. four works, including two Scottish landscapes, at SS. London address.

THOMSON, James 1800-1883
Made designs for architecture and painted views of buildings. Exhib. 28 works at the RA including 'Ullswater from Sparrow Bay', 'Alderton Church, Wilts' and designs. London address.
Bibl: DNB; Irwin.

THOMSON, John fl.1863-1872
Painted landscape and country subjects. Exhib. nine works at the RA including 'The Gloaming' and 'Old Bridge near Rowsley'. Address in Manchester.

THOMSON, John Knighton (Kinghorn) 1820-1888
London painter of genre and historical subjects, who exhib. 1849-83, at the RA 1849-82, BI, SS and elsewhere, titles at the RA including 'The Lover's Grave', 1849, 'The Last Illness of Little Richard Evelyn', 1874 and 'Via Crucis', 1877. His 'First Easter Dawn' was engraved.
Bibl: The Year's Art 1889 (obit.); Bryan.

THOMSON, John Leslie RI RWS ROI RBA RBC NEAC 1851-1929
Scottish painter of landscape and coastal scenes, much influenced by Daubigny and painters of the Barbizon School. Born in Aberdeen, exhib. from 1872, at the RA from 1873, SS, NWS, GG, NG and elsewhere, titles at the RA including 'On the River', 1873, 'After Sunset — Brittany', 1878 and 'A New Forest Stream',

1898. Member of NEAC 1886. The subject-matter of his paintings came from the scenery of the southern and eastern counties of England: Dorset, Poole Harbour, Sussex, the flats of Winchelsea and Rye, the rivers and Broads of Essex, and the general character of a wide open expanse of landscape. He also painted in Normandy and Brittany, and the AJ, 1906, reproduces 'Washing Place: Normandy' — "by J. Leslie Thomson, whose sense of atmosphere, of colour-correspondences, is here admirably exemplified".

Bibl: AJ 1898 pp.53-75 (8 pls.); 1904 p.195; 1906 p.87; 1907 p.162; Studio Summer Number 1900; Cat. de l'Exp. décenn. d. b-arts 1889-1900 Paris 1900 p.302; Caw pp.307-8; Connoisseur LXXXIV 1929 p.60; Who's Who 1929, 1930 (obit.); Brook-Hart.

THOMSON, William fl.1880-1890

Exhib. two works, views at San Remo, Italy, and at Mistley, at SS, and a portrait at the RA. London address.

*THORBURN, Archibald 1860-1935

Animal painter and illustrator, especially of birds. Son of Robert Thorburn ARA, a miniaturist. Specialised in the study of game birds "their forms and plumage, their habits and their flight" (Caw). His pictures are minutely detailed, and show a real knowledge of birds, but they do not contain much imagination or pictorial sense. Exhib. at the RA from 1880, SS and elsewhere.

Bibl: Studio XCI 1926 p.79; Who's Who 1936; Caw p.443; Pavière, Sporting Painters p.83 (pl.42); A. Thorburn, *Thorburn's Birds*, 1967.

THORN, Miss Sarah Elizabeth fl.1838-1846

London painter of genre, animals, portraits and historical subjects, who exhib. 1838-46, at the RA 1842-6, BI and SS, titles at the RA including 'Elizabeth, Queen of Edward IV, Parting with her Youngest Son in the Sanctuary of Westminster', 1842, 'The Lecture', 1843 and 'Portrait of a Spaniel', 1844.

Bibl: Pavière, Sporting Painters.

THORN, T. fl.1887

Exhib. 'A Christmas Gift' at the RA. London address.

THORNBERY, William A.

Painter of shipping and coastal scenes. Now generally thought to be the same as William Thornley (q.v.), painting under another name, a practice sometimes indulged by Victorian artists. He may also be the same as W.A. Thornbury (q.v.).

THORNBURY, Miss H.L. fl.1875

Exhib. a work entitled 'Patience is Virtue' at SS. London address.

THORNBURY, W.A. fl.1883-1886

Exhib. three works, including 'Moonlight' and 'A Misty Day in the Pool', at SS. London address.

THORNE, J. fl.1838-1864

Painted landscape watercolours. Exhib. seven watercolours at SS including 'Rustic Cottages' and 'The Waggon and Horses' and views in Sussex, the Isle of Wight and the New Forest. London address.

*THORNE WAITE, Robert RWS 1842-1935

Painter of landscapes and country scenes, mainly in watercolour. Born in Cheltenham. Studied at South Kensington, and worked in North Wales with Thomas Collier (q.v.). Soon his work was in demand, and he exhib. mainly with the dealer Vokins. He exhib. also at the RWS, elected ARWS 1876, RWS 1884, and also at the RA. Thorne Waite's style is fresh and breezy, in the traditions of Cox, Thomas Collier and E.M. Wimperis (all q.v.). He was particularly fond of painting corn and hayfields, often on the South Downs. See also Waite, Robert Thorne.

Bibl: AJ 1892 pp.182-6; 1895 pp.60, 62; Connoisseur XXVIII 1910 p.315; LIV

1919 p.49; LXVII 1923 p.61; LXXII 1925 p.50; Studio Summer Number 1900. Exhib: Reigate, Bourne Gallery 1976.

THORNELEY, Charles RBA fl.1858-1898

London painter of river and coastal scenes. Exhib. at RA 1859-98, BI, SS, NWS, GG, NG and elsewhere. His titles at the RA include coastal scenes on the South Coast, Wales, the Channel Islands, and Holland.

Bibl: Brook-Hart pls. 118, 119.

THORNHILL, Philip J. fl.1895-1904

Painted figurative subjects. Exhib. eight works at the RA 1895-1904, including 'Venus Sorrowing for Adonis' and 'Viola'. London address.

THORNLEY, Hubert
William

Painters of coastal scenes whose work is very similar, so may have been members of the same family, or even the same artist. Although neither exhib. in London, their fishing scenes are spirited and similar in style to those of Jock Wilson (q.v.). They frequently appear on the London art market. Both artists frequently painted their pictures in pairs. It is now generally thought that William Thornley is the same artist as William A. Thornbery (q.v.).

THORNTON, Alfred Henry Robinson NEAC LG 1863-1939

Painted landscape. Studied at the Slade School and at the Westminster School. Born in India. Lived in Bath, and later at Painswick, Gloucestershire.

Bibl: Who's Who.

THORNTON, Miss Catherine fl.1874-1889

Exhib. two architectural subjects at the NWS. Address in Ickley.

THORNTON, M.J. fl.1887

Exhib. two figurative subjects at the NWS. London address.

THORNTON, W. fl.1837-1865

Painted landscape. Exhib. seven works at the RA, including views in Wales and Surrey, and 11 works at SS including 'St Donant's Castle, Glamorganshire' and 'Lane Scene near Dover'. Address in Reigate, Surrey.

THORNYCROFT, Miss Alyce Mary 1844-1906

Painter and sculptor of figurative subjects. Exhib.14 subjects at the RA including 'Ophelia at the Brook' and 'Edith Seeking the Body of Harold'. Also exhib. two works at the BI and one at SS. Graves (incorrectly) gives her first name as Alyn. Apparently she changed the spelling of her name from Alice in 1865. London address.

Bibl: Elfrida Manning, *Marble and Bronze: The Art and Life of Hamo Thornycroft*, 1982.

THORNYCROFT, Miss Helen 1848-1912

London painter of biblical subjects, genre, flowers and landscape. Daughter of sculptors Mary (1809-95) and Thomas (1815-85) Thornycroft, and sister of sculptors Alyce Thornycroft (q.v.) and Sir William Hamo Thornycroft (1850-1925), the painter Theresa G. Thornycroft (q.v.), and the naval architect and engineer Sir John Isaac Thornycroft (1843-1923). She exhib. 1864-1912, at the RA, SS, NWS, NG and elsewhere, titles at the RA including 'The Pet Thrush', 1867, 'The Martyrdom of St. Luke', 1878 and 'Harebells', 1904. Vice-President of the Society of Lady Artists.

Bibl: See under Miss Alyce Thornycroft.
Exhib: London, 2a Melbury Road, 1894; 1897; 1899.

THORNYCROFT, Miss Theresa Georgina **b.1853 fl.1883**
London painter of biblical and literary subjects. Daughter of the sculptors Mary and Thomas Thornycroft. Exhib. 1874-83, at the RA 1875-83, NWS and GG, titles at the RA including 'Design from the Parable of the Ten Virgins', 1875 and 'The Feeding of the Multitude', 1880. Apparently her most successful work was entitled 'The Hours'.
Bibl: See under Alyce Thornycroft.

THORPE, Mrs. Elizabeth **fl.1869**
Exhib. two marines in 1869. Address in Brussels.

THORPE, John **fl.1834-1873**
London painter of marines and landscape, and animal subjects, who exhib. 1834-73, at the RA 1835-72, BI, SS, NWS and elsewhere (92 works). He specialised in coastal scenery in Devon, Kent, Wales, Sussex, Yorkshire and Scotland, and titles of other subjects at the RA include 'Sheep and Lambs', 1860, 'To the Rescue', 1865 and 'Out at Grass', 1871.
Bibl: Wilson; Brook-Hart.

THORPE, Thomas **fl. late 19th century**
Painted landscape. Lived in Darlington, County Durham, and worked in the north-east. Exhib. in Newcastle.
Bibl: Hall.

***THORS, Joseph** **fl.1863-1900**
Landscape painter. Lived in London, but also worked in the Midlands, where he is regarded as a member of the Birmingham School. Exhib. mostly at SS, also RA 1863-78 and BI. His landscapes are usually rustic scenes with cottages, figures and animals, painted in a style which derives ultimately from the Norwich School. Also exhib. in Birmingham 1869-1900.
Bibl: Pavière, Landscape pl.81.

THORS, S. **fl.1880**
Exhib. a still-life at SS. London address.

THRELFALL, R. **fl.1838-1840**
Painted landscape. Exhib. four works at SS, including views on the Rivers Derwent and Calder, and a view of Caerphilly Castle at the RA. London address.

THRING, G. **fl.1864**
Exhib. a watercolour view of the desert below Suez at SS. Address in Somerset.

THURBER, Mme. Caroline **fl.1901**
Exhib. 'The Little Red Book' at the RA. Address in Paris.

THURNALL, Harry J. **fl.1875-1901**
Painted still-lifes. Exhib. five works at the RA, including 'Dead Game' and 'Lilies and Poppies', and seven works at SS, including 'From the Highlands' and 'Blue Hare and Grouse'. Address in Royston, Cambridgeshire .

THURSTON, Mrs. **fl.1845**
Exhib. a watercolour of a snowy landscape. London address.

THURSTON, John H. **fl.1899**
Exhib. a work entitled 'Breaking Waves' at the RA. Address in St. Ives, Cornwall.

THURSTUN, Mrs. Ray (Charlotte) **fl.1889**
Painted landscape. Exhib. two works, the first 'When the Fields are Dressed in Green', at the RA, and six works at SS, including 'A Kentish Home-stead' and 'After Hop-picking'. Address in Headcorn, Kent.

TICKELL, H. **fl.1842**
Painted a portrait at the RA. London address.

TIDDEMAN, Miss Florence **fl.1871-1897**
Brixton painter of genre, historical subjects and flowers, who exhib. 1871-97, at the RA 1873-97, SS and elsewhere, titles at the RA including 'Florentine Artist of the 15th century', 1874, 'Wild Roses', 1875 and 'A Dark Beauty', 1897.

TIDDEMAN, Miss Letitia E.H. **fl.1870-1890**
Exhib. four genre subjects at the NWS. Address in Stokenchurch, Buckinghamshire.

TIDEY, A.W. **fl.1856**
Exhib. a view of a bridge on the River Dart at the RA. London address. This may be Alfred Tidey (q.v.).

TIDEY, Alfred **1808-1892**
Portrait miniaturist and watercolour painter. Born at Worthing, Sussex. At first worked for Sir William Ross (q.v.) who helped him to obtain commissions. Exhib. at RA 1831-57. A portrait of Sir John Conroy, Controller of the Duchess of Kent's Household, led to many royal commissions. Tidey was a close friend of John Constable and his family, and proposed unsuccessfully to Maria Constable. Tidey married at the age of 48, and moved to Jersey. After a long period of travel, he returned to England in 1873. His brother was Henry Tidey (q.v.).
Bibl: Ormond.

TIDEY, Henry Fryer **NWS** **1814-1872**
Painter of portrait miniatures, and figure subjects, mostly in watercolour. Brother of Alfred Tidey (q.v.). Exhib. 67 works at the RA, mostly portraits, also 'Sea Weeds', etc. and ten watercolours at SS. He also painted scenes from Byron, and Moore's 'Lalla Rookh'. 'The Feast of Roses' was bought from the NWS 1859 exhib. by Queen Victoria to give to Prince Albert. Tidey lived in London, and a sale of his works was held after his death at Christie's, 28 March 1873.
Bibl: AJ 1869, 1872; A.G. Temple, *Guildhall Memories*, 1918 pp.163-4.

TIDMARSH, H.E. **fl.1880-1903**
Painted London views. Exhib. 12 works at the RA, including 'Westminster Abbey' and 'Cheapside', and three works at SS. London address.

TIFFIN, Miss Alice Elizabeth **fl.1873**
Exhib. a view of Salisbury at SS. Address in Salisbury, Wiltshire.

TIFFIN, Henry **fl.1845-1874**
London painter of landscape and genre, who exhib. 1845-74, at the RA 1846-71, BI, SS and elsewhere, titles at the RA including 'Prayer', 1846, 'The Upper End of the Lake of Como from Colico', 1854 and 'Pussy in Mischief', 1869. Brother of artists Alice Elizabeth, James Benjamin and Lydia Emily Tiffin (all q.v.); and the miniature painter Walter Francis Tiffin (exhib. 1844-67 at RA, BI and SS).

TIFFIN, James Benjamin fl.1847-1849
Exhib. three works at the BI including 'Caxton's House, Westminster' and 'A Fruit Piece', and two works at the RA, including 'Bacchanalian Treasures'. London address.

TIFFIN, Miss Lydia Emily fl.1863
Exhib. two watercolour still-lifes of fruit at SS. London address.

TILLEARD, Miss E. fl.1844
Exhib. a watercolour entitled 'Remonstrances' at SS. Address in Tooting.

TILNEY, Frederick Colin 1870-1951
Painted landscape. Also a photographer and decorator. Studied at Westminster. Lived at Cheam, Surrey.

TILT, Archibald fl.1875-1877
Exhib. a 'Dutch Fishing Girl' at SS, and a work at the RA. London address.

TILT, E.P. fl.1868
Exhib. a work entitled 'Ada' at the RA. Address in Epsom, Surrey.

TIMBRELL, James Christopher 1807-1850
Painted and sculpted figurative subjects. Exhib. three works at the RA and five works at SS including 'Summer' and 'The Fisherman's Return'. Born in Dublin. Died in Portsmouth.
Bibl: DNB; Redgrave, Dict; Strickland; AJ 1850.

TIMINGS (TIMMINGS), Samuel fl.1853-1869
Painted landscape. Exhib. six watercolours at SS including views at Aston Park, Birmingham, and two works at the RA. Address in Birmingham. Also exhib. at RBSA 1853-62.

TINDALL, Robert Edwin fl.1857-1863
Painted landscape. Exhib. seven works at the RA including views at Lausanne and three views on the River Wye. Address in Monmouth.

TINDALL, William Edwin RBA 1863-1938
Landscape painter. Born in Scarborough; educated at St. Martin's Grammar School, Scarborough, and studied under L. Timmermans in Paris. Worked in Leeds and Boston Spa. Exhib. from 1888 at the RA and SS, titles at the RA including 'Nature Alone; Adel, Yorkshire', 1888 and 'When Daylight Softens into Even', 1904. Paintings by him are in Leeds and Doncaster AGs. He published *Selection of Subject*.
Bibl: Who's Who in Art 1934; Who Was Who 1929-40.

TINKLER, T.C. fl.1841-1854
Exhib. a design for an opera house and a view in County Mayo, Ireland, at the RA. London address.

TINKLER, W.A. fl.1839
Exhib. a landscape at the RA. London address.

TINLIN, G.D. fl.1880
Exhib. an architectural subject in 1880. London address.

TIPPETT, W.V. fl.1866
Exhib. two works, including 'Harrowing' at SS. Address in Bristol.

TIPPING, Miss Kate fl.1896
Exhib a work entitled 'Onions' at the RA. Address in Leamington, Worcestershire

***TISSOT, James (Jacques Joseph)** 1836-1902
Genre painter. Born in Nantes. Studied at the Beaux-Arts in Paris. Began to exhib. at Paris Salon 1859. His early works are historical, costume pieces, very much in the manner of Henri Leys, whom he visited several times in Antwerp. About 1864 he began to paint subjects of modern life. During the 1860s his work also shows the influence of the Impressionists, notably Manet and Monet. In 1871 he came to London after the fall of the Commune, and began to paint the English conversation pieces for which he is now best known, such as 'Too Early', 'The Ball on Shipboard', 'The Concert', etc. Exhib. at RA 1864-81 SS, GG and the Dudley Gallery. About 1876, Mrs. Kathleen Newton, a divorcee, became his mistress, and she appears in many of his pictures of this period. In 1882 Mrs. Newton died, and Tissot returned to Paris. After painting another series of modern life scenes entitled 'La Femme à Paris', he devoted the rest of his life to religious paintings. Like Holman Hunt before him, he went to the Holy Land several times in search of realistic illustrations for his *Life of Christ*, 1896-7. When he died he was still working on a series of Old Testament drawings. Although Tissot is thought of as Victorian, his art occupies an ambiguous position. In England he is part of the modern-life tradition, although his pictures do have a definite French flavour. In France he is considered to be an interesting minor figure on the fringe of the Impressionist movement.
Bibl: Academy Notes 1875-6, 1881; Correspondent XXV 1896 II; Les Arts 1902 No.9 pp.1-8; Hochland 1904 II pp.24-34; Apollo XVII 1933 pp.255-8; Bate p.90; Bryan; Clement & Hutton; J. Laver, *Vulgar Society — The Romantic Career of J.T.*, 1936; Reynolds, VS pp.33-6, 98-9 (pls.93-4, 98-102); Reynolds, VP pp.173, 180, 183 (pls.126, 129); Maas pp.241-4 (pls. pp.244, 255); Cat. of Tissot exhib., AG of Ontario, Toronto 1968 (with full bibl. and list of exhibs.); Irwin; Wood, Panorama, see Index; M. Wentworth, *J.T.*, 1894; Christopher Wood, *Tissot*, 1986. Exhib: London, Lemercier Gallery 1896; Brooklyn, Institute of Arts and Sciences 1928; London, Leicester Galleries 1933; 1937; Sheffield, Graves AG 1955; Providence, RI, Rhode Island School of Design 1968; Leicester Galleries 1972; London, Barbican Art Centre 1984.

TITCOMB, John Henry 1863-1952
Watercolourist. Studied at the Slade School. Born in London. Lived at St. Ives, Cornwall, and was a member of the St. Ives Society of Artists.

TITCOMBE, William Holt Yates RBA RWA 1858-1930
Painter of realistic genre. Studied at the South Kensington Schools in Antwerp under Verlat, in Paris under Boulanger and Lefèbvre and at the Bushey School of Art under Herkomer, whose style of realism Titcombe's work closely follows. Exhib. 1881-1903, at the RA 1886-1903, SS and elsewhere, titles at the RA including 'Fresh this Morning', 1886, 'Baby's First Market-day', 1893 and 'Good News from the War', 1900. He also exhib. at the Chicago Exhibition in 1893, and at the Paris Salon 1890. From 1887 he was living at St. Ives, Cornwall. In 1892 he married the genre painter, Jessie Ada Titcombe (nee Morison). The AJ reproduces 'Primitive Methodists' (showing simple Cornish fishermen in prayer), and notes: ". . . for 'Primitive Methodists' there should be nothing but praise . . . the expressions he has given to faces and figures, to hands and actions, in this remarkable interior are all thorough."
Bibl AJ 1892 p.290 (pl.), p.292ff.; RA Pictures 1891, 1893-5; Kurtz, Illustrations from the AG at the World's Columbian Exhibition 1893 p.76 (pls.); Studio, *Art in 1898*; Who's Who 1924.

TITCOMBE, Mrs. William Holt Yates fl.1895-1897
(Miss Jessie Ada Morison)
Exhib. three works at the RA including 'The Empty Cage' and
'Springtide'. London address. Her husband (q.v.) was also a
painter.

TITFORD, R.D. fl.1845-1860
Exhib. landscapes at SS and 'A Lane' at the RA. Address in
Bromley, Kent.

TOBIN, Mrs. Clare fl.1889-1890
Exhib two portraits at the GG. Address in Manchester.

TODD, Charles T. fl.1852-1892
Exhib Working an Old Sawpit' at the RA. Address in Tunbridge
Wells, Kent.

TODD, Miss Elizabeth M. fl.1890
Exhib a landscape at the NWS. London address.

TODD, Miss Helen fl.1857-1870
Painted still-lifes. Exhib. two works at the RA, and three
watercolours at SS, including 'Peaches' London address.

TODD, Henry George 1846-1898
Ipswich still-life painter. Exhib mostly at Ipswich Fine Art Society.
Also exhib a still-life at the RA and two works at SS. Todd was
influenced by Edward Ladell (q.v) who lived not far away in
Colchester. His compositions are similar to Ladell's, but painted in
a harder, shinier style. He was fond of introducing English and
Chinese porcelain, usually with fruit on a ledge.
Bibl: H.A.E. Day, *The East Anglian School of Painters.*

TODD, J. Manly fl.1887-1898
Exhib. two works at the RA, the second 'Autumn Evening,
Blythburgh'. Address in Belvedere, Kent.

TODD, John George fl.1861-1892
Painted still-lifes and figurative subjects. Exhib ten works at the RA
including 'Flowers' and 'The Wicket Gate'. Address in Ecouen,
France .

TODD, Ralph fl.1880-1893
Genre and landscape painter, living in Tooting and Newlyn,
Cornwall, who exhib. 1880-93, at the RA 1885-93, SS, NWS and
elsewhere. Titles at the RA are 'Early Morning — the Latest News',
1885, 'A Darkened Home', 1887 and 'The Prodigal's Return', 1893.
Father of Arthur Ralph Middleton Todd (1891-c.1967).
Bibl: RA Pictures 1893 p.l18 (pl.).

TODD, T. fl.1874
Exhib. a watercolour of fruit at SS. Address in Ullverstone,
Lancashire.

TOFANO, Eduardo fl.1888-1900
Painted portraits. Exhib. five works at the RA. London address.

TOFT, J. Alphonso ROI fl.1901 d.1964
Painted landscape. Exhib a work entitled 'The Sport of the Winds'
at the RA. Born in Birmingham. Lived in London

TOFT, Peter Petersen 1825-1901
Danish landscape and topographical painter, who is said to have
settled in London in 1875. He exhib. however, from 1872, at the

RA from 1874-81, SS, NWS, GG, NG and elsewhere. Possibly the
'Peter Toft' given in Graves (Dictionary and RA Exhibitors) is the
same artist. Titles at the RA include 'Gateway of the Bloody
Tower, Tower of London', 1874 and 'Staithes, Coast of Yorkshire',
1881. He died in London .
Bibl: See TB; Hall.

TOLDERVY, W.F. fl.1842-1847
Painted landscape. Exhib. seven works at the BI including 'Near
Knole Park' and 'Sandgate from the Heights, Folkestone', six
works at SS, and five works at the RA. London address

TOLHURST, Miss Edith fl.1888-1891
(Mrs. Fred J. Gordon)
Exhib. two works at the RA, the first 'An Italian Peasant Woman'.
London address.

TOLLEMACHE, Hon. Duff RBC 1859-1936
Painted landscapes, marines and portraits. Exhib. nine works at the
RA including 'Reeds and Rushes', 'Threatening Weather' and
portraits, and one work at SS. Studied at the RA Schools and at the
Académie Julian. Lived in London.
Bibl: Brook-Hart.

TOLLEY, Edward fl.1848-1867
Painted horses and landscape. Exhib. nine works at the RA,
including 'A Favourite Hunting Mare' and 'Strayed from the
Common', three works at the BI, including 'Useful Animals' and
'Had Enough'. London address.

TOLLOCK. B.L. Montague fl.1890
Exhib. a landscape at the NWS. London address.

TOMKINS, Charles F. 1798-1844
Scene painter, draughtsman and caricaturist; landscape painter in
watercolour. Worked for the theatres with W. Clarkson Stanfield and
David Roberts (qq.v.); painted temporary buildings for Queen
Victoria's Coronation; employed by Macready for his Shakespeare
revivals at Drury Lane, and drew for the early numbers of *Punch.*
Exhib. landscapes 1825-44 at the BI and SS. RBA in 1837. The
VAM has two watercolours: 'Dinant on the Meuse' and 'Scene on
the Seashore'. Hardie notes that Tomkins was "much more akin to
the Bonington, Holland, Callow group in his use of precise drawing
and simple washes, with a richer colour accent here and there".
Bibl: Binyon; VAM; Birmingham Cat; Hardie III p.29.

TOMKINS, Miss Emma fl.1823-1840
Painted flowers. Exhib. 12 works at the RA, including 'A Bird's
Nest' and 'Grapes', and ten works at SS, including 'Dahlias' and
'Fishing Boats, Worthing'. London address.

TOMKINS, Miss Isabella A. fl.1860-1873
Painted figurative subjects. Exhib. two works at the BI, 'The Leisure
Day' and 'A Dairy Farm', and one work at the RA. London address.

TOMLIN, G.M. fl.1848
Exhib. a study at the RA.

TOMLINSON, George Dodgson 1809-1884
Huddersfield portrait painter, who exhib. in 1848, 1851 and 1872 at
the RA. Born in Nottingham. Was well-known in Yorkshire as a
portrait painter and copyist. A portrait of Queen Victoria, after
Winterhalter (q.v.), is in Huddersfield Town Hall.
Bibl: The Year's Art 1885 p.229.

TOMLINSON, J. fl.1824-1853
London miniature portrait painter who exhib. 1824-53 at the RA and SS.

TOMLINSON, W. fl.1858-1859
Exhib. two works, 'Early Struggles' and 'Country Snuff-takers', at the RA. Address in Redditch, Worcestershire.

TOMSON, Arthur NEAC 1858-1905
Painter of landscape, genre and animals. Born at Chelmsford, Essex; on leaving school at Uppingham, he studied art at Düsseldorf. Returning to England in 1882, he settled down to landscape painting, working chiefly in Sussex and Dorset. His landscapes were poetic, and rather similar in sentiment to the art of George H. Mason and Edward Stott (qq.v.). Exhib. from 1883 at the RA, and also at SS, GG, NG and NEAC, of which he was one of the early members. Favourite subjects were also cats and other animals. A characteristic example of his work was the 'Chalk Pit', (VAM). He was also an interesting writer on art. He published *J.F. Millet and the Barbizon School,* 1903, and for some years was art critic for the *Morning Leader* under the pseudonym N.E. Vermind. He contributed to the AJ descriptions of places in the southern counties, illustrated by his own drawings, and illustrated *Concerning Cats,* 1892 (poems selected by his first wife Graham R. Tomson). He also wrote a novel, *Many Waters. A* memorial exhib. of his work was held at the Baillie Gallery, 1906, including two of his best works, 'The Happy Valley' and 'Coming Storm'. Died at Robertsbridge, Sussex.
Bibl: AJ 1901 p.231ff. (pl); 1902 p.243ff. (pl.); 1903 p.230ff. (pl.); 1905 p.259 (obit.); 1906 p.275 (pl.); Cat. of Baillie Gallery exhib. 1906 (introduction by Mrs. Pennell); DNB 2nd Supp III; VAM

TONGE, C. fl.1892
Exhib. a landscape at the NG. London address.

TONGE, Robert 1823-1856
Liverpool landscape painter. A friend of William Davis and W.L. Windus (qq.v.), both of whom are said to have painted figures in Tonge's pictures. Tonge's great talent had little chance to mature, as he died very young. He exhib. once at RA and SS. His landscapes and coastal views, mainly painted on the Lancashire coast, are remarkable for their sensitive rendering of light. In 1853 Tonge went to Egypt for his health; he died at Luxor.
Bibl: Marillier; Caw; Staley p.139 (pl.74a).

TONKOWSKY, Paul N. fl.1884
Exhib. 'A Neapolitan Singer' at the RA. Address in Venice.

TONKS, Henry NEAC 1862-1937
Painted watercolours and oils of figurative subjects, interiors and landscapes. Studied at the Westminster School of Art, having abandoned a career as a surgeon. Taught at the Slade School from 1893. Later became Slade Professor. Born in Warwickshire. Lived and died in London.
Bibl: Apollo I 1925 p.123; III 1926 pp.2, 4, 6, 11, l3; IX 1929 p.323; XI 1930 p.307; XXIV 1936 p.302; XXV 1937 p.301; Artwork V 1929 pp.213-35; VI 1930 p.53; Burlington Mag. XXXII 1918 p.37; XXXIX 1921 p.145; XLII 1922-3 p.105; XLVI 1925 p.57; LVI 1930 p.215; LXI 1932 p.xv; LXX 1937 p.94; Connoisseur LXV 1923 p.107; LXVIII 1924 p.113; LXXVIII 1927 p.61; XCVIII 1936 p.290; XCIX 1937 p.353; Studio XXXVII 1906 pp.21, 29; XLIX 1910 pp.3-10; LXI 1914 p.280; CXIII 1937 pp.84, 162; CXIV 1937 p.96; Who's Who 1924; Who's Who in Art 1934; Joseph Hone, *The Life of Henry Tonks,* 1939. Exhib: London, Tate Gallery 1936; Barbizon House 1937.

TONNEAU, F. fl.1877
Exhib. a painting of flowers in 1877. London address.

TONNEAU, Miss J. fl.1878
Exhib. 'Little Shepherd' at SS. London address.

TONNEAU, Joseph fl.1864-1891
Painted figurative subjects. Exhib. five works at the RA including 'Pleasant Reading' and 'What Shall I Say?', five works at SS and four works at the BI. London address.

TOOK, William fl.1857-1892
London painter of landscape and portraits, who exhib. 1857-92, at the RA 1857-73, BI, OWS (21 works) and elsewhere, titles at the RA including 'Portrait of a Boy', 1857 and 'On the East Lynn', 1873.

TOOTAL, James Batty fl.1846-1859
Exhib. a watercolour view of Conisborough Castle at SS. Address in Wakefield, Yorkshire, where there are two works by him in the AG.

TOOVEY, Edwin fl.1865-1900
Leamington landscape painter, who exhib. 1865-7 at SS and elsewhere. The VAM has a watercolour 'Rustic Cottage'. Also exhib. at RBSA 1866-84.
Bibl: VAM.

TOOVEY, Richard Gibbs Henry RPE 1861-1927
Painter of genre landscape and coastal scenes; etcher. Working in Chelsea and Leamington. Exhib. 1879-88, at the RA 1884-8, SS, NWS, GG and elsewhere, titles at the RA including 'The Mill Sluice', 1884, 'Concarneau Harbour', 1885 and 'The Broker's Shop', 1887. Possibly related to Edwin Toovey (q.v.).
Bibl: Brook-Hart.

TOPHAM, Miss fl.1868
Exhib. three still-lifes of fruit in 1868. London address.

TOPHAM, Francis William 1808-1877
Genre painter and watercolourist. Born in Leeds. Came to London about 1830 to work as an engraver of heraldic designs. Took up line engraving, then watercolours and oils. In 1842 elected associate, and in 1843 member, of the NWS; in 1847 he retired to become ARWS, and in 1848 RWS. He usually painted rustic figures, especially peasant girls and children. Travelled in Ireland and Spain in search of suitably picturesque subjects. Exhib. mainly at OWS, also RA 1832-70, BI, SS and NWS. Died at Cordoba, on his second visit to Spain. His remaining works were sold at Christie's, 30 March 1878.
Bibl: AJ 1877 p.176 (obit.); 1880 pp.21-3; F.G. Kitton, *Dickens and His Illustrators,* 1899; Redgrave, Dict; Clement & Hutton; Roget; Binyon; Cundall; DNB; VAM; Hardie III p.l00 (pl.121); Maas p.240 (pl.p.243).

***TOPHAM, Frank William Warwick RI ROI 1838-1924**
Genre painter and watercolourist. Pupil of his father F.W. Topham (q.v.), RA Schools and Gleyre in Paris. Exhib. at RA from 1860, BI, SS, NWS, GG, NG and elsewhere. Titles at RA include many scenes of Italian life and history, and occasional biblical subjects. Works by him are in the Walker AG, Liverpool, and Rochdale AG.
Bibl: AJ 1882 p.108; Clement & Hutton.

TOPHAM, W. fl.1870
Exhib. a figurative subject in 1870. London address.

TOPLIN, J.M. fl.1852
Exhib. a portrait at the RA.

TOPLIS, William A. fl.1875-c.1922
Landscape painter, living in Sheffield and on Jersey and Sark, in the Channel Islands. Exhib. 1875-1902, at the RA 1881-1902, SS and elsewhere, titles at the RA including 'Nature's Architecture, Sark', 1894 and 'A Monarch of the Shore, Sark', 1902.

TÖRMER, B. fl.1852
Exhib. a work entitled 'The Wedding Morning — III Omen' at the RA. Address in Rome.

TORRANCE, James 1859-1916
Portraitist. Represented in the Glasgow AG.
Bibl: Caw; Bate, *Modern Scottish Portrait Painters,* 1910.

TORROMÉ, Francisco J. fl.1890-1893
Painted landscape. Exhib. five works at SS, including 'Lee Bay, North Devon' and 'A Peaceful Nook'. London address.

TORRY, John T. fl.1886
Exhib. two watercolours, the second 'Walberswick', at SS. London address.

TOTHILL, Miss Mary D. fl.1881-1885
Exhib. three landscapes at the NWS. Address in Bristol.

TOUISANT, R. fl.1876
Exhib. 'The Picture Book' at the NWS. London address.

TOULMIN, E.O. fl.1844-1852
Painted landscape. Exhib. seven works at SS including 'Ivy Bridge, Devonshire' and 'Cottages at Chislehurst, Kent', three works at the RA and one work at the BI. London address.

TOUR, J.B. fl.1876
Exhib. a landscape in 1876. Address in Paris.

TOURNEUR, Miss Louise fl.1890
Exhib. a portrait at the RA. Address in Paris.

TOURNIER, Gaspard fl.1878
Exhib. a view of Manchester town hall at the RA. London address.

***TOURRIER, Alfred Holst 1836-1892**
French painter, long resident in London, of historical subjects and genre; illustrator. Exhib. 1854-89, at the RA 1857-88, BI, SS and elsewhere, titles at the RA including 'The Cavalier', 1857, 'Henry II of France and Diana of Poitiers Witnessing the Execution of a Protestant', 1870 and 'Galileo before the Inquisition', 1881. His pictures were often engraved, and his work as a book illustrator, e.g. an edition of Scott, published by Nimmo, attracted attention. The AJ reproduced 'Gold', an historical subject, exhib. at the RA in 1871. He and Lionel J. Cowen (q.v.) seem to have used the same model, as she often appears in both their works.
Bibl: AJ 1875 p.232 (pl.); Bryan; Ormond.

TOURRIER, G.L. fl.1870-1876
Painted figurative and genre subjects. Exhib. four watercolours including 'Without Hope' and 'The Rustic Toilet', at SS, and three works at the RA. London address.

TOURRIER, J. fl.1834-1848
London painter who specialised in coastal scenes and river views in Kent, Ireland and France. Exhib. 1834-48 at the RA, BI and SS, titles at the RA including 'Sea Coast', 1834, 'View in the Pyrenees', 1835 and 'Scene in Ireland', 1843.
Bibl: Wilson.

TOVEY, J. fl.1843
Exhib. 'Ecce Homo' at the BI. Address in Bristol.

TOVEY, Miss Mary S. fl.1872-1876
Painted portraits and figurative subjects. Exhib. seven works at the RA including 'Everyone's Darling', 'O Sweet Pale Margaret! — Tennyson' and portraits, and 11 works at SS. London address.

TOVEY, Samuel Griffiths fl.1847-1865
Bristol painter of architectural subjects, who exhib. 1847-65, at the RA 1847-58, BI and SS, titles at the RA including 'The Lady Chapel, Wells Cathedral', 1847, 'On the Grand Canal, Venice', 1848 and 'Interior of the Campanile of St. Marks, Venice', 1858. He specialised in scenes in Venice.

TOWERS, James ARCA b.1853 living 1934
Landscape painter, living in Liverpool, Birkenhead, Heaverham (near Sevenoaks, Kent) and Purley, Surrey. Educated at the Liverpool College School of Art and the Liverpool Academy of Art. Exhib. from 1878 at the RA, SS, NWS, GG and in Liverpool. Titles at the RA include 'A Welsh Mountain Path', 1878, 'King Arthur's Castle, Tintagel, Cornwall', 1882 and 'Evening in August', 1901.
Bibl: Studio XXIV 1902 p.136; Who's Who in Art 1934; Who's Who 1937.

TOWERS, Samuel RCA 1862-1943
Painted landscape. Exhib. nine works at the RA including 'A Misty October Morning' and 'Thistledown'. Address in Bolton, Lancashire. Also lived at Harvington, Worcestershire.

TOWNLEY, Miss Annie B. fl.1868-1897
Birmingham painter of buildings and coastal scenes. Exhib. at RBSA 1868-97. Exhib. a watercolour entitled 'In the Market Place' at SS. Sister of Elizabeth and Minnie Townley (qq.v.).

TOWNLEY, Miss Elizabeth fl.1868-1869
Birmingham painter of interiors.

TOWNLEY, Miss Minnie fl.1866-1899
Birmingham painter of landscape and flowers. Exhib. four works at the RA including 'Hollyhocks' and 'On the Scheldt', and one work, 'Fir Trees, Malvern Wells', at the RA. Address in Birmingham.

TOWNSEND, Alfred O. fl.1888-1902
Painted landscape. Exhib. four works at the RA, including 'Moonrise — Bristol Harbour' and 'The Silent Pool Above the Dam', and 'A Misty Day' at SS. Address near Bristol.

TOWNSEND, Miss F. fl.1884
Exhib. a landscape at the GG. Address in Nuneaton, Warwickshire.

TOWNSEND, Frederick fl.1861-1866
Painted landscape. Exhib. six works at the RA, including 'Heather in Bloom, Deeside, Braemar', 'Venice' and 'Old Mill, Poltesco Valley, Cornwall'. London address.

TOWNSEND, Mrs. Frederick fl.1866
Exhib. two landscapes in 1866. Address in Fareham, Hampshire.

TOWNSEND, Frederick Henry Linton Jehne 1868-1920
Illustrator and etcher. Studied at Lambeth School of Art. Exhib. two military subjects at RA 1888. Worked for *The Graphic, The Illustrated London News,* and was art editor of *Punch* from 1905.
Bibl: P.V. Bradshaw, *The Art of the Illustrator,* 1918.

TOWNSEND, Frederick John fl.1872
Exhib. 'The Parting Gleam, near St. Rivan, Cornwall' at the RA. Address in Chertsey, Surrey.

TOWNSEND, Henry James 1810-1890
Painter of historical and literary subjects, portraits, genre, animals and landscape; illustrator, etcher and engraver. Born at Taunton, educated as a surgeon, but left that profession to take up art. Made designs for wood engravings, and was a talented etcher, as is shown by his illustrations to Goldsmith's *The Deserted Village,* 1841, and Gray's *Elegy,* 1847, produced by the Etching Club of which he was a member. Also illustrated Mrs. S.C. Hall's *Book of Ballads,* 1847, Milton's *L'Allegro,* 1849 and Thomson's *Seasons,* 1852. Won a £200 prize at the Westminster Hall Competition of 1843. Exhib. 1839-66 at the RA, BI, SS and elsewhere, titles at the RA including 'Sterne and Maria', 1839, 'The Fatal Letter of Charles I Intercepted by Cromwell and Ireton', 1844 and 'Among the Lynmouth Hills', 1849. For some years he was a master in the Government School of Design at Somerset House. The VAM has a study for the prize-winning cartoon of 1843 'Fight for the Beacon — Descent of the Pirates on the English Coast in the Reign of Henry VI'. The AJ reproduces 'Ariel', RA 1845, now at Osborne House, Isle of Wight.
Bibl: AJ 1855 p.188 (pl.); Bryan; VAM; Maas p.27.

TOWNSEND, J. fl.1841-1842
Exhib. 'Near Harrow' and 'A Windmill' at the RA, and a work at the BI. London address.

TOWNSEND, Miss Mary fl.1843-1849
Painted portraits. Exhib. five works at the RA, portraits and a work entitled 'Guardian Angels', four works at the SS, and one work at the BI. London address.

TOWNSEND, Miss Pattie see JOHNSON, Mrs. Patty

TOWNSEND, Miss S.E. fl.1848-1861
Painted figurative and genre subjects. Exhib. nine watercolours at SS including 'The Sister of Mercy', 'The Unheeded Questioner' and 'The Appointed Hour'. London address.

TOWNSHEND, Alice fl.1879
Exhib. a landscape in 1879. London address.

TOWNSHEND, Arthur Louis fl.1880-1886
Painted rustic subjects. Exhib. six works at the RA including 'A Farmyard Study' and 'A Bit on Newmarket Heath'. London address.

TOWNSHEND, James RBA fl.1883 d.1949
Painted landscape. Exhib. eight works at the RA including 'The Last Leaves of Autumn' and 'In Shakespeare's Country'. RBA 1903. London address.

TOZER, Henry E. fl.1889-1892
Exhib. 'Surf and Rocks at the Mouth of the Cove' at the RA. Address in St. Just, Cornwall.

***TOZER, Henry Spernon fl.1900-1930**
Painter of highly detailed cottage interiors, usually in watercolour. He often includes one or two figures, usually an elderly couple.
Bibl: Wood, Paradise Lost.

TRACEY, O. fl.1870
Exhib. a view of Longships Lighthouse at SS.

TRAFFORD, Major fl.1893
Exhib. a view at Karnack, Egypt, at SS. London address.

TRAFFORD, Lionel J. fl.1899
Exhib. 'The Somnambulist' at the RA. London address.

TRAIES, Francis D. 1826-1857
Painted landscape. Exhib. four works at SS including 'Contentment', 'Happy Hours' and 'Sunset'. London address. Son of William Traies (q.v.). Examples are in Exeter Museum.

TRAIES, William 1789-1872
Painted landscape. Exhib. four works at the RA including a view on the River Teign. Address in Exeter. His romantic, idealised landscapes of the West Country have earned him the sobriquet the Devon Claude.

TRAIL, Cecil G. fl.1892
Exhib. a genre subject in 1892. Address in Maldon, Essex.

TRAIN, Edward
Painted landscape. Lived and worked in Northumberland. Subjects mostly mountain scenery. Several works are in the Laing AG, Newcastle.
Bibl: Hall.

TRANTSCHOLD, Manfred fl.1893
Exhib. a genre subject in 1893. London address.

TRAPPES, Francis M. fl.1868-1885
Painted landscape. Exhib. seven works at the RA, including 'Woodcock Shooting' and 'An Essex Waste', and seven works at the SS. London address.

TRAQUAIR, Phoebe Anna 1852-1936
Scottish painter, muralist, designer and enamellist. Born in Dublin; after her marriage in 1873, moved to Edinburgh. Soon began to establish herself as a muralist, mainly of chapels and churches. She was also a highly versatile designer of textiles, books, book covers, metalwork and panels for furniture and interiors of rooms. After 1902 she also began to work in enamels, which have now become her most highly admired works. She exhib. at many arts and crafts exhibs. Her style is highly decorative, brightly coloured and with strong overtones of symbolism and art nouveau. A major exhib. of her work was held at the Scottish National Portrait Gallery in 1993.
Bibl: For full bibl. see Elizabeth Cumming, *Phoebe Anna Traquair,* Scottish National Portrait Gallery, 1993.

TRAVERS, Mrs. Florence fl.1889-1893
Painted figurative and landscape subjects. Exhib. eight works at SS including 'The Primrose Path' and 'Harvesting in Wiltshire'. Address in Weybridge, Surrey.

TRAVERS, George fl.1851-1859
Painter of landscape and coastal scenes, living in Poplar, who exhib. 1851-9, at the RA, BI, SS and elsewhere. Titles at the RA include 'The Way-side', 1851, 'On the Coast', 1852 and 'Evening', 1859. 'Whitsand Bay, Devon — Rain Passing Off' is in the VAM.
Bibl: Cat. of Oil Paintings VAM 1907.

TRAVIS, H. fl.1873
Exhib. 'The Lily of Olympia from Mount Saturn' at the RA. Address in Sydenham.

TREADWELL, Miss M. fl.1872-1875
Painted flowers. Exhib. six watercolours of flowers at SS. Address in Stoke Newington.

TREEBY, J.W., Jnr. fl.1869-1875
Exhib. four works at the RA, including 'An Arab Soldier' and 'The Heron at Rest', and one work at SS. London address.

TREEN, W. fl.1833-1877
Painted portraits. Exhib. three portraits at SS and one portrait at the RA. London address.

TREGO, J.J. William fl.1883
Exhib. a watercolour entitled 'Yarmouth Haven' at SS. London address.

TREGO, W. fl.1862-1875
Painted figurative subjects. Exhib. three works at the BI, including 'Vigilance' and 'A Spanish Lady', and eight works at SS. London address.

TREMEWAN, M. fl.1886
Exhib. a watercolour landscape. Address in Lewisham.

TRENCH, John A. fl.1893
Exhib. 'The Home of the Squirrel' at SS. Address in Birkenhead, Cheshire.

TRENTHAM, Fanny fl.1885
Exhib. 'A Bit of Autumn' at SS. London address.

TRERY, Henry C. fl.1849-1854
Painted animals. Exhib. five works at the RA including 'Sheep and Lambs' and 'Red Deer', and one work at the BI. London address.

TREVELYAN, Lady Pauline Jermyn 1816-1866
The wife of Sir Walter Calverley Trevelyan of Wallington Hall, Northumberland, she was a capable amateur artist. With William Bell Scott and Ruskin (qq.v.) she planned and executed the decoration of the courtyard at Wallington with 'Scenes from the History of Northumberland'.
Bibl: Hall; R. Trevelyan, A *Pre-Raphaelite Circle*, 1978.

TREVOR, Edward fl.1841-1846
Exhib. 'An Interior' and 'A Gipsy Camp' at the RA. London address.

TREVOR, Edward fl.1885
Exhib. a view in Capri at the RA. Address in Manchester.

TREVOR, Miss Helen Mabel 1831-1900
Painted figurative subjects. Exhib. three works at the RA, including 'Breton Boys', and three works at SS, including 'Venetian Bead-stringers' and 'Over the Seas and Far Away'. London address.
Bibl: Strickland.

TRIER, Mrs. Adeline fl.1879-1903
Painted flowers. Exhib. eight works at the RA including 'Peonies' and 'Anemones', and four works at SS. Address in Camberwell.
Bibl: AJ 1902 p.155-6; Connoisseur XXVIII 1910 p.203.

TRIMMINGS, Miss fl.1860
Exhib. a painting of fruit at the RA, and two still-lifes at SS. London address.

TRINGHAM, Holland fl.1891 d.1909
Painted landscape. Exhib. five works at SS, including 'Mousehole, Cornwall' and 'The Land of the Pharaohs', and two works at the RA. London address.

TRINGHAM, Mrs. W. fl.1839
Exhib. a landscape in Argyllshire at the RA.

TROBRIDGE, George F. 1857-1909
Landscape painter in oil and watercolour. Exhib. two landscapes, one in County Down, at SS. Born in Exeter. Died in Gloucester. Headmaster of Belfast School of Art 1880-1901.
Bibl: Strickland.

TROBRIDGE, L. fl.1880
Exhib. a landscape in 1880. London address.

***TROOD, William Henry Hamilton 1848-1899**
Painter of animals, especially dogs. Exhib. at RA 1879-98, SS, NWS, GG and elsewhere. His pictures usually have sentimental titles, e.g. 'A Coveted Bone', 'The Old Man's Darling', 'Home Sweet Home', etc.
Bibl: The Year's Art 1900 p.297; RA Pictures 1893.

TROTMAN, Miss Lillie fl.1881-1893
Painted figurative and genre subjects. Exhib. nine works at SS, including 'Idle Dreams' and 'The Last Gleaner', and one work, 'Little Blue Eyes', at the RA. London address.

TROTMAN, Samuel H. fl.1866-1870
Painted landscapes and marines. Exhib. seven works at SS including 'The Wreckers', 'Near Sherwood Forest' and 'The Sea Bird's Haunt'. London address.
Bibl: Brook-Hart.

TROOT, John S. fl.1890-1892
Exhib. three works, including 'A Sussex Millpond' and 'Evening Stillness', at the RA. London address.

TROUGHTON, R. Zouch S. fl.1831-1865
Exhib. 'A Dangerous Topic' at the BI and 'Charity' at SS. London address.

TROUP, Francis William b.1859 fl.1889-1903
Painted architectural subjects. Exhib. six works at the RA including 'St. John's College, Oxford'. London address.
Bibl: Who's Who in Art 1934; Studio XXII 1901 pp.254-6; Connoisseur XLVI 1916 p.251.

TROUVILLE, Henri fl.1881
Exhib. two landscapes in 1881. Address in Chantilly, France.

TRUEFITT, Miss F. fl.1873
Exhib. a portrait at the RA. Address in Edinburgh.

TRUESDELL, Gaylord S. fl.1898-1899
Exhib. three works at the RA including 'One at a Time, Holland' and 'Changing Pastures'. London address.

TRUSCOTT, Walter fl.1882-1889
Painted marines, landscapes and townscapes. Exhib. 26 works at SS including 'Outward Bound', 'On the Thames off Greenhithe' and views in Genoa, Florence and Venice. Address in Falmouth, Cornwall.

TSCHANN, J. Rudolf fl.1884
Exhib. a portrait of a model at the RA. Address in Teddington, Middlesex.

TUCK, Albert fl.1877-1890
Exhib. five genre subjects at the NWS. London address.

TUCK, E.H. fl.1870
Exhib a watercolour entitled 'Left in Charge' at SS. London address.

TUCK, Harry fl.1870-1893
London painter of genre and landscape, who exhib. 1870-93, at the RA in 1883 and 1884 — both landscapes, SS, NWS and elsewhere.

TUCK, Miss Lucy J. fl.1879-1888
Exhib. two figurative subjects at the NWS. London address.

TUCK, S. fl.1878
Exhib. a caricature in 1878. London address.

TUCK, William Henry fl.1874
Exhib. a portrait at the RA. London address.

TUCKER fl.1837
Exhib. a watercolour entitled 'Odds and Ends' at SS. London address.

TUCKER, Mrs. fl.1838
Exhib. a portrait of an Indian girl at SS. Address in India.

TUCKER, Miss Ada Elizabeth fl.1879-1898
Painted genre subjects. Exhib. four works at SS including 'Art Critics' and 'Little Things Please Little Minds'. Address in Bristol. Daughter of Robert Tucker (q.v.). Also exhib. at RBSA 1883-98. Member of the Society of Lady Artists.

TUCKER, Alfred Robert fl.1894
(The Rt. Rev. Bishop of Mombasa)
Exhib. 'The Victoria Nyanza' at the RA. Address in Surbiton, Surrey. Painted in Africa, Austria and Sicily.
Bibl: J. Silvester, *A.R.T.,* 1926; A.P. Shepherd, *T. of Uganda,* 1929.

TUCKER, Arthur RBA 1864-1929
Painted landscape. Exhib. 14 works at the RA, 1883-1904, including 'A Cornfield, Westmoreland', 'Kentmore Castle' and 'A Mountain Farmstead', and two Scottish landscapes at SS. Born in Bristol, son of the painter Edward Tucker (q.v.). Lived at Windermere.
Bibl: A. Tucker, *Further Leaves from the Sketch Rook of A. Tucker, RBA,* 1917.

TUCKER, Barff fl.1845-1850
Painted figurative subjects. Exhib. three works at the RA, including 'Friar Tuck' and 'Mary Magdalene', and one work at the BI. London address.

TUCKER, Charles E. fl.1880-1904
Exhib. two works at SS, including a watercolour view of Hastings, and three works at the RA, including 'The Forenoon, Holland'. London address.

TUCKER, Edward c.1830-1909
Painted landscape and coastal views. Exhib. 13 works at SS, the majority watercolours, including 'A Wreck', 'A View of Dover from the Sea' and 'Off Scarborough'. Also exhib. two works at the BI and two works at the RA. Address in Woolwich. Father of Arthur and Frederick Tucker (qq.v.).
Bibl: The Year's Art 1910 p.389.

TUCKER, Frank fl.1866-1882
Exhib. five landscapes 1866-82. Address in Bracknell, Berkshire.

TUCKER, Frederick fl.1873-1889
Painted landscape. Exhib. three works at the RA, including 'Upon the Lonely Hills of Cumberland', and a watercolour at SS. Address in Ambleside. Son of Edward Tucker (q.v.).

TUCKER, H. fl.1871
Exhib. a watercolour view of Kirkstall Abbey at SS. Address in Ambleside, Westmorland.

TUCKER, Rev. James J. fl.1835-1841
Painted figurative subjects. Exhib. ten works at SS including 'La Belle' and portraits of Indians. Address in Sangor, India.

TUCKER, Raymond fl.1852-1903
Painter of landscape, portraits, genre and literary subjects, living in Bristol, Sandhurst, Kent and London. Exhib. 1852-1903 at the RA, SS, NWS and elsewhere, titles at the RA including 'Scene near Eaux Chaudes Pyrenees', 1852, 'Desdemona', 1867 and 'Out of a Friend's Garden', 1903. Art Master at Wellington College 1859-1883. Probably a son of Robert Tucker (q.v.).

TUCKER, Robert 1807-1891
Landscape painter, and co-founder of the Bristol Sketching Club in 1833. Secretary of the Bristol Fine Arts Academy. Most of his work is small in scale and monochrome. There was also a Robert Tucker of Exeter recorded.

TUCKER, Tudor St. G. fl.1900-1902
Exhib. five works at the RA 1900-02, titles including 'Springtime' and 'After A Famous Victory'. London address.

TUCKERMAN, S. Salisbury fl.1874-1892
Painted marines. Lived in London until 1879, subsequently in Stourbridge, Worcestershire. Also exhib. at RBSA 1874-92.
Bibl: Brook-Hart.

TUDGAY
Family of marine painters, including F.I.J. and L. Tudgay. Many of their works were joint productions. For full details see bibl.
Bibl: Wilson p.78 (pl.39); Brook-Hart pls.11, 55.

TUGWELL, Miss Emma S. fl.1888
Exhib. two works at SS, the first entitled 'Tit-bits'. London address.

TUITE, J.T. fl.1818-1839
Painted landscapes and marines. Exhib. three works at the RA, including 'View in Flanders' and 'Boulogne Shrimp Catchers', and two works at the BI. Address in Boulogne-sur-Mer, France.

***TUKE, Henry Scott RA RWS 1858-1929**
Genre and portrait painter. Studied at the Slade; in Florence 1880; in Paris 1881-3 under J.P. Laurens. On his return he settled in his

native Cornwall, first at Newlyn, already a centre for French-style *plein-air* painting, and later in Falmouth, where he bought a boat. First exhib. at RA 1879, also SS, NWS, GG, NG, NEAC and elsewhere. Member of NEAC 1886, ARA 1900, RA 1914. Most of his works reflect his love and knowledge of the sea. His first work to attract attention was the dramatic 'All Hands to the Pumps', RA 1889, which was bought by the Chantrey Bequest. Other typical RA titles are 'The First Boat in', 'The Run Home', etc. His style, bold and realistic, was much admired for its feeling of sea and sunlight, and is well suited to his themes of rugged life on the Cornish coast. He was also an industrious painter of male nudes, usually naked boys posed on sunlit beaches.

Bibl: AJ 1907 p.358ff.; Studio Special Number 1919, *British Marine Paintings;* Mag. of Art 1902 pp.337-43; M.T. Sainsbury, *H.S.T.,* 1934; Reynolds, VP; Maas; Brook-Hart; D. Wainwright and C. Dinn, *H.S.T. Under Canvas,* 1989.

TUKE, Miss Maria b.1861 fl.1885-1887
(Mrs. Sainsbury)
Exhib. a view of Falmouth Harbour at the RA. Sister and biographer of H.S. Tuke (q.v.). Her shipping watercolours are very similar to those of her brother. She married Dr. H. Sainsbury in 1899. She was the authoress of a memoir of her brother. See also Miss Maria Tuke Sainsbury.

TULK, Augustus fl.1877-1892
Painted rustic subjects. Exhib. 11 works at SS, including 'Sketch in the Farm', 'Azalea' and 'A Fisher Girl', and two works at the RA. London address.

TULL, N. fl.1829-1852
Painted landscape. Exhib. 25 landscapes at SS and five landscapes at the BI. London address.

TULLY, Sydney S. fl.1896-1897
Exhib. two works, 'Contemplation' and 'Phoebe', at the RA. London address.

TUNBRIDGE, Miss A. fl.1858-1861
Painted fruit. Exhib. three fruit pieces at the BI and one work at SS. London address.

TUNBRIDGE, Miss E. fl.1856-1861
Exhib. four works at the BI including 'An Ancient Gateway near Margate'. London address.

TUNMER, J.H. fl.1873
Exhib. a view in Hyde Park at the RA. London address.

TUPPER, Miss fl.1855
Exhib. two watercolours, 'A Spring Meeting' and 'Vegetables', at SS. London address.

TURCK, Miss Eliza b.1832 fl.1854-1886
Painter of genre portraits, literary subjects, landscape, coastal scenes, architectural subjects and miniatures, both in oil and watercolour. Born in London, of German extraction. On her return from school in Germany in 1848, she studied for six months at Cary's School of Art, afterwards took lessons in oil painting from W. Gale, and in 1852 entered the figure class of the Female School of Art in Gower Street for a further year. 1859-60 she studied in Antwerp. Exhib. 1851-86, at the RA 1854-86, BI, SS and elsewhere, titles at the RA including 'Rus in Urbe', 1858, 'Lady Dorothy in Breton Costume', 1880 and 'In St. Mark's, Venice',

1885. 'Cinderella', RA 1856, was one out of 40 pictures selected by Ruskin for criticism in his *Academy Notes.* "Very pretty, and well studied, but Cinderella does not look the lady of a fairy tale. I am rather puzzled myself to know how her relationship to her remarkable godmother could best be indicated so as to leave her still a quite *real* little lady in a real kitchen. But I am glad to see this sternly realistic treatment, at all events." At the International Exhibition, 1871, she exhib. miniatures and an oil, 'Painter and Patrons'. An exhib. of her watercolours of Brittany (marines, landscapes, natural objects, street views) was held at the Rogers Gallery, Maddox Street in 1879, about which the AJ wrote: "Her colouring is close to nature and full of tender greys, especially in the sky, while her touch is broad, free and Cox-like."

Bibl: AJ 1879 p.79; Ruskin, Academy Notes 1856; Clayton II pp.146-51.

TURMINGER, T.A. fl.1839
Exhib. a view near Waltham at the RA.

TURNBULL fl.1857
Exhib. 'A Seashore' at the BI.

TURNBULL, A. Watson fl.1899-1904
Painted figurative subjects. Exhib. three works at the RA, 1899-1904, including 'Lady Godiva' and 'Tristan and Iolanthe'. London address.

TURNBULL, Mrs. Walter
see BARTHOLOMEW, Mrs. Valentine

TURNER, Mrs. fl.1860
Exhib. 'Evening at the Trossachs, Scotland' at SS. London address.

TURNER, Agnes fl.1882
Exhib. a Swiss subject in 1882. Address in Saltburn, Yolkshire.

TURNER, Anselm fl.1867-1871
Exhib. seven paintings of fruit 1867-71. London address.

TURNER, Arthur fl.1897-1898
Exhib. two works, 'An Autumn Haze' and 'A Golden Afternoon', at the RA. Address in Surrey.

TURNER, Arthur W. fl.1893-1900
Exhib. two works at the RA, the first entitled 'Vi, Daughter of Colonel Morris, as a Jap'. Address in Hetworth, Yorkshire.

TURNER, C.T. fl.1879-1880
Exhib. two cottage scenes at SS and a work entitled 'Cottage Hospitality' at the BI. London address.

TURNER, Charles ARA 1773-1857
Engraver and painter of portraits and figurative subjects. Exhib. 51 works at the RA including many copies or engraved reproductions after portraits, but also including works entitled 'The Mirror — Morning', 'The Widow of the Gamekeeper' and 'There's A Good Time Coming Boys!' London address.

Bibl: For bibl. relating to his work as an engraver, see TB.

TURNER, Claridge fl.1872-1893
Exhib. a watercolour view in Derbyshire at SS. London address. Also lived in Birmingham and exhib. at RBSA 1872-93.

TURNER, Edward fl.1858-1862
Exhib. two cottage scenes at SS and a work entitled 'Cottage Hospitality' at the BI. London address.

TURNER, F.C. 1795-1865
London painter of portraits of horses, shooting subjects, and also general portraits and miscellaneous subjects. Exhib. 1810-46, at the RA 1817-44, BI, SS and elsewhere, titles at the RA including 'Portrait of Master Beecher on the Celebrated Pony Lady-bird, the Property of Captain Beecher', 1836, 'A Subject from Aesop's Fables', 1840 and 'Foxhounds Going Out', 1844. Paintings by him are in the Walker AG, Liverpool, and the City AG, Manchester. Said to be the father of two other sporting artists.
Bibl: Pavière, Sporting Painters (pl.43).

TURNER, F.M. fl.1842
Exhib. a view of Ostend at SS. Address in Reading, Berkshire.

TURNER, Francis fl.1838-1871
London painter of landscape, especially in North Wales, Perthsire and Yorkshire, who exhib. 1838-71, at the RA 1842-69, BI and SS. Titles at the RA include 'East Sutton Park, near Maidstone', 1842, 'On the River Llugwy', 1851 and 'Roche Abbey, Yorkshire', 1869.

TURNER, Frank fl.1866-1874
Exhib. a view of Stratford-upon-Avon at the BI. Address in Warfield, Berkshire.

TURNER, Frank James fl.1863-1875
Painted rustic and country subjects. Exhib. three works at the BI, including 'Home Thoughts' and 'Romance', and three works at SS. London address.

TURNER, G.A. fl.1836-1841
Painted figurative and literary subjects. Exhib. three works at the RA, including subjects from *Two Gentlemen of Verona* and from *Woodstock*, two works at SS, and one work, 'Interior of a Farmer's Stable', at SS. London address.

***TURNER, George 1843-1910**
Painted landscape. Born in Cromford, Derbyshire; worked in Birmingham, Barrow-on-Trent, and Idringehay, Derbyshire. His panoramic, lush landscapes are now very popular, and appear frequently in the salerooms.

TURNER, H.D. fl.1885
Exhib. a work entitled 'Hereby Hangs a Tale' at the RA. Address in Croydon, Surrey.

TURNER, Hawes fl.1884-1901
Painted landscape and genre subjects. Exhib. four works at the RA, including 'Too Fond of Her Book' and 'A Rocky Cove, St. Ives Bay', and four works at SS, including 'On the Thames above Abingdon'. London address.

TURNER, Mrs. Hawes (Jessie) fl.1897-1900
Exhib. two landscapes at the RA. London address.

TURNER, Henry fl.1877
Exhib. a watercolour study of cottages at SS. London address.

TURNER, J. fl.1872
Exhib. a painting of horses at the RA.

TURNER, Miss J. fl.1893-1894
Exhib. a watercolour view of Lichfield Cathedral at SS. London address.

TURNER, Miss Jessie fl.1886-1900
Exhib. a painting of flowers in 1886. Address in Catford. Also exhib. at RBSA 1899-1900.

***TURNER, Joseph Mallord William RA 1775-1851**
Painter and watercolourist. The greatest English artist of the 19th century, and one of the most important figures of the Romantic Movement. Born in London, son of a barber. Studied at RA Schools 1790-3. First exhib. at RA 1790. From the start, he was encouraged and supported by the RA, who elected him ARA 1799, RA 1802. Professor of Perspective 1807-37. In the early 1790s he worked only in watercolour, in the 18th century topographical tradition. In 1790 he made the first of his many sketching tours of England. He met Thomas Girtin (1775-1802), and the two artists worked together at Dr. Monro's house, Turner washing in over Girtin's outlines. Turner acknowledged his debt to Girtin in his remark "if Tom had lived, I should have starved". About 1796 he turned to oil painting. His oils of this period represent a romantic reinterpretation of all the current historical styles then in vogue. He painted Dutch-style landscapes and seascapes in the manner of Van der Neer, Cuyp, Teniers, Ruisdael and Van de Velde; classical landscapes in the style of Claude and Wilson; and after his visit to Paris in 1802, grand historical compositions in emulation of Titian and Poussin. In 1802 he also visited Switzerland, where he painted some of his finest early watercolours, e.g. 'The Great Fall of the Reichenbach', 'Chamonix', etc. The Alps were to inspire several other works, such as 'The Fall of the Rhine at Schaffhausen', 'The Fall of an Avalanche in the Grisons' and 'Snowstorm, Hannibal and his Army Crossing the Alps', all typical of his "visionary evocation of the cosmic forces of Nature" (Butlin). In 1803 he painted 'Calais Pier', the first of his early works to show individual style, but this and many subsequent pictures were bitterly attacked by the critics as unfinished, or "pictures of nothing, and very like". To defend himself, Turner in 1805 adopted the practice of opening his house as a gallery, and from 1806-19 he produced the *Liber Studorium*, a series of engravings of different styles of landscape. He continued his exploration of natural effects and English landscape in watercolours and sketches, but also produced historical pieces, e.g. 'The Battle of Trafalgar'. In 1819 he paid his first visit to Venice. The revelation of light and colour which he found there was soon reflected in the increasingly pale and impressionistic style of his pictures. He returned to Venice in 1835 and 1840. In 1820 he visited Rome, which inspired him to paint another series of Claudian landscapes of Rome and the Campagna. During the 1820s his increasing preoccupation with light and colour resulted in many almost abstract watercolour sketches; best-known are the series of interiors at Petworth. His watercolours undoubtedly influenced his oil painting style. Ideas first tried and experimented with in watercolour were later worked out in oils. Throughout all this, he continued with his Dutch marine pictures, such as 'Port Ruysdael' and the Van Tromp series, and also historical scenes in the Rembrandt style. By the 1830s his style was finally formed, and he produced some of his greatest works, e.g. the Petworth landscapes, 1830-1, many of his finest Venetian scenes, 'The Burning of the Houses of Parliament', 1834, and other fire subjects, and 'The Fighting Temeraire', 1838, the best of his late, finished works. In the 1840s his style became increasingly abstract, e.g. 'Norham Castle' and 'Rain, Steam and Speed', 1844. Many of the swirling, vorticist compositions of this period were never exhib., and were found in his house after his death. In 1843 Ruskin published his celebrated defence of Turner in the first volume of *Modern Painters*. An enormously prolific artist, he bequeathed over 300 oils and nearly 30,000 drawings to the nation. His style has had

many imitators, but no rivals.

Bibl: Main Biographies: G.W. Thornbury, *The Life of J.M.W.T.*, 1862; P.G. Hamerton, *The Life of J.M.W.T.*, 1879; C.F. Bell, *List of Works by T. Contributed to Public Exhibitions*, 1901; Sir W. Armstrong, *T.*, 1902; A.J. Finberg, *T.'s Sketches and Drawings*, 1910; A.J. Finberg, *T.'s Watercolours at Farnley Hall*, 1912; A.P. Oppe, *Watercolours of T.*, 1925; G.S. Sandilands, *J.M.W.T.*, 1928; B. Falk, *T. the Painter*, 1938; A.J. Finberg, *The Life of J.M.W.T.*, 1939; C. Clare, *J.M.W.T. His Life and Work*, 1951; Sir J. Rothenstein. *T.*, 1962; M. Butlin, *T. Watercolours*, 1962; L. Hermann, *J.M.W.T.*, 1963; Sir J. Rothenstein and M. Butlin, *T.*, 1964; John Gage, *Colour in T.*, 1970; G. Reynolds, *T.*, 1970; M. Butlin and E. Joll, *The Paintings of J.M.W.T.*, 2 vols. 1977 (revised 1984); J. Gage, *T. — A Wonderful Range of Mind*, 1987; Andrew Wilton, *T. in his Time*, 1987. Other References: J. Ruskin, *Modern Painters*, 1843; Academy Notes; Redgrave, Dict., Cent.; Roget; Bryan; Binyon; Cundall; DNB: VAM; Reynolds, VP; Tate Cat.; Hutchison; Hardie II, III (see pp.319-20 for full bibl. and list of exhibs.); Maas; Brook-Hart; Irwin; Staley; Turner Studies, periodical publ. by the Tate Gallery, 1980.
Exhib: London, Royal Academy 1975.

TURNER, Miss M. fl.1862
Exhib. a work entitled 'The Last Day of the Holidays' at the BI. London address.

TURNER, Miss Meta P.W. fl.1889-1891
Exhib. a painting of daffodils at SS. London address.

TURNER, Robert fl.1825-1848
Painted rustic subjects. Exhib. seven works at the RA, including 'The Grinder's Dinner Hour' and 'An Applicant for Admission into the Boy's Charity School', five works at the BI, and three works at SS, including 'The Diggery'. London address.

TURNER, T. fl.1808-1839
Painted landscape. Exhib. 18 works at the RA 1808-39, the last of these including 'Cottage Scene, Merionethshire' and 'View near Islington'. London address.

TURNER, W. fl.1857
Exhib. a landscape in 1857. London address.

TURNER, W.A. fl.1844
Exhib. a painting of wild fowl at the RA. London address.

TURNER, W. Eddowes fl.1858-1862
Painted animals. Exhib. three works at the BI, including 'Cattle in the Meadows' and 'View down the Trent', and four works at SS. Address near Nottingham.

TURNER, W.H.M. fl.1860
Exhib. 'An Irish Drove' at SS. Address in Bath, Somerset.

***TURNER, William (of Oxford) 1789-1862**
Landscape painter, mainly in watercolour. Called Turner of Oxford to distinguish him from J.M.W. Turner. Studied under John Varley. His early promise was so great that he was elected ARWS in 1808 at the age of only 18. His work of this period can stand comparison with J. Varley (q.v.) and John Sell Cotman, but his "youthful ardour, promise and innocence were to be spoiled by experience and sophistication" (Hardie). In 1833 he returned to Oxford, where he gave lessons, and produced large numbers of landscapes and topographical views. These later works are usually pleasing and professional, but lack the inspiration of his earlier work. He travelled extensively in England, Wales and Scotland in search of subjects; he was most fond of Scotland, the Lake District, Northumberland, West Sussex and the country round Oxford. Exhib. mainly at OWS (455

works), also RA 1807-57, BI and SS. Works by him are in the Ashmolean and the VAM. His studio sale was held at Christie's, 9 March 1863.

Bibl: DNB; Bryan; Cundall; Binyon; VAM; Redgrave, Dict; A.L. Baldry, *W.T. of Oxford*, Walker's Quarterly XI 1923; M. Hardie, *W.T. of Oxford*, OWS IX 1932; L. Hermann, *W.T. of Oxford*, Oxoniensa XXVI, XXVII 1961-2; Hardie II pp.234-8 (pls.229-31).
Exhib. Oxford, University Gallery 1895.

TURNER, William B. fl. 1887-1888
Exhib. 'A Country Smithy' at the RA and a work at SS. Address in Caernarvonshire.

TURNER, William Lakin 1867-1936
Painted landscape, particularly woodland and mountain scenes. Exhib. 11 works at the RA, including views in Scotland and the Lake District, titles including 'Among the Wild Mountains' and 'A Temple Not Made with Hands', and a work at SS. Studied under his father George Turner (q.v.) and at the West London School of Art. Born at Barrow-on-Trent, Derbyshire. Died at Sherborne, Dorset.

TURNING, H. fl.1839
Exhib. a landscape in 1839. Address in Twickenham, London.

TURPIN, Samuel Hart 1837-1899
Nottingham landscape painter. Friend of Henry Dawson (q.v.), and for many years a scene-painter at Nottingham Theatre Royal. He was a co-founder of the Nottingham Society of Artists.

TURQUAND, Captain G. fl.1873-1874
Exhib. two views of the Tower of London in watercolour. London address.

TURRELL, Herbert fl.1898-1900
Exhib. three works at the RA, including 'St. Dorothea' and 'Elaine, the Lily Maid of Astolat'. London address.

TURTLE, Edward fl.1830-1874
Painted landscape. Exhib. seven works at SS including 'Near Freshwater, Isle of Wight', 'Culvers, by Moonlight' and 'Coast of Cornwall', and another view on the Isle of Wight at the RA. Address on the Isle of Wight.
Bibl: Brook-Hart.

TUSON, G.E. fl.1853 d.1880
Painter of portraits, genre and biblical subjects, working in London, Turkey and South America. Exhib. 1853-65, at the RA 1854-59, BI and SS, titles at the RA being portraits and 'The Cold Bath', 1854. Painted 'The Reception of a Deputation from the Corporation of Manchester by the Sultan, in Buckingham Palace', 1867, for the Town Hall, Manchester. Afterwards he painted genre subjects and portraits in Turkey, and then in Montevideo, where he died. His portrait of General W.F. Williams, Bt., is in the Guildhall AG, London.
Bibl: American Art Review II/I 1881 p.134 (obit.); Bryan; BM Cat. of Engraved British Portraits I 1908 p.320; Ormond.

TUTHILL, Captain J.V. fl.1847
Exhib. 'The Dying Sheldrake' at the RA, 'Mallard and Blackcock' at the BI and 'Grouse' at SS. London address.

TUTILL, G. fl.1846-1858
Painted landscape. Exhib. five works at the BI including 'Douglas Bay' and 'Holy Island Castle', and one work at the RA. London address.

TUTTLE, C. Franklin fl.1882-1883
Exhib. 'Lonely' at the RA, and two works at the SS. London address.

TUTTLE, Mrs. J.B. fl.1889
Exhib. 'Corner in a Village' at the RA. Address in Glasgow.

TWEEDIE, William Menzies 1828-1878
Portrait painter. Born in Glasgow, the son of a lieutenant in the marines. Entered the Edinburgh Academy at the age of 16, and remained there for four years, gaining a prize for the best copy of Etty's 'The Combat'. In 1843 he exhib. a portrait at the RSA. In 1846 he came to London and entered the RA Schools; afterwards he studied for three years in Paris under Thomas Couture. Exhib. 1847-74, at the RA in 1847 'Summer', and 1856-74 BI and SS. 1856-9 he lived in Liverpool, and in 1859 he settled in London. His pictures were not always accepted at the RA and after 1874 they were invariably refused.
Bibl: Ottley; Redgrave, Dict; Bryan; DNB; R.L. Poole III 1925; BM Cat. of Engraved British Portraits VI 1925 p.189.

TWIGG, Miss fl.1821-1840
Painted portraits. Exhib. four portraits, three of clergymen, at the RA. London address.

TWIGG, Mrs. Alvine Klein fl.1888-1889
Exhib. a portrait at the RA and a painting of flowers at SS. London address.

TWIGG, J.H. fl.1839
Exhib. a portrait of 'His Majesty Mahommet, Shah of Persia' at the RA. London address.

TWIGG, Joseph fl.1879-1888
Exhib. three works at the RA, including two views of buildings in France. London address.

TWINING, H. fl.1855
Exhib. a view of Italian scenery at the BI. London address.

TWOART, G.C. fl.1866-1871
Painted portraits and figurative subjects. Also a sculptor. Exhib. eight works at the RA, including portraits and works entitled 'Evangeline' and 'Maidenhood'. London address.

TWYMAN, E. fl.1886
Exhib. a still-life at SS. London address.

TYE, Miss Edith A. fl.1892-1903
Painted flowers. Exhib. 11 works at the RA including 'White Azaleas', 'Carnations' and 'Some Empty Houses', and one work at SS. London address.

TYLOR, J.M. fl.1874
Exhib. a genre subject in 1874. Address in Carshalton, Surrey.

TYNDALE, Thomas fl.1900-1920
Watercolourist and book illustrator, mainly of cottage gardens.
Bibl: Wood, Painted Gardens; Wood, Paradise Lost.

***TYNDALE, Walter Frederick Roofe RI RBI 1855-1943**
Painter of architectural subjects and topographical landscapes, portraits and genre. Born at Bruges; came to England when he was 16; at 18 studied at the Academy in Antwerp, and then in Paris under Bonnat and the Belgian artist Jan Van Beers. Returned to England, and at first worked in oils, painting portraits and genre, and was chiefly known as a portrait painter until c.1890. Settled in Haslemere and gave lessons, and at this point took up watercolours, being much influenced by Claude Hayes and Helen Allingham, who was a friend. He never again used oils. He travelled to Morocco, Egypt, Lebanon, Damascus, Sicily, Italy and Japan, and became well-known for his finely detailed watercolours of Egyptian temples, Tunisian streets, Italian townscapes and other topographical subjects. He held many exhibs.: at the Leicester Galleries in 1912: 'An Artist in Egypt'; at Waring and Gillows in 1913: watercolours of Egypt and Japan; and at the FAS in 1920 and 1924. He was appointed to the censor staff at Havre in 1914, and later was Head Censor (Despatches) at Boulogne. Exhib. from 1880 at the RA, SS, NWS, GG and elsewhere. He also illustrated many topographical books, chiefly for the publishers A. & C. Black: *The New Forest*, 1904 (Methuen), *Wessex, Below the Cataracts*, 1907, *Japan and the Japanese*, 1910, *Japanese Gardens*, 1912, *An Artist in Egypt*, 1912, *An Artist in Italy*, 1913, *An Artist in the Riviera*, 1916, *The Dalmatian Coast*, 1925 and *Somerset*, 1927.
Bibl: Studio XXXI 1904 p.254; XXXVIII 1906 pp.289-97 (pls.); Connoisseur XXXII 1912 p.133; XXXVII 1913 p.122; LVIII 1920 p.244; LXVIII 1924 p.111ff.; LXXII 1925 p.190; Who's Who in Art 1934; Who Was Who 1941-50; Wood, Panorama p.89 (pl.88); Wood, Painted Gardens.
Exhib: London, Fine Art Society 1938; Walker's Gallery 1943; Mathaf Gallery 1984.

TYRRELL, W.A. fl.1854-1857
Exhib. a portrait at the RA. London address.

TYRWHITT, Rev. R. St. John 1827-1895
Exhib. a view in the Holy Land at SS and two landscapes at the RA. Address in Oxford.

TYRWHITT, Walter Spencer-Stanhope RBA 1859-1932
Painted landscape and architectural subjects. Exhib. five works at the RA including views in the Piccola Marina, Capri, and views in Damascus. Born and lived in Oxford. Travelled in Australia.
Bibl: DNB 1899; Who's Who 1924; Who's Who in Art 1934.

TYSON, Miss Alice fl.1889-1892
Exhib. two views of flowers at the RA. Address in Chester.

TYSON, John H. fl.1898-1900
Exhib. three works at the RA including 'In an Old World Village' and 'Flowery June'. Address near Liverpool.

UBSDELL, Richard Henry Clements fl.1828-1849
Miniaturist, illustrator, portrait painter and photographer. Exhib. five works at the RA and one watercolour at SS. Address in Portsmouth, Devon.

ULCOQ, Andrew fl.1889-1897
Exhib. two landscapes at the RA. London address.

ULLMAN, W.M. fl.1882
Exhib. two views of Breton children at the RA. London address.

ULLMER, Frederick fl.1885
Exhib. a work entitled 'Little Mischief' at SS. London address.

ULRICH, Charles F. fl.1889-1890
Exhib. five works at the RA including 'Spanish Letter Writer' and 'Finishing Touches'. Address in Venice.

UNDERHILL, Frederick Charles fl.1851-1875
London painter of genre, coastal scenes and biblical subjects. Born at Birmingham. Exhib. 1851-75, at the RA 1852-67, BI, SS and elsewhere, titles at the RA including 'Sea Coast', 1852, 'The Gipsy Mother', 1855 and 'Hagar and Ishmael', 1863. 'The Dinner Hour' is in Birmingham AG.
Bibl: AJ 1859 pp.82, 121, 168; Birmingham Cat; Brook-Hart

UNDERHILL, Frederick Thomas fl.1868-1896
London painter of fruit, landscape and portraits, who exhib. 1868-96, at the RA 1874-96, SS and elsewhere, titles at the RA being 'Fruit' and 'Pears', 1874, 'On the Ridges, Berkshire', 1877 and 'Andrew W. Levey, Esq.', 1896.

UNDERHILL, William fl.1848-1870
London painter of genre, sporting subjects, coastal scenes and mythological subjects. Born at Birmingham, brother of F.C. Underhill (q.v,). Exhib. 1848-70, at the RA 1849-64, BI, SS and elsewhere, titles at the RA including 'Irish Emigrants', 1849, 'Cupid and Psyche', 1851 and 'The Salmon-trap', 1856. In 1859 the AJ reviewed 'The Raft' (at the Portland Gallery, a man helping a woman out of the sea), as "a daring essay, successful in many points". Paintings by him are in Birmingham and Wolverhampton AGs.
Bibl: AJ 1859 pp.121, 167; Birmingham Cat; Pavière, Sporting Painters; Wilson; Brook-Hart.

UNDERWOOD, A.S. fl.1885
Exhib. a landscape at the NWS. London address.

UNDLEY, Maria A. fl.1873
Exhib. 'Fine Radishes' at SS. London address.

UNNA, Miss Ada fl.1890-1899
Exhib. a painting of roses at SS. London address.

UNWIN, G.A. fl.1871
Exhib. a landscape in 1871. London address.

UNWIN, Miss Ida M. fl.1892
Exhib. a genre subject in 1892. Address in Chilworth.

UPHILL, Miss Jessie H. fl.1896-1904
Exhib. two works at the RA, the first entitled 'Relics of the Brave, Westminster Abbey'. Address in Blackheath, London.

UPTON, John A. fl.1881
Exhib. a study of a head at the RA. London address.

UREN, John Clarkson fl.1885-1898
Painted marines. Exhib. two works at the RA, including 'A Breezy Day on the Cornish Coast', and three works at the NWS. Address in Penzance, Cornwall.
Bibl: Brook-Hart.

URLAND, G. fl.1883
Exhib. a work entitled 'Camp Life in the Thirty Years' War' at the RA.

URQUHART, Gregor fl.1853-1855
Exhib. two works at the BI, including 'Last Moments of Robert Bruce, Chaplain to James VI', and one work, 'Berkshire Rose', at the RA. London address.

URQUHART, William J. fl.1895-1901
Painted figurative subjects. Exhib. seven works at the RA, including 'An Awkward Question' and 'Two Crochets in the Bar'. Address in Leicester.

URQUHARTSON, C.Q. fl.1895
Exhib. a portrait at the RA. London address.

URWICK, Walter Chamberlain 1864-1943
Painter of genre and portraits. Pupil at the RA from 1882. Exhib. 1887-1904 at the RA, NWS and elsewhere, titles at the RA including 'A Stagnant Pool', 1887, 'Sweet and Twenty', 1901 and 'In that New World which is the Old', 1902. Connoisseur illustrates 'Love Hopeth all Things', a painting very much in the style of Frederick Walker (q.v.) showing a mother holding her sick baby with the note: "Wanted — information about a picture by Walter Urwick, 'Love Hopeth All Things', exhib. RA 1896 and sold to a man in the North of England". 'A Kentish Maiden' is in the City AG, Leeds, and another picture is in the Birmingham City AG.
Bibl: Connoisseur LXIII 1922 pp.229-30 (pl.).

URWICK, William H. RPE fl.1867-1881
London landscape painter and etcher, who exhib. 1867-81, at the RA 1872-81, SS and elsewhere. Titles at the RA include etchings and 'Mount Pond, Clapham Common', 1872 and 'Windsor, from Burnham Beeches', 1880.

USSHER, Arland A. fl.1885-1893
Exhib. a work entitled 'Flowing Inshore' at the RA, and three works at the NWS. Address in Dublin.

UTTERSON, Emily fl.1875
Exhib. a genre subject in 1875. Address in Winchester, Hampshire.

UVEDALE, Samuel fl.1845-1847
Painted flowers and fruit. Exhib. three still-lifes at the BI and four works, including a portrait, at SS. London address.

UWINS, James fl.1836-1871
Landscape and topographical painter. Exhib. at RA 1836-71, BI and SS. Painted English scenery, especially in Devon, also views in Spain and Italy. Nephew of Thomas Uwins (q.v.).

***UWINS, Thomas RA 1782-1857**
Genre painter, watercolourist and illustrator. Studied under Benjamin Smith, an engraver, and at RA Schools. At first worked mainly in watercolour, drawing many fashion plates for Ackermann's. Member OWS 1809-18. Also painted portraits and rustic scenes. After 1818 he began to turn more to oil painting, first of French subjects, then following his first visit to Italy in 1824, the picturesque Italian subjects for which he became best known. Exhib. at RA 1803-57, BI, SS, OWS and NWS. ARA 1833, RA 1838. Keeper of the National Gallery 1847-55. Works by him are in the VAM, Glasgow, Leicester, Manchester and Dundee AGs.
Bibl: AJ 1847 p.312; 1857 p.315ff. (obit.); 1859 p.28; Connoisseur LII 1928 p.114; LXVII 1923 p.197; Mrs. Uwins, *A Memoir of T.U.*, 1859 (repr.1978); Studio Special Number 1916, *Shakespeare in Pictorial Art*; Redgrave, Dict., Cent.; Clement & Hutton; Roget; Binyon; Cundall; DNB; VAM; Hardie I p.157 (pl.156); Ormond; Irwin.

V

VACHER, Charles 1818-1883

Watercolour painter of landscape and topographical subjects. Third son of the well-known stationer and bookseller, Thomas Vacher, of 29 Parliament Street. Studied at the RA Schools; in 1839 he went to continue his studies in Rome. Many tours followed, in which he visited Italy, Sicily, France, Algeria and Egypt, making large numbers of sketches. He was a rapid worker and, besides over two thousand sketches which he left at his death, he often executed 12 to 16 highly finished works in one year. He exhib. 1838-81, at the RA 1838-74, BI and SS, but chiefly at the NWS (324 works) of which he became an Associate 1846 and Member 1850. Titles at the RA include such subjects as 'Attila's Invasion; the First View of Italy', 1859, and 'Thebes During the Inundation', 1874. Ruskin admired Vacher's work and said of 'The Kabyle Mountains at Sunset', NWS 1857: "The rocks and aloe on the left are very beautifully drawn, the tone of the distant mountains most true, and all the effects more delicately felt than hitherto in this painter's work"; and of 'Bardj Acouss', NWS 1858: "There is great beauty of tone in many of Mr. Vacher's drawings and their impression is often most pleasing: but he should really leave out the figures for some time to come . . ." His studio sale was held at Christie's, 21 February 1884.
Bibl: Ruskin Academy Notes (OWS 1857; NWS 1857-8); Binyon; Cundall; DNB; VAM.

VACHER, Sydney fl.1882-1893

Exhib. views of buildings and architectural designs. Exhib. ten works at the RA including views of Famagusta Cathedral. London address.

VACHER, Thomas Brittain 1805-1880

Landscape watercolourist. Brother of Charles Vacher (q.v.). For many years he was in business in Parliament Street with his brother George with whom he founded a charitable trust called the Vacher Endowments. His hobby was sketching, and the VAM has many watercolour views made in England, Wales, Scotland, Ireland, Belgium, Germany, Italy and Switzerland.
Bibl: VAM.

VALENTINE, J. fl.1884

Exhib. a landscape in 1884. London address.

VALLANCE, Aylmer fl.1880

Exhib. two watercolours of flowers at SS. London address. Also a designer and author.

VALLANCE, William Fleming RSA 1827-1904

Scottish marine painter; also in his early career painted portraits and genre. Born in Paisley; when his family moved to Edinburgh, he was apprenticed in 1841 as a carver and gilder to Aitken Dott. During his apprenticeship he began to paint portraits and genre, but did not receive proper instruction until he was 23. Studied for a short time at the Trustees' Academy under E. Dallas, and later,

from 1855, under R.S. Lauder (q.v.). Began to exhib. at the RSA in 1849, but did not take up art as a profession until 1857. Exhib. only five works at the RA 1861-73. After 1870 he painted, principally in Wicklow, Connemara, and Galway, a series of pictures of Irish life and character. However, he was eventually best known as a painter of the sea and shipping, and for his atmospheric watercolour sketches of sea and sky. ARSA 1875, RSA 1881.
Bibl: AJ 1898 p.370ff. (pls.); Bryan; Caw; DNB 2nd Supp. 1912; Brook-Hart.

VALLENCE, Miss Fanny fl.1876-1885

Exhib. a painting of fruit at the RA and a subject at SS. London address.

VALLENTINE, Miss Emmeline fl.1864-1870

Painted genre subjects. Exhib. seven works at SS including 'Private and Confidential' and 'Family Cares', and another work at the BI. South London address.

VALTER, Eugene fl.1880

Exhib. a genre subject in 1880. This may be Miss Eugenie Valter (q.v.).

VALTER, Miss Eugenie M. fl.1880-1895

Exhib. a still-life in 1889. Exhib. mainly at RBSA. Address in Birmingham.

VALTER, Frederick E. fl.1878-1900

Birmingham painter of landscapes and animals, mainly cows and sheep. Exhib. two works at SS including 'Turning the Plough'. Exhib. mainly at RBSA. Brother of Henry Valter (q.v).

VALTER, Henry fl.1854-1897

Birmingham landscape painter, who exhib. 1854-64 at the BI, SS and mainly at RBSA. Brother of Frederick Valter (q.v.).
Bibl: Brook-Hart pl. 222.

VAN BEVER, A. fl.1845-1873

Painted figurative and genre subjects. Exhib. six works at the RA including portraits and works entitled 'The Last Rose of Summer'; five works, including a watercolour entitled 'La Biondina', at SS, and three works at the BI. London address.

VAN BIESBROECK, Julius J. fl.1879-1889

Exhib. two works at the RA including 'Borrowed Plumes'. London address.

VAN BRAKEL, Louisa Hoyer fl.1844

Exhib. two paintings of flowers at the RA and two still-lifes at the BI. London address.

VAN BROWN, A. fl.1849

Exhib. a portrait at SS.

VAN DER BOECK fl.1856

Exhib. a work entitled 'The Trumpeter' at the RA.

VANDERLYN, Nathan RI 1872-1946

Watercolourist and graphic artist. Studied at the RCA and the Slade. Born in Coventry, lived and died in London. Exhib. one work, 'With Daisies Pied', at the RA.

VAN DER VELDEN, P. fl.1880

Exhib. two genre subjects at the GG.

VAN DER WEYDEN, Harry F. b.1868 fl.1885-1892
American painter of landscapes and figure subjects, born in Boston. Exhib. six works at SS including 'The Thames above Cookham' and 'Meadow Sweet'. Lived in London and in France.

VAN DE WELD, W. fl.1867
Exhib. a mountain landscape in 1867. London address.

VAN GANGALEN, J. fl.1850
Exhib. two coastal landscapes at the RA.

VAN HAVERMAET, Charles fl.1901-1904
Exhib. four works at the RA 1901-4, including 'The Restorer' and 'The Connoisseur'. London address.

VAN HAVERMAET, P. fl.1879-1882
Exhib. two portraits, one of them of the Earl of Beaconsfield, at the RA. London address.

VAN HIER fl.1880-1881
Exhib. two works, including 'Souvenir of Flushing', at SS. London address.

VAN LUPPEN, Joseph fl.1874
Exhib. one work entitled 'Morning, The Colombier of the Ravine of Failmaigne, Ardennes'. London address.

VAN MOER, F.B. fl.1872
Exhib. a Venetian subject in 1872. London address.

VAN MONK, E. fl.1832-1840
Painted landscape and historical subjects. Exhib. eight works at the RA including 'View near Newport', 'The Itinerant Picture Dealer' and 'The Entry of Joan of Arc into Orleans'. Also exhib. one landscape at the BI and two works at SS. London address.

VAN RAALTE, Mrs. C. fl.1888
Exhib. one work entitled 'News from Abroad; "Where's Father?" ' at the RA. London address.

VAN RUITH, Horace 1839-1923
Painted figurative and Italianate subjects. Exhib. 17 works at the RA 1888-1903, including 'Spring Time in Capri' and 'The Lemon Tree'. Address in Capri, Italy. Lived in London.

VAN SEBEN, Henri fl.1857-1858
Exhib. four works, including 'The Laundress' and 'A Precious Burden', at the BI. London address.

VAN SOEST, Louis W. fl.1895
Exhib. 'A Beech Avenue' at the RA. London address.

VAN WORRELL, A.B. fl.1819-1849
Painted landscape. Exhib. 21 works, the majority landscapes with animals or figures, at the BI, 28 works at SS, including flower pieces and landscapes, and eight works at the RA. London address.

VARLEY, A. fl.1838
Exhib. a landscape at the RA. London address.

VARLEY, Albert Fleetwood 1804-1876
Watercolourist. Elder son of John Varley, and father of John Varley, Jnr. (qq.v.). Worked as a drawing master. His studio sale was held at Christie's, 26 January 1877.

VARLEY, Charles Smith 1811-1888
Landscape painter. Son of John Varley (q.v.). Exhib. 1838-69, at the RA 1839-56, BI and SS, titles at the RA including 'View from Norwood', 1839, 'Ditchling Village, Sussex', 1850 and 'Landscape Effect', 1856.

VARLEY, Cornelius 1781-1873
Painter, in watercolour, of landscapes, marines and architectural subjects; inventor of scientific instruments, notably the graphic telescope. Brother of John Varley (q.v.). Trained by his uncle Samuel, a watchmaker and manufacturer of scientific apparatus, but c.1800 decided to follow his brother's profession and joined him in frequenting Dr. Monro's house. In 1802 he visited North Wales with his brother John, and again in 1803. In 1804 he became one of the founder members of the OWS. Exhib. 1803-69, at the RA, BI, SS, OWS and elsewhere, only 62 works throughout his long career. This may have been due to his early taste for science: he improved the microscope, the *camera lucida* and the *camera obscura*, and at the Great Exhibition of 1851 was awarded a gold medal for the graphic telescope, which he had patented in 1811. The scarcity of his work has hindered general knowledge of its fine quality.
Bibl: AJ 1873 p.328; Redgrave Dict., Cent.; Roget; Binyon; Cundall; DNB; Hughes; VAM; B.S. Long, *C.V.*, OWS XIV 1937; Williams; Hardie II pp.108-10 (figs. 90-1); Maas p.44.

VARLEY, Edgar John fl.1861-1887 d.1888
Painter of landscape and architectural subjects. Son of Charles Smith Varley and grandson of John Varley (qq.v.). Exhib.1861-87, chiefly at SS, but also at the RA 1868-87, NWS, GG and elsewhere, titles at the RA including 'Arundel Castle, Sussex', 1868, 'Rue des Damouettes, Guernsey', 1876 and 'Near the Village of Shalbourne', 1887. He was Curator of the Architectural Museum at Westminster. The VAM has 'View from Gosport, Evening', 1867.
Bibl: Cundall; VAM; Hardie II p.110.

VARLEY, Miss Eliza C. fl.1840-1851
Exhib. three works at the RA, a portrait, a view of St. Albans and a painting of chrysanthemums. London address.

VARLEY, Illingworth fl.1901
Exhib. a work entitled 'Sunshine and Shadow' at the RA. London address.

***VARLEY, John 1778-1842**
Landscape and architectural watercolourist. Brother of Cornelius Varley and father of Albert Fleetwood Varley and Charles Smith Varley (qq.v.). Apprenticed at first to a silversmith, and later to a law stationer. Subsequently he obtained employment with a portrait painter in Holborn, and studied under J.C. Barrow, a teacher of drawing, from about 1794. He was one of the young artists patronised by Dr. Monro. After visiting Peterborough with Barrow, he exhib. for the first time at the RA in 1798: 'Peterborough Cathedral'. Exhib. 1798-1843, at the RA 1798-1841, BI, SS, but chiefly at the OWS, which he helped found in 1804, and where he exhib. 739 works. His early style is broad and simple, deriving great freshness from pure tints and facility of treatment. Varley published works on drawing, perspective and astrology and had a considerable reputation as an art teacher, numbering among his pupils F.O. Finch, William Henry Hunt, Copley Fielding, Turner of Oxford, David Cox, John Linnell, and Mulready (all q.v.). His life ended in poverty.
Bibl: Art Union V 1843 p.9ff. (obit); Redgrave Cent., Dict.; A.T. Story, *James Holmes and J.V.*, 1894; Roget; Binyon; Cundall pp.66, 265; DNB; Hughes; The Walpole Society V 1915-17 p.64; Connoisseur LXVI 1923 pp.73-5 (pl.); LXVII

1923 pp.190, 192, 196 (pl.); LXVIII 1924 pp.71 (pl.), 75; LXX 1924 pp.233, 247; B.S. Long, *List of Works Exhibited by J.V.*, OWS II 1925; Studio XC 1925 p.74; VAM; Charles Johnson, *English Painting*, 1932; BM Quarterly IX 1934-5 p.85; RA 1934; A. Bury, *J.V. of the 'Old Society'*, 1946; Williams; Hardie II pp.98-107 *et passim* (pls.); III *passim;* Maas pp.44, 47, 171; Ormond; Irwin; C.M. Kauffman, *J.V.*, 1984, VAM publication.

VARLEY, John, Jnr. fl.1870-1895 d.1899
Painter of landscape and Oriental subjects (street scenes, genre and landscape in Egypt, India and Japan). Son of Albert Fleetwood Varley and grandson of John Varley (qq.v.). He often causes confusion by using the same signature as his grandfather. Exhib. 1870-95, at the RA 1876-95, SS, NWS, GG and elsewhere, titles at the RA including 'The Island of Philae, Nubia', 1876, 'Fishing Boat on the Nile', 1885 and 'A Potter's Shop, Cairo', 1887.
Bibl: Studio XXXII 1904 p.61; LVIII 1913 p.63.

VARLEY, Mrs. John fl.1883-1886
Exhib. three works, 'Regrets', 'Wild Flowers' and 'A Pet Canary', at SS. London address.

VARLEY, Miss Lucy fl.1886-1897
Exhib. three paintings of flowers at the RA and one at SS. London address.

VARLEY, William Fleetwood 1785-1856
Painter of landscapes and architectural subjects. Brother of John Varley (q.v.). Exhib. 1804-18 at the RA. He taught drawing in Cornwall in 1810, and afterwards at Bath and Oxford. At Oxford he was nearly burned to death by the thoughtless frolic of a party of students, and never recovered from the shock; he died at Ramsgate.
Bibl: AJ 1856 p.148; Redgrave Dict.; Cundall p.265; DNB; Hughes; Williams; VAM; Hardie II p.110, fig. 89.

VASEY, Miss Clara fl.1891
Exhib. a painting of white chrysanthemums at the RA. London address.

VAUGHAN, Miss Letitia fl.1867
Exhib. a portrait at the RA and a head-study of an Italian at SS. London address.

VAUGHAN, T., Jnr. fl.1856-1862
Exhib. two works at the RA, the second an interior view of Pisa Cathedral. London address.

VAUGHAN, W.J. fl.1855-1858
Exhib. four landscapes 1855-8. London address.

VAWSER, Miss Charlotte fl.1837-1875
Landscape painter, living in London and Derby, who exhib. 1837-75, at the RA 1837-65, BI, and SS. Daughter of G.R. Vawser (q.v.). Titles at the RA include 'Effect from Nature in Hampstead', 1837 and 'Eagle Cliff', 1865.

VAWSER, George Robert 1800-1888
London landscape painter, who exhib. 1818-47, at the RA and SS, titles at the RA including 'View near Bolton, Yorkshire', 1836 and 'Sketch from Nature — the Wind about to Change', 1847.

VAWSER, George Robert, Jnr. fl.1836-1875
Landscape painter, living in London and Derby, who exhib. 1836-74, at the RA 1836-65, BI and SS. Son of G.R. Vawser (q.v.). Titles at the RA include 'Effect from Nature', 1836, 'Aysgarth Foss, Yorkshire', 1842 and 'View in Calke Park, Derbyshire', 1865.

VEAL, R.M. fl.1839-1847
Exhib. views near East Grinstead at the BI and RA, and a view in Sussex at SS. London address.

VEDDER, Simon H. fl.1896-1903
Painted and sculpted figurative subjects. Exhib. eight works at the RA including 'Summer Sleep' and 'Playmates'. London address.

VEMAUX, V. fl.1853
Exhib. a view near Boulogne-sur-Mer at the RA. London address.

VENABLES, Adolphus Robert fl.1833-1873
London portrait painter. Exhib. 21 works at the RA between 1833 and 1873.
Bibl: Ormond.

VENABLES, Miss Alice fl.1884
Exhib. a painting of chrysanthemums at SS. Address in Lincoln.

VENABLES, Miss Emilia Rose fl.1844-1846
Painted historical and genre subjects. Exhib. two works, 'Agreeable Intelligence' and 'Thoughtfulness', at the RA, and two works, including a scene in the life of Mary Stuart, at the BI. London address.

VENABLES, Spencer fl.1876-1879
Exhib. three works at SS including 'The Beggar-Boy'. London address.

VENESS, Miss Agnes M. fl.1898-1904
Painted flowers. Exhib. five works at the RA 1898-1904, including 'The Flowers that Bloom in the Spring' and 'Alice in Wonderland'. London address.

VENTNOR, Arthur fl. 1896-1904
Painted genre subjects. Exhib. four works at the RA including 'The Poor Man's Tea' and 'The Labourer's Home'. Address in Norwich.

VERESMITH see WEHRSCHMIDT

VERHEART, Paul fl.1879-1880
Exhib. two works at the RA including 'An Old Woman at Church'. London address.

VERNEDE, Camille fl.1869-1898
Landscape painter, living in London, Poole and Wimborne, Dorset. Exhib. 1869-98, at the RA 1873-98, SS, GG, NG and elsewhere, titles at the RA including 'Fir-trees', 1873, 'Near Poole Harbour', 1896 and 'A Grey Day', 1898.

VERNEDE, H.T. fl.1876-1880
Exhib. two landscapes 1876-80. London address.

VERNER, Frederick Arthur fl.1881-1900
Painted Canadian landscapes and subjects. Exhib. seven subjects at the RA including 'Monarch of the Prairie' and 'Alarmed — Canadian Elk'. London address.

VERNER, Miss Ida fl.1882-1893
Painted portraits. Exhib. eight works at the RA including five portraits and works entitled 'The Reader' and 'In a Studio'. Address in Brighton.

VERNON, Arthur Langley fl.1871-c.1922
Genre painter. Exhib. at RA 1873-97, SS, NG and elsewhere. Painted domestic scenes and interiors, with figures often in period costume. Also sometimes painted scenes with cardinals engaged in some humorous activity.

VERNON, Cyrus fl.1870
Exhib. a watercolour of King Arthur at SS. Address in Manchester.

VERNON, J.R. fl.1855-1858
Painted still-lifes. Exhib. three works at the RA including 'A Bull Finch with Fruit and Flowers'. Also exhib. several works at SS and the BI. London address.

VERNON, J. Arthur fl.1888
Exhib. a work entitled 'To Penmaenmawr' at the RA. London address.

VERNON, Miss Mary fl.1871-1873
Painted flowers. Exhib. five works at SS including 'Rose, Thistle and Shamrock'. Address in Birmingham. Daughter of William H. Vernon (q.v.).

VERNON, R. Warren fl.1886-1893
Painted marine subjects. Exhib. nine works at SS including 'Home of the Kingfisher' and 'The Gloaming', and one work at the RA. London address.

***VERNON, William H. ARBSA 1820-1909**
Birmingham landscape painter, who exhib. 1858-92, at the RA 1872-92, BI, SS and elsewhere, titles at the RA including 'On the Ogwen, North Wales', 1872 and 'A Lonely Mere', 1891. Also exhib. regularly at RBSA. His four daughters were also painters, Mary (q.v.), Ellen, Florence and Norah, and they all exhib. at the RBSA.

VERNON-MORGAN, Mrs. Mary fl.1894
Exhib. 'Spring Flowers' at the RA. Address in Birmingham.

VERRALL, Frederick fl.1884
Exhib. a marine in 1884. London address.

VERRAUS, L. fl.1850
Exhib. a work entitled 'Le Repos' at the RA. London address.

VERREAUX, L. fl.1857
Exhib. a work entitled 'Souvenir de Boulogne' at the BI. London address.

VERSCHAUR, W. fl.1869
Exhib. a genre subject in 1869. This may be the Dutch artist Wouter Verschuur (1812-1874).

VERSEY, Arthur fl.1873-1900
Kilburn painter of landscape, river scenes and rustic genre, who exhib. 1873-1900, at the RA 1880-1900, SS (63 works), NWS and elsewhere. Titles at the RA include 'Measuring Hops in a Kentish Garden', 1883, 'Shrimp Boats on the Yare, Norfolk', 1888 and 'Market Day', 1900.

VERTUE, Julia fl.1848
Exhib. a view of Cromer at the RA. London address.

VERTUE, Rosamond fl.1847
Exhib. a nature study at the RA.

VERWEE, C.L. fl.1864-1865
Exhib. 'A Difficult Case' at the RA, and 'Quite Happy' at SS. London address.

VESEY-HOLT, Miss A. Julia fl.1884
Exhib. a 'Study of Pansies' at the RA. London address.

VETH, Jan fl.1891
Exhib. a portrait in 1891.

VEUSSEL, Emma fl.1853
Exhib. a portrait of the artist's mother at the RA. London address.

VEZIN, Frederick fl.1884-1885
Exhib. three works at the RA: 'My Studio', 'Düsseldorf Racecourse' and 'Moonlight on the Sands'. London address.

VIALLS, Frederick Joseph fl.1884-1885
Exhib. two landscapes at the NWS. London address.

VICKERS, A.H. fl.1853-1907
Landscape painter. Probably related to Alfred Gomersal Vickers and Alfred Vickers (qq.v.), but this is not known for certain. Exhib. at RA once in 1853, BI and SS. Painted landscape views in England, and on the Rhine. His pictures are usually small, and his style a slightly coarse imitation of Alfred Vickers. Usually signed A.H. Vickers.
Bibl: Pavière, Landscape; Brook-Hart pls. 29b, 164.

***VICKERS, Alfred 1786-1868**
Landscape painter. A self-taught artist, whose light and sparkling style has been compared to Boudin. Exhib. at RA 1831-68, BI (125 works) and SS. Painted English views, especially river scenes, in a rapid, sketchy style, using a range of pale greens which is very distinctive. Works by him are in Glasgow, Nottingham and Sheffield AG. His son Alfred Gomersal Vickers (q.v.), was also a painter.
Bibl: Connoisseur LXVI 1923 p.240ff.; Redgrave, Dict.; Wilson pl.42; Pavière, Landscape pl.83; Brook-Hart p. 89 (pl.163).

VICKERS, Alfred Gomersal 1810-1837
Landscape painter; son of Alfred Vickers (q.v.). Like his father, he exhib. mostly at BI, also RA 1827-36, SS and NWS. In 1833 he visited Russia to make drawings for Charles Heath's *Annuals*. Painted views in England, France, Switzerland, Poland and Moscow. Works by him are in the VAM, Leicester and the National Gallery, Dublin. He died young, and his output was not large. Unless his pictures are signed A.G. Vickers they are often confused with those of his father. His studio sale was held at Christie's, 16-17 February 1837.
Bibl: See under Alfred Vickers; Brook-Hart pp.89, 91.

VICTOR, J. fl.1852
Exhib. a Welsh landscape at the BI. London address.

VIDAL, Eugene fl.1888-1896
Exhib. four works at the RA including 'Crossing Sweeper' and 'Youth'. London address.

VIEUSSEUX, E. fl.1859
Exhib. a self-portrait at the RA. London address.

VIGERS, Frederick fl.1884-1897
Painted literary and genre subjects. Exhib. nine works at the RA including 'Found', 'A Little Homestead' and subjects from *The Canterbury Tales*. Address in Horsham, Surrey.

VIGNE, G.T. fl.1842
Exhib. 'A Kashmirean Girl, with a Lotus on her Head to keep off the Heat' at the RA. Address in Woodford, Essex.

VIGOR, Charles fl.1881-1902
Painted portraits and figurative subjects. Exhib. 21 works at the RA including portraits and works entitled 'Do Take Me!', 'Hers, Not His, Upon the Father's Knee' and 'Embers of Love'. London address.

VILLIERES, F. fl.1880-1886
Exhib. four genre subjects 1880-6. London address.

VILLIERS, Frederick 1852-1922
Painted and illustrated military subjects. Exhib. two works, the first entitled 'The Road Home; The Return of an Imperial Brigade from Afghanistan'. Studied at the British Museum, the South Kensington Schools and at the RA Schools. Born and lived in London.

VINALL, C. fl.1872
Exhib. 'A Village Church' at the RA. London address.

VINALL, Joseph William Topham 1873-1953
Painted and etched portraits, landscapes and architectural subjects. Studied at the RCA and at the City and Guilds London Institute. Born in Liverpool. Lived in London.
Bibl: Who's Who in Art 1934; Studio CX 1935 p.46.

VINCENT, Miss D. fl.1893
Exhib. 'Chrysanthemums' at SS. Address in Addlestone, Surrey.

VINCENT, Miss E.M. fl.1893
Exhib. a work at the NWS. London address.

VINCENT, Henry fl.1879-1897
Painted figurative and genre subjects. Exhib. six works at the RA including 'What is it?', 'Private Practice' and 'British Museum — The Way Out', and five works at SS. London address.

VINCENT, Spencer fl.1865-1882 d.1910
Amateur painter of Scottish landscapes. Exhib. 40 landscapes, 1865-82. London address. Honorary RI 1882-3.

VINE, John c.1809-1867
Colchester primitive painter of animals and farm scenes. Exhib. a farm-yard scene at SS. Although badly crippled and deformed, his pictures have a remarkable primitive character.
Bibl: W.G. Benham, J.V. of Colchester, 1932.

VINE, R. fl.1846-1850
Painted fruit. Exhib. three fruit pieces at SS and two works at the RA. London address.

VINER, Edwin b.1867
Painted landscape. Studied at Liverpool School of Art. Born in Birmingham. Lived in Cheshire.

VINER, J. Tickell fl.1821-1854
Painted portraits and figurative subjects. Exhib. 13 works at the RA including portraits and works entitled ' 'Mid Halls and Cities Rude' and 'The Young Artist'. Exhib. four works at SS and two works at the BI. London address.
Bibl: Ormond.

VINTER, Mrs. C. fl. 1853-1874
Painted genre subjects and flowers. Exhib. seven watercolours at SS including 'Enjoying a Crust', 'Working for Dolly' and 'Lilac'. London address.

VINTER, Frederick Armstrong fl.1874-1883
London painter of historical subjects, portraits and genre, who exhib. 1874-83, at the RA 1879-83, SS and elsewhere. Titles at the RA include 'Mildred', 1879, 'Lady Jane Grey', 1880 and 'From Arabia', 1881. Possibly the son of John Alfred Vinter (q.v.) as listed as living at the same address, 29 Monmouth Road. Also at the same address was Harriet Emily Vinter.

VINTER, Miss Harriet Emily fl.1879-1880
Exhib. a watercolour entitled 'Leonora' at SS and a still-life at the RA. London address.

VINTER, John Alfred 1828-1905
Portrait lithographer, and painter of portraits, genre, and literary and historical subjects. Exhib. 1847-1902, at the RA 1848-1902, BI, SS and elsewhere. Many of his lithographed portraits exhib. at the RA were made for Queen Victoria, e.g. 'H.R.H. Prince Leopold George Duncan Albert. After Winterhalter', 1860. Titles of other works exhib. at the RA include 'The Burial of Isabella', 1849, 'The Hamper from Home', 1873 and 'Alone in London', 1881.
Bibl: The Year's Art 1906 p.362; BM Cat. of Engraved British Portraits VI 1925 p.706; Illus. list NPG 1928; Ormond.

VIPAN, Miss E.M. fl.1884-1885
Exhib. a painting of roses at SS. Address in Brighton, Sussex.

VIRGIN, A.F.G. fl.1866
Exhib. two works at SS, the first 'A Dalecarlian Interior'. Address in Stockholm, Sweden.

VIVIAN, Comley fl.1874-1892
Painted portraits. Exhib. ten portraits at the RA and two works including 'Hearts are Trumps' at SS. London address.

VIVIAN, Mrs. Elizabeth Baly RMS b.1846
(Miss Farquhar)
Painted portraits. Born in Warwick. Lived in London.

VIVIAN, Miss J. fl.1869-1877
Painted landscapes. Exhib. six works at SS including views in Venice, Bruges and Rouen. London address.

VOKES, Arthur Ernest 1874-1964
Painted portraits and landscape. Also a sculptor. London address.
Bibl: J.B. Penfold, Tree-Worshipper in Watercolours, 60 Years of Painting by A.E. Vokes, Country Life 26 January 1978.

VOLCK, Fritz fl.1874-1881
Exhib. three watercolours at SS including 'A Gipsy of the Black Forest'. London address.

VON BORWITZ, Miss R.E. fl.1891-1892
Exhib. 'Autumn' at the RA and 'July Gold' at the BI. London address.

VON DER EMBE, K. fl.1853
Exhib. two works, 'Early Impressions' and 'German Peasant Reading the Bible', at the RA. London address.

VON FOWINKEL, Magdalen fl.1831-1846
Exhib. five works at the RA, two portraits, two flower pieces and a view of a castle. London address.

VON GLEHN, A. fl.1881
Exhib. two landscapes in 1881. Address in Brighton, Sussex.

VON GLEHN, Oswald fl.1879-1880
Exhib. two classical subjects, 'Boreas and Orythia' and 'Oenone', at the RA. London address.

VON HANNON, R. fl.1849
Exhib. a snow scene at the RA. Address in Vienna.

VONNER, Mme. A.B.N. fl.1892
Exhib. a work entitled 'Olga' at the RA. London address.

VON STÜRMER, Miss Frances fl.1863-1874
Painted landscape and figurative subjects. Exhib. six works at SS including 'An Ancient Toper', 'Tired of Reading' and landscapes in Lincolnshire and Cornwall. London address.

VON WEBER, Ada fl.1880
Exhib. a watercolour view in Rome at SS. London address.

VOS, Hubert RBA b.1855 fl.1885-1892
Painter of portraits, genre and landscape. Born in Maastricht; studied in Brussels, Paris and Rome. Living in England 1885-92. Exhib. 1888-92, at the RA 1888-91, SS, NWS, GG, NG and elsewhere, titles at the RA including 'A Breton Beggar', 1888, 'A Room in the Brussels Almshouse for Women', 1889 and 'H.E. Mons. de Staal, Russian Ambassador in London', 1890. Later he went to New York, where he became a naturalised American.
Bibl: J. Martin, *Nos peintres et sculpteurs*, II 1898; American Art Annual XX 1923 p.723; The Art News XXIII 1925-6 No.6 p.2; M. Fielding, *Dictionary of American Painters*, 1926; Op de Hoogte XXV 1928 pp.102-5.

VYCHAN, J.L. fl.1873-1877
Painted landscape. Exhib. ten works at SS including views in Ireland, Derbyshire and Bordeaux. Also exhib. two Continental landscapes at the RA. London address.

VYVYAN, Miss M. Caroline fl.1868-1897
Exhib. three works at SS including 'Derelict' and 'A Quiet Hour', and two works at the RA. London address.

WADDELL, D. Henderson fl.1882
Exhib. a view in Dunbar at the RA. London address.

WADDINGTON, Miss Maud fl.1888
Exhib. a landscape at the NWS. Address in Whitby, Yorkshire.

WADDY, Frederick fl.1873-1878
Exhib. a drawing in 1878. London address.
Bibl: Ormond.

WADE, Edward W. fl.1862-1865
Painted landscapes. Exhib. three landscapes including 'Rosslyn Glen' and 'On the Wye, near Whitchurch', and one work at SS. Address in Deptford.

WADE, Fairfax Blomfield fl.1889-1895
Exhib. seven views of buildings at the RA including three of Flixton Hall, Suffolk. London address.

***WADE, Thomas 1828-1891**
Painter of landscape and rustic genre. A self-taught artist, influenced by Pre-Raphaelite techniques. Lived in Preston, Lancashire, and after 1879 in Windermere. Exhib. at RA 1867-90,

BI and elsewhere. Titles at RA 'The Old Smithy', 'An Old Farmhouse', 'Harvest Field', etc. 'An Old Mill', RA 1879, was bought by the Chantrey Bequest for £84.
Bibl: Preston AG Cat. 1907; Wood, Panorama pl.118; Wood, Pre-Raphaelites; Wood, Paradise Lost.

WADHAM, B.B. fl.1871-1883
Painted landscape. Exhib. three works including 'Tal-y-Llyn' and 'A Sunny Nook in Kent' at SS. Exhib. 'Sunny Day in September' at the RA. Address in North Wales and Liverpool.

WADHAM, H.B. fl.1838-1839
Exhib. two works, a self portrait and a sketch of a boy, at the RA. London address.

WADHAM, Percy fl.1901-1902
Exhib. two views of architecture in Avignon and another work at the RA. Address in Windsor, Berkshire.
Bibl: Studio XXX 1904 pp.241-6.

WADHAM, Sarah fl.1880-1881
Exhib. two watercolours, 'Nellie' and 'Maud', at SS. London address.

WADMORE, T.F. fl.1847-1877
Exhib. six views of architecture at the RA including a view of the remains of an ancient church in County Londonderry. Address in London.

WADSWORTH, Mrs. fl.1875
Exhib. a watercolour view in North Devon at SS. Address in Nottingham.

WAGEMAN, Miss D.E. fl.1860
Exhib. a watercolour interior view of a church in Bandon, Ireland, at SS. London address.

WAGEMAN, M., Jnr. fl.1866
Exhib. a still-life at the BI. London address.

WAGEMAN, Michael Angelo fl.1837-1879
Portrait and genre painter. Presumably son of Thomas Charles Wageman (q.v.) as they are listed in Graves at the same address 1836-7. Exhib. at RA 1837-79, BI and SS. Titles at RA portraits and historical genre, e.g. 'Amra and Govinda', 'Celadon and Amelia', and 'Nathan Accusing David'.

WAGEMAN, Thomas Charles 1787-1863
Portrait painter in oil and miniature, and engraver. Exhib. at RA 1816-1848, BI, SS and NWS. Specialised in portraits of famous actors in their leading roles. Appointed portrait painter to the King of Holland. Michael Angelo Wageman (q.v.) also a painter, was presumably his son.
Bibl: Redgrave, Dict; Cundall p.265; VAM Watercolour Cat. 1908; Drawings by British Artists; BM IV 1907; BM Cat. of Engraved British Portraits VI p.559ff.; Burlington Mag. LXIX 1936 p.251; Binyon; VAM; Ormond.

WAGHORN, Frederick fl.1880-1888
Exhib. three works at the RA including 'A Relic of the Middle Ages', and one work at SS. London address.

WAGNER, Edward fl.1862-1870
Exhib. 'The Roadside' at the BI and 'Night' at SS. London address.

WAGREZ, E. fl.1856-1867
Exhib. 'An Interior View in Rome' at the BI. London address.

WAGSTAFFE, S. fl.1876
Exhib. 'A Land-drain near Selby' at SS. Address in Leeds, Yorkshire.

WAIN, Louis William 1860-1939
Painted and drew anthropomorphic animal subjects especially cats. Exhib. 'Disturbed' at SS. London address. His illustrations and drawings were enormously popular in the first decades of this century. Towards the end of his life Wain suffered from mental illness. A large collection of Wain's drawings were sold at Sotheby's Belgravia, 21 March 1978.
Bibl: R.A.M. Dale, *Louis Wain*, 1968; V&A, *Louis Wain*, 1972.
Exhib: London, Parkin Gallery, *Yet Even More Cats of Fame and Promise*, 1977.

WAINEWRIGHT, J.F. fl.1855
Exhib. a view at Hastings at the BI. London address.

***WAINEWRIGHT, John fl.1860-1869**
Very little-known flower painter. Exhib. four pictures at BI and two at SS between 1860 and 1869. Painted large and decorative florals in the manner of Huysum and Van Os.

WAINEWRIGHT, Thomas Francis fl.1831-1883
Landscape painter. Lived in London. A prolific painter, who exhib. over 200 works at SS, also at RA 1832-62, BI and elsewhere. Titles at RA include many landscape sketches and studies.
Bibl: VAM Cat. of Watercolours 1908.

WAINEWRIGHT, W.F. 1835-1857
Painted portraits. Exhib. eight portraits at the RA and three watercolour portraits at SS. London address.

***WAINWRIGHT, William John RWS RBSA 1855-1931**
Birmingham painter and watercolourist of portraits, still-life and genre; stained-glass designer. Born at Birmingham; educated at Sedgley Park College near Wolverhampton. Apprenticed to Messrs. Hardman, stained-glass designers. One of the founders of the Birmingham Art Circle, 1879. For some time he directed the life academy at the Birmingham School of Art under E.R. Taylor (q.v.). Studied painting at the Antwerp Academy, principally under C. Verlat. Shared a studio with F. Bramley (q.v.). Elected A of the Birmingham Society of Artists, 1881. Lived in Paris 1881-4. After a period in London, he spent two years at Newlyn with Edwin Harris and W. Langley (qq.v.). Returned in 1886 to Birmingham where he died. Exhib. from 1882, at the RA (in 1883 'An Ancient Musician'), RWS, SS, but mostly at the RBSA. RWS 1893. Painted a posthumous portrait of David Cox (q.v.) for the RWS.
Bibl: Studio LXV 1915 p.201; Connoisseur LXXII 1925 p.70; LXXV 1926 p.60; LXXXVIII 1931 p.277 (obit.); Birmingham Cat.

WAITE, Charles D. fl.1882
Exhib. a watercolour view of St. Ives at SS. Address in Addiscombe.

WAITE, E. fl.1868
Exhib. a watercolour view of Box Hill from Norbury Park at SS. Address in Croydon, Surrey.

***WAITE, Edward Wilkins RBA 1854-1924**
Landscape painter. Lived in Blackheath, Reigate and Dorking. Exhib. at RA from 1878, also at SS, NG and elsewhere. Titles at RA 'The Felling Season', 'Late Autumn', 'Lingering Autumn', etc. Works by him are in Bristol and Preston AGs.
Bibl: Bristol AG Cat. 1910; Preston AG Cat. 1907; Cat. of Waite exhib., Gainsborough House, Suffolk, 1983; Wood, Paradise Lost.
Exhib: Guildford House Gallery 1986; London, Burlington Gallery 1987.

WAITE, Harold RBA fl.1893-c.1930
Painted landscape. Exhib. three works at SS including 'A Grey Morning'. Exhib. five works at the RA including 'Faggot Cutting'. London address. Later lived near Canterbury, Kent.

WAITE, J. fl.1854-1860
Painted figurative subjects. Exhib. three works at the RA including 'Adam and Eve' and 'A Difficult Lesson', four works at SS including 'Kept In' and 'Heads or Tails', and one work at the BI. London address.

WAITE, James Clarke RBA fl.1863-1885
London genre painter. Exhib. mainly at SS (117 works) where he was a member; also at RA 1863-1884, BI, OWS and elsewhere. Titles at RA 'The Torn Dress', 'A Rustic Genius', 'The Cat with Many Friends', etc.

WAITE, Robert Thorne RWS 1842-1935
Landscape painter, mostly in watercolour. Born in Cheltenham; studied at South Kensington Museum. Exhib. at RA from 1870, SS, NWS, GG, NG, etc., but mostly at OWS. ARWS 1876, RWS 1884. Painted pastoral scenes in Yorkshire and southern England, especially the Sussex Downs; the main influence on his style was Copley Fielding (q.v.). See also under Thorne Waite, Robert.
Bibl: AJ 1892 pp.182-6; 1895 pp.60, 62; Connoisseur XXVIII 1910 p.315; LIV 1919 p.49; LXVII 1923 p.61; LXXII 1925 p.50; Studio Summer Number 1900; VAM; Hardie II pp.233-4 (pl.226); Bourne Gallery, Reigate, Cat. of R.T.W. exhib., March 1976.

WAITE, William Arthur 1875-1896
Birmingham landscape painter. Exhib. two works at SS including 'Black-berry Gathering' and also at RBSA.

WAKE, John Cheltenham fl.1858-1875
Painted landscape and coastal subjects. Exhib. seven works at SS including 'Fishing Boats off Harwich' and 'Morning after the Storm', and three works at the BI including 'Industry'. London address.

WAKE, Joseph fl.1870
Exhib. 'At Vespers' at the RA. Address in Manchester.

WAKE, Miss Margaret fl.1893
Exhib. a still-life in 1883. Address in Crouch Hill.

WAKLEY, Archibald c.1875-1906
Pre-Raphaelite painter in oil and watercolour. Influenced by the aesthetic style of Burne-Jones, De Morgan and Spencer-Stanhope (qq.v.). Exhib. at RA 1906. Showed great promise, but was found murdered in his water closet.
Bibl: The Times 25 May 1906.

WAKLEY, Horace M. fl.1900-1904
Exhib. three views of buildings at the RA. London address.

***WALBOURN, Ernest fl.1897-1904**
Painted landscape usually with girls and children. Exhib. five works at the RA 1897-1904, including 'Poppies among the Peas' and 'On the Allotments'. Address in Chingford, Essex.

WALDEN, E.H. **fl.1855-1865**
Exhib. two works at the RA, the second a 'Study of an Old House, near Salisbury'. London address.

WALDEN, Lionel **fl.1897**
Exhib. 'Bathers' at the RA. Address near Falmouth.

WALE, John Porter **1860-1920**
Painted flowers and gardens in watercolour. Worked for china manufacturers in Worcester and Derby. Born in Worcester. Studied in Worcester and Derby Schools of Art. Died in Derby.

WALES, H.R.H. Princess of **fl.1881-1890**
Exhib. works at the OWS.

WALFORD, Miss Amy J. **fl.1873-1892**
Exhib. a watercolour view at Glion at SS. London address. Also lived in Bromsgrove and exhib. at RBSA.

WALFORD, E. **fl.1859**
Exhib. 'Near Chislehurst, Kent' at SS. London address.

WALFORD, Miss H.L. **fl.1891**
Exhib. a painting of flowers at the NWS. Address in Bushey, Hertfordshire.

WALFORD, Miss Louisa **fl.1897-1904**
Exhib. 'Lilies' and 'Larkspurs' at the RA. Address in Bushey, Hertfordshire.

WALKER, Miss Agnes E. **fl.1887-1900**
Painted portraits and figurative subjects. Exhib. eight works at the RA including five portraits and works entitled 'A Toast' and 'A Difficult Passage', and six works at SS. London address.

WALKER, Miss Alice **fl.1862**
Exhib. 'The Hunchback' at the RA and 'Wounded Feelings' at the BI. London address.

WALKER, Arthur George **RA** **1861-1939**
Sculptor and painter of figurative subjects. Exhib. 27 works at the RA including 'Priam Begging the Body of Hector from Achilles' and 'The Presentation in the Temple', both pictures. Studied at the RA Schools. Lived in London.
Bibl: Who's Who in Art l934; Connoisseur LXXII 1925 p.182; LXXVI 1926 p.124.

WALKER, B.W. **fl.1887**
Exhib. a landscape at the NWS. London address.

WALKER, Miss Breda **fl.1871**
Exhib. a figurative subject in 1871. Address in Cheltenham, Gloucestershire.

WALKER, Charles J. **fl.1864**
Exhib. 'The Milestone' at the RA. Address in Liverpool.

WALKER, Claude Alfred Pennington **b.1862**
Painted landscape, architectural subjects and flowers. Illustrated his own books. Born in Cheltenham, Gloucestershire. Lived in London.

WALKER, Miss Cordelia **fl.1859-1868**
Painted figurative and genre subjects. Exhib. three works at the BI including 'Will You Buy a Toy for the Baby, Ma'am?', three works at SS including a biblical subject, and 'Women of the Himalayas' at the RA. London address.

WALKER, Dougald **b.1865**
Exhib. landscapes at RSA and elsewhere. Was Headmaster of the Northern District School, Perth, and Secretary of the local Art Association.

WALKER, Edward J. **fl.1878-1879**
Exhib. three genre subjects 1878-9. Address in Liverpool.

WALKER, Edwin Bent **fl.1892-1903**
Exhib. four works at the RA including 'On Pleasure Bent' and 'The Dead Bird'. Address in Stockport.

WALKER, Miss Eliza **fl.1860**
Exhib. 'The Return of the Wanderers' at SS. London address.

WALKER, Miss Elizabeth **fl.1877-1882**
Exhib. 'Early Blossoms' and 'Sunflowers' at the RA. London address.

WALKER, Ellen **fl.1836-1849**
Painted portraits and still-lifes. Exhib. nine works at the RA including five portraits and paintings of fruit. London address.

WALKER, Miss Ethel **ARA RBA RP NEAC** **1861-1951**
(Dame Ethel Walker)
Painted portraits, still-life and landscape. Her first three exhibs. at the RA included a portrait and works entitled 'Ironing Day' and 'Under the Pear Tree'. Studied at the Ridley School of Art, at Putney School of Art, at the Westminster School of Art and at the Slade School. Born in Edinburgh. Lived and worked at Robin Hood's Bay, Yorkshire, and in London.
Bibl: Studio LVII 1920 pp.50, 182; LXXVII 1927 p.254; CXIII 1937 p.310; Apollo VII 1928 p.192; XIII 1931 p.307; XVII 1933 p.166; XXI 1935 p.110; XXVI 1937 p.356; Who's Who in Art 1934.
Exhib: London, Lefevre Gallery 1933; Wildenstein Gallery 1936; Little Burlington Galleries 1937; Lefèvre Gallery 1939; 1940; 1942; Leicester Galleries 1946; Great Britain, Arts Council 1952; Redfern Gallery 1952; Roland, Browse & Delbanco 1974.

WALKER, Francis S. **RHA RE** **1848-1916**
Irish genre and landscape painter, and illustrator. Studied at Royal Dublin Society and RHA Schools. Came to London 1868 where he worked for the Dalziel brothers. Later worked as an illustrator for *The Graphic* and *The Illustrated London News*. Made his debut as a painter in 1868 at the Dudley Gallery. Exhib. at RA 1871-1913, SS and NWS. Titles at RA 'A Lazy Fellow', 'The Little Shepherdess', etc. and many views along the Thames. A work by him is in Leeds AG. He illustrated several topographical books, including *The Groves of Blarney*.
Bibl: Mag. of Art 1904 p.140; Who was Who 1916-29.

WALKER, Frank H. **fl.1878-1893**
Painted landscape and rural subjects. Exhib. eight works at the RA including 'Where the Toad and the Newt Encamp' and 'Cold Winter Light', and six works at SS including 'The Path by the River'. London address.

***WALKER, Frederick** **ARA** **1840-1875**
Genre painter and watercolourist. Born in London. First studied from antique sculpture in the BM, then at Leigh's Academy, and RA Schools 1858. Member of Langham Sketching Club. Worked for T.W. Whymper, a wood engraver, for three years. In 1860 he began to contribute drawings to *Once a Week*, in 1861 *Cornhill Magazine*. Before long he had established himself as one of the

most talented young illustrators of the 1860s, illustrating for Thackeray and many magazines. In 1863 he began to exhib. at the RA, and in1864 he scored a great success at the OWS with his exhibs. there. His watercolours are similar in spirit and technique to the work of Birket Foster and W. Henry Hunt (qq.v.). The theme of most of his works is the poetic evocation of simple, pastoral life, e.g. 'Spring', 'Autumn', 'The Violet Field'. His watercolours of this type were very popular, and made high prices in his own lifetime. His large oils, such as 'The Harbour of Refuge', 'Vagrants' and 'The Old Gate', reflect the classicism of his early training, with their consciously posed figures in what Ruskin called "galvanised-Elgin" attitudes. Exhib. at RA 1863-75, OWS and elsewhere. ARWS 1864, ARA 1871. Died of consumption at a tragically young age; buried at Cookham-on-Thames, where many of his pictures were painted. His studio sale was held at Christie's, 17 July 1875.

Bibl: AJ 1876 pp.197-300; 1893 p.277ff.; Portfolio 1870 pp.35-8; 1875 pp.117-22; Print Collector's Quarterly VII 1920 pp.385ff.; Redgrave, Dict, Cent; Roget; Binyon; Cundall; DNB; Gleeson White; VAM: J.C. Carr, *F.W.*, 1885; Sir C. Phillips, *F.W.*, 1894; J.G. Marks, *The Life and Letters of F.W.*, 1896; C. Black, *F.W.*, 1902; J.L. Roget, *F.W.*, OWS XIV 1937; Hardie III pp.134-7 (pls.156-7); Reynolds, VS, VP: Maas pp.235-6 (pl.p.236); Ormond; Wood, Panorama; Wood, Paradise Lost; Newall.

WALKER, G. fl.1847
Exhib. a still-life of game at the BI. London address.

WALKER, G.D.K. fl.1838
Exhib. two still-lifes of game at the RA. London address.

WALKER, Henry fl.1886
Exhib. a landscape in 1886. Address in Worcester.

WALKER, Hirst RBA 1868-1957
Painted landscape and architectural subjects. Born and lived in Yorkshire.

WALKER, Hugh fl.1867-1875
Painted figurative subjects and flowers. Exhib. nine works at SS including 'Ophelia', 'Girl of Charles' Time' and 'Spring Flowers'. London address.

WALKER, J.G. fl.1830-1842
Painted landscape and figurative subjects. Exhib. two coastal subjects at the BI. Exhib. portraits and paintings of rabbis and sportsmen at SS. In the SS lists he is also credited with copies and engravings. London address.

WALKER, J.H. fl.1846
Exhib. a 'Composition' at the RA. London address.

WALKER, James William 1831-1898
Landscape painter in oil and watercolour. Born in Norwich, where he studied at the School of Design. Later lived in London, Bolton, and Southport. Exhib. at RA 1862-93, SS, OWS, GG, NG and elsewhere. Mainly painted views in Lancashire, Cumberland, Wales and Brittany. Visited Rome and Naples in 1881. Works by him are in Norwich, Liverpool and VAM. His wife Pauline (q.v.), was also an artist.

Bibl: W.F. Dickes, *The Norwich School of Painters*, 1905; Cundall p.266; Ormond.

WALKER, Mrs. James William (Pauline) fl.1870-1882
Exhib. 'From Moss, Moor and Pleasaunce' at the RA. Address in

Southport, Lancashire. Also exhib. at SS, OWS and elsewhere. Works by her are in Norwich Museum. She was the wife of James Walker (q.v.).

WALKER, John Eaton RBSA fl.1855-1866
Birmingham genre painter. Exhib. at RA 1858-66, BI, SS, RBSA and elsewhere. Titles at RA 'Venice — a Reverie', 'Abraham Cooper RA' and 'The Earth Hath Bubbles', etc. Painted large and at times ambitious historical pieces.

Bibl: Ormond.

*WALKER, John Hanson 1844-1933 fl.1869
London portrait painter. Exhib. at RA from 1872, SS, GG and elsewhere. Titles at RA also include occasional genre subjects. Portraits by him are in Cheltenham and Derby AGs. Much encouraged and assisted by Lord Leighton (q.v.).

Bibl: L. and R. Ormond, *Lord Leighton*, 1975; B. Morse, *J.H.W.*, 1987.

WALKER, John Rawson 1796-1893
Nottingham landscape painter. Lived in London and Birmingham, but is best known in his native town of Nottingham. Exhib. at RA 1817-45, BI and SS. RA titles also include some historical genre subjects. Painted landscape in many parts of England, but especially in the Midlands around Nottingham. Works by him are in Nottingham AG.

Bibl: AJ 1850 p.65; 1874 p.45; Redgrave, Dict; Bryan; BM Cat. of Drawings by British Artists IV 1907.

WALKER, Miss M.C. fl.1892-1893
Painted genre subjects. Exhib. three works at SS including 'Room for Another' and 'Will She Return?' London address.

WALKER, Miss Marcella M. fl.1872-1901
Genre painter. Exhib. at RA from 1876, also at SS. Titles at RA 'The Sailor's Sweetheart', 'At Her Wheel', 'Flowers of the Field', etc.

WALKER, Mrs. Mary fl.1886
Exhib. 'Fresh from the Market' at SS. Address in Manchester.

WALKER, Miss Mary A. fl.1892
Exhib. 'Old Houses in Brittany' at SS. London address.

WALKER, Miss Maude fl.1887-1892
Exhib. two works, 'A Fencing Master', and 'A Novel', at the RA and two works at SS. London address.

WALKER, Mrs. Pauline see WALKER, Mrs. James William

WALKER, Philip F. fl.1883-1890
Painted harbour scenes and shipping. Exhib. nine works at SS including 'On the Giudecca', 'Coming into Port: Yarmouth' and 'The End of the Gale'. Also exhib. 'On the Solent' at the RA. London address.

Bibl: Ormond.

WALKER, Robert fl.1861
Exhib. an illustration for *Thomson's Seasons* at the RA. Address in Manchester.

WALKER, Samuel fl.1850-1852
Exhib. two portraits at the RA and 'The American Indian' at the BI. London address.

WALKER, Seymour fl.1887-1926
Painted landscape and genre subjects. Exhib. three works at SS including 'A Troopship' and 'Off Hartlepool'. Born, lived and exhib. in West Hartlepool, County Durham.

WALKER, T. fl.1864
Exhib. a work entitled 'The Delectable Mountains' at the BI. London

WALKER, Miss Wilhelmina Augusta fl.1876
Painted figurative and Italianate subjects. Exhib. 'Interior: In the Roman Campagna' at the RA, and nine works at SS including 'His Gift', 'A Point of Controversy' and 'Beatrice'. London address.

WALKER, William OWS 1791-1867
Exhib. 67 works at the OWS. London address.
Bibl: Ormond.

WALKER, William fl.1861-1888
Painted portraits and flowers. Exhib. two works, 'A Magnolia' and 'Il Penseroso' at the RA, and five works at SS. London address.

WALKER, William Eyre RWS RBC 1847-1930
Landscape painter, mainly in watercolour. Exhib. mostly at OWS (197 works) also RA 1885-98, SS, NG and elsewhere. A prolific painter of landscape views in England and Scotland.
Bibl: Hardie III p.163.

WALKER, William Henry Romaine fl.1877-1881
Painted views of architecture. Exhib. two works at the RA including 'A Peep through the Gates at Henry VII's Chapel' and two works at SS. London address.
Exhib: London, Walker's Gallery 1952.

WALL, Miss Emily W. fl.1889-1895
Exhib. two works, 'Doorway of the Chapel of St. Erasmus' and 'A Grey Day on the Thames', at SS and one work, 'Twopence a Bunch', at the RA. London address. Also lived in Bromsgrove and exhib. at RBSA.

WALL, William Archibald b.1828 fl.1857-1872
London landscape painter. Exhib. at RA 1857-72, BI, SS and elsewhere. Titles at RA 'A Shady Stream', 'The Bridle Path', 'On Bexley Common, Kent', etc. Son of William G. Wall (q.v.).
Bibl: Brook-Hart pl.141.

WALL, William G. b.1792 fl.1826-1862
Irish landscape painter. Went to America from 1818 to c.1832. Exhib. 'Mountain Stream, Connemara' at the RA. Returned to Dublin 1832-53, where he exhib. at the RHA and elsewhere. Revisited America again 1856-62. Was a founder member of the National Academy of Design, New York, and a series of views of the Hudson River were published after his drawings in 1820. His son was William Archibald Wall (q.v.).

WALLACE, Miss Ellen fl.1838-1843
Painted figurative subjects. Exhib. five works at SS including 'Hamlet and Ophelia' and 'The Casket'. Address in Carshalton, Surrey.

WALLACE, Harry fl.1886-1891
Painted country subjects. Exhib. five works at the RA including 'A Siesta' and 'The Old Shepherd'. Addresses near Derby and Leamington.

WALLACE, J. fl.1844
Exhib. two Surrey landscapes at the RA. London address. This may be John Wallace, a Birmingham landscape painter who exhib. 1814-40.

WALLACE, James 1872-1911
Painted landscape. Exhib. five works at the RA 1899-1904, including 'Berwick on Tweed' and 'The Market Place, Capri'. Worked and lived in Northumberland. Died in London.
Bibl: Hall.

WALLACE, John 1841-1905
Painted landscape and country subjects. Exhib. six works at SS including 'The Ferry-boat at Dineron' and 'Sunset on the Cam', and three works at the RA including 'Butter Washing' and 'A Northumberland Dairy'. Address in Newcastle-upon-Tyne.
Bibl: Hall.

WALLACE, Robert Bruce fl.1867-1881
Exhib. two watercolours, 'Silent Pleading' and 'My Darling', at SS. Address in Manchester.

WALLANDER, T.W. fl.1869
Exhib. 'Auction of Effects in a Baronial Hall in Sweden' at the RA. London address.

WALLEN, Frederick fl.1867-1869
Exhib. three views of architecture at the RA. London address.

WALLER, A. Honywood fl.1884-1891
Painted landscape and country subjects. Exhib. five works at SS, including 'The Farm Pond' and 'A Quiet Evening' and three works at the RA, including 'Where the Streamlet Curves'. Address in Godalming, Surrey.

WALLER, Annie E. fl.1876-1878
Exhib. three genre subjects 1876-8. Address in Gloucester.

WALLER, Arthur Prettyman b.1872
Studied at Bridgwater School of Art. Exhib. in East Anglia. Became Rector of Waldringfield with Hemley, and was a member of the Society of Parson Painters.

WALLER, C. fl.1863-1865
Exhib. two works at the BI, both paintings of flowers, and two watercolours at SS. London address.

WALLER, F.S. fl.1873-1892
Exhib. a view of Gloucester Cathedral at the RA. Address in Gloucester.

WALLER, John Green fl.1835-1853
Painted portraits and genre subjects. Exhib. five works at the RA including three portraits and 'Hide and Seek: A Study from Nature', and one work at SS. London address.
Bibl: AU 1843 p.210.

WALLER, Lucy fl.1891
Exhib. a watercolour of flowers at SS. Address in Bletchley.

WALLER, Richard fl.1857-1873
Painted figurative subjects. Exhib. eight works at SS including 'The Pest of the School' and 'Circumstantial Evidence', and two works at the RA. London address.
Bibl: Ormond.

***WALLER, Samuel Edmund 1850-1903**

Genre and animal painter. Studied at Gloucester School of Art. Worked for his father, an architect, and on their farm, making many studies of animals. Exhib. at RA 1871-1902, SS and elsewhere. Titles at RA 'The King's Banner', 'Sweethearts and Wives', 'The Huntsman's Courtship', etc. Also worked as illustrator for *The Graphic*. Works by him are in the Tate Gallery. Most of his works are romantic subjects set in 18th century costume. His wife, Mrs. Samuel Edmund Waller (q.v.) was also a painter.

Bibl: AJ 1881 pp.117-20; 1893 pp.314-19; 1896 pp.289-92; RA Pictures 1891-1902; DNB; Poole III 1925; BM Cat. of Engraved British Portraits VI 1925; Pavière, Sporting Painters pl.44.

WALLER, Mrs. Samuel Edmund fl.1871-1916 d.1931
(Miss Mary Lemon Fowler)

Portrait and genre painter. Wife of Samuel Edmund Waller (q.v.). Exhib. in 1871 as Miss Mary Fowler, and then 1872-1916 under her married name at RA, GG and elsewhere. Specialised in portraits of children. See also Miss M.L. Fowler.

Bibl: See under Samuel Edmund Waller.

WALLER, T.J. fl.1860-1865

Painted country subjects. Exhib. seven works at the BI including 'Returning from Pasture' and 'Harvest Time, A Valley of the Wey', and three works at SS. Address in Chertsey.

WALLEY, E. fl.1851

Exhib. an illustration to the *Histoire du Franc de Bruges* at the RA. Address in Bruges, Belgium.

WALLIN, T. fl.1888

Exhib. a work in 1888. London address.

WALLIS, Alfred 1855-1942

Primitive painter of harbour scenes, shipping and landscapes. Spent his early career as a sailor and fisherman. Born at Devonport. Died near Penzance, Cornwall.

WALLIS, G. fl.1842

Exhib. 'The Last Shilling' at the RA and 'The Fall of Napoleon' at the BI. Address in Newington.

WALLIS, George fl.1866-1872

Exhib. a view of Cardigan Bay at the RA. London address.

WALLIS, George Herbert fl.1885-1888

Exhib. three landscapes at GG. Address in Chiswick.

***WALLIS, Henry RWS 1830-1916**

Historical genre painter, in oil and watercolour. Studied in London and Paris. Exhib. at RA 1854, BI, SS, OWS and elsewhere. During the 1850s he was much influenced by the Pre-Raphaelites, and produced many important works. The two best-known are 'The Death of Chatterton' (Tate Gallery), for which Meredith was the model, and 'The Stonebreaker' (Birmingham). Ruskin described the former as "faultless and wonderful". The latter is "one of the gloomiest and most intensely felt essays in social realism to which this frequently chosen subject lent itself" (Reynolds). Among his other works of this period are 'Elaine' and 'Andrew Marvell Returning the Bribe'. Wallis's career is similar in some ways to that of Arthur Hughes (q.v.), for after painting a few Pre-Raphaelite works of importance, the quality of his work thereafter declined. In later life he became a collector and a great expert on pottery.

Bibl: AJ 1876 p.172; 1878 p.180; 1880 p.140; Burlington Mag. XXX 1917 p.123 (obit.); Faenza V 1917 p.33ff.; Who's Who 1916; Bate; Ironside & Gere; Fredeman; Reynolds, VP pp.65, 68-9 (pl.50); Maas pp.13, 133 (pl.); Ormond; Wood, Panorama; Wood, Pre-Raphaelites; Wood, Paradise Lost.

WALLIS, Hugh fl.1894-1899

Exhib. three works at the RA including 'Mallows by the Sea' and 'The Entrance of Spring'. Address in Bushey, Hertfordshire.

WALLIS, J. fl.1826-1849

Exhib. two landscapes at the BI and another at SS. London address.

WALLIS, J.S.B. fl.1854-1865

Exhib. 'Bianca' and 'Viola' at the RA and two works at SS. Address in Stoke Newington.

WALLIS, John C. fl.1897-1901

Painted landscape. Exhib. three works at the RA including 'A Sunset at Kew on Thames'. London address.

WALLIS, Miss Rosa b.1857 fl.1878-1934

Flower painter and watercolourist. Pupil of Royal Cambrian Academy in Manchester. Studied in Berlin. Exhib. at RA from 1881, SS, NWS and elsewhere.

Bibl: AJ 1905 p.159; 1906 pp.96, 160; Connoisseur LXVIII 1924 pp.172, 241; LXXV 1926 p.64; XCIII 1934 p.61; Who's Who in Art 1934.

WALLIS, Walter fl.1851-1891

Painted figurative and genre subjects. Exhib. five works at the RA including 'The Sole Tennants' and 'Looking for Pirates', seven works at SS including 'Grandfather's Garden' and 'Hold On', and one work at the BI. London address. Also lived in Birmingham and exhib. at RBSA.

WALLIS, Whitworth FSA fl.1884

Exhib. a marine in 1884. London address.

WALLS, William RSA RSW 1860-1942

Scottish animal painter and watercolourist. Studied at RSA schools, and in Antwerp. In the Zoological Gardens of Antwerp and London he made many fine studies of wild animals. Exhib. a few works at the RA after 1887; showed mostly at RSA and RSW. ARSA 1901, RSA 1914, RSW 1906. Hardie writes of his work ". . . shows sympathetic and highly skilled craftsmanship . . . few artists have shown greater appreciation of animal life or of its relationship with its landscape environment."

Bibl: Studio 1907, *The Royal Scottish Academy*, p.10; Studio XXII 1901 p.180; XLIII 1908 p.137; LXVIII 1916 pp.125, 152; LXIX 1916 p.96; RA Pictures 1896; Caw pp.441-2 (pl); VAM; Hardie III p.109 (pl.241).

WALMISLEY, Frederick 1815-1875

Genre and portrait painter. Pupil of H.P. Briggs (q.v.) and RA Schools. Exhib. at RA 1838-68, BI and SS. Lived for a time in Rome, and painted genre scenes of Italian life. Also painted portraits and historical genre.

Bibl: Bryan.

WALPOLE, Mary fl.1885

Exhib. a landscape at the NWS. Address in Hampton Court.

WALROND, Sir John W., Bt. fl.1879-1888

Exhib. a view of a courtyard in Cairo at the RA and four works at the NWS. London address.

WALSH, J. fl.1832-1851

Painted literary subjects. Exhib. six works at the RA including subjects from Voltaire and Dante. London address.

WALSH, J.B. 1838-1841
Painted figurative subjects. Exhib. four works at the RA including 'Prometheus Bound' and 'Rousseau and Madame de Warens', and a watercolour at SS. London address. A J.R. Walsh is also recorded, and may be the same person.

WALSH, J.W. fl.1865
Exhib. 'Viola' at the BI. London address.

WALSH, Nicholas 1839-1877
Irish landscapist. Exhib. an interior view of the Coliseum, Rome, at the RA, and a watercolour of Neapolitan peasants at SS. Born in Dublin. Died in Italy.
Bibl: Strickland; AJ 1871 p.126.

WALSH, Tudor E.G. fl.1885
Exhib. a 'Cottage Exterior' at SS. London address.

WALSH, William fl.1823-1837
Painted figures and landscapes. Exhib. 14 works at the BI and four works at the RA, the last of these, a still-life, in 1837. London address.

WALTER, A. fl.1842
Exhib. a beach scene at the BI. London address.

WALTER, Mrs. Arthur fl.1885
Exhib. a landscape at the GG.

WALTER, Mrs. Busse fl.1885
Exhib. a portrait at SS. London address.

WALTER, Miss Emma fl.1855-1891
London fruit and still-life painter. Exhib. at RA 1855-87, NWS and elsewhere, but mostly at SS (66 works). 1857 member of the Society of Female Artists; 1872 Associate of the Liverpool Society of Painters in Watercolours. Many of her works are entitled 'Fresh Gathered' or 'Just Gathered'. "Few can rival this admired artist in brilliancy of colouring or the dewy freshness of her floral groups" (Clayton).
Bibl: AJ 1859 p.84; Clayton pp.199-302.

WALTER, Henry 1786 or 1790-1849
Painted landscape and rustic subjects. Exhib. six works at the RA including 'Cottage at Sewell, Bedfordshire' and Folkestone Beach', six works at the BI, including 'Study of a Bull' and 'Boy Shearing', and two works at SS. Born in London. Died in Torquay.
Bibl: AJ 1849 p.370; Bryan; Binyon; Ormond.

WALTER, Joseph 1783-1856
Bristol marine painter. Lived and worked all his life in Bristol, painting mainly ship portraits, also harbour and river scenes. Exhib. at RA 1834-49, and SS. His works can be seen in Bristol AG, and at the National Maritime Museum, Greenwich.
Bibl Connoisseur XCVII 1936 p.258; Wilson p.82 (pl.42); Brook-Hart.

WALTER, Louis fl.1853-1869
Architectural, landscape and genre painter. Exhib. at RA 1857-61, but more regularly at BI, SS and elsewhere. RA titles mostly views of buildings, including several of Chingford Old Church, Essex.
Bibl: AJ 1859 p.143.

WALTER, M. Alice fl.1880-1882
Exhib. four paintings of flowers 1880-82. Address in Sittingbourne.

WALTER, T. fl.1849
Exhib. two works at SS, 'Caernarvon Castle' and 'Cattle Watering'. London address.

WALTERS, Miss Amelia J. fl.1880-1892
Sculptress and painter of figurative subjects. Exhib. six works at the RA including 'Undine' and 'A Bright Gleam from the West'. London address.

***WALTERS, George Stanfield RBA 1838-1924**
Liverpool landscape and marine painter. Son of Samuel Walters (q.v.). Moved to London 1865. A prolific artist, he exhib. mainly at SS (over 300 works before 1893), also at RA from 1860, BI, NWS and elsewhere. Titles at RA mostly landscapes or coastal views in Wales and Holland. RBA 1867. Drawings by him are in the BM and VAM.
Bibl: Connoisseur LXX 1924 p.184 (obit.); Binyon; Wilson p.82; Brook-Hart .

WALTERS, L. fl.1881
Exhib. a figurative subject in 1881. London address.

WALTERS, Miss Maude fl.1889
Exhib. a figurative subject at GG. London address.

***WALTERS, Samuel 1811-1882**
Liverpool marine painter. Father of George Stanfield Walters (q.v.). Began to exhib. at Liverpool Academy in 1830; member 1841. Although self-taught, he was a competent painter, and enjoyed the patronage of Liverpool and American shipowners. Exhib. at RA 1842-61, BI, SS and elsewhere. Painted mostly pure marine pictures, but occasionally coastal subjects. Lived in London 1845-7; returned and settled in Bootle, Lancashire. Works by him are in the Walker AG, Liverpool, and the Bootle AG.
Bibl: Connoisseur XCVII 1936 p.258ff.; Wilson p.82 (pl.44); Brook-Hart pls.46, 47; A.S. Davidson, *S.W. —Marine Artist*, 1992.

WALTERS, Thomas fl.1857-1865
Painted figurative and genre subjects. Exhib. five works at SS including 'Hudibras's Conflict with Trulla' and 'A Cameronian Prisoner', five works at the BI, including 'Bad News' and 'The Fisherman's Children', and two works at the RA. London address.

WALTON, Mrs. Catherine R. fl.1898-1899
Exhib. two works, the second 'Doorway of S. Pietro Spoleto', at the RA. London address.

**WALTON, Miss Constance RSW fl.1886-c.1951
(Mrs. W.H. Ellis)**
Scottish flower painter. Exhib. two paintings of flowers at the RA. Address in Glasgow.
Bibl: Studio XXXIX 1907 p.258; LXVII 1916 p.262; The Year's Art 1928 p.546.

WALTON, Miss D.S. fl.1890-1892
Exhib. six flower paintings at the NWS. Address in Dorking, Surrey.

***WALTON, Edward Arthur RSA PRSW RP HRWS HRI
1860-1922**
Scottish painter of landscapes and portraits, in oil and watercolour. Studied in Düsseldorf, and then at Glasgow School of Art, where he became friendly with J. Guthrie, J. Crawhall (qq.v.) and others of the emerging Glasgow School. Exhib. at RA from 1883, GG,

NEAC, RSA, RSW and elsewhere. Lived in London from 1894 to 1904, where he was a friend and neighbour of Whistler, then settled in Edinburgh. ARSA 1889, RSA 1905, PRSW 1915-22. Like others of his school, his prime concern was decorative quality, achieved by careful design and balanced tones. Although primarily a landscape painter, he enjoyed a reputation as a portraitist, especially for his sympathetic portrayals of children. Although these are at times over-sentimental, and lack the vigour of Guthrie or Lavery, their colour and tone are always beautiful. Both Caw and Hardie also praise his watercolours for their deftness and subtlety.

Bibl: AJ 1894 p.77ff.; 1906 p.312ff.; Studio XXV 1902 pp.207ff.; XXVI 1902 pp.161-70; LVIII 1913 pp.260-70; LXXXVII 1924 pp.10-16; Special Number 1917-18 p.34ff.; Who Was Who 1916-28; Caw pp.370-3 *et passim* (with pl.); D. Martin, *The Glasgow School of Painting*, 1902; Cat. of the Glasgow Boys exhib., Scottish Arts Council 1968; Hardie III pp.109-10; Irwin, see index.

WALTON, Elijah 1833-1880
Birmingham landscape painter and watercolourist. Studied at Birmingham School of Art and at RA Schools. Travelled widely, visiting Switzerland, Egypt, Greece, the Middle East and Norway. Exhib. at RA 1851-65, BI, SS and elsewhere. Titles at RA include some genre scenes among his early works, but he turned later to views of the many countries in which he travelled. He is best known for his romantic and colourful watercolours of the Alps, and he illustrated several books on the subject. He lived in London, Staines, and Bromsgrove, Worcestershire, where he died.

Bibl: For list of books illus. by, see TB; Clement & Hutton; DNB; Cundall; VAM; Hardie III p.114 (pl.242).

***WALTON, Frank RI PROI RBA 1840-1928**
London painter of landscape and coastal scenes, in oil and watercolour. Exhib. at RA 1862-1924, BI, SS, NWS, GG and elsewhere. Titles at RA include views on the coasts of England, Wales and the Channel Islands. Member of RI, RBA, and PROI. Works by him are in the Walker AG, Liverpool. Occasionally collaborated with Heywood Hardy (q.v.).

Bibl: Connoisseur LXIV 1922 p.242; The Year's Art 1928 p.546 (obit.); RA Pictures 1890-6; Who Was Who 1916-28; Wood, Panorama; Wood, Paradise Lost.

WALTON, George 1855-1891
Painted portraits. Exhib. 11 works at the RA, portraits and a work entitled 'What Lies Beyond?' Studied at Newcastle School of Art, the RA Schools and in Paris. Practised in Australia, London and Newcastle. Born at Blenkinsop, Haltwhistle, Northumberland. Lived in Northumberland and Westmorland.

Bibl: Hall; Irwin.

WALTON, James Trout fl.1851-d.1867
York landscape painter. Brother of Joseph Walton (q.v.). Pupil of Etty (q.v.) at York Art School. Exhib. at RA 1851-63, BI SS and elsewhere. Painted views, especially mountain scenery, in Scotland, Yorkshire and Switzerland.

Bibl: AJ 1868 p.9 (obit.); Redgrave, Dict; Bryan.

WALTON, John Whitehead fl.1834-1865
London portrait and genre painter. Exhib. at RA 1834-65, BI and SS. Titles at RA all portraits. His portrait of Joseph Hume is in the NPG.

Bibl: L. Cust, NPG Cat. II 1902 p.160; BM Cat. of Engraved British Portraits VI 1925; Ormond.

WALTON, Joseph fl.1855-1872
York landscape painter; brother of James Trout Walton (q.v.). Exhib. twice at RA in 1855 and 1863, BI, SS and elsewhere. A picture by him is in York City AG.

WALTON, W.L. fl.1834-1855
Exhib. three watercolours, including two continental views, at SS, and one work, entitled 'Going Home', at the RA. London address.

WALTON, W.S. fl.1853
Exhib. a view of a cottage in Buckinghamshire at the BI. London address.

WALTON, William fl.1861-1867
Exhib. three watercolour landscapes at SS, and one work, a view at Claverton, Somerset, at the RA. Address in Bath, Somerset.

WANDBY, A.J. fl.1842-1848
Painted genre subjects. Exhib. six works at SS including 'The Love-Letter' and 'The Appointment'. London address.

WANE, Richard 1852-1904
Painter of landscape and genre. Lived in London, Wales, and at Egremont, Cheshire. Studied with F. Shields (q.v.) and at Manchester Academy. Exhib. at RA 1885-1904, SS, NWS, GG and elsewhere. Titles at RA mostly coastal scenes with fisherfolk off the coasts of Wales. President of the Liverpool Sketching Club. Works by him are in Wolverhampton and Walker AGs, Liverpool. His daughter Ethel and his son Harold Wane (1879-1900) were also painters.

Bibl: Studio XXIV 1902 p.136; AJ 1904 pp.102-3; Bryan; Brook-Hart pl.223.

WARBURG, Miss Blanche fl.1890-1892
Exhib. two works, a still-life and a portrait, at SS. London address.

WARBURG, Miss Lily A. fl.1896
Exhib. 'A Studio Corner' at the RA. London address.

WARBURTON, Samuel RMS b.1874
Painted portraits and landscapes. Lived in Windsor, Berkshire.

WARD, Alfred fl.1873-c.1927
London genre painter. Exhib. at RA from 1873, SS, GG and elsewhere. Titles at RA 'Monastic Recreation', 'Moon Maidens', 'The Horns of Elfland Faintly Blowing', etc.

WARD, Mrs. Amy Margaret b.1863
Painted animals and flowers. Studied at Lincoln School of Art and under W. Frank Calderon (q.v.). Born in Lincolnshire. Lived at Farnham Royal, Buckinghamshire.

WARD, Miss Annie fl.1886-1898
Exhib. four works at the RA including 'Azaleas' and 'Fairy Tales'. Address in Croydon, Surrey.

WARD, Bernard Evans fl.1879-1897
Painted portraits and figurative subjects. Exhib. 14 works at the RA including portraits and works entitled 'Innocence', 'A Sea Nymph' and 'The Return of the Vikings', and six works at SS. London address.

WARD, Charles fl.1826-1869
Landscape painter. Lived in London, Cambridge and Manchester. Exhib. at RA 1826-61, BI, SS, NWS and elsewhere. Painted views and buildings in England and Wales. A work by him is in Salford AG.

Bibl: Connoisseur XLIV 1916 p.60.

WARD, Charles Daniel ROI b.1872 fl.1898-1935

Painted portraits, figures and landscape. Exhib. three works at the RA, including 'A Goose Girl' and 'A Summer Idyll'. Studied at the RCA. Born in Taunton, Somerset. Lived in Chelsea and later at Blewbury, Berkshire.

Bibl: Who's Who in Art 1934; AJ 1906 p.169; The Graphic 15 July 1911.

WARD, Cyril RCA 1863-1935

Painted landscape. Exhib. 15 works at the RA including 'An Upper Reach of the Conway', 'The Stillness of the Autumn Day' and 'From the Uplands to the Sea'. Address in Manchester. Later lived near Alton, Hampshire.

Bibl: Who's Who in Art; Connoisseur XXXIV 1912 p.258.

*WARD, Edward Matthew RA 1816-1879

Painter of historical genre. Pupil of RA Schools 1835. In Rome 1836-9, visiting Cornelius in Munich on the way. Returned to London 1839. Won a prize in the 1843 Westminster Hall Competition. Exhib. at RA 1834-77, BI, SS, NWS and elsewhere. Painted scenes from English and French history, and literary subjects taken from Goldsmith, Molière, etc. His compositions are at times elaborate, but his sure sense of style and period made him one of the most popular of Victorian historical painters. Works by him are in the VAM, Sheffield and other galleries. ARA 1846, RA 1855. His wife Henrietta Ward (q.v.) was also a painter. His studio sale was held at Christie's, 29 March 1879.

Bibl: AJ 1855 pp.45-8; 1879 pp.68, 72ff. (obit.), 84; J. Dafforne, The Life and Works of E.M.W., 1879; DNB; Bryan; Reynolds, VP pp.32, 35, 39, 59 (pl.35); Maas p.26 (pl.p.109); Ormond; Irwin; Strong.

WARD, Edwin Arthur fl.1883-c.1927

London painter of portraits, who exhib. 1883-1903, at the RA 1884-1903, SS, GG, NG and elsewhere, titles at the RA including 'Shy', 1884 and 'Mei Suji San, Tokyo', 1898. Travelled to India and Japan.

Bibl: E.A. Ward, Recollections of a Savage, 1923.

WARD, Enoch RBA 1859-1922

Painted landscape. Exhib. five works at the RA including 'The Castle at Thun' and 'Patriarch of the Village'. Studied at South Kensington and in Paris. Born in Rotherham, Yorkshire. Went to Chicago as a child. Lived in London.

Bibl: Connoisseur LXII 1922 p.241.

WARD, Miss Eva M. fl.1873-1880

Painted figurative subjects. Exhib. six works at the RA including 'In the Royal Guardrooms, 1720', 'My Pet' and 'Fisherman's Home, Tréport'. London address. Sister of Henrietta Ward (q.v.).

WARD, F.E. fl.1893

Exhib. a view of a house at the RA. Address in Belfast.

WARD, Miss Flora E.S. fl.1872-1876

Painted figurative subjects. Exhib. three works at the RA, including 'Articles of Virtu', and 'The Bridal Morn'. London address. Sister of Henrietta Ward (q.v.).

WARD, George Raphael 1797-1879

Portrait painter, miniaturist and engraver. Son of James Ward, RA and father of Henrietta Ward (qq.v.). Studied with his father and at RA Schools. Exhib. at RA 1821-64, SS and elsewhere. Titles at RA mostly portraits and miniatures, and also engravings after Lawrence, A.E. Chalon, J.P. Knight, Grant and others. His wife Mary (née Webb) was also a miniaturist, exhib. at RA 1828-49, SS and elsewhere.

Bibl: AJ 1880 p.84 (obit.); Connoisseur LXX 1924 p.57; DNB; Bryan; BM Cat. of Engraved British Portraits VI 1925.

WARD, Mrs. Henrietta Mary Ada 1832-1924

Painter of historical genre. Daughter of George Raphael Ward and wife (m.1848) of Edward Matthew Ward (qq.v.). Studied with her father, but her style closely modelled on that of her husband. Exhib. at RA from 1849, and occasionally elsewhere. She painted scenes from English and French history, literary subjects, and genre. Works by her are in Bristol and the Walker AG, Liverpool.

Bibl: AJ 1864 pp.357-9; Connoisseur LX 1921 p.115; LXX 1924 p.57 (obit.); Clayton II pp.161-6; Who Was Who 1916-28; Mrs. E.M. Ward, Memories of 90 Years, 1924.

WARD, Herbert 1863-1919

Sculptor and painter of still-lifes and figurative subjects. Exhib. nine works at the RA 1895-1903, including 'A Bookworm' and 'A Peep at Rabelais'. London address.

Bibl: Connoisseur LXII 1922 p.182.

*WARD, James RA 1769-1859

Animal painter and engraver. Father of George Raphael Ward (q.v.) and brother of William Ward (1766-1826) an engraver. Born in London, the son of a fruit merchant. Studied engraving under J.R. Smith, and in 1783 under his brother William. He gained some success with his own mezzotints of horses and landscapes, and was appointed Painter and Engraver in Mezzotints to the Prince of Wales. In 1817 he gave up engraving for painting. At first he painted domestic and rustic genre in imitation of George Morland, his brother-in-law. Later, under the influence of Stubbs, Gilpin, and most important, Rubens, he began to paint the romantic, dramatic animal pieces for which he is best known, such as 'Bulls Fighting', 'Fighting Horses', etc. In 1815 he painted the monumental landscape 'Gordale Scar' (Tate Gallery) and this led him to attempt more ambitious historical subjects, such as 'The Triumph of the Duke of Wellington', 'The Fall of Phaeton', etc. These pictures were little suited to his talents, and were a failure. After 1830, his powers began to decline, and he became embittered by family tragedies, financial hardship, and quarrels with the RA. In 1848 he was forced to apply to the RA for a pension. Exhib. at RA 1795-1855, BI and SS. ARA 1807, RA 1811. He also painted a number of fine romantic landscapes in watercolour; these and his many spirited oil sketches of animals tend to find more favour today than his large exhib. pieces.

Bibl: AJ 1849 pp.179-81; 1860 p.9 (obit.); 1862 p.169ff.; 1897 pp.185-8; Connoisseur XI 1905 pp.169-71; XXIV 1909 pp.177-82; XXXV 1913 pp.136-42; XCI 1933 pp.13-19; XCV 1935 p.45ff.; XCVII 1936 pp.3-8; Portfolio 1886 (article by F.G. Stephens); Redgrave, Dict., Cent; Roget; Binyon; Cundall; DNB; VAM; J. Frankau, William W. and J.W., 1904; C.R. Grundy, J.W. His Life and Works, 1909; A. Bury, J.W., British Racehorse X, IV, 1958; Arts Council, J.W. exhib. 1960; Hardie II pp.141-2 (pls.117-22); Maas p.72 (pl.p.78); P Summerhayes, J.W. and His Dogs, Country Life 10 February 1972; P. Summerhayes, Great Picture in Obscurity — J.W. and Gordale Scar, Country Life 21 July 1977.

WARD, James fl.1817-1831

Genre and portrait painter. Exhib. at RA 1817-31, SS and elsewhere. Titles at RA mostly portraits, some genre, e.g. 'The Village Ballad Singer', 'Jane Shore at the Door of Alicia', etc. Not to be confused with James Ward, RA (q.v.). Hardie mentions a James Ward (1800-85), a retired pugilist who took up painting, and exhib. landscapes and sporting subjects; this may be the same artist.

WARD, James Charles RBA RBSA fl.1830-1875

London painter of fruit and landscape, who exhib. 1830-75, at the RA (in 1836, one work, a study of fruit), BI and SS (178 works). Also lived in Birmingham and exhib. at RBSA 1838-75.

***WARD, John 1798-1849**
Hull marine painter. Son of a master mariner. Apprenticed as house and ship painter. Influenced by William Anderson, who visited Hull. Painted ship portraits, and shipping scenes, mostly on the Humber. Also visited the Arctic, where he painted whaling ships. Published illustrated books of ships. Did not exhib. in London, but for a provincial artist his work is of remarkably high quality. Another John Ward is listed by Graves as a London painter of sea-pieces, who exhib. 1808-47 at RA, BI, SS and NWS.
Bibl: G.D. Harbron in Burlington Mag. October 1941; *Early Marine Paintings,* Hull Cat. 1951; Wilson p.83 (pl.43); Brook-Hart.

WARD, Mrs. Katherine M. fl.1893-1894
Exhib. three paintings of flowers at the RA. London address.

WARD, Sir Leslie (Spy) 1851-1922
Painter of portraits and architectural subjects; caricaturist; engraver. Eldest son of Edward Matthew Ward (q.v.). Studied architecture under S. Smirke, RA, and at the RA Schools. Like Pellegrini he drew caricatures for many years for *Vanity Fair* 1873-1909; his pseudonym was Spy. He also drew for *The Graphic,* and painted portraits in oil and watercolour. Exhib. from 1868 at the RA, GG and elsewhere, mainly (at the RA) portraits and 'Hall at Knebworth, Herts., Seat of Lord Lytton', 1870 and 'The Mourner; Study in Christ Church, Hants', 1871. Published *Forty Years of Spy,* 1915. His portraits are at the National Gallery, Dublin, the Walker AG, Liverpool, the NPG, and Trinity College, Oxford.
Bibl: Studio LXXXIX 1925 p.202ff. (pls.); Connoisseur XLIX 1917 p.50; L 1918 p.237; LIII 1919 p.230; LXIII 1922 p.119; LXX 1924 pp.57, 59; American Art News XX 1921-2 No.34 p.8; The Year's Art 1923 p.340; VAM; Who Was Who 1916-28; Ormond.

WARD, Martin Theodore 1799(?)-1874
Animal and sporting painter. Son of William Ward (1766-1826) the engraver; nephew of James Ward (q.v.). Studied under Landseer. Exhib. at RA 1820-5, BI and SS. Titles at RA 'A Terrier', 'Returning from Shooting', 'Portrait of a Favourite Hunter', etc. His work shows the influence of his teacher Landseer; in some of his more ambitious pieces the influence of his uncle James can also be detected. He died in poverty in York. A work by him is in Preston AG.
Bibl: AJ 1874 p.154; Bryan; DNB; Pavière, Sporting Painters.

WARD, Orlando Frank Montagu b.1868
Landscape painter. Exhib. a landscape at the NG. London address. Lived and worked in Italy and Paris.
Bibl: Who's Who in Art 1934.

WARD, T. fl.1819-1840
Painted genre subjects and landscape. Exhib. nine works at the RA, 1819-40, including 'Study of a Laughing Girl' and 'Landscape'. London address.

WARD, T.L. fl.1872
Exhib. a genre subject in 1872. London address.

WARD, Thomas fl.1884
Exhib. 'An Artist's Cottage' at the RA. London address.

WARD, William fl.1853-1860
Exhib. three views of architecture, including one of Westminster Abbey, at the RA. London address.

WARD, William fl.1860-1876
Landscape and still-life painter. Exhib. at RA 1863-76, SS and elsewhere. Titles at RA dead birds, English and French landscape views.

WARD, William H. fl.1850-1882
Birmingham painter of fruit and still-life, who exhib. 1850-82 at the RA, BI and SS, titles at the RA including 'Flowers and Fruit', 1855 and 'Fruit, with Pyefinch's nest', 1860. Also exhib. at RBSA.

WARDEN, Miss Dorothy fl.1888
Exhib. 'Two Currents' at SS. London address.

***WARDLE, Arthur RI RBC 1864-1949**
Animal painter. Exhib. at RA 1880-1935, SS, NWS and elsewhere. Painted domestic and wild animals, and sporting subjects. Also used pastel and watercolour. Probably his best medium was pastel, in which he made many wonderful studies of animals (see Studio article in Bibl.).
Bibl: Connoisseur LXVIII 1924 p.113ff.; Studio LXVIII 1916 pp.3-14; RA Pictures 1896 *et passim:* Who's Who; Pavière, Sporting Painters; Wood, Olympian Dreamers.
Exhib: Vicars Gallery 1935.

WARDLE, F. fl.1882-1888
Exhib. two works, 'On the Brent' and 'In the Bracken', at SS. London address.

WARDMAN, Thomas fl.1886
Exhib. a landscape in 1886. Address in Potter's Bar.

WARING, Charles H. fl.1869-1872
Exhib. two watercolour views on the Mumbles at SS. Address in South Wales.

WARING, Henry Franks fl.1901-1903
Exhib. two works at the RA, including 'A Suffolk Homestead'. London address.

WARING, J. fl.1836-1837
Exhib. two Swiss landscapes and a view near Naples at SS. London address.

WARING, John Burley 1823-1875
Painted views of architecture. Exhib. six works at the RA including a sketch of a monument in Venice. London address.

WARING, W.H. fl.1886-1918
Painted landscapes and coastal subjects. Lived in Birmingham and exhib. at the RBSA.

WARNE, Miss Amy C. fl.1900-1902
Exhib. three paintings of fruit at the RA. London address.

WARNE-BROWNE, Alfred J. fl.1892
Exhib. 'Cornish Wreckers' at the RA. London address.

WARNER, Miss A. fl.1874
Exhib. a watercolour entitled 'Cold and Stiff' at SS. Address in Hoddesdon, Hertfordshire.

WARNER, Mrs. A. fl.1876
Exhib. a painting of flowers in 1876. Address in Milford, Surrey.

WARNER, Compton fl.1865-1880
Painted landscape. Exhib. three watercolours including 'Grasmere Lake' and 'Dirty Weather in the Highlands' at SS. Address in Woodford, Essex.

WARNER, Lee fl.1878
Exhib. a painting of flowers in 1878. Address in Aldershot, Hampshire.

WARREN, Albert fl.1887
Exhib. a painting of flowers at the NWS. London address.

WARREN, Albert Henry 1830-1911
Painted genre subjects. Also a designer and architect. Exhib. four watercolours at SS including 'Surrey Peasant Boy' and 'Prize Chrysanthemums', and one work at the RA. Son of Henry Warren (q.v.). Studied with Owen Jones (q.v.), who he helped at the Great Exhibition. Taught members of the royal family, and was Professor of Landscape at Queen's College, London.

WARREN, B. fl.1883
Exhib. an architectural subject at the GG.

WARREN, Bonomi Edward fl.1860-1877
Painted landscape and country subjects. Exhib. 20 watercolours at SS including views in Surrey and works entitled 'Where the Blackbird Builds and Sings', 'A Shady Beechwood' and 'A Woodland Way'. Also exhib. two woodland subjects at the RA. London address.

WARREN, C. Knighton fl.1876-1892
London painter of portraits, genre and historical subjects, who exhib. 1876-92, at the RA 1878-92, SS and elsewhere, titles at the RA including portraits and 'Spring-time', 1878, 'An Egyptian Musician', 1881 and 'Rameses the Great and his Queen Playing a Game of Draughts', 1889. His paintings are to be found in Nottingham and Sunderland AGs.

WARREN, Mrs. C. Knighton (Gertrude M.) fl.1881-1894
Painted genre and figurative subjects. Exhib. ten works at the RA including chalk drawings and works entitled 'The Age of Innocence' and 'If Fairy Tales Were True'. Also exhib. a still-life at SS. London address.

WARREN, Claude fl.1887
Exhib. 'A Suffolk Landscape' at the RA. London address.

***WARREN, Edmund George RI ROI 1834-1909**
Landscape watercolourist. Son of Henry Warren (q.v.). Exhib. from 1852, at the RA (1874, 'In the New Forest'), GG and elsewhere, but principally at the NWS (197 works), of which he became A in 1852 and RI in 1856. ROI until 1903. His work had an almost photographic realism, coming very close to Pre-Raphaelitism at times. Ruskin, however, feared his success was mechanical: "Mr. E.G. Warren's 'Lost in the Woods' and 'Avenue, Evelyn Wood' (NWS 1859), are good instances of deceptive painting — scene painting on a small scale — the treatment of the light through the leaf interstices being skilfully correspondent with photographic effects. There is no refined work or feeling in them, but they are careful and ingenious; and their webs of leafage are pleasant fly-traps to draw public attention, which, perhaps, after receiving, Mr. Warren may be able to justify by work better worthy of it."
Bibl: AJ 1908 p.216 (pl.); Ruskin, Academy Notes NWS 1858-9; VAM; Wood, Paradise Lost; Newall.

WARREN, Miss Fanny C. fl.1865-1866
Exhib. three watercolours, including 'At Henley-on-Thames' and 'Primroses', at SS. Address in Isleworth.

**WARREN, Frances Bramley fl.1889
(Mrs. Burroughs)**
Exhib. 'Relics of the Past' at the RA. London address.

WARREN, H. Broadhurst fl.1887
Exhib. a mountain landscape at the RA. Address in Boston, U.S.A.

WARREN, H. Clifford fl.1860-1885
Painted landscapes and country subjects. Exhib. 17 watercolours at SS including 'Fox Hunting', 'A Shady Morning' and 'On the Arun'. London address.

WARREN, Henry PNWS 1794-1879
Painter of Arabian subjects, genre, landscape and literary subjects. Studied sculpture under Nollekens, with Gibson and Bonomi as his fellow students, entered the RA Schools in 1818; painted both in oil and watercolour. Exhib. 1823-72, at the RA 1823-39, BI, SS, and NWS (Member 1835, President 1839-73, resigned 1873). He turned to watercolours on becoming an RI. Though he had never been to the East his principal pictures represented Arabian scenes and incidents: "His camels and dromedaries have been the denizens of the Regent's Park gardens." The first of these subjects was exhib. in 1840, 'Encampment of Turkish Soldiers in the Desert of Nubia', in 1841 'The Dying Camel' and in 1848 'The Return of the Pilgrims from Mecca': "A large composition of numerous figures picturesquely grouped showing so accurate a knowledge of Eastern manners, customs and dress as almost to make us incredulous about the fact that the artist had never visited the land of Mahommedan." He also drew illustrations for annuals and topographical works, wrote humorous poetry and published a book on watercolours. Knight of the Order of Leopold and Hon. Member of the Belgian Société des Aquarellistes.
Bibl: AJ 1861 pp.265-7 (3 pls.); 1880 p.83 (obit.); Academy Notes NWS 1858; Clement & Hutton; The Portfolio 1880 p.36 (obit.); VAM; Ormond.

WARREN, Miss Sarah M. fl.1889
Exhib. 'A Studio Corner' at the RA. Address in Basingstoke.

WARREN, Slayter fl.1866-1868
Exhib. four works at SS including 'A Quiet Nook' and 'A Scene in Westmoreland'. London address.

WARREN, Miss Sophy S. fl.1865-1878
Landscape painter in watercolour, who exhib. 1865-78, at the RA 1869-78, SS and elsewhere, titles at the RA including 'Evening', 1869, 'A Summer Day on the Thames', 1876, and 'Early Morning Exeter', 1878. Member of the Society of Lady Artists. Her watercolours are in the National Gallery, Dublin, and in the VAM: 'Near Benhill Wood, Sutton, Surrey', 'A Fort on the Shore', 'Pond and Trees — Sunset' and 'Old Mill at Evesham'.
Bibl: VAM.

WARREN, William White b.c.1832 fl.1865-c.1912
Painted landscapes and marines. Lived at Peckham, near London, and painted in Cornwall.
Bibl: Brook-Hart.

WARRENER, William Tom 1861-1934
Painted figurative subjects, portraits and landscapes. Exhib. eight works at the RA including 'A Confession' and 'A Comrade's Visit'. Studied at Lincoln School of Art, the Slade School and in Paris. In Paris he became friendly with William Rothenstein and Toulouse-Lautrec. A French influence is strong in his work. Born and lived in Lincoln.

WARRINGTON, W. fl.1844
Exhib. two stained glass window designs at the RA. London address.

WARWICK, Anne, Countess of fl.1870
Exhib. a portrait drawing at the RA and two works at the GG. London address.

WARWICK, Miss Edith C. fl.1868
Exhib. a watercolour of flowers at SS. London address.

WARWICK, H. fl.1854
Exhib. 'The Aisle by Twilight' at the RA. London address.

WARWICK, R.W. fl.1876-1877
Exhib. two fruit pieces at SS. London address.

WASSE, Arthur fl.1879-1895
Manchester painter of genre and flowers, who exhib. 1879-95 at the RA and SS, titles at the RA including 'Flowers', 1879, 'Lancashire Pit Lasses at Work', 1887 and 'Devotion', 1892.

WASSERMAN, J.C. fl.1880-1882
Exhib. 'Autumn Beauties' and 'In a Meadow' at the RA, and one work at SS. Address in Newcastle-upon-Tyne.

WASSIE, Arthur fl.1881
Exhib. a genre subject in 1881. Address in Manchester.

WATERFIELD, Miss Margaret 1860-1950
Watercolourist and book illustrator. Illustrated a number of gardening books between 1905 and 1922. Exhib. two works, including 'Glengarift', at SS. Lived at Nackington House, near Canterbury, Kent.
Bibl: Wood, Painted Gardens.

***WATERFORD, Louisa, Marchioness of 1818-1891**
(The Hon. Miss Louisa Stuart)
Amateur painter and watercolourist. A friend of Ruskin, Burne-Jones and Watts (qq.v.), she was one of the most talented of all Victorian lady amateurs. Most of her work is in watercolour, and was much admired for its rich Venetian colouring. She painted mythological and biblical subjects, copies after old masters, and genre scenes, especially of children. Exhib. at the GG 1877-82 but most of her work was never exhib. A celebrated beauty, she married the Marquis of Waterford, who was soon afterwards killed in a hunting accident. She retired to live at Ford Castle, Northumberland. In the village school at Ford, she painted a series of biblical scenes of children, which can still be seen there.
Bibl: Fine Arts Quarterly Review II 1864 p.198ff.; Portfolio 1870 p.118; Studio XLIX 1910 pp.283-6; Clayton II p.338; Cundall; VAM; W. Shaw-Sparrow, Women Painters of the World, 1905; C. Stuart, Short Sketch of the Life of L.W., 1892; A.J.C. Hare, The Story of Two Noble Lives, 1892; H.M. Neville, Under a Border Tower, 1896; Hardie III p.267 (pl.280); V. Surtees, Sublime and Instructive etc., 1972.
Exhib: London, 8 Carlton House Terrace 1910; Ford School, Northumberland, 1983, with Cat.

WATERHOUSE, Esther fl.1884-1890
Exhib. a watercolour of chrysanthemums at SS. London address.

***WATERHOUSE, John William RA RI 1849-1917**
Historical genre painter. Studied with his father, also a painter and copyist, and at RA Schools. At first came under the influence of

Alma-Tadema (q.v.) and painted Graeco-Roman subjects, similar to those of Edwin Long (q.v.). Exhib. at RA from 1874, SS, NWS, GG, NG and elsewhere. ARA 1885, RA 1895. Later he evolved a more personal style of the late romantic Pre-Raphaelite type, typical titles 'The Lady of Shalott', 'Circe Invidiosa', 'Ophelia', 'La Belle Dame Sans Merci', etc. He also painted large-scale historical and biblical works. His studio sale was held at Christie's, 23 July 1926.
Bibl: AJ 1893 pp.126, 134; 1909 Christmas No. pp.1-32; Studio IV 1894 pp.103-15; XLIV 1908 pp.247-52; LXX 1917 p.88; Reynolds, VP pp.65, 69, 71 (pl.56); Maas p.231 (pls. pp.20, 230); exhib. at Sheffield AG, October 1978; A. Hobson, The Art and Life of J.W.W., 1980; Wood, Pre-Raphaelites; Wood, Olympian Dreamers.

WATERHOUSE, W. fl.1840-1861
Painted figurative and particularly Mediterranean subjects. Exhib. six works at the RA including 'A Girl of Alvito at the Carnival of Rome' and 'The Mountain Girl'; seven works at the BI and 13 works at SS including 'The Neglected Child' and 'Neapolitans on the Sea-shore'. Addresses in Rome and London.
Bibl: Ormond.

***WATERLOW, Sir Ernest Albert RA PRWS 1850-1919**
Landscape and animal painter in oil and watercolour. Studied in Heidelberg and Lausanne, entered RA Schools 1872, winning the Turner Gold Medal in 1873. Exhib. at RA from 1872, SS, OWS, GG, NG and elsewhere. Hardie writes: "His somewhat idyllic landscapes found mainly in Southern England, are marked by harmony of colour and quiet refinement." Elected ARWS 1880, RWS 1894, PRWS 1897; ARA 1890, RA 1903, knighted 1902. Works by him are in the Tate, Birmingham and the Laing AG, Newcastle. His studio sale was held at Christie's, 6 January 1920.
Bibl: AJ 1890 pp.97-101; 1893 p.166; 1896 (pls. see index); 1903 pp.52-6; Christmas No. 1906; Studio Special Number 1898, A Record of Art in 1898, pp.60-5; Studio Special Number 1900, Modern British Watercolour Drawings; DNB; VAM; Hardie II p.234 (pl.227).

WATERS, Miss Sadie fl.1897
Exhib. a subject at the RA. London address.

WATERS, W.R. fl.1838-1867
Painted portraits and figurative subjects. Exhib. 11 works at the BI including 'Blowing Bubbles' and 'The Nosegay', and eight works at the RA, the majority portraits. Address in Dover, Kent.

WATERSON, David RE 1870-1954
Etched, painted and engraved landscape and portraits. Lived at Brechin, Angus.
Bibl: Caw; further bibl. relating to work as a graphic artist in TB.

WATKINS, Bartholomew Colles RHA 1833-1891
Irish landscape painter. Exhib. three views near Killarney at the RA; three landscapes, one in Norway, at SS, and one work at the BI. Address in Dublin.
Bibl: Strickland.

WATKINS, E. Stanley fl.1898-1902
Exhib. three designs for stained glass at the RA. London address.

WATKINS, Frank fl.1875-1876
Exhib. two works at the RA, the second entitled 'Has Wives as Many as he Will, I Would the Sultan's Gay Lot Fill', and one work at SS. Address in Feltham.

WATKINS, John fl.1855
Exhib. 'The Sunset Hour' at the BI. London address.

WATKINS, John fl.1876-1894
Chelsea genre painter who exhib. 1876-94, at the RA 1884-94 SS, NWS, GG and elsewhere, titles at the RA including 'A Puritan', 1884, 'Maternal Counsel', 1886, and 'An Italian Girl', 1893. Not to be confused with Jonn Watkins, RE, the etcher.

WATKINS, Miss Susan fl.1901
Exhib. 'The Interrupted Lesson' at the RA. Address in France.

WATKINS, Mrs. W. (Kate) fl.1850-1888
Exhib. two interiors and a landscape at the RA. Address in Durham.
Bibl: Hall.

WATKINS, William Wynne fl.1854-1861
Painted figurative subjects. Exhib. five works at the BI including 'A Gipsy's Tent' and 'News from the Seat of War', five works at SS, and one work at the RA. London address.

WATSON, Miss fl.1844
Exhib. 'The Pride of the Harem, or Happy Captive' at the RA. London address.

WATSON, Mrs. fl.1881
Exhib. two watercolours of nasturtiums and apples. Address in Witley, Surrey.

WATSON, Albemarle P. fl.1884
Exhib. 'On the Coast near Plymouth' at SS. Exhib. Kingsbridge, South Devon.

WATSON, Miss Annie Gordon fl.1888
Exhib. 'Pansies: That's for Thoughts' at SS. Address in Ryde.

WATSON, Miss Caroline fl.1829-1843
Painted biblical and figurative subjects. Exhib. six works at the RA, including 'Ahasuerus and Esther' and 'Zillah', and eight works possibly watercolours, at SS. London address.

WATSON, Charles John RPE 1846-1927
Painted and etched landscape and architectural subjects. Exhib. from 1872. Worked in Norfolk, also in Italy and France. Lived in Norwich and London.
Bibl: Relating to work as a graphic artist, in TB; Brook-Hart pl.224.

WATSON, Dawson ARCA b.1864 fl.1891
Painted landscape. Exhib. four works at SS including 'Shade' and 'Rocks and Trees'. Address in Llanwrst, North Wales.

WATSON, Edward Façon fl.1839-1870
Painted figurative subjects and landscapes. Exhib. eight watercolours at SS including 'A View of the Fishponds near Hastings' and 'The Amateur Gilder'. London address.

WATSON, Miss Emma fl.1895
Exhib. 'In a Market Garden' at the RA. Address in Glasgow.

WATSON, F. fl.1857
Exhib. 'Left in Charge' at the RA. Address in Bristol.

WATSON, F.G. fl.1882
Exhib. watercolours of 'Victoria Plums' and 'Apples and Grapes' at SS. Address in Witley, Surrey.

WATSON, George Spencer RA ROI RP 1869-1934
Painted portraits and figurative subjects. Studied at the RA Schools. Exhib. 30 works at the RA including portraits and works entitled

'Joseph Interpreting Pharaoh's Dream', 'Her Hair was Long, Her Foot was Light' and 'The Birth of Aphrodite'. Lived in London and Dorset.
Bibl: AJ 1908 p.174; 1909 p.166; Connoisseur XXVIII 1910 p.207; XXXVI 1913 p.128; XXXIX 1914 pp.42, 275; XLI 1915 p.111; XLII 1915 p.253; XLIX 1917 p.172; LVI 1920 p.59; LVII 1920 p.116; LVIII 1920 p.238; LX 1921 p.116; LXX 1924 pp.114, 178; Studio LXI 1914 p.234; LXII 1914 p.318; LXV 1915 p.129; LXXXII 1921 p.293; LXXXIII 1922 p.45; LXXXV 1923 p.331; Who's Who 1924; Who's Who in Art 1934.
Exhib: London, Fine Art Society 1934.

WATSON, Miss Grace I. fl.1892-1893
Exhib. 'Off Duty' and 'An Old Lady's Friends' at SS, and one work at the RA. London address.

WATSON, Harry RWS ROI RWA 1871-1936
Painted landscape and figurative subjects. Exhib. three works, including 'Sweet September' and 'Wet Sand' at SS. Born in Scarborough, Yorkshire. Spent his childhood in Canada. Studied at the RCA. Worked in Wales, Scotland and France. Lived in London.
Exhib: London, 5a Pall Mall East, London SW1, 1936.

WATSON, Henry 1822-1911
Irish painter. At first worked as a coach painter in Cork, then moved to Dublin and studied at RHA Schools. Painted landscapes, portraits, animals and still-life.

WATSON, Miss J. fl.1863
Exhib. 'An Old Pensioner' at the RA. London address.

WATSON, J. fl.1897
Exhib. a view of a house at the RA. London address.

WATSON, James fl.1900
Exhib. 'A Cottage Garden' at the RA. Address in Newcastle-upon-Tyne.

WATSON, John fl.1847-1852
Painted portraits. Exhib. seven works at SS and three works at the RA. These were possibly miniatures. London address.

***WATSON, John Dawson RWS RBA 1832-1892**
Painter, watercolourist and illustrator. Studied at Manchester School of Design and RA Schools. Exhib. at RA 1853-90, BI, SS, OWS (267 works), GG and elsewhere. Painted genre scenes, often of children. His pictures are usually small, painted on panel or board, and show a Pre-Raphaelite feeling for colour and detail. He was also a prolific and notable illustrator, producing many designs for books and periodicals. He worked for *Once a Week, Good Words, London Society* and others; among the many books he illustrated were *Pilgrim's Progress, Arabian Nights,* and Watt's *Divine and Moral Songs.* Works by him are in the VAM, Norwich, and Liverpool. His brother was Thomas J. Watson (q .v.).
Bibl: AJ 1861 p.46; Chronicle des Arts 1892 p.13; Portfolio 1892 p.VI; Clement & Hutton; DNB; Bate p.90; Cundall; VAM Cat. of Watercolours 1908; Gleeson White; Maas p.237 (pl.).

WATSON, Mrs. Leila fl.1874
Exhib. a drawing in 1874. Address in Croydon, Surrey.

WATSON, P. Fletcher fl.1894
Exhib. 'Hospital at Santa Cruz' at the RA. Address in Manchester.

WATSON, Robert F. fl.1845-1866
Landscape and marine painter, who specialised in coastal views, mainly in the north of England. Exhib. 1845-66, at the RA 1845-64, BI, SS and elsewhere, titles at the RA including 'The *Erebus* and

Terror, under the command of Sir John Franklin, leaving the Coast of Britain, on the Arctic Expedition in 1845', 1849 and 'Vale of Coquet, Northumberland, from the Hill above Lothbury', 1853. The AJ comments on 'Shields, the Great Coal Port, Northumberland', BI 1860: "The view comprehends South Shields, a part of North Shields and the mouth of the Tyne: the subject is treated with too much severity." 'Dutch fishing boats' is in Sunderland AG.

Bibl: AJ 1860 p.79; Wilson; Hall; Ormond; Brook-Hart.

WATSON, Miss Rosalie M. **fl.1877-1887**
London genre painter, who exhib. 1877-87, at the RA 1878-87, SS, NWS, GG and elsewhere, titles at the RA including 'Anxiously Waiting', 1878, ' "She took the gift with a mocking smile, In the flush of her maiden pride" ', 1882 and 'Past and Present', 1887. Member of the Society of Lady Artists.

WATSON, Stewart **fl.1843-1847**
Painted Italianate figurative subjects. Exhib. four works at the RA, including 'Buttari Driving Roman Oxen' and 'The Festa of St. Peter', and three peasant subjects at SS. London address.

WATSON, Thomas Henry **fl.1862-1904**
Exhib. views of architecture and designs for buildings. Exhib. 21 works at the RA 1862-1904, including views of buildings at Florence, Rome and Grenoble, and also a work entitled 'Drying Nets — Cullercoats'. London address.

WATSON, Thomas J. **ARWS** **1847-1912**
Painter of landscape, genre and fishing scenes. Born in Sedbergh, Yorkshire. Studied painting under a private master for a year in London, then a student at the RA Schools. Lived and painted with his brother John Dawson Watson (q.v.), with occasional advice from his brother-in-law Myles Birket Foster (qq.v.). Exhib. from 1869, at the RA from 1871, SS, OWS (122 works), the Dudley Gallery and elsewhere, titles at the RA including 'Waiting for Boats', 1871, 'In a Scotch Fishing Village', 1876 and 'Sunday Morning — Odde, Norway', 1903. A watercolour landscape is in the National Gallery, Melbourne (Cat. 1911).

Bibl: Who Was Who 1929-40; Hall.

WATSON, William **fl.1828-1866**
London painter of miniature portraits, who exhib. 1828-66, at the RA 1828-59, and SS.

WATSON, William, Jnr. **fl.1866-1872 d.1921**
Liverpool animal and landscape painter, who exhib. 1866-72, at the RA (in 1872 only, 'Scotch Cattle') and SS (one). Pupil of Landseer and Rosa Bonheur. Son of William Watson (q.v.). His paintings are in the Walker AG, Liverpool, the Mappin AG, Sheffield (Cat. 1908) Sunderland AG (Cat. 1908) and in the Thomas B. Walker Art Collection, Minneapolis, U.S.A. (Cat. 1913).

Bibl: The Year's Art 1922 p.314.

WATSON, William Peter **RBA** **fl.1883-1901 d.1932**
Painter of genre and landscape, living in London and Pinner. Exhib. from 1883 at the RA, SS and elsewhere, titles at the RA including 'Topsy', 1883, 'Day Dreams', 1889 and 'High Tide on a Norfolk River', 1899. Born in South Shields, died in Bosham, Sussex; studied at the South Kensington Schools and at the Académie Julian in Paris. RBA in 1890. His wife, Mrs. William Peter Watson (q.v.), was also a painter.

Bibl: The Art News, New York XXXI 1933 p.18.

WATSON, Mrs. William Peter **fl.1884-1902**
(Miss Lizzie May Godfrey)
Painted figurative and genre subjects. Exhib. five works at the RA including 'A Thing of Beauty is a Joy for Ever' and 'Day Dreams', and five works at SS, including 'Love's Young Dream'. London address.

WATSON, William Smellie **RSA** **1796-1874**
Scottish portrait painter. Studied at RA Schools, and was a founder member of the RSA. Also painted landscape.

WATT, George Fiddes **RSA** **1873-1960**
Painted portraits. Studied at Gray's School of Art and at the RSA Schools. Born in Aberdeen. Lived in London and later returned to Aberdeen.

WATT, James C. **fl.1893-1898**
Exhib. a view of Brescia town hall and a design for a mausoleum at the RA. London address.

WATT, Miss Linnie **fl.1875-1908**
Genre painter; studied at Lambeth School of Art. Exhib. from 1875 at RA, SS, NWS and elsewhere. Subjects mostly rustic genre and domestic scenes with "children of the Gainsborough, Morland and Constable types" (Clayton). She also painted designs on pottery. Member of the Society of Lady Artists.

Bibl: Clayton II pp.249-50; Morning Post 17 February 1908.
Exhib: London, Dore Gallery 1908.

WATT, W.H. **fl.1854-1857**
Exhib. 'Harvest Time — Sunset' and 'Lost and Found' at the RA, and 'Maternal Pleasure' at the BI. London address.

WATTS, Alice J. **fl.1889**
Exhib. two landscapes at Malvern at SS. London address.

WATTS, Dugard **fl.1901**
Exhib. 'Rustling through the Reeds' at the RA. Address in Colchester, Essex.

***WATTS, Frederick William** **1800-1862**
Landscape painter. Lived in Hampstead at the same time as Constable, who greatly influenced his work. Exhib. mainly at BI 1823-62, also RA 1821-60, SS and NWS. Although he imitated closely many of the elements of Constable's style, he preserved his own distinctive style and colouring. During his own lifetime and after his death his reputation was eclipsed by that of Constable, but his work is now enjoying a well-deserved revival.

Bibl: Pavière, Landscape p.85; Maas p.48 (pl. p.54).

***WATTS, George Frederic** **OM RA HRCA** **1817-1904**
Historical and portrait painter. Born in London, the son of a maker of musical instruments. Apprenticed at the age of ten to William Behnes, the sculptor. Entered RA Schools 1835. First exhib. at RA 1837 'The Wounded Heron'. In 1843 his picture of 'Caractacus' won a £300 prize in the Westminster Hall Competition. With the money he visited Italy, where he stayed in Florence with his friends Lord and Lady Holland. Returned to London 1847, when his composition 'Alfred' won £500 first prize in the House of Lords Competition. Depressed by poor health and lack of commissions, in 1850 he became the permanent guest of Mr. and Mrs. Thoby Prinsep at Little Holland House. He remained there until 1875, when he moved to the Isle of Wight, then to 6 Melbury Road,

London. ARA and RA 1867. His pictures were not popular with the critics or the public and it was not until the 1880s that he began to achieve recognition. Exhibs. of his work were held in Manchester 1880, Grosvenor Gallery 1882 and New York 1884, which quickly established him as a leading Victorian painter. He twice refused a baronetcy, in 1885 and 1894, but finally accepted the Order of Merit. In 1864 he was briefly married to Ellen Terry; in 1886 he married Mary Fraser Tytler, and soon after they built a house, Limnerslease, near Guildford, now the Watts Museum. Exhib. at RA 1837-1904, BI, SS, GG, NG and elsewhere. Watts said of his own paintings: "I paint ideas, not things." The titles of his grand historical works are a reflection of this approach, e.g. 'Love and Death', 'Hope', 'The Spirit of Christianity', 'Love Triumphant', etc. Although he believed in the moral message of his art, his attempt to revive the dead tradition of grand historical painting was a failure. He remained an isolated figure, and founded no school. Today he is better known for the fine and penetrating portraits he painted of many of his famous contemporaries. He was also a sculptor, and a fine academic draughtsman.

Bibl: Main Biographies: C.T. Bateman, *G.F.W.*, 1902; H. MacMillan, *The Life of G.F.W.*, 1903; G.K. Chesterton, *G.F.W.*, 1904 (repr. 1912); Mrs. R. Barrington, *G.F.W. Reminiscences*, 1905; M.S. Watts, *G.F W. The Annals of an Artist's Life*, 3 vols., 1912; E.R. Dibdin, *G.F.W.*, 1923; Miss R.E.D. Sketchley, *W.*, 1924; R. Chapman, *The Laurel and the Thorn*, 1945; W. Blunt, *England's Michelangelo*, 1975.

Other References: For full list of periodicals see TB; J. Laver in *Revaluations* by L. Abercrombie, 1931; Ellen Terry, *Autobiography*, 1933; Lord Ilchester, *Chronicles of Holland House, 1820-1900*, 1937; DNB; Bryan; W. Gaunt, *Victorian Olympus*, 1952; Reynolds, VS, VP; Maas; Ormond; W.L. Hare, *Watts*, 1910; E.H. Short, *Watts*, 1924; R.W. Alston, *The Mind and Work of G.F. Watts*, 1929; Strong; Wood, Olympian Dreamers.

Exhib: Nottingham, Museum and AG 1886; London, Squire Gallery 1939; Great Britain, Arts Council 1954-5; London, Whitechapel AG 1974; London, NPG, *G.F. Watts, The Hall of Fame*, 1975.

WATTS, H.H.　fl.1818-1841
Painted animals and figurative subjects. Exhib. 15 works at SS including 'A Dog Catching Flies' and 'Boys Fishing'. Also exhib. five works at the RA and eight works at the BI. Address in Oxford.

WATTS, James Thomas　RCA RBSA　1853-1930
Liverpool landscape painter, who exhib. from 1873, at the RA from 1878, SS, NWS, GG, RBSA and elsewhere, titles at the RA including 'Beech Trees in Winter', 1878, 'A Bright Day on Barmouth Sands', 1881 and 'The Gipsies' Haunt', 1902. His watercolour 'Nature's Cathedral Aisle', is in the Walker AG (Cat. 1927). His wife, Mrs. James T. Watts (q.v.), was also a landscape painter.

Bibl: AJ 1905 p.353 (pl.); 1907 pp.375-6 (pl.); Studio LXIII 1915 p.217; LXVI 1916 p.214; Connoisseur LXXXVII 1931 p.61; Who's Who in Art 1934 p.449.

WATTS, Mrs. James Thomas　fl.1884-1900 d.1914
(Miss Louisa M. Hughes)
Painted landscape. Exhib. seven works at the RA including 'A Sandy Shore' and 'In Bettws-y-Coed Churchyard'. Address in Liverpool.

WATTS, Leonard T.　RBA　1871-1951
Painted portraits. Studied at St. John's Wood School. Exhib. five works at SS including 'A Quiet Pipe' and 'An Old House: Polperro'. Lived at Findon, Sussex, and later, near Worthing.

WAUDBY, A.J.　fl.1844-1847
Exhib. three works at the RA including 'Devotion' and 'An Interior of a Cottage'. London address.

WAUGH, Miss Elizabeth J.　fl.1879-1885
Exhib. a portrait at the RA and a work entitled 'Waiting for Service' at SS. London address.

WAUGH, Frederick Judd　b.1861 fl.1894-1926
American artist who lived in various places in Europe from 1892 to 1907. Painted landscape and figurative subjects. Exhib. eight works at the RA including 'Nature's Quiet Joys' and 'In the Heart of Great London' and a view on Sark. Address in Sark, Channel Islands.

WAUGH, Miss Nora　fl.1884-1887
Exhib. two works, 'An Old Mountaineer' and 'Scarlet Anemones', at SS. London address.

WAUGH, S.B.　fl.1841-1846
Exhib. a portrait and 'The Mountain Maid' at the RA, and 'Rebecca at the Well' at the BI. London address.

WAY, C.　fl.1861
Exhib. a watercolour of a moonlit Devonshire landscape at SS. Address in Torquay, Devon.

WAY, Charles Jones　RCA　b.1834 fl.1859-1888
Landscape watercolourist. Born at Dartmouth, Devon. Studied at the South Kensington Schools. Worked in Canada in 1859, and was President of the Art Association in Montreal. In 1885 was working in Lausanne, Switzerland. Exhib. 1865-88, from a London address, at the RA, SS, NWS and elsewhere, titles at the RA including 'The Abbey of St. Sulpice', 1884, 'A Winter's Morning at the Foot of Wetterhorn', 1887, and 'Winter's Snow on the Dent du Midi', 1888. His work is represented at the National Gallery, Ottawa.

Bibl: Brun, Schweiz. Ksterlex 3 1913.

WAY, J.　fl.1855
Exhib. 'On the Teign, Devon' at the RA. London address.

WAY, Mrs. John L. (Emily C.)　fl.1886-1896
Painted portraits. Exhib. nine works at the RA including portraits of the Countess of Sandwich and of the late Archibishop of Armagh. London address.

WAY, Thomas R.　1862-1913
Painted landscapes and townscapes. Also a lithographer. Exhib. eight works at the RA including 'The Mouth of the Harbour, Walberswick' and 'Thames Embankment — Evening', and eight works at SS, including 'Pont des Arts, Paris'. London address.

Bibl: AJ 1896 p. 13; The Year's Art 1914 p.446.

WAY, William Cosens　1833-1905
Landscape, genre and still-life painter, in oil and watercolour. Born in Torquay. Studied for six years at South Kensington School. Appointed Art Master at Newcastle-upon-Tyne School of Art with William Bell Scott (q.v.), and remained there for 40 years. Exhib. at RA from 1867, SS, NWS, GG and elsewhere. Works by him are in the VAM and the Laing AG, Newcastle.

Bibl: VAM Cat. of Watercolour Paintings 1908; Cat. of Watercolours Drawings, Laing AG, Newcastle 1939 pp. 107-8; Hall.

WAYLEN, James　fl.1834-1838
Exhib. two portraits and a work entitled 'Marmion Borne Down by the Scottish Spearmen at Flodden' at the RA. London address.

WAYNE, R.S.　fl.1879-1882
Painted landscape. Exhib. seven works at SS including 'Waterfall at Llanbedr' and 'The Wishing Gate'. Address in Llanbedr, Merioneth.

WEALL, Sydney F. fl.1876-1877
Exhib. two landscapes 1876-7. Address in Pinner.

WEAR, Miss Maud Marian b.1873 fl.1903
Portrait painter. Studied at the RA Schools. Exhib. three works at the RA, two portraits and a work entitled 'Much Study is a Weariness of the Flesh'. Lived at Beeding, Sussex, and later at Blockley, Gloucestershire .
Bibl: Studio XXII 1910 p.119; Who's Who in Art 1934.

WEARNE, H. fl.1851-1856
Exhib. three works at the BI: 'Ino and Bacchus' and two works entitled 'Family Party'. London address.

WEATHERHEAD, William Harris RI 1843-c.1903
London painter of genre, who exhib. from 1862 at the RA, BI, SS, NWS and elsewhere, titles at the RA including 'The Market-girl', 1862, 'The Lace Maker', 1871 and 'A Puritan', 1895. RI in 1885, resigned 1903. A watercolour, 'From my Highland Laddie', is in the VAM .
Bibl: VAM.

WEATHERHILL, Miss Mary fl.1858-1880
Painted landscape. Exhib. three works at SS including 'Whitby from the Sea' and 'A Beck near Whitby', the latter a watercolour. Address in Whitby, Yorkshire.

WEATHERHILL, Miss Sarah Ellen fl.1858-1868
Exhib. two works, 'Grandmother's Present' and a watercolour view on the Yorkshire Coast. Address in Whitby, Yorkshire.

WEATHERILL, George fl.1868-1873
Painted marines. Exhib. four works at SS including 'Sunset on the Coast' and 'A Steam Tug Waiting for Ships', the latter a watercolour. Address in Whitby, Yorkshire.
Bibl: Brook-Hart.

WEATHERSTONE, Alfred C. fl.1888-1903
Designed stained glass. Exhib. five works at the RA including 'Music' and 'Adoration of the Magi'. London address.

WEAVER, Miss Emily fl.1900
Exhib. 'Maggie' at the RA. London address.

WEAVER, Herbert Parsons RBA RWA RCA 1872-1945
Painted architectural subjects. Studied at Worcester and at the RCA. Exhib. three works at the RA including views in Lisieux, Normandy, and near Andermatt in Switzerland. Worked extensively abroad. Born at Worcester. Lived in Shrewsbury.

WEAVER, Miss L. fl.1860
Exhib. a 'Landscape and Cattle' at the RA. London address.

WEBB fl.1844
Exhib. a portrait of a horse at the RA. Address in Melton Mowbray, Leicestershire.

WEBB, Miss Amy fl.1886
Exhib. 'Northchurch' at SS. London address.

WEBB, Archibald fl.1825-1866
London painter of coastal scenes in England and France, especially fishing scenes. Exhib. 1825-66, at the RA 1841, BI and SS, the title at the RA being 'The Stranded Coaster', 1841. Member of the Webb family of painters with the London address of Trafalgar Lodge, Chelsea (see also Archibald, RBA, Byron and James

Webb). Also executed two paintings of the Battle of Trafalgar. Represented at the Maritime Museum, Greenwich. Probably the father of Byron and James Webb.
Bibl: Wilson.

WEBB, Archibald, Jnr. RBA fl.1886-1892
London painter of landscape, who exhib. 1886-92, at the RA 1888-92, SS, NWS and elsewhere, titles at the RA including 'St. Paul's from Waterloo', 1888, 'A Breezy Day off Dort', 1890 and 'Rye, from the Hills', 1892. Possibly the son of Archibald Webb (q.v.).

WEBB, Byron fl.1846-1866
London painter of animals especially highland deer in well-painted scenery, portraits of horses, hunting and skating scenes. Member of Webb family of painters (see also Archibald, Archibald Jnr. and James Webb). Exhib. 1846-66, at the RA 1846-58, BI and SS, titles at the RA including 'Red Deer, from Nature', 1846, 'Abdallah', 1854 (the property of Her Majesty The Queen), and 'The Pick of the Fair — Coming Storm', 1858.

WEBB, Miss C. fl.1888
Exhib. 'Roses' at SS. Address in Worcester.

WEBB, E.W. fl.1819-1850
Exhib. 'The Captive' at the RA, and 'Beagles and Rabbits at Rest' at the BI. Also probably the exhibitor of six animal subjects at the RA. London address.

WEBB, Edward 1805-1854
Landscape watercolourist. Studied under the engraver John Pye, and later with Fielding and Cox (qq.v.), both of whom influenced his style. Made many English and French tours. His work is similar to that of Cox Jnr (q.v.). His son was the architect Aston Webb.
Bibl: Connoisseur CLXXXII 1973.

WEBB, Mrs. Eliza fl.1890-1893
Exhib. 'Anemones' and 'Chrysanthemums' at the RA. Address in Old Charlton.

WEBB, Harry George fl.1882-1893
Painted landscape. Exhib. ten works at SS including 'Old Chelsea Church' and 'St. Paul's from the River', and four works at the RA including 'Near Mortlake, Surrey' and 'In the Weald of Sussex'. London address.

WEBB, Henry fl.1861-1873
Worcester landscape painter. Exhib. eight watercolours at SS including 'A Welsh Trout Stream' and 'The Cottager's Home'. Also exhib. landscapes at the RA and RBSA.

WEBB, J. fl.1892
Exhib. a work entitled 'Boy and Bubble' at SS. Address in Dublin.

***WEBB, James 1825-1895**
Marine and landscape painter. Exhib. at RA 1853-88, BI, SS, NWS, GG and elsewhere. RA titles include coastal scenes in England, Wales, Holland and France, and also views on the Rhine. Webb painted in a robust, naturalistic style using a pale range of colours, influenced perhaps by Turner. Works by him are in the Tate Gallery, VAM and nearly all the provincial galleries. Sales of his remaining works and his own collection were held at Christie's, 3 March, 13 June and 13 July 1868. Other members of the Webb family were also artists (see Archibald, Archibald Jnr. and Byron Webb).
Bibl: Burlington Mag. VII 1905 p.328; X 1906-7 pp.341, 347; The Nat. Gall., ed. Sir E.J. Poynter III 1900; Wilson p.83 (pl. 45); Pavière, Landscape pl. 87; Maas p.64; Brook-Hart.

WEBB, K.S. fl.1880
Exhib. a watercolour entitled 'Below the Weir' at SS. Address in Henley-on-Thames, Buckinghamshire.

WEBB, Miss M.D. fl.1874-1885
Painted landscape. Exhib. three works at SS including 'The Red Breast's House' and 'Old Street Concarneau, Brittany', and 'A Pool in the Rocks' at the RA. Address in Dublin.

WEBB, Octavius fl.1880-1889
Painted animals. Exhib. five works at the RA including 'Clumber Spaniel', 'Guarding the Hostage' and 'Waiting for the Master', and 12 works at SS. Address near Guildford, Surrey.

WEBB, Philip fl.1858
Exhib. a church interior view at the RA. London address.

WEBB, Sydney 1837-1919
Dover artist who did not exhib. in London.

WEBB, William Edward c.1862-1903
Painted marines and coastal subjects. Lived in Manchester.
Bibl: The Year's Art 1893; AJ 1904 p.32; Ormond pls. 25, 26, 152.

***WEBB (WEBBE), William J.** fl.1853-1878
Landscape, animal and genre painter. Lived in London; worked in Düsseldorf, and visited Jerusalem and the Middle East. Exhib. at RA 1853-78, BI, SS and elsewhere. Titles at RA include genre, animals, and several Middle Eastern subjects, especially in Jerusalem. He also painted occasional fairy subjects. His painstakingly detailed studies of animals and landscape, and his fondness for painting sheep, reflect the influence of Holman Hunt.
Bibl: H.W. Singer, Kunstlerlexicon IV 1901; Bate p.81 (with pl.); Maas pp.153-4, 227 (pls. pp.154, 227); Wood, Pre-Raphaelites.

WEBER, A. fl.1872
Exhib. three landscapes in 1872. Address in Dartmouth, Devon.

WEBER, Ernest fl.1894
Exhib. 'Moonrise' at the RA. London address.

WEBER, Otto ARWS 1832-1888
Painter of portraits, animals, genre and landscape. Born in Berlin; painted in Paris and Rome; exhib. frequently at the Paris Salon, where he won medals in 1864 and 1869; settled in London in 1872. Exhib. 1874-88 at the RA, OWS, GG and elsewhere, titles at the RA including 'H.H. Prince Christian Victor, Eldest Son of T.R.H. the Prince and Princess Christian of Schleswig-Holstein', 1874, 'A Girl Spinning and her Cow; north of Italy', 1876 and 'Skye Terriers: Pet Dogs of H.M. the Queen', 1876. Painted for Queen Victoria, enjoyed a great reputation for his 'Landscapes with Cattle'. Died in London.
Bibl: Gazette des Beaux-Arts XVII 1864 pp.8, 27 168; 1870 II p.58; 1874 II p.286; Clement & Hutton; Portfolio 1885 p.105; Cundall; DNB; VAM; Bonner Rundschau 22 January 1951 (pls.); also see TB; Ormond.

WEBER, Theodor fl.1871-1873
Painted marines, mainly coastal views of the South Coast of England, and the Continent. A little-known but talented artist.
Bibl: Brook-Hart.

WEBLEY, Sam fl.1900
Exhib. two works, 'Death and the Soldier' and 'Bellepheron Slaying the Chimœra', at the RA. London address.

WEBSTER, Alfred George fl.1876-1894
Lincoln painter of genre, architectural subjects and landscape, who exhib. 1876-94, at the RA 1878-94, SS and elsewhere, titles at the RA including 'Girl Knitting', 1878, 'Bishop Russell's Chapel, Lincoln Cathedral', 1885 and 'The Landward Gate — After Rain', 1893.

WEBSTER, Miss E.A. fl.1857-1870
Exhib. two works, including a view at Warwick Castle, at the RA. Also exhib. at RBSA 1870. Address in Buckinghamshire

WEBSTER, G.R. fl.1878-1879
Exhib. two works at the RA, 'Queen Eleanor's Cross' and 'The Great Born at Harmondsworth'. Address in Slough, Buckinghamshire.

WEBSTER, Moses 1792-1870
Still-life and landscape painter. Apprentice at Derby Porcelain Works. Worked in Worcester, London and Derby. Died in poverty.

WEBSTER, R. Wellesley fl.1889-1899
Painted landscape. Exhib. nine works at the RA including 'Notre Dame, Bruges', 'A Creeping Tide on the East Coast' and 'Towards Evening — New Forest'. Address in Manchester.

WEBSTER, T. fl.1844
Exhib. 'The Violet Seller' at the RA.

***WEBSTER, Thomas** RA 1800-1886
Genre painter. His father, who was a member of George III's household, wanted him to be a musician. As a boy he sang in the Chapel Royal Choir, but after the death of George III, turned to painting. Following an introduction to Fuseli, he became a student at the RA, and won a Gold Medal in 1824. At first he painted portraits, but achieved his first success at the BI in 1827 with 'Rebels Shooting a Prisoner', a picture of boys firing a cannon at a girl's doll. This led him to concentrate on pictures of schoolchildren at play, e.g. 'The Village School', 'The Boy with Many Friends', 'The Truant', etc. which earned him great popularity and prosperity. His style followed that of Wilkie and W. Mulready (qq.v.), who modelled their technique on Teniers and the Flemish School of the 17th century. Most of his pictures are small, and painted on panel. Exhib. at RA 1823-79, BI and SS. ARA 1840, RA 1846, retired 1876. In 1856 he moved to Cranbrook in Kent, where he remained for the rest of his life. He was the senior member of The Cranbrook Colony (q.v.), a group of artists, who lived and worked there every summer, painting genre scenes of everyday life. Webster forms an important link between Wilkie and the Victorian tradition of small Dutch-style genre painting, which continued to flourish right through the period. His studio sale was held at Christie's on May 21, 1887. An exhib. of the Cranbrook Colony was held at Wolverhampton AG in 1977.
Bibl AJ 1855 pp.293-6; 1862 p.138; 1866 pp.40, 330; Redgrave, Cent.; Bryan; DNB; Reynolds VS pp.51-2 *et passim* (pl.8); Reynolds, VP; Maas pp.107, 232 (pl. p.234); Wood, Panorama; Ormond; Irwin; Cat. of the Cranbrook Colony exhib., Wolverhampton AG 1977; Wood, Paradise Lost.

WEBSTER, William fl.1885-1899
Exhib. two works, views at Arundel Park and Frinton, at the RA. Address in Lee, Kent.

WEDD, Ada fl.1885-1887
Painted flowers. Exhib. five works at the RA including 'Winter Flowers' and 'Red and Yellow Roses'. London address.

WEDDERBURN, Miss Jemima fl.1848-1849
(Mrs. Hugh Blackburn)
Exhib. two works at the RA, the second entitled 'Plough Horses Startled by a Railway Engine'. London address. See also Mrs. Hugh Blackburn.
Bibl: Ormond.

WEEDING, N. fl.1843
Exhib. 'An Italian Peasant Girl' at SS. London address.

WEEDON, Augustus Walford RI RBA 1838-1908
London landscape painter in watercolour. Exhib. from 1859, at the RA from 1871, SS (109 works), NWS and elsewhere, titles at the RA including 'An Autumn Evening', 1871, 'Moorland Stream, North Wales', 1876, 'Gathering Peat, Ross Shire', 1898 and 'Stormy Weather, near Sandwich', 1904. Two of his paintings are in Melbourne AG. An exhib. of his work was held at FAS in June 1908.
Bibl: Cundall p.268; A. Dayot, *La Peinture Anglaise*, 1908 p.307.

WEEDON, Edwin fl.1850
Exhib. 'A Dutch Schuyt Beating up the Scheldt' at the RA. London address.

WEEKES (WEEKS), Miss Charlotte J. fl.1876-1890
London painter of genre, historical and literary subjects, who exhib. 1876-90, at the RA 1878-90, SS, GG, NG and elsewhere. Titles at the RA include ' "Does he Really Mean it" ', 1878, 'Amy Robsart', 1880 and 'Feeding Pets', 1884.

WEEKES, Frederick fl.1854-1893
London painter of battle scenes and contemporary genre, who exhib. 1854-93, at the RA 1861-71, BI, SS, NWS and elsewhere. Titles at the RA include 'Captured', 1861, 'Home from the War', 1865 and 'Mustering for a Raid over the Border', 1871. Second son of the sculptor Henry Weekes, RA. Was a great expert on medieval armour and costume.

WEEKES, Henry, Jnr. fl.1849-1888
Painted game, animals and country subjects. Exhib. 26 works at the RA including 'The Orange Stall', 'A Dairy Stable' and 'The Earth Stopper', 19 works at the BI, including 'A Drive on the Downs' and 'Waiting for Hire', and 21 works at SS. London address.

WEEKES, Henry fl.1851-1884 d.c.1910
Genre painter. Eldest son of the sculptor Henry Weekes, RA. Exhib. at RA 1851-84, BI, SS and elsewhere. Titles at RA 'A Dairy Stable', 'The Gipsie's Halt', 'Fancy Rabbits', etc. A work by him is in Leeds AG.

***WEEKES, Herbert William fl.1864-1904**
Genre and animal painter. Brother of Henry Weekes (q.v.) and youngest son of the sculptor Henry Weekes, RA. Exhib. at RA from 1865, BI, GG, SS and elsewhere. His speciality was humorous pictures of animals, usually posed in human situations, e.g. 'You are Sitting on my Nest', 'Prattlers and Cacklers', 'The Patient and the Quacks', 'A Snap for the Lot', etc. Generally known as William Weekes. A contemporary wit described his pictures as "Weekes' Weak Squeaks."

WEEKES, H.T. fl.1864
Exhib. 'Slumber' at SS. London address.

WEEKES, Percy fl.1879
Exhib. a study of a dog at SS. London address.

WEEKS see WEEKES

WEGMAN, R. (?B.) fl.1891
Exhib. a portrait at the RA. Address in Copenhagen.

WEGUELIN, John Reinhard RWS 1849-1927
Painter of genre, classical, biblical and historical subjects, much influenced by Alma-Tadema (q.v.). Studied at the Slade School under Poynter and Legros (qq.v.). Exhib. from 1877 at the RA, SS, GG, NG and elsewhere, titles at the RA including 'The Labour of the Danaids', 1878, 'Herodias and her Daughter', 1884 and 'The Piper and the Nymphs', 1897. After 1893 he worked solely in watercolour.
Bibl: Studio XXXIII 1905 pp.193-201 (9 pls.); Connoisseur LXXVIII 1927 p.254 (obit.); LXXIX 1927 p.261; Who Was Who 1916-1928.

WEHNERT, Edward Henry 1813-1868
German painter of genre and historical subjects; illustrator. Son of a German tailor; born in London. Educated in Germany, where he studied at Gottingen. Returned to England c.1833, in which year he began to exhib.; then he worked for a time in Paris and Jersey, reaching London again in 1837. Exhib. 1833-69, at the RA 1839-63, BI, SS, but chiefly at the NWS, of which he became a Member in 1837. Titles at the RA include 'The Lovers', 1839, 'The Elopement', 1852 and 'The Death of Jean Goujon', 1863. In 1845 he participated in the Westminster Hall Competition. Visited Italy in 1858. His works, many of which are historical genre scenes, are German in their general character. Also drew book illustrations. A watercolour, 'George Fox Preaching in a Tavern', 1865 is in the VAM.
Bibl: AJ 1868 p.245 (obit.); 1869 p.125; Universal Cat. of Books on Art, South Kensington II 1870; Redgrave, Dict.; Bryan; Cundall; DNB; VAM.

WEHRSCHMIDT, Daniel Albert RP 1861-1932
Portrait painter and graphic artist. Engraved works by Holl, Fildes Orchardson (qq.v.) and others. Came to England to study at Herkomer's Bushey School 1883-4. Exhib. at the RA portraits and works entitled 'Down Among the Dead Men'. Once in England he adopted the name Veresmith. Later lived in County Cork and near Taunton, Somerset.
Bibl: Connoisseur XXVIII 1910 p.131; Studio LXV 1915 p.113; Who's Who 1924; Art News XXX 1931-2.

WEIGALL, Arthur Howes fl.1856-1892
Portrait and genre painter. Son of Charles Harvey Weigall. Exhib. 1856-92, at the RA 1856-91, BI, SS and elsewhere, titles at the RA including 'The Nut-gatherer', 1863, 'A Belle of the Last Century', 1866 and 'The Betrothal Ring', 1884. One of his paintings is in Salford AG.

WEIGALL, Charles Harvey 1794-1877
Watercolour painter of portraits, landscape and genre. He also modelled in wax and made intaglio gems. Father of Arthur Howes Weigall (q.v.) and Julia Weigall, both painters of portraits and genre. Exhib. 1810-76, at the RA 1810-54, SS, and NWS (over 400 works). RI in 1834; Treasurer of RI 1839-41. Titles at the RA include 'Frame Containing Impressions from Intaglio Gems', 'Portraits of Dogs, after Reinagle, and Birds', 1826, 'The late Rt. Hon. George Canning; Impression from an Intaglio Gem', 1828 and 'Drawing of Ducks', 1851. 'A Disputed Claim' is in the National Gallery, Dublin, and 'Landscape, with Cottage and Figures on a Sandy Road' in the VAM. He also published *The Art of Figure Drawing*, 1852, *A Manual of the First Principles of*

Drawing, with the Rudiments of Perspective, 1853 and a *Guide to Animal Drawing, for the use of landscape painters,* 1862.

Bibl: Universal Cat. of Books on Art, South Kensington II 1870; Cundall p.268; 4th annual vol. Walpole Society 1914-15 Oxford 1916 pp.53, 209; Cat. of the National Gallery, Dublin, 1920 p.198; VAM.

WEIGALL, Henry, Jnr. 1829-1925
Painter of portraits (in oil and miniatures), and of genre. Known in his earlier years as Henry Weigall Jnr. in distinction from his father Henry Weigall, the sculptor (d.1883). Exhib. from 1846 at the RA, BI, GG, NG and elsewhere. He exhib. 'A Cameo in Pietra Dura' in 1846 at the RA, and subsequently sent in miniatures and portraits on a larger scale, including, in 1852 and 1853, portraits of the Duke of Wellington. Later works included several royal portraits and a number of presentation portraits commissioned for the Gresham Assurance Society, Society of Apothecaries, Jockey Club, Merton College, Oxford, Wellington College, and the Colony of Victorian (Dr. Perry, 1st Bishop of Melbourne, RA 1875). In 1866 he married Lady Rose Fane, daughter of the 11th Earl of Westmorland. JP and DL for Kent. Died at Ramsgate.

Bibl: AJ 1859 p.163; 1860 p.79; Gazette des Beaux-Arts XVIII 1865 p.558; XXIII 1867 pp.91, 216; Ruskin, Academy Notes 1875; Poole II 1925; III 1925 pls.; Connoisseur LXXI 1925 p.112ff. (obit.); BM Cat. of Engraved British Portraits (Index); Apollo V 1927 p.45; Who Was Who 1916-28; Birmingham Cat.

WEIR, Mrs. Archibald (Anna) fl.1884
Exhib. 'Heads or Tails?' at the RA, and 'Noon' and 'On Guard' at SS. Address in Enfield, London.

WEIR, Harrison William 1824-1906
Animal painter, illustrator and author. Born at Lewes; educated at Camberwell. Learnt colour printing under George Baxter, but disliked the work and started independently as an artist. Gradually gained a great reputation for his studies of birds and animals. Drew for *The Illustrated London News, The Graphic, Black and White* and other periodicals, and for many books on animals, including *The Alphabet of Birds,* 1858. He himself wrote many books, including a large work on *Poultry and All About Them.* Exhib. 1843-80, at the RA 1848-73, BI, SS, NWS and elsewhere. A of NWS in 1849, Member 1851, retired 1870. He was a friend of Darwin, a keen naturalist, a great lover of animals and champion of their cause.

Bibl: AJ 1906 pp.95 (obit.), 172; Universal Cat. of Books on Art, South Kensington II 1870; Supp. 1877; Cundall p.168; Who Was Who 1897-1915; VAT; BM Cat. of Engraved British Portraits VI 1925 p.273; Pavière, Sporting Painters.

WEIR, J. Alden fl.1881
Exhib. a figurative subject in 1881. Address in Leatherhead, Surrey.

WEIR, J.W. fl.1869
Exhib. 'The Friends' at SS. London address.

WEIR, P.J. fl.1888
Exhib. a landscape at the NWS. Address in Edinburgh.

WEIR, William fl.1855-d.1865
London genre painter, who exhib. 1855-65 at the RA, BI and SS, titles at the RA including 'The Lesson', 1855, 'Fisher Children on the French Coast', 1858 and 'Teasing the Bairn', 1865. His copy of Wilkie's 'The Blind Fiddler' is in the Walker AG, Liverpool (Cat. 1927, 107).

WEIRTER, Louis RBA 1873-1932
Painted and etched military subjects. Studied at the Board of Manufacturers' Schools, at the RSA and in Paris. Born in Edinburgh. Lived in London and in France.

Bibl: Connoisseur XLIV 1916 p.112; LIII 1919 p.110; Who's Who 1924.

WEISS, José b.1859 fl. to 1904
Painted landscape. Exhib. 17 works at the RA 1887-1904, including 'A Sussex Farmyard', 'Southdown Sheep' and 'A Bright Day on the Arun', and three landscapes at SS. Born in France. Adopted British nationality in 1899. Lived in Sussex.

WELBOURNE, J.W. fl.1837-1839
Exhib. four works at the RA, including 'The Last Home' and 'The Young Entomologist', and one work at the BI. London address.

WELBY, Miss Rose Ellen fl.1879-c.1927
London painter of genre and flowers, who exhib. 1879-1904, at the RA 1888-1904, SS, NWS, GG, NG and elsewhere, titles at the RA including 'Christmas Roses', 1888, 'Waste Ground', 1896 and 'Where Untroubled Peace and Concord Dwell', 1900.

WELCH, Harry J. fl.1881-1892
Painted marines and coastal subjects. Exhib. eight works, including 'Dirty Weather', 'On the Cliffs' and 'Near the Lizard', at the RA, and ten works at SS. London address.

Bibl: Brook-Hart.

WELD, Miss Alice K.H. fl.1881-1888
Exhib. a watercolour entitled 'The Edge of the Common' at SS, and a view of the Palace of Caligula, Rome, at the RA. London address.

WELD, Mary Izod fl.1881
Exhib. a landscape in 1881. London address.

WELFERT, W. fl.1841
Exhib. landscapes in Normandy and Hungary at SS, and also two landscapes at the BI. Address in Geneva.

WELLAND, Mary J.B. fl.1876
Exhib. a portrait in 1876. London address.

WELLES, E.F. fl.1826-1859
Animal and landscape painter, living in Earl's Croom, Worcestershire, London, Cheltenham, Hereford and Bromyard, Herefordshire, who exhib. 1826-56, at the RA 1826-47, BI, SS, and elsewhere. Titles at the RA include 'Manfred, a Race Horse, the Property of Lechmere Charlton Esq.', 1827, 'Study of a Horse's Head', 1831 and 'Landscape with Cattle', 1847.

WELLES, G.W. fl.1849
Exhib. 'A Bit of Effect' at the BI. London address.

WELLESLEY, G.E. fl.1893
Exhib. a portrait in 1893.

WELLS, Miss Augusta fl.1864-1879
Painted figurative subjects. Exhib. nine works at the RA including 'One of Ida's Pupils' and 'At Needlework in the Garden'. London address.

WELLS, George RCA fl.1842-1888
Painter of genre, literary subjects, portraits and landscape, living in London and Bristol, who exhib. 1842-88, at the RA, BI, SS, NWS and elsewhere. Titles at the RA include 'A Scene from Kenilworth', 1849, 'The Belle of the Village', 1854 and 'An Autumn Afternoon on the Llugwy, North Wales', 1880.

WELLS, Mrs. H.W. (Mary) fl.1886
(Miss Mary Hayllar)
Exhib. a work entitled 'On Trust' at the RA. Address in Wallingford. See also Miss Mary Hayllar.

***WELLS, Henry Tanworth RA 1828-1903**
Portrait painter and miniaturist. Pupil of J.M. Leigh. Painted
miniatures up till about 1860, when the development of
photography forced him to take up oil painting. Exhib. at RA 1846-
1903 (239 works), BI, SS, and elsewhere. ARA 1866, RA 1870.
Painted many official and presentation portraits, numbering many
distinguished Victorians among his sitters. His best known work is
the group portrait entitled 'Volunteers at Firing Point', RA 1866,
now the property of the RA.
Bibl: AJ 1903 p.96 (obit.); DNB; Bryan; W.M. Rossetti, *Some Reminiscences*,
1906 p.154; Poole III 1925; BM Cat. of Engraved British Portraits VI 1925; Maas
pp.200, 216 (pl. p.216); Ormond; Wood, Panorama.

WELLS, Mrs. Henry Tanworth fl.1859-1861
(Miss Joanna Mary Boyce)
Painted figurative subjects. Exhib. six works at the RA including
'A Homestead on the Surrey Hills' and 'The Veneziana'. She was
the sister of G.P. Boyce (q.v.). London address.

WELLS, J. fl.1869-1871
Exhib. two watercolours at SS, the second 'H.M.S. Agamemnon,
Broken Up off Deptford, 1870'. London address.

WELLS, Miss J. fl.1875
Exhib. a watercolour view of the village of St. Leger at SS. London
address.

WELLS, John Sanderson RI fl.1890-1940
Genre painter. Exhib. at RA 1895-1914, and SS. Usually painted
genre scenes in 18th century costume, sometimes coaching or
hunting subjects. Also exhib. at RBSA. See also John Sanderson
Sanderson-Wells.
Bibl: AJ 1909 p.40; Studio XXXII 1904 p.297; Pavière, Sporting Painters.

WELLS, Joseph Robert fl.1872-1893
Marine painter, who exhib. 1872-93, at the RA 1877-93, SS, NWS
and elsewhere, titles at the RA including 'A Steam Carrier
Collecting Fish from the Doggerbank Trawl-fleet', 1877, 'Kynance
Cove, Cornwall, January 1881', 1881 and 'A Salt-Marsh', 1882.
Bibl: Wilson; Brook-Hart.

WELLS, L. Jennens fl.1865-1868
Exhib. three paintings of birds. London address.

WELLS, P. fl.1839
Exhib. 'Brecon Castle' at the RA. London address.

WELLS, Robert Douglas RBA 1875-1963
Painted landscape and still-life. Also an architect. Studied at the
London School of Art. Lived in London.

WELLS, William Page Atkinson 1872-1923
Painted landscape. Studied at the Slade and in Paris. Exhib. two
landscapes in 1893. Born in Glasgow. Brought up in Australia.
Lived in Glasgow, Lancashire and on the Isle of Man.
Bibl: Caw; Studio L 1910 pp.266-75; LIX 1913 p.223; Who's Who; Who Was
Who.

WELSCH, F.C. fl.1871-1879
Exhib. views at St. Moritz and on the Venetian lagoon at the RA.
Address in Rome.

WELTI, Albert fl.1896
Exhib. three works, including 'The Rape of Europa', at the RA.
Address in Munich.

WENDT, William fl.1899
Exhib. 'A Cool and Shady Woodland' at the RA. Address in St.
Ives, Cornwall.

WENLEY, H. fl.1858
Exhib. 'On the Nene, Wisbech' at SS. London address.

WENSEL, T.L. fl.1857
Exhib. 'Felice Orsini in Prison' at the RA. London address.

WENT, Alfred fl.1893
Exhib. two works, 'Fireside Recollections' and 'At Full Cry', at SS.
Address in Ilkley, Yorkshire.

WENTWORTH-SHIELDS, Ada fl.1889-1892
Exhib. two works at SS, the first entitled 'The Tender Greeting of
April Meadows'. London address.

WERE, T.K. fl.1876-1877
Exhib. two landscapes, 1876-7. Address in Sidmouth, Devon.

WERNER, Carl Friedrich Heinrich RI 1808-1894
German architectural and landscape painter. Born at Weimar;
studied at Leipzig and Munich. Travelled extensively for many
years in England, on the Continent, in Egypt, Palestine, Greece and
Syria, painting views of the places he visited, chiefly in
watercolour. Exhib. 1860-78, at the RA (1877, 'Interior of the
Cathedral of Ravello, near Amalfi'), and NWS (139 works), of
which he became an A and Member 1860; resigned 1883. He was
also a member of the Venetian Academy.
Bibl: VAM; see also (for long German bibl.) TB.

WERNER, Rinaldo 1842-1922
Painted Italianate subjects. Exhib. three works at SS including
'Temple of Neptune, Paestum' and 'There's Life in the Old Dog
Yet!' Also exhib. eight works at the NWS. Address in Rome. Died
in London.

WERNINCK, Miss Blanche fl.1893
Exhib. a Buckinghamshire landscape at the RA. Address in
Winslow, Buckinghamshire.

WESLAKE, Miss Charlotte fl.1836-1870
Painted fruit and landscape. Exhib. six still-lifes at the BI and six
works at the RA, including 'At Northfleet' and 'Found among the
Blackberries'. Also exhib. a landscape and two fruit pieces at SS.
London address.

WESLAKE, Miss Mary fl.1866
Exhib. 'A Waterloo Veteran' at the RA. London address.

WEST, A. fl.1880
Exhib. a genre subject in 1880. Address in Leatherhead, Surrey.

WEST, Alexander fl.1884
Painted landscape. Exhib. four works at SS including 'Low Tide'
and 'Surrey Scenery', and one Italian landscape at the RA. Address
in Manchester.

WEST, Alice fl.1853
Exhib. 'Fruit and Flowers' at the RA. Address in Poplar.

WEST, Miss Alice L. fl.1889-1892
Painted animals and genre subjects. Exhib. four works at the RA
including 'Catch It!' and 'A Delicate Morsel', and three works
including two watercolour views at the Zoo, at SS. London address.

WEST, Miss Blanche C. fl.1876-1882
Exhib. two works at SS, 'Her Eyes were Homes of Silent Prayer' and 'Still Life', and one work at the RA. London address.

WEST, Charles W. fl.1882
Exhib. figurative subjects. Exhib. four works at the RA including 'Francesca' and 'On Ticklish Grounds', and one work at the RA. London address.

WEST, David RSW fl.1890-d.1936
Painted landscape. Exhib. nine works at the RA including landscapes in Morayshire and works entitled 'Under the Cliff' and 'Fisherwomen Bringing Home the Firewood'. Visited Alaska 1898; elected RSW 1908. Lived mainly at Lossiemouth.

WEST, E. fl.1858
Painted landscape. Exhib. four works at SS, including two views in the Lledr Valley. London address.

WEST, Edgar E. fl.1857-1881
Exhib. a Norwegian landscape at the RA. London address. Also painted in the West Country and Normandy.

WEST, Miss F.B. fl.1845
Exhib. a work entitled 'Admonition' at the RA. London address.

WEST, Frederick E. (?Edgar) fl.1877-1882
Painted landscape. Exhib. five watercolours at SS including 'Windy Day — Coast of Devon' and two Norwegian landscapes. London address. This may be the same as Edgar E. West (q.v.).

WEST, James fl.1883
Exhib. a stained glass window design at the RA. London address.

WEST, Joseph Walter VPRWS 1860-1933
Painted figurative and literary subjects and landscapes. Exhib. 17 works at the RA including 'To Gretna Green', 'The Coming of Arthur' and illustrations to *Love Lies Bleeding* and *The Happy Isles,* and four works at SS. Studied at St. John's Wood School, at the RA Schools and at the Académie Julian. Born in Hull, Yorkshire. Lived at Northwood, Middlesex.

WEST, Miss M.P. fl.1837-1839
Exhib. two portraits at SS and one at the RA. London address.

WEST, Miss Maud Astley fl.1880-1890
Exhib. two flower pieces at the NWS. London address. Studied at Bloomsbury School of Art. Published with M. Low, *Through Woodland and Meadow,* 1891.

WEST, Richard Whately 1848-1905
Landscape painter. Born in Dublin, the son of Rev. John West, Dean of St. Patrick's; named after Archbishop Richard Whately. Educated at St. Columba's College, and in 1866 entered Trinity College and graduated in 1870. Went to Pembroke College, Cambridge, and afterwards was a schoolmaster for a few years. Had no special instruction in painting. Exhib. 1878-88, at the RA, SS, NWS, RHA and elsewhere, titles at the RA including 'A Coal Wharf at Rotherhithe', 1878, 'Piazza and Campanile, Bordighera, Italy', 1885 and 'Summer Day on the Norman Coast', 1888. He went abroad in 1883 on a commission to make sketches in the Riviera for the AJ. In 1885 spent two months in Alassio, and in 1886 was painting in Ireland and in Wales. In 1890 settled

permanently in Alassio, but after that date never exhib. any of his works. A gallery was erected to his memory at Alassio, in which are 122 of his works. It was opened in 1907. Three of his paintings are in the VAM.
Bibl: Strickland.

WEST, Samuel 1810-1867
Painter of portraits and historical subjects. Born in Cork, son of William West (1770-1854), bookseller and antiquary. Studied in Rome. Lithographed a portrait of his father for William West's *Fifty Years' Recollections of an Old Bookseller,* Cork 1830. Came to London, and exhib. 1840-67 at the RA, BI and SS, titles at the RA including 'Head of a Roman; Study from Life', 1840, 'Charles I Receiving Instructions in Drawing from Rubens, whilst Sketching the Portraits of his Queen and Child', 1842, and 'Bringing in a Prisoner — Portraits of Viscount Trafalgar, Lady Edith, Hon. Charles and Hon. Horatio, children of Earl Nelson', 1861. He also exhib. at the RHA in 1847 portraits of the McNeill children and of Sir John and Lady McNeill. He specialised in portraits of children.
Bibl: Cat. of the 3rd Exhibition of National Portraits VAM May 1868 p.107; Redgrave, Dict.; Binyon; DNB; Poole I 1912 p.255; BM Cat. of Engraved British Portraits VI 1925 p.562; Ormond.

WEST, Walter RBA fl.1893
Is supposed to have exhib. a genre subject at the RA. London address.

WEST, William 1801-1861
Landscape painter. Born in Bristol, where he worked for most of his life. In the early part of his career he travelled in Norway and produced many Norwegian landscapes. Later he turned to scenes in Devon and Wales, especially river landscapes with waterfalls. For this reason he is sometimes referred to as 'Waterfall West' or occasionally 'Norway West'. Exhib. mostly at SS, where he became a member in 1851; also exhib. at RA 1824-51, and BI. He was in his early days member of the Sketching Club formed by W.J. Müller, Samuel Jackson, John Skinner Prout and T. Rowbotham (qq.v.). Works by him are in Bristol AG and the VAM.
Bibl: AJ 1861 p.76 (obit); J. Ruskin, *Notes on the SBA,* 1857; Redgrave, Dict.; VAM; Hardie III pp.12, 57; *The Bristol School Artists,* Cat. of exhib. Bristol AG, 1973.

WEST, William D. fl.1852-1877
Painted views of architecture. Exhib. ten works at the RA including views in Seville, Valencia and Florence, and of Westminster Abbey, and three works at the BI. London address.

WESTALL, John fl.1873-1893
Birmingham painter of landscapes and country scenes. Exhib. 'Near Warwick' at SS, and also at RBSA 1877-81.

WESTALL, Robert fl.1848-1889
Painted landscape. Exhib. six works at the RA including 'View of the Vale of Dent, Yorkshire' and 'Evening — Rydal from the Foot of the Lake, Looking towards Grasmere', and five watercolours at SS. London address.

WESTALL, William ARA 1781-1850
Younger brother of Richard Westall Painted landscape. Exhib. 80 works at the RA including views in the West Indies, China and India, as well as in Great Britain. Also exhib. 30 works at the BI, and at SS and the OWS. The great part of this important painter's production was pre-Victorian. Born in Hertford. Lived in London.
Bibl: DNB; Bryan; Cundall; AJ 1899 p.311; Burlington Mag. II 1903 p.298; Connoisseur LX 1921 p.21; LXVI 1923 p.77; C 1935 p.147.

WESTAWAY, W. fl.1853
Exhib. 'A Picture Gallery' at the RA. London address.

WESTBROOK, Miss Annie E. fl.1878
Exhib. 'Haidée' at the RA. London address.

WESTBROOK, Miss Elizabeth T. fl.1861-1886
Painted figurative subjects. Exhib. 14 works at SS including 'Young Ireland' and 'Clarissa', and six works at the RA including 'Light Blue Wins'. London address.

WESTCOTT, Philip 1815-1878
Painter of portraits, historical subjects and landscape. Born in Liverpool; left an orphan at an early date, and became apprenticed to the Liverpool picture restorer Thomas Griffiths. Became established as a painter in Liverpool and became A of the Academy 1843, and Member 1844; Treasurer 1847-53. His portraits were popular in Liverpool, and he had many distinguished sitters, amongst others Mr. Gladstone and Archdeacon Brookes. The Walker AG, Liverpool, has his portrait of Sir John Bent (Mayor 1850-1). In 1855 he moved to London, and exhib. there 1844-61, at the RA 1848-61, BI and SS. However, he did not have great success in the South, and at the end of his life settled in Manchester. His most important work was an historical picture of 'Oliver Cromwell in Council at Hampton Court Palace, on the Persecution of the Waldenses', an elaborate composition for which he accumulated a great wardrobe of costumes, wigs, weapons and armour of the period (Cheetham Library). He also painted landscapes, and at one period of his life refused commissions in order to devote himself to it. He rented a cottage at Cookham, where he painted many Thames subjects, and later a house in Norfolk, from which he used to sail for sketching purposes to favourite spots along the Yare and Bure. His landscapes are principally in watercolour. Among his best portraits are those of Lord Sefton, George Holt, and other members of the Holt family.
Bibl: AJ 1878 p.124 (obit.); Marillier pp.226-9, 259.

WESTERN, A. fl.1897
Exhib. a view in Sardinia at the RA. London address.

WESTERN, Charles fl.1885-1900
Painted landscape. Exhib. three works at the RA including 'The Grey of the Morning' and 'The Top of the Hill', and four works at SS. London address.

WESTHEAD, G. Reade- fl.1883
Exhib. a landscape in 1883. London address.

WESTHOVEN, W. fl.1878
Exhib. a watercolour, 'Calm of Evening', at SS. London address.

WESTLAKE, Miss fl.1864
Exhib. 'Treasures from the Ocean' at SS. London address.

WESTLAKE, Mrs. Alice 1840-1923
(Miss Hare)
Painted landscape. Exhib. three works at the RA including 'View in the Campine, near Breda' and 'Zennor, Cornwall'. London address.
Bibl: DNB.

WESTLAKE, Mary fl.1872
Exhib. a genre subject in 1872. London address.

WESTLAKE, Nathaniel Hubert John 1833-1921
Decorative painter of biblical subjects; stained glass designer; writer. Born at Romsey; studied at Heatherley's and at Somerset House under Dyce and Herbert (q.v.). At the suggestion of W. Burges, RA, went to a firm of glass painters to design; afterwards became Art Manager and partner c.1880; then proprietor. Designed the side windows in St. Martin-le-Grand, and windows in St. Paul's, Worcester and Peterborough Cathedrals, and other prominent churches; also the glass for the Gate of Heaven Church, South Boston, U.S.A.; painted the roof and 14 stations of the chapel of Maynooth College; did the mosaics for the Newman Memorial, Birmingham; painted deocrations for St. Thomas of Canterbury Church, St. Leonard's-on-Sea, and many other churches, besides various altar pieces. Exhib. from 1872, at the RA from 1879, and elsewhere, titles at the RA including 'Study for Painting at E. end of St. Mary of the Angels, Bayswater', 1879 and 'Study for a Painting in St. Mary's Abbey, East Bergholt', 1885. Among his publications are *History and Design in Painted Glass*, 4 vols., and *History and Design in Mural Painting.*
Bibl: The Fine Art's Quarterly Review II 1864 p.198; Universal Cat. of Books on Art, South Kensington II 1870; supp. 1877; Binyon; Humphry, Guide to Cambridge, p.46; Who Was Who 1916-28.

WESTMACOTT, Mrs. H. fl.1866
Exhib. a landscape in 1866. Address in Durham.

WESTMACOTT, Stewart fl.1841-1869
Painted figurative subjects. Exhib. six works at the RA including 'Girl with Mandoline' and 'Tuko-See-Mathla, a Seminole Chief', and portraits; three works at the BI, and six works at SS. London address.

WESTON, The Rev. George Frederick 1819-1887
Amateur painter of landscapes and topography. Lived in Cumbria, but painted mostly on his travels in Europe. Signed with a GFW monogram — not to be confused with G.F. Watts. Exhib. at SS 1840.

WESTON, Lambert 1804-1895
Exhib. a landscape at SS, and a view of Dover Castle at the RA. Address in Dover, Kent.
Bibl: Bryan; AJ 1895 p.191.

WESTPHAL, Miss F. fl.1864-1867
Painted figurative subjects. Exhib. four works at SS including 'A Woman of Heligoland' and 'The Morning Hour', and two works at the RA. London address.

WESTWOOD, Miss Eliza fl.1835-1837
Exhib. two paintings of flowers at the RA. London address.

WESTWOOD, Miss Florence see WHITFIELD, Mrs. Florence

WETHERBEE, George Faulkner RI ROI 1851-1920
Painter of landscapes, genre and mythological subjects. Born in Cincinnati, U.S.A. Educated in Boston; studied art at Antwerp and at the RA Schools. Travelled and lived in the West Indies, France, Germany, Italy, Belgium; finally settled in London. Exhib. from 1873, at the RA from 1880, SS, NWS, GG, NG and elsewhere, titles at the RA including 'Harvest Idyll', 1880, 'Phyllis and Corydon', 1886, and 'The Pool of Endymion', 1901. His work is in galleries in Buffalo, Capetown, and Preston (Cat. 1907).
Bibl: AJ 1900 p.187 (pl.); 1901 pp.183 (pl.), 186; 1905 pp.169 171 (pl.), 184; 1907 p.200 (pl.); 1909 p.170 (pl.); Studio Special Summer Number 1900, *Modern British Watercolour Drawings*, pp.9, 89 (pl.); Kurtz Illustrations from the Art Gallery, the World's Columbian Exhibition 1893 p.95 (pl.); RA Pictures 1895 p.193 (pl.); 1896 p.64 (pl.); Magazine of Art N.S. I 1903 pp.105-10; Who's Who in America VII 1912-13; M. Fielding, *Dictionary of American Painters*, 1926; Who Was Who 1916-28.
Exhib: London, FAS 1903.

WETHERED, Vernon NEAC 1865-1952
Painted landscape. Studied at the Slade School. Made his career as a painter from 1896. Exhib. at the NEAC, at the NG and on the Continent. Born at Clifton, near Bristol. Lived in London.

WETTON, Ernest fl.1895
Exhib. 'Japanese Buddhist Priests at Prayer' at the RA. Address in Maidstone, Kent.

***WHAITE, Henry Clarence RWS PRCA 1828-1912**
Landscape painter, mainly in watercolour. Born in Manchester. Exhib. mainly at OWS, of which he was a member, also RA 1851-1904, BI, SS, GG and elsewhere. A prolific painter of pleasing, if rather conventional, views in England and, especially, Wales, where he died. Ruskin commented on his 'Barley Harvest' (RA 1849): "Very exquisite in nearly every respect. The execution of the whole by minute and similar touches is a mistake." Works by him are in Blackburn, Cardiff, Liverpool, Nottingham and Warrington AG.
Bibl: AJ 1859 pp.122, 168; 1894 pp.267-9 (pls.), 270-1; 1904 p.216 (pl.); 1905 p.352; Studio XXVI 1902 p.54; XXXII 1904 p.61; RA Pictures 1896 p.140; The Year's Art 1913 p.438; J. Ruskin, Academy Notes 1859; Cat. of Manchester City AG 1908; Nottingham AG 1913; Who's Who 1912; Hardie III p.163 (pl.186); Newall.

WHAITE, James fl.1867-1896
Landscape painter, living in Manchester, Liverpool, 1875, and Seacombe, Cheshire 1896, who exhib. 1867-96, at the RA 1870-96, SS, GG and elsewhere. Titles at the RA include 'Mullin's Bay, Cornwall', 1870 and 'The Lledr Valley, North Wales', 1896. A watercolour 'Llyn Idwal', 1867, is in the VAM.
Bibl: VAM.

WHAITE, Miss Lily F. fl.1898
Exhib. 'Poppies' at the RA. Address in Conway.
Bibl: Ormond.

WHALL, Christopher Whitworth 1849-1924
Designed stained glass. Exhib. nine designs and works at the RA including 'The Artist's Mother', and two works at SS. Address in Edmonton.
Bibl: AJ 1895 p.151; Studio XC 1925 pp.364-8; Connoisseur LXXI 1925 p.115.

WHALLEY, Adolphus Jacob fl.1875-1886
Exhib. two works, 'The Squire's Den' and 'Salome with the Head of John the Baptist', at the RA. London address.

WHALLEY, J.K. fl.1874
Exhib. a genre subject in 1874. Address in Liverpool.

WHARTON, J. fl.1864
Exhib. a watercolour entitled 'The Stepping Stone over the Brook' at SS. Address in Newmarket.

WHATLEY, Henry 1842-1901
Landscape. figure and portrait painter; also teacher in Bristol. Exhib. four landscapes at the NWS. Address in Clifton, Bristol. Travelled extensively and produced illustrations for *The Illustrated London News*. His work resembles that of De Wint (q.v.).

WHATELY, Mrs. M. Alice H. fl.1892
Exhib. 'Skylark: A Portrait' at the RA. London address.

WHEATLEY, Mrs. Francis see POPE, Mrs. Alexander

WHEATLEY, William Walter 1811-1885
Prolific topographer, mainly views of Somerset churches. Died in Bath.

WHEELER, Miss fl.1889
Exhib. a view at Hastings at the RA. London address.

WHEELER, Alfred 1852-1932
Painted sporting subjects in the manner of his father John Alfred Wheeler (q.v.). Born near Bath, Somerset.

WHEELER, Miss Annie fl.1868-1885
Painted landscape and flowers. Exhib. six watercolours at SS including 'Autumnal Tints' and 'Field Poppies'. London address.

WHEELER, Edward J. fl.1872
Exhib. a genre subject in 1872 London address.

WHEELER, James Thomas 1849-1888
Painter of landscapes, usually with cattle. Son of John Alfred Wheeler (q.v.).

***WHEELER, John Alfred 1821-1877**
Bath sporting painter. Gained practical knowledge of horses while serving in the army. Retired to take up painting; lived in Bath 1857-77. Painted racing and hunting scenes, and equestrian portraits. Exhib. once at RA in 1875. Father of Alfred and James Thomas Wheeler (qq.v.).
Bibl: Pavière, Sporting Painters p.89 (pl.46).

WHEELER, Miss S.A. fl.1863-1879
Painted fruit and flowers. Exhib. eight works at SS including 'Tulips', 'Fox Gloves' and 'Autumn Berries', and one still-life at the BI. London address.

WHEELER, Mrs. W.H. (Anne) fl.1885-1887
Exhib. five flower pieces at the NWS. Address in Reigate, Surrey.

WHEELER, Walter Herbert 1878-1960
Painted landscape, animals and sporting subjects. Exhib. 11 works at SS including 'A Silver Streak', 'Rippling Waters' and 'Grey Weather: Reigate Heath', and one work at the RA. London address. Grandson of John Alfred Wheeler (q.v.), of the Wheeler family of Bath.

WHEELERSMITH, Olive fl.1884-1886
Exhib. three watercolours at SS including 'A Bit of Wild Rose' and 'After a Gale in Autumn'. Address in Addiscombe, Surrey.

WHEELHOUSE, Miss Mary V. fl.1896
Exhib. 'A Little Red Head' at the RA. Address in Scarborough, Yorkshire.

WHEELWRIGHT, Anna fl.1884
Exhib. 'Vase and Flowers' at SS. London address.

WHEELWRIGHT, Miss Hené P. fl.1871-1885
Painted animals. Exhib. five works at SS including 'Who's That' and 'Only the Cat', and one work at the RA. Address in Hawkhurst.

WHEELWRIGHT, J. Hadwen fl.1834-1849
Painter of biblical, historical and sporting subjects, portraits and genre. Exhib. 1834-49, at the RA 1842-9, BI, and SS, titles at the

RA including 'Cumberland Peasant Girl', 1842, 'Italian Peasant Children in the Neighbourhood of Rome, at a Spring; sketched on the spot', 1846 and 'David Sparing Saul's Life in the Tent', 1849. He also made many copies after paintings in Italy, and several of his watercolours after Fra Angelico, Giotto and Giottino are in the National Gallery, Dublin (Cat. 1920, 198).

Bibl *G. Redford, Descriptive Cat. of a Series of Paintings* in *Watercolour by J.H.W. Taken from Pictures in the Vatican, Uffizi, Pitti, etc.,* 1866; BM Cat. of Engraved British Portraits IV 1914 p.25; Pavière, Sporting Painters

*WHEELWRIGHT, Rowland RBA 1870-1955

Painted historical and classical subjects and also country scenes. Exhib. 12 works at the RA 1895-1904, including 'A Lord of Creation', 'Exchange is no Robbery' and 'Turning the Plough'. Studied under Herkomer at Bushey. Born in Queensland, Australia.

Bibl: Who's Who in Art; Who's Who; Connoisseur LXIII 1922 p.243; LXXIII 1925 p.265: LXXIV 1926 p.59; LXXVI 1926 p.257; Wood, Paradise Lost.

WHEELWRIGHT, W.H. fl.1878-1880

Exhib. two interiors 1878-80. London address.

WHEEN, Miss Helen fl.1870-1872

Exhib. three works at SS including 'Preparing for Friends' and 'A Dish of Tea'. London address.

WHELAN, Miss K.A. fl.1874

Exhib. a watercolour view of a Dartmoor bridge at SS. Address in Ryde, Kent.

WHELDON, James H. fl.1863-1876

Painted marines. Lived in Kingston-upon-Hull, Yorkshire.

Bibl: Brook-Hart

WHEWELL, Herbert RI RCA 1863-1951

Painted landscape. Born in Bolton, Lancashire. Lived in Gomshall, Surrey.

Bibl: Who's Who in Art 1934; Who's Who.

WHICHELO, C. John M. 1784-1865

Marine and landscape painter, who painted many views of the coasts, harbours and dockyards of England. Member of a family of four painters. First known as the illustrator of *Select Views of London,* 1804. About 1818 he was marine and landscape painter to the Prince of Wales. Exhib. 1810-65, at the RA 1810-44, BI 1811-49, and OWS (210 works) 1823-65, becoming A of the OWS 1823. Titles at the RA include 'Morning — Brighton, Fishing Boats Coming in', 1836 and 'A Pilot Boat Going to the Assistance of a Ship on the Goodwin Sands', 1844, and at the BI his large 'Battle of Trafalgar' in 1811. He also worked for a time at teaching. His studio sale was held at Christie's, 10 April 1866.

Bibl: Redgrave, Dict; Roget; Binyon; Cundall p.269; DNB; VAM; Birmingham Cat; Print Collector's Quarterly XVII 1930 p.329; Williams; Wilson; Brook-Hart.

WHICHELO, Henry Mayle, Snr. 1800-1884

Painter of landscapes, marines and architectural subjects, who exhib. 1817-42 at the RA, BI and SS. Brother of C. John M. Whichelo (q.v.). Titles at the RA include 'South-east View of the Transept and Great East Window of Netley Abbey, Hampshire', 1818, 'View of the Clyde near Stonebyres', 1838 and 'Scene near Ewell, Surrey', 1842. His son Henry Mayle Whichelo Jnr. (1826-67) was also an artist.

Bibl: Brook-Hart.

WHICHELO, William J. fl.1866

Exhib. a view in the New Forest and another at SS. Address in Leatherhead, Surrey. Half brother of H.M. Whichelo Jnr.

WHINNEY, Thomas B. fl.1881-1889

Painted views of architecture. Exhib. four works at the RA including 'In the Ambulatory, Westminster Abbey' and 'Where the End of Earthly Things', and a watercolour at SS. London address.

WHIPPLE, John fl.1873-1896

London painter of landscape, genre and river and coastal scenes, who exhib. 1873-96, at the RA 1875-96, SS, NWS, GG, NG and elsewhere. Titles at the RA include 'Near Streatley-on-Thames', 1875, 'Street in Cairo', 1883 and 'Fisher-folks and their Homes', 1889. His wife, Mrs. John Whipple (q.v.), was also an artist.

WHIPPLE, Mrs. John (Agnes) fl.1881-1888

Painted flowers. Exhib. five works at the RA including 'Azaleas' and 'Blackberry Blossoms', and one watercolour at SS. London address.

*WHISTLER, James Abbott McNeill PRBA 1834-1903

Painter, etcher and lithographer. Born in Lowell, Massachusetts, the son of an engineer. As a boy lived in Russia and England. 1851 entered West Point Military Academy. Left to work as a cartographer for the Navy where he learnt the technique of etching. 1855 went to Paris as a student. Met Degas and Fantin-Latour; much influenced by Courbet, as can be seen in 'Au Piano' which was rejected by the Salon in 1859. By 1858 he had completed the 'French Set' of etchings of Paris. 1859 moved to London and began on the first 'Thames Set'. His paintings of this period, such as 'The Music Room', 1860, 'The Coast of Brittany', 1861 and 'The Little White Girl', 1864, still reflect the influence of Courbet and Manet. Moved in 1863 to 7 Lindsay Row, Chelsea, where he met Henry and Walter Greaves and also Rossetti (qq.v.). The influence of Japanese art becomes apparent in his pictures of the 1860s, such as 'La Princesse du Pays de la Porcelaine'. 1866 visited Valparaiso. In the 1870s he began to paint his Nocturnes, and also produced some of his finest portraits, such as those of Carlyle, Mrs. Leyland and 'Portrait of the Artist's Mother', later bought by the Louvre. 1876 painted the Peacock Room (now Freer Gallery, Washington) which led to the break with his patron F.R. Leyland. 1877 exhib. 'Nocturne in Black and Gold — The Falling Rocket' at the first exhib. of the Grosvenor Gallery. The picture was attacked by Ruskin who accused Whistler of "flinging a pot of paint in the public's face". Whistler retaliated by suing Ruskin for libel. The trial took place in 1878, and Whistler was awarded one farthing damages. The costs of the action led to bankruptcy in 1879, and the sale of the White House in Tite Street, built for him in 1877 by E.W. Godwin. 1879-80 visited Venice for the first time, where he produced some of his finest etchings and pastels. 1885 delivered his famous Ten o'Clock Lecture. 1886-8 P of the RBA. 1888 married Beatrix Godwin (née Philip) widow of E.W. Godwin. 1892 settled in Paris. 1897 President of the International Society of Sculptors, Painters and Gravers. 1898-1901 ran his own art school, the Académie Carmen, in Paris. Exhib. at RA 1859-79, SS, GG and elsewhere. As a painter Whistler was primarily interested in the exploration of tones and colour relationships, within a strict and formalised decorative pattern. In this he often shows an affinity with such academic English artists as Albert Joseph Moore (q.v.). The titles of his pictures, 'Arrangements', 'Nocturnes', 'Symphonies', etc., reflect his conscious aestheticism and rejection of the Victorian idea of subject. He was also a watercolourist and

pastellist, but perhaps his greatest contribution to the 19th century was his etching. With justification, he is now classed with Rembrandt and Goya as one of the greatest masters of etching. A wit and dandy, he was one of the most colourful personalities of the 19th century, but his combative nature led him to many feuds and lawsuits, notably those with Ruskin, Oscar Wilde and Sir William Eden (q.v.). Among his many pupils and disciples were Mortimer Menpes and W.R. Sickert (qq.v.).

Bibl: Main Biographies: W.G. Bowdoin, *J.McN.W. The Man and his Work*, 1902; E. Hubbard, *W.*, New York 1902; E.L. Cary, *The Works of J.McN.W.*, New York; A.J. Eddy, *Recollections and Impressions of J.McN.W.*, 1903; A.E. Gallatin, *W. Notes and Footnotes*, New York; T.R. Way and G.R. Dennis, *The Art of W.*, 1903; A. Bell, *J.A.McN.W.*, 1904; M. Menpes, *W. as I knew him*, 1904; H.W. Singer, *J.McN.W.*, Berlin 1904; E.R. and J. Pennell, *The Life of J.McN.W.*, 2 vols. 1908; T.M. Wood, *W.*, 1909; T.R. Way, *Memories of J.McN.W. The Artist*, 1912; J. Laver, *W.*, 1930 (1951); J. Laver, *Paintings by W.*, 1938; J. Laver, *W.*, 1942; H. Pearson, *The Man Whistler*, 1952; H. Gregory, *The World of J.McN.W.*, 1961; D. Sutton, *Nocturne*, 1963; D. Sutton, *J.McN.W.*, 1966; Cats. of prints; F.G. Kennedy, *The Etched work of W.*, 5 vols., publ. by The Grolier Club, New York 1910; T.R. Way, *Lithographs by W.*, 1914; Young, MacDonald, Spencer and Miles, *The Paintings of J.McN.W.*, 2 vols. 1980.

Other References: AJ 1887 pp.97-103: 1905 pp 107-11; Mag. of Art 1902-3 pp.577-84; 1903-4 pp.8-16; Burlington Mag. XIV 1909 pp.204-6; Studio IV 1894 pp.116-21; XXIX 1903 pp.237-57; XXX 1903 pp.208-l8; Cundall; VAM; Reynolds, VS, VP; Hardie III pp.166-8 *et passim* (pls. 196-7); Maas pp.245-7 *et passim* (pls.); Ormond; Brook-Hart; Irwin; Wood, Olympian Dreamers; Newall; R. Getscher, *The Pastels of J.A.McN.W.*, 1991.

Exhib: Liverpool, Robert Dunthorne's Gallery 1893; Paris, Ecole des Beaux-Arts 1905; New York, Keppel & Co. 1905; Pittsburg, Carnegie Institute 1916; Manchester, Whitworth 1933; New York, Knoedler's 1934; Baltimore, 1934; Glasgow, University 1935; New York, Carroll Carstairs Gallery l938; Great Britain, Arts Council 1954; 1960; Paris, Centre Culturel Americain 1961; Cincinnati, Museum 1965; Berlin, State Museum 1969; Glasgow, University 1971; London, Colnaghi's 1971; New York, Wildenstein Galleries 1971; London, Agnews 1972; William Weston Gallery 1976; Tate Gallery 1994.

WHITAKER, Miss fl.1891
Exhib. a portrait in 1891.

WHITAKER, D. fl.1892-1893
Exhib. two landscapes 1892-3. Address in Amersham, Buckinghamshire.

WHITAKER, Frank fl.1844-1880
Painted marines and landscape. Exhib. eight works at SS including 'Porch of Great Hayling Church' and 'Steam Ship *Sinus*'. London address.

WHITAKER, G.G. fl.1873
Exhib. 'A Wintry Evening, near Salcombe, Devon' at the RA. London address.

WHITAKER, George 1834-1874
Painted landscape. Exhib. 15 works, mostly watercolours, at SS, including 'Study at Bude', 'Plymouth, Drake's Island' and 'Autumnal Afternoon on the Cornish Coast'. Address in Exeter, Devon.
Bibl: G. Pycroft, *Art in Devonshire*, Bryan; Cundall; Brook-Hart.

WHITAKER, H. fl.1838
Exhib. a 'View of Blundel Chapel, near Liverpool' at the RA. London address.

WHITAKER, Marston fl.1883
Exhib. two works, 'Fish Street, Clovelly' and 'Girl's Head', at SS. London address.

WHITAKER, William M. fl.1874-1877
Exhib. a genre subject at the Dudley Gallery in 1877. London address. Also lived in Birmingham and exhib. at RBSA.

WHITBREAD, W.E. fl.1870
Exhib. a landscape in 1870. London address.

WHITBURN, Thomas fl.1853-1875
Exhib. three works at SS including 'Wild Apple Buds' and one work at the RA. Address in Guildford, Surrey.

WHITBY, W. fl.1886
Exhib. a landscape at the NWS. Address in Mumbles, Glamorgan.

WHITE, Mrs. A.C. fl.1867-1868
Exhib. two works, 'Sweet Sixteen' and 'Madeline' at SS. London address.

WHITE, Miss Agnes fl.1885-1890
Painted townscapes. Exhib. four works at SS including 'Rye, from Winchelsea' and 'Whitby'. London address.

WHITE, Miss Alice fl.1873-1886
Landscape painter, who lived in London. Exhib. 'The Castle by the Sea' at the RA, four watercolours at SS. Also exhib. in Birmingham.

WHITE, Arthur 1865-1953
Painted landscapes and marines. Studied under Sheffield School of Art. Born in Sheffield. Lived in St. Ives, Cornwall. He was a member of the St. Ives Society of Artists.

WHITE, Mrs. C. fl.1809- 1844
Painted landscape. Exhib. 15 works at the BI (listed as Mrs. John White) including views in the Lake District. Also exhib. five works at the RA, including 'Clearing off after a Storm'. London address.

WHITE, C. fl.1851-1855
Exhib. a view of Lincoln Cathedral and another work at the RA. London address.

WHITE, C.G. fl.1831-1841
Exhib. a watercolour, 'A Fishing-boat Making for Port', at SS, and a view at Hastings at the RA. Address in Poplar, London.

WHITE, C.P. fl.1865-1866
Painted landscape. Exhib. four watercolours at SS including 'Netley Abbey, Sunset' and 'Blowing a Gale off the Coast'. London address.
Bibl: Brook-Hart.

WHITE, Clement fl.1889
Exhib. 'Wimbledon Common' at the RA. London address.

WHITE, D. fl.1864-1869
Exhib. three works at the RA including 'My Portrait' and 'Portrait of a Black'. The third work was possibly a sculpture. London address.

WHITE, Dan fl.1889
Exhib. a portrait at the GG.

WHITE, Daniel Thomas fl.1861-1890
London painter of genre, literary subjects and portraits, who exhib. 1861-90, at the RA 1864-82, BI, SS, GG and elsewhere, titles at the RA including 'Town', 'Country', 1864, 'Dr. Johnson at Rehearsal', 1871 and 'Colonel Newcombe at the Charterhouse', 1878.

WHITE, Miss Dora fl.1888
Exhib. a view of a bridge at the GG. London address.

WHITE, Mrs. E.A.
Exhib. 'Phoebe — from *Mugby Junction',* at the RA. London address.

WHITE, E. Fox fl.1883
Exhib. a landscape at the NWS. London address.

WHITE, Edward/Edmund Richard fl.1864-1908
Painter of landscape, genre and portraits, who exhib. 1864-1908, at the RA, SS, NWS and elsewhere, titles at the RA including 'A Grave-Digger', 1864, 'A School Board Subject', 1886 and 'A Cottage at Witley', 1890. Living at Walham Green in 1908.
Bibl: The Year's Art 1909 p.613.

WHITE, Ernest A. fl.1901
Exhib. 'Margery' at the RA. Address in Anerley.

WHITE, F.G. fl.1843-1858
Exhib. three works, including 'An Oak Tree Stricken by Lightning' and 'The Connoisseur and Weary Boy', at the RA, and three works at SS. Address in Taunton, Somerset.

WHITE, Miss Flora fl.1887
Exhib. a flower piece at the RA. London address.

WHITE, Miss Florence fl.1881-1904
Painted portraits and flowers. Exhib. 22 works at the RA including 'Tulips', 'Treasures' and portraits, and five works at SS. She was a member of the Society of Lady Artists.
Bibl: W. Shaw Sparrow, *Women Painters of the World,* 1905; Connoisseur XXXIX 1914 p.205; XLIX 1917 p.239.

WHITE, Frances J. fl.1870
Exhib. 'The Mountain Stream — Springtime' at SS. Address in Dublin.

WHITE, G.H.P. fl.1849-1861
Exhib. 'Landscape' and 'Brighton Harbour' at the BI. Address in Newton Abbot, Devon.

WHITE, George fl.1885-1890
Painted landscape. Exhib. six works at the RA including 'When Summer and Autumn Blend' and 'Autumn's Palace Paved with Gold'. Address in Heswell, Chester.

WHITE, Col. George Francis 1808-1898
A soldier who made drawings in pencil and watercolour. His views of India and the Himalayas were engraved. He lived in Durham. His wife Ann and his daughter Ella also painted in watercolour.
Bibl: Hall.

WHITE, George Harlow 1817-1888
Landscape painter. Exhib. mostly at SS, also RA 1842-73, BI and elsewhere. Painted landscape views in England, Wales and Ireland, rustic genre, and occasional portraits. In 1871 he went to live in Ontario, Canada, where he painted scenes of early Canadian pioneers. In 1876 he moved to Toronto, where he remained until about 1880, when he returned to England. His Canadian pictures are more valuable than his English ones, as they are of historical and topographical interest to Canadian collectors.
Bibl: J. Russell Harper, *Canadian Painting,* Toronto 1966, pp.191, 430; Ormond.

WHITE, H. fl.1839-1843
Exhib. 'A Page' and a portrait at the RA. London address.

WHITE, Henry fl.1881
Exhib. a watercolour view on Midhurst Common, Sussex, at SS. London address.

WHITE, Henry Hopley fl.1805-1856
Painted landscapes and biblical subjects. Exhib. 18 works at the RA including portraits, 'Ragland Castle, North Wales' and biblical subjects including 'Ruth and Boaz' and a subject from Genesis. London address. Was also a barrister and QC.

WHITE, Miss Isabel G. fl.1892-1902
Exhib. five works at the RA including 'The First Standard', 'A Wayside Flower' and 'Two of Us', and two works at the NWS. Address in Bushey, Hertfordshire.

WHITE, J.H. fl.1849
Exhib. 'An Avenue in Greenwich Park' at SS. London address.

WHITE, J. Talmage fl.1853-1893
London painter of genre and architectural subjects, especially in Italy. Exhib. 1853-93, at the RA 1855-93, BI, SS, GG and elsewhere, titles at the RA including 'Corner of a French Peasant's Court-yard', 1855, 'The Temple of Paestum', 1871 and 'Villa of Catullus, Lago di Garda', 1875. From 1893 living in Capri.

WHITE, Mrs. John see WHITE, Mrs. C.

***WHITE, John RI ROI 1851-1933**
Painter of rustic genre, landscape, marines and portraits. His parents emigrated to Australia in 1856, and he was educated at Dr. Brunton's School, Melbourne. Entered the RSA in 1871, and won the Keith prize for design in 1875. Came south in 1877. Exhib. from 1877 at the RA, SS, NWS, GG and elsewhere, titles at the RA including 'Labour O'er', 1877 and 'Haymaking in Devon', 1895. 'A Village Wedding, Shere, Surrey' is in Exeter Museum.
Bibl: Caw p.281; Who's Who in Art 1934; Who Was Who 1941-50; Pavière Landscape; Wood, Paradise Lost.

WHITE, Miss Josephine M. fl.1893-1898
Painted portraits. Exhib. 12 portraits, which may be miniatures, at the RA. London address.

WHITE, Sidney W. fl.1892-1903
Painted portraits. Exhib. six works at the RA including 'A Bacchante', 'An October Evening on the Lincolnshire Wolds', and portraits. Address in Grimsby, Lincolnshire.
Bibl: The Year's Art 1908 p.581.

WHITE, W. fl.1824-1838
Painted portraits. Exhib. four portraits at the RA and three portraits at SS. London address.

WHITE, W. Tatton fl.1898-1899
Exhib. a view in Ireland and a 'Morning Off St. Ives, Cornwall' at the RA. Address in Southend-on-Sea, Essex.

WHITE, William fl.1824-1838
London portrait painter who exhib. 1824-38 at the RA and SS. Also lived in Swansea. His style is similar to that of George Richmond (q.v.).

WHITE, William fl.1871
Exhib. a landscape in 1871. Address in Brighton, Sussex.

WHITEFORD, Sidney Trefusis fl.1860-1881
Painter of genre, still-life, birds and flowers, who exhib. 1860-81, at the RA 1869-81, SS and elsewhere. Living in Plymouth and London. Titles at the RA include 'Fresh Acquisitions', 1870, 'Study of Flowers', 1876 and 'British Birds', 1880.

WHITEHEAD, Miss Elizabeth fl.1877-c.1930
Painted flowers, landscapes and coastal subjects. Exhib. 12 works at the RA, including 'Christmas Roses', 'French Marigolds' and 'Violets', and three paintings of flowers at SS. Address in Leamington Spa, Warwickshire. Also exhib. at RBSA 1877-97.

WHITEHEAD, Miss Frances M. fl.1888-1897
Flower painter who lived at Shustoke, Coleshill. Exhib. 'Field Clover' at the RA in 1896, and other works at RBSA 1888-97.

WHITEHEAD, Frederick William Newton 1853-1938
Painter of landscape, especially of Hardy's Wessex, still-life, architectural subjects and portraits; etcher. Born at Leamington Spa. His first master in art was John Burgess, of Leamington (q.v.). Studied in Paris at the Académie Julian for three years, and painted at Barbizon and Gretz, studying naturalism. Travelled extensively in France, and worked a great deal in Warwickshire. Exhib. from 1870, at the RA from 1881, SS, Birmingham Art Circle, and elsewhere, titles at the RA including 'The River near Leamington', 1885, 'Street Scene, Algiers', 1892 and 'Tess of the d'Urbervilles' Ancestral Home', 1893 (his first Wessex picture at the RA). It was not until 1893 that he began to paint in Dorset; he met Thomas Hardy, and after that painted many of his pictures in that county. He was much influenced in his art by Constable, and in the varying conditions of light and atmosphere. In 1895 an exhib. of 35 of his Wessex paintings was held in Bond Street.
Bibl: Clive Holland, *The Work of F.W., a Painter of Thomas Hardy's Wessex*, Studio XXXII 1904 pp.105-16 (13 pls.); Birmingham Cat; Brook-Hart.

WHITEHOUSE, Arthur E. fl.1878-1888
Exhib. 'North Ambulatory, Westminster Abbey' and 'Low Tide — Bognor' at the RA, and one work at SS. London address. Also lived in Birmingham and exhib. at RBSA 1878-9.

WHITEHOUSE, Miss Sarah E. fl.1874-1894
Exhib. two works 'Bo-Peep' and 'An Interior' at the RA. Lived in Leamington and also exhib. at RBSA.

WHITELAW, Frederick William fl.1881
Exhib. 'A London Suburb' at the RA. London address.

WHITELAW, S. Frances fl.1882
Exhib. a landscape at the NWS. Address in Taplow.

WHITELEY, John William fl.1882-1916
Painted figurative subjects and landscapes. Exhib. nine works at the RA including 'Under the Cliffs', 'A Lullaby' and 'Toil and Prayer'. Address in Leeds, Yorkshire.

WHITFIELD, Mrs. Florence W. fl.1873-1904
(Miss Florence Westwood)
Birmingham flower painter. Exhib. two paintings of anemones at the RA. Also exhib. at RBSA 1873-90 under her maiden and married names.

WHITFIELD, Miss Helen fl.1890
Exhib. 'A Side Street in Clovelly', and four works at the NWS. London address.

WHITING, Frederic RSW RI RP 1874-1962
Painted portraits, figurative subjects and landscapes. Exhib. two works, 'Doomed' and '6th Dragoons Leaving Albert Docks for South Africa', at the RA. Studied at St. John's Wood Art School, at the RA Schools and at the Académie Julian. Lived in London.
Bibl: Who's Who in Art; Apollo VII 1928 p.146; Connoisseur XLIX 1917 p.172; LII 1918 p.232; LIII 1919 p.229; LIV 1919 p.52; Who's Who.

WHITLEY, G. fl.1868-1869
Painted landscape. Exhib. two landscapes in North London at the RA; two landscapes, including one view in Calcutta, at SS. London address.

WHITLEY, Miss Kate Mary RI fl.1884-1893 d.1920
Leicester painter of still-life and flowers. Born in London, daughter of the Rev. J.L. Whitley of Leicester; educated in Manchester. Exhib. 1884-93, at the RA 1884-92, and NWS, titles at the RA including 'Stones and Fossils', 1884, 'Flowers and Shell', 1885 and 'Cornelians', 1892. Also exhib. in Dresden, Chicago and Brussels. RI 1889.
Bibl: Corporation of Leicester, Permanent AG Cat. 1899 No.96; Who Was Who 1916-28.

WHITLEY, William T. fl.1884-1900
Painted landscape. Exhib. nine works at the RA including 'The Level Waste, the Rounding Grey', 'A Quiet Corner' and 'Sunshine and Shadow', and five works at SS. London address.

WHITMARSH, Mrs. T.H. (Eliza) fl.1840-1851
Painted animals. Exhib. eight works at the RA including 'Frightened Horses', 'The Country Horse-Fair' and 'Landscape', one work at SS and one work at the BI. London address.

WHITMORE, Bryan fl.1871-1897
Painter of landscape and coastal scenes, living in Chertsey, Shepperton, and Southwold, who exhib. 1871-97, at the RA 1882-97, SS, NWS and GG. Titles at the RA include 'Cromer', 1882, 'The Flowing Tide', 1887 and 'Bude Sands', 1897.
Bibl: Brook-Hart.

WHITMORE, William R. fl.1894
Exhib. 'A Moonlit Lane' and 'Winding the Clock' at the RA. Address in Newlyn, Cornwall.

WHITNEY, Miss E. fl.1884
Exhib. a portrait at the NWS. London address.

WHITTAKER, George 1834-1874
West country landscape and coastal painter. Pupil of Charles Williams. Examples are in Exeter Museum.

WHITTAKER, James William 1828-1876
Landscape watercolourist, chiefly of scenery in North Wales. Born at Manchester; apprenticed to an engraver to calico-printers; subsequently, having saved some money, he settled at Llanrwst, North Wales, where he practised as a landscape painter. F.W. Topham (q.v.) saw and admired his work while on a visit to Wales and advised him to stand for election to the OWS. A 1862; Member 1864. Exhib. 1862-76, at the RA 1870-1, OWS (162 works) and

elsewhere. His work was very similar to that of Thomas Collier (q.v.). He was drowned near Bettws-y-Coed, by slipping from the rocky side of a steep gorge above the River Llugwy. Two of his watercolours of Welsh scenery are in the VAM.

Bibl: AJ 1877 p.38 (obit.); Roget II; Bryan; VAM; Hardie III pp.151-2.

WHITTLE, Miss Elizabeth fl.1875-1879
Exhib. two works at SS, 'Pears' and 'Fresh Gathered'. Address in Croydon, Surrey.

WHITTLE, T.S. fl.1862
Exhib. 'The Luxuries of Autumn' at the BI, and a fruit piece at SS. Address in Lewisham, London.

WHITTLE, Thomas, Snr. fl.1854-1868
Still-life and landscape painter. Exhib. mainly at SS, also at BI and RA in 1863-4. Father of Thomas Whittle Jnr. (q.v.).

WHITTLE, Thomas, Jnr. fl.1865-1885
Landscape painter. Son of Thomas Whittle Snr. (q.v.). Exhib. mainly at SS, also at RA 1866-72. Titles at RA 'The Moonlight Hour', 'Palmy Days of Spring', etc.

WHITWORTH, Charles H. ARBSA fl.1875-1913
Birmingham painter of landscapes and coastal scenes. Exhib. 'A Weedy Pond' at the RA, and 'A Silver Birch' at SS. Also exhib. at RBSA 1875-1913.

WHYMPER, Charles RI 1853-1941
Painter, in oil and watercolour, of landscapes, birds, animals and angling subjects; illustrator. Son of Josiah Wood Whymper (q.v.). Exhib. from 1876, at the RA from 1882, SS, NWS, GG and elsewhere, titles at the RA including 'A Wild Cat Trap', 1882, 'Elephants at Early Dawn', 1884, 'The Old Mill at Houghton-on-the-Ouse', 1885 and 'A Snared Hare', 1893. He illustrated books on travel, sport and natural history, and published *Egyptian Birds,* several papers on the pheasantry of England, *Bird Life,* etc., besides many etchings of shooting and fishing from his oils and watercolours. The *Connoisseur* comments on his bird studies at the RI in 1922: "Mr. Whymper's work relies on an almost scientific presentment, correct to the last detail, of the feathered creatures which he chooses to depict." An exhib. of his Egyptian watercolours was held at the Walker Galleries, New Bond Street, 1923.

Bibl: Gilbey, *Animal Painters in England,* 1900; Sketchley, *English Book Illustration of Today,* 1903; Connoisseur LXIII 1922 p.50; LXV 1923 p.238; BM Cat. of Engraved British Portraits VI 1925 p.434; Bulletin of the Worcester Art Museum XVII 1926 p.28; Who Was Who 1941-50; Pavière, Sporting Painters.

WHYMPER, F. fl.1857-1861
Painted landscape. Exhib. three landscapes at the RA; two in Surrey, one on the Seine, and three watercolour landscapes at SS. London address.

WHYMPER, Josiah Wood RI 1813-1903
Landscape watercolourist; engraver. Born in Ipswich, second son of a brewer and town councillor. Apprenticed to a stonemason. In 1829 went to London, where he began wood-engraving, teaching himself and executing shop bills, etc. In 1831 he successfully published an etching of London Bridge. Engraved many illustrations for Black, Murray, Cassell and other publishers. Had lessons in watercolour from W. Collingwood Smith (q.v.), and exhib. from 1844, at the RA 1844-54, SS, NWS (414 works), GG and elsewhere. RI 1854. Died at Haslemere. Ruskin comments on

'The Bass Rock', NWS 1858: "There is no high power of present execution shown in it; but I think the painter must have great feeling, and perhaps even the rare gift of invention . . . I hope this painter may advance far." His son Edward was the well-known Alpinist.

Bibl: AJ 1859 p.175; Ruskin, Academy Notes (NWS) 1858; Roget II; Cundall p.269; DNB 2 Supp. III; VAM; Pavière, Sporting Painters; Hardie III p.137.

WHYMPER, Mrs. J.W. fl.1866-1885 d.1886
(Miss Emily Hepburn)
Watercolour painter of flowers and landscape. Married Josiah Wood Whymper (q.v.) in 1866. Exhib. 1870-85, at the RA 1877-8, SS, NWS and elsewhere, titles at the RA including 'Carnations', 1877 and 'Hollyhocks', 1878.

WHYTE, D. Macgregor 1866-1953
Painted portraits, landscapes and marines. Studied in Glasgow, Paris and Antwerp. Exhib. at the RSA. Born and lived at Oban, Argyllshire.

WHYTE, John G. fl.1877-1886
Painted flowers. Exhib. five works at the RA including 'Apple Blossom' and 'Hill Pasture'. Address in Helensburgh, Dunbartonshire.

WHYTE, William Patrick fl.1883-1888
Exhib. three townscapes at the RA, views in Venice, Perugia and Seville. Address in Paris.

WICKSON, Paul G. fl.1882
Exhib. 'A Graduate' at the RA. London address.

WICKSTEED, C.F. fl.1802-d.1846
Painted landscape and country subjects. Exhib. 55 works at the RA up to 1846, amongst the last of these including 'A Sailor's Wedding', 'An Election' and 'The Country Theatre'. Also exhib. 37 works at the BI, including landscapes and views in London, and nine works at SS. London address.

WIDGERY, Frederick John 1861-1942
Exeter painter of landscape and coastal scenes. Son of William Widgery (q.v.). Studied at the Exeter School of Art, under Verlat at Antwerp, and at the Bushey School of Art under Herkomer (q.v.). Chairman of Exeter Public AG, and a Magistrate of the City. Painted the landscape of south-west England, and especially Dartmoor, and the cliffs and moors of Devon and Cornwall.

Bibl: Studio LXVI 1916 p.62ff. (pls.); G. Pycroft, *Art in Devonshire,* 1883 p.156; Who's Who in Art 1934; Brook-Hart pl.161.

WIDGERY, Julia C. fl.1872-1879
Exeter landscape painter who exhib. 1872-9 at SS. Daughter of William Widgery (q.v.).

WIDGERY, William 1822-1893
Exeter landscape and animal painter. Trained as a stone mason, and self-taught as an artist. Made a good deal of money by producing imitations of Landseer's 'The Monarch of the Glen', and then took up art as a profession. He painted the scenery of Devon and Cornwall (especially Dartmoor), and was "of great local repute", although only exhib. once in London, at SS, in 1866. He also visited Italy and Switzerland. His 'Poltimore Hunt' was engraved by J. Harris.

Bibl: AJ 1893 p.191; G. Pycroft, *Art in Devonshire,* 1883 p.145ff.; Pavière, Sporting Painters.

WIEGAND, N.G. **fl.1869**
Exhib. a coastal subject in 1869. London address.

WIEGAND, W.J. **fl.1882**
Exhib. a figurative subject in 1882. London address.

WIEGAND, W. Paul **fl.1854**
Painted game. Exhib. two game pieces and a watercolour entitled 'A Cold Morning' at SS, and one work at the RA. London address.

WIENS, Siegfried M. **fl.1893-1902**
Painted landscape and figures. Exhib. seven works at the RA including 'A Trout-Stream', 'The Old Still' and 'Fairy Tales'. Address in Sutton, Surrey.

WIENS, Stephen M. **1871-1956**
Painted and sculpted portraits and figurative subjects. Studied at the RA Schools. Exhib. at the RA from 1893. Represented at the Tate Gallery. Probably in fact the same artist as Siegfried M. Wiens (q.v.).

WIFFIN, H.H. **fl.1869**
Exhib. two flower pieces in 1869. Address in Reigate, Surrey.

WIGAN, Miss Bessie **fl.1888**
Exhib. 'Lead Kindly Light!' at the RA. London address.

WIGAND, F.H. **fl.1846**
Exhib. two Roman Street scenes at the RA. London address.

WIGGINS, Carleton **fl.1896-1897**
Exhib. three landscapes at the RA including 'Pastures by the Sea'. Address in St. Ives, Cornwall.

WIGHTON, J. **fl.1863-1866**
Exhib. three works at the RA including 'The Little Messenger' and 'Summer'. London address.

WIGLEY, Miss J.N. **fl.1845**
Exhib. a landscape in 1845. London address.

WIGNELL, Miss P.E. **fl.1872-1875**
Painted figurative and genre subjects. Exhib. seven works at the RA including 'Cherry Ripe', 'Bed Time' and 'In the Market, Great Yarmouth'. Address in Southsea, Hampshire.

WILBERFOSS, T.C. **fl.1873-1877**
Painted views of buildings. Exhib. four works at the RA including 'Watton Abbey, Yorkshire' and views in Bourges and Caen. London address .

WILD, Miss **fl.1840**
Exhib. a watercolour of flowers at SS. London address.

WILD, Mrs. **see GOODALL, Miss Eliza**

WILD, Frank Percy **RBA** **1861-1950**
Painted figurative subjects, portraits and landscape. Exhib. 15 works at the RA including 'The Flute Player', 'Feeding Time' and 'A Lesson in Painting', and two works at SS. Studied at the Antwerp Academy and at the Académie Julian. Born in Leeds, Yorkshire. Lived in Marlow, Buckinghamshire.

WILD, Samuel **1864-1958**
Self-taught painter of landscape. He lived and worked in Newcastle-upon-Tyne, and at different times taught painting in Durham, Newcastle and elsewhere.
Bibl: Hall.

WILDASH, Frederick **fl.1892**
Exhib. 'Autumn on Hampstead Heath' at SS. London address.

WILDAY, Charles **fl.1855-1865**
Exhib. a portrait at the RA and a 'Mother and Child' at SS. London address.

WILDE, Charles, Jnr. **fl.1879**
Exhib. 'Clifton Grove, Early Morning' at SS. Address in Nottinghamshire.

WILDE, William **1826-1901**
Nottingham landscape painter. Exhib. six works at SS including views on the Rivers Trent and Lledr. Painted mainly local views, also Hastings and North Wales, both in oil and watercolour. His watercolours are brightly coloured, detailed, and can be extremely attractive.

WILDMAN, Edmund, Jnr. **fl.1829-1847**
Painted figurative subjects. Exhib. 12 works at SS including 'The Loose Tooth' and 'The Banjo Player'. London address.

WILDMAN, John R. **fl.1823-1839**
Portrait painter. Exhib. eight works at the RA, the majority portraits; nine works at SS, including 'Joseph of Arimathea' and 'A Sleeping Cupid', and four works at the BI. London address. Brother or father of Edmund Wildman (q.v.).
Bibl: Connoisseur XLII 1915 p.108; Ormond.

WILFRED, G. **fl.1878**
Exhib. a watercolour of 'Queen Philippa's Tomb' at SS. London address.

WILKES, Samuel **fl.1857-1859**
Exhib. two works, a view at Ghent and view from Hampstead Heath, at the RA. London address.

WILKES, Miss Sarah **fl.1869**
Exhib. three landscapes at the RA, including two views on Hampstead Heath. London address.

WILKES, Mrs. Sarah **fl.1859-1870**
Painted landscape. Exhib. five watercolours. at SS including views at Hampton Court and on the Thames. London address.

***WILKIE, Sir David** **RA** **1785-1841**
Scottish genre, historical and portrait painter. Born in Cults, Fifeshire. Entered the Trustees' Academy, Edinburgh, at the age of 14. In 1804 he painted 'Pitlessie Fair' which showed his natural talent for depicting scenes of Scottish life. 1805 went to London and entered RA Schools. 1806 'Village Politicians' was an instant success at the RA. ARA 1809, RA 1811. Exhib. at RA 1806-42 and BI. Continued to paint humorous scenes of Scottish life, such as 'Blindman's Buff', 'The Blind Fiddler', 'Village Festival', 'The Penny Wedding', 'The Reading of the Will', 'The Parish Beadle', etc. In 1822 'Chelsea Pensioners Reading the Waterloo Dispatch' was so popular that for the first time a rail had to be put up at the RA to protect it. Although Wilkie was undoubtedly influenced by the techniques of such Flemish painters as Teniers and Ostade, his art remained strongly individual and nationalistic. He visited Paris 1814; Holland 1816; and after a severe illness in 1825, was forced to travel abroad frequently for his health. His visit to Spain in 1817-18 was a turning-point in his career. Influenced by Murillo and Velazquez, he

turned to grander subjects and a broader technique. Among his later works are 'Guerilla's Departure', 'Napoleon and the Pope', 'Sir David Baird Discovering the Body of Tippoo Sahib', 'John Knox Preaching', etc. Unfortunately works of this scale and subject were not really suited to his genius. Appointed Painter in Ordinary to George IV; knighted 1836. In 1840 he visited the Holy Land, and in 1841 died at sea on his way home. His death was commemorated by Turner in 'Peace — Burial at Sea'. Wilkie had many followers and imitators, in Scotland Alexander Fraser, Alexander Carse, William Kidd, etc., and in England Thomas Webster, and the Cranbrook Colony (all q.v.), through whom his style continued to influence genre painting right up to the end of the century. His visits to Spain and the Holy Land also anticipated later developments in Victorian painting. He was also an etcher and watercolourist. Engravings of his works were made in large numbers, and can still be found in many Scottish houses. Exhibs. of his work were held at the Arts Council in 1951 and 1958. His remaining works were sold at Christie's, 25 April 1842; his executors held another sale on 20 June 1860.

Bibl: Biographies: A. Cunningham. *The Life of Sir D.W.*, 1843; A. Raimbach, *Memoir of Sir D.W.*, 1843; Mrs. C. Heaton, *The Great Works of Sir D.W.*, 1868; A.L. Simpson, *The Story of Sir D.W.*, 1879; J.W. Mollett, *Sir D.W.*, 1881; R.S. Gower, *Sir D.W.*, 1902; W. Bayne, *Sir D.W.*, 1903.
Other References: AU 1840 p.10ff.; 1841 p.115ff.; AJ 1859 p.233ff.; 1860 p.236ff.; 1896 pp.183-8; Portfolio 1887 pp.90-7; J. Ruskin, *Modern Painters*; Ruskin, Academy Notes; Redgrave, Dict., Cent; Binyon; Cundall; Caw pp.95-104, *et passim* (2 pls.); DNB; VAM; Reynolds, VS pp.7-8, 45-7 *et passim* (pls. 1-2); Reynolds, VP pp.11-12 (pl.l); Hutchison; Hardie III pp.175-6 (pls.202-4); Maas pls. pp.10, 93, 104-5; Ormond; Irwin; Strong; Wood, Panorama.
Exhib: Paris, Gallery Sambon 1932; Great Britain, Arts Council 1951; Edinburgh, National Gallery of Scotland 1975.

WILKIE, Miss H. fl.1874-1876
Exhib. two Swiss landscapes and a watercolour entitled 'Home Scenes' at SS. London address.

WILKIN, Miss fl.1856-1859
Exhib. two watercolour landscapes at SS, and a view in Rome at the RA. London address.

WILKINS, George fl.1880-1884
Painted landscape. Exhib. four works at SS including 'On the Dee' and 'The Lledr Valley from the Railway Viaduct', and another North Wales landscape at the RA. Address in Duffield, near Derby.

WILKINS, William Noy b1820 fl.1852-1864
Irish amateur landscapist. Exhib. ten landscapes at the BI including views in Wales and Ireland and near Ryde. Also exhib. two views on the Irish Coast near Dublin, and three watercolours at SS. London address.

Bibl: Strickland.

WILKINSON, Alfred Ayscough fl.1875-1881
London painter of views in Venice who exhib. 13 works 1875-81 at SS.

WILKINSON, Charles A. fl.1881-1892
London landscape painter, who exhib. 1881-92, at the RA 1883-92, SS, NWS, GG and elsewhere, titles at the RA including 'On the Thames below Medmenham', 1883, 'The Mountain of Clouds (see Arabian Nights)', 1886 and 'An October Evening', 1892.

WILKINSON, E.W. fl.1881
Exhib. a watercolour view of the Chain Pier at Brighton at SS. London address.

***WILKINSON, Edward Clegg fl.1882-1904**
London painter of genre, landscape and portraits, who exhib. 1882-1904, at the RA 1884-1904, SS, NWS, NG and elsewhere, titles at the RA including 'Sunny Days', 1884, 'In Loving Memory' 1891, and 'The Mill on the Stream', 1904.
Bibl: Wood, Panorama p.151 (pl.160).

WILKINSON, Miss Ellen fl.1853-1879
Painter of flowers and genre, living in London and Chelmsford, who exhib. 1853-79, at SS, RA 1875 and 1876 and elsewhere. Titles at the RA are 'Bon Soir!', 1875 and 'Do you Like Butter?' 1876.

WILKINSON, General Fred. Green fl.1884
Exhib. 'A Sketch of Short Service' at SS. London address.

WILKINSON, Miss Georgiana fl.1855-1876
Painted views of architecture. Exhib. eight works at the RA, including views in Cambridge, York and Seville. London address.

WILKINSON, Hugh fl.1870-1913
Landscape painter, living in Ealing and Brockenhurst, New Forest, who exhib. 1870-1913, at the RA from 1875, SS, GG, NG and elsewhere. Titles at the RA include 'Study in Devonshire', 1875, 'A New Forest Road', 1889 and 'In the Austrian Tyrol', 1903.
Bibl: Illus. Cat. National AG Sydney 1906 No.49.

WILKINSON, L.M. fl.1881
Exhib. a flower piece in 1881. London address.

WILKINSON, Miss Laura fl.1856
Exhib. a fruit piece at the RA. London address.

WILKINSON, M.R. fl.1843
Exhib. a 'Portrait of My Sister' at the RA.

WILKINSON, R.H. fl.1872-1874
Exhib. two watercolours at SS including a work entitled 'Morning after the Gale — Off the Caskets'. London address.

WILKINSON, R. Ellis fl.1874-1890
Painter of genre and landscape, living in Harrow, Ashburton, Devon, Bath and St. Ives, who exhib. 1874-90, at the RA from 1876-90, SS, NWS and elsewhere. Titles at the RA include 'A Spring Morning; by the Undercliff, Isle of Wight', 1877, 'His Last Resource', 1882, and 'Feeding the Ducks', 1887.

WILKINSON, W.F. fl.1858
Exhib. a watercolour landscape and a watercolour view of a church in Le Havre, at SS. London address.

WILLARD, Frank fl.1886
Exhib. a figurative subject in 1886. London address.

WILLATS, Mrs. fl.1881
Exhib. a Venetian subject in watercolour at SS. London address.

***WILLCOCK, George Barrell 1811-1852**
Landscape painter. Born in Exeter. Gave up coach painting to study landscape under his friend James Stark (q.v.). Exhib. at RA 1846-51, BI, SS and elsewhere. Painted most of his works in Devonshire. His style is similar to that of Stark, and it is possible that many of his works have been changed into Starks to enable them to sell for better prices.
Bibl: The Nat. Gall. ed. by Sir E. Poynter III 1900; Pavière, Landscape pl.88.

WILLCOCKS, Miss Mabel fl.1899-1904
Exhib. three portraits at the RA. London address.

WILLENICH, Michel fl.1879
Exhib. views of Liverpool and Brest at the RA. London address.

WILLES, Edith A. fl.1882
Exhib. a watercolour interior view in Westminster Abbey. London address.

WILLES, J. fl.1838
Exhib. two views of Tewkesbury Abbey at the RA. London address.

WILLES, William fl.1815-1849 d.1851
Irish painter of landscape, coastal views, architectural, mythological and literary subjects. Born in Cork; educated at Edinburgh High School and afterwards studied for the medical profession. Did not apply himself seriously to painting until he was 30. Took a prominent part in organising The First Muster Exhibition held in Cork in 1815. Then he went to London and studied at the RA schools. Exhib. 1820-48 at the RA and BI, titles at the RA including 'Landscape: Scene from the Palace of Aegisthus, from the Electra of Sophocles', 1820, 'The Water-log "That ship shall never reach a shore"', 1831, and 'The Round Tower, on the Island of Scottery', 1848. 'The Mock Funeral' was thought to be his best picture. Twenty one of his drawings were engraved for Hall's *Ireland*. On the foundation of the School of Design in Cork in 1849, he was appointed Headmaster.
Bibl: AJ 1851 p.44 (obit.); Redgrave, Dict; Strickland.

WILLETT, Mrs. fl.1849-1850
Exhib. two watercolour flower pieces and a painting of fruit at SS. London address.

WILLETT, Arthur fl.1883-1892
Brighton landscape painter, who exhib. 1883-92, at the RA 1883-8, SS, NWS and elsewhere, titles at the RA including 'Sheltered Corner in March', 1883, 'Mill Stream, Arundel, Sussex, Early Spring', 1885 and 'A Bright Day in the Forest, Late Autumn', 1888.

WILLEY, Miss H. fl.1874
Exhib. a watercolour of 'Spring Flowers' at SS. Address in Bristol.

WILLIAMS, Hon. Capt. fl.1840
Exhib. 'Head of a Spanish Girl' at the RA.

WILLIAMS, Miss fl.1869-1874
Exhib. a watercolour of spring flowers at SS. Address in Bristol.

WILLIAMS, Mrs. fl.1871-1872
Exhib. two landscapes, one in Sheen, Surrey, one in North Wales, at SS. London address.

WILLIAMS, Miss A. Florence fl.1877-1904
Painted landscape and rural subjects. Exhib. five works at the RA including 'A Type of Spring' and 'Golden Sheaves', and six works at SS including 'Wimbledon Common in 1850' and 'The Way to the Old Mill'. London address.

WILLIAMS, A. Sheldon fl.1867-1881
Painted landscape and animals. Exhib. four works at the RA including 'The Startled Squirrel' and 'Troop Horses Returning from Watering', and six works at SS including 'Dartmoor Ponies' and 'Gone Away'. Address in Winchfield, Hampshire.

WILLIAMS, Albert fl.1882-1886
Painted landscape. Exhib. four works at SS including 'A Quiet Spot' and 'Autumn Evening'. London address.

WILLIAMS, Alexander RHA 1846-1930
Irishman who painted landscape and marines. Studied at the Art Schools of the Royal Dublin Society. Exhib. in Ireland, London and abroad. Contributed 48 illustrations to *Beautiful Ireland* by Stephen Gwynk. Born in County Monaghan. Lived in Dublin and on Achill Island, County Mayo.
Bibl: Who's Who 1924; Who's Who in Art 1934; Studio XXV 1902 p.212.

WILLIAMS, Alfred 1832-1905
Landscape painter and traveller. Pupil of W. Bennett (q.v.). Exhib. four works at the RA including 'In the Alps' and 'Glencoe Crags'. Address in Salisbury, Wiltshire.
Bibl: DNB.
Exhib: Alpine Club 1902.

WILLIAMS, Mrs. Alfred see WILLIAMS, Alfred Walter

WILLIAMS, Alfred M. fl.1881-1882
Exhib. 'Discussing the Future' at SS. London address.

***WILLIAMS, Alfred Walter 1824-1905**
Landscape painter. Son of Edward Williams (q.v.). Exhib. at RA 1843-90, BI, SS, NWS and elsewhere. Titles at RA include views on the Thames, in Wales, Scotland and Italy. He painted in a style similar to that of his brother Sidney Richard Percy (q.v.), using the same rather hard colours and metallic finish. His wife Florence Elizabeth, née Thomas, was a painter of fruit and still-life; she exhib. 1852-64 at RA, BI and SS.
Bibl: T.M. Rees, *Welsh Painters*, 1912; Pavière, Landscape; J. Reynolds, *The Williams Family of Painters*, 1975.

WILLIAMS, Miss Annie fl.1890-1904
Painted portraits. Exhib. 16 works at the RA, 1890-1904, all portraits and possibly miniatures. London address.

WILLIAMS, Arthur Gilbert see GILBERT, Arthur

WILLIAMS, Benjamin see LEADER, Benjamin Williams

WILLIAMS, C.F. fl.1827-1841
Painted landscape. Exhib. 17 works mostly watercolours, at SS including views in Devonshire and at Southampton, and three landscapes at the BI. London address.

WILLIAMS, Lieut. C.P. fl.1864-1873
Painted shipping and marines. Exhib. six works, some of them watercolours, at SS, including 'A Ship Drifting Ashore off the Mumbles', and 'Vessels Coming up the Thames'. London address.
Bibl: Brook-Hart.

WILLIAMS, C.R. fl.1851
Exhib. a 'View in the Dudley Caverns' at the BI. Address in Birmingham.

WILLIAMS, Miss Caroline Fanny 1836-1921
Landscape painter; lived in Barnes, London. Exhib. mostly at SS, also RA 1858-76, BI and elsewhere. RA titles mostly views on the Thames, also scenes in Wales. Daughter of George Augustus Williams (q.v.).
Bibl: J. Reynolds, *The Williams Family of Painters*, 1975.

WILLIAMS, Charles Frederick **fl.1841-1880**
Landscape painter. Worked in Exeter, Southampton and London. Exhib. at RA 1845-79, SS and elsewhere. Titles at RA 'View on the Bovey', 'Fishing Boats at Beer', 'Rival Mountains from Carnarvon Bay', etc.
Bibl: Brook-Hart.

WILLIAMS, Christopher David **1873-1934**
Painted portraits, figurative subjects and landscapes. Studied at the RCA and at the RA Schools. Painted in Italy, France, Switzerland, Belgium, Holland, Spain and Morocco. Born in Wales. Lived in London.
Bibl: Who Was Who 1929-40; T.M. Rees, *Welsh Painters*, 1912; Connoisseur XLVIII 1917 p.56; Apollo XXI 1935 p.306.

WILLIAMS, Miss E. Edgington- **fl.1890**
Exhib. 'Fruiterer in Shepherd's Bush Green' at the RA. London address.

WILLIAMS, E.H. **fl.1876-1878**
Exhib. a view of a house in Maine and a view of Llandaff Cathedral at the RA. London address.

WILLIAMS, Edward **1782-1855**
Landscape painter. Father of the Williams Family of painters; his sons were Alfred Walter Williams, Arthur Gilbert, Edward Charles Williams, George Augustus Williams, Henry John Boddington and Sidney Richard Percy (all q.v.). Studied under James Ward (q.v.), his uncle. Exhib. at RA 1814-55, BI, SS and elsewhere. Titles at the RA mostly views along the Thames, and moonlight scenes. Works by him are in Leeds AG and the VAM.
Bibl: AJ 1855 p.244 (obit.); Connoisseur LXVII 1923 pp.41, 56; Redgrave, Dict; T.M. Rees, *Welsh Painters*, 1912; Pavière, Landscape p.139; *The Williams Family of Painters*, exhib. at N.R. Omell Gallery, London, April 1971; J. Reynolds, *The Williams Family of Painters*, 1975

***WILLIAMS, Edward Charles** **1807-1881**
Landscape painter. Son of Edward Williams (q.v.). Exhib. at RA 1840-64, BI, SS and elsewhere. Like his father, he painted mainly views along the Thames; also coastal scenes. Sometimes collaborated with William Shayer (q.v.) on large village or gipsy scenes.
Bibl: Pavière, Landscape pl.89; *The Williams Family of Painters*, exhib. at N.R. Omell Gallery, London, April 1971; Brook-Hart; J. Reynolds, *The Williams Family of Painters*, 1975.

WILLIAMS, Edwin **fl.1843-1875**
Cheltenham portrait painter. Exhib. at RA 1843-75, BI, SS and RBSA. Painted many official and presentation portraits. A portrait of General Napier is in the NPG.
Bibl: Ormond.

WILLIAMS, Mrs. Emily **fl.1869-1890**
Painted figurative subjects. Exhib. five works at the RA including 'Pigmies' and 'Broadway Courtyard in Autumn Sunshine'. Also exhib. nine works at the GG and four works at the NG. London address.

WILLIAMS, Miss Ethel Haynes- **fl.1886-1893**
Exhib. 'Tommy's Birthday Treat' at the RA. London address.

WILLIAMS, F. **fl.1850**
Exhib. two works, 'Augustus finds Cleopatra Newly Dead' and 'Friar Lawrence', at the RA. London address.

WILLIAMS, F.P. **fl.1851**
Exhib. a view at Brookland Park, Hampshire, at SS. London address.

WILLIAMS, Frances H. **fl.1870-1901**
Genre painter. Exhib. mostly at SS, also RA 1884-1901 and elsewhere. Titles at RA 'The Little Mother', 'A Bit of Old Brentford', 'In the Chelsea Pensioners' Garden', etc.

WILLIAMS, Frank W. **fl.1835-1874**
London genre painter. Exhib. at RA 1835-61, BI, SS and elsewhere. Titles at RA mostly historical or literary genre, taken from Shakespeare, Gray, Dickens and others.

WILLIAMS, G.B. **fl.1851**
Exhib. a landscape in 1851.

***WILLIAMS, George Augustus** **1814-1901**
Landscape painter. Son of Edward Williams (q.v.). Exhib. mainly at SS (140 works), also RA 1841-85, BI and elsewhere. A prolific and versatile artist, he painted Thames views, moonlight scenes, coastal subjects and landscapes in Kent, Wales and elsewhere.
Bibl: Pavière, Landscape pl.90; Brook-Hart; J. Reynolds, *The Williams Family of Painters*, 1975.

WILLIAMS, Gertrude M. **fl.1880**
Exhib. a work entitled 'Three Hundred Years Ago' at SS. London address.

WILLIAMS, H. **fl.1856**
Exhib. a view in Westminster Abbey at the RA. London address.

WILLIAMS, H.J. **fl.1828-1877**
Painted landscape. Exhib. 13 works at SS including 'Passing Shower — On Hayes Common' and 'Tintagel Cove — Cornwall', and four landscapes at the RA. London address.

WILLIAMS, H.L. **fl.1892**
Exhib. a work entitled 'All Hot!' at SS. Address in Croydon, Surrey.

WILLIAMS, H.P. **fl.1841-1857**
London landscape painter. Exhib. at RA 1841-57, BI and SS. Titles at RA include views on the Thames, in the South of England, Wales and France.

WILLIAMS, Harry **fl.1854-1877**
Liverpool landscape painter. Painted landscapes and coastal scenes around Liverpool and North Wales. Came to London, where he died in poverty. Exhib. at RA twice, BI, SS and elsewhere.
Bibl: Marillier pp.230-1; Brook-Hart pl.148.

WILLIAMS, Henry **1807-1886**
Painted landscape. Exhib. seven works at the RA including views on the Thames and in the New Forest, and 17 works, including a number of river scenes, at SS. London address.
Bibl: The Year's Art 1887 p.230.

WILLIAMS, Henry **fl.1874**
Exhib. two landscapes in 1874. Address in Penzance, Cornwall.

WILLIAMS, Hugh **fl.1898**
Exhib. 'The Wreath' at the RA. London address.

WILLIAMS, Ida **fl.1876-1880**
Exhib. two figurative subjects 1876-80. Address in Manchester.

WILLIAMS, J. fl.1831-1876
London landscape painter. Exhib. at SS (71 works), also RA and BI. Graves Dictionary lists four other artists called J. Williams, but only three are in Graves RA Exhibitors.

WILLIAMS, J.G. fl.1824-1858
Painted portraits. Exhib. five works at the RA, all portraits, and three works, including a watercolour of children, at SS. London address.

WILLIAMS, J.J. fl.1840
Exhib. a portrait at the RA. London address.

WILLIAMS, J.M. fl.1834-1849
Architectural and still-life painter. Exhib. at RA 1836-49, BI, SS and NWS. Titles at RA still-life, interiors of old buildings and ruins.

WILLIAMS, Mrs. J.S. fl.1881
Exhib. a river landscape at the GG. Address in Glasgow.

WILLIAMS, James Francis RSA 1785-1846
Painted landscape. Exhib. five works at the RA including views of Loch Tay and Rosythe and Dunolly Castles, also exhib. five works, including three Scottish landscapes at the BI, and six landscapes at SS. The great part of his work is pre-Victorian. Address in Edinburgh.
Bibl: Redgrave, Dict; Bryan.

WILLIAMS, James Leonard fl.1897-1898
Exhib. a view of a house at Lingfield, Surrey, and an 'Interior of a Mausoleum' at the RA. London address.

WILLIAMS, James T. fl.1828-1840
Landscape painter. Exhib. 12 works at the RA including 'Westminster Abbey from the Thames', 'Gillingham Fort at Chatham' and 'Mountain Scenery — County Wicklow'. London address.

WILLIAMS, John Edgar fl.1846-1883
London portrait and genre painter. Exhib. at RA 1846-83, BI and SS. Painted mostly official and presentation portraits; also painted several portraits of members of the RA. A work by him is in the Museum of Nottingham.
Bibl: BM Cat. of Engraved British Portraits VI 1925 p.564; Poole III 1925 p.298; Ormond.

WILLIAMS, John Haynes 1836-1908
Genre painter. Studied in Worcester and Birmingham. Came to London 1861. Exhib. at RA 1863-97, BI, SS, NWS, GG, NG and elsewhere. Painted genre scenes, often of a humorous nature, and Spanish subjects. Works by him are in the Tate Gallery and the VAM.
Bibl: AJ 1894 pp.289-93; 1909 p.31 (obit.); RA Pictures 1891-7.

WILLIAMS, John Henry fl.1852-1866
Exhib. a coastal landscape at the BI. Address in Liverpool.

WILLIAMS, Joseph Lionel fl.1834-1874 d.1877
Genre painter and engraver. Son and pupil of Samuel Williams (1788-1853). Exhib. mostly at SS, also RA 1836-74, BI and elsewhere. Titles at RA 'Market Day in the Olden Time', 'A Bit of Gossip', 'Ballad Singers', etc., and historical scenes from Shakespeare, etc. As an engraver he illustrated Milton, Byron, Goldsmith and other books, and worked for the *Art Journal* and *The Illustrated London News*. A work by him is in Sheffield AG.
Bibl: AJ 1877 p.368 (obit.); Bryan.

WILLIAMS, K.E. fl.1890
Exhib. a genre subject at the NWS. London address.

WILLIAMS, L.L. fl.1884
Exhib. 'A Seaside Pasture' at SS. Address in Paris.

WILLIAMS, Miss Lily ARHA 1874-1940
Irish painter who studied at the RHA Schools. Lived in Dublin.

WILLIAMS, Miss M. Josephine fl.1892
Exhib. 'Standard-Bearer' at SS. London address.

WILLIAMS, Miss Nina Haynes fl.1888
Exhib. a fruit piece at the NWS. London address.

***WILLIAMS, Penry 1798-1885**
Painter of Italian genre. Born in Merthyr Tydfil, Wales. Pupil of RA Schools. After 1827 he lived mainly in Rome. Exhib. at RA 1822-69, BI, SS and OWS. Painted Italian landscapes, and scenes of Italian life. His most characteristic type of picture is the view in the Campagna, with peasants in the foreground, and a distant view of Rome beyond. He also painted portraits, including one of his friend John Gibson, RA. His studio sale was held at Christie's, 21 June 1886.
Bibl: AJ 1864 p.101ff.; Connoisseur LVI 1920 p.126; LXXVII 1927 p.59; C. Eastlake, *Life of John Gibson*, 1870 p.241ff.; DNB; T.M. Rees, *Welsh Painters*, 1912 pp.153-7; Ormond.

WILLIAMS, Pownoll Toker fl.1872-1897
London genre and landscape painter. Exhib. at RA 1880-97, SS, NWS, GG and elsewhere. Titles at RA 'A Dying Rose', 'A Corner of a Market Garden' and several Italian genre scenes. An exhib. of his work was held at MacLean's Gallery in the 1880s.

WILLIAMS, R.P. fl.1854-1867
Painted portraits. Exhib. five works at the RA including a portrait of the Governor of Antigua. London address.

WILLIAMS, Richard A. fl.1878-1891
Exhib. a view on Hampstead Heath at the RA and four works, including 'Waifs of the Sea' and 'Near Scalby, Scarborough', at SS. London address.

WILLIAMS, S. fl.1834-1844
Exhib. two landscapes, views in Kent and Connemara, at the RA. London address.

WILLIAMS, Samuel fl.1825-1845
Painted figurative subjects and landscapes. Exhib. ten works at the BI including 'Don Quixote Giving Advice to Sancho', 'Sketching a Countryman' and 'The Village Genius', and one work at the RA. London address.

WILLIAMS, Mrs. Sydney fl.1871
Exhib. a flower piece in 1871. London address.

WILLIAMS, Terrick John RA PRI ROI 1860-1937
Painter of shipping and coastal scenes. Studied in Antwerp and Paris. Exhib. at RA from 1888, SS and elsewhere. Painted bright and colourful harbour and coastal scenes in England, France,

Holland and the Mediterranean. ARA 1924, RA 1933.

Bibl: Studio XC 1925 pp.110-15; Special Number 1919, *British Marine Painting*, pp.34, 132; Apollo XI 1930 p.341; Who's Who in Art 1934; Brook-Hart.

WILLIAMS, Thomas fl.1831-1850

Painted figures and animals. Exhib. three works at the BI, two works at the RA, and two portraits at SS. London address.

WILLIAMS, W.R. fl.1854-1855

Exhib. two architectural subjects at the RA.

WILLIAMS, Walter 1835-1906

Landscape painter. Exhib. mainly at SS, also RA 1854-80 and BI. Titles at RA all views in Wales. Son of George Augustus Williams (q.v.).

Bibl: J. Reynolds, *The Williams Family of Painters*, 1975.

WILLIAMS, Walter fl.1841-1876

Landscape painter. Lived in Bath, Topsham and Torquay. Exhib. at RA 1845-67, BI and SS. Painted landscapes, river and coastal scenes in the West Country, especially Devon and Cornwall.

Bibl: Pavière, Landscape pl.91; Brook-Hart pl.110.

WILLIAMS, Warren ARCA 1863-1941

Painted landscape. Studied at the Liverpool School of Art. Illustrated various works including *Historic Warwick*. Lived at Conway.

Bibl: Who's Who 1938.

WILLIAMS, William Charles fl.1891

Exhib. a painting of chrysanthemums at SS. London address.

WILLIAMS, William Oliver fl.1851-1863

Painted portraits and landscape. Exhib. six works at the RA including portraits and works entitled 'Love Knows No Sleep' and 'A Glimpse into the Future', and two works at the BI. Address in Birmingham.

WILLIAMSHURST, J.H. fl.1876

Exhib. 'The Rustic Cottage on the Road to Leith Hill' at SS. London address.

WILLIAMS-LYOUNS, Herbert Francis b.1863

Painted landscapes and marines. Exhib. in London and Paris. Born at Plymouth, Devon. Lived for a time in Boston, Massachusetts. Lived later in Kingsbridge, Devon.

Bibl: Who's Who in Art 1934; Art News XXIII 1924-5.

***WILLIAMSON, Daniel Alexander 1823-1903**

Liverpool landscape and genre painter. Son of Daniel Williamson (1783-1843) also a painter, and nephew of Samuel Williamson (1792-1840). Left Liverpool for London c.1847, but continued to send pictures to Liverpool exhibs. Like his friend W.L. Windus (q.v.) he was much influenced by the Pre-Raphaelites. About 1860 he returned to Lancashire and settled near Carnforth. Here he painted a number of Pre-Raphaelite landscapes, remarkable for their pure colours and minute fidelity to nature. Later he broadened his style and turned mainly to watercolours, firstly in the idiom of David Cox, later of Turner. Between 1849 and 1871 he exhib. occasionally at the RA, SS and elsewhere. A large number of his works were in the collection of James Smith of Blundell Sands, who left them to the Walker AG, Liverpool.

Bibl: AJ 1904 p.82ff.; Yorkshire Post (Leeds) 14 September 1912; Bryan; Marillier pp.234-40 (pl. p.238); Maas p.237 (with pl.); *The Taste of Yesterday*, exhib. at Walker AG, Liverpool, 1970 no.64.

WILLIAMSON, Frederick fl.1856-1900

Landscape painter. Exhib. at RA 1864-1900, BI, SS, NWS, GG and elsewhere. Specialised in the painting of English landscapes with sheep. In his early period he used Pre-Raphaelite techniques, painting in great detail on panel. A watercolour by him is in the VAM.

WILLIAMSON, H.H. fl.1866-1876

Exhib. 'After a Gale — Off Dunstanborough' at the RA, and two coastal subjects at the BI. London address. This may be the same as W.H. Williamson (q.v.).

Bibl: Brook-Hart.

WILLIAMSON, J.B. fl.1868-1871

Exhib. 'Low Tide at Ramsgate' at the RA. London address. Was Headmaster of Taunton School of Art, and then taught at the Gower School of Art.

Bibl: Ormond.

WILLIAMSON, J.T. fl.1876

Exhib. two marines in 1876. London address.

WILLIAMSON, John fl.1891-1895

Painted portraits and figurative subjects. Exhib. four works at the RA including 'A Poorhouse Incident' and portraits, and 'Waiting for Daddy' at SS. London address.

WILLIAMSON, John Smith fl.1866-1880

London painter of coastal scenes. Exhib. at RA 1866-73, SS and elsewhere. Titles at RA 'Filey Beach', 'Drying Sails — Hastings', 'A Drawn Battle', etc.

Bibl: Wilson; Brook-Hart.

WILLIAMSON, Miss Leila K. fl.1894

Exhib. 'Polly: A portrait' at the RA. London address.

WILLIAMSON, W. fl.1852-1862

Exhib. 'A Squally Day on the Dutch Coast' at the RA. London address.

WILLIAMSON, W.H. fl.1853-1875

London painter of coastal scenes. Exhib. at SS, also RA 1853-75 and BI. Titles at RA 'On the Coast of Kent', 'Stormy Weather, Coast of Holland', etc.

Bibl: Wilson; Brook-Hart pl.90.

WILLIAMSON, W.M. fl.1868-1873

Painted figurative and rustic subjects. Exhib. six works at the RA including 'A Farmyard', 'Taking a Nap' and portraits, and three watercolours at SS. London address.

WILLINK, H.G. fl.1877-1888

Exhib. two landscapes at the NWS. London address.

WILLIS, Edmund R. fl.1847-1851

Painted landscapes with cattle. Exhib. four works at the RA including 'Landscape with Cattle' and 'Cows on a Heath', four landscapes, all including cattle, at the BI, and four landscapes at SS. London address.

WILLIS, Miss Ethel Mary ARMS b.1874

Painted portraits, landscape and flowers. Studied at the RCA, at the Slade School and in Paris. Born and lived in London.

WILLIS, Frank ARE 1865-1932
Engraver and etcher of landscapes and other subjects. Exhib. two works, a portrait and a work entitled 'Posting in North Hungary', as well as two copies, at the RA. Address in Eton, Berkshire.

WILLIS, George William fl.1845-1869
Painted rustic subjects. Exhib. nine works at SS including 'The Shepherd's Home', 'The Favourites' and 'The Minnow Stream', and 'Village Sculptors' at the RA. London address.

***WILLIS, Henry Brittan RWS 1810-1884**
Painter of cattle and landscapes, and lithographer. Born in Bristol, the son of a drawing master, under whom he studied. In 1842 he went to America, but returned in 1843 and settled in London. Exhib. 1844-83 at the RA 1844-61, BI, SS and elsewhere, but chiefly at the OWS (366 works), of which he became A in 1862 and Member in 1863. He painted various picturesque localities in Great Britain, introducing finely composed groups of cattle. His 'Highland Cattle', 1866 was bought by Queen Victoria, and his 'Ben Cruachan Cattle Coming South' was at the Paris Exhibition of 1867. Four of his paintings were engraved in the *Art Union Annual*, 1847. The VAM has several watercolour landscapes, e.g. 'Landscape with a Tidal River, Cows in the Foreground', and also drawings of animals. His paintings are also in Bristol, Leicester, Birmingham and York AGs. His studio sale was held at Christie's, 16 May 1884.
Bibl: AJ 1879 pp.93-6 (3 pls.); Universal Cat. of Books on Art, South Kensington II 1870; Roget; Bryan; Cundall; DNB; BM Cat. of Engraved British Portraits VI 1925 p.715; VAM; Hardie III p.57.

WILLIS, Mrs. Henry Brittan fl.1855
Exhib. a 'Scene near Hastings, Sussex' at the RA. London address.

WILLIS, J. Cole fl.1866-1867
Exhib. three works at the BI, including 'Happiness' and 'A Quiet State of Things', and one work at SS. London address.

WILLIS, John fl.1828-1852
Painted views of architecture. Exhib. six works at the RA including views of Malmesbury Abbey, Lincoln Cathedral and Tewkesbury Abbey, and four works at SS. London address.

WILLIS, Miss Katharina fl.1893-1898
Painted portraits. Exhib. five works at the RA, all of them portraits or portrait studies. London address.

WILLIS, Richard Henry Albert 1853-1905
Landscape painter, sculptor and teacher, born in Cork. Studied in Cork and at South Kensington. Headmaster of Manchester School of Art 1882-92. Exhib. at RA 1882-99. In 1904 appointed Head of Dublin Metropolitan School of Art. Also produced enamels, woodcarvings and stained glass.

WILLIS, W. fl.1845-1857
Exhib. two works at the RA, including 'Time is Precious; Smuggling on the South Coast of Ireland'. London address.

WILLOTT, S. fl.1872-1874
Painted landscape. Exhib. six works at SS including five landscape views in Buckinghamshire. London address.

WILLS, Edgar W. fl.1874-1893
Painter of genre and landscape, who exhib. 1874-93, at the RA 1877-93, SS, GG, NG and elsewhere, titles at the RA including 'A By-road in Autumn', 1877, 'Kine on the Moor', 1888 and 'Spring Blossoms and Flowers', 1892.

WILLS, F. fl.1842-1845
Exhib. two architectural designs and a view of a monument at the RA. Address in Exeter, Devon.

WILLS, Thomas Alexander Dodd 1873-1932
Painted landscape in watercolours. Studied at Liverpool School of Art. Born in London. Lived at Wallasey, Cheshire.

WILLS, William Gorman 1828-1891
Painted portraits and theatrical subjects. Exhib. a portrait and 'Ophelia and Laertes' at the RA. Born in Kilkenny, Ireland. Died in London.
Bibl: Strickland; AJ 1906 p.63.

WILLSHAW, J. fl.1864-1866
Painted fruit. Exhib. four works at the BI including 'Peach and Grapes' and 'A Bit from the Old Apple Tree'. Address in Newcastle-under-Lyme, Staffordshire.

WILLSON, Miss E. Dorothy fl.1900
Exhib. 'A Dewy Morning' at the RA. Address in Leeds, Yorkshire.

WILLSON, Harry fl.1813-1852
Painter of architectural subjects and landscapes; lithographer. Exhib. 1813-52, at the RA, BI, SS and NWS, titles at the RA including 'On the Scheldt', 1827, 'View under the North Entrance of the Cathedral of Chartres', 1835 and 'St. Mark's, Venice', 1852. He published *Fugitive Sketches in Rome and Venice*, 1838, *The Use of a Box of Colours*, 1842, and *A Practical Treatise on Composition*, 1851. A letter to the *Connoisseur* asking for information about Wilson mentions two of his circular views of Venice noting that they are "like strong Guardis but lack the little flecks of white paint; but the drawing is fine and colour brilliant".
Bibl: Universal Cat. of Books on Art, South Kensington II 1870; Connoisseur LXIII 1922 p.162.

WILLSON, John J. 1836-1903
Exhib. two sporting subjects in 1880. Address in Leeds, Yorkshire.

WILLSON, Miss Margaret fl.1888-1902
Exhib. two paintings of flowers, a portrait and a landscape, at the RA. Address in Leeds, Yorkshire.

WILLYAMS, Humphry J. fl.1886-1887
Exhib. two marines at the NWS. London address.

WILMOT, Miss Florence N. Freeman fl.1883-1909
Exhib. three works; two portraits and a view of Newlyn Harbour, at the RA. Address in Gloucestershire. Also lived in Birmingham, and exhib. at RBSA 1883-1909.
Bibl: Who's Who in Art 1934.

WILMSHURST, George C. fl.1897-1900
Exhib. three portraits at the RA. London address.

WILMSHURST, T. fl.1848-1850
Exhib. a portrait study at the RA, and two at RBSA 1850. Lived in London and Birmingham.

WILSON, A. Needham fl.1886-1904
Painted views of architecture. Exhib. ten works at the RA including views of Ely Cathedral and Malmesbury Abbey. Address in Snaresbrook, Essex.

WILSON, Alexander 1819-1890
Landscape painter, textile designer and teacher. Painted in Ayrshire and Renfrewshire.

WILSON, Miss Alice C. fl.1893
Exhib. a painting of poppies at the RA and another work at the NWS. Address in Weybridge, Surrey.

WILSON, Miss Alice M. fl.1873-1876
Painted figurative subjects. Exhib. seven works at SS including 'At the Pier Head', 'A Rest by the Wayside' and 'He Loves Me, He Loves Me Not!' London address.

WILSON, Annie fl.1878
Exhib. two landscapes in 1878. Address in Eastbourne, Sussex.

WILSON, Miss Annie Heath fl.1885-1889
Exhib. two views in Venice at SS. London address.

WILSON, Arthur fl.1873-1878
Exhib. a view of Westminster Abbey at the RA. London address.

WILSON, Miss Catherine A. fl.1856-1857
Exhib. three watercolour flower pieces and one game subject at SS. London address.

WILSON, Charles fl.1832-1855
Painted landscape. Exhib. five works at the RA including 'Near Festiniog' and 'Jacob's Vow', and four works at the BI. London address.

***WILSON, Charles Edward fl.1891-c.1936**
Painted rustic genre subjects in watercolour. Exhib. 17 works at the RA including 'The Light of the Cottage', 'Gathering Blackberries' and 'The Farmer's Daughter', and 13 works at the NWS. Studied at Sheffield School of Art. Born at Whitwell, Nottinghamshire. Lived at Addiscombe, Surrey.
Bibl: Who's Who in Art 1934; Wood, Paradise Lost.

WILSON, Charles Heath 1809-1882
Landscape painter and illustrator. Son of Andrew Wilson (1780-1848), also a landscape painter who settled in Italy in 1826. Returned to Edinburgh in 1833. ARSA 1843, but resigned 1858. Master of the Trustees' Academy 1843-8, then Master of the Glasgow School of Design. Settled in Florence 1869.

WILSON, Chester fl.1846-1855
London genre and portrait painter, who exhib. 1846-55, at the RA 1846-53, BI and SS, titles at the RA including 'The Penitent', 1846, 'An Indian', 1850, and 'Venus Reclining', 1851

WILSON, D.R. fl.1884-1886
Exhib. two works, 'Playfellows' and 'On the Blyth', at SS. London address.

WILSON, David Forrester RSA 1873-1950
Painter of portraits and decorative schemes. Painted decorative panels in the Banqueting Hall of the Glasgow Municipal Buildings. Born and lived in Glasgow.
Bibl: Who Was Who 1941.

WILSON, E. fl.1848
Exhib two German landscapes at the RA. London address.

WILSON, E.J. fl.1864
Exhib. a watercolour view at Hendon at SS. London address.

WILSON, Miss E. Margaret fl.1901
Exhib. a still-life at the RA. Address in Oxford.

WILSON, Edgar W. fl.1886-1890
Exhib. two works at the RA, 'John Bunyan's Mission House' and 'For the Good of Her Health', and one work at the NWS. London address.

WILSON, Ernest fl.1885-1889
Painted landscape. Exhib. seven works at the RA including 'Marshes, Epping Forest' and 'Lengthening Shadows', and four works at the NWS. Address in Snaresbrook.

WILSON, F. fl.1879
Exhib. a landscape in 1879. London address.

WILSON, F.R. fl.1844-1848
Exhib. an architectural view and two designs at the RA. London address.

WILSON, F.S. fl.1892-1893
Exhib. 'Ebb Tide, Polperro' at SS. London address.

WILSON, Miss Florence E. fl.1882-1890
Exhib. two works, paintings of grapes and chrysanthemums, at the RA, and three works at SS. London address.

WILSON, George 1848-1890
Scottish landscape and figure painter. Studied in London. Exhib. two works at the RA, including 'The Quest from Shelley's *Alastor*', and two works at the NWS. London address, but visited Scotland every year. Also travelled in Italy and North Africa.
Bibl: Bate; Bryan; Caw; AJ 1903 p.350; Studio XXX 1904 pp.139-43.

WILSON, H. fl.1843
Exhib. a 'Sketch of a Young Lady' at the RA. London address.

WILSON, H.H. fl.1877
Exhib. 'On the West Lyn' at SS. London address.

WILSON, Harry fl.1888-1899
Painted views of architecture. Exhib. 27 works at the RA including views of Canterbury and Beauvais cathedrals and Welbeck Abbey, and designs fo churches and church furnishings. London address.

WILSON, Harry M. fl.1901-1904
Landscape painter. Exhib. three works at the RA including 'Twilight over the River' and 'A Sunny Hillside'. London address.

WILSON, Harry P. fl.1895
Exhib. 'An Old Salt' at the RA. London address.

WILSON, Miss Helena fl.1857-1861
Flower painter. Exhib. six works at SS including watercolour of cactus and primroses, and a work entitled 'Life and Death'. London address.

WILSON, Herbert fl.1858-1880
London portrait painter, who exhib. 1858-80, at the RA 1864, 1874 and 1876, and BI, SS and GG.

WILSON, J. fl.1855
Exhib. 'The Falls of the Clyde' at the RA. Address in Glasgow.

WILSON, J. Harrington fl.1886
Exhib. a genre subject in 1886. London address.

WILSON, J.T.
There are two painters of this name listed in Graves Dictionary: (1) Painter of portraits and landscape, who exhib. 1833-53 at the RA; (2): Painter of landscapes and genre, who exhib. 1856-82 at the RA, BI, SS and elsewhere. Graves RA Exhibitors joins both these into one, who exhib. 1833-66 and lived in London and Witley and Thursley, near Godalming, titles at the RA including 'Hop Garden, near Tunbridge Wells', 1853, 'The Gardener's Pet', 1860, and 'Where the Stream Runs across the Road'. 1864. The Witley address first occurs in 1861. The VAM has 'Stream and Cottage, Thursley, Surrey', 1863, and the Bethnal Green Museum contains six watercolours by, and one attributed to J.T. Wilson, representing views in that neighbourhood.
Bibl: VAM.

WILSON, James Watney fl.1871-1884
Painted figurative and genre subjects. Exhib. 13 works at SS, including 'The Gardener's Story', 'Forbidden to Accept' and 'A Souvenir of Rembrandt', and three works at the RA, including two portraits. London address.

WILSON, John (Jock) H. RSA 1774-1855
Scottish marine and landscape painter, known as Jock Wilson. Pupil of John Norie and Alexander Nasmyth (q.v.). Moved to London 1795; worked as a scene painter. Exhib. mostly at SS (301 works), also BI and RA 1807-55. Lived in Folkestone and painted coastal and river scenes there, and in France and Holland. Caw writes that "in spite of obvious defects his art remains a vigorous and vital performance". His son John James Wilson (q.v.) was also a painter, and their work is often confused.
Bibl: AJ 1855 pp.192, 204 (obit.); 1875 p.108 (obit.); Portfolio 1887 p71; Studio Special Number 1919, *British Marine Painting*, pp.25, 38; T. Smith, *Recollections of the British Institution*, 1860 p.88; DNB; Bryan; Caw; Wilson p.87 (pl.47); Brook-Hart pl.126.

WILSON, John James 1818-1875
Landscape and marine painter; son of John Wilson (q.v.). Studied under his father, and painted in a very similar style. Exhib. at SS (384 works), BI, and RA 1835-73. A work by him is in Sheffield AG.
Bibl: See under John H. Wilson; Brook-Hart pl.127.

WILSON, Joseph fl.1873-1874
Exhib. three portraits at the RA. London address.

WILSON, Miss Kate fl.1858-1861
Exhib. two watercolours, 'Cherry Blossom' and 'Primroses', at SS. London address.

WILSON, Miss M. fl.1875-1878
Painted marines. Exhib. three works at SS including 'Off Dover' and 'Folkestone Harbour'. Address in Folkestone, Kent.

WILSON, Margaret T. 1864-1912
Painted genre subjects. Represented in Glasgow AG.

WILSON, Miss Maria G. fl.1888
Exhib. a flower piece at SS. London address.

WILSON, Marie fl.1879
Exhib. a view of Tantallon Castle at SS. London address.

WILSON, Oscar 1867-1930
Blackheath genre painter, who exhib. 1886-93, at the RA 1888-9, SS, NWS and elsewhere, titles at the RA including 'Reading the Koran', 1889.

WILSON, P. Macgregor RSW fl.1890-d.1928
Painted portraits, genre and landscapes. Exhib. 'A Summer Day' at the RA. Travelled in North America, Europe and Asia. President of Glasgow Art Club. Born in Glasgow.
Bibl: Who Was Who 1929-40.

WILSON, Patten b.1868 fl.1893-1900
Painted and illustrated literary subjects. Exhib. illustrations to Chaucer's *The Canterbury Tales* at the RA, as well as a number of architectural designs. London address.
Bibl: Sketchley, *English Book Illustration*, 1903; Studio XXIII 1910 pp.186-96.

WILSON, Rosa fl.1853
Exhib. 'A Study' at the RA. London address.

WILSON, S.H. fl.1870
Exhib. 'H.M.S. Monarch and the United States Plymouth' at the RA. London address.
Bibl: Brook-Hart.

WILSON, Stanley fl.1878-1883
Exhib. a still-life at SS. London address.

WILSON, T.F. fl.1852-1854
Exhib. two works, 'A Sleeping Nymph' and 'A Day Dream', at SS. London address.

WILSON, Thomas fl.1834-1849
Painted landscape. Exhib. ten landscapes at the BI, including 'Near Walthamstow' and 'Near West Grinstead'; five works at the RA, including 'At Sunning Hill, Berkshire' and 'In Sydenham Woods', and 13 landscapes at SS. London address.

WILSON, Thomas Harrington fl. 1842-1886
London painter of landscape, genre, portraits, literary and historical subjects. Exhib. 1842-86, at the RA 1842-56, BI and NWS, titles at the RA including 'Mendicant Boys Resting', 1842, 'Blackgang Chine, Isle of Wight', 1846, 'Wishart', 1849, and ' "Sandy", the Dog of the Sappers — a Crimean Hero', 1856.
Bibl BM Cat. of Engraved British Portraits VI 1925 pp.564, 715.

WILSON, Thomas Walter RI ROI 1851-1912
Painter of landscapes, marines and architectural subjects; illustrator. Exhib. 1870-1903, at the RA 1873-6, SS, NWS and elsewhere, titles at the RA including 'The Oldest House in Bayeux, Normandy', Is 'Canal au Hareng, Anvers', 1876, and 'Marche au Bois, Anvers', 1876. RI 1879-1903. One of his watercolours, 'Widowed and Fatherless', is in the National Gallery, Sydney (Cat. 1906). Also painted marine subjects and boat races. Worked as an illustrator for *The Graphic*.
Bibl: The Year's Art 1890 p.236; J. Pennell, *Die Mod. Illustr.*, 1895; Cundall p. 171; BM Cat. of Engraved British Portraits VI 1925 p.564; Wood, Panorama.

WILSON, W., Jnr. fl.1825-1852
Painted marines, shipping and coastal subjects. Exhib. eight works at the RA including 'A Lime Kiln on the Bristol Channel' and 'Cascade near South Brent, Devon', and ten works at SS including 'Calais Pier' and 'Etretat, Coast of Normandy'. London address.
Bibl: Brook-Hart.

WILSON, W. **fl.1871-1875**
Exhib. a portrait at the RA. London address.

WILSON, W. **fl.1885-1892**
Exhib. four works at the RA, including two views on the River Tay and 'Crossing the Bar'. Address in Dundee.
Bibl: Brook-Hart.

WILSON, W. Dower **fl.1872-1874**
Exhib. 'The Muse Erato' at the RA. London address.

WILSON, W.J. **fl.1853**
Exhib. a view of Calais Pier at the RA. London address.

WILSON, Mrs. W.R. **fl.1871-1875**
Exhib. three works at the RA including 'Hyacinths' and 'Portrait of a Lady'. Address in Wakefield, Yorkshire.

WILSON, William A. **fl.1834-1865**
Painter of landscape and architectural subjects, living in London and Woodford Green, Essex. Exhib. 1834-65, at the RA 1834-59, BI and SS, titles at the RA including 'On the Coast near Scheveningen', 1834, 'The Castle from the Market', 1850, and 'Abbeville', 1859.

WILSON, William Heath **1849-1927**
Painter of landscape and genre. Born in Glasgow. Son and pupil of Charles Heath Wilson (q.v.). Exhib. from 1883, at the RA from 1884, SS, GG and elsewhere, titles at the RA including 'Sunset from the Shore of Carrara', 1884, 'Time to Go Home', 1886 and 'Winter Evening, Boxhill', 1899. Headmaster of the Glasgow School of Art.
Bibl: Pavière, Landscape.

WILTON, A.A. **fl.1837**
Exhib. a landscape at the RA.

WILTON, Charles **fl.1837-1847**
Painter of portraits and genre, who exhib. 1837-47, at the RA 1837-46, and SS, titles at the RA including 'A Fancy Portrait', 1837, 'Savoyard', 1841 and 'The Sugar Hogshead', 1846.

WILTON, Kate **fl.1880-1884**
Birmingham flower painter who exhib. 1880-4.

WIMBUSH, Henry B. **fl.1881-1908**
Finchley landscape painter, who exhib. 1881-1904, at the RA 1888-1904, and elsewhere, titles at the RA including 'Fleeting Day', 1888, 'Petit Bo Bay, Guernsey', 1889 and 'Crosse Tête, Jersey', 1904.

WIMBUSH, John L. **fl.1873-1904**
Painted figurative subjects. Exhib. seven works at the RA including 'Lingering Clouds', 'A Saucy Girl' and 'Cupboard Love', and six works at SS. London address.

WIMBUSH, Miss Ruth **fl.1891**
Exhib. 'Students Day in the National Gallery' at the RA, and one work at the NWS. London address.

WIMPERIS, Miss A.J. **fl.1868-1875**
Landscape painter. Exhib. six watercolours at SS including 'A Welsh Cottage' and 'On the Dee'. Address in Chester.

WIMPERIS, Miss D. **fl.1893**
Exhib. a watercolour of 'A Hampshire Cottage' at SS. London address.

***WIMPERIS, Edmund Morison** **VPRI** **1835-1900**
Landscape painter and watercolourist. Born in Chester. Studied wood-engraving under Mason Jackson, and worked as an illustrator for *The Illustrated London News* and other magazines. Gradually he took up painting in oil and watercolour; exhib. from 1859 at RA, SS, NWS, GG, NG and elsewhere. Elected ARI 1873, RI 1875, VPRI 1895. At first his watercolours followed the minute, stippled technique of Birket Foster (q.v.), but later he broadened his style under the influence of Thomas Collier (q.v.), who was his frequent painting companion in the late 1870s and 1880s. Like Cox and Collier, he was fond of bleak and windswept moorland scenes: "He painted expansive landscapes with breadth and decision; he dealt tenderly with the form and movement of spacious skies, and boldly with fleeting shadows cast over broken ground" (Hardie).
Bibl: AJ 1901 p.63; 1909 p.156; Connoisseur LIX 1921 p.55; LX 1921 p.120; The Year's Art 1892 p.122; Mag. of Art 1901 p.173ff.; Cundall; DNB; VAM; E. Wimperis, *E.M.W.,* Walker's Quarterly IV 1921; Pavière, Landscape pl.92; Hardie III p.156-7 (pl.177)

WIMPERIS, Miss F.M. **fl.1875**
Exhib. a study of a child at SS. Address in Chester.

WIMPERIS, Miss S.W. **fl.1868-1871**
Painted flowers. Exhib. five watercolours at SS including 'Thrushes Nest with Japonica' and 'Christmas Roses with Holly'. Address in Chester.

WIMPERIS, Susan **fl.1867**
Exhib. a watercolour entitled 'Give Us This Day Our Daily Bread' at SS. London address.

WINBY, Frederic Charles **1875-1959**
Painter and etcher. Studied at the Slade School and at the Académie Julian. Born at Newport, Monmouthshlre. Lived in London. He was a member of the Langham Sketching Club.
Bibl: Who's Who in Art 1934.

WINCHESTER, G. **fl.1853-1866**
Landscape painter, living in Hastings and Margate, who exhib. 1853-66, at the RA l862 only, BI and SS. Title at the RA 'At Northdown, near Margate', 1862.

WINDASS, John **fl.1884-c.1920**
Painted coastal subjects. Exhib. four works at the RA including 'Receding Tide' and 'White Sands Bay, Sennen', and two works at SS. Address in York.
Bibl: Brook-Hart.

WINDER, J.T. **fl.1875**
Exhib. 'Larks' at the RA. Address in Preston, Lancashire.

WINDER, W.C. **fl.1885**
Exhib. a landscape in 1885. London address.

WINDSOR-FRY, Harry **fl.1884-1893**
Painted figurative subjects. Exhib. two works at the RA, and three works at SS, including 'Angel in the Garden of Lilies'. London address.
Bibl: Who's Who 1938.

***WINDUS, William Lindsay** **1822-1907**
Liverpool Pre-Raphaelite painter. Pupil of William Daniels (q.v.) and the Liverpool Academy. His early works were mostly historical genre, e.g. 'Morton before Claverhouse', 'The Interview of the Apostate Shaxton with Anne Askew in Prison', etc. These works

show considerable talent, particularly in the strong use of chiaroscuro, something he probably learnt from Daniels. Elected associate of the Liverpool Academy 1847, member 1848. In 1850 he visited London and saw Millais's 'Christ in the House of his Parents' and was converted to the Pre-Raphaelite cause. It was through his influence that the Pre-Raphaelites were persuaded to exhib. at the Liverpool Academy, where they were awarded the first prize at several annual shows. His own first Pre-Raphaelite picture was 'Burd Helen', exhib. at the RA in 1856. A slow and uncertain painter, his next important work was not finished until 1859. This was 'Too Late', exhib. at the RA in 1859. Unfortunately the picture was severely criticised by Ruskin, and Windus was so discouraged that he virtually gave up painting. During the next 40 years he painted only a few sketches and drawings, purely for his own amusement, and did not exhib. at all after 1859.

Bibl: AJ 1859 p.171; 1905 p.159; 1907 pp.360, 382; Mag. of Art XXIII 1900 pp.49-56; Ruskin, Academy Notes 1856, 1859; DNB; Bate; Marillier pp.241-54 (2 pls.); Ironside & Gere; Reynolds, VS pp.17, 23, 77 (pl.47); Mary Bennett, *W.W. and the PRB in Liverpool*, Liverpool Bulletin VII no. 3 pp.19-31; Fredeman Section 65 and index; Reynolds, VP pp.66-7 (pls.44-5); Maas pp.132-4; Wood, Panorama; Wood, Pre-Raphaelites.

WING, Adolphus H.A. fl.1848
Exhib. a self-portrait at the RA. London address.

WING, Eliza fl.1848
Exhib. 'Wild Spring Flowers' at the RA. London address.

WING, Mary Louisa fl.1871
Exhib. a watercolour study of flowers at SS. London address.

WING, W. fl.1844-1847
Exhib. two paintings of butterflies at the RA. London address.

WINGATE, Miss Anna M.B. fl.1899-1904
Exhib. two portraits and a work entitled 'A Wasted Vigil' at the RA. London address.

WINGATE, Sir James Lawton PRSA 1846-1924
Scottish landscape painter. Born in Glasgow. Painted in his spare time up to the age of 26, when he first began to study seriously. Exhib. mainly at RSA, also RA from 1880. Painted everyday scenes of country life in Scotland. Because of his lack of early training, his pictures lack good drawing and construction, and depend for their effect on "delicate play of brushwork and subtle modulation of tone and colour" (Caw). His work also reveals a considerable feeling for the poetry of Scottish landscape, especially in his sunsets and moonlight scenes. During the 1880s he worked at Muthill, near Crieff, where many of his best works were painted. Later he turned away from figure painting towards pure landscape. Elected ARSA 1879, RSA 1886, PRSA 1919.

Bibl: AJ 1896 pp.73-6 (with pls.); Studio LXVIII 1916 p.124ff.; also see indexes to Studio vols. XXVIII, XXXIV, XXXVII, XLIII, LXII, LXV, LXIX, LXXX; Connoisseur XXXVII 1913 p.55; LXIX 1924 p.181; Charles Holme, *The RSA, The Studio* 1907; Caw pp.318-21 (with pl.); Dayot, *La Peinture Anglaise*, 1908 pp.262, 282 (pl.); The Scots Pictorial 22 March 1913 p.547 (2 pls.); Irwin.

***WINGFIELD, James Digman fl.1832-d.1872**
Genre painter. Exhib. at RA 1835-72, BI (94 works), SS and elsewhere. Painted landscapes, rustic genre, historical scenes, interiors and garden scenes with figures in period costume. A work by him is in Nottingham AG.

Bibl: AJ 1859 pp.82, 167; Studio XXXII 1904 pp.280, 296; Redgrave, Dict.

WINGFIELD, The Hon. Lewis Strange RHA 1842-1891
Irish amateur painter of figurative subjects. Exhib. four works at the RA including 'Doomed' and 'By the Waters of Babylon We Sat Down and Wept'. The son of Viscount Powerscourt. He was born in Dublin and died in London.

Bibl: DNB; Strickland.

WINGROVE, Annette fl.1864
Exhib. a work at SS. London address.

WINKFELD, Frederic A. fl.1873-1920
Painter of landscapes and marines, working in Manchester and Fulham, who exhib. from 1873 at the RA, SS, NWS and elsewhere. Titles at the RA include 'The Shields', 1873, 'Misty Morning; Oyster Boats Getting under Weigh', 1877 and 'Mouth of the Conway River', 1904. *The Year's Art* lists him as still working in 1920.

Bibl: The Year's Art 1921 p.550; Wilson; Brook-Hart.

WINNEY, Harry fl.1881
Exhib. a view of a church in 1881. London address.

WINSER, T. fl.1870
Exhib. a watercolour view on the River Wharfe, Yorkshire, at SS. London address.

WINSOR, W. fl.1846
Exhib. 'The Point, Portland' at SS. London address.

WINSTON, Anne fl.1847
Exhib. 'Contemplation: A Study' at the RA. London address.

WINTER, Miss A. fl.1893
Exhib. 'Wallflowers' at SS. London address.

WINTER, Cornelius Jason Walter 1820-1891
East Anglian painter. Father of Holmes Edwin Cornelius Winter (q.v.).

WINTER, Holmes Edwin Cornelius 1851-1935
East Anglian painter. His work is often confused with that of his father Cornelius Jason Walter Winter (q.v.). Occasionally he adopted the pseudonym W. Rowland. Eventually overtaken by insanity.

WINTER, J. Greenwood fl.1891-1893
Exhib. a work entitled 'Ode to a Grecian Urn' at SS. London address.

WINTER, Richard Davidson fl.1890-1904
Exhib. two works, entitled 'When the Day is Done' and 'Farm at Dulwich Park', and an engraving after Constable, at the RA. London address.

***WINTER, William Tatton RBA 1855-1928**
Landscape painter. Born in Ashton-under-Lyne. Entered business at an early age in Manchester; studied at the Board School classes and at the Manchester Academy of Fine Arts, gave up business later. Toured through Belgium and Holland, and studied under Verlat at Antwerp. Exhib. from 1884, at the RA from 1889, SS, NWS, NG and elsewhere; also at Munich and the Paris Salon. Titles at the RA include 'A Breezy Upland, Sussex', 1889, 'When Trees are Bare', 1897 and 'The West Wind', 1902. The *Connoisseur* noted his exhib. of watercolours at the Museum Galleries, 1923: "His themes are country glades and suburban heaths, wind-tossed

foliage and placid rivers, rendered with a feeling for atmospheric truth and limpidity of colour." In 1925 the *Connoisseur* again noted his "attractive atmospheric style and delicate perception of colour, typically French in feeling with a faint suggestion of Watteau and Corot."

Bibl: Studio XXX 1904 p.42; LXIII 1915 p.253; Connoisseur XVIII 1910 p.204; XXXI 1911 p.272; LIV 1919 p.180; LXVI 1923 p.119; LXXI 1925 p.183; The Athenaeum 1919 II p.562; Who Was Who 1916-28; Apollo XIV 1931 p.181; VAM Annual Review 1933 p.21.

WINTERBOTTOM, Austin 1860-1919

Exhib. 'Evening: Sketch near Sheffield' at SS. Address in Sheffield.

*WINTERHALTER, Franz Xaver 1805-1873

Portrait painter and lithographer. Studied engraving with his uncle at Fribourg. 1823 studied in Munich under Piloty. Encouraged by the portrait painter Stieler. Settled at Carlsruhe as a portrait painter. He was at once successful, and became Court Painter to Grand Duke Leopold of Bade. 1834 went to Paris, where he painted Queen Marie-Amélie. This launched him on a long and successful career as an international court painter. He painted the royal families of France, England, Belgium, Germany, Austria and Russia. Exhib. at the Paris Salon 1835-68. Chevalier de la Légion d'Honneur 1839; Officer 1857. He only visited England occasionally, mainly to paint Victoria and Albert and their family. These portraits are still in the Royal Collection. He also painted a few portraits of the English aristocracy, mostly members of the court circle, and exhib. four pictures at the RA 1852-67. His career has often been compared to that of Lawrence, but his style remained essentially German. The key to his success was ability to portray his sitters as regal, semi-divine figures, surrounded by the accessories of power, against a grandiose background. His portraits are usually concerned more with status than character. His influence may be detected in the work of some English painters, such as Hayter and Francis Grant (qq.v.). He also occasionally painted landscape sketches, and watercolours.

Bibl: For full bibl. see TB; Ormond; Irwin; Cat. of Winterhalter exhib., NPG 1988.

WINTER-SHAW, Arthur RI 1869-1948

Painted landscapes, often with cattle. Studied at Westminster, at the Slade School and in Paris. Painted in Sussex. Lived at Houghton, Sussex.

WINTLE, Mrs. R.P. fl.1872

Exhib. a portrait at the RA. London address.

WIRGMAN, Charles 1832-1891

Exhib. two Japanese subjects, 1870-6. London address. He was the brother of Theodore Blake Wirgman (q.v.).

Bibl: The Times 17 January 1925.

WIRGMAN, Helen fl.1879-1882

Exhib. four flower pieces 1879-82. London address.

WIRGMAN, Theodore Blake RP 1848-1925

Painter of portraits, genre, historical and literary subjects. Exhib. from 1867 at the RA, SS, NWS, GG, NG and elsewhere, titles at the RA being chiefly portraits, but including 'Andrea del Sarto and his Wife Lucrezia', 1871 and '1793 (During the Revolution in La Vendée, the Royalist women had the choice of letting their children perish with them, or of giving them up to the care of the Republicans)', 1893. His most notable subject, never shown at the

RA, was 'Peace With Honour', which represented Disraeli interviewing Queen Victoria after the signing of the Berlin Treaty in 1878. An engraving was made of this painting and was very popular. Among his best portraits were Hamo Thornycroft, ARA, 1883, Col. Richard Harte Keatinge, 1883, the Bishop of Brechin 1885, the Rt. Hon. Sir James Hannen, 1890, Mrs. Edmund Gosse 1882, and Col. T. Colclough Watson, 1899. Member of the Royal Society of Portrait Painters.

Bibl: RA Pictures 1891-6; Connoisseur XLI 1915 p.113; LXII 1922 p.46; LXXI (obit.); La Renaissance de l'Art Français IV 1921 p.525ff.; BM Cat. of Engraved British Portraits V 1922 p.63; VI 1925 pp.565, 715; Poole 1925 p.287; The Print Collector's Quarterly XII 1925 p.7 Who Was Who 1916-28; Ormond.

WISE, William fl.1823-1876

Painted portraits and figurative subjects. Also a copyist. Exhib. eight works at SS, including portraits and works entitled 'The Little Prisoner' and 'Candlelight', and two works at the RA. London address.

Bibl: Portfolio 1874 pp.l, 40, 60, 87,108;1875 pp.65, 104.

WITCHELL, Miss Lucy fl.1883-1891

Exhib. three works at the RA including 'Bullfinch' and 'A Dead Seagull'. London address.

WITCOMBE, Miss Margaret fl.1855-1871

Landscape painter, living in Guildford and Swanage, who exhib. 1855-71, at the RA 1855-63, BI and SS, titles at the RA including 'A Landscape', 1855, 'Woody Meadows', 1862, and 'The Pathway to the Ruin', 1863.

WITHAM, J. fl.1875-1890

Painted marines.

Bibl: Brook-Hart pl.10.

WITHERBY, Henry Forbes RBA fl. from 1854 d.1907

Painter of landscape and flowers, who exhib. 1854-1907, at the RA, BI, SS and the old Dudley Gallery. Titles at the RA include 'Study of Spring Flowers', 1854, 'The Harvest Moon; Looking Towards Whitby', 1895 and 'Fresh from the Kitchen Garden', 1900. Lived at Highbury, Croydon, Blackheath and Holmehurst, Burley, New Forest.

Bibl: The Year's Art 1907-9.

*WITHERINGTON, William Frederick RA 1785-1865

Landscape and rustic genre painter. Pupil of RA Schools. His early works are mostly rustic genre scenes in the Morland and Wheatley tradition. Later he adapted his style to suit Victorian tastes and painted picturesque landscapes and rustic incidents in a manner similar to William Shayer and F.R. Lee (qq.v.). Like them he painted much in Devon, the West Country and Wales. Exhib. at RA 1811-63 (138 works), BI and SS. Elected ARA 1830, RA 1840. Works by him are in the VAM.

Bibl: AJ 1859 pp.73-5; 1865 p.191; Connoisseur LXIX 1924 p.192; LXX 1924 pp.107, 113; Redgrave, Dict.; Clement & Hutton; Bryan; DNB; VAM; Reynolds, VS p.51 (pl.7); Maas pp.53-4 (pl. p.52); Pavière, Landscape pl.93; Wood, Panorama; Wood, Paradise Lost.

WITHERS, Alfred ROI PS 1856-1932

Painter of landscapes and architectural subjects, very reminiscent of Corot and Diaz. Exhib. from 1881, at the RA from 1882, SS, GG and elsewhere, titles at the RA including 'The Outer Harbour, Whitby', 1882, 'The Golden Hour', 1884, 'From Hilly Pastures', 1889 and 'Nocturne from Lambeth Bridge', 1890. Member of the Pastel Society; Commander of the Royal Order of Alfonso XII; member of

the International Society of Sculptors, Painters and Gravers; member of the Society of Twenty-five English Painters, formed in 1906 (other members including his wife, W. Llewellyn, Sydney Lee, Montague Smyth and Terrick Williams). His wife, Isabelle A. Dods-Withers, was also a landscape painter, painting in a similar style to that of her husband, but in a more purely decorative manner.

Bibl: AJ 1903 pp.184, 186 (pl.); 1904 pp.47 (pl.), 48; 1909 p.171 (pl.); Studio XXXVII 1906 p.112 (pl.); XXXIX 1907 p.152ff; XLI 1907 pp.58 (pl.), 59; XLII 1908 p.135; L 1910 p.27 (pl.); LX 1914 p.145; LXV 1915 p.113; LXVIII 1916 p.54; Who Was Who 1929-40.

WITHERS, Miss Annie fl.1893
Exhib. a figurative subject at the NG. London address.

WITHERS, Mrs. Augusta Innes fl.1829-1865
Painter of flowers, fruit and birds, who exhib. 1829-65, at the RA 1829-46, SS, NWS and elsewhere, titles at the RA including 'Flowers and Fruit from Nature', 1829, 'Apples from Nature', 1833 and 'Hens and Chickens', 1846. In 1833 became Flower painter in Ordinary to the Queen Dowager. Member of Society of Lady Artists.

WITHERS, E.R. fl.1850-1852
Painted portraits. Exhib. five portraits at the RA. London address.

WITHERS, Henry B. fl.1901
Exhib. two works, 'Summer' and a view of a house, at the RA Address in Watford, Hertfordshire.

WITHERS, Miss Maud fl.1878-1880
Exhib. a watercolour of marigolds at SS. London address.

WITHROW, Miss Eva fl.1898
Exhib. 'The Antiquarian' at the RA. London address.

WITTER, Arthur R. fl.1884-1895
Painted landscape. Exhib. four works at the RA including 'Evening Warwick' and 'Cilcen Crag — North Wales', and one watercolour at SS. Address in Liverpool.

WITTER, W.G. fl.1885-1889
Exhib. 'The Quiet of the Woods' and 'Reposing Nature' at the RA. Address in Liverpool.

WIVELL, Abraham 1786-1849
Portrait painter, both oils and miniatures, and inventor of the fire-escape. Exhib. 1822-59, at the RA 1822-54, BI, SS and elsewhere. From 1841 lived in Birmingham. Published, amongst others, *An Inquiry into the History, Authenticity and Characteristic of the Shakespeare Portraits*, 1827.

Bibl: AJ 1849 p.205 (obit.); Supp. to the Universal Cat. of Books on Art, South Kensington 1877; Redgrave, Dict.; BM Cat. of Engraved British Portraits VI 1925; Ormond.

WIVELL, Abraham, Jnr. fl.1848-1865
Birmingham painter of portraits (both oils and miniatures), and domestic genre. Son of Abraham Wivell (q.v.). Exhib. 1848-65, at the RA 1848-9, BI and SS — at the RA all miniatures. He contributed 12 portraits to the opening exhib. at Aston Hall, Birmingham, in 1858.

Bibl: Birmingham Cat.; Ormond.

WOAKES, W.E. fl.1866
Exhib. two works at the BI, 'The Shower Bath on the Lea' and a view in the Forest of Fontainebleau, and one work at the RA. London address.

WOLEDGE, Frederick William fl.1840-1895
Landscape and topographical painter. Published sketches of Brighton. Exhib. a view of Snowdon at the RA. Address in Brighton, Sussex.

WOLF, Joseph RI 1820-1899
Illustrator and painter of animals and birds. Born at Mörz near Coblenz, Germany. From early childhood he was passionately fond of birds, and would spend hours watching and drawing them. Apprenticed for three years to the Brothers Becker, lithographers, of Coblenz, and subsequently became a lithographer at Darmstadt. In order to obtain practical instruction in drawing, Wolf went to Antwerp, where he painted some pictures of birds, and from Antwerp went in 1848 to London, where he obtained employment at the BM. Drew for a very large number of books on natural history, two of the most important being John Gould's *Birds of Great Britain* and *Birds of Asia;* he drew for the Zoological Society. Exhib. 1849-81, at the RA 1849-77, BI, NWS and elsewhere; RI in 1874. Many of his drawings of birds and animals are in the VAM.

Bibl: AJ 1859 p.82; Universal Cat. of Books on Art, South Kensington II 1870; Portfolio 1889 pp.92-9, 152-6, 167-72; A.H. Palmer, *The Life of Joseph Wolf*, 1895; A.B.R. Trevor-Battye, *J.W. 'Artist'*, XXV i 1899; W. Gilbey, *Animal Painting in England*, 1900; Cundall; DNB; *Encyclopaedia Britannica*, 1911 ed.; VAM; *Philobiblon* VIII 1935 p.78ff.; Pavière, Sporting Painters; Hardie III p.163 fig. 192; Maas p.86.

WOLFE, George 1834-1890
Painter of landscapes and coastal scenes, both in oil and watercolour. Lived in Clifton, Bristol. Shared a studio for a time with Samuel Jackson (q.v.). Exhib. 1855-73, at the RA 1857-67, BI, SS and elsewhere, titles at the RA including 'Beach at Dittisham, on the Dart, Devon', 1857, 'In Leigh Woods, Clifton', 1860 and 'A Brig in St. Ives Harbour, Cornwall', 1864. Bristol AG has two oils and two watercolours, and the VAM has one watercolour 'The Shore at Penzance: Ebbing Tide'.

Bibl: VAM; Wilson; Brook-Hart.

WOLFE, Maynard fl.1870-1871
Exhib. a watercolour view of a cloister in Utrecht at SS. Address in Shoeburyness.

WOLFENSBERGER, J. fl.1841-1842
Painted landscape. Exhib. three Italian landscapes at the RA. London address.

*WOLLEN, William Barnes RI ROI RBC 1857-1936
Military, sporting and portrait painter. Exhib. 1879-1922, at the RA, NWS and elsewhere, titles at the RA including 'Football', 1879, 'The Rescue of Private Andrews by Captain Garnet J. Wolseley at the Storming of the Motee Mahal, Lucknow', 1881 and 'The 1st Battalion South Lancashire Regiment Storming the Boer Trenches at Pieter's Hill', 1903. RI in 1888. The *Connoisseur* comments on his exhibs. at the RA in 1916: "Mr. W.B. Wollen gives a spirited presentment of what may be called a 'rough and tumble' battle of the old type, with hand to hand bayonet fighting, in his 'Defeat of the Prussian Guard Nov. 11th 1914'. Better, however, is the same artist's 'Canadians at Ypres', painted with equal spirit and with a far greater concentration of interest."

Bibl: AJ 1905 p.175 (pl.); The Year's Art 1892 p.122; RA Pictures 1896 p.193 (pl.); Cundall p.173; Connoissew XLV 1916 p.120.

WOLMARK, Alfred Aaron 1877-1961
Painter of landscape, portraits and still-life. Born in Warsaw. Exhib. at the RA from 1901, and later internationally. Exhibs. of his work have been held at the Bruton Galleries and the Fine Art Society.

Bibl: AJ 1905 p.192; 1907 p.193; 1911 pp.90-4; Connoisseur XLIV 1916 p.233; XLVII 1917 p.55; LXXIX 1927 p.59; LXXXIII 1929 p.63; Apollo IX 1929 p.70; XXIII 1936 p.231; Who's Who in Art 1934; Who's Who 1938.

WOLSEY, Florence fl.1893
Exhib. a watercolour entitled 'A Southern Belle' at SS. London address.

WOLSTENHOLME, Dean, Jnr. 1798-1882
Sporting and animal painter; son of Dean Wolstenholme Snr. (1757-1837). Painted hunting and fishing scenes; also many portraits of horses and dogs. Exhib. at RA 1818-49, BI and SS. His style is very similar to that of his father, and their work is often difficult to distinguish.
Bibl: Apollo VII 1928 p.160; X 1929 p.196; XV 1932 pp.96-7; Connoisseur LXXXII 1928 p.137, 141ff.; Redgrave, Dict; W. Shaw Sparrow, A *Book of Sporting Painters*, 1931; Pavière, Sporting Painters.

WOLTREK fl.1847
Exhib. a painting of Cupid at the RA. Addresses in Rome and London.

WOLTZE, B. fl.1881
Exhib. a work entitled 'Her First Trouble' at the RA. Address in Huddersfield, Yorkshire.

WOMBILE, T.W. fl.1834-1837
Painted animals. Exhib. four works at SS including portraits of hunters and dogs. London address.

***WONTNER, William Clarke fl.1879-c.1922**
Portrait and figure painter. Exhib. at RA from 1879, SS, NWS, GG, NG and elsewhere. Titles at RA mostly portraits. One of these can be seen in Oriel College, Oxford. He also painted many pictures of female figures, usually half-length or head and shoulders, posed against a marble background, in a style similar to J.W. Godward (q.v.).
Bibl: AJ 1905 p.185; RA Pictures 1892 p.150; Poole 1925; Wood, Olympian Dreamers.

WOOD, C. Haigh fl.1874-1904
Genre painter, living in London, Bury and Taplow, Buckinghamshire, who exhib. 1874-1904, at the RA 1879-1904, SS, NWS and elsewhere. Titles at the RA include 'The Harvest Moon', 1879, 'Chatterboxes', 1889 and 'The Old Love and the New', 1901. Subjects usually elegant ladies in elaborate interiors. His daughter Vivien ws the first wife of the poet T.S. Eliot.

WOOD, Miss Catherine M. see WRIGHT, Mrs. R.H.

WOOD, Daniel fl.1847-1859
Exhib. two works at the RA, 'A Welsh Rustic' and a view of the Villa Borghese, and three works at SS. London address. Also lived in Birmingham and exhib. at RBSA.

WOOD, Daniel fl.1866
Exhib. a painting of fruit at the BI. Address in Cambridge.

WOOD, Miss Dorothea M. fl.1901
Exhib. a portrait at the RA. Address in Princes Risborough, Buckinghamshire.

WOOD, Edgar Thomas fl.1885-1893
Painted landscapes and townscapes. Exhib. six works at SS including views in the City of London and at Lynton, North Devon. London address.

WOOD, Miss Eleanor Stuart fl.1876-1893
Painter of fruit, flowers and portraits, brought up in Manchester, but in 1876 working in London. Exhib. 1876-93, at the RA 1876-86, NWS, GG and NG, titles at the RA all being of fruit and flowers. In the Walker AG, Liverpool, is the portrait of the novelist William Edwards Tirebuck. Member of the Society of Lady Artists.
Bibl: The Year's Art 1893 p.124; cat. of the 10th Spring exhib. of Modern Pictures, Rochdale AG 1913.

WOOD, Mrs. Eleanora C. fl.1832-1856
Painted figurative subjects. Exhib. ten watercolours at SS including 'The Widow's Hope', 'A Young Fawn' and 'Diana and Endymion', and one work at the BI. London address.

WOOD, Eliza A. fl.1888-1889
Exhib. one work at SS. London address.

WOOD, Miss Emmie Stewart fl.1888-1910
Landscape painter. Exhib. at RA from 1888, SS, NWS and elsewhere. Painted quiet, poetic landscapes, reflecting the influence of Corot and the Barbizon school. Titles at RA 'The Silent Loch', 'The Reed Cutters', 'The First Breath of Autumn', etc.
Bibl: The Year's Art 1928 p.556.

WOOD, F.S. Hurd- fl.1897-1901
Exhib. 'A Huntsman' and a portrait at the RA. Address in Leatherhead, Surrey.

WOOD, Frank Watson 1862-1953
Painted marines, landscapes and portraits. Studied in London and at the Académie Julian. Taught at Newcastle School of Art and at Norwich School of Art. Painted in Northumberland. Born in Berwick-on-Tweed.
Bibl: Hall.

WOOD, G.G. fl.1860
Exhib. 'Study of a Tiger' at the RA. London address.

WOOD, G. Swinford RCA fl.1861-d.1906
Exhib. three works at the BI, 'Repose', 'Shut Out' and 'A Dozing African', and one work at the RA. Address in Birkenhead, Cheshire.
Bibl: The Year's Art 1906 p.543.

WOOD, George fl.1844-1854
London painter of historical and mythological subjects, genre, still-life, portraits and-landscape, who exhib. 1844-54, at the RA 1844-9, BI and SS. Titles at the RA include 'Ellen Young at the Grave of her Parents', 1844, 'The Bending of Prometheus', 1845 and 'Old Women Boiling Potatoes', 1845.

WOOD, Herbert fl.1875-1881
Painted landscape. Exhib. six works at SS including watercolours of Whitby and 'Near Torquay'. London address.

WOOD, Miss Hortense fl.1870-1880
Exhib. 'The Fen at Sunset' at the RA. Address in Munich.

WOOD, J. fl.1846-1847
Exhib. two views in Rome at the RA. London address.

WOOD, J.T. fl.1853-1857
Exhib. three views of houses at the RA. London address.

WOOD, J.W. fl.1838
Exhib. a portrait of Count d'Orsay at the RA.

WOOD, James F.R. **fl.1895-d.1920**
Exhib. two works, a portrait and a work entitled 'Fishing Strictly Prohibited', at the RA. London address.
Bibl: The Year's Art 1921 p.346.

WOOD, John **1801-1870**
Painter of portraits, biblical, historical and literary subjects. Studied at Sass's School, and at the RA Schools, where in 1825 he gained the gold medal for painting. Exhib. 1823-62, at the RA (118 works), BI and SS, titles at the RA including mainly portraits, and 'Elizabeth in the Tower after the Death of her Sister Queen Mary', 1836 (which gained a prize at Manchester), 'King Henry VI Taking Refuge in a Cottage after the Battle of St. Albans', 1842 and 'The Entombment of Our Saviour', 1853. He won a great temporary reputation. In 1834 he competed successfully for the commission for the altar-piece of St. James's, Bermondsey. During the latter part of his career he painted chiefly biblical subjects and portraits. His portraits of Sir Robert Peel, Earl Grey, John Britton (NPG), and others have been engraved, as well as several of his fancy subjects.
Bibl: AJ 1870 p.204; Redgrave, Dict.; Bryan; L. Cust, NPG Cat. II 1902 (pl.); DNB.

WOOD, John B. **fl.1900**
Exhib. 'Early Spring' at the RA. Address in Woodbridge, Suffolk.

WOOD, Miss L. Martina **fl.1892**
Exhib. a study at the RA. London address.

***WOOD, Lewis John** **RI** **1813-1901**
Painter of landscape and architectural subjects; lithographer. Exhib. 1831-91, at the RA 1831-72, SS, NWS (205 works) and elsewhere, titles at the RA being chiefly architectural subjects: 'The Old Tower of St. Dunstan's Church, now Pulled Down', 1831, 'Church of Notre Dame at Caen, Normandy', 1855 and 'The Old Church at St. Laurent, Rouen', 1872. After 1836, when he first visited the Continent, he found his best inspiration in the towns and villages of Belgium, Normandy and Brittany. A of RI in 1867; RI 1870; resigned his membership in 1888.
Bibl: AJ 1859 p.80; Studio XLVI 1909 p.142; Gazette des Beaux-Arts I 1859 p.363; VI 1860 p.105ff.; Bryan; VAM Cat. of Oil Paintings 1907; Cundall p.271; Trafalgar Galleries London, The Victorian Painter Abroad, 1965 p.52 (pl.).

WOOD, Lewis Pinhorn **fl.1870-1897**
Painted landscape. Exhib. five works at the RA including 'In the Meadows at Arundel' and 'As the Tree Falls, So Must it Lie', and two watercolours at SS. London address.

WOOD, Lady Mary **fl.1885-1888**
Exhib. five flower paintings at the GG. London address.

WOOD, Matthew **1813-1855**
Irish painter of portraits and rural and domestic subjects. Born in Dublin, and exhib. portraits at the RHA 1826-38. In 1838 he left Dublin and settled in London, where he held a clerkship in the General Post Office. Continued to exhib. at the RHA until 1852, e.g. 'Bashfulness, an Irishman's Failing', 1845, and also acted for some years as agent, collecting pictures in London for its annual exhibs. Exhib. in London 1840-55 at the RA, BI, SS and elsewhere, titles at the RA being mainly portraits and 'A Kerry Peasant's Child', 1845, 'Irish Heath Blossom', 1846 and 'A Norman Peasant', 1852. He committed suicide in 1855, due to the disappointment of not obtaining promotion to a post in his office.
Bibl: AJ 1855 p.284; Strickland.

WOOD, Miss Meynella **fl.1878-1881**
Exhib. a watercolour view of the River Wye at SS. Address in Charlton.

WOOD, R.H. **fl.1865-1876**
London landscape painter, who exhib. 1865-74, at the RA 1866-74, BI, SS and elsewhere, titles at the RA including 'Near Kirkstall, Yorkshire', 1866, 'The Sunset Hour', 1871 and 'The Old Mill', 1872.

WOOD, Robert **fl.1886-1889**
Exhib. single landscapes at the GG and the NWS. Address in Newcastle-upon-Tyne .
Bibl: Hall.

WOOD, Stanley L. **fl.1885-1903**
Painted military subjects. Exhib. five works at the RA including 'Royal Horse Artillery Going Into Action' and 'A Surrender Under Protest: An Incident in the Matabele War', and three works at the NWS. London address.

WOOD, T.W., Jnr. **fl.1867**
Exhib. 'Morning — Kentish Autumnal Landscape with Partridges' at the RA. Address in Chatham, Kent.

WOOD, Thomas **1800-1878**
Painter of marines, landscapes and architectural subjects. Second son of John George Wood, FSA, and brother of John Wood. Chiefly self-taught, but became known for his accurate study of nature. He specialised in views in Wales, Devon, the Isle of Wight, Jersey and at Harrow, where he was drawing master 1835-71, but also executed marines with careful attention to ship construction, rigging, etc. Exhib. at the RA and NWS 1828-53, titles at the RA including 'Westminster Abbey from Dean's Yard', 1838, 'Harrow Church from the N.E.', 1846 and 'H.M.S. Queen, 116 — Portsmouth Harbour', 1853. Member of NWS in 1833.
Bibl: Bryan; Cundall p.271; VAM; Wilson; Brook-Hart.

WOOD, Thomas Peploe **1817-1845**
Landscape painter. Elder brother of the sculptor Samuel Peploe Wood (1827-73). Exhib. 19 works at SS including views on the Kent coast, at Canterbury and at Tunbridge Wells. Also exhib. single works at the BI and at the RA. London address. Painted mainly landscapes with cows.

WOOD, Thomas W. **fl.1855-1872**
Painted animal and figure subjects. Exhib. five works at the RA including 'Study of Dorking Fowls' and 'Old Nancy, Washing', and three watercolours at SS, including 'Portrait of a Lion'. London address.

WOOD, Miss Ursula **b.1868 fl.1901**
Painted landscape and rustic subjects. Exhib. 16 works at the RA including 'A Devonshire Stream', 'Poor Tom's A-Cold' and 'By Candle and Firelight'. London address.
Bibl: Who's Who in Art 1934.

WOOD, William Henry **fl.1878-1881**
Exhib. two views of buildings at the RA. London address.

WOOD, William R. **fl.1889-1902**
Painted landscape. Exhib. five works at the RA including 'Oulton Broad' and 'River, that In Silence Windest'. Address in Lowestoft, Suffolk.

WOOD, William T. **fl.1900-1904**
Exhib. three works at the RA, including 'Summer Heat' and 'Autumn'. London address.

WOOD, William Thomas RWS ROI 1877-1958
Painted landscapes and flowers. Studied at the Regent Street Polytechnic and in Italy. He was an official war artist in 1918. Born in Ipswich, Suffolk. Lived in London.
Bibl: Connoisseur LXI 1921 p.239; LXIV 1922 p.242; LXVI 1923 p.119; LXXII 1925 p.50; XC 1932 p.412; Studio XCIII 1927 p.272; Apollo V 1927 p.232; Who's Who in Art 1934; Who's Who.

WOODCOCK, Miss L. fl.1892
Exhib. a work entitled 'By Fair Ffestinog' at SS. Address in Llandudno, Caernarvon.

WOODFORD, E.B. fl.1878
Exhib. 'The Solent' at the RA. London address.

WOODHAM, W. fl.1841
Exhib. 'Sea View' and 'Near Bromley' at SS. London address.

WOODHOUSE, Miss Dora fl.1899
Exhib. 'Grannie' at the RA. Address in Northampton.

WOODHOUSE, Col. Harvey fl. 1888-1889
Exhib. two historical subjects at the NWS. London address.

WOODHOUSE, J.H. fl.1888
Exhib. a figurative subject at the NWS. Address in Windsor, Berkshire.

WOODHOUSE, William 1857-1939
Animal painter. Exhib. two works 'Doomed' and 'Wolves and Wild Boar', at the RA. Born at Morecambe, Lancashire. Lived in London.

WOODIN, Samuel, Jnr. fl.1798-1843
Painted animals and genre and figurative subjects. Exhib. 39 works at the RA, the later of these including 'All Hot', 'A Lemonade Stall near Paris' and 'The Miser Alarmed'. Also exhib. 19 works at the BI, and eight works at SS. The greater part of his work is Pre-Victorian. London address.

WOODING, R. fl.1858-1874
Painted landscape watercolours. Exhib. 13 watercolours at SS including views on the Wye, in Sherwood Forest and of Rievaulx Abbey. Address in Margate, Kent.

WOODINGTON, William Frederick ARA 1806-1893
Painted and sculpted figurative subjects. Exhib. 47 works at the RA, the majority of these probably sculptures and oil paintings including works entitled 'Christ on the Mount of Olives' and 'Near Gravesend'. Also exhib. three works at the BI and two at SS. London address.
Bibl: The Year's Art 1890 p.231; AJ 1894 p.61; Connoisseur LXIV 1922 p.249.

***WOODLOCK, David 1842-1929**
Painted figurative subjects and landscape, mostly in watercolour. Exhib. 16 works at the RA 1888-1904, including 'A Path Through the Wood', 'Will Shakespeare's Courtship' and 'The Great Door of St. Mark's'. Born in Ireland. Studied and lived in Liverpool. Member of the Liverpool Academy of Arts.
Bibl: Studio LXIII 1915 p.217; Who's Who in Art 1934; Ormond; Wood, Paradise Lost.

WOODMAN, Charles Horwell 1823-1888
Landscape watercolourist. Brother of Richard Horwell Woodman (q.v.), and son of Richard Woodman, miniature painter. Exhib. 1842-85, at the RA 'A Portrait', 1842, BI, SS, NWS and elsewhere. Nine of his watercolours are in the VAM.
Bibl: AJ 1860 p.47; Guide to an Exhibition of Drawings etc. acquired between 1912-14, BM 1914 p.29; Connoisseur LXXII 1925 pp.161, 178.

WOODMAN, Richard Horwell fl.1835-1868
Landscape painter. Son of Richard Woodman, miniature painter. Exhib. 1835-68, at the RA 1848-58, BI, SS and elsewhere, titles at the RA including 'Evening' 1848, 'A Rugged Path', 1851 and 'Forest Scenery', 1858.

WOODROFFE, Paul Vincent b.1875 fl.1904
Exhib. three works at the RA 1900-4, including 'The Penitent' and 'How St. Benet Passed Away Surrounded by his Disciples'. Lived in Campden, Gloucestershire.
Bibl: Who's Who; Who's Who in Art; Studio LXXXII 1921 p.222; XC 1925 p.258; CX 1935 p.314.

WOODROUFFE, R. fl.1835-1854
Painted game. Exhib. four works at the RA including 'A Leveret and a Woodcock' and 'A Pheasant and Rabbit', and four similar subjects at the BI. London address.

WOODRUFFE, Miss fl.1884
Exhib. a figurative subject at the NWS. London address.

WOODS, Albert ARCA 1871-1944
Painted landscape. Studied at St. Ives, Cornwall. Illustrated Colour Book of Lancashire. Born at Preston, Lancashire. Lived in Preston.

WOODS, Miss Ellen M. fl.1874-1881
Exhib. a painting of bluebells at the RA. Address near Bristol.

***WOODS, Henry RA 1846-1921**
Painter of Venetian genre. Studied in his native town of Warrington, Lancashire, and at South Kensington Schools. At first worked as an illustrator for The Graphic and other magazines. Began to exhib. at the RA in 1869, mostly rustic genre, e.g. 'Haymakers', 'Going Home', etc. In 1876, at the suggestion of his brother-in-law Sir Luke Fildes (q.v.), he visited Venice in search of new subjects. He was so taken with life in Venice, that he settled there permanently, and devoted the rest of his life to painting scenes of everyday life in the streets and canals. Exhib. at RA from 1869, SS and elsewhere. Typical titles 'The Gondolier's Courtship', 'Il Mio Traghetto', 'Saluting the Cardinal', etc. His style is very similar to that of his brother-in-law Fildes, and also shows the influence of other members of the foreign colony in Venice, such as M. van Haanen and Eugene de Blaas. Elected ARA 1882, RA 1893. Works by him are in the Tate Gallery, Aberdeen, Liverpool and Leicester AGs.
Bibl: AJ 1886 pp.97-102; 1893 p.192; 1908 p.42; Connoisseur LXI 1921 p.237ff.; RA Pictures 1892-3; J. Greig, H. W., RA, The Art Annual 1917; Who Was Who 1916-28, 1929; Reynolds, VS pp.28, 94; see also references under Sir Luke Fildes.

WOODS, John G.W. fl.1889-1898
Exhib. three works at the RA, including views on the River Stour and on the Kennet Canal. Address in Newbury, Berkshire.

WOODS, W.H. fl.1854
Exhib. two landscapes, one at Clifton, at the BI, and single landscapes at the RA and at SS. Address in Bristol.

WOODTHORPE, R.G. fl.1881
Exhib. two landscapes in 1881. London address.

***WOODVILLE, Richard Caton RI 1856-1927**
Painter and illustrator, mainly of military scenes. Studied in Düsseldorf and Paris. Painted Napoleonic battle scenes, and episodes from many Victorian campaigns, in Afghanistan, Egypt, Africa and elsewhere. Exhib. at RA from 1879, BI, NWS, NG and elsewhere. Works by him are in Bristol and Liverpool AGs, and in

the Royal Collection. His work can be confused with that of his father, also Richard Caton Woodville (1825-55), an American military artist, who settled in London in 1852.

Bibl: Illustrated London News 1895 No.144 pp.137, 419; Connoisseur XLII 1915 p.248; LI 1918 p.110; LXXIX 1927 p.127; The Times 18 August 27; Who's Who 1924; Who Was Who 1916-19; J. Pennell, *Modern Illustration*, 1895; The Year's Art 1901; Ormond; Wood, Panorama.

WOODWARD, Miss Alice Bolingbroke fl.1886-1900
Painted figurative subjects and landscapes. Exhib. seven watercolours at SS including 'A Song without Words' and 'The Robber's Stronghold', and four works at the RA. London address.

Bibl: The Year's Art 1911 p.554.

WOODWARD, Miss Ellen C. fl.1895
Exhib. 'Day Dreams' at the RA. Address in St. Leonard's-upon-Sea, Sussex.

WOODWARD, Miss Mary fl.1893
Exhib. 'God's Acre' and 'A Quiet Corner' at SS. London address.

***WOODWARD, Thomas 1801-1852**
Painter of animals, landscapes, portraits, genre and historical subjects. Born at Pershore, Worcestershire. Pupil of Abraham Cooper, RA (q.v.). Exhib. 1821-52 at the RA, BI and SS, titles at the RA including 'A Child Feeding Rabbits', 1837, 'The Battle of Worcester', 1837, 'Milking Time in the Highlands', 1847, 'The Wild, The Free — Byron's Mazeppa', 1851 and 'Scene in Westwood Park — Lady Diana Pakington with her Favourites', 1852. His two most important paintings are 'The Battle of Worcester' and 'The Struggle for the Standard'. His landscapes, chiefly of Scottish scenery, are generally made subservient to the cattle in them. Occasionally he was employed by Queen Victoria and Prince Albert to make portraits of some of their favourite animals, and among his other patrons were the Duke of Montrose, the Duke of Newcastle, Sir Robert Peel and the Earl of Essex. A picture of 'The Ratcatcher' is in the Tate Gallery. His pictures have been confused with those of James Ward (q.v.).

Bibl: AJ 1852 p.375 (obit.); Redgrave, Dict.; Bryan; BM Cat. of Engraved British Portraits VI 1925 p.325; Pavière, Sporting Painters; *Thomas Woodward*, Cat. of exhib., Spinks, London, 1972; C.W. Graham-Stewart, *T.W. Rediscovered*, Country Life 3 February 1972.

WOOLDRIDGE, Harry Ellis 1845-1917
Exhib. three works including 'Winter Roses' and 'My Last Duchess', and one watercolour at SS. London address.

Bibl: DNB; Who's Who; Who Was Who 1916-28.

WOOLETT, E.J. fl.1835-1855
Painted landscapes of south-east England. Exhib. three works at the RA and two works at SS. London address.

WOOLFORD, Charles H. fl.1892-1894
Exhib. two landscapes at the RA. Address in Musselburgh, Midlothian.

WOOLHOUSE, Miss E. Margaret fl.1896-1904
Exhib. three paintings of flowers at the RA. Address in Staffordshire.

WOOLLAMS, John fl.1836-1839
Exhib. five works at SS including landscapes and two shipping subjects, a view at the BI, and two landscapes at the RA. London address.

WOOLLATT, Edgar 1871-1931
Painted landscape and figurative subjects. Studied at Nottingham School of Art. Born and lived in Nottingham.

WOOLLETT, Henry A. fl.1857-1873
London landscape painter who exhib. 1857-73 at SS and elsewhere

WOOLLEY, Miss Alice Mary fl.1883-1892
Painted flowers. Exhib. four flower pieces at the RA and five flower pieces at SS. Address in Newark-on-Trent, Nottinghamshire.

WOOLLS, Henry fl.1897
Exhib. a landscape in South Wales at the RA. Address in Newington Causeway.

***WOOLMER, Alfred Joseph RBA 1805-1892**
Genre painter. Born in Exeter, studied in Italy. Exhib. mainly at SS (355 works), also BI and RA 1827-50. Painted pleasing genre scenes, usually Watteau-esque gardens with figures in 18th century costume. Works by him are in Glasgow, Liverpool and York AG. Woolmer had a very distinct and personal style, combining rich colours and a fluid technique.

Bibl: AJ 1859 pp.141, 143; Apollo XVIII 1933 p.205 ; Connoisseur C 1937 p.93; Ottley; Maas p.168 (pl.p.166).

WOOLMER, Miss Ethel fl.1888-1903
Exhib. 'The Latest Toy' and 'The Quiet Hour' at the RA, and three works at the NWS. London address.

WOOLMER, Miss Marion fl.1871-1874
Painted figurative subjects. Exhib. five works at SS including 'The Young Adventurer' and 'The Turret Window'. London address.

WOOLNER, Miss Dorothy fl.1891
Exhib. an animal subject at the NWS. London address.

WOOLNOTH, Alfred fl.1872-1889
Painted landscape. Exhib. two works including a view at Glencoe at the RA, and one work at SS. Address in Edinburgh. Also lived in London and Bournemouth.

WOOLNOTH, Charles N. RSW 1815-1906
Exhib. three landscapes at the NWS. London address. Later settled in Glasgow.

WOOLNOTH, Thomas A. 1785-1857
Painted historical subjects and portraits. Exhib. nine works at the RA, the later of these including 'The Meeting of Henrietta Maria and Marie de Medici', 'King Solomon and the Queen of Sheba' and 'The Separation of Sir Thomas More and his Family'. Also exhib. five works at SS and four works at the BI. London address.

Bibl: Redgrave. Dict.; Bryan; Poole; Ormond.

WOON, Miss R. fl.1873
Exhib. 'Wild Flowers' at the RA. London address.

WORBOYS, W.H. fl.1861-1862
Exhib. 'Shepherd's Cottage' and 'The Road to a Farm' at SS. London address.

WORDEN, Miss Dorothy fl.1887-1893
Painted landscape and shipping subjects. Exhib. five works at SS including 'A River Factory' and 'The Quiet Sea and Sky', and two works at the RA. London address.

WORLOCK, S. fl.1873
Exhib. a painting of a stag at SS. London address.

WORMALD, Ada S. fl.1879
Exhib. an interior subject in 1879. Address in Sheffield, Yorkshire.

WORMALD, Fanny fl.1879
Exhib. a flower piece in 1879. Address in Hertford.

WORMALD, Lizzie fl.1865
Exhib. a figurative subject in 1865. Address in Hertford.

WORMLEIGHTON, Francis fl.1867-1885
Painted figurative subjects and landscapes. Exhib. 12 works at SS including 'Prepared for the Ball', 'The Bird's Nest' and 'A Sussex Cottage', and two landscapes at the RA. London address.

WORNUM, Miss Catherine Agnes fl.1872-1877
(Mrs. Frederick Piercy)
Exhib. 'Far Away' at SS and a fruit piece at the RA. London address.

WORRAL, Miss Kate fl.1892
Exhib. a landscape in 1892. London address.

WORRALL, J.E. fl.1862-1868
Painted figurative subjects. Exhib. four works at SS, including 'An Escaped Prisoner' and 'A Half Holiday', and five works at the RA, including two wax statuettes. Address in Liverpool.

WORSDELL, Miss Clara J. fl.1884-1887
Exhib. two paintings of flowers at the RA. Address in Lancaster.

***WORSEY, Thomas RBSA 1829-1875**
Birmingham flower painter. Trained as a japanner (painter upon papier-mâché), but turned to flower painting about 1850 gaining a good practice. Exhib. 1856-74, at the RA 1858-74, BI, SS, Portland Gallery and in the principal provincial towns. The AJ (1859) comments on two of his paintings, 'Primulas' (Portland Gallery): "These flowers are painted with much freshness and delicacy, but the sky does not in anywise assist the group", and 'Apple Blossoms' (SS): "This in its way is really charming. The feeling of the little picture is fascinating, and its truth unimpeachable."
Bibl: AJ 1859 pp.121, 143; 1875 p.279 (obit.); Bryan.

WORSLEY, Charles Nathan fl.1886-1922
Landscape painter, living in London, Sidmouth and Bridgenorth, Shropshire. Exhib. from 1886, at the RA from 1889, SS, NWS and elsewhere, titles at the RA including 'Lisbon from the Tagus', 1890, 'Almada from Lisbon', 1892 and 'On the Lake of Zurich', 1894. His motives included scenes in Switzerland, Spain, Portugal and New Zealand. One of his paintings is in the National Gallery, Auckland, and four watercolours in the National Gallery, Sydney (Cat. 1910).
Bibl: Studio Special Winter Number 1916-17 III, *Art of the British Empire Overseas*; American Art News XXI 1922-3 No.123.

WORSLEY, D. Edmund fl.1833-1854
London painter of landscape and coastal scenes, who exhib. 1833-54, at the RA 1836, BI and SS, the title at the RA being 'Sea Coast; a Sketch', 1836.

WORSLEY, E. fl.1846-1851
Exhib. two sketches at the RA. London address.

WORSLEY, E. Maria fl.1874
Exhib. a fruit piece at the RA. London address.

WORSLEY, Henry F. fl.1828-1855
Landscape and figure painter. Exhib. 14 works at the BI, 1829-38, amongst the later of these including 'View on the Rhine' and 'Carnarvon Castle'. Also exhib. seven works at SS and three at the RA. Address in Bath, Somerset. Drawing Master at King's College 1851-5 in succession to M.E. Cotman.

WORSLEY, R.E. fl.1877
Exhib. watercolour landscapes in Sussex and Staffordshire. London address.

WORTHINGTON, Thomas Locke 1826-1909
An architect who exhib. five views of architecture at the RA including views of Chester Cathedral and of Tom Tower, Christ Church, Oxford. Address in Manchester.

WORTHINGTON, William Henry b.c.1790 fl.1839
Painted literary subjects and portraits. Exhib. 19 works at the RA 1819-39, including amongst the last of these portraits and a subject from *The Winter's Tale,* and two works, including a subject from *Twelfth Night,* at the BI. London address.
Bibl: Redgrave, Dict.; Bryan.

***WORTLEY, Archibald (Archie) James Stuart 1849-1905**
Painter of portraits and sporting subjects. In 1874 he had practical lessons in painting from Millais. When he first met Millais "his interests seemed to be centred in guns and sketch-books", and Millais offered to teach him how to paint *(Life and Letters)*. His work became very popular, and Ruskin comments on 'Miss Margaret Stuart Wortley', RA 1875: "The rightest and most dignified female portrait here." Exhib. from 1874 at the RA, GG, NG and elsewhere, titles at the RA being mainly portraits but also 'In Wharncliffe Chase Winter', 1874. 'The Leader of the Pack', 1878 and 'W.G. Grace Esq.', 1890. He is represented at Lord's Cricket Museum.
Bibl: Ruskin, Academy Notes 1875; J .G. Millais, *The Life and Letters of Sir John Everett Millais,* 1899 II p.61; The Year's Art 1890 p.233; 1906 p.362; Who's Who 1907 (under Lovelace); Pavière, Sporting Painters.

WORTLEY, Miss Mary Caroline Stuart fl.1875-1893
(Lady Wentworth and Countess of Lovelace)
Painted portraits. Exhib. two portraits and a work entitled 'Blanche' at the RA, seven works at the GG and one work at the NG. London address.

WRANGEL, Miss Lily fl.1898
Exhib. a self-portrait at the RA. London address.

WRATISLAW, Miss Matilda E. fl.1871-1884
Exhib. three views of architecture at the RA, including 'San Francesco, Assisi'. She was a member of the Society of Lady Artists. London address.

WRAY, L. fl.1875-1879
Exhib. two genre subjects 1875-9. London address.

WREFORD-MAJOR, W. fl.1874
Exhib. a portrait at the RA. London address.

WREN, John C. fl.1874-1883
Exhib. two watercolour views on the Cornish coast at SS. Address in Penzance, Cornwall.

WREN, Miss Louisa fl.1882-1898
Painted portraits. Exhib. three portraits and a work entitled 'A Bit of Colour, Cairo', at the RA, and five works at the NWS. London address.

WRIGHT, Alan fl.1889-1891
Exhib. two designs and a work entitled 'Crow Not, Croak Not', at the RA. London address.

WRIGHT, Miss Alice M. fl.1892
Exhib. 'A Sketch in the Old Saw-Mills' at SS. London address.

WRIGHT, C. fl.1853-1871
Painted figurative subjects. Exhib. three works at the RA including 'The Mother's Prayer' and 'Too Fond by Half', a portrait at SS, and a study at the BI. London address.

WRIGHT, Miss Caroline fl.1879
Exhib. two landscapes in 1879. Address in Manchester.

WRIGHT, Miss Carrie E. fl.1885-1886
Exhib. 'Still-life' and 'Old Friends' at SS. London address.

WRIGHT, Mrs. D. fl.1861-1865
Painted figurative subjects. Exhib. four works at the BI, including 'A Gipsy Girl' and 'Red Riding Hood', two works at the RA, and two works at SS. London address.

WRIGHT, Edward fl.1878-1883
Exhib. a watercolour view at Polperro, Cornwall, at SS. London address. Also lived in Birmingham and exhib. at RBSA.

WRIGHT, Edward C.J. fl.1887
Exhib. 'Early Morning: Night Boats Coming In' at the RA. London address.

WRIGHT, Miss Ethel fl.1887-1900
(Mrs. A. Barclay)
Painted genre subjects and portraits. Exhib. 19 works at the RA including 'His First and Only Love', 'Bonjour, Pierrot!', 'The Song of Ages' and portraits, and one work at SS. London address.
Bibl: Connoisseur XXXIV 1912 p.264; Studio LX 1914 p.142; Who's Who in Art.

WRIGHT, F.P. fl.1877-1883
Exhib. two paintings of fruit and one of May blossom at SS. London address.

WRIGHT, Frank fl.1901-1904
Exhib. two works, 'Staples Inn' and 'Hauled Up' at the RA. London address.

***WRIGHT, George 1860-1942**
Sporting painter. Lived in Leeds and Oxford. Exhib. at RA and elsewhere from 1892. Painted coaching and hunting scenes, and occasionally other sporting scenes, in a lively and realistic style. His pictures are very often painted in pairs.
Bibl: Pavière, Sporting Painters p.93 (pl.47).

WRIGHT, Gilbert S. fl.1900
Exhib. a work entitled 'How He Won the V.C.' at the RA. Also painted hunting and coaching scenes. London address.

WRIGHT, Miss Grace M. fl.1890
Exhib. a landscape in 1890. London address.

WRIGHT, Miss Gytha Warren- fl.1895
Exhib. a Cornish landscape at the RA. London address.

WRIGHT, H.C. Stepping fl.1883-1888
Painted landscape. Exhib. six works at SS including 'The Ferry, Cowes' and 'A Murky Morning on the Thames'. London address.

WRIGHT, H.T. fl.1830-1844
Exhib. three architectural views including a view in King's College Chapel, Cambridge. London address.

WRIGHT, Helena A. fl.1883
Exhib. a game piece at SS. Address in Nottingham.

WRIGHT, Henry William FSA fl.1867
Exhib. a view of Hastings Castle at SS. London address.

WRIGHT, J. fl.1870-1875
Exhib. three watercolours and another work at SS, including 'Evening — On Windermere' and 'Evening on the Welsh Coast'. London address.

WRIGHT, John 1857-1933
Landscape painter and etcher. Exhib. six works at the RA, 1895-1904, including 'Chipstead' and 'On the Beach'. Address in Chipstead, Kent.

WRIGHT, John Masey 1777-1866
Genre painter, in oil and watercolour. Born in London, the son of an organ builder. First taught by Thomas Stothard. Settled in Lambeth, in the same house as John (Jock) H. Wilson (q.v.). Through him met other artists working for the theatre, and found work as a scenery and panorama painter. Also exhib. at RA 1808-20, BI, SS and OWS 1808-66. Member of OWS 1824. Painted historical and literary genre, especially from Shakespeare, Goldsmith and Cervantes. Also worked as an illustrator for many of the annuals so popular at the time. Hardie writes that "his talent was of the fragile and modest kind which does not lead to any lasting fame."
Bibl: Redgrave, Dict; Roget; Binyon; Cundall; DNB; VAM; Hughes; Birmingham Cat; Williams; Cat. of Drawings by British Artists BM IV 1907; BM Cat. of Engraved British Portraits VI 1925 p.567; Randall Davies, *Victorian Watercolours at Windsor Castle*, 1937; Burlington Mag. LXXII 1938 p.98; Pavière, Sporting Painters; Hardie III pp.85, 87-8; Ormond.

WRIGHT, John William 1802-1848
Painter of portraits and sentimental figure subjects; illustrator. Not related to John Masey Wright (q.v.), and often confused with him. Son of John Wright, miniature painter; began his studies with a view to portraiture in oil, and then devoted himself to watercolour. Exhib. 1823-48, at the RA 1823-46 and OWS; chiefly portraits at the RA, and at the OWS studies with such titles as 'Meditation' or 'There's Nothing Half so Sweet as Love's Young Dream'. Elected A of the OWS in 1831 and a full member in 1841. Hardie notes that "from 1832 to 1851 his lovely, full-breasted, ringleted ladies adorned the pages of such Annuals as *The Keepsake, The Literary Souvenir, Heath's Book of Beauty* and *Fisher's Drawing-Room Scrapbook*. His work is delicate and pleasing, to be treasured only for its contemporary flavour and association . . ."
Bibl: AU 1848 pp.52, 104; Thomas Smith, *Recollections of the British Institution*, 1860 p.95; Ottley; Redgrave, Dict.; Roget; Bryan; Guide to an Exhibition of Drawings etc. by Old Masters etc. acquired between 1912 and 1914 BM 1914 p.24; BM Cat. of Engraved British Portraits VI 1925 p.567; Hardie p.88; Ormond.

WRIGHT, Miss Lilian fl.1893
Exhib. two works at SS, the second a watercolour entitled 'A Place of Nestling Green for Poets Made'. London address.

WRIGHT, Mme. Lois fl.1880
Exhib. a work entitled 'Nina' at the RA. Address in Honfleur, France.

WRIGHT, Marian L. fl.1877
Exhib. a figurative subject in 1877. Address in Paris.

WRIGHT, Mrs. Mary M. fl.1887-1891
Exhib. two landscapes at the RA, 'A Saw-Mill at Engelberg' and 'A Yorkshire Homestead'. Address in Cambridge.

WRIGHT, Miss Meg b.1868 fl.1899
Painted landscape. Exhib. three works at the RA including 'The Mountain Side' and 'Reverie', and three works at SS. Address in Edinburgh .
Bibl: Caw; Studio XXII 1901 p.282; LXV 1915 p.105; LXVII 1916 p.59; Connoisseur XLIII 1915 p.60.

WRIGHT, Nevill fl.1885-1889
Painted Mediterranean subjects. Exhib. four works at the RA including 'Preparing for the Midday Meal; A Scene in Greece' and 'In the Old Arab Quarter, Algiers'. London address.

WRIGHT, Mrs. R.H. fl.1880-1929
(Miss Catherine Wood)
Painter of still-life, flowers and genre. In 1892 married Richard Henry Wright (q.v.). Exhib. 1880-1922 at the RA, SS, GG and elsewhere, titles at the RA including 'Azalea' 1884, 'A Corner of my Study' 1885, and 'Empty Houses' 1898.
Bibl: See under Richard Henry Wright.

WRIGHT, Richard Henry 1857-1930
Architectural and landscape painter, who exhib. 1885-1913 at the RA, NWS and elsewhere, titles at the RA including 'Lotus-land', 1889, 'Siena' and 'Verona — Sunset', 1902. Many of his landscapes were set in Egypt, Italy, Switzerland and Greece.
Bibl: Cats. of RA exhibs.: 1908, 1909. 1910, 1913; for Catherine: 1905, 1909-14, 1916-19, 1922; The Year's Art 1923 p.556.

WRIGHT, Robert Murdoch fl.1889-1897
Exhib. two works, 'After a Storm' and 'Luxor' at the RA, and one work at SS. London address.
Bibl: Poole 1925.

***WRIGHT, Robert W. fl.1871-1889**
London genre painter. Exhib. mainly at SS, also RA and elsewhere. Subjects mostly domestic scenes and interiors, especially of children at play. Titles at RA 'Making Patchwork', 'Baby's Birthday', 'Mind your own Business', etc. Most of his pictures are small, on panel, and painted in the traditional Wilkie-Webster style. Many of his pictures seem to be painted in pairs.

WRIGHT, T. fl.1801-1842
Painted landscapes and house views. Exhib. 31 works at the RA 1801-37, and three works at the BI. His BI exhibs. three views in the Roman Campagna, were his last works. Address in Newark-on-Trent, Nottinghamshire.

WRIGHT, W. fl.1844
Exhib. a view on the Rhone at the RA.

WRIGHT, William fl. 1885-1893
Painted landscape and figurative subjects. Exhib. 13 works at SS including 'No Fire, No Smoke!', 'Far From the World' and 'After the Market', and two works at the RA. London address.

WRIGHT, William F. fl.1874-1879
Painted landscape. Exhib. three works at SS including 'Twixt Winter and Spring' and 'The Beach Walk, Meonstoke', the latter a watercolour. Address in Chichester.

WRIGHT, William P. fl.1882
Exhib. 'The Song Thrush' at SS. London address.

WRIGHT, William T. fl.1890-1891
Exhib. two landscapes at the NWS. Address in Kettering, Northamptonshire.

WROE, Miss Mary McNicholl fl.1881-1899
Exhib. a watercolour of primroses at SS. Address in Manchester.

WÜNNENBERG, Carl fl.1878-1883
Exhib. 'After the Confession' and 'Idyl' at the RA. Address in Rome.

WÜRT, Alen fl.1870
Exhib. a landscape in 1870. London address.

WÜST, A. fl.1874-1876
Exhib. two works at the RA including 'Moonlight — American Forest Scene'. Address in Antwerp.

WYATT, A.C. fl.1883-d.1933
Painted country subjects and views of architecture. Exhib. five works at the RA including 'The Land of the Doones', 'A West Country Stream' and 'Anne Hathaway's Cottage', and 14 works, including watercolours, at SS. London address. Died in Santa Barbara, California.

WYATT, D. fl.1846-1850
Exhib. five views of buildings in Italy, including the Arch of Titus and the Temple of Vesta, at the RA. London address.

WYATT, F. fl.1877
Exhib. two watercolours, 'Going to Market' and 'Waiting for the Coach', at SS. London address.

WYATT, Henry fl.1817-1838
Painted portraits and figurative subjects. Exhib. 35 works at the RA, amongst the later of these including 'The Palmister', 'Meditation' and portraits, 28 works at the BI and 17 at SS. London address.

WYATT, John Drayton fl.1852-1876
Painted views of architecture. Exhib. 25 works at the RA including views of Kenilworth Castle, St. John's College Chapel, Cambridge, and Lichfield Cathedral. London address.

WYATT, Miss Katherine Montagu fl.1889-1903
Painted portraits and figurative subjects. Exhib. eight works at the RA including 'A Norfolk Waste' and 'The Embroideress'. London address.

***WYBURD, Francis John b.1826 fl.1846-1893**
Painter of genre and literary and historical subjects. Educated at Lille; placed as a pupil with Thomas Fairland, lithographic artist; in 1845 won the Silver Medal at the Society of Arts; in 1848 entered the RA Schools. Exhib. 1846-93, at the RA 1846-89, BI, SS and elsewhere, titles at the RA including 'Medora' 1846, 'Amy Robsart and Janet Foster', 1858 and 'The Confessional'. In 1858 Wyburd and George E. Hering, landscape painter, went sketching in north Italy and the Tyrol, which resulted in several pictures, e.g. 'The

Convent Shrine', BI 1862. Most of his pictures are single figures, e.g. 'Lalla Rookh' (little Persian slave), and 'Esther', SS 1875. "The characteristics of Mr. Wyburd's art are principally a perfect realisation of female beauty, an attractive manner in setting out his figures, and a refinement of finish which is sometimes carried almost to excess" (AJ).
Bibl: AJ 1877 pp.137-40 (3 pls.); Studio XXIII 1901 p.118; Clement & Hutton; Studio Year Book of Decorative Art 1907 pp.74-80.

WYBURD, Mrs. Francis John fl.1883
Exhib. a figurative subject at the NWS. London address.

WYBURD, Leonard fl.1879-1904
Painted figurative subjects. Exhib. seven works at the RA including 'A Corner of the Studio' and 'Sweet Summer Days' and seven works at SS, including watercolours. London address.

WYBURD, Miss M. fl.1878
Exhib. a figurative subject at the NWS. London address.

***WYLD, William RI 1806-1889**
Landscape and topographical painter, mainly in watercolour; also lithographer. Pupil of Louis Francia. For a time secretary to the British Consul at Calais. Lived mostly in Paris, where he became a close friend of Bonington. His drawings of Paris are remarkably close to Bonington in style and subject. Exhib. mainly at NWS, also RA 1852-4, and BI. Elected ARI 1849, RI 1879. He painted English and French landscapes and views, and also views in other parts of Europe, especially Venice. He played an important part in the development of watercolour in France. He was awarded two medals at the Salon, and given the Légion d'Honneur in 1855.
Bibl: AJ 1857 p.204; Portfolio 1877 pp.126-9, 140-4, 161-4, 178ff., 193-6; Walpole Society II 1913 p.114ff.; Connoisseur LXXXVII 1913 p.119; Binyon; Cundall; VAM; Hardie II p.145 (pls.127-8); Pavière, Landscape pl.94.

WYLLIE, Mrs. C. fl.1872-1888
(Miss Charlotte Major)
Exhib. figurative subjects at the GG and NG. London address.

WYLLIE, Charles William ROI 1853-1923
Painter of landscape and coastal scenes; brother of William Lionel Wyllie (q.v.). Exhib. at RA from 1872, SS, NWS, GG, NG and elsewhere. Like his brother, he painted harbour scenes, views on the Thames, and the English coast. Two works by him are in the Tate Gallery. Also painted allegorical subjects.
Bibl Connoisseur LXIV 1922 p.242; The Year's Art 1890 p.231; see also under William Lionel Wyllie; Brook-Hart.

WYLLIE, M.A. fl.1885
Exhib. 'A Cosy Corner' at SS. London address.

***WYLLIE, William Lionel RA RI RE 1851-1931**
Painter and etcher of marine and coastal subjects, in oil and watercolour. Son of William Morison Wyllie and brother of Charles William Wyllie (qq.v.). Studied at Heatherley's and RA Schools, where he won the Turner Gold Medal in 1869. Exhib. at RA from 1868, SS, NWS, GG and elsewhere. ARA 1889, RA 1907. Painted harbour and dock scenes, especially in London, coastal scenes, and pictures of the British fleet, which were well-known through engravings and reproductions. Works by him are in the Tate Gallery, Bristol and Liverpool AGs. His son Harold Wyllie (b.1880) was also a marine painter.
Bibl: AJ 1889 pp.221-6; Connoisseur LXXXVII 1931 pp.335, 400 (obit); Apollo VIII 1928 p.105ff.; Who's Who 1924; Who's Who in Art 1934; F. Dolman, *W.L.W. and his Work*, 1899; M.A. Wyllie, *We Were One. Life of W.L.W.*, 1935; Clement & Hutton; Wedmore, *Etcher in England*, 1895 p.165; Wilson; Brook-Hart; Roger Quarm and John Wyllie, *W.L.W.*, 1981.

WYLLIE, William Morison fl.1852-1890
London genre painter. Father of William Lionel Wyllie (q.v.). Exhib. at RA 1852-87, BI, SS, GG, NG and elsewhere. Titles at RA 'The Rustic Oven', 'The Passport Nuisance', 'Landing the Catch', etc.
Bibl: See under William Lionel Wyllie.

WYMAN, Miss Florence fl.1886-1889
Painted flowers. Exhib. six paintings of flowers at SS. London address.

WYMAN, Miss Violet H. fl.1888-1890
Painted genre subjects. Exhib. nine works at SS including 'Maidens and Melody' and 'A Sunny Day'. London address.

***WYNFIELD, David Wilkie 1837-1887**
Historical genre painter. Great-nephew of Wilkie. Studied with J.M. Leigh (q.v.). Exhib. at RA 1859-87, BI and elsewhere. Subjects mainly taken from English 16th and 17th century history. Lived in St. John's Wood, where he was the founder of the St. John's Wood Clique (q.v.). He was also a pioneer photographer, and taught Julia Margaret Cameron, the great Victorian portrait photographer. Died young of tuberculosis. A work by him is in the VAM. An exhib. of his photographs was held at the Alexander Gallery, London, in 1976.
Bibl: AJ 1880 pp.24, 245, 340; Portfolio 1871 pp.84-7; Clement & Hutton; Bryan; Ottley; B. Hillier, *The St. John's Wood Clique*, Apollo June 1964; D. Du Maurier, *The Young George Du Maurier*, 1951; M.A.K. Garner, *D.W. Painter and Photographer*, Apollo February 1973; Strong.

WYNNIATT, Miss Maude fl.1897
Exhib. 'Katie' at the RA. London address.

WYON, John W. fl.1862
Exhib. 'Home Instruction' at the RA. London address.

WYSE, Henry Taylor 1870-1951
Landscape painter. Studied at Dundee School of Art, at Glasgow School of Art and in Paris. Born in Glasgow. Lived in Edinburgh.
Bibl: Who's Who in Art 1934; Connoisseur LXXIII 1925 p.120.

WYSMÜLLER, J.H. fl.1879-1880
Exhib. two Dutch landscapes at the RA and one at SS. London address.

YALLAND, Thomas King RWA 1845-1934
Painted landscape. Born in Bristol. Lived at Fishponds, near Bristol.

YARD, Charles fl.1848-1857
Painted shipping and marines. Exhib. 18 watercolours at SS including 'Ready About', 'Ireland's Eye' and 'Sunset After Storm'. Address in Dublin.

YARNOLD, George B. fl.1874-1876
Landscape painter. Exhib. two views in south-east England and three similar subjects at SS. London address.

YARNOLD, J.W. b.c.1817 fl.1839-1854
London painter of coastal scenes. Exhib. at RA 1841-52, BI and SS. RA titles include views of coasts of England, Wales, Scotland and north France.
Bibl: Wilson; Brook-Hart.

YATES, Miss Caroline Burland fl.1879-1887
(Mrs. T.C. Gotch)
Painted landscape. Exhib. six works at SS. including 'A Village in Cornwall' and 'My Wedding Bonnet', and one work at the RA. Address in Newlyn, Penzance, Cornwall. See also Mrs. T. C. Gotch.

YATES, Frederic 1854-1919
Painted portraits and landscape. Exhib. seven works at the RA including 'St. Paul's Cray Common' and 'Sybil, Daughter of Sir Joseph Spearman, Bart.' Lived at Rydal, Westmorland, and was a founder member of the Lake Artists' Society.
Bibl: Ormond.

YATES, H. fl.1877
Exhib. a view at St. Alban's at the RA. Address in Pembroke.

***YEAMES, William Frederick RA 1835-1918**
Historical genre painter. Born in Southern Russia, where his father was Consul. Lived in Odessa and Dresden before returning to London in 1848. Studied in London under G. Scharf; in Italy 1852-8. Exhib. at RA from 1859, BI, SS, GG and elsewhere. ARA 1866, RA 1878 (retired 1913). Specialised in well-known scenes from English history, usually of the Elizabethan or Cromwellian periods, e.g. 'Lady Jane Grey in the Tower', 'Amy Robsart', 'Prince Arthur and Hubert', etc. His best-known work is the Victorian favourite 'And When Did You Last See your Father?' (Walker AG, Liverpool). Yeames lived in Grove End Road, London, and was a member of the St. John's Wood Clique (q.v.). Other works by him can be seen in the Tate Gallery, Aberdeen, Manchester, Sheffield and Bristol AGs.
Bibl: AJ 1874 pp.97-100; 1895 p.167; Connoisseur LXII 1922 p.176; RA Pictures 1891ff.; The Year's Art 1889; Who Was Who 1916-28; M.H.S. Smith, *Art and Anecdotes: Recollections of W.F.Y.* 1927; Clement & Hutton; Reynolds, VS, pp.83 100-1 (pl.96); B. Hillier, *The St. John's Wood Clique*, Apollo June 1964; Reynolds, VP pp.179, 196 (pls.122, 124); Maas pp.234-5; Strong; Newall.

YEATES, Mrs. A. fl.1857
Exhib. a watercolour of irises at SS. London address.

YEATS, Alfred Bowman b.1867
An architect who painted architectural subjects in watercolour. Lived in London.
Bibl: Who's Who in Art 1934.

YEATS, John Butler RHA 1839-1922
Irish painter of figurative subjects. Exhib. two figurative subjects at the RA and a portrait at SS. Studied at the Slade School and at the RA Schools. He was father of Jack Butler Yeats and William Butler Yeats. Born in County Down, Ireland. Lived in Dublin and New York.
Bibl Connoisseur LXII 1922 p.241.

YEATS, Miss Nelly H. fl.1887
Exhib. 'Roses' at the RA. Address in Malvern, Worcestershire.

YELLOWLEES, William 1796-1856
Scottish portrait painter. Pupil of W. Shiels (q.v.) in Edinburgh. Came to London about 1829, where he became a protégé of Prince

Albert. Exhib. at RA 1829-45. Because of the similarity of his style to that of Raeburn, he was known as the Little Raeburn. A portrait of him is in the Scottish NPG. Caw writes of his portraits: "Little larger than miniatures, they are distinguished by a fullness and richness of impasto and a beauty of colour one does not usually associate with oil-painting on such a small scale."
Bibl: Bryan; Caw p.90; BM Cat. of Engraved British Portraits VI 1925; Ormond.

YETTS, Miss E.M. fl.1857
Exhib. a landscape at SS and 'A Rivulet' at the BI. London address.

YETTS, W. fl.1845
Exhib. three landscapes at SS. Address in Great Yarmouth, Norfolk.

YEWELL, G.H. fl.1877
Exhib. a view of Cairo in 1877. Address in Rome.

YGLESIAS, Mrs. V.P. (Edith) fl. 1890
Exhib. a flower piece at SS. London address.

YGLESIAS, Vincent Philip RBA fl.1873-d.1911
London painter of landscapes, especially river scenes. Exhib. mainly at SS, also RA 1874-1904, GG and elsewhere. Titles at RA 'Thames Barges', 'Moonlight at Whitstable', 'The Flush of Dying Day', etc.

YLASSE, E. fl.1868
Exhib. 'Jewish Shopkeeper' at the RA. London address.

YONGE, Arthur D. fl.1876-1890
Exhib. views on Guernsey, in Cornwall and on the River Meuse. Address in Hastings, Sussex.

YORKE, William Hoard fl.1858-1903
Very little known Liverpool marine painter. Painted mostly ship portraits off Liverpool and the Mersey, examples of which can be seen in Greenwich (National Maritime Museum) and Liverpool. Worked only for local patrons, and did not exhib. in London.
Bibl Wilson p.90; Brook-Hart pl.9.

YOUNG, A.D. fl.1891
Exhib. 'A Bit of Auld Reekie' at SS. London address.

YOUNG, Alexander fl.1889-1893
Painted landscape. Exhib. five works at the RA including landscapes near Edinburgh and in Fife. London address.

YOUNG, B. fl.1850
Exhib. three watercolours including a view of the Taj at Agra at SS. London address.

YOUNG, Miss Bessie Innes SWA fl.c.1890-1935
Painted landscapes, genre and still-lifes. Studied at Glasgow School of Art and in Paris. Born in Glasgow.

YOUNG, Col. C.B. fl.1870
Exhib. an interior at SS. London address.

YOUNG, C.E. fl.1877
Exhib. a landscape in 1877. London address.

YOUNG, Miss Emmeline fl.1874-1889
Exhib. three landscapes at SS and three landscapes at the RA. Address in Huddersfield, Yorkshire.

YOUNG, Miss Frances fl.1855-1874
London genre painter. Exhib. twice at RA, in 1862 and 1871, also BI and SS. Titles at RA 'Evening' and 'The Old Priory, Hampstead'.

YOUNG, George fl.1861
Exhib. a landscape in 1861. London address.

YOUNG, Godfrey fl.1872-1885
Exhib. 'Gorleston Pier' at the RA, and one work at the NWS. London address.

YOUNG, H.H. fl.1885
Exhib. 'In a Garden' at the RA. Address in Horsham, Sussex.

YOUNG, J. fl.1851-1852
Exhib. three works at the BI including 'The Sentinel' and 'The Orange Girl' at the RA. London address.

YOUNG, Miss Lilian fl.1884-1890
London genre painter. Exhib. at RA 1884-8, SS, NWS and elsewhere. Titles at RA 'An Old Pump', 'Wall Flowers', 'Feeding Time', etc.

YOUNG, Miss M.J. fl.1888-1892
Exhib. four works at SS, including 'Drink, Puppy Drink!' and 'A Doubtful Coin'. London address.

YOUNG, Miss Maggie F. fl.1889-1890
Exhib. three paintings of fruit at SS. London address.

YOUNG, O.A. fl.1890
Exhib. a genre subject at the NG. London address.

YOUNG, R.H. fl.1885
Exhib. 'A Grey Day' at SS. London address.

YOUNG, Robert Clouston RSW 1860-1929
Glasgow lithographer who made a large number of watercolour views of the Clyde. Elected RSW 1901.

YOUNG, Stanley S. fl.1890-1904
Painted figurative subjects. Exhib. five works at the RA including 'A Little Waif' and 'Whence Come These Thoughts?'. London address.

YOUNG, William RSW 1845-1916
Landscape painter. Exhib. two landscapes and a work entitled 'Buttercup Time in the Meadows', and a work at SS. Address in Glasgow.
Bibl: Ormond; Irwin.

YOUNGMAN, Miss Annie Mary RI 1859-1919
Genre and still-life painter. Daughter and pupil of John M. Youngman (q.v.). Exhib. mainly watercolours at NWS, also RA from 1886, SS, GG and elsewhere. Titles at RA 'Azaleas', 'A Page to Queen Bess', 'A Work of Patience', etc.
Bibl: W. Shaw-Sparrow, *Women Painters of the World*, 1905.

YOUNGMAN, John Mallows RI 1817-1899
Landscape painter and etcher. Pupil of Henry Sass. Before settling in London, he was a bookseller in Saffron Walden, Essex. Exhib. mainly watercolours at NWS (110 works), also RA 1838-75, BI and elsewhere. Titles at RA 'Lane, Audley End', 'Lane Scene in Essex', 'In Richmond Park', etc. Drawings by him are in the BM. Elected RI 1841. Father of Annie Youngman (q.v.).
Bibl: AJ 1899 p.94; Cundall.

YOUNGS, Laurence fl.1888
Exhib. views of houses at the RA and at SS. London address.

YSENBURG, Count C. fl.1892
Exhib. three works at SS including 'Telling her Beads' and 'A Connoisseur'. London address.

YUNGE, G. fl.1855
Exhib. 'Welsh Peasant' at the RA. London address.

YVON, Adolphe fl.1851-1874
Exhib. three Russian subjects and three portraits at the RA. Addresses in Paris and New York.

ZACHO, Christian fl.1892
Exhib. a view at Menton at the RA. Address in Copenhagen.

ZAHNER, Rudolf fl.1860
Exhib. two Italian landscapes at the RA. London address.

ZAHNER, S. fl.1855
Exhib. a view near Rome at the RA. London address.

ZAMBONI, Count G. fl.1869
Exhib. a Tyrolean landscape at the RA. Address in Florence, Italy.

ZEITTER, John Christian RBA fl.1824-d.1862
Painter and engraver; of German origin. Exhib. mainly at SS (291 works), also RA 1824-41, and BI. Painted genre, landscapes, flowers, and views on the Continent. RBA 1941. His father-in-law was Henry Alken (q.v.) for whom he engraved illustrations of Don Quixote, 1831.
Bibl: AJ 1859 p.143; 1862 p.163; Connoisseur LXXXVII 1931 pp.224, 229; Ottley; Redgrave, Dict.; BM Cat. of Engraved British Portraits III 1912 p.428; Brook-Hart.

ZELENSKI, A. fl.1852
Exhib. two Russian peasant subjects at the RA. London address.

ZELL, Beatrice fl.1880
Exhib. a watercolour of apples at SS. Address in Manchester.

ZEZZOS, A. fl.1889-1890
Exhib. 'A Venetian' at the RA, and two works at the NWS. Address in Edinburgh.

ZIEGLER, Miss fl.1844-1863
Genre and portrait painter. Presumably daughter of Henry Bryan Ziegler (q.v.) as Graves lists them under the same address. Exhib. at RA 1844-63 and SS. Titles at RA 'Wild Ducks', 'Meditation', 'A Portrait', etc.

ZIEGLER, E. fl.1843-1852
Painted figurative subjects. Exhib. six works at the RA, including 'A Village Maid' and 'The Picture Book', and six works at SS. London address.

ZIEGLER, Henry Bryan 1798-1874
Painter of landscape, portraits and rustic genre. Pupil of John Varley (q.v.). Later became drawing-master to Prince George of

Cambridge, Edward of Sachsen-Weimar, and Princess Elizabeth. He was also patronised by William IV, and taught Queen Adelaide drawing. Accompanied the Duke of Rutland on a trip to Norway. Exhib. at RA 1814-72 BI, SS and OWS.

Bibl: Bryan; BM Cat. of Drawings by British Artists IV 1907.

ZILERI, Miss S. fl.1887-1888
Exhib. five works at the RA, including views in Chelsea and figurative subjects. London address.

ZIMMERMAN, Henry RBA fl.1871-1889
Landscape painter. Exhib. mostly at SS, also RA 1872-89, GG and elsewhere. Titles at RA 'The Haunted Mill', 'Haddon a.d. 1650', 'A Surrey Lane', etc.

ZONA, A. fl.1874
Exhib. a figurative subject at the RA. London address.

ZORN, Andrew Leon fl.1883-1893
Painted portraits. Exhib. 12 works at the RA including portraits and works entitled 'Neglected' and 'A Flirt', and seven works at the GG. London address.

ZORNLIN, Miss G.M. fl.1825-1847
Exhib. a landscape and a portrait at SS, and a subject at the RA. London address.

ZWECKER, T.B. fl.1853-1872
Painted figurative subjects and landscapes. Exhib. four works at the BI, including 'The Surprise' and 'A Nursery'; two works at the RA, including 'Mares and Foals', and one work at SS. London address.

ZWESCHERI, Guisi fl.1880
Exhib. two figurative subjects in 1880, London address.

.